D1616182

The New York Times
Film Reviews
1983-1984

The New York Times
Film Reviews
1983-1984

Times BOOKS/ GP

Times Books & Garland Publishing, Inc. / New York 1988

Foreword

In 1970, THE NEW YORK TIMES FILM REVIEWS (1913-1968) was published. It was a five-volume set, containing over 18,000 film reviews exactly as they first appeared in The Times.

The collection was accompanied by a sixth volume, an 1,100 page computer-generated index, which afforded ready access to the material by film titles, by producing and distributing companies, and by the names of all actors, directors, and other persons listed in the credits.

Further volumes appeared in 1971, 1973, 1975, 1977, 1979, 1981 and 1983 reproducing the reviews that were printed in The Times during the years 1969-1970, 1971-1972, 1973-1974, 1975-1976, 1977-1978, 1979-1980, and 1981-1982; the present volume carries the collection through 1984. The index as originally conceived was incorporated into the 1969-1970, 1971-1972, 1973-1974, 1975-1976, 1977-1978, 1979-1980, 1981-1982 volumes and the present volume.

New compilations will be published periodically to keep the collection constantly updated.

Contents

BEST FILMS

Articles listing the best and award-winning films published in The Times appear at the end of each year's reviews. These include the awards of the Academy of Motion Picture Arts and Sciences and the "best films" selections of The New York Times and the New York Film Critics.

The New York Times
Film Reviews
1983

1983

FILM VIEW

VINCENT CANBY

When a Movie Doesn't Have To Pass the Plausibility Test

Plausibility is an unreliable weapon with which to attack a movie you don't like. Five minutes after ridiculing a film for its lack of plausibility, you may well find yourself defending a favorite work against the same sort of charge. The point is that all of us have different thresholds at which we suspend disbelief, and then gladly follow fictions to conclusions we find logical. When we admire a work for whatever reasons, logic can be put on hold. When we don't, we become ferociously, self-righteously logical, stern arbiters of reason.

One of my colleagues, who took a properly dim view of "Kiss Me Goodbye," Robert Mulligan's arid remake of "Dona Flor and Her Two Husbands," was especially put off by the fact that Sally Field, as the widow of a successful Broadway theater director, would have kept her elegant Manhattan townhouse empty for the three years since her husband's death.

> **If we admire a work for whatever reasons, logic can be put on hold.**

The logic: No one is really rich or foolish enough to leave such a valuable piece of property untenanted for such a long period. For reasons particular to her, the film's attitude toward real estate struck her as so outlandishly absurd that it gave the lie to everything else in the movie.

In "Hitchcock," still one of the most cogent books ever printed about film esthetics, Alfred Hitchcock and François Truffaut go on at some length about that portion of the motion picture audience that Hitchcock identifies as "our old friends, 'the plausibles.' " The two filmmakers agree that the worst "plausibles" usually are film critics who, in their effort to be objective, tend to be dull and unimaginative.

I wouldn't completely disagree, but it does seem that everyone has a potential for awful plausibility when the situation is right. Even children, whose imaginations can soar one minute, will, immediately afterwards, become grand inquisitors on behalf of the plausible.

"Let's be logical," Hitchcock says at one point, "if you're going to analyze everything in terms of plausibility and credibility, then no fiction film can stand up to that approach, and you wind up with a documentary."

To which someone who did not sit in on those conversations might add, "Let's be even more logical. It's the responsibility of the filmmaker to create a fictional universe so compelling and complete that we don't notice im-

plausibilities or, if we do, they don't make any difference." The problem is that few films are that compelling or that complete.

Alan Pakula's screen adaptation of "Sophie's Choice" is literate and intelligent but it doesn't seem to have any life of its own except for Meryl Streep and Kevin Kline, but what is admirable about them is the quality of their performances. This is not the same as praising their characterizations as Sophie and Nathan, since characterizations indicate performances perfectly integrated into a film of matching quality.

There's something just a little too studied and self-conscious about "Sophie's Choice" for it to be completely satisfactory. As a result, we tend to nit-pick, to become frightfully plausible about things that otherwise wouldn't matter.

When Sophie, Nathan and Stingo (Peter MacNicol), the young narrator, decide to celebrate Stingo's ascension to a pantheon that already includes William Faulkner and Thomas Wolfe, they dash off the screen in the middle of Flatbush and dash on again, a second later, in the middle of the Brooklyn Bridge, several miles away. How, the plausibles might ask, did they get there? Did they take a taxi? If they took a taxi, what did they talk about en route? The 100 Great Books? The state of pantheons in general? Taxi fares in 1947?

If the movie were working on a more profound level, and if the self-congratulation going on in this scene were not so embarrassing, the audience might accept the characters' high spirits. Because everything seems slightly off-key, we turn cranky and wonder about public transportation and suspect that the bridge setting was chosen because it's more photogenic than Flatbush Avenue.

• • •

No matter how engrossed an audience is in a movie, one false note can destroy everything. It's as if a trust had been betrayed.

As much as I admire "Poltergeist" and the logic of its nightmarish fantasy, the film was very nearly wrecked for me when, toward the end, I realized that the family was going to spend one more night in its haunted home right after the little girl's return from "beyond."

Considering what they'd all just been through, wouldn't they have packed their bags then and there and fled to a refuge in the Holiday Inn? Of course they would have, but then there wouldn't have been an opportunity for the climactic sequence that explains the origins of the film's demons. Luckily this last sequence is wild enough to top those that have preceded it, so that questions of plausibility do not do permanent damage.

Walter Hill's "48 Hrs." is terrifically engaging not because of logic or plausibility but because of the great comic turns by Eddie Murphy and Nick Nolte, which create their own sense of reason within the film. If Mr. Murphy and Mr. Nolte were just a fraction less funny and self-assured, the movie might well have been a disaster.

It's not only that the audience, being aggressively logical by nature, would not easily buy a sequence in which, for example, the two men beat each other to pulps and then walk away with minor bruises, even though other people in the film are, with some frequency, fatally wounded in graphic detail. By exercising tolerance, we accept these things as movie conventions. There is, however, the more serious matter of the plot, which, I suspect, doesn't make consistent sense. There's just enough waste space in the movie for that suspicion always to be lurking around the edges of our enjoyment.

• • •

Sidney Lumet's "The Verdict," about a malpractice suit against a Roman Catholic hospital in Boston, stars Paul Newman as a boozy, ambulance-chasing lawyer who stands to be redeemed if he wins the suit, which seems all but impossible. Mr. Newman's performance is splendid. Among other things, he has discovered the gallant gait — a sort of weightless lope — of someone who's down and almost out but not about to admit it.

Mr. Lumet and Mr. Newman so convincingly stack the cards against this character that the audience expects

1

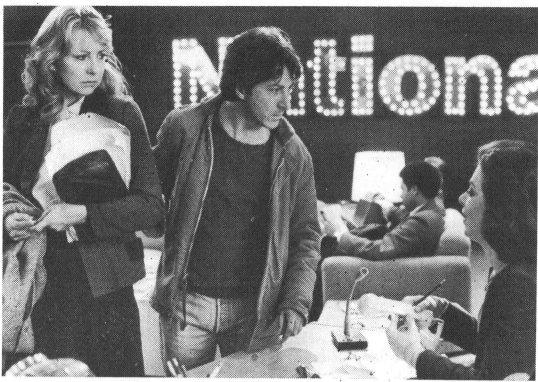

Teri Garr and Dustin Hoffman in "Tootsie"—It has, in the words of François Truffaut, "a thoroughly casual approach to the plausible."

Multiple Targets

AMERICA — FROM HITLER TO MX, directed by Joan Harvey; photography by John Hazard and Jeff Wayman; edited by Miss Harvey, Ken Eluto and Trudy Bagdon; music performed by the 4th Wall Repertory Musicians; produced by Albee Gordon, Ralph Klein and Saul Newton; released by Parallel Films. At the Agee Room in the Bleecker Street Cinema, 144 Bleecker Street. Running time: 90 minutes. This film has no rating.

By JANET MASLIN

JOAN HARVEY'S "America: From Hitler to MX" is an earnest but disorganized documentary that's quite literally all over the map, as Miss Harvey explores far more issues than she can manage. Her theory, largely unsupported here, postulates a connection between everything from the involvement of American corporations in making munitions for Germany during World War II to the ill effects on automobile workers of lead-based paint. These and various other points are illustrated with copious interviews and with newspaper clippings, which slow the film down considerably. It's not easy to read clippings during the course of any film, let alone one that's information-packed and sketchy, too.

In the course of her research, Miss Harvey and her film crew are seen visiting various American sites with a geiger counter (and with no protective clothing), measuring the radioactivity near factories manufacturing nuclear devices. The count appears to be high. There are visits to the families of Navajo workers who mine uranium, discussions of how seriously an exploding nuclear weapon could interfere with computer communications, and discussion of the pessimism of today's children.

●

There are some very sad visits with veterans who were exposed to early nuclear testing ("If I would have known what the cost would be to me personally, I would rather have died in Japan than have my children the way they are today," one man says). And various experts, among them Daniel Ellsberg, testify about whether

that nothing less than a miracle can save the day, or, at least, some brilliant bit of courtroom maneuvering that will have the effect of a twist-ending. Having set up an impossible situation, however, the film simply has the lawyer and his associates stumble onto a key witness. Then, as the film's payoff, the jury — if I understand the film correctly — blithely disregards the judge's instructions to it.

I left the theater in a muddle. I wasn't sure whether the film's point was the jury's lack of logic, that is, its independence from the judge, or whether the film itself was illogical. It's not easy to love a film when you feel it's not been completely honest with you.

There are times, however, when a film is all too honest with its audience, as when someone on the screen accurately voices the audience's objections to what is going on. It's as if the filmmaker, having second thoughts about his own imagination, were attempting to neutralize the plausibles by expressing their thoughts first.

"I can't believe this is happening," says the pretty, plucky, dumb heroine of any horror film when, locked up in a house with a sadistic killer, she steps over the body of her dead fiancé to go to the basement to replace a fuse. Or, as Roy Scheider says in "Still of the Night," when he is about to ransack the office of the woman he loves but who might be a psychotic murderer, "I must be crazy for doing this."

●　　●　　●

"Tootsie" should be a field day for the plausibles. Even though Dustin Hoffman is amazingly convincing when, within the film, he masquerades as an actress named Dorothy Michaels, "Tootsie" is full of plausibility holes.

How, for example, does Michael Dorsey, the Hoffman character, once he has made up his mind to impersonate an actress to land a job, so quickly accumulate the wigs, dresses, shoes, makeup, etc., for the audition? It seems to take him only an hour or two, which would be a quick change even for a veteran drag artist.

And, is it really plausible that Michael Dorsey as Dorothy Michaels could spend a night in a comparatively small bed with the beautiful Jessica Lange without in some fashion giving himself away? Especially when, as we see, the wig he is wearing — complete with curlers — is loose.

Also, is it plausible that the people in the control room, when the soap opera is being broadcast live, would not have stopped the telecast when the "actress" departs from the script to improvise a completely new plot?

And, after this on-air exposé of the true sex of Dorothy Michaels, isn't there some chance that Michael Dorsey and his agent would, indeed, be sued for fraud, as the

agent has warned? Or, if the exposé had successfully introduced a great new plot line into the soap, why wouldn't the producers have hired Michael Dorsey to continue in the show?

"Tootsie," you see, is chock full of implausibilities. It has, in the words of Mr. Truffaut, "a thoroughly casual approach to the plausible."

Yet not one of these plausible questions has any bearing on the success of the film itself. Sidney Pollack, the director, Larry Gelbart and Murray Schisgal, the principal writers, Mr. Hoffman, Miss Lange and everyone else connected with the film create a comic universe so complete and so compelling that all such dopey questions are tabled as they arise.

Like all great fiction, "Tootsie" makes plausibility look obsolete. ■

1983 Ja 2, II:1:1

"AMERICA—FROM HITLER TO M-X"— Herbert Scoville Jr., a former C.I.A. official who became president of the Arms Control Association, is seen in Joan Harvey's anti-war documentary at the Bleecker Street Cinema.

or not the MX missile can be used as a defensive weapon.

· Miss Harvey's film, which formerly had the working title "America: From Hitler to Reagan," and which opens under its current title at the Bleecker Street Cinema's Agee Room today, takes an utterly scattershot approach. Much of the material is potentially alarming, but almost none of it is used effectively. Although the director seems fiercely committed to her subject, she does little to define it coherently. Any narrowing of the film's scope would surely have been an improvement.

1983 Ja 5, C17:1

Affairs of Heart

THE STATIONMASTER'S WIFE (Bolwieser), directed by Rainer Werner Fassbinder; screenplay (German with English subtitles) by Mr. Fassbinder from a novel by Oskar Maria Graf; photography by Michael Ballhaus; edited by Ila Von Hasperg, Franz Walsch and Juliane Lorenz; music by Peer Raben; production company, Bavaria Atelier GmbH. for Zweites Deutsches Fernsehen. At the Lincoln Plaza 1, Broadway between 62 and 63d Streets.

Bolwieser	Kurt Raab
Hani Bolwieser	Elisabeth Trissenaar
Neidhart	Gustal Bayrhammer
Frank Merkel	Bernhard Helfich
Schafftaller	Udo Kier
Ferryman	Gerhard Zwerenz
Windegger	Karl-Heinz von Hassel
Mangst	Volker Spengler
Scherber	Armin Maier
Treuberger	Peter Kern

"The Stationmaster's Wife" was shown as part of this year's New York Film Festival. Following are excerpts from a review by Vincent Canby in The New York Times of Sept. 25, 1982. The film opens today at the Lincoln Plaza 1.

RAINER WERNER FASSBINDER'S "The Stationmaster's Wife" ("Bolwieser") is a misanthropic fairy tale so lushly designed and photographed it seems to have been conceived in a fever dream. "The Stationmaster's Wife" may mark the highpoint of Fassbinder's "Glass Period" of a few years ago. At one point or another almost every image is seen in a mirror, through a window or reflected upward from a shiny surface. Thus everything that happens is put at a slight remove from what should be the grubby reality of Werburg, the small German town where the story takes place in the late 1920's.

It's not quite in the same league with the late, great Fassbinder works — "The Marriage of Maria Braun," "In a Year of 13 Moons," "Lola" and "Veronika Voss" — but it's not far behind them. Oddly enough, for a film commissioned by television, it is almost leisurely in a fashion not characteristic of Fassbinder, whose films, good or not so good, always plummet — straight upward — from the first frame to the last, without a single wasted moment.

"The Stationmaster's Wife," adapted by Fassbinder from a novel by Oskar Maria Graf, is about a not especially ambitious, lower-middle-class Emma Bovary named Hanni (Elisabeth Trissenaar), a dark-haired, voluptuous beauty who doesn't aspire to a higher class, but only to entertain herself in the here and now. Hanni is married to Bolwieser (Kurt Raab), who, being the Werburg stationmaster, is a civil servant with a certain position to maintain. For a while, Bolwieser's slavish if passionate love amuses and satisfies Hanni.

Eventually, Hanni's eye is caught by Merkel (Bernard Helfrich), a

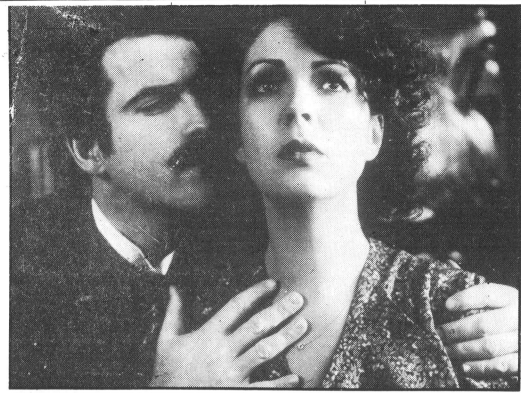

"THE STATIONMASTER'S WIFE"—Kurt Raab and Elisabeth Trissenaar star in Rainer Werner Fassbinder's 1977 film about a petty civil servant undone by his lust for his wife.

butcher so handsome he could be the leading man in a second-rate operetta troupe. Merkel is also a promoter and canny businessman. With financial backing from Hanni, he takes over a local pub and turns it into a small gold mine. A little later Hanni begins another satisfactory affair with the local hairdresser, Schafftaller (Udo Kier), who looks like a German provincial Valentino.

Everybody seems to know of Hanni's liaisons except Bolwieser, who is not stupid but who prefers to ignore the obvious. When Hanni and Merkel decide to sue the town gossips for slander, it is Bolwieser who comes forth as their principal witness. Bolwieser's steadfast loyalty is his undoing. Miss Trissenaar's Hanni is a fascinating creature. In the words of the sort of magazines she might read, she simply follows her heart, and it's not her fault that Bolwieser seems to seek out his fate, as if that fate would demonstrate to Hanni the depth of his love.

Fassbinder again demonstrates a gift for cinematic stylization that none of his contemporaries has ever come close to. How he does it, I don't know. It can only be described: There is a sweet little yellow canary in the Bolwieser apartment, just above the railroad station. When the canary chirps, as it does almost constantly, it sounds as if a fingernail were being drawn across a blackboard.

1983 Ja 12, C21:2

BLACK WAX, directed, produced and edited by Robert Mugge; director of photography, Lawrence McConkey; words and music by Gil Scott-Heron; production company, Mug-Shot Productions for Channel Four Television. At the Agee Room, Bleecker Street Cinema, 144 Bleecker Street. Running time: 79 minutes. This film has no rating.

Vocals and Piano	Gil Scott-Heron
Guitar	Ed Brady
Bass	Robert Gordon
Keyboards and Harmonica	Glen Turner
Drums	Kenny Powell
Percussion	Larry MacDonald
Sax, Flute, Piano	Carl Cornwell
Sax and Flute	Vernon James
Sax	Ron Holloway
Trumpet and Flugelhorn	Kenny Sheffield

By JANET MASLIN

THERE are musicians whose work can't easily be encapsulated by the documentary film format, and there are others, like Gil Scott-Heron, who make a particularly keen impression this way. "Black Wax," a 79-minute portrait of Mr. Scott-Heron made for British television, shows him off to excellent advantage.

The scope of his topical, acerbic songs and poems — among them "Johannesburg," "Angel Dust," "Gun" and "Whitey on the Moon" — is well represented by the excerpts included here, and no single work has a chance to go on too long. The songs are interspersed between scenes of Mr. Scott-Heron wandering through Washington — he has a song about that, too — discussing political ironies as he wanders past national monuments and then ghetto neighborhoods. Some of the film is also set in a nightclub called the Wax Museum, where Mr. Scott-Heron casually addresses the statues of recent Presidents and offers a few opinions about their performances in office.

Mr. Scott-Heron has his wise-guy side, as that may indicate, but it seems secondary here. His nonchalant charm and his intelligence are more evident in the film than occasional glibness. Besides, Mr. Scott-Heron can make glibness something of a virtue. As he leads into "B Movie," offering a routine about nostalgia that would do any stand-up comic proud, Mr. Scott-Heron offers a quick and effective series of wisecracks. "That's what America wants, the good old days," he says. "Remember when we gave 'em hell, when the buck stopped here and you could buy something with it, when the movies were in black and white and so was everything else? Why wait for 1984? Panic now and avoid the rush. So much for the good news."

"Black Wax," which was adroitly directed by Robert Mugge and which opens today for a weeklong run at the Bleecker Street Cinema's Agee Room, offers Mr. Scott-Heron a chance to explain his concerns and convictions at length, and he rises to the opportunity. The musical interludes by this self-proclaimed "bluesologist" feature a loose, deceptively pretty jazz accompanied by the tough, concise lyrics for which Mr. Scott-Heron is best known. Mr. Mugge, in addition to capturing his subject with easy comprehensiveness, has combined the musical and interview footage in a manner that keeps the film from dwelling on any one interlude longer than it should.

1983 Ja 12, C21:2

A Hoodlum's Rise

SLOW ATTACK, directed by Reinhard Hauff; written (German with English subtitles) by Burkhard Driest; director of photography, Frank Bruhne; produced by BloskopFilm; released by New Yorker Films. At the Film Forum, 57 Watts Street. Running time: 112 minutes. This film has no rating.

Nik	Burkhard Driest
Henry	Rolf Zacher
Eva	Katja Rupé
Leila	Carla Egerer
Beekenbrandt	Kurt Raab
Donald	Eckehard Ahrens
Janni	Joey Buschmann

By VINCENT CANBY

"SLOW ATTACK" (original title: "Endstation Freiheit") is a handsome, vivid, emotionally disorienting German film about a tough, youngish hoodlum named Nik Dellmann, who has the battered face of a boxer too long in the ring and who yearns to be a writer.

After eight years in prison on a robbery conviction, Nik re-enters the real world with murder in his heart and a pen in his hand. Within a period of time that seems no more than three weeks, he has had a couple of love af-

fairs, helped to plan the kidnapping of a rich businessman, found a literary style all his own, written and published his first novel and become a celebrity.

•

The primitive chronology of "Slow Attack" is actually the style of the film, which was directed by Reinhard Hauff, praised here two years ago for his "Knife in the Head." The screenplay is by Burkhard Dreist, who also stars as Nik Dellmann.

According to the program notes provided by the Film Forum, where "Slow Attack" opens today, the screenplay is semiautobiographical. It's also self-consciously awkward, something that Mr. Hauff chooses not to hide but to emphasize in a laconic narrative style, especially at the beginning. The film proceeds in the frame-by-frame manner of a spaced-out comic strip. It creates its world not through conventional confrontations but in dramatized disconnections, which are often extremely effective even when completely mysterious. Not until the film is well along do the characters get sorted out.

Among the people who figure in Nik Dellmann's rise to fame are Eva (Katja Rupé), a pretty literary editor who is as turned on by Nik's criminal impulses as by his prose; Donald (Eckehard Ahrens), Eva's husband, who doesn't object when Eva brings Nik to live at their house, and Henry Kirschner (Rolf Zacher), Nik's none-too-bright former cellmate. It is with Henry that Nik plans the kidnapping that becomes the basis for the novel and that, when Henry carries it out, turns into a huge publicity coup for Nik's publishers.

As he did in "Knife in the Head," Mr. Hauff puts all of his very evident directorial skills at the service of the screenplay to realize the almost surreal intensity of Mr. Dreist's dreamlike work. All of the performers are fine and the photography, by Frank Bruhne, makes even the squalid landscapes look beautiful enough for a fairy tale.

I'm not at all sure what "Slow Attack" ultimately means, but it's not quickly forgotten.

1983 Ja 12, C24:1

Political Mysteries

TIME FOR REVENGE, directed and written by Adolfo Aristarain; Spanish with English subtitles; cinematographer, Horacio Maira; edited by Eduardo Lopez; music by Emilio Kauderer; produced by Aires Cinematografica Argentina; an Aries Films -ICH Presentation released through Televicine International. At the 57th Street Playhouse, between Avenue of the Americas and Seventh Avenue. Running time: 112 minutes. This film has no rating.

Pedro BengoaFederico Luppi
Amanda BengoaHaydee Padilla
LarsenJulio De Grazia
TorrensRodolfo Ranni
Bruno Di ToroUlises Dumont
RossiAldo Barbero
BasileEnrique Liporace
AitorJose Joffre Soares
Garcia-BrownArturo Maly
Guido VenturaJorge Hacker
Don BautistaCayetano Biondo
Lea ..Ingrid Pellicori
JorgeJorge Chernov
GoloAlberto Benegas
PolacoMarcos Woinsky
JuezJorge Velurtas

By VINCENT CANBY

ADOLFO Aristarain's "Time for Revenge," which opens today at the 57th Street Playhouse, is a contemporary Argentine political melodrama that is so reticent about its politics that the meaning of its melodrama is ultimately sabotaged. Because it's also the kind of film that is impossible to discuss without going into its plot in detail, bear with me.

At the beginning of the film, Pedro Bengoa (Federico Luppi), a demolitions expert, is in Buenos Aires applying for a job with a large multinational corporation called Tulsaco, the operator of a copper mine in southern Argentina. It turns out that Pedro, who once was a political radical of some sort, obtains the Tulsaco job with forged identity papers. Now in middle age, he wants simply to make some money for his family and to leave activism to others.

When he reports for work at the mine, Pedro is astonished to find Bruno (Ulises Dumont), an old political ally, also working under an assumed name. Bruno is bitter about his life, his wife's death and the terrible working conditions at the mine. Little by little, he persuades Pedro to join him in a scheme to defraud Tulsaco out of several hundred thousand dollars.

Federico Luppi

The idea is to stage a dynamite accident that will, apparently, cause Bruno such emotional shock that he becomes mute. The company, Bruno assures Pedro, will do anything to avoid public scrutiny and, prodded by Bruno's slick lawyer, will settle the case out of court for a sum to be divided with Pedro.

•

The accident is staged but Bruno panics and is killed. In his place, Pedro takes over the scam. In the most effective sequences of the film, Mr. Aristarain, who is both the writer and the director, follows the step-by-step procedures by which Pedro attempts to convince the company and the court of his disability.

Aware that his room may be bugged, he communicates with his wife with a pad and pencil. At night he tapes his mouth shut. Eventually he learns sign language. As the trial goes on, and as the psychological pressures on him build, Pedro becomes increasingly obsessed with winning, not only to expose the company's corrupt practices but also to get the money to flee the country for a life of ease.

The fundamental problem with all this is that we have to take Pedro's idealism on faith. From what we see of him, he looks to be more of an opportunist, though initially a reluctant one. His past is so mysterious that it carries no emotional weight into the melodrama we witness. Is he a Communist, a Socialist, a Peronist? I don't know.

Toward the end, he is so chilly and self-centered that he is seems untouched by the death of Bruno and by the murder of another friend, who had testified on his behalf at the trial. Plausibility is also strained when Pedro, with a fortune in his briefcase, persists in walking around some of Buenos Aires's loneliest streets. He may not really be mute but he does seem incredibly short-sighted. The film's final gesture is brutally dramatic but unsupported by anything that has gone before.

Having said all this, I should add that Mr. Aristarain looks to be a natural-born film maker. Even when "Time for Revenge" is irrational, it's extremely cinematic. It moves surely and swiftly with scarcely a superfluous shot or sound effect. It also is beautifully acted by Mr. Luppi, who has some of the quality of Jean Rochefort; Julio de Grazia, as the lawyer who is not so slimy after all, and Haydee Padilla, as Pedro's frequently ill-used wife.

Argentine political alliances shift so frequently and so subtly that the full meaning of a topical film like this may be available only to the student.

1983 Ja 14, C8:1

Resistance Fighter

THE GIRL WITH THE RED HAIR, directed by Ben Verbong; scenario (Dutch with English subtitles) by Mr. Verbong and Pieter de Vos; director of photography, Theo van de Sande; music by Nicola Piovani; produced by Chris Brouwer and Haig Balian; released by United Artists Classics. At the Lincoln Plaza 3, Broadway between 62d and 63d Streets. Running time: 116 minutes. This film is rated PG.

HannieRenee Soutendijk
HugoPeter Tuinman
An ..Loes Luca
S.D. OfficerAdrien Brine

By JANET MASLIN

THE Dutch film "The Girl With the Red Hair" would be drab even without its chief visual device, which makes it doubly so. The director, Ben Verbong, has faded the film's color so as to emphasize the heroine's flame-shaded coiffure, but he's done this so inexpertly that the hair looks brownish. Everything else in this feature-length film, Mr. Verbong's first, is a muddy green.

"The Girl With the Red Hair," which opens today at the Lincoln Plaza 3, is based on a true story that was undoubtedly more exciting in reality than it is on the screen. It concerns Hannie Schaft, a law student in Amsterdam who joins a Communist-linked resistance group during World War II. She gradually learns to assassinate Nazi collaborators, something she appears to do girlishly and ineptly (although this may have more to do with Mr. Verbong's direction than it does with Miss Schaft's history). Evolving from a demure-looking Dutch miss to a terrorist in wire-rimmed glasses, Hannie eventually has a love affair with a fellow radical, becomes known to the Gestapo by her distinctive tresses, and is made a martyr to her cause.

•

As potentially dramatic as this material might sound, Mr. Verbong has directed it ploddingly, in a slow and clichéd visual style accompanied by the most uninventive mood music imaginable. (The ominous bass notes sound every time Hannie is even five minutes away from trouble.) Renée Soutendijk, who appeared in "Spet-

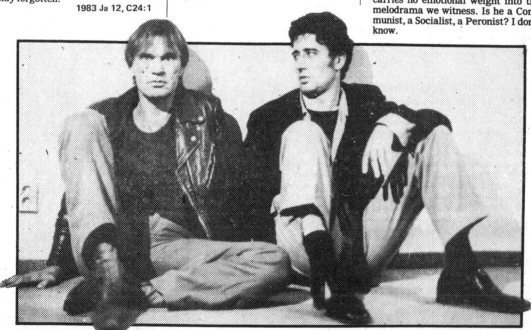

"SLOW ATTACK"—Burkhard Driest, at left, stars with Rolf Zacher in Mr. Driest's semi-autobiographical account of the fortunes of an ex-convict who begins to write about the criminal underworld.

ters" and plays the title role here, brings to the film a prettiness and propriety it probably doesn't need, and Mr. Verbong, who co-wrote the film, has not been able to find much substance in his heroine. However important Hannie may be to the history of Dutch wartime resistance, she's just a standard B-movie heroine here, and not a very compelling one at that.

1983 Ja 14, C12:5

ANARCHISM IN AMERICA, directed and produced by Joel Sucher and Steven Fischler; written by Kristina Boden, Mr. Fischler, Gerald Kagan, Lora Myers, Mr. Sucher; original script by Paul Berman; camera, Mr. Sucher; edited by Miss Boden; presented by Joseph Papp in association with the FDM Foundation for the Arts. At the Public Theater, 425 Lafayette Street. Running time: 75 minutes. This film has no rating.

By JANET MASLIN

The Public Theater's latest free film program, to be shown Saturdays and Sundays at 2 P.M., is an exceptionally lucid and interesting documentary. It's a successful attempt to provide a capsule history and explanation of its subject. Beginning with footage of a new-wave band that mentions anarchy in its lyrics, and proceeding to interviews in which people on the street are asked what they think anarchism means ("I would say that it's a person trying to push his views down everybody's throat"), the film — "Anarchism in America" — proceeds to offer a cogent definition and to dispel as many misconceptions as it can.

As directed by Steven Fischler and Joel Sucher, the film touches quite a few bases. It presents newsreel footage of key figures in the history of American anarchism, among them Sacco and Vanzetti, and Emma Goldman. ("What is your opinion of Italy?" a reporter asks her. "Beautiful country minus Mussolini," she snaps in reply.) And there are contemporary interviews with figures including Mollie Steimer, Emma Goldman's girlhood friend, and the poet Kenneth Rexroth, who reads his Sacco and Vanzetti poem. There is also some discussion of what the film makers take to be anarchism's practical applications, such as food co-ops and town meetings.

Karl Hess, formerly a Newsweek writer and speechwriter for Barry Goldwater, discusses his evolution from Republican to anarchist. And the writer and teacher Murray Bookchin gives an exceptionally articulate description of his own ideological development. He explains why he finds anarchism more all-embracing than Marxism, because he believes it addresses "not just classes but hierarchy." Anarchism can be broadly applied, he says, to forms of domination "which may not have any economic meaning at all."

Mr. Bookchin, like many of the others interviewed, presents a far more serious and provocative side of the subject than the Dead Kennedys, a punk band whose members the directors also interview for an effective contrast. Asked what his group is trying to do, the lead singer says little more than "We like people to think for themselves." While the more thoughtful interviewees certainly reflect the same view, they reflect it in the kind of depth that is ill-served by the glibness of anarchism's pop manifestation. While the film never aims at a particular conclusion, striving to explain rather than to polemicize, this closing footage of the Dead Kennedys

cannot help but suggest how grossly anarchism is trivialized in many such current incarnations.

1983 Ja 15, 16:1

SPRING FEVER, directed by Joseph L. Scanlan; screenplay by Fred Stefan and Stuart Gillard; music by Frank Mollin; produced by John F. Bassett. At the Cinerama, Broadway and 47th Street; 83d Street Quad, Broadway and 83d Street; Orpheum, Third Avenue and 86th Street; 34th Street Showplace, between Second and Third Avenues; Coliseum, Broadway and 181st Street and other theaters. Running time: 94 minutes. This film is rated PG.
WITH: Frank Converse, Susan Anton, Jessica Walter

THE LAST AMERICAN VIRGIN, directed by Boaz Davidson; screenplay by by Mr. Davidson; director of photography, Adam Greenberg; edited by Bruria Davidson; produced by Menahem Golan and Yoram Globus; released by Cannon Releasing Corporation. At the Manhattan, 59th Street between Second and Third Avenues; National 1, Broadway and 43d Street; 86th Street, at Lexington Avenue; Gemini, 64th Street and Second Avenue and other theaters. Running time: 90 minutes. This film is rated R.
GaryLawrence Monoson
KarenDiane Franklin
RickSteve Antin
DavidJoe Rubbo
CarmellaLuisa Moritz

What clearer signs could there be of a post-Christmas movie slump than the arrival of two mindless teen-age movies on the same day? "Spring Fever" and "The Last American Virgin," both of which opened at neighborhood theaters yesterday, are aimed strictly at the drive-in crowd or its downtown equivalent. The second film is the more tolerable of the two, although it owes its locker-room humor to "Porky's," a movie that was regrettably guaranteed to inspire imitation. Even the relatively clean-cut "Spring Fever" has enough raunchy touches to suggest (erroneously) that its characters aren't hopelessly square.

"Spring Fever" is about a spring vacation in Florida, taken by a gorgeous blond mom (Susan Anton) and her similarly tawny daughter, who is a teen-age tennis star. Ordinarily, they live in Las Vegas. The daughter makes friends with another young athlete named Melissa, and together they visit Busch Gardens, which affords the director, Joseph Scanlan, the opportunity for some flamingo and porpoise shots.

Lest this all seem too antiseptic for younger audiences, the plot also manages to involve drug dealing, broken homes and a nightclub featuring male go-go dancers. However, "Spring Fever" is wholesome at heart, and it sets some kind of record for poorly photographed greeting-card sunsets. Miss Anton also does her share of singing. Her co-stars are Frank Converse and Jessica Walter, who is at her very nastiest as Melissa's mom.

Appreciably more interesting is "The Last American Virgin" with its nonstop parade of new-wave hits on its soundtrack. To the off-camera accompaniment of music by the Police, Devo and lots of other current bands, three teen-age boys engage in a variety of pranks. About the funniest involves their luring three girls to somebody's house and coaxing the girls out of their clothes by pretending the kitchen's overflowing supply of Sweet'n Low is actually cocaine. The fattest, dowdiest girl of the three — potentially the wallflower — is the one who demands cocaine most adamantly.

Elsewhere in the story, there's one demure, beautiful girl over whom a couple of the boys fight. There is also a locker room peephole, courtesy of "Porky's," and a lot of jokes that

seem derivative and dumb. The best things about the movie are probably its amusingly modish outfits and hairdos, which demand that the audience keep its eyes open, and the music, which doesn't.

Janet Maslin

1983 Ja 15, 48:2

THEY CALL ME BRUCE, directed and produced by Elliott Hong; screenplay by David Randolph, Johnny Yune, Elliott Hong, Tim Clawson; director of photography, Robert Roth; music by Tommy Vig; distributed by Artists Releasing Corporation through Film Ventures International. At the Rivoli, 49th Street and Broadway; UA East, First Avenue and 85th Street; Manhattan 1, 59th Street and Third Avenue and other theaters. Running time: 88 minutes. This film is rated PG.
BruceJohnny Yune
KarmenMargaux Hemingway
AnitaPam Huntington
FreddyRalph Mauro
Boss of BossesTony Brande
Lil PeteBill Capizzi
Big AlMartin Azarow

By RICHARD F. SHEPARD

It's a long time between such film farces as "They Call Me Bruce," which opened yesterday at the Rivoli II and at neighborhood houses, and one leaves it with mixed emotions. It is a hysterically insane — and inane — comedy send-up of kung fu epics, ethnic stereotypes, movie clichés and stand-up comic routines. But, surprise of surprises, despite your own better judgment, not to mention discerning taste and sophistication, you will find yourself giggling at this mixed bag of familiar silliness.

Perhaps it is because of Johnny Yune, the Korean comic who is starring here in his first film feature and who carries it off with the appealing innocence of the stand-up comic in the guise of a pure-minded nebbish.

●

Maybe it is because Elliott Hong, its producer and director, has a fine eye for comedy pacing, with something in motion every minute. Or then again, could it be that the writers — Mr. Yune, Mr. Hong, David Randolph and Tim Clawson — have tunneled through to Mel Brooks by way of "Saturday Night Live" and strike such a lode of foolishness that it makes your own intellectual props collapse?

A word about plot, although it is not really necessary. Mr. Yune plays an Asian cook who is called Bruce by his Italian gangster bosses because he looks like Bruce Lee, the late kung fu virtuoso. But this Bruce is an inept bumbler who has bruised knuckles and who keeps intact only through a clever tongue. He is sent on a cross-country trip, unknowingly delivering cocaine (he believes it is Chinese flour), and from there on it is all chase and brawl and getaway.

This is all framework for aged gags. Our hero's dying Chinese-philosopher-type grandfather tells him that the most important thing in the world is not money, it's "broads." He later says his grandfather's dying wish was to stay alive. Our man was dismissed from a massage parlor, he says, because he rubbed people the wrong way. Ouch! So why do they evoke a chuckle?

There is no ethnic cliché left untouched here, mostly outrageously: the Italian and Jewish gangster, the Western cowboy, the Japanese tourist, the black minister. The villain is lifted from "The French Connection" with touches of "The Godfather." Superwoman makes a quick change in a telephone booth.

Mr. Yune is abetted in all this by Ralph Mauro, Margaux Hemingway,

Pam Huntington and Tony Brande. It is an instantly forgettable movie, but it does have the cheerful flavor of farce, if you're in the mood. If not, forget it.

1983 Ja 16, 48:3

New Kind of Love

LIANNA, directed, written and edited by John Sayles; director of photography, Austin de Besche; music by Mason Daring; a Winwood Company Production; released by United Artists Classics. At the Embassy 72d Street 2, at Broadway. Running time: 115 minutes. This film is rated R.
LiannaLinda Griffiths
RuthJane Hallaren
DickJon DeVries
SandyJo Henderson
ThedaJessica Wight MacDonald
SpencerJesse Solomon
JerryJohn Sayles
BobStephen Mendillo
CindyBetsy Julia Robinson
KimNancy Mette
SheilaMaggie Renzi
Mrs. HennessyMadelyn Coleman
Lighting AssistantChristopher Elliott

By VINCENT CANBY

JOHN SAYLES has at least two and maybe three different personalities as an artist. He is a serious novelist ("Pride of the Bimbos"), the author or co-author of a number of quite wonderfully uninhibited screenplays for such B-movies as "Battle Beyond the Stars" and "Alligator," as well as the writer-director of his own, far less hysterical films beginning with "The Return of the Secaucus Seven" and now including "Lianna."

How could one man be responsible for a deadpan, monster-movie spoof like "Alligator" as well as "The Return of the Secaucus Seven," a sweet, low-key movie about student activists of the 1960's growing old in the 1970's? It's quite simple, for although the films are very different in styles and concerns, each is illuminated and controlled by the same resolute intelligence.

●

"Lianna," which opens today at the Embassy 72d Street Theater, is like "The Return of the Secaucus Seven" in a number of ways. Everything in it looks and sounds authentic, from the cars people drive to the unrecognized cheerlessness of the parties they go to. The setting is not far from New York City at a New Jersey university to which all of the principal characters are in some way attached. Education is not something one passes through to something else. It is a way of life and a business.

Lianna (Linda Griffiths), the mother of two young children, is married to Dick (Jon DeVries), an arrogant but witty member of the English department, a fellow who prefers teaching courses in documentary films to courses in William Dean Howells. Lianna's best friend, Sandy (Jo Henderson), is the wife of the football coach. When Lianna unexpectedly finds herself in love for the first time in her life, it's with another woman, Ruth (Jane Hallaren), who is her psychology professor.

Lianna, having dropped out of college when she married Dick, who was her English teacher at the time, has gone back to school to get her degree. It's one thing to carry on extramarital heterosexual love affairs on the campus, but something else to announce one's homosexuality. Lianna, being naïve, had not understood this.

Though "Lianna" is about a subject that only yesterday was called explosive, and that even now is not all that commonplace, the film Mr. Sayles has

made about Lianna's rude awakening — to herself and the world — mostly avoids melodramatics. It's neither slick, like "Making Love," nor does it pretend to be about something else, like "Personal Best." It comes close to being antidramatic though it's never banal.

At the center is a woman whose sincerity and guts result first in the collapse of her marriage and then — I think we are meant to believe — in her salvation.

The marriage of Lianna and Dick has been pretty rocky for some time when Lianna drops her bombshell. Dick, who has been freely enjoying himself with his women students, uses Lianna's revelation to turn righteous and indignant. He kicks her out of the house and makes sure the children know the reason.

When Ruth, kindly but firmly, points out the difficulties of their living together, Lianna realizes she must start life over, virtually from scratch. She rents a rather bleak little apartment, takes a job as a supermarket checker and makes occasional visits to a lesbian disco for companionship and sex.

Though Mr. Sayles's methods are antidramatic, the film is full of the kind of middle-class desperation that seldom finds its way into movies, where emotions are usually bigger than life. "Lianna" is never dull but it is so finely tuned that one has to pay attention to receive it properly. It doesn't knock you off your feet, slam you against the wall or leave you gasping for breath. It's civilized.

Miss Griffiths, a Canadian actress who looks a little like Diane Keaton, is splendid. Her Lianna is a perfect Sayles protagonist — stubborn, initially foolish, terrifically earnest and, finally, heroic. She receives excellent support from both Miss Hallaren, whose "older" woman is somewhat too self-controlled to be appealing, and Miss Henderson, as Lianna's baffled best friend who finally accepts a reconciliation of sorts.

Among the actors, the best performance is given by Mr. Sayles himself, as a good-natured, self-absorbed faculty Lothario, but Mr. DeVries also is very funny as the extremely rotten husband. Even the child actors, Jessica Wight MacDonald and Jesse Solomon, are good.

"Lianna" does, however, pose a problem for both Mr. Sayles and the audience. It so effectively simulates the manner and temper of ordinary lives that there is a danger people will not recognize the very real art by which it was created.

1983 Ja 19, C22:1

THE YEAR OF LIVING DANGEROUSLY, directed by Peter Weir; screenplay by David Williamson, Mr. Weir, C.J. Koch, from the novel by C.J. Koch; director of photography, Russell Boyd; edited by Bill Anderson; music by Maurice Jarre; produced by James McElroy; released by MGM/UA Entertainment Co. At the Cinema I, Third Avenue and 60th Street. Running time: 114 minutes. This film is rated PG.
Guy HamiltonMel Gibson
Jill BryantSigourney Weaver
Billy KwanLinda Hunt
Pete CurtisMichael Murphy
Wally O'SullivanNoel Ferrier
Kevin CondonPaul Sonkkila
Colonel HendersonBill Kerr
SukarnoMike Emperio
KumarBembol Roco
HortonoDomingo Landicho
Tiger LilyKuh Ledesma

By VINCENT CANBY

PETER WEIR'S "The Year of Living Dangerously" is a good, romantic melodrama that suffers more than most

good, romantic melodramas in not being much better than it is. This film should be some kind of epic. It's set in and around Jakarta in 1965, in the last months of the flamboyant, one-man rule of President Sukarno, the Indonesian nationalist hero who aspired to be a Third World leader abroad, to reconcile left and right at home and to be the playboy of the Eastern world.

The international intrigue that surrounded Sukarno, the economic chaos he caused and the terrible poverty of the people to whom he gave identity — all this is the sort of material one associates with Graham Greene's stories of power and nobly crossed purposes amid the steamy squalor of emerging nations.

Mr. Weir, who adapted C. J. Koch's Australian novel with Mr. Koch and David Williamson (who wrote "Don's Party"), has all the correct impulses but no real grasp of the humane irony that separates sincere fiction from possibly great fiction.

•

As it stands, "The Year of Living Dangerously," which opens today at the Cinema I, is an entertaining tale about an ambitious young Australian journalist, Guy Hamilton (Mel Gibson), who comes to Jakarta on his first overseas assignment determined to make a name for himself. The times are ripe for such opportunistic advancement.

Every day there is a new rumor of an impending coup. Sukarno, to placate the Communists, offers to sanction a Communist army. The right-wing Moslem generals, supported by the West, resist. Peking is sending a shipload of arms to its Indonesian supporters. Bureaucratic corruption is the order of the day and, in the streets, people are starving to death.

As Guy Hamilton moves through this desperate world, he has the assistance of an extraordinary little man named Billy Kwan, a newsreel cameraman and photographer, half Chinese and half Australian, whose mixed blood and midget size are a life sentence to be an outsider.

Though one can never entirely escape the suspicion that Billy is as much a theatrical device as a character, he's a fascinating, bristly, androgynous figure. The fact that he is played — marvelously well — by a woman, an American actress named Linda Hunt, only works to the film's advantage. It's Billy's fate to play God, and gods are, if not androgynous, then not necessarily condemned to a single sexual identity.

Billy Kwan provides Guy with contacts that enable him to obtain stories his colleagues cannot. He attempts to transform Guy into an activist-journalist, one who, as I. F. Stone once instructed, remembers to consider the victims when he covers a terrifically exciting disaster story. It's also Billy who introduces Guy to Jill Bryant (Sigourney Weaver), an assistant to the military attaché at the British embassy. Because Billy loves but cannot have Jill, a bright, unusually intelligent young woman, he presents her to Guy.

In each Weir film I've ever seen — "Picnic at Hanging Rock," "The Last Wave" and "Gallipoli," the Australian director has shown great imagination and style in the setting up of situations that somehow always fall short of one's expectations at the payoff. Now, with "The Year of Living Dangerously," this problem seems to be not an accident but almost a personal idiosyncrasy. One yearns for "The Year of Living Dangerously" to reach

Sigourney Weaver

heights or depths that, perhaps, Mr. Weir never intended.

The film's physical production, much of it shot on location in the Philippines, is superb, as is the director's handling of the big, crowded scenes of civil turmoil. Best of all are his performers.

If this film doesn't make an international star of Mr. Gibson ("Gallipoli," "The Road Warrior"), then nothing will. He possesses both the necessary talent and the screen presence. Though Miss Weaver has less to work with, she's an equally compelling film personality, one who brings to a role a distinctive manner that fills a lot of the holes left by the writers.

It's one of the odd — and effective — ways in which Mr. Weir works that the film's only erotic love scene is played not on a bed, or even in a clinch, but when the two about-to-be lovers, running out on an embassy dinner party, drive at high speed — just for the hell of it — through a heavily armed roadblock. That, friends, is heat.

Heading the fine supporting cast are Michael Murphy and Noel Ferrier as two of Guy Hamilton's colleagues, and Bembol Roco, as Guy Hamilton's Indonesian assistant.

Not exactly dominating these performances, but providing the film with its dramatic center, is Miss Hunt's haunted Billy Kwan, who keeps detailed files on everyone he loves, weeps at the purity of the voice of Kiri Te Kanawa and, when the chips are down, is capable of the film's single grand gesture.

•

"The Year of Living Dangerously," which has been rated PG ("parental guidance suggested"), contains some vulgar language and a few scenes of violence.

1983 Ja 21, C4:1

MUDDY RIVER, directed by Kohei Oguri; written (Japanese with English subtitles) by Takako Shigemori, after a novel by Teru Miyamoto; camera, Shohei Ando; edited by Nobuo Ogawa; music by Kuroudo Mori; produced by Motoyasu Kimura; At the Cinema Studio, Broadway and 66th Street. Running time: 105 minutes. This film is not rated.
NubuoNobutaka Asahara
Nubuo's Father, ShinpeiTakahiro Tamura
Nobuo's MotherYumiko Fujita
KiichiMinoru Sakurai
Kiichi's Sister, GinkoMakiko Shibata
Kiichi's MotherMariko Kaga
WITH Gannousuke Ashiya, Reiko Hatsune, Keizo Kanie, Yoshitaka Nishiyama, Taiji Yonoyama and Masako Yagi

"Muddy River" was shown as part of the 1982 "New Directors/New Films" series. Following are excerpts from a review by Janet Maslin in The New York Times last April 19. The film opens today at the Cinema Studio, Broadway and 66th Street.

ADMIRERS of the exquisitely understated films of Yasujiro Ozu will understand what Kohei Oguri is after in "Muddy River," even if Mr. Oguri doesn't altogether achieve it. This low-budget, independently made film, Mr Oguri's first, attempts to paint a delicate portrait of life in postwar Japan. The world is seen through the eyes of several children, and theirs is an unhappy, uncertain point of view.

The film focuses on the friendship of two small boys, though it has much to say about the troubled adults in their lives as well.

Nobuo (Nobutaka Asahara) meets Kiichi (Minoru Sakurai) when he sees a barge pull up and anchor near the restaurant that Nobuo's parents manage. Kiichi's mother, as everyone but Nobuo soon understands, is a prostitute who receives customers on the boat. As the shy, mild Nobuo learns more about Kiichi's mother, his own parents befriend the more rambunctious Kiichi and his pretty sister. But none of these friendships is likely to last.

Nobuo's parents have troubles of their own, and so the visiting children provide something of a diversion. Nobuo's father, a discouraged man, who seems old beyond his years, is a war veteran now married for the second time. His first wife is dying in a faraway city and has requested that Nobuo be brought to meet her.

All of this is presented more gently than reflectively, with the style, if not the resonance, to recall the great masters of Japan's postwar cinema.

"Muddy River" is beautifully photographed in black and white, and there are many images that linger in the memory far longer than the film does as a whole, among them a night when Nobuo, at Kiichi's insistence, helps catch and set fire to some crabs, whose tortured scuttling is much more evocative than anything the human actors do. Though Mr. Oguri makes no direct effort to confine the film to Nobuo's point of view, he presents everything with the simplicity that a child might see. Sometimes this makes the film turn plodding; at others it creates something like the purity and precision that Mr. Oguri apparently had in mind.

1983 Ja 21, C4:1

The Good Doctor

THRESHOLD, directed by Richard Pearce; written by James Salter; director of photography, Michel Brault; edited by Susan Martin; music by Micky Erbe and Maribeth Solomon; produced by Jon Slan and Michael Burns; released by Twentieth Century Fox International Classics. At the Murray Hill, 34th Street and Lexington Avenue; Cinema 2, Third Avenue and 60th Street. Running time: 97 minutes. This film is rated PG.
Dr. Thomas VrainDonald Sutherland
Dr. Aldo GehringJeff Goldblum
Dr. Basil RentsAllan Nicholls
Tilla VrainSharon Acker
Sally VrainJana Stinson
Tracy VrainJessica Steen
UsherMavor Moore
Carol SeveranceMare Winningham
AnitaLally Cadeau
Edgar FineJohn Marley
Henry De ViciMichael Lerner
OchenJames Douglas
VivianMarilyn Gardner

"THRESHOLD" is such a rigorously unhackneyed, unhysterical medical drama that what one

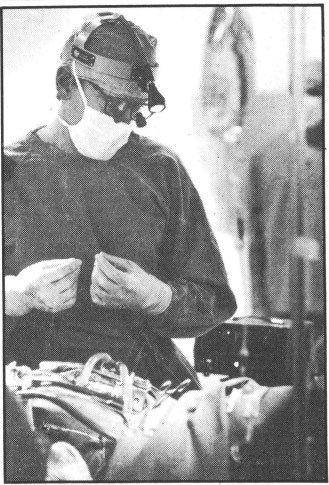

"THRESHOLD"—Donald Sutherland plays an eminent cardiac surgeon who undertakes the implantation of an artificial heart.

remembers about it first is not what one has seen on the screen but all of the clichés that the film makers have triumphantly resisted.

The Canadian film, which opens today at the Cinema Two and Murray Hill theaters, is about Dr. Thomas Vrain (Donald Sutherland), a famous cardiac surgeon who successfully implants the world's first self-contained artifical heart in a human patient. Unlike almost any other hospital drama you've ever seen, "Threshold" scarcely ever leaves its hospital locale and only then to carry forward its principal concerns, which are those of its characters portrayed entirely in terms of their work.

"Threshold" contains no broom-closet romances, no operating-room accidents, no phony sentimentality. It does contain a lot of scenes of surgical procedures of one sort and another, and though they aren't especially bloody, you probably won't want to smoke while watching them.

It's a neat, modest movie about the professional life of a good doctor, played with unexpected warmth, wit and restraint by Mr. Sutherland, and his professional relations with the brilliant, slightly manic research scientist (Jeff Goldblum), who designs the artificial heart, and the sweet young woman (Mare Winningham) who receives it.

Though I suppose "Threshold" could be classified as science fiction, in that such foolproof artifical hearts are still a long way from reality, the movie has the no-nonsense manner of a first-rate documentary. (It was made, by the way, long before an arti-

ficial heart was implanted late last year in Dr. Barney B. Clark in Salt Lake City. However, both the real and the fictional heart were designed by Dr. Robert K. Jarvik.) The direction by Richard Pearce ("Heartland") and the screenplay by James Salter ("Downhill Racer") are full of right decisions that are difficult to describe since they are so perfectly functional.

"Threshold" does not become involved in any moral questions raised by organ transplants. Neither does it stand back far enough from its subject to allow one to see in its drama connections to other aspects of life and living. Unless you're absolutely fascinated by heart surgery, "Threshold" may not be a film you'll want to drop everything to see.

All of the performances are good, and Miss Winningham, who looks strikingly like Genevieve Bujold, is a charmer.

●

"Threshold," which has been rated PG ("parental guidance suggested"), contains a number of scenes of surgical procedures.

Vincent Canby

1983 Ja 21, C5:3

THE MAN FROM SNOWY RIVER, directed by George Miller; screenplay by John Dixon, from a script by Fred Cul Cullen, based on the poem "The Man From Snowy River" by A. B. Paterson; director of photography, Keith Wagstaff; edited by Adrian Carr; music by Bruce Rowland; produced by Geoff Burrowes; released by 20th Century-Fox Film Corporation. At the Baronet, Third Avenue and 59th Street, and other theaters. Running time: 105 minutes. This film is rated PG.

Spur/Harrison	Kirk Douglas
Jim Craig	Tom Burlinson
Henry Craig	Terence Donovan
Mountain Man	Tommy Dysart
Man in Street	Bruce Kerr
Banjo Paterson	David Bradshaw
Jessica	Sigrid Thornton
Clancy	Jack Thompson
Kane	Tony Bonner
Mrs. Bailey	June Jago
Curly	Chris Haywood
Moss	Kristopher Steele
Frew	Gus Mercurio
Short Man	Howard Eynon
Rosemary	Lorraine Bayly
Tall Man	John Nash

THERE are not so many big westerns around that one can easily dismiss the Australian "The Man From Snowy River," which opens today at the Baronet and 34th Street East Theaters. To appreciate it fully, however, one must have a completely uncritical fondness for Kirk Douglas as he acts his heart out in two roles; for picturesque landscapes; for silly plots, and for dialogue that leans heavily on aphorisms too homespun to be repeated in a big-city newspaper.

The movie was directed by George Miller, no relation to the other Australian director of that name who made the excellent "The Road Warrior." This Mr. Miller loves the tools of his trade, including helicopters, booms and dollies, and some things I don't think Hollywood uses much anymore. At first this makes the film fun, but after a while it might make you so woozy you'll want to get off.

The screenplay is set in a turn-of-the-century time and is about the coming of age of a sincere young mountain man named Jim (Tom Burlinson). Mr. Douglas appears as Harrison, a rich, American-born cattle rancher, and as the rancher's mountaineer-brother, Spur, who has a wooden leg and in all other ways is a reminder of Long John Silver. Wanted: a parrot.

●

"The Man from Snowy River," which has been rated PG ("parental guidance suggested"), contains some discreetly vulgar language.

Vincent Canby

1983 Ja 21, C5:6

Breaking His Heart

INDEPENDENCE DAY, directed by Robert Mandel; written by Alice Hoffman; director of photography, Charles Rosher; film editor, Dennis Virkler; music by Charles Bernstein; produced by Daniel H. Blatt and Robert Singer; released by Warner Bros. At the Sutton, Third Avenue and 57th Street. Running time: 110 minutes. This film is rated R.

Mary Ann Taylor	Kathleen Quinlan
Jack Parker	David Keith
Carla Taylor	Frances Sternhagen
Les Morgan	Cliff De Young
Nancy Morgan	Dianne Wiest
Sam Taylor	Josef Sommer
Red Malone	Bert Remsen
Evan	Richard Farnsworth
Shelly	Brooke Alderson
Andy Parker	Noble Willimgham
Rose Parker	Anne Haney

By JANET MASLIN

THERE are times when you can tell everything you need to know about a film in the first few moments. Here is the way "Independence Day" begins with a lyric:

*Around us in everything we see
Some are real and some are fanta-
sy.*

Then we meet the heroine. Mary Ann Taylor (Kathleen Quinlan) is chasing through a small Southwestern town, taking pictures. She is wearing a red vest with lots of pockets, a beret with a feather in it and a bandana.

Clearly, she's a nonconformist. A character. A real live wire.

Mary Ann is crouching in the street, in pursuit of one great photograph or another, when a car comes screeching around the corner. It almost hits Mary Ann. The driver leaps out to quarrel with her, and who does he turn out to be but Jack Parker! Jack (David Keith) has grown up in this town, gone away somewhere, and now come back just in time to have a fling with the colorful Mary Ann. "Maybe I'll break your heart," she winningly declares.

●

The movie is off and running when Mary Ann asks Jack for a date, then badgers him some more, and eventually he succumbs to her wiles. Meanwhile, we learn a thing or two about their respective families. Mary Ann's father (Joseph Sommer) runs an amazingly picturesque wooden-walled diner where his daughter spends her noncreative hours as a bored waitress. Her mother (Frances Sternhagen) is dying of cancer, a fact the film demonstrates by showing her asleep in bed while the television blasts forth Merv Griffin.

As for Jack's family, his meek and weepy sister (Dianne Wiest) is the battered wife of a near-psychotic businessman (Cliff De Young, in what might otherwise have been the Bruce Dern role).

Where do things go from here? As Alice Hoffman's very awkward screenplay has it, things go sprawling all over the place. There's a big, ungainly subplot about the battered wife, who eventually grows suicidal and spends far too much time crying into the camera at close range. Then there's the Jack-Mary Ann love story, which the film alternately pursues and forgets. And there's Mary Ann's career, dealt with in a deus ex machina whereby a Very Famous Photographer (Bert Remsen) makes a special visit to the small town, Mercury, because he wants Mary Ann in his class so badly. "After I saw your photographs, I had to meet you," says he. "I wanted to see if Mercury was real or just some place you just dreamed up." Hard as it may be to believe, this is by no means the film's most unauthentic moment.

●

The regrettable thing about "Independence Day," which opens today at the Sutton, is that it has the makings of a better movie than it has become. The cast, for the most part, is a fine one, and Mr. Keith does a particularly memorable job of rising above his material. Robert Mandel's direction is generally skillful, even if Mr. Mandel does display a fondness for the hackneyed touch. The wife-abuse segments have an air of gravity rather than exploitativeness, and the film deserves some credit for attempting to tackle a subject that's seldom taken seriously on screen. But the drawbacks of "Independence Day" far outweigh its good points, particularly where Miss Quinlan is concerned. Her Mary Ann isn't remotely as adorable as she's supposed to be.

What becomes of Mary Ann? Well, at long, long last she reaches the moment of decision, the time when she must choose whether to stay in Mercury or whether to go to Los Angeles, where she dreams of realizing her artistic potential. If the film makes a case for anything, it's for the idea that Los Angeles would be a better place if people like this would stay home.

1983 Ja 21, C8:1

Out of Time

TIMERIDER, directed by William Dear; written by Mr. Dear and Michael Nesmith; director of photography, Larry Pizer; film editors, Suzanne Pettit, Kim Secrist, R.J. Kizer; music by Mr. Nesmith; produced by Harry Gittes; production company, Zoomo Productions Ltd.; a Jensen Farley Pictures Film. At the Rivoli, Broadway and 49th Street; Gemini, Second Avenue and 64th Street. Running time: 93 minutes. This film is rated PG.

Lyle Swann	Fred Ward
Claire Cygne	Belinda Bauer
Porter Reese	Peter Coyote
Claude Dorsett	Richard Masur
Carl Dorsett	Richard Masur
Carl Dorsett	Tracey Walter
Padre	Ed Lauter
Ben Potter	L.Q. Jones
Daniels	Chris Mulkey
Dr. Sam	Macon Mc Calman
Jesse	Jonathan Bahnks
Terry	Laurie O'Brien
Third Technician	William Dear

"**T**IMERIDER" is about a motorcycle rider who, in the course of a desert race, gets mixed up with a time machine and finds himself in Mexico in 1875. It was directed by William Dear and written by him and Michael Nesmith, a former Monkee, who also wrote the film's music and is its executive producer.

At the point at which I walked out, about 55 minutes into the story, there hadn't been a single characterization, situation, line of dialogue, camera angle or joke to indicate that anyone connected with "Timerider" had the remotest idea of what he was doing. It opens today at the Rivoli and Gemini Theaters.

•

"Timerider," which has been rated PG ("parental guidance suggested"), contains some words that its writers, being jocular, would call no-no's.

Vincent Canby

1983 Ja 21, C24:5

PARSIFAL, an opera in three acts by Richard Wagner; Armin Jordan conducts the Monte Carlo Philharmonic Orchestra and the Prague Philharmonic Choir; directed by Hans Jürgen Syberberg; photography by Igor Luther; costumes by Veronicka Dorn and Hella Wolter; Kundry's costumes by Moidele Bickel; edited by Jutta Brandstaedter and Marianne Fehrenberg; presented by Francis Ford Coppola; a Gaumont (Paris)-T. M. S. Film (Munich) co-production; a Triumph Films release. At Alice Tully Hall, Lincoln Center, tonight at 7. The film will play at the Guild Theater, 50th Street and Rockefeller Plaza beginning Feb. 11 for five weeks. Running time: 255 minutes. This film has no rating.

Amfortas	
	Armin Jordan, sung by Wolfgang Schone
Titurel	Martin Sperr, sung by Hans Tschammer
Gurnemanz	Robert Lloyd
Parsifal 1	Michael Kutter
Parsifal 2	Karen Krick, sung by Reiner Goldberg
Klingsor	Aage Haugland
Kundry	Edith Clever, sung by Yvonne Minton
Knights of the Grail	
	Rudolph Gabler, Urban von Klebelsberg, Bruno Romani-Versteeg, sung by Gilles Cachemaille and Paul Frey
Squires	
	Monika Gaertner, Thomas Fink, David Meyer, Judith Schmidt, sung by Christer Bladin, Tamara Herz, Michel Roider, Hanna Schaer
Bearer of the Grail	
	Amelie Syberberg, sung by Gertrud Oertel

By JOHN ROCKWELL

Hans Jürgen Syberberg's film version of Richard Wagner's music drama, "Parsifal," should enthrall both film lovers and Wagner fans. Mr. Syberberg's work represents not only the summation of his career thus far, but is as gripping, strange and, in the end, devotionally faithful a staging as any Wagner opera has received in our time.

The film will be shown in its American premiere in a special screening at Alice Tully Hall tonight under Francis Ford Coppola's aegis, and then opens for at least a five-week run Feb. 11 at the Guild Theater.

Mr. Syberberg is a West German film avant-gardist of aristocratic Prussian ancestry with an idiosyncratic but deeply conservative love for, not to say obsession with, Germany's past. He is best known here for his three-hour "Ludwig: Requiem for a Virgin King" and his eight-hour "Our Hitler: A Film From Germany." In both one finds a most curious blend of hothouse interior settings, Victorian kitsch, puppets, glowing back-lit projections and disjointed monologues, all of which manage to suggest the essence not just of his ostensible subjects, but of Germany, its myths and its confusions.

Lurking behind both Ludwig, the Bavarian monarch who was Wagner's patron, and Hitler, who thought of Wagner as his spiritual father, is the brooding, bizarre, compelling master of Bayreuth himself. "Parsifal" was Wagner's last work, a mythic tale of the knights of the Holy Grail and of their salvation by a Christlike "pure fool." It is Wagner's ultimate statement of his operatic theories and his mystical notions of redemption, innocence, race and dreams. The story provides Mr. Syberberg's characteristic mélange of associative imagery with a coherence it has heretofore lacked, yet in no way robs his visions of their elusive power. "Parsifal" seems a subject for which Mr. Syberberg must have felt himself destined.

The first step in making this film was to record a new version of the score, which is due out shortly on RCA Records. Originally, the plan had been to make use of a taped performance from Bayreuth, but Wolfgang Wagner, who runs the festival, refused in the wake of Mr. Syberberg's documentary about Winifred Wagner, the composer's English-born daughter-in-law, friend of Hitler and mother of Wolfgang.

The performance recorded for the film enlists the rather unlikely forces of the Monte Carlo Philharmonic Orchestra and the Prague Philharmonic Choir under the baton of the none-too-well-known Armin Jordan. The chorus is not all that wonderful, and some of the special effects (the temple chimes, for instance) are clumsily done. But Mr. Jordan conducts an entirely persuasive account of the score, and the orchestra plays very well for him.

Better still is the singing: This is as strong and evenly cast a "Parsifal" as we have had. Reiner Goldberg, who made his American debut as Guntram at Carnegie Hall last week and who will be the Siegfried in Georg Solti's new Bayreuth "Ring" this summer, makes a vigorous title figure; Yvonne Minton sings as well as she has ever sung as Kundry, and is probably the most convincing singer of the part on records, and Robert Lloyd is a fine, moving Gurnemanz. The other roles are confidently sung, as well. All in all, this is superior to anything the producers could have gotten from the past few years at Bayreuth.

Enter Mr. Syberberg. He sets his "Parsifal" in another of his odd, closed-in, cloistered environments, which gradually reveals itself to be nooks, crannies and surfaces of a giant reproduction of Wagner's death mask. "The Good Friday Spell" takes place before a giant double cave that turns out to be the composer's nostrils. All the imagery is suffused with overstuffed, late-19th-century plush, with the backdrops — often of earlier stagings of Wagner operas or of related artworks, Bosch especially — arrayed like illuminated turn-of-the-century painted postcards.

For his on-screen cast, Mr. Syberberg sometimes uses the actual sing-

Michael Kutter plays Parsifal. Reiner Goldberg sings the role.

ers — Mr. Lloyd most prominently, surprisingly young and virile for Gurnemanz, but sensitive and convincing. Most of the time, however, Mr. Syberberg casts actors who lipsynch to the singing extremely well. The oddity is that the conductor, Mr. Jordan, appears as a suitably afflicted Amfortas. And without exposing the film's greatest surprise — if the word "surprise" can be used for such a stately, sensuous film — it can be said that Mr. Syberberg provides a unique and beautiful solution to the androgynous duality of Parsifal's nature.

But the greatest casting coup comes with the use of Edith Clever, well known from other German films, as Kundry. Miss Clever — who is for Mr. Syberberg the film's center, to judge from the book on the film that has already appeared in German and French — is the finest Kundry this longtime Wagnerian has seen. Her scenes with Parsifal are wonderfully subtle and believable, whether as mother, penitent or seductress.

Just why Mr. Syberberg's scenic innovations don't seem as disturbing as other modern directorial innovations — Patrice Chéreau's Bayreuth "Ring," for instance — is hard to explain. Partly, it is because of their absolute consistency and eccentric but entrancing character. In part it is because Mr. Syberberg's command of the film medium is so sure that subtleties emerge that could never be perceived in an opera house. Above all, Mr. Syberberg has the secret of providing a plethora of allusions in the best modern manner — the final tableau of "The Good Friday Spell" is positively dizzying in its textual density. But instead of their shocking us away from the romantic spell of the music, they reinforce that spell. It's as if Wagner's hypnotic allure and Brecht's intellectualized alienation have been somehow mystically united.

This film will not be to every taste: it is too ponderous and Germanic and, perhaps, weird for that. But it should have an audience, and deserves to become as potent a cult film as the West German cinema has produced. Wagner created his testament in his opera, and Mr. Syberberg — while too young, one hopes, to have made his own testament — has revitalized Wagner for our time without any serious distortion at all.

1983 Ja 23, 46:1

SWEET PEA, a film by Peter Del Monte; story by Bernardino Zapponi; script (Italian with English subtitles) by Mr. Zapponi and Mr. Del Monte; photography by Giuseppe Lanci; edited by Sergio Montanari; music by Florenzo Carpi; produced by Silvio and Anna Maria Clementelli for Clesi Cinematografica in collaboration with the RAI-Second Program and Polytel International; released by Summit Distribution Co. At the 72d Street East, at Second Avenue. Running time: 95 minutes. This film has no rating.

Oliviero	Luca Porro
Cristiano	Fabio Peraboni
Rossana	Valeria D'Obici
Piero	Alessandro Haber
May	Victoria Gadsden
Bamba	Piero Mazzarella
Corazza	Eros Pagni
The animal's man	Leopoldo Trieste

By VINCENT CANBY

Peter Del Monte's "Sweet Pea" ("Piso Pisello") is a sweet, mostly inoffensive Italian comedy based on a single joke that it pursues with the doggedness of a stand-up comic who stays on too long.

Oliviero (Luca Porro) is a bright, beardless 12-year-old boy with the gravity of the nuclear engineer he wants to become and probably will. His is the only voice of sanity and reason in a household slavishly devoted to every new Pop fad and ism.

•

Oliviero's father is a painter who doesn't paint, because Andy Warhol has stolen his thunder, and his mother seems to do something with fabrics and faucets. Their apartment is frequently filled with equally nutty friends drinking, smoking dope and exchanging the latest clichés.

One night, May, a voluptuous young American who has the kind of gigantic breasts that young boys draw inside school notebooks, gets drunk and slips into Oliviero's bed to rest her eyes. When, some weeks later, May announces that she is pregnant and that Oliviero is the father, his mother and father take the news as liberated parents should. May moves in, has the baby, who is named Cristiano and, after a few months of domestic bliss, disappears with the child.

Several years later, when Oliviero is 15, May leaves Cristiano, nicknamed Sweet Pea, at the apartment and disappears again to pursue a career as a model. Oliviero's solemn assumption of his fatherly responsibilities, and his parents' horror at being grandparents, are mildly funny, as are his adventures with Sweet Pea when they run away from home.

Mr. Del Monte, an American-born Italian director, wants to have it both ways with the various eccentrics with which the film is stuffed. Among others, there is a man who steals streetcars, another who talks to animals in the zoo and is fed by them, and a flighty lady who is off to Cambodia to adopt a baby, of which there are plenty at home, though of course they are not Cambodian.

We are meant to find these people colorful and funny as well as far less wise and well-adjusted than the teenage dad. However, the film is basically so muddled that the eccentrics seem no more than unbelievably foolish and Oliviero rather creepily conservative.

"Sweet Pea" does benefit from the work of a number of good performers, including Valeria D'Obici, the memorable shrew in Ettore Scola's "Passione d'Amore," who plays

Oliviero's mother; Victoria Gadsden, as the femme fatale; young Mr. Porro, and especially Fabio Peraboni, who looks to be no more than 3 but takes direction with less self-consciousness than Pia Zadora.

1983 Ja 23, 47:1

VOICE OVER, directed, written and edited by Chris Monger; cinematographer, Roland Denning; music by Schubert/Edward Klak; produced by Mr. Monger, Laurie McFadden, Welsh Arts Council. At the Agee Room in the Bleecker Street Cinema, 144 Bleecker Street. Running time: 105 minutes. This film has no rating.

Ed (Fats) Bannerman	Ian McNeice
"Bitch"/Elizabeth	Bish Nethercote
FX Jones	John Cassady
Celia Krane	Sarah Martin
Frank	David Pearce
Doctor	Stuart Hutton
PAP Boss	Eira Moore
RDOV Boss	Paul Chandler
Bitch's Friend	Carol Owen
Captain Thompson	Jon Groome

By JANET MASLIN

Chris Monger's "Voice Over" has perversity and originality in about equal measure. It tells of a grubby radio star named Fats Bannerman who, at the beginning of the film, holds his audience rapt with a version of "Pride and Prejudice," which he passes off as a serial of his own creation.

Fats's story gradually becomes more modern and more violent, and his life takes a correspondingly bizarre turn. His misogyny, which is fairly profound as the film begins, finally reaches such a dizzying peak that it becomes the film's most distinctive feature.

•

We learn that Fats has been involved in a nasty, violent divorce; he now lives in shabby quarters in a warehouse. We also watch his increasingly abrasive encounters with women, among them an aggressive, unfriendly reporter and two groupies who wind up making fun of Fats's program and rejecting him sexually.

Then an exceedingly strange thing happens: Fats finds a woman in a red dress who has been stabbed and beaten to the point of catatonia. He decides to keep her. He feeds, bathes and dresses her, though the woman is no more animated than a piece of furniture. Eventually, he buys a respectable, middle-class house and moves there with the woman, whose only name — the name Fats has given her — is Bitch.

Meanwhile, Fats's radio demeanor is giving way. He stammers on the air, broadcasts multiple tapes of his voice simultaneously and in general suffers a collapse. At the film's end, Fats hacks his housemate to death in a rhythmic, sexual manner and crouches vacantly over her corpse. She never says a word.

Whatever Mr. Monger's purpose may be in showing Fats's progress from Jane Austen to this juncture, it is of less interest than his method. His "Voice Over," which opened Wednesday at the Agee Room of the Bleecker Street Cinema, is an initially promising film that goes wildly out of control, since its final moments, which ought to be shocking, have a weary and repetitive flavor.

But the early parts of the film, though shot in a primitive style and accompanied by halfway inaudible sound, have their share of energy and black humor, as does Ian MacNeice in the leading role. He makes Fats a wry and idiosyncratic figure, if not an overpoweringly sympathetic one.

1983 Ja 23, 47:1

Obscurity and Comedy Blend To Buoy 'Coup de Torchon'

A movie doesn't have to be altogether clear to be immensely satisfying. Take, for example, Bertrand Tavernier's new French film, "Coup de Torchon" (translated by its distributors as "Clean Slate"), which starts out as a conventional if exotic comedy, set in a small, parched town in French West Africa in 1938, and turns into a most provocative, wittily misanthropic melodrama set in the landscape of the soul.

When we first see Lucien Cordier (Philippe Noiret), the mild-mannered chief of police in Bourkassa, he seems to be a prototypical W.C. Fields character, but without Fields's saving grace of readily expressed fury at careless wives and slovenly in-laws. As Lucien moves around Bourkassa, he accepts the most outrageous insults from the other French colonials with nothing more than sheepish resignation. That which would produce rage in any other man prompts, in Lucien, an embarrassed shrug.

A couple of seedy pimps pay him a bribe to overlook some minor infraction of the law and then, for laughs, dump him in the river with the bodies of black Africans who have died in a dysentery epidemic. When Lucien sees Rose (Isabelle Huppert), his pretty young mistress, being seriously beaten in the street by her husband, he cannot bring himself to help her. He assures a friend, without too much conviction, that it isn't because he's a coward but because the bystanders, knowing his relationship with Rose, would misunderstand his intervention.

Things are equally bad at home. His comically shrewish wife, Huguette (Stephane Audran), devotes herself slavishly to Nono (Eddy Mitchell), her younger brother, a large, lumpish man who hangs around the house all day, half-dressed and often eating Lucien's food.

If Mr. Noiret has the W.C. Fields part, Miss Audran is Cora Witherspoon and Mr. Mitchell is Grady Sutton. Lucien seems to be the last person in Bourkassa to suspect that Nono may not be Huguette's brother and that Nono and Huguette, who hug and kiss a lot, are, in fact, lovers.

• • •

"Coup de Torchon" initially looks to be a kind of adult two-reeler — there's even a running gag about an outdoor privy — and then, imperceptibly, reveals itself to be a metaphysical mystery story, a fascinating one but one whose meaning I'm still trying to figure out. It's not as nice a movie as it originally appears to be. It's a lot like Lucien. Within its rather droll frame, there beats a possibly psychopathic heart.

Lucien is the most complex role that Mr. Tavernier has yet presented Mr. Noiret since they began their collaborations with "The Clockmaker" and "Let Joy Reign Supreme," the historical comedy in which Mr. Noiret gave a bravura performance as Philippe of Orleans, regent for Louis XV during his minority. From the eerie beginning of "Coup de Torchon," during an eclipse of the sun, until its desolate end, Lucien remains an enigma, but the film is of such consistent style and intelligence that we are with it all the way.

Lucien, it turns out, is not quite as impervious to insult as he first appears. After his confrontation with the two pimps, he seeks out a friend in the gendarmerie. "I thought and thought," he tells the amused, patronizing friend, "and finally came to the decision: I don't know what to do."

"It's simple," says the other, in effect. "Fight back." To illustrate the point, the gendarme twice kicks the ever-gullible Lucien in the seat of the pants so forcefully that he goes flying through a closed door into the adjacent waiting room. The sight of Lucien, sprawled on the floor, his dignity lost, causes a good deal of merriment and relieves the boredom of the black Africans sitting there, waiting on the whims of a colonial bureaucracy.

• • •

Thus enlightened, Lucien takes into his own hands a little more of the law than he's entitled to administer.

First he shoots the two pimps and throws their bodies into the river. Not long afterward, he murders Rose's nasty husband, which delights her. This, however, leads Lucien farther and farther into uncharted psychological territory where, to survive, he must assume the role of God.

He doesn't hesitate to murder a loyal African servant who could testify against him, but not before patiently explaining to the terrified man that he deserves execution for collaborating with his oppressors. Eventually Lucien even uses the innocent Rose, whose only sin is a fondness for making love as often as is physically possible, to settle accounts with Rose and Nono.

Does Lucien really mean it when he tells the pretty French school teacher, newly arrived in Bourkassa, that he is Jesus? I'm not at all sure, nor are there any hints in the generally excellent screenplay. At one point Lucien talks moodily about all crimes being collective. At another point he says he's tired of taking the blame for everything that people want him to do — his murders — and won't do themselves. Toward the end he explains himself, "I just help people reveal their true nature." The things he says are muddled but the character is not. He's a man standing at the end of a worn-out highway.

• • •

Whether or not Lucien is certifiably nuts, at least in our terms, is not the issue of Mr. Tavernier's fiction. Lucien functions within the film as a logical extension of the colonial system in which, as he says, one can no longer recognize the difference between good and evil. Expediency and compromise have erased the line of demarcation.

Among other things "Coup de Torchon" is a welcome relief from various film fantasies in which people ("Star Wars," "The Empire Strikes Back") or mythological creatures ("Lord of the Rings," "The Dark Crystal") represent opposing forces of good and evil not by what they do but by how they dress and whether or not they are sweet and cuddly. Mr. Tavernier doesn't introduce such abstractions, but he does show us a world that is remarkable for their absence.

I don't want to make "Coup de Torchon" sound lugubrious because, although it's not exactly heartwarming, it is an unusual kind of film that manages to be most entertaining about subjects generally thought to be solemn and "serious."

Mr. Tavernier has come a long way since he was a film critic and scholar. Though I've not been especially enthusiastic about a couple of his recent films — "A Week's Vacation" was about as galvanizing as its title — he now appears to stand in the forefront of the post-New Wave French filmmakers. To those of us 3,000 miles away, he represents an interesting reconciliation between new French cinéastes and those French establishment directors of the 1940's and 1950's against whom François Truffaut, Jean-Luc Godard and Claude Chabrol turned their youthful scorn.

It's not by chance that his favorite screenplay collaborator is Jean Aurenche, who, with Pierre Bost, wrote "Le Diable au Corps," "Le Blé en Herbe," "The Red and the Black" and other "films of quality" that so enraged Mr. Truffaut and his friends. Mr. Aurenche, now 78, brings to Mr. Tavernier's films a gift for solid construction and dramatic shapeliness that, at best, do not take the place of substance but, instead, illuminate it.

•

"Coup de Torchon," which has been picked to represent France in the competition for this year's foreign-

film Oscar, is not a literary film, although it was adapted by Mr. Tavernier and Mr. Aurenche from a novel, Jim Thompson's "Pop. 1280." Mr. Tavernier is a filmmaker, not someone who photographs prose.

One of the pleasures of "Coup de Torchon" is watching how Mr. Tavernier creates the very particular world of Bourkassa with a minimum of exposition. The flatness of the landscape, the heat, the dust, the sudden windstorms that appear from nowhere, the anonymous black faces that observe everything without visible emotion — these all belong to a specific place in West Africa, but they also describe a civilization.

Though much of the film is extremely funny, there is throughout it a feeling of unstated dread that the seemingly random lunacies accentuate. Example: the local priest busily nailing a Christ figure to a new wooden cross. Termites, he explains, have eaten away two earlier ones.

More important is one's awareness that a mature, self-assured talent is in charge — a storyteller one wants to listen to and trusts.

Mr. Noiret and all of the other members of the cast are very fine. It's especially good to see Miss Huppert in such a lively, funny role, and not in the state of permanent shock in which she usually appears. Miss Audran remains one of France's most elegant comediennes, even when she's supposed to be a provincial shrew. Also noteworthy are Jean-Pierre Marielle, who has a dual role, and Victor Garrivier, who plays Miss Huppert's husband, a fellow so property conscious that he paints a line down their dog's back, one side being his to pet, the other hers.

"Coup de Torchon" is a film for grown-ups. ∎

1983 Ja 23, II:17:1

TREASURE OF THE FOUR CROWNS, directed by Ferdinando Baldi; written by Lloyd Battista, Jim Bryce, Jerry Lazarus, from an original story by Tony Anthony and Gene Quintano; music by Ennio Morricone; a co-production of M.T.G. Productions, Inc. and Lotus Films S.A.; produced by Mr. Anthony and Mr. Quintano; presented by Menahem Golan and Yoram Globus; released by Cannon Films. At the Cinerama, Broadway and 47th Street; Gemini, 64th Street and Second Avenue and other theaters. Running time: 97 minutes. This film is rated PG.
J. T. StrikerTony Anthony
Liz ..Ana Obregon
EdmundGene Quintano
SocratesFrancisco Rabal
Rick ...Jerry Lazarus
Brother JonasEmiliano Redondo
Professor MontgomeryFrancisco Villena

The Lupo-Anthony-Quintano production "Treasure of the Four Crowns" is inspired, as they say, in equal measure by "Raiders of the Lost Ark" and the trio's earlier opus, "Comin' at Ya." That makes it a 3-D adventure film. It comes as close to being unwatchable as a movie can be, as a result of the combined effects of amateur acting, idiotic plot, murky camera work and the cheapest-looking props you can imagine. Even the music is misguided. The score offers the most benign of happy-ending music just as one character's face is turning maggoty and melting.

That's the bad news. The good news is that the coming attractions for "Treasure of the Four Crowns" are delightful, cramming together all the movie's best snake-leaping-out-at-the-audience 3-D effects and boasting wildly about action, excitement, suspense, romance and other things the film hardly delivers. The coming attractions, if you should encounter

them at another theater, are also quite brief, in painful contrast to the film itself, which lasts 97 minutes. I didn't see it all.

•

At the Cinerama II, where the film opened yesterday, the audience was nobody's fool; there were as many people playing video games in the lobby as there were watching the screen. Speaking of the screen, the Cinerama has gotten so dirty that every scene has a parchment texture, regardless of whether it's meant to. This theater is the balcony section of a once-grand movie house, and its angles are now so sharp that there are many seats from which the 3-D effect is totally destroyed. Sit on the sides or way up front, and all you'll get is double vision.

Janet Maslin

•

"Treasure of the Four Crowns" is rated PG ("Parental Guidance Suggested"). It is much too gory for small children.

1983 Ja 23, 47:1

A Career Woman

THE GIRL FROM LORRAINE, directed by Claude Goretta; screenplay (French with English subtitles) by Mr. Goretta, Jacques Kirsner and Rosine Rochette; camera, Philippe Rousselot and Dominique Bringuier; music by Arie Dzierlatka; produced by Yves Peyrot and Raymond Pousaz; a Gaumont/New Yorker Films release. At the Film Forum, 57 Watts Street. Running time: 107 minutes. This film has no rating.
ChristineNathalie Baye
Remy ...Bruno Ganz
ClaireAngela Winkler
PascalPatrick Chesnais

By JANET MASLIN

THE heroine of Claude Goretta's "Girl From Lorraine" is greatly beloved in the small town she has decided to leave. "Farewell, Christine," the local chorus sings sweetly. "Do not go." And then, jokingly: "Here where the dirt never ends/You know we are all

your friends." But Christine is about to move to Paris, where she hopes to work at architectural drafting and pursue the adventurous life of a young career woman. Her friends at home show more than a few traces of good-natured envy as they wistfully bid her goodbye.

"The Girl From Lorraine," which opens today at the Film Forum, is Mr. Goretta's direct yet delicate account of the near-disaster that ensues. Christine (Nathalie Baye) moves to an apartment from whose windows she can watch the Metro going by. She applies for a job, carrying high recommendations from a family friend, only to find her potential employer making a pass at her. She is drawn into an affair with a very shy and attentive Swiss businessman (Bruno Ganz), who also happens to be very married. He breaks off the romance with barely a second thought when the demands of his career with a pharmaceutical concern begin to conflict. He markets tranquilizers.

Christine has a lot of forbearance, but she watches with quiet despair as the situation worsens. Her new acquaintances include an actress regretfully moonlighting as a call girl ("What most of these successful guys need is affection," she says, trying to convince herself as much as Christine), and an executive who is at the very end of his tether. In a restaurant, Christine and this man stare with disbelief as a woman oversees the feeding of steak to her spoiled, tiny dog. The woman, noticing their gaze, retorts "Dogs are just as clean as men, Miss."

There are faintly satirical elements in the screenplay of "The Girl From Lorraine." But Mr. Goretta (who wrote the film with Jacques Kirsner and Rosine Rochette) chooses to direct it in a more sensitive style. Together with Miss Baye, who brings gravity and intelligence to her fine performance here, he gives the film an almost built-in sadness, as well as a reflective spirit. Christine's adventures are odd and individual in their

particulars, but her disillusionment with modern life is something that Mr. Goretta presents in terms that are all-embracing.

Christine eventually finds herself back in the country, but the circumstances are different from those under which she left. Together with the actress-call girl (played with a memorable ruefulness by Angela Winkler), she visits a chateau at which a group of the very wealthy are gathered. Somehow, someone suggests a race along an obstacle course for all the women in the party, with a very large prize for the winner. Christine competes with bankers' wives and daughters for this prize, and with her prostitute friend, heading towards an epiphany that Mr. Goretta has constructed beautifully. "The Girl From Lorraine" moves gently but inexorably towards this remarkable conclusion.

1983 Ja 27, C13:1

Return to East Berlin

ENIGMA, directed by Jeannot Szwarc; screenplay by John Briley, based on a novel by Michael Barak; director of photography, Jean-Louis Picavet; edited by Peter Weatherly; produced by Peter Shaw, Ben Arbeid and André Pergament; released by Embassy Pictures. At 34th Street Showplace, near Second Avenue; Loews State 2, Broadway and 45th Street; Orpheum, Third Avenue and 86th Street, and other theaters. Running time: 101 minutes. This film is rated PG.
Alex HolbeckMartin Sheen
Dimitri VasilkovSam Neill
KarenBrigitte Fossey
Kurt LimmerDerek Jacobi
BodleyMichel Lonsdale
CanarskyFrank Finlay
Melton ..David Baxt
BrunoKevin McNally
HirschMichael Williams
KonstantinWarren Clarke

By JANET MASLIN

THERE are plenty of mysteries about "Enigma" but they aren't necessarily the ones the film makers intended. As directed by Jeannot Szwarc, best known for "Jaws II" and "Somewhere in Time," this is the spy film at its most absurdly hard-boiled and at its most icily perfunctory. It is punctuated by

"A GIRL FROM LORRAINE"—Nathalie Baye, at center, stars in a story about a young working woman's endeavor to build a life for herself in Paris.

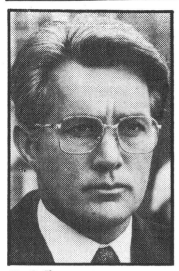

Martin Sheen

crisp titles (indicating the date of each scene), played very close to the vest and riddled with false alarms — as when one character gets a good scare when his cat leaps out from beside the refrigerator, and another when he sees a shadowy shape behind his shower curtain. The silhouette, he discovers, belongs to his own not especially treacherous gray suit.

•

"Enigma," which opens at the Loews State and other theaters today, is also peppered with wise-guy dialogue, as when one team of spies tells a potential recruit: "It's all right. We're the good guys." As far as passion goes, this film tries to be so tough that the hero's chance to tell the heroine he loves her occurs when he is helping her put on a sock. He appears to be addressing the remark to her ankle.

The plot, which is much too fast and furious, concerns an American-born radio broadcaster who has been living in Paris since his defection from East Germany (John Briley's screenplay tends to reel off this kind of detail much too quickly). He is recruited to return to East Berlin, carrying a microprocessor that can unscramble a Russian computer code and thwart a Russian scheme to assassinate five Soviet dissidents on Christmas Day. Got that? Are you sure? In any case, the broadcaster (Martin Sheen) returns to East Berlin and is soon embroiled in all the intrigue that might be hoped for.

He also re-encounters an old flame (Brigitte Fossey), who is the daughter of an important dissident and who is soon in plenty of trouble of her own. Miss Fossey, an otherwise charming and subtle actress, sets some kind of record here in the most-torture-scenes-for-the-leading-lady category. She is repeatedly apprehended and abused by the police, and even so hers is not the film's most thankless role. That perhaps belongs to Sam Neill, an actor from New Zealand who plays a top agent for the K.G.B. Dashing as Mr. Neill is, the enigma of his casting alone is more puzzling than anything the screenplay provides.

In his attempts to keep "Enigma" lively, Mr. Szwarc has kept the actors moving so fast that there is never the much-needed opportunity for them to think. He has also set the film in as many attention-getting locations as possible. Scenes take place amid a collection of religious art, in a grubby

mental hospital and at a swimming pool.

•

"Enigma" is rated PG ("Parental Guidance Suggested"). It contains some nudity and strong suggestions of violence.

1983 Ja 28, C8:1

THE NIGHT OF THE SHOOTING STARS, directed by Paolo and Vittorio Taviani; written (Italian with English subtitles) by the Tavianis and Giuliani G. De Negri, with the collaboration of Tonino Guerra; director of photography, Franco di Giacomo; edited by Roberto Perpignani; music by Nicola Piovani; produced by Giuliani G. De Negri as a co-production with RAI Radiotelevisione Italiana and Ager Cinematografica; a United Artists Classics release. At the Lincoln Plaza 1, Broadway between 62d and 63d Streets. Running time: 106 minutes. This film is rated R.

Galvano	Omero Antonutti
Concetta	Margarita Lozano
Corrado	Claudio Bigagli
Nicola	Massimo Bonetti
Ivana	Norma Martelli
Mara	Enrica Maria Modugno
Rosanna	Sabina Vannucchi
The Priest	Dario Cantarelli
Olinto	Sergi Dagliana
Requiem	Giuseppe Furia
Dilvo	Paolo Hendel

"The Night of the Shooting Stars" was shown as part of the 1982 New York Film Festival. Following are excerpts from a review by Vincent Canby in The New York Times of Sept. 29, 1982. The film opens today at the Lincoln Plaza 1, Broadway between 62d and 63d Streets.

"The Night of the Shooting Stars" is one of those life-affirming films made to order for urban neurotics who behave badly over the breakfast table,

on the subway or in the office. They can attend this Italian film and, by agreeing with its decent sentiments, feel cleansed in some small, vicarious way. Then they can go out and be rotten all over again. It's not a work that makes one think a lot.

The setting is rural Tuscany in August 1944, when the American Army is pushing up the boot of Italy and the Germans are giving ground reluctantly, leaving behind units of paramilitary Italian Fascists who sometimes outdo the Germans in their desperation and brutality.

In the tiny town of San Martino, the citizens are in a quandary. They don't know whether secretly to flee their houses, which the Germans have mined, or to take refuge in the cathedral, where the German commander has promised, they will be safe.

•

"The Night of the Shooting Stars" is mainly the story of those who decide to make their way south to meet the Americans. In form it is what is called a memory film, the events we see being the events as remembered by the narrator, who was a pretty, 6-year-old girl at the time of the flight.

This frame provides the title, because the film begins on a contemporary Aug. 10 — the year's busiest night for shooting stars — when the narrator, now grown, wishes on a star to be able to tell her "loved one" the tale of that earlier Aug. 10 in 1944. "In Tuscany," the audience is told solemnly, "it is said that every shooting

star fulfills a wish."

Also in Disneyland.

The leader of the refugees is a handsome, aristocratic-looking old peasant named Galvano, and in the group there are a busty rich woman whom Galvano once admired from afar, a pregnant peasant bride, her proud bridegroom, Italian Army deserters, resistance fighters, war widows and others, none of whom is characterized in any interesting, unpredictable detail.

Their journey is interrupted by a series of bizarre encounters that are staged with such stateliness that one is always ahead of the film or, more accurately, ahead of the woman who is remembering it all.

•

In the film's only effective sequence, the refugees, having stopped to help some resistance fighters harvest a field of wheat, are suddenly attacked by Italian Fascists.

Far more often, however, the film has a studied, picturesque quality that makes it all seem self-congratulatory and a tiny bit condescending.

"The Night of the Shooting Stars" is the work of Paolo and Vittorio Taviani, the film-making brothers whose "Padre Padrone" was a critical success at the 1977 New York Film Festival. In addition to directing "The Night of the Shooting Stars," they also wrote the screenplay with Giuliani G. De Negri, with the collaboration of Tonino Guerra.

1983 Ja 30, 34:3

FILM VIEW

JANET MASLIN

Sayles Masters the Telling Detail

Every now and then, a movie will serve as a point of reference for the post-Woodstock generation, describing the maturation process in simple but wry terms, and affecting a deceptively nondramatic style. Alain Tanner's "Jonah Who Will Be 25 in the Year 2000" was one. Another was John Sayles's "Return of the Secaucus Seven." And Mr. Sayles's new "Lianna" is another, even if it appears to tackle a subject too limited to have this widespread relevance. Although "Lianna" explicitly tells the story of a 33-year-old wife who leaves her husband for a woman, it's about much more.

By now, it's apparent that Mr. Sayles has a singular talent for couching the most important aspects of growing up and growing older in terms so unprepossessing as to become comic. In "The Return of the Secaucus Seven" he created a house party colored by old friends' unresolved passions — a situation with the potential for the volatility and drama of "Rules of The Game." Yet he then emphasized the most banal aspects of the reunion, to funny and realistic effect. In "Lianna," he does something similar, detailing a woman's decision to alter her life irrevocably, and describing this in a style without a touch of melodrama. That way, the change and turmoil in his heroine's life can be explored with disarming detachment. The lifelike quality of his direction, coupled with the authenticity of his dialogue, make Mr. Sayles's stories hit remarkably close to home.

"Lianna" offers Mr. Sayles the opportunity to consider love, sex, impetuousness, responsibility, parenthood, and any number of other matters vital to contemporaries of his mid-thirtyish characters. That isn't meant to suggest the film's appeal is narrow, but rather to admire its specificity. One of the things Mr. Sayles does best is to anchor his characters to a culture and an era that he makes immediately recognizable using only the

tiniest details and flourishes. What Ann Beattie attempts on the page is a lot like what Mr. Sayles accomplishes on the screen.

"Lianna" is about a faculty wife. Her husband, Dick — this is the sort of characteristic Mr. Sayles makes very telling and sly — is the sort of film and English professor who casually uses "Workers of the world, unite" as a sample sentence to illustrate a totally unrelated matter to his class. He has students who talk about "the place where film and reality intermingle," and who write term papers on topics like "Audie Murphy, America's Tragic Hero."

Dick and Lianna (Jon DeVries and Linda Griffiths) have two children, named Theda

'Lianna' deals with a woman's decision to alter her life irrevocably.

(Jessica Wight MacDonald) and Spencer (Jesse Solomon) by their movie-minded father. Lianna doesn't appear bored with her family, exactly, but she is clearly not flourishing in her capacity as wife and mother.

Lianna attends a night-school class in child psychology or something of the sort, taught by a slightly older, more self-possessed woman to whom she finds herself unexpectedly attracted. So Lianna beams at Ruth (Jane Hallaren), her teacher, and stays after class, and eventually allows herself to be seduced. While this is the pivotal event in the film, Mr. Sayles does not strain

overly hard to explain it in sexual or even psychological terms. And by not dwelling on the reasons for Lianna's behavior, he gives it a broader meaning. "I thought that when I found somebody everything would be all right," says Lianna at one point, a heroine who's been brought up on the platitudes of love songs. "Lianna" explores, among other things, the dangers of believing in that kind of fallacy.

• • •

What Lianna does, along with choosing a lesbian sexual relationship over a heterosexual one, is impulsively to reject the status quo in favor of a life she sees as more romantic, more unconventional, more daring. The direction in which Lianna takes off may be a relatively radical one for the sedate faculty community in which she lives, but her impetuous and somewhat selfish response to the monotony of her life is certainly something that is recognizable in any number of forms. Indeed, a character like Lianna might almost as easily have left Dick for another man. But by involving her with Ruth, Mr. Sayles makes Lianna's behavior seem all the more disruptive to those around her. And he can concentrate as much on Lianna's capacity to wreak havoc this way as he does on her sexual awakening.

What happens? Well, the film begins to explore the consequences of Lianna's decision, though in a relatively nonjudgmental manner. About the harshest attitude Mr. Sayles demonstrates is the feeling that Lianna hasn't given much thought to what her decision will do to those who love her, among them her children ("I haven't thought that far," she says blankly) and even her lover. Ruth, as it turns out, is as unprepared as anyone else for the haste with which Lianna turns her life upside down. She has a career and a reputation to protect. "Some straight women will have an affair with another woman just to see what it's like," Ruth says. "How could I tell?"

• • •

"Lianna" creates an ordinary, very recognizable academic community and then monitors each character's response to the turmoil Lianna creates. It details the children's stoniness, the husband's anger, the women friends' unease and even the male friends' attempts to take advantage of the situation. Mr. Sayles himself plays a rival of Dick's — the first suitor to go racing over to Lianna's barren, low-budget new apartment, having heard that there was no other man involved in the marital breakup.

As it turns out, of course, he hasn't heard the full story, and is wonderfully embarrassed when he does. Mr. Sayles plays this beautifully and delivers some of the film's funniest lines, as when he says, "I'm from California, that stuff doesn't faze me."

Mr. Sayles has filmed "Lianna" in a much more casual, less self-conscious style than might be expected from someone so amusingly well attuned to the nuances of Film Department life. It has an oddly unglamorous look, created by the unfamiliar (and very good) actors he uses and by the bold colors that sometimes dominate the décor. Because the film's style is so offbeat and unassuming, the audience never quite knows what to expect, and a lovely spontaneity develops.

There is Lianna, spotting delicacies her family can't afford in Ruth's cupboard, and declaring what fun it is to have dinner there; "Why don't you call your children and ask if you can stay for dinner?" Ruth asks. Or there is Lianna in a women's bar, overcoming initial alarm and discovering how much she enjoys the dancing.

Undoubtedly the most beautiful moments in "Lianna" come near its ending. In one, Lianna watches a man and woman rehearsing a modern dance routine, and Mr. Sayles intercuts their muscular, almost combative embrace with Lianna's own memories of Ruth, all to the tune of Otis Redding's "I've Been Loving You Too Long." And finally, there's the film's closing image, an embrace of forgiveness between Lianna and one of the many characters who appeared to have abandoned her. Mr. Sayles's generosity and compassion at such moments are rivaled only by the acuity of his homespun vision. ∎

1983 Ja 30, II:17:1

First Picture Shows

BEFORE THE NICKELODEON, directed by Charles Musser; screenplay by Warren D. Leight and Mr. Musser; photography by Rob Issen; edited by Mr. Musser; executive producer, Steve Brier. At the Agee Room in the Bleecker Street Cinema, 144 Bleecker Street. Running time: 60 minutes. This film has no rating.
VOICES:
Thomas EdisonJay Leyda
Porter's Naval RecordRobert Sklar
Corbett-Courtney FightRob Issen
Vitascope's First NightRobert Rosen
"Kiss" ReviewMitchell Kriegman
Eden Musee-War FilmsPeter Davis
Film as a Visual NewspaperD. A. Pennebaker
Biddle BrothersMilos Forman
Terrible TeddyWarren D. Leight
Sampson-Schley ControversyRick King
Fighting the FlamesTony Potter
Melies CatalogueLouis Malle
Jack and the Beanstalk PromoRobert Altman
Jack and the BeanstalkJim Walton
Edison StudioMichael Peyser
Eagle's Nest ReviewGrahame Weinbren
Adolph ZukorSteve Brier
NarratorBlanche Sweet

"Before the Nickelodeon" was shown as part of the 1982 New York Film Festival. Following are excerpts from a review by Janet Maslin in The New York Times of Oct. 9, 1982. The film opens today at the Agee Room in the Bleecker Street Cinema, 144 Bleecker Street.

CHARLES MUSSER'S hourlong documentary "Before the Nickelodeon" traces the pioneering film career of Edwin Porter, whose turn-of-the-century innovations helped move film from the level of "animated photographs" toward something continuous and coherent. It isn't always easy to make modern audiences see the originality of techniques now taken for granted — such as even the most primitive forms of film editing — but Mr. Musser's film illustrates and explains these things with admirable clarity.

The glimpses of Mr. Porter's short films are of great interest, although they are somewhat upstaged by the clips from films by his French contemporary Georges Méliès, whose style looks like sheer wizardry compared with Mr. Porter's more workmanlike efforts.

•

In any case, the turn-of-the-century excerpts would easily have stood on their own merits, if only Mr. Musser had let them. However, he indulges in some silly and unnecessary attempts to jazz up the material. There are cute titles — "Porter Gets in on the Ground Floor" — too much bubbly music and sepia photographs tinted gaudily in pastels.

Mr. Musser has also recruited a sizable cast, including D. A. Pennebaker, Milos Forman, Robert Altman, Peter Davis and Louis Malle, to each read only a few unindentified lines of dialogue. Like the tinting, this seems somewhat beside the point.

1983 F 2, C24:5

Domestic Relations

WHEN JOSEPH RETURNS, written and directed by Zsolt Kezdi Kovacs (Hungarian with English subtitles); photography by Janos Kende; edited by Zoltan Farkas; released by New Yorker Films. At the Film Forum 2, 57 Watts Street. Running time: 92 minutes. This film has no rating.
MariaLili Monori
AgnesEva Ruttkai
JosephGyorgy Pogany
LaciGabor Koncz
The chauffeur's bossMaria Ronyecz
TiborIstvan Bujtor
KarcsiFerenc Palancz
DavidTibor Molnar
ZoltanMark Zala
SanyiSandor Halmagyi
Gray-haired manLaszlo Czurka

"When Joseph Returns" was shown as part of the 1977 New Directors-New Films Series. Following is the review by Vincent Canby in the New York Times of April 15, 1977. The film opens today at the Film Forum 2, 57 Watts Street.

"WHEN JOSEPH RETURNS" is an unsentimental Hungarian film about the edgy relationship between a middle-aged woman and her young, restless daughter-in-law when the son-husband goes to sea for six months. The film, directed and written by Zsolt Kezdi Kovacs, is beautifully acted by Lili Monori as the younger woman and Eva Ruttkai as the mother-in-law, and though the outcome is never in doubt, the manner in which the two women arrive at mutual understanding is surprisingly harrowing in its close-up details.

The girl, whose life had previously been more or less determined by equal doses of television and sex, is a slob, though an extremely pretty one, a person who never stands unsupported if there's a wall to lean against. At first she misses her husband, then resents his absence, and eventually she tears loose to enjoy herself, which, of course, she doesn't. "When Joseph Returns" is the sober sort of movie that one can admire without really liking a lot.

1983 F 3, C20:2

Corporate Espionage

VORTEX, direction, screenplay and editing by Scott B and Beth B; photography by Steven Fierberg; music by Adele Bertei, Richard Edson, Lydia Lunch and the B's; production company, B Movies. At the Waverly, Avenue of the Americas and Third Street. Running time: 90 minutes. This film is not rated.
Anthony DemmerJames Russo
Angel PowersLydia Lunch
Frederick FieldsBill Rice
Pamela FlemingAnn Magnusen
PeterBrent Collins
John AllenBill Corsair
Ron GaversTom Webber
HarryHaoui Montaug
TherapistRichard France
TarmanChris Strang
VitoRichard Prince
Congressman WhiteDavid Kennedy
Doctors Gideon Horowitz and Christof Kohlhofer
Patient-TeletypistDani Johnson
PatientsBill Landis and Andy Whyland
BodyguardKai Eric
Carlo-CopScott B

"Vortex" was shown as part of the 1982 New York Film Festival, Following are excerpts from a review by Vincent Canby in The New York Times of Oct. 1, 1982. The film opens today at the Waverly Theater, Avenue of the Americas and Third Avenue.

"VORTEX" appears to be the chef d'oeuvre of the filmmaking couple who call themselves Scott B and Beth B and their production company, B Movies. It should also be good news for people who are amused by the pop sensibility that interprets a rudely bland kind of cinema tackiness as a statement not just on movies but also on the human condition.

"Vortex" is the first 16-millimeter "superproduction" by the B's, all of whose earlier underground films have been in Super-8. I suspect it really isn't as funny as the same sort of films turned out by George and Mike Kuchar ("The Devil's Cleavage") in the early and mid-1970's. If I seem to hedge, it's because these spoofs are usually far more knowing than funny. One tends to confuse the intelligence that goes into them with humor.

•

"Vortex" is still another private-eye spoof, but one that has the good fortune to have as its star an actress named Lydia Lunch. Miss Lunch is a small, dark-haired young woman who, in the film, seems to be perpetually miffed that she isn't taller. She plays Angela Power, a detective called in to solve the mysterious death of a crooked Congressman, and she immediately becomes embroiled up to her ankles, which aren't too far off the floor anyway, in a tale of multinational corporate espionage.

"Vortex" has long patches of utterly incomprehensible exposition, dopey plot turns and solemn explanations. Though a small, comparatively short — 90-minute — movie, it packs an amazing amount of waste space around each exchange of dialogue. That, too, is part of the style.

It's clear, however, that the B's are very good technicians. Working on what must have been a minuscule budget, they do some very effective things with the sets, the lighting and the camera.

1983 F 4, C5:1

From the Headlines

WITHOUT A TRACE, directed and produced by Stanley R. Jaffe; screenplay by Beth Gutcheon, based on her novel "Still Missing"; director of photography, John Bailey; music by Jack Nitzsche; edited by Cynthia Scheider; released by Twentieth Century-Fox Film Corp. At the Loews State, Broadway and 45th Street, and Tower East, 72d Street and Third Avenue, and other theaters. Running time: 121 minutes. This film is rated PG.
Susan Selky Kate Nelligan
Al Menetti .. Judd Hirsch
Graham Selky David Dukes
Jocelyn Norris Stockard Channing
Margaret Mayo Jacqueline Brookes
Philippe Keith McDermott
Ms. Hauser Kathleen Widdoes
Alex Selky Daniel Bryan Corkill
Pat Menetti Cheryl Giannini
Eugene Menetti David Simon
Polygraph Operator William Deull
Vivienne Grant Joan McMonagle
Malvina Robbins Louise Stubbs

By JANET MASLIN

DURING the nerve-racking opening moments of "Without a Trace," the audience waits for the very worst to happen. A charming little blond-haired boy — who, lest the point be lost, looks quite a bit like Etan Patz — shares an ordinary morning with his mother. He drops clothes on the floor, gets a little argumentative over breakfast, and generally enjoys the ordinary routine that we know will soon be disrupted. By the time little Alex leaves for school, the audience is thoroughly primed for the dreadful realization that he won't be coming home.

"Without a Trace," which opens today at Loew's Tower East and other theaters, carries a closing disclaimer stating that its characters and incidents are fictitious. That is, its story is not supposed to be that of Etan Patz, the 6-year-old New York City boy who disappeared in 1979 while walking from his home to a school bus and who has never been found.

However, the manner in which art, as they say, imitates life is in this film's case unmistakable. While some of the incidentals — the mother's marital status, her address, her occupation — are original to Beth Gutcheon's novel ("Still Missing") and screenplay, the essence of the story has already been told in the headlines, and told with a greater if more painful realism than it is accorded here. The film's sole area of inventiveness lies in its giving this tale the full-blown-Hollywood treatment. That means a tear-jerking ending that sets even the family dog to wagging his tail.

As directed by Stanley Jaffe, a producer ("Kramer vs. Kramer") now making his directorial debut, "Without a Trace" is an extremely manipulative movie, at times very successfully so. It begins powerfully, pulling all the right strings, and its ending has an undeniable force. Mr. Jaffe seems to know just what he wants in these sections of the film, and how to get it. But the middle is a problem. What will happen to the anguished mother, Susan Selky (Kate Nelligan), as she waits to learn the fate of her son Alex? Not much. The film spends a lot of time watching Susan as she sits stonily at her piano, brooding in silence, trying to hold on.

A number of supporting characters are brought in to make Susan's vigil less lonely, among them a frazzled-looking best friend (Stockard Channing), a sympathetic policeman with children of his own (Judd Hirsch), a vaguely caddish ex-husband (David Dukes) and his new mistress, who must deliver the remarkable line, "Well, I can see why Graham's friends laugh at him when they see me." Susan is also seen at work, and we discover that she is an English professor at Columbia, albeit one who attributes "A foolish consistency is the hobgoblin of little minds" to Pope. That would come as a great suprise to Ralph Waldo Emerson; it also makes the scene something of a failure, if its intent is to demonstrate Susan's competence.

For the most part, as played by Miss Nelligan, Susan is an admirably controlled woman and a somewhat aloof one. Her occasional outbursts are more than welcome, since they give the actress her few opportunities here to demonstrate a broad and complex range. Her rare displays of unexpected rage or grief provide the film with its best moments, since so much of what surrounds them is so predictable and essentially so tame. The minimal ingenuity that went into separating this story from real events has not extended far enough to give it any added depth or insight, or even to spin out any additional activity.

Taken on its own terms, "Without a Trace" is a reasonably well-made film, and it's certainly slick enough to hold an audience's attention. But its own terms are very, very limited. The troubling subject that is raised here deserves more thoughtful and imaginative treatment than "Without a Trace" even begins to provide.

•

"Without a Trace" is rated PG ("Parental Guidance Suggested"). It contains intimations of violence, and its story may well frighten children.

1983 F 4, C8:1

Is This What's Next?

VIDEODROME, written and directed by David Cronenberg; director of photography, Mark Irwin; edited by Ronald Sanders; music by Howard Shore; produced by Claude Héroux; released by Universal Pictures. At the Rivoli, Broadway and 49th Street; Gemini, 64th Street and Second Avenue; UA 85th Street, at First Avenue. Running time: 90 minutes. This film is rated R:
Max Renn James Woods
Bianca O'Blivion Sonja Smits
Nicki Brand Deborah Harry
Harlan Peter Dvorsky
Barry Convex Les Carlson
Brian O'Blivion Jack Creley
Masha Lynne Gorman
Bridey .. Julie Khaner
Moses Reiner Schwarz
Raphael ... David Bolt
Rena King Lally Cadeau
Brolley Henry Gomez

WHEN Max Renn, the hero of David Cronenberg's "Videodrome," stumbles across a Malaysian television station that appears to be broadcasting pure sex and brutality, he is stunned. "Torture, murder, mutilation!" he exclaims. "Brilliant! Absolutely brilliant, and almost no production costs. Where do they get actors who can *do* this?" Later on, in a cooler moment, he contemplates this new form of programming and murmurs, "I think it's what's next."

Max is a video entrepreneur, someone who considers it his business to give people what they want, however sordid or sleazy that may be. In Mr. Cronenberg's universe, which is often very clever and inventive, this doesn't make Max an evil man. It merely makes him unprincipled, and therefore vulnerable to the wicked machinations of others. In "Videodrome," these abound. So does poetic justice.

Max is eventually turned into a walking personification of the sexual, violent, media-mad exploitation to which he has contributed.

It would be revealing the most eye-catching and horrific secrets of "Videodrome," which opens today at the Rivoli and other theaters, to describe this physical transformation in any detail. But Rick Baker, responsible for the film's special makeup effects, has devised some tricks that are as droll as they are gruesome, even if the gore does eventually become overpowering. He and Mr. Cronenberg, while easily fulfilling the film's horror requirements, try in addition for a more ironic, satirical style, and at times they achieve it. Though "Videodrome" finally grows grotesque and a little confused, it begins very well and sustains its cleverness for a long while.

What Max quickly discovers, with the audience way ahead of him, is that the sex-and-violence show from Malaysia is neither staged nor a foreign import. It originates in Pittsburgh, and it secretly emits a signal so powerful that the viewer is affected in unthinkable and irreversible ways. By the time Max figures this out, he is already in the grip of Nicki, a seductive and very kinky radio personality, played by Deborah Harry. Radio personality? Well, Nicki is heard giving advice on a self-help show called "Emotional Rescue." Since she is also seen putting out cigarettes on her body, the better to titillate Max, it's fair to wonder whether her on-the-air advice is really of any use.

The other mystery woman in Mr. Cronenberg's convoluted, intrigue-filled screenplay is one Bianca O'Blivion (Sonja Smits), the daughter of a professor who now exists entirely as a library of videotapes. "The monologue is his preferred mode of discourse," Bianca says. Both she and Nicki, who represent opposing elements in Mr. Cronenberg's elaborate scheme, induce in Max the kind of hallucinations that are a special-effects-department's dream, as when a video-cassette becomes throbbing, pulsating flesh, or when a television screen becomes a rounded, menacing mouth the size of a beach ball. Max is never sure where these visions leave off and reality begins; the viewer won't find it easy to tell, either. And there are times when it is dangerously unclear, in the midst of Max's lurid, sadomasochistic fantasies, whether "Videodrome" is far removed from the kind of sensationalism it seeks to satirize.

Mr. Cronenberg, who also directed "Scanners," is developing a real genius for this sort of thing; one measure of the innovativeness of "Videodrome" is that it feels vaguely futuristic, even though it's apparently set in the present.

By far Mr. Cronenberg's most inspired touch is the casting of Mr. Woods, who brings an almost backhanded heroism to the horror genre. In villainous or sinister roles (in films like "The Onion Field" or "Split Image"), Mr. Woods has been startling, but that kind of casting is almost a redundancy. Here, his offhand wisecracking gives the performance a sharply authentic edge. And his jittery, insinuating manner even begins to look like a kind of innocence, in comparison with the calm, soothing attitudes of the video-crazed megalomaniacs he's up against.

Janet Maslin

1983 F 4, C9:1

"WITHOUT A TRACE"—Kate Nelligan co-stars with Judd Hirsch, David Dukes and Stockard Channing in Stanley Jaffe's drama about a mother trying to find her young son, who has disappeared.

THE ENTITY, directed by Sidney Furie; screenplay by Frank DeFelitta, based on his novel; director of photography, Stephen H. Burum; film editor, Frank J. Urioste; music by Charles Bernstein; produced by Harold Schneider; released by Twentieth Century-Fox Film Corp. At the Criterion, Broadway and 45th Street; Gemini, 64th Street and Second Avenue, and other theaters. Running time: 116 minutes. This film is rated R.

Carla Moran	Barbara Hershey
Phil Sneiderman	Ron Silver
Billy	David Labiosa
Dr. Weber	George Coe
Cindy Nash	Margaret Blye
Dr. Cooley	Jacqueline Brookes
Gene Kraft	Richard Brestoff
George Nash	Michael Alldredge
Joe Mehan	Raymond Singer
Dr. Walcott	Allan Rich
Julie	Natasha Ryan
Kim	Melanie Gaffin
Jerry Anderson	Alex Rocco

By RICHARD F. SHEPARD

Things go bump in the night in "The Entity," which opened yesterday at the Criterion and at neighborhood movie houses. The central figure is raped and assaulted by something that we and she and nobody can see but that manifests a frightening force. Furniture is smashed, lightning forks, cars career out of control. Bad business all around.

"The Entity" is based on a novel by Frank DeFelitta, who adapted it for the screen, and everything is supposedly drawn from an account of an actual turn of events that overtook a Los Angeles woman in 1976. It called into play psychiatrists and parapsychologists and caused some debate about whether things were happening as a result of her own mind or because of some malevolent outside force.

In this fictionalized treatment, the evidence is clearly on the side of those who favor an external spirit, an independent but real menace. Even the psychiatrist, whose role is to find that everything comes out of oneself, is finally persuaded, although it takes a sort of minor ice age, created by a futile attempt to trap the evil presence in chilled helium, to convince him.

By film's end, the viewer has really learned little more about the phenomenon than when one sat down to take it in. As it works its way through, the pattern is one of tedious stretches that, wittingly, lead up to bars of spooky music followed by crashes, crackles, screaming, quivering, thudding. Then back to quiet, while the savants stroke their chins and try to make sense of it.

Barbara Hershey, who has the lead role in the production directed by Sidney Furie, carries off her part convincingly, the role of a young mother of three, widowed and later deserted by another man, who is trying to learn enough to get a job only to be attacked repeatedly at this time by the unidentified entity. Ron Silver is effective as the psychiatrist who becomes emotionally involved in the case after finding that his professional approach hasn't worked.

"The Entity" offers thrills in short staccato bursts and dull science in long bursts. If your thirst is for horror, it will not be slaked. If your taste runs to psychiatry, it will not be satisfied. If your fancy is for films that keep you riveted to your seat, you may find that you need a restraining belt by third-quarter time.

1983 F 5, 12:3

PETRIA'S WREATH (Serbo-Croatian with English subtitles), directed by Srdjan Karanovic; based on the novel by Dragoslav Mihajlovic; director of photography, Tomislav Pinter; edited by Branka Ceperac; music by Zoran Simjanovic; production company, Centar Film, Belgrade; a New Yorker Films Release. At the Lincoln Plaza 2, Broadway between 62d and 63d Streets. Running time: 100 minutes. This film has no rating.

Petria	Mirjana Karanovic
Dobrivoje	Marko Nikolic
Ljubisha	Pavle Vujisic
Misa	Dragan Maksimovic
Vela Bugarka	Ljiljana Krstic
Vlajna Ana	Olivera Markovic
Photographer	Mica Tomic
Ing. Markovic	Misha Zutic
Kamenche	Veljko Mandic

By JANET MASLIN

"Petria's Wreath" tells of a Serbo-Croatian woman and her life of almost unbearable hardship, presenting her story in a style that is resolutely plain. Even when events in this story (which is based on a novel by Dragoslav Mihajlovic) are at their most crushingly sad, the film retains a simple dignity that can be quite haunting.

As the film begins, Petria is an old peasant woman living in a cottage with some cats and cheerfully observing that after the third brandy things always begin to look better. This, it turns out, is about as happy as she ever is during the course of the story.

The credits for "Petria's Wreath" (the title is never directly explained), at the Lincoln Plaza 2, show a photograph of the old Petria being cut and pasted and tinted until it is the rosy image of a young woman. This is one of the few whimsical touches from Srdjan Karanovic, whose direction is otherwise rather spare.

The film moves chronologically through the various tragedies of Petria's life, which include an ill-fated first marriage, the loss of two children and the inability to bear others, banishment by one husband and no better luck with another. Through all the illness and death that plague Petria's loved ones, she maintains a quiet perseverance, although she becomes understandably superstitious at times. At the burial of one child, Petria and her husband force a live chicken into the grave, hoping it will spare them any further sorrow. It doesn't.

Mirjana Karanovic, the actress who plays Petria, brings a sturdiness devoid of self-pity to all these grim events, which are meant to unfold against a backdrop of political and economic change. Parades of young Communists march through Petria's village during that part of the story set in the 1950's, and they eventually close the business of a kindly tavern owner who has been Petria's friend. The changing fortunes of the region's coal miners also figure peripherally in the story, although the film's central focus remains firmly fixed on Petria herself. Her own difficulties provide more than enough woe, upheaval and deprivation, and her endurance emerges as something of a minor miracle.

1983 F G, 49:1

Rock Glamour

LET'S SPEND THE NIGHT TOGETHER, directed by Hal Ashby; directors of photography, Caleb Deschanel and Gerald Feil; edited by Lisa Day; music by Mick Jagger, Keith Richards and other composers; produced by Ronald L. Schwary; released by Embassy Pictures. At the Astor Plaza, Broadway, between 43d and 44th Streets; Orpheum, 86th Street and Third Avenue, and other theaters. Running time: 95 minutes. This film has been rated PG.
THE BAND: Mick Jagger, Keith Richards, Charlie Watts, Ron Wood, Bill Wyman, Ian Stewart, Ian McLagan, Ernie Watts, Bobby Keys.

By JANET MASLIN

HAL ASHBY'S "Let's Spend the Night Together" is probably the handsomest rock-and-roll movie ever made, although few others may have aspired to that distinction. Good looks, at least until recently, were never the

Mick Jagger, in the concert film "Let's Spend The Night Together."

point. And no rock film with a claim to authenticity could afford to forfeit its grainy realism. After all, the glamour grew out of roughness and ferocity, not out of wholesome stylishness or sophistication.

But for the Rolling Stones, who with this film once again affirm their status as rock's most durable and dynamic veterans, that raggedness is no longer either essential or apt. So Mr. Ashby has substituted a vibrantly colorful, seamless style in its place. And the results are as exciting and eye-catching as must have been intended.

"Let's Spend the Night Together," which opens today at the Astor Plaza and other theaters, is the classiest of concert movies, even if that sounds as if it ought to be a contradiction in terms. As photographed by Gerald Feil and Caleb Deschanel (of "The Black Stallion"), it looks glorious, particularly in the opening sequences at an outdoor arena. The Stones, photographed from a low angle, loom monumentally large against a bright blue sky, and they project a healthy energy. The scale is enormous, almost as though this were a western. The band's entrance here, at Sun Devil Stadium in Tempe, Ariz., is heralded by thousands of balloons, which look breathtaking when captured in a helicopter shot from afar. It's the magic hour, the prettiest moment of late afternoon, on a sunny day.

Mick Jagger works the entirety of a cleverly slanted stage, and the use of a cordless microphone enables him to clamber into the audience. He doesn't appear concerned about the enormous crowd, even though it was in Altamont, Calif., as recorded in an earlier Stones film, the Maysles' 1970 documentary, "Gimme Shelter," that a rock audience turned into a sinister mob and a man was murdered. Here, the fans are enthusiastic but essentially serene, because this is entertainment of a less histrionic and threatening sort. It's just a concert, a beautifully crafted record of the Stones performing style at this stage of their career, and Mr. Ashby hasn't tried to make it anything more.

Even the touches of candor here — brief footage of the Stones backstage, preparing for a show — serve to emphasize the enormous energy that goes into the performance itself, rather than to distract the audience from the show. The same can be said for a set of old Stones photographs seen during "Time Is on My Side," although the brief use of Vietnam War footage is merely puzzling.

The show itself primarily focuses on the group's recent material, songs such as "Shattered," "Beast of Burden," "She's So Cold," "Hang Fire" and "Waiting on a Friend." There's some novelty to the set because these songs haven't been seen in prior Stones concert films; among those that have, "You Can't Always Get What You Want" is given a different and very stirring treatment here. The 25-song show, which later moves indoors, to the Brendan Byrne Arena in East Rutherford, N.J., does sag somewhat midway through the set. But it builds to a rousing finale, spurred by such new songs as "Start Me Up" and "Miss You," and older ones like "Brown Sugar" and the inevitable "Satisfaction."

The camera chiefly lingers on Mr. Jagger, but it also captures Ron Wood and Keith Richards as they horse around energetically (Mr. Wood, playing a cordless guitar, has a lot of opportunity for roaming the stage). Charlie Watts and Bill Wyman are more seldom seen, and when they catch sight of the camera both have the habit of rolling their eyes in comically exaggerated boredom. After nearly 20 years together, they may indeed feel that way. But nobody in the audience is apt to share that sentiment.

"Let's Spend the Night Together" has been rated PG ("Parental Guidance Suggested"), which has probably been earned by some of the Rolling Stones lyrics. There are fleeting scenes of wartime violence as well.

1983 F 11, C8:1

Suffocating Goodness

WE OF THE NEVER NEVER, directed by Igor Auzins; screenplay by Peter Schreck; director of photography, Gary Hansen; edited by Clifford Hayes; music by Peter Best; produced by Greg Tepper; released by Triumph Films, a Columbia-Gaumont Company. At the D.W. Griffith, Second Avenue and 59th Street, and the Embassy 72d Street 2, at Broadway. Running time: 132 minutes. This film is rated G.

Jeannie	Angela Punch McGregor
Aeneas Gunn	Arthur Dignam
Mac	Tony Barry
Jackeroo	Tommy Lewis
Jack	Lewis Fitz-Gerald
Dan	Martin Vaughan
Dandy	John Jarratt
Landlord	Tex Morton
Goggle Eye	Donald Blitner
Sam Lee	Kim Chiu Kok
Rosie	Mawuyul Yanthalawuy
Cheon	Cecil Parkee
Neaves	Brian Granrott

"WE OF THE NEVER NEVER" is based on a memoir by Jeannie Gunn, who in 1902 accompanied her husband, Aeneas, from Melbourne, Australia, to the remote Northern Territory, where he became the new manager of the Elsey cattle station. The inhabitants of the area were aborigines and white cattlemen, with neither group accustomed to having a white woman in residence. The men, in particular, were suspicious of Jeannie Gunn, thinking she would change their rugged life with her ladylike ways. But Jeannie showed she could be a good sport, and

she adapted to the demands of her new life, and everybody loved her.

If "We of the Never Never" sounds simple, old-fashioned and as suffocatingly noble as its heroine, it is. It's a film of far more anthropological than dramatic interest, since much of the action involves aboriginal characters, and since it was filmed in the thinly settled region Mrs. Gunn actually visited. There is adventure here: (Jeannie being dunked in a river; Jeannie being treed by a bull) that children will enjoy, and the scenery is unusual. But otherwise, little of interest goes on. And the film, in depicting Jeannie's relations with the aborigines, celebrates her open-mindedness with a pride that's dated and unseemly.

•

"We of the Never Never" is pleasant, albeit to a fault, and its actors are prim and decorous in a manner that, once again, will satisfy children more than it does anyone else. Angela Punch McGregor and Arthur Dignam play the Gunns stalwartly, and the direction is by Igor Auzins. Most memorable are the people of Bamyili, Djembere, Beswick, Roper Valley and Ngukkur, who seem to enjoy Miss McGregor's company and the travails of working as movie extras. A little girl (Sibina Willy) is dressed by the Gunns in gingham and brought by them into the main house, where she is treated by the couple as a surrogate daughter. And one elderly man is taught by Miss McGregor's Jeannie to wear pants.

Janet Maslin

1983 F 11, C12:1

IN THE KING OF PRUSSIA, produced, directed and written by Emile de Antonio; photographed by Judy Irola; edited by Mark Pines; music by Jackson Browne and Graham Nash. At the Film Forum, 57 Watts Street. Running time: 92 minutes. This film has no rating.
WITH: Martin Sheen and the Plowshares 8: Daniel Berrigan, S.J., Philip Berrigan, Dean Hammer, Carl Kabat, Elmer Maas, Anne Montgomery, Molly Rush, John Schuchardt.

Expediency was undoubtedly a factor in determining the plain, rough-edged style of Emile de Antonio's "In the King of Prussia," which has been filmed on videotape for a relatively tiny sum. The film's minimalism is also clearly intentional, as Mr. De Antonio begins with footage of a graffiti artist furtively spray-painting the film's title on a white wall, and continues through a series of crudely staged courtroom scenes depicting the trial of a group calling itself the Plowshares 8.

This group of Roman Catholic radicals, which included Daniel and Philip Berrigan, was arrested in September 1980, in King of Prussia, Pa., and charged with damaging several nose cones, designed for nuclear warheads, at the Re-Entry Division of the General Electric Space Technology Center there. They also damaged secret documents, and Mr. De Antonio has some footage of this; he tried to re-create the rest of the incident from the general vicinity of the plant's parking lot. The eight are themselves present for the courtroom scenes, which were filmed just before they were sentenced on 28 charges. The Berrigan brothers and two other defendants received sentences of from three to 10 years, with two- to five-year sentences for the rest of the group. Two of the defendants have served one year and have been released; the others have not yet served their terms.

•

Present for re-enactments of courtroom scenes are actors, including Martin Sheen as a judge very unsympathetic to the defendants' cause. "Nuclear power is not on trial here — you are," he repeatedly tells the defendants. The other performers, playing prosecutor, defense lawyer and jurors, affect a furiously actorish false indignation as they denounce the principals. The Plowshares 8 themselves are best represented when they depart from the courtroom transcript, which is awkwardly read, and appear to be speaking more extemporaneously about their opposition to nuclear warfare. The Rev. Daniel Berrigan, to

whom Mr. De Antonio gives the lengthiest opportunity for speaking on camera, is by far the most eloquent of the group.

But the whole exercise feels like exactly that — no matter how articulate the speakers or how compelling their plight. ("I don't do particularly well in jail," Daniel Berrigan says. "I hate the humiliation. And yet one goes forward.") While Mr. De Antonio eschews Hollywood tactics in presenting this material, his lack of an aggressive alternative makes the film's plainness border on the bland, thus limiting its potential for promulgating

the ideas to which its director and subjects are committed. There are even times when the courtroom footage takes on an absurd edge, as when the spectators purport to annoy the judge by repeatedly singing "Kumbaya." Mr. Sheen's judge feigns violent distress. But he looks as if he could take as many choruses of this as the next fellow.

"In the King of Prussia" is playing at the Film Forum through Feb. 22.

Janet Maslin

1983 F 13, 57:1

FILM VIEW

JANET MASLIN

Casting Can Be a Pivotal Skill

Linda Hunt is the tiny, androgynous actress without whom Peter Weir's "Year of Living Dangerously" probably never could have been made. It isn't that Miss Hunt, who plays a peculiarly omnipresent male journalist named Billy Kwan, steals the movie from its romantic leads; both Sigourney Weaver and Mel Gibson are as coolly glamorous as their roles require. It's simply that Miss Hunt, in the role of the Eurasian dwarf who seems to orchestrate the story, contributes a sense of strangeness that's essential to the film and that is not otherwise fully provided. Without her transfixing presence, this might be just another love story set in a foreign land; with it, the film develops the genuinely exotic quality that is its most distinctive feature.

The inclusion of Miss Hunt here is one of those casting masterstrokes that make all the difference in whether a film will achieve its desired tone. Needless to say, this isn't a common occurrence. Casting is much more likely to account for why a film fails to achieve the most basic credibility — when the prep school boy has a 5 o'clock shadow, or when the plain Jane is someone who'd be absolutely gorgeous without glasses — than to save the day. If you have any doubts as to how much difference casting can make, try to imagine the Bette Davis-Errol Flynn "Gone With the Wind" or the Ronald Reagan "Casablanca." Some casting ideas, fortunately, never get past the suggestion stage.

The most basic kind of casting problem, of course, is the use of an actor or actress who doesn't resemble the character being played. Klaus Kinski, cast as the Irish hero of "Fitzcarraldo," was at an automatic disadvantage, whereas Jason Robards (the actor originally slated for the role) would have looked and sounded much closer to the mark. In "Best Friends," Burt Reynolds is in comparable trouble as a screenwriter who decides to marry his co-author, played by Goldie Hawn. The screenplay, by Barry Levinson and Valerie Curtin, follows both characters on trips to meet one another's parents, and watches each of them regress amusingly while at home. Miss Hawn (who decides she can't sleep with her husband in her parents' house, and whose mother tucks Mr. Reynolds in at night) has a girlishness that helps immeasurably here. But Mr. Reynolds can't be convincing as her boyish spouse.

The character in the screenplay is unmistakably a younger, less self-assured man. Mr. Reynolds has his share of youthful jokiness, but he doesn't have the kind of young man's uncertainty that's been written into this role.

Sometimes successful casting is simply a matter of chemistry — or the lack of it — between two stars. A garrulous, playful leading man may seem convincingly smitten only by the most serenely beautiful actresses, or an actor who plays things close to the vest may require a livelier co-star to draw him out. Paul Newman's reserve was offset by Sally Field's nervousness in "Absence of Malice," but he is teamed in "The Verdict" with Charlotte Rampling, an actress whose restraint matches his own. The icily beautiful Miss Rampling doesn't bring out anything unexpected in Mr. Newman; she seems instead to echo his aloofness, and their scenes together are almost painfully barren.

"IN THE KING OF PRUSSIA"—Martin Sheen, above, portrays a judge and Daniel Berrigan appears as himself in Emile de Antonio's re-creation of the trial of Daniel and Philip Berrigan and others accused of damaging nuclear warheads.

Sidney Lumet, who directed "The Verdict" and who has developed a genius for casting minor roles (this film and "Prince of the City" are exemplary casting accomplishments), has populated the rest of the film with colorful yet controlled supporting players, and Mr. Newman sets off sparks with them all. Only Miss Rampling seems to slow him down, and the character she plays tangles up the plot unnecessarily, too. If the character were eliminated altogether, the film might not suffer much, and it would move at a much faster clip.

When a leading lady is well-chosen for her role, she can change things immeasurably for the characters around her. Imagine Miss Rampling in "Tootsie," for instance, and you imagine a movie very different from the one shrewd enough to feature Jessica Lange. An actress the least bit androgynous or remote might raise questions about just why Dustin Hoffman's Michael Dorsey leaps so easily into his Dorothy Michaels role, thus opening up "Tootsie" to issues more serious and complicated than it is prepared to handle. Miss Lange, on the other hand, is so innately voluptuous that she can't help but make Michael look like an uncomplicatedly red-blooded American boy. By and large, the more demonstrably sexy the leading lady, the more sympathetic and vulnerable her co-star is apt to seem. Richard Gere, stony as could be when teamed with Lauren Hutton, seemed to take on a whole new warmth when confronted with Debra Winger's abandon in "An Officer and a Gentleman."

•

If brilliantly-cast unknowns, like Linda Hunt or the stars of "Diner," are at one end of the casting spectrum, established stars playing roles that match their public qualities are at the other. Bette Midler in "The Rose," Lauren Bacall in "The Fan," Clint Eastwood in a Dirty Harry adventure, Barbra Streisand in just about anything — these performers have the kind of sheer force of personality that outshines the specifics of any role they might play. When the star's overall screen image and the particular role overlap this fully, the impact of the performance is likely to be amplified, not diminished.

What happens, though, when the actor brings certain associations to a role less tangibly — through the force of frequent teamwork with a particular director, rather than through star quality alone? François Truffaut's films with Jean-Pierre Leaud, Bertrand Tavernier's frequent use of Philippe Noiret (who now stars in "Coup de Torchon") or Martin Scorsese's collaborations with Robert De Niro make the most daring use of this kind of casting. Performances like these can't easily be viewed out of context; they become part of a body of work, variations on a theme.

So Mr. De Niro's Rupert Pupkin, in Mr. Scorsese's forthcoming "King of Comedy," will be inextricably related to his Travis Bickle ("Taxi Driver") or his Jake LaMotta ("Raging Bull"), not to mention his characters in "Mean Streets" and "New York, New York," no matter what the particulars of this one role. Casting like this, even if it arises only from sheer force of habit, raises with each new film the question of whether a step forward is truly being taken, whether a necessary addition is being made to the collective work of ths director-star team, whether the actor can sustain the level of his past work without repeating himself or straying too far from what he does best. Of all the casting gambles, this is the riskiest, the one with the highest stakes of all. ■

1983 F 13, II:23:1

TWILIGHT TIME, directed by Goran Paskaljevic; written by Mr. Paskaljevic, Filip David, Dan Tana, Rowland Barber; director of photography, Tomislav Pinter; edited by Olga Skrigin; composer, Walter Scharf; produced by Dan Tana; released by MGM/UA Entertainment Co. At the 68th Street Playhouse, at Third Avenue. Running time: 112 minutes. This film is rated PG.
MarkoKarl Malden
LenaJodi Thelen
IvanDamien Nash
AnaMia Roth
PashkoPavle Vujisic
TonyDragan Maksimovic
MatanStole Arandjelovic
RockyPetar Bozovic
KarloMilan Srdoc
Factory GatemanPeter Carsten
NikolaBora Todorovic
LukaBozidar Pavicevic
DriverDvor Antolic

By JANET MASLIN

"Twilight Time" is a halfway foreign film, which means that it's set in a distant land (Yugoslavia) and populated by some local extras but chiefly written and directed in a conventionally mawkish style that is universal. It's a curious hybrid, and at unexpected moments a gentle and touching one, particularly whenever Yugoslav-born Karl Malden has an opportunity to make the most of his role.

Mr. Malden plays Marko, an elderly grandfather raising two young children who, though the children don't know this, have been abandoned by their parents. Like his son and daughter-in-law, who have moved from the small village in which the film takes place to Germany, Marko had his chance to see the world. He lived in America for 20 years, and his favorite song was the ballroom number of the title; he even won a gramophone in a dance contest back then. But Marko has returned to the village, even if his son has sent a letter declaring his intention to stay away. Marko can't bear to read the real letter to his grandchildren, Ivan and Ana, so he writes a substitute. "Money is important but it is not everything in life," Marko's letter says. "When you live abroad you soon realize there is no place like home among your own people."

"Twilight Time," which opens today at the 68th Street Playhouse, was directed by Goran Paskaljevic in a leisurely, sentimental style that might seem more authentic without the overstated folksiness that abounds. Marko and Ivan, the story's best-played and most compelling characters, are often seen surrounded by conspicuous peasant props, whether that means chickens in the hallway of their farmhouse or simple Yugoslav equipment for baling hay. This would make the film both scenic (it's filmed in a beautiful little mountain village) and absorbing were it not for the hokier touches that frequently intrude.

Marko's favorite phonograph record is used to symbolic excess here, and the dialogue often tends toward clichés. When one character tells Marko "I alwas believed that the truth would set you free," he replies "I always believed it's dreams that keep you going."

•

Nonetheless, Mr. Malden treats the children (Damien Nash and Mia Roth) so tenderly that the film has a genuine sweetness at times. The mood is consistently broken by Jodi Thelen, playing a new schoolteacher who's supposed to be so pretty that when she first gets off the bus the old men in the village are so thunderstruck they stop drinking their beer. Miss Thelen, who was a problem in Arthur Penn's "Four Friends," is one here as well, since she brings an expression of unwarranted rapture to even the most humdrum situations. She smiles excessively, speaks in purring tones and is rosy to a fault.

In any case, this is Mr. Malden's movie, which makes it something of an anomaly since he doesn't commonly play leading roles. Mr. Malden carries "Twilight Time" as well as it can be carried, and he gives it a very effective measure of compassion and humanity.

"Twilight Time" is rated PG ("Parental Guidance Suggested"). It contains very occasional strong language but should not offend children.

1983 F 13, 57:4

An Exodus

LA NUIT DE VARENNES, directed by Ettore Scola; screenplay (French with English subtitles) by Sergio Amidei and Mr. Scola; director of photography, Armando Nannuzzi; edited by Raimondo Crociani; music by Armando Trovaioli; produced by Renzo Rossellini for Opera Film (Rome) and Gaumont-FR3 (Paris); released by Triumph Films, a Columbia/Gaumont Company. Running time: 133 minutes. This film is rated R.
CasanovaMarcello Mastroianni
Nicolas Edme Restif de la Bretonne
.................................Jean-Louis Barrault
Countess Sophie de la BordeHanna Schygulla
Thomas PaineHarvey Keitel
Monsieur JacobJean-Claude Brialy
De WendelDaniel Gelin
Madame Adelaide GagnonAndrea Ferreol
De FlorangeMichel Vitold
Italian barkerEnzo Jannacci
Emile DelagePierre Malet
Jean-Louise RomeufHugues Quester
King Louis VXIMichel Piccoli
Queen Marie-AntoinetteEleonore Hirt

By JANET MASLIN

THE great historical pageant that is Ettore Scola's "La Nuit de Varennes" unfolds with supreme ease. It begins with a series of casual coincidences and weaves them brilliantly into a vision of one of the most important moments in French history, a vision not the least bit limited by the specifics of its place and time.

The time is the French Revolution, and the occasion is the flight of the royal family from Paris to the small town of Varennes, where they will be captured and sent back to their deaths. But the feeling is utterly modern, or perhaps it's timeless. The key issues of the film are the issues of any era. And the humor and generosity with which Mr. Scola presents them are correspondingly enduring.

"La Nuit de Varennes," which opens today at the Lincoln Plaza 3, begins as an Italian theatrical troupe offers re-enactments of Revolutionary scenes to the people of Paris, two years after the fact. It quickly shifts, with a rhythm and reason that are all its own, to the night of the King's flight as it introduces Nicholas Edme Restif de la Bretonne (Jean-Louis Barrault), the writer who documented many of the events of the Revolution, and one of a number of historical personages who will follow in Louis XVI's wake.

•

During a scene in a bordello, sketched by Mr. Scola with an earthy humor that figures throughout the film, Restif learns from a maid at the Royal Palace that the King may be attempting to escape from Paris. He follows along and soon becomes part of a group of travelers that includes one of the Queen's ladies-in-waiting (Hanna Schygulla), the wealthy industrialist De Wendel (Daniel Gelin), an Italian opera singer (Laura Betti), a wealthy widow (Andrea Ferreol), a prissy hairdresser (Jean-Claude Brialy) and others. Also eventually in the group, last but hardly least, are Casanova (Marcello Mastroianni) and Thomas Paine (Harvey Keitel).

All sides of the day's issues are represented within this entourage, with the foremost ideological rift between the progressive Restif and Casanova, now an elderly gentleman who declares: "I miss the sweeter times of yore, when all was harmony and light." However, "La Nuit de Va-

Jean-Louis Barrault, left, Hanna Schygulla and Marcello Mastroianni in scenes from "La Nuit de Varennes."

rennes" is not a film about conflict, and it has no villains. It approaches the forces at work in the revolution even-handedly — with compassion for the peasants whose uprising is about to begin, and also with regret about the violent change that is on its way. Mr. Scola sees change as something that is forever necessary and forever incomplete, which means that only one or two characters in the film regard the imminent revolution with any overriding idealism. Idealism in this film is very much a young man's attitude, and most of the characters are old enough to have a broader, more tolerant world view.

•

The historical characters speak in the voices that might be expected of them (Casanova: "On his throne or not, no king ever made me miss a meal"), but they're never in any danger of becoming puppets. The screenplay, by Mr. Scola and the late Sergio Amideo, never overstates the historical importance of any one event or individual. And so it accomplishes the small miracle of letting these figures exist, in equal measure, as characters within this story and as archetypes or legends. The small talk here is never small (the industrialist, telling a fellow voyager about the day he saw a worker fold his arms and refuse to do his job, calls this "the most terrifying sight I ever saw"). But it is wonderfully casual at some times, quietly resonant at others, and always exquisitely delivered. If "La Nuit de Varennes" offered nothing more than the ensemble acting on display, it would be major and memorable on that basis alone.

Of all the fine performances here, Mr. Mastroianni's is the most dazzling, because he plays the vainest of men without bringing any of his own vanity to the role. This Casanova is on his last legs, rueful about the ways in which his body now disappoints him and yet forever interrupting conversations to powder his nose. He's also a wonderfully gallant figure, and never one of whom the film makes fun; the friendship that develops between Casanova and Restif is one of the most moving things here. Miss Schygulla, whose lady-in-waiting is filled with serene faith in the crumbling order, brings an astonishing composure to her performance, and in her last scene Mr. Scola uses that quality stunningly. Mr. Keitel, Mr. Barrault and the rest of a cast that also includes Jean-Louis Trintignant are superb too. Mr. Trintignant plays the timid deputy mayor of Varennes who keeps the royal family in his home, worrying about his hospitality even as he agrees to have them sent back to Paris.

•

Mr. Scola's direction of "La Nuit de Varennes" isn't overly elegant or schematic, and the film is all the fresher for that. His style is flexible without the slightest trace of gimmickry. When he sees the need for an odd lighting effect or a historical footnote, he simply tosses these things into a narrative that is otherwise simple, beautiful and straightforward. So Casanova can interrupt the story to tell us, while wearing a wool bonnet and sipping soup or tea, why he wasn't very well known at the time the action takes place (his fame, he confides, came with the memoir "published after my death, which, as you all know, occurred in 1798"). And the key figure of Restif can, at the end of the film, stride out of the past and into the present — which, as a representative of a work that both encapsulates and

transcends history, is most assuredly where he belongs.

1983 F 16, C23:1

Oily Fairyland

LOCAL HERO, written and directed by Bill Forsyth; edited by Michael Bradsell; music by Mark Knopfler; produced by David Puttnam; released by Warner Bros. At the Cinema 1, Third Avenue and 60th Street. Running time: 110 minutes. This film is rated PG.

Happer	Burt Lancaster
Mac	Peter Riegert
Ben	Fulton Mackay
Urquhart	Denis Lawson
Moritz	Norman Chancer
Oldsen	Peter Capaldi
Geddes	Rikki Fulton
Watt	Alex Norton
Marina	Jenny Seagrove
Stella	Jennifer Black
Victor	Christopher Rozycki
Rev. Macpherson	Christopher Asante

By JANET MASLIN

GENUINE fairy tales are rare; so is film-making that is thoroughly original in an unobtrusive way. Bill Forsyth's quirky disarming "Local Hero" is both, and it's also proof that Mr. Forsyth's other feature film released here, "Gregory's Girl," was more than a happy accident. The Glasgow-born Mr. Forsyth has put Scottish comedy on the map, for whatever that's worth. He has also developed a dryly whimsical style, very close to a deadpan at times, that allows the strangest events or personages to glide by almost unnoticed. "Local Hero" contains a mermaid, an enchanted village and a possibly magical rabbit. No undue fuss is made about any one of them.

"Local Hero," which opens today at Cinema 1, doesn't begin on a very promising note. It starts in Houston, a place toward which Mr. Forsyth, who wrote and directed the film, has no outstandingly fresh attitude. The tale begins at the headquarters of gigantic Knox Oil, where it is learned — at a meeting in which everyone present has to whisper, because Felix Happer (Burt Lancaster), the board chairman, is snoozing — that the company plans to replace a charming little Scottish fishing village, called Ferness, with an oil refinery.

A Knox employee called Mac MacIntyre (Peter Riegert) is delegated to fly to Ferness to buy the place, and he is chosen because his name makes it sound as if he's well suited to the chore. MacIntyre isn't a Scot; he's the son of Hungarian immigrants who thought MacIntyre was an American name. That makes about as much sense as anything else that goes on here.

Once MacIntyre arrives in Scotland, odd things start to happen — nothing dramatic, nothing you can put your finger on, but undeniably strange. He and a traveling companion, a young Scottish employee of Knox named Danny Oldsen (Peter Capaldi), are en route to Ferness when their car hits a rabbit in a heavy fog. They stop the car in the middle of the road and sleep inside. The next morning, the fog is gone, the rabbit is sitting in the back seat, and the travelers are ready to proceed. But something indefinable has changed. It's as though they have entered into a dream.

Certainly the postcard-perfect town of Ferness has its delightfully dreamlike qualities. Every time Mac and Danny venture out of their inn, the same motorcyclist barrels by and nearly runs them down. The inn itself

Peter Riegert

is managed by Gordon Urquhart (Denis Lawson), who also functions as the accountant next door, and who has a different personality to suit each job. (The accountant is unctuous, the innkeeper vaguely rude.) There is an omnipresent baby whose parents are never identified; a black African minister named Macpherson with an all-white congregation; a lone punk-rock groupie with a red-blue-and-green teased hairdo; and two beautiful women who probably function as muses, named Stella and Marina (Jennifer Black and Jenny Seagrove). Marina swims with exceptional grace. She has, as Danny notices but doesn't mention when he kisses her knee one afternoon, webbed feet.

•

Ferness casts its spell over Mac, who arrives there jealously guarding his battery-powered briefcase, and eventually becomes one of the place's more relaxed denizens. It ought to have a similar effect on the audience, and seduce the viewer just as gradually. The charm and humor of "Local Hero" are so very understated that they may seem elusive at first, but they are undeniably powerful.

The less Mr. Forsyth explains, the more appealingly odd the movie seems, and it manages to be open-ended but not annoyingly cryptic. Besides, even the occasional bits of information about the townspeople aren't very helpful. The more you find out about Ferness — why, say, the entire population of the village is seen sneaking out of the church as MacIntyre, who has come to buy the church, momentarily turns his back — the less you know.

The best thing that Mr. Forsyth does with actors is to induce them to behave as though nothing would surprise them. Everyone here has that air, particularly Mr. Riegert. His performance, which begins as a send-up of young corporate hotshots' demeanor, winds up as that of the movie's straightest straight man, the one who'll barely blink when someone else squirts lemon in his eye. Mr. Lancaster is less steadily present, appearing mostly at the film's beginning and at its end, but he brings with him sufficient authority when, say, he descends on Ferness out of the skies (via helicopter) and immediately begins ordering everyone around. Of course, Ferness isn't the sort of place where anyone takes orders terribly seriously.

"Local Hero" is a funny movie, but it's more apt to induce chuckles than knee-slapping. Like "Gregory's Girl," it demonstrates Mr. Forsyth's uncanny ability for making an audience sense that something magical is going on, even if that something isn't easily explained.

•

"Local Hero" is rated PG ("Parental Guidance Suggested"). It contains some sexually suggestive scenes.

1983 F 17, C25:1

Unusual Kidnapping

THE KING OF COMEDY, directed by Martin Scorsese; written by Paul D. Zimmerman; director of photography, Fred Schuler; music production by Robbie Robertson; released by 20th Century-Fox. At the Coronet, Third Avenue and 59th Street. Running time: 108 minutes. This film is rated R.

Rupert Pupkin	Robert De Niro
Jerry Langford	Jerry Lewis
Rita	Diahnne Abbott
Masha	Sandra Bernhard
Ed Herlihy	Ed Herlihy
Band Leader	Lou Brown
Liza Minnelli	Liza Minnelli

By VINCENT CANBY

IT would be difficult to describe Martin Scorsese's fine new film, "The King of Comedy," as an absolute joy. It's very funny, and it ends on a high note that was, for me, both a total surprise and completely satisfying. Yet it's also bristly, sometimes manic to the edge of lunacy and, along the way, terrifying. It's not an absolute joy by a long shot but, in the way of a film that uses all of its talents to their fullest, it's exhilarating.

"The King of Comedy," which opens today at the Coronet, is most easily categorized as satire. Though television and instant celebrity are two of its principal targets, it has less in common with something like Paddy Chayefsky's "Network" than with Susan Seidelman's "Smithereens."

Like Wren, the aggressive groupie in "Smithereens," Rupert Pupkin, the hero of "The King of Comedy," wants to be celebrated and famous. However, unlike Wren, who has no talent for anything and knows it, Rupert is convinced that he is a great comedian, nothing less than "the king of comedy," which is what he calls himself.

As played by Robert De Niro, in one of the best, most complex and most flamboyant performances of his career, Rupert Pupkin represents the apotheosis of all that is most commonplace in America's increasingly homogenized society. For Rupert, immortality is a series of boffo one-liners.

•

Though there is a little bit of almost every film Mr. Scorsese has ever made in "The King of Comedy," including even "Taxi Driver" and "Raging Bull," this new work is an original. Its excellent screenplay, written by Paul D. Zimmerman, a former film critic for Newsweek, is witty and, even in Rupert's hilarious fantasy sequences, tough. Like all good movies, the film has the measure of the times that produced it.

When we first meet Rupert Pupkin, there is little to distinguish him from all of the other pushy, half-crazed, love-sick fans who wait for their idols outside stage doors, furiously demanding autographs and as likely to turn vicious as they are to swoon with ecstasy at the merest brush with celebrity. Rupert's idol is Jerry Lang-

ford, a late-night, television talk-show host played — with brilliant solemnity — by Jerry Lewis. "The Jerry Langford Show" is obviously modeled on Johnny Carson's, but the Langford character and well-corseted figure suggest the off-stage Bob Hope.

Rupert pursues the defenseless Jerry Langford with the single-minded intensity of the true psychotic. When all other avenues to the achievement of his goal — a 10-minute guest spot on "The Jerry Langford Show" — fail, Rupert and his equally obsessed sidekick, Masha (Sandra Bernhard), a rich groupie with an East Side mansion, decide to kidnap Jerry and to hold him for one of the weirdest ransoms in the history of narrative films. More of the story you need not know.

•

One of the ways in which "The King of Comedy" works so effectively is in the viewer's uncertainty whether it's going to wind up as terrifyingly as is always possible. It's full of laughs, but under all of the comic situations is the awful suspicion that our laughter is going to be turned against us, like a gun.

Mr. Zimmerman's screenplay is ungraciously hilarious when it focuses its attention on pure show biz, as when, in one of Rupert's fantasies, he attempts, with the gravity of a Barbara Walters, to explain the sources of his comic routines. I also cherish its throw-away lines: Rupert, lying in wait for Jerry Langford in a fancy network waiting room, keeps staring at the ceiling. "Is it cork?" he asks, being suave. Says the bored receptionist: "I don't know. Is it dripping on you?"

Though the film is Mr. De Niro's from start to finish, all of the members of the cast are impeccable, including Mr. Lewis, Miss Bernhard, who is new to films and may be one of the decade's comic finds; Diahnne Abbott, as Rupert's skeptical, sometime girlfriend; Catherine Scorsese (the director's mother), as Rupert's mother, who remains a quarrelsome, off-screen voice throughout; Shelley Hack, as the sort of beautiful, cool network secretary who could give lessons in the art of the elegant put-down. Among the real-life personalities who turn up as themselves are Tony Randall, Victor Borge and Dr. Joyce Brothers, who doesn't seem to have any idea that, under these circumstances, she's a not-very-kind joke.

With "The King of Comedy," Mr. Scorsese again confirms his reputation as one of the most authentic, most original voices of his film generation.

1983 F 18, C10:1

Second Conning

THE STING II, directed by Jeremy Paul Kagan; written by David S. Ward; director of photography, Bill Butler; edited by David Garfield; music by Lalo Schifrin; produced by Jennings Lang; released by Universal Pictures. At the Gemini, Second Avenue and 64th Street; Rivoli, Broadway and 49th Street, and other theaters. Running time: 103 minutes. This film is rated PG.
Gondorff Jackie Gleason
Hooker .. Mac Davis
Veronica .. Teri Garr
Macalinski Karl Malden
Lonnegan Oliver Reed

A STING: that's a trick, a swindle, a con. "The Sting II" sounds as if it ought to be one, what with Mac Davis and Jackie Gleason in the Robert Redford and Paul Newman roles. However, the casting of these two accomplishes

at least one thing for the sequel: it lowers the audience's expectations that this will be anything on a par with the original. So on that basis, and on that basis alone, "The Sting II" is better than might have been anticipated.

However, that's not saying much. "The Sting II," which opens today at the Gemini and other theaters, moves slowly, looks terrible and copies the first film shamelessly. Rather than a sequel, it's a retread, with David S. Ward's screenplay supplying hoodlum lingo you could cut with a knife and outlining a set of similar shenanigans.

This time, Mr. Gleason plays Fargo Gondorff, who writes a friend that he's now living in "a big house with a yard." This, in one of the film's few worthwhile witticisms, turns out to be a prison, from which Gondorff is soon released, so that he can embark on a new series of capers. His young accomplice, to whom the letter was sent, is Jake Hooker, a boxer played by Mr. Davis. In "The Sting," the characters played by Mr. Redford and Mr. Newman were *Johnny* Hooker and *Henry* Gondorff. Understand the name change, anybody? Understand whether these characters, whose story takes place in the 1940's, are supposed to be the original 30's matinee idols on a bad day? This can't exactly qualify as a full-fledged mystery, but it's certainly a puzzle.

In any event, Hooker and Gondorff set out to hoodwink Doyle Lonnegan, the Robert Shaw character played dreadfully here by Oliver Reed. They want to convince him that Hooker is a boxer worth betting on, and this involves building sets and faking busy scenarios, just as the last film did. Those who like watching familiar spectacles over and over again will perhaps enjoy this, but it has been charmlessly staged by Jeremy Paul Kagan and filmed in orange hues that make the eyes tired. The title cards of the first film are gone, but whenever the action slows, the ragtime comes pumping in. This time most of the score is Lalo Schifrin's, whereas Marvin Hamlisch provided the Scott Joplin adaptations last time. The current score can't compare.

Mr. Davis is amiable but unglamorous, and Mr. Gleason, looking very unlike himself, performs smoothly. Teri Garr lights up the film as a kind of small-time Mata Hari, and Karl Malden amusingly plays a swell named Macalinski, yet another candidate for suckerdom. Among the few memorable scenes is one in which Mr. Malden and Mr. Davis have a business meeting on a roller coaster, with the camera apparently on board. It may make you motion sick, but at least it's lively.

•

"The Sting II" is rated PG ("Parental Guidance Suggested"). It contains some strong language.

Janet Maslin

1983 F 18, C10:6

TABLE FOR FIVE, directed by Robert Lieberman; written by David Seltzer; director of photography, Vilmos Zsigmond; film editor, Michael Kahn; produced by Robert Schaffel; released by CBS Theatrical Films-Warner Bros. At the Sutton, Third Avenue and 57th Street. Running time: 122 minutes. This film is rated PG.
J.P. Tannen Jon Voight
Mitchell Richard Crenna
Marie Marie-Christine Barrault
Kathleen Millie Perkins
Tilde .. Roxana Zal
Truman-Paul Robby Kiger
Trung .. Son Hoang Bui
Mandy .. Maria O'Brien
Old Man Nelson Welch
Bickering Husband Bernie Hern
Bickering Wife Marla Turner

T HE complex, troubled, nonnuclear modern American family would be one of the movies' most important topics today, if only anyone in post-"Kramer vs. Kramer" Hollywood knew what to do with it. "Table for Five" certainly tackles the subject. However, that's not the same thing as casting any light on it.

Here we have Jon Voight as a divorced dad, J.P. Tannen, who after several years' absence decides to re-establish relations with his three children. The kids are Trung (Son Hoang Bui), Tilde (Roxana Zal) and Truman-Paul (Robby Kiger), and J. P. is probably the guy who named them. His former wife, Kathleen (Millie Perkins), is now married to a lawyer named Mitchell (Richard Crenna), who feels he's just as much a father to the children as J. P. is. Nonetheless, Kathleen and Mitchell hand the brood over to J. P. who — this is to show how impractical he is — takes them all on a fancy sea cruise.

The ship docks at one enormously scenic spot after another. As the production notes explain this, Mr. Voight (whose company financed the film) "specifically wanted to film at the Parthenon in Athens and amidst the Sphinx and Pyramids near Cairo: he felt these structures of seeming permanence would serve as useful juxtapositions in scenes dealing with the fragility of life." This analogy is not merely left to the imagination. It is spelled out as Mr. Voight makes a speech to the children with the Sphinx looking down.

J. P. is supposed to be a terribly self-involved father as the story begins, something David Seltzer's screenplay establishes by having him clown too much and chase every available blonde at the shuffleboard court. (One of these, played sweetly by Marie-Christine Barrault, becomes something of a steady flame.) This, of course, infuriates the children, who add rebelliousness to the list of their trendy problems. Among those are a learning disability (Truman-Paul's) and a foreign-born orphan's resentment toward his adopted parent (Trong's).

It's the latter part of the film that is supposed to make all the difference, as J. P. rises to the role of loving, caring, responsive, supportive parent. If the film carried this off convincingly, all else would be forgivable, but the change never seems particularly real. For one thing, the children, though they perform well individually, don't seem to have much in common with Miss Perkins, Mr. Voight or one another, so the much-discussed fatherhood bond seems strained. And Mr. Voight's responsible-parent earnestness isn't enough of a departure from his initial devil-may-care dad to give the transformation sufficient emphasis.

David Seltzer ("The Omen," "Six Weeks") has packed the screenplay with platitudes, and Robert Lieberman, making his feature debut, directs so that anything surrounding the characters manages, like the Sphinx, to mirror their situation. When they're sad, we see rain on the deck chairs; when they fight, we watch startled diners at neighboring tables as they stare.

However, "Table for Five" isn't as hokey as it could have been. And it has been well shot and edited by Vilmos Zsigmond and Michael Kahn, respectively. Mr. Voight's sincerity is unmistakable; Mr. Crenna makes a stern yet touching stepfather, and

Miss Perkins, best known for "The Diary of Anne Frank," makes a very welcome return to the screen.

•

"Table for Five" is rated PG ("Parental Guidance Suggested"). It contains a little off-color language and several bedroom scenes.

Janet Maslin

1983 F 18, C12:1

Nastiness in Uniform

LORDS OF DISCIPLINE, directed by Franc Roddam; screenplay by Thomas Pope and Lloyd Fonvielle, based on a novel by Pat Conroy; director of photography, Brian Tufano; edited by Michael Ellis; music by Howard Blake; released by Paramount Pictures. At Loews State, Broadway and 45th Street; Orpheum, Third Avenue and 86th Street, and 34th Street Showplace, at Second Avenue. Running time: 103 minutes. This film is rated R.
Will ..David Keith
Bear ..Robert Prosky
General DurrellG. D. Spradlin
AbigailBarbara Babcock
AlexanderMichael Biehn
Pig ..Rick Rossovich
MarkJohn Lavachielli
TraddMitchell Lichtenstein
PearceMark Breland
PoteeteMalcolm Danare
MacabbeeJudge Reinhold
Braselton ..Greg Webb
GilbreathWild Bill Paxton
Gooch ..Dean Miller
CommerceEd Bishop
McIntyreStuart Milligan
TeresaKatharine Levy

By JANET MASLIN

F RANC RODDAM'S crisp, suspenseful "The Lords of Discipline" gives an old-fashioned tale of military-school life some brutal new twists. The customs at Carolina Military Academy, where Pat Conroy's novel (which has been adapted by Thomas Pope and Lloyd Fonvielle) was set, involve a lot more sadism than it takes to build character. The film details the viciousness with which new cadets are hazed and the particular savagery of their racism, all the while telling of how one upperclassman discovers his own courage and rises above all this ugliness. It's a well-crafted story told in extremely nasty terms.

"The Lords of Discipline," which opens today at Loews State and other theaters, may be gritty, but that doesn't necessarily make it realistic. There are plenty of credulity-straining touches here, from a faculty mentor who's practically a guardian angel (Robert Prosky) to an ending that's much too nervy to be believed. Mr. Roddam, who directed "Quadrophenia," seems more concerned with drama than with realism, though, and this film can certainly be dramatic. Few members of the large cast have much chance to stand out from the crowd, but their collective impact is considerable.

•

The hero is Will, played by David Keith with humor and substance. Returning to the academy at the start of a new school season, Will is asked by a cigar-chomping colonel nicknamed Bear (Mr. Prosky) to take on a special task. This year, for the first time, there is a black cadet in the incoming class, and Bear wants Will to make sure the hazing doesn't get out of hand. Both of them know it probably *will* go overboard, and neither seems specially liberal or even humane. The point is simply to preserve decorum at the institution, not to protect this one individual. Or so they say.

The black cadet, Pearce, who is played very compellingly by Mark Breland, is indeed tormented mercilessly. But he holds up better than at

least one of his white classmates, whose deterioration is presented in horrifying detail. Will quietly arranges for Pearce to leave him notes in a particular library book should the going get too tough, but Pearce apparently doesn't need to do this. Every day, though, Will checks the volume for messages. Why doesn't anyone ever take it out of the library? The film leaves this small plot point, and a number of others, unresolved.

●

What Will eventually discovers is the existence of a secret society within the academy, a group using Klanlike tactics to terrify certain recruits. Their exploits help set the movie's abrupt, frightening tone, which Mr. Roddam develops effectively. But the moral climate in which this group has been able to operate is given less attention here than their mere activities, which makes the film a little shallower and more manipulative than it might have been. Still, Mr. Roddam sketches the atmosphere of the academy in extremely vivid and unsettling terms.

Also in the cast, in addition to the excellent Mr. Keith, are G. D. Spradlin as the head of the school, Michael Biehn as the smirkiest of the terrorists and Mitchell Lichtenstein, John Lavachielli and Rick Rossovich as Will's roommates, who help provide the film with its barracks humor. Mr. Rossovich, playing a good-hearted bruiser, returns from vacation to declare: "Listen, you know what I learned this summer? How to kill usin' just my thumbs!" As it turns out, in the atmosphere in which the film takes place, that's the kind of skill that could come in handy.

1983 F 18, C16:4

Made for Each Other

LOVESICK, written and directed by Marshall Brickman; director of photography, Gerry Fisher; edited by Nina Feinberg; music by Philippe Sarde; produced by Charles Okun; released by Warner Bros. At the Gemini, 64th Street and Second Avenue; National, Broadway between 43d and 44th Streets; Murray Hill, 34th Street and Lexington Avenue and other theaters. Running time: 96 minutes. This film is rated PG.
Saul BenjaminDudley Moore
Chloe AllenElizabeth McGovern
Sigmund FreudAlec Guinness
NymphomaniacChristine Baranski
Frantic PatientGene Saks
Mrs. MondragonRenee Taylor
Gay PatientKent Broadhurst
Silent PatientLester Rawlins
Katie BenjaminAnne Kerry
Marvin ZuckermanDavid Strathairn
Ted CarusoRon Silver
ActressAnn Gillespie
Play DirectorJohn Tillinger
Stage ManagerJeff Natter
Second ActressPeggy LeRoy Johnson
Jac ApplezweigLarry Rivers
Larry Geller, M.D.John Huston
Lionel Gross, M.D.Alan King
Harriet Singer, M.D.Selma Diamond
Gunnar Bergsen, M.D.Stefan Schnabel

F ORGET "Six Weeks." Dudley Moore, incomparable in "10" and "Arthur," is back doing what he does best in "Lovesick," Marshall Brickman's sweetly wacky romantic comedy about a successful psychiatrist who betrays his profession by falling wildly in love with one of his patients. The film, which opens today at the National and other theaters, may be the most indigenously New York comedy since Woody Allen's "Manhattan."

I hope psychiatrists don't take "Lovesick" too seriously. Though it makes wicked fun of the entire profession, including many patients, and even though it calls up the amused shade of Sigmund Freud, in the person of Alec Guinness, to make caustic comments from time to time, the

mood is benign and the manner wise and unaggressively hip.

Things start to go both right and wrong for Dr. Saul Benjamin (Mr. Moore) when, through the sudden death of a colleague, he inherits as a patient the beautiful Chloe Allen (Elizabeth McGovern), whose first play is in rehearsal with a famous Hollywood actor as its star. Chloe, born and bred in Illinois, is a believably rare young woman. She's intelligent, talented, capable of inspired recklessness and aware of her own strengths without being intimidated by them

●

If Mr. Brickman's screenplay challenges plausibility in any serious way, it's our suspicion that Chloe is so well adjusted to almost every possibility that she would never be in serious need of therapy.

That, however, is no big problem since Miss McGovern, who looks like the Morton's Salt girl come to voluptuous life, is the kind of screen personality who makes you want to believe everything she does.

Like "Simon," Mr. Brickman's first film as a writer and director, "Lovesick" is not a comedy with outrageous highs and lows. It proceeds with such good-humored, consistent intelligence that it almost seems to be a new form of comedy. It would be impossible to attach a laugh track to such a work, not because it isn't frequently hilarious but because no two people are likely to respond to it in exactly the same way at the same time, which, in this case, is meant as high praise.

"Lovesick" is also a comedy without a single really nasty person in it. There are a number of dopes, like Dr. Larry Geller (John Huston), Saul's avuncular psychiatrist, who tends to fall asleep during Saul's sessions; another psychiatrist, played by Wallace Shawn, who is the first to succumb to Chloe's beauty and intelligence, and Ted Caruso (Ron Silver), the Hollywood movie star who may or may not be modeled on Al Pacino.

●

Saul's patients, all of whom he lets down badly, are pricelessly well played by Christine Baranski, Renée Taylor, Gene Saks, Lester Rawlins, Kent Broadhurst and, especially, by David Strathairn, as a former university professor who is convinced that his brains are being scrambled by radio waves from space.

Larry Rivers, the artist, turns up briefly and most comically as the SoHo artist who is having an affair with Saul's wife, nicely played by Anne Kerry, and Alan King and Selma Diamond are perfectly — that is to say, suitably — humorless as two members of the psychiatric board appointed to rule on Saul's behavior.

Mr. Moore and Miss McGovern are such appealing lovers that the movie successfully bypasses all questions of ethics. You can believe they were made for each other and that although he is a failure as a therapist and unfaithful as a husband, she is the one person who will make all go right. One can't ask much more from a romantic comedy.

●

"Lovesick," which has been rated PG ("parental guidance suggested"), includes some vulgar language and sexy situations.

Vincent Canby

1983 F 18, C19:1

European Sensibility

THE STATE OF THINGS, directed by Wim Wenders; screenplay by Robert Kramer and Wim Wenders; directors of photography, Henri Alekan and Fred Murphy; edited by Barbara Von Weitershausen; music by Jürgen Knieper; produced by Chris Sievernich; a Gray City Release. At the Bleecker Street Cinema, 144 Bleecker Street. Running time: 120 minutes. This film has no rating.
AnnaIsabelle Weingarten
Joan ..Rebecca Pauly
Mark ..Jeffrey Kime
RobertGeoffrey Carey
Julia ...Camilla Mora
JaneAlexandra Auder
FriedrichPatrick Bauchau
Dennis ..Paul Getty 3d
Kate ...Viva Auder
Joe ...Sam Fuller
Production ManagerArtur Semedo
SoundmanFrancisco Baiao
Camera OperatorRobert Kramer
GordonAllen Goorwitz
LawyerRoger Corman

W IM WENDERS'S "State of Things," which was named the best film at last year's Venice Film Festival, is a movie with a very romantic, very European sensibility, not about life, but about films and the people who make them. I feel that I must choose my words carefully here because, although it left me absolutely cold — frigid, really — I know it's the kind of work that will be infinitely fascinating to film aficionados whose priorities I do not share.

On what surface it has, "The State of Things" is about a small, international film crew — the director, the writer, the actors, the cameraman, and the set and lighting people — that has gathered outside Lisbon to shoot a low-budget science-fiction film based on Alan Dwan's "The Most Dangerous Man Alive" (1961). When "The State of Things" starts, the producer of the film-within-the-film has fled back to Hollywood, supposedly to find money with which to complete the project.

●

For several days, the director, writer and actors loaf around their tacky seaside hotel, talking about life and movies, and particularly about whether movies should have stories. At this point, "The State of Things" is all chat and no plot, but then someone says portentously, "A life without stories isn't worth living."

Eventually the film's director, played by Patrick Bauchau, returns to Hollywood to find the missing producer, played by Allen Goorwitz, at which point a melodramatic plot is introduced.

"The State of Things" reminds me a lot of Rainer Werner Fassbinder's far more haphazard but far more fascinating "Beware the Holy Whore." Although there is obviously more to it than I am capable of going into — I'm afraid I'd fall asleep in the process — "The State of Things" has some minor compensations. These include appearances by Viva, now billed as Viva Auder, doing pretty much what she used to do for Andy Warhol and Paul Morrissey; Sam Fuller, who plays the crochety, hard-drinking cameraman, and Roger Corman, the Hollywood producer-director, as a lawyer.

Though the screenplay was written by Mr. Wenders and Robert Kramer ("Ice," "Guns"), both of whom are men whose work I've admired in the past, much of the dialogue sounds to have been improvised. This is sometimes embarrassingly awful, such as in Mr. Goorwitz's big scene at the end; and, infrequently, quite marvelous, as when Paul Getty 3d, who plays the writer of the film-within, talks at length about his terrible California childhood.

You're on your own with this one, which opens today at the Bleecker Street Cinema.

Vincent Canby

1983 F 18, C19:4

CORRECTION

A review of the film "The State of Things" in Weekend on Friday incorrectly identified an actor who delivers a monologue about life in California. He is Geoffrey Carey.

1983 F 23, B1:6

BETRAYAL, directed by David Jones; screenplay by Harold Pinter; director of photography, Mike Fash; edited by John Bloom; music by Dominic Muldowney; produced by Sam Spiegel; released by 20th Century-Fox International Classics. At Cinema 2, Third Avenue and 60th Street. Running time: 95 minutes. This film is rated R.
Jerry ...Jeremy Irons
RobertBen Kingsley
EmmaPatricia Hodge

By VINCENT CANBY

Harold Pinter, the justifiably celebrated English playwright, has done a lot of film work, sometimes adapting his own plays ("The Caretaker," "The Birthday Party") and sometimes adapting the works of others ("The Servant," "Accident," "The French Lieutenant's Woman," among others).

However, nothing he has written for the stage has ever been as simply and grandly realized on the screen as his "Betrayal," adapted by him and directed by David Jones in a way that manages to find the cinema equivalents to what we call — rather lamely, I'm afraid — Pinteresque theater.

Its extraordinary stars are Jeremy Irons, Ben Kingsley (in a role that is about as far as he will ever get from "Gandhi"), and Patricia Hodge, a wonderful English actress, new to films, whose face seems to have been designed for the close-up that reveals secrets reluctantly. Among other things, "Betrayal" is a mystery story. It should also be pointed out that it was brought to the screen by the veteran Hollywood producer Sam Spiegel, more often identified with epics such as "Lawrence of Arabia" and "Nicholas and Alexandra."

●

Despite its antecedents, "Betrayal" is no filmed play. Though I didn't see the stage production when it was done on Broadway in 1980, this "Betrayal" is a riveting film that proceeds through the interlocking love lives of

Patricia Hodge

Ben Kingsley

Jeremy Irons

three special friends. They are Robert (Mr. Kingsley) and Emma (Miss Hodge), who are husband and wife, and Jerry (Mr. Irons), who was Robert's best man as well as his best friend since their college days. For seven of the nine years covered in the film, Jerry and Emma have been lovers.

Much has been made of the fact that "Betrayal" moves backward in time, beginning with a brief, infinitely sad reunion of Jerry and Emma two years after their affair has ended, and winding up nine years earlier, on the night of a drunken party during which Jerry, more or less under the nose of Robert, first declares his love for his best friend's wife.

Though the film moves backward through time, it doesn't have the lugubrious manner of an extended flashback. It moves forward from a sense of lovelessness and loss to discover, at the film's end, the initial ecstasy, which, knowing what we do, is all the more haunting.

I can't think of another recent film that is simultaneously so funny, so moving and so rigorously unsentimental. The writing is superb, and so quintessentially Pinter that it sometimes comes close to sounding like parody, though, in the entire screenplay, there's not one predictable line or gesture, the sort of thing that would expose the fake or the merely hackneyed. This is pure Pinter well served by collaborators.

The most visible of these are the three stars whose work is so closely integrated that it has the effect of a single, three-part performance. Mr. Irons's Jerry, a literary agent, is probably the most reckless and wrongly self-assured of the three friends. Mr. Kingsley's Robert, a book publisher, is the most profoundly sensitive and, eventually, most untrustworthy, and Miss Hodge's Emma the bravest.

The film is also full of vivid off-screen characters, including Judith, Jerry's wife, who has a full-time career as a doctor; an author named Casey who, at the beginning of the film, is writing tired if successful novels and, at the end is being talked about as the year's latest literary discovery, plus children of various ages, one of whom is the subject of one of the most moving monologues Mr. Pinter has ever written.

Mr. Jones, primarily a theater director and, for two years the artistic director of the repertory company of

the Brooklyn Academy of Music, has not only obtained remarkable performances from all of the actors, but he has also found a look and a manner that best suits the Pinter text. Everything in the movie — outside locations, interior sets, costumes, even the weather — looks realistic because it actually is, but, through some process of selection that I'm not sure I understand, it also suggests some other, more intense reality, which is the heart of Pinter theater.

•

Each aspect of the film is loaded with meanings and associations that creep up on you during the performance — even the title. At first "Betrayal" appears to be that of Emma and Jerry of Robert. However, as we slide back through time, Mr. Pinter reveals an entire series of deceptions, some of which are all the more heartless for being profitless and without motive. The pointless lie leaves the deepest wound.

"Betrayal" opens today at the Cinema 2, where, I hope, it will stay a long time and not be rushed into mass distribution. It should be allowed to take its time and, of course, ours.

1983 F 20, 78:1

THE PIRATES OF PENZANCE, direction and screenplay by Wilford Leach; director of photography, Douglas Slocombe; film editor, Anne V. Coates; music by Sir Arthur Seymour Sullivan; produced by Joseph Papp; based on the New York Shakespeare Festival Stage Production; released by Universal Pictures. At Cinema Studio Twin, 66th Street and Broadway; New Embassy 49th, at Seventh Avenue; Eighth Street Playhouse, west of Fifth Avenue, and other theaters. Running time: 112 minutes. This film is rated G.
The Pirate KingKevin Kline
Ruth ..Angela Lansbury
Mabel ..Linda Ronstadt
Major-GeneralGeorge Rose
Frederic ..Rex Smith
Sergeant ..Tony Azito
SamuelDavid Hatton, sung by Stephen Hanan

By JANET MASLIN

"The Pirates of Penzance" has been made into a cheerful movie, but it isn't nearly as deft or distinctive here as it was on stage. The principal cast is still on hand, and still a delight, with the felicitous addition of Angela Lansbury to a group already including Kevin Kline, Rex Smith, George Rose, Linda Ronstadt and Tony Azito. The same director, Wilford Leach, is also here, and he has moved from the stage to the screen less successfully than the players. Mr. Leach's stage production was buoyant and charming. But in

adapting it for film, he has too infrequently seen fit to leave well enough alone.

Visually, the movie is a sugarplum. Its first half takes place on a pastel beach behind which stretches a candy-colored vista — the kind of place where the Jolly Green Giant might spend his summer vacation. Arriving on these shores is the band of pirates, led by their dashing, wonderfully clownish Pirate King (Mr. Kline); the dewy-eyed male ingenue Frederic (Mr. Smith); the giddy band of maiden-only sisters who surround Mabel (Miss Ronstadt), who is herself the sweetest creature this side of Little Bo Peep, and the maidens' incomparable father, the modern Major-General, played by George Rose. Mr. Rose, who performs with impeccable polish, brings the only touch of true Gilbert-and-Sullivan delivery to this production.

•

Speaking of Gilbert and Sullivan, a much later scene has dueling pirates and policemen bursting in on the stodgiest possible production of "H.M.S. Pinafore," with Mr. Kline matching his sword against the orchestra conductor's baton. (And losing.) No one involved with this "Pirates of Penzance" ever intended a traditional Gilbert and Sullivan treatment, to be sure. But the irreverence seemed wittier and less broad on the stage than it does here, undermined as it is by awkward camera angles, fussy scenery and a general loss of spontaneity. Spontaneity, or at least the illusion of it, was one of the stage production's greatest assets.

Here, Mr. Leach seldom films the cast from the medium-long angles that would be most effective. Mr. Kline, who scampered across the stage like a swashbuckling mountain goat, here accomplishes feats that

even a lesser performer could manage with the help of a good editor; he remains a funny and fiery hero, but the excessive cutting and close-ups do him an injustice.

In general, there are too many attempts to single out particular performers when ensemble acting ought to prevail. That doesn't mean the leading players aren't appealing and accomplished, because they are. But they all work better here as part of the group than they do individually, and Mr. Leach hasn't given them enough opportunity to intermingle.

•

The movie is best at its most full-bodied. Especially rousing are the group rendition of "With Catlike Tread" (which will always be better known as "Hail, Hail, the Gang's All Here" in some quarters), Mr. Rose's show-stopping entrance, "A Policeman's Lot Is Not a Happy One," the pretty duets pairing Miss Ronstadt and Mr. Smith, and any exchange featuring Miss Lansbury. Some of the less melodic, more precious scenes are notably weaker. It doesn't help that the color can fade unexpectedly from pink to green, and that there are stretches during which those not fully conversant with the operetta will have difficulty making out its text.

"The Pirates of Penzance" opened on Friday at the Eighth Street Playhouse, Cinema Studio and other theaters. The Times was unable to review it then, since Universal Pictures declined to make it available in advance.

1983 F 20, 80:1

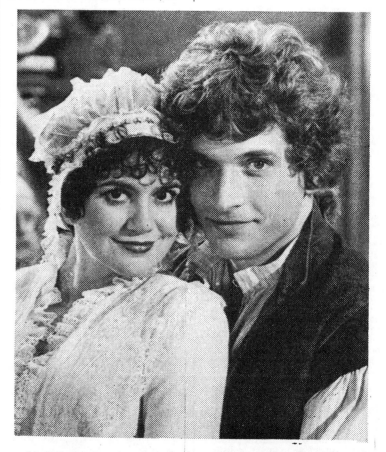

Linda Ronstadt and Rex Smith in the film, "The Pirates of Penzance."

FILM VIEW

JANET MASLIN

'The King of Comedy' Delivers a Passionless Sting

Rupert Pupkin: That's the name of the main character in Martin Scorsese's "King of Comedy," though people sometimes call him Mr. Pipkin or Mr. Pumpkin by mistake. On the basis of his name alone, Rupert inspires a mild disdain; in the flesh, he has much the same effect. He's a pesty, obsessive autograph hound who lives for show business and show business alone, and "The King of Comedy" is his story. But why?

Movie heroes needn't always be likable, and no one has demonstrated that more emphatically than Mr. Scorsese. Nearly all of his films have revolved around largely unsympathetic male characters of violent, unstable temperament, and that is particularly true of the films on which he has collaborated with Robert De Niro. The jittery hoodlum of "Mean Streets," the mercurial big band musician of "New York, New York," Jake LaMotta ("Raging Bull") and Travis Bickle ("Taxi Driver") all share a fiery, unpredictable nature that is fascinating without necessarily being endearing. In these films, the viewer needn't like or sympathize with the leading character to be swept up in his story. Mr. Scorsese's urgent, visceral style, and his and Mr. De Niro's intensity, more than take care of that.

But "The King of Comedy" marks something of a departure, since it tells a story in which the audience can't really become involved, and toward which both director and star demonstrate a certain detachment themselves. As such, it's a provocative but relatively dispassionate addition to the Scorsese-De Niro oeuvre. Rupert Pupkin is first seen as a fan waiting for a talk show host called Jerry Langford (Jerry Lewis) to leave his studio and expressing his contempt for the throngs of other fans around him. "I'm really not that interested, it's not my whole life," sniffs Rupert to someone who wants to make an autograph trade. It isn't true. Being a fan, or at least being obsessed with fame, really *is* Rupert's whole life, and he tracks his prey relentlessly, no matter what the obstacles. Mr. Scorsese ironically accompanies the film's credits with a recording of "Come Rain or Come Shine."

• • •

What drew Mr. Scorsese to a character like Rupert? Probably not the humor alone, since "The King of Comedy" is sometimes funny but never a full-fledged comedy by any means. Mr. Scorsese has said in recent interviews that he sees something of himself in both Rupert and Jerry, who respectively suggest the hustling, up-and-coming artist he . .s in the early stages of his career and the very successful one he is now. Perhaps that explains why "The King of Comedy" never aligns itself on the side of either one of them, and never makes either one a fully-drawn character. Or it might be that the show business milieu here calls for slick, superficial characters who very intentionally have no more humanity than these.

At the beginning of the "The King of Comedy," Rupert hops into Jerry Langford's limousine, bloodying himself slightly in the process and earning Jerry's monogrammed handkerchief as a trophy. The brief conversation he has with Jerry (Rupert says he's at the bottom, Jerry tells him "that's a perfect place to start") convinces Rupert that he can insinuate himself onto The Jerry Langford Show, where he hopes to do a guest shot as a stand-up comic. Subsequent uninvited visits to Jerry's office ("Is that cork?" Rupert asks a receptionist, trying to kill time by discussing the ceiling in the waiting room) make his chances look pretty dim.

When Rupert arrives as an uninvited guest at Jerry's weekend house, the chilly reception he gets from Jerry makes it clear that Rupert's idea of friendliness isn't going to get him anywhere. "That's how you are when you reach the top?" Rupert asks, upon being evicted from the place. "No, I was that way *before*," screams Jerry. Rupert vows to work 50 times harder than Jerry and become 50 times more famous. "Then you'll have idiots like *you* plaguing your life!" Jerry retorts. So Rupert is left with

what looks, at least to him, like the only remaining alternative: kidnapping Jerry, and demanding a guest shot on the Langford show as his ransom.

• • •

"The King of Comedy" doesn't have the kind of psychological detail that "Taxi Driver" did, possibly because there's less here to unravel. Travis Bickle, like Rupert, had a funny name too, but in that case it served to indicate that Travis might have grown up a misfit and an outsider. Travis's letters, his journal entries and the contents of his apartment provided something of a psychological profile, whereas Rupert Pupkin's lair is quite literally a joke. His room is ingeniously fitted out with cardboard cutouts of Jerry Langford, Liza Minnelli and a large, laughing audience, so that Rupert can plop down in the host's chair and pretend there's a talk show going on. "Gotta catch a bus — good luck in Rio," says Rupert to the photograph of Liza, excusing himself from one of these encounters. In scenes like this, Rupert is certainly entertaining, but he's no more flesh-and-blood than his cardboard companions.

Jerry Lewis's Jerry Langford is one of the best things in "The King of Comedy," but he serves to underscore Rupert's one-dimensionality. Unlike Rupert, Jerry does have a sympathetic side, especially when he's being hounded mercilessly or trussed up in masking tape. And he's lonely at the top; even though he's so famous he very nearly generates riots when he walks the streets of New York (this is one of the film's less believable notions), he lives a solitary life in a cheerless modern apartment. If Jerry didn't figure prominently in the movie, if he were seen as an object, the audience might be forced more emphatically to share Rupert's obsession. But Jerry is sufficiently present to make himself a lot more understandable than Rupert, and the audience isn't apt to identify strongly with either of them.

Have Mr. De Niro and Mr. Scorsese approached this character as passionately as they've approached others in the past? It doesn't seem so, thanks to the broad mockery Mr. De Niro brings to the performance. His imitation of a hammy stand-up comedian's mannerisms is uncanny, but it's unmistakably an imitation; this appears to be a character he impersonates rather than inhabits. When Rupert, trying to impress Rita (Diahnne Abbott), lets him leaf through his autograph book and declares "Every King needs a Queen — I want you to be mine," Mr. De Niro plays the scene with hand-waving motions and a smirk. In moments of boastfulness Rupert approaches self-parody, which makes him something new for Mr. De Niro, whose absolute earnestness has been such an important aspect of his past performances. His work in "The King of Comedy" is extremely skillful as far as it goes. But it doesn't go far enough to make Rupert a character rather than a caricature.

Though "The King of Comedy" seems less substantial than past De Niro-Scorsese collaborations, it's a funny, stinging film in which there's much to enjoy. Miss Abbott, Mr. De Niro, Mr. Lewis and the unforgettably alarming Sandra Bernhard (as a fan even crazier than Rupert, looking like an enraged ostrich) deliver fine performances, and the film's satirical edge can indeed be cutting. The larger point of Rupert's feat may be lost in a

heavy-handed ending, but the tiny nuances of his existence on the fringes of show business are very nicely drawn.

Paul D. Zimmerman's screenplay includes a number of fantasy sequences, in which Rupert and Jerry are stars of equal magnitude sharing show-biz banter at Sardi's, or some comparably glamorous watering hole. One fantasy sequence has Jerry telling Rupert how talented he is, pronouncing Rupert's jokes "marvelous." And the network office of Jerry's television show is sketched wittily here, especially in the person of Shelley Hack, playing a beautiful yet impervious blonde who recalls the one Cybill Shepherd played in "Taxi Driver." Miss Hack's self-confident stride, most familiar from her Charlie perfume ads, is used perfectly here as she marches across the spacious reception area, hands Rupert his audition tape, and tells him sweetly but implacably to go home. She's the archetypical show business functionary, with a gorgeous smile that's every bit as insincere as Rupert's own.

The most outrageous touch of show business satire may be Rupert's dream of marrying Rita on network television, with Jerry and Dr. Joyce Brothers as witnesses and a justice of the peace who says, "We'll be back to marry them after this word." Of course, this really did happen, to Tiny Tim and Miss Vicki on The Tonight Show. The territory "The King of Comedy" explores is a realm where truth really is stranger than fiction. ∎

1983 F 20, II:19:1

Movie Mania

CAMERA BUFF (Amator), directed by Krzysztof Kieslowski; screenplay (Polish with English subtitles) by Mr. Kieslowski with additional dialogue by Jerzy Stuhr; photography, Jacek Petrycki; edited by Halina Nawrocka; music by Krzysztof Knittel; production company, the Polish Corporation for Film Production Zespoly Filmowe, TOR unit. At the Film Forum, 57 Watts Street. Running time: 112 minutes. This film has no rating.
Filip Mosz ..Jerzy Stuhr
Irka ..Malgorzata Zabkowska
Anna WioderczykEwa Pokas
DirectorStefan Czyzewski
Osuch ..Jerzy Nowak
Witek ..Tadeusz Bradecki
Piotrek KrawczykMarek Litewka
Television Directors
..........Boguslaw Sobczuk and Andrzej Warchol
Krzysztof ZanussiKrzysztof Zanussi

"Camera Buff" was shown as part of the 1980 New York Film Festival. Following are excerpts from a review by Vincent Canby in The New York Times of Oct. 3, 1980. The film opened yesterday at the Film Forum, 57 Watts Street.

KRZYSZTOF KIESLOWSKI'S "Camera Buff," the new Polish film that shared the top prize at this year's Moscow Film Festival, is a comedy about the transformation of a nice, happily married young man, who asks for nothing more from life than a little peace and quiet, into a raging, obsessed movie maker.

"Camera Buff" touches some of the same points explored far more perceptively and hilariously in Jim McBride's American classic, "David Holtzman's Diary." It's about Filip (Jerzy Stuhr), a purchasing agent for a small factory in provincial Poland, who buys an eight-millimeter movie camera to film his new baby daughter but who gets sidetracked into making a film about his factory's 25th-anniversary celebration.

•

From there, it's only a matter of months, and several more movie shorts, before Filip has been abandoned by his neglected wife, is arguing film esthetics at Lodz and having doubts about the extent to which he should pursue "truth" in his documentaries. One of Filip's films, which exposes management sloppiness, results in the wrong people being dismissed.

Like many movies about movie nuts who are as committed as Filip, "Camera Buff" manifests a strong sense of self-importance. It seems to share Filip's conviction that there is something magical about the camera itself, sometimes confusing the importance of the object photographed with the camera that does the photographing.

Mr. Kieslowski appears to suggest that art — in this case movie making — must be a process by which the artist consumes the raw materials of his experience and then spits them out as finished art, leaving the people around him in the state of gnawed beef bones. This is a vast oversimplification of the creative process and is probably only applicable, really, to the second-rater.

•

The director is on much firmer ground when he is satirizing the jargon of criticism and the clichés of film making. The film is funniest when it shows us Filip escaping from the various personal crises in his life by stepping outside himself and seeing it all as something to be caught in a view-finder.

1983 F 24, C17:1

Save the Hotel

STREET MUSIC, directed by Jenny Bowen; screenplay by Miss Bowen; director of photography, Richard Bowen; edited by Diana Pelligrini; music by Ed Bogas and Judy Munsen; produced by Mr. Bowen and Lawrence Berteau; presented by Pacificon Productions. At the Quad, 13th Street west of Fifth Avenue. Running time: 93 minutes. This film is rated R.

Sadie	Elizabeth Daily
Eddie	Larry Breeding
Sam	Ned Glass
Mildred	Marjorie Eaton
Jasper	W. F. Walker
Hattie	Miriam Phillips
Monroe	D'Alan Moss
Motion Slim	Sam Morford
Mr. Potts	John Romano
Mr. Simmons	David Parr
Julio	Robert Diaz
Alejandro	Osvaldo Villazon 3d
Mrs. Nuncio	Carmen Carillo

By VINCENT CANBY

"STREET MUSIC" is a comparatively elaborate first feature by Jenny Bowen, a San Francisco-based independent film maker, about some all-too-colorful characters in San Francisco's "tenderloin" district.

The principal setting is the ancient Victory Hotel, a most convincing flea-bag that has been condemned by the city to make way for a parking lot. The residents of the Victory, most of whom look authentic, are assorted pensioners and other elderly loners who are too ill equipped to deal with life.

They also include Sadie (Elizabeth Daily), a bouncy little street singer with a big voice, and her lover Eddie (Larry Breeding), a young man who drives a tour bus by day and, by night, tells good-bad jokes to the folks in the lobby, attends birthday parties for hotel cats and, on occasion, makes sure that the old people are securely tucked into their beds.

Miss Bowen's direction of the actors and her secure knowledge of the way the film should look are much more effective than her screenplay, which

Elizabeth Daily

contains isolated moments of humor and pathos but is more frequently too sentimental for its own serious purposes. One believes the expressions on the faces of the characters but not much of what they are required to say.

Central to the film's problem are Sadie and Eddie who, apparently, have chosen to live at the Victory because they are fond of the residents but who then make no attempt to join the others in a doomed campaign to save the place from the wreckers. Eddie's turnabout, which is the film's climax, seems to have been delayed artificially for plot purposes only.

•

Miss Daily, who looks more like Pia Zadora than may be good for her career at this point, and Mr. Breeding seem to be energetic, talented performers. Among the supporting actors, the most noteworthy are D'Alan Moss, as the hotel's fiery young desk clerk, who attempts to turn the "Save the Victory" campaign into a political issue, and Ned Glass, Marjorie Eaton and W. F. Walker, as the most vocal and appealing of the Victory's clientele.

"Street Music" opens today at the Quad Cinema.

1983 F 25, C8:1

Uncommon Trivia

HOLLYWOOD OUT-TAKES & RARE FOOTAGE, a compilation of film clips and interviews of screen idols of the 30's, 40's and 50's. At the Waverly 1, Avenue of the Americas and West Third Street. Running time: 83 minutes. This film has no rating.

THE material contained in "Hollywood Out-Takes & Rare Footage," which opens today at the Waverly 1, is, with the exception of one sequence, strictly for collectors of movie trivia. The exception is a sequence shot for W. C. Fields's classic short "The Dentist." The reason it was never used is self-evident: By early-30's movie standards, it is obscene, as well as hilarious.

A small part of the film is composed of fluffs in which stars like Kay Francis, Carole Lombard, Lou Costello and Humphrey Bogart forget their lines during the shooting of a scene and swear mildly. The rest of the film is devoted to rather ordinary newsreel footage, including the 1939 Oscar awards ceremony and the Hollywood

premiere of the 1954 version of "A Star Is Born," along with do-gooding institutional shorts in which Shirley Temple talks on behalf of the Red Cross, Bette Davis on behalf of war bonds and Frank Sinatra on behalf of religious tolerance.

The appearance of "Mommie Dearest" has added a certain dark humor to a short called "At Home With Joan Crawford," in which the late star solicits contributions for a children's cancer fund. It opens with Miss Crawford saying sweet dreams to some off-screen offspring, closing their bedroom door and decending a staircase to speak directly to the camera in her most gracious-lady manner. As she reminds us that children, after all, are a parent's most precious possessions, all we can think of are those poor kids upstairs, tied to the bedposts.

Vincent Canby

1983 F 25, C8:5

PRIVATE LIFE, directed by Yuli Raizman; screenplay (Russian with English subtitles) by Anatoly Grebnev and Mr. Raizman; cinematography by Nikolai Olonovsky; a Mosfilm Production; an IFEX Films Release in cooperation with Sovexportfilm. At the Carnegie Hall Cinema, Seventh Avenue and 56th Street. Running time: 103 minutes. This film has no rating.
WITH: Mikhail Ulanov, Iya Savvina, Irina Gubanova, Evgeni Lazarev, Alexei Blokhin, Tatiana Dogileva

By JANET MASLIN

Yuli Raizman's "Private Life" offers as detailed a look at ordinary Soviet life as any contemporary Soviet film that has yet been seen here. In addition, it's an effective and well-acted drama.

It concerns a factory executive who is suddenly replaced by a former protégé when his factory is combined with another, and who is then forced to retire. This leads him to reacquaint himself with the members of his extended family, and to resume the routine of the title, which he initially finds very difficult. Mr. Raizman, who directed and co-wrote the film and who is 80 years old, presents these events with a gentle knowingness, and directs them in a plain and forthright style.

•

"Private Life," which opens today at the Carnegie Hall Cinema and is one of this year's Academy Award nominees as best foreign-language film, seems almost deceptively simple. Yet it manages to sketch a complex family portrait, as Sergei Abrikosov (Mikhail Ulyanov) successively encounters the various relatives who share the large, gloomy Moscow apartment that one character deems "a palace."

The family includes Sergei's second wife, who is pleasant and intelligent but so remote from her husband that she always asks him to turn away when she undresses; his two sons, neither greatly respectful of their father; a daughter by his first marriage, who is now a very hard-edged doctor, and grandchildren who don't much want to play with their grandpa. Sergei has been so occupied with his career, the film reveals, that he has quite forgotten how to get along with any of these people. In addition to rekindling these connections, he also pays several poignant visits to a former secretary, whose own story is as affecting and as ruefully modern as any found within Sergei's family.

•

Structurally, the film is a succession of encounters that are individually compelling, perhaps more so than

the conclusion toward which they build. The actors are uniformly good, working in a quietly understated style and allowing center stage to Mr. Ulyanov, who brings a gentle dignity to his performance. In appearance, the film seems almost a documentary, with street and indoor settings (Sergei's office, Moscow restaurants, the family apartment) that reveal much about how life must be conducted in these places. Undoubtedly, Sergei's status as an important and successful man make these scenes less than typical, but they always seem engrossing and real.

"Private Life" isn't a showy film, but it's a sensitive and substantial one. Its Oscar nomination is well deserved.

1983 F 27, 45:1

KAMIKAZE '89, directed by Wolf Gremm; screenplay (German with English subtitles) by Robert Katz and Mr. Gremm, from the novel "Murder on the 31st Floor" by Per Wahloo; director of photography, Xaver Schwarzenberger; edited by Thorsten Nater; music by Edgar Froese; produced by Regina Ziegler; a Regina Ziegler/Trio Film/Oase Film Production. At the Waverly, Avenue of the Americas and West Third Street. Running time: 106 minutes. This film has no rating.

Police Lieutenant Jansen	Rainer Werner Fassbinder
Anton	Günther Kaufmann
Blue Panther	Boy Gobert
The Police Chief	Arnold Marquis
The Nephew	Richy Müller
Barbara	Nicole Heesters
The Personnel Director	Brigitte Mira
The Vice-President	Jörg Holm
Zerling	Hans Wyprächtiger
Elena Farr	Petra Jokisch
Police Doctor	Ute Fitz-Koska
Gangster	Frank Ripploh
Policeman	Hans-Eckardt Eckardt
Plainclothesman	Christoph Baumann
Nurse	Juliane Lorenz
Policewoman	Christel Harthaus
Weiss	Franco Nero

By VINCENT CANBY

The late Rainer Werner Fassbinder appeared in a number of his own films, mostly in small roles, though he was the star of his "Fox and His Friends," and his performance in "Katzelmacher," one of his earliest and most characteristic works, was a key to that film's success.

Now he is the main reason to see Wolf Gremm's "Kamikaze '89," in which he stars as Jansen, a taciturn, tough but humane police lieutenant in a futuristic Germany. The time is 1989, when Germany has become the richest of nations and all economic, social and political problems have been solved. To emphasize his own nonconformist tendencies, Jansen, from start to finish, wears a memorably awful, simulated leopard-skin suit and a bright red shirt.

•

You don't know your science-fiction very well if you don't immediately suspect that life is not great in this chilly paradise, a place that has prohibited the use of alcohol but is so boring that it drives its citizens to drink.

"Kamikaze '89," which opens today at the Waverly Theater, was completed in 1982, shortly before Fassbinder went on to direct what were to become his last two films, "Veronika Voss" and "Querelle," which is still to be released in this country.

"'Kamikaze '89" will be of far more interest to people fascinated by Fassbinder's extraordinary career than to casual filmgoers. It suggests a curious but not surprising blend of influences, including Fassbinder's films, Jean-Luc Godard's "Alphaville," Fritz Lang's "Dr. Mabuse" and Louis Feuillade's virtually endless silent serial "Les Vampyres."

Though puffily overweight, his eyes mere slits in folds of skin, Fassbinder remains an impressive, witty screen

Rainer Werner Fassbinder

Barbara	Clio Goldsmith
Loriol	Jacques François
Charlotte	Cecile Magnet
Emir Faycal	Renzo Montagnani
Laurent	Remi Laurent
Sandrine	Leila Frechet
Andre	Henri Guybet
Jennifer	Yolande Gilot
Umberto	Diulio Del Prete

The title of "The Gift" refers not to a thing but to a person. She is a high-priced call girl hired as a going-away present for a retiring bank employee (Pierre Mondy) by his friends, who hope this will put spice back into his marriage (even though he is married to Claudia Cardinale, who does not lack for spice). Well, look, either you find this an enchanting notion or you don't. In the former case, you're probably an admirer of the school of French bedroom farce to which "The Gift" is an unsurprising but good-natured addition, and perhaps you will enjoy this film for the three S's that are its staples: scenery, silliness and skin. Otherwise, better not bother.

Gregoire Dufour (Mr. Mondy) begins the film at the French bank from which he is retiring, but he soon embarks on a last business trip to Milan. On the train, he is flirted with by the leggy and alluring Barbara (Clio Goldsmith), who has been told where to find Gregoire, and told to behave as if she is madly taken with him. Barbara just about kidnaps Gregoire, sidetracking him to Venice instead of Milan and installing him in a grand hotel that happens to be filled with a number of her jet-set friends — and quite a few of *his*. The hotel eventually becomes jammed with secondary characters, and the expected series of wild coincidences ensues. On more than one but less than five occasions (I lost count), someone is dunked playfully into the Grand Canal.

•

"The Gift," which opens today at the Paris Theater, is frenetic and reasonably cheerful, but it's also uneven. Mr. Mondy carries the film ably, as the bourgeois businessman whose raffish streak blossoms with the call girl's encouragement. And Miss Cardinale is so witty and beautiful she makes the premise almost impossible to believe. Miss Goldsmith is beautiful, too, but beyond that she isn't more than pleasant; her performance works in brief installments, but her long, conversational scenes with Mr. Mondy become very slow. The director, Michel Lang, is more adept at flinging the characters together for one mad misunderstanding after another than he is at sustaining any given mood.

The funny gags here outnumber those that are questionable, but the dopey ones are dopey indeed. Among

Clio Goldsmith

these are jokes about a cross-eyed waiter, a girl who is plain, a man who keeps fussing with his toupee and later loses it, and a traveling sheik and his sex-starved harem.

Janet Maslin

1983 F 27, 48:5

presence as he plays out this satiric charade about a plot to bomb the ultramodern headquarters of the conglomerate that controls all media in this perfect Germany. The conglomerate, which sponsors things such as laughing contests on television to control the minds of the people, is run by a cold fellow known as the Blue Panther.

Is this bomb-plot genuine or is it a ruse to deflect attention from some more dastardly business? One needn't worry too much about such details, though there is a subplot about a plan to destroy the country's last few remaining intellectuals.

The focal point of the film is Fassbinder's easy, neo-Wellesian control of every scene in which he appears — a control that has as much to do with wisdom as with weight.

Mr. Gremm's screenplay, written with Robert Katz and based on Per Wahloo's novel "Murder on the 31st Floor," has moments of mild humor ("There's a 50-50 chance that our man is a woman," says one detective to another), but the movie is more interesting as something to look at than as something by which to be mystified or edified.

It is weirdly handsome, having been beautifully photographed by Xaver Schwarzenberg, who did Fassbinder's "Lola" and "Veronika Voss," and it is punctuated by good supporting performances by Gunther Kaufmann, a Fassbinder veteran who also has put on weight; Franco Nero, who appears briefly as one of the possible conspirators, and the indomitable Brigitte Mira, of Fassbinder's "Mother Kusters Goes to Heaven" and "Chinese Roulette," as one of the Blue Panther's supposedly loyal lieutenants.

Other brief appearances are made by Frank Ripploh, the director and star of "Taxi zum Klo," and Juliane Lorenz, Fassbinder's longtime friend and film editor. However, you have to look fast to spot them.

"Kamikaze '89" is a footnote to film history.

1983 F 27, 48:1

THE GIFT, directed by Michel Lang; screenplay and dialogue (French with English subtitles) by Mr. Lang, based on the play "Bankers Also Have Souls" by Vaime and Terzoli; director of photography, Daniel Gaudry; music by Michel Legrand; produced by Gilbert de Goldschmidt; presented by the Samuel Goldwyn Company. At the Paris, 58th Street west of Fifth Avenue. Running time: 105 minutes. This film is rated R.
Gregoire .. Pierre Mondy
Antonella Claudia Cardinale

FILM VIEW

VINCENT CANBY

Directors Come to Grips With History

As history reinvents itself, so have filmmakers always explored ways in which to interpret those reinventions. From D.W. Griffith to Sergei Eisenstein, from Abel Gance to Cecil B. DeMille, from Erich von Stroheim to Darryl Zanuck, historical films, including two especially successful current releases, have been designed to exploit, teach, amuse, bore and titillate us. Some work in thoroughly conventional ways, as Richard Attenborough's "Gandhi," and some so obliquely that history would appear to be a second thought, as in Ettore Scola's "Nuit de Varennes," which is actually about nothing less than the entire French Revolution.

With Ben Kingsley's beautifully simple, modest performance in the title role, "Gandhi" is a respectful biographical film, produced on a panoramic scale that attends to major events and dates. It illustrates history in the manner of a well-researched textbook that means exactly what it says, its sincerity uncontaminated by the slightest hint of irony.

Because the subject is truly epic and inspiring, it's reassuring that the public is responding to "Gandhi" so enthusiastically, many people seeming to think of it as another "Lawrence of Arabia," though what the saintly Gandhi and the possibly bogus T.E. Lawrence — or their films — have in common is beyond my comprehension.

"La Nuit de Varennes" is equally epic, but the physical scale is small, its manner contemplative, skeptical and sometimes tumultuously funny. Although this may sound like heresy, it's also a far more interesting film than "Gandhi," which has the air of an important news event, something that is required reading.

"Gandhi" is a portrait of an extraordinary man who changed history, though not quite as much as he had hoped. "La Nuit de Varennes" is a consideration of a society in the process of extraordinary change. It neither celebrates nor scoffs but says that this is possibly the way things were, and maybe still are, and one might profitably think upon them.

In the manner of "Travesties," Tom Stoppard's rambunctious 1975 stage play that imagined a meeting of James Joyce, Lenin and Tristan Tzara in Zurich shortly before the Russian Revolution, and of E.L. Doctorow who brought together all sorts of unlikely historical figures in "Ragtime," Mr. Scola and the late Sergio Amedei, who collaborated on the screenplay, look at the French Revolution through the eyes of several historical figures who probably never met, as well as the eyes of several purely fictional characters.

The time is the night and the day in June 1791, two years after the attack on the Bastille, when Louis XVI, Marie Antoinette and their small entourage made their unsuccessful flight from Paris and the gathering force of the French Revolution, which is still the most momentous single event in the history of the modern world.

"La Nuit de Varennes" isn't about the unfortunate, usually underrated Louis and his doomed family. In fact, we get only a glimpse of them at the very end of the film, and then only from the knees down as they are spied on from a stairway in their captivity in a rude Varennes inn. This is as it should be. The particular personalities of Louis and Marie Antoinette are beside the point. They are important only as representations of a complex system, which, I suppose, is why Louis's legs are played by those of Michel Piccoli and Marie Antoinette's feet by those of Eleonore Hirt.

• • •

The principal characters in "La Nuit de Varennes" are an aging, rueful Casanova (Marcello Mastroianni), trying vainly to escape both the revolution in Paris and his exhausting reputation as the world's greatest, most indefatigable lover; Nicolas Edme Restif de la Bretonne (Jean-Louis Barrault), a lowborn writer notorious for pornographic novels that have earned him a reputation as "the Rousseau of the gutter" and "the Voltaire of chambermaids," and Tom Paine, the English-born, American pamphleteer who journeyed to France to urge on the Revolution and later almost became one of the victims of The Terror.

The fictional characters include the Countess Sophie de la Borde (Hanna Schygulla), the passionately devoted lady-in-waiting to the queen; her foppish hairdresser (Jean-Claude Brialy); an Italian opera singer (Laura Betti), a rich bourgeois businessman (Daniel Gelin), and a beautiful widow (Andrea Ferreol), who would like to assuage her grief with Casanova who, though ever gallant, is clearly incapable of saying yes to anybody.

In various combinations and coaches, these characters pursue the fleeing royals, each for his own purpose, some, like Casanova, by accident. Tom Paine and Restif

de la Bretonne, being professional witnesses to history, simply want to know what happens next, while the countess has devoted herself to serving the king and queen in exile if necessary.

In the course of the journey each reacts in unexpected ways to the realization that what he is seeing is not simply another failed royal maneuver but the beginning of a new age that is suddenly as awesome to them as was the news to us of the 1945 bombing of Hiroshima.

Mr. Scola, the Italian director who has made some good films ("We All Loved Each Other So Much," "A Special Day") and some that were not so hot, has never been in better form. Though he is a card-carrying Communist, he doesn't deal in predictable gestures. The expressions on the faces of the members of the Varennes mob in their time of triumph are not necessarily terrifying, but they do reflect something of the uncontrollable momentum of all human events. As such they make a scathing comment on the initial optimism of the early supporters of the Revolution, especially those intellectuals and well-meaning, bourgeois liberals as exemplified by Madame Roland, who wouldn't shut up even on the scaffold ("Oh Liberty! What crimes are committed in thy name!").

All great films are in some fashion perfectly integrated entities. It isn't the subject matter that makes Abel Gance's "Napoleon" the classic it is. Rather, it's Gance's unembarrassed patriotic fervor, evident in virtually every scene, camera angle and frame of that film, which is as rousing as "La Marseillaise" and, possibly, as potentially inflammatory in behalf of wrongheaded causes. Sergei Eisenstein's two-part "Ivan the Terrible" is a nearly overwhelming cinematic experience, as well as a somewhat frightening one, not because of the nature of Ivan but because the film appears to have been composed with the furious concentration of a man desperate to understand his subject and himself and to reinstate his formidable reputation as a filmmaker.

There is, of course, no such thing as a "true" historical film. Every film is, by the nature of its creation, fiction, whether based on fact or fancy. About as close as anyone has come to the purely historical in filmmaking are those austere "teaching films" made for television by the late, great Roberto Rossellini. These are films so totally devoted to the intellectual struggles and accomplishments of their subjects — Socrates, Louis XIV, the Medicis — that the intensity of Rossellini's preoccupation becomes the actual style of the films, which is minimal.

Watching Mr. Attenborough's "Gandhi," I kept thinking of Rossellini and of how he might have presented this remarkable figure. Certainly it would have been with a minimum of spectacle and conventional sentiment. The simplicity of Gandhi, his rigorous and constant struggle with appetites, his absolute dedication to an ideal, no matter how elusive, would, I suspect, have resulted in a Rossellini film in which the camera might never have moved an inch. Even small adjustments in image or lighting might be interpreted as representing all of those frivolous habits and manners that Gandhi so steadfastly denied himself. However, such a film would probably have been seen by only a few people, and those few would be already committed to the subject.

The Attenborough "Gandhi" will reach a far larger audience and, considering its essential earnestness, that's all to the good. The problem, though, is that all films about saintly men tend to look alike, even though the men themselves may be radically different sorts. That's one of the limitations of what is called the "grammar" of conventional filmmaking. We are shown saintliness not in terms of ideas but in terms of far more easily dramatized scenes of confrontation and physical courage.

Mr. Scola's "Nuit de Varennes" has far more in common with Warren Beatty's "Reds" than it does with any other recent historical film, if only because it is as much concerned with one's awareness of history as with the events being recalled. "Reds" is memorable not because of the love story of John Reed and Louise Bryant or because of the Russian Revolution, the most important political event since the French Revolution. It comes to life through the appearances of those real-life "witnesses," whose lined, aged faces and frequently contradictory recollections emphasize not only the passage of time, the waning of aspirations and the confusion that is truth, but also the noble though ephemeral nature of all human endeavor.

This is the most moving aspect of "La Nuit de Varennes," which is acted to the hilt by everyone in it. Mr. Keitel looks a little young and wide-eyed to be the Tom Paine of 1791, when Paine was in his 50's. However, Paine was then observing the Revolution, not yet attempting to participate in it, as when he later became a member of the Paris Convention toward the end of 1792.

Mr. Mastroianni is superb in scene after scene of differing moods. There is one cherished moment when the tired but still game figure of Casanova, walking-stick in hand, his powdered face not in the best of condition, is seen climbing a wooded hill with Laura Betti's opera singer, the two of them singing in imperfect harmony Leporello's "catalogue aria" from "Don Giovanni," which, Casanova admits, he gave Mozart some help with.

Miss Schygulla is magnificent in the film's penultimate sequence, when she finally realizes that the royal family is lost, a scene so beautiful that one has no idea how it can be topped until we see the very end: The wise, amused, sarcastic old Restif de la Bretonne, who has been watching a magic show of scenes of the Revolution, in a carnival booth on the quay across the Seine from Notre Dame, turns away and, very slowly, climbs up the steps up to the self-important bustle of the Left Bank Paris of today. ∎

1983 F 27, II:1:1

Stage Within a Set

PROVINCIAL ACTORS, directed by Agnieszka Holland; screenplay (Polish with English subtitles) by Miss Holland and Witold Zatorski; director of photography, Jacek Petrycki; music by Andrzej Zarycki; produced by the Polish Corporation for Film Production, Zespoly Filmowe, X Unit. At the Film Forum, 57 Watts Street. Running time: 121 minutes. This film has no rating.
KrzysztofTadeusz Huk
Anka ...Halina Labonarska
The directorTomasz Zygadlo
Krystyna ..Ewa Dalkowska
WITH: Iwona Biernacka, Slawa Kwasniewska, Jerzy Stuhr, Kazimiera Nogajowna, Janina Ordezanka, Krystyna Wachelko-Zaleska

By JANET MASLIN

AGNIESZKA HOLLAND'S "Provincial Actors" concerns a dreary Polish theatrical troupe as it stages Stanislaw Wyspianski's "Liberation," debating each nuance of the production with the utmost self-importance.

The play can have more than one meaning, one actor cautions, and "We must be sure it doesn't end up neither one nor the other." On another occasion, a member of the troupe declares, "We must know what we want to convey!" "My idea," another performer later announces, "was to emphasize the borderline between acting and the private self." To all of this weighty discussion, there is a good deal more solemnity than substance.

Miss Holland, who has worked with Andrzej Wajda and Krzysztof Zanussi and whose third feature this is, attempts to interweave the problems and ambitions of the various performers, playfully illustrating their amateurishness while also considering the serious implications of their work. However, she approaches this clumsily, and with a surprisingly heavy hand. On more than a few occasions here, a bold chord on the soundtrack will accompany one melodramatic event or another, and the film's key occurrences are awkwardly presented.

"Provincial Actors," which is at the Film Forum, also concerns the troubled marriage of Krzysztof (Tadeusz Huk), the troupe's leading man, and his wife, Anka (Halina Labonarska), who appear to loathe each other to a phenomenal degree. Anka buys a new negligee; Krzysztof ignores her when she wears it; Anka throws the negligee in the trash. Another domestic quarrel is triggered when Anka complains about her husband's bathroom habits and table manners. On yet another grim evening, Krzysztof is unhelpful as Anka mourns the loss of her cat, who has jumped out the window. Now the cat lies on the bed, between the unhappy lovers. As uses for a dead cat go, this one seems particularly uninspired.

1983 Mr 2, C20:5

Tale of Two Wives

TENDER MERCIES, directed by Bruce Beresford; written by Horton Foote; director of photography, Russell Boyd; edited by William Anderson; music by various composers; produced by Philip S. Hobel; released by Universal Pictures. At Loews Tower East, 72d Street and Third Avenue. Running time: 93 minutes. This film is rated PG.
Mac SledgeRobert Duvall
Rosa Lee ..Tess Harper
Dixie ...Betty Buckley
Harry ..Wilford Brimley
Sue Anne ..Ellen Barkin
Sonny ...Allan Hubbard
Robert ..Lenny Von Dohlen
Reporter ..Paul Gleason
Lewis MenefeeMichael Crabtree
Reverend HotchkissNorman Bennett
Larue ...Andrew Scott Hollon

By JANET MASLIN

WHAT better proof can there be of the distinctiveness of Australian filmmaking than "Tender Mercies," a film by Bruce Beresford that manages to be thoroughly Australian though it features Texas settings and an American cast? Mr. Beresford, the director of "Breaker Morant," has brought a hauntingly spare look to this story, which is set on a prairie as endless and barren as Australia's. And the characters are as silent and unyielding as the landscape. Indeed, "Tender Mercies" has a bleak handsomeness bordering on the arty, but it also has real delicacy and emotional power, both largely attributable to a fine performance by Robert Duvall. Mr. Duvall's versatility seems to know no limit; in his role here as an over-the-hill country singer, he creates yet another quietly unforgettable character.

Mr. Beresford, working with less stiffly moralistic material than he did in "Breaker Morant," has a lighter, easier touch this time. "Tender Mercies," which was written by Horton Foote and opens today at Loews Tower East and other theaters, concerns a defeated-looking drunk who shows up at a remote, ramshackle motel one day and stays. At first, he lingers because he is broke and has offered to work off his debt to the pretty proprietor, Rosa Lee (Tess Harper). Soon he is staying for Rosa Lee herself, and without much ado or conversation, they are married. The gaunt, hollow-eyed Mac (Mr. Duvall) proposes this while helping Rosa Lee with her vegetable garden. Lonely, impoverished Rosa Lee says yes with almost more gratitude than excitement or surprise.

Only later does she learn that Mac used to be Mac Sledge, a famous country singer who drank himself out of a career at the top, and whose former wife was the still-successful country singer Dixie Lee (played by Betty Buckley, who doesn't much look or sound like a country star, but whose powerhouse voice makes any such discrepancies seem negligible). It's not clear whether Rosa Lee has heard of any of them before, but she hasn't had much time in her life for anything as frivolous as country music or its gaudy celebrities.

Though Mac's subsequent recovery of his strength would seem to lead toward a musical as well as a spiritual comeback, Mr. Foote's screenplay has its focus elsewhere. It follows Mac's relationships with his former wife, his daughter, his new bride and her son, weaving them into a sadly contemporary vision of family life and heading toward a final note of affirmation. This is a small, lovely and somewhat overloaded film about small-town life, loneliness, country

Robert Duvall

music, marriage, divorce and parental love, and it deals with all of these things in equal measure. Still, the absence of a single, sharply dramatic story line is a relatively small price to pay for the plainness and clarity with which these other issues are defined.

"Tender Mercies" highlights Mr. Duvall, who is so thoroughly transformed into Mac that he even walks with a Texan's rolling gait, but it also features some superb supporting performances. Ellen Barkin, who was so good as the young wife in "Diner," is even better as Mac's spoiled and troubled daughter, and Miss Harper brings a beautifully understated dignity to the role of a new wife who is not much older than her stepchild. Wilford Brimley is solid and durable as a music-business functionary, and Allen Hubbard does a convincing job as Rosa Lee's young son, whose father died in Vietnam. A great point is made of this, and it's probably one big issue more than a little film like "Tender Mercies" can handle. Like its laconic characters, the film itself seems to have more on its mind than it can manage to say.

•

"Tender Mercies" is rated PG ("Parental Guidance Suggested"). It contains some strong language.

1983 Mr 4, C8:1

Immensely Bracing

BRITANNIA HOSPITAL, directed by Lindsay Anderson; written by David Sherwin; cinematographer, Mike Fash; edited by Michael Ellis; music by Alan Price; produced by Davina Belling and Clive Parsons; released by United Artists Classics. At the Plaza, 58th Street, east of Madison Avenue. Running time: 116 minutes. This film is rated R.
Mr. PotterLeonard Rossiter
Professor MillarGraham Crowden
Phyllis GrimshawJoan Plowright
Dr. MacMillanJill Bennett
Mick TravisMalcolm McDowell
Amanda PersilMarsha Hunt
Ben KeatingRobin Askwith
FlorrieDandy Nichols
Chief Superintendent JohnsFulton Mackay
Sir GeoffreyPeter Jeffrey
MatronVivian Pickles
Red ...Mark Hamill
Sir AnthonyMarcus Powell
Lady FelicityJohn Bett
H.R.H.Gladys Crosbie
MacCreadyAlan Bates

By VINCENT CANBY

INSIDE London's venerable old Britannia Hospital, the administrators, the medical staff and the service personnel are making frantic, last-minute preparations for that day's festive celebration of the hospital's 500th anniversary, which will be marked by a visit by Queen Elizabeth, the Queen Mother. There are, however, unexpected complications, some major, all rude.

Pickets are at the gates protesting the hospital's acceptance of private patients. "No privilege in pain!" screams one placard. The kitchen help refuse to serve these special patients, who include a visiting black African dictator and another fellow described modestly as "our most prominent prime minister since Palmerston."

•

The chief of the service union won't unload a Fortnum & Mason's truck carrying provisions for the royal luncheon. The admissions area hasn't yet been repainted, and in the ultramodern Millar research wing, the brilliant but totally insane Professor Millar is readying the demonstration that will be the highlight of the Queen Mother's visit.

What, exactly, is the nature of the demonstration? It's a scientific breakthrough that the professor describes simply as "man remade." "Oh," says Lady Felicity Ramsen, a very tall, very masculine-looking lady-in-waiting to the Queen Mother, "I do hope it won't be offensive."

It will be, of course, like almost everything that happens in Lindsay Anderson's smashingly funny new comedy, "Britannia Hospital," which opens today at the Plaza Theater.

•

"Britannia Hospital" was written by David Sherwin and has as one of its many stars Malcolm McDowell. Both men collaborated with Mr. Anderson on "If . . . " (1969) and "O Lucky Man!" (1973). Like those two films, in which Mr. McDowell also played the perennial innocent named Mick Travis, "Britannia Hospital" is an outrageous satire on an empire's decline and fall and nearly everyone's refusal to face the situation.

At one point, when the hospital's administrator has given in to the union on a small point, someone shouts, "Britannia belongs to the people now!" It's clear throughout this robust work that Mr. Anderson and his colleagues have doubts as profound about these new owners as they had about their predecessors.

No secret is made of the fact that Britannia Hospital is a metaphor, but the reason the film works with such consistent funniness is not its satire, which is devastating, but the expertly staged and acted farcical complications that turn this day of celebration into a glimpse of the apocalypse.

The metaphor is there for all who care to chew on such things with their popcorn, but it never interrupts the movie or takes precedence over the farce, which is sometimes as grim as it is hilarious. With two decapitations during the lunatic events, plus one scene in which a head simply falls off a torso because it hasn't been properly stitched on, this isn't a comedy for the weak of heart or stomach.

Neither of Mr. Sherwin's two earlier screenplays for Mr. Anderson was anywhere near so terse, wise, commonsensical and witty as "Britannia Hospital." As written by Mr. Sherwin and directed by Mr. Anderson, "Britannia Hospital" discovers high comic order in the chaos of this one day, when the hospital is in the siege of union supporters and angry third-world partisans, while London itself goes gallantly on with its business as terrorists' bombs are exploding everywhere.

Though Mr. McDowell is one of the film's stars, his Mick Travis, who is here an undercover television newsman, is just one of several dozen wonderfully inane characters who come and go with breathless speed from the beginning of the film to the end.

•

Among the more remarkable performers are Graham Crowden, who plays the mad Professor Millar; Leonard Rossiter, as the hospital's implacable administrator; Joan Plowright, as an extremely genteel and staunch union representative; Jill Bennett, as Professor Millar's devoted and equally mad assistant, and Vivian Pickles, as the hospital matron.

A lot of other fine actors appear so briefly that you hardly have time to recognize them. They include Dandy Nichols, Mark Hamill and Alan Bates, who plays a patient not dying speedily enough to suit Professor Millar. "Termination, sister?" the professor asks the nurse. Replies the nurse, with the tiniest touch of distaste: "I'm afraid not. He appears to be lingering."

Three further performers must be mentioned: Marcus Powell, an actor about 3-feet tall, who plays the palace's brisk, no-nonsense chief of protocol; John Bett, as the Queen Mother's lady-in-waiting, and Gladys Crosbie as the Queen Mother, who sails serenely though the final sequences of the film clutching the lavender pocketbook that matches her lavender dress and lavender, off-the-face hat. It's an indication of just how complex are the feelings evoked by the film that the image of Miss Crosbie's Queen Mother is simultaneously hilarious and very moving.

•

One further note: the film's music is by Alan Price, whose score was one of the best things about "O Lucky Man!" His work here is not so immediately remarkable, which is not to underrate it.

"Britannia Hospital," Mr. Anderson's best film to date, is far more successfully intergrated than the two preceding satires. Though the subject is national exhaustion, the effect is immensely bracing.

1983 Mr 4, C10:1

Proclaiming Faith

JONI, directed by James F. Collier; screenplay by Mr. Collier; director of photography, Frank Raymond; film editor, Duane Hartzell; music by Ralph Carmichael; produced by Frank R. Jacobson; released by World Wide Pictures. At the Bombay Cinema, Broadway and 57th Street. Running time: 110 minutes. This film is rated G.
Joni ...Joni Eareckson
John EarecksonBert Remsen
Jay EarecksonKatherine De Hetre
Dick FilbertCooper Huckabee
Dr. SherrillJohn Milford
Lindy EarecksonJay W. MacIntosh
Diana ...Louise Hoven
Don BertolliMichael Mancini
Barbara MarshallCloyce Morrow
Steve EstesRichard Lineback
Kathy EarecksonSarah Rush

BILLY GRAHAM appears briefly in "Joni," which opens today at the Bombay Cinema and which was made by World Wide Pictures, an arm of the Billy Graham Evangelistic Association. So "Joni" is a frankly proselytizing film, one that tells the story of Joni Eareckson, who after a devastating accident managed to reaffirm her Christian faith. Miss Eareckson was paralyzed after a 1967 diving mishap, and the film traces her subsequent experiences, which are filled with optimism and inspiration.

"I would rather be in this chair knowing Him than on my feet without Him, and I never really knew that until this moment," Miss Eareckson finally declares.

What makes this of more interest than it might otherwise be is that the pretty, very wholesome-looking Miss Eareckson plays herself. Even in a film like "The Other Side of the Mountain," which "Joni" resembles in its sunny appearance and uplifting tone, the sight of a healthy, uninjured actress playing the disabled heroine has its distancing effects. Here, the story develops an added poignancy thanks to Miss Eareckson's presence. And the fact that she seems comfortable as an actress is of additional help. The supporting roles of Joni's friends, relatives and hospital roommates are played by actors so clean-cut they would give the film a ring of resounding phoniness were it not for the fact that Joni herself is in much the same mold. Her name, incidentally, is pronounced "Johnny." Her father wanted a boy.

The film follows Joni from the accident in Chesapeake Bay (though the whole film has a glowingly Californian look), through her hospital stay and gradual convalescence at home, as she recuperates to the point of being able to maneuver in a battery-powered wheelchair, and to paint surprisingly well by holding a brush in her teeth. She lives in a beautiful rural setting and is surrounded by fresh-faced people who love her, including a couple of suitors. Their stories are made a little sketchy by the director, James F. Collier, who doesn't explain much about why they did or didn't get along with Joni. Mr. Collier chiefly concentrates on the long walks Joni shares with these companions, riding beside them in her wheelchair as they read to her from the Bible. When one offers Joni his Bible as a gift, her sister declares "You've already got three!" "Well, this one's all marked up — the important parts," Joni replies, adding the fourth to her collection.

At the film's ending, Joni is seen addressing a huge evangelical gathering, proclaiming her faith and being enthusiastically applauded by Mr. Graham.

Janet Maslin

1983 Mr 4, C10:5

CHOICE OF ARMS, directed by Alain Corneau; screenplay (French with English subtitles) by Mr. Corneau; director of photography, Pierre-William Glenn; edited by Thierry Derocles; music by Philipe Sarde; produced by Alain Sarde; released by Summit Feature Distributors Inc. At the Embassy 72d Street, at Broadway. Running time: 117 minutes. This film has no rating.
Noel ...Yves Montand
Mickey ..Gérard Depardieu
NicoleCatherine Deneuve
BonnardotMichel Galabru
Sarlat ...Gérard Lanvin
Savin ..Marc Chapiteau
Serge ..Pierre Forget
Jean ..Christian Marquand
AndréJean-Claude Bouillaud
ConstantiniJean Rougerie
RickyJean-Claude Dauphin
Dany ..Richard Anconina
Corinne ..Marilyn Even
Roland ..Etienne Chicot

"Choice of Arms," which opens today at the Embassy 72d Street Theater, is yet another lethargic, pretentious policer by Alain Corneau, the French director ("Série Noire," "The Case Against Ferro") who claims to have been most influenced by Howard Hawks. That claim amounts to slander.

No film ever made by Hawks has anything to do with the sort of over-blown, neopoetic nonsense favored by Mr. Corneau. His only ability is to take a suspense story and drain it of all possible interest. Shots and sequences are held too long. The dialogue is barely speakable, while the plots manage to be both dim and utterly transparent.

He also has a talent for persuading otherwise sensible actors to work for him. This cast include Yves Montand, Catherine Deneuve, Gérard Depardieu and Christian Marquand. Without exception, the performances are terrible.

Vincent Canby

1983 Mr 6, 65:1

FILM VIEW

VINCENT CANBY

Vitality and Variety Buoy New Movies From Britain

It's still too early to describe it as a trend, but the fact is that three of the best and most entertaining films in New York first-runs at the minute are from Great Britain, with one more coming up soon. One might have been able to say "from England," except that one of the three current offerings is "Local Hero" by Bill Forsyth, who is a Scottish director and Scots don't take kindly to being described as English. Old boundaries are to be respected.

The other two films are Harold Pinter's moving, immaculate "Betrayal," directed by David Jones, and Lindsay Anderson's hilariously nasty satire, "Britannia Hospital," which concludes the horrendous adventures of Mick Travis (Malcolm McDowell), directed by Mr. Anderson and written by David Sherwin, which were begun with "If..." (1969) and continued in "O Lucky Man!" (1973).

Due for commercial release shortly is Peter Greenaway's "The Draughtsman's Contract," one of the most original, beautiful and provocative of the films shown at the 1982 New York Film Festival at Lincoln Center. More about that after it opens.

Whether or not these films are enough evidence on which to conclude that British filmmakers are again in the ascendency, I've no idea. Yet it's good to know that English, Scottish and Irish artists are doing more than turning out not-always-great plays, which sometimes seem to be dominating both Broadway and Off Broadway, and making resolutely tasteful stuff to be shown on public television.

The extraordinary vitality and variety exemplified by these new films are what is so encouraging. There may be life after death, after all.

● ● ●

Like its title, which is not misleading in its irony, even though it doesn't reflect the film's rare, sweet funniness, "Local Hero" reveals the character of its comedy with a wonderfully deadpanned, mock reserve. "Local Hero" also lives up to our expectations of Mr. Forsyth's talents based on "Gregory's Girl," his first feature to be released in this country.

Superficially, at least, "Local Hero" is a somewhat more conventional work than "Gregory's Girl." It has as its star a big Hollywood "name," Burt Lancaster, whose choice of films and whose work in them seem to get better and better with age, and it has a story with a more easily charted beginning, middle and end.

However, beneath that surface, "Local Hero" has the almost surreal appreciation for illogic that is one of the delights of "Gregory's Girl." To call this quality "surreal" may be overstating the case. Mr. Forsyth is no student of André Breton, but his films do depend more than those of most other directors on inexplicable coincidence, and hardly at all on the orderly series of events by which we apprehend the work of more literal filmmakers.

● ● ●

Everything in a Forsyth film is just a little bit out of whack, as if basic laws of nature, including gravity, had been tampered with. Characters seldom respond to conventional stimuli in conventional ways. In a Forsyth film a cuckolded lover is less likely to be humiliated or en-raged than to offer the cuckolder genuine best wishes and a good hot meal. Magic has nothing to do with Mr. Forsyth's comedies and thus, I think, it's really inaccurate to describe them as fairy tales. Instead, like all good artists, he redefines reality in his own cockeyed terms.

"Local Hero" opens and closes in Houston, but its heart and most of its footage belong in Scotland, in a small coastal village that a huge American oil combine, headed by the imposing Mr. Happer (Mr. Lancaster), wants to buy and turn into a giant refinery and transshipment depot. In the imaginations of most liberal, ecology-minded filmmakers, such a plan would evoke horror among the right-minded characters and greed among the greedy.

It is one of the smaller but nicer surprises of "Local Hero" that the villagers, almost to a man, are delighted by their unexpected good fortune. What eventually happens to the plan has less to do with any ideas of protecting the idyllically beautiful landscape than with the whims of two marvelously, poetically self-centered old men.

Though he is not on the screen as long as one would like, Mr. Lancaster is splendidly unpredictable as the oil tycoon, a man so rich and powerful that his psychiatrist comes to him and is told, in no uncertain terms, what the fee will be and what hours will be made available for therapy. In Mr. Lancaster's perfectly controlled nuttiness lies the secret of Mr. Forsyth's comic method, which is as stylish and original as that of any new director to come along in years.

You'll also enjoy Peter Riegert as the young American originally sent to Scotland to open negotiations for the purchase of the village; Denis Lawson, who doubles as the village's hotelier and only accountant; Jenny Seagrove as a beautiful woman who may be a mermaid, though she does use ordinary scuba gear when in the water, and Fulton Mackay, Jennifer Black and Christopher Asante, as some of the village's more prominent citizens. Gordon John Sinclair, who played the teen-age gallant in "Gregory's Girl," appears briefly and unbilled as the unhappy suitor of the village's single, would-be punk-groupie.

●

"Betrayal" is nothing less than the best screen translation yet of a Pinter piece written originally for the theater. As directed by Mr. Jones from Mr. Pinter's own adaptation, "Betrayal" looks as if it had been conceived for the screen rather than "opened up" for it. Time is its principal landscape, across which it moves effortlessly, progressing from a point two years after the end of an adulterous affair back through nine years to the night the affair began.

Though "Betrayal" has a handsome, vaguely chilly look that is in keeping with the spare beauty of the Pinter dialogue, it is an immensely moving film, virtually from the very first few minutes when the former lovers, played by Jeremy Irons and Patricia Hodge, meet as new "old" friends in a London pub.

Mr. Irons, Miss Hodge and Ben Kingsley, as Miss Hodge's husband, are a dazzling acting combination, their work being the sort that delights us within the frame of the film as well as a spectacular exercise of performing talent. Mr. Kingsley's work is especially impressive when seen in conjunction with his performance in the title role of "Gandhi." If Dustin Hoffman's performance in "Tootsie" has any competition for this year's best-actor Oscar, it's Mr. Kingsley's work in "Gandhi," supported, morally if not actually, by this performance in "Betrayal," which won't be eligible for Oscar consideration until next year.

●

The week's most invigorating surprise is "Britannia Hospital," though it is a surprise only if one was somewhat disappointed — as I was — by "O Lucky Man!" in which Mr. Anderson, Mr. Sherwin and Mr. McDowell attempted to satirize virtually the same targets they successfully lay to waste here.

Everything in "Britannia Hospital" is simpler, funnier, more wild and more outrageous than in "O Lucky Man!" and perhaps even in "If...," which I liked very much. In "Britannia Hospital" the physical scale is small and the time scale short, the film being set in a venerable London hospital on the day of its 500th anniversary, as its administrators and staff prepare to meet the Queen Mother, who is the focal point of the birthday celebration.

Outside the hospital, London is in the siege of various demonstrators and terrorists. Inside, the members of the unions are becoming uppity, while the mad Professor Millar (Graham Crowden) prepares the show he will present for the Queen Mother's entertainment: a Dr. Frankenstein-like breakthrough, which will take place in the hospital's new, ultramodern wing, a gift to the hospital from the Banzai Chemical Company of Tokyo.

"Britannia Hospital" is a wicked satire and sharp as a butcher's cleaver — take note that the film contains two decapitations just below the camera's eye. However, its amazing, nearly nonstop hilarity comes not necessarily from the satire but from its appreciation of the methods of farce. The film is a breathless succession of pratfalls and overlapping disasters, of pompous people working seriously at cross purposes, of well-laid plans going madly awry. It's also just as merciless about the worst idiocies of the welfare state as it is about the most cherished traditions of Britain's Tories.

Britannia Hospital is, of course, a metaphor, but don't let that throw you. Mr. Anderson, Mr. Sherwin and the huge, wonderful cast never for a second let on that what they're dealing with is anything but the series of calamities that befall this particular hospital on what had been planned to be such a fine and glorious day. The film's comic life and momentum never depend too much on larger references. They sustain themselves, which was not quite true of "O Lucky Man!" or even of "If...," which, at the time of its release, appeared to harbor neo-Godardian tendencies.

"Britannia Hospital" is brilliantly funny and, on occasion, epically rude, and it's acted with Feydeau-like precision by a group of incomparably comic actors, just a few of whom are Mr. McDowell, Mr. Crowden, Joan Plowright, Dandy Nichols, Jill Bennett, Vivian Pickles, Leonard Rossiter, Marsha Hunt, Marcus Powell, John Bett, and a dear-looking, unflappable little woman named Gladys Crosbie, who plays H.R.H.

Britannia's hospital may be a mess, but its movies are a joy. ∎

1983 Mr 6, II:17:1

Band Follower

JOHNNY WEST, directed and written (German with English subtitles) by Roald Koller; photographed by Bahram Manocherie. At the Film Forum, 57 Watts Street. Running time: 129 minutes. This film has no rating.
JohnnyRio Reiser
MonikaKristina van Eyck
JimmyMelwin (Candy) Canady
ManagerJess Hahn
Max ..Karl Maslo
The Manhattans and The Platters

By VINCENT CANBY

"JOHNNY WEST," Roald Koller's 1977 West German film that opens today at the Film Forum, is a rather sweetly forlorn little movie about a 19-year-old fellow named Hans Michael Westerfeld, self-styled Johnny West, who wants to become an American-style rock star. To this end, he works as a roadie, one of the crew that takes care of the equipment during the German tour of the black American singing group called the Manhattans.

Even though roadies and performers aren't supposed to fraternize, Johnny makes friends with one of the American musicians, who gives him pointers on the electric guitar. Johnny also manages to pick up his own groupie, Monika (Kristina van Eyck), an elegant, well-to-do young woman who, as Johnny follows the Manhattans around Germany, follows Johnny.

Their affair isn't exactly listless, but as they make love, each seems to be wishing for something else. Johnny wants stardom, and Monika the glamour that goes with show business as she imagines it. Most of the time they exist on the promises of jobs and live in third-rate hotel rooms, eating junk food and making their business calls on public telephones.

"Johnny West," which is Mr. Koller's first feature, shares something of Johnny's innocence, but it never mistakes the road scene as anything but overwhelmingly grim. The director also has a contagious fondness for the music of the Manhattans, which is on the soundtrack even when they aren't seen performing on stage.

As played by Rio Reiser, a German rock personality in real life, Johnny is a most unprepossessing screen presence — skinny, introspective and anything but handsome. Yet because of this, he is very convincing as Johnny West. One suspects that he might well be the sort of performer who only comes to life in front of a live audience. When, toward the end of the film, he gets his chance and doesn't do especially well, that's part of Mr. Koller's vision too.

Miss van Eyck's Monika, who looks as if she might be a high-fashion model, remains a beautiful, probably empty enigma to Johnny as well as to the audience. Melwin (Candy) Canady gives a funny, nicely laid-back performance as the musician who befriends Johnny. The Manhattans are breezily self-possessed and attractive, representing a section of American culture that has swallowed up other cultures and thoroughly enjoys the experience.

1983 Mr 9, C17:2

False Proofs

THE CONSTANT FACTOR (Constans), directed by Krzysztof Zanussi; screenplay (Polish with English subtitles) by Mr. Zanussi; photography, Slawomir Idziak; edited by Uszula Silwinska; music by Wolciech Kllar; production company, the Polish Corporation for Film Production "Zespoly Filmowe" TOR Unit. At the Film Forum, 57 Watts Street, between Avenue of the Americas and Seventh Avenue. Running time: 96 minutes.
WitoldTadeusz Bradecki
Witold's MotherZofia Mrozowska
GrazynaMaijorzala Zalaczkowska
StefanCezary Morawski
MariuszWitold Myrkosz
Stefan's WifeEwa Leiczak
ZenekJan Jurewicz
WladekJukuysz Machulski
WlodzimierzMarek Litewka
MateJacek Strzemzalski
ScientistEdward Zebrowski

"The Constant Factor" was shown as part of the 1980 New York Film Festival. Following are excerpts from a review by Janet Maslin in The New York Times of Oct. 9, 1980. The film opened yesterday at the Film Forum, 57 Watts Street, between Avenue of the Americas and Seventh Avenue.

THE chief character in "The Constant Factor," a bracing and disturbing film by Krzysztof Zanussi, is a young Pole with an affinity for mathematics. He has a sense of the world that is clear, practical, even elegant, but as a model it just won't work. "What you can compute ceases to be a mystery," he declares near the end of the film, but by then he has been proven wrong. "The Constant Factor" follows this young man, Witold, into situations to which his brand of logic doesn't apply. Always, it points to death as the most illogical event of all.

When Witold gets an industrial job, he finds himself quite unprepared for the constant chiseling of his superiors, an attitude that extends even to Witold's co-workers when they pad expense accounts. When his mother falls ill, he demands that she be moved out of a draft in the hospital and winds up guaranteeing that she will be left in the draft, since he has offended the doctor he needed to bribe. Played with both stubbornness and naïveté by Tadeusz Bradecki, Witold becomes a touching figure, confounded time and again by his own straightforwardness. He expects things to be manageable, and they never are.

As directed by Mr. Zanussi, "The Constant Factor" seems frequently to be on the verge of greatness, though its promise remains unfulfilled. Directed with a delicacy that contrasts sharply with the drabness of Witold's Poland, it has a light, graceful spirit that carries individual scenes, but fails to bind the film together.

In the film's best scenes, Mr. Zanussi concentrates upon the spaces between his characters; sometimes he even does this literally. When Witold embraces his girlfriend, the camera slips along their silhouettes until it finds a ray of light shining between them.

Earlier in the film, Witold is sent to India on business, where he meets an American who speaks casually about the Indians' mobility. "If they work hard and save the money, they can go to New York just like we've come here," the American says. Then he insists to Witold that "every man has got his own choice — just like you." "No," Witold replies, and the discussion can go no further.

In India, Witold watches the burning of a woman's body on a funeral pyre and is sickened and afraid. Later on, he watches his own mother die. "The Constant Factor" deals more bluntly and frighteningly with death than any film has lately, and this is perhaps its greatest strength. Its courage is impressive, though it remains somehow incomplete.

"The Constant Factor," won the best-director prize at the 1980 Cannes Film Festival.

1983 Mr 10, C18:3

Not in the Morning

VICTORY MARCH, directed by Marco Bellocchio; screenplay (with English subtitles) by Mr. Bellocchio and Sergio Bazzini; director of photography, Franco di Giacomo; produced by Silvio Clementelli; a joint production of Clesi Cinematografica, Rome; Reen Production, Paris, and Lisa Film, Munich; released by Summit Feature Distributors. At the Carnegie Hall Cinema, Seventh Avenue and 56th Street. Running time: 115 minutes. This film has no rating.
WITH Franco Nero, Miou Miou, Michele Placido, Ekkehardt Belle, Nino Bignamini, Patrick Dewaere

By VINCENT CANBY

"VICTORY MARCH," which opens today at the Carnegie Hall Cinema, is a new film by Marco Bellocchio, the Italian director who sometimes makes fascinating movies, like the recently released "Leap Into the Void," and sometimes films that display the same degree of intelligence and idiosyncrasy, but which are not so good as their parts.

It may be that Mr. Bellocchio's films, more than those of any other director I can think of, depend on the mood in which one sees them. They all share an appreciation for the gravely comic, which is frequently difficult to discern under the often hysterical and lunatic events on the screen.

If possible, I think, one should never see a Bellocchio film early in the morning. It takes time to get into synch with the wild rhythm of his films. Seeing "Victory March," as I did, within an hour of breakfast, is like waking up to find your house being dismantled around you. It's a funny situation, but not if it's your house.

"Victory March," directed by Mr. Bellocchio and written by him with Sergio Bazzini, is about the psychological rape of a sensitive, bookish young man in his first year of army service. Passeri (Michele Placido) has good reason to hate this basic training, which doesn't look especially tough from a physical point of view, but which seems to involve more outright sadism and vicious horseplay than any army I've ever heard of.

Passeri is bullied and tricked by the officers and the noncommissioned officers and then, when he becomes a good soldier, is ostracized by the other trainees.

More specifically, "Victory March" is about Passeri's relations with an especially demanding, strict and possibly psychotic young officer, the Captain (Franco Nero), who is so handsome he is almost pretty, and the captain's sexy, sluttish wife, Rosanna (Miou Miou). Though "Victory March" is not easily identifiable as a comedy, it's like a slapstick version of John Huston's "Reflections in a Golden Eye."

When he's at home, the captain, a fitness nut, does push-ups and regularly beats Rosanna, who accuses him of being impotent. Out of boredom, Rosanna spends her afternoons shoplifting and having casual affairs. Early in the film the captain sets out either to break Passeri or to mold him into a perfect soldier.

In one of Mr. Bellocchio's most effective scenes, the captain takes Passeri into his office, locks the door and proceeds to knock the young man around so brutally that, at long last, he fights back.

From this moment on, Passeri begins to change, to see the captain as some sort of ideal and the army as the only fit place for such ideals. When the captain asks Passeri to shadow Rosanna to find out whom she's sleeping with, he accepts, with somewhat predictable results. Passeri becomes her lover.

"Victory March" is both well cast and well acted. Mr. Nero's demonic looks turn the captain into a more enigmatically interesting figure than written, and Mr. Placido and Miou Miou are perfect victims, though extremely noisy much of the time. The late Patrick Dewaere is also good as Rosanna's lover, a performance that is even more hysterical than the others.

In Mr. Bellocchio's best films, including "Fist in the Pocket" and "Leap Into the Void," one doesn't worry about the lunacies of the characters, since they all appear to inhabit the same universe. "Victory March" isn't so well integrated. Passeri too often seems to have wandered into the film from another, more conventional kind of fiction. Further, the screenplay has an unfortunate symmetry to it. After having seen the first half, one knows pretty much what must happen in the second half. This has the effect of betraying the redeeming comic value of Mr. Bellocchio's strange and haunted work.

1983 Mr 11, C8:1

Cross-Cuts to Art

ELISA, VIDA MIA, screenplay and direction by Carlos Saura (Spanish with English subtitles); cinematography, Teo Escamilla; edited by Pablo G. Del Amo; produced by Elias Querejeta; released by Nicole Jouve Interama. At the Thalia, Broadway and 95th Street. Running time: 120 minutes. This film has no rating.
Luis...................................Fernando Rey
ElisaGeraldine Chaplin
AntonioNorman Briski
IsabelIsabel Mestres
JulianJoaquin Hinojosa
DoctorFrancisco Guijar

NEAR the end of Carlos Saura's "Elisa, Vida Mia," Fernado Rey, in the role of an aging ascetic named Luis, talks movingly to his daughter, Elisa (Geraldine Chaplin), about his youthful artistic pretensions. He recalls that he used to spend hours and days polishing a letter, getting the syntax right, refining the thoughts and elevating the tone. Now, he admits, he prefers the spontaneous letter, unrefined, natural, with crossed-out words. Luis has no interest in Art.

Yet Art is mostly what "Elisa, Vida Mia" seems to be about.

There is, at its heart, a small, coherent story about the reunion of Luis and Elisa after a 20-year separation. The principal setting is Luis's remote farmhouse in an extremely photogenic part of Castile, where he works on what seems sometimes to be his autobiography and sometimes a novel. The autobiography-novel consists mostly of Luis's fantasies about Elisa's life, her failed marriage and her recollections of her childhood, including the day he walked out on the family.

Sometimes we see these events as they are remembered or imagined by Luis, sometimes as Elisa's very own fantasies. In between we see scenes of their week together at the farm.

Mr. Saura's cross-cuts between reality and fantasy exemplify the sort of Art Luis says he so abhors. "Elisa, Vida Mia" is a mostly passionless, intellectual sort of puzzle, with clues provided by classy literary and musical references.

The main reasons to see the film are the two leading performances. Mr. Rey is always an interesting presence, and Miss Chaplin, as in all of her Saura films, reveals qualities of feeling, control and beauty that no other directors have ever found.

Young Ana Torrent, of "The Spirit of the Beehive," is seen briefly as Elisa as a little girl. In the fantasies and flashbacks, Miss Chaplin also plays her own mother, which leads to a certain amount of intentional confusion about the relations of the father and the daughter.

The 1977 Spanish film opens today at the Thalia for a two-day run.

Vincent Canby

1983 Mr 11, C8:5

Musical Visits

SAY AMEN, SOMEBODY, directed by George T. Nierenberg; photography by Ed Lachman and Don Lenzer; edited by Paul Barnes; produced by Mr. Nierenberg and Karen Nierenberg; a GTN Production. At the 68th Street Playhouse, at Third Avenue. Running time: 100 minutes. This film is not rated.
WITH: Willie Mae Ford Smith, Thomas A. Dorsey, Sallie Martin, Delois Barrett Campell, Billie Barrett Greenbey, Rhodessa Barrett Porter, Edward O'Neal, Edgar O'Neal, Zella Jackson Price, Michael Keith Smith, Billy Smith, Jackie Jackson and Bertha Smith.

"Say Amen, Somebody" was shown as part of the 1982 New York Festival. Following are excerpts from a review by Janet Maslin in The New York Times of Oct. 5, 1980. The film opens today at the 68th Street Playhouse, at Third Avenue.

THE beauty of gospel music comes shining through in "Say Amen, Somebody," a rousing documentary by George T. Nierenberg, who has also made a documentary about jazz tap dancing. In "Say Amen, Somebody," Mr. Nierenberg visits with two of gospel's legendary performers, Thomas A. Dorsey and Mother Willie Mae Ford Smith. It's Mr. Dorsey who gives the film its title, as he tells the camera crew a long story and lets them know they ought to be a little more vocally responsive. Mr. Dorsey isn't used to listeners who aren't noticeably moved by what he has to sing and say. The film makes it clear why.

The camera visits a storefront church, a convention of gospel performers, classes where Mr. Dorsey explains the songs he has written and those where Mrs. Smith (known as Mother Smith) instructs would-be gos-

pel soloists. It also visits a lot of kitchens and living rooms, where the music is no less stirring than it is on stage. Members of the Smith family reminisce about Mother Smith's career, and Mr. Dorsey talks about his own background and about how gospel got started. "The Father of Gospel Music" is Mr. Dorsey's nickname.

Other performers are seen in the film as well, most notably the O'Neal twins, who talk about whether gospel is religion or entertainment, and the Barrett Sister, three women who stop the show on more than one occasion. In the film, Delois Barrett Campbell, the lead singer, is heard performing before large, ecstatic groups of listeners, and she's also heard singing over the dishes in her own modest kitchen. Then she and her husband, the Rev. Frank Campbell, get into a little discussion about her career. Delois is planning a trip abroad, and her husband is unhappy about it. "I'll be glad when our ministry can be together, as a husband and wife team, more than your sisters' team," he says. Delois considers this for a long moment, then says "You want some eggs with your sausage?" Mother Smith says she had this kind of husband trouble, too.

●

The music alone would be enough to make "Say Amen, Somebody" worth seeing. But it has warmth and friendliness, too, and some of its family scenes are as memorable as its songs. Mother Smith debates with a bashful grandson about whether women ought to be allowed to preach; her children visit a dilapidated railway station and remember tearfully how their mother used to embark on journeys away from home. No one is more moved, though, than when the music begins. And the music, as seen and understood here, is joyful, communal and deeply moving.

1983 Mr 11, C10:1

Lifeless Bawdiness

TALES OF ORDINARY MADNESS, directed by Marco Ferreri; screenplay by Mr. Ferreri, Sergio Amidei and Anthony Foutz; story by Mr. Amidei and Mr. Ferreri, based on short stories by Charles Bukowski; director of photography, Tonino Delli Colli; film editor, Ruggero Mastroianni; music by Philippe Sarde; produced by Jacqueline Ferreri; released by Fred Baker Films. At the Gemini, Second Avenue and 64th Street. Running time: 107 minutes. This film has no rating.

Charles Serking	Ben Gazzara
Cass	Ornella Muti
Vera	Susan Tyrrell
Vicky	Tanya Lopert
Bartender	Roy Brocksmith
Young Girl on Beach	Katia Berger
Landlady of Beach House	Hope Cameron
Fat Woman	Judith Drake
Pimp	Patrick Hughes
Teen-age Runaway	Wendy Welles
Publisher	Jay Julien

By JANET MASLIN

THE best that can be said for Marco Ferreri's "Tales of Ordinary Madness" is that somewhere inside its unworkable blend of pretension and pornography, there's a serious film about art and sexual abandon struggling to get out. The worst, which can be said with considerably more accuracy, is that Mr. Ferreri's film is strained, absurdly solemn and full of inadvertent howlers.

Based on stories by Charles Bukowski, "Tales of Ordinary Madness" features Ben Gazzara as Charles Serking, a Beat sort of poet, whose artistic process involves boozing, promiscuity and watching the occasional sea gull on the beach. It's the second pursuit that keeps him busiest, as on the day

he spies a likely prospect on the sands at Venice, Calif., and follows her home. On the bus, Vera (Susan Tyrrell) eyes Charles so lasciviously it's a wonder the driver doesn't hit a lamppost. But when Charles reaches her apartment — leaping through the door and clamping a hand over her mouth, rapist-style — she asks haughtily, "Do I know you?"

Soon enough, she is parading around in black underwear and telling Charles, "I want you to be mean to me — next time I want you to use your belt."

"I don't wear a belt," says Charles, who prides himself as much on his impecuniousness as on his rip-roaring machismo. "You'll have to lend me one."

Apparently Vera isn't satisified with this, because a few moments later, she calls the police.

On another red-letter day in the life of this ladies' man, he wanders into a bar and meets a young prostitute named Cass, played by Ornella Muti. "Do you really think I'm pretty?" she asks. Well, sure, Charles thinks so. So Cass takes out a 6-inch gold safety pin and runs it through her face, prompting the bartender to complain, "Cass, I told you not to pull that in here — it's bad for business." Meanwhile, Charles looks on in quiet admiration, deciding that Cass is the woman of his dreams, although each time he later encounters her, she generally bears a new slice mark or puncture wound.

This scene, from a brief Bukowski story titled "The Most Beautiful Woman in Town," has an urgency and economy on the page that are lacking here. The movie, paralyzed with admiration for such anecdotes, tends to drag them out until they become unequivocally ridiculous. "Tales of Ordinary Madness," which opens today at the Gemini Theater, concentrates solely on the lurid aspects of Mr. Bukowski's writing and exaggerates these so greatly that all else is lost. Mr. Ferreri, whose daring has been well noted in films like "The Last Woman" and "La Grande Bouffe," invests this tale with such undue gravity that even its bawdiness becomes lifeless.

●

Mr. Gazzara staggers through the film with clear but ill-advised faith in the material, even though most of the performances that surround him are unrelievedly dreadful. Miss Muti is an eye-catching exception. But Miss Tyrrell puts in an appearance that she will not easily live down.

1983 Mr 11, C13:3

TRENCHCOAT, directed by Michael Tuchner; written by Jeffrey Price and Peter Seaman; director of photography, Tonino Delli Colli; edited by Frank J. Urioste; produced by Jerry Leider; released by Buena Vista Distribution Co., Inc. At the National 1, Seventh Avenue and 44th Street and other theaters.

Mickey Raymond	Margot Kidder
Terry Leonard	Robert Hays
Inspector Stagnos	David Suchet
Eva Werner	Gila Von Weitershausen
Nino Tenucci	Daniel Faraldo
Princess Aida	Ronald Lacey
Marquis De Pena	John Justin
Lizzy O'Reilly	Pauline Delany
Sean O'Reilly	P. G. Stephens
Esteban Ortega	Leopoldo Trieste
Corporal Lascaris	Brizio Montinaro
Afro-Dite	Martin Sorrentino

By JANET MASLIN

Margot Kidder plays a gumshoe in the Sam Spade mold in "Trenchcoat," which opened yesterday at the National and other theaters. As turnabouts go, this one works better than might be expected. Miss Kidder is smart and snappy in the role of Mickey Raymond, whose father

wanted a boy and whose usual job is that of a court stenographer. The film follows her to Malta for a two-week vacation, during which she plans to try her hand at writing a detective novel. "Malta Wants Me Dead," it's going to be called.

She doesn't have time for much work on the book, since every new scene brings another wild coincidence — almost everyone in the movie turns out to be a prowler, smuggler, kidnapper, international terrorist or double agent. The better to cope with all this, Mickey begins sporting the trenchcoat of the title plus a felt hat, whose brim she tries to flip expressively as she says things like, "I got a fin for anybody in here that knew Harry Benjamin." Since "Trenchcoat" is pretty much a comedy, the best reply to that offer, in the little bar where Mickey presents it, is: "What's a fin?"

●

As directed by Michael Tuchner and written by Jeffrey Price and Peter Seaman, "Trenchcoat" is good-humored and lightly entertaining. It wouldn't work with the wrong actress in the leading role, but Miss Kidder is emphatically right. She's bright, funny and perfectly capable of carrying the movie on her own. As it happens, the supporting roles are played in a broad style that suits the material nicely, and Robert Hays makes a disarming leading man. As befits the story's pattern of constant deceit and intrigue, Mr. Hays pretends at various times to be a doctor, a lawyer, an anthropologist, a jewelry salesman and a former speechwriter for Eugene McCarthy.

"Trenchcoat" is rated PG ("Parental Guidance Suggested"). It contains a little bit of gore and some harsh language, but is otherwise suitable for children.

1983 Mr 12, 13:3

10 TO MIDNIGHT, directed by J. Lee Thompson; written by William Roberts; director of photography, Adam Greenberg; music by Robert O. Ragland; edited by Peter Lee Thompson; produced by Pancho Kohner and Lance Hool; released by The Cannon Group Inc. At the Rivoli, Broadway and 49th Street and other theaters. Running time: 100 minutes. This film is rated R.

Leo Kessler	Charles Bronson
Laurie Kessler	Lisa Eilbacher
Paul McAnn	Andrew Stevens
Warren Stacey	Gene Davis
Dave Dante	Geoffrey Lewis
Nathan Zager	Robert Lyons
Captain Molony	Wilford Brimley
Jerry	James Keane
Bunny	Iva Lane
Tina	Katrina Parish
Peg	Shawn Schepps

By RICHARD F. SHEPARD

If "10 to Midnight," the new Charles Bronson film that opened yesterday at the Rivoli and assorted neighborhood houses, is not among the worst of its kind, then it is because its kind is among the worst of any kind.

This is a police and murder thriller laced with blood and sex. It is also a propaganda piece that argues against laws that let brutal slayers escape with insanity pleas. The cards are certainly stacked here, as Mr. Bronson, a cop, loses his job for making up phony evidence against the fellow we all know for a crazed, naked sex killer who stabs young women in various degrees of undress. This is such a villain that one must approve the vengeful finale that defies the law.

The suspense generated in this most cheaply sensational recounting set in Los Angeles is episodic, rising at the time of the kill and receding into boredom at other times. The actors, directed by J. Lee Thompson, seem a reasonably competent crew, although in this raunchy, bloodstained, moral-

izing account there is not much opportunity to demonstrate.

Gene Davis is the epitome of evil as the heavy in all this, although he epitomizes it mostly in deadpan fashion. Lisa Eilbacher, as Mr. Bronson's daughter, is refreshingly natural.

Geoffrey Lewis, as the dissembling defense attorney, is a convincing, even humorous, caricature of the breed. Mr. Bronson is Mr. Bronson. Not to worry, "Hill Street Blues."

1983 Mr 13, 62:5

FILM VIEW

VINCENT CANBY

'Tender Mercies' Stands Out

The season is out of joint. This is the time of year when distributors usually get rid of all of those movies they don't think are worth releasing in the prime moviegoing times of Christmas and the midsummer months. Yet there have been more new films of interest in the last few weeks than I can remember in any comparable period in a number of years.

One of the latest of these is "Tender Mercies," a funny, most appealing and most sharply observed film that's set in rural Texas and concerns, among other things, people who sing "Jesus Saves," without making fun of them. Based on an original screenplay by Horton Foote, who received an Oscar for his adaptation of "To Kill a Mockingbird," and directed by Bruce Beresford, the Australian director ("Breaker Morant") in his American debut, "Tender Mercies" is likely to become the year's most unexpected hit, sometimes called "a sleeper," which has always seemed to me to be a phrase that contradicted itself.

If any other actor except Robert Duvall were playing the leading role in "Tender Mercies," that of a down-and-out country-and-Western singer, you'd probably call this the performance of his career. But Mr. Duvall has contributed so many brilliant performances to such films as "True Confessions," "Apocalypse Now," "The Great Santini" and "The Seven Percent Solution" that it doesn't do justice to him to suggest that "Tender Mercies" is somehow better. It's great and different. It's also the performance of an extraordinary American actor in the midst of an exceptional career.

In all respects "Tender Mercies" is so good that it has the effect of rediscovering a kind of film fiction that has been debased over the decades by hack moviemakers, working according to accepted formulas, frequently to the applause of the critics as well as the public.

"Tender Mercies" is a warm film, by which I mean something very different from sentimental. The good "warm" film, as opposed to the good "cool" film, never leaves one in any doubt as to what it's about or how one is supposed to respond to it. Its surprises come not through any breakthroughs in style, or from shock, or from disorienting juxtapositions of content that force one to reexamine one's relations with the universe.

Instead, like "Tender Mercies," it works through conventional means to find the special that we always hope exists within the ordinary.

If it isn't still too soon to attempt to identify the most important film development in the 1970's, I'd say it was the emergence of a kind of cool — commercial movies can't support a fancy term like Modernist — film that owes more than a frame or two to the radically new-looking films made by Jean-Luc Godard in the late 1950's and 60's. These films, as well as the cool films that came after, especially those of Rainer Werner Fassbinder, insist that audiences make choices while looking at the films. They often don't mean exactly what they say. They favor medium long-shots that allow the audience to choose where to look. A close-up may be used more for decoration than to italicize a point. The people on the screen — sometimes they can't even be described as characters — are not to be identified with but, instead, to be scrutinized and considered, as if they were previously unknown fauna.

In its extreme form, as in Fassbinder's classic, "In a Year of 13 Moons," the cool film may be beautiful to look at but resolutely off-putting as it demands that we pay attention to things most of us would prefer to ignore. The cool film initially makes us uneasy, though ultimately it may be far more involving than the more ordinary warm film because we've had to contribute to it. The warm film soothes.

Though Godard and Fassbinder films have never been wildly successful in the mass American market, an increasing number of films that do reach this market show the influences of these cool moviemakers. Martin Scorsese's best films — "Taxi Driver," "Raging Bull" and "The King of Comedy" — do not go gently into one's memory. They are entertaining but they also disturb us by forcing us to consider people and situations that undermine our feelings of self-assurance and well-being.

Though "Betrayal" is extremely moving, it also is a cool film. It keeps its three characters at an equal distance from us so that no one character has a distinct emotional advantage over the other two.

Two typical examples of warm films are Richard Attenborough's "Gandhi," a wholehearted endorsement of a man whose saintliness is never in doubt, and "The Night of the Shooting Stars," by Paolo and Vittorio Taviani, a movie that sides with the angels, with heroic "little" people, but so unequivocally that it seems a tiny bit smug. The principal thing the audience discovers in a film like this is its own — not the characters' — worthiness. The filmmakers have done all of the work and labeled every character so clearly that all we have to do is nod in approval.

"Tender Mercies" is an equally warm film but you know that, like its hero, Mac Sledge (Mr. Duvall), it is aware of the bottomless pit that awaits those who lose their bearings in life. "Tender Mercies" is full of surprises, the major one being that a film that so unembarrassedly and unashamedly endorses the so-called old-fashioned values could be both moving and provocative.

Mr. Foote and Mr. Beresford achieve a kind of tender heroism, something missing from "The Night of the Shooting Stars," in two ways. They dramatize the depths of their characters' feelings so successfully that we share them, and they allow us to understand just how fragile are the lives we are watching. It's only by seeing this fragility that we have any idea of their true strength.

When first seen, Mac Sledge is a boozing has-been, a once-famous country-and-Western singer and songwriter, drifting through rural Texas doing odd jobs for room, board and bottle. One day he comes upon the isolated motel and service station run by Rosa Lee (Tess Harper), a pretty Vietnam widow who is 15 years younger than Mac and has a 9-year-old son, nicknamed Sonny (Allan Hubbard). Unlike the writing in most warm films, Mr. Foote's screenplay — the best thing he's ever done for films — doesn't overexplain or overanalyze. It has a rare appreciation for understatement, which is the style of its characters if not of the actual narrative.

After a week or two working for Rosa Lee, Mac starts drinking less and less and, after two months, he's off the sauce entirely, at which point he proposes. They are working side by side in the garden, hoeing. "Would you think about marrying me?" says Mac. "Yes," says Rosa Lee, "I will." That is that and they return to their work.

•

For much of the film we're never quite sure how lasting Mac's cure will be. Only gradually do we realize that it's the result of his love for Rosa Lee and Sonny, combined with the physical and emotional exhaustion that have accumulated over the years. Mac never has to say anything to that

effect. It's apparent in every line and in every gesture, big and small.

Although understatement is the style of the characters, "Tender Mercies" is packed with dramatic incidents, sometimes bordering on melodrama, which involve not only Mac's relations with Rosa Lee and Sonny but also with his ex-wife Dixie (Betty Buckley), who is still a star on the country-and-Western circuit, and their pretty, troubled, teen-age daughter, Sue Anne (Ellen Barkin). More about what happens is unimportant to spell out, except to emphasize that it's never predictable.

Mr. Beresford's "Breaker Morant" was a good, solid film based, I'm told, on a good, solid play. I suspect that the success of "Tender Mercies" has less to do with any similarities between Australia's outback and rural Texas than with the director's secure sense of what he wants to see on the screen and his ability to put it there. Beginning with Mr. Duvall, the film is perfectly cast, not with types but with superior actors.

Tess Harper, a Texas actress who makes her film debut as Rosa Lee, will be one of this year's discoveries. A young woman with an oddly asymmetrical blonde beauty, she has the kind of concentration one usually associates with actors who've had long stage experience. However, since young Allan Hubbard, who plays her son and who has never acted professionally before, shares that concentration, I suspect it must be the work of Mr. Beresford.

Almost as fine are Ellen Barkin, as

Mac's spoiled, doomed daughter, and Betty Buckley, who is currently in Broadway's "Cats," as Mac's ex-wife, a tough, determined, savvy, show-biz type.

The film's beautiful physical "look" — lots of long, low, flat horizons under great expanses of cloudless blue sky — is as idealized as the sentiments expressed in the country-and-Western music on the soundtrack, which also gives the film its lilting pace. Good films as genuinely warm and sweet as "Tender Mercies" are rare. I don't want to oversell it, but if an essentially nonmusical movie can be called a toe-tapper, "Tender Mercies" is it. ∎

1983 Mr 13, II:21:1

Muscles and Music

ARIA FOR AN ATHLETE, direction and screen-play by Filip Bajon (Polish with English subti-tles); photography by Jerzy Zielinski; music by Zdzislaw Szostak; produced by the Polish Corpo-ration for Film Production "Zespoly Filmowe," Film Unit "TOR"; a New Yorker Films Re-lease. At the Film Forum, 57 Watts Street. Run-ning time: 108 minutes. This film has no rating.
Wladyslaw Goralewicz Krzysztof Majchrzak
WITH: Pola Raksa, Roman Wilhelmi, Bogusz Bilewski, Wojciech Pszoniak, Ryszard Pietru-ski, Zdzislaw Wardein

By JANET MASLIN

FILIP BAJON'S "Aria for an Athlete" is the story of a cham-pion Polish wrestler at the turn of the century, a bald and brawny fellow who evolves into a music lover and a gentleman. It's a tale of some but not overwhelming in-terest, told by Mr. Bajon with a seri-ousness and intensity more admirable than magnetic. However, it's a varied and colorful film, well acted by Krzysztof Majchrzak as the enor-mous, gentle-eyed athlete who col-lects statues of Atlas. At times, this belle-époque strongman seems no less burdened than the statues.

Wladyslaw Goralewicz, a character based on three actual Polish wres-tlers, first talks his way into a side-show as a small boy, pleading "Can you take me into your circus? I'm the ugliest boy in town." Later, as a young giant, he is advised by a circus crony to slam his head on a door, so as to achieve a suitably scarred look about the ears. Eventually, he be-comes one of a beefy crew of fair-ground wrestlers who butt heads and chests in the wrestling style of the day. Rivalry with other wrestlers forces him out on his own, where he becomes enormously successful and is exposed to the sophisticated temp-tations of the era. "You should try your luck in the wide world," a men-tor tells him, promising "women in black dresses, the opera and opium."

These are the days when a muscle-man allowed himself to be run over by an 800-pound car, and "all Paris went mad about it," as one character pro-claims. Mr. Bajon, who takes great pains to depict the wrestlers' life in detail, also concentrates on the era and captures it effectively at times. His wrestlers travel through Europe, even winding up in a bullfighters' camp when Goralewicz asks a one-eyed comrade: "Cyclops, where's the end of the world."

●

He replies: "As far as I know, it's Portugal," and Goralewicz is there when we see him next.

"Aria for an Athlete," which opens today at the Film Forum, captures the unusual details of Goralewicz's life as

it follows his running feud with some fellow wrestlers, his peculiar mar-riage and the heights of sadness and pleasure that music seems to arouse in him. But it's a film that, like its characters, can be stolid and never seems to have a great deal of spark.

1983 Mr 16, C21:4

Action in Asia

HIGH ROAD TO CHINA, directed by Brian G. Hut-ton; screenplay by Sandra Weintraub Roland and S. Lee Pogostin, based on the book by Jon Cleary; director of photography, Ronnie Taylor; film editor, John Jympson; music by John Barry; produced by Fred Weintraub; released by Warner Bros. At the Sutton, Third Avenue and 57th Street; National, Seventh Avenue and 44th Street; Murray Hill, 34th Street, east of Lex-ington Avenue, and other theaters. Running time: 105 minutes. This film is rated PG.
O'Malley .. Tom Selleck
Eve .. Bess Armstrong
Struts .. Jack Weston
Bradley Tozer Wilford Brimley
Bentik .. Robert Morley
Suleiman Khan Brian Blessed
Alessa Cassandra Gava
Charlie Michael Sheard
Lina .. Lynda Marchal
Officer Timothy Carlton
Ahmed Shayur Mehta

PROBABLY without intending to, the producers of "High Road to China" have made an action-adventure comedy in which everybody and everything — and thus the film itself — seem to have been spun off from other, better films, particularly Steven Spielberg's "Raiders of the Lost Ark."

"High Road to China," which opens today at the Sutton and other theaters, is set in a sort of mythical "Roaring 20's," which can be immediately iden-tified because a young woman is seen doing a mad Charleston in an early scene. It's about a cross-continental air chase from Turkey to China, un-dertaken by a dizzy but very rich young woman (Bess Armstrong) and a hard-drinking former World War I air ace (Tom Selleck), whose services and two fine old biplanes she has hired in the search for her long-lost father.

In the course of the film, they are taken prisoner by a Moslem sheik, played so evilly by Brian Blessed that "High Road to China" recalls the ra-

cial and religious prejudices of an earlier era of movie-making.

Miss Armstrong, who was seen as the second, prettier wife in Alan Alda's "The Four Seasons," is the best thing in the film, though even she seems to be a cross between Julie An-drews and Carol Burnett. Mr. Selleck is, indeed, a handsome actor, but his good looks here have no individual personality, which may be the script's fault. He appears to have been put to-gether by a police artist attaching Fred MacMurray's hairline and fore-head to James Brolin's eyes and nose and Clark Gable's mouth and chin.

The subsidiary roles are played by Robert Morley, who has little to do ex-cept fume; Jack Weston, as Mr. Sel-leck's mechanic, nicknamed Struts, and Wilford Brimley as Miss Arm-strong's eccentric father, who is actu-ally less a Hemingway spinoff than a conscious parody.

The not-great screenplay is by San-dra Weintraub Roland and S. Lee Pogostin, and Brian G. Hutton ("Where Eagles Dare") is the direc-tor. Only one action sequence — when Miss Armstrong and her employees escape from the wicked sheik — has the style and humor missing from the rest of the movie. The film's two bi-planes, named Dorothy and Lillian after the Gish sisters, do their name-sakes justice. They are beautiful.

●

"High Road to China," which has been rated PG ("Parental Guidance suggested"), contains some mildly vulgar dialogue.

Vincent Canby

1983 Mr 18, C4:3

WILD STYLE, written, produced and directed by Charlie Ahearn; photographed by Clive David-son and John Foster; edited by Steve Brown; music by Chris Stein; produced by Fred Braith-waite and Jane Dickson; presented by the Film Society of Lincoln Center and the department of film of the Museum of Modern Art as part of the "New Directors/New Films" series. At the 57th Street Playhouse, between Avenue of the Ameri-cas and Seventh Avenue. Running time: 85 minutes. This film has no rating.
Raymond Zoro Lee George Quinones
Phade Frederick Braithwaite
Rose Lady Bug Sandra Pink Fabara
Virginia .. Patty Astor
Zroc Andrew Zephyr Witten
Raymond's Brother Carlos Morales
Boy with Broom Alfredo Valez
Art Patron .. Niva Kislac
TV Producer .. Bill Rice
Curator Glenn O'Brien
Zoro Double Dondi White
Gangster Pookie Daniels
Champagne Winner Chief Rocker Busy Bee
Community Organizer Joe Lewis

By VINCENT CANBY

THE 1983 "New Directors/New Films" series, sponsored by the Film Society of by the Film Society of Lincoln Center and the department of film of the Mu-seum of Modern Art, begins modestly and in good faith tonight with the showing of Charlie Ahearn's "Wild Style" at the 57th Street Playhouse at 8:30.

The film, which will be shown again tomorrow at 3:30 P.M., looks to be a partly improvised piece of fiction, about the cheeky, high-spirited art of the south Bronx, that is, subway graf-fiti, also known as "writing," and about rapping and breaking.

●

For the benefit of the uninitiated, rapping refers to a very particular kind of musical communication, in which the singer, backed by a monoto-nous, rhythmic beat, talks in rapid, al-ways nervy rhymes that proclaim the singer's superiority in one sort of en-deavor or another. Like good calypso, good rapping is a mixture of the primitive, sophisticated and topical.

Breaking, or break-dancing, is a way of dancing to these and other forms of music, a religious experience with extraordinary athletic skills. The high point of a great break-dancer's turn may be a pirouette on his head.

The slight narrative of "Wild Style" is about Raymond (Lee George Qui-nones), a skinny, outwardly mild-mannered Bronx teen-ager by day and, by night, the notorious "Zorro," a celebrated but unidentified spray-paint artist for whom every subway car is an empty canvas. Raymond scorns his fellow graffiti artists who turn their talents to legitimate, com-missioned murals on the walls of play-grounds and business establishments.

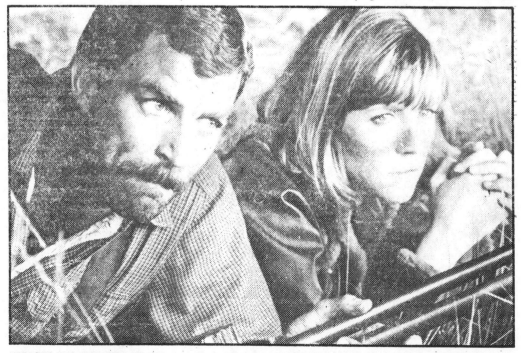

"HIGH ROAD TO CHINA"—Tom Selleck plays a World War I flying ace, down on his luck in the Far East in the 1920's, who is hired by Bess Armstrong to find her father.

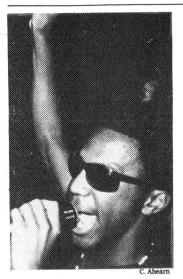

Chief Rocker Busy Bee in "Wild Style," in the "New Directors/ New Films" series

"Graffiti is taking risks," says Raymond, who likes to dodge over and around third rails in the subway yards at night. He prefers painting in the dark since, after all, "I know all my colors by heart." He also likes outwitting the police as he makes the world more exotic.

"Wild Style" also has a slight love story involving Raymond and Rose Lady Bug (Sandra Pink Fabara), a spray-paint muralist who brings Raymond back to his senses when he takes his art too seriously.

Mostly, however, "Wild Style" is a series of random encounters of graffiti artists, rappers and breakers, leading up to a giant rap-break concert in a Lower East Side band shell decorated by Raymond.

●

Unfortunately for the film, Mr. Ahearn, who is an artist as well as a film maker, never discovers a cinematic rhythm that accurately reflects and then celebrates the rare energy and wit of the artists within the film. Too often "Wild Style" has the effect of dampening the enthusiasm of its amateur actors or of not being able to keep up with their nonstop pace. It always seems to be trailing them, as if it were a little brother who can't run as fast as the others.

The subjects are appealing, especially Mr. Quinones, a graffiti artist in real life, and Frederick Brathwaite as a very cool artist-promoter, who attempts to transform Raymond's midnight talents into fame and riches. The film includes one rap contest, which goes at such a clip that it may leave you exhausted, and a funny East Side art-world party, where Raymond is seduced by a beautiful, relentless patroness of all things temporarily new.

"Wild Style" lacks a lot of the style of the people in it, but it never neutralizes their vitality.

1983 Mr 18, C8:3

A QUESTION OF SILENCE (De Stilte Rond Christine M.), written and directed by Marleen Gorris (Dutch with English subtitles); camera by Frans Bromet; edited by Hans van Dongen; music by Lodewijk de Boer; produced by Matthijs van Heijningen, Sigma Films; a Quartet Films release presented by the Film Society of Lincoln Center and the department of film of the Museum of Modern Art as part of the "New Directors/New Films" series. At the 57th Street Playhouse, between Avenue of the Americas and Seventh Avenue. Running time: 92 minutes. This film has no rating.

Court Appointee Cox Habbema
Christina M. Edda Barends
Waitress Nelly Frijda
Secretary Henriette Tol
Ruud Edyy Brugman
Boutique Manager Dolf de Vries
Police Inspector Cees Coolen
Pathologist Onno Molenkamp
Judge Hans Croiset

THE feminist cause will not be well served by "A Question of Silence," a Dutch film that tells of three women who stomp, kick and pummel to death a male shopkeeper. The incident is triggered when one of the women tries furtively to steal some merchandise. The manager sees her and is all set to chastise her, when two other female patrons, who don't know the first woman and don't know the manager either, defiantly pocket some merchandise to show their solidarity. At this, the manager breaks into a cold sweat, and no wonder. Moments afterward, he is beaten to a pulp.

Why? Well, apparently because he is a man, and the three shoppers have all been ill treated by other men that they know. "Do you think there are people who won't think you are mad?" asks the woman psychiatrist who has been appointed to study this case, and from whose point of view the film is presented. "Yes," says one of the accused. "Women." Sure enough, female spectators in the courtroom where this case is eventually tried greet the womens' testimony with applause.

"A Question of Silence," which was written and directed by Marleen Gorris and is part of the "New Directors/ New Films" series, may not be part of any commonplace genre. But that doesn't keep it from being predictable. The three suspects themselves, who are described more than once as "ordinary" women, are a beleaguered mother, a nice middle-aged woman who likes to knit and a secretary who resents her boss and is capable of working as a prostitute to demonstrate just how contemptuous of men she can be. The psychiatrist, who is first shown to be very happy with her husband, grows to hate him during the course of the story, and finds herself attracted to the most bold and outspoken of her patients. On her desk, she prominently displays a book by Doris Lessing.

"A Question of Silence" will be shown tonight at 6 o'clock and tomorrow at 1 P.M. at the 57th Street Playhouse.

Janet Maslin

1983 Mr 18, C8:5

IREZUMI — SPIRIT OF TATTOO, directed by Yoichi Takabayashi; screenplay (Japanese with English subtitles) by Chiho Katsura, based on the novel by Baku Akae; photography by Hideo Fujii; music by Masaru Sato; produced by Yasuyoshi Tokuma and Masumi Kanamaru; presented by the Film Society of Lincoln Center and the Department of Film of the Museum of Modern Art, as part of the New Directors/New Films series. At the 57th Street Playhouse, between Avenue of the Americas and Seventh Avenue. Running time: 108 minutes. This film has no rating.
Kyogoro Tomisaburo Wakayama
Akane Masayo Utsunomiya
Fujieda Yusuke Takita
Harutsune Masaki Kyomoto
Katsuko Harue Kyo
Haruna Naomi Shiraishi
Horiatsu Taiji Tonoyama

By VINCENT CANBY

Yoichi Takabayashi's "Irezumi — Spirit of Tattoo" ("Sekka Tomurai Zashi") is a romantically deceptive Japanese film about a young Tokyo secretary who, to please her middle-age lover, spends two years of her life having her back elaborately tattooed.

"Irezumi — Spirit of Tattoo" at the 57th Street Playhouse.

A tattoo, like a diamond, is forever, but it can't be hocked.

In "Irezumi" it represents a number of things, including fidelity and the total submission of the tattooed woman to her lover, who can, of course, change his mind while she cannot.

"Irezumi" is not an easy movie to respond to initially. It has its share of what are crudely called "howlers," especially in its subtitles. It's also difficult to fathom the extraordinary passivity of the beautiful Akane to her lover, a mild-mannered librarian who wears conservative business suits and a Burberry scarf, and in all ways is utterly ordinary except for his passion for tattooed skin.

●

Yet, as "Irezumi" goes on, the film becomes increasingly involving and erotic until, finally, we accept its ellipses and rather large chunks of exposition that explain what happened before the movie started.

"Irezumi" will be shown at 6 P.M. today and 1 P.M. tomorrow at the 57th Street Playhouse in the New Directors/New Film Festival.

Next to Akane, the most important character in the film is Kyogoro, the elderly Kyoto tattooist who agrees to come out of retirement to execute one last work of art. As a psychiatrist might examine someone who wants a sex-change operation, the old man questions Akane at length about her motives, repeatedly making the point that the tattoo can't guarantee happiness and may possibly ruin her life.

He further explains that the process is not only long and painful, but also that his methods are — well — unorthodox. Just how unorthodox, Akane doesn't understand until her first session.

At that time, Kyogoro introduces her to his assistant, a handsome young man named Harutsune, whose function it is to lie naked under Akane, her back bare and her buttocks discreetly covered by a cloth, as the old man punctures her skin with tiny, razor-sharp knives.

Says the old man solemnly, "A woman's skin is most beautiful when it is embraced." One might also think it would be difficult to execute a tattoo on a body that is writhing with such contradictory passions.

●

In no time at all, Akane has accepted this pain/pleasure routine and become emotionally involved with the young man, though she never sees him outside the studio and never seems to think of leaving the lover for whom she is undergoing this transformation.

It's not easy to describe "Irezumi" without making it sound like more of a howler than it actually is. Mr. Takabayashi is more interested in esthetics than psychology. Freud has no place in this world. Though I'm not sure what the film's concerns are, they are not to be analyzed in terms of character.

The film provides us with a glimpse into an ancient cultural system as it survives, in kinky shards, in contemporary Japan. In one of the film's more arresting sequences, we see Kyogoro's plain-faced daughter ironing clothes and watching television while, in the next room, Akane, Harutsune and Kyogoro continue their rigorous labors of love.

The performers, all unknown to me, are excellent, particularly Masayo Utsunomiya as Akane. Mr. Takabayashi, who, at 52, is not exactly a young director, seems to be a serious romantic, his style being simultaneously rich, especially in his frequent use of flashbacks, and spare. I suspect too, that "Irezumi" contains more wit and irony than we ever understand from the subtitles.

1983 Mr 19, 10:3

AND GOD CREATED THEM, directed by Jacobo Morales; screenplay (Spanish with English subtitles) by Mr. Morales; director of photography, Carmelo Rivera; edited by Tony Cortes and Mr. Morales; music by Pedro Rivera Toledo; produced by Mr. Morales; presented by The Film Society of Lincoln Center and The Department of Film of the Museum of Modern Art, as part of the New Directors/New Films Series. At the 57th Street Playhouse, between Avenue of the Americas and Seventh Avenue. Running time: 120 minutes. This film has no rating.
WITH: Miguel A. Suarez, Pedro Juan Figueroa, Benjamin Morales, José Luis Marrero, Gladys Rodriguez, Esther Sandoval, Carlos Augusto Cestero, Norma Candal, Daniel Lugo, Jacobo Morales

By JANET MASLIN

"And God Created Them" is the work of Jacobo Morales, a Puerto Rican actor, writer and director of very apparent wit and ability. Made on a $200,000 budget and boasting no particular technical polish, this collection of ironic, often funny vignettes manages to be entirely disarming. "And God Created Them" will be shown this evening at 8:30 and tomorrow at 3:30 at the 57th Street Playhouse, as part of the New Directors/ New Films series.

Each of the five separate anecdotes here concerns prosperous Puerto Rican characters who at first seem ordinary, controlled, urbane and respectable. And each of the episodes, which were written by Mr. Morales, takes a wicked delight in eventually unmasking its principals.

There is a bishop-cum-businessman, for instance, who makes a real-estate deal with a member of his flock. The realtor then confesses that he has swindled the clergyman — but he won't allow the deal to be canceled, nor will he permit the bishop to use the information he's heard in confession. Another, equally sardonic anecdote

concerns the funeral of a rich businessman, attended by his two sons, who will soon become bitter rivals, and his very sexy widow, who married the deceased only a day before and who all of the male mourners want to console.

Mr. Morales specializes in narrative surprises. There is one segment detailing the guilty secrets of two men and a woman trapped in an elevator, and another about an unlovely middle-age woman who, though she is surrounded by young beauties, mysteriously manages to attract the best-looking man in a swinging nightclub. Mr. Morales's best turnabout of all is reserved for the last segment, titled "The Other Woman." It wouldn't be fair to reveal the details, but this tale plays a wonderful trick upon the audience, and it's set up with a cunning that, in retrospect, seems quite diabolical.

A small troupe of actors, including Mr. Morales himself, appear in different roles in different segments, but this isn't the only explanation for the film's unified feeling. Mr. Morales's view of a certain segment of affluent, urban Puerto Rican society is keen and consistent. It's expressed with vitality and simplicity in the various stories here.

1983 Mr 19, 11:1

THE PERSONALS, directed and written by Peter Markle; directors of photography, Mr. Markle and Greg Cummins; edited by Stephen E. Rivkin; music by Will Sumner; produced by Patrick Wells; released by New World Pictures. At the Waverly, Avenue of the Americas and Third Street. Running time: 90 minutes. This film is rated PG.
Bill .. Bill Schoppert
Adrienne .. Karen Landry
Paul ... Paul Eiding
David .. Michael Laskin
Shelly ... Vicki Dakil
Jennifer .. Chris Forth
Jay ... Patrick O'Brien
Party Hostess Arlene Simon
Reader Secretary Barbara Kingsley
Bill's Bar Pickup Peggy Knapp
Matchmaker John Lewin
Punk Girl at Reader Char Baehr

By VINCENT CANBY

Bill (Bill Schoppert) is an almost perfect representation of today's idealized, upwardly mobile — though forever middle-class — consumer society. He's a successful magazine publisher in Minneapolis and newly single. His wife has left him for another man, and while he's not exactly suicidal, he's lonely and at loose ends. More or less as a joke, he puts a personals ad in The Twin Cities Reader, describing himself as a "SWM," 32, who is interested in, among other things, Picasso and chicken Kiev.

The letters pour in, including one from a young woman named Shelly, who doesn't mind that he's not Jewish and scares him nearly fatally on their first and only date. On his second try, he meets Adrienne (Karen Landry), who looks like a gift for any man who's ever had fantasies about Margot Kidder. She's pretty, bright, seemingly self-sufficient, funny, literate and a psychologist — just about everything that people who use such ad columns claim to be but seldom are.

This is the easy-going basis for "The Personals," a breezy first feature written and directed by Peter Markle, a young, Minneapolis-based film maker whose earlier works have been short films and television commercials. That background is evident throughout "The Personals," but then the film is about the sort of people who might very well see themselves in terms of the slow-motion, richly scored lyricism one associates with ads for menthol cigarettes.

The film opens today at the Waverly Theater.

Whenever "The Personals" threatens to become annoyingly cute, which happens from time to time, the good humor and common sense of the film makers usually save things. The movie rolls along with the smooth stylishness of the roller skaters in a Minneapolis park, whom Bill at first envies and then emulates. In fact, much of the film appears to have been shot on roller skates, often at roller-skate level.

Mr. Markle appears to be a funny man, and though the butts of his jokes aren't entirely new, his manner is pleasingly light. He's particularly good with his throwaway lines, including dialogue overheard in a singles bar. She: "You must come to my shop. I sell designer shoes." He: "I don't have designer feet."

One may or may not believe that anyone as well-adjusted as Bill would ever have to place a personals ad or that a psychologist like Adrienne would ever answer it if he did. Plausibility is less important than the way this love story is acted out, which is with charm and self-awareness.

Mr. Schoppert's Bill manages to be comic without seeming to be stupid. At times the actor may remind you of a slightly larger, stockier Buck Henry, but he has his own, distinctively average-guy personality. Miss Landry's role is not as clearly written, but Adrienne's bewilderment with the affair in which she finds herself is very appealing. Also good is Paul Eiding as Bill's best friend, a fellow who has been married since he was 22 and takes great delight in telling Bill how to use his new-found freedom.

"The Personals" is as sunny as — but a lot funnier than — a film designed to promote the joys of living in Minneapolis, which it often resembles. Minneapolis? According to "The Personals," it's a place of perpetual summer, clear skies, gentle lakes, safe parks, clean streets, high employment and pretty, long-legged, tanned young women in short shorts who live on roller skates.

•

"The Personals," which has been rated PG ("parental guidance suggested"), contains some mildly vulgar dialogue.

1983 Mr 20, 60:1

BETRAYAL: THE STORY OF KAMILLA, directed by Vibeke Lokkeberg; written by Vibeke Lokkeberg in cooperation with Terje Kristiansen; director of photography, Paul Rene Roestad; presented by The Film Society of Lincoln Center and The Department of Film of the Museum of Modern Art as part of the New Directors/New Films Series. At the 57th Street Playhouse, between Avenue of the Americas and Seventh Avenue. Running time: 108 minutes. This film has no rating.
WITH: Nina Knapskog, Kenneth Johansen, Helge Jordal, Vibeke Lokkeberg, Karin Zetlitz Haerem, Renie Thorleifsson, Klaus Hagerup, Johnny Bergh, Kjell Pettersen and Marie Takvam.

"Betrayal: The Story of Kamilla" is less interesting for itself than for its promise of greater things to come from Vibeka Lokkeberg, the young Norwegian woman who wrote and directed it and plays — beautifully — a leading role.

The film will be shown in the New Directors/New Films Festival at the 57th Street Playhouse today at 6 P.M. and on Tuesday at 8:30 P.M.

The time is shortly after the end of World War II and the place is Bergen, on Norway's west coast. The film's theme is dislocation and disillusion, mostly as experienced by a pretty,

Nina Knapskog as "Kamilla" in "Betrayal: The Story of Kamilla."

solemn little girl named Kamilla, who lives with her exhausted parents in a small flat above her father's shoe-repair shop and laundry.

A dark cloud hangs over Kamilla's father who — though this is never fully explained — seems to have collaborated with the Nazis during the German occupation of Norway and, as a result, has a bundle of illegal money secreted in the apartment.

The film is called "The Story of Kamilla," but it's far more effective in the way it dramatizes the hopelessness of marriages gone permanently sour and of adult lives that have reached dead ends.

"The Story of Kamilla" becomes contrived and hollow when, toward the end, it imposes on its child actors attitudes and dialogue that have less to do with childhood than with an adult's perception of childhood. At one point, when Kamilla and her small boyfriend run away from home, the movie seems to be on the point of turning into a pre-teen "Elvira Madigan."

Otherwise, however, "The Story of Kamilla" is full of vignettes that identify Miss Lokkeberg as a film maker of feeling and imagination. I think especially of a scene in which Kamilla's mother and another woman, each abandoned by her husband and bored out of her mind by the drabness of life, invite a lingerie salesman to come into the apartment, buy most of his wares and then get nuttily drunk with him.

The performances are superior, including those of Miss Lokkeberg as Kamilla's mother, Helge Jordal as her father and Nina Knapskog in the title role.

Vincent Canby

1983 Mr 20, 60:1

NEXT YEAR IF ALL GOES WELL, directed by Jean-Loup Hubert; screenplay (French with English subtitles) by Mr. Hubert, Josyane Balasko and Gérard Zingg; director of photography, Robert Alazraki; edited by Helene Viard; music by Vladimir Cosma; produced by Serge Laski and Jean-Claude Fleury; production companies, Les Films de L'Alma, SFPC (Paris) C.C.F.C. (Paris); released by New World Pictures. At the Cinema 3, 59th Street and Third Avenue. Running time: 95 minutes. This film is rated R.
Isabelle Isabelle Adjani
Maxime Thierry Lhermitte
Huguette Marie-Anne Chazel
Henry .. Michel Dussarrat
François Moinet Bernard Crommbe
Isabelle's father Fred Personne
Isabelle's mother Antoinette Moya
The fan of Major Gutterbill Virginie Thevenet
Grandpa ... Paul Vally
Grandma Louise Rioton
Tantine Madeleine Bouchez
Prune Matwenn Le Besco
Barnaby Sébastien Demarigny

Jean-Loup Hubert's "Next Year If All Goes Well" is a fragile French comedy about . . . well, not about very much at all, which is its chief problem. It concerns a young career woman, Isabelle (Isabelle Adjani), and her lover, a cartoonist named Maxime (Thierry Lhermitte), as they grapple with their ambivalence concerning parenthood and the prospect of marriage. Though their domesticity is amusingly disrupted when Isabelle's parents come to visit, they otherwise seem to be getting along. Then Isabelle decides she wants a baby and Maxime decides he doesn't, and they must settle the issue by quarreling, trying out infidelity and having a lot of heart-to-heart talks with their various friends.

"Next Year If All Goes Well," which opens today at Cinema 3, is a pleasant movie but not a particularly compelling one. Mr. Lhermitte makes a nicely unaffected leading man. And Miss Adjani is a gifted actress and a beauty, though she parades about in some of the least flattering costumes you may ever see. Together, they are sweet and reasonably believable, though somewhat mirthless in the film's most pointedly comic moments. Actually, this isn't so much a comedy as it is a light-hearted film about serious matters. That light-heartedness never produces much charm, and it finally amounts to a considerable limitation.

During the course of the story, Maxime and Isabelle see their own problems mirrored in the marriage of Huguette (Marie-Anne Chazel) and Henry (Michel Dussarrat), two close friends with young children. And they visit Isabelle's parents, who make all guests don special slippers so as not to damage the marble floors in their home. Mr. Hubert presents this with low-keyed humor, and he also follows the adventures of a local ladies' man. These subplots serve to give the film a busy and well-populated feeling, if not a particularly energetic one.

The screenplay, which was co-written by Mr. Hubert, Josyane Balasko and Gérard Zingg, sounds as if it was based on at least a few real experiences of the writers' various friends, and that gives the film its greatest advantage. There may indeed be characters or events one might recognize here; the only question is whether they are any more interesting on the screen than they were in your own real life, or anyone else's.

1983 Mr 20, 60:1

A FAREWELL TO THE LAND (Saraba Itoshiki Daichi), written and directed by Mitsuo Yanagimachi (Japanese with English subtitles); cinematography by Masaki Tamura; edited by Sachiko Yamaji; music by Toshiaki Yokota; produced by Mr. Yanagimachi, Tetsuya Ikeda and Michihiko Ikeda; presented by the Film Society of Lincoln Center and the Department of Film of the Museum of Modern Art as part of The New Directors/New Films Series. At the 57th Street Playhouse, between Avenue of the Americas and Seventh Avenue. Running time: 130 minutes. This film has no rating.
Yukio Yamazawa Jimpachi Nezu
Junko Kumiko Akiyoshi
Akihiko Jiro Yabuki
Fumie Miyako Yamaguchi
Daijin ... Keizo Kanie
Fumiko Aoi Nakajima
Ine ... Sumiko Hidaka
Koichiro Koen Okumura
Junko's mother Sumie Sasaki

By JANET MASLIN

Mitsuo Yanagimachi's "Farewell to the Land" is an unusually tough and contemporary Japanese drama from its first scene, of a family cleaning up the debris created by a very destructive son, to its violent and troubling conclusion. The story was suggested by news items, one of them concerning a man who comes to no good after abandoning his family and moving in with another woman. But it is Mr. Yanagimachi's careful, resonant treatment of the material that distinguishes this film. The story may be partly true, and it is told straightforwardly, but "Farewell to the Land" is most memorable for its haunting, even hallucinatory moments.

The film concerns a man named Yukio, who drives a dump truck in a newly industrialized part of Japan. He has a vicious temper and, after the deaths of his two children, a problem with drugs. The film follows his deteriorating relationship with a more successful brother, Akihiko, and his leaving his pregnant wife, Fumie, to begin an affair with Junko, a former girlfriend of his brother's. This romance is launched as Yukio offers Junko a ride down a stark, modern highway that stretches straight to the horizon, providing Mr. Yanagimachi with a typically plain yet resonant image.

The film's most striking moments, like this one, are emphasized no more emphatically than its simplest ones, yet they linger for a long while. A funeral held during an eclipse, a shabby house with traditional Japanese décor plus an electric fan, a sexual encounter in a pigpen, a man beating his pregnant wife in the mud, even a woman's hand dropping the pieces of a note from her mother out a window. Even the more sordid of these scenes have a strange beauty. Serenity and viciousness quietly collide throughout the film, as surely as the modern industrial architecture seen here collides with Mr. Yanagimachi's intense, almost surreal visions of the land itself.

"A Farewell to the Land" will be shown tonight at 8:30 and tomorrow at 6 P.M. at the 57th Street Playhouse, as part of the New Directors/New Films series.

1983 Mr 20, 60:3

FILM VIEW

JANET MASLIN

There's More To Scenery Than Meets The Eye

I saw the same Fifth Avenue balcony in two different films last week, playing two different roles. One day it turned up in "Tales of Ordinary Madness," as part of the Rockefeller Center office where a fast-living, fiercely independent-minded poet, modeled on Charles Bukowski and played by Ben Gazzara, goes to meet with his straitlaced New York publisher.

The very next morning, I watched the leading character in Sandy Tung's forthcoming film, "A Marriage," visit the same spot, which was now supposed to be a slightly less staid-looking lawyer's office, although by now it had begun to seem more real than any scene that contained it. Sometimes movie locations do have a way of doing that; they supersede the scenes in which they're used, interjecting an element of reality into situations that are otherwise entirely fabricated. Sometimes the locations take on a life of their own.

One thing of which I'm certain: The degree to which a movie location is memorable has almost nothing to do with the quality of the film in which it appears. You may be as apt to remember the singles' bar where Dustin Hoffman met Mia Farrow in the otherwise forgettable "John and Mary" as the Lincoln Center restaurant where Diane Keaton and Woody Allen parted in "Annie Hall." A restaurant, when skillfully used (as the Russian Tea Room is in "Tootsie"), can be as atmospheric and influential a piece of scenery as, say, Monument Valley.

But when it comes to the great outdoors, grand scenery stands a significant chance of overpowering the actual scene for which it is a backdrop, especially if the film has little else to recommend it. Currently, "The Gift" and "Table for Five" are two of the less exciting movies in town, but anyone who sees them will recall their settings long after the plots and performances have been forgotten. "Table for Five" follows Jon Voight, as a bachelor father, on a round-the-world cruise with his three children as they visit the Sphinx, the Parthenon, and a number of other places you'd love to look at, no matter how dim the movie that contains them. "The Gift" is an otherwise silly sex comedy, but it does include a number of scenes in which the actors are dunked into Venice's Grand Canal.

There's more to movie scenery than vicarious tourism, of course, although films may be the easiest and only way of seeing India ("Gandhi"), Arabia ("Lawrence of Arabia"), Australia (anything from "The Chant of Jimmie Blacksmith" to "Breaker Morant" to "Gallipoli"), or any other distant place not on one's immediate personal itinerary. Certainly any frequent filmgoer develops the feeling of having seen the world, even if the experience is only second-hand. Although most movies deliberately glamorize and falsify the locations they present, some sense of the actual place is inevitably transmitted.

When the setting is enchanting and an essential part of the film that contains it, as a particular Scottish coastal village is in Bill Forsyth's "Local Hero," then the sense of place is wholly wedded to the film's characters, its story, and its overall sensibility. A beautiful setting for a less than sunny film, on the other hand, can have an ironic and even distancing effect. The Taviani Brothers' "Night of the Shooting Stars" is set in the Tuscan countryside during World War II, as the people of a tiny village hide from, and finally do battle with, their Fascist enemies. The Tavianis create a stirring sense of the landscape, and of the villagers' closeness with nature and with one another, that extends even into the film's most brutal scenes.

And yet at moments when the film is relatively indefinite about its characters and their relationships, the scenery becomes distractingly lovely. The Tavianis' story must take place in this village, and the use of the scenery could not be more appropriate or necessary. But at moments when the film's grip on its dramatic elements weakens, its scenery can become disproportionately powerful, and it can undermine the otherwise tense yet fanciful overall mood.

Movies set closest to home are the ones whose settings can have the most magical effects on audiences. Urban sites that have been immortalized on the screen develop a certain aura, and they never look ordinary again. There are those of us who never ride the subway without thinking of "The Warriors," or pass Times Square or the westernmost block of 57th Street without being reminded of "Taxi Driver." It's not that these films used New York more extensively than dozens of other films have; it's just that each used it so consistently and with such a powerful sense of purpose as to redefine everyday locations in terms of a particular story.

Films that do this, even to a minor degree, develop utterly individual visions of the city. The New York of "Annie Hall" isn't anything like the New York of "An Unmarried Woman," even though both were set in the same general area at approximately the same time. Films like "Serpico," "The In-Laws," "The Goodbye Girl," "Saturday Night Fever" and now "The King of Comedy" use settings that must have been used plenty of other times. Yet each of these films, like countless other creditable movies made here, seems to have its own very distinctive turf.

Mr. Tung's "Marriage," which will be part of the Museum of Modern Art's New Directors/New Films series, was shot almost entirely on Staten Island, and it's an example of how a seemingly unremarkable setting can be made interesting, even exotic. Here, Staten Island seems a varied and spacious locale — a series of houses, apartments and suburban scenes that mirror a married couple's evolution. Spanning a decade and a half, the film follows its leads from one Staten Island site to another, and eventually into Manhattan, with a sense of place that remains well-defined from beginning to end. In terms of mystery or glamour, Staten Island isn't the India of "Gandhi," or even the San Francisco of "Bullitt" or the Southern California of "American Graffiti." But Mr. Tung manages to make it someplace revealing, and someplace very distinctly his own. ∎

1983 Mr 20, II:19:1

> The frequent filmgoer develops the feeling of having seen the world, even if the experience is second-hand.

33

Comical Conductor

CHOPIN, written and directed by Luciano Odorisio (Italian with English subtitles); camera, Nando Forni; edited by Antonio Uterzi; presented by the Film Society of Lincoln Center and the department of film of the Museum of Modern Art as part of the "New Directors/New Films" Series. At the 57th Street Playhouse, between Avenue of the Americas and Seventh Avenue. Running time: 100 minutes. This film has no rating.

Francesco Michele Placido
Nicolino Tino Schrinzi
Marta Giuliana De Sio
Gianni Lino Troisi
Andrea Adalberto Maria Merli
WITH Guido Celano, Fabio Traversa

By JANET MASLIN

"CHOPIN" is an odd title for Luciano Odorisio's spirited comedy, which turns out not to be about the composer himself, but about a small Italian provincial city, where a new orchestra is being assembled. There appears to be considerable competition for the conductor's job, and this provides Mr. Odorisio with what little excuse he needs for a plot. For the most part, though, his film is cheerfully anecdotal, without any well-defined center but with a wit and intelligence that help hold it together.

"Chopin" is also very adroitly acted, by a cast headed by Michele Placido and Giuliana De Sio. They play Francesco and Marta, the foremost conducting hopeful and his sexy, faithless, but very companionable wife. Francesco, who has a way of becoming physically ill every time he thinks of anyone else's landing the job, is a 40-ish academic less troubled by Marta's frequent infidelities than by his own unrealized ambitions. Somehow, the two seem to have a satisfying marriage.

●

The movie, which is set in the city of Chieti, introduces a group of music-world oddballs and gossips, including one very minor character who has earned the nickname of the title, by trying to pass off one of Chopin's compositions as his own. All of them are busily engaged in speculation about the new orchestra, and there is some feeling that a local-born conductor now living in Milan, named Serano, will be invited back. Maestro Serano does indeed appear, but in a moving and unexpected way, as he re-encounters Francesco, who is a longtime friend. Mr. Odorisio makes their meeting sound the film's most stirring note.

Mr. Odorisio, who has worked with the Taviani brothers and Marco Ferreri, gives the film some amusing details, including Francesco's and Marta's electrified version of Botticelli's Venus (it's a lamp), and a couple of Indian house guests who think it is beautiful and would give anything to buy it from them. He also fills the soundtrack with some very unlikely music, including one country-and-western-style song by an Italian pop crooner and the theme from "New York, New York." The latter is played with the film's opening credits, as we first see Chieti, a city whose medieval architecture and charming setting don't accurately mirror the show-business ambitions of some of its denizens.

"Chopin" will be shown tonight at 8:30 and tomorrow at 6 P.M., at the 57th Street Playhouse, as part of the "New Directors/New Films" series.

1983 Mr 21, C10:4

A Life of Habits

JEANNE DIELMAN, 23 QUAI DU COMMERCE, 1080 BRUXELLES, directed by Chantal Akerman; French with English subtitles; photographed by Babette Mangolte. At the Film Forum, 57 Watts Street. Running time: 198 minutes. This film has no rating.
WITH: Delphine Seyrig, Jan Decorte, Henri Storck, J. Doniol-Valcroze.

By VINCENT CANBY

LIKE its blunt title, Chantal Akerman's "Jeanne Dielman, 23 Quai du Commerce, 1080 Bruxelles," deals in unadorned facts. It's about the looks and sounds of ordinary things and people, which it records with such precise, unsettling clarity that it has the effect of finding threats in mundane objects and doom in commonplace characters.

It's not difficult to understand the extraordinary underground reputation of this lengthy (three hours and 18 minutes), very beautiful Belgian film, made in 1975 and starring Delphine Seyrig, a screen presense comparable, perhaps, only to Garbo. Miss Seyrig has participated in a number of supposedly experimental films over the years, but in none as original and ambitious as this.

●

"Jeanne Dielman" is not quite like any other film you've ever seen, though it does recall the early films of Jean-Luc Godard as well as some of the work of our structuralist film makers of the late 1960's and 70's. It's as fastidious and deadpanned as its title character, a genteel, middle-class widow-and-mother who supports herself and her teen-age son by prostitution each afternoon, in her depressingly tidy apartment, with a series of fastidious gentlemen callers, middle-aged and older.

"Jeanne Dielman," which opens today at the Film Forum, has been described as minimalist, though I don't see how any film this long and so packed with information could be equated with minimalism as defined in painting. The manner of the film is spare, but the terrible, obsessive monotony of the life it observes is ultimately as melodramatic as, say, Roman Polanski's "Repulsion."

Miss Akerman records three crucial days in the life of Jeanne Dielman (Miss Seyrig) as if she were observing the habits of some previously unknown insect.

Jeanne Dielman is first discovered in the tiny, immaculate kitchen of her Brussels flat, her back to the camera, washing dishes in the sink. For some time, she doesn't turn around, and the camera simply waits until she does. She wears a smock to protect her sensible skirt, blouse and cardigan sweater from unsightly soap or grease stains. The door bell rings.

Jeanne walks out of the frame and, after a bit, the camera follows her into the hall where, just outside the frame, she greets that afternoon's client. When the pair disappear into Jeanne's bedroom, the unmoving camera stares down the hall at the closed door for what seem to be several minutes, like a well behaved dog.

In the course of these three days, the perfectly ordered, utterly empty world of Jeanne Dielman comes apart, but Miss Akerman's method of dramatizing this breakdown has little to do with ordinary theatrical gestures.

Instead, we are forced to watch this woman so closely that when her routine is interrupted in any way it has the emotional force of a tragic event. Jeanne's life is held together by habits, by the mechanics of housekeeping. She never leaves a room without switching off the light. She washes herself in exactly the same way every morning, shines her son's shoes in the very same order. When she talks, it's only to correct her son or to supply some requested information. Any other communication is to be avoided.

●

Miss Seyrig, though she has never looked more beautiful, is a fascinating, self-mockingly frumpy Jeanne Dielman, who is less a character than some nightmarish representation of a woman. Curiously, Miss Seyrig's elegant features do not look out of place in this bourgeois world, which, as recorded in the photography of Babette Mangolte, is as stylized as Miss Seyrig's presence.

"Jeanne Dielman" is not a movie to see if you're in a hurry to go somewhere else. It demands total attention. If one gives it anything less its revenge will be a boredom so complete it might be fatal.

It's also not a movie to see on an empty stomach. At various points in the film the camera watches Jeanne as she cooks. Without cutting away or using any other ellipses, the movie attends to Jeanne's cooking as if it were a documentary, showing us how she prepares, among other things, what seems to be a succulent meat loaf and paper-thin, breaded, veal cutlets. At the film's end, I was both moved and starved.

1983 Mr 23, C25:4

A Folk Parable

THERE LIVED A WRESTLER (Oridathu Oru Phayaivaan), written, edited and directed by P. Padmaraian; in Malayalam with English subtitles; cinematographer, Vipindas; music by Johnson; producer, R. Suresh; produced by Thundathil Films (Trivandrum); presented by the Film Society of Lincoln Center and the Department of Film of the Museum of Modern Art as part of the New Directors/New Films Series. At the 57th Street Playhouse, between Avenue of the Americas and Seventh Avenue. Running time: 120 minutes. This film has no rating.
WITH: Rasheed, Nedumudi Venu, Jayanthy, K. G. Devaki Amma, Ashok, Jayadevan, Kariachen, Krishnankutty Nair.

By JANET MASLIN

THERE is a simplicity bordering on the primitive to P. Padmarajan's "There Lived a Wrestler," and it gives the film an innocent appeal. The action takes place in a minuscule Indian village where very little ever happens, and the title character is, as one villager puts it, "an elephant sent from heaven." He appears one night by the riverbank, as the few young men of the area hunt for frogs, which are considered a great delicacy. He announces that he is a wrestler. Soon the villagers are feeding him all their best frogs and everything else in sight, in hopes of fattening him up for what they hope will be a money-making wrestling match.

The presence of the wrestler, who signs his name with a drawing of a conch shell and is never called anything other than "the wrestler," changes the lives of the villagers in various ways. He turns the sleepy local tailor into a shrewd businessman. And he forces one older woman to keep a sharp eye on her hens, which have a way of disappearing when the wrestler grows hungry. He also marries the prettiest, and possibly the only, young woman in town. His dance of courtship, performed as he wears wrestling togs and an extremely silly grin, involves flexing his muscles and staggering gleefully up to his bride, then throwing her in the air. This makes, without doubt, for a cinematic love scene unlike any other.

The tale told by Mr. Padmarajan has the feeling of a folk parable, and is acted enjoyably by a thoroughly unself-conscious cast. The highlights of the film are a wrestling match, in which the village's usual population of about eight is augmented by several dozen extras, and a scene in which someone tries to impress the aforementioned pretty young woman by showing her a tiny tape recorder and an aerosol can.

"There Lived a Wrestler" will be shown tonight at 6 P.M. and Saturday at 1 P.M. at the 57th Street Playhouse, as part of the New Directors/New Films series.

1983 Mr 23, C26:3

Family Fortunes

THE DAWN, written and directed by Arifin C. Noer; in Bahasa Indonesian with English subtitles; cinematography by M. Soleh Rusiani; edited by Supandi; music by Embie C. Noer; produced by PPFN (Pusat Produksi Film Negara); presented by the Film Society of Lincoln Center and the Department of Film of the Museum of Modern Art as part of the New Directors/New Films Series. At the 57th Street Playhouse, between Avenue of the Americas and Seventh Avenue. Running time: 170 minutes. This film has no rating.
Temon ... Dani Marsuni
WITH: Suparmi, Amorso Katamsi, Suwastinah, Anthonius Yacobus, Nunuk Khaerul Umum, Susanto Anthonius, Rini Satiti, Charlie Sahetapy, Jalang C. Noer dan Faqih Syahrir

"THE DAWN," written and directed by Arifin C. Noer, is a patriotic, sentimental, very long movie that means to be an Indonesian "Birth of a Nation." The setting is Jakarta in 1945, just after the Japanese surrender to the Allies in Tokyo Bay, when Indonesian nationalists were preparing their war of liberation, first against the Japanese and then against the Dutch.

The film follows the fortunes of one aristocratic Indonesian family, its servants and their friends in the course of the liberation struggle. Although it was shot in wide-screen, color and sound, "The Dawn" looks extremely old-fashioned and is of more historical than cinematic interest. I left after seeing something more than half of it.

"The Dawn" will be shown in the New Directors/New Films Festival at the 57th Street Playhouse today at 8:30 P.M. and tomorrow at 6 P.M.

Vincent Canby

1983 Mr 23, C26:4

Out West Story

THE OUTSIDERS, directed by Francis Coppola; screenplay by Kathleen Knutsen Rowell, based on the novel by S. E. Hinton; edited by Anne Goursaud; music by Carmine Coppola; produced by Fred Roos and Gray Frederickson; released by Warner Bros. At the Criterion, Broadway and 45th Street; Beekman, Second Avenue and 65th Street, and other theaters. Running time: 94 minutes. This film is rated PG.
Dallas Winston Matt Dillon
Johnny Cade Ralph Macchio
Ponyboy Curtis C. Thomas Howell
Darrel Curtis Patrick Swayze
Sodapop Curtis Bob Lowe
Two-Bit Matthews Emilio Estevez
Steve Randle Tom Cruise
Tim Shephard Glenn Withrow
Cherry Valance Diane Lane
Bob Sheldon Leif Garrett

Randy Anderson	Darren Dalton
Marcia	Michelle Meyrink
Jerry	Gailard Sartain
Buck Merrill	Tom Waits
Store Clerk	William Smith

By VINCENT CANBY

IT'S as if someone had handed Verdi a copy of "The Hardy Boys Attend a Rumble" and, holding a gun to the poor man's head, forced him to use it as a libretto. Or, try to imagine a "West Side Story" that is set in Tulsa, Okla., in the 1960's, with no dancing or singing, but with a lot of not-super Carmine Coppola soundtrack music replacing the Leonard Bernstein score. Or, think of a remake of "Rebel Without a Cause" directed by someone under the delusion he's D. W. Griffith shooting "The Birth of a Nation."

If you still don't get the picture, you may have to go see Francis Coppola's "Outsiders," which, coming on the heels, so to speak, of "One From the Heart," leads one to suspect that Mr. Coppola is no longer with us, but up with his entourage observing the world from a space platform.

"The Outsiders," which opens today at the Criterion and other theaters, isn't conventionally bad. It is spectacularly out of touch, a laughably earnest attempt to impose heroic attitudes on some nice, small characters purloined from a "young-adult" novel by S. E. Hinton, the woman who wrote the novel on which "Tex" was based.

•

"The Outsiders" is not an accident. Even though the continuity is sort of jumpy, and even though some principal characters seem to have become minor in the cutting room, it looks to be exactly the movie Mr. Coppola wanted to make. To those of us who can't buy Mr. Coppola's inflated attempts at myth making, it's a melodramatic kid-film with the narrative complexity of "The Three Bears" and a high body count.

Like "Tex," a far more successful, far less pretentious film, "The Outsiders" means to be about the world as it appears to its teen-agers, kids who are orphans or whose parents have abandoned them. It's about two opposing social groups, the poor boys who live on the wrong side of the Tulsa tracks and defiantly call themselves "greasers," after the foreign substance on their hair, and the "socs," pronounced "soshes," the rich society kids who live in big white houses on hills.

•

More specifically, it's about three "greasers." They are Ponyboy Curtis (C. Thomas Howell), whose parents are dead and who's being raised by his older brother; Johnny Cade (Ralph Macchio), a hysterical Sal Mineo type, who can't go home because his parents are such drunken slobs, and Dallas Winston (Matt Dillon), who plays a James Dean role with more early Marlon Brando mannerisms than Dean ever thought of using.

In the course of "The Outsiders," one of the "socs" is accidentally knifed to death by a "greaser," forcing Ponyboy and Johnny to go into hiding in an abandoned church in the country. There, among other things, they eat baloney sandwiches, read "Gone With the Wind" out loud, consider the manifold meanings of a "pome" by Robert Frost about sunsets and discuss the possibility of finding an ideal world without either "greasers" or "socs." In "West Side

Matt Dillon in Francis Coppola's "Outsiders."

Story" that was a song called "Somewhere."

With the help of Dallas, they also become heroes by saving a bunch of small schoolchildren who, when the boys are away temporarily, wander into the abandoned church, which mysteriously bursts into flame. Don't ask me to make sense of this, I'm just reporting the facts.

The film ends with a climactic rumble between the "greasers" and the "socs" that settles old scores and — I think — helps Ponyboy grow up.

Mr. Coppola photographs all of this as if it were the story of Alexander the Great, but the epic vision only makes the story and the characters look more puny and foolish. The young actors are given lines that even Laurence Olivier couldn't read sanely. Diane Lane, the young beauty of "Cattle Annie and Little Britches," comes off fairly well, but that may be because her role, that of a society girl who sympathizes with the "greasers," appears to have been drastically cut.

•

"The Outsiders," which has been rated PG ("Parental Guidance suggested"), contains some vulgar dialogue as well as the kind of violence that leaves three of its young characters dead.

1983 Mr 25, C3:1

Obsessive Romance

BABY, IT'S YOU, direction and screenplay by John Sayles, based on a story by Amy Robinson; director of photography, Michael Ballhaus; edited by Sonya Polonsky; produced by Griffin Dunne and Miss Robinson; released by Paramount Pictures. At the Coronet, Third Avenue and 59th Street. Running time: 105 minutes. This film is rated R.
Jill	Rosanna Arquette
Sheik	Vincent Spano
Mrs. Rosen	Joanna Merlin
Dr. Rosen	Jack Davidson
Mr. Capadilupo	Nick Ferrari
Mrs. Capadilupo	Dolores Messina
Miss Vernon	Leora Dana
Mr. Ripeppi	William Joseph Raymond
Mr. McManus	Sam McMurray

PLASTIC furniture covers. Baby-blue knee socks. A car with push-button transmission. Two teen-age girls in biology class, talking about their love life as they coolly dissect a frog. These and other well-chosen details of a 1960's adolescence are captured by John Sayles with characteristically witty precision in "Baby, It's You," a love story that's as much about the era in which it's set as about the characters it follows.

Indeed, the time (early to mid-60's) and place (Trenton) of Mr. Sayles's film have a way of superseding the high-school lovers who are meant to be at the movie's center. Jill Rosen (Rosanna Arquette) and Sheik Capadilupo (Vincent Spano) happen to be strangely matched and self-involved even by teen-age standards, which is one reason the movie doesn't entirely work as a tale of obsessive romance. Jill is poised, popular, a little aloof and hoping to be a star performer some day; in line with this, she stars triumphantly in a high-school play and practices singing "Stop! In the Name of Love!" in front of the mirror in her bedroom. As for Sheik, he's a sharp dresser with a passionate devotion to Frank Sinatra. "The way I figure it, there's only three people in the world that matter," he tells Jill early in their courtship. "Jesus Christ, Frank Sinatra and me."

Mr. Sayles's screenplay introduces these unlikely lovers in the school cafeteria and follows them long enough to make "Baby, It's You," which opens today at the Coronet, feel more like two movies than one. In its second half, Jill has moved on to Sarah Lawrence, discovered marijuana, let her hair go wavy and become much less of a social success, yet somehow she's still in touch with this high-school beau.

This would make more sense if she and Sheik had been on a firm footing in the old days, but their courtship begins as a very one-sided affair. Sheik, who's got a nasty temper and absolutely no respect for the school's rules, virtually stalks Jill through the corridors until she begins to notice him. One way he attracts her attention is by slicking back his hair and wearing suits in the classroom, which certainly helps him stand out in the crowd. He is helped in these efforts by a loving Italian mama who dutifully irons his pants.

Mr. Sayles's teen-agers are a bit more rueful and knowing than most. They seem to be well on their way to becoming the thirtyish characters of "Return of the Secaucus Seven" or "Lianna," two films in which Mr. Sayles demonstrated a surer sense of his characters than he does here. Jill, who is played crisply and confidently by Miss Arquette, fits more comfortably into Mr. Sayles's scheme, as a headstrong girl who begins to lose her bearings as the story moves on. But Sheik, though he's made powerful and sympathetic by Mr. Spano, seems perpetually ready to drift out of the movie entirely. When he moves to Miami and gets a job lip-synching Sinatra hits in a seedy nightclub, he seems to have passed the point of no return. But the film is determined to stay with him.

Music is a major part of "Baby, It's You," as the title may indicate. The score consists of rock songs that more or less correspond to the time, although Sheik's entrances are accompanied by Bruce Springsteen songs; these may be anachronistic, but they suit Sheik to a T. These touches, as well as the generally impeccable period details and the evocative cinematography by Michael Ballhaus (who shot many of R.W. Fassbinder's later films), suggest that "Baby, It's You" was a labor of love for everyone involved.

Janet Maslin

1983 Mr 25, C6:5

Mean-Spirited

BAD BOYS, directed by Richard Rosenthal; written by Richard Di Lello; directors of photography, Bruce Surtees and Donald Thorin; film editor, Antony Gibbs; music by Bill Conti; produced by Robert Solo; released by Universal Pictures. At the New York Twin, 66th Street and Second Avenue; Loews Showplace, 34th street between Second and Third Avenues; Loews New York Twin, Second Avenue and 66th Street; 86th Street East, at Third Avenue; 8th Street Playhouse, east of Avenue of the Americas and other theaters. Running time: 123 minutes. This film is rated R.
Mick O'Brien	Sean Penn
Ramon Herrera	Reni Santoni
Gene Daniels	Jim Moody
Horowtiz	Eric Gurry
Paco Moreno	Esai Morales
J. C. Walenski	Ally Sheedy
Viking Lofgren	Clancy Brown
Tweefy	Robert Lee Rush
Wagner	John Zenda
Carl Brennan	Alan Ruck
Warden Bendix	Tony Mockus
Terrell	Erik Barefield
Perretti	Dean Fortunato
Ricky Lee	Lawrence Mah

By JANET MASLIN

THE reform-school saga "Bad Boys" gets off to a crackling start, as it intercuts the stories of two teen-age hoodlums about to run afoul of the law. They're also about to become deadly enemies, after Mick O'Brien (Sean Penn) becomes the hit-and-run killer of a young Puerto Rican boy.

The victim is the brother of Paco Moreno (Esai Morales), an especially hard-boiled gang member, who vows revenge on Mick, even though Mick has become temporarily unavailable. A judge, declaring Mick to have a sociopathic personality, has sentenced him to Rainford Juvenile Correctional Facility. This, if the movie's persistent claims to realism are to be believed, is an outstandingly vile place even as snakepits go.

However, Rainford, as the movie presents it, has some peculiar attributes. For all the sadism and the ugliness on display — whoever did the black-eye makeup for this movie really worked overtime — it's a peculiarly orderly place. For every bad youth of any given minority, there's a correspondingly nice prison official. And such basic elements of prison nastiness as racial infighting and homosexual rape are relatively soft-pedaled here.

•

Rainford's two tyrants among the inmates are a black thug and a white one, and they are implausibly ousted by the much smaller Mick and his roommate, Horowitz. As played by Eric Gurry, the tiny prodigy Horowitz is a real scene stealer. But it's impossible to believe either that he wandered into Rainford on his way to the Bronx High School of Science (the screenplay's explanation for his presence is only slightly less far-fetched), or that he'd survive for even 15 minutes in such a place.

Though "Bad Boys," which opens today at Loew's New York Twin, has been directed by Richard ("Halloween II") Rosenthal with a shrewdly manipulative flair, it eventually becomes nothing but ugly and sustains that quality to the bitter end. After all, there is almost nothing in the script by

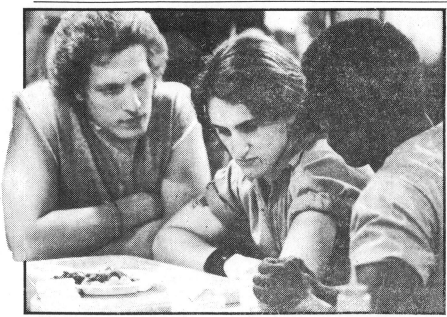

"BAD BOYS"—Clancy Brown and Robert Lee Rush menace Sean Penn, above center, in an institution for young criminals.

"MAX DUGAN RETURNS"—Jason Robards, at left, plays an ex-convict who seeks out his widowed daughter. Herb

Richard Di Lello to make Mick O'-Brien sympathetic. The best he can do, by the end of the drama, is to refrain from killing somebody; that's about the size of his moral redemption. Not much improvement from the story's beginning, which presents him as a ruthless petty criminal simply waiting to go on to bigger, if not better, things.

•

Sean Penn's performance is the chief thing that separates "Bad Boys" from mere exploitation. The film is by no means uniformly well acted; some of the goons are even more goonish than the story requires. But Mr. Penn, who has been given almost nothing to say and only the most mundane of hopes and dreams (he wants to be with his girlfriend, nicely played by Ally Sheedy), gives Mick a quiet forcefulness and some superb instincts where his own self-protection is concerned. The audience is sure to be on Mick's side, not because he's admirable in any way but because Mr. Penn makes it clear that he's got a chance to survive. That, in the movie's mean-spirited scheme, is no minor accomplishment.

1983 Mr 25, C8:1

Joy in a Suitcase

MAX DUGAN RETURNS, directed by Herbert Ross; written by Neil Simon; director of photography, David M. Walsh; edited by Richard Marks; music by David Shire; produced by Mr. Ross and Mr. Simon; released by Twentieth Century-Fox Film Corp. At the Criterion, Broadway and 45th Street; Gotham, Third Avenue and 58th Street; 34th Street East, near Second Avenue. Running time: 98 minutes. This film is rated PG.
Nora McPhee Marsha Mason
Max Dugan Jason Robards
Brian Costello Donald Sutherland
Michael McPhee Matthew Broderick
Mrs. Litke Dody Goodman
Coach Roy Sal Viscuso
Luis Panchito Gomez
Charley Lau Charley Lau
Pat Mari Gorman
Kevin Costello Brian Part
Older Woman Billie Bird

IT'S a measure of Neil Simon's ingenuity that "Max Dugan Returns," a film whose premise is more than a little unsavory when you stop to think about it, manages to be a complete crowd pleaser anyhow. Mr. Simon's original screenplay is fast and buoyant, and Herbert Ross's direction shows off the abundant jokes to their best possible advantage. There are certainly some

questionable ingredients to the story, but you're not likely to notice them while the film is under way. You're likely to be laughing.

"Max Dugan Returns," which opens today at the Gotham and other theaters, begins by introducing Nora McPhee (Marsha Mason), an upbeat but impoverished teacher who lives with her teen-age son, Michael (Matthew Broderick), in a shack-like dwelling in Venice, Calif. One rainy night, there's a knock on the door. A sinister-looking fellow appears, dressed in black and carrying some mysterious suitcases. The man turns out to be a long-lost relative: he's Max Dugan (Jason Robards), the father who deserted Nora years ago. This, and Max's declaration that his doctor has given him only a few months to live, ought to give the film its somber side. But Mr. Simon skips right past to the suitcases themselves, which contain money. With this, Max intends to buy his way into Nora's and Michael's good graces.

•

Well, Nora doesn't like this at first. She thinks Max, who has collected the money in Las Vegas under extremely shady circumstances, might just be a bad influence. But Max is a fairy godfather, and he winds up buying off Nora and Michael so spectacularly that they soon become unable to resist him. The movie's biggest sight gags occur each time Nora or Michael returns home to a new pile of loot, which is usually wrapped in a red ribbon whether it's animal, vegetable or mineral. One time they even arrive to find the shack completely remodeled, with gingerbread and grillwork and potted plants where the grayish, peeling facade used to be.

It's to the great credit of everyone responsible for "Max Dugan Returns" — Mr. Simon, Mr. Ross, Miss Mason, Mr. Broderick, Mr. Robards and Donald Sutherland, in the role of an ordinary police detective who wears a wardrobe by Giorgio Armani — that the film really flies. It's well acted, speedily paced and full of outlandish suprises, not the least of them a gift in the form of a Chicago White Sox batting coach, Charley Lau.

•

Mr. Sutherland is particularly relaxed and charming as the officer who meets Nora on the first of several times her car is stolen during the

course of the story. As Nora, Miss Mason is a more comfortable and self-assured comedienne than usual. And Mr. Robards makes Max Dugan a larger-than-life-size comic creation. His Max is stately and sneaky all at once, with far too much panache to be mistaken for any run-of-the-mill moneybags. Max is not merely the bearer of gifts; he's also full of Simonesque advice for his family, as when he suggests that Michael study philosophy when he goes to college. Can you make any money in philosophy, Michael wants to know? "It depends which one you have," Max replies.

Mr. Simon's appears to be a simple, pragmatic "Keep the customer satisfied." In that, he has succeeded once again.

•

"Max Dugan Returns" is rated PG ("Parental Guidance Suggested"). It contains a little strong language but is suitable for most children.

Janet Maslin

1983 Mr 25, C8:5

Housewifely Horrors

DIRTY DISHES (La Jument Vapeur), written and directed by Joyce Bunuel; in French with English subtitles; camera, François Protat; edited by Jean-Bernard Bonis; music by Jean-Marie Senia; a Quartet Films Release; presented by the Film Society of Lincoln Center and the department of film of the Museum of Modern Art. At the 57th Street Playhouse, between Avenue of the Americas and Seventh Avenue. Running time: 92 minutes. This film has no rating.
Armelle Carole Laure
Husband Pierre Santini
Friend Liliane Roveyre
WITH Liza Braconnier, Daniel Sarky, Bernhard Haller

MOVIE housewives have been breaking down with some regularity recently, but none has done it quite so comically as Armelle (Carole Laure), the increasingly anxiety-ridden Parisian wife and mother in Joyce Bunuel's 1978 French comedy, "Dirty Dishes" ("La Jument Vapeur").

The film is the first feature to be directed by Mrs. Bunuel, the Brooklyn-born wife of Juan Bunuel, the film-

making son of Luis Buñuel. It will be shown in the "New Directors/New Films" Festival at the 57th Street Playhouse today at 8:30 P.M. and tomorrow at 6 P.M.

The beautiful Miss Laure, the French-Canadian actress who is usually seen in more steamy films made by her husband, Gilles Carle, is here revealed to be an expert comedienne, especially in the first half of the film, when Mrs. Buñuel inventories the horrors of housewifely bliss.

"Dirty Dishes" is at its best when it is describing the banality of Armelle's existence, as she slops around the apartment with a vacuum cleaner, listens to a call-in radio show on sane sexuality, goes shopping in a ferociously Americanized supermarket and, once, attends a porn film with two giggly women friends.

What is Armelle's future? There's a hint, she thinks, when she, her husband and their children stop at a highway restaurant during a Sunday outing. Sitting next to them, looking utterly bewildered, is a senile old woman, who has been purposely left by her son. Says the harried restaurant manager, "She's the third this month."

Armelle's eventual descent into madness is, I suppose, the entire point of the film, but it's not half so effective and convincing as the very funny, awful events that lead up to it. Mrs. Buñuel has a satirist's eye and ear, and she's sharp enough not to have to use the breakdown to make the film's case.

Vincent Canby

1983 Mr 25, C12:5

THE KILLING OF ANGEL STREET, directed by Donald Crombie; screenplay by Evan Jones, Michael Craig, Cecil Holmes; original story by Mr. Craig; director of photography, Peter James; edited by Tim Wellburn; music by Brian May; produced by Anthony Buckley; released by Satori. At the D.W. Griffith, 59th Street and Second Avenue. Running time: 98 minutes. This film has no rating.
Jessica Simmonds Liz Alexander
Jeff Elliott John Hargreaves
B.C. Simmonds Alexander Archdale
Tommy Riley Reg Lye
Sir Arthur Wadham Gordon McDougall
Alan Simmonds David Downer
Nancy Simmonds Caz Lederman
Scotty Brendon Lunney
Collins Allen Bickford

Rick James	David Waters
Ben	Ric Herbert
Zoe	Pnina Bloch
Mr. Benson	John Stone
Tina Benson	Arkie Whiteley
Mander	Norma Kaye
Melville	Peter De Salls
Ethel Townley	Connie Hobbs
Government Minister	Peter Collingwood
Sergeant Forbes	Brian Anderson
Max	Bar Barratt
Les	Anthony Martir

By VINCENT CANBY

"The Killing of Angel Street," the Australian melodrama at the D.W. Griffith Theater, is an earnest, self-righteous attack on ruthless land developers riding roughshod over the little folks of Sydney. The film is said to be based loosely on actual events, but it so overstates its case that it's likely to give social activism a bad name.

Almost everyone connected with the film has done better things before and since. Donald Crombie ("Caddie") is the director, and John Hargreaves, one of the stars of "Don's Party," plays the key role of a left-wing journalist.

1983 Mr 26, 20:6

THE BLACK STALLION RETURNS, directed by Robert Dalva; screenplay by Richard Kletter and Jerome Kass, from the novel "The Black Stallion Returns" by Walter Farley; director of photography, Carlo Di Palma; edited by Paul Hirsch; music by Georges Delerue; produced by Tom Sternberg, Fred Roos and Doug Claybourne; released by MGM/UA Entertainment Co. At the Cinerama, Broadway and 47th Street; Eastside Cinema, Third Avenue between 55th and 56th Streets; 86th Street Twin, at Lexington Avenue and other theaters. Running time: 103 minutes. This film is rated PG.

Alec Ramsay	Kelly Reno
Raj	Vincent Spano
Kurr	Allen Goorwitz
Meslar	Woody Strode
Abu Ben Ishak	Ferdinand Mayne
Tabari	Jodi Thelen
Alec's Mother	Teri Garr
Tiny Man	Doghmi Larbi
Raj's Father	Angelo Infanti
Scarface	Luigo Mezzanotte
Foreign Legion Officer	Franco Citti

By VINCENT CANBY

"The Black Stallion Returns," directed by Robert Dalva, who was nominated for an Oscar as the editor of the 1979 "Black Stallion," is just about everything that Carroll Ballard's first film was not.

It is funny, unpretentious and fast-paced. It has a kind of comic-book appreciation for direct action and no time whatsoever for mysticism or for scenery for its own sake, though most of it was shot in Morocco and is fun to look at. It may well disappoint everyone who loved the original film, but I suspect that lowbrow kids will enjoy it immensely.

"The Black Stallion Returns" is based on yet another of Walter Farley's 16 Black Stallion novels for children. It picks up the story of young Alec Ramsay, again played by Kelly Reno, a few years after the end of the initial film. Alec, now older and much taller, his mom (Teri Garr), and the stallion he calls Black, live in contentment on an idealized farm not far from New York City.

•

Trouble arrives with the appearance late one night of representatives of two opposing North African desert tribes, one good, one bad. Both are intent on stealing Alec's beloved stallion and taking him back to the Sahara to compete in an intertribal horse race, the outcome of which can decide a tribe's fortunes for the next five years.

This very tall tale really gets under way only when Alec decides to pursue the horse thieves by stowing away on

"THE BLACK STALLION RETURNS"—Kelly Reno and the horse known as The Black co-star in the sequel to "The Black Stallion."

an amphibious, Casablanca-bound, Pan American clipper — the time is 1947. In the course of the adventure, Alec is befriended by a young university-educated Arab named Raj (Vincent Spano) and his bodyguard (Woody Strode), a good sheik named Abu Ben Ishak (Ferdinand Mayne) and the sheik's pretty granddaughter (Jodi Thelen). He also learns about mirages, camel breakdowns, friendship, loyalty and hospitality.

The film's most visible villain is Kurr, a clumsy, ill-tempered oaf who, as played with fitting overemphasis by Allen Goorwitz, looks like a double for Yasir Arafat.

Nothing too unpredictable ever happens in the Richard Kletter-Jerome Kass screenplay, but that also is its charm. As the stalwart hero, Kelly Reno is very appealing, possibly because he's a lot less passive than he was in the first film. He and all of the other members of the cast act as if they were having a picnic, recreating the simple, straightforward pleasures of a pre-World War II B-movie, which, more than anything else, "The Black Stallion Returns" resembles.

•

"The Black Stallion Returns," which has been rated PG ("Parental Guidance Suggested"), contains some mildly vulgar language and no violence of an especially frightening or unreasonable nature.

1983 Mr 27, 54:4

SPRING BREAK, produced and directed by Sean S. Cunningham; written by David Smilow; director of photography, Stephen Poster; edited by Susan Cunningham; music by Harry Manfredini; released by Columbia Pictures. At Loews State, Broadway and 45th Street and other theaters. Running time: 95 minutes. This film is rated R.

Nelson	David Knell
Adam	Perry Lang
Stu	Paul Land
O.T.	Steve Bassett
Susie	Jayne Modean
Joan	Corinne Alphen
Ernest Dalby	Donald Symington
May Dalby	Mimi Cozzens
Geri	Jessica James
Eddie	Richard B. Shull
Eesh	Daniel Faraldo
Dalby's Henchmen	John Archie, Robert Small
Ames	Fred Buch

Four college-age lugs with the collective brains of a surfboard head for Fort Lauderdale in "Spring Break," a movie in which leering and beer-drinking are everybody's favorite pursuits. Together, they attend a wet-T-shirt contest, a Teeny Weeny Bikini contest, and other, similar galas that take on a certain sameness very quickly and that constitute the film's only real events. Each beer-guzzling marathon inevitably leads to one of those bathroom scenes that provide the film with just about its only jokes.

"Spring Break," which opened yesterday at Loew's State and other theaters, was directed none too delicately by Sean ("Friday the 13th") Cunningham and released by Columbia Pictures, which is a subsidiary of Coca-Cola. The movie happens to have worked Coke at least momentarily into its plot. There's a moment when one of the boys is brought by a girl to her hotel room, and before there's so

much as a clinch the boy announces he's thirsty. A Coke would be nice, says his date. So the boy runs down to a very prominently featured Coke machine and buys about six cans' worth. Good customer!

Janet Maslin

1983 Mr 27, 54:4

HALF A LIFE, directed by Romain Goupil, in French with English subtitles; camera by Pierre Goupil, Jean Chiabaut and Renan Polles; edited by Françoise Prenant and Sophie Goupil; developers and presenters by Marin Karmitz; presented by the Film Society of Lincoln Center and the Film Department of The Museum of Modern Art as part of the New Directors/New Films Series. At the 57th Street Playhouse, between Avenue of the Americas and Seventh Avenue. Running time: 95 minutes. This film has no rating.

By VINCENT CANBY

According to "Half a Life" (French title: Mourir à Trente Ans), Romain Goupil's autobiographical film-memoir about growing up in France in the 1960's and 70's, the 32-year-old film maker is actually two people living in invigorating disharmony within one skin.

The first Romain Goupil is — and seems always to have been — a movie nut, partly, he says, because he found at an early age that it was easier to make movies than to learn how to spell. The other Romain Goupil has been a fiery political activist since his high-school days. Unfortunately for the activist, the movie maker's sense of irony and his ability to see life in long-shots continually interrupt the career of the would-be revolutionary.

When it is dealing with the movie-madness that erupted all over Europe and America in the late 60's and early 70's, "Half a Life" is one of the brightest, funniest films of its kind since Jim McBride's classic "David Holzman's Diary." "Half a Life" will be shown in the New Directors/New Films Festival at the 57th Street Playhouse today at 8:30 P.M. and tomorrow at 6 P.M.

The film is also an earnest attempt to evoke the memory of Michel Recanati, Mr. Goupil's teen-age political mentor and comrade-in-arms for more than 10 years. Recanati, whom we see in footage shot by Mr. Goupil when they were parading, speaking at revolutionary-youth rallies and discussing the future of mankind at home, seems to have burned himself out before he was 30. He committed suicide in 1978, having been unable to find a place for himself in a world after the hoped-for revolution, begun in May 1968, fizzled out.

Though Recanati's suicide haunts "Half a Life," Recanati himself remains a shadowy, rather pathetic figure, a young man who apparently threw himself into politics to avoid facing more immediate, potentially more embarrassing facts about himself. Unlike his comrades, Recanati was uneasy with women and frightened of sex. As if not to embarrass his friend any further, Mr. Goupil doesn't explore these points too closely.

Recanati's life and death are just two of the elements in Mr. Goupil's own coming-of-age, which "Half a Life" recalls with great humor and wit through clips from his earliest home-movies, newsreel footage and interviews with old friends.

•

There is a lot of François Truffaut's Antoine Doinel in the Romain Goupil we see in "Half a Life," especially in Mr. Goupil's inability to commit himself to any one cause for very long without seeing the other side. He was

also, it seems, a rather sloppy dialectician.

He remembers having written a long, sober, worthy piece on revolutionary Cuba and having forgotten to mention Che Guevera even once. Mr. Goupil's principal drawback, it seems, is the artist's bifocal vision. During the height of his revolutionary activities, he says, "We disliked Maoists, the Communist Party and all organized parties. We liked Le Monde, movies and Italian ices."

"Half a Life," the work of a talented, extremely self-aware new director, is one of the best films I've yet seen in this year's New Directors/New Films series.

1983 Mr 27, 55:1

WEND KUUNI, written and directed by Gaston J.M. Kabore; in More with English subtitles; camera, Sekou Ouedraogo; edited by Andree Davanture; music by Rene B. Guirma; produced by Direction du Cinema de Haute-Volta, Ouagadougou; presented by the Film Society of Lincoln Center and the department of film of the Museum of Modern Art as part of the "New Directors/New Films" series. At the 57th Street Playhouse, between Avenue of the Americas and Seventh Avenue. Running time: 75 minutes. This film has no rating.
Wend KuuniSerge Yanogo
Pognere ..Rosine Yanogo
Tinga ...Joseph Nikiema
Lale ..Colette Kabore
KoudbilaSimone Tapsoba
The TravellerJean Ouedraogo
Bila ...Yaya Wima
TimpokoMartine Ouedraogo

SUZANNE SUZANNE, produced and directed by James V. Hatch & Camille Billops; camera, Dion Hatch; edited by Michael Kirchberger; presented by the Film Society of Lincoln Center and the department of film of the Museum of Modern Art as part of the "New Directors/New Films series." At the 57th Street Playhouse, between Avenue of the Americas and Seventh Avenue. Running time: 26 minutes. This film has no rating.

"Wend Kuuni" ("Gift of God"), a 75-minute feature from Upper Volta, and "Suzanne Suzanne," a 26-minute American documentary produced and directed by James V. Hatch and Camille Billops, make up the "New Directors/New Films" program that will be shown at the 57th Street Playhouse today at 1 P.M.

"Wend Kuuni," written and directed by Gaston J. M. Kaboré, is a gentle fable set in a precolonial Africa, about a mute little boy who, found starving in the bush, is raised with love and kindness by the Mossi tribe. How Wend Kuuni, as the boy is named, comes to regain his speech provides the narrative shape of the film, which also recalls the manners, mores and rituals of a time of peace and plenty.

•

In "Suzanne Suzanne," a young black woman named Suzanne, who is a former drug addict, and her beautiful mother, Billy, a contestant in the 1976 Mrs. America contest, try to come to terms with each other and with a troubled past.

As they are interviewed, separately and together, and as they talk with other members of what appears to be a big, loving family, there emerges the story of the family's domination by Suzanne's handsome, finally alcoholic father, who beat her and her mother and asked of them a perfection that eluded him up to his death in 1967. The film is without mannerisms and speaks for itself.

Vincent Canby

1983 Mr 27, 55:1

EVENING PERFORMANCE (Función de Noche), directed by Josefina Molina; screenplay (Spanish with English subtitles) developed by Josefina Molina, Jose Samano, Lola Herrera; fragments from the play "Cinco Horas con Mario" by Miguel Delibes; camera, Teo Escamilla; edited by Nieves Martin; music by Alejandro Masso and Luis E. Aute; produced by Sabre Films; an Arcadia Films Release; presented by the Film Society of Lincoln Center and the Department of Film of the Museum of Modern Art as part of the New Directors/New Films Series. At the 57th Street Playhouse, between Avenue of the Americas and Seventh Avenue. Running time: 90 minutes. This film has no rating.
Lola ...Lola Herrera
Daniel ...Daniel Dicenta
NataliaNatalia Dicenta Herrera
DaniDaniel Dicenta Herrera
PriestLuis Rodriguez Olivares
Fortune TellerMargarita Forrest
DoctorDr. Rafael del Pino
Stage ManagerJacinto Bravo
Company ManagerFrancisco Terres
ActorSantiago de las Heras
ElectricianAntonio Cava
StagehandDemetrio Sanchez
Juana ..Juana Ginzo

In Josefina Molina's "Evening Performance," two people whose long marriage is being annulled meet to discuss the situation and then proceed to talk it to death. She says: "The children have become a burden to me — a wonderful burden, but a burden." He says: "I say that love can exist at first sight." She says: "I've done nothing for myself. I've done it all for others." And a fortune teller, who also figures briefly in the proceedings, declares: "Marriage always leaves its mark on the children."

The man and the woman are Lola Herrera and Daniel Dicenta, two Spanish actors who married in 1960, separated in 1967, and in 1980 legalized their separation. Their conversation takes place in Miss Herrera's dressing room in a Madrid theater, and it has a documentary flavor as it drones on and on. Both Miss Herrera and Mr. Dicenta, who filmed while conducting such candid conversations, speak in serious, measured tones much less animated than any they might attempt on stage. The importance of the situation undoubtedly explains this but doesn't change the talky, becalmed feeling of Miss Molina's film. The audience finds itself listening in on a personal but not notably spontaneous or intimate conversation and probably learning little it doesn't already know.

•

"Evening Performance," of which I saw most but not all, was shown at the 57th Street Playhouse Friday and yesterday as part of the New Directors/New Films series, on a bill with "SPFX," an energetic and cheerfully jumbled 11-minute short by the actor Bob Balaban, whose appearance in "Close Encounters of the Third Kind" figures into his own film. "SPFX," which is ostensibly about a man (Mandy Patinkin) who'd rather do square roots than marry his girlfriend (Kathryn Grody), manages to include a glimpse of Richard Dreyfuss playing cards with an extra-terrestrial, some scenes in which Wallace Shawn plays the director of a "Close Encounters"-like movie, and a "Reds"-style witness, a woman who simply sits and reminisces. "We used to hang around in the old days together," she says. "Spielberg, Lucas and I — but not that girl."

Janet Maslin

1983 Mr 27, 55:1

JOE'S BED-STUY BARBERSHOP: WE CUT HEADS, written, edited and directed by Spike Lee; photographed by Ernest Dickerson; music by Bill Lee; produced by Zimmie Shelton and Mr. Lee; presented by the Film Society of Lincoln Center and the Film Department of the Museum of Modern Art, as part of the New Directors/New Films series. At the 57th Street Playhouse, between the Avenue of the Americas and Seventh Avenue. Running time: 60 minutes. This film has no rating.

THE TRUUUUTH (La Veritáaaa), written, interpreted and directed by Cesare Zavattini; (in Italian with English subtitles) director of photography, Arturo Zavattini; edited by Gino Bartolini; music by Za; produced by Marina Piperno; a RAI Radiotelevisione Italiana/Relac Films co-production. Also part of the New Directors/New Films series. Running time: 100 minutes. This film has no rating.
WITH: Pietro Barreca, Vittorio Amandola, Pietro Zardini

By JANET MASLIN

"Joe's Bed-Stuy Barbershop: We Cut Heads" is an hourlong drama by Spike Lee, in which a portrait of the community emerges through Mr. Lee's depiction of a shop, its owner, the gangsters who'd like to muscle in

on him, and his patient and supportive wife, who is herself a Bedford-Stuyvestant social worker. It's a more blunt, less folksy film than the title, which is taken from the shop's neon sign, might indicate.

And Mr. Lee has directed it in an affecting, if slightly stilted, manner. The problems of Zachariah Homer (Monty Ross), who inherits the shop after gangsters toss his partner in the river, are made to seem compelling, understandable and perhaps inevitable, too. The film has been scored by Bill Lee, the bassist who is the 25-year-old director's father.

On the same bill at the New Directors/New Films series, to be shown tonight at 8:30 and tomorrow at 3:30 P.M., is "The Truuuuth," a mannered, desperately unfunny comic film about an elderly lunatic who is supposedly more sane than anyone around him. Cesare Zavattini, who collaborated on many screenplays with Vittorio De Sica, directed "The Truuuuth" and plays the flamboyant, hand-waving lunatic himself.

1983 Mr 27, 55:5

RAT TRAP (Elippathayam), written and directed by Adoor Gopalakrishnan (in Malayalam with English subtitles); photography by Ravi Varma; music by M.B. Srinivasam; edited by M. Mani; produced by Ravi, General Pictures. Presented by The Film Society of Lincoln Center and The Department of Film of the Museum of Modern Art as part of The New Directors/New Films Series. At the 57th Street Playhouse, between Avenue of the Americas and Seventh Avenue. Running time: 121 minutes. This film has no rating.
Unni ...Karamana
Rajamma ..Sarada
Sridevi ...Jalaja
JanammaRajam K. Nair
Janamma's sonPrakash
Estate managerSoman
Estate managers' sonJohn Samuel
The matchmakerB.K. Nair
WITH: Joycee, Thampi, B. Nair.

The Indian film "Rat Trap" presents the decline of a privileged household in very vivid terms, and with a delicate combination of sympathy and irony. The head of the household is Unni (Karamana), a man unreasonably pampered by his sisters and very nearly paralyzed by his fear of outside influences. When he grows terrified of rats, at the film's beginning, several are caught by the sisters, then brought to the river and slowly drowned. By the end of the film, the rats' plight has been closely equated with Unni's own.

As directed by Adoor Gopalakrishnan, "Rat Trap" is slow, thoughtful and engrossing. It presents Unni and his family as near-captives, not merely of their house but also of their history. And it accomplishes this through a series of minute, well-chosen details. The action is set almost entirely within the family's compound, which is presided over by Unni's gentle, long-suffering sister (Sarada) and regarded with particular admiration by an impoverished woman determined to flirt with Unni, though this is just about impossible. Unni is someone who, though he appears to own the only pair of shoes in the area, will turn back on his way to a wedding after encountering a puddle that might muddy his feet.

Janet Maslin

1983 Mr 27, 55:5

JOM (Jom or the Story of a People), directed by Ababacar Samb Makharam; written (in Wolof with English subtitles) by Mr. Makharam and Babacar Sine; camera, Peter Chappell and Orlando Lopez; edited by Alix Regis; music by Lamine Konte; produced by Baobab Film, Senegal, in collaboration with Zweites Deutschen Fernsehen (ZDF, West German television); pre-

A scene from the African film "Wend Kuuni," part of the New Directors/New Films series at the 57th Street Playhouse.

sented by the Film Society of Lincoln Center and the department of film of the Museum of Modern Art as part of the "New Directors/New Films" series. At the 57th Street Playhouse, between Avenue of the Americas and Seventh Avenue. Running time: 80 minutes. This film has no rating.

Dieri ...Oumar Seck
Khaly ..Oumar Gueve
MadieumbeAmadou Lamine Camara
N'DougoutteAbou Camara
M. Diop ...Zator Sarr
Mademoiselle DiopFatou Samb Fall
Mademoiselle SallN'Deye Ami Fall
Koua Thiaw ..Dumi Sene
Governor ...Charly
Canar FallMakhouredia Gueye
Madieumbe's WifeM'Bayang Gaye
Dieri's WifeAimee Diallo
Dieri's SisterIsseu Niang
First MaidKewe N'Diaye
Second MaidFatou Fall
Third MaidDeba N'Diaye
Officer ..Jacques Maillard
Mademoiselle Sall's girlfriendMadiodio Lam

By JANET MASLIN

IN Senegal, where Ababacar Samb Makharam's "Jom" was made, the Wolof word of the title means something akin to "courage" or "dignity." The film helps define the word, which has no exact English equivalent, through a series of tales related by a griot, or storyteller. Modern characters who are engaged in a strike against a local industrialist are given courage and inspiration by the griot's historical anecdotes. All of this is presented by Mr. Makharam through vivid pageantry, and with a passion and intensity that reflect considerable jom of his own.

The chief anecdotes concern a turn-of-the-century prince named Diéri (Oumar Seck), who murdered a white colonial official who had insulted him, and then went bravely to his death in battle; and a celebrated dancer who visits the old Senegalese city of St. Louis and while she is there improvises a jom-inspiring dance on behalf of the community's oppressed maids. Her wildly energetic dance, performed before a large and admiring crowd, is one of the film's particular high points.

"Jom" will be shown tonight at 8:30 and tomorrow at 6 P.M. at the 57th Street Playhouse, as part of the "New Directors/New Films" series.

1983 Mr 28, C12:3

2 Lives, 15 Years

A MARRIAGE, directed and written by Sandy Tung; director of photograhy, Benjamin Davis; edited by Michael R. Miller; music by Jack Waldmn; produced by David Greene; presented by the Film Society of Lincoln Center and the department of film of the Museum of Modern Art, as part of the New Directors/New Films Series. At the 57th Street Playhouse, between the Avenue of the Americas and Seventh Avenue. Running time: 90 minutes. This film has no rating.

Ted ...Ric GitLin
Nancy ..Isabel Glasser
Jane ...Jane Darby
Mark ..Jack Rose

By JANET MASLIN

TED (Ric GitLin) and Nancy (Isabel Glasser) grow from starry-eyed high school kids into disenchanted young professionals on the brink of a divorce in "A Marriage," Sandy Tung's knowing and believable portrait of their union.

The story spans about 15 years, and "A Marriage" is one of those films in which you can tell precisely when the scenes take place by the leading man's haircut. Scraggly during the 1960's, and even as the idealistic young Ted enters film school, the hairdo gets progressively slicker as he winds up directing commercials.

There's more at work in "A Marriage" than mere nostalgia or appearances, however amusingly Mr. Tung presents the period details at times.

(One of the film's better gags works on the sight of Miss Glasser's miniskirt alone.) Mr. Tung isn't a stylistic groundbreaker, but he does have a gift for making his characters seem absolutely real. And Mr. Tung's instincts about what glimpses of their story to include are especially sound. If "A Marriage" isn't an altogether surprising film, it's certainly one that has more than its share of charm.

Nancy is in knee socks when Ted first follows her home from school, and the film traces the early stages of their courtship with particular acuity and humor. Later on, after the pregnancy scare and the wedding and the fight while buying furniture, the couple become disheartened and their problems get a little soapier.

Throughout it all, Mr. Tung gets away with potentially sappy tactics (such as his intercutting of the couple's divorce with flashback memories of their wedding ceremony) simply by handling them with sufficient freshness and retaining that realistic air. The film gets its biggest laugh with a closing title declaring that this story, by a director who's a Staten Island-born film maker just like Ted, has nothing to do with persons living or dead.

"A Marriage" will be shown tonight at 8:30 and tomorrow at 6 P.M. in the 57th Street Playhouse, as part of the New Directors/New Films series cosponsored by the Film Society of Lincoln Center and the Department of Film of the Museum of Modern Art. On the same bill is "A Ritual," a transfixingly bizarre 18-minute short by Andy Anderson that is liable to be long remembered by anyone who sees it.

A woman, played by Julie Withers, comes home to an almost-empty apartment, switches on an absurd public-television cooking program (which we hear continuously but never see), and begins to prepare a meal. She spends a long time slicing meat with a knife that is very sharp. Then she aligns a chair with the front door, ties the sash of her bathrobe to the doorknob, kneels on the chair, props the knife between the door and her abdomen, and waits. The suspense that Mr. Andersen generates is nearly unbearable, and the ending he dreams up is perfect.

1983 Mr 30, C21:1

A Colonel's Quest

THE MISSION (Ferestedah), written, produced, edited and directed by Parviz Sayyadm, from a story by Hesam Kowsar and Parviz Sayyad; in Farsi with English subtitles; camera by Reza Aria; a co-production of the New Film Group, New York, and Arla Film Production, Munich, West Germany; presented by the Film Society of Lincoln Center and the department of film of the Museum of Modern Art, as part of the New Directors/New Films Series. At the 57th Street Playhouse, between the Avenue of the Americas and Seventh Avenue. Running time: 110 minutes. This film has no rating.

The Agent from TeheranHooshang Touzie
The ColonelParviz Sayyad
Maliheh ..Mary Apick
His EminenceMohammad B. Ghaffari
Maziar ...Hatam Anvar
FarzahenHedyeh Anvar
Gaffar ...Kamran Nozad

"THE MISSION," written, produced, directed and edited by Parviz Sayyad, is an appealing, technically accomplished oddity — a clear-eyed, ironic, small-scale melodrama, shot entirely in and around New York City by Iranian exiles, the Farsi dialogue translated by English subtitles.

Though the film's concerns are serious, the style is often comic. The mission of the title is that of a religiously dedicated, young Iranian revolutionary, sent from Teheran to New York to assassinate a former colonel in the Shah's secret police. In the course of his assignment, the young man, played with sometimes fiercely funny solemnity by Hooshang Touzi, discovers that those issues that at home seemed to be either black or white have suddenly turned into various shades of disconcerting gray.

Mr. Sayyad, who himself gives a rather jolly, relaxed performance as the former colonel, now a janitor, is a facile film maker. The film moves smoothly from satire and comedy to drama and melodrama. All of the performers are good, and Mr. Sayyad's use of New York locales exceptionally good. This is no tourist's view of the city.

One highlight: a sequence in which the agent from Teheran, after tailing his target for days, finds himself saving the colonel from possible murder at the hands of a couple of ordinary, run-of-the-mill subway muggers.

"The Mission" will be shown in the New Directors/New Films Festival at the 57th Street Playhouse today at 6 P.M. and tomorrow at 8:30 P.M.

Vincent Canby

1983 Mr 30, C21:2

Disputed Interview

THE WIZARD OF BABYLON, directed by Dieter Schidor; commentary (German with English subtitles) by Wolf Wondratschek; camera, Carl-Friedrich Koschnik and Rainer Lanuschny; edited by Rice Renz; music by Peer Raben; production company, Planet Film GmbH; released by New Yorker Films. At the Film Forum, 57 Watts Street. Runnng time: 82 minutes. This film has no rating.
WITH: Jeanne Moreau, Brad Davis and Franco Nero

By VINCENT CANBY

"THE WIZARD OF BABYLON," which opens today at the Film Forum, is another footnote to the career of the late Rainer Werner Fassbinder, which means that it's something not to be missed by anyone interested in the career of that rare, disturbing film maker. It's an 82-minute documentary on the making of Fassbinder's last film, "Querelle," scheduled to open here in the near future. The documentary was produced by Dieter Schidor, the producer of "Querelle" and one of its principal actors.

Though "The Wizard of Babylon" is not an independent achievement to equal Les Blank's "Burden of Dreams," about the making of Werner Herzog's "Fitzcarraldo," it is an effectively insinuating trailer for "Querelle" and should become one of the sources for all future students of Fassbinder's work.

•

Central to the film is an extended interview that Mr. Schidor had with Fassbinder approximately 10 hours before the director's death last June. It's this interview that Fassbinder's mother sought unsuccessfully to have removed from the film by court order.

Because the English subtitles that translate the German dialogue are not consistently clear, one can't always be sure whether it's the subtitlist or Fassbinder who's being obscure. However, enough recognizable Fassbinder comes through the fog of words to make the session riveting.

Fassbinder, wearing jeans, a pink shirt, a gray fedora and dark glasses, lounges on a leather couch. He smokes constantly and looks like a skeptical, beached walrus as he responds to Mr. Schidor's questions. Some of these he clearly finds silly though others prompt serious, carefully considered answers that certainly aren't those of someone strung out on booze or drugs, at the end of his rope.

He is especially brisk when Mr. Schidor characterizes "The Marriage of Maria Braun" and "Veronika Voss" as "feminist films." "I don't make feminist films," he says, "but films about human society."

He's also very articulate when it comes to differentiating between the reality of a film and that of the literary work on which it is based. "Querelle" has been described by him elsewhere as not being an adaptation of the Jean Genet novel but a film "about" the novel.

•

Much more conventional are the interviews with the stars of "Querelle," including Jeanne Moreau, Franco Nero and Brad Davis. Mr. Nero and Mr. Davis express absolutely no reservations about "Querelle" and their work in the film, though both actors are reported to have had problems coming to terms with some of the brutally explicit, homosexual business that Fassbinder required of them. Miss Moreau, whom the narrator describes as having been in films longer than Fassbinder has been on earth, is funny and candid in discussing what was once a rather dangerous friendship with Mr. Genet years ago.

The bits and pieces of "Querelle" that we see being shot make it look as if it will be one of Fassbinder's most highly stylized films, its locale appearing to be a surreal unit set that becomes a ship, a barrroom, a bordello and a dockside. Drenching the soundtrack from time to time is an impressionistic commentary, spoken by the actor Klaus Lowitsch, composed, we are told, of stories, thoughts and reminiscences supplied the film makers by Fassbinder himself.

1983 Mr 30, C25:1

A Brooklyn Bridge

MONTY PYTHON'S THE MEANING OF LIFE, directed by Terry Jones; written by Graham Chapman, John Cleese, Terry Gilliam, Eric Idle, Terry Jones, Michael Palin; photographed by Peter Hannan; edited by Julian Doyle; choreography by Arlene Phillips; director of animation and special sequence, Terry Gilliam; produced by John Goldstone; released by Universal Pictures. At the Rivoli 1, Broadway and 49th Street; Gemini 1, 64th Street and Second Avenue. Running time: 103 minutes. This film is rated R.
WITH: Graham Chapman, John Cleese, Terry Gilliam, Eric Idle, Terry Jones, Michael Palin, Carol Cleveland, Judy Loe, Simon Jones, Andrew MacLachlan, Valerie Whittington, Patricia Quinn, Mark Holmes, Jennifer Franks, Peter Lovstrom, Imogen Bickford-Smith, Victoria Plum, George Silver, Angela Mann, Anne Rosenfeld

By VINCENT CANBY

"MONTY PYTHON'S THE MEANING OF LIFE" is a monumental revue, the "Ben Hur" of sketch films, which is to say that it's a tiny bit out of proportion, something like a Brooklyn Bridge constructed to span a bathtub.

This latest endeavor by six of the funniest men ever to chip away at British tradition is sometimes hilarious and colossally rude but, as often as it evokes laughs, it overwhelms them by the majesty of its production and special effects.

In their comparatively conventional narrative films, particularly "Monty

Python and the Holy Grail" and "Life of Brian," the members of the Monty Python troupe have demonstrated that it's possible to make wildly insane "book" comedies that look as impressive as "Apocalypse Now." Revues, however, must appear to be lighter than air.

"Monty Python's the Meaning of Life" recalls the format of "Monty Python's Flying Circus," those wonderfully irreverent television shows — collections of mad sketches, surreal graphics and interruptions within interruptions — with which they made their initial reputation.

It has a theme of sorts, as defined by the title, but it's still an extremely loose collection of sketches, songs and interruptions that send up sex, religion, middle-class manners, upper-class twits, all things genteel and, perhaps for the first time on screen, goldfish that talk.

•

The film, which opens today at the Rivoli and other theaters, is at its best when it is least spectacular, almost intimate. After a lugubriously unfunny "short feature" that opens the film, "The Meaning of Life" settles down to the usual Monty Python concerns, presented in seven or eight separate sequences with titles such as "Growth and Learning," "Middle Age," "The Autumn Years" and "Death."

Among the highlights is a sequence set in the chapel of an ancient English public school where the rector, Michael Palin, intones, "Forgive us, Lord, for this, our dreadful toadying," which is the cue for a wicked hymn in which the singers plead to be spared deaths by boiling or by being cooked in a wok.

In the section, "The Miracle of Birth, Part II, the Third World," which is set in a Yorkshire mill town, a poor, unemployed dad decides to sell his children for medical experiments because the stork — a real stork — simply will not stop dropping babies down the chimmney. There follows a huge, riotous production number about birth control, something to offend Roman Catholics everywhere.

Protestants also are ridiculed but with not the same bite or wit. Poor Protestants.

•

The Python troupe is at its most marvelously typical in a sketch in which a middle-aged American couple, on a package tour somewhere exotic, dine in a restaurant called the Dungeon Room. This is a place that has live victims hanging from its walls, and a maître d' who presents them with menus from which to choose the conversation-of-the-evening. Being adventurous types, they pick Philosphy, with predictably chaotic results.

In the Python scheme of things, heaven turns out to be a hotel that looks as if it might be a Holiday Inn on Waikiki Beach.

Not so great are an elaborate dining room sketch, with much vomiting, which seems to have been inspired by "La Grande Bouffe," a World War I sketch and an organ transplant sketch.

•

Eric Idle, who wrote or collaborated on most of the songs, does a brief, very comic take-off on Noel Coward and, with Mr. Palin, impersonates a number of well-groomed ladies. John Cleese physically towers over his associates, but each member of the troupe, which also includes Terry Gil-

liam, Graham Chapman and Terry Jones, is in fine form. Mr. Jones also is the film's director and Mr. Gilliam is the man responsible for the sometimes inspired animation.

"Monty Python's the Meaning of Life" is funny but, being unreasonable, I wish it were funny from start to finish.

1983 Mr 31, C13:5

Step-Family Story

MAN, WOMAN AND CHILD, directed by Dick Richards; screenplay by Erich Segal and David Z. Goodman, based on the novel by Erich Segal; director of photography, Richard H. Kline; edited by David Bretherton; music by George Delerue; produced by Elmo Williams and Elliott Kastner; released by Paramount Pictures. At Loew's Tower East, 72d Street and Third Avenue, and 57th Street Playhouse, between Avenue of the Americas and Seventh Avenue. Running time: 101 minutes. This film is rated R.

Bob Beckwith	Martin Sheen
Sheila Beckwith	Blythe Danner
Bernie Ackerman	Craig T. Nelson
Gavin Wilson	David Hemmings
Nicole Guerin	Nathalie Nell
Margo	Maureen Anderman
Jean-Claude Guerin	Sebastian Dungan
Jessica Beckwith	Arlene McIntyre
Paula Beckwith	Missy Francis
Davey Ackerman	Billy Jacoby
Louis	Jacques Francois

By JANET MASLIN

BOB BECKWITH, an American professor of English, has just finished delivering a lecture to some French colleagues, offering, as one of them puts it, "a day the Sorbonne will never forget." That same day, he is injured slightly in an auto accident and brought to the office of the beautiful Nicole, who is deemed "the best doctor in all of Normandy." Once Bob is patched up, he and Nicole stroll through a picturesque fishing village. "Now I understand why so many Impressionists came here to paint," Bob declares.

He and Nicole share a romantic picnic. Nicole says, "I have a tendency to use my studies and my patients as . . ."

"As a shield against personal relationships?" asks Bob.

"Perhaps," she admits.

"That could change," he says.

This all takes place to the tune of "Plaisir d'Amour," and against the

"MONTY PYTHON'S THE MEANING OF LIFE"—Terry Jones, Eric Idle, John Cleese and the rest of the British troupe star in this comedy about such subjects as birth, sex, rugby, organ transplants and life after death. Mr. Jones directed.

backdrop of a beautiful seascape and a picture-postcard sunset. Inspired by all this, Bob and Nicole impetuously go skinnydipping.

"Man, Woman and Child," which opens today at Loew's Tower East and other theaters, all has much the same tenor as this encounter, but it isn't a movie about Bob and Nicole. It's about Bob (Martin Sheen) and his wife, Sheila (Blythe Danner), and what happens when the consequences of that devil-may-care little swim become known. Ten years after Bob sets the Sorbonne on its ear (this episode comes as a flashback a little while into the movie), Bob receives a phone call. Nicole (Nathalie Nell) has been killed in an accident, leaving behind a son Bob didn't know he had. How will Sheila adjust? "Hey, c'mon, hon," Bob tells her. "You're not gonna let this shatter our whole relationship, are you?"

As a matter of fact, she's not. "Man, Woman and Child," which bears the unmistakable stamp of its author, Erich Segal, is about wonderful people coping wonderfully with a situation that would seriously frazzle just

Blythe Danner and Martin Sheen in Dick Richards's "Man, Woman and Child," at Loew's Tower East.

about anyone else. Sheila — who is played beautifully by Miss Danner, much more imaginatively than this movie deserves — invites little Jean-Claude to come visit with the Beckwith clan, which also includes two young daughters. If such a thing were to happen in any normal family, there might be a pillow fight or two among the children. Miraculously, there's no sibling rivalry here, even though Bob makes it crystal clear that he loves Jean-Claude much more than he loves either daughter and probably more than he loves his wife.

•

America is more than ready for an interesting movie about the problems of step-families, but "Man, Woman and Child" isn't the one. Mr. Sheen's Bob, like the Albert Finney character in "Shoot the Moon," is something of a self-involved bully, and the movie is pretty much on his side. As Jean-Claude, who has an all-bangs haircut right out of a Keane painting and is ludicrously well behaved, begins to please his father by displaying athletic prowess and wearing a baseball cap, Bob just melts. And the movie lets him.

True, Jean-Claude is a great chef, too, so perhaps it's not fair to imagine there's any sexism here. It's just that this story, like "Love Story," exists at a mind-boggling remove from anybody's genuine experience or emotions. When the film takes a moderately realistic turn at the last minute, it's committing box-office suicide. By this point, it's simply too late for anything down to earth to happen.

As directed by Dick Richards, "Man, Woman and Child" has wholesome good looks and a modicum of energy, but it's finally too lightweight and phony to be much fun. "Makes 'Without a Trace' look like 'Notes From the Underground,' " someone in the preview audience was heard to say, apparently trying to place "Man, Woman and Child" within the spectrum of current films about parent-child calamities.

1983 Ap 1, C8:1

URGH! A MUSIC WAR, directed by Derek Bur- bidge; creative consultants, Miles Copeland and Ian Copeland; edited by Simon Milne; produced by Michael White; released by Lorimar Pic- tures. At the Bleecker Street Cinema, 144 Bleecker Street. Running time: 92 minutes. This film has no rating.
THE BANDS: Police, Wall of Voodoo, Toyah Wil- cox, Orchestral Manoeuvres in the Dark, Oingo Boingo, Echo & the Bunnymen, Jools Holland, XTC, Klaus Nomi, Go Go's, Dead Kennedys, Steel Pulse, Gary Numan, Joan Jett, Surf Punks, Au Pairs, Cramps, Devo, Alley Cast, Gang of Four, 999, Flestones, X, UB40

IN the summer and fall of 1980, a crew of film makers went to work capturing concert per- formances by more than 25 new wave rock groups in New York, Cali- fornia and Europe. A sound track album from "Urgh! A Music War" was released in 1981, but the film is only coming to the surface now. It opens a one-week run today at the Bleecker Street Cinema and starting April 8 it will be shown on Fridays and Saturdays at midnight.

"Urgh! A Music War" consists of 25 songs or song fragments performed by 24 bands. The opening and closing songs are played by The Police, the most commercially successful group involved. Apparently, the idea behind the format was that the film be "democratic" and reflect the anti-eli- tist sentiments of the movement it documents. But few rock groups can communicate much of what they stand for or are capable of in one song.

"Urgh!" is a jumble, and a mislead- ing jumble. Some of its strongest and most significant bands — X, UB40, The Cramps, The Au Pairs — are rep- resented by snippets that fail to indi- cate the dimensions of their talent or to reproduce a fraction of the excite- ment they can create. At least two of the best bands in the original filming, Pear Ubu and Magazine, failed to make it into the final cut. And several bands have progressed considerably, or broken up, since the film was shot.

There are some bright spots — a riveting exercise in the building and releasing of musical tension by the Gang of Four, a joyous "We Got the Beat," from the Go Go's. But they aren't enough to salvage a rushed, un- even film.

Robert Palmer

1983 Ap 1, C9:1

FILM VIEW

VINCENT CANBY

Some Bright New Talent Commands Attention

If part of the fascination of Martin Scorsese's fine, dark comedy "The King of Comedy" is the possibility that, at almost any minute, it might blow up in one's face, like a Johnny Carson doll with a time-bomb inside it, then one of the people responsible for this curious mix- ture of danger and lunacy certainly must be Sandra Bern- hard, one of a number of new performers who are giving this season a certain amount of class.

Some of the others: Denis Lawson, George Gaynes, Linda Hunt, Bess Armstrong, Graham Crowden, Gladys Crosbie, Diane Lane and Tess Harper. They aren't all ac- tually "new," either to life or to films. Miss Crosbie, who plays the staunch, imperturbable Queen Mum in Lindsay Anderson's "Britannia Hospital," has obviously been around a while — it shows in her exceptional poise.

They are, however, comparatively new to the con- sciousnesses of American moviegoers and, as such, they deserve the kind of individual mention it isn't always pos- sible to give them in daily reviews.

The actor's life is a precarious one. Every role may be the last. Not until the name appears above the title can an actor feel there might possibly be some continuity of employment. Let's pay attention now.

• • •

Miss Bernhard is brand new to films. "The King of Comedy" is her first screen role and the role, as well as her performance in it, are so eccentric there is a danger that all of the roles she may be offered from now on will be variations on the crazy she plays here. I hope not, since there are all sorts of clues in the Scorsese production that she can do other things.

In "The King of Comedy" Miss Bernhard, whose ca- reer to date has been as a stand-up comedienne, plays the edgy, obsessed young woman who helps the Robert De Niro character in his maniacal plot to gain fame and for- tune by kidnapping television's biggest star, played by Jerry Lewis.

It's not a sympathetic role. The character is too seri- ously disturbed to generate warm feelings even in the comic moments, but the performance is so vivid, consis- tent and intense that no one leaving the theater will fail to remember her. Miss Bernhard doesn't achieve this all on her own. She is backed by Mr. Scorsese, Mr. De Niro and Paul Zimmerman, who wrote the screenplay — all of them at their best.

Yet, her looks and her manner — in this film she's continually ricocheting between sarcastic snarls and des- perate, naïve hopefulness — suggest she is someone who could give Gilda Radner a run for the money.

• • •

Denis Lawson, who plays the enterprising Scottish ac- countant, hotel owner and pub-keeper in Bill Forsyth's "Local Hero," has made other films, including Alain Ren- ais's unfortunate "Providence," without attracting much attention. "Local Hero" could change all that. I can't remember his work in "Providence" at all, but then I've put most of that film out of my mind, except for John Giel- gud's performance and the stylized sets.

When one is not familiar with the work of an actor, it is difficult to separate the person from the role being played. Acknowledging that, Mr. Lawson still appears to be a young actor of special comic style. The material is awfully good, but he himself has the sort of unaggressive handsomeness that seems to fit the role in "Local Hero" without necessarily defining it. The definition is achieved through the sharpness of his intelligence. This, in turn, is his screen presence.

By one means and another, he eventually becomes the center of the film, even though it stars Burt Lancaster in top form and even though Peter Riegert plays the title role with becoming, funny, bewildered modesty. Mr. Lawson is the canny conscience of the Scottish village, around which everything in "Local Hero" revolves.

The Finnish-born George Gaynes has been appearing in opera and Broadway musical comedies ("Wonderful Town") for years, often in support of a female star. His role in "Tootsie," as the supremely self-confident soap- opera star and lady-killer, is also in support of a female star, Dustin Hoffman, but this time the performance is so memorably funny, in such memorably funny circum- stances, that I doubt he'll much longer remain one of those actors whose looks are as familiar as his name, though one never puts the two together.

One of the terrible facts of the actor's life is that he can go on in show after show, and in film after film, doing consistently fine work, but if the show or the film doesn't in some way present that work properly, its art goes unac- knowledged. "Tootsie" is doing a lot of good things for a number of people, including Mr. Gaynes.

• • •

Until the release of Peter Weir's "The Year of Living Dangerously," the name of Linda Hunt was unknown to me, though I've since learned that for some time she has been acquiring a number of admirers for her work in the theater. Currently, she is being praised for her work in "Top Girls," Caryl Churchill's oddball new comedy at the Public.

In "The Year of Living Dangerously" she plays a he, Billy Kwan, the tiny, androgynous, Australian-Chinese journalist who identifies with the Third World and whose disillusion with Indonesia's President Sukarno is designed to be the heart of the movie. "The Year of Living Danger- ously" goes to pieces at the end. It's as if Mr. Weir had run out of money, patience and imagination three-quarters of the way through and abandoned whatever it was he origi- nally set out to do. Even so, the role he and his collabora- tors wrote for Miss Hunt, and her controlled, sorrowful performance in it, help make the film far more disturbing than the stylish romantic melodrama it has become by the time the closing credits come on.

• • •

I may be the only person in the country who doesn't know Bess Armstrong as a television star ("Eight Is Enough," among other shows). Before Brian D. Hutton's not-great adventure-comedy "High Road to China," I'd seen her only once, as the pretty, sexy, casually predatory young second-wife, the successor to Sandy Dennis, in Alan Alda's "The Four Seasons."

Her spirited performance in the Hutton film is something of a mini-tri- umph on two levels — over the materi- al, which is game but lame, and over the personality that seems to have been imposed on her, that of a cheeky, spoiled, 1920's flapper. She registers as a sort of cross between Julie An- drews and Carol Burnett, which is not a bad cross, but she also has a person- ality of her own that may one day be liberated. She's a cheering film pres- ence with a brisk way with dialogue, even when it's not as funny as the writers originally thought.

•

Graham Crowden and Gladys Crosbie are just two of the dozen or so great British character actors who re- veal the farcical method of "Britannia

Hospital," the tumultuous Lindsay Anderson-David Sherwin satire that New York critics seem to find much funnier than their London colleagues did.

Mr. Crowden, a lean, aristocratic-looking madman, has been doing his bit for queen and empire for years, going back to Karel Reisz's "Morgan: A Suitable Case for Treatment" and the Anderson-Sherwin "O Lucky Man!" However, never before "Britannia Hospital" has he had screen material to build for him a reputation to match the one he has for his London theater performances.

He is just about superb in "Britannia Hospital" as the brilliant, modern-day, totally bonkers Dr. Frankenstein, a character whom the filmmakers trust to deliver the comedy's most serious thoughts, suitably blended with utter nonsense.

Miss Crosbie, as Queen Mother Elizabeth, who shows up in the film just in time to unlock the ceremonial door to Armageddon, is so appealing that, I suspect, if "Britannia Hospital" were an American film, she'd be signed up and spun off in a new TV sitcom series, "The Queen Mum Visits"

In "The Outsiders," Diane Lane ("A Little Romance," "Cattle Annie and Little Britches") plays a small role, that of a pretty, rich girl who sympathizes with the poor boys who live on the wrong side of Tulsa and call themselves "greasers." Her role looks abbreviated, which it may have been in the editing room, but the actress emerges as the biggest, least synthetic character in the entire film, adapted from one of S. E. Hinton's "young-adult" novels. Miss Lane is not quite reason enough to see the movie, but if you're caught inside the theater, she makes the experience a lot less painful than it would otherwise be.

•

Several weeks ago I wrote about "Tender Mercies" with mention of Tess Harper, the lovely new Texas actress who makes her screen debut as Robert Duvall's second wife.. She's worth further mention, not only because she's that good but because it's a way of responding to a reader who knows Miss Harper's stage work.

The reader took exception to my suggestion that at least part of Miss Harper's performance, including her extraordinary concentration, should be credited to the way Bruce Beresford, the director, handled the actors. Said the reader, perhaps with justification, "I assure you Tess Harper has always known how to concentrate," or words to that effect.

Screen acting, you see, isn't safely analyzed in too great a detail by someone who wasn't on the set during the shooting of the film or in the lab when it was edited. At best it can be described and appreciated. Miss Harper's performance in "Tender Mercies" is rare and affecting, however it came to be. ∎

1983 Ap 3, II:15:1

THE COLORS OF IRIS, direction and screenplay by Nikos Panayotopoulos; in Greek with English subtitles; photography by Nikos Kavoukidis; music by Stamatis Spanoudakis; produced by George Papalios. At the Public Theater, 425 Lafayette Street. Running time: 100 minutes. This film has no rating.
WITH: Nikitas Tsakiroglou, George Dialegmenos, Vangelis Kazan, Eleni Kirana

By JANET MASLIN

A FILM crew is on the beach, at work on a perfume commercial, at the beginning of Nikos Panayotopoulos's "The Colors of Iris," when a strange man appears carrying an umbrella. He apologizes for spoiling the shot, then walks into the sea and disappears without a trace. This mystery — and, as draped in portentousness as it is by Mr. Panayotopoulos, it's a Mystery with a capital M — is the pretext for a film about the various members of the film crew and how they interpret the disappearance.

At the center of the story is a composer, played by Nikitas Tsakiroglou, who, while delving into the disappearance, has a chance to re-examine his own life. He is writing a musical, from which the film takes its title. "A musical without a finale," he remarks more than once, "is like a knight without a horse."

Mr. Panayotopoulos, whose film opened yesterday at the Public Theater, has said that his film contains 100 references to other movies. Quite a few of them, most notably the film noir touches that play very peculiarly in the film's sunny Athenian settings, could have readily been dispensed with.

At one point, the composer visits the actress who appeared in the perfume ad. He is searching for the truth. She begins to discuss color, saying: "Maybe I see what I say is red when I actually see something blue. Maybe you say you see something blue when you actually see something yellow."

"You're a . . .?" the composer inquires. "I'm a philosophy student," the woman interrupts. "I dabble in modeling." Dabbling indeed.

1983 Ap 6, C14:6

Champions at Play

THE GREAT CHESS MOVIE, co-directed by Gilles Carle and Camille Coudari; produced by Helene Verrier for the National Film Board of Canada in collaboration with Radio Canada; distributed by the National Film Board of Canada. At the Film Forum, 57 Watts Street. Running time: 79 minutes. This film has no rating.
WITH: Anatoly Karpov, Viktor Korchnoi, Bobby Fischer, Fernando Arrabal

By VINCENT CANBY

"THE GREAT CHESS MOVIE," which opens today at the Film Forum, is a practically perfect documentary of its kind. It's a funny, wise, passionate, witty inquiry into chess, which is called a game, and acknowledged to be ancient, though it might be more accurately described as a way of thinking about the world and dealing with it.

The film is the work of Gilles Carle, the French-Canadian director best known for his fiction films, and Camille Coudari, the Syrian-born, Canadian chess master who also appears in the film as one of the game's spokesmen. Another is Fernando Arrabal, the Spanish playwright and sometime film maker ("Viva la Muerte"), who, from his appearances here, also seems to be one of the game's most irrepressible gadflies as well as an articulate chess critic and commentator.

•

Like all good documentaries, "The Great Chess Movie" is so informative — and so informed by the film makers' fascination with the subject — that it makes no difference whether

"THE GREAT CHESS MOVIE"—Anatoly Karpov is among the chess masters profiled in Gilles Carle's Canadian documentary. Fernando Arrabal provides commentary on the players, including Bobby Fischer and Viktor Korchnoi.

or not you've ever seen a chessboard to enjoy the film thoroughly.

"The Great Chess Movie" offers some wonderfully candid portraits, via newsreel footage and interviews, with such chess greats as Bobby Fischer, Viktor Korchnoi, the Soviet master who defected in 1976, and Anatoly Karpov, the younger Soviet master who inherited the world title when Mr. Fischer declined to defend it.

There also are brief résumés of the history of the game and of the future possibilities of computer chess and glimpses of some of the great matches of the last 10 years. These include the one in which Mr. Fischer triumphed at Reykjavik, Iceland, and the match at Merano, Italy, in which Mr. Korchnoi, the defector, faced Mr. Karpov, one of the Soviet Union's most effective if unofficial ambassadors-at-large.

•

Sounding off throughout the film is Mr. Arrabal who, wearing a black derby and what appears to be a black-and-white jockey's jacket, and smoking a cigar, looks more than a little like José Ferrer playing Toulouse-Lautrec.

He's very funny as he interrupts a press conference at Merano to direct a political question at Mr. Karpov and, on other occasions, at ease in a garden, he's full of pungent opinions about almost everybody and everything relating to chess. In this country he'd be an immediate star.

1983 Ap 6, C15:3

Tijuana Trekkers

LOSIN' IT, directed by Curtis Hanson; screenplay by B. W. L. Norton; story by B. W. L. Norton and Bryan Gindoff; director of photography, Gil Taylor; edited by Richard Halsey; music by Ken Wannberg; produced by Mr. Gindoff and Hannah Hempstead; released by Embassy Pictures. At Loews State, Broadway and 45th Street, and Orpheum, 86th Street and Third Avenue. Running time: 98 minutes. This film is rated R.
Woody ... Tom Cruise
Dave Jackie Earle Haley
Spider John Stockwell
Kathy Shelley Long
Wendell John P. Navin Jr.
El Jefe Henry Darrow
Chuey Hector Elias

GUESS what they're losing in "Losin' It," which opens today at Loews State and other theaters? Here are some hints: They're losing it in a bor-

dello, and they're losing it in Tijuana. This is the story of four fun-loving American teen-agers who head south of the border for a little excitement, traveling in a fancy red convertible. The locals don't seem to like these gringos much, pointing out, "You come to Mexico to do things you wouldn't do in your own country." They have a point, though it's one that the movie doesn't work overtime to pursue.

"Losin' It," which was directed by Curtis Hanson, isn't without its likable moments, but it isn't overloaded with them, either. At first, it seems a mindlessly upbeat boys-will-be-boys film, with one of the four a sex-crazed, gnomish fellow trying to dress like a Frank Sinatra album cover (the time is the mid-1960's), and another a Jerry Mather look-alike who'd rather spend his money on illegal firecrackers than on fast women. The film would have had a certain unity if it had remained on the opening note of uncomplicated foolishness. By the story's end, though, there have been torture scenes, barroom brawls, jailhouse quarrels and plenty of other unwelcome mishaps.

The screenplay, by B. W. L. Norton (co-author of the story with Bryan Gindoff), has to strain to the breaking point to work a character named Kathy into it. The boys meet her when they stop at a grocery store to buy some Twinkies for the road; Kathy is fighting with her husband, and she impetuously hitches a ride with the boys, who are much younger than she. If you believe that, then you'll probably have no trouble with such subsequent developments as Kathy's deciding to get a divorce in Tijuana and her wandering around, blithely and without an escort, through this city of sin. Actually, the movie's Tijuana looks like a nice clean movie set, so there's no reason to think she's in any danger.

Kathy isn't much of a character, but she is played charmingly by Shelley Long, who looks like a very pretty scarecrow and who demonstrates impressive talents as a physical comedienne. She's the best thing in the movie, although John P. Navin Jr. is also fairly funny as the fireworks tycoon. The Sinatra fan is played by Jackie Earle Haley with an avidity that borders on the alarming, but the performance has its moments. Like almost everyone else in the cast, Mr. Haley gives the impression that he might fare much better in a different movie.

Janet Maslin

1983 Ap 8, C4:5

OUT OF THE BLUE, directed by Dennis Hopper; screenplay by Leonard Yakir and Brenda Nielson; director of photography, Marc Champion; edited by Doris Dyck; music by Tom Lavin; produced by Leonard Yakir and Gary Jules Jouvenat; released by Discovery films. At the Waverly, Avenue of the Americas and West Third Street; New Yorker, Broadway and 89th Street. Running time: 89 minutes. This film is rated R.
Cebe Linda Manz
Don Dennis Hopper
Kathy Sharon Farrell
Charlie Don Gordon
Dr. Brean Raymond Burr
Paul Eric Allen
Carol Fiona Brody
Anderson David Crowley
Jean Joan Hoffman

By JANET MASLIN

TRANSITIONS barely exist in Dennis Hopper's "Out of the Blue," a work of affecting, if largely unexplained, intensity, and one whose collective associa-

tions are far more powerful than its story. Mr. Hopper's films, particularly this one, are more like time capsules than movies anyhow. They seem to be collections of free-floating cultural artifacts, assembled roughly but with honesty and passion. There is incoherence, too; "Out of the Blue" is more lucid than Mr. Hopper's "The Last Movie" but perhaps less direct than his "Easy Rider."

"Out of the Blue," which opens today at the Waverly and New Yorker theaters, concerns a streetwise tomboy called Cebe (Linda Manz), her sultry mother (Sharon Farrell), and her "sexy and tough" father, Don (Mr. Hopper), who has spent the last several years in jail. His crime, depicted in the film's opening moments, was driving a truck into a school bus filled with children. It would seem to be the most reckless thing Don is capable of, but it's only the beginning of a film in which drug use, incest, teen-age waywardness and the collapse of a family are key concerns. The movie's wildness is well established long before its genuinely explosive ending.

•

The film throws together Cebe's punk aspirations, her adulation of Elvis Presley, her mother's slatternly habits, her father's wild, drunken ravings and dozens of posters, slogans and songs. The theme music, from Neil Young's "Rust Never Sleeps" album, is a haunting accompaniment to Mr. Hopper's sometimes stunning imagery. The best moments of "Out of the Blue" have both the beauty and the banality of found art, as when Mr. Hopper is seen working atop a garbage heap, surrounded by hundreds of seagulls, to the tune of Mr. Young's "Thrasher." At another, equally haunting moment, Cebe sits blankly in a vine-clogged, abandoned greenhouse singing "Heartbreak Hotel."

It isn't always clear what Mr. Hopper is after here, yet for the most part his film manages to feel deliberate and distinct. The actors' rambling, improvisatory style — it's barely possible to believe that the family relationships defined by Leonard Yakir's and Brenda Nielson's screenplay are real — is so sustained that it becomes highly effective, even when Mr. Hopper is raving lines like "Elvis, Elvis, Elvis — oh, man, I know about Elvis."

Miss Farrell and Don Gordon, as a much-too-close family friend, have what might have been the Dyan Cannon and Ben Gazzara roles, but they both seem vibrant here. Raymond Burr turns up as a psychologist in one of the film's funnier scenes, as Cebe halfheartedly fools with the toys on his desk and listens to her mother's lies about the family. Miss Manz, who is the film's real star, is a tough, scrappy, androgynous figure here. Her scenes with Mr. Hopper work especially well, though this father and daughter may not resemble any other father and daughter you've ever seen. In any case, whatever wavelength Mr. Hopper is on here, she's on it too.

1983 Ap 8, C6:5

Overtaken by Fate

THE FLIGHT OF THE EAGLE, directed and edited by Jan Troell; screenplay by George Oddner, Ian Rakoff, Klaus Rifbjerg and Jan Troell, based on the novel by Per Olof Sundman; director of cinematography, Jan Troell; produced by the Swedish Film Institute, Jörn Donner; released by Summit Feature Distributors Inc. At the Sutton, Third Avenue and 57th Street. Running time: 141 minutes. This film has no rating.

Salomon August Andrée Max von Sydow
Nils Strindberg Goran Stangertz
Knut Fraenkel Sverre Anker Ousdal
Lachambre Clément Harari
Gurli Linder Eva von Hanno
Anna Charlier Lotta Larsson
Nils Ekholm Jan-Olof Strandberg
GVE Svedenborg Henric Holmberg
Mina Andrée Mimi Pollak
Lundstrom Cornelis Vreswijk
Andrée's sister Ulla Sjoblom
Alfred Nobel Ingvar Kjellson
Oscar II Brunno Sorwing
The Captain Ake Whitney
Nansen Knut Husebo

By VINCENT CANBY

FOR reasons not entirely clear, doomed polar expeditions remain almost endlessly fascinating. It may be because cold landscapes, unlike the jungles and rain forests of the tropics, do not overwhelm the past with fecundity. Instead, polar regions preserve it, sometimes for millennia, deep frozen, as a silent lesson to us all.

Jan Troell's "The Flight of the Eagle," the Swedish nominee for the Oscar as the best foreign-language film of the year, is the story of Salomon August Andrée, Nils Strindberg and Knut Fraenkel who, in 1897, took off from Spitsbergen in a hydrogen-filled balloon in what turned out to be a lunatic attempt to fly over the North Pole to claim it for Sweden. The three men were never again seen alive.

In 1930 the crew of the Norwegian ship Bratvaag discovered the remains of the expedition on the island of Viton. The balloon, which was supposed to be able to stay in the air for weeks, had landed three days after takeoff. Though the bodies of the explorers had been partly eaten by polar bears, they were identifiable. More important, Andrée's diaries had been preserved, along with the undeveloped negatives of a number of photographs the men had taken during their uncertain flight and subsequent journeying across the Arctic wastes.

"The Flight of the Eagle" uses as the basis of its screenplay a "documentary novel" about the expedition, written in 1967 by Per Olof Sundman, a work that apparently includes a lot of speculation on the nature of the three explorers and on the exact sequence of events that preceded their deaths.

The film, which opens today at the Sutton theater, is so good that it makes one want to know more, especially how much of it is documented by Andrée's diaries and how much of it is invented by the novelist and film makers.

As characterized in the screenplay, and as acted by Max von Sydow, Andrée is an extremely complex figure. He's internationally known as an "aeronaut," although he has spent less than a few hours on any single balloon flight. He's a self-absorbed bachelor with a profound attachment to his old mother and, only late in life, does he experience anything like a serious romantic affair. He's thoughtful and vain. He's dedicated to science but also, it seems, a mystic. He's a humanitarian who's willing to sacrifice himself and his associates rather than face the humiliation of defeat.

The other two men are somewhat more easy to understand. Strindberg (Göran Stangertz), a first cousin once removed of the great Swedish playwright, is a young scientist whose devotion to Andrée persuades him to disregard his own common sense. Fraenkel (Sverre Anker Ousdal) is an engineer, the replacement for an old friend of Andrée's who backs out at the last minute when he realizes that Andrée's expectations of the balloon

Max von Sydow in "The Flight of the Eagle."

are far from realistic.

"The Flight of the Eagle," magnificently photographed by Mr. Troell, who also wrote the screenplay with three collaborators, leaves a lot of questions unanswered. Yet the adventure is both panoramic and unusually intimate. Toward the end of the expedition, the personal drama of the three men, as they are overtaken by fate, is detailed with an intensity that is as moving as the earlier sequences are spectacular.

Mr. Troell has a novelist's love of digression, which makes for a very long film that has an appealing kind of 19th-century leisureliness to it. There's an extended sequence set in Paris, where the three men go to be outfitted, to check on the construction of the balloon, to take in the cancan dancers and to be sculptured in wax for museum viewing.

Later, in an eerie sequence before the start of the expedition, Andrée presents his beloved mother with a duplicate of his own, life-sized wax head, which she regards coolly. It's not because it looks like Salome's dirty work, which it does, but because she doesn't like the beard on it. The son, holding the head in his lap, dutifully pulls out the chin whiskers while his mother sews.

There are also a rather large number of flashbacks devoted to Strindberg's idealized memories of the young woman (Lotta Larsson) he leaves behind — an enchanting creature who glows in Renoir colors — and to Andrée's relations with a Stockholm matron (Eva von Hanno), an affair that never seems as passionate or important as it's supposed to be.

Mr. von Sydow, Mr. Stangertz and Mr. Ousdal are each very fine. The huge, briefly airborne balloon is marvelous to behold, and so is the entire physical production.

1983 Ap 8, C8:1

PRIVILEGED, directed by Michael Hoffman; written by Mr. Hoffman, David Woollcombe and Rupert Walters; director of photography, Fiona Cunningham Reid; edited by Derek Goldman; music by Kudos Points; produced by Richard Stevenson; released by New Yorker Films. At the Lincoln Plaza Cinema, Broadway between 62d and 63d Streets. Running time: 94 minutes. This film has no rating.
Edward Robert Woolley
Anne Diana Katis
Lord Adrian Hughie Grant
Lucy Victoria Studd
Jamie James Wilby
Justin Simon Shackleton
Imogen Imogen Stubbs
Wilf Mark Williams

"**P**RIVILEGED," which opens today at the Lincoln Plaza Theater, is a prettily precocious but overwrought undergraduate melodrama, shot entirely in and around Oxford University by students, in collaboration with the university's drama department and distinguished alumni, including John Schlesinger. It would look awfully good in a student film festival.

The story is about a handsome young student pursuer of women named Edward and his comeuppance in the course of a student production of "The Duchess of Malfi." The events of Webster's tragedy somehow become tangled with those in the lives of Edward and the other actors in the play, but to no real purpose.

•

The members of the attractive cast include Robert Woolley, as the caddish Edward; Diana Katis, who plays both the Duchess of Malfi and the young woman Edward may or may not really love; Victoria Studd as the pretty, rich young thing with whom Edward toys briefly, and Hughie Grant, as a decadent young peer who seems to have read a lot of early Evelyn Waugh.

The screenplay, which is frightfully moral if incoherent, was written by Michael Hoffman, a young Rhodes scholar from Boise, Idaho, who is also the film's director, and David Woollcombe and Rupert Walters. Richard Stevenson, an American fellowship student at Oxford, is the producer. Oxford is picturesque.

Vincent Canby

1983 Ap 8, C8:5

"THE PRIVILEGED"—Diana Katis (above, left) plays a headstrong young actress in love with another student (Robert Woolley) enrolled in the drama department of Oxford University.

FILM VIEW

VINCENT CANBY

Old Ways Color New Movies

It's not only a man's world, but a very young man's world, one usually without adults and one in which women, even young ones, are bit parts.

In "The Outsiders," Francis Ford Coppola's screen version of S. E. Hinton's "young-adult" novel, the only parents on view are dumb-show figures, a pair of battling, screaming silhouettes seen against a tacky window shade.

In "Bad Boys," a sort of young-adult "Big House," set in a juvenile correctional facility, or what used to be called a reform school, the parents are't exactly the vanished breed they are in "The Outsiders," but they aren't any better. There's one mom who entertains gentlemen callers in her bathtub, one dad who's ineffectual, another who's an unemployed boozer and one harried mom who hasn't the time to give her children the kind of love that would keep them out of the trouble the movie is all about.

In "Spring Break," an extremely limp update on "Where the Boys Are," just one set of parents is seen: a rich, foolish woman and her second husband, a priggish political aspirant. The only parents in "The Lords of Discipline" are an aristocratic Southern couple who, you may be sure, have stuffed their son with all of the wrong values.

About the only decent parent in this current bunch of young-adult movies is played by Teri Garr in "The Return of the Black Stallion," and since her son and the movie take off for North Africa almost immediately,

she's not around long enough to correct the impression that parents are, at best, dead.

However, it isn't just the parents who get short shrift in these films. Women — the girlfriends of the young male protagonists — are an even more hopeless lot. They are frequently pretty and always loyal, which is about all of the equipment they need for their assigned roles: cheerleaders at the big game called Life being played by the young men.

In "Bad Boys," Ally Sheedy is seen as a young woman who is brutally raped, but her rape is not important. It's the rapist's way of taking revenge on his victim's boyfriend. She's not even a sex object in her own right.

Neither is Diane Lane in "The Outsiders." She just hangs around the edges of the film, wringing her hands and looking worried while the young men, who belong to two rival Tulsa gangs, read "Gone With the Wind," discuss Robert Frost and prepare to rumble, possibly unto death.

It's more than a little ironic that the only film to present young women as something more than witnesses is by far the worst, most foolish of the lot. This is "Spring Break," which is about the annual spring migration of college students to Fort Lauderdale. Though the movie, like its young heroes, spends most of its time ogling, the young women thus ogled are allowed to be pursuers as often as they are pursued. That's not much, but it's something.

It's astonishing that in spite of all of the extraordinary social changes that have taken place in this country in recent years, movies designed for younger audiences remain so firmly rooted in the attitudes of the 1930's and 1940's. Even though their language is more frank, and even though consummated sex is now second in importance only to beer in their lives, these kids inhabit a soci-

ety governed by rules of behavior as formal, bleak and hypocritical as those in the Age of Chivalry.

This may be an accurate picture of the American situation in 1983, but it's also a romantic projection of the way kids like to see themselves, especially those who have enough sense to be bored blind by the cheery formulas of television's situation comedies. Stories about kids misunderstood by shortsighted, self-interested parents have always been terrifically appealing and, at their best, they reflect a basic truth about childhood.

That is that children actually are different from adults. Even when they aren't smaller, they remain disenfranchised until they're 18. Much of the time they actually are on the defensive. If the Capulets and the Montagues had played softball with their kids, there wouldn't have been any tragedy. Romeo and Juliet paid the supreme sacrifice for their parents' stupidities.

What is odd in these current films is not their doomy romanticism, which Mr. Coppola knowingly carries beyond the brink in his golden-hued melodrama of acne and angst, but their unembarrassed depictions of societies dominated by men/boys. There's no outrage expressed. Even in movies of the 30's and 40's, there was usually some sweet young thing who'd step forward and say something to the effect that men must stop their senseless wars, that women/girls had had enough. The women/ girls in these films don't even say that. Unless they're raped, they remain totally outside the concerns of the films that surround them.

Don't get me wrong. This is not some furious, feminist crusade that demands that in gang warfare movies, like "The Outsiders" and "Bad Boys," the girls be shown playing roles equal to those of the boys. That wouldn't be any more realistic than the myth-making Mr. Coppola attempts in "The Outsiders."

The interesting thing is that the people who buy the tickets that make these films popular must include a lot of young women who share the movies' visions of a male-dominated world and, up to a point, are entertained by them. The initial box office response to "The Outsiders" seems to indicate that the film is going to override a generally bad press to become a genuine hit.

It's possible that one of the reasons these films are as popular with women/girls as with men/boys is that the actors in them, for all of the violence of the narratives, are a remarkably unthreatening lot. With the exception of Matt Dillon who, at age 18, plays an avuncular sort of macho figure to the younger boys in "The Outsiders," most of the actors are a dreamy, androgynous lot. They don't look tough and when they are required to act tough, there's no sense of danger, even when the violence ends in death.

There's no way of proving this, but it may be that Richard Rosenthal's "Bad Boys" wouldn't have been anywhere near as popular as it's been if it had starred a rougher, less poetic actor than Sean Penn, who plays a vicious 17-year-old who winds up in the slammer for, among other things, a manslaughter committed during an attempted drug robbery.

As written, the character of Mick O'Brien is a laconic, possibly psychotic hoodlum, but, as represented by Mr. Penn, he is as other-worldly, and almost as pretty, as an Italian Renaissance angel sent to earth for The Annunciation.

•

This is also true of Esai Morales, who plays Mr. Penn's Hispanic rival, a fellow whose muscles seem to have nothing to do with his face, which is soft. When the two young men have their final showdown in the cellblock, the battle is about as ferocious as that of a couple of female wrestlers in a tank of mud. It's not that both young men aren't good actors, but that they've been cast and directed to deny

Attitudes of the 1930's and 1940's remain deeply rooted in movies for the young.

the sleazy realities of the tale they're telling.

Mr. Rosenthal, like Mr. Coppola, knows what he is doing.

The same cannot be said of Sean S. Cunningham, who wrote and directed "Spring Break," and, one must assume, was responsible for assigning the roles. The young actors appear not to have been cast to deny the essential chauvinism of the comedy, but as a series of mistakes. They're all wimpish.

It is, perhaps, stretching things to include "The Black Stallion Returns" in this group of male-dominated movies for younger audiences. "The Black Stallion Returns" is a nice, uncomplicated, action-oriented adventure film, and the young protagonist, played by Kelly Reno, who starred in the original "Black Stallion," could as easily have been a girl as a boy.

By far the best film of this lot is Franc Roddam's "The Lords of Discipline," based on a novel by Pat Con-

roy, who also wrote the novel on which "The Great Santini" was based. "The Lords of Discipline" is only mentioned here becase it, too, is set in an exclusively male-dominated world, that of the Carolina Military Academy, which is the film's fictitious name for The Citadel.

•

"The Lords of Discipline" not only has a first-rate, melodramatic screenplay, written by Thomas Pope and Lloyd Fonvielle, involving a fascistic secret society of undergraduates, but it is about something other than adult irresponsibility. It's the story of the initially reluctant moral commitment of one upper classman, who's been assigned to see to it that the academy's first black cadet somehow survives all of the efforts to make him resign.

The film is beautifully acted by David Keith as the upper classman, Mark Breland as the black cadet, Robert Prosky as an academy officer who may or may not be part of the plot to keep the school all-white, and G. D. Spradlin as the commandant. That there are no women in the film, at least none who have any vital plot function, is not a way of looking at life, as in the other films, but an accurate representation of the movie's very particular world.

If you haven't seen it yet, "The Lords of Discipline" is worth catching up with — an exceptionally solid, intelligent and entertaining piece of work. ∎

1983 Ap 10, II:17:1

Electra in Four Hours

O THIASSOS (The Traveling Players), written and directed by Theodor Angelopoulos (in Greek with English subtitles); photography by George Arvanitis; music by Loukianos Kilaidonis; produced by George Arvanitis. At the Public Theater, 425 Lafayette Street. Running time: 230 minutes. This film has no rating.

"O Thiassos" (The Traveling Players) was shown as part of the 1976 New Directors/New Films series at the Museum of Modern Art. Following are excerpts from a review that appeared in The New York Times of April 10, 1976. The film opens today at the Public Theater.

"**O** THIASSOS" is a new Greek film of startling beauty and originality — that is, for the first two hours or so. But it lasts four hours. Length is part of its problem. A much greater problem is that the political message that is only one of the threads in the first part thickens into hawser dimensions, strangling the film and the audience along with it.

Translated as "The Traveling Players," "Thiassos" is a bloated, spoiled masterpiece. Theodor Angelopoulos, whose third film this is, possesses enormous talent; large enough to show clearly through his monstrous lack of restraint and often to overcome it. Since restraint is easier to acquire than genius, there is a basis for hoping that we are seeing the work of someone who is destined to become a truly great film maker.

•

"Thiassos" attempts to tell the story of modern Greece through the wanderings of a band of actors, an unskilled provincial group that sings and dances in front of village theaters to lure audiences inside for a performance of a rough shepherd's play. ·

The action begins in 1939, goes

through World War II and the civil war, and ends in 1952. Using flashbacks, flash-forwards and narrated recollections, it manages to suggest a broader time span, from the 1920's up to the time of the colonels' coup.

The film's structure is even more complex than its time frame. It is the story of political developments in Greece as they affect the villages visited by the troupe: the right-wing prewar Metaxas dictatorship, the national unity of right and left during the brief fight against the Axis, the civil war and — as the film sees it — the victory of reaction over popular forces.

At the same time it is the story of the troupe itself; the decimation of the company under the stress of personal and political passion. Mr. Angelopoulos manages to blend both things — the jealousies and betrayals within the company and the political divisions of right and left — into a retelling of the Electra tragedy.

•

The acting and camera work are flawless. Mr. Angelopoulos takes many risks. He holds camera or characters still for minutes on end; he has scenes that consist of one character addressing the camera at length. Usually these things work, in surprising ways.

But the film begins to flag in the middle. In part, the deliberate pace becomes excessive. Many of the slow gestures begin to seem like affectations.

Furthermore, the message begins to shed its complexity and become simply a tract praising the Communist forces who lost the civil war and attacking and caricaturing the conservative victors and their British and American allies.

The excessive politicization in a work of normal dimensions and equal talent would simply be a flaw. Here it is immensely magnified. The discoveries of the first two hours turn into a relentless pounding during the last two.

1983 Ap 12, C12:5

Sharing Vodka

LIGHT YEARS AWAY, directed by Alain Tanner; written by Mr. Tanner, based on the novel "La Voie Sauvage" by Daniel Odier; director of photography, Jean-François Robin; edited by Brigitte Sousselier; music by Arie Dzierlatka; produced by Pierre Heros; a New Yorker Films Release. At the Bleecker Street Cinema, 144 Bleecker Street. Running time: 95 minutes. This film has no rating.

Yoshka Poliakoff	Trevor Howard
Jonas	Mick Ford
Betty	Bernice Stegers
The Lawyer	Henri Virlogeux
The Dancer	Odile Schmitt
Man with the truck	Louis Samier
Thomas	Joe Pilkington
Man in the bar	John Murphy
The drunk boy	Mannix Flynn
Owner of the cafe	Don Foley
Owner of the village bar	Jerry O'Brien
Cop	Vincent Smith
Girl at village dance	Gabrielle Keenan

By VINCENT CANBY

IN "Light Years Away," his first film in English, the Swiss director Alain Tanner turns away from the social and political realities that inform his best films to embrace a kind of terminal mysticism.

It's as if this militantly left-wing film maker had given up on this world to contemplate the next: our problems are not to be solved, but set aside in favor of a journey to the center of the self.

Because Mr. Tanner ("La Salamandre," "In the Middle of the World"

and "Jonah Who Will Be 25 in the Year 2000") is such a gifted director, "Light Years Away" is not a foolish film. However, it's a surprisingly muddled work to come from someone whose roots are so firmly planted in an established European intellectual tradition, a man whose wise skepticism has always reinforced his vision of social change. I can't believe that "Light Years Away" is anything but a footnote to the Tanner career.

The film, which opens today at the Bleecker Street Cinema, is set in the year 2000, and its young hero is named Jonas, which seems to be merely a coincidence, without tangible relation to the earlier, far richer film. Jonas is also the name of the young hero of "La Voie Sauvage," Daniel Odier's novel, which is the basis of the Tanner screenplay.

The world that Jonas (Mick Ford) has inherited appears to be in a kind of postapocalyptic depression that is physical as well as spiritual. Though the film was shot in Ireland, principally on the wild and beautiful west coast, the setting is never identified. "Light Years Away" is one of those films set in a universal Anywhere, which turns out to be Nowhere.

It's the fantastic tale of the spiritual education of Jonas, a drifter who is working in a pub when first seen by a possibly lunatic old hermit named Yoshka Poliakoff (Trevor Howard), whose origins are Russian, which may or may not be significant. I think not.

Yoshka lives in the middle of a huge junkyard, which looks like the remains of 20th-century civilization, and spends his days working in an old hangar, which, until near the end the film, remains off limits to his apprentice. In the meantime, Yoshka makes up a series of arbitrary trials for the younger man. He makes him sort junk. "Things, like people, belong in families," he says. At another point he asks Jonas to tend the roadside gasoline pump, which, when someone at long last stops for gas, turns out to be empty.

For a long time the old man is quarrelsome and stingy with Jonas, but he appreciates the younger fellow's steadfastness. When Yoshka returns to the junkyard one morning battered and bruised, he instructs the apprentice to bury him up to his head in the ground, then bring him a glass of water once a day. By way of explanation, he says, "You've got to dig down into the earth to become fertilized."

The point of the trials is to test Jonas's spirit, though this part of the film remains fuzzy to me. When Jonas has finally proved himself, he's told of Yoshka's mission, which is to fly away, "beyond the galaxies," on the wings that he has been making in the hangar.

It's at this point that "Light Years Away" really does come apart, even as fantasy. It's not unreasonable to ask why Yoshka, who has taught Jonas all about the oneness of matter, who enjoys transcendental meditation and who communes with things, as well as with birds and beasts, needs anything as cumbersome and as unreliable as home-made wings to fly. Why doesn't he just sit down, open his eyes very wide, and soar away into his inner consciousness?

Though the point of the film eludes me, "Light Years Away" is not dull. It is acted in lively, disciplined, comic style by Mr. Howard and Mr. Ford. Its brooding, mostly sunless landscapes are appropriately otherworldly. Further, Mr. Tanner's screenplay is filled with seductively funny, Beckett-like

vignettes. There's one in which the two men sit in the cab of Yoshka's pickup truck, parked outside the hangar, while they share a quart of vodka and watch the spectacle of a night thunderstorm, laughing and hooting as if they were seeing "Friday the 13th" at a drive-in.

1983 Ap 15, C7:1

Truck Torture

DUEL, directed by Steven Spielberg; screenplay by Richard Matheson, based on his published story; director of photography, Jack A. Marta; film editor, Frank Morriss; music by Billy Goldenberg; produced by George Eckstein; released by Universal Pictures. At the Manhattan 1, 59th Street between Second and Third Avenues. Running time: 90 minutes. This film is rated PG.

David Mann	Dennis Weaver
Cafe Owner	Eddie Firestone
Man in Cafe	Gene Dynarski
Gas Station Attendant	Tim Herbert
Old Man	Charles Seel
Old Man in Car	Alexander Lockwood
Old Woman in Car	Amy Douglass
Waitress	Shirley O'Hara
Lady at Snankerama	Lucille Benson
The Truck Driver	Cary Loftin
Car Driver	Dale VanSickle

By JANET MASLIN

STEVEN SPIELBERG first made his mark with a film about a diabolical truck, a subject that would seem to have only limited possibilities. In fact, Mr. Spielberg's 1971 television film "Duel" took advantage of the very narrowness of its premise, building excitement from the most minimal ingredients and the simplest of situations. The theatrical version of "Duel" at the Manhattan Twin theater may contain a few extra close-ups of its leading man's nose, but otherwise it works as well on the wide screen as it did on the small one. Even without benefit of hindsight, "Duel" looks like the work of an unusually talented young director.

"Duel" begins when a California businessman embarks on a car trip and happens to pass a certain truck on a two-lane road. The truck, which seems to have a mind of its own (the driver is never clearly seen), wants revenge and spends the rest of the journey getting at it. The trip, which is a succession of nerve-wracking chases (truck gets behind car and forces it to speed up; truck gets in front of car and tries to force it off the road; truck butts car into path of oncoming train, etc.), was indeed a long one. According to the production notes, Dennis Weaver, who plays the car's driver, put in more than 2,000 miles during the 16-day shooting schedule.

•

"Duel" might almost have been a silent film, because it expresses so much through action and so little through the words that are here. Mr. Weaver is David Mann, the film's only real character, and he's given a few internal monologues that only awkwardly express Mann's anxiety. (After one encounter with the truck, he thinks: "Twenty, twenty-five minutes out of your whole life and then all the ropes that kept you hangin' in there are cut loose. And there you are, back in the jungle again.")

These and a few whimsical conversations from a call-in radio show are really all the character development the movie provides, and they're much weaker than the ingenious visual effects. Mr. Spielberg wasn't purely a special-effects director in those days, and he isn't one now, but the people in "Duel" seem particularly remote. The minor characters, at the various

stops Mann makes along the highway, are uniformly freakish. And Mann himself is shown to be a henpecked husband who regains his masculinity only through the contest on the road. Incidentally, his children are seen (when Mann makes a telephone call to his wife) playing raptly with a toy robot at home while their parents quarrel.

•

Mr. Weaver is the film's ostensible leading man, but his responses are seldom complex or surprising. The vehicles are the real stars of "Duel," and whenever the chase is interrupted by the relatively primitive people on hand (at a truck stop and, in one particularly odd sequence, at a gas station run by a woman who keeps pet snakes, spiders and lizards), the film loses its momentum and becomes somewhat clumsy. The ending is abrupt, too, but the main impression left by "Duel" is one of talent and energy. Mr. Spielberg seemed, with this film, to be headed for bigger and better things. Sure enough, he was.

"Duel" is rated PG ("Parental Guidance Suggested"). Its theatrical version contains a few words that may not have been in the television version.

1983 Ap 15, C10:1

The Dancing Welder

FLASHDANCE, directed by Adrian Lyne; screenplay by Tom Hedley and Joe Eszterhas, story by Mr. Hedley; director of photography, Don Peterman; film editors, Bud Smith and Walt Mulconery; music by Giorgio Moroder; choreographed by Jeffrey Hornaday; produced by Don Simpson and Jerry Bruckheimer; released by Paramount Pictures. At the Orpheum, Third Avenue and 86th Street; Astor Plaza, Broadway and 44th Street; 34th Street Showplace, near Second Avenue and other theaters. Running time: 96 minutes. This film is rated R.

Alex	Jennifer Beals
Nicky	Michael Nouri
Katie Hurley	Belinda Bauer
Hanna Long	Lilia Skala
Frank Szabo	Phil Bruns
Cecil	Malcolm Danare
Secretary	Lucy Lee Flippin
Richie	Kyle T. Heffner
Junior Jean	Sunny Johnson
Jake Mawby	Ron Karabatsos
Heels	Durga McBroom
Rosemary Szabo	Micole Mercurio
Tina Tech	Cynthia Rhodes
Johnny C.	Lee Ving

"FOXES," the first feature by Adrian Lyne, is best remembered for the distinctively dewy, tender look it gave to the pretty young girls in its cast. "Flashdance," Mr. Lyne's second feature, wants to be a lot more. It wants to be about love and style and dancing and ambition, about how, as one character puts it, "when you give up your dream, you die." All those things that "Saturday Night Fever" was about, in other words.

These are noble aspirations, but they are apparently way outside the reach of Mr. Lyne, who never brings the least bit of credibility or emotion to his story. His talents lie elsewhere: when it comes to trend-spotting and girl-watching, Mr. Lyne is in the vanguard, and these are the things for which "Flashdance" is most notable. That, and for the very nubile young actresses in its cast, and for the heroine's remarkably soulful-looking dog.

"Flashdance," which opens today at Loew's Astor Plaza and other theaters, is set in Pittsburgh, and much of it was photographed there. Despite this incontrovertible evidence, the film gives the impression that Pittsburgh is not a place with which the

British Mr. Lyne has acquainted himself. So he uses its industrial settings, in a film that otherwise has the texture of a cream puff, to add a fashionable trace of grit. Its heroine, believe it or not, is supposed to be a welder.

Alex (Jennifer Beals) is a radiant, doe-eyed young beauty who welds by day, dances by night, exercises in every spare moment, is sweet to everyone she knows, and never gets tired. Isn't that grand? Alex's whole life is a fashion fantasy, and Mr. Lyne — who began by directing commercials — makes it lovingly detailed. So Alex lives in a loft scattered artfully with dressmakers' dummies, and she always manages to weld in interesting garb. At night, the bar at which she dances is like no bar Pittsburgh ever saw.

Where the tables are, a group of more-or-less ordinary Joes drink and congregate, beer-commercial style. But the stage has such a sleek black design that it barely matches the rest of the place. And the show-stopping dancing is a combination of new wave sadomasochism and calisthenic pornography. When the camera isn't ogling some slender young thing in leotards, it's watching, say, a woman in white face makeup throw herself repeatedly against a high-tech grid, as if she were receiving a beating. Pretty trendy stuff for an audience of welders at Miller time.

The screenplay, by Tom Hedley and Joe Eszterhas, packs in the dance scenes and a whole lot more. There is a mentor (Lilia Skala) who encourages Alex to become a ballerina. There is an insipidly pleasant boss who'd like to date Alex, though she's much too principled to go out with her employer. (So he discharges her; then they go out.) There is a lot more, in the way of fights, romances and even a death, but the movie somehow treats these things as evenhandedly as it presents Alex's exercise sessions.

And there's the high-speed street dancing of the title, usually the province of young black men, at which Alex is virtually the world's only proficient white teen-age girl. The few brief flashdancing scenes (with a double doing the fanciest acrobatics for Miss Beals) are crowd-pleasers, and they're emblematic of what the movie does best. With a score by Giorgio Moroder, and with ingenious costumes that are utterly au courant, "Flashdance" contains such dynamic dance scenes that it's a pity there's a story here to bog them down.

The story doesn't help Miss Beals either, because she's at her least convincing when having to register any emotion other than rapture. However, she's a lovely young actress with a sweetly flirtatious manner, and the movie uses her most effectively when it simply watches her. Much of the film's interest comes from wondering what she'll be seen doing next — maybe riding her bicycle romantically alone at midnight (anyone else tried that in Pittsburgh lately?), or perhaps lying in the afternoon light in her daintily worn denims, communing with her hound. In one scene, it even appears that Miss Beals's hair is being tousled through her hard hat. That's not possible, of course, but it's no less realistic than anything else in the movie.

Janet Maslin

1983 Ap 15, C13:1

April in Paris?

WAITING FOR GAVRILOV, directed by Pyotr Todorovsky; screenplay (Russian with English subtitles) by Sergei Bodrov; camera, Yevgeny Guslinsky; a Mosfilm Production; an IFEX Films Release. At the 72d Street Cinema, east of Second Avenue. Running time: 80 minutes. This film has no rating.

Rita	Ludmila Gurchenko
Gavrilov	Sergei Shakurov
Uncle	Evgeny Evstegneev
Slava	A. Vasilyev
Victor	Mikhail Svetin
Pasha	Sbilowski
Tanya	S. Ponomareva
Lucya	Natalya Nazarova
Victor	S. Sokolov

THE Soviet gaiety to be found in Pyotr Todorovsky's "Waiting for Gavrilov" is so atypical you may start to think it's April in Paris. Actually, it's spring-time in Odessa, where a buoyant young woman and her buoyant friends and family rush to City Hall. They're on their way to a wedding — hers — except that the bridegroom doesn't arrive. So the family skips the wedding feast and goes home. And the would-be bride wanders blithely through the park near City Hall, having all sorts of wholesome, life-affirming encounters with the strangers she meets there.

The star of "Waiting for Gavrilov," which opens today at the Embassy 72d Street, is Ludmila Gurchenko. She, according to the production notes, is often described as 'the Shirley Mac-Laine of the Soviet Union.' " Actually, that's not too far off the mark, be-cause Miss Gurchenko is a pert, leggy actress without whose effervescence the film would not be possible. Friendly and in unaccountably high spirits, she befriends all the young lovers she meets, encounters several of her own acquaintances, comforts her teen-age daughter and does some impromptu disco dancing with a cheerful crowd.

●

Mr. Todorovsky presents all this in the manner of Gallic fluff, complete with happy extras and hyperactive musical score. There's even a tiny subplot involving a puppy. Occasionally, a somber note will slip through, as when the heroine's uncle tells a big-hearted waitress: "I've always been kind to you girls. Your lives are full of drama." For the most part, though, "Waiting for Gavrilov" is lighter than light, and not sufficiently tinged with the rueful wisdom that's usually associated with the genre.

●

On the same bill is Zbigniew Rybc-zynski's "Tango," this year's Oscar-winning animated short subject. In a room with three doors and a window, various figures appear, each one performing a single act over and over again — there's a boy throwing a ball, a woman putting a child to bed, a couple making love, a man changing a light bulb and about 10 others. Eventually, they're all in the room simultaneously, which is more apt to make one wonder how Mr. Rybczynski synchronized the action than to prompt thoughts of man's indifference to his fellows, which is presumably the point.

Janet Maslin

1983 Ap 15, C14:1

ABUSE, directed, written and edited by Arthur J. Bressan Jr.; cinematography by Douglas Dickinson; music by Shawn Phillips; a Steven R. McMillin Production; a Promovisional International release. At the Cinema 3, 59th Street and Fifth Avenue. Running time: 93 minutes. This film has no rating.

"WAITING FOR GAVRILOV"—Clockwise from top left, Natalya Nazarova, S. Sokolov, S. Ponomareva, Evgeny Evstegneev and Ludmila Gurchenko star in a romantic comedy set in Odessa and directed by Pyotr Todorovsky.

Larry Porter	Richard Ryder
Thomas Carroll	Raphael Sbarge
Dr. Bennett	Steve W. James
Kathy Logan	Kathy Gerber
Professor Rappaport	Jack Halton
Laura Alexander	Mickey Clark
Mr. Carroll	Maurice Massaro
Mrs. Carroll	Susan Schneider
Dean Kinkaid	Jean Garrett
Samantha	Pam Poitier

"ABUSE," which opens today at the Cinema 3, is a frail little movie that pretends to be a serious study of child abuse. In reality it's an unintentionally funny, lyrical, homosexual romance about an all-too-convincingly amateur New York film maker, a man in his mid-30's, and the 14-year-old boy who steals his heart.

As part of his fellowship, Larry Porter (Richard Ryder) is making a documentary about abused children, their parents and the possible treatment for both parents and children. In the course of his work, he meets Thomas Carroll (Raphael Sbarge), a boy whose mother and father alternately coddle their son and torture him by, among other things, holding lighted cigarettes to his bare chest. Thomas first becomes the star of Larry's film, then his lover.

If "Abuse" were a better film, one might be able to call it sordid. It's only tacky. In style it's reminiscent of the sort of pseudo-educational, sane-sex movies made in the 1950's, especially Kroger Babb's "Mom and Dad." The actors are awkward, the dialogue is clumsy and the resolution preposterous.

About half the movie is devoted to footage about abused children, including morgue photographs, confessions of reformed child abusers and recollections by adults who were abused as children. The rest of the film poses the question of whether or not Larry and Thomas can find happiness in San Francisco.

Vincent Canby

1983 Ap 15, C29:1

LONE WOLF McQUADE, directed by Steve Carver; screenplay by B. J. Nelson, story by H. Kaye Dyal and B. J. Nelson; director of photography, Roger Shearman; film editor, Anthony Redman; music by Francesco De Masi; produced by Yoram Ben-Ami and Mr. Carver; released by Orion Pictures. At Loews State, Broadway and 45th Street; Orpheum, 86th Street and Third Avenue; Murray Hill, 34th Street and Lexington Avenue, and other theaters. Running time: 105 minutes. This film is rated PG.

J.J. McQuade	Chuck Norris
Rawley Wilkes	David Carradine
Lola Richardson	Barbara Carrera
Jackson	Leon Isaac Kennedy
Kayo	Robert Beltran
Dakota	L. Q. Jones
Sally	Dana Kimmell
T. Tyler	R. G. Armstrong
Jefe	Jorge Cervera Jr.
Molly	Sharon Farrell
Falcon	Daniel Frishman
Snow	William Sanderson
Burnside	John Anderson

In "Lone Wolf McQuade," which opened yesterday at the Loews State and other theaters, Chuck Norris plays a rugged, weathered, two-fisted, two-footed Texas Ranger who, at key moments, throws down his guns to indulge his talents in the martial arts.

Mr. Norris is good, and he looks enough like David Carradine, who plays the principal villain, to be a long-lost Carradine brother. The supporting cast includes Barbara Carrera, Sharon Farrell, Leon Isaac Kennedy, Robert Beltran and L. Q. Jones. Daniel Frishman appears as a very tiny Mr. Big, a disadvantaged dwarf who zips around in his motorized wheelchair being nasty and sarcastic to everyone.

The plot, set in and around El Paso, is unimportant and nonstop, like an old-fashioned, Saturday afternoon serial, which isn't at all bad. Steve Carver, the director, understands that in such films action is content.

●

"Lone Wolf McQuade," which has been rated PG ("Parental Guidance suggested"), contains a lot of mildly vulgar dialogue as well as violence that, though comparatively bloodless, results in a high death rate among the bad guys.

Vincent Canby

1983 Ap 16, 12:4

Route of Riddles

INVITATION AU VOYAGE, directed by Peter Del Monte; French with English subtitles; written by Mr. Del Monte and Franco Ferrini, based on the novel "Moi et Ma Soeur" by Jean Bany; photographed by Bruno Nuytten; edited by Agnes Guillemot; music by Gabriel Yared; produced by Claude Nedjar; released by Triumph Films, a Columbia/Gaumont company. At the Plaza, 58th Street east of Madison Avenue. Running time: 93 minutes. This film is rated R.

Lucien	Laurent Malet
Woman on the turnpike	Aurore Clement
Timour	Mario Adorf
Jeanne	Nina Scott
The Old Man	Raymond Bussieres

By JANET MASLIN

PLOT is not paramount in Peter Del Monte's "Invitation au Voyage," but the details of the narrative certainly warrant some mention. A young man named Lucien is grief-stricken at the death of his adored twin-sister Jeanne. So he fits her body into an instrument case and carries her through France atop his car, on a

journey home.

He meets a succession of odd characters along the way, all of whom have romantic obsessions to rival his own. "If I die, what will you do?" Jeanne had once asked Lucien, and his answer had been "Make you live again." By the film's end, he has in some sense kept that promise.

These are some of the events contained in "Invitation au Voyage," a film not overly concerned with events per se. Mr. Del Monte's direction concentrates on the peripheral details, as when, after Jeanne electrocutes herself in the bathtub (providing the film with one of its more dramatic New Wave tableaux), he offers a shot of water going down a drainpipe. Touches like these, elegantly rendered by the cinematographer Bruno Nuytten, help to give the film its "Diva"-like veneer of stylishness and abstraction.

"Invitation au Voyage," which opens today at the Plaza theater, has enough of this superficial gloss to hold an audience's attention. It never lacks for detail or density, but there's little of the passion that might have made this more than an empty exercise. Lucien's incestuous obsession with Jeanne (who is a New Wave singer with the stage name Nina Scott, which is also the name of the actress who plays her) is expressed though video footage of Nina in performance,

Visually arresting as this may be, it's too affectless to draw the audience into Lucien's point of view. That isn't what Mr. Del Monte is after anyhow, since emotion plays so small a role here. But what he does attempt, despite the film's careful parallels and congruences, is seldom fully articulated. The detachment, the empty and episodic quality, the title allusion to Baudelaire all further the film's mood, but there's no real synthesis of these elements. Eventually, the collection of startling images begins to seem self-defeating and slight. The habit of generating tiny, unnecessary riddles only adds to the film's hollow feeling, especially when the explanations prove disappointing.

The cast is well-chosen, particularly those actors playing characters Lucien meets on his journey. Among them are Mario Adorf, as a man who claims to have killed his wife and then claims to be lying, and Aurore Clement, as the charming hitchhiker who, like everyone else here, is invested with a few tics too many (she's a kleptomaniac). She pronounces Lucien "a phantom — you're here without being here." In the fashionably bloodless modern world of "Invitation au Voyage," that comes close to being a compliment.

1983 Ap 21, C20:3

EXPOSED, directed, written and produced by James Toback; director of photography, Henri Decae; film editor, Robert Lawrence; music by Georges Delerue; released by MGM/UA Entertainment Co. At the Sutton, Third Avenue and 57th Street. Running time: 99 minutes. This film is rated R.
Elizabeth CarlsonNastassia Kinski
Daniel JellineRudolf Nureyev
Rivas ...Harvey Keitel
Greg MillerIan McShane
MargaretBibi Andersson
Curt ..Ron Randell
Vic ...Pierre Clementi
MarcelDov Gottesfeld
Nick ..James Russo
Bridgit GormannMarion Vareila

By JANET MASLIN

THE title of James Toback's "Exposed" suggests sensationalism, a quality the film simultaneously attempts and

Nastassia Kinski

disdains. International terrorism, fashion modeling and the attention-getting casting of Rudolf Nureyev and Nastassia Kinski are the film's most noticeable ingredients, yet it affects such insouciance that these elements are never fully exploited.

"Exposed" is certainly the best film Mr. Toback has yet directed, with "Fingers" and "Love and Money" the others. But while "Exposed" is more polished, it has less urgency than its predecessors, affecting a paralyzing superiority to the cinematic commonplaces that might have served as its anchor.

The central figure in "Exposed," which opens today at the Sutton, is Miss Kinski's Elizabeth Carlson, a nice girl from a Midwestern farm. She is first seen at college, being lectured to by Mr. Toback as a hot-tempered English professor who addresses his class on Leslie Fiedler and Goethe's "The Sorrows of Young Werther." He also turns out to be having an affair with his prettiest pupil, who tells him she is tired of him, at which point he slugs her.

Soon Elizabeth is off to New York, where she becomes, in rapid succession, a waitress, a world-famous model and an inadvertent participant in a scheme of international intrigue. She is also sought after by Daniel Jelline (Mr. Nureyev), a celebrated violinist who wins Elizabeth's heart by breaking into her apartment, and wins the rest of her by running his violin bow across her torso. This moment, like so many in "Exposed," seems less intent on directly achieving what it's after than on sounding a note of gratuitous novelty and daring. There's very little going on between Mr. Nureyev and Miss Kinski here, violin bow notwithstanding. Mr. Nureyev seems stilted as the suitor with unusual tactics (in addition to housebreaking, he courts Elizabeth by following her down the street, reciting a poem and then darting away).

And his uneasiness is accentuated by the utterly immediate, natural presence of Miss Kinski, who displays a much greater range here, and a much more appealing quirkiness, than she has before. Miss Kinski's Elizabeth is so animated and willful, in fact, that the film's treating her as a pawn doesn't fit. "Woman, who was the angel of redemption, becomes the angel of death," Mr. Toback reads from Mr. Fiedler, in his professorial cameo. Yet Miss Kinski seems more active and vital here than do any of the men whose fate she influences.

From its first panoramic shot of Paris, which is where Elizabeth will

eventually be drawn, "Exposed" has been handsomely photographed by Henri Decae and interestingly if eccentrically cast. (Bibi Andersson plays a simple farmer's wife, Harvey Keitel a kingpin of the international underground, and there are a number of curious cameos.) All of the characters say more, and do less, than they need to, until the film finally arrives at a note of would-be tragedy that's only deflating. The film's ambitions get in the way of its action all the way through.

One sort of action that does erupt here periodically, though, is the unexpected brawl. The film is full of them, from a fight between extras at a record store, to an unusually clumsy street mugging (Miss Kinski is practically talked to death by the robber's accomplice), to a surprise later appearance by Mr. Toback as the professor still dogging his sweetheart's steps. Far from fostering the impression that the world is a violent place, these outbursts merely make it seem a more contrived and histrionic one.

1983 Ap 22, C10:1

Musical Moods

TO BEGIN AGAIN, directed by José Luis Garci; screenplay (in Spanish with English subtitles) by Mr. Garci and Angel Llorente; director of photography, Manuel Rojas; music by Johann Pachelbel and Cole Porter; produced by Mr. Garci; released by 20th Century-Fox International Classics. At the Baronet, Third Avenue and 59th Street. Running time: 93 minutes. This film is rated PG.
AlbajaraAntonio Ferrandis
Elena ...Encarna Paso
Roxiu ...Jose Bodalo
Gervasio LosadaAgustin Gonzalez
Ernesto ..Pablo Hoyo
CarolinaMarta Fernandez Muro
SabinoPablo del Hoyo

THE winner of this year's Academy Award as Best Foreign Film, José Luís Garci's "To Begin Again," was clearly the sentimental favorite. It tells of a gentle, decent, distinguished man who, as is made known during the course of the story, is also dying. Just after having received the Nobel Prize for Literature, he returns to his native Spain, where he has not been since the Civil War, to visit with a boyhood friend, rekindle a romance with an old sweetheart, and generally retrace his past. Though the film seems to be building toward a four-hanky ending, it concludes on a more reserved, contemplative note of quiet resignation.

"To Begin Again," which opens today at the Baronet theater, is "dedicated to those who grew up in the 1930's" and "to that interrupted generation, thank you." It's a film with a noticeable lack of young characters, and with a heartfelt wistfulness that unites its older principals. "Men and women can love until the very last moments of their lives," says the chief character, Prof. Antonio Albajara (Antonio Ferrandis), and the film affirms that idea. It follows Albajara and Elena (Encarna Paso), his old flame, as they fondly resume an affair dating back to the days when Cole Porter's "Begin the Beguine" was their favorite song.

•

The film is awash with "Begin the Beguine," which is played in many different versions and is interrupted only by the strains of Pachelbel's familiar "Canon"; that, too, is heard over and over and over again. The score confines itself to the melancholy beauty of this music, and the film it-

self is similarly repetitive in mood. The nobility of Albajara, his joy in recapitulating his life and his bittersweet view of the future are all established early in the film, and Mr. Garci never goes beyond the recognition of these sentiments. The film's power, like that of the reiterated music, is blunted by the lack of real development or variety.

Though Albajara is identified as a Nobel laureate, he needn't necessarily have been. His sympathetic and admirable qualities are well enough established by the kind, honest face of Mr. Ferrandis. "He had one of those faces that lets you know you're with someone real," Albajara says of another character, though he could apply the remark to himself just as aptly. Albajara's simple, polite demeanor even misleads the manager of his hotel, who makes no particular fuss about this guest until Albajara receives a congratulatory phone call from King Juan Carlos. The manager's subsequent antics offer a little mild clownishness and provide the film with its only form of comic relief.

•

Even in a year in which many of the better foreign films failed to receive Academy Award nominations, the award to "To Begin Again" is somewhat surprising. While a creditable entry, it is not noticeably superior to "Coup de Torchon," "Private Life" and "The Flight of the Eagle," three of this year's other Oscar nominees.

Janet Maslin

1983 Ap 22, C10:5

Unearthly Appetites

THE DEADLY SPAWN, direction and screenplay by Douglas McKeown, from a story by Ted A. Bohus, John Dods and Mr. McKeown; director of photography, Harvey Sirnbaum; edited by Marc Harwood; music by Michael Perilstein; produced by Mr. Bohus; released by 21st Century Distribution. At the Cinerama, Broadway and 45th Street, and other theaters. Running time: 90 minutes. This film is rated R.
Charles.....................Charles George Hildebrandt
Tom ..Tom De Franco
FrankieRichard Lee Porter
Ellen ...Jean Tafler
Kathy ...Karen Tighe
Aunt MillieEthel Michelson
Uncle HerbJohn Schmerling
Sam ...James Brewster
Barbara ..Elissa Neil

"THE DEADLY SPAWN," which opens today at the Cinerama and other theaters, is an amateurish, resolutely unscary, low-budget horror film about people-eating creatures — looking like tadpoles with teeth — that have ridden to earth on a meteorite. The film may possibly be justified as a metaphor for suburban life in New Jersey, where it was shot.

Vincent Canby

1983 Ap 22, C11:1

A Courtesan's Love

LA TRAVIATA, directed, written and designed by Franco Zeffirelli; director of photography, Ennio Guarnieri; film editors, Peter Taylor and Franca Sylvi; original music by Giuseppe Verdi; opera lyrics by Francesco Maria Piave; conductor and music director, James Levine with the Metropolitan Opera Orchestra and Chorus; choreographed by Alberto Testa; produced by Tarak Ben Ammar; released by Universal Pictures. At the Paris, 58th Street west of Fifth Avenue. Running time: 112 minutes. This film is rated G.
Violetta ..Teresa Stratas
AlfredoPlacido Domingo
GermontCornell MacNeil
Baron ..Alan Monk

FloraAxelle Gall
AnninaPina Cei
GastoneMaurizio Barbacini
DoctorRobert Sommer
MarquisRicardo Oneto
GiuseppeLuciano Brizi
MessengerTony Ammirati
WITH: Russell Christopher, Geraldine Decker, Ferruccio Furlanetto, Charles Antony, Michael Best, Ariel Bybee and Richard Vernon, and Ekaterina Maksimova and Vladimir Vassiliev of The Bolshoi State Academic Theater

By VINCENT CANBY

OPERA does not transfer easily to the screen. When it is done more or less straight, as a stage production recorded on film, it tends to look like a gigantic, somewhat clumsy marionette show, no matter how fine the voices. Not much more successful have been attempts to make opera cinematic by placing it in recognizable landscapes, played by nonsinging actors from whose bodies enormous voices magically flow without apparent physical effort.

The two forms do not exactly war with each other. Rather, they have different interests that are less often reconciled by the film maker than they are subjugated, the interests of one at the expense of the other.

All of which is recalled by way of emphasizing the triumph of Franco Zeffirelli, who wrote, designed and directed the dazzling new screen version of "La Traviata," by Giuseppe Verdi, which opens today at the Paris.

I'm not sure that Mr. Zeffirelli has discovered any new principles by which all operas can be made more readily accessible to the screen. However, his "Traviata" is a very real personal triumph, the result of his obvious love and knowledge of opera, which he has directed both here and abroad, and of his experience as a film maker. It's not by chance that all of his earlier films, including the disastrously monosyllabic "Endless Love," have seemed more operatic than cinematic.

Fifteen years ago Mr. Zeffirelli made his hugely popular "Romeo and Juliet," which looked a lot better than it sounded, something that most audiences couldn't have cared less about. It was, after all, a movie.

This "Traviata" is something else entirely, a film adaptation of a classic work that never has the manner of something scaled down or souped up for a mass audience, though I suspect it will be immensely popular anyway. Verdi's genius will out, especially when presented with the talent, intelligence and style that have gone into this production.

Starring in the title role is Teresa Stratas, the Canadian-born Metropolitan Opera soprano who has come a long, long way since she made her motion picture debut in 1961, playing an Indian squaw in something called "The Canadians." As Violetta, Miss Stratas not only sings magnificently but she also looks the role. With her large, dark doe-eyes, her elegant cheekbones and her small, slight figure that seems to have the strength of someone possessed, which Violetta is, Miss Stratas is a screen presense as riveting to watch as to listen to.

It's an acting performance of breathtaking intensity. It's so good that it eclipses, for the moment anyway, the memory of Greta Garbo in "Camille," George Cukor's 1937 adaptation of the Dumas play that was also the basis of Piave's libretto for Verdi.

The camera is not as kind to Placido Domingo, who looks a little mature to be playing Alfredo, the passionate young man to whom the pleasure-bent, fatally consumptive courtesan, Violetta, gives her heart. Yet the enchantment of the movie is such that initial disbelief almost immediately gives way to the beauty of the Domingo voice and the easy self-assurance of his performance, which is far more than just respectable.

How much better to have Mr. Domingo, the man as well as his voice, than some other tenor, one who's five-by-five, or a vapid young actor lip-synching the voice of someone else.

The opera's only other major role, that of Germont, Alfredo's father, who precipitates the drama by persuading Violetta to renounce his son, is played and sung with effortless style by Cornell MacNeil. The film's conductor and musical director was James Levine, with the Metropolitan Opera Orchestra and Chorus. Featured in the spectacular second act ball scene are Ekaterina Maksimova and Vladimir Vassiljev of the Bolshoi State Academic Theater.

Having cast the film very close to perfection, Mr. Zeffirelli has staged it in a way that serves both the film and the grandeur of the score.

There are small but important adjustments, none more effective than the film's opening, which becomes the frame for what comes later. After the credits (silent), set against pastel-colored shots of mid-19th century Paris, we hear the melancholy prelude as the camera enters Violetta's house with the manner of a discreet bailiff. Sheets cover the furniture in rooms lit only by light filtered through curtained windows.

Though Violetta lies dying in her bedroom at the far end of the apartment, the place is teeming with people — creditors, appraisers, movers — all busily dismantling the home of someone not yet dead. Violetta, still alive but already a ghost, rises and wanders through the rooms, unnoticed by all except one young workman who stares at her with the unembarrassed wonder of someone recognizing a notorious legend. In her delirium Violetta sees the happy days.

The opera's first two acts are thus gracefully turned into a single, continous flashback in which we witness her meeting with Alfredo, their few months of idyllic love in the country and then her renunciation of Alfredo to spare his family disgrace.

Some of Mr. Zeffirelli's montages, in which he opens up the opera, become a bit treacly, particularly when he's showing us how Violetta and Alfredo wiled away the hours in their country retreat. Others, however, are surprisingly effective, including the ones in which we see Alfredo's sister, for whose happiness Violetta has been urged to give up Alfredo. The actress, unidentified, who plays the sister, looks to have come out of a Rossetti painting and helps fix the film in its time.

"La Traviata" benefits from Mr. Zeffirelli's talents as a designer as much as from his gifts as a director. The physical production is lush without being fussy. Nor is it ever overwhelming. This possibly is because at key moments we are always aware of details that, however realistic, remind us that what we are witnessing is not life but a grand theatrical experience.

It's not to be missed.

1983 Ap 22, C13:1

In New York

ANGELO MY LOVE, directed and written by Robert Duvall; director of photography, Joseph Friedman; edited by Stephen Mack; music by Michael Kamen; released by Cinecom International Films. At the Lincoln Plaza 1. Running time: 115 minutes. This film has not been rated.
Angelo EvansHimself
Michael EvansHimself
Ruthie EvansHerself
Tony EvansHimself
Debbie EvansHerself
Steve (Patalay) TsigonoffHimself
Frankie WilliamsHimself
George NicholasHimself
PatriciaKaterina Ribraka

By VINCENT CANBY

ANGELO EVANS, who stars as himself in Robert Duvall's new film "Angelo My Love," is a motion-picture natural like Cary Guffey, the little boy in "Close Encounters of the Third Kind," and Drew Barrymore in "E.T." That's apparent throughout this easygoing, high-spirited lark of a movie that Mr. Duvall, still better known as an actor than as a writer-director, has made about New York City gypsies, focusing mainly on the restless life and times of Angelo Evans.

Mr. Duvall first came upon Angelo, who was then 8 years old, in 1977, when he overheard him on Columbus Avenue having what sounded like a lovers' quarrel with a woman in her late 20's. Out of that encounter grew "Angelo My Love," which is fiction, designed by Mr. Duvall, though the dialogue was often improvised by the gypsy actors, most of whom play themselves. The result is another perceptive, unexpectedly confident work by Mr. Duvall, who made his debut as a director in 1977 with "We're Not the Jet Set," an unsentimental documentary about the members of a colorful — and well-to-do — Nebraska farm family.

Mr. Duvall picks colorful subjects, but they aren't especially easy. As one watches "Angelo My Love," one is likely to go through a succession of contradictory responses to Angelo — initial disbelief, followed by laughter, followed by a suspicion that Angelo is too good to be true, followed by surrender. However Mr. Duvall obtained this performance, it is fascinating.

Angelo is a kind of idealized sumtotal of all New York street kids no matter what their ethnic backgrounds. He is physically small but he has such a big, sharply defined personality that he seems to be a child possessed by the mind and experiences of a con man in his 20's. Then, as the movie goes on, one sees Angelo moving from glib, smart-talking self-assurance to childhood tears and back again, all in the space of a few seconds of screen time. This, too, may be part of Angelo's con, but it's also unexpectedly moving as well as funny. Angelo, among other things, is scared of ghosts.

Supporting Angelo, with no more self-consciousness than he displays, are his older brother Michael, who looks to be 14 but who gets married in the course of the movie, his mother, Ruthie, his sister Debbie, his girlfriend Patricia (Katerina Ribaka) and a hilarious, pretty, very tiny, excruciatingly professional country-and-western singer named Cathy Kitchen, who introduces Angelo to the glamour of show business.

Angelo's father, Tony Evans, appears only in a couple of scenes, taking a back seat to the other members of the family. This is the only awkward note in the film. At first the audience assumes from his nonappearance that a father doesn't exist, but perhaps this is simply an indication

Angelo Evans in the new film by Robert Duvall.

that Tony doesn't want to be an actor.

Next to Angelo, the film's most riveting character is Steve (Patalay) Tsigonoff. Playing a bumbling, Captain Hook type of villain, Steve steals a ring belonging to Angelo, which provides the film with a plot of sorts. Mr. Tsigonoff, a big, paunchy slob, who is fearfully timid without a snort of booze, and his crabby sister Millie (Millie Tsigonoff) are the movie's low-comedy relief. When they are on the screen together, stealing chickens or arguing about flat tires, you might think you were seeing Jiggs and Maggie from George McManus's ancient comic strip "Bringing up Father."

Heading the list of obviously talented people who assisted Mr. Duvall are Gail Youngs, his associate producer as well as his wife, Joseph Friedman, the director of photography, and Stephen Mack, the editor.

"Angelo My Love" opens today at the Lincoln Plaza 1.

1983 Ap 27, C17:5

Strange Roomers

MOON OVER THE ALLEY, directed and edited by Joseph Despins; photography, Peter Hannan; music, Galt MacDermot; screenplay and lyrics, William Dumaresq; a British Film Institute Production Board film. Running time: 104 minutes.
WITH Doris Fiswick, Peter Farrell, Erna May, John Gay, Sean Caffrey, Sharon Forester, Patrick Murray, Lesley Roach, Basil Clarke, Bill Williams, Vari Sylvester, Joan Geary, Norman Mitchell, Leroy Hyde, Miguel Sergides and Debbie Evans.

"Moon Over the Alley" was shown as part of the 1976 New Directors/New Films Series at the Museum of Modern Art. Following are excerpts from a review by Lawrence Van Gelder that appeared in The New York Times of April 3, 1976. The film opened yesterday at the Public Theater, 425 Lafayette Street.

IF the artistic vision of "Moon Over the Alley" were as sharply focused as its camera, this British film might merit some outright praise rather than the benign nod of acknowledgement that seems its proper due.

This is a film with a nice eye for a little piece of London life, centering on an aged rooming house abutting the alley of the title in what is said to be the Notting Hill section. The alley itself is the nightly resting place of a vagabond couple — he a music-playing simpleton, she an elderly woman named Sybil, given to sententiousness and song. The house is owned by a docile husband and a moody, tough Ger-

49

man woman, whose teen-age son is in love with the local tobacconist's daughter.

The roomers include a black couple with an infant, a reclusive man with an unspecified interest in little girls, an Irishman who says he is trying to save up enough to transform his 17-year engagement into marriage and a young Californian who is willing to pay an excessive rent to sleep under the stairs because money doesn't matter — singing does.

In the neighborhood, there are pot-smoking hippies, squatters, violent youths, a homesick Indian convinced the world will soon end and the pub where Jack, the Irishman, and Jimmy, the black roomer, work behind the bar. In the world at large, forces are at work to demolish the rooming house and remake the neighborhood despite individual and collective protest.

From a purely pictorial standpoint, "Moon Over the Alley," directed and edited by the Canadian-born Joseph (Chuck) Despins, and photographed in black and white by Peter Hannan, records its people, their lives and their neighborhood with neither sentimentality nor condescension. The look and the atmosphere are right. But this film, with music by Galt McDermot (of "Hair") cannot make up its mind what it wants to be — musical, social document or something that might be called a mystical, given the aptly named Sybil's efforts to impart fateful power to the full moon that is its chief symbol.

1983 Ap 27, C19:4

Beautiful Sailor

QUERELLE, directed and screenplay by Rainer Werner Fassbinder; based on the novel "Querelle de Brest" by Jean Genet; cinematography by Xaver Schwarzenberger; music and songs by Peer Raben; produced by Dieter Schidor; released by Triumph Films. Running time: 106 minutes. This film is rated R.
Querelle Brad Davis
Lieutenant Seblon Franco Nero
Lysiane Jeanne Moreau
Roger Laurent Malet
Robert/Gil Hanno Poschl
Nono Gunther Kaufmann
Mario Burkhard Driest
Vic Dieter Schidor
Marcellin Roger Fritz
Matrose Michael McLernon
Theo Neil Bell
Armenier Harry Baer
Paulette Nadja Brunkhorst

By VINCENT CANBY

BECAUSE it happens to be Rainer Werner Fassbinder's final film, "Querelle" has had imposed on it a terrible burden. Even the ads imply this, describing it with solemnity as "Fassbinder's last statement," which it is, but only in terms of chronology. It's as if we were meant to believe that Fassbinder knew he was going to die last June and prepared "Querelle" as a summation of everything that had gone before. It's not. Fassbinder had many talents, but soothsaying wasn't one of them.

"Querelle" is a mess, and of value mostly for the ways in which it defines the particular strengths and limitations of the most important European film maker of his generation. In relation to the great films that mark his short but prolific career, "Querelle" is a detour that leads to a dead end. In earlier days, Fassbinder would have simply moved on to the next project. That, unfortunately, is not now possible, and we are stuck, more or less, with this film as a coda, which Fassbinder never intended.

"Querelle," which opens today at the Cinema Studio, the Manhattan and the Waverly Theaters, is one of the riskiest films Fassbinder ever made, the result of hundreds of bold choices, some of them intelligent, but almost all of them wrong.

To begin with, there was his decision to make a film based on "Querelle de Brest," the 1953 Jean Genet novel about an incredibly beautiful and depraved French sailor who, in the way of Genet, finds salvation in the utter degradation by which he denies the real world to create a world of his own. "Querelle de Brest" is the most conventionally coherent of Genet's novels, of which "Our Lady of the Flowers" is the masterpiece, but it isn't easily adapted to the screen, especially by Fassbinder.

Fassbinder's skepticism and his gifts as a social satirist have little to do with Genet, a poet and a believer whose devotion is expressed through a series of reversals of Christian dogma and rituals. Fassbinder, for all of his loudly proclaimed anarchist views, was always a true product of the bourgeoisie, a dutiful son to a fond mother, who frequently appeared in his films.

Genet, born illegitimate, raised in foster homes, went on to spend most of his earlier life in prisons. He is truly classless, essentially stateless, identifying — when he is able to identify with anyone outside himself — only with what the gentle folk call the dregs of society: stool pigeons, pimps, prostitutes, thieves and murderers.

Virtually the only bonds between Fassbinder and Genet are a willingness to shock and an aggressive lack of self-consciousness about their homosexuality. In almost every other way, they are not opposites but representatives of different dimensions of time and space.

Fassbinder seems to acknowledge their differences in the opening credits, in which it's stated that "Querelle" is "about" the Genet novel, instead of being based on it. This doesn't get him off the hook. It would have if Fassbinder had then gone on to make a Fassbinder film, but "Querelle" is a hopeless, incoherent muddle of Genet's novel and Fassbinder's sensibility.

•

The film takes place in an unmistakably mythical port called Brest, represented by a smashingly spectacular, highly stylized unit set of the sort that works more often in the theater than in a film. The world of this film is theatrically dreamlike, which again has not much to do with Genet, whose fictional world is fantastic but filled with its own realistic sights, sounds, odors and sensations of heat and cold.

It's also foreign territory to Fassbinder, whose gift was to be able to distill from reality not fantasy but a super-reality, always attached to specific time and place. Fassbinder has helped himself to Genet's characters and to many of the novel's situations and then used them, half-heartedly, to score his own points — sort of. The film is so chopped up and fey that it's not possible to know exactly what its points are.

The film follows the descent into Hell of the young sailor Querelle, described by Genet as "the Angel of the Apocalypse" but who, as played by Brad Davis, looks like a clean-cut American college boy dressed for a costume ball.

As Querelle moves through this dramatically lighted stage set called Brest, he murders one sailor, seeks "execution" for his crime by allowing himself to be brutally sodomized, which he enjoys, and then finds his own salvation by becoming a stool pigeon. Querelle hands over to the police a friend, a simple-hearted Polish dockworker, who accepts responsibility for his own crimes as well as Querelle's.

Querelle also has a sort of running, love-hate relationship with his brother, Robert (Hanno Poschl), a masochistic affair with Mario (Burkhard Driest), a police inspector who wears Hell's Angels drag, and a somewhat less satisfactory relationship with Lysiane (Jeanne Moreau), the brothel madam who is Robert's mistress. Watching all this, as if he were a peeping tom, is Lieutenant Seblon (Franco Nero), a naval officer on Querelle's ship. Seblon, dressed in a uniform out of "The Student Prince," worships Querelle from afar, that is, from his closet, and dictates his longings into a handy tape recorder.

From time to time throughout the film, Fassbinder inserts title cards on which are printed patches of original Genet prose, as if the director were trying to establish connections between the film and the book, even as they are drifting aimlessly apart.

•

For something that might be called a Fassbinder-Genet joint-venture, "Querelle" is exceedingly discreet, resolutely unshocking and unprovocative. If it spoke with a single voice — it was apparently shot in English but is being released here with a German sound track — that voice would be a steady drone.

Except for some things that Miss Moreau does, "Querelle" is not only humorless but also uncharacteristically witless. The actors aren't called upon to act but to keep a straight face, which may sometimes be difficult for the audience. Mr. Davis, Mr. Nero and Miss Moreau do what they can, but they behave like people abandoned in a foreign country without money or passports.

Miss Moreau has more than her share of thankless lines, as well as one unintentionally hilarious song to sing. The music is by Fassbinder's talented long-time collaborator, Peer Rabin, and the lyrics by Oscar Wilde: "Each man kills the thing he loves . . . dah-dee-dah-dee-dah."

Like so many other things in "Querelle," they aren't good enough.

1983 Ap 29, C8:5

Creeping Tarantulas

SOMETHING WICKED THIS WAY COMES, directed by Jack Clayton; screenplay by Ray Bradbury; based on the novel by Mr. Bradbury; music by James Horner; produced by Peter Vincent Douglas; released by Buena Vista. Running time: 94 minutes. This film is rated PG.
Charles Halloway Jason Robards
Mr. Dark Jonathan Pryce
Mrs. Nightshade Diane Ladd
Dust Witch Pam Grier
Tom Fury Royal Dano
Will Halloway Vidal Peterson
Jim Nightshade Shawn Carson
Little Person No. 1 Angelo Rossitto
Little Person No. 2 Peter D. Risch

By JANET MASLIN

IN the center of a small, old-fashioned town, the autumn leaves are blowing down Main Street — that is, a wind machine is blowing the leaves across a movie-set evocation of small-town Americana. "Something Wicked This Way Comes," the Walt Disney production of Ray Bradbury's 1962 novel, begins on such an overworked Norman Rockwell note that there seems little chance that anything exciting or unexpected will happen.

So it's a happy surprise when the film, which opens today at the National and other theaters, turns into a lively, entertaining tale combining boyishness and grown-up horror in equal measure. In tiny Green Town, Ill., the arrival of a highly unusual carnival triggers some strange events, which are witnessed by the inseparable team of Jim Nightshade (Shawn Carson) and Will Halloway (Vidal Peterson). The townspeople, at first entranced by the unexpected carnival troupe, are soon affected in increasingly sinister ways that are best not revealed here, but are certainly good for a shock or two.

When Jim and Will figure out what the carnival is up to, they become the prey of its ringleader, a Mr. Dark (Jonathan Pryce), who organizes an entire parade through Green Town just to scout for the boys. Jim and Will watch the parade covertly, picking out two yellow-draped floats for special notice. "They're coffins!" cries one boy. "Yeah — kid-sized!" the other says.

The gee-whiz quality to this adventure is far more excessive in Mr. Bradbury's novel than it is here, as directed by Jack Clayton. Mr. Clayton, who directed a widely admired version of "The Turn of the Screw" some years ago gives the film a tension that transcends even its purplest prose.

•

The horror here, which involves some elaborate special effects, is very much in the service of a story about a father and son who rediscover each other, which gives it an added dimension. Without Jason Robards as the father who has disappointed Will, and is given a chance to redeem himself through the evil that the carnival creates, the movie might be nothing but eerie. As it is, the tender moments between father and son help keep the science fiction on a human scale.

"Something Wicked This Way Comes," which also features the beautiful Pam Grier as a demonic temptress (she is first seen fondling a pet spider) and Diane Ladd as Jim's vaguely neglectful mother, shouldn't bore adults in the audience. But its fancifulness makes it a film best suited to children, though it may scare them at times. One of Jim's and Will's worst nightmares features about 100 tarantulas creeping into one boy's bedroom and, needless to say, creeping all over the boy as well. Children of all ages, be forewarned.

1983 Ap 29, C8:5

California Youth

VALLEY GIRL, directed by Martha Coolidge; written and produced by Wayne Crawford and Andrew Lane; director of photography, Frederick Elmes; released by Atlantic Releasing. Running time: 95 minutes. This film is rated R.
Randy Nicolas Cage
Julie Deborah Foreman
Loryn Elizabeth Daily
Tommy Michael Bowen
Fred Cameron Dye
Stacey Heidi Holicker
Suzie Michelle Meyrink
Samantha Tina Theberge
Beth Brent Lee Purcell
Driving Teacher Richard Sanders
Sarah Richman Colleen Camp
Steve Richman Frederic Forrest

ALL the touchstones of Valley Girl lingo turn up in the opening moments of Martha Coolidge's "Valley Girl," which opens today at the National and other

theaters, raising the question of where the movie has to go. The answer, regrettably, is not much of anywhere.

The plot revolves around one very fashionably dressed suburban girl, Julie, and her efforts to exchange an old boyfriend ("It's like I'm totally not in love with you anymore, Tommy — I mean, it's so boring") for a new one. Not much happens here, nor does much happen to Julie's Woodstock Generation parents, who appear periodically to compromise their daughter's unassailable cool by forcing her to help out in their health-food store.

Julie's old beau is a straitlaced surfer type, while the new one has more of a punk look. So the screenplay contains a speech or two about how appearances aren't really everything, a point also applicable to Julie's mom and dad (played by Colleen Camp and Frederic Forrest). But the movie doesn't pursue this very thoroughly, and it sounds a one-joke note that's seldom as funny as it means to be. After an inspired opening montage of Julie and her girlfriends as they shop (replete with close-ups of labels, price tags and credit cards), the film settles into a rut and stays there. The characters and their jargon are occasionally amusing, but there's no action, no conflict, no overwhelming satire and nothing to jolt them out of their lethargy.

As played by Deborah Foreman, Julie is pretty, conventional and a little dull; certainly she's much too passive to carry the movie. Of her suitors, only Nicolas Cage as the downtown type (he likes louder music than his suburban counterparts, and knows more people who put colored rinses in their hair) has any vitality. Miss Coolidge, best known for her documentaries, seems not to know what to emphasize here and to have no unifying attitude toward her subject. With characters as dimensionless as these, the film needs either greater irony or greater sympathy than it demonstrates.

On the West Coast, where they know about such things, "Valley Girls" may conceivably strike a funnier and a more familiar chord than it does in New York, but I doubt it. Too much of the film is too aimless, like an overlong and awkward scene between one girl's mother and the young delivery boy she may or may not be trying to seduce. ("Plastics," she tells him, but not even the "Graduate" reference gives the scene any spark.)

The best things are the costumes, the hit-filled soundtrack and the occasional Valley gag that works, like the tender moment when Julie tries to tell her dad she's got a problem she'd like to discuss with him. "That's easy," he says, before she can even explain. "Take it back and get the more expensive ones. The expensive ones always fit better." Incidentally, how the proprietors of a small health-food store can support Julie's formidable clothes-buying habit is never adequately explained.

Janet Maslin

1983 Ap 29, C10:1

Looking at War

YEAR ZERO: THE SILENT DEATH OF CAMBODIA, a documentary produced and directed by David Munro; photographed by Gerry Pinches; edited by Jonathan Morris; narrated by John Pilger. At the Public Theater, 425 Lafayette Street. Running time: 52 minutes. This film has no rating.

BENEATH THE ANGKA: A STORY OF THE KHMER ROUGE, a documentary produced, written and directed by Justin Ackerman; photographed by Eugene Squires; edited by Dominique Auvray and Nguyen Long; music by Brian Eno and Klaus Shultze. Running time: 70 minutes. This film has no rating.

F two short films about Cambodia opening today at the Public theater, one will make you weep; the other will prompt quite a different response from most audiences.

"Year Zero: the Silent Death of Cambodia" is the heartbreaking one. Directed in 1979 by David Munro, and featuring the British journalist John Pilger, it is a blunt, straightforward assessment of Pol Pot and the Khmer Rouge, and as such it contains a wealth of horrifying information. "For me, coming here has been like stumbling onto something I could never imagine," Mr. Pilger says in his introduction. The film corroborates that impression all too well.

It contains before and after footage of Phnom Penh (among the after are scenes of the gutted National Library, which was converted into a pig sty) and interviews with those who survived Khmer Rouge detention. Two artists, among the eight survivors of a 12,000-person group, attribute their having been spared to the fact that they produced idealized busts and paintings of Pol Pot.

•

The film makers ask captured Khmer Rouge soldiers how and why they could kill so many of their countrymen. In the most tragic scenes of all, they visit a hospital where many of the patients are starving children, and where most will soon die because medicine is unavailable. Mr. Pilger explains how diseases like anthrax have become evident in the absence of penicillin, and that international relief organizations have been slow to supply aid for fear of seeing it diverted. At the time of filming, Mr. Pilger says, a total of three relief planes had landed in Cambodia in nine months.

"If the horrors of this documentary have any purpose, it is not just to assault the emotions," Mr. Pilger concludes. Rather, the goal is "to put Cambodia back on the human map." To that end, "Year Zero" unfolds in a controlled fashion, without resorting to sensationalism and allowing the facts to speak for themselves. It's an extremely moving film, and one that does little to prepare audiences for its co-feature, Justin Ackerman's 1982 "Beneath the Angka: A Story of the Khmer Rouge."

Mr. Ackerman and his crew were permitted to film in 1981 a band of Khmer Rouge troops in the jungle as they fought "an endless war of retribution with the unclean past." Forgive and forget, Mr. Ackerman seems to urge, albeit in a rambling and somewhat disorganized manner. The film shows the Khmer Rouge in a gentle light, accompanying footage of their more benign activities (conducting a dance pageant, playing with children, honoring wounded veterans) with a breathless litany of rhetoric. "Such is the austerity of a patriotism whose only justice is the remains of war," goes some typical narration, read in a relentless monotone. Aside from a few statements to the effect that "grave mistakes were evidently made," the Khmer Rouge's recent history is not elaborated upon.

Janet Maslin

1983 Ap 29, C17:5

Twilight Years

THE HUNGER, directed by Tony Scott; screenplay by Ivan Davis and Michael Thomas; based on a novel by Whitley Strieber; music by Michel Rubini and Denny Jaeger; director of photography, Stephen Goldblatt; produced by Richard A. Shepherd; released by M-G-M/UA Entertainment Co. At the RKO Cinerama, Broadway at 47th Street; RKO 86th Street Twin, Lexington at 86th Street; East Side Cinema, Third Avenue at 55th Street; 8th Street Playhouse, 52 West 8th Street; Loews 83d Street Quad, Broadway at 83d Street. Running time: 98 minutes. This film is rated R.
Miriam..............................Catherine Deneuve
John.......................................David Bowie
Sarah Roberts............................Susan Sarandon
Tom Haver..................................Cliff de Young
Alice Cavender...............................Beth Ehlers
Lieutenant Allegrezza.....................Dan Hedaya
Charlie Humphries.........................Rufus Collins
Phyllis..................................Suzanne Bertish
Ron...James Aubrey

SHE came out of Egypt more than 2,000 years ago. En route to the present day, she picked him up in England in the 18th century. Today they live on Manhattan's East Side in a magnificent marble palazzo, a grand mausoleum stuffed with antiques that were new when they were acquired. They are Miriam and John Blaylock — young, beautiful and permanently engaged in a search for new blood.

As played by the immaculately beautiful Catherine Deneuve and David Bowie, who becomes an increasingly interesting screen presence with each succeeding film, the Blaylocks are very good company. That is, if one has a taste for vampire films, especially vampire films that look as trendy and chic as Tony Scott's "Hunger." If Bendel's made movies, they'd look like this.

•

"The Hunger," which opens today at the Cinerama and other theaters, is a love story not necessarily for the ages, but about them. Specifically, it's about what happens when 200-year-old John begins to show his years, which occurs almost overnight. His last blood fix, provided by a young couple picked up at a disco, hasn't worked, and Miriam, like any other concerned wife, seeks medical advice. She goes to Dr. Sarah Roberts (Susan Sarandon), a brilliant young scientist engaged in research about the aging process. At first, Miriam wants medical help, then she wants Sarah.

What makes "The Hunger" so much fun is its knowing stylishness, which Mr. Scott, who makes his theatrical film debut here, has brought to movies from a career in commercials and documentaries. Here is a film that, for once, is appropriately served by fast cuts, overlapping dialogue, flashy camera work, wildly fashionable clothes and décor so elegant that only mythical creatures could sit around in it.

Mr. Scott and his collaborators, Ivan Davis and Michael Thomas, who wrote the screenplay based on Whitely Streiber's novel, knew what they were up to and how to get it.

•

Though "The Hunger" has all the elements that people who seek out horror films expect, it is not, strictly speaking, a horror film. Rather, it is a film of visual sensations, not all of which are quite so explicit as the sight of Miss Deneuve making love to the innocent Miss Sarandon, while simultaneously giving her a blood transfusion.

The screenplay, the direction, the performances, the photography (by Stephen Goldblatt) and the production design (by Brian Morris) are all of a piece. The movie reeks with chic, but

never, for one minute, takes itself too seriously, nor does it ever slop over into camp.

Miss Deneuve and Mr. Bowie have the manners and looks of very special characters, Beautiful People who are ageless but, underneath it all, exhausted. When John starts to go downhill, his mate of two centuries is genuinely concerned — you don't live with a guy that long without developing a relationship. She does all she can, but when she realizes he's a hopeless case, she gets another coffin ready in the attic, where there are already quite a few. Poor John won't ever die, he'll just disintegrate into a pile of dust that feels pain.

•

A technical highlight of the film is a scene in which John, sitting in the waiting room of a doctor's office, ages from 30 to 85 in front of our eyes. It's not done, as in werewolf movies, through a series of superimpositions, but so subtly that one at first isn't quite sure it's happening, any more than John is.

Miss Sarandon puts her mark on the film with one of her now-obligatory nude scenes, which she does extremely well in addition to being a good performer with her clothes on. Cliff de Young plays her lover, who eventually gets dumped for more exotic friends, and 14-year-old Beth Ehlers is Alice, the little girl next door who joins John and Miriam in impromptu afternoon musicales — John on cello, Miriam on piano and Alice on violin — and stays for dinner.

Vincent Canby

1983 Ap 29, C32:1

ALSINO AND THE CONDOR, directed by Miguel Littin; screenplay (Spanish with English subtitles) by Mr. Littin, Isidora Perez Turrent; cinematography by Jorge Herrera and Pablo Martinez; edited by Miriam Talavera; music by Leo Brower; production: Nicaraguan Film Institute, Cuban Institute of Cinematographic Art and Industry, Latin American Production of Mexico, Costa Rican Cinematographic Cooperative. At the Cinema 3, Third Avenue and 60th Street. Running time: 89 minutes. This film has no rating.
Frank..Dean Stockwell
Alsino...Alan Esquivel
Mama Abuela............................Carmen Bunster
The Major.................................Alejandro Parodi
Rosario......................................Delia Casanova
Lucia.....................................Marta Lorena Perez
Don Nazario..........................Reinaldo Miravalle
Lucia's grandfather....................Marcelo Gaete
The Dutch adviser.....................Jan Kees De Roy

Alan Esquivel in the title role of "Alsino and the Condor."

By VINCENT CANBY

Miguel Littin's "Alsino and the Condor," which opens today at the Cinema 3 Theater, is a politically angry film with the manner of a mournful fable — a very odd but haunting mix. It can't quite bring itself to say what's on its mind, but instead, like a child who is shy, it points at things with furious if silent disapproval.

"Alsino and the Condor," a co-production of Nicaragua (where it was made), Mexico, Cuba and Costa Rica, is a film about injustice and revolution, not looked at directly but seen, as if in passing, by Alsino, a solemn little peasant boy who, more than anything else, wants to fly.

When a United States military "adviser" named Frank (Dean Stockwell) takes Alsino for a spin in his helicopter, Alsino is not impressed. He doesn't like the noise or the paraphernalia of technology. He wants to fly on his own, like a bird, which he does in his dreams though, unfortunately, he always forgets how he does it when he wakes up.

•

Late one moonlit night, Alsino creeps out of the tiny farmhouse he shares with his grandmother, climbs to the top of his favorite tree and, with his arms outstretched, takes off. Instead of flying, the boy crashes to earth and becomes a physically crumpled wreck, to be known forever after as "Hunchback."

Though "Alsino and the Condor" is sorrowful, it is never sentimental, which, for Mr. Littin, a Chilean director living in exile in Mexico, is as much of an accomplishment as getting the film produced at all. "Alsino and the Condor" is the first fiction feature ever made in Nicaragua.

Mr. Littin is most at ease, and most effective, when he keeps to the point of view of Alsino, very nicely played by Alan Esquivel, who looks a little like the boy in François Truffaut's "Wild Child." The movie is a fairy tale turned inside out. Here the monster is not transformed into a prince, but the prince into a monster, at least physically, who eventually finds a more important kind of release in a new identity as a Sandinist rebel.

"Alsino and the Condor" is full of painful scenes witnessed without apparent emotion by the boy, now a hunchback, as he wanders the Nicaraguan countryside. He seems hardly to bat an eye as he passes Government troops as they massacre peasants and burn their farms. Until he finds political commitment, he is not beyond feeling but beyond its expression, which gives particular impact to the film's final freeze frame.

Less effective as drama is Mr. Littin's portrayal of the pro-Government bullies, and especially of all United States advisers, in the characterization of just one fellow, summed up in Mr. Stockwell's role. Frank is seen as a well-meaning but fatally ignorant sort who, when desperate, turns brutal. There's nothing wrong with the concept of the character; it's just that it seems to belong to another, far less subtle film.

At its best, "Alsino and the Condor" has something of a Latin American "Candide" about it. It's never uproariously funny, but it is wise and just a little bit lunatic, as when Alsino, in his wanderings, comes across a Good Friday religious procession. The boy, stony-faced as always, goes up to relieve the burden of the man portraying Christ on His way to Calvary. Screams the angry pilgrim, "Find your own cross!"

"Alsino and the Condor" was one of the five nominees for this year's foreign-language film Academy Award, won by Spain's "To Begin Again."

1983 My 1, 69:1

Cinema Chic Catches the Eye But Misses the Mind

In "The Hunger," a new film directed to the nines by Tony Scott, Catherine Deneuve and David Bowie play the achingly chic Miriam and John, who live in an East Side Manhattan palazzo more grand than most embassies, surrounded by several millennia of art objects, without any visible means of support and not even any visible domestic help.

One must suppose that when their satin sheets need changing, Miriam or John orders new ones by telephone and tosses the old ones into the industrial-sized incinerator in the basement, which also receives guests who have overstayed their welcome. Miriam and John are a very special couple who have been together for years — approximately 200.

Miriam, who has a frosty, ageless beauty and dresses in tomorrow's couture fashions, was born in Egypt before the time of Christ and is a vampire. Toward the end of the 18th century she met John in England and bestowed on him eternal life, which, as he's now beginning to realize, isn't all that it's cracked up to be. As "The Hunger" opens, John can't sleep properly. Those periodic blood-fixes don't provide the sustenance they once did. Poor John is starting to decay.

In the course of a few hours, sitting in a doctor's waiting room, John ages from 35 to 85 right in front of our eyes, thus physically manifesting the boredom that the rest of us, under similar circumstances, would internalize by thumbing yet again through the National Geographic.

John wants to die, but he's doomed to live on forever as a pain-wracked bag of bones, stashed away in a coffin in the attic, along with the undead remains of all of the other lovers acquired by Miriam over the centuries.

Though "The Hunger" sounds absurd and, indeed, is absurd if one insists on being rational about it, it shouldn't be dismissed. It's entertaining in the thoroughly decadent way of what might now be called cinema chic. It's more entertaining and less offensive than Jacques Beineix's "Diva," which exemplifies cinema chic, and makes a tiny bit more sense than "Exposed," James Toback's romantic melodrama about high-fashion and international terrorism, which is cinema chic if only because it can't be taken too seriously as anything else.

Cinema chic is not something that most directors, with the possible exception of Mr. Scott and Mr. Beineix, set out to make. It's what they wind up with when the rest of the movie is overwhelmed by a visual style that stops at nothing to catch the eye but, having caught the eye, doesn't follow up with something that can be passed on to the mind or the emotions. It's surface glitter, production design, bizarre costumes, extravagant camera movements — all of which can be entertaining in themselves, like a layout in Vogue, without being especially important.

It's filmmaking as apparently influenced by the jazzy techniques of television commercials and by some of the more outrageous conceits of high-fashion photographers. It's also a film whose elegant "look" not only is the point of the film but also becomes a way of observing the world.

In a magazine, when we see pencil-thin mannequins posed against a crowd of New Delhi beggars, we are not meant to consider India's urban problems but hemlengths. In much the same way in "Exposed," when we watch Harvey Keitel and his associates as they make elaborate plans to bomb a Paris railway station, it's impossible to think about the consequences of that act since Mr. Keitel seems not to be running a terrorist gang but a modeling agency. His "operatives," beautiful and young and dressed in the height of casual elegance, are a gang that can't shoot straight or even park a car properly.

Cinema chic has its origins in Italy, whose mostly left-wing filmmakers, including Francesco Rosi ("Illustrious Corpses") and Elio Petri ("Investigation of a Citizen Above Suspicion") have been its avant-garde, and whose cinematographers, including Vittorio Storaro, Giuseppe Rotunno and Pasquale de Santis, its major technicians.

This is not to say that everything that Mr. Storaro photographs — which has included Bernardo Bertolucci's "The Conformist" and "Last Tango in Paris," as well as Francis Coppola's "Apocalypse Now" — is cinema chic, but only that when a movie like Mr. Bertolucci's "Luna" doesn't measure up to its high-fashion look, the result is cinema chic.

> Michelangelo Antonioni was probably the father of cinema chic.

This Italian "look" has been imported on occasion. Mr. Rotunno, Federico Fellini's favorite cameraman, poured it all over Bob Fosse's "All That Jazz," though more frequently it has simply been imitated, as in Paul Schrader's terrifically chic looking "American Gigolo" and "Cat People."

If any one director can be described as the father of

çinema chic, it must be Michelangelo Antonioni, whose "L'Avventura" was its seminal film. Like "L'Avventura," Mr. Scott's far less pretentious "Hunger" is not about an awful lot but so consistently, so eye-blindingly beautiful to look at that you could take almost any frame of it, place a bottle of Calandre in the foreground, and create a perfume ad that would fit into the pages of even the snootiest slick magazine.

In "Blow-Up," Mr. Antonioni exhibited a command of color equal to his use of black-and-white in "L'Avventura," "La Notte" and "Eclipse," and made a movie by which all succeeding cinema chic must be measured. "Blow-Up" is so rich-looking one can almost feel the textures of the grass in the park where a murder may or may not have happened, of the building facades and of the huge sheets of paper on which nude models frolic for the benefit of the high-fashion photographer. One is entertained even while suspecting that the whole thing is a shaggy dog story.

•

This is also true of "Exposed," though some members of the audience at the Cinema I last Friday afternoon couldn't suppress their giggles during the film's climactic shoot-out adjacent to the Seine. It wasn't, I suspect, that they found the sight of several dying characters funny but because, after of number of arbitrary plot twists, they didn't believe a minute of it.

What they did believe, however, was the way the film looks — it was photographed by Henri Decae — and it looks so chic that one sits through it as if witnessing an eccentric spectacle. Its chief and virtually only attraction, if you discount the uncomfortable performance by Rudolf Nureyev, is Nastassia Kinski, who plays a super-successful high-fashion model. Miss Kinski manages to be both animated and beautiful, especially in scenes in which she is alone, even though she looks enough like Mr. Nureyev, who is not beautiful, to be his sister.

The reason that "The Hunger" is such an inoffensive example of cinema chic is that it doesn't pretend to be anything except an extremely classy-looking vampire film, Susan Sarandon notwithstanding. (In the current issue of American Film, Miss Sarandon, who plays the lover who succeeds Mr. Bowie in Miss Deneuve's affections, says she thinks of the film as being not about blood-sucking but "relationships.")

•

"The Hunger" is about blood-sucking, but about blood-sucking among the beautiful and well-to-do, by people who never appear in the same clothes twice, who drive around in limousines, who like classical music and are usually seen — as photographed by Stephen Goldblatt — through sheer, gracefully billowing curtains or in a focus so soft it could make the face of a hippopotamus look like an angel's. As cinema chic goes, it's quite rare. "The Hunger" has the courage not to attempt to disguise its essentially frivolous nature by imposing on its audience some failed political, social or psychological interpretations. ∎

1983 My 1, II:17:1

Shaggy Dachshund

THE FALLS, directed, written and edited by Peter Greenaway; photographed by Mike Coles and John Rosenberg; music by Michael Nyman and Brian Eno. At the Public Theater, 425 Lafayette Street. Running time: 185 minutes. This film has no rating.
WITH: Peter Westley, Aad Wirtz, Michael Murray, Lorna Poulter, Patricia Carr, Adam Leys, Mary Howard, Sheila Canfield, Evelyn Owen, Hilary Thompson, Carole Myer, Monica Hyde, Colleen Thomas, Nell Hopkins, Dewi Thomas, Peter Sacre, Keith Pendlebury, Robert Warby, and others.

By VINCENT CANBY

THAT Peter Greenaway is an unusually gifted new film maker was apparent last year when the New York Film Festival presented "The Draughtsman's Contract," an extraordinarily handsome Restoration comedy-mystery that will be released here commercially later this spring. That he has a fully developed absurdist sense of humor was apparent earlier when the festival showed his 1980 short, "Act of God," made up of a series of interviews with people from all walks of life who had survived being struck by lightning.

Now get ready for his 1980 feature, "The Falls," an epic — three hours and five minutes — shaggy-dog story that pretends to be a documentary about the decline and fall of mankind after what's referred to simply as VUE, or "Violent Unknown Event." We are told that no less than 19 million people around the world were affected by this catastrophe, the exact nature of which remains as much of a mystery as its epicenter, which may have been either in a "boulder orchard" in Yorkshire or outside a London tube station.

In the course of "The Falls," we are given the case histories of no less than 92 VUE victims, who are sometimes interviewed, sometimes recalled by loved ones or who sometimes remain as statistics gravely read out on the soundtrack by a series of narrators.

•

To make matters more simple, the film maker has arbitrarily limited his survey to a cross section of those victims whose surnames begin with the letters "F-a-l-l," so that all the people we learn about have such names as Falla, Fallabus and — my favorite — a young woman called Loosely Fallbute.

"The Falls" opened yesterday at the Public Theater as part of the American Film Institute's presentation of a retrospective of independent films produced by the British Film Institute. It will be shown at the Public every day at 8 P.M. through Sunday.

Though "The Falls" is much too long for its own good, its rewards are real. Mr. Greenaway is a genuine wit with a grand imagination and a poet's fondness for lists. The entire film is a series of lists — of victims, of diseases, of symptoms, of various kinds of plants and wild life, of places and, especially, of birds. Touched upon throughout the film, although no definite conclusions are reached, is what's called "the responsibility of birds." It's suggested that VUE was some sort of diabolical scheme by birds to regain their supremacy over humans.

VUE victims, we learn, speak their own languages, and since there is a different language for each VUE victim, a certain amount of confusion has ensued. They also develop bird habits and a passion for birds, which results in a number of catastrophic attempts to fly. The victims change physically.

Some start to grow feathers. One young man has bird lice. Another suffers from what the narrator calls "malo-dorous" breath.

Mr. Greenaway is the irrepressible anthropologist of this mad, doomed new world. He is fascinated by the multiplicity of new languages, particularly by one that encourages punning and by another that is "lazy and gentle and requires an unusual amount of saliva." Among its social institutions is the San Luis Rey Society, whose members became VUE victims while on bridges that crossed over water.

•

There are dozens of narratives, including one about a woman who persisted in trying to teach her dogs how to fly. The last we hear of her, she has been fined three kroner after one dog, pushed out of a plane at 2,000 feet, plummeted into a Copenhagen playground. The charge: "Exercising a dog in a public place without a lead."

About halfway through "The Falls" you may start making your own interpretation of it, though almost any interpretation will work, at least part of the time. To me "The Falls" often works as an epic send-up of film critics of the sort who are obsessed by films to the exclusion of everything else and who would happily devote a lifetime to the analysis of a single frame of almost any Hitchcock film. Among other things, "The Falls" contains a number of references to Alfred Hitchcock and particularly to "The Birds."

However, it's not really necessary to interpret "The Falls" to enjoy it, not if you enjoy Lewis Carroll, Sight and Sound magazine, Magritte, the British Broadcasting Corporation, the kind of jokes small children love, linguistics and disaster journalism. Recalls the bereaved mother of one VUE victim, "He would have been an excellent long-distance ice-skater."

1983 My 4, C17:4

Spare the Innocent

DOCTOR DETROIT, directed by Michael Pressman; screenplay by Carl Gottlieb and Robert Boris and Bruce Jay Friedman; story by Mr. Friedman; director of photography, King Baggot; edited by Christopher Greenbury; music by Lalo Schrifrin; produced by Robert K. Weiss; released by Universal Pictures. At the Rivoli 1, Broadway and 49th Street; Gemini 2, 64th Street and Second Avenue; 86th Street East, at Third Avenue, and other theaters. Running time: 89 minutes. This film is rated R.
Clifford SkridlowDan Aykroyd
Smooth WalkerHoward Hesseman
Monica McNeilDonna Dixon
Jasmine Wu ...Lydia Lei
Diavolo WashingtonT. K. Carter
Thelma ClelandLynn Whitfield
Karen BlittsteinFran Drescher
Mom ...Kate Murtagh
Arthur SkridlowGeorge Furth
Margaret SkridlowNan Martin
Harmon RousehornAndrew Duggan

By VINCENT CANBY

"DOCTOR DETROIT," which opens today at the Rivoli and other theaters, is an entertainingly slapdash variation on the comedy about the mild-mannered professor who, through a series of improbable coincidences, finds himself up to his ears in the high life outside academe and enjoys every minute of it.

•

Dan Aykroyd's Clifford Skridlow is a professor of English at a small, Middle Western college, which, like so many institutions in life as well as in comedy, is in financial straits. A specialist in the literature of courtly love, Clifford is a thoroughly nice jerk, neither as idiotic as Jerry Lewis's classic

Dan Aykroyd in "Doctor Detroit."

Nutty Professor or as shy as Gary Cooper's Bertram Potts in Howard Hawks's "Ball of Fire." When the gauntlet is thrown down, Clifford doesn't hesitate to retrieve it.

In this case the professor finds himself called on to protect four beautiful Chicago working women — hookers, actually — who have been abandoned by their pimp and who are in danger of being acquired by Mom (Kate Murtagh), Chicago's most notorious crime czar. In his efforts to defend the innocent, Clifford assumes the identity of the fictitious Doctor Detroit, a syndicate boss designed to intimidate Mom, if not scare her to death. Dr. Detroit wears a blondish fright wig, lavender pants, gold jacket and a knight's armored glove on his right hand.

"Doctor Detroit," which was directed by Michael Pressman and written by Carl Gottlieb, Robert Boris and Bruce Jay Friedman, is in no way a classic in itself but it's often amusing in the way it makes use of routines so familiar that they seem classic.

•

Among other things, there are the professor's joyful discovery of sex and drugs, his more or less accidental triumph over Mom in a slapstick confrontation in a junkyard and an extended climactic sequence in a hotel, where the professor must divide his time between one ballroom, where a college financing party is in progress, and another where, as Doctor Detroit, he is the host of an underworld ball.

Mr. Aykroyd has a good, low-key comic personality that serves this sort of thing very well up to a point. However, his apparent intelligence prevents the film from ever turning into inspired lunacy. His feet are firmly planted on the ground, which is both his charm and his limitation.

The good supporting cast includes George Furth and Nan Martin, as Clifford's eccentric parents; T. K. Carter, as Clifford's streetwise chauffeur; Howard Hesseman, as the pimp who runs out on his employees; Andrew Duggan, as the college's richest alumnus, the man who endowed its Harold Robbins Chair of Literature, and especially Donna Dixon, Lydia Lei, Lynn Whitfield and Fran Drescher as the four slightly used but beautiful maidens in distress. Miss Murtagh, who has the manner of a self-assured prison matron, is very agreeable as Mom.

1983 My 6, C10:1

Suitably Fiery

ALL BY MYSELF, directed, produced and photographed by Christian Blackwood; edited by Susan Ardo Berger; associate producer, David Schmerler. At the Film Forum 1, 57 Watts Street. Running time: 85 minutes. This film has no rating.
WITH: Eartha Kitt

By JANET MASLIN

EARTHA KITT'S sheer force of personality is enough to make "All By Myself" an attention-getting documentary, even if it reflects Miss Kitt's abrasiveness as memorably as her prodigious energy. Christian Blackwood, who produced and directed this profile, clearly intends it admiringly. But he has captured Miss Kitt's stagy, disingenuous side just as surely as he's conveyed her strength. The woman seen here is most memorable for her willfully eccentric singing style, her inch-long eyelashes and her very short fuse.

•

Mr. Blackwood, whose documentary opened this week at the Film Forum, attempts to provide some contrast to the mannered, public side of Miss Kitt's personality. So in addition to filming her at her most flamboyant — dressed to the nines at a celebration of the Reagan inauguration, where she turns on the charm for such colleagues as Joan Fontaine and Virginia Graham — he seeks out the ostensibly quiet moments as well. These include the singer harvesting vegetables in her Southern California garden (she is later shown distributing the produce among young girls who are her dance pupils), talking confidentially about love and making a visit to her mother's grave.

These scenes, which reveal Miss Kitt in a stark and cosmetic-free light, are the film's attempt to get to the essence of its subject. That they feel less than wholly spontaneous is a significant disappointment, since the show-biz ebullience in the rest of the film requires some ballast. In these moments of forced candor, Miss Kitt shifts her expression suddenly, angrily and dramatically, seeming to have the camera in mind even when she pointedly ignores it. In a small Southern town, while visiting her mother's grave, she delivers a tearful monologue while walking heedlessly away from the camera. Seeming to ignore the film makers, she nevertheless keeps talking and remains well within microphone range.

When asked about her romantic history, she throws her head back in full-bodied laughter, then snarls "Stupid!" a minute later. These sharp contrasts are a lot more valuable in her singing performances, which combine her metallic vibrato with the powerfully offbeat delivery that has earned her a devoted following. The film is at its best when it simply accepts Miss Kitt as a force of nature, affectations and all, and captures her thousand-watt stage manner. Sometimes — as when she startles a little girl at the inaugural party by asking, "You wouldn't know who I am, would you? Tell the truth! I'm Cat Woman!" — she can be quite riveting. At others — as when Mayor Koch is glimpsed seated at a dais behind her, looking drowsy during her one of her songs — she's not.

•

Miss Kitt's well-publicized contretemps with Lady Bird Johnson, in which she attempted to introduce the subject of the war in Vietnam into an afternoon of White House propriety, is discussed here only briefly. In the context of the film, it's only one of the many acts of bravado that make her a suitably fiery subject for Mr. Blackwood's profiling methods.

1983 My 6, C10:2

Dare to Defy

THE WHITE ROSE, directed by Michael Verhoeven; screenplay by Mr. Verhoeven and Mario Krebs; director of cinematography, Axel De Roche; edited by Barbara Hennings; music by Konstantin Wecker; a Michael Verhoeven/Sentana Films Production with Hessischer Rundfunk/CCC Filmkunst, Berlin; a Teleculture Films Release. At the Manhattan 1, 59th Street between Second and Third Avenues. Running time: 108 minutes. This film has no rating.
Sophie Scholl Lena Stolze
Hans Scholl .. Wulf Kessler
Alex Schmorell Oliver Siebert
Willi Graf .. Ulrich Tuker
Christoph Probst Werner Stocker
Professor Huber Martin Benrath
Traute Lafrenz Anja Kruse
Fritz Ulf-Jurgen Wagner
Gisela Schertling Mechthild Reinders
Falk Harnack Peter Kortenbach
Mr. Scholl Gerhard Friedrich
Mrs. Scholl Sabine Kretzschmar
Werner Scholl Heinz Keller
Inge Scholl Susanne Seuffert
Elisabeth Scholl Christine Schwarz
Herta Probst Beate Himmelstoss
Clara Huber Monika Madras
Nazi Student Leader Hans-Jurgen Schatz
Dr. Wust Werner Schnitzer
Galeiter Giesler Reinhold K. Olszewski
Lubianka .. Agnes Csere

By JANET MASLIN

LIKE the young German martyrs whose World War II story it tells, Michael Verhoeven's "White Rose" is resoundingly decent and sincere. The intrinsically stirring story of these dissidents, who risked their lives to disseminate anti-Nazi literature in the Munich of 1942 and 1943, is enough to give this film an almost automatic emotional power.

While Mr. Verhoeven's pacing isn't always galvanizing, and while the individual characters seem somewhat faceless at times (despite the camera's habit of photographing them at intimately close range), "The White Rose" has an honesty and urgency that override its occasional colorlessness. It's a forthright tale of heroism, plainly and deliberately told.

"The White Rose," which opens today at the Manhattan I theater, begins with the arrival in Munich of Sophie Scholl (Lena Stolze), a sturdy, fresh-faced 21-year-old student. She soon takes up residence with her brother, Hans (Wulf Kessler), and meets several of his friends, whose covert anti-Nazi activities she soon discovers. These young men are engaged in printing and disseminating forbidden leaflets, and Sophie persuades them to let her join their ranks. As the only woman in this underground group, she finds numerous occasions on which to prove her mettle in tiny but essential ways. Two of the film's more suspenseful sequences involve Sophie's stealing blank paper to supply the group's mimeograph machine, and her attempting to buy 50 stamps at the post office, even though that in itself is deemed suspicious behavior.

Mr. Verhoeven imbues Sophie's story with a warmth and richness of detail, qualities that help compensate for its lack of an inner dimension. The portrait of Sophie and her courage may be only sketchily drawn — a few scenes that show her to be part of a large family, a few in which she rebukes her beau for not challenging the war effort — but the era itself has been carefully recreated. The settings look authentic and natural, and so do the extras; when a little girl rolls a hoop down the street in one corner of the frame, she really appears ab-

Lena Stolze in "The White Rose."

sorbed in that activity. "The White Rose" is as memorable for the small cross-section of wartime Germany it provides as for its saga of outstanding courage.

•

The film centers around university life in Munich, where the war has thus far intruded only indirectly. The presence of SS officers in the lecture halls casts an understandable pall, and one visiting Nazi speaker touches off a riot by telling the female students that their energies would be better used in breeding sons for the Reich than in attending classes. The students, Sophie and Hans among them, are a polite and well-scrubbed bunch who have been driven to uncharacteristic rebellion by the dire nature of their circumstances. The film closes with photographs of the real White Rose martyrs, handsome and well bred, looking very much like the actors who play them.

What did the White Rose leaflets actually say? "And now every convinced opponent of National Socialism must ask himself how he can fight against the present 'state' in the most effective way, how he can strike it the most telling blows . . . Sabotage," the third of the group's fliers declared. For all their moral outrage, the group's statements may not have had much efficacy in wartime Germany; during the film, the university's most dissident professor tells the students as much. And he refuses to aid their activities beyond a certain point, though he sympathizes with their cause. One more reminder of the perilousness of the group's mission is the fact that this professor was himself executed in 1943, along with five young members of the White Rose underground organization.

1983 My 6, C13:1

The Jewish Life

ROUTES OF EXILE: A MOROCCAN JEWISH ODYSSEY, produced and directed by Eugene Rosow; written by Linda Post; camera, Armand Marco, Affonso Beato and Jeri Sopanen; edited by Mr. Rosow and Anne Stein; narrated by Paul Frees; co-produced by Howard Dratch. At the 72d Street East, at Second Avenue. Running time: 90 minutes. This film has no rating.

By RICHARD F. SHEPARD

"ROUTES OF EXILE: A MOROCCAN JEWISH ODYSSEY," which yesterday opened an engagement through next Thursday at the 72d Street East Theater, is a fascinating film about the oldest of Jewish experiences, the Diaspora, told in terms of the once-thriving Jewish community of Morocco.

What the documentary lacks in slick cinematography it more than compensates for in the dramatic theme it explores. In the mid-1940's, there were 350,000 Jews in Morocco. Today, there are 18,000, about as many as the number of Moroccan Jews who migrated to Montreal. Another quarter of a million immigrated with high expectations to Israel, where, according to the film, they and their offspring will alone count for more than half of the population of the Jewish nation within a short time.

Produced by Howard Dratch and Eugene Rostow — who is also its director — the film sets out to see how these people lived with the Arabs in Morocco, with other Jews in Israel and with the French-Canadians in Montreal. The producers took their cameras to all of these countries and turned them, with objective sympathy, on the various situations.

The film makers also have found footage from the past that communicates the flavor of the cloistered Jewish life in Moroccan towns and of the way that Jewish farmers lived in peace with their Arab neighbors. One sees Jewish traders dealing with Berbers and catches glimpses of Jewish Moroccan folkways. But one also learns of the anti-Semitism, a constant minor chord that occasionally became terrifyingly dominant in relationships often marked by cordiality and trust.

In Israel, the film crews logged the lamentable strains between the older Israelis of northern European Ashkenazi background and the Sephardic Moroccans, who are looked down upon by virtue of their different culture and views. Moroccan Jews in Israel are proud of their heritage and of Israel and of the role they played in settling the new cities built around Israel's edges as deterrents to invaders. But it is not a happy story that unreels here, with simmering resentments reflected in explosive statements on screen.

"Route of Exiles" presents the situation, poses the questions that exist, but, wisely, does not forecast the future. What is sad is the complete cutoff of Jews remaining in Morocco from their relatives and friends in Israel; Morocco allows no communications with the other country.

In 90 minutes, the documentary approaches the situation of the migrant or the immigrant or the refugee, who goes from a place he always called home to another home, whether the spiritual one of Israel or the ones primarily for earning a living, in France or Canada. The situation of the Moroccan Jews has its uniqueness, but it also has aspects that attest to the universality of the hopes and disappointments of those who have uprooted themselves.

1983 My 6, C15:3

Eccentric Rewards

THE SANDGLASS, directed by Wojciech J. Has; based on the story "The Sanatorium Under the Sign of the Hourglass," by Bruno Schulz; in Polish with English subtitles; director of photography, Witold Sobocinski; edited by Janina Niedzwiedzka; music by Jerzy Maksymiuk; produced by Polish Corporation for Film Production, Silesia Film Unit; released by Sandglass. At the Thalia, 95th Street and Broadway. Running time: 124 minutes. This film has no rating.

Joseph ..Jan Nowicki
Jacob ...Tadeusz Kondrat
Adela ...Halina Kowalska
Dr. GotardGustaw Holoubek
WITH: Mieczyslaw Voit, Bozena Adamek, Ludwik Benoit, Henryk Boukolowski, Severyn Dalecki, Julian Jabczynski, Jerzy Przybyski, Wiktor Sadecki, Janina Sokolowska, Tadeusz Schmidt, Szymon Szurmiej, Jan Szurmiej, Michal Szwellich, Pawel Unrug, Filip Zylber and others.

THERE is an amazing fluidity to Wojciech Has's "The Sandglass," a 1973 adaptation of a story by the Polish writer Bruno Schulz. There's also a good deal of obscurity, since each scene in this dreamlike fantasy film leads into its successor with no apparent logic or urgency. "The Sandglass," which is gracefully directed and only marginally exasperating, opens today at the Thalia.

The story on which it is based, "The Sanatorium Under the Sign of the Hourglass," concerns a young man named Joseph who visits his dying father in a mysterious, half-abandoned sanatorium. It is explained to Joseph, to the extent that anything is explained, that in this place time lacks its usual meaning, and that events that might not ordinarily overlap can coexist here. Joseph soon finds himself in a morass of memories, fantasies and visions which express the longings and frustrations of his boyhood and to some extent the dangers facing his countrymen at the time the story was written. Mr. Schulz, a Polish Jew, was killed by the SS in his hometown in 1942.

•

As directed by Mr. Has, the film drifts easily from one setting to another, with a rhythm and reasoning all its own. When Joseph, played by Jan Nowicki, crawls under a bed in the sanatorium, for instance, he emerges from the other side into a crowded Polish village that hasn't been seen before, a village where the Jews dance and chant together, where Joseph's father is miraculously alive and well, and where many of the residents are dressed as giant birds. Such eccentricities certainly make "The Sandglass" an unusual film. It's by no means an unrewarding one.

Janet Maslin

1983 My 6, C16:1

STILL SMOKIN', directed by Thomas Chong; written by Mr. Chong and Cheech Marin; director of photography, Harvey Harrison; edited by David Ramirez and James Coblentz; music by George S. Clinton; produced by Peter MacGregor-Scott; released by Paramount Pictures. At Loews State, Broadway and 45th Street; Orpheum, 86th Street and Third Avenue, Bay Cinema, Second Avenue and 31st Street and other theaters. Running time: 91 minutes. This film is rated R.
Cheech ...Cheech Marin
Chong ...Tommy Chong
Promoter ..Hans Van In't Veld
Hotel ManagerCarol Van Herwijen
Assistant ManagerShireen Strooker
Hotel Maid ...Susan Hahn
BellboysArjan Ederveen, Kees Prins
Barge WaitressMarlette Bout
Barge Lady ..Fabiola
Queen BeatrixCarla Van Amstel

With "Still Smokin'," Cheech Marin and Tommy Chong are scraping the bottom of their barrel and finding only bits and pieces of the characters and comedy routines that were so successful in their earlier films, including "Up in Smoke," "Nice Dreams" and "Cheech and Chong's Next Movie."

This one is as tired as the pot-smoking Cheech and Chong always pretend to be, being a haphazard narrative film made up to go around the team's personal appearance at an Amsterdam theater last year. Preceding the

sketches — not great — that are the film's climax, the two men laze around Amsterdam having fantasies about lubricious chambermaids, homosexual sauna baths, fame and drugs.

If the fellows don't take more care in the future, Cheech and Chong's next movie could be Cheech and Chong's last movie.

"Still Smokin' " opened yesterday at Loews State and other theaters.

Vincent Canby

1983 My 7, 16:3

Overdecorated

NUDO DI DONNA, directed by Nino Manfredi; screenplay (Italian with English subtitles) by Agenore Incrocci, Ruggero Maccari, Mr. Manfredi and Furio Scarpelli with the collaboration of Silvana Buzzo; story by Mr. Manfredi and Paolo Levi; director of photography, Danilo Desideri; edited by Sergio Montanari; music by Maurizio Giammarco and Roberto Gatto, and Vittorio and Gianni Nocenzi; produced by Franco Committeri; released by Horizon Films in association with Wonder Movies Inc. At the Gemini 2, 64th Street and Second Avenue. Running time: 112 minutes. This film has no rating.
Sandro ..Nino Manfredi
Laura/RiriEleonora Giorgi
PiredduJean-Pierre Cassel
Zanetto ...George Wilson
Giovanni ..Carlo Bagno

NINO MANFREDI'S "Nudo di Donna" isn't the first film to tell the story of a wife who, dismayed by her husband's indifference, masquerades as a sexpot and becomes his glamorous mistress. It may be, however, the first film to present such a tale with this much suffocating fanciness, this many unwarranted allusions to paintings and this sort of mind-boggling attention to interior decoration.

There is also a fashionable vagueness to the exposition, so that the viewer may never really know whether the blonde, brunette and redhead variously played by Eleonora Giorgi, as the hero's wife, are the same woman. Or whether they represent three different facets of a single entity. Or whether somebody just thought it would be interesting to try out different hair colors.

"Nudo di Donna," which opens today at the Gemini, is set in Venice, a city which almost invariably looks more beautiful and more exotic on screen than it does here. It's the kind of gaudy, touristy film in which somebody in the background is apt to be headed for the Carnival in full regalia (scenes of the Viareggio Carnival are worked into the story), or perhaps to be blowing glass.

In the foreground is Sandro, the unhappy husband who, in the middle of an early amorous scene with his wife, Laura, falls asleep at a crucial moment. The spark has gone out of their marriage, Sandro fears. The spark returns when Sandro, visiting the palazzo of a fashion photographer (one of the many scene-stealing interiors in the movie), spies a gigantic blowup of a nude blonde woman asleep on her stomach. She has crossed her legs in the same way that Laura does. Is she Laura? Who is Laura, anyway? What does it all mean?

The model is identified as a local prostitute named Riri, whom Sandro tracks down and who looks just like Laura but has red hair. She also has a lot of gauzy, red-and-purple sequined outfits. And her pink-and-blue apartment features decorative crates on the walls, elaborate sculpture, a bed painted to resemble the tree from

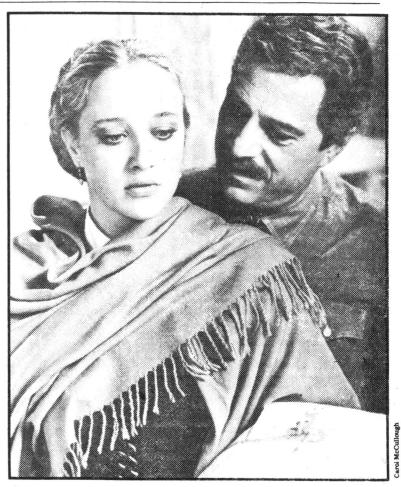

Carol McCullough

"NUDO DI DONNA"—Eleanora Giorgi and Nino Manfredi, who also directed, star in an Italian comedy about a married couple who separate during Carnival in Venice.

which Eve took the apple from the serpent and a picture of a giant ice cream soda. One day, after a quarrel with her, Sandro arrives at the apartment to find that the prostitute has disappeared, leaving the place — by this film's standards, anyway — bare. All the decorative items are still in place. But the stand that held Riri's wig is missing.

Mr. Manfredi, best known in this country for "Bread and Chocolate," attempts a seriocomic mood and winds up with a generally self-important and solemn one. The film drifts into such a grand scale, pondering the nature of womanhood as it does, that the story line suffers badly and the film becomes a succession of garish set pieces. In one of these, Carnival revelers dress as World War II American soldiers and their dance partners, some of them even in blackface. Mr. Manfredi lingers aimlessly on this overblown episode, then moves on to the next one.

Janet Maslin

1983 My 13, C7:5

Stomach in the Air

BREATHLESS, directed by Jim McBride; written by Mr. McBride and L. M. Kit Carson; director of photography, Richard H. Kline; film editor, Bob Estrin; music by Jack Nitzsche; produced by Martin Erlichman; released by Orion Pictures. At the Coronet, Third Avenue and 59th Street; 34th Street Showplace, near Second Avenue; Criterion, Broadway and 45th Street and other theaters. Running time: 105 minutes. This film is rated R.
Jesse LujackRichard Gere
Monica PoiccardValerie Kaprisky
Prof. Paul SilversteinWilliam Tepper
Lieutenant ParmentalJohn P. Ryan

Sergeant EnrightRobert Dunn
TolmatchofWaldemar Kalinowski
Carliot ...Miguel Pinero
Birnbaum ...Art Metrano
Berrutti ..Gary Goodrow
Dr. BoudreauxEugene Lourie

By VINCENT CANBY

JESSE LUJACK (Richard Gere), a rootless young petty thief with a broken heart tattooed on his chest, has no past aside from a string of aliases. He has no future, either, except for some fuzzy dreams about going to Mexico, which, though he lives in Los Angeles, seems as far away as Chicago. The only thing all his own is a police record. He lives in a glittery world of neon and plastic, where everything is up for grabs and where everything is disposable, including himself.

As much as Jesse can bring himself to think about his life, which might be measured in cars stolen and women slept with en route to nowhere, Jesse identifies with Marvel Comics's Silver Surfer, a tragicomic superhero who is never in the right galaxy at the right time. Like the Silver Surfer, Jesse is intensely serious about himself and surprisingly funny.

Monica Poiccard (Valerie Kaprisky) is something else entirely — French born and bred, upper middle class, a brilliant student of architecture, who has definite plans for her future. In the way of movies, Jesse and Monica are made for each other, not for life but for about three days. That's how long it takes for Jesse and Monica to live their entire, overheated lifetime together after Jesse, in a panic, has shot and killed a highway policeman who wanted to give him a

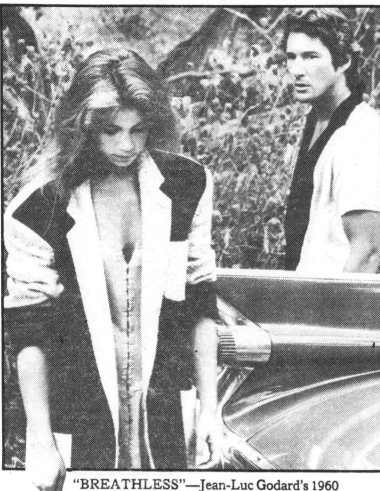

"BREATHLESS"—Jean-Luc Godard's 1960 film about an obsessive attraction is remade by Jim McBride as a starring vehicle for Valerie Kaprisky and Richard Gere.

speeding ticket.

If some of this sounds familiar, it's supposed to, since Jesse and Monica are 1983 variations on the doomed lovers played by Jean-Paul Belmondo and Jean Seberg in Jean-Luc Godard's seminal masterpiece, "Breathless."

"Breathless" is also the name of this jazzy remake, directed by Jim McBride and written by him and L. M. Kit Carson. It opens today at the Coronet and other theaters.

Why, it's reasonable to ask, would anyone in his right mind want to remake a classic as idiosyncratic as "Breathless"? Its story is not important, being not much different from those of dozens of other movies made before and since. Even its mixture — startling at the time — of cool nihilism and sentimentality is not all that interesting today.

"Breathless," Mr. Godard's first feature, remains important for the way it questioned the look, sound and methods of all narrative films that had gone before and for the way it changed those looks, sounds and methods ever afterward.

Mr. Carson, who starred in the title role of Mr. McBride's classic, "David Holtzman's Diary," has been quoted as saying that because the original "Breathless" had profoundly influenced him and Mr. McBride, they had wanted to restate "an emotional experience." Maybe so, but it's a little like trying to reinvent the light bulb to pay homage to Thomas Alva Edison. It can't be easily done, and the new "Breathless," which is entertaining in

its own way, carries a very heavy burden of built-in doubt.

Mr. McBride's "Breathless," though it keeps amazingly close to the original in its details, is more like a high-class "Dirty Mary Crazy Harry," John Hough's 1974 B-picture that gained a large and dedicated following among the serious and not so serious. "Breathless" has a lot of mindless drive, but it's also funny. It's full of knowing quotes from other movies and from literature — William Faulkner in addition to Marvel Comics. It's less a film maker's journey of discovery than the film maker's testimony to his awareness of "cinema," and sometimes it's just too much.

If anything, "Breathless" looks too good for its own good. Richard Sylbert's production design is still another example of high cinema chic. There can't be a single Los Angeles wall mural that doesn't turn up as a background at one point or another, so frequently, in fact, that there are times one wishes the camera would let us look at the art work and forget the actors. When Monica goes swimming, the images are held long enough for even the dimmest member of the audience to recall those David Hockney paintings.

Because the movie looks so filthy rich and so elegantly composed, the emotional experience thus restated becomes a tiny bit confused. Among other American "extras," this "Breathless" has its obligatory title song, soundtrack music that won't shut up and dialogue that spells out

what's happening from start to finish.

"You're like one of those rides at Disneyland," Monica says. "You make me dizzy," Jesse says. "You know, when you're driving and you go over a bump and your stomach sort of hangs in the air? That's me around you — breathless." It's not always easy to know when Mr. McBride and Mr. Carson are kidding.

The two principals are extremely effective. Mr. Gere plays Jesse Lujack with an uninhibited, lunatic energy that frequently comes close to parody, but it also gives the film a nervous, nutty quality that fits. As Monica, Miss Kaprisky, a new, 19-year-old French actress, is as beautiful as the young Genevieve Bujold, simultaneously sexy and calculating, intelligent and a little stupid.

I still don't understand why Mr. McBride and Mr. Carson elected to do the film but, considering the more obvious possible pitfalls, they could have done a lot worse. That is meant to be praise.

1983 My 13, C10:1

Spying From Above

BLUE THUNDER, directed by John Badham; written by Dan O'Bannon and Don Jakoby; director of photography, John A. Alonzo; edited by Frank Morriss and Edward Abroms; music by Arthur B. Rubinstein; produced by Gordon Carroll; released by Columbia Pictures. At Loews State, Broadway and 45th Street; Orpheum, 86th Street and Third Avenue; 34th Street Showplace, near Second Avenue. Running time: 110 minutes. This film is rated R.

Murphy	Roy Scheider
Braddock	Warren Oates
Kate	Candy Clark
Lymangood	Daniel Stern
Icelan	Paul Roebling
Fletcher	David S. Sheiner
Montoya	Joe Santos
Chochrane	Malcolm McDowell
Sgt. Short	Ed Bernard
Mayor	Jason Bernard

JOHN BADHAM'S "Blue Thunder," which opens today at Loews State and other theaters, comes as close to being a big-screen video game as any movie this year. The popularity of video games being what it is, the movie's future doesn't appear to be in doubt.

The film does have a story of sorts, being about a conspiracy to deny Los Angeles citizens their civil rights, but this is only important as a frame on which to hang a succession of old-fashioned thrills, the kind that can be experienced in today's new-fashioned pinball parlors.

The film's star is a futuristic helicopter, called the Blue Thunder, which is capable of speeds unusual for a helicopter and equipped with surveillance devices that can see and hear conversations inside buildings and on the ground. The enemy is a group of fascistic military and government types, who plan to trick the Los Angeles Police Department into using this plane for mind as well as mob control.

Supporting the plane, which is spectacular, are Roy Scheider, who plays a neurotic — and thus good — pilot of helicopters for the police department; the late Warren Oates, as his trusted superior; Daniel Stern, as Mr. Scheider's young sidekick, and Malcolm McDowell, who is suitably suave and ruthless as an Air Force colonel who wants Mr. Scheider dead. Candy Clark makes some unrewarding appearances as the young woman who loves Mr. Scheider but cannot compete with his awful memories of Vietnam. In the form of flashbacks, these memories attack their victim with

symptoms that are much like those for malaria.

The action sequences are what the film is all about, and these are remarkably well done, including a climactic, largely bloodless shootout among helicopters and jet fighters over Los Angeles. However, one does itch to be able to fire a few rounds for oneself, but that, I suppose, is what pinball parlors are for.

Vincent Canby

1983 My 13, C17:4

Family Farce

LA BOUM, directed by Claude Pinoteau; written (French with English subtitles) by Danièle Thompson and Claude Pinoteau; camera, Edmond Sechan; edited by Marie-Joseph Yoyotte; music by Vladimir Cosma; produced by Alain Poiré; A Gaumont International Productions/Marcel Dassault co-production; released by Triumph Films, a Columbia/Gaumont Company. At the Plaza, 58th Street, east of Madison Avenue. Running time: 100 minutes. This film has no rating.

François	Claude Brasseur
Françoise	Brigitte Fossey
Vic	Sophie Marceau
Poupette	Denise Grey
Vanessa	Dominique Lavanant
Eric	Bernard Giraudeau

By JANET MASLIN

FOR American audiences, to whom French films once represented the ultimate in chic, it's going to be something of a shock to watch a Gallic comedy like Claude Pinoteau's "Boum" — one that takes its inspiration less from the great French films of yesteryear than from American television situation comedies. Not that "La Boum" isn't entertaining. In its pleasantly predictable way, it is. It's just that a French heroine who keeps a Muppet poster on her bedroom wall or who has the kind of madcap family that might ordinarily be found on a hit television series, seems to be something of a cultural hybrid. Her parents' good-natured philandering is the only recognizably French contribution to the formula.

"La Boum," which opens today at the Plaza, follows a pretty, pouty 13-year-old named Vic (Sophie Marceau) through the first of what will undoubtedly be many romances. ("La Boum II" is already in the works.) She has a best friend who claims to see 10 American movies a week, a foxy great-grandma who knows everyone at La Coupole and parents who are approaching their first marital disagreement, although not even this unhappy development is allowed to damage the film's lighthearted mood. Vic also has a wild crush on a certain garçon, whom her great-grandma (Denise Grey) is sporting enough to photograph on the sly. Giant likenesses of the handsome boyfriend soon mingle with the Muppets on Vic's bedroom wall.

•

Mr. Pinoteau intersperses Vic's romantic adventures with those of her mother, an ambitious and somewhat high-strung illustrator named Françoise (Brigitte Fossey), whose dentist husband (Claude Brasseur) has been casually unfaithful to her. The dentist's deception is revealed after his mistress, in order to induce her lover to stay overnight, phones Françoise and says the dentist has broken his leg in an auto accident. This leads to a fake cast, a deliberately wrecked car and, finally, to more lies than the dentist can handle. When the parents'

troubles become apparent to their daughter, though, she's less upset than might be expected. Her first concern is for how their separation will affect the "boum," or teen-age party, that she has been planning.

There are two long party scenes in the film, both of them capturing a teen-age ambience nicely and both loaded with jokes about the generation gap, which is the film's subject to the extent that it has one. At one "boum," the host's parents are caught sneaking into the kitchen by their horrified son, who complains that it will spoil the party if anyone learns that grownups are around; the parents apologize meekly, explaining that they were hungry. Meanwhile, a gang of dads in trenchcoats gathers at a pay phone near the site of the party, determined to get through to their daughters (who are, of course, tying up the line). "I'm going up there," one father bravely declares, as if this were the Charge of the Light Brigade. Actually, that bat-

tle may have been less daunting than this one.

•

The humor of "La Boum" is all of this cheerfully routine sort, and for the most part, it keeps moving. Mr. Brasseur and Miss Fossey help to make the parents as sympathetic and interesting as is possible, and Miss Grey makes the spunky great-grandma a lot more bearable than she might have been. Miss Marceau is convincingly obstinate and bubbly by turns, depending on whether she's with her parents or with her friends, which certainly makes her a convincing teen-ager.

The slangy subtitles make the kids' already Yankee-influenced behavior seem even more so. When one girl pronounces somebody as handsome as Alain Delon, the titles declare him "as handsome as Paul Newman."

1983 My 13, C28:1

FILM VIEW

VINCENT CANBY

Are Video Games About To Zap the Action Movie?

More and more these days one attends to the mayhem within an action movie with impatience, as if watching other people play video games, which, when the history of entertainment is written, may turn out to be the breakthrough of our era. Old-fashioned movies can't easily compete with the wizardry that, for a small price, allows anyone to be the hero of his own action epic.

One sits in the dark of the movie theater and squirms helplessly at each successive encounter with the enemy, dodging missiles in "Star Wars" and dried bones in "Conan the Barbarian," reaching for weapons that aren't there, cheering a direct hit on the opposing forces and feeling exhausted at the end, if not necessarily satisfied. This has always been true of certain kinds of movies, but now that more and more movies look and sound like video games, and now that more and more video games look and sound like movies, it seems possible that the new art form might well swallow up the old.

If the principal point of an action movie has always been to afford the viewer the vicarious pleasure of being in the thick of it, then the experience that allows the viewer to enter the action and to control it, as a video game does, must be more satisfying than an experience that excludes the viewer, all other things being equal. It's true, unfortunately, that all other things often are equal these days, since most action films aren't especially strong on characters or plot.

Consider John Badham's new action-adventure melodrama, "Blue Thunder," set in contemporary Los Angeles. It's full of futuristic hardware, elaborately executed visual and sound effects and, when the action gets going, it's fairly relentless. Yet, because the screenplay is so small it could have been written on the head of a pin, the movie isn't especially fulfilling. The best way to describe "Blue Thunder" is as Hollywood's most ambitious video game substitute of the season to date.

Though star billing goes to Roy Scheider as Frank Murphy, a highly neurotic helicopter pilot with the Los Angeles police, and featured billing goes to Malcolm McDowell, who plays Cochrane, a nasty, right-wing, United States Air Force colonel, all of the people in "Blue Thunder" are far less interesting — and far, far less complex — than the title machine. This is the Blue Thunder, which may not be quite "the ultimate weapon" the ads say it is, although it's certainly impressive.

The Blue Thunder is the latest thing in helicopters, capable of speeds comparable to those of conventional aircraft and equipped with all sorts of advanced weaponry as well as with surveillance equipment, which enables the pilot to monitor conversations on the ground and to take pictures through walls. On the eve of 1984, Big Brother has arrived in Los Angeles.

• • •

As a story for the film, the screenwriters have come up with the sort of conspiracy plot that was so popular in the paranoid 1970's: Some remarkably self-assured representatives of what used to be known as the military-industrial complex plan to start race riots in order to demonstrate the effectiveness of the Blue Thunder in controlling restless civilians. Frank Murphy, while taking the Blue Thunder out for a trial spin, just happens to fly by the building where the plotters are plotting. He understands their awful designs and spends the rest of the movie trying to convince his superiors that something evil is afoot.

One of the ironies the film makes nothing much of is the fact that Frank is able to discover this plot only with the help of the Blue Thunder's advanced monitoring devices.

The screenwriters make obligatory attempts to establish Mr. Scheider's character as something more than a function of the plot, which it isn't. Frank Murphy, as we are shown several times in comically intrusive flashbacks, is haunted by his memories of Vietnam, especially by a traumatic experience that forever links him to the arrogant colonel played by Mr. McDowell.

An explanation of just what happened in Vietnam, which is one of the film's two extremely dim mysteries, is withheld until the end in order to justify Frank Murphy's strange, almost psychotic behavior. He's unreliable not only on the job but with a young woman (Candy Clark) who turns up with a child from time to time to tell him that she loves him. In addition to the Air Force colonel, the only other characters in the movie, none more substantial than an electronic blip, are Murphy's faithful sidekick (Daniel Stern) and his tough, crusty but understanding police captain, played by Warren Oates shortly before he died last year.

• • •

All of this, however, is simply decoration for a movie whose main reason for being, obviously, is not to explore character, Vietnam, fascism or urban problems, but to allow the members of the audience to participate in the action, and the action isn't bad. In the very long climactic sequence, Mr. Scheider, at the controls of the Blue Thunder, flying high and low over Los Angeles, is called upon to face attacks by Air Force fighter-jets equipped with homing missiles and a one-to-one encounter with Mr. McDowell at the controls of another chopper.

Though this sequence has been comparatively well photographed and edited, "Blue Thunder" is so lacking in conviction and style in every other way that, at the end, the viewer is less likely to feel exhilarated, as he does after something as winning and witty as "Raiders of the Lost Ark," than nerve-racked.

What's missing is the feeling of being in charge — if not in control — that one would have if "Blue Thunder" were a real video game and not just a big-screen imitation. One watches the film with a certain amount of awe for the efforts being made by the moviemakers but with little sense of participation, which, I suppose, awaits the film's inevitable metamorphosis into a video game.

Ever since movies began, the people who make them have been searching for ways by which to bring the members of the audience into the life of the screen. Sound and color have helped. Periodically we are presented with 3-D demonstrations, which are never completely satisfactory. The 3-D world is seen in depth, but it always looks sort of miniaturized, removed and dead until some object comes crashing out from the frame of the screen.

Huge, semi-surround screens, like that used for the original Cinerama, can sometimes give the audience a feeling of being inside the action of the movie, but seldom to any particular dramatic advantage.

Audiences are drawn into movies not by the literal reality of what they're seeing but by various devices of dramatic invention that invite emotional and/or intellectual response. At their very best, movies, which we accept in a passive way, have the effect of prompting us to think and feel in such a manner that the passive experience becomes something akin to active.

In one fashion and another we work while watching a good film. However, even the dumbest video game demands more in the way of physical skill and coordination — a more active participation — of the player than the best film demands of its viewer.

Thus it seems possible that video game technology, which appears to be advancing at a far faster rate than the art of filmmaking, might one day make obsolete all action-suspense films or, at least, force the people who make them to support the film's action with something more than the perfunctory plotting of "Blue Thunder."■

1983 My 15, II:13:1

Panhandler's Advice

REACHING OUT, directed, written and produced by Patricia Russell; director of photography, David Sperling; edited by Jim McCreading; music by Elizabeth Swados; a Par Films Production. At the Embassy 72d Street, at Broadway. Running time: 90 minutes. This film is rated R.

John Stevens	Toni Craig
Frank Mesina	Frank McCarthy
Mrs. Stuart	Betty Andrews
Mr. Stuart	Douglas Stark
Pat Stuart	Pat Russell
Florence Byrd	Tyre Truro
Agent	Ralph Carlson
Acting Teacher	Marketa Kimbrel
Psychiatrist	Victor Truro
Drunk	Ron Max
Girl With Apartment	Mary Milne
Waiter	Ric Wynn

By JANET MASLIN

PATRICIA RUSSELL has written, directed, helped finance and starred in "Reaching Out," a film that opens today at the Embassy 72d Street theater for reasons that probably only Patricia Russell would understand. This badly dated period piece recalls the early 70's at their dingiest, as a not very sympathetic young woman wanders through New York in search of companionship and self-expression.

She has come to New York after the death of her mother, who drank too much and burned her daughter's breakfast. She is escaping a marriage to a man who said things like "You haven't cleaned this place at all since I mentioned it last week!" As created by Miss Russell, the young woman — called Pat — views everything in similarly black-and-white terms, and is a whiny, self-pitying victim through and through.

•

Among the more notable things Pat does, in this lifeless, amateurish chronicle of her adventures, are to ask a panhandler if he knows where she can find a New York apartment, visit a singles bar and feign surprise and shock every time anyone tries to pick her up, and decide she'd like an acting career. In line with this last ill-advised ambition, she meets a man who helps her do acting exercises and advises her that "It's important that you don't hide in front of an audience." Apparently, Miss Russell has taken this notion very much to heart.

The dull goings-on in "Reaching Out" are accompanied by a score by Elizabeth Swados, a collection of shrill and strident ballads. "Oh King Daddy, Mr. Magical Magician, Mr. Playing-Around-With-My-Head" is a sample lyric, and there's lots more where that came from.

1983 My 16, C20:5

Society's Influence

THE GORDIMER STORIES: COUNTRY LOVERS, screenplay by Nadine Gordimer; directed by Manie Van Rensburg; SIX FEET OF THE COUNTRY, screenplay by Barney Simon; directed by Lynton Stephenson; NADINE GORDIMER INTERVIEW, Joachim Braun, narrator; released by Teleculture. At the Film Forum 1, 57 Watts Street. Running time: 110 minutes. These films have no rating.

By VINCENT CANBY

THE opening today at the Film Forum of "The Gordimer Stories," the collective title for a series of seven short films based on stories by South Africa's Nadine Gordimer, is something more of a literary event than an occasion of cinema. This is not to underrate the imagination of the films, which, based on the two that I've seen, is first-rate, but to emphasize that what is being served in this program is a quality of mind that is most completely and gracefully revealed in Miss Gordimer's prose.

Though the Gordimer novels and short stories frequently reflect the extraordinary racial laws and social prohibitions that divide her country, and impose on it a kind of seething calm, she is an artist first and a polemicist second but, because she is such a marvelous writer, her political points are all the more devastating.

What one never forgets when reading her work is that it's her mind that illuminates the world she sees, and not the other way around. It's quite conceivable that she would still be the writer she is today even if she'd been born and bred in Norwich, Vt.

The main program of the Film Forum's Gordimer show is made up of two stories, "Six Feet of the Country," a 30-minute film adapted by Barney Simon and directed by Lynton Stephenson, and "Country Lovers," a one-hour film adapted by Miss Gordimer and directed by Manie van Rensburg, plus a half-hour interview with Miss Gordimer conducted by Joachim Braun. This program will be shown daily at 4 and 8 P.M. through May 31.

"Oral History" and "Praise," each of which is an hour long, will be shown together daily at 6 and 10 P.M. through May 24, to be succeeded, May 25 through May 31, by a program made up of "Good Climate, Friendly Inhabitants" and "A Chip of Glass Ruby." "City Lovers," which was originally presented at the New York Film Festival last year, will be screened on Saturdays at 2:45 P.M.

"Country Lovers" is a delicate and ferocious tale about the love affair of a young Afrikaner and the pretty black girl who grows up with the boy on his father's prosperous farm. The point of the story is the manner in which the innocence of the pair is ultimately destroyed by the Immorality Act, which, in the interview film, Miss Gordimer describes with her usual precision as "that iniquitous and disgusting piece

David Goldblatt

Films from stories by Nadine Gordimer, plus an interview, at Film Forum.

of legislation."

The tale is beautifully acted by Ryno Hattingh and Nomse Nene as the lovers and is related in such a low key that the full horror of it is not apparent until it's almost over. This is the way things are, we are told, with no futher comment necessary.

Almost as effective is "Six Feet of the Country," about a young couple from Johannesburg who, in an effort to save their marriage, buy a cottage in the country. Instead of finding peace, however, they find that the country divides them even further as the young wife becomes involved in the efforts of a black laborer to give his brother, a refugee from Rhodesia, now Zimbabwe, a proper funeral.

In her interview with Mr. Braun, Miss Gordimer talks eloquently about the part that politics plays in her writing: it's not especially conscious, but it is inevitable.

"Even in their most intimate relationships," she says, people are influ-

"REACHING OUT"—Pat Russell portrays a woman who learns to stand on her own as she forges a new life as an actress in New York after the dissolution of her marriage.

enced "by the kind of society they live in and by the attitudes of society." Apartheid, she says further, which places a person of one color in authority over a person of another color, "carries over into personal relationships that have nothing to do with, perhaps, crossing the color bar."

It's amazing that with the exception of "Oral History," which was shot in Kenya, all of the films in the series were made in South Africa, with South African actors, directors and technicians. It will also be amazing if the series, produced by West German television interests, isn't picked up for television showing here.

1983 My 18, C26:4

Portrait of the Artist

THE BILL DOUGLAS TRILOGY: MY CHILD-HOOD, direction and screenplay by Bill Douglas; photography, Mick Campbell; edited by Brand Thumin; produced by Geoffrey Evans. Running time: 48 minutes.
JamieStephen Archibald
TommyHughie Restorick
GrandmotherJean Taylor-Smith
Tommy's fatherBernard McKenna
Jamie's fatherPaul Kermack
Tommy's motherHelena Gloag
Jamie's motherAnn Smith
MY AIN FOLK, direction and screenplay by Bill Douglas; photography by Gale Tattersall; edited by Peter West; produced by Nick Nacht. Running time: 55 minutes.
MY WAY HOME, direction and screenplay by Bill Douglas; photography, Ray Orton; edited by Mick Audsley; production company, British Film Institute Production Board. Running time: 72 minutes. At the Public Theater, 425 Lafayette Street.

"The Bill Douglas Trilogy" was shown as part of the "British Film Now" series in 1980 at the Paramount Theater. Following are excerpts from a review by Vincent Canby that appeared in The New York Times of Sept. 23, 1980. The film opened yesterday at the Public Theater, 425 Lafayette Street.

"**M**Y CHILDHOOD," "My Ain Folks" and "My Way Home," the three films that make up what's now known as "The Bill Douglas Trilogy," are about growing up wretched and poor in a Scottish mining town.

Financed by the British Film Institute's Production Board, Mr. Douglas set out on this exploration of his own past in 1970 and worked off and on for the next eight years with two of the same actors, most notably Stephen Archibald, who plays Jamie, the Douglas surrogate figure, from adolescence into young manhood. The only thing in films at all like this record of Jamie's growth is François Truffaut's Antoine Doinel series.

"The Bill Douglas Trilogy" is a far different sort of work and, needless to say, is not to be compared with Mr. Truffaut's classic comedies. The Douglas films, photographed mostly in grim, grainy black and white, give the initial impression of being starkly realistic, partially because a moviegoer automatically associates such details of poverty and loneliness with the realism of documented truth. I emphasize "partially" because I suspect that in the eight years Mr. Douglas spent making these films, he was also discovering his method and evolving a point of view toward himself. The man who in 1972 completed the 48-minute "My Childhood," which initiates the trilogy, is nowhere near the film maker who completed "My Way Home" in 1978. The trilogy records the journey of a film documentarian who became a film poet.

"My Childhood" recalls the bleak-

ness of Jamie's early years, living in two barren rooms with his older half-brother Tommy (Hughie Restorick) and his ancient maternal grandmother. Jamie's coal-miner father, who had never been married to his mother, lives across the street with Jamie's paternal grandmother, a selfish, small-minded old lady with pretentions to gentility.

"My Childhood" and the following "My Ain Folks" inventory Jamie's childhood losses — the friendship of a prisoner of war who must return to Germany at the war's end; his maternal grandmother, who, seemingly long overdue, slips into senility and death; his lunatic mother, who dies in an asylum without knowing him, and then Tommy, who, when their grandmother dies, is sent to an orphanage while Jamie is shifted over to his paternal grandmother.

The trilogy seems almost as taciturn as its characters, and it's not until one reaches the third part that one realizes exactly how expressive Mr. Douglas's style is. The dark chilli-

ness of the first two parts of the trilogy is suddenly replaced by the brilliant sunlight of Egypt, where Jamie is sent after joining the Royal Air Force. The Egypt he sees is not exotic. The sunlight is too intense. The routine is boring. A recreation area is simply one lot of sand fenced off from another lot. Arbitrarily. Yet Egypt is warm.

Though "My Way Home," the trilogy's third part, is no less taciturn than the two preceding parts, it successfully reflects the emotional awakening of Jamie in a sparely, obliquely detailed account of his friendship with another soldier, a cheerful, bookish, middle-class young man who finds Jamie's inarticulateness just this side of being unbearable. The nature of their friendship, like everything else in these films, is muted, understated, but its profound effects are never in doubt.

"The Bill Douglas Trilogy" is a remarkable endeavor, a unique record of an unsentimental education.

1983 My 18, C26:5

Rare Chaplin Cuts

By VINCENT CANBY

A LOT of rare and wonderful material is contained within the three 52-minute segments of Thames Television's "Unknown Chaplin," the Charlie Chaplin documentary screened here yesterday at the Museum of Broadcasting, where it will be shown again June 21. It says something about the curious relationship between theatrical films and television that this material should be presented to us under the auspices of a television company.

The most spectacular of the documentary's revelations is a hilarious, completely self-contained, seven-minute sequence that Chaplin shot for — and then cut from — "City Lights" (1931). In this routine, which exemplifies the Chaplin method, Charlie's tramp nearly brings an entire city to a stop by trying to dislodge a piece of wood from a sidewalk grill.

Almost as good are extended sequences showing the master at work directing the beautiful Edna Purviance, the leading lady of so many of his Mutual Film Company comedies, and Virgina Cherrill, the blond beauty who played the blind girl in "City Lights."

"Unknown Chaplin" is another labor of love and skill produced by Kevin Brownlow and David Gill, and was made possible largely through the cooperation of Chaplin's widow, Oona, who gave the historians permission to use material never before released for public showing.

Among the rarities in this material are a sequence from an uncompleted Mutual comedy titled "The Professor," about a none-too-successful flea-circus impresario, and a series of sequences that describe Chaplin's obsession with perfection as he refines two magnificent gags for "The Cure" (1917), set in a health spa. I particularly cherish the wheelchair jokes.

This material must be invaluable to film scholars because Chaplin was never very articulate about how he worked. In his Mutual period (1916-17), Chaplin put his ideas down not on paper but on film, most of which he later destroyed. In these clips from

Charlie Chaplin editing rare film in a documentary.

"The Cure" it's possible to watch how a gag progresses from a single, sometimes conventional idea into the fully orchestrated mayhem that appears in the final cut.

In the clips from "The Immigrant," also 1917, we see how a comparatively slim restaurant routine, featuring Chaplin and Miss Purviance, evolves into the sort of ironic vision of American life that gives substance to even the most blithe of his comedies.

Those interviewed for "Unknown Chaplin" include Lita Grey, Georgia Hale and Miss Cherrill, who discusses her trials with Charlie during the production of "City Lights" with disarming frankness and intelligence. About three-quarters of the way through the filming, Chaplin dismissed Miss Cherrill and replaced her with Miss Hale. We even see the final, heart-breaking scene of "City Lights" played by Miss Hale. However, common sense and economics eventually prevailed and Chaplin rehired Miss Cherrill to complete the film, doubling her salary to $150 a week.

Miss Grey and Miss Hale also talk candidly about their roles in the production of "The Gold Rush" (1925), in which Miss Grey, then Mrs. Chaplin, initially starred. When pregnancy

forced her to withdraw from the film, she was replaced by Miss Hale, and the film, which had been shooting at great expense on location in northern California, was restarted, virtually from scratch, back at the studio.

"Unknown Chaplin" contains a certain amount of padding, including home movies, studio tours and publicity shots, but it's also a chest of treasures that either have not been seen before or have seldom been available to ordinary folk. That discarded opening for "City Lights" alone makes "Unknown Chaplin" the kind of event that serves history, scholarship, films and entertainment.

1983 My 19, C19:1

SPACEHUNTER: ADVENTURES IN THE FOR-BIDDEN ZONE, directed by Lamont Johnson; screenplay by Edith Rey and David Preston and Dan Goldbert and Len Blum; story by Stewart Harding and Jean Lafleur; director of photography, Frank Tidy, 3-D consultant, Ernest McNabb; special visual effects produced by Fantasy II Film Effects; edited by Scott Conrad; music by Elmer Bernstein; produced by Don Carmody, John Dunning and Andre Link; released by Columbia Pictures. At Loews State, Broadway and 45th Street; New York Twin, Second Avenue and 66th Street; 34th Street Showplace, near Second Avenue; 86th Street Twin, at Lexington Avenue. Running time: 90 minutes. This film is rated PG.
WolffPeter Strauss
NikiMolly Ringwald
WashingtonErnie Hudson
ChalmersAndrea Marcovicci
OverdogMichael Ironside
Grandman PattersonBeeson Carroll
ChemistHrant Alianak
MeaganDeborah Pratt
ReenaAleisa Shirley
NovaCali Timmins
JarrettPaul Boretski
DusterPatrick Rowe
Barracuda LeaderReggie Bennett

By JANET MASLIN

"Spacehunter," which opened yesterday at Loews State and other theaters, has attracted more experienced personnel than most 3-D movies do. And, unlike most films of its genre, it attempts to do more than send bats and snakes and yo-yos hurtling from the screen. It attempts so much that it will probably remind you of at least a dozen other pirate, gladiator, horror and science-fiction stories, because its own plot is none too distinctive and is seriously overcrowded.

There's so much going on in "Spacehunter," which is subtitled "Adventures in the Forbidden Zone," that it's easy to forget about the 3-D much of the time. The film could as easily have been shot in the usual way, and perhaps it would have looked a lot better; like most 3-D movies, "Spacehunter" is dingy-looking, with most scenes a rusty shade of brown. The 3-D comes in handy when a slimy-looking monster, of which there are quite a few here, happens to lurch unexpectedly toward the camera, or when there are asteroids on view. But the director, Lamont Johnson ("The Groundstar Conspiracy"), treats this more as an action movie than as a cavalcade of gaudy special effects.

The story concerns a handsome hero named Captain Wolff (Peter Strauss), who travels to a plague-infested planet called Terra 11, which even through 3-D glasses looks suspiciously like Monument Valley (some of the movie was indeed shot in Utah). In the twisted dialect of the screenplay, he is an "Earther." He embarks on a mission to rescue three other Earthers, who undoubtedly work as fashion models on their home planet and who have been captured by a mean-tempered lecherous tyrant named Overdog (Michael Ironside). Captain Wolff is helped on his mission by his old buddy Washington (Ernie Hudson) and a squeaky-voiced teen-

age orphan called Niki (Molly Ringwald), who eventually comes to look on Wolff as a partner and a Dad.

A great many mutants, battles, bizarre sets and torture scenes later, the Earth girls are finally rescued. Their names are Nova, Meagan and Reena.

•

"Spacehunter" is rated PG ("Parental Guidance Suggested"). It contains some off-color language and a few sexual innuendoes.

1983 My 21, 29:1

BILL COSBY — "HIMSELF," written and directed by and starring Bill Cosby; director of photography, Joseph M. Wilcots; edited by Ken Johnson and Steve Livingston; produced by Jemmin Inc.; released by Twentieth Century-Fox International Classics. At the Gotham Cinema, Third Avenue and 58th Street. Running time: 105 minutes. This film is rated PG.

"Bill Cosby — 'Himself,' " produced, written and directed by Bill Cosby, is a concert film recording the highlights of four performances given by Mr. Cosby at Toronto's Hamilton Place Performing Arts Center in May 1981.

Like Mr. Cosby, the film is a generous-spirited, low-keyed and occasionally funny ramble through the star's life, especially his apparently happy marriage. The major part of the show is devoted to his confrontations with five children who have not quite driven him crazy as they have provided him with material for his act.

Mr. Cosby is so relentlessly nice that a certain on-screen monotony develops that probably would not be evident if one were seeing him live, on the stage, without the interference of cinema technology. Among the subjects up for discussion are booze, drugs, natural childbirth, dentists and the untrustworthiness of very small kids. One smiles a lot and laughs now and then.

The film opened yesterday at the Gotham Cinema.

•

"Bill Cosby — 'Himself,' " which has been rated PG ("parental guidance suggested"), contains some mildly vulgar words.

Vincent Canby

1983 My 21, 31:5

FILM VIEW

JANET MASLIN

Under the 1983 Chic, Movies Still Leer At Women

With more of James Bond, Superman and "Star Wars" just over the horizon, and with remakes of everything from "Unfaithfully Yours" to "Where the Boys Are" on their way, it doesn't look as though movies are currently offering anything different. Sometimes it even seems an act of faith merely to keep on watching the same old formula films, hoping for something — anything — that's a little bit new.

But new developments, when they do occur, are not invariably occasions for celebration. Last summer there was "Porky's," which may have brought a little novelty to the realm of soft-core exploitation but could hardly be considered an improvement on what had gone before. This year there is "Flashdance," an equally exploitative, infinitely more dishonest movie that epitomizes the newest genre of the moment, and the one that has crept up on us most gradually: progressive-looking porn.

Porn was out of fashion in the post-"Deep Throat" 70's, having been temporarily replaced by equally graphic horror movies and also having arrived at an impasse, since it had gone about as far as it could go. Even in major movies, sex played a less important role than it had in the late 60's and early 70's, when there was a climate of freedom and some pioneering to be done. Also, the women's movement had induced a temporary cautiousness among filmmakers, many of whom must have been uncertain of how to depict sex without offending large portions of the audience. Now that the dust has settled, though, filmmakers are apparently less afraid of feminists. And they've noticed that horror has run its course, paving the way for an updated, postfeminist sex film so modern that it doesn't even require what would seem to be a very basic ingredient: sex itself.

Not even the most obviously exploitative movies for teen-agers, like "Spring Break" (four fun-loving buddies have a hot time in Fort Lauderdale) or "Losin' It" (four fun-loving buddies have a hot time in Tijuana), bother with ordinary old sex any more. They keep busy with beach scenes, wet T-shirt contests and the various other forms of ogling that can be passed off as red-blooded fun. The rites of spring, as depicted in films like these, are cheerful and impersonal, as groups of nubile teens let the mating dance take precedence over mating itself. Real sex is probably more grown-up than any of these movies care to be, and it would call for distinct and individual characters. The new-style porn movie is much more occupied with characters who think, act and travel in groups.

The biggest difference between these films and their forebears is in the attitudes displayed by the girls, who once would have ignored or objected to the ogling but now regard it as sport. Feminist attitudes of the 70's have been transmogrified into a hearty sexual permissiveness, so that the girls (in "Porky's") being peeped on in a locker room wind up having a good laugh over this and get even with a practical joke of their own. In "Spring Break," lest anyone find a wet T-shirt contest for women objectionable, there's a similar contest for men too, and everyone drinks a lot of beer and has a rollicking good time. The feminist message of the 70's has been filtered through the sadistic ethos of the dead-babysitter movie until it now proclaims that women are willing and eager, and that toughness or resistance is simply part of their allure. Whatever you want from her, the male teen-age audience for these movies is being told, she'll go you one better. She wants it, too.

A lot of the success of "Flashdance" is attributable to its soundtrack, which includes original music by Giorgio Moroder that has been supervised by Phil Ramone, and which has already generated a hit title song by Irene Cara. And although the movie, by making the most of its music and its red-hot dancing, takes a lot of its inspiration from "Saturday Night Fever," it's much less of a drama than that film was, and much more of a carefully calculated tease. As directed by Adrian Lyne, "Flashdance" is a girl-watcher's delight, though it masquerades as the tale of an innocent, hard-working welder who reads French Vogue on her coffee breaks at the mill, and who wants nothing more than to make it as a dancer, to express herself, to be somebody.

Why, you may well ask, have the screenwriters seen fit to make beautiful young Alex (Jennifer Beals) a part-time welder? To show that she is a nice, honest, unaffected creature, though everything else about the movie indicates otherwise. Alex is unbelievably coy, whether she's scrubbing the floor in her black beaded evening gown (every frame in this film is a fashion fantasy) or looking astonished when, after a night at the bar in which she dances, somebody tries to jump her in the parking lot.

• • •

The movie even includes scenes of another bar, a strip club called the Zanzibar, which is meant to provide contrast with nice old Mawby's, where Alex and the other dancers dress in their New Wave best and then slither along the stage or douse themselves with water, or even simulate being beaten. (The audience for all this is a group of fellow Pittsburgh welders, who never yell anything rude at the dancers and whose interest in progressive dance and fashion is certainly commendable, if a little bit unlikely.) This, says the film, is how artistic-minded girls express themselves, as opposed to those naughty, old-fashioned tarts down at the Zanzibar. The audience may find this distinction elusive, to say the very least.

On its own terms, which are purely those of an up-to-the-minute girlie film with a good soundtrack, "Flashdance" has turned out to be a crowd-pleaser. The two teen-age boys sitting behind me at a Saturday night show, who had a long talk about a game of strip spin-the-bottle before the movie, were both seeing it for the second time, and they were crazy about Miss Beals, as well they might be. But the annoying thing about "Flashdance" is its ludicrous plot, which creates friends, a beau and a mentor for Alex, as if she were something other than cheesecake. These details are more or less an equivalent for the pin-up caption that tells all about the model's hopes and dreams and hobbies, and they feel entirely phony. The movie turns from sexy to laughable whenever Alex abandons her dancing and posing to throw a pretty tantrum, or to cry over the failure of a friend to win an ice-skating competition or (with about the same degree of emotion) over the death of an old friend.

"Flashdance" doesn't have any sex scenes, incidentally, and it contains virtually no nudity. It doesn't need any of that. It concentrates entirely on soft-core seductiveness, in its very latest version, replete with barbells and leotards and dance routines and styl-

ized, model-like changes of mood. The theater at which I saw it last weekend began the show with a trailer for "Stayin' Alive," which suggested John Travolta might be back soon in a male version of much the same thing. That would be even more of a novelty than "Flashdance," but it wouldn't change the fact that films like these are usually about women. Even if the women are as seemingly modern as the heroine of "Flashdance," even if they look and sound a little more independent-minded than they once might have, the function they're fulfilling on the screen isn't really new. It may have been camouflaged, but at heart it hasn't changed.

1983 My 22, II:21:1

Creatures of Long Ago

RETURN OF THE JEDI, directed by Richard Marquand; screenplay by Lawrence Kasdan and George Lucas; story by Mr. Lucas; director of photography, Alan Hume; visual consultant, Ernest McNabb; edited by Sean Barton, Marcia Lucas, Duwayne Dunham; special visual effects by Richard Edlund, Dennis Muren, Ken Ralston; production designer, Norman Reynolds; costume designers, Aggie Guerard Rodgers, Nilo Rosid-Jamero; sound design by Ben Burtt; music by John Williams; mechanical effects supervision by Kit West; makeup and creature design by Phil Tippett, Stuart Freeborn; produced by Howard Kazanjian; Mr. Lucas, executive producer; Robert Watts and Jim Bloom, co-producers; released by 20th Century-Fox Pictures. At Loews Astor Plaza, Broadway at 44th Street; 34th Street Showplace, near Second Ave.; and Orpheum, Third Ave. at 86th Street. Running time: 2 hours, 13 minutes. This film is rated PG.

Luke Skywalker Mark Hamill
Han Solo .. Harrison Ford
Princess Leia Carrie Fisher
Lando Calrissian Billy Dee Williams
C-3PO .. Anthony Daniels
Chewbacca Peter Mayhew
Anakin Skywalker Sebastian Shaw
Emperor .. Ian McDiarmid
Yoda ... Frank Oz
Darth Vader David Prowse
Voice of Darth Vader James Earl Jones
Ben (Obi-Wan) Kenobi Alec Guinness
R2-D2 .. Kenny Baker
Moff Jerjerrod Michael Pennington
Admiral Piett Kenneth Colley
Bib Fortuna Michael Carter
Wedge ... Denis Lawson
Admiral Ackbar Tim Rose
General Madine Dermot Crowley
Mon Mothma Caroline Blakiston
Wicket ... Warwick Davis
Paploo .. Kenny Baker
Boba Fett Jeremy Bulloch
Oola .. Femi Taylor
Sy Snootles Annie Arbogast
Fat Dancer Claire Davenport
Teebo .. Jack Purvis
Logray Mike Edmonds
Chief Chirpa Jane Busby
Ewok Warrior Malcolm Dixon
Ewok Warrior Mike Cottrell
Nicki .. Nicki Reade
Stardestroyer Controller No. 1 Adam Bareham
Stardestroyer Controller No. 2 Jonathan Oliver
Stardestroyer Captain No. 1 Rip Miller
Stardestroyer Captain No. 2 Tom Mannion
Jubba Puppeteers
 Toby Philpott, Mike Edmonds, David Barclay
Puppeteers
 Michael McCormick, Deep Roy, Simon Williamson, Hugh Spirit, Swim Lee, Michael Quinn, Richard Robinson

By VINCENT CANBY

WILL Han Solo ever fly again or is he forever doomed to remain a wall decoration in the pleasure palace of Jabba the Hutt?

Does Princess Leia do her own hair or does she pay someone to make it look that way?

Who, or perhaps what, is Salacious Crumb?

When will Luke Skywalker become a true Jedi knight?

Where does Yoda do his shopping? ·

Will Darth Vader sacrifice his only begotten son so that evil might triumph? And, speaking of Vader, when he takes off his mask, what is underneath? James Earl Jones? David Prowse? A cantaloupe?

•

All but two of these questions — plus dozens more you never thought to ask — are answered in "Return of the Jedi," the concluding film in George

Carrie Fisher and Harrison Ford in "Return of the Jedi."

Lucas's phenomenally popular space-fantasy trilogy that began triumphantly with "Star Wars" (1977) but slowed down a good deal with "The Empire Strikes Back" (1980).

"Return of the Jedi," written by Lawrence Kasdan and Mr. Lucas and directed by Richard Marquand, doesn't really end the trilogy as much as it brings it to a dead stop. The film, which opens today at Loews Astor Plaza and other theaters, is by far the dimmest adventure of the lot.

All of the members of the old "Star Wars" gang are back doing what they've done before, but this time with a certain evident boredom. They include Harrison Ford (Han Solo), Carrie Fisher (Princess Leia), Mark Hamill (Luke Skywalker), the voice of James Earl Jones (the voice of Darth Vader) and Alec Guinness Ben (Obi-Wan) Kenobi, who died a picture or two back but won't get off the screen.

On hand but unseen are the people who either activate or wear the costumes representing such non-human characters as C-3PO, R2-D2, Chewbacca and Yoda.

The movie also introduces a number of new animated creatures, which are probably already in your corner toy store and will make a mint in subsidiary rights for Lucasfilm Ltd., the "Star Wars" parent company. The most attractive of these are some small, teddy-bear-like creatures called Ewoks, which serve the functions once left to friendly pygmies in old Tarzan movies.

"Return of the Jedi" contains a number of scenes that are the space-fantasy equivalent to local color scenes in travelogues. We see Ewoks dancing; Jabba the Hutt, who looks like a rubber Buddha, as he eyes Princess Leia in a harem costume; plus other assorted creatures that are so without visual character that one remembers only isolated features — teeth, saliva, fur, toes.

The film's battle scenes might have been impressive but become tiresome because it's never certain who is zapping whom with those laser beams and neutron missiles. The narrative line is virtually nonexistent, and the running time, though only slightly more than two hours, seems longer than that of "Parsifal."

For the record, there are two mo-

ments in "Return of the Jedi" that evoke legitimate smiles. One is a chase sequence in which the Ewoks whiz around a redwood forest on jet-propelled air-sleds and the other is a single line of appropriately arch dialogue: "You're a feisty little one, but you'll soon learn respect."

•

"Return of the Jedi," which has been rated PG ("Parental Guidance Suggested"), contains some battles that are more busy than violent and one death scene that evokes no emotional response whatsoever.

1983 My 25, C24:1

Chewing Frogs Legs

HEADS OR TAILS (Pile ou Face), directed by Robert Enrico; screenplay (French with English subtitles) by Michel Audiard; adapted by Marcel Julian, Robert Enrico and Mr. Audiard from the novel "Follow the Widower" by Alfred Harris; director of photography, Didier Tarot; film editor, Patricia Neny; music by Lino Leonardi; produced by Georges Cravenne; presented by Julian and Beverly Schlossberg; released by Castle Hill Productions. At the Embassy 72d Street 1, at Broadway; Running time: 100 minutes. This film is not rated.

Louis Baroni Philippe Noiret
Edouard Morlaix Michel Serrault
Laurence Bertil Dorothée
Inspector Larrieu Pierre Arditi
Chief Inspector Bourgon-Massenet ..Jean Desailly
Senior Detective Lampertuis André Falcon
Detective Maupas Fred Personne
Zep ... Gaelle Legrand
Michele (Baroni's Daughter) Guilhaine Dubos
Baroni's Son-in-Law Bernard Le Coq
Swiss Lawyer Jacques Maury
Dr. Lacazeaux Jean Pierre Helbert

By VINCENT CANBY

PHILIPPE NOIRET, who was so fine in Bertrand Tavernier's "Coup de Torchon," and Michel Serrault, best known in this country for his performances as Zaza in the two "Cage aux Folles" movies, appear to be making the most of a not great provincial meal in Robert Enrico's "Heads or Tails" (Pile ou Face), the French film that opens today at the Embassy 72d Street 1.

The dramatic comedy, set in and around the port of Bordeaux, is about Louis Baroni (Mr. Noiret), an aging, eccentric detective, who sets out to prove that Edouard Morlaix (Mr. Serrault) actually shoved his nagging wife out the window to her death, an

incident the police have officially labeled an accident.

As his investigation proceeds, Baroni develops a sort of fondness for the milquetoast Morlaix, but that doesn't stop him from dogging the poor man's tracks at all hours instead of attending to a far more explosive crime of the moment, which involves drug trafficking and, perhaps, scandal in high places.

Just why Baroni, himself a widower, should take such an interest in Morlaix becomes clear to the audience long before it's supposed to. Mr. Enrico, a French director of the third rank, is not terribly subtle. He pulls his punches so systematically that it becomes virtually the film's style, which Mr. Noiret and Mr. Serrault serve in the broadness of their performances.

Mr. Noiret, his lower lip always at a droop, his hair awry and his clothes unkempt, alternately snarls or behaves with the weariness of a man who, in any other movie, probably wouldn't get out of bed. In contrast, Mr. Serrault plays the murder suspect with a comically overstated fastidiousness. He's always neatly dressed and, though on the defensive, always in charge.

The two actors are full of tricks and mannerisms that, on stage, would get one or the other fired. Mr. Noiret has a way of elaborately understating lines to which Mr. Serrault is meant to respond with some passion. Mr. Serrault, who is almost a foot shorter than Mr. Noiret, reacts by delivering his lines directly to Mr. Noiret's chest.

Each is too good and too witty an actor to be caught chewing the scenery. Instead they chew the dialogue as if the individual lines were skinny frogs legs, savoring bits and pieces of meat wherever they can be found. Neither man thinks that the frogs legs are super, but they are both hungry actors who enjoy such dining, as much for the company as for the food.

Most prominent in the supporting cast is Dorothée, the slim, bright, very pretty young woman who played Sabine in "Love on the Run," François Truffaut's final Antoine Doinel comedy. Here, as a sweet, compassionate television newscaster, she's a delight, but not around long enough. The movie also offers some attractive views of the Bordeaux waterfront.

"Heads or Tails" is a painless way to kill time between appointments.

1983 My 27, C4:5

How to Be a Man

TOUGH ENOUGH, directed by Richard O. Fleischer; screenplay by John Leone; director of photography, James A. Contner; edited by Dann Cahn; music by Michael Lloyd and Steve Wax; produced by William S. Gilmore; Michael Leone and Andrew D. T. Pfeffer, executive producers; released by 20th Century-Fox. At the Criterion, Broadway and 45th Street; Gemini, Second Avenue and 64th Street; and neighborhood theaters. Running time: 106 minutes. This film is rated PG.

Art Long Dennis Quaid
Caroline Long Carlene Watkins
P. T. Coolidge Stan Shaw
Myra .. Pam Grier
James Neese Warren Oates
Tony Fallon Bruce McGill
Bill Long Wilford Brimley
Gert Long .. Fran Ryan
Christopher Long Christopher Norris
Wet T-Shirt Girl Terra Perry
Big John Big John Hamilton
Heckler in Torreyson's Steve Ward
Girl in Torryson's Susann Benn
Tigran Baldasarian Steve (Monk) Miller
Jackhammer Malamud Jimmy Nickerson
Gergor Samsa Rod Kieschnick
Ike Kennedy Preston Salisburya
Mad Dog Redfeather Darryl Poafpybitty
Mando Chandovar Tino Zaragoza

By JANET MASLIN

A CONTEST mentality is peculiarly apparent in "Tough Enough," a very dull boxing movie with no other distinguishing features. The film begins with a wet-T-shirt contest in a country and western bar, and it quickly moves on to something called the Toughman competition, which combines elements of "Rocky" and "Let's Make a Deal." Aspiring Toughmen are summoned into a boxing arena two at a time ("Come on down!" cries an announcer in game-show tones). They slug it out, and then the winner fights another winner, until only the two toughest Toughmen remain. When one of these is victorious, he raises his arms and bounces up and down to a recognizably "Rocky"-like theme. He also wins a big cash prize.

"Tough Enough," which opens today at the Criterion and other theaters, is the story of Art Long (Dennis Quaid), who becomes the Toughman champ, even though he'd rather be a country and western singer, and even though every other Toughman aspirant is noticeably bigger than he. Art's story of personal triumph is not the sort of thing in which audience members can vicariously participate, since it is acted and directed (by Richard Fleischer) in so utterly lifeless a way. Mr. Quaid and a number of the other actors here — Stan Shaw, Pam Grier, Wilford Brimley, Bruce McGill and the late Warren Oates — have been better in other movies.

The screenplay, by John Leone, leaves the characters at a perpetual loss for words. "Well, it's always something," Art's wife says when he comes home with the news that he's been pelted with a hamburger while performing at the country and western bar. When Miss Grier, as the wife of Art's friend, is asked why anyone would enter a Toughman contest in the first place, she replies: "Well, for money. And I guess it just has to do with being male."

•

"Tough Enough" is rated PG ("Parental Guidance Suggested"). It contains some partial nudity.

1983 My 27, C8:1

Shame on Father

THEY DON'T WEAR BLACK TIE (Eles Nao Usam Black-Tie), directed by Leon Hirszman; story and screenplay (Portuguese with English subtitles) by Gianfrancesco Guarnieri and Mr. Hirszman; photography by Lauro Escorel; edited by Eduardo Escorel; music by Radames Gnatalli; an Embrafilm S.A./Leon Hirszman Production. At the Cinema Studio I, Broadway at 66th Street. Running time: 122 minutes. This film has no rating.
Romana Fernanda Montenegro
Otavio Mr. Guarnieri
Tião Carlos Alberto Ricelli
Maria Bete Mendes
WITH Milton Gonçalves, Rafael de Carvalho, Leila Abramo, Anselmo Vasconcelos and Francisco Milani

"They Don't Wear Black Tie" was shown in the 1982 "New Directors/New Films" series at the Festival Theater. Following are excerpts from a review by Janet Maslin that appeared in The New York Times of April 18, 1982. The film opens today at the Cinema Studio I, Broadway at 66th Street.

AT the beginning of the Brazilian film "They Don't Wear Black Tie," a middle-class boy and girl are making plans to live happily ever after. Maria (Bete Mendes) is pregnant by the handsome young Tião (Carlos Alberto Ricelli), and that helps accelerate their plan to rush into marriage. Everything looks rosy. "They Don't Wear Black Tie" is an extremely successful, politically aware drama about how the bloom falls off the rose.

We learn a lot about both families during the part of the story devoted to marriage plans. Maria shares a room with her kid brother, played by the same young actor who played the title role in "Pixote.") Her father is an amiable drunk who is one night killed by a mugger. On Tião's side, both his mother (Fernanda Montenegro) and father (Gianfrancesco Guarnieri) are loving, hard working, interesting and admirable. Maria has many of these qualities herself. Only Tião — bland, nice, good-looking Tião — begins to seem something of a disappointment.

•

The film chronicles the process by which Maria realizes that Tião is not the man she thought he was. Her understanding of Tião's weakness is heightened by the political activity surrounding a local strike, at the factory where Tião, his father and Maria are all employed. When the labor trouble begins, Tião manfully warns Maria that she'd better stay home, exhibiting just the kind of stubborn sexism this courageous heroine refuses to tolerate. Later on, he violates the basic tenets of his upbringing by becoming a scab. And Maria declares that her child will be very, very proud of his grandfather, even if he never has a kind thought about his father at all.

There's nothing either stilted or preachy about the way "They Don't Wear Black Tie" tells its story. The director, Leon Hirszman (who wrote the screenplay with Mr. Guarnieri), keeps the action swift and interesting, and the characters never degenerate into politically commendable puppets.

1983 My 27, C8:5

Perhaps or Never

THE TROUT (La Truite), directed by Joseph Losey; screenplay (French with English subtitles) by Mr. Losey and Monique Lange from a novel by Roger Vaillard; photography by Henri Alekan; edited by Marie Castro-Vazquez; music by Richard Hartley; produced by Gaumont-S.F.P.C.-T.F.I. Delerue. At the Baronet Theater, Third Avenue at 59th Street. Running time: 105 minutes. This film is not rated.
Frederic Isabelle Huppert
Galuchat Jacques Spiesser
Lou Jeanne Moreau
Rambert Jean-Pierre Cassel
St.-Genis Daniel Olbrychski
Mariline Lisette Malidor
Daigo Hamada Mr. Yamagata
Verjon's Father Jean-Paul Roussillon
Gloria Alexis Smith
WITH Ruggero Raimondi and Craig Stevens

"The Trout" was shown at the New York Film Festival in 1982 at Lincoln Center. Following are excerpts from a review by Janet Maslin that appeared in The New York Times on Nov. 1, 1982. The film opens today at the Baronet Theater, Third Avenue at 59th Street.

JOSEPH LOSEY originally hoped to make "The Trout" years ago with a young Brigitte Bardot in the title role of a coldish, bemused, rather predatory country girl. Perhaps Miss Bardot was what he needed, because the character's sexual magnetism and her profound effect on the lives of everyone around her become improbable unless they are very palpably demonstrated.

Frédérique, who is now played by Isabelle Huppert, is at the heart of a story that leaps from France to Japan, from the provinces to the jet set and from the primitive work of trout breeding to the machinations of multinational corporations. Frédérique is the one and only linchpin this story has.

In the novel on which "The Trout" is based, Roger Vailland described "a power struggle that shows itself at every moment in acts and movements of intense clarity, and with such a violence that every living thing is forced to express itself with the utmost precision and elegance."

That elegance is certainly on display in Mr. Losey's film, but the clarity is nowhere to be found. Just as Miss Huppert's wan presence creates something of a vacuum in the title role, so does Mr. Losey's vague, open-ended approach make for a film that is glittering but shapeless. Mr. Losey appears to have worked so hard, so long and so painstakingly that he's reached the point of diminishing returns.

There is so much detail about each of the many characters that it amounts to no details at all. Most of them are first seen in a bowling alley, where they are thunderstruck by the gaminelike qualities of Frédérique, who is wearing a T-shirt that says "Perhaps" on one side and "Never" on the other, as she bowls contentedly in the next lane.

The individual scenes in "The Trout" are so elaborately detailed that the film's parts are much more arresting than the whole. When Frédérique and her homosexual husband, Galuchat, are picked up at the bowling alley by a group of chichi (and unlikely) bowlers, the story becomes a string of encounters, some of them marked by an impertinence that is fresh and funny, even if it doesn't contribute greatly to the central drama.

As much as it is about anything, "The Trout" is about the sexuality that, while never seen on the screen, is an implicit part of the nature of the characters. There is the American matron (a brief cameo appearance by Alexis Smith), who claims to have "made love 33,000 times, in 13 world capitals," never in cities with populations under 100,000.

There is Rambert (Jean-Pierre Cassel), a rich businessman whose pursuit of Frédérique somehow leads him to her husband, and there is Lou (Jeanne Moreau), Rambert's wife, who makes what Mr. Losey has called one of the film's key remarks: "Nowadays, homosexuality and heterosexuality mean nothing. You're sexual or you're not." The film intimates this point much more successfully than it illustrates it.

Mr. Losey, at the age of 73, has no shortage of observations to make, but "The Trout" isn't able to present them in a coherent form. His film is by no means dull, however; it frequently achieves a great stylishness, and it moves very energetically.

1983 My 27, C10:3

FILM VIEW

VINCENT CANBY

The Force Is With Them, But the Magic Is Gone

Riding an M-104 bus up Broadway last week, I overheard two young men, both in their late teens, discussing the imminent release of "Return of the Jedi," the third installment of George Lucas's initial "Star Wars" trilogy. Their excitement was real, you might say palpable, until one fellow suddenly turned pensive. He was disoriented. If he had been five years younger, he would have cried. "What happened in the second one?" he said. "I don't remember it too well. I only saw it once."

To which his friend replied by giving a long, carefully detailed synopsis of "The Empire Strikes Back," describing the various calamities and triumphs of Han Solo, Princess Leia, Luke Skywalker, Darth Vader, Yoda and all of the other creatures, live and manufactured, that have become the principal exports of Lucasfilm, Ltd., Mr. Lucas's own empire.

I must confess I was impressed. I'd just seen "Return of the Jedi" at a press screening and, for the life of me, couldn't exactly remember what happened in it. Of course, I'd only seen it once.

I don't mean that I don't remember bits and pieces of "Return of the Jedi," such as the reconciliation, early in the film, of Han Solo and Princess Leia, after Han has been defrosted from a large lump of — I think — carbon,

and shortly after Luke Skywalker has saved Leia from the clutches of a longish, rectangular shaped creature that has a face but looks more like a lascivious sofa. I also remember the revelations about who is related to whom, involving Luke, Leia and Darth Vader, but that may be because I already knew them or had earlier overheard them on a bus.

Still vivid in my memory, too, is the scene in which Darth Vader finally takes off his mask and we see not James Earl Jones, who has been droning on and on in that mellifluous voice of his through all three "Star Wars" movies, but someone else entirely, though whether the actor is Sebastian Shaw or David Prowse, I've no idea.

Like the other members of the preview audience with whom I saw the film, I feel fondly toward the Ewoks, the race of small, teddy bear-like creatures Mr. Lucas has introduced in "Return of the Jedi," but I didn't once join the other viewers to drool a long, sweetly sighed "Ooooooh" whenever an Ewok did something cute.

Lastly — that is, lastly among the things I best remember — there are the periodic appearances of Alec Guinness as the see-through ghost of the benevolent Ben (Obi-Wan) Kenobi, but that may be because I kept wondering if, when an actor plays a role in which he's transparent, he receives a less substantial salary than when he's opaque.

Otherwise, "Return of the Jedi" is already pretty dim in my memory, more dim than "The Empire Strikes Back," which came out three years ago, and it's nowhere near as present in my thoughts as "Star Wars," which, I must admit, I saw twice, but twice within the first three weeks of its release in 1977.

Let's face it — the magic has gone.

To cite a few small problems: I seldom have any idea where things are happening in "Return of the Jedi." All of the locations — including the moons, the other planets, the death stars and all but the smallest spaceships — look pretty much alike with one exception. The exception is the California redwood forest that is the setting for a quite wonderful chase sequence. The sight of the Ewoks, zipping around those huge, ancient trees on what appear to be jet-propelled air-sleds, is marvelous but, like the rest of the movie, it doesn't lead anywhere.

As I watched "Return of the Jedi" I began to feel a profound sense of dislocation, as if I'd been too long in a state of artificially induced weightlessness. The joys of watching space battles as envisioned by wizards in studios and laboratories are not inexhaustible. It may be that such sequences, which seemed so spectacular in "Stars Wars," have since been too often imitated to hold our imaginations the way they once did.

More troublesome is the film's resolute witlessness. This is not to say that "Return of the Jedi" isn't cheerful. Heaven knows, it never stops winking at us, as if it had a tick. Yet the wit that was apparent in "Star Wars" has changed into into a mechanical kind of facetiousness. It has the manner of a tired convention and is no more or less spontaneous than a telephone operator's instruction, "Have a nice day."

Most troublesome of all is the suspicion that "Star Wars" has not — as many of us originally believed — spawned a new film literature but, instead, a new film conglomerate that, like all major industries, works in completely impersonal ways. It must be significant that having directed "Star Wars" himself, Mr. Lucas assigned Irvin Kershner to direct "The Empire Strikes Back" and Richard Marquand to direct "Return of the Jedi."

Though Mr. Lucas may have overseen all aspects of these productions directed by others, they are not quite his films and not quite theirs. They are assembly line products, stamped with the Lucas approval but not with his passion or jealous commitment. They're toys manufactured according to certain basic specifications.

Exemplifying this impersonality is the increasing emphasis on mechanical marvels-as-characters. The charms of C-3PO and R2-D2, who, in "Star Wars," seemed to be the greatest new comedy team since Laurel and Hardy, are wearing out faster than even those of Harrison Ford's Han Solo, Carrie Fisher's Leia and Mark Hamill's Luke Skywalker, even though the charms of these three human characters have less to do with idiosyncratic performance than with plot function.

We see Han, Leia and Luke as mythic characters reduced amusingly to comic-book terms. However, in "Return of the Jedi," even the moviemakers seem tired of Han, Leia and Luke; otherwise why all of the attention given to the supporting puppets, many of which are so badly lit and photographed that it isn't possible to get any idea of what they're supposed to look like?

I've no doubt that Mr. Lucas will reap another fortune from "Return of the Jedi," but a lot of us hope that he'll control that fortune instead of letting it control him. Maybe it's time he got back to directing movies and stopped fussing with his empire. That, however, is based on the assumption that he wants to direct movies even more than he wants to be a Walt Disney-like mogul for the 80's and 90's — an assumption that may be wrong.

In "Skywalking, the Life and Times of George Lucas," a clearheaded, appreciative but unauthorized biography to be published by Harmony Books in June, Dale Pollock writes, "It's ('Return of the Jedi') his favorite script, although he worries that the more he likes a script, the less popular the film is. He is so fond of 'Jedi' that he even flirted with the idea of directing it. Sanity quickly returned: 'I took one look at the amount of work and thought, Oh, my God, my life is complicated enough.' " ∎

1983 My 29, II:15:1

"RETURN OF THE JEDI"—Mark Hamill as Luke and Carrie Fisher as Leia prepare for derring-do in the third installment of the Star Wars saga.

Dancing to Life

LIEBELEI, directed by Max Ophuls; screenplay (German with English subtitles) by Hans Wilhelm and Curt Alexander, from the play "Liebelei" by Arthur Schnitzler; photography, Franz Planer; editor, Friedel Buchoff; music, Theo Mackeben; executive producer, Fred Lissa; production company, Elite Tonfilm Productions. At the Public Theater, 425 Lafayette St. Running time: 88 minutes. This film is not rated.
Fritz Lobheimer...............Wolfgang Liebeneiner
Christine WeiringMagda Schneider
Mitzi SchlagerLuise Ullrich
Theo KaiserWilly Eichberger
Hans WeiringPaul Hoerbiger
Baron EggerdorffGustaf Gruendgens
Baroness EggerdorffOlga Tschechowa

"Liebelei" was shown as part of the 12th New York Film Festival at Lincoln Center in 1974. Following are excerpts from a review by Nora Sayre that appeared in The New York Times of Sept. 30, 1974. The film opens today at the Public Theater, 425 Lafayette Street.

THE conviction that the past can be canceled out, that it "doesn't count" any more, is one of the illusions that feeds romantic tragedy. That notion is beautifully illustrated in Max Ophuls's adaptation of Arthur Schnitzler's "Liebelei." As elsewhere, Schnitzler also stressed the importance of living in the present, of savoring what may be suddenly snuffed out.

The movie, made in 1932 and set in Vienna, 1910, focuses on a touching love affair between a shy singer (Magda Schneider) and a vulnerable young officer (Wolfgang Liebeneiner) whose feelings surface most sensitively despite all his strict military training. Before they met, he was involved with a married baroness. He breaks with his mistress — but although the liaison is over, her husband kills him in a duel. Evidently, being punished for the wrong thing — or paying for a chapter of life that's past — were recurrent themes of Schnitzler's. And meeting the right person after you've spent too long with the wrong one was the kind of irony that the playwright was fond of exploring.

"Liebele" embodies what Edmund Wilson defined as Schnitzler's gift for "lightly handled tragedy," and Ophuls's own lightness of style is as beguiling here as it later was in Schnitzler's 'La Ronde.'' Amid the waltzes, the cafes, the elaborate staircases and winding back streets, the moments of emotional consequence are marvelously detailed. When the Baron (Gustaf Gruendgens) learns of his wife's adultery, he runs through his own palatial home and glares at the rooms where the couple met in a manner that's truly frightening; later, when he discovers that one of her keys fits her lover's door, he

grinds it to and fro in the lock with outraged bitterness.

Ophuls was at his best when he caused climates of feeling to build or change. As the singer and the officer begin to fall in love, their mutual absorption is subtly conveyed as they dance very slowly to rapid, noisy music — they don't know that they're not with the rhythm. The scene is cleverly contrasted by the next one, in which the officer dances correctly but unenthusiastically with the woman whom he no longer wants. When the hero — celebrating his freedom from the Baroness — romps and fools about with his friends before a party, he and they seem particularly childlike and innocent; hence they (and we) are utterly unprepared for the Baron's sudden, threatening entrance.

The movie makes the code of "honor" appear very stupid — and when another youthful officer protests that any shot that isn't fired in self-defense is "criminal," his rebellion against the military is a denunciation of all senseless duels. All in all, it's a privilege to see a movie that is romantic without being sentimental. Since that distinction is rarely respected now, it's exhilarating to learn what Ophuls achieved more than 40 years ago

1983 My 31, C10:5

No Place Like Home

CHICKEN RANCH, directed by Nick Broomfield and Sandi Sissel; camera, Miss Sissel; edited by Julian Ware; produced by Nick Broomfield; production company, Central Television; a First Run Features Release. At the Film Forum, 57 Watts Street. Running time: 84 minutes. This film has no rating.
The People of the Chicken Ranch.......Themselves

By JANET MASLIN

IN "Soldier Girls," his documentary about female G.I.'s enduring the rigors of basic training, Nick Broomfield offered a relaxed, insightful view of his young subjects and their peculiar camaraderie. In "Chicken Ranch," Mr. Broomfield, along with his co-director, Sandi Sissel, attempts something similar in a very different setting.

This documentary studies a legalized brothel in Nevada, a place that seems more like a modern-day motel or sorority house than an old-fashioned palace of sin. Once the inspiration for "The Best Little Whorehouse in Texas," before it moved to Nevada, the Chicken Ranch now has plastic covers on its furniture, a MasterCard sign on its front door and residents who declare, "We're still ladies, you know, no matter what we do for a living."

Most of the scenes in "Chicken Ranch" take place in the brothel's reception room, where the visitors — a busload of Japanese tourists, in one memorable sequence — watch the prostitutes line up in evening gowns, and then select their partners. The potential for luridness in such episodes is quickly dissipated by scenes in which the prostitutes giggle, compare notes and reveal an unmistakable contempt for their clients.

"The customer is king, you know that," chides Walter, the proprietor of the Chicken Ranch, after the Japanese tourists complain of being treated brusquely. The women nod, but they show no real signs of agreeing with that.

"Chicken Ranch," potentially an exploitative film, winds up a thoroughly depressing one, since it concentrates on those features of the Chicken Ranch that are most sordid and sad.

A few of the clients gave permission to be filmed, and they are seen haggling shamelessly with the women about money. Walter, who is on his best behavior and who makes a sanctimonious speech about the importance of "the urge to promulgate" early in the film, is later seen losing his temper, threatening the film makers and firing Mandy, a chunky blonde who has been a prostitute since she was 13. The women are treated like children by their madam, Fran, who functions as a stern but supportive den mother. And they appear to enjoy her protectiveness. One young woman, an ex-manicurist, is reduced to tears at the thought of leaving the Chicken Ranch after several months' stay, even though she is equally tearful in reflecting on how the Chicken Ranch has affected her.

"Chicken Ranch," which opens today at the Film Forum, presents these scenes in a perceptive but noncommittal way. In the interests of objectivity, Mr. Broomfield and Miss Sissel have left their material somewhat shapeless and presented it without enough of an overview. Only the film's cruelest scenes, such as one in which two of the "girls" are routed out of a sound sleep to serve unexpected customers at the 24-hour-a-day brothel, hint that the Chicken Ranch is anything other than a benign, efficient business establishment, truly a place where (as a song from the Broadway musical has it), "There's nothin' dirty going on." That song, played at the beginning and end of this documentary, is one of the few ironic touches in a film that would have benefited from others.

1983 Je 1, C14:2

One Is Rose-Colored

THE MAN WITH TWO BRAINS, directed by Carl Reiner; written by Mr. Reiner, Steve Martin and George Gipe; director of photography, Michael Chapman; edited by Bud Molin; music by Joel Goldsmith; produced by David V. Picker and William E. McEuen; released by Warner Bros. At the National, Broadway and 44th Street; Beekman, Second Avenue and 65th Street; Art, Eighth Street and University Place; Loews 83d Street, at Broadway and other theaters. Running time: 90 minutes. This film is rated R.
Dr. Michael HfuhruhurrSteve Martin
Dolores BenedictKathleen Turner
Dr. NecessiterDavid Warner
ButlerPaul Benedict
Dr. PasteurRichard Brestoff
RealtorJames Cromwell
TimonGeorge Furth
Dr. BrandonPeter Hobbs
Dr. ConradEarl Boen
Gun SellerBernie Hern
OlsenFrank McCarthy
InspectorWilliam Traylor
FranRandi Brooks
GladstoneBernard Behrens

By JANET MASLIN

WHERE would a man with two brains keep the extra one? Why, in a jar, of course — a jar covered with a straw hat and decorated with a fake mouth, so that it can be taken for romantic rowboat rides and, when the moment is right, given a shy kiss on the lid.

As played by Steve Martin, the title character of "The Man With Two Brains" has his ghoulish and silly sides, that's for sure. But he's also a famous brain surgeon, who wears bunny ears with his operating clothes and who carries around tabloid clippings stating that Dolly Parton wants to have his baby. He's a funny, guileless fellow, so innocent he barely realizes that he's in trouble at his own wedding when the judge says, "You may kiss the bride," and the bride says, "Not now." He can be wonderfully literal at times, as when he pauses while carrying his new bride over the threshold, declaring, "I want this moment to last forever!" Sure enough, the next morning he's still there.

In "The Man With Two Brains," which like "The Jerk" and "Dead Men Don't Wear Plaid," was directed by Carl Reiner, Mr. Martin comes a little closer to finding a film format that suits his endearingly brazen and whimsical talent. His funny new film, which opens today at the Beekman and other theaters, isn't any more consistent than his others have been; if anything, it's less unified than "Pennies From Heaven." But the pacing here is steady even when the plot is not, and Mr. Martin consistently radiates his own weird blend of confidence and humor. One of these days, Mr. Martin and Mr. Reiner may well make a seamless, clever movie together. For the time being, this one is on the slight side, but it has its inspired moments and its not infrequent bursts of real hilarity. That ought to do.

"The Man With Two Brains" has an overcomplicated plot revolving around Dr. Michael Hfuhruhurr, whose name I am not going to spell more than once. Michael is a widower, whose first wife happened to be named Rebecca, and who early in the movie meets, runs over, operates on and marries a seductive beauty named Dolores (Kathleen Turner), all of this in very quick succession. Dolores, a bombshell before the wedding, turns out to be standoffish afterward. And, as Michael reasons, "When a woman who's just had major brain surgery tells you she has a headache, you've got to listen."

Just how Michael squabbles with Dolores, meets a mad doctor (David Warner) who lives in a castle-style condominium ("From the outside, it doesn't look this roomy," Michael says, gazing at the sizable moat) and falls in love with a brain named Anne need not be discussed in detail. What's worth mentioning is the film's hit-or-miss humor, which often has a teenage raunchiness and which works more often than it doesn't, and the cheerfully incongruous pastels of its color scheme. As photographed by Michael Chapman, Mr. Martin may turn up in a lime-colored suit for a meeting with Anne, who is herself a very unbrainlike shade of rose.

This is Mr. Martin's movie, and he brings to it the ingeniously dopey presence that's become his trademark; he easily carries even the most dubious moments in the rather jumbled screenplay, which was written by Mr. Martin, Mr. Reiner and George Gipe. An especially pleasant surprise is Miss Turner, who was so wooden a heroine in "Body Heat" and is such a witty and scene-stealing one here.

1983 Je 3, C8:1

"THE MAN WITH TWO BRAINS"—Steve Martin plays the role of a world-famous brain surgeon in a comedy directed by Carl Reiner and co-starring Kathleen Turner and David Warner.

FILM REVIEWS

FILM REVIEWS

FILM REVIEWS

FILM REVIEWS

FILM REVIEWS

FILM REVIEWS

spire.

Young Mr. Broderick, a Tony nominee for his current Broadway performance in Neil Simon's "Brighton Beach Memoirs," is very serious and grave — and thus very appealing — as the unassuming computer wizard. His David is alarmed and genuinely frightened by the forces he sets in motion, but he is also a bit pleased. He's pleased, that is, until he realizes that the world will probably end about two hours before he has a chance to see his girlfriend, Jennifer (Ally Sheedy), in a brief television appearance.

In addition to Miss Sheedy, who was a bright spot in "Bad Boys" and here succeeds in being distinctive in an ordinary role, the supporting cast includes Dabney Coleman, as a harried computer scientist who suspects David of being a Communist agent, and Barry Corbin, as a short-tempered Air Force general. John Wood, the fine English stage actor ("Travesties," "Amadeus"), plays the not easily actable role of the eccentric genius who originally programmed the computer, which, rather like HAL in Stanley Kubrick's "2001," has taken on a life of its own.

"WarGames," which opens today at the Cinerama and other theaters, leaves one with the nagging suspicion that the possibility of thermonuclear war is worth more thought than has gone into this particular film. In its own jolly way, "WarGames" has made our fears as small and manageable as those concerning some loathesome waxy buildup on the kitchen floor.

•

"WarGames," which has been rated PG ("Parental Guidance Suggested"), contains some mildly vulgar language.

1983 Je 3, C17:1

A Melbourne Wife

NORMAN LOVES ROSE, written and directed by Henri Safran; director of photography, Vincent Monton; edited by Don Saunders; music by Mike Perjanik; produced by Mr. Safran and Basil Appleby; a Norman Films Limited Production; released by Atlantic Releasing Corporation. At the Cinema 1, Third Avenue and 60th Street. Running time: 98 minutes. This film is rated R.
Rose..Carol Kane
Norman..Tony Owen
Norman's FatherWarren Mitchell
Norman's MotherMyra De Groot
Michael..David Downer
Maureen..Sandy Gore
Charles..Barry Otto

INTO the annals of really rotten movie ideas comes "Norman Loves Rose," an Australian Jewish domestic comedy about an infertile young couple and the wife's unusual solution to their problem. After taunting her husband about his inadequacy for a while, she begins an affair with his smarmy, unctuous, 13-year-old brother. A lighthearted theme song attributes the virility of little Norman, who's still in kneepants, to chicken soup.

"Norman Loves Rose," which was produced, directed and in part written by Henri Safran and which opens today at Cinema I, contains some equally entertaining subplots. One is about a playboy dentist who leaves his wife to chase a sex-crazed blonde, while the wife stays home and curses him. Another involves the parents of Norman (Tony Owen) and his older brother, Michael (David Downer). The mother (Myra De Groot) gossips, meddles and overfeeds her family,

while steadily nagging her husband (Warren Mitchell) about his prostate problem.

As Rose, the childless, dissatisfied Melbourne wife with a consuming interest in American soap operas, Carol Kane speaks in a very uncertain Australian-Yiddish accent and is at her most unpleasant when simpering at the 13-year-old-boy. Advertisements for the movie show a drawing of a buxom, pregnant Miss Kane that resembles her not at all, and a likeness of a towheaded boy wearing a baseball cap and glove. Tony Owen, Miss Kane's actual co-star, has brown hair and does not play baseball in the movie.

Janet Maslin

1983 Je 3, C20:5

SALAMANDER, directed by Peter Zinner; screenplay by Robert Katz, based on the novel by Morris West; director of photography, Marcello Gatti; film editor, Claudio Cutry; music by Jerry Goldsmith; produced by Paul Maslansky; released by ITC Films International. At the Sutton, Third Avenue and 57th Street. Running time: 107 minutes.
Bruno ManziniAnthony Quinn
Dante ..Franco Nero
StefanelliMartin Balsam
Lili AndersSybil Danning
Director ..Christopher Lee
MalinowskyCleavon Little
Surgeon..Paul Smith
Elena ..Claudia Cardinale
LeporelloEli Wallach
Roditi ..John Steiner
GiorgioneRenzo Palmer

By VINCENT CANBY

"The Salamander," at the Sutton Theater, is a comatose melodrama about a neo-Fascist plot to take over the Government of Italy. Though it was made in Italy, it is so completely without character, national and individual, that it could have been produced on the Isle of Wight.

It stars Franco Nero, as the Italian intelligence officer who uncovers the

plot, plus Eli Wallach, Anthony Quinn, Martin Balsam and Christopher Lee, as some of the Italians Mr. Nero deals with. Claudia Cardinale, looking frosty and wan, walks on several times in some pretty clothes, and Sybil Danning plays an extremely unlikely Polish agent.

The Robert Katz screenplay, based on a novel by Morris West, is, unfortunately, comprehensible, in large part because the movie is more often narrated than dramatized. Peter Zinner, one of Hollywood's most esteemed film editors ("The Godfather," "A Star Is Born," "The Deer Hunter"), makes his debut as a director with "The Salamander." It's not exactly a feather in his cap or, for that matter, anybody else's.

•

"The Salamander," which has been rated PG ("Parental Guidance Suggested"), contains two totally unconvincing scenes of physical torture.

1983 Je 5, 53:1

THE DIVINE EMMA, directed by Jiri Krejcik; screenplay (Czech with English subtitles) by Zdenek Mahler and Jiri Krejcik; director of photography, Miroslav Ondricek; musical directors, Frantisek Belfin and Josef Chaloupka; produced by the Barrandov Studios, Prague, International Film Exchange LTD. and Goldmine Film Associates LTD. in association with Ceskoslovensky Filmexport; a United Artists Classics Release. At Embassy 72d Street 2, at Broadway. Running time: 107 minutes.
Emma DestinBozidara Turronovova
Victor ..George Kukura
Samuel ..Milos Kopecky
The ColonelJiri Adamira
Singing Voice of Emma Destin
Gabriela Benackova

By JANET MASLIN

As film biographies go, Jiri Krejcik's "Divine Emma" is decorous and rather dull. It depicts the Czechoslovak diva Emma Destin (or Emmy

Bozidara Turzonovova

Destinn, as she is more commonly known) and her activities during World War I. "She was a star in the world of opera and a true patriot of Czechoslovakia," the opening credits proclaim. The film establishes this in a plodding manner that isn't very likely to arouse new interest in Miss Destinn's life, nor liable to tell her admirers anything they don't already know.

"WAR GAMES"—Matthew Broderick and Ally Sheedy are high school students involved in a computer game that brings the world to the brink of war.

66

After a brief prelude glossing over Miss Destinn's triumphs in "Madama Butterfly" and other operas, and briefly showing her recording with Caruso, the film describes her wartime ordeal. She was interned at her Bohemian chateau by the Austrian authorities, after being caught carrying a secret message from America in her fur-trimmed cape. While at the chateau, she bursts into song frequently and suffers through the last stages of a love affair. There are operatic flourishes on the soundtrack and in Emma's conversation, as when she says things like "Poor Tosca, she too thought that love is stronger than death."

"The Divine Emma," which opens today at the Embassy 72d Street theater, stars Bozidara Turronovova, a handsome actress who never appears to be doing her own singing, and, in fact, is not. The singing voice of Emma Destinn is supplied by Gabriela Benackova. It is heard in the opening montage of her greatest performances, and in some closing scenes that show Emma performing for masses of her countrymen, who wear colorful native costumes and who congregate in lovely pastoral settings. Emma herself wears frocks and gowns, not dresses. In a fancy costume drama like this one, mere dresses would never do.

The most noteworthy aspect of "The Divine Emma" is the cinematography, which is by Miroslav Ondricek and provides warm, opulent tones that suit the film's generally pleasant, unsurprising mood.

●

"The Divine Emma" is rated PG ("Parental Guidance Suggested"). It contains some very mild scenes of wartime violence.

1983 Je 5, 54:1

FILM VIEW

VINCENT CANBY

Log of a Voyage Into Murky Waters

What with one thing and another, unseen films accumulate so that, from time to time, it's necessary to spend a day catching up. It's not dangerous duty in any conventional sense. However, when the films aren't great, seeing three or four of them back-to-back becomes a test, a little like being on a submarine cruise under the polar ice cap. Sanity is risked. The following is the log of one such day, Friday, May 27.

Leave port at 11:35 A.M. People with well-ordered lives crowd the streets, getting an early start on a three-day weekend. Arrive, shortly before noon, at the Baronet on Third Avenue at 59th Street to catch the first performance of the opening day of Joseph Losey's "La Truite" ("The Trout"), which was respectfully received when it was presented last fall in the New York Film Festival at Lincoln Center.

I first sit in the smoking section on the left side of the theater but, when a fellow smoking a cigar takes the seat in front, I move to the nonsmoking section — there's nothing like a cigar to make a cigarette smoker feel pure. In the seven minutes before the start of the film I stare at a revolving scratch on the multicolored, kaleidoscopic image that woozily repeats itself on the screen between shows. The house fills up, mostly with senior citizens and what appear to be lone-wolf Losey aficionados.

● ● ●

Twenty minutes into "The Trout," I begin to think longingly of that scratched kaleidoscopic image. It's not as pretty as "The Trout," but it makes as much sense. "The Trout" has an all-star European cast headed by Isabelle Huppert, the Marlene Jobert of the 1980's; Jeanne Moreau, who is for the ages; Jean-Pierre Cassel and Daniel Olbrychski, best known for his Polish films with Andrzej Wajda; plus Alexis Smith in a cameo appearance. The film is based on Roger Vailland's French novel, which I haven't read, which may be part of my problem in attempting to comprehend the movie.

To begin with it seems to be about a pretty young country girl (Miss Huppert) who grows up working on a trout farm where her father and the other lecherous old men fool around with the young girls. Miss Huppert quickly learns how to get what she wants from men without having to do anything except, occasionally, to bare a small breast.

Because she hates men, Miss Huppert marries her childhood sweetheart (Jacques Spiesser), an alcoholic young homosexual who appears to hate men as much as women, except for Isabelle. The couple move to Paris where Isabelle continues to be a contagion, virtually a social disease. Rich men take one look at her and lose their wits. Her victims include Mr. Olbrychski, who lives with a beautiful black fashion model (Lisette Malidor), who shaves her head, which looks as polished as Yul Brynner's, and Mr. Cassel, who is married to Miss Moreau, a deeply unhappy, elementally wise "older" woman.

When Isabelle, a determinedly free spirit, runs off to Tokyo on a short trip with Mr. Olbrychski, with whom she never sleeps, her husband attempts suicide and is nursed back to health by Mr. Cassel, who may want the young man for himself or simply as a means to get to Isabelle. At this point Isabelle starts changing her clothes a lot, becoming increasingly chic, which, in this film, is equated with decadence. Because the film itself is so relentlessly chic, it too is designed to represent decadence, I suppose.

Miss Moreau, who weeps frequently but with discretion, lives in a lovely, ultramodern country house whose architect receives credit in the end titles. She also changes her clothes a lot and swishes around in them in high style, even though unhappy. She's especially unhappy when wearing long scarves, casually draped around the neck and over the shoulder. Luckily she never rides in open roadsters with wire wheels.

● ● ●

As they say at the Ritz, one thing leads to another and before you know it one character has been conked on the head with a log and promptly died. Isabelle winds up running a trout farm in Japan and acting as the head of what seems to be an international conglomerate devoted exclusively to trout.

I'm not kidding. Never has a film by a major director been so abjectly "serious," but what it's being serious about, I've no idea.

The title must be the key. Throughout the film, between present action and flashbacks, Mr. Losey cuts to shots of Isabelle's expressionless face superimposed onto underwater shots of trout swimming in a tank. Sometimes the trout snap at each other, but mostly they just laze around as they wait to be smoked, pan-fried or broiled.

Is Miss Huppert supposed to be trout-like? If so, what, exactly, does it mean to be trout-like? Her dialogue offers no clues. It's pithy and totally mysterious. "Moi, j'aime tout," she says at one point, though she's equally nasty to everyone. "I'm never in a hurry, even on a plane," she says importantly at another point, while sitting on a plane.

Everyone in the movie talks in long, perfectly balanced sentences that are full of the sort of arcane insights that impress French audiences but tend to leave Americans giggling. "Representing the government," one lady says to a former diplomat at a classy luncheon party, "one either repeats oneself or contradicts oneself." Chew on that for a while, folks.

When the lights came up at the end, no one booed or behaved rudely. After so much elegant decadence, I fled by BMT to the nitty-gritty of Times Square.

● ● ●

2:25 P.M. I go to Loews State to see "Spacehunter, Adventures in the Forbidden Zone," a science-fiction fantasy in 3-D advertised as "the first movie that puts you into outerspace." Loews State has a beautiful gold lamé curtain and, thus, no kaleidoscopic images rolling around what would otherwise be a blank screen. Waiting for the movie to start, the audience stares at gold lamé and listens to golden oldies, including "I'm Putting All My Eggs in One Basket."

The director of "Spacehunter" is Lamont Johnson, who has made some dopey movies and some good ones, including "The Groundstar Conspiracy" and "The Last American Hero." This one has one major flaw: You can't see it.

The technology of 3-D — the sort for which one must wear little cardboard glasses — appears to be taking giant strides backward. At Loews State so

little light reaches the screen that the color print I saw looked as if it had been filmed in a sepia-tinted monochrome. The film's titles pop out of the screen all right, but they are unreadable, and the action within the film, incomprehensible. A thick dark cloud seems to have become stuck under the sun.

Three-quarters of the way through the film I throw the glasses away, watch the blurred images on the screen for a few minutes and then depart. If the people at Universal don't come up with a 3-D system better than this, they may as well write off their forthcoming "Jaws 3-D" right now. This kind of 3-D doesn't increase audience participation. It shuts you out. It makes you feel as if you're looking at the world through the wrong end of a telescope.

3:50 P.M. I move up Broadway to the Rivoli Theater, where I have a choice between a horror film, "Gates of Hell," which, from the posters, looks as if it might be a naturalized Italian film with an English-dubbed soundtrack, and "Chained Heat," an all-out exploitation film: "What these women did to get into prison is nothing compared to what they will do to get out." It stars Linda Blair, late of the two "Exorcist" movies, and "Stella Stevens as Taylor." Stella Stevens gets terrible movies but she does get good billing.

It's no contest between "Gates of Hell" and "Chained Heat." The combination of the graphic if meaningless title, Miss Blair and the incomparably funny Miss Stevens is almost irresistible. I should have resisted more.

"Chained Heat" might be fun to see with a gang of friends. There is a kind of appealing bravado in the sight of a lot of mostly pretty, apparently well brought up young actresses strutting around the corridors of this slammer, scantily clad, saying unprintable things, acting butch, and having knife fights even though they look as if the sudden appearance of a cockroach would send them into hysteria. In the role of a crooked assistant warden, Miss Stevens is, as always, attractive, but Miss Blair, who has a steely, hard-as-nails screen presence, is hopelessly miscast as a naïve, innocent victim of the system.

I leave after having seen the end of the film and 45 minutes or so of the beginning. I'm too tired to laugh, too jaded to cry, and depressed. Is this what movies are all about? Each of the three theaters I've been in has been well-filled.

Under ordinary circumstances I would have called it a weekend. Three movies — that is, one complete movie and parts of two others — are more than enough viewing for one day. I plow on, not as confident as I am desperate. I push farther up Broadway to 89th Street and the New Yorker Theater to see John Sayles's "Baby It's You."

Someone up there has been watching me — I am rewarded. I'd been all over the city looking for the bluebird when all the time, just as Maeterlinck taught us, the blue bird had been in my own, Upper West Side backyard.

Even acknowledging the fact that, after what I'd been through, almost any halfway decent movie would look good, "Baby It's you" is something special, better even than "Lianna"

and "The Return of the Secaucus Seven," though without the latter film's very particular social impact.

"Baby It's You" is a delight, an affectionate but unsentimental memoir, set mostly in Trenton, N.J., about the affair of a bright, pretty, middle-class high school girl named Jill (Rosanna Arquette), who wants to be an actress, and a fellow student, a pushy, hair-slicked-back young man nicknamed Sheik (Vincent Spano). Sheik is so exuberantly full of himself that he has no inkling at all that he will forever be a second-rater. As Sheik sees things, there are just three important people in the world, "Jesus Christ, Frank Sinatra and me." He plans to become a singer like Mr. Sinatra but he doesn't pay any attention to his voice — "it's not that important." Style is what counts and, to Sheik, style is being the best dresser on the block.

"Baby It's You" follows the comic course of this sad affair from high school into Jill's college years at Sarah Lawrence, while Sheik is in Miami working as a dishwasher in a nightclub five nights a week and, on weekends, lip-synching Sinatra records to the delight of middle-aged tourists.

"Baby It's You" is set in the late 60's and early 70's but it's too full of contemporary life and emotion to seem nostalgic. It's also clear-eyed and untricky and contains two splendid performances. Miss Arquette's Jill, who looks a lot like a young Rita Tushingham, may or may not become the actress she aims to be, but she visibly grows up in the course of the movie. Also, to her sadness, she grows away from Sheik who, as played by Mr. Spano, becomes an American character of totally unexpected pathos. Once again Mr. Sayles discovers a truth inside a cliché.

Friday was not, after all, a voyage to nowhere. ■

1983 Je 5, II:19:3

Managerial Change

TRADING PLACES, directed by John Landis; written by Timothy Harris and Herschel Weingrod; director of photography, Robert Paynter; music by Elmer Bernstein; produced by Aaron Russo; released by Paramount Pictures. At Loews State, Broadway and 45th Street; Orpheum, Third Avenue and 86th Street; 34th Street Showplace, between Second and Third Avenues and other theaters. Running time: 106 minutes. This film is rated R.
Louis Winthorpe 3dDan Aykroyd
Billy Ray ValentineEddie Murphy
Randolph DukeRalph Bellamy
Mortimer DukeDon Ameche
ColemanDenholm Elliott
OpheliaJamie Lee Curtis
BeeksPaul Gleason
BarneyBo Diddley
WhittingtonAlfred Drake
King KongJim Belushi
PenelopeKristin Holby

By JANET MASLIN

FROM the zany, slapdash comedy of "National Lampoon's Animal House" and "The Blues Brothers," John Landis has graduated to the consummately slick entertainment that is "Trading Places."

This shrewd but very likable movie, more polished than Mr. Landis's others, is geared to a much wider audience than even the sizable "Animal House" crowd. It's a big, lavishly staged farce that aims to please even those who favor sophisticated screwball comedy, a genre to which it is greatly indebted. Indeed, Preston

"TRADING PLACES"—Eddie Murphy, posing as a crippled veteran, tries to con Don Ameche out of some money, while P. Jay Sidney looks on in John Landis's comedy.

Sturges might have made a movie like "Trading Places" — if he'd had a little less inspiration and a lot more money.

●

"Trading Places," which opens today at Loew's State and other theaters, may not be fresh, but it certainly is funny. As played by a strange but well-chosen cast representing several Hollywood generations (from Don Ameche and Ralph Bellamy to Jamie Lee Curtis), it features an amusing turnabout gimmick and perhaps the two actors best suited to bringing it off. Both Dan Aykroyd and Eddie Murphy, the movie's stars, attempt to move beyond their inspired "Saturday Night Live" mugging here, offering sustained characterizations and playing things relatively straight. They've traded some of their facetiousness and a lot of their spontaneity for a less uproarious but more serviceable comic style.

As the tale begins, we are introduced to Louis Winthorpe 3d (Mr. Aykroyd), a rich twit of peerless pomposity. In the elegant, wood-paneled mansion where he resides, Winthorpe is fed breakfast in bed and then

dressed by his British butler (Denholm Elliott), after which he is whisked off to the huge Philadelphia commodity brokerage firm that he heads. But Winthorpe, it soon turns out, does not own the company; he merely manages it. The owners are two extremely sneaky older gentlemen, the Duke brothers. ("Mother always said you were greedy," snaps one. "She meant it as a compliment," the other replies.) And where Winthorpe is concerned, they have a big surprise in store.

The Duke brothers (played delightfully by Mr. Bellamy and Mr. Ameche) make a scientific wager. What would happen if an aristocratic chump like Winthorpe were forced to switch places with the lowliest derelict on the streets of Philadelphia? Would breeding will out, or would the two men take on each other's behavioral characteristics? In the course of theorizing about this, the two brothers encounter Billy Ray Valentine (Eddie Murphy), who is posing as a blind, legless beggar outside their club. This strikes the brothers as being rather enterprising of Billy Ray, and they decide he's the man to be put in Win-

thorpe's handmade leather shoes.

With a magical swiftness, Winthorpe finds himself in jail and Billy Ray has been installed in the mansion, which belonged to the Duke brothers after all. At first, Billy Ray isn't quite used to the place, and so he steals little curios from the drawing room and invites some ghetto friends over for a wild party. It doesn't take long for Billy Ray to scream at these revelers: "Hey, hey, hey — have you people ever heard of *coasters*?" Meanwhile, the newly disgraced Winthorpe has found his way to a pawnshop, where he tries to peddle "the sports watch of the '80's" to a hip proprietor played by Bo Diddley.

•

"Trading Places" is on solid ground while the jokes about this turnabout hold out. Later on, it gets a little shakier as Winthorpe and Billy Ray band together to outsmart the Dukes, since this extravagant-looking film is itself too obviously enamored of wealth and prosperity to rail at the establishment with any real conviction. Everyone in the film aspires to the prosperity that is also so cleverly mocked here. In a particularly inspired touch, Winthorpe's blueblooded fiancée is played by Kristin Holmby, the cool, brunette model who embodies much the same values in her Ralph Lauren ads. Needless to say, she does not exactly stand by Winthorpe when the chips are down.

Mr. Aykroyd and Mr. Murphy aren't required to do much teamwork, but they work together deftly when the occasion arises. Throughout most of the film, they appear in parallel sub-plots, each in a role that appears tailor-made to his talents. Mr. Aykroyd makes a wonderfully convincing stiff, and he plays Winthorpe with a hilarious rigidity that eventually (in a memorable sequence that has Winthorpe masquerading as a mad Santa) heads right over the edge. Mr. Murphy (who gets a hand merely for walking into a bar in this movie, from audiences that doubtless remember his barroom triumphs in "48 Hours") is once again playing a ghetto wise-guy turned well-heeled dandy, and doing it very appealingly. The supporting cast is also quite good, most notably Mr. Ameche, Mr. Bellamy, Mr. Elliott and Miss Curtis, who manages to turn a hard-edged, miniskirted prostitute into a character of unexpected charm.

1983 Je 8, C16:1

THE RETURN OF MARTIN GUERRE, directed by Daniel Vigne; screenplay (French with English subtitles) by Mr. Vigne and Jean-Claude Carriere; director of photography, Andre Neau; edited by Denise de Casabianca; music by Michel Portal; produced by Société Française de Production Cinematographique and Société de Production de Films Marcel Dassault; released by European International Distribution Ltd. At the 68th Street Playhouse, at Third Avenue. Running time: 111 minutes. This film has no rating.
Martin Guerre ...Gerard Depardieu, Bernard Pierre Donnadieu
Bertrande de RolsNathalie Baye
Jean de CorasRoger Planchon
Judge RieuxMaurice Jacquemont
Catherine BoereIsabelle Sadoyan
Raimonde de RolsRose Thiery
Pierre GuerreMaurice Barrier
Young MartinStephane Pean
Young BertrandeSylvie Meda
JeanneChantal Deruaz
GuillemetteValerie Chassigneux
AugustinTcheky Karyo
AntoineDominique Pinon
SanxiAdrien Duquesne
The CureAndre Chaumeau
JacquesPhilippe Babin

By VINCENT CANBY

THIS is, as they say, a true story. In 1549 a young peasant named Martin Guerre disappeared from the small village of Artigat in the foothills of the Pyrenees in southwestern France. He left behind his wife of seven years, Bertrande de Rols, a young son, his parents and other members of a large, comparatively prosperous family.

All had not been going well for Martin, who seems to have been something of a misfit and a joke. He was able to consummate his marriage only after the village priest had exorcised his "demons." The day before Martin vanished, his father had accused him of stealing and selling several sacks of family grain.

•

Eight years later, after his parents had died, Martin Guerre returned to Artigat to reclaim his wife and property. Bertrande greeted him warmly, and no one questioned his identity, though he had changed considerably for the better. The villagers delighted in his stories of army life and were dazzled by the fact that he had learned how to read and write. He fathered two more children, one of whom died, and worked his farm hard and profitably.

This new life was without incident until the appearance in Artigat of three vagabonds, who identified Martin as Arnaud du Thil, a young man who had soldiered with the real Martin who, they said, was alive and living in Flanders. None of this would have caused a serious stir until the day that Martin asked his uncle to account for how he had handled his property while Martin was away. Shortly after, the uncle filed suit against Martin, charging him with being an imposter.

All of this is by way of being an introduction to "The Return of Martin Guerre," a fine new French film that retells the tale that has already served as the basis for novels, plays and operettas. Writers of history and fiction are forever indebted to one Jean de Coras, the Toulouse parliamentary counselor appointed to handle the case and who later wrote a detailed account of Martin Guerre's two trials, which are the center of the film.

"The Return of Martin Guerre," which opens today at the 68th Street Playhouse, is social history of an unusually rich sort. It has a quality of immediacy to equal Le Roy Ladurie's extraordinary book "Montaillou," in which Mr. Ladurie reconstructs the social life of a French village in the 14th century.

As directed by Daniel Vigne, a French film maker new to American audiences, and as written by him and Jean-Claude Carrière, "The Return of Martin Guerre" has the kind of shapeliness that one associates more often with fiction than fact. However, though it resolves the mystery of Martin Guerre, it also leaves room in which to speculate on the nature of life in 16th-century Artigat, on its institutions — especially the church — on family ties, on the sanctity of marriage, property and money.

Gérard Depardieu, who has recently been in danger of becoming a parody of his own striking screen personality, is superb as the returned veteran. The hulking Depardieu looks the way a 16th-century peasant should look or, as Mr. Vigne has said in an interview, he's one of the few contemporary actors who wouldn't be a sight gag in the period costumes. His is a beautifully executed performance, its power always controlled and not, as sometimes happens with Mr. Depardieu, exercised for its own flamboyant sake.

Almost as good and, in her own way, almost as mysterious is Nathalie Baye as the wife, whose fidelity is rewarded when Martin returns as a far better husband than when he left. Chief among the excellent supporting actors are Roger Planchon, who plays Jean de Coras, the investigator who is too wise to be shocked by the trials' revelations, and Maurice Barrier, as the uncle who initiates the court actions against Martin.

Most of the film was photographed in southwestern France, not far from Artigat, which André Neau, the cameraman, has lighted to suggest the tones of amber, olive and umber associated with Bruegel's paintings of 16th-century village life. Michel Portal's original score, like the performances and the dialogue, avoids sounding archaic, without being anachronistic.

Like "La Nuit de Varennes," "The Return of Martin Guerre" is a period film that, without seeming effort, speaks to our moment.

1983 Je 10, C12:5

Dramatic Buildup

HEATWAVE, directed by Phillip Noyce; screenplay by Marc Rosenberg and Mr. Noyce, based on an original screenplay by Mark Stiles and Tim Gooding; cinematographer, Vincent Monton; edited by John Scott; music by Cameron Allan; produced by Hilary Linstead; released by New Line Cinema Corporation. At Cinema Studio 2, Broadway and 66th Street. Running time: 92 minutes. This film is rated R.
Kate Dean...Judy Davis
Steven WestRichard Moir
Peter HousemanChris Haywood
Robert DuncanBill Hunter
Phillip LawsonJohn Gregg
Victoria WestAnna Jemison
Freddy DwyerJohn Meillon
Mick DaviesDennis Miller
Cigar-smoking bodyguardPeter Hehir
Mary FordCarole Skinner
Barbie Lee TaylorGillian Jones
Dick MolnarFrank Gallacher
Annie ...Tui Bow
Jim TaylorDon Crosby
Evonne HousemanLynette Curran

By JANET MASLIN

AN air of portentousness pervades "Heatwave," a compelling but murky Australian drama by the very talented director of "Newsfront," Phillip Noyce. The city of Sydney is heading for a hot, muggy Christmas as the drama unfolds. The Eden Project, an elaborate housing development in which glass-walled apartments will rest on a treelike frame, is scheduled to replace some older buildings downtown. The tenants of those buildings protest vehemently against Eden, which is the work of a developer who "came here with nothing but his nerve and made millions," according to one of his admiring associates. "That's what this country's all about."

"Heatwave," which opens today at Cinema Studio 2, traces the growing attraction between Steven West, the architect who will have his first major design contract with the Eden project, and Kate Dean (Judy Davis), a radical activist committed to seeing the project stopped. Steven seems to lead

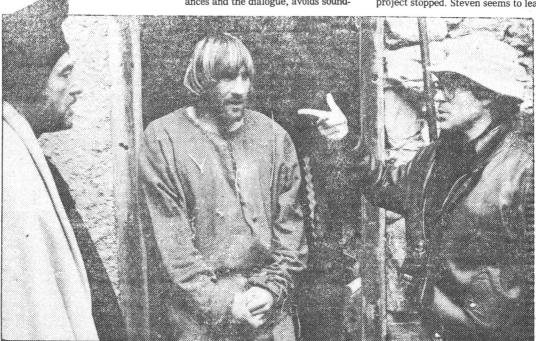

Roger Planchon, Gérard Depardieu and Daniel Vigne, director of "The Return of Martin Guerre"—"Time means nothing. What's important is what the film recounts universally."

a privileged and complacent life as the film begins. But through exposure to the fiery Kate, and through his own re-evaluation of the motives behind Eden, he finds his confidence in the project eroding. "This is not what I've worked for — it's something completely different," he eventually says, looking at the Eden plans that have during the course of the battle changed considerably for the worse.

•

The story of this housing crisis is marked by much violence and confrontation, and it eventually explores the values of everyone involved. Kate at first seems a stubborn, unyielding firebrand, whose idea of protesting Eden is to dress as a waitress at a party celebrating the project, then to throw a tray of shrimp at the developer. But she evolves into a symbol of her community's resistance, and a pawn in a progressively dangerous game. Steven, meanwhile, becomes increasingly critical of the ways in which his city is being remodeled for the benefit of the rich. And the story, of course, has its symbolic dimension, as evidenced by Eden's ironic title and its implications for Australian culture as a whole.

Mr. Noyce weaves and reweaves this material, using occasional slow motion and an eerie musical score. Inevitably, he creates the expectation that events within the film will come to mean more than they finally do. "Heatwave" has its memorable images and a lot of intensity, but it never quite coalesces, ending on an abruptly dramatic note not entirely warranted by what has come before. The sense of danger that Mr. Noyce has created so effectively throughout the film is somehow dissipated in the exaggerated drama of its final moments.

•

The actors are serious and convincing, particularly Richard Moir as Steven and Anna Jemison as the woman who begins to lose him when Kate catches his eye. As Kate, Miss Davis radiates a strength and purity of purpose that outweigh the brittleness after a while. Her performance is as uncompromising as the character she plays, which makes it admirable in ways that don't always work to the film's advantage.

1983 Je 10, C17:4

Palace Life in India

OCTOPUSSY, directed by John Glen; screen story and screenplay by George MacDonald Fraser and Richard Maibaum and Michael G. Wilson; director of photography, Alan Hume; edited by Peter Davies and Henry Richardson; music by John Barry; produced by Albert R. Broccoli; released by M-G-M/U.A. Entertainment Corporation. At the National 2, Broadway and 44th Street; Gemini 1 and 2, 64th Street and Second Avenue; 86th Street Twin 2, at Lexington Avenue; New Yorker 2, Broadway and 88th Street; Bay Cinema, Second Avenue and 31st Street and other theaters. Running time: 130 minutes. This film is rated PG.

James Bond	Roger Moore
Octopussy	Maud Adams
Kamal	Louis Jourdan
Magda	Kristina Wayborn
Gobinda	Kabir Bedi
Orlov	Steven Berkoff
Twin One	David Meyer
Twin Two	Tony Meyer
Vijay	Vijay Amritraj
Q	Desmond Llewelyn
M	Robert Brown
Gogol	Walter Gotell
Minister of Defense	Geoffrey Keen
Gwendoline	Suzanne Jerome

LET'S face it: the sensationally successful and long-lived James Bond films will not quit, and for good reason.

"OCTOPUSSY"—Roger Moore is cast once again as agent 007 in a new James Bond adventure, and Desmond Llewelyn reappears as the quartermaster, "Q."

They are "Star Wars" fantasies for the middle-aged of all ages. "Octopussy," the 13th in the series that began with "Dr. No" in 1961, is actually better than most.

The film, which opens today at the National and other theaters, makes no pretense of being based on anything except the Ian Fleming character and the high good humor and wit of the film makers. Agent 007 faces a succession of unspeakable dangers and obliging women with the absurdly overstated, indefatigable waggishness that has outlived all imitations. Roger Moore, who plays Bond yet again, is not getting any younger, but neither is the character. The two have grown gracefully indivisible.

•

Much of the story is incomprehensible, but I'm sure that the characters include a crazy Soviet general (Steven Berkoff), who is as feared by the Russians as by the Allies; a decadent Afghan prince (Louis Jourdan), who gambles with loaded dice and would not hesitate to blow up the world for personal profit, and the glamorous tycoon of the film's title (Maud Adams), who lives in a lake palace in Udaipur, India, from which she runs an international business empire of hotels, airlines and an East German circus.

The point of any Bond adventure is its incredible gadgets — this film includes a virtually pocket-size jet plane — and the variations worked on the chases, sequences that, like great vaudeville gags, build from one surprise to the next to discover the unexpected topper. In "Octopussy" the best of these are a hilarious, pre-credit sequence in which Bond flees Cuba, another in India where Bond finds himself in league with a tiger in the course of an unusual "shoot" and one across East Germany involving an automobile, a circus train and an atomic bomb.

George MacDonald Fraser, Richard Maibaum and Michael G. Wilson are responsible for the story and screenplay, which was directed by John Glen, who does much better than he did with "For Your Eyes Only." However, the material is markedly better, and the budget seems noticeably larger. Peter Lamont's production design is both extravagant and funny.

"Octopussy," which has been rated PG ("Parental Guidance Suggested"), includes a lot of low-voltage sexual hanky-panky and some scenes of mayhem that are more picturesque than realistically violent.

Vincent Canby

1983 Je 10, C17:4

L'ETOILE DU NORD, directed by Pierre Granier-Deferre; screenplay (French with English subtitles) and adaptation by Jean Aurenche, Michel Grisolia and Mr. Granier-Deferre, from "La Locataire" by Georges Simenon; director of photography, Pierre William Glenn; edited by Jean Ravel; music by Philippe Sardi; released by United Artists Classics. At the Plaza, 58th Street, east of Madison Avenue. Running time: 101 minutes. This film is rated PG.

Madame Baron	Simone Signoret
Edouard	Philippe Noiret
Sylvie	Fanny Cottençon
Antoinette	Julie Jezequel
Monsieur Baron	Jean Rougerie
Moise	Jean-Pierre Klein
Valesco	Jean-Yves Chatelais
Domb	Michel Koniencny
The Engineer	Jean Dautremay
Arlette	Patricia Malvoisin
Nemrod	Gamil Ratib
Jasmina	Liliana Gerace
Albert	Pierre Forget

By JANET MASLIN

The chain of events that leads Pierre Granier-Deferre's "Etoile du Nord" from a bazaar in Alexandria to a boardinghouse in Brussels is not easily explained. It's not meant to be, because the film's early scenes have a deliberately disjointed and mysterious style. But it gradually emerges that Edouard (Philippe Noiret), a Frenchman who has been living in Egypt, has decided in 1934 to return to Europe, and that en route he has met a beautiful young gold digger named Sylvie (Fanny Cottençon).

Because Edouard has nothing to his name except the huge jeweled ring given him by an Egyptian benefactor, he is not Sylvie's first choice for a partner in shipboard romance. A Mr. Nemrod, a wealthy Egyptian businessman, is. But there's something about Edouard's gentle, helpless manner that intrigues Sylvie, and she begins a secret affair with him anyhow. At the same time, Edouard experiences some serious disappointments. He discovers that the ring he has been treasuring is a fake. And Edouard sits by silently in a hotel lobby as an amorous Nemrod escorts both Sylvie and one of her beautiful friends up to his bedroom.

•

Soon after this, Nemrod takes a train from Brussels to Paris, and is murdered en route. Edouard takes the same train and is back in Brussels the next morning, wearing a bloodstained coat stuffed with money and claiming he cannot remember a thing.

Although it generates some suspense over the question of whether or not Edouard has committed this murder, "L'Etoile du Nord," which opens today at the Plaza, isn't strictly a crime story. The events leading up to the fateful train journey (L'Etoile du Nord is the name of the train) are re-

Simone Signoret and Philippe Noiret in a scene from "L'Etoile du Nord."

vealed relatively early in the film. The real heart of the tale is what comes later. Because all the newspapers are featuring the murder prominently, Sylvie advises Edouard to hide at the boardinghouse run by her mother. Sylvie fades from the story soon after this, and her sturdy, sad-eyed mother (Simone Signoret) emerges as an unexpectedly compassionate soulmate for Edouard.

Madame Baron (Miss Signoret) runs the boardinghouse with a stern hand, doling out the better meals to the more prosperous customers and presiding heavily over the humorless dinner-table conversation. The new boarder, with his grand tales of Egypt and his innate sweetness, can't help but arouse the interest of some members of the household, and the enmity of others. The events occurring within the boardinghouse aren't as surprising or indirect as the film's early section, but they are more touching, as played by Miss Signoret and Mr. Noiret. Their mutual understanding is developed slowly and delicately, even if at times it seems mildly anticlimactic.

Here, as in his recent films for Bertrand Tavernier, Mr. Noiret projects an astonishing blend of earthiness and ambiguity. His Edouard has a warmth and apparent guilelessness even at the story's most mystifying moments. Mr. Noiret is an actor with a rare capacity for immediacy on screen, but his very naturalness can make it too easy for a director to leave his character unexplained. To some extent, that's what happens here. "L'Etoile du Nord" is finally rather narrow, for all the meanderings of its

"L'ETOILE DU NORD"—Simone Signoret portrays the keeper of a Brussels boarding house in a murder mystery based on a Georges Simenon novel set in the 1930's. Philippe Noiret co-stars in the film, directed by Pierre Granier-Deferre.

plot, and an essential part of Edouard is somehow missing.

It is to the great credit of Mr. Noiret and Miss Signoret that they find resonance and subtlety in the material, even when the screenplay, an adaptation of Georges Simenon's "Locataire" by Jean Aurenche, Michel Grisolia and Mr. Granier-Deferre, is at its most spare. Mr. Granier-Deferre, who has been adapting Simenon regularly since the 1970 "Le Chat," makes this a carefully appointed and colorful film featuring two memorable performances, if only occasional moments of real passion or surprise.

1983 Je 12, 66:1

FILM VIEW

VINCENT CANBY

Brazil's Passionate Cinema Novo Delivers a Fine Movie

"They Don't Wear Black Tie" isn't a great title. There's something show-offy and a little bit patronizing about it, as if Leon Hirszman, the director, felt he had to introduce the characters and to explain that, unlike the rest of us who dine regularly on caviar and champagne, his people are simple, working-class folk.

However, that's about the only reservation to be expressed about this small, strong, extremely moving and beautifully directed and acted new Brazilian film, which was presented in last year's New Directors/New Films series and, since May 27, has been playing to appreciative audiences at the Cinema Studio.

There's no way of knowing for sure but it may be that a lot of the people seeking out "They Don't Wear Black Tie" share a large, nearly terminal case of the yawns after having seen many of the other movies currently showing. In the context of such high-tech suspense thrillers as "WarGames" and "Blue Thunder," of such exercises in ultrachic-and-corn as "Flashdance" and "Diva," and of the general run of numbingly fancified space fantasies, the deceptively commonplace virtues of this Brazilian film are a tonic. They're a throwback to an earlier kind of filmmaking that now almost seems brand-new.

"They Don't Wear Black Tie" doesn't have the field to itself. There are other such films available, but the truly good, intelligent ones are few — "Tender Mercies," the six one-hour films based on stories by Nadine Gordimer, and, perhaps, "Heads or Tails," Robert Enrico's French comedy that might be a little too commonplace were it not for the extravagant performances by Philippe Noiret and Michel Serrault.

In a class by itself, of course, is "Betrayal," Harold Pinter's adaptation of his own play, directed by David Jones.

Superficially, anyway, "They Don't Wear Black Tie" recalls the politically concerned American cinema of the 1930's and 1940's, a kind of filmmaking that, in recent decades, has virtually ceased to exist except for such isolated works as Martin Ritt's "Norma Rae" and Barbara Kopple's documentary feature, "Harlan County, U.S.A." The principal problem with most of the concerned films turned out by Hollywood before and after World War II — especially those concerned with labor troubles — is that they all tend to look and sound as much alike as the socialist-realist dramas that were made in Stalinist Russia.

Mr. Hirszman and "They Don't Wear Black Tie" represent another cinema tradition entirely, one that is still known as Cinema Novo, though it has now been around for a couple of decades. The Brazilian filmmakers associated with Cinema Novo have only one thing in common — a passionate conviction of the need for economic, social and political reform. That they have managed to survive —

their passion unimpaired — approximately 20 years of contradictory political conditions in Brazil is, in itself, something of a victory for lives of engagement.

What has made this movement so invigorating is the diversity of styles of the filmmakers thus committed. Not many of the films we've seen in this country have been great, but few have been dull.

Among the more memorable have been Nelson Pereira dos Santos's "Vidas Secas," a traditionally poetic view of the wretched lot of peasants in the poverty-stricken northeast; Joaquim Pedro de Andrada's "Macunaima," a furious, slapstick fairy tale that used cannibalism as its metaphor, and the films of the late Glauber Rocha, especially "Antonio das Mortes" and "Black God, White Devil," in which the filmmaker attempted to make cinematic use of Brechtian theatrical devices, with results that were more bewildering than illuminating.

By far the most successful Cinema Novo film imported to date has been Hector Babenco's brilliant "Pixote," the toughest film of its kind since Luis Buñuel's "Los Olvidados."

Mr. Hirszman, who is now in his mid-40's, appears to be somewhat more conventional judging from "The Deceased," made in 1965 and seen here only briefly in 1971, "Sao Bernardo," made in 1972 and released here in 1980, and now "They Don't Wear Black Tie."

Of his three films, by far the most adventurous is "Sao Bernardo," a visually beautiful, unsentimental, neo-Marxist epic about an ambitious, illiterate peasant who, through bribery, murder and hard physical labor, rises to become a quintessential capitalist. The film takes the form of the confession of the former peasant, Paulo Honorio, as, without regrets, he recounts the story of his life. "The truth is," Paulo says at one point, "I never knew which were my good deeds and which were the bad." At another point he says that if he had it all do do over, he knows he would behave exactly as he did before.

Though Mr. Hirszman takes the classical Marxist view of the class struggle, he dramatizes it in terms of individual people in whom the struggles go on. No single label would ever quite define a single character.

"Sao Bernardo" and "They Don't Wear Black Tie" are thus far more complicated in their methods and effects than the politically committed foilms thatn are part of our Hollywood heritage. The class struggles in Mr. Hirszman's films are confused by the fact that the members of one class often have their roots in another. The world he sees isn't black and white but a thousand shades of gray. People aren't evil, but an obsessive respect for money and property is.

"They Don't Wear Black Tie" makes no effort to maintain the sort of detachment expressed by Mr. Hirszman in "Sao Bernardo." The only hint of detachment is in its title, which suggests — incorrectly — that we're about to go on a sightseeing tour among the lower orders. The film, however, doesn't condescend.

Set in a working class neighborhood of São Paulo, it begins as the love story of Maria (Bete Mendes) and Taio (Carlos Alberto Ricelli) who, when they learn that Maria is pregnant, decide they'd better hurry to get married. This news is not greeted with cheers by their families, espcially by Taio's father, Otavio (Gianfrancesco Guarnieri), who works in the same factory that employs Maria and Taio and is aware that a strike is pending. The lovers are, for all practical purposes, penniless.

Otavio, who has spent three years in jail for his political activism, knows that the strike is premature and will be easily crushed. However, even though he has worked against the strike, he is committed to union solidarity and will support the action.

His son Taio is not so committed and, though otherwise honorable in all ways that count in his society, he is willing to listen when he's promised money and advancement if he crosses the picket lines. In the arguments with which Taio comes to defend his actions, which will forever separate him from his family, one can hear the echo of Paulo Honorio as he explains himself in "Sao Bernardo."

"They Don't Wear Black Tie" is full of sentiment but the sentiment is neither cheap nor sentimental. It is well earned through the rigor of Mr. Hirszman's material and his style, which might be described as realism without picturesque frills. That it is set in another part of the same urban forest as Mr. Babenco's "Pixote" is suggested by the appearance of Fernando Ramos da Silva, the extraordinary young actor who plays the title role in "Pixote."

In the Hirszman film, young Mr. da Silva's character is called Blie and is explained as having been adopted by Maria's family. This may or may not be a hint that the ending of "Pixote" is not as bleak as we all thought when we saw it. Pixote, who was last seen headed for a life of major crime, has found a decent home after all.

Most important of all, "They Don't Wear Black Tie" is wonderfully well acted, particularly by Mr. Guarnieri, who not only plays Otavio with immense authority but also collaborated on the film's screenplay with Mr. Hirszman. Almost as good are Fernanda Montenegro, who was the star of Mr. Hirszman's "The Deceased" and who here appears as Taio's staunch mother; Miss Aendes, whose Maria is really the film's political center, and Mr. Ricelli, whose Taio, though a fink, is as moving as any of the other characters in the film.

This, I suspect, is because it's easier for overfed, guilt-ridden members of the bourgeoisie to identify with Taio's pathetically desperate opportunism than with the extraordinary heroism of the others. I also suspect that this was not some accident that happened during production, but that it was a conscious decision on the part of Mr. Hirszman in the way the role of Taio was written and cast. In this insidious fashion the filmmaker persuades us to see his truth not by forcing old agit-prop role-models on us, but by making us squirm through identification with the wrong character.

"They Don't Wear Black Tie" is an extremely good film. ■

1983 Je 12, II:21:1

How to Make Soup

IRRECONCILABLE MEMORIES, by Klaus Volkenborn, Karl Siebig, Johann Feindt; in German with English subtitles; presented in association with Goethe House. Running time: 87 minutes. This film has no rating.
OF JUDGES AND OTHER SYMPATHIZERS, by Axel Engstfeld; in German with English subtitles; at the Film Forum, 57 Watts Street. Running time: 60 minutes. This film has no rating.
WITH: Peggy Parnass

By JANET MASLIN

THE ironies to be found in "Irreconcilable Memories" might have been overpowering, but they have been delicately presented by the three directors of this West German documentary. The 98-minute film, which was directed by Klaus Volkenborn, Karl Siebig and Johann Feindt, consists almost entirely of interviews with two men whose wartime experiences, were greatly at odds.

Ludwig Stiller, a former bricklayer, remembers fighting against Franco's forces in Spain, having left Germany in 1933 after the Nazis came to power, and his subsequent internment in France. Henning Strumpell, the other interviewee, is a career officer who fought on the other side in Spain as a fighter pilot, was a lieutenant colonel in World War II and was promoted to general in the postwar West German Army.

This chillingly understated documentary, which opens today at the Film Forum, visits both men at home. Mr. Stiller lives simply with his wife who has a difficult time making ends meet, and talks passionately of his union sympathies and his opposition to remilitarization after World War II. Meanwhile, the very prosperous General Strumpell sits in a room filled with antiques and family portraits, reflecting on a dutiful and glorious past.

The contrast between the beliefs and recollections of these two men is presented gently, and all the more effectively, amid their personal histories and current circumstances. The conversation is occasionally interrupted by the sight of Mr. Stiller, who walks with some difficulty, wandering through the working-class Remscheid neighborhood in which he lives or of General Strumpell and his wife spending a Frankfurt social afternoon with another, equally privileged couple.

The film begins slowly, with Mr. Stiller's reflections on how soup should be made, but its tension escalates as the two men delve more deeply into their memories. Both seem well aware of the camera and the ways in which this footage may be used, though the men never meet nor address one another directly.

At the film's ending, General Strumpell speaks to the camera a little irritably, saying he hopes this material won't be presented in ways that aren't flattering, and then cordially invites whoever is behind the camera to join him in a toast. It's a measure of the subtlety of the interviews here that the general, revealed here in a human light but hardly a sympathetic one, is unaware that the damage has already been done.

•

On the same bill is "Of Judges and Other Sympathizers," a sketchier documentary making a more direct attempt to link Germany's present with its past. Footage and interviews concerning the wartime judiciary, which handed out death sentences to those who stole shoe polish or told political jokes, are interspersed with allegations about the system of justice in present-day West Germany.

The director, Axel Engstfeld, uses a Jewish court reporter named Peggy Parnass to focus these issues, filming her as she dictates notes and makes accusatory observations. He has also used more than enough footage of his camera surveying the empty corridors of a courthouse, which suggests that his thesis might be more effectively illustrated than it has been here.

1983 Je 15, C17:1

Le Bourgeois Russe

FLIGHTS OF FANCY, directed by Roman Balayan; script (Russian with English subtitles) by Victor Merezhko; camera, Vilen Kalluta; music by Vadim Khrapachov; an Aleksandr Dovzhenko Kiev Film Studios Production; an International Film Exchange/Sovexportfilm Release in association with the Center for Publc Cinema. At the Carnegie Hall Cinema, Seventh Avenue and 56th Street. Running time: 90 minutes. This film has no rating.

Sergei Makarov	Oleg Yankovsky
Larisa	Ludmila Gurchenko
Nikolai Pavlovich	Oleg Tabakov
Nina Sergeyevna	Ludmila Ivanova
Natasha	Ludmila Zorina
Alisa	Elena Kostina
Alisa's friend	Oleg Menshikov
Sveta	Lubov Rudneva
Sculptor	Alexander Adabashian
Director	Nikita Mikhalkov
Trackwoman	Elena Chernyak
Masha	Alyona Odinokova

By VINCENT CANBY

IT may be time for a historian with a passion for mini-projects to do an in-depth piece on the relentless rise of the Soviet Cinema of the Bourgeoisie, exemplified by the 1982 Oscar winner, "Moscow Does Not Believe in Tears," and now by Roman Balayan's "Flights of Fancy," which opens today at the Carnegie Hall Cinema.

Human nature is much the same on both sides of the Iron Curtain, these films tell us at some length. Unfortunately they also tell us at some length that the new bourgeois Soviet film makers are just like ours — 20 to 40 years ago. It is, I suppose, reassuring

"IRRECONCILABLE
MEMORIES"—Ludwig Stiller, a
German leftist who fought beside the
Spanish Loyalists, appears in a
German documentary at the Film
Forum 1.

"FLIGHTS OF FANCY"—Oleg
Yankovsky and Ludmilla Gurchenko
star in a Soviet film about a Moscow
architect afflicted with midlife crises.

to realize that clichés know no bound-
aries in time or space.

⬤

"Flights of Fancy," presented at
this year's Cannes Film Festival, is a
comedy about the midlife crisis of Ser-
gei Makarov, who seems to be at-
tached to — and paid by — an office
where people make architectural
drawings, but he doesn't appear to do
any work there. His boss and his col-
leagues are amazingly indulgent to-
ward his slapdash habits, his lies, his
failed jokes and his constant need of
someone else's cash. They sympa-
thize with the fact that his 40th birth-
day is approaching, which Sergei re-
gards as being worse than cancer.

The film follows Sergei around for
several days as he makes his bad
situation even worse. When his wife
discovers him with a young mistress,
she kicks him out. The young mis-
tress, in turn, falls for a younger man.
Sergei treats his beautiful former mis-
tress, who still loves him and allows
him the free use of her car, as if she
were his grandmother.

The most curious thing about
"Flights of Fancy" is that the film re-
fuses to see Sergei as the tiresome
boor that he is. It spoils him endlessly
while the audience may groan with fa-
tigue. Actually, Oleg Yankovsky, who
plays Sergei, is an attractive perform-
er, as is Ludmila Gurchenko, who
plays the former mistress, but their
material is dreadful.

Even worse are the flights of fancy
of Mr. Balayan, the director, and
Vadim Khrapachov, who wrote the
soundtrack score. They appear to
have overdosed on Fellini films and
learned nothing. There's even a kind

of budget version of the final sequence
of "8 1/2," and the entire movie is
awash in Nino Rota-like music in
which, inexplicably, one discovers the
melody of "Strangers in the Night."

1983 Je 15, C20:5

'Supe' the Intellectual

SUPERMAN III, directed by Richard Lester;
screenplay by David and Leslie Newman; direc-
tor of photography, Robert Paynter; edited by
John Victor Smith; music by Ken Thorne; an
Alexander Salkind Presentation; released by
Warner Bros. At the Criterion Center, Broadway
and 45th Street; Manhattan 1 and 2, 59th Street,
east of Third Avenue; Murray Hill, 34th Street
near Third Avenue; Loews 83d Street Quad, at
Broadway; 86th Street Twin, at Lexington Ave-
nue; Coliseum, Broadway and 181st Street and
other theaters. Running time: 124 minutes. This
film is rated PG.
Superman/Clark KentChristopher Reeve
Gus GormanRichard Pryor
Perry WhiteJackie Cooper
Jimmy OlsenMarc McClure
Lana LangAnnette O'Toole
Vera WebsterAnnie Ross
Lorelei AmbrosiaPamela Stephenson
Ross WebsterRobert Vaughn
Lois LaneMargot Kidder

By JANET MASLIN

SUPERMAN — or "Supe," as
Richard Pryor has taken to
calling him by the end of "Su-
perman III," which opens
today at the Criterion Center and
other theaters — has become a famil-
iar figure on the screen. It's easy to
take him for granted. After all, for
audiences accustomed to intergalac-
tic travel and endless technological
wizardry, someone who can merely
fly through the air to stop a falling
elevator may not be much of a novelty
anymore. Or so the makers of this se-
quel, which is by no means as lumber-
ing as "Superman," but not quite so

sprightly as "Superman II," would
seem to believe.

For a sequel that takes place on
such a grand scale, Richard Lester's
"Superman III" is surprisingly off-
hand. It's almost as though Super-
man, now that all the zap! and pow!
and boom! are behind him, has shed
his comic-book pizazz to become an
ordinary fellow. He seems to spend
much more time as Clark Kent in this
installment, for one thing. For an-
other, even when he does perform
miracles — freezing a lake with his
icy breath in one episode, then flying
the instant glacier to the scene of a
chemical fire — the action is some-
what low-key.

⬤

This film's Superman is a fellow
who, while the fire blazes, will stand
patiently in a laboratory listening to a
scientist explain about the flash point
at which certain volatile substances
will explode. Not that Superman, who
is once again played smashingly by
Christopher Reeve, shouldn't know
his share of chemistry — it's just that
he began as a comic-book character,
and he is one still, for all the extra
color and vitality these films have
given him. He's a man of action, first
and foremost, and there's nothing
wrong with a little cartoonish enthu-
siasm to accompany his adventures.
Yet even the musical flourishes in
"Superman III" are unaccountably
mild.

The film begins with a Rube Gold-
bergish chain of accidents that finally
calls for the presence of you-know-
who, whose arrival ought to be her-
alded with plenty of fanfare. Mr. Les-
ter directs the mishaps with a charm-
ing ease, but he makes Superman's
entrance relatively nonchalant, too.

The screenplay, by David and

Leslie Newman, divides itself be-
tween the activities of the hero and his
new set of adversaries. But this time
the villains have an edge: Richard
Pryor. Mr. Pryor very appealingly
plays a down-on-his-luck dishwasher
(he's first seen in a funny scene on an
unemployment line) who discovers he
has a great talent for computers and
whose abilities are not lost on the
ridiculously rich industrialist from
whose company he has embezzled a
little spending money. (He spends it
on a hot new red convertible, which is
how the industrialist catches him in
the first place.) This wealthy villain,
played nattily by Robert Vaughan, is
so rich he's never worn the same
socks twice. He even has his own roof-
top ski slope right in the middle of
downtown Metropolis, which makes
for one of the film's more inspired
sight gags.

⬤

The film divides itself, a little too
strenuously, between the computer in-
trigue masterminded by Mr. Vaughan
and some of Superman's own story.
As Clark Kent, Superman attends his
high-school reunion in Smallville,
takes up with an old flame, Lana Lang
(Annette O'Toole), while Lois Lane is
on vacation and has a personality
crisis brought on by some quasi-Kryp-
tonite Mr. Pryor has devised. As a
part of this development, he turns up
in a dirty maroon cape, guzzles beer,
chases women and spitefully straight-
ens the Leaning Tower of Pisa. These
imaginative developments culminate
in a nasty fight between Superman
and Clark Kent, who like the good and
bad sides of Darth Vader, must slug it
out for dominance. Along with com-
puter tricks, a number of which "Su-
perman III" also contains, split per-
sonalities seem to be big this summer.
Anyone who has been following the
"Superman" saga will find this in-
stallment enjoyable enough, but some
of the magic is missing. At its best, the
series has relied on humor, enthu-
siasm, big, bold colors and the amaz-
ingly apt presence of Mr. Reeve. This
time, there are Mr. Pryor and the
Grand Canyon and a bit more psycho-
logical dimension, all of them worth-
while but none strictly necessary. His
simplicity remains the Man of Steel's
greatest and most underrated super-
power.

⬤

*"Superman III" is rated PG
("Parental Guidance Suggested"). It
contains some mildly strong language
and some sexual innuendoes during
Superman's dirty-cape phase.*

1983 Je 17, C4:5

FANNY & ALEXANDER, direction and script
(Swedish with English subtitles) by Ingmar
Bergman; cinematographer, Sven Nykvist;
edited by Sylvia Ingemarsson; music by Daniel
Bell, Benjamin Britten, Frans Heimerson, Rob-
ert Schumann and Marianne Jacobs; production
company, Cinematograph AB for the Swedish
Film Institute, the Swedish Television SVT 1,
Sweden, Gaumont, France, Personafilm and
Tobis Filmkunst, BRD; released by Embassy
Pictures. At Cinema I, Third Avenue and 60th
Street and Cinema 3, at the Plaza. Running
time: 190 minutes.
Fanny EkdahlPernilla Allwin
Alexander EkdahlBertil Guve
Carl EkdahlBörje Ahlstedt
JustinaHarriet Andersson
Aron ...Mats Bergman
Filip LandahlGunnar Björnstrand
Oscar EkdahlAllan Edwall
Ismael ...Stina Ekblad
Emilie EkdahlEwa Fröling
Isak JacobiErland Josephson
Gustav Adolf EkdahlJarl Kulle
Aunt EmmaKäbi Laretei
Alma EkdahlMona Malm
Bishop Edvard VergerusJan Malmsjö
Lydia EkdahlChristina Schollin
Helena EkdahlGunn Wallgren
Maj ...Pernilla Wallgren

By VINCENT CANBY

EVEN as you watch Ingmar Bergman's new film, "Fanny and Alexander," it has that quality of enchantment that usually attaches only to the best movies in retrospect, long after you've seen them, when they've been absorbed into the memory to seem sweeter, wiser, more magical than anything ever does in its own time. This immediate resonance is the distinguishing feature of this superb film, which is both quintessential Bergman and unlike anything else he has ever done before.

"Fanny and Alexander" is a big, dark, beautiful, generous, family chronicle, which touches on many of the themes from earlier films while introducing something that, in Bergman, might pass for serenity. It moves between the worlds of reality and imagination with the effortlessness characteristic of great fiction as it tells the story of the quite marvelous Ekdahl family.

•

The time is 1907, and the setting is the provincial city of Uppsala. The Ekdahls represent all that is most civilized about the upper middle classes. The source of their money is commerce, but art is the center of their lives. Long before the start of the film, Oscar Ekdahl, a wealthy businessman, fell in love with and married Helena Mandelbaum, a beautiful stage actress, and built a theater for her in Uppsala.

When the film opens on Christmas Eve, the Ekdahl family is gathering for its annual holiday rituals. Helena, now old but still beautiful and a woman of great style, faces the festivities with less joy than usual. She's beginning to feel her age, and various members of the family worry her. Her eldest son, Oscar, who now manages the theater and whose wife, Emilie, is its star, is not looking well. Even though he's not a good actor, she notes dryly, he is insisting on playing the ghost in their new prouction of "Hamlet."

Her second son, Carl, is a self-pitying failure, a professor, who hates his career and loathes his servile, German-born wife. The youngest son, Gustav Adolf, is a bon vivant, a successful restaurateur with a pretty wife, who loves him dearly and finds his alliances with chambermaids only natural, in view of his inexhaustible sexual appetites.

Among the grandchildren, Helena's favorites are Alexander, who is a very solemn, sage 10, and Fanny, several years Alexander's junior, who are the children of Oscar and Emilie. Also virtually a member of the household is Isak Jacobi, a well-to-do antiques dealer and money lender who, years ago, was Helena's lover and, later, her husband's best friend. Time, in this film, is as soothing as it is relentless.

"Fanny and Alexander" follows the fortunes of the Ekdahl family for a little more than one tumultuous year, during which the ailing Oscar dies of a stroke and the newly widowed Emilie marries the local Bishop, a stern, handsome prelate of the sort who preaches "love of truth" and whose severity his women parishoners find immensely erotic.

Though most of the film is seen through the eyes of Alexander, all of "Fanny and Alexander" has the quality of something recalled from a distance — events remembered either as they were experienced or as they are imagined to have happened. In this fashion Mr. Bergman succeeds in blending fact and fantasy in ways that never deny what we in the audience take to be truth.

"Fanny and Alexander" has the manner of a long, richly detailed tale being related by someone who acknowledges all of the terrors of life without finding in those terrors reason enough to deny life's pleasures.

"It is necessary and not in the least bit shameful," a slightly drunk Gustav Adolf says in the film's final, joyous sequence, "to take pleasure in the little world — good food, gentle smiles, fruit trees in bloom, waltzes." This happy occasion is the banquet celebrating the joint christening of his illegitimate daughter by the pretty chambermaid named Maj and Emilie's new daughter by the Bishop. Says Gustav Adolf: "Let us be happy while we are happy. Let us be kind and generous and affectionate and good."

•

There are repeated references in "Fanny and Alexander" to this "little world," which in the film refers to the Ekdahl's theater, a place of melodrama, comedy, dreams, magic and moral order, in contrast to the increasing chaos of life outside.

The world of "Fanny and Alexander" also has its share of melodrama and comedy and magic and, finally, of moral order as it might be perceived by a teller of fairy tales.

The film's most riveting sequences are those that recount the unhappy adventures of Emilie, when at the request of her new husband, she takes Fanny and Alexander to live in the Bishop's palace, carrying with them no possessions except the clothes they wear on their backs. The Bishop's palace is a great, terrifying prison, a bleak mausoleum dominated by the scolding presences of the Bishop's mother and unmarried sister and haunted by the ghosts of the Bishop's dead wife and two dead daughters. How Fanny and Alexander are eventually rescued, and how the Bishop meets his come-uppance, are among the most wondrous scenes Mr. Bergman has ever realized.

There's also an extraordinary sequence set in Isak's cluttered antiques shop where Fanny and Alexander are hidden after their rescue, especially a scene, set in the middle of the night, in which Alexander is convinced he's having a philosophical discourse with God.

In contrast are the exuberant Ekdahl family get-togethers, the love scenes, the moments of intimacy between Helena and old Isak. The ghost of the dead Oscar turns up frequently, sometimes just looking tired, sometimes worried about the way things are going. In one beautiful moment, Helena, alone in her summer house in the country, looks up to see Oscar watching her. Holding his hand in hers, she says with infinite, sweet sadness: "I remember your hand as a boy. It was small and firm and dry."

The members of the huge cast are uniformly excellent, most particularly Gunn Wallgren, as Helena; Ewa Frolong, who looks a lot like a young Liv Ullmann, as Emilie; Jan Malmjo, as the tyrannical Bishop, the character that, Mr. Bergman says, he most identifies with; Jarl Kulle, as the life-loving Gustav Adolf; Allan Edwell, as Oscar, both living and dead; Borje Ahlstedt, as Carl; Erland Josephson, as Isak; Harriet Andersson, as a ferocious maid who tends the children at the bishop's palace; Pernilla Wallgren, as Gustav Adolf's saucy mistress, and, of course, Bertil Guve, the remarkable young boy who plays Alexander, and Pernilla Allwin, who plays Fanny.

"Fanny and Alexander," which opens today at the Cinema I and Cinema 3, is still another triumph in the career of one of our greatest living film makers.

1983 Je 17, C8:1

FILM VIEW

VINCENT CANBY

30's Comedy In the 80's

In addition to being the funniest American movie comedy of the year to date, John Landis's "Trading Places" has several other things going for it. It establishes Eddie Murphy, who made his big-screen debut late last year in Walter Hill's "48 Hrs.," as the brightest young comic actor to hit Hollywood in a decade. The screenplay, by Timothy Harris and Herschel Weingrod, rediscovers and brings up to date a kind of social awareness that was so important to such comedies of the 30's and 40's as "My Man Godfrey" and "Sullivan's Travels." And it demonstrates that Mr. Landis ("The National Lampoon's Animal House," "The Blues Brothers") is capable of directing a comedy of precise style as well as those that are accumulations of gargantuan, often messy effects.

As Janet Maslin has already pointed out, the basic situation of "Trading Paces" is one that might have ap-

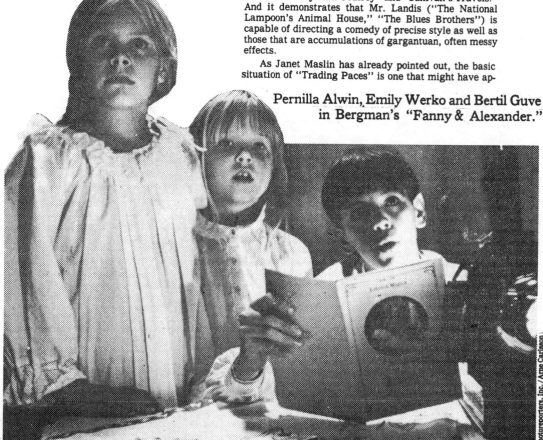

Pernilla Alwin, Emily Werko and Bertil Guve in Bergman's "Fanny & Alexander."

Photoreporters, Inc. / Arne Carlsson

pealed to Preston Sturges. Indeed, it seems such a likely gimmick for a 30's comedy that I'm not at all sure it wasn't, though I can't think of the title.

It's quite appropriate that, behind the opening credits of "Trading Places," we hear the overture from "The Marriage of Figaro," since all that follows has a certain Mozartian balance to it. Here is a comedy about role-changing and disguises. It's also about lifetime circumstances miraculously altered for either good or bad, and about a couple of suave, nasty old codgers who have the money and the power to play God and to effect those miracles.

Even in its casting, "Trading Places" recalls the Hollywood of the long-ago in that it presents Ralph Bellamy ("The Awful Truth," "His Girl Friday") and Don Ameche ("In Old Chicago," "Alexander Graham Bell") as a pair of ferocious, mannerly, multimillionaire-brothers who, to settle a bet, nearly wreck the lives of two innocents.

Randolph Duke (Mr. Bellamy) and Mortimer Duke (Mr. Ameche) are the real powers behind the prestigious Philadelphia brokerage house of Duke & Duke, which is nominally run by their protégé, a WASPy, Harvard-educated numbskull named Louis Winthorpe III (Dan Aykroyd). When Randolph and Mortimer are not arguing about investments, they are arguing about the nature of man. Mortimer is convinced that genes are everything, that good bloodlines will triumph over all adversity. Randolph holds to the theory that man is what his environment makes him.

To put their conflicting theories to the test, they arrange to disgrace poor Louis Winthorpe III, the sort of fellow who has never put toothpaste on his own toothbrush, and to send him out into the world without even his innocuous reputation. They will then replace him as the head of Duke & Duke with a small-time, black con artist named Billy Ray Valentine (Mr. Murphy) who, when first seen, has gotten himself dressed up as a legless, blind, Vietnam vet to panhandle outside Randolph and Mortimer's club.

It is Randolph's conviction that Louis, once deprived of his job, his money and his social position, will turn to a life of crime and degradation and that Billy Ray, late of the ghetto, will rise to meet the challenges of his exalted responsibilities at Duke & Duke.

Initially all seems to go as Randolph has predicted. Louis's fall from grace is made even worse when his former mentors frame him as a drug-dealer in front of his beautiful, snobbish fiancée, Penelope (Kristin Holby). His old school chums drop him. Even his valet, Coleman (Denholm Elliott), professes not to know him. He buys a gun. He drinks too much. He begins to wear clothes of the cheapest fabrics that never match. Then he does the unpardonable thing of showing up at the Duke & Duke Christmas party, dressed in a seedy Santa Claus suit and behaving in a thoroughly disorderly manner.

Randolph and Mortimer, however, haven't reckoned on the love of the good woman who saves Louis from the pits. She is Ophelia, a big-hearted hooker who wears the tiniest of miniskirts, and who is played with marvelous good humor by Jamie Lee Curtis, in her first solid role in a nonhorror movie.

• • •

Billy Ray adjusts to his position as a commodities wizard with somewhat more ease. After one big blowout at which he entertains his former barroom pals at his town house, Billy Ray becomes property-proud. He doesn't want slobs around who put drink glasses on polished wooden table tops and who stub out cigarettes on the Persian carpets. He also settles in happily as a wheeling and dealing capitalist.

According to "Trading Paces," a ritzy environment may not tell the entire story of one's success, but it sure helps. That, however, is only part of the film's story.

Though the premise of "Trading Paces" recalls the kind of social comedies made by Sturges, Frank Capra and Gregory La Cava, its point of view is very much of the existentially hip, rootless 80's. When Billy Ray Valentine and Louis Winthorpe eventually join forces to teach Randolph and Mortimer a lesson, their idea is not to expose the corruption of the system, but to expose only Randolph and Mortimer and, subsequently, to get their own sizable piece of the action.

That the film's final sequence is the least successful suggests an odd truth: that the moral certitudes that were reflected in the comedies of 40 years ago, which usually ended in the pious realization that money isn't everything,

gave those comedies a satisfactory dramatic shape that's often lacking today. There's great pleasure in seeing a couple of big-time con artists like Randolph and Mortimer brought low, but that pleasure is short-lived, not on moral grounds but because Louis and Billy Ray appear to have taught them such a small lesson.

That may be to take "Trading Places" far more seriously than necessary. The film's pleasures are unequivocal, beginning with the lithe, graceful, uproarious performance of Mr. Murphy. His is an infinitely resourceful comic presence in a role that is not much different from the one he played in "48 Hrs." However, Mr. Landis and the writers have also given him the opportunity to do a couple of the burlesque turns of the sort for which he gained his fame originally, on television's "Saturday Night Live." A terrific career is in store.

As the woefully naïve Louis Winthorpe III, Mr. Aykroyd gives the best performance in his film career, which, for a while anyway, seemed inextricably bound up with that of John Belushi. He has some very funny sequences in "Dr. Detroit," though that performance suffers from the character's identity crisis. Louis is a much more cohesive, cleanly defined role — he is the ultimate WASP-boob, but an ultimate WASP-boob who, given a reasonable amount of time, is able to wise up.

I'm not sure that in their younger days Mr. Bellamy and Mr. Ameche ever appeared to be the comic artists they are in "Trading Places," but then in their younger days they seldom received comedy roles as sharply written as those of Randolph and Mortimer Duke. On the screen Mr. Bellamy has had a long and rich career as a character actor, but this is one of the few times, aside from Ernst Lubitsch's "Heaven Can Wait," that Mr. Ameche has been as funny as he is meant to be. When, in response to Randolph's accusation, "Mother always said you were greedy," Mr. Ameche says, "She meant it as a compliment," the line is pure Jack Benny.

Not quite in the same league as "Trading Places," though full of mad flights of fancy that are almost surreal, is Carl Reiner's "The Man With Two Brains," written to the particular measure of its star, Steve Martin, by Mr. Reiner, Mr. Martin and George Gipe, who earlier collaborated on "Dead Men Don't Wear Plaid."

If "Trading Places" has connections to old-time Hollywood social comedies, "The Man with Two Brains" has its connections to the sort of star-comic vehicles that once were tailored to fit the specific talents of Jerry Lewis and Bob Hope, though, for me, Mr. Martin's screen personality isn't easily defined. This is because he is always playing someone who, within the film, has won recognition for some achievement or another, though the audience is invited to see him mostly as a jerk, as in "The Jerk," which was also directed by Mr. Reiner.

This leads to a certain amount of confusion. We laugh at the situations more often than we laugh at or with the star himself. He seems to function as the center of a comic universe, in which the comedy revolves around him without his being seriously involved. He's certainly not a straight man but, as a comedian, he is an invisible comic force.

In "The Man with Two Brains," Mr. Martin plays the world's most brilliant surgeon, a fellow who is to

brains what Dr. DeBakey is to hearts. The funniest character in the film, however, is not the nutty doctor, in whose operating room cats are always running rampant, but Dolores Benedict (Kathleen Turner), the beautiful, predatory woman he marries under the wrongheaded impression that she is just slightly less pure than Orphan Annie. Miss Turner is splendidly farcical in a role that is a send-up of the character she played with such steamy effect in "Body Heat."

Mr. Martin is one of our oddest screen personalities. He's obviously intelligent, witty, talented, engaging, and he makes his living trying desperately to make a fool of himself. The results are disorienting as often as they are funny. ■

1983 Je 19, II:23:1

Overnight Success

PRIX DE BEAUTE, directed by Augusto Genina; written (French with English subtitles) by Mr. Genina, René Clair, Bernard Zimmer, Alessandro de Stefani; photographed by Rudolf Maté, Louis Née; distributed by Nicole Jouve Interama. Running time: 97 minutes. This film has no rating.
A CONVERSATION WITH LOUISE BROOKS, directed by Richard Leacock; photographed by Sandy Dannunzio; made for German television. At the Film Forum, 57 Watts Street. Running time: 23 minutes. This film has no rating.

THE Film Forum's new program, which opens a three-week engagement today, is for dedicated film students, amateur as well as professional: the New York theatrical premiere of "Prix de Beauté," a not-great but historically important film made by the now-legendary Louise Brooks in Paris in 1930, plus "A Conversation with Louise Brooks," a 23-minute interview with Miss Brooks conducted by Richard Leacock at her Rochester apartment in 1974.

"Prix de Beauté" is not a film to compare with Miss Brooks's two G. W. Pabst classics, "Pandora's Box" (1929) and "Diary of a Lost Girl" (1929), or with her two best-known Hollywood films, Howard Hawks's "Girl in Every Port" (1928) and William Wellman's "Beggars of Life" (1928).

•

The French film, directed by Alberto Genina and listing René Clair among its writers, is thin stuff, a romantic melodrama about a pretty Parisian typist (Miss Brooks) who, against the wishes of her jealous, macho lover, enters and wins a beauty contest that will make her an international movie star, literally overnight. The entire point of the film is its heavily ironic fade-out sequence, set in a private projection room, in which the image of the new star sings — with a voice actually supplied by the young Edith Piaf — over the recently murdered corpse of the actress on the screen.

Miss Brooks is a lovely, unusually idiosyncratic screen presence but the film is something of an effort to sit through. It's not a silent but it's not yet a real talkie. The use of a soundtrack seems to have made it necessary to speed up the screen action so that everything is just a little out of sync with life. Miss Brooks's French dialogue has been dubbed by a French actress and there are virtually no sounds on the soundtrack except those that are absolutely essential to the telling of the story. Still, the film offers the opportunity to see Miss Brooks at the height of her curiously short career.

"PRIX DE BEAUTE"—Louise Brooks plays a Parisian typist who wins a beauty contest and must choose between romance and a career.

The Leacock interview is interesting as far as it goes, but it has the manner of something truncated. Miss Brooks answers the questions more fully and with more zest than the comparatively perfunctory questions seem to deserve. Even at the age of 68 she comes across as the bright, articulate, amused, uncompromising individualist who, long before she was 30, turned her back on movies to lead her own life — and who has lived long enough to write some of the most perceptive pieces ever written about movie-making, acting and Hollywood manners of the 1920's.

Obligatory as supplementary reading for this program is "Lulu in Hollywood," a collection of some of Miss Brooks's pieces, published by Knopf last year, and the late Kenneth Tynan's fine profile of Miss Brooks, which is contained in his "Show People," published by Simon and Schuster in 1979.

Vincent Canby

1983 Je 22, C15:3

Law and Order?

THE SURVIVORS, directed by Michael Ritchie; written by Michael Leeson; director of photography, Billy Williams; production design, Gene Callahan; film editor, Richard A. Harris; music by Paul Chihara; costumes, Ann Roth; produced by William Sackheim; a Rastar-William Sackheim Production; released by Columbia Pictures. At Loews State, Broadway and 45th Street; Tower East, Third Avenue and 71st Street, and other theaters. Running time: 102 minutes. This film is rated R.
Sonny PalusoWalter Matthau
Donald QuinelleRobin Williams
Jack LockeJerry Reed
Wes HuntleyJames Wainwright
Candice PalusoKristen Vigard

By VINCENT CANBY

WITHIN the first 15 minutes of Michael Ritchie's "Survivors," a comedy that is less black than severely mottled, a lot of peculiar things happen, some of them quite funny.

Donald Quinelle (Robin Williams), a neatly dressed junior executive, is ushered into the company board room, which is empty except for the boss's parrot. The parrot promptly dismisses him. "A bird can't fire me," Donald screams at the secretary sitting outside. "I'm upper management." The secretary whips out a small pistol and aims it at Donald. "You better believe it," she says firmly.

Almost at the same time, Sonny Paluso (Walter Matthau), the owner of a service station, is being told by telephone that his station is being closed. Years of loyal service mean nothing — the economic situation being what it is. Two minutes later, the entire service station goes up in a giant, surprisingly nonfatal explosion, the result of a cigarette carelessly dropped by the same Donald Quinelle who has just been dismissed.

Shortly after that, Donald and Sonny, who don't yet know each other, have made their separate ways to a highway diner where each, sitting alone, is thinking nasty thoughts about fate. A holdup man enters, his face hidden in a black hood, starts saying rude things and pointing his gun around. Donald and Sonny, each fed up with life in general, make a crazy attempt to disarm the bandit, which they do, but Donald gets a slug in the shoulder as the bandit flees. For about five minutes, the two men are hailed as heros.

After this promising beginning, "The Survivors" is all downhill, largely because Michael Leeson's screenplay has no particular point of view about anything. It refuses to identify itself either as a straight comedy or as a satire, though it dabbles in both.

Donald, the outraged private citizen, suddenly becomes a law-and-order fanatic. He leaves his pretty, sensible fiancée and joins a paramilitary commune in Vermont, where, for a hefty fee, people are rigorously trained by an obvious nut on how to prepare themselves for the collapse of civilization and the new Dark Ages.

In the meantime, the bandit, who is named Jack (Jerry Reed), is threatening to murder both Donald and Sonny for having fingered him for the cops. Jack, you see, is also out of a job and desperate. Having been let go as a mob hit man, he has been reduced to holding up diners that serve terrible coffee. For the purposes of the comedy, we are meant to believe that the three men actually have a lot in common. That they clearly don't have anything at all in common, either as characters or actors, leaves "The Survivors" with no place to go.

The film, which opens today at the Loews State and Tower East Theaters, expresses a vaguely liberal point of view, but not even this is consistent. It is, rather, middle-class safe. This is most apparent at the end, when Mr. Matthau, who is gallant to a fault as an actor, must deliver a foolish, platitudinous speech on America's ability to deal with its problems peaceably, something that everything else in the movie denies.

Mr. Williams does a number of his hysterical, overwrought comedy turns that don't easily fit into the comparatively straight comedy that Mr. Matthau is playing. Most of the time Mr. Matthau stands around watching the others, being patient and only occasionally appearing to be bored. Mr. Reed, whose role makes no sense at all, looks bewildered.

Most astonishing is that a director of Mr. Ritchie's taste and talent ("Semi-Tough," "Smile" and "The Candidate") could have allowed a project of such utter foolishness to get to the point that it was actually filmed. A lot of money has been spent on the first-rate cast and on what appears to have been a long location trip

Doreen	Annie McEnroe
Betty	Anne Pitoniak
TV Station Manager	Bernard Barrow
Jack's Wife	Marian Hailey
Detective Matt Burke	Joseph Carberry
Wiley	Skipp Lynch
Waitress	Marilyn Cooper

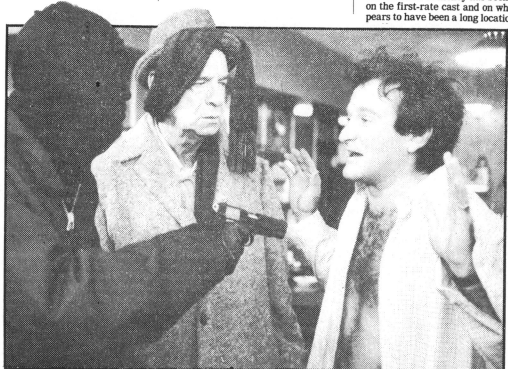

"THE SURVIVORS"—A hooded, pistol-pointing Jerry Reed menaces Walter Matthau and Robin Williams, portraying two victims of contemporary unemployment in Michael Ritchie's film.

in Vermont, seen in spectacularly photogenic, Christmas card-like winter scenes.

No one seems to have paid any attention to the screenplay or to have considered the awful truth that Mr. Matthau and Mr. Williams, each performers of great charm, don't play together very well. They belong to different dimensions of time and reality.

1983 Je 22, C20:6

Surreal History

THE DRAUGHTSMAN'S CONTRACT, directed by Peter Greenaway; screenplay by Mr. Greenaway; photography by Curtis Clark; edited by John Wilson; music by Michael Nyman; produced by David Payne; production company, the British Film Institute in association with Channel Four Television. At Cinema 2, Third Avenue and 60th Street. Running time: 103 minutes. This film is not rated.

Mr. Neville	Anthony Higgins
Mrs. Herbert	Janet Suzman
Mrs. Talmann	Anne Louise Lambert
Mr. Talmann	Hugh Fraser
Mr. Noyes	Neil Cunningham
Mr. Herbert	Dave Hill
Mr. Seymour	David Gant
The Poulencs	David Meyer and Tony Meyer
Mr. Parkes	Nicholas Amer
Mrs. Pierpoint	Suzan Crowley
Mrs. Clement	Lynda Marchal
Statue	Michael Feast
Philip	Alastair Cummings
Mr. Van Hoyten	Steve Ubels
Augustus	Ben Kirby

"The Draughtsman's Contract" was shown as part of the 20th New York Film Festival at Alice Tully Hall. Following are excerpts from a review by Vincent Canby that appeared in The New York Times on Oct. 2, 1982. The film opens today at the Cinema 2, Third Avenue and 60th Street.

"THE DRAUGHTSMAN'S CONTRACT" may well be cinema's first Restoration comedy-mystery. It's a none-too-solemn, enigmatic tale of murder set in a great English country house in 1694, when morals among the newly rich were as loose as absolutely possible and manners were mad mannerisms of dress, speech and behavior.

Peter Greenaway creates an extraordinarily detailed picture of a historical period, not as it was, but as it is imagined by a somewhat surreal artist today. He's also a wizard with a budget. Working with some $500,000 provided by the British Film Institute in association with Channel Four Television, he has made an astonishingly elegant film, and one that is as mind-bendingly rich to listen to as to see.

To the film's collection of schemers, dupes and delighted voyeurs, words are weapons and the complete sentences — in which the characters always speak — are battle plans. The screenplay is as dense with bossy epigrams as the magnificent English landscape is lush with foliage of every conceivable shade of green.

•

The draughtsman of the title is a certain Mr. Neville (Anthony Higgins), an ambitious, handsome young man who makes his living by traveling from one country house to the next, executing bloodless drawings of the property in return for modest fees and the hospitality of the house.

Anthony Higgins, who plays the protagonist in "The Draughtsman's Contract."

At the start of "The Draughtsman's Contract," Mrs. Herbert (Janet Suzman) and her daughter Mrs. Talmann (Anne Louise Lambert) are pleading with Mr. Neville to stay with them at their country house to do a series of drawings to present as a surprise to Mr. Herbert, who will be away on business in Southampton during that time.

After much sparring, he agrees, but only on the condition that in addition to his fee and the usual hospitality, Mrs. Herbert also agrees to give him her favors when he sees fit. Almost swooning at the awfulness of it all, Mrs. Herbert promptly accepts.

Mr. Neville is proud and tyrannical in all things. When he draws, he demands that the landscape be immaculate, with no member of the household or its staff in his line of vision. He is somewhat more tolerant of the sheep. He does his perfectly chilly, technically correct drawings initially unaware of the peculiar details that are creeping in, an unexplained jacket here, a ladder to a second-floor window there.

Not until the very forward Mrs. Talmann, who is as sexually starved as her mother, points out these mysterious details does Mr. Neville take notice. It's just possible, Mrs. Talmann points out, that these are hints of some dreadful "misadventure," namely her father's murder, and that the artist could possibly become "an accessory to the misadventure."

•

Mr. Neville is intrigued but too self-assured to worry, even when Mrs. Talmann more or less blackmails him into making a contract with her similar to the one that the draughtsman has with her mother. He enjoys himself immensely without ever suspecting that he has become a victim in the age-old war of the classes.

Mr. Greenaway recounts all this coolly, with an eye for detail as keen as the draughtsman's, but also with a number of not immediately explainable images that are simply absurdist. The performances are as comically arch as the material, particularly Miss Suzman's, Miss Lambert's and Mr. Higgins's. Though the settings and landscapes are nothing less

than opulent, the excellent photography by Curtis Clark is spare, unfancy, unhackneyed.

Mr. Greenaway is not Congreve, nor does he pretend to be. "The Draughtsman's Contract" is fun not because it is an imitation of anything, but because its sensibility is that of a 20th-century social satirist. Mr. Greenaway is an original.

1983 Je 22, C26:4

Proto-Fassbinder

SHADOW OF ANGELS, directed by Daniel Schmid; screenplay (German with english subtitles) by Mr. Schmid and Rainer Werner Fassbinder, based on a play by Mr. Fassbinder; director of photography, Renato Berta; edited by Ila Von Hasperg; music by Peer Raben and Gottfried Hungsperg; produced by Michael Fengler and Jordan Bojilov; production of Albatros, Munich, and Artcofilm SA, Geneva. At the Bleecker Street Cinema, 144 Bleecker Street. Running time: 108 minutes. This film has no rating.

Lily Brest	Ingrid Caven
Raoul	Rainer Werner Fassbinder
The Real Estate Mogul	Klaus Löwitsch
Frau Muller	Annemarie Duringer
Muller	Adrian Hoven
Chief of Police	Boy Gobert
Kleiner Prinz	Ulli Lommel
Zwerg	Jean-Claude Dreyfus
Emma	Irm Hermann
Marie-Antoinette	Debria Kalpataru
Oscar	Hans Gratzer
Mann Thomas	Peter Chatel
Violet	Ila Von Hasperg
Tau	Gail Curtis
Olga	Christine Jirku
Jim	Raul Gimenez
Hans Von Gluck	Alexander Allerson
Hellfritz	Harry Baer

ANYONE interested in the kind of theater in which the late Rainer Werner Fassbinder worked might want to make an effort to see "Shadow of Angels" ("Schatten der Engel"), which opens today at the Bleecker Street Cinema. The 1976 German film, directed by Daniel Schmid, is based on a Fassbinder play, adapted by Mr. Schmid and Mr. Fassbinder, who also plays a small role in it.

"Shadow of Angels" is an intensely solemn, diadactic, declamatory work about the sins of capitalism, the awfulness of life in general and the terrible things that happen to actors when they must talk in fruity aphorisms.

•

Lily Brest (Ingrid Caven) is beautiful but a total failure as a streetwalker, possibly because she is too skinny and too chic looking to attract the sort of gents who favor streetwalkers. When, at the end of the day, she goes home empty-handed, Raoul (Mr. Fassbinder), her sour husband, lets her warm up for a few minutes before sending her out into the cold again. "Beat me," says Lily. "Beat you!" Raoul says, as affronted as only an indifferent husband can be. "Beating means love."

Back on the street, Lily and her pals trade girl-talk. "A healthy life is like dew on Judgment Day," says one. Says another, "When no one sings, silence reigns."

Lily's fortunes improve when she is picked up by a rich Jewish real-estate operator (Klaus Löwitsch), who pays her not to have sex with him but to listen to him talk. His conversation, which is mostly about the crookedness of the system by which he benefits, isn't great, but it's more interesting than random thoughts about dew on Judgment Day. One things leads to another. Raoul enters into a joyless homosexual liaison, and Lily receives her fondest wish, which I can't reveal. I can say, however, that she feels guilty because her father, a female impersonator, was a Nazi who sent Jews to the gas chambers.

Apparently, some critics have interpreted the film as being anti-Semitic for its presentation of the real-estate tycoon as a crook. Though some anti-Semitic remarks may not have been translated by the film's English subtitles, this fellow, played with great charm by Mr. Löwitsch, is about the only recognizable human in the film.

Some of this film's social and political concerns were later to turn up in far more cogent and complex fashion in Mr. Fassbinder's later classics, "The Marriage of Maria Braun" and "Lola." In "Shadow of Angels," the talk is either bloated or dull. Miss Caven looks terrific, and the physical production has the spare elegance of a very handsome stage production.

•

On the same bill is a 1981 short by Jean-Luc Godard, "Letter to Freddy

Bauche,'' in which, in his usual paradoxical way, Mr. Godard explains why he finds it impossible to carry out his commission to make a film about the 500th anniversary of Lausanne, which, of course, ''Letter to Freddy Bauche'' is. The film, dedicated to Robert Flaherty and Ernst Lubitsch, is small enough to look like a throwaway item, but it's still vintage Godard.

Vincent Canby

1983 Je 24, C8:1

Weak Pitching

YELLOWBEARD, directed by Mel Damski; screenplay by Graham Chapman, Peter Cook, Bernard McKenna; director of photography, Gerry Fisher; film editor, William Reynolds; music by John Morris; produced by Carter De Haven; released by Orion Pictures. At Paramount, Columbus Circle; Tower East, 72d Street and Third Avenue and other theaters. Running time: 101 minutes. This film is rated PG.

Yellowbeard	Graham Chapman
Moon	Peter Boyle
El Segundo	Richard Cheech Marin
El Nebuloso	Tommy Chong
Lord Lambourn	Peter Cook
Gilbert	Marty Feldman
Dan	Martin Hewitt
Dr. Gilpin	Michael Hordern
Commander Clement	Eric Idle
Betty	Madeline Kahn
Captain Hughes	James Mason
Blind Pew	John Cleese
Mr. Crisp and Verdugo	Kenneth Mars
Flunkie	Spike Milligan
Lady Churchill	Susannah York
Lady Lambourn	Beryl Reid
Queen Anne	Peter Bull

By LAWRENCE VAN GELDER

IF pitching, as Connie Mack once said, is 75 percent of baseball, what value might be assigned to a script destined to serve an extensive assortment of comic actors?

For an answer, consider the pirate movie ''Yellowbeard,'' opening today at the Paramount, Tower East and other theaters, as the vehicle for a trans-Atlantic cast starring Graham Chapman, John Cleese and Eric Idle of the Monty Python troupe, Cheech and Chong, Peter Cook, Peter Boyle, Madeline Kahn, Kenneth Mars, Spike Milligan and Marty Feldman, who died last year while in Mexico City making the movie.

All these frequently ebullient, irreverent zanies are tossed — together with such customarily more staid types as James Mason, Susannah York, Beryl Reid and Peter Bull — into a tale of the quest for treasure cached in 1687 on a tropical island by the bloodthirsty Yellowbeard (Graham Chapman), before his incarceration in London.

Once Yellowbeard breaks out of prison, 20 years later, an assortment of old enemies and their henchmen, as well as the Queen's Navy, Yellowbeard's putative son, Dan (Martin Hewitt), and the boy's mother (Miss Kahn) all take to the high seas as part of the effort to find and take possession of the plunder.

Despite Yellowbeard's doubts about Dan's true lineage (he's more interested in gardening than killing), the young man is essential to the venture because his mother has had the treasure map tattooed on his head.

The script that propels these principals is credited to Graham Chapman of the Pythons; Peter Cook, who first came to prominence in ''Beyond the Fringe,'' and Bernard McKenna.

They clearly have no reservations about sending up pirate movies, royals and British prisons. And while their writing offers an occasional chuckle — mainly in the form of insult disguised as obsequiousness in ad-

Graham Chapman playing the title role of ''Yellowbeard.''

dress (''your holy ruthlessness,'' ''your molestation'') or an occasional play on words (''acute 'earing' '' mistaken for a reference to jewelry), the frequency of the wit tends to be intermittent and of varying quality and, at its best, to be reminiscent of superior efforts in Python movies.

As for that other element of the script — the action — under the direction of Mel Damski, it tends mainly to plod, especially between the time the rival factions set sail and their arrival on the treasure island.

What ''Yellowbeard'' establishes is that for even the funniest of performers, a good script may be as essential as pitching is to baseball.

●

The PG (''Parental Guidance'') rating of ''Yellowbeard'' appears attributable to an assortment of four-letter words, dismemberments, torture, killings and jests about rape.

1983 Je 24, C10:2

Beyond Twilight

TWILIGHT ZONE — THE MOVIE, created by Rod Serling; music by Jerry Goldsmith; produced by Steven Spielberg and John Landis; released by Warner Bros. At RKO Twin, Broadway and 45th Street; Sutton, Third Avenue and 57th Street; 34th Street Showplace, near Second Avenue; New York Twin, Second Avenue and 66th Street and other theaters. Running time: 102 minutes. This film is rated PG.

PROLOGUE AND SEGMENT 1

Written and directed by John Landis; director of photography, Stevan Larner; film editor, Malcolm Campbell.

Passenger	Dan Aykroyd
Driver	Albert Brooks
Bill	Vic Morrow
Larry	Doug McGrath
Ray	Charles Hallahan
Bar Patron	Steven Williams
French Mother	Annette Claudier
Vietnamese	Joseph Hieu, Albert Leong
Charming G.I.	Stephen Bishop

SEGMENT 2

Directed by Steven Spielberg; screenplay by George Clayton Johnson, Richard Matheson and Josh Rogan; story by Mr. Johnson; director of photography, Allen Daviau; film editor, Michael Kahn.

Mr. Bloom	Scatman Crothers
Mr. Conroy	Bill Quinn
Mr. Weinstein	Martin Garner
Mrs. Weinstein	Selma Diamond
Mrs. Dempsey	Helen Shaw
Mr. Agee	Murray Matheson
Mr. Mute	Peter Brocco
Miss Cox	Priscilla Pointer

SEGMENT 3

Directed by Joe Dante; screenplay by Richard Matheson, based on a story by Jerome Bixby; director of photography, John Hora; film editor, Tina Hirsch.

Helen Foley	Kathleen Quinlan
Anthony	Jeremy Licht
Uncle Walt	Kevin McCarthy
Mother	Patricia Barry
Father	William Schallert
Ethel	Nancy Cartwright

SEGMENT 4

Directed by George Miller; screenplay by Richard Matheson, based on a story by Richard Matheson; director of photography, Allen Daviau; film editor, Howard Smith.

Valentine	John Lithgow
Sr. Stewardess	Abbe Lane
Jr. Stewardess	Donna Dixon
Co-Pilot	John Dennis Johnston
Creature	Larry Cedar
Sky Marshal	Charles Knapp
Little Girl	Christina Nigra
Mother	Lonna Schwab

''TWILIGHT ZONE—THE MOVIE''—Kathleen Quinlan reacts in terror in a film inspired by the Rod Serling television series.

By VINCENT CANBY

ROD SERLING'S phenomenally successful television series, ''The Twilight Zone,'' which had a five-year network run beginning in 1959 and which seems to have been in reruns ever since, has now passed through its own twilight zone and become a flabby, mini-minded behemoth called ''Twilight Zone — the Movie.''

The film, which opens today at the Sutton and other theaters, is composed of a prologue, written for the movie, plus four separate stories, each of them either based directly on a script from the television series or suggested by one. A lot of money and several lives might have been saved if the producers had just rereleased the original programs.

●

Of the four stories, the last, directed by George Miller, is tops, meaning that it's pretty good. This tale, based on ''Nightmare at 20,000 Feet,'' is about a tense airplane passenger who, during a night flight in a thunderstorm, looks out his window and becomes convinced that some sort of creature is dismantling the outboard engine.

Mr. Miller, the Australian director who demonstrated his talent for spectacular action with ''The Road Warrior,'' does what he can with this limited material, and John Lithgow is both legitimate and comic as the hysterical passenger.

The film's third segment, based on a tale called ''It's a Good Life,'' contains a number of wildly eerie possibilities that are never satisfactorily developed. Kathleen Quinlan plays an innocent young woman who finds herself drawn into a macabre household whose inhabitants behave like Tom, Jerry, Bugs Bunny and other cartoon characters that are forever playing on the screens of the house's dozens of television sets. The master of the house is a sweet-looking, arbitrarily vicious little boy, Anthony, played by Jeremy Licht.

●

Joe Dante, the director, never finds a style for the piece, which should somehow combine the comic, the scary and the satirical. Trivia experts might note that Billy Mumy, who played Anthony in the original teleplay, has a small role as an adult in this film version.

Except for the central performance by Scatman Crothers, the film's second segment, based on the episode called ''Kick the Can,'' is inept in every way. Of all unlikely people, Steven Spielberg directed this rather ugly, sentimental comedy set in an old-people's home.

John Landis, currently represented by the stylish ''Trading Places,'' is responsible for the film's first segment, a muddled antibigotry lesson about a fellow who hates blacks, Jews and Orientals. Through a series of ''Twilight Zone'' twists of fate, the fellow finds himself being persecuted as a Jew in Nazi-occupied France, lynched as a black by Ku Klux Klansmen in the South and shot at as a Vietnamese by American soldiers in Vietnam.

It was while making this segment that Vic Morrow, who gives a good

Vic Morrow in one of the episodes of "Twilight Zone — The Movie"

performance as the bigot, and two Vietnamese children were killed in a production accident.

Mr. Landis also directed the film's prologue, which features Dan Aykroyd and Albert Brooks. It's funny and extremely short.

•

"Twilight Zone — the Movie," which has been rated PG ("parental guidance suggested"), contains some unrefined language.

1983 Je 24, C15:1

PORKY'S II: THE NEXT DAY, directed by Bob Clark; written by Roger E. Swaybill, Alan Ormsby, Bob Clark; director of photography, Reginald H. Morris; edited by Stan Cole; music by Carl Zittrer; produced by Don Carmody and Bob Clark; released by 20th Century-Fox. At the Gotham, Third Avenue and 58th Street; Criterion, Broadway and 45th Street and other theaters. This film is rated R.

Pee Wee	Dan Monahan
Tommy	Wyatt Knight
Billy	Mark Herrier
Mickey	Roger Wilson
Tim	Cyril O'Reilly
Meat	Tony Ganios
Wendy	Kaki Hunter
Brian	Scott Colomby
Balbricker	Nancy Parsons
John Henry	Joseph Running Fox
Carter	Eric Christmas
Reverand Flavel	Bill Wiley
Gebhardt	Edward Winter

By LAWRENCE VAN GELDER

Just in time to rescue the summer in the name of unpretentious, un-self-conscious, foul-mouthed fun, the gang from Angel Beach High turned up yesterday at the Criterion Center and a host of other theaters in "Porky's II: The Next Day."

Yes, Pee Wee, Wendy, Tommy, Billy, Tim, Meat, Brian and Frank are back; and what's more — while surrendering nothing of their interest in sex, their genius for elaborate pranks, their propensity for four- and five-letter words and their zest for vengeance — they seem to have developed a modest interest in Shakespeare and an enhanced social conscience.

•

Gone are the loutish roadhouse owner Porky and his corrupt sheriff brother, who — to their ultimate regret — cheated and bedeviled the boys from Angel Beach High in last summer's popular "Porky's." In their place are a set of timeless targets, as worthy of battle in the more liberal and liberated 1980's as they were in the 50's: religious hypocrites seeking to repress great literature, the Ku Klux Klan and spineless, double-dealing politicians.

So, amid references to such icons of the 50's as Marilyn Monroe, Jayne Mansfield and Ava Gardner, and to music by Chuck Berry, the McGuire Sisters, the Fontaine Sisters and Bill Haley and the Comets, the Angel Beach gang from Flordia sallies forth once more to do battle.

The catalyst is an evening of Shakespeare being prepared as a school production by Pee Wee's mother, a drama teacher. Not only does this potpourri of scenes provide a vehicle for the students' customary low-brow humor (Bill is badgered into admitting he is playing a fairy; Meat must wear a garlanded blond wig and a skirt), but it also serves to bring on the villains.

Miss Balbricker (Nancy Parsons), the killjoy gym teacher, turns up with a bombastic minister named Flavel (Bill Wiley), who denounces Shakespeare as indecent; the Klan attacks a Seminole Indian youth (Joseph Running Fox) who plays Romeo to the Juliet of the irrepressible Wendy (Kaki Hunter), and Gebhardt (Edward Winter), a slick city commissioner, not only reneges on a promise to defeat the Reverend Flavel's efforts to shut down the show but also tries to seduce Wendy.

This last endeavor leads to one of the fine low-comic set-pieces of "Porky's II," wherein Wendy, wearing a flamboyant spangled gown and trailing a boa — her bosom artificially inflated with a squishy mixture of greenish soup, corn, carrots and whatnot — sashays into an ornate restaurant in Miami for her rendezvous with the smug Commissioner Gebhardt.

•

Matching this is a segment in which Pee Wee (Dan Monahan) prepares a reprisal against his buddies for a hor-

"PORKY'S II: THE NEXT DAY"—Don Monahan stars as Peewee, whose prurience ignites the gang from Angel Beach High.

rifying machete attack that sent him fleeing naked into the night during one of his repeated efforts to divest himself of his virginity in "Porky's." To this end — and unaware that his friends are eavesdropping — Pee Wee arranges with a carnival bellydancer (Cisse Cameron) to portray Graveyard Gloria, a normally sedate librarian who becomes overwhelmed with lust when in proximity to a cemetery.

Once again, the proceedings have been directed with high energy and rapid pace by Bob Clark, and the results are slicker and more sophisticated than before. Refined sensibilities may understandably recoil from all this: high art is not among the aspirations of "Porky's II." But lots of lowdown fun? Well, that's another matter.

1983 Je 25, 12:3

FILM VIEW

It Takes More Than Gimmicks

Are there new ideas for movies any more? This summer, there hardly seem to be. Audiences that once enjoyed the luxury of deciding what they cared to see can now choose chiefly what to see *more* of. What's worse, few of the current sequels, remakes and rehashes appear to have arisen out of any genuine need for their characters to be resurrected, or their stories to be retold. There's simply money to be made by providing more of the same: The motives for making a sequel are, in most cases, quite transparent — capitalize on the success of the familiar hit, instead of risking something uncertain and new. So the goose that lays golden eggs has been persuaded to work overtime.

The idea of spinning new films out of successful ones has always been with us, and it has certainly brought dividends; think only of those Saturday afternoon serials in the 1930's, which positively thrived on repetition and familiarity. And where would the "Thin Man" or "Andy Hardy" series or the Astaire-Rogers musicals have been if their makers had worried overly about originality? Isn't it just as well that Hitchcock remade "The Man Who Knew Too Much," or that George Cukor directed yet another version of "A Star Is Born"? Imitation has long been a sincere and legitimate form of flattery for filmmakers, and the results have been known to outshine the originals.

But derivation has never before enjoyed anything like its current pre-eminence. Hollywood may never have been more dangerously and unimaginatively beholden to its own past than it is right now.

The trouble with offering audiences more of "Star Wars," more of "Superman," more of "Psycho" or more of James Bond (not to mention more "Jaws," "Porky's," "Saturday Night Fever" and "Smokey and the Bandit," whose sequels are also scheduled for this summer) is that even when there's more to sell, there may not necessarily be more to see. Yet the fact that many films, especially most good ones, reach a point at which they really are *over* seems to inhibit no one, as far as sequel-making is concerned.

٭

Only if a first film had made a point of leaving its hero on the brink, full of hope and promise — say the way "Saturday Night Fever" left John Travolta's Tony Manero — can a sequel be coaxed out of the hero's subsequent adventures ("Stayin' Alive," the "Saturday Night Fever" sequel directed by Sylvester Stallone, is scheduled to open next month). Of course, some films are able to turn their characters' very incompleteness into a likable, even useful trait. François Truffaut's Antoine Doinel, for instance, suffered the pangs and uncertainties of adolescence in a number of successive movies. However, if the original film has created well-drawn characters and allowed them to fulfill their dramatic destinies during the course of the story, chances are that definitiveness will work to the first film's advantage — and render

a continuation out of the question. The mistake of most sequels lies in trying to carry an original story beyond the point where its concerns have naturally been resolved. Only characters who have no real concerns — like the teen-age warrior Luke Skywalker or a cardboard figure like Superman — have the potential to go on forever, provided the filmmakers bring a little ingenuity to their variations on the original formula and have the good sense not to alter it beyond recognition.

When "Star Wars" first appeared in our movie cosmos, it promised a saga that could go on virtually forever. For one thing, George Lucas suggested as much; for another, the film itself left audiences eager for more. Six years later, the "Star Wars" phenomenon has snowballed

to the point where theaters advertising a new installment — and showing absolutely nothing — could probably break their own house records on opening day. Audiences want "Star Wars" movies no matter what their quality.

Yet "Jedi" surprisingly shows "Star Wars" to be running out of steam. The problem is, in part, one that afflicts several of today's other sequels as well: slavish mimicry of the most superficial gimmicks of the first film coupled with an increasingly hazy memory of the spirit which gave the original its substance or energy. "Star Wars" dazzled audiences with its humor, its boyishness, its technical wizardry and its thoroughly gung-ho spirit of adventure. Technical feats have grown increasingly prominent as the series continues, but the other qualities that sent the first film into the box-office stratosphere have been de-emphasized — to the point where, if "Jedi" had been the first installment of the "Star Wars" series, there might never have been a series at all. The light-sabers, the Yoda dolls, the promotional glasses at Burger King — none of it might have happened.

Paradoxically, The "Star Wars" trio of Luke Skywalker, Han Solo and Princess Leia owed much of their buoyancy, at the beginning of the series, to the fact that they were so charmingly paper-thin. Somehow, they've grown more solemn and complicated as the story has progressed. So "Jedi," which has more noise and violence and bizarre imagery than the earlier films ("Star Wars" scholars of the future will doubtless have much to say about the scene in which terrified young warriors are thrown into a throbbing red pit), also has more pretensions to psychological depth. Luke Skywalker must contemplate whether his dad, Darth Vader, is "good" or "bad." He must learn from Yoda about death. The rivalry between Luke and Han for Leia must be laid to rest. Such developments might be useful in another movie, but here they merely bog things down. The "Star Wars" characters were never meant to develop into fuller human beings; they need only have continued to kid one another and race through space. And all these psychological probings give its last installment a quality of spurious seriousness.

Nor was Superman ever meant to depart from his original comic-book dimensions, as he does in "Superman III." An actor looking just the way Superman ought to look, flying thrillingly through the air and performing rescue after rescue, is really all the "Superman" movies needed in order to survive. Indeed, the second film had this, and it also had a quick sense of humor and a witty visual equivalent of the original comic book style. "Superman II" was a thorough success, and in "Superman III" that success has been tampered with. It's as though the filmmakers had grown tired of their simple but workable movie miracle, preferring instead to put Superman through a series of nostalgic moments, personality problems and action scenes strangely lacking in action.

"Superman" hasn't lost its potential as an on-going serial, though; the only way that will happen is if the series loses Christopher Reeve, who does a lot to make this larger-than-life characterization believable. The regular characters remain simple and well-defined, and the potential for crowd-pleasing exploits remains unlimited — especially with the inclusion of new stars on the level of Gene Hackman or Richard Pryor. "Superman" is one of those formulas that could be best perpetuated through close adherence to the original. All the "Superman" movies need do in order to sustain themselves is to somehow avoid change, growth, development or anything else that might challenge their one-dimensional charm — while at the same time continuing to generate an air of novelty. Needless to say, preserving that kind of simplicity isn't simple at all.

James Bond, on the other hand, has been around for so many years that he now must either deepen or become dull. But 13 films and two Bonds into this series, its hero is still the same smirky girl-watcher, still unnaturally imperturbable and debonair. His lasciviousness was a cheerful joke to begin with; now it verges on the strange. Roger Moore looks long-in-the-tooth for some of the mayhem in "Octopussy," the latest Bond film and, by the series' standards, actually one of the better ones. Yet there's been no attempt to make Bond's growth reflect the obvious, and by no means unbecoming, changes in its star.

The unreality and glamour of Bond's life were the series' initial drawing card, as audiences marveled at a man with so many gadgets and so many girls. But isn't he getting tired? Thinking about his own mortality ("Octopussy" begins with the death of Bond's colleague 009)? Wondering about settling down? Nope. James Bond continues to race around the globe, winking meaningfully at bikini-clad cuties and looking very much as though he

could use a good nap. It's easy to understand why the makers of the Bond films are reluctant to tamper with a proven formula. But their caution may eventually catch up with them. If the Sean Connery Bond movie due later this summer shows a little more humanity and dimension than "Octopussy," it may turn out to be the more durable of the two. As it is, the series is in danger of getting not more engaging — but more lifeless and thin.

A sequel made after a long passage of time has a particular problem in the possibility of being dated. "The Twilight Zone: The Movie," with three of its four segments based on episodes of Rod Serling's early-1960's television show, has a peculiar, time-warp quality not wholly attributable to its science-fiction style. The first episode (the one that isn't adapted from the series) concerns racism and prejudice, yet it relies on a turnabout no timelier than "Black Like Me," the book in which a white writer told of his experiences masquerading as a black man. Here, a foul-mouthed, vicious racist played by the late Vic Morrow is turned, successively, into a Jew, a black and a Vietnamese. One of these reversals would have made the point better than three. And the whole episode has a preachy, outmoded flavor.

Another segment, based on the "Twilight Zone" episode called "It's a Good Life," concerns a little boy who terrorizes adults with his mysterious power to make all of his wishes come true. This segment, directed with a lot of visual ingenuity by Joe Dante, has a strangely old-fashioned notion of what the boy's wishes would be (they all have to do with yesterday's cartoons, rather than today's video games). Further, the fear of a child's disproportionate powers seems more of a baby-boom fantasy than a contemporary one. In any case, this "Twilight Zone" movie would have been scarier had it tried harder to recreate the stylized eeriness of the original — and more immediate if it had substituted more immediate concerns for ones dating back to the heyday of Mr. Serling's television series.

It's ironic that two of the summer's most imaginative déja-vu movies are those that sounded least promising, sight unseen — one of which is not a sequel proper but a true homage in form of a remake. Why redo "Breathless"? And why turn "Psycho" into "Psycho II"? Certainly, each of the original films seemed complete and unassailable — and both created an atmosphere that would seem hard to expand upon. Yet each of the second generation films has its unexpected vitality. Both approach the classics on which they're based without undue fear, reverence or ambition. That may not be the way to create cinematic landmarks or to break the bank. But, given the timidity of most of the other sequels around, at least it's refreshing.

Reversing the nationalities in "Breathless" — making this the story of an American gangster and a French girl, rather than the reverse situation to be found in Jean-Luc Godard's classic — was a bold move. It may even have been in some ways an ill-advised one, since the finished product's borrowed existential urgency goes largely unexplained. However, Jim McBride, who directed this remake, has given it an intensely American flavor and a strong sense of place (Los Angeles) and time (right now, and not a minute later). The film has taken a great deal from Godard, but by no means all of its energy is secondhand. Mr. McBride may be fired as much by his love of old movies as by his desire to do anything new. But arguably it's the fire that counts, no matter what ignites it.

Richard Franklin's "Psycho II" is surprisingly lively, too, and also surprisingly modest in its ambitions. The most gratifying thing about it, aside from its funny and unexpected jokes about the original "Psycho," is Mr. Franklin's assumption that his audience knows the Hitchcock film virtually frame by frame. In view of that, he's more intent on commenting on the original than on outdistancing it.

Despite some rare exceptions, that may be virtually the most that a new film based on a top-flight older one can do. A sequel like "Psycho II" is little more than a valentine, shared by director and audience and briefly recalling the glories of the original. The story of Norman Bates ended definitively in his jail cell, just as "Breathless" ended with the death of Jean-Paul Belmondo. There's nothing more to say. But there is room, in a season of almost-automatic spinoffs, for sequels or remakes that understand their secondary function and are satisfied with merely reflecting or recalling older, better films, not outshining, outsmarting and outearning them. Perhaps there's more room for retreads like these than for those that aim higher. Still, not even the best sequel is a true substitute for the excitement of something genuinely new.

1983 Je 26, II:1:5

Ardor Unleashed

DRUGSTORE ROMANCE, screenplay (French with English subtitles), direction and editing by Paul Vecchiali; director of photography, George Strouve; music by Gabriel Faure and Ronald Vincent; a Diagonale production; a Libra Cinema 5 Films Release. At the Cinema Studio, Broadway and 66th Street. Running time: 126 minutes. This film has no rating.

Jeanne/Michele	Helene Surgere
Pierre	Nicolas Silberg
Emma	Beatrice Bruno
Melinda	Myriam Mezieres
Anna	Christine Murillo
Marcelle	Liza Branconnier
Pupuce	Emmanuel Lemoine
Louis	Louis Lyonnet
Sonia	Sonia Saviange
Mother	Madeleine Robinson

By LAWRENCE VAN GELDER

IN a short story called "The Sensible Thing," F. Scott Fitzgerald wrote: "There are all kinds of love in the world, but never the same love twice." Given the tedious passion on display in "Drugstore Romance," a French film opening today at the Cinema Studio, it is to be hoped Fitzgerald was right.

•

To witness but once the manifestations of ardor of a classical-music-loving Paris auto mechanic named Pierre, who becomes smitten with a woman he sees at a performance of Fauré's Requiem, should suffice even for the most irrepressible romantic.

The smug, narcissistic Pierre, played by Nicolas Silberg, who bears a Gallic resemblance to Robert Taylor, lays siege to the object of his devotion in various ways, including taking up residence in his car outside her pharmacy, where he puts out a doormat, surrounds his vehicle with plants and flowers, bays at the gathered onlookers and occasionally plasters himself, a bit Christlike, against the store.

From time to time, the pharmacist (Hélène Surgère), who sometimes goes by the name Jeanne and other times by the name Michele, encourages Pierre's suit; sometimes, she repulses him. And when this happens, Pierre puts on his Fauré records and he sulks, he weeps, he throws tantrums, assaults his fellow mechanics, acts shabbily toward his mother and worries the mostly elderly denizens of the lane where he lives.

The romance grows no more beguiling when Jeanne/Michele, saying she has only three months to live, agrees to run off with Pierre and consummate their love, amid scenes of frontal nudity, games of blind man's buff and lines like, "I'm trying to make death give you up."

•

Bereft of coherent motivation and beset by rudimentary acting by its principals — given to such mannerisms as the furrowed brow and the moue — "Drugstore Romance," directed by Paul Vecchiali, seems less an effort to distill art from life than to create cinema from contrivance.

The movie, also known as "Corps à Coeur," was an opening-night attraction of the 1980 "New Director/New Films" series at the Museum of Modern Art. That evening, the series was opened by John Sayles's "Return of the Secaucus Seven." That "Drugstore Romance" was overlooked seems understandable.

1983 Jl 1, C8:4

Coast Caper

HAMMETT, directed by Wim Wenders; screen-play by Ross Thomas and Dennis O'Flaherty; adaptation by Thomas Pope, based on the book by Joe Gores; photography by Philip Lathrop and Joseph Biroc; edited by Barry Malkin, Marc Laub, Robert Q. Lovett and Randy Roberts; music by John Barry; produced by Fred Roos, Ronald Colby and Don Guest; presented by Francis Ford Coppola; released by Orion Pictures/Warner Bros. At the Beekman, Second Avenue and 65th Street and other theaters.

Hammett	Frederic Forrest
Jimmy Ryan	Peter Boyle
Kit Conger-Sue Alabama	Marilu Henner
English Eddie Hagedorn	Roy Kinnear
Eli	Elisha Cook
Crystal Ling	Lydia Lei
Lieutenant O'Mara	R. G. Armstrong
Detective Bradford	Richard Bradford
Fong Wei Tau	Michael Chow
Punk	David Patrick Kelly
Donaldina Cameron	Sylvia Sidney
Gary Salt	Jack Nance
Doc Fallon	Elmer L. Kline
Pops	Royal Dano

By VINCENT CANBY

"HAMMETT," the first major American movie by Wim Wenders, the sometimes excellent German director ("The Goalie's Anxiety at the Penalty Kick," "The American Friend"), isn't quite the mess one might expect, considering the length of time it's been in production and the number of people who seem to have contributed to it. It's not ever boring, but heaven only knows what it's supposed to be about or why it was made. One answer would serve both questions.

It opens with a note to the effect that Samuel Dashiell Hammett was a real person, but that everything that follows is fiction. Why make a fiction film about the man who virtually invented the low-life private-eye genre with such novels as "The Maltese Falcon" and "The Glass Key"? According to the film's publicity material, Joe Gores, who wrote the novel that inspired the movie, wanted to explore the relationship between Hammett's early career as a detective with the Pinkerton Agency and the stories he later wrote. There's also mention of something called "the central tension existing between his two worlds."

There's very little tension in this movie, though there is a good deal of confusion. The screenplay, set in San Francisco in 1928, is neither good enough to exist on its own as straight film noir, like Lawrence Kasdan's "Body Heat," nor is it witty and funny enough to succeed as parody, like Carl Reiner's technically masterly "Dead Men Don't Wear Plaid."

Most disappointing is the total absence of Mr. Wenders's point of view as a European cinéaste fascinated by American movies, the quality that distinguished his beautiful, melancholy caper film, "The American Friend," as well as his less successful but still interesting "The State of Things."

"Hammett" is about Hammett (Frederic Forrest), often called Sam, not only because Samuel was actually his first name but also because we are thus meant to associate him with his most famous fictional creation, Sam Spade. When first met, Sam, a struggling author who writes for the pulps, is sitting in his cheap San Francisco apartment finishing a new tough-guy yarn. He smokes one cigarette after another, coughs his lungs to shreds, slugs whisky and, at least once, is viewed upward from beneath the keys of his ancient Underwood.

The film's story — as opposed to the flashes of stories we see in Sam's imagination — involves Jimmy Ryan (Peter Boyle), a father figure to Sam and a former Pinkerton agent, who wants the younger man's help on a new case, and Crystal Ling (Lydia Lei), a young Chinese prostitute Jimmy is searching for. The cast of supporting characters includes a beautiful librarian, who loves Sam truly and well; a gun-crazy, sadistic punk; the punk's older, elegantly mannered, English-accented lover, a criminal lawyer; a couple of crooked San Francisco detectives, and a half-dozen rich and prominent citizens who are being blackmailed.

It is apparently the film's arrogant intention to convince us that the caper we see in "Hammett" is the real-life story that eventually prompted Hammett to write "The Maltese Falcon." That, I think, is called chutzpah.

●

"Hammett" is not difficult to sit through. Mr. Forrest, who was miscast or, maybe, misdirected in "One From the Heart," is an attractive, easygoing Hammett, a fellow who looks and behaves as if he might well be a writer. It is, however, a mostly passive role, that of the writer as observer. Mr. Boyle's role, as written, makes no sense, but Miss Lei is nicely wicked as a sort of Oriental Mary Astor.

Roy Kinnear plays the part that Sydney Greenstreet made larger than life in John Huston's classic 1941 film, "The Maltese Falcon." Elisha Cook, who played the punk in that film, turns up here as a taxi driver who helps Sam out of tight places, and Sylvia Sidney, beautiful, gallant woman, plays a tiny role as one of the people who aids Sam's investigation. Samuel Fuller, the director who has appeared in other Wenders films, also makes a brief appearance in "Hammett."

The best things about the film are its atmospheric, slightly stylized sets, which include teeming Chinatown streets and alleys and one old-fashioned opium den. The photographers were Philip Lathrop and Joseph Biroc, and Dean Tavoularis and Eugene Lee were the production designers. Ross Thomas and Dennis O'Flaherty wrote the screenplay. The film, whose executive producer is Francis Ford Coppola, starts today at the Beekman and other theaters.

●

"Hammett," which has been rated PG ("Parental Guidance Suggested"), contains some partial nudity and a lot of the tough-guy words that wouldn't have been heard in movies 40 years ago.

1983 Jl 1, C8:1

STROKER ACE, directed by Hal Needham; screenplay by Hugh Wilson and Hal Needham, based on the novel "Stand on It" by William Neely and Robert K. Ottum; director of photography, Nick McLean; edited by Carl Kress and William Gordean; music by Al Capps; produced by Hank Moonjean; released by Universal Pictures. At the Rivoli 1, Broadway and 49th Street; Gemini 1, Second Avenue and 64th Street; UA East 85th Street, at First Avenue, and other theaters. Running time: 96 minutes.

Stroker Ace	Burt Reynolds
Clyde Torkle	Ned Beatty
Lugs	Jim Nabors
Aubrey James	Parker Stevenson
Pembrook Feeney	Loni Anderson
Doc Seegle	John Byner
Dad Seegle	Frank O. Hill
Woman with Lugs	Cassandra Peterson
Arnold	Bubba Smith
Jim Catty	Warren Stevens
Charlie	Alfie Wise
Crew Chief	Jim Lewis

HAL NEEDHAM'S "Stroker Ace," which opens today at the Rivoli and other theaters and stars Burt Reynolds as a stock-car racer, is the must-miss movie of the summer. It's a witless retread of the earlier, far funnier road-movie collaborations of Mr. Needham and Mr. Reynolds, especially of their two "Smokey and the Bandit" movies.

The cast includes Jim Nabors, as Mr. Reynolds's faithful mechanic; Loni Anderson, lately of television's "WKRP in Cincinnati," who does a rather sweet, Marilyn Monroelike turn as a virginal public-relations woman; Ned Beatty, as the owner of a chain of roadside restaurants, and Parker Stevenson, as Mr. Reynolds's principal competitor on the track.

Nobody comes off well, especially Mr. Nabors, and the usually game, self-mocking Mr. Reynolds. Their material is terrible, and both men appear to be suffering from that strange show-business disease, the most obvious symptom of which is that the hair on one's head turns increasingly dark and unaccountably thick with age.

●

"Stroker Ace," which has been rated PG ("Parental Guidance Suggested"), includes some vulgar language but not much else.

Vincent Canby

1983 Jl 1, C8:5

"HAMMETT"—Marilu Henner and Frederic Forrest, as Dashiell Hammett, star in a thriller set in 1928 and directed by Wim Wenders. Opening Friday at the Beekman and other theaters.

"STROKER ACE"—Burt Reynolds portrays a zany stock-car racer in a comedy opening Friday at the Rivoli 1, Gemini 1 and UA 85th Street.

FILM VIEW

VINCENT CANBY

Ingmar Bergman Pays Homage To a Family

It's Christmas Eve, 1907. Helena Ekdahl, the matriarch of a large, prosperous family in a town very much like Uppsala, Sweden, moves around the family apartment making a hostess's last-minute inspection before the arrival of the guests — her sons, daughters-in-law, grandchildren and old friends. As she passes through the handsome rooms, cluttered with the beloved debris of time, now ablaze in the light of hundreds of candles, she has the manner of a captain followed by his sergeants, except that the sergeants are two elderly housemaids.

Before dismissing the maids, Helena turns on Vega, the grumpier of the two attendants. "Why are you moody?" It's less a question than an imperial accusation against which there is no defense. "I'm not moody," says Vega, who begins to seethe. "Nonsense," says Helena with the easy self-assurance of the powerful, "you're always moody on Christmas Eve." That said, Helena sweeps out of the room to meet her guests, to reminisce with a former lover, to worry about the health of her children and her own awareness of a life now mostly behind her. When she's safely gone, the furious maid snarls with satisfaction, "The old bitch!"

It's a very funny moment and just one of many that early in "Fanny and Alexander," Ingmar Bergman's possibly most serene and imaginative new film, suggests the many levels of intimacy, love, impatience, trust, dependency and friendship that we associate with large families, if not as we know them from life today, then as we know them from the literature of earlier eras.

Large families, at least in America, have all but disappeared if we are to believe most of our novels, plays and films as well as official statistics. Television sitcoms dote on single-parent households, which are populated by smart-talking children, some possibly adopted, and usually equipped with comic doorbells. For the most part movies don't find even the small family unit an especially topical subject, unless the unit, for one reason or another, is coming apart as in "Ordinary People," "Kramer vs. Kramer" and "The Great Santini," each, incidentally, based on a novel. The only contemporary and original American film that deals seriously with family ties is "Tender Mercies," and it has other things on its mind as well.

• • •

It may be significant, as Michiko Kakutani reported in last week's cover story on Mr. Bergman in The New York Times Magazine, that one of the Swedish director's favorite American television shows is "Dallas," which is really about the American family as a privately held corporation locked into a constant state of proxy war. Still, the great popularity here and abroad of "Dallas" and its imitators must have something to do with a shared longing for close, continuing family ties that are all but impossible today.

It's a time when fewer and fewer marriages make it through even a single decade, when geographical mobility is taken for granted by most large businesses, and when it's increasingly rare that a family can accommodate its own elderly. It's not by accident that real estate operators today describe the houses they sell as "homes." Because any family's life expectancy at a single address has become increasingly short, it's as if the real estate people felt obliged to convince their clients that new houses come onto the market complete not only with every conceivable appliance but prehallowed in time and

with heirlooms in the unfinished attic. Polly Adler did not go far enough. A house is not a home until a family has lived in it.

The best of our contemporary playwrights who have explored family relationships — I think particularly of Lanford Wilson ("Talley's Folly," "The Fifth of July") and A. R. Gurney Jr. ("The Dining Room") — write with humor, sadness, regret and a kind of gallant acceptance of the inevitability of change, but their works are of necessity tied to the banalities of our society. We still can appreciate the comic grandeur of Chekhov's "Seagull," "Cherry Orchard," "Uncle Vanya" and "Three Sisters" but, until the appearance of "Fanny and Alexander," it didn't seem possible that anyone in the late 20th century could find some equivalent.

• • •

Gone, too, are the sort of big family comedies that playwrights turned out in the 1920's and 1930's, two good examples of which are in current revival, George Kaufman and Moss Hart's "You Can't Take It With You" and Eugene O'Neill's "Ah, Wilderness," the benign dream of the terrible reality represented by O'Neill's "Long Day's Journey Into Night." The wisecracks, the eccentricities and the optimism of these comedies have been co-opted — and debased in the process — by the writers of television's situation comedies. Only Neil Simon, in "Brighton Beach Memoirs," has turned back the clock with some measure of success.

The initial appeal of "Fanny and Alexander" is that it is a big, multigenerational family film, and though it is set near the turn of the century, Mr. Bergman has not turned back the clock. This is a most modern, original film work — funny, wise, unhurried, beyond fads and fashions.

There are splendid moments that recall Chekhov, especially one hilarious and bitter late-night bedroom scene between Carl Ekdahl, Helena's second son, a boozing, unhappy professor, and his servile, German-born wife, Lydia. Things get off to a bad start when Carl complains, "My teeth are itching." He accuses Lydia of smelling bad. She isn't insulted, but calmly denies it. He then turns on fate itself. "How is it that one becomes second-rate?" he asks, then moans, in this order of importance, "Oh insomnia, poverty and humiliation!"

• • •

Chief among the other characters are Helena's eldest son, Oscar, who runs the Ekdahl theater, which was built by Helena's late husband, a businessman, as a tribute to his wife who had been an actress; Oscar's pretty wife, Emilie, who now is the star of the theater; their children, 10-year-old Alexander and 8-year-old Fanny; Helena's youngest son, Gustav Adolf, a cheerfully randy restaurateur with goat-like goatee; Alma, Gustav Adolf's adoring, understanding wife; Maj, the pretty, lame nanny who becomes Gustav Adolf's mistress, with the approval of everyone in the family; the widowed Bishop Vergerus, who becomes Emilie's second husband; and the sage, always somewhat mysterious Isak Jacobi, the old antique dealer and moneylender who, years before, was Helena's lover.

In the course of the little more than 12 months of the story, there is one death, one marriage and two births. As the gothic centerpiece of the film, which is surrounded by love and sunlight, there is the extended sequence in which Emilie, having been widowed, marries the handsome, truth-loving bishop and takes Fanny and Alexander to live in the bishop's palace, which is more terrifying than Mr. Rochester's manor house. In addition to the bishop's frozen-faced mother, his unmarried sister and a possibly crazy maid (played by the same Harriet Andersson who was the nubile maid in "Smiles of a Summer Night"), the place is inhabited by an ogre, who remains in an upstairs bedroom, and the ghosts of two dead children. For Alexander there's also bitter corporal punishment as the bishop attempts to beat into him an appreciation for a love that is "pure and strong, not blind and sloppy."

The film is a portrait of the artist not as a young man but as a little boy, Alexander, who sees all and says very little. The film's principal metaphor is theater, which, for Mr. Bergman, represents not artifice but the reality by which the chaos of the outside world

can be ordered and, for a short time anyway, comprehended. In "Fanny and Alexander," the Ekdahls are actors in the theater that the protective family unit represents.

•

Though "Fanny and Alexander" is set in 1907, which appears to be a time of social tranquillity, that seems almost to be a narrative convenience. Most definitely the film is not about the good old days. For Helena and Isak, whose love has simmered down to an enduring friendship, their good old days were 30-40 years ago. When Helena asks Isak if age saddens him, he answers, "No. . .everything is just getting worse. Worse weather, worse people, worse machines, worse wars. The boundaries are burst, and all the unspeakable things spread out and can never again be checked. . ."

For Emilie, 1907 is the blossoming present-day, when, having just fallen in love with the bishop, life is full of great hopes. For Alexander, 1907, which will one day be his good old days, is a time of trial and uncertainty. It is Alexander who questions the existence of God and the order of things that allows the use of pain and humiliation to enforce salvation. It is Alexander, too, who believes in magic and the manifold, mysterious possibilities of all things, such as the ancient mummy in Isak's shop, which glows in the dark and, if one looks carefully, appears to breathe. In this respect the film has a close connection to Mr. Bergman's screen adaptation of "The Magic Flute," which, for reasons I've never understood, many people seem to regard as an aberration in the Bergman canon.

Every member of the huge cast is excellent. This is ensemble performing of the highest order, but a few of the actors must be mentioned — Gunn Wallgren (Helena), Ewa Froling (Emilie); Pernilla Wallgren (Maj), Jan Malmsjo (the bishop), and Bertil Guve (Alexander).

"Fanny and Alexander" is long — more than three hours — but watching it is like allowing oneself to be swept up in a big novel. Though it touches on some of the darker themes explored in earlier Bergman films, it places them in a context that celebrates the tangible pleasures of a highly civilized life. It's neither optimistic nor pessimistic. It acknowledges the existence of unanswerable questions and moves on. Above all, it is blithe. ∎

1983 Jl 3, II:11:1

Christmas in Pigalle

NEIGE, directed by Juliet Berto and Jean-Henri Roger; screenplay (French with English subtitles) by Marc Villard from an idea by Miss Berto; camera, William Lubtchansky; edited by Yann Dedet; music by Bernard Lavilliers and François Breant; produced by Ken and Romaine Legarguant; Babylone Films, Odessa Films, Marion's Films and F3-O.D.E.C. At the Public Theater, 425 Lafayette Street. Running time: 90 minutes. This film is not rated.

Anita	Juliet Berto
Willy	Jean-François Stevenin
Jocko	Robert Liensol
Bruno Valles	Paul le Person
First Policeman	Patrick Chenais
Second Policeman	Jean-François Balmer
Bobby	Res Paul I Nephtali
Betty	Nini Crepon

"Neige" was shown as part of the 1982 New Directors/New Films Series. Following are excerpts from a review by Vincent Canby that appeared in The New York Times of April 17, 1982. The film opens today at the Public Theater, 425 Lafayette Street.

Juliet Berto

"NEIGE" (Snow), the first feature to be directed by the actress Juliet Berto and Jean-Henri Roger, who was a member of Jean-Luc Godard's Dziga Vertov group, is an actorly sort of movie in the manner of something by John Cassavetes. Though it is far more tightly written and edited than a film by Mr. Cassavetes — indeed, it looks almost too slick and professional for its own good — "Neige" (which in French slang means "dope") is full of meaty roles for actors and is not overly encumbered by a story that might get in their way.

The setting is Pigalle during its gaudy Christmas fair, and the characters are hustlers, barkeeps, whores, drug addicts, cops and pushers who live off the tourists in search of sleaziness. Marc Villard's screenplay, based on an idea by Miss Berto, focuses mainly on Anita (Miss Berto), who works part-time in a bar and full-time as a mother figure to a young West Indian drug peddler named Bobby (Res Paul I Nephtali) and to anyone else in need.

Anita is a most romantic character. Miss Berto, who is beginning to look more and more like Jeanne Moreau, plays her solemnly and well, with her mouth always turned down and an expression that embraces the sorrows of the world.

Some of the characters who wander in and out of Anita's life, in addition to Bobby, are Jocko (Robert Liensol), a black evangelist who acts as her streetwise guardian angel; Willy (Jean-François Stevenin), a karate expert who would like to settle down with Anita, an idea she finds horribly square, and Betty (Nini Crepon), an addict-transvestite.

As directors, Miss Berto and Mr. Roger pack the film with bizarre, jazzy atmosphere, all lovingly photographed by William Lubtchansky. Its sights aren't the usual ones — no Sacre Coeur or tawdry nightclub shows — but they are, nevertheless, sights. It's all gritty and grim, and just a bit too colorful.

1983 Jl 5, C10:1

Rampant Impatience

DEADLY FORCE, directed by Paul Aaron; screenplay by Ken Barnett, Barry Schneider and Robert Vincent O'Neil; story by Mr. Barnett; director of photography, Norman Leigh and David Myers; edited by Roy Watts; music by Gary Scott; produced by Sandy Howard; released by Embassy Pictures. At Loews State, Broadway and 45th Street; New York Twin, Second Avenue and 66th Street. Running time: 95 minutes. This film is rated R.
Stoney Cooper	Wings Hauser
Eddie Cooper	Joyce Ingalls
Joshua Adams	Paul Shenar
Sam Goodwin	Al Ruscio
Ashley Maynard	Arlen Dean Snyder
Otto Hoxley	Lincoln Kilpatrick
Harvey Benton	Bud Ekins
Diego	J. Victor Lopez
Lopez	Hector Elias
Jesus	Ramon Franco
Maria	Gina Gallego

"DEADLY FORCE," which opens today at Loews State and other theaters, is full of the utterly witless, rhythmical motion associated with manufactured-for-television movies, in which one can predict plot developments by the placement of the commercial interruptions. There are, unfortunately, no commercial interruptions here. However, it isn't necessary to be a seer to know what must happen next in this story of a young, tough, macho former policeman, his wife, who is a television news reporter, and the hunt for a homicidal maniac in Los Angeles.

The film, directed by Paul Aaron, is less about crime detection than about impatience. All the characters in the movie are seething with impatience of one sort or another. The former policeman (Wings Hauser) is impatient with his wife, from whom he is separated, because she pretends not to love him. She is impatient with him because he resents her career. The chief of the Los Angeles detectives is impatient with both of them because they keep interfering with his investigation, and ultimately, the killer is impatient with his fate.

Impatience is easily acted and very dull to watch for any length of time.

Vincent Canby

1983 Jl 8, C4:3

SCREWBALLS, directed by Rafal Zielinski; written by Linda Shayne and Jim Wynorski; director of photography, Miklos Lente; edited by Brian Ravok; music by Tim McCauley; produced by Maurice Smith. At the National, Broadway and 44th Street; Gramercy, 23d Street and Lexington Avenue; Loews 83d Street Quad, Broadway and 83d Street and other theaters. Running time: 80 minutes. This film is rated R.
Rick McKay	Peter Keleghan
Bootsie Goodhead	Linda Shayne
Howie Bates	Alan Daveau
Brent Van Dusen III	Kent Deuters
Melvin Jerkovski	Jason Warren
Purity Bush	Lynda Speciale

Under the title "Screwballs," a wizened clone of "Porky's" opened yesterday at the National and other local theaters.

Afflicted with an intermittent greenish tint, bereft of adequate acting, starved for wit and originality, generally miscast and directed with a palpable lack of grace, "Screwballs" is set in a fictitious high school called Taft and Adams.

The plot concerns the efforts of some of the male students— several of whom appear old enough to have graduated perhaps a decade earlier — to see the bare bosom of a young woman named Purity, the school's goody-goody. "Screwballs" establishes that — in the absence of talent — teen-age prurience, old Thunderbirds, rock music and hula hoops do not add up to entertainment.

Lawrence Van Gelder

1983 Jl 9, 10:4

Current Events

TARGET NICARAGUA: INSIDE A COVERT WAR, produced and directed by Saul Landau; photographed by Haskell Wexler. Running time: 40 minutes.
QUEST FOR POWER: SKETCHES OF THE AMERICAN NEW RIGHT, produced and directed by Saul Landau and Frank Diamond. Running time: 50 minutes. At the Film Forum, 57 Watts Street. These films have no rating.

TWO Saul Landau documentaries, "Quest for Power: Sketches of the American New Right" and "Target Nicaragua: Inside a Covert War," comprise the new program opening a special one-week engagement at the Film Forum today.

By far the better of the pair is "Target Nicaragua," a 40-minute record of a trip to Nicaragua taken late last year by Mr. Landau and Haskell Wexler, the cinematographer. The two men interviewed dozens of people involved in Nicaragua's efforts to protect its Sandinista Government against outside forces, mostly from across the border with Honduras. Mr. Landau has already written about this trip most effectively in a piece that appeared on the Op-Ed page of The New York Times on March 28.

•

The film's footage is graphic and harrowing. There is sorrow in the interviews with peasants who attempt to carry on their lives in the midst of the border clashes. The film makers' anger is evident in an interview with a former Argentine agent, who says he acted with the cooperation of the Central Intelligence Agency, and in another interview with a Nicaraguan, now in prison in Nicaragua, who says he was paid by the Argentine agent to blow up the country's oil refinery and cement plant.

It is Mr. Landau's point, in this film as well as in his Op-Ed piece, that if the United States is conducting a covert war against the Sandinista Government, it should either make it constitutionally legal in a formal declaration of war by Congress, or desist immediately.

•

Far less effective, even as biased film making, is "Quest for Power," which is a somewhat too sketchy report on the American New Right. The 50-minute film, produced and directed with Frank Diamond, features interviews with the Rev. Jerry Falwell, founder of the Moral Majority, Phyllis Schlafly, who led the fight against the proposed equal rights amendment, Richard Viguerie, the New Right's direct-mail specialist and others connected with the movement.

However, by concentrating on the movement's more obvious fanatics and on some of its more outrageous arguments, the film undermines its own serious intentions. Mr. Landau, whose documentary "Fidel" was a model of its kind, should have done better.

Vincent Canby

1983 Jl 13, C16:3

Campus Innocence

THE FIRST TIME, directed by Charlie Loventhal; screenplay by Mr. Loventhal, Susan Weiser-Finley and W. Franklin Finley; story by Mr. Loventhal; director of photography, Steve Fierberg; edited by Stanley Vogel; music by Lanny Meyers; produced by Sam Irvin; a New Line Cinema Production. At the Embassy 72d Street, at Broadway. Running time: 95 minutes. This film is rated R.

Charlie	Tim Choate
Dana	Krista Errickson
Rand	Marshall Efron
Wendy	Wendy Fulton
Ron	Raymond Patterson
Goldfarb	Wallace Shawn
Eileen	Wendie Jo Sperber
Gloria	Cathryn Damon
Karen	Jane Badler
Melanie	Bradley Bliss
Polly	Eva Charney
Rick	Bill Randolph
Leon	Rex Robbins
Joel	Robert Trebor

By LAWRENCE VAN GELDER

AT Blossom College, the women outnumber the men eight to one. And when it comes to experience with the opposite sex, a freshman named Charlie Lichtenstein, whose true love is the movies, is outnumbered by practically everyone on campus.

Ingredients like these have been known to constitute the recipe for summertime movies cynically concocted for an audience of undemanding Yahoos who cackle at each leaden innuendo, ape each leer and all but slaver at what passes on screen for romance.

But "The First Time," which opens today at the Embassy 72d Street, is something different. The first feature film of Charlie Loventhal, who reportedly was 22 years old and a student at Sarah Lawrence College when he started this project with the encouragement of the director Brian De Palma, who was a visiting professor, it is a deft and ingratiating beginning.

Mr. Loventhal has assembled an ideal cast — with such performers as Wallace Shawn as Jules Goldfarb, a film professor who disdains the commercial in favor of such art as his masterwork, "Grasping Reality," perhaps 30 seconds of grainy black-and-white showing a hand unclenching to an organ rendition of Beethoven's Fifth Symphony; Marshall Efron as an adviser whose apparently avuncular advice to Charlie about losing his virginity masks anthropologic prurience; and Krista Errickson as Dana, a campus queen whose good looks are exceeded only by her selfishness.

Filming on the Sarah Lawrence campus, Mr. Loventhal has used these cast members to two primary ends: an affectionate, good-humored study of the less-than-suave young man about campus; and an adroit sendup of film-making courses and film competitions. Despite the clear preference of Dr. Goldfarb for the avant-garde and the outspoken disdain for coherence of his classmate Joel Moscowitz (Robert Trebor), Charlie has no doubts about where his inclinations lie. His room is a shrine to Laurel and Hardy, the Marx Brothers, Woody Allen and James Bond.

So, while worrying about his innocence in an atmosphere of casual sex, Charlie is also turning out film, particularly the James Bond pastiche that he plans to enter in the climactic Blossom College Film Festival.

Does Charlie lose his innocence? Does he win the competition? That Mr. Loventhal has arranged answers that skew the norm is but one more index of his promise.

1983 Jl 13, C16:3

Gentleman Robber

THE GREY FOX, directed by Phillip Borsos, written by John Hunter, photographed by Frank Tidy, edited by Frank Irvine, music by Michael Conway Baker and The Chieftains, produced by Peter O'Brian, a Zoetrope Studios Presentation

produced with the participation of the Canadian Film Development Corporation and Famous Players Ltd., a United Artists Classics Release. At the Baronet, Third Avenue and 59th Street. Running time: 92 minutes. This film is rated PG.

Bill Miner	Richard Farnsworth
Kate Flynn	Jackie Burroughs
Shorty	Wayne Robson
Jack Budd	Ken Pogue
Fernie	Timothy Webber
Detective Seavey	Gary Reineke
Louis Colquhoun	David Petersen
Al Sims	Don Mac Kay
Jenny	Samantha Langevin
Tom	Tom Heaton

By VINCENT CANBY

"THE GREY FOX," Phillip Borsos's Canadian film that opens today at the Baronet, is a gentle, intelligent, very leisurely paced western with one terrific asset: Richard Farnsworth.

Mr. Farnsworth is the stunt man who turned actor and received an Oscar nomination for his work in in the otherwise not memorable "Comes a Horseman." Like Greta Garbo, Walter Brennan, Cary Guffey and Catherine Deneuve, Mr. Farnsworth has the sort of face the camera adores. It finds in his sharp, pale blue eyes, in the age lines and in the texture of skin weathered, apparently, by decades in the open air all kinds of emotions, which may be acting or which may simply be the richness of the features given to him by nature.

●

As Bill Miner, a gentlemanly old stagecoach robber, trying to pick up his life after 30 years in prison, Mr. Farnsworth is a delight, his face an ever-changing landscape of the soon-to-be-vanished frontier.

The time is shortly after the turn of the century, when stagecoaches have become scarce. The film's modest screenplay, by John Hunter, is about Bill's attempts to enter the Age of Steam by adapting his methods to train robberies. The first attempt is a disaster but the second one is slightly more successful.

While hiding out in a small town in British Columbia, he meets and falls in love with a pretty, firmly opinionated feminist-photographer named Kate Flynn (Jackie Burroughs), whose high cheekbones the camera likes almost as much as it does Mr. Farnsworth's entire face. They are a very attractive couple. There are also some nice performances by Wayne Robson as Bill Miner's excitable sidekick and Timothy Webber as a Canadian policeman who would prefer not to have to arrest Bill.

The film has been beautifully photographed by Frank Tidy, which is not to say that it is too beautiful. The small towns and the countrysides look bleak and damp. It's the sort of world in which one's feet are always wet. Mr. Borsos, the director, makes funny use of clips from Edwin S. Porter's 11-minute 1903 classic, "The Great Train Robbery," which is as exciting to Bill as "Star Wars" is to members of another generation, though more instructive.

The film is almost too decent to find fault with. Such decency is refreshing up to a point, when monotony threatens to set in. That it doesn't is to the credit of Mr. Farnsworth's remarkably appealing, steadfast screen presence.

●

"The Grey Fox," which has been rated PG ("Parental Guidance Suggested"), contains some mildly vulgar language.

1983 Jl 13, C17:4

"THE GREY FOX"—Richard Farnsworth is cast as Bill Miner, a legendary bandit, in a prize-winning Canadian film directed by Phillip Borsos.

Still Afoot

STAYING ALIVE, directed by Sylvester Stallone; screenplay by Mr. Stallone and Norman Wexler, based on characters created by Nik Cohn; director of photography, Nick McLean; edited by Don Zimmerman and Mark Warner; music by Frank Stallone and the Bee Gees; produced by Sylvester Stallone and Robert Stigwood; released by Paramount Pictures. At the Ziegfeld, Avenue of the Americas and 54th Street. Running time: 96 minutes. This film is rated PG.

Tony Manero	John Travolta
Jackie	Cynthia Rhodes
Laura	Finola Hughes
Jesse	Steve Inwood

ONLY the presence of John Travolta turns "Staying Alive" from an unqualified disaster into a qualified one. Mr. Travolta is able to radiate warmth and sweetness even under the direst of circumstances, which are certainly the ones in which he finds himself here. As directed by Sylvester Stallone, who is also co-writer and co-producer, "Staying Alive" is a sequel with no understanding of what made its predecessor work. The first film was funny and touching, powered by a phenomenally successful score. This one is clumsy, mean spirited and amazingly unmusical.

"Staying Alive," which opens today at the Ziegfeld, resumes the story of Tony Manero five years later. He's now a dancer living in Manhattan, and he's after all those things that today's movie characters feel especially eager to pursue: success, celebrity and a beautiful body (his own). He has clearly developed the last and is hoping it will bring him the first two, as he auditions, in various "All That Jazz"-inspired sequences, for roles in Broadway musicals. En route to the predictable triumph, he romances two other dancers, a good-hearted chorus girl (Cynthia Rhodes) and a smirky, sarcastic star called Laura (Finola Hughes).

Tony first sees Laura as she performs one of the ungainly, Apache-inspired dance routines that contribute all too heavily to the choreography. Laura whirls her hair. Tony grins. In the movie's primitive terms, this (plus a romp through Central Park) means it might be love. However, Laura turns out to be rich and snooty, and she sneers insult after insult at Tony, who under Mr. Stallone's tutelage has unfortunately learned to sneer back. The dialogue, also written by Norman Wexler, consists almost entirely of cheerless wisecracks., interrupted occasionally by small talk about how fabulous the Broadway show is going to be.

The show, titled "Satan's Alley" ("a journey through hell that ends with an ascent to heaven," as one character describes it), is particularly dreadful. The costumes, by Bob Mackie, are gaudy even by Mr. Mackie's standards, and the dancers writhe through graceless contortions. Mr. Travolta looks terrifically agile, but that's not enough to save these sequences. However, the audience supposedly loves the show and loves Tony and decrees that he will be a big star. This prompts him to stride through Times Square in a final, show-biz epiphany. And it induces Mr. Stallone, at long last, to play the title song, which is left over from the first film but provides the only musically uplifting moment in the second.

There are a few new songs by the Bee Gees; they're pleasant, but little more, and they have been unaccountably buried beneath the dialogue. Songs by Frank Stallone, the director's brother, are featured much more prominently. According to the production notes, these "were chosen over hundreds of major contenders." Nevertheless, they are rivaled only by the arhythmic editing and by the outstandingly unpleasant performances by Miss Hughes and Steve Inwood (as the show's choreographer) as the most grating things here.

Mr. Travolta survives the film, but he would have been better off almost anywhere else — even in "Flashdance." That, not "Staying Alive," turns out to be the "Saturday Night Fever" knockoff of the summer.

●

"Staying Alive" is rated PG ("Parental Guidance Suggested"). It contains faintly suggestive dance routines and infrequent off-color language.

Janet Maslin

1983 Jl 15, C8:5

On Being Anybody

ZELIG, directed and written by Woody Allen, director of photography, Gordon Willis; edited by Susan E. Morse; music by Dick Hyman; produced by Robert Greenhut; a Jack Rollins and Charles H. Joffe Production; released by Orion Pictures/Warner Bros. At the Beekman, Second Avenue and 65th Street and other theaters. Running time: 84 minutes. This film is rated PG.

Leonard Zelig	Woody Allen
Dr. Eudora Fletcher	Mia Farrow
Dr. Sindell	John Buckwalter
Glandular Diagnosis Doctor	Marvin Chatinover
Mexican Food Doctor	Stanley Swerdlow
Dr. Birsky	Paul Nevens
Hypodermic Doctor	Howard Erskine
Experimental Drugs Doctor	George Hamlin
Workers Rally Speaker	Peter McRobbie
Martin Geist	Sol Lomita
Sister Ruth	Mary Louise Wilson
Actress Fletcher	Marianne Tatum
Actor Doctor	Charles Denney
Actor Koslow	Michael Kell
Actor Zelig	Garrett Brown
Miss Baker	Sharon Ferrol
Charles Koslow	Richard Litt
Martinez	Dimitri Vassilopoulos
Paul Deghuee	John Rothman
Sister Meryl	Stephanie Farrow
City Hall Speaker	Francis Beggins
Dr. Fletcher's Mother	Jean Trowbridge
On-Camera Interviewer	Ken Chapin
Hearst Guests	Gerald Klein, Vincent Jerosa
Lita Fox	Deborah Rush
Lita's Lawyer	Stanley Simmonds
Zelig's Lawyer	Robert Berger
Helen Gray	Jeanine Jackson
Zelig's Wife	Erma Campbell
Wrist Victim	Anton Marco
House-Painting Victim	Louise Deitch
Vilification Woman	Bernice Dowis
Greek Waiter	John Doumanian
Rally Chancellor	Will Holt
Carter Dean	Bernie Herold
Themselves	Susan Sontag, Irving Howe, Saul Bellow, Bricktop, Dr. Bruno Bettelheim, Prof. John Morton Blum
Calvin Turner	Marshall Coles Sr.
Older Dr. Fletcher	Ellen Garrison
Mike Geibell	Jack Cannon
Ted Bierbauer	Theodore R. Smits
Older Paul Deghuee	Sherman Loud
Older Sister Meryl	Elizabeth Rothschild
Oswald Pohl	Kuno Spunholz
Announcers	Ed Herlihy, Dwight Weist, Gordon Gould, Windy Craig, Jurgen Kuehn

By VINCENT CANBY

WHO was Leonard Zelig? These facts we know: that he was born in New York around the turn of the century into a Jewish immigrant family and that his father, Morris, was a Yiddish actor. The only reference to Morris in theater archives indicates that he was coolly received when he played Puck in an orthodox version of "A Midsummer Night's Dream."

Scott Fitzgerald, in his journals, reports meeting someone named Leonard Zellman at a 1928 garden party on Long Island and finding him charming and urbane, with a nice turn of phrase and impeccably dressed. Not long afterward a baseball player calling himself Lou Zelig turned up at the Florida training camp of the New York Yankees. Still later, the same guy is seen in Chicago, first as a member of the Capone mob and then, curi-

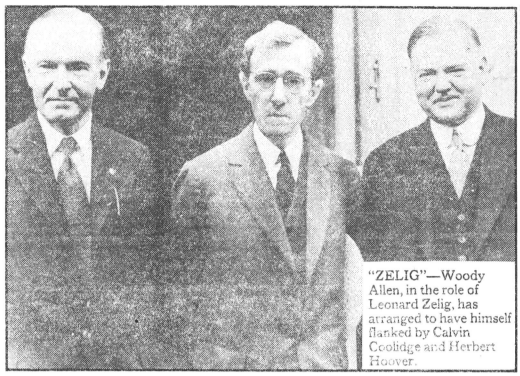

"ZELIG"—Woody Allen, in the role of Leonard Zelig, has arranged to have himself flanked by Calvin Coolidge and Herbert Hoover.

ously, as a black jazz musician.

Leonard Zelig is all these people and more. He is Woody Allen's most brilliant, most inspired fictional creation, and the movie that contains him, called simply "Zelig," is the writer-director-actor's most brilliant work. Though "Zelig" looks as if it were a small film, it is a jam-packed powerhouse of film-making wit, wisdom, hilarity and technology. It is "Citizen Kane" miraculously transformed into a side-splitting comedy.

•

In many ways, "Zelig" recalls "Take the Money and Run" (1969), Mr. Allen's first feature as a triple-threat man, while Leonard Zelig has a lot in common with that earlier film's earnest but frequently troubled hero, Virgil Starkweather. Virgil, you may remember, is the would-be bank robber whose first job was stalled as the teller studied the holdup note. "This is a gub."

"Zelig" has the form of a solemn documentary about the life and times of Leonard Zelig (Mr. Allen) in the late 1920's and 30's, and the larger lessons to be learned about American society from his brief but stunning celebrity. It opens with Susan Sontag, the critic ("Against Interpretation"), photographed in living color, looking great and looking back over the decades to Zelig's odd career. This we see in bits and pieces of old black-and-white newsreels, faded newspaper clippings and photographs, early films made during his medical treatment, home movies and contemporary interviews with some of the fictional survivors of that era, as well as with real people such as Miss Sontag, Saul Bellow and Dr. Bruno Bettelheim.

•

What emerges is a sweet but uproariously funny portrait of a 1920's America suffering from the quintessential American malady of the 1980's. Leonard Zelig's problem is that he has absolutely no identity he can call his own. He is a cipher, as close to the theoretical concept of zero as Bertrand Russell could define. He is so pathologically nil that, over the years,

he has developed the unconscious ability to transform himself, physically and mentally, into the image of whatever strong personality he's with.

In the company of an American Indian, he becomes an American Indian. While in therapy with an eminent psychiatrist, Dr. Eudora Fletcher (Mia Farrow), he becomes an eminent psychiatrist, though a very boastful, male one. Among other things, he tells her that he's currently treating two pairs of Siamese twins suffering from split personalities, adding, "I receive fees from eight people." As Mr. Bellow observes late in the film, Leonard Zelig's "sickness was at the root of his salvation."

"Zelig" traces the bizarre course of that salvation, from the time he becomes a typically nutty 1920's culture hero, nicknamed "the chameleon man" by the tabloids, competing for newspaper space with flagpole sitters, politicians, playwrights and other well-known folk, through an early, temporary cure, then a few terrible years in which the public turns against him, until his final triumph.

Though the movie is composed entirely of more or less official footage from newsreels and other simulated public sources, it also successfully recounts Zelig's private story, especially the love affair that develops between him and Dr. Fletcher as she is treating him.

Mr. Allen has never been more firmly funny and — this is not a contradiction — more attractively unobtrusive as he is as the unreliably mild-mannered Leonard. As Dr. Fletcher, Miss Farrow is also wonderfully funny and appealing, always attempting to behave with professional severity that can't adequately conceal her strong leaning toward recklessness.

•

The supporting cast is huge. It's a virtual guide to all of the fine, still relatively unknown character actors available in New York. Each is splendid, even those who go through the film without ever saying a line, since much of this footage is supposed to date from the silent-film 20's.

Some who must be mentioned are Ellen Garrison, who appears in contemporary interviews as the Dr. Eudora Fletcher of today; Mary Louise Wilson and Sol Lomita, as Leonard's money-grubbing sister and brother-in-law, who come to no good end through their entanglement with a mediocre, cowardly bullfighter; Stephanie Farrow, the sister of Mia, who appears as Eudora's sister, and Garrett Brown and Marianne Tatum, who play Leonard and Eudora in clips from "The Changing Man," Mr. Allen's romantic, beautifully photographed idea of how a 1935 Warner Brothers movie about Zelig might look.

•

Technically, "Zelig" is something of a cinematic marvel in the way that Gordon Willis, the cinematographer, Santo Loquasto, the production designer, and Susan E. Morse, the editor, have matched and blended the genuinely antique film footage with their new material. Dick Hyman's musical score is equally evocative and fitting. Their accomplishments make all the gadgetry and laboratory stuff in even our most stupendous science-fiction epics look like kid stuff.

Can you imagine a most authentic-looking shot of Leonard Zelig wrestling with the priests surrounding Pope Pius XI on a Vatican balcony? Or another of Leonard, temporarily a member of Hitler's entourage, peeking around his Führer to wave delightedly to an appalled Dr. Fletcher, who's in the audience during a giant Munich rally? In "Zelig" you'll see these and even wilder flights of cinema fancy.

The movie's wit never flags. "French intellectuals," the film's stentorian narrator assures us of Zelig, "see him as a symbol for everything." As important as the humor, and quite unexpected, considering the high quotient of satire and parody, is the film's generosity of spirit.

The in-person appearances of Miss Sontag, Mr. Bellow, Irving Howe, Dr. Bettelheim, Bricktop and Prof. John Morton Blum, who is here identified as the author of "Interpreting Zelig,"

manage to send up Warren Beatty's use of his "witnesses" in "Reds," but without making idiots of the people themselves. If anything, their appearances testify to fine senses of the absurd not always apparent in their own work.

"Zelig," which opens today at the Beekman Theater, is Woody Allen's triumph. It's one more demonstration that he, rather than any of his more conventional, mainstream contemporaries, is the premier American film maker of his day.

"Zelig," which has been rated PG ("parental guidance suggested"), may contain some vulgar language or suggestive situations, though I can't remember anything that would startle a child or lead him or her astray.

1983 Jl 15, C8:1

CORRECTION

A review of the movie "Zelig" in Weekend on Friday misidentified the production designer. He is Mel Bourne. Santo Loquasto designed the costumes.

1983 Jl 18, B1:6

Age-Old Story

PUBERTY BLUES, directed by Bruce Beresford; screenplay by Margaret Kelly, based on the novel by Kathy Lette and Gabrielle Carey; director of photography, Don McAlpine; edited by Bill Anderson; musical director, Les Gock; produced by Joan Long and Margaret Kelly; released by Universal Pictures. At the Cinema Studio, Broadway and 66th Street. Running time: 87 minutes. This film is rated R.
Debbie ... Nell Schofield
Sue .. Jad Capella
Garry ... Geoff Rhoe
Danny .. Tony Hughes
Tracey ... Sandy Paul
Cheryl ... Leander Brett
Bruce ... Jay Hackett

By JANET MASLIN

BRUCE BERESFORD'S "Puberty Blues" from Australia begins with the sight of two decidedly unglamorous teen-age girls as they wend their way across a crowded beach, which is ringed with ugly high-rise buildings. The homeliness and candor of the moment prove to be the best qualities of a coming-of-age film that also has its familiar and even foolish sides, culminating as it does in one girl's brave, convention-shattering decision to buy and use a surfboard of her own.

The universal teen-age condition, once again represented as a passel of worries about sex and parents and popularity, is given no new dimension here. And the heroine's struggle for independence culminates in nothing more drastic than her decision to breach the protocol of the waves, since her friends regard surfing as a thrill reserved exclusively for boys. Nevertheless, the film has a plainness that can be disarming (and that marks its only noticeable similarity to "Breaker Morant" and "Tender Mercies," other and more successful films by Mr. Beresford).

"Puberty Blues," which opens today at the Cinema Studio, is based on a novel of the same name by Kathy Lette and Gabrielle Carey, which purported to tell all about the mores of surfer teen-agers in the Sydney vicinity.

As narrated by Debbie (Nell Schofield), it tells of two schoolgirl pariahs and their attempts to ingratiate them-

selves with the "right" crowd. In the interests of this, they find themselves taking drugs and catering to the whims of surfer boyfriends, who sometimes want perfunctory sex, but more frequently demand to be brought snacks.

The boys' boorishness is somewhat exaggerated here, and so is the stupidity of parents who barely notice when their children develop a drug-induced torpor or come home much too giggly at midnight. The movie is at its best when concentrating on the simpler details of Debbie's existence, such as how and where her family lives or how she gets along with friends at school. The friendship between Debbie and Sue (Jad Capelja), a prettier girl, who starts out the film in pigtails and seems to grow sunnier and more confident as the story progresses, is better delineated than any of the larger matters at hand.

One aspect of adolescence that the movie particularly overplays is the mechanical, unromantic nature of the sex between its characters. In order to make the point that the surfers are oafish and unfeeling, Mr. Beresford depicts various young lovers undressing wearily in separate rooms, then tumbling into bed with barely a peck on the cheek by way of preliminaries. That may be true to the novel; it may even be true to life. But in the context of this essentially gentle movie, it's just a little too hardhearted.

1983 Jl 15, C13:1

NOW AND FOREVER, directed by Adrian Carr; screenplay by Richard Cassidy, based on the novel by Danielle Steel; director of photography, Don McAlpine; music by Graham Russell; produced by Treisha Ghent and Carnegie Fieldhouse; released by Inter Planetary Pictures, Inc. At the National Twin, Broadway and 44th Street; New York Twin, Second Avenue and 66th Street; Olympia Quad, Broadway and 107th Street; Gramercy, 23d Street near Lexington Avenue. Running time: 93 minutes. This film is rated R.
Jessie Clark Cheryl Ladd
Ian Clark .. Robert Coleby
Astrid Bonner Carmen Duncan
Margaret Burton Christine Amor

By JANET MASLIN

Imagine the surprise of the mostly male audience at the National Twin when "Now and Forever," which opened there yesterday, turned out to be a movie for the women. It stars Cheryl Ladd, sporting a headful of blonde curls and looking a little like

"PUBERTY BLUES"— Neil Schofield and Jad Capelja, at left, play teenagers who come of age on Australia's surfing beaches.

Julie Christie turned sorority girl. She plays a boutique owner in Sydney, Australia, which is not the kind of detail best appreciated by the National's usual crowd.

Miss Ladd may be overly pert, but she's well-suited to her role in this mild-mannered romance. She plays Jessie, the kind of woman who, even when her life is crushed, destroyed and shattered (which of course it is, since the screenplay is based on a novel by Danielle Steele), remembers to dress snappily and do cute things with her hair.

•

Jessie remains a fully dressed fashion plate throughout virtually all of the movie. Since the film is aimed at women, however, her husband, Ian, is a handsome, sensitive fellow who's usually seen bare-chested. Even the love scenes, which were a lot daintier than the audience might have preferred, concentrate chiefly on Ian's charms. He generally approaches Jessie, clad only in his faded jeans, while his wife is engaged in something properly girlish, like wearing a terry-cloth bathrobe and brushing her hair.

The plot, very much in the service of these fashion details, concerns a false charge of rape against Ian (who *has* been unfaithful to Jessie, just to give the movie spice) and the strain that is subsequently put on the marriage. After a reasonably suspenseful courtroom scene, Ian is sent to prison. He puts a nice picture of Jessie right beside his miserable cot.

•

However, things aren't as bad as they sound. While incarcerated, Ian writes a best-selling novel. ("Ricocheting vehicle catapulted" and "into the smoky haze" were the only two phrases I could make out in the page he was seen typing.) Meanwhile, Jessie goes to the country, does a lot of horseback riding, finds a little cottage and decorates it, and spends long, gauzy moments thinking about the power of love.

1983 Jl 16, 14:1

FILM VIEW
VINCENT CANBY

Woody Allen Continues to Refine His Art

In this land of unlimited opportunity, a place where, to paraphrase Woody Allen, any man or woman can realize greatness as a patient or as a doctor, we have only one commercial American filmmaker who consistently speaks with his own voice. That is Woody Allen, gag writer, musician, humorist, philosopher, playwright, stand-up comic, film star, film writer and film director.

Though it runs a mere but delicious 84 minutes, "Zelig," his new, remarkably self-assured comedy, is to his career what the 15½-hour "Berlin Alexanderplatz" is to Rainer Werner Fassbinder's and the three-hour-plus "Fanny and Alexander" is to Ingmar Bergman's. This incongruity in running time may be a law of nature. Woody Allen is much shorter than Mr. Bergman and never has he tipped the scales to equal the heft Mr. Fassbinder was carrying around in the years before his death.

"Zelig" is small but it's one of those Allen comedies by which all his other films will be compared. One can make associations between Woody Allen and Mr. Bergman and Mr. Fassbinder if only because it's understood that exceptional films by great filmmakers are never really comparable. When they are mentioned in the same breath, it's to suggest relative importance and "Zelig" is a Woody Allen masterpiece.

It's a summation and a perfection of methods and ideas that have been turning up in all his films, from "Take the Money and Run" (1969) through "Stardust Memories" (1980) and "A Midsummer Night's Sex Comedy" (1982). He is unique. One would have to go back to the silents to find any other American filmmaker who has so successfully — and over such an extended period of time — attended to his own obsessions.

• • •

When movies learned how to talk, the best American filmmakers did not exactly lose their voices but they were forced to disguise them. The art and the eccentricities of D.W. Griffith and Erich von Stroheim could not be easily accommodated by the structure of the talking-picture studios. The global business that American moviemaking became during the Depression demanded a nonstop flow of what Hollywood calls "product" to fill movie theaters around the world. Studio heads did not have the time or the money to cater to the special obessesions of filmmakers unless they paid off at the box office.

Because many of our best filmmakers of the 1930's and 1940's made their livings by turning out a random assortment of romantic comedies, westerns, musicals and historical dramas, it took critics a good 30 years before they were able to recognize the consistency of the voices in the films of such people as Billy Wilder, Howard Hawks, John Ford, George Cukor and Vincente Minnelli. To hear those voices is not always easy. Sometimes they are so faint they can only be heard by the most devoted cinema student.

The situation today is no better and possibly even a little worse. There are fewer films being made, at constantly escalating costs, and thus fewer opportunities for filmmakers to develop any sort of recognizable style. Two of our most successful filmmakers, Francis Ford Coppola and George Lucas, are to be recognized less as artists than as tycoons. Steven Spielberg has made several fine, idiosyncratic films, including "Close Encounters of the Third Kind" and "Raiders of the Lost Ark," but I'm not sure I recognize any single voice within them, especially after seeing his dismal little contribution to "Twilight Zone—the Movie."

Martin Scorsese has his own voice — urban, hip and a little lunatic. It's also unsentimental and chilly. Thus, when it's not disguised by effective melodrama, as it is in "Taxi Driver" and "Raging Bull," the public tends to be put off, as they seem to have been by "The King of Comedy."

A commercial filmmaker doesn't have to have a particularly strong individual style to make halfway decent and sometimes very good films. Witness the career of Michael Curtiz, a most ordinary director whose work includes such classics as "Yankee Doodle Dandy" and "Casablanca." John Badham is the director of two of this summer's more popular films, "WarGames" and "Blue Thunder," but can anyone find a Badham personality within those films?

"Trading Places" is one of the best American comedies in a long time, but I'd be hard-put to assign more responsibility for the film's success to its director, John Landis, than to Timothy Harris and Herschel Weingrod, who wrote it, or to the members of the cast headed by Dan Aykroyd, Eddie Murphy, Don Ameche, Ralph Bellamy and Jamie Lee Curtis.

The Woody Allen film career must be one of the oddest in the history of the American sound cinema. He doesn't hang around Hollywood. He lives and works mostly in New York. He never went to a film school. His only connection to television was his early years as a joke writer and then, later, as a performer or a guest on talk shows.

Since 1969, he has written and directed 11 films, in 10 of which he was the star, acted in one film, "The Front," which was written and directed by others, and acted in another, "Play It Again, Sam," which he adapted from his own play but which was directed by Herbert Ross. He's also written one lovely, uncharacteristic play, "The Floating Light Bulb," which was done at Lincoln Center.

In addition, he has written and published several collections of humorous pieces, which, to his stupefaction, are classified as nonfiction when they appear on best-seller lists.

• • •

The most exciting thing about his career is being able to see how he has continued to develop and refine his control of a medium in which, quite frequently, less is more. "Zelig" is both a writer's and a director's film, a movie that could not have been made if Mr. Allen hadn't served time as a stand-up comedian and as a ferocious student of films, as well as the kind of writer who is so comfortable at the typewriter that he doesn't hesitate to write "on speculation." One of the more invigorating aspects of "Zelig" is its technical wizardry by which new black-and-white footage and new soundtracks are seamlessly blended with a lot of material dating from the 1920's and 1930's.

"Zelig" is full of wonderful echoes. Its form is not unlike that of "Take the Money and Run," since it's presented as a solemn documentary on the life and times of one Leonard Zelig (Mr. Allen). Zelig, a classic Allen creation, is an initially mysterious and nutty character who, in the 1920's, briefly enjoyed a celebrity equal to that of Charles A. Lindbergh, Jack Dempsey, Queen Marie of Rumania, Charles Ponzi and Alvin "Shipwreck" Kelly, some of the stars of what Frederick Lewis Allen called "The Ballyhoo Years" in his book "Only Yesterday."

Though Mr. Allen tells us that Leonard Zelig was a celebrity of the 1920's, Zelig's claim to fame is something that very much reflects the concerns of our 1980's. Zelig, you see, is a man so completely and so pathologically without any identity of his own that, without conscious effort, he takes on the physical, mental and emotional characteristics of any strong personality he's with.

In the course of "Zelig," we witness "the chameleon man's" rise to celebrity, his miraculous cure, his awful fall from public favor and, eventually, his rehabilitation as seen through "old" newsreel footage, early interviews with him, home movies and footage shot during his treatment by Dr. Eudora Fletcher (Mia Farrow). Throughout the film there are contemporary interviews with fictional characters as well as with such real representatives of the intelligentsia as Susan Sontag, Saul Bellow, Dr. Bruno Bettelheim and Irving Howe, each of whom discusses Zelig's place in history much like the "witnesses" in Warren Beatty's "Reds."

The use of these simulated newsreels and other "factual" material always keeps the story of Zelig one step removed from the audience. "Zelig" is a movie with very few of the kind of private moments that we expect in fiction films. Yet "Zelig" is not only pricelessly funny, it's also, on occasion, very moving. It works simultaneously as social history, as a love story, as an examination of several different kinds of film narrative, as satire and as parody.

It's just because Mr. Allen is such a brilliant parodist that some of his more recent films have run into trouble with the critics. His films made in what appears to be the

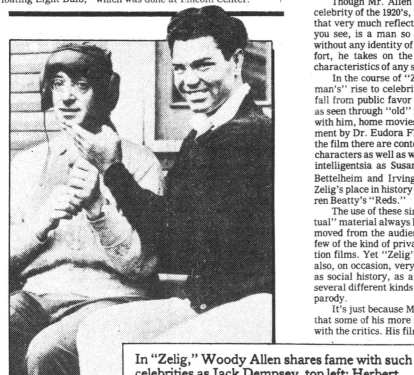

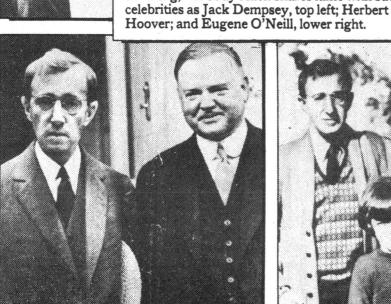

In "Zelig," Woody Allen shares fame with such celebrities as Jack Dempsey, top left; Herbert Hoover; and Eugene O'Neill, lower right.

style of Ingmar Bergman ("Interiors," "A Midsummer Night's Sex Comedy") or Federico Fellini ("Stardust Memories") look amazingly authentic even though they deal with obsessions totally Mr. Allen's. Seeing only the exteriors of these films — and I had trouble penetrating the beautiful, bleak surfaces of "Interiors" — one tends to see not the original work beneath but only the superficial resemblances to the works of others.

● ● ●

This has angered a lot of people who, having pledged their allegiance to Woody Allen-the-funnyman, have become disoriented by the realization that Woody Allen is "serious." With the possible exception of "What's Up, Tiger Lily" (1966), the schlocky Japanese spy movie to which he attached his own, sidesplitting English soundtrack, no Woody Allen movie has ever been more or less serious than another of his works. He's always been serious. It's the audiences who have been frivolous.

In "Zelig" he reassures us that he can still be funny and moving without making the sort of insistent filmic references in which he delights but which can be infuriating to others. "Zelig" is a nearly perfect — and perfectly original — Woody Allen comedy. ■

1983 Jl 17, II:1:4

Two Men of God

GOD'S ANGRY MAN, produced, directed and written by Werner Herzog; photographed by Thomas Mauch; edited by Beate Mainka-Jellinghaus. Running time: 46 minutes. This film has no rating.
HUIE'S SERMON, produced, directed and written by Werner Herzog; photographed by Thomas Mauch; edited by Beate Mainka-Jellinghaus. Running time: 40 minutes. Both films distributed by New Yorker Films. At the Film Forum, 57 Watts Street. This film has no rating.

By VINCENT CANBY

THE way some writers keep notebooks about subjects that interest them and that may, one day, serve as the bases for works of fiction, is the way that Werner Herzog, the German director ("Fitzcarraldo," "La Soufrière"), sometimes makes short documentary films. These Herzog "notebooks," however, are complete in themselves — small, self-effacing works of art.

Two such films, the 40-minute "Huie's Sermon" and the 46-minute "God's Angry Man," both made in 1980, open a limited engagement today at the Film Forum. The subject of each is an American man of God of the sort that might be expected to fascinate this fine, eccentric European film maker, one of whose obsessions is the study of the obsessions of others.

●

"Huie's Sermon" is set almost entirely in a black church in Brooklyn not otherwise identified, though I assume it's Baptist. The film is a direct recording of one lively, upbeat Sunday service, from the processional, "Step to Jesus," through the minister's sermon, "God Still Has Control." Huie, the preacher, begins conventionally enough but he quickly builds to a hand-clapping, amen-saying climax that finds many of the parishioners on their feet as Huie's enthusiasm takes hold.

Mr. Herzog clearly appreciates Huie's delivery and his stage presence, which is a mixture of television pitchman, stand-up comedian, gospel singer, cheerleader and heavenly coach.

Not so clear is Mr. Herzog's feeling toward Dr. W. Eugene Scott, the subject of "God's Angry Man."

Dr. Scott, a white, Southern California evangelist, is seen conducting his business on his daily television show and being interviewed by Mr. Herzog in his limousine and in the lonely splendor of his house, which, he emphasizes, is owned by his church.

Beatriz Schiller

Werner Herzog

Dr. Scott appears to be almost too ideally Southern California — in the way Evelyn Waugh saw Southern California — to be true. He has the handsome, unlined middle-aged features of a road-company leading man. His white hair is so perfectly combed you might suspect he sleeps in a hairnet. Setting off his elegant appearance are his three-piece suit and his perfectly coordinated haberdashery.

On his television show, Dr. Scott talks mostly about money, urging his viewers to send in funds and pledges of funds to support his ministry. When the funds don't come in fast enough, he takes a vow of silence, staring at the camera with mute disgust until the proper total is reached. (In May of this year, the Federal Communications Commission revoked the license of Dr. Scott's television station in Glendale, Calif., because he refused to reveal how the funds he collected over the air were being used. However, he is still available on other television stations.)

On his telecasts, Dr. Scott portrays himself as an innocent besieged by bumbling bureaucrats and, in particular, by the F.C.C. In between, he says such things as "This is not a show. It's a feast." Or, before asking for money: "God's honor is at stake every night." He tells Mr. Herzog that both his popularity and unpopularity are the result

of his always taking a stand. "I make a choice," he says. "I polarize people."

Never, however, in this film do we learn how he stands on anything except the F.C.C. and money. This may be the fault of the film or it may be the secret of the success of a man who, according to Mr. Herzog, is all style and absolutely no content.

1983 Jl 20, C14:3

Color and Killing

LIQUID SKY, directed by Slava Tsukerman; screenplay by Mr. Tsukerman, Anne Carlisle and Nina V. Kerova; director of photography-Yuri Neyman; edited by Sharyn Leslie Ross; music by Mr. Tsukerman, Brenda I. Hutchinson and Clive Smith; produced by Mr. Tsukerman; released by Cinevista. At the Waverly Theater, Avenue of the Americas and Third Street. Running time: 112 minutes. This film is rated R.
Margaret and Jimmy Anne Carlisle
Adrian Paula E. Sheppard
Sylvia Susan Doukas
Johann Otto Von Wernherr
Owen Bob Brady
Katherine Elaine C. Grove
Paul Stanley Knap
Vincent Jack Adalist
Lester Lloyd Ziff

By JANET MASLIN

SLAVA TSUKERMAN is a Soviet émigré who has lived in New York City since 1976, apparently long enough for him to get the lay of the land. Mr. Tsukerman's "Liquid Sky," which opens today at the Waverly, presents a vision of the city that is genuinely startling. His film, with a heroine who is sometimes a hero and who is apt to show up in a red corset with matching red-and-blond skunk hairdo, can hardly be for everyone. But the right audiences are bound to appreciate the originality displayed here, not to mention the color, rage, nonchalance, sly humor and ferocious fashion sense.

"Liquid Sky," which takes its title from a term for heroin, revolves around an actress named Anne Carlisle, who plays two roles. Sometimes she is Larry, a handsome male model with a slicked-back hairdo and faint mustache. Most of the time she is Margaret, who was once a brunette from Connecticut, but is now a mirthless, hollow-eyed beauty with coloring, or rather a lack of same, resembling Andy Warhol's.

More often than not, Margaret sports something bizarre in her hair or something brightly colored slashing across her cheekbones; her appearance is constantly changing. So is the world around her, once a Frisbee-size spaceship lands amid the beer bottles and other debris on the roof of her neon-streaked penthouse.

●

Occasionally, the film adopts the space creature's point of view. This allows Mr. Tsukerman to introduce high-contrast visuals in red, purple and green, culminating in the explosion of what looks like an electronic meatball. Apparently, this means that the creature is experiencing intense pleasure, which it derives either from heroin or, later, from murdering Margaret's sex partners. All of this, lurid and weird as it may sound, is related in a virtually matter-of-fact manner.

The plot isn't the film's greatest asset, nor are its insights into Margaret, Larry and the brave new world of affectless androgyny that they inhabit. Instead, it's the overall resourcefulness of Mr. Tsukerman and his talented colleagues that gives "Liquid Sky" its high style.

Visually bright and arresting, with

a varied and insinuating electronic score, the film is full of eye-catching images. These range from the sight of Margaret clambering to the top of her building in an unbuttoned satin wedding gown, as a kind of space-age King Kong, to her sexual confrontation with Larry, in which the look-alikes taunt each other before an audience of cheering fashion photographers and hair stylists. "Behind your back everybody laughs at you — they call you Chicken Woman," Larry hisses. "You're the most beautiful boy in the world," Margaret says in a tone of the utmost contempt. Make what you will of the moment, but it's not one that's easily forgotten.

●

There is some humor to "Liquid Sky" (as when a visiting German astrophysicist, having traveled to New York in search of the U.F.O, wonders, "How can I study the behavior of this creature if it's on private property?"). But this isn't quite a comedy, since its wit is so very dry, and since there is such a lot of viciousness to accompany the droll touches.

Margaret, the ultimate in passivity when it comes to anything other than changing her outfits, is raped, beaten and otherwise abused during the course of the story. But she takes this with relative calm, along with the killing of her various suitors. Things can turn ugly very swiftly in Mr. Tsukerman's scheme of things. A marital quarrel may involve the husband's drug habit rather than his failure to do the dishes, and a fight between female roommates escalates almost casually to the point where one is wielding a switchblade.

Margaret's tough little roommate Adrian is played with a fierce intensity by Paula E. Sheppard, who also delivers a couple of performance-art numbers during the course of the story. Like most of the cast, she seems as nasty as she is natural, although these qualities reach their pinnacle in Miss Carlisle's performance. Even without the wild plumage and phosphorescent makeup, Miss Carlisle would have a versatile and photogenic presence here. And she is indeed "truly as androgynous as David Bowie himself," as Margaret describes herself with equal amounts of irony and pride.

●

Mr. Tsukerman's apparent familiarity with Margaret, Larry and their surroundings would seem to belie his Soviet origins. So the U.F.O. imagery comes in handy. There can hardly be a better metaphor for a foreign-born director's response to New York and the outermost fringes of its New Wave.

1983 Jl 22, C10:1

Family Problem

CLASS, directed by Lewis John Carlino; written by Jim Kouf and David Greenwalt; director of photography, Ric Waite; edited by Stuart Pappe; music by Elmer Bernstein; produced by Martin Ransohoff; released by Orion Pictures. At Movieland, Broadway and 47th Street; Loew's Twin, Second Avenue and 66th Street; Waverly Twin, Avenue of the Americas and Third Street; New Yorker, Broadway and 88th Street. Running Time: 100 minutes. This film is rated R.
Ellen Jacqueline Bisset
Skip Rob Lowe
Jonathan Andrew McCarthy
Mr. Burroughs Cliff Robertson
Balaban Stuart Margolin
Roscoe John Cusack
Roger Alan Ruck
Allen Rodney Pearson
Kennedy Remak Ramsey
Lisa Virginia Madson
Susan Deborah Thalberg

"CLASS"—Jaqueline Bisset and Andrew McCarthy, at right, star in a romantic comedy opening Friday at Loews New York Twin, Movieland and local theaters.

By VINCENT CANBY

"CLASS" is like the donkey who found himself at equal distances between two bales of hay and starved to death. The movie can't make up its mind whether it's a lighthearted comedy, set in what appears to be a posh New England-style prep school just outside Chicago, or a romantic drama about a teen-age boy who has a torrid affair with his roommate's mother. Either way it's pretty awful.

When "Class" is not being indecisive, it's contradicting itself. The advertisements, for example, tell the entire story: "The good news is Jonathan's having an affair. The bad news is she's his roommate's mother." Yet the way the film has been put together indicates that the revelation of the identity of the older woman, which comes midway through the film, is supposed to be as much of a surprise to the audience as it is to Jonathan.

The screenplay by Jim Kouf and David Greenwalt, which is absurd on almost any level, is not appreciably helped by the direction of Lewis John Carlino (of "The Great Santini" and "Resurrection") or by the performances.

Jacqueline Bisset behaves like a woman at her wit's end as she searches for the character of Ellen Burroughs. This is the rich, heedless society woman who picks up Jonathan in a Rush Street bar and, five minutes later, is tearing his clothes off in an elevator, a scene that looks like a replay of her airplane "romance" in "Rich and Famous." Ellen may or may not be crazy, but she is stupid.

She apparently believes Jonathan's story about being a graduate student at Northwestern University and embarks on a serious affair with him. However, though she's the star of the film, Miss Bisset's role is really of secondary importance. The plot is mostly concerned with the friendship of her son, Skip (Rob Lowe), and Jonathan (Andrew McCarthy) during their first semester at Vernon Academy and how that friendship is strained when Skip bursts into a motel room to find Jonathan in bed with mom. As idiotic "discovery" scenes go, this one must be a classic, though it's not meant to be funny.

Mr. Lowe and Mr. McCarthy are as adequate as their material allows them to be. Cliff Robertson shows up in several scenes as Ellen's husband and Skip's father.

"Class" opens today at the Movieland and other theaters.

1983 Jl 22, C10:5

JAWS 3-D, directed by Joe Alves; screenplay by Richard Matheson and Carl Gottlieb, story by Guerdon Trueblood, suggested by the novel "Jaws" by Peter Benchley; director of photography, James A. Contner; edited by Randy Roberts; music by Alan Parker; produced by Rupert Hitzig; released by Universal Pictures. At the Gemini 2, 64th Street and Second Avenue; Rivoli 1, Broadway and 49th Street; 86th Street East, at Third Avenue. Running time: 97 minutes. This film is rated PG.
Mike BradyDennis Quaid
Kathryn MorganBess Armstrong
Philip FitzRoyceSimon MacCorkindale
Calvin BouchardLouis Gossett, Jr.
Sean BrodyJohn Putch

By JANET MASLIN

"Jaws 3-D" is a movie with unusual timing, since its real star — you know who that is — doesn't appear until an hour into the story. By that time he (who is this time a she) has worked up quite an appetite, and proceeds to eat some tourists and employees at Sea World, in Florida. That park is the second biggest star of this movie, which is no match for "Jaws" but probably no worse than "Jaws II."

I had to read the production notes for "Jaws 3-D," which opened yesterday at the Rivoli and other theaters, to realize that two of the nice young men in the story are supposed to be the sons of Police Chief Brody of Amity, who was played by Roy Scheider in the first two films. Mike (Dennis Quaid), who has certainly grown up quickly, is now chief engineer at Sea World, and his brother Sean (John Putch) has come to visit. Also on hand are Kathryn (Bess Armstrong), a spunky marine biologist who is having the underwater equivalent of an office romance with Mike.

Nothing much happens to any of them during the film's first hour, which revolves around the capture of a reasonably harmless great white shark hardly bigger than a station wagon. Kathryn wants to keep it alive in captivity, while a sleazy film maker named FitzRoyce (Simon MacCorkindale) thinks the shark ought to be killed on camera. Then the little shark's mother puts in an appearance. The mother is roughly the size and shape of a 35-foot-long battering ram,

Aside from integrating the mother shark into the wonders of Sea World — as a fin behind a chorus line of water skiers, say — the chief job of the director, Joe Alves, is to find ways to call attention to the 3-D process.

Although "Jaws 3-D" introduces some novel inside-the-shark's-mouth chewing shots, it's less gory than its predecessors. Without Steven Spielberg's timing or John Williams's music, the shark's periodic visits become feeding scenes rather than ferocious attacks. It's like watching someone make regular raids on a refrigerator in search of midnight snacks.

1983 Jl 23, 11:1

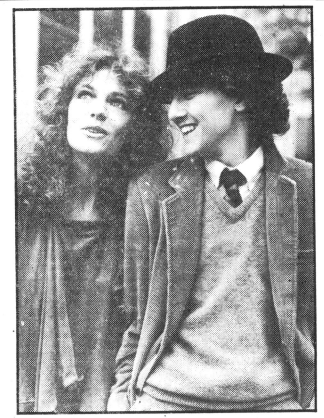

"JAWS 3-D"—A killer shark spreads terror at an aquarium, Friday at the 86th Street East, Gemini, Rivoli and Cinema II.

FILM VIEW

VINCENT CANBY

'Staying Alive' Succumbs to A Host of Missteps

Not even second-rateness comes cheap these days. According to Sylvester Stallone — the co-producer, the co-writer and, all by himself, the director of "Staying Alive"— the film's principal, though unintentionally hilarious set, which is supposed to represent the set for a serious Broadway dance-musical called "Satan's Alley," cost more than do many films today.

The depressing thing about this minor revelation is that one can believe it, though not because the set is espe-

cially elaborate, like 20th Century-Fox's gigantic Old New York street set for "Hello, Dolly!," or intricate, like the house of horrors Steven Spielberg built for "Poltergeist."

The "Staying Alive" set is a large, rectangular space, equipped with elevating platforms, surrounded on three sides by what appear to be see-through plastic balconies. It is here that the film's seemingly endless finale is danced out amid great bursts of colored smoke and disco lighting effects. It looks like something left over from a not-great Oscar telecast production number.

Yet one is convinced of the truth of Mr. Stallone's remark if only because, since everything else in the film has been so mindlessly inflated, there's no reason to believe that the cost of this set should be an exception.

Of all of this season's sequels and spinoffs, including "Return of the Jedi," "Octopussy," "Twilight Zone — the Movie," "Porky's II," "Psycho II," "Superman III" and the self-described "all new all new" "Jaws 3-D," Mr. Stallone's update of John Badham's "Saturday Night Fever" must be the most outrageously wrongheaded, without being original for a minute. The only person who comes through the experience intact is John Travolta, who once again plays Tony Manero, the role that transformed him into a hot Hollywood property in the first film.

It's not completely accurate to say that Mr. Travolta comes through intact. Rather, he comes through augmented. That is, physically. One of Mr. Stallone's duties on this production was, apparently, to oversee a body-building regime that markedly increased Mr. Travolta's musculature. He still looks good, but another couple of months and it will be too much. He'll find himself competing with Arnold Schwarzenegger for "Son of Conan the Barbarian."

● ● ●

What went wrong with "Staying Alive" is not difficult to figure out. For starters there is the screenplay that, according to the film's production notes, Mr. Stallone completely rewrote when he signed on to direct. The notes, however, aren't clear about whether he rewrote the work of some unnamed author or that of Norman Wexler, who receives co-writer credit, or rewrote the work of some unnamed author with Mr. Wexler. Students of trivia may want to get to the bottom of this more than I do.

The only thing completely clear is that this screenplay totally misses the point of the appeal of "Saturday Night Fever," which Mr. Wexler wrote, based on a magazine piece by Nik Cohn, with no help from Mr. Stallone.

To backtrack a minute: "Saturday Night Fever" is about a decent, inarticulate young man named Tony Manero, who works in a Brooklyn paint store during the week and, on weekends, becomes — as movies of this sort frequently say — "somebody" when he goes to the Odyssey discothèque and dances. Tony may have trouble remembering whether it's Shakespeare's "Romeo and Juliet" or Zeffirelli's "Romeo and Juliet," but when he discos he becomes physically articulate and discovers a transporting sense of identity.

The Tony Manero of "Saturday Night Fever" is and always will be a good-hearted neighborhood kid, even when he's 50. When, at the fade-out of the first film, he's seen headed over the bridge for Manhattan, the audience must suspect that he'll be back in Brooklyn before the week is out. Tony is the kind of guy who needs the reassurances of the other guys on his block.

● ● ●

What passes for the story of "Staying Alive" is something else entirely. It's less a story than an epilogue, a competely out-of-character one that's been inflated to feature-length.

It's six years after the end of "Saturday Night Fever," and Tony, having gone over the bridge and stayed, has become a fairly hip Manhattanite, though he still talks Brooklynese. He makes ends meet by bartending at night, teaching dance by day and, in between, auditioning for Broadway shows. He's not a different character — he's no character at all. No role has been written. He's nothing that Mr. Travolta's screen personality doesn't supply. He's as much of a cipher as Woody Allen's Leonard Zelig and nowhere near as much fun.

In attempting to update "Saturday Night Fever" by means of his "Rocky" formula — Mr. Nobody Becomes Mr. Big — Mr. Stallone has replaced the unsentimental gallantry of the first film with pure, if mean-spirited corn. This fantasy isn't good old-fashioned, backstage fun, like "42d Street," the movie, but a blatantly misguided attempt toward fulfillment of wishes that don't exist.

People earlier responded to Mr. Travolta's Tony Manero, not because he was on his way to Broadway stardom but because he was a good-hearted, aimless fellow of no great brain power who found, by accident, that he could do something better than most other people in his neighborhood. The "new" Tony Manero represents a different kind of fiction.

He also is no longer very good-hearted. His mistreats the one young woman who loves him, Jackie (Cynthia Rhodes), a chorus dancer, to make time with Laura (Finola Hughes), the lead dancer in Jackie's show. Then, by some magical coincidence, Tony, Jackie and Laura all get jobs in the same new Broadway show, "Satan's Alley," the title being an unfortunate reference to an earlier Stallone flop film called "Paradise Alley." When the lead dancer of this new show displays unmistakable signs of possessing no talent, Tony simply rehearses the fellow's routines all one night and takes over the top spot the next day.

The preview audience with which I saw "Staying Alive" was remarkably quiet and, though there were some ill-timed giggles now and then, it wasn't until near the end that one realized the silence was that of stunned boredom instead of rapt enchantment. In the film's final sequence, after Tony Manero has been acclaimed as Broadway's newest star by an ecstatic first-night crowd, the docile, adoring Jackie asks him if he'd like to go out to celebrate. Tony beams. "You know what I wanna do?" he says. "I wanna strut!"

The soundtrack comes up with the pulsating, big-beat title song, one of the Bee Gees hits from the first film, and the members of the preview audience suddenly roared with pleasure. They'd been made aware of everything they'd been missing so far in this new film, which features songs by Frank Stallone, the director's brother, over those by the Bee Gees.

However, Mr. Stallone even ruins this reprise. The movie cuts to night shots of Tony moving happily through Times Square and 42d Street to the rhythms of "Staying Alive," but from the several close-ups of Tony's blue-jeaned rear-end, he seems less to be struttin' than to be cruisin'.

All the choices in the movie intend to be shrewd but they come out wrong.

Mr. Travolta will survive "Staying Alive," which, in fact, may make money, but Mr. Stallone's magic as a director of anything except the "Rocky" movies is yet to be proved. Just for the record, let it be noted that the film's choreography makes the movements of Jennifer Beals and her stand-ins in "Flashdance" look like purest Martha Graham.

●

A much more easy-to-take sequel is "Superman III," though Richard Lester, the director, and David and Lesley Newman, who wrote the screenplay, now appear to have gone about as far as they can with the entire idea. One of the oddities of the film is that Christopher Reeve is sometimes a lot funnier than his co-star, Richard Pryor. Mr. Reeve is most solemnly comic in a sequence in which Superman/Clark Kent has an identity crisis induced, I think, by Kryptonite. He starts to drink. He's short-tempered with people in distress. Even the brilliant scarlet of his Superman trunks fades to a mean rust color.

The "Superman" films have followed a curious course. The first was not terrific, but the second was a lot of fun. "Superman III" is not as amusing as "II," but it's still a superman leap over the first. Do we really need "IV"? ∎

1983 Jl 24, II:15:1

Boredom or Love?

WAYS IN THE NIGHT, directed by Krzysztof Zanussi; screenplay (in German with English subtitles) by Mr. Zanussi; director of photography, Witold Sobocinski; edited by Liesgret Schmitt-Klink; music by Wojciech Kilar; produced by Hartwig Schmidt for Westdeutscher Rundfunk; released by TeleCulture. At the Cinema Studio 2, Broadway and 66th Street. Running time: 98 minutes. This film has no rating.
Friedrich..................................Mathieu Carriere
Countess Elzbieta...................Maja Komorowska
Hans AlbertHorst Frank
Mattei AmideiZbigniew Zapasiewicz
Friedrich's motherImgard Forst
CharlotteDiane Korner
1st OfficerPeter Kuiper
2d OfficerAndrzej von Schoenaich
3d OfficerPeter Drescher
Police OfficerWolfgang Gronebaum
SchuttzClaus Enskat
Harpsichord tunerHans-Karl Friedrich
Farm managerEdward Dziewonski
GertrudLilly Towska
WITH: J. Colonna Walewska, S. Jaskiewicz, C. Morawski, F. Priwiezlenrew, B. Rachwalska, M. Robakiewicz

By VINCENT CANBY

IT is meant as praise to say that "Ways in the Night," which opens today at the Cinema Studio 2, has the manner of a private communication that intends that all the rest of us learn from its secrets. The German-language film, made for West German television, was directed by Krzysztof Zanussi, the Polish director known here principally for his "Family Life," "A Woman's Decision" and "Contract."

"Ways in the Night" seems less like the usual international co-production than a compact between its German and Polish participants to attempt to keep the past alive in order to learn what we will from it.

Mr. Zanussi's screenplay, set during the height of World War II, is about the peculiar relationship that grows up between Friedrich (Mathieu Carriere), a handsome, well-born officer in the German Army, and Elzbieta (Maja Komorowska) the proud Polish countess whose country estate is being occupied by Friedrich's company.

Friedrich, just recently returned from the pleasures of occupied Paris, and awaiting assignment to the Russian front at any minute, begins to court the countess more or less out of boredom. She is not conventionally pretty, but she has a voluptuous, old-fashioned beauty and a fiercely independent mind. The more Elzbieta insults Friedrich, the more serious become his intentions.

Much to the chagrin of a cynical fellow officer, who likes to lecture Friedrich on matters of esthetics, Friedrich falls seriously in love with the aristocrat. He sends her presents of food, which she rejects. He asks permission to browse in her library. She sneers at the request. If he wants something, she says, she is certain he'll feel free to take it anyway. They are kindred spirits, he tells her, since they both are devoted to art and beauty. He's a barbarian, she replies. Otherwise why would he be wearing such a uniform?

During the weeks of this courtship, partisan activity around the chateau grows more intense. On the orders of the Germans, two Polish resistance fighters are hanged on the estate. Friedrich begins to feel terrible doubts, at times, actually guilty. As Mr. Zanussi presents him, he is one of the most sympathetic Germans ever seen in a World War II film, and the unfortunate uses to which the victimized Polish countess puts him create a typically Zanussi situation, one in which sympathies are tested instead of soothed.

Mr. Zanussi, who studied physics and philosophy before becoming a film maker, makes movies in which the theatrical is always at the service of the theoretical. His characters begin as ideas and points of view, and only later take on the idiosyncrasies that make them particular. As a result, he needs fine actors to transform his rather heavy, solemn intelligence into serious, living drama, and he has them in Miss Komorowska and Mr. Carriere. They are splendid and, like the film itself, handsome, cool and melancholy.

1983 Jl 27, C17:1

Wagging Tongues

PAULINE AT THE BEACH, directed by Eric Rohmer; screenplay (French with English subtitles) by Mr. Rohmer; photography, Nestor Almendros; edited by Cecile Decugis; music by Jean-Louis Valero; produced by Margaret Menegoz for Les Films du Losange and Les Films Ariane; released by Orion Classics. At the Lincoln Plaza 1, Broadway between 62d and 63d Streets. Running time: 94 minutes. This film is rated R.

Pauline Amanda Langlet
Marion Arielle Dombasle
Pierre Pascal Greggory
Henry Feodor Atkine
Sylvain Simon De La Brosse
Louisette ... Rosette

By VINCENT CANBY

IT is late summer on the coast of Normandy where the beaches are broad and the weather unpredictable. As always, the North Atlantic is far too cold for anyone used to swimming in the soothing warmth of tropic seas, but the afternoon sun is bright and hot and the breezes are bracing.

This is the halcyon setting of "Pauline at the Beach," Eric Rohmer's effortlessly witty, effervescent new French film that opens today at the Lincoln Plaza 1. "Pauline at the Beach" is a comedy of romantic manners about six civilized people, each of whom works stubbornly, and at cross purposes, to enlighten someone else about the true nature of love. It's a sunny month in the country.

Marion is a young, beautiful, successful fashion designer from Paris, currently in the process of divorcing a husband because she couldn't respond to his slavish devotion. Not unkindly she says of her marriage: "That wasn't love. It was fidelity." Marion is waiting to fall in love for the first time. She wants an all-consuming love, one, she says, "that burns."

•

Henry, somewhat older (that is, somewhere in his 30's), is an ethnologist who lives most of the year in the South Pacific. He is divorced and vacationing in Normandy with his small daughter. Passion, says Henry, is behind him. He enjoys his freedom. He lives "without luggage, physical or moral." He is initially amused when Marion falls into bed with him the night of the day they first meet. Then he becomes uneasy.

Pierre, young and athletic and a perpetual student, is a former beau of Marion's. As gravely humorless as he is good-looking, he sets out to talk Marion into loving him instead of the unreliable Henry.

Pauline, Marion's 15-year-old cousin, has never been in love, unless one counts a flirtation when she was 6, or her passing thoughts about a 17-year-old boy she saw in a restaurant in Italy the year before. Pauline watches her elders as if she were witnessing the incomprehensible rites of a tribe of aborigines. On the beach she meets and becomes pleased with Sylvain, a young man her age who shares her skepticism with the others.

The sixth member of the group, who is not socially a part of the group, is Louisette, a lusty "local" girl who sells candy on the beach by day, has two boyfriends and enough time to give herself to anyone else who pleases her.

•

"Pauline at the Beach" is not a farce, but it has many farcical elements as Marion, Henry, Pierre, Pauline, Sylvain and, from time to time, Louisette meet, eat, drink, dance, talk, make love, swim, wind-surf and argue about love. The desires are erotic, but the talk is high-toned until they try to straighten out misunderstandings about who was in bed with whom and why. Innocent couples are caught hiding naked in bathrooms. Feelings are hurt, pride is wounded, hopes dashed and, in the end, only the resolute, all-seeing Pauline is a tiny bit wiser.

Mr. Rohmer opens the film with a quote from Chrétien de Troyes, the 12th-century French romantic poet: "A wagging tongue bites itself." Never for a minute do the tongues stop wagging in "Pauline at the Beach." As the comedy accelerates, they wag more and more desperately as each character, acting, he or she thinks, with the purest of motives, attempts to convince someone else why he/she should/should not love her/him.

Marion, played by the spectacularly lovely blonde, blue-eyed Arielle Dombasle, who had a small role in Mr. Rohmer's "Le Beau Marriage," attempts to snare Henry by adopting the same tactics her boring husband used with her. After being unfaithful to Marion, Henry is worried, but only for a minute. "I hate making people cry," he says as if admitting it to be his worst fault. "I'm too nice."

The lugubriously honest Pierre almost wrecks everyone's vacation by telling the truth, which turns out to be false. In "Pauline at the Beach," as in almost every other Rohmer film, self-deception is the basis of the comedy.

Though Miss Dombasle's is the film's most enchanting performance — she could become France's next major film personality — they are all quite marvelous. As Pauline, the sage teen-ager, a character that is virtually an axiom in Rohmer comedy, Amanda Langlet is both charming and steadfast. Pascal Greggory is sternly comic as the curably pompous Pierre and Feodor Atkine excellent as Henry. An actress named simply Rosette is delectable as the easygoing, no-nonsense Louisette.

As usual, Nestor Almendros's photography perfectly serves the Rohmer vision, which, this time, is not idealized but rather more realistic, the colors being comparatively muted compared to the abundant richness of those that defined the midsummer comedy of "Clair's Knee."

I hope that "Pauline at the Beach" will win new admirers for Mr. Rohmer, one of the most original and elegant film makers at work today in any country. Though his films depend a lot on talk, don't be misled. They are literate but not especially literary, even if the English-language subtitles reinforce this impression.

Mr. Rohmer's works could not exist in any other form. Their particular character would float off any printed page. They combine images, language, action and cinematic narrative fluidity to create a kind of cinema that no one else has ever done before. "Pauline at the Beach" is another rare Rohmer treat.

1983 Jl 29, C6:5

BLUE SKIES AGAIN, directed by Richard Michaels; written by Kevin Sellers; director of photography, Don McAlpine; edited by Danford B. Greene; music by John Kander; produced by Alex Winitsky and Arlene Sellers; released by Warner Bros. At the Guild 50th, between Fifth Avenue and Avenue of the Americas. Running time: 110 minutes. This film is rated PG.

Sandy Mendenhall Harry Hamlin
Liz West .. Mimi Rogers
Dirk Miller Kenneth McMillan
Lou Goff ... Dana Elcar
Paula Fradkin Robyn Barto
Chico (Brushback) Carrasco Marcos Gonzales
Alvin (Wallstreet) Chandler Clik Cozart
Calvin Berry Joey Gian
Carroll Brezki Doug Moeller
Ken Lagarmarsino Andy Garcia
Roy Williams Tommy Lane

"BLUE SKIES AGAIN," which opens today at the Guild Theater, successfully demonstrates so many different kinds of ineptitude that it might well be studied in film schools as a lesson in how not to make a genre movie. This one is about the baseball rookie who becomes a major league star, not overnight but in half an inning with one hit.

What makes "Blue Skies Again" slightly different is that the rookie is a pretty, freckle-faced young woman who, even though she's a great second baseperson and a fine hitter, won't be considered for a position with the Denver Devils because of her sex.

Paula Fradkin, nicely played by the newcomer Robyn Barto, faces every possible kind of prejudice, but the audience is still ahead of the movie all the way. Paula doesn't have a triumph or a defeat that isn't predictable. The events aren't exactly telegraphed in advance, but delivered slowly by a postman with sore feet.

Except for Miss Barto, all the actors give performances that are as silly as their roles. Chief among them are Harry Hamlin, as the owner of the Denver Devils; Mimi Rogers, as the agent who promotes the woman player, and Kenneth McMillan, who usually can do no wrong, as the spineless manager of the Devils. The screenplay — his first — is by Kevin Sellers, the son of Arlene Sellers who, with Alex Winitsky, produced the film.

The director is Richard Michaels, who comes to theatrical films from television where, apparently, he developed a taste for the nonessential detail and the scene that leads nowhere.

•

"Blue Skies Again," which has been rated PG ("Parental Guidance Suggested"), contains some vulgar language.

Vincent Canby

1983 Jl 29, C8:3

Quest for a Gizmo

KRULL, directed by Peter Yates; written by Stanford Sherman; director of photography, Peter Suschitzky; edited by Ray Lovejoy; music by James Horner; produced by Ron Silverman; released by Columbia Pictures. At Loews State, 45th Street and Broadway; Orpheum, 86th Street and Third Avenue; 34th Street Showplace, near Second Avenue and other theaters. Running time: 126 minutes. This film is rated PG.

Colwyn ... Ken Marshall
Lyssa ... Lysette Anthony
Ynyr .. Freddie Jones
Widow of the Web Francesca Annis
Torquil Alun Armstrong
Ergo ... David Battley
Cyclops Bernard Bresslaw
Kegan .. Liam Neeson
Seer ... John Welsh
Titch .. Graham McGrath
Turold ... Tony Church
Eirig .. Bernard Archard
Vella ... Belinda Mayne

"KRULL" is a gentle, pensive sci-fi adventure film that winds up a little too moody and melancholy for the "Star Wars" set, though that must be the audience at which it is aimed. It concerns a handsome prince, his beautiful bride and a band of sidekicks something like Robin

"PAULINE AT THE BEACH"—Amanda Langlet, as Pauline, tells her cousin, played by Arielle Dombasle, about an early romantic crush in Erich Rohmer's new film.

"KRULL"—Lysette Anthony and Ken Marshall, playing the royalty of a distant planet, prepare for a confrontation with an evil creature.

Hood's, not to mention an enchanted movable mountain and a little golden gizmo that has magical powers.

If Peter ("Breaking Away") Yates sounds like an odd choice to direct such a tale, he does rise to the challenge, giving the film poise and sophistication, as well as a distinctly British air. But these qualities, however worthwhile, may not be exactly what "Krull" needed.

"Krull," which opens today at Loews State and other theaters, concerns Prince Colwyn (Ken Marshall) and his long journey to recover the magic Glaive, a five-pronged bejeweled gadget that looks like a kitchen utensil with talons and is capable of spinning like a forked Frisbee. He is also in search of his beautiful bride, Princess Lyssa (Lysette Anthony), who looks like a storybook heroine and who is kidnapped by a red-eyed villain, The Beast, in the story's early moments.

•

Before the Princess vanishes, she and Colwyn indulge in some unexpectedly grown-up flirting, which is part of what distinguishes "Krull" from some of its kiddie-oriented competition. There are also characters who speak resignedly about death, and a bizarre but moving sequence about long-lost love. And the mostly British cast performs with more delicacy than the usual gee-whiz adventure film requires. However, "Krull" is muted and unemphatic, too. And for all its unusual touches, it doesn't fully feel like anything new.

A lot of effort has obviously gone into the the most ambitious episodes in "Krull," most notably a sequence in which an older character called Ynyr (Freddie Jones), who has been the young Colwyn's adviser, goes to visit a woman he loved years ago. She (Francesca Annis) has been transformed into the Widow of the Web and now lives at the heart of a colossal cobweb, which is guarded by a king-size crystal spider.

As Ynyr reminds her of their youth together, the woman is transformed into the beauty she once was, and the sequence develops some emotional weight. And yet the elaborate set,

which appears to be the size of a plane hangar, overpowers most of the sentiment without contributing to it. The film's visual inventions, while distinctive, aren't interrelated enough to create an overall mood.

•

There are hints of other movies, from "Star Wars" to "Dragonslayer," in the screenplay by Stanford Sherman. Indeed, the story of a young hero aided by an older mentor, surrounded by a band of funny-looking sidekicks as he quests after something that will save his kingdom from ultimate destruction, is a story that's being told with some regularity these days. However, Mr. Sherman also incorporates some wit and intelligence into the proceedings. And Mr. Yates works hard to bring understatement and dimension to the material. His "Krull," which is decorous and dignified throughout, has more depth than excitement.

Mr. Marshall and Miss Anthony bring the fairy-tale lovers to life very sweetly, and Mr. Marshall later embodies all the nobility and heroism any handsome prince could need. In his entourage are a Cyclops (Bernard Bresslaw), a comical magician (David Battley), and a tough-looking robber (Alun Armstrong), all of whom provide color and comic relief. The cast also includes a group of Clydesdale horses who fly. In so doing, they take off more definitively than the rest of the movie ever does.

•

"Krull" is rated PG ("Parental Guidance Suggested"). It contains a few moderately gory torture and battle scenes.

Janet Maslin

1983 Jl 29, C10:1

NATIONAL LAMPOON'S VACATION, directed by Harold Ramis; screenplay by John Hughes; director of photography, Victor J. Kemper; film editor, Pem Herring; music by Ralph Burns; produced by Matty Simmons; released by Warner Bros. At RKO Warner, Broadway and 47th Street; RKO 86th Street, at Lexington Avenue; Manhattan, 59th Street between Second and Third Avenues and other theaters. Running time: 100 minutes. This film is rated R.
Clark GriswoldChevy Chase
Ellen GriswoldBeverly D'Angelo
Aunt EdnaImogene Coca
Cousin EddieRandy Quaid
Rusty GriswoldAnthony Michael Hall
Audrey GriswoldDana Barron
Roy WalleyEddie Bracken
Kamp Komford ClerkBrian Doyle-Murray
Cousin CatherineMiriam Flynn

By JANET MASLIN

HOW far does the four-square, straight-arrow Clark W. Griswold family travel in "National Lampoon's Vacation"? Far enough for some fast, funny satire, and not so far out that the humor turns sloppy. "National Lampoon's Vacation," which is more controlled than other Lampoon movies have been, is careful not to stray too far from its target. The result is a confident humor and throwaway style that helps sustain the laughs — of which there are quite a few.

"National Lampoon's Vacation," which opens today at the RKO Warner and other theaters, has a sly, deadpan feeling, as it follows the Griswolds from their purchase of a new car (a station wagon, naturally) through their problem-plagued drive across the country. They are headed west for Walley World, an amusement park built by the creator of Marty Moose. But along the way there are side trips, some planned and some otherwise. Though Dad likes to handpick those sights that the family will see (like "the House of Mud — only the largest free-standing mud dwelling ever built, that's all"), he also has a way of driving with his eyes closed, or ignoring large "DETOUR" signs. Inevitably, this leads to some unplanned excursions.

•

Chevy Chase plays Clark Griswold with much more of an edge than he's brought to any other recent roles; he makes this Dad a perfect square, with a droll, tongue-in-cheek style that doesn't turn snide. The whole family entourage here — including Beverly D'Angelo as the long-suffering Mom and Dana Barron and Anthony Mi-

"NATIONAL LAMPOON'S VACATION"—Chevy Chase and Beverly D'Angelo, portraying husband and wife, indulge in some outdoor dining in a comedy directed by Harold Ramis and featuring Imogene Coca, Randy Quaid and Christie Brinkley.

chael Hall as two kids in the back seat who never seem to quit fighting — is steadily amusing, and not too far removed from the real thing.

Even in an outstandingly funny sequence in which the Griswolds visit some terrible relatives, the comedy stays on track. That's no small accomplishment, since the deadbeat Cousin Eddie (played hilariously by Randy Quaid) wants to borrow money, and says, while cooking dinner: "I don't know why they call this stuff Hamburger Helper. It does just fine by itself." Cousin Eddie also has a daughter who's about 13, and who confides, "I French kiss, and Daddy says I'm the best."

This, and a horrible dog joke, are the film's humor at its riskiest; most of the gags are more subdued, the sorts of cartoonish witticisms that might turn up in a magazine parody. The screenplay, by John Hughes, keeps these witty but simple. And Harold Ramis (who directed "Caddyshack" and co-wrote "Animal House" and "Meatballs") gives the gags their expert timing and keeps the slow stretches to a minimum.

The characters here eventually become more fully drawn than the material might suggest; an audience that follows them from tourist trap to tourist trap will get very used to them after a while. So the movie goes a little too far when it introduces Christie Brinkley as a temptress who (like Suzanne Somers in "American Graffiti") drives the hero wild simply by cruising past seductively in her sports car. Pretty soon, this all-American family man is ready to betray wife, kids, station wagon and the memory of his wife's rotten Aunt Edna (Imogene Coca), all for the chance to chase this temptress. Since the versatile Miss D'Angelo is sympathetic and likable here, and since she and Mr. Chase work well together, the element introduced by Miss Brinkley throws things off. It temporarily makes Clark, who has previously been just a well-meaning jerk, seem like a mean one instead.

Reality doesn't often intrude on a movie this slight and buoyant, though — not even when the elements of the comedy are all too authentic. A bed with Magic Fingers that misfires, or a campsite plagued with every pest imaginable, or even Monument Valley ("Oh, there's got to be a phone or a gas station around here somewhere!"). In "National Lampoon's Vacation," these touches of the ordinary are presented with a cleverness that's anything but humane.

1983 Jl 29, C10:4

PRIVATE SCHOOL, directed by Noel Black; written by Dan Greenburg and Suzanne O'Malley; director of photography, Walter Lasally; edited by Fred Chulack; music by various composers; produced by R. Ben Efraim and Don Enright; released by Universal Pictures. At Gemini 1, 64th Street and Second Avenue; National 2, Broadway and 44th Street; Loews 83d Street, at Broadway; Grammercy, 23d Street near Lexington Avenue. Running time: 90 minutes. This film is rated R.
Christine .. Phoebe Cates
Jordan ... Betsy Russell
Jim .. Matthew Modine
Bubba .. Michael Zorek
Miss Dutchbok Fran Ryan
Betsy .. Kathleen Wilhoite
Chauncey .. Ray Walston
Ms. Copuletta Sylvia Kristel
Roy .. Jonathan Price
Rita ... Karl Lizer
Mr. Flugel ... Richard Stahl

By JANET MASLIN

How can you tell who's who in a movie like "Private School," which opened yesterday at the National and other theaters? It isn't hard. The girls are the ones scampering about in nighties or towels or flimsy underwear, most of which they have a way of losing at the slightest provocation. The boys are the sweaty, breathless ones who chase desperately after the girls, hoping to take Polaroids of them while they're undressing, or maybe watch them in the shower.

The film makers are the ones who, while realizing that they probably aren't working at the zenith of their talents, understand the realities of the film business. Movies like "Private School" usually make money, no matter how sleazy or derivative they happen to be.

•

"Private School" stars Betsy Russell as the great-looking bad girl, and Phoebe Cates as the great-looking nice one, with Matthew Modine as the listless Romeo who must choose between them. It also presents a very drawn-looking Sylvia ("Emmanuelle") Kristel in a cameo role — as a sex education teacher — that reveals her to have no particular flair for comedy. Other characters include the obligatory prune-faced school headmistress, and a few parents who turn out to be even more avidly oversexed than their teen-age offspring.

"Private School" was written by Dan Greenburg and Suzanne O'Malley, and directed by Noel Black, whose interesting "Pretty Poison" earned him a footnote in American film history about a decade ago. "Private School" won't warrant another one.

1983 Jl 30, 11:4

FILM VIEW

VINCENT CANBY

Independent Movies Take a Turn for the Better

Not so many good, individually stylish independent films reach commercial distribution that we can ignore those that finally do break through, even when they are something less than perfect. In some cases the imperfections are what catch the attention, as in Slava Tsukerman's deadpan delirium of a drug dream, "Liquid Sky," and Charlie Loventhal's "First Time," a classy update on undergraduate comedies.

The people who make independent films — by which I mean films conceived, financed and produced outside the major companies — are always in a bind. Not only are they required to function creatively, as artists, but they must also be able to raise the considerable sums necessary to get their projects made.

After that, if they are lucky enough to obtain commercial release, they find themselves competing with multimillion-dollar blockbusters for the attention of the audience. If their films are too special, either in subject matter or style, the larger public will ignore them, but if they are too conventional, they will be dismissed as philistine by that more adventurous portion of the public that might be expected to support them. Making it as an independent isn't easy.

This has been an especially lean year for independent films in the commercial market. About the only ones worth noting are Robert Duvall's "Angelo My Love," Sam Raimi's resolutely schlocky "Evil Dead," and Susan Seidelman's "Smithereens" and Paul Bartel's "Eating Raoul," both of which actually arrived late in 1982. Now, in the space of less than 10 days, there have opened two new, decidedly different independent works, each of which provides its own kind of relief from the general run of commercial movies.

"Liquid Sky," which has the manner of a comic strip about New York's punk culture, was produced, directed and co-written by Mr. Tsukerman, a 44-year-old Soviet émigré who has been living in New York only since 1976.

Looking at "Liquid Sky," one must be surprised that he was able to stand Moscow as long as he did. The film is a celebration of virtually every antisocial attitude one can think of, photographed in Day-Glo colors, punctuated by video images in which colors bleed into each other, scored with electronic music and acted with the either bored or mean mannerisms that, in punk, represent sophistication.

Far more conventional is Mr. Loventhal's sweet-tempered "First Time," which looks and sounds as if it were a spinoff of "Home Movies" (1980), the undergraduate comedy that Brian De Palma made with his students, including Mr. Loventhal, when he was teaching at Sarah Lawrence College several years ago.

A word of caution about both films: Though they are in commercial release, they cannot be approached in quite the same way one would approach a film sponsored by the major production companies. This doesn't mean that one should lower one's expectations. Rather one should be able to shift them to appreciate the odd and unexpected virtues contained by each.

"Liquid Sky" prompts a number of contradictory reactions. It looks terrific and it often sounds simple-minded, though it's difficult to tell just how much of this is intentional. It is essentially funny, but there are few real laughs. Anne Carlisle, an eccentrically beautiful model-actress who plays the dual leading role, is so effective as both Margaret and Jimmy that I watched the entire film without being certain the two were the same person. Yet I'm not sure she's even a good actress. Finally, though both Margaret and Jimmy are beautiful, each often looks exactly like Andy Warhol.

"Liquid Sky," written by Mr. Tsukerman, Miss Carlisle and Nina V. Kerova, who is also a Soviet émigré, is not easily described, being a comic but unsmiling fantasy about Margaret, who bleaches her hair and paints her face light blue (and white and gold), and the Unidentified Flying Object (a space ship the size of a dinner plate) that lands atop Margaret's penthouse apartment. Some of the other characters are Margaret's female lover, Adrian, who sings in a punk club and deals dope on the side; Jimmy, a junkie who snarls a lot at Margaret; a West German scientist who has followed the space ship to New York, and various lovers, sons, and friends.

Life is pretty boring for Margaret, even when she is being beaten up and raped, which happens with some frequency, until, unknown to her, the extra-terrestrial starts mixing into her affairs. Margaret suddenly finds herself a femme fatale — everyone who makes love to her dies and vanishes at the very peak of sexual pleasure. I won't go into the not exactly solemn explanation of the connection between Margaret and the alien creature, but it's not giving away too much to reveal that the film concludes with an unconventional ascension into heaven.

More than anything else, "Liquid Sky" is an alien's vision of America as a civilization light-years beyond all others in decadence, something the film accepts without comment. Mr. Tsukerman also appears to be a wizard with a budget. Though produced on a budget of between $400,000 and $500,000, "Liquid Sky" looks to have cost several times that.

• • •

Where Mr. Tsukerman goes from here, I've no idea, but he seems to possess a rare and unusual talent. Among other things, nobody else has ever photographed that great old lady of New York skyscrapers, the Empire State Building, and made it look like an addict's vision of the world's tallest, sharpest hypodermic needle.

Mr. Loventhal's "First Time" owes a lot not only to Mr. De Palma's "Home Movies" but also to those early, even more anarchic De Palma comedies, "Greetings" and "Hi, Mom." However, where "Home Movies" was thrown slightly off-balance by the star-turn by the otherwise genial Kirk Douglas, "The First Time" is more fully integrated. All the members of the cast are on the same, crazy wavelength.

A lot of things about "The First Time" are nothing if not familiar. Even the title sounds used, but the entire project reeks with youthful optimism. Only someone with enormous faith could believe that a story about a shy young male virgin might once again be funny — and then go on to prove it. By some alchemy I don't understand, Mr. Loventhal and his actors make the characters seem far funnier than they have any right to be, given the format. I say format since "The First Time" looks as if it could be an outline for a television sitcom.

Chief among these characters is Charlie Lichtenstein (Tim Choate), a freshman at Blossom College, a women's institution that has only recently seen fit to admit men. At Blossom, where there are eight females for every male, Charlie dreams of making love and making movies. When the chips are down, however, he's probably more interested in movies than love. Mr. Choate, an extremely winning performer, is surrounded by a first-rate cast that includes Wallace Shawn, as Blossom College's immensely humorless professor of film; Marshall Efron, as Charlie's faculty adviser; Raymond Patterson as Charlie's suite-mate; Cathryn Damon, as Charlie's mom, and Wendy Fulton, as Charlie's most faithful girlfriend.

Mr. Loventhal's achievement is to discover the humor still to be found in situations involving overprotective mothers and young women who are more aggressive than young men. The only essential ingredient that "The First Time" lacks is bad taste, something that no early De Palma film was ever without.

Mr. Loventhal's unfortunate good taste is, to a certain extent, neutralized by his un-self-conscious enthusiasm about movies in general and this one in particular. Every frame of "The First Time" seems to be shouting "Hey, mom, I'm making a movie!" This is especially true in those sequences set in Charlie's film classes, presided over by Mr. Shawn's Professor Goldfarb, described by Charlie's mother as "that phony, pathetic, pigmy person."

While the other students, including one young man who wears an eye patch, swoon over Professor Goldfarb's avant-garde epics and attempt to imitate them, Charlie, to the disgust of the others, goes on making conventional comedies as his class projects. Mr. Loventhal's attacks on academe's avant-garde are as funny as they are broad. His message — much the same as Preston Sturges's "Sullivan's Travels" — is that art is all very well in its place but movies that make people laugh are far more precious.

It's interesting that the more outrageous of these two new independent works was made by Mr. Tsukerman, the older man, and that the younger fellow made the more conservative film. Mr. Loventhal should have no trouble entering the mainstream of American movie production.

1983 Jl 31, II:15:1

Hollywood Inside Out

A GEORGE KUCHAR SAMPLER, six short films written and directed by George Kuchar: "Hold Me While I'm Naked," "Pagan Rhapsody," "A Reason to Live," "Wild Night in El Reno," "I, an Actress" and "The Mongreloid." At the Film Forum, 57 Watts Street. Running time: 94½ minutes. These films have no rating.

By LAWRENCE VAN GELDER

IMAGINE a Hollywood of the late 40's and 50's operating on a shoestring — actresses who look like smeared fantasies of Joan Crawford or Gloria Swanson or Lana Turner; apartments situated in tenements rather than swank neighborhoods; stained and broken plumbing; plastic statuary; props and symbols featuring artificial birds; leading men who offer their women not champagne but milk; a vista from the window that is as likely to be the Bronx as anywhere else, and dialogue that plumbs the depths of banality: "The fog is coming. It will give you strength."

And under it all, the swelling, portentous music of high melodrama (playing tinnily, of course); gaudy color or the chiaroscuro use of black and white, and plots to match: tortured directors in search of leading ladies for their latest epic; men trapped in stifling relationships, women afflicted with angst.

To imagine all this is to conjure up a vision of three of the six films that constitute the George Kuchar Sampler that opens today at the Film Forum.

In these films — "Hold Me While I'm Naked" (1966), "Pagan Rhapsody" (1970) and "A Reason to Live" (1976) — Mr. Kuchar at once pays homage to and satirizes the films of such directors as Douglas Sirk, films that clearly fired his childhood imagination and nourished the ambition that earned him renown in the 1960's as an underground film maker. Yet behind the effective pastiche, behind the sardonic understanding of Hollywood, there lies as well a compassionate sense of the human condition, especially of loneliness.

Mr. Kuchar, who came out of New York and now teaches in San Francisco, is represented on the Film Forum program by three later works — "I, an Actress" (1977) a 10-minute film that shows him at work with one of his actress students; "Wild Night in El Reno" (1977) a 6-minute work mainly devoted to violent atmospheric conditions outside a motel in Oklahoma, and "The Mongreloid" (1978), a 10-minute reminiscence about the director and his dog.

Although interesting for the glimpses it gives of Mr. Kuchar at work, the first of these films is not nearly so amusing as it seems to hope to be; the second is competent, and the third something of a mixed bag — a worthwhile idea whose efforts at humor seem derivative of Mel Brooks, but whose atmosphere of nostalgia and artistic isolation is clearly Mr. Kuchar's own.

All in all, the sampler is an instructive excursion into the work of an offbeat film maker.

1983 Ag 3, C21:3

Spirited Testimonial

LANGLOIS, a documentary about Henri Langlois, directed by Eila Hershon and Roberto Guerra. At the Public Theater, 425 Lafayette Street. Running time: 52 minutes. This film has no rating.

TO herald the publication of Richard Roud's biography of Henri Langlois, the Public Theater is offering free showings of "Langlois," a spirited testimonial to this quintessential film enthusiast, the late founder of the Cinémathèque Française. This 52-minute documentary, made in 1971, offers a whimsical, anecdotal portrait, interspersing interviews with Mr. Langlois's admiring associates with footage of him as he walks around Paris, holding forth on anything from a house in which Jean Renoir once lived to the black and white swans he spies in a park.

"This beautiful black is the black of the cinema," he says, pointing to one swan. "This" — pointing to several — "is the black and white of the cinema. And the red" — indicating the black swan's bill — "is the heart of the cinema." This portrait, by Eila Hershon and Roberto Guerra, makes it clear that Mr. Langlois could find cinematic overtones in virtually anything, and that he did so with passionate intensity.

Simone Signoret tells of how Mr. Langlois might halt the showing of a film if he felt the audience to be unworthy of what it was seeing: " 'No, you're too stupid,' he would say, and then he'd show them 'Potemkin' in the dining room of Mr. Langlois's mother's tiny apartment, during the German occupation, at a time when the screening of a Soviet film would have been forbidden." Mr. Langlois himself recollects that as a child, he found it "too strong" to watch films whose characters wore modern dress, since it was impossible for him to believe these were works of fiction. So he watched historical films instead.

He was "a man of destiny, born to do one thing," according to Lillian Gish, who, along with Ingrid Bergman, Catherine Deneuve, Jean Renoir, Jeanne Moreau and François Truffaut, is interviewed here. (So are Kenneth Anger and Viva, though their comments are considerably less germane.)

Mr. Langlois points out former homes of his own and of the Cinémathèque, the present-day facilities of which are briefly seen. There is also a bit of newsreel footage of the heated protests against Mr. Langlois's brief dismissal early in 1968, demonstrations that prefigured those that would erupt that May.

What emerges, even more distinctly than the intensity of Mr. Langlois's love of film, is the tremendous debt of gratitude owed him by all those who play a part in this affectionate tribute.

Starting today, "Langlois" will be shown free at 2 P.M. on Fridays, Saturdays and Sundays all month, in conjunction with the Public Theater's 12-day series of films that Mr. Langlois especially treasured.

Janet Maslin

1983 Ag 5, C10:5

STAR CHAMBER, directed by Peter Hyams; screenplay by Roderick Taylor and Mr. Hyams; director of photography, Richard Hannah; edited by Jim Mitchell; music by Michael Small; produced by Frank Yablans; released by 20th Century-Fox. At the Paramount Theater, at Columbus Circle, the Tower East Theater, 72d Street and Third Avenue, and other theaters. Running time: 109 minutes. This film is rated R.

Michael Douglas in a scene from "The Star Chamber."

Steven Hardin	Michael Douglas
Benjamin Caulfield	Hal Holbrook
Detective Harry Lowes	Yaphet Kotto
Emily Hardin	Sharon Gless
Dr. Harold Lewin	James B. Sikking
Arthur Cooms	Joe Regalbuto
Lawrence Monk	Don Calfa
Detective James Wickman	John DiSanti
Stanley Flowers	DeWayne Jessie
Hingle	Jack Kehoe
Detective Kenneth Wiggen	Larry Hankin
Detective Paul MacKay	Dick Anthony Williams
Louise Rachmil	Margie Impert
Martin Hyatt	Dana Gladstone

By JANET MASLIN

PETER HYAMS has shown himself, with films like "Busting," "Outland" and "Capricorn One," to be a stylish, flippant director, capable of generating a great deal of suspense as well as action scenes that really pack a wallop. "The Star Chamber," which opens today at Loews Tower East and other theaters, begins so excitingly that Mr. Hyams appears to have outdone himself.

Two undercover detectives, trailing a suspicious-looking man, find a clever way of obtaining his gun without a search warrant. The man, we know, has murdered several elderly women and stolen their welfare checks. When this man gets to court, the very decent and honorable-looking Judge Steven Hardin (Michael Douglas) knows this, too. But he also knows that the gun has been obtained in a questionable manner and that he cannot uphold the legality of the search. So Judge Hardin lets this murderer go free — and the judge's tormented conscience sets in motion the events that turn "The Star Chamber" into a tale of vigilante justice.

Mr. Hyams repeats and builds on several more such episodes, which, dramatically loaded and legally questionable as they may be, are very forceful indeed. So it is a great disappointment, halfway into the movie, to find "The Star Chamber" so far off the track that its credibility almost entirely disappears. Judge Hardin, who begins the film as a sympathetic and well-drawn character, eventually finds himself much too deeply enmeshed in developments no audience will believe. And the notion of vigilante justice, to which the title refers (this was the arbitrary and tyrannical English court — abolished in the 17th century — with the power to overrule other judicial bodies) becomes muddled and even neutralized by the time the story is over.

"The Star Chamber" has a well-meaning urgency, and it is an entertaining film even when it becomes so

"THE STAR CHAMBER"—Peter Hyams's film explores what happens when a group of judges loses faith in the system and decide to take the law into their own hands. Michael Douglas, Hal Holbrook and Yaphet Kotto are among the stars.

thoroughly misguided. Mr. Douglas plays crusading heroes very well, and the supporting cast has for the most part been well chosen. Mr. Hyams works with such bold strokes that he tends to turn criminals into jumpy, wild-eyed mad-dog types, which means that the actors in the thug roles are at a great disadvantage. Heaven knows, there was no need for any of this visual underscoring of the notion that accused criminals are a depraved form of low life; the screenplay takes care of that by generally making them drug pushers or child molesters, with the occasional murderer for good measure. Not with aces up your sleeve or in your hat brim could you achieve a more thoroughly stacked deck.

Still, the screenplay, by Roderick Taylor and Mr. Hyams, has almost enough snap to make up for its unfair and improbable sides. And some of the supporting roles, both as written and as played, have an unmistakable power. James B. Sikking, as the father of a murdered boy, is able to voice some of the film's most strident sentiments in a wrenching, persuasive way. And Hal Holbrook for a while carries a quiet authority, as the older judge who was Hardin's mentor, though his hints about a modern-day Star Chamber (which is never called by that name in the movie) are dropped a little too casually for most tastes. These are life-and-death matters, after all, even if it turns out they are being decided in a lavishly appointed conference room, equipped with green lamps and rows of leather armchairs, in the older judge's suburban home. What is this room used for when the secret court is not in session? That is only one of the tinier snags that the plot ultimately encounters.

Yaphet Kotto, as a police detective whose activities overlap with Judge Hardin's, and Sharon Gless, as the judge's devoted and wisecracking wife, are also shown off to good advantage. The supporting perform-

ances that work well far outnumber the overwrought ones, just as the film's ability to entertain triumphs, at least for a while, over its innate confusion. But "The Star Chamber" can't live up to its own initial promise — nor does it really live up to Mr. Hyams's. His powerhouse style finally sabotages the issues raised by "The Star Chamber," which remain much more delicate than the treatment they have been given here.

1983 Ag 5, C8:5

Teen-Age Daydreams

RISKY BUSINESS, directed and written by Paul Brickman; directors of photography, Reynaldo Villalobos and Bruce Surtees; edited by Richard Chew; music by Tangerine Dream; produced by Jon Avnet and Steve Tisch; released by Warner Bros. At the Sutton, Third Avenue and 57th Street, and other theaters. Running time: 98 minutes. This film is rated R.
Joel	Tom Cruise
Lana	Rebecca De Mornay
Miles	Curtis Armstrong
Barry	Bronson Pinchot
Glenn	Raphael Sbarge
Guido	Joe Pantoliano
Joel's father	Nicholas Pryor
Joel's mother	Janet Carroll
Vicki	Shera Danese
Rutherford	Richard Masur
Jackie	Bruce A. Young
Chuck	Kevin C. Anderson
Kessler	Sarah Partridge

ALTHOUGH Paul Brickman's "Risky Business" shows an abundance of style, you would be hard pressed to find a film whose hero's problems are of less concern to the world at large. Joel Goodsen (Tom Cruise) is an affluent suburban teen-ager, sex-starved yet smug, whose erotic daydreams begin to come true, once his parents go on vacation and leave him to hold the fort.

Joel's rebellion starts slowly, as he downs a glass of expensive Scotch with his TV dinner, but it escalates in a hurry. Eventually, he winds up operating an impromptu brothel, as well as driving his father's $40,000 car into the drink. Even feats like these manage to work to Joel's advantage.

As written and directed by Mr. Brickman, "Risky Business" is part satire, part would-be suburban poetry and part shameless showing off. Mr. Brickman's talents are evident, but they're unevenly applied to this material; he's as capable of a slow, loving shot of a lawn being watered as of a witticism that's original and wry. The best things in "Risky Business," opening today at the Sutton and other theaters, really are fresh, like Joel's fantasy of finding the house surrounded by the police as a man with a megaphone warns "Get off the baby sitter!" On the other hand, there are too many moments when Mr. Brickman's pretensions fly out of control.

The casting is especially erratic. Joel's suburban parents, played by Nicholas Pryor and Janet Carroll, are crude caricatures. And a few of his friends are terrifically unappealing, speaking too slowly and savoring every nuance of some less than fascinating dialogue. On the other hand, Rebecca De Mornay is disarming as a call girl who looks more like a college girl, and who figures importantly in Joel's clean-cut daydreams. Mr. Cruise makes Joel's tranformation from straight arrow to entrepreneur about as credible as it can be made.

Mr. Brickman, who favors a lot of portentous, panning camera motions, occasionally interjects something really unexpected, like the music that blares wildly when Joel starts his father's sports car, then stops abruptly as the car stalls. One funny moment, also tied to the music (the film has a highly effective rock score, with electronic incidental music by Tangerine Dream), has Joel bursting out of his dull workaday personality by suddenly grabbing a candlestick, then a fireplace poker and pretending he's one very raunchy rock star.

Mr. Brickman, who wrote the screenplay for Jonathan Demme's "Handle With Care," makes his directing debut here, and it's both promising and exasperating. Though his film can be all too knowing at

times, it lacks much irony or distance where the real importance of either Joel or his situation are concerned.

However, "Risky Business" improves as it goes along — once it gets past, say, Joel's solemnly presented fantasy of a girl in a shower who asks him to wash her back, thus making him three hours late to take the college boards and ruining his future. This sequence begins the movie, and it seems to be rendered altogether seriously. Only toward the end — when Joel sinks the Porsche, or when his mother discovers that her beloved crystal egg has been cracked (Joel finds himself using it as a sort of football) — are these sorts of tragedies seen in any kind of perspective.

Janet Maslin

1983 Ag 5, C13:1

Liddy Clark in the film "Kitty and the Bagman."

Back-Lot Gangsters

KITTY AND THE BAGMAN, an Australian film directed by Donald Crombie; screenplay by John Burney and Phillip Cornford; director of photography, Dean Semmler; produced by Anthony Buckley; released by Quartet/Films Inc. At the 57th Street Playhouse. Running time: 95 minutes. This film is rated R.
Kitty O'Rourke	Liddy Clark
Lil Delaney	Val Lehman
The Bagman	John Stanton
Cyril Vikkers	Gerard McGuire
Doris de Salle	Collette Mann
Chicka Delaney	Reg Evans
Sarah Jones	Kylie Foster
Sam	Ted Hepple
Thomas	David Adcock
Larry O'Rourke	David Bradshaw
Simon Mornington	Anthony Hawkins
Slugger	Paul Chubb
Train Driver	John Ewart

DONALD CROMBIE'S "Kitty and the Bagman" takes place in a very odd part of Australia: the part that adjoins the old Warner Bros. back lot, or so it seems. That, at least, is the feeling of this colorful gangster movie, with its unlikely Australian air.

"Kitty and the Bagman," which opens today at the 57th Street Playhouse, takes place during the Roaring Twenties and is set in an area that may not have been known to roar. Nevertheless, it is full of flappers, gamblers, mobsters and thugs, with a pert heroine who runs a casino and proves herself to be the toughest customer of all.

Kitty O'Rourke, played with great sang-froid by Liddy Clark, arrives at the Sydney waterfront after the unexpected arrest of her husband, who turns out to have been a small-time crook. Kitty hopes to get work as a seamstress, but that idea is ridiculed by one of her new waterfront acquaintances ("Seamstress? That's rich! All they do with clothes 'round here is try and tear 'em off you!").

So Kitty takes the hint, and goes into various other kinds of business. In short order, she has become the "Crime Queen of the Waterfront," as one newspaper headline describes her. To go along with this new position, she develops a whole gangland coterie, including at least one Salvation Army-lass-turned-prostitute and a red-hot rival named Lil.

Mr. Crombie fills the movie with barroom scenes, forbidden trysts, shootouts and a train robbery, all of which contribute to the old-time Hollywood air. Somehow, the women here, among them Miss Clark and Collette Mann, as a plump sidekick, emerge as much more vibrant creatures than the men, which may be attributed in part to the ladies' many-beaded and rainbow-colored outfits. As the gentleman of the title, a corrupt policeman muscling in on Kitty's operation, John Stanton cuts so cool a figure that most of his acting seems to be done by either his tilted hat brim or his square, sturdy jaw.

Mr. Crombie, who also directed "Caddie," makes this an elaborate costume drama and a homage to Hollywood gangster lore, rather than a tale in which the characters are followed closely. Though the terse Bagman eventually falls for Kitty, and notwithstanding the title, this is more of a period piece than a romance. Whether such rip-roaring goings-on were ever prevalent in Australia, or whether they took anything like the form seen here, is probably of less import than the fact that Mr. Crombie has presented them so affectionately.

Janet Maslin

1983 Ag 5, C14:5

Rural Nostalgia

VALENTINA, a Spanish film directed by Antonio Jose Betancor; screenplay by Lautano Murua, Mr. Betancor, Carlos Escobedo and Javier Moro; from the novel "Days of Dawn" by Ramon J. Sender; director of photography, Juan A. Ruiz Anchia; music by Riz Ortolani; produced by Javier Moro and Carlos Escobedo; released by the Frank Moreno Company. At the Coronet, Third Avenue and 59th Street. Running time: 85 minutes. This film has no rating.
Mosen Joaquin...............................Anthony Quinn
Pepe..Jorge Sanz
Valentina.......................................Paloma Gomez
Don Jose..Saturno Cerra
Dona Luisa.....................................Conchita Leza
Don Arturo.....................................Alfredo Luchetti
Dona Julia......................................Marisa de Leza

PEPE, we are told at the beginning of Antonio José Betancor's "Valentina," is "a typically intelligent and sound Spanish man, capable of making his dignity a kind of religion." The film begins with the news that Pepe has been killed during World War II, and it flashes back to his childhood to explain how he came to be a person of such conviction.

A key figure in his childhood was his playmate Valentina, who grew up with him in a small village in northern Spain. As the screenplay, based

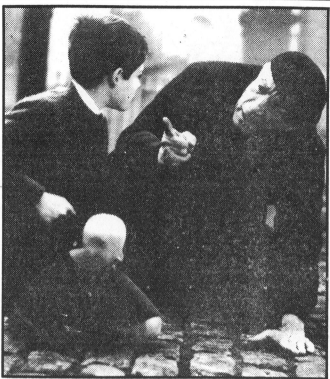

"VALENTINA"—Anthony Quinn plays the role of a priest opposite young Jorge Sanz in the Spanish director Antonio Betancor's movie about a man reflecting on his past.

on the novel "Days of Dawn" by Ramon J. Sender, puts it: "In the middle of so much misery, Valentina was God's sweet jest."

As this may suggest, "Valentina" is a nostalgic and somewhat florid glimpse of young Pepe's rural upbringing, with Pepe and Valentina as such precocious preteen-age romantics that the soundtrack seems to erupt with music each time they meet. The film, which is mostly a set of atmospheric vignettes, watches Pepe as he dreams of becoming a poet while he sits atop the tiled roof of his family's home, gazing off at a beautiful Spanish vista. It follows his troubles with his strict father and his intense and beneficial relationship with a local priest, played by Anthony Quinn. Mr. Quinn, who performs in Spanish here, does well with a role that is as suffused with sentiment as the rest of the film and that is too often upstaged by the less riveting adventures of the children.

"Valentina," which opens today at the Coronet, is prettier than it is compelling, and at times (as when Pepe's father scolds him for inadvertently killing some pet pigeons, waving a dead bird's wing as he speaks), it is not exactly pretty, either. Mr. Betancor seems to celebrate both Pepe's feistiness and his poetic side, even though the two frequently seem incompatible. But these, in the film's scheme, are the ingredients of Pepe's later heroism, which is celebrated here more thoroughly than it is explained.

"Valentina" is rated PG ("Parental Guidance Suggested"). It contains some minor incidents of violence.

Janet Maslin

1983 Ag 5, C15:3

Mistaken Identity

I MARRIED A SHADOW, directed by Robin Davis; screenplay by Patrick Laurent and Robin Davis, from the novel "I Married a Dead Man" by William Irish; director of photography, Bernard Zitzerman; music by Philippe Sarde; produced by Alain Sarde; released by Spectrafilm. At the Paris Theater, 58th Street, west of Fifth Avenue. Running time: 110 minutes. This film has no rating.
Hélène/Patricia.........................Nathalie Baye
Pierre.......................................Francis Huster
Frank..Richard Bohringer
Léna...Madeleine Robinson
Monsieur Meyrand......................Guy Tréjan
Fifo...Victoria Abril
Patricia.....................................Véronique Genest

By JANET MASLIN

THROUGH a series of incredible but entertaining coincidences, two pregnant women exchange identities at the beginning of "I Married a Shadow," the romantic thriller by Robin Davis that opens today at the Paris Theater.

Based on a novel by William Irish, (with the title "I Married a Dead Man," which captures the situation much more accurately), the movie has a tricky and convoluted plot that recalls Hitchcock, even if Mr. Davis's direction doesn't often do the same. Much of the old-fashioned suspense is undoubtedly attributable to Mr. Irish, who also wrote "Rear Window" as well as "The Bride Wore Black."

"I Married a Shadow" begins as Hélène (Nathalie Baye) is being berated by her lover, Frank, who is foul-tempered and unemployed. Moments later, he throws her out of his car and abandons her, even though she is eight months pregnant. With nowhere to go and no other family, Hélène is desperate, and on a whim she decides to take a train south. On the train, she meets a woman named Patricia Meyrand and her new husband Bertrand. They are en route to Bordeaux, where Patricia is to meet her in-laws for the first time.

Further coincidence leads Hélène to don a dress of Patricia's, as well as her wedding ring, just before the

Nathalie Baye in the film "I Married a Shadow."

train crashes. Hélène awakens in a hospital to find that her baby has been born, Patricia and Bertrand have been killed, and the Meyrand family is eager to take her home. Never having met their new daughter-in-law, they have mistaken Hélène for her. And Hélène's efforts to correct the error are understandably only half-hearted. After all, she had nowhere to go. And the Meyrands are wealthy vintners with another son, Pierre (Francis Huster), who is handsome, unmarried and terribly concerned about his new sister-in-law's welfare.

Out of this contrived but intriguing situation, Mr. Irish's novel wove a series of further perils and coincidences. The audience will see most of these coming well before they arrive, but they're enjoyable anyhow. Mr. Davis tends to underscore the action in ways that worked better for Hitchcock than they do for him (as when, on two occasions, he positions Hélène and her handsome new brother-in-law in profile, with flames between them in the background, to indicate that theirs is a tempestuous relationship). However, his direction is generally simple and streamlined. And it suits the material, even if it never quite makes the most of it.

Miss Baye, the subdued and accomplished French actress whose ubiquity is beginning to rival Isabelle Huppert's, makes a sympathetic heroine if not a particularly demonstrative one. Her performance is careful and restrained, and only in those few moments (romping through the vineyards with Pierre) when she must register wild happiness is she in the least bit unconvincing. During most of the story, Hélène/Patricia is tense and apprehensive, qualities Miss Baye conveys very well.

In the small role of the nasty Frank, Richard Bohringer is suitably coarse and temperamental. One more character in the mystery is Fifo (Victoria Abril), the beautiful and jealous vineyard hand who loves Pierre and resents the newcomer bitterly. Miss Abril tosses her hair and flashes her eyes a lot, and in one memorable sequence she and Pierre are seen at a party, enjoying themselves in a hearty peasant manner with some of the other workers. Mr. Davis, to convey this, brings on a troupe of guitar-playing folk singers, who sing merrily and slap one another's backs and drink wine from the bottle. The movie fares better in its more coolly understated moments.

1983 Ag 10, C16:5

Fassbinder's Coda

BERLIN ALEXANDERPLATZ, a German film directed and written by Rainer Werner Fassbinder; from the novel "Berlin Alexanderplatz" by Alfred Döblin; director of photography, Xaver Schwarzenberger; edited by Juliane Lorenz; music by Peer Raben; produced by Peter Marthesheimeir; released by Teleculture Films. At Lincoln Plaza Cinema. Broadway between 62d and 63d Streets, and Vandam Theater, 15 Vandam Street. Running time: 15 hours, 21 minutes. This film has no rating.

Franz Biberkopf	Günter Lamprecht
Eva	Hanna Schygulla
Mieze	Barbara Sukowa
Reinhold	Gottfried John
Lina	Elisabeth Trissenaar
Frau Bast	Brigitte Mira
Minna	Karin Baal
Ida	Barbara Valentin
Herbert Virchow	Roger Fritz
Meck	Franz Buchreiser

Following are excerpts from a review by Vincent Canby that appeared in The New York Times of July 10, 1983. The film opens today at Lincoln Plaza Cinema and Vandam Theater.

THE New York theatrical premiere of Rainer Werner Fassbinder's "Berlin Alexanderplatz," the late German director's masterly, 15½-hour television adaptation of Alfred Döblin's epic 1929 novel of postwar Berlin, stands to become one of the year's most important cinema events. Its importance goes far beyond the Fassbinder career, though we must now reevaluate that career in light of "Berlin Alexanderplatz," a 1980 work that has the effect of being the coda we did not see in Fassbinder's final film, the lamentable "Querelle."

When it was shown in Germany, "Berlin Alexanderplatz" was in 13 segments, totaling 13½ hours, plus a two-hour epilogue. At the Lincoln Plaza Cinema it will be more or less parceled out to the public in three-hour chunks over a five-week period.

Totally impractical — at least from any levelheaded business point of view — is the way in which I saw the film, that is, in two sections, one lasting seven and a half hours, the other eight, on successive days.

In "Berlin Alexanderplatz" Fassbinder has created a huge, magnificent melodrama that has the effective shape of a film of conventional length. There's never before been anything quite like it, possibly because no film maker of comparable stature has ever tried to work on such a grand scale, with the exception of Erich von Stroheim when he attempted to realize his vision of "Greed."

Throughout his short but spellbinding career — more than 30 features between 1969 and 1982 — Fassbinder concentrated on films that reflected his own idiosyncratic visions, while occasionally putting his talent in the service of the works of others, most successfully in his adaptations of Theodor Fontane's "Effi Briest" and Vladimir Nabokov's "Despair," based on an English-language screenplay by Tom Stoppard. It's in this small group of adaptations that "Berlin Alexanderplatz" belongs, towering above all of the others.

"Berlin Alexanderplatz" is a serio-comic, two-volume epic about the life, death and salvation of one Franz Biberkopf, a former transport worker who, when first met, is leaving prison after a four-year term for having beaten to death his prostitute-mistress in a drunken fury. The time is 1927 and Franz, a hulking, self-confident fellow given to sudden rages and quick remorse, makes a vow to himself to remain "decent."

It's not easy. There are no jobs open to him. For a while, he sells tie-clips on the street, becomes a vendor of the National Socialist newspaper "The People's Observer" though he has no use for the Nazis, flirts with anarchism and finally becomes involved with a mob of crooks — comic but deadly parodies of the crooks in early Fritz Lang movies.

Fassbinder adds at least one important character and changes the tone of several others but otherwise sticks closely to the Döblin novel, in which Franz, moving from one mistress to the next, getting into one scrape after another, blames fate for his troubles instead of recognizing the rottenness of the world and double-crossing friends for what they are.

In the film's apocalyptic finale, Franz, mad as a hatter, has a long dialogue with Death, comparable to a jazzy sort of Dostoyevsky vision, in which Death lectures Franz on the need to look with his eyes and see, to listen with his ears and hear. In attempting to be "strong" and "decent," says Death, Franz has remained naïve without being innocent.

As Death talks to Franz in New Testament terms, the movie also makes associations between Franz and Jeremiah, Job and Abraham. Then, like Christ, Franz dies and is resurrected in the person of someone who looks exactly like Franz Biberkopf and has his papers in his pocket.

At the center of the film is the remarkable performance of Günter Lamprecht as Franz. He is a large, doughy-looking fellow with small eyes, a big stomach and a certain sweetness that makes understandable the loyalty he inspires in the series of women who live with him. Mr. Lamprecht must rant, rave, laugh crazily, booze, brawl and never — not for a minute — be ridiculous while behaving in ridiculous ways.

Almost as important to the film is Gottfried John, a tall, lanky man whose features look to have been carved out of wood, who plays Reinhold, a pathological killer and stuttering ladies' man whom Franz persists in considering his very best friend.

Fassbinder has surrounded Mr. Lamprecht and Mr. John with virtually all of the members of his great stock company, whose familiar faces on this screen give the film the manner of a grand finale. They include Brigitte Mira, Irm Hermann, Ivan Desny, Volker Spengler, Udo Kier and, especially, three actresses who are identified with the director's greatest work.

Hanna Schygulla ("Maria Braun") is radiant — again — as the high-class prostitute and former mistress of Franz who continues to watch over him; Elisabeth Trissenaar ("The Stationmaster's Wife," "In a Year of 13 Moons") is one of Franz's more pliant mistresses, and Barbara Sukowa ("Lola") is nothing less than superb as Mieze, a streetwalker, years younger than Franz, whose love for him prompts him to commit what becomes a mortal sin and leads to her death. Miss Sukowa gives a performance worthy of the young Lillian Gish.

"Berlin Alexanderplatz" was made into a German film in 1931 by Piel Jutzi. Mordaunt Hall, in reviewing Jutzi's "Berlin Alexanderplatz" in the May 11, 1933, issue of The New York Times, noted that it was "an adaptation of Alfred Döblin's two-volume novel, which is said to have been among those tossed to the flames yesterday in Berlin." Yet it survives, triumphantly.

1983 Ag 10, C18:5

Boy Gets Girl

THE GOLDEN SEAL, directed by Frank Zuniga; screenplay by John Groves, from the novel "A River Ran Out of Eden" by James Vance Marshall; director of photography, Eric Saarinen; edited by Robert Q. Lovett; music by Dana Kaproff; produced by Samuel Goldwyn Jr.; released by The Samuel Goldwyn Company. At the Rivoli, Broadway and 49th Street, and the Eastside Cinema, Third Avenue between 55th and 56th Streets. Running time: 95 minutes. This film is rated PG.

Jim	Steve Railsback
Crawford	Michael Beck
Tania	Penelope Milford
Eric	Torquil Campbell
Semeyon	Seth Sakai
Alexei	Richard Narita
Gladys	Sandra Seacat
Tom	Peter Anderson

By JANET MASLIN

PETS are hard to come by on the Aleutian Island of Unak, where a boy named Eric lives with nary a squirrel to play with in "The Golden Seal," which opens today at the Eastside Cinema. Alone with his parents on the rocky isle, Eric — whose father calls him Boy — longs for a puppy, which he is planning to name Girl.

Just after the puppy proves unobtainable, Eric spies what he thinks may be a golden seal. Golden seals, we learn, are creatures so magical that some doubt their existence and others offer huge rewards for their capture. A blind Aleut patriarch (Seth Sakai) declares that if such a seal is ever found, it will bring peace and harmony to the world.

Long ago, Eric's father, Jim Lee (Steve Railsback), may once have seen one. At first he doubts his son's discovery, but the audience knows better: Eric has indeed found a golden seal. What's more, he has befriended it and romped and played with it in slow motion. The seal wears gold makeup but is also photographed in a yellowish light that makes Eric, when he's seen beside it, look golden too.

Seal fanciers, this is your movie. Though it means to concentrate on little Eric and the lessons he learns about the beauty of nature and the fallibility of his elders, his story is easily upstaged by that of his new found friend. Actually, there are two seals, supposedly mother and newborn pup, but really about the same size; the best way to tell them apart is by the whiskers. They waddle and arf and leap out of the water. These are pretty much the high points of the movie.

Of the flipperless performers, only Michael Beck makes much of his role, which is that of Crawford, a seal-hunting heavy from a larger island. As written by John Groves, whose screenplay is based on a novel called "A River Ran Out of Eden" by James Vance Marshall, the part is simply a standard redneck role. Nevertheless, Mr. Beck puts quite a bit of life into it, which is more than the other cast members manage.

They include Penelope Milford, as the mom who stays home while Eric and his dad go out exploring, and Torquil Campbell, who brings an excess of wide-eyed innocence and too-careful enunciation to the role of the boy. Frank Zuniga, the film's director, has one "Wilderness Family" saga to his credit. Here, as in that film, he displays neither a keen eye for scenery nor an aversion to sentimental slush.

Seven real seals play the two seal characters in the story. They were trained by Steve Martin, an animal specialist, were watched over by a veterinarian, Dr. Martin R. Dinnes,

Torquil Campbell with the other star of "The Golden Seal."

and painted yellow by Allen Apone, who used two substances, one for the beach shots and another for those in the water. Seldom does anyone pet any of the seals in the movie, possibly because their paint is delicate and possibly because (as the production notes intimate) they bite.

•

"The Golden Seal" is rated PG ("Parental Guidance Suggested"), because of something the precocious Eric exclaims when he hits his thumb with a hammer.

1983 Ag 12, C4:5

CUJO, directed by Lewis Teague; screenplay by Don Carlos Dunaway and Lauren Currier, from the novel "Cujo" by Stephen King; director of photography, Jan De Bont; music by Charles Bernstein; produced by Daniel H. Blatt and Robert Singer; released by Warner Bros. At the National, Broadway and 44th Street; RKO 86th Street, at Lexington Avenue; Gemini, 64th Street and Second Avenue; Bay Cinema, 31st Street and Second Avenue; Loews 83d Street and other theaters. Running time: 97 minutes. This film is rated R.

Donna Trenton	Dee Wallace
Tad Trenton	Danny Pintauro
Vic Trenton	Daniel Hugh-Kelly
Steve Kemp	Christopher Stone
Joe Camber	Ed Lauter
Charity Camber	Kaiulani Lee
Brett Camber	Billy Jacoby
Gary Pervier	Mills Watson
Bannerman	Sandy Ward
Masen	Jerry Hardin

Dee Wallace in "Cujo."

By JANET MASLIN

Not since the Baskervilles has there been a hound as horrible as Cujo, the film version of whose story opened yesterday at the National and other theaters. Based on a novel by Stephen King, "Cujo" tells of a lovable St. Bernard who, after being bitten by a rabid bat, becomes a good deal less lovable. He is soon covered in blood and slime, ready to attack anyone he sees. And his principal targets are a mother and her terrified little boy.

Unlike some of the other films based on Mr. King's fiction, "Cujo" doesn't rely on the supernatural. The situation is hardly realistic, but neither is it so farfetched that an audience won't even bother to care about the characters. Early sequences establish that both Donna (Dee Wallace) and Vic (Daniel Hugh-Kelly) dote on their son, Tad (Danny Pintauro), even though the couple's marriage appears to be foundering. Little Tad sleeps in a room that, like the child's room in "Kramer vs. Kramer," has reassuring clouds painted on its walls. The boy is afraid there are monsters in his closet. But every night his parents persuade him that there's nothing to be afraid of.

●

A chain of coincidences lead the parents to separate, and mother and son to visit an auto-repair shop in a very isolated spot. Unbeknownst to them, there's no one alive in the area but Cujo, and no one expected for a good long while. During a long section of the movie, mother and son sit trapped in their stalled car, under the watchful eye of what has by now evolved into one very disgusting-looking dog. It's possible to make out the contours of an ordinary St. Bernard under all that muck and makeup, but the dog's appearance does become genuinely frightening

●

As directed by Lewis Teague, "Cujo" is by no means a horror classic, but it's suspenseful and scary. The performances are simple and effective, particularly Miss Wallace's. And Danny Pintauro does a good job as the frightened child. All three of the principals have done either commercials or soap-opera work in the past, which perhaps accounts for the all-American blandness that, in a film like this, is almost an advantage.

The family members seem believably typical, which makes their encounter with the demonic dog all the more involving. Be warned: if you find yourself too caught up in "Cujo," you'll have a hard time looking your own pooch in the eye.

1983 Ag 13, 13:1

CURSE OF THE PINK PANTHER, directed by Blake Edwards; Written by Blake Edwards and Geoffrey Edwards; director of photography, Dick Bush; edited by Ralph E. Winters; music by Henry Mancini; produced by Blake Edwards and Tony Adams; released by M-G-M/UA Entertainment Company. At the Embassy, Broadway and 72d Street; 72d Street Playhouse, east of Second Avenue, and other theaters. Running time: 110 minutes. This film is rated PG.

Sir Charles Litton	David Niven
George Litton	Robert Wagner
Dreyfus	Herbert Lom
Chandra	Joanna Lumley
Lady Litton	Capucine
Bruno	Robert Loggia
Professor Balls	Harvey Korman
Cato	Burt Kwouk
Clifton Sleigh	Ted Wass
Juleta Shane	Leslie Ash
Bored Walter	Graham Stark
François	André Maranne
Colonel Bufoni	Peter Arne

To say that Blake Edwards's "Curse of the Pink Panther" is aimed

"CURSE OF THE PINK PANTHER"—Ted Wass plays a detective in a new comedy directed by Blake Edwards.

at easy-to-please audiences is to understate the case considerably. It's aimed at those who'll be satisfied with another snappy credit sequence, a few of the old familiar faces, and very little more.

Not unfunny, and not really an offense to the memory of Inspector Clouseau, it's merely a movie with very little reason to exist. Only occasionally does it turn ghoulish, as when Detective Sgt. Clifton Sleigh (Ted Wass) wanders into a wax museum filled with likenesses of the late Peter Sellers, and pinches the cheek of one of them.

Detective Sleigh has been located by the by-now-venerable Dreyfus, to investigate the disappearance of Dreyfus's nemesis, Clouseau. The search for the world's greatest detective is being conducted by computer, and Dreyfus — who of course doesn't want Clouseau found at all — has secretly reprogrammed the machine to find the world's worst detective.

Apparently, he succeeds, for once Sleigh is recruited from the New York City Police Department, he proves to be every bit as comically accident-prone as the man he's looking for. Mr. Wass's humor is mostly physical. He stumbles even more fre-

quently than his predecessor did, and subjects Herbert Lom's Dreyfus to a lot of the usual abuse. These physical gags look as though they'd have worked a lot better for Mr. Sellers. But Mr. Wass makes adequate use of them, too.

Robert Wagner, Capucine, Harvey Korman, Bert Kwouk and the late David Niven make what are in effect longish cameo appearances, as Sleigh revisits the scenes of Clouseau's various exploits. Also in the large cast, inexplicably, is Patricia Davis, President Reagan's daughter, playing a French newscaster. Not even those undiscriminating enough to find this "Pink Panther" film as charming as any of the others will imagine that this newscaster's French accent is genuine.

●

"The Curse of the Pink Panther" is rated PG ("Parental Guidance Suggested"). Its humor is a little bawdier than that of other films in this series.

Janet Maslin

1983 Ag 13, 13:1

THE MAN WHO WASN'T THERE, in 3-D, directed by Bruce Malmuth; screenplay by Stanford Sherman; director of photography, Frederick Moore; edited by Harry Keller; music by Miles Goodman; produced by Frank Mancuso Jr. release by Paramount Pictures. At the Guild Embassy, Broadway and 49th Street, and other theaters. Running time: 111 minutes. This film is rated R.

Sam Cooper	Steve Guttenberg
Cindy Worth	Lisa Langlois
Boris Potemkin	Jeffrey Tambor
Ted Durand	Art Hindel

By LAWRENCE VAN GELDER

Anyone who cherishes the sensation of having his eyes sucked out of his head like the pimentos from a pair of olives will probably lose no time beating a path to any of the myriad local theaters that yesterday accepted the tenancy of the summer's latest 3-D movie, "The Man Who Wasn't There."

Aside from such physical afflictions of 3-D, the moviegoer will thereupon be subject to instruction in the further shortcomings of these films and may well depart having concluded that the process of making a good 3-D movie begins with assembling such elements of a good 2-D movie as a well-written script and inspired direction.

Without these, a movie — and "The Man Who Wasn't There" serves as fitting an example as a corpse to an anatomy class — is likely to arrive in a sorry state.

The plot in this instance concerns itself with a young State Department aide who, on his already frenetic wedding day in Washington, finds himself on the run — a suspect in the murder of a man who leaves him a silvery ball containing phials of an invisibility potion.

●

Pursuing this blue elixir and its formula are an assortment of agents, much given to bumbling. There are the henchmen of the sinister and homicidal Ten Duyck, who has already partaken of it and is thus seen only as clothes hung on an invisible frame. And, in cahoots, there are the paladins of the Soviet Union and the United States — the former worried about "100 million invisible Chinese marching into Moscow," the latter, about "20 million invisible Mexicans strolling across the Texas border."

Aside from such geopolitical wit, the movie tends toward food fights, clumsy chases and voyeurism. The plot element of invisibility is exploited to enable the hero (Steve Guttenberg, seen previously in "Diner") to invade the shower room of a girls' school and to enable some aged voyeurs to witness the lovemaking between the invisible hero and a corporeal woman. The most notable uses of the 3-D process are in having a couple of knives hurled at the audience and a few smoke rings blown at the audience. Neither is novel, nor is the rest of the movie.

1983 Ag 13, 13:1

LA PASSANTE, directed by Jacques Rouffio; screenplay by Jacques Rouffio and Jacques Kirsner; director of photography, Jean-Jacques Cazoit; music by Georges Delerue; released by Libra Cinema Five Films. At the Plaza Theater, 58th Street, east of Madison Avenue. In French with English subtitles. Running time: 106 minutes. This film has no rating.

Elsa Weiner/Lina Baumstein	Romy Schneider
Max Baumstein	Michel Piccoli
Max Baumstein (as a child)	Wendelin Werner
Michel Weiner (editor)	Helmut Griem
Maurice Bouillard	Gerard Klein
Charlotte	Dominique Labourier
Ruppert Von Leggaert/Federico Lego/The Ambassador	Mathieu Carriere

"THE MAN WHO WASN'T THERE"—A sinister, invisible man confronts Lisa Langlois and Steve Guttenberg, while Bill Forsyth holds them at gunpoint in a comedy-adventure.

By JANET MASLIN

In Romy Schneider's last film before her death, Jacques Rouffio's "Passante," she plays two women, remarkably similar although 50 years apart. The modern-day Lina (Miss Schneider in black leather) is the devoted wife of Max Baumstein, a Swiss political activist, and in the 1930's, Elsa (the actress wearing softer colors, and with a sweeter expression) was the equally loving wife of Michel Weiner, an anti-Fascist newspaper editor in Berlin.

The events that link these two women are set forth in a screenplay (by Mr. Rouffio and Jacques Kirsner) based on a novel by Joseph Kessel, and they are melodramatic but compelling. They are also somewhat overcomplicated, and the exposition involves a modern-day trial sequence that is periodically interrupted by 1930's flashbacks. These constitute the chief part of the drama.

After Max Baumstein (Michel Piccoli), the dignified leader of a group called Solidarity International, astonishes the world by murdering the Paraguayan Ambassador to France, the film begins to explain Max's boyhood. As a 12-year-old Jewish boy in Berlin, he was saved from the Nazis by Elsa, who was not herself Jewish and who later brought him to Paris with her. The film tells of Elsa's efforts to remain hopeful while all around her was crumbling, and it details her touching relationship with the young boy.

The wartime story is told effectively enough to make the modern-day courtroom scenes seem almost unnecessary, even if Max's final action is an essential part of the tale. Certainly they break the mood, and remind an audience that this is fiction, however disturbing and believable its facts may be.

•

Elsa, formerly a beautiful and renowned singer, is reduced to becoming a habitué of a sleazy Parisian nightclub; meanwhile, she struggles tirelessly to obtain the release of her husband, Michel (Helmut Griem), who has been imprisoned. Miss Schneider, who weeps freely and has a convincingly troubled air, makes Elsa's slow decline seem real, and likewise her enduring optimism. The supporting players are equally authentic, except when they appear in waxen makeup for the 50-years-later scenes. Wendelin Werner and Gerard Klein, both newcomers, are convincing and natural in the roles of 12-year-old Max and a champagne dealer who comes to befriend Elsa.

The events detailed in "La Passante" are cruel, but they're all too familiar to students of this sort of fiction. And they may have seemed less histrionic on the page than they do here — when, say, Elsa makes a brief, impassioned speech pleading for her husband's rescue, and the speech is greeted by applause, or when someone's courtroom declaration prompts a similar show of approval. Still, "La Passante" has been acted and directed with conviction. And its subject can't help but be disturbing, even when presented in an unremarkable way.

1983 Ag 14, 47:1

FILM VIEW

JANET MASLIN

When Style Overrides Content

A certain method of filmmaking reached its zenith in 1972, when Bob Rafelson put his actors on elephants in "The King of Marvin Gardens." Since the scene took place on the beach in Atlantic City, why elephants? was a good question; however, why *not* elephants? seemed closer to what, if anything, Mr. Rafelson had in mind. His film was one of the period's purest examples of style for style's sake, when directors were liable to call as much attention as they could to the tiniest (or even the most elephantine) random touches. A "Performance" or a "Drive, He Said" may have had a lot of these hallmarks, but the era's most forgettable films had even more of them. It was an approach that could easily lead to excess, and it could be affected by just about anybody — *vide* the record producer James William Guercio's "Electra Glide in Blue."

Films from that time, whatever their quality, tend to look terrifically dated now. With today's master technicians making intergalactic adventures look simple on the screen, it's hard to share the self-congratulatory pride of a director who'll devote 30 seconds to birds in flight over a snowbank, or the sight of a hand slowly reaching out to close a closet door. Martin Scorsese may still be able to turn the sight of an Alka-Seltzer fizzing in a glass into something ominous and memorable (as he did in "Taxi Driver"). But by and large, these elaborate, tiny flourishes have grown increasingly rare.

The director whose career thrives today is apt to work in an uncomplicated, much more anonymous style, the way John ("War Games," "Blue Thunder") Badham or John ("Trading Places") Landis does. Even Adrian Lyne, whose "Flashdance" is one of the more self-consciously stylish movies of the summer, concentrates exclusively on selling the film's music and its star, rather than on more personal touches of his own. When Mr. Lyne interrupts the music to show the heroine at home with her dog, or in dreamy-eyed conversation with her beau, he isn't stamping the film with any attitude of his own; he's trying to build a better greeting card.

"LA PASSANTE"—Romy Schneider plays a dual role — a German refugee in Paris in the 30's and a contemporary woman whose prominent husband is accused of murder — in the Jacques Rouffio film.

So Paul Brickman's "Risky Business," which has a modern look and is contemporary enough in its conception, nonetheless has a faintly dated feeling. There's so much style here, all of it so obtrusive, that the film seems a throwback to the elephants-on-the-beach era. Not since then may audiences have seen a film begin and end with a close shot of its hero's eye blinking behind sunglasses, or have been shown a door that sweeps open surrealistically as two characters embrace. Mr. Brickman, who makes his directing debut here, shows a great many signs of talent and originality, which make all the more maddening his penchant for showing off.

● ● ●

"Risky Business" is about a high school boy named Joel, who grows up in an affluent North Shore suburb of Chicago. It isn't necessarily autobiographical, but Mr. Brickman did spend his adolescence under similar circumstances, which may explain why the film, like so many first novels, has a somewhat myopic air. The problems faced by Joel, as he minds the manicured lawn and the impeccable house while his parents are away, become just about the film's entire focus — that, and the fulfillment of Joel's sexual fantasies, which begin to come to life soon after his parents leave him home alone. Joel's situation takes some increasingly comic turns as the film progresses. But much of the time, his story is presented with a deadpan humor that borders dangerously on dead seriousness.

Mr. Brickman directs with a lot of assurance. His film has an ironically glossy look, and at times it's capable of a sly humor. And he is not afraid to give "Risky Business" its own distinctive stamp — which, at a time of such directorial anyonymity, ought to be cause enough for admiration. Yet "Risky Business" may also be too much of a good thing, in that it's a film that perhaps would have benefited from a little less flair. For Mr. Brickman, more like the novices of a decade ago than those of today, is capable of being stylish to a fault — and not always able to harness that style in the service of his story.

● ● ●

It's a problem of proportion. How much grandeur, how many slow panning shots and elaborate fantasy sequences, can be channeled into the tale of a rich suburban schoolboy? During the course of the movie, Joel (played with a lot of understatement by Tom Cruise) moves from mildly slothful rebellion (like gnawing on a TV dinner before he's thawed it) to the more deeply insurrectionary activities of losing all the furnishings of his parents' house, and driving his father's Porsche into Lake Michigan. He also meets and romances an uncommonly chic and wholesome prostitute named Lana (played disarmingly by Rebecca de Mornay), and somehow makes $8,000 in one evening by turning the house over to Lana and her friends. If this all sounds as though Joel is headed for disaster, he isn't. "Risky Business" is a movie in which everything stays comfortable and ends well, with its hero, who seemed hip enough when the story began (despite his nagging parents and his clean-cut look), winding up hipper than ever before it's over.

Nothing that "Risky Business" has to say about middle-class life, about adolescence, even about taking unexpected chances to overcome one's inhibitions, warrants the fanfare that it is given here. Instead, Mr. Brickman, who wrote the offbeat, funny screenplay for Jonathan Demme's "Handle With Care," has the material for another light, loose-jointed comedy. A movie this amusingly insubstantial — indeed, the triviality of many of the events here sometimes becomes one of the film's better sources of humor — shouldn't have to struggle under the weight of directorial ambition. And a young director capable of such sophistictated technique ought to be able to keep the effects on a scale with their subject. That's at least as important as any of the fancy footwork.

Someone whose teen-age children had giggled their way through "Porky's II" recently told me that the same kids had been disappointed in "National Lampoon's Vacation," which isn't isn't nearly so sophomorically silly and which is aimed at an older crowd. These same kids were off to "Risky Business," which is about someone roughly their age, but which will probably be the movie they like least of all. Thanks to its excess of style, "Risky Business" is neither fish nor fowl; it's too solemn for the bathroom-joke set, yet older audiences may find the material inconsequential and the hero rather spoiled. It's best suited to audiences that admire directorial technique above all else, and for whom a film's plot, characters, and even moral concerns can be easily overshadowed by a camera trick that's clever. Audiences like that were once easier to find, and easier to please, than they are today.

■

1983 Ag 14, II:15:3

Collage of Memories

THE MIRROR, directed by Andrei Tarkovsky; screenplay (Russian with English subtitles) by Mr. Tarkovsky and Aleksandr Misharin; cinematography, Georgy Rerberg; edited by L. Feiginova; music by Eduard Artemyev, J. S. Bach, Pergolese, Purcell; produced by E. Waisberg; production company, Mosfilm Unit 4. At the Film Forum, 57 Watts Street. Running time: 106 minutes. This film is not rated.

Natalia	Margarita Terekhova
Ignat, age 5	Philip Yankovsky
Ignat, age 12	Ignat Daniltsev
Father	Oleg Yankovsky
Lisa	Alla Demidova
Military Instructor	Yuri Nazarov
Natalia as an old woman	L. Tarkovskaya

By LAWRENCE VAN GELDER

AMONG artistic creations, there are those that speak to a universal audience and those that speak mainly to their creator.

Into that latter category falls "The Mirror," a 1974 film by the Soviet director Andrei Tarkovsky, best known for such films as "My Name Is Ivan," "Andrei Rublev," which won a prize at Cannes in 1970, and "Solaris."

"The Mirror," opening today at the Film Forum, is a collage of apparently autobiographical memories, assembled in color and in black and white, unreeled at times in slow-motion — shards composed of childhood recollections, of incidents in the breakup of a marriage, in the contest of husband and wife for the custody of their son, of life in a country home, of shattered ambition, and more; all intermingled with historical background in the form of events in the Soviet Union before and during World War II and with documentary footage from the Spanish Civil War and from World War II; and all suffused with a sense of loss.

●

Nearly 10 years after its creation, "The Mirror" abounds with symbols that have become clichés: sudden winds sweeping across fields of high grass, objects moving without apparent impulse, bodies levitating, fires of mysterious origin, ominous but unrecognizable and unexplained figures who suddenly inhabit the landscape, windblown curtains, lamps that flicker into darkness, dripping milk, glowing coals, a bird set free from a hand, individuals who vanish like ghosts.

To be sure, much of this is expressed in images of lingering beauty; and the same materials employed in "The Mirror" have, of course, been forged by others into art that speaks to a wide audience. But here, Mr. Tarkovsky appears so absorbed in grappling with his own demons that universality suffers. His arrangement of fragments from a life chooses to illuminate through the process of arrangement more than through the revelation of character. And so Natalia, the unhappy wife, and Ignat, the forlorn son, and the all-but-unseen father remain enigmatic.

"The Mirror" opens with a metaphor: a televised scene in which a therapist, employing hypnosis, cures a young man of his speech affliction. Like the young man in this scene, Mr. Tarkovsky is struggling toward expression in the vexatious film that is "The Mirror." In the end, he has spoken, and while this accomplishment is not to be dismissed, it is to be regretted that his cinematic speech — his assessment of life — seems not so much part of a poetic dialogue with humankind but instead a therapeutic soliloquy.

1983 Ag 17, C16:3

For Dangerfield Fans

EASY MONEY, directed by James Signorelli; written by Rodney Dangerfield, Michael Endler, P. J. O'Rourke, Dennis Blair; director of photography, Fred Schuler; edited by Ronald Roose; music by Laurence Rosenthal and Billy Joel; released by Orion Pictures Corporation. At the Rivoli, 49th Street and Broadway; New York Twin, Second Avenue and 66th Street; 34th Street Showplace, near Second Avenue; New Yorker, Broadway and 88th Street; Waverly, Avenue of the Americas and Third Street and other theaters. Running time: 95 minutes. This film is rated R.

Monty Capuletti	Rodney Dangerfield
Nicky Cerone	Joe Pesci
Mrs. Monahan	Geraldine Fitzgerald
Rose Capuletti	Candy Azzara
Louie	Val Avery
Paddy	Tom Noonan
Julio	Taylor Negron
Belinda Capuletti	Lili Haydn
Clive Barlow	Jeffrey Jones
Allison Capuletti	Jennifer Jason Leigh

By JANET MASLIN

"EASY MONEY" is strictly for the easy laughers, or at least for those who find Rodney Dangerfield an irresistible card. Mr. Dangerfield has some funny moments here, but he also has a screen presence that's decidedly strange. He won't stand still, being given to constant jerking motions, and neither will he refrain from eye rolling and mugging at the slightest opportunity. Almost never, during the course of a very long 95 minutes, do these tics have anything to do with what is ostensibly going on.

"Easy Money," which was directed by James Signorelli and opens today at Loews New York Twin and other theaters, casts Mr. Dangerfield as a baby photographer named Monty Capuletti who'd rather be out boozing, gambling and otherwise cavorting with his buddies than coaxing recalcitrant toddlers into saying "cheese." He cheerfully misbehaves throughout the first third of the movie, to the chagrin of his middle-class family, until receiving the news that his mother-in-law (Geraldine Fitzgerald, wearing sensible shoes and a blue-white wig) has been killed in an airplane crash. She has left this ne'er-do-well pots of money, but only on the provision that he can reform.

●

Most of the jokes (in a screenplay by Mr. Dangerfield, P. J. O'Rourke, Michael Endler and Dennis Blair) are ones that might be expected. The more unusual touches tend to backfire, like a subplot which has Mr. Dangerfield's demure blond daughter (Jennifer Jason Leigh) marrying into a Hispanic family. So little is made of this idea that it comes dangerously close to turning into an unfunny ethnic joke, although Taylor Negron (as Julio, the groom) appears to be trying to make something of the material. A number of the performers, also including Joe Pesci as Monty's buddy and Candy Azzara as his wife, take an earnest approach to roles that hardly seem to warrant one.

The only extended gag that works has to do with Mr. Dangerfield's wardrobe, which somehow becomes the basis for a new high-fashion concept. "The Regular Guy Look" it is christened, and it involves a number

of eye-catching outfits in pure polyes-
ter. Mr. Dangerfield himself appears
in a pair of swim trunks decorated
with dollar bills, during a sequence
that finally shows him rolling in loot.
This is a lot funnier than an earlier
scene, in which he has been confined
to a hospital room with his injured
rump hoisted in the air, apparently in
an unusual form of traction. "Easy
Money" has a lot more of the latter
kind of humor than the former.

1983 Ag 19, C8:5

YOR, THE HUNTER FROM THE FUTURE, di-
rected by Anthony M. Dawson; screenplay by
Robert Bailey and Anthony M. Dawson, based
on the novel "Yor" by Juan Zanotto and Ray
Collins; director of photography, Marcello Mas-
ciocchi; film editor, Alerto Morlani; music by
John Scott; produced by Michele Marsala; re-
leased by Columbia Pictures. At Criterion Cen-
ter, Broadway and 45th Street; Loews Orphe-
um, 86th Street near Third Avenue, and other
theaters. Running time: 105 minutes.
Yor .. Reb Brown
Ka-Laa ... Corinne Clery
Overlord ... John Steiner
Ena ... Carole Andre
Pag ... Alan Collins
Roa .. Ayshe Gul
Ukan .. Aytekin Akkaya
Tarita .. Marina Rocchi
Kay .. Sergio Nicolai

By JANET MASLIN

"Yor, the Hunter From the Fu-
ture" is based on an illustrated,
comic-strip novel, a work that is un-
doubtedly a lot more literate than the
film itself. The movie, which opened
Friday at the Criterion Center and
other local theaters, follows a mus-
cle-bound cave man hero and his ad-
ventures across a dreary, sun-baked
landscape remarkable chiefly for its
phallic rock formations.

Yor is accompanied by Ka-Laa (Co-
rinne Clery), a simpering cover-girl
type who says things like "Yor,
you're so different from the other
men I've seen!" No wonder — Yor is
a handsome, bare-chested fellow
wearing a skimpy loincloth and a
fluffy blond coiffure. Every other
man on the planet seems to be sport-
ing an abundance of dark tatters, a
"Planet of the Apes" type hairdo and
a beard.

Reb Brown, who plays Yor, trots
across the pseudo-prehistoric terrain
looking genial and speaking fluent
Californian. When he offers his com-
rades the blood of a dead dinosaur,
declaring "Drink! The blood of your
enemy makes you stronger," he
might as well be pitching orange
juice. There is also an anachronistic
air to the disco theme song, with
lyrics saying something like "Yor!
He's a man, he's a man." I couldn't
make them out any more clearly than
that, and am not altogether sure they
were sung in English.

"Yor" was directed by Anthony M.
Dawson, who also has "Hercules,
Prisoner of Evil" to his credit. It ap-
parently concludes on a futuristic
note, but if its spaceships are on a par
with its pterodactyls, then they prob-
ably look like lampshades. I didn't
see it all, and can't imagine who
would want to.

"Yor" is rated PG ("Parental
Guidance Suggested"). It contains at
least one mating scene and some
bloodshed.

1983 Ag 21, 54:3

METALSTORM: THE DESTRUCTION OF
JARED-SYN, directed by Charles Band; writ-
ten by Alan J. Adler; director of photography,
Mac Ahlberg; visual effects by Frank H.
Isaacs; edited by Brad Arensman; music by
Richard Band; produced by Charles Band and
Alan J. Adler; released by Universal Pictures.
At Rivoli 1, Broadway and 49th Street; Gemini

1, 64th Street and Second Avenue; 86th Street
East, at Third Avenue, and other theaters. Run-
ning time: 84 minutes. This film is rated PG.
Dogen ... Jeffrey Byron
Jared-Syn Mike Preston
Rhodes .. Tim Thomerson
Dhyana ... Kelly Preston
Hurok .. Richard Moll
Baal ... R. David Smith
Aix .. Larry Pennell
Zax ... Marty Zagon
Poker Annie Mickey Fox

By LAWRENCE VAN GELDER

As though to give meaning to the
expression "snail's pace" and to con-
fute the premise that imitation is a
form of flattery, a 3-D movie called
"Metalstorm: The Destruction of
Jared-Syn" opened Friday at local
theaters.

When the first screening had
reached its conclusion at the Rivoli,
one of the incoming patrons was
heard to ask: "Was it bad?"

"I think," he was told by a member
of the noon audience, "it was terri-
ble."

No contradiction is forthcoming
here. "Metalstorm" is a slow-mov-
ing, thoroughly derivative movie that
makes little use of the possibilities of
3-D.

Set in a barren landscape, this
futuristic adventure revolves around
the efforts of a young man named
Dogen, employed as a type of peace
officer known as a Ranger, to rescue
the blonde Dhyana, a damsel in dis-
tress, and, at the same time, to
thwart the evil Jared-Syn and his rot-
ten son, Baal, who seek to incite a
tribe of Cyclopean creatures to insur-
rection.

While awaiting the unsurprising
outcome, there is plenty of time to
count the sources: the Bible (burning
bushes and a creature named Baal);
the Odyssey (Cyclops); old westerns
where Indian tribes were put up to no
good by land-hungry Caucasians; as-
sorted sword-and-sorcery movies, as

well as "Superman" (powerful crys-
tals); the "Star Wars" saga (weap-
ons and flying machines); "Raiders
of the Lost Ark" (music); "The Road
Warrior" (a leather costume for the
hero); "The Deep" (a voracious lam-
prey-like creature), and "Tron" (an
excursion into another dimension).

Absent such diversion, attention
must be paid to a plot filled with clap-
trap about life forces, deadly crys-
tals, lost cities and the sort of megalo-
mania that customarily afflicts vil-
lains like Jared-Syn in contrast to the
modest pluck of heroes like Dogen.

Somewhere past the middle of all
this, Dogen's sidekick — an ex-
Ranger and veteran of the wars —
proclaims, "I'm gettin' too old for
this stuff." Anyone of any age with a
modicum of taste is bound to agree.

1983 Ag 21, 56:4

FILM VIEW

JANET MASLIN

When Role And Actor Are Perfectly Matched

Among the many reasons for the longevity of
"The Return of Martin Guerre," a beautiful
and moving film that after nearly three
months' run at the 68th Street Playhouse is
still generating attendance figures described
by Variety as "amazing," is the exceptionally good use it
makes of France's most talented and ubiquitous screen
star. He is, of course, Gérard Depardieu, who plays what
is apparently the title role in this medieval mystery, and
who has by now proven himself to be enormously prolific
and changeable. He has played everything from a petty
hoodlum ("Loulou") to a leader of the French Revolution
(in Andrzej Wajda's forthcoming "Danton"), and his
screen accomplishments include acts of both heroism
and masochism (most notably his self-emasculation in
Marco Ferreri's "Last Woman"). He has by now worked
for many of Europe's most renowned directors, as well
as some of its most eccentric. Yet few of his earlier roles
have suited him as fully as this one does.

Even for actors less brilliant than Mr. Depardieu,
the perfect matching of performer and role can be enor-
mously satisfying — as is evident in several recent mov-
ies which manage to accomplish this unusual feat. A
stroke of ideal casting can give a film a sense of right-
ness, even if little else about it radiates this same assur-
ance. In the case of Daniel Vigne's "Return of Martin
Guerre," the starring performance is only one of numer-
ous successful ingredients, among them the meticulous
historical detail and the suspenseful unraveling of the
central riddle. This revolves around the identity of the
title character, who has disappeared as a young husband
and resumes his marriage years later.

The man certainly resembles Martin Guerre, and he
remembers much about Martin's earlier years; even his
wife believes she recognizes him. And yet when men
from a nearby village suggest the man may be an impos-
tor, several of his neighbors echo this complaint and de-
mand a trial. Not until the very last minutes of a lengthy
and tension-filled courtroom sequence is the situation re-
solved, with a revelation that proves far more satisfying
than a mere factual solution. Mr. Depardieu's closing

speech at the trial becomes an unexpectedly stirring dec-
laration, and a measure of both the film's generosity and
the actor's extraordinary powers.

Many of Mr. Depardieu's past roles have empha-
sized this, as does a face that's coarse-featured by matinee
idol standards, and a rude, rakish manner. Roles like
these, for Bertrand Blier ("Going Places," "Get Out
Your Handkerchiefs"), Maurice Pialat ("Loulou") and
others, turn the actor into a sexy lout, and often a very
clever one, while overlooking anything else he may be
capable of. On the other hand, his more white-collar roles
— as the aspiring actor in François Truffaut's "Last
Metro," the bourgeois husband in Mr. Truffaut's
"Woman Next Door," or even the textile executive in
Alain Resnais's "Mon Oncle d'Amérique" — find him in
a restrained, slightly overcivilized condition. He can
seem much more brutish and direct than his surround-
ings, which is often (certainly in "The Woman Next
Door") part of the point. An actor cast closer to type in
that film might never have brought such authenticity to
its tragic outcome.

In his current film, Mr. Depardieu's rude physical-
ity, his quick-wittedness and his disarmingly gentle qual-
ity are able to emerge simultaneously, thanks to the un-
usual demands of the role. Costumed as the perfect
physical embodiment of a medieval peasant, he appears
simple, guileless and kind. But he also radiates a quality
of conscious intelligence that forces the audience to won-
der over and over whether it is being taken in by a liar of
extraordinary cunning.

• • •

The performance is so clever that it can support ei-
ther interpretation until the film is virtually over — and
on second viewing, once the outcome is known, Mr.
Depardieu's skill is all the more apparent. His Martin
Guerre becomes a tremendously sympathetic figure,
whose behavior is so much more complex and indirect
than his passions that he's almost an anachronism. One
of the especially appealing things about "The Return of
Martin Guerre" is its incongruously modern feeling, gen-
erated chiefly by the actors. Along with Nathalie Baye,
who plays his wife, Mr. Depardieu projects a controlled
intelligence that shines all the brighter in a setting that is
deceptively plain.

Chevy Chase isn't exactly to the American cinema
what Mr. Depardieu is to the French, needless to say. But
he, too, can currently be found in a role that suits him
ideally, as the all-American Dad who, as he puts it, is

"takin' the whole tribe across coun-
try" in "National Lampoon's Vaca-
tion." That Mr. Chase does a hilari-
ous, letter-perfect job with this may
be exceedingly hard to believe, espe-
cially for those who've followed the
more checkered parts of his career —
"Oh, Heavenly Dog," say, or "Under
the Rainbow." Though "Foul Play"
displayed him as a potentially appeal-
ing leading man (in the then-popular
romance-thriller-comedy-kitchen
sink genre), he's been a disappoint-
ment ever since. Far from lacking
ability, Mr. Chase may have had a lit-
tle too much of it for his own good —

enough to approach most of the characters he played with a mocking, wise-guy superiority. Not an attitude likely to win over an audience, that's to be sure.

That Mr. Chase fails to condescend to the character he plays here, a go-getter and family man named Clark W. Griswold, must be considered an act of remarkable restraint on his part; certainly it's what keeps the film from degenerating into one long sneer. And the fact that Mr. Chase seems to share a hint of the character's complacency makes him an inspired casting choice here. Somehow, he is able to take Griswold seriously as he sighs "I've spent the last 15 years developing newer and better food additives — I guess I've missed an awful lot," or as he later snarls, "This is no longer a vacation — it's a Quest for Fun."

This isn't a movie for anyone too young (it's aimed at a relatively grown-up audience) or too demanding. But its humor stays lively all the way through, thanks in large part to the excellent casting of the Griswold family. There probably aren't many other actors who could convincingly grow damp-eyed at the beauty of Walley World, the theme park that the Griswolds have traveled cross-country to see.

It isn't clear Mr. Chase is performing with exceptional subtlety here, or whether he's functioning almost as a found object — and it doesn't much matter. There are instances in which a performer can enhance a film immeasurably merely by appearing or behaving in a certain way, rather than by concentrating intently on the business of acting. That may well be the case with Arielle Dombasle, the ravishing blonde who plays the pivotal character of Marion in Eric Rohmer's "Pauline at the Beach."

Miss Dombasle, who very nearly upstaged the heroine of Mr. Rohmer's last film, "Le Beau Mariage" by appearing in the relatively small role of the heroine's friend, is shown here to be an object of fascination for everyone she meets. Yet she is also seen to be somewhat vain, petulant and shallow, qualities which Miss Dombasle conveys through her dress, or her posture, or the way she holds her head when someone else is speaking. Miss Dombasle's behavior is as controlled and spare as everything else in the film, and her presence is so utterly consistent with other elements of the tale that this may well be an instance of flawless acting. Or perhaps it's only the casting that is ideal.

1983 Ag 21, II:17:1

BEER is to the Canadian hop-heads Bob and Doug ("Eh?") McKenzie as marijuana is to Cheech and Chong, though Bob and Doug are by far the more infantile duo. (One of them, whenever he's in trouble, actually sucks his thumb.) The McKenzies are the creation of two Second City TV veterans, Rick Moranis and Dave Thomas, who wrote, directed and star in "Strange Brew," a movie that's barely there. The McKenzies are genial enough, and once in a while they're vaguely funny. But their film is so ephemeral that you may hardly be aware of watching it, even while it's going on.

"Strange Brew," which opens today at the RKO Warner Twin and numerous other theaters, follows Bob and Doug on their quest for beer. They go to work at a beer factory, where two villains, played by Paul Dooley and a desperately out-of-place Max von Sydow, are planning to use beer to control the world. They even have a big wall-size map of the world, so they can plot their conquests. Behind the map is a bathroom, which, in view of all the beer that's consumed during the movie, is undoubtedly a great convenience.

•

During the course of the adventure, the McKenzies are separated. This makes them cry. Ultimately, one is trapped inside a giant storage tank, where the villains plan to drown him in beer. Instead, he drinks his way out. This is actually one of the funnier things in the movie, which also has a sequence in which the McKenzies paint a white stripe on a black Labrador retriever and fool a crowd of beer-drinking revelers into thinking it is a giant skunk.

At the end of the film, which starts and ends as if it were a home movie, the McKenzies evaluate their directorial prowess. One of them makes a little speech thanking the academy, and the other declares this "a good $5 worth for me and my whole family." Maybe. Anyone who's partial to the McKenzies' humor doubtless has a fondness for beer. The price of a ticket could buy enough beer for an experience at least as memorable as this one.

•

"Strange Brew" is rated PG ("Parental Guidance Suggested"). It contains a few mild obscenities.

Janet Maslin

1983 Ag 26, C8:1

Role Swapping

MR. MOM, directed by Stan Dragoti; written by John Hughes; director of photography, Victor J. Kemper; edited by Patrick Kennedy; music by Lee Holdridge; produced by Lynn Loring and Lauren Shuler; released by Twentieth Century-Fox Film Corporation. At the Gotham, Third Avenue and 58th Street; Loews State, Broadway and 45th Street; Orpheum, 86th Street at Third Avenue; 34th Street Showplace, near Second Avenue, and other theaters. Running time: 108 minutes. This film is rated PG.

Jack	Michael Keaton
Caroline	Teri Garr
Alex	Frederick Koehler
Kenny	Taliesin Jaffe
Megan	Courtney & Brittany White
Ron	Martin Mull
Joan	Ann Jillian
Jinx	Jeffrey Tambor
Larry	Christopher Lloyd
Stan	Tom Leopold
Humphries	Graham Jarvis
Eve	Carolyn Seymour
Bert	Michael Alaimo
Doris	Valri Bromfield
Phil	Charles Woolf
Annette	Mirriam Flynn

"MR. MOM"—Teri Garr and Michael Keaton play a couple who exchange traditional roles. She becomes the family breadwinner; he, a house husband.

"**M**R. MOM" is a very creaky comedy about a househusband, whose plight is presented as a terrible humiliation. Though Jack (Michael Keaton) proclaims himself "a regular Phil Donahue" when it comes to being enlightened about women in the workplace, the first half of the movie revolves around his annoyance about his wife's having a job.

"Mr. Mom," which opens today at the Orpheum and other theaters, would be funny if it had jokes. That's not so self-evident as it sounds, because it's not a claim that every failed comedy can make. The actors here, Mr. Keaton and Teri Garr, are likable and bright, and the situation has possibilities. Very little is made of them, except for such predictable developments as Jack's going to the supermarket with the kids in tow, and knocking over soup cans and fruit.

As directed by Stan Dragoti, "Mr. Mom" fares better in the husband's domestic setting than in the wife's executive suite. When she lands a job in advertising, she is chased by an amorous boss (Martin Mull) and wows her colleagues with her surprising knowledge of how to sell groceries to housewives, the material is simply hopeless. John Hughes, who wrote the much funnier screenplay for "National Lampoon's Vacation," comes up with only a few novel touches, the best of them when Jack tries to show his wife's boss that he's not a sap. Answering the door dressed in overalls and conspicuously toting a chainsaw, he announces that he also paints, sculpts and writes poetry. "Honey," he cries, "if you call and I'm not here, I'll be at the gym or the gun club."

Mr. Keaton, who had a supporting role in "Night Shift" and stole the movie, played a pimp that time. Here, he's cast as a nice guy, but he doesn't seem comfortable in the role. He's at his best when the film gives him time off for all that good behavior and lets him show a more wicked side. Only when he's lured by housewives into a poker game (using supermarket coupons instead of chips) or when he's lecturing a 4-year-old about kicking his baby-blanket habit before it leads to bigger things — like quilts — does he really seem to be at home.

•

"Mr. Mom" is rated PG ("Parental Guidance Suggested"). It contains some mildly vulgar language.

Janet Maslin

1983 Ag 26, C8:4

Honor and Horror

MERRY CHRISTMAS MR. LAWRENCE, directed by Nagisa Oshima; screenplay by Nagisa Oshima and Paul Mayersberg, based on the novel "The Seed and the Sower" by Laurens van der Post; director of photography, Toichiro Naraushima; edited by Tomoyo Oshima; music by Ryuichi Sakamoto; produced by Jeremy Thomas; released by Universal Classics. At the Baronet, Third Avenue and 59th Street. Running time: 120 minutes. This film is rated R.

Celliers	David Bowie
Lawrence	Tom Conti
Yanoi	Ryuichi Sakamoto
Hara	Takeshi
Hicksley-Ellis	Jack Thompson
Kanemoto	Johnny Okura
De Jong	Alistair Browinig
Celliers' Brother	James Malcolm
Celliers, age 12	Chris Broun

DAVID BOWIE plays a born leader in Nagisa Oshima's "Merry Christmas Mr. Lawrence," and he plays him like a born film star. Mr. Bowie's screen presence here is mercurial

STRANGE BREW, directed by Dave Thomas and Rick Moranis; written by Mr. Moranis, Mr. Thomas and Steven De Jarnatt; director of photography, Steven Poster; edited by Patrick McMahon; music by Charles Fox; produced by Louis M. Silverstein; released by M-G-M/UA Entertainment. At RKO Warner Twin, Broadway and 47th Street; Eastside Cinema, Third Avenue between 55th and 56th Streets; 85th Street, at First Avenue, and other theaters. Running time: 90 minutes. This film is rated PG.

Doug McKenzie	Dave Thomas
Bob McKenzie	Rick Moranis
Brewmeister Smith	Max von Sydow
Claude Elsinore	Paul Dooley
Pam LaRose	Lynne Griffin
Jean LaRose	Angus Macinnes
The Inspector	Tom Harvey
Henry Green	Douglas Campbell
Ted	Brian McConnachie
Jack Hawkland	Len Doncheff
Gertrude	Jill Frappier
The Judge	David Beard

"MERRY CHRISTMAS, MR. LAWRENCE"—
David Bowie stars in Nagisa Oshima's film about a
contest of wills between Allied prisoners and their
Japanese captors during World War II.

and arresting, and he seems to arrive at this effortlessly, though he manages to do something slyly different in every scene. The demands of his role may sometimes be improbable and elaborate, but Mr. Bowie fills them in a remarkably plain and direct way. Little else in the film is so unaffected or clear.

"Merry Christmas Mr. Lawrence," which opens today at the Baronet and the Bay Cinema, is sometimes tense and surprising, sometimes merely bizarre. It's an intriguing if inconsistent effort, by the director of "In the Realm of the Senses," to use a Japanese-run prisoner-of-war camp as a means of exploring the bewildering nature of war. In Java, in 1942, the British lieutenant colonel of the title (Tom Conti) is reunited with Jack Celliers (Mr. Bowie), a major from New Zealand whose powers of self-control and defiance seem to know no bounds. Lawrence, who understands his Japanese captors far better than any of his comrades do, must look on in helpless understanding as they marvel at Celliers's remarkable strength of spirit and ultimately respond to it with savagery and fear.

"They're a nation of anxious people, and they could do nothing individually, so they went mad en masse," Lawrence says of the Japanese. The two main Japanese characters who have brought him to this understanding are Sergeant Hara (Takeshi), a brutal figure who taunts Lawrence while also admiring him, and Captain Yonoi (Ryuichi Sakamoto), the handsome young camp commander, who has a fierce belief in the samurai

code. Both of these actors perform at an obvious disadvantage, since their English is awkward and the motives of their characters are imperfectly revealed. However, they are able to convey the complex affinity that exists between captors and prisoners, a point that is made most touchingly in a brief postwar coda.

"Merry Christmas Mr. Lawrence" can be brutal and blunt, not just in its scenes of hara-kiri (there are several of these) but in its occasionally stilted execution. The screenplay, by Mr. Oshima and Paul Mayersberg, has a curiously dislocated quality. Though it's based on a novel ("The Seed and the Sower") by Laurens van der Post, the film seems almost more Japanese in its New Zealand sequences than it does in the prison camp.

These scenes, which are flashbacks to Celliers's boyhood, involve the way in which he feels he has wronged his brother, who is an angelic-looking blond boy with a beautiful singing voice and a hunchback. This exceedingly odd anecdote, more consistent with the film's code of honor than with Celliers's probable history, is most remarkable for Mr. Bowie's ability to stand side by side with a boy of 10 or so, both of them sporting school blazers, and somehow pass for a slightly older brother.

Mr. Conti has some fine moments here, too, but his is the more passive and less mysterious role. He is also saddled with some of the film's more simplistic dialogue, and some of its more obscure responses. "Merry Christmas Mr. Lawrence" is closer to a curiosity than to a triumph, though

its conception is certainly ambitious. Mr. Oshima has staged the film in a spacious tropical setting and filled it with a great number of extras. Even so, Mr. Bowie always stands out from the crowd.

Janet Maslin

1983 Ag 26, C10:1

A Son's Search

DANIEL, directed by Sidney Lumet; screenplay by E.L. Doctorow, based on his novel "The Book of Daniel"; director of photography, Andrzej Bartkowiak; edited by Peter Frank; music by various composers; produced by Burtt Harris; released by Paramount Pictures. At the Coronet, Third Avenue and 59th Street. Running time: 130 minutes. This film is rated R.

Daniel IsaacsonTimothy Hutton
Jacob AscherEdward Asner
Paul IsaacsonMandy Patinkin
RochelleLindsay Crouse
Selig MindishJoseph Leon
Susan IsaacsonAmanda Plummer
Phyllis IsaacsonEllen Barkin
Linda MindishTovah Feldshuh
Robert LewinJohn Rubinstein
Lise LewinMaria Tucci
Frieda SteinJulie Bovasso

By JANET MASLIN

AS "the story of two generations of a family whose ruling passion is not success or money or love, but social justice," Sidney Lumet's film "Daniel" — thus described by Mr. Lumet and by E. L. Doctorow, whose screenplay is based upon his own novel — is a work of noble and unusual ambitions. That these ambitions become the film's most admirable element is a sign of just how difficult it must have been to bring this material to the screen, as well as an indication of problems that are more mundane.

As was the case with Mr. Doctorow's "Ragtime," history and fiction are mingled here, in a manner that is innovative but that can also become confusing. Audiences not closely familiar with the case of Julius and Ethel Rosenberg may not be certain where they differ from Mr. Doctorow's Paul and Rochelle Isaacson, whose story is told here in highly compassionate terms (the film views their fate as abhorrent, though it does not speak explicitly to the question of their innocence or guilt). While it does not present a new argument about the Rosenbergs (as does the current book "The Rosenberg File: A Search for the Truth," in which Ronald Radosh and Joyce Milton postulate the guilt of Julius Rosenberg and at least the complicity of his wife), its more bombastic passages amount to an indirect partisanship that will undoubtedly fuel the continuing controversy surrounding the case.

"Daniel," which opens today at the Coronet Theater, incorporates its thinly fictionalized version of the Rosenberg story into a larger family drama: that of a son searching to determine the truth about his parents, and through this quest finally coming to terms with their values and their legacy. This material hardly lends itself to any standard movie treatment. Imagine a courtship scene between two young radicals, as the young man passionately lectures his future bride about the means of production, and you may have some idea of how idiosyncratic "Daniel" can be. With Paul Robeson singing on the soundtrack, and with its painstaking re-creations of rallies, Bronx neighborhood scenes and college vignettes set in the late 1930's and early 40's, "Daniel" means to evoke a powerful sense of the radical left in that period.

Timothy Hutton in Daniel

But its use of these memories, and of the passions they arouse, is less sure than its ability to conjure them up.

•

In Mr. Doctorow's novel "The Book of Daniel," the title character is the grown son of the Isaacsons, who, like the Rosenbergs, have been convicted and executed for participating in a conspiracy to commit atomic espionage. The very narration of the novel, as Daniel tries to keep to the third person but frequently lapses into the first, is a measure of the intensity of his struggle. Daniel's bitterness throughout the book is a vital part of his efforts to come to terms with his parents' histories and with his own. The two generations are seen as closely intertwined, chiefly through anguish the son exhibits while he relives his parents' nightmare.

The film is less passionate and more ponderous, a work composed of much more disparate pieces. It begins with an extreme close-up of a scowling, furious Daniel (Timothy Hutton) as he recites a definition for electrocution, and this device is repeated periodically throughout the film (with Daniel explaining a different form of punishment in each instance). These scenes, which are all that remain of the narrator's tone, effectively capture Daniel's rage — but do not convey that his struggle is painful and continuing, and that he is in the process of change. As a result, much of the movie is angry and self-righteous, without sufficiently close links between Daniel's story and that of his parents, and without the sympathetic elements that make the novel a complex, human story, rather than a tract.

Mr. Doctorow's screenplay would seem to be a lot like his novel; indeed, many of the passages of dialogue are virtually the same. The trouble is that they have been transported whole, so that they now become overbearing speeches. Scene after scene in the film begins as a new supporting character — the cast, like the casts of most recent Lumet films, is enormous — launches into a windy and uninterrupted soliloquy. Mr. Lumet, far from keeping the histrionics in check, seems to have actively encouraged his actors to go for broke during each one's show-stopping minute or two. The film's dramatic progress is repeatedly halted as actors in minor roles indulge themselves to the utmost, offering what are clearly

meant to be bravura turns.

This isn't a film that can easily withstand so many interruptions, since its structure is already fragmented. In addition to intercutting Daniel's late-1960's story with that of his parents, Mr. Lumet also fractures time within the flashbacks; when the Isaacson family boards a bus to attend a Paul Robeson concert in Peekskill, N.Y. (which would later develop into a riot), they aren't seen arriving until almost an hour later. Of course, this isn't forgetfulness on Mr. Lumet's part. It's consistent with a strategy of presenting all of the exposition early in the story and saving for last all the scenes that are unavoidably wrenching. The film ends with two lengthy, detailed electrocution sequences, followed by two funeral scenes, followed by a coda that cannot help being uplifting. This is moving, and then some — it's enough to make the audience feel clobbered.

"Daniel" has been directed in what is immediately recognizable as Mr. Lumet's recent style. There is somber, stylized lighting. There are plenty of long shots. And there is unusual casting, which is ordinarily one of the things this director does best. Here, though, there are too many moments in which the casting undercuts the film's plausibility. For instance, John Rubinstein does a good job as Daniel's stepfather, but he simply doesn't look much older than Mr. Hutton or than Amanda Plummer, who plays his sister. The members of the Isaacson family don't much resemble one another, either. And Lindsay Crouse, who as Rochelle has a Yiddish-speaking mother and a husband who in one scene dances around a room like Tevye, still has traces of the brogue she used as an Irish nurse in Mr. Lumet's "Verdict."

Miss Crouse, along with Edward Asner as the Isaacsons' lawyer, gives the kind of heavy, sturdy performance that is the order of the day here. The few actors who attempt anything more offbeat — like Ellen Barkin, who has a scene-stealing presence in the tiny role of Daniel's wife — are left with little to do. Miss Plummer brings a frightening urgency to the role of Daniel's troubled sister, but she's almost too real and unpredictable for her surroundings here. Ilan M. Mitchell-Smith and Jena Greco do a good job playing childhood versions of Daniel and his sister. Mr. Hutton has some fine moments, particularly in the latter part of the movie. But his role, as written and edited, lacks context and continuity.

If the book succeeds in emerging finally as Daniel's story, the movie remains more focused on Paul and Rochelle. Miss Crouse and Mandy Patinkin — who has some very touching moments with Daniel as a boy, explaining the hidden radical messages in everything from a day at the beach to a Wheaties package — both work very hard at those key characterizations. And at the last minute the movie spoils it all.

When Rochelle says goodbye to her children, even the tiny daughter has been directed to walk across the room and pause dramatically while speaking. Their mother has hardly flown out the door when, seconds later, in rushes their father, behaving like a punch-drunk Jimmy Durante. These are the moments when the audience hardly needs to see showy acting, when instead it needs to believeit is seeing a family caught in an agony of unprecedented dimension.

1983 Ag 26, C10:4

Lindsay Crouse and Mandy Patinkin portray a wife and husband resembling Ethel and Julius Rosenberg, who were executed in 1953 for conspiracy to commit espionage.

HERCULES, written and directed by Lewis Coates; director of photography, Alberto Spagnoli; edited by Sergio Montanari; music by Pino Donaggio; produced by Menahem Golan and Yoram Globus; released by M-G-M/U.A.-Cannon Group. At the Warner Twin, Broadway and 47th Street; 86th Street Twin, at Lexington Avenue; Manhattan Twin, 59th Street between Second and Third Avenues and other theaters. Running time: 99 minutes.

Hercules	Lou Ferrigno
Circe	Mirella D'Angelo
Arianna	Sybil Danning
Cassiopea	Ingrid Anderson
King Minos	William Berger
King Augias	Brad Harris
Zeus	Claudio Cassinelli
Hera	Rossana Podesta
Athena	Delia Boccardo
Dorcon	Yehuda Efroni
Valcheus	Gianni Garko

By LAWRENCE VAN GELDER

Though it may come as a surprise in certain circles, it seems that some millennia before Jor-El dispatched his son from Krypton to the planet Earth to earn renown under the name Superman, there was a similar occurrence.

The earlier champion, a son of the god Zeus, bore the name Hercules. His heroic exploits — among them triumph over the Cretan bull, cleansing of the Augean stables, vanquishing the monstrous Hydra — have been celebrated by poets and well chronicled through the ages, but rarely in the form seen Friday, when a motion picture called "Hercules" opened at local theaters.

As a result, classical scholars and revisionist historians may be tempted to augment the dozen labors that form the basis of the Hercules legend by adding a 13th: enduring the ignominy of a film that ransacks mythology, comic books, science fiction and hoary adventure movies to produce a result that evoked frequent derisive laughter during the city's first screening at noon yesterday in the RKO Warner Twin.

●

This is the movie that asks the question — aloud, mind you, and in a portentous voice — Will evil triumph over good? and proceeds to answer it most predictably in the course of a juvenile tale that runs from the crea-

tion of the universe to the destruction of Atlantis.

At the center of it all — strangling serpents as an infant and growing up to slay a bear and launch it into outer space, to survive tests of his strength, to mete out condign punishment to mechanical monsters, to best assorted male and female villains, to survive rivalries among the gods and to win the hand of the fair Cassiopea — is Lou Ferrigno in the title role.

Here Mr. Ferrigno, the bodybuilding champion best-known previously as the green-skinned creature who appeared when Bill Bixby's volatile metabolism caused him to burst his shirt and metamorphose into the Incredible Hulk on television, is once again called upon mainly to flex his inflated muscles and lend himself to the sometimes less than special effects. "Hercules," as its cast makes one constantly aware, is not a production that staked its future on thespian art.

No good will come of detailing how this film's narrative departs from classical mythology to traffic in baser materials from "Superman" to "Star Wars." Suffice it to say that the results are a tribute to the materials.

●

"Hercules" is rated PG ("Parental Guidance Suggested"). It contains a certain amount of bloodletting, combat, skulls and the word "damn."

1983 Ag 28, 61:1

And in This Corner

BELOW THE BELT, directed by Robert Fowler; suggested by Rosalyn Drexler's novel "To Smithereens"; music by Jerry Fielding; vocal direction by Billy Preston; produced by Mr. Fowler and Joseph Miller; released by Atlantic Releasing Corp. At the Film Forum, 57 Watts Street. Running time: 98 minutes. This film is rated R.
WITH: Regina Baff, Mildred Burke, Jane O'Brien, Shirley Stoler

By JANET MASLIN

ROBERT FOWLER'S "Below the Belt" has a plainness and sincerity that mark it as this director's first feature film, which indeed it is. "Below the Belt," which opens today at the Film Forum, also has a milieu all its own. It is set in the world of female wrestlers, a number of whom appear in the film and help account for its considerable color.

Credits for "Below the Belt" describe the film as "suggested by" Rosalyn Drexler's novel "To Smithereens," and note that Miss Drexler was once on the wrestling circuit.

A fascination with this world is not imperative in appreciating the merits of "Below the Belt," but it helps. The story is appealing, but it is also on the aimless side, as it follows the evolution of Rosa Rubinsky, waitress, as she becomes Rosa Carlo, the Mexican Spitfire. (Miss Drexler actually wrestled under the latter name.) It culminates in her challenging the meanest and toughest of her co-wrestlers. This rival, called Terrible Tommy (and played by the wrestler Jane O'Brien), is a big blonde with a front tooth missing and a swagger that recalls the young Marlon Brando's.

"Below the Belt" does not treat any of these women as freaks, and it is not a voyeuristic effort. Mr. Fowler's direction captures an unexpected sweetness about these feisty characters, even if it lacks forcefulness.

Regina Baff gives a spunky, if untutored, performance as Rosa, and her easygoing presence contributes a lot to the film's feeling of naturalness. Also in the cast is the enormous Shirley ("Seven Beauties") Stoler. The film's one sight gag involves Miss Stoler getting out of a car that has gone off the road, while several other, lighter wrestlers are inside. As soon as she is clear, the car flips over.

1983 Ag 31, C21:1

"BELOW THE BELT"—Regina Baff and Sierra Pecheur portray, respectively, Rosa Rubinsky and Verne Vavoom in Robert Fowler's film about women wrestlers.

Musical Roots

CHICAGO BLUES, directed by Harley Cokliss. At the Bleecker Street Cinema, 144 Bleecker Street, as part of the Jazz Film Series. Running time: 50 minutes. This film has no rating.
WITH: Dick Gregory, Johnie Lewis, Muddy Waters, Floyd Jones, Buddy Guy, J. B. Hutto and Junior Wells.

By JON PARELES

"CHICAGO BLUES" is an angry film. To document Chicago blues at its source, the British director Harley Cokliss went to South Side clubs, storefront churches and homes. He wound up with both a performance film and an anti-travelogue on ghetto life. It is a stark, forceful combination.

Although it was made in 1972, "Chicago Blues" is having its New York theatrical premiere tonight at the Bleecker Street Cinema as part of the Greenwich Village Jazz Festival's film series.

Without condescending to viewers, "Chicago Blues" sketches the history of the music — the rural blues that came to Chicago with black migrants from the South and was transformed by urban life and electric guitars.

Johnie Lewis, who moved to Chicago in 1943, plays a country-blues about being a "poor boy in a strange city," and later a bluesy gospel song. Willie Dixon, a major blues songwriter, improvises a Mississippi-style field holler. Floyd Jones, in his living room, plays a country-style blues about the stockyards. And the congregation at the Liberty Union Church sings an exuberantly out-of-tune hymn — the blues in its Sunday clothes.

We also see sweaty club performances of electric blues. When "Chicago Blues" was made, a "blues re-

vival" was peaking as white rock bands remade blues classics for a larger audience. Some of the film's commentary — by a narrator, a Chicago alderman, the musicians themselves and Dick Gregory — is understandably defensive, reclaiming the blues for its black inventors. In "Chicago Blues," such originals as Muddy Waters, J. B. Hutto, Buddy Guy and Junior Wells are still playing for small, all-black club audiences.

While the musicians play, the camera prowls Chicago's streets, showing prison-like housing projects, "black power" graffiti and tenements reflected in glass-walled skyscrapers. "Chicago Blues" treats the musicians with genuine respect and doesn't prettify the ghetto. The blues, it reminds us, starts where people live.

1983 S 1, C28:1

'TIL THE BUTCHER CUTS HIM DOWN, a documentary by Philip Spalding; narrated by William Russell; distributed by Rhapsody Films. At the Bleecker Street Cinema, 144 Bleecker Street, as part of the Jazz Film Festival. Running time: 53 minutes. This film has no rating.
WITH: Punch Miller

By JON PARELES

The mawkish, morbid streak in " 'Til the Butcher Cuts Him Down" starts with the title. But it's worth putting up with because the 1971 documentary is the only way to see Kid Punch Miller in action; the trumpeter died soon after the film was finished. It will be shown tonight as part of the Greenwich Village Jazz Festival film series.

Ernest Miller was a few years older than Louis Armstrong and played around New Orleans in the 1920's with Kid Ory's band and his own groups. William Russell, the curator of the

Tulane University jazz archives and the film's narrator, credits him with adding the filigrees of "fast fingering" to the jazz trumpet vocabulary.

After moving to Chicago, Miller joined Jelly Roll Morton's band in 1927, but says in the film that he was discharged for heavy drinking. He led a fast life in the 1920's and 30's and worked in Chicago and New York. But as New Orleans jazz went out of fashion he dropped out of sight, playing at carnivals and rock-and-roll shows. After returning to New Orleans in 1956, he led one of the first Preservation Hall bands.

•

The film shows two Punch Millers. One is a musician who's still in superb form, in footage from Preservation Hall and from his last public performance, at the New Orleans Jazz and Heritage festival. His puckish solos cut through the Preservation Hall nostalgia, and at a Heritage Festival rehearsal the trumpeter Dizzy Gillespie all but takes notes. Miller also sings a few choruses of the blues in a smooth, droll style all his own.

Elsewhere, the film tries to tug heartstrings. We see Miller as a frail old man — being helped up the stairs to the hospital; pointing out, in an old photograph, the trumpet that Louis Armstrong gave him, and recalling the way he would dream a song, then wake up and write it down. In one poignant scene, Miller and his family listen to an old record; the family mistakes Kid Ory's trombone for the trumpet.

Even with its end-of-an-era clichés, and a long digression about New Orleans funerals, " 'Til the Butcher Cuts Him Down" is a well-deserved memorial.

1983 S 3, 13:3

NIGHTMARES, directed by Joseph Sargent; written by Christopher Crowe and Jeffrey Bloom; directors of photography, Mario DiLeo and Gerald Perry Finnerman; edited by Rod Stephens and Michael Brown; music by Craig Safan; produced by Christopher Crowe; released by Universal Pictures. At RKO Warner Twin, Broadway and 47th Street; Gemini, 64th Street and Second Avenue; 86th Street East, at Third Avenue; Loews 83d Street Quad, at Broadway and other theaters. Running time: 99 minutes. This film is rated R.

Wife	Cristina Raines
Husband	Joe Lambie
Clerk	Anthony James
Newswoman	Clare Nono
Neighbor	Raleigh Bond
Newsman	Robert Phelps
Little Girl	Dixie Lynn Royce
Glazier	Lee James Jude
J.J.	Emilio Estevez
Mrs. Cooney	Mariclare Costello
Mr. Cooney	Louis Giambalvo
Pamela	Moon Zappa
Zock	Billy Jacoby
Willie	Joshua Grenrock
Mazenza	Gary Cervantes
Root	C. Stewart Burnes
Pedro	Andre Diaz
Phyllis	Rachel Goslins
Z-Man	Joel Holman
Jeffrey	Christopher Bubetz
Emiliano	Rudy Negrete
Bishop's Voice	James Tolkan
MacLeod	Lance Henriksen
Del Amo	Tony Plana
Sheriff	Timothy Scott
Bishop	Robin Gammell
Mother	Rose Marie Campos
Steven Houston	Richard Masur
Claire Houston	Veronica Cartwright
Brooke Huston	Bridgette Andersen
Mel Keefer	Albert Hague
Radio Announcer	Howard F. Flynn

By JANET MASLIN

Nothing spoils a horror story faster than a stupid victim. And "Nightmares," an anthology of four supposedly scary episodes, has plenty of those.

For instance, the first tale, entitled "Terror in Topanga," begins with a couple watching television reports that a mad killer is loose in their

neighborhoods. Immediately after this, the wife (Cristina Raines) decides she must go out for cigarettes, even though she is also (we find this out later) low on gas. When she steps out of her car to buy the cigarettes, she leaves the car unlocked. If it were to turn out that she later ran out of gas with a certain knife-wielding somebody hidden in the back seat, would it really be anyone's fault but her own?

"Nightmares," which opened yesterday at the RKO Warner Twin and other theaters, also has a segment called "Night of the Rat," about a woman who believes there are rats between the walls of her house, and the husband who cautions her not to hire any "shyster rat-catchers" to solve the problem. Smart again. There's also a teen-ager whose obsession with video games gets out of control, and a priest who loses faith and leaves his parish, only to be attacked by a demonic truck. This latter tale has a noticeable debt to Steven Spielberg's "Duel."

"Nightmares" was directed by Joseph Sargent and was originally made for television. That means its separate, unrelated episodes are linked by pauses that feel like commercial breaks. It also accounts for a certain blandness to the acting. Two different cinematographers shot the movie, which is drab-looking throughout.

The advertisements for "Nightmares" announce, "Each summer one film opens that you've never heard of — and that you'll never forget." Right on one count, anyhow.

1983 S 3, 14:5

LONELY HEARTS, directed by Paul Cox; screenplay by Mr. Cox and John Clarke; director of photography, Yuri Sokol; edited by Tim Lewis; music by Norman Kaye; production company, Adams Packer Film Productions Pty. Ltd. At the Lincoln Plaza Cinema, Broadway between 62d and 63d Streets. Running time: 95 minutes. This film is rated R.

Patricia Curnow	Wendy Hughes
Peter Thompson	Norman Kaye
George	Jon Finlayson
Pamela	Julia Blake
Bruce	Jonathan Hardy
Patricia's mother	Irene Inescort
Patricia's father	Vic Gordon
Peter's father	Ted Grove-Rogers
The wig salesman	Ronald Falk
The detective	Chris Haywood
Sally Gordon	Diana Greentree
The psychiatrist	Margaret Steven
Rosemarie	Kris McQuade

By VINCENT CANBY

"Lonely Hearts" is the terrible title of a good, new Australian comedy about the romance of a flawed, middle-aged piano tuner and a pretty, no-longer-young, sexually repressed bank clerk.

When first seen at his elderly mother's funeral, Peter, the piano tuner, doesn't seem to be a very promising hero. His toupee is the kind that only fools the man underneath it. Staying home to care for mum has taken its toll on him. Among other things, he shoplifts small, insignificant items at the local supermarket.

However, he's not to be counted out. Though far from what might be called normal, Peter is not yet an emotional basket case. He takes matters into his own hands. Through a Melbourne dating service he is put in touch with Patricia, a painfully shy woman who, though well into her 30's, has just moved out of her family's house into her own apartment, a break she discusses endlessly in 50-minute hours with her psychiatrist.

"Lonely Hearts," which the Australian Film Institute named the best film of 1982, features an enchanting

performance by Wendy Hughes as the tentative, inarticulate Patricia and an extremely good one by Norman Kaye as Peter. Further, it introduces American audiences to Peter Cox, the director, who may be a bright new film-making talent.

I qualify that statement only because the screenplay, written by Mr. Cox and John Clarke, is not as successfully realized as the performances or Mr. Cox's direction, which displays a number of the kind of lunatic touches that virtually define the comedy of Bill Forsyth ("Gregory's Girl," "Local Hero"). The screenplay does not exactly let Peter and Patricia down, but it requires that they sometimes behave in ways that are surprising only because they are arbitrary, representing the needs of the film instead of coherence of character.

"Lonely Hearts" probably should be applauded for not making a big, melodramatic, Freudian deal out of Peter's kleptomania, but it also may be carrying kleptomaniac liberation too far to ignore completely the causes and effects.

Having registered those more or less formal complaints, I must also admit having smiled with "Lonely Hearts" much of the time — from the opening, when a car full of funeral mourners finds itself racing the hearse to the cemetery, to the final

sequence, when Patricia sees Peter without his wig for the first time and laughs out loud.

•

Like Scotland's Mr. Forsyth, Mr. Cox, who was born in Holland and moved to Australia when he was in his 20's, seems to be a director who likes what might be described as an errant soundtrack. This is one in which one hears odd noises that, because they are never explained, increase the surreally comic perspective. Throughout Peter's interview at the dating service, someone contines to saw wood in the next office. Odd bits of music as well as sound effects enrich the images. The movie thrives on nonessential, eccentric details and sequences, some of the funniest having to do with an amateur production of Strindberg's "Father," starring Peter and Patricia.

Most prominent in the excellent supporting cast are Julia Blake and Jonathan Hardy, as Peter's sister and brother-in-law, and Jon Finlayson, who plays a sort of Aussie amateur Hal Prince directing "The Father." Mostly, though, the film belongs to Mr. Kaye, who looks like a somewhat older, scaled-down version of Michael Caine, and Miss Hughes, a classically beautiful actress who, here, succeeds in suggesting plainness without sacrificing the beauty. They are a very attractive pair.

1983 S 4, 58:3

Norman Kaye and Wendy Hughes in Paul Cox's "Lonely Hearts."

FILM VIEW

JANET MASLIN

'Daniel' Confuses More Than One Issue

When a film begins the way "Daniel" does, it's being either very foolhardy or very brave. The opening image is that of the narrator in tight close-up, scowling furiously as he describes the process of electrocution. Moments later, we see this same young man at a family dinner, sounding no less bitter or sarcastic as he quarrels with his younger sister, who is herself equally enraged. It's a daunting beginning, at the very least. Any audience is bound to be uneasy in the presence of such an abrupt outburst of anger.

Rage is at the heart of "Daniel," a film about children whose parents have been executed on political charges, and whose story bears unmistakable resemblances to the controversial Rosenberg case. The rage exists on both the personal level, since the two young principals obviously feel greatly aggrieved, and on a broader political plane; while the film avoids explicit evidence as to the guilt or innocence of the executed couple, it expresses enormous outrage over their fate.

Had these larger political concerns been more successfully articulated and linked to the personal development of its characters, then "Daniel," independent of any debate as to its historical justification, might have been formidable in its fury. Instead, its indignation becomes aimless and dissipated, though it is no less abrasive for its lack of a clear target. "Daniel" mixes fact and fiction freely, yet it never strikes a successful balance between developing its characters and presenting a clear and coherent attitude toward the events in which they are implicated. The audience is allowed neither a close understanding of these characters nor any clear knowledge of what they stand for or what they've done.

Foremost in the mind of anyone who's heard about "Daniel" is doubtless the question of whether or not this is indeed a film about Ethel and Julius Rosenberg. This isn't a question that wholly vanishes after the film has been seen. Its narrator is the son of Paul and Rochelle Isaacson (Mandy Patinkin and Lindsay Crouse), a couple who, like the Rosenbergs, have been implicated in conspiracy to commit espionage, and who are subsequently executed. Much about the Isaacsons' story, which is presented as a series of golden-hued flashbacks that interrupt Daniel's late-1960's narrative, evokes the Rosenbergs. For instance, the Isaacsons' electrocution sequences, which are presented in elaborate detail, closely match accounts of the Rosenbergs' final moments. However, the specific issues of the Rosenberg case are not addressed. And "Daniel" makes no attempt to insure that its evocations of the affair are identifiable or even consistent.

• • •

In part, this may be attributable to the historical uncertainties surrounding the Rosenberg case (on which new light has recently been cast by the new book "The Rosenberg File: A Search for the Truth," a lengthy and fascinating investigative work by Ronald Radosh and Joyce Milton). Another reason is undoubtedly the fact that "Daniel," which was directed by Sidney Lumet, has a screenplay by E. L. Doctorow based on Mr. Doctorow's own novel, "The Book of Daniel." That 1971 work interweaves history and fiction in a wholly idiosyncratic manner. As the book's Daniel recounts his parents' story, grappling conspicuously with the material of his past and constantly trying out different narrative tones, his own story becomes much more immediate than the memories he summons. The book charts Daniel's progress from an embittered victim of circumstance to someone who has come to terms with his own history.

Mr. Doctorow, in presenting Daniel as a highly sympathetic character, freely altered the facts of the Rosenberg story to heighten that impression. The children in the novel become a protective older brother and a fragile young sister, rather than two brothers. And the key witness who testified against the Isaacsons was removed to the status of family

friend, though in the Rosenberg case this witness was David Greenglass, Ethel Rosenberg's brother. Discussion of the trial was avoided almost entirely, as was speculation as to what, if any, activities the Isaacsons might have been involved in. Such changes make far more sense on the page, where they are more obviously in the service of a larger fiction, than in the much more literal medium of film. On screen, they merely serve to obscure the issue of the Isaacsons' guilt. The film also suffers from the loss of Daniel's narrative voice, which gave the book much of its immediacy and strengthened the link between his story and that of his parents.

Far from attempting to win the audience's interest and sympathy in ordinary ways, "Daniel" seems to demand these things as its due — apparently assuming the viewer's agreement with its point of view, however vaguely that has been presented. The film doesn't quite bully the viewer, but neither does it go to any undue lengths to make itself appealing. Its tone remains bitter, almost punishing, much of the way through. Its lighting is so oppressive that there's a subtle sense of relief each time the yellow glow of the flashbacks gives way to the 60's scenes' brighter hues. The soundtrack, which includes a number of recordings by Paul Robeson, is beautiful but so somber that when the sweet, lilting voice of Caroline Doctorow (the author's daughter) accompanies the film's closing moments, it creates a palpable lift. Mr. Lumet seems determined to offer very few such gentle satisfactions, though.

To add to its generally stern and self-righteous quality, "Daniel" sometimes makes its political points in terms that, on the level of character, are almost incomprehensible. How is an audience meant to regard a scene like that of Paul Isaacson's visit with his family during his army years? Paul sits at the center of a room, surrounded by friends and relatives who watch him lovingly as he tells of having been in the South, where he has marveled at the simple dignity of those who work the land. The other actors sit rapt as Mr. Patinkin, whose performance is for the most part very impressive, delivers an awkward monologue on the subject. Then he gets up, turns on the phonograph and begins dancing ecstatically around the room — and *still* nobody makes a move to interrupt him. The other actors simply watch him and clap, though surely Paul's statements would prompt other discussion at any actual gathering. The tendency of the characters in "Daniel" to make speeches rather than speak, or to behave uniformly at meetings or rallies, contributes to the film's polemical air and to its general strategy of overpowering, not persuading, the audience.

• •

Mr. Lumet's Isaacsons emerge, rather fuzzily, as lovable ideologues, lecturing their children about the hidden economic messages on a Wheaties box (Mr. Patinkin does this beautifully) and singing along to "Peat Bog Soldiers." But we are told of the rightness of their cause, rather than its nature. Their fate, when it befalls them, seems an utter mystery, as does much about the texture of their lives. If they are not exactly the Rosenbergs, neither are they allowed to become anyone else that the audience might understand.

The Daniel of the film's last scene appears at an enormous anti-war demonstration in Central Park — even though, as the film attempts to link Daniel's awakening 60's radicalism with the politics of his parents, it

The film mixes fact and fiction freely, but doesn't achieve a balance between character and events.

is attempting a giant leap rather than arriving at a logical conclusion. At the rally, Daniel is seen looking peaceful at last, though his thoughts are left unexplored, suggesting nothing more specific than that he may at last have been released from the burden of his history. In contrast, the Daniel of Mr. Doctorow's novel compares his parents' politics to his own much more directly when he remarks, after having had his eyes blackened and his teeth knocked out at an anti-war demonstration in Washington: "It is a lot easier to be a revolutionary nowadays than it used to be." That one observation of Daniel's offers more insight into the pain and irony of his situation, and more sense of his personal ordeal, than anything in the movie. ■

1983 S 4, II:11:1

A Latin Beat

THE LAST FIGHT, directed and written by Fred Williamson; director of photography, James Limmo; produced by Mr. Williamson and Jerry Masucci; released by Best Film and Video Corporation. At the National, Broadway and 44th Street, and other theaters. Running time: 89 minutes. This film is rated R.

Jesse Crowder	Fred Williamson
Joaquin	Willie Colon
Andy	Ruben Blades
Nancy	Nereida Mercado
Sally	Darlanne Fluegel
Pedro	Nick Corello
Papa	Sal Corollo
Slim	Izzy Sanabria

"THE LAST FIGHT," which opens today at the National and other theaters, is a movie about boxing, set in New York and scored with a Latin beat. It stars the Latin music personalities Ruben Blades and Willie Colon as, respectively, a salsa singer-boxer and the Latin hood who sells the boxer out to the mob.

•

Fred Williamson, one of the more popular black stars of the early 1970's, wrote, produced and directed "The Last Fight," and plays a small role as a high-minded former cop. This is strictly for audiences presold on salsa and, to a lesser extent, boxing movies.

Vincent Canby

1983 S 7, C20:1

Courage

JOM (Jom, or the Story of a People), directed by Ababacar Samb Makharam; written (in Wolof with English subtitles) by Mr. Makharam and Babacar Sine; camera, Peter Chappell and Orlando Lopez; edited by Alix Regis; music by Lamine Konte; produced by Baobab Film, Senegal, in collaboration with Zweiltes Deutschen Fernsehen (ZDF, West German television). At the Film Forum 2, 57 Watts Street. Running time: 80 minutes. This film has no rating.

Dieri	Oumar Seck
Khaly	Oumar Gueye
Madjeumbe	Amadou Lamine Camara
N'Dougoutte	Abou Camara
M. Diop	Zator Sarr
Mademoiselle Diop	Fatou Samb Fall
Mademoiselle Sall	N'Deye Ami Fall
Koua Thiaw	Dumi Sene
Governor	Charly
Canar Fall	Makhouedia Gueye
Madjeumbe's Wife	M'Bayang Gaye
Dieri's Wife	Aimee Diallo
Dieri's Sister	Isseu Niang
First Maid	Kewe N'Diaye
Second Maid	Fatou Fall
Third Maid	Deba N'Diaye
Officer	Jacques Maillard

"Jom" was shown as part of the 1983 New Directors/New Film Series. Following are excerpts from a review by Janet Maslin that appeared in The New York Times last March 28. The film opens today at the Film Forum 2, 57 Watts Street.

IN Senegal, where Ababacar Samb Makharam's "Jom" was made, the Wolof word of the title means something akin to "courage" or "dignity." The film helps define the word, which has no exact English equivalent, through a series of tales related by a griot, or storyteller. Modern characters who are engaged in a strike against a local industrialist are given courage and inspiration by the griot's historical anecdotes.

All of this is presented by Mr. Makharam through vivid pageantry, and with a passion and intensity that reflect considerable jom of his own.

The chief anecdotes concern a turn-of-the-century prince named Dieri (Oumar Seck), who murdered a white colonial official who had insulted him, and then went bravely to his death in battle; and a celebrated dancer who visits the old Senegalese city of St. Louis and while she is there improvises a jom-inspiring dance on behalf of the community's oppressed maids. Her wildly energetic dance, performed before a large and admiring crowd, is one of the film's high points.

1983 S 7, C21:2

Karma's Coming

REVENGE OF THE NINJA, directed by Sam Firstenberg; screenplay, James R. Silke; director of photography, David Gurfinkel; edited by Mark Helfrich; music by Rob Walsh and W. Michael Lewis and Laurin Rinder; produced by Menahem Golan and Yoram Globus; an M-G-M/U.A. Cannon Group release. At Warner 2, Broadway and 47th Street; Eastside Cinema, Third Avenue between 55th and 56th Streets;

East 85th Street, at First Avenue and other theaters. Running time: 90 minutes. This film is rated R.

Cho Osaki	Sho Kosugi
Dave Hatcher	Keith Vitali
Lieutenant Dime	Virgil Frye
Braden	Arthur Roberts
Caifano	Mario Gallo
Grandmother	Grace Oshita
Cathy	Ashley Ferrare

By LAWRENCE VAN GELDER

BEGINNING yesterday, anyone proffering $5 at the ticket windows of the RKO Warner Twin and some other local theaters could purchase transport to a community where the deadly medieval Japanese art of the ninja clashes with the modern methods of the Mafia — namely Salt Lake City.

Should this intelligence come as an assault on credibility, consider further the vehicle — a sadistic, bloody, foul-mouthed action movie called "Revenge of the Ninja," whose physical exploits owe as much to the talents of editors as to the prowess of the performers. In this movie, the martial ways of the ninja — described as professional soldiers who specialized in espionage and assassination some 400 years ago — are employed by both the Japanese hero and the American villain.

•

The former, from a family still emboroiled in ninja bloodshed, is persuaded by the latter to emigrate from Tokyo to open an art shop. But the villain's real scheme is to use the shop's imported Japanese dolls as repositories for heroin he is selling to the Mafia. When the local Mafia don hedges on the deal, the villain — employing his ninja skills — takes on the don and his henchmen. Caught up in all this are the hero's mother, his little boy, and the obligatory blonde who serves as the villain's spy on the hero and as a foil for the cackling Oriental henchman given to sexually assaulting or torturing her. And, in the end, of course, it is up to the hero, Cho Osaki, played by Sho Kosugi, to set things right, because, as he proclaims, "Only a ninja can stop a ninja."

Those who seek wisdom from such movies as this might also savor these words from the hero's mother: "You cannot escape your karma, my son. Even if you go as far as America, it will come for you, believe me."

•

Though Salt Lake City is not expressly identified, it is clearly the site where the body count rises after the hero's wife and other family members are done in by a ninja massacre at the film's start in a place specifically designated as Tokyo, Japan. The reluctance to identify Salt Lake City is understandable, because the police force involved in "Revenge of the Ninja" is generally ill-informed and slow to react, as when a swarm of heavily armed Mafiosi take up positions outside a new high-rise.

A moment like this makes Salt Lake City look like Beirut. But for a movie like this, credibility is checked at the door.

1983 S 8, C23:1

CITY NEWS & NEWS BRIEFS, produced, directed, written and edited by David Fishelson and Zoe Zinman; director of photography, Jonathan Sinaiko; music by Saheb Sarbib, Jules Baptiste, Peter Gordon, Monty Waters, Duke Ellington and the Normal; released by Cinecom International Films. At the 72d Street on Broadway. Running time: 81 minutes. This film has no rating.

Tom Domino	Elliot Crown
Daphne	Nancy Cohen
Frenchy	Thomas Trivler
Lou	Richard Schlesinger
Dee Dee	Valerie Felitto
Tony	Tony Mangia
Gail	Gail Gibney
Punch	David Fishelson
Judy	Zoe Zinman

"CITY NEWS," written, directed and edited by David Fishelson and Zoe Zinman, is a comedy about an ambitious young editor of a New York City underground paper and his rise to fame and power by drawing a weekly cartoon about his love affair with a young woman named Daphne.

Elliot Crown plays the editor, and Nancy Cohen plays Daphne. They aren't bad, but the postsynchronized-sound film looks like the sort of student work best shown to members of the family and friends of the cast and crew.

•

On the same bill with "City News" are two mildly amusing shorts, "Too Much Oregano," about a contretemps in an Italian restaurant, and "Ballet Robotique," in which industrial robots appear to be moving to themes from Bizet, Tchaikovsky and Delibes. They open today at the Embassy 72d Street Theater.

Vincent Canby

1983 S 9, C6:2

Suburban Fatalism

LUCIE SUR SEINE, directed by Jean-Louis Bertuccelli; screenplay (French with English subtitles) by S. Majerowitcz; adaptation by Mr. Bertuccelli; photography, Jean-François Robin; edited by André Gaultier; music by Gabriel Yared; produced by Janus Film-Klaus Hellwig; distributed by M. K. 2 Diffusion. At the Carnegie Hall Cinema, Seventh Avenue and 56th Street. Running time: 90 minutes. This film has no rating.

Louis	Patrick Depeyrat
Lucie	Sandra Montaigu
Nonoeil	Akim Oumaouche
Chantal	Maryline Even
Cafe Owner	André Chaumeau
Mechanic	Jacques Rispal
Chantal's Mother	Maria Verdi
Barbentane	Pierre Meyrand
Chabrier	Philippe du Jannerand
First Inspector	Michel Such
Nonoeil's Father	Kadour
Mother	Paulette Frantz
Social Worker	Philippe de Keuchel
Charly	Aboubakar Touré
Inspector No. 2	Guy Franquet

No Port in a Storm

THE MOON IN THE GUTTER, directed by Jean-Jacques Beineix; screenplay (French with English subtitles) by Mr. Beineix, based on a novel by David Goodis; director of photography, Philippe Rousselot; edited by Monique Prim and Yves Deschamps; music by Gabriel Yared; produced by Lise Fayolle; released by Triumph Films, a Columbia-Gaumont Company. At Cinema 3, 59th Street, at the Plaza Hotel. Running time: 126 minutes. This film is rated R.

Gerard	Gérard Depardieu
Loretta	Nastassia Kinski
Bella	Victoria Abril
Newton Channing	Vittorio Mezzogiorno
Frank	Dominique Pinon
Lola	Bertice Reading
Tom	Gabriel Monnet
Freida	Milena Vukotic
Jesus	Bernard Farcy
Dora	Annie-Marie Coffinet

By VINCENT CANBY

"LUCK is like a butterfly," says the tough, doomy young heroine of "Lucie sur Seine," directed by Jean-Louis Bertuccelli. "It lives and dies too fast." Lucie, who can also quote Rimbaud, has been disconnected by the dreariness of life in the working-class Paris suburb where she lives with her slovenly mother, her Arabic stepfather and her adolescent half-brother, who shows porn films to his classmates for profit. Lucie is lost, lost.

This may be why she falls precipitously in love with a young man who admits to having murdered two people in a supermarket holdup and who, having just savagely beaten her, shyly asks if he can spend the night. Without wiping away the blood that is coagulating under her nose, Lucie says yes.

Even more overripe than "Lucie sur Seine" is another new French film, "The Moon in the Gutter," Jean-Jacques Beineix's first film since "Diva," a romantic drama set in some extremely expensive-looking, bizarrely lighted studio sets, which are meant to represent a sordid but fantastic "port with no name." In this magical noplace Gérard (Gérard Depardieu), a great ox of a stevedore, wanders the streets at night in search of redemption. He's also looking for the man who raped his beloved sister, who in self-loathing then staggered into an alley and cut her own throat with a rusty razor.

From time to time throughout "The Moon in the Gutter" we see the moon reflected in the gutter in Day-Glo paint that stands for remembered blood. We also witness an ice-eating contest in a barroom and a love scene played in a yard in front of an ambulance sitting atop wooden blocks. A soundtrack narrator comes in occasionally to comment on events in the manner of "Hiawatha." "After many moons . . ." he says at one point.

Who was responsible for the death of Gérard's sister? Gérard's alcoholic brother Frank is one suspect. Another is Newton Channing, the rich young man who drinks himself to oblivion every night in a waterfront dive. Gérard himself is not entirely above suspicion. We are told that he was in the hospital the night it happened, but "The Moon in the Gutter" is not a movie you can easily trust.

There is even the possibility that Loretta (Nastassia Kinski), Newton Channing's glamorous sister, is involved. The film announces Loretta's first appearance — framed in darkness in the doorway of the waterfront dive — with the sort of thunder, lightning and musical fanfare more commonly associated with the arrival of the deity in a Cecil B. DeMille film.

Loretta may or may not know something, but that's not as important to the film as what she represents to Gérard. Rich, beautiful, immaculately dressed in couture clothes, she is his one chance to escape from the miserable port of no name to, one assumes, a port that has a name, perhaps Shreveport.

•

"The Moon in the Gutter," which opens today at the Quad and Cinema 3 Theaters, and "Lucie sur Seine," which opens today at the Carnegie Hall Cinema, don't look at all alike but they have more in common than their French origins.

They virtually define a mistakenly solemn, achingly poetic kind of French film making that has absolutely nothing to do with life and everything to do with earlier, usually far better films. It's as if their directors had looked at the world around them, seen nothing of special interest and then turned for inspiration to the films of admired predecessors. Both films are new, but they look secondhand.

In the publicity material for "The Moon in the Gutter," Mr. Beineix and his associates attempt to make legitimate their overproduced, undernourished exercise in sentimental aliena-

"LUCIE SUR SEINE"—Akim Oumaouche and Sandra Montaigu are in Jean-Louis Bertuccelli's film about people who live marginal existences on the outskirts of Paris and dream of escape.

"THE MOON IN THE GUTTER"—Nastassia Kinski is an heiress who becomes involved with a dockworker, Gerard Depardieu, who is obsessed by the death of his sister.

tion by citing the titles of no fewer than 15 French and American movies. Included are "Le Jour Se Leve," "In a Lonely Place," "They Live by Night," "Vertigo," "Taxi Driver," "Port of Shadows," "Pepe le Moko," "Touch of Evil" and "La Bête Humaine." Not mentioned is "Snow White and the Seven Dwarfs," which, I think, is quite as pertinent as most of the others.

"Lucie sur Seine" was made on a fraction of the budget required for "The Moon in the Gutter" but it was shot on locations outside Paris that are no less picturesque in their seediness than Mr. Beineix's elegant studio sets. "Lucie" is disarming for its small scale. Also, it doesn't need voluminous publicity material to tell the audience that it's coming out of the same tradition of poetic commer-

cial cinema that so inspires Mr. Beineix and that earlier inspired Mr. Bertuccelli's "Ramparts of Clay" (1971), a somewhat more successful film, which was about life and death in a North African village.

"Lucie sur Seine," about life and death in a Paris suburb, expresses a kind of fatalism that its tiny characters cannot support. Though nicely played by Sandra Montaigu, Lucie is less a character than a good actress's busy impersonation of one, much like Juliet Berto's performance in "Neige," which also professes to see truth in squalor.

Louis (Patrick Depeyrat), the driver of a laundry truck who turns to murder, is also a phantom character, a comment on society lifted from films made 30 to 40 years ago. The only positive thing to say about "Lucie sur Seine" is that it contains one good plot twist, which, unfortunately, comes too late to save it.

There is really nothing at all decent to say about "The Moon in the Gutter," which, like "Diva," is fancified film making but, unlike "Diva," doesn't mean to be funny, which it frequently is.

Mr. Depardieu walks through the movie looking as if he had a stomachache, though it may be that he only wishes that he hadn't gotten involved. The actor, so fine in "The Return of Martin Guerre," is nothing more than terrible here.

Miss Kinski, though photographed with great care, behaves like someone who's never been in a movie before. She doesn't seem to know what to do with her hands or her mouth, which is not the sort of thing that femmes fatales can worry about without losing some of their glamour.

I haven't read the David Goodis novel on which the screenplay is based, but I assume that it contains something more by way of a resolution to its mystery than the film. It's one of the contradictions often demonstrated by film makers like Mr. Beineix that, though they model their films on earlier pop classics, they eschew coherent plots as if such narratives would get in the way of personal statements. After sitting through "The Moon in the Gutter" one realizes that it isn't the characters who are alienated (there's no evident life within the film from which to be alienated), but the director.

In "Lucie sur Seine," Louis, the murderer, dreams of running away to Lebanon, as if Lebanon were the land of Oz and not the war-shredded country we know it to be. In "The Moon in the Gutter," Gérard wants to escape from the port of no name with Loretta in her sporty red roadster. That neither man makes it says less about the human condition than it does about the imaginations of Mr. Bertuccelli and Mr. Beineix. Boiled down, each film is about real estate and how difficult it is to get away from the old neighborhood.

1983 S 9, C8:1

FILM VIEW

VINCENT CANBY

At 20, 'The Leopard' Is Fleeter Than Ever

Nearly 20 years to the day after its New York premiere, "The Leopard," the late Luchino Visconti's screen adaptation of Giuseppe de Lampedusa's epic novel of Sicily at the time of the Risorgimento, has returned to New York. This time "The Leopard" is being shown in the Italian-language version that is called "the original," although no original, single-language version of the film ever existed, and with 25 minutes of footage restored. The reappearance of this enchanting work proves that, under the right circumstances, two decades make no difference whatsoever but 25 minutes can transform a very good film into a possibly great one.

When it opened here in August 1963, "The Leopard" was shown in an English-language version in which Burt Lancaster, who plays the title role, that of the aging Prince Fabrizio de Salina, spoke his own English dialogue, as did Claudia Cardinale, while almost everyone else was dubbed into English by — among others — such well-known actors as Howard da Silva, Thomas Gomez and Kurt Kaznar. Even the late Bosley Crowther, then The New York Times film critic and an articulate advocate of the dubbing of foreign-language films into English, found the "The Leopard's" English soundtrack pretty awful.

He wrote that Mr. Lancaster's New York City-born, American-bred voice was all wrong for the character of the grand Sicilian aristocrat, and that the voice used to dub Alain Delon, the French actor who plays Prince Fabrizio's nephew, Tancredi, was "not appropriate."

• • •

"The Leopard" is a souvenir of that era of Italian filmmaking when Babel was the rule, when actors of three or four different nationalities, playing in the same scene, would each speak his own language, which would, later be dubbed as required for the various versions of the film distributed around the world. Since there were more Italian actors in the film than those of any other nationality, it's probably not too great a stretch to call the Italian version the original.

Yet this version also has its language problems. The voice that speaks Mr. Lancaster's Italian lines has very little in common with the voice that has become so familiar to us over his nearly 40-year film career. The Italian voice is raspy and rough, and sounds much like something that might be speaking Italian-accented English in a spaghetti Western. Every time Prince Fabrizio opens his mouth, it's a shock, and one that doesn't diminish much as the film progresses.

Nevertheless, Mr. Lancaster looks so majestic — his massive build and his fair coloring set him apart from everyone else in the film — and he moves with such self-assured grace that one eventually comes to accept as a minor inconvenience this sense of vocal dislocation, which would be a major flaw in any film less enveloping. This may or may not be his greatest performance — there's no way of telling without the voice — but it's a visually arresting one, and one that points the way to the great performances later in his career.

Twenty years ago when the English-dubbed version of "The Leopard" was released, Visconti carried on a rather noisy campaign, largely in the London press, to disassociate himself not from the film's English soundtrack but from the unauthorized cuts the distributors had made to shorten the running time from 185 to 160 minutes. At that time I remember thinking that, while he was morally correct, the cuts didn't seem to make that much difference. The film seemed long, but it was very good anyway. The odd thing now is that "The Leopard," at 185 minutes, actually seems shorter (or less noticeably long) than at 160 minutes — for several interesting reasons.

• • •

The Lampedusa novel, which the screenplay follows in every important detail, is not a conventional, what-happens-next narrative. Though not especially introspective, "The Leopard," the film as well as the novel, is contemplative. It's about a civilization on the edge of radical social change, recounted in the leisurely tempo of the day-to-day activities of the Salina family, particularly those of Prince Fabrizio, who is the soul of the story. It's a succession of family dinners, picnics, parties, hunting expeditions, religious observances and, in one instance, a marvelous scene in which the Prince analyzes the Sicilian character: "their vanity is greater than their wretchedness."

The time is 1860, just as the forces of Garibaldi are preparing to invade Sicily to bring down the Bourbon dynasty and form a united Italy under the monarchy of Victor Emmanuel II. The middle class is about to succeed the aristocracy as the power behind the various thrones.

Unlike his nephew Tancredi, who joins Garibaldi, Fabrizio does not welcome the revolution, but neither does he fight it. He accepts it as inevitable, and his resignation becomes the mood and virtually the method of the film, which is wise, ironic, rueful and — let's admit it — extremely romantic. It's "Gone With the Wind" without the melodrama, which may not appeal to everyone. Visconti recreates a lost era with documentary-like details, the accumulation of which gives the film its fascination and its central character his stature.

In cutting 25 minutes from the original film in 1963, the distributors of "The Leopard" may have thought they were speeding up the pace though, in fact, they did just the opposite because there was no real narrative to speed up. They didn't remove entire episodes or scenes. They "trimmed" them, most apparently in the magnificent ball sequence that concludes the film. That sequence, which ran 40 minutes in 1963, must now run at least 10 minutes longer and it is superb.

By eliminating details that must have seemed to them to be merely décor, the distributors only emphasized the film's lack of a story line. The replaced footage now reveals the shapeliness and elegance of the movie Visconti conceived, which is more about the inevitablity of change than about the specific nature of those changes.

This theme recurs throughout Visconti's work, in good films like "Senso" (1954), also set against the background of the Risorgimento, "Rocco and His Brothers" (1961), and "The Innocent," completed shortly before the director's death in 1976, and in some films not so good, especially "Death in Venice" (1971) and "Conversation Piece" (1974).

Visconti was as successful as a director of opera as he was of films, but the melodrama that is accepted as a convention of opera almost always capsizes the films in which he introduced it. There are several excep-

tions, "Ossessione" (1942), his unauthorized adaptation of James M. Cain's "The Postman Always Rings Twice," "Rocco" and "The Damned," a lurid, hallucinatory melodrama about the home-life of a Krupp-like family at the dawn of Hitler's thousand-year Reich.

In "Death in Venice," Visconti trivialized Thomas Mann's concerns as well as his own. Here the theme of change boils down to the sight of poor old Aschenbach (Dirk Bogarde) tinting his gray hair black and putting on hideous rouge to hide his age from the Polish youth who has bewitched him.

In "Conversation Piece," Mr. Lancaster plays a wealthy, reclusive art historian, a role that has a number of things in common with Prince Fabrizio, but Visconti makes the mistake of showing us the rampaging hordes who are overturning civilization. They turn out to be not Huns of any sort, but simply a pushy, overdressed, nouveau riche marquesa and her chattering, supposedly depraved children. (There's something almost quaint about Visconti's various conceptions of depravity as represented in "Conversation Piece," "The Damned," "Death in Venice" and especially in "Ludwig" (1972). To the rest of us, it always looks unerotic and self-conscious, though I suspect that Visconti, unlike Cecil B. De-Mille, believed in the profound wickedness of what he was showing us.)

Like Lampedusa, Visconti was himself the descendant of an ancient aristocratic family. The Viscontis trace their roots back to the 14th century Dukes of Milan and beyond that to Desiderius, the father-in-law of Charlemagne. In "The Leopard," as in none of his other films, Visconti manifests an ease with — and an affection for — his material, which is resolutely reflective and non-melodramatic. The film is not only about a man of rare tastes, but it demonstrates those tastes. "The Leopard" is a pageant of music, painting, architecture, landscapes, ideas.

Bracketing Mr. Lancaster at the center of the film are the very young, extraordinarily handsome Alain Delon, as Fabrizio's nephew Tancredi, and the devastatingly beautiful Claudia Cardinale as the rich bourgeoise Tancredi marries. In being dashing, Mr. Delon literally dashes around like Robin Hood, and Miss Cardinale sometimes affects a forced kind of sauciness, but both performances represent an earlier style of acting that Mr. Delon and Miss Cardinale have long since left behind. Miss Cardinale has one particularly marvelous scene when, reacting to a rude story told her during a stuffy dinner party, her laughter builds into hysterical giggles that almost disrupt the evening.

For all of his prestige in Europe, especially in Italy and France, Visconti has never had an easy time of it with American critics and members of the American public. Only "Rocco," "The Leopard," "The Damned" and, to a lesser extent, "The Innocent," received much attention. It took more than 30 years for "Ossessione" to be seen in a 35mm print, partially because of copyright problems. "Senso" (1954) was shown on American television as "The Wanton Countess" long before it was theatrically released in 1968.

My pleasure at finally seeing "The Leopard" in its entirety is, however, mixed with a certain amount of apprehension. The word from Paris is that the summer's big hit there has been a reconstituted, four-hour-and-five-minute version of "Ludwig," to which I reacted very dimly when it was initially released here with a running time of just under three hours. Visconti may again be vindicated. Time, I trust, will eventually tell. ■

1983 S 11, II:21:5

Life Out of Balance

KOYAANISQATSI, directed by Godfrey Reggio; photography by Ron Fricke; edited by Mr. Fricke and Alton Walpole; music by Philip Glass; produced by Mr. Reggio; production company, the Institute for Regional Education. At the 57th Street Playhouse, between Avenue of the Americas and Seventh Avenue. Running time: 87 minutes. This film is not rated.

"Koyaanisqatsi" was shown as part of the 1982 New York Film Festival. Following are excerpts from a review by Vincent Canby that appeared in The New York Times on Oct. 4, 1982. The film opens today at the 57th Street Playhouse.

"KOYAANISQATSI" is a slick, naïve, chic, maddening, sometimes very beautiful movie that, if it were a book, would look great on a coffee table. The film is an 87-minute essay in images and sound on the state of American civilization. As non-narrative films go, it is remarkably seductive, but so are the color photographs in National Geographic.

"Koyaanisqatsi" is the first feature film by the 42-year-old Godfrey Reggio, a former member of the Christian Brothers Teaching Order, who, according to his official biography, more recently has been "interested in the impact of the media in conveying ideas rather than promoting commodities."

•

Mr. Reggio must be something of a promoter to have been able to get the film's financing — approximately $2.5 million — from an organization called the Institute for Regional Education in Santa Fe, N.M. He was also successful in obtaining the collaboration of two talented artists, Philip Glass, the avant-garde composer ("Einstein on the Beach"), and Ron Fricke, the cameraman. Together, the three have made a frequently hypnotic "folly" of a movie.

The film's title is a Hopi Indian word that, according to Mr. Reggio, means "life out of balance," which 'Koyaanisqatsi' sets out to dramatize. It opens with images suggesting the earth's creation out of flames and then moves into an extended, lyrical passage composed mostly of splendid aerial shots of the Southwest.

Inevitably, the film turns its attention to the uses that man has made of the natural resouces and beauties of the earth. Mr. Reggio and his collaborators mean, I think, "Koyaanisqatsi" to be a stimulus to thought, though it seems to be an unequivocal indictment when the title is translated as "life out of balance."

Don't worry about the "ideas." Enjoy the scenery, natural and manmade, photographed in just about every way imaginable, slow motion, time lapse and fast action, in tight close-ups and hallucinatory long shots. The cloud and sea stuff you've

seen before, but the city sequences are wild and rough and emotionally moving. Lights from automobiles traveling on a city artery are made to look like a lava flow, sometimes like self-propelled jelly beans. A sequence in which great buildings are demolished becomes so beautiful that all meaning is drained from the images.

"Koyaanisqatsi" is an oddball and — if one is willing to put up with a certain amount of solemn picturesqueness — entertaining trip.

1983 S 14, C22:4

Romantics in India

HEAT AND DUST, directed by James Ivory; novel and screenplay by Ruth Prawer Jhabvala; edited by Humphrey Dixon; music by Richard Robbins; produced by Ismail Merchant; released by Universal Pictures. At the Paris Theater, 58th Street west of Fifth Avenue. Running time: 130 minutes. This film is rated R.
Douglas Rivers..................Christopher Cazenove
OliviaGreta Scacchi
Mr. CrawfordJulian Glover
Mrs. CrawfordSusan Fleetwood
Dr. Saunders.....................Patrick Godfrey
Mrs. SaundersJennifer Kendal
The NawabShashi Kapoor
The BegumMadhur Jaffrey
HarryNickolas Grace
Major MinniesBarry Foster
Lady MackleworthAmanda Walker
Chief PrincessSudha Chopra
AnneJulie Christie
Inder LalZakir Hussain
ChidCharles McCaughan
MajiParveen Paul
Dr. GopalJayut Kripliani
Dacoit ChiefSaiid Khan
LeelavatiLeelabhai

By VINCENT CANBY

"INDIA changes a person," someone says in "Heat and Dust," just as other travelers from the West have been saying in fiction about India for the last 100 or so years. What makes the old line so poignant in this fine new film is the understanding that the changes wrought by India aren't necessarily accidental, involuntary or even very mysterious. Instead, they've been sought out by generations of tourists, some less heedless than others, who, as often as not, are infatuated by an idea of India long before they set foot on the subcontinent.

"Heat and Dust," which opens today at the Paris Theater, is Ruth Prawer Jhabvala's wise, multilayered, essentially comic adaptation of her own novel for her longtime screen collaborators, James Ivory, the director, and Ismail Merchant, the producer. "Heat and Dust" may be their most thoroughly satisfying collaboration since their first film, "The Householder" (1963), and their second, "Shakespeare Wallah" (1965).

•

The new movie, demonstrating a sort of literary complexity that seldom works well on the screen, cuts back and forth between two parallel stories separated by nearly 60 years. At the heart of the first, set in the mid-1920's, is Olivia (Greta Scacchi), a pretty, well-born young Englishwoman, the wife of a very proper British civil servant, who falls into a disastrous affair with the local reigning prince (Shashi Kapoor), a charming, apparently completely corrupt nawab.

Framing the story of Olivia is that of Anne (Julie Christie), the granddaughter of Olivia's sister. Anne not only represents today's liberation movement, she might also be one of its victims in ways she doesn't acknowledge. After an unhappy affair at home, Anne comes to India to research the story of her long-dead great-aunt Olivia. With her files of old

Greta Scacchi in James Ivory's "Heat and Dust."

letters and a tape recorder for interviews, Anne settles down in Satipur with a middle-class Indian family that, by chance, lives in the house where Olivia and Douglas (Christopher Cazenove), her husband, acted out their unhappy tale.

"Heat and Dust" derives its comic power from the differences between Olivia and Anne, and the similarities, which Anne, who is also a romantic, more or less forces into being. In the way that it is played, Anne's affair with her young Indian landlord (Zakir Hussain) is cheerful and none too serious. It's just that the landlord is at hand when she needs someone.

Miss Christie, who makes too few movies, is lovely and commonsensical as Anne. Her intelligence perfectly reflects that of the film itself. As the lost Olivia, Miss Scacchi, an Italian-born, English-bred actress new to films, dominates "Heat and Dust." She looks a little like Susan Sarandon but has her own kind of not completely suppressed fire. It's a good role, exceptionally well played. Mr. Kapoor, who has made a number of Merchant-Ivory productions, is both funny and mysterious as the nawab, whose perfect manners may be the mask of either a fool or a villain.

Mrs. Jhabvala's screenplay is full of rich characters. There is Harry (Nickolas Grace), a blythe young Englishman who appears to be a permanent guest at the palace of the nawab, for whom he is an intimate companion and court jester. Harry is the sort of man who says of the riots that swept Satipur in the 1920's, "When all these things began to happen, I just ran away to Olivia's and asked her to play some Schumann."

There are also a stern English doctor (Patrick Godfrey) who abhors Olivia's behavior and condemns her publicly; the doctor's weepy wife, very nicely played by Jennifer Kendal, who was so good in the Merchant-Ivory-Jhabvala "Bombay Talkie," and the imperious begum, the nawab's chain-smoking mother, played by the beautiful Madhur Jaffrey, first seen in "Shakespeare Wallah."

•

If the contemporary story is not as involving as that of Olivia and the nawab, it's partly because the contemporary problems are far more prosaic. It's as if the passage of time that witnessed the independence of India and its partition, as well the in-

troduction of jet travel for the budget-minded, had neutralized all possibility of heroic romance. When Olivia runs away from her adoring English husband, who is, after all, a decent fellow, the act is political as well as personal. When Anne invites her landlord into her bed, it's simply convenient.

Next to Anne, the most appealing character in the contemporary story is Chid (Charles McCaughan), a breezy American hippie who has come to India to find truth nearly 20 years after such quests were fashionable. Instead of truth, Chid ruins his liver. Walter Lassally, who has photographed most of the recent Merchant-Ivory films, does an exceptionally handsome job on this one.

Mr. Ivory and Mrs. Jhabvala have been working together so long that it's difficult for an outsider to know exactly who contributed what to any of their collaborations. Together, over the years, they have evolved a kind of ironic, civilized cinema that doesn't quite correspond to anyone else's. Of all their collaborations, none has been more graceful, funny, literate or entertaining than "Heat and Dust."

1983 S 15, C18:3

Centerville Is Missing

STRANGE INVADERS, directed by Michael Laughlin; written by William Condon and Mr. Laughlin; director of photography, Louis Horvath; film editor, John W. Wheeler; music by John Addison; produced by Walter Coblenz; released by Orion Pictures Corp. At Loews State, Broadway and 45th Street and other theaters. Running time: 93 minutes. This film is rated PG.

Charles Bigelow	Paul LeMat
Betty Walker	Nancy Allen
Margaret	Diana Scarwid
Willie Collins	Michael Lerner
Mrs. Benjamin	Louise Fletcher
Earl	Wallace Shawn
Waitress/Avon Lady	Fiona Lewis
Arthur Newman	Kenneth Tobey
Mrs. Bigelow	June Lockhart
Professor Hollister	Charles Lane
Elizabeth	Lulu Sylbert
Tim	Joel Cohen

By VINCENT CANBY

"STRANGE INVADERS," which opens today at Loews State and other theaters, is a tasteful monster movie with a terrible secret: it eats other movies.

In its belly one might find bits and pieces of "Invasion of the Body Snatchers," "Close Encounters of the Third Kind" and maybe even "The Day the Earth Stood Still" and, like all movie-eating movies, it's not always sure of its own identity.

"Strange Invaders" begins in Centerville, Ill., on a soft summer night in 1958, described in a title card as "a simple time," the era of Ed Sullivan, Elvis Presley and Dwight D. Eisenhower. On this night a huge spacecraft appears over Centerville and seems to ingest its inhabitants after surrounding them with bolts of lightning.

Cut 25 years into the future, to 1983, in fact. The place is New York City, where Charles Bigelow (Paul Le Mat), a professor of entomology at Columbia University, becomes worried when he cannot reach his former wife, who has left their daughter with him to go to Centerville to attend a funeral. The telephone being of no help, Charles drives out to Centerville to investigate and finds a ghost town, a place inhabited by zombielike humans and some messy-looking alien creatures who steal his dog and wreck his car.

"Strange Invaders," which was directed by Michael Laughlin and written by him and William Condon, displays an attractively casual attitude toward plot and history as it follows the efforts of Charles Bigelow and Betty Walker (Nancy Allen), a journalist, to solve the mystery of Centerville.

Also involved in the adventure are an inscrutable woman named Mrs. Benjamin (Louise Fletcher), who is the head of something called the National Center for U.F.O. Studies; Margaret Bigelow (Diana Scarwid), Charles's former wife, who may not be exactly what she seems, and Willie Collins (Michael Lerner), who encountered the aliens years earlier and has been in a loony bin ever since.

One of the more intriguing suggestions made by the screenplay is that the Eisenhower Administration, for which John Foster Dulles set foreign policy, might have entered into a secret, long-term treaty with representatives from another planet. Considering the conservative nature of foreign policy under Mr. Dulles, I find this a hilarious conceit.

Mr. Laughlin clearly has a sense of humor. He also knows enough to hire good actors, even when the roles aren't much, and inventive special-effects people, who have created several modestly spectacular sequences.

"Strange Invaders," which has been rated PG ("Parental Guidance Suggested"), includes some mildly vulgar dialogue as well as a couple of scary scenes that might upset very, very small children.

1983 S 16, C8:1

SMOKEY AND THE BANDIT, PART 3, directed by Dick Lowry; written by Stuart Birnbaum and David Dashev, based on characters created by Hal Needham and Robert L. Levy; director of photography, James Pergola; edited by Byron Brandt, David Blewitt and Christopher Greenbury; music by Larry Cansler; produced by Mort Engelberg; released by Universal Pictures. At Gemini 1, 64th Street and Second Avenue; Loews 83d Street Quad 3, at Broadway; Warner Twin 1, Broadway and 45th Street; 86th Street East, at Third Avenue, and other theaters. Running time: 88 minutes. This film is rated PG.

Buford T. Justice	Jackie Gleason
Cletus/the Bandit	Jerry Reed
Little Enos	Paul Williams
Big Enos	Pat McCormick
Junior	Mike Henry
Dusty Trails	Colleen Camp
Tina	Faith Minton
The Real Bandit	Burt Reynolds
Police woman	Sharon Anderson
Latin woman	Silvia Arana
Hippie	Alan Berger

By JANET MASLIN

The already skimpy running time of "Smokey and the Bandit, Part 3," which opened yesterday at the RKO Warner I theater, is padded by an opening montage of earlier "Smokey" scenes, including shots of Burt Reynolds lounging in a zebra-print hammock. He is grinning, as well he might, because he has been able to sit out "Part 3" altogether.

What has he missed? An interminable car chase punctuated by dumb stunts and even dumber dialogue, plus the well-worth-missing sight of Paul Williams in a dress. Mr. Williams and Pat McCormick play a father-son team who make a bet that Sheriff Buford T. Justice (Jackie Gleason) cannot ride from Florida to Texas with a giant replica of a fish affixed to his patrol car.

There's little more to the plot than that, so Mr. Williams and Mr. McCormick (who appear in drag, in combat fatigues, in cow outfits, and so on) are about all that the new film has to make up for the loss of Mr. Reynolds's glamour. There's also a shameless attempt to dress Jerry Reed up in Mr. Reynolds's red shirt, and give him the origial Banditmobile plus a Sally Field-type companion (Colleen Camp). However, Mr. Reynolds is gone, and whatever was enjoyable about the "Smokey" formula went with him.

Hal Needham, the original director, has also disappeared. He has been replaced by Dick Lowry, whose principal stylistic trick is that of opening as many scenes as possible with shots of bathing-suited cuties — who turn out to have nothing whatsoever to do with the action. They're part of the same yahoo ambience that produces a "comical" duel between two black men driving a truck full of chickens, and a group of Ku Klux Klansmen who try to intercept them. Sheriff Justice ultimately knocks the Klansmen into a tar pit, and the chickens land all over them, and everybody has a laugh, good-old-boy style.

This film is rated PG ("Parental Guidance Suggested") because it contains many off-color remarks and double-entendre.

1983 S 17, 30:4

Swamp Noises

CROSS CREEK, directed by Martin Ritt; screenplay by Dalene Young, based on Marjorie Kinnan Rawlings' Memoirs "Cross Creek;" director of photography, John A. Alonzo; film editor, Sidney Levin; music by Leonard Rosenman; produced by Robert B. Radnitz; released by Universal Pictures. At the Plaza, 58th Street east of Madison Avenue. Running times: 127 minutes.

Marjorie Kinnan Rawlings	Mary Steenburgen
Marsh Turner	Rip Torn
Norton Baskin	Peter Coyote
Ellie Turner	Dana Hill
Geechee	Alfre Woodard
Mrs. Turner	Joanna Miles
Paul	Ike Eisenmann
Floyd Turner	Cary Guffey
Tim's Wife	Toni Hudson
Leroy	Bo Rucker
Charles Rawlings	Jay O. Sanders
Tim	John Hammond
Postal Clerk	Tommy Alford
Man in the Rocking Chair	Norton Baskin
Store Keeper	Terrence Gehr
Preston Turner	Keith Michel
Mary Turner	Nora Rogers
Minister	Kenneth V. Vickery
Sheriff	C.T. Wakefield
Max Perkins	Malcolm McDowell

By JANET MASLIN

THE rural life imagined by Martin Ritt, in films like "Norma Rae" and "Conrack" and "Sounder" and now "Cross Creek," doesn't have much to do with rural life as anyone else knows it. But it has its own sort of power and integrity, Hollywood-style. In their simple log cabins decorated with carefully selected antiques, living in remote swamps that somehow produce florist-caliber house plants, Mr. Ritt's characters live out bucolic fantasies that might, in the hands of any less dedicated director, seem pure hokum. Somehow, Mr. Ritt manages to use this very artificiality in the service of an optimism that is very much his own.

Mr. Ritt may not bring anything like realism to these tales — even when, as in the case of "Cross Creek," they are indeed based on real events. But he does endow them with passion and sincerity. "Cross Creek" may be set in a remote Florida bayou, but it's so full of familiar faces that you may begin suspecting that even the fawn in the cast has appeared in a road-show production of "Bambi."

Nevertheless, these ingredients all work on their own terms. And the film's central performance has a strength and sweetness that transcends any artificiality there may be to its setting.

Mary Steenburgen plays Marjorie Kinnan Rawlings, author of "The Yearling," in this adaptation of the author's memoir. The film is set in 1928, and it begins with Marjorie's abrupt decision to leave her husband and move to an extremely remote orange grove, where she expects to live in utter isolation while concentrating on her writing. Though the peculiarities of this decision are left unexplained — it's not clear why she has chosen this spot, or what her former life was like, or how she is supporting herself — the strangeness of Marjorie's ambition is compelling enough to carry the first section of the film. Miss Steenburgen is almost entirely taciturn at first, but the mere spectacle of her setting up shop in this extremely forbidding locale holds its own fascination.

The house she has bought, which at first is seen to be a ramshackle hut with a foot-deep coating of cobwebs, is quickly refurbished; in fact, Marjorie apparently paints, cleans and patches the place all on her own, pausing only to listen sleeplessly to the weird noises of the swamp every evening. There's an obvious satisfaction in watching the graceful, fine-boned Miss Steenburgen hard at work at these somewhat improbable chores.

And then, in almost no time, the seemingly uninhabited swamp brings forth a devoted servant (Alfre Woodard), several farm workers to help with the oranges, and a family of neighbors. These simple, backwoods folk include Rip Torn as the hard-drinking Pa, Cary Guffey ("Close Encounters of the Third Kind") as a little, harmonica-playing boy in overalls, and Dana Hill ("Shoot The Moon") as the young girl whose pet fawn, Flag, will go on to "Yearling" fame.

A local hotel operator is played by Peter Coyote, who appeared as the mysterious fellow with the keys in "E.T." When Marjorie settles down to her writing and is visited by her editor, Max Perkins, it's by no means inconsistent to find him played by Malcolm McDowell, Miss Steenburgen's real-life husband, whose American accent is no less plausible than most of the others' Southern drawls. The casting is no less anomalous than anything else about the movie.

The individual elements of "Cross Creek" may seem absurd at times — like the impoverished young mother who has no water for bathing and wears a dress made from potato sacks though she still appears to have a tidy manicure — but the essential romanticism that unites them is not. Unlike so many films about writers at work, this one doesn't aspire to anything gritty. If Miss Rawlings, instead of pacing and fretting and chain-smoking, is shown sitting all day and all night typing eagerly, looking beautiful in a bare nightgown with her hair streaming down her back, the image is no less memorable for its loveliness. "Cross Creek" means only to offer an utterly idealistic portrait of a woman who knows what she wants, sets out to accomplish it and overcomes every obstacle. Her triumphs, however contrived or sentimentalized, really do feel like triumphs here.

Much of the credit for that is attributable to Miss Steenburgen, who manages to seem more authentically of the place and of the period than anything or anyone else here. Severely beautiful in the early scenes that establish the character's sternness and reserve, she later radiates a pride and diligence that sometimes give way to delightful mischief.

Miss Steenburgen eloquently embodies the self-sufficiency and determination that "Cross Creek" means to eulogize, but she does more idiosyncratic things, too. It's a measure of the performance's appeal, and the movie's singular notion of folksiness, that some of Miss Steenburgen's most entertaining moments come in a scene in which she admits to having shot a neighbor's pig. However little authentic light this scene casts on country living, it does say a lot about the film's farfetched but unmistakable charm.

●

"Cross Creek" is rated PG ("Parental Guidance Suggested"). It contains occasional harsh language.

1983 S 21, C19:4

Learning

EDUCATING RITA, directed by Lewis Gilbert; screenplay by Willy Russell; director of photography, Frank Watts; edited by Garth Craven; music by David Hentschel; produced by Lewis Gilbert; released by Columbia Pictures. At Cinema 2, Broadway and 47th Street. Running time: 114 minutes. This film is rated PG.
Dr. Frank Bryant..........................Michael Caine
RitaJulie Walters
BrianMichael Williams
TrishMaureen Lipman
JuliaJeananne Crowley
DennyMalcolm Douglas
Rita's FatherGodfrey Quigley
ElaineDearbhla Molloy
BursarPat Daly
CollinsKim Fortune
TigerPhilip Hudwood
LesleyHilary Reynolds
PriceJack Walsh

THE title character in "Educating Rita" is a housewife who yearns so mightily for knowledge that she embarks

on a tutorial program, soon becoming the favored protégé of a boozy English professor.

This self-styled student is such a bundle of spunk and intellectual curiosity that you can probably picture her: intense, serious, mousy and, of course, beautiful when she takes off her glasses. Why is it, then, that Rita when we first see her is a tarty-looking creature dressed in a short tight skirt and long black stockings, teetering adorably on her high heels and sporting pink streaks in her dyed blond hair?

●

The reason is that "Educating Rita," opening today at Cinema 2 and directed by Lewis Gilbert, based on the long-running London stage hit by Willy Russell, is an awkward blend of intellectual pretension and cute obvious humor. It's the perfect play about literature for anyone who wouldn't dream of actually reading books. Rita — who is actually named Susan, but who has rechristened herself in honor of Rita Mae Brown, one of the few authors with whom she is familiar at the beginning of the story — is eventually heard quoting William Blake from memory, airing a few opinions about Chekhov, and raving about the excitement she has experienced while watching "Macbeth" for the first time. This, in the play's terms, is more than enough to establish her quick eager mind and her extraordinary openness to new ideas.

Dr. Frank Bryant, the sodden and disheveled professor played by Michael Caine, is shown to be so dazzled by Rita's promise that he's reluctant to interfere with her innocence. "I don't know that I want to teach you," he says. "What you have is already too valuable." Nonetheless, "Educating Rita" chronicles the process by which Rita, under Frank's tutelage, resumes her real name, lets her hair go brown and begins dressing in denims, like the other students. Meanwhile, Frank learns to drink less, and is told by Rita/Susan that his own poetry has "a direct link through to the 19th-century tradition of, like, wit and classical allusion."

The audience will be ahead of this and possibly *too* far ahead in presuming that it will lead to a student-teacher romance. Even though Rita's marriage (to a lout who burns her books and complains loudly when she won't accompany him to his pub) and Frank's longtime love affair (with a fellow academic) both seem shaky, and even though there's a lot of after-hours activity in the tutorial relationship, Frank and Rita part as chastely as they have met.

When, early in the film, Frank extracts a liquor bottle from behind a copy of "The Lost Weekend" on a shelf otherwise devoted to Milton and Gibbon, it becomes apparent that "Educating Rita" will underscore everything as heavily as it possibly can. Sure enough, Mr. Gilbert (who directed three James Bond films and who also directed Mr. Caine in "Alfie") proves to have an approach as ponderous as Mr. Russell's. The essentially two-character play has been opened up to the point that it includes a variety of settings and subordinate figures, but it never approaches anything lifelike. The long arm of coincidence touches all of the minor characters, whose actions exist only to comment on those of Rita and Frank.

Julie Walters, who also played Rita on the stage, seems older than her 26-year-old character, and works overly hard at a lower-class accent and a relentless pixieishness. Much of this is attributable to the material; there seems no graceful way for Rita to make an entrance into Frank's office after he opens the door to find her helpfully oiling its lock for him. (In her early scenes, Rita is all unsolicited helpfulness and nonstop chatter.) Mr. Caine never fails to be a commanding actor, but he is not helped here by the paunchy, pink-eyed look of the character, or the endless and embarrassing drunk scenes in which he is trapped. His world-weary delivery in the early scenes promises more character development than actually occurs; he simply remains world-weary throughout, except when mistily proclaiming his admiration for his pupil.

●

"Educating Rita" is rated PG ("Parental Guidance Suggested"). It contains some tough language, most of it colloquially British and relatively quaint.

Janet Maslin

1983 S 21, C21:1

Subtle Subversions

EL BRUTO, directed by Luis Buñuel; script (Spanish with English subtitles) by Mr. Buñuel and Luis Alcoriza; photography by Agustin Jimenez; edited by Jorge Bustos; music by Raul Lavista; production by Oscar Dancigers, International Cinematografica; a Televicine International presentation, released through Plexus Film Distributors. At the Public Theater, 425 Lafayette Street. Running time: 83 minutes. This film is not rated.

"EDUCATING RITA"—Julie Walters is Rita, a working-class hairdresser in search of learning, and Michael Caine is her disillusioned English professor in Lewis Gilbert's film version of the Willy Russell play.

Paloma..Katy Jurado
Pedro..................................Pedro Armendariz
CabreraAndres Soler
MecheRosita Arenas
WITH: Roberto Meyer, Beatriz Ramos, Paco Martinez, Gloria Mestre

By VINCENT CANBY

"EL BRUTO," which opens today at the Public Theater, will be a treat for students of the great Luis Buñuel, who died in July at the age of 83. The Mexican film was made in 1952 when Buñuel, for the first time in his life, was busy earning a decent living by turning out popular comedies and melodramas for Latin American audiences and, occasionally, making films of real distinction. "El Bruto" is not one of these, but it was bracketed by a couple that are, "Los Olvidados" (1950) and "The Adventures of Robinson Crusoe" (1952).

Some years after making "El Bruto," Buñuel was quoted as saying that it might have been "all right" but that the producers had insisted on changes "from top to bottom." He added, "Now it's just another film with nothing extraordinary in it." Buñuel scholars, however, will appreciate the amount of subtly subversive material that the master has been able to slip into a conventional melodrama about the exploitation of the poor by the venal, mendacious members of the bourgeoisie.

The screenplay, written by Buñuel and Luis Alcoriza, is about a big, brawny, slow-witted butcher (Pedro Armendariz), nicknamed El Bruto, who terrorizes the rent-striking residents of a Mexico City tenement on the orders of the vicious landlord, to whom the younger man feels great loyalty.

Not until El Bruto has accidentally killed one of the strikers and fallen in love with the dead man's daughter does he realize that he has been badly used by the landlord, who — he's the last one to realize — is actually his natural father.

The film is punctuated by moments of wicked humor, a number of which feature the voluptuous Katy Jurado. She plays the landlord's much-too-young wife, whose eye wanders from her middle-aged husband to his ancient father and then to his handsome, if slow, illegitimate son. When Miss Jurado and Mr. Armendariz first meet on the screen, the sound-track music promises nothing less than Armageddon.

With the exception of Miss Jurado's, none of the performances is any good. Mr. Armendariz, whose El Bruto is supposed to suggest someone on the order of Lenny in "Of Mice and Men," prefers to play the role in the smiling style of a Latin American matinee idol.

The film's two most memorable scenes are one in which Miss Jurado teases her old father-in-law by letting him have his tequila only by sucking it off her index finger and, at the very end, a scene in which Miss Jurado has a very mysterious encounter with a rooster. The latter is the sort of joke that would have delighted Buñuel, an unreconstructed surrealist even when working in potboilers.

1983 S 21, C22:3

THE FINAL OPTION, directed by Ian Sharp; screenplay by Reginald Rose; original story by George Markstein; director of photography, Phil Meheux; edited by John Grover; produced by Euan Lloyd; released by M-G-M/U.A. Entertainment Company. At National 1, Broadway and 44th Street; 86th Street Twin, at Lexington

Avenue; Eastside Cinema, Third Avenue between 55th and 56th Streets. Running time: 125 minutes. This film is rated R.

Captain Peter Skellen	Lewis Collins
Frankie Leith	Judy Davis
Secretary of State Arthur Curry	
	Richard Widmark
General Ira Potter	Robert Webber
Commander Powell	Edward Woodward
Colonel Hadley	Tony Doyle
Rod	John Duttine
Bishop Crick	Kenneth Griffith
Jenny Skellen	Rosalind Lloyd
Helga	Ingrid Pitt
Ryan	Norman Rodway
Major Steele	Maurice Roeves

By JANET MASLIN

"THIS is being done in the name of peace!," sneers the terrorist, who is wearing a machine gun over her strapless evening gown. She has captured a group of American diplomats, and in exchange for these hostages she is demanding that a smallish nuclear explosion be arranged and televised. This, she says, will be an unusual and certainly attention-getting way of making the world aware of the need for disarmament.

Are these the typical tactics of antinuclear activists? Not exactly, but then "The Final Option" is not a typical movie. Although someone is careful to mention that there are "ordinary, decent people" active in the peace movement, the film makers don't seem to believe anything of the kind. Antinuclear protesters are very definitely the villains here, and seldom has a more rabid bunch of pinko peaceniks been seen on the screen.

We first see Frankie Leith (Judy Davis) at a peace demonstration, as the camera lingers on the clownish makeup and silly behavior of many of the marchers. Frankie is the ringleader of a group of leftist terrorists in London. Unlike many leftist terrorists, she lives in an extremely posh, very elaborately decorated apartment, complete with bearskin rug on the floor. She mentions something about "Daddy's money" by way of explaining this apparent incongruity.

At her group's headquarters, Frankie is all business, wearing battle fatigues as she paces past Che

Lewis Collins directed by Ian Sharp in "The Final Option."

Guevara posters. She is similarly serious when the group puts on topical cabaret skits. This group, which provides the most bizarre nightclub act this side of "Flashdance," stages a Bob Fosse-type dance routine to the tune of "Yankee Doodle," with masked ghouls wearing American flags and wielding hats and canes. At the center of all this supposed satire stands Frankie herself, in a silver cape and gray makeup. She's all dressed up as a nuclear warhead — and it isn't even Halloween!

Sitting in the audience is suave, handsome Capt. Peter Skellen of the Special Air Service regiment (Lewis Collins), who has been sent to infiltrate Frankie's operation. This isn't difficult; he simply sits down at a table with Frankie, buys her a drink, announces he'd like to go to bed with her and offers a debonair leer.

Frankie, who is apparently lonely and lovesick under all that leftist rhetoric, is delighted. She takes Skellen home, invites him to move in with her and immediately begins asking his opinions about the group's various strategies. Theirs is a cosy living arrangement — when he compliments her on her perfume, she smiles and murmurs, "Not bad for a revolutionary!" — despite the fact that Skellen already has a wife and baby at home. Though other wives and babies might object to such on-the-job activities, Skellen's is evidently an unusually understanding family.

•

Skellen may not be a totally appealing character, but he's the best thing the movie has to offer. Mr. Collins, a British television star, has a cool, tight-lipped manner, somewhere between James Bond's and Clint Eastwood's. In a less ludicrous drama he might fare very well. Here, he must wander "inconspicuously" — in a blazer with brass buttons — through the headquarters of the scruffy terrorists, until their takeover of the United States Embassy catapults him into action.

Once this happens, he bides his time and waits for the ideal moment to rescue Richard Widmark and Rob-

"THE FINAL OPTION"—Below, an antinuclear terrorist group takes over the residence of the United States ambassador in England during Ian Sharp's thriller, starring Judy Davis and Richard Widmark.

ert Webber, who are among the captured dignitaries. Both these actors add a welcome note of stability and sanity to the otherwise shrill goings-on, and they're almost enough to make up for Miss Davis. Sour and sarcastic, she gives a performance even more unpleasant than must have been required. Some of her choices of roles since "My Brilliant Career" have been baffling enough, but her reasons for tackling this one are an utter mystery.

Ian Sharp, who directed "The Final Option," accompanies its political message with a lot of violent action, including a fistfight between Skellen's sweet, demure wife and a baby-hating female terrorist who behaves like Ilse, she-wolf of the S.S. There are also several sadistic beatings, plus a trigger-happy ending.

•

A final note states that there have indeed been many terrorist takeovers of diplomatic headquarters around the world. If this is meant to underscore the movie's credibility, it doesn't.

1983 S 23, C8:1

A Different Beat

EDDIE AND THE CRUISERS, directed by Martin Davidson; screenplay by Mr. Davidson and Arlene Davidson, based on the novel by P. F. Kluge; director of photography, Fred Murphy; edited by Priscilla Nedd; music by John Cafferty; produced by Joseph Brooks and Robert K. Lifton; released by Embassy Pictures. At Loews State, Broadway and 45th Street; New York Twin, Second Avenue and 66th Street; 34th Street Showplace, near Second Avenue, and other theaters. Running time: 94 minutes.

Frank Ridgeway	Tom Berenger
Eddie Wilson	Michael Paré
Doc Robbins	Joe Pantoliano
Sal Amato	Matthew Laurance
Joann Carlino	Helen Schneider
Kenny Hopkins	David Wilson
Wendell Newton	Michael (Tunes) Antunes
Maggie Foley	Ellen Barkin
Lew Eisen	Kenny Vance
Keith Livingston	John Stockwell
Lois	Joe Cates
Barry Siegal	Barry Sand
Gerry Rivers	Vebe Borge

THERE hasn't yet been a successful movie about the early days of rock-and-roll, even though the subject is certainly capable of generating a lot of emotion. Not even the better efforts in this genre, from "Stardust" and "The Idolmaker" to "The Buddy Holly Story," have captured anything akin to the excitement of the music itself. The behind-the-scenes drama — the wild ambition, the wheeling and dealing, the image making — convey such different sentiments from the music's explosive, euphoric feeling that there's bound to be a built-in incongruity, for one thing. For another, rock seems to be much more easily embodied than explained.

"Eddie and the Cruisers," which opens today at the Loews State and other theaters, attempts to enliven the rock-history formula by adding new elements of pretension and mystery. It's about Eddie (Michael Paré), a New Jersey rocker who hit the big time in 1963 and then drove off a bridge. Eddie read enough of Rimbaud to make an album called "Season in Hell," and his friends wonder if he didn't, like the poet, willfully vanish. They also wonder where the "Season in Hell" tapes have gone, since the album was never released and the tapes would undoubtedly be valuable.

While the mystery works its way toward a somewhat unsurprising and positively Gothic denouement, the film goes about its real business: recreating the heyday of Eddie and the

Cruisers, and contrasting that time with the present. This is done through the character of Frank Ridgeway (Tom Berenger), nicknamed Wordman, who joined the Cruisers as a foil to the visceral, hard-rocking Eddie. Frank, now an English teacher, remembers his time with the Cruisers in a series of flashbacks. These are triggered by an interviewer named Maggie Foley (Ellen Barkin), who wants to tell the band's story on her television show.

As directed by Martin Davidson, who directed "Hero at Large" and who is also co-author of this script with Arlene Davidson, "Eddie and the Cruisers" is vivid, full of conviction and more than a little foolish at times. Eddie's startling good looks (in the John Travolta-Matt Dillon street-kid style) and his energetic sound (the songs are by John Cafferty, who also does Eddie's singing) are accompanied by enough artistic self-importance to make the character less sympathetic than he might be. When Eddie declares furiously that he wants the audience to know what he's singing about, and the song he's singing is "Betty Lou's Got a New Pair of Shoes," it's hard not to feel that he's becoming a prima donna. Similarly, Eddie's final declaration, "If we can't be great, then there's no point in ever playing music again," stretches the material's potential for melodrama to its limit, and beyond.

•

Some of the details ring uncannily true, like the slick "oldies" nightclub act that one of the Cruisers is still doing nearly 20 years after Eddie's supposed death. Other aspects of the movie are inexplicably wrong. Eddie's music sounds good, but it also sounds a lot like Bruce Springsteen's, and it would not have been the rage in 1963. Nor were there then many bands with personnel like the Cruisers': a few young white rockers, a black saxophonist who looks twice their age, and one woman, who plays the tambourine. Mr. Davidson obviously cares a lot about the era, and there's plenty of other evidence that he knows how it looked and sounded; the same can be said for John Lyon, a k a Southside Johnny, who served as the film's technical adviser. So the anachronisms are a greater mystery than that of Eddie's disappearance.

Mr. Paré makes a fine debut; he captures the manner of a hot-blooded young rocker with great conviction, and his lip-synching is almost perfect. Unlike the other Cruisers, who include Matthew Laurance and Joe Pantoliano, he isn't forced to shift frequently from 1963 to the present and back again; as a result, they all seem old for the early scenes and not old enough for today. Ellen Barkin, as the reporter, has the film's most awkwardly written role. And Helen Schneider, as the tambourinist, looks sultry but distinctly out of place, since she's a young woman playing what was then — and still is, for the most part — very much a young man's game.

•

"Eddie and the Cruisers" is rated PG ("Parental Guidance Suggested"). It contains some strong language.

Janet Maslin

1983 S 23, C8:3

A Florin's Value

ERNESTO, directed by Salvatore Samperi; screenplay (Italian with English subtitles) by Barbara Alberti, Amedeo Pagani, Salvatore Samperi, based on the novel by Umberto Saba; photography by Camillo Bazzoni; a co-production of Clesi Cinematografica/Jose Frade Producciones Cinematografica/Albatros Production; an International Spectrafilm Distributors, Inc. release. At the Embassy 72d Street, at Broadway and the 8th Street Playhouse, at Avenue of the Americas. Running time: 95 minutes. This film is not rated.
ErnestoMartin Halm
WITH Michele Placido, Virna Lisi, Turi Ferro, Lara Wendel, Conchita Velasco, Francisco Marso, Miranda Nocelli

By LAWRENCE VAN GELDER

IF there is a border that separates the journeymen among film makers from the artists, then it may well be positioned where the talent to observe human behavior ends and the genius to illuminate it begins.

Such speculation seems only natural after viewing "Ernesto," an Italian-language film that opened yesterday at the Embassy 72d Street and the Eighth Street Playhouse.

•

Set in the Trieste of 1911, where the same relatively modest sum, a florin, would buy a pet blackbird, a prostitute or the labors of a stevedore in unloading two carloads of heavy sacks, this film by Salvatore Samperi, based on a novel by Umberto Saba, centers on a dapper teen-age rebel employed by a prosperous merchant.

In the course of the film, Ernesto (Martin Halm) enters into a homosexual relationship with one of the stevedores, samples the services of a prostitute, is smitten with a pretty 15-year-old boy from a wealthy family and finds himself en route to marrying the boy's twin sister.

What is it that motivates Ernesto? The movie suggests that it is in the genes and leaves it at that. After all, his Jewish mother, played by Virna Lisi, once outraged the conventions by marrying a gentile who abandoned her while she was pregnant with the boy.

And, while Ernesto talks a good deal — professing affection for animals over humans, an attachment to socialism, an innate artistry sufficient to make him a concert violinist — he remains essentially unrevealed. Only at the very end, when Ernesto turns wordlessly toward the camera in the midst of his engagement party and indicates that neither marriage nor the years to come will subdue the rebel within, does the director vouchsafe the audience a glimpse of the boy's thoughts.

What is left, then, is the Mr. Samperi's talent for observation. The costumes, the buildings, the boats, the artifacts, the settings all conjure up a bygone era, bathed in the halcyon glow of the years before World War I.

The same glow extends to Ernesto, in his clothing, the drape of his watch chain, his cane. It illuminates him from the outside with affection and compassion but the mind within remains largely hidden.

1983 S 23, C12:5

THE BIG CHILL, directed by Lawrence Kasdan; written by Mr. Kasdan and Barbara Benedek; director of photography, John Bailey; edited by Carol Littleton; music by various composers; produced by Michael Shamberg; released by Columbia Pictures. At Alice Tully Hall, 7:30 P.M., and Avery Fisher Hall, 9 P.M., as part of the 21st New York Film Festival; presented by the Film Society of Lincoln Center Inc. in cooperation with the Motion Picture Association of America. Running time: 104 minutes. This film is rated R.
Sam...................................Tom Berenger
Sarah.................................Glenn Close
Michael..............................Jeff Goldblum
Nick...................................William Hurt
Harold...............................Kevin Kline
Meg..................................Mary Kay Place
Chloe................................Meg Tilly
Karen...............................JoBeth Williams
Richard.............................Don Galloway
Minister............................James Gillis
Peter the Cop......................Ken Place
Harold and Sarah's Son...........Jon Kasdan
Running Dog Driver................Ira Stiltner
Autograph Seeker..................Jacob Kasdan
Alex's Mother......................Muriel Moore
Airline Hostess....................Meg Kasdan
Annie.................................Patricia Gaul

By VINCENT CANBY

IN the opening sequence of "The Big Chill," Lawrence Kasdan's sweet, sharp, melancholy new comedy, seven friends, who went through the University of Michigan together and are veterans of the activist 1960's, meet at the funeral of one of their comrades, who has inexplicably committed suicide. The setting is a small Baptist church somewhere in the South.

The first speaker, the church pastor, rather helplessly concedes that he didn't know the man he must bury. He attempts to be fair to a memory he does not share, but everything he says comes out slightly wrong, as when he talks of the deceased's "seemingly random series of occupations," without then going on to disprove the "seemingly."

The mourning friends are constantly teetering between laughter and tears, which is the mood of this very accomplished, serious comedy, which will be shown tonight at Lincoln Center to start the 21st New York Film Festival. The 7:30 P.M. showing will be at Alice Tully Hall and the 9 P.M. showing at Avery Fisher Hall.

"The Big Chill," which begins its regular commercial engagement at the Paramount and other theaters next Thursday, is an unusually good choice to open this year's festival in that it represents the best of mainstream American film making. Among other things, it's a reminder that the same people who turn out our megabuck fantasies are often capable of working even more effectively on the small, intimate scale of "The Big Chill."

It's a particular achievement for Mr. Kasdan, who made a stunning directorial debut with "Body Heat," which he also wrote, after writing the screenplays for "Continental Divide" and, with George Lucas, for "Raiders of the Lost Ark" and "The Empire Strikes Back." Barbara Benedek shares "The Big Chill" writing credit with him.

"The Big Chill" is a somewhat fancy variation on John Sayles's "Return of the Secaucus Seven," in that these 60's survivors all seem to have climbed higher in the 70's, so that their sense of dreams lost and ideals betrayed is sharper and, possibly, more romantically dramatic.

Meg (Mary Kay Place), having once been a dedicated public defender, has abandoned her poor and — she ruefully concedes — often guilty clients to become a successful corporation lawyer. Sam (Tom Berenger), a very nice guy and probably a second-rate actor, is the star of a popular television series that embarrasses him. Recalling the earnest fellow he used to be, he says solemnly, "At least once each show I try to put in something of value." Michael (Jeff Goldblum) wanted to become a novelist and has settled for the jazzy career

Meg Tilly in "The Big Chill."

of a writer for People magazine.

Harold (Kevin Kline) and Sarah (Glenn Close), who have fared better than any of their friends, live an enlightened suburban existence. He is the owner of a successful shoe-retailing company, and she is a physician. Karen (JoBeth Williams) says she is happy but is really bored to tears by the devotion of her husband, Richard (Don Galloway), a stranger to this group, and by the housewife she has become.

•

The most complicated member of the group is Nick (William Hurt), a Vietnam veteran who once enjoyed some fame as a psychologist on a West Coast radio call-in show but who now lives an aimless, rootless life supported by drugs. Completing the group at this postfuneral weekend is Chloe (Meg Tilly), the pretty, much younger woman, who was living with Alex, the dead man, at the time of the suicide and who is completely unconcerned by the specter of time's passing that haunts the rest.

As much as any one character can be the focus in a film of this sort, the enchantingly funny and direct Chloe is the center of the narrative. While the others are being mopey as they drive from the church to the cemetery, Chloe expresses her disappointment at having to ride in an ordinary car and not in the limousine with Alex's mother. Everything is still new to Chloe, including, she concedes, limousines. Later, as if to root out the genteel self-consciousness that has overtaken the mourning friends, she announces: "Alex and I made love the night before he died. It was fantastic!"

In the course of their weekend together in an extremely photogenic, antebellum mansion outside Beaufort, S.C., the friends move from depression to high spirits, to boozy, druggy confessions, accusations and revelations of long-hidden disappointments. By the end, several members of the group have made important decisions, which may or may not change their lives, while the others resume the routines they left the preceding Friday.

•

Mr. Kasdan is one of the finest of Hollywood's new young writers but "The Big Chill," like "Body Heat," demonstrates that he is a writer who works as much through images as through words. "The Big Chill" is packed with frequently witty visual

information that sometimes contradicts and sometimes supports what the characters say about themselves. There's a wonderfully funny montage early in the movie in which we see each character as defined in the contents of his or her overnight bag. The soundtrack is loaded with 60's music that recalls, without sentimentality, everything the friends have grown away from.

The performances represent ensemble playing of an order Hollywood films seldom have time for, with the screenplay providing each character with at least one big scene. If the actors were less consistent and the writing less fine the scheme would be tiresome. In "The Big Chill" it's part of the fun.

Two reservations should be noted. The character of the dead Alex never comes through as vividly as it should. What does come through — a portrait of an exceptionally gifted, charming, dedicated man, whose life effectively stopped with the excitement and promise of the 60's — blends so thoroughly with that of Mr. Hurt's Nick that one can't be sure if this is the point or if it's a weakness in the conception.

Further, there is the matter of what happened to Nick in Vietnam. We are told on several occasions that his sexual life is over, but why is left for us to speculate about. It's never clear whether he has been physically or emotionally impaired, or both.

This might well be a reference to poor old Jake Barnes of Hemingway's "Sun Also Rises," a book that college students have been poring over for 50 years now in their fruitless search for clues to the exact nature of Jake's problem. Considering the frankness with which the characters in "The Big Chill" discuss everything else, this discretion is ridiculous.

1983 S 23, C14:3

L'ARGENT, directed by Robert Bresson; script (French with English subtitles) by Mr. Bresson; camera, Pasqualino de Santis and Emmanuel Machuel; edited by Jean-François Naudon; production, Marion's Films and F R 3/Eos Films SA. At Alice Tully Hall, as part of the 21st New York Film Festival; presented by the Film Society of Lincoln Center in cooperation with the Motion Picture Association of America. Running time: 90 minutes. This film is not rated.
YvonChristian Patey
The Little Old LadySylvie van den Elsen
Father of the Little Old LadyMichel Briguet
Elise.......................................Caroline Lang
YvetteJeanne Aptekman
LucienVincent Risterucci
The Female PhotographerBeatrice Tabourin
The Male PhotographerDidier Baussy
NorbertMarc Ernest Fourneau
MartialBruno Lapeyre
Father NorbertAndré Cler
Mother NorbertClaude Cler

By VINCENT CANBY

That Robert Bresson, the veteran French director, is still one of the most rigorous and talented film makers of the world is evident with the appearance of his beautiful, astringent new film, "L'Argent," which will be shown at the New York Film Festival in Lincoln Center today at 12:30 P.M. and tomorrow at 7 P.M. Mr. Bresson does not make films casually — "L'Argent" is only his 13th since his first feature, "Les Anges du Pêche" (Angels of the Streets), was released in 1943.

The man who made "Diary of a Country Priest," "Pickpocket" and "Lancelot du Lac" is at the top of his very idiosyncratic form with "L'Argent," which has nothing to do with the Emile Zola novel or Marcel L'Herbier's film adaptation of that novel. The Bresson film is inspired by

Christian Patey in "L'Argent."

a Tolstoy short story, and though I've never read it, I would assume that Mr. Bresson has turned it to his own purposes.

•

Set in contemporary France in an unidentified city that sometimes seems to be Paris but probably isn't, "L'Argent" (Money) is a serenely composed film that tells a ruthless tale of greed, corruption and murder without once raising its voice. It goes beyond the impartiality of journalism. It has the manner of an official report on the spiritual state of a civilization for which there is no hope.

The narrative is mainly concerned with Yvon, a young truck driver framed by some bourgeois shopkeepers who identify him as the source of counterfeit notes. Because he has no criminal record, Yvon is given a suspended sentence, but he loses his job anyway. Soon he agrees to participate in a bank holdup to obtain money to support his wife and child.

The holdup fails and Yvon is packed off to jail, where things go from very bad to far, far worse. He loses all sense of compassion and, when he is paroled, he is beyond any redemption except God's.

Like all Bresson films, "L'Argent" can't be interpreted exclusively in social, political or psychological terms. Mr. Bresson's characters act out dramas that have been in motion since the birth of the planet. He's not a fatalist, but he insists on recognizing inevitable consequences, given a set of specific circumstances. "L'Argent" would stand up to Marxist analysis, yet it's anything but Marxist in outlook. It's far too poetic — too interested in the mysteries of the spirit.

As usual, Mr. Bresson has cast the film largely with nonprofessionals, a practice that contributes importantly to the film's manner. Christian Patey, the young man who plays Yvon, possesses the dark, almost pretty good looks of something idealized, apotheosized. He is not only Yvon, but also the representation of all innocents who have been betrayed by a system that rewards corruption.

•

Mr. Patey's is what amounts to a carefully designed nonperformance. He doesn't act his lines. He recites them as simply as possible, as do all of the performers. They give the impression of traveling through the

events of the narrative without being affected by them, which reduces any chance that the film will prompt sentimental responses.

The look of "L'Argent" accentuates this chilliness. The images have the clean, uncharacterized look of illustrations in the annual report of a large corporation. They are perfectly composed and betray no emotions whatsoever. This distance between the appearance of something and what it means is one of the methods by which the power of any Bresson film is generated.

"L'Argent" is not an easy film. It's tough but it's also rewarding, and it's the kind of film that justifies film festivals.

1983 S 24, 11:1

THE WIND, directed by Souleymane Cissé; script and dialogue (Bambara with English subtitles) by Souleymane Cissé; photography by Etienne Carton de Grammont; music by Pierre Gorse, Radio Mogadiscio and Folklore Mali; produced by Souleymane Cisse. At Alice Tully Hall, as part of the 21st New York Film Festival; presented by The Film Society of Lincoln Center in cooperation with the Motion Picture Association of America. Running time: 100 minutes. This film is not rated.
WITH: Balla Moussa Kelta, Ismaila Sarr, Fousseyni Sissolo, Goundo Guisse, Oumou Diarra, Dioncounda Kone, Yacouba Samabaly, Ismaila Cisse, Massitan Ballo, Oumou Kone, Dounamba Coulibaly.
REASSEMBLAGE, directed, written and narrated and produced by Trinh T. Minh-ha. At Alice Tully Hall, as part of the 21st New York Film Festival; presented by The Film Society of Lincoln Center in cooperation with the Motion Picture Association of America. Running time: 40 minutes. This film is not rated.

By JANET MASLIN

Souleymane Cissé's "Wind," from Mali, begins on a relatively light-hearted and familial note, though it may take New York Film Festival audiences a little while to untangle the family relationships that are being described.

At the relatively modern household of a provincial military governor, there are two senior wives plus one young, tarty and ill-behaved one; domestic quarrels are lively and involve them all. The governor's daughter, a student named Batrou, is in love with Ba, who lives with a grandfather from a tribal background and a tiny grandmother who douses Ba with water when she suspects he has been taking drugs. At this, Ba pounces on the old woman and tries to pummel her until his towering grandfather interferes. Here, as in the other household, modern and traditional influences mix uneasily, and there's little on which the young people can model themselves. An old era is over, but the new one hasn't yet begun. This is especially apparent at the university Batrou attends, where student unrest is on the rise.

Mr. Cissé's film, while at first it follows the love affair between Ba and Batrou, moves on to study the incompatibility of their families and the incongruities that mark the culture in which they live. Drugs, tennis and contemporary furniture have all found their way into the confines of this society. Rather than signs of progress or prosperity, these things appear to be reflections of a deep dissatisfaction that, by the end of the film, has erupted into violence.

Mr. Cissé's feeling for his characters is strong, and they are vividly drawn; his film works best when it approaches them individually, since the group scenes are sometimes too indirect and mildly confusing. The courtship of Ba and Batrou is an unusual one — both are very shy and they're seldom alone, but on one of

the rare occasions when they are, they share a bath — and many of the family scenes are similarly idiosyncratic. The film's most impassioned sequence is a mystical one in which Ba's grandfather communes with a deity, praying for his grandson's future, and in a broader sense, that of his culture.

Another film on the same festival bill is "Reassemblage," by Trinh T. Minh-ha, a Vietnamese director now living in Berkeley, Calif. "'A film about what?' my friends ask," Miss Minh-ha repeats several times in voice-over. "A film in Senegal. But what in Senegal?" Her friends were right to wonder.

A collection of images — women, breasts, children, herds of animals — is examined; meanwhile, in voice-over, the director considers their meaning from the standpoint of semiotics and derides those who bring to bear foreign values and insensitivity upon ethnological studies (she mentions a Peace Corps volunteer who couldn't hear the tribesmen through his Walkman). In the end, she says, "What I see is life looking at me." Her film is no more startling or specific than that conclusion.

Both "The Wind" and "Reassemblage" will be shown tonight at 6 o'clock and tomorrow at 2 P.M. at Alice Tully Hall.

1983 S 24, 11:1

THE STORY OF PIERA, directed by Marco Ferreri; screenplay (Italian with English subtitles) by Piera Degli Esposti, Dacia Maraini and Mr. Ferreri, from a story by Piera Degli Esposti and Dacia Maraini; director of photography, Ennio Guarnieri; edited by Ruggero Mastroianni; music by Philippe Sarde; production by Faso Film S.R.L./T. Films/Sara Films/Ascot. At Alice Tully Hall, as part of the 21st New York Film Festival; presented by The Film Society of Lincoln Center in cooperation with the Motion Picture Association of America. Running time: 106 minutes.
PieraIsabelle Huppert
EugeniaHanna Schygulla
The FatherMarcello Mastroianni
Piera as a childBettina Gruhn
Elide ..Tanya Lopert
The MidwifeAlche' Nana'
MassimoMaurizio Donadoni
Cent Mille LiresLidia Montanari
Tito/GiasoneAngelo Infanti

The films of Marco Ferreri have a kind of aggressively grotesque intensity about them that, as often as not, inspires laughter, sometimes intentional, as well as shock. He delights in making audiences uncomfortable, which, given the nature of his subjects, isn't very difficult to do.

In "La Grande Bouffe" (1973) a group of friends quite happily overeat to the point of death. "The Last Woman" (1976), one of his wittiest, roughest films, is about the terrible redemption of a gross male chauvinist who uses an electric carving knife to mutilate himself.

Mr. Ferreri's films look realistic but they are essentially lunatic cartoons, meant to be deadly serious. His new film, "The Story of Piera," is a lunatic cartoon that isn't especially serious, at least in any consistent way. The film will be shown at the New York Film Festival at Lincoln Center today at 3 P.M. and 9 P.M.

"The Story of Piera," which looks terrifically chic, stars the incomparable Hanna Schygulla with Marcello Mastroianni and Isabelle Huppert, all of whom act with as much intelligence as the circumstances allow. However, somewhere around the start of the second hour it's apparent that Mr. Ferreri's comedy has turned into a very heavy, entirely theoretical piece about the nature of love and sexuality. Beyond that, I'm not at all sure.

Hanna Schygulla in "The Story of Piera," directed by Marco Ferreri.

Piera, played by Miss Huppert, has indeed had a strange life. Her mother, Eugenia (Miss Schygulla), is defined as a free spirit, not because she might be certifiably bonkers but because she wanders the streets of the city picking up men and enjoying them when, as and how she wishes. Piera's father (Mr. Mastroianni) is a Communist organizer who loves Eugenia deeply but is resigned to the fact that he cannot satisfy her sexually.

The film opens with Piera's birth at the end of World War II and proceeds through her childhood, adolescence (when she is played by a fine young actress named Bettina Gruhn) and young womanhood until, out of nowhere, she has become a famous actress whose entire repertory appears to be "Medea."

Throughout her life Piera has an intense love-hate relationship with her mother, who plays an intimate part in Piera's introduction to sex. Piera also has intensely sexual feelings about her father. When they kiss, mouths wide open, Eugenia gets a tiny bit huffy. Piera also has a younger brother, who remains off-screen most of the time. That he doesn't figure in the film, reinforces the suspicion that Mr. Ferreri isn't as interested in exploring forbidden realms of sexuality as much as he is in photographing Miss Huppert in various quasi-sexual positions with her mom and dad.

•

Miss Schygulla is as beautiful and mysterious as ever, even when the material seems simply to be muddled. Most of the time Mr. Mastroianni looks embarrassed, perhaps for those of us who are watching the film. Miss Huppert, France's busiest interpreter of gamines, seems overworked.

Vincent Canby

1983 S 24, 11:5

FORBIDDEN RELATIONS, directed by Zsolt Kezdi-Kovacs; in Hungarian with English subtitles; director of photography, Janos Kende; production company, Objektiv Studio. At Alice Tully Hall, as part of the 21st New York Film Festival; presented by the Film Society of Lincoln Center in cooperation with the Motion Picture Association of America. Running time: 90 minutes. This film is not rated.

Juli ...Lili Monori
GyorgyMiklos B. Szekely

Lili Monori in Zsolt Kezdi-Kovacs's "Forbidden Relations."

The MotherMari Torocsik
The FatherJozsef Horvath
Juli's BrotherJozsef Toth
Old Pista ...Tibor Molnar
The DoctorGyorgy Banffy
The PolicemanLaszlo Horvath

By VINCENT CANBY

En route home to visit her parents after the suicide of her husband, Juli, a serious young woman, meets an attractive, slightly older fellow named Gyorgy, a tailor, who is traveling to the same village. Juli and Gyorgy immediately respond to each other. Both carry psychic scars. Juli realizes that she will never know why her husband killed himself. Gyorgy, having had two unsuccessful marriages, is sure he's one of life's losers.

•

When they arrive in the village late in the evening, Juli does not go on to her parents but stays with Gyorgy for an ecstatic night of love. The next day she learns that Gyorgy is her older half-brother, the product of her mother's first marriage.

This is the sort of revelation that belongs in either farce or grand opera. "Forbidden Relations" is neither. After experiencing some shock, Juli and Gyorgy accept the dread news and vow to follow their affair wherever it might lead.

This is pretty much the premise of Zsolt Kezdi-Kovacs's "Forbidden Relations," the Hungarian film that will be shown at the New York Film Festival at Lincoln Center today at 9:30 P.M. and tomorrow at 6:15 P.M. It's a mixed bag.

"Forbidden Relations" initially appears to be far more serious than it actually is. It's very nicely acted by Lili Manori as Juli and Miklos B. Szekely as Gyorgy. The shots of rural Hungary, which appears to be strangely underpopulated for middle Europe, are exotic.

Further, it's possible to see political import in Juli and Gyorgy's defiance of the law, as if their antisocial behavior were true anti-Socialism. Yet laws against incest aren't entirely stupid, even in Communist countries. The greatest, bravest thing that Juli and Gyorgy do is demonstrate, to the people who administer the law, the limitations of the system.

•

I'm also confused by the responses of other characters within the film to the couple's unembarrassed decision to live together and have children, between their periodic prison sentences.

Juli's mother, who is, of course, also Gyorgy's mother, reports them to the police. Later she is seen buzzing happily around the child of this union, and still later she goes crazy at the horror and humiliation of it all.

I find it difficult to believe that, even in rural Hungary, Juli would not somehow have heard of this older half-brother long before she goes to bed with him. The movie isn't good enough to make these questions seem unimportant.

1983 S 25, 59:1

LA SIGNORA DI TUTTI, directed by Max Ophuls; script (Italian with English subtitles) by Mr. Ophuls, Hans Wilhelm and Curt Alexander, based on a novel by Salvator Gotta; director of photography, Ubaldo Arata; edited by Ferdinando M. Poggioli; production company, Novella-Film. At Alice Tully Hall, as part of the 21st New York Film Festival; presented by the Film Society of Lincoln Center in cooperation with the Motion Picture Association of America. Running time: 89 minutes. This film is not rated.

Gabriella MurgeIsa Miranda
Roberto NanniFederico Benfer
Alma NanniTatiana Pawlova
Loenardo NanniMemo Benassi
Anna ...Nelly Corradi

By JANET MASLIN

The elegance and pathos of Max Ophuls's great films of the 1950's, such as "Lola Montes" and "The Earrings of Madame De" are also evident in his early work "La Signora di Tutti," a 1934 Italian film that is being shown today as a New York Film Festival retrospective selection. So is an uncharacteristic bluntness, which was so thoroughly refined out of Mr. Ophuls's later style.

His heroine here is a film star who, at the beginning of the film, attempts suicide, and whose disgrace-filled past is later revealed in flashback. These flashbacks begin as a gas mask is lowered toward her, as she lies on an operating table. Even this macabre image is one that Mr. Ophuls was capable of making seem beautiful.

•

The glamorous singing star Gaby Doriot, whose career we first learn of by watching her poster being printed and listening to her manager's negotiations, proves to have started out as a sweet schoolgirl. Her reputation is badly damaged when an older teacher pays her too much undue attention, however. So a while later, a wealthy young man who lives nearby is taking a considerable risk when he invites her to a party — a greater risk, in fact, than even he can suspect. Gaby's talent for tragedy will eventually affect this young man's entire family.

Gaby herself, played by Isa Miranda, is seldom a figure of much complexity. When she realizes that another character has died but that Gaby herself will escape being caught in a compromising situation with the dead woman's husband, her shocking laugh reveals something very much at odds with the innocence of her usual demeanor. For the most part, when Gaby profits from the hardships of others, she is able to do so without sacrificing the air of honesty and simplicity that so incompletely reflects her fuller feelings. Compared with Mr. Ophuls's later heroines, this one is far less passionate and more indirect.

•

The visual trademarks of Mr. Ophuls's style are very much in evidence here, in a film rich with mirror images and unusually graceful camera motions. When Mr. Ophuls depicts a businessman who is about to face a disastrous meeting, his camera pans smoothly across the long conference table; when his heroine first dances with a man who will change her fate forever, the camera hypnotically tracks the couple as they whirl and whirl. Gaby's flirtation with a married man includes a conversation between them as both are in motion, he driving his automobile and Gaby rowing parallel to him on a pond.

"La Signora di Tutti" hasn't all of the polish of which Mr. Ophuls was capable, and Gaby is not his most mesmerizing heroine. But it prefigures his later work, and also displays a remarkable precocity. It will be shown today at 5 P.M., and should fascinate anyone familiar with Mr. Ophuls's subsequent masterpieces.

1983 S 25, 59:1

FILM VIEW

VINCENT CANBY

A Partnership Waxes Strong

One of the subsidiary pleasures provided by the appearance of "Heat and Dust" is the realization that this haunting, beautiful high-comedy marks the 20th anniversary of its collaborators: James Ivory, the director; Ismail Merchant, the producer, and Ruth Prawer Jhabvala, the novelist who has written all of the best Merchant-Ivory screenplays.

Such long-term associations in films are rare. Offhand, I can only think of a handful of others: Billy Wilder and his writing collaborator, I. A. L. Diamond; Luis Buñuel and Jean-Claude Carrière, who worked with Buñuel not only on his screenplays but also on his autobiography, "My Last Breath," published this summer just before Buñuel's death at 83; and François Truffaut and Jean-Pierre Léaud, the young actor who actually grew up in

front of the camera in Mr. Truffaut's Antoine Doinel films made between 1959 and 1979.

It may have something to do with the terrific pressures in commercial filmmaking that such collaborations, which are much like difficult marriages, tend to fall apart too soon, that is, before the collaborators have had time to accumulate the experiences that would enrich their work. Compared to most commercial films, which result from what might loosely be described as one-night stands, the Merchant-Ivory-Jhabvala films, which come out of a relationship that continues, not only seem different but they are different.

Beginning with "The Householder" in 1963 and "Shakespeare Wallah" in 1965, the Merchant-Ivory-Jhabvala films speak in their own particular voice. It's a voice that has deepened over the years and become increasingly distinctive, even when the filmmakers move away from the Indian subjects that dominate their work.

● ● ●

Their films haven't always spoken with equal facility. There have been times in the past when they have appeared to be too civilized to come to a direct point, or when, as in their handsome adaptation of Jean Rhys's "Quartet," the point was too literary to be fully realized in a film. Still, it's this very literary quality — the sense of literature — that distinguishes the Merchant-Ivory-Jhabvala work from that of anyone else making movies in English today. They remind us that movies need not always stagger us, blow our minds or knock us out to move us deeply, and that occasionally, perhaps, no direct point can be the point of a narrative.

India was initially the thing that brought the collaborators together. Mr. Merchant is Indian. Mr. Ivory, an American, wanted to make films in India, and Mrs. Jhabvala, half-Polish, half-German, educated in England, lived with her Indian husband in India, the setting of her early novels. It's not surprising that India became the setting for the early Merchant-Ivory-Jhabvala films.

India is also the setting for "Heat and Dust," which Mrs. Jhabvala adapted from her 1975 novel. But though the India we see in the film — as India was in the 1920's and as it is today — is intensely, unmistakably real, it's also more richly metaphorical than in any of the other Merchant-Ivory-Jhabvala films, which is, I suspect, a natural result of their longtime collaboration. Among other things, the film's India is a perfectly manicured croquet lawn where the British raj and Indians play for stakes of life and death. It's also a restless state of mind, and a dirty, hot, alien landscape that overwhelms one young English woman in the 1920's and, 60 years later, provides some kind of redemption for that lost lady's great-niece.

● ● ●

As the Merchant-Ivory-Jhabvala collaboration has continued over the years, the work has become both simpler and more complex, which, I suppose, is a rather complicated way of saying that the collaborators have become increasingly sure of themselves.

One of their most delicate, most witty films is the 60-minute "Autobiography of a Princess," made in 1975 for television. This is virtually a two-character, one-set piece in which a scatty, self-absorbed, exiled Indian princess (Madhur Jaffrey) and a tired old Englishman

(James Mason), who served the princess's late father as secretary of state, meet to celebrate the old maharajah's birthday, as they do each year.

Like almost all Merchant-Ivory-Jhabvala films, "Autobiography of a Princess" is about coming to terms with irretrievable loss — the loss of money, position, youth, ideals, purpose, national identity. In Mrs. Jhabvala's work, the adjustments made are sometimes comic and sometimes melodramatic in ways that are almost farcical. In the filmmakers' canon, India is, first and foremost, the thing lost — to the British raj, of course, but also to those Indians who have so identified with the British that they no longer are completely sure who they are.

Compared to the seeming simplicity of "Autobiography of a Princess," which takes place in a single afternoon, "Heat and Dust" is an epic that tells two parallel stories separated by 60 years. The first, set in the

1920's, is about Olivia Rivers (Greta Scacchi), the pretty, bored wife of a very proper British civil servant, and what happens when she encourages her seduction by a playboy Indian prince (Shashi Kapoor). Intercut with this story is that of Anne (Julie Christie), Olivia's great-niece, who comes to India to research the story of her notorious aunt's fall from grace. Anne, like Olivia, has her own romantic Indian interlude but, unlike Olivia's, it's a rather passionless affair. "Heat and Dust" seems to discover that not only has India been lost, but also the possibility of grandly reckless acts like Olivia's.

One of the qualities that distinguishes the Merchant-Ivory-Jhabvala collaborations is the usually rigid control of sentiment. Their films are comedies, not only because they aren't classically tragic but because they remain at such a cool distance from their characters that we are allowed the long view denied to the people within the story. In "Shakespeare

Wallah" there is something very funny as well as moving about the members of that Shakespearean troupe who travel around an independent India that no longer has time for them. Their self-absorption is the essence of comedy.

A typical Jhabvala character is Chid (Charles McCaughan), the American hippie in "Heat and Dust," who has come to India to find Truth and nearly dies of liver and kidney diseases. When last seen, he's being shipped back to Iowa, where cleanliness rates next to godliness.

●

Mrs. Jhabvala and Mr. Ivory aren't cruel but they can be extremely sharp. In "Bombay Talkie" (1970), an English woman novelist, beautifully played by the same Jennifer Kendal who appears in "Heat and Dust," walks a thin line between farce and soap opera as she tries to deal with an India she cannot comprehend.

When the Museum of Modern Art holds its Merchant-Ivory-Jhabvala retrospective at the end of this year, one of the seeming revelations will be the recognition of the large number of superb performances the films contain. These include Mr. Mason and Miss Jaffrey in "Heat and Dust," Miss Kendal in "Bombay Talkie," Rita Tushingham and Michael York in "The Guru" (1969), Maggie Smith and Alan Bates in "Quartet," Dame Peggy Ashcroft in "Hullabaloo Over Georgie and Bonnie's Pictures" (1980), and Wesley Addy and Helen Stenborg in "The Europeans" (1979), the Henry James adaptation about which I had reservations though it delighted many of my colleagues.

A most unexpected treat is "Roseland" (1977), which tells three interlocking stories set almost entirely inside Manhattan's famous ballroom. The film comes as close to being sentimental as anything the collaborators have ever done, but it's also very funny. The wonder of "Roseland" is Mrs. Jhabvala's extraordinarily accurate ear for New York speech.

Mr. Ivory, Mrs. Jhabvala and Mr. Merchant have created a kind of comic cinema that elevates dialogue to a position of importance it hasn't enjoyed since, possibly, the wisecracking screwball comedies of the 30's and 40's. Mrs. Jhabvala doesn't write wisecracks. Her dialogue suggests the richness of dialogue read in a novel, but has the economy demanded in films. These Merchant-Ivory-Jhabvala films fit into no one else's category. Instead they define a new one into which, perhaps, the work of others will follow. ■

1983 S 25, II:19:1

IN THE WHITE CITY, directed by Alain Tanner; in French and Portuguese with English subtitles; director of photography, Acacio de Almeida; edited by Laurent Uhler; music by Jean-Luc Barbier; production company, Tobis Lisbon and Filmograph Geneva; produced by Paulo Branco, Mr. Tanner and Antonio Vaz da Silva; a Gray City Films Release. At Alice Tully Hall in the 21st New York Film Festival; presented by the Film Society of Lincoln Center in cooperation with the Motion Picture Association of America. Running time: 108 minutes.
Paul ... Bruno Ganz
Rosa ... Teresa Madruga
Elisa ... Julia Vonderlinn
Proprietor Jose Carvalho
Thief With the Knife Francisco Baiao
Second Thief Jose Wallenstein
Waiter ... Victor Costa
Waitress Lidia Franco
Friend in the Tavern Pedro Efe
Woman in the Train Cecilia Guimaraes
Girl in the Train Joana Vicente

Bruno Ganz in "In the White City," directed by Alain Tanner.

By VINCENT CANBY

"IN THE WHITE CITY," the new film by the Swiss director Alain Tanner ("La Salamandre," "Jonah Who Will Be 25 in the Year 2000," among others), is set in Lisbon, but the city of the title is less a particular place than a series of states of mind.

Paul, an engineer aboard an oil tanker, goes ashore for a couple of days and, when his ship is ready to sail, stays on at his hotel overlooking the harbor. At first, he spends his days walking around the city taking movies with his Super-8 camera. He revels in the anonymity of the foreign port. He gets drunk and into brawls. He eats and sleeps according to no particular schedule and, between drinking bouts, flirts with Rosa, who is both the hotel's chambermaid and bartender.

Paul writes letters to Elisa, his girlfriend back home in Switzerland, and sends her his home movies, which are mostly impersonal records of streets, building facades and unknown people going about ordinary tasks. Quite soon, Paul seems on the point of losing all contact with the world of routine and responsibility.

●

"In the White City," which is about Paul's extended time out of time, will be shown at the New York Film Festival today at 9:30 P.M. and tomorrow at 6:15 P.M. It's a very reflective, literary film. Though there isn't much dialogue in it, its concerns are the sort that less frequently turn up on the screen than in written fiction, where interior voyages of discovery can be charted more easily in words than in images, even images as rich as Mr. Tanner's.

In the course of "In the White City" Paul achieves something akin to a completely weightless state as he drifts into an affair with the pretty, gentle, far-from-foolish Rosa. The part of him that Rosa sees is a man with no hold on a past or a future that would give him direction. At the same time there is another part of him that remains aloof from the white city. That Paul observes with fascination his own passivity and reports his reactions at length in letters to Elisa.

When Paul's wallet and money are stolen, he assumes Rosa will care for him, at which point she departs. He writes Elisa: "Nothing really exists for me. I'm a liar trying to tell the truth."

"In the White City" is full of odd and arresting moments but it leaves no strong impression in my memory. It's a little as if Paul's bemusement were contagious. When it ends, it still seems unfinished, which is, I suspect, exactly what Mr. Tanner and his collaborators intended. It's not an accident — apparently — that the film carries no screenplay credit. According to the producers, it was improvised by the director and the members of the cast, which is headed by Bruno Ganz as Paul and Teresa Madruga as Rosa.

•

Mr. Ganz, who is known principally for his German films ("Knife in the Head," "The Wild Duck"), is emerging as one of the best actors in European cinema today. In this film he delivers a remarkably sharp, complex portrait of a man who sets out to explore his own essentially irrational being without losing touch with what passes for the rational world. Though "In the White City" is virtually a one-man film, Miss Madruga is also extremely good — and unpredictable — as Rosa.

Most of the film is in French, but the soundtrack also includes dialogue in German, English and Portuguese.

1983 S 26, C10:5

Dreaming About Ho

BOAT PEOPLE, directed by Ann Hui; screenplay (Chinese with English subtitles) by K. C. Chiu; story by Tien Kor; director of photography, Chung Chi-Man; edited by Wong Yee-Sun; music by Law Wing-Fai; produced by Chui Po-Chu; production company, Bluebird Movie Enterprises Ltd. At Alice Tully Hall, as part of the 21st New York Film Festival; presented by the Film Society of Lincoln Center in cooperation with the Motion Picture Association of America. Running time: 106 minutes. This film is not rated.

Akutagawa	Lam
The Madame	Cora Miao
Cam Nuong	Season Ma
To Minh	Andy Lau
Ah Thanh	Paul Chung
Inoue	Wong Shau-Him
Officer Nguyen	Ji Mengshi
Comrade Le	Jia Meiying
Comrade Vu	Lin Shujin
Cam Nuong's Mother	Hao Jialin
Ah Nhac	Wu Shulun
Second Brother	Guo Junyi
Commander of Zone 16	Lin Tao
First Officer in Zone 15	Guo Hengbao
Doctor in Zone 15	Zhang Dongsheng
Second Officer in Zone 15	Cai Jianzhou
To Min's Father	Wang Huangwen
Woman Neighbor	Meng Pingmei

By JANET MASLIN

THE subject of Ann Hui's "Boat People" would not seem to lend itself to ordinary movie-making tactics, since the film depicts the horrendous living conditions to be found in the northern part of Vietnam in 1978, three years after the war ended. However, Miss Hui brings a conventional — and for the most part highly effective — storytelling talent to bear upon this material. She's able to create both sensationalism and drama, even if her film never generates an air of realism, or frees itself from coincidence and cliché.

Miss Hui's film, which is being shown tonight and tomorrow night at the New York Film Festival, is certainly powerful. But it could hardly be confused with either a political tract or a documentary. The central character of "Boat People" is a Japanese photojournalist named Akutagawa (Lam), who is on a lengthy return visit to Vietnam under the watchful eye of a woman guide from the Cultural Bureau.

Initially, she escorts him to a New Economic Zone near DaNang, where he is shown a group of happy school-

Lam, in the film "Boat People."

children. They perform a song for him:

Last night I dreamed of Chairman Ho.
I longed to hug him, to shower kisses on him.
May Chairman Ho live 10,000 years.

The journalist is delighted, saying "I never thought I'd come back to find so many healthy, happy children."

The rest of the film gives the lie to this sunny image; before it's over, the journalist has even returned furtively to the same zone and found the same children sleeping naked in appallingly overcrowded barracks. Miss Hui, who is from Hong Kong, made "Boat People" with the cooperation of the Chinese Government and shot it on Hainan Island. The film's view of life in Communist Vietnam is unremittingly and, given the Chinese Government's emnity to the Vietnamese, not unexpectedly harsh. And yet "Boat People" isn't as controversial as might be expected, since its criticism is very much in the service of its clear and simple dramatic needs.

The photojournalist eventually involves himself with a single family, and especially with a single young girl, Cam Nuong (Season Ma). Her mother is a prostitute; her younger brother is a scavenger who has picked up American slang and street savvy ; her baby brother is the child of a unknown father, and Cam Nuong's own father was killed in the war. Through Cam Nuong, the journalist learns secret after lurid secret about street life in DaNang. After she takes him to a "chicken farm," where children search the corpses of the recently executed, looking for valuables, the journalist can't bear to eat his steak dinner that evening.

There's more than a little melodrama to the efforts of this visitor to save Cam Nuong from a life of despair and ruin. However, Miss Hui manipulates her material astutely, and rarely lets it become heavy-handed. Even a subplot about a glamorous Madam (Cora Miao) is handled with restraint, as are another woman's sudden suicide and some glimpses of a labor camp, where the prisoners are forced to dismantle mine fields. Vivid and disturbing as such moments are, they feel like shrewdly calculating fiction rather than reportage.

1983 S 27, C17:5

Ah, Those French!

DANTON, directed by Andrzei Wajda; screenplay (French with English subtitles) by Jean-Claude Carriere, based on "L'Affaire Danton" by Stanislawa Przybyszewska with the collaboration of Mr. Wajda, Agnieszka Holland, Boleslaw Michalek and Jacek Gasiorowski; photography by Igor Luther; edited by Halina Prugar-Ketling; music by Jean Prodromides; produced by Margaret Menegoz/Les Films du Losange in collaboration with Production Group X of Warsaw Barbara Pec-Slesicka; a Triumph Films Release. In Alice Tully Hall, as part of the 21st New York Film Festival; presented by the Film Society of Lincoln Center in cooperation with the Motion Picture Association of America. Running time: 136 minutes. This film has no rating.

Danton	Gerard Depardieu
Robespierre	Wojciech Pszoniak
Eleonore Duplay	Anne Alvaro
Lacroix	Roland Blanche
Camille Desmoulins	Patrice Chereau
Louison Danton	Emmanuelle Debever
Amar	Krzysztof Globisz
Herman	Ronald Guttman
Tallien	Gerard Hardy
Couthon	Tadeusz Huk
Panis	Stephane Jobert
Lindet	Marian Kociniak
Barere de Vieuzac	Marek Kondrat
Saint Just	Boguslaw Linda
Heron	Alain Mace
Legendre	Bernard Maitre
Fabre d'Eglantine	Lucine Meiki
Philippeaux	Serge Merlin
Collot d'Herbois	Erwin Nowiaszack
Carnot	Leonard Pietraszak
Fouquier Tinville	Roger Planchon
Frere d'Eleonore	Angel Sedgwick
Bourdon	Andrzej Seweryn
David	Franciszek Starowieyski
Billaud-Varenne	Jerzy Trela
Chanteuse boulangerie	Anne-Marie Vennel
Westerman	Jacques Villeret
Lucile Desmoulins	Angela Winkler
Herault de Sechelles	Jean-Loup Wolff
Vadier	Czeslaw Wolleiko
Chef des gardes	Wladimir Yordanoff
Servante des Duplay	Malgorzata Zajaczkowska
Lebas	Szymon Zaleski

By VINCENT CANBY

COMPARED to the massive scale of the Russian Revolution, the French Revolution of 1789-95 seems almost to have been a chamber piece. Though armies supporting Louis XVI crossed France's border seeking to save the Bourbon monarchy, and though all of France eventually become involved in the bloodshed, the most decisive battles of the Revolution were fought in Paris, in the political clubs and on the streets.

In Paris, the Revolution's leaders, with the backing of the angry mobs, set policies that the rest of the country, left to their own devices, would probably have disowned, at least initially. The course of the Revolution was shaped by a small group of extraordinary men, all young, who started out as idealists, then became comrades and close friends, godfathers to one another's children. Within four years, they had split into factions as mortal enemies. Men did not hesitate to send to the guillotine former boon companions, now branded as traitors to the fatherland.

This peculiar, dreadful intimacy of a handful of remarkable personalities is vividly dramatized in "Danton," Andrzej Wajda's fine, comparatively ascetic historical film that will be shown at the New York Film Festival at Lincoln Center today at 9:30 P.M. and tomorrow at 6:15 P.M.

•

Chief among these personalities are Georges Danton and Maximilien Robespierre. Danton is the passionate, vulgar, not entirely honest man of the people, a hugely popular leader of the Revolutionary left who becomes increasingly moderate as the Revolution adopts policies of extermination. Robespierre, called "the incorruptible," is the small, fastidiously dressed, rigorously moral lawyer from Arras who, being convinced that Danton's moderation is a betrayal of the Revolution, engineers his trial and execution. "Robespierre, you will follow me within three months!" the furious Danton

Wojciech Pszoniak as Robespierre in "Danton."

screams as he is hauled off to the guillotine and, as things turned out, he was absolutely right.

"Danton," a Franco-Polish co-production, was directed in France by Mr. Wajda from a screenplay by Jean-Claude Carriere, based on a stage play by Stanislawa Przybyszewska. Gerard Depardieu, who is, of course, a French actor, stars as the sympathetic Danton. Wojciech Pszoniak, a Polish actor, shares star billing as the thin-lipped voice of reason, Robespierre. That the Robespierrists, all of whom are seen as fanatics, some slightly less opportunistic than others, should be played by Polish actors, while the earthy, hearty, mostly honest Dantonists are played by French actors, is just one of the possible reasons why the Polish Government has not yet seen fit to release the film at home.

Without stretching things too much, I suppose, Mr. Wajda presents us with a Danton who is the articulate conscience of the Revolution, someone, perhaps, not entirely unlike Lech Walesa, the popular spokesman of Poland's Solidarity movement. On the other hand, Robespierre is seen as being completely removed from the practical needs and real feelings of the people, a stern father-figure of a dictator, a man who doesn't hesitate to approve the murder of thousands of people for the fatherland's ultimate good.

In an interview in Le Monde, Mr. Wajda denies all associations between 18th-century France and 20th-century Poland, though he does say that Danton represents the West and Robespierre the East.

Whether or not these associations hold true are beside the point of the film. "Danton" brilliantly illuminates one of the most fascinating periods of the French Revolution — those early months in 1794 when Danton, having been in self-imposed retirement in the country, returned to Paris to attempt to stop the Terror. Louis had been beheaded in January 1793. By October 1793, the Terror was picking up momentum, with the execution of Marie Antoinette, the liberal-thinking Duc D'Orleans, the chatty, letter-writing Madame Roland, and the leaders of the Girondists, the Revolution's moderates. In returning to Paris instead of fleeing the country, as his friends advised him to do, Danton knew he was leaving his head exposed to the guillotine.

In keeping with the chamber-piece nature of this Revolution, "Danton" is played out in a series of mostly small, intimate, beautifully defined confrontations between the robust, commonsensical Danton and the steely Robespierre. It's to Mr. Carriere's credit, as the screenwriter, that these scenes should be so truly dramatic and understandable, even, I suspect, to someone who has no special knowledge of or interest in the course of the Revolution.

It's to Mr. Wajda's credit that though his sympathies are clearly with Danton, played with all stops out by Mr. Depardieu, it is Robespierre, played with silky neuroticism by Mr. Pszoniak, who emerges as the film's most arresting, possibly tragic figure.

Not so effective are those scenes that attempt to place the personal-political drama in the context of a city and a nation in rebellion. There is something as perfunctory as there is obligatory about the crowd scenes. They remind me, in fact, of those Hollywood mobs, led by Blanche Yurka as Madame Defarge, that were out to get Charles Darnay in the 1935 "A Tale of Two Cities." It also doesn't help that the French dialogue of the Polish actors, including Mr. Pszoniak, has not been especially well post-synchronized with the movements of the actors' lips.

Mr. Wajda and Mr. Carriere haven't exactly cleaned up Danton's reputation, but the bad things remain off-screen. There are references to the taking of bribes, to his love of women and property, and he himself asks forgiveness for having formed the notorious Committee of Public Safety, the body through which Robespierre came to control the country. Not emphasized at all is Danton's part in the September 1793 massacre in which mobs were encouraged to ransack Paris prisons and, without discrimination, murder everyone they could lay hands on as agents of the feared monarchist counterrevolution. Danton was not as clean as a hound's tooth.

What the film does most effectively is dramatize his later conviction that the Revolution's fury was itself a betrayal of the Revolution, as he says so eloquently in the trial that is the film's climax.

In addition to Mr. Depardieu and Mr. Pszoniak, the excellent cast includes Patrice Chereau as Danton's journalist-friend, Camille Desmoulins; Angela Winkler as Lucille Desmoulins, Camille's wife who followed him to the scaffold; Boguslaw Linda, as Saint Just, and Roger Planchon, who is particularly good as Fourquier Tinville, who prosecuted Danton and his associates in a rigged trial.

"Danton" is a major work from this major film maker.

1983 S 28, C19:1

BEYOND THE LIMIT, directed by John Mackenzie; screenplay by Christopher Hampton, based on the book "The Honorary Consul" by Graham Greene; director of photography, Phil Meheux; edited by Stuart Baird; produced by Norma Heyman; released by Paramount Pictures. At Loews State, Broadway and 45th Street; Orpheum, 86th Street at Third Avenue; 34th Street Showplace, at Second Avenue, and other theaters. Running time: 103 minutes. This film is rated R.
Honorary Consul Charley Fortnum Michael Caine
Eduardo Plarr Richard Gere
Colonel Perez Bob Hoskins
Clara .. Elpidia Carrillo
Leo Joaquim de Almeida
Aquino .. A. Martinez
Leon's wife Stephanie Cofsirilos
Diego Domingo Ambriz
Doctor Humphries Leonard Maguire
Senora Plarr Adriana Roel
Pablo ... Eric Valdez

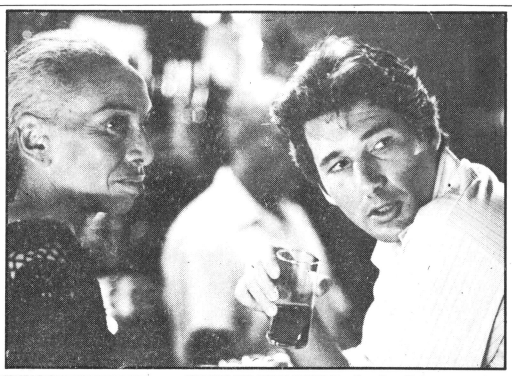

By VINCENT CANBY

WITH the exception of Sir Carol Reed's screen adaptation of "The Third Man," which is a classic of sorts, the celebrated stories of Graham Greene have not been made into especially celebrated films. This is possibly because, although Mr. Greene writes exceptionally good, well-balanced narratives, the film versions don't have the time or the means to dramatize the crises of conscience that give the stories their weight.

Stripped to the bare bones of events, a Greene-based film tends to be too schematic — too carefully plotted, really — to evoke the pleasures of surprise and recognition that separate a good film from a well-meaning, even well-acted, ordinary one.

This is particularly true of "Beyond the Limit," the grossly meaningless title that has been attached — like a bathtub to a car — to the screen adaptation of "The Honorary Consul," Mr. Greene's 1973 novel. The film opens today at the Loews State and other theaters.

With the best of intentions and no little talent, John Mackenzie, the director, and Christopher Hampton, the writer, have made a movie that in some respects becomes an unkind criticism of the novel. "The Honorary Consul" is a much more complicated, mysterious work than one might suspect from this rather literal if quite faithful condensation.

The setting is a small city in northern Argentina, on the banks of the Paraná River adjacent to Paraguay. The central character is Dr. Eduardo Plarr (Richard Gere), an up-and-coming physician who has chosen to practice in this provincial backwater rather than in Buenos Aires because his English-born father remains a political prisoner in Paraguay. When he was 14 years old, Plarr, who was born in Paraguay, and his Paraguayan mother were shipped off to safety and exile in Argentina, where, when the story starts, they are still awaiting word from his father after years of silence.

"BEYOND THE LIMIT"—Josefina Echanove and Richard Gere are seen in the screen version of the Graham Greene novel "The Honorary Consul." Michael Caine and Bob Hoskins co-star.

Plarr's life is apolitical until one day he is gotten in touch with by a friend out of his childhood, Leon, a priest who has abandoned the church, taken a wife and become a member of the Paraguayan underground. Leon blackmails Plarr into obtaining information about a coming visit to the province by the United States Ambassador. The plan is to kidnap the ambassador, to hold him as ransom tor Paraguayan political prisoners, including Plarr's father.

The unknowing source of information about the trip is Charley Fortnum (Michael Caine), a rum-soaked has-been and the province's honorary British consul. Coincidentally, Charley Fortnum's beautiful young Indian wife, Clara (Elpidia Carrillo), is Plarr's mistress.

When the kidnap plot goes awry and the wrong person is taken hostage, Plarr is forced into a devastating re-evaluation of his own life and of his relations to Clara, whom he doesn't love, and to Charley, whom he has betrayed with possibly fatal consequences.

One clue why the film never seems as exciting as it should is contained in the above paragraphs. When it takes so much space to outline the basic situation in a film, it often means that there is more plot than life in it. It's also possible that Mr. Mackenzie, whose "Long Good Friday" was an exceptionally good British gangster film, and Mr. Hampton have been too faithful to the original. Though some characters have been dropped and others combined, "Beyond the Limit" moves with a dutiful sense of obligation to cover all the important story points, and so slowly that any reasonably alert member of the audience will be ahead of it.

Mr. Gere gives a good, intense performance in a role that has been written more in terms of action than interior development. He even struggles successfully with the sort of layered accent that Laurence Olivier

loves — that of a second-generation Englishman born and raised in Spanish-speaking Latin America among several different Spanish accents.

Mr. Caine looks a bit too handsome and self-assured to be quite the "small beer" that Charley Fortnum is supposed to be, but his screen presence gives the film an intelligence it wouldn't have otherwise. Bob Hoskins, so fine as the mob chief in "The Long Good Friday," is excellent as the charming, ruthless police chief, and Miss Carrillo is superchic even when in distress.

The best thing about "Beyond the Limit" is the physical production. The movie's locations — it was shot mostly on or near Mexico's Gulf Coast — look absolutely Argentine.

1983 S 30, C4:3

Enemies and Lovers

HANNA K., directed and produced by Costa-Gavras; written by Franco Solinas from an original screenplay by Mr. Solinas and Costa-Gavras; director of photography, Ricardo Aronovich; film editor, Françoise Bonnot; music by Gabriel Yared; released by Universal Pictures. At Cinema 1, Third Avenue and 60th Street. Running time: 111 minutes. This film is rated R.
Hanna Kaufman Jill Clayburgh
Victor Bonnet Jean Yanne
Joshue Herzog Gabriel Byrne
Selim Bakri Mohamed Bakri
Amnon David Clennon
Professor Leventhal Shimon Finkel
The Stranger Oded Kotler
Russian Woman Michal Bat-Adam
Dafna .. Dafna Levy
Capt. Allenby Bridge Dan Muggia

COMPARED with the explosive nature of Costa-Gavras's best melodramas, which would include his recent "Missing," his new film, "Hanna K.," is a large, soggy dud. The film, which opens today at Cinema 1, is a political melodrama without a pay-off, based on a screenplay that seems unfinished, with characters who are still in the typewriter gasping for breath that will never come.

Hanna Kaufman (Jill Clayburgh) is virtually a one-woman diaspora. The script never says so but from her accent it's apparent that she originated in the United States. Then, for reasons never made plausible, she seems to have gone to Paris, where she married a Frenchman named Victor (Jean Yanne), from whom, at the start of the film in Israel, she has long been separated but not divorced. Victor's only function in the film is to fly from Paris to Israel from time to time to listen to plot exposition and to allow Hanna to imitate, not kindly, his frequently unintelligible French accent.

When we first see Hanna K. she has been settled in Israel for some time, received her law degree and become pregnant as the result of a casual affair with Joshué Herzog (Gabriel Byrne), the district attorney for Jerusalem, a man she doesn't love. Whether or not she should have the baby is argued over at length, and the question cues one of the screenplay's more unfortunate lines, "All this fuss over a few drops of sperm."

•

The baby is not the point of the movie though. That comes when Hanna is appointed by the court to defend Selim Bakri (Mohamed Bakri), a handsome young Arab accused of being a terrorist. Lo and behold, Hanna finds herself opposing the father of her as yet unborn child publicly, in court, as well as privately, at home. This is the stuff of great comedy, as George Cukor, Ruth Gordon and Garson Kanin demonstrated with "Adam's Rib." It's pretty silly in a supposedly serious movie.

In two separate trials, Joshué argues that all the circumstantial evidence supports the state's case against Selim. Hanna defends her client by saying that Israel's policies on Arab refugees are responsible for Selim's crimes, if, indeed, there are any. She produces evidence to the effect that Selim has been illegally slipping into Israel not to plant bombs but to reclaim his family's ancestral home, illegally seized by the Israeli Government.

Life isn't easy for Hanna. During the trials, she receives threatening phone calls. She's accused of being too idealistic and a possible danger to the state. When, finally, she takes Selim into her home as her lover as well as her friend, the scene is set for a terrible confrontation.

Unfortunately, nothing happens.

•

Costa-Gavras and Franco Solinas, who wrote the film, appear to have been too intimidated or, maybe, too baffled by the complexity of Arab-Israeli relations to be decisive in any way whatever. Everything about the film is halfhearted, including the way in which the film makers dramatize what they take to be Israel's paranoia about Arabs. They characterize Selim as a victim of that paranoia, but they are never unequivocal about his innocence.

As so often happens in a film in which the characters have been manufactured to fit the plot, none of the performers is especially compelling. They are messengers not characters — mouthpieces for dopey dialogue.

Vincent Canby

1983 S 30, C8:1

Marshmallow Steak

BRAINSTORM, directed by Douglas Trumbull; screenplay by Robert Stitzel and Philip Frank Messina; story by Bruce Joel Rubin; director of photography, Richard Yuricich; film editors, Edward Warschilka and Freeman Davies; music by James Horner; produced by Mr. Trumbull; released by M-G-M/U.A. Entertainment Company. At the Ziegfeld, Avenue of the Americas and 54th Street. Running time: 106 minutes. This film is rated PG.

Michael Brace	Christopher Walken
Karen Brace	Natalie Wood
Lillian Reynolds	Louise Fletcher
Alex Terson	Cliff Robertson
Gordy Forbes	Jordan Christopher
Landon Marks	Donald Hotton
Robert Jenkins	Alan Fudge
Hal Abramson	Joe Dorsey
James Zimbach	Bill Morey
Chris Brace	Jason Lively
Security Technician	Darrell Larson

By JANET MASLIN

IN a button-pusher's paradise, replete with the dazzling array of hardware that "Brainstorm" so effectively utilizes, a group of scientists is poised on the brink of an astonishing discovery. They have created a device that allows one person to experience vicariously the sensations of others. If Person A, wearing a specially designed helmet, eats a piece of steak with nuts, chocolate sauce and marshmallow on top (that's the meal used in the experiment), Person B can taste the same stuff and share in the same indigestion.

When the scientists discover that their invention actually works, they excitedly drink a toast to its seemingly endless possibilities. "Brainstorm," which opens today at the Ziegfeld and other theaters, follows the scientists as they then discover that there are less purely research-minded individuals, in the military and in industry, who can imagine more sinister uses for the device. It also follows Dr. Michael Brace (Christopher Walken), one of the inventors, and his wife, Karen (Natalie Wood), as their marriage falters. But mostly it follows the helmet itself, since this is indeed the movie's real star.

•

Douglas Trumbull, the special-effects wizard, has devised an unusually varied high-tech look for "Brainstorm." The laboratory where the scientists work looks amazingly sophisticated but also very lived in; the helmet itself is refined from a collection of lights and wires and lenses to something streamlined and sleek. Later on, when an automated assembly line is established to mass produce these machines, Mr. Trumbull makes its very immaculateness seem sinister. And when the place is sabotaged, it becomes a sudsy mess, which in this orderly and detail-conscious film, seems even more wicked than it would anywhere else.

The most special of the effects are, of course, reserved for those images provided by the helmet. To say that this device captures the ultimate sensation is hardly hyperbolic, since one of the scientists, while experiencing a heart attack, manages to slip into the apparatus and switch on its recording equipment. Mr. Trumbull can't convey this for real, thank goodness. But he can certainly make believable the frightening and then euphoric fireworks that explode across the screen.

The film's human characters haven't been given a wildly compelling drama of their own, but their activities are always interesting. Louise Fletcher, as Michael's co-inventor, Dr. Lillian Reynolds, gives a superb performance, playing a woman whose excitement about her work is matched only by her fury at watching that work subverted. Cliff Robertson, looking genial and wearing riding boots, plays the corporate head who's supposed to be providing his scientists with reassurance, though it's soon clear he has other interests to serve.

Mr. Walken is misplaced, never convincingly seeming the brilliant inventor. However, he's better in the later action sequences than in the early lab scenes, where his vaguely dissipated air clashes with the crisp surroundings. He and Natalie Wood make more sense as an estranged couple, early in the film, than they do as reunited lovers later on. In any case, this is the sort of film in which we learn more about the Brace family by watching the bicycle-like contraption Michael rides to work or the house he has custom-designed with an indoor swimming area than by listening to anything they say.

However adversely it must have affected the morale of those involved in making "Brainstorm," the death of Natalie Wood hasn't damaged the film. Her performance feels complete. Playing a more mature character than she had done before, Miss Wood brought hints of a greater sturdiness and depth to this role, which is pivotal but relatively small.

•

"Brainstorm" is rated PG ("Parental Guidance Suggested"). It contains some nudity and strong language.

1983 S 30, C17:1

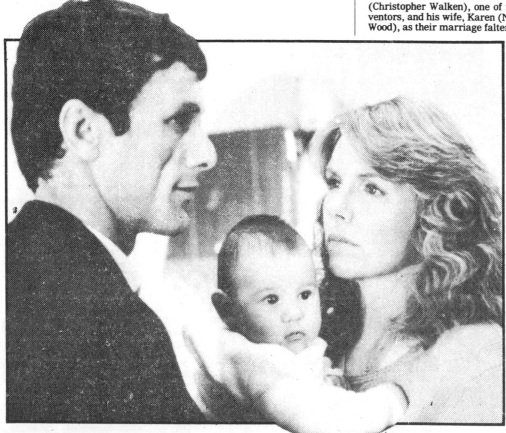

"HANNA K."—Mohamed Bakri, as an enigmatic Palestinian arrested as an infiltrator, and Jill Clayburgh, as the lawyer called upon to defend him in Israel against the prosecutor who fathered her child, star in the Costa-Gavras film.

THE LONELY LADY, directed by Peter Sasdy; screenplay by John Kershaw and Shawn Randall, based on the novel by Harold Robbins; adaptation by Ellen Shepard; director of photography, Brian West; edited by Keith Palmer; music by Charles Calello; produced by Robert R. Weston; released by Universal Pictures. At the Rivoli, Manhattan Twin and other theaters. Running time: 92 minutes. This film is rated R.

Jerilee Randall	Pia Zadora
Walter Thornton	Lloyd Bochner
Veronica Randall	Bibi Besch
Vincent Dacosta	Joseph Cailo
Guy Jackson	Anthony Holland
George Ballantine	Jared Martin
Joe Heron	Ray Liotta
Carla Maria Peroni	Carla Romanelli
George Fox	Olivier Pierre
Joanne Castel	Kendal Kaldwell
Bernie	Lou Hirsch
Walt Thornton Jr.	Kerry Shale
Nancy Day	Sandra Dickinson

Pia Zadora plays an ambitious creature who marries a very successful older man, then claws her way to the top of the movie business in "The Lonely Lady," which opened yesterday at the Rivoli. "The Lonely Lady," based on one of Harold Robbins's later and lesser novels, follows the career of Jerilee Randall, an aspiring writer, as she pursues her muse. Winning an award while in high school — the trophy looks like an Oscar that's been left out in the sun too long — she states her credo: "I always try to make at least one of my characters honest and open and worried about some important issue." Naturally, with an attitude like that, she goes far.

•

Before she's out of pigtails and overalls, Jerilee has married the important writer Walter Thornton, who falls for her after she says how much she loves to "talk writing." (In practical terms, this means Jerilee and Walter mention Pushkin while they are out jogging.) Then Walter takes her to the set of a movie he has written, which has something to do with medieval peasants. The leading lady complains about the speech Walter has written for a scene in which her child is being buried. So Jerilee goes off and writes a better speech, which goes in its entirety: "Why?"

When Walter protests, Jerilee says she has followed his instructions to "cut, condense, get a clear line," so what's the problem? Suffice it to say

that Jerilee's speech is used, and that these two literary lions don't stay married very long.

•

You've got to say this much for Miss Zadora: she's got spunk. Admirers of camp classics owe her a debt of gratitude for "Butterfly." This time, though, she's the tiny centerpiece of a badly acted slovenly looking movie that isn't even much fun. None of the extras, and very few of the supporting players, seem like people who ought to be acting for a living. The costumes for everyone except Miss Zadora are ill-fitting and ugly, and the set decoration is simply a nightmare. No one has even gone to the trouble of making the novels Jerilee is supposed to have written look like real books.

A great many scenes take place in restaurants, perhaps for lack of a better idea from Peter Sasdy, the director. In these restaurants, the characters talk about "points," "$75,000 up front for you," and what for Mr. Robbins are apparently other fine points of the writing trade.

Janet Maslin

1983 O 1, 13:5

ERENDIRA, directed by Ruy Guerra; screenplay (Spanish with English subtitles) by Gabriel Garcia Márquez; director of photography, Denys Clerval; edited by Kenout Peltier; music by Maurice Lecoeur and Editions Saravah; produced by Alain Queffelean; production company, Les Films du Triangle. At Alice Tully Hall, as part of the 21st New York Film Festival; presented by the Film Society of Lincoln Center in cooperation with the Motion Picture Association of America. Running time: 103 minutes. This film has no rating.

The Grandmother	Irene Papas
Erendira	Claudia Ohana
The Senator	Michael Lonsdale
Ulysses	Oliver Wehe
The Photographer	Rufus
Ulysses' mother	Blanca Guerra
The Grocer	Ernesto Gomez Cruz
Ulysses' father	Pierre Vaneck
The Smuggler	Carlos Cardan
Blacaman	Humberto Elizondo
The Commandant	Jorge Fegan
The Postman	Francisco Mauri
The Truck Driver	Sergio Calderon
The Conveyor	Martin Palomares
The Buffoon	Salvador Garcini
The Fiance	Felix Bussio Madrigal
The Musician	Juan Antonio Ortiz Torres
The Missionary	Carlos Calderon
The Indian Chief	Rene Barrera

By VINCENT CANBY

Once upon a time, in a vast, otherwise empty desert, there is a great house filled with paper flowers and enough inflammable bric-a-brac to satisfy several generations of antique dealers. Here, with their pet ostrich, live a pretty, solemn-faced slavey named Erendira and her Gorgon of a grandmother, an imperious lady whose house and manners deny the destitution all around them.

One night, when Erendira forgets to put out the candles, the house and all its contents are consumed by flames. "My poor darling," sighs Grandmother to Erendira, "your life will not be long enough to repay me."

•

Nevertheless, she has a plan. Grandmother sets up the virginal Erendira as a prostitute. Her first customer is the local desert grocer, who pays 200 pesos and three days' worth of provisions. Erendira quickly becomes the most famous, most popular courtesan in the region. She and Grandmother travel in an exotic procession from one location to the next, Grandmother being carried in a sedan chair, Erendira following on foot.

Wherever they set up shop, in their increasingly grand tent, becomes the focal point of all sorts of subsidiary

enterprises. There are snake charmers, games of chance, food sellers, musicians. Life around them is a continuous carnival. The obedient Erendira goes about her business without complaint, accepting each new outrage with the silence of a guilt-ridden pilgrim on her way to a holy shrine.

That is, she seems to accept it until the appearance of a golden-haired young man named Ulysses, who becomes her liberation.

This is more or less the shape of "Erendira," a fabulous fairy tale based on an original screenplay by Nobel laureate Gabriel García Márquez and directed by Ruy Guerra in Mexico, though the original location was Mr. García Márquez's native Colombia. The film will be shown at the New York Film Festival at Lincoln Center today at 3 P.M. and tomorrow at 9:30 P.M.

Readers of Mr. García Márquez's "One Hundred Years of Solitude" may recognize something of the story of Erendira. The novelist wrote it first as a screenplay 10 years ago, then reduced it to about a page and a half in "Solitude." When arrangements to make this film were settled, Mr. García Márquez had to reconstruct from memory the first screenplay, which had been lost.

"Erendira" has a kind of dreamy if monotonous charm to it. Unlike the Surrealist comedies of the late Luis Buñuel, the "magical realist" comedy of Mr. García Márquez's screenplay never abruptly shocks or surprises us. It's sometimes funny, but everything is presented in the same hallucinatory manner that is essentially soothing, even when it comes to murder.

•

The best single thing in the film is the big, broad, comic performance by Irene Papas as Grandmother. This is, I think, the first time I've ever seen Miss Papas in a comedy, and the first time I've ever seen her laugh on screen and really mean it. She is quite wonderful as a sort of cross between the Madwoman of Chaillot and the Queen of Hearts, being most positive when she is being most nonsensical.

Claudia Ohana, a young Brazilian actress, is charming as the long-suffering Erendira. Michel Lonsdale appears briefly as a lonely politician who helps Erendira, and Oliver Wehe plays Ulysses.

The physical production is extremely handsome and appropriately fantastic and, like the screenplay, should be enjoyed for what it appears to be and not for what it might symbolize. One decodes Mr. García Márquez at one's own risk.

1983 O 1, 16:3

LOST ILLUSIONS, directed by Gyula Gazdag; screenplay (Hungarian with English subtitles) by Mr. Gazdag and Miklos Gyorffy and Gyorgy Spiro, based on the second part of Balzac's novel; director of photography, Miklos Jancso Jr.; music by Istvan Martha; production company, Objektive Studio, Budapest. At Alice Tully Hall, as part of the 21st New York Film Festival; presented by the Film Society of Lincoln Center in cooperation with the Motion Picture Association of America. Running time: 106 minutes. This film has no rating.

Laszlo Sardi	Gabor Mate
Kriszta	Dorottya Udvaros
Luszto	Robert East
Daniel	Boguslaw Linda
Mrs. Barsony	Agi Margittai
Mrs. Deszkas	Ilona Beres
Flora Koves	Juli Basti
Finta	Laszlo Sinko
Dori	Ferenc Bessenyei
Vermes	Lajos Oze
Kamuti	Imre Eck

The Hungarian director Gyula Gazdag has transposed the middle section of Balzac's "Lost Illusions" from

Paris in the mid-19th century to the Budapest of 1968, though he might just as well have moved it to the moon. If the purpose of this feat of gamesmanship is to demonstrate the universality of "Lost Illusions," it might as readily have been accomplished in the book's natural time and place as in this updated setting.

However, the arbitrariness of Mr. Gazdag's decision isn't as damning as it could have been. His film, while straining a bit too hard to sustain its parallels to Balzac's far richer and more intricate story, has a vitality of its own. It tells of Laszlo Sardi — Balzac's Lucien Chardon — and his efforts to launch his literary career amid the snobbery and sophistication of a big city.

Laszlo has a novel and a volume of poems to publish, but he first finds work at a newspaper, writing literary and drama reviews. When his ambition, and the coaxing of one of his superiors, leads him to write two different articles voicing two different opinions about the same book, a friend counsels: "You become a real journalist not when you're first published, but when your name is on an article you had nothing to do with."

The film follows Laszlo through a literary community divided into factions and governed by expediency, which is drawn with a cynicism modeled on Balzac's, though with only a fraction of the wit or complexity. Eventually he becomes a great success, attracting the admiration of his peers and the particular fondness of a sexy young drama student named Kriszta (Dorottya Udvaros). Their courtship, with Kriszta in miniskirts and the Who or the Bee Gees blaring in the background at parties, is a far cry from anything in the novel, no matter how timely that work still remains. At least Mr. Gazdag, with his co-scenarists, Miklos Gyorffy and Gyorgy Spiro, has resisted the temptation to populate his film with characters whose only purpose is to recall the original and who have no real function here. Instead, the film remains economical and compact.

Gabor Mate plays Laszlo with an ingenuousness that blossoms convincingly into overconfidence, and Miss Udvaros makes an appealing heroine. The Budapest settings are reasonably apt and also rather drab. When a latter-day movie theater substitutes for the grand theater in which one of Balzac's early scenes takes place, for instance, or a Budapest cafeteria replaces a favorite students' hangout in the Latin Quarter, the film can't help but pale by comparison.

"Lost Illusions" will be shown tonight at 6 and tomorrow at 2 P.M. as part of the New York Film Festival.

Janet Maslin

1983 O 1, 16:3

THE GOLDEN EIGHTIES, directed by Chantal Akerman; screenplay (in French with English subtitles) by Jean Gruault and Chantal Akerman; photography by Michel Houssiau; edited by Nadine Keseman and Francine Sandberg; music by Marc Herouet; produced by Marilyn Watelet; production company, Paradise Films. At Alice Tully Hall, as part of the 21st New York Film Festival. Presented by the Film Society of Lincoln Center in cooperation with the Motion Picture Association of America. Running time: 80 minutes.
WITH: Aischa Bentebouche, Francesca Best, Kath Best, François Beukelaers, Daniela Bisconti, Warre Borgmans, Anne-Marie Cappeliez, Cathy Carrera, Amid Chakir, Eric Chale, Aurore Clement, Harry Cleven, Nicole Debarre, Patrick Dechene, Goele Derrick, Jo Deseur, Annick Detollenaere, Patricia Frans, Herman Gilis, Ionna Gkizas, Lucy Grauman, Catherine Jauniaux, Michel Karchevsky, Martine Kivits,

Pia Zadora in "The Lonely Lady."

Fabienne Lambert, Francine Landrain, Hélène Laplower, Dominique Laprique, Susanna Lastreto, Marie-Line Lefevre, Lio, Carmela Locantore, Daniela Luca, Xavier Lukomsky, Florence Madec, Cécile Marcandela, Estelle Marion, Rachel Michael, Blase Mills, Agnes Muckensturm, Anne Nelissen, Claire Nelissen, Magali Noel, Yvette Poirier, Christine Pouquet, Isabelle Pousseur, Marie-Rose Roland, Nel Rosiers, Pascale Salkin, Marc Schreiber, François Sikivie, Guy Swinnen, Samy Szlingerbaum, Nora Tilly, Nicole Valberg, Johann Van Assche, Florence Vercheval, Yvon Vromman, Gabrielle Wellbach, Michel Weinstadt, Nathalie Williame, Jean-Claude Wouters, Bernard Yerles, Simon Zaleski

By JANET MASLIN

In the first section of Chantal Akerman's "Golden Eighties," a number of actors are seen on videotape, rehearsing lines that are intentionally absurd. The camera studies the auditioners intently as they invest meaningless dialogue with unwarranted passion ("Actually red is not my color, you see," one woman declares emotionally in a clothing store). They seem to be speaking about a broken love affair, a tryst that takes place in a shop's dressing room, and the glories of Canada, among other things. The screenplay is by Miss Akerman and Jean Gruault, whose motives here are no less obscure than those of their characters.

As directorial instructions are issued from off-camera, the actors continue to strike poses we understand to be excessive and false. And the lines, repeated in different ways by different auditioners, begin to take on some slight meaning of their own. Songs and dances are also haphazardly rehearsed, the songs with lyrics of flawless silliness, the dances emphasizing the desultory clacking of high-heeled shoes on a tile floor.

This rehearsal stage of "The Golden Eighties" goes on for nearly an hour, which may seem long until it is noted that Miss Akerman had 40 hours of material from which to sift. Though the early stages of the film triggered a sizable exodus from the press screening of "The Golden Eighties," which was shown last night as part of the New York Film Festival, the last few minutes were livelier. At this point, the brief musical that has been rehearsed is finally unveiled. Facetious in the extreme, it takes place in a shopping mall and features singing shampooists in a beauty parlor and other curiosities.

The ending of the film, no less urgent than any of the rest of it, is a 360-degree look at Brussels. Miss Akerman, in voiceover, thanks her cast and thanks the city.

1983 O 2, 59:1

LAST NIGHT AT THE ALAMO, directed by Eagle Pennell; screenplay by Kim Henkel; directors of photography, Brian Huberman and Eric Edwards; music by Chuck Pinnell and Wayne Bell; produced by Mr. Henkel and Mr. Pennell. At Alice Tully Hall, as part of the 21st New York Film Festival; presented by the Film Society of Lincoln Center in cooperation with the Motion Picture Association of America. Running time: 80 minutes. This film has no rating.
CowboySonny Davis
ClaudeLou Perry
IchabodSteve Matilla
MaryTina Hubbard
JaniceDoris Hargrave
SteveJ. Michael Hammond
LisaAmanda LaMar
GingerPeggy Pinnell
PokeDavid Schied
SkipperGeorge Pheneger
WillieHenry Wideman
WayneJohn Heaner
HectorErnest Huerta
ConniePam Feight
RayHenry Kana
DarlaSarah Hudgins
LoisJeanette Wiggins
MavisJudie Stephens
SlimHi Bice
LionelKim Henkel
Bo ..Eagle Pennell

Eagle Pennell's "Last Night at the Alamo" is a small film that raises both the hope and the possibility that Mr. Pennell will make bigger ones. Shot in a primitive style, and using both accents and equipment that sometimes make its sound a little muddy, it's the ribald and faintly mournful chronicle of a seedy Houston hangout that's about to close its doors for the last time, much to the chagrin of the regular clientele.

This includes Cowboy (Sonny Davis), a local hero with a reputation to live up to and a hat he'd better keep on; Claude (Lou Perry), who's in the process of being thrown out by his wife and who curses her imagina-

tively and incessantly throughout the film; and Ichabod (Steve Matilla) and Mary (Tina Hubbard), a combative couple but clearly a love match. From the moment when they first drive up, with Ichabod at the wheel of their Pest Control van, to the point at which, after much boasting and advertising from Ichabod, they disappear in the direction of the Paradise Motel, these two provide the film with much of its comic relief.

•

As directed by Mr. Pennell and written by Kim Henkel (who also wrote "The Texas Chainsaw Massacre"), "Last Night at the Alamo" has

a surface energy and a subliminal bleakness that work well together. A large cast of incidental characters, including the writer and director in tiny roles, all join in cursing, drinking, carousing and otherwise preparing themselves for imminent disaster.

"Last Night at the Alamo" will be shown today at 4:30 P.M. at the New York Film Festival at Lincoln Center. Though it's been shot in black and white, the material itself is very much in color.

Janet Maslin

1983 O 2, 60:3

FILM VIEW

VINCENT CANBY

Festival Movies Ought to Challenge Us

A second thought: As much as I admire "The Big Chill," Lawrence Kasdan's wise, rueful comedy about some 1960's activists 15 years after all the excitement has died down, I'm not at all sure that it was the best choice to open the current New York Film Festival at Lincoln Center. "The Big Chill" belongs in this international event, but as the opening attraction it gets things off to a deceptively easy start.

This is not to say that "The Big Chill" is commonplace, but that the character of the festival could have been better defined with the sort of movie that would have unsettled the members of the first-night audience rather than soothed them. More than anything else, perhaps, the festival is important for forcing us to look at films in new and different ways, for testing our patience, for wiping away the cobwebs that accumulate in any 12 months of conventional moviegoing.

One of the most appealing things about the Kasdan film is its demonstration that the same American filmmakers who turn out commercial blockbusters are also capable of producing smaller, far more personal works. Before making his smashing debut as a director-writer two years ago with "Body Heat," a tough, witty, expertly plotted variation on Hollywood's hard-boiled melodramas of the 1940's, Mr. Kasdan had written the screenplays for "The Empire Strikes Back," with George Lucas, and "Continental Divide." He also collaborated with Mr. Lucas on this year's "Return of the Jedi."

Having shown that he can compete with the slickest of high-priced writers in Hollywood's fantasy 'n' fun department, he has now gone on to make a comedy that is unusually personal by commercial American standards. "The Big Chill' is a reminder that Hollywood is loaded with talent that we tend to take for granted because the kinds of films made are so severely limited.

When people say, "Let's go to a movie tonight," the unexpressed desire is to be amused and entertained with the least possible effort. They might well go see "The Big Chill," and get slightly more than they anticipated. They clearly would not want to be confronted by the crazy predicament of Luis Buñuel's classic "Exterminating Angel," in which a bunch of elegantly dressed dinner party guests are, for reasons never explained, unable to leave at the end of the evening. Nor would they seek out a science-fiction film without a single spaceship, set in a

Paris that looks exactly the Paris of today, as in Jean-Luc Godard's "Alphaville," which opened the 1965 New York festival. Festival films aren't easy.

This isn't to say that films at the New York festival should be approached as if they were a kind of duty, like an exercise class, though they do make us stretch, even the ones that aren't successful.

Take, for example, Marco Ferreri's "Story of Piera," an Italian film that, I think, means to be a comedy. The film covers 20-odd years in the lives of a mother (Hanna Schygulla), a father (Marcello Mastroianni) and a daughter (Isabelle Huppert) who act out — at least, in part — the frowned-upon sexual fantasies that the rest of us come to terms with on psychiatrists' couches. Because the movie doesn't make too much sense on a realistic level, one tries to see it as the sort of surreal comedy that isn't bound by the rules of conventional film narratives.

The setting — a handsome, unidentified Italian town in which we see scarcely any other inhabitants — suggests this, as do the actions of the characters, for whom all logical connections between causes and effects have been suspended.

However, even when one makes these allowances, "The Story of Piera" remains muddled. I clearly remember individual scenes, one of the most arresting being the final sequence, in which Miss Schygulla and Miss Huppert dance nude together on an otherwise deserted beach. But I haven't the foggiest notion what was in the filmmaker's head. All I could think was that Mr. Ferreri, whose "Grande Bouffe" and "Last Woman" I'd admired earlier, had passed over into some private twilight zone of the imagination.

• • • •

Far more successful and far more rigorous is Robert Bresson's "Argent," the kind of film that gives film festivals a reason for being. "L'Argent" is only the 13th feature made by Mr. Bresson, 75, since the appearance of his first full-length work, "Les Anges du Peche," in 1943. As this is being written, the festival is only three days old, but it's a good bet that 'L'Argent" will remain one of the most original and fascinating films in the entire event.

Bresson films, which look and sound like those of no other filmmaker, alive or dead, are austere, limpid morality tales, photographed with almost scientific clarity and acted mostly by nonprofessionals. By using amateurs, who move through his films without attempting to act, Mr. Bresson creates a kind of cinema in which characters are not seen but represented, as dramatically and effectively as they would be by actors wearing masks.

"L'Argent" is as stern as a Marxist lecture on the sins of capitalism, but behind the film's dour nature there is a kind of dreamy mysticism that's anything but Marxist. It's the story of the corruption of an innocent young man, a truck driver, who is framed as a distributor of counterfeit money. Through no initial fault of his own, the young man loses his wife and child, is thrown into prison and eventually becomes an unrepentant murderer.

•

In the world of "L'Argent," society is corrupt, but the corruption is less important materially than spiritually. Love of money is punished with the severity of an Old Testament prophet going after the idol worshipers.

An important but subsidiary character in the film is the young man who

perjures himself by identifying the truck driver as the counterfeiter. Later, filled with remorse, the perjurer tries to make amends but suffers a martyr's fate during a prison break.

One cannot attend to a Bresson film as if one were watching "Flashdance." It doesn't overwhelm the viewer with horrendously loud sounds and sexy images. It doesn't invite the audience to identify with characters or events. But by denying all the tricks of the sentimental, realistic cinema, "L'Argent" forces the audience to come to it on its own terms. The satisfaction in a film of this sort comes not just from being entertained but from a sense of discovery, of having had one's perceptions enriched.

Another festival entry that will seem alien to most moviegoing Americans is "In the White City," the new film by Alain Tanner, the Swiss director of "La Salamandre" and "Jonah Who Will Be 25 in the Year 2000."

Like all Tanner films, "In the White City" has something to do with the experience of being Swiss, that is, with. being the product of a small, landlocked, famously clean and efficient country that has remained safely neutral for centuries, while the rest of the world has gone through various social, political and religious cataclysms. To be born Swiss, Mr. Tanner seems to say, is to have been prenatally alienated.

"In the White City" is about a Swiss merchant seaman named Paul (Bruno Ganz), an engineer aboard an ocean-going tanker who jumps ship in Lisbon. Paul takes a room in a small hotel overlooking the harbor and proceeds to abandon himself to the moment. He drinks, fights, makes love, at first enjoying the sense of utter irresponsiility. As time passes, he becomes aware that he cannot shake off his past or deny the future, which is attached to the woman he left at home. He must return to the real world, which, for better or worse, is Switzerland, or what Switzerland represents.

•

"In the White City" has no screenplay. It is an improvisation of its director and the members of the cast, principally, I assume, Mr. Ganz. It doesn't have the predictable shapeliness of a conventional film and, although it doesn't wander the way improvisations are inclined to do, it's not strong on suspense. One stays with the film to watch how Mr. Tanner and Mr. Ganz, having created a singularly vivid character, are going to give point to the film that contains him.

They don't succeed entirely, but they do make a notable attempt to use film to record the kind of interior journey that more frequently is found in written fiction. It's a nearly perfect festival film.

1983 O 2, II:21:1

THE NEW BABYLON, direction and script by Grigory Kozintsev and Leonid Trauberg, from an idea by P. Bliakin; photography by Andrei Moskvin and Yevgeny Mikhailov; music by Dmitri Shostakovich. At Radio City Music Hall, Avenue of the Americas and 50th Street, as part of the 21st New York Film Festival; presented by the Film Society of Lincoln Center in cooperation with the Motion Picture Association of America. Running time: 106 minutes. This film has no rating.

Louis PoirierElena Kuzmina
Jean ..Pyotr Sobolevsky
GrasselinDavid Gutman
An actressSophie Magarill
Lutro ...Sergei Gerasimov
Old PoirierS. Gusev
ThérèseJanina Jeimo
A washerwomanA. Gluchkova
A soldier in the National Guard
 Yevgeni Cherviakov
Old shop assistantAndrei Kostrichkin
Young girl at the barricades Anna Zarazhinskaya
Shop AssistantVsevolod Pudovkin

By VINCENT CANBY

ONE of the major treats of the current New York Film Festival at Lincoln Center will be the one-time-only screening tonight of that classic of Soviet silent cinema, Grigory Kozintsev and Leonid Trauberg's "New Babylon" (1929). The film is as much a celebration of Expressionistic cinema, of which it is a delirious example, as it is of the Paris Commune of 1873, which is its subject.

For this special retrospective presentation, the festival moves temporarily to Radio City Music Hall, where "The New Babylon" will be shown at 9:30 P.M. with — and this is a large part of the spectacle — the Radio City Music Hall Chamber Orchestra, under the direction of Omri Hadari, playing the film's original musical score by Dmitri Shostakovich. When the film opened here (to tepid reviews) on Dec. 1, 1929, which, by chance, was the also the opening day of G. W. Pabst's "Pandora's Box," it was without the Shostakovich score.

•

Tonight's Radio City screening will be the first opportunity the general public in this country has had to see and hear the film as it was designed to be presented. If tonight's showing matches the Friday afternoon press preview, it should be a smash.

Immediately after the preview Mr. Hadari apologized for the occasional lapses in synchronization between the orchestra and the film, though these were not immediately apparent to most members of the audience.

What was gloriously apparent was that this Shostakovich score, the composer's first for a motion picture, is a model of its kind — witty, occasionally rousing and often extremely funny all on its own, though it never comes between the images and the audience. One never has the wish to turn it off or, at least, down, as one does while listening to Carmine Coppola's relentless score for Abel Gance's "Napoleon."

This difference in scores, of course, also represents the difference between the two films. "Napoleon" is a big, grandly patriotic emotional binge. "The New Babylon" is something else entirely, a series of wicked political sketches, not unlike Goya's "Disasters of War."

•

The title comes from a huge, wildly busy monument to capitalist enterprise, Paris's New Babylon Department Store, where, at the beginning, we meet some of the representative types who function as the film's characters. These include a passionate young saleswoman (Elena Kuzmina), the jaded, wine-sipping boss of the store (David Gutman), a liberal journalist (Sergei Gerasimov) and a baffled young soldier (Pyotr Sobolevsky) who becomes a victim of a bourgeois conspiracy against the people of France.

The movie unfolds in a series of tableaux vivants that illustrate the course of the Franco-Prussian War. In short, brusque, sometimes bitter

scenes we see the initially crazy patriotism of the French in their war against Prussia, their astonishment at the news of the surrender of their armies, the refusal of the Paris working people to accept surrender and, finally, the establishment of the Paris Commune, by which the people of Paris took over their own Government only to be brutally crushed by the French Army backed by the power and money of the middle class.

The highly stylized, black-and-white photography by Andrei Moskvin and Yevgeny Mikhailov is spectacularly good, especially in the music hall scenes. In one of the film's most ironic and witty sequences, the members of the bourgeoisie, gathered outside Paris at Versailles, attempt to persuade the soldiers of the French Army to attack Paris and take back control from the Communards. Some patriotic fat-cat starts to sing "The Marseillaise," which is picked up by others, until everyone is weeping with excitement, no one apparently aware that "The Marseillaise" keeps being infiltrated by Can-Can music.

•

One of the most curious aspects of this sort of Expressionistic cinema is the way in which all of its characters, when they are not on the screen, seem to be watching the film as it is unreeling. This is the effect of a most particular kind of editing by which characters in one scene are made to appear to be commenting on the events of the preceding scene, though they couldn't have any awareness of them. Thus, immediately after we see the cuckolded boss of the department store exchange his honor for a government contract, we see the patrons in a dance hall applauding hysterically. It's not always subtle but it is eerily effective.

Mr. Kozintsev, who died in 1973, went on to make a number of other celebrated films, including the Soviet "Hamlet" that opened the 1964 New York Film Festival. Mr. Trauberg, who is reportedly very much alive, directed on his own a number of films, including a 1960 version of Gogol's "Dead Souls."

1983 O 3, C15:1

Woman Speaks Up

RED LOVE, directed by Rosa von Praunheim; script (in German with English subtitles) by Mr. Von Praunheim; camera, Mike Kuchar and Mr. Von Praunheim; music by Ideal, Dina-Testbild, Jakob Lichtmann; produced by Mr. Von Praunheim. At Alice Tully Hall, as part of the 21st New York Film Festival; presented by the Film Society of Lincoln Center in cooperation with the Motion Picture Association of America. Running time: 80 minutes. This film has no rating.
WITH: Sascha Hammer, Mark Eins, Helga Goetze, Olga Demetriescu, Rose Hammer, Bettina Sukroff, Barbara Gould, Tu Tu, Sarah Pfeifer, Eddie Constantine

By JANET MASLIN

ROSA VON PRAUNHEIM'S "Red Love" takes the form of a tirade about sexuality, revolving around the ideas of Helga Goetze, a West German woman in her late 50's who has a radical viewpoint and more than enough candor. She speaks of the marriage that produced seven children and 30 years of sexual monotony and goes on to explain how she has become radicalized. Her impressions are intercut with a continuing playlet, based on a feminist novel by Lenin's Minister of Culture, Alexandra Kollontai, about a

woman who breaks with her early ideals to enter into a more or less conventional bourgeois marriage.

With her close-cropped hair, forthright manner and arm-waving gestures so demonstrative they verge on becoming spasmodic, Miss Goetze is an impassioned speaker if not always a persuasive one. She shows off some loud and feverish paintings, one depicting a large uterus with a tiny warrior imprisoned therein. She also outlines a four-point plan that is more remarkable for the fervor with which she describes it than for its potential efficacy.

•

She would like to become a courtesan and preside over a salon, she says; she'd also like to see "a temple of prostitution" that is run by women; she'd like "to offer 10 men and 10 women the chance to get together and work on their sexuality." She would also like to see schoolchildren participate in sexual activities so as to work out their aggression at an early age. Mr. von Praunheim's presentation of all this sometimes rises to a pitch of stridency to match Miss Goetze's own. His film begins with the sound of a woman's angry shouting, and it uses furious New Wave music here and there; the domestic setting for the playlet is starkly modern and red, white and black. Miss Goetze seems passionate about her beliefs and she is sometimes genuinely provocative. The film itself is more an eccentric document than an effective framework for what Miss Goetze has to say.

"Red Love" was shown at the New York Film Festival at Lincoln Center.

1983 O 4, C13:2

State of the World

PASSION, directed by Jean-Luc Godard; screenplay (French with English subtitles) by Mr. Godard; director of photography, Raoul Coutard; music by Mozart, Ravel, Dvorak, Beethoven and Faure; produced by Alain Sarde; a French/Swiss Co-Production; SaraFilm/Sonimage/Films A2 (Paris) Film & Video Productions (Switzerland); a United Artists Classics Release. At Alice Tully Hall, as part of the 21st New York Film Festival; presented by the Film Society of Lincoln Center in cooperation with the Motion Picture Association of America. Running time: 87 minutes. This film has no rating.
WITH: Isabelle Huppert, Hanna Schygulla, Michel Piccoli, Jerzy Radiwilowicz, Laszlo Szabo, Sophie Lucachevski, Patrick Bonnel, Myriem Russel, Magaly Campos, J. F. Stevenin

By VINCENT CANBY

JEAN-LUC GODARD'S "Passion," which will be shown at the New York Film Festival at Lincoln Center today at 9:30 P.M. and tomorrow at 6:15 P.M., is much more light-hearted — breezy even — than I'm afraid almost any description can make it sound. Using a small group of absolutely splendid actors, who follow their leader with extraordinary confidence, Mr. Godard has made a funny, fractured, totally self-absorbed movie, without a real story, about the making of a movie that has no real story.

The result, which he calls "Passion," is less a narrative film than an essay on the artistic process, which in this case happens to be the process by which a movie is made, with side comments on painting, music, films, labor relations, film distribution and love, plus a few jokes. Question: "What is a catastrophe?" Answer: "The first stanza of a love poem."

"Passion" is not a romantic view of movie making, nor are there any

grand metaphors here. It's about people slogging on in their professions, as uncertain of what they're up to now as they are of the future. Throughout his career Mr. Godard has always been a couple of years ahead of his contemporaries. He still is. As did his "Every Man for Himself," "Passion" points the way to a kind of intensely personal yet commercially oriented film making that would stand in relation to mainstream movies the way quarterlies stand to mass-circulation weeklies and monthlies.

•

"Passion" is the Godard report on the state of the world as it appeared to him at the time the film was being made. On hand to help him realize his thoughts on film, and to help him get the kind of big budget that will ease the film's way into more or less conventional theaters, are no less than Hanna Schygulla, Isabelle Huppert, Michel Piccoli, and, perhaps best of all, Raoul Coutard, the great cameraman identified with almost all of the classic Godard films of the 1960's, including "La Chinoise" and "Weekend."

The setting appears to be Switzerland, where a film called "Passion" is in the process of being directed on a comparatively small soundstage by two men, Jerzy (Jerzy Radziwilowicz), who is Polish, and Laszlo (Laszlo Szabo), who, I think, is Hungarian, though he's not on the screen as much as Jerzy. The movie being shot has no story, which makes the high-strung Italian investors uneasy, but Jerzy keeps explaining that he can't write a story until he has lived it, and Jerzy's living a story is what "Passion" is all about.

The story he lives is not "Gone With the Wind." It's largely a series of comic misunderstandings and arguments involving a pretty little, outspoken factory worker named Isabelle (Miss Huppert), Hanna (Miss Schygulla), who owns the motel where the film company is staying, and with whom Jerzy has an affair, and Michel (Mr. Piccoli), Hanna's husband, who owns the factory where Isabelle works.

The film-within includes the reproduction of a number of masterpieces by Rembrandt, Goya, Delacroix and others as "living" pictures, which allows for some funny, off-hand gags about casting. Says Jerzy, with impatience about an actress brought in for his consideration, "She's too pretty for Delacroix." The total confusion on a movie set is detailed with deadpan, slapstick humor as the director works solemnly around nude women, horses, carpenters, bookkeepers and bored stagehands.

In one quintessentially Godardian sequence, Miss Schygulla, whom Jerzy apparently wants to play in the film-within, sits talking to the director as she watches — with embarrassment but increasing fascination — her own image struggling to lip-sync an operatic aria on a video monitor.

"Passion" looks beautiful — effortlessly so — and its images remain in the memory long after one has ceased to worry about the shape or the conventional sense of the movie. It's not easy to make a film without a story, nor is it easy to respond to such a film with a few, well-chosen, definitive phrases. I suspect that "Passion" may well be the sort of film that, in the future, will make up a small but solid portion of video-cassette sales. Mr. Godard remains in the vanguard.

1983 O 4, C13:2

Atop a Mountain

DHRUPAD, directed by Mani Kaul; in Hindi with English subtitles; camera, Virendra Saini; edited by Ashok Tyagi; produced by Films Division, Government of India. At Alice Tully Hall, as part of the 21st New York Film Festival; presented by the Film Society of Lincoln Center in cooperation with the Motion Picture Association of America. Running time: 72 minutes. This film has no rating.

MANI KAUL'S delicate "Dhrupad" explores an exquisite form of Indian classical music, dating from the 15th century and possessed of a mesmerizing intricacy. The film isn't so much a documentary as it is an exploration.

Much of it is given over to performances by the Dagar Brothers, who occasionally stop to discuss their music, or to describe their family's longtime involvement with this musical form. As one of them explains, the family has contained two singers, one instrumentalist and one theoretician for as long as he can remember. This is the combination of talents he believes necessary for mastery of the music.

•

"Dhrupad" gently observes the musicians as they sit atop a beautiful mountain fortress and perform. As the camera traces the curves of the architecture and examines the landscape around them, and with a narrator's occasional commentary, this music — whose "sweep is very wide, very magnificent," according to one of the performers — casts its spell. If anything, the vocal sounds that the Dagars produce are even more astonishing than their instrumental prowess, because their voices seem to echo the instrumental sounds perfectly.

One particular highlight of the film is the brothers' brief demonstration of how voice patterns can be varied to accompany particular musical patterns. In only a few moments' time, they demonstrate how very much expertise and perfectionism are required in the creation of these haunting sounds.

"Dhrupad" will be shown this evening at 6:15 as part of the New York Film Festival.

Janet Maslin

1983 O 4, C14:5

Going Public

SEEING RED, directed, edited and produced by Julia Reichert and James Klein; camera, Stephen Lighthill, Sandi Sissel and Martin Duckworth. At Alice Tully Hall, as part of the 21st New York Film Festival; presented by the Film Society of Lincoln Center in cooperation with the Motion Picture Association of America. Running time: 100 minutes. This film has no rating.

"**S**EEING RED," a documentary by Julia Reichert and James Klein about the history of American Communism, works best on the level of anecdote. The film makers interview longtime activists who describe why and how they first joined the Communist Party, how they were affected by the 1956 revelations about Stalinism and what their lives and politics have subsequently been like. The material is presented appreciatively and more or less uncritically, even on several occasions when the interviewees' evident rationalizations would seem to call for lengthier discussion.

"Seeing Red" is less successful in offering an overview of its subject

than in presenting individual histories, which are supplied by the interviewees, who are seen in their homes or at their workplaces. On the individual level, these recollections are very often touching.

Janet Maslin

1983 O 4, C14:5

Water on the Feet

NOSTALGHIA, directed by Andrei Tarkovsky; screenplay (Italian with English subtitles) by Mr. Tarkovsky and Tonino Guerra; director of photography, Giuseppe Lanci; edited by Amedeo Salfa and Erminia Marani; music by Giuseppe Verdi, Ludwig Van Beethoven, Russian folk songs; production companies, Opera Film Productions for RAI Channel 2/Sovin Film/Gaumont. At the Alice Tully Hall, as part of the 21st New York Film Festival; presented by the Film Society of Lincoln Center in cooperation with the Motion Picture Association of America. Running time: 130 minutes. This film has no rating.

Gortchakov	Oleg Yankovsky
Eugenia	Domiziana Giordano
Domenico	Erland Josephson
Gortchakov's Wife	Patrizia Terreno
Chambermaid	Laura De Marchi
Domenico's Wife	Della Boccardo
Civil Servant	Milena Vukotic
Farmer	Alberto Canepa

By VINCENT CANBY

ANDREI TARKOVSKY'S "Nostalghia" (Nostalgia), which will be shown at the New York Film Festival at Lincoln Center today at 9:30 P.M. and tomorrow at 6:15 P.M., is the first film to be made outside of Russia by this relentlessly poetic, Soviet director. The setting is Italy, where the hero, Gortchakov (Oleg Yankovsky), has come to research the life of a 17th-century Russian composer who spent a long time in Italy, was terribly homesick, finally went home, became an alcoholic and committed suicide.

In the course of the film, Gortchakov does very little research and a lot of musing, which often takes the form of lovely flashbacks and fantasies, most of which are seen in monochrome as compared to the living color of the other lovely images. Loveliness, I'm afraid, is really what this movie is all about. The Italian landscapes, frequently heavily misted, the ancient churches, the old towns, the occasional peasant, and the leading lady (Domiziana Giordano) are so lovely one feels that Mr. Tarkovsky's private world was created for camera-carrying tourists.

Gortchakov is homesick, but his homesickness is a kind of madness (I think). He is rude to his Italian guide, Eugenia (Miss Giordano), who would

Domiziana Giordano in Andrei Tarkovsky's film "Nostalghia."

like to have an affair with him. He spends a lot of the time in very dark rooms. The only person who touches him is a genuinely mad fellow (Erland Josephson) who, when last seen, is setting fire to himself in Rome after exhorting citizens to seek the answers to their problems in nature.

Mr. Tarkovsky, whose earlier films include "Andrei Rublev," "Solaris" and "Stalker," may well be a film poet but he's a film poet with a tiny vocabulary. The same, eventually-boring images keep recurring in film after film — shots of damp landscapes, marshes, hills in fog, and abandoned buildings with roofs that leak. The meaning of water in his films isn't as interesting to me as the question of how his actors keep their feet reasonably dry.

In "Nostalghia" Mr. Tarkovsky also shows a new if unproductive fondness for the image with a dark door or a passageway in the middle of the screen. Sometimes actors walk in or out of those passageways and doors, but mostly we just wait and hope. Nothing happens.

1983 O 5, C23:1

Small and Good

HEART LIKE A WHEEL, directed by Jonathan Kaplan; written by Ken Friedman; director of photography, Tak Fujimoto, film editor, O. Nicholas Brown; music by Laurence Rosenthal and other composers; produced by Charles Roven; released by 20th Century-Fox Film Corporation. At Alice Tully Hall, as part of the 21st New York Film Festival; presented by the Film Society of Lincoln Center in cooperation with the Motion Picture Association of America. Running time: 113 minutes. This film is rated PG.

Shirley Muldowney	Bonnie Bedelia
Connie Kalitta	Beau Bridges
Jack Muldowney	Leo Rossi
Tex Roque	Hoyt Axton
Don Garlits	Bill McKinney
John Muldowney (aged 15-23)	Anthony Edwards
Sonny Rigotti	Dean Paul Martin
Carlos	Jesse Aragon
Chef Paul	Paul Bartel

By JANET MASLIN

JONATHAN KAPLAN'S "Heart Like a Wheel" is about a sports figure who struggles to the top of a grueling profession. Since the character is a real woman, racing driver Shirley "Cha Cha" Muldowney, and since her triumph seems in some ways a very lonely one, this biographical film is something out of the ordinary. Its story is unusual, but it's told in a style that is immediate and understandable, and that never opts for heroism at the expense of authenticity. The movie doesn't concentrate on glorifying its heroine. It simply tries to make her seem reachable and real, and it succeeds.

The best thing about "Heart Like a Wheel" is its idiosyncrasy. Jonathan Kaplan, the film's director, and Ken Friedman, who wrote the screenplay, never pretend that there is a general lesson to be found in Miss Muldowney's very singular story. She was married early to a mechanic who never realized his dream of owning his own garage, and it wasn't long before her ambition surpassed her husband's. When she reached the point of choosing between her career and her family, Miss Muldowney doesn't appear to have had much choice. She took the only route that could have suited her, and accepted the sometimes unpleasant consequences of that decision.

•

In addition to tracing Miss Muldowney's marriage, the film follows her romance with a man named Connie

Bonnie Bedelia in "Heart Like a Wheel."

(The Bounty Hunter) Kalitta, a fellow driver who became her partner and lover, and finally her rival. It also takes her through the difficult process of finding acceptance in an all-male professional community. None of these things evolves entirely predictably, though; anyone who thinks "Heart Like a Wheel" sounds like a feminist tract will be startled by the sight of Shirley in white boots and hot pants, at least a decade into her career and now under the influence of Connie, as she's asked by an interviewer, "What do you think of Women's Lib?" As Shirley shakes her long, gaudy earrings and laughs, it's clear that she's nobody's ideologue.

Indeed, Mr. Kaplan and Mr. Friedman use the men in Shirley's life — the father who called her "my little filly" but encouraged her independence, the loving but incompatible husband, the impossible Connie, and her son, John, who became part of her crew — as a way of lending the film structure. The audience, well aware of how hard Shirley worked for her success, also sees her professional progress in stages that are linked to her romantic life. This is established in visual terms right at the start, when Shirley and her new husband go right from the wedding to the abandoned gas station he hopes to buy. The vision of Shirley in her wedding gown leaning on a gas pump as she listens to her husband's plans for the future is only one of many images here that inextricably combine love and the automobile. Indeed, when Shirley and her husband Jack are courting, Mr. Kaplan composes a series of necking-in-the-back-seat shots that seem more than ordinarily apt.

•

The slender, sweet-faced Bonnie Bedelia may seem a delicate actress to play Shirley Muldowney, but she's not any more of a cream puff than the woman she plays. Miss Bedelia gives a fine performance, combining flintiness and strength with a gentler sensibility. Her Shirley talks tough — "Not bad for an old broad in a used car, eh?" she asks after winning an important race — but she also has a more delicate side, one that sustains plenty of damage during the course of the story. Miss Bedelia carries Shirley from high school through her mid-40's and manages to be convincing at every stage. The whole film, in fact, makes time transitions that are very believable. And its period details are effective enough to offer a kind of capsule pop history of the working-class milieu in which it's set.

Beau Bridges does a very convincing job as Connie, alternately bad-tempered and flirty, and managing to tell one woman too many that she's 'the number one thing in my life." Leo Rossi is also good as Jack Muldowney, combining the glamour of a handsome young drag racer with the hint of subsequent defeat. In smaller roles, Hoyt Axton is bearish and appealing as Shirley's father, while the director Paul Bartel ("Eating Raoul") does a cameo as a French chef.

Mr. Kaplan, who directed "White Line Fever" and "Over The Edge" as well as several lesser-known features, combines the best qualities of a B-movie maker — close attention to speed and economy — with clear signs of a larger talent. His "Heart Like a Wheel," a very good small movie rather than a more broadly ambitious one, will be shown at the New York Film Festival tonight at 9:30 and tomorrow night at 6:15.

•

"Heart Like a Wheel" is rated PG ("Parental Guidance Suggested"). It contains some off-color language.

1983 O 6, C30:1

ROMANTIC COMEDY, directed by Arthur Hiller; screenplay by Bernard Slade, based on his stage play; director of photography, David M. Walsh; edited by John C. Howard; music by Marvin Hamlisch; produced by Walter Mirisch and Morton Gottlieb; released by M-G-M/UA Entertainment Corporation. At the Baronet, Third Avenue and 59th Street; Festival, Fifth Avenue and 57th Street; 34th Street Showplace, at Second Avenue, and other theaters. Running time: 103 minutes. This film is rated PG.

Jason	Dudley Moore
Phoebe	Mary Steenburgen
Blanche	Frances Sternhagen
Allison	Janet Eilber
Kate	Robyn Douglass
Leo	Ron Leibman
Maid	Rozsika Halmos
Minister	Alexander Lockwood
Young Woman	Erica Hiller
Timmy	Sean Patrick Guerin
TV Reporter	Dick Wieand
Bartender	Brass adams
Maître D'Hôtel	Stephen Roberts
Bus Boy	Santos Morales
Doctors	Fran Bennett, George Tyne
Passer-by	Tom Kubiak

By VINCENT CANBY

TAKING a good idea and several very good actors, Arthur Hiller, the director, and Bernard Slade, who adapted his Broadway play for the screen, have made a movie of remarkably little wit, humor, charm or interest. It's called "Romantic Comedy," which is an expression of its aspirations, and it opens today at the Baronet and other theaters.

Jason Carmichael (Dudley Moore) is a popular New York playwright in need of a collaborator to give him inspiration. Phoebe Craddock (Mary Steenburgen) is a small-town English teacher with an urge to write. On the day that Jason is being married at his Sutton Place house to a rich, brainy, beautiful young woman named Allison (Janet Eilber), Jason and Phoebe meet and, on the spur of the moment, form a partnership. Through thin but mostly thick, it lasts for the next 15 years.

•

They have a few flops but also a string of hit shows that, one assumes, are not much different from the play on which this film is based. Throughout this time the two writers, while obviously attracted to each other, avoid sexual entanglement. Jason stays true to his wife, and Phoebe to her typewriter. There is one brief episode while they're on the road in Chicago, but Jason pretends not to remember.

As the movie unpacks — to say "unfolds" would suggest a grace it doesn't possess — the audience is meant to yearn for these two supposedly clever, attractive nonlovers to find each other.

However, we don't. Miss Steenburgen is very appealing, suggesting a woman rather like Elaine May, though Miss May wouldn't be caught dead mouthing this dialogue. But Mr. Moore, ordinarily a most winning performer, isn't this time. It's difficult to tell whether the fault is in the material, the production or him.

A lot of it must be in the character as written. Jason is just as obnoxious as everyone says. Although the film was shot almost entirely in New York and usually looks authentic, one doesn't believe a thing that happens, possibly because the characters cease to exist each time they walk off the screen.

Frances Sternhagen plays Jason's protective agent with attractive briskness, though she could just as well have phoned it in from Connecticut. Ron Leibman plays a newspaper reporter to whom Phoebe is briefly married, and Robyn Douglass has a couple of small scenes as a temperamental Hollwood actress. It doesn't look to have been emotionally rewarding work.

•

"Romantic Comedy," which has been rated PG ("Parental Guidance Suggested"), contains some mildly vulgar dialogue and situations.

1983 O 7, C8:1

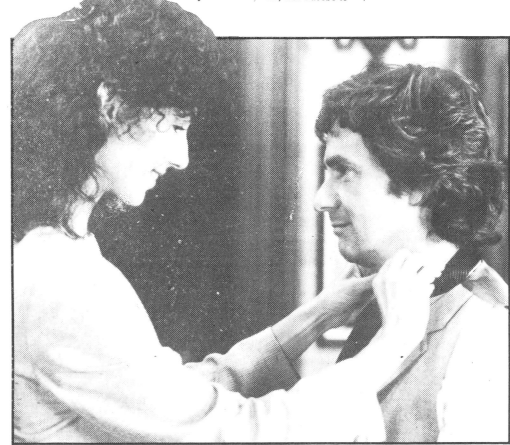

"ROMANTIC COMEDY"—Mary Steenburgen and Dudley Moore are the stars of Arthur Hiller's screen adaptation of the 1979 Bernard Slade play about two talented, successful collaborating authors.

Picking a Fight

RUMBLE FISH, directed by Francis Coppola; screenplay by S. E. Hinton and Mr. Coppola, based on the novel by Miss Hinton; photography by Stephen H. Burum; edited by Barry Malkin; music by Stewart Copeland; produced by Fred Roos and Doug Claybourne; released by Universal Pictures. At Alice Tully Hall, as part of the 21st New York Film Festival; presented by the Film Society of Lincoln Center in cooperation with the Motion Pictures Association of America. Opens Sunday at Loews Tower East. Running time: 105 minutes. This film is rated R.

Rusty-James	Matt Dillon
Motorcycle Boy	Mickey Rourke
Patty	Diane Lane
Father	Dennis Hopper
Cassandra	Diana Scarwid
Steve	Vincent Spano
Smokey	Nicholas Cage
B.J. Jackson	Christopher Penn
Midget	Larry Fishburne
Patterson	William Smith
Mr. Harrigan	Michael Higgins
Biff Wilcox	Glenn Withrow
Benny	Tom Waits

By JANET MASLIN

THE stunning black-and-white cinematography in Francis Coppola's "Rumble Fish" functions rather like a cold compress, subduing a film that is otherwise all feverish extremes. Mr. Coppola made "Rumble Fish" just after "The Outsiders," and apparently in the same breath.

Adapting another of S. E. Hinton's novels, Mr. Coppola has sought to imbue a story about tough teen-agers with the rhapsodic passion of opera, the sharp contrasts of German Expressionism, the angst of existentialism and the imagery of Dada. That he can accomplish part of this is a measure of this director's still-enormous talent. That he would choose to is a sign of how very paradoxical, even aimless, Mr. Coppola's work has become.

"Rumble Fish," which will be shown tonight at 9:30 and tomorrow at 3 P.M. as part of the New York Film Festival, and which opens Sunday at Loews Tower East, concerns two brothers, one called Rusty-James (Matt Dillon) and the other the Motorcycle Boy (Mickey Rourke). In the unidentified city where Rusty-James still lives, his brother is regarded as a born leader, a mythic figure, a heroic veteran of gang warfare. Rusty-James, by contrast, doesn't have a real gang to follow him or a real battle to fight. In awe of his much more clever brother, he isn't sure how he can follow in the Motorcycle Boy's footsteps. Their father, a benign drunk played by Dennis Hopper, isn't much help to either of them, and there's nowhere else for Rusty-James to turn.

To the extent that "Rumble Fish" has a story, that's about it. However, the narrative is not a first concern of Mr. Coppola's here. From the first scenes in which a sky of fast-rolling clouds is contrasted with some graffiti about the Motorcycle Boy, the film is a mélange of wildly overblown imagery. There are red and blue fish (the only signs of color in the film), clocks everywhere, beautifully balletic fight scenes, pulsating music (by Stewart Copeland of the Police), and a sequence in which Rusty-James, suffering a head injury, actually levitates. Floating face down with a cigarette in his mouth, grinning at his pool-playing buddies and his grieving sweetheart (Diane Lane), Rusty-James quite literally watches his life drift by.

As this may suggest, "Rumble Fish" exerts more than a little fascination, even at its most absurd. When Mr. Coppola positions his two heroes against an enormous clock-face, which happens to be tied to a parked truck, his audacity can't help but be attention-getting. But the film is so furiously overloaded, so crammed with extravagant touches, that any hint of a central thread is obscured. Mr. Coppola has wandered so far from whatever attracted him to the material that neither he nor Miss Hinton, who collaborated on the screenplay, can even begin to convey whatever they regarded as its essential concerns.

As an actors' showcase, "Rumble Fish" remains interesting long after its visual affectations have worn thin. Mickey Rourke, who plays the Motorcycle Boy, has so much quiet authority that he comes close to making sense of the character, which can't have been easy. With his hair cut oddly so that the hairline suggests a heart, and with a gentle intelligence that transcends even the silliest lines ("Well, even the most primitive society has an innate respect for the insane," he's forced to say, by way of explaining himself), he does an outstanding job.

So does Miss Lane, as the epitome of a teen siren, sometimes appearing in a school uniform and sometimes in black lingerie. Mr. Dillon has played too many dumb-but-sensitive thugs by now, but the measure of his performance here is in the way Rusty-James changes in his brother's presence. Mr. Dillon can shed his swaggering facade and suggest weakness and uncertainty just when those things are needed.

A number of the images in "Rumble Fish" are more memorable than the film is as a whole, sometimes for the wrong reasons. When the two brothers stand outside Benny's Billiards, and the glass door of that establishment reflects the most beautiful and dramatic cloud patterns racing by, it's impossible not to be distracted by questions of just how the shot was achieved, and just why. The clouds may mean to suggest the speed at which Rusty-James's life is rushing past him, or, the inevitability of his fate, or the very inexorability of time itself. But this is still only Benny's Billiards, after all.

1983 O 7, C10:3

Return Engagement

NEVER SAY NEVER AGAIN, directed by Irvin Kershner; screenplay by Lorenzo Semple Jr., based on a story by Ian Fleming, Kevin McClory and Jack Whittingham; director of photography, Douglas Slocombe; music by Michel Legrand; produced by Jack Schwartzman; released by Warner Bros. At the Criterion Center, Broadway and 45th Street; Manhattan 1 and 2, 59th Street between Second and Third Avenues, and other theaters. Running time: 130 minutes. This film is rated PG.

James Bond 007	Sean Connery
Largo	Klaus Maria Brandauer
Ernst Stavro Blofeld	Max von Sydow
Fatima Blush	Barbara Carrera
Domino	Kim Basinger
Felix Leiter	Bernie Casey
Q	Alec McCowen
M	Edward Fox

ONE of the key questions of the current film season can now be answered: This is the better Bond, and by a wide margin. It's not a matter of casting—though Sean Connery makes a welcome return in "Never Say Never Again," Roger Moore has certainly done nicely with the role — but rather one of creaks. Last summer's "Octopussy" reworked the same old Bond formula in all its anachronistic glory, with 007 winking his way through the usual intrigue, a figure of devilish charm and inexhaustible vigor. In "Never Say Never Again," however, the material has been successfully updated. Here, time has caught up with Bond — and he's very much the better for wear.

"Never Say Never Again," which opens today at the Criterion Center and other theaters, finds Bond taking the health cure after all those years of high living. Packed off to a spa, and berated for a past checkered with too many martinis and too much white bread, he's subjected to herbal enemas and various other indignities. When a sultry woman tells him she'd like to see him in half an hour, it's for a massage. However, Bond still travels with a suitcase packed with vodka and caviar, and he hasn't lost his flair for adventure. After fighting a murderous giant and nearly wrecking the health facility, he's off to the Bahamas and Monte Carlo for what's at least in part a remake of "Thunderball."

As directed by Irvin Kershner, "Never Say Never Again" has noticeably more humor and character than the Bond films usually provide. It has a marvelous villain in Largo, the globe-trotting playboy who implements a SPECTRE scheme to hijack two American cruise missiles and hold them for ransom. Largo, superbly played by Klaus Maria Brandauer (who starred in "Mephisto"), is wickedly competitive with Bond and fiercely possessive of the beautiful Domino (Kim Basinger), who's virtually a prisoner on a yacht that's bigger than most battleships. You don't need any of Bond's special sleuthing equipment, provided for him by Q (Alec McCowen) in a brief but delightful scene, to guess which one will wind up with the leading lady.

With Bernie Casey and Edward Fox as Bond's colleague and boss, respectively, and with Barbara Carrera gorgeous but awfully overwrought as a deadly rival, Mr. Connery is in lively company. He combines the wry reserve of yesteryear with a hint of weariness that, in the context of the screenplay's insistence on adventure, is genuinely amusing. In his post-Bond career, Mr. Connery easily proved himself to be an actor of far more resourcefulness than his 007 films had indicated. In "Never Say Never Again," the formula is broadened to accommodate an older, seasoned man of much greater stature, and Mr. Connery expertly fills the bill.

•

"Never Say Never Again" is rated PG ("Parental Guidance Suggested"). It contains what one character calls "some gratuitous sex and violence," and it wouldn't be a Bond movie without them.

Janet Maslin

1983 O 7, C13:1

BURROUGHS, directed by Howard Brookner; photography by Richard L. Camp, Mike Southon, James Lebovitz, Tom DiCillo, Howard Brookner, Cathy Dorsey, Larry Shiu and Anthony Balch; edited by Scott Vickrey and Ben Morris; produced by Mr. Brookner and Alan Yentob; production company, Citifilmworks, Inc. At Alice Tully Hall, as part of the 21st New York Film Festival Running time: 86 minutes. This film has no rating.
WITH: Lauren Hutton, William S. Burroughs, Patti Smith, Otto Belue, Mortimer Burroughs, Terry Southern, Allen Ginsberg, Lucien Carr, Herber Huncke, William S. Burroughs Jr.,

By JANET MASLIN

Rarely is a documentary as well attuned to its subject as Howard Brookner's "Burroughs," which captures as much about the life, work and sensibility of its subject as its 86 minute format allows. Part of the film's comprehensiveness is attributable to William S. Burroughs' cooperation, since the author was willing to visit old

"NEVER SAY NEVER AGAIN"—Sean Connery, back in action as James Bond, seeks the villains who stole nuclear warheads.

haunts, read from his works, and even playfully act out a passage from "Naked Lunch" for the benefit of the camera. But the quality of discovery about "Burroughs" is very much the director's doing, and Mr. Brookner demonstrates an unusual degree of liveliness and curiosity in exploring his subject.

The film touches on Mr. Burroughs' writing, his travels, his present life in New York, his complicated friendships, and his unusually troubled family history. The camera accompanies the author back to the house in St. Louis where he grew up, as he reads from a new novel about his boyhood, "The Place of Dead Roads." ("I don't want that boy in the house again, he looks like a sheep-killing dog," goes one apparently autobiographical excerpt.) There is a visit with his brother Mortimer, who tells William "I tried to read 'Naked Lunch' and read halfway through it and I pitched it."

Tracing the author to Mexico, the film describes the death of his wife Joan, shot by him in a modified William Tell experiment one drunken evening. "I always thought she had challenged him into it," says the author's close friend Allen Ginsberg, who is a generous and helpful presence throughout the film. "Just an absolute piece of insanity," Mr. Burroughs says himself. The saddest scenes in "Burroughs" are those depicting William S. Burroughs, Jr., the child of that union, who had serious drug and drinking problems when the film was being shot and has since died. After the author's somewhat presumptuous young assistant has pronounced himself more of a son to his mentor than William, Jr. was, the camera watches this threesome share an awkward meeting. The senior Mr. Burroughs, who in his mordantly funny way seems very much at ease throughout the rest of the film, appears painfully uncomfortable during his son's brief visit.

"His morals are probably Boy Scout morals, and the last thing he wants anyone else to know is that," says the author's friend Lucien Carr. Through interviews, snapshots and some unusually expressive home movies, the film presents Mr. Burroughs' drug use, his bisexuality, his friendships and his living arrangement as part of a larger spontaneity, and of an incongruous innocence. "He's a hard guy to get into bed, that's why I like him," says Patti Smith, one of numerous friends and acquaintances who help round out this very vivid portrait. But the crowning touches come from Mr. Burroughs himself, who does everything from demonstrating his technique for "cut-outs"—cut a page of writing into quarters, rearrange them, and retype whatever new word are formed—to playing doctor. He does during a very gory, bizarrely funny enactment of a scene from "Naked Lunch," with the transvestite Jackie Curtis playing his nurse.

On the same bill with "Burroughs," which will be shown tonight at 6 as part of the New York Film Festival, is another excellent documentary, Jacki Ochs' "The Secret Agent." This is a tough, angry look at the consequences of exposure to the chemical Agent Orange on veterans and others, a chilling issue that is effectively addressed here.

1983 O 8, 33:1

ENTRE NOUS, directed by Diane Kurys; screenplay (French with English subtitles) by Miss Kurys; photography by Bernard Lutic; edited by Joele Van Effenterre; music by Luis Bacalov; produced by Ariel Zeitoun; released by United Artists Classics. At Alice Tully Hall, as part of the 21st New York Film Festival; presented by the Film Society of Lincoln Center in cooperation with the Motion Picture Association of America. Running time: 110 minutes. This film has no rating.
Madeleine ..Miou Miou
Lena ...Isabelle Huppert
Michel ...Guy Marchand
CostaJean-Pierre Bacri
RaymondRobin Renucci
CarlierPatrick Bauchau
Monsieur VernierJacques Alric
Madame VernierJacqueline Doyen
FlorencePatricia Champane
SophieSaga Blanchard
ReneGuillaume Le Guellec
SarahChristine Pascal

By VINCENT CANBY

Neither of Diane Kurys's two previous films, "Peppermint Soda" (1977) and "Cocktail Molotov" (1980), gives any hint of the wonderfully sustained artistry that she demonstrates in "Entre Nous," her very personal, moving new film that, all of a sudden, places her among those in the forefront of the commercial French cinema.

"Entre Nous," which is titled "Coup de Foudre" in France, is something like Lawrence Kasdan's "Big Chill" in that it has the looks and manner of a conventional film but, in addition, has the sort of intelligence that seldom survives the smog of compromises in conventional film making. "Entre Nous" will be shown at the New York Film Festival at Lincoln Center today at 12:30 P.M. and tomorrow at 9 P.M.

•

Because "Entre Nous" is mainly about the friendship of two quite different women, each of whom eventually takes charge of her own life, the film may be in danger of being labeled feminist, which, I suppose, it is, at least in part. However, because the term is usually applied to consciousness-raising literature as glumly represented by films like Agnes Varda's "One Sings, the Other Doesn't," the term doesn't do justice to the specific idiosyncracies of Miss Kurys's work. "Entre Nous" is not the sort of film that soothes by supplying upbeat answers. It doesn't have answers of any kind. Like all serious works of narrative fiction, it examines people in particular situations and makes some speculations about what it finds. After that, it's for each of us to interpret according to his own circumstances.

•

The time is 1942. Lena (Isabelle Huppert), a young Belgian Jew, is interned in southern France awaiting deportation to Germany. Unknown to her, she has caught the eye of a camp worker, Michel (Guy Marchand), a French Legionnaire, also Jewish, who is soon due for discharge. In a note slipped to her one day inside a piece of bread, Michel proposes to Lena. If she marries him, he writes, she'll be allowed to leave the camp. It's not especially romantic, but Michel is young and presentable and Lena is practical. She accepts.

Intercut with these early, tragislapstick adventures of Lena are scenes of the courtship and marriage of the bourgeois Madeleine (Miou Miou), an art student whose young husband is killed in a partisan raid just a few months after their marriage.

The film then cuts forward to 1952 in Lyons, where Lena now lives with her two small daughters and the attentive, hard-working Michel, who has become the prosperous owner of a garage. One afternoon at a grade-school pageant, Lena meets Made-

Miou Miou with Guillaume Le Guellec, who plays her son in Diane Kurys's "Entre Nous."

leine, now a mother with a small son and married to a good-looking rather feckless fellow named Costa (Jean-Pierre Bacri), a would-be actor.

"Entre Nous" is the minutely detailed story of the rare friendship that develops between the two women over the next few years as each faces a succession of crises that, at last, alter their lives. Lena, the more conventional of the two, slowly grows from a prematurely dowdy duckling into a sleek, smart, self-assured woman. She has never been in love with Michel, but they seem to have an exceptionally good marriage. They amuse each other and both are genuinely delighted in their children.

Madeleine's life with Costa is a good deal more bleak. He gets into one financial scrape after another, and the childish ways that once amused her are no longer funny. She's bored with Costa, sorry for — and a little bored by — her shy son, and wants desperately to start life over, preferably in Paris.

•

"Entre Nous" is not a movie-as-short story. It's a novel-sized film, the kind that is so perfectly realized in vivid incidents that, not until the end does one realize how big it is and how effortlessly it has covered so much social and psychological territory. Like Mr. Kasdan, Miss Kurys is a first-rate writer with a director's vision and command of technique. The first quarter of the film — before Lena and Madeleine meet in Lyons — is virtually all exposition, but it is not only packed with detail, it is almost breathlessly suspenseful.

As admirable as the film's clear, unsentimental, long view of things are the beauty and the humor of many of its seemingly throwaway moments. It's marvelous about both the boredom and the joys of family life, about minor crises (when a child locks himself in a bathroom), and major ones, when, at last, a marriage is finally, irrevocably over. Late in the film there is a short but momentous scene aboard a night train to Paris that is stunning in its economy.

Miou Miou, whom I don't think I've seen since she played the dyed blonde supermarket cashier in Alain Tanner's "Jonah Who Will Be 25 in the Year 2000," is an entirely new screen personality as the gravely pretty, dark-haired Madeleine. As written, this role leaves much for the audience to fill in or to speculate on, which is what Miss Kurys is doing in the film.

In the central role of Lena, which Miss Kurys says is based on her own mother, Miss Huppert is superb, better than she has been in years — strong, funny, self-assured. Audiences who only know her as a professional waif in things like "The Trout," "Loulou" and "Coup de Torchon," won't recognize the authority in this fresh, unhackneyed performance.

Also extremely fine is Mr. Marchand as Michel, one of the most appealing boors ever to be found in a conventional movie. Mr. Bacri is also good as Madeleine's bewildered husband. Special mention must also be made of the excellent work Miss Kurys has obtained from Patricia Champane and Saga Blanchard, as Lena's small daughters, and Guillaume de Guellec, who plays Madeleine's little boy.

"Entre Nous" is one of this festival's few unqualified hits.

1983 O 8, 35:3

HELLS ANGELS FOREVER, directed by Richard Chase, Kevin Keating and Leon Gast; written by Peterson Tooke and Mr. Chase; original concept by Sandy Alexander; cinematography by Mr. Keating; music by various composers; produced by Mr. Chase, Mr. Alexander and Leon Gast; a Bayfide Films Production in association with Wescom Productions; distributed by RKR Releasing, Inc. At Movieland, Broadway and 47th Street and other theaters. Running time: 92 minutes. This film is rated R. WITH: The Hells Angels, Willie Nelson, Jerry Garcia, Johnny Paycheck and Bo Diddley.

By LAWRENCE VAN GELDER

As documentaries go, "Hells Angels Forever" is not the sort to be remembered for the dispassion and depth of its inquiry.

The film, newly arrived at Flagship Theaters and trailing its own praise as "the true story of an American phenomenon," starts from the premise that the brotherhood of motorcyclists known as Hells Angels has long been the target of a conspiracy by law enforcement authorities aimed at its destruction.

•

Imbued with this fundamental bias, asking soft questions, settling for easy, frequently inarticulate and often inaudible answers, and failing to argue persuasively, "Hells Angels Forever" cannot satisfy genuine curiosity about the roots, rites and raison d'être of this durable organization.

What remains, then, is largely a narcissistic, somewhat paranoid, sometimes self-conscious home movie, constructed mainly around footage of Angel gatherings, Angel outings, Angel leathers and Angel bikes, whose cumulative visual monotony is fleshed out with stills, footage from films like "The Wild One," and the music of such performers as Willie Nelson, Johnny Paycheck, Jerry Garcia and Bo Diddley.

Individuals intent on the pictures rather than the fine print may overlook the fact that "Hells Angels Forever" credits its original concept to Sandy Alexander, described as the founding president of the New York Chapter of Hells Angels, and the fact that Mr. Alexander is a co-producer of the film. As a bit of early narration states, this is the Angels' story told their own way.

•

This, then, is a self-serving documentary whose reliance on the testimony of Angels is so substantial as to subject it to grave doubt when it raises questions and purports to provide answers about the organization's

·purposes, its members' treatment of women, its attitude toward blacks, its reputation for violence, its overt fondness for Nazi trappings and allegations of its involvement in racketeering.

Are audiences really to believe, as one of the Angels' defense lawyers suggests, that if you took away the bikes and the leather and the hair and the tattoos, all that would be left would be a bunch of Goldwater Republicans?

1983 O 9, 69:3

EAGLE'S WING, directed by Anthony Harvey; screenplay by John Briley, based on an original story by Michael Syson; cinematography by Billy Williams; edited by Lesley Walker; music by Marc Wilkinson; produced by Ben Arbeid; released by the Samuel Goldwyn Company, a Rank Organization Film. At the Thalia, 95th Street and Broadway. Running time: 104 minutes. This film has no rating.
Pike ..Martin Sheen
White BullSam Waterston
Henry ...Harvey Keitel
The WidowStephane Audran
JudithCaroline Langrishe
The Priest ..John Castle
Sanchez ...Claudio Brook
Red Sky ..Jorge Luke
Lame WolfJosé Carlos Ruiz
Miguel ..Manuel Ojeda
Gonzalo ..Jorge Russek
Jose ...Pedro Damieari
MonkFarnesio De Bernal
Girl ..Cecilia Camacho
Don Luis ..Julio Lucena
Shaman ..Enrique Lucero

By JANET MASLIN

The grandly actorish manner of Anthony Harvey's ''Lion in Winter'' is less at home in the American West than it was in the court of medieval England, on the evidence of ''Eagle's Wing,'' a 1979 film by Mr. Harvey, previously unreleased in America, that opens today at the Thalia.

Its main character is an Indian brave — stern, noble, silent and mighty, played by the very un-Indian-like Sam Waterston. Also in the cast are Martin Sheen and Harvey Keitel as two seasoned pioneer types, and Stephane Audran as a beautiful widow. They all acquit themselves reasonably well while never dispelling the feeling that they're desperately out of place.

Also in the cast is a white horse, which has about as many lines of dialogue as anyone else in this taciturn drama. The trapper (Mr. Sheen) and the brave (Mr. Waterston) engage in a vaguely mystical duel for the horse, which changes hands a couple of times. John Briley's screenplay, from a story by Michael Syson, fails to invest this contest with the kind of purely visual meaning that might make up for the absence of conversation.

Mr. Sheen does talk, but mostly to the horse or himself. Mr. Waterston must rely on sign language, with both the horse and a traveling young Irish woman (Caroline Langrishe) whom he takes prisoner. However, the silence is no less oppressive than the occasional dialogue, which is thick with atmosphere. One woodsman: ''I wonder why you got kicked out of the army.'' Second woodsman: ''I didn't get kicked out of the army, I walked out. And I scattered a few teeth along the way, too.''

1983 O 9, 72:1

SO FAR FROM INDIA, directed by Mira Nair; photography by Mitch Epstein; edited by Ann Schaetzel; produced by Miss Nair. At Alice Tully Hall, as part of the 21st New York Film Festival; presented by the Film Society of Lincoln Center in cooperation with the Motion Picture Association of America. Running time: 52 minutes. This film has no rating.

The clash of cultures revealed in Mira Nair's ''So Far From India,'' which was shown at the New York Film Festival together with ''Dhrupad,'' creates some fascinating contradictions, which Miss Nair has ably explored.

Her film examines the marriage of Ashok Sheth and his wife, Hansa. Ashok moved to New York only days after the wedding, to a woman he barely knew; the match was arranged in the traditional way. Now Ashok sells magazines in a subway station at 116th Street, lives in a cell-sized apartment and cherishes his new freedom.

●

The film follows Ashok through such American activities as a visit to a store that sells running shoes. Then it follows him back to India, where Hansa waits with a baby he has never seen, and with a great many questions as to her future.

One out of three families on Ashok's street has sent somebody to America. And Hansa's sister once told Ashok: ''You are the engine that has to pull a whole train of cars to America.'' But it's not clear whether even his wife and child constitute too many cars for Ashok, who at one point declares: ''You forget everything in America — who's your wife, who's your brother. Your life is your own.''

Miss Nair captures much about Indian family closeness, American isolation and the illusions that would-be immigrants may harbor about visiting America. It's a cold place, Ashok's relatives declare repeatedly, but it must be very luxurious. They regard India as peaceful and beautiful, America as unpleasant but somehow necessary. Both attitudes are perceptively examined by Miss Nair.

Janet Maslin

1983 O 9, 72:1

STREAMERS, directed by Robert Altman; screenplay by David Rabe; photography by Pierre Mignot; edited by Norman Smith; produced by Mr. Altman and Nick J. Mileti; released by United Artists Classics. At Alice Tully Hall, as part of the 21st New York Film Festival; presented by the Film Society of Lincoln Center in cooperation with the Motion Picture Association of America. Running time: 118 minutes. This film has no rating.
Billy ..Matthew Modine
Carlyle ..Michael Wright
RichieMitchell Lichtenstein
RogerDavid Alan Grier
Rooney ..Guy Boyd
Cokes ..George Dzundza
MartinAlbert Macklin
Pfc. Bush ..B. J. Cleveland
Lt. Townsend ..Bill Allen
M.P. LieutenantPaul Lazar
M.P. Sergeant KilickPhil Ward

By VINCENT CANBY

''Streamers,'' Robert Altman's screen adaptation of David Rabe's tough, bloody, sorrowful stage play, is a maddening movie. It goes partway toward realizing the full effect of a stage play as a film, then botches the job by the overabundant use of film techniques, which dismember what should be an ensemble performance.

''Streamers'' will be shown tonight at 8:30 at Avery Fisher Hall as the official closing presentation of the 21st New York Film Festival at Lincoln Center.

●

Mr. Rabe's play, one of the major hits of the 1976-77 New York theater season, is confined to a single set, a bleak room in an Army barracks where five soldiers, under the bleary eyes of two boozy old sergeants, are awaiting assignment to Vietnam. The

Michael Wright is taken into custody in Robert Altman's ''Streamers.''

young men joke, reminisce, get drunk, fight and, in the way of foreshortened time in the theater, suddenly find themselves in a brutal life-and-death confrontation none of them could have predicted, or prevented.

Much of the power of the play is generated by this limited playing area, which is another expression of trapped lives. Mr. Altman has not attempted to disguise the theatrical origins of the film by moving outside this room.

As he did with ''Come Back to the Five and Dime, Jimmy Dean, Jimmy Dean,'' the director seems to relish the challenges offered by these physical limitations. Yet, also as in ''Jimmy Dean,'' he then makes what turn out to be all the wrong decisions in an effort to transform the play into a movie.

It's not possible to shoot such a film entirely from a fixed position in a middle distance, something equivalent to a seat in the auditorium of a legitimate theater. However, it also doesn't work to split up the overall view of the action in an endless succession of medium and tight close-ups, as Mr. Altman does. These have the effect of putting each actor into his own clear-plastic envelope, unless he's sharing the film frame with someone else.

I find it somewhat amusing that when ''Streamers'' was shown at this year's Venice Film Festival, its six principal actors were given a joint award for their ensemble performing, which is just what the movie doesn't offer.

The actors are good but Mr. Altman's camera, which has an elephantine presence of its own, upstages them. Each time an actor launches into a big, bravura monologue, the camera begins to move in on him, ponderously, with the awesome momentum of the Queen Elizabeth 2 approaching her berth. One forgets the camera is supposed to be recording a performance for fear that it is

going to run over the actor.

These things have the further unfortunate effect of calling attention to the highly literary quality of the script. Nobody in the theater ever pretends that what we're watching is reality. Movies, whether they intend to or not, evoke reality. Thus, much of Mr. Rabe's quite stunning dialogue, so startling on the stage, comes out sounding like much too much typewriting. Even though the film, which follows the stage script closely, has been cut, it seems three hours longer to watch.

●

Of the actors, Michael Wright, as Carlyle, a bad-mouthing, streetwise black, comes off least intimidated by the camera. It's a great role and when Mr. Wright is on the screen the film has a vital life of its own. Mitchell Lichtenstein plays Richie, the homosexual soldier, so broadly that the question of whether or not Richie ''is'' or ''isn't,'' which is supposed to be the trigger for the melodrama, doesn't exist in the movie.

●

Matthew Modine is good as Billy, the straight soldier terrified of what Richie may represent; David Alan Grier is Roger, the middle-class black soldier, and Albert Macklin plays the young soldier who, at the beginning of the film, is busy slitting one wrist, in this way to win a discharge. Guy Boyd and George Dzundza play the two drunken sergeants very well, but because of the way the film is shaped, each seems to be on screen too long.

''Streamers'' is not a movie. It's not a piece of theater. It's something less than either one.

1983 O 9, 73:1

FILM VIEW

VINCENT CANBY

'Rear Window'—Still a Joy…

After having had two retrospective showings at the 21st New York Film Festival, which closes tonight, Alfred Hitchcock's 1954 *chef d'oeuvre*, "Rear Window," has reopened in New York to become, quite simply, the most elegantly entertaining American film now in first run in New York or, possibly, in second-, third- or even fourth-run. Its appeal, which goes beyond that of other, equally masterly Hitchcock works, remains undiminished.

"Rear Window," which has been out of circulation for a number of years, is the first of five Hitchcock films that will be coming back to theaters in the next several months — the others being "Vertigo" (1958), "The Man Who Knew Too Much" (1955), "The Trouble With Harry" (1956) and "Rope" (1948).

As much as I admire all of these, especially "Vertigo," I can't imagine that any one of them will top the feelings of exhilaration that are prompted by "Rear Window," this most bittersweet of Hitchcockian suspense-romances. Make no mistake about it: "Rear Window" is as much of a romance as it is a brilliant exercise in suspense.

It's a very upper-middle class kind of Manhattan romance, played to the sophisticated nines by James Stewart, who, with Cary Grant, is the quintessential Hitchcockian hero, and the meltingly beautiful Grace Kelly in what is probably her most successful performance, one in which the facts of her public personality and the fiction of the film become marvelously mixed. Supporting them is the incomparable Thelma Ritter, whose voice could clean an oven, as the wisecracking representative of the happy though caustic proletariat.

• • •

Ever since I saw "Rear Window" when it was initially released, I've had fond memories of it, but, as rarely happens, those memories turned out not to do full justice to the film I went back to see last Sunday morning at the Cinema Studio. Everything about it is a joy, even the new print, the color quality of which is far superior to that of the 1963 "Leopard," also in reissue now.

What is responsible for the film's immense appeal? In a very general way, it effortlessly demonstrates all that we now understand to be the splendor of the Hitchcockian cinema of the absurdly logical. Yet "Rear Window" enchants us immediately, and need not be analyzed to death to achieve its place in the pantheon.

In "Hitchcock," François Truffaut's series of interviews with the director, published in 1967, Hitchcock says of "Rear Window" that he was "feeling very creative at the time. The batteries were well charged." He was also at the beginning of a terrifically fruitful collaboration with John Michael Hayes, who wrote the screenplay for "Rear Window," based on a story by Cornell Woolrich, and went on to do the screenplays for "To Catch a Thief" (1955), "The Trouble With Harry" and "The Man Who Knew Too Much."

However, nothing Mr. Hayes did before or after "Rear Window" quite equals the explosive concision of this possible mainstream masterpiece. In no other Hitchcock film, perhaps, not even in "Notorious," do the events of the adventure play such an integral part in the development of the love story.

As "Rear Window" begins — in a sequence that is a model of condensed exposition — L. B. Jeffries (Mr. Stewart), nicknamed Jeff, lies back in sweaty sleep in a wheelchair, his left leg propped up, enclosed in a plaster cast. The wheelchair is by the open window in Jeff's 10th Street studio in Greenwich Village. It is not yet 8 A.M., but the temperature is already in the 90's. Across the court, a couple sleeping on the fire escape stirs. We watch other anonymous, heat-exhausted city dwellers come to sluggish life.

Jeff, we quickly learn, is a top-notch news photographer who broke his leg while covering an automobile race for a Life-like magazine. He has one more week in the cast and he's impatient with everybody, including his boss (who remains an off-screen presence), his nurse (Miss Ritter) and his bright, sharp-tongued, loving friend, Lisa Fremont (Miss Kelly).

Lisa wants to get married, but Jeff cannot believe that anyone who travels in the pre-jet set that Lisa does, and who apparently spends as much time as she does on clothes, could last long in the sort of grubby, dangerous places to which his assignments carry him. The suspense of the film is provided by Jeff's growing suspicion that the jewelry salesman (Raymond Burr) who lives across the way has murdered and dismembered his wife. The film's comedy is provided by Lisa's showing that, when the chips are down, she's as capable

Grace Kelly's career must be one of the oddest.

of breaking-and-entering a possible murderer's apartment, scaling a wall to do so, as she is of wearing couture gowns. Jeff's delight in Lisa matches our delight in Miss Kelly.

All of the film's production elements are superior, especially the huge set, designed by Hal Pereira and built at the Paramount studio. It represents the best of studio artifice, being a unit that includes the rear of Jeff's apartment as well as his view of the garden court and buildings that enclose the court. There is one comparatively large, comparatively new apartment building, which is flanked by what appear to be brownstones, one Federal house and other buildings that have been remodeled out of all associations to the past. As lighted and photographed by Robert Burks, this set is as much a character as any of the actors in the film.

•

There is one detail about the set that forever fixes the film in the early to mid-1950's. That is the total lack of window air-conditioners around the garden court, even though the temperatures hang in the 90's through the course of the story. We see old-fashioned electric fans but no air-conditioners, possibly because there would be no story in this age of nearly universal artificial refrigeration, even for the budget-minded. Air-conditioners would mean closed windows, and "Rear Window" is completely dependent on open windows.

At the time "Rear Window" was first released, there was a certain amount of self-righteous outrage directed at the film's seemingly casual attitude toward voyeurism, sometimes called Peeping Tomism. I was mystified by those criticisms, then and now, and not necessarily because all of us probably tend to peep at one point or another, given the opportunity.

Hitchcock himself deals with this criticism in the film's classic final sequence, in which the suspected murderer, on whom Jeff has been happily spying for several days, confronts Jeff in person. "What do you want of me?" says the haggard, emotionally exhausted man. It's one of the keys to the movie. "What do you want of me?" Jeff doesn't answer, but everyone watching the film, spying on it, is suddenly brought up short with the realization that our entertainment has been provided by a rather coldly cavalier attitude toward another man's anguish.

At the heart of the film are the grand performances of Mr. Stewart, whose longtime star status in Holly-

Alfred Hitchcock—"The batteries were charged."

wood has always obscured recognition of his talent, and Miss Kelly, who, after receiving star billing in three previous films, showed that she was entitled to it in "Rear Window."

After nearly 30 years, the enormous glamour of these two personalities remains as fresh and attractive as ever.

The Kelly career must be one of the oddest as well as one of the briefest of any major star identified with the old studio system. Beginning with her first film, "14 Hours," in 1951, she made all of 11 films before her retirement in 1956 to marry the Prince of Monaco. Yet those 11 films firmly established a witty, sexy screen personality that no one since has ever matched. When she left the screen, it was difficult not to assume that she had simply moved on to another role that she would play in her own impeccable style.

The most moving and in some ways funniest moment during the telecast of the wedding of Britain's Prince Charles and Lady Diana several years ago was the moment when Princess Grace came down the aisle of St. Paul's on the arm of her son, Prince Albert. Being the most junior in rank of the representatives of "reigning monarchs" on hand, Grace and Albert led off that particular procession. However, it also seemed as if the empire were recognizing her quality — her determination, her talent and her beauty. The lady had class. ▪

1983 O 9, II:21:1

Kindest Cut of All

PHAROS OF CHAOS, directed by Wolf-Eckart Buhler and Manfred Blank; photographed by Bernd Fiedler; edited by Mr. Blank; produced by Mr. Buhler. At the Film Forum, 57 Watts Street. Running time: 119 minutes. This film has no rating.
WITH: Sterling Hayden.

By JANET MASLIN

DOCUMENTARY film making is at its most laissez-faire in "Pharos of Chaos," a profile of the actor Sterling Hayden by the West German film

makers Wolf-Eckart Buhler and Manfred Blank. Mr. Hayden — disdainful of his acting career, ashamed of having named names before the House Un-American Activities Committee in the 1950's and tremendously proud of his accomplishments as a seafarer — is undoubtedly a very interesting man.

He apparently was also, at least at the time the film was shot, an extremely heavy drinker. "You have a record of exactly what alcoholism is," he tells the film makers — and, to the extent to which they have anything identifiable, it is indeed this.

"Pharos of Chaos," which opens today at the Film Forum, was mostly filmed aboard the barge — apparently in Europe at the time — where Mr. Hayden lives.

●

A contentious Mr. Hayden spends several long afternoons in rambling conversation with the film makers, drinking wine and evidently smoking hashish all the while. Inevitably, this leads to a certain diffuseness of thought, which the film makers do nothing to mask. Every discussion is allowed to proceed far beyond its natural conclusion. "We had vaguely hoped that Hayden would drink less during filming," a narrator says at one point, but no one ever has the temerity to say "Cut."

Mr. Hayden has little to say about his Hollywood days, but a number of anecdotes about his drinking. He tells of seeing a panhandler and, while getting ready to give the man money, asking him, "How are you fixed for change?" The panhandler, deciding that Mr. Hayden looked even worse than he did, answered, "Brother, this morning I can't spare a dime."

Mr. Hayden sounds apologetic about his drinking, and somewhat bewildered by it. "What confuses me, if you'll excuse me," he says, "is I ain't all that unhappy. So why do I drink, I don't know." One morning, he describes having fallen into the canal the night before and very nearly drowning before being rescued by the son who lives with him. The film makers report this so matter-of-factly that their own attitude toward their subject begins to seem nonchalant to an absurd degree.

Mr. Buhler and Mr. Blank reveal a keen eye for the useless detail. Filming Mr. Hayden so stiltedly that they seem almost to be afraid of him, they rely on slow, restrictive camera movements to capture even the most tangential remarks. Half the scenes here feel like outtakes, as when Mr. Hayden sighs, "Jesus Christ, what an afternoon!" at a time when nothing appears to have been happening for a good 10 minutes. This makes for an unhappy spectacle all around, especially since Mr. Hayden seems excited about the film project and eager to communicate his thoughts and his history. Had the film makers carefully conveyed less about this tortured yet still-commanding figure, their film would undoubtedly have revealed more.

1983 O 13, C13:1

A Shake and a Song

HEARTLAND REGGAE, directed by Jim Lewis; cinematography by Mr. Lewis, John Swaby and Tony Marsh; editing by Mr. Lewis, Randal Torno and John Mayes; produced by John W. Mitchell an/ Canada Offshore Cinema Ltd. in association with Tuff Gong interntional & Media Aides Ltd. At the 8th Street Playhouse, at Avenue of the Americas. Running time: 90 minutes. This film has no rating.

WITH: Bob Marley and The Wailers, Peter Tosh, Jacob Miller and Inner Circle Band, Little Junior Tucker, Althea and Donna, Judy Mowatt and The Light of Love; U — Roy, Dennis Brown, Lloyd Parkes and We the People Band, Ras Lee Morris, The I-Threes, Natty Garfield

"HEARTLAND REGGAE" hinges on a handshake — a meeting, during the violent election year of 1978, between Prime Minister Michael Manley of Jamaica and his opponent and successor, Edward Seaga. It's a film and not a snapshot because it took place onstage at a concert by Bob Marley and the Wailers, adding a bit of gravity to what is basically a reggae concert movie.

The film's main asset is rare performance footage of Mr. Marley, who died in 1981. Ill-lit and often shot from unfortunate angles, the film still captures Mr. Marley's otherworldly stage presence — such extreme concentration on his songs that he almost seemed possessed by them.

The remaining hour includes good performances by the roly-poly singer Jacob Miller, who died in 1980, and the toaster, or rap singer, U-Roy — neither of whom had been seen much in the United States — plus a club show by the former Wailer Peter Tosh and a song each from other acts.

These are assembled apparently at random, and recorded clearly but without much bass. Holding together the concert scenes are inexplicable transitions involving a Rastafarian who declaims as torches burn, rides a motorcycle, goes swimming, lies in a hammock and smokes marijuana.

Frustrating as it is, "Heartland Reggae" still holds some documentary appeal for Bob Marley fans.

1983 O 14, C4:3

A New Old West

THE BALLAD OF GREGORIO CORTEZ, directed by Robert M. Young; screenplay by Victor Villasenor; screenplay adaptation by Mr. Young, based on the book "With His Pistol in His Hand" by Americo Paredes; director of photography, Ray Villalobos; edited by Arthur Coburn and John Bertucci; music by W. Michael Lewis and Edward James Olmos; produced by Moctesuma Esparza and Michael Hausman; released by Embassy Pictures. At Cinema 1, Third Avenue and 60th Street. Running time: 99 minutes. This film is rated PG.
Gregorio Cortez.................Edward James Olmos
Frank FlyJames Gammon
Boone ChoateTom Bower
Reporter BlakelyBruce McGill
Captain RogersBrion James
Mike TrimmellAlan Vint
Sheriff MorrisTimothy Scott
Romaldo CortezPepe Serna
Sheriff GloverMichael McGuire
CowboyWilliam Sanderson

By JANET MASLIN

"THE BALLAD OF GREGORIO CORTEZ," which opens today at Cinema I, offers two different perspectives on a legendary Texas manhunt. The sincerity of Robert M. Young's film is readily apparent, yet in its soft-spoken and serious way, "The Ballad of Gregorio Cortez" presents a no less exaggerated portrait of the old West than the wildest and woolliest cowboy sagas. If frontier characters didn't truly rope and ride and yell "Yahoo!" without interruption, neither can they have been as solemn, quiet and reflective as the figures in this deliberately muted drama.

The style of the film, which first appeared last year on public televison as part of the American Playhouse series, seems designed to create a greater intimacy and honesty than might usually be possible in a Western setting. But this intentional sim-

Edward James Olmos in "The Ballad of Gregorio Cortez."

plicity, though it grows increasingly effective as the film proceeds, is often so anachronistic that it creates as much distance between characters and audience as the more familiar rip-roaring cowboy style.

In 1901, a young Mexican named Gregorio Cortez (Edward James Olmos) killed a sheriff in Gonzales, Tex., after he misunderstood a question the sheriff asked him. At the subsequent trial, it was revealed that an interpreter had inadvertently distorted the sheriff's meaning and turned an inquiry into a threat. In any case, Cortez fled, and was chased for 11 days and 450 miles by a 600-man posse, which was led by the Texas Rangers. It may be some measure of the film's understatement that an audience never has the sense that so many men or miles were ever involved.

Mr. Young works hard to communicate the pathos of Cortez's situation, as a young husband and father who is hunted, captured, and subjected to a trial with an outcome that is a fait accompli. (The real Gregorio Cortez served 12 years of a 50-year sentence and was freed on the Governor's pardon.) Mr. Young also conveys some sense of the Texas Rangers at this point in their history, reaching toward respectability and attempting to shed some of their frontier ways. While all these things are presented in dramatic terms, the film has the feeling of an educational presentation.

The performances are often sympathetic, particularly that of Mr. Olmos, who starred in "Zoot Suit," and a cast that includes Bruce McGill, Brion James, Barry Corbin and Rosana DeSoto. But much of the acting share the one-note quality of the rest of the film, and also some of its detachment and passivity.

"The Ballad of Gregorio Cortez" tells what sounds like a stirring story, and its plainness would seem to be an asset. But something more was needed here, if not in the way of fireworks then maybe just in verisimilitude. The events may be real, and even the settings are authentic; the courthouse in which Mr. Young filmed the trial scene is the one in which Mr. Cortez's trial actually took place. That's not the sort of authenticity that the film lacks. What it's missing is the spark, surprise and immediacy that might have made its principals feel like people, rather than key figures in a well-meaning historical pageant.

●

"The Ballad of Gregorio Cortez" is rated PG ("Parental Guidance Suggested"). It contains some scenes of violence.

1983 O 14, C6:5

Ice and Mice

NEVER CRY WOLF, directed by Carroll Ballard; screenplay by Curtis Hanson, Sam Hamm and Richard Kletter, based on the book by Farley Mowat; narration written by C. M. Smith and Eugene Corr and Christina Luescher; director of photography, Hiro Narita; edited by Peter Parasheles and Michael Chandler; music by Mark Isham; produced by Lewis Allen, Jack Couffer and Joseph Strick; presented by Walt Disney Pictures. At the Gemini 2, 64th Street and Second Avenue. Running time: 105 minutes. This film is rated PG.
Tyler.........................Charles Martin Smith
Rosie...............................Brian Dennehy
Ootek..........................Zachary Ittimangnaq
Mike...............................Samson Jorah
Drunk...............................Hugh Webster
WomanMartha Ittimangnaq
Hunter No. 1Tom Dahlgren
Hunter No. 2Walker Stuart

By VINCENT CANBY

CARROLL BALLARD'S "Never Cry Wolf," which opens today at the Gemini 2 Theater, is a perfectly decent if unexceptional screen adaptation of Farley Mowat's best-selling book about the author's life among Arctic wolves. Being virtually a one-character film, and largely a straightforward record of that character's daily observations of the ways of the wolf, the film is considerably different from the melodramatic romance of Mr. Ballard's "Black Stallion."

In the interests of fiction, Mr. Mowat's first-person narrator in the book has been transformed into a character named Tyler (Charles Martin Smith), who, like the author, is a biologist sent into the Canadian Arctic to study the habits of Arctic wolves, which were then being blamed for the wholesale slaughter of caribou. Instead of finding ruthless, savage killers, Tyler discovers that wolves, though carnivorous, live mostly on a diet of mice, mate for life and are loving fathers to their cubs.

●

One of the book's more controversial points is that wolves and caribou exist in a symbiotic relationship. Wolves, according to Mr. Mowat, attack only weak and sick caribou, in this way helping to insure that only the fittest caribou are around to re-create the species. In their turn, the caribou provide wolves with a certain number of tasty feasts. It is Mr. Mowat's conviction that hunters, not wolves, have been responsible for the drastic reduction in caribou herds in recent years.

"Never Cry Wolf" looks to be one of those films somewhat more exciting to make than it is to watch, which is not to say there aren't a number of good things in it. The film makers are, unfortunately, all-too-faithful to the heavily jocular tone of Mr. Mowat's book, which reminds me a lot of the sort of hearty, "little-did-I-know-but" journalism I used to eat up in Field & Stream.

In their favor, Mr. Ballard and the people who wrote the screenplay avoid contrived melodrama. As played by Mr. Smith ("American Graffiti," "More American Graffiti"), the biologist is an appealingly eccentric fellow who, at the beginning, is made to seem unbelievably incompetent for the sake of both comedy and drama.

That is, I find it difficult to accept the fact that the biologist, just after an airplane has left him in the middle of an icy wilderness, in a snowstorm, would promptly get out his typewriter and, wearing woolen gloves, attempt to type up his initial reactions. A little later, acting like a man who might get lost in Bryant Park, he goes clumping across a frozen lake and falls through the ice.

After that, the movie treats him and his adventures without condescension. Though Tyler gives names like George, Angeline and Uncle Albert to the wolves he observes, and though he attributes anthropomorphic attitudes to them, the wolves themselves remain always at a distance, most of the time ignoring the presence of the biologist who is studying them.

The humor is as wholesome as it is instructive. In one sequence, Tyler sets out to mark his territory in the same way the wolves do, by urinating on bushes and rocks on the perimeter of his land. He is amused to realize that what has taken him a half a day, plus huge quantities of tea, to do, the wolf accomplishes in less than an hour, without stopping to drink water or tea.

Much Boy Scout sort of fun is also made of Tyler's successful attempt to live on mice, in this way to prove that an animal as large as a wolf can subsist on small rodents, if enough of them are consumed. Tyler eats mice in soup, in stew and even en brochette, usually leaving the tail as the last thing to disappear down his throat. In what is perhaps an homage to earlier Walt Disney movies in which animals act like people, there is a not-super scene in which mice are shown watching Tyler as he eats an all-mouse meal, squealing their horror in ways that, I assume, we are meant to see as cute.

The only other characters in the film are Rosie (Brian Dennehy), a bush pilot who comes to represent everyone who would exploit the Arctic wilderness for private gain; Ootek (Zachary Ittimangnaq), a wise old Eskimo who teaches Tyler many wolf

Charles Martin Smith

secrets, and Mike (Samson Jorah), a younger Eskimo who must kill wolves to support his family and send his children to school.

The scenery is often spectacularly beautiful. Mr. Smith is at his best when he is playing Tyler straight, without the comic exaggerations that suggest a small child showing off in front of adults. Perhaps the best thing about the film is that the wolves are never made to seem like strange but cuddly dogs. They look like wolves, not especially threatening but still remote and complete unto themselves.

•

"Never Cry Wolf," which has been rated PG ("Parental Guidance Suggested"), contains some scenes near the end when wolves are shown attacking a caribou, but the carnage is discreet.

1983 O 14, C8:1

Russian Resolution

26 DAYS IN THE LIFE OF DOSTOYEVSKY, directed by Alexander Zarkhi; screenplay by Vladimir Vladimirov and Pavel Finn; cinematographer, Vladimir Klimov; produced by the Mosfilm Studio; distributed by International Film Exchange in association with Sovexportfilm. Running time: 84 minutes. This film has no rating.
Fyodor Dostoyevsky..............Anatoly Solonitsin
Anna SnitkinaYevgenia Simonova
Appolinaria SuslovaEva Shikulska

THE 1981 Russian film "26 Days in the Life of Dostoyevsky" that begins a two-day run at the Thalia today is about several distraught weeks in the life of Fyodor Dostoyevsky in 1866. Pursued by creditors, mourning the deaths of his wife and his brother and working under the threat of bondage to his publisher, Dostoyevsky eventually triumphed over his writer's block and gloomy nature to finish "The Gambler."

Helping the 45-year-old writer, who was already a celebrity in St. Petersberg, was his pretty, 19-year-old secretary, Anna Snitkina, who later married him.

The film, which is handsome and well-acted, takes a rather conventional view of genius at work. The production is less interesting in itself than as evidence of the great staying power of the veteran Soviet director, Alexander Zarkhi, who was born in 1908 and who has been making movies since 1928, initially in collaboration with Joseph Heifitz ("Baltic Deputy," 1937), and alone since the early 1950's.

Anatoly Solonitsin, who has been seen here in leading roles in Andrei Tarkovsky's "Andrei Rublev," "Solaris" and "Stalker," plays Dostoyevsky with a good deal of passion, though it's difficult to see how he could have finished "The Gambler" in time to meet his deadline when dictating to a secretary who would — according to this film — burst into tears when she didn't like the way the characters were behaving.

Writer's block is a mysterious problem every writer must come to terms with on his own. Weepy secretaries are not mysterious. They should be dismissed at the first quiver of the lower lip.

Despite the tears, Yevgenia Simonova is very attractive as Anna, and Eva Shikulska, a blue-eyed beauty, is most convincing as Appolinaria, a wicked mistress whom Dostoyevsky seems to have mourned much more than he did his first wife.

Vincent Canby

1983 O 14, C8:5

Happy New Year

GET CRAZY, directed by Allan Arkush; screenplay by Danny Opatoshu, Henry Rosenbaum and David Taylor; edited by Kent Beyda and Michael Jablow; music by Michael Boddicker; produced by Hunt Lowry; a Herbert Solow Production. At Manhattan Twin, Second Avenue and 66th Street; Loews State, Broadway and 45th Street; Greenwich Twin, Greenwich Avenue and 12th Street. Running time: 92 minutes. This film is rated R.
Reggie WankerMalcolm McDowell
Max WolfeAllen Goorwitz
Neil Allan ...Daniel Stern
Willy LomanGail Edwards
Sammy FoxMiles Chapin
Colin BeverlyEd Begley Jr.
Susie ...Stacey Nelkin
King BluesBill Henderson
Auden ...Lou Reed
Captain CloudHoward Kaylan

IF a few of the characters in "Get Crazy," the hip, good-humored rock-and-roll comedy opening today at Loew's State and other

theaters, sound familiar, they certainly should. The action takes place on New Year's Eve at a Fillmore-like theater. The roster of performers is headed by one Reggie Wanker (Malcolm McDowell), a cockney egomaniac with 20 years of superstardom behind him, a socialite wife, a taste for high living, and a drummer (John Densmore of the the Doors) with a decidedly Rolling Stones-like demeanor.

Also appearing at the show, and even more readily recognizable, is a one-time rock bard whose career has been faltering of late. Auden, played by Lou Reed, is first seen sitting in the exact posture of Bob Dylan on the cover of his "Bringing It All Back Home Album," props and all. The mysterious woman in the red dress is still there, still holding that cigarette. By now she's covered with cobwebs and dust.

Allan Arkush, who directed "Rock and Roll High School" and who once worked at the Fillmore, obviously knows his territory. He and the screenwriters (David Opatoshu, Henry Rosenbaum and David Taylor) have filled the movie with knowing gags, most of them funny and reasonably shrewd. The plot is able to work in a band of hippies straight out of 1968 (with Howard Kaylan of Flo and Eddie, who is very amusing as their leader), two corporate yes-men (played by the onetime teen faves Bobby Sherman and Fabian Forte), a punk (Lee Ving of Fear) so vicious he's got to be chained to a staircase

when the other members of his band aren't watching him, and plenty of sight gags. One of these, if it can be called a sight gag at all, involves the funeral of a legendary black blues musician. The mourners all wear little black hats and sunglasses, and they're all blind.

•

Obviously "Get Crazy" isn't for everyone, but those well-disposed toward rock will find it energetic and funny. Everyone in the large cast, which also includes Daniel Stern, Allen Goorwitz, Miles Chapin and Ed Begley Jr. in backstage roles, seems to have taken a playful approach to the material, and the performances have a loose, cheerful tone. The various cameos are witty, and even the performance scenes work well. Mr. McDowell was brave enough to do his own singing, and he's mastered a few Jaggeresque stage moves.

The blues singer Bill Henderson performs with a backgroup group of orthodox Jews that has been booked by mistake, and a girls' punk band called Nada, led by Lori Eastside, puts in a convincing appearance. Miss Eastside, who's very lively here, was apparently hired as the film's choreographer before this role was developed to suit her. That kind of spontaneity has worked well for Miss Eastside, and very well for the film as a whole.

Janet Maslin

1983 O 14, C11:1

FILM VIEW

VINCENT CANBY

Longevity— The Real James Bond Mystery

One of the earliest and staunchest supporters of the James Bond films was Bosley Crowther, the late film critic of The New York Times, but by 1967 even he was beginning to suspect that enough was enough. Writing about "You Only Live Twice," the fifth of the phenomenal series started in 1963 with "Dr. No," Mr. Crowther said sadly, "The sex is minimal. But, then, Bond is getting old."

Two years later, another critic in The Times described "On Her Majesty's Secret Service" as "the sixth and possibly last installment in the adventures of 007." That writer, mourning his own youth in the 1960's when he had been naïve and seduced by the Bond films, decided they were not at all harmless and, in fact, "essentially sadistic and cruel."

Today James Bond is not only alive and benign, but the entire Bond phenomenon seems to have obtained an extraordinary new lease on life. At the moment there are two new James Bond films in release, "Octopussy," which opened in June and stars Roger Moore, and "Never Say Never Again," which opened in New York the week before last and returns Sean Connery to the role in which he was succeeded by Mr. Moore in 1973.

In addition, new, best-selling Bond novels continue to

be written by John Gardner under an agreement with the estate of Ian Fleming, who died in 1964.

As attractive as the character of 007 is, and as amusing as most of the films have been, this longevity is as mysterious to me as it is rare. All that one can do with any certainty is describe the phenomenon.

There's never been another series of films that have endured with quite the same élan as the Bond movies. All other films in long-running series have been B-movies, like the various Charlie Chan and Sherlock Holmes mysteries turned out in the 1930's and 40's. Only Bond has always traveled first-class.

Some statistics are in order to understand the series' relation to the decades through which it has passed. Including "Dr. No," there have been 14 Bond films, seven with Mr. Connery in the Bond role, six with Mr. Moore and one, "On Her Majesty's Secret Service" (1969), with George Lazenby, who departed after one try.

In 1967 there was also a huge, all-star Bond comedy, "Casino Royale," produced by Charles Feldman but unrelated to any other other Bond movies. The film version of "Casino Royale," based on Mr. Fleming's first Bond novel, was directed by six people, including John Huston, with a cast that included Woody Allen, as "Jimmy Bond," James's nephew, and an actress billed as "Jacky Bisset" playing a character called "Miss Goodthighs."

The first eight Bond films were produced by Albert Broccoli and Harry Saltzman. When Mr. Saltzman sold his interest in the rights after "Live and Let Die" in 1973, Mr. Broccoli carried on alone. Kevin McClory owns the rights to "Thunderball," which he produced with Mr. Connery as the star in a joint arrangement with Mr. Broccoli and Mr. Saltzman in 1965, and which he has now rather freely readapted as "Never Say Never Again."

To recapitulate the titles of the Bond films and their dates of release: "Dr. No," 1963; "From Russia With Love," 1964; "Goldfinger," 1964; "Thunderball," 1965; "You Only Live Twice," 1967; "On Her Majesty's Secret Service," 1969; "Diamonds Are Forever," 1971; "Live and Let Die," 1973; "The Man with the Golden Gun," 1974; "The Spy Who Loved Me," 1977; "Moonraker," 1979; "For Your Eyes Only," 1981; "Octopussy," 1983, and "Never Say Never Again," 1983.

When the film version of "Dr. No" came out, it was shortly after President John F. Kennedy had admitted that the Bond novels were among his favorite reading matter. Whether accurately or not, the first films made from the Bond novels came to characterize a number of aspects of the Kennedy Administration with its reputation for glamour, wit and sophistication, and its real-life drama and melodrama. Indeed, the President himself could be seen as a kind of Bond figure, and the 1962 Cuban missile crisis as a real-life Bond situation.

Even so, the series managed to outlive the era with which it was originally identified, though the films themselves did not radically change in formula: James Bond, the invincible, sexually omnipotent male, after numerous brushes with death, often in the form of chases, and after sleeping with a minimum of two women before finding Miss Right, with whom he also sleeps but without a clear conscience until the fadeout, saves the world from destruction, often at the hands of S.P.E.C.T.R.E., a terrorist organization with continuing ties to no one nation or ideology.

Just as the Cuban missile crisis did not dim the appeal of Bond movies about nuclear confrontations, the subsequent political assassinations, the Vietnam build-up, the antiwar demonstrations, Watergate, the oil crises and the wars in the Middle East have not apparently affected the public's enjoyment of Bond's make-believe world. Somehow Bond movies seem to sail above all realities without actually denying them. Neither do the films argue with critics who charge them with being callous, violent or chauvinist. They neutralize criticism as often as not by being too witty and good-humored to be taken too seriously.

The Bond films have survived all imitators, including the Our Man Flint and Matt Helm adventures. They have survived the sexual revolution that, in a casual way, they once represented in James's perfectly frank enjoyment of casual, promiscuous sex. Now, however, compared to the heroes of other contemporary films, James looks to be a practitioner of courtly love.

For all of Bond's wild, wild ways, no movie containing him has ever gone out with a rating more racy than PG, which is what "King Kong" received. As far as I can remember, Bond has never used drugs of his own accord, not even marijuana. Further, his fondness for the extra-dry martini seems almost to be a throwback to the 1930's. Could it be that he has managed to stay hip by being gloriously square?

One of the major reasons for the series' continuing critical success is not a big secret: Each film costs a fortune to make but virtually every cent of it is on the screen. The magnificent space-war that is the climax of "Moonraker" is as stylish as anything done by Lucasfilm. The outlandish sets, whether Dr. No's underwater laboratory or the volcano landing-pad in "You Only Live Twice," are almost always totally convincing.

The increasing dependence on elaborate physical gags, some of the finest of which often turn up in pre-credit sequences, does not mark a falling off of the intelligence of the films. On the contrary, these gags are simply glorifying the kind of action in which the Bond films traffic. Bond himself is certainly not an introspective sort. With or without the sometimes heavily facetious quips, he's a man of action, but random action in movies soon becomes tiresome. Eighty years ago, movie audiences may have ducked in their seats at the sight of a streetcar rolling toward them, but they soon collected themselves and demanded more complicated thrills.

It's to the credit of the people who make these films that the physical gags, the looks of the films and their soundtracks have continued to become increasingly spectacular.

Some of the people to be credited include Terence Young, director of "Dr. No," "From Russia With Love" and "Thunderball"; Guy Hamilton, director of "Goldfinger," "Diamonds Are Forever," "Live and Let Die" and "The Man with the Golden Gun"; and Lewis Gilbert, director of "You Only Live Twice," "The Spy Who Loved Me" and "Moonraker."

After seeing "Never Say Never Again," which was directed by Irvin Kershner, I'm not at all sure the public wants to worry about James Bond's getting old, though the film very wittily acknowledges that he — and Mr. Connery — are not quite as young as they once were. Having admitted that fact at the start of the film, where Bond is at a health farm getting back into the shape that too many women and too many martinis have denied him, "Never Say Never Again" goes on to show Bond/Connery performing at the same tireless pace he has displayed in every previous film.

Though Mr. Moore has done perfectly acceptable work as James Bond since he took over the role in "Live and Let Die," the character still seems to belong to Mr. Connery, even though "Never Say Never Again" is not quite as splashy an entertainment as "Octopussy," the Bond/Moore movie.

At times "Never Say Never Again" seems almost somber, which is not unpleasant though it's a contradiction in terms. Bond movies are meant to be escapist, not introspective, which is a quality that Mr. Connery, who's now a better actor than ever, brings to the film.

"Never Say Never Again" also has a terrifically witty villain, Largo, who, as played by Klaus Maria Brandauer, the star of "Mephisto," is a madman to rank with Joseph Wiseman's Dr. No, Gert Froebe's Goldfinger and Geoffrey Holder's Baron Samedi. Appearing in several throwaway scenes is Max von Sydow as Blofeld, the evil genius who runs S.P.E.C.T.R.E., a role that has been played in the past by Donald Pleasance and Telly Savalas.

I still don't understand the appeal of the Bond films, though I respond to them as faithfully as millions of other people. It's not their stories — I can't remember one plot from another without rereading old reviews. They are beautifully cast, but at this minute I'm not sure whether Herve Villechaize appeared in "The Spy Who Loved Me" or "The Man With the Golden Gun." The women in the films are fantastic, but so are the women in Playboy.

It's possible, of course, that the Bond movies, which once seemed so smartly, wickedly sophisticated, now reassure us by their courtly manners and by the orderliness of a world in which S.P.E.C.T.R.E., though never permenently defeated, never triumphs. In an era in which total victory might also mean total defeat, equilibrium is suddenly most alluring. ∎

1983 O 16, II:21:1

A Dancing Gypsy

CARMEN, (Spanish with English subtitles), directed by Carlos Saura; interpretation by Mr. Saura and Antonio Gades; choreography by Messrs. Saura and Gades; director of photography, Teo Escamilla; edited by Pedro del Rey; produced by Emiliano Piedra; an Orion Classics release. Running time: 99 minutes. This film is rated R.

Antonio...................................Antonio Gades.
Carmen...................................Laura del Sol
Paco.......................................Paco de Lucia
Cristina...................................Cristina Hoyos
Juan y Madrid.........................Juan Antonio Jiménez
Escamillo.................................Sebastian Moreno
Pepe Girón..............................José Yepes
Featured dancerPepa Flores

By VINCENT CANBY

AS saucy, wanton, inexhaustible femme fatales go, Carmen, the Spanish gypsy who first appeared in Prosper Mérimée's 1845 novel, must be one of the most popular and long-lived. Principally responsible, I suppose, is the continuing popularity of Bizet's 1874 opera. That "Carmen" goes on and on and on, whether conventionally performed, as it's done in most of the world's opera houses, or whether "adapted," as in Rodgers and Hammerstein's "Carmen Jones" and in Peter Brooks's production "Carmen," which will open shortly in the Vivian Beaumont Theater.

Since 1915, when Geraldine Farrar, the American soprano, appeared in a silent-movie version, "Carmen" has turned up fairly regularly on movie screens. Among the various incarnations have been the 1946 French film with Viviane Romance, the 1948 version ("The Loves of Carmen") with Rita Hayworth, Otto Preminger's screen version of "Carmen Jones" (1954) and, in 1968, Radley Metzger's "Carmen Baby," a made-in-Yugoslavia exploitation film with rock music standing in for Bizet's score.

One of the best of these very free adaptations must be Carlos Saura's flamenco "Carmen," which opens today at the Plaza Theater. Conceived by Mr. Saura and Antonio Gades, the famed dancer-choreographer and former director of the National Ballet of Spain, this "Carmen" combines dance, Bizet music and a modern if very slim narrative to find its own contemporary equivalent to the passionate 19th-century grandeur of the opera.

Mr. Saura, who directed the film, and Mr. Gades, who choreographed it and plays a central role, use as the frame of their film the story of a dance company rehearsing "Carmen," a production that seems to be as freely conceived as the film itself.

The search for the perfect leading lady turns up a beautiful, dark-haired young dancer named, coincidentally, Carmen (Laura Del Sol). In the course of practice sessions and rehearsals, Antonio (Mr. Gades), the troupe's director, choreographer and leading male dancer, falls in love with his star. When it comes to men, this Carmen's attention span is just as short as that of the Mérimée character.

The contemporary frame is not great and, by the time the movie is approaching its supposedly tragic climax, it has become quite awful. Miss Del Sol has a sultry screen presence, but her modern-day Carmen doesn't seem wicked or driven

"CARMEN"—Laura del Sol and Antonio Gades play the leads in the Spanish director Carlos Saura's modern-day interpretation of the enduring story of obsession and treachery.

enough to create the sort of mayhem necessary. The parallels between the contemporary story and Mérimée's don't work for a minute.

However, a lot of the other things do. Virtually the entire film is set in a large rehearsal hall in which Antonio and his dancer-singers, in practice clothes, go through the key scenes of their production, dancing sometimes to Bizet music — taken from a recording of the opera starring Regina Resnick and Mario Del Monaco — and sometimes to flamenco music provided by the troupe's own musicians.

In this way the film serves up bits and pieces of the opera to surprisingly moving effect. There's a riveting sequence near the start of the movie when Paco De Lucia, the guitarist in the movie as he is in life, adapts a Bizet melody to become a flamenco lament. The opera's fight between Carmen and another woman, who also works in the cigarette factory, becomes a dance of the sort of blinding vicious energy that one seldom ever encounters in an opera house. In this way, too, Mr. Saura succeeds in rediscovering many of the emotions that may elude today's opera audiences.

Miss Del Sol, Mr. Gades and Cristina Hoyos, who plays a leading dancer in Antonio's company as well as Carmen's rival at the cigarette factory, are so fine dancing their uncostumed variations on Bizet that it's always a letdown when the film insists on paying attention to the modern story. One longs to watch these performers do an entire, classic "Carmen" production, but in the physically pared-down, bare-stage

manner of their rehearsal hall.

Mr. Gades, who looks somewhat like a Spanish version of Roman Polanski, is terrific as long as he is dancing or showing others what to do and how. Unfortunately, as the modern equivalent to Don José, the soldier whose life is ruined by Mérimée's Carmen, he is not very persuasive at all. It's too bad but probably inevitable that the film ends with a giggle instead of a gasp.

1983 O 20, C21:3

Eerie and Unsettling

THE DEAD ZONE, directed by David Cronenberg; screenplay by Jeffrey Boam, based on the novel by Stephen King; director of photography, Mark Irwin; edited by Ronald Sanders; music by Michael Kamen; produced by Debra Hill; released by Paramount Pictures. Running time: 103 minutes. This film is rated R.
Johnny SmithChristopher Walken
Sarah BracknellBrooke Adams
Sheriff BannermanTom Skerritt
Dr. Sam WeizakHerbert Lom
Roger StuartAnthony Zerbe
Henrietta DoddColleen Dewhurst
Greg StillsonMartin Sheen
Frank DoddNicholas Campbell
Herb SmithSean Sullivan
Vera SmithJackie Burroughs
Sonny EllimanGeza Kovacs

By JANET MASLIN

THE combined talents of the novelist Stephen King, the director David Cronenberg ("Scanners") and the producer Debra Hill (who has the second and third "Halloween" films to her credit) would seem to suggest something much scarier than "The Dead Zone," a well-acted drama more

eerie than terrifying, more rooted in the occult than in sheer horror. It's a sad, sympathetic and unsettling movie, quietly forceful but in no way geared to the cheap scream.

As with "Cujo," the last film to have been adapted from one of Mr. King's novels, the story has its roots in reality even when its most fanciful elements come into play. This approach may not compete goosebump-for-goosebump with horror films of the chain-saw genre, but it works on its own terms. It's clear by now that film adaptations of Mr. King's books, which include "Carrie" and "The Shining" as well as the forthcoming "Christine," have their own brand of validity and momentum, and that these qualities may be even more apparent on the screen than they are on the page.

"The Dead Zone," which opens today at Loew's State and other theaters, evolves out of an automobile accident. A schoolteacher named Johnny Smith (Christopher Walken) is injured after a visit to his sweetheart, Sarah Bracknell (Brooke Adams); unlike many horror film victims, he isn't being punished for sexual promiscuity, since this has been a very chaste date. He falls into a coma — and when he awakens, five years have gone by. In the interim, Sarah has married another man, although she has never stopped loving her former fiancé. And Johnny has somehow developed the power of second sight.

What makes the film strangely believable is Johnny's reluctance to exploit this new power. As played hauntingly by Mr. Walken, Johnny is a guileless and rather passive man, one who regrets his new circumstances but cannot really fight them. After Johnny is made aware of his psychic abilities by Dr. Sam Weizak, a helpful and compassionate figure played by Herbert Lom, he tries very hard not to use them. But he can't avoid that: shaking hands with another person reveals that person's fate to Johnny. When he sees something evil, he can't help interceding.

"The Dead Zone" confines itself to a small-town setting as it involves Johnny in solving a murder, preventing an accident and finally in shaping the outcome of a political campaign. Mr. Walken handles these episodes thoughtfully and convincingly, and he also brings warmth to the ongoing, mostly unrequited love affair in Johnny's life. As Sarah, Miss Adams has a sparkling grin and a very appealing presence here, though most of her role involves the dandling of a baby. The baby figures instrumentally in the plot, since "The Dead Zone" is a film in which little is wasted.

Mr. Cronenberg's direction is vivid and effective; his pacing is a little unemphatic at times, but the film's individual scenes are very well staged. There's one murder here and one ritual suicide, but all in all this is a much less gory film than Mr. Cronenberg's recent "Videodrome." In this film as in that one, the hero stumbles onto something that may bring enormous power to whoever controls it, and he must then decide where his own responsibility lies. The treatment of that theme here is considerably less shrill than it was in "Videodrome," but no less powerful.

The excellent supporting cast, with a particularly good performance from Mr. Lom, includes Tom Skerritt as a sheriff entreating Johnny to help hunt a killer and Anthony Zerbe as a millionaire who thinks Johnny can help his withdrawn son. Martin Sheen

is colorful if overblown as a demagogue who's running for office and doesn't appreciate the full extent of Johnny's bizarre abilities until it is too late. And Colleen Dewhurst also appears, in the brief and bloody role of a mother who is loyal — much too loyal — to her murderous son.

1983 O 21, C8:1

Catching Up

THE RIGHT STUFF, written and directed by Philip Kaufman, based on the book by Tom Wolfe; director of photography, Caleb Deschanel; edited by Glenn Farr, Lisa Fruchtman, Stephen A. Rotter, Tom Rolf and Douglas Stewart; music by Bill Conti; production designer, Geoffrey Kirkland; special visual creations by Jordan Belson; visual consultant, Gene Rudolf; produced by Irwin Winkler and Robert Chartoff; executive producer, James D. Brubaker; a Ladd Company release, distributed by Warner Bros. Running time: 3 hours, 11 minutes. This film is rated PG.
Chuck YeagerSam Shepard
Alan ShepardScott Glenn
John GlennEd Harris
Gordon CooperDennis Quaid
Gus GrissomFred Ward
Glennis YeagerBarbara Hershey
Pancho BarnesKim Stanley
Betty GrissomVeronica Cartwright
Trudy CooperPamela Reed
Deke SlaytonScott Paulin
Scott CarpenterCharles Frank
Wally SchirraLance Henriksen
Lyndon B. JohnsonDonald Moffat
Jack RidleyLevon Helm
Annie GlennMary Jo Deschanel
Scott CrossfieldScott Wilson
Louise ShepardKathy Baker
Marge SlaytonMickey Crocker
Rene CarpenterSusan Kase
Jo SchirraMittie Smith
MinisterRoyal Dano
Liaison ManDavid Clennon
Air Force MajorJim Haynie
RecruitersJeff Goldblum, Harry Shearer
Chief ScientistScott Beach
Nurse MurchJane Dornacker
GonzalesAnthony Munoz
Head of ProgramJohn P. Ryan
Life ReporterDarryl Henriques
Eric SevareidEric Sevareid
Slick GoodlinWilliam Russ
Dwight D. EisenhowerRobert Beer
Eddie HodgesErik Bergmann
Aide to Lyndon B. JohnsonJames M. Brady
Sally RandPeggy Davis
Henry LuceJohn Dehner
AborigineDavid Gulpilil
Pretty GirlO-Lan Shepard

By VINCENT CANBY

"THE RIGHT STUFF," Philip Kaufman's rousing, funny screen adaptation of Tom Wolfe's book about Project Mercury and America's first astronauts, is probably the brightest and the best rookie/cadet movie ever made, though the rookies and cadets are seasoned pilots and officers.

The film almost makes one glad to be alive in spite of famines, wars and even "the greenhouse effect," which, if the Environmental Protection Agency is correct, means that the entire earth is inside its own space capsule that's rapidly overheating. "The Right Stuff" is full of short-term pleasures that yield to doubts only after the film is over.

•

Although the film, which opens today at the Beekman and other theaters, focuses mainly on the care, feeding, training and exploitation of the astronauts, its most commanding figure is not an astronaut but a great test pilot, Chuck Yeager, who exemplifies everything represented by the title.

Mr. Yeager, who in 1947 became the first man in the world to break the sound barrier, was not a member of Project Mercury but his story, in the film as in the book, more or less frames those of the astronauts. Systematically testing himself as well as his planes or, in the jargon of the space trade, "pushing the outside of the envelope," Mr. Yeager was the man against whom any pilot who thought he had the right stuff measured himself.

As played by Sam Shepard, the tall, lanky playright-actor, the film's

133

Chuck Yeager seems also to personify the reason and sanity that came close to being lost in the United States's hysterical drive first to catch up with the Soviet Union's space program and then to surpass it. Both as the character he plays and as an ironic screen presence, Mr. Shepard gives the film much well-needed heft. He is its center of gravity.

The three astronauts who come most vividly to life in the film are John Glenn (Ed Harris), the "clean Marine" who made this country's first successful orbital flight (and who today is the Democratic Senator from Ohio seeking his party's Presidential nomination); Alan Shepard (Scott Glenn), the first American to ride a space capsule in suborbital flight, and Gordon Cooper (Dennis Quaid), the comically self-confident astronaut whose successful orbital flight brought Project Mercury to its conclusion.

Much was made of Mr. Wolfe's accomplishment in finding the astronauts' idiosyncrasies that give the lie to the handsome, cookie-cutter profiles that were promoted, especially in Life magazine, during the life of Project Mercury in the late 1950's and early 1960's. Like the book, the movie strips away the nonsense to find — underneath the nonsense — men who are not really much different from their official portraits.

It's true that not all of the other astronauts were taken by the pieties that flowed so effortlessly from John Glenn's lips during his public appearances publicizing Project Mercury. It's also true that we see Alan Shepard violently objecting when Glenn attempts to scold the other astronauts for hell-raising and womanizing after hours. The astronauts use four-letter words and tell scatalogical jokes. We are even given indications that the marriage of Gordon and Trudy Cooper (Pamela Reed) is not as happy as it might be.

Yet these men remain virtually flawless heroes, almost too good, decent and brave to be true, and it's a measure of how successful the movie is that one is inclined to believe it. The movie doesn't say it but it's difficult to look at "The Right Stuff" without thinking that they represent the last gasp of 19th century American WASPdom.

Because they are generally so perfect, the movie's most appealing astronaut is Gus Grissom, (Fred Ward), who made Project Mercury's second suborbital flight, the one that ended in something of a mess when the capsule's hatch was prematurely blown and the capsule lost. Does or doesn't Gus Grissom have the right stuff? This impertinent question keeps the movie from becoming the unadulterated paean to American heroism and know-how it might otherwise have been.

"The Right Stuff" is very long — over three hours — but it has to be to cover the ground and space it must. Mr. Kaufman's screenplay is very efficient in the way it introduces so many characters and then crosscuts among them without confusion or repetition. The domestic lives of John Glenn, Gordon Cooper and Gus Grissom are movingly detailed. Best of all, the flight footage is remarkably convincing, from Shepard's first suborbital flight, when a full bladder threatened the entire operation, through Glenn's three orbits of the earth, and his perilous decent, and, finally, Chuck Yeager's last flight, his near-fatal attempt to set a new speed record in the NF-104 airplane.

Sam Shepard and Barbara Hershey appear as the legendary test pilot Chuck Yeager and his wife, Glennis, in the new film about America's journey into the space age.

Some things are not so good. The early desert sequences at Muroc, now Edwards Air Force Base, are so poetically photographed one gets the impression that the sun seldom sets in this desert but hangs always at 5 P.M. There is a perfunctory, service-comedy jokiness about urine specimens and barium enemas during flight training. The movie sees all Government officials as idiots, especially a couple of recruiters played by Jeff Goldblum and Harry Shearer. Though President Eisenhower is treated with a sort of dim respect, Lyndon B. Johnson, seen first as the Senate Majority Leader and then as Vice President, is made to look like a publicity-seeking buffoon. As played by Donald Moffat, who looks enough like the late politician to make a career impersonating him in revues, the movie's Lyndon Johnson is a character taken out of context.

More troublesome is the gingerly way the movie deals with the exploi-

tation of the astronauts, particularly their deal with Time Inc. that gave Life magazine exclusive rights to their stories. Is one correct in assuming that the astronauts saw this as simply their due, their financial reward for celebrityhood, another glorious benefit provided by this land of opportunity? One can't be sure.

Very clear, however, is the meaning of the final sequence in which the film cross-cuts between the heroic Chuck Yeager, testing his NF-104 over the California desert, and the astronauts in Texas, captured symbols of heroism, attending a gaudy, Lyndon Johnson-hosted barbecue that stars them alongside Sally Rand, the fan dancer.

There's not a weak performance in the entire film. In addition to those actors already mentioned, I'd like to cite Barbara Hershey, who plays Chuck Yeager's wife, Glennis; Mary Jo Deschanel, as Annie Glenn; Veronica Cartwright, as Betty Grisson, a

wife who has very mixed feelings about the treatment of her husband; and Kim Stanley as Pancho Barnes, the tough-talking owner of the desert saloon that becomes a hangout for pilots at Edwards Air Force Base.

•

"The Right Stuff," which has been rated PG ("Parental Guidance Suggested"), contains some vulgar language.

1983 O 21, C5:1

6-Point Fireworks

ALL THE RIGHT MOVES, directed by Michael Chapman; screenplay by Michael Kane; director of photography, Jan DeBont; edited by David Garfield; music by David Campbell; produced by Stephen Deutsch; released by 20th Century-Fox. Running time: 113 minutes. This film is rated R.
Stef...Tom Cruise
NickersonCraig T. Nelson
Lisa ...Lea Thompson
Pop ...Charles Cioffi
Greg ...Gary Graham

Salvucci	Paul Carafotes
Brian	Christopher Penn
Suzie	Sandy Faison
Bosko	James A. Baffico
Jess Covington	Mel Winkler
Tank	George Betor
Shadow	Leon Robinson
Mouse	Jonas C. Miller
Fox	Keith Ford
Tracy	Paige Price
Charlotte	Debra Varnardo
Coach	Donald A. Yannessa
Sherman Williams	Kyle Scott Jackson
Henry the Bartender	Victor Arnold
Teacher in Auditorium	Dick Miller
Drunk in Bar	Clayton S. Beaujon
Kurowki	William L. Stibich
Girl at Party	Mercy L. Rigby
Angela	Emma Floria Chapman
Woman at Wedding	Mary Mihaljevic
Friend No. 1	Dana Hoover
Friend No. 2	Laurel Eatman
Principal	Donald B. Irwin
Civics Teacher	Darlene Dudukovich
Gina	Valerie Zabala
Detectives	John W. Simkovic, Bill Slivosky
Guard	Greg Jacobs
Official	Thomas R. Boyd
Walnut Heights Center	Phillip Zdunczyk

TODAY'S version of the Horatio Alger story doesn't necessarily involve hard work. It may center on sheer ambition, which is shown to lead inexorably, even automatically, to glory. The latest example of this is "All the Right Moves," a well-made but sugar-coated working-class fable about a football star. It concerns a nice boy who wants to "be somebody," the athletic career that he hopes will bring him a college scholarship and the Pennsylvania steelmill town from which he's determined to escape. The bluer the collar of such a young man, the more miraculous the payoff he will eventually receive — or at least that's the current Hollywood logic.

"All The Right Moves," which opens today at the Criterion Center and other theaters, is about Stef Djordjevic (Tom Cruise), a clean-cut young hero in a bleak little town. Stef's father and brother already work in the local steel mill, American Pipe and Steel, from which the town — Ampipe — takes its name. Ampipe is so dismal that when when a friend of Stef's is forced to marry his cheerleader girlfriend, the newlyweds go to Pittsburgh for their honeymoon. There's nothing to do in Ampipe but drink, weld and root for the local football team.

•

Stef dreams of becoming an engineer, and he has a sweetheart named Lisa (Lea Thompson) who wants to be a musician. For the time being, they must content themselves, respectively, with the football team and the high school band. The film takes these and other school activities very seriously, just as it carefully charts the course of Stef and Lisa's romance. A pep rally, a typing class, an away game at which the other team's touchdowns are commemorated with fireworks — events like these are chronicled here with the utmost gravity.

As directed by Michael Chapman, the superb cinematographer whose credits include "Raging Bull" and "Taxi Driver," "All the Right Moves" is by no means a bad film or a disingenuous one. Its sense of place is distinct, its acting convincing and its sentiments feel sincere. But for all its air of realism and grit, the film has a fairy-tale quality. It's also full of racial and sexual stereotypes, from the black football players who are better dancers than their white teammates to the coach's wife whose woman-to-woman chat with Lisa is rich with feminine intuition.

Tom Cruise, who starred in "Risky Business," makes Stef honest and believable, though in Stef's hotter-tempered scenes Mr. Cruise seems

overly mild. He's better at suggesting Stef's worried, tentative side and his boyish bravado than at conveying the discipline and determination through which Stef hopes to succeed. As the coach who becomes Stef's antagonist, and who has his own ambitions of bidding Ampipe adieu, Craig T. Nelson is a daunting and effectively mysterious figure here, someone whose motives are only partially explained by Michael Kane's screenplay.

•

Among the other notable performances here are that of Miss Thompson, who conveys exactly what Lisa will be like when she's fully grown, and Christopher Penn, who makes Brian, the shotgun bridegroom, a touching figure. Unlike Stef, he faces a grim future, although he seems no less clever or talented than his luckier teammate. It's just that Stef, being the movie's hero, is the one who has a last-minute miracle in store.

Janet Maslin

1983 O 21, C10:3

Wartime Choice

UNDER FIRE, directed by Roger Spottiswoode; screenplay by Ron Shelton and Clayton Frohman; story by Mr. Frohman; director of photography, John Alcott; music by Jerry Goldsmith; edited by Mark Conte; produced by Jonathan Taplin; Edward Teets, executive producer; distributed by Orion Pictures. Running time: 108 minutes. This film is rated R.

Russel Price	Nick Nolte
Oates	Ed Harris
Alex Grazier	Gene Hackman
Claire	Joanna Cassidy
Isela	Alma Martinez
Journalist	Holly Palance
Nightclub Singer	Ella Laboriel
Jazz Combo	Samuel Zarzosa, Jonathan Zarzosa, Paul Picasso
Boy Photographer	Oswaldo Doria
Businesman	Fernando Elizondo
Regis Seydor	Hamilton Camp
Jazy	Jean-Louis Trintignant
Hub Kittle	Richard Masur
Guerrilla Leader	Jorge Santoyo
Guerrilla Woman	Lucina Rojas
Waiter	Raul Garcia
Captured Businessman	Victor Alcocer
Time Stringer	Eric Valdez
Young Journalist	Andaluz Russel
Arresting Officer	E. Villavicencio
Prison Priest	Enrique Lucero
Interrogating Officer	Enrique Beraza
Miss Panama	Jenny Gago
Sandinistas at Leon	Elpidia Carrillo, Martin Palmares, Gerardo Moreno
Pedro	Eloy Phil Casados
Priest	Carlos Romano
Somoza	Rene Enriquez
Soldier at Matagalpa	Jose Campos Jr.
TV Camera Crew	Halim Camp, Antonio Mata Jr.
Small Boy	Julio Cesar Vazquez
Commandante Cinco	Martin Lasalle
Commandante	Filipe Ytuarte
Rafael	Jorge Zepeda
Soldiers at Roadblock	Alfredo Gutierrez, Jose Marin
Soldiers at Jazy's house	J. A. Ferral, E. Baramona, Octavio Cruz
Woman at Shanty Town	Leonor Llausas
Boy Soldier	Juan Carlos Meizveiro
Squadron Commander	Humberto Vilches
Hotel Clerk	Roberto Dumant
Muchachos at Jazy's house	Ahui Camacho, Arturo R. Doring, Bruno Bichir

ROGER SPOTTISWOODE'S "Under Fire" examines the consciences of three ambitious, globe-trotting journalists, each presented as being tops in his or her field, and decides that there comes a time when a journalist must forget impartiality and become committed.

This sounds somewhat better than it plays in "Under Fire," a romantic melodrama set in 1979 Nicaragua, in the weeks just before the fall of the dictatorship of President Somoza and the triumph of the revolutionary Sandinist forces.

The three journalists, who are first seen in Chad, whose war they've apparently worked for all the bylines they can get, are Russel Price (Nick Nolte), a hot-shot, free-lance photog-

Nick Nolte in "Under Fire."

rapher; Alex Grazier (Gene Hackman), a roving correspondent for Time magazine, and Claire Stryder (Joanna Cassidy), who seems to be a free-lance radio correspondent, the sort who uses a tape-recorder instead of a typewriter and whispers into her mike such scoops as "I see a woman running down the street carrying a pig."

Claire has been Alex's mistress but, as the movie begins, they are cooling it and her affections are switching to Russ. This, however, is not the real point of the film, which is about the curious radicalization of Russ and Claire once they reach Nicaragua. Mr. Spottiswoode and his writers picture the Nicaraguan revolution as being somewhat smaller and more full of coincidences than it probably was. Though we see other reporters, Russ, Alex and Claire appear to be the only people really working.

For Russ this means getting some exclusive pictures of a revolutionary leader known as Rafael, who is presented by the film as being the inspiring heart and soul of the Sandinist movement. Just after Somoza has announced the death of Rafael, Russ is contacted by Sandinistas. They take him and Claire to a hideaway where, he is told, he will be allowed to photograph their leader. There's just one hitch, however. Rafael actually is dead, and Russ is asked to shoot the corpse in such a way that the truth will be subverted.

Their argument is that President Carter is considering sending additional aid to Somoza, but if the Americans believe Rafael is living, they will not continue to back the incompetent dictator. "I'm a journalist," says Russ. "This has nothing to do with journalism," says the rebel as, of course, it doesn't.

Russ wrestles with his conscience. Says Claire, of the picture Russ may or may not take, "It sure will be a prize-winner!" Russ: "I've won enough prizes." Claire: "But not a war." Russ, who has seen people murdered by representatives of the Somoza regime and has met a young rebel who loves freedom and the Baltimore Orioles, throws his lot in with the rebels. He takes the picture and the Sandinistas successfully get rid of Somoza or, as Claire might say into her mike, they "topple the tyrant."

•

"Under Fire," which was written by Ron Shelton and Clayton Frohman, from a story by Mr. Frohman, means well but it is fatally confused. It's silly enough to use a real, bloody war as the backdrop — the excuse,

really — for the raising of the consciousnesses of a couple of mini-characters. It's even worse that the photographer's decision to fake a crucial picture is presented as a heroic choice.

This certainly does give a new interpretation to the old Hiram Johnson quote to the effect that the first casualty of war is truth. Senator Johnson, I think, meant that to be a warning or, as the authors of "1066 and All That," another example of crazy history, might put it, "not a Good Thing." From this film, you might think that Russ's decision will win him a Pulitzer Prize.

There's plenty of thought to be given to journalists who get so caught up in the practice of their trade — seeing the world entirely in terms of the stories they write about it — that they forget that the events they're covering involve the lives and deaths of real people. "Under Fire" just muddles the issue.

Fortunately it's not good or convincing enough to do much damage. The three leading characters are not individuals but functions of the mixed-up plot. One subsidiary character is of somewhat more interest.

He is a viciously amoral, apolitical American mercenary soldier, extremely well played by Ed Harris, who, I report with some awe, uses many of the same mannerisms here that are so effective in his performance as John Glenn in "The Right Stuff."

"Under Fire" opens today at the Astor Plaza and other theaters.

Vincent Canby

1983 O 21, C13:1

Carousel Incidents

AMERICANA, produced and directed by David Carradine; story and screenplay by Richard Carr, based on "The Perfect Round" by Henry Morton Robinson; director of photography, Michael Stringer; music by Craig Hundley; edited by Mr. Carradine and David Kern; executive producer, Skip Sherwood; released by Crown International Pictures. Running time: 91 minutes. This film is rated PG.

The American Soldier	David Carradine
Jess's Daughter	Barbara Hershey
Mike the Garage Man	Michael Greene
Ole Storekeeper	Arnold Herzstein
Sandy	Sandy Ignon
John	John Barrymore 3d
Greg	Greg Walker
Cop	Bruce Carradine
Old Lady	Glenna Walters
The Colonel	Fran Ryan
The Lieutenant	Claire Townsend
Wrecking Yard Man	David Kern
Jake	Dan Haggarty
New Storekeeper	Buz Storch
Bartender	James Kelly Durgin
Grateful Dead Fan	Rick Van Ness
The Local Dog	Buffalo
The Fighting Dog	Masagwa
The people of Drury, Kansas, as themselves	

A MERRY-GO-ROUND provides the overworked central metaphor for David Carradine's "Americana," a film that seems to have emerged from a time warp very much the worse for wear. Shot in the mid-1970's, written by Richard Carr from a novel by Henry Morton Robinson, it features Mr. Carradine as a soldier who arrives in Kansas with his Vietnam experience fresh in his mind. He is, in the words of one of the film's few characters to do much talking, "one weird dude."

In the middle of town, he spies a run-down old carousel and takes on the project of restoring it to usefulness. The entire film concentrates on carousel-related incidents. An elderly storekeeper sells the soldier supplies while offering folk truisms like, "You don't bother nobody, nobody'll bother you around here." A local policeman

(Bruce Carradine) harasses him, as do the town bullies. A garage mechanic (Michael Greene) displays mixed and volatile feelings about the soldier and his project. And a barefoot girl in a thin little frock watches the repair process, running away each time the soldier sees her. Barbara Hershey, as this prairie nymph, does nothing here but spill out of her dress and scamper bashfully away from the camera.

Mr. Carradine's screen presence is always one of quiet authority, but as a director he demonstrates no notion of how to harness that power. His silence here borders on the inarticulate, and the screenplay's sparingness in explaining his past is far too stony. There is at least as much presumption to the title as there is authenticity. And the use of amateur actors — "the people of Drury, Kansas," as themselves, say the credits — is less a help than an affectation.

The climactic scene in "Americana," which opens today at the Embassy 72d Street theater, involves a dog. The soldier is taunted into fighting the dog, and he kills it. He must do this in order to earn the last part needed to restore the merry-go-round's motor. Finally, he weeps over the carcass, places it on a carousel seat, sets the machinery in motion and walks away. Anything this moment reveals about Vietnam and about America, not to mention about

dogs and merry-go-rounds, has been said better elsewhere.

•

"Americana" has been rated PG ("Parental Guidance Suggested"). It contains moderately strong language and sexual innuendoes.

Janet Maslin

1983 O 21, C14:5

FILM VIEW

VINCENT CANBY

A Tale of Two B-Movies: One's Plain, the Other Fancy

"Rumble Fish," a teen-age gang film with aspirations to create its own mythology, set in what may be Tulsa, Okla., is Francis Coppola's second attempt within the year to make a mountain of a movie out of a molehill of a young-adult novel by S. E. Hinton. Like "The Outsiders," which was released in March, "Rumble Fish" is full of unintentional giggles but, unlike that earlier film, "Rumble Fish" has a feverish, partially redeeming, cockeyed grandeur to it. Probably no one else but Mr. Coppola would have the nerve to attempt such a mixed-up film, the ability to obtain the financing for it, or the talent to make it as interesting as it is in spite of its comically inflated pretensions.

• • •

"Rumble Fish" is not a success, but there is something deserving of attention in its failure. Mr. Coppola thinks BIG, which is better than not thinking at all.

A nearly perfect mate to "Rumble Fish" is Jonathan Kaplan's "Heart Like a Wheel," which is also essentially a B-movie but one that glories in the very smallness — the literalness — that "Rumble Fish" will have nothing to do with. The two films seen back to back, as I saw them by chance last week, vividly illustrate the sorts of things commercial American film makers do best and worst.

One knows that "Rumble Fish" means to be serious when it starts out in black-and-white and stays that way, with the exception of scenes in a pet store where we see Siamese fighting fish. The fish, which, of course, are symbolic, are shown to be red or blue in otherwise black-and-white images. Just what they symbolize I'm not at all sure, but it has something to do with fighting for territory.

Life in the unidentified city that is the setting of "Rumble Fish" is not what it once was. There are no real street gangs any more. Drugs, apparently, have so destroyed the fiber of the youthful hoods that they couldn't care less about rumbling on a large scale. Even the city doesn't appear to be itself. Though it looks as if it is in the Middle West, it's full of thick waves of vapor that at times suggest a London fog, at other times the smoke from a pile of burning leaves that's gotten out of hand. Clouds fly over this city fast, as if they couldn't wait to get someplace else, like Dallas or Fort Worth.

The city in general and a young man named Rusty-James (Matt Dillon) in particular are haunted by the memory of a fellow known as the Motorcycle Boy, who is Rusty-James's older brother. For a few brief, idyllic years, it seems, Motorcycle Boy (Mickey Rourke) gave the youth of this city someone to look up to. He was a born leader, but then he disappeared. In scene after scene, Rusty-James wanders desolately around this picturesque, black-and-white city, under its scudding clouds, in front of its dark shadows, searching for a future. He hangs out in Benny's Billiards, fights an occasional two- or three-man rumble, and now and then makes out with a pretty girl named Patty (Diane Lane).

When Motorcycle Boy suddenly returns with tales of having driven all the way to California, Rusty-James and his pals expect life will take on meaning again. The audience expects that a plot will develop. Everyone winds up

dissatisfied.

At one point Rusty-James joins some of his friends for an orgy at a summer resort, but the orgy, though steamy, lasts for no more than a minute of screen time, as if reflecting the short attention spans of Rusty-James and his friends. On two succeeding nights, Rusty-James gets badly beaten up, but each morning he reappears none the worse for wear. He tells his brother that he (Motorcyle Boy) could be a Pied Piper and maybe lead a new gang, but Motorcycle Boy is not interested. "Rumbles are boring," he says.

• • •

The movie is nothing if not symmetrical. It opens with Rusty-James being advised that he is expected to fight a fellow named Wilcox at 10 that night "under the arches behind the pet store." I had originally thought that this was a random bit of poetry, since the association of a pet store with a gang fight seemed so — well — unusual. Not at all. The pet store plays a key part in the film's climax, when Motorcycle Boy decides to break into the store and free all the pets, especially the Siamese fighting fish, which he wants to put into the river so they can swim all the way to the ocean.

Mr. Coppola treats Rusty-James and Motorcycle Boy as if they were figures in a Norse saga, gods dispossessed from Olympus or Round Table knights after the decline of Camelot. The soundtrack announces their arrivals and departures with portentous, mod-primitive orchestrations. Even the weather attends to their moods. When the camera spies a bar called "Cain's," Mr. Coppola also appears to want to make something of the relationship of the two brothers, though nothing comes of it, certainly nothing on the order of fratricide.

Why does one stay with "Rumble Fish" from start to finish? Mainly, I think, to see just how far Mr. Coppola will go in his attempt to transform these small, inarticulate characters into mythological creatures. The movie is grandiose, but grandiosity on this scale can be fascinating. There's something almost Promethean about its wrongheadedness, as there was with "One From the Heart."

The late Maxwell Anderson became equally windy in his attempts to turn the grim facts of the Sacco-Vanzetti affair into the verse tragedy of "Winterset." But Anderson, at least, had a good story. The only point of these Coppola-S. E. Hinton collaborations is to present teenage audiences with bogusly heroic characters they can see as extensions of themselves.

Whether or not they are successful depends, I suspect, on just how much fruity dialogue the kids will swallow in the course of any one film. Among my favorite lines: "He's like royalty in exile — yuh know what I mean?" and "California is like a beautiful wild girl on heroin, not aware she's dying."

"Rumble Fish" rivets the attention in the way it so tirelessly attempts to disguise what might have been a perfectly respectable B-movie about urban teen-agers. "Heart Like a Wheel" is a B-movie and proud of it.

With a marvelous simplicity and appreciation for detail, "Heart Like a Wheel" tells the real-life story of Shirley (Cha-Cha) Muldowney, a Schenectady house-

wife, mother and waitress who became one of this country's most successful drag racers. Bonnie's story is very particular, one that means exactly what it says and doesn't pretend to represent anything but what we see. Like the best B-pictures of yesteryear, "Heart Like a Wheel" has has an absolutely accurate eye and ear for the way its blue-collar characters look, dress, talk, decorate their houses, fight, love, eat and otherwise amuse themselves.

When first seen, Shirley is 4 or 5, the apple of her dad's eye, sitting on his lap as he speeds down a country highway, allowing her to steer to get a "feel" for the wheel. Cut some years into the future and Shirley is the "second" to her boyfriend, Jack, who drag races at night and, by day, works and saves to own his own garage. When Jack refuses to take up a drag-race challenge, Shirley steps in and wins the $100 purse. From that moment on, it's first downhill and then up for Shirley as she heads toward her succession of championships.

Shirley's ambitions, and the ways she goes about realizing them, may or may not have application to other women seeking to break with convention. Mr. Kaplan, the director, and Ken Friedman, who wrote the screenplay, never take their eyes off the road, which is the story, to search the stars for some greater meaning. However, because they appreciate Shirley's idiosyncrasies, as well as her spirit, intelligence and feelings, they have made a film that is as socially instructive and moving as it is entertaining. They aren't so jaded that, to find the point in Shirley Muldowney's life, they must turn her into a goddess of the Tarmac.

Mr. Kaplan is a film maker who obviously knows what he is doing. His "Over the Edge," released here in 1981 but produced several years earlier, is the best movie about teen-age despair since "Rebel Without a Cause." It's also a lot funnier and a lot less sentimental than the Nicholas Ray movie. "Heart Like a Wheel" is even more sure of itself.

Exemplifying the efficiency and humor of the movie is the strong, funny, sharply observed performance of Bonnie Bedelia as Shirley, who ages approximately 25 years in the course of the story. Miss Bedelia, one of our most under-used movie resources, hasn't had a decent role in films since "They Shoot Horses, Don't They?" (1969), in which she played an Okie marathon dancer. The actress has come a long way since her waif days. Excellent support is provided by Leo Rossi, who plays Jack Muldowney, the husband who sticks by her a lot longer than most husbands might, and Beau Bridges, as a driver who teaches Shirley just about everything she knows about racing, cars and after-hours infidelity.

"Heart Like a Wheel" is a terrifically winning small movie — lithe, bright and self-aware. ∎

1983 O 23, II:19:1

Tourist's View

SANS SOLEIL, directed written, photographed and edited by Chris Marker; produced by Anatole Dauman/Argos Films; distributed by New Yorker Films. At the Film Forum, 57 Watts Street. Running time: 100 minutes. This film is not rated.
Narrator: Alexandra Stewart

By VINCENT CANBY

WHEN Chris Marker, the veteran French film maker and longtime practitioner of cinéma vérité, talks about the "involved objectivity" of his films, a phrase that seems to contradict itself, he's also describing the contradictions within those movies, especially within "Sans Soleil," his new work that opens today at the Film Forum.

In "Sans Soleil" Mr. Marker pretends to be examining the quality of contemporary life, though what he actually is doing is examining his own, not always coherent or especially interesting reactions to our world. "San Soleil" is a totally self-absorbed movie that closes out all but the most devoted Marker students.

Photographed mostly in Japan and West Africa, the film cross-cuts between random shots of bewildered, poverty-stricken Africans and scenes set in the supposedly more civilized banlieues of Tokyo.

At times "Sans Soleil" looks like a rather circumspect "Mondo Cane," a travelogue that is resolutely unsensational except for one sequence in which the audience watches as a giraffe is shot to death and then eaten by vultures. Mr. Marker also jazzes up some sequences by inserting clips from old horror films or by putting his footage through a video synthesizer.

At its best, the film expresses a leisurely sort of curiosity about the ways others live. Much of the time, though, its manner alternates between that of a patronizing tourist and that of an amateur anthropologist, even when it's examining the faces of sleeping passengers on a Japanese train. "Now," says the narrator, "all I'm interested in are the banalities of life."

Unfortunately, that's not quite true. Banalities, presented simply and purely, might be fascinating, but Mr. Marker refuses to let his banal images reveal their secrets on their own. "Sans Soleil" is smothered by its insistent narration, which keeps up a nonstop, usually uninformative commentary on the scenes being shown. Alexandra Stewart, who here sounds as if she'd taken too many elocution courses, speaks the English language prose that is full of poetic non sequiturs, oddball facts and similes that frequently don't work at all.

At one point the film cuts to San Francisco, where Mr. Marker makes a solemn pilgrimage to the locations used by Alfred Hitchcock in "Vertigo." Even to someone who shares Mr. Marker's admiration for "Vertigo," this kind of reverence is ridiculous. It also seems to expose the essential nature of the film. "Sans Soleil" is less concerned with the quality of life on this planet than with its own desperate, much more private search. That search is for a film format into which the director can stuff all the footage from his vacation travels.

As one who has admired Marker films in the past, particularly "Le Joli Mai," a cinéma-vérité portrait of Charles de Gaulle's France, "Sans Soleil" is a great letdown.

1983 O 26, C24:2

Cultural Dislocation

THE TWO WORLDS OF ANGELITA, directed and produced by Jane Morrison; written (Spanish with English subtitles) by Jose Manuel Torres Santiago, Rose Rosenblatt and Miss Morrison; director of photography, Affonso Beato; edited by Suzanne Fenn; music by Dom Salvador; presented by Puerto Rican Foundation for the Humanities; a First Run Features Release. At the Carnegie Hall Cinema, Seventh Avenue and 56th Street. Running time: 73 minutes. This film is not rated.
Angelita..............................Marien Perez Riera
FelaRosalba Rolón
ChuitoAngel Domenech Soto
Dona AngelaDelia Esther Quinones
Don CurroRoberto Rivera Negrón
ManoloPedro Juan Texidor
FortunaIdalia Pérez Garay
Goyin ...Bimbo Rivas
Rosa ..Geisha Otero
LittlemanMalik Mandes
LindaSandra Rodriguez

"THE TWO WORLDS OF ANGELITA" ("Los Dos Mundos del Angelita") is a simple, direct film about the problems that face the members of one Puerto Rican family when they leave what appears to be an idyllic rural community to make new lives on Manhattan's Lower East Side. The movie, which opens today at the Carnegie Hall Cinema, is a first feature by Jane Morrison, whose earlier films have been documentaries.

Most of the story is seen through the dark, expressive eyes of Angelita (Marién Pérez Riera), the small daughter who accompanies her mother, Fela, north to join her father, Chuito. According to his letters home, Chuito has found a fine new job in Manhattan. When the job falls through because he doesn't speak English, the family is put to emotional as well as economic tests.

Though Angelita also has language problems in school, both she and her mother find it easier to adapt than Chuito. At the end it is appparent that the family has been permanently broken.

Miss Morrison handles this fictional material as if she were making a documentary. Her refusal to deal in what might be melodramatics — to go beyond the general to the specific — is good up to a point. After that, one longs for something that would give the narrative particular impact.

In a documentary, when the camera studies the faces of people from real life, it often finds unexpected truths. In "The Two Worlds of Angelita," the camera studies the actors and finds only actors simulating real life. That they are good actors doesn't hide the thinness of the material.

Cultural dislocation is a big subject, but the effect of "The Two Worlds of Angelita" is to make it seem distant and dim, both less moving and less important than it is.

The film is in Spanish with English subtitles.

Vincent Canby

1983 O 28, C4:3

Live and In Character

RICHARD PRYOR HERE AND NOW, directed and written by Richard Pryor; cameramen, Vincent Singletary, Kenneth A. Patterson, Joe Epperson, Tom Geren, Johnny Simmons, Dave Landry; edited by Raymond Bush; produced by Bob Parkinson and Andy Friendly; released by Columbia Pictures. At Loews State, Broadway and 45th Street; Orpheum, 86th Street at Third Avenue; 34th Street Showplace, near Second Avenue. Running time: 94 minutes. This film is rated R.

By JANET MASLIN

DURING the concert performance that is recorded in "Richard Pryor Here and Now," Mr. Pryor is presented with a live crab by someone in the audience. He makes a few jokes about this, of course, but he also does much more: He talks to the crab, talks about it, even imagines how it must feel about being in the limelight. Letting it creep around the seat of a

"THE TWO WORLDS OF ANGELITA"—Marien Perez Piera is the 9-year-old girl through whose eyes is seen the search of a young Puerto Rican couple for a new life in New York,

stool, for instance, he supposes that the crab must be discovering that the world is round.

This is just one of the many demonstrations in this film of Mr. Pryor's amazing and hilarious empathy, of his ability to ascribe feelings to anyone or anything he sees. Together with his relentlessly bawdy wit and his brilliant physical mimicry, this makes him a concert performer of seemingly endless range. It's possible that a dozen more Pryor performance films will leave the format feeling tired, but that doesn't seem very likely. Mr. Pryor appears able to incorporate any subject into his uniquely animated conversation.

Among the things he talks about (almost none of what he says is quotable, thanks to the idiosyncrasies of his vocabulary) are Africa, the American South, his trip to the White House (for a screening of "Superman III") and his very unsatisfactory meeting with President Reagan, the difference between being married to a white woman and a black one, drugs and alcohol. The last two, which he says he gave up seven months before the film was made, provide him with opportunities for extended and very detailed comic impressions.

In tracing every possible step of a drunk's night out, from his conversation with the police (he offers two versions: what the drunk thinks he is saying, and what he actually sounds like) to the hangover, Mr. Pryor is very much in his element. There's plenty of opportunity here for the specifically scatological humor that is a trademark of his, and a chance to capture the drunk's streetwise side. Even more important than Mr. Pryor's ability to make such a routine funny, though, is the generosity of his perceptions. He's able to be crude without being unkind, and he's able to make the drunk seem ridiculous without any loss of basic sympathy.

•

Mr. Pryor doesn't solely impersonate people, of course. During the course of this performance, he also turns himself into a dog (alarmed by its master's bizarre behavior), the wind (waiting around the corner to give some unsuspecting pedestrian a wicked chill) and various parts of his own body (those that are apparently his favorite, or at least the ones he is happiest discussing). He also mimics people in the audience and very adroitly silences the occasional heckler. Mr. Pryor isn't a bully, but no one who gives him any backtalk gets the better of him at all.

"Richard Pryor Here and Now," which opens today at the Loews State and other theaters, was written and directed by Mr. Pryor. It features a bit of introductory commentary, occasionally careless camerawork, more audience reaction shots that his other films have had and a return to the strong language that his last concert film toned down, language that might sound gratuitous from a lesser performer but amounts to an integral part of Mr. Pryor's comic vision.

1983 O 28, C8:1

Unearthly Birth

POSSESSION, directed by Andrzej Zulawski; screenplay by Mr. Zulawski; adaptation and dialogue by Mr. Zulawski and Frederic Tuten; director of photography, Bruno Nuytten; music by Art Phillips; production manager, Jean-Jose Richer; released by Limelight International Films, Inc. At the Rivoli, Broadway and 49th Street, and other theaters. Running time: 97 minutes. This film is rated R.

Anna and Helen	Isabelle Adjani
Marc	Sam Neill
Heinrich	Heinz Bennent
Margie	Margit Carstensen
Bob	Michael Hogben
Zimmermann	Shaun Lawton
Heinrich's mother	Johanna Hofer
Detective	Carl Duering

ANNA (Isabelle Adjani), a wife, mother and part-time teacher of ballet, is full of anxiety, and "Possession," the movie that contains her, is one long anxiety attack.

Anna is so full of anxiety, in fact, that she eventually gives birth to it, screaming hysterically, vomiting and hemorrhaging in a subway corridor. The little fellow at first looks like a small, bloody squid. A few weeks later it looks like a comparatively mature octopus. In no time at all, it has assumed still another identity. All of these manifestations, which are supposed to be evil but look like eccentric toys, have been fabricated at great expense by Carlo Rambaldi, the special effects expert who made Dino De Laurentiis's King Kong and the unspeakable thing in "Alien."

•

This is about all I can make of "Possession," which has been described as "an intellectual horror film." That means it's a movie that contains a certain amount of unseemly gore and makes no sense whatsoever.

The film, a French-West German co-production shot in English, was written and directed by Andrzej Zulawski, a Russian-born Polish film maker. When it was shown at the 1981 Cannes Film Festival, Miss Adjani won the award for best actress, and the movie ran for something more than two hours. One critic reported that the Cannes audience was "traumatized" by it. New York audiences may be reduced to helpless laughter.

Part of the problem may be that the film has been drastically cut to its present 80-minute running time. Even so, it's possible to see that "Possession" would look fairly preposterous at any length. As Anna, Miss Adjani is required to play a succession of increasingly foolish mad scenes. In addition, for no point that I can see, she also turns up as a pretty, normal school teacher named Helen.

"Possession" is a veritable carnival of nose bleeds. Because the three leading characters — Anna, her husband, Marc (Sam Neill), and her lover, Heinrich (Heinz Bennent) — all knock each other violently around, they play most of their scenes in one state of bloodiness or another. At times, the living-color "Possession" recalls Roman Polanski's black-and-white "Repulsion," though only because Miss Adjani is required to slice up as many male victims as Catherine Deneuve did in the earlier, far better film.

•

I'm not sure Miss Adjani deserved her Cannes award for acting, but she deserved it for something, maybe juggling. At one point, while trying to cut off her own head with an electric carving knife, she must scream out lines on the order of "Why must you keep nagging me?" and "Can't you see that I hate you?" The film's dialogue always misses some of the intensity of the images.

The various accents also are a problem. Mr. Bennent, like many Germans speaking an English they aren't at home in, has trouble with his r's. "Doan weesist me" seems to mean "Don't resist me." Miss Adjani's French accent and Mr. Neill's Australian accent add to the confusion. The film was shot in Berlin, which appears to be a giant camp for displaced actors.

"Possession" opens today at the Rivoli and other theaters.

Vincent Canby

1983 O 28, C10:1

Two for the Road

THE WICKED LADY, directed by Michael Winner; screenplay by Leslie Arliss and Mr. Winner; additional dialogue by Gordon Glennon and Aimee Stuart, from the book by Magdalen King-Hall; director of photography, Jack Cardiff; edited by Arnold Crust; music by Tony Banks; produced by Menahem Golan and Yoram Globus; released by M-G-M/U.A.-Cannon Group Release. At the Rivoli, Broadway and 49th Street; Sutton, Third Avenue and 57th Street; Greenwich, Greenwich Avenue and 12th Street; Loews 83d Street Quad, at Broadway and other theaters. Running time: 98 minutes. This film is rated R.

Lady Barbara Skelton	Faye Dunaway
Captain Jerry Jackson	Alan Bates
Hogarth	Sir John Gielgud
Sir Ralph Skelton	Denholm Elliott
Lady Kingsclere	Prunella Scales
Kit Locksby	Oliver Tobias
Caroline	Glynis Barber
Aunt Agatha	Joan Hickson
Moll Skelton	Helena McCarthy
Doll Skelton	Mollie Maureen
Lord Kingsclere	Derek Francis

By VINCENT CANBY

"**T**HE WICKED LADY," the 1945 English costume drama that helped make James Mason into an international star, has been turned into what seems to be an expensively produced, mostly cheerless adventure-comedy by Michael Winner ("Death Wish," "Death Wish II,"

"THE WICKED LADY"—Faye Dunaway, playing a well-bred London woman during the Reformation with a taste for adventure, pours a poisonous drink for her suspicious butler, portrayed by John Gielgud.

etc.).

The film, which opens today at the Sutton and other theaters, stars Faye Dunaway as Lady Barbara Skelton, the role originally played by Margaret Lockwood, that of a Restoration schemer who, out of boredom, becomes a bandit. Alan Bates plays the James Mason role, a bandit who teaches Lady Barbara more than the ropes of the trade.

●

The members of the first-rate cast, all ill-used, include Denholm Elliott, as Lady Barbara's unfortunate husband; Sir John Gielgud, as the Skelton family's disapproving major domo, and Glynis Barber and Oliver Tobias as a pair of young lovers badly treated by the title person.

Because Mr. Winner, the director, shares his screenplay credit with Leslie Arliss, who wrote and directed the 1945 film, I suspect the new screenplay must bear a close resemblance to the earlier movie. However, I don't remember the 1945 picture as being as funny as the new one attempts to be. The 1983 "Wicked Lady" is lugubriously arch in the way of a movie betrayed by its director and cast, who decided to send it up in the course of production.

Miss Dunaway, who never comes onto the screen without looking as if she's wearing the film's total budget, plays Lady Barbara as she might be played by the Joan Crawford we saw in her "Mommie Dearest." It's not only that she displays no comic gifts whatsoever, but that she appears to be learning how to act in some neo-primitive manner. Lust is registered by a tight-lipped smile. A single raised eyebrow is puzzlement; boredom is elevated surliness, and when an idea is supposed to be forming inside her head, her eyes pop out dangerously, as if being displaced by a foreign substance.

●

Jack Cardiff has photographed the elegant 17th-century settings with a good deal of style and humor, which aren't apparent in the screenplay that sounds suspiciously 1945ish. "You are very bold, sir," says the flirty Lady Barbara to a handsome young man she's just met at her own wedding reception. "And you, my lady," he says, "are the most exciting woman I've ever met."

Mr. Bates has a few genuinely lively moments toward the end in the film's best sequence. This is a public hanging in which nothing goes right, when the condemned gets off with sore throat and one of the most prominent ladies in the audience gets beaten with a bull whip. It's also fun watching Sir John roll his eyes in pious horror at all the evil he sees under his very nose. This "Wicked Lady" is the sort of movie in which everything hangs out when bodices are ripped open.

1983 O 28, C16:1

GOING BERSERK, directed by David Steinberg; written by Dana Olsen and Mr. Steinberg; director of photography, Bobby Byrne; edited by Donn Cambern; music by Tom Scott; produced by Claude Heroux; released by United Artists. At the National, Broadway and 44th Street; Gemini, 64th Street and Second Avenue; 85th Street East, at First Avenue, and other theaters. Running time: 85 minutes. This film is rated R.
John Bourgignon John Candy
Chick Leff Joe Flaherty
Sal Di Pasquale Eugene Levy
Nancy Reese Pat Hingle
Patti Reese Ann Bronston
Mrs. Reese Eve Brent Ashe

Grandmother Reese Elizabeth Kerr
Sun Yi Richard Libertini
Angela .. Dixie Carter
Dr. Ted ... Paul Dooley
Bruno Ronald E. House
Clarence Kurtwood Smith
Muhammed Ernie Hudson

John Candy is easily the funniest thing in "Going Berserk," an affably stupid comedy that's saddled with too much plot and that hasn't nearly enough energy to go with it. Mr. Candy plays John Bourgignon, a tubby limousine driver whose exploits are much too numerous to chronicle in detail. He's involved in an assassination plot and a jailbreak, among other things, with a good cast that includes Pat Hingle, Richard Libertini, Alley Mills, Paul Dooley, Eugene Levy and Joe Flaherty.

"Going Berserk," which opened yesterday at the National and other theaters, was co-written (with Dana Olsen) and directed by the comedian David Steinberg, who brings a throwaway style to many of the film's gags. Even when they're funny — as is a bit involving Mr. Candy, a pair of handcuffs and a dead body — the film's better scenes have an undue nonchalance.

●

Though some of the characters are extremely broad, like Mr. Levy's impression of a movie director named Sal Di Pasquale, whose biggest hit has been something called "Kung Fu U.," the film never loses its overly relaxed tone. Even the parts that are clever give the impression that they might well have benefited from a little more liveliness.

Among the better routines is a brief spoof of 1950's television, with Elinor Donahue of "Father Knows Best" playing her own television mother, and the irrepressible Mr. Candy as a seriously overgrown Beaver Cleaver.

Janet Maslin

1983 O 29, 19:1

The Play Goes On

TESTAMENT, directed by Lynne Littman; screenplay by John Sacret Young, based on the story "The Last Testament" by Carol Amen; director of photography, Steven Poster; edited by Suzanne Pettit; produced by Jonathan Bernstein and Miss Littman; released by Paramount Pictures. At the Baronet, Third Avenue and 59th Street. Running time: 90 minutes. This film is rated PG.
Carol Wetherly Jane Alexander
Tom Wetherly William Devane
Brad Wetherly Ross Harris
Mary Liz Wetherly Roxana Zal
Scottie Wetherly Lukas Haas
Hollis Philip Anglim
Fania ... Lilia Skala
Henry Abhart Leon Ames
Rosemary Abhart Lurene Tuttle
Cathy Pitkin Rebecca De Mornay
Phil Pitkin Kevin Costner
Mike ... Mako
Larry Mico Olmos
Hiroshi Gerry Murillo
Billdocker J. Brennan Smith

By JANET MASLIN

THE strategy of Lynne Littman's disturbing "Testament" is to depict the most enormous of disasters — a nuclear holocaust — in terms that are comparatively banal. In her effort to drive home the human cost of such a calamity, Miss Littman concentrates on the most ordinary details of life in a California town. For the Wetherly family, around whom the film revolves, the quintessentially humdrum day before the catastrophe is full of errands and squabbles and dirty laundry. Yet the very drabness of this day takes on poignancy when seen in the light of what follows.

The first half of "Testament," the section describing the family's usual

life, is contrasted with post-holocaust scenes, in which the Wetherlys watch the slow, grim decline of their community. Tom (William Devane), the gung-ho dad who has gone on a business trip to San Francisco, has not been heard from since the awful moment when the Wetherlys' television reception was interrupted and their living room suffused with a bright orange glow.

Meanwhile, Carol (Jane Alexander) remains as sturdy as she can for the sake of the couple's daughter and two sons. She cannot be hopeful, since there is nothing to hope for. The best she can do is sit quietly by as the after-effects of the nuclear explosions manifest themselves, images that the film sometimes presents very powerfully indeed. When "Testament" presents a mother burying a tiny corpse that has been wrapped in a child's gaily printed sheet, it is at its most unsettlingly plausible.

●

"Testament," which opens today at the Baronet, is powerfully acted, especially by Miss Alexander. And it undoubtedly strikes a frightening chord. But its emphasis on the ordinary, so effective in the film's opening scenes, makes the later moments unduly hard to believe. One subsequent event that we see, for instance, is a grade-school enactment of "The Pied Piper of Hamelin," which the children are performing. The play has plenty of relevance to what has happened, since it ends with the thought that the town's children have disappeared until the time comes when the townspeople really deserve them. But in the event of a nuclear holocaust, wouldn't the people of Hamelin, Calif., cancel a performance of the school play?

The short story upon which the film is based ("The Last Testament," by Carol Amen) hasn't room for many such details, but John Sacret Young's screenplay develops quite a number of them. The garbage, for instance, is no longer collected. Famine sets in, and there are long, long lines for gasoline. This is all plausible, but what's missing is a corresponding attention to larger issues. The screenplay never specifies which country pressed the button, for instance, or what events in world politics led up to this terrible turn of events. Nor do the people of Hamelin have much of an opportunity to voice grief, panic, rage or any other of the emotions they might be expected to have. For the most part, they just persevere quietly and wait for the worst.

●

Miss Littman, who directed and was co-producer of "Testament," gives its individual scenes a very realistic air, even if the film's overall conception is sometimes strained. The casting is particularly adroit, since Miss Alexander and Mr. Devane are convincing as both longtime spouses and suburbanites and since the down-to-earth qualities of both stars contribute to the homespun feeling of the drama. Also in the cast are Philip Anglim and Rebecca de Mornay in small but effective roles, and Ross Harris, Roxana Zal and Lukas Haas, who perform touchingly as the doomed children.

Only when "Testament" refers to things Miss Littman could not illustrate — that 1,300 people in the town have died, for instance, when we've seen only a few dozen on screen — are the limitations of the film's very

small budget made apparent. For the most part, it's a simple and resourceful film and one that has been made with unmistakable conviction.

●

"Testament" is rated PG ("Parental Guidance Suggested"). Its subject matter might easily frighten small children.

1983 N 4, C8:1

On-the-Job Training

EXPERIENCE PREFERRED... BUT NOT ESSENTIAL, directed by Peter Duffell; screenplay by June Roberts; director of photography, Phil Meheux; edited by John Shirley; music by John Scott; produced by Chris Griffen; released by the Samuel Goldwyn Company. At Embassy 72d Street Twin, at Broadway. Running time: 80 minutes. This film is rated PG.
Annie Elizabeth Edmonds
Mavis Sue Wallace
Doreen Geraldine Griffith
Paula Karen Meagher
Arlene Maggie Wilkinson
Mike ... Ron Bain
Hywel Alun Lewis
Ivan Robert Blythe
Wally Roy Heather
Dai Peter Doran
Helen Arwen Holm
Nin Sion Tudor Owen
Gareth Robert Gwilym
Now Mostyn Evans
Howard Paul Haley
Mrs. Howard Margo Jenkins
M.C. Jerry Brooke

PETER DUFFELL'S "Experience Preferred ... but Not Essential," which opens today at the Embassy 72d Street Theater, is a gentle British comedy with a lot of charm. Set in a Welsh coastal hotel in the summer of 1962, it follows a waitress named Annie (Elizabeth Edmonds) through certain rites of passage. Annie is sweet, soft-spoken and a good listener, which is convenient, since the hotel's employees are a colorful lot and there's plenty for her to observe. Everyone else has a past, Annie decides, and she has none — which is a situation that has certainly been remedied by the time the film is over.

Though some of the film's humor is on the cute side, most of it is enjoyably dry. Once Annie has found her way to the hideous garret where she is to room, she quickly settles into a hotel routine that includes tolerating the eccentricities of the other waitresses and feigning sleep during the nightly visits of the resident somnambulist, a burly fellow who wanders about in the nude. By day, he's a much more decorous character, living in a room filled with silver-framed portraits of the royal family.

●

The various personalities give the feeling of having been based on real people, even if the screenwriter, June Roberts (who did indeed work in such a hotel 20 years ago), turns some of them into stereotype oddballs. The humor and drudgery of waitressing are captured nicely, and so are the vicissitudes of the summer romances that are under way.

Everyone has a courtship in the works, even Annie, who soon attracts the attention of a fellow worker named Mike (Ron Bain). He compliments her blue eyes lavishly ("They're brown," snaps another waitress; "Not to me," Mike replies) and brings her dinner on a tray. He also claims to come from a place as dismal as Annie's own hometown. "If you could draw a map of Scotland in the shape of a human skull, it would resemble a distinctly dead brain cell," he says, by way of locating the town geographically.

Mr. Duffell draws some very good ensemble acting from his cast,

particularly from the women when they gossip or compare notes; the sense of the waitresses' camaraderie gives the film a warmth to match its humor. The period details are also well chosen, funny and go a long way toward setting the film's slightly threadbare, appealingly offbeat tone.

There's a lot to like about "Experience Preferred ... but Not Essential," especially the demure Miss Edmonds (who ends the film with a smile of quiet triumph, when she's finally grown ladylike enough to attract a boy she meets on a bus). And Mr. Duffell, who begins many morning scenes with the sight of the milk truck struggling toward the hotel kitchen, sketches the atmosphere and routine of the hotel very successfully. The place seems real and, in its own way, weirdly inviting.

●

"Experience Preferred ... but Not Essential" is rated PG ("Parental Guidance Suggested"). It contains some strong language and sexual references.

Janet Maslin

1983 N 4, C11:1

Too Many Monitors

THE OSTERMAN WEEKEND, directed by Sam Peckinpah; screenplay by Alan Sharp, adaptation by Ian Masters, based on the book by Robert Ludlum; director of photography, John Coquillon; edited by Edward Abroms and David Rawlins; music by Lalo Schifrin; produced by Peter S. Davis and William N. Panzer; released by 20th Century-Fox Film Corporation. At the National 1, Broadway and 44th Street; Manhattan 2, 59th Street between Second and Third Avenues; 86th Street, at Lexington Avenue, and other theaters. Running time: 102 minutes. This film is rated R.
John Tanner........................Rutger Hauer
Lawrence Fassett.......................John Hurt
Bernard Osterman..............Craig T. Nelson
Richard Tremayne................Dennis Hopper
Joseph Cardone................Chris Sarandon
Ali Tanner...............................Meg Foster
Virginia Tremayne................Helen Shaver
Betty Cardone.....................Cassie Yates
Stennings..........................Sandy McPeak
Steve Tanner.................Christopher Starr
Maxwell Danforth...............Burt Lancaster

By VINCENT CANBY

"WHAT would you do," the ad asks, "if a total stranger proved to you that your three closest friends were Soviet agents?" If you were a muckraking Los Angeles television journalist named John Tanner, you'd go ahead with a reunion weekend at your house and allow the Central Intelligence Agency to hide television cameras and microphones in every nook, cranny, closet, bedroom and bathroom, thus to collect evidence against your three closest friends.

This is the beginning of "The Osterman Weekend," Sam Peckinpah's film version of Robert Ludlum's best-selling espionage-suspense novel. It's also virtually the last coherent thing that happens in the film, which opens today at the National and other theaters.

●

"The Osterman Weekend," which is not without its amusing moments, is like a very elaborate private joke. It's as if Mr. Peckinpah read the book and Alan Sharp's screen adaptation, and decided that the only way to deal with so much outrageously unbelievable plotting was to make it, if possible, totally incomprehensible, and then stuff it so full of gratuitous sex and violence that the audience wouldn't notice anything else.

There's really nothing else to ex-

plain the film's brazenly bad-taste opening, in which the camera spies on a bilingual (French-English) couple as they make love and then, while the husband is having a quick shower, watches impassively as three men execute his wife by inserting a hypodermic needle into her nose. Nor is there much to justify the next sequence, in which Burt Lancaster, who plays the head of the Central Intelligence Agency, and another man discuss a possible espionage plot in such detail and at such length that the audience begins to panic. Because there's absolutely no way to remember all these facts, as Mr. Peckinpah well knows, this, too, must be a joke at the audience's expense.

So far, so good. Then, however, the movie gets completely out of hand. "The Osterman Weekend" starts to behave like a noisy, garrulous barroom drunk who doesn't know that he's not making any sense. He won't shut up. He's crude, and he laughs too much at witticisms only he knows the meaning of. When someone attempts to tell him there's no point to the story, he crows in triumph that that, precisely, is the point.

You can't win with a movie like this.

At its best, "The Osterman Weekend" has a kind of hallucinatory craziness to it. Much of it gives the impression of having been made in a television store. You've never seen so many television screens in one movie. Virtually every scene that we see straight is also seen as it appears on a television monitor, one being watched by someone who shouldn't be watching. The man who once made such great movies as "The Wild Bunch," "The Ballad of Cable Hogue" and "Junior Bonner" has fallen in love with the whole messy subject of surreptitious surveillance, but he doesn't yet know how to turn it into a movie.

Some individual sequences — including a car chase early in the film — have the lunatic humor that might have made the rest of the film bearable, though probably nothing would justify the film's final blood bath. As it now stands, this sequence looks like a parody of the final shootout in "The Wild Bunch."

In addition to Mr. Lancaster, the cast includes Rutger Hauer, the supervillain of "Blade Runner," who is not super as this film's hero; John Hurt, as a C.I.A. man; Craig T. Nelson, Dennis Hopper and Chris Sarandon, as the three men suspected of espionage, and Meg Foster, who has the bluest eyes to be found in a movie full of blue-eyed actors, as Mr. Hauer's baffled wife.

Everyone is adequate.

1983 N 4, C11:1

Selling Bazookas

DEAL OF THE CENTURY, directed by William Friedkin; written by Paul Brickman; director of photography, Richard H. Kline; film editors, Ned Humphreys and Jere Huggins; music by Arthur B. Rubinstein; produced by Bud Yorkin; released by Warner Bros. At the Warner, Broadway and 47th Street; Gemini 2, Second Avenue and 64th Street and other theaters. Running time: 98 minutes. This film is rated PG.
Eddie Muntz......................Chevy Chase
Mrs. DeVoto.................Sigourney Weaver
Ray Kasternak.................Gregory Hines
Frank Stryker...................Vince Edwards
Gen. Cordosa................William Marquez
Col. Salgado.................Eduardo Ricard
Lyle..............................Richard Herd
Babers.........................Graham Jarvis
Harold DeVoto.................Wallace Shawn
Ms. Della Rosa................Randi Brooks

"DEAL OF THE CENTURY," which opens today at the RKO Warner and other theaters, fails as a satire, partly because it seems to think that all it has to do to win an audience is to announce its good intentions, and partly because it's terrible. Its heart is in the right place its mind is some place else, perhaps at a fat farm.

The movie, directed by William Friedkin from an original screenplay by Paul Brickman, is staunchly against the arms race, which it attempts to make fun of through the adventures of two arms salesmen played by Chevy Chase and Gregory Hines. The film's co-star is Sigourney Weaver, who plays the widow of another arms dealer.

●

With "Risky Business," which he wrote and directed, Mr. Brickman proved he was a funny man, but there is an alarming scarcity of humor in "Deal of the Century." The film's invention begins and ends with the sight of Mr. Chase selling bazookas as if they were potato peelers and jet aircraft as if they were vacuum cleaners.

Most of the film's other inspirations look like Hollywood surplus. We are asked to giggle at the sight of a pompous Central American dictator holding forth in a presidential palace overrun with chickens, to guffaw

when Mr. Hines announces he is about to declare himself for Jesus and to throw our hats in the air when the movie visits an arms trade show whose slogan is "Arms for Peace." The paradoxes aren't very provocative.

Worse is the total lack of wit apparent in the direction of Mr. Friedkin, whose inability to build a gag to a proper payoff amounts to a major career disability in anyone who wishes to do comedy. As the romantic leads, Mr. Chase and Miss Weaver are attractive performers who behave as if they truly loathed each other. Maybe it's just the material, which defeats them as well as Mr. Hines and Wallace Shawn, who makes an extremely brief appearance as Miss Weaver's husband. The only person in the movie who appears to have an idea how to play comedy of this sort is Vince Edwards, who is sometimes funny as the mean, driven, completely unethical head of a plane manufacturing company.

● ● ●

"Deal of the Century," which has been rated PG ("parental guidance suggested"), contains a lot of foul language.

Vincent Canby

1983 N 4, C13:3

FILM VIEW

JANET MASLIN

Who Are This Movie's Real Heroes?

When Tom Wolfe wrote about the Mercury astronauts in "The Right Stuff," he redefined their heroism in terms that a whole new generation could understand. The astronauts' "own" (they worked closely with the staff of Life magazine) account of their exploits, "We Seven," was written in 1962 and presents an outstandingly bland portrait geared to the American temperament of that time. "What kind of man," the Life writers' introduction asks, "would be strong enough physically to sustain the tremendous stresses and strains of a flight through space, and then be wise enough — and strong enough in other ways — to sustain the pressures of public adulation when he returned home?" The answers prove to be as upbeat and unsurprising as the question is rhetorical.

Mr. Wolfe, without detracting from the courage of the astronauts or the importance of their achievements, managed to describe their heroism in a brilliantly flamboyant style that was both celebratory and wry, a style attuned to an era in which traditional-seeming heroes are regarded with as much suspicion as wonder. His book captured the ironies of the astronauts' situation, the stubborn competitiveness that had brought them to the top of their profession, the routine humiliation of the testing process to which they were subjected and the exhilaration of flight that made their prodigious efforts worthwhile. Aside from being infinitely more colorful than their own, Mr. Wolfe's vision of the astronauts cast their heroism in human terms and effectively contrasted the pettier aspects of their experience with the vastness of

their triumphs. It placed their achievements in a larger perspective, and it displayed a conviction that modern heroism can incorporate luck, brashness and humor along with the more traditional attributes.

The fact that Philip Kaufman's film version of "The Right Stuff" does not present a correspondingly compelling notion of modern heroism is the chief reason why it emerges as an enormously entertaining film but not a great one. The film has its own ideas of what heroism means, but they are neither as clearly expressed as Mr. Wolfe's nor as persuasive. At the same time, they're a great deal more overbearing, with their emphasis on the exalted aspects of heroism and disdain for the brouhaha that, in this day and age, inevitably attends it.

• • •

The psychiatrist Robert Coles defines a hero as "a person of high character — especially brave or sensitive or compassionate. In past centuries, such individuals were unashamedly, explicitly worshiped. They were gods or, to put it more intellectually, their lives were regarded as aspects of divinity." There are times when Mr. Kaufman's film attempts to convey a heroism of just such grandiose proportions. But there are also times when his film is deliberately deflating, and the conjunction of these two attitudes isn't graceful or lucid enough to avoid being jarring.

Chuck Yeager, the test pilot who without fanfare broke the sound barrier in 1947, and whose continued ·record-shattering achievements constitute a major reference point for both Mr. Wolfe and Mr. Kaufman, is the true hero of "The Right Stuff." But his heroism becomes peculiarly distorted when it is presented on the screen. Yeager's solitary triumphs are meant to be exactly that; as played by Sam Shepard with a great show of matinee-idol stoicism, Yeager challenges the very sky itself with each new exploit, almost wholly oblivious to the rivalry of other fliers. And he listens with silent amusement to television news of the Mercury team, scornful of the publicity that attends their every move. (To the extent that "The Right Stuff" has a villainous presence, it is that of the press, whose arrival is signaled by what sound like locusts on the soundtrack.)

If Chuck Yeager is a magnificent loner on the page, on the screen he seems virtually a god. Everything about the performance and the way it is presented becomes larger than life; when he does something as unremark-

able as drinking a glass of beer, the liquid in his glass is seen against a huge golden sunset. The virtues of modesty, simplicity and independence, so crucial to Mr. Yeager's brand of heroism, are visually contradicted by the self-consciously mythmaking manner in which he is filmed here. Inevitably, this can't help but weaken the contrast between Mr. Yeager and the Mercury team, a contrast on which the film's notion of heroism depends.

The Mercury astronauts — who began as test pilots, were surrounded with hoopla, and found themselves assigned tasks that could just as easily be executed by chimpanzees — represent an achievement more complicated than Mr. Yeager's, and in some respects less pure. If he performed in a vacuum, they performed in a fishbowl. They did not simply pursue excellence for its own sake; their motives were more complex, and so were their circumstances. "The Right Stuff" isn't a film about motives, remaining surprisingly superficial (at least for a contemporary film) about the inner lives of its characters. But it does appear to be passing judgment on the public aspects of the astronauts' careers, particularly in an elaborate sequence that juxtaposes an enormous barbecue honoring these heroes with the image of Yeager, alone as usual and attempting another audacious flight.

Who are the real heroes here? The film doesn't appear to be sure. It presents Yeager as a higher breed of individualist, yet it also wants to celebrate the Mercury adventurers on a slightly less exalted level. And it means to poke gentle fun, if not at the

Mercury seven, then certainly at much of the fuss that surrounded them. A climate of heroism is repeatedly created and then dispelled, as though the final result of such waffling could create anything but confusion. However, the best thing about the film is the way in which its astronauts do develop an aura of heroism all the same. They are so appealingly played, and they display such visible toughness, group loyalty and bra-

vado, that even their united stand against the scientist who'd like to deny them a window in the space capsule becomes an act to be applauded.

Audiences may admire these heroes even more than the film seems to, since their achievements are presented with some semblance of realism (as opposed to the pure grandiosity that surrounds Yeager's) and at the same time are so undeniably bold. One of the rare incidents of failure here, in which the film's Gus Grissom accidentally sinks his space capsule after its door flies open, hardly seems a lack of courage. Though the audience sees Mr. Grissom greeted by a pathetically small parade (as opposed to the hero's welcome that Alan Shepard Jr. is accorded) and watches his wife throw a tantrum because she won't be invited to the White House, it also has been made to understand the audacity of what he has attempted. How can the viewer believe this man has failed at all?

Unlike the airborne cowboy whom the movie idealizes, the astronaut is performing in public rather than in utter isolation. Perhaps that makes the stakes even higher. And perhaps the relative helplessness of the astronaut in his capsule — as opposed to the test pilot with more individual control of his flight — requires a brand of bravery all its own; certainly the scenes of John Glenn's risky re-entry into the earth's atmosphere are among the film's most stirring.

But for the most part, the film seems to be presenting this kind of heroism as almost mundane, and contrasting it with something higher. "The Right Stuff" does not make this distinction well, and need not have made it at all. At its best, and almost in spite of itself at times, the film conveys the modern-day heroism — the physical bravery, the eagerness to excel, the fallibility and also the glory — of them all. ■

1983 N 6, II:21:1

Solemn Soap Opera

MONKEY GRIP, directed by Ken Cameron; screenplay by Mr. Cameron in association with Helen Garner; film editor, David Huggett; music by Bruce Smeaton, Mark McEntee and Christina Amphlett; produced by Patricia Lovell; a Cinecom International Films Release. At the Embassy 72d Street, at Broadway. Running time: 101 minutes. This film has no rating.

Nora .. Noni Hazlehurst
Javo .. Colin Friels
Gracie .. Alice Garner
Willie ... Harold Hopkins
Lillian .. Candy Raymond
Clive ... Michael Caton
Martin .. Tim Burns
Angela Christina Amphlett
Gerald Don Miller-Robinson
Rita ... Lisa Peers
Eve .. Cathy Downes

By JANET MASLIN

SOAP operas come in all shapes and sizes, but they rarely have either the solemnity or the setting of "Monkey Grip." Situated in a section of Melbourne, among what seems to be a group of aging hippies who are active in the Australian rock scene, it tells of a freewheeling single mother named Nora (Noni Hazlehurst), who looks a lot tougher and more independent than she sounds.

Though Nora changes lovers and living quarters frequently (carefully hanging up a portrait of Virginia Woolf whenever she moves), she is desperately attached to a man who isn't good for her. We know this from the things she declares in voice-over, such as: "I think I already knew this one was going to be trouble. Still, a person shouldn't be ashamed to wish for love."

The man is Javo (Colin Friels), who despite his drug habit, public rudeness, refusal to commit himself and general unreliability is deemed by Nora to be a good catch. The film follows their affair and a number of subsidiary ones, to the point where it's difficult to keep track of who is sleeping with whom within Nora's circle of friends. Not only is it difficult, it's virtually beside the point. Though "Monkey Grip" does feel like it's about real people, they aren't necessarily people whose personal

Alice Garner and Noni Hazelhurst are daughter and mother in "Monkey Grip," about an Australian mother's obsessive relationship with a man.

dramas are compelling enough to bear feature-length scrutiny.

●

Ken Cameron, who directed the film (and who co-wrote it with Helen Garner, from her 1977 novel), gives it a snappy, distinctive visual personality that's painfully at odds with the vacuity of the material. The performers are often very good, but none of them can, say, refer to a love affair as "a complicated dance to which the steps hadn't quite been learned" without risk of being giggled off the screen. When Nora finally reads Javo's diary and discovers what his prose is like (" 'Where am I?' I asked with my body? 'You're here,' she said with her eyes"), it's a wonder she can be heartbroken over the loss of him. But heartbreak is most of what "Monkey Grip" is about.

The film, which opens today at the Embassy 72d Street theater, contains a lot of mediocre rock music (Nora helps write a hit song, it turns out) as well as a fair amount of soft-core sex, which goes a long way toward explaining what Nora and Javo see in each other. Some of this takes place by candlelight and with musical accompaniment from Nora's preadolescent daughter Gracie (Alice Garner), who's conveniently at the piano in the next room.

Gracie, who helpfully throws the I Ching for her mother from time to time, has certainly seen a thing or two where Nora is concerned. "I think she's trying to tell me something," says Javo, when the little girl seems surly after catching the two in bed together au naturel. "Ah, she just doesn't like changes," says Nora, who for a woman so desperately overconcerned about some things is amazingly indifferent to others.

1983 N 7, C16:5

Angel or Devil?

SUSANA, directed by Luis Buñuel; screenplay by Jaime Salvador, based on the novel by Manuel Reachi; a Televicine International presentation; released by Plexus Film Distributors. At the Public Theater, 425 Lafayette Street. Running time: 82 minutes. This film is not rated.
SusanaRosita Quintana
Head of householdFernando Soler

By VINCENT CANBY

LUIS BUNEL'S "Susana," which opens at the Public Theater today, is a most engaging potboiler made by the master in Mexico in 1951. Though Buñuel never for a minute attempts to disguise the film's intentions to entertain a large, undiscriminating Latin American audience, "Susana" is full of the sort of Buñuelian touches that forever separate all of Buñuel's films, the potboilers as well as the classics, from those of everyone else.

The heroine is Susana (Rosita Quintana), a beautiful, sultry, blond temptress and inmate at a women's reformatory. When first seen, Susana's being thrown into a solitary cell for misbehaving. Says the corrections officer, helpfully delivering all of the exposition the film contains, "Imagine, she's been here two years and is worse than ever!"

●

Susana is no good and knows it. She doesn't ask favors from anyone. Ultimately, however, because her cell is so filthy and so full of rats, bats, cockroaches and tarantulas, Susana is moved to seek His help. She prays to God for a miracle that will free her from this hell. Presto, the bars of her

window fall out into her hands.

Making her way across the dark, rain-swept, Brontean landscape, Susana seeks shelter at the hacienda of a wealthy ranching family, whose loving members insist that the homeless one stay on in their care. Only a superstitious old servant woman suspects the newcomer is more devil than angel.

In less time than it takes to write this synopsis, Susana has turned the peaceful hacienda into a battlefield. Lusting after her — and fighting to get there first — are Jesus, the handsome young ranch hand; Alberto, the family's son and heir; and Guadalupe, Alberto's father, a God-fearing man and the faithful husband of the beautiful, patient Dona Carmen.

●

Though the movie means to be steamy, Buñuel is apparently more amused than shocked by Susana's brazen ambition and the no-nonsense way she goes about her conquests. Toward the end, when the traffic in and out of Susana's bedroom is fairly heavy, the movie has the manner of a grandly operatic farce.

Miss Quintana is suitably outrageous as Susana, a kind of rough sketch of the character who would later appear in the person of Catherine Deneuve in Buñuel's 1970 classic, "Tristana." That film is also recalled because of the appearance of Fernando Soler, who plays the susceptible Don Guadalupe and who looks remarkably like Fernando Rey, the star of Buñuel's last, great films.

1983 N 8, C9:2

Future Society

BORN IN FLAMES, produced, directed and edited by Lizzie Borden; camera by Ed Bowes and Al Santana; story consultant, Ed Bowes; music by The Bloods, Ibis, The Red Crayola; distributed by First Run Features. At the Film Forum, 57 Watts Street. Running time: 90 minutes. This film is not rated.
Honey (Phoenix Radio)Honey
Isabel (Radio Regazza)Adele Bertei
Adelaide NorrisJeanne Satterfield
Zella WylieFlo Kennedy
Socialist Youth Review Editors
 Pat Murphy, Kathryn Bigelow, Becky Johnston
FBI AgentsRon Vawter, John Coplans
Women in Army
 Hillary Hurst, Sheila McLaughlin, Marty Pottenger
TV Newscasters
 John Rudolph, Valerie Smaldone, Warner Schreiner

By JANET MASLIN

THE futuristic feminism of Lizzie Borden's "Born in Flames" is livelier than might be expected, with its militancy even accompanied by a modicum of topical humor. Set 10 years after a socialist revolution in the United States, it tells of a society in which armed bands of whistle-blowing female bicyclists swoop down on would-be rapists, and of male construction workers who protest that their female colleagues are monopolizing the best jobs.

Lizzie Borden (that is her real name), whose film opened at the Film Forum yesterday, does not develop these or any other notions very elaborately. Instead, she presents a variety of radical feminist ideas, without much attention to the narrative that contains them. When militant black lesbians encounter white feminist punk musicians, for instance, there is so much ideology to be dealt with that ordinary exposition is out of the question.

The film is set up as a series of encounters, montages and improvised-

An actress called Honey appears in a feminist fantasy, "Born in Flames," at the Film Forum.

sounding political discussions that finally erupts into terrorist activity of an unusual nature. When this development is reported by the media, the participants are described as a "girl gang," which is indication of the screenplay's brand of humor. Miss Borden wrote the film, as well as produced, directed and edited it.

Even with its brash and very natural performers (including Flo Kennedy, the political activist, and a basketball player named Jeanne Satterfield who is very effective in the role of a black lesbian leader) and its loud feminist-rock accompaniment, "Born in Flames" feels more like a manifesto than anything else. There is nothing particularly cinematic in its conception. Miss Borden's montages feel like isolated, still images of women in various walks of life rather than closely woven variations on particular themes, and her characters' rhetoric can be windy in the extreme.

It is not the stridency that mars "Born in Flames"; if anything, that is the film's best feature, producing an aggressive energy that Miss Borden sometimes channels well. But "Born in Flames," while inventive, is also much too diffuse and overcrowded. Only those who already share Miss Borden's ideas are apt to find her film persuasive.

1983 N 10, C17:1

STAR 80, directed and written by Bob Fosse, based in part on "Death of a Playmate" by Teresa Carpenter; director of photography, Sven Nykvist; edited by Alan Heim; music by Ralph Burns; produced by Wolfgang Glattes and Kenneth Utt; released by Warner Bros. At Cinema 1, Third Avenue and 60th Street and Cinema 3, 59th Street and Central Park South. Running time: 104 minutes. This film is rated R.
DorothyMariel Hemingway
PaulEric Roberts
Hugh HefnerCliff Robertson
Dorothy's MotherCarroll Baker
Aram NicholasRoger Rees
GebDavid Clennon
Private DetectiveJosh Mostel
EileenLisa Gordon
Nightclub OwnerSidney Miller

By VINCENT CANBY

ON Aug. 14, 1980, Dorothy Stratten, a pretty, fresh-faced model from Vancouver, British Columbia, was

shot to death by her estranged husband, Paul Snider, a small-time promoter, in the house they once shared in Los Angeles. After murdering Miss Stratten, Mr. Snider turned the shotgun on himself. Miss Stratten had acquired a certain amount of fame as Playboy magazine's "1980 Playmate of the Year," and had just finished production on her first major film, Peter Bogdanovich's "They All Laughed."

The sensational circumstances of her death far outdistanced in news value any of the accomplishments of her life. When "They All Laughed" was released 15 months later, it demonstrated that Miss Stratten possessed a charming screen presence and might possibly have become a first-rate comedienne with time and work.

●

Dorothy Stratten's life and death, and the piece written about it by Teresa Carpenter in the Village Voice, are the bases of Bob Fosse's new film, "Star 80," which, like his "Lenny" and "All That Jazz," is a dazzling display of cinematic pyrotechnics. Watching "Star 80" is like witnessing a huge sound-and-light show, one designed not to call up the history of the pyramids, the Parthenon or even the Brooklyn Bridge but a contemporary world where sleaziness has triumphed.

Though Mr. Fosse, who wrote and directed "Star 80," obviously has some doubts about whether a young woman's appearance as a Playboy centerfold represents extraordinary personal achievement, something to equal Madame Curie's, the movie, which looks like a Playboy centerfold from time to time, isn't so sure.

In addition to its super-glittery physical production and the restless, almost psychotic pacing of the story, "Star 80" features a sweet, terrifically accomplished performance by Mariel Hemingway ("Manhattan," "Personal Best") in the title role.

Make no mistake about it: Miss Hemingway, a beauty who looks a lot like Miss Stratten, is not giving an impersonation but a true performance, as fully realized as the somewhat limited circumstances allow. There is an alertness, humor and intelligence to her work that immediately identifies

Mariel Hemingway in "Star 80."

her as one of our best young film actresses, someone who reinvents character in her own image rather than simply miming it.

Dorothy Stratten is not the center of the film, though. She is its passive victim. The center is Paul Snider, acted with great, flamboyant intensity by Eric Roberts. The film's Paul Snider is a fast-talking, narcissistic pretty-boy who makes ends meet by pimping and about whom someone says, with admiration: "He could remember everybody's name. It was a real talent."

He's also a sadistic, certifiably lunatic slob. He's the sort of loser who might have gone through life without a major accident had it not been for Dorothy, someone he could actually promote into the supposedly glamorous show-biz world to which he aspired.

Like the film itself, Mr. Roberts's performance is initially riveting. It's a technical tour-de-force in the way he alters both his looks and his voice. Finally, though, both the film and the performance become a little bit aimless as they mark time for the bloody climax we know is to come.

"Star 80," which opens today at the Cinema 1, is not only about sleaziness, it also has the effect of exemplifying the sleazy values it means to satirize, partially because it is so totally self-referential. It never appears to notice the existence of a world outside this tiny corner where life is made up of Playboy mansions, centerfolds, schlock movies and self-promotion.

Playboy's publisher, Hugh Hefner, as portrayed with a good deal of wit by Cliff Robertson, comes in for some gentle ribbing. When Hugh makes his evening appearance at the apparently nonstop Playboy mansion party, he moves through the assembled guests like a pajama-clad guru, offering fatherly pats and advice on clean living to the adoring young women around him.

•

The movie's form is not easily described, being a combination of flashbacks to the afternoon of the murder and suicide, interviews with Dorothy at the peak of her Playboy career, reminiscences by her mother (Carroll Baker) and other people who knew either Dorothy or Paul. Some of Miss Hemingway's best moments are in the interviews in which she struggles to be as sincere as humanly possible in answering such weighty questions as "How does it feel to pose in the nude?" and "Do you enjoy being famous?"

Roger Rees, a Tony award winner for his performance on Broadway in "Nicholas Nickleby," plays with a sort of holy benevolence the Peter Bogdanovich character, here called Aram Nicholas.

"Star 80" is not a dull film by any means. However, it's a movie without a payoff. The story of Dorothy Stratten is pathetic, but only another Playboy model might find it tragic. Mr. Fosse has failed to connect it in any moving or significant degree with other aspects of human history, which is how Norman Mailer transformed the story of a loser named Gary Gilmore into a great American novel. Had Dorothy's story not ended in murder and suicide, nobody would have noticed.

1983 N 10, C26:3

An Era Revisited

PURPLE HAZE, directed by David Burton Morris; written by Victoria Wozniak; story by Thomas Kelsey, Miss Wozniak and Mr. Morris; director of photography, Richard Gibb; film editor, Dusty Nabili; produced by Thomas Anthony Fucci; released by Triumph Films. At the 57th Street Playhouse, between Avenue of the Americas and Seventh Avenue. Running time: 97 minutes. This film is rated R.

Matt Caulfield	Peter Nelson
Jeff Maley	Chuck McQuary
Derek Savage	Bernard Baldan
Kitty Armstrong	Susanna Lack
Walter Caulfield	Bob Breuler
Margaret Caulfield	Joanne Bauman
Phoebe Caulfield	Katy Horsch
Angela	Heidi Helmen
Marcus	Tomy O'Brien
Dorm Snitch	Dan Jones

By VINCENT CANBY

THE story goes something like this: There's this guy named Caulfield who gets shipped out of a preppie Eastern school for misbehaving. He didn't really do anything terrible. I mean he didn't run off with the dean's daughter, for God's sake. He just didn't shape up according to a lot of really boring regulations.

Caulfield goes home and, well, things are even worse there than they were at school. His mother looks like a worn-out flower. His father isn't deaf, but he can't hear anything that Caulfield has to say. The only person who pays attention to him is his younger sister, Phoebe, called "Phoeb" by Caulfield. One thing leads to another and Caulfield has to move out of the house and, well, life is really stupid when it's not just plain boring.

If this sounds familiar, it should. It's more or less a synopsis of J. D. Salinger's "The Catcher in the Rye." It's also more or less a synopsis of a movie called "Purple Haze," written by Victoria Wozniak and directed by David Burton Morris.

I assume "Purple Haze" is intended as a tribute to the Salinger classic that has influenced the lives of so many young people who later decided they wanted to become film makers. Though Miss Wozniak and Mr. Morris have lifted character names from Mr. Salinger, their movie isn't good enough to be called a rip-off.

•

There are also some major differences in plot details. The film's Caulfield, when first seen, is a Princeton student, not a prep school fellow. The movie is not set in the early 1950's but in 1968, the year that President Johnson decided not to run for a second elected term, Senator Robert Kennedy was assassinated, flower children advised making love not war and Mayor Daley's policemen roughed up demonstrators at the Democratic National Convention in Chicago.

"Purple Haze" recalls all of these things through newsreel footage, as if to certify the importance of its hero's sense of alienation. However, Caulfield, though he's nicely played by Peter Nelson, is such a passive, taciturn fellow that he's far less interesting than the era he's supposed to inhabit.

"Purple Haze," which opens today at the 57th Street Playhouse, is an independent feature that appears to have been shot mostly in and around Minneapolis. The technical credits are good.

1983 N 11, C8:1

The Boy Stands Alone

I AM THE CHEESE, directed by Robert Jiras; written by David Lange and Mr. Jiras, from the novel by Robert Cormier; director of photography, David Quaid; edited by Nicholas Smith; music by Jonathan Tunick; produced by David Lange. At the Gemini Twin, 64th Street and Second Avenue. Running time: 95 minutes. This film is rated PG.

Adam	Robert MacNaughton
Betty Farmer	Hope Lange
David Farmer	Don Murray
Dr. Brint	Robert Wagner
Amy	Cynthia Nixon
Young Adam	Frank McGurran
Gardener	Russell Goslant
Mr. Hertz	Robert Cormier

By JANET MASLIN

"I AM THE CHEESE" has the homespun simplicity that its title betrays, and the clumsiness, too. It concerns a 15-year-old boy named Adam Farmer, who has on many occasions had "The Farmer in the Dell" sung to him; from this the film (and Robert Cormier's novel, on which it is based) takes its title. Adam is the cheese, the one who stands alone. Fortunately, this imagery is invoked only a couple of times.

The film, which opens today at the Gemini theater, has a mystery plot that involves Adam, his parents, secret identities, a Government agent, a group of bullies, a psychiatrist and several layers of flashback. Certainly all this has the potential to hold an audience's attention. But the film has been so weakly directed by Robert Jiras that it has a glum, dispirited air, and none of the suspense or pacing that might link its various elements together. Not even the Vermont settings help to enliven the material, although they're certainly authentic. One scene, set in a small-town store, features large bags of something called Earlybird Worm Bedding in the background.

Robert MacNaughton, who played the older son in "E.T.," makes a gentle and sympathetic Adam, conveying the boy's troubled nature and his feeling of being constantly embattled. Adam is seen throughout the film at various stages of a long bicycle journey. The trip is interrupted freqently, by memory sequences, flash-forward glimpses of Adam with his psychiatrist (played by a sturdy but none-too-doctorly Robert Wagner), phone calls to a girlfriend back home (played pertly by Cynthia Nixon) and unpleasant encounters with various Vermont townspeople, all of whom are unaccountably nasty and contribute to the young man's feeling of isolation. Along the way, Adam thinks frequently of his parents, a bizarrely jolly twosome (played by Hope Lange and Don Murray) who eventually do something so foolish as to bring on tragedy and throw all credibility out the window.

•

"I Am the Cheese" is rated PG ("Parental Guidance Suggested"). It contains brief violence and occasional strong language, none of which would render it unsuitable for the adolescent audience at which it is aimed.

1983 N 11, C12:4

YOUNG WARRIORS, directed by Lawrence D. Foldes; written by Mr. Foldes and Russell W. Colgin; director of photography, Mac Ahlberg; edited by Ted Nicolou; music by Rob Walsh; produced by Victoria Paige Meyerink; released by Cannon Films. At the Rivoli, Broadway and 49th Street and other theaters. Running time: 105 minutes. This film is rated R.

Lieut. Bob Carrigan	Ernest Borgnine
Sgt. John Austin	Richard Roundtree
Beverly Carrigan	Lynda Day George
Kevin Carrigan	James Van Patten
Lucy	Anne Lockhart
Scott	Tom Reilly
Stan	Ed De Stefane
Fred	Mike Norris
Professor Hoover	Dick Shawn
Ginger	Linnea Quigley
Jorge	John Alden
Heather	Britt Helfer

By JANET MASLIN

For the first half hour or so, "Young Warriors" appears to have been mistitled, because it revolves around four spoiled Malibu-bred fraternity boys. Sharing a dormitory room with a Pia Zadora poster on the wall, these lunkheads favor practical jokes, casual sex and beer-guzzling. The only potential warfare in their future is apt to be the battle of the bulge.

Things change drastically, however, after Kevin (James Van Patten), who is very protective of his younger sister Tiffany (played by April Dawn, an actress more notable for her name than for her performance), has been gang-raped and murdered on the night of the senior prom. Quicker than you can say "Death Wish," Kevin and his friends have abandoned their former foolishness and traded in their v-neck velours for mean-looking military garb. They roam the streets carrying automatic weapons, hunting Tiffany's killers and in the meanwhile looking for other, unrelated wrongdoers, whom they blow to smithereens.

The audience at the Rivoli theater, where "Young Warriors' opened yesterday, greeted this transformation with hearty cheers.

The film's opening dedication to King Vidor seems presumptuous, in view of the material and its something-for-everyone brand of exploitation. However, the director, Lawrence D. Foldes doesn't bungle the movie on its own B-movie terms. It may be cheap, but it isn't dull.

•

The cast includes Ernest Borgnine as Kevin's policeman father and Richard Roundtree as another policeman, neither of whom can catch the desperadoes who attacked Tiffany. The cast also includes several Hollywood offspring, including James (son of Dick) van Patten, Anne (son of June) Lockhart, and Mike (son of Chuck) Norris. Dick Shawn turns up as a sociology professor, bemoaning "social erosion" and "doing your own thing." While listening to this lecture, the still clean-cut Kevin becomes so distressed that he throws a chair out a window, a harbinger of the violence that is to come.

1983 N 12, 12:1

143

BOAT PEOPLE, directed by Ann Hui; screenplay (Chinese with English subtitles) by K. C. Chiu; story by Tien Kor; director of photography, Chung Chi-Man; edited by Wong Yee-Sun; music by Law Wing-Fai; produced by Chui Po-Chu. At the Plaza, 58th Street, between the Avenue of the Americas and Seventh Avenue. Running time: 106 minutes. This film is not rated.

Akutagawa	Lam
The Madame	Cora Miao
Cam Nuong	Season Ma
To Minh	Andy Lau
Ah Thanh	Paul Chung
Inoue Wong	Shau-Him
Officer Nguyen	Qi Mengshi
Comrade Le Kia	Melving
Comrade Vu Lin	Shujin
Cam Nuong's Mother	Hao Jialin
Ah Nhac	Wu Shujun
Second Brother	Gua Junyi
Commander of Zone 16	Lin Tao
First Officer in Zone 15	Guo Henpbao
Doctor in Zone 15	Zhang Dongsheng
Second Officer in Zone 15	Cai Jianzhou
To Min's Father	Wang Huangwen
Woman Neighbor	Meng Pingmei

"Boat People" was shown as part of the 1983 New York Film Festival. Following are excerpts from a review by Janet Maslin, which appeared in The New York Times last Sept. 24. The film opens today at the Plaza, on West 58th Street.

The subject of Ann Hui's "Boat People" would not seem to lend itself to ordinary movie-making tactics, because the film depicts the horrendous living conditions to be found in the northern part of Vietnam in 1978, three years after the war ended. However, Miss Hui brings a conventional — and for the most part highly effective — storytelling talent to bear upon this material. She's able to create both sensationalism and drama, even if her film never generates an air of realism, or frees itself from coincidence and cliché.

Miss Hui's film could hardly be confused with either a political tract or a documentary. The central character of "Boat People" is a Japanese photojournalist named Akutagawa (Lam), who is on a lengthy return visit to Vietnam under the watchful eye of a woman guide from the Cultural Bureau.

Initially, she escorts him to a New Economic Zone near Danang, where he is shown a group of happy schoolchildren. They perform a song for him:

Last night I dreamed of Chairman Ho.
I longed to hug him, to shower kisses on him.
May Chairman Ho live 10,000 years.

The journalist is delighted, saying "I never thought I'd come back to find so many healthy, happy children."

The rest of the film gives the lie to this sunny image; before it's over, the journalist has even returned furtively to the same zone and found the same children sleeping naked in appallingly overcrowded barracks. Miss Hui, who is from Hong Kong, made "Boat People" with the cooperation of the Chinese Government, and shot it on Hainan Island. The film's view of life in Communist Vietnam is unremittingly and, given the Chinese Government's enmity to the Vietnamese, not unexpectedly harsh. And yet "Boat People" isn't as controversial as might be expected, because its criticism is very much in the service of its clear and simple dramatic needs.

1983 N 13, 78:1

The actor Lam, holding child, plays the role of a Japanese photographer who returns to Vietnam in Ann Hui's "Boat People," a film from Hong Kong

FILM VIEW

VINCENT CANBY

What Makes Audiences Fond of 'Rita'?

For a people who pride themselves on a populist kind of anti-intellectualism and who mistrust any apparent signs of education, Americans are awfully eager to pay good money to see commonplace movies that appear to exalt teachers and any institutionalized learning process. It's as if they were saying that they admire educations, even though they wouldn't want their sisters to go out with one.

All of us have wept on cue through "Goodbye, Mr. Chips," "The Corn Is Green" and "To Sir With Love," among other valentines to literacy. Now add another billet-doux to this list. It's called "Educating Rita" and it's turning into one of the surprise hits of the season. The English film, which opened here to good if not great reviews in September, seems to be benefiting from word of mouth, which may or may not be grammatical but is certainly favorable. Whatever the reason, there are long lines of patrons, mostly young, waiting to get into the New Yorker theater to see it every weekend.

To be utterly fair, "Educating Rita" has two large assets: the enormously professional, slick performances by Michael Caine, as a boozy, self-pitying poet-turned-tutor in an English "open" university, and Julie Walters, as a slangy, brassy young hairdresser with an unquenchable thirst for knowledge.

The screenplay is by Willy Russell, based on his London stage hit in which Miss Walters scored something of a triumph. That experience shows in her Billie Dawn-like screen performance, which, under Lewis Gilbert's direction, goes at about twice the speed of life, something that initially prevents us from worrying too much about the screenplay's idiocies.

• • •

Miss Walters has some of the gamine quality — as well as the no-nonsense lower lip — of the Shirley MacLaine we first came to know in "The Trouble With Harry" and "Around the World in 80 Days." However, it may be taken as an indication of the film's true feelings toward education that Miss Walters, who plays the title role, becomes increasingly less attractive with each succeeding Blake poem she learns by heart and with each new (to her) Chekhov play she reads. She's not exactly hideous by the time she passes her university entrance exams with distinction, but a lot of the bloom has slid weightily off the rose.

Rita was born Susan, but at the start of the film she is calling herself Rita out of admiration for Rita Mae Brown, author of "Rubyfruit Jungle," which she thinks is terrific. She also admires Harold Robbins, though she hasn't taken his name, and the snobbish manners of university students and the way they dress. She is married to a decent if chauvinist laboring man, Denny, who wants her to have a baby. Instead, Rita sets out to better herself through education, knowing, as her mother once said during a pub sing-along, that "there must be better songs to sing."

The ease with which Rita acquires her knowledge must be one of the miracles of modern education. Though we see her in libraries from time to time, and carrying books, and even looking at them longingly, she never seems to read — she's always being interrupted. Nevertheless, in the course of one year, Rita becomes a sort of Midlands Mary

McCarthy. We can tell the seasons are passing by the periodic nature shots: branches, first in leaf and then bare, and grass, first green, then covered with what appears to be very expensive, fake snow.

• • •

We can also tell that time is passing by the frequency and the weight of the literary references, which are, all told, pretty priceless. Rita initially has terrible trouble getting through "Foster's 'Howard's End,'" which she thinks must be a dirty book from its title. "Peer Gynt," however, presents her with no problems. She devours William Blake and, when off screen, she apparently commits his entire oeuvre to memory.

Before you know it, Rita is dropping names all over the place — "Of Human Bondage" (to make a joke about bondage books), "Saint Joan," Yeats, Shakespeare. It's the poor old bard who is responsible for the movie's most embarrassing scene, in which Rita, having just attended a performance of "Macbeth," bursts into a hall where Mr. Caine is lecturing to tell him about how transported she has been by the magnificence and ferocity of the poetry. This particular speech is full of the kind of jokey terms that I associate with an American comedian, whose name I've forgotten, who used to do a routine in which he'd recount the plot of "Hamlet" in hillbilly language.

The highpoint of the film, at least for me, is actually a little throwaway scene designed to demonstrate Rita's arrival in academe. Rita is seen swinging her way happily across the campus when a student hails her and asks her to settle an argument for him and his chums. "It has to do with Lawrence's early works," he says, which, we suddenly realize, must be only one of Rita's specialties.

What might be called the emotional plot of "Educating Rita" has to do with the relationship that grows up between Rita, for whom, you might say, an entirely new world is opening, and Mr. Caine's tired, burned out, would-be poet-tutor. Rita's remarkable progress pleases him immensely, but what drives him even further into drink is not the suspicion that she might have made a pact with the devil (she certainly hasn't acquired her knowledge through study) but his sudden jealousy of her new friends and of her satisfaction in being able to talk about "matters of importance."

What's going on in the mind of the movie is not easily fathomed. While educating Rita, Mr. Caine's tutor asks himself what can it profit a man if he gains an education and loses his "uniqueness." That is a fairly dopey idea, but he also appears to look on Rita's transformation not as education but as sophistication, and in a way he's right. Yet the movie shares Rita's awe of books, as if they were talismans, magic objects not to be read but to be carried around in a tote bag, their titles invoked to stun all enemies. By the end of the film, however, Rita is O.K. She has her education and though she has lost her husband and close ties with her family, she's facing her uncertain future with enlightened determination.

• • •

Just why "Educating Rita" should find such a responsive audience here, I've no idea. Granted that Mr. Caine and Miss Walters are very persuasive in a sentimental way, and that the dialogue is what's sometimes called snappy. However, the film is as sexless as a telephone book and it wouldn't recognize an idea unless it was dressed up in a chicken suit.

Some of the appeal of "Educating Rita" may be that it makes book knowledge seem both manageable and unthreatening. Knowledge, as we see it in this film, has nothing to do with thoughts, feelings, fears, doubts, work, confusion, loneliness. It's something one acquires, more or less passively, like a sunburn. All one has to do is to sit in the right place at the right time. Thus, because anyone who wants book knowledge can get it fairly easily, it's value is diminished and the state of not having it is made to seem less — well — intimidating. The bottom line: There's nothing wrong with being a slob. ■

1983 N 13, II:17:1

Sharing Last Days

IN FOR TREATMENT, a film from Het Werkteater; directed by Erik van Zuylen and Marja Kok; screenplay (Dutch with English subtitles) devised by the actors; camera, Rene van den Berg; edited by Hans van Dongen; a Werkteater Production. At the Thalia, Broadway and 95th Street. Running time: 95 minutes. This film is not rated.
Mr. de WaalHelmert Woudenberg
Frank ...Frank Groothof
Dr. HagemanHans Man In't Veld
Mrs. de WaalMarja Kok
Anja Vonk ..Daria Mohr
Frank's fatherHerman Vinck
Nurses
 Olga Zuiderhoek, Shireen Strooker, Gerard Thoolen
Co-assistantIvan Wolffers
Patient ..Joop Admiraal

By VINCENT CANBY

FILMS about the terminally ill are not casually recommended. The problem is not only that one knows how they must turn out. There's also the awareness that before it reaches its inevitable conclusion, it has to make certain obligatory points about faith, courage and what might be called enlightened resignation. The possibilities for surprise are limited.

Acknowledging all of these things, I hasten to say that "In for Treatment," a 1979 Dutch film that opens a two-day run at the Thalia today, is one of the more interesting and original movies available in New York this weekend. It's not a discovery to equal "Stevie," which the Thalia saved from oblivion a couple of years ago, but it's a small, spare, beautifully acted drama from a most unlikely source, a Dutch theater collective that calls itself the Werkteater.

"In for Treatment" is an exceptionally cinematic screen recording of two Werkteater theatrical pieces devised, apparently, by the actors themselves, and turned into a single, cohesive film by Erik van Zuylen and Marja Kok, who receive credit as the directors of the film.

It is initially the story of a tall, 40-ish fellow named de Waal, who owns a successful nursery business, is happily married and has a son who is about to get married. One day de Waal goes to the hospital for some routine tests relating to a leg that is bothering him. The day of tests stretches into a week of "observation." Then, without his being entirely aware of what's happening, he finds himself out of the ward and in a semiprivate room, being treated with that mixture of condescension and polite dread still reserved for the terminally ill in some hospitals.

De Waal has an inoperable brain tumor. In common with so many people who stay away from doctors because they think they can deny the existence of things they don't know about, de Waal continues to suspect that he would have been all right if he just hadn't come to the hospital in the first place.

The film is also the story of Frank, a much younger fellow with whom de Waal shares his semiprivate room. Frank also has cancer and, unlike de Waal, has refused to recognize the seriousness of his symptoms. How the two men react to each other and to their individual circumstances and how their doctors learn from them is pretty much the substance of the film, which is often achingly moving but never sentimental.

The performers, who have the advantage of being entirely new to American audiences, are remarkable. Helmert Woudenberg, who looks a little like a solemn Jacques Tati, is de Waal, and Frank Groothof

is Frank. Hans Man In't Veld plays the principal doctor and Miss Kok, one of the film's two directors, is de Waal's wife.

Although "In for Treatment" has its roots in the theater, it never for a minute looks like anything except an extremely accomplished, small-scale film, one that has the abrasive impact of a fine documentary but which exercises the privileges of fiction.

1983 N 18, C5:3

Thirst for Knowledge

YENTL, produced and directed by Barbra Streisand; screenplay by Jack Rosenthal and Miss Streisand, based on Isaac Bashevis Singer's "Yentl, the Yeshiva Boy"; edited by Terry Rawlings; music by Michel Legrand, lyrics by Alan and Marilyn Bergman; released by M-G-M/ U.A. At the Ziegfeld, Avenue of the Americas and West 54th Street. Running time: 134 minutes. This film is rated PG.
Yentl.................................Barbra Streisand
AvigdorMandy Patinkin
HadassAmy Irving
PapaNehemiah Persoff
Reb Alter VishkowerSteven Hill
ShimmeleAllan Corduner
Esther RachelRuth Goring
Rabbi ZalmanDavid De Keyser
Tailor ...Bernard Spear
Mrs. ShaemenDoreen Mantle
Peshe ...Lynda Barron
BooksellerJack Lynn
Mrs. KovnerAnna Tzelniker

By JANET MASLIN

THE facts that Barbra Streisand has produced, directed and is co-author of "Yentl," and that she stars in it wearing a pillbox-contoured designer yarmulke, do not adequately convey the sincerity of the effort. The best thing about "Yentl," which opens today at the Ziegfeld and other theaters, is its earnestness. It may resemble a vanity production from afar (or at close range, too, for that matter), but even at its kitschiest it seems to be heartfelt. That goes a long way, though not far enough, toward saving the film from its own built-in difficulties.

Miss Streisand plays the title character, from Isaac Bashevis Singer's story of a Jewish girl in Eastern Europe who disguises herself as a boy in order to get an education. Yentl is a long-haired lass as the film begins, living in a shtetl with the set-designed prettiness of a minor Disneyland. In an opening sequence, Yentl contemplates buying a fish, an activity in which the shtetl's other women are busily engaged. Just then a cart comes along, carrying the volumes of Talmudic scholarship that the women are forbidden to study. "What do you want?" asks the fishmonger. Yentl looks away from the fish and gazes longingly at the books instead.

•

Once the film has indicated, in this way and about six dozen others, that Yentl is frustrated by her feminine destiny, and once her scholarly father (played touchingly by Nehemiah Persoff) has expressed confidence in his daughter and then died, the stage is set for Yentl's transformation. She cuts off her hair, dons Chaplinesque baggy pants and heads for the Yeshiva, where she hopes to pass as a male student. As it happens, Miss Streisand makes a wonderful boy, pert and quick-witted, and her masquerade is by no means unconvincing. She brings a disarming humility to her performance as Anshel (the male name she adopts), not afraid to appear unglamorous or to be upstaged by a pretty co-star.

As Hadass, Amy Irving embodies what is supposed to be the feminine

Barbra Streisand is producer, director, co-writer and star of "Yentl," based on the Isaac Bashevis Singer tale of a woman who disguises herself as a man to get a Talmudic education.

ideal of the time, in contrast to the feisty Yentl. Hadass is the demure fiancée of Avigdor (Mandy Patinkin), a fellow Yeshiva student to whom Yentl is desperately attracted. When it is decreed that Avigdor may not marry his doll-like sweetheart, whom he adores for the way she waits on him hand and foot, Yentl-Anshel is recruited for the role of bridegroom. This may sound like a morass of sexual ambiguity, but that's not the way it plays. If anything, the movie is curiously devoid of sexual overtones, seeing masculinity strictly as a form of power, femininity as oppression, and unrequited lust as a good thing for Miss Streisand to sing about at periodic intervals.

•

No audience will ever complain about hearing Miss Streisand sing. But her musical talents — in fact, all of her talents — have been far better used elsewhere than they are here. The songs, with music by Michel Legrand and lyrics by Marilyn and Alan Bergman, constitute an ongoing interior monologue for Yentl, but they have been slapped so awkwardly onto the narrative at times — with Yentl sometimes singing over other characters' dialogue — that they neither advance nor amplify the action. (Sometimes they actually stop it cold, as in a candelight elegy for Yentl's father, with Miss Streisand giving the prayerful melody some very show-biz inflections.) During several of the songs, the lip-syncing is conspicuously clumsy, reflecting a technical sloppiness that is evident throughout the movie.

While there's no mistaking the fact that Miss Streisand has lavished great attention on some of the film's details — things like lace curtains, Oriental rugs, food and flowers, and various peripheral touches that hammer home the characters' ideas —

her carelessness about others is perplexing. The cinematography, by David ("Chariots of Fire") Watkin, might have been expected to be lovely, but many scenes have a muddy hue. The music bursts forth irregularly, sometimes from Yentl's mouth and other times from her silent thoughts, to the point where it becomes confusing. The lighting is so odd that in one scene a corner in the left foreground looks ready to burn up the frame. In the scene that has Yentl finally confessing her secret to Avigdor, the light descends unflatteringly from above, perhaps suggesting that a ray of truth is falling on the characters, and perhaps suggesting a studio with a broken window.

•

"Yentl" works best during its middle sequences, when the audience has been caught up in the premise and in the Yentl-Avigdor romance. Mr. Patinkin is warm and personable here, and he and Miss Streisand share some affecting moments. But the film begins laboriously, and the note on which it ends is a dreadful one. After telling Mr. Singer's story in terms that make sense to a modern audience — despite its period setting and premise, the film often has a contemporary feeling — Miss Streisand reverts abruptly to the original, relatively harsh resolution.

She follows this with a scene of Yentl singing on a boat, "Funny Girl"-style, as she sails away from Europe and toward the New World. The boat is packed with immigrants, yet Yentl somehow finds an entire empty deck to prance across. Then she strides through the ranks of the other travelers, singing at the top of her lungs while none of the bleak-looking refugees even bats an eye. Yentl is wearing two different knitted hats and a matching sweater. You'd

think her fellow passengers would have noticed the outfit, at the very least.

•

"Yentl" is rated PG ("Parental Guidance Suggested"). It contains some suggested nudity and sexual references.

1983 N 18, C10:1

Marital Discord

VASSA, directed by Gleb Panfilov; screeenplay (Russian with English subtitles) by Mr. Panfilov based on Maxim Gorky's play "Vassa Zheleznova"; director of photography, Leonid Kalashnikov; music by Vadim Bibergan; produced by Mosfilm. At Carnegie Hall Cinema, Seventh Avenue and 56th Street. Running time: 106 minutes. This film is not rated.
Vassa..Inna Churikova
AnnaValentina Telichkina
RachelValentina Yakunina
Vassa's BrotherVadim Medvedev

"**V**ASSA" is Gleb Panfilov's glum adaptation of a play by Maxim Gorky, "Vassa Zheleznova," detailing the tragedy of a powerful heiress in the precarious Russia of 1913. The title character, a woman of great wealth who has a ruthlessness to match, engineers the downfall of her husband once his philandering threatens the family's reputation. Not even her husband's suicide appears to shake the resolve of Vassa, who is so oppressive a presence in her own household that her absence provokes a virtual orgy of celebration on the part of other members of her family.

This powerful, daunting heroine is played by Inna Churikova, who is Mr. Panfilov's wife, with a dolorous sternness that is only finally mitigated by gentler emotions. The performance has intensity but not much variation,

and the same thing is true for the film as a whole. "Vassa," which was the grand prize winner at the International Film Festival in Moscow this year, and which opens today at the Carnegie Hall Cinema, seems an intelligent but largely unreflective rendering of Gorky's play, announcing the evil of the characters and the decadence of their class rather than capturing the nuances of their situation.

The film has been ambitiously mounted for the most part, and occasionally it becomes unexpectedly effective. On one family outing, Vassa coaxes her grandson, whom she refuses to return to her daughter-in-law because the young woman is a revolutionary, to understand his birthright. "Do you know whose it is?" she asks him, as the family sails on a lavish barge. "Ours!" cries the boy. "Ours means nobody's," says Vassa. "Say 'It's mine!' " He does, and she rewards him with a candy.

Janet Maslin

1983 N 18, C10:5

Pirate With Scruples

NATE AND HAYES, directed by Ferdinand Fairfax; screenplay by John Hughes and David Odell; screen story by Mr. Odell; director of photography, Tony Imi; edited by John Shirley; music by Trevor Jones; produced by Lloyd Phillips and Rob Whitehouse; released by Paramount Pictures. At Loews State, Broadway and 45th Street, and Orpheum, 86th Street and Third Avenue; 34th Street Showplace, at Second Avenue, and other theaters. Running time: 100 minutes. This film is rated PG.
Captain Bully Hayes.................Tommy Lee Jones
Nate ..Michael O'Keefe
SophieJenny Seagrove
Ben Pease ...Max Phipps
Count von RittenbergGrant Tilly
Mr. BlakeBruce Allpress

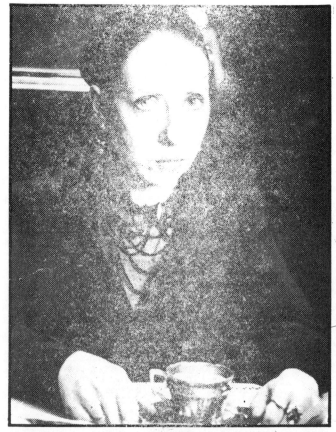

Inna Churikova stars in "Vassa," the Russian director Gleb Panfilov's version of a Maxim Gorky play about an heiress and her revolutionary daughter-in-law.

"NATE AND HAYES," which opens today at Loews State and other theaters, tries unsuccessfully to be that buoyant, rollicking pirate movie we all remember having seen in our youth and which they don't make anymore.

•

It's set in the South Pacific in the mid-19th century and is about a free-booting fellow named Captain Bully Hayes (Tommy Lee Jones), a pirate with scruples, meaning that he refuses to be a part of the slave trade. The Nate of the title is, more formally, Nathaniel Williamson (Michael O'Keefe), the stuffy son of missionaries and a young man who, in the course of the story, learns about a life of adventure from the older, wiser Bully Hayes.

Though Mr. Jones ("Coal Miner's Daughter," "The Executioner's Song"), Mr. O'Keefe ("The Great Santini") and Jenny Seagrove, who plays a spunky young woman named Sophie (which allows for a joke about a choice she must make), are attractive, lively actors, the movie is no fun at all. An old man with a peg leg would have no trouble keeping ahead of the plot, which, among other things, involves cannibals, sailing ships, one early iron-clad warship and a sequence in which Hayes trades guns for gold with Polynesians whom he describes as "anticolonialists." As pirates go, Hayes, it seems, is a bit left of center.

Even the movie's scenery is unreliable. At times these tropics look like the Fiji Islands and at other times like the somewhat more temperate New Zealand. Ferdinand Fairfax, the director, allows the actors to strain for comic effects that aren't there. He also seems uncertain about the action sequences, some portions of which look to have been carefully choreographed, while others appear to have been improvised at the last minute.

•

"Nate and Hayes," which has been rated PG ("parental guidance suggested"), contains some surprisingly explicit violence for a film that is supposed to be an escapist adventure.

Vincent Canby

1983 N 18, C30:3

Home in Indiana

A CHRISTMAS STORY, directed by Bob Clark; screenplay by Jean Shepherd and Leigh Brown and Bob Clark, based on the novel "In God We Trust, All Others Pay Cash" by Mr. Shepherd; director of photography, Reginald H. Morris; film editor, Stan Cole; music by Carl Ziffrer and Paul Zaza; produced by Rene Dupont and Mr. Clark; released by M-G-M/U.A. At the Guild, 50th Street between Madison and Fifth Avenues; Loews 83d Street, at Broadway; Greenwich Twin, Greenwich Avenue and 12th Street, and other theaters. Running time: 98 minutes. This film is rated PG.

Mother	Melinda Dillon
The Old Man	Darren McGavin
Ralphie	Peter Billingsley
Randy	Ian Petrella
Flick	Scott Schwartz
Schwartz	R.D. Robb
Miss Shields	Tedde Moore
Grover Dill	Yano Anaya
Scot Farkus	Zack Ward
Santa Claus	Jeff Gillen
Ming the Merciless	Colin Fox
Flash Gordon	Paul Hubbard

THERE are a number of small, unexpectedly funny moments in "A Christmas Story," but you have to possess the stamina of a pearl diver to find them.

The film, which opens today at the Guild and other theaters, is about growing up in the early 1940's in a middle-size city in Indiana. In particular it's about 9-year-old Ralphie Parker (Peter Billingsley) who, more than anything else in the world, wants to own a genuine Red Ryder air rifle, one that comes complete with a shockproof compass and a sundial set into its stock.

"A Christmas Story" tells how Ralphie fares in his campaign to win such a Christmas present from his father and mother (Darren McGavin and Melinda Dillon) and a good deal of what it was like to be young in pre-World War II Indiana.

•

Just about everything that is good about "A Christmas Story" can be attributed to Jean Shepherd, the novelist and radio-television humorist who wrote the book "In God We Trust, All Others Pay Cash," from which the screenplay was adapted by him, by his wife, Leigh Brown, and by Bob Clark, the director. The best thing to be said about Mr. Clark as a director is that he admires Mr. Shepherd's wildly hyperbolic humor, though he doesn't have much of a gift for translating it to film.

Mr. Shepherd is a most engaging raconteur who transforms small stories of everyday life into tall tales of fantastic adventure. In his words, an after-school encounter between Ralphie and a neighborhood bully named Scot Farkus becomes a collision of Olympian deities. Mr. Shepherd himself reads the sometimes very funny voice-over commentaries on the screen action and, you may be sure, is responsible for the bits and pieces of 1940s trivia we see. These include the sight of Ralphie's younger brother so bundled up in a pre-miracle-fabric snowsuit that he can't even move his arms. Those were the days.

•

Mr. Clark, the director of "Porky's" and "Tribute," does not have a light touch. However, his heavy touch is not quite the same thing as Mr. Shepherd's habit of finding humor through the exaggeration of language. The movie's big comic pieces tend only to be exceedingly busy. Though Mr. Billingsley, Mr. Gavin, Miss Dillon and the actress who plays Ralphie's school teacher (Tedde Moore) are all very able, they are less funny than actors in a television situation comedy that one has chosen to watch with the sound turned off.

Most of the period details are good and accurate. However, I'm not at all sure that the curriculum at the Warren G. Harding Public School, which Ralphie attends, would require that 9-year-olds read "Silas Marner."

•

"A Christmas Story," which has been rated PG ("parental guidance suggested"), contains some vulgar language, though not one particular word that Mr. Shepherd, talking on the soundtrack, describes as "the queen-mother of dirty words."

Vincent Canby

1983 N 18, C36:1

A NIGHT IN HEAVEN, directed by John Avildsen; screenplay by Joan Tewksbury; director of photography, David Quaid; edited by John Jan Hammer; produced by Gene Kirkwood and Howard Koch Jr.; released by 20th Century-Fox. At Gotham, Third Avenue and 58th Street; Criterion, Broadway and 45th Street, and other theaters. Running time: 83 minutes. This film is rated R.

Rick	Christopher Atkins
Faye	Lesley Ann Warren
Whitney	Robert Logan
Patsy	Deborah Rush
Tony	Deney Terrio
Slick	Sandra Beall
Shirley	Alix Elias
Mrs. Johnson	Carrie Snodgress
Eve	Amy Levine
Jack Hobbs	Fred Buch
Louise	Karen Margret Cole
Revere	Don Cox
Tammy	Veronica Gamba
Pete	Joey Gian
Russel	Bill Hindman
Ivy	Linda Lee
Alison	Rosemary McVeigh

By VINCENT CANBY

"A Night in Heaven," which opened yesterday at the Criterion and other theaters, has the style if not the explicit content of a pornographic film, the sort of movie in which the story is simply an excuse to examine at great length a very limited number of particular activities. Here, however, the particular activities are somewhat less instructive.

The movie's only spectacle is the sight of some rather good actors walking around, often smiling, with egg on their faces. Chief among them is the hugely talented Lesley Ann Warren ("Victor/Victoria"), who plays a high-school speech teacher and the sex-starved wife of a mopey scientist (Robert Logan) attached to the Kennedy Space Center in Florida.

Out of boredom as much as anything else, she has a one-night stand with one of her students (Christopher Atkins), who moonlights as a male go-go dancer. As a result of this indiscretion, all boredom breaks loose. Carrie Snodgress, whose new career consists of doing throwaway roles in bad movies, plays the mother of Mr. Atkins.

Joan Tewkesbury is credited with having written the original screenplay, but whether what is on the screen is what she wrote is anybody's guess. I'd prefer to think that her work has been mutilated to attain its present look, which is that of a non-stop procession of red herrings from one side of the screen to the other and back again. John Alvidsen is the director.

1983 N 19, 19:3

THE BIG SCORE, directed by Fred Williamson; written by Gail Morgan Hickman; director of photography, Joao Fernandes; edited by Dan Lowenthal; music by Jay Chaffaway; produced by Michael S. Landes and Albert Schwartz; released by Almi Film. At RKO Warner, Broadway, between 47th and 48th Streets. Running time: 85 minutes. This film is rated R.

Hooks	Fred Williamson
Angi	Nancy Wilson
Davis	John Saxon
Gordon	Richard Roundtree
Parks	Ed Lauter
Easy	D'Urville Martin
Goldy	Michael Dante
Koslo	Bruce Glover
Mayfield	Joe Spinell
J. C.	Frank Pesce
Jumbo	Tony King
Cheech	James Spinks

By LAWRENCE VAN GELDER

Does it sound familiar: the dedicated narcotics cop, the pushers who manage to evade punishment thanks to their repulsive lawyers, the big drug raid that ends in a wild shootout during which a million dollars disappears?

Of course, the dedicated cop — he's Fred Williamson as Frank Hooks of Chicago in "The Big Score," which arrived yesterday at many local theaters — is suspected by his superiors of stealing the money. So they suspend

him and relieve him of his service revolver, whereupon he becomes the target of the homicidal henchman of the porcine lout at the pinnacle of the drug trade, who is also convinced he has the money.

•

And, what's worse, as a warning, the villains kill the little cat that is the pet of the good — but tough — cop's estranged wife (Nancy Wilson), who still has a very soft spot for him in her heart, as well as a place for him in her bed and a bar stool for him in the nightclub where she sings and presents jazz artists on the order of Ramsey Lewis.

Well, what is a poor cop to do except take matters — and hand grenades and a machine gun and sometimes a pistol — into his own hands?

"The Big Score," therefore, is one of those movies characterized by a high death toll and low originality. As star and director, Mr. Williamson has traveled this route before. His aspirations seem to rise no higher than competent escapist entertainment that taxes no one's intellect, pushes the police yarn to no new levels and advances cinematic art not a whit.

He has surrounded himself with a good cast — for example, John Saxon and Richard Roundtree as fellow cops: the former being blasted and burned away; the latter simply disappearing from the narrative for no apparent reason.

•

Here and there through "The Big Score" there are flashes of wit and an appreciation of irony that raise the suspicion that Mr. Williamson is capable of more. But there is always an audience for twice-told tales and B-movies, and here Mr. Williamson has come to rest. Insatiable moviegoers may be unable to resist seeing "The Big Score" in a theater. Normal fans can wait until it turns up on television. And if it never does, they can rest assured that somewhere they've seen it all before.

1983 N 20, 67:3

AMITYVILLE 3-D, directed by Richard Fleischer; written by William Wales; director of photography, Fred Schuler; film editor, Frank J. Urioste; music by Howard Blake; produced by Stephen F. Kesten; released by Orion Pictures Corporation. At Loews State, Broadway and 45th Street; Orpheum, 86th Street and Third Avenue, and other theaters. Running time: 93 minutes. This film is rated PG.

John Baxter	Tony Roberts
Nancy Baxter	Tess Harper
Elliott West	Robert Joy
Melanie	Candy Clark
Harold Caswell	John Beal
Emma Caswell	Leora Dana
Clifford Sanders	John Harkins
Susan Baxter	Lori Loughlin
Lisa	Meg Ryan
Jeff	Neill Barry
Roger	Pete Kowanko

The third in a 3-D series, as in "Jaws 3-D" or now "Amityville 3-D," simply isn't a good idea. Once the first two films in a series have exhausted most opportunities for action, the third is liable to average half a dozen exposition scenes for every eventful episode. And 3-D exposition is the stuff of which headaches are made; the footage tends to be so dark that you can barely tell whether it's night or day. There's no reason why something like a domestic quarrel need be photographed with gloomy 3-D lighting, even if there are dishes being thrown.

"Amityville 3-D," which opened at Loews State and other theaters Friday, is the shadowy saga of a writer (Tony Roberts) for Reveal magazine who separates from his wife (Tess Harper) and decides to move into the

world-famous haunted house with the help of his new companion (Candy Clark). The cast is good, but the characters are idiots. For instance, when Miss Clark takes a photograph of the realtor who is selling the house, and develops it to find the realtor's face rotted (he is subsequently consumed by insects, it turns out), Mr. Roberts says something must be wrong with the film.

Mr. Roberts, for his part, declares the house a great Long Island antique, and exclaims eagerly over the hole in the basement ("I guess this is supposed to be, uh, the gateway to Hell"). It's a terrific bargain, he decides. Many scary effects later, he is definitively proved wrong.

Janet Maslin

"Amityville 3-D" is rated PG ("Parental Guidance Suggested"). It contains enough violence to frighten small children.

1983 N 20, 68:3

LA BALANCE, directed by Bob Swaim; written by Mr. Swaim and M. Fabiani; director of photography, Bernard Zitzermann; edited by Françoise Javet; music by Roland Bocquet; produced by Georges Dancigers and Alexandre Mnouchkine; released by International Spectrafilm; At the Paris, 58th Street west of Fifth Avenue; Running time: 102 minutes. This film is rated R.

Nicole	Nathalie Baye
Dédé	Philippe Leotard
Palouzi	Richard Berry
Tintin	Christophe Malavoy
Le Belge	Jean-Paul Connart
Le Capitaine	Bernard Freyd
Carlini	Albert Dray
Simoni	Florent Pagny
Arnaud	Jean-Daniel Laval
Picard	Luc-Antoine Diquero
Massina	Maurice Ronet

By JANET MASLIN

The slam-bang police thriller is familiar enough as an American genre, but with "La Balance" Bob Swaim has effectively transposed it to Paris. Mr. Swaim's film is shrewd, gritty and exciting in the tradition of "The French Connection" or "Dirty Harry," even if its band of plainclothes policemen have distinctly Gallic mannerisms. As members of the Territorial Brigade, an elite force in Paris, they keep American movie

posters on their office walls, and they love to eat. When they ransack a suspect's apartment, as they do in one sequence, they do not neglect to taste the meal — rabbit with pistachios — that is cooking on the stove.

"La Balance," which opens today at the Paris theater, has a title that is translated unhelpfully as "dimedropper." What it means is police informer, and the film revolves around the role of such figures in the activities of the Territorial Brigade. When a key informer is murdered at the beginning of the story, the police group led by Inspector Palouzi (Richard Berry) must locate and coerce another candidate. They settle on Dédé (Philippe Leotard), who is either a pimp or an out-of-work hoodlum, depending on whether the description is the police's or his own. In any case, his principal meal ticket is a slinky, streetwise prostitute named Nicole (Nathalie Baye).

Miss Baye seems to be enjoying herself immensely as Nicole, departing conspicuously from the more somber characters she ordinarily plays. In a variety of tarty outfits, she slinks through the streets of the area around La Madeleine, picking up customers and then stopping for sweets at nearby Fauchon. She has a healthy appetite and, apparently, a happy existence, since she and Dédé share a certain degree of domestic coziness. Both Mr. Leotard, who makes a feisty and surprising Dédé, and Miss Baye won French César awards for their performances in "La Balance."

There is some excellent ensemble acting done at police headquarters as well, as the young, hip officers under Palouzi bring an unmistakable playfulness to even the most dangerous of their duties. The film seems just this side of flippancy at times — it's suspenseful but improbable, for instance, that a young officer would drive into a dangerous ambush with his Walkman playing, so that he could not hear the instructions of his colleagues. However, this particular touch leads to a dramatic shootout that becomes one of the most startling action scenes here. While the police tactics seen in the film might well give the viewer pause, they're gener-

ally presented so skillfully by Mr. Swaim that they don't prompt any immediate objections.

"La Balance" is very well-detailed and involving, though it's more successful in conveying general atmosphere than in delving deeply into the lives of the principals. The effects of his work on Palouzi are revealed

more or less indirectly. And the effects on Nicole and Dédé of their involvement with the police become more inexorable than surprising. Nevertheless, "La Balance" is very entertaining on its own terms, a vivid and street-smart portrait of the Parisian underworld and those, on both sides of the law, who work there.

1983 N 20, 72:1

FILM VIEW

VINCENT CANBY

Good Little Movie

D o you feel not up to being overwhelmed? Would you like to save the "don't-miss" movie of the year until someone else insists that you see it? Are you looking for a film that won't knock your socks off, leave you devastated or explode in your face? Do you sometimes suspect that you simply aren't good enough for most of the movies that are available?

If you answer yes to any one of these questions you might want to see "Experience Preferred. . . but not Essential," a small, sweet English comedy that slipped into town several weeks ago and could, given the proper care, be around a lot longer than some of the other, far more ambitious, far more expensive new films.

To call "Experience Preferred. . ." a small film is not to patronize it but to describe its scale. Set entirely in a middle-class resort hotel on the Welsh coast, the comedy covers one summer in the life of Annie (Elizabeth Edmonds), a nice, initially rather plain, dark-haired young woman who works as a waitress at the hotel for several months before entering university. There's nothing psychologically wrong with Annie. The only thing she suffers from is inexperience, a complaint that has been pretty well cured by the end of the summer.

• • •

"Experience Preferred. . ." is not quite in the same league with Bill Forsyth's two marvelous comedies, "Gregory's Girl" and "Local Hero," though the films have several things in common, including an uncanny way for avoiding the anticipated cliché. They also share a totally unflappable manner. No matter what happens, these films pretend not to be surprised, which is very much a part of their comic method.

There are times when Annie's adventures at the Hotel Grand seem about to erupt into melodrama but, rest assured, they never do. This is not to say that life at the Grand is entirely sunny. Take the case of Paula, a professional waitress (as opposed to Annie's student-waitress) who in all ways is self-confident and commonsensical except when it comes to Hywel, a handsome waiter whom she loves desperately. Hywel beats Paula as frequently as he makes love to her, but if that's the price she must pay for his attentions, Paula doesn't complain. She just puts on dark glasses when she has to hide a black eye.

"Experience Preferred. . ." regards Paula's predicament with compassion but without tears. It's not something to be worried over unduly. More often than not, the film seems ready to laugh, not at Paula but at the situation in which she finds herself. The film expresses the same sort of attitude toward the weepy Arlene, a waitress who is in her mid-30's and several months pregnant by an elderly gent who only giggles when she asks what he intends to do about her "condition." Arlene tells the other waitresses that she's sure she wouldn't weep so much if her customers would just stop ordering kippers, which remind her of her seducer.

• • •

At first Annie is treated by her colleagues with a certain amount of condescension. They work for their livings; she, to finance an education. Eventually, though, she becomes as much a part of the ec-

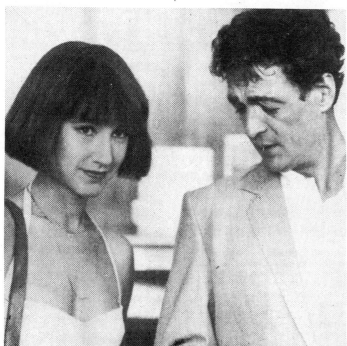

Nathalie Baye and Philippe Leotard in "La Balance."

centric Grand establishment as any of the others employees. Her initiation into womanhood is conducted with a great deal of humor, style and surprise by a youngish Scotsman named Mike (Ron Bain), a chef who unembarrassedly courts Annie by providing her with all sorts of fancy dishes not available to her colleagues.

"Experience Preferred. . ." is the kind of movie that is impressive as much for the things it avoids doing as for the things it does do, a quality that usually suggests the work of far more seasoned filmmakers than its director and its writer appear to be.

The film was directed by Peter Duffell, whose not especially impressive earlier credits include a horror film called "The House That Dripped Blood" (1970) and the 1972 adaptation of Graham Greene's "England Made Me." The screenplay was written by June Roberts, identified as a producer making her screenwriting debut. The only person connected with "Experience Preferred. . ." whose experience is impressive is David Puttnam, the producer whose credits include Alan Parker's "Bugsy Malone," Ridley Scott's "Duellists" and Hugh Hudson's "Chariots of Fire."

• • •

However they did it, in whatever combination of talents, Mr. Duffell, Miss Roberts and Mr. Puttnam have made a wonderfully engaging, low-keyed comedy that demonstrates a fine appreciation for sight gags, running gags, bizarre characters and unexpected reversals in fortune. They also introduce what is, to me, virtually an entirely new set of accomplished British character actors and actresses.

These include Miss Edmonds, whose Annie provides the eyes through which we see everyone else; Mr. Bain as the amorous young chef; Karen Meagher as Paula, whose life with Hywel is pure True-Romance; Alun Lewis as Hywel, the waiter who, when he is not beating on Paula, is perfecting a hilariously earnest Elvis Presley imitation; Maggie Wilkinson as the weepy Arlene; Sue Wallace, as Annie's staunch roommate, and Robert Blythe, as the hotel's bartender, whose love for a young male colleague does not go unrequited.

"Experience Preferred. . ." doesn't always have the courage of its own eccentricities, as do Mr. Forsyth's "Gregory's Girl" and "Local Hero." It exhibits a rather ordinary compulsion always to explain its characters and events more than is necessary and, at the end, to tie up all loose ends with utmost neatness. This tendency toward narrative symmetry, which doesn't seem to interest a neo-surrealist filmmaker like Mr. Forsyth, is the only truly commonplace thing about "Experience Preferred. . ."

Even that contributes to its appeal in a way. Like Jonathan Kaplan's "Heart Like a Wheel," an American film that it doesn't resemble in any other way at all, "Experience Preferred. . ." is not a movie you have to dress up — or down — for. It's a movie you can drop in on, without making a big deal of it. If you arrive late, you won't feel completely inadequate, and when you leave, you won't feel exhausted — or insulted. It's a charmer. ∎

1983 N 20, II:17:1

Murder Mystery

BEYOND REASONABLE DOUBT, directed by John Laing; screenplay by David Yallop; director of photography, Alun Bollinger; edited by Michael Horton; music by Dave Fraser; produced by John Barnett; released by Satori Entertainment. At the Sutton, Third Avenue and 57th Street. Running time: 111 minutes. This film is not rated.
Bruce HuttonDavid Hemmings
Allan ThomasJohn Hargreaves
John HughesTony Barry
Len DemlerMartyn Sanderson
David MorrisGrant Tilly
Vivien ThomasDiana Rowen
Kevin RyanIan Watkin
Paul TemmTerence Cooper

By JANET MASLIN

IT'S a pity that "Beyond Reasonable Doubt" has been so amateurishly directed, because the real-life crime it examines is potentially of interest.

It involves the disappearance of a New Zealand couple from their dinner table, on which the remains of a meal of flounder are still to be found. Also in the now-abandoned house is the couple's baby, and although its parents have been missing for five days the infant has apparently been fed during that period. By whom? And who has murdered the parents? One of the unfortunate things about the film is that even after lengthy investigation, it attempts no answer to either question.

"Beyond Reasonable Doubt," which opens today at the Sutton Theater, concentrates on the events that implicate Arthur Allan Thomas, a 32-year-old farmer and former sweetheart of the missing woman, in the crime. The real Mr. Thomas did in-

deed serve nine years for the murders before being pardoned. On the film's evidence, Mr. Thomas appears to have been framed by an overzealous detective, Inspector Bruce Hutton (David Hemmings), who is determined to solve the case no matter what the cost.

It is possible, though not likely, that fans of detective fiction will find the circumstantial evidence in this case sufficiently interesting to offset the film's dramatic shortcomings, which are huge. The evidence, which involves bullets of a particular type and an autombile axle eventually found with one of the bodies, is discussed in considerable detail. However, the facts are presented very monotonously by a wooden cast (Mr. Hemmings, the most animated figure in the drama, is the only one who's the least bit lively). And as directed by John Laing, the film is relentlessly overexposed and drearily staged. Neither the seriousness of the crime nor the beauty of the New Zealand landscapes comes through.

1983 N 22, C16:4

Two for the Road

RETURN ENGAGEMENT, a documentary directed by Alan Rudolph; director of photography, Jan Kiesser; edited by Tom Walls; music by Adrian Belew; produced by Carolyn Pfeiffer; associate producer, Barbara Leary; released by Island Alive. At the Embassy 72d Street, at Broadway. Running time: 90 minutes. This film has no rating.
Debate ModeratorCarole Hemmingway

ANY movie ought to be in trouble when it opens with G. Gordon Liddy, the convicted Watergate burglar and author ("Will"), singing a hearty, full-throated version of "America" to piano accompaniment provided by Timothy Leary, the former Harvard professor who became the spokesman for the turned-on flower people of the 1960's. What, possibly, can the movie do for an encore?

This movie, "Return Engagement," which starts today at the Embassy 72d Street Theater, does quite a lot of amusing stuff, though how much of it is true documentary, put-on or out-and-out self-exploitation, I'm not at all sure. It is, I suppose, a combination of the three, which means that it's something like an all-American success story.

•

Here we have the spectacle of two originally very different men as they now join forces to tour America, "debating" their respective political and moral codes, but having more in common with Daisy and Violet Hilton, the Siamese twins, than with Abraham Lincoln and Stephen Douglas.

The two men are not exactly freaks, but one has the suspicion that they wouldn't be showing off in this way if they could possibly make a living in some other fashion. Whether accurately or not, the movie suggests that the world has passed them by and that this personal appearance tour is one of the last ways in which each can turn his individual notoriety to profit.

The curious thing is that both men come across as far more interesting, humorous, decent, sensitive and aware than they do in their writings. Alan Rudolph, the director, may possibly be somewhat responsible for this. Maybe not.

The film's highlight is not one of their on-stage appearances, but a breakfast on a sunny Chateau Mar-

mont terrace shared by Mr. and Mrs. Leary and Mr. and Mrs. Liddy. In many ways they sound like two attractive, intelligent, middle-aged couples from suburbia, talking about home life, marriage, children and sex, making the time pass as best they can while away from home at an obligatory convention. That's show biz.

Vincent Canby

1983 N 23, C10:5

Waif Adrift

HILARY'S BLUES, directed by Peter Jensen; screenwriter, Elmer Kline; edited by Stan Rapjohn; music by Bill Marx; lyrics by Marilyn Lovell; produced by Mack Gilbert; released by Golden Union Films. At the Bleecker, 144 Bleecker Street. Running time: 80 minutes. This film is rated R.
HilaryMelinda Marx
HelenDiane Berghoff
HarveySean Berti
Commune LeaderAlan Mann
PhotographerAlan Dumont
DetectiveBill Wegney

"HILARY'S BLUES" was made in 1973 and is only now being released, presumably on the theory that audiences are ready for hippie nostalgia. Even if they are, they probably aren't ready for this.

Set in 1967 in Venice, Calif., the film follows the waif of the title as she drifts from bad to worse. She gets arrested, joins a commune, takes up with a man she meets on a park bench, works as a topless model, and contracts gonorrhea. Only at the film's closing, when an acquaintance of Hilary's takes LSD and then confuses her baby with the Thanksgiving turkey, does the film display any definite attitude toward such goings-on. In this last instance, at least, it disapproves.

•

"Hilary's Blues," which opens today at the Bleecker Street Cinema, stars Melinda Marx, Groucho's daughter, who seems quite demure in comparison with her seedy surroundings. Miss Marx doesn't say much, but every now and then a wispy voice is heard on the soundtrack, singing "If you were me/ who would you be?" This expresses her thoughts about as fully as they are expressed here, because Peter Jensen's direction does little more than combine hippie excess with frequent non-sequiturs.

The film's druggy atmosphere may contribute something to its flower-power verisimilitude, but not enough time has passed to make this sort of incoherence look like period charm.

Janet Maslin

1983 N 23, C16:1

ROCKABY, directed by D. A. Pennebaker and Chris Hegedus. At the Film Forum, 57 Watts Street. Running time: 57 minutes. This film has no rating.
WITH Billie Whitelaw and Alan Schneider
JOE CHAIKIN GOING ON, directed by Steven Gomer; a Gomer-Heller Production. At the Film Forum. Running time: 58 minutes. This film has no rating.
WITH Joseph Chaikin, Sam Shepard, Ronnie Gilbert

By VINCENT CANBY

STUDENTS of the theater and, for that matter, anybody interested in the contemporary theater, will want to see the

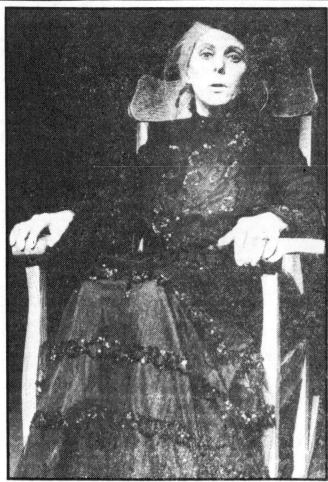

Irene Haupt

The British actress Billie Whitelaw stars in "Rockaby," the Samuel Beckett play that is the subject of a documentary of the same name.

new program opening today at the Film Forum. On the bill are the 57-minute "Rockaby," a record of the preparations and rehearsals for the world premiere performance of Samuel Beckett's play "Rockaby," and "Joe Chaikin Going On," a 58-minute documentary on the life and work of Joe Chaikin, the Brooklyn-born actor, director and avant-garde theater force.

"Rockaby," made by D. A. Pennebaker and Chris Hegedus, is not only something for the archives but it's also terrifically entertaining. The film documents the day-by-day progress of the "Rockaby" rehearsals from the first meeting of its director, Alan Schneider, and its star, the beautiful and brilliant Billie Whitelaw, until the night of its first public performance at a Beckett festival in Buffalo.

Because the Beckett text is a compact 15 minutes, the documentary further benefits by being able to include in the film a complete recording of the the play as it was seen in Buffalo. In between, the audience is able to sit in on conferences between Mr. Schneider and Miss Whitelaw, who is not only the star of "Rockaby" but its entire cast, and see clips from earlier Whitelaw performances in Beckett plays, including what must have been a classic portrayal of Winnie in a Beckett-directed production of "Happy Days."

"Joe Chaikin Going On," directed by Steven Gomer, benefits from the appearance of Sam Shepard, the

actor and playwright, who talks well and at length about Mr. Chaikin, whom he equates with England's Peter Brook and Poland's Jerzy Grotowski as an innovator in modern theater. We see bits and pieces of work by Mr. Chaikin's Open Theater, including a production of Mr. Beckett's "Endgame," and various examples of Mr. Chaikin's work as an actor, excerpts that are too short for a film audience to form any reliable opinion of its own.

1983 N 23, C16:3

TERMS OF ENDEARMENT, directed by James L. Brooks; screenplay by Mr. Brooks, based on Larry McMurtry's novel; director of photography, Andrzej Bartkowiak; edited by Richard Marks; music by Michael Gore; produced by Mr. Brooks, Martin Jurow and Penny Finkelman; released by Paramount Pictures. At the Coronet, Third Avenue and 59th Street; Baronet, Third Avenue and 59th Street; Astor Plaza, Broadway and 44th Street, and other theaters. Running time: 129 minutes. This film is rated PG.

Emma Horton..............................Debra Winger
Aurora GreenwayShirley MacLaine
Garrett BreedloveJack Nicholson
Vernon DahlartDanny DeVito
Flap HortonJeff Daniels
Sam BurnsJohn Lithgow
Rosie ...Betty King
Patsy ClarkLisa Hart Carroll
TeddyHuckleberry Fox
Tommy ,.......................................Troy Bishop
MelanieMegan Morris
Young Tommy HortonShane Serwin
Young Emma GreenwayJennifer Josey

By JANET MASLIN

"**T**ERMS OF ENDEARMENT" is a funny, touching, beautifully acted film that covers more territory than it can easily manage. It's the 30-year saga of a mother and daughter; the story of a charmingly eccentric woman who, in her 50's, finally permits herself to fall in love; and the chronicle of a troubled marriage between a young professor and his whimsical bride. It's a comedy, offbeat and lighthearted, then turns painfully and unexpectedly tragic in its final half hour.

A lesser movie might flail hopelessly between such drastic extremes, and "Terms of Endearment" does falter here and there. But it somehow manages to incorporate a great many dramatic threads. If it doesn't always do so with the same grace or economy, neither does it ever fail to be enormously appealing, thanks to the bright, witty, larger-than-life performances that James Brooks has elicited from his stars.

•

"Terms of Endearment," which opens today at the Coronet, the Baronet, Loews Astor Plaza and other theaters, is based on Larry McMurtry's novel of the same title. Mr. Brooks's screenplay doesn't follow the novel exactly, eliminating numerous incidental characters and adding at least one major figure, but it does echo the book's arch dialogue and its considerable sprawl. Mr. Brooks appears to have paid minimal attention to the pacing problems of the material, or to the fact that it frequently meanders. Instead, he concentrates on charm. And charm, at least on a scene-by-scene basis, is something "Terms of Endearment" has in abundance.

At the center of the movie is Aurora Greenway, a stern, fussy, wildly glamorous blond creature played with perfect composure by Shirley MacLaine. In the film's opening scene, Aurora awakens her infant daughter Emma to make sure the baby hasn't succumbed to crib death, and this mother-daughter dynamic persists long into Emma's adulthood. Emma, a beleaguered yet somehow radiant young woman played by Debra Winger, remains in her mother's orbit long after marrying Flap Horton (Jeff Daniels), whom Aurora despises, and bearing him three children. When the young Hortons tell Aurora that the first of these is on the way, she shrieks with typical delicacy "Why should I be happy about being a grandmother?"

But grandmotherhood and the unavoidable fact of her own increasing age finally force Aurora into the arms of her wily next-door neighbor, a former Astronaut named Garrett Breedlove. This is the character Mr. Brooks has added to the story, and as played by Jack Nicholson he becomes a masterly comic invention, with a magnificent repulsiveness that Mr. Nicholson turns into pure hilarity. Garrett is capable of making a mere lunch invitation sound amazingly obscene, and when he flirts with Aurora over the hedge that separates their houses, he threatens to ooze over into her yard. Miss MacLaine's deliberate coolness makes her a perfect foil for this sort of thing, and her scenes with Mr. Nicholson are among the film's most delightful.

"Terms of Endearment," which affects a drily eccentric humor like Mr. McMurty's particularly in its opening scenes, takes a while to get going; an audience may not realize that a bride and groom making love to show tunes (like "Gee, Officer Krupke") in their unpainted shack will evolve into characters who are genuinely affecting

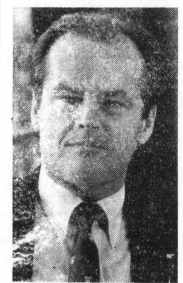

Jack Nicholson in the film "Terms of Endearment."

over the course of the story. After a while, though, the film seems to relax about establishing its own cleverness, and it moves on more comfortably to follow the characters and their lives.

By the time one of the women becomes ill — anyone who goes to this film expecting a light comic diversion had better bring along at least four hankies for the hospital scenes — the film has established its emotional base, and its ending is indeed wrenching. Miss MacLaine and Miss Winger bring great conviction to these final moments, just as they have brought buoyancy to what had come before. Miss MacLaine has one of her best roles in Aurora, and her performance is a lovely mixture of longing, stubbornness and reserve. Miss Winger again shows herself to be an astonishingly vital screen actress, able to imbue even the relatively drab Emma with urgency and passion.

•

There are some lovely supporting performances in "Terms of Endearment" too, most notably John Lithgow's as the bashful Iowa banker who becomes Emma's lover after encountering her in the supermarket. Mr. Lithgow plays this entire episode clutching a canned ham in his left arm, yet he manages to make this touch seem sweet rather than sardonic. Danny De Vito is also quite good as Vernon Dahlart, whose name captures the flavor of his character and who is one of the many Texan moths around Aurora's flame. As Flap, Mr. Daniels seems pleasant but ordinary, without the immense scale of the three other principals. This doesn't seem to be the fault of the performance, but rather that of the screenplay. As written, Flap is an indistinct character. It's never quite clear why Aurora can't stand him, or why Emma can.

Because the screenplay concentrates so heavily on the characters' wit and devotes so little attention to their backgrounds — no one who hasn't read Mr. McMurtry will have any idea how Aurora came by the Renoir she keeps in her bedroom, for instance — the film's production design is particularly important. As executed by Polly Platt, it is particularly good, giving a colorful but realistic sense of who the principals are and how they live. Andrej Bartkowiak's handsome cinematography also con-

tributes to the film's high gloss. And Mr. Brooks, even when struggling with the demands of his narrative, continues to bring out the best in this material: its humanity and its humor.

•

"Terms of Endearment" is rated . PG ("Parental Guidance Suggested"). It contains some cheerfully rude language and occasional sexual suggestiveness.

1983 N 23, C18:4

Fire Folk

FIRE AND ICE, directed by Ralph Bakshi; screenplay by Roy Thomas and Gerry Conway; characters created by Mr. Bakshi and Frank Frazetta; edited by A. David Marshall; music by William Kraft; produced by Mr. Bakshi and Mr. Frazetta; released by 20th Century-Fox Film Corporation. At the National, Broadway and 44th Street, and other theaters. Running time: 81 minutes. This film is rated PG.

Larn	Randy Norton
Teegra	Cynthia Leake
Darkwolf	Steve Sandor
Nekron	Sean Hannon
Jarol	Leo Gordon
Taro	William Ostrander
Juliana	Eileen O'Neill
Roleil	Elizabeth Lloyd Shaw
Otwa	Mickey Morton
Tutor	Tamarah Park
Monga	Big Yank
Pako	Greg Elam

By JANET MASLIN

IF you love comic books but can't bear the unnecessary bother of turning pages, "Fire and Ice," which opened yesterday at the National theater, may be for you. It would help if you were a sex-obsessed 12-year-old boy, but it isn't essential.

The movie is a collaboration between Ralph Bakshi, an animator, and Frank Frazetta, a graphic artist. Most of the film concentrates on battles between primitive fire fanciers and ice people, who would seem to have little in common. However, they all wear loincloth-like outfits and are well-muscled. And although some of the characters merely grunt, others put their thoughts into words ("Your sister is not wholly unattractive — as lesser beasts go"), they don't seem very different under the skin.

Mr. Bakshi, whose animated figures have the precise shapes and movements of live actors, sets characters with names like Nekron or Teegra against the lurid, glowering pastel panoramas that Mr. Frazetta's fans will recognize. The backgrounds and characters, though ambitiously executed, aren't particularly compatible, because there's nothing in Mr. Frazetta's steep phallic landscapes that speaks to Mr. Bakshi's overly sleek cavemen. A third, if unacknowledged, influence on the film is Calvin Klein. No one wears designer jeans, of course — hardly anyone even wears clothes — but Princess Teegra is posed rump-first at every possible opportunity. Twelve-year-old fantasy-adventure fans, take note.

1983 N 24, C12:1

OF UNKNOWN ORIGIN, directed by George P. Cosmatos; screenplay by Brian Taggert, based on the book "The Visitor" by Chauncey G. Parker; edited by Robert Sivli; music by Ken Wannberg; produced by Claude Heroux; released by Warner Bros. At the Rivoli, Broadway and 45th Street; Manhattan 1, 59th Street between Second and Third Avenues; 86th Street, at Lexington Avenue and other theaters. Running time: 102 minutes. This film is rated R.

Bart Hughes	Peter Weller
Lorrie Wells	Jennifer Dale
Eliot Riverton	Lawrence Dane
James Hall	Kenneth Welsh
Clete	Louis Del Grande
Meg Hughes	Shannon Tweed

PETER WELLER, one of our best young stage and screen actors, is not at all bad in a rather terrible, Canadian suspense-horror film mysteriously titled "Of Unknown Origin," which suggests something from outer space.

The creature in "Of Unknown Origin" is from inner space, namely the basement, being a rat that attempts to take over the recently gentrified house belonging to Bart Hughes (Mr. Weller), a hot-shot executive on-the-make who finds himself playing Ahab to this rather humdrum rat's Moby Dick.

•

The comic possibilities of this are generally ignored in Brian Taggert's screenplay and the direction of George P. Cosmatos, which features about as many shots from the point of view of the rat as of Bart Hughes. There also are a lot of close-ups of the rat's jaws and front teeth, which, somehow, never seem as frightening as overly intimate.

The movie opened yesterday at the Rivoli and other theaters.

Vincent Canby

1983 N 24, C17:1

Question of Honor

QUIET DUEL, directed by Akira Kurosawa; screenplay by Mr. Kurosawa and Senkichi Taniguchi, based on a play by Kazuo Kikuta; cinematographer, Shoichi Aizaka; music by Akira Ifukube; produced by Daiei production; produced by Hisao Ichikawa and Shojiro Motoki; a Daiei production. At the Thalia, Broadway and 95th Street. Running time: 95 minutes. This film has no rating.

Kyoji Fujisakik	Toshiro Mifune
Kyonosuke Fujisaki	Takashi Shimura
Misao Matsugi	Miki Sanjo
Susumu Nakada	Kenjiro Uemura
Takiko Nakada	Chieko Nakakita
Rui Minegishi	Noriko Sengoku
Corporal Horiguchi	Junnosuke Miyazaki
Patrolman Nozaka	Isamu Yamaguchi
Nurse Imai	Hiroko Machida

By VINCENT CANBY

STUDENTS of the work of Akira Kurosawa may want to make a trip to the Thalia theater, where a double bill of "Rashomon" (1950) and "The Quiet Duel" (1949) opens a two-day run today. "Rashomon" is an acknowledged Kurosawa classic. "The Quiet Duel," which is, I'm told, having its New York theatrical premiere, is a footnote to a great career.

Based on a Japanese stage play, "The Quiet Duel" appears to be a heavily disguised parable about the long-range effects of the kind of militarism that led Japan to defeat in World War II. The film is about the terrible ordeal faced by a dedicated young physician (Toshiro Mifune), who contracts syphilis while operating on a syphilitic patient during the war. Knowing that the treatment is long and the cure unreliable, the doctor, after the war, refuses to tell his fiancée his reason for ending their engagement. His argument is that if she knew the truth, she would be willing to wait forever, which, the doctor reasons, would be unfair.

•

The movie's "problem" seems remote to us now not only because syphilis is not quite the lifelong sentence it was when the film was made, but also because the codes of honor being acted on appear to be designed to increase and perpetuate guilt

Toshiro Mifune in "Quiet Duel."

rather than to alleviate it. The film's most effective scenes are not those of renunciation and sacrifice but those occasional explosions in which the condemned young doctor questions the fate that has given him the punishment for a crime he has never committed. He is, he tells us, a virgin.

Mr. Mifune gives a fine, restrained performance, while the late, great Takashi Shimura ("Ikiru," "Rashomon" and "The Seven Samurai") has a much smaller role as the young man's extremely understanding father. The screenplay's theatrical origins are not apparent in Mr. Kurosawa's easy, unobtrusive style, but they certainly are evident in a hysterical subplot involving the reappearance of the soldier who first infected the doctor, along with the poor soldier's pregnant wife.

1983 N 25, C10:1

A Bronx Teen-Ager

WILD STYLE, written, produced and directed by Charlie Ahearn; photographed by Clive Davidson and John Foster; edited by Steve Brown; music by Chris Stein; produced by Fred Braithwaite and Jane Dickson. At the Embassy 46th Street, on Broadway. Running time: 85 minutes. This film has no rating.

Raymond Zoro	Lee George Quinones
Phade	Frederick Braithwaite
Rose Lady Bug	Sandra Pink Fabara
Virginia	Patty Astor
Zroc	Andrew Zephyr Witten
Raymond's Brother	Carlos Morales
Boy with Broom	Alfredo Valez
Art Patron	Niva Kislac
TV Producer	Bill Rice
Curator	Glenn O'Brien
Zoro Double	Dondi White
Gangster	Pookie Daniels
Champagne Winner	Chief Rocker Busy Bee
Community Organizer	Joe Lewis

"Wild Style" was shown as part of the 1983 New Directors/New Films Series. Following are excerpts from Vincent Canby's review, which appeared in The New York Times last March 18. The film opened Wednesday at the Embassy 46th Street, on Broadway.

"WILD STYLE" looks to be a partly improvised piece of fiction, about the cheeky high-spirited art of the South Bronx, that is; subway graffiti, also known as "writing," and about "rapping" and "breaking."

For the benefit of the uninitiated, rapping refers to a very particular kind of musical communication, in which the singer — backed by a monotonous rhythmic beat — talks in rapid, always nervy rhymes that proclaim the singer's superiority in one sort of endeavor or another. Like good calypso, good rapping is a mixture of the primitive, sophisticated and topical.

Breaking, or break-dancing, is a way of dancing to these and other forms of music, a religious experience with extraordinary athletic skills. The high point of a great breakdancer's turn may be a pirouette on his head.

The slight narrative of "Wild Style" is about Raymond (Lee George Quinones), a skinny, outwardly mild-mannered Bronx teenager by day and, by night, the notorious "Zoro," a celebrated but unidentified spray-paint artist for whom every subway car is an empty canvas. Raymond scorns his fellow graffiti artists who turn their talents to legitimate commissioned murals on the walls of playgrounds and business establishments.

"Graffiti is taking risks," says Raymond, who likes to dodge over and around third rails in the subway yards at night. He prefers painting in the dark because, after all, "I know all my colors by heart." He also likes outwitting the police as he makes the world more exotic.

"Wild Style" also has a slight love story involving Raymond and Rose Lady Bug (Sandra Pink Fabara), a spray-paint muralist who brings Raymond back to his senses when he takes his art too seriously.

Mostly, however, "Wild Style" is a series of random encounters of graffiti artists, rappers and breakers, leading up to a giant rap-break concert in a Lower East Side band shell decorated by Raymond.

Unfortunately for the movie, Charlie Ahearn, the writer, producer and director of the film, who is an artist as well as a film maker, never discovers a cinematic rhythm that accurately reflects and then celebrates the rare energy and wit of the artists within the movie. Too often "Wild Style" has the effect of dampening the enthusiasm of its amateur actors or of not being able to keep up with their nonstop pace. It always seems to be trailing them, as if it were a little brother who can't run as fast as the others.

The subjects are appealing, especially Mr. Quinones, a graffiti artist in real life, and Frederick Braithwaite as a very cool artist-promoter who attempts to transform Raymond's midnight talents into fame and riches. The film includes one rap contest, which goes at such a clip that it may leave you exhausted, and a funny East Side art-world party, at which Raymond is seduced by a beautiful relentless patroness of all things temporarily new.

"Wild Style" lacks a lot of the style of the people in it, but it never neutralizes their vitality.

1983 N 25, C10:4

FILM VIEW

VINCENT CANBY

Celebrity Isn't Much to Celebrate in These Movies

"You look familiar," the cab driver said, turning around to speak to his fare, a woman who, by chance, has written some of the greatest words ever heard spoken from the American stage and screen. "Should I know you?" The woman, who later admitted to feeling some pleasure at the question, told the fellow her name. There was a moment's silence. Then, "I never heard of you." End of conversation.

We live in the age of celebrity, something that television, more than any tool of our society, has made gloriously, crazily, instantaneously possible. Men who sell fur coats are celebrities. So are cats who, by laboratory trickery, appear to cha-cha-cha. It doesn't make any great difference what one can do or, indeed, if one can do anything, as long as one has a familiar face or, better still, a "name," that is, a name that's immediately recognized by people who don't have one.

This curious state of affairs has recently provided the subtext for an increasing number of movies of far more than routine interest, including Philip Kaufman's "Right Stuff," Bob Fosse's "Star 80," Martin Scorsese's "King of Comedy," Woody Allen's "Zelig" and "Stardust Memories" and, bear with me, even Barbra Streisand's "Yentl."

Should the planet survive, Andy Warhol's greatest contribution to an understanding of American culture in the second half of the 20th century may turn out to be not be his paintings — does anyone really know what the life span of acrylic paint is going to be anyway? — but his laconic observation that eventually everybody will be famous for 15 minutes. It sometimes seems that this Golden Age of universal People magazine-hood has already arrived.

Our gossip columnists, responding to our insatiable curiosity, not only make celebrities out of the spouses of the famous, but out of people who perform services for them as hairdressers, interior decorators, paid companions and dressmakers. Wives, husbands, children and in-laws of the legitimately famous or notorious cannot be denied their own bit of reflected celebrity. The awful truth is that today it's increasingly easy to acquire fame. In the 1920's and 30's it was necessary to do something, which could be almost anything — fly an ocean, abscond with millions of dollars, murder your lover's husband/ wife, preferably in some manner that couldn't be described in a family newspaper, sit on a flagpole, swim the English Channel, write "Gone With the Wind," eat goldfish, be responsible for a multiple birth or, like Haile Selassie, get yourself invaded.

Today it's perfectly legitimate to acquire fame through the most direct route possible, that is, by self-advertising. Would any of us have any idea of who they were if their own radio and television advertisements had not made us aware of Tom Carvel, Frank Perdue and any number of other people hawking their stocks and bonds, jewelry stores, ems, carpets, wines and free salad bars in restaurant.

• • •

Prescient as always, Ruth Gordon and Garson Kanin sent up this particular kind of self-promotion in their classic 1954 comedy, "It Should Happen to You," in which Judy Holliday, under the direction of George Cukor, played a young woman named Gladys Glover whose fondest wish was to be well known.

Gladys Glover possessed no particular talent for anything. She just wanted everyone to know that she was alive and available and on this planet. Because she couldn't carve her initials on the Sphinx, like one of Napoleon's homesick soldiers in Egypt, she did what to her seemed the next best thing. She rented a Columbus Circle billboard and had her named emblazoned on it. Wren, the strident heroine of Susan Seidelman's witty "Smithereens," is a Gladys Glover figure for the 80's.

Fame once was something that automatically followed accomplishment, whether in the arts, politics, sciences or in one of the more notorious antisocial activities. In recent decades fame has become an ephemeral end in itself, something that, I suspect, very few people would be able to resist were the possibility of fame presented to them.

No matter that fame would cost one the loss of privacy, the freedom to fail in obscurity, the opportunity to behave at something less than one's full capacity — all that is a small price to pay for recognition. This is possibly because we have come to equate such recognition as an accomplishment in itself, and with more than 200,000,000 people walking anonymously around this nation, there may be something in that. If there is no heavenly book — up there — with all of our names written in it, we might as well scheme to get them written in one fashion or another down here.

The paltry nature of fame and, by inference, of the society that makes such fame desirable is the true substance of "Star 80," Mr. Fosse's glittery, almost breathless melodrama based on the life and death of the unfortunate Dorothy Stratten, the pretty, naïve, possibly talented Vancouver, B. C., model who achieved what is apparently the goal of millions of pretty, naïve, possibly talented young women by becoming a Playboy magazine Playmate of the Year, only to be brutally murdered by her estranged husband.

"Star 80" is certainly not a boring picture to watch. However, there is so much sound, light and violence coming off the screen that you're likely to feel rather more violated than you want to be by a mere movie. The film is also a little lopsided, being more about Dorothy's psychotic husband, Paul Snider, than about Dorothy, but the film's key scene, to me, anyway, is a sad, wan moment toward the end when Dorothy (beautifully played by Mariel Hemingway), being as sincere and honest as her limited capacities allow, attempts to describe what being famous means to her.

What it boils down to, she says with crushing earnestness, is being in an airport waiting room and having a complete stranger come up to ask for her autograph. "Star 80" is a most canny piece of movie making, but it might have been a great film had Mr. Fosse allowed himself to express more anger and disgust with the culture in which Dorothy briefly flourished and was so wastefully used. As it is, "Star 80" is so neutral in this respect, it could almost be a Playboy magazine promotion.

Mr. Kaufman's "Right Stuff" is rousing, funny and expertly put together. Possibly because the movie is about real people, most of whom are still living, it also seems fairly gentle when it comes to the way in which the Mercury astronauts were exploited, first by the United States Government, which was in such a panic to catch up with the Soviet space program, and then by Life magazine, which purchased the rights to the stories of the astronauts and their families.

These astronauts were — and are — genuine celebrities, men of achievement, but the toll of that celebrity is treated mostly as a joke, twice at the expense of the late Lyndon B. Johnson. In the film's most poignant sequence, though, we get a glimpse of what celebrity — or slighted celebrity — might mean.

This is when Betty Grissom (Veronica Cartwright), whose husband Gus (Fred Ward), is more or less short-changed on a hero's welcome after his flight ends with the sinking of his space capsule. Betty had expected a tickertape parade and tea at the White House, trading recipes with Jacqueline Kennedy. Instead, she and Gus are given a tacky suite in a Cape Canaveral motel, with a refrigerator stocked with beer. Betty goes into a good, full-scale tantrum — the celebrity system had promised them more in the way of rewards.

It must say something about the climate of the times that Americans don't want to see celebrity kidded too mercilessly. This, I think, must be one of the reasons that Mr. Scorsese's "King of Comedy," with its excellent screenplay by Paul Zimmerman, appeared to offend a lot of people. Rupert Pupkin (Robert De Niro), the aggressive, obsessed hero of the film is possibly crazy. Yet the subversive message passed on by Mr. Scorsese and Mr. Zimmerman is that this certified horror of an all-American boy achieves his goal of fame and fortune by committing a major crime. However, he doesn't become a celebrity just because he is a kidnapper — that might be acceptable in some perverse way — but because he turns out actually to be a first-rate television comedian. For reasons I don't understand, many people found this insupportable.

•

Even more distressing to many people was Woody Allen's wildly exaggerated self-portrait in "Stardust Memories," about a famous, successful motion picture writer-director-star named Sandy, a fellow who longs to do "serious" films instead of come-

dy. The gallery of fans, critics and all-round kooks who go with Sandy's celebrity was, admittedly, ghoulish, but Mr. Allen was being even more scathing about himself and his own hang-ups. That, however, cut no ice with the paying customers, who saw only one part of the movie, that part in which the paying customers, the people who had made him a star, were portrayed as imbeciles. What, I think, they missed, was Mr. Allen's attempt to deal honestly with the contradictions he acknowledges to exist within himself: the drive to succeed, to be famous, to be recognized, as opposed to the fear that, once celebrated, an awful truth will out — that is, that the celebrity is an impostor.

He's also dealing with celebrity in "Zelig," but in a far more lighthearted, seemingly more impersonal way, though I suspect that "Zelig," which is about a man with no personality of his own, is really far more personal than is "Stardust Memories." Zelig's problem is also a fear common to almost everyone who has grown to maturity in this time of instant analysis, when garage mechanics talk of relationships and a 9-year-old child might demand better "bonding" between his parents.

"Zelig" is really the last word on contemporary celebrity, being, in effect, a chronicle of the celebrity of a man with absolutely no talent of his own. It's the story of the stunning triumph of zilch.

The most obvious prerogative of celebrity is power. For some, it's the power to get tables in the best restaurants without making advance reservations. For Barbra Streisand, it's the power to produce, direct and co-write a movie, which is called "Yentl."

"Yentl," I guess, ought to be attended just to see just how far off the mark enormous celebrity can lead a fine performer who, in every other way, is a woman of modest talents if unstoppable ambition. "Yentl" isn't conventionally bad. It's a big, wooden, inert ark of a movie waiting, high and dry, for someone to provide a flood so that it might float away. It never does.

"Yentl" just sits up there on the screen, screaming its head off much of the time, singing one long, dreadful song, the music by Michel Legrand and lyrics by Alan and Marilyn Bergman. I'm told that technically the score consists of a number of songs but to my admittedly tin ear, it sounded like a single bleat. "Yentl" is certainly not about celebrity but it demonstrates its sometimes awful impact on the contemporary American scene. ∎

1983 N 27, II:17:1

WAR AND PEACE, a film (in German with English subtitles) by Heinrich Böll, Volker Schlöndorff, Alexander Kluge, Stefan Aust and Axel Engstfeld; fiction sequences written by Mr. Böll; "From the Standpoint of the Infantry" written by Mr. Kluge; camera by Franz Rath, Igor Luther, Werner Luring, Thomas Mauch and Bernd Mosblech; edited by Dagmar Hirtz, Beate Mainka-Jellinghaus, Carola Mai, Barbara von Weitershausen; produced by Eberhardt Junkersdorf and Theo Hinz; English version and post production by Barry Brown; narrated by Axel-Torg Gros; a TeleCulture Films Release. At the Vandam, 15 Vandam Street. Running time: 85 minutes. This film has no rating.
Kevin Kellerher Jürgen Prochnow
Mac Broker Gunther Kaufmann
Nikolai Raiski Manfred Zapatka
Ivan Golkov Karl-Heinz Merz
Joe Heinz Bennent
Oscar Edgar Selge
Margot Angela Winkler
Albert Michael Gahr
General Hans-Michael Rehberg
Inteviewer Dieter Traier

By JANET MASLIN

The 1982 German film "War and Peace," now playing at the Vandam, is a collaboration between the Nobel Prize-winning author Heinrich Böll and the noted directors Volker Schlöndorff and Alexander Kluge, along with Stefan Aust and Axel Engstfeld.

Not surprisingly, in view of the number of important collaborators involved, the structural coherence of the material is slight. But the film does have a consistent tone, one that is measured and chilling, as the film makers argue the case for unilateral disarmament and examine the prospective perils of nuclear war, particularly for West Germany.

The role that West Germany might play in a hypothetical nuclear war between the United States and the Soviet Union is discussed in some detail, and the film includes footage of protests in West Germany against the emplacement of Pershing II and cruise missiles within that country's borders. Some, but less, attention is given to the presence of Soviet missiles across the border.

•

However, the film's approach to the arms debate, while always strongly pro-unilateral disarmament, is frequently as oblique as it is polemical. A description of the effects of a nuclear explosion on nearby households, for instance, is accompanied by a scene of feet dressed in red house slippers pacing around a kitchen. In the event of a nuclear explosion, the narrator tells us, glass shards from the kitchen windows could obliterate anyone inside.

In the course of outlining its warning about the threat of nuclear war, the film employs newsreel footage, brief fiction sequences (one by Mr. Kluge, the others written by Mr. Böll and directed by Mr. Schlöndorff), vintage civil defense material ("Put out any flames which have caused your clothes to catch fire," says the helpful narrator in one such film clip), scenes in Beirut resembling those in Mr. Schlöndorff's film "Circle of Deceit," and even long excerpts from a "CBS Reports" program on United States defense policies regarding Europe. Merely by including excerpts from the commercials that presumably accompanied the "CBS Reports" program — one for beer and one for Jello — the film makers contrast the size of their concerns with the banality of such visions of supposedly normal and happy life, thus underscoring their point about how much more urgent this issue is than any other.

•

Sometimes the film sounds a note of overly heavy irony. There is a sketch by Mr. Böll about a brother's refusal to let his sister (played by Angela Winkler) into his fallout shelter, and there is Mr. Schlöndorff's remarkably revealing footage of the Versailles summit conference — featuring, among other curious details, the sight of fountains being turned on for President Reagan's red-carpet arrival, and being turned off immediately after.

Some excessively broad strokes are reserved for an interview with Sam Cohen, described here as "father of the neutron bomb" and seen dining jovially with his family. His children, Mr. Cohen tells an interviewer, regard his invention "with tremendous indifference."

"My wife couldn't care less about the bomb," he adds. "She's concerned with her tennis and with keeping up the house, and she's totally unconcerned with these grim matters."

The rest of us, as the film emphasizes repeatedly, would do well to take these issues more seriously.

1983 D 3, 15:1

FILM VIEW

VINCENT CANBY

Talented Actors Enrich a Fine Script

Let's get one thing straight immediately: James L. Brooks's "Terms of Endearment" is not a perfect movie. This comedy about a middle-class Texas widow, her daughter and their respective lovers sort of meanders around a plot that covers approximately 30 years. It contains one more fatal illness than you may want to witness, and every now and then Mr. Brooks's sit-com background ("The Mary Tyler Moore Show," "Rhoda," "Lou Grant," Taxi," etc.) is apparent in the film's inability to resist a fast response that may not be entirely in character with the person responding.

All of this, however, is beside the point. "Terms of Endearment" must be one of the most engaging films of the year, to be cherished as much for the low-pressure way in which it operates (no mammoth star egos to contend with, no major themes to intimidate) as for the fact that it contains what are possibly the best performances ever given by Shirley MacLaine and Jack Nicholson.

That both Miss MacLaine and Mr. Nicholson are fine actors shouldn't come as a surprise to anyone, but in recent years each has seemed to be making do by doing less and less in roles that really didn't require more and more. Miss MacLaine was splendid in "Being There," but that film belonged to Peter Sellers. Mr. Nicholson was equally good as the young Eugene O'Neill in "Reds," but he wasn't on the screen all that much, and his performance consisted as much in just being there, looking the way he was made up to look, as in anything he actually did.

• • •

In "Terms of Endearment," both actors act. They give fully realized performances that enrich the odd, contradictory, extremely well written characters contained in Mr. Brooks's adaptation of the novel by Larry McMurtry. Performances of this degree of intelligence and experience demand, of course, good initial material and sensitive direction and editing, but the finished performances also reflect those particular, mysterious idiosyncrasies supplied by the actors and never easily analyzed by those of us on the outside.

I know it's probably not fashionable to admit it, but, for all of us, what we know about actors' private lives does have an influence on how we respond to their work as actors. Sometimes it increases our interest. Quite often, however, it tends to interfere with what we are seeing on the screen. I doubt that legitimate theater critics would have been quite as outraged by Elizabeth Taylor's physical appearance in "Private Lives" if we all hadn't more or less grown up believing in her undying quality as a femme fatale. To see her looking plump is to have our dreams betrayed.

Jane Fonda's politics may attract some audiences and put off others. To succeed, her films have to be better than just good, which they've frequently been. Vanessa Redgrave's magnificence as an actress has become completely confused with a lot of political statements that are idiotic enough to put off even those partisans she would help.

I also suspect that Shirley MacLaine's very busy private life, as recorded by herself among others, has had some effect on the way that a lot of people look at her work as an actress. Outspoken feminist and sexual revolutionary (well, sort of), author of best-selling books with cutesy titles ("Don't Fall off the Mountain"), someone who is on a first-name basis with all sorts of people in and out of government, including Wilbur Mills, deep thinker about reincarnation, Miss MacLaine has sometimes seemed too busy creating a public character to be able to create the fictional ones that are a performer's profession.

Under ordinary circumstances these thoughts might not be relevant, but they have a lot to do with the great surprise and immense pleasure audiences will feel when they see "Terms of Endearment." This is the performance that Miss MacLaine has been getting into condition for ever since she made her screen debut in Alfred Hitchcock's "The Trouble With Harry," and then went on through the high years of films with Billy Wilder ("The Apartment," "Irma La Douce") and a number of low years, represented by such recent, instantly disposable items as "Loving Couples" and "A Change of Seasons." The performances have not been second-rate but the movies never seemed up to her caliber.

For all its occasional lapses, "Terms of Endearment" is.

The film is the story of a possibly smothering mother-daughter relationship that is immediately defined in the film's very first scene: A young Aurora Greenway (Miss MacLaine) insists on waking her infant daughter, Emma (later to be played by the equally incandescent Debra Winger), to make sure the baby hasn't succumbed to crib death, while the voice of her off-screen husband tells her, in polite terms, to lay off the kid. Aurora's problem throughout "Terms of Endearment" is that she can't.

When next met, Aurora, a smashing looking young widow, is returning from her husband's funeral to her handsome, upper-middle class house in suburban Houston, trailed by a 6-year-old Emma who is dutiful but clearly exercises a mind of her own by traipsing across the neatly tended grass and not on the walk. One of the achievements of "Terms of Endearment" and of Miss MacLaine, is that, under all ordinary expectations of fiction, even of comic fiction, Aurora Greenway should be a bitch.

That she isn't is one joy of the movie in which, through Miss MacLaine's marvelous performance, we watch her grow up, first in the way she deals with a bunch of properly boring suitors, the kind who don't seriously threaten her middle-aged maidenhood, and then in her dealings with the spirited, exasperated but loving Emma.

Aurora is that bane of the New Woman, a housewife and, apparently, proud of it, though she has no husband to go with the title. She runs her house with precision, is determined in bringing up Emma to enjoy the fruits of a strict if liberal education and background, and only impossibly imperious when Emma decides to marry Flap Horton (Jeff Daniels), a good-looking young English instructor whom Aurora finds to be somewhat beneath her beloved Emma. On the day of Emma's wedding to Flap, Aurora, who has principles, decides not to be a hypocrite. She stays away from the ceremony. Her parting shot to Emma: "Remember, you're not special enough to overcome a bad marriage." It may be difficult to believe, but that turns out to be a very funny line, even though Aurora, in common with so many too-loving parents, has an uncanny knack for cutting her child down to size, supposedly for her own good.

Aurora's real education begins when she enters into a passionate though belated affair with the man next door, Garrett Breedlove (Mr. Nicholson), who enjoys some local celebrity, being a former astronaut. For a number of years Aurora has watched with interest and distaste as the high-living, frequently drunk Garrett has wined, dined and bedded a series of beautiful young women next door, or, you might say, right under Aurora's nose.

Mr. Nicholson's Garrett Breedlove, who is not in Mr. McMurtry's novel, is one of the strongest, funniest, sweetest characters Mr. Nicholson has ever played. Among other things, he might well be considered "The Right Stuff" 20 years later. Gone to flab, which he half-heartedly tries to control by doing laps in his pool, he has lived too long as a successful bachelor to be drawn into the kind of lasting relationship that a woman like Aurora Greenway has been brought up to expect and, really, to need. Aurora hasn't kept herself in such tight control all these years to allow herself to be used lightly by a man like Garrett.

The courtship and mating of Aurora and Garrett are among the happiest, most adult depictions of contemporary sexual standards ever seen in a contemporary film designed for general audiences. It's also pricelessly funny as we watch Aurora making decisions by which she comes to abandon her former uptightness. It is, in fact, this latent recklessness, which has always existed just beneath the surface of Miss MacLaine's Aurora, that has made the character so appealing even when she was being so impossible to those near and dear.

One of the film's troubles is that the story of the marriage of Emma and Flap, which is cross-cut with the affair of Aurora and Garrett, isn't really as interesting, though it turns out to be crucial to the shape of the film. Miss Winger is a stunning young actress, and her trials with Flap, all predicted by dear old mom, are detailed with a good deal of insight, but the movie goes into low gear when Miss MacLaine and Mr. Nicholson leave the screen.

That, fortunately, is not too often in the case of Miss MacLaine, and her final scenes in the film are among the best things she — or any other actress, for that matter — has done on screen this year. There's a gravity and intelligence in this work that justifies everything Miss MacLaine has ever done before and, if the gods are attending, will win her not only an Oscar nomination, but the award itself.

"Terms of Endearment" is the first film to be directed by Mr. Brooks, who came out of television to write and produce the well-received "Starting Over" several years ago. Not having read Mr. McMurtry's novel, I can't be sure how much of the screenplay's wit is his or Mr. McMurtry's, but the character of Garrett Breedlove is a genuinely inspired creation. There is a tendency, especially early in the film, for "Terms of Endearment" to go for the flip, easy laughs. (These, unfortunately, are emphasized in the film's trailer, which I saw by chance several weeks ago, and don't do the film full justice.)

●

However, the film's wit extends even beyond good characterizations and funny lines. It's there in the interior decor of Aurora's house (production design by Polly Platt) and in the way Aurora dresses. Seeing how she dolls herself up in an overly frilly frock by Oscar de la Renta for her first date with Garrett Breedlove, which turns out to be a drunken lunch, I was reminded of Calvin Trillin's piece about Mr. de la Renta in The Nation a couple of years ago. The dress defines everything we need know about Aurora Greenway up to that point, and says more than a little something about her hang-ups. What I'm trying to say is that the dress itself is very funny — something I've never in my life written about a dress before. It's while wearing this dress, I think, that Aurora, fighting off the crude, obligatory advances of the ex-astronaut, says prettily, "Remember, impatient boys sometimes miss dessert."

Among other things, "Terms of Endearment" is about a woman who will never, ever say such a thing again. ■

1983 D 4, II:21:1

Every Inch a King

THE DRESSER, directed by Peter Yates; screenplay by Ronald Harwood; director of photography, Kelvin Pike; film editor, Ray Lovejoy; music by James Horner; produced by Mr. Yates; released by Columbia Pictures. At Cinema 2, at Broadway and 47th Street. Running time: 118 minutes.

Sir	Albert Finney
Norman	Tom Courtenay
Oxenby	Edward Fox
Her Ladyship	Zena Walker
Madge	Eileen Atkins
Frank Carrington	Michael Gough
Irene	Cathryn Harrison
Violet Manning	Betty Marsden
Lydia Gibson	Sheila Reid
Geoffrey Thornton	Lockwood West
Mr. Godstone	Donald Eccles
Horace Brown	Llewellyn Rees
Benton	Guy Manning

By VINCENT CANBY

THE time is 1940, some months after Dunkirk but still more than a year before the United States's entry into World War II. The German Luftwaffe is reducing Britain's cities to rubble and Winston Churchill is rallying the citizens to meet their finest hour. Among those responding are the members of one of the seediest repertory companies ever assembled to carry the Bard to what Margot Metroland would call the lower orders, mostly in the provinces.

"I've been reduced to old men, cripples and nancy boys," bellows Sir (Albert Finney), the troupe's increasingly confused old star, referring to his supporting players. Not only are all of the good actors in uniform but the theaters that Sir is accustomed to playing are being bombed out from under him. His world is vanishing but the ghosts that haunt Sir in these last days are not out of life but the memories of great roles.

"What is tomorrow night's play?" Sir, exhausted after a performance of "Othello," asks Norman (Tom Courtenay), his faithful dresser, nanny and confidant.

"Lear," says Norman.

"How does it start?" says Sir.

The film that contains Sir and Norman is "The Dresser," Ronald Harwood's screen adaptation of his 1981 Broadway play, which has been directed with immense affection for actors and acting by Peter Yates.

"The Dresser" is a very curious work. The movie itself isn't satisfying in a conventional way, but it is great fun if you are moved by actors and acting even when the mechanics of the playwrighting do not quite match the mechanics of the playing. This is not to underrate Mr. Harwood's work. These two roles didn't write themselves. Yet the characters thus created by Mr. Harwood and the two splendid actors have a rather limited emotional payoff within the eventually meoldramatic circumstances of the film.

When "The Dresser" opened on Broadway with Mr. Courtenay as Norman and Paul Rogers as Sir, Mr. Courtenay received the greater part of the attention focused on the two star performances. It is one of the measures of the particular success of Mr. Yates's film version that Mr. Finney's Sir is every bit as riveting as Mr. Courtenay's Norman, and that the two actors, even if for a very brief time, give you a very flashy run for your money.

Though most of the film takes place inside the theater where an exhausted, emotionally ravaged Sir is preparing to play Lear for the 427th time, the film moves outside for a couple of quite marvelous scenes that open up the play without letting the life out of it.

There is one sequence in which the fussy, brandy-swigging Norman attempts to herd his raggle-taggle troupe from one train to another in a steam-filled station crowded with service people and other wartime travelers. His actors simply can't walk as fast as Norman. "Please," says the desperate Norman to the train's engineer, "Wait just a minute. They're old actors." The engineer refuses and the train starts up when, from the far end of the platform, comes the commanding voice of Sir, "Stop the train!" The train stops and Sir, his somewhat younger wife and the others are able to board.

In another, far more harrowing scene, a temporarily deranged Sir lurches through the streets of a provincial city, discarding his clothes, ranting against fate, vowing to give it all up and acknowledging his defeat, to the embarrassment and curiosity of the onlookers. All the time Norman is pursuing him, trying to protect the old man and to bring him back to some sort of sanity.

This is the film's recurring image — that of the mad Lear crashing ever closer to the edge of the known world while the sorrowing Fool attempts to prevent inevitable disaster.

This works at first, but then the analogy between Lear and Fool and Sir and Norman gives out. Mr. Finney's Sir is a vain, irascible, funny, fascinating, actory turn, but he is not an especially tragic figure, and Mr. Courtenay's Norman is a sharp-tongued, loyal, heart-breakingly limited, backstage queen, a middle-aged man who moves from deceptively un-

threatening camp mannerisms to serious ferocity within a single speech.

After a while one wonders why the other characters in their lives, including Sir's wife, known as Her Ladyship (Zena Walker), and Madge (Eileen Atkins), the manager of the troupe who has loved Sir for 20 years, really play such small roles in the disaster we witness. It's just possible that the relationship between Norman and Sir doesn't appear big and encompassing enough to exclude the others to the extent we see.

I am also somewhat perplexed about how we are supposed to feel about Sir as an actor. Early in his career, Mr. Harwood actually worked as a dresser for the late Donald Wolfit and wrote a popular biography of Wolfit, who, like Sir, spent many years playing the provinces. In 1947, in a London revue called — I think — "Sweetest and Lowest," Hermione Gingold got one of her biggest laughs by asking another cast member if he knew the difference between Laurence Olivier and Donald Wolfit. The answer, which brought down the house both times I saw the show: "Laurence Olivier is a tour de force. Donald Wolfit is forced to tour."

Not long after that, Wolfit won the London acclaim he had so long sought, playing "King Lear," and went on to receive the knighthood denied to Sir. Yet though the other actors and the audiences within "The Dresser" sometimes talk about how great Sir has just been on stage, what the film audience sees are bits and pieces of performances that remind me, at least, of all of the jokes once told about Wolfit.

This is not important to one's enjoyment of "The Dresser." It's only something to think about as you watch two terrifically gifted performers have an actor's field day with, of course, the aid and affection of the writer and the director.

•

"The Dresser," which has been rated PG ("Parental Guidance Suggested"), contains some mildly vulgar language.

1983 D 6, C19:1

Newcomers

FIRST CONTACT, produced and directed by Bob Connolly and Robin Anderson; photography by Tony Wilson and Dennis O'Rourke; edited by Stewart Young and Martyn Down; distributed by Filmmakers Library. Running time: 54 minutes. This film has no rating.
TROBRIAND CRICKET, directed by Jerry W. Leach and Gary Kildea; produced by the Office of Information, Government of Papua, New Guinea; distributed by University of California Extension Media Center. At the Film Forum, 57 Watts Street. Running time: 54 minutes. This film has no rating.

By JANET MASLIN

"WE believed our dead went over there, turned white, and came back as spirits. That's how we explained the white man: our own dead had returned." Those are the words of a black New Guinea tribesman who had never seen a white man before 1930, when three Australian prospectors, the Leahy brothers, arrived in what they believed was an uninhabited part of the New Guinea highlands. The Leahys were not anthropolgists or serious film makers, but they happened to have brought along a movie camera in case they encountered anything of interest.

"First Contact," produced and directed by Bob Connolly and Robin Anderson, is an astonishing record of the meeting between the Leahys and — by the film's estimate — about a million tribesmen whose existence had been unknown to the outside world. In addition to the Leahys' footage, which captures this clash of cultures with an un-self-consciousness that is virtually absolute, the film also includes some fascinating present-day footnotes. The two surviving Leahys, and a great many members of the tribe, are on hand to reminisce about the initial meeting and view some of the 1930 footage. Their viewpoints are no less divergent today than they were 50 years ago.

Some of the natives, who are now in more or less modern dress, remember their original perceptions of the white men in amusing detail. When they saw the prospectors' rucksacks, for instance, "we thought their wives must be in those bags." The Leahys' khaki trousers fostered another misconception: "We thought they must not have body wastes in them because they were wrapped up so neatly." Among their other, less benign recollections is the Leahys' shooting a pig to show the natives what guns could do, and to discourage any would-be thieves. This is actually captured on film, as is the tribe's first exposure to airplanes, gramophones and tin cans.

•

While the tribesmen remember this first brush with the white man as both miraculous and terrifying, the Leahys sound far less sensitive to the effects of their presence. "There were hordes of them around, sing-singing all the time," says one brother, to set the scene. And, in describing what he calls "the native way of life," one Leahy thinks "they didn't have anything better than what they have now." The film makers clearly feel otherwise, but they don't force the issue, nor do the tribesmen themselves. "First Contact" has a wistfulness and humor that accompany even its most startling revelations.

On the same fine double bill at the Film Forum, in very much the same vein, is "Trobriand Cricket," by Jerry W. Leach and Gary Kildea. Also filmed in Papua, New Guinea, it demonstrates in rueful and often hilarious terms the ways in which the British game of cricket has been adapted by the native population and turned into a good-natured war game. The film presents songs, chants, and, when the game is rained out, one team's suspicions that their opposition cheated by invoking weather magic.

1983 D 7, C24:5

Eccentric Twosome

CAN SHE BAKE A CHERRY PIE?, directed and written by Henry Jaglom; cinematography by Bob Fiore; music by Karen Black; produced by M. H. Simonsons; an International Rainbow Picture; a Jagfilm; a World Wide Classics Release; distributed by the Frank Moreno Company. At the 68th Street Playhouse, at Third Avenue. Running time: 90 minutes. This film has no rating.
Zee..Karen Black
Eli...Michael Emil
Larry.....................................Michael Margotta
Louise....................................Frances Fisher
Mort...........................Martin Harvey Friedberg
Young Man at Cafe......................Robert Hallak

By JANET MASLIN

HENRY JAGLOM'S "Can She Bake a Cherry Pie?" is either a two-or a three-character romance, de-pending on whether you consider the Upper West Side of Manhattan a principal party to the action. Certainly the neighborhood is a key ingredient of the movie's appealing quirkiness, and of its mildly bohemian mood.

Set mostly within a 10-block radius of the Museum of Natural History, the film details the love affair between a woman who likes to wear long black tights in the summertime and a man who finds it therapeutic to hang upside-down in his closet. They have met in a cafe on Amsterdam Avenue, where Zee (Karen Black) was crying over the menu. Understandably, Eli (Michael Emil) couldn't help but notice.

Mr. Jaglom, who seems to intend this as a gentle, modern comedy of manners, really lets these characters speak for themselves. Zee: "You seem to have a lot of energy, and it gets stuck in your forehead." Eli: "Do you ever have the experience that people tell you they don't know what you're saying?" A total stranger in the same cafe: "The key to happiness, you know what it is? If you can take a cab whenever you want, you're happy." Though the film sometimes seems in danger of chattering away its welcome, there is a loose, funny abandon to much of the conversation here, and certainly plenty of spontaneity.

The plot is almost an afterthought. Zee, miserable at being left by her husband, is easily diverted by the fast-talking Eli, who is ready to discuss anything from love to old movies to vitamin deficiencies with the utmost seriousness. Zee, for her part, adores singing (the film includes more musical footage of Miss Black than it needs). Will this eccentric twosome fall deeply in love? The movie, with its very contemporary casualness and doubt, doesn't even pretend to know the answer to such a question.

Mr. Emil and especially Miss Black seem likable and natural here; Miss Black, in particular, seems to be throwing all traces of vanity and nervousness to the winds, and the result is a surprisingly sweet and affecting character. A younger couple, Louise and Larry (played by Frances Fisher and Michael Margotta, respectively), cross paths with Eli and Zee repeatedly, thanks to their trained pigeon, Eddie. While Louise sits in the cafe with Eddie on her head, Larry uses the bird as an icebreaker with any new woman who happens to be around.

"Can She Bake a Cherry Pie?" opens today at the 68th Street Playhouse. Among its more unexpected touches is the presence of Orson Welles, playing a magician who tries — unsuccessfully — to make zoo animals disappear.

1983 D 8, C22:3

Car Crazy

CHRISTINE, directed by John Carpenter; screenplay by Bill Phillips, based on the novel by Stephen King; director of photography, Donald M. Morgan; edited by Marion Rothman; music by Mr. Carpenter in association with Alan Howarth; produced by Richard Kobritz; released by Columbia Pictures. At Loews State, Broadway and 45th Street; Orpheum, 86th Street at Third Avenue; Bay Cinema, Second Avenue and 31st Street, and other theaters. Running time: 116 minutes. This film is rated R.
Arnie..Keith Gordon
Dennis......................................John Stockwell
Leigh......................................Alexandra Paul
Darnell.......................................Robert Prosky
Junkins...............................Harry Dean Stanton
Regina Cunningham.................Christine Belford
LeBay...................................Roberts Blossom
Buddy..................................William Ostrander
Mr. Casey................................David Spielberg
Moochie...............................Malcolm Danare

By JANET MASLIN

"CHRISTINE," written by Stephen King and directed by John Carpenter, is about a haunted car that isn't quite haunted enough. Though the car, a 1958 red Plymouth with a wicked grin, is capable of trampling, burning, asphyxiating and squashing its enemies, and though it performs these feats to the sound of vintage rock-and-roll songs, "Christine" isn't terribly eerie. Only in a scene in which the car fixes itself, actually smoothing out its dented fenders and crushed doors *for free*, does the film take on a transcendently supernatural feeling.

"Christine," which opens at the Loews State and other theaters today, doesn't have very much to say about the American teen-ager's love for his automobile, since the case of this particular Plymouth is hardly representative. Not every car, after all, has an owner who loves it so devotedly that he's willing to kill anyone who swats the upholstery. And not every car owner is on a first-name basis with his vehicle, as in, "Now I'll just be a minute; I've got to get my wallet out of Christine."

No, the case of Christine and Arnie (Keith Gordon) is something special. Arnie is a creep, wearing thick glasses and carrying his lunch to school in a brown paper bag, until the moment when he spies the decrepit Christine. *We* know she's no good — in a 1957 prelude, Christine has already bitten one man and choked another while still on the assembly line in Detroit — but for Arnie this is love. He buys the car, ditches his glasses, wins the heart of the prettiest girl at school and begins to model his sharp clothes and swaggering manner on the 1950's rock songs that Christine adores. Arnie's new R-rated vocabulary helps make it clear that this is not a television movie, though in other respects it might as well be.

The early parts of the film are engaging and well acted, creating a believable high school atmosphere. Unfortunately, the later part of the film is slow in developing, and it unfolds in predictable ways. The special effects are good, the performances are nicely deadpan, and the score (old rock songs selected by Michael Ochs) is clever. But Christine herself is something of a bust. For those who'd like to find out the fine details about this car, such as why her odometer runs backward, reading Mr. King is essential.

Like the recent "Dead Zone," which was somewhat more ambitious, "Christine" is only a moderately engrossing film. The teen-age performances are suitably gung-ho, and the veteran actors Harry Dean Stanton, Roberts Blossom and Robert Prosky have small, well-drawn roles. But Mr. King's device of turning mundane objects into terrible threats — demonic car, demonic dog ("Cujo") — may simply work better on the page than on the screen. Even a car that playfully locks out one person while trying to kill another, as its radio plays "Keep a-Knockin' But You Can't Come In," still seems more like something to drive than something at the heart of a bad dream.

1983 D 9, C10:5

Shooting and Loving

SUDDEN IMPACT, directed and produced by Clint Eastwood; screenplay by Joseph C. Stinson; story by Earl E. Smith and Charles B. Pierce, based on characters created by Harry Julian Fink and R.M. Fink; director of photography, Bruce Surtees; edited by Joel Cox; music by Lalo Schifrin; released by Warner Bros. At Warner Twin 1 and 2, Broadway and 47th Street; 86th Street Twin, at Lexington Avenue; 83d Street Quad 4, at Broadway, and other theaters. Running time: 117 minutes. This film is rated R.

Harry Callahan	Clint Eastwood
Jennifer Spencer	Sondra Locke
Chief Jannings	Pat Hingle
Captain Briggs	Bradford Dillman
Mick	Paul Drake
Ray Parkins	Audrie J. Neenan
Kruger	Jack Thibeau
Lieutenant Donnelly	Michael Currie
Horace King	Albert Popwell
Officer Bennett	Mark Keyloun
Hawkins	Kevyn Major Howard
Leah	Bette Ford
Mrs. Kruger	Nancy Parsons

"SUDDEN IMPACT," which opens today at the Warner Twin and other theaters, is the fourth of the "Dirty Harry" films starring Clint Eastwood, but the first of them to be directed by the star. It desperately needs the hand of Don Siegel, Mr. Eastwood's longtime associate who has been responsible for the actor's best films, including "The Beguiled" and "Escape From Alcatraz."

Mr. Siegel also directed the original "Dirty Harry" (1971), which wasn't a great movie but looks like a classic next to "Sudden Impact."

This time Harry Callahan (Mr. Eastwood), the independent-minded San Francisco homicide detective who shoots first and refuses ever to worry about consequences, is assigned to a case involving a series of especially nasty — and graphically shown — murders. Because we see the murderer, beginning with the opening sequence, there's not even any mystery in the movie.

The killer is Jennifer Spencer (Sondra Locke), who looks as if she should be running a boutique at Big Sur but who, in the film, is presented as a serious painter — sort of neo-Edvard Munch in style — by day, and, by night, a vengeful psychopath who goes around shooting men, first in the genitals and then in the forehead. The men, we learn, brutally raped her and her younger sister 10 years earlier, leaving the sister in a permanent state of catatonia.

The screenplay bears a remarkable resemblance to "Death Wish," especially in its impatience with the system of justice that most of us accept because nothing else has been shown.

By my count, more than a dozen people are murdered on camera, about half by Miss Locke and most of the others by Mr. Eastwood. This gives them something in common as lovers. When they walk off into this movie's version of a sunset at the end — it actually looks like a shopping mall — we are meant to believe they'll live happily ever after or, at least, until one of them is unfaithful. In this film that would mean that he or she would feel the itch to go out alone to blast someone.

The screenplay is ridiculous, and Mr. Eastwood's direction of it primitive, which is surprising because he has shown himself capable in such films as "The Outlaw Josey Wales" and "The Gauntlet." Among other things, the movie never gets a firm hold on its own continuity. Sometimes scenes of simultaneous action appear to take place weeks or maybe months apart. Not that this makes much difference.

Vincent Canby

1983 D 9, C12:4

After seven years, Clint Eastwood returns to the role of Dirty Harry Callahan, the tough San Francisco detective, in "Sudden Impact."

Impossible High

SCARFACE, directed by Brian De Palma; screenplay by Oliver Stone; director of photography, John A. Alonzo; edited by Jerry Greenberg and David Ray; music by Giorgio Moroder; produced by Martin Bregman; released by Universal Pictures. At the National Twin, Broadway and 44th Street; Gemini Twin, 64th Street and Second Avenue; 86th Street East, between Second and Third Avenues; 83d Street Quad, at Broadway; Greenwich Twin, Greenwich Avenue at 12th Street; Coliseum, Broadway at 181st Street and other theaters. Running time: 170 minutes. This film is rated R.

Tony Montana	Al Pacino
Manny Ray	Steven Bauer
Elvira	Michelle Pfeiffer
Gina	Mary Elizabeth Mastrantonio
Frank Lopez	Robert Loggia
Mama Montana	Miriam Colon
Omar	F. Murray Abraham
Alejandro Sosa	Paul Shenar
Bernstein	Harris Yulin
Chi Chi	Angel Salazar
Ernie	Arnaldo Santana
Angel	Pepe Serna
Nick the Pig	Michael P. Moran
Hector the Toad	Al Israel

By VINCENT CANBY

"SCARFACE," Brian De Palma's update of the 1932 classic directed by Howard Hawks and written by Ben Hecht, is the most stylish and provocative — and maybe the most vicious — serious film about the American underworld since Francis Ford Coppola's "Godfather." In almost every way, though, the two films are memorably different.

This "Scarface," which was written by Oliver Stone, contains not an ounce of anything that could pass for sentimentality, which the film ridicules without mercy. "The Godfather" is a multigenerational epic, full of true sentiment. "Scarface," which is actually a long film, has the impact of a single, breathless anecdote, being about one young hood's rapid rise and fall in the southern Florida cocaine industry.

Where the Coppola film worked on our emotions in unexpected ways, discovering the loves and loyalties that operated within one old Mafia don's extended family, "Scarface" is a relentlessly bitter, satirical tale of greed, in which all supposedly decent emotions are sent up for the possible ways in which they can be perverted.

"Scarface" opens today at the National and other theaters.

To someone who never felt completely at ease with Mr. De Palma's flashy, big-budget exercises in grand guignol ("Carrie," "The Fury"), or even with his far more witty and more successful "Dressed to Kill" and "Blow Out," which were as important as examples of film criticism as they were as films, "Scarface" should be a revelation. Here is a movie of boldly original design that looks like some crazy cinematic equivalent to those gaudy Miami Beach hotels, the ones with inappropriately elegant names and interior decorations that suggest that Madame du Barry might have been Louis XV's minister of culture.

Tony Camonte, the Chicago gangster in the 1932 "Scarface," the role of the Italian-American mob boss that made Paul Muni a major star, is now called Tony Montana and played by Al Pacino with such mounting intensity that one half expects him to self-destruct before the film's finale. Though a busy performance, it's not a mannered one, meaning that it's completely controlled.

The new Scarface is a small-time Cuban punk, one of supposedly hundreds among the 125,000 or so legitimate refugees that the Castro Government allowed to immigrate to Florida in the spring of 1980. Quick-witted, hollow-eyed Tony Montana hasn't one redeeming feature, but his greed and ambition are so all-consuming that they are heroic in size if not in quality.

Tony has absolutely no compunction about murdering for profit, which quickly endears him to a Batista Cuban refugee who is the chief of the Bolivia-to-Florida cocaine traffic. In almost less time than it takes to write this synopsis, Tony has succeeded his former mentor and married the now-dead man's mistress, Elvira, a silky blonde junkie played by Michelle Pfeiffer, a beautiful young actress without a bad — or even an awkward — camera angle to her entire body.

•

Mr. Stone follows the general outlines of the Hecht screenplay with at least one notable difference. Tony's fall comes not only because he ignores the underworld maxim to the effect that one should never underestimate the other man's greed. To his misfortune, he also ignores a second rule: "Don't get high on your own supply." This is a major switch on the work of Hecht, who might have guffawed at the suggestion that Al Capone, Chicago's most powerful Prohibition gangster, might have been done in by alcoholism, though Capone did have syphilis.

Mr. De Palma never understates anything when overstatement will work better. Never is this more evident than in the last quarter of the film, in which we are treated to the spectacle of the paranoid, cocaine-addicted Tony Montana as he loses control of himself and his business. Mr. De Palma pushes "Scarface" very close to the brink of parody when, near the end, the strung-out Tony plays his Götterdämmerung with a large, humiliating clump of cocaine stuck to the end of his nose. It's like watching a Macbeth who is unaware that his pants have split.

Leading up to the final shootout at Tony's Miami mansion, which looks like a slightly smaller Fontainbleau — the chateau, not the hotel — there are a series of scenes of slaughter of such number and explicitness that the film barely escaped receiving an X rating instead of the R it now has. These scenes include dismemberments, hangings, knifings and comparatively conventional shootings by small arms and large. Be warned.

•

Supporting Mr. Pacino and Miss Pfeiffer who, though she's not on screen that much, will not be easily forgotten, is a large cast of excellent supporting actors. Chief among them are Steven Bauer, who plays Tony Montana's loyal lieutenant (the role played by George Raft in the original); Mary Elizabeth Mastrantonio, as Tony's once-innocent sister; Miriam Colon, who is especially effective as Tony's old-fashioned mother; Paul Shenar, as an elegant Bolivian cocaine supplier; Harris Yulin, as a crooked Miami narcotics detective, and Robert Loggia, as the boss whom Tony succeeds.

All of the film's technical credits are fine — the photography by John A. Alonzo, the music by Giorgio Moroder, and the art direction by Ed Richardson. Though most of the location work was done in and around Los Angeles, the film looks amazingly like southern Florida in every tacky way, from sleazy hotels to those gigantic palaces-by-the-sea for transients.

I'm not at all sure what the film means to say about American business methods, though I suspect that

FILM VIEW

VINCENT·CANBY

How Should We React to Violence?

Al Pacino stars in Brian De Palma's "Scarface" as a Cuban refugee who becomes involved in the cocaine trade in Miami.

Mr. De Palma and Mr. Stone would not be unhappy if it were seen as an ironic parable. For all his evil ways, Tony Montana, unlike some legitimate businessmen, always deals in first-class goods, though this may have less to do with his commitment to fair trade than with a desire to save his neck.

I also suspect that "Scarface" will be seen as something of an inside joke in Hollywood and other high-flying communities where cocaine is not regarded with the horror it is by this film. There is no other way to interpret the film's penultimate scene, in which Tony Montana sits in his throne room, his face buried in what appears to be at least $5 million worth of the controlled substance.

Yet the dominant mood of the film is anything but funny. It is bleak and futile: What goes up must always come down. When it comes down in "Scarface," the crash is as terrifying as it is vivid and arresting.

1983 D 9, C18:3

THE KNIGHT, direction and screenplay by Lech Majewski (in Polish with English subtitles); cinematography by Czeslaw Swirta; music by Zdislaw Szostak; produced by the Polish Corporation for Film Production "Zespoly Filmowe," "Profil" Unit. At the Thalia, Broadway and 95th Street. Running time: 87 minutes. This film has no rating.
Knight......................................Piotr Skarga
Herophant..........................Daniel Olbrychski
Youngest MonkAndrzej Hudziak
PrincessKatarzyna Kozak
Monk ICzeslaw Meissner
Old MonkStanislaw Holly
CrispinPawel Sanakiewicz
VieslavPiotr Machalica

"**T**HE KNIGHT" is a haunting, austere parable that has been directed with assurance by Lech Majewski, whose flair for starkly poetic compositions often manages to outshine the elliptical quality of his material. Made in 1980, it has a medieval setting. It follows a knight on his quest for a mythical harp, one which will supposedly heal the ills of his nation.

Questions of faith help to shape the knight's journey, as he encounters various priests and questions their dedication to their calling. One priest is so moved by the knight's mission that, finding the knight lying ravaged by a terrible disease, he decides to absorb the illness himself. He lies face down on the sand in a crucified posture, at which point the knight's sores are suddenly healed. These same lesions cover the priest when, moments later, he arises.

Mr. Majewski demonstrates considerable flair for this sort of imagery, and his film retains its spare, arresting visual style throughout. Only late in the fable, when a band of seemingly reborn people cavort on the beach and form what resembles a conga line, is the spell broken. Though the mysticism of the material takes precedence over its politics, the film's central metaphor has clear pro-Solidarity implications. Mr. Majewski has since left Poland and is now making a film in English, which on the evidence of "The Knight," is well worth anticipating.

Janet Maslin

1983 D 9, C30:5

Does the new "Scarface" deserve to be rated "X" for violence? Is an "R" rating too lenient for "Star 80"? Should any movie that contains a single usage of one particular four-letter word — the word that the humorist Jean Shepard describes as "the queen-mother of dirty words" — deserve an automatic "R"? Will we ever see the day when it will be possible to give an "X" on principle to all of Clint Eastwood's "Dirty Harry" movies, including the new "Sudden Impact"?

The motion picture industry's film rating board, moviemakers (including the special effects experts who make it possible to chop off a head in front of our very eyes), concerned parents and frockless, frequently bewildered amateurs like movie reviewers continue to wrestle with the question of who should or shouldn't see certain kinds of movies.

Very early in an otherwise forgettable pirate movie titled "Nate and Hayes," Hayes, a dashing, 19th-century rogue played by Tommy Lee Jones, is running through the tropical forest on a Pacific isle, attempting to elude some bloodthirsty Polynesian natives. At one point, between the facetious quips with which he comments on his precarious situation, one of Hayes's sidekicks is fatally impaled inside what appears to be a giant bamboo mousetrap. For half a moment Hayes — and the camera — impassively study the poor fellow, who has become a human sea urchin, and then carry on the escape.

Later in the movie, which goes into an extended flashback, the human sea urchin turns out to have been one of Hayes's most loyal crew members. Even at the time of the man's death, Hayes's good-natured heartiness had seemed callous. Later, it's scarily incomprehensible.

"Nate and Hayes," which in most other ways is a film designed for the adolescent and teen-age trade if I've ever seen one, is rated "PG" ("parental guidance suggested").

Near the beginning of "Scarface," which is the jazzy update if not quite a remake of the 1932 Howard Hawks-Ben Hecht classic, Al Pacino, playing a Cuban refugee-hood on the make in Miami, is forced to watch while some unreliable Colombian cocaine smugglers start to dismember his business associate with a portable electric saw. The "Scarface" camera, which usually has all of the discretion of a thoughtless undertaker, looks away just before the blade strikes, but we see the terrified Pacino as his face is bathed in his friend's blood.

In the course of "Scarface," the audience is also treated to the spectacle of a man being hanged by the neck from a helicopter in midflight, the comparatively bloodless execution of two other crooks and, at the end, a spectacularly staged, bloody assault on a Miami mansion in which just about everybody dies. When Mordaunt Hall, who was then The New York Times's movie critic, wrote about the original "Scarface" on May 20, 1932, he said:

"The slaughter in 'Scarface'... is like that of a Shakespearean tragedy."

I'm not so sure that the slaughter in the new film, cannily written by Oliver Stone and directed by Brian De Palma with a good deal of extremely dark humor, is Shakespearean, but it becomes, toward the end, relentless. However, this bleak, harrowing relentlessness is one of the conscious points of an intelligent, highly exploitable if, for some, offensive film.

For others, nothing will match the bloody, blithe offensiveness of "Sudden Impact," which is a nearly two-hour justification of a vengeful young woman who goes around northern California shooting men, first in the genitals, then in the forehead. Though the movie's allure is exactly the same as a porn film's, the rating is "R."

•

Because the initial "X" rating of "Scarface" was subsequently overturned by the members of an appeals board, the "R"-rated "Scarface" now just going into release is, I'm told, pretty much the version of the film that the rating board labelled "X." When I saw the film the other day, my initial reaction was surprise. If I'd been a member of the film rating board, I'd have given "R" ratings to both "Nate and Hayes" and "Scarface." This "Scarface" is too good — too rich in characterizations and incidents and too serious in its point of view — to deserve to be classified with the porn movies that glory in their X-iness. At the same time, "Nate and Hayes" is too mindlessly cruel to be a "PG." The film rating board, under the direction of Richard D. Heffner, has, I think, gone in the right direction by calling as much — if not more — attention to violence as to sex in their ratings, but they're still limited in what they can do.

Unlike film critics, the members of the rating board cannot allow themselves to make esthetic judgments about the films they're rating. Thus they must use the same criteria when rating a piece of out-and-out junk like "Death Wish II" as when rating "Scarface." When a movie is bad, small in its aspirations and crude in its execution, explicit violence of the sort that is today commonplace in movies becomes insupportable. These films make the world and life seem cheap.

Good movies — and I realize this is the sort of general statement that can't be easily proved — enrich our perceptions of what life is and what it can be. An obvious example of this is a movie like Ingmar Bergman's

"Fanny and Alexander." "Scarface" is a far cry from "Fanny and Alexander" but it is a film that makes some real attempt to reflect the manners, morals and values of the society in which it takes place. It is ironic that the sheer gaudiness of "Scarface's" visual overstatement is what will be found most offensive, since its message is only a slight variation on those messages carried by the old Warner Bros. gangster movies. Says "Scarface": "Crime — and cocaine sniffing — do not pay." They also look tacky.

The film rating board is further hampered by not being allowed to publicize the specific reasons for the ratings that have been given to individual movies. Does such and such a movie carry an "R" because of its goriness or because someone uses the queen-mother of dirty words? For those people who pay attention to ratings, this information would be a service. It might also help if there were a rating between "X" and "R," or between "R" and "PG." All of this, however, comes under the heading of consumer services.

I'm not at all sure that films today are more violent than they were 10 years ago, though I suspect that they sometimes seem to be because the techniques by which violence can be made more explicit have been refined. The big leap toward more explicit violence was made in the late 60's and early 70's, partially as the result of the supposedly new freedoms allowed producers by the rating board, which replaced the old Production Code.

Remember the furor caused by Sam Peckinpah's "Wild Bunch" (1969), a fine film but one that, as I remember it, is certainly as violent as "Scarface"? Remember, also, Roman Polanski's unintentionally hilarious "Macbeth" (1971), in which Mr. Polanski successfully upstaged Shakespeare by trotting out Lady Macbeth to do her sleep-walking scene stark naked? Did anyone notice whether her eyes were open though their sense was shut? He then ended that feature-length joke by treating us to the sight of Macbeth's head being lopped off, on camera, to roll away into some prehistoric gutter.

Ever since "The Great Train Robbery," succeeding moviemakers have sought to out-do their predecessors' technical achievements. When it comes to action and adventure films involving violence, this has meant going just a little further than an earlier movie. In 1931 Mervyn Leroy's "Little Caesar" and William Wellman's "Public Enemy" were greeted by all sorts of cries of outrage.

In his review of "Public Enemy," Mr. Hall noted with some alarm the laughter with which Broadway audiences reacted to the film's wilder bits of mayhem — the same laughter, I suspect, that will be prompted in audiences watching the new "Scarface." Whether that laughter is cruel or cathartic, or some combination of the two, I've no idea. Yet if you take the trouble to see "Little Caesar" and "Public Enemy" today, and they are well worth seeing, you will be amazed at how tame they now look. People pull the triggers of tommy guns and victims collapse as if with fright. Though severely punctured, the bodies don't bleed in any rude, offensive way.

The furor over "Little Caesar" and "Public Enemy" prompted the people who ran the Production Code to get tough with moviemakers, to set out all sorts of do's and don't's relating to the portrayal of crime on screen. Samples: "The techniques of murder must be presented in a way that will not inspire imitation. Brutal murders are not to be presented in detail."

When Warner Bros. released the original "Scarface" a year later, they subtitled it — piously — "The Shame of the Nation." Moviemakers finally grew tired of all the hassling with the Code people and started to make pictures of the same sort, only with lawmen, instead of gangsters, as the heroes, "G-Men" being one of the most successful.

Because one's reaction to violence on the screen is so subjective, it's difficult for anyone — including the members of the film rating board — to deal with it in any fashion that's going to satisfy everyone. I remember being deeply moved and saddened by "The Wild Bunch," but when I saw Mr. Peckinpah's latest, equally violent and almost totally nonsensical "Osterman Weekend," I felt like saying a rude word. Very loud.

The film made so little sense that it appeared that the only reason for producing it was to insult the audience. That is, by bathing them in the same fake blood with which Mr. Pacino is splattered in the new "Scarface." However, "Scarface" is a legitimately vivid tale of corruption. "The Osterman Weekend" is so esthetically frail that it has the effect of being about nothing but how to destroy people in photogenic ways.

"The Osterman Weekend" is sleazy, without having anything to say about sleaze itself, which is the subject matter of Bob Fosse's dazzling looking but depressing "Star 80." "Star 80" is actually not all that violent. It's a tease that manipulates us by means of what we already know. Because most of us who go in to see the film are aware that it's based on a real-life murder, we sit through the movie in increasing anxiety waiting for the fatal event, which, when it occurs, is an anticlimax. In some curious way the movie makes us feel guilty for not having more compassion for its unfortunate heroine. If "Star 80" seems brutal, that, I think, is the principal reason.

The most consistently brutal films being made these days are, of course, the low-budget horror films that often come and go so fast they don't even get reviewed. Yet not all horror films are alike. Most are terrible, crudely made and unworthy of any consideration as examples of nouveau American Grand Guignol.

These are set in sorority houses, summer camps and high schools and are not examples of sex-and-violence but sex-with-violence. Dismemberment by a deranged killer stalking lovers' lane is a frequent penalty for what used to be called petting. The boyfriends who attempt to protect their dates may get axes embedded in their skulls, which are shown in loving detail. Anyone who has had to sit through a number of these movies must be struck not only by the effrontery of the violence, but by the sheer joy and good humor they often inspire in the audiences, which, for reasons I don't understand, are largely made up of couples on dates.

There are occasional Grand Guignol films that do work — horror films that are essentially comic in the brazen, cunning way in which the filmmaker knowingly plays on the relationship between film and audience. "The Texas Chainsaw Massacre," directed by Tobe Hooper, who went on to make "Poltergeist" with Stephen Spielberg, is one of these.

Who should or shouldn't be able to see these movies, as well as "Scarface," "Star 80" and, for that matter, "The Osterman Weekend"? It's a question that the members of the motion picture industry and concerned members of the public have been wrestling with for more than half a century, but it's an unequal match. Because no 10 people are likely to agree on any kind of formula for more than five minutes, it's the question that wins.

1983 D 11, II:23:1

Conflicting Desires

THE EYES, THE MOUTH, directed by Marco Bellocchio; story and screenplay (in Italian with English subtitles) by Mr. Bellocchio with the collaboration of Vicenzo Cerami; director of photography, Giuseppe Lanci; edited by Sergio Nuti; music by Nucola Piovani; produced by Enzo Porcelli with the collaboration of Enea Ferrario; released by Triumph Films. At Lincoln Plaza 2, Broadway between 62d and 63d Streets. Running time: 100 minutes. This film is rated R.

Giovanni Pallidissimi	Lou Castel
Wanda	Angela Molina
Mother of the Pallidissimi family	
	Emanuelle Riva
Uncle Nigi	Michel Piccoli
Father of Wanda	Antonio Piovanelli
Agostino	Giampaolo Saccorola
Adele	Viviana Toni
Doctor	Antonio Petrocelli

By JANET MASLIN

"THE EYES, THE MOUTH," by Mario Bellocchio, takes the form of a morose postmortem, as an Italian family grieves for a young man who has committed suicide. The dead man, Pippo, has left behind a mournful mother, as well as a pregnant young madonna-to-be, Wanda. He has also left a twin brother, Giovanni. The film is Giovanni's story, to the extent that it is anyone's at all.

Lou Castel, who plays Giovanni, was also the star of Mr. Bellocchio's far more successful "Fist in the Pocket," a film that at one point in "The Eyes, the Mouth" Giovanni and Wanda go to see. "It seems a lifetime ago," remarks Giovanni, observing what is supposed to be a performance from his days as a young actor. Now, Giovanni tells Wanda: "I'm dated. Your generation doesn't even know I exist. I'm starting over, but I don't know where from."

•

"The Eyes, the Mouth," which opens today at the Lincoln Plaza, is an attempt to dramatize not only Giovanni's artistic struggle but the conflicting desires that draw him toward his mother and toward Wanda. As expressed by the director in his writing about the film, these ambitions are far-reaching indeed. "In this movie I would like to demonstrate through concrete facts and the characters themselves that it is possible to recover that triangular fusion of the eyes and the mouth, experienced maybe only for a few moments in the childhood so as to recover a free and wise sexuality," Mr. Bellocchio has written.

The film itself is light-years away from expressing any of this coherently, however. And far too much of it feels like melodramatic foolishness, especially a climactic sequence in which Giovanni masquerades as Pippo's ghost to soothe his anguished mother. "I miss your cookies," he says, wearing eerie white makeup and weeping. After that he reminisces about his mother's generosity, declaring "'You don't eat enough, not nearly enough' — that could be your epigraph.'" After this, Giovanni escapes to the arms of Wanda, who washes the ghost makeup off his face while he takes solace in patting her swelling stomach. At times like these, the film's psychological underpinnings seem preposterous.

Angela Molina makes a radiant Wanda, even though there's not much of a character for her to play; Wanda is half maternal serenity and half high-spirited rebelliousness, and her only real means of expressing herself is by shaking of her long black hair. As Giovanni's uncle, Michel Piccoli has a quiet, effortless authority that the other characters lack. Mr. Castel, in keeping with the rest of the film, has a moody and despairing demeanor. In mourning the loss of his midsixties angry young man persona — "an angry, antisocial type," as Giovanni describes his former self to Wanda — he is at his most convincing.

1983 D 14, C24:1

Accident or Murder?

SILKWOOD, directed by Mike Nichols; written by Nora Ephron and Alice Arlen; director of photography, Miroslav Ondricek; edited by Sam O'Steen; music by Georges Delerue; produced by Mr. Nichols and Michael Hausman; presented by ABC Motion Pictures; a Twentieth Century-Fox Release. At the National, Broadway and 44th Street; Tower East, 72d Street and Third Avenue and other theaters. Running time: 131 minutes. This film is rated R.

Karen Silkwood	Meryl Streep
Drew Stephens	Kurt Russell
Dolly Pelliker	Cher
Winston	Craig T. Nelson
Angela	Diana Scarwid
Morgan	Fred Ward
Paul Stone	Ron Silver
Earl Lapin	Charles Hallahan
Max Richter	Josef Sommer
Thelma Rice	Sudie Bond
Quincy Bissell	Henderson Forsythe
Gilda Schultz	E. Katherine Kerr
Mace Hurley	Bruce McGill
Wesley	David Strathairn
Curtis Schultz	J. C. Quinn

By VINCENT CANBY

TAKING many of the facts of the life of Karen Silkwood, the young laboratory worker and union activist who, in 1974, died in an automobile crash that some believe to have been murder, Mike Nichols has directed a precisely visualized, highly emotional melodrama that's going to raise a lot of hackles.

Though far from perfect, "Silkwood" may be the most serious work Mr. Nichols has yet done in films, and that would include "Who's Afraid of Virginia Woolf?," "The Graduate" and "Catch-22." Perhaps for the first time in a popular movie has America's petrochemical-nuclear landscape been dramatized, and with such anger and compassion.

•

"Silkwood," which opens today at Loew's Tower East, also offers another stunning performance by Meryl Streep, who plays the title role. Having won her first Oscar for "Kramer vs. Kramer" and her second for "Sophie's Choice," Miss Streep looks to be on what the Las Vegas people call "a roll."

Her portrait of the initially self-as-

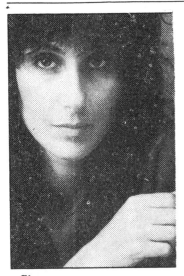

Cher

sured and free-living, then radicalized and, finally, terrified Karen Silkwood is unlike anything she's done to date, except in its intelligence. It's a brassy, profane, gum-chewing tour de force, as funny as it is moving.

There are, however, problems, not unlike those faced by Costa-Gavras in his "State of Siege" and "Missing," and they are major. Mr. Nichols and his writers, Nora Ephron and Alice Arlen, have attempted to impose a shape on a real-life story that, even as they present it, has no easily verifiable shape. We are drawn into the story of Karen Silkwood by the absolute accuracy and unexpected sweetness of its Middle American details and then, near the end, abandoned by a film whose images say one thing and whose final credit card another. The muddle of fact, fiction and speculation almost, though not quite, denies the artistry of all that's gone before.

This much about Karen Silkwood's life apparently is not in dispute: She was born in Texas, went through one year of college and had three children by a common-law husband, whom she left when she moved to Crescent, Okla., to work in Kerr-McGee's Cimarron Plutonium Recycling Facility there. At Cimarron, she earned a reputation as someone who couldn't be pushed around.

She lived for a while with a young co-worker named Drew Stephens and was known to drink and to pop pills. At the same time, she grew increasingly troubled by the sloppy safety conditions under which she and the other Cimarron employees worked when handling dangerous, highly radioactive plutonium.

One result was that she threw herself into union work and was herself "contaminated" by radioactive materials, though in ways that have never been satisfactorily explained. At the time of her death, she was alleged to have gathered evidence that would force the plant to close. On the night of the car crash, she was driving alone to Oklahoma City to meet David Burnham, a reporter for The New York Times, to tell her story.

Because of these circumstances, there are those who contend that she was murdered to keep her silent. At this point she had become almost as unpopular with many employees, who didn't want to lose their jobs, as she was with management. There are others who are convinced that her car crash was an accident, caused by her known use of tranquilizers and pain killers. They speculate further that her contaminations were, in fact, not accidents but self-inflicted, in a misguided attempt to dramatize the true gravity of conditions at the Cimarron facility, which, subsequently, was shut down.

●

Mr. Nichols and his writers attempt to acknowledge most of these theories and, in so doing, end their film in utter confusion. However, until these closing scenes, in which "Amazing Grace," heard on the soundtrack, is used as if it were caulking to plug the holes in a leaky boat, "Silkwood" is a very moving work about the raising of the consciousness of one woman of independence, guts and sensitivity.

In the small-town atmosphere of Crescent, Miss Streep's Karen is, for understandable reasons, notorious. She shares a ramshackle house with her current lover, Drew (Kurt Russell), who's just as casual in his attachments as she is in hers, and with her best friend Dolly Pelliker (Cher), a practicing lesbian. At one point the more or less ménage à trois becomes four when they are joined by Dolly's newest lover, Angela (Diana Scarwid), who works as a beautician in a funeral parlor.

At the plant, Karen takes no lip from the company bosses and sounds off noisily about love, sex and whatever else that comes to mind, to the shocked delight of her more conservative co-workers. That popularity begins to vanish, though, when she joins the battle over safety conditions.

If Miss Streep is superb, Mr. Russell and Cher are very, very good. After his years with Walt Disney and then in action-adventure films ("Escape from New York," "The Thing"), Mr. Russell has become a star with the looks of a leading man and the substance and wit of a character player. Whether or not Cher is a great actress, I'm still not sure, but when you take away those wild wigs she wears on television, and substitute something a little less riveting for her crazy Bob Mackie gowns, there's an honest, complex screen presence underneath.

The entire cast is exceptional, especially Sudie Bond, as one of Karen's older co-workers; Craig T. Nelson, as a man who may be doctoring negatives for the company's protection; Josef Sommer and Ron Silver, as union executives; Bruce McGill, who must represent virtually the entire Kerr-McGee management team, and Graham Jarvis, as one of the specialists who alerts the union members to the dangers they face.

As the screenplay catches the Texas-Oklahoma speech rhythms, and as these rhythms are re-created by the members of the cast, the work of Miroslav Ondricek, the cameraman, is equally successful. It captures the essense of the contradictions that exist in the petrochemical-nuclear landscapes of Oklahoma and Texas, where huge, sophisticated industrial facilities are set upon vast plains, otherwise occupied only by isolated farms, small towns and the sorts of roadhouses that haven't changed since the repeal of Prohibition.

I realize that films shouldn't be judged in bits and pieces, but it's difficult not to see "Silkwood" in that way. For most of its running time it is so convincing — and so sure of itself — that it seems a particular waste when it goes dangerously wrong. It's like watching a skydiver execute all sorts of graceful, breathtaking turns, as he appears to ignore gravity and fly on his own, only to have him smash to earth when the chute doesn't open.

1983 D 14, C27:1

Murder in Moscow

GORKY PARK, directed by Michael Apted; screenplay by Dennis Potter from the novel by Martin Cruz Smith; director of photography, Ralf-D. Bode; edited by Dennis Virkler; music composed by James Horner; produced by Gene Kirkwood and Howard W. Koch Jr.; released by Orion Pictures. At Loews Paramount, Broadway at 61st Street; Loews N.Y. Twin, Second Avenue at 67th Street, and other theaters. Running time: 130 minutes. This film is rated R.

Arkady Renko	William Hurt
Jack Osborne	Lee Marvin
William Kirwill	Brian Dennehy
Iamskoy	Ian Bannen
Irina	Joanna Pacula
Pasha	Michael Elphick
Anton	Richard Griffiths
Pribluda	Rikki Fulton
General	Alexander Knox
Golodkin	Alexei Sayle

By JANET MASLIN

THE colorless, frozen setting against which "Gorky Park" unfolds has been oddly but compellingly rendered in Michael Apted's screen version of Martin Cruz Smith's best-selling novel, even though the movie's peculiarities ultimately pose some problems. Substituting Helsinki for Moscow, and having the leading character, a Russian police detective, played by an American actor affecting a British accent, Mr. Apted has certainly tailored the material in provocatively idiosyncratic ways.

On the whole, Mr. Apted's approach to the material is archly effective, making for a crisp, intricate thriller, well able to hold an audience's interest. However, viewers unfamiliar with the novel may be better disposed toward the movie than Mr. Smith's readers will be, since the screen version of this detective drama is less effectively atmospheric than the book. A lot of information has been crammed into Dennis Potter's shrewd screenplay, to be sure. But the film must juggle so much crime data that it barely has time for the glimpses of Moscow life that helped make Mr. Smith's story memorable.

"Gorky Park," which opens today at Loews Paramount and Loews New York Twin, has been aptly named, since the Moscow park of the title represents the hope and freedom toward which the leading character, the police detective Arkady Renko, is slowly drawn. Gorky Park, Mr. Smith wrote, "was the only place in the city where you could fantasize"; in another passage, he described it as "the purest heart of the city." And Gorky Park, in the opening scenes of this thriller, is the site at which three mutilated murder victims are discovered, touching off an investigation that links the police investigator Renko, the K.G.B., a sinister American businessman, the obligatory femme fatale and even some highly prized animals, whose presence turns out to be crucial to the plot.

●

The story is convoluted but it unfolds carefully, with most of the elements painstakingly explained. There is a lot of emphasis on forensic evidence in the murders, much of it quite gruesome; the movie actually has a "cadavers by" credit, and it spends a fair amount of time in the autopsy room. However, the gore does not seem gratuitous, and the autopsy footage yields fascinating if grisly results. Renko, following the course of this investigation, is led more and more intimately into a web of deception and intrigue.

William Hurt's performance as Renko is the mainspring of the movie and also its most rivetingly strange element. Mr. Hurt, for some reason affecting the voice of an adenoidal Briton, brings an ironic detachment to the performance, which serves him very well in the film's early sequences. Later on, when Renko falls for the insolent beauty played by

Meryl Streep in a scene from "Silkwood," — a tale of nuclear martyrdom

Frank Connor

Murder and conspiracy in Moscow link Lee Marvin, William Hurt and Ian Bannen in "Gorky Park," based on the Martin Cruz Smith best seller.

Joanna Pacula and spars with Lee Marvin's ruthless American entrepreneur, that reserve becomes more stifling. Mr. Hurt's Renko never seems truly willing to risk much for Miss Pacula, even though the screenplay indicates that he ought to be. And the changes in Renko as the film progresses don't seem terribly pronounced, partly as a result of Mr. Hurt's coolly controlled presence and partly because the screenplay has pared away Renko's friends and family history, thus providing a much sketchier dossier on the character than Mr. Smith did.

Although "Gorky Park" seems to grow more tangled and affectless as it progresses, it remains a taut, clever thriller throughout, with Mr. Apted's direction establishing its intensity immediately and sustaining it well. Ralf G. Bode's cinematography and James Horner's score go a long way toward setting a hauntingly bleak mood, and the supporting players, particularly Brian Dennehy and Ian Bannen, are excellent. Only in its most formulaic spy-movie flourishes does the film seem ordinary, or does Mr. Hurt seem to be operating by rote. At the end of the film, he blankly declares "Look at me, what do you see? A Russian — I could never be anything else." Though there's not much to be done with the line anyway, his Renko makes it sound even more disingenuous than it had to.

1983 D 16, C6:5

THE MAN WHO LOVED WOMEN, directed by Blake Edwards; screenplay by Blake Edwards, Milton Wexler and Geoffrey Edwards; director of photography, Haskell Wexler; edited by Ralph Winters; music by Henry Mancini; produced by Blake Edwards and Tony Adams; released by Columbia Pictures. At Movieland, Broadway at 47th Street; Loews N.Y. Twin, Second Avenue at 67th Street, and Loews 34th Street Showplace, 238 East 34th Street. Running time is 118 minutes. This film is rated R.
David ..Burt Reynolds
MariannaJulie Andrews
Louise ...Kim Basinger
Agnes ..Marilu Henner
CourtneyCynthia Sikes
Nancy ..Jennifer Edwards
Janet ..Sela Ward
SvetlanaEllen Bauer
Enid ...Denise Crosby

IT takes an inordinate amount of time to build up momentum, but once it does, "The Man Who Loved Women," Blake Edwards's "Americanization" of Fran-

çois Truffaut's 1977 French comedy, skates successfully over the thin ice.

Chief among its virtues is the performance of Burt Reynolds as David Fowler, a celebrated Los Angeles sculptor and an unexpectedly gentle and honorable, if obsessed, womanizer. Like Bertrand Morane in the Truffaut film, David Fowler is used by women as much as he uses them. That this is the most consistently funny, disciplined performance that Mr. Reynolds has yet done is a direct reflection of the idiosyncrasies of the character, as well as of Mr. Edwards's strong but sympathetic direction.

"The Man Who Loved Women" is not top-drawer Blake Edwards — nothing to equal the best of the Pink Panther films, "10" or "Victor/Victoria." There's something about the material that seems inhibiting. The Truffaut film is a rueful, personal fantasy. Mr. Edwards's is more theoretical.

There are a number of funny one-liners and at least one hilarious slapstick sequence, involving Krazy Glue, a small dog and a shag rug. But the overall tone is more autumnal than, perhaps, anyone realized while the film was being made.

This is not only because the film opens with the funeral of the recently dead David Fowler and works backward through time, but also because, with two exceptions, the women who pass through his life aren't especially interesting. The screenplay by Mr. Edwards, Milton Wexler and Geoffrey Edwards, doesn't build to any climax. It coasts toward a known destination.

The two actresses who give Mr. Reynolds a run for his money are Kim Basinger ("Never Say Never Again"), as a Texas millionaire's oversexed young wife, who favors impromptu assignations in public places, and Julie Andrews, who plays David's analyst and, eventually, his most understanding lover. Miss Andrews is awfully good at listening, which all fine actresses must be, but she's far more entertaining as an all-out comedienne.

In his publicity statements, Mr. Edwards is full of praise for the Truffaut film, but in the film's screen credits, there is not one mention of the earlier film, of Mr. Truffaut or of Michel Fermaud and Suzanne Schiffman, who

collaborated with Mr. Truffaut on the screenplay.

I've no doubt that Mr. Edwards cleared all the legal rights before setting out on this "Americanization." It seems he also purchased the right not to acknowledge officially that the earlier film ever existed — that is, to rewrite history.

"The Man Who Loved Women" opens today at the Movieland and other theaters.

Vincent Canby

1983 D 16, C8:1

Warsaw Wags

TO BE OR NOT TO BE, directed by Alan Johnson; screenplay by Thomas Meehan and Ronny Graham; director of photography, Gerald Hirschfeld; edited by Alan Balsam; music by John Morris; produced by Mel Brooks; released by Brooksfilms. At Gotham, Third Avenue at 58th Street; Criterion, Broadway at 44th Street; Loews 34th Street Showplace, at Second Avenue, and other theaters. Running time: 107 minutes. This film is rated PG.
Frederick Bronski............................Mel Brooks
Anna BronskiAnne Bancroft
Andre SobinskiTim Matheson
Colonel ErhardtCharles Durning
Professor Siletski............................José Ferrer
Captain SchultzChristopher Lloyd
Sasha ..James Haake
RavitchGeorge Gaynes
RatkowskiGeorge Wyner
Dobish ..Jack Riley

By VINCENT CANBY

EVERYBODY can relax. Mel Brooks's remake of Ernst Lubitsch's 1942 classic, "To Be or Not to Be," is smashingly funny. I'm not at all sure that it's a classic, but it's so good in its own right, in the way it preserves and revives the wonderfully farcical situations of the original Edwin Justus Mayer screenplay, that you leave the theater having a brand-new high. It opens today at the Criterion and other theaters.

With Mr. Brooks in the Jack Benny role, renamed Frederick Bronski, a hammy, egotistical stage star modestly described as "world famous in Poland," and Anne Bancroft, Mr. Brooks's real-life wife, as Frederick's actress-wife, Anna (the Carole Lombard role), this "To Be or Not to Be" scarcely misses a comic beat

right from the opening sequence.

The time, of course, is August 1939, and the place, Warsaw, on the eve of World War II. Frederick and Anna Bronski are, as they themselves might say, "discovered" in mid-performance on the stage of their Bronski Theater, doing what their public apparently thinks they do best.

As we see it, this is a hilarious, seriously tacky Fred Astaire-Ginger Rogers song-and-dance turn to "Sweet Georgia Brown." You haven't ever heard "Sweet Georgia Brown" until you've heard Mr. and Mrs. Brooks sing it in Polish, as they kick up their little feet in unison, this way and that, shake their shoulders in what passes for slinky sophistication and smile in a moonily patronizing way at their adoring audience.

●

It's a difficult number to top, and though they never really do top it, "To Be or Not to Be" never falls much below this high standard, set so perilously early in the entertainment. Mr. Brooks and Miss Bancroft played together once before, in his "Silent Movie" in which she had a cameo role, but this is their first co-starring romp. It's one in which we are allowed to discover for ourselves what they seem to have known all along — they were made for each other. Though she gives the impression of towering over him in her high-fashion, elegantly nutty way, he comes up to her size through brainy madness and epic self-assurance.

It's no news that Mr. Brooks is one of our national treasures. The revelation for film audiences is that Miss Bancroft is such a wildly gifted comedienne. She is not a foil, but an equal partner, who never fails to meet Mr. Brooks's comic challenges and who, I suspect, provides him with the sort of solid presence that allows him to reach the heights he does. Performing singly or in tandem, they are terrific.

●

The new screenplay, directed by Alan Johnson, who choreographed the memorable "Springtime for Hitler" number in Mr. Brooks's "Producers," closely follows that for

Mel Brooks and Anne Bancroft star in "To Be or Not to Be," a remake of the 1942 comedy about a Polish theater troupe scheming against the Nazis.

Tim Matheson in Mel Brooks's film "To Be or Not to Be."

the Lubitsch production, being about the efforts of the members of the Bronski Theater company to thwart the efforts of the Nazis to crack the Polish underground, once Warsaw is occupied. The plot involves the use of more fake beards, assumed identities, suspicions of adultery, misplaced dead bodies and narrow escapes than you'll normally find in an entire season of movie farces.

As is his custom, Mr. Brooks has surrounded himself with a cast of top-notch farceurs. Some are new to us in this sort of thing, like Miss Bancroft and Tim Matheson, who plays the dashing Polish aviator who courts Miss Bancroft in her dressing room every time her husband is on stage, doing his celebrated "Highlights From 'Hamlet' " turn.

Though we've seen most of the other actors before, we haven't seen them to such delectable advantage: José Ferrer, as a thoroughly, happily nasty Polish collaborator; Charles Durning, who plays an amorous Nazi colonel nicknamed by Berlin "Concentration Camp Erhardt" ("we do the concentrating, the Poles do the camping"); George Gaynes, as an especially actorly member of the Bronski troupe, and Lewis J. Stradlin, another member of the company.

Some of the additions to the Lubitsch original are marvelous, including the aforementioned "Sweet Georgia Brown" and a song-and-sketch number called "A Little Peace," in which Mr. Brooks impersonates a none-too-masculine Hitler in a revue called "The Naughty Nazis."

Mr. Brooks's uncontrollable urge to carry bad taste so far that it might possibly become redeeming is evident from time to time, as in a line referring to contributions to theater by Jews, gypsies and homosexuals. As if to make amends he turns Anna's faithful dresser, Sasha (James Haake), into a swishily courageous homosexual, who wears his pink triangle with pride, and allows one member of his supporting cast to recite Shylock's most famous soliloguy, seriously. These are not among the film's great inspirations.

Though most of the material in this "To Be or Not to Be" appears to come from the old Mayer screenplay, the film also successfully incorporates jokes from other movies, including the scene from "My Little Chickadee" in which W. C. Fields snuggles in bed with a goat he assumes to be

Mae West, and from other sources so old they are probably anonymous. Yet old jokes are part of the fun of farce, where the anticipation of a great gag actually increases its comic impact.

One thing does bother me, and that's the modest billing given to Edwin Justus Mayer as well as to Melchior Lengyel, who wrote the story on which the first screenplay was based. Despite the fact that so much of this film is lifted directly from the Lubitsch movie, the new film's screenplay is credited — in an early, prominent title — to Thomas Meehan and Ronny Graham, with mention of Mayer and Lengyel coming only after we've read the names of various producers, the cameraman, the production designer, the composer, the editor and the costume designer.

This is ridiculous. I've consistently admired Mr. Graham's work since "New Faces of 1952," and I should think that this almost grudging mention of the source material would give him, at least, pause.

In the production notes, Mr. Brooks is quoted as saying that he doesn't think this film should be described as a remake. He points out that when the great male star of each succeeding generation does "Hamlet," the production is not called a remake. That's true, but when each great star of a succeeding generation does "Hamlet," "Hamlet" doesn't have a new author.

When the Lubitsch film was released in March 1942, the terrible realities of World War II and the death of Miss Lombard made it difficult for audiences as well as critics to respond to the film's brilliant comedy. I hope that nothing will come between today's audiences and this exuberant delight.

●

"To Be or Not to Be," which has been rated PG ("Parental Guidance Suggested"), contains rude language and other material that, though not obscene, might well offend a number of people, which is par for the course in any Mel Brooks film.

1983 D 16, C10:1

They're 'Bye-Bye'

UNCOMMON VALOR, directed by Ted Kotcheff; screenplay by Joe Gayton; directors of photography, Steven Burum and Ric Waite; edited by Mark Melnick; music by James Horner; produced by John Milius and Buzz Feitshans; released by Paramount Pictures. At the Guild, 33 West 50th Street; Embassy Twin, Broadway at 72d Street; 72d Street East, First Avenue at 72d Street. Running time is 105 minutes. This film is rated R.
Jason RhodesGene Hackman
Harold MacGregorRobert Stack
Blaster ...Reb Brown
SailorRandall (Tex) Cobb
Scott ...Patrick Swayze
Wilkes ...Fred Ward
Curtis JohnsonHarold Sylvester
ChartsTim Thomerson

"UNCOMMON VALOR" is about a Vietnam veteran, Col. Jason Rhodes. whose son has been missing in action for more than 10 years and who returns to Southeast Asia in hopes of rescuing the boy. Even though the colonel is played by an actor as intelligently resourceful as Gene Hackman, and even though the plot sounds as if it might have some psychological dimension to it, "Uncommon Valor" is mostly an action movie, and

Gene Hackman recruits a group of Vietnam veterans to search for his son, missing in Laos, in "Uncommon Valor," an adventure film opening Friday at the Guild.

not much more.

"Uncommon Valor," which opens today at the Embassy Twin and other theaters, was directed by Ted Kotcheff, who has progressed from "The Apprenticeship of Duddy Kravitz" and "Fun With Dick and Jane" to recent works (including "North Dallas Forty" and "First Blood") in a more he-man vein. If anything, "Uncommon Valor" bears more of the stamp of his co-producer, John Milius ("Dillinger," "Conan the Barbarian"), than it does of Mr. Kotcheff. The characters are bold and brawny, and their conversation, while emphatically patriotic and gung-ho, is seldom very memorable, except for its lively euphemisms. "What you have is instant rag doll," someone says, for instance, explaining in a training session how to immobilize an enemy with one neat blow to the brain stem.

"Uncommon Valor" isn't exactly talky, but it does spend a lot of time in the plotting, recruiting and training stages, before the actual caper begins. Colonel Rhodes enlists the financial backing of an oil tycoon (Robert Stack), who is also the father of a missing soldier. He then rounds up the former Army buddies of Frank, his own son. We don't know much about Frank, who is seen only briefly and who is mentioned occasionally, but hardly even described (the film is so weak on the Rhodes family angle that Frank's mother, played by Gail Strickland, has a total of about 30 seconds' screen time). However, Frank's pals represent a convenient cross-section of macho America.

The movie can't wait to get the grinning blond body builder Blaster (Reb Brown), the black executive Johnson (Harold Sylvester), the gigantic Sailor, played by Randall (Tex) Cobb, and the unhappy husband Charts (Tim Thomerson) out of their doldrums and into their "Dirty Dozen" machinations. Also in the group is a sensitive sculptor named Wilkes, played by Fred Ward, who is smaller than his teammates and so much more interesting an actor that he nearly steals the show. Together, the group trains at an imitation prisoner-of-war camp stateside, playfully staging combat maneuvers, like one in which the victim gets a sign reading "Wiped-out" or "Bye-Bye" or "History" around his neck. After

enough of this, they are presumably ready for a climactic trip to Laos to rescue the prisoners. The audience is ready by this point, that's for sure.

Action fans may well find "Uncommon Valor" enjoyably familiar, but for others it will smack of war movie déjà-vu, despite the new angle provided by its concern for American soldiers missing in action in Vietnam. Mr. Hackman and Mr. Ward, certainly worth watching here, are much more so in their other recent films, Mr. Hackman in "Under Fire" and Mr. Ward in "The Right Stuff" and "Silkwood."

Janet Maslin

1983 D 16, C12:1

Saving the World

TWO OF A KIND, written and directed by John Herzfeld; director of photography, Fred Koenekamp; edited by Jack Hofstra; music adapted by Patrick Williams; produced by Roger M. Rothstein and Joe Wizan; released by 20th Century-Fox. At the Rivoli, Broadway and 49th Street; Gemini 1, Second Avenue at 64th Street; RKO 86th Street Twin, Lexington Avenue; Murray Hill, 34th Street near Third Avenue and other theaters. Running time: 90 minutes. This film is rated PG.
Zack...............................John Travolta
DebbieOlivia Newton-John
CharlieCharles Durning
RuthBeatrice Straight
EarlScatman Crothers
GonzalesCastulo Guerra
BeazleyOliver Reed
StuartRichard Bright
OscarVincent Bufano

CAN it really have been *that* difficult to find a passable screen vehicle for John Travolta and Olivia Newton-John? Any old romantic fluff should have sufficed, and yet something as horrible as "Two of a Kind" has been tailor-made for its stars. The results are so disastrous that absolutely no one is shown off to good advantage, with the possible exception of the hairdressers involved. The coiffures don't always upstage the material, but when they do, it's a blessing.

"Two of a Kind," which opens today at the Rivoli and other theaters, has a plot that supposedly originates in heaven. God (with voice supplied by Gene Hackman, who had the good sense to go uncredited) is all set to destroy the world, when a band of angels (including Beatrice Straight,

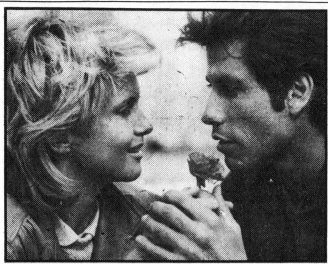

Olivia Newton-John and John Travolta appear in the romantic comedy "Two of a Kind."

Charles Durning and Scatman Crothers) involve him in a wager. If the two selfish earthlings played by Mr. Travolta and Miss Newton-John can somehow become better people in a week's time and if they can fall in love the world will be saved.

Those may not sound like very high stakes, but in view of the characters the two stars play, the bet seems virtually unwinnable. Mr. Travolta plays an unsuccessful inventor, who keeps a poster of Einstein on his wall; Miss Newton-John is a bank teller with Queen Elizabeth on her wall (clearly, the set designer has worked overtime). They meet when Mr. Travolta tries to rob Miss Newton-John's bank, in one of the many whimsical encounters here that aren't nearly so cute as they are meant to be. For instance, the couple's second meeting occurs when Mr. Travolta falls off a moving vehicle on to Miss Newton-John, squashing her.

•

"Two of a Kind," which marks the directing debut of John Herzfeld, seems utterly rootless, geographically and otherwise. It's not even clear what city we're supposed to be seeing; one car chase begins in Manhattan and then appears to shift to some boulevard in Los Angeles, which has been relabeled "83d

Street." Far more damaging is the fact that no element of reality has been allowed to intrude on the pure show-business superficiality of the exercise. The film is so synthetic that when the Devil (Oliver Reed) and the angels do battle, they use today's home-video techniques for their weaponry. "Freeze," cries one side, and the action stops. "Fast-Forward!" cries the other. "Rewind!"

Not even the most ardent Travolta or Newton-John fans are liable to like the stars' notions of how these characters should behave. Mr. Travolta has nothing better to do here than he did in "Staying Alive"; these *have* been two of a kind for him, and a third could be calamitous. Miss Newton-John makes a very unconvincing young career girl, and the fact that's she's also supposed to be an aspiring actress leads to dialogue about her dramatic talents that is, under the circumstances, embarrassing.

Janet Maslin

"Two of a Kind" is rated PG ("Parental Guidance Suggested"). It contains a few sexual references and some stupid double-entendres that may not even amuse viewers in their early teens.

1983 D 16, C12:6

FILM VIEW

VINCENT CANBY

It Seems Time To Celebrate Cinematic Togetherness

time of year when
re persons take it
tify their opinions
sort and another.
much a part of the

season as holiday depression, overdrawn bank accounts and plastic Christmas trees. It's something in which some of us participate with a certain amount of feigned diffidence, as if it weren't seemly to express such preferences so blatantly. This year, however, the diffidence may not be all that feigned, at least in connection with one category of movie awards.

These are the performance awards. Not in a number of years have there been so many films that featured not just one or two outstanding performances, but what should be described as outstanding collective performances, a phrase I use to distinguish them from what is usually referred to as ensemble work.

Ensemble work, at least as I understand the phrase, refers to the work of actors working together, sharing the same scenes, the same frames of film, sometimes working harmoniously with each other and sometimes even against each other, being inspired to find new dimensions to their work as much from a sense of competition as from stimulation by another's work.

The term "ensemble acting" has been borrowed from the legitimate theater and is sometimes used rather loosely in films since, through the editor's magic, it is possible to create an impression of ensemble work that never happened at all.

There's a story to the effect that Marlon Brando and Rod Steiger scarcely saw each other in the great taxicab scene they shared in the Elia Kazan-Budd Schulberg "On the Waterfront." According to this story, because the two actors were not especially fond of each other, they played together only in the master shots — those shots that set the scene of the two sitting in the back of a taxicab. After that, each played out his portion of that extremely intense scene alone, while the other actor was off somewhere else, safely out of the line of vision of the actor then acting.

• • •

Whether or not this is true, the acting in "On the Waterfront" gives the impression of having been ensemble work of high order.

The term "collective performance" is just a way to avoid the possibility of mistaking the genius of the director and the editor for the ensemble work of the actors, no matter how fine they are individually. It also recognizes that there are many films featuring uniformly excellent performances by actors whose roles never cross those of a number of the other actors in the same film.

This year there have been so many examples of excellent ensemble and collective performing that it seems as if it's going to be nothing less than an act of criminal negligence to cite the work of a few individual actors.

From the very opening sequence of the new "To Be or Not to Be," when Mel Brooks and Anne Bancroft as "the Alfred Lunt and Lynn Fontanne of Poland," sing (while hoofing) a sidesplitting version of "Sweet Georgia Brown" in Polish, it's apparent that this remake of the 1942 Ernst Lubitsch classic is going to benefit hugely from the extraordinary responsiveness of these two performers to each other. It's their teamwork, rather than just their individual performances, that makes this "To Be or Not to Be" such a lark. Unfortunately there's no award for teamwork.

• • •

"Britannia Hospital," Lindsay Anderson's rambunctiously funny, farcical satire on a seriously bleak national situation, is virtually a Guide Michelin to the great actors available to British filmmakers today. I doubt that even one of these performers will be nominated for any awards by anybody, but let it be recorded, in this space at this point in time, that the following should be honored collectively: Graham Crowden, Joan Plowright, Malcolm McDowell, Dandy Nichols, Alan Bates, Vivian Pickles and dear Gladys Crosbie, who, as Queen Mother Elizabeth, is the comedy's loyal, unwavering hilarious center.

John Landis's "Trading Places" has a funny screenplay by Timothy Harris and Herschel Weingrod, but what makes it pay off is the ensemble playing of Eddie Murphy with Dan Aykroyd, of Ralph Bellamy with Don Ameche, and from the work of these four, taken collectively, with Denholm Elliott and Jamie Lee Curtis. "Trading Places" may look like Eddie Murphy's movie, but it's really a communal triumph.

So also is "Terms of Endearment." That Shirley MacLaine gives what is possibly the best performance of her career is not exactly an accident. It has a lot to do with her responding to the strength of the work done by everyone else in the film, especially Jack Nicholson, Debra Winger and John Lithgow, who, if I remember correctly, shares no scenes at all with Miss MacLaine.

• • •

Philip Kaufman's "Right Stuff" features three immediately outstanding performances — those of Sam Shepard as Chuck Yeager, Ed Harris as John Glenn and Scott Glenn as Alan Shepard, but the film is more notable as a collective performance than as ensemble performing. Mr. Shepard's Chuck Yeager has very little to do with the other characters in the course of the movie. Instead, he seems to preside over them as a sort of living American myth, one designed to raise the consciousnesses of the others.

A more easily identifiable example of top-notch ensemble film performing is Lawrence Kasdan's "Big Chill," in which eight wonderful actors give the impression of working in the most productive kind of creative harmony. They are William Hurt, Kevin Kline, Glenn Close, Tom Berenger, JoBeth Williams, Mary Kay Place and Jeff Goldblum, with Meg Tilly, as the only outsider in the reunion group, becoming the focal point of the film not only because of her obvious youth but because she provides the film with its emotional perspective. Any award to one of these actors without recognition of the others would be a bad joke.

"The Dresser," Peter Yates's screen version of Ronald Harwood's play, adapted by Mr. Harwood, is something of a hybrid. It's a spectacular example of team playing between Albert Finney as Sir, the hammy, aging, English actor-manager, who's in the midst of a physical and emotional breakdown, and Tom Courtenay as Norman, Sir's loyal dresser, confidant and fool. Initially it seems that there is a kind of profligacy in the casting of such extraordinarily fine actors as Edward Fox, Zena Walker, Eileen Atkins and Michael Gough in what are really only colorful bit roles. By the time the film is over, however, one realizes that what one has been seeing is a demonstration of the classic repertory system, in which the stars of one night will be the messengers and spear carriers of the next.

• • •

In this case, though, I suspect that "The Dresser" would have been equally as spectacular as a joint acting turn by Mr. Finney and Mr. Courtenay even without its talented supporting cast. That's not a reflection on the supporting actors but a recognition of the sort of two-character piece Mr. Harwood has written.

Another such piece is "Educating Rita," a film about which I have many grave reservations, but not about the acting. It would do a great disservice to Michael Caine to give an award to Julie Walters, who plays the title role, without recognizing Mr. Caine's remarkable contribution to that performance and to the film itself. If I were a betting sort, I'd lay down money that Miss Walters will wind up with an Oscar nomination, and Mr. Caine won't. It's a bet I wouldn't mind losing.

Is it possible that one day such shared awards will be taken as a matter of intelligent course and not as a sort of cop-out or political compromise, as they often are at the Cannes Film Festival, where the *modus operandi* seems to be to give as many awards to as many people as possible without looking completely asinine? Perhaps, at the year's end, there should be an award given to whoever displayed the most intelligence, foresight, daring and sensitivity in the casting of the year's best acted (collectively) film, whether that person was the director, the producer, the financial backer or someone's mother-in-law.

To isolate one performance from those performances that surround it, and to recognize it with a prize, transforms what is supposed to be an award for great performing to the status of a symbol. Each year's winners, we more or less understand, may have given good performances but are more important as representing what great — even good — acting can be.

One of this year's most exciting performances is that of last year's Oscar winner, Meryl Streep, in the title role of Mike Nichols's "Silkwood." Her Karen Silkwood is such a wonderfully vivid, fully realized characterization out of lower Middle America, and it's so unlike anything else she has ever done, that Miss Streep seems on the verge of becoming her own, one-woman acting ensemble. Yet her performance in "Silkwood" does not stand alone. It represents the Streep talent in full bloom, but also the Streep talent as it connects with the talents of Cher, Kurt Russell, Sudie Bond and Craig T. Nelson, among others.

As acting is a communal endeavor, our awards should, in some fashion, be designed to acknowledge this. Otherwise they are merely whimsical. ∎

1983 D 18, II:21:1

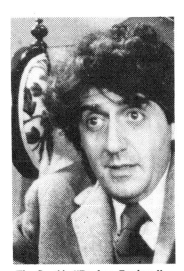

Tim Conti in "Reuben, Reuben."

A Slothful Sot

REUBEN, REUBEN, directed by Robert Ellis Miller; screenplay by Julius J. Epstein from the Peter DeVries novel and "Spofford," the Herman Shumlin play; director of photography, Peter Stein; edited by Skip Lusk; music by Billy Goldenberg; produced by Walter Shenson; released by Twentieth Century-Fox. At the Sutton, Third Avenue at 57th Street. Running time: 100 mins. This film is rated R.

Gowan McGland	Tom Conti
Geneva Spofford	Kelly McGillis
Frank Spofford	Roberts Blossom
Bobby Springer	Cynthia Harris
Lucille Haxby	E. Katherine Kerr
Dr. Haxby	Joel Fabiani
Mare Spofford	Lois Smith
C. B. Springer	Rex Robbins
Edith McGland	Kara Wilson

By VINCENT CANBY

THE character of Gowan McGland is pure Peter DeVries, and "Rebuen, Reuben," adapted from the DeVries novel by Julius J. Epsteinand directed by Robert Ellis Miller, is one of the most buoyantly satiric fables yet made from a DeVries work. It's a small, unpushy movie of rare wit.

Gowan McGland is an epic mess of underemployed talent. He's a nonwriting Scottish poet who has chosen to exile himself in the rich, fiercely quaint, exurban Connecticut community of Woodsmoke. Gowan gives an occasional lecture, drinks nonstop and makes love to bored, middle-aged women who come to him in his shabby digs at the Dew Drop Inn. For pocket money he steals the tips left for waiters in the expensive restaurants his wealthy patrons take him to.

In his baggy brown tweed suit, the only one he owns, he looks like the human manifestation of a hangover. It would seem he bathes only on the equinoxes and only on those that fall on a Saturday. He suffers a terminal case of what he frankly calls laziness but which one of his more literary-minded mistresses calls sloth.

As played by Tom Conti, the English actor who was applauded for his performance in "Whose Life Is It Anyway?" on Broadway, Gowan is a wonderfully engaging character. Like Joyce Carey's Gulley Jimson, he's someone who's great fun to watch but who'd be impossible to share even a county with.

"Reuben, Reuben," which is taken mostly from the central portion of the DeVries novel and from a stage adaptation written by Herman Shumlin, is about several months in the life of Gowan McGland, whose surname is no accident, during which his squalid existence is brightened by a tawny blonde named Geneva Spofford (Kelly McGillis). As Mr. DeVries knew, though the movie doesn't admit it, Geneva's extraordinary youth and beauty mask the soul of a shrew. That, however, is the story that follows Gowan's in the DeVries novel.

•

Gowan's other conquests include Bobby Springer (Cynthia Harris), the head of the local women's club, and Lucille Haxby (E. Katherine Kerr), the wife of a celebrated dentist. If the film has any clear-cut moral, it's that you shouldn't make love to the wife of a dentist, not if the dentist is jealous and not if you have a bad dental situation.

Teeth play a large part in poor Gowan's problems. His teeth are in terrible shape. When he's not in actual pain, he's worrying about losing the last upper tooth that can support a permanent bridge. Says Gowan at one point, "I've always seen myself as backing toward the grave, tooth by tooth, poem by poem." Since Gowan has virtually ceased to write, you might think that he thinks he'll live forever.

Mr. Epstein clearly has a fondness for Mr. DeVries's language. The "Reuben, Reuben" screenplay is full of — without being overstuffed with — good lines. It has the kind of appreciation for the oddness of words you seldom find in films.

Early in the movie there's a monologue by Frank Spofford (Roberts Blossom), Geneva's eccentric grandfather, who refuses to describe himself as "merely" a chicken farmer. "There's nothing 'mere' about chicken farming," he says, a line that more or less forces us to think about chicken farming, for a minute, anyway.

"Reuben, Reuben," which opens today at the Sutton Theater, works very quietly, obliquely. It has the class of the veteran craftsmen who made it, including Mr. Miller, the director of "The Heart Is a Lonely Hunter," and Mr. Epstein, whose credits reach back to 1935. Either alone or in collaboration, Mr. Epstein has written such films as "Four Daughters," "Mr. Skeffington" and "Casablanca," which was done with his twin brother, Philip G. Epstein, and Howard Koch.

That the film suggests something of the quality of the sort of English films we used to see in the 1960's is also understandable. The producer is Walter Shenson, the American film maker who, during a long residence in England, produced such memorable films as "The Mouse That Roared," "A Hard Day's Night" and "Help."

Mr. Conti is fine in a big, rich role, but the members of the large supporting cast are equally good in roles that are sometimes far too brief. The landscape is filled with some of New York's best performers, including Miss Kerr, Miss Harris, Mr. Blossom, Lois Smith and Scott Coffey, among others. As the younger woman in Gowan's life, Miss McGillis, an actress new to films, looks to be a find.

Though "Reuben, Reuben" is thoroughly enjoyable, and as stylishly acted as any American film of the year, it does have a problem that, I suspect, is built-in. As we see it, the life of Gowan McGland is a little too sweetly funny to support the film's eventual shape. Had it been nastier and more cruel, we might feel that what happens is both inevitable and arbitrary, a contradiction embraced by great comedy. As it is, "Reuben, Reuben" turns out to be a joke, the kind that, like a pun, calls attention to itself and seems to be at the expense of the audience.

1983 D 19, C 12:5

Show-Business Heart

DEAR MR. WONDERFUL, directed by Peter Lilienthal; written by Sam Koperwas; director of photography, Michael Ballhaus; songs by Joe Pesci and Larry Fallon; produced by Joachim von Vietinghoff. At the Film Forum, 57 Watts Street. Running time: 100 minutes. This film has no rating.

Ruby Dennis	Joe Pesci
Paula	Karen Ludwig
Ray	Evan Handler
Sharon	Ivy Ray Browning
Louie	Frank Vincent
Hesh	Paul Herman
The Guest	Tony Martin

By JANET MASLIN

THE German director Peter Lilienthal has filmed "Dear Mr. Wonderful" on what, for him at least, is alien territory. The film is set in New York and

Jersey City, yet it has a fascinatingly incongruous European texture. Mr. Lilienthal's film, which opens at the Film Forum today, isn't always succinct, but even when it drifts it does so in intriguing ways.

"Dear Mr. Wonderful" is the story of Ruby Dennis, owner of a bowling alley-plus-nightclub called Ruby's Palace. As played by Joe Pesci (who wears a conspicuously terrible toupee for the role), Ruby is a man who genuinely believes in the things he loves, even though the thing he loves best — nightclub singing — is something not everyone would view so sentimentally. Much as his "Raging Bull" co-star Robert De Niro did in "The King of Comedy," Mr. Pesci plays a man who's got a little piece of show business where his heart ought to be.

The film watches Ruby progress toward a spiritual crisis of some delicacy, a breakdown that is somewhat out of keeping with the realm in which he travels. It also traces developments in the lives of a large number of supporting characters, from the nephew (Evan Handler) heading gradually toward crime, to the sister (Karen Ludwig) who finds a new and more satisfying life by creating a partial rupture with her family. Mr. Lilienthal brings a powerful sense of family and community to these characters. They seem to exist in a smaller, friendlier, more reflective world than that of Ruby's Palace, even though the ambience of the bowling-alley bistro is used very effectively by the director.

There are a number of touches to the film that don't ring quite true but are compelling for their very incongruity. For instance, when Ruby takes an interest in an aspiring singer named Sharon (Ivy Ray Browning), and they meet for a meal, Sharon asks whether Ruby has brought enough food. "I eat a lot, that's all," she says, with an utterly disarming, slow smile. Miss Browning seems so simply and naturally voluptuous here that it hardly matters whether another, more authentic Sharon would really say such a thing.

Mr. Lilienthal has assembled an excellent and very natural cast, and the performances give the film an authenticity it otherwise might lack. Mr. Pesci makes a credible and touching Ruby, and he doesn't sing badly at all. Miss Ludwig brings a lot of vitality to the role of Ruby's beleaguered sister. Though a subplot about the future of the bowling alley is less effectively staged than some of the domestic scenes, the ambience of Ruby's Palace is vividly rendered. A guest appearance from Tony Martin, who make a brief visit to the nightclub and then goes out to bowl while Ruby is singing, also contributes to the film's odd but genuine immediacy.

1983 D 21, C26:4

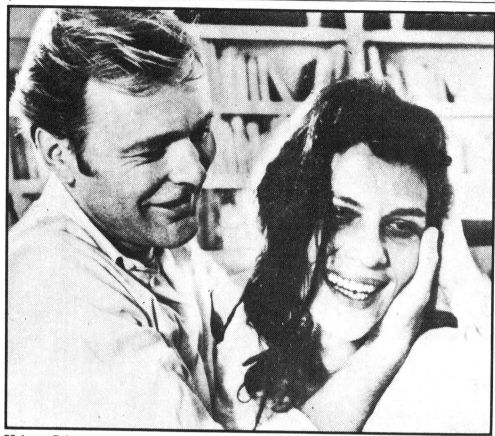

Helmut Griem and Grischa Huber star in "Malou." Written and directed by Jeanine Meerapfel, the film tells the story of a young woman, her marriage to a German Jewish architect and her obsession with the memory of her French-born mother.

Remembering Mother

MALOU, written (German with English subtitles) and directed by Jeanine Meerapfel; camera, Michael Ballhaus; edited by Dagmar Hirtz; music by Peer Raben; produced by Regina Ziegler Filmproduktion. At the 72d Street East, at Second Avenue. Running time: 93 minutes. This film has no rating.

Malou	Ingrid Caven
Hannah	Grischa Huber
Martin	Helmut Griem
Paul	Ivan Desny
Lotte	Marie Colbin
Albert	Peter Chatel
Lucia	Margarita Calahorra
Paul's father	Lovan Hensbergen
Paul's mother	Liane Saalborn
Hannah, 12 years old	Cordula Riedel
Uncle Max	Jim Kain

WITH: Dietrich Mattausch, Winnetou Kampmann, Heidi Speisser, Peer Raben, Estrongo Nahama, Carl Duering, Antonio Skarmeta, Constanza Lira, Angela Villaroel, Gerhard Hesse, Michael Boehme, Friedbert Rometsch, Reinhardt vom Bauer, Freidhelm Lehmann, H. H. Müller, Annemarie Geyer.

"Malou" was shown as part of the 1982 New Directors/New Films Series. Following are excerpts from Vincent Canby's review that appeared in The New York Times on April 25, 1982. The film opens today at the 72d Street East, at Second Avenue.

THE values of "Malou," the first feature to be written and directed by Jeanine Meerapfel, a German film maker, reveal themselves unexpectedly, much like those of a friendship with someone who initially seems demanding and self-centered but whose genuine decency and intelligence become evident with time.

Hannah (Grischa Huber), otherwise a happily married young woman, is obsessed by the memory of her French-born mother Malou (Ingrid Caven), a mysterious figure, long dead, who existed entirely at the mercy of the men in her life. Hannah loves her husband, Martin (Helmut Greim), an ambitious German architect, but resents her commitment to him. She doesn't want to wind up the sodden, emotional wreck that Malou was when she finally died in Buenos Aires in 1967.

Hannah is not especially appealing at first. She is moody, willful and sarcastic. One day, without warning, she sets out to find the ghost of Malou by visiting the places where her mother lived and worked before meeting Hannah's father. It's not an easy search, because Malou's stories were often contradictory. In some stories she works as a maid for a wealthy French family. In others she has some small fame and following as a nightclub chanteuse. Always, however, she is dependent on the kindness of men.

Miss Meerapfel's screenplay takes place on three levels — in the reality of the present and Hannah's marriage, in Hannah's fantasies about Malou, and in Hannah's own memories of her childhood. Malou's fate is a graceful disintegration in booze and despair through her trust in men who treat her badly.

•

Miss Caven, who has been seen here in a number of Rainer Werner Fassbinder films, is a beauty, and her Malou is a spirited, lost woman who must consciously work to achieve the sort of passivity that she understands is expected of her.

Just how much of the character we see on the screen, in fantasies and flashbacks, is Malou as she actually was or how much is her daughter's imagination is never certain. That eventually is beside the point of the film, which is less about Malou than about Hannah's efforts to come to some understanding about her own self.

•

All of the performances are good, but Miss Huber's is particularly effective. The role of Hannah is not written in a way that invites casual sympathy. She is difficult and abrasive, but, finally, comprehensible.

1983 D 22, C22:1

Aural High

GOSPEL, produced and directed by David Leivick and Frederick A. Ritzenberg; director of photography, David Myers; musical supervisor, Miles Goodman; edited by Glenn Farr; distributed by Aquarius Releasing Inc. At the 57th Street Playhouse, between Avenue of the Americas and Seventh Avenue. Running time: 92 minutes. This film is rated G.
WITH James Cleveland and the Southern California Community Choir; Walter Hawkins and the Hawkins Family, with the Love Center Choir; the Mighty Clouds of Joy; Shirley Caesar; Twinkie Clark and the Clark Sisters

THERE is some wildly exhilarating music to be heard in "Gospel," a concert film featuring some of the finest performers in gospel music. Filmed on the concert stage of a theater in Oakland, Calif., where the film's acts perform before an enraptured audience, "Gospel" offers the neophyte an exciting sampler of pre-eminent gospel musicians. For the already converted, the film captures these performers vividly and at very close range.

"Gospel," which opens today at the 57th Street Playhouse, begins at an almost impossibly high energy level. The Mighty Clouds of Joy take the stage, and soon drive the audience into an absolute frenzy; when one of the singers steps off the stage to mingle with the fans, it seems as though he will have to shake hands with every dancing, clapping, ecstatic soul in the house. This group's appearance, which would make a fine coda for a less rousing music film, is only the beginning of "Gospel." Subsequent highlights include the appearances of the Clark Sisters, huge women in chiffon, who reach an almost transcendent state before their set is over, and James Cleveland, the veteran gospel star who has taught many of the film's other performers much of what they know.

Like each of the gospel groups here, Mr. Cleveland and the Southern California Community Choir have their own particular shtick. In their case, it has to do with a drummer who keeps on playing long after Mr. Cleveland, drenched in sweat and a vision of pure jubilation, is supposedly ready to quit. Mr. Cleveland takes the drumsticks away, but the drummer has others. Then the drummer is bodily carried off the stage, while the audience screams for more. Finally, he comes back, and the show, whose future was never really in doubt, joyously continues.

Though there is at least as much show business as religion to this sort of routine — James Brown and Elvis Presley used to feign fatigue as artfully as Mr. Cleveland does here — the concert doesn't lose track of its essentially devout message. Even when Shirley Caesar, who bills herself as "The Electrifying Evangelist," has one of her singers — a man in flashy maroon-and-white dinner clothes — hoist the microphone stand on his back as though it were a cross, and even though Miss Caesar then pantomimes driving nails into his hands with her microphone, the material retains its innocence and conviction.

•

"Gospel" has been directed by David Leivick and Frederick A. Ritzenberg, with slow, sweeping cinematography by David Myers. In production notes for the film, Mr. Ritzenberg describes watching a performance by the Clark Sisters: "It seemed that the whole building was going to take off and rise toward heaven. It was a high that I had never experienced before." Now, for movie audiences, "Gospel" communicates something comparable.

Janet Maslin

1983 D 23, C8:1

ZIGGY STARDUST AND THE SPIDERS FROM MARS, a documentary concert film by D. A. Pennebaker; filmed by James Desmond, Mike Davis, Nick Doob, Randy Franken, D. A. Pennebaker; edited by Lorry Whitehead; produced by MainMan in Association with Pennebaker Inc.; presented by Twentieth Century-Fox International Classics; a Miramax Release. At the 8th Street Playhouse, at Avenue of the Americas. Running time: 91 minutes. This film is rated PG.
WITH: David Bowie

By JON PARELES

"Ziggy Stardust and the Spiders From Mars" — a film of a 1973 David Bowie concert at the Hammersmith Odeon in London at which the singer announced a short-lived retirement from performing — will fascinate Mr. Bowie's fans. It will also exasperate them.

For one thing, the title is misleading. When this footage was shown in 1974 on the "In Concert" television series, it was more truthfully called "Bowie '73 With the Spiders From Mars," since Mr. Bowie had already released "Aladdin Sane," his follow-up album to "The Rise and Fall of Ziggy Stardust." And although Mr. Bowie reportedly remixed the sound

David Bowie as "Ziggy Stardust."

track last year, the music starts out murky and clears only slightly in the course of the film that opened yesterday at the 8th Street Playhouse.

But the real problem was the choice of D. A. Pennebaker as documentarian. Although Mr. Bowie's starting point, particularly in his glitter-rock incarnation of the early 1970's, was cabaret and musical theater, Mr. Pennebaker's film views the music not as a theatrical performance, but as a Dionysiac incitement to riot. When we should be seeing Mr. Bowie's openly calculated gestures and his sometimes chilling gaze, or getting a sense of what he looked like against the backdrop of his band, Mr. Pennebaker shows us screaming girls.

Back in 1973, Mr. Bowie was a divided performer — by turns an actor playing a unisexual Cassandra, a cabaret singer, a hard-rocker, even a bit of a mime. Some of his death-haunted songs — notably a version of Jacques Brel's bathetic "My Death" — seem pretentious now, although at the time they made a defiant statement about rock's eternal, hedonistic present tense.

•

Yet there is still power in the figure Bowie made of himself — an androgynous space waif, his expression flickering from innocence to a knowing superiority. And as glitter-rock recedes into the past, Mr. Bowie's costumes are starting to look outrageous again. There he is, in a white toga-miniskirt with knee socks, or in an asymmetrical leotard that extends to one arm and the opposite leg, or in a striped outfit that makes him look like a combination of Robin Hood and a grasshopper.
Mr. Bowie established an international reputation with his 1972-73 concerts. But Mr. Pennebaker, with his usual preoccupation with rock as orchestrated chaos, gives us a glimpse — only a glimpse — of the reason why.

1983 D 24, 17:5

Love and Revenge

WUTHERING HEIGHTS, (Abismos de Pasion), directed by Luis Buñuel; screenplay by Mr. Buñuel, Arduino Maiuri, and Julio Alejandro de Castro, based on the Emily Bronte novel; director of photography, Agustin Jimenez; edited by Carlos Savage; music by Wagner adapted by Raul Lavista; produced by Oscar Dancigers; released by Plexus Film. In Spanish with English subtitles. At the Public, 425 Lafayette Street. Running time: 90 minutes. This film is not rated.
Catalina.....................................Irasema Dilian
AlejandroJorge Mistral
Isabel ..Lilia Prado
EduardoErnesto Alonso

By VINCENT CANBY

OF all of the Mexican films that Luis Buñuel made for the mass market of Spanish-speaking audiences, his 1954 screen adaptation of Emily Brontë's "Wuthering Heights," called "Abismos de Pasion" when released in Mexico, is probaby the work that's most full of riches for those of us who consider Buñuel one of the great film directors of all time. It opens today at the Public Theater, a premiere of sorts, though it was shown by the Museum of Modern Art in 1976 and may have been shown at Spanish-lanuage theaters here in the 1950's.

"Abismos de Pasion" — the Spanish title seems much more appropriate than the Brontë original — is an almost magical example of how an artist of genius can take someone else's classic work and shape it to fit his own temperament without really violating it. This "Wuthering Heights" is nothing if not Spanish in its tone. It's also Roman Catholic down to its toes in the way that it reflects the particular obsessions of the self-described nonbeliever who made it.

Among the more remarkable things about "Abismos de Pasion" is how little Buñuel has changed the story, at least the story as adapted by Ben Hecht and Charles MacArthur for the 1939 William Wyler screen version.

It's still the tale of the mystical, all-consuming love of the well-born Cathy (here named Catalina) for her childhood sweetheart, the handsome, rudely tyrannical, former stable boy, Heathcliff, renamed Alejandro by Buñuel. The English moors are now the barren hills of rural Mexico and what once seemed to be a romantic rebellion against the genteel manners of Anglican England has now become a darker, timeless war between the forces of light and darkness.

Alejandro (Jorge Mistral) is driven not just by his love of Cathy and desire for revenge against the family that humiliated him as a boy. He has, as subsidiary characters say more than once, made a pact with the Devil, and we may well believe it. This is actually a far more reasonable explanation of how, during a mysterious absence, he acquired the enormous wealth that he now uses to humble his former masters. After all, rude, unmannerly stable boys don't easily become rich overnight.

Catalina (Irasema Dilian) is also a

far gutsier, far less sentimental character than Merle Oberon's Cathy, who seemed primarily motivated by the willfulness of a pampered child. In Buñuel's scheme of things, the love that flows between Alejandro and Catalina is so strong — and so beyond analysis in any ordinary emotional or sexual terms — that we can take it that she is part of any pact that Alejandro may or may not have made with anyone, including Beelzebub. When Catalina announces that she loves Alejandro "more than the salvation of my soul," the point is to shock the Roman Catholic audiences as much as the other characters within the film.

Buñuel, of course, never makes any reference to the Devil without a wink of mock astonishment. In an opening message to the audience he tells us that what we're about to see is a story about characters at the mercy of their instincts and passions. To Catalina's faithful husband, Eduardo (Ernesto Alonso), and to his sister, Isabel (Lilia Prado), who loves Alejandro and, unfortunately, marries him, passions and instincts represent a hideous state of pre-Christian damnation.

Eduardo and Isabel are believers. They are among the saved. They are civilized, a point with which Buñuel has a good deal of fun as he shows us the studious Eduardo carefully pinning a live butterfly to a mat and Isabel out on a morning stroll, shooting vultures. If the civilized are more savage than the heathen, Buñuel would prefer the company of the lost.

There's also an astonishing amount of self-awareness in Buñuel's Catalina and Alejandro. They accept their fate as lovers who will go beyond the grave together with an unemotional kind of placidity. When Catalina warns Isabel not to marry Alejandro, it's not because she is jealous but because she knows that Isabel will be crushed casually and without anything that might be called redeeming malice — Isabel will have simply gotten in the way of fate.

At key moments, Miss Dilian displays a terrific fondness for the smug, self-satisfied smile, but that is a convention of the melodramatic acting of the time. She looks like any number of other blond Mexican actresses Buñuel used at this period of his career, representing an idealization later to be exemplified in the talent and the grand, chilly beauty of Catherine Deneuve in "Belle de Jour" and "Tristana." Mr. Mistral is a more than adequate Alejandro, though his handsomeness appears to be that of a Latin American spinoff of Victor Mature.

Mr. Alonso, who was later to play the title role in Buñuel's 1955 comic masterpiece, "The Criminal Life of Archibaldo de la Cruz," is exceptionally good as Eduardo.
Among the other reasons that "Abismos de Pasion" is not to be missed is the film's final sequence, which is just as breathtaking as the final sequence of "Tristana" — and even more outrageous.

1983 D 27, C11:2

FILM VIEW

VINCENT CANBY

After a Slow Beginning, A Rousing Conclusion

The year 1983 was not exactly a vintage year for films, but now, at the end, it looks to have been a lot better than it promised to be during the spring and summer. At that point it appeared quite possible that the makers of plastic monsters and directors-as-puppeteers had taken command of the commercial film industry. The prospect was scary without being in the least bit exciting, like second-rate horror films.

Some of the most popular if not exactly most compelling performances of 1983 were given not by actors but by the special effects men who made Superman fly and by mechanized dolls — the tired old white shark in "Jaws 3-D" and George Lucas's stock company of disguised teddy bears in "Return of the Jedi." Live-action actors who can act, it seemed, might soon be obsolete.

Then, too, there was the matter of helicopters. I suspect that at this minute there are people on campuses all over the country writing learned theses on the esthetic impact on movies of helicopters, both as ends in themselves and as means to ends. Ends in themselves? Helicopters are the leading characters in John Badham's "Blue Thunder" and play supporting roles in the same director's "WarGames."

Even more tiresome, though, is the evolution of the helicopter as a screen technique or tool — some would say crutch — as freely overused by today's filmmakers as jump-cuts, zooms and freeze frames. I have the impression that at least 70 percent of today's films wouldn't ever get off the ground if the directors had been denied those introductory helicopter shots that drop us gently and boringly into the movie's locale.

> Four of the year's most important events were, in effect, reprises.

Clint Eastwood's "Sudden Impact" is a nonstop demonstration of an adage that must be stitched on every sampler in Hollywood: When in doubt, call in the helicopters. Almost every other sequence either starts with the camera descending onto the scene in a helicopter or sailing off, heavenward, by means of a chopper. I can't prove it, but I doubt that the late, great Luis Buñuel — one of this year's major collections by the Grim Reaper — ever made use of a helicopter. If he did, it must have been done so unobtrusively that I can't remember it. Buñuel's masterpieces are shot mostly at eye level, which, though it doesn't deny the existence of God, doesn't call on Him to correct the inadequacies of the director, the writer and the other partners in the film's creation.

However, even if the year produced only two films that I think stand a chance of becoming classics, there were finally so many films of far above average quality that the making up of a 10-best list was especially difficult and — let's face it — in some instances absolutely arbitrary. One can always supplement a 10-best list by appending the list of the 10 runners-up, but even these 20 titles don't hint at the variety and the sometimes unexpected excitement of this year's releases.

Four of this year's most important events were, in effect, reprises: the rerelease of Alfred Hitchcock's incomparably elegant "Rear Window," featuring what must be the quintessential James Stewart performance and one by Grace Kelly that forever captures her idealized beauty and wit; the rerelease of Luchino Visconti's "Leopard," which demonstrates, among other things, that the young Burt Lancaster's talents were really no less than those of the older man we have applauded in "Atlantic City" and "Local Hero"; the Regency Theater's retrospective devoted to the comic genius of Preston Sturges and, finally, a film that isn't, to be perfectly correct, a theatrical film.

* * *

This is Thames Television's "Unknown Chaplin," three 52-minute television programs, produced by Kevin Brownlow and David Gill with the cooperation of Charlie Chaplin's widow, Oona, which was not shown in a theater or even on TV, but at the Museum of Broadcasting. The three programs are a rare and wonderful collection of out-takes from Chaplin films that show us — in a manner I've never seen before — how a master filmmaker and comedian worked. Nothing else quite like it exists.

A certain amount of reevaluation must go into the compilation of any 10-best list, and this year it has proved to be a bit embarrassing in at least one case, that of John Landis's "Trading Places." Here's a movie that I liked so much when I saw it that caution was tossed into the air-conditioning system. I described it as nothing less than "the funniest American movie comedy of the year to date." Now it doesn't even place in the top 20. The fact is that I don't like it any less now, but, for one reason and another, I like 20 other films more.

There are a number of other films that deserve such special mention, everything from Peter Greenaway's whimsical, three-hour avant-garde epic, "Fails," to James L. Brooks's "Terms of Endearment," a commercial film if there ever was one. Also: the Sidney Lumet-E.L. Doctorow production, "Daniel," which was provocative, extremely well acted and very, very serious; "The Dresser," with its two great star-turns by Albert Finney and Tom Courtenay; Blake Edwards's remake of François Truffaut's "Man Who Loved Women," mostly for Burt Reynolds's unexpectedly fine performance; the just-opened "Reuben, Reuben," in which Tom Conti stars as one of Peter DeVries's most hapless heroes; Peter Weir's "Year of Living Dangerously," with its memorable performance by Linda Hunt, and John Sayles's two entries, "Lianna" and "Baby, It's You."

Here, then, is the list of the 10 best films of 1983, in alphabetical order:

"Berlin Alexanderplatz." This monumental (15½-hour), made-for-television mini-series stands to become a theatrical film classic, even if its theatrical showings have to be limited. "Berlin Alexanderplatz" is a fitting coda to the brief, brilliant career of Rainer Werner Fassbinder. This adaptation of Alfred Doblin's classic novel embraces much of everything Fassbinder had done before, with its mixtures of visual styles, its bitter, ironic view of society and its display of the talents of the members of the Fassbinder "stock" company, including Hanna Schygulla, Elisabeth Trissenaar, Barbara Sukowa, and Brigitte Mira. At the center of the film are the great performances by two actors not previously identified with the director — Gunter Lamprecht and Gottfried John.

"Betrayal." Even if one had never seen a Harold Pinter play on the stage, one could, I think, get some real measure of his particular theatrical talent by watching this most moving and funny film, adapted by Mr. Pinter from his own play and directed by David Jones in a way that finds cinematic equivalents to the stage experience. The performances by Ben Kingsley, Patricia Hodge and Jeremy Irons, as the lovers whose story we watch from the end to the beginning, are among the best of this or any year.

"The Big Chill." Lawrence Kasdan, the screenwriter ("Star Wars," among other scripts) demonstrated he was also a first-rate director with "Body Heat." "The Big Chill," about the reunion of seven activists of the 1960's, turned Establishment-siothful in the 1980's, confirms the promise of "Body Heat." Arguments that he has just made a more commercial version of John Sayles's "Return of the Secaucus Seven" do not take into account the differing natures of the two films. "The Big Chill" is a big, intelligent commercial comedy — Hollywood moviemaking at its best. It also has splendid performances by Tom Berenger, Glenn Close, Jeff Goldblum, William Hurt, Kevin Kline, Mary Kay Place, Meg Tilly and Jo-Beth Williams.

"Fanny and Alexander." Here is yet another chef d'oeuvre by one of the three or four greatest filmmakers alive today, Ingmar Bergman. "Fanny and Alexander," a family chronicle, is Bergman at the top of a form that is humane, comic, fantastic, mystical and not easily imitated, even by filmmakers who hire Bergman's favorite cameraman, Sven Nykvist, to give them a "Bergman look." The huge cast is impeccable, including the late Gunn Wallgren, who plays the matriarch of a wealthy theatrical family in Uppsala at the beginning of this century; Erland Josephson, Ewa Froling, Jan Malmsjo, Pernilla Wallgren and Harriet Andersson.

"Heart Like a Wheel." Once every couple of years a movie comes along that reminds us of the potential delights of what used to be described as B-pictures. Jonathan Kaplan's "Heart Like a Wheel," based on the real-life story of a woman race-car driver, Shirley "Cha-Cha" Muldowney, is such a film. Like many B-pictures, "Heart Like a Wheel" is about what people do as much as it's about what they think and feel. Because Shirley, who is beautifully played by Bonnie Bedelia, spends much of her time on the track, action is built into the movie through the nature of her career. The film is also about lower-middle-class America, what it looks like and what it feels like to be on the inside of it, looking up. Mr. Kaplan ("White Line Fever" and "Over the Edge") is a comer.

"The King of Comedy." With this funny, very chilly satire of America's infatuation with celebrity, any kind of celebrity, the director Martin Scorsese confirms his reputation as one of the most authentic, most original voices of his film generation. Starring in Paul D. Zimmerman's fine, original screenplay, is Robert De Niro, giving his sometimes frighteningly comic all as Rupert Pupkin, a nobody who wants more than anything else to be a somebody like Johnny Carson, if Johnny Carson looked like Jerry Lewis, who is also splendid in the movie. An excellent comedienne, new to films, Sandra Bernhard, matches Mr. De Niro's inspired craziness.

"Local Hero." Bill Forsyth, the Scottish filmmaker who knocked us over with "Gregory's Girl," continues to demonstrate his most original, oddball comedy talents with "Local Hero." It's about an impossibly powerful American oil man, played with loving understatement by Burt Lancaster, and what happens when he decides to buy an impoverished Scottish village. The cast of mostly British actors is superb, but I remember most clearly Denis Lawson, as an innkeeper; Jenny Seagrove, who plays a mermaid, and Peter Riegert, an American actor, who plays Mr. Lancaster's factotum, an achiever with the soul of a poet.

"The Right Stuff." The writer-director Philip Kaufman does right by Tom Wolfe's best-selling, fondly satirical book about the making of America's Mercury astronauts. It's rousing and funny and played with enormous wit and energy by Sam Shepard, Ed Harris, Scott Glenn, Fred Ward, Veronica Cartwright and Pamela Reed, among others. Though

the satire sometimes gets so fuzzy you can't be entirely sure just what is being satirized, the movie is unusually perceptive about the American scene and the sometimes not-great motives that lead to greatness, that is, to the discovery of the right stuff.

"Tender Mercies." Bruce Beresford, the Australian director ("Breaker Morant"), Horton Foote, the playwright and screenwriter ("To Kill a Mockingbird") and the star, Robert Duvall, combine their talents to create that very rare sort of American movie, one that is sweet without being sentimental. "Tender Mercies" is the story of the rehabilitation of a down-and-out country-and-western singer, played by Mr. Duvall, through the love of a good woman and his own innate guts. It's melodramatic and funny, and it introduces American audiences to a lovely new actress named Tess Harper, who plays the widow-lady Mr. Duvall courts and wins in monosyllables. If you haven't seen it yet, don't miss it when it comes back.

"Zelig." It's been said before and it will be said again — that is, by me — that Woody Allen is America's premier filmmaker, and "Zelig" is his small, short, unassuming, major triumph. It's a classic — "Citizen Kane" reduced to 87 minutes of great good humor, wit, wisdom and daz-

ures of the French Revolution, Danton, played by Gérard Depardieu, and Robespierre, played by Wojciech Pszoniak; Mike Nichols's "Silkwood," the first major movie set in America's petro-chemical-nuclear landscape, with top performances by Meryl Streep, Kurt Russell and Cher; Erich Rohmer's "Pauline at the Beach," another of the kind of civilized comedies about love and loss that only Mr. Rohmer can make.

Also "Heat and Dust," a return to India with James Ivory, the director, Ruth Prawer Jhabvala, the writer, and Ismail Merchant, the producer, a civilized and lovely work that introduces a beautiful new actress named Greta Scacchi; "To Be or Not to Be," Mel Brooks's rude and wonderful remake of Ernst Lubitsch's 1942 classic that starred Jack Benny and Carole Lombard, whose role is now role played by Anne Bancroft; "La Nuit de Varennes," Ettore Scola's wise and rueful fiction about some events that were taking place while Louis XVI and Marie Antoinette were attempting their aborted flight from the Paris mobs; "The Draughtsman's Contract," Peter Greenaway's quirky Restoration comedy-mystery that — be warned — has no satisfactory solution, and "The Return of Martin Guerre," the year's best, most contemporary courtroom

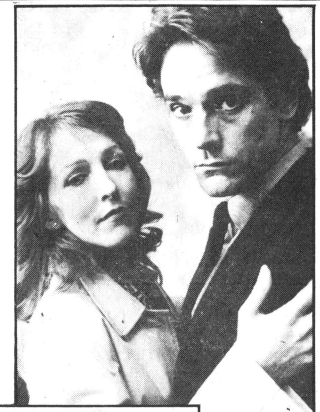

zling technical effects. Though it's set in the 1920's and 1930's, Zelig (Mr. Allen) is the perfect hero for the well-analyzed 80's, a man with no identity whatsoever that he can call his own. "Zelig," more than any other Woody Allen film, is a series of nonstop highlights, which would include individual gags, scenes and performances, by Mr. Allen as well as Mia Farrow, Ellen Garrison and such real-life types as Susan Sontag, Irving Howe, Bruno Bettelheim, Bricktop and Prof. John Morton Blum. I smile just thinking about it.

The runners-up, in no order of preference are: Brian De Palma's tough, bloody, extravagant, excessive "Scarface," which is among the best things he's ever done for the big-budget cinema; Lindsay Anderson's "Britannia Hospital," written by David Sherwin, a mercilessly funny satire on the end of empire; Andrzej Wajda's "Danton," a sort of chamber-movie about two of the major fig-

drama though it is set 400 years ago, directed by Daniel Vigne and featuring another great performance by Gérard Depardieu.

That's not a bad year.

1983 D 25, II:15:1

Critics Pick 'Endearment'

"Terms of Endearment," James Brooks's adaptation of Larry McMurtry's mother-daughter story spanning 30 years, was voted the best film of 1983 by the New York Film Critics Circle yesterday. "Fanny and Alexander," Ingmar Bergman's vision of a turn-of-the-century Swedish childhood, was voted best foreign film, and

Mr. Bergman was voted best director.

Shirley MacLaine was named best actress and Jack Nicholson was named best supporting actor for their performances in "Terms of Endearment." Robert Duvall was voted best actor for "Tender Mercies." Linda Hunt was voted best supporting actress for "The Year of Living Dangerously." The screenplay award went to Bill Forsyth for "Local Hero." Gordon Willis was named best cinematographer for "Zelig."

The awards will be presented Jan. 29 at Sardi's.

The 27 members of the New York Film Critics' Circle are:

Kathleen Carroll of The Daily News, chairman.
David Ansen of Newsweek.
Joy Gould Boyum of The Wall Street Journal.
Dwight Brown of The Black American.
Vincent Canby of The New York Times.
Richard Corliss of Time magazine.
Judith Crist of The Saturday Review.

Above, Patricia Hodge and Jeremy Irons in "Betrayal"— "moving and funny"; and, at left, Peter Riegert, Burt Lancaster and Peter Capaldi in "Local Hero," another example of the director Bill Forsyth's "original, oddball comedy talents"

David Denby of New York magazine.
Bernard Drew of Gannett Newspapers.
Richard Freedman of Newhouse Newspapers.
Joseph Gelmis of Newsday.
Roger Greenspun of Penthouse magazine.
Molly Haskell of Vogue and Playgirl magazines.
J. Hoberman of The Village Voice.
Pauline Kael of The New Yorker.
Alex Keneas of Newsday.
Howard Kissel of Women's Wear Daily.
Jack Kroll of Newsweek.
Ernest Leogrande of The Daily News.
Janet Maslin of The New York Times.
Rex Reed of The New York Post.
Andrew Sarris of The Village Voice.
Richard Schickel of Time magazine.
John Simon of The National Review.
David Sterritt of The Christian Science Monitor.
Bruce Williamson of Playboy magazine.
William Wolf of New York magazine and The Asbury Park Press.

1983 D 22, C10:5

Shirley MacLaine and Robert Duvall Receive Oscars for Best Acting

United Press International

Jack Nicholson, with the Oscar he received as best supporting actor for "Terms of Endearment."

Associated Press

Linda Hunt after winning Oscar as best supporting actress for "The Year of Living Dangerously."

Associated Press

James L. Broooks, who received an Oscar as best director for "Terms of Endearment."

"The Night of the Shooting Stars," the impressionistic World War II fable set in a small Italian village, has been voted best film of 1983 by the National Society of Film Critics, a 43-member group representing critics from New York, Los Angeles, Chicago and other cities.

Paolo and Vittorio Taviani, the brothers who jointly directed "The Night of the Shooting Stars" shared the group's best director award.

The 37 members who attended the group's meeting Monday evening at the Algonquin Hotel also voted Debra Winger best actress for her performance in "Terms of Endearment" and Sandra Bernhard best supporting actress for "The King of Comedy." Gérard Depardieu was named best actor for both "Danton" and "The Return of Martin Guerre." Jack Nicholson was named best supporting actor for "Terms of Endearment."

The group's best screenplay award went to Bill Forsyth for "Local Hero." Hiro Narita was named best cinematographer for "Never Cry Wolf."

The meeting was presided over by the group's chairman, Jonathan Baumbach of Partisan Review.

1984 Ja 4, C14:6

By ALJEAN HARMETZ

Special to The New York Times

HOLLYWOOD, April 9 — Robert Duvall, for his performance as an alcoholic singer who comes to terms with life in "Tender Mercies," and Shirley MacLaine, for her performance as an impossible mother in "Terms of Endearment," won the Academy Awards for best acting tonight. The Oscars were presented at the 56th annual awards ceremony at the Dorothy Chandler Pavilion of the Los Angeles Music Center.

"Terms of Endearment" was a popular choice as best picture of the year. In addition to accepting that award, James L. Brooks took home two other Oscars for writing and directing "Terms of Endearment," a tragicomedy about the relationship of a mother and daughter over a period of 30 years.

Mr. Brooks seemed almost in tears as he came to the stage for the second time to say "I'm overwhelmed. I'm very grateful."

Jack Nicholson became the third male actor ever to receive Academy Awards in both acting categories, winning an Oscar as best supporting actor for his performance as a boozy former astronaut gone to seed in "Terms of Endearment." He previously won as best actor in 1975 for his role as a sane man in an insane asylum in "One Flew Over the Cuckoo's Nest."

When his name was called, Mr. Nicholson sauntered to the stage. He offered his congratulations to "John and Sam, Charles and Rip," the four other nominees — John Lithgow, Sam Shepard, Charles Durning and Rip Torn. He ended his thank you's in typical Nicholson nonchalant style,

with "All you rock people down at the Roxy and up in the Rockies, rock on."

Jack Lemmon and Robert De Niro are the only other actors to win Oscars as best actor and best supporting actor.

Slowly and regally, Linda Hunt, who is considerably shorter than five feet, walked on to the stage to accept her award as supporting actress for her role as a male dwarf in "The Year of Living Dangerously. In a graceful thank you speech, she said, "This is extraordinary." She spoke of an Indonesian /phrase, "Water from the moon," which "means that which is unattainable, the impossible, that which one can never have or know."

"Making 'The Year of Living Dangerously' for me was water from the moon," she said.

In the evening's first upset, Horton Foote won the award for best original screenplay for "Tender Mercies." Lawrence Kasdan and Barbara Benedek were expected to win for "The Big Chill."

"Fanny and Alexander" from Sweden, Ingmar Bergman's loving re-creation of the world of his childhood, won as best foreign language film. Mr. Bergman has said that "Fanny and Alexander" — which tells the story of two children who move from a protected life to a spartan one and, through the help of magic, back again — is his last theatrical film. The award was accepted by the wife of the director, who is currently at work in Europe.

Sven Nykvist, Mr. Bergman's long-time collaborator, won as best cinematographer for the gleaming woods and rich interiors of Fanny and Alexander's world. He won an Oscar in 1973 for Mr. Bergman's "Cries and Whispers." In accepting the award, Mr. Nykvist said he wanted "to thank

a man who I have had the good fortune to work with for about 25 years on 22 pictures, Ingmar Bergman."

"Fanny and Alexander" also won for costume design and art direction.

Four awards were won by "The Right Stuff," the story of the first seven American astronauts and the legendary test pilot who preceded them. "The Right Stuff," which was based on the journalist Tom Wolfe's popular history of the American space program, won for original song score, film editing, sound effects editing, and sound. Although almost unanimously critically praised, the $28 million "Right Stuff" was 1983's biggest disappointment at the box office.

In the short film category, the winner for best animated film was "Sundae in New York," a four-minute montage on New York starring a clay figure of Mayor Koch. "Boys and Girls," based on a short story by Alice Munro about a girl who is stereotyped by her farm family into a woman's role, won for live action.

Both documentary awards went to dance films. The short documentary award was won by "Flamenco at 5:15," about a dance school in Canada. The feature-length documentary Oscar was awarded to "He Makes Me Feel Like Dancin'," a film about Jacques d'Amboise, the former principal dancer with the New York City Ballet and the National Dance Institute he started for children in New York.

Some of the winners sitting in the audience tonight were not waiting in suspense.

The Academy of Motion Picture Arts and Sciences always presents a handful of special awards. Those awards usually honor a lifetime of work rather than the achievement of

Associated Press

Shirley MacLaine arriving at awards ceremony last night. She was named best actress.

a single year. Occasionally, they make amends to someone who has been passed over for the yearly awards. Cary Grant, for example, was given an honorary Oscar in 1969 "for his unique mastery of the art of screen acting." During his long career, Mr. Grant had only been nominated twice for best actor — for "Penny Serenade" in 1941 and "None But the Lonely Heart" in 1944. In retrospect a few decades later, the ease and elegance of his comic acting seemed to have been unfairly ignored.

Hal Roach, the 92-year-old creator of the "Our Gang" series of two-reel shorts, was similarly saluted with an honorary Academy Award tonight. Mr. Roach, who started in movies as a dollar-a-day extra in 1912, was one of the kings of silent comedy and the man who teamed Laurel and Hardy and gave a start to such directors as Frank Capra, George Stevens and Leo McCarey. One of Mr. Roach's shorts won him an Oscar more than 50 years ago, the Laurel and Hardy two-reeler "The Music Box" in 1931-32. He also won another award, in 1936, for an Our Gang short, "Bored of Education."

"Return of the Jedi" received a special Oscar. The top money-making movie of 1983 and the last film in George Lucas's "Star Wars" trilogy, "Return of the Jedi" was voted a special achievement award for visual effects for Richard Edlund, Dennis Muren, Ken Ralston and Phil Tippett.

Visual effects is one of several categories in which a special committee has three options: to give no award, to choose a film to honor with the Oscar, or to select two or three movies that will then compete for the award. In makeup, another of those special categories, no achievement was considered worthy of an Oscar this year. Last year, the Neander-thals of "Quest for Fire" defeated the aging of Ben Kingsley as "Gandhi" in the makeup category.

One of the Academy's standard honorary awards was not given to-night, the Thalberg Award, which goes to "a creative producer" for his body of work. The award, named for Irving Thalberg, the legendary "boy genius" who was the creative force at M-G-M in the 1930's, has been given 26 times. Mr. Bergman received the award in 1970.

The Oscars have always seemed to honor the art, not the science, of motion picture making. To redress the balance, in 1980 the Academy established an award to recognize accomplishments that advanced the technology of the motion picture. This year's winner of the Gordon E. Sawyer Award, which was named for the last sound director of the Samuel Goldwyn Studio, is Dr. John G. Frayne.

Dr. Frayne began working in the movie industry in 1929, during the birth of sound in films, and his technical achievements span the history of movies with sound. He co-invented the stereo disk cutter, which is now standard in the recording industry, the sphere densitometer, and the inter-modulation techniques of distortion measurements. That last achievement won him a special Academy Award in 1953. He also developed the sound recording techniques and their reproduction for optical sound recording systems that led to stereo-optical formats used by films today.

Eleven other scientific or technical achievement awards were handed out at a banquet 10 days ago. Ten were the less important plaques and certificates. However, an Oscar was given to the 80-year-old Dr. Kurt Larché for the development of an arc discharge lamp for motion picture projection.

Associated Press

Duvall getting hug from the singer Dolly Parton after being named best actor for role in "Tender Mercies." Shirley MacLaine won as best actress

The Jean Hersholt Humanitarian Award was given to M. J. (Mike) Frankovich, a veteran film maker who helped Variety Clubs International establish eight hospital wings. The award is named for one of the early presidents of the Academy, an actor who was twice honored with an Oscar for charitable works.

The Academy of Motion Picture Arts and Sciences is divided into 14 branches, and each branch nominates entries for achievement in its own field. Thus, the 1,154 actors nominated the candidates for the four acting awards, while the 168 film editors chose the nominees for editing achievements. All Academy members, except members of the non-voting associate branch, nominated the best picture candidates.

There are currently 4,048 voting members. Because members must have achieved a certain status in the industry before they are allowed to join, their average age is considerably higher than the 17-to-25-year-old range of today's core moviegoers.

The actors branch is by far the largest. In addition to the 168 film editors, there are 363 writers; 312 producers; 284 members-at-large; 271 sound editors; 268 executives; 238 art directors and costume designers; 233 musicians; 224 directors; 221 publicists; 207 makers of short films, and 105 cinematographers.

This year, 223 feature-length films were eligible for nomination, almost 50 more than last year; 26 of those movies were nominated. Except in

the foreign language, documentary, and short film categories, a movie must have played in the Los Angeles area seven days in a row during 1983 in order to be eligible.

Foreign language films, documentaries, and short films are nominated by committee. The Academy shows the nominated short films on a special night, and only those members present are allowed to vote. In the long documentary and foreign film category, members must certify that they have seen all five nominated films before they are given a ballot. Thus, in each of the three categories, less than 500 members are likely to be able to vote.

For this year's foreign language film award, 26 foreign countries nominated one film each. Federico Fellini's "And the Ship Sails On" (Italy) did not make the finals. Because "Fanny and Alexander" was picked by the foreign language committee as a finalist, the film was not eligible to be considered for best picture of the year. However, since it played in Los Angeles during 1983, it was eligible for all the other awards and was nominated for six Oscars.

Only one actor or actress has won four acting Oscars. Katharine Hepburn was awarded the trophy as best actress in 1932-33 for "Morning Glory," 1967 for "Guess Who's Coming to Dinner," and 1981 for "On Golden Pond." In 1968, she was honored for "The Lion in Winter," in a tie with Barbra Streisand.

Two performers have won three Os-

Winners Of Oscars

LOS ANGELES, April 10 (AP) — *The following is a list of winners at the 56th annual Academy Awards Monday night.*
Picture: "Terms of Endearment."
Actor: Robert Duvall, "Tender Mercies."
Actress: Shirley MacLaine, "Terms of Endearment."
Supporting Actor: Jack Nicholson, "Terms of Endearment."
Supporting Actress: Linda Hunt, "The Year of Living Dangerously."
Director: James L. Brooks, "Terms of Endearment."
Foreign-Language Film: "Fanny and Alexander," Sweden.
Original Song: "Flashdance . . . What a Feeling" ("Flashdance").
Original Screenplay: Horton Foote, "Tender Mercies."
Screenplay Adaptation: James L. Brooks, "Terms of Endearment."
Cinematography: Sven Nykvist, "Fanny and Alexander."
Original Score: Bill Conti, "The Right Stuff."
Original Song Score or Adaptation Score: Michel Legrand and Alan and Marilyn Bergman, "Yentl."
Art Direction: "Fanny and Alexander."
Costume Design: "Fanny and Alexander."
Documentary Feature: "He Makes Me Feel Like Dancin'."
Documentary Short Subject: "Flamenco at 5:15."
Film Editing: "The Right Stuff."
Animated Short Film: "Sundae in New York."
Live Action Short Film: "Boys and Girls."
Sound: "The Right Stuff."
Sound Effects Editing: "The Right Stuff."
Honorary — Hal Roach.
Jean Hersholt Humanitarian — M. J. Frankovich.
Visual Effects Achievement — "Return of the Jedi."
Scientific-Technical Achievement — Dr. Kurt Larché, projection lamps.
Gordon E. Sawyer Sound Achievement — Dr. John G. Frayne.

cars apiece. Walter Brennan won as supporting actor in 1936, 1938, and 1940. Ingrid Bergman won as best actress for "Gaslight" in 1944 and "Anastasia" in 1956 and as best supporting actress for "Murder on the Orient Express" in 1974.

Twenty-two performers have now won two acting Oscars — in addition to Mr. Nicholson, they are Bette Davis, Luise Rainer, Vivien Leigh, Olivia de Havilland, Jane Fonda, Glenda Jackson, Elizabeth Taylor, Helen Hayes, Maggie Smith, Meryl Streep, Shelley Winters, Spencer Tracy, Fredric March, Gary Cooper, Marlon Brando, Jack Lemmon, Robert De Niro, Anthony Quinn, Peter Ustinov, Jason Robards and Melvyn Douglas.

The largest number of nominations this year went to "Terms of Endearment," which had 11. It was followed by "The Right Stuff" with eight, and "Fanny and Alexander" with six.

1984 Ap 10, C15:1

The New York Times
Film Reviews
1984

1984

Tidying Up a Few Matters as '83 Fades From the Screen

This morning, as we get ready to push on into the unknowns of 1984, there are some matters relating to the already dim 1983 calendar year that should be discussed before it's too late. It's a mixed bag of thoughts. I'm thinking of "Silkwood" (and of the film's virtues that were overlooked in sober discussions of the fictional uses of fact), of opera movies (is that a contradiction in terms?), of screen writers (God bless at least some of them), and of the world of haute couture, which is beyond mine.

Mike Nichols's "Silkwood," written by Nora Ephron and Alice Arlen, was not an easy film to review. It was necessary to go into such detail about the known facts of Karen Silkwood, the Crescent, Okla., lab worker whose life and death called attention to the sloppy working working conditions in nuclear plants, that I think I short-changed the film's rare understanding of its eccentric characters and the sorts of lives they lead.

The fine performances of Meryl Streep, Cher and Kurt Russell have been written about at some length, but not much has been said about the manner in which the film works, and about the chances it takes in presenting — as heroines and heroes — mixed-up people one doesn't often find in conventional commercial movies.

The film's Karen Silkwood is, to say the least, flawed. She casually sleeps around. She drinks, pops pills and has abandoned her three children by her common law husband. Yet, Mr. Nichols and the writers succeed in making her sympathetic without denying the realities. I'm not quite sure how this is done, except through the artistry of all concerned.

The life of the film's Karen Silkwood is composed entirely of loose ends, until she becomes a union activist. Just how loose are those ends is dramatized with enormous effect throughout the movie. There's a beautiful sequence early in the film when Karen, her present lover (Mr. Russell) and her best friend (and, the film hints, former lover), played by Cher, go to visit Karen's children in Texas.

The three drive all night only to arrive the next morning to find that they can have the children for just an hour or so. In the following scene, set in a fast-food joint that one can almost smell, with the children fidgeting, spilling their fast-food and going to the bathroom, "Silkwood" defines with humor and heart-breaking clarity how Karen's maternal feelings are bound up with feelings of relief that she's not saddled with parenthood.

The film describes the odd living arrangements of its three principal characters without once bothering to explain them, which is also rare in commercial films that usually feel it necessary to justify any deviation from the norm. "Silkwood" respects the intelligence of the audience. That's what makes it so unexpectly comic and humane, as in a scene in which the macho Mr. Russell, having gotten in a lucky punch in a fist fight, jumps into his truck and beats a something less than glorious retreat before the other guy can catch him.

"Silkwood" is a far better film than the controversy surrounding it might lead you to believe.

• • •

That Franco Zeffirelli's beautiful, lush screen adaptation of Verdi's "La Traviata" did not show up on many 10-best lists, including mine, needs some explanation. I liked it terrifically when it came out in April and I still do. As a film version of an opera, "Traviata" is topped only by Ingmar Bergman's 1975 screen adaptation of Mozart's "The Magic Flute," which did make the 10-best list that year. Is there a double standard at work? Possibly.

Mr. Zeffirelli's "Traviata" is opera transferred to screen in a manner designed as much as possible to recreate the experience of watching the work in an opera house. He takes the liberties needed to make it cinematic, but the film is essentially a loving theatrical experience. The Bergman film not only recreates the theatrical experience, but frames that experience in such a way that we always are aware that what we're seeing is a comment on the live presentation.

Mr. Zeffirelli's "Traviata" is a great screen record of an operatic performance, even though it's a performance that one would never see in just this way in an opera house. Mr. Bergman's "The Magif Flute" is a great film. That, I think, is the major difference between the two works.

A couple of months ago, Ernest Lehman, the president of the Writers Guild of America, West, acting on the behalf of his constituents, courteously objected to a piece I'd done on the James Bond phenomenon, since I'd managed to use up nearly 2,000 words without once mentioning the name of any of the people who wrote those films. He had a point, and it was publicly acknowledged. Now I seem to be getting it again, not for failing to mention film writers, but for mentioning too many of them.

In a favorable daily review of Mel Brooks's remake of "To Be or Not to Be," I had — it now turns out to be — the nerve to suggest that it was, perhaps, a tiny bit rude for Tom Meehan and Ronny Graham to receive their own separate title card as authors of the new screenplay, while Edwin Justus Mayer, who wrote the 1942 classic, and Ernst Lubitsch, who directed it, receive small credit somewhere down after the name of the new film's costume designer.

Now both Mr. Meehan and Mr. Graham are objecting, courteously but firmly, to any hint that they are taking credit where credit is not due, which is not quite what my point was. Both stress the fact that very few lines of dialogue from the original film are used in the new film. Said Mr. Graham, courteously, "It doesn't take two years to Xerox an old screenplay." That may be true, but having just read the original screenplay, I felt, on seeing the new film, that it owed an awful lot to the old. I really don't care how much or little they used — the new film is good, but it simply could not have existed had

not Mayer and Lubitsch done a lot of most original work earlier.

I was also told something to the effect that the Writers Guild forbade giving Mayer and Lubitsch more prominent mention. Hollywood has over the decades freely remade all sorts of films without giving any credit whatsoever to the work of preceding artists. In Hollywood, when you own all the rights to a property, you also have the right, apparently, to rewrite history, to render people invisible. It may be that Mr. Brooks and his associates weren't legally required to make any mention at all of the Lubitsch classic. They did so out of the goodness of their hearts, which, I suppose, is why there may be some irritation when their generosity isn't applauded.

Blake Edwards is also objecting to my objections — expressed in the daily review of his "The Man Who Loved Women" — that there is no mention in the screen credits of the 1977 François Truffaut film, which he has, in his words, "Americanized." Mr. Edwards has never tried to hide the fact that his new film is based on the Truffaut work. The official publicity material quotes Mr. Edwards at length on why he wanted to do an American version. Why, then, is there no mention of Mr. Truffaut on the screen?

Mr. Edwards says that that was part of his arrangement when he acquired the rights. "Mr. Truffaut," he says, "did not want his name on the film."

My interest in all this has nothing to do with contracts, with who owns the rights to do what, or with who wants what for his ego. After all, money can buy almost anything. My interest was in historical accuracy, which is not to sound pious. I know that in decades to come students will come upon Mr. Edwards's "Man Who Loved Women" and wonder at its close resemblance to the Truffaut "Man Who Loved Women."

•

Haute couture is a phrase that has always fascinated me, partially because I wonder what the opposite would be. Couture bourgeois? Would sackcloth and ashes be couture en bas? All I know about haute couture is what I read in the society columns, where the celebrated guests at glit-

tery dinner parties are often less celebrated than the designers whose labels are pinned to their backs. In other words, I wouldn't know an Adolfo from an Adidas.

Kristi Zea, the costume designer for "Terms of Endearment," writes in to amplify something I'd said in the Dec. 4 column about the hit film. She says that she, not Oscar de la Renta, designed the hilariously frilly, very busy dress that Shirely MacLaine wears on her first date with Jack Nicholson. "Lest we unnecessarily 'ruffle' Oscar de la Renta's talented and creative feathers," she writes, "I should like to inform you that the only original 'de la Renta' used on Shirley MacLaine.T . . was the skirt and blouse she wore in the gazebo scene with Jack Nicholson."

"The 'lunch dress,' " she goes on, "was inspired by several contemporary styles, including Mr. de la Renta's, but designed by me expressly for this film and made at Western Costume in California."

Whew!

It's not easy making things perfectly clear. ■

1984 Ja 1, II:11:1

Joy of Individuality

BASILEUS QUARTET, written and directed by Fabio Carpi; director of photography, Dante Spinotti; edited by Massimo Latini; music by Schubert, Debussy, Ravel, Smetana, Beethoven, Wagner, Bellini, Rodgers-Hart and Donaldson-Kahn; produced by C.E.P.; released by Libra/Cinema 5 Films. At the Lincoln Plaza, Broadway at 63d Street. Running time: 118 minutes. This film is not rated.

Edo	Pierre Malet
Alvaro	Hector Alterio
Diego	Omero Antonutti
Oscar Guarneri	Francois Simon
Guglielmo	Michel Vitold
Finkel	Alain Cuny
Mario Cantone	Gabrielle Ferzetti
Sophia	Veronique Genest
Lotte	Lisa Kreuzer

By VINCENT CANBY

"BASILEUS QUARTET," written and directed by Fabio Carpi, a film maker new to me, is a witty, intelligent little film about the dead-end of a certain kind of art. Like "Reuben, Reuben," this Franco-Italian coproduction is an entertainment for people who prefer a sort of literate decency of feelings to shocks provided by the unknown.

The lives of the surviving members of the Basileus Quartet, a chamber group that has been playing successfully around the world for more than 30 years, are turned upside down after the death of the leader, Oscar Guarneri. The three aging musicians decide to split up to pursue those pleasures they've denied themselves too long.

Diego (Omero Antonutti) finds himself a pretty young companion through an "agency," takes her to the zoo and buys her ice cream, but theh he's profoundly shocked when she suggests they go to bed. Alvaro (Hector Alterio), a handsome, urbane fellow, full of rueful self-awareness, goes for a medical check-up and learns that the high life he led as a very young man has left him with a multitude of chronic infirmities, including prostatitis. Guglielmo (Michel Vitold), is an incurable romantic with a taste for pretty boys, though he flees when he's approached by one in a movie theater.

Several weeks after they've disbanded, the three men meet for tea and to compare notes on the great happiness and relief each has experienced in his freedom. When a handsome young musical prodigy named Eduardo Morelli (Pierre Malet) appears on their scene, the three old fellows debate for less than five seconds before deciding to put the Basileus Quartet back on the road. How this remarkably talented newcomer, renamed Edo Morel by Guglielmo, who sees himself as a character out of Proust, revitalizes and then destroys the quartet is the heart of "Basileus Quartet," which opens today at the Lincoln Plaza 1 Theater.

Though the general course of the drama is never unpredictable, "Basileus Quartet" is full of subsidiary surprises, none more satisfactory than Edo who, as written by Mr. Carpi and as played by Mr. Malet, is an unusually complicated mixture of talent, ambition, self-indulgence, singleness of purpose and immense patience. With a gentleness that is actually comic for being so firm, Edo resists the three older men's attempts to bring him into the cloistered life they have followed. He thoroughly enjoys the beautiful women who throw themselves at him as they travel around Europe. He drinks and gambles, is late for rehearsals and, in a scene in which you might think there would be no comedy left, he turns them on to the joys of marijuana. Poor old Guglielmo, as might be expected, completely loses his head over the boy.

"Basileus Quartet" has much of the purity of tone and leanness of line of the marvelous music (Beethoven, Schubert, Bellini, Ravel, among others) heard on the sound track. So do the actors, especially when their characters are becoming unglued in one fashion or another.

Mr. Carpi is a director of taste, which never gets out of control to the point of stuffiness. He also has the

humor and wisdom not to freight his story with esthetic implications that might get in the way of the audience's emotional responses. Without ever forcing things, "Basileus Quartet" works so sweetly that, though it is completely conventional, it's almost exotic.

1984 Ja 4, C13:5

Street-wise Boys

THE HORSE, directed by Ali Ozgentürk; screenplay (Turkish with English subtitles) by Isil Ozgentürk; director of photography, Kenan Ormanlar; music by Okay Temiz; produced by Asya Film/Kentel Film. At the Film Forum, 57 Watts Street. Running time: 116 minutes. This film is not rated.

Father	Genco Erkal
Son	Harun Yesilyurt
Merchant	Ayberk Colok
Remzi	Yaman Okay
Foolish Woman	Guler Okten

By JANET MASLIN

ECONOMIC hardship forces a father and son to leave their small Turkish village and seek work in Istanbul in "The Horse," a bleak examination of living conditions in that city. As the father and son struggle to become fruit peddlers, living in an outdoor courtyard with a group of other workers, the film explores the wretchedness and hopelessness of their plight.

"The Horse," which opens today at the Film Forum, often errs on the side of obviousness in underscoring the pitiable nature of its characters' situation. Genco Erkal and Harun Yesilyurt, who play the father and boy, tend to cower mousily in the face of adversity. And the film's editing, like the performances, leaves little to the imagination. But Ali Ozgentürk has directed the film with conviction, if not with much delicacy, so that the awfulness of the characters' troubles does make itself felt. The excellent cinematography by Kenan Ormanlar attributes greatly to the film's authenticity.

At some points "The Horse" seems like a lesser "Pixote" describing the life of a city through the exploits of its street-wise boys. The young villager falls in with a band of much more

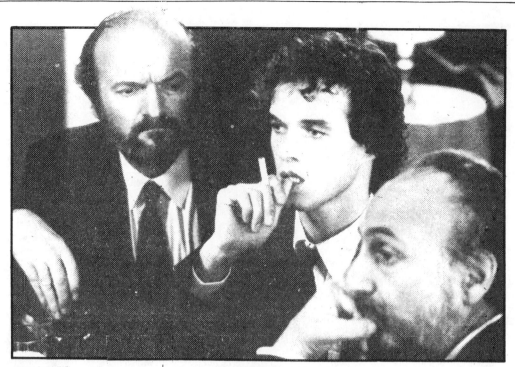

Pierre Malet (above, flanked by Omero Antonutti, left, and Hector Alterio) stars in Fabio Carpi's "Basileus Quartet," a drama about a successful string quartet that is disrupted when a young virtuoso joins the ensemble.

savvy city dwellers, who expose him to pop culture (one of them has made up a smutty little song about the television program "Dallas"), prostitution and the trick of extorting money from mourners at cemetaries. This is by no means the most grim element in "The Horse," since one of the adult characters sells the corpses of indigent peddlers to medical schools.

Most of the time "The Horse" chronicles this misery in a blunt, documentary-like style. Only occasionally does the film approach subjectivity in conveying the father's response to what he must endure. Near the end of the film, when the father wanders from his slum quarters into a relatively prosperous and modern section of the city his sense of painful disorientation is almost palpable for the viewer. "The Horse" is always sad, but it too seldom touches the audience this closely.

1984 Ja 4, C14:3

Old Boy Spy Work

THE RIDDLE OF THE SANDS, directed by Tony Maylam; screenplay by Mr. Maylam and John Bailey, based on the book by Erskine Childers; director of photography, Christopher Challis; edited by Peter Hollywood; music by Howard Blake; produced by Drummond Challis; released by Satori Entertainment Corp. At the Murray Hill, 34th Street and Lexington Avenue, and the Gemini Twin, Second Avenue at 64th Street. Running time: 98 minutes. This film has no rating.

Charles Carruthers	Michael York
Clara	Jenny Agutter
Arthur Davies	Simon MacCorkindale

174

Dollmann	Alan Badel
Von Bruning	Jurgen Andersen
Frau Dollmann	Olga Lowe
Grimm	Hans Meyer
Bohme	Michael Sheard
The Kaiser	Wolf Kahler
Withers	Ronald Markham

By JANET MASLIN

"THE RIDDLE OF THE SANDS" is not a camel movie, in spite of its title. In fact, much of it takes place on water. This is a film version of Erskine Childers' popular and prophetic 1903 novel, which told the fanciful story of how a couple of adventurous English yachtsmen stumbled upon a German fleet off the northwest coast of Germany, and thereby thwarted a German invasion of England. When, on the eve of the first World War, Lord Brassey strayed on his yacht Sunbeam into a restricted German harbor filled with U-boats, the novel took on an additional prescience.

The film version is a slow but affable period piece, with enough chin whiskers, straw boaters and busy-looking extras to suit children of all ages. Its two handsome heroes are Arthur Davies (Simon MacCorkindale) and Charles Carruthers (Michael York), who were college chums and are now reunited in the name of intrigue. Not long after Davies makes the acquaintance of a German family on board a yacht called Medusa, he grows suspicious of his new acquaintances and summons his foppish schoolmate.

•

Carruthers arrives wearing fancy shoes, and toting what he gallantly delightedly refers to as his portmanteau. But he soon abandons his gentlemanly ways and actively involves himself in solving the mystery onto which Davies has stumbled. By the time Kaiser William II has put in an appearance, the plot has become somewhat confusing, but it need not be fully deciphered by young viewers. They will surely understand that the man with the point atop his helmet is important, that a treacherous international plot has been nipped in the bud and that Davies and Carruthers have, more or less singlehandedly, saved England.

As directed by Tony Maylam, "The Riddle of the Sands" is the sort of lavish, agreeably simple movie that might formerly have been shown at the Radio City Music Hall. (It opens today at the Murray Hill and other theaters.) It is prop-heavy in a way that few films bother to be these days, which at the very least saves it from visual monotony.

•

Appearances tend to upstage everything else about the film; Jenny Agutter may stumble somewhat with the German accent required by the story (she calls Arthur "Arsa"), but she looks great as a Gibson Girl. Mr. York fortunately makes fun of his own stuffiness by landing in the mud in his finery, and from that point on, he becomes a suitably vigorous leading man. Mr. MacCorkindale grows more plausible as the spy story progresses. But he has such a slow, wide-eyed delivery at first that he appears to be addressing himself to the grade-school set, which may indeed constitute the film's ideal audience.

1984 Ja 6, C8:1

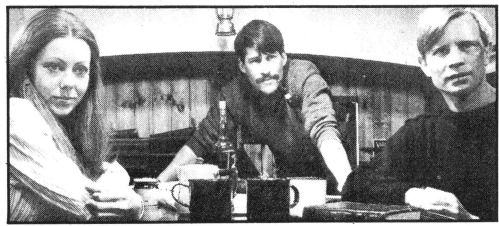

Jenny Agutter, Simon MacCorkindale and Michael York in "The Riddle of the Sands," a film based on Erskine Childer's spy story.

NOSTALGHIA, directed by Andrei Tarkovsky; screenplay (Italian with English subtitles) by Mr. Tarkovsky and Tonino Guerra; director of photography, Giuseppe Lanci; edited by Amadeo Salta and Erminia Marrgani; music by Giuseppe Verdi, Ludwig van Beethoven, Russian folk songs; production companies, Opera Film Productions for RAI Channel 2/Sovin Film/Gaumont. At the Lincoln Plaza Quad, Broadway between 62d and 63d Streets. Running time: 130 minutes. This film has no rating.

Gortchakov	Oleg Yankovsky
Eugenia	Domiziana Giordano
Dominico	Erland Josephson
Gortchakov's Wife	Patrizia Terreno
Chambermaid	Laura De Marchi
Dominico's Wife	Delia Boccardo
Civil Servant	Milena Vukotic
Farmer	Alberto Canepa

"Nostalghia" was shown as part of last year's New York Film Festival. Following are excerpts from Vincent Canby's review that appeared in The New York Times Oct. 5. The film opens today at the Lincoln Plaza Quad, Broadway between 62d and 63d Streets.

Andrei Tarkovsky's "Nostalghia" ("Nostalgia") is the first film to be made outside of Russia by this relentlessly poetic Soviet director. The setting is Italy, where the hero, Gortchakov (Oleg Yankovsky), has come to research the life of a 17th-century Russian composer who spent a long time in Italy, was terribly homesick, finally went home, became an alcoholic and committed suicide.

In the course of the film, Gortchakov does very little research and a lot of musing, which often takes the form of lovely flashbacks and fantasies, most of which are seen in monochrome as compared to the living color of the other lovely images. Loveliness, I'm afraid, is really what this movie is all about. The Italian landscapes, frequently heavily misted, the ancient churches, the old towns, the occasional peasant, and the leading lady (Domiziana Giordano) are so lovely one feels that Mr. Tarkovsky's private world was created for camera-carrying tourists.

Gortchakov is homesick, but his homesickness is a kind of madness (I think). He is rude to his Italian guide, Eugenia (Miss Giordano), who would like to have an affair with him. He spends a lot of the time in very dark rooms. The only person who touches him is a genuinely mad fellow (Erland Josephson), who when last seen is setting fire to himself in Rome after exhorting citizens to seek the answers to their problems in nature.

Mr. Tarkovsky, whose earlier films include "Andrei Rublev," "Solaris" and "Stalker," may well be a film poet, but he's a film poet with a tiny vocabulary. The same eventually boring images keep recurring in film after film — shots of damp landscapes, marshes, hills in fog, and abandoned buildings with roofs that leak. The meaning of water in his films isn't as interesting to me as the question of how his actors keep their feet reasonably dry.

1984 Ja 8, 47:1

Domiziana Giordano plays the role of an interpreter in "Nostalghia," the first film made outside the Soviet Union by Andrei Tarkovsky. Set in Italy, the film deals with a Russian poet (Oleg Yankovsky) who is conducting research on the life of an 18th-century Russian composer.

A Better Life

EL NORTE, directed by Gregory Nava; screen-play (Spanish with English subtitles) by Mr. Nava and Anna Thomas; cinematography, James Glennon; film editor, Betsy Blankett; music by the Folkloristas, Melicio Martinez, Emil Richards, Linda O'Brien, Samuel Barber, Giuseppe Verdi and Gustav Mahler; produced by Miss Thomas; a Cinecom International/Island Alive Release. At the Baronet, Third Avenue and 59th Street. Running time: 139 minutes. This film has no rating.
Rosa Xuncax........................Zide Silvia Gutierrez
Enrique XuncaxDavid Villalpando
Arturo XuncaxErnesto Gomez Cruz
Lupe XuncaxAlicia del Lago
Pedro ...Eraclio Zepeda
Josefita ...Stella Quan
RamonRodolfo Alejandre
Nacha ..Lupe Ontiveros

By JANET MASLIN

A SMALL, personal, independently made film with the sweep of "El Norte," with solid, sympathetic performances by unknown actors and a visual style of astonishing vibrancy, must be regarded as a remarkable accomplishment.

Gregory Nava, who directed the film and co-wrote it with his wife, Anna Thomas (she is the film's producer), is a relative neophyte. Mr. Nava, who is of Mexican-Basque ancestry and who grew up in San Diego, is a U.C.L.A. film school graduate who has one extremely low-budget 1973 feature ("The Confessions of Amans") to his credit. But he has brought so much assurance to his current film that it emerges as a virtually seamless saga.

"El Norte," which opens today at the Baronet, follows two Indians, a brother and sister, from their native Guatemala to the promised land of Los Angeles, and gives the power of inexorability to their journey. The film's opening portion, set in a small, remote Indian village, is so brilliantly colored and so filled with startling imagery that it approaches the "hallucinogenic realism" of modern Latin American fiction. Arturo Xuncax, a worker on a coffee plantation, is murdered by soldiers for trying to organize his fellow laborers, and his son, Enrique (David Villalpando), finds Arturo's head hanging from a tree. When Arturo's wife, Lupe, disappears soon afterward, their daughter, Rosa (Zaide Silvia Gutiérrez), comes home to find the house filled with butterflies. Rosa and Enrique, though they have flourished in this sunny setting, decide they must flee to escape their parents' fate. Having heard grand tales of flush toilets, having seen visions of lawn sprinklers, having gazed with wonder at borrowed, well-worn back issues of Good Housekeeping, they decide to travel northward.

The colors drain from James Glennon's superb cinematography as the trip progresses. When Rosa and Enrique reach Tijuana, they find a drab-looking shantytown filled with would-be emigrants to the United States and sleazy hucksters trying to swindle these travelers out of their meager savings. Finally, having found one "coyote" (a paid escort for the border crossing) who isn't out to cheat them, they make a hellish journey through an abandoned, rat-infested sewer pipe. When at long last they reach the other side and see the San Diego skyline, the sound track erupts with rapturous-sounding music.

In Los Angeles, where their tiny, filthy room nonetheless has the plumbing and electricity they once dreamed of, Enrique and Rosa seem to thrive. They find store-bought clothing in bright colors that recall the woven garments of their former home. They take an adult education course in English and learn to say "It is usually very smoggy." Enrique finds a job in an expensive restaurant, where the staff is fed croissants in the kitchen. The Hispanic workers find these not as tasty as Mexican food but eat them anyway.

Rosa, befriended by a shrewd older woman named Nacha (Lupe Ontiveros) who has perfected the art of smiling blankly and idiotically to reassure the gringos, finds work as a maid. The house where she and Nacha work is so posh, though, that the computerized controls for the washing machine are way beyond Rosa's comprehension. Desperate with worry, Rosa suddenly catches a glimpse of the swimming pool and remembers with pleasure her former means of washing clothes. But the lady of the house is horrified. She wouldn't dream of letting Rosa do the laundry in this old-fashioned way, she says. "I couldn't stand the thought of her in here, *scrubbing..*"

There are plenty of opportunities for broad satire here, but Mr. Nava doesn't indulge in that. Instead, he concentrates closely on Rosa and Enrique, who are played so plainly and touchingly (both Miss Gutiérrez and Mr. Villalpando are experienced Mexican stage actors making their film debuts) that the audience cannot help but empathize. This is one movie in which the white, English-speaking characters are strictly walk-ons; Mr. Nava thoroughly immerses the audience in the world of Hispanic exiles, even paying attention to the vocabulary differences between different groups. When Rosa and Enrique try to disguise themselves as Mexicans, they are advised to add a certain epithet to their vocabularies and to use it frequently.

Using a broad, sturdy style punctu-

Zaide Silvia Gutierrez, at far left, and David Villalpando, at center, play brother and sister who flee Guatemala after their father's death and make their way to the United States in "El Norte."

ated frequently by dream imagery — in this film, a fashion model in a Los Angeles factory can look as exotic as a rare bird in a tropical landscape — Mr. Nava makes "El Norte" real and involving throughout. If his film follows a more predictable course in its later stages, it nonetheless retains its hold on the audience's sympathies. Rosa and Enrique may never emerge as anything more than simple, decent innocents, but Mr. Nava never allows them to become anything less. He presents their story in terms that are simple but far-reaching, so that its cultural and political implications are apparent and so that its humanity is always felt.

1984 Ja 11, C15:1

The Good and the Bad

ANGEL, directed by Robert Vincent O'Neil; screenplay by Mr. O'Neil and Joseph M. Cala; director of photography, Andy Davis; edited by Charles Bornstein and Wilt Henderson; music by Craig Saffin; produced by Roy Watts and Don Borchers; released by New World Pictures. At Loews State 2, Broadway and 45th Street; Orpheum 1, 86th Street and Third Avenue and other theaters. Running time: 93 minutes. This film is rated R.
Angel/Molly..................................Donna Wilkes
Kit CarsonRory Calhoun
Billy Boy ...John Diehl
Lieutenant AndrewsCliff Gorman
Mae ..Dick Shawn
Mosler ...Susan Tyrrell

By VINCENT CANBY

FIFTEEN-YEAR-OLD Molly, a pert student in pigtails at the exclusive North Oaks Prep School in Los Angeles, is called in for a little talk by her faculty adviser, a kindly woman who's worried about Molly's obsession with books. "You know," she says with concern, "there's more to life than straight A's."

Molly knows only too well.

As the advertisements say, Molly is an honors student by day and, by night, a Hollywood hooker known as Angel.

"Angel," which opens today at Loews State 2 and other theater, is another fearless "problem film," Southern California-style. How, this movie asks, can Molly do her homework, which one night includes reading the entire first act of "King Lear," and turn enough tricks to pay her tuition at North Oaks? It's not easy, especially when there's also a killer at large, preying on Molly and her winsome associates of the street.

This is only Jan. 13, but as movie vehicles go, "Angel" will almost certainly turn out to be one of the top sleazemobiles of 1984. It comes very close to being so consistently ridiculous that it's not unentertaining. You simply can't imagine the heights that inappropriate dialogue can attain until you hear Molly say to a couple of street friends: "Gee, I'm glad I found you two. I'm on my way to the morgue." Even as she picks up clients and even as her friends are being dismembered by the not-so-mysterious killer, Molly talks like Winnie Winkle.

Despite her trade, which she does not like, Molly is, as they say in films of this sort, "still a child." As played by Donna Wilkes, who looks to be an extremely mature 15, she dresses and behaves like a dirty old man's idea of a nymphet, whether she's on the North Oaks campus or swinging her beaded bag along the Sunset Strip.

The film pretends to be somewhat more shocked than it really is by Molly's unusual behavior, which is explained by the fact that she was abandoned by her parents. The killings are shown in some unpleasant detail and, for reasons that are well known to the

producers, Molly is often seen passing through the frequently crowded girls' shower room at good old North Oaks. Apparently it's the only way to get to the library.

"Angel" is not without its peculiar amusements, but the performances are not among them. Dick Shawn, in full drag, plays Molly's aging transvestite friend as if he were trying to imitate Jack Lemmon in "Some Like It Hot." Susan Tyrrell appears as Molly's good-hearted, lesbian landlady, and Rory Calhoun, wearing enough fake hair to stuff a sofa, appears as an old-time cowboy actor. John Diehl is the killer, and Cliff Gorman seems to be in permanent shock as a Los Angeles detective, the only straight person in the movie. They're all quite bad, if good-humored.

Robert Vincent O'Neil directed the movie and wrote the screenplay with Joseph M. Cala.

1984 Ja 13, C12:5

The Coast of Norway

KAMILLA, directed by Vibeke Lokkeberg; written by Vibeke Lokkeberg in cooperation with Terje Kristiansen; director of photography, Paul Rene Roestad. At Lincoln Plaza 3, Broadway between 62d and 63d Streets. Running time: 108 minutes. This film has no rating.
WITH Nina Knapskog, Kenneth Johansen, Helge Jordal, Vibeke Lokkeberg, Karin Zetlilitz Haerem, Renie Thorleifsson, Klaus Hagerup, Johnny Bergh, Kjell Pettersen and Marie Takvam.

Nina Knapskog portrays a 7-year-old girl through whose eyes is seen a family in turmoil in Norway after World War II. The film, "Betrayal: The Story of Kamilla," was written, directed by and stars Vibeke Lokkeberg.

"Kamilla" was shown in last year's "New Directors/New Films" series. Following is Vincent Canby's review, which appeared in The New York Times last March 20. The film opens today at Lincoln Plaza 3, Broadway, between 62d and 63d Streets.

"KAMILLA" is less interesting for itself than for its promise of greater things to come from Vibeke Lokkeberg, the young Norwegian woman who wrote and directed it and plays — beautifully — a leading role.

The time is shortly after World War II, and the place is Bergen, on Norway's west coast. The film's theme is dislocation and disillusion, mostly as experienced by a pretty, solemn little girl named Kamilla, who lives with her exhausted parents in a small flat above her father's shoe-repair shop and laundry.

A dark cloud hangs over Kamilla's father who — though this is never fully explained — seems to have collaborated with the Nazis during the German occupation of Norway and, as a result, has a bundle of illegal money secreted in the apartment.

•

The film is called "Kamilla," but it's far more effective in the way it dramatizes the hopelessness of marriages gone permanently sour and of adult lives that have reached dead ends.

"Kamilla" becomes contrived and hollow when, toward the end, it imposes on its child actors attitudes and

dialogue that have less to do with childhood than with an adult's perception of childhood. At one point, when Kamilla and her small boyfriend run away from home, the movie seems to be on the point of turning into a pre-teen-age "Elvira Madigan."

Otherwise, however, "Kamilla" is full of vignettes that identify Miss Lokkeberg as a film maker of feeling and imagination. I think especially of a scene in which Kamilla's mother and another woman, each abandoned by her husband and bored out of her mind by the drabness of life, invite a lingerie salesman to come into the apartment, buy most of his wares and then get nuttily drunk with him.

The performances are superior, including those of Miss Lokkeberg as Kamilla's mother, Helge Jordal as her father and Nina Knapskog in the title role.

Vincent Canby

1984 Ja 13, C8:1

HOT DOG, directed by Peter Markle; written by Mike Marvin; director of photography, Paul G. Ryan; edited by Stephen Rivkin; music by Peter Bernstein; produced by Edward S. Feldman; released by M-G-M/U.A. Entertainment Corp. At the Warner, Broadway and 47th Street; Gemini, 64th Street and Second Avenue; 86th Street, at Lexington Avenue and other theaters. Running time: 96 minutes. This film is rated R.
Dan David Naughton
Harkin Patrick Houser
Sunny Tracy N. Smith
Rudi John Patrick Reger
Squirrel Frank Koppola
Kendo James Saito
Sylvia Fonda Shannon Tweed
Slasher George Theobald
Heinz Marc Vance
Fergy Erik Watson
Michelle Lynn Wieland

By JANET MASLIN

If a ski movie like "Hot Dog" appeared during warmer weather, it might qualify as escapism. At this time of year, it's more like a cheap vacation. Set in Squaw Valley and revolving around the World Cup Free-

style competition, it features a cast of cute, young hopefuls who battle on the slopes by day and mingle in the hot tubs after sundown. It's a beach party movie, marginally better than the average, with snow taking the place of surf.

"Hot Dog," which opened yesterday at the RKO Warner Twin and other theaters, stars David Naughton, of the Dr Pepper commercials as something of a senior statesman; that may provide some idea of the age of the crowd. Mr. Naughton presides over the rivalry between a nasty Austrian ski champ (John Patrick Reger) and a boyish Californian type named Harkin (Patrick Houser), who sings. "My sister says I'm, uh, as good as John Denver," says Harkin bashfully, after stopping the movie in its tracks with a sensitive ballad.

Since the other characters have names like Squirrel, Fergy and Kamikaze, Harkin is the movie's apparent hero. But its real heroes are the stunt skiers, since some of the sports footage is quite lively. Mike Marvin, who wrote the screenplay and who directed the second unit sequences, obviously knows his ski feats. He knows less about character, though, and the nonskiing part of the script concerns itself mostly with cooking up pretexts for the ski bunnies in the cast (Tracy N. Smith and Shannon Tweed are the two female leads) to doff their clothing. A sauna, a waterbed and a heart-shaped bathtub figure prominently in the film's dramatic development, and so does the nowadays obligatory wet T-shirt event.

At least Peter Markle, the film's director, keeps the mood light and less moronic than it might have been: He also fills the movie with innumerable plugs for everything from the motel with the waterbeds to the brand of beer shared by skiers while on the slopes. Despite the latter, nobody breaks a leg.

1984 Ja 14, 10:1

FILM VIEW

JANET MASLIN

Powerful Emotions

An astonishing burst of applause greeted the penultimate moments of Alfred Hitchcock's 1958 "Vertigo" at the performance I attended last week — astonishing because, only seconds later, the film's real ending left the audience gasping in disbelief. Those who had cheered the happy-looking near-finale must not have seen "Vertigo" before. They must have been caught off-guard by this film's stubborn, single-minded intensity, and by its uncharacteristic (for Hitchcock) reluctance to please.

The commonplaces about "Vertigo" — that it is Hitchcock at his most obsessive, his most perverse, his most sexual — don't even begin to convey how very haunting this film is, or how bizarre. Nor do they describe the sheer daring with which the director, in this film, defies both logic and audience expectations, working in a much riskier and more passionate style than the coolly controlled one that became his trademark. Another thing these observations don't convey is the degree to which "Vertigo" now looks dated, though its brilliance remains unmistakable. There's nothing else like "Vertigo" in the Hitchcock canon — nothing so urgent, so feverish and also, paradoxically, so contrived.

Surely "Vertigo" is the Hitchcock film that arouses the strongest emotions, both on and off the screen. Those who regard it as Hitchcock's masterpiece will be matched, now that the film has been re-released, by those who find it more dated than the other current reissue,

"Rear Window," and less prodigiously charming. Indeed, a segment of this same above-mentioned "Vertigo" audience apparently found the film laughable, joking on the way out of the theater about why neither Kim Novak's shoes nor her eyebrows are lost when, midway through the film, she dives into the San Francisco Bay.

One of the peculiarities of "Vertigo" is the relative primitivism that, from the pre-computer graphic whorls of the titles, to the awkward dream sequence, to the uneasy, faintly Joan Fontaine-ish quality of Miss Novak's performance in her early scenes, keeps the film from coming fully to life. These flaws haven't prevented "Vertigo" from becoming many people's favorite of all Hitchcock films; certainly (along with "Notorious," "Strangers on a Train" and "Psycho") it's one of mine. But they do insure that the film be watched for its fastidious symmetry and its extraordinarily rich subtext, rather than on the simple story level. It was never, after all, one of Hitchcock's most popular entertainments.

The supremely astute essay on "Vertigo" by the critic Robin Wood, in his book "Hitchcock's Films," is essential reading for its thorough thematic analysis. The film's morbidity, its obsession with the past, its parallelisms and its visual style are all explored at great length, although Mr. Wood readily overlooks Miss Novak's performance and other mundane shortcomings. The film's only real flaw, according to Mr. Wood, is a plot point. Who could be sure that a man watching his beloved falling from a bell tower would not remain at the scene of the accident — even a man who suffered, as James Stewart's Scottie Ferguson does, from a dread of falling?

Scottie — who, as Mr. Wood points out, is a man so adrift that not even his name remains consistent throughout the film — develops his vertigo in an opening sequence, which has the startling visual economy characteristic of the rest of the film. A glimpse of the Golden Gate Bridge, a shot of a criminal running across a rooftop, and the sight of the great James Stewart in hot pursuit establish Mr. Stewart's Scottie as a San Francisco detective. Seconds later, Scottie hangs desperately from the rooftop, and a police colleague dies while trying to save him. How does Scottie get down from the rooftop, then? We never know, but it is at this point that "Vertigo" abandons pure logic, adopting its own dreamlike reasoning.

"Vertigo" is divided in half, with its sections linked to the two women played by Miss Novak, an elegant blonde named Madeleine Elster and a tawdry redhead named Judy Barton. Madeleine's husband hires the now-retired Scottie to follow Madeleine, claiming that his wife has a mysterious and dangerous fascination with a long-dead woman named Carlotta Valdes. During the course of this pursuit, which is presented as a series of silent visits to unnaturally empty San Francisco locales, Scottie falls in love with Madeleine, only to lose her to what Madeleine describes as a preordained fate. This part of the film may seem relatively implausible — the Carlotta Valdes story, especially as described by Miss Novak in her archly aristocratic guise, is never really convincing — but it is subtly and powerfully seductive. By the time Scottie encounters Judy Barton, whom he attempts to remake into his lost Madeleine, his obsession has taken on enormous poignancy. And Miss Novak's Judy, pleading for redemption and a second chance in the film's final moments, becomes such a sympathetic figure that the film's ending is truly heartbreaking.

Hitchcock's most idiosyncratic stroke here, aside, of course, from the intensely sexual, even fetishistic process of letting Scottie dress Judy as Madeleine the way another man might *undress* his lover, was that of revealing Judy's secret well before the denouement; the book on which the film was loosely based ("D'Entre les Morts," by Pierre Boileau and Thomas Narcejac) saved this revelation for last. At the cost of considerable suspense, Hitchcock heightened the audience's identification with these characters tremendously, and he turned the film's climax into an agony. The sight of Mr. Stewart, dragging the helpless Miss Novak up the stairs to the same bell tower we have seen before, and insisting he can triumph over the past, is perhaps the most wrenching image Hitchcock ever created. Of all his heroines haunted by the past, from Joan Fontaine in "Rebecca" to Ingrid Bergman in "Notorious," this is the one whose pain is most palpable. And Scottie is Hitchcock's most passionate hero, a man whose obsession is so extreme and unrelenting that the audience cannot help but share it with him.

Even for a Hitchcock film, "Vertigo" is unusually meticulous; today's audiences can watch it as closely for the intricate color scheme (Madeleine, for instance, wears blacks and grays but has an essentially green aura) as for its deeper themes. Hitchcock's absolute control was not lessened by the emotional intensity he brought to this pet project; if anything, it became even more rigorous. Nothing is casual here, not the scene in which Scottie playfully tries to cure his vertigo by advancing up a stepladder (this establishes him as a rationalist, though reason will later fail him), and not even the lighter scenes of Scottie with his pal and ex-girlfriend, Midge. As played so pertly by Barbara Bel Geddes, Midge is nonetheless such a carefully drawn character that she always wears the identical sweater, albeit in different colors. When Midge appears, after a number of scenes in pastels, wearing a red version of her outfit, Hitchcock signals trouble as surely as he might have by sounding an alarm.

If "Rear Window" seemed a pleasant surprise when it re-emerged last fall, "Vertigo" now seems shocking. For those who remember it fondly as Hitchcock's lost masterpiece, there are some surprisingly rough edges; for those to whom it is unfamiliar, it may seem almost unbearably cruel. What is sure to startle anyone is the spectacle of a film, especially so emotionally powerful a film, whose every element is so precisely geared to the larger whole. No director today exerts the kind of unrelenting control that Hitchcock did. And Hitchcock, for all his remarkable powers of reason, never shaped a film as fervently or perversely as he did this one. ∎

1984 Ja 15, II:19:1

Inside Story

BACKSTAGE AT THE KIROV, written and directed by Derek Hart; director of photography Ivan Strasburg; edited by Kenneth Levis; produced by Gregory Saunders and Kenneth Locker; presented by Armand Hammer Productions. At the Guild, 33 West 50th Street. Running time: 78 minutes. This film has no rating.
WITH: The Orchestra of the Kirov Theater, the Kirov Theater and its dancers.

By JENNIFER DUNNING

WHAT happens to the "Children of Theater Street" after they are graduated from the Vaganova Choreographic Institute in Leningrad and move on, if gifted and lucky, to the Kirov Ballet? The subject of a 1977 documentary of the same name, those children begin the even harder and more uncompromising life glimpsed in "Backstage at the Kirov," which opens today at the Guild Theater.

Some of the ballet figures best known to Western audiences have passed through the historic school and company, among them Anna Pavlova, Vaslav Nijinsky, George Balanchine and, more recently, Rudolf Nureyev, Natalia Makarova and Mikhail Baryshnikov. It was the ballet company for which Marius Petipa created "The Sleeping Beauty" and two acts of "Swan Lake," and the school through which Agrippina Vaganova developed the teaching system that was to influence so strongly the look of 20th-century ballet technique.

And so, for the ballet enthusiast, almost any facet of the Kirov is of interest. And "Backstage at the Kirov" provides a rare and mostly absorbing look at what goes on in the theater studios, dressing rooms, wings and on the stage itself as the company prepares its repertory, most notably Petipa's second act of "Swan Lake." The film also touches on social history, in part through the use of contemporary films and graphics, suggesting the atmosphere of life in the city from czarist days on into 1983, the company's bicentennial anniversary.

For the general audience, "Backstage at the Kirov" provides yet another glimpse of the physically and emotionally demanding life of the dancer. There is a telling scene, for instance, with a pretty ballet student who is either too shy or too proud to respond to her teacher's taunts. A grim rehearsal scene seems like a real-life Myrtha, the death-dealing spirit queen of "Giselle."

A young ballerina giggles about the worship poured on her by a fan, trying unsuccessfully for a tone of modest nonchalance as she talks to an older and less prominent dancer. In one of the most memorable moments in a knowingly photographed film, the camera moves in on a foot shifting agonizingly in its toe shoe in a balance. And "Backstage at the Kirov" succeeds in re-creating, without sentimentality, the magical atmosphere of the theater, particularly in the wings, during a performance, in those moments when the performers are no longer quite themselves nor yet the characters they portray.

But "Backstage at the Kirov" has serious flaws. One would imagine, through much of the film, that there were no male dancers or students at the Kirov. Far too many moments are spent lingering on unimpressive performances by Galina Mezentseva and Konstantin Zaklinsky in the lead roles of "Swan Lake." And the debut of the very promising young Altynai Assylmuratova in the testing role of Odette, the Swan Queen, in another performance of the ballet, is surprisingly truncated and flat, given the fact that Miss Assylmuratova's preparation for that debut provides a story line.

The film's worst defect, however, is its lack of information. A few of the interviewees are identified, among them Oleg Vinogradov, director of the Kirov, and Olga Moiseyeva, a teacher and coach. But who is the wild young choreographer whose experimentation reduces his hapless cast to wry grins and increasingly desperate compliance in the funniest of the film's comic moments?

Miss Assylmuratova and Miss Mezentseva are identified as they are interviewed. But there is no mention in the credits of the dancers and theater personnel in the film, an exasperating omission that suggests an oddly casual attitude toward its audience and subject.

1984 Ja 18, C24:3

Latin Views

WHEN THE MOUNTAINS TREMBLE, a documentary directed by Pamela Yates and Thomas Sigel; cinematographer, Mr. Sigel; edited by Peter Kinoy; music by Ruben Blades; produced by Mr. Kinoy; released by Skylight Pictures. Running time: 83 minutes. This film has no rating.
WITH: Rigoberta Menchu as the storyteller
NICARAGUA: REPORT FROM THE FRONT, a documentary directed by Deborah Shaffer and Thomas Sigel; cinematography by Mr. Sigel; edited by Judith Sobol; music by Javier Bajana, Sarah Plant, Giovanni Ayola and Leon Serna; produced by Miss Shaffer and Pamela Yates; a Skylight Pictures Production; released by First Run Features. At the Film Forum, 57 Watts Street. Running time: 32 minutes. This film has no rating.

By VINCENT CANBY

UNITED STATES foreign policy toward Guatemala and Nicaragua is examined with undisguised but emotionally effective bias on behalf of left-wing movements in two new documentaries opening today at the Film Forum.

"When the Mountains Tremble," directed by Pamela Yates and Thomas Sigel, is an 83-minute feature that is as much about the history of United States-Guatemala relations as about the contemporary situation. The centerpiece of the film is a young peasant woman, Rigoberta Menchu, who testifies about her own radicalization as a result of the deaths of her two brothers and her father.

"Nicaragua: Report From the Front," directed by Deborah Shaffer and Mr. Sigel, is a short, tough, harrowing film containing interviews with key members of Nicaragua's revolutionary Sandanista Government as well as with key members of the opposition. These include leaders of the Honduras-based, American-supported rebels, known as contras, composed in part by former members of the National Guard of President Anastasio Somoza Debayle.

Though only 32 minutes long, "Report From the Front" is the more persuasive of the two films, partially because of some very unusual footage. The film makers had access to both sides in the continuing struggle and, at one point, accompany a contra raid into Nicaragua.

Statements by President Reagan and Edgar Chamorro, the leader of the contras in Honduras, are played off against interviews with the Sandanista officials, including the country's foreign minister, plus an interview with Robert G. Torricelli, a Democratic Representative from New Jersey and a member of the House Foreign Affairs Committee. When Mr. Torricelli denounces what he calls the illegality of United States support of anti-Sandanista forces, Jeane J. Kirkpatrick, the chief delegate to the United Nations, answers in a separate interview that policy is not related to law.

"When Mountains Tremble" is a more ambitious film that, in addition to the testimony of Miss Menchu, contains a lot of documentary footage as well as some not very effective "reenactments" of history, especially a 1954 dinner at which the United States Ambassador, John E. Peurifoy, played by Eddie Jones, warns the then President of Guatemala, Jacobo Arbenz Guzman (Shawn Elliot), that the United States will not tolerate the proposed Arbenz economic reforms that infringe on United States business interests. President Arbenz was shortly afterward replaced by a military man.

This film is best when it sticks to Miss Menchu's simply stated testimony and to interviews, such as those with Mario Cardinal Casariego, the Archbishop of Guatemala, a firm supporter of United States policy, and with various Roman Catholic priests who have aligned themselves with the peasants.

One particularly interesting sequence is devoted to the increasing popularity in Guatemala of evangelical movements that, according to the film, are essentially conservative since they preach that all social action should be left in the hands of God.

Both films are of extremely high technical quality, which is worth noting considering the difficulties under which some of the footage was shot.

1984 Ja 18, C24:3

Virtue Violated

DEEP IN THE HEART, written and directed by Tony Garnett; director of photography, Charles Stewart; edited by William Shapter; music by Mike Post; co-produced by Mr. Garnett and David Streit; released by Warner Bros. At the Manhattan Twin, 59th Street and Third Avenue. Running time: 99 minutes. This film is rated R.
Kathleen Sullivan Karen Young
Nancy ... Suzie Humphreys
Miss Davis Helena Humann
Larry Keeler Clayton Day
Chuck ... Ben Jones

By JANET MASLIN

THE viewer's sympathies are certainly with Kathleen, the heroine of Tony Garnett's "Deep in the Heart," when she is raped by her date. Kathleen (Karen Young), after all, is an innocent Irish Catholic schoolteacher. Her date, Larry Keeler (Clayton Day), is a swinger, a gun enthusiast and a corporate lawyer. Furthermore, Larry says things like "the build-up in government-supported welfare programs is contradictory to the frontier spirit." And on the night of the attack, he serves Kathleen some venison from a deer that, he is proud to say, he has bagged himself.

After this, "Deep in the Heart," which opens today at the Manhattan Twin, goes off the deep end. Kathleen cuts off her long blond hair. She throws out her frilly dresses, begins dressing in cowboy drag, and buys a gun and learns how to shoot, all with the object of teaching Larry a lesson. By the time she has cornered him at a rifle range and is stalking him like so much big game, she seems no more appealing than he did. Kathleen's revenge involves a trick, but that hardly helps.

•

From its opening view of the Texas Book Depository to its occasional lectures on American history (Kathleen teaches history in a Dallas high school), "Deep in the Heart" underscores what it perceives as the relationship between violence and American life; Kathleen even has a picture of John Lennon in her living room.

Mr. Garnett, who wrote, produced and directed the film and who is a British-born film maker now living in Los Angeles, has handled this with enough understatement to have induced real sharpshooters to appear in the movie; Ray Brantley, the owner of a Dallas store stocking 15,000 firearms, plays himself. So although the film's anti-firearm message is presented with more subtlety than it might have been, the narrative still seems crude. The rape, for instance, is preceded by a scene in which Larry watches a boxing match between two women in a Dallas nightclub. And

The state of life in Guatemala is the focus of "When the Mountains Tremble."

Kathleen has just talked with her parents back in Boston. They have asked her to keep on being a nice girl.

"Deep in the Heart" does seem serious and sincere. There is little sensationalism here, though there might have been plenty. Miss Young, who looks so girlish that she at first seems to be one of the high school students, gives an affectingly natural performance. She helps to make the film disturbing, though it might have been much more so if its screenplay were less blunt. Mr. Day also acts in a natural style, but his is the more implausible role of the two. After the rape, he must tell the nearly catatonic Kathleen that this is "partially your own fault for being so irresistible."

1984 Ja 18, C24:3

Armchair Relaxation

CORRUPT, directed by Roberto Faenza; screenplay by Ennio de Concini, Roberto Faenza, Hugh Fleetwood, based on the novel "The Order of Death" by Mr. Fleetwood; photography by Giuseppe Pinori; music by Ennio Morricone; produced by Elda Ferri in association with Jean Vigo and RAI; released by New Line Cinema. At the Embassy 72d Street, at Broadway. Running time: 99 minutes. This film is rated R.
Lieutenant Fred O'Connor Harvey Keitel
Leo Smith ... John Lydon
Margaret Smith Sylvia Sidney
Lenore Carvo Nicole Garcia
Bob Carvo Leonard Mann

A MOVIE as bizarre as Roberto Faenza's "Corrupt" can't help but exert a certain fascination. Even though it's based on a novel, "The Order of Death" by Hugh Fleetwood," it seems to have been pulled out of thin air.

"Corrupt," which opens at the Embassy 72d Street theater today, centers on a police lieutenant named Fred, who is morally bankrupt but who is apparently pretty shrewd about real estate. Any extra funds Fred has accumulated on the job (he concentrates on drug traffickers) have been invested in a huge co-op on Central Park West. Fred does not live here, but he and an equally crooked partner (Leonard Mann) share the ownership and visit the place occasionally. The apartment is virtually empty, but there are two armchairs in the living room; sometimes Fred puts on his robe and slippers and sits in one, looking out the window. Never has a man looked less relaxed in robe and slippers than Harvey Keitel, who plays Fred.

•

Soon a third character insinuates his way into the secret apartment. He is Leo Smith, a mysterious and sickly looking young stranger who has been following Fred and who confesses to a string of cop killings. "The first time I saw you, I knew I could confess to you," Leo tells Fred. Since a cop killer has been on the loose, Fred takes this confession seriously. He locks Leo in the bathroom, puts boards and soundproofing on the windows and begins beating Leo and feeding him from a dog bowl.

With its sadomasochism, its exchange of identities, its questions about guilt and complicity, and its reliance upon a rock star to provide the requisite kinkiness (Leo is played by John Lydon, also known as Johnny Rotten of the Sex Pistols), "Corrupt" recalls "Performance" slightly, although its craziness is less inspired. And when the film reveals that Leo is really the heir to a great Hudson Valley fortune, commuting from Rhinecliff each time he supposedly kills a

179

policeman, it all becomes irremediably wild.

Nicole Garcia is effective, but mostly absent, as the wife of Fred's partner; for the most part, this is an intense, claustrophobic melodrama about the relationships among the men in the story. Mr. Lydon, who has just the right insinuating, runty quality for Leo, makes a strong impression, and in a better film would make an even stronger one. Mr. Faenza has given "Corrupt" some momentum and tension, but there's absolutely nothing to hold it together. It's set in New York, but its angst and intensity feel Italian. The whole thing might just as well be taking place on the moon.

Janet Maslin

1984 Ja 19, C16:5

Murder and Mirth

SCANDALOUS, directed by Rob Cohen; screenplay by Mr. Cohen and John Byrum; story by Larry Cohen, Rob Cohen and Mr. Byrum; director of photography, Jack Cardiff; edited by Michael Bradsell; music by Dave Grusin; produced by Arlene Sellers and Alex Winitsky; released by Orion Pictures. At Loews State, Broadway and 45th Street; 34th Street Showplace, between Second and Third Avenues; New York Twin, Second Avenue and 66th Street; 83d Street Quad, at Broadway and 66th theaters. Running time: 94 minutes. This film is rated PG.

Frank Swedlin	Robert Hays
Porno Director	Ron Travis
Simon Reynolds	M. Emmet Walsh
Uncle Willie	John Gielgud
Purser	Ed Dolan
Flight Coordinator	Paul Reeve
Stewardess	Alita Kennedy
Fiona Maxwell Sayle	Pamela Stephenson
Lindsay Manning	Nancy Wood
Inspector Anthony Crisp	Jim Dale

By JANET MASLIN

"SCANDALOUS" is a charmless caper movie that seems chiefly a pretext for the characters to keep changing their clothes. John Gielgud, as an aristocratic con man, appears in a punk outfit. Pamela Stephenson, as his fashionable niece, turns up as a redhead, a brunette and a blonde. Robert Hays, playing a television reporter, keeps a relatively low profile, but then he is supposed to be relatively naïve. "We wanted this movie, which is a murder mystery and a romantic comedy, to be both a soufflé and a glass of white wine," Rob Cohen, the film's director and co-screenwriter, has said. Well, not every soufflé rises.

"Scandalous," which opens today at Loews State and other theaters, takes place in London, which exists here as a series of posh, somewhat overdecorated interiors. Frank Swedlin (Mr. Hays) becomes involved in a murder investigation, and he also becomes involved with the beautiful, mysterious Fiona Maxwell Sayle (Miss Stephenson). The screenplay, by Mr. Cohen and John Byrum, presents Fiona at first as brittle and unpleasant. But she is soon saying things like: "You belong to an endangered species, Frank. You've got a good heart."

•

Mr. Cohen has assembled a strong cast and elicited performances ranging from adequate to embarrassing. Mr. Gielgud, who also turns up as a Japanese businessman, projects a fine, sporting professionalism and no strong interest in the nonsense that is going on around him. Mr. Hays seems affable but a little bland. Miss Stephenson is energetic and pretty, but the overabundant disguises rob her of any distinct personality; you might

not recognize her if she were wearing a raincoat in another film. Jim Dale, as a seemingly moronic police inspector, has an awful role. He is not helped by comparisons with the young Laurence Olivier, whose photograph hangs prominently in his Scotland Yard office.

•

"Scandalous" is rated PG ("Parental Guidance Suggested"). It contains some strong language and sexual innuendoes.

1984 Ja 20, C4:5

Mystery Revealed

CONFIDENTIALLY YOURS, directed by François Truffaut; screenplay (French with English subtitles) by Mr. Truffaut, Suzanne Schiffman and Jean Aurel, from "The Long Saturday Night" by Charles Williams; cinematography by Nestor Almendros, Florent Bazin and Tessa Racine; edited by Martine Barraque and Marie-Aimée Debril; music by Georges Delerue; a production of Les Films du Carosse/Films A2/Soprofilms; released by International Spectrafilm Distributors Inc. At the Paris, 58th Street, west of Fifth Avenue. Running time: 111 minutes. This film is rated PG.

Barbara Becker	Fanny Ardant
Julien Vercel	Jean-Louis Trintignant
M. Clement	Philippe Laudenbach
Marie-Christine Vercel	Caroline Sihol
Commissioner	Philippe Morier-Genoud
Bertrand Fabre	Xavier Saint Macary
Jacques Massoulier	Jean-Pierre Kalfon
Eden Cinema cashier	Anik Belaubre
Louison	Jean-Louis Richard
Angelface	Yann Dedet
Female shalsher	Nicole Felix
Detective Lablache	Georges Koulouris
Policeman Jambrau	Roland Thenot
Inspector Poivert	Pierre Gare
Slavic Reveler	Jean-Pierre Kohut-Svelko
Secretary	Pascale Pellegrin

By VINCENT CANBY

IF you terrifically admire the work of a particular director, as I admire the films of François Truffaut, who has made more certifiable classics than any other French director of his generation, with the exception of Jean-Luc Godard, you tend to feel he's obliged always to equal if not to top himself. That's not being reasonable or fair, but it explains the special disappointment when a new work doesn't measure up to expectations.

This is pretty much my reaction to Mr. Truffaut's latest comedy, "Confidentially Yours" (titled "Vivement Dimanche" in France), which opens today at the Paris Theater.

"Confidentially Yours," based on Charles Williams's American mystery novel "The Long Saturday Night," is a bright, knowing, somewhat too affectionate variation on the sort of bloodless murder mysteries that were as much a staple of Hollywood production schedules in the 1930's and 40's as they were of the lending libraries of that era. It falls somewhere between the Nancy Drew stories and the film adventures of Nick and Nora Charles that were spun off from Dashiell Hammett's "Thin Man."

•

Barbara Becker, played by the dark-haired, full-lipped, ravishingly beautiful Fanny Ardant, the star of Mr. Truffaut's "Woman Next Door," is the wise, sarcastic, self-assured secretary to Julien Vercel (Jean-Louis Trintignant), a real-estate broker in a small town in the south of France. When, in the course of several hours, Julien's wife's lover is found murdered and then his wife, Julien becomes the chief suspect.

Because he must go into hiding, it is Barbara who becomes the amateur gumshoe who clears her boss, an assignment she accepts even though Julien has just dismissed her. The dismissal is, of course, a joke. Barbara has secretly loved Julien for months, even though she's aware that he prefers cheeky, rather cheap-looking blondes to classic brunettes with heads on their shoulders.

That the mystery of "Confidentially Yours" isn't especially mysterious is not important. The adventures of Nick and Nora Charles never exactly freighted the brain, but they had style and, as played by the incomparable William Powell and Myrna Loy, the amateur detectives were hugely appealing. What I find most mysterious about "Confidentially Yours" is the attraction the piece has obviously had for Mr. Truffaut.

•

In earlier films like "Shoot the Piano Player," "The Bride Wore Black" and the vastly underrated "Mississippi Mermaid," he has transformed not especially promising pulp fiction into films of a unique wit, style and perspective, movies that discovered levels of feeling and intel-

Fanny Ardant in François Truffaut's "Confidentially Yours."

ligence that had nothing to do with the source material.

In "Confidentially Yours," Mr. Truffaut has not made any kind of comment on the original fiction. Rather he has re-created it without adding anything of particular interest, except a series of references to other movies and movie makers he has admired. There is absolutely no sense of the cosmic void that in the past has set off even the sweetest of Mr. Truffaut's comedies, including "Stolen Kisses." Unlike his "Last Metro," which managed to be both a romantic melodrama and a series of comments on romantic melodrama, this film is so flat and perfunctory that, in my shock, I have the terrible feeling I've missed the point.

•

Though "Confidentially Yours" means, I think, to be romantic, there is virtually no visible rapport between Miss Ardant and Mr. Trintignant, who is also an attractive performer. For reasons I don't understand, their scenes together seem less romantic than worrying. One is aware that the director's sense of fun is not reaching the screen, so all that one is conscious of are two good actors more or less playing down to tiny characters. The impulse then is to take them and their absurd situations far more seriously than anyone intended.

Next to the spirited, sexy performance by Miss Ardant, the best thing in the movie is the almost comically functional black-and-white photography by Nestor Almendros.

No Truffaut film is without its gloriously funny touches, but the ones in "Confidentially Yours" are a series of isolated smiles of recognition, leading nowhere.

1984 Ja 20, C6:1

Jean-Louis Trintignant finds himself a murder suspect in "Confidentially Yours," a salute by François Truffaut to the style of American films in the 1940's. Fanny Ardant co-stars as the "Girl Friday" who tries to clear his name.

Farce in Greece

JUPITER'S THIGH, directed by Philippe de Broca; screenplay (French with English subtitles) by Mr. de Broca and Michel Audiard; cinematography by Jean-Paul Schwartz; edited by Henri Lanoe; music by Georges Hatzinassios; produced by Alexandre Mnouchkine, George Dancigers and Robert Amon; a co-production of Les Films Ariane and Mondex Films; distributed by Quartet/Films Inc. At the Thalia, 95th Street, near Broadway. Running time: 96 minutes. This film is rated PG.

Lise Tanquerelle......................Annie Girardot
Antoine LemercierPhilippe Noiret
Hubert PochetFrancis Perrin
Agnes PochetCatherine Alric

"**J**UPITER'S THIGH," which opens today at the Thalia, is one of those so-called lost films that wasn't desperately in need of discovery. It is Philippe de Broca's 1979 sequel to his 1978 French farce, "Dear Detective," in which Annie Girardot, as a funnily two-fisted Paris police inspector, was courted by a womanizing, somewhat pompous professor of Greek, played by Philippe Noiret.

At the beginning of "Jupiter's Thigh," Lise Tanquerelle (Miss Girardot), having just made a big drug bust, is late for her wedding to Antoine Lemercier (Mr. Noiret), at which the officiating priest blesses the match as a union of law and order with academe. That may be the high point.

•

The rest of the film, which takes place during the couple's honeymoon in Greece, is a frantically staged farce, in which the newlyweds attempt to help a young French archeologist (Francis Perrin) and his flighty wife (Catherine Alric) recover a priceless bit of ancient Greek sculpture, originally discovered by the archeologist. There are a couple of murders, endless chases and some frightfully colorful scenery and subsidiary characters, all Greek.

Mr. de Broca, like his countryman, Claude Lelouch, has made some funny, charming comedies in the past, but when he makes bad films, like this one, you begin to suspect that he and Mr. Lelouch are, in fact, the same person. "Jupiter's Thigh" is undistinguished and indistinguishable from any number of other de Broca and Lelouch comedies, a number of which have starred the capable Miss Girardot and Mr. Noiret.

"Jupiter's Thigh," which is rated PG ("Parental Guidance Suggested"), contains some partial nudity.

Vincent Canby

1984 Ja 20, C6:5

Small-Town Invasion

THE LOVELESS, written and directed by Kathryn Bigelow and Monty Montgomery; director of photography, Doyle Smith; film editor, Nancy Kanter; music by various composers; produced by Grafton Nunes and A. K. Ho; released by Atlantic Releasing. At the Waverly, Avenue of the Americas and Third Street. Running time: 84 minutes. This film is rated R.

Tarver ..J. Don Ferguson
Vance..Willem Dafoe
Telena ..Marin Kanter
Davis ...Robert Gordon
Debbie ...Tina L'Hotsky
La VilleLawrence Matarese
Ricky ...Daniel Rosen
HurleyPhilip Mont Kimbrough
Buck ..Ken Call

"**I**T'S a terrible thing, being born too late. "The Loveless," a pathetic homage to the 1950's, has been made by two writer-directors, Kathryn Bigelow and Monty Montgomery, who share an unmistakable longing for that era. But their

nostalgia expresses itself no more interestingly than through a lot of silly, lifeless posturing, plus the use of colors like chartreuse.

This movie, a slavish homage to "The Wild One," is full of peach and aqua luncheonette scenes, which give it some minuscule visual edge over the original. But otherwise, it's no improvement. Its evocation of tough-guy glamour is ridiculously stilted. ("This endless blacktop is my sweet eternity," says the not-very-Brandoesque hero.) And it regards the past with absolutely no perspective or wit.

"The Loveless," which opens at the Waverly today, has more to do with fashion than with film, and even in that respect it seems a little ludicrous. The motorcycle toughs who come tearing into a small town — actually, no one moves very quickly in this painfully slow exercise — are dressed in white T-shirts and black leather, to be sure. But in this day and age, they're fops rather than menacing invaders.

They are led by Vance (Willem Dafoe), who spends a lot of time zipping and unzipping his jacket expressively and who presumably embodies the ultimate in tough chic. The closest Vance comes to expressing any emotion is when another character commits the hippest act he can imagine. It's suicide, and Vance, while a little bit sorry, is mostly impressed.

Along with colors and music that evoke the 50's (Robert Gordon, callow and pouty as one of the gang members, also provided a couple of the songs), the film makers have incorporated the good old sexism of that period. The gang includes one blonde, played by Tina L'Hotsky, who talks and dresses as nastily as the others, but also functions as an all-purpose moll. And the movie's heroine, a pretty local girl named Telena (Marin Kanter), sneers at Vance as a prelude to sleeping with him.

Janet Maslin

1984 Ja 20, C8:5

FILM VIEW

VINCENT CANBY

'El Norte': A Fine Movie Fueled by Injustice

In 1973 Gregory Nava, a young graduate of the Film School of the University of California at Los Angeles, produced, photographed, directed, edited and, with Anna Thomas, his wife, wrote a most unusual, neo-Bressonian medieval romance called "The Confessions of Amans." The movie, which had a brief release here in 1977, was produced in Spain for less than $20,000, with a small cast and with costumes and props left over from Samuel Bronson's "El Cid."

"The Confessions of Amans" was a very beautiful film, though not an especially pretty one, a chilly, tightly disciplined tale of the tragic love affair of a young philosophy tutor and the wife of the lord of the manor. Like the great Robert Bresson, Mr. Nava appeared to be less interested in the heat of the passion of the lovers than in the succession of moral choices their passion represented. Everything in "The Confessions of Amans" was seen at a distance, as if being reconstructed — with as little distortion as possible — from official records.

Now with "El Norte," a far more elaborate as well as a more conventional film, Mr. Nava and Miss Thomas are again demonstrating their remarkable technical proficiency — on an apparently modest budget — in a story of far greater immediacy.

"El Norte" is not exactly a great film, but it's a very good one that, through the devices of fiction, manages to provoke a number of healthily contradictory feelings about the world we all inhabit at the moment. I don't think it means to be especially political but, in its way, it makes far more political sense than something like "Under Fire," with which it shares certain Central American roots, though the two films are otherwise not alike at all.

• • •

"El Norte" has something of the manner of a wonderful and terrible fable, being a record of the adventures of two young Guatemalan Indians, a brother and sister who must flee their mountain village after their father is murdered for antigovernment activities and their mother is imprisoned. Believing in the pictures they've seen in old copies of Good Housekeeping, which report that even the lowliest United States peons have flush toilets and TV sets and that no one is too poor not to own an automobile, they walk and ride their way north through Mexico to Tijuana and, finally, to Los Angeles.

Until its arbitrarily tragic ending, "El Norte" seems about to make one of the most boldly original and satirical social-political statements ever to be found in a film about the United States as a land of power as well as opportunity.

Until the film's last few sequences, life in Los Angeles is everything that Enrique and Rosa had imagined it would be. Enrique, bright, good-looking and eager, works his way up from busboy to "waiter's assistant" in an elegant Beverly Hills restaurant. Rosa, though baffled by things like computerized washing machines, finds a decently paying job as a cleaning woman for a rich lady who

positively aches with concern for the world's underprivileged.

However, the real and most poignant point of "El Norte" is not the tragedy that befalls the brother and sister, but the ease and the eagerness with which, after their initial homesickness, they adapt themselves to the gringo world. There may not be that much gold in the streets here any longer, but the plastic society enchants them.

I know it's not a reviewer's place to tell a moviemaker how his film should have been made, but Enrique and Rosa's simply detailed, totally cheerful denial of their ancient roots would, I think, have been far more devastating than the melodrama that overtakes "El Norte" like a severe cold.

Until that happens, "El Norte" has much of the somber sweetness of the story of Hansel and Gretel, transplanted to Central and North America in the 1980's. Unlike "Under Fire," it doesn't muse woozily on — and at a safe emotional distance from — the injustices suffered by the peasants and all of the other poor in a repressive society of economic exploitation. Nor does it use those injustices more or less as a device of dramatic convenience, to raise the consciousnesses of visiting Yankees. "El Norte" demonstrates those injustices in terms as vivid and as arresting as the spectacular landscapes.

• • • •

Mr. Nava obviously adores a lot of this picturesque footage more than is absolutely necessary to make his point, but this is one film in which a certain amount of picturesqueness is called for, certainly if the northward journey of Enrique and Rosa is to have visual as well as dramatic impact. The director also has an unfortunate fondness for dreams and apparitions that are not sufficiently interesting or even bizarre, but "El Norte" becomes increasingly more self-assured — that is, better — as the brother and sister travel north.

Unlike Vittorio and Paolo Taviani, the directors of "The Night of the Shooting Stars," which has just been named the best movie of 1983 by the National Society of Film Critics, Mr. Nava does not patronize his "little people." This has something to do with the straight, unactorly quality of the performances, especially by Zaide Silvia Gutierrez as Rosa and David Villalpando as Enrique, two splendid Mexican actors. It also is a reflection of the filmmaker's attention to immediate dramatic detail, which doesn't allow for too much time for editorializing about faith, love, courage, good and evil — abstractions that have broken the back of more than one small, would-be serious film.

Though "El Norte" is more specific in satirizing American society than it is in exploring the basic issues of Latin American unrest, it is timely in a way that major movie producers dream that their films will be, though they seldom are. It is so timely, in fact, that when I came out of the Baronet Theater, where I saw "El Norte" last week, a man was waiting on the sidewalk to give depart-

ing patrons handbills announcing the new program at the Film Forum.

● ● ●

This program, which opened Wednesday, consists of two angrily effective documentaries, "Where the Mountains Tremble," a feature dramatizing the background of the Guatemalan political scene that is the basis for "El Norte," and "Nicaragua: Report from the Front," a 32-minute film update on attempts to overthrow the Sandinista Government. Among other things, "Nicaragua: Report from the Front" includes footage shot by the filmmakers who joined a raid by "contras," the Honduras-based rebels, into Nicaraguan territory adjacent to Honduras. Pamela Yates and Thomas Sigel are the directors of "When the Mountains Tremble" and Mr. Sigel and Deborah Shaffer the directors of "Nicaragua."

"El Norte" and the two documentaries go well together.

1984 Ja 22, II:17:1

Two Mothers

ENTRE NOUS, directed by Diane Kurys; screenplay (French with English subtitles) by Miss Kurys; photography by Bernard Lutic; edited by Joele Van Effenterre; music by Luis Bacalov; produced by Ariel Zeitoun; released by United Artists Classics. At Cinema Studio 1. Running time: 110 minutes. This film has no rating.
Madeleine Miou Miou
Lena .. Isabelle Huppert
Michel Guy Marchand
Costa Jean-Pierre Bacri
Raymond Robin Renucci
Carlier Patrick Bauchau
Monsieur Vernier Jacques Alric
Madame Vernier Jacqueline Doyen
Florence Patricia Champane
Sophie Saga Blanchard
Rene Guillaume de Guellec
Sarah Christine Pascal

"Entre Nous" was shown as part of last year's New York Film Festival. Following are excerpts from Vincent Canby's review that appeared in The New York Times on Oct. 8. The film opens today at the Cinema Studio 1, Broadway and 66th Street.

NEITHER of Diane Kurys's two previous films, "Peppermint Soda" (1977) and "Cocktail Molotov" (1980), gives any hint of the wonderfully sustained artistry that she demonstrates in "Entre Nous," her very personal, moving new film that places her among those in the forefront of the commercial French cinema.

"Entre Nous," which is titled "Coup de Foudre" in France, is something like Lawrence Kasdan's "Big Chill" in that it has the looks and manner of a conventional film but, in addition, has the sort of intelligence that seldom survives the smog of compromises in conventional film making.

Because "Entre Nous" is mainly about the friendship of two quite different women, each of whom eventually takes charge of her own life, the film may be in danger of being labeled feminist, which I suppose it is, at least in part. However, because the term is usually applied to consciousness-raising literature as glumly represented by films like Agnes Varda's "One Sings, the Other Doesn't," the term doesn't do justice to the specific idiosyncracies of Miss Kurys's work.

●

"Entre Nous" is not the sort of film that soothes by supplying upbeat answers. It doesn't have answers of any kind. Like all serious works of narrative fiction, it examines people in particular situations and makes some speculations about what it finds. After that, it's for each of us to interpret according to his own circumstances.

The time is 1942. Lena (Isabelle Huppert), a young Belgian Jew, is interned in southern France awaiting deportation to Germany. Unknown to

her, she has caught the eye of a camp worker, Michel (Guy Marchand), a French Legionnaire, also Jewish, who is soon due for discharge. In a note slipped to her one day inside a piece of bread, Michel proposes to Lena. If she marries him, he writes, she'll be allowed to leave the camp. It's not especially romantic, but Michel is young and presentable and Lena is practical. She accepts.

Intercut with these early, tragi-slapstick adventures of Lena are scenes of the courtship and marriage of the bourgeois Madeleine (Miou Miou), an art student whose young husband is killed in a partisan raid just a few months after their marriage.

The film then cuts forward to 1952 in Lyons, where Lena now lives with her two small daughters and the attentive hard-working Michel, who has become the prosperous owner of a garage. One afternoon at a grade-school pageant, Lena meets Madeleine, now a mother with a small son and married to a good-looking rather feckless fellow named Costa (Jean-Pierre Bacri), a would-be actor.

"Entre Nous" is the minutely detailed story of the rare friendship that develops between the two women over the next few years as each faces a succession of crises that, at last, alter their lives. Lena, the more conventional of the two, slowly grows from a prematurely dowdy duckling into a sleek, smart, self-assured woman. She has never been in love with Michel, but they seem to have an exceptionally good marriage. They amuse each other and both are genuinely delighted in their children.

Madeleine's life with Costa is a good deal more bleak. He gets into one financial scrape after another, and the childish ways that once amused her are no longer funny. She's bored with Costa, sorry for — and a little bored by — her shy son, and wants desperately to start life over, preferably in Paris.

●

"Entre Nous" is not a movie-as-short story. It's a novel-sized film, the kind that is so perfectly realized in vivid incidents that, not until the end does one realize how big it is and how effortlessly it has covered so much social and psychological territory.

Like Mr. Kasdan, Miss Kurys is a first-rate writer with a director's vision and command of technique. The first quarter of the film — before Lena and Madeleine meet in Lyons — is virtually all exposition, but it is not only packed with detail, it is almost breathlessly suspenseful.

As admirable as the film's clear, unsentimental, long view of things are the beauty and the humor of many of its seemingly throwaway moments. It's marvelous about both the boredom and the joys of family life, about minor crises (when a child locks himself in a bathroom), and major ones, when, at last, a marriage is finally, irrevocably over. Late in the film there is a short but momentous scene aboard a night train to Paris that is stunning in its economy.

Miou Miou is an entirely new screen personality as the gravely pretty dark-haired Madeleine. In the

central role of Lena, which Miss Kurys says is based on her own mother, Miss Huppert is superb, better than she has been in years — strong, funny, self-assured.

1984 Ja 25, C17:5

Creative Endurance

AND THE SHIP SAILS ON, directed by Federico Fellini; original idea and screenplay (Italian with English subtitles) by Mr. Fellini and Tonino Guerra; photography by Giuseppe Rotunno; edited by Ruggero Mastroianni; music by Gianfranco Plenizio; lyrics by Andrea Zanzotto; produced by Franco Cristaldi for R.A.I.; released by Triumph Films. At Cinema 1, Third Avenue at 60th Street. Running time: 128 minutes.
Orlando Freddie Jones
Ildebranda Cuffari Barbara Jefford
Aureliano Fuciletto Victor Poletti
Sir Reginald J. Dongby Peter Cellier
Lady Dongby Norma West
Dorothy Sarah Jane Varley
Grand Duke of Harzock Fiorenzo Serra
Princess Lherimia Pina Bausch
Count of Bassano Pasquale Zito
Prime Minister Philip Locke
Edmea Tetua Janet Suzman

By VINCENT CANBY

THOUGH the occasion of Federico Fellini's "And the Ship Sails On" initially seems somber, the film often looks like a joyful act of cinematic prestidigitation. At its best moments "And the Ship Sails On" floats serenely above the realities of ordinary movies — not to deny the validity of those realities but to expand the imagination.

Like "Amarcord," Mr. Fellini's new work is enchantingly stylized, a bold testament to the artifice of studio-made movies, which the one-time neo-realist director ("La Strada," "Nights of Cabiria") now makes his message as well as his style. Unlike "Amarcord," however, "And the Ship Sails On" has no easily recognizable, visible center, which may be off-putting even to Fellini aficionados. It's not a film about anything as specific as childhood memo-

Isabelle Huppert and Miou-Miou star in "Entre Nous," Diane Kurys's film about the friendship of two women who first met as children during World War II.

ries. Rather, it's a succession of mostly comic commentaries on art and artists, whose self-absorption Mr. Fellini finds both wickedly funny and very moving.

•

The time is July 1914, less than three weeks after the assassination of the Archduke Francis Ferdinand by a Serbian nationalist at Sarajevo, the event that was to serve as the pretext for the start of World War I.

The occasion is a memorial cruise aboard a marvelously fantastic luxury liner, whose passengers have come together to honor the art of a recently deceased diva named Edmea Tetua. In the course of the cruise, the climax of which is to be the ceremonial spreading of the diva's ashes on the waters off the Adriatic island of her birth, the passengers bicker, make love and indulge their furious rivalries to the hilt. They include vain tenors, imperious sopranos, conductors with secret sex lives, some of the diva's former lovers, as well as an obsessed Italian count, who has turned his cabin into a museum stuffed with memorabilia, and an androgynous Austro-Hungarian archduke and his blind sister, the Princess.

The comparative tranquillity of the cruise is broken on the second day when the liner picks up a large group of Serbian refugees, including some who may well be terrorists. At first the elegant passengers tend to be gracious to the poor refugees, who, after a bit, attempt to take over first class. That, of course, is going too far. The refugees are quickly dispatched to the lower decks.

The plot, if one can call it that, also involves a homesick rhinoceros being shipped to an Amsterdam zoo, and an Austro-Hungarian battleship, whose captain demands the return of the Serbian refugees. This, in turn, prompts Mr. Fellini to give us his version of the events that led to war.

This is more or less the outline of the film, which doesn't depend for 10 seconds on anything as conventional as identifiable characters or a narrative. Nor, in fact, is the film very much concerned with the imminent demise of one civilization and birth of another. The film is not a farewell, either to an era or a diva, but it is about the mysterious endurance of the creative impulse, which the film maker appears to equate with mankind's capacity for survival. That, however, may be to weight the show with more than Mr. Fellini ever intended.

I use the word "show" for a purpose. "And the Ship Sails On" is more like a circus than an ordinary movie, though the characters are drawn mostly from the world of grand opera. The show's ringmaster is an ebullient, middle-aged journalist called Orlando (Freddie Jones), who often talks directly to the camera and who invites us to share his asides about the lunacies we are watching.

Among these lunacies is the film's dazzling opening sequence in which we witness the passengers' arrivals at dockside, prior to boarding the liner Gloria. The movie begins as a sepia-tinted silent film, accompanied only by the whirr of the ancient projector. As the images slide into color, so does the sound come up. At the end of the sequence, one of the conductors on hand leads the passengers, the crew, the dockworkers and everyone else within the film frame in a hilariously solemn pastiche that appears to have been put together from bits and pieces of Verdi's "Forza del Destino," with new lyrics by Andrea De Carlo.

In "And the Ship Sails On" Mr. Fellini does to a number of favored opera scores what he does to the reality of conventional movies. He turns those scores upside down and inside out, adding new lyrics when it pleases him and, in general, doing the kind of outrageous acts that must be designed to offend all purists. Some of this is very funny, as in a sequence in which the ship's captain takes his noted passengers below to see the boiler room. When one of the stokers asks for a song, one tenor obliges, only to be joined in a fearful competition by another tenor and, eventually, by all of the other singers on hand.

There are also sequences that seem to be unnecessarily opaque, one of

Freddie Jones as Orlando, ringmaster of Fellini's "And the Ship Sails On."

which involves the princess and her brother's prime minister. Some important characters appear suddenly in the middle of the movie and as suddenly disappear. One of these is a mad Russian opera star who claims he can hypnotize a chicken simply by singing to it, which he does.

Though the movie has its share of lost moments, it is constantly being brought up to new peaks of pleasure in ways that only Mr. Fellini can carry off. At least a half-dozen of these equal anything in the somewhat more consistent "Amarcord."

•

The cast, as is usual in a Fellini film, is an odd assortment of international actors. They have been chosen primarily for the way they look since all of the dialogue, as is also Mr. Fellini's custom, has been post-synchronized in an Italian that, much of the time, doesn't fit the lip movements.

In addition to Mr. Jones, the cast includes Barbara Jefford, as an especially handsome diva who wants to succeed the dead Edmea Tetua; Janet Suzman, who is seen as Edmea in some short film clips, and Peter Cellier, as an English conductor who finds pleasure in his wife's infidelities. It's difficult to comment on the performances, principally because actors in a Fellini film exist to be moved about and photographed as the director sees fit, which, I suspect, has less to do with acting than with behavior and, possibly, patience.

Far more important to the film's ultimate effect are the contributions of Giuseppe Rotunno, Mr. Fellini's

favorite cameraman; Dante Ferretti, the art director, and Maurizio Millenotti, the costume designer.

"And the Ship Sails On," which opens today at the Cinema 1, is to most movies what the Folies-Bergère was to the theater, a celebration of spectacle, even when it exists only for its own sake.

•

"And the Ship Sails On," which has been rated PG ("Parental Guidance Suggested"), includes some mildly suggestive sexual sequences.

1984 Ja 26, C17:1

7the Avenue Stories

BROADWAY DANNY ROSE, directed and written by Woody Allen; director of photography, Gordon Willis; edited by Susan E. Morse; music by Dick Hyman; produced by Robert Greenhut; a Jack Rollins and Charles H. Joffe Production; released by Orion Pictures Corporation. At the Beekman, 65th Street and Second Avenue; 34th Street Showplace, between Second and Third Avenues; New Yorker 1 and 2, Broadway and 88th Street and other theaters. Running time: 84 minutes. This film is rated PG.
Danny Rose Woody Allen
Tina Vitale Mia Farrow
Lou Canova Nick Apollo Forte
The Comics
 Sandy Baron, Corbett Monica, Jackie Gayle,
 Morty Gunty, Will Jordan, Howard Storm, Jack
 Rollins, Milton Berle
Ray Webb Craig Vandenburgh
Barney Dunn Herb Reynolds
Vito Rispoli Paul Greco
Joe Rispoli Frank Renzulli
Johnny Rispoli Edwin Bordo
Johnny's Mother Gina Deangelis

By JANET MASLIN

THE tale of "Broadway Danny Rose" unfolds in the Carnegie Delicatessen on Seventh Avenue, a place previously better known for pastrami than for storytelling. As Danny's exploits are revealed, by a borscht belt Scheherazade who shares the details with a group of fellow comics, it becomes clear that this is the perfect setting for Woody Allen's new fable. The skating penguins and singing parrots who are Danny's clients (he is an agent and personal manager) would fit right into this utterly show-biz locale. So would Danny himself, as the apotheosis of chintzy, small-time theatricality, and as one of the funniest and most touching characters Mr. Allen has yet created.

Danny Rose, we learn from the storytellers (who include Sandy Baron, Corbett Monica, Jackie Gayle and Will Jordan), had a specialty: handling talent of the iffiest caliber. ("I'll let you have her at the old price, which is anything you want to give her," he wheedles in one of the film's many flashbacks, negotiating a deal

for a woman who plays melodies on water glasses.) Danny's roster includes his balloon act, his blind xylophone player and his hypnotist ("I promise you, if your wife never wakes up again, I'll take you to the restaurant of your choice — do you like Chinese food?" Danny diplomatically asks the husband of a woman in an irreversible trance.) His one marginally reputable client is Lou Canova, an over-the-hill singer who once had a hit record ("Agita") about indigestion.

It was Lou Canova who launched Danny on his remarkable adventure, the one on which this graceful and hilarious movie focuses. It began, innocently enough, with Lou's comeback engagement at the Waldorf-Astoria, which Danny had miraculously arranged. He had coached Lou in every detail ("Don't forget to do 'My Funny Valentine,' with the special lyrics about the moon landing!"), but Lou wanted one thing more: he wanted his mistress, Tina Vitale, to be there. So Danny was sent to fetch Tina in New Jersey. It should have been a simple errand. Why, then, did it lead to a curse on Danny's head and a contract on his life?

"Broadway Danny Rose," which opens today at the Beekman, the New Yorker and Loew's 34th Street Showcase, proceeds so sweetly and so illogically that it seems to have been spun, not constructed. Mr. Allen works with such speed and confidence these days that a brief, swift film like this one can have all the texture and substance of his more complicated work. Like almost all of his films, this one is a romance at heart, with some of the obligatory images (a walk along a pier in the later afternoon; a long shot of a couple strolling through the woods) that have become part of his romantic idiom. But the love story here is so ingeniously submerged that the characters never express their feelings directly. The closest thing here to a boudoir scene takes place in a warehouse, with the two principals fully clothed, tied together, barely acquainted, very embarrassed, and nonetheless experiencing an attraction that they will remember long after the adventure is over.

Considering the peculiarities of the characters they play, the film's stars — Mr. Allen as Danny, Mia Farrow as Tina, and Nick Apollo Forte as Lou Canova — act in an amazingly natural style. A certain amount of handwaving goes with Mr. Allen's role (as do costumes combining multiple plaids, and the habitual use of the words "sweetheart" and "darling").

Photoreporters/Brian Hammil

Woody Allen and Mia Farrow in "Broadway Danny Rose."

But he brings such gentleness and understatement to this performance that it's one of his very best. As for Miss Farrow, her comic talents here are a revelation. In tight pants, teased hair and dark glasses, screaming in fluent Brooklynese about Lou's rumored tryst with "a cheap blonde," Tina is hardly recognizable as Miss Farrow when Danny first meets her. The accent is perfect, and well sustained; the outfit is so brilliantly ghastly that it somehow makes her look all the more ravishing.

As the unsentimental widow ("He had it comin'!") of a man with unmistakable mob connections, Tina has her own hard-nosed credo, which she voices midway through the story: "You know what my philosophy of life is? It's over quick, so have a good time. You see what you want, go for it. Don't pay any attention to anybody else. And do it to the other guy first, 'cause if you don't he'll do it to you." By the end of the story, though, she is ready to voice the values of one of Danny's innmerable uncles: "Acceptance. Forgiveness. Love."

Mr. Forte, who was himself a singer of the ruffled-shirt school when recruited for the movie, is an absolute natural. He blusters through his role with the absolute confidence that is the essential — perhaps the only — ingredient in Lou's mystique. In addition to giving a performance that goes a long way toward making the film credible, Mr. Forte has written "Agita," a supremely awful song that, strange to say, you might just find yourself humming on the way home.

Among the most gratifying things about "Broadway Danny Rose," which is one of Mr. Allen's more modest films but also one of his very best, is the level of ensemble work that has been achieved by his familiar behind-the-scenes team. The costumes, this time by Jeffrey Kurland, and the production design, by Mel Bourne, are subtly hilarious throughout. The casting director, Juliet Taylor, has recruited a memorable gallery of bit players (among them is Gerald Schoenfeld of the Shubert Organization, playing an agent much shrewder than Danny Rose.) Dick Hyman's score and Susan E. Morse's editing are perfectly apt. And Gordon Willis, again working in black and white, manages to do exquisite photographic work in some very unlikely places — a diner, a warehouse filled with helium balloons, a dinner party at which one guest is a bird wearing a dress and bonnet. Even the swamps of New Jersey look beautiful.

•

"Broadway Danny Rose" is rated PG ("Parental Guidance Suggested.") It contains occasional off-color language, but it ought to be suitable for most children.

1984 Ja 27, C8:1

Wrong Is Right

LOVE LETTERS, directed and written by Amy Jones; director of photography, Alec Hirschfeld; edited by Wendy Greene; music by Ralph Jones; produced by Roger Corman; released by New World Pictures. At the Embassy 72d Street, at Broadway. Running time: 94 minutes. This film is rated R.
Anna ..Jamie Lee Curtis
Oliver ..James Keach
Wendy ..Amy Madigan
Danny ..Bud Cort
Mr. Winter ..Matt Clark
Mrs. WinterBonnie Bartlett
Ralph ...Phil Coccioletti
Edith ...Shelby Leverington
Chesley ..Rance Howard
Marcia ..Betsy Toll
Sally ...Sally Kirkland

By VINCENT CANBY

"LOVE LETTERS" is about the brief, unhappy affair of an independent young single woman and a happily married man. It's one of those affairs that absolutely everyone knows to be doomed from the start, including the audience.

The film, however, does have one compensation — the appearance of Jamie Lee Curtis as Anna Winter, the obsessed heroine who, through Miss Curtis's performance, is a lot more interesting than she otherwise has any right to be.

Miss Curtis is an arresting screen presence who, having survived such scare-and-scream films as "Halloween," "Prom Night," "Terror Train" and "Halloween II," has made just one major film to date, "Trading Places." She deserves more, certainly more than "Love Letters," which would be even mushier than its title were it not for her. As the clean, precise bone structure of her face cuts through the fuzzily romantic camerawork, her direct, no-nonsense manner and style give the film a sense of urgency not evident in anything else.

Amy Jones both wrote and directed the screenplay about the desperate love of Anna Winter, a disk jocky on a small, listener-sponsored radio station, for Oliver Andrews (James Keach), a successful Los Angeles commercial photographer. Oliver never attempts to hide his marital state from Anna, who, as the affair progresses, becomes convinced that, as the screenplay puts it more than once, "there are times when it's right to do wrong." Anna demands that Oliver give up his wife and children and marry her.

Helping to convince Anna that such drastic action is correct are some old love letters she has found, written to her now-dead mother years before by the ideal lover that Anna's father never was. Along with a lot of soupy Chopin, we hear on the sound track much of the text of these letters, which, I think, are meant to be moving though, more often than not, they are simply unfortunate. How else to describe the letter-writer's declaration to his mistress, "Together we are more than the sum of our parts"?

Miss Jones even borrows clichés, as in a scene in which Anna and a friend go to see "From Here to Eternity" and hear Deborah Kerr whisper into the ear of Burt Lancaster, "I never knew it could be like this."

•

Mr. Keach is not at all bad but the material doesn't help him. Miss Jones looks to be a far better director — one with a good sense of time and place and the way these characters might live — than writer. The screenplay is a hoot.

The supporting cast includes Bud Cort, who plays a spaced-out disk jocky; Amy Madigan, as Anna's best friend, and Shelby Leverington, as Oliver's understanding wife. The movie opens today at the Embassy 72d Street. It's R-rated, mostly, I guess, because of a lot of artily photographed sex scenes, including some photographed as if the camera were a mirror on the ceiling.

1984 Ja 27, C14:1

Steve Martin in Arthur Hiller's "Lonely Guy's Book of Life."

THE LONELY GUY, produced and directed by Arthur Hiller; screenplay by Ed Weinberger and Stan Daniels; adaptation by Neil Simon, based on the book "The Lonely Guy's Book of Life" by Bruce Jay Friedman; director of photography, Victor J. Kemper; edited by William Reynolds and Raja Gosnell; music by Jerry Goldsmith; released by Universal Pictures. At the Gemini, 64th Street and Second Avenue; Rivoli, Broadway and 49th Street; Orpheum, 86th Street and Third Avenue, and other theaters. Running time: 93 minutes. This film is rated R.
Larry ...Steve Martin
Warren ...Charles Grodin
Iris ..Judith Ivey
Jack ..Steve Lawrence
Danielle ...Robyn Douglass
Merv Griffin ...Merv Griffin
Dr. Joyce BrothersDr. Joyce Brothers
Schneider TwinsCandi Brough, Randi Brough

By JANET MASLIN

Bruce Jay Friedman's "Lonely Guy's Book of Life" didn't have any plot to speak of. The film version doesn't either, though not for lack of trying. If you can get past the movie's aimlessness and its visual drabness, it has its share of isolated laughs. Steve Martin fits right in to the sad-sack role of the title, playing a dateless greeting-card writer who can't believe his ill fortune.

Fortunately, he finds someone to talk to. At the beginning of "The Lonely Guy," which opened yesterday at the Rivoli and other theaters, Mr. Martin's Larry comes home to find his girlfriend in bed with another man. He's perfectly willing to ignore this ("This your cigar here, honey?" he asks innocently), but she is not. Larry is sent packing, and given the garbage to take out with him. He winds up on a park bench holding all his meager possessions. There, he is joined by another lonely guy named Warren (Charles Grodin), who shows him the ropes.

•

Helped by Warren, who in his rumpled sweaters and crooked glasses is the embodiment of pure depression, Larry learns to sit around and complain. "Look at that guy, he's got a girl. He wasn't born with his arm around her — he must have met her *somewhere!*" Larry grouses. Warren, who is losing his hair, complains that it costs him as much to get a haircut as it does someone like Michael Landon. Together, Larry and Warren give a party that is populated entirely by huge cardboard cutouts of famous people. When the only live guests arrive — the police, who've come to make them turn the music down — they are most impressed with this setup. "Do you know if they've got Gene Hackman?" one officer asks, wanting to rent the same fake friends.

"Yes they do, but you have to reserve him a week ahead," Warren says.

When it strikes this deadpan tone, "The Lonely Guy" can certainly be funny; the idea of a New York in which bachelors bellow from the rooftops for their lost girlfriends or drop like flies off the Manhattan Bridge, has its bleak appeal. Unfortunately, the screenplay, which is by Ed Weinberger and Stan Daniels from an adaptation by Neil Simon, doesn't even begin to sustain this droll humor. It involves Larry in a silly love affair with a divorced woman (played by Judith Ivey, who tries but can't do much with her role). It turns him into the author of a best-selling book like Mr. Friedman's, and lands him on "The Merv Griffin Show" on television. It tries a little bit of everything, and winds up with an air of messy desperation.

•

Mr. Martin, who takes so well to the pathos of the role that he even turns up as Charlie Chaplin's Little Tramp in one scene, seems most comfortable here in his scenes with Mr. Grodin. He does least well in sequences that have the director, Arthur Hiller, working against the material's essential gloom. Whenever the film tries for sprightliness, it stumbles. When it gives in to the basic misery of Larry and his situation, though, it begins to make some sort of morose comic sense.

Dr. Joyce Brothers, displaying a previously undiscovered sense of humor, figures amusingly in the film's final resolution. Steve Lawrence is less successfully cast as a swinger who, when it comes to womanizing, supposedly puts Mr. Martin's Larry to shame.

1984 Ja 28, 11:5

SLAYGROUND, directed by Terry Bedford; screenplay by Trevor Preston, based on a novel by Richard Stark; director of photography, Stephen Smith; edited by Nicolas Gaster; music by Colin Towns; produced by John Dark and Gower Frost; released by Universal Pictures. At Loews State 2, Broadway and 45th Street; Orpheum 1, 86th Street and Third Avenue, and other theaters. Running time: 89 minutes. This film is rated R.
Stone ..Peter Coyote
Abbatt ...Mel Smith
Madge ..Billie Whitelaw
Costello ..Philip Sayer
Sheer ..Bill Luhrs
Joni ...Marie Masters
Orzel ..Clarence Felder
Lonzini ...Ned Eisenberg
Laufman ...David Hayward
Danard ...Michael Ryan
Lucy ...Barret Mulligan
Jolene ..Kelli Maroney
GreteMargareta Arvidssen
Doctor KingRosemary Martin

By LAWRENCE VAN GELDER

In a convalescent economy, analysts eager for some gauge of the disposability of income may profitably study the number of admissions to "Slayground," an exercise in mayhem and ineptitude that opened yesterday at Loews State 2, the Orpheum and other theaters.

Looking like a movie, talking like a book ("too young, too full of himself") and plotted about as tightly as a chicken-wire screen, "Slayground," which is — as its title indicates — littered with corpses and resonant with gunfire, is principally adept at shooting itself in the foot.

•

What, after all, is one to make of a movie in which a gabby and previously invincible professional killer, who repeatedly has the protagonist defenseless in his gunsight, manages to wind up dead? What is one to make of the protagonist, who pulls off an armored car robbery at the beginning of

the movie, is not shown to spend so much as a nickel of the loot thereafter, but is desperate for funds by the latter part of the film? What is one's credibility to make of the protagonist's pistol, which at one point fires 12 shots without pause for reloading? What is one to make of the screen credits, which attribute the plot to a novel by Richard Stark when the production notes say it is based on a novel by Donald Westlake?

As for the plot, it deals with a fellow named Stone, played by Peter Coyote, who is filled with remorse and targeted for execution after the wheelman for his armored car heist — the one who was "too young, too full of himself" — manages to broadside a limousine during the getaway, killing the 9-year-old daughter of a rich man. Though Stone's remorse is supposed to relate to the killing of a child, two other people are appar-

ently dead in the limousine (to say nothing of the armored car guards); and it is altogether likely that Stone's grief grows from his realization that he now faces a murder charge if caught.

•

By all indications, the police have no interest in the matter. No law enforcement officer is visible in "Slayground," which, by unofficial tally, contains the corpses of 12 humans, one dog and several fowl. Vengeance is the province of the dead child's father, who hires the professional killer to track down Stone and his accomplices.

This is a process, carried out against bleak backgrounds in the United States and Britain, that takes the life of several innocents and is likely to sap the spirit of filmgoers in search of quality.

1984 Ja 28, 14:5

FILM VIEW

VINCENT CANBY

'Danny Rose': Runyonesque But Pure Woody Allen

"**B**roadway Danny Rose" is Woody Allen's most Conradian film to date. It's also as sweet and funny and generous-spirited as anything he's ever done, which, I suppose, sounds like a contradiction in terms, if only because Joseph Conrad is not widely known for sweetness, humor and generosity of spirit. In the world of "Broadway Danny Rose," Joseph Conrad might well be a tasteless Polish joke.

Yet "Broadway Danny Rose," which has just opened with "Zelig" still fresh in our memories, is like a Conradian voyage up an exotic river in an unknown land. It's a tale told not by one Marlow but by seven, about a mysterious character of flawed nobility and about how this man deals with Fate's droppings.

Broadway Danny Rose, you see, is Lord Jim with his pants falling down, the sort of Kurtz who might be the topic for discussion during a long afternoon of storytelling at the Carnegie Deli. The seas he sails are the shark-infested waters of show biz, especially of show biz as it's known in the lesser hotels of the Catskills and in tacky nightclubs around the country that might import — for one night only — a bill of performers consisting of a bird act and a single, one-legged tap-dancer.

• • •

"Broadway Danny Rose" gets the new year off to an exhilarating start and again demonstrates how America's foremost popular filmmaker continues to enrich his work. Here is a love letter not only to American comedy stars and to all of those pushy hopefuls who never quite make it to the top in show biz, but also to the kind of comedy that nourished the particular genius of Woody Allen.

Let other people write solemn theses on the sight gags of Buster Keaton, the largely unsung legacies of Goodman Ace, the timing of Jack Benny, the delivery of Bob Hope, the brilliant noon of Milton Berle and the golden autumn of George Burns. In "Broadway Danny Rose," Woody Allen somehow manages to provoke us into considering these men as national treasures, even if one doesn't share Mr. Allen's high regard for each of them.

Though he deals in fiction, Mr. Allen's new film, like many of those of François Truffaut, functions also as criticism. "Broadway Danny Rose" has the shape and manner of the kind of zany comedy that Bob Hope used to turn out by the yard for Paramount. The format is familiar but the show itself is illuminated by an awareness of its heritage provided by the comedy stars and also-rans of radio, film and television. Through a comic personality that is all his own, Woody Allen allows us to rediscover the joys of what might be called formula comedy, not only by sticking to the formula but by finding surprising variations within it.

• • •

Among the comics who gather at the Carnegie Deli whenever they're in New York and at liberty, Broadway Danny Rose (Mr. Allen) is a legend in his own time. This is not because of his success as a talent agent and personal manager, but because of his failures. His list of clients includes not only a one-legged tap-dancer, but also a parrot that sings "I Gotta Be Me," hypnotists, has-beens, and a woman who calls forth semiclassical songs by the deft rubbing of the rims of water glasses of various shapes and capacities. Danny Rose's flaw, which is as built-in as any flaw can be, is that he's too decent and small-time ever to hold onto those clients who, on occasion, make it to the big time — meaning Vegas and Atlantic City.

• • •

The frame of "Broadway Danny Rose" recalls Conrad's "Youth." Seven comics are sitting around the Carnegie Deli one afternoon, worrying about gags that don't work and talking about the good old days, when someone brings up Danny Rose. Just the mention of his name makes the listeners laugh. They then start telling Danny Rose stories, each man attempting to top the previous storyteller with a succeeding chapter in Danny Rose's eventful if not especially glorious career.

The tale that comes out is about Danny's crazy relationship with one Lou Canova (Nick Apollo Forte), described by one of the narrators as being a typical Danny Rose client in that he is a has-been with a big ego and a drinking problem. In the 1950's, one of the comics remembers, Lou Canova had a song on the charts for 15 minutes. Danny latches onto Lou when Lou can't even get a job in the Catskills. Danny coddles him, advises him on what clothes he should wear and what songs (often "Volare") he should sing for those rare dates Danny is able to book.

Lou is not only a has-been with a big ego and a drinking problem, he is an overweight slob, paying alimony to two or three earlier wives, supporting a current wife and already involved with a new young woman named Tina Vitale (Mia Farrow), who Lou thinks is the height of class.

As played by Miss Farrow with a Brooklyn accent and what appear to be padded hips, Tina Vitale is one of the funniest, brassiest, least sentimental "dumb blondes" to come down the pike in years. Tina's solemnly expressed philosophy is that "yuh only live once." When Lou suddenly seems about to become a star all over again as a result of renewed public interest in the schmaltzy songs he sang in the 1950's, it is Tina who persuades him to leave Danny Rose and sign with a big-time agent.

This, however, is before she has met Danny Rose, with whom she eventually shares a two-day adventure fleeing from some mob "soldiers," who are out to avenge the honor of Tina's former lover, the overwrought, suicidal scion of a mob family. It is, of course, a classic case of mistaken identity, since Danny Rose had been acting as "the beard" — that is, as Tina's escort, to allow the much-married Lou Canova to see her in public.

• • •

There's a lot of Damon Runyon in the plotting, and a lot of Bob Hope in the gags, but "Broadway Danny Rose" is still pure Woody Allen, though it's Woody Allen in an especially benign mood. The film shares his fondness for and delight in the art of working comics, as represented by the chorus of narrators played by Sandy Baron, Corbett Monica, Jackie Gayle, Morty Gunty, Will Jordan, Howard Storm and Jack Rollins (who is one of Mr. Allen's long-time producing associates). Also making a nice, modest appearance — as himself — is Milton Berle.

Mr. Forte, whose first film this apparently is, gives an extraordinarily good performance as the large-egoed, small-talented Lou Canova, mostly by playing the role with total belief. To see him wowing the over-50 nightclub patrons with his tear-stained versions of hits from yesteryear is both funny and endearing. Never before, perhaps, has Mr. Allen so successfully shaped his humor without letting the sharp edges show. I relish Mr. Allen when the sharp edges show and when taste approaches poor, but

"Broadway Danny Rose" wouldn't support it. It's a different kind of Woody Allen comedy.

Also immensely appealing is his treatment of Mia Farrow, who responds to Mr. Allen's direction with verve and terrific wit. A lot of people who delighted in her performance as the earnest, resourceful psychiatrist in "Zelig" possibly will not recognize the physical as well as emotional transformation of the actress who, as Tina Vitale, briefly brightens the life of Broadway Danny Rose.

In keeping with the nature of the film, Mr. Allen's own performance is unusually self-effacing. Though the movie itself reminds me of what might once have been a Bob Hope vehicle, Mr. Allen's Danny Rose comes close to being a straight man, the foil for all of the mad characters who swirl about him.

As Woody Allen serves them and the film, his career carries on, with style. ∎

1984 Ja 29, II:13:1

Reformatory Rituals

SCRUBBERS, directed by Mai Zetterling; written by Miss Zetterling, Roy Minton, Jeremy Watt; music by Michael Hurd; distributed by Orion Classics. At the Film Forum, 57 Watts Street. Running time: 90 minutes. This film is rated R.
Annetta.................................Chrissie Cotterill
Carol.......................................Amanda York
Kathleen.............................Elizabeth Edmonds
Eddie..Kate Ingram
Glennis.....................................Kathy Burke

By JANET MASLIN

IN "Scrubbers," her portrait of a British reformatory for delinquent young women, the director Mai Zetterling accomplishes at least one of her objectives: dramatizing this potentially lurid material without resorting to the usual forms of exploitation. If "Scrubbers" avoids tawdry sexism, though, it has a viciousness that comes close to being exploitation of a different variety.

The ugliness of life in this Borstal is depicted graphically, from the fist fights to the obscenities to the daily ritual of emptying chamber pots. This may suggest a film of uncompromising toughness, but "Scrubbers" also has its sentimental side. One of the film's key characters is the feisty Annetta (Chrissie Cotterill), an inmate who pines incessantly for the child from whom she has been separated. Miss Zetterling is not beyond making explicit madonna-and-child allusions in a sequence that shows Annetta trying to visit her little girl.

"Scrubbers," which opened yesterday at the Film Forum, is compelling all the same. Focusing on two young runaways who land inside a high-security institution, it explores all the rituals of reformatory life. One inmate sings filthy ditties from dawn to dusk, since this is the only form of subversion that remains available to her. Others flaunt their sexuality defiantly, and form attachments with one another by passing cigarettes and love letters after curfew. Carol (Amanda York), the other young newcomer, is befriended by the lesbian Eddie (Kate Ingram), who's so tough that she can cut in front of the others, when they're lined up for the bathroom, merely by crooking her thumb. Eddie offers Carol protection, and Carol, as a demonstration of loyalty, has Eddie's name tattooed on her breast.

•

Miss Zetterling, having assembled a strong cast of newcomers (the only familiar face is that of Elizabeth Edmonds, who starred in "Experience Preferred . . . but Not Essential"),

puts them through paces that alternate between extreme violence and contrivance. A neatly composed shot of the young women assembling doll parts in a factory, for instance, speaks all too blatantly of their frustration. And a final showdown, as two young inmates square off in a kitchen full of boiling cauldrons, is so conspicuously choreographed that its impact is blunted. "Scrubbers" is at its best when it avoids the clichés that grow almost automatically from this material.

•

The film has a surprising, almost incongruous, degree of technical polish. The cinematography by Ernie Vincze is so crisp that, in a mess-hall sequence, the yams and peas served for dinner become outstandingly colorful details in a panorama that is otherwise a dreary, metallic gray.

1984 F 1, C16:4

Searching for 'More'

RECKLESS, directed by James Foley; written by Chris Columbus; director of photography, Michael Ballhaus; edited by Albert Magnoli; music by Thomas Newman and other composers; produced by Edgar J. Scherick and Scott Rudin; released by MGM/UA Entertainment Corp. At Warner Twin, Broadway and 47th Street; 34th Street Showplace, between Second and Third Avenues; New York Twin, Second Avenue and 66th Street; 86th Street, at Lexington Avenue; 83d Street Quad, at Broadway and other theaters. Running time: 90 minutes. This film is rated R.
Johnny Rourke......................Aidan Quinn
Tracey Prescott.....................Daryl Hannah
John Rourke Sr.Kenneth McMillan
Phil Barton............................Cliff De Young
Mrs. Prescott............................Lois Smith
Randy Daniels.........................Adam Baldwin
Peter Daniels............................Dan Hedaya
David Prescott..........................Billy Jacoby
Donna.....................................Toni Kalem
Cathy Bennario........................Jennifer Grey

By JANET MASLIN

A TITLE like "Reckless" is a challenge for any movie to live up to, especially when its accompanying screenplay treads the familiar territory of the defiant teen-ager. That this film, which marks the directing debut of James Foley, works even briefly is something of a wonder. Contrived and clichéd as it turns out to be, "Reckless" has enough vitality to carry it for a while, although it never stops recalling other films. "Breathless," "Flashdance," "Risky Business" and "All the Right Moves" are a few of the more recent films of which it may remind you. And if it looks a bit like "The Deer Hunter," that's because some of it was shot in the same West Virginia town (Weirton).

"Reckless," which opens today at Loews New York Twin and other theaters, is about the predictable fury that tough, rebellious Johnny Rourke (Aidan Quinn) stirs up in well-off, well-bred Tracy Prescott (Daryl Hannah). Johnny has a motorcycle and is the romantic outcast of his high-school crowd. The others say things like: "Hey, whatever happened to you, Rourke? You used to be normal." And Johnny says things like, "I grew out of it."

•

Johnny's the kind of guy who likes to challenge himself by driving his bike as close as he can to a beer can he's placed on the edge of a precipice. When a waitress catches his eye, he simply stalks her to the ladies' room

and has his way with her. Most significant, when a high-school teacher asks his class to answer the question, "What do you hope to get out of life?" Johnny's answer is "More!" He is, to cite the Bruce Springsteen song that might just as well have been in the movie (although the film's own score is very dynamic), born to run.

Tracy, not surprisingly in this scheme of things, is a cheerleader with a boyfriend (Adam Baldwin) who's dullsville and a well-meaning mom (Lois Smith) who beams her deepest approval and love when presenting Tracy with her first charge card. When the first of many wild plot contrivances flings Tracy and Johnny together at a prom, Johnny presents her with a black carnation, changes the record on the turntable to something more frenetically punkish and draws Tracy into a whirling, wildly energetic dance. To Mr. Foley's credit, he stages this sequence much more excitingly than a mere description might make it sound.

•

Unfortunately, the screenplay for "Reckless" (by Chris Columbus) is so painfully tongue-tied that Johnny and Tracy wind up with little to say to each other. They can barely converse. Johnny's insinuating sneer and Tracy's sullen, defiant glare are the principal means by which the characters communicate, and it doesn't take long for this to become wearing. And when it's time for the sexual fireworks that are meant to be the film's very essence, the affair seems more careful and choreographed than ever.

Though Mr. Foley can't really rise above the obviousness of this material — a subplot about Johnny's unhappy life with his father (Kenneth McMillan) is almost numbingly familiar — he tries hard to give the film a distinctive style. Appearances become everything here, for the performers as well as for the director. Miss Hannah, the pouty and very acrobatic blonde who did such startling calisthenics in "Blade Runner," is best here when she's in motion or

Dana Gillespie, at left, plays a kindly official, and Amanda York plays one of the troubled inmates in "Scrubbers."

under the camera's admiring gaze. Neither she nor Mr. Quinn sustains the conversational scenes very well, though some of that is the screenplay's doing. Mr. Quinn doesn't do much more than convey the exaggerated boldness that is Johnny's outstanding trait. Since it's a quality that might well have been made to seem ridiculous, Mr. Quinn's keeping it sympathetic is much to his credit.

1984 F 3, C8:1

Porno for Chickens

STUCK ON YOU, directed by Michael Herz and Samuel Weil; written by Stuart Strutin, Warren Leight, Don Perman, Darren Kloomok, Melanie Mintz, Anthony Gittleson, Duffy Ceaser Magesis, Michael Herz and Lloyd Kaufman; director of photography, Mr. Kaufman; edited by Darren Kloomok and Richard Haines; produced by Mr. Kaufman and Mr. Herz; released by Troma Inc. At the Rivoli, Broadway and 49th Street. Running time: 90 minutes. This film is rated R.
Judge GabrielProf. Irwin Corey
Carol GriffithsVirginia Penta
Bill AndrewsMark Mikulski
Artie PouletAlbert Pia
Bill's MotherNorma Pratt
NapoleonDaniel Herris
CavewomanDenise Silbert
CavemanEddie Brill
EveJune Martin
AdamJohn Bigham
IsabellaRobin Burroughs
ColumbusCarl Sturmer
PocahontasJulie Newdow
Queen GueneverePat Tallman
King ArthurMr. Kent
JosephineBarbie Klellan
Lance GriffithsLouis Homyak
Indian ChiefBen Kellman

TROMA INC., the outfit whose prior oeuvre includes "Squeeze Play!" (a smutty comedy about a women's baseball team) and "Waitress!" (a smutty comedy about a restaurant), has gone ever-so-slightly respectable with "Stuck on You." Troma's style can't exactly be called distinctive, but at least it's identifiable. Dumb gags, food fights and bathroom jokes are accompanied, if not redeemed, by an overriding cheerfulness and a willingness to try just about anything. The humor never rises above the level of idiocy, but at least it's good-natured.

The talents of the film editor Ralph Rosenblum and the choreographer Jacques D'Amboise are barely noticeable in "Stuck on You," which opens today at the Rivoli and other theaters. No one's individual contribution stands out from the chaos. Pegged to a nearly nonexistent plot about a couple (Virginia Penta and Mark Mikulski) engaged in a palimony suit, the film isn't much more than a succession of sketches. Some of these involve chickens, because the hero, Bill, is supposedly hard at work developing a device that will induce hens to be hyperproductive. Of course, this means lots of gags that feature broken eggs.

The funnier chicken-inspired episodes include one featuring a porno movie for the feathered set and a scene in which Bill comes home with a briefcase full of tiny chicks ("Hey, you didn't bring your work home again, did you?" complains Carol, Bill's roommate). In another sequence, a grown chicken gets loose in an office and uses the typewriter to peck something from Shakespeare.

Another authentically funny bit, which is not chicken-related, has Bill using an oil can and finally a tow truck to help Carol squeeze into her very tight jeans.

Dopey historical gags are also abundant, like one that has Columbus crossing a cardboard ocean in a Pinto. Most of these aren't particularly funny, and neither is Prof. Irwin

Corey, who is the film's ostensible star. Mr. Corey stammers and sputters and gets food on his face. That, more or less, is the witty part of his performance, so imagine the rest.

Though most of the acting is unabashedly amateurish, Miss Penta is appealingly vivacious. And Norma Pratt has a brief, funny scene as Bill's very unpleasant, very small mother.

Janet Maslin

1984 F 3, C8:5

A Different Romance

A WOMAN IN FLAMES, a film by Robert van Ackeren; in German with English subtitles; screenplay by Mr. van Ackeren and Catharine Zwerenz; photography by Jurgen Jurges; edited by Tania Schmidtbauer; produced by Robert van Ackeren and Dieter Geissler; a Libra Cinema 5 Films Release. At the Plaza, 58th Street, east of Madison Avenue. Running time: 106 minutes. This film has no rating.
EvaGudrun Landgrebe
ChrisMathieu Carriere
KurtHanns Zischler
YvonneGabriele Lafari

By VINCENT CANBY

DON'T fool around with gigolos, especially a gigolo whose fondest wish is to open a restaurant. Because this sort of gigolo is unreliable, it's best not to ignore his artichokes vinaigrette and, for heaven's sake, don't upset him when he's about to dazzle you with a spectacular entree. In anger, he just might flambé more than the steak Diane.

That, I think, is the sum and substance of "A Woman in Flames" ("Die Flambierte Frau"), directed by Robert van Ackeren, a young German film maker whose eccentric talents have been compared to those of the late Rainer Werner Fassbinder by some European critics. Mr. Fassbinder's films are an acquired taste and so, perhaps, are Mr. van Ackeren's. However, after watching "A Woman in Flames," his first to be commercially released in New York, I have the feeling that it may not be easy making that adjustment.

"A Woman in Flames," which opens today at the Plaza Theater, strikes me as being a lot funnier than it intends to be, though it's not much fun. As a satire it's so slow-motion that anyone with half a brain is ahead of it long before its curious penultimate sequence.

Eva (Gudrun Landgrebe), a beautiful university student, drops out of school and leaves her stuffy lover to become a prostitute. She needs the money to live well, and she enjoys her freedom of choice. She also enjoys the power she has over men, particularly when she's playing what the sado-masochistic crowd calls the dominatrix. One doesn't have to be a fetishist to find Eva a sight for sore eyes in her skimpy, chrome-studded, leather lingerie.

Eva is a smashing success as a rather choosy streetwalker, but she makes a basic mistake. She falls head over high, spiked heels for Chris (Mathieu Carriere), a handsome young man and a former student of business administration. Chris, it turns out, is also a prostitute, though he calls himself a gigolo, but he's an exceedingly gentle man who treats his male and female patrons with equal ease and sincerity.

The relationship of Eva and Chris at first appears ideal. They move into

a chicly furnished flat, one that provides separate workrooms. In no time at all, their joint bank account is positively stuffed.

●

Then things begin to sour. Chris's bourgeois breeding will out. He becomes jealous of Eva's customers. Eva is shocked down to her pointy-toed boots when he says, "I want to have a baby with you." The poor man has no idea how much fun Eva has been having. Without telling her, he has invested all their money in the art gallery-restaurant of his dreams. For Eva this is the absolute end.

"I fell in love with a gigolo," she says with scorn. "I don't want to grow old with the owner of a restaurant."

"A Woman in Flames" has been taken very seriously abroad as a scathing send-up of middle-class values, though the values it sends up have already been sent up more thoroughly and more wittily by other film makers, including Mr. Fassbinder in "The Marriage of Maria Braun," among other films. "A Woman in Flames" wears a very dead pan, but without much wit the movie looks like a slightly warped romantic comedy.

Miss Landgrebe is a real beauty, a sort of young Romy Schneider with blue eyes instead of green. She behaves as, I assume, she has been directed to — to produce a succession of enigmatic facial expressions that seem entirely foreign to her. Mr. Carriere is a good actor and perfectly adequate to the odd demands of the film, though he seems most uncomfortable when he has to talk about growing too old to function as a gigolo much longer.

1984 F 3, C11:1

Removing the Mess

INVESTIGATION, directed by Etienne Perier; screenplay (French with English subtitles) by Andre G. Brunelin; adaptation by Mr. Brunelin and Mr. Perier, based on the novel "Le Moindre Mal" by Jean Laborde; cinematography by Jean Charvein; music by Paul Misraki; produced by Adolphe Viezzi; a co-production of Les Films de la Tour/Les Productions Jacques Roltfeld/Les Films de la Drouette; released by Quartet/Films Inc. At the Thalia, Broadway and 95th Street. Running time: 116 minutes. This film is rated R.
Stéphane BertinVictor Lanoux
The JudgeJean Carmet
Muriel OlivierValerie Mairesse
GaspardMichel Robin
WITH: Jacques Richard, Gerard Jugnot, Francis Lemaire, Anne Bellec, Alain Doutey

ETIENNE PERIER'S "Investigation" ("Un Si Joli Village"), the 1979 French film that opens today at the Thalia on a bill with Jean-Luc Godard's "Breathless," is an unpretentious, amusing mystery film, a cat-and-mouse game in which the roles of cat and mouse are continually reversed.

At the start of the film, Stéphane Bertin (Victor Lanoux), owner of a prosperous tannery that is the sole support of a small village, is seen as he methodically cleans up the mess after he has killed his wife — whether accidentally or not, we're never sure — during a domestic argument.

The next day Stéphane boldly announces that his wife has suddenly left him and that he is moving in with his young, pregnant mistress, Muriel (Valerie Mairesse), the village schoolteacher. The villagers, who have long been aware that Stéphane and his wife loathe each other, accept his explanation at face value. They also realize that without Stéphane, the tannery would close and the village would become bankrupt.

The subsequent investigation into Madame Bertin's disappearance is led by the Judge (Jean Carmet), a small, mild-mannered but obstinate man, who becomes obsessed with proving Stéphane's guilt. The Judge represents justice and Stéphane economic clout. The resolution of the film is comparatively low-key but satisfying, and so are the performances and the provincial scenery.

Vincent Canby

1984 F 3, C11:1

Search for Conductor

DEAR MAESTRO, written and directed by Luciano Odorisio (Italian with English subtitles); camera, Nando Forni; edited by Antonio Uterzi; at the Lincoln Plaza 3, Broadway between 62d and 63d Streets.
FrancescoMichele Placido
NicolinoTino Schrinzi
MartaGiuliana De Sio
GianniLino Troisi
AndreaAdalberto Maria Merli
WITH Guido Celano, Fabio Traversa

"Dear Maestro" was shown as part of last year's New Directors/New Films Series under the title "Chopin." Following are excerpts from Janet Maslin's review that appeared in The New York Times on March 21. The film opens today at the Lincoln Plaza 3, Broadway between 62d and 63d Streets.

"CHOPIN," as "Dear Maestro" was originally called, was an odd title for Luciano Odorisio's spirited comedy, which turns out not to be about the composer himself, but about a small Italian provincial city, where a new orchestra is being assembled. There appears to be considerable competition for the conductor's job, and this provides Mr. Odorisio with what little excuse he needs for a plot. For the most part, though, his film is cheerfully anecdotal, without any well-defined center but with a wit and intelligence that help hold it together.

"Dear Maestro" is also very adroitly acted, by a cast headed by Michele Placido and Giuliana De Sio. They play Francesco and Marta, the foremost conducting hopeful and his sexy, faithless, but very companionable wife. Francesco, who has a way of becoming physically ill every time he thinks of anyone else's landing the job, is a 40-ish academic less troubled by Marta's frequent infidelities than by his own unrealized ambitions. Somehow, the two seem to have a satisfying marriage.

The movie, which is set in the city of Chieti, introduces a group of music-world oddballs and gossips, including one very minor character who has earned the nickname of "Chopin" by trying to pass off one of Chopin's compositions as his own. All of them are busily engaged in speculation about the new orchestra, and there is some feeling that a local-born conductor now living in Milan, named Serano, will be invited back. Maestro Serano does indeed appear, but in a moving and unexpected way, as he re-encounters Francesco, who is a longtime friend. Mr. Odorisio makes their meeting sound the film's most stirring note.

Mr. Odorisio, who has worked with the Taviani brothers and Marco Ferreri, gives the film some amusing details, including Francesco's and Marta's electrified version of Botticelli's Venus (it's a lamp), and a couple of Indian house guests who think it is

beautiful and would give anything to buy it from them. He also fills the soundtrack with some very unlikely music, including one country-and-western-style song by an Italian pop crooner and the theme from "New York, New York." The latter is played with the film's opening credits, as we first see Chieti, a city whose medieval architecture and charming setting don't accurately mirror the show-business ambitions of some of its denizens.

1984 F 3, C13:3

SIGNALS THROUGH THE FLAMES (The Story of the Living Theater), directed and edited by Sheldon Rochlin and Maxine Harris; texts from "The Diaries of Judith Malina" and "The Life of the Theater" by Julian Beck; cinematography, Mr. Rochlin; music by Carlo Altomare; produced by Mr. Rochlin, Miss Harris and Rachel McPherson; a Mystic Fire Production. At the Eighth Street Playhouse, near Avenue of the Americas. Running time: 97 minutes. This film has no rating.

By VINCENT CANBY

"Signals Through the Flames," which opened a one-week engagement Friday at the Eighth Street Playhouse, is a good, lucid introduction to the work and goals of the Living Theater, as well as to the personalities of Julian Beck and Judith Malina, his partner and wife, who together founded the avant-garde theater company in 1947. The film's appearance coincides with the Living Theater's current engagement at the Joyce Theater, the group's first extended New York engagement since 1969.

The 97-minute documentary, produced, directed and edited by Sheldon Rochlin and Maxine Harris, follows the nomadic movements of the Becks around the world after they went into self-imposed exile following the closing of their New York theater by the tax men in 1964. It includes clips from their two seminal productions, Jack Gelber's "Connection" (1959) and Kenneth H. Brown's "Brig" (1964), which, even from the evidence supplied by this appreciative film of their subsequent productions, seem to remain among their most accomplished work.

•

Also shown are clips from more recent productions done in Europe, where the Becks have enjoyed far more acclaim than they have on their home territory.

In response to offscreen questions, Mr. Beck and Miss Malina discuss at length their confrontations with civil authorities, their arrests (once, in Brazil, for "subversion"), and define their lifelong commitment to a revolutionary art in which politics and theater are inseparable. Their continuing passion is most appealing, though there are times when their vocabulary sounds like jargon.

From the bits and pieces we see of their later productions, it sometimes appears that their policy of "collective creation" results in a performance art in which abstract concepts act as a kind of invisible shield between the work performed and the audience. This may be why Living Theater actors so frequently invade the audience — in an attempt to make the contact denied by the substance of the work itself.

•

Talking informally with the film makers, Mr. Beck and Miss Malina are most persuasive, especially when one realizes that they are thinking out loud, continuing their attempts to bring some order out of life's chaos. In one sequence, Mr. Beck is seen in the kitchen of his Rome flat, talking randomly about "our hunting society," one that "asserts its strength through killing."

"One can't kill," he says with vehemence as he prepares a vegetable dinner. "I begin right here in my own kitchen, with my own life. You can't kill animals in order to live." He looks down at the handsome carrot in his hand. "Maybe you shouldn't even kill vegetables." He pauses, then adds briskly, "That's another story."

He shreds the carrot.

The best thing about "Signals Through the Flames" is the manner in which it demonstrates the Becks's long-lived dedication and enthusiasm, whether making plays or family meals.

1984 F 5, 47:1

FILM VIEW

VINCENT CANBY

Fellini Charts His Latest Magical Mystery Tour

In the early 1960's, sometime after he had finished "8½" and when he was about to start production of "Juliet of the Spirits," Federico Fellini was quoted as saying:

"Up until now, I've always done stories where the requirements of the plot, or the setting, or the fact that the action is meant to be taking place in the present day, have prevented me from transfiguring everything in the way I'd like — the furnishing of a room, the face of an actor, the general atmosphere of a scene. That's why, from time to time, I dream of making a film with historical costumes and in color to tell a fable relating solely to the imagination, which would not have any clearly defined intellectual, ethical structure: reality within the imagination."

Since making that statement, this Italian cinema master has pursued "reality within the imagination" with a vengeance, keeping more and more inside the walls of the motion picture studio where, on great sound stages, he can rule a world whose natural laws are invented by him. There is no gravity. Planets move in arbitrary orbits. Everything is possible through the film technicians' magic. The patently fake is accepted as only natural.

It is therefore an intentional joke in "And the Ship Sails On," Mr. Fellini's newest film and one of his most visually splendiferous, when someone observes of the sun that is setting into the waters of the Adriatic, "It looks so beautiful, it seems to be painted," which, quite apparently, it is. The audience can see the set painter's brush strokes.

This increasing exaltation of — and obsession with — obvious studio artifice is the most distinguishing aspect of the recent, extraordinary Fellini career, which can't easily be compared to that of any other major filmmaker.

The late, great Luis Buñuel, a true Surrealist, had no special interest in cinema trickery. Though he did on occasion shoot on actual locations, he, like Fellini, preferred to make his films in the comfort of a studio, not because he was interested in studio artifice but because the studio was more convenient.

Buñuel's Surrealism depended not on camera tricks, special effects or bizarre décor. It was based on the disorienting juxtaposition of easily identifiable but contradictory realities, such as the predicament of the black tie-and-evening gown guests in "The Discreet Charm of the Bourgeoisie." They sit down to enjoy an elegant dinner only to discover that they are actors, on a stage in front of an audience, appearing in a play whose lines they don't know.

Buñuel abhorred any techniques that suggested fanciness. He photographed his films with almost puritan plainness: a master shot to establish the scene, with subsequent cuts to close-ups and medium shots to report the actions and reactions of the characters.

• • •

Mr. Fellini's Surrealism — if, indeed, it can be called that — is something else entirely, a kind of byproduct of his love of visual spectacle and his impatience with the rules of conventional narrative films. The fantastic mov-

A galley at sea is the setting for the hypnosis of a chicken in Federico Fellini's "And the Ship Sails On"— "stylized cinema at its most dazzling"

ies he has made since "Juliet of the Spirits" are really not all that different from the neorealist films — "I Vitelloni," "La Strada," "Nights of Cabiria" — that initially earned him his international reputation. It's just that the neorealism has become wildly, gaudily poetic, while the sensibility of the director remains that of a social critic and satirist.

In his "Satyricon" (1969), Mr. Fellini created what he described — accurately, I think — as an ancient Roman world that is as remote and strange as some science-fiction world of the future. In one sequence, "Fellini Satyricon" (1969) features a Mediterranean galley that looks less like anything that could float upon water, much less be rowed, than a futuristic space station. "Fellini Roma" (1972), his tribute to the city he loves almost in spite of himself, masquerades as a documentary, though most of it was photographed in the studio.

In "Casanova" (1976) he shows us a mid-18th-century Europe — created entirely in the studio, of course — that suggests a civilization locked in terminal winter. Though he had "dressed" all of his preceding films with grotesque human figures, including dwarfs, hunchbacks, hermaphrodites, amputees, albinos, giants and harpies, he went one step further in "Casanova." He reordered the looks of his star to resemble those of some exhausted Martian. He transformed the facial features of Donald Sutherland, who played the title role, by giving him an unnaturally high forehead and an aristocratic nose obviously not his own.

• • •

With "Casanova" Mr. Fellini seemed at last to have realized that earlier expressed dream to transfigure absolutely everything, to tell a fable relating solely to the imagination, without any clearly defined intellectual, ethical structure.

However, it was impossible for Mr. Fellini completely to do away with intellectual and/or ethical structures. "Casanova" is as much concerned with the director's feelings of sex and guilt as "La Dolce Vita" and "Juliet of the Spirits." It's just a great deal more bleak.

"Fellini Satyricon," which pretends to be an unprejudiced look at a pre-Christian world without faith or order of any kind, emerges as an argument on behalf of the sort of order imposed by the Roman Catholicism he has so frequently satirized. As jazzy and freewheeling as "Fellini Roma" looks to be, it is, at heart, a movie that expresses a middle-aged man's ruefully mixed feelings about what is called progress in the modern world. It's a nightmare vision of the glories that once were Rome's petering out in an apocalyptic traffic jam made possible when absolutely everybody has the economic means with which to buy an automobile.

•

Mr. Fellini's love of odd spectacle, representing the private world of his own dreams and fantasies, did not suddenly appear from nowhere in "Juliet of the Spirits."

"La Dolce Vita" and "8½," his two last, great black-and-white films, are full of hints of things to come. Remember that wonderfully comic sight of the statue of Jesus as, suspended from a helicopter, it goes flying over the rooftops of Rome in "La Dolce Vita," or the climactic sequence of "8½," in which Guido (Marcello Mastroianni), the philandering, emotionally blocked film director, becomes reconciled with all of the characters that have figured in his life.

Fantasy and spectacle have always been an important factor in Fellini films. However, one thing has changed in these later films. That is, that spectacle has become an end in itself, being more interesting, and thus more important, than what the films are supposed to be about, possibly because it's increasingly difficult at times to know what, really, they are about.

Only in "Amarcord" (1973) has he attained the perfect synthesis of spectacular style with what I assume to be content. In this dreamy, funny recollection of an Italian childhood in the 1930's, the exquisite images — whether they are a peacock's magical appearance after a snowstorm or the sight of the liner Rex sailing across a cellophane sea — describe the process by which the past is transformed into enchanted myth.

•

When the spectacle overwhelms what appears to be the film's subject, the Fellini film tends to become too chilly for complete comfort. This is a problem with "Casanova" and it would have severely damaged "City of Women" (1980) had not the guilt-ridden, womanizing hero been played by Mr. Mastroianni, an actor whose intelligent, comic screen presence perfectly represents Mr. Fellini's view of himself.

"And the Ship Sails On" is not "Amarcord," but it contains some of the most wondrous sequences Mr. Fellini has ever done. Set in July 1914, just before the outbreak of World War I, it is a highly comic — and often musical — meditation upon art and artists, mostly drawn from the world of grand opera.

The occasion is a memorial cruise aboard a magnificent luxury liner whose passengers have come together to honor the career of a recently deceased diva. The cruise director and host of the show — for the film is more a show than a narrative — is a newspaperman (Freddie Jones) who talks directly to the camera as he introduces the characters and comments on their foibles.

Unlike "Orchestra Rehearsal" (1979), which saw the rise and fall and rise of civilization in the course of a single orchestra rehearsal, "And the Ship Sails On" is not to be read as

metaphor but to be enjoyed as a cinema circus. The film's vain tenors, imperious sopranos, kinky conductors and various hangers-on in the opera world are to be appreciated and wondered at in much the same way that we regarded the various types of clowns in Mr. Fellini's feature-length essay on the circus, "The Clowns" (1970).

•

In addition, however, "And the Ship Sails On" demonstrates Mr. Fellini's vision of stylized cinema at its most dazzling. There's not a truly representational set in the entire film. The dockside from which the liner Gloria departs on its ill-fated cruise, at the film's start, is initially introduced as it might be seen in an old silent film but, as the images pick up color and as real sound is heard on the soundtrack, the location comes to suggest something that might be seen at the Metropolitan Opera, if the Met could spend millions on a single set.

The interior of the liner, including a gigantic boiler room, is beyond a set-decorator's dream of avarice. Among the "characters" there is one clearly man-made rhinoceros, who is homesick and on his way to an Amsterdam zoo, and a seagull that prefers to ride in the first-class dining room rather than to fly at sea on his own. Like all Fellini films, this one is full of feeling but never for a second sentimental.

I won't attempt here to interpret "And the Ship Sails On" — I'm not at all sure that I could anyway — but I can promise you that if you enjoy the cinema of imagination, meaning films that look and sound like those of no other living director, you cannot afford to pass up this rare, funny, surprising display. ∎

1984 F 5, II:15:1

Historical View

THE COMPLEAT BEATLES, a documentary directed by Patrick Montgomery; written by David Silver; narrated by Malcolm McDowell; edited by Pamela Page; produced by Mr. Montgomery and Stephanie Bennett; a Teleculture Films Release of a Delilah Film Production in association with MGA/UA Home Video. At the Festival, Fifth Avenue and 57th Street. Running time: 120 minutes. This film has no rating.

By JANET MASLIN

"THE COMPLEAT BEATLES," a two-hour documentary on the group's thrilling rise and subsequent evolution, is surprising on at least two scores. For one thing, the fact that this film, which opens today at the Festival Theater, has previously been available on video cassette would seem to indicate that it might be stale or negligible. It's not.

For another, if the tidal wave of nostalgia surrounding the 20th anniversary of the band's American debut engenders the feeling that nothing about the Beatles remains to be said, "The Compleat Beatles" proves otherwise. A third surprise, in addition to the film's merit and its relative novelty, is the fact that it makes the the group's now-familiar story so very moving.

•

As directed by Patrick Montgomery, "The Compleat Beatles" manages to avoid almost all the visual clichés that have come to accompany

John Lennon in 1966.

the band's story. The film does not, for instance, bother with footage of the Beatles on the Ed Sullivan show, "Toast of the Town," nor does it indulge in any jazzy editing reminiscent of Richard Lester's "Hard Day's Night" style. What it does, with the help of impressive research and some unusual interview material, is trace the Beatles' career from the very beginning, capturing the Horatio Algerish aspects of their success, the charm that constituted the heart of their vast appeal, the strong personalities that emerged within the group and the weariness that brought on its breakup. No matter how much you know about the Beatles' history, some of this material is bound to strike you as new, even if it's only the street scene of a fan explaining her painting, which is titled "A Sprout of a New Generation." It's a picture of Paul McCartney, growing out of a landscape.

A great deal of the film concentrates on the early days, when the Beatles were the Quarrymen, and Paul still had a part in his hair. Mr. Montgomery has come up with an extensive array of still photographs and even a little newsreel material to illustrate this early part of the story. Gerry Marsden, of Gerry and the Pacemakers, explains what skiffle music meant to young would-be rockers. And Tony Sheridan, whose record of "My Bonnie" is the first on which the Beatles played, talks about the importance of the band's Hamburg days. Interspersed with these interviews are some remarkable snapshots, taken long before the Beatles learned to guard their expressions and think about their stage images. These photographs cast immeasurable light on the self-consciousness of some of their subsequent poses.

The key interview subject here is George Martin, the Beatles' record producer, who coolly and thoughtfully describes his work with the band. Mr. Martin, a debonair figure who seems to have been remarkably immune to the fads and fashions that the Beatles engendered, describes recording sessions (some of which are actually seen here, among them the session for the Beatles' first album) and explains how certain specific effects were achieved — "the most overpowering sound you ever heard in your life," for instance, which is what he says John Lennon requested for the ending of "A Day in the Life." Mr. Martin also talks of editing two cuts together to produce "Strawberry

Fields Forever'' and tells of the reluctance of Capitol Records to issue Beatle singles in the pre-"I Wanna Hold Your Hand'' days. Of "Please Please Me,'' at the time when it was a hit in England, Mr. Martin recalls a Capitol executive saying, "Sorry, it wouldn't mean anything in this country.''

The Beatles themselves are glimpsed in moments of unusual candor. As the excellent narration (provided by Malcolm McDowell) explains how unprepared the band was for such overwhelming success, we see footage of George Harrison driving a convertible, trying to pick up Ringo Starr outside Ringo's row house in Liverpool while hordes of teen-agers storm the car. Mr. Montgomery avoids much of the flippant interview material that usually accompanies descriptions of the band's first American tour, opting instead for clips in which the group members speculate quietly about their future. Ringo says he's hoping to "make a few bob and then open a hairdressing salon.'' George hopes their success will last four years. John thinks 10 years would be nice, but three months would be more realistic.

•

Mr. Montgomery isn't averse to using unflattering footage, like the television appearance, on a gaudy turquoise and orange set, in which the Beatles perform woefully inadequate versions of "Nowhere Man,'' "Yesterday'' and "If I Needed Someone''; his point here, ably illustrated, is that the group's studio techniques had become too sophisticated for live performance.

To fault him (though only slightly), he's also willing to manipulate some of the material to bear out notions of what the Beatles' mood must have been. For instance, early, ecstatic scenes of the group arriving at airports are contrasted with a later glimpse of their arriving somewhere on a raw and windy day, with a bass note on the soundtrack for accompaniment. As wearying as the group's touring must have become, Mr. Montgomery needn't have underscored the point quite so obtrusively.

1984 F 10, C8:1

Musical Romancers

UNFAITHFULLY YOURS, directed by Howard Zieff; screenplay by Valerie Curtin and Barry Levinson and Robert Klane, based on a screenplay by Preston Sturges; director of photography, David M. Walsh; edited by Sheldon Kahn; original music by Bill Conti; produced by Marvin Worth and Joe Wizan; released by Twentieth Century-Fox Film Corporation. At the Warner Twin, Broadway and 47th Street; Sutton, Third Avenue and 57th Street, and other theaters. Running time: 97 minutes. This film is rated: PG.
Claude EastmanDudley Moore
Daniella EastmanNastassja Kinski
Maxmillian SteinArmand Assante
Norman RobbinsAlbert Brooks
Carla RobbinsCassie Yates
GiuseppeRichard Libertini
Jess KellerRichard B. Shull
Jerzy CzyrekJan Triska
JanetJane Hallaren
Bill LawrenceBernard Behrens

By VINCENT CANBY

DUDLEY MOORE may not want to play Hamlet but his ambition to play more or less straight roles has resulted in a series of unfortunate performances in even more unfortunate films — "Six Weeks,'' "Lovesick'' and "Romantic Comedy.'' Actually, "Lovesick'' wasn't all that bad but, let's face it, Mr. Moore is never going to be Cary Grant.

However, when he's doing the supposedly low comedy of pratfall, disguise, drunkenness and fruitlessly manic endeavor, he's an incomparable performer. As he demonstrated in "Arthur'' and "10,'' he can be intelligent, sophisticated and brilliantly funny as an all-out clown.

"Unfaithfully Yours,'' Howard Zieff's updated remake of Preston Sturges's 1948 comedy, which starred Rex Harrison and Linda Darnell, offers both Dudley Moores, the would-be romantic leading man and the obsessed troll, though the troll comes on too late to save the movie. "Unfaithfully Yours'' opens today at the Sutton and other theaters.

•

The original film was not one of Sturges's best, something to rank with "The Lady Eve,'' "The Palm Beach Story'' and "Sullivan's Travels.'' However, the Sturges film, even before it reached its classically funny slapstick climax, did offer us Mr. Harrison in one of his most accomplished, urbane performances as a world-famous symphonic conductor who suddenly becomes obsessed by suspicions of the infidelities of his much younger wife, played by Miss Darnell.

The Zieff film, based on an adaptation of the Sturges script by Valerie Curtin, Barry Levinson and Robert Klane, is played most of the time as a perfectly sincere romantic comedy interrupted by a slight misunderstanding. It's about Claude Eastman (Mr. Moore), an internationally acclaimed conductor who might be modeled on Leonard Bernstein; his much younger, very beautiful actress-wife, Daniella (Nastassja Kinski), and Max Stein (Armand Assante), the solo violinist who may or may not be Daniella's lover.

The heart of the Sturges film are three fantasies in which the conductor imagines how he will deal with the illicit lovers, plus a final sequence in which he attempts to carry out one of his plans for revenge. The new film limits the conductor's fantasies to one and further dulls the satiric edges by

making it plain that the wife is innocent.

Mr. Moore is very funny as, during a concert featuring the possibly cuckolding violinist, he imagines how he will dispose of both his wife and the violinist in a private, postconcert celebration. Then his plans go wildly astray. Until then, though, the movie is an uphill slog.

The movie does contain attractive supporting performances by Albert Brooks as Claude Eastman's personal manager; Richard Libertini as Claude's valet, and Richard B. Shull as a private eye whose report initiates the conductor's suspicions. Both Mr. Libertini and Mr. Shull would be completely at home in an authentic Sturges comedy.

Miss Kinski is a major problem. She's a beauty, all right, but she appears to have no flair whatever for comedy of this sort, or maybe of any sort. I suspect that she's a far more intelligent actress than Miss Darnell, but this isn't an asset. What made Miss Darnell's performance so funny, and made the original film seem much sexier than this liberated one, was the apparent vacuity of the Darnell character. One never doubted the possibility that she might be carrying on with any number of men at the same time without giving any of them a moment's thought.

•

"Unfaithfully Yours,'' which has been rated PG ("parental guidance suggested''), contains some partial nudity and some mildly vulgar language.

1984 F 10, C7:1

Hidden Morals

BURROUGHS, directed by Howard Brokner; photography by Richard L. Camp, Mike Southon, James Lebovitz, Tom Dicillo, Howard Brookner, Cathy Dorsey, Larry Shiu and Anthony Balch; edited by Scott Vickrey and Ben Morris; produced by Mr. Brookner and Alan Yentob; production company, Citifilmworks

Inc. At the Bleecker Street Cinema, 144 Bleecker Street. Running time: 86 minutes. This film has no rating.
WITH Lauren Hutton, William S. Burroughs, Patti Smith, Otto Belue, Mortimer Burroughs, Terry Southern, Allen Ginsberg, Lucien Carr, Herber Huncke, William S. Burroughs Jr.

"Burroughs'' was shown as part of last year's New York Film Festival. Following are excerpts from Janet Maslin's review that appeared in The New York Times on Oct. 8. The film opens today at the Bleecker Street Cinema, 144 Bleecker Street.

RARELY is a documentary as well attuned to its subject as Howard Brookner's "Burroughs,'' which captures as much about the life, work and sensibility of its subject as its 86-minute format allows. Part of the film's comprehensiveness is attributable to William S. Burroughs's cooperation, since the author was willing to visit old haunts, read from his works and even playfully act out a passage from "Naked Lunch'' for the benefit of the camera. But the quality of discovery about "Burroughs'' is very much the director's doing, and Mr. Brookner demonstrates an unusual degree of liveliness and curiosity in exploring his subject.

The film touches on Mr. Burroughs's writing, his travels, his present life in New York, his complicated friendships and his unusually troubled family history. The camera accompanies the author back to the house in St. Louis where he grew up, as he reads from a new novel about his boyhood, "The Place of Dead Roads.'' ("I don't want that boy in the house again, he looks like a sheep-killing dog,'' goes one apparently autobiographical excerpt.) There is a visit with his brother Mortimer, who tells William, "I tried to read 'Naked Lunch' and read halfway through it, and I pitched it.''

Tracing the author to Mexico the film describes the death of his wife, Joan, whom he shot in a modified William Tell experiment one drunken

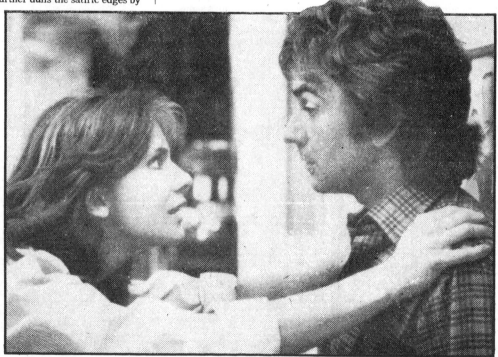
Nastassia Kinski confronts Dudley Moore in "Unfaithfully Yours,'' Howard Zieff's remake of the 1948 Preston Sturges comedy about a symphony orchestra conductor who suspects his wife of infidelity.

evening. "I always thought she had challenged him into it," says the author's close friend Allen Ginsberg, who is a generous and helpful presence throughout the film. "Just an absolute piece of insanity," Mr. Burroughs himself says.

The saddest scenes in "Burroughs" are those depicting William S. Burroughs Jr., the child of that union, who had serious drug and drinking problems when the film was being shot and who has since died. After the author's somewhat presumptuous young assistant has pronounced himself more of a son to his mentor than William Jr. was, the camera watches the three share an awkward meeting. The senior Mr. Burroughs, who in his mordantly funny way seems very much at ease throughout the rest of the film, appears painfully uncomfortable during his son's brief visit.

"His morals are probably Boy Scout morals, and the last thing he wants anyone else to know is that," says the author's friend Lucien Carr. Through interviews, snapshots and some unusually expressive home movies, the film presents Mr. Burroughs's drug use, his bisexuality, his friendships and his living arrangement as part of a larger spontaneity, and of an incongruous innocence. "He's a hard guy to get into bed, that's why I like him," says Patti Smith, one of numerous friends and acquaintances who help round out this very vivid portrait.

But the crowning touches come from Mr. Burroughs himself, who does everything from demonstrating his technique for "cut-outs" — cut a page of writing into quarters, rearrange them and retype whatever new words are formed — to playing doctor. He does so during a very gory, bizarrely funny enactment of a scene from "Naked Lunch," with Jackie Curtis, a transvestite, playing his nurse.

1984 F 10, C12:1

Amiable Automatons

ANDROID, directed by Aaron Lipstadt; screenplay by James Reigle and Don Opper; director of photography, Tim Suhrstedt; edited by Andy Horvitch; music by various composers; produced by Mary Ann Fisher; released by Island Alive. At the Waverly, Avenue of the Americas and Third Street. Running time: 81 minutes. This film is rated PG.
Dr. Daniel Klaus Kinski
Max .. Don Opper
Maggie .. Brie Howard
Keller .. Norbert Weisser
Mendes Crofton Hardester
Cassandra Kendra Kirchner
Terrapol: Neptune
 Gary Corarito, Mary Ann Fisher, Darrel Larson, Ian Scheibel
Terrapol: Minos .Wayne Springfield, Julia Gibson
Terrapol Landing Party
 Randy Connor, Roger Kelton, Rachel Talalay, Johanne Todd

"ANDROID," which opens today at the Waverly Theater but was made two years ago, is an essentially cheerful, knowing little science-fiction film that positively celebrates the shoestring on which it was made. The basic sets — all interiors — are those roomy space ships and space stations left over from such Roger Corman cheapie classics as "Battle Beyond the Stars" and "Galaxy of Terror," refurbished and repainted as needed.

The screenplay, though, is less suspenseful than dryly comic, which may be why Mr. Corman, who originally sponsored the production, allowed the film makers to buy back the rights to it last year.

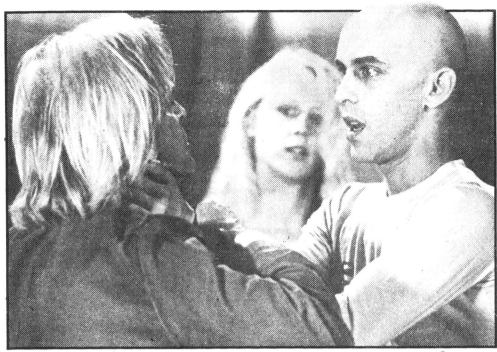

While Kendra Kirchner looks on, Don Opper throttles Klaus Kinski in "Android," a science-fiction story set in the year 2036 on a remote station in space, where a lone researcher has been involved in the construction of the perfect female android.

The time is 2036, and the setting is a forgotten space station inhabited by a certain mad Dr. Daniel (Klaus Kinski) and Max 404, a gentle android, who, as played by the skinny Don Opper, suggests both a Marcel Marceau character and the young poet in Eugene O'Neill's "Ah, Wilderness."

Because Dr. Daniel spends most of his time working on the production of ever better androids, which have been outlawed on earth since an android rebellion called — I think — "the Munich uprising," Max is left pretty much to himself. He spends his days playing video games, watching old movies ("Metropolis," "It's a Wonderful Life") and dreaming of visiting earth, much as a young human male might dream of the big city.

Not so great is the film's story, which has something to do with the arrival of three escaped convicts and their attempts to take over the space station from Dr. Daniel and Max. One nice touch, however: the sight of Max, as he prepares for his first trip to earth, packing a valise with his own spare parts, including a couple of glass eyeballs, some plastic fingers, a plastic forearm, plus a Bogartlike fedora.

Mr. Kinski, as the mad doctor, is almost as benign as the poetic Max. Appearing as the villains are Brie Howard, Norbert Weisser and Crofton Hardester. It's probably no accident that Kendra Kirchner, who plays Dr. Daniel's newest, most perfect android, looks like a calendar version of Eve, as well as like Edwina Booth in "Trader Horn."

In addition to acting in the film, Mr. Opper wrote the screenplay with James Reigle. Aaron Lipstadt is the director, and Mary Ann Fisher the producer. I assume they are a lively lot even though the film doesn't always make complete sense.

Vincent Canby

1984 F 10, C28:1

FILM VIEW

VINCENT CANBY

Toward Women, Movies Are Two-Faced

Teen-angel or succubus? Virgin or whore? Should we continue to put the blame on Mame, boys, and is it true that the devil is a woman?

You might think that after more than half a century, moviemakers — and the people who go to movies — would have become bored by these somewhat less than probing questions, especially since there are now more films that take women seriously than we've had at any time in years, but not at all.

The age-old male fantasy about woman's sexual duplicity appears to have endured unscathed into the age of Women's Liberation. Women may well be making their presences felt more than ever before in business, government, science and the arts, and even as characters in other movies, but there are still producers catering to the delirious male suspicion that within every innocent young thing there exists the soul of a wanton.

One of the more unintentionally hilarious of these is the recent "Angel," whose title character, as the ads truthfully describe her, is a high school honors student by day and a Hollywood hooker by night. In "A Woman in Flames," Robert Van Ackeren's flatfooted German satire, a phenomenally beautiful young university student, played by Gudrun Landgrebe, drops her classes to become an extremely successful and fulfilled prostitute. Last week's ABC Sunday Night Movie, "My Mother's Secret Life," was touted with the ad line, "16 year old Tobi Blake doesn't know that the most wonderful mother in the

world. . .is the most expensive woman in town.''

I didn't see that one, but the ads appear to have been designed to make the reader believe that Toni's mother is that heroine beloved of so many porn films: the suburban housewife as a part-time hooker.

• • •

What makes these films look so curious and even out-of-date right now is that they exist, side-by-side, with an increasing number of films that at least attempt to take women seriously, even when the films are comedies. Not since the 70's and the success of "An Unmarried Woman," "Julia" and "The Turning Point," among others, has there been such a variety of movies in which the roles of women — as something other than sirens — have been predominant.

One of the biggest box-office hits of the season is James L. Brooks's "Terms of Endearment," with its extraordinary performances by Shirley MacLaine and Debra Winger, playing a mother and a daughter coping with each other and with life.

"Terms of Endearment" could hardly be called a feminist handbook. Though the dialogue is bright, the form is neo-soap opera. The most appealing thing about the film is the decency with which it considers the problems of a not especially liberated woman, the pushy, opinionated, well-to-do widow, Aurora Greenway, played by Miss MacLaine, who has no career, doesn't work and doesn't especially want to, and whose entire existence has been wrapped up in her one child.

Yet "Terms of Endearment" is surprisingly affecting in describing the somewhat late self-realization of Aurora when, after years of abstinence, she enters into a hugely satisfying, if ultimately fruitless affair with an over-the-hill astronaut, played to perfection by Jack Nicholson. It's just possible that one of the reasons that "Terms of Endearment" is so popular with the mass audience is because it demonstrates liberation in thoroughly understandable sexual terms.

• • •

Far more hip is Mike Nichols's "Silkwood," not because of the controversy surrounding the death of its real-life heroine, Karen Silkwood, but because of the way in which it depicts, without moralizing, how she lived. It would have been unthinkable 20 or maybe even 15 years ago to make a film about such a woman without somehow showing her death to have been inevitable — the wages of her very freely lived life.

"Silkwood" works as socially relevant melodrama, but it's most startling as a glimpse into the unconventional manners of the lower middle class that, in most fiction, is idealized. The sexual lives of Karen (Meryl Streep), her lover, Drew Stephens (Kurt Russell), and her best friend, Dolly Pelliker (Cher), are as cheerfully haphazard as those of the members of a 60's commune. Yet Karen, Drew and Dolly are also extremely ordinary people.

What defines the story as extraordinary — and makes it so moving — is the sight of this imperfect woman, Karen, as she stumbles onto social and political commitment. Miss Streep's Karen Silkwood becomes truly heroic but, in keeping with these muddled times, her heroism never justifies the more or less random sloppiness of the rest of her life. She's one of the most complex and interesting women to be seen on the screen in a long time, certainly since Miss Streep's Oscar-winning performance in "Sophie's Choice."

•

Any discussion relating to women and current films must make some reference to Barbra Streisand and her "Yentl," but since "Yentl" is less about women or Woman than about the power of the superstar, it doesn't seem especially significant.

More pertinent, really, is the box-office success of "Educating Rita," a movie I didn't much like but one that gives a good actress, Julie Walters, a flashy role that, apparently, reaches a lot of people where it counts. Amy Jones's."Love Letters" is a sudsy romantic drama about the pain endured by an intelligent young single woman in a brief affair with a married man. The movie would be unendurable were it not for the presence of Jamie

Lee Curtis as the suffering heroine. Like Sigourney Weaver, Miss Curtis is the kind of strong, spirited actress who can go a long way toward making the new "women's" films work when everything else is second-rate.

By far the most exciting of these films about women is Diane Kurys's funny, moving, virtually epic new French film, "Entre Nous," which actually is a feminist movie, though one so completely and thoroughly realized that it doesn't for a second appear to be scoring arbitrary points at the expense of men. The movie it most reminds me of — and this will take some explaining, I suppose — is John Cassavetes' "Husbands" (1970), if only because it's also about friendship, that most difficult of all relationships to define dramatically.

•

"Husbands" is an exasperating movie. It's overlong. It wanders. It allows its stars — Mr. Cassavetes, Peter Falk and Ben Gazzara — to improvise long after someone should have cried "cut" or, maybe, "uncle." But it remains in the memory as Mr. Cassavetes's most vivid and affecting film, something I must admit I didn't feel at the time I originally saw it.

"Entre Nous" is a very different kind of movie, beautifully written by

Miss Kurys and, though it covers a lot of time and geography, so tightly controlled and dramatically efficient that it seems half as long as it really is.

The film, which opens in 1940, covers approximately 12 years in the lives of two very different sorts of women. They are Lena (Isabelle Huppert), a Belgian-born Jew, married to good-hearted but conventionally insensitive fellow who saved her from a German prison camp during the war, and Madeleine (Miou Miou), a pretty, would-be artist, locked into a loveless marriage with a handsome, feckless would-be actor. The principal setting is Lyons where, in 1952, the two women meet during a grade school pageant.

•

Neither of Miss Kurys's two earlier films, "Peppermint Soda" and "Cocktail Molotov," hints at the talent that is evident throughout "Entre Nous," which is as much a social history as it is an exploration of an emotional landscape not often seen in movies. The two women are not lesbians, though there are times when each appears to be flirting with the other, not to make a sexual conquest but, in some mysterious fashion, to acknowledge a friendship not certified by less seductive gestures.

Miss Huppert and Miou Miou are individually superb and superbly balanced as characters. I'm also astonished that though the two women are far more interesting characters than their individual husbands and lovers, there is no sense of a put-down. It says something about the measure of Miss Kurys's control of her material that although Michel (Guy Mar-

'Entre Nous' is funny, moving, virtually epic.

chand), Lena's husband, is portrayed as something of an unfeeling slob, he's never unsympathetic. That Madeleine's husband, Costa (Jean-Pierre Bacri), is no match for his wife says less about his rather feeble character than it does about the rigorous demands that Madeleine makes on life.

The relationship between the two women is the center of the movie, though "Entre Nous" is not a polemic on the order of Agnes Varda's "One Sings, the Other Doesn't." As much as it's about what happens to Lena and Madeleine and how, at crises, each comes to the aid of the other, it's also about France in those early postwar years and about the awakening of a political consciousness that was to reach a climax in May 1968, long after the movie itself has ended.

Most important of all, Miss Kurys has dramatized her film with effortlessly vivid incidents that define everything that's on her mind. Not once does anybody have to talk about issues or causes or feelings. "Entre Nous" illuminates the lives of its characters so beautifully it never has to explain them.

Miss Kurys is a major new filmmaker.

1984 F 12, II:19:1

John Hughes in "That Sinking Feeling."

Teen-Age Robbers

THAT SINKING FEELING, directed and produced by Bill Forsyth; screenplay by Mr. Forsyth; director of photography, Michael Coulter; edited by John Gow; music by Colin Tully; released by the Samuel Goldwyn Company. At the Lincoln Plaza Cinema, 63d Street and Broadway. Running time: 82 minutes. This film is rated PG.
RonnieRobert Buchanan
Vic ...John Hughes
Wal ...Billy Greenlees
SimmyDouglas Sannachan
Alec ...Alan Love
The Wee ManEric Joseph
Eddie the DriverEddie Burt

By VINCENT CANBY

"THE action of this film," a preopening credit announces, "takes place in a fictitious town called Glasgow. Any resemblance to any real city called Glasgow is purely coincidental." The setting does, indeed, look a lot like the real Glasgow, but what happens there on the grubby back streets, in the rubbish-strewn vacant lots, vast warehouses and rain-soaked parks is pure enchantment. Here is a contemporary fairy tale in which just about everybody has a skin problem.

The film, which opens today at the Lincoln Plaza and other theaters, is Bill Forsyth's 1979 "That Sinking Feeling," the first feature to be written and directed by the young Scottish film maker whose second and third features, "Gregory's Girl" and "Local Hero," have already established him as a most original, major film humorist.

Though Mr. Forsyth was apparently reluctant to have this early, extremely low-budget, 16-millimeter work released here, he need not worry, at least about those of us who were bewitched by the two later comedies.

"That Sinking Feeling" doesn't have quite the panache of "Gregory's Girl" and "Local Hero." However, it is a lyrically amiable, funny introduction to Mr. Forsyth's talent and his particular world, which is inhabited exclusively by lunatic teen-agers, self-possessed adolescents and solemn tots. Though the backgrounds are real enough, everything that happens in the foreground is touched by magic.

Strictly speaking, I suppose, "That Sinking Feeling" might be classified as a caper film, being about the conception, the planning and, finally, the execution of an improbably near-perfect crime: the stealing of 90 stainless-steel sinks by a gang of eager but none-too-bright kids. The leader is a fellow named Ronnie who, early in the film, admits that he has just tried

to kill himself by drowning in a bowl of cornflakes and milk. After much introspection, Ronnie decides that there must be more to life than suicide, with which his mates agree.

It's Ronnie who hits on the complicated plan, involving an ever-widening circle of thieving conspirators, to break into the warehouse and make off with the sinks, which, he estimates, will bring in small fortunes for all. Among his associates are Vic and Wal, who are to disguise themselves as women to keep the warehouse's night watchman busy; Bobby, something of a wizard at chemistry, who concocts a sleeping potion that will allow them to "borrow" a bakery delivery truck, and a small black boy called the Wee Man, who never says much but plays a key role in the heist.

Among the fringe characters are Vic's girlfriend Mary, who frowns a lot anyway but even more when Vic starts to take an unnatural interest in her clothes as well as her lipstick, and Eddie, the innocent driver of the bakery van who, one doctor predicts at the end, won't wake up until 2068. "He'll be a billionaire," the nurse says with delight, "Eighty years of sick benefits!"

"That Sinking Feeling" doesn't move — it ambles from one seemingly found moment to the next, and though it's not as dense with odd detail as the later Forsyth films, it's never bereft of them. Like the somewhat better-manicured landscape of "Gregory's Girl," this grubby Glasgow is full of mysterious characters, including one small figure in a bright red jogging suit who, without explanation, frequently turns up in a scene, jogging purposefully to nowhere.

Robert Buchanan, who plays the second-best friend of the hero of "Gregory's Girl," is a very winning Ronnie, a pint-sized poet with a gift for unlikely crime. John Gordon Sinclair, who was so fine as Gregory in the later film, has a very small role in this one, but he also is a very funny if mostly mute presense. As Vic, John Hughes almost makes off with the film, particularly as we see his personality change from fairly hip teenager to rather prissy, prematurely matronly woman, when he gets into drag. Billy Greenlees, who played Gregory's pastry-baking pal in "Gregory's Girl," is hilariously bemused as the other "girl," who nearly drives the night watchman mad with desire.

"That Sinking Feeling" is a gentle film, but that gentleness cannot obscure the strength of its intelligence and wit. Mr. Forsyth is one of a kind, and "That Sinking Feeling" is one long, very broad smile, punctuated here and there with genuine belly laughs.

•

"That Sinking Feeling" has been rated PG ("Parental Guidance Suggested"), perhaps because someone feels that it will set a bad example for toddlers with antisocial inclinations. The rating otherwise seems rather harsh for a comedy of such good cheer.

1984 F 15, C21:4

Lots of Folk Singing

CHORDS OF FAME, directed by Michael Korolenko; produced by Korolenko, David Sternburg, Mady Schutzman. At the Film Forum, 57 Watts Street. Running time: 88 minutes. This film has no rating.
WITH: Pete Seeger, Oscar Brand, Odetta, Peter Yarrow, Tom Paxton, Dave Van Ronk, Eric Andersen, Jerry Rubin, Abbie Hoffman and Bill Burnett.

IN OUR HANDS, produced by Robert Richter and Stanley Warnow; camera and editing by 350 Independent film makers; distributed by Libra Cinema 5. Running time: 89 minutes. This film has no rating.
WITH: James Taylor, Holly Near, Meryl Streep, Peter, Paul & Mary, Ellen Burstyn, Orson Welles, Dr. Helen Caldicott, Dr. Benjamin Spock, the Rev. William Sloan Coffin

By JANET MASLIN

FOR those with a lingering interest in the folk singers of the 1960's and the political and cultural climate in which they flourished, Michael Korolenko's "Chords of Fame" is worth recommending for some of the raw material that it contains. But Mr. Korolenko, in assembling this portrait of the late singer-songwriter Phil Ochs, has taken an exasperating approach to his subject. Reasonable as it would be to expect the music and photographs of the real Mr. Ochs to figure prominently in this documentary, Mr. Korolenko has replaced him with a double. All the other key characters in this story appear as themselves.

In "Chords of Fame," which opens today at the Film Forum, the very caustic and intense Mr. Ochs is portrayed by Bill Burnett, who is so callow and bland in the role that he captures nothing of his mercurial subject. Mr. Burnett's slight vocal resemblance to the singer is no justification for the lengthy impersonation on which the film is centered. In trying to progress from a furiously energetic, wisecracking young man to the dissipated and discouraged figure who eventually took his own life, his range is pitifully limited. To suggest Mr. Ochs in his hard-drinking later days, for instance, Mr. Burnett preserves his own clean-cut manner but staggers around in a raincoat with a large stain.

•

What little information there is about Mr. Ochs to be gleaned here is contained in the comments of those who knew him. Friends like Jerry Rubin, Abbie Hoffman and Jim Glaser speak of the contradictory charm and abrasiveness in the singer's character, and the manager Harold Leventhal mentions Mr. Ochs's fierce jealousy of his contemporary, Bob Dylan. The club owner Mike Porco tells of having to evict Mr. Ochs in his later days, and how perversely likable he was even then. The animated manner of Michael Ochs gives some sense of his late brother's character, as do the rueful reminiscences of his sister, Sonny.

As for Mr. Ochs's music, it is best represented here by the other veteran folk singers who are glimpsed here, if only briefly. Eric Andersen sings "When I'm Gone," and calls it one of Mr. Ochs's loveliest songs; Pete Seeger and Oscar Brand convey the spirited sarcasm of "Draft Dodger Rag." Tom Paxton, Dave Van Ronk and Bob Gibson are seen performing a few seconds' worth of "That's The Way It's Gonna Be." And, most movingly, a chorus of friends sings the beginning of "Crucifixion," Mr. Ochs's most ambitious song. But the singer's own voice is almost entirely absent from this biography, and this omission makes "Chords of Fame" seem, at the very best, incomplete.

•

On the same bill, "In Our Hands" is an account of a peace rally in Central Park on June 12, 1982, that featured some of the same personnel that appears in "Chords of Fame," together with updated versions of some of the same attitudes as well. Camera, sound and editing here are by 350 different independent film makers, with Robert Richter and Stanley Warnow overseeing the project.

Not surprisingly for such a technically complicated film, "In Our Hands" tends toward a certain amount of repetition, particularly in scenes that show marchers boarding buses in various distant spots at dawn, and in others that convey a carnival atmosphere. The film is best when it confines itself to the speeches and music that were heard at the rally, and to the stirring spectacle of so many marchers gathered in the spirit of a single cause.

1984 F 16, C23:1

Stealing for Good

LASSITER, directed by Roger Young; screenplay by David Taylor; director of photography, Gil Taylor; film editor, Benjamin A. Weissman; music by Ken Thorne; produced by Albert S. Ruddy; released by Warner Bros. At Criterion Center, Broadway and 45th Street; Manhattan Twin, 59th Street, east of Third Avenue; Bay Cinema, Second Avenue at 32d Street; 83d Street Quad, at Broadway; 86th Street Twin, at Lexington Avenue, and other theaters. Running time: 100 minutes. This film is rated R.

Lassiter	Tom Selleck
Sara	Jane Seymour
Kari	Lauren Hutton
Becker	Bob Hoskins
Breeze	Joe Regalbuto
Smoke	Ed Lauter
Max Hofer	Warren Clarke
Allyce	Edward Peel
Askew	Paul Antrim
Quaid	Christopher Malcolm
Eddie Lee	Barrie Houghton

THERE'S not much variety to what Tom Selleck does on the screen. It goes without saying that he seems friendly and looks preternaturally handsome, that he wears clothes well and changes them with amazing frequency. But he doesn't appear to have more than a passing interest in anything that goes on around him, so why should you? Though "Lassiter" flings Mr. Selleck into a plot involving Nazis, diamonds and beautiful but depraved German aristocrats, you may soon lose track of the fine points. Even by the standards of escapist entertainment, little of "Lassiter" seems to matter.

"Lassiter," which opens today at the Criterion and other theaters, is set in pre-World War II London, where Mr. Selleck, as the title character, is a highly successful jewel thief (he looks great in black cat-burglar garb). The Federal Bureau of Investigation and Scotland Yard jointly enlist his help in capturing some uncut diamonds that might otherwise be used to finance Nazi activities, and in the course of this, Lassiter must commingle with a wicked and elegant countess (he looks great in evening clothes). Lauren Hutton plays the countess, and meanwhile, back at home, Lassiter also has the beautiful Sara (Jane Seymour) waiting. It all sounds glamorous, but somehow, it's not.

•

The dialogue, from David Taylor's screenplay, runs toward lines like, "Lassiter! It won't be that difficult, not for a man like you," and, "Careful, Nick! She's a woman with appetites — *unusual* appetites." Notwithstanding the efforts of some good actors in the supporting cast (Bob Hoskins, Joe Regalbuto, Ed Lauter) and a spirited performance from Miss Seymour, Mr. Selleck remains the film's chief, if not only, attraction.

There are indications that he might fare better with less gimmicky material and with more of the self-mocking humor that surfaces here only briefly. In the meantime, "Lassiter" is designed solely for audiences whose interest is in ogling the star. As directed by Roger Young, it contains a bit more nudity and violence than the tepid material actually warrants — an indication that the film may be aimed more at Mr. Selleck's international following than his local admirers.

Janet Maslin

1984 F 17, C10:5

Struck in the Sun

BLAME IT ON RIO, produced and directed by Stanley Donen; screenplay by Charlie Peters and Larry Gelbart; director of photography, Reynaldo Villalobos; edited by George Hively and Richard Marden; music by Cy Coleman, Ken Wananberg, Oscar Catro-Neves; released by 20th Century-Fox Film Corporation. At Criterion Center, Broadway, between 44th and 45th Streets; Gotham Cinema, Third Avenue and 58th Street; Murray Hill, 34th Street, near Third Avenue, and other theaters. Running time: 107 minutes. This film is rated R.

Matthew Hollis	Michael Caine
Victor Lyons	Joseph Bologna
Karen Hollis	Valerie Harper
Jennifer Lyons	Michelle Johnson
Nicole Hollis	Demi Moore
Eduardo Marques	Jose Lewgoy
Signora Botega	Lupe Gigliotti
Peter	Michael Menaugh
Helaine	Tessy Callado

OF all the remakes, credited and uncredited, now coming into New York theaters, two of the most joyless must be "Crackers" (reviewed on page C19) and "Blame It on Rio," which, though there is no acknowledgment of the fact, is based on a 1977 French comedy by Claude Berri, "One Wild Moment," released in this country in 1981.

The comedy wasn't great when it was called "One Wild Moment," but it's far more offputting as "Blame It on Rio," directed by Stanley Donen, with a cast headed by Michael Caine, Joseph Bologna and Valerie Harper, and a screenplay by Charlie Peters and Larry Gelbart.

•

As before, the story is about a middle-aged man (Mr. Caine), who is seduced by the beautiful teen-age daughter of his best friend (Mr. Bologna) during a month's holiday by the sea. In this case, the sea is the South Atlantic, off Rio de Janeiro's great beaches and topless sunbathers.

Youth participating in peace rally in scene from "In Our Hands."

Though the scenery can't be faulted, there's not a single funny or surprising moment in the movie. However, "Blame It on Rio" is not simply humorless. It also spreads gloom. It's one of those unfortunate projects that somehow suggests that everyone connected with the movie hated it and all of the other people involved.

Michelle Johnson, a new actress who looks like a Cosmopolitan girl, plays the seductive teen-ager, and Demi Moore plays her best friend, that is, Mr. Caine's daughter, who is not pleased about her father's affair. The camera is kind to these young women, and to those beautiful, tanned anonymous bodies on the Rio beaches. It makes everybody else look either angry or sick.

"Blame It on Rio" opens today at the Gotham and other theaters.

Vincent Canby

1984 F 17, C10:5

Blue-Collar Chic

FOOTLOOSE, directed by Herbert Ross; screenplay and lyrics by Dean Pitchford; director of photography, Ric Waite; choreographer, Lynne Taylor-Corbett; edited by Paul Hirsch; produced by Lewis J. Rachmil and Craig Zadan; released by Paramount Pictures. At Loews State, Broadway and 45th Street; Orpheum, 86th Street, near Third Avenue; 34th Street Showplace, between Second and Third Avenues, and other theaters. Running time: 106 minutes. This film is rated PG.

Ren MacCormack	Kevin Bacon
Ariel	Lori Singer
Vi Moore	Dianne Wiest
Shaw Moore	John Lithgow
Wendy Jo	Elizabeth Gorcey
Rusty	Sarah Jessica Parker
Willard	Christopher Penn
Chuck	Jim Youngs

By JANET MASLIN

ENJOY the terrific title sequence of "Footloose" while it lasts, not just for its montage of interesting-looking dancers' feet and red-hot musical accompaniment, but also for its promise of the jumpy, colorful, exciting movie that, unfortunately, is not to follow. Instead, "Footloose" is a "Flashdance" set in farm country, with tractors supplying the blue-collar chic and the flash mostly missing. The single burning idea behind the movie can be summed up as follows: Don't Knock the Rock.

"Footloose," which opens today at Loews State and other theaters, is set in a small, religious Middle Western town where bopping is strictly forbidden. Into this cloistered climate comes Ren (Kevin Bacon), a city kid with a portable cassette player and a punk haircut. Ren falls for a pretty girl and leads a crusade to force the town elders to allow a prom to take place, and that's about all the movie has to it. That, and a cast that's appealing almost in spite of the material and a selection of hits-to-be that enliven the soundtrack immensely.

•

As directed by Herbert Ross and written by Dean Pitchford, the movie has a Hollywood patina, a none-too-ingenuous simplicity and a tendency to overexplain. We are told, for instance, that people don't trust Ren because he is an outsider and that Ariel (Lori Singer) likes him for precisely that reason. John Lithgow, playing the fuddy-duddy of a minister who is Ariel's father, is given endless opportunities to denounce "this obscene rock-and-roll music, with its gospel of easy sexuality and relaxed morality."

On the slightly less literal level, we are made to realize that Ariel is a daredevil when she stands astride both a car and a truck as a second truck approaches in the other lane. Though this should have been enough to make the point, Ariel later, in much the same spirit of adventure, dashes in front of an oncoming train.

Fortunately, Kevin Bacon is a very likable actor, especially when he finally frees himself from the sullenness that is one of Ren's affectations. Mr. Bacon endures a lot here, including a "Flashdance"-inspired solo dance number (would anyone really prance around a lot of farm equipment in what he believed to be a private moment?) and a scene in which the kids at the drive-in burst spontaneously into musical motion. He's even credible in a scene in which, after he supposedly dances strenuously in an out-of-town club, his white T-shirt is miraculously sweat-free.

Fine points like these (and the question of where Ren is getting his spiky hair trimmed in the conservative little town of Bomont) can be noticed throughout "Footloose." How can you help wonder, after Ren proves his mettle by participating in a "chicken" race on tractors and his rival's vehicle tumbles off the road, why nobody in tiny Bomont asks after the missing machinery?

Like the rest of today's video-happy teen-age entertainments, "Footloose" doesn't expect to be watched closely or taken seriously. It wants to fill the screen with catchy music and pretty kids, and this it certainly accomplishes. Miss Singer looks lovely, even on the night when she comes home with a black eye (nobody asks about this, either), and she is dynamic to the point of constant darting.

Christopher Penn very nearly steals the movie as Ren's hayseed friend, and the two share a musical scene (to Deniece Williams's "Let's Hear It for the Boy") that's almost as sensational as the opening credits. Sarah Jessica Parker, as Ariel's friend, and Dianne Wiest, as her mother, are also impressive, although Miss Wiest's role is so awkwardly introduced that she stops the movie momentarily. "It's 20 years now I've been a minister's wife," she begins, an hour into the story, though she's been virtually invisible before this, and by now her complaints seem very much beside the point. The point, apparently, is to have fun and keep on dancing.

1984 F 17, C12:3

Jacques Perrin in Pierre Schoendoerffer's 'Crabe Tambour.'

Warrior Adrift

LE CRABE TAMBOUR, a film by Pierre Schoendoerffer; screenplay (French with English subtitles) by Jean-François Chauvel and Mr. Schoendoerffer, based on Mr. Schoendoerffer's novel; photographed by Raoul Coutard; edited by Nguyen Long; music by Philippe Sarde; produced by Georges de Beauregard; a co-production of A.M.L.F.-Lira Films-Bela Production-T.F.1; distributed by Interama. At the Public, 425 Lafayette Street. Running time: 120 minutes. This film has no rating.

Captain	Jean Rochefort
Doctor	Claude Rich
Chief Engineer	Jacques Dufilho
Willsdorff	Jacques Perrin
Bar Hostess	Odile Versols
Francine	Aurore Clement
Lieutenant	Morgan-Jones
Officer of Fishing Fleet	Hubert Laurent
Bongo-Ba	Joseph Momo
Babourg	Pierre Rousseau
Bar Owner-Gendarme	Fred Personne
Bochau	François Landolt
Rector	Bernard Lajarrige

By VINCENT CANBY

TO come to the point immediately, "Le Crabe Tambour," Pierre Schoendoerffer's 1977 French film based on his own French novel, is one of the grandest, most beautiful adventure movies in years. It may be somewhat old-fashioned in its emphasis on courage, honor and the glory of war, no matter what the cause. However, it's also wonderfully old-fashioned in its convoluted, romantic narrative, which moves from Vietnam, during the collapse of France's control of Indochina in the 1950's, to East Africa, Algeria, Brittany, Newfoundland and the stormy fishing grounds on the Grand Banks.

The only recent film to which it can be compared is John Huston's adaptation of Rudyard Kipling's "Man Who Would Be King," though it more consciously calls to mind the tales of Joseph Conrad through specific references to "Heart of Darkness" and "The Nigger of the Narcissus."

"Le Crabe Tambour" opens at the Public Theater today for a one-week engagement, which, I trust, will be extended, or the film will be moved to another house. The film has taken too long to get here to disappear too quickly.

•

"Le Crabe Tambour" ("Drummer Crab") is the nickname for the mysterious central character, Willsdorff (Jacques Perrin), an Alsatian, whose doomed, out-of-date career is recalled through the tales of three naval officers currently serving aboard a French supply ship in the North Atlantic.

Willsdorff, whose story is based on

Kevin Bacon stars in "Footloose," directed by Herbert Ross and dealing with teenage rebellion against the constraints of life in a small, Middle Western town.

that of a still-living Frenchman named Pierre Guillaume, is a 20th-century Lord Jim, whose story begins shortly before the fall of Dien Bien Phu. When first seen on his Mekong River boat, hugging a large black cat with yellow eyes, Willsdorff looks too good to be true. He's incredibly self-assured and perhaps just a little bit crazy. He's also very young, very handsome and very blond, a white god among what used to be called the heathen.

Willsdorff clearly loves war, though what motivates that love remains ambiguous right up to the end, but his obsession touches everyone he meets, including the members of his Vietnamese crew and the other French officers whose paths cross his. Even when covered with filth or humiliated in defeat, Willsdorff appears to be immaculate, cool and impersonally cheerful, in the way of a man who possesses some formidable, unshared secret.

Sailing toward a French fishing fleet off Newfoundland, the three officers on the supply ship tell their stories in interlocking flashbacks. We learn, among other things, that Willsdorff spent three years in a Vietnamese prison after Dien Bien Phu, that he attempted to sail back to France on a Chinese junk, that he was captured on the Red Sea by African "rebels" and later ransomed by the French Navy.

Still later, he turns up in Algeria during the war of independence and joins a military plot designed to foil President De Gaulle's negotiations to end that war. Once again he lands in prison.

It's this last adventure that forms the curious moral center of the story. It turns out that the supply-ship's captain (Jean Rochefort), once Willsdorff's co-conspirator, had turned against his comrade at a key moment in the failed "putsch." The other narrators are the supply ship's doctor (Claude Rich) and the ship's philosophical chief engineer, played with great humor by Jacques Dufilho.

•

The film's references to recent French political history are, I'm told, easily understood by French audiences though local audiences, to get the full impoprt, will have to read the "footnotes" prepared by Elliott Stein for the Public Theater engagement. However, I also suspect that the film would work as well without the notes, if only because the politics is what Alfred Hitchcock used to call "the MacGuffin," the excuse for the story that is eventually less important than the story itself.

I haven't read Mr. Schoendoerffer's novel, which was published in this country in 1978 in an English translation that's now out of print. The New York Times review was not appreciative. However, this big, richly detailed film works wonderfully as its own excuse.

•

Mr. Schoendoerffer, a successful journalist, as well as novelist and film maker, adapted his book with Jean-François Chauvel. Willsdorff's brother, who is an important off-screen character in "Le Crabe Tambour," is one of the heroes of Mr. Schoendoerffer's first novel, "The 317th Section," published in France in 1963 and, a year later, made into a film by him that hasn't been released in New York as far as I can learn.

That "Le Crabe Tambour" successfully maintains its epic sweep from start to finish is a credit to the

novelist-director and to the fine performances by Mr. Perrin, Mr. Rochefort, Mr. Rich and Mr. Dufilho, and, especially, to the extraordinary photography by Raoul Coutard. Mr. Coutard, who photographed most of the early "new wave" classics by Jean-Luc Godard and François Truffaut — each one stylistically different — outdoes himself.

"Le Crabe Tambour" is a visual tour de force, by which I don't mean that it's just beautiful, which it often is, but that the camerawork perfectly reflects the concerns of the narrative, which was filmed in Thailand, Africa, France and on the North Atlantic. These wintry seascapes are among the most stunning sequences I've ever seen in a conventional movie.

•

"Le Crabe Tambour" is always, however, a movie. There are things missing from it that might have been made clear in a novel. The character of Willsdorff remains a dreamlike figure, one always seen through the eyes of others. He has no unguarded moments. In this day and age, one can't help wondering about his sex life, if any. There's something almost prepubertal about the film's exclusive interest in the Willsdorff legend, but then "Le Crabe Tambour" is a series of tales told in a ship's wardroom, on its bridge, in its engine room and, in one moving sequence, in a lonely little Newfoundland bar call the Joyful Cod.

The questions that linger at the end of the film do not diminish it but possibly fix "Le Crabe Tambour" more firmly in the memory. The film, which is myth making of a most exhilarating sort, longs for a kind of heroic literature not easily accommodated in our liberated age.

1984 F 17, C17:1

Bungling Burglars

CRACKERS, directed by Louis Malle; screenplay by Jeffrey Fiskin; director of photography, Laszlo Kovacs; edited by Suzanne Baron; music by Paul Chihara; produced by Edward Lewis and Robert Cortes; released by Universal Pictures. At the Baronet, Third Avenue and 59th Street and other theaters. Running time: 92 minutes. This film is rated PG.
Weslake..................................Donald Sutherland
Garvey...Jack Warden
Dillard..Sean Penn
Turtle..Wallace Shawn
Boardwalk.......................................Larry Riley
Ramon...Trinidad Silva
Maxine.................................Christine Baranski
Jasmine...........................Charlaine Woodard
Maria..Tasia Valenza
Lazzarelli...Irwin Corey
Don Fernando...........................Edouard DeSoto
Slam Dunk.......................Anna Maria Horsford
Artiste.............................Mitchell Lichtenstein

"CRACKERS," which opens today at the Baronet and other theaters, simply proves that with the right material an intelligent director of demonstrated style and a cast of thoroughly accomplished comic actors can make as painfully witless a comedy as any knucklehead on the block.

The material here is a screenplay, credited to Jeffrey Fiskin ("Cutter's Way"), based on Mario Monicelli's 1960 Italian comedy, "Big Deal on Madonna Street," about a group of inept safecrackers. In this wan, updated revision, directed by — of all people — Louis Malle ("Pretty Baby," "Atlantic City," "My Dinner With André"), the locale has been shifted from colorful Italy to colorful San Francisco. The characters more or less match those in the original film, although they now also recall

the sorts of colorful slobs John Steinbeck and William Saroyan wrote about in their sentimental moods.

For the record, the principal actors are Donald Sutherland, as the leader of the gang; Wallace Shawn, as his small sidekick, an always hungry fellow who'll eat anything, including catfood sandwiches; Jack Warden, as the mingy owner of a pawnshop; Sean Penn, as a dull-witted electrician; Larry Riley, as a pimp who can't concentrate on his career because he must take care of his baby son, and Trinidad Silva, as a hot-headed young Chicano who worries more about his sister's honor than the thievery at hand.

Two performances stand out above the others, those of Christine Baranski, one of the New York theater's treasures, who plays a wacky, fun-loving meter maid, and Tasia Valenza, a New York model who plays Mr. Silva's not-so-innocent sister.

In every other way, the movie is a mistake.

•

"Crackers," which has been rated PG ("Parental Guidance Suggested"), contains some mildly vulgar language and gestures.

Vincent Canby

1984 F 17, C19:3

FILM VIEW

VINCENT CANBY

A Great Cameraman Weaves an Epic Spell

After one has watched movies for a living over a period of years, the surprises become increasingly rare. It's not that one's senses have been dulled, though that can happen after a stretch of films that are neither very good nor very bad. Those are the ones that anesthetize the senses.

Rather it's that very few films come along about which one doesn't have some expectations — high or low — because of previous work by the same directors, writers or actors. Also, one would have to lead an impossibly cloistered life not to be aware occasionally of the annunciations of the publicity and advertising people who, like Satan, never sleep. Only once in a while does a very good and sometimes great film suddenly appear on the scene without — is it all right to say? — warning.

"Stevie," with its superb performance by Glenda Jackson as the poet Stevie Smith, was such a discovery, showing up a couple of years after its production for an unheralded two-day run at the Thalia. Though I'd seen a couple of films by Rainer Werner Fassbinder, I was completely unprepared for the extraordinary talent revealed by the New Yorker Films retrospective devoted to his work in the mid-70's. More recently, Bill Forsyth, the Scottish filmmaker, more or less crept into our consciousnesses with "Gregory's Girl" and "Local Hero." With the opening here last week of his very first feature, "That Sinking Feeling," it's now safe to say that Mr. Forsyth is a major director with a comic vision unlike anyone else's.

This week's — and perhaps this year's — revelation is a 1977 French film called "Le Crabe Tambour" ("Drummer Crab"), which has just opened at the Public Theater with less public notice than might accompany a Mick Jagger arrival at Kennedy Airport. "Le Crabe Tambour," a hugely romantic film about war and honor and empire, whose sensibilities are firmly rooted in the 19th century, is not the first feature by its director, Pierre Schoendoerffer, but it's the first one I'm aware of and, as far as I can tell, the first to receive commercial release in New York.

• • •

"Le Crabe Tambour," playing at the Public through Thursday, is a complex movie that owes more than a little to Joseph Conrad. The film, adapted by Jean-Francois Chauvel and Mr. Schoendoerffer from Mr. Schoendoerffer's own novel, is a series of interlocking tales about a shadowy French naval officer, nicknamed Crabe Tam-

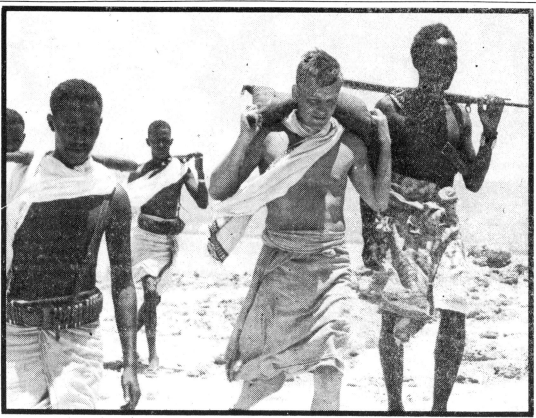

Jacques Perrin, center, in the title role of Pierre Schoendoerffer's "Crabe Tambour," at the Public Theater—"a complex movie that owes more than a little to Joseph Conrad: a series of interlocking tales about a shadowy French naval officer."

bour — based, incidentally, on a real-life character — as he is remembered by three officers on a French frigate in the North Atlantic in the 1970's.

The man they recall, played by Jacques Perrin, serves on a French riverboat during the last days of French rule in Indochina in the 50's, is captured and imprisoned there for three years and later turns up in Algeria, where he is one of the leaders in a military plot to subvert President de Gaulle's negotiations to end the Algerian war for independence.

The film's splendid cast — most of whom are better known to me than Mr. Schoendoerffer — includes Jean Rochefort, Claude Rich, Jacques Dufilho and Odile Versois, in addition to Mr. Perrin. However, it isn't just the performances or the wonderfully convoluted and sometimes not entirely clear story that command attention. It's the grand "look" of the film.

● ● ●

From the opening shots to the last, "Le Crabe Tambour" is spellbinding. I can't really say that its "look" is familiar, or that I could recognize the work of a particular cameraman, only that the film has a visual sweep and an old-fashioned majesty that perfectly reflect a story that moves from Indochina to the Red Sea and the African east coast, to Algeria to Brittany and, finally, to the fishing banks off Newfoundland in midwinter. Its seascapes are among the most breathtakingly evocative I've ever seen in a commercial motion picture.

Not until the titles came up at the end of the film did I realize that this remarkable work was that of Raoul Coutard, once best known as the cameraman-in-residence to Jean-Luc Godard (including "Breathless," "A Married Woman" and "Two or Three Things I know about Her") and François Truffaut (including "The 400 Blows," "Shoot the Piano Player," "Jules and Jim" and "The Bride Wore Black"). Among his other credits: Costa-Gavras's "Z" and "The Confession."

● ● ●

The magnificence of Mr. Coutard's photography in "Le Crabe Tambour" is reason enough to see the film even if one might find its politics inscrutable or, as Elliott Stein says in some invaluable "footnotes" prepared for the Public Theater presentation, "out-of-date."

Although it's extremely difficult for laymen, including most movie reviewers, to know exactly who is responsible for the "look" of any particular film, it should be possible at this point to acknowledge Mr. Coutard's geni-

us, that is, his rare ability to realize the very different objectives of each of the major directors he has worked with.

He is not one of those cameramen who carries a particular visual style around with him, from one film to the next. Nor, apparently, does he hire himself out to recreate a Godard "look" or a Truffaut "look" in the way that Federico Fellini's favorite cameraman, Giuseppe Rotunno, was imported to lend a Fellini "look" to Bob Fosse's "All That Jazz."

Along with good film acting, good cinematography remains the least well understood — by myself, among others — component of filmmaking. Too often we tend to confuse prettiness with purpose, attention-getting techniques with the more fundamental needs of a film. When a cameraman becomes closely identified with the work of one director, he tends to become as typecast as any character actor in the Golden Age of the great Hollywood studios. Sven Nykvist is a terrific cameraman, but most of the people who hire him are hoping to buy the frosty, limpid Ingmar Bergman "look."

However, even the cameramen themselves often disagree about what is good or bad work. In his book, "Hollywood Cameramen" (Indiana University Press, 1970), Charles Higham quotes Arthur Miller, not the playwright but the cameraman ("The Song of Bernadette," "A Letter to Three Wives"), as having found "The Lion in Winter" to be "one of the most beautiful pictures I ever saw, but it has a fault, it's *too* beautiful.

"It's like walking through the Louvre and at first you see a Picasso and you want to study every brushstroke, but after an hour and the 15th picture, you might as well be looking at The Saturday Evening Post's cover. . . the overall effect is so beautiful, it's boring. It wears out the eye."

In 1980 there was a bit of a tempest when Gordon Willis, Woody Allen's cameraman on "Manhattan" and a

man closely associated with filmmaking on the East Coast, failed to be nominated for an Oscar by the members of the cinematographers' branch of the Academy of Motion Picture Arts and Sciences. At that time, Haskell Wexler, an Oscar-winning cameraman for "Who's Afraid of Virginia Woolf," suggested that the Hollywood cameramen weren't actually plotting to deny Mr. Willis his due. "I don't think they're sophisticated enough to plot," he said. "I think it's simply that their standards, ideas and visual responses are all past references. . . they don't respond to Gordon's style of lighting, which I think is beautiful — those big dark areas. . ."

Mr. Willis (the two "Godfather" films, "All the President's Men") is not likely to be typecast as a result of his movies with Mr. Allen. One of the joys of the Willis work for Mr. Allen has been the different demands made by such films as "Stardust Memories," in which he fondly satirizes the Fellini "look," "Zelig," which is a recreation of the "looks" of both newsreels and fiction films of the 1920's and 30's, and the current "Broadway Danny Rose," which mimics the absolutely functional "look" of Hollywood studio comedies of the 1940's and 50's.

Nestor Almendros is another cameraman whose work so efficiently realizes the visions of his directors that, I suspect, only an eye far more practiced than mine could immediately identify an Almendros "look." Compare his work on "The Wild Child" with what he did for "Claire's Knee," "The Last Metro," "Kramer vs. Kramer" or, for that matter, "The Blue Lagoon." There is no Almendros signature "look."

Neither is there any easily recognizable Raoul Coutard "look," which is why the strong, vivid, epic quality of the cinematography of "Le Crabe Tambour" is such an invigorating surprise. It's a surprise because I've always thought of him in connection with those early Godard and Truffaut classics, and it's invigorating because the physical scope of the Schoendoeffer film makes demands on his talents I've never seen before. It's astonishingly fine work. ■

1984 F 19, II:15:1

Cat-and-Mouse Game

THE UNAPPROACHABLE, directed by Krzysztof Zanussi; script by Mr. Zanussi and Edward Zebrowski; edited by Inge Behrens, Karin Nowarra; music by Wojciech Kilar; director of photography, Slawomir Idziak; sound by Bernhardt Reicherts and Robert Nerz; set designers, Jan Schlubach and Albrecht Konrad; costume designer, Anna Biedrzycka-Sheppard; executive producer, Horst Burkhard; a German co-production of Regina Ziegler Filmproduction and Zweites Deutsches Fernsehen, Mainz; released by TeleCulture. At the Vandam Theater, 15 Vandam Street. Running time: 92 minutes. This film is not rated.

Claudia .. Leslie Caron
Photographer Daniel Webb
Marianne .. Leslie Malton

By VINCENT CANBY

KRZYSZTOF ZANUSSI, the Polish director, has made some good films, including "Family Life" and "Contract," but "The Unapproachable," which opens today at the Vandam Theater, is not one of them. Actually, it's not even Polish. It was made in West Germany two years ago, in English, with Leslie Caron, who is still

most attractive and still basically French, playing opposite a young actor named Daniel Webb, who is, I assume, English. The setting is a Berlin suburb, but it could be the moon.

"The Unapproachable" is a pint-size drawing room comedy. However, it's one that moves occasionally into other rooms of the house and has aspirations to be a political metaphor. Though it doesn't look at all bad, it sounds terrible. Everybody in the film's cast of three — count 'em three — speaks in perfectly formed sentences that often have the shape of aphorisms ("One feels a healthy hatred against those one has wronged").

The screenplay, by Mr. Zanussi and Edward Zebrowski, is a cat-and-mouse game played entirely in talk. A young man (Mr. Webb) wheedles his way into the great mansion where the beautiful, apparently legendary Claudia (Miss Caron) lives as a recluse, attended only by her maid (Leslie Malton).

The man first claims he has been mugged and wants to use the phone. When Claudia, a former actress, points out that his bruises are boot polish and the blood under his nose clearly fake, the man says he is an art-history student, who only wants to photograph her Canalettos "from the Venetian period."

A lot of water has gone under the bridge, though, before the story creeps even this far. Claudia and the young man manage to get off a number of fast ones on love, ambition and the bourgeois roots of the world's great revolutionaries (Cromwell, Robespierre, Marx and Che Guevara) before they go upstairs, where, of course, there is even more talk.

The dialogue, though lengthy, is padded with dozens of what might be called upper-class asides on the order of "More sarcasm?" or "Am I being indiscreet?" It's the kind of deadening talk in which one person is likely to say, "I wasn't speaking literally," and the other, as if speaking for the screenwriters, says, "This Ping-Pong game has gone on long enough."

The man is up to no good, of course, but, as is likely to happen in such fiction, even a schemer, if low born and poor, becomes a victim of the power and ruthlessness of the extremely rich.

Working with only two characters on the screen at any one time, Mr. Zanussi is hard put to keep things fluid. This necessitates the occasionally absurd camera angle and that the characters get up and change chairs a lot — the sorts of things that are supposed to camouflage lack of

Leslie Caron in "The Unapproachable," opening today at Vandam.

action in a stage comedy and, in a film, do nothing but call attention to the fact.

Miss Caron has such quality that, though she can't bring this foolishness off, one never doubts that she might be quite smashing with better material. Mr. Webb and Miss Malton also demonstrate possibilities, but that's all.

1984 F 24, C8:1

The Lighter Side

ONE MAN'S WAR (La Guerre d'un Seul Homme), directed by Edgardo Cozarinsky; screenplay (French with English subtitles) by Mr. Cozarinsky, based on a text from Ernst Junger's "Parisian Diaries"; edited by Christine Aya and Véronique Auricoste; music by Hans Pfitzer, Richard Strauss, Arnold Schonberg and Franz Schreker; produced by Jean-Marc Henchoz; production company, Marion's Films. Running time: 105 minutes. This film is not rated.

"One Man's War" was shown as part of the 1982 New York Film Festival. Following are excerpts from Janet Maslin's review, which appeared in The New York Times on Oct. 8, 1982. The film opens today at the Public Theater, 425 Lafayette Street.

EDGARDO COZARINSKY has aptly described his "One Man's War" as "a documentary fiction." He has also referred to it as a dialogue between found objects. The objects, in this case, are the remarkably calm, somewhat banal wartime journals of Ernst Junger, a German writer and army officer living in occupied Paris in World War II, and newsreel footage of Paris as it really was. Mr. Cozarinsky has woven these elements together in an eloquent and provocative way.

Mr. Junger's journal concentrates partly on the lighter side of wartime life or at least on creating the impression that such a thing existed. Newsreels praise the ingenuity of Parisian designers, who made clever hats out of newspaper or invented elegant devices in which to carry one's ration cards. Mr. Junger, for his part, thinks of dinner at the Tour d'Argent, musing that "at times such as these, to eat well gives a feeling of power." Mr. Cozarinsky follows this particular point with footage of a soup line, but easy irony is not often his objective.

•

Although it includes some grisly shots of wartime casualties, the film does not concentrate on brutality per se. It pays much more attention to the process by which French and Germans alike may have tried to ascribe normality to abnormal situations. One of Mr. Junger's few descriptions of violence is devoted to an execution he witnessed. "In many small ways, I was able to make the whole thing more human," he notes, observing that the dead man had been handsome and allowing the five small bullet holes on the man's chest to remind him of dew drops. The French themselves seem to have had no small appetite for scenes of models wearing fur coats at the zoo (a kangaroo appears very confused by one woman's kangaroo coat) and for the insistently cheerful songs of Maurice Chevalier.

Mr. Cozarinsky juxtaposes what he calls "Aryan" music by Hans Pfitzer and Richard Strauss with "Degenerate" music by Arnold Schonberg and

Franz Schreker. Most of his film's contrasts are more subtle than sharp, and they are quite effective. "One Man's War" may not reveal much that is new, but it casts familiar observations in a newly disturbing light.

1984 F 24, C9:1

Executive Calling

CIRCLE OF POWER, directed by Bobby Roth; screenplay by Beth Sullivan and Stephen Bello, suggested by a book by Gene Church and Conrad D. Carnes; director of photography, Affonson Beato; edited by Gail Yasunaga; music by Richard Markowitz; produced by Gary L. Mehlman; presented by Televicine International. At the Thalia, Broadway and 95th Street. Running time: 97 minutes. This film has no rating.

Bianca Ray	Yvette Mimieux
Jack Nilsson	Christopher Allport
Lyn Nilsson	Cindy Pickett
Jordan Carelli	John Considine
Buddy Gordon	Walter Olkewicz
Chris Morris	Leo Rossi
Ted Bartel	Scott Marlowe
Tony Annese	Carmen Argenziano
Jean Annese	Mary McCusker
Uwe	Denny Miller
Ben Davis	Hugh Gillin

By LAWRENCE VAN GELDER

IF George Orwell were alive, chances are that he would look with some favor on "Circle of Power," Bobby Roth's attack on monolithic belief systems, which opens today at the Thalia.

And it seems fair to speculate that Orwell's appreciation would extend beyond the "Big Brother Is Watching" T-shirt worn by one of the minor characters at the secluded estate where executives from a high-powered, omniscient corporation called Mystique have gathered with their wives for a few days of what is euphemistically called executive-development training.

•

As administered by Yvette Mimieux and her aides, the training has as its prerequisite an agreement to waive all rights and as its content all the charm of a prisoner-of-war camp in which individuals are stripped of their dignity and psychologically and physically abused — but all in the supposed quest of the truth that will liberate them to realize their full potential as leaders.

Mingled here, then, are comments on corporate ambition, on peer pressure, on pack behavior, on trendy weekends in the woods for the latest pop therapy, on religion (chalices and a crucifix are among the props) and, ultimately, on totalitarianism.

Mr. Roth, whose previous films have dealt with such subjects as the American dream and trade unionism, class struggle, and politics in medicine, manages not to belabor his message. For the most part, "Circle of Power," whose executive producer is the actor Anthony Quinn, concentrates on fairly fast-moving narrative and conflict involving a well-orchestrated cast of characters, whose all-too-human flaws include such shortcomings as obesity and alcoholism.

•

Besides Miss Mimieux — all golden hair, cool air, white raiments and the power to award success, the focal figure of the drama is Christopher Allport as Jack Nilsson, portraying the sort of decent, all-American young executive who naturally elicits the support of the audience.

By saving Nilsson and his wife (Cindy Pickett) for last among the executives to be called to account, Mr. Roth generates suspense, al-

Cindy Pickett

though the unraveling of their fate has an air of haste and a lack of genuine tension that are at odds with expectations.

Still, the serious concerns and technical skills of "Circle of Power" make it a worthwhile movie for 1984.

1984 Mr 2, C5:1

Family in Turmoil

DEMONS IN THE GARDEN, directed by Manuel Gutiérrez Aragón; screenplay (Spanish with English subtitles) by Mr. Gutiérrez Aragón and Luis Megino; director of photography, Jose Luis Alcaine; edited by Jose Salcedo; music by Javer Iturralde, J. Mostazo and Gustav Mahler; produced by Mr. Megino; released by Spectrafilm. At the Lincoln Plaza Cinema, Broadway between 62d and 63d Street. Running time: 100 minutes. This film is rated R.

Angela	Angela Molina
Ana	Ana Belen
Gloria	Encarna Paso
Juan	Imanol Arias
Oscar	Eusebio Lazaro
Juanito	Alvaro Sanchez-Prieto
Traveling Salesman	Francisco Merino
Osorio	Rafael Diaz
Projectionist	Pedro Del Rio
Family Doctor	Eduardo McGregor

MANUEL GUTIERREZ ARAGON'S "Demons in the Garden" ("Demonios en el Jardin"), a 1982 Spanish film that has won awards at European festivals, is not very long (100 minutes), but it has the generous scope of a large novel, being about three generations of a small-town family in the years immediately after the Spanish Civil War.

The narrative is not easily synopsized, but its center is 8-year-old Juanito, the illegitimate son of Juan, who leaves home to become what everyone believes to be an important member of the Franco regime, and Angela, the family slavey. The other members of the family are Gloria, the matriarch who runs the family store, called the Garden, Gloria's two sons, Oscar and Juan, and Oscar's pretty young wife, Ana.

•

At one point, when Juanito comes down with rheumatic fever, the doctor warns that he must be pampered, which turns Juanito into a small, comic monster, at least temporarily. There is some suggestion that the way Juanito uses his illness to blackmail the family is not unlike the constant specter of Communism that Franco used in part to maintain his power in Spain.

"Demons in the Garden" is too diffuse to be so simply characterized.

Mr. Gutiérrez Aragón and Luis Megino, with whom the director wrote the screenplay, keep very straight faces throughout the movie, which is essentially comic while always teetering on the brink of melodrama. That the movie is never as funny as it seems to want to be may have something to do with the English subtitles or, possibly, with associations that are lost on American audiences.

All of the performers are good, most notably Angela Molina, seen earlier in Luis Buñuel's "That Obscure Object of Desire" who plays Juanito's mother; Encarna Paso, as the matriarch; Imanol Arias, as Juanito's father, who, it turns out, is one of Franco's private waiters, and Alvaro Sanchez-Prieto, who is very fine as Juanito.

•

"Demons in the Garden," which opens today at the Lincoln Plaza Cinema, has the manner of a private joke. One can recognize its intelligence without being able to respond to it.

Vincent Canby

1984 Mr 2, C5:3

Acid Satire

THIS IS SPINAL TAP, directed by Rob Reiner; written by Christopher Guest, Michael McKean, Harry Shearer and Mr. Reiner; director of photography, Peter Smokler; supervising film editor, Robert Leighton; film editors, Kent Beyda and Kim Secrist; music and lyrics by Mr. Guest, Mr. McKean, Mr. Shearer and Mr. Reiner; produced by Karen Murphy; released by Embassy Pictures. At the New York Twin, Second Avenue and 66th Street; Greenwich, Greenwich Avenue and 12th Street; Loews 83d Street Quad, at Broadway, and other theaters. Running time: 82 minutes. This film is rated R.

Marty DiBertiRob Reiner
David St. HubbinsMichael McKean
Nigel TufnelChristopher Guest
Derek SmallsHarry Shearer
Mick ShrimptonR. J. Parnell
Viv SavageDavid Kaff
Ian FaithTony Hendra
Tommy PischeddaBruno Kirby
Heavy Metal Fans
 Kimberly Stringer, Chazz Dominguez, Shari Hall
Ethereal FanJean Cromie

By JANET MASLIN

"THEY are treading water in a sea of retarded sexuality and bad poetry," says one fictitious rock critic of the equally fictitious Spinal Tap, a British heavy-metal band. "That's just nit picking, isn't it?" is one band member's calm rejoinder, but he's wrong. Spinal Tap *does* embody rock-and-roll at its most horrible, and yet "This Is Spinal Tap," a mock-documentary following the band's American tour, isn't mean-spirited at all. It's much too affectionate for that. And it stays so wickedly close to the subject that it is very nearly indistinguishable from the real thing.

"This Is Spinal Tap," which opens today at Loews New York Twin and other theaters, is a witty, mischievous satire, and it's obviously a labor of love. The four screenwriters — Christopher Guest, Michael McKean, Harry Shearer and Rob Reiner — all appear in the film, the first three as Spinal Tap members, and Mr. Reiner (who directed) as the film maker who is telling their story. Mr. Reiner introduces the film by explaining that Spinal Tap has earned "a distinguished place in rock history as one of England's loudest bands" and then presents the members of the group. Even their names are funny — David St. Hubbins, Nigel Tufnel, Mick Shrimpton, Viv Savage and Derek Smalls.

There's an in-joke quality to the film, one that will make it all the more hilarious to anyone at all knowledgeable about either the esthetic or the business aspects of pop music. However, you need not have heard a band like Spinal Tap to find its story highly amusing. The film traces the stages of its career, from early imitation-Beatle days (the musicians are seen on television, smiling sappily and wagging their hair) to a psychedelic period (they are seen flanked by go-go dancers and wearing beatific expressions) to the unfortunate present. Their American tour reveals them to be approaching their final stylistic incarnation, which involves screamingly loud solos, tight spandex pants and the use of a giant horned skull on stage.

Michael McKean as the lead vocalist in "This is Spinal Tap."

"The Boston gig has been canceled. I wouldn't worry about it, though, it's not a big college town," says Ian Faith (Tony Hendra), the group's not-very-reassuring manager. Ian's duties involve running interference with the head of the group's record company, Sir Denis Eton-Hogg (Patrick MacNee), and quelling any backstage tantrums. (Nigel, played with fabulous stupidity by Mr. Guest, has one such fit about the provisions in his dressing room; the bread is the wrong shape for the cold cuts, and he can't make proper sandwiches.) And it is Ian, who, when asked if Spinal Tap's popularity might be slipping, explains coolly that "their appeal is becoming more selective."

•

Among the more inspired bits are several involving Spinal Tap's stage show. There is also a tender moment at Elvis Presley's grave, as the group's members try to sing "Heartbreak Hotel" in homage to the King and wind up quibbling over the harmony. And there is Spinal Tap's encounter with a rocker whose career, unlike theirs, is on the rise. "Listen, we'd love to stand around and chat," says Howard Hesseman, playing the other star's manager and delivering the perfect record business brushoff. "But we've got to sit down in the lobby and wait for the limo."

The most appealing thing about "This Is Spinal Tap," aside from the obvious enthusiasm of all concerned, is the accompanying lack of condescension. Mr. Guest, in particular, does a wonderful job of capturing his character's sincere idiocy. Mr. McKean is also appealing as the

group's most gullible member, who is under the spell of a girlfriend (June Chadwick) who can tell him on the telephone that he's been eating too much sugar ("she says my larynx is fat"), a girlfriend who winds up trying to manage the band with the help of her astrological charts. And Mr. Shearer is quietly funny as the nondescript Tap member, the one who sees Nigel and David as "fire" and "ice" and thinks his own role is "to be in the middle of that, like lukewarm water."

One of the key problems with which the band grapples, during the course of the movie, is that its latest proposal for an album cover has been deemed unprintable by its record company. The musicans are furious when another artist gets permission to use a cover they think is almost equally obnoxious, until it is explained to them why their own illustration is worse. "It's such a fine line between stupid and ... " "And clever," muse the band members collectively. It certainly is— and the delightful "This Is Spinal Tap" stays on the right side of that line.

1984 Mr 2, C6:1

Moving Over

OVER THE BROOKLYN BRIDGE, directed by Menahem Golan; written by Arnold Somkin; director of photographer, Adam Greenberg; edited by Mark Goldblatt; music by Pino Donaggio; produced by Mr. Golan and Yoram Globus; released by MGM/UA and Cannon Group. At Warner Twin, Broadway and 47th Street; 86th Street Twin, at Lexington Avenue; Gemini 1, Second Avenue at 64th Street; Greenwich Playhouse Twin, Seventh Avenue and 12th Street and other theaters. Running time: 108 minutes. This film is rated R.

Alby ...Elliott Gould
ElizabethMargaux Hemingway
Uncle BenjaminSid Caesar
Phil ...Burt Young
BeckyShelley Winters
Cheryl ...Carol Kane
Leonard ShermanJerry Lazarus
Ruth ShermanFrancine Beers
Seymour ShermanLeo Postrel
Sarah ShermanRose Arrick
Herbert ShermanMatt Fischel
Cynthia ShermanLynnie Greene

"ALBY (Elliott Gould) owns a tiny luncheonette in Brooklyn, but aspires to move into the big time with a chic restaurant on Manhattan's East Side. Alby is a diabetic, has a Jewish mom (Shelley Winters), a rich uncle in the garment district (Sid Caesar) and lives with a beautiful, Philadelphia-born WASP named Elizabeth (Margaux Hemingway).

The movie that contains Alby and his problems is Menahem Golan's "Over the Brooklyn Bridge," a crudely humorless romantic comedy that has more failed ethnic jokes than might be heard in a decade of Miami Beach nightclubing. There are jokes about Jews, Italians, WASP's, Puerto Ricans and Irish Catholics. There isn't, however, any real screenplay.

There's only a basic situation, something about Alby's being afraid to commit himself to Elizabeth. Thus, to get a loan from his rich uncle, he agrees to marry a nice Jewish girl (Carol Kane), who isn't all that nice.

Mr. Golan's comic touch is not great, which doesn't help the performances by pros on the order of Mr. Gould and Mr. Caesar. The movie isn't a complete loss, though. It uses so many Manhattan and Brooklyn locations that it might easily be recycled as a promotional film.

"Over the Brooklyn Bridge" opens today at the Warner Twin and other theaters.

Vincent Canby

1984 Mr 2, C6:5

Muse and Courtship

HARRY and SON, directed by Paul Newman; screen story and screenplay by Ronald L. Buch and Mr. Newman; director of photography, Donald McAlpine; edited by Dede Allen; music by Henry Mancini; produced by Mr. Newman and Mr. Buck; released by Orion Pictures. At the Rivoli Twin, Broadway and 49th Street; New York Twin, Second Avenue and 66th Street; 83d Street Quad, at Broadway; Eighth Street Playhouse, 52 West Eighth Street, and other theaters. Running time: 118 minutes. This film is rated PG.

Harry ...Paul Newman
HowardRobby Benson
Katie ..Ellen Barkin
TomWilford Brimley
Sally ...Judith Ivey
RaymondOssie Davis
SiemanowskiMorgan Freeman
NinaKatherine Borowitz
LawrenceMaury Chaykin
LillyJoanne Woodward
Al ..Michael Brockman
WaitressCathy Cahill
AndyRobert Goodman
Jimmy ...Tom Nowicki

By VINCENT CANBY

"HARRY AND SON," starring Paul Newman, directed by him and written by him with Ronald L. Buck, is a big-screen blowup of the sort of "I love you, Pop" television play that littered the small screen 25 years ago.

Harry (Mr. Newman) is a widower and something of a master when it comes to working the controls that guide the huge wrecking ball for his demolition crew. He's also the dad of Howard (Robby Benson), a sensitive young man, who works in a carwash by day and, at night, tap-tap-taps out fiction on his manual typewriter, hoping to become a modern Ernest Hemingway.

Harry, whose values are blue-collar macho, feels that Howard and fellows like him are the reason the country is turning to Jell-O. He also has mysterious, splitting head pains at awkward moments. Howard thinks his father is terrific, but can't bring himself to say so. Howard tries to brighten their womanless home by serving wine with supper, though, as everyone in the audience who hasn't fallen asleep knows, Harry drinks nothing but beer, the prominently displayed brand being Budweiser.

•

"Harry and Son," which opens today at the Rivoli and other theaters, is a decently intentioned but rather drab mess of a movie. Among other things, it's about Harry and Howard, Howard and his muse, Howard's courtship of a pregnant young woman named Katie (Ellen Barkin) about how not to cope with terminal illness and Lilly (Joanne Woodward), who owns a pet store and loves Harry from afar, though they live next door to each other.

Mr. Newman has done creditable work as a director before ("Rachel, Rachel," "Sometimes a Great Notion"), but "Harry and Son" looks like a first effort, partly because the screenplay has no focus and no particular tone of voice. Each of the actors, including Mr. Newman, must create his own character as he goes along, as if furnishing his own wardrobe. One is always aware of actors acting, sometimes quite well, but never for a moment does one become caught up in the film's circumstances.

•

Mr. Newman's Harry is a charming boor. Mr. Benson tries to be appealing. Indeed, he works so hard at it that his sincerity becomes oppressive. Miss Barkin ("Diner," "Tender Mercies") is somewhat more successful, but the role is a dim one. Only

Miss Woodward, who isn't on the screen much, makes a clearly defined impression as a good-hearted woman who isn't afraid to buck conventions as the need arises.

The setting is Florida's east coast, nicely photographed by Donald McAlpine, the Australian cameraman. Though the characters use a lot of words that are still taboo on television, the entire project feels as small and dated as a "Studio One" show of the 1950's. Public manners and morals have changed since then, but clichés endure, like the Rock of Gibraltar.

•

"Harry and Son," which has been rated PG ("Parental Guidance Suggested"), contains some vulgar language and partial nudity.

1984 Mr 2, C12:3

Problems of Genre

AGAINST ALL ODDS, directed by Taylor Hackford; screenplay by Eric Hughes; director of photography, Donald Thorin; edited by Fredric Steinkamp and William Steinkamp; music by Michel Colombier and Larry Carlton; produced by Taylor Hackford and William S. Gilmore; released by Columbia Pictures. At Loews State, Broadway and 45th Street; Orpheum, 86th Street, near Third Avenue; 34th Street Showplace, between Second and Third Avenues; 83d Street Quad, at Broadway, and other theaters. Running time: 125 minutes. This is rated R.

Jessie Wyler	Rachel Ward
Terry Brogan	Jeff Bridges
Jake Wise	James Woods
Hank Sully	Alex Karras
Mrs. Wyler	Jane Greer
Ben Caxton	Richard Widmark
Tommy	Dorian Harewood
Edie	Swoosie Kurtz
Steve Kirsch	Saul Rubinek
Ed Phillips	Pat Corley
Head Coach	Bill McKinney
Bob Soames	Allen Williams

THERE is plenty of evidence to support the idea that "film noir," the late 1940's genre marked by shadow and duplicity, cannot successfully be updated for the 80's. There is also reason to wonder why the task would even be attempted, since modern characters who deliver the genre's dated dialogue or espouse its notions of evil can't help but seem mannered and false. Despite all that, Taylor Hackford's "noir"-ish "Against All Odds" has a lot of appeal. If Mr. Hackford has done nothing more than make a steamy, sinister, great-looking detective film cum travelogue, he's still managed to come up with something fast-paced and eminently entertaining.

"Against All Odds," which is based on Jacques Tourneur's 1947 "Out of the Past" and opens today at Loews State and other theaters, has a dazzling beginning, even if its plot, as *noir* plots do, finally gets somewhat out of hand. A handsome football player, abruptly cut from his Los Angeles team, is dispatched to the Yucatan, hired to find a beautiful runaway heiress. As played by Jeff Bridges and Rachel Ward, this stunningly photogenic duo shares a voluptuous tropical idyll, one that ultimately leads them to treachery and murder.

•

There is, of course, a lot more to it than that; Mr. Hackford has populated the film with colorful supporting characters and intertwined them in a plot involving professional sports, gambling, real estate, and blackmail. That the plot machinations are intelligible at all is largely a tribute to the supporting performers, many of whom — Richard Widmark,

Alex Karras, Jane Greer, Saul Rubinek, Dorian Harewood and especially Swoosie Kurtz — make far sharper, more vivid impressions here than the brevity of their roles would seem to allow.

Mr. Bridges's naturalness as the good-hearted football player Terry Brogan is one of the chief things that make the movie likable. For all the skepticism that Eric Hughes's screenplay allows him, Mr. Bridges seems trusting and unsuspicious enough, in the middle of all other double-dealers and two-timers in this story, to invite a good deal of empathy; he does a particularly fine job with one confessional monologue about his football career. Mr. Bridges is unexpectedly well suited to this romantic fall-guy role, and he's effectively contrasted with James Woods, as a sleekly reptilian Hollywood entrepreneur.

Mr. Woods may not be hugely credible as the spurned lover who hires Mr. Bridges to find Miss Ward, but the rivalry between the two men sets off plenty of sparks. The hair-raising car chase that introduces and defines their relationship is no means the most tension-filled of their encounters.

Miss Ward is suitably sexy as the runaway heiress, but hers is an awkward role. She's certainly beautiful enough to lend credibility to the two men's fierce rivalry over her favors, but she doesn't seem complex enough to be the treacherous she-devil this material requires. Mr. Hughes, unlike Daniel Mainwaring (who wrote "Out of the Past") hasn't drawn the character quite that way; Miss Ward's Jessie is meant to be more mixed-up than wicked, or at least that's the way she sounds. But the depths of evil into which everyone presumably plunges require more than mere carelessness or irresponsibility from the story's temptress.

In fact, the corruption at the heart of the film doesn't count for much, either; it isn't startling enough to make the dénouement work, nor is Mr. Hackford very helpful in his unsporting reluctance to adhere to *film noir* tradition and kill off virtually everybody. No matter. "Against All Odds" is so lively and enjoyable on its own terms that its genre problems, while real, are easily overlooked. Mr. Hackford's brand of glossy, romantic escapism doesn't have to work as an homage. It has a vitality of its own.

Janet Maslin

1984 Mr 2, C14:3

Russian Riff

JAZZMAN, directed by Karen Shakhnazarov; written (Russian with English subtitles) by Alexander Borodyansky and Mr. Shakhnazarov; photography by Vladimir Shevtsik; music by Anatoly Kroll; a Mosfilm Production. At the Guild, 33 West 50th Street. Running time: 80 minutes. This film has no rating.

Konstantine	Igor Sklyar
Stefan	Alexander Chorny
George	Nikolai Averyuskin
Ivan	Pyotr Shcherbakov
Katie	Elena Tsiplakova
Clementine Fernandez	Larissa Dolina

By LAWRENCE VAN GELDER

IN an era when the attention of the world is frequently fixed with fear and misgiving on rivalry between the United States and the Soviet Union, it seems safe to say that American superiority rests unchallenged in two realms: jazz and

Jeff Bridges in "Against All Odds," which opens today.

the movie musical.

To reach such a conclusion is not to dismiss out of hand the puppylike charm of the Soviet film "Jazzman," which opens today at the Guild. But audiences raised on "The Glenn Miller Story" and "The Benny Goodman Story" — to name but two in a long line of such rag-to-riches biographies — are likely to regard the Soviet version as lacking the narrative skill and the musical joys that nourish even these less than monumental films.

Still, "Jazzman" — tracing the origin, hard times and rise of a jazz quartet from the late 1920's in Odessa to the 1960's in Moscow — possesses just enough of the genre's typical ingredients to beguile audiences in the manner of any beloved tale in its twice-told incarnation.

Here, for example, is the young conservatory student, haled before a faculty-student court for playing his kind of music and told he should be forbidden to play jazz. "I won't give up jazz," he vows. Expelled, he recruits two street musicians — a banjo player and a drummer — and when the three of them are jailed after a brawl at a party for a jazz-loving gangster, they find their saxophonist, who used to play in a military band. "The main thing now," says the former student, "is to work out our own style." One can almost hear Jimmy Stewart, as Glenn Miller, trying to get a fix on his "sound."

But instead of Glenn or Benny, here are characters named Kostya, Stefan, Ivan and George. Instead of the Tin Pan Alley despots who who turn deaf ears to young iconoclasts in American musicals, here are apparatchiks who accuse the heroes of decadence and trying to popularize music of a bourgeois culture, despite the hero's argument that the black origins of jazz make it the music of the oppressed and therefore revolutionary. And instead of the June Allyson or Donna Reed who used to inspirit the hero when no one else seemed to understand, "Jazzman" makes do with a Soviet gangster who heard some jazz in Chicago in 1908 and a naval captain whose expertise is also imported.

"Jazzman" is said to be based on actual events, and the director Karen Shakhnazarov has assembled an ingratiating cast for his tale of the Soviet Union's first "djhaz" band, bathed the proceedings in a nostalgic glow, invested them with good humor

and camaraderie and buoyed them with a bouncy score by Anatoly Kroll. But by American standards, "Jazzman" could profit by still richer music, by a touch of romance, and by a transition between the repetitious rejections of the band that occupy most its length and the sudden flash-forward to ultimate vindication that is its climax. Though its narrative would profit by more evolution and less revolution, "Jazzman" ranks among musicals as a pleasant curiosity.

1984 Mr 7, C19:1

No Longer in Kansas

THE WORLD OF TOMORROW, produced and directed by Tom Johnson and Lance Bird in association with the TV Lab at WNET/13; written by John Crowley; edited by Kate Hirson; a production of Media Study/Buffalo; distributed by Direct Cinema Ltd. At the Film Forum, 57 Watts Street. Running time: 78 minutes. This film has no rating.
Narrator Jason Robards

By VINCENT CANBY

"**T**HE World of Tomorrow," which opens today at the Film Forum, is a fine, funny feature-length documentary about the New York World's Fair of 1939, when, for a few, short, glittery months, Western civilization paused between the Depression and World War II.

The fair, devoted to the material and scientific wonders awaiting in the world of tomorrow, was held over for a second season in the summer of 1940, but by then the Netherlands, Belgium and France had fallen to the Germans, and business at the fair was disappointing. "The World of Tomorrow," the fair's official theme,

Robin Holland

A button from the fair.

had come to be less a promise than a threat.

Using newsreel footage, home movies and some wonderfully revealing promotional movies shown within the fair, Tom Johnson and Lance Bird, who produced and directed the film, and John Crowley, who wrote it, have created an exceptionally perceptive film-essay on the cockeyed optimism that since the mid-19th century has been a historical obligation for all right-thinking Americans.

"The past is black and white," says Jason Robards, the sound track narrator. "The future is color," and the black-and-white newsreel footage, which opens the film, slowly merges into the color footage of the home movies and the official films made to celebrate the fair itself.

As the audience gets its first glimpse of the fair's splendid, stark-

white trylon and perisphere, surrounded by acres of color-coordinated pavilions and midway rides, we hear Judy Garland's Dorothy, in a line from the sound track of "The Wizard of Oz," whisper her suspicions to Toto. "I have a feeling," she says, "that we're no longer in Kansas."

Her feeling was shared by millions of visitors from around the world who crowded into the fair that first summer to be stunned by a vision of the future that was a cross between Oz and what now seems to us to be a comically dated super civilization. It was a place where each object was to be streamlined whether or not, like a washing machine, it would ever be required to overcome wind resistance.

Mr. Johnson, Mr. Bird and Mr. Crowley are amused by the fair's mixture of naïveté, hoopla, scientific marvels and stunning architecture, but they also understand the fair's place in our cultural history.

Among the film's highlights is an extended clip from a Westinghouse film in which a small, cynical, Depression-bred Indiana boy is converted to faith in the American future by an avuncular Westinghouse scientist. "Prosperity and pessimism," says the scientist, "don't go well together."

Whatever lingering doubts a fair visitor might have had usually vanished after a tour of the General Motors "Futurama" exhibit, a spectacular forecast of the America of 1960, when all recognizable cities have mysteriously disappeared, to be replaced by a succession of model cities connected by a vast, pollution-free network of superhighways filled with General Motors cars.

"The World of Tomorrow" is a perfect companion piece to the earlier collaboration of the three film makers, "America Lost and Found," the vivid, unsentimental film-essay on America during the Depression that was shown here at the Public Theater in 1979.

1984 Mr 7, C20:3

A Novel Family

THE HOTEL NEW HAMPSHIRE, directed by Tony Richardson; screenplay by Mr. Richardson, from the novel by John Irving; director of photography, David Watkin; edited by Robert K. Lambert; music by Offenbach; produced by Neil Hartley; released by Orion Pictures. At Astor Plaza, Broadway and 44th Street; Tower East, Third Avenue and 71st Street, and other theaters. Running time: 110 minutes. This film is rated R.

John	Rob Lowe
Franny	Jodie Foster
Frank	Paul McCrane
Father	Beau Bridges
Mother	Lisa Banes
Lilly	Jennie Dundas
Egg	Seth Green
Freud	Wallace Shawn
Chip Dove	Matthew Modine
Iowa Bob	Wilford Brimley
Bitty Tuck	Cali Timmins
Junior Jones	Dorsey Wright
Ronda Ray	Anita Morris
Susie the Bear	Nastassia Kinski
Miss Miscarriage	Amanda Plummer
Ernst	Matthew Modine
Screaming Annie	Gayle Garfinkle

By VINCENT CANBY

"THE HOTEL NEW HAMP-SHIRE," Tony Richardson's screen adaptation of John Irving's best-selling novel, is relentlessly faithful to the source material, which is to comic literature, including the works of Kurt Vonnegut Jr. and Joseph Heller, what whoopee cushions are to wit.

The movie looks great, but Mr. Irving's modern fable about the eccentric Berry family is less fabulous than

Jodie Foster in "The Hotel New Hampshire," based on John Irving's novel.

flatulent. Like the novel, the movie is windy with aphorisms ("Life is serious, but art is fun") and vest-pocket-size admonitions: "Keep passing open windows"; otherwise you might jump out.

The members of the Berry family are nothing if not life-affirming, even in suicide.

In addition to Father (Beau Bridges) and Mother (Lisa Banes), they are Franny (Jodie Foster), the elder daughter, who talks tough but is true blue underneath; Frank (Paul McCrane), the elder son, who early on announces that he is "queer" to the shock of no one, perhaps because he seems to have no sex life whatsoever; Lilly (Jennie Dundas), the younger daughter, who remains stunted at the height she reached at age 8; Egg (Seth Green), the youngest of the Berry litter, and John (Rob Lowe), the second son. It is John who narrates the tale, lifts weights with his crusty grandfather, Iowa Bob (Wilford Brimley), and lusts after his sister Franny, but who otherwise is a cipher.

Among the other all-too-colorful characters are a failed Viennese animal trainer named Freud (Wallace Shawn) and his aging bear State o' Maine; a young woman (Nastassja Kinski) called Susie the Bear because she is so insecure she wears a bear's suit; Miss Miscarriage (Amanda Plummer), who is supposed to be a Viennese terrorist, but acts more like a Dickens slavey, and Ronda Ray (Anita Morris), a libidinous waitress at the Hotel New Hampshire.

You are right if you think that sounds less like a cast of characters than an inventory of special effects.

Mr. Richardson, who first hoped to make two films from the Irving novel, demonstrates a good deal of skill in the way he successfully squeezes most of the Berry family adventures into a film of normal length. It couldn't have been easy.

After a brief flashback to the courtship and marriage of Father and Mother Berry, "The Hotel New Hampshire" follows a fairly chrono-

logical course as it details, first, the family's ownership of a hotel in Dairy, N.H., and, second, its move to Vienna to help Freud, always identified as "the other Freud," in a hotel venture there that ends explosively.

In the third and last part, the Berrys return to this country, where Lilly finds fame (as well as pain) as the best-selling author of a novel called "Trying to Grow Up," Frank becomes a successful agent and Franny a big-time movie star. By the film's life-affirming end, Franny and John have joyously consummated their relationship, thus to be able to get on with their lives with other partners, and Susie the Bear has grown out of her bear suit.

I have a sinking feeling that even this synopsis might make the film seem funnier than it ever is. A major problem, especially in a movie seen in one sitting, is that so many colorful characters tend to cancel one another out. The film's big comic set-piece — in which Franny, Lilly, John and Frank teach a lesson to the young man who raped Franny — works not even as fantasy, to say nothing of comedy. It was done better in "Myra Breckinridge."

Like the novel, the movie means to be trendy but it is out of touch, though not exactly out of date. It has no recognizable center of interest, no anchor for our attention. It's a series of whoopee-cushion gags.

Everything that happens is so laboriously prepared you can see what's coming. The Berry family dog seems to have been named Sorrow only so that after he has been put to sleep, stuffed by a taxidermist and then falls into the sea, someone can give us the thought, "Sorrow floats." "Hmmm," you might say, "how true." Yet I think we might be able to say something equally true had the stuffed dog gone straight to the bottom. "Sorrow sinks," which, of course, it often does.

The performances are a mixed lot. Miss Foster, one of our loveliest young actresses, shows more flair than she ever has before, but she had better watch those malteds between classes at Yale. Miss Dundas is sweet and solemn as the tiny novelist, and Mr. McCrane is stalwart as the homosexual brother. Mr. Bridges and Miss Banes are straightforward and attractive as the parents, but Mr. Lowe, who actually looks like Miss Foster, is colorless in every other way.

Miss Kinski is absolutely humorless as Susie the Bear, and Mr. Shawn and Miss Plummer almost choke on their Viennese accents. The only person shown to good advantage is Miss Morris, who brightened Broadway's "Nine" and here not only looks sensational but also is reasonably comic.

More than anything else, "The Hotel New Hampshire" is exhausting. It opens today at the Astor Plaza and other theaters.

1984 Mr 9, C8:1

A Liking for Fish

SPLASH, directed by Ron Howard; screenplay by Lowell Ganz, Babaloo Mandel and Bruce Jay Friedman; screen story by Mr. Friedman, based on a story by Brian Grazer; director of photography, Don Peterman; edited by Daniel P. Hanley and Michael Hill; music by Lee Holdridge; produced by Mr. Grazer; released by Buena Vista Distribution Company. At National, Broadway and 44th Street; Gramercy, 23d Street at Lexington Avenue; UA East, First Avenue and 85th Street; Coliseum, Broadway and 181st Street; Olympia Quad, Broadway and 107th Street, and other theaters. Running time: 111 minutes. This film is rated PG.

Daryl Hannah

Allen Bauer	Tom Hanks
Madison	Daryl Hannah
Walter Kornbluth	Eugene Levy
Freddie Bauer	John Candy
Mrs. Stimler	Dody Goodman
Mr. Buyrite	Shecky Greene
Dr. Ross	Richard B. Shull
Jerry	Bobby Di Cicco
Dr. Zidell	Howard Morris
Tim the Doorman	Tony Di Benedetto

By JANET MASLIN

THOUGH Ron Howard's comedies don't adhere to any familiar formulas — Mr. Howard's funny "Night Shift" was about a prostitution ring operating out of a morgue, and his even more disarming new "Splash" is about a mermaid in Manhattan — they have a comfortably old-fashioned flavor. "Splash" may feature a heroine with fins, but it's mostly a standard love story, albeit one with some delightful new twists. The boy (Tom Hanks) is a lonely bachelor with a single overriding wish: "to meet a woman, fall in love, get married, have a kid and see him play a tooth in the school play." And the girl (Daryl Hannah) at first knows only one word of English: "Bloomingdale's."

"Splash," which opens today at the National and other theaters, accomplishes the improbable with some enchanting underwater sequences, scenes that make credible the thought that Daryl Hannah might really be a mermaid. Following a brief prologue in which she meets Allen Bauer, played by Mr. Hanks when both are children, the mermaid reappears to save his life when he falls overboard near Cape Cod. There are hints that Allen may be susceptible to aquatic creatures in the décors of both his office and his apartment, since there are large fish tanks in both places (only rarely does Mr. Howard use such unnecessarily broad strokes). But nothing in his past hints at how hard Allen will fall for the beautiful, innocent mermaid once she sprouts a pair of tawny legs and follows him home.

Much of the humor grows out of the way in which the mermaid, who takes the name Madison after the avenue, reacts to strange new stimuli, such as Crazy Eddie commercials on television. As likable a leading man as Mr. Hanks is, though, and as beguiling as Miss Hannah is in her Boticelliesque incarnation here, the film would not be nearly so successful without the

bulldozing presence of John Candy, as the hero's hilarious brother. The mere sight of the tubby Mr. Candy is funny enough (the spectacle of him playing racquetball really is something to see). But he also gets most of the better lines in the screenplay by Lowell Ganz, Babaloo Mandel and Bruce Jay Friedman. "What are you looking at?" Mr. Candy screams at the employees of his family's business, after the man-mermaid love affair has been revealed to the press. "You never saw a guy who slept with a fish before? Get back to work!"

"Splash" could have been shorter, but it probably couldn't have been much sweeter. Only purists will quibble with the blissfully happy ending, which has the lovers swimming through a shimmering underwater paradise that is supposed to be the bottom of the East River.

•

This film is rated PG. It contains some fleeting nudity and mild sexual overtones.

1984 Mr 9, C15:1

Drugs and Death

MIKE'S MURDER, written and directed by James Bridges; director of photography, Reynaldo Villalobos; edited by Jeff Gourson and Dede Allen; music by John Barry; a Skyewiay Production; a Ladd Company Release through Warner Bros. At Criterion Center, Broadway and 45th Street; Gemini, Second Avenue and 64th Street; 83d Street Quad, Broadway and 83d Street; 86th Street Twin, at Lexington Avenue; Bay Cinema, Second Avenue and 32d Street, and other theaters. Running time: 109 minutes. This film is rated R.

Betty	Debra Winger
Mike	Mark Keyloun
Phillip	Paul Winfield
Pete	Darrell Larson
Patty	Brooke Alderson
Sam	Robert Crosson
Richard	Daniel Shor
Randy	William Ostrander

"**M**IKE'S MURDER," written and directed by James Bridges ("Urban Cowboy," "The China Syndrome"), has the form of melodrama, but it's really a moonily romantic elegy for Mike (Mark Keyloun), a good-looking, two-bit Hollywood hustler and amateur drug dealer.

During a one-night stand, Mike so charms a supposedly intelligent, spunky young woman named Betty (Debra Winger) that she spends the next six months longing for him, although it's quickly apparent to everyone in the audience that Mike is no more or less reliable than any other pick-up and that his sexual preferences are, well, divided.

•

For perhaps the first 15 minutes of "Mike's Murder," it seems that Mr. Bridges might possibly pull off the trick of making a first-class movie about second-rate people, but then stars get in his eyes. The writer-director is as dopily infatuated with Mike as are the film's other characters, including Betty, a middle-aged photographer named Sam (Robert Crosson) and Phillip (Paul Winfield), a successful record producer, who found Mike on an Indiana highway and brought him West as his companion.

Says Phillip, who wears caftans and who'll never get over his love of Mike, "He was always preparing faces for the faces he met."

Mr. Bridges, who gave Miss Winger her big break in "Urban Cowboy," leaves her high and dry in this one.

Though she receives top billing, she has no role to play. Betty, a teller in a drive-in bank, exists only as a sort of token female in a narrative primarily concerned with male hustling and drugs.

A case might be made that Mike's story is a cautionary one, that his fate represents the corruption of innocence, but this movie appears to be less interested in fate than in making Los Angeles low life seem as exotic as it is dangerous.

Though the subject is tough, the movie is wide-eyed and naïve, like Randy. Randy (William Ostrander), Phillip's muscular young manservant, exclaims at one point: "It's

been a weird week. I know two people who have been murdered, both drug-related." That's one of the film's better moments.

"Mike's Murder" opens today at the Criterion and other theaters.

Vincent Canby

1984 Mr 9, C16:1

FILM VIEW

VINCENT CANBY

French Words for a California Condition

If you were as baffled as I was by the use of the term "film noir" to describe François Truffaut's light-hearted mystery comedy, "Confidentially Yours," you might want to take a look at Taylor Hackford's "Against All Odds," which virtually defines film noir as it has survived from the monochromatic 1940's into the full-color 1980's. "Against All Odds" also defines a relatively new film noir subcategory: California noir.

"Confidentially Yours," though shot in black-and-white, is about as noir as an Agatha Christie whodunit photographed in glorious Eastmancolor. It's a slightly screwball romantic comedy built around a story that includes several relatively bloodless murders. The mood is benign, and the style, like the dialogue, is good-natured and teasing.

"Against All Odds" is something else entirely, being about greed and double-dealing among people of power, as well as about passions that initially seem grand and, more often than not, turn out to have been mere exercises in lust. It's about disappointment and disillusion. Most important, "Against All Odds" is about sleaziness as a way of life that could only be possible in southern California.

In his "Encyclopedia of Film" (Crowell, 1979), Ephraim Katz defines film noir as "a term coined by French critics to describe a type of film that is characterized by its dark, somber tone and cynical, pessimistic mood."

He goes on to say that film noir specifically describes "those Hollywood films of the 40's and early 50's which portrayed the dark and gloomy underworld of crime and corruption" with heroes, as well as villains, who "are cynical, disillusioned and often insecure loners, inextricably bound to the past and unsure or apathetic about the future."

That's about as good a definition of film noir as I've ever read, but it doesn't include an additional characteristic that I associate with film noir classics, including Billy Wilder's "Double Indemnity" and Orson Welles's "Touch of Evil," and with all but one of the more recent variations. That is, that the true film noir is always set in or around Los Angeles, with, perhaps, extended location trips to Mexico.

• • •

The modern film noir is so indigenous to southern California that the genre might well be renamed California noir. It's as convenient a way as any to describe the particular concerns of Robert Altman's "Long Goodbye" (1973), Roman Polanski's "Chinatown" (1974), Ulu Grosbard's "True Confessions" (1981) and, now, the just-opened "Against All Odds," which is a good movie, and James Bridges's "Mike's Murder," which isn't.

When, occasionally, a film noir is set somewhere else, it tends to succeed to the extent that the new location suggests both the sprawling seediness of pre- and post-World War II Los Angeles and the dazzling, sunlit vulgarity of

contemporary southern California. Lawrence Kasdan's neoclassic "Body Heat" (1981) takes place on the east coast of Florida, north of Miami, but its landscapes and architecture, as well as its manners, evoke the southern California of the 1940's.

It's not a coincidence that writers like Raymond Chandler and Ross Macdonald set their private-eye tales in southern California. Nor is it only for the sake of convenience that American film noir producers have chosen to place so many of their movies in and around Los Angeles.

Southern California occupies a very special place in the collective American fantasy. It represents our last continental frontier. After a couple of centuries of pushing ever farther westward, Americans, having reached Los Angeles, found themselves hemmed in by the Pacific Ocean. Take one more step and you're in the surf. There was no place else to go, but why go farther anyway?

• • •

To the millions of Americans who migrated to California in the 1930's, 1940's and 1950's, Los Angeles was the end of the rainbow. Land was cheap, at least initially. New industries were starting up. The weather was kind to the infirm, the old and the very young. There was so much room that everyone could have his own front yard, and even the most bizarre religious and political sects could be tolerated, if only because they could occupy their own spaces without immediately arousing the prejudices of others. It was the promised land. It was also the home of the greatest dream factory in the history of the world — Hollywood.

Southern California is no better or worse than any other part of the country, but because its economy and culture are comparatively new, and because it continues to be a pacesetter for fashions and fads, it appears to exemplify the nation's achievements as well as its failures. It's a place where rich, beautiful people can be just as unhappy and lonely as poor, ugly ones.

Southern California is a metaphor for the rest of the United States. That film noir should become California noir is perfectly understandable. In southern California the difference between expectation and reality is as apparent as the layer of smog that, for days on end, will separate the citizens on the ground from a sky of unblemished, matchless blue.

This is what film noir — at its best — is all about.

• • •

"Against All Odds," an updated remake of Jacques Tourneur's "Out of the Past" (1947), which I've never seen, doesn't rank with "Body Heat," "True Confessions" or "Chinatown," but it's a most entertaining, intelligent demonstration of the genre's perverse pleasures. Like "True Confessions" and "Chinatown," the story has something to do with a crooked real estate deal and the corruption of public officials through the machinations of powerful business interests.

Its hero, Terry Brogan (Jeff Bridges) is none too clean to start with. He's an aging, out-of-work professional football player who, having once agreed to shave points for a big-time bookie, finds himself blackmailed into taking on an unpleasant private-eye assignment: finding the bookie's mistress, a rich, beautiful, well-born young woman who has disappeared into Mexico after having stabbed her lover and stolen $50,000 from him.

This central situation is classic to film noir: a hero who is essentially decent, though seriously compromised in the eyes of the world, unjustly cashiered from the only job he knows, alienated from a world that once adored him, now flat broke but driving a Porsche.

Also classic is what happens when Terry Brogan finally finds the heiress, Jessie Wyler (Rachel Ward), hiding on the island of Cozumel off the Yucatan coast. After a couple of weeks spent in a steamy, tropical idyll with Jessie, Terry resigns his assignment without bothering to let his bookie-friend know. The chase that follows requires one murder and

leads the pair back to Los Angeles where it all started.

In a stunning car race down Sunset Boulevard at the beginning of the film, Mr. Hackford and his screenwriter, Eric Hughes, establish the real subject of "Against All Odds," which is about lives lived speeding down the wrong side of the road around blind curves. Everybody in the movie is heading for a blind curve — the bookie, played with evil, self-assured charm by James Woods; Jessie's avaricious, still beautiful mother (Jane Greer) and her mother's tycoon-lover (Richard Widmark); the lawyer (Saul Rubinek), who became rich managing Terry's football career; as well as Jessie and Terry.

"Against All Odds," like "True Confessions" and "Chinatown," is at heart a political film, though Mr. Hackford and his associates probably would prefer that it not be labelled as such. It doesn't preach in any fashion, but its view of life in the once-promised land is dark indeed.

•

What saves it from being a rather perfunctory, slickly executed film-noir thriller is the character of Terry Brogan who, as written by Mr. Hughes and played by Mr. Bridges, is a remarkably fresh, unhackneyed version of one of fiction's most durable heroes. Terry is the misused innocent. He's not the brightest guy on the block, but even in this southern California world where everyone is compromised, he somehow manages to hang onto a shard of self-respect.

The other new film noir is California noir at its most inscrutable. This is "Mike's Murder," which James Bridges ("Urban Cowboy") wrote as well as directed. It stars Debra Winger ("Terms of Endearment"), who is totally bereft, acting-wise, as a pretty but somewhat too susceptible teller at one of Los Angeles's drive-in banks.

Betty (Miss Winger) has one ecstatic night of love with a hustling young man named Mike (Mark Keyloun) and then spends most of the rest of the movie waiting — with extraordinary patience — for him to call her again, though she is aware that he deals in drugs and seems to have a far more active life as a homosexual than as a heterosexual.

If "Against All Odds" is given weight and meaning by the fully realized characterization of Terry Brogan, "Mike's Murder" falls completely apart because Miss Winger's bank teller has no identity whatsoever. She exists only as a function of the plot, which is meant to draw our attention to the kinds of rootless, wasted lives that can be lived in a more chi-chi style in Los Angeles than in, say, Toledo. The movie is worse than incredible. It's sentimental.

Not everything that happens in "Against All Odds" is totally logical and believable, but it has class. It also has a lot of funny, tough-guy dialogue that recalls the black-and-white film noir of the 1940's and 1950's. I especially like the response of Mr. Woods, as the ruthless bookie, when Terry Brogan asks him if the friendly dog with him actually belongs to him. (It belongs to the bookie's missing mistress.) Says the bookie, as if shocked, "Now what kind of dog would hang around me?" ∎

1984 Mr 11, II:17:1

Demon Seeds

CHILDREN OF THE CORN, directed by Fritz Kiersch; screenplay by George Goldsmith, based on a story by Stephen King; director of photography, Raoul Lomas; edited by Harry Keramidas; music by Jonathan Elias; produced by Donald P. Borchers and Terrence Kirby; released by New World Pictures. At Loews State, Broadway and 45th Street; Orpheum, 86th Street and Third Avenue, and other theaters. Running time: 93 minutes. This film is rated "R."
Dr. Burt StantonPeter Horton
Vicky BaxterLinda Hamilton
DiehlR. G. Armstrong
IsaacJohn Franklin
MalachaiCourtney Gains
Job ..Robby Kiger
SarahAnneMarie McEvoy
RachelJulie Maddalena
JosephJonas Marlowe
AmosJohn Philbin
Boy ..Dan Snook
Dad ..David Cowan
MomSuzy Southam
Mr. HansenD. G. Johnson
Hansen customers
 Patrick Boylan, Elmer Soderstrom, Teresa Toigo

By VINCENT CANBY

IT'S a peaceful, parched Sunday morning of late summer in the tiny Nebraska farming community of Gatlin. It's that lazy hour between the end of church services and the start of Sunday dinner when most kids feel at loose ends — but not this morning. The Gatlin children, at the direction of pint-sized Isaac, who looks like the demon seed of John Brown, rise up and with cool dispatch murder everyone in Gatlin over the age of 19. They use butcher knives, hatchets, sickles and whatever else is handy.

All of this takes place in the swift, efficient, blood-splattered precredit sequence that begins "Children of the Corn," another horror film from what must be the busiest word processor in the fiction business, the one belonging to Stephen King ("Carrie," "The Shining," "Christine" and others).

Mr. King didn't actually write the screenplay, only the short story that was adapted by George Goldsmith and directed by Fritz Kiersch. However, for those who take Mr. King seriously, this is high-proof King corn, which is to say it has a kick to it even though it hasn't much taste.

In "Children of the Corn," which opens today at Loews State and other theaters, Mr. King pursues an obsession he shares with a number of other writers of the macabre, including Ray Bradbury and Saki (H. H. Munro), that is, that children, either singly or traveling in packs, are not to be trusted with anything sharp and pointed or blunt and heavy.

After the prologue, the film jumps three years ahead, when your average nice-guy horror-film hero, Dr. Burt Stanton, and his friend Vicky, motoring from the East Coast to Burt's hospital residency in Seattle, find themselves in Gatlin and up to their necks in murderous tots.

In the course of this terrible day, Burt and Vicky meet the small but ferocious Isaac, the minister on earth for He Who Walks Behind the Rows; Isaac's teen-age enforcer, a freckle-faced, red-haired boy named Malachai; Rachel, who is Isaac's executive in charge of human sacrifices, and what appear to be the last two unconverted kids in town, Job and his 8-year-old sister Sarah, who draws pictures of events that haven't taken place yet. Aside from Job and Sarah, they are a crew to shame the Manson family.

As such movies go, "Children of the Corn" is fairly entertaining, if you can stomach the gore and the sound of child actors trying to talk in something that might be called farmbelt biblical. John Franklin and Courtney

Gains, as Isaac and Malachai, respectively, aren't completely at ease with the dialogue, but they look absolutely right. AnneMarie McEvoy is both sweet and alarmingly self-possessed as Sarah, and Peter Horton and Linda Hamilton play the endangered motorists without condescension.

Especially effective is the film's physical look. Shot in Iowa, which passes for Nebraska, the film is full of beautifully evocative, broad, flat, sun-baked landscapes, in which even cornfields are made to seem menacing.

As happens too often in fiction of this sort, the resolution fails to top the buildup. There is one arbitrary resurrection from the dead, and when we finally do see He Who Walks Behind the Rows, it turns out to be He Who Burrows Between the Rows, like a gopher. Gophers, even satanic ones, aren't terribly intimidating.

1984 Mr 16, C7:2

A Rampaging Pop

TANK, directed by Marvin J. Chomsky; written by Dan Gordon; director of photography, Don Birnkrant; edited by Donald R. Rode; music by Lalo Schifrin; produced by Irwin Yablans; released by Universal Pictures. At Gemini, Second Avenue and 64th Street; Rivoli, Broadway and 49th Street; 86th Street East, at Third Avenue, and other theaters. Running time: 113 minutes. This film is rated "PG."
ZackJames Garner
LaDonnaShirley Jones
BillyC. Thomas Howell
ElliottMark Herrier
General HubikSandy Ward
SarahJenilee Harrison

"THE bottom line," says Billy (C. Thomas Howell), the teen-age son of Sgt. Maj. Zack Carey (James Garner), "is that he's my father, and I love him."

"Tank," this week's only "I love you, Pop" comedy-drama, has something extra. In addition to a father, a mother (Shirley Jones) and a dead older brother, whose memory haunts Billy, the movie has a World War II Sherman tank that has been lovingly rebuilt in his free time by Zack, a gung-ho, regular Army man.

At the beginning of "Tank," when the Carey family arrives to take up new duties at an Army base in Georgia (actually Fort Benning), someone asks the sergeant, in effect, "Why a tank?" "Because," he says, "it's hard to shoot yourself while cleaning it."

He doesn't say that it's also the most important prop in the movie, which is mostly about Zack's rampage when a redneck sheriff frames young Billy on a marijuana charge and ships him off to a prison farm.

Zack's response is to climb into his tank and, accompanied by a pretty, squeaky-clean teen-age prostitute, go on his own private warpath. First he drives into town, levels the sheriff's office as if with a bulldozer, shoots up the telephone system, goes out to the prison farm where he frees Billy and then — still in the tank — heads for Tennessee, where he thinks Billy will receive a fair trial. Zack apparently believes that things have changed in Tennessee since the Scopes trial.

"Tank" is supposed to be a mad, glorious demonstration of American individualism, as exemplified in Zack's two-day tank journey through hostile Georgia territory to the Tennessee line. The flight catches the fancy of radio, television and newspaper reporters, so that, by the time Zack nears his destination, the entire country is cheering him on.

Dan Gordon's original screenplay wobbles uncertainly between sadistic

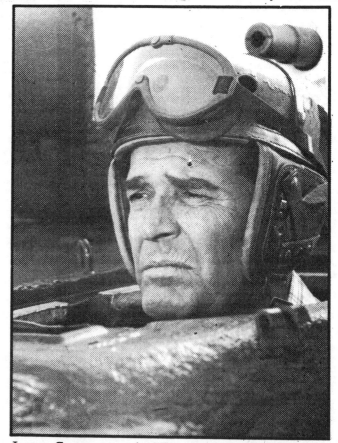

James Garner stars in "The Tank," Marvin Chomsky's film about an Army sergeant who uses a tank to rescue his son from a small-town sheriff.

melodrama and populist farce. Because Marvin J. Chomsky, the director, is more convincing in detailing the vicious events that prompt Zack's rampage than in finding the comedy of the flight, "Tank" becomes implausible all the way round.

Mr. Garner has a good, no-nonsense way with comic lines, of which there aren't an overabundance. The only other performance worth noting is that of G. D. Spradlin, who plays the redneck sheriff, the sort of role that is easier to take when played for laughs by Jackie Gleason in the "Smokey and the Bandit" comedies.

"Tank" is as immediately forgettable as a lesser, made-for-television movie. It opens today at the Gemini and other theaters.

•

"Tank," which has been rated "PG" ("Parental Guidance Suggested"), contains some vulgar language and several unpleasant scenes, in which innocent people are beaten up in order to get the plot rolling.

Vincent Canby

1984 Mr 16, C8:1

Water's What Counts

THE ICE PIRATES, directed by Stewart Raffill; written by Mr. Raffill and Stanford Sherman; director of photography, Matthew F. Leonetti; edited by Tom Walls; music by Bruce Broughton; produced by John Foreman; released by MGM/UA Entertainment Company. At the Warner Twin, Broadway and 47th Street; 86th Street Twin, at Lexington Avenue; Eastside Cinema, Third Avenue and 55th Street and other theaters.
Jason....................................Robert Urich
Princess KarinaMary Crosby
RoscoeMichael D. Roberts
MaidaAnjelica Huston
KilljoyJohn Matuszak
ZenoRon Perlman
Supreme CommanderJohn Carradine
NannyNatalie Core
ZornJeremy West
WendonBruce Vilanch
Count PaisleyAlan Caillou

"THE ICE PIRATES," which opens today at the Warner and other theaters, is a busy, bewildering, exceedingly jokey science-fiction film that looks like a "Star Wars" spinoff made in an underdeveloped galaxy.

The story has something to do with the hijacking of space freighters loaded with ice because, in this film's galaxy, water is in short supply and what there is of it is controlled by forces of evil. In addition to a number of robots, the cast includes Robert Urich, Mary Crosby and Anjelica Huston. The special effects aren't great either.

•

"The Ice Pirates," which has been rated PG ("Parental Guidance Suggested"), contains dialogue heavily laced with double-entendre witlessness.

Vincent Canby

1984 Mr 16, C8:5

GERMANY PALE MOTHER, script and direction by Helma Sanders-Brahms; in German with English subtitles; camera, Jürgen Jürges; edited by Elfi Tillack and Uta Periginelli; music by Jürgen Knieper; produced by Ursula Ludwig; a New Yorker Films Release. At the Public Theater, 425 Lafayette Street. Running time: 145 minutes. This film has no rating.
HeleneEva Mattes
HansErnst Jacobi
HanneElisabeth Stepanck
LydiaAngelika Thomas
UlrichRainer Friedrichsen
Tante IhmchenGisela Stein
Onkel BertrandFritz Lichtenhahn
AnnaAnna Sanders

By JANET MASLIN

Helma Sanders-Brahms's "Germany Pale Mother" is narrated by a woman who says she is telling her parents' story, as well as her country's. Her parents' courtship began during the Nazis' rise to power, and it was, she says, "perfectly normal, only it happened at this time, in this country." Their marriage was marked by long separations, as Hans (Ernst Jacobi) went off to fight in the war, and Helene (Eva Mattes) stayed home, raising her daughter and enduring almost every imaginable physical hardship.

As played by Miss Mattes, Helene is a thick, stolid, long-suffering creature. During the course of the film, she gives birth to a child during an air raid, survives the destruction of her home, is raped by American G.I.'s, has all her teeth removed, and develops a facial paralysis that is so disfiguring that she is forced to wear a black drape at the dinner table. As both a woman and as a metaphor for her country's hardships, Helene is a figure of formidable misery.

"Germany Pale Mother," which takes its title from Bertolt Brecht's 1933 poem and which will be playing at the Public Theater for another week, uses a peculiarly changeable style in presenting Helene's unhappy life. The slow, painful realism that characterizes most of the film is occasionally interrupted by more fanciful passages, such as the one in which Helene guides her tiny daughter Anna through the ruins of a Nazi crematorium, cheerfully telling the child a macabre fairy tale. Hans first spies Helene in a scene of similarly heightened tone, as he and a friend spend a beautiful spring day rowing on a river, and happen to watch as Helene is taunted by some Nazis. They let their dog bite her sweater and still Helene does not cry out. Her unusual perseverance is the quality that wins Hans's attention.

•

Miss Sanders-Brahms establishes virtually everything about her characters early in the film, and begins to repeat herself subsequently; there are, for instance, at least three different lengthy scenes depicting Hans's visit home on furlough, and Helene's unwillingness to have sex with him. "Germany Pale Mother," which begins with a reading of Brecht's poem, seems to descend steadily, as it progresses, from the poetic to the mundane. Its conclusion ought to be startling, but it has very little impact, because the audience, like Helene, has already been through so much.

1984 Mr 18, 52:1

THE WELL, written, directed and edited by David Greenwald; (in Yiddish with English subtitles); director of photography, Paul Ziller; music by Leon Odenz; produced by Paula Pevzner; released by Well Productions. At the Manhattan 1, 59th Street between Second and Third Avenues. Running time: 30 minutes. This film has no rating.
SammyJeff Nishball
MotherRaquel Yossiffon
Uncle MoisheMoishe Rosenfeld
FatherItzek Gottesman
TeacherAvram Malowicki
ShochetRabbi Jacob Axelrod
GypsyHelen Perle
ForemanAlfred Cherry
Upset ManTibor Feldman
SingerIrina Fogelson
ActorHy Wolfe
ActressHelen Rubinstein
AccordionistGanna Gutkin
HecklerSteve Amateau

"The Well" is a Yiddish-language short feature that depicts a young Jewish man from Eastern Europe in 1939 as he gradually becomes aware

of the fate that awaits his people. When he goes to the well in his tiny village, he finds it muddy, and the gravity of this omen is conveyed through much overreaction and pantomime.

Heavy with foreboding, the film follows Sammy (Jeff Nishball) to America, which he has learned about while reading Life magazine during his rabbi's lectures about the promised land. There, he works in the garment business and learns, to his horror, about events in Europe (the film ends in 1942). As written, directed and edited by David Greenwald, "The Well" is earnest but very amateurish. The parable probably has more emotional impact in synopsis than it does in Mr. Greenwald's brief but awkward screen version.

A GENERATION APART, directed by Jack Fisher; written by Ed Fields; edited by Danny Fisher; music by Peter Arnow; produced by Jack Fisher and Ed Fields in association with Peter Arnow; released by City Lights Productions, Inc. Running time: 56 minutes. This film has no rating.

WITH: Alan Fisher, Esther Fisher, Joseph Fisher, Jack Fisher, Danny Fisher, Mary Gelfman, Shelley Gelfman, Peter Braun, Yoram Lowenstein, Zenek Rybowski

On the same bill, at the Manhattan I theater, is the documentary "A Generation Apart," which examines the same subject from a very different and much more original perspective. Jack Fisher, the son of two Holocaust

survivors, uses his brothers, his parents and several friends of similar background to help examine the effects of the concentration camps on survivors and their children. The results can be surprising, as when a young woman named Shelley Gelfman says about her mother's harrowing wartime recollections: "The truth is, the stories excite me. As painful as they are, there's something alive about them."

Mr. Fisher's attempts to involve his parents and two brothers in a group discussion have curious results. "Do you think Mom and Dad did a good job bringing you up?" the oldest brother is asked, and he seems embarrassed by the question. This brother, said by his parents to have been the apple of everyone's eye and the family's first child born after the Holocaust, has grown up to be a diffident artist, and he finally asks his younger sibling: "Do you really want to lay on everybody this Holocaust business? How relevant really is it to your personal life?" In its roundabout and somewhat unfocused way, "A Generation Apart" attempts to answer that question and produces some fascinating family data, if not any definitive conclusions.

Janet Maslin

1984 Mr 18, 53:1

FILM VIEW

VINCENT CANBY

'Spinal Tap' Draws Laughter From Rock

It was only a small step from the sort of rock-concert film pioneered by D. A. Pennebaker in "Don't Look Back" (1967) to the rock concert-tour film exemplified by Albert and David Maysles' tough but vivid "Gimme Shelter" (1970), which recorded the small talk, the music and the mayhem that occurred during a national tour by the Rolling Stones.

Some of these rock documentaries have been memorable, like Michael Wadleigh's "Woodstock" (1970), some disappointing, like Martin Scorsese's "Last Waltz" (1978), which was about the 1976 farewell concert of The Band in San Francisco, and some unexpectedly entertaining, like Pierre Adidge's "Mad Dogs and Englishmen" (1971), which recorded for posterity the cheerful chaos and confusion of an American tour by the British rock star Joe Cocker.

That these films might be more important to the participants as vehicles for the promotion of record albums than as either social history or as movies was made all too apparent with the release in 1973 of "Elvis on Tour." This was the unintentionally hilarious, obviously "authorized" — meaning totally controlled by the star and his advisers — filmed record of one of Presley's last and, apparently, not exactly triumphant tours, directed in part by the same Pierre Adidge who was responsible for the Joe Cocker film.

Elvis was not in top form at the time, but what he lacked in voice, physique and all-round, basic charisma, the filmmakers attempted to supply by treating him as if he were someone who'd come to earth to take responsibil-

ity for our sins. It wasn't "Heartbreak Hotel" we heard on the soundtrack when Elvis was initially shown in godlike silhouette, wearing his sequined Batman cape, but the first few bars of "Thus Spake Zarathustra."

All of these films, plus others I don't even remember anymore, are the source material for one of the brightest, funniest American film parodies to come along since "Airplane!" It is Rob Reiner's "This Is Spinal Tap," a movie of such wonderfully high-class nuttiness that I suspect it might prove as entertaining to audiences who've never seen a rock-concert film as to those who take their rock very seriously, and are familiar with the various ages through which rock has progressed, at least since the advent of the Beatles.

• • •

Good parody has always been rare but seemingly never more rare than today though not from want of many people trying. Television, especially late-night weekend television, is full of bright, eager young performers knocking themselves out in attempts to ridicule what they see to be the idiocies that surround us.

However, since the first batch of "Saturday Night Live" performers moved on to the big time, and since "SCTV" has vanished from the free-TV screen, there hasn't been much in the way of parody to laugh about. The current "Saturday Night Live" crew may possibly recover from the loss of Eddie Murphy, though I doubt it, and I've not seen anything except tireless efforts on Home Box Office's "Not Necessarily the News," where random rudeness passes for parody.

"This Is Spinal Tap" doesn't equal Mel Brooks's "Young Frankenstein," but it's almost as funny and as dense with absurd detail as "Airplane!" That's something of a feat, since the subject of "This is Spinal Tap" is comparatively arcane.

The film is the first to be directed by Mr. Reiner, who is familiar to most Americans as the slobbish Meathead of "All in the Family," but it seems to have been a truly collaborative effort among Mr. Reiner, who also plays in the film, and his co-stars, Christopher Guest, Michael McKean and Harry Shearer, who share the screenplay credit with the director.

• • •

"This Is Spinal Tap" purports to be a documentary, "or, if you will," says the director of the film-within-the-film, "a 'rockumentary,'" about the first American tour in six years of a British heavy metal band called Spinal Tap.

Mr. Reiner, looking a bit like Robert Altman in a Navy cap labeled "USS Doral Sea," plays the documentary director, friendly Marty DiBergi, who opens the movie with a few remarks about his own career ("You may remember my commercial about the small dog that chases the covered wagon underneath the sink.") Marty then tells us about his longtime affection for the band, which, he notes solemnly, was responsible not only for some of the most original music to come out of Britain, but also for some of the loudest.

He then introduces the members of the band, including lead vocalist David St. Hubbins (Mr. McKean), Nigel Tufnel (Mr. Guest), the moody lead guitarist, and Derek Smalls (Mr. Shearer) who, during an interview at one point, tells Marty, "We are incredibly lucky. We have two visionaries in the band," meaning David and Nigel. "They are like fire and ice." Asked where he fits in, Derek says he sees himself as a conduit between the other two, "sort of, well, like lukewarm water."

• • •

Like all respectable rock-concert-tour films, this one mixes psychedelic concert footage (lots of below-the-pelvis, into-the-lights shots) with soul-searching, self-conscious interviews, plus candid shots of the band members cavorting with groupies and you-are-there sequences that catch moments of unexpected drama, including a record autographing party to which nobody comes. This "contemporary" footage is, in turn, supplemented with kinescopes of the band's early TV appearances, eight drummers ago, back in the days when they wore Beatles-like, Dutch-boy haircuts and string ties.

Things go bad for Spinal Tap right at the top of the tour. Sir Denis Eton-Hogg (Patrick MacNee), the president of Polymer Records, objects to the jacket design for their new album, "Smell the Glove," to which Polymer's artists relations person, Bobbi Flekman, played with pricelessly funny, frosty condescension by Fran Drescher, can only agree. She calls the cover, showing a naked woman on all fours with a dog collar around her neck, "sexist." "What's wrong with its being sexy?" asks Nigel.

What happens to Spinal Tap on tour shouldn't happen to Liberace. Dates are canceled right and left. When the Seattle gig falls apart, they wind up playing Seattle's Lindbergh Air Force Base for the monthly "at ease" weekend, where the cleanshaven soldiers and their dates flee the Spinal Tap sound. In Cleveland, they get lost trying to make their way to the stage from their dressing room, and an attempt to introduce a new, Druidical theme to the performance fails because the Stonehenge set comes out 18 inches high instead of 18 feet. On another occasion, Derek remains trapped inside a giant plastic egg that is supposed to open — but doesn't — at the start of the performance.

All of these things, including the loss of their drummer, Mick Shrimpton (R. J. Parnell), are taken in stride. The real trouble starts when David's girlfriend, Jeanine Pettibone (June Chadwick), joins the tour and begins to second-guess the group's manager, Ian Faith (Tony Hendra). More than that, you need not know.

The performances are spectacularly comic, though I still can't believe that Mr. McKean, Mr. Guest and Mr. Shearer are not English. Whatever they are, their accents seem remarkably authentic. Even the bit roles are played with fine, lunatic authority.

It's not easy putting together a film parody as richly detailed with events, language and visual gags as "This Is Spinal Tap." Time and a great deal of care must have been taken — luxuries that are denied television's parodists, who are required to come up with new routines every week. No wonder they fall back on a method that relies principally on shock or on what is taken to be impertinence.

"This Is Spinal Tap" is sometimes wonderfully rude. The fate of the band's pre-Mick Shrimpton drummer can't be reported in a newspaper that is written to be read at the breakfast table. Yet the film works not because it is shocking but because it is essentially so fond, if not consistently admiring, of its subject. Mr. Reiner, who is the son of another great parodist, Carl Reiner, and his associates have made one of the season's most satisfying comedies, as well as the rock-concert-tour film that tops all the others. ■

1984 Mr 18, II:17:1

Agent Orange

THE SECRET AGENT, directed by Jacki Ochs; edited by Daniel Keller and Jacki Ochs; music by Country Joe McDonald; produced by Mr. Keller and Jacki Ochs; a Green Mountain Post Film/Human Arts Association Production; distributed by First Run Features. At the Film Forum, 57 Watts Street. Running time: 56 minutes. This film has no rating. Narrated by Max Gail.

Three Bodies

SL-1, produced, directed, written, photographed and edited by Diane Orr and C. Larry Roberts; music by Brian Eno, Popol Vuh; a Beecher films Production; distributed by direct Cinema, Ltd. At the Film Forum, 57 Watts Street. Running time: 60 minutes. This film has no rating.

By JANET MASLIN

THE cinema of contamination, which has grown timely enough to have engendered commercial hits such as "The China Syndrome" and "Silkwood," has two more hard-hitting documentaries to add to its roster. Jacki Ochs's "Secret Agent," which was shown at last year's New York Film Festival, details the illness and the indignation of Vietnam veterans who were exposed to Agent Orange, and contends that the manufacturers of this chemical withheld evidence of its toxicity from the United States Government. Disturbing as "The Secret Agent" is, its co-feature at the Film Forum, "SL-1," is even tougher.

"SL-1," made by C. Larry Roberts and Diane Orr, is a grisly meticulous examination of the details of a nuclear accident. The explosion took place in 1961, at the Atomic Energy Commission's SL-1 reactor in Idaho Falls, Idaho. Three workers were killed, and there was evidence that one of them, in the midst of marital problems, might have triggered the accident deliberately.

•

The film makers consider this question of motivation, and try to speculate about what might have induced the man to do such a thing. But they concentrate on well-documented, utterly horrifying minutiae. Disposal of the three bodies and removal of radioactive waste in and around the reactor eventually exposed 790 people to harmful levels of radiation, despite elaborate attempts to alleviate the danger.

A worker attempting a cleanup mission in the reactor would typically spend four hours suiting up and then showering, and for all that would only accomplish eight minutes of actual work. Parts of the bodies of the three dead men had to be removed and buried separately, because they were "hot" enough to be considered high-level nuclear waste. This surgical work had to be performed using knives and hacksaws fastened to the ends of long poles. Truly, this was — as someone in the film describes it — "a new way to die."

•

The film makers' style is one of grim understatement, and it is highly effective. Using documents obtained under the Freedom of Information Act to reconstruct the story, and making especially chilling use of a Government-filmed re-enactment of the disaster, they create an enormously sobering record of the accident, its lessons and its legacy. ■

1984 Mr 21, C14:4

Cost of Leaving

MUSICAL PASSAGE, directed by Jim Brown; director of photography, Mr. Brown; edited by Paul Barnes; produced by Mr. Brown, David Karpoff and Ginger Turek; a Films Incorporated Release. At the Festival, 57th Street and Fifth Avenue. Running time: 73 minutes. This film has no rating.

By VINCENT CANBY

"MUSICAL PASSAGE," directed and photographed by Jim Brown ("The Weavers: Wasn't That a Time!"), is a feature-length documentary that beautifully, and without seeming effort, translates the film maker's admiration and affection for his subject into dramatic, moving images.

"Musical Passage," which opens today at the 57th Street Playhouse, is an unaffected, unqualified delight.

The film's subject is the Soviet Emigré Orchestra and its founder, Lazar Gosman, who, with his wife, emigrated to this country in 1977 from Russia where he had been music director of the Leningrad Chamber Orchestra. Mr. Gosman, currently pro-

fessor of violin and chamber music at the State University of New York at Stony Brook, formed the Soviet Emigré Orchestra in 1979, using some American musicians as well as émigrés.

•

"Musical Passage" is very much like Mr. Gosman — small, expressive, intense, articulate and, sometimes, very funny, even about serious matters. The movie alternates between interviews with Mr. Gosman, his wife and the other musicians, and sequences in which we see the Soviet Emigré Orchestra in rehearsal and in performance, in Virginia, Florida and, finally, at New York's Carnegie Hall.

There is a lot of music and all of it first-rate, but the heart of the film is in the interviews in which Mr. Gosman and the others talk about music, America and the high cost of emigration in terms of careers interrupted and the breakup of families and friendships. "When I came to this country," says Mr. Gosman, "I had nothing. No money, no music, only my violin." Within a few years, he had his orchestra, his position at Stony Brook and a fine modern house that he calls Mortgage Manor.

At one point Mrs. Gosman remembers how they succeeded in getting her husband's beloved violin out of the Soviet Union. Because she had her own passport under her maiden name, she declared the violin as her own, but she still had to bargain with Soviet emigration authorities on how much she was willing to pay to take the instrument outside the country. She shrugged her shoulders. It had sentimental value, she told them, but she wasn't willing to pay much for the privilege of keeping it. The emigration people shrugged their shoulders and told her take it.

Some of the other musicians weren't so lucky.

After he requested permission to leave Russia, Grigory Zaritsky, the émigré orchestra's principal second violin, spent two years without work and had to sell his violin to feed his family. Elmira Belkin, another violinist, divorced her husband to be able to come to New York with their daughter.

The film's highlight is a performance of the last movement of Haydn's Symphony No. 45 in F Minor, the "Farewell Symphony," in which the musicians, using candles for illumination, extinguish the candles and leave the stage as each part is completed. To Mr. Gosman, this is a dramatic representation of Russia's loss through emigration. As each man, woman and child leaves the country, the light becomes just a little more dim.

1984 Mr 21, C20:3

RACING WITH THE MOON, directed by Richard Benjamin; screenplay by Steven Kloves; director of photography, John Bailey; edited by Jacqueline Cambas; produced by Alain Bernheim and John Kohn; released by Paramount Pictures. At the Coronet, Third Avenue and 59th Street; 34th Street East, near Second Avenue. Running time: 110 minutes. This film is rated PG.
Hopper .. Sean Penn
Caddie Elizabeth McGovern
Nicky .. Nicolas Cage
Mr. Nash .. John Karlen
Hopper's mother Rutanya Alda
Sally .. Suzanne Adkinson
Annie .. Carol Kane

RACING WITH THE MOON," directed by Richard Benjamin from an original screenplay by

a fine new writer named Steven Kloves, is an exceptionally appealing movie about subjects you may think you've already had enough of — growing up, first love and the shouldering of arms and other responsibilities. However, "Racing With the Moon" demonstrates such intelligence and wit that the result is an unexpected pleasure.

The place is the small town of Point Muir in northern California. The time is the winter of 1942-43, just a year after Pearl Harbor, when Henry (Hopper) Nash, played by Sean Penn, and his best friend Nicky (Nicolas Cage) are finishing high school and getting ready to enter the Marines. It's a time of expectations, doubt, utter confusion and ever-possible calamity.

Henry is not a great student but he's both dutiful and independent. He's not a lightweight. Off hours he earns pocket money as a pinboy at the local bowling alley. He's the only child of a loving mother, who wants him to be a concert pianist, and an absent-minded father, the town gravedigger. When his father calls him Argus, Henry says patiently, for probably the zillionth time: "Dad, Argus is the dog. I'm Henry."

Nicky is the hell-raiser of the pair, far more sophisticated than Henry in all matters that count at their age. It's Nicky who fixes up Henry with Annie (Carol Kane), Point Muir's only tart, on a double date designed to reassure the apprehensive parents of Nicky's girlfriend, Sally, that their daughter is well chaperoned. Annie almost blows her genteel cover as she waits with the two boys and Sally's parents for Sally to finish dressing. "Say," says Annie, "could I have a drink?" "Or some candies? Or something?"

•

"Racing With the Moon" is very much of its time, being the kind of fiction in which young men who don't take precautions frequently find themselves with young women who

are pregnant, which is what happens to Nicky and Sally. Henry and the pretty, sensitive Caddie (Elizabeth McGovern), with whom he falls in love, are far luckier, though the course of their affair is not exactly rubble-free.

Mr. Kloves's screenplay moves between comedy and drama with assurance, never pulling its punches or reaching for the easy laugh, and somehow managing to suggest sadness and loss even in the most blissfully romantic sequences. This gives "Racing With the Moon" the kind of sharp edge that is very rare in American film comedies and is never seen in television sit-coms.

Mr. Benjamin, whose first film as a director was the uproarious "My Favorite Year," finds just the right mixture of giddiness and bewilderment in the material and in the young actors. This tone is consistent, whether Henry and Nicky are conning a couple of sailors in a pool game, or Henry, assaulted equally by love and lust, attempts to lure Caddie into skinny dipping with the argument, "You can wear your understuff and all that, since it is January."

Mr. Kloves's dialogue is very special, and so are the performers who speak it. Mr. Penn (of "Bad Boys" and "Fast Times at Ridgemont High") is turning into one our best young film actors. He's easy and slightly laid back in the manner of someone in command of his resources. Mr. Cage is very good as Nicky, and Miss McGovern is a teenager's dream of womanliness.

For the most part, the period detail seems accurate, but "Racing With the Moon," which opens today at the Coronet and other theaters, is so good in all important ways that when it isn't verifiably accurate I'm prepared to accept the detail as an idiosyncrasy rather than as an anachronism.

Vincent Canby

1984 Mr 23, C5:1

LE BAL, a French film by Ettore Scola; screenplay by Ruggero Maccari, Jean-Claude Penchenat, Furio Scarpelli and Mr. Scola; from the stage work of the Théâtre du Campagnol, based on an original idea by Mr. Penchenat; cinematography by Ricardo Aronovich; edited by Raimondo Crociani; music by Vladimir Cosma; produced by Giorgio Silvagni; released by Almi Classics. At Cinema 1, Third Avenue and 60th Street. Running time: 112 minutes. This film has no rating.
WITH Etienne Guichard, Regis Bouquet, Francesco de Posa, Arnault LeCarpentier, Liliane Delval, Martine Chauvin, Danielle Rochard, Nani Noel, Aziz Arbia, Marc Berman, Geneviève Rey-Penchenat, Michel van Speybroeck, Michel Toty, Raymonde Heudeline, Anita Picchiarini, Olivier Loiseau, Monica Scattini, Christophe Allwright, François Pick, Chantal Capron, Jean-François Perrier, Rossana Di Lorenzo

By VINCENT CANBY

IT is early evening. An elderly porter moves around a cavernous, dimly lighted Parisian dance hall preparing things for another night's revels. Chairs on table tops are placed back on the floor; bottles are set out on the bar. The bartender comes in, makes a few minor adjustments, turns on the gaudy lights and selects a disco number on the jukebox. A large, mirrored globe over the center of the dance floor begins to revolve.

One by one, lonely, purposeful women arrive, all somewhat past their prime. Each pauses at the top of the staircase before making her very studied entrance. Each sweeps down the staircase, crosses the dance floor to the mirrored wall opposite to refresh her makeup and then turns to stake out her territory for the night, a small, ringside table.

The men, equally lonely and each a distinctive type, arrive as a comic chorus line. They stand at the bar, striking poses indicating various degrees of boredom as they eye the women on the other side of the room.

In this fashion Ettore Scola begins "Le Bal," a strikingly handsome, very stylized film spectacle that condenses approximately 50 years of European social and political history into one night at the dance hall. "Le Bal," which sometimes recalls the

Elizabeth McGovern and Sean Penn star in "Racing With the Moon," a story of first love set in a small coastal town in the north of California.

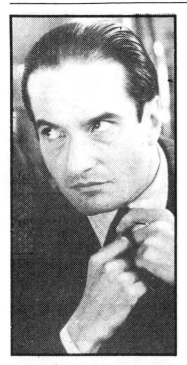

Marc Berman, as an unsavory character in the film "Le Bal."

kind of comedy of which Jacques Tati was master, is a series of vignettes in music and dance without a single word of spoken dialogue. People come together, flirt, fight, are reconciled and, at the end, go their separate ways. I'm afraid that at this dance hall, as in life, people rarely exit together.

The film moves from the comparatively drab present back in time to 1936 and the gaudy days of the Popular Front, when a coalition of France's leftist parties won political power and promised a new era of social progress. Scene by scene, the movie then inches forward to World War II, the German occupation, the liberation, the postwar Marshall Plan years, the Algerian war, May of 1968 and, finally, the present again.

Mr. Scola ("La Nuit de Varennes," "A Special Day") makes no attempt to hide the film's origins as a theatrical piece devised by Jean-Claude Penchenat, who also appears in the movie, for the Théâtre du Campagnol. Instead, he emphasizes those origins, sometimes more effectively than at others. At its best, "Le Bal" is a graceful, dreamlike extravaganza, a cavalcade of a half-century of popular music and manners, danced and mimed by a large cast of elegantly deadpan clowns, some of whom play a number of roles, while others remain more or less in a single character from start to finish.

When cinematic invention flags, especially in the later sequences relating to the Algerian war and the student uprisings of 1968, the scheme becomes tiresome and the vignettes more obligatory than illuminating or witty. "Le Bal" is an elaborate stunt that, on the screen, misses the presence of live actors and the accumulating excitement that can be so exhilarating in a theatrical performance.

After a while, the faces of the actors become blurred and watching them turns into an identification game. Is that aging woman in the final sequence the overprotected, virginal daughter of the 1936 sequence?

Is the black marketeer seen in the postwar segment supposed to be the same man who was the collaborator during the occupation? Are we dealing with characters or ideograms? Is the point of the film that nothing really changes?

I don't think we are meant to ask such questions. I also suspect that in a stage presentation we wouldn't, but the screen images are so specific that when the mind wanders, one tends to ask questions that are all too literal.

Most of the time, the eye and the ear are so dazzled that the mind shuts up. The stylization is very beautiful in a chilly, impersonal way, and the soundtrack contains a wonderfully appealing collage of 50 years of popular music. We hear — and see danced — the ebullient, breathless, quintessentially French java, as well as the tango, rumba, fox trot, lindy, twist and disco, among others. There are songs by Charles Aznavour, Charles Trenet, Irving Berlin and even Rouget de Lisle, whose "Marseillaise" is heard as recorded by Django Reinhardt and Stèphane Grapelli.

The best of the vignettes are comic, though the film's single most arresting moment is the return from the war of a Resistance fighter who, one leg shy, still manages to dance with verve. Michel van Speybroeck does an amusing imitation of a Jean Gabin type, who for a few minutes interests an aristocratic woman who come to the dance hall to watch the lower orders at play.

In the late-1940's segment, Mr. Penchenat and Chantal Capron do a comically inadequate turn as spinoffs of Fred Astaire and Ginger Rogers. Jean-François Perrier turns up throughout the film playing a variety of fastidious eccentrics, including a Wehrmacht officer, and Marc Berman plays a series of despicable types, including the collaborator and the black marketeer.

Because "Le Bal" is a spectacle, most of the performers unfortunately remain anonymous, though their contributions are enormous. The film has been choreographed as much as directed in any conventional sense, but the physical production is outstanding. In the 1936 sequence, Mr. Scola and his cameraman, Ricardo Aronovich, miraculously drain virtually all the color from the images to create a look that suggests hand-tinted photographs that have begun to fade. More than anything else, these exemplfy the mood of the entire film.

"Le Bal" opens today at the Cinema 1.

1984 Mr 23, C6:1

Corrupted Morals

L'ARGENT, directed by Robert Bresson; script (French, with English subtitles) by Mr. Bresson; camera, Pasqualino de Santis and Emmanuel Machuel; edited by Jean-François Naudon; production, Marion's Films and FR 3/Eos Films SA. At Lincoln Plaza 3, Broadway, between 62d and 63d Streets. Running time: 90 minutes. This film is not rated.

Yvon..................................Christian Patey
Little Old LadySylvie van den Elsen
Father of Little Old LadyMichel Briguet
Elise.....................................Caroline Lang
Yvette.............................Jeanne Aptekman
Lucien.........................Vincent Risterucci
Female PhotographerBeatrice Tabourin
Male PhotographerDidier Baussy
NorbertMarc Ernest Fourneau
MartialBruno Lapèvre
Father NorbertAndré Cler
Mother NorbertClaude Cler

Christian Patey in "L'Argent."

"L'Argent" was shown in last year's New York Film Festival. Following are excerpts from Vincent Canby's review in The New York Times of Sept. 24. The film opens today at the Lincoln Plaza 3, Broadway, between 62d and 63d Streets.

THAT Robert Bresson, the veteran French director, is still one of the most rigorous and talented film makers of the world is evident with the appearance of his beautiful, astringent new film, "L'Argent" ("Money"). Mr. Bresson does not make films casually — "L'Argent" is only his 13th since his first feature, "Les Anges du Pêche," was released in 1943.

The man who made "Diary of a Country Priest," "Pickpocket" and "Lancelot du lac" is at the top of his very idosyncratic form with "L'Argent," which has nothing to do with the Emile Zola novel or Marcel L'Herbier's film adaptation of that novel. The Bresson film is inspired by a Tolstoy short story, and though I've never read it, I would assume that Mr. Bresson has turned it to his own purposes.

Set in contemporary France in an unidentified city that sometimes seems to be Paris but probably isn't, "L'Argent" is a serenely composed film that tells a ruthless tale of greed, corruption and murder without once raising its voice. It goes beyond the impartiality of journalism. It has the manner of an official report on the spiritual state of a civilization for which there is no hope.

The narrative is mainly concerned with Yvon, a young truck driver framed by some bourgeois shopkeepers, who identify him as the source of counterfeit notes. Because he has no criminal record, Yvon is given a suspended sentence, but he loses his job anyway. Soon he agrees to participate in a bank holdup to obtain money to support his wife and child.

The holdup fails and Yvon is packed off to jail, where things go from very bad to far, far worse. He loses all sense of compassion, and when he is paroled, he is beyond any redemption except God's.

Like all Bresson films, "L'Argent" can't be interpreted exclusively in social, political or psychological terms. Mr. Bresson's characters act out dramas that have been in motion since the birth of the planet. He's not a fatalist, but he insists on recognizing inevitable consequences, given a set of specific circumstances.

"L'Argent" would stand up to Marxist analysis, yet it's anything but Marxist in outlook. It's far too poetic — too interested in the mysteries of the spirit.

As usual, Mr. Bresson has cast the film largely with nonprofessionals, a practice that contributes importantly to the film's manner. Christian Patey, the young man who plays Yvon, possesses the dark, almost pretty good looks of something idealized, apotheosized. He is not only Yvon but also the representation of all innocents who have been betrayed by a system that rewards corruption.

Mr. Patey's is what amounts to a carefully designed nonperformance. He doesn't act his lines. He recites them as simply as possible, as do all of the performers. They give the impression of traveling through the events of the narrative without being affected by them, which reduces any chance that the film will prompt sentimental responses.

The look of "L'Argent" accentuates this chilliness. The images have the clean, uncharacterized look of illustration in the annual report of a large corporation. They are perfectly composed and betray no emotion whatever. This distance between the appearance of something and what it means is one of the methods by which the power of any Bresson film is generated.

1984 Mr 23, C10:3

Open Admissions

POLICE ACADEMY, directed by Hugh Wilson; screenplay by Neal Israel, Pat Proft and Mr. Wilson; story by Mr. Israel and Mr. Proft; director of photography, Michael D. Margulies; edited by Robert Brown and Zach Staenberg; music by Robert Folk; produced by Paul Maslansky; released by Warner Bros. At Warner Twin, Broadway and 47th Street; Sutton, 57th Street and Third Avenue; Bay Cinema, Second Avenue and 32d Street; 86th Street Twin, at Lexington Avenue; 83d Street Quad, at Broadway, and other theaters. Running time: 101 minutes. This film is rated R.

Carey Mahoney..................Steve Guttenberg
Karen ThompsonKim Cattrall
Lieutenant HarrisG. W. Bailey
Moses HightowerBubba Smith
Leslie BarbaraDonovan Scott
Commandant LassardGeorge Gaynes
George MartinAndrew Rubin
TackleberryDavid Graf
Sergeant CallahanLeslie Easterbrook
Larvell JonesMichael Winslow
Mrs. FacklerDebralee Scott
Doug FacklerBruce Mahler

"POLICE ACADEMY" is a rude, crude, noisy, sometimes disarmingly funny, liberated-sexist low comedy. The movie, which opens today at the Warner and other theaters, is "Animal House" redecorated as a school for police officers.

The setting appears to be a large United States city situated somewhere in Canada, where there are often palm trees in the distance, geographical contradictions that reflect the blithely haphazard scheme of things. The story is about what happens when the woman Mayor of this mythical United States city decides to abandon all entrance requirements to the police academy, thus attracting a large proportion of the country's lame-brained and emotionally halt.

A lot of the gags don't work, but Hugh Wilson, who was responsible for television's "WKRP in Cincinnati" and who makes his debut as a director of theatrical films with "Police Academy," knows what he's about. He remains unembarrassed by the material. The movie plows through one outrageous sequence to the next

with the momentum of a freight train.

He's also cast the film with a lot of extremely good comic actors. Most memorable are George Gaynes (of "Tootsie") as the police academy's supremely resilient commandant; Steve Guttenberg ("Diner") as a recruit who wants to be kicked out of basic training, but always fails; Michael Winslow as a fellow named Monsignor Larvell, M.D., who can imitate all manner of sounds; G. W. Bailey (of television's "M*A*S*H"), the academy's short-tempered senior instructor; Kim Cattrall, a most unlikely recruit from the Social Register; the towering Bubba Smith, a recruit who has given up his career as a florist to become a policeman; Marion Ramsey, a recruit who doesn't like to raise her voice, and Leslie Esterbrook as a pretty instructor who mixes business with pleasure.

•

Georgina Spelvin ("The Devil and Miss Jones") appears in a cameo role to do more or less what she does in pornographic films, though off camera.

Vincent Canby

1984 Mr 23, C12:1

MY BEST FRIEND'S GIRL, directed by Bertrand Blier; screenplay (French with English subtitles) by Mr. Blier and Gerard Brach; cinematography by Jean Penzer; edited by Claudine Merlin; music by J. J. Cale; produced by Alain Sarde. At the Plaza, 58th Street, east of Madison Avenue. Running time: 99 minutes. This film is not rated.
Micky .. Coluche
Viviane Isabelle Huppert
Pascal Thierry Lhermitte
Hoodlum Farid Chopel
Doctor François Perrot
Flirt ... Daniel Colas

By JANET MASLIN

The story of two buddies whose friendship is altered by an accommodating woman, a creature who is luscious but either passive, duplicitous or dim, is practically a staple for Bertrand Blier, the director of "Going Places" and "Get Out Your Handkerchiefs." That Mr. Blier's casual misogyny continues to have its light side is really no small accomplishment.

In "My Best Friend's Girl," he tells of a good-looking sucker named Pascal (Thierry Lhermitte) who works at a ski resort and who one morning invites his older, mother-hen of a best friend, Micky (the French comedian Coluche), to meet last night's catch. There, in Pascal's bed, is the coyly adorable Viviane (Isabelle Huppert), wearing little more than a determinedly seductive smile.

•

"From now on, she's my most precious possession!" declares the wildly enthusiastic Pascal, who happens to work during the day. He orders Micky, who's on the night shift as a disk jockey, to keep an eye on Viviane — a chore that Micky somewhat overdoes, thanks to Viviane's inexhaustible flirtatiousness. "How can you be such a tramp?" Micky later asks with wonderment. "I've had lots of practice," Viviane answers calmly. "I was lucky enough to start very young, so it's become second nature."

The sheer casualness with which the Pascal-Viviane-Micky triangle develops is one of the best things about "My Best Friend's Girl," which sustains its offbeat and sardonic tone for much longer than might sound possible. The action takes place in Pascal's peculiar lair,

Isabelle Huppert in the film "My Best Friend's Girl."

which is the ski bum's equivalent of a tree house — there are all manner of odd passages and ladders, even a movable hatch that separates the building's two floors. Here, the three principals interact with the constant schussing of tiny skiers in the distant background; there's even a ski tow that goes right by Pascal's front door. This is by no means the least eccentric thing about the movie, since each of the characters has plenty of visible quirks. The plump Micky sleeps in pastel-color long underwear, with a bandana tied rakishly around his neck. Viviane likes to do the housecleaning wearing black lingerie and fluffy red mules.

•

"My Best Friend's Girl," which opens today at the Plaza, remains amusing for as long as this air of whimsy can prevail. When it eventually settles down to the issue of the two men's friendship and to the war between the sexes, it does so with more sodden results. "Can men and women be just friends?" Micky is made to wonder ruefully. "It'd be nice for once," says Viviane, who by the end of the film has shown the strongest real emotion here. She sheds a single, mascara-streaked tear.

As the tough-cookie courtesan of Mr. Blier's latest sex fable, which the director wrote with Gérard Brach, Miss Huppert reveals a talent for coolly poised comedy; she is funny and delectable in what might have been quite an unappetizing role. Mr. Lhermitte makes a durable straight man, although there's so much going on around him that he can't help seeming the odd man out. And Coluche, in making Micky's overprotectiveness of his friend seem charming rather than deeply neurotic, makes a most important contribution to the movie's fanciful tone.

"My Best Friend's Girl" isn't Mr. Blier at his most radical, but one needn't necessarily miss that side of his talent. It's slight but funny. What it reveals about relations between the sexes isn't powerfully illuminating. But it has a lot to say about ski resorts, that's for sure.

1984 Mr 25, 56:1

For De Mille, Moses' Egypt Was Really America

This has been a week for catching up — with "Splash," the mermaid comedy that's fast becoming one of the biggest live-action hits in the history of the Walt Disney empire, with "Seeing Red," the Oscar-nominated documentary by Julia Reichert and James Klein, and with the formidable shade of the late Cecil B. De Mille, specifically with his 1956 "Ten Commandments," which is being rereleased to coincide with the religious holidays.

First the good news: "The Ten Commandments" is something not to be missed, a gaudy, grandiloquent Hollywood classic of a kind they really don't make any more, not, I suspect, because Hollywood has grown up or because contemporary audiences would hoot at them. Rather it's because the 19th-century medicine-show sensibility that created such films no longer exists. It's as long-gone as the Indian-head penny, the Chautauqua circuit, dime novels and the dance of the seven veils. "The Ten Commandments" is nothing if not Americana.

The film, the last to be directed as well as produced by De Mille, who died in 1959, is the story of Moses, "as told in the Old Testament," reported one reviewer with his tongue in his cheek, "and as reflected in other ancient writings consulted by Mr. De Mille." It's also as American as apple pie and the striptease, alternately ceremonial and teasing, stern and giddy, full of scenic marvels, many of which are no less impressive for being patently fake.

I'd love to know what other ancient writings De Mille consulted, though I doubt that they dictated the film's very particular literary style. The dialogue is so laden with overripe language you fear that this particular golden bough is going to break under the weight. That it never does and that, in fact, the three-hour-plus film is extremely easy to sit through, is a reflection of De Mille's basic if primitive storytelling genius. This "Ten Commandments" owes as much to the kind of melodramas once played on showboats as to the Old Testament.

Boiled down to its essentials, the story is that of the prodigal son, or maybe the drunkard, who enjoys a miraculous character reformation. Turning his back on his shallow friends and a life of pleasure and debauchery, he goes on to save the poor family he'd initially spurned.

The prodigal son is, of course, Moses, the Nile foundling who was raised as a prince of Egypt. The shallow friends are his adoptive brother, the ruthless Ramses, soon to be pharaoh, and the beautiful, wicked Nefretiri, the princess of Egypt who used to run after Moses' body and, we are led to believe, occasionally caught it. The members of his poor family are the Jews in Egyptian bondage, whose cause Moses espouses once he learns his true identity.

Though De Mille, who made his first film, "The Squaw Man," in 1913, appreciated a good, simple, easy-to-follow narrative, one preferably with an uplifting moral point, he also understood the appeal of the sort of visual spectacle that was beyond the reach of the 19th-century American theater.

His most happy and, possibly, most personal film is "The Greatest Show on Earth" (1952), being, in effect, a circus film about a circus, which is what De Mille's art was all about. However, his most memorable films are those heavy-breathing costume epics ("The Sign of the Cross," "Cleopatra," "Samson and Delilah") that teach fearsome lessons about the wages of sin and, at the same

time, give us ordinary folk a chance to see what first-class sin, committed on a grand scale, looks like.

"The Ten Commandments," which De Mille had also made in 1923 as a black-and-white silent film, is the Old Testament cast with American faces, much as Renaissance artists filled their paintings with recognizable contemporaries. As Moses, Charlton Heston manages to suggest both the rugged American frontiersman of myth as well as the God who creates Adam in Michelangelo's Sistine Chapel fresco. With the exception of Yul Brynner, who plays Ramses, and Sir Cedric Hardwicke, seen briefly as a very upper-class English pharoah, the principal cast members are All-American, which, I think, must explain some of De Mille's popularity. Either they are as pretty as figures in a Coca-Cola ad or as folksy as those in Norman Rockwell's work.

The huge cast includes Edward G. Robinson, who gives the film's liveliest, funniest performance as a renegade Jew named Dathan, Anne Baxter, Yvonne De Carlo, John Derek, Debra Paget, Nina Foch, John Carradine, Vincent Price, Douglass Dumbrille, Henry Wilcoxon and H. B. Warner. Watching it is almost like reading a movie-trivia book.

Among the film's great set-pieces are the parting of the Red Sea, which looks to have been photographed in eight pieces and then pasted together, the spectacle of God's burning finger writing the 10 Commandments on slabs of stone, the Nile waters turning to blood and, my favorite scene, an intimate one really, in which Mr. Brynner's Ramses returns to the palace after Moses has successfully led the children of Israel out of Egypt. He slumps down onto his throne and scowls. Sneers Princess Nefretiri (Miss Baxter), slumped down on her throne, "You didn't even kill him." Says Ramses with some petulance, "His god is God."

That's a comparatively straight line compared to the rest of the dialogue, which includes such nifties as "Is it the fragrance of myrrh that scents her hair or the odor of sheep?" and "God opens the sea with a blast of his nostrils."

Something else entirely but also quintessentially American is "Seeing Red," a feature-length documentary composed of interviews with about a dozen old-time American leftists, all of whom were at one time members of the Communist Party and one of whom still is. The film is less about dogma, however, than about American idealism.

These were Communists who managed to stay with the party even after the Hitler-Stalin pact of 1939 and who lived through the late 40's and early 50's as dedicated party members. They are most moving when telling about their terrible awakening after Khrushchev's unmasking of Stalin in 1956. Though bewildered and profoundly disillusioned, most of these witnesses stand by the party's social programs they believed in and worked for.

Miss Reichert, who is the film's interviewer as well as co-producer and co-director, points out the contradiction between the questioning, independent spirit that led these people to join the party and their total submission to whatever line the party laid down. It's not something they can easily explain. Dorothy Healy, who joined the party at the age of 14, asks herself, "Did we waste our lives?" and then says staunchly, "The act of struggling was important."

When Miss Reichert mentions espionage, one woman says the subject never came up during her experience in the party, and that anyone who'd suggested it would have been laughed at. Though the film shows us news photos of Julius and Ethel Rosenberg, "Seeing Red" never mentions the Rosenberg case. This, I assume, is because espionage is beside the point of

a film that, like Warren Beatty's "Reds," is as much about one's memories of the past as about the past itself.

"Seeing Red" is a fine, tough companion piece to "Union Maids," made by Miss Reichert, Mr. Klein and Miles Mogulescu in 1977, documenting the role of women in the Chicago labor movement in the 20's and 30's. It's social history of a high order.

●

The following is a late, unreasonably biased, minority report, and one that is given with some defensiveness, considering the unanimously favorable reviews received by "Splash" and the extraordinary business it's doing at the box office. The thing is, well, I really didn't like it much, as sweet and harmless as it is. Being literal minded, I've never understood the erotic possibilities of mermaids, even mermaids who mysteriously grow legs when on dry land. Fish are great on the dinner table and beautiful to see underwater, when one is scuba-diving, but that's about as far as it goes. ■

1984 Mr 25, II:19:1

Learning With a Dog

THE REVOLT OF JOB, directed by Imre Gyongyossy and Barna Kabay; screenplay (Hungarian with English subtitles) by Mr. Gyongyossy, Mr. Kabay, Katalin Petenyi; director of photography, Gabor Szabo; edited by Katalin Petenyi; music by Zoltan Jeny; produced by Mafilm Tarsulas Studio, Starfilm, Macropus Film, ZDF-MTV Productions; a Sefel Pictures International Presentation; distributed by Teleculture, Inc. At the 68th Street Playhouse, at Third Avenue. Running time: 98 minutes. This film has no rating.
Job .. Ferenc Zenthe
Roza .. Hedi Temessy
Lacko .. Gabor Feher
Jani .. Peter Rudolf
Ilka .. Leticia Caro

By JANET MASLIN

WHAT recourse could there be for a Hungarian Jew in 1943, able to anticipate his fate but powerless to save himself? In "The Revolt of Job," the Jewish farmer of the title attempts the illicit act of adopting a Christian child, hoping that the boy will be able to carry on his tradition and possess his legacy. The latter involves more than mere worldly goods, although Job is a prosperous

man. During the course of the story, Job (Ferenc Zenthe) teaches young Lacko (Gabor Feher) as much as he can about his life, his values and his God.

"The Revolt of Job," which opens today at the 68th Street Playhouse, may sound as though it ought to be somber. If anything, it has a surprising, and sometimes excessive, sweetness. On the way home from the orphanage where Job has found him, Lacko adopts a feisty little sheep dog, and together the boy and dog learn lesson after lesson about life on Job's farm. The boy's secular and religious educations are inextricably intertwined in this setting, as when Job, trying to explain that God is everywhere, is asked by Lacko whether God is in frogs.

●

The writer-directors, Imre Gyongyossy and Barna Kabay (who were joined in the screenplay by Katalin Petenyi), make some attempt to present the story from a childlike perspective, which only serves to make it seem overly precious at times. There is much emphasis on Lacko's adorable rambunctiousness, as when he spies on the handsome young servant couple who will see to the boy's future after Job and his wife, Roza (Hedi Temessy), have been deported by the Nazis. When this terrible moment arrives, incidentally, the Christians of the village wave tearfully to their former neighbors, and a small band plays mournful music. For all its oblique references to the Holocaust, "The Revolt of Job" has an air of sunny unreality.

●

Job, who has lost seven children before adopting Lacko and whose troubles recall those of his biblical namesake, is played by Mr. Zenthe as a sturdy and admirable figure, if not a particularly complex one. The cast is attractive, as is Gabor Szabo's muted cinematography, and the film has a bucolic charm. The only intrusion of so-called culture into this remote setting arrives with a traveling troupe of performers, who put on a little pantomime and then show a film to the townsfolk, charging a couple of corncobs each for admission.

Lacko cannot believe this new technological miracle, but he is reassured that "the cinema is for everybody." He's also told "Fear not, art isn't dangerous for good people, only for bad people." Sentiments like these, whatever else might be said about them, do violate the studied simplicity of the rest of the film.

"The Revolt of Job" is one of this year's Academy Award nominees in the best foreign-film category.

1984 Mr 28, C19:3

THE GOOD FIGHT, produced and directed by Noel Buckner, Mary Dore and Sam Sills; edited by Mr. Buckner; narrated by Studs Terkel; distributed by First Run Features. At the Film Forum, 57 Watts Street. Running time: 98 minutes. This film has no rating.
Soldiers ..
Bill Bailey, Ed Balchowsky, Bill McCarthy, Steve Nelson, Abe Osheroff, Tom Page, Milt Thompson, Milt Wolff
Nurses Ruth Davidow, Salaria Kea, Dolly Hutchins
Ambulance driver Evelyn Hutchins
The voice of La Pasionaria Colleen Dewhurst
WITH: Jennie Chaikin and John Houseman

By VINCENT CANBY

THE spirit of the old American Left remains undiminished, at least on movie screens. Already in the middle of a successful New York first run is the

Milt Wolff as member of Abraham Lincoln Brigade in "The Good Fight."

Oscar-nominated "Seeing Red." Now comes another equally fine documentary, "The Good Fight," which features the moving testimony of 11 veterans of the Lincoln Brigade, that small force of very young American volunteers who went to Spain to fight for the Loyalist cause in the Spanish Civil War (1936-39).

Though "The Good Fight" covers some of the same ground as "Seeing Red," the two films should be seen as complementing each other. "Seeing Red" is the story of an era. "The Good Fight" is about that same era as it is reflected in the various American responses to what was probably the single, most important event of that era, the war in Spain that, after the fact, could be recognized as the curtain-raiser for World War II.

"The Good Fight," which opens today at the Film Forum, was produced and directed by Noel Bruckner, Mary Dore and Sam Sills. They've done an excellent job, not only in organizing their material but in eliciting that material in on-screen interviews, which are supported by newsreel footage and even in a clip from "Blockade," a not-great movie that is notable chiefly as the only major Hollywood film to deal with the Spanish war.

Not always remembered now is that the Spanish Civil War, in which Hitler and Mussolini supported the rebel forces of Generalissimo Francisco Franco, was not a popular cause in this country. The United States, along with Britain, France and the other Allied powers, vowed not to intervene on behalf of the elected Republican Government of Spain. Only the Soviet Union and Mexico offered support.

What makes the testimony in "The Good Fight" so effective is the veterans' shared conviction, more than 40 years after the fact, that the war against Franco was, indeed, the good fight, though at that time it also seemed a lost one. Americans have always been keen on "good fights," but the members of the Lincoln Brigade, unlike the young men who formed the Lafayette Escadrille in World War I, were motivated more by politics than by any sense of romance and adventure.

The members of the Lincoln Brigade, many of whom had been active in leftist political groups, were not rich kids out on a lark to defend the status quo. They were poor as well as rich, women as well as men, black as well as white — all convinced that something important in the evolution of the world's political consciousness was being destroyed in Spain. Among other things, as one man points out in

"The Good Fight," the Lincoln Brigade was the first truly integrated American fighting force. And, as anyone who was in World War II remembers, racial integration in the United States armed services wasn't even complete by the time that war ended.

Among the film's witnesses are Bill Bailey, the politically active long-shoreman and whose case of testimony can also be heard (and seen) in "Seeing Red"; Dave Thompson, an upper-class Californian and nephew of Stephen Vincent Benét, and Brooklyn-born Milt Wolff who, at 23, became a commander of the Lincoln Brigade, many of whose members were still in their teens. By the time the Lincoln Brigade was withdrawn from Spain, approximately half of the 3,200 volunteers were dead.

Very stirring too is the testimony of the women, pint-size Evelyn Hutchins, who drove an ambulance in Spain (and who has died since filming her interview), and Salaria Kea O'Reilly and Ruth Davidow, who were nurses. Ed Balchowsky, a pianist and folk singer who lost his right arm in Spain, recalls the songs of the war, some with lyrics designed to affront self-important visitors to the Loyalist front, including the American Communist Party's Earl Browder.

Studs Terkel speaks the sound track narration. Colleen Dewhurst recites an English translation of the speech given by Dolores Ibarruri (the formidable Spanish Communist known as La Pasionara) to the members of the Lincoln Brigade the day they sailed home from Barcelona.

"The Good Fight" is both sorrowful and inspiring.

1984 Mr 28, C24:4

'Godfathers' United

LES COMPERES, directed by Francis Veber; story and screenplay (French with English subtitles) by Mr. Veber; cinematographer, Claude Agostini; edited by Marie Sophie Dubus; music by Vladimir Cosma; a co-production of Fideline Films, Efve Films and D.D. Productions; released by European International Distribution Ltd. At the Paris, 58th Street west of Fifth Avenue. Running time: 92 minutes. This film has no rating.
François PignonPierre Richard
Jean LucasGérard Depardieu
ChristineAnny Duperey
PaulMichel Aumont
TristanStephane Bierry
RalphJean-Jacques Scheffer
MilanPhilippe Khorsand
JeannotRoland Blanche
VerdierJacques Frantz
RaffartMaurice Barrier
Mme. RaffartCharlotte Maury
LouiseGiselle Pascal
StephanePatrick Blondel
MicheleFlorence Moreau

IN "Les Compères," the frenetic French farce that opens today at the Paris, Pierre Richard ("The Tall Blond Man With One Black Shoe") and Gérard Depardieu join forces to find the runaway teenage son of a former mistress, each man having been led to believe that he is the boy's father. The principal setting is Nice. The boy couldn't care less about being reclaimed, and the gags are like bulls that wear bells to warn everyone of their approach.

Most of the jokes are pegged to the personality differences between the two "godfathers." Mr. Richard, who is best when he tries least, plays a failed poet, given to easy tears, severe depressions and suicide attempts. Mr. Depardieu has the film's funniest moments as a totally absorbed, macho investigative reporter who never for a minute suggests that he knows that what he's doing is supposed to be amusing.

In grudging partnership, the two

fellows deal with gangsters, teen-age hoods and plot complications that, though very light, seldom float.

"Les Compères" was written and directed by Francis Veber, who wrote the screenplay for the two "Cage aux Folles" films. As he tirelessly demonstrates, comedy is hard work.

Vincent Canby

1984 Mr 28, C24:6

A Title at Last

GREYSTOKE: THE LEGEND OF TARZAN, LORD OF THE APES, directed by Hugh Hudson; screenplay by P. H. Vazak and Michael Austin, based on the story "Tarzan of the Apes" by Edgar Rice Burroughs; photographed by John Alcott; film editor, Anne V. Coates; music by John Scott, Elgar, Boccherini and D'Albert; produced by Mr. Hudson and Stanley S. Canter; released by Warner Bros. At Criterion Center, Broadway and 45th Street; Beekman, Second Avenue and 65th Street; Murray Hill, 34th Street, near Third Avenue, and other theaters. Running time: 129 minutes. This film is rated PG.
Lord GreystokeRalph Richardson
Capt. Phillippe D'ArnotIan Holm
John Clayton, Tarzan Lord of the Apes
.........................Christopher Lambert
Jane PorterAndie MacDowell
Lord EskerJames Fox
Jeffson BrownIan Charleson
Maj. Jack DowningNigel Davenport
Lord Jack ClaytonPaul Geoffrey
Lady Alice ClaytonCheryl Campbell
Sir Hugh BelcherNicholas Farrell
OllyColin Charles
RubyElaine Collins
Boat captainDavid Endene
Captain BillingsRichard Griffiths
WhiteTristam Jellineck
OlivestoneRoddy Maude-Roxby
WillyHilton McRae
Sir Evelyn BlountJohn Wells
Tarzan at 12Eric Langlois
Baby TarzanTali McGregor
Tarzan at 5Daniel Potts
DeanRavinder
IrisHarriet Thorpe
BullerDavid Suchet

By VINCENT CANBY

FROM the most unlikely source material comes the season's most unexpected, most invigorating surprise, "Greystoke: the Legend of Tarzan, Lord of the Apes," a huge, lavishly produced period film that is part adventure, part comedy of manners and part somber melodrama.

Hugh Hudson, director of the Oscar-winning "Chariots of Fire," and his associates have made something much more than a good fantasy.

They have discovered reserves of feeling and beauty in the old Edgar Rice Burroughs tales that remained unexplored by Burroughs himself and by the dozens of journeymen who have been cranking out Tarzan movies and television serials over the years.

"Greystoke," which opens today at the Criterion and other theaters, is also a little weird, at least as far as Tarzan movies go. It's a highly romantic, Pop variation on the "wolf boy" story considered in such austere fashion by François Truffaut in "The Wild Child." At the same time, it's an unusually intelligent and serious entertainment for the mass market.

●

The sheer physical scope of the film, as well as the abrupt, rough, explicit bloodiness of some of the jungle material, have little to do with the "me Tarzan, you Jane" fantasies that have been with us virtually since Burroughs published "Tarzan of the Apes" in 1914. Burroughs went on to write a couple of dozen sequels that, in turn, served as the inspiration for any number of Tarzan movies featuring everyone from Elmo Lincoln (1918) to Miles O'Keefe (1981), though the late Johnny Weissmuller is the Tarzan most of us remember most vividly.

"Greystoke" isn't in competition with its predecessors. It's a different order of fiction entirely. Among other things, it doesn't leave much room for sequels.

The fine screenplay, credited to P. H. Vazak, said to be the pseudonym for Robert Towne, who conceived the project, and Michael Austin, is nothing if not comprehensive. It opens in 1885 in Britain, at the great country house — a palace, really — of the sixth Earl of Greystoke (Sir Ralph Richardson), as his son, Lord Jack Clayton, is preparing to leave for Africa, taking with him his pregnant, young wife, Lady Alice.

In the leisurely fashion of 19th-century fiction, the film thus recounts the background of Tarzan, whose parents, the Claytons, are subsequently shipwrecked on the Ivory Coast. There, six months later, Tarzan is born and, on the death of his parents, adopted by a large family of carefully

characterized chimpanzees who are loving, short-tempered, extremely protective and given to practical jokes.

In some of its most remarkable footage, "Greystoke" shows us Tarzan's growing up from infancy to childhood, adolescence and manhood. Shortly after his adoptive mother is killed by pygmies, Tarzan comes upon a wounded Belgian explorer, Capt. Phillippe D'Arnot (Ian Holm), and nurses him back to health. It is D'Arnot who finally identifies Tarzan and takes him to England, where approximately one-third of the film is set.

●

People who think of Tarzan movies as being synonymous with the Dark Continent of B-fiction, with playful chimpanzees as comic relief, with lost cities of gold and elephants' graveyards, may not be pleased by the long sojourn of "Greystoke" in Edwardian England.

They may also be shocked that the name "Tarzan" is never spoken in the movie. Until D'Arnot identifies him, he is not called anything by the apes, who communicate in a series of grunts, growls, beeps and whinnies not translated by English subtitles. Not until he is home at Greystoke does he receive a name, Lord John Clayton, heir to his grandfather's title.

The most inspired invention of Mr. Hudson and the writers is the creation of the character of the old earl who, as played by Sir Ralph in one of his most moving and wise performances, dominates the film. That this was to be Sir Ralph's last film performance before his death makes it all the more moving, though it would have been one of the highlights of his film career in any case.

Almost as good is Mr. Holm, nominated for an Oscar for his work in "Chariots of Fire," as the man who, with patience, humor and understanding, introduces Tarzan to the spoken language — first French, then English — and the ways of civilized society.

●

This Tarzan's Jane is the old earl's American ward, charmingly played by Andie MacDowell, who abandons her elegant English suitor (James Fox) to fall into a discreet affair with Tarzan at Greystoke. One of the film's most offbeat and funny moments is when Tarzan — apelike, on all fours — sneaks into Jane's bedroom late one night to consummate his courtship. Will he tear her clothes off, chew her neck or indulge in some other mating practice frowned upon by upper-crust Edwardians? The audience has a right to be genuinely concerned.

A new actor named Christopher Lambert, born of French parents in New York and raised in Switzerland, is very good as the long-lost heir, of whom it can be asked, "You can take the English lord out of the jungle, but can you take the jungle out of the English lord?"

Mr. Lambert, a handsome young man with strong, brooding features, is remarkably believable and affecting both as the naked ape of Africa and then as the uncomfortable aristocrat, who tries desperately to fit in with his new family. That this Tarzan is supposed to be a great mimic provides the movie with some of its comedy as well as with its very real pathos.

The film's penultimate sequence, in

Sir Ralph Richardson

which Tarzan goes berserk after an unfortunate encounter with an old African friend at London's Natural History Museum, packs an emotional wallop rare even in far more sober-sided movies.

The African sequences, shot in Cameroon, are of stunning, steamy beauty, but no more effective than the British locations, including the old earl's vast estate, which is made up of three of Britain's greatest houses, including Blenheim. John Alcott's photography provides a visual equivalent to the film's stately narrative style, full of majestic camera movements that suggest something of what we take to have been the pace of the Edwardian era.

Mention should also be made of the work of Rick Baker, who designed the ape makeup; Peter Elliot, who is listed as "primate choreographer," and Roger Fouts, "primate consultant." Real chimpanzees and small human actors in champanzee suits are so effectively integrated that, I suspect, only a sharp-eyed, fault-finding chimp could tell which is which.

"Greystoke" runs for something more than two hours, but there's not a dull moment in the film. However, there are indications at times that the original footage has been truncated, which sometimes results in major scenes being played without a proper buildup.

These aren't reservations, but observations. "Greystoke" is one of the most thoroughly enjoyable films of its kind I've ever seen.

•

"Greystoke," which has been rated PG ("parental guidance suggested"), contains some brutally effective scenes that may disturb parents as much as children.

1984 Mr 30, C5:1

MY BROTHER'S WEDDING, written and directed and photographed by Charles Burnett; edited by Tom Pennick; music by Johnny Ace and John Briggs; produced by Mr. Burnett and Gaye Shannon-Burnett; presented by the Film Society of Lincoln Center and the Department of Film of the Museum of Modern Art. At the 57th Street Playhouse, between Avenue of the Americas and Seventh Avenue. Running time: 120 minutes. This film has no rating.
Pierce MundyEverett Silas
Mrs. MundyJessie Holmes
SoniaGaye Shannon-Burnett
Soldier RichardsRonnie Bell
Wendell MundyDennis Kemper
Sonia's FatherSy Richardson
Sonia's MotherFrances Nealy

THE obvious amateurishness of the acting in Charles Burnett's "My Brother's Wedding" and the director's own very stiff, rudimentary technique don't damage the film as much as they might, perhaps because of the innocence and clarity with which Mr. Burnett approaches his material. The locale is south central Los Angeles, and the action takes place in neat, clean settings populated by a cast that sounds very genteel. Actually, most of them are supposed to be struggling and impoverished, with the exception of the rich, unpleasant woman whom Pierce Mundy's brother plans to marry.

The story is about Pierce (Everett Silas) himself, a naïve young man who still lives at home and needs to choose between his family's values and those of a rowdy but very influential friend. During the course of the film, Pierce interacts with a wide cross-section of characters, whose cumulative effect is to create a portrait of the community at large. Pierce's problem is most sharply outlined when, on the day of the title, he must choose between family and friendship, and take an important step in his own development.

•

While there is almost no verisimilitude to the film, and not much surprise or excitement, Mr. Burnett does convey the essential decency of Pierce. The best performance in the film comes from Jessie Holmes, who plays Pierce's mother in a warm, spontaneous style that's less actorish or stilted than anything else here.

"My Brother's Wedding" is part of the "New Directors/New Films" series. It will be shown tonight at 8:30 and tomorrow at 1 P.M.

1984 Mr 30, C7:1

Fish Seller to Actress

AH YING, directed by Allen Fong; screenplay (Cantonese, Mandarin and English, with English subtitles) by Sze Yeun-ping and Peter Wang; cinematography by Chang Lok-yee; edited by Chow Muk-leung and Ng Kam-wah; music by Violet Lam; a Feng Huang Motion Picture Company Production; presented by the Film Society of Lincoln Center and the Department of Film of the Museum of Modern Art. At the 57th Street Playhouse, between Avenue of the Americas and Seventh Avenue. Running time: 110 minutes. This film has no rating.
Ah YingHui So-ying
Cheung Chung-pakPeter Wang
Ah Ying's fatherHui Pui
Ah Ying's motherYao Lin-shum
Ah Ying's boyfriendCheng Chi-hung
The married brotherHui Wai-hon
Ah Lin ...Hui So-lin
Ah Kei ...Hui So-kei
Ah KamHui So-kam
Ah LamHui So-lam
Ah ShanLau Ka-chun
Ah Lin's boyfriendCheung Ka-yan

ALLEN FONG'S "Ah Ying" attests to the Westernization of Hong Kong society, and is itself a striking illustration of that process. While David Bowie posters and American songs occupy the attention of the film's title character, Mr. Fong (whose real name is Fong Yuk-ping) shapes a film around her that in its own way, while revealing much about the character and her friends and family, has a second-hand feeling.

Ah Ying's parents run a fish stall in the marketplace, and require her to work in the family business. But she wants to become an actress, and she gradually attaches herself to a local film school, taking an acting class and doing some clerical work there. When asked to put on some kind of a

Peter Wang helps Hui So-ying on a Hong Kong rooftop in "Ah Ying."

performance at the first class, Ah Ying sings "Time in a Bottle" in English and impresses everyone. Her teacher, Cheung Chung-pak (Peter Wang), is a knowing hipster who leads the class through encounter-group exercises and the like, and whose own ambition is to become a film maker. The local financiers seem to like him, but his idealism is utterly uncompromising, and so he has a difficult time finding backing.

Mr. Fong has said that he based the film on the real life of Hui So-ying, who plays Ah Ying, and that it also owes something to the story of a now-deceased film maker friend of his. This may be part of why the two main characters in "Ah Ying" don't seem to have much to do with each another, despite the screenplay's efforts to engineer a platonic romance between them. The film is lifelike to the extent that it depicts believable people, but there is no attempt to engage them in a compelling drama. Like his own film maker-character, Mr. Fong seems convinced that merely transposing real experience to the screen is enough to hold an audience's interest.

The scenes involving Ah Ying's family seem less artificial than the film school episodes, and have somewhat more drama to them. A family of about eight lives in a two-room flat, and in this setting Ah Ying is addressed simply as "Third Sister." It's not surprising, then, that she seeks the wider and more personalized recognition that an actress commands. By the end of the film, Ah Ying is triumphantly co-starring in a play with her revered teacher, he playing an old man and she a prostitute who, for some reason, seems to be dressed as a drum majorette.

"Ah Ying," which is part of the "New Directors/New Films" series, will be shown tonight at 6 P.M. and tomorrow at 3:30.

Janet Maslin

1984 Mr 30, C7:1

MISUNDERSTOOD, directed by Jerry Schatzberg; screenplay by Barra Grant, based on a novel by Florence Montgomery; director of photography, Pasqualino De Santis; film editor, Marc Laub; music by Michael Hoppe; produced by Tarak Ben Ammar; released by M-G-M/U.A. Entertainment Company. At the Gemini, 64th Street and Second Avenue; 86th Street Twin, at Lexington Avenue; 83d Street Quad, at Broadway, and other theaters. Running time: 91 minutes. This film is rated PG.
Ned ...Gene Hackman
AndrewHenry Thomas
Will ...Rip Torn
MilesHuckleberry Fox
KateMaureen Kerwin
LillySusan Anspach
Mrs. PaleyJune Brown
Lucy ..Helen Ryan
AhmedNadim Sawalha
Mrs. JallouliNidal Ashkar

By JANET MASLIN

NED RAWLEY (Gene Hackman) becomes the newly widowed father of two boys at the beginning of "Misunderstood," a film whose emotional territory is as familiar as its geography is exotic. The Rawleys live in a palace in Tunisia, which (we are told in passing) happens to be a byproduct of Ned's phenomenal success in the shipping business after World War II. The house, attention getting enough to occupy center stage in another movie, is treated quite casually in this one, presumably because the Rawleys have other things to think about: Ned's coolness toward his older son, the need of both boys for parental attention and everyone's memories of Mom.

Soapy as it sounds, "Misunderstood," which opens today at the Gemini and other theaters, isn't awash in sentiment. It isn't really awash in anything, being a mélange of vague texture, interesting scenery and sad situations. There is so little real plot or feeling to the film, in fact, that the cast's contribution becomes crucial. Without Gene Hackman and two appealing young actors to hold the audience's attention, there wouldn't be a movie here at all.

Huckleberry ("Terms of Endearment") Fox and Henry ("E. T.") Thomas play the well-bred sons whom Ned does and does not, respectively, favor. Their antics, both together and with their screen father, provide the film with its only raison d'être, as the drama moves toward its sole revelation: that a father needs to love his children and children need to feel loved.

The approach of the director, Jerry Schatzberg, to this material (which is taken from a 19th-century novel by Florence Montgomery, which later became a film called "Incompreso") is to prowl cautiously around it instead of getting to the heart of things. So "Misunderstood" never stoops to the level of tear-jerking, even though it might have been livelier if it had. No sad memories of the boys' mother here; instead, there are a few brief flashbacks of a radiant Susan Anspach, who looks much too robust to have succumbed to a mysterious Tunisian malady. Not until the end of the film does anyone even do much weeping over the loss.

The father-son scenes are ably acted, and so are the scenes of the boys together. Both young actors, and particularly Mr. Thomas, make it clear that their talents are likely to last. Rip Torn is also on hand, effectively if somewhat improbably, as Ned's bereaved brother-in-law. All these actors seem ready and able to supply the strong passions that "Misunderstood," rather bewilderingly, never bothers to tap.

"Misunderstood" is rated PG ("Parental Guidance Suggested"). It contains a minimal amount of strong language.

1984 Mr 30, C10:1

Left on the Ice

ANTARCTICA, directed by Koreyoshi Kurahara; screenplay by Tatsuo Mogami, Kan Saii, Toshiro Ishido and Koreyoshi Kurahara; director of photography, Akira Shiizuka; edited by Akira Suzuki and Koreyoshi Kurahara; music by Vangelis; produced by Masaru Kakutani and Koretsudu Kurahara; released by 20th Century-Fox Entertainment. At the Ziegfeld, Avenue of the Americas and 54th Street. Running time: 112 minutes. This film is rated G.
WITH Ken Takakura, Tsunehiko Watase, Eiji Okada, Masako Natsume, Keiko Oginome, Takeshi Kusaka, Shigeru Koyuma, So Yamamura

By LAWRENCE VAN GELDER

"ANTARCTICA," Japan's nominee for the Academy Award for best foreign film, is a beautiful movie, which is not to say that it is a fine one.

From a scenic standpont, "Antarctica," opening today at the Ziegfeld, possesses many virtues. The stark landscape of snow and ice that serves as the principal setting for its account of the travail of 15 sled dogs inadvertently left behind in 1958 by a Japanese scientific expedition offers itself to the camera's eye in many guises: dazzling by daylight, blued by the advent of darkness, bathed orange by the setting sun, powdered by winds, shrouded by storms.

Present, too — in unusual footage captured during the long night of the Antarctic winter — is the play of heavenly light known as the Aurora Australis.

But such balm for the eye, provided by the cinematography of Akira Shiizuka and augmented by the creamy music of Vangelis, who provided the memorable score for "Chariots of Fire," cannot conceal the genuine defects of "Antarctica."

Its very simple story — displaying first the talent and heroism of the dogs, their abandonment (chained to the ice), the shame and grief of their handlers, the dogs' adventures and the eventual return of the men to discover the dogs' fate — has been stretched to nearly two hours.

Larding the screenplay are repetitive, almost rudimentary depictions of the anguish of the dogs' scientist-handlers, portrayed by Ken Takakura and Tsunehiko Watase. The director, Koreyoshi Kurahara, fares no better with the dogs themselves: Investing them with no memorable traits of character to distinguish one from another, he leaves the screen to be labeled intermittently with their names. Though the story is said to be true, little can be known in actual detail of the fate of several of the dogs. Yet an omniscient English-language narrator purports to tell all that happened in the absence of human witnesses.

Still, "Antarctica" is said to be a great success in Japan, where two of the dogs portrayed in the film have achieved national celebrity.

Some children may be responsive to the movie's tale of hardship and to its furry heroes. Some adults may derive much satisfaction from the sheer prettiness of the scenery. But beneath the sentiment and the scenery lies a shallow movie.

1984 Mr 30, C10:5

TOO SHY TO TRY, directed by Pierre Richard; screenplay (French with English subtitles) by Jean-Jacques Annaud, Mr. Richard and Alain Godard; cinematography, Claude Agostini; music by Vladimir Cosma; produced by Georges Casati; an Albina Production; released by Films Inc.-Quartet. Running time: 90 minutes. This film is rated PG. At the Thalia, Broadway and 95th Street.

Pierre............................Pierre Richard
Aldo.............................Aldo Maccione
Agnes..........................Mimi Coutelier
Player.........................Robert Castel
Trucker......................Catherine Lachens
Manager....................Jacques François

"TOO SHY TO TRY," which opens a two-day run today at the Thalia, is a 1978 French comedy starring — and directed by — Pierre Richard, the tall blond man who co-stars with Gérard Depardieu in "Les Compères," a slightly newer French comedy, which opened Wednesday at the Paris.

This one is no better and no worse than "Les Compères" but much the same, being built entirely around the personality deficiences of the character played by Mr. Richard, who, in this case, takes a correspondence course to overcome his timidity. Like "Les Compères," much of the comedy is set in and near the Hotel Negrosco in Nice, where Mr. Richard goes in pursuit of a beautiful, blonde, young woman with whom he's fallen hopelessly in love.

Mr. Richard's co-star is Aldo Maccione, who is sometimes quite funny as the man who sold the correspondence course to the hero and who, though a con man at heart, stays around to help his student. Mimi Coutelier is very attractive as the young woman, who turns out not to be exactly what she seems.

•

"Too Shy to Try," which has been rated PG ("parental guidance suggested"), contains some mildly vulgar, utterly inoffensive lines and situations.

Vincent Canby

1984 Mr 30, C17:3

Her Sister's Missing

ROMANCING THE STONE, directed by Robert Zemeckis; written by Diane Thomas; director of photography, Dean Cundey; edited by Donn Cambern and Frank Morriss; music by Alan Silvestri; produced by Jack Brodsky and Joel Douglas; released by 20th Century-Fox Film Corporation. Running time: 101 minutes. This film is rated PG. At the Criterion Center, Broadway, between 44th and 45th Streets; Gotham Cinema, Third Avenue at 58th Street; 34th Street Showplace, between Second and Third Avenues, and other theaters.
Jack Colton..............................Michael Douglas
Joan WilderKathleen Turner
RalphDanny DeVito
Ira ..Zack Norman
Juan ..Alfonso Arau
ZoloManuel Ojeda
GloriaHolland Taylor
ElaineMary Ellen Trainor
Mrs. IrwinEve Smith

"ROMANCING THE STONE," which opens today at the Gotham and other theaters, is an elaborately produced, mostly charmless adventure-comedy that intends to make fun of a kind of romantic fiction that's one step removed from what the movie is all about.

The film was directed by Robert Zemekis, whose slam-bang direction was perfectly suited to "Used Cars" but looks gross here, from an original screenplay by Diane Thomas. It has the jokey, aren't-we-hilarious manner of something thought up in a story conference, where all the participants had split their sides laughing — and then had gone to lunch.

•

After an opening sequence that must be one of the longest put-ons in movie history, the film becomes the story of Joan Wilder (Kathleen Turner), a beautiful, prissy young writer of hugely successful romance novels published by Avon Books, which, incidentally, is also publishing the "novelization" of Miss Thomas's screenplay.

In slightly more time than it takes to write this, Joan Wilder, who is so timid that she would find a Bloomingdale's white sale an adventure, is up to her neck in the movie's potboiler of a plot. In an attempt to ransom her kidnapped sister, she lands in the middle of the jungles of South America in the company of a handsome American adventurer, Jack Colton (Michael Douglas), searching for buried treasure and dealing with a murderous Colombian policeman and two doltish American con men.

The film looks spectacularly expensive, but it has a mind the size of a tsetse fly's, which, I know, is found only in central and southern Africa, but then this film, which is supposed to be set in Colombia, was shot — with some real style — in Mexico. At one point, when Joan and Jack take refuge inside the remains of a crashed airliner high in a rain forest, I wondered to myself when the poisonous snake would appear. Would you believe it? No sooner wondered than done. The entire movie goes that way, though the payoffs never exceed the anticipation.

The relentlessly smart-aleck screenplay might have been saved by performers of more easy screen appeal. Miss Turner, who can play melodrama or comedy, as she demonstrated in "Body Heat" and "The Man With Two Brains," can't carry this burden by herself, and Mr. Douglas appears to have no sense of humor whatever. However, it probably would have taken a team like Gable and Colbert to pull this off.

The supporting cast includes Danny DeVito (of television's "Taxi") and Zack Norman (of Henry Jaglom's "Sitting Ducks") as the buffoonish con men and Mexico's Manuel Ojeda as the crooked Colombian cop.

You might get some idea of what it's like when I tell you that the movie's funny bone is exposed when someone hauls off and swats the bloody stump of the villain's just-amputated right arm.

•

"Romancing the Stone," which has been rated PG ("parental guidance suggested"), includes some mildly vulgar language and the amputation noted above.

Vincent Canby

1984 Mr 30, C19:1

KUKURANTUMI: THE ROAD TO ACCRA, directed by King Ampaw; written by King Ampaw, Ralf Franz and Thilo Kline; cinematography by Eckhard Dorn; edited by Anja Cox; produced by Peter Wohlgemuth-Reinery; a Reinery Verlag & Filmproduktion in association with Afro Movies Ltd. and North German Television; presented by The Film Society of Lincoln Center and The Department of Film of the Museum of Modern Art. At the 57th Street Playhouse, between Avenue of the Americas and Seventh Avenue. Running time: 83 minutes. This film has no rating.

AddeyEvans Oma Hunter
AbenaAmy Oppiah
BobDavid Dontoh
MaryDorothy Ankomah
MensahGeorge Wilson
KofiErnest Youngman
SeewaaRose Flynn
BoafoFelix Asant Larbi
AlhaiiKwesi France
Old ManEmmi L. Lawson

"Kukurantumi: the Road to Accra," a co-production of Ghana and West Germany, is a comparatively lively, good-humored film about a very sad subject — the breakdown of family relationships under the pressures of what's called progress. The film is the first feature to be directed by King Ampaw, a Ghana film maker trained in West Germany and Austria and now a director with the Ghana Broadcasting Corporation.

The screenplay, by Mr. Ampaw and two German writers, is about Addey, a hard-working family man who makes his living driving a lorry between Accra, the capital, and his small village of Kukurantumi, which, in a local dialect, means "the place where everything is too heavy to pick up." When he is dismissed from his job for reasons beyond his control, Addey arranges a marriage between his pretty daughter, Abena, and a rich, middle-aged businessman she doesn't love. Abena rebels and, with Bob, the poor young man she loves, runs off to Accra where things go from bad to worse.

Though its story is not a happy one, the film contains a good deal of rambunctious humor. The performances are awkward but also refreshingly straightforward, without guile.

"Kukurantumi" will be shown at the 57th Street Playhouse today at 6 P.M. and tomorrow at 8:30 P.M., as part of the New Directors/New Films series sponsored by the Lincoln Center Film Society and the Museum of Modern Art's Department of Film.

Vincent Canby

1984 Ap 1, 51:1

THE FAMILY GAME, written and directed by Yoshimitsu Morita (Japnaese with English subtitles); based on a novel by Yohei Honma; cinematographer, Yonezo Maeda; edited by Akimasa Kawashima; produced by Shiro Sasaki and Yu Okada; a co-production of Art Theater of Japan, New Century Producers and Nikkatsu Studio; presented by The Film Society of Lincoln Center and The Department of Film of the Museum of Modern Art. Running time: 107 minutes. This film has no rating.
YoshimotoYusaku Matsuda
MumataJuzo Itami
The MotherSaori Yuki
Older BrotherJunichi Tsujita
ShigeyukiIchirota Miyagawa

By VINCENT CANBY

"Everybody in my family is too much," says a voice on the sound track as, during the opening credits, we see the members of that family lined up, side by side, at the narrow, possibly imported Scandinavian dining table, noisily slurping their food and sticking elbows and arms into each other's faces. They are only four — father, mother, older brother and the hero-narrator, Shigeyuki, a misunderstood teen-ager — but they look like the figures in some dreadful, bourgeois parody of The Last Supper.

With these arresting images, Yoshimitsu Morita, a new young Japanese director, opens his wickedly funny "The Family Game," a stylish, deadpan comedy about Japan's comparatively affluent, utterly directionless, new middle class.

•

"The Family Game" is not always easy to follow, but it's almost always funny and, from the opening shots until the last, it's a visual adventure. The succession of brilliantly colored, often geometric compositions satirize the worst aspects of what might be called Japan's economic modernism. Mr. Morita, 34 years old, is clearly someone to watch.

It's fitting that "The Family Game" should be one of the opening attractions of this year's New Direc-

tors/New Films Festival sponsored by the Film Society of Lincoln Center and the Museum of Modern Art's Department of Film. Mr. Morita's film, which was first shown yesterday, will be shown at the 57th Street Playhouse at 1 P.M. today.

The family — it has no last name — lives in a high-rise apartment building in a flat that is spick-and-span and modern. On the walls there are one not-super Utrillo print and something that looks like a tacky souvenir bought in Cairo. Unfortunately the flat also is so tiny that no one has any privacy.

Shigeyuki's older brother has to walk through Shegeyuki's bedroom to get to his own. When mother and father want to have a private talk, they go downstairs and sit in their Toyota.

We never are told what father does for a living, but he makes enough money so that mother doesn't have to work — she amuses herself with leather crafts — and the sons can go to the good schools. Older brother does well at his studies but Shigeyuki is a disappointment. As the film opens, father and mother have just hired another in what has apparently been a long line of tutors for him.

"The Family Game" is mostly concerned with the confrontations between Shigeyuki and this new fellow, Yoshimoto, a good-looking, blandly arrogant, completely inscrutable university student who, having been promised a bonus if the boy's grades improve, is not about to fail at the job. At their first session Yoshimoto asks the boy to read something aloud, which the boy does with no interest whatsoever.

"You're cute," says the tutor, betraying no sarcasm. "All those pimples — the symbol of youth." He leans over and kisses the boy's pimply cheek.

Thus begins Shigeyuki's unsentimental education, which the tutor carries out largely by keeping the boy off balance. He sometimes encourages him with words but as often as not he ridicules him and slaps him around. Once, when Shigeyuki concedes that he is afraid of a fellow student, the tutor teaches the boy some karate basics.

Shigeyuki's grades do improve, but "The Family Game" isn't about Shigeyuki's immediate problems. It's about the futility of education unrelated to wisdom, about appliances that save time in which to do nothing, about urban landscapes from which all references to nature have been removed.

The film's next to last scene — a dinner to celebrate Shigeyuki's scholastic triumph — turns into a grotesquely funny shambles as the tutor, acting as sort of avenging angel, shows the family members exactly what he thinks of them. This one-man riot is the humanist's only response to the genteel inhumanism we've been witnessing throughout the film.

All of the performances are good but Ichirota Miyagawa is very good as the young Shigeyuki, and Yusaku Matsuda is wonderfully comic as the tutor.

In addition to directing, Mr. Morita adapted the screenplay from a novel by Yohei Honma. I assume he is also responsible for the extraordinary visual design, though Yonezo Maeda was the cameraman and Katsumi Nakazawa the art director. It's risky to make predictions on the basis of just one film, but "The Family

Game" is so rich that Mr. Morita would seem to be one the most talented and original of Japan's new generation of film makers.

1984 Ap 1, 57:1

THE PRINCESS, directed by Pal Erdoss; written (in Hungarian with English subtitles) by Istvan Kardos; cinematography by Lajos Koltai, Ferenc Pap and Gabor Szabo; produced by Mafilm, Tarsulas Studio; presented by the Film Society of Lincoln Center and the Department of Film of the Museum of Modern Art. At the 57th Street Playhouse, between Avenue of the Americas and Seventh Avenue. Running time: 113 minutes. This film has no rating.
Jutka ...Erika Ozsda
Zsuzsa ..Andrea Szendrei
Peter ..Denes Diczhazy
Andras ..Arpad Toth
Jutka's sisterJuli Nyako
Truck driverLajos Soltis

Pal Erdoss's "Princess" is an ironically titled film if ever there was one; its heroine is addressed as "princess" only once during the course of the story, and then by a weak-kneed, apologetic boyfriend who has failed to protect her from rape. Jutka (Erika Ozsda) is anything but the privileged creature of the title. A tough, lonely teen-age girl who has come to Budapest to work in a textile mill, Jutka becomes the focus of Mr. Erdoss's examination of courtship rituals, teen-age mores and motherhood.

"The Princess," with a delicate look despite the deliberately grainy black and white cinematography, has a realistic, even documentarylike tone. But it has also been well shaped by Mr. Erdoss, and its details are keenly observed. As Jutka, who turns 16 years old during the course of the story, begins her job at the mill and moves into a factory workers' hostel, the film explores these settings without losing sight of its heroine. As played by Miss Ozsda, Jutka holds the audience's empathy and interest even when she is at her most uncommunicative and unyielding.

Having been raised by now-deceased foster parents and spent time in a state institution, Jutka goes to look for her real mother, and takes such an accusatory tone that the reunion turns disastrous. The young woman's longing for a mother is highlighted even more emphatically when Jutka's friend, Zsuzsa, gives birth to an illegitimate daughter. Jutka becomes the child's only champion, insisting that the baby not be relegated to a fate like her own. Her impassioned defense of the child is Jutka's most deeply felt emotion during the course of the story.

The film also follows her progress as she learns more about men — one suitor tries to seduce her, as he has other mill girls, by luring her to his parents' house and feeding her his mother's chicken. "It's only the kids from the country who buy such stuff," he says disparagingly of Jutka's outfit, instead offering her a sweatshirt with the Eiffel Tower on it; this is much more sophisticated and authentic, he explains. Jutka is always suspicious, particularly at times like these, but she's also secretly susceptible to such advances. By the end of the film, she has lost much of this innocence the hard way.

Mr. Erdoss makes this a credible portrait, having interviewed many female workers from the provinces as part of his research for an earlier documentary. But he also creates an engrossing drama, and never lets the well-drawn background details interfere with his characters. This is a very successful first feature, and one that establishes Mr. Erdoss as a director of considerable subtlety and

promise. It is being shown at 3:30 P.M. today at the 57th Street Playhouse, as part of the "New Directors/New Films" series.

Janet Maslin

1984 Ap 1, 57:1

STRAIGHT THROUGH THE HEART, directed by Doris Dorrie; screenplay (German with English subtitles) by Jelena Kristl; cinematography by Michael Goebel; edited by Thomas Wigand; music by Paul Shigihara; produced by Denyse Noever; presented by The Film Society of Lincoln Center and The Department of Film of the Museum of Modern Art. At the 57th Street Playhouse, between Avenue of the Americas and Seventh Avenue. Running time: 91 minutes. This film has no rating.
Anna ...Beate Jensen
Armin ..Sepp Bierbichler
Marlies ..Gabrielle Litty
Marisol ..Nuran Filiz
Messenger ..Jens Müller-Rastede
Supermarket ManagerJoachim Hoepner

By JANET MASLIN

On a whim, the heroine of Doris Dörrie's "Straight Through the Heart" goes to an estate sale and tries to sweet-talk a man into selling her his refrigerator. On another whim, she dyes her hair bright blue. The unlikely upshot of these two minor occurrences is a proposition from the middle-age dentist who has been selling his late mother's possessions that she move in with him, on a basis that is nothing if not provocative and highly unusual.

He senses that she might restore some of the excitement that is missing from his life, he says. On the evening when he arrives home to find Anna Blume (Beate Jensen) lying on the floor in a black gown, having drawn police-style chalk outlines of her body all over the carpet, Armin (Sepp Bierbichler) believes that Anna may indeed be restoring it. Anna, for her part, maintains her studied sullenness and continues to write the self-addressed letters ("Dear Anna Blume") that underscore her loneliness. But gradually, she finds herself more and more drawn to this peculiar man, just as he begins, in no uncertain terms, to reveal his own profound detachment and indifference.

•

Miss Dörrie, who directs "Straight Through the Heart" in a fascinatingly self-assured fashion, seems to intend

her film as a parable about relations between the sexes. As Anna evolves from a bored, slovenly brunette grocery clerk into a fiercely independent blue-haired ingénue, and finally into a bizarrely blonde stay-at-home mother, she seems to be illustrating Miss Dörrie's metaphorical notion of a woman's destiny. Oddly enough, the film is much more interesting literally than it is in general terms. Miss Dörrie has such firm control of her arrestingly strange narrative, and the performances are so compelling, that "Straight Through the Heart" is riveting even at face value.

The style in which the story unfolds is hardly realistic, but it isn't more than a beat or two away. There is the map of the world in Anna's bedroom wall, providing a jarring backdrop to the couple's boudoir discussions; there is the red satin fortune teller's turban Anna gives Armin for her birthday; there is Anna's decision to fake pregnancy in order to hold the attention of her once-ardent suitor. Miss Dörrie insinuates these touches so easily into the film's overall framework that her style remains powerful and consistent throughout. At its best, her film seems to have a heightened and unexpected dimension, as when Armin, ignoring Anna at home, tells her he's doing it not for the usual husbandly reason but because he is using his computer to play chess with a man in Japan. Or when Anna tells him, "You're the first man I've slept with and still called 'Sir.'"

•

Both of the leading performers are quietly mesmerizing, particularly Miss Jensen, who demonstrates an uncanny natural ability to hold the audience's interest. The screenplay, by Jelena Kristl, is virtually a two-character piece, and as its title suggests it both explores the boundaries of a love affair and culminates in violence. Miss Dörrie, making an exciting feature debut after numerous shorts and documentaries for German television, sustains the material's tension, interest and originality throughout.

"Straight Through the Heart" will be shown tonight at 8:30 and Wednesday at 6 P.M. at the 57th Street Playhouse as part of the "New Directors/New Films" series.

1984 Ap 1, 57:1

FILM VIEW

VINCENT CANBY

Back From Oblivion

With the arrival of "Greystoke: The Legend of Tarzan, Lord of the Apes," the fine new film by Hugh Hudson ("Chariots of Fire"), it's apparent that Edgar Rice Burroughs's fictional wild child is as resilient as he is resourceful, and that in one fashion and another he will probably outlive us all. Three years ago, after the release of John and Bo Derek's camp classic, "Tarzan, the Ape Man," I thought the end had come.

It seemed then that the only decent thing to do was to send Tarzan on to that great Barnes & Noble in the sky, the one reserved for remaindered heroes of childhood fiction. The one-time king of the jungle had received fourth billing under Miss Derek's prettily predatory Jane and went through the entire film without being trusted with anything recognizable as dialogue. Tarzan hadn't been tamed exactly. He'd been turned into a minor sex object.

Great myths, however, do not go gently into oblivion. I should have known that Tarzan has spoken to the imaginations of too many generations of readers, including

filmmakers and moviegoers, to be fatally humiliated by an indiscretion on the order of the 1981 movie. Tarzan, in books and on film, is a continuing industry.

Burroughs (1875-1950) published "Tarzan of the Apes," the first of dozens of Tarzan stories, in 1914, and movie versions soon followed. Among the actors who have played Tarzan in feature films, serials and television series — most of whom are otherwise unremembered — are Elmo Lincoln, the first major Tarzan ("Tarzan of the Apes," 1918), P. Dempsey Tabler, James Pierce, Frank Merrill, Herman Brix, Glenn Morris, Buster Crabbe, Gordon Scott, Ron Ely, Mike Henry and Jock Mahoney. Miles O'Keeffe, of whom nothing much has been heard since, appeared as the nonspeaking Tarzan in the Dereks' film.

The greatest Tarzan of them all, though, was the late Johnny Weissmuller, the Olympic swimmer whose superb physique and gentle nature more or less set the standard by which all later Tarzans were measured to their disadvantage. At its best, the Weissmuller Tarzan was a comic-book hero come to life. He was a simple, unsophisticated superman whose character was completely defined in action, whether wrestling crocodiles and saving Jane from unfriendly snakes, or swinging effortlessly from vine to vine on the M-G-M backlot.

● ● ●

This Tarzan's jungle was as familiar as a boy's backyard, though somewhat more fraught with perils, and small enough to allow for any number of coincidental meetings, the sorts of encounters that provided these movies with their plots. In the Africa that M-G-M created for Johnny Weissmuller's Tarzan, it would have taken Stanley no more than 12 minutes to locate Livingstone.

I'm not sure why it's true but it can hardly be a coincidence that the authors of three of the most popular fiction series of all time are products of the 19th century: Sir Arthur Conan Doyle (1859-1930), the creator of Sherlock Holmes; L. Frank Baum (1856-1919), the author of the first Oz books, and Burroughs, who is remembered principally for the Tarzan stories though he wrote lots of other things as well.

That Conan Doyle, Baum and Burroughs continue to be read is, most importantly, a reflection of the ability of each writer to create fictional worlds that don't date, perhaps because each grew up in an era when things at least appeared to be more stable than they do today. The world of Sherlock Holmes is so rich that a talented writer like Nicholas Meyer was able to explore it, as if touring a foreign land, and then write his own Holmes adventure, "The Seven-Per-Cent Solution," which somehow fused Mr. Meyer's mid-20th century sensibility with Conan Doyle's.

The continuing appeal of the Tarzan stories — especially as they have been interpreted in B-movies, serials and television series — has less to do with literature or

with character than with pure, unadulterated fantasy. Long gone from these Tarzan dramatizations is any real sense of man's testing himself in primeval nature that, though filled with danger, is, as Jean Jacques Rousseau taught, essentially good, being uncontaminated by civilization.

In "Tarzan of the Apes," Burroughs was popularizing the sort of "wolf boy" myths that had fascinated Europe since the Middle Ages, and which François Truffaut later explored with both compassion and irony in his "Wild Child." In his film, based on the journals of Jean Itard, who worked with the "wild boy of Aveyron" at the beginning of the 19th century, Mr. Truffaut came to a conclusion that Rousseau would not have appreciated. Civilization, he decided, might not be perfect but it was certainly better than living in the state of perpetual fear, hunger, pain and ignorance that living in the wild represented.

Burroughs took a far more romantic view. He idealized his wild child, making him heir to the Earl of Greystoke, one of England's richest peers, and having him raised by some remarkably loving and understanding apes. When the young man is found in the African jungle and identified, he is taken back to civilization, where he finds it difficult to adjust.

In "Greystoke: The Legend of Tarzan, Lord of the Apes," Mr. Hudson appears to have utilized much more of the source material than has any other filmmaker, at least in the sound film era, but not as much as the producers would have you believe. The new movie, written by P. H. Vazak (which is reported to be a pseudonym for Robert Towne, who wrote the initial version of this screenplay) and Michael Austin, is unlike any other Tarzan movie you've ever seen. It is a wonderful original, a series of variations on themes suggested by the Burroughs stories but never considered in any depth.

●

As much as it was in "Chariots of Fire," England is a major presence in "Greystoke," nearly half of which takes place there, which is one aspect among many others in the film that will not delight audiences anticipating a conventional adventure tale. Mr. Hudson doesn't pay much attention to the horrors of Victorian England. Instead he pays tribute to what was fine and good and honorable, all of which qualities are exemplfied in the imposing figure of Tarzan's grandfather, Lord Greystoke, the last film role to be played by Sir Ralph Richardson before his death.

It's not for nothing that the film is called "Greystoke," for both the character of Lord Greystoke and Sir Ralph's richly funny, moving performance dominate the film and give

point to the later tribulations of Tarzan when he is brought to England to become Lord John Clayton, the old earl's heir. (The name "Tarzan," though used in the cast list, is never spoken in the movie. Tarzan, of course, is never called anything we can recognize in the extended sequences in which we see the orphaned child in Africa as a baby, at age 5, 12 and then as a young man with the apes who have raised him. When he finally receives a name, it is that of his father.)

As Burroughs popularized the various wolf-boy legends, Mr. Hudson and his associates seem consciously to be popularizing Mr. Truffaut's austere, contemplative "Wild Child." The succession of boys who play Tarzan all look a little bit like the wild child in the Truffaut film, as does Christopher Lambert, who gives an unexpectedly powerful and witty performance as the grown Tarzan, whether coping in the jungles of Africa or in the barbed brambles of upper-class English society. (There are also times when Mr. Lambert looks like a young Jean-Paul Belmondo, and he may be one of the few contemporary actors who can make the switch from loincloth to dress suit without appearing to be ridiculous.)

●

Connections to "The Wild Child" are further reinforced by the presence and performance of Ian Holm as the Belgian scientist, Phillippe D'Arnot, who discovers Tarzan in the jungle and painstakingly teaches him the ways of civilization, including how to speak: This Tarzan's first human language is French. Mr. Holm's Phillippe D'Arnot exhibits the same qualities of curiosity, patience, kindness and humor of the Jean Itard played by Mr. Truffaut in "The Wild Child."

Though the African sequences are splendid — I, for one, could never tell the real chimpanzees from the small actors in the chimp suits — they are also sometimes explicitly brutal and, what's more suprising, very sorrowful. Just how very young children will respond to this, I've no idea.

●

At times "Greystoke" seems to be an inventory of all the losses a child can endure in the process of growing up. In this film Tarzan loses not one father but three. Though he finds the love of a sweet young woman named Jane Porter (Andie MacDowell) in England, he also finds himself caught in terrifying fashion between two ways of life. "Greystoke" so vividly demonstrates Tarzan's dilemma that, at the end of the film, whatever decision he makes must, inevitably, be a tragic one. We've come a long way from "Me Tarzan. You Jane."

Just 70 years after his conception, Tarzan has grown up. ■

1984 Ap 1, II:21:1

SKYLINE, written and directed by Fernando Colomo; in Spanish with English subtitles; cinematography by Angel Luis Fernandez; edited by Miguel Angel Santamaria; music by Manzanita; production director, Antonio Isasi; presented by The Film Society of Lincoln Center and The Department of Film of the Museum of Modern Art. At the 57th Street Playhouse, between Avenue of the Americas and Seventh Avenue. Running time: 83 minutes. This film has no rating.
Gustavo FernandezAntonio Resines
PatBeatriz Perez-Porro
Jaime BosJaime Nos
RoyRoy Hoffman
ElizabethPatricia Cisarano
IreneIrene Stillman
ThorntonWhit Stillman

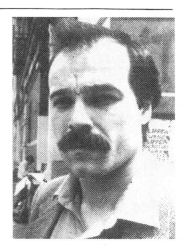

Antonio Resines in "Skyline."

By VINCENT CANBY

GUSTAVO (Antonio Resines), a freelance photographer from Spain, arrives in New York on a summer holiday in hopes of making contaets that will further his career in this country. A stocky, well-bred young man full of self-assurance, he talks confidently of Life and Newsweek as his two most likely opportunities.

He begins well enough. He has sublet a large airy loft downtown that comes complete with an undemanding cat. Through a couple of friends from home, he gradually expands his social circle to include artists and other photographers, a number of young women and one photographer's agent named Thornton.

Thornton tells him that he doesn't just like Gustavo's work, he loves it. However, he must also say, quite frankly, that it's old-fashioned. It's what New York photographers were doing five years ago.

Gustavo is not sure he understands. If something was good five years ago, why should it not be good today? His reaction is one of enlightened puzzlement.

●

This is more or less the tone of "Skyline" ("La Linea del Cielo"), a witty, low-keyed Spanish comedy, written and directed by Fernando Colomo, shot entirely in New York in Spanish and English. The film will be shown at the 57th Street Playhouse tomorrow at 8:30 P.M., in the "New Directors/ New Films" festival sponsored by the Film Society of Lincoln Center and the Museum of Modern Art's Department of Film.

Nothing of great moment happens to Gustavo during his visit, but Mr. Colomo discovers comedy everywhere. A first date with a pretty young woman starts off well enough, but at the end of the evening Gustavo must confess, "She lived above 100th Street and I below 9th. Our love was impossible." Some friends of friends, whom he has asked to look at his photographs and tell him exactly what they think, say his work is absolutely beautiful and, in fact, exactly like the photographs in a just-published book devoted to the facades of buildings in TriBeCa. Would he like to borrow it?

At a cocktail party Gustavo listens intently as a young woman tells a long, complicated story about having bumped into Jacqueline Onassis in an Upper East Side apartment house lobby after Mrs. Onassis emerged from a stuck elevator. Everyone finds

the story pricelessly funny and Gustavo is sure that he's missed some vital point.

"Skyline" is a slight but endearing comedy that, like Gustavo, regards New York with a mixture of wonder, amusement, open-mindedness and skepticism.

Mr. Resines is a very droll Gustavo, a fellow who never loses his cool, partly because, being a tourist in a mysterious land, he doesn't want to be impolite and because, at heart, he has realized that for him it will never be more than a nice place to visit.

Mr. Colomo never forces the comic events or overstresses the ironies. The movie possesses a charm that, though gentle, is firmly rooted in the realities of a completely self-absorbed civilization.

1984 Ap 3, C15:1

Adolescent Folly

ZAPPA, directed by Bille August; screenplay (Danish with English subtitles) by Mr. August and Blarne Reuter, based on the novel by Blarne Reuter; cinematography by Jan Weincke; edited by Janus Billeskov Jansen; music by Bo Holten; production management by Ib Tardin and Janne Find; an International Spectrafilm Release; presented by The Film Society of Lincoln Center and The Department of Film of the Musum of Modern Art. Running time: 103 minutes. This film has no rating.

Sten ..Peter Reichardt
Bjorn ..Adam Tonsberg
Mulle ..Morten Hoff
Sten's motherSolbjorn Hoifeldt
Sten's fatherBent Raahaugh
Bjorn's brotherThomas Nielsen
Bjorn's fatherArne Hansen
Bjorn's motherLone Lindorff
Mulle's fatherJens Okking

By JANET MASLIN

AT first glance, the protagonists of Bille August's "Zappa" look as though they must lead charmed lives. Tall, slender, uncommonly handsome young Danes, they are reaching adolescence during an era of quiet prosperity (the year is 1961). Their families are solidly upper middle class; their suburb is pretty and serene. What can go wrong for boys like Bjorn (Adam Tonsberg) and Sten (Peter Reichardt)? Mr. August's film, which is named for Sten's sinister, carnivorous pet fish, does a powerful job of tracing the boys' growing delinquency.

"Zappa," which will be shown tonight at 8:30 and Thursday at 6 P.M. as part of the New Directors/New Films series, depicts these young characters and their families in a remarkably assured and telling style. The film studies both boys and their protégé, a fatter and less guarded classmate named Mulle (Morten Hoff), who is eager to become a member of their clique. Mulle's background is more working class than those of the other two, and his manner more spontaneous and less guarded. Inevitably, this encourages the sadism of the bullying Sten, who tries to make Mulle swallow insects and otherwise prove his loyalty to the gang.

Mulle, who is played very expressively by Mr. Hoff, doesn't stand up to much of this treatment. In some ways, that makes him luckier than the reserved, careful Bjorn, who stays closer to Sten, and tacitly becomes a party to more of his viciousness. Bjorn's ultrapleasant family life and his polite young sweetheart (who looks like a preteen version of Eva Marie Saint, and who already wipes Bjorn's shirt clean for him in a doting, housewifely fashion) indicate what his past has been like, and

where his future may lie. How, then, has Sten involved him in burglaries, in alcoholic outings and worse? Though Bjorn himself doesn't understand his own complicity entirely, he clearly feels powerless to free himself from Sten's influence.

If Mr. August, who makes "Zappa" a forceful and enveloping drama, errs at all on the side of predictablity — and he generally doesn't — it is in laying much of blame for the boys' foibles squarely at their parents' doors. Sten's is the more prosperous family, and he is the more neglected child, with a mother who is frequently in a yoga-induced trance, and who seldom speaks to him. When his father finally moves out, and Sten manfully surprises his mother with a candlelit dinner, she says, "You couldn't know it, but in Mom's new diet, fats like that are out of the question." Wry as this kind of caricature may be, it doesn't suit the film's otherwise understated style.

Nor do the glimpses of what his home life is like for Bjorn, whose family means well but which doesn't pay much attention to him. When he tries to tell his mother that he has been out with Sten and the gang, vandalizing Sten's father's new apartment, she barely listens. She is so preoccupied with the news that Sten's parents have separated that she doesn't even catch wind of her own son's crime.

But Bjorn's confusion is for the most part delicately outlined, and it has been beautifully conveyed by Mr. Tonsberg, whose passivity is as essential as his faintly ironic manner. His character's growing pains become extremely palpable here, as does the atmosphere of complacency in which these problems develop and then get out of hand. Mr. August has made "Zappa" a suspenseful, moving drama, with concerns that are as troubling as they are universally recognizable.

1984 Ap 3, C15:1

Remembering

KADDISH, a documentary directed, produced and edited by Steve Brand; cinematography by Robert Achs; music by Andy Statman; a Ways and Means Production; presented by the Film Society of Lincoln Center and the deparrnent of film of the Museum of Modern Art. At the 57th Street Playhouse, between the Avenue of the Americas and Seventh Avenue. Running time: 92 minutes. This film has no rating.

THE Klein family, profiled in Steve Brand's film "Kaddish," has been powerfully influenced by the legacy of a father, Zoltan, who survived the Holocaust and who raised his son, Yossi, in its shadow. Zoltan, who died when the filming was partially completed, is implicitly at the center of Mr. Brand's film, while the highly articulate Jewish activist Yossi is its dominant spokesman. Using interviews, home movies, glimpses of the Kleins at various stages in their lives, Mr. Brand makes a comprehensive attempt to tell Zoltan's story and to explain how it has shaped Yossi's attitudes. He also captures a strong sense of the son's love for his father.

"I cannot tell you how many times this child was jailed," says Breindy Klein, Yossi's mother. As a child, Yossi says, he had nightmares about being pursued by Nazis on the boardwalk at Coney Island. By the time he reached the sixth grade he was a published writer, campaigning for the release of Soviet Jews (he was later ar-

rested during a demonstration in Moscow). Growing up in Brooklyn's Borough Park, Yossi assumed a certain fatalism along with his sense of Jewish tradition. "If this is what happened to millions of Jewish families who lived exactly the way we did, what's going to happen to us?" he asks. He also says, "I'm very much afraid of bringing children into a world where there aren't survivors of the Holocaust."

Mr. Brand, who filmed the Kleins over a period of five years (there is also a beautiful sister, Karen, who during that interval entered into a traditional Jewish marriage and became a housewife and mother), captures a lively sense of the father-son dialogue that existed between Yossi and Zoltan, and he succeeds in providing a family context for Yossi's pessimism. In Yossi, the film has an intelligent and provocative spokesman.

The film's focus is so narrow, though, that it risks becoming a mere forum for Yossi's opinions, without developing a wider frame of reference. As sweeping as Yossi's concerns about the Holocaust and about the future of his people are, they are presented here with such obsessiveness that they seem to overpower all other aspects of his life. When a closing title says that Yossi has moved to Israel and married, the news is surprising, because Mr. Brand's film portrait suggests a man with little time for such outside interests. However, the son's energy and intelligence are captured here, as are their ties to the father and his history.

"Kaddish" will be shown tonight at 6 o'clock and Saturday at 8:30 as part of the New Directors/New Films series.

Janet Maslin

1984 Ap 3, C15:1

Robert Duvall is a member of a troubled farm family in "Stone Boy."

Pea-Picking Time

THE STONE BOY, directed by Chris Cain; screenplay by Gina Berriault, director of photography, Juan Ruiz-Anchia; edited by Paul Rubell; music by James Horner; produced by Joe Roth and Ivan Bloch; released by Twentieth Century Fox Film Corporation. At Cinema 3, 59th Street at the Plaza. Running time: 93 minutes. This film is rated PG.

Joe HillermanRobert Duvall
Andy JansenFrederic Forrest
Ruth JansenGlenn Close
George JansenWilford Brimley
Arnold HillermanJason Presson
Lu JansenGail Fisher
AmalieCindy Fisher
Nora HillermanSusan Blackstone
Eugene HillermanDean Cain

By VINCENT CANBY

"THE STONE BOY" is about a grief so special and so private that the film has the effect of seeming to force us to invade its privacy, making us feel more uncomfortable than moved.

One idyllic summer morning Arnold Hillerman, a 12-year-old Montana farm boy, and his brother, Eugene, 17, get up before dawn to pick peas. Against his brother's advice, Arnold insists on taking along his shotgun, hoping to bag a wild duck, even though it's out of season. As Arnold is climbing through a barbed wire fence, the gun becomes snarled. During Arnold's efforts to free it, the gun goes off, instantly killing Eugene.

For some time the stunned Arnold sits on the ground staring at his brother's body. Then he picks up his pail and proceeds to the field to pick peas. Peas must be picked before daylight, his father has said, or they wilt.

By the time Arnold returns to the house, the rest of the family is at breakfast. Where's Eugene? "He's in the field," says the boy. "He's dead. I shot him."

"The Stone Boy," which opens today at the Cinema 3, is the mournful tale of how Arnold (Jason Presson) comes to terms with his grief and of how the other members of the family come to terms with Arnold. The boys' father, Joe Hillerman (Robert Duvall) is so full of anger that he can't bring himself to comfort the surviving son. "Leave him alone," he tells his wife, Ruth (Glenn Close), "and maybe he'll realize what he's done." In the middle of the night after Eugene's funeral, the terrified

Jason Presson plays Arnold in "The Stone Boy."

Arnold seeks out his mother. "Go back to bed," she says through the closed door.

When the sheriff asks Arnold why he didn't run back to the house as soon as the accident happened, all he can say is, "I didn't believe it."

Eventually everything that goes wrong with the Hillerman family is traced back to the shooting at the barbed wire fence. Arnold's randy Uncle Andy (Frederic Forrest) makes a point of comforting Eugene's young girlfriend and stays to seduce her, which leads Uncle Andy's pregnant wife Lu (Gail Youngs) to have a miscarriage. At one point, Lu screams at the boy, "It's all your fault!"

"The Stone Boy" is full of good performances, particularly by young Jason Presson as the boy who suffers more trials than Job; Wilford Brimley, as Arnold's grandfather, the only person who comprehends Arnold's bewilderment; Miss Youngs, who makes something quite affecting of the unhappy Lu, and Mr. Forrest, as the essentially decent but loutish Uncle Andy.

●

Mr. Duvall and Miss Close have the film's most difficult roles, which, as written, are so taciturn and unsympathetic that one is inclined to turn away from them as they turn away from their son.

The screenplay, adapted by Gina Berriault from her own short story, means to be unhysterical, honest and sincere, which it is. However, Chris Cain, the director, whose first theatrical film this is, has fancified it with such pretty, often heavily filtered color photography, favoring such things as attention-getting low-angle shots and shots into the sun, that it seems as if he didn't trust the material. This idealized look keeps interrupting — upstaging, really — the film's emotional content, which is enormous, but which most of the time is kept at a far remove from the audience.

●

"The Stone Boy," which has been rated PG ("parental guidance suggested") contains nothing obviously obscene or vulgar, but the basic situation might well prove harrowing to children.

1984 Ap 4, C25:1

Down on the Farm

BIQUEFARRE, directed by Georges Rouquier; screenplay (French with English subtitles) by Mr. Rouquier; director of photography, André Villard; edited by Geneviève Louveau; music by Yves Gilbert; produced by Marie-Françoise Mascaro, Midas S. A. Bertrand van Effenterre, Malila Films; released by New Yorker Films; presented by The Film Society of Lincoln Center and the Film Department of the Museum of Modern Art. At the 57th Street Playhouse, between Avenue of the Americas and Seventh Avenue. Runing time: 90 minutes. This film has no rating.
HenriHenri Rouquier
MariaMaria Rouquier
Raoul PradalRoger Malet
LucienMarius Bénaben
HortenaHélène Bénaben
MarcelAndré Bénaben
MartineFrancine Bénaben
GenevièveMarie-Hélène Bénaben
RochRoch Rouquier
RaymondRaymond Rouquier
JeanetteGeorgette Rouquier

By VINCENT CANBY

THIRTY-SEVEN years after "Farrebique," Georges Rouquier, the French director best known for his documentaries, returned to the farming community in Aveyron in south-central France to pick up the story of the Rouquier family, his cousins who had been featured in his earlier film, which was a huge critical success in its time and which is considered to be a classic of its kind.

The result, "Biquefarre," is as moving for the director's persistence of vision as for the film itself, which records, in low-key, quasi-documentary style, the revolutionary changes that have taken place not only in agriculture, but also in the social and economic life of the community.

"Biquefarre," which was awarded a special jury prize at the 1983 Venice Film Festival, will be shown at the 57th Street Playhouse today at 8:30 P.M. and tomorrow at 6 P.M., in the New Directors/New Films Festival sponsored by the Film Society of Lincoln Center and the Museum of Modern Art's Department of Film. Mr. Rouquier, at 75, is not exactly a new director, but there is something timeless about his enthusiasm that qualifies his film for showing under these auspices.

Like "Farrebique," the new film makes no attempt at being cinéma vérité. Mr. Rouquier, an admirer of the great American documentary film maker Robert Flaherty, doesn't attempt to discover drama as he shoots. Instead, he works with nonprofessional performers — in this case, farmers — who act out staged sequences that correspond to events in their own lives.

"Farrebique" recorded the end of an era as three generations of the Rouquier family debated whether or not to bring electricity to their farm or to use the money to repair the old farmhouse. In the course of four seasons, one son courted his future bride, the old grandfather prepared for death, and life went on in a series of idyllically photographed scenes,

some shot in stop-motion, which celebrated the cyclical nature of all existence.

"Biquefarre," which includes brief clips from the first film, is less self-consciously poetic and more matter-of-fact in the manner in which it documents the lives of the surviving Rouquiers and their new in-laws and children. The old stone farmhouse is still there but empty. The family has moved nearby to a new, modern house that is, comparatively speaking, a state-of-the-art farmhouse. So is the farm itself, where cows are milked mechanically, the feed is vitamin-enriched and the pesticides may be contaminating the farmers and the landscapes as well the pests.

The major "event" of "Biquefarre" is the family's ultimately successful attempt to increase their holdings by the purchase of Biquefarre, an adajcent farm property that will allow them to increase production and survive in the increasingly competitive agricultural market. In one of the film's most effective scenes, Raoul, the old bachelor who is selling Biquefarre and moving to Toulouse, tells a community meeting that all farmland should be owned by the community to insure more equitable opportunities for all farmers. He is shouted down as a possible Marxist.

The relationships of the characters are not always clear. There also are times when "Biquefarre" will seem curiously old-fashioned to audiences now accustomed to the supposedly inobtrusive camera of cinéma vérité. Yet the very self-consciousness of the nonprofessional actors — we are never for a second led to believe they aren't aware of the camera — as well as the gaps in what passes for a narrative, combine to produce a sense of authenticity that often gets lost in far more slick, contemporary "fact" films.

1984 Ap 5, C15:1

Store-Bought Asylum

MOSCOW ON THE HUDSON, directed and produced by Paul Mazursky; written by Mr. Mazursky and Leon Capetanos; director of photography, Donald McAlpine; edited by Richard Halsey; music by David McHugh; released by Columbia Pictures. At Loews Astor Plaza, Broadway and 44th Street; New York Twin, Second Avenue and 66th Street; 34th Street Showplace, between Second and Third Avenues; 83d Street Quad, at Broadway; Greenwich Playhouse Twin, Seventh Avenue and 12th Street, and other theaters. Running time: 115 minutes. This film is rated R.
Vladimir Ivanoff Robin Williams
Lucia Lombardo Maria Conchita Alonso
Lionel Witherspoon Cleavant Derricks
Orlando Ramirez Alejandro Rey
Boris Savely Kramarov
Anatoly Elya Baskin
Yuri Oleg Rudnik
Vladimir's Grandfather Alexander Beniaminov
Vladimir's Mother Ludmila Kramarevsky
Vladimir's Father Ivo Vrzal
Sasha Natalie Iwanow
Lionel's Grandfather Tiger Haynes
Lionel's Mother Edye Byrde
Lionel's Stepfather Robert Macbeth

A scene from Georges Rouquier's film "Biquefarre."

By VINCENT CANBY

BOTH Vladimir Ivanoff, a young Soviet circus musician, who defects to the United States at the end of an American tour, and Robin Williams, the actor who plays Vladimir with fine comic intensity, are most engaging characters — spirited, skeptical, but still capable of wonderment. Yet Paul Mazursky's "Moscow on the Hudson" doesn't seem to know what to do with them. They are men without a movie.

"Moscow on the Hudson," which opens today at Loews Astor Plaza and other theaters, isn't ill conceived. Rather, it seems unfinished, not yet thought through. Even the title doesn't quite fit, since the New York City that Vladimir discovers is far more densely populated by Southern blacks, Latin Americans, Western Europeans, Orientals and Indians from India than by Russians. It sounds as if it were one of those titles around which a screenplay was eventually composed.

No film by Mr. Mazursky (director of "An Unmarried Woman") is ever totally unrewarding, though "Tempest" came close. "Moscow on the Hudson" contains one extremely funny sequence, when, after what has been an extended prologue set in the Moscow that's on the Moscow River, Vladimir decides to chuck everything and to remain in New York just as his circus colleagues are boarding the bus that will take them to the plane.

If you're going to defect, Bloomingdale's, that great repository of Western civilization, would seem the perfect place in which to come to such a decision, and Mr. Mazursky and Leon Capetanos, with whom the director wrote the screenplay, succeed in making something quite wonderful of this idea.

Chaos in a department store is almost always funny, and it is in this tumultuous sequence, in which prissy floorwalkers, members of the Soviet secret police, the store's public-relations personnel, New York City policemen and Federal Bureau of Investigation agents all are working at cross purposes.

It also contains the movie's only genuinely moving moments. In the course of the diplomatic hurricane, Vladimir, who is the calm eye at its center and who doesn't yet comprehend the immensity of his act, is befriended by Lucia Lombardo (Maria Conchita Alonso), a beautiful, romantic, Italian-born cosmetics clerk, and Lionel Witherspoon (Cleavant Derricks), a supercool Bloomingdale's security guard, who offers Vladimir temporary living quarters in his family's Harlem apartment.

Thereafter, with somewhat more self-assurance than the screenplay warrants, "Moscow on the Hudson" settles down to recount Vladimir's mostly lighthearted adventures in Manhattan. He quickly finds his own apartment in the East Village, falls in love with Lucia and secures a best friend, Lionel, as well as a series of jobs — dishwasher, street vendor, chauffeur and, finally, saxophonist, his true vocation.

Defection and exile are large subjects, but "Moscow on the Hudson" realizes little of the profound drama and comedy that are so poignantly defined in even a small movie like "Musical Passage," Jim Brown's documentary about the members of the Soviet Emigré Orchestra.

Mr. Mazursky's fictional conceits

do not do justice to Vladimir or to his situation, either in the Soviet Union or this country. In spite of Mr. Williams's extraordinarily complex performance — his Russian sounds amazingly, comically authentic — the introductory scenes in Moscow recall the kind of consumer-oriented jokes that Hollywood was cranking out in the post-"Ninotchka" 1940's in a movie like "Comrade X." Even the film's Manhattan, with the exception of Bloomingdale's, is not explored with much sense of surprise or humor.

Vladimir's ease at finding jobs must also strike some members of the audience as miraculous, especially when he suddenly turns up as the uniformed driver of a rental limousine. How did he get his license? Have Mr. Mazursky and Mr. Capetanos spent any time recently at the Motor Vehicles Bureau in Lower Manhattan? If they had, they might have realized that when it comes to bureaucracy and long lines, cities of the West do not have to take lessons from those of the East.

Toward the end of the film, when "Moscow on the Hudson" is running low on plot, Vladimir's eyes are opened when he is mugged in his own hallway. At this point, the film makers try to make some kind of solemn point, which, as I understand it, is that the democratic freedoms include not only those of speech, religion and assembly, but also of physical assault by strangers.

The performances are first-rate, starting with Mr. Williams, Mr. Derricks and Miss Alonso. Especially good in supporting roles are Tiger Haynes, as Lionel's grandfather;

Cleavant Derricks and Robin Williams star in "Moscow on the Hudson," a comedy about a Soviet defector.

Elya Baskin, as Vladimir's Soviet colleague, a circus clown whose talk of defection leads directly to Vladimir's act, and Alejandro Rey, as Vladimir's Cuban-born lawyer. One of the best things in the film is David McHugh's soundtrack score, which is jazzy and sweet in the derivative, slightly old-fashioned manner of contemporary Soviet popular music.

1984 Ap 6, C12:1

HARD TO HOLD, directed by Larry Peerce; screenplay by Tom Hedley; story by Mr. Hedley and Richard Rothstein; director of photography, Richard H. Kline; edited by Bob Wyman; music by Tom Scott; produced by D. Constantine Conte; released by Universal Pictures. At the Rivoli, Broadway and 49th Street; Gemini Twin, Second Avenue at 64th Street; 86th Street East, between Second and Third Avenues; 34th Street Showplace, between Second and Third Avenues, and other theaters. Running time: 93 minutes. This film is rated PG.

James Roberts	Rick Springfield
Diana Lawson	Janet Eilber
Nicky Nides	Patti Hansen
Johnny Lawson	Albert Salmi
Owen	Gregory Itzen
Casserole	Peter Van Norden
The James Roberts Band	
Bill Mumy, Tony Fox Sales, Mike Baird, Robert Popwell	
Toby	Tracy Brooks Swope

By JANET MASLIN

D RIPPING sweat, with the backstage lights glinting off his jeweled belt and his single earring, James Roberts escapes to his dressing room, collapsing beside the Space Invaders machine. He's drained. He's exhausted. He's a very famous rock star, and he has just whipped another adoring audience into a lather.

"Deep focus, deep focus," whispers James's manager, easing James out of one vest and into another, getting him ready for the encore. "Five more minutes and you can go home." James shuts his eyes, pauses for a moment and then, dramatically,

Janet Eilber and Rick Springfield fall in love in "Hard to Hold."

thrusts his fist heavenward. "Let's do it!" he cries, and races triumphantly back to the stage.

"Hard to Hold" is a movie for anyone who thinks this sounds like real behind-the-scenes rock-and-roll ambiance and for anyone who thinks Rick Springfield is a real rock star. It's not a movie for anyone else, except perhaps film students, who will find that Larry Peerce has included more weak transitions, conversational clichés, unflattering camera angles and ethnic restaurant scenes in this film's mere 93 minutes than some directors manage in an entire career.

Designed solely as a vehicle for Mr. Springfield — who demonstrates little spontaneity here but some sense of humor, or at least an ability to laugh on cue — "Hard to Hold" has a story with all the verve and originality of James Roberts's name. All it's about is James's ardent, inexplicable pursuit of Diana Lawson (Janet Eilber), a woman he meets in a traffic accident. She is a serious sort; we know that because we see her home in bed, swathed in Laura Ashley bedding and reading The New Criterion. She is also independent enough to resist James somewhat, so that they can have lengthy discussions about whether, as the screenplay puts it, to commit.

Miss Eilber is another of the prim, toothy actresses, and she looks enough like Mr. Springfield to be his sister; however, the film tries gamely to generate some sexual chemistry between them. They do a lot of smooching in public places, sometimes setting off riots, because Jamie is so famous. At other times nobody seems to recognize him.

Also in the film is Patti Hansen, the fashion model, who makes her first appearance wearing a glittery turquoise getup and brandishing a broken bottle. Her role, which is that of Jamie's songwriting partner and former wife, makes so little sense that it ought to set some kind of record. Miss Hansen has a heavy New York accent and a serious case of the

fidgets, but she does look great and conveys at least a hint of the rock-and-roll atmosphere that the movie otherwise lacks.

"Hard to Hold" isn't the first rock-and-roll movie in which anyone has ever said (as James does to his smug, superior manager): "The music's changin', Owen, you know. We gotta change with it." However, it *is* the first film I've seen in which the heroine has asked the hero whether he has herpes.

●

"Hard to Hold" is rated PG ("Parental Guidance Suggested"). It contains several bedroom scenes and a little nudity.

1984 Ap 6, C16:5

Moving Up

SUGAR CANE ALLEY, directed by Euzhan Palcy; screenplay (French, with English subtitles) by Miss Palcy, based on the novel "La Rue Cases Negres" by Joseph Zobel; director of photography, Marie-Joseph Yoyotte; music by Groupe Malavoi, Roland Louis, V. Vanderson, Brunoy Tocnay, Max Cilla, Slap Cat; produced by Sumafa-Orca-N.E.F. Diffusion; released by Orion Classics; presented by the Film Society of Lincoln Center and the Film Department of the Museum of Modern Art. At the 57th Street Playhouse, between Avenue of the Americas and Seventh Avenue. Running time: 103 minutes. This film has no rating.
José..............................Garry Cadenat
M'Man Tine........................Darling Legitimus
Medouze.....................................Douta Seck
Monsieur St.-Louis.................Joby Bernabe
Le Gereur.......................Francisco Charles
Léopold's mother................Marie-Jo Descas
Madame St.-Louis................Marie-Ange Farot
Monsieur Roc........................Henri Melon
Douze Orteils......................Eugene Mona
Carmen.................................Joel Palcy

EUZHAN PALCY brings so much warmth to her film "Sugar Cane Alley" that even a funeral scene midway through has an unexpected sweetness. Set in Martinique in 1931, "Sugar Cane Alley" explores the lives of black plantation workers through the eyes of a quiet, perceptive 11-year-old orphan. More than the story of how José, who is played beautifully by Garry Cadenat, makes his way out of the shantytown of the title to become a brilliant student and, perhaps later, a writer, "Sugar Cane Alley" is the story of an entire way of life. In describing it, Miss Palcy chooses her details sparingly and well.

In "Sugar Cane Alley," which will be shown tonight at 8:30 and tomorrow at 1 P.M. as part of the New Directors/New Films series, José lives primitively but happily in a shack with his grandmother, M'Man Tine (played by Darling Legitimus, whose performance is as gently memorable as her name). At first, the richly sepia-toned film simply traces the routine of their daily lives and observes José's exploits with the other black children living in the alley. There is the day, for instance, when they find an egg, decide to cook it and divide it a dozen or so ways, happen upon some alcohol while attempting to start a fire, and very nearly wind up burning down the village.

●

The most important influence on José is an old man named Medouze (Douta Seck), who talks to the boy about Africa and helps instill in him the feeling that there may be more to life than what happens on the plantation. Medouze's legacy is largely responsible for José's desire to pursue his education. A bright student but also a very shy one, José wins a par-

tial scholarship to a school in the capital, Fort-de-France, where his classmates are the sons of a much higher social stratum. There, he is accused of cheating on his first composition assignment. The teacher has no evidence of such misconduct, but he cannot believe that José's essay, without having been copied, can be so good.

Slowly but carefully, Miss Palcy creates a sense of the time, the place, the traditions and the state of racial relations in the shantytown of the title. José's friend Léopold is the son of a white landowner, the one on whose plantation all the Sugar Cane Alley residents labor. Léopold's white father and black mother live as a married couple, but both Léopold and José are shocked by the father's deathbed refusal to acknowledge his son. "It's not a mulatto's name, it's a white man's name" is the dying man's explanation. Without overemphasizing this or anything else in her film, Miss Palcy captures the simplicity and spirituality of José's elders, the indifference of their white masters and a sense of what will be gained and lost by all of them in their progress toward the future.

Janet Maslin

1984 Ap 6, C24:3

THE FIANCEE, directed by Gunter Reisch and Gunther Rücker; screenplay (German with English subtitles) by Mr. Rücker, based on the trilogy "The House With the Heavy Doors" written by Eva Lippold; cinematography by Jürgen Brauer; edited by Erika Lehmphul; music by Karl-Ernst Sasse; a co-production between DEFA Studio for Feature Films, Berlin Group and GDR Television; presented by The Film Society of Lincoln Center and the Department of Film of the Museum of Modern Art. At the 57th Street Playhouse, between Avenue of the Americas and Seventh Avenue. Running time: 105 minutes. This film has no rating.
Hella.............................Jutta Wachowiak
Reimers........................Regimantas Adomaitis
Lola...............................Slavka Budinova
Frenzel..........................Christine Gloger
Irene.....................................Inge Keller
Olser.............................Kathe Reichel
Hensch.....................Hans-Joachim Hegewald

The East German film "The Fiancée" tells of the ordeal of a woman who was sentenced to 10 years in a Nazi prison during the 1930's after she had been found guilty of treason. As quietly well acted as the leading role is by Jutta Wachowiak, and as serious as the film is most of the time, it is also surprisingly shrill.

"The Fiancée," which was partially directed by Günther Rücker (who fell ill midway through the filming, and whose duties were assumed by Günter Reisch), will be shown today at 3:30 and tomorrow at 6 P.M. as part of the New Directors/New Films series.

●

Hella's crime is relatively minor, since she has acted as an accomplice to her lover's subversive activities. Nonetheless, she finds herself in solitary confinement in a women's prison, where she is bullied by sadistic matrons and subjected to a variety of abuses. At first she does little but make paper flowers; later, she is returned to the company of other women and assigned to laundry duty. Only political prisoners are entrusted with the job of doing the Nazi officials' washing. Eventually, she finds some solace in the prison library, and in frustratingly brief, heavily monitored visits with her lover.

Based on the writings of Eva Lippold, who herself was a Communist activist imprisoned during the 1930's, "The Fiancée" unfolds in a generally blank and uninflected style. It is of

more interest as an example of East German cinema than on its own merits.

Janet Maslin

1984 Ap 7, 13:3

'Up the Creek'

By LAWRENCE VAN GELDER

Heralds of the season come in many forms: robins, crocuses and movies like "Up the Creek," yesterday's arrival at Loews State and numerous other theaters in and around the city.

Aiming for "Animal House" or "Porky's" and plummeting somewhere in the neighborhood of "Screwballs," this movie is one of those compounds of college competition, bare-breasted women, booze and casual sex that is Hollywood's idea of a direct connection to the disposable income of adolescents loosed for spring vacation.

In their quest for originality, the producers have plucked Tim Matheson and Stephen Furst from the ranks of "Animal House" and Dan Monahan from "Porky's" and "Porky's 2" and laden them and Sandy Helberg with the heroes' roles in a purported comedy about an intercollegiate whitewater rafting race.

This quartet — Mr. Matheson as the suave ladies' man, Mr. Furst as the glutton, Mr. Helberg as an alcoholic and Mr. Monahan as the innocent-looking romantic — portray the four worst students at Lepetomane University, "the single worst educational institution in the country."

Because no student has ever won an award for anything, and the only recorded achievement by an alumnus is a parole, Lepetomane's dean — in quest of some glory — manages to enlist these underachievers in the race by means of a threat and on promise of a degree in the major of their choice if they manage to win.

Standing between the foursome and the thrill of victory are the blond villains of Ivy University, the dishonest race organizer, a disqualified crew from a military academy and a screenplay that is as short of innovation and genuine wit as it is long of wind.

Neither the music by the likes of Cheap Trick and the Beach Boys nor the antics of a dog named Jake who is as raunchy as his master (Mr. Matheson) can elevate this movie from the ranks of failed derivations.

"Up the Creek" draws moviegoers into a ridiculous ordeal, all right, but certainly not in the way film makers intended.

1984 Ap 7, 13:3

TUKANA, directed by Chris Owen and Albert Toro; screenplay (Tok Pisin with English subtitles) by Mr. Toro and Mr. Owen, adapted from an original story by Mr. Toro; cinematography by Mr. Owen; edited by Les McLaren; presented by the Film Society of Lincoln Center and the Department of Film of the Museum of Modern Art. Running time: 120 minutes. This film has no rating.
Tukana................................Albert Toro
Josephine......................Francesca Samosa
Lucy...................................Regina Tulsa
Tukana's mother....................Emily Beani
Tukana's father...............Timothy Hamanin
Tohiana....................Wenceslas Noruke
Imitator...................................Nohang

By VINCENT CANBY

"Tukana" is somewhat more important as anthropology than as cinema, being a straightforward fictional account of the problems facing young people in the North Solomons Province of Papua, New Guinea.

The principal setting is the island of Bougainville, in the Solomons, the scene of some of the toughest fighting in the early months of World War II. The war is far removed from "Tukana," remembered only by one ancient islander who amuses young audiences by imitating Japanese soldiers.

●

"Tukana" is named for its main character, a young man caught between the ways of his ancestors and those of the generation that would rather buy speedboats on time than spend time making canoes. In the course of the film, Tukana, played by Albert Toro, flunks out of provincial college and returns to his village, where he drinks too much, is rude to old people and resists a marriage arranged by his parents.

Before he comes to his senses and vows to becomes a teacher, he goes to work in Bougainville's copper mines and has an unhappy affair with a pretty, mean-tempered young woman who, having received a good education, would rather spend her days reading comic books than contributing to the welfare of her community.

●

"Tukana" was directed by Chris Owen, an Australian film maker, and co-directed by Mr. Toro, who gives a very decent performance in the title role. Also effective are Francesca Samosa and Regina Tulsa, the women in Tukana's life, and Wenceslas Noruke, as Tukana's hell-raising friend who eventually startles everyone by becoming an agricultural expert.

"Tukana" is a report on the life and times in a part of the world seldom seen in theatrical films. It will be shown at the 57th Street Playhouse today at 6 P.M. and tomorrow at 3:30 P.M., in the New Directors/New Films festival sponsored by the Film Society of Lincoln Center and the Museum of Modern Art's department of film.

1984 Ap 7, 13:5

WHERE THE BOYS ARE, directed by Hy Averback; screenplay by Stu Krieger and Jeff Burkhart; director of photography, James A. Contner; film editors, Melvin Shapiro and Bobbie Shapiro; music by Sylvester Levay; produced by Allan Carr; released by Tri Star Pictures. At the National, Broadway and 44th Street; Manhattan Twin, 59th Street between Second and Third Avenues, and other theaters. Running time: 97 minutes. This film is rated R.
Jennie................................Lisa Hartman
Scott...............................Russell Todd
Carole................................Lorna Luft
Sandra..............................Wendy Schaal
Chip............................Howard McGillin
Laurie......................Lynn-Holly Johnson
Barbara...............................Louise Sorel
Maggie..............................Alana Stewart
Tony....................Christopher McDonald
Camden.......................Daniel McDonald

By JANET MASLIN

No one's going to make any great claims for the original "Where the Boys Are," but at least it had a certain innocence. This, after all, was the film in which boy-crazy Yvette Mimieux was willing to do anything, even have sex, in order to land a husband from the Ivy League.

The new "Where the Boys Are," which is dumb, vulgar and mostly humorless — and which has almost nothing to do with the first film — has

no such nostalgic charm. Instead, it's about four predatory coeds who arrive in Fort Lauderdale with their drugs, their booze and their bathing suits, along with their inflatable male doll. They keep busy by going to wild parties and sharing the camera's penchant for ogling bodies on the beach. They say things like "Check out those hamstrings!"

•

The stars, Lisa Hartman and Russell Todd, share a talent for looking good in torso-fitting outfits, and they also share the kind of small talk in which the screenplay specializes. (He: "I love this time of morning. It's so peaceful.") Also in the cast are Wendy Schaal as a virginal heiress, who does a chaste striptease while under the influence; Lynn-Holly Johnson, as the most lecherous of the bunch; Alana Stewart, as a very improbable society matron, and Lorna Luft, who seems much more-good-natured and appealing than the movie warrants.

Miss Luft, as a coed who decides to go on vacation without her longtime boyfriend, later enters a Hot Bod Contest, which the boyfriend happens to be watching. He says: "God, Carole, I thought I knew you. I guess I was wrong." It took two people, Stu Krieger and Jeff Burkhart, to write the screenplay.

•

It should be noted that the music is resoundingly mediocre, and that the original theme song isn't used here. It should also be noted that the producer, Alan Carr, who also made "Can't Stop the Music," has done it again. And it should be pointed out that the National theater, at which "Where the Boys Are" opened yesterday, spoiled whatever fun there was to be had by running the trailer for the movie, presumably left over from last week, just before the show. The trailer wasn't better than the real film, but it was shorter.

1984 Ap 7, 14:5

Raymond Cloutier

JUST A GAME, directed by Brigitte Sauriol; screenplay (French with English subtitles) by Miss Sauriol and Monique Messier; cinematography by Paul Van der Linden; edited by Marcel Pothier; music by Yves Laferrière; produced by Miss Messier, Yves Michon and Jacques Pettigrew; presented by the Film Society of Lincoln Center and the Department of Film of the Museum of Modern Art. At the 57th Street Playhouse, between Avenue of the Americas and Seventh Avenue. Running time: 101 minutes. This film has no rating.
Mychèle ... Marie Tifo
André Raymond Cloutier
Catherine Jennifer Grenier
Julie ... Julie Mongeau

By JANET MASLIN

As the Canadian film "Just a Game" begins, 13-year-old Catherine (Jennifer Grenier) is being picked up from her sailing lesson by her father, André (Raymond Cloutier). Catherine looks a little pouty about this, but we don't know why. Neither does her friend Maude (Julie Desjardins), who comments on what a dish Catherine's dad is. She cannot know that as soon as Catherine and her father drive away, he will berate her for having boyfriends, then take off his pants and once again try to force his daughter into the sort of activity that has made this family so troubled and so close.

If "Just a Game," which was directed by Brigitte Sauriol, were not in fact a selection of the New Directors/New Films festival, it would hardly seem like festival fare. Though the treatment is tawdrier, the film doesn't approach the subject of incest in any more depth than the television movie "Something About Amelia" did. "Just a Game" has been indifferently acted, and its screenplay is predictable. Much more energy is spent in documenting the family's problem than in understanding it.

•

Catherine spends a while trying to find a way to reveal her terrible secret, and then she tries to save her younger sister from a similar fate. In order to do this, she finds her father's cache of kiddie porn and leaves it under her mother's pillow. Her mother (Marie Tifo) is understandably upset, and becomes even more upset when she comes home to find her husband acquainting his 10-year-old daughter with the household sport. It was at this point, about two-thirds of the way into the film, that I left.

"Just a Game" will be shown tonight at 8:30 and Tuesday at 6 P.M. at the 57th Street Playhouse as part of the New Directors/New Films series.

1984 Ap 8, 64:3

THE TERENCE DAVIES TRILOGY, written and directed by Terence Davies; presented by the Film Society of Lincoln Center and the Department of Film of the Museum of Modern Art. At the 57th Street Playhouse, between Avenue of the Americas and Seventh Avenue. Running time: 101 minutes.
PART I: CHILDREN
Cinematography and lighting by William Diver; edited by Digby Rumsey and Sarah Ellis; produced by the British Film Institute.
WITH: Phillip Maudsley, Nick Stringer, Val Lilley, Robin Hooper

PART II: MADONNA & CHILD
Cinematography by William Diver; edited by Mick Audsley; produced by The National Film & TV School.
Tucker, age 40 Terry O'Sullivan
Mother, age 60 Sheila Raynor
WITH: Paul Barber, Dave Cooper

PART III: DEATH & TRANSFIGURATION
Cinematography and editing by William Diver; produced by Greater London Arts Association/British Film Institute.
Tucker, age 8 Iain Munro
Tucker, age 50 Terry O'Sullivan
Tucker, age 70 Wilfred Brambell
Mother, age 35 Lisa Parker
Mother, age 80 Jeanne Doree

By VINCENT CANBY

"The Terence Davies Trilogy," written and directed by Terence Davies, is an extremely dour, guilt-ridden little film about growing up poor, Roman Catholic and neurotic in Liverpool.

Specifically, it's about George Tucker, who, in the film's three segments ("Childhood," "Madonna and Child" and "Death and Transfiguration"), moves from childhood to old age and death in a state of penalizing lovelessness. Though artfully photographed in black-and-white, with much emphasis on religious iconography, the trilogy denies itself the freedoms of fiction, sticking to the grim details of George's life as if it were a psychiatric case history.

George, played by various actors at various ages, is beaten up and misunderstood at grammar school. At home he lives in fear of his father, who, though dying, terrifies George by slapping his mother around. Throughout his life, George remains devoted to his wispy mother. By the time he has grown up and has a boring job as an office clerk, George has become the sort of man who, after serving mum her nightcap of cocoa, slips out of the house wearing leather drag to cruise the city's homosexual hangouts.

"The Terence Davies Trilogy" has the manner of many other first works, being both too truthful and not truthful enough. It distorts what I take to be the truth by paying no attention to the impulses — and discipline — that eventually led to the creation of just such a film as this. It's Joycean but without the liberating spirit of humor and rebelliousness.

"The Terence Davies Trilogy" will be shown at the 57th Street Playhouse today at 3:30 P.M. and Tuesday at 8:30 P.M., as part of the New Directors/New Films series sponsored by the Film Society of Lincoln Center and the Museum of Modern Art's Department of Film.

1984 Ap 8, 64:3

FILM VIEW

VINCENT CANBY

Musicals Move Ahead While Looking Back

First there was "Saturday Night Fever." Then came "Flashdance" and "Staying Alive," the awful sequel to "Saturday Night Fever." Now, with "Footloose," a film with one foot in the historic past and one in the 80's, it does seem at last as if American musical films are getting a new look.

Like a bin full of jellybeans, "Footloose," directed by Herbert Ross, who began his career as a choreographer, is more easily inventoried than criticized. In case you haven't heard, this hugely popular film, which has been called the current season's "Flashdance," though it was apparently on the drawing board long before "Flashdance," is about a young Chicagoan named Ren (Kevin Bacon) who leads a successful crusade to be allowed to hold a senior prom in a small Middle Western town, where popular music and dancing have been outlawed.

It seems that several years before the film opens, the son of the pastor of the local "Risen Christ Is King" Baptist Church was killed in an auto accident, following a school dance at which hard liquor was drunk and who knows what was smoked. Since then, there has been no dancing allowed in Bomont because, as the pastor (John Lithgow) puts it, "When kids dance together, they become sexually irresponsible."

As a matter of fact, he's right, though, as the film repeatedly demonstrates, the young people of Bomont can become sexually irresponsible even without the help of "obscene rock and roll." When, however, near the end of the film, the pastor relaxes his opposition to the prom, it's not because he realizes that he's fighting a losing battle but because Ren has appeared before the town council to make a case for dancing-as-celebration using quotes from the Bible, including Ecclesiastes ("... there's a time to mourn and a time to dance").

Just before the fadeout there's a shot of the pastor and his cautiously liberated spouse (Dianne Wiest) embracing as they remember the good old days when they, too, danced.

Watching "Footloose," you may get a certain feeling of déjà vu. Much more than "Flashdance," whose narrative is so frail that it exists as little more than an abstract structure on which the disco numbers are suspended, this comparatively plot-laden new movie recalls the B-pictures of the 40's, 50's and 60's in which teen-agers taught their initially scandalized elders the joys of swing, then rock and, briefly, the twist. In the typical finale, there would always be a shot of granny and gramps, approvingly tapping their toes to the new beat and sometimes even, as the ancient phrase went, cutting a rug.

However, in those innocent, pre-pill days, when the now-defunct Production Code monitored movie mores, and when "going all the way" never actually happened between teen-agers, even off screen, dancing was always to be understood as a euphemism for sex. As the beat of the music became more pronounced over the years, so did the associations between dance and what we all knew it to represent. The lyrics for "Rock Around the Clock" didn't leave much to that generation's imagination.

However, now that sexual prohibitions have been relaxed, in movies as in real life, the point of a pop music-and-dance film like "Footloose" has become quite different from something like Sam Katzman's 1962 epic, "Don't Knock the Twist."

In "Footloose" as in "Flashdance" and "Saturday Night Fever," the dancing heroes and heroines are not expressing sexual longings they dare not give in to. It's apparent that most of them are as sexually active as they have time for. Rather, they are acting out more fuzzy feelings that, because the characters are almost illiterate, can never be expressed in words. What those feelings have to do with varies from scene to scene, from movie to movie.

In his big number in "Footloose," Ren, feeling misunderstood and out of step with small town manners, goes to an abandoned warehouse where, all alone except for some farm equipment, he dances away his angst. It makes no difference that the actual dancing is done by a double, Peter Tramm, who is listed in the credits as "stunt dancer." The spectacularly choreographed number exists as spectacle for its own sake. If it's exhilarating, and it is, it's in spite of the the film's dopey narrative, which also includes a mysterious subplot about — I'm not kidding — book-burning.

In "Flashdance," the heroine, acted by Jennifer Beals but danced, mostly, by Marine Jahan, frequently disco-dances alone in her tastefully appointed factory-loft, or on stage at what must be the world's most unlikely Pittsburgh beer joint, just for the sheer athletic pleasure of it.

An argument can be made that the dancing in "Footloose" has something to do with social protest, as it did back in the days of movies featuring the twist. A political point is scored when the pastor finally approves of the prom. However, in "Flashdance," though the choreography isn't great and though it contains gestures that the Production Code people might once have described as "suggestive," the dancing is an eye-filling display that is its own reason for being. Nobody is protesting anything. It's also erotic, not because its messages are hidden but because they aren't. Dancing is not a substitute for sex but another means of expression entirely.

The successful way in which "Flashdance" was promoted through the release of excerpts from the film as MTV video cassettes obviously did not go unnoticed by the producers of "Footloose." The film's "warehouse" production number is being given a big MTV play where, I suspect, it might look even better than it does in a film encumbered with so much absurd plot.

•

I've no idea whether or not these MTV videos are more than a fad, but they've already changed the look of theatrical films like "Flashdance" and "Footloose." What the long-range effects will be is anybody's guess — possibly for the better, in that they have made the public receptive to more abstract concepts than they usually get in movies, but possibly also for the worse. That is, if producers start to conceive of feature films as nothing much more than collections of scenes to be merchandized as video cassettes.

Though it has a jazzy look, "Footloose" has less in common with "Flashdance" than it does with those films in which popular music and dance were employed as a means of self-expression and/or social protest — films that have been with us since the beginning of the sound era, officially launched with "The Jazz Singer."

In that historic 1927 chestnut, Jack Robin (Al Jolson) simply could not help singing what he called jazz, which, in "The Jazz Singer," meant "Mammy," though it was his dying father's wish that he become a cantor. Jack Robin, born Jakie Rabbinowitz, could not deny his instincts and, by the end of the movie, his widowed mother was in the audience at the Winter Garden Theater, applauding her son doing a blackface number.

That reconciliation is not much different from the one that ends "Footloose." ■

1984 Ap 8, II:19:1

Population Control

THE BALLAD OF NARAYAMA, directed by Shohei Imamura; screenplay (Japanese with English subtitles) by Mr. Imamura, based on two novels by Shichiro Fukazawa; cinematography by Masao Tochizawa; music by Shinichiro Ikebe; produced by Toei Company, Ltd. and Imamura Production, Tokyo; presented by The Film Society of Lincoln Center and The Department of Film of the Museum of Modern Art. At the 57th Street Playhouse, between Avenue of the Americas and Seventh Avenue. Running time: 129 minutes. This film has no rating.
Orin Sumiko Sakamoto
Tatsuhei Ken Ogata
Oei Chieko Baisho
Risuke Tonpei Hidari
Tamayan Aki Takejo
Katsuzo Shoichi Ozawa

By VINCENT CANBY

NATURE is so rich and the life force so rampant in Shohei Imamura's "The Ballad of Narayama" that, after a preview screening, I was almost relieved to walk out into the man-made pollution of Times Square. Nature, thus prettified by Mr. Imamura, is almost as artifical as a world in which a virgin forest has been removed to make way for a cement-paved parking lot.

The new Japanese film, based on the same Shichiro Fukazawa stories that inspired Keisuke Kinoshita's 1958 film of the same name, means to be an ironic but life-affirming commentary on our so-called civilization by contrasting it with the manners and customs in a primitive Japanese mountain village 100 years ago.

Existence is not easy in the mountain village. Famine always threatens. The population is controlled mainly by tossing out newborn male children to die in the rice paddies. Female babies are retained for potential childbearing. If, by chance, a village elder has not died by age 70, the eldest child must carry the old person to a secret place near the summit of Mount Narayama, where the ancient one is left to die of starvation and exposure. In this fashion the community makes sure that there will be enough food for the survival of the rest of the villagers.

•

Like the Kinoshita film, Mr. Imamura's is concerned mainly with a hard-working, tough, 69-year-old woman named Orin, whose family includes two grown sons, one a widower and one a possibly simple-minded bachelor, and assorted grandchildren. Though she's in remarkably good shape, Orin feels that it's time she made the journey to Narayama.

She's lived long enough and she's tired. Once she has found a new wife for her widowed son, as well as a woman who will consent to make love with the other son, she insists that Tatsuhei, the widower, carry out his obligations to her, the family and the community by making the trip up Narayama.

This is the principal story of "The Ballad of Narayama," which also includes subplots about the villagers' merciless punishment of a family of thieves — they are buried alive — and a somewhat more light-hearted one about a young woman whose dying father insists that she sleep with every man in the village to atone for his own incestuous indiscretion.

Mr. Imamura is not a subtle film maker. He attempts to shock the audience into the realization that though this life order is harsh, it is beautiful in an efficiency that's prompted as much by love as by material needs. At one point, we watch old Orin as she systematically smashes out her teeth to be able to convince Tatsuhei that her years of usefulness are over.

•

The director puts great store by visual repetitions that emphasize the oneness of all nature. When a young man and a young woman are making frantic love in a field, he shows us

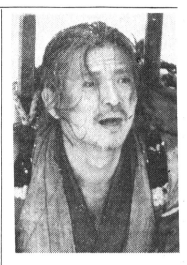

Ken Ogata in a scene from film "The Ballad of Narayama."

snakes, frogs, grasshoppers and birds engaged in similar pursuits. Unfortunately, an image of frogs, even in an amorous condition, evokes less wonder than amusement. In this world, it's not dog-eat-dog but snake-eat-rat and then, to balance things, rat-eat-snake, all seen in tight, nature-movie close-ups.

He's also fond of sequences that announce the changing of the seasons. The winter landscape melts toward spring and climaxes in an explosion of buds and grass, accompanied by the chirping of birds and the babbling of brooks containing frisky trout.

Though the performances are good, especially Sumiko Sakamoto's as Orin and Ken Ogata's as Tatsuhei, "The Ballad of Narayama" is too picturesque to reflect the simple austerity of the story it tells.

The sophisticated photographic techniques, including the long, lovely helicopter shot of snow-covered mountains that opens the film, have little to do with the primitive lives contained in the movie itself. The ultimate effect is not to celebrate nature, or to shock us out of our civilized lethargy, but to exploit nature in a manner designed to impress jaded audiences without actually disturbing them.

I'm not at all surprised that the movie won the grand prize at last year's Cannes Film Festival where, as I see it in my imagination, the audience applauded it madly and then went off to dine at three-star restaurants.

"The Ballad of Narayama" will be shown today at the 57th Street Playhouse at 6 and 8:30 P.M., in the New Directors/New Films Festival sponsored by the Film Society of Lincoln Center and the Museum of Modern Art's Department of Film.

1984 Ap 9, C14:5

IMPROPER CONDUCT, directed by Nestor Almendros and Orlando Jiménez-Leal; written (French and Spanish with English subtitles) by Mr. Almendros and Mr. Jimenez-Leal; cinematography by Dominique Merlin; edited by Michel Pion; produced by Margaret Menegoz, Barbet Schroeder and Michel Thoulouze; a coprodution of Les Films du Losange and Antenne 2; presented by the Film Society of Lincoln Center and the department of Film of the Museum of Modern Art. At the 57th Street Playhouse, between the Avenue of the Americas and Seventh Avenue. Running time: 110 minutes. This film has no rating.
Commentary by Michel Dumoulin
WITH: Reinaldo Arenas, Susan Sontag, Heberto Padilla, Caracol, Guillermo Cabrera Infante, Armando Valladares, Fidel Castro, Ana Maria Simo, Juan Goytisolo, Carlos Franqui, Martha Frayde, Renne Ariza

By VINCENT CANBY

"IMPROPER CONDUCT" ("Mauvaise Conduite") is something very rare in films — an intelligent attack on Fidel Castro's Cuban revolution, mostly as recorded in interviews with 28 Cuban exiles, including former members and supporters of the Castro regime.

The movie's tone is civilized, but the testimony is as savage as it's convincing. There's no possibility for the tempered, long view of events that makes such films as "Seeing Red" and "The Good Fight" so moving. In those two films, survivors of the wars fought by the old American Left look back with pride, humor and sometimes regret. The wounds remembered in "Improper Conduct" are still raw. There is less disillusion here than continuing rage.

The film, one of the best in this year's New Directors/New Films festival, has been jointly directed by two prominent Cuban exiles, Nestor Almendros and Orlando Jiménez-Leal. Mr. Almendros is the Academy Award-winning cameraman ("Days of Heaven") who has worked most memorably with Eric Rohmer and François Truffaut, and Mr. Jiménez-Leal is the co-director of "El Super" (1979), a very funny if sad comedy about Cuban exiles adjusting to life in Manhattan.

"Improper Conduct" will be shown at the 57th Street Playhouse today at 8:30 P.M. and tomorrow at 6 P.M.

The film opens with newsreel footage covering the defection in Paris in 1966 of 10 members of the Cuban National Ballet Company, an event that surprised many Castro supporters in this country, where the revolution was — and still is — a popular cause among liberal members of the intelligentsia. At the time, the defections seemed to be an isolated event. However, as recalled by the witnesses in "Improper Conduct," they were simply the first public evidence of the disenchantment that had begun several years earlier as the Castro Government took an increasingly hard line against so-called "antisocial" elements.

These included political and artistic dissidents and homosexuals, particularly male homosexuals, whose presence embarrassed the Latin macho image that the Castro Government sought for itself. As one witness testifies, homosexuals could be tolerated within the Government, as well as within the police, as long as they were "manly" homosexuals. Any suggestion of effeminacy could be interpreted as counter-revolutionary.

The witnesses in "Improper Conduct" include distinguished writers, journalists, playwrights, doctors, poets and painters, as well as more ordinary folk such as tour guides and hairdressers, a number of whom spent time in one or more of the country's forced-labor camps. It's to the film's credit that it also includes the testimony of Caracol, a transvestite nightclub performer, whose story is as relevant to the film as that of anyone else.

One of the most eloquent witnesses is Armando Valladares, the poet who had spent 22 years in prison before being released, largely at the urging of President François Mitterrand of France. Mr. Valladares, interviewed in Madrid, tells one especially harrowing story of a 12-year-old boy, imprisoned for a minor offense, who was tortured by guards and raped by other inmates.

Intercut with these interviews, filmed in Paris, New York, Miami, London, Rome and Madrid, are excerpts from a 1979 television interview in which the Cuban Premier asserts that his revolution cannot be accused of having killed one citizen or of having tortured one prisoner.

"Tell me," he says, "any other examples of this in history."

Susan Sontag, the American critic and a former supporter of the Castro regime, describes the Castro campaign against homosexuals as "a heritage, in a way a 'Puritan' one, that is deeply embedded in the morals of the Left." She continues: "The discovery that homosexuals were being persecuted in Cuba shows, I think, how much the Left needs to evolve."

"Improper Conduct" is the first legitimately provocative anti-Castro film I've seen.

1984 Ap 11, C19:1

Fearful Camels

FROM SOMALIA WITH LOVE, directed and written by Frédéric Mitterand; cinematography by John Cressey; edited by Luc Barnier; music by Jean Wiener; produced by Les Films du Losange and FR 3; narrated in English by Mr. Mitterand; presented by The Film Society of Lincoln Center and The Department of Film of the Museum of Modern Art. At the 57th Street Playhouse, between Avenue of the America and Seventh Avenue. Running time: 100 minutes. This film has no rating.

FREDERIC MITTERAND'S "From Somalia With Love" exists as a visitor's meditation on that country, with reflections on the culture, history, climate and population of Somalia delivered by a narrator's lulling monotone. These observations are interspersed with the same man's memories of a love affair, which are linked with his thoughts about Somalia in an insistent but oblique fashion.

Mr. Mitterand, who operates a chain of art-house theaters in France and who is the nephew of President François Mitterand, has directed the film in something like a "Hiroshima, Mon Amour" style, with an intermingling of personal and historical information. It feels mannered and familiar in that regard, but in documentary terms it is more interesting. Mr. Mitterand's images of Somalia convey an evocative sense of the place, and they are effectively narrow and specific. Even in showing, say, the sight of screaming camels being hoisted onto cargo ships so that they can be sold abroad, the film conveys a very particular and bizarre impression.

"From Somalia With Love," which will be shown tonight at 8:30 P.M. as part of the New Directors/New Films series, is addressed to the narrator's missing lover. "What a shame; it's too late; between us the post still doesn't work," he says. "The cinema, however, has an advantage over letters: I can both send you these letters and keep them close to myself." That implies both urgency and intimacy, while Mr. Mitterand's film is too coolly dispassionate to have either.

1984 Ap 12, C16:3

A Lot of Dachshunds

TURUMBA, directed and written by Kidlat Tahimik (in Tagalog with English subtitles); distributed by Flower Films. At the Film Forum, 57 Watts Street. Running time: 95 minutes. This film has no rating.
WITH: Herman Abiad, Katrin Luise

By JANET MASLIN

"TURUMBA," the second feature by the Philippine film maker Kidlat Tahimik, unfolds in a gradual and deceptively deadpan style. It takes place in a small village, where the festival of the title is an occasion for every family to make papier-mâché figurines. Beginning by showing the various customs that surround the festival, it follows the process by which one family starts a manufacturing operation, eventually producing 25,000 toy dachshunds for the 1972 Munich Olympics.

"Turumba," which opened yesterday at the Film Forum, is acted in a slightly stiff style, since it is just scripted enough to lack spontaneity. That does not mean it is without wit, however. Mr. Tahimik's screenplay interjects all sorts of incongruously Western locutions, like "export order," into the speech of the villagers, and has them marvel over each new dividend that their prosperity brings — a radio that plays rock songs in the jungle, for instance, or an electric fan. When a truck arrives to cart the 25,000 toy dogs away, the people gather around it for a farewell. Or they may, as one local cynic suggests, be thanking the truck for exorcising the devil.

The plainness of "Turumba" gives it an insinuating, almost offhanded humor that by no means undermines the seriousness of the villagers' plight. By the end of the film, they have become ever more successfully westernized, with the film's two main characters about to embark for their first trip to Europe. Not exactly by coincidence, there is a typhoon on the horizon.

1984 Ap 12, C20:5

PRIVATES ON PARADE, directed by Michael Blakemore; screenplay and lyrics by Peter Nichols; director of photography, Ian Wilson; edited by Jim Clark; music by Denis King; produced by Simon Relph; released by Orion Classics. At Cinema 2, Third Avenue and 60th Street. Running time: 96 minutes. This film is rated R.
Major Giles Flack..............................John Cleese
Acting Capt. Terri Dennis..............Denis Quilley
Sgt. Maj. Reg Drummond..........Michael Elphick
Acting Lieut. Sylvia Morgan..........Nicola Pagett
Flight Sgt. Kevin Cartwright..........Bruce Payne
Sgt. Len Bonny.................................Joe Mella
Sgt. Charles Bishop.....................David Bamber
Sgt. Eric Young-Love....................Simon Jones
Sgt. Steven Flowers..................Patrick Pearson
Lee ..Phil Tan
Cheng ..Vincent Wong

By VINCENT CANBY

BEHIND the opening credits of "Privates on Parade," a cartoon sun sinks slowly behind a cartoon palm tree, setting, in effect, on the entire British Empire. The simple, comic image is a fitting way to begin this fine, witty, extremely self-assured English film, which opens today at the Cinema 2.

Adapted by Peter Nichols from his own stage play and directed to near-perfection by Michael Blakemore, "Privates on Parade" is something seldom seen in movies — a melodramatic farce that comes complete with songs, dances, lewd jokes, sudden death, teary sentiment and smashing performances. Under ordinary circumstances, screen realism and the old plausibility factor make such stylization a risky business.

•

Mr. Blakemore, currently represented on Broadway by his direction of Michael Frayn's farce "Noises Off," succeeds brilliantly, suggesting the kind of cinematic approach that might have worked for the screen version of Joan Littlewood's "Oh, What a Lovely War." Richard Attenborough turned that small, sardonic stage piece into a huge white elephant of a movie, loaded with stars and spectacular sets, the sort of pageant one might expect to see in celebration of Stonehenge's first millennium.

The scale of "Privates on Parade" is small, but the effect is large and lethally funny. The time is 1948, and the place is Singapore where a raggletaggle bunch of British soldiers is on special assignment as something called the Song and Dance Unit, Southeast Asia. Their mission: to put together a revue called "Jungle Jamboree" as entertainment for mainland troops, at that time fighting Communist-led guerrillas for control of the Malay Peninsula.

•

The group's commanding officer, a madly gung-ho fellow named Maj. Giles Flack, is convinced that World War III has begun, and though real bullets are being fired and men are being killed, he refuses to see the equally dirty business that is going on in his own eccentric command. As played by the incomparable John Cleese, the tallest and one of the funniest of the Monty Python troupe, Major Flack has the dangerous innocence of an Evelyn Waugh hero.

He likes to give impromptu seminars to his troops on the two principal causes of the decline of the West ("luxury and blasphemy") and to

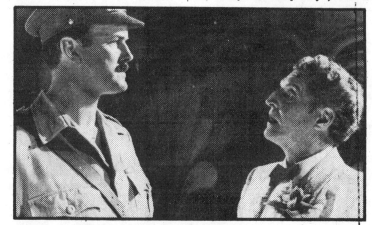

John Cleese appearing with Denis Quilley, right, in "Privates on Parade."

toast "the victory of Christian enlightenment," but he is serenely unaware that one of his most trusted aides is busily engaged in selling arms and ammunition to the enemy.

He's also naïve when it comes to theater and theater people, magnificently represented by Acting Capt. Terri Dennis, who has been recruited in London to put "Jungle Jamboree" together. Terri is the role of a lifetime, and Denis Quilley, who heretofore has been seen only in small assignments in this country, never lets us forget it.

His Terri is a camp figure of heroic proportions, an aging music-hall queen, who calls his troops "dears." When he is using a more personal approach, he changes the genders of their given names so that Reggie becomes Regina, Eric is Erica and Leonard Leonora. When at the end of his short tether and in need of swearing, he lets out a furiously theatrical "Oh, Jessica!"

It's a hilarious, show-bizzy performance, as sentimental as it is wise and as broad as Asia, especially when he puts on drag, as he frequently does, to perform the series of pint-size production numbers in the show-within-the-film. He's a pricelessly coquettish Carmen Miranda, and peculiarly enough, when he puts on a blond wig to impersonate Patti Andrews of the Andrews Sisters, singing something sidesplitting called "Pistol-Packing Deputy of Okinawa," he looks like — and has the dignity of — Rose Kennedy.

The large cast of fine supporting players, mostly unknown in this country, includes Michael Elphick, as a smoothly brutal sergeant; Nicola Pagett, as the troupe's only female member, a beautiful young woman who is frowned upon by the officers because she is half-Indian and half-English; Joe Melia, as a noncommissioned officer whose every other word is obscene, and Patrick Pearson, as a new recruit, who, in the manner of the entire film, is never surprised by the unconventional behavior of everyone around him.

Mr. Blakemore's most important achievement is the way he effortlessly shifts among the film's many contradictory moods, from innocent farce into melodrama, from reality into that compressed reality obtained through song and dance. The film's production numbers are tiny but elegant. Mr. Pearson and Miss Pagett do a Fred Astaire-Ginger Rogers takeoff that is simultaneously sweet, tacky and lovely. Mr. Melia and David Bamber, who plays his fellow soldier and lover, sing and dance a soft-shoe routine that, if this were live theater, would stop the show.

Denis King composed and orchestrated the excellent original score, which includes Mr. Nichols's own, very accomplished, parodic lyrics. A note of caution: do not get up to leave when the film appears to be over. An epilogue, seen behind the closing credits, is so good that one wants the movie to keep on going. That, I think, is almost unheard of these days.

1984 Ap 13, C8:1

ICEMAN, directed by Fred Schepisi; screenplay by Chip Proser and John Drimmer; story by Mr. Drimmer; director of photography, Ian Baker; edited by Billy Weber; music by Bruce Smeaton; produced by Patrick Palmer and Norman Jewison; released by Universal Pictures. At the Sutton, Third Avenue and 57th Street; National, Broadway and 44th Street; U.A. East 85th Street, at First Avenue, and other theaters. Running time: 101 minutes. This film is rated PG.

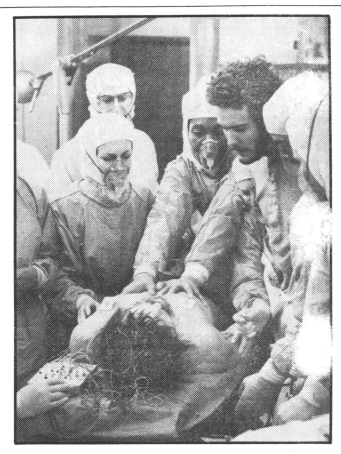

A team of scientists in "Iceman" scrutinizes a primitive creature. Timothy Hutton and Lindsay Crouse star in the Fred Schepisi film.

Dr. Stanley Shephard.................Timothy Hutton
Dr. Diane Brady..........................Lindsay Crouse
Charlie...John Lone
Whitman......................................Josef Sommer
Dr. Singe..................................David Strathairn
Dr. Vermeil....................................Philip Akin
Loomis.......................................Danny Glover
Mabel..Amelia Hall
Hogan......................................Richard Monette
Maynard.....................................James Tolkan

By JANET MASLIN

"ICEMAN" isn't much of a movie, but what a science project! There in the Arctic wilds, scientists discover a block of ice in which a Neanderthal man has been frozen (this footage is actually quite beautiful). Then they transport the specimen back to their lab and begin slicing the ice with lasers, as the camera records every drip. When the thawing is complete, they prepare to perform an autopsy on the man, who has also been hooked up to a battery of machines. Suddenly, there are some unexpected beeps. It's brain-wave activity! Cancel the autopsy, please.

There's a certain ghoulish excitement to all this, but it is quickly dissipated. Pretty soon, the caveman, who had a bluish pallor in his frozen state, has developed a surfer's tan and a proclivity for leaping about and screeching. In the elaborate artificial enviroment that the lab's bears had been using, he takes up residence and begins making fires, hunting small animals and resuming other old habits. John Lone does a fine job of making the caveman sympathetic, and he is wildly animated in the role. But the material has its limitations.

So do the scientists' roles, as envisioned in the screenplay by Chip Proser and John Drimmer. As Dr. Stanley Shephard, Timothy Hutton looks realistically dedicated and disheveled, and conveys an intense fascination with the project. As Dr. Diane Brady, Lindsay Crouse uses snappishness and irritability to convey concentration. On their own they're relatively charmless, even in a quasiromantic scene in which he says, "I want to unfreeze you, to check your vital signs."

But the caveman, nicknamed Charlie, somehow brings out their humanity, especially in a scene in which Dr. Brady, as part of the experiment, enters Charlie's lair. Moments later, Charlie shocks Dr. Brady by attempting what, in view of his 40,000 years in isolation, probably shouldn't have caught her by surprise. After all, 40,000 years is a long time.

Fred Schepisi's direction of "Iceman" has a solemn, high-tech feeling, with a great many shots of scientists marching down long corridors as they discuss the project in staccato tones; these parts of the film aren't very different from what might be seen on a television medical show. Sequences involving Mr. Lone's Charlie have more poetry, although they, too, seem ploddingly literal much of the time. The ending, on the other hand, sounds a more metaphorical note, but its exact import is not made clear. Five viewers might well give five accounts of the film's closing moments.

•

"Iceman" is rated PG ("Parental Guidance Suggested"). It contains some sexual suggestiveness and mildly strong language.

1984 Ap 13, C10:1

Blame the TR's

SUBURBIA, directed by Penelope Spheeris; screenplay by Miss Spheeris; director of photography, Timothy Suhrstedt; edited by Ross Albert; produced by Bert Dragin; released by New Horizons. At the Waverly 2, Avenue of the Americas at Waverly Place. Running time: 99 minutes. This film is rated R.
Jack....................................Chris Pederson
Evan.......................................Bill Coyne
Sheila.................................Jennifer Clay
Tom..............................Timothy Eric O'Brien
Razzle................................Michael Bayer
Joe Schmo..........................Wade Walston
Ethan...................................Andrew Pece
Keef......................................Grant Miner
De Generate.......................Dee Waldron
Mattie...............................Maggie Ehrig
T'resa..............................Christina Beck
Peg Leg...........................Andre Boutilier

BETWEEN its alarming though not especially pertinent precredit sequence, in which a baby is fatally attacked by a Doberman pinscher, and its apocalyptic finale, in which another innocent is lost, Penelope Spheeris's "Suburbia" is a clear-eyed, compassionate melodrama about a bunch of young dropouts who call themselves "The Rejected" or, for short, the TR's.

The TR's range in age from about 6 to 18 and enjoy a squalid, comparatively happy if not tranquil existence in an abandoned bungalow in a Los Angeles area that's been condemned to make way for a new freeway. Mostly refugees from broken, lower-middle-class families, they live a version of a punk-rock life-style that is actually more picturesque than dangerous, though a local vigilante group, Citizens against Crime, blames the TR's for all the ills of the community.

The gang includes Jack, a good-looking young man who wears a single earring and is disenchanted because his mother has given him a black stepfather, the only decent adult in the film; Evan and his baby brother, Ethan, who have run away from an alcoholic mother; Joe, who disapproves of his father's homosexuality; Sheila, whose father would alternately molest her sexually and then beat her; plus one drug addict, one fellow who can only relate to rats and two young women with hair dyed rose color who like to be read to from fairy tales.

"Suburbia," which opens today at the Waverly 2, was written as well as directed by Miss Spheeris, the talented young woman who produced the Albert Brooks comedy "Real Life" and then made the highly regarded documentary "Decline of Western Civilization," about Los Angeles's punk-rock scene.

Her new film is probably the best teen-agers-in-revolt movie since Jonathan Kaplan's "Over the Edge." It's far better than Francis Ford Coppola's "Outsiders" and "Rumble Fish," having none of the ersatz poetry that was poured like maple syrup over the two Coppola movies.

•

"Suburbia" is at its best when it is simply observing the randomness of the lives of its young people, watching them at aggressive play in a punk-rock club, stealing food from suburban freezers or just sitting around in the garbage of their beloved pad. The performances by the nonprofessional young actors are self-conscious and completely believable.

In this sort of film, unfortunately, a plot is obligatory. Though Miss Spheeris's is not particularly far-fetched, it is contrived, and its order-liness seems alien to the documentary-like, aimless reality of everything else. The plot gives shape to the

movie, but in doing that, it also undercuts the film's more serious intentions. "Suburbia" is a good genre film.

Vincent Canby

1984 Ap 13, C10:1

A Wartime Romance

SWING SHIFT, directed by Jonathan Demme; written by Rob Morton; director of photography, Tak Fujimoto; edited by Craig McKay; music by Patrick Williams; produced by Jerry Bick; released by Warner Bros. At the Gemini, Second Avenue and 64th Street; Warner, Broadway and 47th Street; Art, University Place and Eighth Street. Running time: 112 minutes. This film is rated PG.

Kay Walsh	Goldie Hawn
Lucky Lockhart	Kurt Russell
Hazel Zanussi	Christine Lahti
Biscuits Toohey	Fred Ward
Jack Walsh	Ed Harris
Annie	Sudie Bond
Jeannie Sherman	Holly Hunter
Laverne	Patty Maloney
Violet Mulligan	Lisa Pelikan
Edith Castle	Susan Peretz
Johnny Bonnano	Joey Aresco
Clarence	Morris (Tex) Biggs

"SWING SHIFT," directed by Jonathan Demme and written by Rob Morton, a pseudonym, is a sweet romantic comedy about America's World War II "soldiers without guns," the women who gave up their household duties to fill the sudden demand for workers in industries once staffed exclusively by men. At the war's end, most of the women went back to their pots and pans, but the first shots had been fired in the mid-20th century war for women's liberation.

As he has already demonstrated

In "Swing Shift," Goldie Hawn portrays a Navy wife working in a factory during World War II.

with "Handle with Care," also known as "Citizens' Band," and for "Melvin and Howard," Mr. Demme has a special talent for locating the humor and pathos within the commonplace experiences of American life. In "Swing Shift," he and five exceptionally gifted performers — Goldie Hawn, Kurt Russell, Christine Lahti, Ed Harris and Fred Ward — gracefully bend, without breaking, the clichés of a kind of romantic fiction not too far removed from World War II movies about the home front.

When her husband Jack (Mr. Harris) joins the Navy after Pearl Harbor, Kay Walsh (Miss Hawn), who has never before been employed as anything except a homemaker, takes a job as a riveter at the McBride Aircraft Company outside Santa Monica. Kay's subsequent adventures are not exactly unique, but, as played by Miss Hawn and her associates, they have the charm of an adult fable, one that at any minute might turn bleak.

Kay first acquires a new friend, Hazel Zanussi (Miss Lahti), a tall, beautiful, wise-cracking sidekick, the sort of role that, 40 years ago, would have been played somewhat more grotesquely by Joan Davis. She also picks up an initially unwanted suitor — handsome, smooth-talking Lucky Lockhart (Mr. Russell), a foreman at the aircraft factory who, it turns out, has a bad heart. This not only keeps him out of the service, but provides the movie with a certain amount of uneasy suspense. Is the civilian Lucky likely to succumb while Jack Walsh, serving on a cruiser in the Pacific, survives?

Lucky is a musician first and a factory worker second. He's also a genuinely nice guy and after a year or so of his gentle but persistent attentions, Kay gives in. It's at this point that Mr. Demme and the film's pseudonymous writer start working their variations on World War II formula fiction.

•

The affair prompts a lot of guilt feelings in Kay, but the audience knows, through Miss Hawn's expert performance, that it actually is possible to love two men at the same time. The audience, in fact, is pulling for her, and even looking for flaws in the absent Jack to justify her actions. That Jack remains a decent fellow , even after he returns unannounced and suspects the truth, adds uncharacteristic complexity to the tale. It also comes very close to being unbelievable, and might have been, if the playing and the direction were less assured.

"Swing Shift," which opens today at the Gemini and other theaters, offers Miss Hawn her best role since "Private Benjamin," and she is most winning. She's looking great these days and, at times, even a bit like Marilyn Monroe, though the public personality is far more knowing and wise. Mr. Russell continues to grow as an actor and here, wearing glasses and the haircut of the period, he's hardly recognizable as Meryl Streep's lover in "Silkwood."

"Swing Shift" is one of those movies in which characters are revealed solely in terms of contemporary action, which requires that the actors themselves — by the way they look, sound and behave — supply what in written fiction would be exposition. Miss Lahti is so good that she turns a secondary role into a major one, even though her character's surname is Zanussi. (It used to be a Hollywood practice to give leading characters Anglo-Saxon or Celtic names, while identifying secondary characters with names suggesting other ethnic backgrounds.)

Mr. Harris and Mr. Ward, currently appearing as two of the more colorful astronauts in "The Right Stuff," are fine in much smaller roles in "Swing Shift." Mr. Ward, in fact, is scarcely on screen long enough to establish any character at all, but gives weight that is not in the screenplay to the role of Hazel Zanussi's philandering fellow, a dance-hall owner.

About the screenplay: according to the official credits, it was written by Rob Morton. A spokesman for the producer confirms that this is a pseudonym for Nancy Dowd ("Slapshot," "Coming Home"). There have also been reports — unconfirmed — that Robert Towne, whose contributions to "Greystoke" are credited to "P.H. Vazak," wrote additional material for "Swing Shift," though it's unknown whether any of this unconfirmed material is in the finished film.

Despite what seem to have been certain differences of opinion in the course of the production, "Swing Shift" plays very smoothly. No one need be ashamed.

•

"Swing Shift," which has been rated PG ("parental guidance suggested"), contains some not overly explicit sexual scenes and mildly rude language.

Vincent Canby

1984 Ap 13, C13:1

FRIDAY THE 13TH — THE FINAL CHAPTER, directed by Joseph Zito; screenplay by Barney Cohen; story by Bruce Hidemi Sakow; music by Harry Manfredini; produced by Frank Mancuso Jr.; released by Paramount Pictures. Running time: 91 minutes. This film is rated R. At Loews State, Broadway and 45th Street; Orpheum, 86th Street and Third Avenue, and other theaters. Running time: 91 minutes. This film is rated R.

Trish	Kimberly Beck
Tommy Jarvis	Corey Feldman
Rob	E. Erich Anderson
Doug	Peter Barton
Sara	Barbara Howard
Jimmy	Crispin Glover
Ted	Lawrence Monoson

By JANET MASLIN

A promise is a promise, or at least it ought to be. But despite its title, "Friday the 13th — The Final Chapter" shows no signs of being the last in its none-too-illustrious line. By the end of the film, the vicious killer, Jason, has indeed been bested by a small boy who attacks him with a machete ("splitting his skull in two, lengthwise," as the production notes explain for the purist's benefit). The experience has such an unfortunate effect on the boy himself that at the film's end he appears all set to resume his machete work for "Friday the 13th V."

The first, second and third films in the series are lovingly recapitulated in an opening montage in "The Final Chapter," which opened yesterday at Loews State and other theaters. Meanwhile, a camp counselor tells his charges: "I don't want to scare anyone, but I want to give it to you straight about Jason. His body has never been found." Just our luck, we find it. It's under a sheet in a hospital somewhere and in no time flat it has dispatched a couple of morgue attendants and gone out in search of its favorite prey: cute teens.

"Did you hear about that place next door? It's being rented by some kids!" No sooner have a pretty blond mother and daughter exchanged these famous last words than their secluded neck of the woods fills up with the sort of kid who, in order to make Jason's work simplicity itself, obligingly goes skinny dipping alone. Among these new housemates, most of the girls are sexually aggressive, even pushy; the boys, meanwhile, discuss doubts about their virility. The boys seem at some slight disadvantage until Jason arrives.

While not exactly an actress picture, "The Final Chapter" takes pains to make its characters a little more personable than the horror-movie norm. This is unfortunate, since there is nothing to do during the second half of the film but watch them die.

1984 Ap 14, 15:1

WILD HORSES, directed by Derek Morton; screenplay by Kevin Wilson; director of photography, Doug Milsome; edited by Simon Reece; produced by John Barnett; released by Satori Entertainment. At Eastside Cinema, Third Avenue between 55th and 56th Streets. Running time: 90 minutes. This film has no rating.

Dan Mitchell	Keith Aberdein
Jack Sullivan	John Bach
Harry Sullivan	Kevin Wilson
Mary Mitchell	Kathy Rawlings
Anne Mitchell	Helena Wilson
Sara	Robyn Gibbes
Sam Richardson	Tom Poata
Andy	Marshall Napier
Kingi	Matiu Mareikura
Jones	Martyn Sanderson
Joe	Peter Tait
Tyson	Bruno Lawrence
Benson	Michael Haig
Ranger	Richard Poore

By VINCENT CANBY

WE'VE had American westerns, Italian westerns, Spanish westerns, Yugoslav westerns, Aus-

tralian westerns and now "Wild Horses," a New Zealand western that opens today at the Eastside Cinema. Don't add it to your must-see list.

"Wild Horses," directed by Derek Morton from an original screenplay by Kevin O'Sullivan, is said to be based on fact. In the 1960's, the Government authorized the killing or trapping of all animals in Tongariro National Park not indigenous to New Zealand's North Island. These included deer and wild horses. The screenplay is about an idealistic, recently out-of-work young logger who takes his wife and child to the park and, with two former rodeo riders, tries to make his living catching the wild horses for later sale. Also roaming the park are deer hunters in the pay of a venison-packing company. The deer hunters maintain that the horse-catchers scare away their prey and begin shooting the wild horses at random and in quantity.

•

The confrontations between the two sides are not of great moment, though the director solemnly invests them with the trappings of the sort of classic westerns in which homesteaders face down greedy cattle barons.

"Wild Horses" is full of familiar mannerisms — long shots of riders silhouetted against the sky, speeches that make reference to rugged individualism, a hero who is identified with a white horse and a villain who rides a black one. Nothing works, though. Mr. Morton's attempts to impose a shape on his material are like those of a small, earnest child trying to fit together two noncontiguous pieces of a jigsaw puzzle.

•

The cast includes two actors who helped make Roger Donaldson's "Smash Palace" so memorable. Bruno Lawrence, who played the lead in "Smash Palace," appears as the black-clad villain, and Keith Aberdein, who was the policeman in that earlier film, plays the obsessed hero. Like everyone else in the movie, they are dwarfed by the scenery.

1984 Ap 19, C15:1

Two Survivors

CHAMPIONS, directed by John Irvin; screenplay by Evan Jones, based on the book "Champion's Story" by Bob Champion and Jonathan Powell; edited by Peter Honess; music composed and conducted by Carl Davis; produced by Peter Shaw; an Embassy Pictures Release. At the Tower East, Third Avenue and 72d Street, and the 57th Street Playhouse, 57th Street, between Avenue of the Americas and Seventh Avenue. Running time: 115 minutes. This film is rated PG.

Bob Champion	John Hurt
Peter	Gregory Jones
Snowy	Mick Dillon
Valda Embiricos	Ann Bell
Jo	Jan Francis
Nick Embiricos	Peter Barkworth
Josh Gifford	Edward Woodward
Burly Cocks	Ben Johnson
Barbara	Kirstie Alley
Mary Hussey	Alison Steadman
Griffith Jones	Jonathan Newth
Nurses	Ceri Jackson, Francesca Brill
Graham	Andrew Wilde
Dr. Merrow	Judy Parfitt
Sally	Carolyn Pickles
Helen	Fiona Victory
Emma Hussey	Julie Adams
Richard Hussey	Michael Byrne
Nicky Hussey	Richard Adams

By VINCENT CANBY

IN the summer of 1979, Bob Champion, one of Britain's leading jockeys, was told that he had cancer and that he would live no more than eight months without chemotherapy. Not long afterward, Aldaniti, his favorite mount, suffered a leg injury. Though Aldaniti was not put down, as the veterinarian recommended, he was not expected

to race again.

That Bob Champion and Aldaniti both survived and went on together to win the 1981 Grand National Steeplechase is something of a miracle, as well as testimony to their courage and the wonders of modern medicine.

Taking this true story as their source material, John Irvin, the director, and Evan Jones, the screenwriter, have worked an antimiracle: They've made a movie, "Champions," that is almost totally devoid of suspense and emotional impact. I'm not sure why this happens, but it can't have been easy.

The main problem is not that we know how it's all going to turn out, though the hindsight with which the film is conceived gives it a kind of smugness. There is more of a problem in the casting of John Hurt as Bob Champion. Mr. Hurt (of "Elephant Man," "Heaven's Gate") is too good an actor to play for the sort of pathos that such narratives demand.

He has an intelligent, serious, but not especially appealing screen presence that would make something more immediately compelling of his ordeal, which the film dramatizes at length. The audience is spared few of the details of his chemotherapy and its side effects, including drastic weight loss, weakness, baldness, nausea and intense depression.

Far more damaging are the contributions of the director and the writer. When confronted by important decisions, Mr. Irvin ("The Dogs of War," "Ghost Story") and Mr. Jones appear to make all the wrong ones. In sequence after sequence, Mr. Irvin cross-cuts between two scenes in a manner that annihilates interest instead of creating it. A simple, straightforward story is made to look complicated by fancy editing. Also, the dialogue that means to be sharp and lifelike too often destroys its own intentions.

"What's the matter?" a hospital visitor cheerily asks Bob just after one of his testicles has been removed.

"They gelded you at last?" The audience laughs not with the rueful Bob, but at the film's unfortunate stab at wit.

In one way and another, the film makers even manage to turn the climactic Grand National, one of the most spectacular races in the world, into an anticlimax. The film's real ending is a final credit card that reports that Bob Champion has retired from racing, opened his own training stable, married happily and fathered a son, born Nov. 3, 1983.

"Champions" opens today at the Tower East and 57th Street Playhouse.

•

"Champions," which has been rated PG ("Parental Guidance Suggested"), includes some harrowing hospital scenes as well as some mildly vulgar language.

1984 Ap 20, C8:1

Praying for a Kiss

KIPPERBANG, directed by Michael Apted; screenplay by Jack Rosenthal; director of photography, Tony Pierce-Roberts; edited by John Shirley; produced by Chris Griffin; released by MGM/UA Classics. At the 68th Street Playhouse, Third Avenue and 68th Street. Running time: 85 minutes. This film is rated PG.

Alan	John Albasiny
Ann	Abigail Cruttenden
Geoffrey	Maurice Dee
Miss Land	Alison Steadman
Tommy	Garry Cooper
Headmaster	Robert Urquhart
Abbo	Mark Brailsford
Shaz	Chris Karallis
Eunice	Francis Ruffelle
Maureen	Nicola Prince

By JANET MASLIN

THE schoolboy nostalgia of "Kipperbang" is as decorous as an English garden and as colorful as some of the epithets that are bestowed upon the film's leading character — a "weed," a "beast of the field" and a "lying toad." In reality, he is a 14-year-old public-school student and cricket enthusiast in the England of 1948, pray-

ing that he will receive his first kiss "early next week at the latest, weather permitting."

"Kipperbang" is the sort of film that allows Alan Duckworth (John Albasiny), who is known to his classmates as Quack Quack, to surmount impossible odds in attracting the girl of his dreams. It takes a class play, in which Alan is cast as a most unlikely ladies' man, to bring the miraculous kiss within his reach. In a less lofty film, Alan might simply embrace Ann (Abigail Cruttenden) and savor the experience as a rite of passage. Here, he makes a speech and learns a lesson instead.

•

The best things about "Kipperbang," which opens today at the 68th Street Playhouse, are the richly evocative look of the production (David Puttnam was the executive producer) and the screenplay by Jack Rosenthal, which includes some clever turns of phrase. Structurally, the material is more ordinary, as it intercuts Alan's adventures with illicit affairs among the teachers at his school. An English teacher is involved with a handsome young groundskeeper, who is renowned as a war hero; during the war, she had a fling with the married headmaster. The teacher, played as an otherwise very chaste character by Alison Steadman, seems, if anything, a bit less worldly than her students. And the final irony of the groundskeeper's story is more than this otherwise-delicate movie can bear.

There are flashes of undue hindsight and precocity in Alan, who, as played by Mr. Albasiny, also tends to strain too hard for charm. The daydreams that intrude upon Alan's reality are somewhat awkward, although they may have been more graceful upon the page. Imagining his life as a great cricket match, Alan supplies a running commentary at key moments: "Once more Duckworth is left frustrated and forlorn at the wicket," he tells himself on the occasion of one near-kiss. The film, which is otherwise gentle and even languid, isn't really playful enough to

The mind of the British schoolboy Duckworth, played by John Albasiny, is filled with dreams of glory on the cricket field and of kissing his schoolmate Ann (Abigail Cruttenden) in "Kipperbang."

accommodate such flights of fancy.

"Kipperbang," which is rated PG (Parental Guidance Suggested), contains a little bit of school-boy talk about sex.

1984 Ap 20, C11:3

In Search of a Scoop

AND NOTHING BUT THE TRUTH, written and directed by Karl Francis; photographed by Curtis Clark; edited by Neil Thomson; music composed and conducted by Alun Francis; produced by Sophie Balhetchet and David Payne; released by Castle Hill Productions. At the Embassy 72d Street Theater, at Broadway. Running time: 90 minutes. This film has no rating.
SophieGlenda Jackson
O'MallyJon Finch
MartinKenneth Colley
JamesJames Donnelly
WilliamsEmrys James
BrigitteKaren Archer
HendersonSimon Jones
Elwyn DaviesHuw Ceredig
PhotographerAlun Lewis
FlynneDermot Crowley

"AND NOTHING BUT THE TRUTH" is an unconvincing little English melodrama about a small group of frightfully dedicated television journalists and how their efforts to expose wrongdoing are constantly thwarted by vested interests and craven superiors.

The film stars Glenda Jackson and Jon Finch as the journalists, described by their superior — accurately, it turns out — as being too emotional and subjective about their work. The director, Karl Francis, who himself is a former television journalist, puts great store by the sort of realism that, in film fiction, is too calculated to be effectively realistic.

•

Everybody looks just a little too exhausted, smokes too many unwanted cigarettes and is all too ready to snarl sarcastic remarks that here pass for ironic wit. The two unrelated stories whose coverage exhausts the journalists are about a fugitive leader of the Irish Republican Army, and a crooked real-estate scheme in Wales, involving the construction of a nuclear-power plant.

"And Nothing but the Truth," which opens today at the Embassy 72d Street Theater, is not utter nonsense, but it overstates its case so thoroughly and boringly that it leaves the audience with nothing to respond to.

Vincent Canby

1984 Ap 20, C15:1

FILM VIEW

VINCENT CANBY

Third World Truths

Euzhan Palcy's "Sugar Cane Alley" sneaks up on you with what at first seems to be its artlessness, as if it were a tale being told by someone too shy to look you directly in the eye. There is, however, something so dependably right about its choices of images, events and actors that you eventually realize that what initially seemed to be artlessness is

a conscious style. It's neither mock-primitive nor sophisticated, but a style thoroughly at the service of its narrative, which is a deceptively gentle — almost polite — tale about growing up black, poor, proud and fiercely ambitious on the French West Indian island of Martinique in the early 1930's.

"Sugar Cane Alley," which was one of the hits at the just-concluded New Directors/New Films Festival and is now in commercial release, is Miss Palcy's first feature, a film debut that could be as important as any in the festival's 13 years of existence. In that time the festival has presented first — or early — features by such directors as Hector Babenco ("Pixote"), Wim Wenders ("The Goalie's Anxiety at the Penalty Kick"), John Sayles ("The Return of the Secaucus Seven") and Wayne Wang ("Chan Is Missing").

The annual New Directors/New Films Festival, sponsored by the Film Society of Lincoln Center and the Museum of Modern Art's Department of Film, is not always an unmitigated joy. The people responsible for choosing the programs often seem to be dedicated as much to social anthropology as to cinema. This results in long hours of viewing well-meaning but dreary movies about alien cultures, overdeveloped as well as underdeveloped, works more remarkable for having been made at all than for anything they might demonstrate of a particular new talent.

The landscape of "Sugar Cane Alley" is no more or less exotic than the Wales seen in "How Green Was My Valley" or "The Corn Is Green," films that it recalls though it is decidedly different. I might even say that it's better than either of those studio-made films, not because its locations are authentic but because its passions are more raw and less cinematically genteel.

"Sugar Cane Alley" opens with what looks like a series of sepia-tinted, picture-postcard views of Martinique as it was in the 1930's and, to a certain extent, as it still is today, once you leave the protective, insistently pleasure-bent compounds such as the one run by the Club Med. These postcard shots are "official" souvenirs of a world inhabited by anonymous, mute people, who appear to exist solely for the purpose of providing subjects for the cameras of the tourists.

The focus of the story is 11-year-old Jose, played with rare, unself-conscious candor by Garry Cadenat, a handsome, brown-skinned little boy who seems to have a secret life to match that of Jose's. Young Mr. Cadenat is not just a screen presence but an actor. Jose is a small boy who, you can believe as you watch the movie, will one day grow up to be a writer like Joseph Zobel, who wrote the novel, "La Rue Cases Negres," on which Miss Palcy based her screenplay.

I've no idea whether the novel really is autobiographi-

Darling Legitimus and Garry Cadenat play grandmother and grandson in "Sugar Cane Alley," drawn by the director Euzhan Palcy from life in the 1930's on her native Martinique.

cal but, by the end of "Sugar Cane Alley," it seems perfectly probable that Jose possesses the talent, discipline, wit and stamina to be a first-rate author of original vision.

• • •

Most movies about writers usually are of an indescribable, unintentionally funny awfulness. Think of "Youngblood Hawke," "Beloved Infidel" and "Heart Beat," to name just three lulus in which supposedly serious writers — a fictionalized Thomas Wolfe and unreasonable facsimiles of F. Scott Fitzgerald and Jack Kerouac — sit around tap-tap-tapping out their great prose, which, from the evidence provided on the screen, appears to come straight from God, pre-paragraphed. I can think of only one film in recent years — "Celeste" — in which a writer, Marcel Proust, is a compelling figure, but "Celeste," as its title indicates, is less about Proust than about his devoted housekeeper, Celeste.

"Sugar Cane Alley" is not about the process of writing, a solitary pursuit that firmly resists dramatization, but about the boyhood of one very special, curious, all-seeing child whom we watch as he goes through the process of growing up. Miss Palcy's achievement is that the audience believes the growth taking place within the story.

If movies have never found a satisfactory way in which to deal with writers' writing, they have always had a sure-fire subject in stories about the pursuit of knowledge, which, for some reason, strikes deep responses in all types of audiences. It makes no difference that, in films on the order of "Educating Rita," the "education" bears less resemblance to the gaining of wisdom than to weight-lifting; the subject is still a moving one.

In "Sugar Cane Alley," the audience sees Jose studying from time to time and, in one scene, we hear a bit of an essay he's written. However, his real education comes not from the books that the supposedly educated Rita absorbs in her sleep, but from his observations of the world around him and his relations with a number of exceptionally sympathetic people — experiences that the audience can understand first-hand.

The most important of these characters is his grandmother, M'Man Tine, a wonderfully tough, pipe-smoking old woman who is raising the orphaned Jose on the sugar plantation where she has been a cane-cutter all her life. This role is played by an actress named Darling Legitimus with a no-nonsense sweetness that, like the movie itself, makes itself known only gradually. The measure of the actress, as well as of the role, is only fully evident by the end.

The movie begins in a manner that seems peculiarly diffident, as if it didn't know yet what it was to be about. You can't even be sure in these introductory sequences that Jose is the center of the film, which takes its time to describe the quality of life on the huge sugar plantation where the workers live in shacks and are always in debt. After the children of the cane cutters nearly burn down their shanty town, having got themselves wildly drunk on some illicit rum, "Sugar Cane Alley" zeroes in on Jose and the people and events that shape his mind.

In addition to his grandmother, there is an old man named Medouze, who dreams of an African homeland he never knew and who gives the boy his first political lessons, some of which, you can bet, Jose will eventually discard. After telling Jose that manumission has meant only that slave masters have been replaced by bosses, Medouze preaches acceptance of those conditions that seem to be beyond change, which is something that Jose will never agree to. It is from Medouze, though, that Jose begins to understand something about his own black identity.

Among Jose's friends is a school pal named Leonard, the son of the white plantation owner and a beautiful, snobbish black mistress, who slaps Leonard around for playing with black children. On his deathbed, Leonard's father refuses to recognize the boy as his son, and thus to enable Leonard to inherit not only the lands but also a name. "It's always been a white name," says the dying man. "It doesn't belong to mulattos."

Another influential character in Jose's life is Carmen, a breezy young man in his twenties, whom Jose is teaching how to read and write. Jose worships Carmen's sophisticated urban manners and his aim to go to Hollywood one day to become a great movie star. To this end, Carmen is not only learning how to read and write, he is saving his money, working at several jobs at once — as first mate on a river boat, ticket taker at a Fort de France movie theater and as a servant in the Fort de France house of a rich French family.

In one of the film's most beautifully effective, understated sequences, Jose, having been wrongfully accused of cheating at the new Fort de France school where he's on scholarship, runs to find Carmen at the rich family's townhouse. The usually supportive Carmen provides no comfort, though. He proudly shows the boy through the mansion, finally winding up in the master bedroom where, lounging on the magnificent bed, he boasts to Jose about being the lover of the mistress of the house. The audience's shock and disappointment are equal to the boy's.

On the evidence of "Sugar Cane Alley," Euzhan Palcy is a new writer-director of exceptional abilities. In this first film she vividly brings to life Third World truths discovered right in the middle of what is still designated as a department of "metropolitan France."

1984 Ap 22, II:17:1

Off Course

DRIFTING, directed by Amos Guttman; screenplay by Amos Guttman and Edna Mazia; director of photography, Yossi Wein; edited by Anna Finkelstein; music by Arik Rudich; produced by Kislev Films Ltd. Released by NU-Image Films. At the 8th Street Playhouse, 8th Street at Sixth Avenue. Running time: 80 minutes. This film has no rating.
Robi ...Jonathan Sagalle
Han ..Ami Traub
Ezri ...Ben Levin
Rachel ..Dita Arel
Baba ...Boaz Torjemann
Robi's FatherMark Hasmann

By JANET MASLIN

THE chief character in Amos Guttman's "Drifting," which opens today at the 8th Street Playhouse, is a desultory would-be film maker. "I'm busy with my film right now" is the sort of thing he likes to say, although during the course of "Drifting" his only activities related to film making are to wonder how he can raise some money and muse about whether it would be worthwhile to dramatize the life of Ramon Novarro.

Most of what Robi (Jonathan Sagalle) concerns himself with here is his homosexuality; except for this and his film making, nothing seems to interest him at all. Though "Drifting" is set in Israel, almost all of it takes place in Robi's apartment and almost none of it reflects the setting at large.

•

Mr. Guttman's strong and mostly unsentimental portrait of Robi is diminished by the film's overall aimlessness and by its utter lack of narrative energy. People simply wander into and out of Robi's life, and if his character evolves during the course of the story, the change is difficult to decipher. At both the ending and the beginning of "Drifting," he is heard to ask wearily what this film is about; at neither time does he even attempt an answer.

With his close friend Han (Ami Traub), Robi is seen cruising a local park, and during the course of the story he encounters visiting teenagers, a couple of injured Arab terrorists and even a former girlfriend who tries to coax him back to heterosexuality. Robi sometimes demonstrates a streak of idiosyncratic cruelty, but for the most part he is a passive sort. It seems to run in the family. Robi's grandmother, with whom he lives, pretends to ignore most of what goes on in Robi's room, even when three or four exceedingly strange lodgers turn up for the night. Only occasionally does she berate her grandson, shouting about pederasty and asking what she is supposed to tell people who want to know why he isn't married yet.

"Drifting" has been so poorly subtitled that much of it reads like something out of a comic strip. "I don't go much t'the parks, y'know" goes a typical line of dialogue.

1984 Ap 23, C12:1

Traveling Courtesan

ERENDIRA, directed by Ruy Guerra; screenplay (Spanish with English subtitles) by Gabriel García Márquez; director of photography, Denys Clerval; edited by Kenout Peltier; music by Maurice Lecoeur and Editions Saravah; produced by Alain Queffelean; production company, Les Films du Triangle. At the Lincoln Plaza Cinema, Broadway, between 62d and 63d Streets. Running time: 103 minutes. This film has no rating.
Grandmother ...Irene Papas
Erendira ...Claudia Ohana
SenatorMichael Lonsdale
Ulysses ..Oliver Wehe
Photographer ...Rufus
Ulysses' motherBlanca Guerra
GrocerErnesto Gomez Cruz
Ulysses' fatherPierre Vaneck
SmugglerCarlos Cardan
BlacamanHumberto Elizondo
CommandantJorge Fegan
PostmanFrancisco Mauri
Truck DriverSergio Calderon
ConveyorMartin Palomares
BuffoonSalvador Garcini
FianceFelix Bussio Madrigal
MusicianJuan Antonio Ortiz Torres
MissionaryCarlos Calderon
Indian ChiefRene Barrera

"Erendira" was shown as part of last year's New York Film Festival. Following are excerpts from Vincent Canby's review, which appeared in The New York Times on Oct. 1. The film opens today at the Lincoln Plaza Cinema, Broadway, between 62d and 63d Streets.

ONCE upon a time, in a vast, otherwise empty desert, there is a great house filled with paper flowers and enough inflammable bric-a-brac to satisfy several generations of antiques dealers. Here, with their pet ostrich, live a pretty, solemn-faced slavey named Erendira and her Gorgon of a grandmother, an imperious woman, whose house and manners deny the destitution all around them.

One night, when Erendira forgets to put out the candles, the house and all its contents are consumed by flames. "My poor darling," sighs Grandmother to Erendira, "your life will not be long enough to repay me."

•

Nevertheless, she has a plan. Grandmother sets up the virginal Erendira as a prostitute. Her first customer is the local desert grocer, who pays 200 pesos and three days' worth of provisions. Erendira quickly becomes the most famous, most popular courtesan in the region. She and Grandmother travel in an exotic procession from one location to the next, Grandmother being carried in a sedan chair, Erendira following on foot.

Wherever they set up shop, in their increasingly grand tent, becomes the focal point of all sorts of subsidiary enterprises. There are snake charmers, games of chance, food sellers, musicians. Life around them is a continuous carnival. The obedient Erendira goes about her business without complaint, accepting each new outrage with the silence of a guilt-ridden pilgrim on her way to a holy shrine.

That is, she seems to accept it until the appearance of a golden-haired young man named Ulysses, who becomes her liberation.

This is more or less the shape of "Erendira," a fabulous fairy tale based on a screenplay by the Nobel laureate Gabriel García Márquez and directed by Ruy Guerra in Mexico, though the original location was Mr. García Márquez's native Colombia.

"Erendira" has a kind of dreamy if monotonous charm to it. Unlike the Surrealist comedies of the late Luis Buñuel, the "magical realist" comedy of Mr. García Márquez's screenplay never abruptly shocks or surprises us. It's sometimes funny, but everything is presented in the same hallucinatory manner that is essentially soothing, even when it comes to murder.

The best single thing in the film is the big, broad comic performance by Irene Papas as Grandmother. This is, I think, the first time I've ever seen Miss Papas in a comedy, and the first time I've ever seen her laugh on screen and really mean it. She is quite wonderful as a sort of cross between the Madwoman of Chaillot and the

225

Queen of Hearts, being most positive when she is being most nonsensical.

Claudia Ohana, a young Brazilian, is charming as the long-suffering Erendira. Michael Lonsdale appears briefly as a lonely politician who helps Erendira, and Oliver Wehe plays Ulysses.

The physical production is extremely handsome and appropriately fantastic and, like the screenplay, should be enjoyed for what it appears to be and not for what it might symbolize. One decodes Mr. García Márquez at one's own risk.

1984 Ap 27, C8:5

The Midlife Blues

HOME FREE ALL, directed and written by Stewart Bird; director of photography, Robert Levi; edited by Daniel Loewenthal; music by Jay Chattaway; produced by Mr. Bird and Peter Belsito; a Libra Cinema 5 Films Release. At the Embassy 72d Street, at Broadway. Running time: 93 minutes. This film has no rating.

Barry	Allan Nicholls
Al	Roland Caccavo
Cathy	Maura Ellyn
Rita	Shelley Wyant
Lynn	Lucille Rivin
Marvin	Lorry Goldman
Chastity	Janet Burnham
Carlos	José Ramon Rosario
Therapist	Daniel Benzalli
Melanie	Melanie Bradshaw

By JANET MASLIN

THINGS are not going at all well for Barry, the middle-aged hero of Stewart Bird's "Home Free All." He'd like to be a writer, but for the time being he is selling kitchen gadgets on a street corner near Macy's. His therapist has canceled his treatment for lack of payment. His girlfriend finds him sexually disappointing, and says so. His past as a radical doesn't seem to have much place in his present. "I'm tired of being far-out and broke," he says.

In "Home Free All," which opens today at the Embassy 72d Street theater, Barry (Allan Nicholls) teams up with an equally dissatisfied friend from his Bronx boyhood, and together they search for something a little more meaningful than their current lives seem to offer. To call it "search" is to put it too strongly, since the film has a distinctly uneventful feeling, even when it is at its most offbeat. Whether Barry and Al (Roland Caccavo) go to the race track or to a Buddhist retreat (they do both during the course of the film, with equal offhandedness), there's an ordinariness to their adventures. This seems to be less of a deliberate effect by Mr. Bird than an absence of directorial pacing and control.

The film often sounds as though it means to be funnier than it plays, since its comic timing tends to be way off. The poignancy of Barry and Al's situation is left equally vague; even though their current lives are filled with disappointment, the film never conveys much sense of a promising past. Al's talk about the garment business in which he now works, and the marriage in which he feels trapped, easily becomes more wearing and mundane than affecting. Of all the film's mildly dejected characters, only Barry and his building superintendent (played by José Ramon Rosario) have much appeal.

Mr. Nicholls makes Barry a character most audiences would want to like, a friendly, bearish, highly spontaneous fellow who says what's on his mind. But he never seems riveting enough to provide the film with a center, and his problems become tedious long before the final scene, which has Barry and Al on a sofa in a suburban living room, discussing a trip to Disney World.

1984 My 2, C25:1

Question of Safety

DARK CIRCLE, directed and produced by Judy Irving, Chris Beaver and Ruth Landy; screenplay, photography and editing by Miss Irving and Chris Beaver; music by Gary Remal and Bernard Krause; production company, the Independent Documentary Group. At the Film Forum 2, 57 Watts Street. Running time: 82 minutes. This film is not rated.
WITH: Don Gabeo, Marlene Batley, Raye Fleming, Rex Haag, Pam Solo, Sumiteru Tanaguchi and Richard McHugh.

"Dark Circle" was shown as part of the 1982 New York Film Festival. Following are excerpts from Vincent Canby's review, which appeared in The New York Times on Oct. 8, 1982. The film opens today at the Film Forum 2, 57 Watts Street.

"DARK CIRCLE" is a well-made if grim documentary look at what life holds for people in and around the Rocky Flats Nuclear Weapons Facility near Denver. The film is the joint effort of Judy Irving, Chris Beaver and Ruth Landy.

"Dark Circle" shares with Mary Benjamin's "12 Minutes to Midnight" the conviction that the possibility of World War III is only one of the dangers to be understood in this nuclear age. Even if the arms are never used, these film makers say, the installations where they are manufactured as well as nuclear power plants are threatening the life of the planet in ways that are quite as lethal if less immediately spectacular.

The film makers question nuclear safety procedures in a series of interviews with people who have worked at Rocky Flats or live in its vicinity, including one man who, in the course of the film, dies of a brain tumor.

Among others interviewed are the father of a young girl who has died of bone cancer, two elderly women suffering from leukemia, a United States Navy veteran who took part in the Nagasaki A-bombing and now has leukemia, as well as two Japanese victims of the Nagasaki raid.

"Dark Circle" is an urgent horror story.

1984 My 2, C25:1

A Quest

THE MISSION (Ferestedah), written, produced, edited and directed by Parviz Sayyad, from a story by Hesam Kowsar and Parviz Sayyad; in Farsi with English subtitles; camera by Reza Aria; a co-production of the New Film Group, New York, and Aria Film Production, Munich, West Germany. At Cinema 3, 59th Street and Fifth Avenue. Running time: 110 minutes. This film has no rating.

The Agent from Teheran	Hooshang Touzie
The Colonel	Parviz Sayyad
Maliheh	Mary Apick
His Eminence	Mohammad B. Ghaffari
Mazlar	Hatam Anvar
Farzahen	Hedyeh Anvar
Gaffar	Kamran Nozad

"The Mission" was shown as part of the 1983 New Directors/New Films series. Following are excerpts from Vincent Canby's review, which appeared in The New York Times on March 30, 1983. The film opens today at the Cinema 3, 59th Street at Fifth Avenue.

"THE MISSION," written, produced, directed and edited by Parviz Sayyad, is a clear-eyed, ironic, small-scale melodrama, shot entirely in and around New York City by Iranian exiles, with the Farsi dialogue translated by English subtitles.

Though the film's concerns are serious, the style is often comic. The mission of the title is that of a religiously dedicated, young Iranian revolutionary, sent from Teheran to New York to assassinate a former colonel in the Shah's secret police. In the course of his assignment, the young man, played with sometimes fiercely funny solemnity by Hooshang Touzi, discovers that issues that at home seemed to be either black or white have suddenly turned into various shades of disconcerting gray.

Mr. Sayyad, who himself gives a rather jolly, relaxed performance as the former colonel, now a janitor, is a facile film maker. The film moves smoothly from satire and comedy to drama and melodrama. All of the performers are good, and Mr. Sayyad's use of New York locales exceptionally good. This is no tourist's view of the city.

One highlight: a sequence in which the agent from Teheran, after tailing his target for days, finds himself saving the colonel from a couple of ordinary, run-of-the-mill subway muggers.

1984 My 2, C25:1

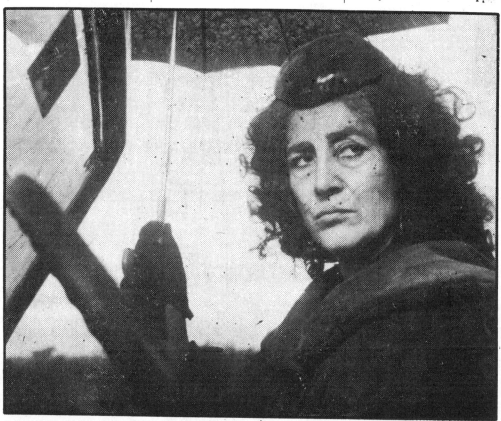

Irene Papas, above, stars as an outrageously wicked grandmother in "Erendira," a film based on an erotic fable written by Gabriel Garcia Marquez and directed by Ruy Guerra.

Never Mind Jamaica

THE BOUNTY, directed by Bernard Williams; screenplay by Robert Bolt, based on the book "Captain Bligh and Mr. Christian" by Richard Hough; director of photography, Arthur Ibbetson; edited by Tony Lawson; music by Vangelis; produced by Bernard Williams; released by Orion Pictures Corporation. At Loews State, Broadway and 45th Street; New York Twin, Second Avenue and 66th Street; 34th Street Showplace, at Second Avenue and other theaters. Running time: 132 minutes. This film is rated PG.

Fletcher Christian	Mel Gibson
Lt. William Bligh	Anthony Hopkins
Admiral Hood	Laurence Olivier
Captain Greetham	Edward Fox
Fryer	Daniel Day-Lewis
Cole	Bernard Hill
Young	Philip Davis
Churchill	Wi Kuki Kaa
Mauatua	Tevaite Vernette
Adams	Philip Martin Brown

By VINCENT CANBY

ON the basis of three films, it is now possible to say that the Pacific Ocean is not Dino De Laurentiis's cup of tea. This world-roaming Italian producer has made good movies ("Europe '51," "Serpico"), as well as a couple of classics (Federico Fellini's "Strada" and "Nights of Cabiria") but his projects set in the South Pacific seem to go to pieces, like Somerset Maugham characters who become unglued in the tropics.

First there was his remake of "King Kong," then his remake of "Hurricane," based on the novel by Charles Nordoff and James Norman Hall, and now "The Bounty," which opens today at Loew's State and other theaters.

The new film is not a remake of M-G-M's 1935 and 1962 films, both titled "Mutiny on the Bounty," which were based on material in Nordoff and Hall's fictionalized "Bounty" trilogy. Using as its source material the Richard Hough book, "Captain Bligh and Mr. Christian," published in England in 1972, "The Bounty" means to be a far more historically accurate version of the great sea saga that rocked the British Admiralty toward the end of the 18th century.

•

For the benefit of those who came in late, the basic facts are these: in 1787 the British naval ship Bounty, in the command of Captain William Bligh, was sent out from England to Tahiti to take on a cargo of breadfruit to transport to Jamaica, the idea being that breadfruit would provide a far cheaper diet for Jamaica's slaves than the bananas they craved.

Two years later, after a long and apparently happy stay in Tahiti, the Bounty crew, under the leadership of Fletcher Christian, mutinied against Bligh and took over the Bounty, which they then sailed to Pitcairn Island, taking with them their Tahitian wives and friends. Bligh and 18 loyal crewmen were put into a small boat and cast adrift in the sea where, it was assumed, they would soon perish. Bligh confounded all by successfully sailing his boat across nearly 4,000 miles of open ocean to reach the Dutch island of Timor — one of the great navigational feats of modern times.

In the two earlier Bounty films, Bligh, played first by Charles Laugh-

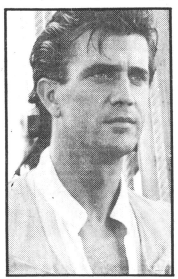

Mel Gibson as Fletcher Christian in the film "The Bounty."

ton and then by Trevor Howard, was characterized either as a sadist or a fool. Fletcher Christian was seen as a romantic hero, especially by Clark Gable in 1935, though in the 1962 film Marlon Brando added a few foppish mannerisms and was given a not very tragic death scene.

"The Bounty," which stars Mel Gibson as Fletcher Christian and Anthony Hopkins as Bligh, attempts to rehabilitate Bligh's reputation, at least up to a point, and to discover in Christian a far more troubled, more complicated identity than has been seen before. That seems like a good idea but the evidence on the screen proves that one fools around with legendary characters, even historically inaccurate ones, at some peril.

In addition to Mr. Hopkins and the American-born, Australian-bred Mr. Gibson, one of our best new young actors, a lot of very good people are involved in this venture, including the English playwright Robert Bolt, who wrote the screenplay, and Roger Donaldson, the Australian-born New Zealand director remembered in this country for "Smash Palace." However, nothing in the film really works.

The narrative is a series of flashbacks framed by Bligh's testimony in his own defense when, after his return to England, he faces court-martial for having lost the Bounty. It's one of the film's so-called revelations that Bligh and Christian were friends who had earlier served together and, when alone, were on a first-name basis. Yet, by seeing Bligh as a less mad character than we've known him to be in the earlier films, "The Bounty" makes Fletcher Christian's behavior seem nothing more than petulant.

We watch Bligh fretting and sweating at the sight of his crew members running gloriously amok with the magnificent looking Tahitian women, but his discipline, though harsh, doesn't appear to be all that outrageous, considering what discipline could be in the British Navy at that time. What's going on in Fletcher Christian's head — when he suddenly decides to mutiny — remains vague in the screenplay, though he has been having a passionate time with a pretty Tahitian princess and has gone native to the extent of allowing himself to be tatooed.

•

Both Bligh and Christian are unfinished characters in a screenplay that may or may not have been tampered with. The production, shot in Tahiti, New Zealand and England, is elaborate without being especially interesting to watch. When the Bounty initially arrives in Tahiti, and the smiling natives jump into their canoes, loaded down with garlands and other trinkets, and as the music comes up on the sound track, you may think you've seen and heard all this before, and you have, in dozens of other movies, including "Bounty" movies.

"The Bounty" seems to want to be different, but it doesn't know how. The film's big set piece — the wild storm sequence in which Bligh attempts unsuccessfully to sail the Bounty around Cape Horn — is so badly shot and edited you don't know what's happening. Even the Bounty itself, rebuilt to scale at large cost, looks like a steel-hulled ship encased in wood, which it is. The movie seems to have been planned, written, acted, shot and edited by people who were constantly being overruled by other people. It's totally lifeless.

Prominent in the supporting cast

are Laurence Olivier, seen briefly as a majestic Admiral Hood, the senior officer in charge of Bligh's court-martial, and Edward Fox, who looks elegantly high-toned and cross as the prosecuting officer.

•

"The Bounty, which has been rated PG ("Parental Guidance Suggested"), includes lots of shots of partly nude (that is, topless) Tahitian women, which is the way they dressed before the missionaries got to them.

1984 My 4, C8:1

Sublet Fantasies

RENT CONTROL, directed by Gian L. Polidoro; screenplay by John Menegold, Sherill Tippins; director of photography; Benito Frattari; edited by Ed Orshan and Jim Cookman; music by Oscar De Mejo and Ian North and other composers; produced by Benni Korzen; a Group S Films Release. At the Waverly, Avenue of the Americas at Third Street. Running time: 86 minutes. This film has no rating.

Leonard Junger	Brent Spiner
Anne	Elizabeth Stack
Milton Goeller	Leonard Melfi
Margaret Junger	Jeanne Ruskin
Nancy Junger	Annie Korzen
Barbara	Leslie Cifarelli
Jim	Charles Laiken
Stan	Roy Brocksmith
Mrs. Spovic	Anita Bosic
Shelley Junger	Robin Pogrebin
Sharon Junger	Abigail Pogrebin
Jeanne Junger	Kimberly Stern

SCENE: an Upper West Side bar, on a Saturday afternoon. Leonard Junger, an aspiring young television writer, runs into an acquaintance named Milton Goeller, a disagreeably egotistical, successful, free-lance writer of exposé pieces. As Milton proceeds to get thoroughly drunk, he tells Leonard about his latest bit of scandal-mongering, a book that will finger a prominent United States Senator as a murderer.

Says the boozy, patronizing Milton, "Believe me, I'm going to have to hide in London when this book comes out." Says Leonard, "Are you going to sublet your apartment?"

"Rent Control," which tells of the desperate lengths Leonard will go to in his search for an apartment, is a genially uneven Manhattan comedy whose heart is a lot nastier than the movie can ever admit openly. The film, which opens today at the Waverly Theater, was made entirely in New York on a shoestring by Gian Polidoro, the Italian director ("To Bed or Not to Bed"), and written by him (under the name of John Menegold) and Sherill Tippins.

The film is so confidently cockeyed in short takes that one longs for it to be much better than it is from start to finish. The apartment Leonard seeks (one with two bedrooms for $300 a month) is not for himself. It is, rather, a lure to bring back to Manhattan from Alaska his ex-wife, her current boyfriend and Leonard's small daughter.

Leonard becomes so caught up in apartment-hunting that he even forgets his writer's block — he has been working on a proposal for a public television series about medieval French kings. ("Take Charles the Cruel," Leonard says at one point, "exactly like Nixon.")

In his eagerness to find an apartment, he even tries to blackmail some of the people mentioned in his friend's book, with results that are more absurdly melodramatic than the film can easily justify, even as comedy.

"Rent Control" doesn't work consistently but it has a lot of nicely oddball moments and it features a num-

ber of gifted New York performers. These include Leonard Melfi, the playwright, who plays Milton Goeller. Mr. Melfi is not on the screen very long but he's extremely funny, creating a character who suggests Joseph Heller as Mr. Heller might be played by Lionel Stander.

Almost as good are Brent Spiner, as the single-minded Leonard; Elizabeth Stack (Robert's daughter), as a beautiful mystery woman Leonard encounters in his travels; Jeanne Ruskin, as Leonard's ex-wife; Annie Korzen as Leonard's sister, and Roy Brocksmith, as a very unlikely New York hood.

Vincent Canby

1984 My 4, C13:3

Adolescent Insanity

SIXTEEN CANDLES, directed and written by John Hughes; director of photography, Bobby Byrne; edited by Edward Warschilka; music by Ira Newborn; produced by Hilton A. Green; released by Universal Pictures. At the Gemini, 64th Street and Second Avenue; Movieland, Broadway and 47th Street; UA East 85th Street, at First Avenue, and other theaters. Running time: 95 minutes. This film is rated PG.

Samantha	Molly Ringwald
Mike Baker	Justin Henry
Jake	Michael Schoeffling
Caroline	Haviland Morris
Long Duk Dong	Gedde Watanabe
Geek	Anthony Michael Hall
Jim Baker	Paul Dooley
Brenda Baker	Carlin Glynn
Ginny	Blanche Baker
Howard	Edward Andrews
Dorothy	Billie Bird
Helen	Carole Cook
Fred	Max Showalter
Randy	Liane Curtis
Bryce	John Cusack
Cliff	Darren Harris

By JANET MASLIN

JOHN HUGHES'S "16 Candles" is a cuter and better-natured teen comedy than most, with the kinds of occasional lapses in taste that probably can't hurt it in the circles for which it is intended. The middle of the film wastes time on a bit more house-wrecking and car-crashing than is absolutely necessary, and there are some notably unfunny ethnic jokes. But most of the the movie is cheerful and light, showcasing Mr. Hughes's knack for remembering all those aspects of middle-class American adolescent behavior that anyone else might want to forget.

Mr. Hughes, who makes his directorial debut after having written "National Lampoon's Vacation," "National Lampoon's Class Reunion" and "Mr. Mom," is far from infallibly funny, but enough of his humor hits the mark. He begins "16 Candles," which opens today at the Gemini and other theaters, with a quick introduction to Samantha (Molly Ringwald), the film's heroine, and to the large and seemingly affectionate family that is about to forget her birthday.

From Samantha's home life, which is all intramural squabbling and fights for the bathroom, Mr. Hughes then moves on to high school. He captures, among other things, the sorts of messages that 16-year-old girls send one another in study hall, and the unbearable goofiness of freshman boys as they travel by the busload.

The plot revolves around Samantha's birthday, which goes from bad to worse, and her crush on a handsome senior named Jake (Michael Schoeffling), who already has a girlfriend — the kind of girlfriend who tells him adoringly "I fantasize that I'm your wife and we're, like, the richest, most popular adults in

town." To make things worse, Samantha is being pursued by a character who is known as the Geek (Anthony Michael Hall), and for good reason. Back home, her prettier sister (Blanche Baker) is about to get married, and all of her grandparents have arrived for the wedding. When Samantha stumbles into her own room to find one set of grandparents in their underclothes, Mr. Hughes puts the "Twilight Zone" theme on the soundtrack.

•

Sophomoric as it may be, "16 Candles" shows Mr. Hughes to be well able to direct his own dialogue and to juggle a cast of all-American comic caricatures. Miss Ringwald plays Samantha in a relatively natural style, which makes her virtually the only creature in the story with any feelings; the others are affectionately exaggerated, like the father (Paul Dooley) who never quite seems to be listening to his daughter, or the kid brother (Justin Henry) who has refined sister-baiting to an art form. When the movie goes too far, as it does with a stupid subplot about a sex-crazed Oriental exchange student or a running gag about a young woman in a body brace, at least it manages to bound back relatively soon thereafter.

•

"16 Candles" is rated PG ("Parental Guidance Suggested"). It contains some adolescent talk about sex and some brief nudity.

1984 My 4, C14:1

PURPLE HEARTS, duced by Sidney J. Furie, ... en by ... Natkin and Mr. Furie; director of photography, Jan Kiesser; edited by George Grenville; music by Robert Folk; released by Warner Bros. At the Warner, Broadway at 47th Street and Tower East, 71st Street and Third Avenue. Running time: 116 minutes. This film is rated R.

Don Jardian	Ken Wahl
Deborah Solomon	Cheryl Ladd
Wizard	Stephen Lee
Hallaway	Annie McEnroe
Brenner	Paul McCrane
Zuma	Cyril O'Reilly
Hanes	David Harris
Jill	Hillary Bailey
Gunny	Lee Ermey
Lieutenant Colonel Larimore	Drew Snyder

SELDOM has the long arm of coincidence received the workout that it gets in Sidney J. Furie's "Purple Hearts," as it flings together Dr. Don Jardian and Nurse Deborah Solomon against the backdrop of war-torn V___ am. The film begins with a dedi___ on to the Vietnam War's 347,30_ Purple-Heart recipients, though it also seems aimed at the nation's millions of soap-opera fans. Whenever the film's war scenes verge on becoming believable, which is often enough, the love story is allowed to take over.

When we first meet Dr. Jardian, he is speaking fluent doctorese ("Prep him for O.R., this arm and leg gotta come off right now!") and is frantically overworked. Somehow, he then abandons all his other patients to fly one particular wounded soldier to Da Nang. There, he is watching though the operating room window while a team of surgeons attempt an emergency operation, he spots a pair of pretty eyes above one particular surgical mask. That's Nurse Solomon. Since they are stationed at different bases, Dr. Jardian and Nurse Solomon spend the rest of the movie trying to arrange free weekends and visit one another, just as they might in a college romance.

Mr. Furie, who produced, directed

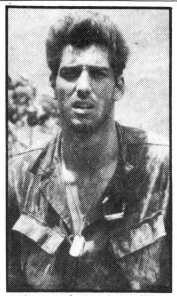

Ken Wahl plays a surgeon in the film "Purple Hearts."

and co-wrote "Purple Hearts," does not appear to be cavalier towa_d _he subject of Vietnam, any r_____ did in "The Boys _____ Like that film, h_ _ a large cast of _n Vietnam a__ ____ __ life an_ ___ ____ soldiers there. / ___ ___e again demonstrates _ ___ringing out the best in un__ ___rlooked actors; Stephen ___ _arris and James Whitmore J_ ___ong those who do well in sup_ __es here. But Mr. Furie als_ _____weakness for just the sort of Hollywood hokiness that can discredit any movie, from the commanding officer who spits out "The hell you say!" at every opportunity to the kettledrum that accompanies Nurse Solomon's announcement that she, for the umpteenth time, is leaving.

Ken Wahl is great-looking and very photogenic, though his mumbling and his streetwise manner make him an unlikely choice for the "million-a-year surgeon" of the screenplay. He seems credible and appealing enough in the combat scenes, but when he and Cheryl Ladd, who plays Nurse Solomon, engage in their endless banter, the sparks just fail to fly. Both of them do better with the material's lighter moments, and even with an ending so contrived it may make your teeth ache, than they do at registering the overall horror and uncertainty of war. But then, its dedication notwithstanding, "Purple Hearts" isn't that kind of movie anyhow.

"Purple Hearts" opens today at the RKO Warner and other theaters.

Janet Maslin

1984 My 4, C15:1

THE BUDDY SYSTEM, directed by Glenn Jordan; written by Mary Agnes Donoghue; director of photography, Matthew F. Leonetti; edited by Arthur Schmidt; music by Patrick Williams; produced by Alain Chammas; released by Twentieth Century-Fox Film Corporation. At the Plaza, 58th Street off of Fifth Avenue; the Embassy 2, Broadway and 46th Street, and other theaters. Running time: 111 minutes. This film is rated PG.

Joe	Richard Dreyfuss
Emily	Susan Sarandon
Carrie	Nancy Allen
Mrs. Price	Jean Stapleton
Tim	Wil Wheaton
Jim Parks	Edward Winter
Dr. Knitz	Keene Curtis

"THE BUDDY SYSTEM," based on an original screenplay by Mary Agnes Donoghue, looks and sounds like a lesser Neil Simon comedy. Miss Donoghue has studied the master carefully, but without learning how to turn out the abrasive one-liners that sometimes can make this kind of movie fun in spite of itself.

The film, which opens today at the Plaza and other theaters, is about the eccentric relationship of a pretty, spirited unwed mom (Susan Sarandon) and a would-be novelist-inventor (Richard Dreyfuss), and how they are brought together by the woman's lonely, all-too-knowing young son (Wil Wheaton). The cast also includes Jean Stapleton, in her first film role since leaving "All in the Family," as Miss Sarandon's parent, who comes across as a sort of de-ethnicized Jewish mother, and Nancy Allen, as the dumb blonde whom Mr. Dreyfuss thinks he loves throughout most of the movie.

The actors are attractive and the southern California settings are amazingly life-like, though the whole thing might have been done more efficiently as a one-set situation comedy. The director is Glenn Jordan, who directed "Only When I Laugh," a real Neil Simon film, with a good deal of class.

•

"The Buddy System," which has been rated PG ("Parental Guidance Suggested"), contains some vulgar language.

Vincent Canby

1984 My 4, C15:2

BREAKIN', directed by Joel Silberg; screenplay by Charles Parker and Allen DeBevoise and Gerald Scaife; story by Mr. Parker and Mr. DeBevoise; director of photography, Hanania Baer; music by Gary Remal and Michael Boyd; edited by Larry Boch, Gib Jaffe and Vincent Sklena; produced by Mr. DeBevoise and David Zito; released by MGM/UA and the Cannon Group. At the National 2, Broadway and 44th Street; Eastside Cinema, Third Avenue between 55th and 56th Streets. Running time: 90 minutes. This film is rated PG.

Kelly	Lucinda Dickey
Ozone	Adolfo Quinones
Turbo	Michael Chambers
Franco	Ben Lokey
James	Christopher McDonald
Adam	Phineas Newborn 3d
Electro Rock 1-3	
Bruno Falcon, Timothy Solomon, Ana Sanchez	

By VINCENT CANBY

"Breakin'," which opened yesterday at the National and other theaters, features a number of good, mostly small-scale demonstrations of break-dancing, the energetic street choreography that is now in process of being co-opted and merchandized by big-time show business.

The principal performers are Lucinda Dickey ("Grease 2"), a classically trained dancer, Adolfo (Shabba-Doo) Quinones and Michael (Boogaloo Shrimp) Chambers, who are exhaustingly good, given a little room in which to leap, shake and, from time to time, stand on their heads and turn their legs into propellers. The film, directed by Joel Silberg in and around Los Angeles, employs a very small story that is meant to be functional but still interrupts the dancing far too often.

•

"Breakin'," which has been rated PG ("Parental Guidance Suggested"), includes some vulgar language.

1984 My 5, 17:1

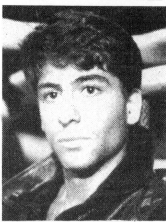

Vincent Spano in "Alphabet City."

ALPHABET CITY, directed by Amos Poe; screenplay by Gregory Heller and Mr. Poe; director of photography, Oliver Wood; edited by Grahame Weinbren; music by Nile Rodgers; produced by Andrew Braunsberg; released by Atlantic Releasing Corporation. At the Manhattan, 59th Street between Second and Third Avenues; Orpheum, 86th Street and Third avenue, and other theaters. Running time: 98 minutes. This film is rated R.

Johnny	Vincent Spano
Angie	Kate Vernon
Lippy	Michael Winslow
Mama	Zohra Lampert
Sophia	Jami Gertz
Louisa	Laura Carrington
Gino	Raymond Serra
Juani	Daniel Jordano
Tony	Kenny Marino

By LAWRENCE VAN GELDER

"Alphabet City," which opened yesterday at the Manhattan 1 and other theaters in and around the city, is one of those exercises in romantic film making that owe more to the history of cinema than to the reality of the milieu that is their subject.

Here is a film that draws its title from the Lower East Side Avenues — A, B and C — that are its setting, and takes as its subject the criminal activities of a young man named Johnny (Vincent Spano), who has been granted this fief by organized crime.

Without a pang of conscience, he oversees its drug trade, collects protection money from its nightspots, and, at gunpoint, discourages the aspirations of potential rivals. But he draws the line at carrying out orders to burn down the apartment house where his mother and sister live, and thus finds himself the object of the deadly wrath of his overlord.

Though the inspiration for "Alphabet City" may be rooted in fact, the execution is decidedly lyrical. The director, Amos Poe, misses no opportunity to refract headlights, savor reflections on wetted streets, bathe interiors in smoke, candlelight and colored light, suffuse exteriors with fog, underline the ominous with thunderclaps and aim his camera from odd angles. The effect is to draw attention to a technique that is, at best, derivative, and to romanticize characters and settings to the point that they chafe against the bounds of credibility.

•

As Johnny, Mr. Spano, who made such a strong impression last year in John Sayles's "Baby, It's You," proves again to be a sympathetic leading man. And Michael Winslow, who plays Lippy, a drug addict who is Johnny's deputy and literal deus ex machina, manages to enliven the proceedings whenever he turns up. But taken as a whole, "Alphabet City" is too pretty to be real and too real to be pretty.

1984 My 5, 17:1

FILM VIEW

VINCENT CANBY

Movies Tend To Soar on Wings of Plausibility

The first few minutes of any movie are as crucial to its success as are the first few seconds in the takeoff of a fully loaded 747 jumbo jet, lumbering heavily down the runway, gathering the extraordinary speed necessary to become airborne. And every time the plane does become airborne, it seems a miracle.

Nobody is in danger of anything except boredom if a movie doesn't rise. It's always possible — even if it rarely happens — that it will lift off at some later point. It's more usual though, that these initial minutes establish the tone of the film as well as the kind of trust that determines just how one is going to respond to everything that comes after.

More than anything else, movie audiences, including reviewers, want to fly — to believe in what they're seeing, and good movies, no matter how fantastic they may be, somehow manage to set up the necessary lines of communication between the screen and the audience. Not all audiences — thank heavens — are homogenized. Each person's demands on a movie are different, which helps to explain why two people, who may agree on just about everything else, will violently differ in their responses to the same movie. There's no right or wrong in this area, just inclinations and biases whose origins are beyond easy discovery. The movie that occasions one person's enchantment can prompt another's orgy of nit-picking, often in the name of plausibility.

• • •

Take the case of Paul Mazursky's "Moscow on the Hudson," a movie that leaves the runway only intermittently, not because it ever really becomes airborne but because it hits a bump. Watching it is like driving to Trenton in a DC-10. I was somewhat distanced from it — a euphemism for being bored by it — when the young Soviet émigré musician, the role played by Robin Williams, seems to have no trouble in finding a succession of decently paying if menial jobs in Manhattan, as well as his own, apparently affordable studio apartment. This seemed to me to be just another example of the way in which Mr. Mazursky was failing to acknowledge the real facts of life of this city, which he pictures, with not great originality, as being inhabited exclusively by picturesque people from somewhere else.

In response to my reponses to the film, one reader wrote in to say that although he could take the movie or leave it, the ease with which the Williams character finds employment had been the real-life experience of his son-in-law, also a Soviet émigré, who had not stopped working since he arrived. What I took to be implausible was perfectly plausible to him.

Another letter writer, however, was incensed by the film's political bias, expressed by, among other things, he says, the fact that the Williams character flies out of a Moscow that is shown to be a drab, bitterly cold, snowy city and arrives in a sunny Manhattan, seemingly bathed in perpetual summer. "Does Mr. Mazursky know," the letter writer asked, "that Moscow and New York are on the same side of the equator?" I think he does.

• • •

In this instance, the reader/moviegoer missed a time-lapse within the movie. The Moscow prologue of the movie is separated from the Manhattan sequences, where most of the film is set, by what we are led to assume has been a long tour of the United States that comes to its conclusion in New York. That, I think, is a plausible explanation for what is, in fact, Mr. Mazursky's reasonable, though not inspired, decision to emphasize the differences between the two societies by means of weather and seasons.

Given the right circumstances — that is, circumstances that, for one reason or another, we believe — most of us can be persuaded to accept the most implausible circumstances as the logical order of the universe. More than anything else, I suspect, the lively, funny, loving performance by the late Sir Ralph Richardson as the eccentric old Earl of Greystoke transforms "Greystoke: the Legend of Tarzan, Lord of the Apes" into one of the most moving and entertaining films of its kind ever made. It's not for nothing that Sir Ralph more or less opens the film and that his spirit hangs over everything that subsequently happens, even when he's not on the screen.

Just the reverse happens in the opening sequences of Fred Schepisi's elaborate, solemnly vacuous "Iceman," which is about the successful defrosting of a 40,000-year-old Neanderthal man, nicknamed Charlie, by a group of American scientists operating out of a sort of Disneyland North, above the Arctic Circle.

• • •

Mr. Schepisi, the Australian-born director ("The Devil's Playground," "The Chant of Jimmy Blacksmith," "Barbarosa"), has won something of a reputation as being "good" with primitives, very much the way the late George Cukor was once thought to be "good" with women. However, from the very start of "Iceman" one can see that he's in deep trouble with a thoroughly silly screenplay that he attempts to gussy up with, among other things, pretty visual effects:

The scientists are busily removing from the frozen terrain a mysterious object encased in a photogenic, coffin-shaped block of ice. Dressed in their shiny, space-age Arctic gear, wearing heavily tinted glasses to protect their eyes from the glare, they move about like creatures from another planet as the ice-coffin is attached to the helicopter that will ferry the trophy back to base. So far, O.K.

Then the camera, positioned beneath the helicopter just behind the suspended ice block, gives us an aerial tour of the snowy wilderness. However, the helicopter, instead of flying over the icecap, flies between the icy outcroppings that dot the landscape. It is a pretty sequence but one's first thought is that this seems an extremely impractical way to get the treasure safely home since, at any minute, it might be smashed to smithereens.

•

Things become no more plausible back at the base, the purpose of which is never clearly explained, though it seems as expensive and purposeful as Cape Canaveral. At one point I thought the scientists were supposed to be drilling for oil, but there are no rigs around and no equipment that would appear to be useful for taking in-depth mineral samples. What they do have, however, is a large, temperate "environment," the sort of space any zoo would be proud to possess, in which they have been growing berries and keeping wild boars. By chance, these are just the things that Charlie, once he has been thawed out, is craving. They then put a miraculously healthy Charlie into this man-made environment, the better to be able to study him.

I must say that "Iceman" never bored me, but it turned me into the kind of plausibility nut I haven't been since I began watching movies at the age of 5 or 6, vying with my peers to be the first one to shout "Fake!" every time an obviously painted backdrop came on the screen.

•

Having been handed a script that, at its best moments, is a wan though benign reminder of the original version of "The Thing," Mr. Schepisi seems uncertain whether to distract the audience's attention by décor or to send up the clichés of a certain kind of science-fiction. Unfortunately, he plays it straight most of the time, though Timothy Hutton, as the scientist who succeeds in establishing contact with the ancient man, does wear a lot of furs so stylish one expects to see the name of Maximilian in the end-credits.

In the entire film there's not one genuinely surprising or moving moment that might persuade the audience to suspend disbelief. At its center the film seems to be mainly about Mr. Hutton's scientist's rediscovering his own humanity in his relationship with Charlie. Man, "Iceman" tells us, is something more than the sum of his parts that can be dissected and analyzed. Man also has a soul, as poor old Doc Frankenstein learned. There's nothing wrong with this message, except that it's denied by the nonessential questions that keep interrupting one's concentration, and which are prompted by the foolishnesses of the production.

•

Even if one can buy the ease with which Charlie is revived — the explanation, it seems, is that he was flash-frozen — one is then distracted about where, even on this comfy Arctic base, the scientists would find a new fur loincloth to replace the 40,000-year-old remnant he was wearing when found. Charlie lives happily in his fake Neanderthal world until the day he finds the hose that circulates the water in his elegant cage. Had he once looked up earlier, of course, he would have seen a man-made ceiling and the control booth from which the scientists are monitoring him. I think it's something of a disservice to all Neanderthals to suggest they never lifted their gaze above the ground. The condition of the sky was probably quite important to them, on a day-to-day basis.

However, if plausibility questions ruined "Iceman" for me, they also made it possible to sit through one of the most aggressively unpleasant horror films I've seen in years,

"Friday the 13th — the Final Chapter." This is the fourth and supposedly the last of the phenomenally successful films in the series. Opening with brief reprises of the principal stabbings, impalings, decapitations and hatchet attacks from the previous films, this one goes on to show the mad Simon murdering more than a dozen new victims, including a dog named Gordon, but mostly teen-agers during or just after sexual intercourse.

If the film possessed any sense of reality and if its continuity were not so peculiar that nobody ever seems to find the bodies that Simon leaves behind him, rather like old laundry, the movie would be unbearable. As it is, "The Final Chapter" is an anthology of contemporary horror film tricks, something that is not without scholarly interest. For everyone else, the first three minutes are quite enough. ∎

1984 My 6, II:17:1

A Ritual

IREZUMI — SPIRIT OF TATTOO, directed by Yoichi Takabayashi; screenplay (Japanese with English subtitles) by Chiho Katsura, based on the novel by Baku Akae; photography by Hideo Fujii; music by Masaru Sato; produced by Yasuyoshi Tokuma and Masumi Kanamaru. At the Lincoln Plaza Cinema, Broadway, between 62d and 63d Streets.
KyogoroTomisaburo Wakayama
AkaneTasayo Utsunomiya
FujiedaYusuke Takita
HarutsuneMasaki Kyomoto
Katsuko ..Harue Kyo
HarunaNaomi Shiraishi
HoriatsuTaiji Tonoyama

"Irezumi — The Spirit of Tattoo" was shown as part of the 1983 New Directors/New Films Series. Following are excerpts from Vincent Canby's review that appeared in The New York Times on March 19, 1983. The film opens today at the Lincoln Plaza Cinema, Broadway, between 72d and 73d Streets.

YOICHI TAKABAYASHI'S "Irezumi — Spirit of Tattoo" ("Sekka Tomurai Zashi") is a romantically deceptive Japanese film about a young Tokyo secretary who, to please her middle-age lover, spends two years of her life having her back elaborately tattooed. A tattoo, like a diamond, is forever, but it can't be hocked.

In "Irezumi" it represents a number of things, including fidelity and the total submission of the tattooed woman to her lover, who can, of course, change his mind while she cannot.

•

"Irezumi" is not an easy movie to respond to initially. It has its share of what are crudely called "howlers," especially in its subtitles. It's also difficult to fathom the extraordinary passivity of the beautiful Akane to her lover, a mild-mannered librarian who wears conservative business suits and a Burberry scarf, and in all ways is utterly ordinary except for his passion for tattooed skin.

Yet, as "Irezumi" goes on, the film becomes increasingly involving and erotic until, finally, we accept its ellipses and rather large chunks of exposition that explain what happened before the movie started.

Next to Akane, the most important character in the film is Kyogoro, the elderly Kyoto tattooist who agrees to come out of retirement to execute one last work of art. As a psychiatrist might examine someone who wants a sex-change operation, the old man questions Akane at length about her motives, repeatedly making the point that the tattoo can't guarantee happiness and may possibly ruin her life.

He further explains that the process is not only long and painful, but also that his methods are — well — unorthodox. Just how unorthodox, Akane doesn't understand until her first session.

At that time, Kyogoro introduces her to his assistant, a handsome young man named Harutsune, whose function it is to lie naked under Akane, her back bare and her buttocks discreetly covered by a cloth, as the old man punctures her skin with tiny razor-sharp knives. Says the old man solemnly, "A woman's skin is most beautiful when it is embraced." One might also think it would be difficult to execute a tattoo on a body that is writhing with such contradictory passions.

In no time at all, Akane has accepted this pain/pleasure routine and has become emotionally involved with the young man, though she never sees him outside the studio and never seems to think of leaving the lover for whom she is undergoing this transformation.

It's not easy to describe "Irezumi" without making it sound like more of a howler than it actually is. Mr. Takabayashi is more interested in esthetics than psychology. Freud has no place in this world. Though I'm not sure what the film's concerns are, they are not to be analyzed in terms of character.

•

The film provides us with a glimpse into an ancient cultural system as it survives, in kinky shards, in contemporary Japan. In one of the film's more arresting sequences, we see Kyogoro's plain-faced daughter ironing clothes and watching television while, in the next room, Akane, Harutsune and Kyogoro continue their rigorous labors of love.

The performers, all unknown to me, are excellent, particularly Tasayo Utsunomiya as Akane. Mr. Takabayashi seems to be a serious romantic, his style being simultaneously rich, especially in his frequent use of flashbacks, and spare. I suspect too, that "Irezumi" contains more wit and irony than we ever understand from the subtitles.

1984 My 9, C23:1

Clash of Cultures

TENDERNESS AND ANGER, written and directed by Johannes Flutsch; camera, Carlo Varini; edited by Mr. Flutsch and Hannelore Kunzi. At the Film Forum, 57 Watts Street. Running time: 90 minutes. In German with English subtitles. This film has no rating.
WITH: Cesa Family

By JANET MASLIN

MOST of "Tenderness and Anger," which opens at the Film Forum today, takes place in a Swiss forest where a gypsy couple and their two children have temporarily set up housekeeping. Johannes Flutsch's documentary, with an intimate, informal feeling, patiently observes that authentic family and its way of life.

Cesa and Beatrice talk of wanting things to be different for their son, Bajo, and daughter, Sorelei, even while celebrating the freedom of their nomadic life. "Here in the woods, I've got the nicest TV you can have," Cesa says, pointing to the scenery surrounding him. He is seen teaching his son to shoot a pellet gun and his daughter to help in the family knife-sharpening trade.

Whatever tension there is in "Tenderness and Anger" grows out of the interaction between the gypsies and Swiss society. Mr. Flutsch quotes from a 1964 government edict declaring, "these people are incapable of understanding how objectionable and dangerous their way of life is. So you must get through to the children." Cesa and Beatrice wage a continuing battle with local authorities over their children's education, which the parents are seen providing in the family caravan.

Mr. Flutsch's principal approach to his material is a direct one: he simply lets the various family members talk. Only when the authorities visit the caravan, as they do during the course of the film, or when the caravan pulls onto a superhighway and holds up traffic does the film find a visual expression of the tension generated by the gypsies' presence in so orderly a land.

Since Cesa is a garrulous but not always spellbinding talker, the film would have benefited from a bit more structure than the director, with his more passive approach to the material, cares to impose. An additional problem is created by the subtitles, which are offered simultaneously in French and in English and are somewhat sloppy in both.

1984 My 9, C24:1

Pituitary Pangs

FIRESTARTER, directed by Mark L. Lester; screenplay by Stanley Mann, based on the novel by Stephen King; director of photography, Giuseppe Ruzzolini; edited by David Rawlins; music by Tangerine Dream; produced by Frank Capra Jr. At the Rivoli, Broadway and 49th Street; Gramercy, 23d Street, near Lexington Avenue; New Yorker Twin, Broadway and 88th Street; 86th Street East, at Third Avenue, and other theaters. Running time: 116 minutes. This film is rated R.
Andrew McGeeDavid Keith
Charlie McGeeDrew Barrymore
Dr. Joseph WanlessFreddie Jones
Vicky McGeeHeather Locklear
Captain HollisterMartin Sheen
John RainbirdGeorge C. Scott
Irv MandersArt Carney
Norma MandersLouise Fletcher
Dr. PynchotMoses Gunn
Taxi DriverAntonio Fargas

LITTLE CHARLENE — nicknamed Charlie — McGee doesn't want to set the world on fire but, with increasing frequency, she does. Sometimes something just comes over her, and what she wills in her mind actually happens. Once, standing in an airport lobby, she sees a young soldier telling his pregnant, tearful girlfriend that he doesn't want to settle down yet. Charlie gets carried away, and the

The history, traditions and problems of a still-nomadic gypsy family, traveling Switzerland's superhighways in a handmade wooden caravan, are the subject of "Tenderness and Anger," a documentary by Johannes Flutsch.

soldier's shoes miraculously burst into flame.

"Firestarter," this month's screen adaptation of a Stephen King novel, is a good, stylish mixture of the kind of hokey horror and science-fiction elements in which Mr. King specializes. It has a first-rate cast headed by the small, extremely self-assured Drew Barrymore ("E.T."), who plays Charlie, supported by David Keith, who appears as her troubled dad, and George C. Scott, wearing a graying pony tail and one glass eye, who is the film's manic villain. Mr. Scott is supposed to covet Charlie's special "power," here called pyrokinesis, but he is such a forceful presence that he could probably teach Charlie a thing or two.

●

The screenplay, by Stanley Mann, bears more than a little resemblance to "The Fury," which was directed by Brian De Palma, who made his first big commercial hit by directing the screen version of Mr. King's "Carrie," which also had to do with brain power. Can you follow? In any case, "Firestarter" is about a top-secret Government agency and its experiments in what might be called remote-control extermination.

About half the film is a chase, in which Charlie and her father are pursued by Government agents, and the rest is set on the agency's elegant Virginia plantation, where Charlie is forced to perform dreadful demonstrations of her talents. These are explained by the fact that Charlie's mother and father, when they were nice, ordinary college kids, participated in Government-financed experiments that did terrible things to their pituitary glands.

●

In this sort of movie, explanations are less important than what happens and how. Mark L. Lester, the director, and the special-effects people keep the film moving at a fiery clip, and in such graphic detail that the

film's R rating is thoroughly deserved.

Also prominent in the supporting cast are Art Carney, Louise Fletcher, Martin Sheen and Moses Gunn. The film opens today at the Rivoli and other theaters.

Vincent Canby

1984 My 11, C8:1

A Free Spirit

GABRIELA, directed by Bruno Barreto; screenplay (Portuguese with English subtitles) by Leopoldo Serran and Mr. Barreto, from the novel "Gabriela, Clove and Cinnamon" by Jorge Amado; cinematography, Cerlo di Palma; edited by Emmanuelle Castro; music by Antonio Carlos Jobim and Gal Costa; produced by Harold Nebenzal and Ibrahim Moussa; an MGM/UA Classics Release. At Cinema 1, Third Avenue and 60th Street. Running time: 102 minutes. This film is rated R.
Gabriela...Sonia Braga
Nacib.......................................Marcello Mastroianni
Tonico BastosAntonio Cantafora
ColonelPaulo Goulart
CapitaoNelson Xavier
EngineerNuno Leal Maia
TuiscaFernando Ramos
MalvinaNicole Puzzi
GloriaTania Boscoli
RamiroJofre Soares
PrincePaulo Pilla

By JANET MASLIN

THERE is an unguarded, uncharacteristic moment in "Gabriela" in which Sonia Braga actually seems to be pulling *down* the hem of her very short and flimsy dress. For the most part, though, Miss Braga spends the film doing what she does best, and staying covered up is not one of her specialties.

Miss Braga, who first played the role of Jorge Amado's Gabriela (from his novel "Gabriela, Clove and Cinnamon") in a soap opera for Brazilian television, is reunited for the film with Bruno Barreto, who directed her in "Dona Flor and Her Two Husbands." Together, they give this film the sunny, seductive gloss that is its only real asset.

Filmed in the beautiful little coastal village of Parati, Brazil, "Gabriela" introduces its heroine as a bedraggled creature caked with blue mud; she and some fellow

Bahians have wandered here in search of water during a drought. Gabriela's sweet and acquiescent nature is somehow apparent to Nacib, the foreign-born bar proprietor who hires her to cook for his establishment. Soon enough, the alluring Gabriela has added certain other services to her work regimen.

As played by Miss Braga, Gabriela is all compliance and availability; she is such a free and generous spirit that she washes Nacib's laundry wearing a smile, a skimpy outfit and a flower in her hair. But the social pressures of the town make themselves felt when Nacib, realizing how attracted every other man is to Gabriela, decides to marry her. Respectability means Gabriela must wear real clothes, keep them on and sleep apart from Nacib until the wedding day. Gabriela, uninhibited as she is, breaks the last of these strictures, and the second one, too.

"Gabriela," which opens today at Cinema I, is less successful in capturing the book's numerous minor characters than it is in basking in Miss Braga's inexhaustible glow. With Marcello Mastroianni as a plump and affectingly timid Nacib, the film makes some attempt to convey a cross-section of the town's political and social life, as represented by those activities that take place in Nacib's bar. But the minor characters seem incomplete, and Mr. Barreto never manages to weave their stories together. Whenever the film wanders away from Gabriela, it seems to dawdle aimlessly before finding her again.

Since Gabriela's repertory is limited, a certain monotony sets in after a while. Mr. Barreto's touch is becoming more delicate, but his version of Mr. Amado's story has neither the texture nor the urgency that might have made it more than a pretty little daydream. The film seems ready to end long before it does, after an overabundance of songs by Antonio Carlos Jobim about Gabriela and her beauty.

1984 My 11, C14:1

Marcello Mastroianni plays the role of a provincial tavern keeper who falls in love with a rustic woman in "Gabriela," adapted from the Jorge Amado novel.

Being the Best

THE NATURAL, directed by Barry Levinson; screenplay by Roger Towne and Phil Dusenberry, based on the novel by Bernard Malamud; director of photography, Caleb Deschanel; edited by Stu Linder; music by Randy Newman; produced by Mark Johnson; released by Tri Star Pictures. At the Sutton, Third Avenue and 57th Street; National, Broadway and 44th Street, and other theaters. Running time: 134 minutes. This film is rated PG.
Roy Hobbs..................................Robert Redford
Max Mercy,......Robert Duvall
Iris GainesGlenn Close
Memo ParisKim Basinger
Pop FisherWilford Brimley
Harriet BirdBarbara Hershey
JudgeRobert Prosky
Red BlowRichard Farnsworth
WhammerJoe Don Baker
Sam SimpsonJohn Finnegan
Ed HobbsAlan Fudge
Young RoyPaul Sullivan Jr.
Young IrisRachel Hall
Ted HobbsRobert Rich 3d

By VINCENT CANBY

WHEN it was published in 1952, "The Natural," Bernard Malamud's first novel, was received with rather grudging admiration. Now, more than 30 years and many celebrated works later, "The Natural," the story of the rise and fall of a legendary baseball player, is still seen as something of a Malamud aberration. Though it remains one of his most popular novels, it's not easily associated with works like "The Fixer" and "Dubin's Lives," in which the writer explores aspects of the Jewish experience, past as well as present.

Yet "The Natural" really isn't all that different. Though Roy Hobbs, its almost incredibly innocent hero, is as American as a figure in a Norman Rockwell magazine cover, the tale is full of those concerns for myth and morality that separate Mr. Malamud's narratives from those of all lesser writers.

The story of Roy Hobbs's romantic quest to become "the best there is" — the player against whom all subsequent players will forever be measured to their disadvantage — is as magical, funny and sad as anything Mr. Malamud has ever written. It seems realistic, but it is also fantastic and mysterious. Though Roy Hobbs is the quintessential small-town American boy of the 1920's, he has not only the strengths but also the flaws of the great heroes who survive outside their time.

David Keith and Drew Barrymore star in "Firestarter," based on Stephen King's novel about a girl with pyrokinetic powers.

These things need to be said in connection with the big, handsome, ultimately vapid screen adaptation of "The Natural" that opens today at the Sutton, National and other theaters. When a literary work of such particular and long-lived appeal is turned into a movie, one must assume that the adapters wanted not only to preserve but, possibly, also to illuminate it.

Instead, Roger Towne and Phil Dusenberry, who wrote the screenplay, and Barry Levinson, the director, seem to have taken it upon themselves to straighten out Mr. Malamud's fable, to correct the flaws he overlooked. They supply explanations that the novel resolutely avoided, reshape characters for dramatic convenience and, strangest of all, they transform something dark and openended — truly fabulous — into something eccentrically sentimental.

All of this might be justified if the film then succeeded on its own as something else. However, this "Natural" may well baffle people who come upon the remains of its story for the first time and wonder what Mr. Malamud was up to.

When we first see Roy Hobbs (Robert Redford), the year is 1924, and he's on his way from his farm home in the West to Chicago to try out for the Cubs. Enroute, the train makes a whistle stop at a small prairie town, where, at the local carnival, the scout accompanying Roy makes a crazy bet with two fellow passengers, Max Mercy (Robert Duvall), a famous sports columnist, and baseball's then reigning king, the Whammer, who, as played by Joe Don Baker, is the spitting image of Babe Ruth.

The $100 bet is that Roy can strike out the Whammer in three pitches, which is exactly what Roy does, thus promising to change the face of baseball exactly as he has set out to do. Unfortunately, he has also attracted the interest of a pretty young 1920's siren named Harriet Bird (Barbara Hershey). Later that night in the club car, Harriet flirts with Roy and talks to him about Sir Lancelot and Homer. She persists in asking him what he's looking for, but all that poor Roy can say is that he wants to be the best. Roy has never heard of the Holy Grail.

Their first night in Chicago, Harriet invites Roy to her hotel room where, dressed in something sheer and indiscreet, as well as a black hat with a widow's veil, she shoots him in the stomach with a silver bullet. Since this takes place early in the film, I'm not giving away important plot developments. Everything that happens afterward is in someway related to the near fatal-encounter in that Chicago hotel room in 1924.

•

The film then skips forward 15 years when Roy shows up at the dugout of the last-place New York Knights to become the oldest rookie in the major leagues. The movie, like the book, never tries to explain what Roy has been doing in those 15 years, nor why he has at long last resumed his baseball career.

Instead it concentrates on Roy's miraculous rise to glory, which promises to save the Knights from the greedy clutches of their owner. Very much a part of this are Roy's love affairs, one with Iris Gaines (Glenn Close), the virtuous sweetheart he left at home and who suddenly turns up in the ball park in Chicago to break Roy's losing streak, and Memo Paris (Kim Basinger), the beautiful, wanton niece of the club's manager, Pop Fisher (Wilford Brimley).

Up to this point, the film pretty much follows the outlines of the novel. However, when Roy is once again tempted as he was in Chicago

Jurgen Vollmer

Robert Redford in "The Natural."

15 years before, the movie takes it upon itself to save Roy from any further transgressions, possibly because "The Natural" is, after all, a big-budget commercial entertainment of the kind that is supposed to warm the heart, not shiver the timbers. The brooding moral fable becomes a fairy tale.

If the source material were not so fine and idiosyncratic, it would not be worth worrying about the film's peculiar failures. However, given all that it might have been, one wants it to be better.

The baseball sequences are beautifully staged — up to a point: the movie always tells us when Roy and his homemade bat, Wonderboy, are going to hit a homer because that homer ball always comes at him in slow motion. Caleb Deschanel's glowy, idyllic camera work also overstates moods to such an extent that it seems to be an end in itself, rather than a means to an end. In much the same way, Randy Newman's sound track score at times seems to be telling the story two bars ahead of the action on the screen.

The supporting performances are good, especially those of Miss Basinger; Mr. Duvall; Mr. Brimley; Richard Farnsworth, as the Knights' coach; Robert Prosky, as the Knight's scheming owner; and Michael Madsen in the small role of Bump Bailey, the star of the Knights until the appearance of Roy Hobbs. Darren McGavin makes an interesting if unbilled appearance as the big-time bookie who is behind the scheme to wreck Roy's career. Miss Close and Miss Hershey are little more than functions of the plot.

Mr. Redford's performance is difficult to analyze. At times his almost legendary presence as a major movie star perfectly fits the character of Roy, who is as much of a legend as the actor. At other times, his diffidence appears to be that of a movie star who is afraid someone's going to ask for his autograph. Though he looks terrific, especially on the field in action, the performance is chilly. It's so studied that there's very little spontaneous emotion for the audience to react to.

Mr. Levinson, who both wrote and directed "Diner," the small, exquisitely realized comedy about growing up aimless in Baltimore, here seems to be at the service of other people's decisions. Though entertaining in short stretches, "The Natural" has no recognizable character of its own.

•

"The Natural," which has been rated PG ("parental guidance suggested"), contains some vulgar language.

1984 My 11, C15:1

HARDBODIES, directed by Mark Griffiths; screenplay by Steve Greene and Eric Alter and Mr. Griffiths; director of photography, Tom Richmond; edited by Andy Blumenthal; music by various composers; produced by Jeff Begun and Ken Dalton; released by Columbia Pictures. At Loews State, Broadway and 45th Street; Orpheum, 86th Street at Third Avenue, and other theaters. Running time: 102 minutes. This film is rated R.

Scotty Grant Cramer
Kristi Teal Roberts
Hunter Gary Wood
Rounder Michael Rapport
Ashby Sorrells Tickard

By JANET MASLIN

"We spent years trying to get our businesses to work the way we wanted so we could come and do this!" declares one of the three middle-aged lechers who decide to move to a California beach to ogle the teenage talent. Thus begins "Hardbodies," which tells of what happens when the lechers hire a smug, oversexed beach boy named Scotty (Grant Cramer) to help them make cute little friends.

Though Scotty briefly complains that his job sounds sleazy ("You're makin' me sound like a pimp, ha ha — how much?"), he warms to the task, and a lot of partying ensues. However, this isn't the kind of sexy California beach film that lulls you into a pleasant stupor. It's the kind that makes you wish for a biblical plague.

"Hardbodies," which opens today at Loews State and other theaters, doesn't have an easy time giving hedonism a bad name. It has to trot out some of the most mindless avaricious women in all California, the "hardbodies" of the title who, as Scotty explains it, "want something better out of life — faster cars, richer boyfriends, a better deal." These creatures, most of whom are on roller skates, are eventually won over by the fact that the none-too-attractive businessmen (somebody nicknames them "Dumpy, Frumpy and Lumpy") have money to burn.

Among the few moments of sentiment here is the one in which Scotty comforts a blonde who is experiencing a rare flash of introspection. "You don't know what it's like when they call you names like Airhead, Dingaling, Yoyo, Bimbo — there's no way you can know that, Scotty," she sobs. Scotty gives her a sympathetic fondle. This is the closest thing to a serious conversation contained anywhere in the movie.

1984 My 12, 12:5

Onset of Deliquency

ZAPPA, directed by Bille August; screenplay (Danish with English subtitles) by Mr. August and Bjarne Reuter, based on the novel by Bjarne Reuter; cinematography by Jan Weincke; edited by Janus Billeskov Jansen; music by Bo Holten; production management by Ib Tardin and Janne Find; an International Spectrafilm Release; at the 68th Street Playhouse, at Third Avenue. Running time: 103 minutes. This film has no rating.

Sten Peter Reichardt
Bjorn Adam Tonsberg
Mulle Morten Hoff
Sten's mother Solbjorn Hojfeldt
Sten's father Bent Raahaugh
Bjorn's brother Thomas Nielsen
Bjorn's father Arne Hansen
Bjorn's mother Lone Lindorff
Mulle's father Jens Okking

"Zappa" was shown as part of this year's New Directors/New Films series. Following are excerpts from Janet Maslin's review, which appeared in The New York Times on April 3. The film opens today at the 68th Street Playhouse, at Third Avenue.

AT first glance, the protagonists of Bille August's "Zappa" look as though they must lead charmed lives. Tall, slender, uncommonly handsome young Danes, they are reaching adolescence during an era of quiet prosperity (the year is 1961). Their families are solidly upper middle class; their suburb is pretty and serene. What can go wrong for boys like Bjorn (Adam Tonsberg) and Sten (Peter Reichardt)? Mr. August's film, which is named for Sten's sinister, carnivorous pet fish, does a powerful job of tracing the boys' growing delinquency.

"Zappa" depicts these young characters and their families in a remarkably assured and telling style. The film studies both boys and their protégé, a fatter and less guarded classmate named Mulle (Morten Hoff), who is eager to become a member of their clique. Mulle's background is more working class than those of the other two, and his manner more spontaneous. Inevitably, this encourages the sadism of the bullying Sten.

If Mr. August, who makes "Zappa" a forceful and enveloping drama, errs at all on the side of predictablity — and he generally doesn't — it is in laying much of blame for the boys' foibles squarely at their parents' doors. Sten's is the more prosperous family, and he is the more neglected child, with a mother who is frequently in a yoga-induced trance, and who seldom speaks to him. When his father finally moves out, and Sten manfully surprises his mother with a candle-lit dinner, she says, "You couldn't know it, but in Mom's new diet, fats like that are out of the question." Wry as this kind of caricature may be, it doesn't suit the film's otherwise understated style.

Nor do the glimpses of what his home life is like for Bjorn, whose family means well but doesn't pay much attention to him. When he tries to tell his mother that he has been out with Sten and the gang, vandalizing Sten's father's new apartment, she barely listens. She is so preoccupied with the news that Sten's parents have separated that she doesn't even catch wind of her own son's crime.

But Bjorn's confusion is for the most part delicately outlined, and it has been beautifully conveyed by Mr.

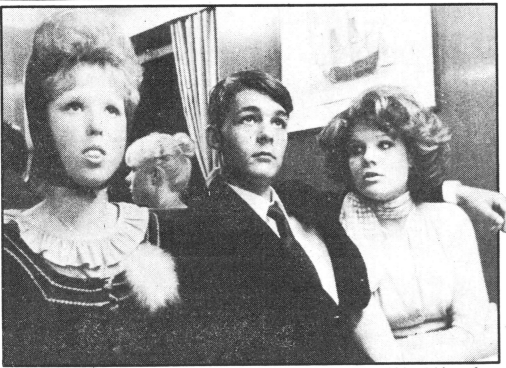

The suburbs of Copenhagen are the setting for "Zappa," a story of friendship and cruelty among upper middle class teen-agers in the early 1960's.

Tonsberg, whose passivity in the role is as essential as his faintly ironic manner. His character's growing pains become extremely palpable here, as does the atmosphere of complacency in which these problems develop and then get out of hand. Mr. August has made "Zappa" a suspenseful, moving drama, with concerns that are as troubling as they are universally recognizable.

1984 My 16, C24:3

Preppy Adventures

MAKING THE GRADE, directed by Dorian Walker; screenplay by Gene Quintano, from a story by Mr. Quintano and Charles Gale; director of photography, Jacques Haitkin; edited by Dan Wetherbee; music by Basil Poledouris; produced by Mr. Quintano; released by MGM/UA and Cannon Group. At the Loews Twin, Second Avenue and 67th Street; Loews State, Broadway and 45th Street; 86th Street Twin, at Lexington Avenue, and other theaters. Running time: 105 minutes. This film is rated R.
Eddie Keaton...................................Judd Nelson
Tracey HooverJonna Lee
Mr. HarrimanGordon Jump
Coach WordmanWalter Olkewicz
NickyRonald Lacey
Palmer WoodrowDana Olsen
Rand ..Carey Scott
Bif ..Scott McGinnis
DiceAndrew Clay
Skip ...John Dye
BlimpDaniel Schneider

"**M**AKING the Grade," which opens today at Loews State and other theaters, is as close to faceless as is possible for a movie composed of conventional images. The film means to be a comedy about the adventures of a tough city fellow when he's hired by a rich young man to take his place at a snobbish Eastern prep school. The humor, some of it looking and sounding as if it had been lifted from "The Official Preppy Handbook," is wan, and the direction, by Dorian Walker, without character of any sort. I left after watching approximately an hour of it.

Vincent Canby

1984 My 18, C10:5

An Avenger

DANNY BOY, directed by Neil Jordan; screenplay by Mr. Jordan; director of photography, Chris Menges; edited by Pat Duffner; music by various composers; produced by Barry Blackmore; released by Triumph Films, a Columbia/Gaumont Company. At Waverly Twin, Avenue of the Americas and Third Street. Running time: 92 minutes. This film is rated R.
Annie...................................Veronica Quilligan
DannyStephen Rea
Bill ...Alan Devlin
Ray ...Peter Caffrey
DeirdreHonor Heffernan
BrideLise-Ann McLaughlin
GroomIan McElhinney
Best ManDerek Lord
BloomRay McAnally
BonnerDonal McCann
Aunt MaeMarie Kean
BouncerDon Foley

"**D**ANNY BOY" displays the technical proficiency of its director, Neil Jordan, without making more than a fleeting claim on the audience's attention. That may make it sound like an overstylish effort, but in fact, Mr. Jordan's film has a homespun style and story, which makes its

Stephen Rea plays a musician seeking revenge in "Danny Boy."

remoteness doubly odd.

Set in a small Irish town, "Danny Boy" traces a musician's reaction to a double murder outside the club where he has been playing. Danny (Stephen Rea) watches gangsters kill a friend, who has failed to pay them protection money, and also gun down a mute girl who wanders onto the crime scene. The killings leave Danny so enraged that he spends the rest of the film finding the murderers, and avenging the crime.

There's nothing of "Death Wish" to "Danny Boy," however; if anything, Mr. Jordan's film is a morose, sentimental elegy to the dead woman, and a celebration of Danny's sensitive nature. Empty interludes with his lover Deirdre (Honor Heffernan), a singer who performs "Strange Fruit" a couple of times during the film without anything like Billie Holiday's intensity, punctuate Danny's equally dispirited search for the killers. As played by Mr. Rea, Danny isn't an unsympathetic figure, but he's in no way capable of making the search compelling. Even Danny's confrontations with his prey manage to lack the tension that should have been there automatically.

Though "Danny Boy," which opens today at the Waverly, is so wanting in momentum, it has a plain, quiet style that might have worked better with different material. Chris Menges's cinematography is the best thing in it.

Janet Maslin

1984 My 18, C11:1

A Poet and Admirers

BEYOND GOOD AND EVIL, directed by Liliana Cavani; screenplay (Italian with English subtitles) by Miss Cavani, Franco Arcalli and Italo Moscati; original story by Miss Cavani; director of photography, Armando Nannuzzi; edited by Mr. Arcalli and Robert Jose Pomper; music by Daniele Paris; produced by Robert Gordon Edwards. At the Carnegie Hall Cinema, Seventh Avenue and 56th Street. Running time: 106 minutes. This film has no rating.

Lou Andreas-Salomé................Dominique Sanda
Friedrich NietzscheErland Josephson
Paul RéeRobert Powell
Elisabeth NietzscheVirna Lisi
Peter GastPhilippe Leroy
Franziska NietzscheElisa Cegani
Bernard ForsterUmberto Orsini
Karl AndreasMichael Degen
Dr. DulcamaraAmedeo Amodio
MalvidaCarmen Scarpitta
AmandaNicoletta Macchiavelli

By JANET MASLIN

FRIEDRICH (FRITZ) NIETZSCHE, played by Erland Josephson, Lou Andreas-Salomé (Dominique Sanda) and Paul Rée (Robert Powell), whose ménage à trois is examined in Liliana Cavani's "Beyond Good and Evil," are spending an evening together. Fritz dares Lou to take a vase off the piano and use it as a chamber pot; Lou, the oft-proclaimed free spirit of the three, calmly obliges. Then Lou and Paul couple on the floor, with an anguished Fritz looking on and finally grasping Paul's hand. At last, weary of all the merriment, Lou pauses. "Intellectuals!" she says.

To give Miss Cavani's film the benefit of the doubt, which may be more than fair, its abruptness suggests the kind of overzealous editing that may have been necessitated by some of the film's sexual explicitness, and that may not have been entirely the director's doing. In any case, "Beyond Good and Evil" has a choppiness often bordering on the incoherent. That may not keep it from attracting curiosity seekers, since Miss Cavani's cast is good, her characters are historically significant, and her direction is every bit as hysterically lurid as it was in "The Night Porter."

In "Beyond Good and Evil," which opens today at the Carnegie Hall Cinema, Miss Cavani attempts to touch the steamy, erotic essence of whatever went on among Miss Andreas-Salomé, the poet and essayist whose admirers included Freud and Rilke, and two of her foremost lovers. The problem is not Miss Cavani's directness, but her utter lack of any accompanying approach. Those events she takes to be crucial to her characters' sexuality are presented more than bluntly, but very little else about them is made known. The result is a series of overwrought episodes, desperately lacking a larger context and bordering on the absurd.

One of the worst of these involves Elisabeth (Virna Lisi), the neurotic sister who loves her brother Fritz all too well. When Fritz (which comes out "Freets" in the dubbed Italian voices of the players) brings Lou to Elisabeth's house, it is more than the sister can bear. And when Lou and Fritz are late for lunch, the enraged Elisabeth tells her maid to begin serving without them. The maid holds out a plate bearing a chicken. Elisabeth reaches for it with her knife and fork, then, unable to control her fury, rips the chicken to pieces with her bare hands. Though the sequence seems designed to offer some sort of psychological insight, it is memorable only for Elisabeth's table manners.

Though "Beyond Good and Evil" is as graphic as it can be, it manages to remain peculiarly unerotic, perhaps because Miss Cavani's explicitness seems so literal. When she depicts the details of, say, a homosexual gang rape or a visit to a bordello, her frankness says more about her inability to convey such things metaphorically or imaginatively than it does about courage.

1984 My 18, C14:1

Strangers on a Train

FINDERS KEEPERS, directed by Richard Lester; screenplay by Ronny Graham, Terence Marsh and Charles Dennis; director of photography, Brian West; edited by John Victor Smith; music by Ken Thorne; produced by Sandra Marsh and Terence Marsh; released by Warner Bros. At the Warner Twin, Broadway and 47th Street; Art, Eighth Street and University Place, and other theaters. Running time: 92 minutes. This film is rated R.

Michael Rangeloff	Michael O'Keefe
Standish Logan	Beverly D'Angelo
Century	Louis Gossett Jr.
Georgiana Latimer	Pamela Stephenson
Josef Sirola	Ed Lauter
Stapleton	David Wayne
Mayor Frizzoli	Brian Dennehy
Ormond	Jack Riley

By VINCENT CANBY

FOR a farce, especially a farce directed by Richard Lester, "Finders Keepers" takes an unconscionable amount of time to get going, but don't be too impatient.

It begins with a bizarre but not immediately funny sequence in which a man is seen in the middle of the night walking up the drive to a mansion, carrying an ordinary kitchen chair. When he arrives at the front steps, he carefully puts the chair down, climbs onto the seat, and jumps to the third step, thus, the camera shows us, avoiding the electric-eye alarm system.

Once in the house, the burglar and a young, very blond woman, dressed in saucy widow's weeds, relieve the mansion safe of its contents, which turn out to be $5 million in cash belonging to the "widow's" father.

Cross-cut with these particulars is a sequence about an earnest young man who manages a women's Roller Derby team, the members of which become dangerously antagonistic when they learn their latest booking is nonexistent.

•

Not until the absconding couple and the fleeing, failed Roller Derby manager meet aboard a train heading from Oakland, Calif., to New York, does the movie begin, but when it does, "Finders Keepers" becomes a genially oddball comedy of a sort not often successfully made these days. The film, which opens today at the Warner Twin and other theaters, is full of irreverent gags and miniminded characters who would be quite at home in Preston Sturges's Morgan's Creek.

There are, most prominently, Michael Rangeloff (Michael O'Keefe), the erstwhile Roller Derby entrepreneur, and Standish Logan (Beverly D'Angelo), a pretty, exceptionally foul-mouthed actress Michael meets on the train. Also aboard the train is the stolen $5 million hidden in a casket that supposedly conceals the remains of a Vietnam veteran — the movie is not heavy with good taste.

Michael, having accidentally found the hiding place of the loot, is now disguised as a soldier, accompanying the vet's body home. Standish, whose career is stalled, is on her way to Denver to have a nervous breakdown. Among their fellow passengers are Michael's foster father (Louis Gossett Jr.), who's a breezy con man, and the fellow who originally stole the money (Ed Lauter). The burglar's accomplice (Pamela Stephenson), still wearing her startling widow's weeds, must follow the train in a bus, which, as we are shown, is filled with cheery nuns who will not stop singing rounds of "Row, Row, Row Your Boat", when she's trying to worry about the money.

Other characters who figure in the proceedings are Stapleton (David Wayne), "the world's oldest railroad conductor," and a number of greedy, scheming citizens in the small Nebraska town where everything comes to a manic conclusion.

"Finders Keepers," which was adapted by Ronny Graham, Terence Marsh and Charles Dennis from a novel by Mr. Dennis, has a lot of charm best described as loose jointed. It's not especially graceful, but it grows increasingly funny as it approaches the Nebraska showdown. Involved in these sequences are the small town's crooked Mayor (Brian Dennehy); a two-story farmhouse, atop a flatbed truck, being moved to a new location; a real soldier who has deserted, and the resurrection of someone thought to be dead, a situation that prompts a credulous young woman to report to her uncle breathlessly, "Cousin Lane has risen!"

•

Some of the film's best lines go to Mr. Wayne's Stapleton, a meddling old fellow who can telephone President Nixon — the time is 1973 — and get through to him. For reasons that don't have much to do with the plot, Stapleton also has a fondness for dogs, including, he says, English setters and Labrador repeaters.

Though the pacing of the film is uneven — its highpoints stand out like clumps of trees in the flat Nebraska landscape, "Finders Keepers" is unexpectedly satisfying. The good humor and the wit are even retroactive, making the opening sequences seem funnier than they actually were.

The cast members, beginning with Mr. O'Keefe, Miss D'Angelo and Mr. Wayne, are as talented a group of comic actors as has been collected in an American film since Jonathan Demme's "Melvin and Howard."

Mr. Lester (director of "A Hard Day's Night," "Help!" and the last two "Superman" films) wastes too much footage setting up the basic situation, but once that's out of the way, "Finders Keepers" is a breeze.

1984 My 18, C10:1

Himalayan Exploits

INDIANA JONES AND THE TEMPLE OF DOOM, directed by Steven Spielberg; screenplay by Willard Huyck and Gloria Katz; story by George Lucas; director of photography, Douglas Slocombe; film editor, Michael Kahn; music by John Williams; produced by Robert Watts; released by Paramount Pictures. At Loews Astor Plaza, Broadway and 44th Street; Orpheum, 86th Street at Third Avenue; 34th Street Showplace, at Second Avenue, and other theaters. Running time: 118 minutes. This film is rated PG.

Indiana Jones	Harrison Ford
Willie Scott	Kate Capshaw
Short Round	Ke Huy Quan
Mola Ram	Amrish Puri
Chattar Lal	Roshan Seth
Captain Blumburtt	Philip Stone
Lao Che	Roy Chiao
Wu Han	David Yip
Kao Kan	Ric Young
Chen	Chua Kah Joo
Maitre d'	Rex Ngui
Chief Henchman	Philip Tann
Weber	Dan Aykroyd
Chinese Pilot	Akio Mitamura
Chinese Co-Pilot	Michael Yama
Shaman	D. R. Nanayakkara
Chieftain	Dharmadasa Kuruppu
Sainu	Stany De Silva
Little Maharajah	Raj Singh
Eel Eater	Art Repola
Sacrifice Victim	Nizwar Karanj

By VINCENT CANBY

IF you've ever been a child or, barring that, if you've ever been around children, ages 7 to about 11, you may remember the sort of game in which each child attempts to come up with the vilest, most disgusting, most repulsive, most stomach-turning meal he can think of. It might consist of sheeps' eyes in runny aspic, live cockroaches wrapped in spider webs, juicy worms à la king and bats' brains with anchovies and chocolate sauce.

The children squeal with delighted horror as each new dish is described, finding it all delicious fun, though any adults in the vicinity will probably feel sick.

This may well be the public's reaction to Steven Spielberg's exuberantly tasteless and entertaining "Indiana Jones and the Temple of Doom," which opens today at Loews Astor Plaza and other theaters, and which already is causing a ruckus because of its PG rating.

The film is called a "pre-sequel" to Mr. Spielberg's enormously popular "Raiders of the Lost Ark," since it's about the pre-"Raiders" exploits of that earnest, usually unshaved, remarkably quick-witted archeologist-adventurer with the battered fedora, Indiana Jones (Harrison Ford).

The time is 1935 and the place is a Shanghai nightclub. Behind the opening credits, we watch a comically klutzy, Busby Berkeley-like production number featuring an American entertainer, Willie Scott (Kate Capshaw), backed by a line of Asian chorus girls, tap-dancing their gold hearts out and singing — sometimes with Chinese lyrics — Cole Porter's "Anything Goes."

•

It's an unfortunate measure of how the film works that this opening sequence is the best, funniest, most efficient one in the movie. It not only introduces Indiana Jones and Willie, who loathe each other on first sight (the better to fall in love later), but it also ends with a great barroom brawl in which a priceless diamond gets lost in a shower of similarly shaped ice cubes.

After that, "Indiana Jones and the Temple of Doom" doesn't exactly go downhill, it just runs along on a plain, but at such breakneck speed one doesn't have time to question things too closely. There's a wild chase through Shanghai's cluttered streets, with Indiana's getaway car being driven by his pint-sized, 12-year-old chauffeur-sidekick, Short Round (Ke Huy

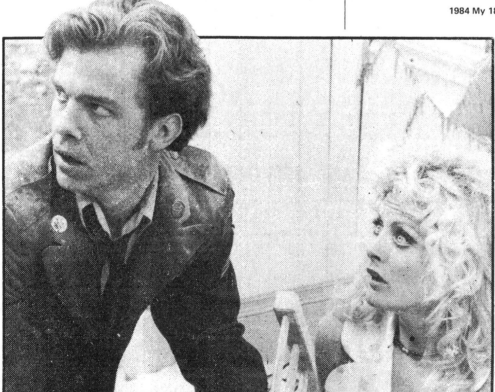

Michael O'Keefe and Beverly D'Angelo star in "Finders Keepers," a comedy adventure whose ingredients include a missing $5 million, a Vietnam war hero, a lovely neurotic, a con man, a revenge-bent female Roller Derby team and a transcontinental train.

Harrison Ford in the film "Indiana Jones and the Temple of Doom."

Quan), followed by a flight westward in a fine old Ford Tri-Motor, from which Indiana, Willie and Short Round must bail out without benefit of parachutes.

Most of the film takes place in a remote Himalayan province and involves (1) a village from which all the children have mysteriously vanished, (2) a sacred rock with magical powers, and (3) a cult of Kali worshipers (remember "Lives of a Bengal Lancer"?), whose practices include human sacrifice.

The screenplay, written by Willard Huyck and Gloria Katz ("American Graffiti"), from a story by George Lucas, is serviceable but no match for the witty one by Lawrence Kasdan for "Raiders." Unlike "Raiders," the new movie's script never quite transcends the schlocky B-movie manners that inspired it. Though it looks as if it had cost a fortune, "Indiana Jones" doesn't go anywhere, possibly because it's composed entirely of a succession of climaxes. It could end at any point with nothing essential being lost.

•

Watching it is like spending a day at an amusement park, which is probably what Mr. Spielberg and his associates intended. It moves tirelessly from one ride or attraction to the next, only occasionally taking a minute out for a hot dog, and then going right on to the next unspeakable experience.

These include a quite fine movie equivalent to a roller-coaster ride, a walk through a pit full of scorpions and cockroaches, as well as a maharajah's banquet where the menu features the kind of dishes (live baby snakes, chilled monkey brains) that children will find simultaneously revolting and hilarious while the rest of us reach for our Tums.

There's no doubt about it — the movie, in addition to being endearingly disgusting, is violent in ways that may scare the wits out of some small patrons. The kidnapped Indian children, when finally found, are seen being flogged as they slave away deep in the maharajah's mines, though the flogging is so exaggerated that it seems less real than cartoon-like.

There's a vivid sequence in which a man, being offered to Kali, is slowly lowered into a fiery pit, but not before a priest has removed the victim's heart with his bare fingers. This, however, is not only a film-making

trick but a trick within the film itself, something that older children may understand more readily than their adult guardians. Nevertheless, it's something to give parents pause.

Mr. Ford has become very good at this sort of characterization in this sort of film. He gives an exceptionally skillful comic performance, demonstrating the kind of easy charm and timing that eluded Michael Douglas in his somewhat similar role in "Romancing the Stone."

Miss Capshaw is most attractive and surprisingly good-natured, even though most of the time she isn't expected to do much more than squeal. At one point this prompts Indiana to say to Short Round, "The biggest trouble with her is the noise," as he chooses to ignore the python that has slithered up to her. Ke Huy Quan, whose first film this is, is a very good comic sidekick who, in moments of stress, which come often, sounds a little like Donald Duck.

"Indiana Jones" is too shapeless to be the fun that "Raiders" is, but shape may be beside the point. Old-time, 15-part movie serials didn't have shape. The just went on and on and on, which is what "Indiana Jones" does with humor and technical invention.

•

"Indiana Jones and the Temple of Doom," which has been rated PG ("Parental Guidance Suggested"), contains a lot of explicit violence of the sort described above.

1984 My 23, C21:1

Sausages With Music

IN HEAVEN THERE IS NO BEER?, produced, directed and photographed by Les Blank; edited by Maureen Gosling; distributed by Flower Films. Running time: 51 minutes. This film has no rating.
SPROUT WINGS AND FLY, directed and photographed by Les Blank; produced and co-directed by Alice Gerrard and Cece Conway; edited by Maureen Gosling; distributed by Flower Films. At the Film Forum, 57 Watts Street. Running time: 30 minutes. This film has no rating.

By JANET MASLIN

ONE of the many happy participants in Les Blank's "In Heaven There Is No Beer?" observes, at the end of the film, that he would prefer polka music to remain well outside the mainstream of American popular culture. That way, the music and its enthusiasts could retain the joyful, un-self-conscious vitality that is captured so beautifully here.

"In Heaven There Is No Beer?" opens today at the Film Forum, on a double bill with another of Mr. Blank's wonderfully jubilant documentaries about music, "Sprout Wings and Fly." As versatile an ethno-musicologist as Mr. Blank clearly is (he has also made films about Lightnin' Hopkins, Dizzy Gillespie and Cajun and Tex-Mex music, among other subjects), his approach to his material involves at least as much warmth as scholarship. The music, as depicted here, becomes a natural, unfiltered reflection of people's lives and values, as well as

something that fills them with delight.

"In Heaven There Is No Beer?" is enough to win converts to polka, that's for sure. Mr. Blank visits a number of intensive polka sessions (one of them an 11-day marathon) and observes the wildly enthusiastic participants. A few wear traditional polka garb, but a lot more dance in anything from double-knit polyester suits to bikinis, and all seem to be having a fabulous time. And if loving polka music means bucking convention, so much the better: one young woman says she wishes she could go to school with a huge radio blasting polka tunes, so that others could share the fun.

•

Mr. Blank's playfulness here matches that of the participants. To illustrate a song called "Someone Stole a Kizska," he films his editor, Maureen Gosling, as she re-enacts the sausage theft of the lyrics; then he even shows Polish sausage being made, while the music tootles on. Mr. Blank also examines the dancers' Polish patriotism and their polka regalia, concluding that they may find a close and authentic sense of community through this form of folk art.

He brings much the same perspective to a shorter film, "Sprout Wings and Fly," that profiles the bluegrass musician Tommy Jarrell. Mr. Blank's talent for finding genuine, unpretentious originals is again in evidence as he visits Mr. Jarrell and his friends and relatives in an Appalachian setting. Interspersed with Mr. Jarrell's music are family scenes and reminiscences. One elderly woman puts down her garden hoe to sing a courting song she recalls from her girlhood. Mr. Jarrell himself remembers a man who had such a bad corn on his toe that he lopped the toe off, then covered it in ashes to stop the bleeding. Somehow, as told by Mr. Jarrell, the story never becomes macabre enough to lose its humor.

•

Mr. Blank presents Appalachian musicians, as he does polka dancers, without condescension and without even a hint of stereotyping. He relishes their individuality and shares their enthusiasm, and the open, receptive attitude of his films is their very best feature.

1984 My 23, C24:1

Killing Boredom

HEAT OF DESIRE, directed by Luc Beraud; written (French with english subtitles) by Mr. Beraud and Claude Miller; photographed by Bernard Lutic; edited by Joelle Van Effenterre; music by Eric Demarsan; produced by Lise Fayolle and Giorgio Silvagni; released by Triumph Films, a Columbia/Gaumont Company. At the Plaza, 58th Street east of Madison Avenue. Running time: 89 minutes. This film is rated R.
Serge Laine Patrick Dewaere
Carol .. Clio Goldsmith
Helene Jeanne Moreau
Max ... Guy Marchand
Rognon Pierre Dux
Martinez Jose-Luis Lopez Vasquez

By JANET MASLIN

A TIMID academic is caught up in a reckless erotic escapade in "Heat of Desire," the latest of several thinking-man's sex films to have opened here in the last few weeks. It begins, most improbably, when the pouty mistress (Clio Goldsmith) of a politician announces that she is bored with her lot and determines to have a fling

Polka-dancing and its devotees are the subject of "In Heaven There Is No Beer?," one of two documentaries by Les Blank at the Film Forum.

Clio Goldsmith and the late Patrick Dewaere star in "Heat of Desire." Luc Beraud's erotic fantasy about a dreamy intellectual who is transformed into a man of action under the influence of an enigmatic siren. Jeanne Moreau co-stars.

with the very next man she sees. He turns out to be a pale, nervous professor of philosophy, played by Patrick Dewaere, who looks terribly gaunt here and committed suicide after completing the role.

"Heat of Desire," which opens today at the Plaza theater, was directed by Luc Beraud, whose previous film was "Like a Turtle on Its Back," about an author suffering from writer's block. Mr. Beraud has a way with slightly offbeat subjects, and much of his work is appealingly idiosyncratic. This time, though, his material (he co-wrote the film with Claude Miller) is more joyless and contrived. It follows the professor's progress away from his constricted, humdrum life toward something more adventuresome, yet it manages to chart his course in predictable ways.

Serge Lane (Mr. Dewaere) encounters Carol (Miss Goldsmith) just as he and his wife are about to embark on an expense-paid trip to Barcelona for a speaking engagement. Carol's allure is such that she soon has Serge telephoning his wife, telling her to cancel her travel plans. Soon Serge and Carol are sequestered in a posh Barcelona hotel room, making love, playing childish games (they use most of the bedding to construct an indoor version of a tree house), and running up a formidable room service bill.

The vixenish Carol seems interested only in sex and tourism, and Serge, calling her his "drug," is soon under her spell. This eventually leaves him alone, desperately in debt, and on the brink of total irresponsibility, a condition he finds both frightening and exhilarating. The film is most interesting when it concentrates on

Serge's transformation, most meandering when it spins a subplot about Carol's mysterious relatives, even though they are played amusingly by Jeanne Moreau and Guy Marchand. Serge's break with his past is most effectively rendered through tiny details, like the bright yellow shoes he begins wearing as his situation becomes increasingly dire. The same shoes have been seen earlier on a fellow academic, whom Serge must rob in order to pay the caviar bill.

Miss Goldsmith, having played the sex kittenish title role in "The Gift," is once again statuesque and coy in a role that has her spending a lot of time basking au naturel in the moonlight. She looks great, and her comic hauteur is effective in scenes calling for a tempermental popsy; otherwise, her range seems limited. Still, she convincingly fills the role of the temptress who drives Serge wild.

Though this film, unlike Mr. Beraud's earlier one, does not deal with writing specifically, it has a faintly literary flavor. If anything, Serge's voice-over narration seems to find more meaning in the events of the story than the camera does. And the film wanders in a novelistic fashion, savoring minor incidents and traveling at a leisurely pace. This is an appealing aspect of Mr. Beraud's style but also, in this case, a somewhat inappropriate one. Neither the characters nor the story here entirely warrant such scrutiny.

1984 My 25, C10:1

COLD FEET, written and directed by Bruce vanDusen; director of photography, Benjamin Blake; edited by Sally Joe Menke; music by Todd Rundgren; produced by Charles Wessler; released by Cinecom International Films. At 72d Street East, between First and Second Avenues; Embassy 72d Street, Broadway and 72d Street and other theaters. Running time: 96 minutes. This film has no rating.

Tom Christo	Griffin Dunne
Marty Fenton	Marissa Chibas
Leslie Christo	Blanche Baker
Bill	Mark Cronogue
Louis	Kurt Knudson
Harold Fenton	Joseph Leon
Psychiatrist	Marcia Jean Kurtz
Dr. Birbrower	Peter Boyden
Executives	Dan Strickler, John Jellison
Susan	Mary Fogarty

By VINCENT CANBY

AT the beginning of Bruce vanDeusen's "Cold Feet," which means to be a hip romantic comedy, two young, upwardly aspiring Manhattan couples are breaking up.

Tom Christo (Griffin Dunne), a director of television films, sleeps on a mattress in the living room while his wife, Leslie (Blanche Baker), mopes alone in the bedroom. When the alarm rings, Leslie shuffles out to wake Tom and ask what's bothering him. You don't have to be a therapist to know that what's bothering him are Leslie's wooly-bunny bedroom slippers, her hypochondria, her hypoglycemia and her whiny conversation — "I don't have any of my stuff ready for pottery class."

Meanwhile, in another part of the forest, Marty Fenton (Marissa Chibas), a research scientist studying depression in rats, is refusing to get back into bed with her boyfriend, Bill (Mark Cronogue). There's nothing really wrong with Bill except that he's an overbearing, take-over guy and Marty wants her own "space." At her psychiatrist's later that morning, Marty compains: "I don't feel things I want to feel any more. I don't feel the intensity."

It isn't long before the newly divorced Tom and the separated Marty find each other, but it takes the entire movie before each is ready to risk consummation of their perfect friendship by going to bed. Before that happens, there's more intensely sincere and dopey talk about "relationships" than you're likely to hear in a year of radio phone-in shows.

Mr. vanDeusen, who wrote and directed "Cold Feet," has some good things going for him here, including his two principal actors — Mr. Dunne and Miss Chibas, and a nice feeling for time and place as well as for small problems that loom large.

Though he doesn't hesitate to score easy points on the idiocy of television executives and the sniffly, aimlessness of women like Leslie, he appears to find nothing really funny about Tom and Marty. He treats them and their problems with what, I'm sure, he means to be honesty, but that has the effect of making them seem far more boring than they really are. One problem is that never for a minute do you believe they are the career successes they are supposed to be.

Another is that the film maker resolutely refuses to recognize the humor of the cant Tom and Marty talk, and since there's not a truly satiric moment in the entire film, "Cold Feet" appears to be as numbingly self-absorbed as they are. Because the film doesn't place them in any kind of larger context, one gets the impression that they are the entire world, which makes "Cold Feet" more truly depressing than any comedy can be and survive. Their world will not end in a nuclear holocaust but in a horrible gridlock of clichés about relationships and identities.

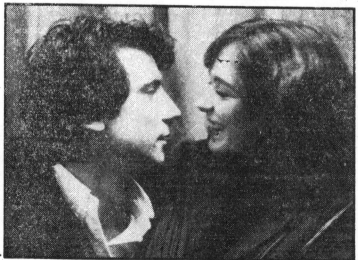

Griffin Dunne and Marissa Chibas portray discontented lovers who find each other in the comedy film "Cold Feet."

"Cold Feet" is the first feature film to be made by Mr. vanDeusen, a successful producer of television commercials This background is all too apparent in the film's slick style, including overlapping dialogue so insistent that at times you think the sound track is out of synch.

The point of allowing dialogue from a succeeding scene to invade the one before usually is to speed things up, to create a sense of pace. For some strange reason, it has the effect of slowing this film down to a crawl. At the same time, it suggests that the characters are no more important than models in commercials who are more interested in the spring freshness of their menthol cigarettes than in each other.

Both Mr. Dunne and Miss Chibas are such attractive, intelligent performers that they almost persuade you to believe things that aren't in the screenplay, or in the direction. Miss Baker is also initially amusing as the foolish Leslie, but she's so foolish that some of that foolishness rubs off onto her husband. How could he ever have married her? No adequate answer is supplied.

"Cold Feet" opens today at the 72d Street East and Embassy 72d Street Theaters.

1984 My 25, C12:1

FLESHBURN, directed by George Gage; screenplay by Beth and George Gage, based on the book "Fear in a Handful of Dust" by Brian Garfield; director of photography, Bill Pecchi; edited by Sonya Sones; music by Arthur Kempel; produced by Beth Gage; released by Crown International Pictures. At the Warner, Broadway and 47th Street; Olympia Quad, Broadway and 107th Street and other theaters. Running time: 90 minutes. This film is rated R.
Sam MacKenzieSteve Kanaly
Shirley PinterKaren Carlson
Earl DanaMacon McCalman
Jay PinterRobert Chimento
Calvin DuggaiSonny Landham
Jim BrodyRobert Alan Browne
SmyleyDuke Stroud
Marine SergeantLarry Vigus
ChrisNewton John Skinner
Stunts
 Jack Dunlap, Ed Adams, Will Morton, John Pearce

"Fleshburn," which opened yesterday at the Warner Twin and other theaters, is an inert action movie about a crazed Vietnam veteran, who's also an American Indian, who kidnaps the four psychiatrists — three men and a woman — who had him committed. He takes them to the middle of the Arizona desert, where he leaves them to perish, with the help of the sun and his own spells.

What should be a cat-and-mouse game, turns into a mouse-and-mouse game. The movie is more barren than the desert in which it's set. It's so boring that one's heart leaps up when a cliché looms on the horizon, but that usually turns out to be a mirage. There aren't even any psychiatrist jokes.

The film, which is based on a novel by Brian Garfield, who also wrote the novel "Death Wish," was directed by George Gage and written by him and Beth Gage, his wife. The cast includes Steve Kanaly, best known for "Dallas," Karen Carlson, Macon McCalman, Robert Chimento and Sonny Landham. Actually, they are virtually the entire cast, if you don't count the occasional animal, bird, insect or cloud.

Vincent Canby

1984 My 26, 13:1

FILM VIEW

VINCENT CANBY

Immigrants Define America On Screen

"When we come over here," a rueful Russian-Jewish immigrant remembers in "Hester Street," "we say, 'Goodbye Lord, I'm going to America.'" More than by anything else, America is defined in movies by the ways in which the eventual reality — for better or worse — differs from the expectations.

A recent batch of American movies — big studio productions like "Moscow on the Hudson" and "Scarface" and small, independent features on the order of "El Norte," "Liquid Sky," "The Mission" and "Musical Passage" — reflects a variety of expectations and experiences far more complicated and, at times, far more critical than Americans are accustomed to seeing.

In Joan Micklin Silver's wise, beautifully performed "Hester Street," which was made in 1975 and belongs to the more readily acceptable view of America as the fabulous melting pot, a naïve, waif-like young immigrant named Gitl (Carol Kane) loses her foolish, hellbent-on-assimilation husband, but discovers her own identity. Gitl's America is not exactly what she expected — it is even more rewarding.

Paul Mazursky's "Moscow on the Hudson," a comedy about a Soviet émigré musician who bolts for freedom in Bloomingdale's, is equally optimistic though nowhere near as convincing as "Hester Street," possibly because things appear to have been made too easy for the émigré by the sentimentality of the filmmaker.

Both films, however, belong to a long and rich tradition of movies that describe in largely uncritical detail the hope that America has held out for generations of immigrants. As in Elia Kazan's "America, America" (1963) and Jan Troell's "Immigrants" (1972) and "New Land" (1973), the emphasis is on the economic and social injustices left behind, which illuminate and make worthwhile the émigré experience in this country.

• • •

In these films, hopes are fulfilled, though not always in anticipated ways. A price must be paid for freedom: Late in "Moscow on the Hudson" the émigré musician (Robin Williams) encounters a comparatively benign mugger — but the price is always worth it.

By far the most poignant of the new movies in this tradition is Jim Brown's efficient, straightforward documentary feature, "Musical Passage," in which Lazar Gosman, the founder (in 1979) and conductor of the Soviet Emigré Orchestra, and some of his musicians talk not only about the rewards of emigration but also about the tremendous emotional toll.

In Mr. Brown's interviews with Mr. Gosman and the others, we understand something that somehow seems to get lost in even the most well-meaning, sincere fiction films. That's the realization that America is, after all, a country founded on departures from somewhere else, on decisions that break up families and on the kind of courage — sometimes to be interpreted as self-centeredness — that seldom are demanded of the native-born. Not many of us, I suspect, have any idea of the kind and the amount of soul-searching it takes to decide to move from a known world, no matter how repressive it is, to what might possibly be a fantasy land.

• • •

In one way and another, the illusory America — the land that promises everything and gives something else — is the subject of "Scarface," "El Norte" and even the hallucinatory "Liquid Sky."

Brian De Palma's satirical "Scarface" is about a Cuban punk (Al Pacino), tossed out of Castro's Cuba, who becomes, for a short time, anyway, the king of Miami's lucrative cocaine trade. What more could a punk hope for? When the punk is finally defeated, it's not because the dream didn't measure up to reality, but because he's become hooked on his own goods.

It's not a pretty picture, nor was it meant to be. I'm not sure that "Scarface" is as anti-drug and anti-violence as its producers, rather defensively, claim. However, its hysterical overstatement — exemplified when Mr. Pacino plays his Götterdämmerung with a clown-like blob of cocaine on the tip of his nose — is as legitimate a comment on life in America, and on the kinds of films it makes, as is the consistently sunny nature of "Moscow on the Hudson."

Though "Scarface" can be compared to Francis Coppola's two "Godfather" films, it's something else entirely. "The Godfather," especially the first film, is anything but satirical. It's a full-bodied epic, an emotionally involving, essentially cautionary tale about immigrants whose drive for money and power is not much different from the activities of 19th-century American robber barons who, after all, made this country great.

There's a sense of sadness about "The Godfather," not because the system itself is wrong, but because these particular characters perverted the dream the rest of us recognize as legitimate, for reasons that, initially at least, are comprehensible. The audience can identify with the family relationships, vicariously enjoy the risks the characters take, admire their curious loyalties and, at the end, feel pleasurably, romantically drained, and possibly a little bit superior.

"The Godfather" is far closer to a film like "America, America" than it is to the more ambiguous vision of "Scarface."

• • •

"El Norte," directed by Gregory Nava and written by him and Anna Thomas, is a remarkably affecting, beautiful looking but somber tale about two Guatemalan peasants, a brother and sister, who, to escape political repression, walk, bus and hitchhike their way up through Central America and Mexico to the promised land of Beverly Hills.

From ancient copies of Good Housekeeping they have learned that everyone in the United States has flush toilets, television sets and automobiles and, when they arrive, they can almost believe it. The reality of American life overtakes them not in the form of some terrible new repression, but almost as an accident, and this is where the film goes weak.

The film is very funny at the expense of well-to-do Beverly Hills liberals who want to help the underprivileged, and it dramatizes the unsophisticated nobility of the two peasants without condescension. However, the disaster that strikes them is arbitrary. Far more tragic than the death that actually occurs is the possibility, which arises about three-quarters of the way through the film, that these two immigrants will cheerfully abandon their heritage to embrace the plastic materialism of their new land.

Some of the most provocative comments on the American experience have recently been coming from foreign-born directors who find themselves here either as visitors or as exiles.

"Liquid Sky," directed by Slava Tsukerman, a Soviet émigré, is a witty, visually stunning science-fiction fable about some strung-out, Manhattan punk-scene types and the flying saucer that changes their lives. Though "Liquid Sky" doesn't seem to have a thought in its head about politics or the American experience, the · film itself appears to be an exuberant émigré's expression of relief at being in a new land. It's a psychedelic trip, an explosion of ideas, jokes, irreverent asides and technical tricks that simply couldn't be tolerated in the Soviet Union.

"The Mission" was shot entirely in New York and mostly in the Farsi language by Parviz Sayyad, an Iranian émigré. As you watch it, you suddenly have the feeling that the city you think you know has become as mysterious as Teheran. The story is hermetic, about an Iranian hit-man sent over to assassinate a former colonel in the late Shah's secret police. Though the hit-man's contacts are almost entirely with other Iranians, he begins to question his mission — with results that are both comic and seriously melodramatic.

For "The Mission," America — specifically New York City — is a kind of eccentric no-man's land, which, for reasons I don't quite understand, comes as a refreshing shock.

A much more gentle film, and one that shows us how we look to a sympathetic but skeptical outsider, is "Skyline" ("La Linea del Cielo"), a comedy about a young Spanish photographer on vacation in Manhattan. The film was shown at this year's New Directors/New Films Festival. Made here last summer by the Spanish director Fernando Colomo, "Skyline" has the manner of a breezy report, adressed to friends back home, on the odd behavioral patterns of upwardly mobile Americans in the arts. The focus is short but the details are vivid and sometimes very funny.

•

One of the most memorable of these films is the bittersweet "El Super" (1979), which is less a criticism of America than it is a description of homesickness, being about a middle-class, middle-aged Cuban émigré who's been reduced to being a Manhattan building super. The film, exceptionally well acted by Raymundo Hidalgo-Gato in the title role, was co-directed by Leon Ichaso and Orlando Jiminez-Leal. (Mr. Jiminez-Leal is also the co-director, with Nestor Almendros, of "Improper Conduct," the anti-Castro documentary that was also shown at this year's New Directors/New Films Festival.)

By far the best of these offshore contemplations of America is Werner Herzog's simultaneously sober and hilarious "Stroszek" (1977). Three German misfits — a none-too-bright prostitute, a possibly crazy old man and a mentally retarded younger fellow — immigrate to northern Wisconsin, in midwinter, in the wildly mistaken conviction that they're coming to the promised land. Mr. Herzog is too intelligent a filmmaker to think that any one film can sum up an entire country's experience. "Stroszek" is, instead, a sort of jazz riff on the immigrant theme.

Wim Wenders, another extremely talented German director, also has looked at America, with mixed results as far as America is concerned. "The American Friend" is a slick, glossy, entertaining, sometimes impenetrable underworld movie with cameo appearances by American directors Sam Fuller and Nicholas Ray, icons of the European cinema.

Though shot on location in America as well as Germany, the film sees America not as we immediately recognize it but as it has been defined in Hollywood gangster films of the 40's and 50's, which, I suppose, is a kind of tribute. The same is true of Mr. Wenders's meticulously produced but vacuous "Hammett,"

supposedly inspired by the pre-"Maltese Falcon" and "Thin Man" career of Dashiell Hammett.

Although Isaac Singer's "Yentl" has nothing to do with America, Barbra Streisand fixed that small oversight in her film adaptation. Seeing "Yentl" as a vision of America is the only way to understand the film's last scene, in which Yentl stands on the stern of a seagoing vessel, singing her heart out.

If you listened to the lyrics, you couldn't hear what she was really saying. It was "Goodbye Lord, I'm going to America!" After buzzing through Ellis Island in no time flat, this Yentl will soon be starring on Broadway in the Ziegfeld Follies. ■

1984 My 27, II:15:1

Lives of Crime

ONCE UPON A TIME IN AMERICA, directed by Sergio Leone; screenplay by Mr. Leone and Leonardo Benvenuti, Piero de Bernardi, Enrico Medioli, Franco Arcalli and Franco Ferrini, based on the novel "The Hoods" by Harry Grey; director of photography, Tonino Delli Colli; film editor, Nino Baragli; music by Ennio Morricone; produced by Arnon Milchan; released by Warner Bros. At Criterion, Broadway and 45th Street; Beekman, Second Avenue and 65th Street; Murray Hill, 34th Street, east of Lexington Avenue, and other theaters. Running time: 135 minutes. This film is rated R.

Noodles	Robert De Niro
Max	James Woods
Deborah	Elizabeth McGovern
Jimmy O'Donnell	Treat Williams
Carol	Tuesday Weld
Joe	Burt Young
Frankie	Joe Pesci
Cockeye	William Forsythe
Patsy	James Hayden

By VINCENT CANBY

SERGIO LEONE, the Italian director who gave class to the term "spaghetti western," has made some weird movies in his day but nothing to match "Once Upon a Time in America," a lazily haullucinatory epic that means to encapsulate approximately 50 years of American social history into a single film.

Although it's set almost entirely in New York, and although it's about a group of tough, Brooklyn Jewish boys who speak American argot as they grow up to become legendary mob figures, the movie looks and sounds more authentically Italian than your average San Gennaro festival.

We've come to expect this sort of thing from Mr. Leone, whose best westerns, including "The Good, the Bad and the Ugly" and "A Fistful of Dollars," are very personal, very Italian meditations on American movies that impressed him as a child. What is not expected is that his name should be attached to a film that makes so little narrative sense.

"Once Upon a Time in America" is not a disaster on the order of "Heaven's Gate." Having been cut from 3 hours and 47 minutes, which was its running time at this year's Cannes Festival, to its present time of 2 hours and 15 minutes, it plays like a long, inscrutable trailer for what might have been an entertaining movie. It is, I suppose, theoretically possible to remove that much footage from such a lengthy film and still have something coherent at the end, but this version seems to have been edited with a roulette wheel.

Like most films that have been so clumsily abbreviated, this shorter version of "Once Upon a Time in America" seems endless, possibly because whatever internal structure it might have had no longer exists.

It's a collection of occasionally vivid but mostly unfathomable incidents in which people are introduced and then disappear with the unexplained suddenness of victims of mob murders.

The screenplay, by Mr. Leone and five others, cannot be easily synopsized. It begins in the 1920's in a long prologue set in the Williamsburg section of Brooklyn, the jungle where the five young friends, including Max and Noodles, learn their trade as petty thieves and arsonists. Though this is the most coherent portion of the film, the audience is inclined to become restless waiting for Noodles to grow up to be played by Robert De Niro, Max to be played by James Woods and Deborah, the girl Noodles loves, to be played by Elizabeth McGovern.

When, at last, the film does more or less leap to the early 1930's, Max has become the gang boss, Noodles his possibly psychotic lieutenant and Deborah a rising young Broadway dancer. Other characters who turn up in the course of the next 36 years of the story are a Jimmy Hoffalike union boss (Treat Williams), a Detroit housewife (Tuesday Weld), who

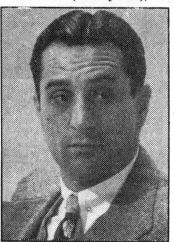

Robert De Niro in Sergio Leone's "Once Upon a Time in America."

makes something more than pocket money as a part-time prostitute, and a couple of hoods played by Joe Pesci and Burt Young.

Mr. De Niro and Mr. Woods might well be giving good performances, but it's impossible to tell from the evidence being shown here. At one point, the story appears to require that each assumes the other's character.

Mr. Williams is on screen such a short time that the role can be understood only if one knows something about the rise and fall of the real Jimmy Hoffa. It's just another example of the perverse ways in which this movie works that Deborah, as played by Miss McGovern, is far less appealing than she is as a mysterious, wide-eyed little girl played by Jennifer Connelly in the prologue. Only Miss Weld's performance seems to survive the chaos of the editing.

Nothing in the movie looks quite the way it should. Hilarious anachronisms abound, as might be expected in a production that was shot in Rome, Montreal and New York. When Deborah leaves for Hollywood from Grand Central, the terminal looks like Rome's and the 20th Century Limited like the Orient Express.

"Once Upon a Time in America," which is not to be confused with Mr. Leone's far wiser "Once Upon a Time in the West" (1969), opens today at the Beekman and other theaters.

1984 Je 1, C8:1

Faintly Futuristic

STREETS OF FIRE, directed by Walter Hill; written by Mr. Hill and Larry Gross; director of photography, Andrew Laszlo; edited by Freeman Davies and Michael Ripps; music by Ry Cooder; produced by Lawrence Gordon and Joel Silver; released by Universal Pictures. At the National, Broadway and 44th Street; Gemini, 64th Street and Second Avenue, and other theaters. Running time: 94 minutes. This film is rated PG.

Tom Cody	Michael Paré
Ellen Aim	Diane Lane
Billy Fish	Rick Moranis
McCoy	Amy Madigan
Raven	Willem Dafoe
Reva	Deborah Van Valkenburgh
Ed Price	Richard Lawson
Officer Cooley	Rick Rossovich
Clyde	Bill Paxton
Greer	Lee Ving

IF Walter Hill has directed any of the players in "Streets of Fire," his self-proclaimed "rock-and-roll fable," to do anything but talk tough and look hot, it doesn't show on the screen. Sexy posturing is what "Streets of Fire" is about — and if it were sexier or less humorless, it might really work. Mr. Hill had made a stimulating but finally exhausting exercise in thrill seeking, with a credo that is best summed up by the lyrics of an ear-splitting opening number: "You and me may be goin' nowhere baby/But we should be goin' nowhere fast!"

"Streets of Fire," which opens today at the National and other theaters, has a lot more to do with desperado lore than with rock-and-roll, though it is accompanied by a loud and overpersistent score. (Aside from some arrestingly strident slide-guitar instrumentals by Ry Cooder, who provided the lovely score for Mr. Hill's "Long Riders," most of the music does more harm than good.) Its hero is a handsome loner named Cody (Michael Paré), the sort of guy who could easily get the girl but is much too cool to bother. That's just as well, since the heroine is a tempestuous singer who is kidnapped by a gang of raping, pillaging motorcycle heavies even before the opening credits are over.

•

Visually, "Streets of Fire" lies somewhere between "The Wild One" and "Blade Runner," as a lot of 1950's-influenced new wavers in black leather (the setting is "another time, another place") race through decaying urban settings that have a bleak, nocturnal, faintly futuristic beauty. The urban romanticism tends toward neon signs reflected in mud puddles and confrontations in an alley beneath elevated tracks. Mr. Hill is a superb stylist, and the gap between the visual effects and their narrative idiocy is enough to make you weep. As in "The Warriors," he has constructed a great looking but essentially pointless pop parable.

Part of the trouble lies with the screenplay by Mr. Hill and Larry Gross; even if you don't mind its misogyny ("Listen, skirt, let me make it simple for you — take a hike!"), the whole thing is problematically crude. None of the characters is anything but tongue-tied, not even Amy Madigan's hard-as-nails McCoy, the woman warrior who helps Cody rescue the singer (Diane Lane) from her kidnappers and who nearly steals the movie in the process. The characters' names, like Ellen Aim and Billy Fish, aren't nearly so evocative as they seem intended to be.

There aren't any great performances, but there are some great faces: Mr. Paré's heroic gaze; Deborah Van Valkenburgh's long-suffering, world-weary innocence; even Willem Dafoe's perfectly villainous

punk heavy and the four singers who
make up a black a capella musical en-
semble, The Sorels. Miss Lane is
blander than the others, hardly con-
vincing as a singer. But she looks
great in tight costumes.

For all its studied sultriness, the
movie feels unsexy, perhaps because
its inspiration is the kind of hard-
hearted western that concentrates on
manly combat while eschewing all
sentiment. "Streets of Fire," inciden-
tally, is violent enough to raise a few
eyebrows over its PG rating. Though
there is little gore, the film includes
lots of explosions, a sledgehammer
fight and sexual molestation. More
than merely including this violence, it
celebrates it as well.

•

*"Streets of Fire" is rated PG
("Parental Guidance Suggested")
for the reasons mentioned above.*

Janet Maslin

1984 Je 1, C8:5

Greenery on Genesis

STAR TREK III: THE SEARCH FOR SPOCK, di-
rected by Leonard Nimoy; written and
produced by Harve Bennett, based on "Star
Trek," created by Gene Roddenberry; director
of photography, Charles Correll; edited by Rob-
ert F. Shugrue; music by James Horner; re-
leased by Paramount Pictures. At Loews State,
Broadway and 45th Street; Orpheum, 86th
Street at Third Avenue; 34th Street Showplace,
at Second Avenue, and other theaters. Running
time: 108 minutes. This film is rated PG.
KirkWilliam Shatner
SpockLeonard Nimoy
McCoyDeForest Kelley
ScottyJames Doohan
ChekovWalter Koenig
SuluGeorge Takei
UhuraNichelle Nichols
SaavikRobin Curtis
DavidMerritt Butrick
Trainee FosterPhil Morris
Mr. AdventureScott McGinnis
Commander MorrowRobert Hooks
Spock, age 9Carl Steven
Spock, age 13Vadia Potenza
Spock, age 17Stephen Manley
Spock, age 25Joe W. Davis

By JANET MASLIN

"STAR TREK III: The Search
for Spock" finds the same
old gang in a gloomy mood.
Spock is dead (or at least
he would appear to be, to anyone who
hasn't seen his likeness on movie
posters all over town). The Starship
Enterprise is ready for mothballs.
Even the crew's 23d-century leisure
suits are beginning to seem passé.
It's not hard to feel, while watching
the opening sections of this latest in
the "Star Trek" series, that you're
getting a little too old for this kind of
thing — and that *they* are, too.

But "Star Trek III," which opens
today at nearly 2,000 theaters across
the country and dozens of them here,
is helped by the gung-ho spirit with
which the cast, director and screen-
writer approach their material. They
all seem to believe wholeheartedly in
the "Star Trek" saga, relishing every
bit of jargon, every new space crea-
ture, every wheep and bleep of their
computer screens. Leonard Nimoy,
who directed this third installment,
hasn't matched the playfulness and
energy of "Star Trek II," but he's
way ahead of the first film, making
up in earnestness what he lacks in
style. That kind of conviction, while
sometimes verging on undue self-im-
portance, goes a long way toward
making the material touching.

The humanity of the "Star Trek"
series, unexpected as it is in a sci-fi
setting, remains the series' best fea-

ture. The members of the Enterprise
crew, a too-perfect interracial and
sexual mix, share a longstanding
friendship by now. That lends some
resonance to their mourning over
Spock's demise, even if their grief is
expressed in somewhat ludicrous
terms (Captain Kirk: "This time
we've paid for the party with our
dearest blood!").

Their troubles, for those who keep
track of such things, are compounded
by the Klingons, a race of bony-
headed villains who fly about in a
pterodactyl-shaped ship and are led
by a wicked priestess in a low-cut
gown. These Klingons track the En-
terprise crew to the rapidly self-de-
structing Genesis planet, which has
greenery that would do any Beverly
Hills florist proud. The adventure ul-
timately carries them to Vulcan,
Spock's home planet, where Dame
Judith Anderson presides over mysti-
cal rites. As for Spock, he's dead all
right. But thanks to the miracle of
Vulcan mind-melding, the situation is
not beyond hope.

•

The "Star Trek" saga remains a
television series at heart, even in its
wide-screen incarnations. For all the
fancy effects and sprawling panora-
mas, the scale remains small. The
disadvantage to this — a certain
visual blandness, even tackiness, to
the story's more grandiose settings —
is well outweighed by the intimacy
that exists among Enterprise crew
members, and by their seriousness
and avidity about what seem to be the
silliest minutiae (a blinking sign, for
instance, that reads "Life form! Life
form!" while scanning the Genesis
planet). That's what longtime
Trekkies love about the series, and
it's still here — a little the worse for
wear, but mostly untarnished.

While it's to Mr. Nimoy's credit
that he doesn't milk Spock's situation
for excessive eulogizing, a little less
directorial reserve might have made
for a more satisfyingly weepy ending.
Still, there are no big catharses to be
had here anyhow; that's the nature of
an ongoing series. And this surely re-

mains one of them. It isn't even nec-
essary to sit through the film to know
what its closing words will be. They
are, of course: "And the adventure
continues."

•

*"Star Trek III: The Search for
Spock" is rated PG ("Parental Guid-
ance Suggested"). It contains some
futuristic violence, like the strangling
of a giant space maggot, but on the
whole it should not scare most chil-
dren.*

1984 Je 1, C14:3

EDITH AND MARCEL, directed by Claude Le-
louch; screenplay (French with English subti-
tles) by Mr. Lelouch; collaboration on screen-
play and dialogue, Pierre Uytterhoeven and
Gilles Durieux; director of photography, Jean
Boffety; edited by Sandrine Pery; music by
Francis Lai; produced by Mr. Lelouch; re-
leased by Miramax Films. At 57th Street Play-
house, between the Avenue of the Americas and
Seventh Avenue. Running time: 140 minutes.
This film has no rating.
Edith Piaf and Margot de Villedieu Evelyne Bouix
Marcel CerdanMarcel Cerdan Jr.
Charles AznavourHimself
Jacques BarbierJacques Villeret
Francis RomanFrancis Huster
Loulou BarrierJean-Claude Brialy
Lucien RouppJean Bouise
CharlotCharles Gerard
GinouCharlotte de Turckheim
MarinetteMicky Sebastian
Margot's FatherMaurice Garrel
GuiteGinette Garcin
Jo LongmanPhilippe Khorsand

By VINCENT CANBY

She was a singer from the streets
who became the toast of all France.
He was a prizefighter whose fists con-
quered all Europe and, briefly, all the
world. They met, fell heedlessly, rap-
turously in love, joined their legends
and, ultimately, became a movie,
which is all-awful.

"She" is Edith Piaf, the French
chanteuse who died in 1963 at the age
of 48. "He" is Marcel Cerdan, the
French boxer who took the middle-
weight title from Tony Zale in 1948,
lost it to Jake La Motta in 1949 and
then, in the same year, succumbed in
an airplane crash in the Azores,
flying from Paris to New York to be
with his beloved and to fight La Motta
in a return bout. The movie is Claude
Lelouch's "Edith and Marcel," which

opens today at the 57th Street Play-
house.

•

One might better have said that
Piaf "died" and that Cerdan "was
killed," but those words wouldn't ac-
curately reflect the overripe but al-
ways genteel syntax of "Edith and
Marcel," which is to cinema what
movie magazines are to journalism.
If possible, you might want to see it
while sitting under a dryer.

Mr. Lelouch, who came onto the in-
ternational scene with "A Man and a
Woman" in 1965, is the most popular
film maker in all France, possibly be-
cause he puts his heart into his work,
as well as every romantic gesture he
has seen in a lifetime of moviegoing.

He doesn't just photograph Edith
and Marcel. Their every appearance
in this film amounts to a celebration,
which often makes the camera so
giddy that it sweeps in great dizzy cir-
cles around them. Though Edith and
Marcel don't fall in love until the
movie is about half over, the mystical
manner in which Mr. Lelouch cross-
cuts between their stories suggests
that God is somehow arranging their
union.

And, as if the grand love affair of
Edith and Marcel weren't enough for
the emotionally starved movie audi-
ence, Mr. Lelouch supplements it
with a parallel love story that adds a
new, quite unlikely twist to Edmond
Rostand's "Cyrano de Bergerac."
This subplot is about Margot, a beau-
tiful, well-born young French woman
who, during the German occupation
of France in World War II, falls in
love with her pen pal, Jacques, a
French soldier in a prisoner-of-war
camp. Because Jacques is a dumpy,
virtually illiterate fellow, he allows a
handsome articulate friend to dictate
his letters to Margot, with predict-
able complications later on.

Exactly what the story of Margot
and Jacques has to do with Edith and
Marcel is not easily understood, ex-
cept that Evelyne Bouix plays both
Edith and Margot, to no particular
point.

Marcel Cerdan Jr., who also has

DeForest Kelley, Walter Koenig, William Shatner, James Doohan and George
Takei team up once again as the crew of the U.S.S. Enterprise in "Star Trek III:
The Search for Spock." Leonard Nimoy, who plays Spock, directed the movie.

been a boxer, plays his father with a kind of modest, unexciting integrity, helped by a strong physical resemblance. In accepting the role, Mr. Cerdan found himself in the curious position of re-enacting the love affair that broke up the marriage of his mother and father.

•

Miss Bouix, who resembles a young Anouk Aimee as Margot, looks like a very refined, prettified edition of the real Piaf, whose legendary earthiness is nowhere to be seen. The Piaf songs,

which Miss Bouix lip-synchs so effortlessly you might think the sounds were coming from heaven, include old Piaf recordings as well as new tracks made by Mama Bea, a French rock singer. Charles Aznavour, who was a friend of Piaf and worked with her in the 1940's and 50's, plays a somewhat older version of his young self.

"Edith and Marcel" has been cut by 30 minutes for its American release but, at two hours and 15 minutes, it's still a very long devotional service.

1984 Je 3, 60:4

FILM VIEW

VINCENT CANBY

Hitchcock's 'Rope': A Stunt to Behold

"What a lovely evening," says the impeccably dressed Brandon (John Dall) to his impeccably dressed, great and good friend Philip (Farley Granger), as he draws back the curtains in their elegant penthouse living room to reveal the Manhattan skyline. "Pity we couldn't have done it with the curtains open, in bright sunlight."

The "it" Brandon is talking about is the carefully planned, coolly executed "thrill" murder of their long-time friend, David Kentley, whose impeccably dressed, still-warm body they've just hidden in an antique chest that occupies a prominent place in their living room.

In this fashion, Alfred Hitchcock sets the tone for "Rope," his seldom seen, underrated 1948 movie that turns Chicago's infamous old Leopold-Loeb murder case into something approximating drawing-room comedy. "Rope" follows "Rear Window" (1954), "Vertigo" (1958) "The Trouble with Harry" (1956) and "The Man Who Knew Too Much" (1955) as the last of five Hitchcock films that are now being given first-rate revivals by Universal Pictures.

• • •

"Rope" is not exactly a picture to warm your heart, take your mom to or make out by. The Arthur Laurents screenplay, adapted from Patrick Hamilton's play, is full of the kind of self-conscious epigrams and breezy ripostes that once defined wit and decadence in the Broadway theater. "What would you say to some champagne?" Brandon asks one of his guests at the post-murder cocktail party he's giving. "Hello, champagne," says the guest.

The film is so chilly you could ice champagne in it or place it around a silver serving dish of fresh caviar. It really is the "stunt" that Hitchcock calls it in "Hitchcock," François Truffaut's series of interviews with him, but it looks far more interesting now than either Hitchcock or Truffaut thought 20 years ago. And, once you get in touch with its dated speech rhythms, even its archness is acceptable.

"Rope" is not merely a stunt that is justified by the extraordinary career that contains it, but one of the movies that makes that career extraordinary. "I really don't know how I came to indulge in ["Rope"]," Hitchcock said almost apologetically to Truffaut, though he then went on to describe exactly why he did:

Hitchcock was interested in seeing whether he could find a cinematic equivalent to the play, which takes place in the actual length of time of the story. To do this, he decided to shoot it in what would appear to be one long, continuous "take," without cutaways or any other breaks in the action, though in fact there would have to be a dis-

guised break every 10 minutes, which was as much film as the camera could contain.

These breaks he usually accomplishes by having the camera appear to pan across someone's back, during which dark close-ups the film reel is changed. Not all of these disguises are equally effective, as Hitchcock himself later realized. However, his obsession with telling a story without resorting to the usual methods of montage, and

The film is so chilly you could ice champagne in it or place it around a serving dish of caviar.

without cutting from one shot to another, results in a film of unusual, fascinating technical facility, whose chilliness almost perfectly suits the subject.

"Rope" is about as dispassionate as a film can be, at least one that pretends to be about human beings. Its unemotional calm is like that of the frontier woman Lincoln used to describe, to make the point that there are times when a lack of bias is counterproductive. Coming out of her log cabin one morning to find her husband in mortal combat with a bear, the woman shouted, "Go it, man. Go it, bear."

It's not that "Rope" doesn't eventually take sides. There's a rather awful speech at the end in which the two young murderers' former prep-school teacher, Rupert Cadell (James Stewart), who brought up his prize pupils on Nietzsche's superman theories, suddenly recants and admits that all his theorizing has been hogwash. Until then, however, "Rope" has taken in the events of the story in the manner of a cat that, ignored by the guests, ambles freely around the apartment — the film's single set — appearing to be bored, completely uninterested in the action, but not missing a trick.

In "Rope," Hitchcock is less concerned with the characters and their moral dilemmas than with how they look, sound and move, and with the overall spectacle of how a perfect crime goes wrong.

• • •

As the movie opens, Brandon, who easily dominates his homosexual lover, Philip, is in the process of strangling the unfortunate David with a piece of ordinary clothesline. David's only crime seems to be that he's "ordinary," meaning, among other things, that he's engaged to be married. With remarkable dispatch, the two young men place David's remains into the chest and attend to last-minute preparations for the cocktail party they're giving for a small, select group of guests, including David's father, aunt and fiancée, and Rupert, the former teacher whose somewhat muddled ideas they've put into practice.

"Brandon," says Philip, "you don't think the party is a mistake, do you?"

"Being weak is a mistake," says Brandon.

"Because it's human?" says Philip.

"Because it's ordinary," says Brandon.

When I saw the film last week at the Cinema Studio, the audience collapsed with laughter at Philip's tentative suggestion that the party might be a mistake, but this was, I think, the laughter of disorientation rather than derision. There are a lot of laughs in "Rope" but most of these are ghoulish ones, though Mr. Granger's Philip is so distraught right from the beginning that almost everything he says or does strikes the audience as comic.

The Granger role is impossible. However, Mr. Dall is exceptionally effective as the imperious, self-assured mastermind of the couple. It's another measure of Hitchcock's wiles that, though the film was made back in the days when any sug-

gestion of homosexuality was supposedly taboo, "Rope" is immediately explicit without actually committing any offenses the Production Code people could object to. Constance Collier and Sir Cedric Hardwicke add a certain classy tone to the film as, respectively, the young victim's aunt and father, but Mr. Stewart is a problem.

This, I suspect, has something to do with the role, for which he is miscast. It's a smooth performance without being believable for a minute, possibly because it seems highly unlikely that the man we see on the screen could ever have spouted the nonsense attributed to him. He's also too down-to-earth and pragmatic ever to have been intrigued by the foppish manners and mini-intellect of the murderous Brandon.

That "Rope" does become emotionally involving has nothing to do with character identification and everything to do with watching a cinema master at work, as he denies himself the usual tools of his trade to find out just how effective the camera can be, working more or less on its own. It swoops and pries about the set, moving from close-ups to long shots to medium shots, with a kind of studied indifference. One high point: While the guests are discussing something of no great moment just off-screen, the camera, catlike, stares at the chest as the maid gets ready to put some books back into it, unaware, of course, that the chest is already fully occupied.

Hitchcock loved to put himself, as a filmmaker, into positions as impossible as those in which he placed his characters. In some ways "Lifeboat" is as much of a stunt as "Rope," being set entirely in a tiny lifeboat. Having made "Rope," however, he never indulged himself in this way again, though he did occasionally use the long, uninterrupted take in other films, most notably in the beautiful introductory sequence of "Topaz."

"Rope" is not an unrecognized Hitchcock masterpiece, but one cannot understand the truly bold originality of the man without seeing it. ∎

1984 Je 3, II:19:1

One Man's Struggle

THE GUEST, directed by Ross Devenish; written by Athol Fugard; camera, Rod Stewart; edited by Lionel Selwyn; produced by Gerald Berman; distributed by RM Productions, London. At the Film Forum, 57 Watts Street. Running time: 114 minutes. This film has no rating.
Eugene Marais Athol Fugard
Dr. A.G. Visser Marius Weyers
Oom Doors Gordon Vorster
Tante Corrie Wilma Stockenstrom
Doorsie James Borthwick
Louis Emile Aucamp
Little Corrie Susan MacLennan
Brenda Trix Pienaar
Stuurie Dan Poho

By VINCENT CANBY

TAKING as his source material a few months in the life of Eugene Marais (1871-1936), the South African poet, naturalist and morphine addict Athol Fugard has written a vivid, austere screenplay that, although it has nothing to do with race relations, is a nearly perfect analogue for such prize-winning Fugard plays as "Master Harold and the Boys" and "A Lesson from Aloes."

"The Guest," directed by Ross Devenish and starring Mr. Fugard himself as Marais, is set in 1926, when Marais, in one of his periodic attempts to overcome his habit, is per-

suaded by a doctor-friend to go into comparative isolation on an Afrikaner farm.

It's not an easy time either for Marais or for the plain, pious farmers who become his keepers. In the following months Marais successively ignores, threatens, wheedles and terrorizes his hosts as, each week, his dosage is lessened. Each week, too, as his physical dependency recedes and his sanity returns, his panic about an existence without drugs increases.

In "The Guest," which opens today at the Film Forum, the struggle is not against a repressive social system but a terrible internal battle to subdue an addiction that destroys the life that the morphine briefly makes bearable.

Mr. Fugard and Mr. Devenish, who earlier collaborated on the fine film adaptation of the playwright's "Boesman and Lena" (1976), keep the focus of the film short. They discover the drama of the tormented, ravaged man and the unsophisticated Afrikaner farmers in the specific details of day-to-day life — at the dinner table, during long afternoons when Marais wanders aimlessly around the farm, and in the middle of the night when he is beseiged by dreams.

The small but excellent supporting cast includes Gordon Vorster, Wilma Stockenstrom, James Borthwick, Emile Aucamp and Susan Mac Lennan, as the members of the farm family, and Marius Weyers, as Marais's infinitely patient doctor.

Marais, whose seminal but still controversial studies, "The Soul of the Ape" and "The Soul of the White Ant," were hailed by Robert Ardrey in his "African Genesis," is a bristly, brilliant, doomed character in Mr. Fugard's performance, which is intense without being busy or mannered.

"I hurt, therefore I am," says the haggard Marais, whose drug-taking began as a treatment for migraines. Marais is obsessed by pain, which becomes, for him, "the principal condition of all existence." "Escape from pain," he says, "is the purpose of all striving." He goes on to equate knowledge with grief — "the man who increases knowledge increases sorrow."

It comes as no surprise when the end title card notes that 10 years later, as Marais was going through another attempt at withdrawal, he put a gun to his head and blew his brains out.

"The Guest" is both agonizing and liberating as it documents one man's very particular struggle, which is, perhaps, far more universal than most of us would ever care to acknowledge.

1984 Je 6, C19:1

Determined Men

ESCAPE FROM SEGOVIA, directed by Imanol Uribe; screenplay (Basque and Spanish) by Mr. Uribe and Angel Amigo; director of photography, Jabier Agirresarobe; edited by Julio Pena; music by Amaia Zubiria and Xavier Lasa; produced by Mr. Amigo; released by Grange Communications. At the Bleecker Street Cinema, 144 Bleecker Street. Running time: 98 minutes. This film has no rating.
Ion Polosa Xabier Elorriaga
Pxuno Etxaniz Virginia Mataix
Maruja Fernandez Klara Badiola

By JANET MASLIN

IMANOL URIBE takes a crisply journalistic approach in detailing "Escape From Segovia," an account of the escape of 29

The escape of 30 Basque prisoners in Spain — set against the Basque separatist movement in 1976 — is the basis for "Escape From Segovia."

Basque prisoners from a Spanish prison in 1976. The film was produced and co-written by Angel Amigo, who participated in the jailbreak, and who displays a keen memory for its particulars. The film unfolds in a careful considered style, avoiding sensationalism and concentrating on the fine points of the prisoners' complicated plan.

"Escape from Segovia," which opens today at the Bleecker Street Cinema, makes less attempt to shape or analyze the event than simply to describe it. The rebellion of the Basque separatist movement against Spanish authority is only indirectly examined. But what the film lacks in larger political context is made up for in quiet excitement, as the prisoners begin the painstaking chore of digging a tunnel for their getaway. They construct a fake tile panel to cover a section of one bathroom wall, then dig behind it, using a homemade flashlight for illumination, and using stock pots from the kitchen to carry away dirt. Eventually, they make their way to freedom and to the French border, only to wander through the woods, chased by the police and not quite certain which side of the border they are on.

•

The film divides itself equally among the numerous escapees, so that no strong characters emerge individually; instead, there are many minor roles, some played by real ex-inmates of Segovia Prison. Mr. Uribe is careful not to force the drama toward a falsely happy ending, or even a truly conclusive one. Instead, his film follows the pattern of real events. One prisoner was wounded, another killed, and 22 were recaptured and sent back to jail.

•

For all the film's emphasis on the inmates' unhappiness, its depiction of the conditions within Segovia Prison is relatively benign. The prisoners are able to congregate in privacy, and the guards are less brutal than ignorant (one prisoner has a disagreement with a guard about whether "Moby Dick" started out as a book or a movie). Even the film's harshest sequence, in which a man and his fiancée are strip-searched preparatory to their jailhouse wedding, somehow concludes on a note of triumph. Humiliated and angered as they are by the search, the lovers still manage

to retain their innocence and hopefulness during the wedding ceremony. Another film might show the reunion of these newlyweds after the husband's escape, but Mr. Uribe is careful to avoid sentimentality of that kind.

1984 Je 6, C21:1

Agents of Reality

GHOSTBUSTERS, directed by Ivan Reitman; written by Dan Aykroyd and Harold Ramis; director of photography, Laszlo Kovacs; film editor, Sheldon Kahn, with David Blewitt; music by Elmer Bernstein; produced by Mr. Reitman; released by Columbia Pictures. At Loews State, Broadway and 45th Street; New York Twin, Second Avenue and 66th Street; 34th Street Showplace, between Second and Third Avenues; 83d Street Quad, at Broadway, and other theaters. Running time: 105 minutes. This film is rated PG.
Dr. Peter Venkman Bill Murray
Dr. Raymond Stantz Dan Aykroyd
Dana Barrett Sigourney Weaver
Dr. Egon Spengler Harold Ramis
Louis Tully Rick Moranis
Janine Melnitz Annie Potts
Walter Peck William Atherton
Winston Zeddmore Ernie Hudson
Mayor David Margulies

By JANET MASLIN

GHOSTBUSTING — the systematic pursuit and apprehension of any spooks, vapors or phantasms to be found in a metropolitan area — seems a perfect profession for Bill Murray. It requires a cool head, which Mr. Murray most assuredly has, as well as the ability to remain unruffled by bizarre apparitions — the sight, say, of a fat green ghost in a hotel corridor, gobbling the scraps off somebody's room-service tray. This kind of work calls for the kind of sang-froid that, coming from Mr. Murray, amounts to facetiousness of the highest order.

Ready and able as he is to take on the ordinary chores that come his way in "Ghostbusters" (like carrying around a sample of suspicious slime, or investigating a haunted refrigerator), Mr. Murray also seems game for the full-fledged horror parody that "Ghostbusters" could have been. But, however good an idea it may have been to unleash Mr. Murray in an "Exorcist"-like setting, this film hasn't gotten very far past the idea stage. Its jokes, characters and story line are as wispy as the ghosts themselves, and a good deal less substantial. (The ghosts, incidentally, are

Unfortunately, it's funniest when being most nasty. The high point of the film comes when Kate, Billy's pretty girlfriend, admits why she hates Christmas. It seems that when she was a child, her dad disappeared on Christmas Eve, only to be discovered some days later, decomposing, halfway down the chimmney in his Santa Claus suit.

•

"That," says Kate, "is how I found out there is no Santa Claus."

"Gremlins" takes a fairly jokey view of all its characters, including Kingston Falls's own wicked witch, a wealthy, ferociously mean-spirited woman — nicely played by television's Polly Holliday — who refers to an impoverished widow's two small children as "deadbeats."

None of the other actors, including Hoyt Axton (Rand Peltzer), Zach Galligan (Billy) and Phoebe Cates (Kate) has a chance against the mogwai and the gremlins, made by Chris Walas. These mechanical animals aren't very lovable, but they are cleverly devised, and one knows where one stands with them.

•

"Gremlins," which has been rated PG ("Parental Guidance Suggested"), may not be ideal entertainment for younger children for the reasons described above.

1984 Je 8, C10:4

Sidewalk Ballet

BEAT STREET, directed by Stan Lathan; screenplay by Andy Davis, David Gilbert and Paul Golding; story by Steven Hager; director of photography, Tom Priestly Jr.; edited by Dov Hoenig; choreographer, Lester Wilson; music produced by Harry Belafonte and Arthur Baker; produced by David V. Picker and Mr. Belafonte; released by Orion Pictures. At Rivoli, Broadway and 49th Street; Gemini Twin, 64th Street and Second Avenue; 83d Street Quad, at Broadway; Greenwich Playhouse, 12th Street and Seventh Avenue, and other theaters. Running time: 102 minutes. This film is rated PG.

Tracy	Rae Dawn Chong
Kenny	Guy Davis
Ramon	Jon Chardiet
Chollie	Leon W. Grant
Carmen	Saundra Santiago
Lee	Robert Taylor
Cora	Mary Alice
Domingo	Shawn Elliot
Monte	Jim Borrelli
Henry	Dean Elliott
Luis	Franc Reyes
Angela	Tonya Pinkins
Alicia	Lee Chamberlin

"**B**EAT STREET," which opens today at the Rivoli and other theaters, is designed for everybody who still hasn't had his or her fill of break dancing, or who doesn't yet understand that break dancing, rap singing and graffiti are legitimate expressions of the urban artistic impulse.

The film, directed by Stan Lathan and produced by David V. Picker and Harry Belafonte, has a small, modest story about some South Bronx kids who are attempting to dance, rap and spray paint their way to fame and fortune. Among its talented young performers are Guy Davis, the son of Ossie Davis and Ruby Dee, who plays a disk jockey with a special gift for the rhymed improvisation that's called rapping; Rae Dawn Chong, the daughter of Tommy Chong of Cheech and Chong, as a university music major; Jon Chardiet, as a graffiti artist who swoons with excitement every time he sees a subway car that hasn't yet been decorated, and Robert Taylor, as a very young, very gifted break dancer,

The film's melodrama adequately supports the nearly nonstop music

John Seakwood/Outline

Tony Draughon displays his talent in "Beat Street."

and dancing, but the film itself is best understood as a trailer for the soundtrack album, the music for which was produced by Mr. Belafonte and Arthur Baker. If the album catches the intensity and wit of the film's big finale, it should be a smash.

•

"Beat Street," which has been rated PG ("Parental Guidance Suggested"), contains some vulgar language.

Vincent Canby

1984 Je 8, C10:5

Ritual and Prayer

TIBET: A BUDDHIST TRILOGY, written (in Tibetan with English subtitles) and directed by Grant Coleman; produced and photographed by David Laselles; photography by Michael Warr; edited by Pip Heywood; a production of Thread Cross Films. At the Van Dam Theater, 15 Van Dam Street. Running time: 231 minutes. This film has no rating.

By JOHN CORRY

IN "Tibet: A Buddhist Trilogy," the film and its subject are as one. The four-hour, three-part film explores Tibetan culture in exile, not so much to explain it as simply to present it. Specifically, it wants to capture a spiritual experience, and in this it fails and succeeds in almost equal measure. Much of what we see is hypnotic; much is merely boring. The film opens today at the Vandam Theater.

The first part of the film, "A Prophecy," is the most comprehensible. It visits the Dalai Lama and his followers in India, where they have built a social structure based on Tibetan Buddhism, but tempered, it seems, by democratic socialism.

Thus, we see Indian Tibetans in communes, sharing in cooperative ventures — carpet making, for one. When the Dalai Lama addresses them, he offers gentle homilies, mixing politics and morality. "The future will lead to the rule of the masses, to a social democracy," he says. "When we look at it from this point of view, the invasion of Tibet has been something good for the Tibetans — providing we can follow the right path for the future."

The second part, "The Fields of the Senses," brings us Tibetan farmers

and monks in a remote village in northern India. The farmers rake the fields rhythmically. The monks chant and pray. Subtitles give us literal interpretations — complicated descriptions of the "inconceivable mansion," of mandalas that blend into the lotus and of "unequaled sublime enlightment." The British film maker Graham Coleman is giving us Tibetan Buddhism on its own terms. A spiritual experience, however, does not necessarily translate into film images.

The most compelling and indeed most comprehensible sequence here is of a ritual cremation. Tibetan Buddhism may preach a reverence for life, but the afterlife seems infinitely more real. At the cremation, monks pray for and advise the departing spirit.

The third and longest part of the film, "Radiating the Fruit of Truth," shows us a single ritual ceremony. How a filmgoer reacts to this will be commensurate with how much interest in Tibetan Buddhism the earlier parts of the film have aroused. "Tibet: A Buddhist Trilogy" is scheduled to run through June 21.

1984 Je 8, C10:5

An Everest of Sorts

UNDER THE VOLCANO, directed by John Huston; screenplay by Guy Gallo, based on the novel by Malcolm Lowry; director of photography, Gabriel Figueroa; edited by Roberto Silvi; produced by Moritz Borman and Wieland Schulz-Keil; released by Universal Pictures. At Cinema 1, Third Avenue and 60th Street. Running time: 112 minutes. This film is rated R.

The Consul	Albert Finney
Yvonne	Jacqueline Bisset
Hugh	Anthony Andrews
Dr. Vigil	Ignacio Lopez Tarso
Dona Gregoria	Katy Jurado
The Brit	James Villiers
Bustamante	Carlos Riquelme
Diosdado	Emilio Fernandez
Herr Krausberg	Gunter Meisner

By JANET MASLIN

BY the time Malcolm Lowry had finished filling "Under the Volcano" with "signs, natural phenomena, snatches of poems and songs, pictures, remembered books and films, shadowy figures appearing, disappearing, and reappearing," according to Douglas Day, Mr. Lowry's biographer, the book "finally became not a novel at all but a kind of monument to prodigality of vision." Cer-

tainly it evolved, as Mr. Lowry expanded his short story of the same name into the 1947 novel, into one of the most haunting and difficult works of modern fiction.

That this densely allusive work is also tantalizingly cinematic has made it an Everest of sorts, from the film maker's standpoint. The book, aside from an opening chapter that dissolves into flashback, spans only a 24-hour period (the Day of the Dead, in November 1938) and involves few principal characters: Geoffrey Firmin, an alcoholic former British Consul living in a small Mexican town; Yvonne, the Consul's estranged wife, who has just returned to him, and Hugh Firmin, Geoffrey's rakish young half-brother, with whom Yvonne has had an affair.

This would seem to make the book manageable in cinematic terms, especially since two of the characters have film-related backgrounds, and since Mr. Lowry himself, having attempted to work in Hollywood, even relies on cinematic devices from time to time. Yet "Under the Volcano" contains so little clear, external action and is so deeply internalized by the Consul's fevered imaginings that a true and coherent screen equivalent is unimaginable.

•

John Huston, whose film of "Under the Volcano" opens today at Cinema I, has attempted it anyhow, in a film that is especially impressive for the courage, intelligence and restraint with which it tackles an impossible task. The film's limitations are readily apparent: it hasn't sufficient scope to use a day in the Consul's life, as the novel does, to convey everything about the man's consciousness and to offer a vision of the land in which he is dying. What it can do, and does to such a surprising degree, is to bring the characters to life and offer fleeting glimpses into the heart of Mr. Lowry's tragedy.

Drunkenness, so often represented on the screen by overacting of the most sodden sort, becomes the occasion for a performance of extraordinary delicacy from Albert Finney, who brilliantly captures the Consul's pathos, his fragility and his stature. Alcoholism is the central device in Mr. Lowry's partially autobiographical novel. (The author, like the Consul, was capable of drinking shaving lotion when nothing more potable was at hand.) Yet the Consul's drinking is astonishingly fine-tuned, affording him a protective filter while also allowing for moments of keen, unexpected lucidity. Mr. Finney conveys this beautifully, with the many and varied nuances for which Guy Gallo's screenplay allows.

For instance, when the exquisite Yvonne (played elegantly and movingly by Jacqueline Bisset) reappears in Cuernavaca one morning, she finds her ex-husband in a cantina, still wearing his evening clothes. He turns to gaze at her for a moment, pauses briefly, and then continues talking as if nothing had happened. Seconds later, he turns again and looks at Yvonne more closely, still not certain whether or not this is a hallucination. It takes a long while for the fact of Yvonne's return to penetrate the different layers of the Consul's inebriated consciousness, and Mr. Finney delineates the process with grace and precision, stage by stage. At other times, and in other degrees of drunkenness, his Consul is capable of anything from mischievous wit to sudden panic to the toocareful syntax of someone speaking as if trying to walk a straight line.

The political foreboding of Mr. Lowry's novel — the hints of the coming world war, and the Consul's eventual martyrdom at the hands of Fascist thugs — is less fully captured. The same can be said for the religious and mystical aspects of Mr. Lowry's work. Mr. Huston sounds all these notes, to be sure, and includes many of the book's key symbols; the white horse, the twin volcanos and "The Hands of Orlac" are all here, for anyone who cares to notice. But he refrains from forcing the viewer to grapple excessively with imagery that, in a film of less that two hours' time, borders on being bewildering and cannot help but go largely unexplained.

•

Daring as it is to have brought "Under the Volcano" to the screen in this faithful but incomplete form, Mr. Huston has done so without making compromises in the process. He appears to have made exactly the film he wanted to, a serious work rather than an entertainment of universal appeal. To the considerable extent that it succeeds, it owes a great deal to the warmth and humanity contributed by the actors.

That is especially true of Mr. Finney and Miss Bisset, who make credible the strange story of the Firmins' marriage, and of Anthony Andrews, suitably callow and flamboyant as Hugh. Even the minor characters are strongly drawn, particularly the "Brit" (played by James Villiers) who wonders why the Consul is taking a nap in the middle of the road, and who rouses Firmin to a few minutes' worth of arch-Britishisms ("Awfully decent of you, old chap!" the Consul gaily declares). It was a witty scene of Mr. Lowry's, and it has been preserved here perfectly.

1984 Je 13, C21:4

Albert Finney as the tormented alcoholic Consul in "Under the Volcano," based on the Malcolm Lowry novel.

Mother's 'in a Box'

CAREFUL HE MIGHT HEAR YOU, directed by Carl Schultz; written by Michael Jenkins; director of photography, John Seale; edited by Richard Francis-Bruce; composer, Ray Cook; produced by Jill Robb; released by T. L. C. Films, division of 20th Century-Fox Entertainment Inc. At the Paris Theater, 58th Street, west of Fifth Avenue. Running time: 116 minutes. This film has no rating.

P. S.	Nicholas Gledhill
Vanessa	Wendy Hughes
Lila	Robyn Nevin
George	Peter Whitford
Logan	John Hargreaves
Agnes	Isabelle Anderson
Vere	Geraldine Turner
Ettie	Colleen Clifford
Diana	Julie Nihill
Mrs. Grindel	Beth Child
Winnie Grindel	Pega Williams

By VINCENT CANBY

WHAT appears to be a bright light is seen in the dark as muffled voices are heard offscreen. When the camera pulls back, the light turns out to be the reflection in the unblinking eye of a small boy, lying in bed and listening to the muffled conversation of the adults in the next room. Occasionally, he can make out individual words, frequently punctuated by cautionary "shhhh's."

The small boy is named William but called P. S. because his mother, during her pregnancy, referred to the baby as the postscript to her apparently tumultuous life, which was to end abruptly during P. S.'s delivery. P. S. has been brought up by his mother's sister Lila and Lila's husband, George, in genteel circum-

stances in a rundown section of Sydney, Australia. On this particular night, sometime in the depressed 1930's, P. S., now 6 years old, becomes aware that momentous, possibly fearful events are in store.

His social, globe-trotting aunt, Vanessa, another of his mother's sisters, is about to sweep in from London to claim at least partial custody of the boy. P. S. has a father, Logan, but he has disappeared into the gold fields of the north.

•

All of this is communicated in the first few minutes of "Careful He Might Hear You," a richly acted and richly produced family drama about the nasty custody struggles for P. S., who, as played with remarkable assurance by Nicholas Gledhill, remains the calm center of an increasingly hysterical film. The Australian movie, which opens today at the Paris, is an adaptation of a 1963 novel by Sumner Locke Elliott, the Australian-born writer, who was one of the most successful contributors to the golden age of American television in the 1950's.

When Vanessa (Wendy Hughes) is first seen, standing high on the deck of the P & O liner pulling into the Sydney dock, she seems to be everything that a small, imaginative boy like P. S. might have dreamed of. She's an extremely chic fairy godmother. She's tall, beautiful, cool and collected, everything that P. S.'s Aunt Lila and Uncle George are not. She has lost her Australian accent and deals decisively with matters that are

likely to cause endless muddles for the sweet but asthmatic Lila and the jolly but bumbling George.

Largely for the boy's own good, Lila and George agree to Vanessa's plan to keep P. S. during the week, in the rented mansion she shares with her elderly cousin Ettie, whose companion Vanessa is and who is the real source of Vanessa's riches. He's enrolled in a private school, starts taking music and riding lessons, and gets his first inkling of the messes that well-meaning adults can make of their lives.

"Careful He Might Hear You," directed by Carl Schultz and adapted by Michael Jenkins, is extremely good when it's dealing directly with P. S. and seeing the world with his clear-eyed vision, taking everything in and giving back as little as possible. P. S. is a great one for reserving judgment, whether he's being sent up by a haughty schoolteacher, who makes fun of his accent, or finding an uncharacteristically hysterical Vanessa climbing into his bed one night during a thunderstorm, which transforms her into a raving psychotic.

It's far less successful when the grave, soon-to-be-wise P. S. is offscreen, when it must attempt to explain the tangled relationships of Vanessa, Lila and another eccentric sister, as well as of Logan, a good-natured, drunken bum, who shows up briefly to make matters even worse for poor P. S. Mr. Jenkins's screenplay can't quite cram in all of the details of the novel that make these relationships clear. The movie be-

comes a series of revelations, which are meant to be startling, but are too often overwrought in unintentionally comic ways.

All of the performances by the adult actors are good, but they seem to have been encouraged — at least partly by the script — never to let well enough alone.

P. S.'s first meeting with his father, summoned back to Sydney by Vanessa, who wants to take the boy to England, is initially very moving. Both John Hargreaves, who plays the unreliable Logan, and young Mr. Gledhill are funny and touching as they overcome their first embarrassment, but then things slip into the melodrama that dogs the film from the beginning and finally overwhelms it. The accident, which brings the story to some kind of ending in the novel, looks awkward and arbitrary on the screen.

•

Though the film's big moments are not great, "Careful He Might Hear You" is full of smaller scenes that, without overemphasizing the sentiment, efficiently evoke P. S.'s curious world. Not until he's almost 7 does anyone allow him to speak of his mother as "mother." Lila and George have taught him to refer to her only as "Dear One." Death is never mentioned when they visit her grave, only that she is "in a box." Lila and George, as kind as they are, are almost as unfeeling as the possibly bonkers Vanessa.

"Careful He Might Hear You" is so good in so many of its details that one

Nicholas Gledhill and Robyn Nevin portray nephew and aunt in "Careful He Might Hear You," a prize-winning Australian film about a struggle for the affections of a 6-year-old boy.

wants it to be tougher, sharper — less flabby — than it perhaps wants to be. As it is, it's the cinema equivalent of the fiction in what used to be called slick magazines.

1984 Je 15, C8:1

Toward Black Unity

MARIGOLDS IN AUGUST, directed by Ross Devenish; written by Athol Fugard; camera by Michael Davis; edited by Lionel Selwyn; produced by Jonathan Cohen and Mark Forstater; distributed by RM Productions, London. At the Film Forum, 57 Watts Street. Running time: 87 minutes. This film has no rating.
Daan...Winston Ntshona
Melton...John Kani
Paulus OlifantAthol Fugard

By VINCENT CANBY

"MARIGOLDS IN AU-GUST," which opens today at the Film Forum, is the third in the trilogy of small, remarkably vivid and moving South African films written by — and starring — Athol Fugard and directed with informed devotion to the material by Ross Devenish. "Marigolds" also reunites Mr. Fugard with Winston Ntshona and John Kani, the two splendid actors with whom he collaborated in the creation of two of his best plays, "Sizwe Banzi Is Dead" and "The Island."

More than either "Boesman and Lena," the first of the trilogy and an adaptation of a stage piece, or "The Guest," which Mr. Fugard wrote directly for the screen, "Marigolds in August" has the neatness and shape-

liness of a theatrical play, even though it is also an original screenplay. This is not to criticize the film, but to describe the effect of its single-minded narrative, which, though filled with odd, unexpected, completely cinematic details, never wastes a second on anything picturesque or otherwise superfluous. The Fugard dialogue is clean, simple and direct in the fashion of a poet who appears to have discovered the original meaning of words.

Daan (Mr. Ntshona) regards himself with a certain amount of pride and satisfaction. As a black man, he makes a passable living as a gardener and general handyman in a white, middle-class, seaside community outside Port Elizabeth. Such jobs are scarce. One day, when a desperate young black man named Melton (Mr. Kani), comes by looking for work, the jealous Daan physically threatens him and finally runs him out of town in an actual chase.

•

What might have turned into a bloody, fruitless battle is averted by a chance encounter with an old friend of Daan's, the wise, grizzled Paulus (Mr. Fugard) who, being a "colored," that is, of mixed blood, knows the worst of both the white and the black worlds of South Africa. There is a kind of saintliness to Paulus, a loner who makes his skimpy living by catching cobras and puff adders in the national park and selling them in Port Elizabeth.

Paulus at first watches Daan's overbearing treatment of the fearful Melton with a certain amount of pa-

tient weariness. Daan couldn't care less that one of Melton's children has just died of starvation and that his second child is also sick. Finally, Paulus asks the older black man what he would do if he were in Melton's shoes. This simple, basic question has never entered Daan's head. His immediate response, "But I'm not."

Although not as harrowing and dramatic as "The Guest," and not as timeless as the journey through life that is the theme of "Boesman and Lena," "Marigolds in August" is as wise, tough and theatrically effective as either of the two earlier pieces. The reconciliation — such as it is — that Paulus effects between Daan and Melton can be seen as the first, tentative step toward the goal of black unity that will one day bring the end to apartheid.

I don't mean to put too much stress on the film's social consciousness, though anyone familiar with Mr. Fugard's work knows that he is a dramatist and poet committed to a cause. "Marigolds in August" works not simply because of its politics, however, but because Mr. Fugard and Mr. Devenish have successfully taken a small, commonplace incident and discovered the particular within it.

Though "Marigolds in August" moves throughout the seaside community and the adjacent parklands, and though it observes unobservant white South Africans going about their daily lives, the film comes very close to being as claustrophobic as a piece on the stage would be. In fact, it might even benefit from the physical restrictions that would be imposed on it by the stage.

The performances are wonderful, and all of a piece. Mr. Fugard, Mr. Ntshona and Mr. Kani work together with the ease, humor and self-assurance of a great, three-man repertory company.

1984 Je 20, C21:1

The Dream of Life

AFTER THE REHEARSAL, directed by Ingmar Bergman; written by Mr. Bergman; director of photography, Sven Nykvist; edited by Sylvia Ingemarsson; produced by Jorn Donner; produced by Cinematograph for Personafilm/Munich; released by Triumph Films, a Columbia/Gaumont Company. At Lincoln Plaza Cinema 1, Broadway between 62d and 63d Streets. Running time: 72 minutes. In Swedish with English subtitles. This film is rated R.
Henrik VoglerErland Josephson
Rakel ...Ingrid Thulin
Anna EgermanLena Olin
Anna, 12 years oldNadja Palmstjerna-Weiss
Henrik, 12 years oldBertil Guve

By VINCENT CANBY

AUGUST STRINDBERG'S heavily symbolic "Dream Play" has never been wildly popular in this country. It has a cast of 50, requires sets that are virtually unrealizable, has no coherent story line and is obsessed with the spectacle of human suffering during the dream that is Life. There are no conventional characters or, as someone says in a different context in "After the Rehearsal," Ingmar Bergman's fine new chamber film, "Everything represents. Nothing *is*."

Gilbert W. Gabriel, writing in the 1920's, observed that Americans "seem always to react to Strindberg with that antagonism which neurotics exhibit in the presence of the downright insane."

"After the Rehearsal," which opens today at the Lincoln Plaza, might well be called "Ingmar Berg-

man's 'Dream Play,' " though, to all outward appearances, it's just about everything the Strindberg play is not. It is small, tightly constructed, utterly specific, played in one set — the stage on which "The Dream Play" is being rehearsed — and has a cast of three.

They are Henrik Vogler (Erland Josephson), the aging director now working on his fifth production of "The Dream Play"; Anna Egerman (Lena Olin), Henrik's very young, pretty, ambitious leading lady, and Rakel (Ingrid Thulin) an over-the-hill, once-great actress, now made unreliable through drink, who has accepted a humiliating two-line role from Henrik, a former lover.

•

Though "After the Rehearsal," produced for television, runs a scant 72 minutes, it's as much a survey of the human condition as Strindberg's play, even if that condition is seen exclusively from Mr. Bergman's severely particular point of view. That is, the vantage point of an artist, nearing the end of a long and very successful career, for whom his art — the theater and his work in it — is life, and everything else has the effect of illusion.

As the film opens, Henrik, exhausted at the end of the day's rehearsal, sits at a small table on the stage, his head resting on his arms, possibly asleep. Anna suddenly comes on, saying that she must have misplaced a valued bracelet during rehearsal. It doesn't much matter that the encounter could be a dream since, for Henrik, his dreams are other people's reality. It soon becomes obvious that Anna has lied about the bracelet and that she thinks she may be in love with the director, who is one of her father's oldest friends.

Moving around the prop-furniture left over from ancient productions of "Hedda Gabler," "Tartuffe," "The Father" and even earlier "Dream Plays," Henrik and Anna talk about their work together, Henrik's obligations as the director and her worth as an actress. Like Henrik, Anna is on the point of discovering the theatrical reality that is the escape of others.

When Anna admits her longstanding hatred of her dead mother, it's clear that her mother, also an actress, was one in Henrik's apparently long line of mistresses. In the course of the scene, Henrik and Anna are director and actress, father and daughter, lover and beloved.

•

Rakel bursts in and, taking no notice of Anna (who, of course, may not be there any more than she is), scolds Henrik for having abandoned her, for scorning her age (46), and especially for remaining, she thinks, uncommitted to his actors. She insults him, ridicules him, describes in graphic detail her affair with the doctor who is supposed to be treating her and, finally, leaves with his promise to come to supper that night.

After Rakel's exit, Henrik and Anna, in one of the most magical, beautifully sustained love scenes in any Bergman film, imagine the course of their possible love affair. In tight close-ups and in just a few pages of extraordinary dialogue, they experience the initial promise and excitement of the affair, the elation of fulfillment, the joy of working together, the furious, jealous fights, followed by reconciliations during which they make plans for a limitless fu-

ture. As they see it with both humor and longing, they remain together for this production's opening night, then separate and, years later, meet as friends.

•

Strindberg's "Dream Play" also figures prominently in Mr. Bergman's big, flamboyant, Oscar-winning "Fannie and Alexander," which he has said will be his last theatrical film. Whether or not he holds to that, he has demonstrated his right to explore in depth — in a film like "After the Rehearsal" — his own very private obsessions that, because he is an artist of the first rank, cannot avoid having application outside the arcane world of the theater.

Although it's a very different kind of film, "After the Rehearsal" is as passionate, knowledgeable and funny about the stage as François Truffaut's "Day for Night" is about movies. The Bergman characters aren't that different from the rest of us, but the eccentricities of their profession make demands on them that produce insights that most ordinary folk don't have to face.

•

Some of the Bergman aphorisms — at least as translated from the Swedish by the English subtitles — sound a little orotund, but most of the dialogue is spare, clear and to the point. Mr. Josephson has one especially moving monologue in which, as he describes the function of a stage director, he also exposes Henrik's possibly sadistic need to "administrate, provide and organize what is inexpressible, frightening and dangerous." "I take no part in the drama," he says. "I materialize it."

Quite as good as Mr. Josephson are Miss Olin, who had a small role in "Fannie and Alexander," and Miss Thulin, whose single, extended scene in this film is both a sensational acting turn by itself and a recollection of her long association with Mr. Bergman in such films as "Brink of Life," "Wild Strawberries" and "The Silence."

"After the Rehearsal" may well be another Bergman classic.

1984 Je 21, C14:1

Hayseed Heavy

RHINESTONE, directed by Bob Clark; screenplay by Phil Alden Robinson and Sylvester Stallone; screen story by Phil Alden Robinson, based on the song "Rhinestone Cowboy" by Larry Weiss; director of photography, Timothy Galfas; edited by Stan Cole and John Wheeler; music by Dolly Parton; released by 20th Century-Fox Film Corporation. At the Coronet, 59th Street and Third Avenue; Criterion, Broadway, between 44th and 45th Streets, and other theaters. Running time: 111 minutes. This film is rated PG.

Nick	Sylvester Stallone
Jake	Dolly Parton
Noah	Richard Farnsworth
Freddie	Ron Leibman
Barnett	Tim Thomerson
Father	Steven Apostle Pec
Mother	Penny Santon
Elgart	Russell Buchanan
Luke	Ritch Brinkley
Walt	Jerry Potter
Billie Joe	Jesse Welles
Maurie	Phil Rubenstein

THE self-deprecating charm that won America's hearts in "Rocky," as Sylvester Stallone shambled along talking to his pet turtles, is all but gone. In "Rhinestone," which opens today at the Coronet, Criterion and other theaters, Mr. Stallone does nothing but swagger, mug adorably, deliver stupid wisecracks and wear set upon set of form-fitting clothes.

Erland Josephson and Lena Olin star in "After the Rehearsal," an Ingmar Bergman film that explores the relationship of an eminent director with two of his actresses during preparations for a production of a Strindberg play.

His role is that of a New York cabbie who isn't supposed to be able to sing throughout most of the story, and who, by the end of it, is. There's a moment in "Top Secret" in which the villains decide to torture their prisoner with Leroy Neiman paintings, then realize that this would violate the Geneva Convention. The authors doubtless hadn't seen Mr. Stallone in a spangled cowboy suit, trying to belt out something tuneful.

Miraculously, in spite of all this, "Rhinestone" isn't unrelievedly terrible. It is helped by a director, Bob Clark, who treats the material good-humoredly and takes it lightly, as well as by a funny supporting cast. Richard Farnsworth, delightfully deadpan as an old-timer in a small Tennessee town, listens to a song of Mr. Stallone's and declares "Wal, that was scary, son — for a minute there, we thought you was gonna explode." The best thing in "Rhinestone," though, is Dolly Parton, who seems able to survive just about any movie unscathed. Miss Parton radiates such a perfect combination of sweetness and grit that she's a match for any co-star, even this one.

•

The only plot device, in the screenplay by Mr. Stallone and Phil Alden Robinson, has Miss Parton playing a country singer named Jake who makes a bet with Ron Leibman, as Freddie, a business manager who is all show-biz sleaze; Jake wagers that she can turn the next man she sees into a country star. To do this, once Mr. Stallone's Nick has screeched into view as the New York cabbie, Jake and her charge head for her hometown. There, she teaches Nick invaluable country skills, like playing the spoons.

The clash of cultures is funny at times: When Jake offers a "Howdy" to Nick's father, Nick says "That means 'Howyadoin?'" and Nick's father says, 'I know what 'Howdy' means, I read.'" Most of the time, though, the culture gap is expressed

through witless insults, like "How'd you get that greasy look, combin' your hair with a pork chop?" The screenplay is much too heavy on the hayseed jokes, though one musical sequence does a funny job of parodying a country and western song.

As Mr. Stallone wends his way through barnyards and country cabins, the material retains some comic potential. But as the inevitable romance springs up between the two stars, their lack of rapport becomes all too noticeable. And the musical numbers are trouble in more ways than one. Mr. Stallone wildly overdoes the early sequences, which are meant to establish him as a no-talent, as though his ordinary singing voice would not have made the same point. Aside from rendering the plot even more implausible than it had to be, this creates an impression of false modesty from which the movie never quite recovers.

Janet Maslin

1984 Je 22, C10:5

TOP SECRET!, directed by Jim Abrahams, David Zucker and Jerry Zucker; written by Mr. Abrahams, David Zucker, Jerry Zucker and Martyn Burke; director of photography, Christopher Challis; edited by Bernard Gribble; music by Maurice Jarre; produced by Jon Davison and Hunt Lowry; released by Paramount Pictures. At Embassy 1, Broadway and 46th Street; Embassy 2, Broadway and 47th Street; Tower East, Third Avenue and 71st Street, and other theaters. Running time: 90 minutes. This film is rated PG.

Nick Rivers	Val Kilmer
Cedric	Omar Sharif
Hillary Flammond	Lucy Gutteridge
Dr. Flammond	Michael Gough
Nigel	Christopher Villiers
Du Quois	Harry Ditson
Deia Vu	Jim Carter
Chocolate Mousse	Eddie Tagoe
Latrine	Dimitri Andreas
General Streck	Jeremy Kemp
Colonel Von Horst	Warren Clarke
Major Crumpler	Trimstram Jellinek
Bookstore Proprietor	Peter Cushing
Young Hillary	Mandy Nunn
Young Nigel	Lee Sheward
Albert Potato	Sydney Arnold

By VINCENT CANBY

CONSIDER Omar Sharif staring earnestly out of a coffin-shaped bundle of metal splinters and wires that was once

Sylvester Stallone is a cabbie and Dolly Parton is a singer in "Rhinestone."

a Mercedes-Benz, which has recently been compacted with the indestructible, uncompactable Omar inside it; or, a white cow, covered with large black polka dots, ambling across a soggy field, in the manner of a beast that 'knows there are a thousand tomorrows, wearing rubber boots; or, the recollection of an East German who says that he had an uncle who was born in the United States, "but he escaped during the Carter Administration—in a balloon."

These are some of the reasons you might want to walk rather than run to see "Top Secret!", the first theatrical film to be written and directed by Jim Abrams, David Zucker and Jerry Zucker since the release of their riotous parody "Airplane!", the original, not the sequel.

"Top Secret!" comes nowhere near "Airplane!" but in its own cheerful, low-pressure way, it's about as amiable an entertainment as you will find this summer. It's not so hip as "Ghostbusters," but then you never get the feeling that you're watching someone else's private joke, played by people who are simply too laid back to share the punch lines. The people who made "Top Secret!" — and who appear in it — have the enormous energy and outgoing good will of the college kids who used to say, "Let's put on a show!"

Unlike "Airplane!", which devoted itself to sending up one, very easily identifiable kind of popular film and which was performed by a large cast of almost-stars whose careers were made in such films, "Top Secret!" is based on no immediately recognizable antecedent. It's mostly a parody of East-West espionage movies, as they might have been fashioned to suit a performer like Elvis Presley or even Fabian, something that no East-West espionage film ever was.

The film, which opens today at the Embassy and other theaters, isn't bouncing off something so familiar that we automatically respond to every foolish variation it works. It has no comic center of gravity to keep it from wandering around its own landscape, as aimless as it is amiable.

The story has something to do with an East German plot to reunite Germany, apparently by bottling up the United States fleet just inside the Strait of Gibraltar. There's also something about a secret weapon and, more important, a huge cultural festival in East Germany designed to distract the attention of the Western powers from events in the Mediterranean. This really is a funny idea — I mean, can you imagine the Joint Chiefs of Staff being so concerned with whether or not Leonard Bernstein appears at a cultural festival that they would not read their daily intelligence reports? Maybe Mr. Abrams and the Zucker brothers know something the rest of us don't.

The cast is full of engaging actors, few of whom, with the exception of Mr. Sharif, who plays an allied agent, and Michael Gough, as a scientist imprisoned in East Germany, are especially well known to movie audiences. Val Kilmer is extremely funny in the Presley-Fabian role, that of a popular American rock-and-roll star who, at the last minute, substitutes for Mr. Bernstein at the cultural festival.

At the drop of the merest song cue, Mr. Kilmer is ready to jump atop a nightclub table and suddenly transform a sedate, elegantly dressed crowd into a giant, frenetic produc-

Inside the cow, which is inside East Germany, are some of the characters in "Top Secret," a parody of World War II movies created by the people who created "Airplane." Val Kilmer, Lucy Gutteridge, Omar Sharif and Peter Cushing are among the stars.

tion number built around "Tutti Frutti." The best of these parodies, though, is something called "Skeet Surfing," based on "Surfin' U.S.A."

Supporting Mr. Kilmer are Lucy Gutteridge, as a pretty young thing, whose scientist father is imprisoned by the East Germans; Christopher Villiers, as the leader of the East German underground who, just by chance, was once marooned on a "Blue Lagoon"-like desert isle with Miss Gutteridge, something seen in a quick flashback, and the venerable Peter Cushing, who has a tiny but funny role as the proprietor of an East German shop specializing in "rare Swedish books."

With the exception of the sequences involving Mr. Sharif and the polka-dot cow, there are no moments in "Top Secret!" that you'll remember with the vividness with which you may recall almost everything in "Airplane!" However, I can't imagine a nicer way to lose a couple of hours.

•

"Top Secret!", which has been rated PG ("parental guidance suggested"), contains some vulgar dialogue and situations.

1984 Je 22, C10:1

LE DERNIER COMBAT, directed by Luc Besson; screenplay (French with English subtitles); director of photography, Carlo Varini; edited by Sophie Schmit; music by Eric Serra; produced by Mr. Besson and Mr. Jolivet; production company, Les Films du Loup; released by Triumph Films. At the Waverly, Avenue of the Americas and Third Street. Running time: 90 minutes. This film is rated R.
Man..Pierre Jolivet
Doctor......................................Jean Bouise
Captain......................................Fritz Wepper
Brute..Jean Reno
Dwarf......................................Maurice Lamy
Woman in the Cell............................Petra Muller
Captain's Men
 Pierre Carrive, Bernard Havet, Jean-Michel Castanie, Michel Doset, Marcel Berthomier, Garry Jode
Captain's Concubine..............Christiane Kruger

LUC BESSON'S "Dernier Combat" sounds like a feat of gamesmanship, but it certainly doesn't play that way. Mr. Besson has filmed this futuristic fantasy in black and white, using no dialogue and, for his locations, only a series of crumbling, deserted buildings. Amazingly, the lack of conversation isn't a serious handicap, since the leading actor, Pierre Jolivet (who also wrote the script with Mr. Besson) is as wordlessly expressive as the direction.

"Le Dernier Combat" ("The Last Battle") is an oddity, and a little overlong for its slender premise. But it's also a bravura first film, using the simplest means, yet managing to incorporate humor, pathos, suspense and even a well-articulated definition of basic human needs.

The differences between French and American science fiction are made immediately clear here. "Le Dernier Combat" begins after an unexplained holocaust has devastated the planet, but it doesn't waste time explaining the particulars, instead allowing the audience to piece things together as the film unfolds. Nor does it embroil the hero in any scheme for conquest or revenge. Instead, Mr. Jolivet, alone with just a few banged-up bits of machinery and nary a laser-sword in sight, wanders across the landscape encountering the few other creatures left alive. The audience gradually develops a very basic sense of what is required for this, or any, man's survival.

In this Gallic fantasy, much more attention is paid to cooking than to the world's fate. And when Mr. Jolivet finally encounters a doctor (Jean Bouise), now barricaded in a deserted hospital, and the two strike up a companionship of sorts, the film touchingly conveys the simple satisfaction of a shared meal.

Their growing trust finally blossoms into a single word of greeting (though the characters can't speak, it

is never explained why they can't write notes to one another) and into the doctor's sharing his best-kept secret. That, too, seems more a function of the French imagination than the American.

Mr. Besson, working in Cinemascope, gives the film a light and expansive look, fashioning an expressive and sometimes witty visual style out of virtually nothing. It is some measure of his directorial prowess to say that a synopsis of "Le Dernier Combat," aside from spoiling its several surprises, might feel silly in ways that the completed film, slight but in its own way utterly engrossing, does not.

Janet Maslin

1984 Je 22, C12:1

Village Villainy

THE POPE OF GREENWICH VILLAGE, directed by Stuart Rosenberg; screenplay by Vincent Patrick, based on his novel; director of photography, John Bailey; edited by Robert Brown; music by Dave Grusin; produced by Gene Kirkwood; released by MGM/UA Entertainment Company. At the Paramount, Broadway and 61st Street; New York Twin, Second Avenue and 66th Street; 83d Street Quad, at Broadway; 86th Street Twin, at Lexington Avenue; Greenwich Playhouse, Seventh Avenue and 12th Street, and other theaters. Running time: 122 minutes. This film is rated R.
Paulie..Eric Roberts
Charlie..Mickey Rourke
Diane..Daryl Hannah
Mrs. Ritter..................................Geraldine Page
Barney......................................Kenneth McMillan
Pete..Tony Musante
Burns......................................M. Emmet Walsh
Bedbug Eddie..................................Burt Young
Bunky......................................Jack Kehoe
Paulie's Father..............................Philip Bosco
Nunzi......................................Val Avery

"THE POPE OF GREEN-WICH VILLAGE," which opens today at the Paramount and other theaters, is a singularly gross and unattractive screen version of Vincent Patrick's novel, adapted by him and directed by Stuart Rosenberg in the seeming

delusion that he was making another "Mean Streets."

Everything about the movie, about the get-rich-quick scheme of a couple of Italian-American punks in Greenwich Village, is slightly out of kilter, including the narrative, which is less a story than a display of acting mannerisms.

At its heart is the curious, totally mysterious relationship between Charlie (Mickey Rourke), a bar manager, who dreams of owning his own Connecticut restaurant, and his dimwitted cousin Paulie (Eric Roberts), a pathologically dishonest young man, utterly dependent on Charlie. All hell breaks loose when Paulie involves the unknowing Charlie in a heist of $150,000, which, unluckily for them, belongs to the local Mafia don.

Mr. Roberts's very busy, mannered performance reminds me of the line in Ingmar Bergman's "After the Rehearsal" in which the character of the director says of an actress, "One is only as bad as that if one is talented." Mr. Roberts is acting, all right, with every pore, but he appears to have absolutely no rapport with anybody else in the film. In contrast, Mr. Rourke's performance is measured, thoughtful and, as far as possible under the circumstances, full of feeling.

Appearing in supporting roles are Daryl Hannah, as Mr. Rourke's very unlikely WASP girlfriend; Kenneth McMillan, as an aging safecracker, and Burt Young, once again doing his

Mickey Rourke as Charlie in "The Pope of Greenwich Village."

mob-chief role. Walking away with what there is of the movie, though she is seen in just two brief scenes, is Geraldine Page, who is splendidly funny and sad as the tough, whisky-sodden mother of a crooked cop who comes to no good end.

Vincent Canby

1984 Je 22, C12:4

Maturing Martially

THE KARATE KID, directed by John G. Avildsen; written by Robert Mark Kamen; director of photography, James Crabe; edited by Bud Smith, Walt Mulconery and Mr. Avildsen; music by Bill Conti; produced by Jerry Weintraub; released by Columbia Pictures. At the Ziegfeld, Avenue of the Americas and 54th Street; Baronet, Third Avenue and 59th Street. Running time: 126 minutes. This film is rated PG.
Daniel..................................Ralph Macchio
Miyagi.........................Noriyuki (Pat) Morita

Ali	Elisabeth Shue
Kreese	Martin Kove
Lucille	Randee Heller
Johnny	William Zabka
Bobby	Ron Thomas
Tommy	Rob Garrison
Dutch	Chad McQueen
Jimmy	Tony O'Dell
Freddy	Israel Juarbe
Mr. Mills	William Bassett
Jerry	Larry B. Scott

By JANET MASLIN

A LARGE part of "The Karate Kid" — the best part, really — seems to be taking place inside a fortune cookie. It is here, in the serene realm of Oriental wisdom, Hollywood-style, that a teenager named Daniel (Ralph Macchio) is taught lesson after lesson about life. His instructor is an elderly man named Mr. Miyagi, played by Noriyuki (Pat) Morita, who is first seen trying to catch flies with a pair of chopsticks. Throughout the film, Mr. Miyagi sustains a scene-stealing, if hokey, eccentricity.

Mr. Miyagi easily becomes a perfect father figure for Daniel, thanks to the old man's patience, understanding and seemingly infinite knowledge. His incredible command of karate is another plus as far as Daniel is concerned, since the boy is newly transplanted from Newark to California, and frequently finds himself being savaged by large, affluent blond bullies who dress like Michael Jackson. Mr. Miyagi teaches him to defend himself and, along the way, to become a man.

"The Karate Kid," which opens today at the Ziegfeld and other theaters, has the makings of a genuinely heart-warming two-man drama, with Mr. Morita a charming cut-up and Mr. Macchio gently likable in the Robby Benson role. But neither the director, John G. Avildsen, nor the screenwriter, Robert Mark Kamen, is content to leave well enough alone. Their film is full of extras, from the supporting characters who barely have anything to do to the Bill Conti music that blasts annoyingly through the final climactic fight scene. Even deleting the fun-in-the-sun teen-age montages that crop up periodically would improve the film greatly, or at least cut down on its penchant for wasting time.

●

Since "The Karate Kid" is essentially a fairy tale, Mr. Avildsen's broad directorial touches often shatter its gentle mood. Yet the bullies are shown to be unbelievably rotten (their leader is a drill sergeant-type karate instructor, who makes his students do pushups on their knuckles). The score is pushy and loud. And the extras, like the modelly looking parents of Daniel's rather superfluous young sweetheart, are made of wood. The only sections of the film that really work are those concerning Daniel and his mentor, and even this relationship is taken too far. Long after we know of their affection for each other, long after Daniel and Mr. Miyagi know this too, the film includes a dreadful drunk scene in which the old man confesses several key facts about his past and then shows his Medal of Honor.

When karate is not being treated as the latest excuse for an "Impossible Dream" success story, and when the film is able to find more in Daniel's martial-arts career than pure "Rocky"-esque competitiveness, "The Karate Kid" exhibits warmth and friendly, predictable humor, its greatest assets. Midway through the story, an obvious but highly effective sequence has Mr. Miyagi saddling Daniel with one herculean home-repair chore after another, tasks that have no apparent connection with his karate training. It is irresistible, if not surprising, to watch this culminate in the boy's angry outburst, the old man's quiet bemusement and the revelation that painting, sanding and waxing have plenty to do with karate after all.

●

"The Karate Kid" is rated PG ("Parental Guidance Suggested"). It contains some strong language and mild violence.

1984 Je 22, C16:3

FILM VIEW

VINCENT CANBY

Huston's 'Volcano' Pays Homage to The Novel

W hen, in 1957, at the age of 48, Malcolm Lowry was found dead in the small rented house he was sharing with his wife, Margerie, in Ripe, England, the doctor described the writer's end as "death by misadventure." As had been his custom for most of his adult life, Lowry had been drinking heavily that evening. After a ferocious argument with his wife, who fled under the possibly correct impression that she was fleeing for her life, he had continued to drink and, apparently, also taken a number of barbiturates.

"Death by misadventure": It's a phrase that would have appealed to the alcoholic, prodigiously self-destructive Lowry, whose life had become so thoroughly confused with his work that he sometimes suspected, according to Stephen Spender, that "he was not a writer so much as being *written*." It might even have been uttered by his extraordinary fictional creation, Geoffrey Firmin, usually called the Consul, the British consul in Mexico whose last day on earth is both the subject of and the frame for Lowry's only major work, "Under the Volcano," which, over the years, has been wildly praised and condescendingly panned and never goes out of print.

● ● ●

Begun as a short story in 1936, "Under the Volcano" finally emerged, 11 years and four painstaking revisions later, as something of a huge, overstuffed steamer trunk of a novel, into which Lowry attempted to pack not only his own past, present and future but also those of the entire Western world. It's a difficult, maddening, sometimes spellbinding book in which absolutely nothing appears to have been left out: Peter Rabbit, the cabala, Dante, Aztec mythology, restaurant menus, Karl Freund's 1935 film adaptation of "The Hands of Orlac," Cervantes, Mexican timetables, the degrees of sky clarity, Nazis, the Spanish Civil War, and on and on.

To push one's way through this densely layered novel is to invite a kind of artificially induced schizophrenia. One is simultaneously exhilarated and depressed, seduced and abandoned, fascinated and exhausted, charmed and intimidated, and, ultimately, made to feel at home in a world more terrifying than one has ever imagined possible. In this time of literary cool, when less is more and indirection and ellipses are the accepted modes of communication, "Under the Volcano" is fat with words, as unseemly as the Consul himself dressed in black tie and dinner jacket but wearing no socks.

Though it's symmetrical, it's not a neat and tidy work. Nor is it somehow made more comprehensible and reassuring by the existence of a large body of other major Lowry novels, which might dispel the awful suspicion that the reader, here, is a participant in a ceremony that is nothing less than cannibalistic. Lowry lived his life so as to be able to consume it as fiction.

This is the virtually impossible source material for John Huston's mesmerizing new film, "Under the Volcano," adapted by a fine young writer named Guy Gallo and presented by Michael and Kathy Fitzgerald, who were also key figures in the realization of Mr. Huston's beautiful screen adaptation of Flannery O'Connor's difficult — but not *as* difficult — "Wise Blood." I'm still not convinced that prose works of such particular literary complexity and concerns should be made into movies. However, "Under the Volcano" is so rich and evocative that it becomes a persuasive argument that such movies — when they are made with the intelligence and artistry of this one — deserve to be attended to with the same appreciation we reserve for films that more easily fit the medium.

●

Make no mistake about it: "Under the Volcano" is *not* the novel. No film could ever be, not even one running the 15½ hours of Rainer Werner Fassbinder's "Berlin Alexanderplatz," which is, after all, like a Dickens novel, that is, a tale composed of character and event. An "Under the Volcano" that ran for 15½ hours would, I suspect, be incomprehensible to just about everyone except a few Lowry scholars, who could argue, rightly, that instead of watching a film of that inflated length, one might more profitably read the book.

●

Without distorting the Lowry novel in any essential way, Mr. Huston and his associates have made a movie that functions as a moving homage to the novel. It's also a homage to Lowry himself, who, in the brilliant performance of Albert Finney in the role of the Consul, emerges as a far more interesting, exuberant, tragic character than any chronic drunk has a right to be, in real life or in fiction. What becomes more immediately clear and more immensely affecting in the film than in the book, largely through Mr. Finney's performance, is that the Consul's addiction is, mysteriously, not only a weakness but a conscious choice, and a heroic one at that.

This, of course, is the alcoholic Lowry's rationalization, but then as alcoholic as Lowry was, he did complete his extraordinary novel, and not many doomed addicts can say that.

I seriously doubt whether "Under the Volcano," the film, will make complete narrative sense to anyone not at least partially familiar with the novel. The novel occupies approximately 24 hours, but its surface events are not, until the end, especially coherent or dramatic. It isn't the flashbacks that give the novel substance and texture, but the random thoughts and free associations that come and go and come again in the Consul's tormented mind on this particular day, Nov. 1, 1938, celebrated as the Day of the Dead in Mexico.

In the course of this day, the Consul, now out of a job and at loose ends, must face his past in the return to Cuernavaca of his divorced wife, Yvonne (Jacqueline Bisset), whom he had earlier more or less thrown into the arms of his younger half-brother, Hugh (Anthony Andrews), who is now staying with him. Were it not for Mr. Finney's amazingly variegated, sometimes grandly comic performance, I also doubt whether anyone would understand why Yvonne would have returned to the Consul and why Hugh, a freelance journalist who has fought with the Loyalists in Spain, would have such affection for a man who is, at best, impossible, and, at worst, heading toward a disaster that threatens to carry the rest of them with him.

The movie never functions as a "pony" for the novel. It is full of symbols and references that remain untranslated on the screen, but there is depth of feeling among the three principal characters that, in the book, tends to be more theoretical than actual. Miss Bisset, looking both beautiful and drawn — Yvonne has just spent the last week or so traveling to Mexico — successfully creates a film character that carries the kind of psychological baggage one usually only understands in written fiction.

There's an exquisite sequence about halfway through the film when the Consul, Yvonne and Hugh, all slightly drunk by this time, riding a rural bus, have a nasty encounter with the neo-Nazi police who have, it turns out, just murdered a possibly politically active, left-wing peasant. It's an unwanted reminder of the war in Spain that Hugh can't quite bring himself to return to. Later, at lunch at a forbiddingly picturesque, bullring restaurant, Hugh goes into the ring to face the bulls to the acclaim of the audience, which triggers one of the film's most poignant, full-bodied scenes, in which the Consul's love for his ex-wife and half-brother can only be expressed in delicious (to him) self-defeating fury.

Though full of doom, this "Under the Volcano" is also hugely romantic. The tangled love lives of the Consul, Yvonne and Hugh seem to have a contemporary importance that was mostly missing in the various film versions of Ernest Hemingway novels we've seen over the years — novels that were also written in their own time but, like "Under the Volcano," now are seen as period pieces. This is partially because Mr. Huston and Mr. Gallo have not attempted to supply neat justifications for the behavior of the characters.

This very mysteriousness becomes one of the film's virtues. "Under the Volcano" appears to honor the "unfilmablity" of the novel as well as the

intelligence of its audience. It's not an especially shapely film, but it ranks with the best work Mr. Huston has ever done. It also demonstrates that good movies can sometimes be inspired by source material that most sane, lesser filmmakers wouldn't touch with a man-made, electronically operated gremlin. ∎

1984 Je 24, II:1:1

A Future of Sorts

THE 4TH MAN, directed by Paul Verhoeven; screenplay (Dutch with English subtitles) by Gerard Soeteman, based on the novel by Gerard Reve; director of photography, Jan de Bont; edited by Ine Schenkkan; music by Loek Dikker; produced by Rob Houwer; a Spectrafilm release. At the Plaza, 58th Street, east of Madison. Running time: 104 minutes. This film has no rating.

Gerard Reve Jeroen Krabbe
Christine Halsslag Renee Soutendijk
Herman Thom Hoffman
Dr. De Vries Dolf de Vries
Ria Geert de Jong
Funeral Director Hans Veerman
Josefs Hero Muller
Adrienne Caroline de Beus
First Husband Reinout Bussemaker
Second Husband Erik J. Meijer
Third Husband Ursul de Geer

By JANET MASLIN

THE visual symbolism in Paul Verhoeven's "4th Man" is so fevered and relentless that the film has the feeling of a feature-length hallucination. Certainly it's a departure from the more earthbound works ("Soldier of Orange," "Spetters") of this Dutch director. Mr. Verhoeven this time concentrates on Christian imagery, the prescience of his central character and an overpoweringly portentous color scheme. Such material might benefit from a more delicate touch than Mr. Verhoeven's. But what he lacks in subtlety, he does make up in sheer intensity.

"The 4th Man," which opens today at the Plaza theater, is seen from the point of view of Gerard Reve (Jeroen Krabbe), evidently a notorious writer. (There is a real Gerard Reve, and the screenplay by Gerard Soeteman is based on Reve's novel.) The film's opening scenes find Gerard waking, badly hung over, in the Amsterdam apartment that he shares with a homosexual lover. That day, he leaves for an out-of-town speaking engagement, and en route to his destination has a series of visions that foretell his future.

The credits have shown a spider entrapping flies beside a piece of religious statuary. Gerard, at his lecture engagement, soon meets a similar creature in human female form. Christine (Renee Soutendijk) is a beautician who favors a dramatic shade of red, and who — she tells Gerard as she is giving him a light trim — has named her own brand of haircare products Delilah. "The 4th Man" races along at a rapid clip, but it finds time for its fair share of black humor.

The final, tidy resolution of Gerard's troubling premonition is less startling than the process by which the vision unfolds. Gerard imagines, among other things, a slaughterhouse containing three animal carcasses, a living representation of Christ on the cross that excites his prurient appetites, and the ghastly spectacle of his own castration. Mr. Verhoeven illustrates, and even repeats, such things in the same doggedly meticulous spirit that has him regulating the colors of Christine's wardrobe —

Jeroen Krabbe and Renee Soutendijk in the Dutch film "The 4th Man," directed by Paul Verhoeven.

which goes from red, to blue, to red again, with a final interlude of gray. Another key woman, appearing in a blue raincoat and carrying red roses, ultimately completes the rigid scheme.

The cinematography, by Jan de Bont, is on the blunt side, which contributes to the heaviness of the film's touch. But Mr. Verhoeven manages to convey an irresistible fascination with the pieces of this puzzle, and to juggle them energetically, which helps a lot. Mr. Krabbe and Miss Soutendijk play their roles with just the lunatic intensity that the material requires, daring to be nearly ridiculous and sometimes gamely crossing that line. They share a number of memorably heated encounters, including a bedroom scene during which Gerard allows that he thinks Christine would make an attractive boy. Christine doesn't say so, but she's got some interesting plans for Gerard, too.

1984 Je 27, C21:4

Cowboy Rescuers

BRADY'S ESCAPE, directed by Pal Gabor; written by William W. Lewis; story by Mr. Gabor; cinematographer, Elemer Ragalyi; film editor, Norman Gay; music by Charles Gross; produced by Robert Halmi Jr.; released by Satori Entertainment. At Eastside Cinema, Third Avenue between 55th and 56th Streets; Embassy 3 and 4, 47th Street and Broadway. Running time: 96 minutes. This film has no rating.

Brady John Savage
Miki Kelly Reno
Klara Ildiko Bansagi
Dr. Dussek Laszlo Mensaros
Wortman Ferenc Bacs
Csorba Dzsoko Rosic
Moro Laszlo Horvath
Sweede Matyas Usztics

By VINCENT CANBY

PAL GABOR'S "Brady's Escape," the World War II adventure film that opens today at the Eastside Cinema and other theaters, is a United States-Hungarian co-production and, like so many of the early European co-productions, it has no real identity of its own. It's a decent,

rather characterless movie with more political good will than dramatic impact.

It seems clear that Mr. Gabor is less at home with action movies than with the kind of social satire so precisely realized in his "Angi Vera," the Hungarian film released here in 1979. "Brady's Escape," shot entirely in Hungary with John Savage and Kelly Reno as its stars, is the story of an American flier, shot down over the Hungarian plains during the war, and how a group of heroic Hungarian horsemen — cowboys who are called csikos in Hungarian — helps him make his way to Yugoslavia.

The film doesn't really avoid the clichés of such fiction, including the narrow escapes from vicious Nazi police and a brief love affair with a pretty member of the underground, but it doesn't overplay them. In movies of this sort, however, such discretion is not necessarily productive of anything except points for good taste, which are not what action movies are all about.

Mr. Savage, as the airman, and Mr. Reno ("The Black Stallion" and "The Black Stallion's Return"), who plays a hero-worshiping young Hungarian horseman, are more than adequate in roles that are simply functions of the plot. The Hungarian supporting actors exhibit great faces but aren't required to do much else. The one exception is Ildiko Bansagi, as the young woman who falls discreetly in love with Mr. Savage. She's both a good actress and a great beauty.

1984 Je 28, C17:1

ANOTHER COUNTRY, directed by Marek Kanievska; screenplay by Julian Mitchell, based on his original stageplay; director of photography, Peter Biziou; film editor, Gerry Hambling; produced by Alan Marshall; an Orion Classics Release. At Cinema 2, Third Avenue and 60th Street. Running time: 90 minutes. This film is rated PG.

Guy Bennett Rupert Everett
Tommy Judd Colin Firth
Barclay Michael Jenn
Delahay Robert Addie
Devinish Rupert Wainwright
Fowler Tristan Oliver
Harcourt Cary Elwes
Menzies Fredrick Alexander
Wharton Adrian Ross-Magenty
Yevgeni Geoffrey Bateman
Martineau Philip Dupuy

Colin Firth and Rupert Everett are the protagonists in "Another Country," an adaptation of a play inspired by Britain's Burgess-Maclean spy scandal.

By VINCENT CANBY

"ANOTHER COUNTRY," the English film that opens today at the Cinema 2, is a well-acted, literate but insufferably smug little movie that fictionalizes the life of Guy Burgess, who with Donald Maclean defected to Moscow in the early 1950's. Burgess and Maclean were among the first to be revealed of that small group of Englishmen who, though born to upper-middle-class privilege in the 1920's, turned to Communism in the depressed 1930's and lived double lives as Soviet agents.

Much of interest has been written about this subject, and much has been made of the effect of the English public-school system on these young men. However, no work has quite so localized the problem as has "Another Country," adapted for the screen by Julian Mitchell from his successful London play.

•

"Another Country" is certainly not trivial, but even allowing for dramatic license, it freights an unhappy homosexual love affair between two schoolboys with more in the way of dire political consequences than it can reasonably bear. The problem is not in the fiction itself but in its portentous presentation and in the free way Mr. Mitchell makes associations between the fictional Guy Bennett and the real Guy Burgess. Like Costa-Gavras in other circumstances, the

playwright is asking us to certify his fiction because it's based on fact, though which is what few of us can be expected to know.

The film opens in contemporary Moscow where a now-aged Guy Bennett (Rupert Everett), for reasons that have more to do with getting a movie started than with character, has agreed to be interviewed by a Western reporter. This is, it seems, the first time he's met any member of the press in the years he's been in the Soviet Union. The story he gives the reporter, a young woman, makes the movie, but it might make her editor apoplectic. She clearly has no nose for hard news.

•

What we get instead is a self-pitying, rueful, romantic tale of the awfulness of life in an ancient English public school in the 1930's. At its center is the friendship of Guy Bennett, a dark, Byronically handsome young man, who fancies himself an esthete and who accepts the horrors of the school system in return for its rewards, and Tommy Judd (Colin Firth), who attends the school against his will, refuses to play the gentleman's game, and is already a hard-line Marxist.

Each is the perfect audience for the other's eccentricities. Tommy is appalled and amused at Guy's Wildean poses of decadence, while Guy is fascinated by the articulate Tommy's single-minded pursuit of politics. Tommy isn't especially surprised when Guy falls in love with a hand-

some fellow student named Harcourt (Cary Elwes), feeling sure that it's just another one of Guy's bids for attention.

Things turn serious all the way around, however, after another student commits suicide, having been caught in flagrante delicto. The school's student prefects are less concerned with the fact of homosexual affairs than with the publicity that attends this latest mess. When they learn about Guy's newest liaison, they use the evidence to blackball the wonderfully arrogant fellow from becoming one of the school "gods," or leaders, in his senior year.

According to "Another Country," this is the blow that eventually leads Guy to a career as an agent and, finally, to lonely exile in the Soviet Union.

•

As long as the film doesn't seem to be telling us that we're witnessing the decline of the West on the playing fields of England, it's an effective, essentially conventional melodrama of the sort beloved by London's West End audiences. Marek Kanievska, the Czechoslovak-born director, whose first theatrical feature this is, obtains good performances from Mr. Everett, Mr. Firth and the large supporting cast, including Anna Massey, who's splendid in a couple of short scenes as Guy's mother. If the film never successfully overcomes the suspicion that it's not quite as anti-public-school as it pretends to be, this seems built into the material.

Were it more profoundly, seriously outraged, "Another Country" couldn't be as charming and pretty as it often is. It would be ugly and rude and disturbing in ways that are totally beyond this movie.

•

"Another Country," which has been rated PG ("parental guidance suggested"), includes some vulgar language and one short scene showing a homosexual encounter.

1984 Je 29, C8:1

The Couple Next Door

IT'S NEVER TOO LATE, directed by Jaime de Arminan; screenplay (Spanish with English subtitles) by Mr. de Arminan and Juan Carlos Eguillor, based on an idea by Concha Gregori; cinematography by Teo Escamilla; edited by José Luis Matesanz; music by Jose Nieto; produced by Francisco Hueva; an Incine & Impala Production; released by Films Inc. At the Thalia, 95th Street, near Broadway. Running time: 98 minutes. This film has no rating.
AntonioJosé Luis Gomez
Teresa ..Angela Molina
UrsulaMadeleine Christie
WITH Maria Silva, Maite Blasco, Eduardo Calvo, Chus Lampreave, Julia Trujillo, Josefina del Cid, Julia Lorente

By JANET MASLIN

THE premise of Jaime de Arminan's "It's Never Too Late" is rendered all the more strange by the clean, crisp fashion with which the film unfolds. It concerns 73-year-old Ursula (Madeleine Christie), a virginal, sweet-faced, white-haired Basque woman, who is quietly obsessed with the young newlyweds whose window faces her own. She is particularly interested in the husband, Antonio (José Luis Gomez), fabricating reasons to visit him when his wife is away and on one occasion stealing a wedding picture. She takes this home, cuts out the photo of the wife's face, and replaces it with a likeness of herself.

Working calmly toward the most extraordinary of domestic events (in something like the way Louis Malle's "Murmur of the Heart" did), "It's Never Too Late," which opens today at the Thalia, follows the course of Ursula's obsession. She begins to think, after watching Antonio and Teresa (Angela Molina) make love, that she herself is pregnant. What's more, her doctor thinks so, too. The family of this genteel spinster is horrified, not to say bewildered, by this course of events, but no one is more puzzled than Antonio himself when Ursula, with whom he has never been more than distantly cordial, arranges a clandestine meeting to tell him that he is the father of her child.

•

If Mr. de Arminan's film, which was made in 1977, never achieves the kind of transcendent vision that might finally illuminate this story, it does progress in an involving way, handsomely photographed by Teo Escamilla, with a fine performance by Miss Christie as the sometimes mystified, sometimes almost diabolical mother-to-be. Miss Molina has a pouty intensity as the bride who suspects her husband may be seeing another woman, without dreaming that her rival is old enough to be her grandmother.

1984 Je 29, C8:4

Suburban Hercules

CONAN THE DESTROYER, directed by Richard Fleischer; screenplay by Stanley Mann; story by Roy Thomas and Gerry Conway, based on the character created by Robert E. Howard; film editor, Frank J. Urioste; music by Basil Poledouris; produced by Raffaella de Laurentiis; released by Universal Pictures. At Rivoli, Broadway and 49th Street; Gemini, Second Avenue and 64th Street; 86th Street East, between Second and Third Avenues; Gramercy, 23d Street, between Park and Lexington Avenues; New Yorker, Broadway and 88th Street, and other theaters. Running time: 103 minutes. This film is rated PG.
ConanArnold Schwarzenegger
Zula ...Grace Jones
BombaataWilt Chamberlain
Akiro the WizardMako
MalakTracey Walter
Queen TaramisSarah Douglas
Princess JehnnaOlivia D'Abo
Man Ape/Thoth-AmonPat Roach
Grand VizierJeff Corey
TograSven Ole Thorsen
Village HecklerBruce Fleischer
LeaderFerdinand Mayne

IT'S neither a man nor a bird but it could be a moose wearing a sweatband. Actually, it's large-jawed, Austrian-born Arnold Schwarzenegger in the title role of "Conan the Destroyer," the first in what threatens to be a long line of sequels to his "Conan the Barbarian" (1982). The movie opens today at the Rivoli and other theaters.

In case you came in late, Conan is the old Weird Tales magazine character created in 1932 by Robert E. Howard for the soda-fountain set. Conan is a sort of cut-rate Hercules, the mythological hero of what's called the Hyborean Age, which, from what we see in "Conan the Destroyer," looks to be about 30 minutes east of Los Angeles by freeway. Though the film was made entirely in Mexico, on some rugged locations handsomely photographed by Jack Cardiff, the sensibility is Southern California suburban, complete with patio cookouts. The only difference is that the meat on the spit is likely to be an unfriendly barbarian neighbor.

In this film, directed by Richard Fleischer and written by Stanley Mann, Conan goes off on a quest for a magical stone, guarded by a wizard, at the behest of wicked Queen Tamaris (Sarah Douglas). Am I going too

A quest for a magical horn occupies Arnold Schwarzenegger in "Conan the Destroyer."

fast? With him on the trek are Princess Jehenna (Olivia D'Abo), a virgin; Malak (Tracey Walter), a comic sidekick who, in the face of danger, is likely to say, "Let's flee"; Bombaata (Wilt Chamberlain), the queen's hired assassin, and Zula (Grace Jones), an extremely tall female warrior whose hair style is Hyborean punk.

The special effects aren't bad, and there are fewer decapitations than in "Conan the Barbarian." Mr. Fleischer seems to want this film to be funnier than was the first one, directed by John Milius, but Mr. Schwarzenegger, a body builder who can lift freight trains, can't easily get his tongue into his cheek. He's better at bopping horses, camels and other barbarians, and is very good reading such lines as "Into the boat!" and "Into the tunnel!" and, at a key moment, "Take the chool!" which, in the context, is understood to mean "Take the jewel!"

●

"Conan the Destroyer," which has been rated PG ("parental guidance suggested"), contains a lot of loud swordplay and somewhat less loud impalements.

Vincent Canby

1984 Je 29, C8:4

A Vehicle for Vehicles

CANNONBALL RUN II, directed by Hal Needham; written by Mr. Needham, Albert S. Ruddy and Harvey Miller, based on characters created by Brock Yates; director of photography, Nick McLean; edited by William Gordean and Carl Kress; music by Al Capps; produced by Mr. Ruddy; released by Warner Bros. At Criterion Center, Broadway and 45th Street; 86th Street Twin, at Lexington Avenue; 83d Street Quad, at Broadway; Gemini, Second Avenue and 64th Street; Art, Eighth Street, east of Fifth Avenue, and other theaters. Running time: 108 minutes. This film is rated PG.

J.J. McClure	Burt Reynolds
Victor-Chaos	Dom DeLuise
Blake	Dean Martin
Fenderbaum	Sammy Davis Jr.
Sheik	Jamie Farr
Betty	Marilu Henner
Hymie	Telly Savalas
Veronica	Shirley MacLaine
Jill	Susan Anton
Marcie	Catherine Bach
Fisherman 1	Foster Brooks
Fisherman 2	Sid Caesar
Jackie	Jackie Chan
C.H.P. 1	Tim Conway
King	Ricardo Montalban
Homer	Jim Nabors
Fisherman 3	Louis Nye
Mrs. Goldfarb	Molly Picon
Don Don	Charles Nelson Reilly
Tony	Alex Rocco
Slim	Henry Silva
Frank Sinatra	Himself
143	

FANS of Don Knotts, Jim Nabors, Sammy Davis Jr., car crashes and trained orangutans may want to celebrate the opening of "Cannonball Run II" today at the Movieland and other theaters. For anyone else, it's a mixed blessing at best. Directed in slam-bang style by Hal Needham, the film is an endless string of cameo performances from a cast whose funny participants are badly outnumbered and whose television roots are unmistakable. When Doug McClure turns up as the blond-haired slave of an Arab sheik, explaining that he's an actor and he hasn't had a series job in seven years, the movie is as clever as it's going to get.

Burt Reynolds is a reliable presence behind the wheel of one of the film's many vehicles, which are involved in a cross-country chase that goes nowhere, literally and figuratively. (Connecticut, the racers' supposed destination, winds up looking exactly like California.) As Mr. Reynolds's sidekick, Dom DeLuise is the life of the party, and Shirley MacLaine and Marilu Henner seem to be enjoying themselves as Mr. Reynolds's two other passengers, chorus girls masquerading as nuns. They use what Mr. DeLuise calls a "Boy-Nun, Boy-Nun" seating plan.

The rest of the huge cast ranges from sleazy (Susan Anton and Cath-

erine Bach as vamps in skin-tight jumpsuits) to superfluous. Most of those performers who've been absent from the screen for a while look the worse for wear. Dean Martin has a bedroom scene with a woman much, much younger than he, and Frank Sinatra appears briefly, playing a king. Telly Savalas calls everyone "baby." Mr. Reynolds, Mr. Davis and Mr. DeLuise do a harem dance in drag.

The fact that "Cannonball Run II" isn't much good may not prevent it from becoming this summer's best-loved lowest-common-denominator comedy, if only because of the utter absence of any competition.

●

"Cannonball Run II" is rated PG ("Parental Guidance Suggested"). It contains brief nudity and some mildly smutty innuendoes.

Janet Maslin

1984 Je 29, C14:5

BACHELOR PARTY, directed by Neal Israel; screenplay by Neal Israel and Pat Proft, story by Bob Israel; director of photography, Hal Trussell; edited by Tom Walls; music by Robert Folk; produced by Ron Moler and Bob Israel; released by Twentieth Century-Fox Film Corporation. At the Gotham, Third Avenue and 58th Street; 34th Street East, at Second Avenue; UA East, 85th Street and Third Avenue; National, Broadway and 44th Street, and other theaters. Running time: 111 minutes. This film is rated R.

Rick Gassko	Tom Hanks
Debbie Thompson	Tawny Kitaen
Jay O'Neill	Adrian Zmed
Mr. Thompson	George Grizzard
Mrs. Thompson	Barbara Stuart
Cole Whittier	Robert Prescott
Dr. Stan Gassko	William Tepper
Dr. Tina Gassko	Wendie Jo Sperber
Rudy	Barry Diamond
Gary	Gary Grossman
Ryko	Michael Dudikoff
Brad	Bradford Bancroft
Phoebe	Martina Finch
Ilene	Deborah Harmon
Bobbi	Tracy Smith

Tom Hanks in "Bachelor Party."

By JANET MASLIN

It takes much longer than might be expected for "Bachelor Party," which opened yesterday at the National and other theaters, to degenerate into a mindless mob scene. Until it takes that turn for the worse, the movie is actually funny. That is, it's as funny as "Police Academy," which like this film was written by Neal Israel and Pat Proft. And it's certainly funnier than it has been made to look by its advertising campaign, which seems to feature the usual gang of suspects enjoying the usual sophomoric sex romp.

Tom Hanks plays Rick Gassko, the somewhat reluctant recipient of a bachelor bash. Unlike the young heroes of similar films, Mr. Hanks's Rick actually likes his fiancée, Debbie (played fetchingly by Tawny Kitaen), and is able to tell her apart

Dom DeLuise and Burt Reynolds star in "Cannonball Run II," a sequel dealing with a cross-country automobile race with no rules or regulations.

from other women. And, unlike other comparable heroines, Debbie isn't so stupid. She knows what kind of party Rick's friends are planning, and isn't looking forward to it any more than he is. It doesn't take long for Neil Israel, who directed, to make that point, and that goes a long way toward making the characters and the movie likable.

Mr. Hanks's suave smart-alecky manner owes a lot to Bill Murray, but he's funny and engaging even if he isn't doing anything new. The early

part of the film has him systematically horrifying Debbie's friends and relatives, to the point that Debbie's father (George Grizzard) hires his daughter's old boyfriend to break up the match. The boyfriend offers to swap his Porsche for Debbie, which is a fatal mistake. Rick and his gang of friends wind up dangling the boyfriend out a hotel window, and revamping his Porsche so that its horn plays "La Cucaracha."

1984 Je 30, 11:1

FILM VIEW

VINCENT CANBY

Don't Despair, There's More At Hand Than Escapism

Don't be buffaloed: This summer need not be completely dominated by "Ghostbusters," "Gremlins," "Indiana Jones and the Temple of Doom," "Star Trek III" and "Romancing the Stone." Alternative movies are available.

What are alternative movies? Well, they're not to be confused with what is sometimes referred to as alternative cinema — the rather fancily elevated term used by the avant-garde to distinguish their often short, frequently nonlinear, abstract-expressionist or structuralist experiments from the general run of feature-length, commercial films.

Alternative movies are simply movies — good ones and not especially hip, which is not to say they're old-fashioned. They may not be simple, but then they aren't likely to prompt parents to write irate letters to editors complaining about misleading ratings. Alternative movies rarely contain decapitations, space ships or jazzy, laboratory-made special effects.

They run the gamut from the great Chaplin films, which will be shown in the summer-long retrospective at the Public Theater, and the classic Jean Renoirs that can be seen, double-billed, every Thursday at the Thalia, to the giant, 60-year jubilee of M-G-M films now playing at the Regency. They may be very old, like the early Chaplin shorts at the Public, comparatively recent, like Eric Rohmer's elegant 1969 comedy, "My Night at Maud's," now playing at the Film Forum 2, or brand new, like John Huston's fascinating and heroic attempt to film Malcolm Lowry's "Under the Volcano."

The point is that there is an alternative to the sorts of occasionally entertaining kiddie movies, like "Indiana Jones" and "Ghostbusters," which, by the sheer magnitude of their popular success, virtually demand that the rest of us take a look at them, if only to find out what all the fuss is about (and, possibly, to become convinced that the end of Western civilization is at hand).

• • •

The most exiciting by far of the newly available alternative movies is Ingmar Bergman's "After the Rehearsal," a film by, for and about adults and something that is, not, strictly speaking, a film at all. The three-character, one-set, 72-minute production was originally made to be seen on television, but it is more complex and profoundly moving than just about any other theatrical film of the current season.

In it Mr. Bergman, in the character of Henrik Vogler (Erland Josephson), an aging theatre director, examines his long and successful career, and his not so successful private life, in dreamlike encounters with two women who are important to him. The set is the stage where Henrik

has just finished the day's rehearsal for a new production of Strindberg's "Dream Play," the fifth of Henrik's career, and the women are Anna Egerman (Lena Olin), his pretty, ambitious young leading lady, and Rakel (Ingrid Thulin), as one of his former mistresses and a once-great star who has accepted what is little more than a walk-on in this new production.

Coming to "After the Rehearsal" after looking at a succession of movies that, like "Gremlins," are intended to be escapist but, more often, are exhausting in their relentless efforts to shock and amuse, is like receiving absolution for someone else's sins. "After the Rehearsal" is all talk — Swedish talk translated by English subtitles — and one reads it as often as one watches it. Yet the effect of the language and of the performances is like that of a remarkable short story. There's not an excessive line or gesture in the entire piece.

• • •

For Henrik the theater is life and, in the theater in which he works, that life revolves around him. In this small world, he is teacher, interpreter, arbiter and conscience. His is always the last word. It's a Godlike role that, he has come to understand, does not, unfortunately, confer immortality. Henrik is feeling his age. His teeth are coming loose. The love affairs that once enriched and rejuvenated him now have become either haunting, not altogether happy memories or promises he no longer has the drive to keep.

Though his encounters with Anna and Rakel on the stage of this otherwise empty theater may well be imaginary, they are absolutely specific — Henrik is not someone who idly daydreams. The alcoholic Rakel, in the grandly angry, sorrowful figure of Miss Thulin, comes on to remind him of every moment of hubris he's ever indulged himself. She moves him but she also represents the awful immutability of the past. What's done has been done. He cannot love her again. He can only be kind and try not to allow her to bore him, which, in her self-destructive way, is what she seems intent on doing.

Anna has everything Rakel has lost, including a future that, for a few theatrically charged moments, Henrik shares. At the start of the film, Henrik and Anna are director and actress, then father and daughter and, finally, in a scene of the kind of pure magic that film directors seldom achieve, they imagine the stormy, ecstatic course of a love affair from beginning to end.

Though "After the Rehearsal" is moviemaking of the highest order, it has the particular excitement of something seen live, in the theater, in a performance that is at this moment unique.

• • •

Athol Fugard is not just the great South African playwright. He is among the greatest living playwrights today, second only, perhaps, to Samuel Beckett. His great-

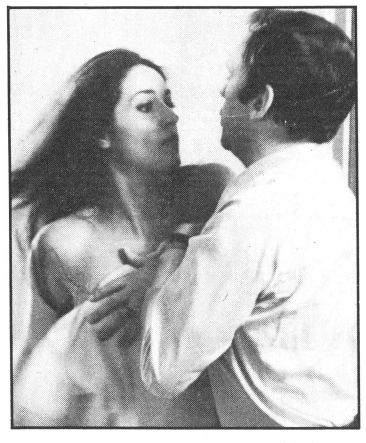

Now in local theater are films such as "Marigolds in August," with Winston Ntshona, far left; "My Night at Maud's," with Françoise Fabian and Jean-Louis Trintignant; and "After the Rehearsal," with Ingrid Thulin, below, that provide rewards for audiences seeking something besides "kiddie movies."

by the gut emotions of his other work.

The Fugard "trilogy" would be worth playing in repertory, but in the kind of Off Off Broadway movie theater that wouldn't have to earn blockbuster grosses to meet its overhead.

Upcoming alternative movies include two films featured at this year's New Directors/New Films Festival: "Improper Conduct," a fine, angrily biased documentary, directed by Nestor Almendros and Orlando Jimenez-Leal, in which Cuban exiles of all stripes talk about the "truth" of Castro's revolution, and "Skyline," Fernando Colomo's gently funny, satirical comedy about the adventures of a young Spanish photographer on the loose in a Manhattan that will forever baffle him.

It's sometimes fun to stand in line to get in to see something like "Indiana Jones and the Temple of Doom." It's also sometimes more rewarding to seek out the alternatives. ■

1984 Jl 1, II:13:1

ness is not easily described, mostly because the usual subject matter of his plays — his outrage with the politics of apartheid — tends to distract attention from the voice in which his plays are written, a voice unlike that of any other contemporary playwright.

In the mid-70's, Mr. Fugard, in collaboration with a remarkably capable and appreciative South African director, Ross Devenish, made three films, "Boesman and Lena," adapted from a Fugard play; "The Guest," based on an original screenplay by Mr. Fugard about several terrifying months in the life of Eugene Marais, the South African naturalist and lifelong drug addict; and "Marigolds in August," another original Fugard screenplay that again dramatizes, in miniature, South Africa's terrible heritage.

There is still a chance to get to the Film Forum to see "Marigolds in August," with a cast headed by Mr. Fugard and Winston Ntshona and John Kani, the two black South African actors with whom Mr. Fugard collaborated to create "Sizwe Banzi Is Dead" and "The Island."

And "The Guest," which played at the Film Forum earlier this year, is scheduled to open on Friday at the Festival. Because "The Guest" is not as immediately political as "Boesman and Lena" and "Marigolds in August" — it's about the nightmare struggle of Eugene Marais, played by Mr. Fugard, to kick his morphine habit — it's possible to hear the precise, poetically spare language of the playwright with a clarity sometimes overwhelmed

LAST NIGHT AT THE ALAMO, directed by Eagle Pennell; screenplay by Kim Henkel; directors of photography, Brian Huberman and Eric Edwards; music by Chuck Pinnell and Wayne Bell; produced by Mr. Henkel and Mr. Pennell. At Greenwich Playhouse 2, Greenwich Avenue and 12th Street; Running time: 80 minutes. This film has no rating.

Cowboy	Sonny Davis
Claude	Lou Perry
Ichabod	Steve Matilla
Mary	Tina Hubbard
Janice	Doris Hargrave
Steve	J. Michael Hammond
Lisa	Amanda LaMar
Ginger	Peggy Pinnell
Poke	David Schied
Skipper	George Pheneger
Willie	Henry Kana
Wayne	John Heaner
Hector	Ernest Huerta
Connie	Pam Feight
Ray	Henry Kana
Darla	Sarah Hudgins
Lois	Jeanette Wiggins
Mavis	Judie Stephens
Slim	Hi Bice
Lionel	Kim Henkel
Bo	Eagle Pennell

"Last Night at the Alamo" was shown as part of last year's New York Film Festival. Following are excerpts from a review by Janet Maslin that appeared in The New York Times Oct. 2, 1983. The film opens today at the Greenwich Playhouse 2, Greenwich Avenue and 12th Street.

EAGLE PENNELL'S "Last Night at the Alamo" is a small film that raises both the hope and the possibility that Mr. Pennell will make bigger ones. Shot in a primitive style, and using both accents and equipment that sometimes make its sound muddy, it's the ribald and faintly mournful chronicle of a seedy Houston hangout that's about to close its doors for the last time, much to the chagrin of the regular clientele.

This includes Cowboy (Sonny Davis), a local hero with a reputation to live up to and a hat that he'd better keep on; Claude (Lou Perry), who's in the process of being thrown out by his wife and who curses her imaginatively throughout the film, and Ichabod (Steve Matilla) and Mary (Tina Hubbard), a combative couple but clearly a love match. From the moment when they first drive up, with Ichabod at the wheel of their Pest Control van, to the point at which, after much boasting and advertising from Ichabod, they disappear in the direction of the Paradise Motel, these two provide the film with its comic relief.

As directed by Mr. Pennell and written by Kim Henkel (who also wrote "The Texas Chainsaw Massacre"), "Last Night at the Alamo" has a surface energy and a subliminal bleakness that work well together. A large cast of incidental characters, including the writer and director in tiny roles, all join in cursing, drinking, carousing and otherwise preparing themselves for imminent disaster.

Though the film has been shot in black and white, the material itself is very much in color.

1984 Jl 3, C10:5

2d of a Trilogy

THE LAST SEA, a film by Haim Gouri, Jacquot Ehrlich and David Bergman; (in Hebrew, Yiddish and French with English subtitles) produced by Benny Shilo and Yehezkel Avneri for Ghetto Fighters' House, Israel; edited by Mr. Ehrlich; music by Yossi Mar-Hayim; distributed by Jewish Media Services. At the Film Forum, 57 Watts Street. Running time: 105 minutes. This film has no rating.

By VINCENT CANBY

"THE LAST SEA," which opens a two-week engagement today at the Film Forum, is a moving tribute to the illegal Jewish immigrants — Holocaust survivors — who, between 1945 and 1948, overcame incredible hardships to get to Palestine and, by their numbers and presence, helped to make inevitable the birth of the Jewish state.

The film doesn't attempt to document the diplomatic and political maneuvering that led to the founding of Israel. Instead, it favors an almost impressionistic style, which requires that the viewer bring to it his own knowledge of the events. Old newsreels and rare footage from private film collections, covering the end of World War II and concluding with scenes of the overloaded blockade runners arriving off Palestine, are supplemented with dozens of tape-recorded reminiscences. By remaining anonymous voices on the soundtrack, these specific recollections give the movie an epic sweep, a sense of the unalterable movements by which history is made.

"The Last Sea," made by Haim Gouri, Jacquot Ehrlich and David Bergman, is the second in a trilogy of documentaries devoted to the Holo-

caust and the Israeli state. The first film, "The 81st Blow," was a 1975 nominee for the Oscar as the best feature-length documentary. Now being prepared is the third film, tentatively titled "A Nation Fighting for Its Existence."

1984 Jl 4, C7:5

Aliens in a Trunk

REPO MAN, directed and written by Alex Cox; director of photography, Robby Muller; edited by Dennis Dolan; music by Tito Larriva and Steven Hufsteter; produced by Jonathan Wacks and Peter McCarthy; released by Universal Pictures. At Eighth Street Playhouse, Avenue of the Americas. Running time: 92 minutes. This film is rated R.
Bud	Harry Dean Stanton
Otto	Emilio Estevez
Miller	Tracey Walter
Leila	Olivia Barash
Lite	Sy Richardson
Agent Rogersz	Susan Barnes
J. Frank Parnell	Fox Harris
Oly	Tom Finnegan
Lagarto	Del Zamora
Napo	Eddie Velez
Kevin	Zander Schloss
Debbi	Jennifer Balgobin
Duke	Dick Rude

By VINCENT CANBY

"REPO MAN," the first feature to be written and directed by a bright new film maker named Alex Cox, is a most engaging reprieve from Hollywood's general run of laidback comedies of simulated nastiness and half-baked nonchalance.

"Repo Man," which opens today at the Eighth Street Playhouse, is the real thing. It's a sneakily rude, truly zany farce that treats its lunatic characters with a solemnity that perfectly matches the way in which they see themselves. Its a neo-Surreal, southern California fable, set in a landscape inhabited by failed punk rockers, automobile-repossession men who behave as if they were the knights errant of capitalism, some creatures from outer space, as well as a television evangelist who preaches against "godless Communism abroad and liberal humanism at home." At its end, there's nothing less than an ascension to heaven in a 1964 Chevy Malibu.

The innocent Percival who wanders through this not entirely mythological world is Otto (Emilio Estevez), a self-described white, suburban punk, who, though he wears an earring and the prescribed haircut, can't make it with his disenchanted peers. He snarls a lot and attempts to look alienated, but he has a dreadful weakness. Otto keeps getting interested and not only interested but involved.

After one mishap and another, Otto winds up working as a "repo man" for the Helping Hands Acceptance Company, a seedy repossession outfit, whose star employee is a veteran named Bud (Harry Dean Stanton). Bud, who assumes reponsibility for Otto's education, is a fast-talking, beat-up looking guy with a worry line for every vehicle repossessed and a word of wisdom for every eventuality. "A repo man's life is always intense," he might say after a near-fatal accident on the highway, or, apropos of something else, "The more you drive, the less intelligent you get." That Bud is never entirely sober contributes to the general air of cheerful incoherence.

Exactly what happens in "Repo Man" — I suppose it should be called the narrative — can't be easily synopsized, which is one of the film's failings. However, most of what happens is very funny, including Alex's any-

Harry Dean Stanton plays an auto repossession man in "Repo Man."

thing-but-sentimental affair with Leila (Olivia Barash), a pretty young woman, who for reasons never made clear is convinced that the aforesaid 1964 Chevy Malibu contains the bodies of four aliens in its trunk. "We must find it right away," she says with desperation, "or they could turn into moosh."

It's not easy reasoning with someone like Leila or, for that matter, with anything that happens in the film, which at times seems like a cross between "Close Encounters of the Third Kind" and "Used Cars." What is clear, however, is that Mr. Cox, a young Englishman, who studied at the film school of the University of California at Los Angeles, is a movie maker of wit and vision.

"Repo Man" is full of throwaway sight gags — odd bits of business seen at the corner of the film frame — and its sound track is sometimes as dense with bizarre non sequiturs as the sound track on a Robert Altman film. All of the performances are good, but those of Mr. Stanton and Mr. Estevez are excellent.

"Repo Man" frequently seems to be as zonked as Mr. Stanton's cocaine-sniffing Bud. It's not a big-budget, "Ghostbusters" of a movie, but it's very entertaining, and though it's rude in an R-rated way, it has the good taste never to promise more than it can deliver.

1984 Jl 6, C8:5

THE GODS MUST BE CRAZY, written, directed, edited and produced by Jamie Uys; cameras by Buster Reynolds and Robert Lewis; music by John Boshoff; released by 20th Century Fox Entertainment, Inc. At 57th Street Playhouse, between Avenue of the Americas and Seventh Avenue. Running time: 109 minutes. This film is rated PG.
Andrew Steyn	Marius Weyers
Kate Thompson	Sandra Prinsloo
Xi	N!xau
Sam Boga	Louw Verwey
The Reverend	Jamie Uys
Mpudi	Michael Thys
Jack Hind	Nic De Jager
First Card Player	Fanyana Sidumo
Second Card Player	Joe Seakatsie
President	Ken Gampu
Narrator	Paddy O'Byrne

By JANET MASLIN

"THE GODS MUST BE CRAZY" starts off looking like a work of anthropology, albeit rather a silly one.

A group of bushmen are seen in Botswana, living a life extolled by an unseen narrator as a simple, happy one. They are entirely self-sufficient, he explains, and they know no greed or violence or envy. They live in an absolutely arid part of the Kalahari desert, extracting water from roots and arranging leaves at night to collect the dew.

Their serenity is shattered one day when an airplane flies by and its pilot drops a Coke bottle into their midst. This bottle, which the tribe thinks has been sent by the gods, becomes something to covet and squabble over, as well as a potential weapon.

"The Gods Must Be Crazy" takes its title from the reaction of one bushman (Xao) to this new object, and spins whatever plot it has around his efforts to return the bottle to the gods themselves. Wandering away from his homeland, he gets as far as the fringes of so-called civilized society. His encounter with an odd assortment of city dwellers, who are themselves making tentative forays into the Kalahari, provides the film with its basis for a comedy about the clash of cultures.

"The Gods Must Be Crazy," which opens today at the 57th Street Playhouse, is even funnier than it is eccentric, which is saying quite a lot. The whole thing has a spontaneous, slapdash feeling, and the movie is full of pratfalls, particularly on the part of Marius Weyers, who plays an oafish scientist at the local game preserve. His mission is to escort a ladylike new schoolteacher, played by Sandra Prinsloo, to her new post in the desert, and one of his problems is that his Land Rover has neither windshield nor brakes. Jamie Uys, the film's South African director, is able to breathe new life into the hokiest physical gags, and his actors help matters by making their bumbling seem utterly convincing.

"The Gods Must Be Crazy" seems itself almost as guileless and simple as it imagines the bushmen to be. But its innocence, rather than seeming like undue naïveté, is credible and charming. A film like this could as easily have been made in the mid-1950's as today, since there are no real signs of the world outside the Kalahari. That will doubtless make Mr. Uys's film seem hopelessly unrealistic to some viewers, and purely escapist to others. The latter group will find a lot to laugh at here.

The supporting cast consists almost entirely of animals, and they do a fine job. A herd of hippos and another of giraffes make delightful cameo ap-

pearances. And Mr. Uys gets a particularly good performance out of the wart hog that frightens the principals while they are hiding chastely in the bushes, trying to change their clothes.

"The Gods Must Be Crazy" is rated PG ("Parental Guidance Suggested"). It contains brief partial nudity.

1984 Jl 9, C16:1

Another Romance

ANOTHER TIME, ANOTHER PLACE, directed by Michael Radford; screenplay by Michael Radford, based on the novel by Jessie Kesson; edited by Tom Priestley; music by John McLeod; produced by Simon Perry; released by the Samuel Goldwyn Company. At Lincoln Plaza, Broadway between 62d and 63d Streets. Running time: 101 minutes. This film is rated R.
Janie	Phyllis Logan
Luigi	Giovanni Mauriello
Umberto	Gian Luca Favilla
Paolo	Claudio Rosini
Dougal	Paul Young
Beel	Gregor Fisher
Finlay	Tom Watson
Kirsty	Jennifer Piercey
Meg	Denise Coffey
Jess	Yvonne Gilan
Else	Carol Ann Crawford
Alick	Ray Jeffries
Jeems	Scott Johnston
Raffaello	Corrado Sfogli
Antonio	Nadio Fortune
Officer	Peter Finlay
Randy Bob	David Mowat
P.O.W.	Stephen Gressieux

By VINCENT CANBY

THE luminous presense of Phyllis Logan, a fine young Scottish actress who, like Vanessa Redgrave, can look believably plain and unbelievably beautiful at almost the same second, lights up Michael Radford's "Another Time, Another Place," a somber, extremely symmetrical new British film that opens today at the Lincoln Plaza Theater.

The film, directed by Mr. Radford and adapted by him from a novel by Jessie Kesson, is set in northern Scotland in 1944-45 and is about the liberating if frantically brief love affair of Janie (Miss Logan), the young wife of a taciturn, chilly-natured older farmer, and a young, hot-blooded Italian prisoner-of-war named Luigi (Giovanni Mauriello).

Like any movie that insists on equating the emotions of its characters with the seasons, "Another Time, Another Place" is often quite picturesque but also lugubrious, that is, if one knows that when winter follows autumn, spring is not far behind. The landscapes are as important as the people.

Mr. Radford is too good a director to allow "Another Time, Another

Members of the Kalahari bushmen of Botswana in scene from the film "The Gods Must Be Crazy."

Phyllis Logan and Paul Young in the British film "Another Time, Another Place."

Place" to become sentimental, but not quite good enough to find ways by which to make the film itself as exciting as Miss Logan. "Another Time, Another Place" looks and sounds authentic, and it has moments of pathos, but it is resolutely unsurprising, partly because the plotting is so dour. There's no doubt that the outcome of this affair must be grim. The only suspense is what, specifically, is going to go wrong.

Miss Logan, however, is a radiant actress, full of surprises that are worth attending to. There's an early sequence in which her grimly obedient wife is suddenly transformed into a laughing girl by the music and dancing at a village party. The scene in which Janie is initially seduced by Luigi, a fast-talking, essentially harmless scamp, is made unexpectedly moving by our awareness that as much as he is taking advantage of her, she is using him.

Mr. Mauriello is very good as the lonely, perfectly ordinary prisoner of war for whom, at a key moment, Janie is willing to risk her entire future, not out of love but because of a sense of justice. Also noteworthy are Paul Young, as Janie's husband; Denise Coffey, whose face looks like something painted by Vermeer, as one of Janie's younger friends, and Yvonne Gilan as a farm woman, widowed in the fighting at Monte Cassino, who can't bring herself to fraternize with the Italian prisoners of war.

"Another Time, Another Place," like its title, is ordinary, but it's an ordinary movie with one very out-of-the-ordinary performance.

1984 Jl 11, C26:1

THE LAST STARFIGHTER, directed by Nick Castle; written by Jonathan Betuel; director of photography, King Baggot; film editor, C. Timothy O'Meara; music by Craig Safan; produced by Gary Adelson and Edward O. Denault; released by Universal Pictures. At Rivoli, Broadway and 49th Street; Gemini, 64th Street and Second Avenue; 86th Street East, at Third Avenue; 83d Street Quad, at Broadway; New Yorker, Broadway and 88th Street. Running time: 100 minutes. This film is rated PG.
Alex Rogan Lance Guest
Grig .. Dan O'Herlihy
Maggie Gordon Catherine Mary Stewart
Jane Rogan Barbara Bosson
Xur ... Norman Snow
Centauri .. Robert Preston
Enduran .. Kay E. Kuter
Lord Kril ... Dan Mason
Louis Rogan Chris Hebert
Rylan Bursar John O'Leary
Kodan Officer George McDaniel
Female Rylan Sergeant Maggie Cooper
Rylan Technician Charlene Nelson
Rylan Sergeant Bruce Abbott
Friendly Alien John Maio

By LAWRENCE VAN GELDER

IN a summer holding no promise of a fresh new installment in the "Star Wars" saga, terrestrial yearning for entertainment culled from outer space will have to content itself with "The Last Starfighter," today's arrival at the Rivoli and other theaters.

Bearing visible traces of "Star Wars," "Close Encounters of the Third Kind," "The Wizard of Oz," "Paradise Lost," tales of knightly heroism, the immemorial daydreams of young men for wider horizons and, yes, even "The Music Man," this juvenile adventure is less inspired than derived. But where some imitations suffer from pallor induced by anemic substance and spirit, "The Last Starfighter" taps its sources with the zest of a vampire, and the result, if unoriginal, is nevertheless buoyant with nourishment.

•

Built around a computer game called Starfighter — Atari Inc. receives a screen credit — "The Last Starfighter" is essentially the the story of a college-age young man struggling against the limited promise of his life. Alex Rogan (Lance Guest), whose mother runs the decrepit Starlite Starbright Trailer Court in the middle of nowhere, finds that his prowess at destroying spacecraft of the evil empire of Ko-Dan in the game has prompted his recruitment in a genuine space war.

It seems that the Space League of Planets has recruited so-called starfighters from throughout the galaxy, and who should have bent the rules a little by doing a bit of recruiting on Earth (which is too immature for membership in the league) but Prof. Harold Hill himself.

Well, his name has been changed to Centauri, but it is once again Robert Preston, who is called upon to reprise his "Music Man" role as the fast-talking, smooth-tongued recruiter who comes to earth to induce Alex to leave behind mom, kid brother and girlfriend to zoom off to the planet Rylon and try his hand at heroism.

What enhances the dramatic credibility of "The Last Starfighter" and invests it with a good deal of charm is the reluctance of Alex — who has heretofore been determined to avoid a future characterized by pickup trucks, Saturday night beer busts and the local city college — to don the

hero's mantle. After all, he reasons, to fight in a war is to risk death.

Into the mix that resolves the plot go an attack that destroys all the starfighters but Alex; extraterrestrial hit men who seek his destruction on earth; a perplexed robot disguised as Alex; Alex's unsuspecting girlfriend, Maggie (Catherine Mary Stewart); an iguanalike mentor and navigator called Grig, and an assortment of up-to-date space hardware, combat scenes and adrenal music by Craig Safan.

Though it is occasionally talky, and though its plot takes a while to crank up, "The Last Starfighter," directed by Nick Castle, is more often than not good-humored, bent on action and even touching. Fans of "Star Wars," which was suffering a dearth of inventiveness by the time of "Return of the Jedi," should be able to make do — and make do nicely.

•

"The Last Starfighter" is rated PG, apparently because of a couple of familiar expletives and a few creatures that by terrestrial standards could be considered the stuff of nightmares.

1984 Jl 13, C5:2

Play School

CLASS ENEMY, directed by Peter Stein; screenplay (German with English subtitles) by Mr. Stein and Juergen Klose, based on a play by Nigel Williams; camera, Robby Mueller; edited by Inge Behrens; produced by Regina Ziegler; released by Teleculture Inc. At the Vandam Theater, 15 Vandam Street. Running time: 125 minutes. This film has no rating.
Angel ... Greger Hansen
Pickel .. Stefan Reck
Koloss ... Jeana-Paul Raths
Vollmond ... Udo Samel
Fetzer .. Ernst Stoetzner
Kebab .. Tayfun Bademsoy

"CLASS ENEMY," which opens today at the Vandam Theater, is of somewhat more theatrical than cinematic interest, being a German film adaptation of Nigel Williams's English play, now set in West Berlin, instead of London, and directed for the screen by Peter Stein, one of the more celebrated figures in the European theater.

Like the play, which was done Off Broadway in 1979, the film is essentially a one-set piece, taking place in a beat-up, graffiti-decorated schoolroom where six teen-age delinquents argue and fight as they await the latest in what has been a series of terrified teachers.

They are Fetzer (Ernst Stoetzner), the raging, sadistic leader of the pack; Angel (Greger Hansen), a slim young man who affects swishy mannerisms; Pickel (Stefan Reck), who has a spectacular case of acne; Vollmond (Udo Samel), a stocky, quiet young man, whose interior fury matches the fury that Fetzer doesn't hesitate to demonstrate; Koloss (Jean-Paul Raths), who sports a yellow and black punk hairdo, and Kebab (Tayfun Bademsoy), a young Turk who can express himself only in the smashing of windows.

•

In the course of the film's two-hour running time, the young men alternately despair of ever receiving another teacher and plan ways by which to humiliate whoever should arrive. At Fetzer's insistence, each takes a turn at teaching the others. When Angel attempts to explain sex to them, Fetzer cuts him off with a curt, "We want knowledge, not facts."

Pickel is unexpectedly eloquent as he describes the making and tending of flower boxes. Vollmond delights them by demonstrating how to make "Berlin meatballs" without meat, the success of which leads to a brutal confrontation between the comparatively sensitive Vollmond and Fetzer.

Considering the nature of the material, Mr. Stein's staging is remarkably fluid. Yet there are problems built into such material, which, on the screen, seems more schematic — and predictable — than it might within the artificial context of the theater, where questions of plausibility and reality need not arise. The actors play at such high pitch from start to finish that the reading of the not-great English subtitles comes almost as a relief.

The photography, by Robby Mueller, is aggressively, appropriately flashy, much in the manner of the characters themselves. The camera almost never stops moving. It swoops and circles around the action, sometimes lies on the floor and occasionally seems to be hanging from the ceiling.

Unlike Robert Altman, in his screen adaptation of David Rabe's play "Streamers," Mr. Stein seldom makes the mistake of isolating an actor in a tight close-up to emphasize a big dramatic moment. Most of the time, all of the actors can be seen within the same frame, so that the viewer never has time to forget each character's relationship with the others.

All of the actors, especially Mr. Stoetzner, who has some of the power of Gérard Depardieu, are fine, though they are a bit elderly to be entirely convincing as teen-agers.

The changing of the locale to Berlin makes some of the film's points seem more arcane than they would in England, where class differences are more important to the fate of the characters than the sort of economic miracle by which these young Germans have been abandoned.

Vincent Canby

1984 Jl 13, C6:1

Le Broadway!

THE MUPPETS TAKE MANHATTAN, directed by Frank Oz; screenplay by Mr. Oz, Tom Patchett and Jay Tarses; story by Mr. Patchett and Mr. Tarses; director of photography, Robert Paynter; film editor, Evan Lotman; music and lyrics by Jeff Moss; Muppet design and construction, Caroly Wilcox; produced by David Lazer; released by Tri-Star. At Manhattan Twin, 59th Street, east of Third Avenue; National, Broadway and 44th Street; Gramercy, 23d Street at Lexington Avenue; 86th Street Twin, at Lexington Avenue; 83d Street Quad, at Broadway, and other theaters. Running time: 93 minutes. This film is rated G.
Kermit the Frog, Rowlf, Dr. Teeth, Swedish Chef, Waldorf Jim Henson
Miss Piggy, Fozzie, Animal Frank Oz
Gonzo, Chester Rat, Bill Frog, Zoot Dave Goelz
Rizzo the Rat, Gil Frog Steve Whitmire
Scooter, Janice, Statler Richard Hunt
Camilla, Lew Zealand, Floyd Jerry Nelson
Jenny .. Juliana Donald
Ronnie ... Lonny Price
Pete .. Louis Zorich
WITH Art Carney, James Coco, Dabney Coleman, Gregory Hines, Linda Lavin, Joan Rivers, Elliott Gould, Liza Minnelli, Brooke Shields

By VINCENT CANBY

"THE MUPPETS TAKE MANHATTAN" doesn't quite tell the entire story. With their various television shows and two feature films already under their felt belts, Jim Henson's Muppets have long since taken not only Manhattan, but also London, Los Angeles, Eugene, Ore., and Chillicothe, Ohio. All that notwithstanding to the contraire, as Miss Piggy

might wish to dire, they arrive today at the National and other theaters, and nous sommes theirs.

This isn't to say that this particular extravaganza, directed by Frank Oz, is in the same super league as "The Muppet Movie" and "The Great Muppet Caper." This may be only an impression, based on the fact that the past always looks greener than the present, but "The Muppets Take Manhattan" seems just a little less extraordinaire than the two other features.

Kermit the frog gets to ride no bicycles this time. Miss Piggy has no grand, Esther Williamslike water ballets to perform, but, like many of the films of the great Garbo, her material isn't as important as her doing it at all. She's one of the great showbiz creations of our age, a pousse-café of personalities, including a dash of Bette Midler, a soupçon of Shirley Temple and a layer of Olivia de Havilland atop a base of Joan Crawford.

•

"The Muppets Take Manhattan" recalls "Babes in Arms," "Babes on Broadway" and "Girl Crazy," that is, if Mickey Rooney had been a frog and Judy Garland a pig. This difference in ethnic backgrounds is the hurdle that the love of Kermit and Miss Piggy continually has to surmount. Says a hard-hatted construction worker at one point in the new film, "Hey lookit Waldorf — a frog and a pig! They look like they're in love." Replies Waldorf, "Kinda makes you sick, doesn't it?"

Life is never going to be easy for Kermit and Miss Piggy, but in "The Muppets Take Manhattan" it's almost always fun. In this installment of their continuing story, the Muppets are first discovered performing the rousing finale of their college show, "Manhattan Melodies," which Kermit and Miss Piggy, like Mickey and Judy, decide to take to the Great White Way.

Broadway! It's what they've always dreamed of, but when the raggle-taggle troupe of frog, pig, bear, chicken and other, not easily identifiable creatures arrives, they find the doors of all the reputable theatrical producers closed to them. At the end of their ropes, they come to one especially seedy office inhabited by Dabney Coleman, playing one of his most richly nasty roles.

"Who's out there?" Dabney shouts at his receptionist. "Just a frog with a musical," the young woman replies. "Send them in," says Dabney, who represents Broadway's dark underbelly. Even without an audition, he agrees to produce "Manhattan Melodies" — all he demands is $300 from each member of the troupe.

•

It's not until they run into Ronnie (Lonny Price), a young man who wants to make his own mark on Broadway, that they find a producer who appreciates their talents. The Muppets eventually do take Manhattan, but not before they've survived all sorts of reverses, split up and gone their separate ways, and lost Kermit to a bad case of amnesia.

There are some charming production numbers, including Kermit's "Together Again" at the top of the show, and a lot of rambunctious comedy sketches, including one in which Kermit, disguised as a big Broadway producer, and some overhelpful rats nearly close down Sardi's

forever. Joan Rivers appears briefly as a department-store saleswoman who attempts to help Miss Piggy with her makeup. "Eyebrows?" Miss Rivers says. Answers Miss Piggy, "Pigs don't have eyebrows." Miss Piggy gets eyebrows.

Among the other guest stars are Elliott Gould, Liza Minnelli, James Coco, Art Carney and Gregory Hines. Louis Zorich is funny as a nice, helpful, harassed coffee-shop owner who feeds the Muppets in their lean days, and Juliana Donald is sweetly innocent as his daughter.

Do Kermit and Miss Piggy exchange nuptial vows, tie the knot, take the big step and middle-aisle it? Moi's lips are sealed.

1984 Jl 13, C10:4

FILM VIEW

VINCENT CANBY

'The Alamo' Is an Offbeat American Barroom Ballad

"Last Night at the Alamo," an 82-minute import from Texas, photographed on grainy, black-and-white film stock, is a small, unassuming, all-American classic. It's the kind of low-budget, regional movie that suddenly reminds us that, between New York and Hollywood, there's a vast, unruly, exuberant continent and filmmakers still capable of seeing and hearing what's going on in it. It's simultaneously funny and bleak, sweet and unsentimental. If I had to choose the one current film that most accurately reflects what a certain kind of American life is like today, this would be the film.

That, I realize, is going out on a limb. "Last Night at the Alamo" has nothing to do with the so-called major issues of our time, but never for a minute does its total preoccupation with the small crises of its boozy, inarticulate characters deny the existence of those major issues. Like most of the people in this country, Cowboy and Claude, Ichabod and Mary, Lisa, Ginger, Janice, Skipper and Willie — who are the principal figures in "Last Night at the Alamo" — have other, seemingly more important things on their minds.

The film, which was shown at last year's New York Film Festival at Lincoln Center and is just now going into commercial release, was written by Kim Henkel, whose only previous claim to fame is the screenplay for the notorious "Texas Chainsaw Massacre," and directed by Eagle Pennell, whose "Whole Shooting Match" was one of the comic treasures of the 1979 New Directors/New Films Festival.

"Last Night at the Alamo" is so good, in fact, that when I think about it I want to drop names, including those of Mark Twain, Sam Shepard and David Mamet, among others, people who have heard America singing and delighted in the delirious cacophony of missed notes and lyrical, often obscene non sequiturs. It's not by chance that the names of Mr. Shepard and Mr. Mamet come to mind. "Last Night at the Alamo" has as idiosyncratic a voice as the works of those two playwrights, the best of their generation in the American theater.

• • •

If I hadn't seen "The Whole Shooting Match," which was written as well as directed by Mr. Pennell, there

would be a great temptation to credit this "voice" entirely to Mr. Henkel. However, since "Last Night at the Alamo" sounds very much like the earlier film, though it's far more precisely focused, one must assume that Mr. Pennell and Mr. Henkel are exceptionally responsive collaborators who are good for each other.

In form, "Last Night at the Alamo" recalls that time in the American theater 40 years ago when the barroom was the world and the man behind the bar was, if not God, then His surrogate. Into this world would wander the the misfits, the down-and-outs, the con men, hookers and backsliding members of the bourgeoisie who, in the course of the evening, usually found some sort of absolution. A lot of terrible plays used this setting, but also some good ones, including William Saroyan's fairly whimsical "Time of Your Life" and the one that towers above all the others, Eugene O'Neill's monumental "Iceman Cometh."

Just what happened to this genre, I'm not sure. It may possibly be that playwrights decided that enough was enough, that the whole idea had become a bit tiresome, though, since playwrights, even good ones, are often reluctant to part with a cliché, the disappearance might be attributed to more natural causes, especially the changing function of the neighborhood bar in American life. Corner pubs are still the virtually private clubs for millions of Americans, but, with the introduction of television in the 1950's and now video games, it may be that the customers — at least, in the minds of playwrights — aren't experiencing the epiphanies they once did when the only competition was provided by the pool table or a juke box.

• • •

It may also be, of course, that as our playwrights and stage designers discovered a more cinematic theatrical method, they were liberated from the restrictions of the one-set play, and moved away from the metaphorical barrooms into a metaphorical stage space that could be anywhere.

As playwrights found new freedom in fluid stage design, it now seems — and I emphasize "seems" — that some of our filmmakers are finding their own kind of new freedom in the challenge offered by vastly restricted film

spaces. It's just a coincidence, but two of the most interesting of the new releases are both essentially one-set movies.

They are Ingmar Bergman's "After the Rehearsal," which never moves from the stage where a rehearsal of Strindberg's "Dream Play" has just finished, and now "Last Night at the Alamo," which is set entirely in and around a seedy Houston bar called The Alamo, which, on this night, is due to close forever, to be torn down by the "Olshaw Demolishing Company (Texas's largest)" to be replaced by a fancy new high-rise. The Alamo is not to be confused with Gilley's, the giant Houston beer palace that was the principal location for "Urban Cowboy." The Alamo, you realize, has been slowly going broke for years and, as someone has said of the Barn, the real Houston bar that doubles for the Alamo in the film, "If it has five people in it, it's a busy night."

• • •

There are no epiphanies in "Last Night at the Alamo," and Skipper (George Pheneger), the bartender, is nobody's idea of God. A slight, even-tempered man, Skipper simply serves the drinks and, with remarkable forbearance, requests that rowdy customers, on the verge of a major physical confrontation, please step outside if they want to do that sort of thing.

As the film opens, the Alamo regulars are gathering to celebrate the bar's last night, which means drinking beer as usual and awaiting the appearance of Cowboy (Sonny Carl Davis), a favored Alamo regular who, it seems, may be able to save the place from ultimate destruction. As the Alamo customers talk about Cowboy, you begin to suspect that O'Neill's Hickey may be alive and well and living in Texas.

Everybody speaks of Cowboy with awe, especially Ichabod (Steven Matilla), a hotheaded young man who wishes he had a "neat" nickname, like Cowboy, instead of Ichabod — his real name is William. Cowboy's major admirer is Claude (Louis Perryman), a man approaching unhappy middle age who spends much of his time arguing on the pay telephone with his wife, Marcie, a character who remains forever off screen tending to her over-applianced house, which has two separate telephones, with two separate listings, for their two children.

When Cowboy finally appears, he turns out to be a good-looking, smooth-talking, over-the-hill high school hero who has, with immense satisfaction, just told off his construction boss and is, once more, out of a job. In the course of the evening, Cowboy's plan to save the Alamo comes to nothing — it has something to do with contacting a Texas legislator, with whom Cowboy roomed during his one and only year at college — and nobody's life is radically altered. The following night, it becomes apparent, the old Alamo gang will simply shift their base to another bar called the B & B. However, a lot of life has been revealed, often hilariously and sometimes with wonderfully discreet pathos.

One can have nothing but admiration for the simplicity and ease with which Mr. Pennell, Mr. Henkel and their actors bring this ordinary moment of blue-color existence to vivid screen life. Mr. Davis and Mr. Perryman, who played quite similar characters in "The Whole Shooting Match," are superb as Cowboy and Claude, whether acting with each other or with any of the other members of the remarkable cast.

Mr. Matilla, a New York actor, is priceless as the easily overheated Ichabod, and Tina-Bess Hubbard, an exceptionally pretty young woman now teaching dance and acting in Munich, is very funny as Claude's pliant young girlfriend, Mary. Mary doesn't put her foot down often, but she does think that Claude shouldn't blame people for being fat, which leads to a serious discussion on whether someone with a beer belly can accurately be called fat. When finally at her wit's end with Ichabod's behavior, Mary is likely to scream, "When you talk to me, keep that eye open. I don't want it twitching at me!"

The dialogue is so good that it doesn't sound as if anyone could have actually written it. Though mostly so vulgar and obscene that little of it can be quoted here, it has the ring of metareality. Abstract notions never enter the mind of anyone at the Alamo. Everyone is completely absorbed by things and events in the present tense. Near the end, after Claude has returned to the bar after an unsuccessful attempt to burn down his own house, he receives still another call from the furious Marcie.

"I guess I better be getting home," he tells the solicitous Cowboy. "I ain't never going to hear the end of this."

•

"Last Night at the Alamo," which is American filmmaking of, I think, an exceptional order, was produced by Mr. Pennell and Mr. Henkel for $50,000, half of which was provided by the National Endowment for the Arts, and the rest by a group called the Southwest Alternate Media Project (affectionately known as "SWAMP"), in the form of film equipment and office space. It was shot in three and one-half weeks.

There's something extremely reassuring that the state that gave us the real Alamo, "Dallas" (the show, not the city) and all of those legendary oil fortunes, should also have given us this film, which is as small as Texas is big. Apparently some Houston boosters are not pleased with "Last Night at the Alamo," which they feel makes the city look tacky. It does, though benignly. In the film's opening, very gray establishing shots, the city's great glass-and-steel high-rises are a vision of high-tech at its least humane and least functional. The characters in "Last Night at the Alamo" are people who live in buildings where it's still possible to open the windows.

"Last Night at the Alamo" should give heart to a lot of filmmakers and, I hope, delight a large film audience.

∎

1984 Jl 15, II:15:1

Indicted Society

CRUEL STORY OF YOUTH, written and directed by Nagisa Oshima; in Japanese with English subtitles; photography by Takashi Kawamata; music by Riichiro Manabe; produced by Shochiku Film; distributed by New Yorker Films. At the Film Forum, 57 Watts Street. Running time: 96 minutes. This film has no rating.
KiyoshiYusuke Kawazu
MakotoMiyuki Kuwano
Yuki ..Yoshiko Kuga
FatherJun Hamamura
The DoctorFumio Watanabe
The Gangster ..Kei Sato
HorioKan Nihonyanagi
The TeacherToshiko Kobayashi

By VINCENT CANBY

"CRUEL STORY OF YOUTH," which opens today at the Film Forum and is Nagisa Oshima's second film, was produced in 1960, but the theater's new color-and-Cinema-Scope print is so resplendent that the movie could have been made last year. There are few color prints being shown in our first-run theaters that are as rich as this one.

This is more than an idle comment on the excellent quality of the projection at the Film Forum. Mr. Oshima, one of Japan's longest-running controversial directors ("Death by Hanging," "The Ceremony," "In the Realm of the Senses," "Merry Christmas, Mr. Lawrence"), makes movies that frequently look as if they'd been lit by lightning. Though the images are often bleak and the landscapes sunless, the colors have the peculiar, unnatural brightness of things seen in a flash in a thunderstorm.

The movies themselves have a kind of condensed narrative style that also suggests their own very particular reality.

Having admitted these virtues, I must also admit that I still find it difficult to respond to his movies with the enthusiasm and excitement of many colleagues. The problem is partially due to contemporary political and social references that remain forever unexplained to the outsider.

•

"Cruel Story of Youth," which was Mr. Oshima's first major box-office hit in Japan, is the seemingly dispassionate tale of the decline and fall of a pair of middle-class Tokyo teenagers. They are Makoto, a pretty girl who looks as if she had been brought up reading nothing but Seventeen, and Kiyoshi, a good-looking young student who first seduces Makoto and then talks her into a racket by which they extort money from older men picked up by Makoto.

Though the print is spankingly fresh, there is something dated and neo-Godardian about Mr. Oshima's pretended lack of passion. Clearly he is an articulate social critic. The aimless deliquency of Makoto and Kiyoshi is intended to be a scathing indictment of an entire society. Yet the distance at which he chooses to tell this story has the effect of making it seem less chilly and shocking than merely dim. And when he contrasts the self-indulgences of Makoto and Kiyoshi with the disillusion of slightly older, former student activists, I'm completely confused, perhaps because I still associate student activism with the late 1960's, which, of course, were still years off at the time this film was made.

Whether or not you respond to the film's story, the visual style is always interesting, even when not terribly revealing. There's not a predictable shot in the entire movie, which is full of oddly off-center close-ups, panoramic shots of dead landscapes and occasional sequences shot with a hand-held camera, which appears to have the short attention span of its two unhappy lovers.

1984 Jl 18, C20:3

Nice Place to Visit

SKYLINE, written and directed by Fernando Colomo; in Spanish with English subtitles; cinematography by Angel Luis Fernandez; edited by Miguel Angel Santamaria; music by Manzanita; production director, Antonio Isasi. At the Embassy 72d Street, at Broadway. Running time: 83 minutes. This film has no rating.
Gustavo FernandezAntonio Resines
PatBeatriz Perez-Porro
Jaime Bos ..Jaime Nos
Roy ..Roy Hoffman
ElizabethPatricia Cisarano
IreneIrene Stillman
ThorntonWhit Stillman

"Skyline" was shown as part of this year's New Directors/New Films Series. Following are excerpts from Vincent Canby's review, which appeared in The New York Times on April 3. The film opens today at the Embassy 72d Street, at Broadway.

GUSTAVO (Antonio Resines), a freelance photographer from Spain, arrives in New York on a summer holiday in hopes of making contacts that will further his career in this country. A stocky, well-bred young man full of self-assurance, he talks confidently of Life and Newsweek as his two most likely opportunities.

He begins well enough. He has sublet a large airy loft downtown that comes complete with an undemanding cat. Through a couple of friends from home, he gradually expands his social circle to include artists and other photographers, a number of young women and one photographer's agent named Thornton.

Thornton tells him that he doesn't just like Gustavo's work, he loves it. However, he must also say, quite frankly, that it's old-fashioned. It's what New York photographers were doing five years ago. •

•

Gustavo is not sure he understands. If something was good five years ago, why should it not be good today? His reaction is one of enlightened puzzlement.

This is more or less the tone of "Skyline" ("La Linea del Cielo"), a witty, low-key Spanish comedy, written and directed by Fernando Colomo, shot entirely in New York in Spanish and English. The film opens today at the Embassy 72d Street.

Nothing of great moment happens to Gustavo during his visit, but Mr. Colomo discovers comedy everywhere. A first date with a pretty young woman starts off well enough, but at the end of the evening Gustavo must confess, "She lived above 100th Street and I below Ninth. Our love was impossible."

•

At a cocktail party Gustavo listens intently as a young woman tells a long, complicated story about having bumped into Jacqueline Onassis in an Upper East Side apartment house lobby after Mrs. Onassis emerged from a stuck elevator. Everyone finds the story pricelessly funny and Gustavo is sure that he's missed some vital point.

"Skyline" is a slight but endearing comedy that, like Gustavo, regards New York with a mixture of wonder, amusement, open-mindedness and skepticism.

Mr. Resines is a very droll Gustavo, a fellow who never loses his cool, partly because, being a tourist in a mysterious land, he doesn't want to be impolite and because, at heart, he has realized that for him it will never be more than a nice place to visit. The movie possesses a charm that, though gentle, is firmly rooted in the realities of a completely self-absorbed civilization.

1984 Jl 18, C20:3

Curing the Empress

THE NEVERENDING STORY, directed by Wolfgang Petersen; screenplay by Mr. Petersen and Herman Weigel; director of photography, Jost Vacano Bvk; edited by Jane Seitz; music by Klaus Doldinger and Giorgio Moroder; produced by Bernd Eichinger and Dieter Geissler; released by Warner Bros. At Criterion Center, Broadway and 45th Street; Beekman, 65th Street and Second Avenue; Murray Hill, Third Avenue and 34th Street; New Yorker Twin, Broadway and 88th Street, and other theaters. Running time: 94 minutes. This film is rated PG.

Bastian	Barret Oliver
Bastian's Father	Gerald McRaney
Bullies	Drum Garrett, Darryl Cooksey, Nicholas Gilbert
Koreander	Thomas Hill
Teeny Weeny	Deep Roy
Night Hob	Tilo Prückner
Cairon	Moses Gunn
Atreyu	Noah Hathaway
Falkor's Voice	Alan Oppenheimer
Engywook	Sydney Bromley
Urgl	Patricia Hayes
Childlike Empress	Tami Stronach

HAVING made a good, conventional service melodrama, "Das Boot," Wolfgang Petersen, who received Oscar nominations as director and writer of that very popular German film, has now done something completely different — and not very good.

"The Neverending Story," which opens today at the Criterion and other theaters, is a graceless, humorless fantasy for children, combining live actors and animated creatures in mostly imaginary settings. Mr. Petersen's story, which, unfortunately, compares itself to "Alice in Wonderland," is about Bastian (Barret Oliver), an unhappy little American boy, who finds himself drawn inside a fairy tale he's reading called "The Neverending Story."

This is set in a land called Fantasia, where there is a Sea of Possibilities and a Swamp of Sadness, and where the empress lives in a place called the Ivory Tower, which actually looks like a gigantic version of the sort of perfume bottle Jean Harlow might have tossed at Clark Gable in a 1930's comedy.

The hero of the tale-within-the tale is another little boy, Atreyu (Noah Hathaway), described as "the hunter of the purple baffalo," who's sent on a quest, the aim of which is to find a cure for the ailing empress, the only person able to save Fantasia from extinction. Fantasia, you see, is in the grip of a terrible disease called the Nothing. Or, as someone explains to Atreyu, it's what happens when "people lose their hopes and forget their dreams."

•

The fact that Fantasia looks like Nowhere raises a rather profound philosophical question. Is it possible for Nowhere to be destroyed by Nothing? The child who can grasp this concept should be immediately packed off to the Sorbonne. When the movie is not sounding like "The Pre-Teen-Ager's Guide to Existentialism," it's simply a series of resolutely unexciting encounters between Atreyu and the creatures that alternately help and hinder his mission.

Considering that the credits of the people who worked on this film include such movies as "2001," "The Empire Strikes Back," "Alien" and "Raiders of the Lost Ark," the special effects appear to be supremely tacky, like the things one might find in a down-at-the-heel fun house. The creatures include a large friendly bat, a "racing snail" and a dragon with white fur and feathers that suggests an impractical bath mat.

"The Neverending Story" may have cost a mint to produce, but the result is bargain-basement.

•

"The Neverending Story," which has been rated PG ("Parental Guidance Suggested"), should not frighten most small children, but it may put them prematurely to sleep.

Vincent Canby

1984 Jl 20, C5:1

Lenny Von Dohlen in the computer movie "Electric Dreams."

High-Tech Love

ELECTRIC DREAMS, directed by Steve Barron; written by Rusty Lemorande; director of photography, Alex Thomson; film editor, Peter Honess; music by Giorgio Moroder; produced by Mr. Lemorande and Larry DeWaay; released by MGM/UA Entertainment Company. At Movieland, Broadway and 47th Street; Sutton, Third Avenue and 57th Street, and other theaters. Running time: 96 minutes. This film is rated PG.

Miles	Lenny Von Dohlen
Madeline	Virginia Madsen
Bill	Maxwell Caulfield
Edgar	Bud Cort
Riley	Don Fellows
Frank	Alan Polonsky

IF conflict is the essence of drama, there is a serious impediment to a love triangle where one element must rely on its rival to let it meet the object of its desire.

That is the sort of thing that happens when one of the claimants for the love of a young woman is a computer, and it is just one of the flaws besetting "Electric Dreams," opening today at Movieland, the Sutton and other theaters.

"Electric Dreams" is a mélange of electronic gadgetry, rock and classical music and the latest graphics, tied to a story that pits a bumbling young architect named Miles against his personal computer, named Edgar, in a contest for the affections of a lovely young cellist named Madeline, who has moved in upstairs.

In its efforts to attract a wide audience, "Electric Dreams," directed by Steve Barron (also credited with staging Michael Jackson's video of "Billie Jean"), taps not only the computer craze but also draws upon a score by Giorgio Moroder, songs by such pop attractions as Culture Club, Heaven 17 and Jeff Lynne, music by Tchaikovsky and Bach, the principal plot element of "Cyrano de Bergerac," the physical attractions of San Francisco and a dedication to the memory of the early computer Univac I.

The film is part comedy about the architect (Lenny Von Dohlen) and his efforts to use a computer to organize his life and help him design an earthquake-resistant brick; part story of young love, taking off from the arrival of the attractive Virginia Madsen as the cellist; part tale of a computer with delusions of humanity, arising when the cellist is beguiled by music created by the machine.

In the failure of "Electric Dreams" to blend and balance its ingredients properly, plot elements are lost (the brick), credibility is overtaxed (the lovelorn computer), and what remains is high tech without being high art.

"Electric Dreams" is rated PG (Parental Guidance Suggested), possibly because of one discreet bedroom scene and the computer's propensity for tantrums.

Lawrence Van Gelder

1984 Jl 20, C6:5

ONE DEADLY SUMMER, directed by Jean Becker; adaptation and dialogue (French, with English subtitles) by Sebastien Japrisot; director of photography, Etienne Becker; edited by Jacques Witta; music by Georges Delerue; a Société Nouvelle de Cinema/Capad/TF 1 Films production; released by Universal Pictures. At Coronet, Third Avenue and 59th Street. Running time: 130 minutes. This film is rated R.

She	Isabelle Adjani
Pin Pon	Alain Suchon
Cognata	Suzanne Flon
Pin Pon's Mother	Jenny Cleve
Mickey	François Cluzet
Boubou	Manuel Gelin
Gabriel	Michel Galabru
She's Mother	Maria Machado
Henri IV	Roger Carel
Leballech	Jean Gaven
Touret	Max Morel
Josette	Cécile Vassort
Georges Massigne	Martin Lamotte
Ferraldo	Jacques Dynam
Brochard	Raymond Meunier
Calamite	Evelyne Didi

IT may be about time that somebody found a screenplay for Isabelle Adjani in which she doesn't have to go mad. Miss Adjani can go mad very persuasively ("The Story of Adele H.") and, with the exception of "Possession," without sacrificing her looks. She is, in fact, a good actress, whether playing sane or bonkers, but most of her movies these days are duds in which she is drearily type-cast.

She's not yet out to lunch at the start of "One Deadly Summer," but she is clearly poised to go. In this new French film, directed by Jean Becker and adapted by Sebastien Japrisot from his own mystery novel, Miss Adjani is seen as an emotionally unstable young woman who seeks to identify and then kill the three men — one of whom is her father — who beat up and raped her mother 17 years earlier.

The setting is a small village in the south of France, a place filled with colorful characters and likely suspects. It's also filled with various people's memories, which the director insists on showing the audience in more detail than is always necessary. The plot, however, is less complicated than devious.

In addition to Miss Adjani, who looks smashing in a series of flimsy little dresses, the cast includes Alain Souchon, who plays the earnest young mechanic she marries and brings to emotional ruin, and Suzanne Flon, as a deaf old woman and one of the few people in the village who understands Miss Adjani's problems.

"One Deadly Summer" opens today at the Coronet.

Vincent Canby

1984 Jl 20, C10:5

Freshman Strategy

REVENGE OF THE NERDS, directed by Jeff Kanew; screenplay by Steve Zacharias and Jeff Buhai; story by Tim Metcalfe, Miguel Tejada-Flores, Mr. Zacharias and Mr. Buhai; director of photography, King Baggot; edited by Alan Balsam; music by Thomas Newman; produced by Ted Field and Peter Samuelson; released by 20th Century-Fox Film Corporation. At Gotham, Third Avenue and 58th Street; 34th Street East, near Second Avenue; UA East, 85th Street and First Avenue; National, Broadway and 44th Street, and other theaters.

Suzanne Flon and Isabelle Adjani star in "One Deadly Summer," a suspense film in which Miss Adjani — as a woman of mystery — wreaks psychological havoc in a French village.

By LAWRENCE VAN GELDER

HAD the authors of the Book of Psalms in the Old Testament or Matthew in the New Testament beheld "Revenge of the Nerds," it is altogether likely that they would have put their papyrus to the torch rather than inscribe it with the forecast that the meek would inherit the earth.

"Revenge of the Nerds," opening today at the Criterion Center, 34th Street East, Gemini 1 and other theaters, is yet another aspirant for the sort of summertime comedy laurels (and box-office success) captured six years ago by "National Lampoon's Animal House" and more recently by "Porky's."

The nerds in question — "nerd" being a slang term defined by the Second College Edition of the New World Dictionary as "persons regarded as contemptibly dull, unsophisticated, ineffective, etc." — are freshmen on one of those fictional campuses beloved of such film makers.

Slightly more than a dozen of these outcasts — among them a couple of hometown friends (Robert Carradine, who builds robots, and Anthony Edwards, a computer-friendly user), an effeminate black, a pre-teen-age genius, a slob called Booger and a Japanese who snaps lots of pictures — are persecuted by the football players who belong to a fraternity called Alpha Beta and scorned by the alluring women who belong to Pi Delta Pi.

In gaining their so-called revenge, the pariahs turn to a previously all-black fraternity for a charter and physical protection, employ hidden cameras to spy on the nude coeds and win an interfraternity competition, whose contests include belching.

In this attenuated 90-minute movie, only a couple of scenes — Mr. Carradine caparisoned as a Hugh Hefner look-alike after losing his virginity and the outcasts performing as a rock band — display inventive wit.

It is the absence of genuine comedy that exposes glaringly the film's fundamental attitude of condescension and scorn toward blacks and women, and a tendency toward stereotyping that clashes violently with its superficial message of tolerance, compassion and fair play.

"Revenge of the Nerds" doesn't do much for movies or nerds.

1984 JI 20, C8:5

Eddie Murphy operates a tank in "Best Defense," a comedy of misadventure directed by Willard Huyck and co-starring Kate Capshaw and Dudley Moore, who plays an incompetent defense engineer.

Temple of Nothing

BEST DEFENSE, directed by Willard Huyck; screenplay by Gloria Katz and Mr. Huyck, based on the novel "Easy and Hard Ways Out" by Robert Grossbach; director of photography, Don Peterman; film editor, Sidney Wolinsky; music by Patrick Williams; produced by Gloria Katz; released by Paramount Pictures. At State, Broadway and 45th Street; Orpheum, 86th Street at Third Avenue; 34th Street Showplace, at Second Avenue, and other theaters. Running time: 94 minutes. This film is rated R.

Wylie Cooper	Dudley Moore
Landry	Eddie Murphy
Laura	Kate Capshaw
Morgan	Michael Scalera
Loparino	George Dzundza
Clare Lewis	Helen Shaver
Frank Joyner	Peter Michael Goetz
Spy	David Rasche

By VINCENT CANBY

IT really isn't easy to make a movie as mind-bendingly bad as "Best Defense." It takes hard work, a very great deal of money and people so talented that it matters when they fail with such utter lack of distinction.

Also, I suspect, it takes a special kind of closed society, in which a bunch of supposedly intelligent film makers can sit around for a couple of years and successfully convince themselves that what they're doing isn't the mistake it's suddenly revealed to be when the public sees it.

"Best Defense," opening today at Loews State and other theaters, is of an awfulness to make one yearn to see such comparable clinkers as William Friedkin's "Deal of the Century" and Richard Brooks's "Wrong Is Right." These were also intended to be contemporary comedies about United States foreign policy, about munitions manufacturers and about the funny people who live in third-world countries.

It's not that foreign policy and munitions aren't likely subjects for a real comedy, but Willard Huyck, who directed "Best Defense," and Gloria Katz, who produced it, and who together wrote the screenplay, appear to have learned everything they ever wanted to know about the world by carefully reading weekly tabloids sold in supermarkets.

"Best Defense" doesn't even make sense as a movie. The dreadful Katz-Huyck script cross-cuts for no apparent purpose between two stories, one set today and the other in 1982. In the current section, Eddie Murphy is seen as a United States Army officer in Kuwait, where he's about to demonstrate a new "wonder" tank, equipped with some terrifically advanced ground-to-air missiles. In the 1982 section, we see Dudley Moore, as a muddle-headed inventor, in the process of not quite perfecting this great new weapon.

•

More about the plot will never pass my lips. The jokes have a lot to do with Mr. Murphy's potency compared with Mr. Moore's impotence; with the comic, Italianate accents of the two dumb Kuwaiti soldiers who share the tank with Mr. Murphy; with

Anthony Edwards and Robert Carradine portray a couple of campus pariahs in the comedy "Revenge of the Nerds," dealing with their efforts to give the school's "beautiful people" their comeuppance.

Mr. Moore's lusting after his wife (Kate Capshaw) and a co-worker (Helen Shaver); with industrial espionage, and, for a comic capper, with a war that breaks out between Iraq and Kuwait. Can you wait?

The only two decently funny performances in the film are given by George Dzundza and David Rasche.

Mr. Huyck and Miss Katz, who are man and wife, earlier wrote the screenplays for "American Graffiti" and "Indiana Jones and the Temple of Doom." Unmentioned in their official studio biographies is the fact that they also wrote the screenplay for "Lucky Lady."

"Lucky Lady," move over.

1984 Jl 20, C10:1

FILM VIEW

VINCENT CANBY

Relief From Laser Duels

It could be just a coincidence, perhaps not, but it does seem as if there may be brewing a small, desperate mini-revolt against the huge, somewhat dumbfounding popularity of the science-fiction, fantasy and college humor films now dominating American movie theaters. Not a revolt among filmmakers but among audiences, and not necessarily among all audiences, but those in the major cities that can support a few theaters whose patrons seek something more than laser beam duels and food fights.

One might ordinarily think this a good thing. There really ought to be movies for people who aren't consistently dazzled by special effects and comedy routines of something less than the freshest order. Yet very few of these counter-pop films offer much to crow about. The best that can be said is that they represent a backlash against expensively produced junk. More often than not, however, the most popular of these movies represent middlebrow filmmaking that is as limited, soothing and undemanding in its way as the comic book movies with which they are competing.

I'm thinking of movies like "The Natural," Barry Levinson's resolutely untroubling, cheery film adaptation of Bernard Malamud's fine, troubling, very dark novel; "Another Country," Marek Kanievska's screen version of Julian Mitchell's literate and sometimes witty West End play, which unfortunately attempts to blame all high treason in the British government on the homosexuality rampant in England's toniest public schools.

Also, "Careful, He Might Hear You," a well-acted Australian soap opera about a little boy's troubled childhood amid various custody fights; "Another Time, Another Place," another well-acted but depressingly tasteful English drama that, instead of disturbing the audience, caters to the audience's own high opinion of itself; and "Edith and Marcel," Claude Lelouch's madly sentimental and overproduced French film about the love affair of Edith Piaf and Marcel Cerdan, which — surprisingly, considering how dreadfully tasteful and pretty it is — quickly flopped at the New York box office.

By far the most popular of these recent, classily made, middlebrow films are Sir Richard Attenborough's Oscar-winning "Gandhi" and "Educating Rita," Lewis Gilbert's film version of Willy Russell's London play, which became one of the unexpected American box-office hits last year.

It's not especially easy to knock some of these films, nor does it necessarily increase one's own popularity. There are a number of persuasive reasons why they should be supported, including the obvious one that there aren't so many movies about recognizable people being

Recent movies that represent "a backlash against expensively produced junk" include "Another Country," upper left, with Rupert Everett and Colin Firth; "Another Time, Another Place," left, with Phyllis Logan and Giovanni Mauriello; and "Careful, He Might Hear You," with Nicholas Gledhill and Robyn Nevin.

made these days that we can afford to be unkind to the ones that do come along. Also, almost all of these films have their good points.

"Gandhi" may not have changed the course of current history, but it probably introduced one of the great men of our age to more people than any number of books have done to date. Though it equates the thirst for knowledge to the mindless routine of bodybuilding, "Educating Rita" has two superior performances by Michael Caine and Julie Walters. A fine new English actress named Phyllis Logan shines in the precious gloom of "Another Time, Another Place," and "Another Country" can be enjoyed as a rather funny, bitchy movie about upper-class English decadence — that is, if you forget that what you're seeing and listening to is supposed to explain nothing less than the Decline of the West.

● ● ●

It isn't that these films are terrible — they aren't. It's just that they aren't good enough, and that too often they are dealing in preconditioned responses. "Gandhi" turns its title character into an unqualified saint, never acknowledging any flaws or even any of his bizarre eccentricities. "Educating Rita" depends on our respect for great books — as long as someone else reads them. "The Natural" transforms a nightmare vision of America into a heroic, optimistic dream. In one way and another, each of these movies hangs a "Do Not Disturb" sign over the brain.

Almost 30 years ago, that small, angry band of young French film critics, including François Truffaut, Jean-Luc Godard and Jacques Rivette, was merciless toward what was then the filmmaking establishment in France. They thought these older directors incredibly stuffy and compared their work unfavorably to Hollywood films in which they found strong, original, completely cinematic visual styles. It was against this French "tradition of quality" — literate, carefully written films, often based on famous novels — that they rebelled, eventually by making their own idiosyncratic films that became the basis of the New Wave.

It may not be stretching things too much to suggest that the extraordinary popularity of today's big-budget kiddie films could, eventually, prompt such a strong reaction that we could find ourselves up to our necks in a new tradition of quality all our own. These would be perfectly genteel, middlebrow movies that would appear to be far better than they actually are in comparision to the junk that went before.

I'm overstating the case, of course. I don't really expect that the bottom will ever drop out of the market for razzle-dazzle movies whose principal audiences are teen-agers. The thing that is depressing is that some of our best filmmakers, including Steven Spielberg ("Indiana Jones and the Temple of Doom," "Gremlins") and George Lucas (the "Star Wars" trilogy), don't seem to feel they can afford the time and the risk involved in making other kinds of movies. They may be right, considering the high cost of production and the absolute necessity of attracting the biggest possible audience just to break even.

The situation isn't entirely bleak. Truly good, provocative, personal films do occasionally burst through the middlebrow barrier. Diane Kurys's "Entre Nous" initially looks as if it owes more to the French "tradition of quality" than to the New Wave. It's a big, expensive, beautifully written movie, acted by stars. Yet it is as personal — and autobiographical — as Mr. Truffaut's "400 Blows."

Being a master, Ingmar Bergman has become something of an institution, which carries with it the risk of following in his own tradition of quality. In spite of that, "After the Rehearsal" may be one of the most uncompromisingly revealing movies he's ever made, as risky in its self-obsessed subject matter as in its limited physical scale. Mr. Bergman never plays it safe. Nor is it ever possible to know beforehand just how one is going to react to a Bergman film.

"Under the Volcano" would seem to define — for our era — what Mr. Truffaut and his associates meant by the "tradition of quality." It's based on the Malcolm Lowry novel that many consider a modern classic. It's directed by that grand old veteran of the American moviemaking establishment, John Huston. It has a literate screenplay by Guy Gallo and it is acted by one of the day's leading figures of stage and screen, Albert Finney.

Even so, Mr. Huston fools us. This "Under the Volcano," although it is faithful to the book, is also faithful to the extent of being as ambiguous and sometimes as jejune as the novel. It doesn't attempt to clarify the complexities of its drunken, doomed hero, the Consul, who, as played by Mr. Finney, is far more interesting than I ever found character in the book.

Mr. Huston never attempts to explain or even rationalize the Consul. Instead, the director simply tracks the Consul on this last day of the man's life, as if he were reporting it as a journalist might. The movie is set apart from most other film versions of difficult novels by being as much *about* the novel as it is an interpretation of it.

One further bright spot: Eagle Pennell's "Last Night at the Alamo," written by Kim Henkel, and to which an entire column was devoted last week. It's superbly comic and completely original, but it's also dirty-mouthed and unpredictable. It's not a movie you'd take home to meet your mother. ■

1984 Jl 22, II:15:1

PURPLE RAIN, directed by Albert Magnoli; screenplay by Albert Magnoli and William Blinn; director of photography, Donald L. Thorin; edited by Albert Magnoli; music by Prince; produced by Robert Cavallo, Joseph Ruffalo and Steven Fargnoli; released by Purple Films Company and Warner Bros. At the Criterion, Broadway and 45th Street; Gemini, Second Avenue and 64th Street; Art, Eighth Street and University Place; RKO 86th Street, at Lexington Avenue. Running time: 111 minutes. This film is rated R.

Record Rain

The Kid	Prince
Apollonia	Apollonia Kotero
Morris	Morris Day
Mother	Olga Karlatos
Father	Clarence Williams 3d
Jerome	Jerome Benton
Billy Sparks	Billy Sparks
Jill	Jill Jones
Chick	Charles Huntsberry
Dez	Dez Dickerson
Brenda	Brenda Bennett
Susan	Susan

By VINCENT CANBY

"PURPLE RAIN," which introduces Prince, the rising young rock performer, to theatrical films, is probably the flashiest album cover ever to be released as a movie. However, like many album covers, "Purple Rain," though sometimes arresting to look at, is a cardboard come-on to the record it contains.

Prince's soundtrack recording has already become one of the summer's big sellers, while the almost confessional single, "When Doves Cry," is at the top of the charts. The movie, which opens today at the Criterion and other theaters, may also become a hit, but it's of a different caliber entirely.

●

Here is a narrative film with music, shot and edited in the jazzily manic, staccato style favored by every rock documentary since "Woodstock," at the center of which there is the small, slight, somewhat nervous figure of Prince himself. When performing on-stage, as he is in much of the film, whether photographed frontally, in profile or silhouetted against a man-made aurora borealis, he can be a riveting spectacle. Off the stage, his screen presence is a pale reflection of the dynamic recording personality.

With his mass of carefully tended, black curly locks and his large, dark doe eyes, he looks, in repose, like a poster of Liza Minnelli on which someone has lightly smudged a mustache. When astride his large motorcycle, as he is from time to time, the image suggests one of Jim Henson's special effects from a Muppets movie: Kermit the Frog on a Harley-Davidson. In the depths of depression, pacing back and forth in his dressing room, he expresses all the pent-up rage of a caged mouse.

●

The screenplay, written by Albert Magnoli, the director, and William Blinn, and reported to contain certain autobiographical elements, focuses on the public and private torments of the Kid (Prince), a Minneapolis rocker on the rise. He's a driving young singer obsessed with getting to the top and away from his black father (Clarence Brown 3d), an alcoholic, wife-beating former musician, and his mother, played by the Greek actress Olga Karlatos, another show-biz dropout, who drinks along with dad, whom she can't quite bring herself to leave.

Also figuring in the story, which, without the music, would simply be another story about teen-age angst, are Apollonia (Apollonia Kotero), a strikingly beautiful young woman, who not only is a singer but also understands the Kid's need for love;

Prince, the rock performer, stars in the film "Purple Rain."

Morris (Morris Day), a cheerfully lecherous, outrageously vain, zoot-suited rock performer, who lusts after stardom and Apollonia, and other members of such Minneapolis groups as Prince's Revolution, Mr. Morris's Time and Miss Kotero's Apollonia 6.

Though Prince is somewhat less androgynous than Michael Jackson is, everything about him and the movie suggests cross-overs between opposites, or, at least, compromises between different modes of expression.

Prince's music, which lifts the movie without exactly carrying it, has black, white, rock and gospel roots. Prince's background is also mixed. The movie uses all the clichés of the rock concert film, except for the split screen, but it's supposed to be a seriously affecting romantic drama.

"Purple Rain" is playing in theaters but it demonstrates the skills of the recording industry far more effectively than it does those of movie making. Though its women characters are supposed to be strong and independent, they are suckers for the men who knock them around with brutal regularity.

In one of the dizziest of the film's nonmusical interludes, the Kid takes Apollonia for a motorcycle spin in the country, tricks her into skinny dipping while he, fully clothed, looks on and then, when she tries to climb back onto the bike for the return to town, he maliciously teases her by pretending to drive away. Instead of belting him, as might be expected, she comes to understand his desperate longing for love and his inability — because of dad and mom — to give it. Where is Dr. Joyce Brothers when a kid really needs her?

With the exception of one comic bit based on the old Abbott and Costello "Who's on first" routine, "Purple Rain" is completely without humor. The only wit comes in the music and in some of Prince's lyrics, especially those for "When Doves Cry," "Darling Nikki," "Let's Go Crazy" and the title song.

The offstage stuff is utter nonsense. Mr. Magnoli, whose first theatrical film this is, has seen to it that the movie is so efficiently edited that the story ends sometime before the movie does. This is all right because it allows the movie to close with two successive musical numbers, which, in "Purple Rain," are the only things that count.

1984 Jl 27, C5:1

Not-O. K. Corral

HEART OF THE STAG, directed by Michael Firth; screenplay by Neil Illingsworth; director of photography, James Bartle; edited by Michael Horton; music by Leonard Rosenman; produced by Don Reynolds and Michael Firth; released by New World Pictures. At the Embassy 72d Street, at Broadway, and the Quad Cinema, 13th Street near Fifth Avenue. Running time: 94 minutes. This film is rated R.
Peter Daly Bruno Lawrence
Robert Jackson Terence Cooper
Cathy Jackson Mary Regan
Mary Jackson Anne Flannery
Jack Bostwick Michael Wilson
Young Cathy Susanne Cowie
Shearing Gang
 John Bach, Tim Lee, Greg Naughton, Tania Bristowe.

"**H**EART OF THE STAG," which opens today at the Embassy 72d Street and Quad theaters, is a dreary New Zealand melodrama about incest on a sheep ranch.

The cast is headed by Bruno Lawrence, best known in this country for his performance in "Smash Palace," as the drifter who falls in love with the daughter (Mary Regan) of the rich rancher (Terence Cooper), who doesn't like other men moving in on his territory. His territory includes not only his daughter-mistress, but also the deer on the ranch, especially the great stag that the rancher stalks in the manner of an obsessed grammarian going after a mixed metaphor. Observing these events is the rancher's sullen wife (Anne Flannery), confined to a wheelchair by a stroke and apparently too frightened to object to the unorthodox sleeping arrangements.

The screenplay was written by Neil Illingsworth and directed by Michael Firth. Only their mothers might love what they've done.

Vincent Canby

1984 Jl 27, C6:5

CHEECH & CHONG'S THE CORSICAN BROTHERS, directed by Thomas Chong; screenplay by Cheech Marin and Thomas Chong; director of photography, Harvey Harrison B.S.C.; edited by Tom Avildsen; music by Geo; produced by Peter MacGregor-Scott; released by Orion Pictures Corporation. At the Rivoli, Broadway at 49th Street, and the Gemini, Second Avenue at 64th Street. Running time: 90 minutes. This film is rated PG.
Corsican Brothers
 Cheech Marin and Thomas Chong
The Queen's Adviser/Ye Old Jailer ... Roy Dotrice
Princess I ... Shelby Fiddis
Princess II .. Rikki Marin
The Queen ... Edie McClurg
Princess III .. Robbi Chong
The Gypsy .. Rae Dawn Chong
The Waiter ... Simono
The Midwife Kay Dotrice
Martin ... Martin Pepper

By VINCENT CANBY

"Cheech & Chong's the Corsican Brothers" marks something of a comeback — and maybe even an advance — for Cheech Marin and Thomas Chong, whose last movie, "Still Smokin'," carried their particular style of simulated nonchalance over the edge into a Southern California nowhere, though it was set in the Netherlands.

"The Corsican Brothers" isn't in the same league with their earlier "Up in Smoke" and "Nice Dreams." However, their screenplay, written by them and directed by Mr. Chong, marks the first time they've attempted to adapt their identities to fit someone else's genre, in this case, an adventure classic by Alexandre Dumas about twin brothers so psychically joined that when one receives the lash, the other screams in pain.

Most curious — and likely to be a major disappointment to many of their fans — is that there's not one major reference to marijuana in the entire film, possibly because "pot,"

which would have been pronounced "poe," wasn't wildly popular in 16th-century France. Don't despair, though. There is a nonstop series of cheerfully low jokes that, as usual, are best when in very poor taste, about beautiful women, body functions and minorities, including homosexuals.

In this particular film, which opened yesterday at the Rivoli and other theaters, they turn a small corner of old France into a chaos of rude comedy routines, most of which have as their butt an especially decadent aristocrat, mugged with reckless abandon by Roy Dotrice.

Using their familiar screen personalities, those of the excitable Mexican-American (Cheech) and the laid-back sophisticate (Chong), they play themselves from birth into active middle age. What plot there is has mostly to do with Chong's fiery revolutionary activities, which allow him to use a number of fine old vaudeville chestnuts, including "They rape the fields and pillage the women!" Among the weapons the pair use are incendiary potatoes, called "bombs-de-terre."

Much — maybe just a little too much — is made of the fact that when Mr. Dotrice's lecherous aristocrat attempts to play some amorous sado-masochistic games with Cheech, it's Chong who responds to the whip.

Good moment: Near the end, when the mad snobbish nobleman is vanquished, he must scream, "You can kick me if you want, but don't touch me."

The film, which was shot in France, includes some unusually exotic scenery for a Cheech & Chong vehicle, most of which, aside from that one disastrous movie done in the Netherlands, have capitalized on the tacky atmosphere of Southern California.

"Cheech & Chong's the Corsican Brothers," which has been rated PG ("Parental Guidance Suggested"), includes a lot of vulgar language and situations.

1984 Jl 28, 15:5

FILM VIEW

VINCENT CANBY

Post-Mortem on Flops

At 1 P.M. on Thursday, July 19, in the Criterion 1 Theater, a vast, enclosed space containing 1,300 seats, there were, by my count, exactly 21 paying customers when the lights went down for the showing of "Rhinestone," a failed dream of a summer box-office blockbuster starring Sylvester Stallone and Dolly Parton. I'd had to run to catch the movie, for this was the last day of the kind of disastrous four-week first run that sends producers back to their palm readers.

The next day at 2 P.M., in the same theater on Times Square, on the first day of the moveover run of "Cannonball Run II," which had been playing at the Criterion 2 for three weeks, things were even worse. There were 12 people in the house. This didn't include the projectionist who sauntered into the auditorium at showtime and, after exchanging some genial small talk with two customers, went up to the booth to begin the film. The atmosphere was informal and seemed almost down-home, but it's difficult to feel truly down-home when surrounded by 1,288 empty seats. It's like picnicking in a graveyard. It also recalls that great, apocryphal horror story that theater owners like to tell when they are feeling especially blue:

A movie patron telephones the theater box office and asks, "What time does the show start?" Answers the ticket seller, "What time can you get here?"

· · ·

In terms of total box-office receipts, this has been a very good summer for a few Hollywood producers, that is, the people who made "Ghostbusters," "Indiana Jones and the Temple of Doom," "Gremlins," "Romancing the Stone," "Star Trek III" and "Bachelor Party," among others. However, for every smash hit there are always a dozen flops. My problem — and, I suppose, it's a problem shared by most producers — I can never tell, even *after* the fact, why some of these films turn into huge popular successes while others, no better or worse, fail so dismally.

These hits and flops alike were each conceived in the spirit of hustling showmanship, by people who assume they have their fingers on the public pulse, and who will stoop to almost any dizzy level to make a buck. The extraordinary — and perhaps healthy — thing is not that they frequently fail, or that they sometimes hit a jackpot, but that public tastes remain so resolutely mysterious.

The concept of "Rhinestone" must have seemed a natural. After all, it teams the ineffable Dolly Parton, whose box-office appeal appeared to have been demonstrated by the success of "The Best Little Whorehouse in Texas," with Sylvester Stallone, the star, writer and sometimes director of the "Rocky" movies, in a comedy about a country-and-Western singer (Miss Parton) who, on a bet, attempts to turn a loudmouthed New York

Why were 'Rhinestone' and 'Cannonball Run II' playing to empty seats?

cabbie (Mr. Stallone) into a country-and-Western performer in just two weeks.

It's not the greatest story in the world, but then the plot of "Ghostbusters" isn't exactly terrific either, and though I've never been Mr. Stallone's biggest fan, I can read the "Rocky" box-office figures as well as the next person. What the producers of "Rhinestone" did not take into consideration, however, is that Mr. Stallone has made only one successful film ("First Blood") that was not a "Rocky" movie.

· · ·

Nor did they seem to have any worries about how Miss Parton and Mr. Stallone would play off each other when put together on the same movie set. The awful truth, as "Rhinestone" shows, is that the pairing of the determinedly sunny-natured Miss Parton and the determinedly egocentric Mr. Stallone doesn't work for a second. They never seem frosty with each other, but their screen personalities have nothing in common except a certain self-satisfaction with her/his own physique.

A kind of genial self-mockery is built into everything that Miss Parton does, whether acting or singing. This isn't to say that she isn't always totally committed in her performances, only that she has the ability to give her all to what she's doing and, at the same time, to appear to be standing a little apart from it, as if to say, "Come on, folks, it's only a movie." This is something that Mae West was able to bring off when she was at top form.

Mr. Stallone's self-assurance is so unclouded by any doubt or distance that much of the time in "Rhinestone" he doesn't seem to be aware that there's anyone else in the movie. On those few occasions when he and Miss Parton go into a clinch, he seems to be hugging himself. When, early in the film, he is supposed to show us what a god-awful singer he is, his obvious satisfaction with the spectacle he's making of himself neutralizes the point of the scene. It's not that the character thinks he's good, which might be funny, but that the actor thinks he's terrific, which isn't.

· · ·

Mr. Stallone comes on so strong, and takes up so much screen space — he's listed as co-author of the screenplay — that it looks to be a way of up-

staging his costar. However, Miss Parton wasn't born yesterday. When Mr. Stallone hams it up, she moves a little to one side and laughs. As a matter of fact, she spends much of "Rhinestone" just laughing. She's as strong-willed in her way as he is in his, and knows that her only defense against this onslaught of ego is to appear to be amused by it. Nobody's going to catch Dolly feuding and fussing in public.

Having said all this, I still don't understand why "Rhinestone" has done so poorly. It's not a great movie but it's not absolutely, irretrievably terrible. It has a good Dolly Parton score, including one legitimately witty number called "Physical Attraction" that she and Mr. Stallone do together, and a parody C & W lament in which a man rues the loss of his woman who, he sings, "had a duty to her crops."

The members of the supporting cast do very well whenever they get the chance, particularly Ron Leibman, as Miss Parton's lecherous manager, Tim Thomerson, as Miss Parton's hard-drinking, mean-tempered Tennessee beau and most especially Richard Farnsworth, who plays Dolly's down-home dad with such amused, self-effacing modesty that he steals every scene he's even near.

If I were a producer and I had made "Rhinestone," only to watch it go down the drain, I'd be convinced there is no justice in the world. Far worse movies, with seeming far less to offer in terms of box-office stars, have not done as badly. I'd investigate the used car business.

•

Somewhat more easy to understand is the comparative lack of interest in "Cannonball Run II" though, since tastelessness didn't hurt the first "Cannonball" film, nor the "Smokey and the Bandit" films that also starred Burt Reynolds, I'm somewhat baffled why the public has turned its back on this one. How is one ever to know when tastelessness will pay off and when it won't? However, "Cannonball Run II" does encourage the members of its once all-star cast to behave with such witless, insidey, TV talk-show nonchalance that it brings out the worst in just everybody except the resilient Dom DeLuise.

•

The others include an unwell looking Dean Martin, a fine but ineffective Sammy Davis Jr., Shirley MacLaine being extremely good-natured as a showgirl disguised as a nun, Sid Caesar, Charles Nelson Reilly, Jim Nabors, Telly Savalas, Ricardo Montalban and, of course, Mr. Reynolds.

The film, directed by Hal Needham, who has made entertaining "road" action-comedies in the past, is a sort of belabored, small-scale version of the belabored but big-scale "Mad, Mad, Mad, Mad World," being about an auto race from California to Connecticut that appears to have been shot entirely on one stretch of highway in Arizona. That is, everything except for "the king's" scenes.

"The king" is Frank Sinatra, playing himself, and treated with the deference that might be shown a reigning pope, if any pope would consent to do a cameo appearance in a movie of this sort. The director apparently shot Mr. Sinatra all by himself, even in scenes in which he's supposed to be sharing the frame with the other actors.

Perfectly capping the self-centered, show-biz facetiousness of everything that has gone before in the movie are the supposed "outtakes," scene fluffs, which are shown with the film's end-credits. Mr. Reynolds and Mr. Needham have done this before, and it's a gimmick that, I suspect, the public has begun to tire of and to be a bit suspicious of, even a public raised on TV comedy in which actors break up at their own funniness.

•

The unfortunate thing about these "outtakes" is that they look to have been better directed than the film that precedes them.

Mr. Reynolds has done a lot of good work in the past, but his more recent films, including last summer's dreadful "Stroker Ace," and "The Man Who Loved Women," Blake Edwards's not unentertaining remake of François Truffaut's French comedy, have not been doing well at the box office.

This may be the reason he has cast this "Cannonball Run" sequel with so many "names." Whatever the reason, the names do not help the film nor, it seems, have they interested the fickle public that only a few years ago was buying Mr. Reynolds in just about any movie he chose to make. "Cannonball Run II" is not that much worse than some of the other Reynolds films that cleaned up.

Watching "Cannonball Run II" with only 11 other people in a 1,300-seat house is an unsettling experience. Is this the revenge of the nerds?

•

Two weeks ago, in a piece about Eagle Pennell's "Last Night at the Alamo," I inadvertently attributed the screenplay of his earlier film, "The Whole Shootin' Match," to him alone. That screenplay was written by Mr. Pennell and Lin Sutherland. ∎

1984 Jl 29, II:15:1

The Bad Scientist

THE LOST ONE, directed by Peter Lorre; screenplay by Peter Lorre, Benno Vigny and Axel Eggebrecht; director of photography, Vaclav Vich; edited by C.O. Bartnig; music by Willi Schmidt-Gentner; produced by Arnold Pressburger; released by Fred Pressburger. At Film Forum 1, 57 Watts Street. Running time: 98 minutes. This film is in German with English subtitles and has no rating.
Dr. Carl Rothe.................................Peter Lorre
Hoesch/Novak..............................Karl John
Inge Hermann.........................Renate Mannhardt

By VINCENT CANBY

"THE LOST ONE" ("Der Verlorene"), the 1951 German film that opens today at the Film Forum, is the only movie that was directed by the late Peter Lorre, one of America's favorite character actors in the 1940's and 50's. Though "The Lost One" isn't exactly a masterpiece, it's an interesting expression of the frustration

Peter Lorre was not only the star but the director of this 1951 film, "The Lost One." In his sole venture as a director, the actor portrayed a researcher in germ warfare for the Nazis.

of Lorre's creative personality, after he found himself in a comfortable kind of dead end in the Hollywood studio system.

In look and tone "The Lost One" shows the influences of Lorre's early career in the German cinema, especially of the work of Fritz Lang and of "M," which brought Lorre to the attention of American film producers. It's a good deal less successful as an attempt to illuminate the Nazi phenomenon, which it analyzes in a series of rather perfunctory clichés.

Lorre not only directed and starred in the film, but also, with Benno Vigny and Axel Eggebrecht, wrote the screenplay, which is reportedly based on the true story of a Nazi scientist who wound up as a murderer and suicide in a postwar refugee camp.

•

In Lorre's version of this story, Dr. Karl Rothe (Lorre) is first seen as an avuncular doctor, kindly tending to the camp's weary inmates shortly after the war. The appearance of his former assistant, a young man named Hoesch (Karl John), prompts a series of chronological flashbacks that reveal Rothe's awful secret.

It seems that in 1943 he had been just a simple but brilliant scientist doing research in bacteriology, unmindful of the war going on around him and of the regime for which he was working. Rothe's life is shattered when the Gestapo tells him that his pretty young fiancée has been sending the results of his research to the Allies and has been having an affair with Hoesch, who, unfortunately for her, is also an informer for the Gestapo.

•

Back home that night, Rothe strangles the young woman, though it's never made clear whether his rage is prompted by her infidelity or her treason. Having once murdered, Rothe cannot stop, which is where "The Lost One" may lose contemporary audiences. The point seems to be that Rothe, without passion or reason, does pretty much what the Nazis are doing on a grander scale. The complicated but not complex story also includes a subplot about the unsuccessful attempt on Hitler's life.

Lorre's carefully controlled, intense performance is far more impressive than the movie that surrounds it. It's also moving in a way he could not have foreseen, in that it demonstrates how his physical being — his distinctive looks and manners — would inevitably limit the sorts of roles available to him in spite of his talent.

"The Lost One" is a curiosity.

1984 Ag 1, C21:3

Battle Zone

THE BOSTONIANS, directed by James Ivory; screenplay by Ruth Prawer Jhabvala; adapted from the novel by Henry James; director of photography Walter Lassally; edited by Katherine Wenning and Mark Potter; music by Richard Robbins; produced by Ismail Merchant; released by Almi Pictures Inc. At Cinema 1, Third Avenue at 60th Street. Running time: 120 minutes. This film is not rated.
Basil Ransom.................................Christopher Reeve
Olive Chancellor......................Vanessa Redgrave
Verena Tarrant........................Madeleine Potter
Miss Birdseye................................Jessica Tandy
Mrs. Burrage.............................Nancy Marchand
Dr. Tarrant.......................................Wesley Addy
Dr. Prance...Linda Hunt
Adeline Luna......................................Nancy New
Mr. Pardon......................................Wallace Shawn

By JANET MASLIN

OLIVE CHANCELLOR, the fiercely intense 19th-century feminist whose attachment to a pretty young protégée sets Henry James's "Bostonians" in motion, is a character Vanessa Redgrave was born to play. The casting of Miss Redgrave in this role has an aptness bordering on the un-

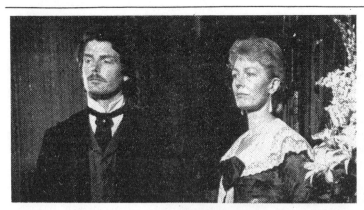

Christopher Reeve and Vanessa Redgrave in film adaptation of "The Bostonians" by Henry James.

canny, because even Mr. James's descriptions of his heroine suggest a figure very like the actress.

Olive has a smile "just perceptible enough to light up the native gravity of her face," he wrote. "It might have been likened to a thin ray of moonlight resting upon the wall of a prison." And "the curious tint of her eyes was a living colour; when she turned it upon you, you thought vaguely of the glitter of green ice." There is in Olive, as there is in Miss Redgrave, "a quick, piercing question, a kind of leaping challenge, in the whole expression."

In "The Bostonians," which has been ably and enthusiastically adapted for the screen by the director James Ivory, the screenwriter Ruth Prawer Jhabvala and the producer Ismail Merchant, Olive meets her match. The story revolves around the rivalry between this prim, severe idealist and her charming and cynical Southern cousin, Basil Ransom, when they find themselves drawn to the same radiant young woman. No screen version of "The Bostonians" could succeed without a Basil formidable enough to hold his own in this tug of war. So it's a major and especially happy surprise to see how convincingly Basil has been embodied by Christopher Reeve, whose other non-Superman performances have displayed little of the ease and versatility that he reveals here.

The moral ambiguity of James's novel has been skillfully captured in the film, as has its remarkable modernity. As Olive and Basil struggle over which of them is to possess Verena Tarrant, the innocent young woman whose naïve talent for public speaking has drawn her an ardent following, the book's sympathies shift frequently. The film's do, too. The viewer is perhaps more aware of the depth of Olive's passion for the young woman than Olive is herself; on the other hand, Basil, who wants to remove Verena from the public arena and keep her at home, has a frankness that becomes as appealing as his ideas are objectionable. Even when he tells Verena "Dear Miss Tarrant, what is most agreeable to women is to be agreeable to men!" Basil manages a certain flirtatious gallantry No wonder Olive fears him.

The film has a sunny, rapturous look that could no more be mistaken for ordinary romanticism than could Mr. James's astute, decorous prose. Though it readily conveys the amorous feelings of all three principals, the film never suggests that their mere happiness is all that is at stake. The battle between progressive and

reactionary forces has been personalized here, but not eclipsed. And the course it follows is both dramatic and surprising, culminating in a final image that, on the page at least, takes one's breath away. If the final seconds of the film are not a match for James's closing sentence, the lapse is uncharacteristic. More often than not, the film stays very close to its mark.

The casting is so good that anyone familiar with the novel will easily be able to guess which roles the supporting players have been given. Of course, Linda Hunt is Dr. Prance, the drily sardonic companion of the elderly abolitionist and Emersonian Miss Birdseye (played by Jessica Tandy). Nancy Marchand makes a perfect Mrs. Burrage, the supremely pragmatic matron who would like to be Verena's mother-in-law. And as Verena's faith-healing father, Wesley Addy is every inch the quack.

Only occasionally is the casting questionable, as with Nancy New, who turns Olive's marriage-minded sister into too much of a modern-day popsy, or Wallace Shawn, who makes the avaricious and star-struck journalist Mr. Pardon somewhat goofy. The newcomer Madeleine Potter does an admirable job of breathing life and intelligence into the dangerously simple Verena. But she doesn't fully demonstrate the physical magnetism that would help explain the young woman's extraordinary hold over her admirers.

"The Bostonians," which opens today at Cinema I, unfolds elegantly but not always smoothly. The settings at times seem more antique-laden and less expressive than they might have been, and the pacing is much less graceful than the material itself. The editing advances the story without always building it, so that separate scenes have a way of seeming very separate indeed. But the performances, especially that of the astonishing Miss Redgrave, generate an urgency and momentum to match Mr. James's own.

1984 Ag 2, C15:1

FIRST NAME: CARMEN, directed by Jean-Luc Godard; screenplay by Anne-Marie Mieville; adapted from the novel "Carmen" by Prosper Merimee; director of photography, Raoul Coutard; edited by Suzanne Lang-Willar; music by Beethoven; produced by Alain Sarde; released by International Spectrafilm Distributors Inc. At the Lincoln Plaza Theater, Broadway, near 62d Street. Running time: 85 minutes. This film is in French, with English subtitles, and is not rated.
Carmen X Maruschka Detmers
Joseph Bonnaffe Jacques Bonnaffé
Claire Myriem Roussel
Boss Christophe Odent
Uncle Jean Jean-Luc Godard
Fred Hyppolite Girardot

By VINCENT CANBY

"I DON'T know much," says a woman's voice on the soundtrack, "but I know the innocent don't control the world," which is another way of saying that today's meek don't inherit much earth. This is the initial proposition of Jean-Luc Godard's fine, contemplative, ever-surprising new comedy, "First Name: Carmen," which then goes on to suggest that the only hope for the innocent and meek is to start the world all over again. From scratch.

This isn't anything new for Mr. Godard, who expressed much the same sentiments in the revolutionary films of his Maoist period and even earlier. What is new is the total lack of formal political dogma and, in its place, a deadpan, cockeyed, witty re-examination of the values of Western civilization, in terms that make as much use of comic books as of the classics of our culture.

It's an indication of just how young movies are, and of how consistently original Mr. Godard's films continue to be, that it's impossible to compare his work to that of any other film maker in the commercial cinema. Although it's not yet time to relate him to Picasso, one has to go outside films — to painting, sculpture and music, arts with centuries of tradition — to suggest the idiosyncratic importance of this most unpredictable of today's film makers.

With the exception of the films of Luis Buñuel, Rainer Werner Fassbinder and maybe two or three others, commercial movies, which are less old than this century, have no real modernist tradition. They remain stuck in romantic realism. All by himself, Mr. Godard has moved through his own modernism, which began with "Breathless" and includes the films made with his Dziga-Vertov collective, to what is now something akin to postmodernism.

Like its two immediate predecessors, "Every Man for Himself" ("Sauve Qui Peut/La Vie") and "Passion," the new film, which opens today at the Lincoln Plaza, has the form of a narrative film. In fact, it's another Godardian essay in sound

and images, which tells a seriously funny tale of love and death. The screenplay, by Anne-Marie Mieville, Mr. Godard's longtime associate, is more or less adapted from the old Prosper Merimée novel and the Bizet opera, updated to the present with music supplied by Beethoven — the late quartets — and one song, a gravelly blues number, by Tom Waits.

As has always been his fashion, Mr. Godard couldn't care less about entertaining an audience through its identification with the emotions of the film's characters. He forces us to regard them as bizarre if perfectly reasonable creatures from another planet that looks as if it were a mirror image of our own.

In this case, the characters include a self-possessed, willful young woman named Carmen, played by a stunningly pretty Dutch actress, Maruschka Detmers; a handsome, naïve policeman, Joseph (Jacques Bonnaffé), who falls in love with Carmen as she and her pals are staging a very bloody holdup of a bank; the other members of her gang, who pose as documentary film makers to disguise their thievery; and Carmen's Uncle Jean (Mr. Godard), a sick, washed-up, possibly lunatic old movie maker, who keeps his tape recorder in the fridge.

Cross-cut with this narrative are interludes in which the members of a string quartet rehearse the Beethoven works. Until the film's apocalyptic finale, the presence of the musicians baffles even Uncle Jean, who wanders through the movie like a heavily tranquillized White Rabbit. However, the Beethoven quartets, like the occasional shots of the seashore at Trouville and of Paris at night, have something of the purpose of exposition in a conventional movie, recalling traditions that these characters neither see nor hear.

This is a description of the narrative, though it doesn't begin to describe the effect of its succession of sequences, many of them shaggy-dog stories.

When first seen in a hospital room, unshaven, wearing a black overcoat over his hospital-issue pajamas,

Maruschka Detmers and Joseph Bonaffé star in Jean-Luc Godard's, "First Name: Carmen," about a terrorist and aspiring filmmaker known as Carmen X.

Uncle Jean is being threatened by eviction. Says the all-business nurse, "If you have no fever by Friday, you're leaving." Uncle Jean, who has been "expelled" by the movie industry, clearly finds the hospital the perfect place to write, although all he has to show for one day's creativity is the line, "Badly seen, badly said." Says the nurse, who later turns up as Uncle Jean's script girl, "You've worked hard today!"

Uncle Jean is drawn into the main events when Carmen comes to ask for the use of his apartment in Trouville and to offer him the chance to make his movie comeback directing her and her friends.

This is to be the gang's "cover" in their planned kidnapping of a millionaire businessman, an endeavor that comes to involve not only Uncle Jean but also the love-lost Joseph, whom Carmen, as might be expected, treats very badly.

In the only bit of dialogue remotely connected to the Bizet opera, Carmen tells Joseph, "If I love you, that's the end of you." Joseph, however, refuses to get the point, not even when, in front of him, she attempts to disrobe a hotel bellboy.

The affair of Carmen and Joseph, sometimes seen in explicitly erotic detail, is not in itself erotic since the film — Mr. Godard — is more interested in the awful things women do to men emotionally. On the other hand, the film is also full of rude suggestions of what men like to do with women physically.

"First Name: Carmen" contains a lot of typically Godardian aphorisms: "The police are to society what dreams are to people," and "The goal of classic capitalism was to produce the best goods possible . . . In today's world . . . the machines have started to produce goods nobody needs, from atom bombs to plastic cups." Some of these thoughts are better than others.

The film progresses through a series of ellipses that, after a steady diet of "and then" narratives, which leave nothing to the imagination, are at first baffling and then revivifying.

"First Name: Carmen," by far the freest, funniest "Carmen" in this year of unconventional "Carmens," is not a movie to be seen in a lazy way. It's not to be dropped in on after a large dinner or sandwiched between important engagements. It's both lucid and mysterious, and I'm not at all sure that Mr. Godard could explain everything in it, or even that he should.

Working on the outer edge of the commercial cinema, he is seeking new film forms and new audience responses. In "Every Man for Himself," someone says, "I want to *do* things, not just name them." That's exactly what this great director, who's fed up with the cinema of simple representation, which is really another way of "naming" things, is up to with "First Name: Carmen."

1984 Ag 3, C6:1

Un-Ordinary People

GRANDVIEW U.S.A., directed by Randall Kleiser; screenplay by Ken Hixon; director of photography, Reynaldo Villalobos; edited by Robert Gordon; music by Thomas Newman; produced by William Warren Blaylock and Peter W. Rea; released by Warner Bros. At Movieland, Broadway at 47th Street; Gemini, Second Avenue and 64th Street, and Gramercy, 23d Street near Lexington Avenue. Running time: 98 minutes. This film is rated R.
Michelle (Mike) CodyJamie Lee Curtis
Tim PearsonC. Thomas Howell
Ernie (Slam) WebsterPatrick Swayze
Donny VintonTroy Donahue
Candy WebsterJennifer Jason Leigh
Bob CodyWilliam Windom

By JANET MASLIN

"GRANDVIEW, U.S.A." begins and ends with montages of small-town people doing small-town things. The rest of it is not nearly so reassuringly ordinary. As directed by Randal ("Grease") Kleiser, "Grandview, U.S.A." depicts a little Middle Western community full of colorful oddballs, all of whom flaunt their eccentricities. The movie has about three times as many of these characters as it needs.

There is Mike (Jamie Lee Curtis), who runs the demolition-derby arena passed on to her by her late father, and whose real name is Michelle. Then there's Tim (C. Thomas Powell), whose fondness for aquatic animals may or may not have something to do with his accidentally submerging his father's brand-new white Cadillac in mud. Also in Grandview, and not having any clear connection to either of the other equally unrelated principals until the movie is well under way, is Slam (Patrick Swayze), who is unhappy about the fact that his baby doll of a wife (Jennifer Jason Leigh) is fooling around with Troy Donahue.

It takes a long while to realize where "Grandview, U.S.A.," which was written by Ken Hixon, is headed: It's headed for a tidy, happy ending that coincides with a picturesque Memorial Day parade. This finale is inconsequential enough to suggest that the movie's real purpose is flinging the characters together rather than leading them anywhere. Mr. Kleiser seems to have something like "Handle With Care" in mind, even though his film, unlike that one, lacks a unifying sense of humor.

Some of it is funny, like the scenes of Tim's family, headed by a gruff father (Ramon Bieri), who looks a lot like a cabbage-patch doll. And plenty of it misfires; a scene in which Slam finally declares he's been carrying the torch for Mike and then comically throws up, for example. More often than not, things seem to happen for absolutely no reason, as when Tim imagines himself the star of a rock video on MTV. This gives Mr. Kleiser the chance to display his mastery of the form, which is undoubtedly fun for him. But its point is pretty much lost on the audience, and is even more so when he repeats the same gimmick a little while later.

"Grandview, U.S.A." is slight, but it has a good enough cast to keep it watchable. Miss Curtis is appealing even in the tough, tomboyish incarnation upon which the screenplay insists; one scene has her negotiating the sale of a car while talking to Mr. Swayze and not giving an inch in the bargain. Mr. Swayze looks a lot like Kurt Russell and has something of the same good-natured presence and easy charm. Mr. Howell is funny in the family scenes and suitably callow as the 17-year-old who asks 27-year-old Mike whether she is sensitive about her age. William Windom and M. Emmet Walsh make brief but welcome appearances.

There's a fine line between the kind of inspired whimsy to which "Grandview, U.S.A." evidently aspires and the mildly misfiring farce that much of it is. The film is best when it's least strenuous, but too much of it tries too hard. And too many of its minor characters have names like Johnny Maine, Larry Hurlbuck, Cowboy and Moose Shook.

1984 Ag 3, C8:4

The Story of Isabelle

LA PETITE SIRENE, directed and produced by Roger Andrieux; screenplay by Roger Andrieux; adapted from the novel "Les Petites Sirènes," by Yves Dangerfield; director of photography, Robert Alazraki; edited by Kenout Peltier; music by Alain Maline; released by World Artists Releasing. At the Metro, 96th Street and Broadway. Running time: 104 minutes. This film is not rated.
IsabelleLaura Alexis
GeorgesPhilippe Léotard
NellyEvelyne Dress
BénédicteMarie Dubois
VéroniqueMarianne Winquist
ClaireDiane Sorelle

"LA PETITE SIRENE" isn't the usual film about a love affair between a 14-year-old girl and a 40-year-old man, if there is indeed a usual version by now. Directed in 1980 by Roger Andrieux, it has a heroine, Isabelle (Laura Alexis), who is not the customary nymphet and who does not attract the interest of a man much her senior merely by removing a few key articles of attire. Isabelle is very serious and rather plain, at least compared with the other members of her family, all of whom are tall and blond. And her fixation on Georges (Philippe Léotard) has less to do with mature love than with fairy tales.

In "La Petite Sirène," which opens today at the Metro, Isabelle somehow decides to re-enact Hans Christian Andersen's story of "The Little Mermaid," albeit on her own terms. She chooses Georges as her prince after he whistles at her; actually, he is whistling at her prettier cousin, but Isabelle is willing to overlook the difference. She begins following

Georges and flinging herself at him shamelessly, a process the film records in ways that make Georges's response more or less credible throughout. None of the seduction is depicted in sexual terms, since the relationship has more to do with Isabelle's overworked imagination and Georges's inevitable appreciation of her flattery.

Mr. Andrieux at one point sends Isabelle to the movies, where she watches "The Story of Adèle H." with a great deal of empathy. The reference is apt, but it may serve to remind the audience that François Truffaut's film was about a grander obsession and approached it in a far more thoughtful way. "La Petite Sirène" is finally somewhat pointless, finding more importance in its own congruence with the Andersen fable than in anything else. Still, it progresses gently, and much of it unfolds in a natural and believable style.

Mr. Léotard isn't an overdemonstrative actor, but there's something very durable in his bruised look and his affable manner. His understated appeal is the film's greatest asset. And Miss Alexis is both funny and demure. She is an American, but with the right kind of wide-eyed solemnity and a peculiar fashion sense, she becomes utterly convincing in her French schoolgirl's role.

Janet Maslin

1984 Ag 3, C15:1

FILM VIEW

VINCENT CANBY

'Bostonians': A Proper Jamesian Adaptation

In the 23 years since Ismail Merchant, the producer, and James Ivory, the director, first approached Ruth Prawer Jhabvala about adapting one of her novels for the screen, the three have collaborated on more than 10 films, originals and adaptations, mostly of Mrs. Jhabvala's novels but also of novels by Jean Rhys ("Quartet") and Henry James ("The Europeans").

There has been some wonderful work, the early "Shakespeare Wallah" (1965) the uncharacteristic "Roseland" (1978) and last year's "Heat and Dust." Though not all of their collaborations have been equally successful either at the box office or with the critics, they've shared a consistently literate sensibility that, through two extraordinary decades, hasn't once been overwhelmed by the fashions of the moment. The three have not only endured as collaborators but, it's now apparent, they have enriched and refined their individual talents to the point where they have now made what must be one of their best films as well as one of the best adaptations of a major literary work ever to come onto the screen.

This is "The Bostonians," described by both Edmund Wilson and F. R. Leavis, as one of Henry James's two most important novels — the other being "The Portrait of a Lady." I write these words with a certain amount of admiring embarrassment, having only recently admitted

that my heart sinks every time I hear that one filmmaker or another has turned his beady eye toward some acknowledged classic on the 10-foot bookshelf.

• • •

"The Bostonians" is, from its opening shot to last, a rare delight, a high comedy with tragic undertones, acted to passionate perfection by a cast of the best actors ever assembled by the Merchant-Ivory-Jhabvala team. It's a major achievement, both as a film with its own identity and as an example of how an exceedingly complex novel can be made into a movie without sacrificing anything except the particular rewards of reading James's dense, singularly convoluted prose, which comes complete with the author's comments interjected by an unseen, Godlike "I."

This is not to criticize James but to acknowledge that his syntax and his asides to the reader are not things for which there will ever be a satisfactory cinematic equivalent.

Unlike John Huston's "Under the Volcano," which is as much an impression of the Malcolm Lowry novel as it is a literal version of it, "The Bostonians" is as pure Henry James as I can imagine on the screen. It has a film life of its own, something that was difficult to see in the intelligent but terribly reverent Merchant-Ivory-Jhabvala adaptation of "The Europeans." It's far better than Peter Bogdanovich's very good adaptation of James's "Daisy Miller," which was underrated, mostly because of its major asset, the presence of Cybill Shepherd in the title role. Jack Clayton's film version of "The Innocents" ("The Turn of the Screw"), adapted from William Archibald's play, was perfectly acceptable, but it was at a far remove from the James story.

What must strike anybody coming upon "The Bostonians" without having read the novel first, or even without having read it in the last 25 years, is how eerily contemporary it seems, even though the setting is Boston in 1875 and even though it moves at that unhurried pace we now equate with 19th-century manners. Beneath the beautifully realized period settings and costumes, and waiting to break free of the polite and often very funny discourse, there is a furious contest being waged that reflects in surprisingly vivid detail a battle of the sexes that still goes on.

• • •

At the heart of the film are three fascinating characters.

Olive Chancellor (Vanessa Redgrave) is a rich, well-born Bostonian, who has committed herself to the liberation of her sex with a steely fanaticism and an ample purse, which otherwise remains tightly closed. Her most sacred hope, in James's words, is "that she might be a martyr and die for something." Olive, on fire for a cause that in 1875 is thought to be a mad eccentricity, is a woman totally devoid of humor but possessing profound depths of feeling, the nature of which is expressed in her relations with men, most of whom disgust her. The more intelligent ones can only hope to earn her distrust.

Basil Ransom (Christopher Reeve), a lawyer from the South of Reconstruction and a distant cousin of Olive's, represents everything that Olive thinks she is fighting. He is an archconservative, especially in politics, which includes his feelings toward women. As James puts it, ". . . the way he liked them — not to think too much, not to feel any responsibility for the government of the world." James adds, "He, too, had a vision of reform, but the first principle of it was to reform the reformers."

• • •

In the middle of this curious triangle is pretty, innocent Verena Tarrant (Madeleine Potter), the daughter of a hustling quack who deals in mesmerism and faith healing and under whose auspices Verena is gaining some measure of fame as a riveting speaker on behalf of women's rights. When first introduced in the story, she is — again in James's words, "the most extraordinary mixture of eagerness and docility. . .She took all that was given her and was grateful, and missed nothing that was withheld."

It's a measure of how well the film works that James's original words so efficiently describe not only the film's characters but the performances of Miss Redgrave, who may be giving the performance of her film career; Mr. Reeve, who here, for the first time, demonstrates his ability to go way beyond Superman with charm and guts we've never seen before, and Miss Potter, an actress new to films, who is splendid in what is the movie's most difficult role.

Early in the film, at a rather shabbily genteel, feminist meeting where Verena gives one of her impromptu "talks," Olive Chancellor and Basil Ransom simultaneously fall in love with Verena. Basil's passion is, of course, the more conventional. He finds her words ridiculous but the young woman spouting them thoroughly enchanting. Olive sees in Verena someone who, under her guidance, can become the Joan of Arc of the women's movement.

Olive has no inkling of the possible

Vanessa Redgrave and Madeleine Potter play leading roles in "The Bostonians," James Ivory's screen adaptation of the Henry James novel. Christopher Reeve co-stars.

sexual aspects of her love. She is domineering and affectionate toward Verena but when she, in effect, buys Verena from her tacky parents and brings her to share her Back Bay house, her goal is to serve the movement and to save the girl and her gifts for the cause of womankind. The idea of sex — any kind of sex — would be appalling to her.

•

The supporting cast of characters includes Miss Birdseye (Jessica Tandy), an ancient lady who has been a member of just about every radical cause since she was jailed in prewar Georgia in connection with her abolitionist activities; Mrs. Burrage (Nancy Marchand), an elegant and witty New York matron, who supports the movement and whose son wants to marry Verena, with her blessing; Dr. Tarrant (Wesley Addy) and Mrs. Tarrant (Barbara Bryne), Verena's unfortunately lower-class parents.

Also, Dr. Prance (Linda Hunt), an abbrasive, independently minded medical doctor who remains a friend to Olive and Mrs. Birdseye, even though she finds the movement somewhat comical; Mr. Pardon (Wallace Shawn), a thoroughly opportunistic journalist who wants a part of the action if and when Verena turns to public performing on the lecture circuit; and Adeline Luna (Nancy New), Olive's worldly, widowed older sister, who has a dreadful little son named Newton and who wouldn't mind taking the impoverished Basil Ransom as her second husband.

It's also a measure of how well the film works that no discussion of "The Bostonians" could be complete without mentioning these subsidiary characters and the marvelous actors who play the roles. They are as integral to the texture of the film as James's sentences are to the novel.

True to James, the film plays terrible tricks on all our assumptions. Basil Ransom is a committed male chauvinist. His ideas are Southern feudal, but he's most attractive and intelligent and, for a while, anyway, one longs for him to save Verena from the clutches of the overwhelming Olive. At the beginning, Olive seems to be a coldhearted, aggressively self-deluding do-gooder but, by the film's end, one is on the point of rooting for her, which is the ambiguous way James wrote her and the remarkable way in which Miss Redgrave plays her.

•

Also true to James is the film's peculiar conclusion, which seems to be a happy one, but it's also one that reflects the last sentence of the novel, after Basil Ransom has led the liberated Verena away from the distraught Olive Chancellor. Writes James of the tearful Verena, "It is to be feared that with the union, so far from brilliant, into which she was about to enter, these were not the last she was destined to shed."

One amusing footnote: When the novel first appeared in 1886, William James, Henry's brother, took special exception to the characterization of Miss Birdseye ("a confused, entangled, inconsequent, discursive woman"), seeing it as an attack on Elizabeth Peabody, a member of the Transcendentalists and an activist in all sorts of good causes. Not only is Miss Tandy's radiant Miss Birdseye seen in a far more appreciative light, but Mrs. Jhabvala at one point has Olive finishing a long letter to "Miss Peabody." As far as I can find, this is the only reference to Elizabeth Peabody in the film so, I suppose, it might be a way of placating Henry's critical brother.

I suspect there will be much more to be said about this film in the weeks and months to come. In the meantime, rank it among the finest film adaptations of a classic novel that anyone has yet made. ■

1984 Ag 5, II:15:1

Nelly Frijda and a policeman are seen in the Dutch film "A Question of Silence."

A QUESTION OF SILENCE ("De Stilte Rond Christine M."), written and directed by Marleen Gorris (Dutch with English subtitles); camera by Frans Bromet; edited by Hans van Dongen; music by Lodewijk de Boer; produced by Mathijs van Heijningen, Sigma Films; a Quartet Films release. At the Waverly Theater, Avenue of the Americas and Third Street. Running time: 92 minutes. This film has no rating.

Court AppointeeCox Habbema
Christina M.Edda Barends
Waitress ..Nelly Frijda
SecretaryHenriette Tol
Ruud ..Edyy Brugman
Boutique ManagerDolf de Vries
Police InspectorCees Coolen
PathologistOnno Molenkamp
Judge ..Hans Croiset

"A Question of Silence" was shown as part of 1983's New Directors/New Films Series. Following are excerpts from Janet Maslin's review, which appeared in The New York Times on March 18, 1983. The film opens today at the Waverly Theater, Avenue of the Americas and Third Street.

The feminist cause will not be well-served by "A Question of Silence," a Dutch film that tells of three women who stomp, kick and pummel to death a male shopkeeper.

The incident is triggered when one of the women tries furtively to steal some merchandise. The manager sees her and is all set to chastise her, when two other female patrons, who don't know the first woman and don't know the manager either, defiantly pocket some merchandise to show her their solidarity. At this, the manager breaks into a cold sweat, and no wonder. Moments afterward, he is beaten to a pulp.

Why? Well, apparently because he is a man, and the three shoppers have all been ill-treated by other men they know. "Do you think there are people who won't think you are mad?" asks the female psychiatrist who has been appointed to study this case, and from whose point of view the film is presented. "Yes," says one of the accused. "Women." Sure enough, female spectators in the courtroom where this case is eventually tried greet the women's testimony with applause.

"A Question of Silence," which was written and directed by Marleen Gorris, may not be part of any commonplace genre. But that doesn't keep it from being predictable. The three suspects themselves, who are described more than once as "ordinary" women, are a beleaguered mother, a nice, middle-aged woman who likes to knit, and a secretary who resents her boss. The psychiatrist, who is first shown to be very happy with her husband, grows to hate him during the course of the story, and finds herself attracted to the most bold and outspoken of her patients. On her desk, she prominently displays a book by Doris Lessing.

1984 Ag 5, 44:6

Polyurethane Dreams

THE WHOLE SHOOTIN' MATCH, directed by Eagle Pennell; written and produced by Mr. Pennell and Lin Sutherland; camera and music by Mr. Pennell; art director, Jim Rexrode; executive producer, John Jenkins; released by New Line Cinema. At the Bleecker Street Cinema. Running time: 101 minutes.

Lloyd ..Lou Perry
Frank ..Sonny Davis
PauletteDoris Hargrave
Olan ..Eric Henshaw
T. FrankDavid Weber
Old ManJames Harrell

"The Whole Shootin' Match" was shown as part of the 1979 New Directors/New Films Series. Following are excerpts from Vincent Canby's review, which appeared in The New York Times on April 21, 1979. The film opens today at the Bleecker Street Cinema, near Thompson Street.

LLOYD (Lou Perry), who looks like a younger Sam Pickens, and Frank (Sonny Davis), whose hair is receding with increasing speed as he approaches his mid 30's, are not losers in any tragic sense. They simply dream beyond their means. Though they live in rural Texas, they (like the rest of us) are subjected to a constant barrage of hype designed to make them dissatisfied with their lives. By the time that Eagle Pennell's "Whole Shootin' Match" opens, they've already failed as farmers of frogs, of chinchillas and of flying squirrels, and they're ready to chance their fortunes once again, this time in the polyurethane business. As Lloyd points out, "There's money to be made from rich hippies who like to spread (polyurethane) all over their houses."

"The Whole Shootin' Match," the first feature to be directed by the 25-year-old Mr. Pennell, is a loving, indulgent, funny, very casual movie about the ups and downs of a couple of innocent, self-defeating American clowns.

"The Whole Shootin' Match" is often a technical mess, but never for a moment is it out of control. Even the clumsiness of the photography works as a reflection of the sort of lives led by its characters. When someone walks off screen, it's as if the camera couldn't keep up or had been distracted by something of less importance. The sepia print is faded in the way of jeans that have been left too long in the sun.

The outcomes of Lloyd and Frank's various get-rich-quick schemes are predictable enough, but far from predictable are Mr. Pennell's feelings for his characters and the performances he obtains from his actors. These are both surprising and invigorating.

Mr. Perry and Mr. Davis are fine as the bumbling entrepreneurs and Doris Hargrave is terrifically appealing as Frank's frequently forgotten wife, a former high-school beauty who suspects she married the wrong man, but makes do with a lot of good humor, sex and a newfound faith in Jesus.

"The Whole Shootin' Match" reportedly cost $30,000. It sometimes looks it, yet the movie has something 9 out of 10 far more expensive features don't have — a way of getting in touch with life.

1984 Ag 8, C16:6

Rocky With Hoofs

PHAR LAP, directed by Simon Wincer; screenplay by David Williamson; director of photography, Russell Boyd; edited by Tony Paterson; music by Bruce Rowland; produced by John Sexton; released by 20th Century-Fox. At the Loews Tower East, Third Avenue and 71st Street. Running time: 107 minutes. This film is rated PG.

Tommy WoodcockTom Burlinson
Dave DavisRon Leibman
Harry TelfordMartin Vaughan
Bea Davis ..Judy Morris
Vi TelfordCelia De Burgh
Cashy MartinRichard Morgan

THE movie "Phar Lap" is as much of a crowd pleaser as the champion Australian race horse for whom it is named. In a gently rousing style that should appeal in equal measure to adults and children, it tells of the rise of this legendary prize winner, who was something of a four-legged Rocky. "Phar Lap" isn't a surprising movie; it has too much dialogue on the order of "That horse is going to be a champion — can't anyone understand that? He's going to be a champion!" for that. But in its own way, it's a winner.

About a half-hour into "Phar Lap," which opens today at Loews Tower East, it becomes clear to the audience that this heroic horse simply isn't going to lose. From the early scenes in which the New Zealand-born Phar Lap (whose name is a phonetic spelling of the Thai word for "lightning") arrives in Melbourne, the film quickly progresses toward his early racing victories, which are excitingly recreated. But after this is established, the film needs to generate interest in other ways, and it does so. Some of that revolves around the relationships between Phar Lap's owner (Ron Leibman), his trainer (Martin Vaughan) and the stableboy (Tom Burlinson), who understan' Phar Lap best, and whom the hor really does seem to love.

Some of the film also concerns the racing-world attitudes that eventually cause trouble for Phar Lap. As someone tells Dave Davis, the owner played by Mr. Leibman, after his champion has won one race too many: "Look Dave, if something's good that's O.K. But if something's too good, that upsets the entire system." Phar Lap died under mysterious circumstances after his biggest victory, at Agua Caliente in Mexico on April 5, 1932. And that event, as presented by the movie, will leave not

Tom Burlinson aboard the horse chosen to play Phar Lap

a dry eye in the house.

"Phar Lap" generates a lot of what would have to be called human interest, even if much of it is about a horse. The affection between Phar Lap and young Tommy Woodcock (Mr. Burlinson) is touchingly rendered, from the way Tommy has his own nickname for his charge (Bobby) to the way Phar Lap eats the shirts of any other stableboys who try to touch him. The battle of wills between kindly Tommy and the trainer Harry Telford (Mr. Vaughan) is also captured nicely; Telford believes in training the horse mercilessly, whereas Tommy takes a more sympathetic approach. Mr. Leibman's Dave Davis is the slangy (and somewhat anachronistic) high roller of the story, on which the real Mr. Woodcock served as a technical adviser. Mr. Leibman makes Davis quite abrasive at times, but he's also a relief from the film's occasional tendency toward sugar coating.

As directed by Simon Wincer, "Phar Lap" sounds a predictable but effective note; when a jockey declares, "If anything catches us today, mate, it'll have to have wings," the audience can't help finding him stirring. Mr. Wincer's most noticeable failing is in too often pre-empting the audience's growing excitement. The soundtrack tends to swell with victory music long before Phar Lap has actually won his races, for instance. And Tommy Woodcock is seen beaming with pride before Phar Lap ever pulls into the lead. And this racing movie, like any racing movie, would be much more thrilling if its races were not filmed partly in slow motion.

●

"Phar Lap" is rated PG ("Parental Guidance Suggested"). It contains occasional strong language.

Janet Maslin

1984 Ag 10, C8:1

Apocalypse Again

RED DAWN, directed by John Milius; screenplay by Kevin Reynolds and John Milius; director of photography, Ric Waite; edited by Thom Noble; music by Basil Poledouris; produced by Buzz Feitshans and Barry Beckerman; released by MGM/UA Entertainment Company. Running time: 114 minutes. This film is rated PG.
Jed	Patrick Swayze
Robert	C. Thomas Howell
Erica	Lea Thompson
Matt	Charlie Sheen
Daryl	Darren Dalton
Toni	Jennifer Grey

By JANET MASLIN

TO any sniveling lily-livers who suppose that John Milius, having produced "Uncommon Valor," directed "Conan the Barbarian" and written "Apocalypse Now," has already reached the pinnacle of movie-making machismo, a warning: Mr. Milius's "Red Dawn" is more rip-roaring than anything he has done before. Here is Mr. Milius at his most alarming, delivering a rootin'-tootin' scenario for World War III.

The place: a small, all-American town. The time: sooner than you think, mister. A history teacher is telling his class about Ghenghis Khan, when he looks out the window and sees enemy parachutists landing. We learn from a 15-second preamble that the United States has lost all its allies, and that the Soviet Union is badly in need of food. Soon enough, we see, beneath a bumper sticker that says "They can have my gun when they pry it from my cold dead fingers," the corpse of a American citizen, being relieved of his weapon by an invading soldier.

In Calumet, Colo., where the action takes place, a band of brave high-school boys heads for the mountains, taking with them bows and arrows and lots of Coca-Cola. They hide out for awhile, initiating themselves in the ways of the wild — drinking the blood of a deer they kill, for instance, or urinating into the radiator of their truck when it runs out of water. Eventually, they are ready to infiltrate Calumet's Main Street, and what they see there is horrible. The citizens have been rounded up in a detention camp, which used to be the local drive-in. The drugstore's supplies are so depleted that there's only one lone bottle of Charlie on the shelves. The movie theater is playing "Alexander Nevsky."

The band of teen-agers, calling themselves the Wolverines, after the town's football team, and joined by two girls whose grandfather refers to them as "my heirlooms," begins a guerrilla war against the invaders, some of whom are Cuban and Nicaraguan.

The rest of the film follows the course of this fateful struggle and is confined to Calumet, with only occasional news bulletins from "Free America," as much of the country is now known. An outsider the kids encounter tells them what's happening in Denver, for instance: "They live on rats and sawdust bread and, sometimes, on each other." This same outsider, asked "Who's on our side?" by one Wolverine, replies, "Six hundred million screamin' Chinamen."

"Last I heard there were a *billion* screamin' Chinamen," the Wolverine answers.

"There were" is the grim reply.

●

"Red Dawn," which opens today at the National and other theaters, may be rabidly inflammatory, but it isn't dull. Mr. Milius does know how to keep a story moving. He might well have turned this into a genuinely stirring war film, if he had not also made it so incorrigibly gung-ho. But the effectiveness of its chilling premise, from a story by Kevin Reynolds, is dissipated by wildly excessive directorial fervor at every turn. Those who consider the events set forth in "Red Dawn" to be probable are no more apt to find the movie credible than those who regard them as ludicrous.

The cast of "Red Dawn" has obviously been through a lot; the production notes quote John Early, technical adviser, as saying that the actors were taught military discipline and combat techniques, and that "we took them out into the hills and ran them from sunup to sundown."

They also had a lot to contend with in the screenplay, by Mr. Reynolds and Mr. Milius, which is hard-bitten enough to be virtually unplayable at times. Powers Boothe, who delivers those bulletins from the free zone, must also declare, when asked what his wife was like, "I met her in a closet at a party. Couldn't stand her at first, but once it took, I loved her so bad it hurt."

Mr. Boothe does a good job anyway, and so does Ron O'Neal as a Cuban commander leading the Calumet occupation. Ben Johnson and Harry Dean Stanton appear very briefly, Mr. Stanton to shout, "Avenge me! Avenge me!" from behind the barbed wire at the drive-in.

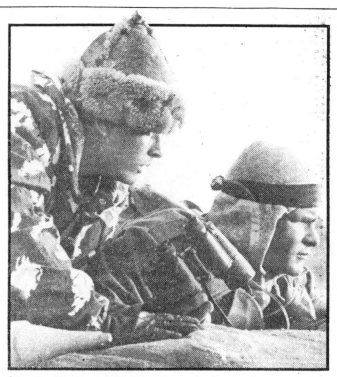

Charlie Sheen and Patrick Swayze study the terrain in "Red Dawn," John Milius's fantasy about an invasion of the United States.

The younger players, among them Patrick Swayze, C. Thomas Howell and Lea Thompson, are adequate but less memorable. Their roles consist mainly of carrying out small-scale military maneuvers and reacting to such awful spectacles as the image of a band of Calumet citizens being executed by a firing squad. They sing "America the Beautiful" just before they're shot — but their patriotism is not in question, and the movie might have been a little less overbearing without the song.

●

"Red Dawn" is rated PG ("Parental Guidance Suggested"). It contains considerable violence, most of it not very explicit.

1984 Ag 10, C11:1

CORRECTION

A review of the film "Red Dawn" yesterday gave its rating incorrectly. It is PG-13.

1984 Ag 11, 25:6

A Star Was Born

MY NAME IS ANNA MAGNANI, directed by Chris Vermorcken; screenplay by Leonor Fini and Liliane Becker; photography by Jan Franco Transunto and Rufus J. Bohez; edited by Eva Houdova; music by Willy De Maesschalck; released by Interama. At the Thalia, 95th Street, near Broadway. Running time: 100 minutes. This film is not rated.
Anna Magnani (in film clips)
Vittorio De Sica
Roberto Rossellini
Luchino Visconti
Pier Paolo Pasolini
Claude Autant-Lara
Federico Fellini

"MY NAME IS ANNA MAGNANI," the first feature film directed by Chris Vermorcken, a Belgian woman, is an adequate but not particularly illuminating documentary on the life and work of the now-legendary Italian actress who died in 1973. The best thing about it is that it can be seen — at the Thalia, starting today — on a double bill with Roberto Rossellini's "Open City," which contains one of the greatest of all Magnani performances.

The film is informative about the actress's early career in the theater, but it can't possibly do more than report how others feel about her talent. Among those who talk about Magnani are Rossellini, Federico Fellini, Luchino Visconti, Claude Autant-Lara, Marco Bellochio, Franco Zeffirelli, Marcello Mastroianni, Laura Betti and, most effectively, Eduardo De Filippo, the playwright and director.

Much of the film is devoted to a long, not-great interview with the actress, in which she is solemnly asked questions that would not weight down a fan magazine, and which elicit the expected responses. Supplementing this material are clips from Magnani films, the best being from her work with Rossellini and from Jean Renoir's great "Golden Coach."

Vincent Canby

1984 Ag 10, C12:4

Cybernetic Sleuthing

CLOAK AND DAGGER, directed by Richard Franklin; screenplay by Tom Holland; director of photography, Victor J. Kemper; edited by Andrew London; music by Brian May; produced by Allan Carr; released by Universal Studios. At the Gemini, Second Avenue, at 64th Street; Warner, Broadway and 47th Street, and 86th Street East, between Second and Third Avenues. Running Time: 101 minutes. This film is rated PG.
Davey Osborne	Henry Thomas
Jack Flack-Hal Osborne	Dabney Coleman
Rice	Michael Murphy
Kim Gardener	Christina Nigra
George MacCready	John McIntire
Eunice MacCready	Jeanette Nolan

THE last thing we need right now is another movie about a boy caught up in the world of computer games — but "Cloak and Dagger," while fitting that mold, is clever and enjoyable anyhow. Some of its success is attrib-

utable to Henry Thomas's ability to make the film's game-obsessed hero absolutely convincing; Mr. Thomas appears to have taken his character, Davey Osborne, every bit as seriously as Davey takes the game of the title. But the movie's secret weapon is Dabney Coleman, who looks very dull and suburban in his role as Davey's father — and very racy in his *other* role as Davey's imaginary playmate.

As Jack Flack, international spy nonpareil, Mr. Coleman turns up in smoke-colored leather and a tilted black beret, hovering in the shadows to give Davey tactical advice at every turn. Davey has a predilection for spy melodrama anyhow and has long since made Jack Flack a regular part of his fantasy life. But Jack comes in especially handy after Davey somehow gets caught up in a *real* adventure, involving pilfered government secrets, a murdered scientist and very large villains, who are after Davey's hide. These secrets are seen in the form of computer-animated aeronautical plans, which are something new. And they are contained on a microchip, which someone has hidden inside an Atari "Cloak and Dagger" game. There seem to be at least a hundred plugs for Atari during the movie.

•

"Cloak and Dagger," which opens today at the Gemini and other theaters, has been directed very playfully by Richard Franklin, who managed to bring similar high spirits to "Psycho II." In addition to tossing in the occasional spy-movie homage (there's certainly a Hitchcock touch to Mr. Franklin's choice of villains), he has kept the story moving and the actors lively. In addition to Mr. Thomas and Mr. Coleman, who are both very good, the cast includes Bill Forsythe as a computer wizard with a keen understanding of small boys, and Michael Murphy as an insinuatingly casual heavy. John McIntire and Jeanette Nolan are also good in cameo roles. And Christina Nigra is poised and outgoing as Davey's little

Jeanette Nolan, Henry Thomas and John McIntire are thrown together in "Cloak and Dagger," about a young boy with a vivid imagination who accidentally comes upon an espionage plot.

playmate, with whom he remains in close walkie-talkie communication. Miss Nigra does a nice job here, but she serves to remind the audience how deliberately adorable most child actors are — and how exceptional is Mr. Thomas's utterly un-self-conscious gravity.

•

"Cloak and Dagger" is rated PG ("Parental Guidance Suggested"). It contains some minimal mayhem.

Janet Maslin

1984 Ag 10, C 16:1

FILM VIEW

JANET MASLIN

Movies for Every Teen-Ager's Wish

"I've been to another planet, Ma," confesses the hero of "The Last Starfighter," looking awfully pleased with himself and only the tiniest bit contrite, as if he'd put an infinitesimal nick in the family car. Breathes there any teen-ager, anywhere, who wouldn't love to stun his mother this way?

"The Last Starfighter" is about as perfect an instance of teen-age wish-fulfillment as can be found in a movie this summer — and this summer, as no one can help but notice, teen-age wish-fulfillment is everything. "The Last Starfighter" isn't exactly the best film in town, since at least one of the planets the camera zooms past resembles a matzoh ball. But in some ways it's really the most pure.

Consider, in contrast, "The Karate Kid," a movie for and about teen-agers that seems to have been made entirely by adults, and very Hollywood-minded adults at that. The "Rocky"-like premise has a scrawny, affable teen-ager named Daniel (Ralph Macchio) conquering impossible

'The Last Starfighter' is a near-perfect instance of teen-age wish fulfillment.

odds to become a karate champion. John Avildsen, who directed this and "Rocky" and is still not content to let a triumph resonate in its own way, again uses the climactic bout as an occasion to clobber his audience with a Bill Conti score.

Noisy glorification of the purely self-interested victory is standard stuff these days, and we may as well get used to it. But is it really necessary for Daniel's wise Oriental mentor, Mr. Miyagi (Pat Morita), who gives karate lessons as well as broader philosophical instruction, to present the boy with a car? Or a couple of bonsai? These dwarf trees are given to Daniel at the end of a scene in which Mr. Miyagi has been pruning the trees, which are among the half-dozen he has lovingly cultivated. Daniel asks him how he knows where to cut. Close your eyes, Mr. Miyagi tells him, and imagine a tree; then cut the real tree to match what you imagine. Daniel comes away from this not only with a little more loot, but also with the notion that self-expression is the loftiest, if not the only, esthetic standard.

Like the Ghostbusters who become magazine cover celebrities, Daniel attains a degree of success that doubtless strikes most teen-age viewers as more desirable than realistic. Even at its most calculatedly charming, "The Karate Kid" never strikes a note that isn't ambition-centered and resoundingly pre-fab. This scaled-down version of an adult success story has none of the ingenuousness that makes "The Last Starfighter" so appealing. Nor does it have the wildly unpredictable energy of another current adolescent fantasy, "Purple Rain."

Had "Purple Rain," in which the rock star Prince makes his screen debut, been directed in "Karate Kid" style, its story could easily have been made to seem just as bogus, and its hero just as self-involved. More or less fortunately, it has been directed (by Albert Magnoli) with a primitivism bordering on incompetence. The beers are

passed right in front of the camera in the night-club scenes, and the actors are often in visible danger of being beaned by the overhead mikes.

The story would seem like the same old show-biz success saga if it had been presented with any lucidity at all. But the very ineptitude of the dramatic passages in "Purple Rain" amounts to a form of spontaneity, which is part of what made "Purple Rain" last week's number one box-office success. The Kid, played by Prince, is an aspiring star with a troubled home life and a sadistic attitude towards the opposite sex (this unfortunate rough edge to the film is certainly something a more adequate director would have smoothed).

However, none of this really comes through, since the players' physical presence is enough to upstage any and all of their dialogue. Along with his co-star, Appolonia Kotero, who has a wardrobe even Frederick of Hollywood might consider on the tarty side, Prince simply parades through the movie in his finery, interrupting the dramatic monotony with frequent songs.

In the usual show business movie, a star credibly enacts the process of making it big, a star who is less believable in the story's climactic performance scenes than in the preceding drama. "Purple Rain" offers the reverse, since Prince comes to life only when on stage. And amazingly, the musical sequences have a way of lending credence, or at least interest, to the rest of what happens. The screenplay's discussion of the Kid's professional problems may be mundane, but Prince's performances have a ferocity that transcends everything around him. He genuinely seems more concerned with his own art than with the attendant celebrity or glory.

Called to the stage for an encore at the film's triumphant finale, for instance, he doesn't bask in the applause; he greets the cheers with a smirk of bemused defiance. He does give the impression, as one 16-year-old explained to another on the way out of the theater, of being "a real artist, another Jimi Hendrix. When Michael Jackson does something, you know there are a lot of guys sitting around a table making his decisions for him. Prince is the real thing. He plays his own instruments and writes his own songs and does what he wants." For all its shoddiness, "Purple Rain" lets that fierce independence come through loud and clear.

Like "Purple Rain," which takes place in a Minneapolis setting populated by stranger-looking creatures than the million dollar mutants of "Star Trek," "The Last Starfighter" brazenly reshapes the world to suit its hero. That undoubtedly has a lot to do with both films' adolescent appeal. Alex Rogan, played delightfully and a little sheepishly by Lance Guest, lives in the Starlite Starbrite trailer park with a poster of the Eiffel Tower on his wall. Apparently, he's interested in travel. He's also interested in the video game of the title, and he gets to be so good at it that he's recruited for an interplanetary war.

Who recruits him? A kindly father figure (Robert Preston) whose space ship is something like a sports car, and who whisks Alex to another world in the time it might take for a $3.40 taxi ride. Who greets him when he gets there? A partially bald female alien who nonetheless has a little blonde hair and the voice of a geisha. What happens in the trailer park while Alex is away? He gets a robot double, who amounts to a kind of unexpected twin brother and best friend. Not surprisingly, Alex also uses the robot to torment his actual younger sibling, Louis.

All of this is tailor-made to the specifications of the teen-age viewer, none of it more than the finale. What other intergalactic hero has ever returned on a spaceship to his trailer park, the better to impress his family and friends? It's typical of the movie's charming off-handedness that the neighbors, after greeting Alex warmly, start to wander off before he can even climb back on board for another adventure. Or that the mob of intergalactic citizens who cheer his victories, à la the last scene in "Star Wars," seems to consists of about six extras. After all, this is only a B movie, however appealing. And Alex, even if he's saved "hundreds of worlds, including Earth," is only a teen-age hero. ■

1984 Ag 12, II:17:1

Film-Within-a-Film

STRANGERS KISS, directed by Matthew Chapman; screenplay by Blaine Novak and Matthew Chapman; original story by Blaine Novak; director of photography, Mikhail Suslov; edited by William Carruth; music by Gato Barbieri; executive producer, Michael White; co-producer, Hercules Bellville; associate producer, Sean Ferrer; released by Orion Classics; at the Embassy 72d Street theater at Broadway. Running time 93 minutes: This film is rated R.

The DirectorPeter Coyote
Carol Redding/BettyVictoria Tennant
Stevie Blake/BillyBlaine Novak
Farris, the ProducerDan Shor
Frank SilvaRichard Romanus
ShirleyLinda Kerridge
EstobanCarlos Palomino
ScandelliVincent Palmieri
JimmyJay Rasumny
Mikey ..Jon Sloan
HanrattyArthur Adams
Tony the RoseJoseph Nipote
Miss SteinJeannette Joseph

By JANET MASLIN

THE Hollywood of 1955 is the setting for "Strangers Kiss," a film whose characters are caught up in the making of a movie and are much more concerned with behind-the-scenes machinations than with what eventually ends up on the screen. To some extent this also seems true of the makers of "Strangers Kiss" themselves, though their film has enough independence and zeal to overcome much of its myopia.

"Strangers Kiss," which opens today at the Embassy 72d Street theater, has a film noirish flavor and a lot of very peculiar touches, starting with its casting. When the Director (Peter Coyote) and his producer, Farris (Dan Shor), need a leading man for the film they are planning, we see them audition a series of actors who are all wrong for the role — only to settle on Stevie Blake (Blaine Novak). Mr. Novak's chief qualification, apparently, is that he wrote the story for "Strangers Kiss" and co-wrote the screenplay. Though he doesn't do badly in the part and eventually demonstrates an offbeat charm, he is so conspicuously miscast that the film is thrown substantially off-balance.

While making a film-within-the-film that resembles Stanley Kubrick's "Killer's Kiss," the Director encourages a romance between Stevie and Carol Redding (Victoria Tennant), who are his stars. He thinks this will generate more excitement on screen, though he also knows it will create trouble with Frank Silva

(Richard Romanus), the gangster who is Carol's possessive lover and who is financing the film to keep her happy. Carol is supposed to be the novice here and Stevie the more experienced actor. But it's another peculiarity of the casting that the beautiful Miss Tennant seems far more poised than her co-star.

"Strangers Kiss" assiduously contrasts the off-screen and on-screen relationships between Stevie and Carol, which would seem to give it the feeling of a formal exercise. But the director, Matthew Chapman, approaches his material more imaginatively than that. "Strangers Kiss" has a brisk pace and a minimum of self-consciousness, and it has been photographed by Mikhail Suslov in a sharp, arresting style. The performances are sometimes stiff, but they also have plenty of intensity.

Mr. Shor and Mr. Romanus make the most of their relatively small roles. And Mr. Coyote is outstandingly good; he has an assurance bordering on villainy as the Director and brings a shrewd sense of irony to the role. But neither the screenplay nor the performance makes it entirely clear whether the movie he's directing is supposed to be better or worse than the one we are watching.

1984 Ag 13, C19:1

Revolutionaries

HALF A LIFE, directed and written by Romain Goupil; in French with English subtitles; camera by Sophie Goupil, Jean Chiabaut and Renan Polles; edited by Françoise Prenant; produced by Marin Karmitz; released by New Line Cinema. Running time: 95 minutes. This film has no rating.
WITH: Michel Recanati and Romain Goupil

Following are excerpts from a review by Vincent Canby of "Half a Life" that appeared in The New York Times on March 27, 1983. The film, which opens today at the Film Forum, 57 Watts Street, was shown as part of the 1983 New Directors/New Films series.

ACCORDING to "Half a Life" (French title: Mourir à Trente Ans), Romain Goupil's autobiographical film-

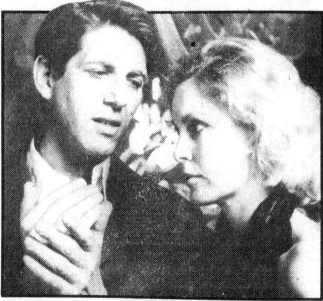

Peter Coyote plays a director and Victoria Tennant a mysterious actress in "Stranger's Kiss," set in the Hollywood of the 50's.

memoir about growing up in France in the 1960's and 70's, the 32-year-old film maker is actually two people living in invigorating disharmony within one skin.

The first Romain Goupil is — and seems always to have been — a movie nut, partly, he says, because he found at an early age that it was easier to make movies than to learn how to spell. The other Romain Goupil has been a fiery political activist since his high school days. Unfortunately for the activist, the movie maker's sense of irony and his ability to see life in long-shots continually interrupt the career of the would-be revolutionary.

When it is dealing with the movie-madness that erupted all over Europe and America in the late 60's and early 70's, "Half a Life" is one of the brightest, funniest films of its kind since Jim McBride's classic "David Holzman's Diary."

The film is also an earnest attempt to evoke the memory of Michel Recanati, Mr. Goupil's teen-age political mentor and comrade-in-arms for more than 10 years. Recanati, whom we see in footage shot by Mr. Goupil when they were parading, speaking at revolutionary-youth rallies and discussing the future of mankind at home, seems to have burned himself out before he was 30. He committed suicide in 1978, having been unable to find a place for himself in a world after the hoped-for revolution, begun in May 1968, fizzled out.

Recanati's life and death are just two of the elements in Mr. Goupil's own coming-of-age, which "Half a Life" recalls with great humor and wit through clips from his earliest home movies, newsreel footage and interviews with old friends.

There is a lot of François Truffaut's Antoine Doinel in the Romain Goupil we see in "Half a Life," especially in Mr. Goupil's inability to commit himself to any one cause for very long without seeing the other side. His film is the work of a talented, extremely self-aware new director.

1984 Ag 15, C22:5

Marital Madness

THE WOMAN IN RED, directed and written by Gene Wilder; director of photography Fred Schuler; edited by Christopher Greenburg; music by John Morris; produced by Victor Drai; released by Orion Pictures Corporation. At Loews Paramount, 61st Street and Broadway and the Beekman, 65th Street and Second Avenue. Running time: 87 minutes. This film is rated PG-13.
Theodore Pierce Gene Wilder
Buddy ... Charles Grodin
Joe .. Joseph Bologna
Ms. Milner Gilda Radner
Didi .. Judith Ivey
Michael ... Michael Huddleston
Charlotte Kelly Le Brock

By JANET MASLIN

THERE'S a curiously dated feeling to Gene Wilder's "Woman in Red," or at least a sense of dislocation: after all, lighthearted American comedies about men desperate to cheat on their wives have been more or less out of vogue since "The Seven Year Itch." Mr. Wilder's film is a remake of the 1977 French comedy "Pardon Mon Affaire," which explains some of its Gallic casualness; its hero is meant to be charmingly guilt-free, and his wife sympathetic but dim. Fortunately, most of the film is more appealing than its premise.

•

"The Woman in Red," which opens today at the Beekman and other theaters, is about Teddy Pierce, whom

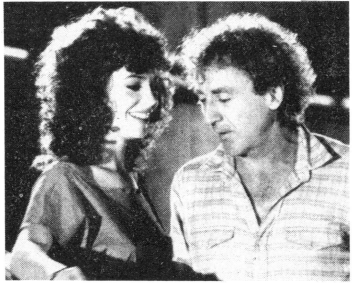

Sid Baldwin

Gene Wilder and Kelly Le Brock in the comedy "The Woman in Red," directed and written by Mr. Wilder.

Mr. Wilder has described as "just an ordinary, essentially decent guy who gets in over his head." He has a nice but unremarkable wife named Didi (Judith Ivey), a close-knit group of male buddies and a wild crush on a beautiful model named Charlotte (Kelly Le Brock). The movie concentrates on Teddy's efforts to evade his wife and a smitten but bad-tempered co-worker (Gilda Radner) and to chase Charlotte. But it is at its gentle, knowing best in scenes about men.

Joseph Bologna, Charles Grodin and Michael Huddleston play Teddy's longtime cronies, aiding him in his adultery scheme while also engaging in monkey business of their own. One of them (Mr. Huddleston) is fooling around with a surgeon's wife, whom he will visit only if her husband is performing major surgery; another (Mr. Bologna) calls his wife "my Saint Theresa" until she finds out about his philandering and strikes back. Mr. Grodin plays Teddy's closest confidant, who turns out to have a bigger secret than the movie can comfortably handle. But the revelation is followed by a lovely, low-key scene of rapprochement between him and Mr. Wilder.

Miss Ivey and Miss Radner both play straight women to Mr. Wilder's amiable Teddy, and both of them play it somewhat dumb. (Miss Ivey does a fine job and has an easier time of it than does Miss Radner, whose character is alarmingly and unflatteringly severe.) Michael Zorek is funny as the worst boyfriend anyone's teenage daughter ever had. Mr. Wilder, who has improved greatly as a director, has also written the screenplay, and done it with an eye to everyone's sympathetic foibles. But Teddy remains the principal focus. Although he operates in a near-perfect moral vacuum, he manages to do so with at least a superficial appeal.

•

Whether Teddy is taking up horseback riding to impress Charlotte or turning instant hipster with a silly new suit and hairdo, Mr. Wilder manages to make him reasonably likable. He's even more so when he comes close to getting caught, and the film contains several scenes in which his ingenuity is put to the test. In one of these, Teddy quickly rethinks his plan to get away for the evening after Didi

finds a loaded gun and accidentally shoots a hole in his underwear. In another, Teddy finally makes a date with the sultry Charlotte and arrives with her at a surprise party — given for his birthday, and attended by his entire family.

•

"The Woman in Red" is rated PG-13 (Special Parental Guidance for Children Under 13). It contains some brief nudity and a number of sexual references.

1984 Ag 15, C24:1

DREAMSCAPE, directed by Joseph Ruben; screenplay by David Loughery, Chuck Russell and Mr. Ruben; director of photography, Brian Tufano; edited by Richard Halsey; music by Maurice Jarre; produced by Bruce Cohn Curtis; released by 20th-Century Fox. At the Criterion Center, Broadway between 44th and 45th Streets, the Gotham Cinema, Third Avenue at 58th Street and other theaters. Running time: 98 minutes. This film is rated PG-13.
Alex Gardner Dennis Quaid
Paul Novotny Max von Sydow
Bob Blair Christopher Plummer
The President Eddie Albert
Jane DeVries Kate Capshaw
Tommy Ray Glatman David Patrick Kelly
Charlie Prince George Wendt

"DREAMSCAPE" is an enjoyably half-baked movie, and if it were any less farfetched it would

be less fun. Its plot concerns psychics, dream warfare and the mental health of the President of the United States who, as played by Eddie Albert, has been having nuclear-attack nightmares and is in a very bad way. "It's beginning to affect my job," the President says. "The man is falling to pieces," an associate later complains.

Not content to dabble in world politics once its psychics begin to manipulate the President's dreams, "Dreamscape" also tells the story of Alex Gardner (Dennis Quaid). Alex, according to the screenplay by David Loughery, Chuck Russell and Joseph Ruben (who also directed), is the kind of guy who keeps a saxophone lying casually around his living room, just in case he's feeling musical. He is also a former psychic who is recruited for an experiment at Thornhill College, where the scientific team includes a kindly father-figure (Max von Sydow) and his good-looking protégé (Kate Capshaw). Together, they teach Alex how to enter into other peoples' dreams.

So far, this is promising. But "Dreamscape," which opens today at the Gotham Cinema and other theaters, is mostly maladroit, without the kind of high gloss or confidence that might help carry its audience along. So it never makes enough of its dream-sharing gimmick. Instead of concentrating on suspense, for instance, the film at one point involves Alex in a low-comedy experiment about a man's dream that his wife is cheating on him, but the sequence isn't funny and it doesn't fit the rest of the story. More clever is the scene in which Alex interjects himself into an erotic dream of Dr. Jane DeVries' (Miss Capshaw), but not even this is very skillfully staged.

The presence of Miss Capshaw and Mr. Quaid's faint resemblance to Harrison Ford have led to some "Indiana Jones" lookalike advertisements for "Dreamscape," even though the two films have almost nothing in common. (A little boy with a small role in "Dreamscape" has been placed prominently in the advertisements, doubtless to suggest another similarity.) Actually, "Dreamscape" is less notable for its fantasy sequences than for the sang-froid of its two villains: Christopher Plummer as a sleekly sinister Presidential associate, and David Patrick Kelly as his psychotic henchman. Mr. Kelly is particularly good here, or at least he's particularly creepy. He has a

Christopher Plummer and Max von Sydow co-star in "Dreamscape," a science-fiction thriller about a young man with psychic powers.

nasty smile and a powerfully insinuating manner, as when he tells Mr. Plummer, "I don't touch drugs — I'm messed up enough already."

•

"Dreamscape" is rated PG-13 (Special Parental Guidance for Children Under 13). It contains a few gory dream sequences that might frighten small children.

Janet Maslin

1984 Ag 15, C24:4

Kinky Harry

TIGHTROPE, directed and written by Richard Tuggle; director of photography, Bruce Surtees; edited by Joel Cox; music by Lennie Niehaus; produced by Clint Eastwood and Fritz Manes; released by Warner Brothers. At the Movieland, 47th Street and Broadway, the Loews 83d Street Quad, on Broadway, and other theaters. Running time: 114 minutes. This film is rated R.

Wes Block	Clint Eastwood
Beryl Thibodeaux	Genevieve Bujold
Detective Molinari	Dan Hedaya
Amanda Block	Alison Eastwood
Penny Block	Jennifer Beck
Leander Rolfe	Marco St. John

By JANET MASLIN

CLINT EASTWOOD turns kinky in "Tightrope," playing a police inspector investigating a string of sex crimes and succumbing to the wiles of some of the prostitutes he questions. But it's only a temporary aberration. For the most part, "Tightrope" is a crisp thriller that is essentially faithful to the "Dirty Harry" formula, notwithstanding its attempts to give Mr. Eastwood's character what the production notes call "an added dimension of complexity." Kinks or no kinks, Mr. Eastwood does his usual turn as the most hard-boiled, relentless detective in town.

The town this time is New Orleans, and the plot seems to take Mr. Eastwood's Wes Block into every massage parlor in the French Quarter. But Wes is a homebody, too, raising two young daughters and pining for the wife who left him. (The older of the girls is played nicely by Alison Eastwood, the star's lanky blond 12-year-old daughter.)

The movie begins at a time when Wes's domestic evenings are being routinely interrupted by phone calls, each announcing that another prostitute has been murdered. The investigation brings Wes into contact with an earnest feminist named Beryl (played with energy and intelligency by Genevieve Bujold) from the city's rape-prevention center, who is eager to help catch the rapist and who is very emphatically not Wes's type.

•

The disclosure that some of the prostitutes appeal to Wes has a plot function in the screenplay (by Richard Tuggle, who also directed): Wes's activities threaten to implicate him in the murder investigation, and they make him a particular target for the killer. This side of Wes seems also to serve some larger purpose for Mr. Eastwood, and it does add an unexpected element to his otherwise impenetrable persona.

"Tightrope," which takes its title from the thin line Wes walks in trying to keep his impulses in check, spends a lot of time exploring Wes's attitudes toward women. It contrasts his relationships with the prostitutes with the relationship he develops with Beryl, and it even explores the father's feelings about his daughters' sexuality.

All of this is intriguingly if not very delicately rendered, and Mr. Eastwood plays his role earnestly. But he still is more compelling when he knits his brow and mutters some Dirty Harryism than at any other time. That's not a reflection on the caliber of his performance; it's a measure of the sheer star quality of his most unforgettable role.

•

"Tightrope" isn't quite top-level Eastwood, but it's close. The detective story isn't as intricate as it might have been, and there are a couple of awkward moments (among them a final violent flourish that may strike audiences as more laughable than scary). Still, this is a suspenseful, involving detective drama with one of the screen's most durable tough-guy heroes, doing what he does best and still managing to show something new.

1984 Ag 17, C6:1

Clint Eastwood and his daughter Alison play father and daughter in "Tightrope," about a detective hunting for a vengeful killer in New Orleans.

Primitive Romance

SHEENA, directed by John Guillermin; screenplay by David Newman and Lorenzo Semple Jr.; director of photography, Pasqualino De Santis; edited by Ray Lovejoy; music by Richard Hartley; produced by Paul Aratow; released by Columbia Pictures. At the Loews State, Broadway and 45th Street, the Loews Orpheum, 86th Street near Third Avenue, and other theaters. Running time: 117 minutes. This film is rated PG.

Sheena	Tanya Roberts
Vic Casey	Ted Wass
Fletcher	Donovan Scott
Shaman	Elizabeth of Toro
Countess Zanda	France Zobda
Prince Otwani	Trevor Thomas

"SHEENA" is the perfect summer movie for anyone who's dissatisfied with the season's intentional comedies, and who doesn't believe in looking a gift horse in the mouth. Actually, it's more like gift zebra. A zebra is what Sheena is supposed to be riding throughout the film, even though she is instead seen atop a black-and-white painted horse. This point, which is never explained, may provide some indication of just how many bats "Sheena" has in its belfry — and of why it's the funniest film in town.

"Sheena," which was directed by John Guillermin ("The Towering Inferno") and opens today at Loews State and other theaters, begins with a slow-motion credit sequence in which the scantily clad Sheena (Tanya Roberts) bounces awkwardly on her "zebra," looking mighty uncomfortable. She is accompanied by a shamelessly "Chariots of Fire"-like score. It develops that she was left in the jungle as a child and has grown up to be the foxy blond leader of a large tribe of spear-carrying African warriors. The movie's obliviousness to the sexual and racial implications of this story is absolute.

Some of "Sheena" is about a military coup in a mythical African kingdom, where the new ruler wears a satin baseball jacket, drives a snappy red convertible and has henchmen who are the fashion-page ultimate in guerrilla chic. The rest of it is about the romance between Sheena and Vic Casey (Ted Wass), a big-shot television journalist. Since Sheena is in intimate telepathic communication with everything in the animal kingdom, the courtship scenes between her and Vic tend to have unusual flourishes. When they kiss, they may just send several thousand flamingos into flight, or be interrupted by some of Sheena's elephant friends.

•

"Sheena" is less of a love story than a health club movie, since much of it is devoted to ogling the tan and muscular Miss Roberts. She is in very good shape. That, unfortunately, is the best that can be said for her performance. Although the screenplay (by David Newman and Lorenzo Semple Jr.) leans toward full-blown kitschiness, Miss Roberts makes

Tanya Roberts foils an African coup, does in a band of mercenaries and falls in love with a American television correspondent in the title role of "Sheena."

every ill-advised effort to play it straight. When the handsome, noble tribeswoman (Elizabeth of Toro) who has raised Sheena dies, for instance, Miss Roberts tries to stand by thoughtfully as a hard-working elephant digs the grave.

And when it's time to bathe, she merrily tells Vic, "You're as dirty as a warthog! Remove those strange skins you wear!" (Needless to say, Sheena has no qualms about removing skins of her own.) In leading the tribal warriors into battle, Miss Roberts addresses them as "my people" as if there were nothing even the teeniest bit incongruous about her position. The extras look understandably bewildered.

It may take place deep in the jungle, but "Sheena" still manages to incorporate quite a bit of suburban small talk. When Vic rides behind Sheena on the "zebra," he tells her that her hair smells "fantastic" and asks her what she washes it in. "Zanzan beans," Miss Roberts says pluckily. "What else would a woman use?" Soon they have settled into some form of domestic comfort, and Vic is telling Sheena of his admiration for "you — the Zamboulis — everything you've got going here."

"Sheena" isn't the kind of bad movie that makes you wish the film makers and players had done things better. They seem to have done exactly as they pleased, and made the right movie for all the wrong reasons.

•

"Sheena," which is rated PG (Parental Guidance Suggested), contains a good deal of nudity.

Janet Maslin

1984 Ag 17, C8:3

Boarding-School Life

SECRETS, directed by Gavin Millar; screenplay by Noella Smith; director of photography, Christopher Challis; edited by Eric Boyd Perkins; music by Guy Woolfenden; produced by Chris Griffin; released by the Samuel Goldwyn Company. At Quad Cinema, 13th Street between Fifth Avenue and Avenue of the Americas. Running time: 77 minutes. This film is rated R.
MotherHelen Lindsay
Doctor JefferiesJohn Horsley
LouiseAnna Campbell Jones
SydneyDaisy Cockburn
TrottieRebecca Johnson
JaneLucy Goode

By LAWRENCE VAN GELDER

WHAT marks a movie, novel or play as dated are not its costumes, events or attitudes but the point of view of the storyteller. "Secrets," an import from Britain opening today at the Quad, is a dated movie.

What illuminates this defect is a similar recent movie titled "Kipperbang." Both were originally produced for television in England as part of a series called "First Love." Both deal with adolescents in school — "Secrets" with girls at a boarding school in 1963; "Kipperbang" with students at a coeducational day school not long after World War II. Both are concerned with secret rituals: "Secrets" pivots on the possession by one student of her dead father's for-males-eyes-only Masonic ritual and on evidence of his infidelity; "kipperbang" is a code word used by an in-group at the day school, where one young man dreams incessantly of kissing a cool young beauty.

•

Both are frail stories, but "Kipperbang," which was directed by Michael Apted, generates a gentle charm that vaults the years by underscoring the visible action with a satirical narration of imagined cricket-field heroism, which lends a humorous adult perspective to the awful seriousness of that first kiss.

In "Secrets," directed by Gavin Millar, no apparent viewpoint shapes the material. The story, whose elements include a widowed mother, competition for a scholarship and suspicions of teen-age pregnancy, simply plods along, recording its events and boarding-school life in dogged fashion. No perspective of the 1980's sheds light on the mores of the 60's. Not much unfolds in "Secrets" besides monotony.

1984 Ag 17, C13:3

High-Tech Travel

THE PHILADELPHIA EXPERIMENT, directed by Stewart Raffill; screenplay by William Gray and Michael Janover; director of photography, Dick Bush; edited by Neil Travis; released by New World Pictures. At the Rivoli, Broadway and 49th Street; the Gemini, Second Avenue at 64th Street, and other theaters. Running time: 102 minutes. This film is rated PG.
DavidMichael Paré
AllisonNancy Allen
LongstreetEric Christmas
JimBobby Di Cicco
ClarkKene Holliday
Young PamelaDebra Troyer

IN view of the fact that its heroes travel from 1943 to the present and perhaps back again, it's remarkable that "The Philadelphia Experiment" contains so few surprises. It's a pleasant but fairly standard movie about a subject that's anything but. Stewart Raffill, who directed "The Adventures of the Wilderness Family," seems to be in over his head with the high-tech aspects of his story. But at least he's able to keep it moving.

Michael Paré

"The Philadelphia Experiment," which has some pretensions as "science-fact," is about tests that took place in and around the Philadelphia Navy Yard in 1943 in an attempt to develop a means of rendering Navy ships invisible to enemy radar. The results of the project are, as the phrase goes, shrouded in secrecy, and so the movie picks up where the facts leave off. It follows two young seamen named David (Michael Paré) and Jim (Bobby Di Cicco) through some fake-looking lightning effects, and then into a strange land filled with new inventions. When they wander into a bar and discover video games and pop-top soda cans, David and Jim realize just how seriously the project has gone wrong.

•

The movie, which opens today at the Rivoli and other theaters, doesn't make much of the possibilities this situation raises. David and Jim's perceptions of 1984 don't seem fresh or startling (although David does see President Reagan at a televised news conference and mutter, "I know this guy! Is this another movie?"). And the film doesn't make more than a passing effort to see what will happen when they encounter friends and relatives who have aged by 41 years. Instead, it throws David together with the friendly, helpful Allison (Nancy Allen), and along comes the predictable romance.

Nothing looks good in "The Philadephia Experiment," not even the handsome Mr. Paré. He doesn't sound good, either, speaking with a deep, nasal mumble in heavy Brooklynese. Miss Allen has a sweet, easy-going quality that's helpful, but she doesn't have much of a role. Mr. Di Cicco is very affable and outgoing, but he isn't around for long. And Louise Latham makes a brief but effective appearance as a 60-ish version of a character we've seen earlier; hers might easily have been the movie's most implausible role.

"The Philadelphia Experiment" is rated PG ("Parental Guidance Suggested"). It contains a small amount of violence and strong language.

Janet Maslin

1984 Ag 17, C17:4

MEATBALLS PART II, directed by Ken Wiederhorn; screenplay by Bruce Singer; director of photography, Donald M. Morgan; edited by George Berndt; music by Ken Harrison; produced by Tony Bishop and Stephen Poe; released by Tristar Pictures. At the Rivoli Twin, Broadway between 49th and 50th Streets, the 72d Street East, between First and Second Avenues, and other theaters. Running time: 87 minutes. This film is rated PG.

AlbertPaul Reubens
JamieArchie Hahn
CopNick Ryan
FlashJohn Mengatti
NancyTammy Taylor
CherylKim Richards

By LAWRENCE VAN GELDER

"Morons, wimps, losers," goes the most heartening line in "Meatballs Part II." It's a description — and blessedly accurate, too — of the inhabitants of Camp Sasquatch, delivered by Col. Batjack Hershy, the militaristic imbecile who runs the rival Camp Patton on the other side of the lake.

Camp Sasquatch is the setting for "Meatballs Part II," which, like some Frankenstein's monster constructed of parts of other, sometimes better movies, lurched into the Rivoli and other theaters yesterday.

Trailing bits of "Rocky" and "E.T." and using a plot device from the 1983 film "Screwballs," which itself aspired to be "Porky's," "Meatballs Part II" shares with 1979's "Meatballs" not much more than a summer camp setting.

This time — amid the efforts of two senior counselors to find sexual privacy, amid prurience and budding romance involving an innocent blonde preppy and a young punk given a choice of a counselor's job or reform school, and amid the efforts of some of the little campers to harbor an extraterrestrial — the future of Camp Sasquatch is in peril. Unless Flash, the punk, can beat Mad Dog, the Camp Patton paladin, in a boxing match to determine the annual "Champ of the Lake," Sasquatch will become the possession of Batjack Hershy. No one need lose much sleep worrying about the outcome.

Pallid writing, awkward acting, familiar situations and tired jokes make the morons, wimps and losers of "Meatballs Part II" easy to pass up.

"Meatballs Part II" is rated PG. It contains some attempts at sexual comedy and at least one vulgar word.

1984 Ag 18, 13:2

LIFE IS A BED OF ROSES, directed by Alain Resnais; screenplay (French with English subtitles) by Jean Gruault; director of photography, Bruno Nuytten; edited by Albert Jurgenson and Jean-Pierre Besnard; music by M. Philippe Gérard; produced by Philippe Dussart; distributed by International Spectrafilm Distribution Inc. At the Lincoln Plaza, Broadway between 62d and 63d Streets. Running time: 111 minutes. This film is rated PG.
Walter GuariniVittorio Gassman
Michel ForbekRuggero Raimondi
Nora WinkleGeraldine Chaplin
Livia CerasquierFanny Ardant
Robert DufresnePierre Arditi
Elisabeth RousseauSabine Azema

Following are excerpts from a review by Janet Maslin of "Life Is a Bed of Roses" that appeared in The New York Times on Sept. 29, 1983. The film was shown as part of the 1983 New York Film Festival. It opens today at the Lincoln Plaza 3, Broadway between 62d and 63d Streets.

Alain Resnais's new film "Life Is a Bed of Roses" is nothing if not elliptical. So it was fortunate that Mr. Resnais appeared after the press screening to discuss what his intentions had been. "I never had the idea that the audience should go out of the theater scratching its head and asking questions about the meaning of the film," Mr. Resnais said. He also said, "The important thing for us is that we wanted to make a comedy."

The film, which was written by the distinguished screenwriter Jean Gruault, can be humorous. But it's liable to prompt as much head-scratching as laughter. Mr. Resnais and Mr. Gruault, who also collaborated much more successfully on "Mon Oncle D'Amérique," have made a far more precious and facetious film this time, one whose purposes are often far from apparent.

•

"Life Is a Bed of Roses" exists on three levels, each of a deliberate — and at times equally delightful — eccentricity. First there is a World War I scenario, if "scenario" can properly describe the screenplay's bizarrely theatrical style. The wealthy Michel Forbek (played by the opera singer Ruggero Raimondi) announces plans to build what he calls "The Temple of Happiness," a fanciful palace that is never completed.

Enough of this cheerfully weird structure is erected, however, for Forbek to stage an experiment therein. A group of his friends are isolated in the palace, dressed in flesh-colored silk robes and delicately coaxed back into an infantile innocence, or at least that is Forbek's intention. Cries of "Love! Happiness!" accompany the experiment, most of the film's characters have the habit of bursting into saccharine song.

At what seems to be the present time, a different congregation assembles on the same spot. The castle has become an educational institution, with a staff that praises the place as "typical of early 20th-century symbolist architecture." A dashing architect (Vittorio Gassman) has another opinion. "Is that thing edible?" he asks. "It's not architecture, it's pastry."

•

Attending a weekend conference is a very naïve creature who happens to be named Miss Rousseau (Sabine Azema), and who sweetly sings "The man I'll fall in love with is not a bar of soap." (This is not the complete nonsequitur it sounds like.) Also on hand is Nora Winkle (Geraldine Chaplin), an American who appears dressed for combat and who makes a wager that she can orchestrate a love affair between two of the other participants.

Also woven through "Life Is a Bed of Roses" is a medieval pageant, pitting a king against a heroic young warrior in a fanciful landscape.

Although the film has a deliberately distancing, non-realistic style, and although its uniquely skewed logic effectively prevents the audience from trying to regard it rationally, the film winds up more purely confounding than can have been intended.

1984 Ag 19, 63:1

FILM VIEW

JANET MASLIN

Hey, Don't Forget the Audience

In theory, any filmmaker has at least a passing interest in how audiences will respond to what he or she puts on the screen. In practice, we've all had moments — sitting in a darkened theater watching something that has absolutely no bearing on any form of human experience — when that proposition seemed more than a little doubtful. There are times when filmmakers seem to be entirely without understanding of their audience, when they seem concerned only with posterity, or perhaps with one another. Whatever they're thinking of, they certainly aren't thinking of you.

What other explanation can there be for Giorgio Moroder's "Metropolis," the current dance movie that was formerly Fritz Lang's 1925-26 silent classic? In these pages two weeks ago, Mr. Moroder explained that he had had no extraordinary affinity for "Metropolis" itself. But, he said, there had been a suggestion by "someone at Paramount that I do something with a silent movie." So he looked at 20 of them before settling on Mr. Lang's futuristic parable. The film has now been retitled, slightly restructured, and fleshed out with screamy songs by such rock and roll mediocrities as Pat Benatar, Loverboy and Billy Squier.

Like other movies suffering from comparable directorial myopia, this "Metropolis" has an inadvertent effect on the viewer that's very much at odds with what Mr. Moroder must have had in mind. His intention, presumably, was to dust off the movie and galvanize the crowd. But Mr. Moroder's musical effects are so arbitrary that they don't really heighten the action. Instead, they make the audience mindful of how routinely and systematically most pop movie scores are created.

What Mr. Moroder has done here isn't so very different from what he did for "Flashdance" or for so many others: interject songs of varying quality into the action, whether they belong there or not. The banal lyrics that accompany "Metropolis" don't even attempt to reflect what is happening on the screen, and they eventually become both tiresome and irrelevant. This must indeed have been an exercise and a challenge for Mr. Moroder, but for the audience it remains mystifying. The very quiet crowd with which I saw the film seemed thoroughly baffled by the experience.

Audiences for John Milius's "Red Dawn" probably feel more shellshocked than bewildered. They may even be hopping mad, which seems a reasonable response to Mr. Milius's outrageous arm-twisting. The director, who is also the co-screenwriter, approaches his material with utter conviction and may well believe that he is trumpeting a significant warning. The threat, in this case, is that worsening global politics (outlined in a brief prelude to the film) will lead to a Soviet invasion of a small, wholesome Colorado town.

• • •

The best that can be said for "Red Dawn" is that Mr. Milius has directed it with a raving, foaming, red-blooded gusto; in other words, it isn't dull. The quiet persuasion that winning the audience's hearts and minds would entail is not what he's attempting here; he seems more eager to give the viewer a good scare, and his story indeed has the potential for that. Yet "Red Dawn" goes so far overboard that it becomes ludicrous. The town of Calumet, Colo., overrun by comic-book Communists who are held at bay by a plucky little band of high school heroes, becomes the setting for a preposterous film, not a persuasive one.

The problem again seems to be lack of insight into the audience's reaction. When Mr. Milius has one of the Wolverines (the teen-agers' self-chosen nickname) drink a ritual cup of stag's blood, does he really suppose this will do nothing more than convince viewers that the kid has moxie? This flourish and dozens of others like it give "Red Dawn" a dementedly feverish quality that amounts to a kind of energy. But they also under-

cut the already faint credibility of this virulently alarmist fable. So does the screenplay, with its gritty if implausible references to things like "people waking up with their throats cut."

At least "Sheena," which stands to become the inadvertent comedy hit of the season, isn't proselytizing. If anything, it seems blithely unaware of any larger implications to its story. Telling how Sheena, the movie's vixenish blonde heroine, becomes the spiritual and military leader of hordes of spear-carrying black tribesmen, for instance, requires a directorial innocence bordering on pure oblivion. And yet John ("The Towering Inferno") Guillermin, who directed "Sheena," is able to sustain this level of un-self-consciousness throughout the movie.

The audience is expected, I guess, to wonder how such a lovely creature as the leggy, half-dressed Sheena (played with unbelievable woodenness by Tanya Roberts) can accomplish her miraculous feats. But Sheena, from the moment she first gallops onto the screen in slow motion, riding a horse painted to look like a zebra and bouncing painfully to accentuate her heaving bosom, cuts rather a self-contradictory figure. Starting off as the mightily independent comic strip heroine on whose adventures the story is based, this Sheena soon turns into a clingy, helpless bit of fluff. All it takes is meeting the right man, in this case a white television journalist who talks a lot about winning Emmys.

"Sheena" begins with some mumbo-jumbo about "the healing earth"; this is a magical spot in which an ailing black man is immersed at the beginning of the movie, only to emerge completely cured. He is naked, which makes sense under the circumstances and attracts no particular attention. But when the film's white hero is pulled from the same spot at the end of the movie, he is no sooner above ground than someone frantically hands him a towel; soon he and Sheena are seen lounging domestically, in a jungle setting that might as well be Beverly Hills. "Sheena" winds up telling us a lot — much more than we need to know — about the filmmakers' sexual and racial attitudes, not to mention their notions of bourgeois respectability. But it offers very little in the way of old-fashioned, escapist, vine-swinging jungle adventure. And that, presumably, is what the audience was expecting. Hasn't anyone been thinking of the audience at all? ■

1984 Ag 19, II:15:1

Spy Puzzle

THE JIGSAW MAN, directed by Terence Young; screenplay by Jo Eisinger; director of photography, Freddie Francis; edited by Peter Hunt, Alan Strachan and Derek Trigg; produced by S. Benjamin Fisz; released by United Film Distribution Company. At the Rivoli, Broadway and 49th Street, Gemini, Second Avenue and 64th Street, and other theaters. Running time: 96 minutes. This film is rated PG.

Sir Philip Kimberly	Michael Caine
Adm. Sir Gerald Scaith	Laurence Olivier
Penny	Susan George
Jamie Fraser	Robert Powell
Sir James Charley	Charles Gray
Milroy	Michael Medwin
Matthews	Anthony Shaw

By LAWRENCE VAN GELDER

WITH bursts of choler and sly wit, Laurence Olivier provides a zesty centerpiece for "The Jigsaw Man," the latest in a long line of British thrillers to trade on spies, moles, double agents, defections, betrayed lovers and the long, cold war between the K.G.B. and M.I.6.

For the latest match in this staple of 20th-century entertainment, begin-

ning today at the Rivoli, Gemini and the Coliseum, players of more than ordinary interest have been assembled. Not only is there Mr. Olivier, as Adm. Sir Gerald Scaith, head of the British Secret Services, but there is also Michael Caine, playing Sir Gerald's predecessor, Sir Philip Kimberley, who long ago defected to the Soviet Union. And there are Susan George, as Sir Philip's daughter, and Robert Powell, as her lover — a man who has concealed his true profession from her.

•

On the other side of the camera is Terence Young, who directed such James Bond films as "Dr. No," "From Russia With Love" and "Thunderball." This time, Mr. Young is directing a film derived from a novel written by Dorothea Bennett, his wife.

The plot, as is customary, is convoluted. Sir Philip, the defector who has become an aging, alcoholic nuisance

Michael Caine in the British spy thriller "The Jigsaw Man."

to the Russians, is given plastic surgery and a new name, whipped into shape and dispatched to Britain to recover a microfilmed list of Soviet agents he hid long before. Certain that the Russians will kill him once he serves their purpose, Sir Philip seeks asylum upon reaching Britain, then escapes the British, demands a huge sum for his microfilm, re-enters his daughter's life and becomes the object of a manhunt by both the British and the Russians. Although the main line of the story is clear enough, truncated subplots involving homosexual lovers, old animosities, off-screen events and peripheral characters occasionally confuse matters in a way that suggests that Mr. Young was trying to preserve too much of his source material.

Nevertheless, with so many seasoned professionals involved, "The Jigsaw Man," once it gets going, moves briskly through spy literature's familiar landscape of move and countermove, enlivened by the vigor and variety of Mr. Olivier's performance.

●

"The Jigsaw Man," rated PG (Parental Guidance Suggested), contains some gamy language and the sort of violence common to its genre.

1984 Ag 24, C4:5

Seaman Ashore

IN THE WHITE CITY, directed and written by Alain Tanner; in French and Portuguese with English subtitles; director of photography, Acacio de Almeida; edited by Laurent Uhler; music by Jean-Luc Barbier; produced by Paulo Branco, Alain Tanner and Antonio Vaz Da Silva; released by Gray City. At the Cinema Studio, Broadway near 66th Street. Running time: 108 minutes. This film is not rated.

Paul	Bruno Ganz
Rosa	Teresa Madruga
Elisa	Julia Vonderlinn
Hotel Owner	Jose Carvalho
Thief	Francisco Baiao
Second Thief	Jose Wallenstein
Waiter in Bar	Victor Costa

"In the White City" was shown at last year's New York Film Festival. Following are excerpts from Vincent Canby's review, which appeared in The New York Times Sept. 26, 1983. The film opens today at the Cinema Studio, Broadway near 66th Street.

"IN THE WHITE CITY," the new film by the Swiss director Alain Tanner ("La Salamandre," "Jonah Who Will Be 25 in the Year 2000," among others), is set in Lisbon, but the city of the title is less a particular place than a series of states of mind.

Paul, an engineer aboard an oil

tanker, goes ashore for a couple of days and, when his ship is ready to sail, stays on at his hotel overlooking the harbor. At first, he spends his days walking around the city taking movies with his Super-8 camera. He revels in the anonymity of the foreign port. He gets drunk and into brawls. He eats and sleeps according to no particular schedule and, between drinking bouts, flirts with Rosa, who is both the hotel's chambermaid and bartender.

Paul writes letters to Elisa, his girlfriend back home in Switzerland, and sends her his home movies, which are mostly impersonal records of streets, building facades and unknown people going about ordinary tasks. Quite soon, Paul seems on the point of losing all contact with the world of routine and responsibility.

●

In the course of "In the White City" Paul achieves something akin to a completely weightless state as he drifts into an affair with the pretty, gentle, far-from-foolish Rosa. The part of him that Rosa sees is a man with no hold on a past or a future that would give him direction. At the same time, there is another part of him that remains aloof from the white city.

When Paul's wallet and money are stolen, he assumes Rosa will care for him, at which point she departs. He writes Elisa: "Nothing really exists for me. I'm a liar trying to tell the truth."

●

"In the White City" is full of odd and arresting moments, but it leaves no strong impression in my memory. It's not an accident — apparently — that the film carries no screenplay credit. According to the producers, it was improvised by the director and the members of the cast, which is headed by Bruno Ganz as Paul and Teresa Madruga as Rosa.

Mr. Ganz, who is known principally for his German films ("Knife in the

Helen Mirren, as the widow of an assassinated policeman, and John Lynch, as her young lover, embrace in a scene from "Cal."

Head," "The Wild Duck"), is emerging as one of the best actors in European cinema today. In this film he delivers a remarkably sharp, complex portrait of a man who sets out to explore his own essentially irrational being without losing touch with what passes for the rational world. Though "In the White City" is virtually a one-man film, Miss Madruga is also extremely good — and unpredictable — as Rosa.

Most of the film is in French, but the soundtrack also includes dialogue in German, English and Portuguese.

1984 Ag 24, C4:5

Alain Tanner's "In the White City," shown last year at the New York Film Festival, relates the experiences of a Swiss sailor who abandons ship in Lisbon.

Bittersweet

CAL, directed by Pat O'Connor; screenplay by Bernard Maclaverty; director of photography, Stuart Craig; edited by Michael Bradsell; music by Mark Knopfler; produced by Stuart Craig and David Puttnam; released by Warner Bros. and Goldcrest. At the U. A. Gemini, Second Avenue and 64th Street. Running time: 102 minutes. This film is rated R.

Marcella	Helen Mirren
Cal	John Lynch
Shamie	Donal McCann
Skeffington	John Kavanagh
Cyril Dunlop	Ray McAnally
Crilly	Stevan Rimkus

"CAL" is a beautiful, mournful movie about Northern Ireland. Though much of it takes the form of a love story, intimations of violence are everywhere. The film begins with a murder and soon cuts to a scene in a slaughterhouse, where the father of the title character is employed. Cal (John Lynch), sad-eyed and painfully thin, was himself once employed at the "abattoir" (as his father calls the slaughterhouse) but is now out of work. Instead, he has reluctantly been recruited by friends as an accessory to Irish Republican Army terrorist activities, including the killing we have already seen.

The victim was a Protestant policeman. And the demure, quiet woman (Helen Mirren) with whom Cal gradually becomes fascinated is the policeman's young widow, Marcella. Cal first spots her at the library, sees her in church, then finds some pretext for visiting the home where she lives with her prosperous in-laws. There, in a well-appointed farmhouse whose furnishings include many photographs of the British royal family, the shy, uneasy Cal is hired as a helper by the dead man's parents.

"Cal," which has been gracefully adapted by Bernard Maclaverty from his 1983 novel and equally well directed by Pat O'Connor, uses the smaller details of this story to outline the larger situation. It takes place in several well-drawn households, including the one Cal and his father, Shamie (Donal McCann), share, the only Roman Catholics in a Protestant neighborhood. "Whisperin' in our own house!" declares the father with indignation, on the night an anony-

mous, threatening letter is delivered and the two men sit up all night guarding their home. Like many of the battles waged in "Cal," this is a losing one.

At the farmhouse, Cal listens in sorrowful silence to the owners' harsh opinions of his Catholic countrymen, and to their occasional references to the murder. He wants to do penance in some way and also separate himself from the terrorists who find him a convenient accomplice. The film brings implicit religious overtones to Cal's search for redemption, but it never loses sight of the plainness and realism that are its best features.

The love story, played in gentle, gradual stages by Miss Mirren and Mr. Lynch, brings out the best in both performers. Miss Mirren, through a reserve that disappears 'layer by layer, makes Marcella a woman of unexpected substance and generosity, one who is no more comfortable with the pain and paradoxes of Northern Ireland than Cal is himself. Mr. Lynch, a good but less experienced performer with a narrower range, has simpler and more physical ways of communicating that same regret. His quiet gravity is one of the most memorable things about the movie. Another is Mark Knopfler's exceptionally lovely and haunting score.

Janet Maslin

1984 Ag 24, C6:1

Emotional Overflow

LOVE STREAMS, directed by John Cassavetes; screenplay by Ted Allan and John Cassavetes, based on a play by Ted Allan; director of photography, Al Ruban; edited by George C. Villasenor; music by Bo Harwood; produced by Menahem Golan and Yoram Globus; released by the Cannon Group Inc. At the Coronet, Third Avenue and 59th Street. Running time: 141 minutes. This film is rated PG-13.
Sarah Lawson................................Gena Rowlands
Robert HarmonJohn Cassavetes
Susan ..Diahnne Abbott
Jack LawsonSeymour Cassel
MargaritaMargaret Abbott
Albie SwansonJakob Shaw

By JANET MASLIN

THERE'S no other American director who can do what John Cassavetes does on the screen. There may not be many who would want to. Mr. Cassavetes's work, in "Love Streams," as in his earlier films, is as overflowing with emotional constructs as it is barren of other forms of thought. It's excessive and idiosyncratic all the way. Yet Mr. Cassavetes, as both actor and director, is never without his own peculiar magnetism and authority. Once again, he is able to galvanize a long, rambling, quirky psychodrama through sheer force of personality.

"Love Streams," which opens today at the Coronet, has the style, cast and concerns with which Mr. Cassavetes' devotees are familiar. The director stars as Robert, a famous author who is "writing a book on night life," which means that he's a kind of den father to a household full of clean-cut young prostitutes and that his nights on the town often leave him drunk, bruised and bloody. Gena Rowlands plays Sarah, a self-proclaimed "very happy person" who likes to visit sick relatives — anyone's relatives — and is fragile enough to have lately been institutionalized. Their stories remain parallel for the film's first hour, but they run together when Sarah comes to stay at Robert's house. It is gradually revealed that she is his sister.

The second half of the film, in which this new closeness between Robert and Sarah accentuates their neuroses, has a different tone from the first half, which is all exposition. It takes a while for Mr. Cassavetes (who wrote the screenplay with Ted Allan, based on Mr. Allan's play) to introduce a number of subsidiary characters. Among them are the sultry nightclub singer (Diahnne Abbott) whom Robert pursues desperately and just as desperately abandons; the 8-year-old son (Jakob Shaw) who pays Robert an unexpected visit ("I haven't seen him since he was born; we were just going over old times," the father casually explains), and Sarah's husband (Seymour Cassel), whom she calls to tell brightly: "Jack? I'm almost not crazy now." The real drama barely involves these people at all. It centers on Robert and Sarah, who are meant to be seen as two sides of the same coin.

Because Mr. Cassavetes is so much better equipped to consider his characters individually than in tandem, because his speciality is the long close-up monologue rather than the dialogue or the reaction, "Love Streams" is more successful in sketching Robert and Sarah separately than in bringing them together. Once they meet, the film gives itself over to outlandish devices, like an operetta fantasy in which Sarah sings to her husband and daughter about the breakup of their family, and to outlandish humor. There is the moment, for instance, when Sarah decides Robert needs something to love and brings him home two miniature horses, a goat, a parrot, a duck, some chickens and a very large dog. The spectacle of Sarah arriving at Robert's place with most of these creatures in a single taxi is funny enough. But the joke goes on too long.

It is repeated several times in "Love Streams" that "love is a stream — it's continuous, it doesn't stop," and that "a beautiful woman has to offer a man her secrets." So "Love Streams" is of less interest for its verbal insights than for the offbeat energy of its best scenes. In one of these, Sarah goes alone to a bowling alley in an evening dress, bowling alone to show how cheerful she can be. Miss Rowlands is vibrant enough to make this scene appealing, rather than bizarre.

Mr. Cassavetes has a fine long sequence in which he introduces his newly discovered son to a life of casual flamboyance, whisking him off to Las Vegas and teaching him how to drink beer. The outstanding moment in Miss Rowland's performance — and in the film itself — comes when she takes a spur-of-the-moment trip to France, arriving there with fur coats, several steamer trunks, lots of shopping bags and at least a dozen other pieces of luggage. She needs a porter, but the only one available speaks no English. She tries to tell him about the bags in fractured French, but he blinks uncomprehendingly. "You can understand me if you want to," Sarah tells him then, with a definiteness that very nearly makes it true — and with the authority that much of Mr. Cassavetes's film possesses.

•

"Love Streams" is rated PG-13 (Special Parental Guidance for Those Younger Than 13). It contains a good deal of sexual suggestiveness, none of it explicit.

1984 Ag 24, C8:5

Laura Levine

Youthful friendship between two girls from different backgrounds is the subject of "Old Enough," with Neill Barry, Rainbow Harvest and Sarah Boyd.

Class Clash

OLD ENOUGH, directed and written by Marisa Silver; director of photography, Michael Ballhaus; edited by Mark Burns; music by Julian Marshall; produced by Dina Silver; released by Orion Classics. At the Embassy 72d, on Broadway. Running time: 91 minutes. This film is rated PG.
Lonnie ..Sarah Boyd
KarenRainbow Harvest
Johnny ...Neill Barry
Mr. BrucknerDanny Aiello
Mrs. BrucknerSusan Kingsley
Carla ...Roxanne Hart

LONNIE (Sarah Boyd), the barely adolescent heroine of Marisa Silver's "Old Enough," gives her age as "almost 11¾," which makes her new friend, Karen (Rainbow Harvest), seem grown up indeed. Karen is a very sexy-looking 14, and she knows about such mature things as wearing makeup and dressing to obvious advantage. Since Karen is also lower class and street-wise, she even knows how to shoplift the makeup from the local drugstore.

Lonnie, on the other hand, comes from a well-off family and knows how to pronounce "vichyssoise." "Old Enough" is a chronicle of the friendship and the culture clash that spring up between Lonnie and Karen one summer.

"Old Enough," which opens today at the Embassy 72d Street, has been sweetly directed by Miss Silver, who has a better feeling for film making and for adolescent friendships than she does for the class differences on which the story trades. The girls' families have been written (also by Miss Silver) as ethnic stereotypes; Lonnie's parents say unrelated things to each other as the maid serves breakfast, and Karen's father (Danny Aiello) sits on the sofa in his undershirt, watching television and drinking beer. Fortunately, the movie is centered on the girls themselves, and pays only minimal attention to each one's extraordinary naïveté about how the other half lives.

Both young actresses are appealing. Miss Boyd is tomboyish, with a fresh, direct manner, and the more voluptuous Miss Harvest is a beauty. The film has an especially clear understanding of the power plays that go on between girls of their age, and it follows the friendship's stages. It

works best when the two are alone, since Miss Silver's sense of how either would behave in social situations is less credible. When they both go to a dance held for Lonnie's snobbish schoolmates and Karen is given the cold shoulder, for instance, the episode seems stiff and exaggerated all around.

Still, Miss Silver is a young director who for the most part works with a lot of assurance. The superb cinematography is by Michael Ballhaus, who worked on the best-looking of Rainer Werner Fassbinder's films, and who gives this one a bright urban patina. Neill Barry is likable in what is more or less the Matt Dillon role, that of Karen's handsome, tongue-tied brother. Roxanne Hart does a nice job as the 32-year-old whom Lonnie and Karen consider a much older woman.

•

"Old Enough" is rated PG ("Parental Guidance Suggested"). It contains some profanity and sexual innuendoes.

Janet Maslin

1984 Ag 24, C10:4

OXFORD BLUES, directed and written by Robert Boris; director of photography, John Stanier; edited by Patrick Moore; music by John Du-Prez; produced by Cassian Elwes and Elliott Kastner; released by MGM/UA Entertainment Company. At the Embassy, 46th Street and Broadway, and other theaters. Running time: 96 minutes. This film is rated PG.
Nick ...Rob Lowe
Rona ..Ally Sheedy
Lady VictoriaAmanda Pays
Colin ...Julian Sands
GeordieJulian Firth
Simon ..Alan Howard

By LAWRENCE VAN GELDER

If midtown seems suddenly aswarm with figures bent under an invisible weight, they may be moviegoers taxed by the burden of credulity imposed by "Oxford Blues," which opened yesterday at the Embassy and other theaters.

Though it makes no formal pretensions toward science fiction, "Oxford Blues" is a film caught in a time warp — grafting a central character from the 1980's onto a story out of the 20's and 30's.

In it, a swaggering University of Nevada dropout from Las Vegas

named Nick Di Angelo (Rob Lowe), smitten with yearning for a beauteous Oxford student named Lady Victoria (Amanda Pays), parlays a $1,500 bribe to a computer genius, a one-night stand with a grateful divorcée and some luck at the gaming tables into a year at Oriel College.

•

Oriel College traces its origins to 1326. "Oxford Blues" may be traceable to 1938, when F. Scott Fitzgerald (though he received no screenplay credit) worked on the script of "A Yank at Oxford." "Oxford Blues," with its Gatsbyesque romance, its clash of classes, its athletic glory — (Nick, like Robert Taylor before him in "A Yank at Oxford" is a talented oarsman) — is a Fitzgerald story.

But though Oxford University's architecture and traditions may be timeless, attitudes have changed. And it is more than a little difficult to believe, in this age of the global village, that Nick could be as ignorant and insensitive toward Oxford as he is, or that Oxford would find his narcissistic brashness a novelty worthy of its vexation.

The scenery, however, is handsome, and Miss Pays is indeed the sort of beauty who might have inspired Fitzgerald. But on the subject of credible motivation, "Oxford Blues" is likely to have left him depressed.

•

"Oxford Blues" is rated PG-13, (Special Parental Guidance for Those Younger Than 13) apparently because of a four-letter word regularly used by some of the Oxonians to describe Nick and because of a couple of relatively modest sex scenes.

1984 Ag 25, 9:1

Guns and Victims

PHOENIX BIRD, directed by Jon Bang Carlsen; photographed by Alexander Gruszynski; edited by Anders Refn; produced by Ebbe Preisler. Running time: 50 minutes.
YOUR NEIGHBOR'S SON: THE MAKING OF A TORTURER, directed by Joergen Flint Pedersen and Erik Stephenson; in Greek with English subtitles; photographed by Alexander Gruszynski; edited by Peter Engleson; produced by Ebbe Preisler. At the Film Forum, 57 Watts Street. Running time: 55 minutes. These films are not rated.

By LAWRENCE VAN GELDER

THE quest for truth that tempts its seekers to employ the techniques of fiction becomes an issue in two provocative Danish films — "Phoenix Bird" and "Your Neighbor's Son: The Making of a Torturer" — opening today at the Film Forum 1.

"Phoenix Bird," the work of Jon Bang Carlsen, employs staged flashbacks and other dramatic episodes to enhance its portrait of James R. Jarrett, a Vietnam veteran and former policeman who runs the Phoenix Fire Arms Training Center in Arizona. There, Mr. Jarrett — who smokes Camels, always wears a glove on his right hand (even when sleeping), frequents topless bars and is fearful of socialism — teaches families, husbands, wives, children, how to use firearms to defend themselves. Guns, he maintains, are a guarantee of liberty.

•

Though the staged footage indisputably lends visual excitement to "Phoenix Bird," giving it the atmosphere of an adult cops-and-robbers game, the fact that it casts Mr. Jarrett as an actor makes him a collaborator in a process that should confine

him to the role of subject. And that may account for the fact that what "Phoenix Bird" seems most to need is a determination to plumb Mr. Jarrett's psyche more than to record his machismo.

As for "Your Neighbor's Son," it is an examination by Joergen Flint Pederson and Erik Stephensen of the process by which the military junta that ruled Greece from 1967 to 1974 turned seemingly decent young men into torturers.

Though some of these men themselves attest to their crimes, the film re-creates the training that brought them to a point at which they willingly brutalized their fellow men. Though the training is indeed harsh, the film's re-creation of it makes it seem but slightly crueler than the training at other military boot camps. And if not all of the men subjected to the training became torturers, might not the fictional footage have been more fruitfully exchanged for documentary inquiry in an effort to once again explain the banality of evil?

What makes "Your Neighbor's Son" memorable and unnerving, though, is the sight of one of the victims, years after his torture, half-paralyzed, groping for words to express his ordeal.

It is possible to take issue with the techniques of "Your Neighbor's Son," but it is impossible to regard its torturers or its victims without realizing that the view may be a view into a mirror.

1984 Ag 29, C19:2

Border Patrollers

FLASHPOINT, directed by William Tannen; screenplay by Dennis Shryack and Michael Butler; director of photography, Peter Moss; edited by David Garfield; music by Tangerine Dream; produced by Skip Short; released by Tri-Star Pictures. At the National, Broadway and 44th Street; 34th Street East, at Second Avenue; 86th Street East, at Third Avenue, and other theaters. Running time: 93 minutes. This film is rated R.
Logan Kris Kristofferson
Ernie .. Treat Williams
Sheriff Wells Rip Torn
Ellen .. Tess Harper
Doris .. Jean Smart

By JANET MASLIN

BOB LOGAN (Kris Kristofferson) and Ernie Wiatt (Treat Williams) are border-patrol officers in a remote part of southern Texas, which means that it is their job to find things in the desert. During the course of "Flashpoint," which opens today at the National and other theaters, they come across a drug-smuggling operation, a stalled car with two attractive women inside, and a buried jeep containing very mysterious and controversial cargo. It is this last discovery that turns "Flashpoint" from a good-humored buddy movie into a conspiracy story — a chilly, paranoid fantasy of a sort no longer fashionable on the screen.

One reason why such films have fallen from favor is the ultimate absurdity of most of the theories they propound. "Flashpoint" isn't as far gone as "Winter Kills," which is still the genre's reigning champion, and it has its provocative aspects, but it certainly makes a leap or two. That the audience will be way ahead of the screenplay (by Dennis Shryack and Michael Butler, based on a book by George La Fountaine), not to mention ahead of Logan and Wiatt, doesn't mean that the film is without its surprises. The plot takes enough hairpin turns to keep anyone guessing.

Tess Harper and Kris Kristofferson in William Tannen's "Flashpoint."

You needn't know that William Tannen, who directed "Flashpoint," is a director of commercials, with credits including the single most expensive advertisement spot ever filmed (it was for Diet Coke) to recognize his command of the advertising idiom. When the officers find a dust-covered car stalled somewhere in the desert, the camera swirls around it as loftily as if this were a brand-new Plymouth in Monument Valley. The whole movie, which was photographed by Peter Moss, looks good, even the scenes that don't have to. An opening scene of Mr. Williams in the shower, as he suffers from a hangover, is all bright, crisp, close-up visuals, in notable contrast to the wretchedness the character is supposed to be feeling.

Mr. Tannen doesn't link the film's two heroes closely, visually or otherwise; though they are supposed to be devoted friends, Mr. Kristofferson's Logan and Mr. Williams's Wiatt are individually striking but don't have much team spirit. However, Mr. Tannen's strength is his ability to grab his audience's interest quickly and to hold on to it, even by the most superficial means. Even when the movie doesn't entirely make sense, it manages to be effective.

•

As the two women who turn up in the stalled car, Tess Harper and Jean Smart have the most thankless roles. They're window dressing at best, and at worst red herrings, since the hints that they may have something to do with the conspiracy plot come to nothing. This part of the movie revolves around a group of blue-suited Government functionaries, led by the mysterious and rather overdone Carson (Kurtwood Smith), who tells Logan, "Every morning I wake up and thank God for drugs and subversion and murder — because without them we'd all be out of a job."

In the face of such cynicism, Mr. Kristofferson and Mr. Williams maintain a tough-guy geniality and an even keel. Each of them makes the most of his relatively narrow role, with Mr. Kristofferson as the seasoned pro given to salty aphorisms, and Mr. Williams as his more idealistic and arrogant young sidekick. Roberts Blossom turns up briefly but effectively as a snappish old coot living in a desert trailer. And Rip Torn has a high old time playing the local sheriff, obviously enjoying both the thickness of his accent and the vagaries of his role. In a closing scene that has him disclosing one last detail of the conspiracy, both Mr. Torn and his character just about take the cake.

1984 Ag 31, C6:5

BOLERO, directed, written and photographed by John Derek; music by Peter Bernstein and Elmer Bernstein; produced by Bo Derek; released by the Cannon Group. At Rivoli, Broadway and 49th Street; 34th Street Showplace, at Second Avenue; 86th Street Twin, at Lexington Avenue; Quad, 13th Street, west of Fifth Avenue, and other theaters. Running time: 105 minutes. This film has no rating.
Ayre McGillvary Bo Derek
Cotton Gray George Kennedy
Angel Contreras Andrea Occhipinti
Catalina Terry Ana Obregon
Paloma Olivia d'Abo
Sheik Greg Bensen
Robert Stewart Ian Cochrane
Evita Mirta Miller
Moroccan Guide Mickey Knox
Young Valentino No. 1 Paul Stacey
Young Valentino No. 2 James Stacey

By JANET MASLIN

The fact that "Bolero," which opened yesterday at the Rivoli, was threatened with an X rating will surprise anyone who sees it, especially those who go for X-rated reasons. Most of Bo Derek's antics look distinctly chaste, and when she appears *au naturel* to do something other people might do clothed — riding a horse, for instance — the effect is less erotic than inappropriate. For some reason, the movie's sex scenes, which are relatively few, have been directed as slapstick. The chief exception is a final, more graphic tryst that takes place in the clouds, with a purple neon sign behind Miss Derek reading "ecstasy."

Miss Derek hasn't exactly been miscast in "Bolero," since the plot seems very much beside the point. But there are roles that would suit her better than that of a virginal schoolgirl. The movie, which has a 1920's setting that neither the actors nor the costume designer take the least bit seriously, begins with her graduation. She celebrates this by flinging off her clothing on the college lawn, declares to a classmate "In the ways of love, we're kindergarten toddlers!" and spends the rest of the movie making strenuous efforts to remedy that situation.

•

The plot sounds like that of a straight porn film, which is what "Bolero" would have become with anyone other than John Derek direct-

Ana Obregon, Olivia d'Abo and Bo Derek frolic in "Bolero," about a wealthy young woman in the 1920's who seeks a Valentino-like lover in Spain.

ing. Mr. Derek, who also wrote the screenplay, shows off his wife in an oddly self-contradictory way. He's glad to flaunt her tanned torso and her radiant smile, which is fortunate, since these are the movie's only assets. But he has directed her to remain insufferably coy, so that the trysts are played for awkward laughs and each love scene is prefaced by an orgy of nail-biting, hair-tossing and whinnying. In one memorable scene, Miss Derek greets her bullfighter lover (as opposed to the other one, who's an Arab sheik) with a sheet covering her from head to toe, crowned with a Prussian helmet. She is dressed as a ghost, she explains, telling him "I thought you should be as scared to death as I am."

Appearing in a succession of strange but attention-getting outfits — toreador pants in one scene, a pearl bridle in another — Miss Derek remains as preternaturally gorgeous as ever. And both she and Mr. Derek display more assurance than they had in their Tarzan film, which works in their favor. But the star would be a lot more appealing if she tried less assiduously to please; a little less of her automatic, too-friendly smile would make a world of difference. Her falseness isn't helped by Mr. Derek's dialogue, which tends to sound like very bad pulp romance. "You say that we never found ecstasy — that it was like quicksilver, always promising next time," Miss Derek tells the bullfighter. "Angel, I *want* ecstasy. Let's find it!"

The rest of the cast includes an enjoyably feisty young girl (Olivia d'Abo), several men strategically chosen for looks that rival Miss Derek's and the kind of acting talents she easily outshines, and George Kennedy. Mr. Kennedy, as the gruff, kindly chauffeur who accompanies Miss Derek on her exploits, is the straight man of the year.

1984 S 1, 9:5

C.H.U.D., directed by Douglas Cheek; screenplay by Parnell Hall; story by Shepard Abbott; director of photography, Peter Stein; produced by Andrew Bonime; released by New World Pictures. At Loews State, Broadway and 45th Street; Orpheum Twin, 86th Street and Third Avenue; 83d Street Quad, at Broadway; Gramercy, 23d Street between Park and Lexington Avenues, and other theaters. Running time: 88 minutes. This film is rated R.
WITH: John Heard, Daniel Stern, Christopher Curry

By LAWRENCE VAN GELDER

In this summer when discarded alligators have been discovered maturing in local waterways, is it stretching urban paranoia too far to contemplate the existence of other strange creatures in our midst? Not for makers of horror films.

As evidence, take "C.H.U.D.," yesterday's arrival at Loews State Twin and other theaters. If you believe the advertisements, C.H.U.D. stands for cannibalistic, humanoid underground dwellers, but it is one of the pleasant revelations of this enjoyable horror film that C.H.U.D. also stands for something else. Just what else is tied closely enough to a newsworthy local controversy to lend the proper measure of credibility to the plot, whose heroes are a photographer and a model; a police captain with a missing wife and a hippie who runs a soup kitchen for the homeless, especially for those who live in such underground dens as subway and sewer tunnels. The creatures can be counted among the victims, and the villain is that veteran heavy, the United States Government.

The absolute conviction with which Daniel Stern addresses the role of the hippie, A.J., goes a long way toward making "C.H.U.D." work, and he receives a goodly measure of support from John Heard as the photographer and from Christopher Curry as the policeman. Helping matters are a knowing feel for the atmosphere of New York City, occasional flashes of wit in the script by Parnell Hall and commendable restraint (presumably by the director Douglas Cheek) in the administraition of the requisite doses

of monsters.
"C.H.U.D." makes no pretension toward serious theses about government or the environment. It is meant to be light commercial entertainment, and in the category of horror films it stands as a praiseworthy effort.

1984 S 1, 10:5

FILM VIEW

JANET MASLIN

Summer Sets the Crackpot Bubbling

In the summertime, park benches are normally the forum for crackpot theories. This season, more than the usual number of weird notions are also finding their way onto the screen. From "Dreamscape," which postulates that psychics can enter and alter other people's dreams, to "The Philadelphia Experiment," whose characters hurtle 41 years into the future because of some electromagnetic mix-up, bizarre scientific theories have abounded. And you needn't believe, say, that the household pets will multiply if they get wet, to enjoy the sheer farfetched ingenuity of such notions. Credibility matters far less than the conviction, cleverness and internal consistency with which a crackpot theory is expounded on the screen.

The truly great crackpot theories — like the notion, courtesy of "Invasion of the Body Snatchers," that there might be brainwashed replicas of one's friends and neighbors growing in a cabbage patch somewhere — have had metaphorical relevance to the times in which they appeared. So the evil-clone fantasy had Cold War overtones in its 1956 "Body Snatcher" incarnation, and incorporated elements of feminism into the mid-70's version that was "The Stepford Wives." Even Steven Spielberg's beatific space-travel movies, "E. T." and "Close Encounters of the Third Kind," spoke to some key feature of the period in which they were made, to a sense of spiritual emptiness and religious yearning. But this summer's "Gremlins" doesn't even have the broader moral underpinnings of 1982's "Poltergeist." This season's pseudoscientific fantasies have been largely self-contained, and not even the most exotic have been very far-reaching.

Among these films, it was "Gremlins" that started off with the best idea, and "Gremlins" that in some ways stopped farthest from its mark. The first part of the film held forth the promise that a prime bit of small-town Americana would be shaken to its foundations by the title monsters, once they were transmogrified from fluffballs into cackling demons. And the transformation itself was so shrewdly staged that it more or less made the movie.

• • •

But the bad gremlins, once they took over the movie as well as the town, never really lived up to their potential for inspired mischief. They had the capacity to bring to life the townsfolk's worst fantasies, and the audience's too, but they settled instead for being adorable. Gremlins that sang along with a Disney movie, as these did during one of the film's showiest sequences, were impressive on a technical level. But they had long since ceased to be diabolical.

Though there was considerable violence in the latter part of the film, "Gremlins" never really touched on anyone's deeper fears. The creatures turned up in closets and in kitchen appliances, but that sort of thing is now relatively standard. The horror didn't emerge, as it did in "Poltergeist," from ubiquitous, surprising sources like a television set or someone's dinner. Even a horrible-looking thing called "C.H.U.D.," for which I recently saw coming attractions, had a glimmer of something better geared to the audience's nightmares than "Gremlins" in its theory of weird underground creatures living in the sewer system of

a large city, and occasionally bursting forth from the manholes. "C.H.U.D." stands for "Cannibalistic Humanoid Underground Dwellers," in case anyone's interested.

"The Philadelphia Experiment" grew out of a premise that had almost as many interesting possibilities as "Gremlins" did. The movie, which purports not very convincingly to be "science-fact," starts out with a Navy experiment to render ships invisible to radar. Then, with a few bolts of fake-looking lightning, it shows that the experiment has gone haywire and transferred two startled sailors from 1943 to 1984. At this point, the film abandons all claims to credibility, but it does have a chance to examine the conditions created by time travel. Will the sailors encounter older versions of themselves, or of their loved ones? How will the future strike them? Will their actions in the future have the power to change the past? The film never gets beyond the dabbling stage with any of these questions, unfortunately. And it spends the rest of its time involving one of the sailors in a romance that, in view of the 41 years that separate the lovers, turns out to be surprisingly mundane.

• • •

For every film that never fully realizes its potential for bizarre scientific speculation, there's one that overplays its hand. That's what happens to "Dreamscape," even though it approaches its premise with a welcome playfulness that's rare in this genre. "Dreamscape" might have worked well enough as a movie about dream warfare, since it postulates a means by which psychics can disrupt the dreams of other people, and thus make trouble. It can even manage a romance between a handsome young psychic (Dennis Quaid) and a pretty scientist (Kate Capshaw), since this leads to a funny sequence in which he insinuates himself into one of her erotic dreams. (When she realizes what has happened, she wakes up understandably enraged.)

However, "Dreamscape" goes farther than it had to by giving the President bad dreams, and intimating that his precarious mental health may lead to a nuclear war. The film didn't have to go this far to scare the audience, and it winds up with too many irons in the fire. "Dreamscape" is still fun, in its jumbled way, but it didn't need Presi-

dential politics to give it weight; if anything, that extra touch makes the whole movie seem ludicrous. The lesson here — as in John Milius's "Red Dawn," which is far and away the craziest fantasy film of the season — is that a little bit of doomsday politics goes a long way, and that the case is very easily overstated. The summer has produced no more overwrought single image than the sight of a teen-age American freedom fighter, in Mr. Milius's film, practicing to liberate Communist-overrun Colorado by quaffing a hearty mugful of stag's blood.

The dismaying popularity of Mr. Milius's film, which may be attributable in part to its alarmist politics, also owes a lot to the director's obvious faith in his material and to the film's all too consistent point of view. These are the things a crackpot fantasy needs in order to sway an audience, whether the fate of America is at stake or simply (as in "The Last Starfighter") the ability of one teen-age video-game whiz to save the galaxy. Luc Beraud's "Dernier Combat" was a recent French film that postulated a post-atomic world in which human beings could no longer speak, and in which the sky would occasionally rain fishes. Without dialogue, color, expensive sets or anything fancy, Mr. Beraud was able to make this vision clear, self-contained and even suspenseful, if not particularly credible. When even the most farfetched fantasy is realized with this kind of shrewdness, it's not so very crazy at all.

1984 S 2, II:11:1

CORRECTION

The Film View column in the Arts and Leisure section last Sunday misidentified the director of the movie "Le Dernier Combat." He was Luc Besson.

1984 S 9, 2:6

Odyssey With Feeling

AMERICAN PICTURES, (Part 1) written, directed and photographed by Jacob Holdt; produced and distributed by the American Pictures Foundation. At the Film Forum, 57 Watts Street. Running time: 105 minutes. This film has no rating.

By LAWRENCE VAN GELDER

OUT of 100,000 miles of hitch-hiking across the United States, out of 3,000 photographs, out of myriad adventures in a five-year odyssey in the 1970's, a Danish self-styled vagabond named Jacob Holdt has fashioned a visually powerful examination of America's impoverished. Part I of his compilation, titled "American Pictures" and based on a slide show, opens today for a two-week run at the Film Forum.

Blacks, Indians, Chicanos — many of them living hopeless lives in tumbledown shacks where more than 350 families offered Mr. Holdt their hospitality — are the focus of his attention. At times these poor are contrasted with the wealthy who also opened their homes and their minds to Mr. Holdt, but for the most part it

Poverty is explored in "American Pictures," a documentary by Jacob Holdt, a Dane who lived with more than 300 families while hitchhiking around the United States.

is the blacks who fill his lens, his thoughts and his emotions.

When his odyssey began, Mr. Holdt was en route from Canada, where he had been working, to South America, which he hoped to visit. But he never made it. His letters home aroused such disbelief that his family sent him a camera, and Mr. Holdt, who was not a photographer, began compiling a record.

In the course of his travels, he was held up at gunpoint, he met a former slave said to be 134 years old, he ran guns for the Indians at Wounded Knee; he attended a Ku Klux Klan meeting where a cross was burned; he stayed with a black woman whose home was firebombed, apparently because of her hospitality, and whose brother burned to death in the attack.

The photographic record makes an intense impact. The story of poverty, of the lingering effects of slavery, is told at times in dulled eyes, severed limbs, filthy surroundings. But Mr. Holdt also notes that photographs cannot show hunger, nor can they show winter wind knifing through openings in the shacks where so many blacks still live. So some narration is necessary.

Narration, though, is the film's weakness. While the eloquent Mr. Holdt's compassion is commendable, he seems to have arrogated to himself the role of scold and philosopher. At times, his holier-than-thou tone grows wearisome; and at times, his generalizations (e.g., that United States reluctance to permit citizens to visit Cuba is based on fear that Americans will see that economic egalitarianism has eradicated racism) seem shallow.

But his pictures are paramount. No one can gaze upon them without agreeing that such poverty and despair should not be countenanced. It will be some measure of the tenor of the times to see whether this striking record from the sometimes-activist 70's stirs more than idle curiosity in the 80's.

1984 S 5, C16:5

Rohmer Miniature

FULL MOON IN PARIS, directed and written by Eric Rohmer (in French with English subtitles); edited by Cecile Decligis; music by Elli and Jacno; produced by Margaret Menegoz for Les Films du Losange and Les Films Ariane; released by Orion Classics. At Lincoln Plaza Cinema, Broadway, between 62d and 63d Streets. Running time: 102 minutes. This film is rated R.
Louise...............................Pascale Ogier
Octave.............................Fabrice Luchini
Remi...............................Tcheky Karyo
Bastien.........................Christian Vadim
Camille............................Virginie Thevenet
Marianne......................Anne-Severine Liotard

By VINCENT CANBY

ERIC ROHMER shoots his movies in 35 millimeter. He uses full-size actors, seen in long shots, medium shots and close-ups, mostly away from the studio in recognizable landscapes and interiors. His technology is that used by every other movie maker in the commercial cinema. Yet his films — "My Night at Maud's," "Clair's Knee," "The Marquise of O," "Pauline at the Beach," among others — look and sound like those of no other contemporary writer-director in his native France or, for that matter, anywhere else in the world.

Mr. Rohmer's films come as close as may be possible to being cinema equivalents to the great 16th- and 17th-century miniatures, which were regarded at first as "painting in small," but eventually came to be appreciated for their own esthetics, for a charm and delicacy that simply weren't possible to see in larger canvases. Mr. Rohmer's best comedies have an intimacy and precision of detail, visual, verbal and psychological, that one doesn't find in the work of any other contemporary film maker.

"Full Moon in Paris" ("Les Nuits de la Pleine Lune"), which opens today at the Lincoln Plaza, could be a small masterpiece, though to call it small is not to make reference to its size or length or even to its place on a scale of masterpieces that would include such things as "The Birth of a Nation," "Citizen Kane" and "Rules of the Game." It is small only in its

Pascale Ogier and Fabrice Luchini star in Eric Rohmer's "Full Moon in Paris."

scope, which focuses exclusively on one wonderfully headstrong, positive young woman and her pursuit of an impossible goal.

•

Louise (Pascale Ogier) knows what she wants and has no doubt that, given a reasonable amount of cooperation from the men who love her, she can attain it. Louise wants to love and to be loved and to remain free. She has no interest in promiscuity, only in social liberation.

Louise works in a minor capacity at a design firm in Paris and in her off hours, to fulfill her artistic impulses, makes quite dreadful little lamps out of various kinds of neon tubing. When first seen, she's living in a Paris suburb, a "new town" of perfect banality, in a modern apartment with her architect-lover Rémi (Tcheky Karyo) and commutes by train to her job in Paris. As much as she can, Louise loves Rémi, one of the designers of the new town. However, Rémi's possessive adoration has begun to make her uneasy.

"We're so close to being happy," Louise says with a sigh to a friend about her affair with Rémi. She is nothing if not earnest, refusing to recognize that a miss, in her case, is as good as a mile.

Their schedules don't blend well. Rémi likes to rise early, do setting-up exercises and play tennis before having breakfast and going off to the office. Louise prefers to stay up late, go to parties that bore Rémi — "dancing is bad for the circulation," he says — and meet new people, particularly new men.

She longs, she says at one point, for "the pain of loneliness." She feels hemmed in, even by her platonic, married lover Octave (Fabrice Luchini), a totally self-absorbed writer, whose self-absorption cannot comprehend why Louise, if she is bored by Rémi, continues to refuse to sleep with him. "That would ruin everything," says Louise with immense patience to the impatient Octave.

Louise is very good at convincing herself that what she does is to insure the happiness of everyone else. Rémi accepts this only with great difficulty when she announces that she has taken a small flat for herself in Paris. It will provide her with the solitude she seeks, she explains to Rémi, but, more importantly, it will mean that when she stays out late at the parties he doesn't enjoy, she won't wake him on her return to the suburbs.

As in all Rohmer films, Louise, Rémi and Octave talk well and at length, with utter sincerity, analyzing themselves and their lives thoroughly and, for the most part, wrongly.

The comedy of "Full Moon in Paris" is not knee-slapping. It grows out of these small but important contradictions between the reality of the characters' lives and the manner in which they perceive themselves. In this new film, the comedy accumulates to the point where the conclusion is both extremely funny and sorrowful, though scarcely tragic.

Miss Ogier, who is the daughter of Bulle Ogier and looks more like Bulle Ogier's sister than her daughter, is a skinny, angular beauty, with deepset, elegantly lidded eyes that express Louise's determination, foolishness, intelligence, gaiety and sadness within any single frame of film. She's the quintessential Rohmer woman.

The men in her life — none is a villain — are almost as funny and complex, especially Mr. Luchini as Octave who, in the course of a cafe rendezvous with Louise, gets so carried away by the wisdom of his own words that he must take out his notebook and write them down before he forgets them. A brief, comic appearance is made by Christian Vadim as Bastien, a sexy musician with whom Louise, up to then faithful to Remi, "goes all the way," which is how her French dialogue is translated by the English subtitles.

"Full Moon in Paris" ranks with the very best of Rohmer. Enlightened self-deception is the system in this tiny universe, and it's invigoratingly comic to behold.

1984 S 7, C5:1

Up the Mountain

THE BALLAD OF NARAYAMA, directed by Shohei Imamura; screenplay (Japanese with English subtitles) by Mr. Imamura, based on two novels by Shichiro Fukazawa; cinematography by Masao Tochizawa; music by Shinichiro Ikebe; produced by Toei Company Ltd. and Imamura Production, Tokyo. At the Festival, Fifth Avenue, near 57th Street. Running time: 129 minutes. This film has no rating.
Orin .. Sumiko Sakamoto
Tatsuhei ... Ken Ogata
Oei ... Chieko Baisho
Risuke .. Tonpei Hidari
Tamayan .. Aki Takejo
Katsuzo .. Shoichi Ozawa

"The Ballad of Narayama" was shown in this year's "New Directors / New Films" series. Following are excerpts from Vincent Canby's review, which appeared in The New York Times on April 9. The film opens today at the Festival, Fifth Avenue at 57th Street.

NATURE is so rich and the life force so rampant in Shohei Imamura's "Ballad of Narayama" that, after a screening, I was almost relieved to walk out into the manmade pollution of Times Square. Nature, thus prettified by Mr. Imamura, is almost as artifical as a world in which a virgin forest has been removed to make way for a cement-paved parking lot.

The new Japanese film, based on the same Shichiro Fukazawa stories that inspired Keisuke Kinoshita's 1958 film of the same name, means to be an ironic but life-affirming commentary on our so-called civilization by contrasting it with the manners and customs in a primitive Japanese mountain village of 100 years ago.

Existence is not easy in the mountain village. Famine always threatens. The population is controlled mainly by tossing out newborn male children to die in the rice paddies. Female babies are retained for potential childbearing. If, by chance, a village elder has not died by age 70, the eldest child must carry the old person to a secret place near the summit of Narayama, the mountain where the ancient one is left to die of starvation and exposure. In this fashion the community makes sure that there will be enough food for the survival of the rest of the villagers.

Like the Kinoshita film, Mr. Imamura's is concerned mainly with a hard-working, tough, 69-year-old woman named Orin, whose family includes two grown sons, one a widower, the other a possibly simple-minded bachelor, and assorted grandchildren. Though she's in remarkably good shape, Orin feels that it's time she made the journey to Narayama.

She's lived long enough, and she's tired. Once she has found a new wife for her widowed son, as well as a woman who will consent to make love with the other son, she insists that Tatsuhei, the widower, carry out his obligations to her, to the family and the community by making the trip up Narayama.

Mr. Imamura is not a subtle film maker. He attempts to shock the audience into the realization that though this life order is harsh, it is beautiful in an efficiency that's prompted as much by love as by material needs.

The director puts great store by visual repetitions that emphasize the oneness of all nature. When a young man and a young woman are making frantic love in a field, he shows us snakes, frogs, grasshoppers and birds engaged in similar pursuits. Unfortunately, an image of frogs, even in an amorous condition, evokes less wonder than amusement.

He's also fond of sequences that announce the changing of the seasons. The winter landscape melts toward spring and climaxes in an explosion of buds and grass, accompanied by the chirping of birds and the babbling of brooks containing frisky trout.

Though the performances are good, especially Sumiko Sakamoto's as Orin and Ken Ogata's as Tatsuhei, "The Ballad of Narayama" is too picturesque to reflect the simple austerity of the story it tells.

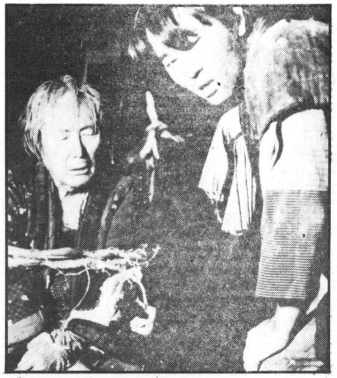

The fragile balance of life and nature is the subject of "The Ballad of Narayama," set in a remote Japanese village a hundred years ago.

The sophisticated photographic techniques have little to do with the primitive lives contained in the movie itself. The ultimate effect is not to celebrate nature, or to shock us out of our civilized lethargy, but to exploit nature in a manner designed to impress jaded audiences without actually disturbing them.

1984 S 7, C6:1

THE LAST WINTER, directed by Riki Shelach; screenplay by John Herzfeld, based on an original idea by Dan Wolman from a short script by Ruth Epstein; cinematographer, Amnon Salomon; produced by Jacob Kotzky; released by Tri Star Pictures. At D.W. Griffith, 59th Street and Second Avenue, and Greenwich Twin, Greenwich Avenue and 12th Street. Running time: 90 minutes. This film is rated R.

Maya	Yona Elian
Joyce	Kathleen Quinlan
Eddie	Stephen Macht
Sara	Zipora Peled
Col. Rosenfeld	Michael Schnider
Aaron	Avi Ruia
Michael	Brian Aaron
Unit Commander	Michael Shilo
Guest appearance	Yossi Werzanski as David
Mr. Levi	Yehuda Fux
Judith	Naoami Sharon
Corporal	Zafrir Kochonovsky

By LAWRENCE VAN GELDER

What would happen if — in the midst of war — each of two women identified the same man, seen in grainy news film of prisoners, as her husband?

This is the plot device that propels "The Last Winter," a film from Israel that opened yesterday at the D.W. Griffith and the Greenwich.

•

The women, Maya (Yona Elian), an Israeli journalist, and Joyce (Kathleen Quinlan), a somewhat haughty and spoiled-looking East Sider married to an Israeli, are among the relatives of missing Israeli soldiers who meet at a military communications center where officials are showing film of prisoners held in Egypt. "The Last Winter," directed by Riki Shelach, traces the relationship of initial hostility and eventual love generated between the two women as they wait during the Yom Kippur War of 1973 to see if either of their husbands will return.

Though "The Last Winter" may be commendable for its interest in exploring friendship between women, it is, unfortunately, a clumsily written and acted film that overstays its welcome and opts for an anticlimactic ending worthy of soap opera.

•

Characters have a way of explaining relationships and events that are obvious within the context of the film or need no elaboration: Maya begins a letter to Joyce with the words, "It's a little over a week since you left Israel." A widowed friend of Maya feels compelled to identify a man named Nathan as her husband. And various minor characters give amateurish readings to their lines.

Still, there are moments — such as the scene when the prisoners finally return — that seize the emotions; and the still-volatile politics of the Middle East make examination of the impact of war on families far from an idle exercise. One can only regret that "The Last Winter" does not carry it out with subtler, more penetrating art.

1984 S 8, 10:4

FILM VIEW

JANET MASLIN

A Tale of the Big Spectacle And the Good Little Movies

Once upon a time, in the not-too-distant future, there was an average American town. Every Friday night the people drove to the movie theater, hoping that there might be something new. But "Ghostbusters" had been there all summer. And the hit held its ground, even though all the town's elders had already seen it and the children now wore "Ghostbusters" T-shirts and knew all the words to the theme song. So on Friday evenings, the people would turn away from the theater in great sadness. They would go home, watch "Dallas" reruns and wait for "Dune," the next hit on the horizon, which was supposed to be coming at Christmastime.

This cautionary tale, chilling but true, was nearly enacted all across America this summer, and things aren't about to get better. Unless we resort to what my colleague, Vincent Canby, has called "alternative" movies and moviegoing, we can expect the cycle of fewer and bigger hit films to continue until it reaches its logical extreme. Some day there may be one new film, only one, crammed with special effects and starring Harrison Ford, and we'll have to see it or risk the consequences. If we aren't careful, the blockbuster will become the only game in town.

Alternative moviegoing is the sole means of warding off this awful prospect, and, especially in a city like New York, it shouldn't really be such a tremendous sacrifice. There happen to be a number of good, small movies around at the moment, films that crept into town with relatively little fanfare. And if they aren't on a scale with the summer's biggest spectacles that's just fine. As films about astonishing creatures go, a "Phar Lap" can't entirely outdistance "Gremlins" but it can certainly hold its own.

• • •

"Phar Lap," which hasn't yet attracted much of a following, is an old-fashioned success story that almost any audience ought to enjoy. It's a particularly good movie for children. That its hero is a horse detracts nothing from the film's human interest qualities, since Phar Lap has the Rockyesque traits we often associate with two-legged stars. Starting off as an underdog, he becomes Australia's greatest racehorse, and a great favorite with the fans. The film, which is set in the late 20's and early 30's, traces the true story of Phar Lap's meteoric rise with a simple, irresistible momentum.

There's more to the film than the horse and his triumphs, since it also depicts the unfair methods by which the racing community tried to handicap this champion. And it details the mysterious circumstances of his death in 1932. But the main thing that makes "Phar Lap" so likable is the straightforward enthusiasm with which its story is told. The love between Phar Lap and his trainer, Tommy Woodcock (Tom Burlinson), might seem hokey in a film of less obvious sincerity; here, it becomes charming. Everything you might want in a horse movie — competition, cheering crowds, rampant anthropomorphism — is here in abundant supply.

The Irish film "Cal" brings a similarly plain style to a very different subject: the conflict in Northern Ireland, as filtered through a tragic romance. What makes "Cal" so outstandingly good is the haunting delicacy with which it frames its central situation. Cal (John Lynch) is a skinny, inarticulate young man who has lost his job in a slaughterhouse, and whose prospects are in every way bleak. He and his father are Catholics living in a Protestant neighborhood, virtually in a state of siege. Cal has been pressured into playing a role in certain terrorist ac-

tivities, most notably the assassination of a Protestant policeman, but he now wants to put this behind him. That is made impossible by Cal's growing fascination with a demure, reserved older woman (Helen Mirren) who happens to be the policeman's widow.

Cal and the widow, Marcella, become closer after he is hired as a farmhand by the dead man's wealthy parents. Cal's proximity to the wife and parents of his victim, together with increasing pressure from his former cronies to resume his role as their accomplice, give the film its palpable, mounting tension. The director, Pat O'Connor, controls this masterfully, as he does the gradualness with which Cal and Marcella reveal themselves to one another. "Cal" is subtly observed, and very evocatively detailed — Stuart Craig's cinematography and Mark Knopfler's score add immeasurably to its air of quiet catastrophe. The film, like the novel by Bernard MacLaverty on which it's based, conveys Northern Ireland's agony in both individual and general terms.

The two main characters in "Cal" barely speak, but they manage to convey everything about themselves during the course of the film. In John Cassavetes's "Love Streams," Robert (Mr. Cassavetes) and Sarah (Gena Rowlands) talk incessantly and somehow reveal very little. Mr. Cassavetes, garrulous and mystifying as ever, has created another lengthy psychodrama, this one about a brother and sister who are one another's emotional opposites: she is too dependent, he is chronically noncommital. There wouldn't be enough substance here for a greeting card, let alone a two and a half hour movie, were it not for the powerful personality with which Mr. Cassavetes invests his work.

Monopolizing the camera the way he and Miss Rowlands do here may be self-indulgence of a sort, but each of them rises readily to the occasion. Both project the larger-than-life personalities that, in Mr. Cassavetes's films, take on such extraordinary magnetism. "Love Streams" isn't going to win Mr. Cassavetes new converts, but those who marvel at his cinematic sleight-of-hand will continue to do so. Even in the long, erratic format that he favors, Mr. Cassavetes manages to offer his audience frequent and attention-getting surprises.

Finally, anyone in the market for even more alternative moviegoing might consider "Cloak and Dagger," another good children's movie with a fair amount of adult appeal. Dabney Coleman's double role as a glamorous spy and a Dad in doubleknits is the film's secret weapon. And the young actor Henry Thomas makes the film's hero an ordinary boy, which is by no means an ordinary accomplishment. "Cloak and Dagger" was directed by Richard ("Psycho II") Franklin and produced by Allan Carr, who recently wrote to complain that his name hadn't been mentioned in reviews of this nice little movie. Mr. Carr noted that he had been mentioned very prominently, on the other hand, in connection with the horrid "Where the Boys Are," which he also produced. I suppose he's got a point.■

1984 S 9, II:25:5

Paging Red Brigades

A JOKE OF DESTINY, directed by Lina Wertmuller; screenplay (in Italian with English subtitles) by Miss Wertmuller and Age, story by Miss Wertmuller and Silvia D'Amico Bendico; director of photography, Camillio Bazzoni; edited by Franco Fraticelli; music by Paolo Conte; produced by Giuseppe Giovannini; released by Samuel Goldwyn Co. At the Plaza, 58th Street east of Madison Avenue. Running time: 105 minutes. This film is rated PG.

Vincenzo De Andreiis	Ugo Tognazzi
Maria Theresa	Piera Degli Esposti
Minister of the Interior	Gastone Moschin

Ugo Tognazzi in Lina Wertmuller's "Joke of Destiny"

Minister's Assistant Roberto Herlitzka
Capt. of the Digos Renzo Montagnani
Terrorist Enzo Jannacci
Adalgisa .. Valeria Golino
Young Carabiniere Massimo Wertmuller
Pot-smoking grandmother Livia Cerini
Wife of Minister Antonella D'Agostino
Maria's sister ... Pina Cei
Driver ... Pierluigi Misasi

By VINCENT CANBY

THE Italian Minister of Finance is on his way to a press conference, riding in the back of his new Japanese-manufactured, state-of-the-art, computer-controlled limousine, equipped with every known device designed to thwart Italy's state-of-the-art terrorists.

As he and his chauffeur roll — hermetically sealed — through Rome, fountains play silently outside the windows of the soundproofed limousine. Suddenly disaster strikes. The great vehicle lurches to a stop in the middle of the street, brought to heel, so to speak, not by terrorists but a malfunctioning computer.

When the chauffeur tries to get out of the car to check the engine, he finds that he and his V.I.P. passenger are locked in. Even the electronically activated windows can't be opened. At which point the Minister and the chauffeur are discovered, first by two none-too-bright carabinieri, then are followed by Vincenzo De Andreiis (Ugo Tognazzi), an ambitious Member of Parliament, whose appointment as Undersecretary of State was recently blocked by the Minister and who is the owner of the elegant villa overlooking the disaster scene.

Vincenzo, seeing an opportunity to recoup his fortunes with the trapped Minister, helps the carabinieri to push the limousine into the seclusion of his garage, while S.O.S. signals are sent out to the Secret Service, the Fiat Research Center and the Minister's aides. However, first things first: Under no circumstances is news of the breakdown to be made public. It's felt that it might embarrass the Government and invite terrorist intervention.

•

In this way, Lina Wertmuller's new political farce, "A Joke of Destiny," gets off to a flying start that turns out to be extremely short-lived. In spite of its pretentious title, the movie would seem to contain all of the sure-fire elements that make farce fun — as much for the elements that are sur-

prising as for those that are farcically obligatory.

In addition to the stuffy, enraged Minister and the craven Vincenzo, the characters include Vincenzo's bored wife; the bored wife's lover — a handsome young member of the Red Brigades who has just escaped from prison and is hiding in the villa's basement; the gardener, who's also a countertenor, and Vincenzo's pretty, 15-year-old daughter, who takes a passionate liking to the younger of the two carabinieri, asks him to deflower her and, when he resists, handcuffs herself to him and throws away the key.

The movie begins wonderfully, and one is ready to believe that the director who made "Love and Anarchy," "Swept Away" and the serio-comic classic, "Seven Beauties," is about to recoup the reputation that crashed on the rocks of "The End of the World in Our Usual Bed on a Night Full of Rain." But then the jokes that provide the film's energy slowly go as dead as the limousine's batteries.

As Vincenzo, automobile mechanics, computer experts and other low-comedy clowns attempt to free the Minister, the audience continues to laugh for a while, with increasing infrequency but with hope, as if the laughter might start the movie up again. However, it's like trying to start a Sherman tank by pushing it. By the time "A Joke of Destiny" arrives at its completely unearned, unsupported surreal conclusion, the movie has gone down as irrevocably as the most fouled-up computer system.

It's too bad. Miss Wertmuller has a talent for farce, but she negates it in her attempts to make all too obvious points about technology-gone-amok, political opportunism and individual vanity. As the film procedes, the timing also becomes more and more uncertain and the comic inventions less and less inspired until, finally, we are asked to laugh at the feeble spectacle of a marijuana-smoking grandmother.

The film looks good and the members of the cast, most of whom are unknown to me with the exception of the gracefully funny Mr. Tognazzi, are an attractive crew. Most worthy of note are Piera Degli Esposti, as Mr. Tognazzi's wife; Roberto Herlitzka as the Minister's officious assistant, and Massimo Wertmuller, the director's nephew, who plays the popeyed carabiniere suddenly beloved by Vincenzo's daughter.

This is the kind of movie that, had it been a play, might have been fixed during a long, out-of-town tryout. Instead, "A Joke of Destiny" opens today — as is — at the Plaza Theater.

•

"A Joke of Destiny," which has been rated PG ("parental guidance suggested"), contains some mildly vulgar situations.

1984 S 12, C21:1

Maori Vengeance

UTU, directed by Geoff Murphy; screenplay by Mr. Murphy and Keith Abeiden; director of photography, Graeme Cowley; film editors, Michael Horton and Ian John; music by John Charles and The New Zealand Symphony Orchestra; produced by Mr. Murphy and Don Blakeney; presented by Glitteron Films and The Pickmen Film Corporation. At the Beekman, Second Avenue and 65th Street. Running time: 104 minutes. This film is rated R.
Te Wheke Anzac Wallace
Williamson Bruno Lawrence
Colonel Elliot Tim Elliott
Lieutenant Scott Kelly Johnson
Wiremu Wi Kuki Kaa
Kura ... Tania Bristowe
Emily Williamson Ilona Rodgers
Matu .. Merata Mita
Henare .. Faenza Rueben
Puni .. Tom Poata
Vicar Martyn Sanderson
Belcher .. John Bach
Eru .. Dick Puanaki
Corporal Jones Sean Duffy

By LAWRENCE VAN GELDER

IN a virgin land under settlement by isolated farmers in the 19th century, mounted troops descend suddenly upon a peaceful native village and slaughter the inhabitants.

But the scene is not the American West, nor is the native scout who stands repelled and outraged amid the carnage and swears vengeance on the perpetrators an American Indian.

The tale that follows — of violence that begets violence, of a quest for justice and understanding among colonists and natives that reverberates to this day — is not the narrative of a Hollywood western but that of "Utu," a film from New Zealand that opens today at the Beekman.

In a week when a new exhibition of Maori art at the Metropolitan Museum illuminates a remote culture, "Utu" not only sheds further light on Maori history but, by its parallels, provides a means for seeing ourselves as others may long have seen us. On its simplest level, "Utu," set in the year 1870, resembles the cavalry and Indians movie, so stylized a staple of American film making and moviegoing that both creators and viewers were often desensitized to its essential tale of killing, dispossession and devastation of age-old civilizations. "Utu," too, is a film of unsettling violence, but its exotic setting and characters, rooted in history and coupled with the talent of the director, Geoff Murphy, make this an eloquent violence that refreshes familiar material and imbues it with emotional impact.

Cutting back and forth between the trial of the captured Maori called Te Wheke and the events that impelled him to rebel in the name of honor, "Utu" is suffused with respect for Maori customs and with regret for the excesses of colonists and Maori alike that elevate it beyond conventional adventure into a sort of lament played against a landscape of almost paradisiacal beauty.

To illustrate his cautionary tale, Mr. Murphy — who wrote the screenplay with Keith Abeiden (the policeman in "Smash Palace,") — employs an assortment of characters who, for the most part, have the grace to be complex and often unpredictable: Te Wheke himself (Anzac Wallace) who resorts to murder in responding to murder;, Lieutenant Scott (Kelly Johnson) a New Zealand-born officer whose love of country clashes at times with his sense of duty; Williamson (Bruno Lawrence, the father in "Smash Palace"), a settler who undertakes his own campaign of vengeance after his wife is killed in a Maori raid; Colonel Elliot (Tim Elliott), the brutal, pompous English officer in charge of suppressing the rebellion; Kura (Tania Bristowe), a young Maori woman whose attraction to Lieutenant Scott strains her Maori loyalties, and Wiremu (Wi Kuki Kaa), the cultivated, chess-playing Maori scout for the militia who is the repository of the ultimate justice that bridges the cultures.

Mingling history, anthropology, adventure and parable, "Utu," like "Smash Palace," is another testament to the vigor of film making in New Zealand.

1984 S 13, C21:2

The Mysterious East

THE FAMILY GAME, written and directed by Yoshimitsu Morita (Japnaese with English subtitles); based on a novel by Yohei Honma; cinematographer, Yonezo Maeda; edited by Akimasa Kawashima; produced by Shiro Sasaki and Yu Okada; a co-production of Art Theater of Japan, New Century Producers and Nikkatsu Studio; running time: 107 minutes. This film has no rating.
Yoshimoto................................Yusaku Matsuda
Mumata ...Juzo Itami
Mother ..Saori Yuki
Older Brother Junichi Tsujita
Shigeyuki Ichirota Miyagawa

"The Family Game" was shown as part of this year's "New Directors / New Films" series. Following are excerpts from Vincent Canby's review, which appeared in The New York Times on April 1. The film opens today at the Lincoln Plaza, Broadway, between 62d and 63d Streets.

"EVERYBODY in my family is too much," says a voice on the soundtrack as, during the opening credits, we see the members of that family lined up, side by side, at a narrow, possibly imported Scandinavian dining table, noisily slurping their food and sticking elbows and arms into one another's faces. They are only four — father, mother, older brother and the hero-narrator, Shigeyuki, a misunderstood teen-ager — but they look like the figures in some dreadful, bourgeois parody of the Last Supper.

With these arresting images, Yoshimitsu Morita, a new young Japanese director, opens his wickedly funny "Family Game," a stylish, deadpan comedy about Japan's comparatively affluent, utterly directionless new middle class.

"The Family Game" is not always easy to follow, but it's almost always funny and, from the opening shots until the last, it's a visual adventure. The succession of brilliantly colored, often geometric compositions satirize the worst aspects of what might be called Japan's economic modernism. Mr. Morita, 34 years old, is clearly someone to watch.

The family — it has no last name — lives in a high-rise apartment building in a flat that is spick-and-span and modern. On the walls there are one not-super Utrillo print and something that looks like a tacky souvenir bought in Cairo. Unfortunately, the flat also is so tiny that no one has any privacy.

Shigeyuki's older brother has to walk through Shigeyuki's bedroom to get to his own. When mother and father want to have a private talk, they go downstairs and sit in their Toyota.

We never are told what father does for a living, but he makes enough money so that mother doesn't have to work — she amuses herself with leather crafts — and the sons can go to the good schools. Older brother does well at his studies, but Shigeyuki is a disappointment. As the film opens, father and mother have just hired another in what has apparently been a long line of tutors for him.

"The Family Game" is mostly concerned with the confrontations between Shigeyuki and this new fellow, Yoshimoto, a good-looking, blandly arrogant, completely inscrutable university student, who, having been promised a bonus if the boy's grades improve, is not about to fail at the job. At their first session Yoshimoto asks the boy to read something aloud, which the boy does with no interest whatsoever.

"You're cute," says the tutor, betraying no sarcasm. "All those pimples — the symbol of youth." He leans over and kisses the boy's pimply cheek.

Thus begins Shigeyuki's unsentimental education, which the tutor carries out largely by keeping the boy off balance. He sometimes encourages him with words, but as often as not, he ridicules him and slaps him around. Once, when Shigeyuki concedes that he is afraid of a fellow student, the tutor teaches the boy some karate basics.

Shigeyuki's grades do improve, but "The Family Game" isn't about Shigeyuki's immediate problems. It's about the futility of education unrelated to wisdom, about appliances that save time in which to do nothing, about urban landscapes from which all references to nature have been removed.

The film's next-to-last scene — a dinner to celebrate Shigeyuki's tutor, acting as sort of avenging angel — shows the family members exactly

Yusaku Matsuda in Yoshimitsu Morita's "Family Game."

what he thinks of them. This one-man riot is the humanist's only response to the genteel inhumanism we've been witnessing throughout the film.

In addition to directing, Mr. Morita adapted the screenplay from a novel by Yohei Honma. I assume he is also responsible for the extraordinary visual design, though Yonezo Maeda was the cameraman and Katsumi Nakazawa the art director. It's risky to make predictions from just one film, but "The Family Game" is so rich that Mr. Morita would seem to be one of the most talented and original of Japan's new generation of film makers.

1984 S 14, C3:1

Memory Lane

SWANN IN LOVE, directed by Volker Schlöndorff; screenplay (French, with English subtitles) by Peter Brook, Jean-Claude Carriere and Marie-Hélène Estienne; adaptation by Mr. Schlöndorff, based on the novel "Un Amour de Swann" by Marcel Proust; photography by Sven Nykvist; music by Hans-Werner Henze; released by Orion Classics. At the Paris, 58th Street, west of Fifth Avenue. Running time: 110 minutes. This film is rated R.
Swann...Jeremy Irons
Odette de Crecy.............................Ornella Muti
Baron de Charlus.............................Alain Delon
Duchesse de Guermantes...........Fanny Ardant
Madame Verdurin.......Marie-Christine Barrault
Madame Cottard...........................Nathalie Juvet
Sous-maîtresse.............................Charlotte Kerr
Madame de Gallardon...........Philippine Pascale
Madame de Cambremer Charlotte de Turckheim
Monsieur Cottard............Jean-François Balmer
Monsieur Verdurin.............Jean-Louis Richard
Duc de Guermantes....................Jacques Boudet
Forcheville....................Roland de Chaudenay
Saniette...Bruno Thost
Biche...Roland Topor
Chloée..Ann Bennent
Young man....................................Nicolas Baby
Madame Verdurin's guest.....Catherine Lachens
Head of protocol........................Hubert Balsan
Monsieur Vinteuil.......................Jean Aurenche
Mademoiselle Vinteuil........Veronique Dietschy
Aimé...Jean-Pierre Kopf

By VINCENT CANBY

"SWANN IN LOVE" is Volker Schlöndorff's small, prettily decorated, unrevealing fragment lifted — gently and with all due respect — from Marcel Proust's monumental, seven-volume "Remembrance of Things Past."

It's as if someone had decided to copy and then recreate one of the great rooms of the chateau at Blois on the scale of a suburban, split-level ranch house. One remains more impressed by the eccentricity of the desire than by the result: a room that stands by itself without particular function and unrelated to any landscape.

"Remembrance of Things Past" is a literary work whose sheer length and multitude of characters tend to make it seem far more intimidating than it becomes, once one has made the big plunge into it. Then, suddenly, the reader, especially the reader of Terence Kilmartin's fine variation on C. K. Scott Moncrieff's original English translation, is plunged into an astonishingly vivid, enveloping world of the imagination — a reconstruction of life in the haute monde of Paris, as Proust knew it or thought it to be, from the 1880's through World War I.

•

"Swann in Love," taken mostly from Proust's first two volumes, "Swann's Way" and "Within a Budding Grove," supplemented by bits and pieces of later volumes, is the story of the tormented love of Charles Swann, a very rich member of the upper bourgeoisie and one of the few Jews to be accepted into the high society of Paris in the 1880's, for a beautiful courtesan, Odette de Crecy.

In his obsessive passion, Swann sees in Odette the qualities he admires in the female figures in paintings by the masters. She is innocent, mysterious, surprising and, perhaps most important, something to be owned and, once safely possessed, something no longer to be tormented by.

Unknown to Charles, Odette is far simpler and less mysterious than he gives her credit for being. Essentially she's a good-hearted, ambitious, uncomplicated, professional woman, who loves Charles as much as she can love anybody, which is more than he will ever believe.

In "Swann in Love," adapted by Mr. Schlöndorff from a screenplay by Peter Brook, Jean-Claude Carrière and Marie-Hélène Estienne, Mr. Schlöndorff attempts to tell the story of Swann and Odette within the frame of a single day in the life of the now aged, terminally ill Charles. In the span of this one day, Charles goes about Paris, attending salons and dinner parties, remembering, in splintery flashbacks, the events of his courtship of Odette.

As Charles pursues Odette in his memories, he is aware of being blinded by jealousy and love, while also not even liking her very much. He is humorless when she is gay, tired and without interest when she is responsive. Always he wants to know — and to forgive — everything about her other affairs, with women as well as with men. He overwhelms her and frightens her until, at last, almost as an anticlimax, he marries her.

•

The French-language film, with the English Jeremy Irons as Swann and

Jeremy Irons in "Swann in Love."

the Italian Ornella Muti as Odette, has been attractively cast. However, in spite of all Mr. Schlöndorff's efforts to make a movie that stands on its own, one that demonstrates its own style, it can never escape the sense that it's some sort of mad supersynopsis.

In addition to Mr. Irons and Miss Muti, a number of major performers have been cast in tiny supporting roles, which, considering the small scale of the film, can never be as complex as the originals, or even as complex and interesting as the actors themselves. They're without any dramatic dimension whatever.

Alain Delon, made up to look like either Alphonse or Gaston in a music-hall sketch, appears as the Baron de Charlus, the witty, womanizing esthete who, as a younger man, introduced Charles to Odette and, in the later novels, became the notorious homosexual whose reputation is probably known even to people who've never looked into "Remembrance."

At no point is Mr. Delon allowed to play the baron as the sort of person who might have been the boon companion to a man of Swann's fastidious tastes. Instead, all we see is the Charlus who powders his cheeks, wickedly eyes pretty young footmen and is rude to poor boys who resist his advances.

Marie-Christine Barrault plays Madame Verdurin, the rich, domineering salon hostess, who at first pushes Swann's cause with Odette and then, when she realizes he will never be one of her "faithful," attempts to block it. Miss Barrault is fine in her few, brief scenes, but there's virtually no characterization. There can't be. There's certainly no suggestion of the irony to come when, at last, she becomes the Princesse de Guermantes, leader of that circle she'd always scoffed at as "the bores."

Also wasted are both Fanny Ardant and the role she plays, that of the Duchesse de Guermantes, whose great fondness for Charles Swann still doesn't prevent her from warning him that if he marries "that creature," Odette will never be received in her drawing room or that of anyone else in society.

Mr. Irons is on his way to becoming a great romantic actor, on stage as well as screen, but in "Swann in Love," he behaves as if tranquillized. His anxiety looks extremely handsome, but also vacant. Miss Muti comes off better. There is just the slightest touch of the common in her beauty, the merest trace of the ordinary in her manner, both of which reflect the essential nature of the woman Charles loves without ever really knowing.

The physical production is all that money and the photography by Sven Nykvist can attain. However, the original music, by Hans Werner Henze, which includes the sonata containing "the little phrase" that is the "national anthem" of the love of Charles and Odette, suggests no period or place whatever. The director's decision to rely on original music — music to which the movie audience can have no conditioned feelings — was a bold one that doesn't work.

Mr. Schlöndorff has made some very creditable adaptations of literary works, especially "Young Törless" and "The Tin Drum," but this film is beyond him. Of all the classic or difficult novels that have been turned into movies this year, including the excellent Merchant-Ivory-Jhabvala adaptation of Henry James's "Bostonians," "Swann in Love" is the most difficult and the least satisfactory. I suspect that it's not even interesting enough to persuade people to search out the original. If you haven't read "Remembrance of Things Past," it doesn't make a great deal of sense, but, if you have, it doesn't make enough.

"Swann in Love" opens today at the Paris Theater.

1984 S 14, C4:1

Living the End

DEATH WATCH, directed by Bertrand Tavernier; screenplay by Mr. Tavernier and David Rayfiel, based on the novel "The Unsleeping Eye" by David Compton; cinematography by Pierre-William Glenn; edited by Armand Psenny and Michael Ellis; music by Antoine Duhamel; produced by Gabriel Boustani and Janine Boustani; a Selta Films-Little Bear-Antenne 2-Sara Films-Gaumont-SFP-TV 13 (Munich) co-production; released by Quartet-Films. At the Thalia, 95th Street and Broadway. Running time: 100 minutes. This film is rated PG.
Katherine Mortenhoe..............Romy Schneider
Roddy...Harvey Keitel
Vincent Ferriman..............Harry Dean Stanton
Tracey...Thérèse Liotard
Gerald Mortenhoe.....................Max von Sydow

BERTRAND TAVERNIER'S 1979 "Death Watch," which opens today at the Thalia on a double bill with Jean-Luc Godard's "Alphaville," is a muted science fiction melodrama that doesn't work very well either as science fiction or as melodrama. It may be that it's too intelligent for its own good.

The English-language film, shot entirely in Scotland by the French director, is about the efforts of some TV hustlers in the near future to create the ultimate in a human-interest television series. It's a show called "Death Watch," which seeks out people with terminal diseases, who are paid by the television company for the rights to record the last months of their lives.

At the beginning of the film, Harvey Keitel, as one of the show's star reporters, has just had his left eye replaced by a mini-camera, which not only sends back to the home studio everything he sees, but also records the sound. He's a one-eyed, audio-

Romy Schneider

visual wonder.

The subject of his current assignment is a young woman, played by Romy Schneider, who seems to be dying of that dread disease called boredom. I'm not kidding. That's what the doctor tells her. She works in a publishing house with a computer named Harriet, which composes very popular, trashy romantic novels.

The supporting cast includes Harry Dean Stanton, who doesn't seem completely at ease as the go-getting producer of the TV series, and Max von Sydow, who turns up in the closing scenes as Miss Schneider's former husband, a philisophical musicologist who lives alone — significantly — at Land's End in Cornwall. The movie is full of references like the one to Land's End, but they never produce the resonances that are promised.

Mr. Keitel and the late Miss Schneider are good, but the movie, by the man who made "The Clockmaker" and "Let Joy Reign Supreme," among other things, is a disappointment.

"Death Watch," which has been rated PG ("parental guidance suggested"), includes some vulgar language.

Vincent Canby

1984 S 14, C6:5

Planetary Plantation

THE BROTHER FROM ANOTHER PLANET, directed, written and edited by John Sayles; director of photography, Ernest Dickerson; score by Mason Daring; produced by Peggy Rajski and Maggie Renzi; released by Cinecom internatonal Films. At Embassy 72d Street, at Broadway. Running time: 110 minutes. This film has no rating.
The Brother Joe Morton
Fly .. Darryl Edwards
Odell ... Steve James
Smokey Leonard Jackson
Walter ... Bill Cobbs
Noreen Maggie Renzi
Men in Black John Sayles, David Strathairn

"THE BROTHER FROM AN-OTHER PLANET," written, directed and edited by John Sayles, is an extremely low-key comedy about the adventures of a black extraterrestrial — the "Brother" of the title — come to earth to escape slavery on Planet X.

Mr. Sayles works best in the quietly realistic, comic style of "Baby It's You," "Lianna" and "The Return of the Secaucus Seven." "The Brother From Another Planet," set in major part in Harlem, means to be fantastic

as well as funny and satiric, and from time to time, it is each of these things. Mostly, though, it's a nice, unsurprising shaggy-dog story that goes on far too long.

Among the good things in it is Joe Morton's sweet, wise, unaggressive performance as the often bewildered Brother, who has three clawlike toes on his two, pawlike feet, but otherwise looks like anybody else. He cannot speak, but he can heal wounds and fix video games simply by the touch of his hand. His silences baffle the rummy old regulars at the Harlem bar where he hangs out, but he enchants a pretty nightclub singer by his gentleness. However, she tells him after one blissful night of love, "You really must do something about those toenails."

Supporting Mr. Morton are more than a dozen character actors for whom Mr. Sayles has written some very good, wacky incidental scenes and dialogue, most of which are more entertaining than the principal plot line.

Mr. Sayles himself turns up as one of two extraterrestrial bounty hunters who arrive in Harlem in search of the escaped space slave. The film maker was funnier and far less self-conscious as the male chauvinist in "Lianna."

"The Brother From Another Planet" opens today at the Embassy 72d Street Theater.

Vincent Canby

1984 S 14, C6:5

Justics vs. Injustice

A SOLDIER'S STORY, directed by Norman Jewison; screenplay by Charles Fuller, based on his play "A Soldier's Play"; director of photography, Russell Boyd; edited by Mark Warner and Caroline Biggerstaff; music by Herbie Hancock; produced by Mr. Jewison, Ronald L. Schwary and Patrick Palmer; released by Columbia Pictures. At the Baronet, Third Avenue and 59th Street, and Guild, 33 West 50th Street. Running time: 102 minutes. This film is rated PG.
Captain Davenport.............Howard E. Rollins Jr.
Sergeant Waters Adolph Caesar
Private Wilkie Art Evans
Corporal Cobb David Alan Grier
Private Smalls David Harris
Captain Taylor Dennis Lipscomb
C. J. Memphis Larry Riley
Corporal Ellis Robert Townsend
Pfc. Peterson Denzel Washington
Private Henson William Allen Young
Big Mary Patti LaBelle
Lieutenant Byrd Wings Hauser

COMBINING mystery, history, sociology and inquiry into the psychopathology of hatred and the poison of accommodation to injustice, Charles Fuller's Pulitzer Prize-winning "Soldier's Play" has been translated to the screen under the title "A Soldier's Story."

Directed by Norman Jewison ("In the Heat of the Night") and employing not only the playwright as screenwriter but also the talents of many of the cast from the Negro Ensemble Company production that introduced the play in 1981, "A Soldier's Story," opening today at the Baronet and Guild 50th Street, proves once again to be tense drama.

•

By all indications, Mr. Jewison has remained faithful to the sturdy carpentry of the original, erected on a foundation of murder and rising to its climax on a structure of alternating investigative interrogations and flashbacks that satisfy justice by exposing those who committed the crime and serve humankind by illuminating its deeper causes.

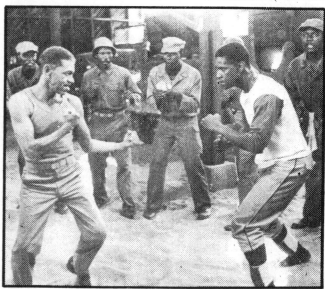

Adolph Caesar and Denzel Washington square off in "A Soldier's Story," adapted by Charles Fuller from his Pulitzer Prize-winning play.

Mr. Fuller's story takes place during World War II, at an Army base in Louisiana, where Vernon Waters, a black platoon sergeant, has been shot to death with a .45 caliber automatic while returning drunk to the base one night.

Much to the astonishment of not only the black troops in the platoon but the white officers on the base as well, a black captain — a lawyer, in fact — is dispatched from Washington in an effort to find the killer. Ku Klux Klan, suggest some of the troops. White officers, suggests a captain commanding Sergeant Waters's company. None of your business, suggests the Southern colonel who commands the base. "The worst thing you can do in this part of the country," he says, "is to pay too much attention to the death of a colored soldier under mysterious circumstances."

But Capt. Richard Davenport, played by Howard E. Rollins Jr., who made a memorable screen debut as Coalhouse Walker in "Ragtime," is determined to press on. Once again, Mr. Rollins gives an arresting performance under volatile dramatic circumstances. But he is not alone. The cast as a whole is expert, particularly Adolph Caesar, as the tortured Sergeant Waters, who is joined by Larry Riley, Denzel Washington and David Alan Grier from the Negro Ensemble Company production.

For his part, Mr. Jewison, filming mainly at Fort Chaffee, Ark., has opened up the play by using such interiors as the bar where the troops hang out and exteriors on and around the base. But perhaps most commendably, he has let Mr. Fuller's drama speak for itself, applying the skills of a film maker to polish the facets that lent such substance to the drama: the 1944 wartime background against which black officers were a rarity and black troops were kept from combat, though the time was approaching when they would go to war, the Army would integrate and the nation would lurch a bit closer to the ideal of justice.

"A Soldier's Story" is rated PG, apparently because of violence inherent to its plot and some strong language.

Lawrence Van Gelder

1984 S 14, C10:5

EXTERMINATOR 2, directed, written and produced by Mark Buntzman; director of photography, Bob Baldwin; edited by Thierry J. Couturier and Danny Retz; music by David Spear; produced by Menahem Golan and Yoram Globus; released by Cannon Films. At RKO Warner, Broadway and 47th Street; RKO 86th Street, at Lexington Avenue, and other theaters. Running time: 88 minutes. This film is rated R.
Johnny Eastland Robert Ginty
X .. Mario Van Peebles
Caroline Deborah Geffner
Be Gee .. Frankie Faison
Eyes ... Scott Randolph
Spider Reggie Rock Bythewood
Red Rat Bruce Smolanoff
Head Mafioso David Buntzman
Tony ... Kenny Marino
Squealer .. Derek Evans
Monster .. Irwin Keyes
Philo Robert Louis King

By LAWRENCE VAN GELDER

In the guise of entertainment, a trashy sequel to the trashy 1980 movie "The Exterminator" opened yesterday at the RKO Warner and other theaters under the title "Exterminator 2."

This is the sort of action movie that begins with the execution of the elderly owners of a mom and pop liquor store and goes on to traffic in murdering an armed guard by electrocuting him while a subway train runs over him, in kidnapping and injecting a terrified young woman with narcotics, in smashing the legs of a female dancer before killing her, and in incinerating and impaling villains.

Once again, the purported hero is the Vietnam veteran Johnny Eastland (Robert Ginty), a listless-looking, muffin-faced vigilante whose principal weapon is a flamethrower he likes to turn against New York street criminals.

This time, he is pitted against a small army of psychopaths led by X (Mario Van Peebles), a megalomaniac with a coiffure inspired by some Inca equivalent of Sassoon, ideas by Hitler and compassion from Attila the Hun. X and his punks scheme to take control of the city after stealing half a million dollars from an armored car and using it to buy narcotics from the Mafia.

Goaded to what passes for rage by the murder of his dancer girlfriend, Eastland and his pal Be Gee, the owner-driver of a large green garbage truck, wreak vengeance on their foes.

Discriminating audiences will make a point of shunning this movie,

1984 S 15, 14:5

FILM VIEW

VINCENT CANBY

Cockeyed at 'Red Dawn'

As Leo McCarey's "My Son John" epitomized the anti-Communist paranoia of the 1950's, with sometimes unintentionally funny results, "Red Dawn," John Milius's shoot-'em-up World War III fantasy, provides an unusual glimpse into the mind of a certain kind of contemporary archconservative. It's not, heaven knows, the intellectual kind of archconservative.

Rather, it exposes for all to see the cockeyed nightmares of those on the lunatic fringe, the self-styled patriots who might even embarrass the members of the John Birch Society. It's a movie that says that guns don't kill people, but people who kill people, without going that one step further to acknowledge that it's people with guns who kill people.

"Red Dawn" is one of those rarely terrible movies that you cannot afford to miss — technically proficient, emotionally infantile and politically nuts, though not, I think, especially dangerous. It's too ludicrous.

"Red Dawn" seems also to be the work of a man who is sick and tired of being on the receiving end of criticism aimed by the world's have-nots at the world's haves. Don't these people realize that it's not easy being rich and powerful and right? How about a little sympathy for the big guy?

To provide answers to these and a lot of other questions you perhaps never thought to ask, Mr. Milius, with Kevin Reynolds, has written an apocalyptic fable designed, among other things, to refurbish the United States's international image by showing it to be, in awful fact, the world's most misunderstood underdog.

There is no other way to interpret this vision of World War III, set in the small town of Calumet, Colo., at the foot of the Rocky Mountains, in which most of middle America has been occupied by "the armies of Cuba and Nicaragua, sweeping up through Mexico," apparently disguised as tourists and gardeners. The armies of Cuba and Nicaragua? From the way Mr. Milius sees the balance of power, you must assume that the armies of Grenada are holding the Gulf Coast from Florida to Texas.

However, the armies of Cuba and Nicaragua don't defeat us all by themselves — Mr. Milius isn't quite that paranoid. They are a part of a giant Soviet invasion force that, through one ruse and another, has defeated the United States military, leaving the fate of America in the hands of a few teen-age guerrillas in Calumet, Colo. It seems that there is a small zone called "F.A." (Free America), though exactly where this might be I couldn't figure out while watching the movie.

I also had trouble understanding just how Mr. Milius's war was initially fought. A few lines of exposition at one point indicate that nuclear weapons have knocked out New York and Washington and some other major cities, but that both sides early understood that further use of nuclear arms was impractical, so that, as one character says, "It's just the same old conventional war all over again."

"What about Yurp (Europe)?" one boy asks. "They-'re sitting this one out," says a kindly old man played by Ben Johnson. "I guess they figured they'd been through two already and that was enough. Not England, though, but they can't hold out forever."

I really don't think that Mr. Milius is as mindlessly chauvinist as his movies, including "The Wind and the Lion," would indicate. But his thinking is so small and wishful that it amounts to a huge distortion of the possibilities as well as of the facts.

"Red Dawn" understands that nuclear weapons can cause horrendous destruction, but it's also airily confident that after a few cities have been destroyed, the combatants will come to their senses and return to the use of ordinary airplanes and tanks and rockets, as long as they last and, after that, one character says wistfully, "maybe swords."

That is probably the key to the dreams of Mr. Milius, who is a chivalrous though completely mixed-up romantic at heart, wanting to return to a 19th-century America inhabited by medieval knights. I know that doesn't make sense, but sense is not what "Red Dawn" is all about. It's both aggressively inflammatory in its predictions about the course of the Red Menace in the 1980's, and sloppily sentimental in its treatment of its teen-age guerrilla-patriots, six young men and two young women who talk, dress and behave very much in the manner of kids who might well have had posters of Che Guevera on their bedroom walls.

•

They are a physically tough, incredibly effective commando group but — this is their human side — they also are given to manly hugs of encouragement and tears from time to time, even though the father of two of the boys has forbidden them ever to cry again. Mr. Milius couldn't very easily make an adventure film — which "Red Dawn" means to be — romanticizing six teen-age Cuban guerrillas in their Marxist war against the Batista dictatorship. He's done the next best thing. He's co-opted the romance of guerrilla war by reversing the roles of Cuba and America, which is neither easy nor plausible.

There's something extraordinarily peculiar about the sight of six ordinary American teen-agers acting as if they'd learned their lessons by studying Fidel Castro's guerrilla tactics, an irony of which Mr. Milius is very much aware. About the only interesting character in the film is the Cuban officer in charge of the pacification of Calumet, Colo., and the surrounding territory.

This fellow, named Bella and played by Ron O'Neal in the film's only decent performance, is murderously efficient at first but he finally comes to loathe his role as occupier when he's more used to being a liberator. Just how this can be coherently interpreted in the context of the rest of the film, I don't know, since "Red Dawn" would, in every other way, appear to support a United States occupation of all of Central America, in this fashion to prevent the armies of Cuba and Nicaragua from sweeping up through Mexico to take over Calumet, Colo.

•

A group that calls itself the National Coalition on Television Violence, formed because its members feel that the ratings of the Motion Picture Association of America are inadequate, has come out with an official statement calling "Red Dawn" the most violent movie ever made.

By this group's count, the film, which runs 114 minutes and has a PG rating, averages 134 acts of violence an hour. This may be true, but the violence in "Red Dawn" is mostly so impersonal and conventional — so obviously the work of special effects experts — that the movie seems less violent even than Mr. Milius's earlier comic-strip of a film, "Conan the Barbarian."

Of far greater concern than its violence is the manner in which "Red Dawn" makes small and comprehensible a war that many experts believe would be the last. It doesn't exactly defuse healthy anxiety. It ignores it by substituting for a vision of the possible holocaust a contemporary cowboys-and-Indians yarn that, like many of our earlier cowboys-and-Indians movies, is not without its racist undertones.

Because the troops occupying Calumet, Colo., are mostly Cuban and Nicaraguan, they frequently speak in Spanish that is solemnly translated by English subtitles. Watching the film, as I did 10 days ago, in the Embassy 2 Theater on Seventh Avenue, with an audience that included a number of people who clearly understood the Spanish without the subtitles, I had the unsettling feeling that Mr. Milius's vision was not having quite the effect he intended.

Though the audience was caught up in the melodrama of the physical action, it did not automatically view the Cuban and Nicaraguan soldiers as the demons they were supposed to be. To a lot of people in that audience, the occupation of the United States by Latin Americans, no matter what their politics, was certainly not a fate worse than death. Maybe Mr. Milius should get around more. America is a lot less homogenized than he seems to understand.

The projection equipment at the Embassy 2 also had the effect of making its own comment on Mr. Milius's view of the future. Though the director apparently did not intend that we should feel that nuclear weapons had poisoned the atmosphere or had created a screen between earth and sun, the film I saw was so dimly lit that even scenes shot in broad daylight looked eerily dark. Because there wasn't enough light coming from the projector, the entire story appeared to be taking place during the last days of autumn, just before the coming of the nuclear winter. ∎

1984 S 16, II:19:1

Philippine Glimpses

BONA, directed by Lino Brocka; screenplay (Tagalog with English subtitles) by Cenen Ramones; photographed by Conrado Balthazar; produced by Nora Villamayor. At the Film Forum, 57 Watts Street. Running time: 90 minutes. This film has no rating.
Bona Nora Aunor
Gardo Philip Salvador
Bona's Father Rustica Carpio
Bona's Mother Venchito Galvez
Katrina Marissa Delgado

By LAWRENCE VAN GELDER

BONA loves Gardo. Gardo loves Gardo. Gardo loves going to bed with almost any woman he can attract. Once — apparently in the absence of anyone better — he even takes Bona to bed, but by the next morning, the matter seems to have slipped his mind.

Bona is a grave-looking woman who drops out of school to pursue her crush on the narcissistic Gardo by moving in with him, more as a servant than anything else. Gardo, in the estimation of Bona's enraged father, is either a second- or third-rate actor in Philippine action movies.

Bona (Nora Aunor) and Gardo (Philip Salvador) are the central figures in "Bona," a film from the Philippines directed by Lino Brocka, whose publicity describes him as a prolific film maker and likens him to Rainer Werner Fassbinder.

Prolific he may be, but, while technically unobjectionable, "Bona," which opens today at the Film Forum, fails to shed much light on the wellsprings of Bona's obsessive love for Gardo. A young woman's attraction and devotion to a sleazily handsome actor are understandable, and so at first it not surprising that Bona is willing to fetch water so that Gardo can have warm baths; that she

scrubs his floors and mends his clothes and cooks for him in the house they share in a poor neighborhood.

But right from the start, it is also clear that Gardo is not exactly a flawless jewel of humanity: he is beaten up by the relatives of one of his women; he is a drunk; he brings home an assortment of other women; he disappears for extended periods; he leaves it to Bona to arrange an abortion for one of his lovers, and finally — after Bona has been essentially disowned by her family — Gardo informs her that he is selling the house they share and going off with another woman.

About five minutes of Gardo would be enough to make most people explode. But it takes Bona about 90 minutes. And since she seems reasonably intelligent and sensitive and is alert from the outset to Gardo's slights, the writing and direction of "Bona" must be faulted for failing to supply dramatically valid explanations for her patience.

"Bona" is chiefly interesting as an example of Philippine film making and for its glimpses of life in the neighborhood where Bona and Gardo live.

1984 S 19, C23:1

The Voice of God

AMADEUS, directed by Milos Forman; screenplay by Peter Shaffer; director of photography, Miroslav Ondricek; edited by Nena Danevic and Michael Chandler; choreography and opera staging by Twyla Tharp; music by Wolfgang Amadeus Mozart; music conducted by Neville Marriner; produced by Saul Zaentz; an Orion Pictures Release. At Paramount, Broadway and 61st Street and Tower East, Third Avenue at 72d Street. Running time: 158 minutes. This film is rated PG.

Antonio Salieri	F. Murray Abraham
Wolfgang Amadeus Mozart	Tom Hulce
Constanze Mozart	Elizabeth Berridge
Emanuel Schikaneder	Simon Callow
Leopold Mozart	Roy Dotrice
Katerina Cavalieri	Christine Ebersole
Emperor Joseph II	Jeffrey Jones
Count Orsini-Rosenberg	Charles Kay
Parody Commendatore	Kenny Baker
Papagena	Lisabeth Bartlett
Frau Weber	Barbara Bryne
Young Salieri	Martin Cavani
Count Von Strack	Roderick Cook
Karl Mozart	Milan Demjanenko
Francesco Salieri	Peter DiGesu
Father Vogler	Richard Frank
Kappelmeister Bonno	Patrick Hines
Archbishop Colloredo	Nicholas Kepros
Salieri's Servant	Philip Lenkowsky
Priest	Herman Meckler
Baron Van Swieten	Jonathan Moore
Lorl	Cynthia Nixon
Hospital Attendant	Brian Pettifer
Salieri's Valet	Vincent Schiavelli
Count Arco	Douglas Seale
Young Mozart	Miroslav Sekera
Conductor	John Strauss
Wig Salesman	Karl-Heinz Teuber

By VINCENT CANBY

FROM the initial production of Peter Shaffer's "Amadeus" at the National Theater in London in 1979, through all of the refinements that preceded the play's New York premiere in 1980, and now, in the even more extensive rewriting and adjustments made by Mr. Shaffer for Milos Forman's handsome, music-filled screen version, one thing has remained constant and exhilarating.

That is Mr. Shaffer's ability to celebrate genius — in this case, that of Wolfgang Amadeus Mozart — in a fashion that is simultaneously illuminating, moving and just. It's a major achievement, especially in films where genius is usually represented and dramatized as some kind of ill-humored, social eccentricity.

•

On film, the core of this extraordinary drama continues to be the paradox represented by Antonio Salieri who, as court composer to Joseph II, the Holy Roman Emperor, was Mozart's most ferocious adversary as

Tom Hulce (below) portrays Wolfgang Amadeus Mozart and F. Murray Abraham plays his adversary, Antonio Salieri, in Milos Forman's filming of Peter Shaffer's "Amadeus."

well as the only person in Vienna to comprehend the magnificence of Mozart's gifts.

Very early in the film there's a marvelous moment when Salieri, played with immense, tragic humor and passion by F. Murray Abraham, hears for the first time the music of the young prodigy who has become the talk at the Hapsburg court in Vienna. In words that could only have been written by a playwright with a rare understanding of music, Salieri describes how the notes interact, one hanging over another, intersected by others, to bring out feelings of sweetness and pain that send Salieri rushing from the room in delirious panic.

"This was music I'd never heard before," says Salieri, whose face melts into ashen jelly. "It seemed to me the voice of God."

In "Amadeus," which opens today at the Paramount and Tower East Theaters, we hear, almost as if for the first time, which is the way with great music, long, glorious passages from the operas, concertos, sonatas and masses and, through the obsession of Salieri, we come to understand something of their particular divinity. "If He did not want me to praise Him with music," the mad old Salieri says to an uncomprehending priest, "why did He give me the desire?"

As in the play, the frame of the film is Salieri's "confession," 32 years after the death of Mozart in 1791 at the age of 35, about the events that led up to his — Salieri's — "murder" of the "obscene child" whom God had chosen to be his magic flute on earth. It is through Mozart, Salieri says in his rage, that God had poured music that, as Mr. Shaffer believes, is testimony that a divine spark can exist in mankind.

As directed for the stage by Peter Hall, "Amadeus" was a "black opera," a highly stylized phantasmagoria that moved between past and present in a spectacular unit set, one that even comprehended the states of mind of old Salieri, the self-described patron saint of mediocrities, as he lay in the siege of memories of real events and those he has imagined.

Mr. Forman and Mr. Shaffer, acknowledging the differing demands of stage and screen, have opened up the play. They are able to include excerpts from the operas, which couldn't be shown on the stage, but they've also made a far more literal work.

Having been shot entirely in and around Prague — which stands in for Emperor Joseph II's Vienna — the movie looks wonderfully authentic. A centerpiece of the musical sequence is Prague's jewel-like Tyl Theater, where Mozart actually conducted the first performance of "Don Giovanni." Never for a minute does this "Amadeus" seem like a filmed play.

Yet, for all of the right decisions, and in spite of the abundance of music, conducted by Neville Marriner, something also has been lost. Mr. Shaffer is a playwright of grand theatricality, and even when translated to film with intelligence and love, his work misses the particular rigors imposed by the limitations of the stage. This "Amadeus" is fascinating and it may be even more humane than the play, and though the impact is not necessarily less, it is decidedly different.

Mr. Abraham, whose first starring film role this is, is very fine as Salieri, initially secure — "Everybody liked me," he remembers, "and I liked myself" — and then increasingly lunatic as he plots Mozart's downfall.

A major but very effective switch in the film is the climactic sequence in which Salieri schemes to snatch "a bit of divinity" from the dying Mozart. As Mozart lies exhausted in bed, dictating the score of the Requiem Mass, the desperate Salieri takes down the notes in his own hand, in this fashion to pass off the work as his own. It may not be history, but it's the high point of this drama.

As Mozart, Tom Hulce, though extremely American in looks and voice, gets better and better as the drama progresses. He has the absolutely implacable self-assurance, the scatological humor and the manic manner of the Mozart revealed in his letters, a fellow who can scribble some of the

greatest music the world has ever heard amid rude jokes, with no self-consciousness about either.

Mozart's is not as interesting a role as that of Salieri. Mozart is never in doubt about his talents. The music is safely in his head — all he has to do is write it down. When, at last, he is sick and dying, though still not depleted, the defeat is only physical.

Most of the other performances are good, especially those of Jeffrey Jones, as the Emperor, and Roy Dotrice, as Mozart's exacting father, the "Commendatore" to his profligate son. Not so great is Elizabeth Berridge as Mozart's beloved Constanze — a large casting mistake. Miss Berridge is pretty and suitably silly, but it's probably not her fault that she suggests her native Westchester far more often than 18th-century Vienna.

The glimpses of the operas are so good that one wants to see more. They include "The Marriage of Figaro," about which the Emperor complains that "there are too many notes," "The Abduction From the Seraglio" and "The Magic Flute," and, in one of the film's most imaginative, most hallucinatory sequences, a parody version of "Don Giovanni," whose obscenities, of course, delight the now ailing Mozart.

Mr. Forman, who created a highly original film out of the virtually formless stage production of "Hair," has preserved the fascinating heart of Mr. Shaffer's play, and made it available to millions who might never enter a legitimate theater. Well done.

•

"Mozart," which has been rated PG ("parental guidance suggested"), contains a lot of language that sounds more vulgar today than it did to Mozart and his contemporaries.

1984 S 19, C23:1

¡Ole!

CARMEN, directed by Francesco Rosi, from the opera by Georges Bizet; libretto by Henri Meilhac and Ludovic Halevy, based on the novella by Prosper Merimee; screen adaptation by Mr. Rosi and Tonino Guerra; in French with English subtitles; director of photography, Pasqualino De Santis; editing by Ruggero Mastroianni and Colette Semprun; conducted by Lorin Maazel; with the Orchestre National de France and Chorus and Children's Chorus of Radio-France; choreography by Antonio Gades; produced by Patrice Ledoux for Gaumont/Marcel Dassault (Paris)/Opera Film Produzione (Rome); released by Triumph Films. At Cinema Studio, Broadway and 66th Street. Running time: 152 minutes. This film is rated PG.

Carmen	Julia Migenes-Johnson
Don Jose	Plácido Domingo
Escamillo	Ruggero Raimondi
Micaela	Faith Isham
Dancairo	Jean-Philippe Lafont
Remendado	Gerard Garino
Mercedes	Susan Daniel
Frasquita	Lilian Watson
Zuniga	John Paul Bogart
Morales	François Le Roux
Lillas Pastia	Julien Guiomar
Guide	Accursio Di Leo
Manuelita	Maria Campano
Court Dancers	
	Cristina Hoyos, Juan Antonio Jimenez
Old dancer	Enrique El Cojo
Escamillo's double	Santiago Lopez
Carmen's friends	
	Aurora Vargas, Carmen Vargas, Concha Vargas, Esperanza Fernández, Lourdes Garcia, Maria Gómez, Pilar Becerra
With: Antonio Gades Dance Company	

By VINCENT CANBY

THREE months after the frostily received world premiere of "Carmen" in Paris in 1875, Georges Bizet, its composer, died. Within 10 years "Carmen" had become one of the world's most popular operas — and it still is.

The old Prosper Mérimée story simply will not slip off into obscurity. It will not die, with or without its rousing Bizet score, most of which is so familiar that it can sound like self-

parody even when played and sung straight. There have been silent movie adaptations, sound movie adaptations, with the Bizet score used as soundtrack music, and Oscar Hammerstein II's idiomatic, American interpretation, "Carmen Jones," which was done initially on the stage and then as a film.

More recently there have been Carlos Saura's flamenco "Carmen," choreographed by and starring Antonio Gades, Peter Brook's severely condensed "Tragédie de Carmen," and even a Jean-Luc Godard entry, "First Name: Carmen," which, in Mr. Godard's way of doing things, contains far more Beethoven than Bizet.

•

Now Francesco Rosi, the Italian director ("Eboli," "Three Brothers," among others), has made what must be the definitive screen adaptation, which opens today at the Cinema Studio. It's titled "Bizet's Carmen" to distinguish it from all of the other "Carmens" designed, it seems, to put in, take out or clarify all those elements that Bizet had the poor taste to ignore before dying of a heart attack.

Whether or not — like me — you find the joys of "Carmen" somewhat limited, Mr. Rosi's "Carmen" is special. Here is a full-scale, unembarrassed screen-opera, with its recitatives replaced by the bits of spoken dialogue that were heard in the first Paris production, filmed entirely in spectacular Andalusian settings that no opera house could ever hope to reproduce.

The first-rate cast of singer-actors is headed by the American-born mezzo, Julia Migenes-Johnson, in the title role; Plácido Domingo as Don José, the naïve corporal from Navarre who abandons his career, his fiancée and even his terminally ill mother for the love of Carmen; Ruggero Raimondi as Escamillo, the bullfighter whose celebrity and arrogance are more appealing to Carmen than Don José's solemn fidelity, and Faith Esham as Micaela, the simple country girl whom Don José jilts for the young, free-spirited, mocking, self-possessed, gypsy woman.

The settings — bullrings, city squares and streets, taverns and mountain passes — are all real, but they have been photographed, by Pasqualino De Santis, with such attention to austere design that they never call attention to the essential contradiction between the reality of cinema and the artificiality of the operatic form.

With the exception of several sequences, Mr. Rosi doesn't attempt to embellish the original opera by opening it up in obvious ways to take advantage of the camera's mobility. Yet, when he does do just that, he does it with purposeful effect.

The film's opening sequence is a brutal, sorrowful intimation of things to come — close-ups, in slow-motion, of a great bull in the last moments of his unequal fight with the torero. As the bull, blood pulsating from the wounds in his body and then gushing from his mouth, struggles in ever smaller circles to renew his attack, we hear the cheers of the crowd, which become a kind of prelude to the familiar overture that, here, suddenly sounds less commonplace than ironic.

In voice, Miss Migenes-Johnson may not be the world's greatest Carmen, but she has a lovely, deep mezzo-soprano that is far more than adequate. She's also a striking screen presense, not conventionally pretty but possessing a lean, angular beauty

Plácido Domingo and Julia Migenes-Johnson in Francesco Rosi's film of Bizet's "Carmen."

that perfectly defines the riveting and romantic nature of a woman who drives men wild. Hers is a passionate, unsentimental Carmen whose repeatedly announced commitment to her own freedom transforms the conventional femme fatale into a woman of commanding stature.

Mr. Domingo is in splendid voice and form, and his physically robust Don José is as heroic as it's possible to make a character whose doom, like that of the bull, is less tragic than accidently unfortunate, if obligatory. Mr. Raimondi has come a long way since his very stiff, virtually hypnotized performance in the title role of Joseph Losey's peculiar "Don Giovanni." He has the voice, the profile and the manner to make one believe that this Escamillo is a great toreador. Micaela is more a function of the plot than a character, but Miss Esham is very pretty and near the end, when she pours out her lament for the now-lost Don José, the music and her voice create a truly moving moment.

Perhaps the best thing about this "Carmen" is its completeness. Only when one hears — and understands — all of the choruses, which Mr. Brook and other interpreters have cut away in attempts to get to the core of the drama, does one come to appreciate again the great, familair melodies, as well as other, less overdone moments, such as the second-act quintet, which is about as close as "Carmen" ever gets to wit.

Even if you feel as if you've had "Carmen" for the next decade, in any shape or form, Mr. Rosi's "Bizet's Carmen" is worth attending to.

•

"Bizet's Carmen," which has been rated PG ("parental gudiance suggested"), contains some not terribly explicit sexual gestures and, perhaps more important, the initial bullfight sequence, which is brutality of an exceptionally graphic order.

1984 S 20, C21:1

ALL OF ME, directed by Carl Reiner; screenplay by Phil Alden Robinson, based on the novel "Me Two" by Ed David; adaptation by Henry Olek; director of photography, Richard Kline; edited by Bud Molin; music by Patrick Williams; produced by Stephen Friedman; released by Universal Pictures. At Loews State, Broadway and 45th Street; Gemini, Second Avenue and 64th Street; 86th Street East, at Third Avenue; New Yorker, Broadway and 88th Street, and other theaters. Running time: 93 minutes. This film is rated PG.

Roger Cobb	Steve Martin
Edwina Cutwater	Lily Tomlin
Terry Hoskins	Victoria Tennant
Peggy Schuyler	Madolyn Smith
Prahka Lasa	Richard Libertini
Burton Schuyler	Dana Elcar
Tyrone Wattell	Jason Bernard
Margo	Selma Diamond
Fred Hoskins	Eric Christmas
Fulton Norris	Gailard Sartain
Gretchen	Neva Patterson
Mr. Mifflin	Michael Ensign
Dr. Betty Ahrens	Peggy Feury
Divorce Lawyer	Nan Martin

By JANET MASLIN

SOME things simply have to be seen to be believed, and the sensational teamwork of Steve Martin and Lily Tomlin in "All of Me" is one of them. If this, the best American comedy since "Tootsie," doesn't have you in stitches, check your vital signs: you may be in as much trouble as Edwina Cutwater, the dying dowager Miss Tomlin plays. Edwina is expiring fast as the movie begins, and she is about to embark on a master plan whereby she will leave her own body and inhabit a much prettier one.

"And what makes you think you can do that?" asks Roger Cobb (Mr. Martin), the lawyer Edwina doesn't much like. "Because I'm rich," Edwina answers, and indeed she is: she takes her pills dipped in caviar and wears diamonds on her deathbed. But when the last moments arrive,

Edwina's swami (Richard Libertini) fumbles the vessel that contains her soul. She lands inside Roger, who, upon first hearing her voice inside him, thinks he must be "picking up 'General Hospital' in my fillings."

Things haven't been going much better for Roger than they have for Edwina. He doesn't much care for the cases that come his way (one client "needs you to set up a Bermuda corporation, so he can write off his honeymoon," his receptionist reports). He knows he must concentrate harder on his legal work, and he's even planning to buy a vest. But Edwina's presence changes everything, and it provides Mr. Martin with the greatest comic opportunity of his career. Mr. Martin handles the physical aspects of this role — playing Roger with his left side, Edwina with his right — so brilliantly that there are times when it's almost possible to forget this is an illusion.

•

Even if it consisted only of inspired physical comedy, "All of Me," which opens today at Loews State and other theaters, would be a delight. But as directed by Carl Reiner, written by Phil Alden Robinson and played by a wonderful ensemble cast, the movie is as genuinely witty as it is peculiar. Mr. Martin and Mr. Reiner attempted something vaguely similar in "The Man With Two Brains," but in that case, since one of the brains was in a jar, the results were somewhat macabre. This time, their instincts are far sounder, and their film progresses much more smoothly.

Much of this is attributable to the startling way in which Mr. Martin and Miss Tomlin complement each other. Though each has only a short while to establish an individual personality before the merger occurs, and though Miss Tomlin is mostly seen in mirrors after Edwina takes up residence inside Roger, each half of this freakish creature is immediately identifiable. When a hand slaps Mr. Martin awake in the morning, there's no doubt that it's Edwina's hand.

The possibilities for Roger-Edwina to get into trouble are endless, and Mr. Reiner and Mr. Robinson have been shrewdly selective. There are plenty of physical gags — Mr. Martin yanking himself first one way down the street, then the other — but there are better, more complicated jokes, too. A courtroom scene, in which Roger must try a case that's vital to

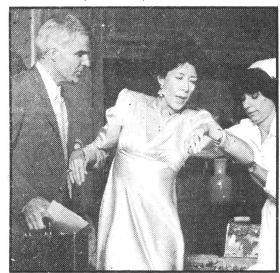

Lily Tomlin plays a sickly rich woman whose soul winds up in the body of a lawyer, played by Steve Martin, in Carl Reiner's "All of Me."

his career, becomes an occasion for hilarious role reversal when Roger proves to be asleep; Edwina must act the masculine lawyer instead. She does this by spitting, growling, putting her feet on the desk, and finally screaming inwardly to wake Roger, who can't believe the trouble she's gotten him into. On top of everything else, they disagree — very noisily — about the merits of the case.

•

Edwina's morals are so different from Roger's that they have a difficult enough time going to the bathroom together, let alone romancing the beautiful blonde (Victoria Tennant) whom Edwina was supposed to become. When Roger gets into bed with her, Edwina quells his ardor by thinking about "very old nuns and dead kittens."

Mr. Martin's astonishing performance is the film's most conspicuous asset, but the entire cast is good. Mr. Libertini makes an uproarious swami, operating so entirely on his own wavelength that his response to a telephone ringing in his hotel suite is to flush the toilet merrily. Selma Diamond is suitably droll as Roger's secretary, and Miss Tennant, while no outstanding comedienne, has a poise and beauty to rival Grace Kelly's. Madolyn Smith is funny as the girlfriend trying to make Roger "say the M-word."

But it's Mr. Martin and Miss Tomlin, doing his and her best work in films thus far, who are at the heart of the film's success, especially when they abandon their animosity and generate the warmth to become friends. "All of Me" ends on a grace note, with the two of them engaged in a marvelous, celebratory little dance. There's a lot here for them to celebrate.

•

"All of Me" is rated PG (Parental Guidance Suggested). It contains a somewhat explicit bathroom scene.

1984 S 21, C6:1

When It Sizzles

UNTIL SEPTEMBER, directed by Richard Marquand; written by Janice Lee Graham; director of photography, Philippe Welt; edited by Sean Barton; music by John Barry; produced by Michael Gruskoff; released by MGM/UA Entertainment Corporation. At 83d Street Quad, at Broadway; New York Twin, Second Avenue and 66th Street; 34th Street Showplace, near Second Avenue; Greenwich Twin, Greenwich Avenue and 12th Street. Running time: 110 minutes. This film is rated R.
Mo Alexander Karen Allen
Marcia .. Johanna Pavlis
Isabelle de la Pérouse Marie-Catherine Conti
Xavier de la Pérouse Thierry Lhermitte
Laurence de la Pérouse Tiphanie Spencer
David de la Pérouse Olivier Spencer
Carol Rochelle Robertson
Jenny Raphaelle Spencer
Andrew .. Hutton Cobb
Philip Christopher Cazenove
Carry ... Steve Gadler
Madame Durand Edith Perret
Sylvia ... Nitza Saul
Sophie Hélène Desbiez

IT all begins when Mo Alexander (Karen Allen), a perky American from the Midwest, misses her flight out of Paris. Through a series of coincidences too perfect for close scrutiny, this denim-clad vagabond winds up in the posh apartment of a former schoolmate named Chantal. Chantal, like every other serious Parisian, is out of town for her August vacation. So are the wife and children of Chantal's next-door neighbor, Xavier de la Pérouse (Thierry Lhermitte). Xavier has an even fancier apartment and just happens to be the best-looking, best-dressed

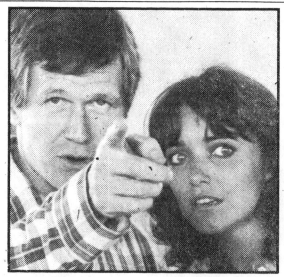

Thierry Lhermitte and Karen Allen fall in love in Richard Marquand's "Until September,"

Frenchman this side of Louis Jourdan.

Harsh reality does not figure prominently in "Until September," which opens today at Loews New York Twin and other theaters. But as romantic fluff, it is not without its charms, especially in its early stages. Mo, who has apparently arrived in Paris with a great many francs (or at least a very good credit rating), has soon acquired a glamorous wardrobe and is being squired about town by Xavier, who lectures her suavely about wines. Mo sees this as purely platonic, and there are a great many — *too* many — scenes in which she firmly bids Xavier good night at Chantal's door. Eventually, if only to establish that Paris weaves a magic spell and that their heroine is not an idiot, the movie's director, Richard Marquand, and screenwriter, Janice Lee Graham, allow the inevitable to happen.

After this, things slow down somewhat as "Until September" devotes itself to examining cross-cultural differences. French toast is not really French, Xavier explains. Mo, for her part, rhapsodizes about "cornfields and wheatfields that spread out as far as the eye can see." The biggest difference between them is something of more consequence, since Mo believes in fidelity and in not getting her feelings hurt. But Xavier coolly manages both a wife and a full-time mistress.

"I'm just an odd girl to fill up an odd month that you didn't know what to do with!" Mo complains, with some justification. In a movie like this, Xavier's answer must inevitably be, "Everything's been so beautiful — let's not spoil it."

Mr. Marquand, who after "Eye of the Needle" and "Return of the Jedi," is certainly working in a different mode, knows enough to keep a hint of happiness on the horizon, and to lay on lots of scenery. And his stars work well together, despite all the screenplay's contrived sparring and the boundless gusto of all-American Mo. Miss Allen's great asset here is her vibrant *joie de vivre,* Mr. Lhermitte's his smooth, matinee idol manner. Christopher Cazenove is worldly and unflappable as a married British friend of Xavier's. They all perform ably, if predictably, and are only marginally upstaged by Paris, the movie's real star.

Janet Maslin

1984 S 21, C6:3

Rogue Dreamers

WINDY CITY, written and directed by Armyan Bernstein; director of photography, Reynaldo Villalobos; film editor, Clifford Jones; music by Jack Nitzsche; produced by Alan Greisman; released by Warner Bros.-CBS Theatrical Films. At Gemini, Second Avenue and 64th Street. Running time: 105 minutes. This film is rated R.
Danny .. John Shea
Emily ... Kate Capshaw
Sol ... Josh Mostel
Mickey ... Jim Borrelli
Bobby Jeffrey DeMunn
Pete .. Eric Pierpoint
Marty Lewis J. Stadlen
Eddie James Sutorius
Michael Niles McMaster
Sherry ... Lisa Taylor
Mr. Jones Nathan Davis
Ernesto Louie Lanciloti

"GOD knows, we were dreamers," recalls the hero of "Windy City" in voiceover. "Everybody was gonna be somebody — me, I was gonna be a great writer." In fact, Danny (John Shea) *does* write a book by the film's end, a tome entitled "All the Sad Young Men," chronicling the rueful good times of Danny and his childhood buddies, who call themselves the Rogues. "You and me, we could've been the kind of guys they write about in books," one Rogue tells another midway through the story.

Armyan Bernstein, who wrote and directed "Windy City," also wrote

"One From the Heart," a film best remembered for aspects other than its screenplay. Nevertheless, "Windy City," which opens today at the Gemini, manages to recall the misty uneventfulness of Francis Ford Coppola's much-publicized fiasco. Danny has two major crises to handle during the course of the story: the mortal illness of his best friend (Josh Mostel) and the imminent marriage of his best girl, Emily (Kate Capshaw). Even so, little of any consequence seems to happen.

•

A lot of the film consists of flashbacks to the courtship of Danny and Emily, who look great and trade loads of leaden banter. During the early phase of their sparring, Mr. Bernstein — who loves to invoke other, better movies — offers a glimpse of "His Girl Friday"; later, when Emily's wedding day approaches, it's time to refer to "The Graduate." Mr. Bernstein pays much less attention to more fundamental matters, such as giving the audience some idea of who Emily is marrying or why she prefers him to Danny. The bridegroom has virtually no speaking lines, and he and Emily are seen together only once or twice, staring blankly at each other. Whenever Danny and Emily meet, on the other hand, she smiles, he melts and the music swells mightily.

The romance is entirely pat; as for the old-gang-of-mine gatherings, when Danny compares them to a beer commercial, he's not far off the mark. Mr. Shea has far too much gravity for the superficiality and soddenness of this material; Miss Capshaw is certainly eye-catching, but she brings little more than a one-note vivacity to her role. Neither they nor any other two actors could bring off the fight scene that wrecks their love affair, since the fight is about Danny's writing talents.

"I'm not a writer — I'm kidding myself!" he shouts.

"Danny, the world needs storytellers! The world needs to be inspired!" she answers.

This fracas takes place in their picture-perfect apartment, its entrance hallway decorated with a collection of cute hats.

The supporting Rogues, among them Mr. Mostel, Lewis J. Stadlen and Jim Borrelli, are forced to try too

Kate Capshaw and John Shea star in "Windy City," a story of romance and friendship written and directed by Armyan Bernstein.

hard for something like a "Big Chill" conviviality. Renting a limousine and a pirate ship are only two of the more strained adventures upon which Mr. Bernstein has them embark.

Janet Maslin
1984 S 21, C10:5

The Heart of Texas

PLACES IN THE HEART, directed and written by Robert Benton; director of photography, Nestor Almendros; edited by Carol Littleton; music by John Kander; produced by Arlene Donovan; released by Tri-Star Pictures. At Coronet, Third Avenue and 59th Street. Running time: 110 minutes. This film is rated PG.

Edna Spalding	Sally Field
Margaret Lomax	Lindsay Crouse
Wayne Lomax	Ed Harris
Viola Kelsey	Amy Madigan
Mr. Will	John Malkovich
Moze	Danny Glover
Frank	Yankton Hatten
Possum	Gennie James
Albert Denby	Lane Smith
Buddy Kelsey	Terry O'Quinn
Tee Tot Hightower	Bert Remsen
Royce Spalding	Ray Baker
W. E. Simmons	Jay Patterson

By VINCENT CANBY

OUT of the memories of his boyhood in Waxahachie, Tex., during the Great Depression, and within the unlikely tradition of the old-fashioned "mortgage" melodrama, Robert Benton has made one of the best films in years about growing up American. Its title is "Places in the Heart," which is misleading in its sentimentality, for the film itself, though full of sentiment, demonstrates in every other way the writer-director's built-in junk-detector.

"Places in the Heart," which opens today at the Coronet Theater, is a movie about the process of remembrance, as well as about the events remembered. The terrible harshness of some of the events recalled has been softened by time, which also has invested those events with mythic importance. "Places in the Heart" is a family tale handed down from one generation to the next, full of wonder and longing and love.

The time is 1935, and the setting is the small town of Waxahachie and the gentle Texas countryside surrounding it. When her husband is killed in an accident, Edna Spaulding (Sally Field) finds herself, after 15 years of marriage, with two small children to support, a farm on which the bank is about to foreclose, less than $200 in the bank and no talent for anything except cooking and keeping house, which, for the self-employed, paid no

Sally Field as Edna Spaulding, a young widow in Robert Benton's film "Places in the Heart."

more then than it does now.

"Places in the Heart" is the moving and often funny story of how Edna Spaulding, through hard work, grit and a certain amount of luck, manages to see things through. Edna, as beautifully played by Miss Field, has a lot of the steadfastness that distinguished the actress's Oscar-winning performance in "Norma Rae." However, Edna is also a much less sophisticated personality, whose growth, in the course of the film, reflects an almost 19th-century faith in the possibilities of the American system, not as the system was, but as one wanted to believe it to be.

As a title, "Places in the Heart" is also misleading in that it befogs the disciplined nature of the movie, which sees time and place with a critical eye and reserves its affection for the remarkable people who survived hardships that were at first beyond their imaginations. Like the best work of Jean Renoir and François Truffaut, "Places in the Heart" never denies the existence of the void that lies just beyond the film's horizon, and which infuses even the sunlit scenes with tension and foreboding.

•

In addition to Edna Spaulding, the principal characters include her sister Margaret (Lindsay Crouse), who supports herself, her smooth-talking, philandering husband, Wayne (Ed Harris), and their child by working as a beautician; Viola Kelsey (Amy Madigan), Margaret's best friend, who has slipped into an extramarital affair with Wayne; Mr. Will (John Malkovich), Edna's misanthropic, blind boarder; Edna's two small children (Yankton Hatten and Gennie James), and, probably most important, Moze (Danny Glover), a black hobo who stops by the farm one evening looking for work, steals the silver and winds up teaching Edna how to plant and harvest cotton.

With the exception of one spectacular sequence in which a tornado tears through Waxahachie and another sequence involving the Ku Klux Klan, the film moves through a series of rather ordinary events, discovering in them not clichés but essential meanings. The strong, sweet emotions aroused by close relationships, among friends as well as among family members, are revealed with unaffected clarity and a sense of surprise. Considering the stinginess manifest in so many aspects of our lives, the existence of such decency is as unexpected as it is welcome.

Each member of the large cast is fine, but especially noteworthy are the performances of Miss Field, Miss Crouse, Mr. Malkovich, most recently seen on the New York stage in "Death of a Salesman" and "True West," and Mr. Glover, who was so fine in the Broadway production of Athol Fugard's "Master Harold ... and the Boys."

The film was photographed entirely in and around Waxahachie by Nestor Almendros, Mr. Benton's gifted cameraman on "Kramer vs. Kramer" and "Still of the Night." They have given the film the idealized look of the work by some of the better, now-anonymous painters who, supported by Federal subsidies during the Depression, traveled around the country covering the walls of public buildings, in small towns and large, with murals that weren't always flattering to the people who commissioned them.

"Places in the Heart" is a tonic, a revivifying experience right down to the final images, which, like those at the end of Luis Buñuel's "Tristana,"

carry us back to the very beginning of the cycle of these particular lives.

•

"Places in the Heart," which has been rated PG ("parental guidance suggested"), contains some scenes of physical violence.

1984 S 21, C8:1

THE EVIL THAT MEN DO, directed by J. Lee Thompson; screenplay by David Lee Henry and John Crowther, based on a novel by R. Lance Hill; music by Ken Thorne; produced by Pancho Kohner; released by Tri-Star Pictures. At National 2, Broadway and 44th Street; Manhattan 2, 59th Street between Second and Third Avenues; Orpheum 1, 86th Street and Third Avenue; Gramercy, 23d Street near Lexington Avenue, and other theaters. Running time: 90 minutes. This film is rated R.

Holland	Charles Bronson
Rhiana	Theresa Saldana
Molloch	Joseph Maher
Lomelin	José Ferrer
Max	Rene Enriquez
Briggs	John Glover
Randolph	Raymond St. Jacques
Claire	Antoinette Bower
Aristos	Enrique Lucero
Cillero	Jorge Luke
Karl	Mischa Hausserman
Cannell	Roger Cudney

By JANET MASLIN

Whatever else Charles Bronson can do, audiences show up simply to watch him kill. The fact that "The Evil That Men Do," Mr. Bronson's latest, nominally concerns itself with human-rights violations merely makes the violence all the juicier.

Mr. Bronson plays Holland, a professional hit man living in scenic retirement in the Cayman Islands when he is recruited to rub out a notorious sadist, one Dr. Molloch (Joseph Maher). In order to persuade Holland to travel to Latin America to take the case, a university professor (José Ferrer) arrives on the island to show him videotapes of the doctor's victims, who describe atrocities in lavish detail. Holland isn't easily won over, but the most recent victim is a friend of his, a journalist who has been stripped and tortured with electrodes all over his body. That is the movie's opening scene.

•

1983

Charles Bronson

There was plenty of audience participation at the National theater, where "The Evil That Men Do," which was directed by J. Lee Thompson, opened yesterday. Other crowd favorites, in addition to the electrode sequence, were a barroom scene in which Mr. Bronson inflicts an unspeakable form of pain on an enemy, and another scene in which he shoots off someone's head. "He was wearing a bulletproof vest," Mr. Bronson says matter-of-factly, to explain why this particular victim required extra buckshot.

The cast, mostly affecting Latin American accents to go with the film's setting, includes Theresa Saldana as Holland's nagging companion, the journalist's widow ("Don't you ever want to wash your hands raw, just to scrub the death off them?" she asks), and Raymond St. Jacques, who appears to be having some fun with the role of the doctor's chief henchman. Mr. Bronson is stony as ever, and a little more nattily dressed.

1984 S 22, 35:3

FILM VIEW

VINCENT CANBY

Three New Movies Enrich Their Genres

Part of the pleasure of watching "The Importance of Being Earnest" or "The Seagull" or "Death of a Salesman" or "Charley's Aunt," or just about any good, time-tested play with which one is familiar, is knowing the work well enough to be able to anticipate what's about to happen, and then, if all goes as it should, to be surprised all over again. In each case there are obligatory moments that, in superior productions, seem utterly new, though they also benefit from one's earlier encounters with them.

Movies are something else. The vast majority of remakes, being based on classics that are still available for screening, come nowhere near the originals, though some

of them have had their own rewards, such as the performances of Mel Brooks and Ann Bancroft in "To Be or Not to Be." Mostly, it's simply not possible to see what new directors and new casts will do with material we know well. The material has been at least partially rewritten, updated or in some other way rearranged.

With the exception of those very occasional screen adaptations of classic plays, such as the Olivier "Hamlet" and the Soviet "Hamlet," which really aren't comparable, we never get the opportunity to match the work of new directors and new actors against the work of earlier people using the same material. Instead, the best that we can do is to watch how different filmmakers work within familiar genres, that is, to see how they respond to the challenges of specific types of films that impose their own rules and limitations on them.

The best directors acknowledge their obligations to a genre and then go on to discover new ways of dealing with them, in the manner of John Ford and his westerns or Alfred Hitchcock and his suspense classics. Only Hitchcock could have made what is, in effect, a great "chase" film ("Rear Window") in which the hero spends most of his time in one room in a wheelchair. These directors don't necessarily transcend the genre, but they do enrich its possibilities.

• • •

Among three current cases in point is Robert Benton's fine new "Places in the Heart," which rediscovers the true sense of longing for home in the meaning of the word "nostalgia," more recently used by Joe Franklin and others to identify a longing for just about anything more than two weeks old, whether it's a Michael Jackson "golden oldie" or a fad on the order of rainbow-dyed hair.

The two other films, each very different, are Francesco Rosi's "Bizet's Carmen," in which the original opera becomes a fully realized motion picture, and this summer's Clint Eastwood hit, "Tightrope," a Dirty Harry-type of American police film that manages to insert some neat twists into a story carefully crafted out of the clichés it embraces.

"Tightrope," written and directed by Richard Tuggle, is very far from being a great film. It's not a movie that will win many new fans for Mr. Eastwood, but for everyone else who has watched the Eastwood screen personality develop over the years, it's surprisingly entertaining. Mr. Tuggle and his star apparently know exactly when to meet the expectations of the Eastwood fans and when to do something a little different.

I say it's "surprisingly entertaining" because the opening sequence promises so little. It's a standard horror-movie beginning in which a lone young woman, walking home through the deserted streets of a big city (New Orleans) at night, is trailed by a possibly homicidal maniac, who is seen only from the back or from the ankles down to his jogging shoes.

• • •

The man *is* a homicidal maniac and the poor young woman does meet a ghastly end. The plot: how the tough detective, played by Mr. Eastwood, finally tracks down the killer, but only after the killer has done away with a number of other young woman, threatened the detective's children and his new woman friend (Genevieve Bujold) and, almost in passing, murdered a middle-aged baby sitter and stuffed her body into the clothes dryer.

This description is not meant to interest anyone not already committed to Mr. Eastwood. "Tightrope" is stuffed with clichés, some brutal and misogynous, but it also presents Mr. Eastwood with a character of — for him — comparative complexity, a fellow whose fear of women may not be all that different from that of the man he is hunting. This might not seem much to the uninitiated, but it's actually a major variation on his "Dirty Harry" movies, which heretofore have been as rigid in their structures as Ice Capades shows and Noh dramas have been in theirs.

There have been two superlative opera films in recent years, Ingmar Bergman's screen adaptation of Mozart's "Magic Flute" and Franco Zeffirelli's adaptation of Verdi's "Traviata." If Mr. Rosi's "Bizet's Carmen" is not quite in that league, it's only because — for me, anyway — Bizet's opera is not in the same league with either "The Magic Flute" or "La Traviata." Mr. Rosi does, however, succeed in solving problems that Mr. Bergman and Mr. Zeffirelli either didn't have to face or successfully avoided.

• • •

"Carmen" is realistic in the way that "The Magic Flute" isn't. Also, unlike "La Traviata," most of which takes place in interiors that Mr. Zeffirelli could gracefully stylize, "Carmen" takes place largely in exteriors — in the main square of Seville, in the mountains where the gypsy smugglers have their hide-out, and just outside the Seville bullring.

It's one thing to emphasize, as Mr. Bergman could, the theatricality of "The Magic Flute," by making his film appear to be an extension of a theatrical performance. It's quite another problem to shoot "Carmen" without such a "frame," in recognizable exteriors in which the characters are seen and heard singing their lungs out.

That "Bizet's Carmen" works both as opera and as a film can be credited to the casting and to the visual design, which, by some art I don't quite understand, protects the singer-actors in such a way that they are never upstaged by — or allowed to look ridiculous in — the often stunningly beautiful, real-life landscapes.

The cast is headed by Julia Migenes-Johnson in the title role, Placido Domingo as the doomed Don José, Ruggero Raimondi, who played the title role in Joseph Losey's unfortunate "Don Giovanni," as Escamillo, the bullfighter, and Faith Esham as Micaela. They're all in good voice but, equally important to a film, they're all convincing as screen personalities.

Miss Migenes-Johnson is not a conventional Carmen, the gypsy beauty who dances around with a red carnation stuck between her teeth. She is slightly built and looks something like a young, Latin version of Rita Tushingham, but she has the passion and style of a singular woman, without which "Carmen" becomes a corny joke. Mr. Domingo, who didn't appear to be entirely at ease in Mr. Zeffirelli's "Traviata," looks and sounds in fine form here, and Mr. Raimondi, whose Don Giovanni was overwhelmed by a peculiarly abstract Losey production, is splendid as the arrogant bullfighter.

If there can be such a thing as a realistic screen opera, "Bizet's Carmen" is it.

•

With "Places in the Heart," set in a small Texas town in the Depression, Mr. Benton ("The Late Show," "Kramer vs. Kramer," among others) has made made his most adventuresome film to date. I say it's adventuresome because he has had the courage as well as the talent and taste to take characters and incidents that, over the years, have become clichés in the hands of others and found in them their original dramatic impact and meaning.

"Places in the Heart" is about a poor widow-woman (Sally Field), the sort of character once beloved by silent filmmakers, trying to bring up two small children on a farm on which the bank is about to foreclose. Subsidiary characters include a faithful black farmhand (Danny Glover); the widow's sister (Lindsay Crouse) who works as a beautician to support herself, her philandering husband (Ed Harris) and her child; an initially misanthropic blind man (John Malkovich), who's a veteran of World War I, and even some members of the Ku Klux Klan.

The film is semi-autobiographical not only in that the characters are based on members of Mr. Benton's own family, but also in that he shot it entirely in Waxahachie, Tex., where he was born and grew up. Though full of melodrama, it is never melodramatic. It is a magnificently acted, clear-eyed memory film. That is, it's as much about what we'd like America to have been as it's about what it actually was. It's gentle and severe simultaneously, sorrowful without being maudlin and illuminated by the love and wit of the man who made it.

The difficulty with a film like "Places in the Heart" is to persuade audiences to see the film itself — and not the films it's like, to be aware of all the inspiration and discipline that make it an original rather than a replay of second-rate Americana that you've seen before. From its extraordinary opening sequences through the haunted images that close the film, "Places in the Heart" never makes a wrong choice. Though this is September, and we have three more months to go, I cannot believe that it won't remain one of the finest American films of 1984. ■

1984 S 23, II:19:1

After High School

THE WILD LIFE, directed by Art Linson; written by Cameron Crowe; director of photography, James Glennon; edited by Michael Jablow; music by Edward Van Halen and Donn Landee; produced by Mr. Linson and Mr. Crowe; released by Universal Pictures. At Warner Twin 2, Broadway and 47th Street; Orpheum, Third Avenue and 86th Street and other theaters. Running time: 95 minutes. This film is rated R.
Tom DrakeChristopher Penn
Jim ConradIlan Mitchell-Smith
Bill Conrad ..Eric Stoltz
Eileen ..Jenny Wright
Anita ...Lea Thompson
Tony ..Brin Berliner
Harry ...Rick Moranis
David CurtissHart Bochner
Donna ..Susan Blackstone
Julie ...Cari Anne Warder
Craig DavisRobert Ridgely
Mr. Parker ..Jack Kehoe

By JANET MASLIN

"**T**HE WILD LIFE," which opens today at the Eastside Cinema and other theaters, is something like a sequel to "Fast Times at Ridgemont High." The characters are different, but the perspective on teen-age Americana, West Coast-style, is very much the same.

This time around, though, the material is less funny. Some of that is attributable to a director, Art Linson, with a heavier hand than that of Amy Heckerling, who gave the first film its sprightly, offbeat style. Then there's the fact that comically reckless teenage characters inevitably seem a little sadder once they're out of high school.

Also, the new film doesn't so much follow "Fast Times" as repeat it. Cameron Crowe, who masqueraded as a high school student to write the book on which the first film was based, and who wrote the screenplay for "The Wild Life," has come up with some promising new possibilities here, like a tough-as-nails 15-year-old boy (Ilan Mitchell-Smith) who's obsessed with Vietnam, and his straight-laced older brother (Eric Stoltz), who leaves the bosom of his family to move into a singles complex replete with doctors and stewardesses. But too much of the material seems familiar, almost deliberately so. The filmmakers have even recruited Christopher Penn, Sean's younger brother (who was so good in "All the Right Moves" and "Footloose"), dyed his hair blond, and cast him in something very like his brother's role as a stoned surfer in "Fast Times."

As Tom Drake, a wrestler rather

than a surfer, Mr. Penn does a fine job of playing the consummate slob. But neither he nor much else about "The Wild Life" gets past the earlier film's shadow. Lea Thompson is appealing as the old flame who's been jilted by Bill Conrad (Mr. Stoltz), who now considers himself too mature to go out with mere high school girls, and who then finds herself another boyfriend. ("We don't go out for three months and this is what happens?" cried the indignant Bill when he finds out.) Rick Moranis, last seen pining after Sigourney Weaver in "Ghostbusters," this time shows up in a new wave wardrobe and a lot of strange hairdos to pursue the equally unavailable Eileen (Jenny Wright). Eileen is either Tom Drake's fiancée or someone who can barely stand him, depending upon whom you ask. Tom's the one who announces their engagement, which he views mostly as an excuse to throw himself a bachelor party.

Feisty, self-possessed little Jim (Mr. Mitchell-Smith), whose favorite film is "Apocalypse Now" and who listens to Jimi Hendrix and Jim Morrison with a vengeance, is easily the film's most interesting invention. But he is given an unnecessarily "big" scene, a minor epiphany that is conventional if not altogether false; Miss Thompson's Anita gets one of these, too. The film's best sequence has the Conrads' mother taking video movies of her older son's efforts to pack up and leave home. That episode has both the zaniness and the ring of truth that were so evident in the earlier film, and are so much scarcer here.

1984 S 28, C8:4

Generations Apart

IRRECONCILABLE DIFFERENCES, directed by Charles Shyer; written by Nancy Meyers and Mr. Shyer; director of photography, William A. Fraker; edited by John F. Burnett; music by Paul De Senneville and Olivier Toussaint; produced by Arlene Sellers and Alex Winitsky; released by Warner Bros. At Movieland, Broadway and 47th Street; Sutton, Third Avenue and 57th Street; 86th Street Twin, at Lexington Avenue and other theaters. Running time: 112 minutes. This film is rated PG.
Albert Brodsky Ryan O'Neal
Lucy Van Patten Brodsky Shelley Long
Casey Brodsky Drew Barrymore
David Kessler Sam Wanamaker
Phil Hanner Allen Garfield
Blake Chandler Sharon Stone
Maria Hernandez Hortensia Colorado

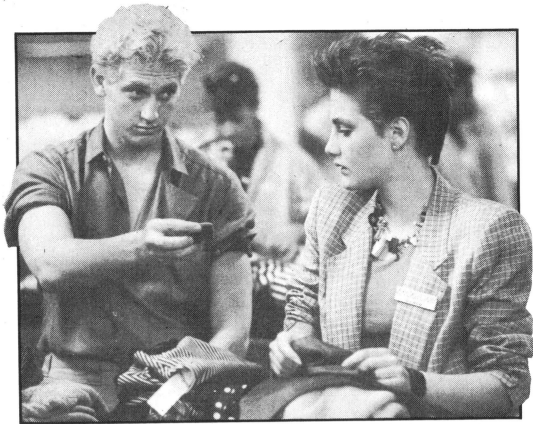
Christopher Penn and Jenny Wright star in "The Wild Life," about a young man preparing to face life as a single adult after graduation from high school.

A COY little girl's plan to "divorce" her parents is the pretext for "Irreconcilable Differences," which opens today at Movieland and other theaters, though the film itself is mostly about the adults and the process by which they go show-biz. The Brodskys — Albert Brodsky (Ryan O'Neal) and Lucy Van Patten Brodsky (Shelley Long) — are seen in flashback as down-to-earth young idealists when they first meet. But that doesn't last, especially after Albert, a film buff, gets a chance to direct a movie of his own. Soon he is a rich, famous Hollywood director.

Albert's secret is his encyclopedic knowledge of great film makers from Ernst Lubitsch to Jean Renoir, a secret which Charles Shyer, who directed and co-wrote "Irreconcilable Differences," presumably shares. Mr. Shyer, according to the production notes, had his actors study classic comedies like "The Lady Eve" and "His Girl Friday." But he himself appears to have learned little from the masters.

●

It does look as though Mr. Shyer, along with his wife and co-scenarist, Nancy Meyers (they also co-wrote "Private Benjamin"), knows a thing or two about the side-effects of Hollywood success. And some parts of the film, like the sequence in which Albert directs his own "Heaven's Gate" — a musical version of "Gone With The Wind," with Albert's new girlfriend (Sharon Stone) as a singing Scarlett — are amusingly well-observed. But Mr. Shyer has no idea how to frame this material, let alone make it funny. Most of "Irreconcilable Differences" is terribly flat; the camerawork is dim and unflattering, the sets are bare even when they're supposed to look lived in and some of the dialogue is simply beyond the actors. What is Ryan O'Neal supposed to do with a line like "I dunno, I was never really comfortable around women"?

Mr. O'Neal's charm and professionalism shine through such handicaps, as do Miss Long's talents as a comedienne. A sequence in which she, with the help of heavy padding, is supposed to grow slovenly and fat is saved from ludicrousness by the convincing anguish she brings to the Brodskys' marital breakup. Both adult stars work hard to make the movie likable, even when it turns into

the story of two overpaid egomaniacs (Lucy, after years of helping her husband with his screenplays, eventually becomes a famous novelist). As their daughter, Drew Barrymore, is much too studiously adorable, a far cry from the sweetly un-self-conscious performer she was in "E.T."

●

"Irreconcilable Differences" is rated PG ("Parental Guidance Suggested"). It contains brief nudity.

Janet Maslin

1984 S 28, C10:5

Music Videos

BODY ROCK, directed by Marcelo Epstein; screenwriter, Desmond Nakano; director of photography, Robby Muller; edited by Richard Halsey; choreographer, Susan Scanlan; music supervisor, Gaylon Horton; produced by Jeffrey Schechtman; released by New World Pictures. At Loews State, Broadway and 45th Street and New York Twin, Second Avenue and 66th Street and other theaters. Running time: 93 minutes. This film is rated PG-13.
Chilly D Lorenzo Lamas
Claire Vicki Frederick
E-Z Cameron Dye
Darlene Michelle Nicastro
Terrence Ray Sharkey
Chilly's Mother Grace Zabriskie
Carolyn Carole Ita White
Donald Joseph Whipp
Ricky Riccardo Oz Rock
Magick La Ron A. Smith

"B ODY ROCK," which opens today at Loew's State and other theaters, looks not like a theatrical film but like a series of music videos that have been spliced together to make a feature-length presentation.

It's set in New York and has a disposable story about a bunch of ambitious young rap singers, break-dancers and graffiti artists. It's really little more than a series of musical performances, intentionally unrelated to

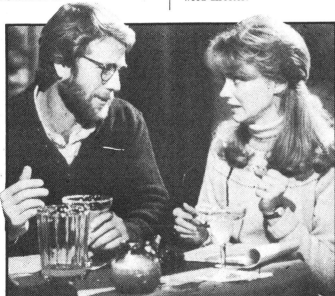
Ryan O'Neal and Shelley Long fall in and out of love in "Irreconcilable Differences" and find themselves sued for divorce by their 10-year-old daughter.

recognizable life, seen in settings that are fancily photogenic, whether the setting is a South Bronx street or the interior of a neon-lit disco.

Lorenzo Lamas, of television's "Falcon Crest," plays the lead, that of a young man-on-the-make, as if he'd ordered his stylishly garish costumes as well as his performance from the 1982 John Travolta catalogue. He forgot to order a role, however. Though he sings a little, raps a little and makes a few attempts at break-dancing, "Body Rock" never lets us know what it is that makes him a star within the film. It could be that the movie's subversive point is that we live in an age in which — to succeed — one must be able to do absolutely nothing well.

Even though the music is loud and the beat unrelenting, the movie has the effect of a soporific. It's of such slight dramatic interest that, toward the end, when a beautiful, heedless, amoral young woman ends a night on the town by mixing something in her blender, one's attention becomes riveted by the blender's possible contents. Is it something to stave off a hangover? Some sort of vitamin-enriched diet supplement? Liquified cocaine? "Body Rock" never tells.

Ray Sharkey, who has done much better, plays the entrepreneur who sees magic in Mr. Lamas's noncharacter, and La Ron A. Smith plays a small, indefatigable break-dancer named Magick. The rest is noise.

•

"Body Rock," which has been rated PG-13 (Special Parental Guidance for Those Younger Than 13), contains some four-letter words and some partial nudity.

Vincent Canby

1984 S 28, C12:5

Growing Debt

COUNTRY, directed by Richard Pearce; written by William D. Wittliff; director of photography, David M. Walsh; edited by Bill Yahraus; music by Charles Gross; produced by Mr. Wittliff and Jessica Lange; released by Beuna Vista Distribution Company. At Avery Fisher Hall, Lincoln Center, as part of the 22d New York Film Festival. Running time: 108 minutes. This film is rated PG.

Jewell Ivy Jessica Lange
Gil Ivy .. Sam Shepard
Otis .. Wilford Brimley
Tom McMullen Matt Clark
Marlene Ivy Therese Graham
Carlisle Ivy Levi L. Knebel
Arlon Brewer Jim Haynie
Louise Brewer Sandra Seacat
Fordyce Alex Harvey
Missy Ivy Stephanie-Stacie Poyner

By VINCENT CANBY

"COUNTRY," which opens the 22d New York Film Festival tonight at Lincoln Center, is a good, decent, 1930's Depression movie set in the mid 1980's, about the problems of farmers as they attempt to cope with the vagaries of Federal farm policies, which are no more easy to predict than the extremes of weather in the Middle West.

Although written by William D. Wittliff, directed by Richard Pearce ("Heartland"), who took over the job of direction from Mr. Wittliff, and co-starring Sam Shepard, the Pulitzer prize-winning playwright and actor, the film, more than anything else, reflects the drive, conviction and intelligence of Jessica Lange, its star and co-producer.

•

Just a few years ago, Miss Lange made her film debut as King Kong's pretty, brainless beloved in the terri-

ble remake of the 1933 classic. She's come a long way since, having won an Oscar last year for her very comic performance in "Tootsie" and having been nominated for another for her even finer performance in the highly dramatic "Frances," the biography of Frances Farmer. Miss Lange is not only an exceptionally talented and beautiful woman, she's a force of nature.

It's this elemental strength, both as an actress and as the character she plays in the film, that shapes "Country," mostly for the better. With "Frances" and now "Country," Miss Lange joins Barbra Streisand, Jane Fonda and Goldie Hawn — that small group of American actresses who have successfully shown that they are the most important "authors" of their own careers.

"Country," shot largely in Iowa under often terrible climatic conditions, looks as raw and beautiful as the winter landscapes. It's full of compassion for its battered, bewildered farmers but, once you get the film's rhythm, it's surprising only in the small variations it works on events that are never unexpected.

"Country" is the story of Gil Ivy (Mr. Shepard) and his wife, Jewell (Miss Lange), their three children and Jewell's crusty old dad, Otis (Wilfred Brimley), as they face an autumn and winter in which just about everything goes wrong.

A tornado during the corn harvest drastically reduces their crop, which, when they finally get it to market, brings 73 cents a bushel less than it has cost them to raise. Simultaneously, the officials of the Federal farm assistance agency, who, in earlier, palmier years, had encouraged Gil and Jewell to take advantage of liberal lending policies, start calling in their loans.

As they face bankruptcy and the loss of their lands, some farmers do what stockbrokers did in 1929, choosing death before fiscal dishonor. Jewell, however, is of sterner stuff. She fights the bureaucrats with the kind of populist fervor that, in the early years of this century, resulted in farm collectives, and later was dramatized by Frank Capra in films in which Gary Cooper stood up — initially alone — for the rights of the little people.

Just what the film's politics are, I'm not sure. Perhaps it doesn't mean to have any. Yet one does wonder when, in a scene set in the farm agency office, one sees a portrait of President Reagan on the wall. But then one realizes that the loans that have come back to haunt Gil and Jewell were probably granted during the Carter Administration.

At the same time, the sort of intense individualism represented by Gil and especially by Jewell — by their commitment to farming as a way of life and by their affirmation of the satisfactions of hard work — would seem to demonstrate the more conservative position that there's nothing wrong with the system that sweat can't correct. "Country" seems to be both for and against "big government." Or maybe it's just pro-people.

•

This is only worth going into because "Country," more than any other recent commercial film, is genuinely interested in very specific social and economic conditions. It takes farmers seriously.

It's also very good in the ways it captures the routine of farm life as lived by these particular characters, who are representative but far from

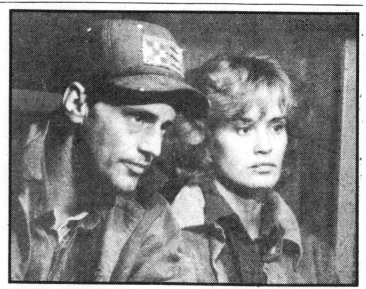

Sam Shepard and Jessica Lange in "Country."

ordinary. The young actors who play the Ivy children are very effective, especially Levi L. Knebel, a nonprofessional who plays the teen-age son. Mr. Brimley, as the patient grandfather, and Matt Clark, as a government bureaucrat who has a change of heart, also are good.

Mr. Shepard is incapable of giving anything less than a strong performance, but here the screenplay shortchanges his characterization. About half-way through the film, with little or no preparation, Gil Ivy falls to pieces emotionally. Because it doesn't fit with what has gone before, it seems more like an arbitrary plot device to provide Miss Lange's Jewell with the opportunity to become a 1980's earth mother, with all of the film's most important lines.

"Country" adds up to less than the sum of its parts. Its big scenes — the tornado that almost wipes out the Ivy family at the beginning, the tumultuous, Government-sponsored auction at the end — are never as moving as the small, almost throw-away scenes that come in-between. "Country" is at its best when it's least self-conscious, when a little girl, left alone with her baby sister, joyously makes up the baby with lipstick and rouge, or when Miss Lange desperately competes with a shepherd dog to round up several dozen sheep being taken away to settle a debt.

By an unfortunate coincidence, "Country" and Robert Benton's new film, "Places in the Heart," share a number story points as well as a concern with unsophisticated, rural characters caught in unusual circumstances. The films really aren't comparable, though. "Places in the Heart" is mythic. "Country" has the sharp edge of informed journalism.

•

"Country," which has been rated PG ("Parental Guidance Suggested"), contains some mildly vulgar language and inoffensive sexual references.

1984 S 28, C20:1

AMERICA AND LEWIS HINE, directed by Nina Rosenblum; written by Daniel V. Allentuck, from the book; edited by Lora Hays; photographed by Robert Aachs, Kobi Kobayashi and John Walker; music by various composers; produced by Miss Rosenblum and Mr. Allentuck. At Alice Tully Hall, Lincoln Center, as part of the 22d New York Film Festival. Running time: 56 minutes. This film has no rating.

LOS SURES, directed by Diego Echeverria; photography, Mark Benjamin and Alice Weber; edited by Kathryn Taverna; produced by Mr. Echeverria. At Alice Tully Hall, Lincoln Center, as part of the 22d New York Film Festival. Running time: 58 minutes. This film has no rating. With: Tito Lopez, Marta Aviles and her children, Cuso Soto and his co-workers, Evelyn Borges, Ana Maria Soto, Pastora Ayala, "Renegade 13."

By LAWRENCE VAN GELDER

Deceptive is the word for documentaries. At their best, they can give the impression of being artless, effortless visual recordings that almost accidentally illuminate their subject. In truth, they are — or should be — full of deliberate, sophisticated choices by which the film maker defines his material.

These thoughts come to mind after watching the pair of documentaries — "America and Lewis Hine" and "Los Sures" — that will be shown at 6 o'clock tonight at Alice Tully Hall as part of the 22d New York Film Festival.

•

Though both are virtuous, the superior is "America and Lewis Hine," a tribute to the socially conscious still photographer who recorded the high tide of immigration at Ellis Island, the abuses of child labor in the mills, mines and fields of America, the crushing life of steelworkers in Pittsburgh and eventually the craftsmanship, pride and heroism involved in the construction of the Empire State Building.

"Los Sures" ("The Southerners") are the inhabitants of South Williamsburg whose lives are explored through the testimony of five inhabitants of the poor Hispanic neighborhood in Brooklyn.

"America and Lewis Hine" has the luxury of being a documentary about a compiler of documentaries. Mr. Hine, whose work influenced subsequent generations of photographers, is defined through his work, which possessed the art of defining others. So, in a way, the task of his chroniclers was made easy. But the judicious selection of accompanying film clips, music and narration by Nina Rosenblum and Daniel V. Allentuck deepen the self-portrait Mr. Hine created through his own photographs by setting him neatly in the context of the times that produced him.

On the other hand, "Los Sures" relies almost entirely on the testimony of its five subjects — a young

man who steals cars, a mother of five living on welfare, a middle-aged woman who believes in spiritualism, a 43-year-old laborer and a young woman who has risen from the welfare rolls to acquire a college degree and a job with a social agency.

Life, they agree repeatedly, is hard in a neighborhood where those who die violently are memorialized by paintings on sidewalks and walls. Though Diego Echeverria's film may be an accurate record of the way things are in "Los Sures," it leaves a viewer yearning for the kind of filmmaking choices that reach outside "Los Sures" if necessary to shed more light on the past that created it and on the possibilities of the future.

1984 S 29, 14:4

STRANGER THAN PARADISE, directed and written by Jim Jarmusch; director of photography, Tom Dicillo; edited by Mr. Jarmusch and Melody London; music by John Lurie; produced by Sara Driver; a Samuel Goldwyn Company Presentation. At Alice Tully Hall, Lincoln Center, as part of the 22d New York Film Festival. Running time: 90 minutes. This film is rated R.
Willie .. John Lurie
Eva .. Eszter Balint
Eddie .. Richard Edson
Aunt Lottie .. Cecillia Stark
Billy .. Danny Rosen
Man with money .. Rammellzee
Airline agent .. Tom Dicillo
Factory worker .. Richard Boes

By VINCENT CANBY

Jim Jarmusch's "Stranger Than Paradise" looks as if it had been left on the windowsill too long. Shot in 16-millimeter black-and-white, and now blown up to 35 millimeter, its images appear to have been aged by the sun and by general neglect until they've faded into a uniform shade of gray. When, occasionally, there's a splotch of comparatively pure black or white, the effect is disorienting until you recognize what Mr. Jarmusch is up to — that is, discovering the ludicrously sublime in the supremely tacky. The film, a prize-winner at this year's Cannes festival, is something quite special.

"Stranger Than Paradise" will be shown at the New York Film Festival at Alice Tully Hall tonight at 9 o'clock and tomorrow at 4:30 P.M., and will open its regular commercial engagement at the Cinema Studio 2 on Monday. Among other things, it is one of the most original, wonderfully oddball, independent American films to turn up at the Lincoln Center festival in years, or at least since the showing of Eagle Pennell's "Last Night at the Alamo" last year.

Eszter Balint in Jim Jarmusch's "Stranger Than Paradise."

The two films otherwise don't have much in common except their tiny budgets and each director's rare appreciation for the ridiculous. "Last Night at the Alamo" is a gregarious sort of comedy, full of oversize emotions and good humor. By comparision, "Stranger Than Paradise" is inhibited, its visual manners almost as lazy as those of Rainer Werner Fassbinder's "Katzelmacher," in which the camera often seems just too tired to follow a character as he walks offscreen, knowing full well that if it waits long enough, the character will walk back on.

"Stranger Than Paradise" is a "Marty" that Jean-Paul Sartre might have appreciated, about hanging out, not in hell but in a permanent purgatory. This world sometimes looks like an eerily underpopulated New York City, a rundown but genteel working-class section of Cleveland or that scrubby part of the east coast of Florida that has yet to be transformed into a vacation paradise, where the motels always have vacancies, even at the height of the season, and where the swimming pools are filled with weeds, not water.

Though Mr. Jarmusch's screenplay does contain a number of subsidiary roles, it's virtually a three-character piece. They are Willie (John Lurie), a 30ish, horse-faced fellow who, though Hungarian-born, has been in this country 10 years and has no trace of any accent; his pal Eddie (Richard Edson), who looks like a condensed version of Willie, even down — or up — to the cheap fedoras they seldom remove, even to sleep, and Eva (Eszter Balint), Willie's pretty, 16-year-old cousin from Budapest who is forced to spend 10 days at Willie's grimy little New York room before going on to live with an elderly aunt in Cleveland.

Until the arrival of Eva, Willie appears to be perfectly content with his life on the outer fringes of capitalism. He has no visible means of support, and appears to make ends meet by playing the horses and occasionally cheating at cards. At first the presence of the taciturn, pony-tailed Eva seems a rude intrusion to Willie, especially when she asks why TV dinners are called TV dinners or what a quarterback does when his team is on defense.

She's a drag until she casually shoplifts food and cigarettes for them, at which point Willie begins to see her as a kindred spirit. He gets so carried away by what passes for affection in his life that he even buys her a present. When she opens the shopping bag and takes out the dress, her brow furrows. "Well?" says Willie. "I think it's kind of ugly," says Eva. They speak the same language.

"Stranger Than Paradise" is about the curious, unspoken alliance of Willie, Eva and Eddie and their adventures in New York, Cleveland and, finally, Florida. They are as lost but also as quietly gallant as the three German misfits who seek their fortunes in Wisconsin in Werner Herzog's "Stroszek." The film has no big scenes, and it takes a while to get the hang of it, but once you do, it's as funny as it is wise. Mr. Jarmusch isolates the film's series of tiny vignettes by extended blackouts that, at the beginning, seem to be an affectation, but then come to be the visual equivalent of the dead space that surrounds each character.

The quality of Mr. Jarmusch's humor is not easily described. It's there in the spare dialogue, as when Willie and Eddie, in a blinding snowstorm, are driving through Cleveland to find Eva, and Eddie asks, quite sincerely, if Cleveland looks like Budapest. "Of course not," says Willie. Later, when they are leaving Cleveland, Eddie muses, "You know, it's kind of funny. You're some place new, and everything looks just the same."

Wherever they go, the world of Willie, Eva and Eddie does look just the same. The Florida they find is not unlike a large vacant lot in Cleveland, though without the snow. Their adventures, however, are very particular, and the film ends on a note that slides without effort, like a piece of music, from the hilarious to the funny to the haunting.

The three lead performers are extremely good, never for a second betraying the film's consistently deadpan style. In a couple of short scenes, Cecilia Stark, as the elderly aunt in Cleveland, nearly walks off with the picture, but "Stranger Than Paradise" is too much of an integrated piece of work for any one performer to steal it. Mention must also be made of Tom Dicillo's camera work, which is as funny and self-assured as the performances and Mr. Jarmusch's realization of his initial concept.

Here is one festival movie that should hang around for a good, long while.

1984 S 29, 14:3

A HILL ON THE DARK SIDE OF THE MOON, directed by Lennart Hjulstrom; script (in Swedish with English subtitles) by Agneta Pleijel; cinematography by Sten Holmberg and Rolf Lindstrom; edited by Lasse Lundberg; produced by Bert Sundberg; production company, MovieMakers Sweden AB for the Swedish Film Institute, the Swedish Television SVT 1, Sandrews & MovieMakers; a Crystal Pictures, Inc. Release. At Alice Tully Hall, Lincoln Center, as part of the 22d New York Film Festival. Running time: 101 minutes. This film has no rating.
Sonya Kovalevsky .. Gunilla Nyroos
Maxim Kovalevsky .. Thommy Berggren
Foufa Kovalevsky .. Lina Pleijel
Ann-Charlotte Leffler .. Bibi Andersson
Gustaf Edgren .. Ingvar Hirdwall
Gosta Mittag-Leffler .. Iwar Wiklander
Martha Mittag-Leffler .. Gerd Hegnell
Greta .. Birgitta Ulfsson
Anton .. Roland Hedlund

In view of the fact that it supposedly depicts two very serious 19th-century intellectuals, "A Hill on the Dark Side of the Moon" is surprisingly sappy. She (Gunilla Nyroos) is the brilliant mathematician Sonya Kovalevsky, a prize-winning scientist and the world's first woman university professor in her field. He (Thommy Berggren) is Maxim Kovalevsky, a fellow Russian exile who coincidentally shares the same last name, a radical scientist with a firm belief in feminism.

The film, directed by Lennart Hjulstrom and written by Agneta Pleijel, is supposed to be the true story of how the two Kovalevskys met and fell in love at Stockholm University in the 1880's. For all the rigor and originality this material promises, the film manages to offer only a few solemn remarks about differential equations before dissolving into romantic mush.

After professing their admiration for each other's academic credentials — the few lectures of Sonya's that we see are drowned out by background music and then followed by wild applause — the lovers begin to grapple with an issue that is more mundane. Sonya, who is very plain, believes strongly in fidelity. Maxim, the feminist, believes in every woman's right to do whatever makes her happy, and in his own right to fool around.

storm, are driving through Cleveland to find Eva, and Eddie asks, quite sincerely, if Cleveland looks like Budapest. "Of course not," says Willie. Later, when they are leaving Cleveland, Eddie muses, "You know, it's kind of funny. You're some place new, and everything looks just the same."

Neither of the starring performances is sufficiently captivating to override the essential banality of the love story; on the sidelines, Bibi Andersson as a celebrated writer (named Ann-Charlotte Leffler) and Lina Pleijel as Sonya's daughter draw a fair amount of interest away from the principals.

"A Hill on the Dark Side of the Moon" — the title denotes the place that Sonya ironically says may be named for her some day if she continues to pursue the empty rewards of academic glory — won prizes at the Taormina Film Festival this year. The film won the Silver Charybdis, and Miss Nyross and Mr. Berggren won the Golden Polyphemus. This is cause to wonder both how film festival awards get their names and what else was being shown.

"A Hill on the Dark Side of the Moon" will be shown at 2 P.M. today and at 6:15 P.M. tomorrow as part of the New York Film Festival.

Janet Maslin

1984 S 30, 58:1

DIARY FOR MY CHILDREN, directed and written by Marta Meszaros; director of photography, Miklos Jancso Jr.; music by Zsolt Dome; a Mafilm-Budapest Studio Production; a New Yorker Films Release. At Alice Tully Hall, Lincoln Center, as part of the 22d New York Film Festival. Running time: 106 minutes. This film has no rating.
Juli .. Zsuzsa Czinkoczi
Magda .. Anna Polony
Janos .. Jan Nowicki
His son .. Tamas Toth
Grandpa .. Pal Zolnay
Grandma .. Mari Szemes

By VINCENT CANBY

"Diary for My Children" by Marta Meszaros, the highly regarded Hungarian director who's best known in this country for "Adoption," "Women" and "Just Like Home," is her most politically explicit film yet seen here. That Miss Meszaros was able to make the film at all is some kind of political statement, but the film contains much more. "Diary for My Children" will be shown at the New York Film Festival at Alice Tully Hall tonight at 7 and tomorrow at 9:30.

Like Juli (Zsuzsa Czinkoczi), the new film's solemn, skeptical teen-age heroine of "Diary for My Children," Miss Meszaros, at the age of 5 migrated to the Soviet Union in 1936 with her father, a sculptor, who was later arrested and then officially disappeared. This new film begins with Juli's return to Hungary in 1947, in the company of her fearful grandparents, to live with her politically committed, Stalinist aunt, Magda (Anna Polony).

Though Juli, played with a kind of independent stoicism by Miss Czinkoczi, is the heart of the film, as well as its eyes and ears, it's Magda who is the most complex and interesting character.

Once a young, fiery revolutionary who endured prison and torture, Magda survived to see her revolution triumph, after which, for what she considered the greater good, she shaped her principles to fit monolithic Stalinism. It is this stern Magda, the faithful party hack, against whom Juli rebels, at first in minor ways, such as cutting classes to spend hours at the movies, and then by making an irrevocable break. Though the movie never sentimentalizes Magda by suggesting that she would ever deny her life's work, as other Stalinists later did, the character, as written and directed by Miss

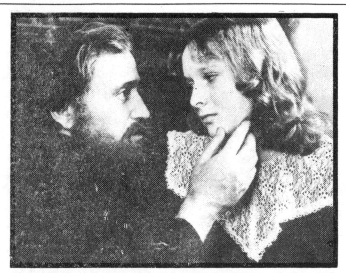

Zsuzsa Czinkoczi and Jan Nowicki in "Diary for My Children."
The film, set in Hungary in 1946, is directed by Marta Meszaros.

Franciso Rabal in Mario Camus's "Holy Innocents." The film,
based on the Miguel Delibes novel, is set in the rural Spain of 1960.

Meszaros and played by Miss Polony, provides the film with its sorrowful tone.

Magda is not a stupid woman. It's one of the better ways in which the film works that it is through the reminiscences of one of Magda's former comrades, who becomes a victim of the Stalinist purges she supports in the late 1940's, that Juli comes to understand something of Magda's sacrifices in the name of the Communist Party and its revolution. To understand Magda, however, is not necessarily to like her. She is a fact of history.

Miss Meszaros makes use of a lot of newsreel footage of the period, which is blended with her new material to create an unusually graphic picture of Hungarian political, cultural and social life in the late 40's. One of the funniest, most poignant scenes is a dreary birthday party for the spoiled young son of a party leader. Not so effective, if only because they are redundant, are a series of flashbacks that describe Juli's relations with her father and mother in the Soviet Union and the trauma she experienced on losing them.

All of the performances are good, including that of Jan Nowicki, who plays the disillusioned party worker whose imprisonment brings the film to its conclusion. Also good is the black-and-white photography of Miklos Jansco Jr., the son of the talented, extremely independent Hungarian director who has recently worked mostly abroad.

The film is also illuminated by everything we know to have happened after "Diary for My Chidren" ends, including the aborted Hungarian uprising of 1956, the Soviet invasion and then the gradual thaw that, among other things, has allowed Miss Meszaros to make this movie.

1984 S 30, 58:1

THE HOLY INNOCENTS, directed by Mario Camus; screenplay (Spanish with English subtitles) by Antonio Larreta, Manuel Matll and Mr. Camus, based on the novel by Miguel Delibes; director of photography, Hans Burmann; edited by Jose Maria Biurrun; music by Anton Garcia Abril; produced by Julian Mateos; released by the Samuel Goldwyn Company. At Alice Tully Hall, Lincoln Center, as part of the New York Film Festival. Running time: 108 minutes. This film has no rating.
Paco ... Alfredo Landa
Azarias ... Francisco Rabal
Regula .. Terele Pavez
Nieves .. Belen Ballesteros
Quirce .. Juan Sánchez
The Little One Susana Sánchez

Dona Purita Agata Lys
Don Pedro Agustin Gonzalez
Master Ivan Juan Diego
The Marchioness Mary Carillo
Miriam .. Maribel Martin
Senorito de la Jara José Guardiola
Physician Manuel Zarzo

By JANET MASLIN

On a feudal farm in northern Spain, stereotypical images of noble, earthy peasants are made unexpectedly touching in Mario Camus's "Holy Innocents," which focuses on the travails of one peasant family. As gatekeepers to the large country estate of a marchioness and her family in the 1960's, these workers are privy to all the aristocracy's cruelty and callousness.

Mr. Camus, along with recording the highhandedness with which the peasants are treated, captures both the hardship and the richness that characterize the lives of these workers. He works particularly hard at conveying their closeness to animals, with whom they live in primitive proximity, and to the land.

The film has a section named for each of its chief characters. These are Paco (Alfredo Landa), who has a preternatural talent for helping the young master Ivan (Juan Diego) with his hunting, and who can crawl like a bloodhound to sniff out a dead bird; Azarías (Francisco Rabal), who prefers live birds and trains them lovingly, although his simplemindedness and appalling hygienic habits have made him a pariah; Nieves (Belén Ballesteros), the pretty daughter who hopes to go to the city to seek her education but is recruited as a housemaid, and Quirce (Juan Sánchez), the son who's even more determined to make his escape. Their mother, Régula (Terele Pávez), tends another child, a brain-damaged girl, and holds the family together fiercely. It is she who, when approached by any of the aristocrats, can deliver the most dutiful "We're here to serve."

"The Holy Innocents" introduces these people in a gradual and engrossing way, without overly stressing the reprehensible ways they are treated. The film builds its case slowly and carefully and, if anything, it seems less predictable in its later moments than it does at first. One scene shows the marchioness (Mary Carillo) handing out coins to the peasants to commemorate one of her rare visits. This relatively mild episode is given no more emphasis than the sequence in which Master Ivan, who is especially eager to have Paco accompany him on a hunting trip, simply

refuses to take the servant's word that his broken leg, which is in a cast, has really incapacitated him. It was on one of Master Ivan's earlier hunting trips that the leg was broken.

"The Holy Innocents" is acted in a plain, utterly convincing style, particularly by Mr. Landa, who arouses great compassion. It culminates in a scene that, even in light of the story that has preceded it, comes as a shock.

1984 S 30, 58:3

IMPULSE, directed by Graham Baker; written by Bart Davis and Don Carlos Dunaway; director of photography, Thomas Del Ruth; edited by David Holden; music by Paul Chihara; produced by Tim Zinnemann; released by Twentieth Century-Fox Film Corporation. At Criterion, Broadway and 45th Street; Gotham, Third Avenue and 58th Street, and other theaters. Running time: 91 minutes. This film is rated R.
Stuart .. Tim Matheson
Jennifer .. Meg Tilly
Dr. Carr .. Hume Cronyn
Bob Russell John Karlen
Eddie ... Bill Paxton
Margo ... Amy Stryker
Sheriff ... Claude Earl Jones
Howard .. Robert Wightman
Mrs. Russell Lorinne Vozoff

There's a lot of "Twilight Zone" to the premise of "Impulse," a small-town science fiction thriller that opened yesterday at the Criterion. Imagine a Middle Western town in which everyone, without warning, begins acting on his every whim. While the children play vicious practical jokes, old men on Sutcliffe's Main Street play games like kick-the-can; in the bank, people steal money simply because they see it lying around. Everyone, quite without inhibition,

says anything that comes to mind.

"Impulse" has a lot to work with as it chronicles the increasing craziness that envelops the town. The screenplay, by Bart Davis and Don Carlos Dunaway, gets the story off to an eerie start and develops it effectively for a while, as Jennifer Russell (Meg Tilly) and her boyfriend, Dr. Stuart Ames (Tim Matheson), return to Sutcliffe for a visit because Jennifer's mother has attempted suicide. The mother is being attended by Dr. Carr (Hume Cronyn), who is no more inhibited than anyone else. Dr. Carr has been periodically torturing Jennifer's mother by tinkering with her respirator.

"Impulse" doesn't sustain its cleverness by bringing any moral dimension to the odd behavior of its characters; it simply deteriorates into an action movie after a while, as Jennifer flees for her life when she realizes that she's the only person in town not afflicted by a bizarre disease.

Miss Tilly is well able to hold the audience's interest, though, and Mr. Matheson, while not very convincingly doctorish, makes a good action hero. Graham Baker, who also directed "The Final Conflict," displays a more credible style touch this time but ends the film on a flat note. The story's possibilities for devilishness are never fully realized.

Janet Maslin

1984 S 30, 58:5

Meg Tilly in the romantic thriller "Impulse,"

FILM VIEW

VINCENT CANBY

Stage and Screen Go Their Separate Ways

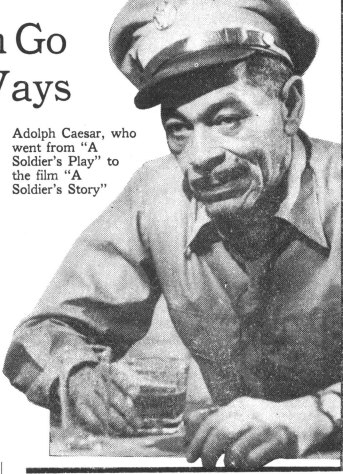

Adolph Caesar, who went from "A Soldier's Play" to the film "A Soldier's Story"

Hollywood — meaning movies in general — and the American theater have parted company. That may seem like a strange if not lunatic thing to say hard on the heels of the successful openings of the Milos Forman-Peter Shaffer screen adaptation of Mr. Shaffer's "Amadeus," the Norman Jewison-Charles Fuller screen adaptation of Mr. Fuller's Pulitzer Prize-winning "Soldier's Play," retitled "A Soldier's Story," and Francesco Rosi's surprisingly cinematic "Bizet's Carmen," which is nothing less than a full-scale screen opera.

Yet the success of each of these films calls attention to the fact that the best American playwrights, as well as all serious playwrights everywhere, are increasingly committed to the creation of a kind of stage literature that is complete unto itself, which cannot easily be adapted to the needs of the screen without compromising the particular art of the original.

These playwrights, including Mr. Shaffer, understand the theater to be a kind of prison, but one whose severe restrictions — whose unrealities — make possible a kind of language you will respond to nowhere else. It's a place where the audience becomes an active participant in the exercise of the playwright's imagination, and where artifice, instead of being exhausting, as it can be in movies, is liberating.

The best playwrights don't adapt themselves to the limitations of the stage. They soar over them. Whether the stage is safely protected by a proscenium arch, or thrust out into the auditorium or even if it's set in the middle of a vast space, completely surrounded by the audience, the theater makes possible a heightened, poetic, not nessarily realistic sort of experience that cannot be duplicated by movies. That our newer playwrights glory in this may be the best thing that's happened to the theater in years and, eventually, it should be good news for moviemakers, most of whom work best when working with original material.

What's happening has been in work for a couple of decades. The American theater has long since ceased being represented by Broadway, which mostly means multimillion-dollar musicals and an ever decreasing number of straight plays.

The American theater today is no longer Broadway. It's Off Broadway, Off Off Broadway and regional theaters, which, though they, too, feel the economic pressures that have shriveled Broadway's appetite for the bold, have nourished and supported such original, not easily categorized American playwrights as Sam Shepard, David Mamet, John Guare, David Rabe and Lanford Wilson and, from abroad, the daddy of them all, Samuel Beckett.

About the only truly original, major playwright to have continued to receive Broadway productions is England's Harold Pinter, who is also about the only playwright of his caliber whose recent stage work has, on one occasion, been accurately reflected in a screen version, that is, in David Jones's fine film adaptation of "Betrayal."

From the 1930's into the 1960's, it was the exception to the rule when the hit Broadway play did not find its way to the screen. Like the theater of London's West End, the American theater — Broadway — was then essentially realistic or, at least, not so *un*realistic that a popular play could not be adapted to the screen without enormous adjustments in the work's sound, look and tone. Indeed, most of the work written for our popular theater had the manner of something calculated to wind up on a soundstage.

The classic comedies of Kaufman and Hart, the great musicals of Rodgers and Hammerstein, the major plays by Tennessee Williams and Arthur Miller, and even some by the greatest, most demanding of them all, Eugene O'Neill, eventually became films. Some were extraordinarily fine, like Elia Kazan's screen adaptation of "A Streetcar Named Desire," Frank Capra's version of Kaufman and Hart's "You Can't Take It With You," and the Tony Richardson-directed screen version of John Osborne's "Entertainer," with Laurence Olivier repeating one of his most memorable stage performances.

Some were simply terrible, like the hammy "Mourning Becomes Electra" with Rosalind Russell and Katina Paxinou, and many more were fairly perfunctory if popular, like the various Rodgers and Hammerstein film adaptations, most notably, "The Sound of Music."

The good news about the screen adaptation of "Amadeus" is that it preserves and perhaps makes even more humane the heart of Mr. Shaffer's fascinating play. This is the mad spectacle of Antonio Salieri, self-styled "patron saint of mediocrities" and the only man in Vienna to appreciate fully the genius of "that obscene child," Mozart, as he plots to destroy Mozart and, in passing, to steal a little bit of his divinity.

Mr. Shaffer, who worked closely with Mr. Forman in writing the screenplay, has conscientiously removed or made "cinematic" most of what might be called the play's staginess. It is now set in a real world — Prague, which stands in for 18th-century Vienna — and the film audience is treated to a lot of beautifully conducted and sung excerpts from the Mozart operas. All the right decisions have been made, and this "Amadeus" is certainly a movie, not a photographed play.

Yet something important has also been lost, that is, the sort of impact one can only get in the theater when everything works, as it did in Peter Hall's production of "Amadeus," to produce an emotional high that transcends the rationality by which movies work. The play's magnificent single set, designed by John Bury, was only slightly less important to the play's success than Mr. Shaffer's vision and words.

The set, among other things, represented the prison of Salieri's obsession from which neither the play nor Salieri could ever break free. It was a visual manifestation of the play's internal structure. Remove it, as the filmmakers have had to do, and the movie, in spite of the music and the excellent performance of F. Murray Abraham as Salieri, seems almost aimless at times. This "Amadeus" continues to delight the mind, but it just sort of wanders to its conclusion.

Mr. Shaffer ("Equus," "Black Comedy," among others) is the most unembarrassedly theatrical of contemporary playwrights, and to see a Shaffer work made more or less realistically is to see only part of his special talent.

Mr. Fuller's "Soldier's Story" makes a good, conventional, thought-provoking whodunit, one that loses little on film that it possessed in the theater, just because the play itself is the sort that accommodates itself to the limitations of the stage rather than — as Mr. Shaffer's plays do

— capitalizing on those limitations. All that Mr. Jewison had to do with Mr. Fuller's screenplay was to make visual all of those locations on the Army base that were simply suggested in the play.

As a theater piece, "A Soldier's Play" is very much in the tradition of the well-made play that dominated — some could say that it had a stranglehold on — Broadway for the better part of this century. It's a play with a beginning, middle and an end, a play that takes place in a recognizable landscape and a work that never for a minute evokes states of mind and emotion of a sort that can only be experienced in the theater. It's a solid piece of work but it's a couple of hundred years removed from the plays of people like Mr. Shepard or Mr. Mamet. Unlike, say, Mr. Shepard's "Fool for Love," "A Soldier's Play" might just as successfully have been conceived as a movie.

It's not a put-down to say that "Bizet's Carmen" is a first-rate movie musical. It is, of course, an opera, one of the most popular ever written, and one that, being grittily realistic and almost completely without humor, adapts, as Mr. Rosi demonstrates, to the realism of films. There is, of course, all that singing to deal with, but Mr. Rosi has so isolated and framed the real-life locations that the music is no more jarring than it is in a screen adaptation of something by Rodgers and Hammerstein.

Not all well-made plays, of course, adapt with equal ease to film. Neil Simon makes plays probably as well as anyone in the modern theater, but few of his comedies, with the exception of "California Suite" and "The Sunshine Boys," have seemed as funny on the screen as they have on the stage, possibly because the frantic pacing and relentless wisecracks are working against the realism of movies.

Only one of Lillian Hellman's expertly crafted plays, "The Little Foxes," duplicated its stage success on film, and this because William Wyler, the director, and Gregg Toland, the cameraman, understood that one of the fundamental satisfactions of the stage experience is being able to take in the entire stage "image" at any one moment. To this end, they shot much of the film in the kind of deep focus that allows the audience to see a number of characters on screen at the same time, and with equal clarity, thus to be able to respond to the interaction of various warring factions.

• • •

This is just the sort of thing that Robert Altman failed to do in his film version of David Rabe's "Streamers." Mr. Altman made no foolish attempts to "open up" the play by taking it very far from the Army barracks that is its locale. However, he insisted on shooting the film with so many tight close-ups that one often forgot that there were actually as many as five or six people participating in one way or another in a scene at one time, instead of the two or three who were being isolated by the camera. The effect was to fracture the drama, leaving it a pile of separate components at the end, instead of creating the single, harrowing, haunting impact of the stage experience.

Every play, whether it has only two characters on stage at one time, like "The Gin Game" or 20-some, as does the last scene in "The Front Page," the Ben Hecht-Charles MacArthur classic, is seen by the audience in what moviemakers would call a single, unvarying long-shot. The audience's attention can be directed to one part of the stage or another by movement, action and dialogue, but a stubborn patron can always chose to stare at the dramatically irrelevant if he wants. This freedom is one of the pleasures of the theater, as opposed to the pushiness of most movies, which only let us see what the director, writer and editor have deemed dramatically proper and fit.

This is also one of the reasons that stage farces — I think of "Hotel Paradiso" and "A Flea in Her Ear," especially — have so frequently failed as movies. Farce, perhaps more than any other form of theater, demands that we see, at one moment, the entire farcical panorama of a hotel corridor or lobby to be able to enjoy the accumulating complications. When these elements are separated by individual shots — close-ups, medium and long shots — the comedy evaporates.

In the past there have been a number of exceedingly fine adaptations of plays — Laurence Olivier's "Henry V," Sidney Lumet's "Long Day's Journey Into Night," Milos Forman's almost miraculous conversion of "Hair" into a film musical, and Howard Hawks's classic transformation of the Hecht-McArthur "Twentieth Century" to film.

Films and stage, however, have always offered different sorts of pleasures. Because tricks are so easy to carry off in films, the manifest absence of trickery on screen can seem astonishingly good, whether funny or dramatic. Charlie Chaplin, who came out of English music hall, understood this when, in "The Circus," he had the tramp trapped in a cage with a lion, both seen together, in a single shot, and not separated either by trickery or isolating shots.

Tricks on the stage are just that much more fun because they are so much more difficult than in films. One of my fondest memories of the theater is not something on the order of the Laurence Olivier-Vivien Leigh "Caesar and Cleopatra," but a moment in S. N. Behrman's "Pirate," with Alfred Lunt and Lynn Fontanne, when Lunt, for plot reasons, had to walk across a tightrope stretched 15 feet above the floor, from one side of the stage to the other. Everyone in that audience knew that Lunt, although a splendid actor, was probably not much of a tightrope walker. Yet there was no way the play could avoid this moment of truth.

Then, just as the actor stepped off a set's balcony onto the tightrope, a flat, simulating the lower half of the set, dropped to the stage, providing the actor with a safe but unseen board by which he could make his crossing. It was a stunningly funny, theatrical moment, as well as testament to the brilliant ingenuity of Lemuel Ayres, who had designed the set. There's no way that such an effect could be duplicated on the screen.

As our best filmmakers — Woody Allen, Martin Scorsese, Robert Benton, Francis Coppola, Steven Spielberg, Brian De Palma — are exploring the possibilities of films, mostly through original work that couldn't possibly fit on a stage, our best dramatists are writing plays that have only the remotest chances of being turned into big-budget, commercial motion pictures.

Nobody in his right mind — I hope — would attempt to make a movie from Mr. Shepard's "Fool for Love," "Buried Child" or "True West," though that one has been taped for television, which may be one of television's most underused functions: that is, the recording — with as little tampering as possible — of stage experiences that won't transfer easily to the screen. Mr. Shepard, Mr. Mamet, Mr. Guare and the others write each in his own fashion, each in his own style. In this way they are helping to create a far more vital, more independent theatrical form, one that understands the unique rewards of the live theater.

Mr. Shepard, Mr. Mamet and Mr. Guare have all written or contributed to screenplays — Mr. Guare with special success in his original screenplay for Louis Malle's "Atlantic City." Their theatrical work, however, celebrates not the similarities between the stage and films, but the differences. This is as it should be, for a healthier theater and a healthier cinema. ∎

1984 S 30, II:1:3

Passion and Fate

A LOVE IN GERMANY, directed by Andrzei Wajda; screenplay (German with English subtitles) by Boleslaw Michalek, Agnieszka Holland and Mr. Wajda, from the novel "Eine Liebe in Deutschland" by Rolf Hochhuth; director of photography, Igor Luther; edited by Halina Prugar-Ketling; music by Michel Legrand; produced by Arthur Brauner for CCC Filmkunst (Berlin)/Gaumont/TF 1 Films Production/Stand'art (Paris); released by Triumph Films. At Alice Tully Hall, Lincoln Center, as part of the 22d New York Film Festival. Running time: 107 minutes. This film is rated R.
Paulina Kropp Hanna Schygulla
Maria Wyler Marie-Christine Barrault
Mayer Armin Mueller-Stahl
Elsbeth Schnittgens Elisabeth Trissenaar
Wiktorczyk Daniel Olbrychski
Stanislaw Zasada Piotr Lysak
Karl Wyler Gerard Desarthe
Dr. Borg Bernhard Wicki
Schulze Ralf Wolter
Narrator Otto Sander
Klaus Ben Becker
HerbertThomas Ringelmann
Zinngruber Friedrich G. Beckhaus

By VINCENT CANBY

Hanna Schygulla in Andrzej Wajda's film "A Love in Germany."

AS she demonstrated in Ettore Scola's witty meditation on the French Revolution, "La Nuit de Varennes," Hanna Schygulla will survive the death of Rainer Werner Fassbinder. It was Fassbinder who originally discovered her and for whom she made a whole series of extraordinary films, from the early "Katzelmacher," through "Effi Briest" and, perhaps the best of them all, "The Marriage of Maria Braun."

•

Now, in Andrzej Wajda's "Love in Germany," she gives what must be called a triumphant performance, one that ranks with the best of her work with Fassbinder, in a film that must be the most romantic ever made by Mr. Wajda, the great Polish

director whose best films, from "Ashes and Diamonds" through "Man of Marble" and the recent "Danton," have always been shaped by his political conscience.

"A Love in Germany," which will be shown at the New York Film Festival at Alice Tully Hall tonight at 6:15 and tomorrow at 9:30 P.M., is certainly full of political concerns, but it's also a story about a love so all-consuming that its consequences seem less tragic than liberating, politically as well as emotionally. Though it's nowhere near as sexually explicit and violent as Nagisa Oshima's "In the Realm of the Senses," "A Love in Germany" recalls the monomaniacal, self-obsessed passions of the Japanese film.

The screenplay, written by Mr. Wajda with Boleslaw Michalek and Agnieszka Holland, is based on a novel I haven't read by Rolf Hochhuth, best known here as the German playwright who, in the 1960's, offended just about everybody at least part of the time with his unflattering portraits of Pope Pius XII in "The Deputy" and Winston Churchill in "Soldiers."

"A Love in Germany" is set during World War II in the small German town of Brombach, sometime before the eventual collapse of the Third Reich was even suspected by most citizens. The children of Brombach happily suck on lollypops decorated with sugar swastikas. The news from the fronts isn't yet so hopeless that the deaths in battle of husbands and fathers can't be accepted as noble sacrifices in the cause of the fatherland.

In Brombach, everybody knows everybody else's business, and as long as certain activities — those that don't actually threaten the tiny community — aren't flaunted, most people look the other way. Thus almost everyone, from her neighbors to the mayor, are aware that Paulina Kropp (Miss Schygulla), the mother of a small son and whose husband is away in the army, has something more than a passing interest in Stanislaw (Piotr Lysak), the handsome, much younger, Polish prisoner of war who has been billeted in Brombach as a kind of boy-of-all-work.

Paulina runs a small, well-stocked grocery store, where she is assisted in the heavy work from time to time by Stanislaw, who lives across the street with an elderly couple. There is every indication that Paulina loves her absent husband, but the affair with Stani, as she calls him, is something quite other, a passionate sexual liaison that comes to dominate every aspect of her life.

Both Paulina and Stani are aware that sexual relations between German nationals and P.O.W.s are forbidden by a law, which decrees the death penalty for the foreigner and imprisonment for the German. Yet Paulina and Stani become increasingly careless about hiding their relationship. Paulina, especially, seems to exult in it. Her happiness makes her euphoric.

Before a rendezvous with Stani in the woods on the outskirts of Brombach, she drops by the local pharmacy and, after making a few innocuous purchases in front of her friends, boldly asks the pharmacist for a condom. As the affair progresses to the consternation of her closest friends, her fever makes her ever less cautious. When Stani comes in by the middle of the day, she virtually tears his clothes off in the front window of the ever-unlocked shop. It isn't long before the lovers are informed upon

by a neighbor who covets Paulina's very profitable little business.

Nobody, especially the army officer in charge of the prosecution, wants to see the case through to its inevitable end. Stani's death sentence can be avoided if it can be proved — or certified — that he is actually German. But Stani refuses to be thus "Germanized" in a bogus physical exam. If Paulina will testify that she was raped, she also might avoid the consequences. The manner in which each lover embraces fate is both exhilarating and terrible. Love so self-destructive is so rare that it appears ludicrous to everyone not a party to it.

This is the secret of the film, and one that perhaps no actress except Miss Schygulla could make so sexually vivid and even so politically important. Miss Schygulla's Paulina is a grandly heedless character, and though Stani, nicely played by Mr. Lysak, seems at first to be something of a victim of her passion, he too achieves a kind of heroic stature as the film moves to its foregone conclusion.

Mr. Wajda has cast the film impeccably. The supporting players include such stars as Marie-Christine Barrault, as the neighbor who wants Paulina's shop; Elisabeth Trissenaar, as Paulina's best friend who finally refuses to condone the affair; Armin Mueller-Stahl, as the officer who desperately tries to save the lovers; Daniel Olbrychski, as one of Stani's fellow P.O.W.s, and Bernhard Wicki, as Brombach's civilian doctor who craftily avoids being a participant in the prosecution.

"A Love in Germany" initially appears to be an uncharacteristic Wajda work. Love of this kind has seldom if ever interested him in the past. Yet "A Love in Germany" may be one of his most effective films, evoking, effortlessly, large, haunting associations from a small set of extremely specific circumstances.

1984 O 2, C13:2

Impressions

A SUNDAY IN THE COUNTRY, directed by Bertrand Tavernier; screenplay (French with English subtitles) by Mr. Tavernier and Colo Tavernier, based on the novel "Monsieur Ladmiral va bientôt mourir" by Pierre Bost; director of photography, Bruno De Keyzer; edited by Armand Psenny; music by Gabriel Fauré; produced by Alain Sarde; a coproduction of Sara Films/Films A2/Little Bear; an MGM/UA Classics Release. At Alice Tully Hall, Lincoln Center, as part of the 22d New York Film Festival. Running time: 94 minutes. This film has no rating.
Monsieur Ladmiral Louis Ducreux
Irène ... Sabine Azema
Gonzague (Edouard) Michel Aumont
Marie-Thérèse Genevieve Mnich
Mercedes Monique Chaumette
Madame Ladmiral Claude Winter
Emile ... Thomas Duval
Lucien .. Quentin Ogier
Mireille Katia Wostrikoff
First Little Girl Valentine Suard
Second Little Girl Erika Faivre
Accordionist Marc Perrone
Open-Air Dance Hall Servant Pascale Vignal
Hector Jacques Poitrenaud

By JANET MASLIN

BERTRAND TAVERNIER'S "A Sunday in the Country" is exquisite — purposefully and almost painfully so — from beginning to end. Set at the turn of the century, on a single day at the country home of an elderly French gentleman, it records the particulars of a visit from his children.

The household of Monsieur Ladmiral (Louis Ducreux), run by a single devoted servant (Monique Chaumette) whose master holds her greatly in awe, is ritually readied for the vari-

Louis Ducreux protrays Monsieur Ladmiral, in Bertrand Tavernier's film "A Sunday in the Country."

ous meals, naps, meanderings and pleasantries that will mark the day.

•

Mr. Tavernier observes these preparations with the same care and acuity that he brings to the family's interaction. In addition to underscoring the fact that Monsieur Ladmiral is an artist of wide renown, the film's painterly style is well attuned to its characters. Their behavior through the events of the day rarely breaches the prevailing air of mannerliness and comfort. Yet Mr. Tavernier, while conveying the elegance of the proceedings, is able, slowly and perceptively, to reveal all the inner workings of this family and much about its history.

"A Sunday in the Country," which was written by Mr. Tavernier and Colo Tavernier, his wife, and based on the novel "Monsieur Ladmiral va bientôt mourir" by Pierre Bost, is one of the director's very best films, acted as beautifully and thoughtfully as it is staged. The early part of the day, devoted to a visit by the septuagenarian's son Edouard (Michel Aumont) and his wife and children, displays just how little import the son's dutifulness has for his father. Edouard, who has been called Gonzague for most of his life, has a plain, proper, faintly vulgar wife named Marie-Thérèse (Genevieve Mnich) who has engineered the name change and a great deal more about her husband's life. Edouard also has three handsome, well-dressed children who ought to be the apple of their widowed grandfather's eye. Yet a portrait of a beautiful young woman, and a few passing conversational references, make it clear that the painter's daughter Irène is his more beloved child.

Irène (Sabine Azema) arrives from Paris midway through the day, thin and glamorous and thrilling. She has all the vitality her brother lacks, a fact of which he and his wife are unpleasantly aware. And the old man makes no effort to hide his adoration. Even Mercédès, the housekeeper, is as appreciative with Irène as she has been sullen towards Marie-Thérèse. Irène's visit, though brief, has an enormous effect on her father, her brother and even on the film's visual style. It is in Irène's company that Monsieur Ladmiral visits a rollicking outdoor dance hall, where Mr. Tavernier mounts the film's most visually breathtaking sequence. Everything

Sabine Azema plays a daughter who pays a surprise visit to her father, a noted painter.

about the colors and costumes, the faces and gestures of the extras, makes this an Impressionist painting come to life.

Monsieur Ladmiral, painting in a controlled and classical style despite his awareness of contemporaries like Cézanne and Monet (he makes a number of observations about the work of his fellow artists during the course of the film), is drawn by his daughter toward different, more vital notions of both art and life; this influence of Irène's helps shape the film's lovely closing scene. Mr. Tavernier is particularly graceful in weaving the family's affairs into the film's perceptions about painting, until the two themes ultimately fuse.

The overpowering visual approach makes the actors work within narrow confines; each of them says as much through appearance as through word, thought or deed. The cast has been well-chosen with this in mind. Miss Azema and Miss Chaumette are particularly adroit. So is Mr. Ducreux, who makes the old gentleman rueful and affecting without sentimentalizing him. Even Miss Mnich, in the unflattering role of Marie-Thérèse, gives Mr. Tavernier exactly what is called for. He seems in full control of every performer, every image, every frame.

1984 O 2, C14:3

A Distant Solidarity

FAR FROM POLAND, produced and directed by Jill Godmilow in collaboration with Susan Delson, Mark Magill and Andrzej Tymowski; director of photography, Jacek Laskus; piano, Michael Sahl. At the Film Forum, 57 Watts Street. Running time: 106 minutes. This film has no rating.
Ruth Maleczech Anna Walentynowicz
Mark Margolis Adam Zarewski
John Perkins Gen. Wojciech Jaruzelski
William Raymond K-62
David Warrilow voice of General Jaruzelski

By STEPHEN HOLDEN

JILL GODMILOW'S "Far From Poland" is a curiosity — a full-length apology for not creating the film she set out to make. Four years ago, Miss Godmilow happened to be in Poland at the time of the Gdansk shipyard strikes that precipitated the Solidarity movement. Seized by the prospect of filming history in the making, she rushed home to New York and raised the money to take a camera crew back to Warsaw. But they were denied visas.

All of this is earnestly recounted on screen by Miss Godmilow in the prologue to "Far From Poland," which opens today at the Film Forum. Made up of fragments of dreams, autobiography, documentary footage and re-enacted interviews in New York, this personal collage-movie doesn't add up to very much.

Very quickly, the film maker begins ridiculing the artistic and political dreams she entertained as a documentarian. We are shown a videotape, "Another Flaming Liberal," made by her boyfriend Mark (Mark Magill), in which he mocks her determination to show "a whole nation turning itself into a real community, with a new vision." Later, with the screen dark, and a piano tinkling in the background, Miss Godmilow recounts her dreams of telephone conversations with Fidel Castro in which he urges her to give up the project. The movie's epilogue, a cinematic injoke, presents scenes she imagines to be outtakes from a future Andrzej Wajda film in which an actor playing Gen. Wojciech Jaruzelski, is shown returning to civilian life.

Interwoven are floundering attempts to tell the story of Solidarity. The movie includes footage Miss Godmilow herself describes as disappointing, which was sent to New York by the Solidarity Film Agency before the Polish Government imposed martial law. Snippets of American television coverage of Polish unrest are interspersed with dry roundtable discussions with Polish intellectuals to whom the film maker seems to listen in rapt awe.

The liveliest sequences are "re-enactments of interviews published in Poland during Solidarity. The actors, members of the Mabou Mines stage troupe who affect Eastern European accents, include Ruth Maleczech and William Raymond. Miss Maleczech gives the role of Anna Walentynowicz, the crane operator whose firing brought on the first Gdansk strike, a luminous solidity and stubborn passion that for a few moments illuminate the screen with real drama. And Mr. Raymond gives a sly, comic performance as a paranoid government censor known only as K-62.

But a movie that wants to question the "myth" of documentary film truth succeeds only in reiterating the obvious point that momentous events, when contemplated from afar, can mean almost anything to anyone.

1984 O 3, C22:5

Polish Orientation

SHIVERS, directed by Wojciech Marczewski; screenplay (Polish with English subtitles) by Mr. Marczewski; photography by Jerzy Zielinski; music by Andrzej Trzaskowski; production management, Zbigniew Tolloczko; produced by The Polish Corp. for Film Production "Zespoly Filmowe"; a New Yorker Films Release. At Alice Tully Hall, as part of the 22d New York Film Festival. Running time: 106 minutes. This film has no rating.
WITH: Tomasz Hudziec, Teresa Marczewska, Marek Kondrat, Zdzislaw Wardejn, Teresa Sawicka, Jerzy Binnczycki, Bogdan Koca, Zygmunt Bielawski

By JANET MASLIN

The Polish film "Shivers" is a tacit account of the making of a monster. It follows the process by which an adolescent boy named Tomasz (Tomasz Hudziec) is transformed from a quiet, shy student into a budding ideologue in the Poland of 1955.

As directed by Wojciech Marczewski, "Shivers" has a grimy, impoverished look in its early sections. Tomasz, who lives with his parents and younger brother in a small, homey apartment, is always dirty. Mr. Marczewski offers a sense of both the family's life together — their father is seen disciplining his sons and sending them off to bathe in kitchen washtubs — and of the disorder and despair Tomasz encounters in the classroom. His glum, cynical teacher gives the required lessons and also hints bitterly about those things his students are forbidden to read, study or think.

Not surprisingly, this teacher is soon ousted and replaced by a more rigorous Stalinist. The students are asked, by their new teacher and visiting officials, to stop going to church ("Do you have the courage to say to your parents, this coming Sunday, 'No'? And to say to your conscience 'Yes'?). They are even directed to disrupt a clerical procession on the day of worship.

Tomasz remains fairly inconspicuous throughout these character-building rituals, but he becomes more upset and more noticeable after the authorities suddenly arrest his father. Soon afterward, and already afflicted with the tremors of the title, Tomasz is recruited for an elite Stalinist "All-Poland Camp,". where the students are encouraged to write essays telling "everything I know

Tomasz Hudziec in the Wojciech Marczewski film "Shivers."

about my parents" or "everything I know about one of my campmates."

The large former estate at which the camp is housed is mysteriously leaky, and Mr. Marczewski often pauses to let the camera examine the water dripping, the muck seeping down the walls. Compared with the frank grubbiness of the film's early sections, this latter portion has a far more insidious look, which matches the changes in Tomasz and his fellow students. Mr. Marczewski depicts the process by which they change in ways that are by no means pat. Most of the students retain some degree of doubt and confusion, even as the perform more and more obediently. Even their stern camp counselor (Teresa Marczewska), who feels a few motherly stirrings towards Tomasz, is capable of wavering in her dedication to the Stalinist cause.

The death of Stalin, and the other external events that have a direct impact on Tomasz's life, are depicted with an obliqueness and delicacy that are all the more noticeable amid the meanness of the boys' circumstances and the earthiness of the film's visual style.

"Shivers," which will be shown tonight at 6:15 and Saturday at 11:30 as part of the New York Film Festival, was made in 1981 and awarded a Silver Bear at the Berlin Film Festival in 1982.

1984 O 4, C16:1

On the Road

CAMMINA CAMMINA, directed, written (Italian with English subtitles), cinematography and editing by Ermanno Olmi, music by Bruno Nicolai; produced by RAI-Radiotelevisione Italiana-Scenario. At Alice Tully Hall, as part of the 22d New York Film Festival. Running time: 150 minutes. This film has no rating.
Mel Alberto Fumagalli
Rupo Antonio Cucciarre
Kaipaco Eligio Martellacci
The shepherd Renzo Samminiatesi
Cushi Marco Bartolini
Nohad Lucia Peccianti
Woodsmen
........ Guido Del Testa, Tersilio Ghellardini, Aldo Fanucci
Arupa Fernando Guarguaglini
Her companion Anna Vanni
Astioge Giulio Paradisi
Astioge's wife Rosanna Cuffaro

By VINCENT CANBY

ERMANNO OLMI'S "Cammina Cammina" (Keep Walking, Keep Walking) opens with a good deal of exuberant promise as the peasants in a small village in northern Italy prepare to celebrate the Nativity by re-enacting the pilgrimage to Bethlehem of the wise men. There's a lot of rude pushing, shoving, laughing and general high spirits as the members of the pagaent's cast search for the right costumes and props. Says one little boy to his friend, "You look like a girl dressed like that."

All this, though, comes before and during the opening credits, after which "Cammina Cammina" turns into a fairly straightforward movie about the journey of the Magi, based on New Testament stories as well as on legends that have accumulated over the centuries. The focus of the film is the priest, Melchior, called Mel in the film, and the trials faced by him and his flock as they follow the trail of the Christmas star — over moor and mountain, field and fountain — to the manger in the Holy Land.

Along the way they join forces with two other Magi, have an unsatisfactory, offscreen meeting with King Herod in Jerusalem, before beholding Mary, Joseph and the baby Jesus in Bethlehem.

Once Mr. Olmi forsakes the rural present for the mythical, rural past, the movie becomes almost intolerably solemn and tedious, though handsomely photographed in rugged Italian terrain and filled with the extraordinary faces of its nonprofessional actors. With two exceptions, the characters are more representative and less particular than those that can be seen in the stained-glass windows of almost any well-preserved Gothic church.

One of these exceptions is Mel (Alberto Fumagalli), a brooding Old Testament sage who accurately foresees the coming of Christ and then behaves badly when the chips are down. The other is a small boy, Rupo (Antonio Cucciarrè), Mel's servant and the film's voice of reason, who refuses to accept the Old Testament's concept of a God who demands blood sacrifices, even if only of a lamb. As a pageant, "Cammina Cammina" is far less colorful and even provocative than might have been the pageant put on by the peasants seen in the precredit sequence.

Mr. Olmi ("The Tree of Wooden Clogs") is at his most pseudo-poetic and arid here. He seldom successfully dramatizes his paradoxes, which, ultimately, are reduced to an exchange between Mel and a follower toward the film's end. The follower berates Mel for having stolen away from Bethlehem in the middle of the night instead of staying to prevent Herod's massacre of the innocents. Says Mel, by way of explanation, "We shall build temples to celebrate the coming of God to earth." Replies his accuser, "Above all, you shall celebrate His death."

This is an interesting idea, but it comes too late to occupy the mind throughout the long succession of mostly impersonal, stately and awfully picturesque scenes that precedes it.

1984 O 4, C16:5

Within the Beyond

THE ADVENTURES OF BUCKAROO BANZAI, directed by W. D. Richter; written by Earl Mac Rauch; director of photography, Fred J. Koenekamp; edited by Richard Marks and George Bowers; music by Michael Boddicker; produced by Neil Canton and Mr. Richter; released by Twentieth Century Fox Film Corporation. At Murray Hill, 34th Street and Lexington Avenue, and other theaters. Running time: 100 minutes. This film is rated PG.

Mark Magill

Ruth Maleczech in "Far From Poland."

Buckaroo Banzai	Peter Weller
Dr. Emilio Lizardo/Lord John Whorfin	
	John Lithgow
Penny Priddy	Ellen Barkin
New Jersey	Jeff Goldblum
John Bigbooté	Christopher Lloyd
Perfect Tommy	Lewis Smith
John Emdall	Rosalind Cash
Professor Hikita	Robert Ito
Reno Nevada	Pepe Serna
President Widmark	Ronald Lacey
Secretary of Defense	Matt Clark
Rawhide	Clancy Brown

WATCHING "The Adventures of Buckaroo Banzai" from beginning to end is like coming into the middle chapters of some hilariously overplotted, spaced-out 1930's adventure serial, neither the beginning nor the end of which ever comes into sight. At its best, which it frequently is, it's a lunatic ball, an extremely genial, witty example of what is becoming a movie genre all its own. That is, the science-fiction farce, which includes the current "Repo Man" and the virtually seminal "Liquid Sky."

"Buckaroo Banzai," which opens today at the Murray Hill and other theaters, was written by Earl Mac Rauch ("New York, New York") and marks the directorial debut of W. D. Richter, whose previous credits have been as a writer ("Slither," the remake of "Invasion of the Body Snatchers" and "Brubaker," among others). Mr. Rauch and Mr. Richter make a most winning writer-director team.

•

Absolutely nothing in "Buckaroo Banzai" is quite clear, nor is it supposed to be, though most of it is very funny, beginning with the opening sequence.

In this, Buckaroo Banzai (Peter Weller), the son of an American mother and a Japanese father, an adviser to United States Presidents, and a leader of a rock group called the Hong Kong Cavaliers, is late arriving at a desert site, where he is to test a new, supersonic automobile, because he is busy performing a brain operation of a delicacy beyond the capacity of all other surgeons.

Buckaroo is obviously someone very unusual, even for sci-fi farce. As played in gravely comic style by Mr. Weller, he never gives any indication that he knows he's a combination of Buck Rogers, the Shadow, Bruce Lee, Christopher Reeve's Superman, Dr. Kildare and any two members of the Monty Python troupe.

In the course of these adventures, Buckaroo comes upon a complex plot to destroy the world when, driving his supersonic car, he passes briefly into "the eighth dimension." This space, within our space, is inhabited by extraterrestrials, "electroids from Planet 10," beings who landed in New Jersey in 1938 during Orson Welles's legendary "War of the Worlds" broadcast, here revealed for the first time not to have been a hoax. Poor Mr. Welles, according to Mr. Rauch and Mr. Richter, was hypnotized into making that false declaration.

Also involved in the spiraling complications are a small but important gadget called the "overthruster," and such characters as a suicidal young woman named Penny Priddy (Ellen Barkin); Dr. Emilio Lizardo (John Lithgow), a mad Italian scientist who, when first seen, is confined to a hospital for the criminally insane, and one good extraterrestrial (Carl Lumbly, disguised as a Rastafarian.

Other characters seen from time to time include Buckaroo's extremely square doctor-pal (Jeff Goldblum), henchmen good and bad, large and

small, plus the American President, who is usually seen hanging upside down in some therpeutic device in his room at Walter Reade Hospital, often being urged by his aides to sign a declaration of war — the short form — against the Soviet Union.

Mr. Lithgow is a madman to make Doctor Mabuse look like a disadvantaged pussycat. He's the perfect adversary for Buckaroo, a fellow given to such exclamations as "The deuce you say!" and to uttering aphorisms on the order of "Don't be mean, because no matter where you go, there you are." I also am haunted by the line, "Why is that watermelon there?" though I've now forgotten the context.

Equal to the importance of the screenplay, the direction and the performances are the production design by J. Michael Riva and the various special effects provided by Michael Fink, Peter Kuran and others, working separately and together.

"Buckaroo Banzai" may well turn out to be a pilot film for other theatrical features, though this one would be hard to top for pure, nutty fun.

•

"Buckaroo Banzai," which has been rated PG ("Parental Guidance Suggested"), includes some vulgar language and some not very alarming violence.

Vincent Canby

1984 O 5, C8:5

Lesson in Learning

TEACHERS, directed by Arthur Hiller; written by W. R. McKinney; director of photography, David M. Walsh; edited by Don Zimmerman; music by various composers; produced by Aaron Russo; released by MGM/UA Entertainment Corporation. At Astor Plaza, 44th Street and Broadway; Orpheum 1, 86th Street near Third Avenue; 34th Street Showplace, between Second and Third Avenues; 83d Street Quad, at Broadway and other theaters. Running time: 153 minutes. This film is rated R.

Alex	Nick Nolte
Lisa	Jobeth Williams
Roger	Judd Hirsch
Eddie	Ralph Macchio
Rosenberg	Allen Garfield
Dr. Burke	Lee Grant
Herbert	Richard Mulligan
Ditto	Royal Dano
Horn	William Schallert

By JANET MASLIN

"TEACHERS" is Arthur Hiller's attempt to do for public education what he did for medicine in "The Hospital," and the results are very un-

even. Whenever "Teachers" begins to seem a realistic appraisal of the public school system — and there are many scenes in which it does — the film is apt to break its own mood with false-sounding dialogue, conspicuous miscasting or a very broad gag.

"Teachers," which opens today at Loew's Astor Plaza and other theaters, conveys the ambiance of a large, chaotic public high school without spending much time on the students themselves. Instead, it concentrates on activity in the faculty lounge (where a union official is agitating to get the teachers three extra minutes of free time in the morning) and presents classroom scenes from the teachers' point of view.

This gives "Teachers" some novelty among high school movies, as does the atmosphere of lunacy that often prevails at John F. Kennedy High. Indeed, one of the substitute teachers (Richard Mulligan) is a *real* lunatic, a psychiatric out-patient who is hired by mistake. Responding with great enthusiasm to the chance to teach a history class, he is soon dressing up as Abraham Lincoln to read the Gettysburg Address, or as George Washington to re-enact the crossing of the Delaware

•

Nick Nolte, as Alex Jurel, comes to work in Hawaiian shirts and Ray-Ban glasses and is supposed to be the only genuinely kid-loving teacher at the school. Mr. Nolte has some good moments here, particularly in those scenes that pit him against the staff's more conservative faction, but he is never believable as someone who's held a teaching job for 15 years.

Neither is Jobeth Williams, who is also appealing, particularly convincing as one of Alex's former students. She plays Lisa, an idealistic lawyer who's working on the case that has the whole administration on tenterhooks: a suit against the school by a student who claims he graduated without learning to read. The issue, like many here, is raised but then more or less abandoned.

"Teachers" does look as though it's taking place in a real school, and it has a solid cast. Allen Garfield is particularly credible as a teacher who's being tormented — he's even bitten — by a student who has singled him out for special malice. Judd Hirsch does a nice job as Alex's feisty colleague. So does Ralph Macchio, of "The Karate Kid," as Alex's most troublesome pupil. Lee Grant makes

a caustic school board supervisor who is no admirer of Alex's relaxed style, and William Schallert is the apprehensive principal.

•

W. R. McKinney, who wrote the screenplay, alternates believable episodes with several that are anything but. Alex and Lisa's talk about whether Alex has the guts to be honest — or, as the screenplay puts it, to "walk naked down the hall" — leads to Lisa's attempt actually to do so. And Alex is given a clichéd, anticlimactic speech about whether he can really fight to make a difference.

On the other hand, some of the screenplay's most farfetched touches work, like the sequence in which a teacher who is so bored that he has fully automated his class's routine actually expires at his desk while reading a newspaper. It's at least a day before any of the students even notice.

1984 O 5, C10:1

Details From Life

A BIGGER SPLASH, directed and produced by Jack Hazan; screenplay by Mr. Hazan, and David Mingay; director of photography, Mr. Hazan; editor, Mr. Mingay; music, Patrick Gowers and Greg Bailey; a Buzzy Enterprises Ltd. production. Running time: 105 minutes. At Embassy 72d Street, at Broadway.

Painter	David Hockney
Painter's friend	Peter Schlesinger
Dress designer	Ossie Clark
Designer's wife	Celia Clark
Friend	Mo McDermott
Collector	Henry Geldzahler
Dealer	Kasmin

"A Bigger Splash" was shown as part of the 1974 New York Film Festival. Following are excerpts from Vincent Canby's review, which appeared in The New York Times on Oct. 4, 1974. The film opens today at Embassy 72d Street, at Broadway.

"A BIGGER SPLASH" is a fiction film about David Hockney, one of the more successful and durable of the English pop artists to come out of the 1960's, in which Mr. Hockney and his friends play themselves in situations that may or may not have happened in life.

A note in the festival program draws a parallel between what Jack Hazan, the director-cameraman-producer of this film, is doing in "A Bigger Splash" and what Mr. Hockney's paintings do when the artist takes details from life, strips them to their essential lines and colors, then projects them into larger-than-life reality on huge canvases.

Perhaps because most movie screens are already larger than life, the effect of this fragmented, often self-conscious film is to make the subject seem sort of small and drab, a fact that is immediately denied whenever we are given a chance to look at the paintings themselves.

•

There is a kind of story line to the film, which, we're told, was three years in the making. It's about Mr. Hockney's inability to finish a painting when his lover for the last five years, another artist named Peter Schlesinger, walks out on him. His friends worry about him. They worry

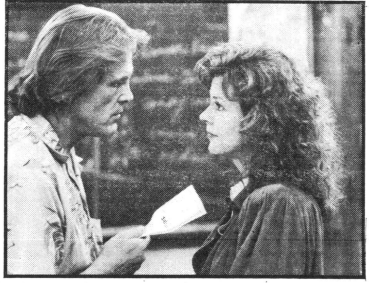

Nick Nolte and JoBeth Williams star in the satirical comedy "Teachers," set in an urban high school.

about a forthcoming show, and they worry about the décor of his house. "It looks like a waiting room now," says Celia Birtwell, a beautiful young woman who looks a lot like Andy Warhol's Viva. Another friend says, "When love goes wrong, it's more than two people who suffer."

In these moments, there's a suggestion of the satire that is almost always evident in Mr. Hockney's paintings, but the film's Hockney-like gags are mostly blunt, as when Henry Geldzahler of the Metropolitan Museum of Art is "discovered" striking the pose in which Mr. Hockney once painted him.

•

The manner of making the film — in London, Geneva, California and New York, whenever the artist's schedule permitted — has as much to do with the non-content of the film as with its style. There are only the slightest traces of the outrageous self-promotion and put-on that once were so much a part of the pop scene. "A Bigger Splash" is unforgivably solemn, something that Andy Warhol and Paul Morrissey would never have allowed.

1984 O 5, C12:1

Teen Trouble

SAVAGE STREETS, directed by Danny Steinmann; written by Norman Yonemoto and Mr. Steinmann; director of photography, Stephen L. Posey; edited by Bruce Stubblefield and John O'Conner; music by Michael Lloyd and John D'Andrea; produced by John C. Strong III; distributed by Motion Picture Marketing, Inc. At Warner, Broadway and 47th Street and other theaters. Running time: 93 minutes. This film is rated R.

Brenda	Linda Blair
Underwood	John Vernon
Jake	Robert Dryer
Vince	Johnny Venocur
Fargo	Sal Landi
Red	Scott Mayer
Rachel	Debra Blee
Francine	Lisa Freeman
Stevie	Marcia Karr
Maria	Luisa Leschin

"SAVAGE STREETS" offers R-rated exploitation with a vengeance. The movie, which stars Linda Blair, as the leader of a high school gang of girls called the Satins, suggests a hybrid of "Porky's" and "The Road Warrior," but set on Sunset Boulevard.

The film, which opens today in local theaters, hangs its yards of nudity, violence and obscenity on the story of what happens when the Satins run afoul of the Scars, a cackling band of cocaine dealers and sex maniacs. In reprisal for a practical joke, the Scars rape Brenda's deaf-mute sister, Heather, in the gym while Brenda is distracted in a screaming fight in a nearby locker room. Later, after a fracas in a local rock club, they pitch Francine, a pregnant bride-to-be and charter member of the Satins, over a bridge.

It remains for Brenda to seek retribution. Donning a studded black body suit and armed with crossbow, switchblade and flammable fluids, she makes sure that the Scars get their due in a protracted and grisly finale.

"Savage Streets" doesn't even have a rudimentary continuity between its scenes, and its performances are crude cartoons. The one quality it does exude is a kind of manic delight in its own awfulness.

Stephen Holden

1984 O 5, C14:3

Symbolic Exercise

THREE CROWNS OF THE SAILOR, directed by Raul Ruiz; screenplay (French with English subtitles) by Mr. Ruiz, with the collaboration of Emilio de Solar and François Ede; photography, Sacha Vierny; edited by Janine Verneau and Valéria Sarmiento; music by Jorge Arriagada; production companies, I.N.A. and Antenne 2. At Alice Tully Hall, as part of the 22d New York Film Festival. Running time: 117 minutes. This film has no rating.

The sailor	Jean-Bernard Guillard
The student	Philippe Deplanche
The officer	Jean Badin
Maria	Nadège Clair
Mathilde	Lisa Lyon
The captain	Claude Derepp
The blindman	Frank Oger

RAUL RUIZ'S "Three Crowns of the Sailor," at the New York Film Festival, should delight students of semiotics and probably no one else. Filled with signs, symbols, letters, forms of currency, impenetrable aphorisms and images that are deliberately self-contradictory, it had easily the highest walk-out rate (at the press screening, anyhow) of any festival selection thus far.

"Three Crowns of the Sailor" is described in festival advertising as "deliberately unsynopsizable." In addition to being a bad sign, that's an understatement. The film's rambling, nonsensical narrative has an internal consistency of sorts, but it also has an utter lack of momentum. Even though there are flashes of humor and a great deal — an overabundance, in fact — of imagination to the Chilean-born Mr. Ruiz's work (which is in French), the ultimate effect is one of tedium.

"Don't believe it, it's only red paint," says a character who then bleeds to death. "When you're only beautiful, you're always alone," says another. "Tonight is starry," the narrator (Jean-Bernard Guillard) writes in a letter to his mother. "The stars are twinkling. I'm ready to forget the slaps at Christmas, the beating on my 10th birthday,"

•

"By the way, why are you chewing gum?" this same narrator asks a prostitute (Nadège Clair) who calls herself the Virgin Mary. "It's not me," she says, "it's another girl. Of course, she's much prettier. They call her 'By-the-way,' she's always saying it."

Mr. Ruiz's way with a non sequitur is distinctive, but it's more intriguing in small doses than in this very large one. And it's not put to any discernible purpose here. For every clever touch, there are 10 listless, pointless ones. Eventually, the two leading characters declare "Our presence here is gratuitous, like most of the things in life" and they seem to have a point. Or, as the screenplay by Mr. Ruiz with Emilio de Solar and François Ede also puts it, "May God explain the guts of a million ants."

"Three Crowns of the Sailor" will be shown tonight at 6:15 and Monday night at 6:15.

Janet Maslin

1984 O 5, C14:3

A Moral Cloud

A FLASH OF GREEN, directed, photographed and edited by Victor Nunez; screenplay by Mr. Nunez, based on a novel by John D. MacDonald; music by Charles Engstrom; produced by Richard Jordan. At Alice Tully Hall, as part of the 22d New York Film Festival. Running time: 131 minutes. This film has no rating.

Jimmy Wing	Ed Harris
Kat Hubble	Blair Brown
Elmo Bliss	Richard Jordan
Brian Haas	George Coe
Mitchie	Joan Goodfellow
Jackie Halley	Jean De Baer
Aunt Middie	Helen Stenborg
Leroy Shannard	William Moohey
Doris Rohl	Isa Thomas
Dial Sinnat	Bob Murch
Ross Halley	John Glover
Nan Haas	Joan MacIntosh
Borklund	Bob Harris

By VINCENT CANBY

In certain parts of the world there's a spectacular but rare phenomenon that, on Florida's west coast, is known fondly as "the green flash," something that happens only if the western horizon is absolutely free of haze. Just as the upper rim of the setting sun disappears beneath the Gulf of Mexico, there can occur, for a fraction of a second, a brilliant emerald illumination of the entire western sky, so bright and brief that it seems as if an hour's worth of the aurora borealis has been condensed into this one dazzling explosion of light.

Because it happens only at the cocktail hour, the green flash can prompt a certain number of disputes. Martinis can induce a false green flash. There's also the problem that if one stares at any setting sun long enough, one is likely to see all sorts of colors, in addition to green. Yet the green flash does exist — I've seen it — and it's breathtaking.

In Victor Nuñez's "Flash of Green," which is set on the west coast of Florida and takes its title from this phenomenon, one waits and waits for that single moment that will light up the film in some unforgettable way. It never comes, but the movie is well worth attending to in spite of this one important failure. The film is the second feature to be written and directed by Mr. Nuñez, the Florida film maker who delivered a bona fide green flash with "Gal Young 'Un," his spare, beautiful adaptation of the Marjorie Kinnan Rawlings story.

"A Flash of Green" is being shown at the New York Film Festival at Alice Tully Hall tonight at 9:30 and Thursday at 6:15.

Mr. Nuñez does not make simple films. In the first few minutes of his new one, adapted from the novel by John D. MacDonald, something happens that forever clouds the film's horizon. Jimmy Wing (Ed Harris), a newspaper reporter in the small town of Palm City, accepts a bribe to provide information with which his boyhood friend, Elmo Bliss (Richard Jordan), an ambitious county commissioner, can blackmail opponents of an ecologically disastrous land development scheme.

Jimmy's easy fall from grace becomes increasingly difficult to understand as the film proceeds since, in every other way, he seems to be an innately honorable, moral man, facing dreadful personal difficulties with courage. He is loyal to his hospitalized young wife, dying of some unspecified, degenerative brain disease, and acts as the surrogate father to the children of his best friend's widow, Kat (Blair Brown). He genuinely loves those Florida coastal areas of keys, mangrove swamps and mud flats that are unlike the geography any other place in this country.

The movie would have us believe that he accepts the bribes so that in some way he can alleviate the rottenness of an inevitable situation. Just how he might do this is never made clear or believable. This built-in confusion dogs an otherwise estimable, offbeat contemporary drama, well acted by Mr. Harris, Miss Brown and especially by Mr. Jordan, who here gives his best film performance to

Ed Harris in the Victor Nuñez film "Flash of Green."

date. The members of the large supporting cast are equally good, including George Coe, Isa Thomas, Helen Stenborg, Joan Goodfellow and Jean De Baer.

•

However, there is something unwieldy about the screenplay, though I'm in no position to know whether it's actually better or worse for the contributions of the credited "script consultants," Gill Dennis, Mr. Harris and Mr. Jordan. The film is very effective in catching the sense of time and place and in defining the contradictory feelings of characters for one another, Jimmy for Kat and, particularly, Jimmy for the genially conniving Elmo Bliss. At one point Elmo says that "the world needs folks like me, Jimmy, folks with a real love for power." A little later, Elmo confidently rationalizes his actions by saying that "all the wild things and the magic places have already been lost forever." Elmo is the film's most vivid, interesting character.

It seems to take Jimmy an unusually long time to see the light, and then only after several lives have been wrecked and a couple of people seriously injured. Though his turnabout seems to spin out the movie to an unconscionable length, what happens during his uneasy rehabilitation is the best, most complex part of the movie.

"A Flash of Green" is not perfect, but it is provocative and nearly always intelligent.

1984 O 5, C14:3

The Bleak Life

KILLING HEAT, written and directed by Michael Raeburn; based on the novel "The Grass Is Singing" by Doris Lessing; cinematography by Bille August and Fritz Schroder; edited by Thomas Schwalm, Lasse Dahlberg, Bjorn Isfalt and Temba Tana; produced by Mark Forstater; released by Satori Entertainment Corporation. At Eastside Cinema, 55th Street and Third Avenue. Running time: 104 minutes. This film has no rating.

Mary Turner	Karen Black
Dick Turner	John Thaw
Moses	John Kani
Tony Marston	John Moulder-Brown

By STEPHEN HOLDEN

"KILLING HEAT," Michael Raeburn's adaptation of Doris Lessing's first novel, "The Grass Is Singing," is a bleak, troubling film whose erratic leading performance

by Karen Black throws this serious portrait of African colonial life dramatically askew.

Shot on location in Zambia, "Killing Heat," which opens today at Eastside Cinema, tells the story of a 30-year-old unmarried secretary who, more out of desperation than affection, marries Dick Turner (John Thaw), a farmer who is having difficulty living off the land in a rural area of southern African. Returning to his farm immediately after their marriage, the town-bred Mary (Miss Black) tries briefly to find the bright side of the life she's settled for. But the heat, the dirt and the monotony of farm life unnerve her. Fearful and high strung to begin with, Mary slowly but steadily loses her mental grip.

Events also work against the Turners. A fire destroys their crops, and Dick suffers recurrent bouts of malaria. While he's sick, Mary must supervise the native farmhands, and although her husband has been able to maintain an understanding with them, Mary uses them to vent her frustrations, ordering them about and punishing them with a tyrannical hysteria.

When Mary finally loses touch with reality, Moses (John Kani), the partly educated houseboy, whom she has tormented the most and who is vaguely torn between Christianity and his tribal beliefs, cares for her, dressing her and even brushing her hair. Although the sexually charged relationship apparently remains unconsummated, it breaks enough taboos to engender violent tragedy.

•

Mr. Raeburn, the writer and director, tells this downbeat drama in a direct, somewhat choppy style that makes frequent parallels between the parched, African landscape, rumbling with earthquakes, and Mary's loss of control. And he has elicited understated, finely tuned performances from the two male principals. As a tight-lipped but good-hearted loser who has to struggle constantly to keep from giving into despair and rage, John Thaw endows Dick Turner with a sympathetic blend of decency and creeping hopelessness. John Kani gives an equally complex performance in which his pride is constantly at odds with a pathetic, inarticulate longing.

In the context of these tightly controlled performances, Miss Black acts with a physical extravagance that is out of tune with the rest of the actors. The last half hour is a prolonged, tedious mad scene in which the star, her face covered with powder, flutters about the farmhose like an English colonial Blanche DuBois. She is as unconvincing as her very changeable English accent.

1984 O 5, C16:1

STRIKEBOUND, direction and screenplay by Richard Lowenstein; photography by Andrew DeGroot; edited by Jill Bilcock; music by Declan Affley; produced by Miranda Bain and Timothy White. At Alice Tully Hall, as part of the 22d New York Film Festival. Running time: 100 minutes. This film has no rating.
Wattie Doig Chris Haywood
Agnes Doig Carol Burns
Idris Williams Hugh Keays-Bryne
Charlie Nelson Rob Steele
Harry Bell Nik Forster
Police Sergeant Anthony Hawkins
Mine manager David Kendall
Meg Marion Edward
Yugoslav scab Lazar Rodic
Ernie Reg Evans
Salvation Army Officer May Howlett
Welsh singer Declan Affley

Politician Denzil Howson
Grocer Charles Gilroy
Reverend Busby Ivor Bowyer
Mrs. King Kirsty Grant

By VINCENT CANBY

"Strikebound" is an earnest, worthy Australian film that reconstructs the true story of a coal miners' strike in the small town of Korumburra in the mid-30's. It was written and directed by Richard Lowenstein, who is only 24 years old, and is based on interviews conducted over a period of years by his mother, Wendy Lowenstein, an oral historian.

"Strikebound," which is feature-length, will be shown at Alice Tully Hall in the New York Film Festival tonight at 6 o'clock and tomorrow at 4:30 P.M. On the same program is "How Far Home," a 29-minute documentary about the gathering of veterans at the National Statue to Vietnam Veterans in Washington on Veterans Day 1982.

Considering the youth of its writer-director and the comparatively small budget on which it was made, "Strikebound" is a technically impressive film that firmly avoids souped-up melodramatics. The eventually successful strike of the 100 miners at Korumburra apparently occupies a special place in the history of the Australian labor movement, which, at that time, looked to the Communist Party for leadership in the absence of any real support by the Labor Party.

The film is based on the real-life story of two remarkable characters, Wattie Doig (Chris Haywood), a miner who became a militant Communist activist, and his wife, Agnes (Carol Burns), who progressed from staunch Presbyterianism to membership in the Salvation Army and, finally, to labor organization. Agnes, well played by Miss Burns, provides "Strikebound" with a passionate heart.

The film otherwise seems to fall between fiction and fact. It denies itself the kind of speculation that fiction allows, and, since it is, after all, a reconstruction, it seldom discovers the unexpected events and feelings that can illuminate a documentary. Every frame of the film has been so carefully composed — even its soundtrack has a self-consciously deliberate manner — that one can never forget for a second that one is required to react with reverence and awe.

"Strikebound" is a good film but never a surprising one.

•

Though much shorter, "How Far Home" packs a lot more emotional weight than the feature it accompanies. The veterans we see and hear — who come in all sizes, shapes, colors and degrees of articulateness — create a panorama of pathos and courage of a sort that is not necessarily beyond fiction, just different from it. The film makers responsible for "How Far Home" are Bestor Cram, the director; Rusty Sachs, the associate director, and Donald Scott, the executive producer. They and their associates have done fine work.

1984 O 6, 15:5

THE TIMES OF HARVEY MILK, directed by Robert Epstein; photography by Frances Reid; edited by Deborah Hoffman and Mr. Epstein; music by Mark Isham; produced by Richard Schmiechen; released by Teleculture Films Inc. Running time: 87 minutes. This film has no rating. At Alice Tully Hall, as part of the 22d New York Film Festival.

By JANET MASLIN

"Harvey stood for something more than just him," someone remarks in "The Times of Harvey Milk," and this warm, well-made documentary makes that eminently clear. The personality of the slain San Francisco Supervisor, who along with Mayor George Moscone was shot in 1978 by the disgruntled former Supervisor Dan White, comes through strongly, but personality is not the film's foremost concern. Robert Epstein, who co-directed the equally affecting "Word Is Out," indicates the ways in which Harvey Milk was emblematic of one segment of society and Dan White of another. And he traces the clash that arose between them.

•

This conflict is intrinsically so dramatic that the film can rely on a simple, straightforward style without lacking for momentum or emotion. Mr. Epstein uses abundant news footage of both Mr. Milk and Mr. White, and the ironies are overwhelming. Mr. White, for instance, is heard advocating neighborhood baseball teams and suggesting that maybe his district could challenge Harvey Milk's district to a game. "Dan White comes across as the kind of son any mother would be proud of," a television reporter declares.

Harvey Milk is seen as friendly, charming, intense and instinctively political; in lobbying for a law on dog droppings, for instance, he deliberately plants a specimen in the park and then steps in it during a television interview, to help make his point. Mr. Milk's friends and associates contribute many anecdotes to the film's portrait of him, but Mr. Epstein is generally careful to keep them in context. Harvey Milk's political career and the victory it represented for San Francisco's homosexual community is contrasted with the first stirrings of Moral Majority, stirrings to which Mr. White was especially responsive.

The film examines the controversy surrounding Proposition 6, the proposed California ordinance barring homosexuals from teaching in public schools, an issue on which Mr. Milk and Mr. White were sharply divided. It was four days after the proposition was defeated, thanks in large part to Harvey Milk's efforts, that Mr. White resigned his post. Five days later, Mr. White announced he had changed his mind and wanted to be a Supervisor again. It was 12 days after that, on the morning when Mayor Moscone had planned to announce that he would not reinstate Mr. White, that the shootings took place.

Since Mr. Milk's political career embodies the rise of the homosexual community's political power in San Francisco, and since the results of Mr. White's brief trial were evidence of a backlash, the film would have benefited from devoting closer attention to the trial itself. Mr. White's tearful confession, which was thought to have helped sway the jury toward its verdict of involuntary manslaughter, is heard. But his comments explaining his mysterious and abrupt resignation are not, even though they might have revealed something of Mr. White's mental state at the time, and shed some light on the verdict.

The "Twinkie defense" — the notion that junk food had made Mr. White temporarily insane — and the fact that homosexuals and minorities were not on the jury are cited. But they hardly explain why Mr. White, who carried a gun and 10 extra rounds of ammunition on the day of the killings and crept through a City Hall

San Francisco Examiner

Harvey Milk, subject of the film "The Times of Harvey Milk."

window to avoid metal detectors in the lobby, was found to have committed an unpremeditated act.

•

If Mr. Epstein can't fully explain what happened, he can certainly tell the story with urgency, passion and, finally, indignation. Toward the end of the film, a young black man asks rhetorically what sort of sentence he might have received for such a crime. Another interviewee speculates that Mr. White's staunch support for middle-class values and opposition to the homosexual community's growing power contributed to his light sentence (he was released from prison last January). And a third man suggests how pivotal Harvey Milk and his cause may have been to the verdict: "I think if it were just Moscone who'd been killed, he would have been in San Quentin for the rest of his life."

"The Times of Harvey Milk" will be shown tonight at 7:30 as part of the New York Film Festival.

1984 O 7, 86:1

CLASS RELATIONS, directed and written and edited by Jean-Marie Straub and Danièle Huillet; in German with English subtitles; photography by William Lubtchansky; production companies, Janus Film and Fernsehen, Hessischen Rundfunk and NEF-Diffusion. At Alice Tully Hall, as part of the 22d New York Film Festival. Running time: 126 minutes. This film has no rating.
Karl Rossmann Christian Heinisch
Stoker Reinald Schnell
Line Anna Schnell
Captain Klaus Traube
Head cashier Hermann Hartmann
Uncle Jacob Mario Adorf
Schubal Gerard Semaan
Pollunder Friedrich Wilhelm Vobel
Klara Anne Bold
Delamarche Harun Farocki
Robinson Manfred Blank
Chef Kathrin Bold
Waiter Alf Bold
Bruneida Laura Betti

By VINCENT CANBY

More than the films of any other directors, the minimalist works of Jean-Marie Straub and Danièle Huillet, his wife and collaborator, demand that one be in a mood so receptive that it borders on the brainwashed.

If one is worried about a telephone bill or is thinking about train schedules, or if the air-conditioning system is circulating air that's more chilled than necessary, one cannot attend to a Straub-Huillet film with the proper concentration. Given the slightest excuse, the mind flees the relentlessly purposeful inaction on the screen.

This is said by way of confession for I've been fascinated by at least two of their films — "The Chronicle of Anna Magdalena Bach" and their adaptation of Arnold Schönberg's "Moses and Aaron" — and been threatened with dreamless slumber by others.

Their latest, "Class Relations," based on Franz Kafka's first novel, "Amerika" (1912), falls somewhere between the two extremes, possibly because when I saw it at a press screening I'd already seen one film in the morning and was freezing through this, the second film of the day. "Class Relations" is far less minimal than even "Moses and Aaron," but then it doesn't have Schönberg on the soundtrack.

There's also the problem that the Straubs's dry, deadpanned cinema is not really as well suited to this particular Kafka work as one might expect. Like the Straubs, Kafka resolutely refuses to evoke any kind of emotional identification in his audience. Yet "Amerika" is also far funnier than the Straubs can allow their movie to be.

"Class Relations" is often witty and is beautifully photographed — in settings that suggest Kafka's imaginary America, which looks nonspecifically European — without ever being even minimally humorous.

Following the Kafka text with some fidelity, "Class Relations" is about the adventures of a young European immigrant named Karl Rossmann who, even before he gets off the boat in New York harbor, discovers a land where everyone, namely Karl, is presumed guilty until proved innocent, which, of course, is impossible in the Kafka universe.

However, unlike Joseph K. in "The Trial," Karl is neither destroyed by his presumed guilt nor liberated by his ultimate acceptance of it. Karl Rossmann is infinitely practical and resilient as he moves with steadfast serenity from one unearned put-down to the next.

•

Among those he encounters are his Uncle Jacob, who has become wealthy and a United States Senator in this fabulous land; a couple of drifters — one Irish and one French — whom he befriends and who immediately attempt to swindle him in various ways; a kindly woman — a hotel cook — who is at first nice to Karl but then is disturbed by some trumped-up charges relating to his moral character, and a once-beautiful, overweight singer, who doesn't find Karl physically or emotionally stimulating.

Though the Straubs do, in fact, move their camera throughout these adventures, the camera somehow gives the impression that it would prefer to stay where it is. It's a cat that wants to sit in the sun. The minimalism is expressed in the impassive attitudes of the actors, and in the manner in which they deliver their dialogue, which sounds as if they were giving instructions on how to put on one's life jacket in case of an unscheduled landing at sea.

Robert Bresson does something similar, but the point in the Straubs' film is not to call attention to the distance between actor and dramatized circumstance, as in Bresson, but to deny the viewer any chance to respond in predictable ways.

Though Karl moves through America as an innocent, he's not filled with any crazy, Candide-like optimism. He's utterly, consistently rational, incapable of surprise and when, at the end, he seeks relief by going off to the

Christian Heinisch in a scene from the film "Class Relations."

Nature Theater of Oklahoma, one may be sure he'll rise above whatever it turns out to be. Though always misjudged, Karl has no sense of guilt, and so the system doesn't terrify him. It simply doesn't work as well as it might.

•

Working within a style that doesn't offer them conventional "big" moments, the actors are unusually good. Standouts are Christian Heinisch, who plays Karl with solemn, angelic patience; Mario Adorf, as Karl's expansive, inscrutable Uncle Jacob; Laura Betti, as the singer, and Kathrin Bold, as the cook who does her best to support Karl in the face of all of the nonevidence against him.

1984 O 7, 86:1

L'AMOUR PAR TERRE, directed by Jacques Rivette; screenplay (French with English subtitles) by Mr. Rivette, Pascal Bonitzer, Marilù Parolini and Suzanne Schiffman; photography by William Lubtchansky; edited by Nicole Lubtchansky; produced by Martine Marignac; a Spectrafilm Release. At Alice Tully Hall, as part of the 22d New York Film Festival. Running time: 126 minutes. This film has no rating.
Charlotte Geraldine Chaplin
Emily .. Jane Birkin
Paul .. André Dussolier
Clement Jean-Pierre Kalfon
WITH: Isabelle Linnartz, Facundo Bo, Laszlo Szabo, Sandra Montaigu, Eva Roellens

The opening sequence, in which two high-spirited women compete for the affections of a debonair man, is only the first of many playful illusions Jacques Rivette constructs in "L'Amour par Terre."

It soon develops that these are actors, performing the "apartment theater" that is their specialty, and that they have altered the play to turn one character into an alcoholic and tack on a happy ending. No matter, says the playwright — who is himself quite debonair and who drops in unexpectedly after the performance. He's not offended. And he has some other, more interesting material he'd like to discuss with the cast.

•

"L'Amour par Terre" (Love on the Ground) follows the two raffish actresses, Emily (Jane Birkin) and Charlotte (Geraldine Chaplin), to the house of the playwright, Clément (Jean-Pierre Kalfon), an outlandishly colorful setting (designed by Roberto Plate) that is the film's boldest illusion of all. Full of trompe l'oeil columns and walls, with rooms that ingeniously echo one another, the house has a wildly exaggerated theatricality. It becomes the perfect setting for the playwright's latest project: a three-character piece based on real events connecting him, his associate, Paul (André Dussolier), and a woman with whom they were both involved. The play does not have a final act, Clément tells his guests, because the story isn't over yet.

The film spans the week or so between Clément's summons to the two women and the date on which he wants the play performed, and most of it takes place inside the house. The screenplay, which is by Mr. Rivette, Pascal Bonitzer, Marilù Parolini and Suzanne Schiffman, wittily affords the director a great many opportunities for a brand of gamesmanship that enlivens the film without trivializing it. Mr. Rivette is able to sustain a complex, shifting relationship between the real and the theatrical without losing the film's overriding sense of fun.

From the moment when Paul pulls a white dove out of Emily's muffler ("I hate people who have things up their sleeves," says she) it's clear that everyone in the story is an illusionist to some degree. Paul is one quite literally, and he conjures up images of both Charlotte and Emily that startle the women considerably. The process by which Clément's theatrical work is molded to fit reality, and vice versa, is rendered in a clever, entertaining style that fits perfectly with the behavior of the participants, since Mr. Rivette displays a cool ingenuity that matches that of the performers. Even when it becomes entangled in the romances that take shape during the course of the week, the film sustains its trickiness and sophistication.

•

Miss Birkin and Miss Chaplin make an invigorating team, and the combination of their offbeat styles is full of surprises. The actresses seem as passionately dedicated to their roles as Emily and Charlotte become, even when Mr. Rivette has them fall amusingly into colloquial English or break the mood in some equally offbeat way. The rest of the small cast also performs with intelligence, resourcefulness and full involvement in the material's peculiar demands.

"L'Amour par Terre" was shown yesterday as part of the New York Film Festival.

Janet Maslin
1984 O 7, 86:5

FILM VIEW

VINCENT CANBY

Hanna Schygulla Achieves Greatness

The 22d New York Film Festival at Lincoln Center, now at midpoint, has gotten off to an unusually impressive start with the premieres of "Country," a beautiful looking, sincere if sobersided paean to American agriculture with a good, tough performance by Jessica Lange, its star and co-producer; "Diary for My Children," Marta Meszaros' memoir about growing up in Stalinist Hungary, and Jim Jarmusch's very funny "Stranger Than Paradise," one of the most original American comedies currently on view.

However, the big news of the festival's first week must be the triumphant performance by Hanna Schygulla in Andrzej Wajda's "Love in Germany," an uncharacteristically romantic Wajda film with, characteristically, strong political implications. Though "A Love in Germany" is one of the Polish director's finest films in recent years, it is Miss Schygulla's presence that transforms the movie into a cinematic event.

With "A Love in Germany," it is apparent that Miss Schygulla has at long last become one of the great European film actresses of our era, comparable only to Jeanne Moreau, who has been around a few more years but with whom Miss Schygulla shares a willingness toward career risks.

That it has taken Miss Schygulla some time to achieve this recognition — as an independent, fully developed, star personality — is only because her career has been so closely bound up with that of one filmmaker, the late Rainer Werner Fassbinder. It was with Fassbinder that she made her film debut in 1969 in "Love Is Colder Than Death," which was also his first film, and with whom she then went on to create an entire gallery of Fassbinder-designed portraits.

The most memorable of these are the small-time Munich tart in "Katzelmacher," the obedient, doomed baroness in Fassbinder's adaptation of Theodor Fontane's "Effi Briest," and the heroine of "The Marriage of Maria Braun," a character described as "the Mata Hari of the postwar German economic miracle" and the role for which she received an Oscar nomination.

Miss Schygulla was certainly not typecast by Fassbinder, and though he conceived brilliant films that made use of her talents even as he was showing them off, he was not an easy man to work with. As she said in an interview here last year, she owes her career to him, but he was also "a destructive force," someone who needed "to possess" his actors, "to manipulate them, to play masochistic games with them. All that didn't amuse me at all — and, finally, I had to leave."

This she did do, leaving Fassbinder a couple of years before his death in 1982, after she had completed "Lili Marleen" and before he — with his nonstop working habits — went on to make in quick succession "Lola," "Veronika Voss" and "Querelle."

The films of Miss Schygulla's post-Fassbinder career have included Ettore Scola's "Nuit de Varennes," Jean-Luc Godard's "Passion" and Marco Ferreri's "Story of Piera," each demonstrating her faith in first-rate directors who don't always give her as much as she gives them. This is another trait she shares with Miss Moreau, whose trust and talent have probably been abused by great filmmakers more frequently than those of any other actress alive today.

Miss Schygulla wasn't abused by Mr. Godard, but "Passion," like all Godard works, is the director's film from start to finish. The actors are simply his tools. "The Story of Piera," in which she co-stars with Marcello Mastroianni and Isabelle Huppert, remains one of Miss Schygulla's own favorite films, but its rewards aren't readily seen by someone who wasn't on the set while it was being made. In it Miss Schygulla plays the kind of sexually free spirit — a woman who says "yes" to life and to any man who looks her way — that is more interesting in theory than in the finished film.

She is charming in "La Nuit de Varennes," as the loyal lady-in-waiting trying to catch up with Marie Antoinette on the night of the queen's aborted flight from the French Revolution. Yet her role in "La Nuit de Varennes" makes use of only a fraction of the Schygulla talents.

Mr. Wajda and "A Love in Germany" provide Miss Schygulla with one of the richest roles of her career to date, something to equal the demands of both "Effi Briest" and "Maria Braun," and because the film itself is so good, nothing she does is undercut by the failures of others. She doesn't tower over the film, as a good performer might in a lesser work, or appear to be visiting it, as Miss Moreau does in Fassbinder's otherwise incomprehensible "Querelle." Miss Schygulla fits *into* "A Love in Germany," illuminating it as it illuminates her.

The screenplay, based on a novel by Rolf Hochhuth, is a story of the kind of grand, heedless passion that one doesn't often find outside of the world of opera, about a love so all-consuming that the inevitable ending can be seen as the only affirmitive act possible in a small, rotten world.

Mr. Hochhuth is the German playwright who briefly shocked theater audiences in the 1960's with, first, "The Deputy," which questioned the actions of Pope Pius XII during World War II, and then "Soldiers," in which he suggested that Winston Churchill was not a war hero but a war criminal to equal those tried at Nuremberg.

• • •

"A Love in Germany," set in a small German town at the height of Hitler's military successes during World War II, dramatizes the sorrowful consequences of the Nazi laws against sexual relations between Germans and people of "inferior races." The story, which is said to have been inspired by a true event, is about Paulina Kropp (Miss Schygulla), a seemingly rather average hausfrau, whose husband is off in the army and who minds their small grocery story in his absence, and the ecstatic affair she drifts into with a Polish prisoner-of-war, Stanislaw (Piotr Lysak), who is handsome and naïve and almost young enough to be her son.

Most of the other people in Brombach — Paulina's village — are aware of what's going on between her and Stani, who has been assigned to the town as a sort of one-man work force and is billeted across the street from Paulina's shop. A few people are shocked, but a surprising number are ready to shrug their shoulders and look away. Then, however, both Paulina and Stani become so carried away by their love that they begin to flaunt it. It isn't long before someone informs on them, though this is only when Paulina makes a hysterical, public spectacle of herself in the local hospital after Stani has had an accident.

Miss Schygulla, I suspect, is one of the few actresses anywhere today who could succeed in making Paulina's love for Stani seem so erotic, and then to make that eroti-

cism seem so important that it's worth the sacrifice of both herself and her lover. The last quarter of the film is the minute, harrowing record of how Paulina and Stani turn aside all efforts to save them. Mayer, the practical if not especially humane army officer assigned to prosecute the case tries as delicately as he can to find excuses for them, but the more he tries, the more stubborn and flamboyant they become until, by the end, one understands that their decision is, at heart, a political as well as personal victory.

"A Love in Germany" is one of the most moving, provocative, dramatically sustained films that Mr. Wajda has ever made, but it's as much a personal victory for Miss Schygulla as for the Polish director ("Danton," "Man of Marble," "Ashes and Diamonds," among others). Though Fassbinder gave Miss Schygulla a number of great roles, the role of Paulina is a once-in-a-career sort of part. It allows her to discover extraordinary resources within a woman who, except for this love, might have forever remained commonplace.

Miss Schygulla's special appeal is not easily defined. Now approaching her 40th birthday, she has — as the film festival ads put it — "a new maturity," but maturity, new or old, is not the secret. With her full cheeks and smallish chin, she is not classically beautiful, but she can't be photographed in any way that denies the intelligence of what she's doing. The mysterious expressiveness that Fassbinder recognized in her — and helped to develop — has never been more amply realized than it is in "A Love in Germany."

Hanna Schygulla has arrived. ∎

1984 O 7, II:17:1

Standing Alone

MAN OF FLOWERS, directed by Paul Cox; screenplay by Mr. Cox and Bob Ellis; photography, Yuri Sokol; edited by Tim Lewis; music by Gaetano Donizetti; produced by Jane Ballantyne and Mr. Cox; a Spectrafilm Release. At Alice Tully Hall, as part of the 22d New York Film Festival. Running time: 91 minutes. This film has no rating.
Charles Bremer Norman Kaye
Lisa ... Alyson Best
David Chris Haywood
Jane ... Sarah Walker
Art teacher Julia Blake
Psychiatrist Bob Ellis
Postman Barry Dickins
Coppershop man Patrick Cook
Angela Victoria Eagger
Father Werner Herzog
Mother Hilary Kelly
Young Charles James Stratford
Aunts Eileen Joyce, Marianne Baillieu

By JANET MASLIN

THE leading character in Paul Cox's "Man of Flowers" is Charles Bremer (Norman Kaye), a wealthy Australian esthete who lives alone, studies drawing and flower arrangement, and writes frequent letters to his dead mother. His contact with others is rare, remote and more than a little ghoulish, as when he stands naked in his mirrored bathroom, speaking to a radio evangelist on his cordless telephone. He is asking if the evangelist doesn't share his feeling that flowers have a sensual allure.

The most important relationship in Charles's life, the one about which he writes to his mother, is with Lisa (Alyson Best), a young artist's model. Charles pays Lisa $100 weekly to come to his house and remove her clothes to the tune of the "Love Duet" from "Lucia di Lammermoor." Immediately after watching her, Charles runs across the street and rapturously plays the church organ.

•

There is some small element of humor to "Man of Flowers," as when Charles attends the art class for which Lisa poses; he is ordered to "take that vegetable matter off that poor girl" after drawing Lisa with leaves across her torso. Much of it is deadly serious, however. The Freudian flashbacks of a shifty-eyed young Charles, his punishing father (the brief, silent role of the father is played by Werner Herzog) and his

sexy mother seem very much in earnest. So do Charles's walks through public parks in search of the erotic statuary he so admires.

Mr. Cox, who directed and co-wrote the film (and who previously directed "Lonely Hearts"), brings a hint of the macabre to Charles, his fascination with Lisa, and his contact with the loutish, over-the-hill "action" painter (Chris Haywood) who is Lisa's lover. So does Mr. Kaye, who plays the role with a measured politeness that makes Charles's unrequited longings all the more noticeable. "Man of Flowers" has glimmers of both satire and potential horror, but its prevailing tone, while somber, seems more than a little silly. Even Mr. Cox's intentional humor threatens to run away with whatever compassion Charles's loneliness is meant to arouse.

•

Mr. Kaye's performance steadies the film somewhat, and Mr. Haywood makes the artist amusingly arrogant and slovenly; the floral still life he finally comes up with at Charles's request is one of the film's better touches. Miss Best's Lisa is blander, understandably. Except for the strip-tease, there's not much to be done with her role.

"Man of Flowers" will be shown tonight at 9:30 and tomorrow at 6:15 P.M. as part of the New York Film Festival.

1984 O 9, C14:4

MEMOIRS OF PRISON, directed by Nelson Pereira dos Santos; screenplay (Portuguese with English subtitles) by Mr. dos Santos, based on the autobiographical novel by Graciliano Ramos; photography by Jose Medeiros and Antonio L. Soares; edited by Carlos Alberto Camuyrano; produced by Lucy and Luiz Carlos Barreto. At Alice Tully Hall, as part of the 22d New York Film Festival. Running time: 174 minutes. This film has no rating.
Graciliano Ramos Carlos Vereza
Heloisa Ramos Gloria Pires
Dr. Cabral Paulo Porto
Captain Lobo David Pinheiro
Soares .. Jofre Soares
Manoel Nildo Parente
Mario Pinto Joseh Dumont
Gaucho Wilson Grey
Cubano Waldyr Onofre
Arruda Jackson De Souza
Desiderio Tonico Pereira
Goldberg Jorge Cherques
Leonardo Antonio Almelleiras

IN the early 1960's, Nelson Pereira dos Santos, the Brazilian director, made a very studied, handsome film adaptation of "Vidas Secas," Graciliano Ramos's classic novel about social conditions in Brazil's arid, poverty-stricken northeast. In 1972, another Ramos novel, "Sao Bernardo," was the basis of a film by Leon Hirszman. "Sao Bernardo' ' was even angrier and more successful than "Vidas Secas" for the way Mr. Ramos's Marxism was expressed in the almost surreal tale of the rise and fall of an illiterate Brazilian peasant-turned-capitalist.

Now Mr. dos Santos has taken a semi-autobiographical novel written by Mr. Ramos in the 1940's and turned it into a very long film, "Memoirs of Prison," which was shown at the New York Film Festival at Alice Tully Hall last night and will be screened again today at 9 P.M.

"Memoirs of Prison" is an earnest, well-acted movie. However, it has the possibly unintentional effect of seeming to be more about the difficulties faced by a writer (Mr. Ramos) in prison — it's not easy getting paper and ink — than about the repressive political conditions that resulted in the imprisonment of thousands of left-wing, mostly Communist dissidents.

In the film's early sections, Mr. Ramos, played by Carlos Vereza, is arrested on charges that are never specified and sent to a prison where conditions are remarkably lax. He continues to write novels and short stories, which are smuggled out and successfully printed. He not only is allowed private visits with his wife, but when one of his novels is published, he's also able to hold a publication party inside the prison walls.

It isn't long before he's packed off to a penal colony where, on the arrival of the inmates, the chief guard announces that the purpose of their incarceration is not their rehabilitation but their eventual deaths. Even though conditions here are worse than before, Mr. Ramos continues to write, in full view of often sympathetic guards, recording the stories of the political prisoners as well as those of the thieves and murderers with whom they are billeted.

Eventually, possibly because of the publicity afforded him as a celebrated writer, Mr. Ramos is freed.

"Memoirs of Prison" is oddly undramatic — unmoving, really — principally because it is, first, about Mr. Ramos's writing and, only second, about the terrible mistreatment he sees. The movie's compassion and political convictions are upstaged by its concern about whether the writer is going to be able to safeguard his manuscripts. It's analogous to the film review in which the critic spends more space telling the readers what a dreadful time he had getting to the theater than describing his reactions to what he saw when he eventually got there.

Mr. Vereza's performance reflects the passive nature of the role, which is that of the observer. Some of the smaller roles are far more interesting, including that of Heloisa Ramos, played by Gloria Pires, who, in the course of the film, changes from worried mother and wife to a woman of courage who fights actively for her husband's release.

Vincent Canby

1984 O 10, C18:3

Gloria Pires in Nelson Pereira dos Santos' film "Memoirs of Prison."

Solace and Silliness

COMFORT AND JOY, directed and written by Bill Forsyth; director of photography, Chris Menges; edited by Michael Ellis; music by Mark Knopfler; produced by Davina Belling and Clive Parsons; released by Universal Pictures. At Plaza, 58th Street, east of Madison Avenue. Running time: 106 minutes. This film is rated PG.

Alan	Bill Peterson
Maddy	Eleanor David
Charlotte	C.P. Grogan
Trevor	Alex Norton
Colin	Patrick Malahide
Hilary	Rikki Fulton
Mr. McCool	Roberto Bernardi

By VINCENT CANBY

IT is late afternoon of Christmas Eve. Shoppers push their way through the aisles of a crowded Glasgow department store, the air thick with the all-too-jolly sounds of recorded holiday music. The camera pays particular attention to one beautiful young woman, a chic redhead who, with the air of a professional, succeeds in stuffing various unpaid-for knickknacks and articles of clothing under her amply cut fur coat.

Following the shoplifter at a discreet distance is a worried-looking young man. It seems almost as if he didn't want to arrest her.

As things turn out, he doesn't. He's not a cop anyway. He (Bill Paterson) is a local disk jockey, professionally known as Dickie Bird but whose real name is Alan. The young woman, Maddy (Eleanor David), is Alan's girlfriend, a free soul who has successfully furnished most of their shared apartment with objects thus acquired.

On their way home in the car, Maddy happily inventories the day's "take," much of which consists of clothes of the wrong size and things on the order of cigarette lighters disguised as small Eiffel Towers. Alan, who loves Maddy too much to give her an ultimatum, rather tentatively suggests that she might better steal practical things, like food.

Later that night, after they've shared a cozy dinner with wine and after they've made love, Maddy starts taking down pictures, piling her clothes on the bed and, in all other ways, behaving as if she were going on a long trip. When Alan asks what she's doing, she says with the patience of a teacher explaining the obvious to a pupil, "I'm leaving." Pause, as she continues to dismantle the apartment. Maddy adds, "I meant to tell you about it ages ago, but the occasion just never arose."

When Maddy walks out on Alan in the first few minutes of "Comfort and Joy," the new comedy by Bill Forsyth, the Scottish director of "Gregory's Girl" and "Local Hero," something very dear is lost to the movie as well as to Alan. Maddy is a most charming eccentric, and though Alan has his own, self-mocking, dour appeal, the film audience is likely to miss her as much as Alan does, though she does return from time to time to light up his dreams.

"Comfort and Joy," which opens today at the Plaza Theater, is about Alan's efforts to live through the worst week of his life after Maddy's departure. A friend, who has come by to console him, looks around the empty apartment and says, none too helpfully, "Everything here is you."

The friend agrees that Maddy might well be irreplaceable, but adds, "You were submerged in another person's personality. Let's face it. You were a subperson."

It's in exchanges like this, and in Alan's initially mysterious encounters with a number of other eccentrics, that Mr. Forsyth is best able to demonstrate his very particular brand of comedy, in which the irrational comes to seem absolutely reasonable.

Most of "Comfort and Joy" is about Alan's efforts to break loose, not only from his relationship with Maddy but also from his public personality as a disk jockey. He longs to become a serious radio journalist. To prove himself as a reporter, he becomes the unappreciated mediator in a war between two branches of the same Italian family out to control the ice cream market on Glasgow's streets.

"Comfort and Joy" is a charming film on its own, but something of a disappointment when compared to "Gregory's Girl" and "Local Hero," in which the inventions were more consistently comic and crazy. One good running gag throughout "Comfort and Joy" is the series of radio newscasts that punctuate Alan's holiday week — "No less than eight Christmas truces are in jeopardy today." There's also some very funny business about a radio station's celebrity look-alike contest in which few of the contestants look like anybody but themselves.

Mr. Paterson moves through "Comfort and Joy" with a lot of the intensity of a somewhat older Gregory, the hero of "Gregory's Girl," who spent most of that film attempting to reconcile his dreams with reality. The subsidiary characters, including the very funny Miss David and a Mafioso-type ice-cream king named Mr. McCool, are also attractive, but "Comfort and Joy," unlike the earlier Forsyth films, doesn't slip up on you — it almost slips away.

●

"Comfort and Joy," which has been rated PG ("parental guidance suggested"), contains some mildly vulgar language.

1984 O 10, C19:1

Sentimental Journey

GARBO TALKS, directed by Sidney Lumet; written by Larry Grusin; director of photography, Andrzej Bartkowiak; film editor, Andrew Mondshein; music by Cy Coleman; produced by Burtt Harris and Elliott Kastner; released by the MGM/UA Entertainment Company. At Loews New York Twin, Second Avenue and 66th Street; Loews 34th Street Playhouse, between Second and Third Avenues; Loews 83d Street Quad, at Broadway; Greenwich Playhouse Twin, Greenwich Avenue at 12th Street, and other theaters. Running time: 105 minutes. This film is rated PG-13.

Estelle Rolfe	Anne Bancroft
Gilbert Rolfe	Ron Silver
Lisa Rolfe	Carrie Fisher
Jane Mortimer	Catherine Hicks
Walter Rolfe	Steven Hill
Angelo Dokakis	Howard Da Silva
Sonya Apollinar	Dorothy Loudon
Bernie Whitlock	Harvey Fierstein
Elizabeth Rennick	Hermione Gingold
Shepard Plotkin	Richard B. Shull
Mr. Morganelli	Michael Lombard
Mr. Goldhammer	Ed Crowley
Garbo	Nina Zoe and Betty Comden

By VINCENT CANBY

QUITE early in Sidney Lumet's sentimental new comedy, "Garbo Talks," Anne Bancroft as Estelle Rolfe, the last word in Jewish mothers in contemporary film literature, learns that she has an inoperable brain tumor. As her initial fury turns into resignation, a wisecrack surfaces. "I always knew everybody's got to die," she tells her son, Gilbert (Ron Silver), "but I really thought I'd be the exception."

No comedy about terminal illness can escape moments of awful stickiness, but "Garbo Talks" has a lot of others that are funny in the slick Broadway style of which Neil Simon is the master. Though Larry Grusin, whose first theatrical film this is, is not yet in a league with Mr. Simon, he has written a number of comic scenes and lines that are played with great

Bill Paterson and C. P. Grogan, in foreground at left, play leading roles in "Comfort and Joy," a new comedy from the Scottish director Bill Forsyth.

Anne Bancroft in "Garbo Talks."

verve by Miss Bancroft and Mr. Silver, who behave as if the silver cord that binds them were no more emotionally constricting than a rubber band.

Estelle is an aggressively eccentric woman who wears space shoes, tells off construction workers in their own language, espouses all liberal arguments and is so regularly arrested, on behalf of one good cause and another, that she is known at many jail houses. Gilbert's secretary only has to ring him in a certain way for him to suspect that Estelle is back in the slammer. This puts a further strain on his already difficult marriage to Lisa, a homesick, snippy Californian, played by Carrie Fisher in her first successful breakout from her "Star Wars" movies.

Estelle's only wish before she goes off to New York Hospital — to die what seems to be a painless death, though she does have headaches and dark circles do appear around her eyes — is to meet her lifelong idol, the reclusive Greta Garbo.

Most of "Garbo Talks," which opens today at Loews New York Twin and other theaters, is about Gilbert's adventures in and around New York in his search for the actress, who has been in retirement for more than four decades. At one point, Lisa goes back to California, after learning that Gilbert has stopped working and they are living on their savings. "Are you serious?" she screams at him. "My father says that's like spitting on God!"

Lisa is replaced by a far more sympathetic young woman, Jane Mortimer (Catherine Hicks), a would-be actress. Among the other subsidiary characters, who get on and off fast in what are essentially specialty numbers, are an exhausted old freelance photographer (Howard da Silva); an aging actress (Hermione Gingold) who's playing the nurse in a Joseph Papp production of "Romeo and Juliet" in the park, though she's inclined to wobble when the director pleads with her to stand still; the photographer's nutty agent (Dorothy Loudon), and a lonely Fire Island resident, a role played by Harvey Fierstein with far more wistfulness than it warrants.

Drifting gracefully through the last quarter of the film is the title character herself, seen mostly in the distance, from the back, wearing a long coat, slacks and a large, floppy hat.

Playing this Garbo, almost as a stand-in, is Nina Zoe, though everybody who cares about the Broadway theater will recognize Betty Comden, who plays the Garbo figure in the film's final, very funny moments. Adolph Green, Miss Comden's writing partner, appears briefly as himself, during a party scene, to deliver a bit of arcane film history that becomes a key to the film's resolution.

For a conventional film, "Garbo Talks" contains three unusual monologues, two of which are delivered by Mr. Silver and Miss Bancroft. The third — and best — is delivered by Steven Hill who, as Gilbert's father, finds real pathos in a long speech in which he explains why he originally fell in love with Estelle and then why, just as inevitably, he fell out of love and divorced her.

Mr. da Silva and Miss Gingold are quite wonderful in their turns, and Miss Loudon might have been too if, as is her custom, she didn't insist on doing what amounts to a Groucho Marx imitation. A little less Loudon would be much more.

●

Miss Bancroft is so good that she almost manages to make her big last moment work. Though the scene is not embarrassing, it has a tear-jerking desperation that the film otherwise successfully avoids.

Mr. Silver sails through the more solemn moments as effortlessly as the funny ones, which include a marvelous encounter with a Fraser-Morris manager. Gilbert, newly hired as a Fraser-Morris delivery man, is told: "We do not tolerate rudeness. There's still a place for the rich in New York City!"

It's fun seeing Fraser-Morris being sent up. However, there's something unpleasant about the way the film purloins Miss Garbo's legend and even her reputation for being something less than a big spender. As one of the world's best-known, most admired screen actresses from Hollywood's golden era, she is, I suppose, in the public domain. Yet it would be reassuring to know that the film makers were not themselves cheap, and that they had paid her well for this multimillion-dollar invasion of what has been her own long search for privacy.

●

"Garbo Talks," which has been rated PG-13 ("Special Parental Guidance for Those Younger than 13"), contains some vulgar language.

1984 O 12, C8:1

Tales in a Cave

THE FIRST TURN-ON, directed by Michael Herz and Samuel Weil; written by Stuart Strutin; director of photography, Lloyd Kaufman; edited by Adam Fredericks and Richard King; produced by Mr. Kaufman and Mr. Herz; released by Troma Inc. At Criterion, Broadway and 45th Street; 83d Street Quad, at Broadway and other theaters. Running time: 85 minutes. This film is rated R.
Michelle Georgia Harrell
Mitch Michael Sanville
Henry Googy Gress
Danny Anderson John Flood
Annie Goldberg Heidi Miller
Alfred Zitzler Al Pia
Mrs. Anderson Betty Pia
Madame Gumbo Gilda Gumbo
Lucy the Hooker Lara Grills
Barbara Billingham Kristina Marie Wetzel

"THE FIRST TURN-ON!" is the kind of movie that looks so cheap even the rocks seem made out of cardboard. And rocks have a role to play, since the story begins when Michelle

(Georgia Harrell), a nature counselor from Camp Big Tee-Pee, finds herself sealed in a cave with four of her teenage charges. To while away the hours before they're rescued, they regale one another with tall tales of losing their virginity.

This teen sex farce, which opens today at the Criterion and other theaters, looks at virginity from roughly the point of view of an 11-year-old boy. If being a virgin is synonymous with being a creep, losing that status is a gross and embarrassing experience — like going through a food fight.

With the exception of the prudish Michelle, the women in "The First Turn-On!" are evil, leering seductresses, while beneath their pathetic braggadocio, the boys are frightened, quivering slobs. "If I ever get out of here, I'll change my subscription from Penthouse to National Geographic," one of them vows, fearing suffocation under those odd-looking rocks. Viewers of the film might want to do the same.

Stephen Holden

1984 O 12, C8:5

Family Discord

A NOS AMOURS, directed by Maurice Pialat; screenplay (French with English subtitles) by Arlette Langmann and Mr. Pialat; photography by Jacques Loiseleux; edited by Yann Dedet; music by Henry Purcell; produced by Livradois, Gaument, FR3; released by Triumph Films. At Alice Tully Hall, as part of the 22d New York Film Festival. Running time: 102 minutes. This film has no rating.
Suzanne Sandrine Bonnaire
Robert Dominique Besnehard
The father Maurice Pialat
The mother Evelyne Ker
Anne Anne-Sophie Maille
Michel Christophe Odent
Luc Cyr Boitard
Martine Maite Maille
Bernard Pierre-Loup Rajot
Jacques Jacques Fieschi
Marie-France Valérie Schlumberger
The American Tom Stevens

By JANET MASLIN

SUZANNE (Sandrine Bonnaire), the teen-age heroine of Maurice Pialat's "A Nos Amours," is as naturally and heedlessly amoral as the title character in Mr. Pialat's 1980 "Loulou," and the film follows the course of her flirtatiousness. In the credit sequence, standing in a skimpy white outfit at the prow of a yacht, she is radiantly confident and has everything ahead of her. Mr. Pialat's film is in no way judgmental, but it knowingly and regretfully watches that initial promise slip away. As Suzanne later puts it, "It's as if my heart had run dry."

●

The film observes Suzanne astutely but from some slight distance; it never seems entirely to understand her. Mr. Pialat is at his best with this approach, developing the portrait gradually, without bold strokes or easy answers. As the film traces more about Suzanne's friends and family, it becomes richer and richer, culminating in a bravura scene in which the troubled and newly extended family is quietly chastised by Suzanne's father. This man, in some ways the film's pivotal character, is played with intelligence and quiet authority by the director.

Suzanne is first seen at summer camp, rehearsing a romantic play; her suitor is being played, none too convincingly, by another young girl. But Suzanne is soon ready to move on to the real thing. She shows up in a nearby bar one night and has a brief, affectionless tryst with an American

she meets there. This is her first such encounter, but it is followed by many others, and Suzanne's promiscuity becomes legend among her friends. Her girlfriends can't help but mind Suzanne's seemingly indiscriminate interest in their boyfriends as well as her own.

"I'm only happy when I'm with a guy," Suzanne remarks at one point, and indeed she seems less and less happy at other times. Her father, in a rare late night confessional talk with his daughter, tells her that she used to smile more, and at this Suzanne drops her slatternly manner and becomes unexpectedly childlike. Miss Bonnaire plays Suzanne so naturally that it is only rarely, at moments like these, that she seems to be acting at all. Yet she is able to convey Suzanne's essential remoteness and her confused, conflicting feelings about her sexual power.

As Suzanne's inability to love becomes increasingly noticeable to those around her — while being fitted for a wedding gown, she's still capable of making a furtive date with an old boyfriend — the film follows the growing discord in her family. The father has moved out, and his wife and son are all the more enraged by Suzanne's wanton behavior. The brother in particular becomes increasingly violent. That Suzanne's at-home wardrobe is as slovenly and girlish as her street clothes are provocative is one of many tacit, well-observed details Mr. Pialat provides.

●

The cast, including Dominique Besnehard as Robert, the brother, and Cyr Boitard as the young boyfriend Suzanne alternately abuses and pines for, is uniformly convincing in a natural style like Miss Bonnaire's. Neither the acting nor the direction is ever obtrusive enough to mar the sense of a realistic and troubling story, perceptively told.

"A Nos Amours" will be shown tomorrow night at 7 as part of the New York Film Festival.

1984 O 12, C10:4

Two Brothers

BLOOD SIMPLE, directed by Joel Coen; screenplay by Joel and Ethan Coen; photography by Barry Sonnenfeld; edited by Roderick Jaynes and Don Wiegmann; music by Carter Burwell; produced by Ethan Coen. At Alice Tully Hall, as part of the 22d New York Film Festival. Running time: 96 minutes. This film has no rating.
Ray John Getz
Abby Frances McDormand
Julian Marty Dan Hedaya
Private Detective M. Emmet Walsh
Meurice Samm-Art Williams

BLACK humor, abundant originality and a brilliant visual style make Joel Coen's "Blood Simple" a directorial debut of extraordinary promise. Mr. Coen, who co-wrote the film with his brother Ethan, works in a film noir style that in no way inhibits his wit, which turns out to be considerable. This is a film in which a dying man, mistakenly shot by a woman who cannot see him (and who meant to kill someone else), can hear her shout one more insult at the intended victim — and answer her, "Well, ma'am, if I see him I'll sure give him the message."

A lot of dying is done in "Blood Simple," and almost none of it is done right. The plot concerns four people — a bar owner (Dan Hedaya), his wife (Frances McDormand), the bartender whom the wife runs off with (John Getz), and the private detec-

tive hired to kill the runaway couple (M. Emmet Walsh, the veteran character actor, who plays him with a mischievousness that is perfect for the role).

Their paths cross, re-cross and tangle to the point where the plot becomes a series of ingenious mistakes and misapprehensions. When the bartender, for instance, finds the bleeding, lifeless body of the bar owner, he thinks the wife shot her husband; he loves her, so he cleans up the mess and takes the body away to bury it. But the body is not so dead as it ought to be. And besides — we know, but nobody in the film does — it was the detective who did the shooting.

•

For all the plot's potential ghoulishness, Mr. Coen often interjects the kind of visual cleverness that underscores the playful mood. A long, late-night tracking shot from one end of the Neon Boot bar to another actually tracks along the surface of the bar itself — and when there is a drunk passed out on the bar, the camera simply lifts up and flies over him, then continues on its route.

A conversation is sharply interrupted by the sound, and sight, of a newspaper flying right into a plate-glass window. A car, embarking at night on a secret mission in a newly furrowed field, is seen the next morning to have left very clear tracks perpendicular to all the furrows. The film's final shootout, though grisly, also manages to have its share of bizarre humor and even beauty.

The camera work by Barry Sonnenfeld is especially dazzling. So is the fact that Mr. Coen, unlike many people who have directed great-looking film noir efforts, knows better than to let handsomeness become the film's entire raison d'être. In addition to its stylishness, "Blood Simple" has the kind of purposefulness and coherence that show Mr. Coen to be headed for bigger, even better, things.

"Blood Simple" will be shown tonight at 6:15 and tomorrow at 9:30 P.M. as part of the New York Film Festival.

Janet Maslin

1984 O 12, C10:4

WITHOUT WITNESS, directed by Nikita Mikhalkov; written (Russian with English subtitles) by Mr. Mikhalkov, Sofia Prokofyeva and Ramiz Fataliyev; photographed by Pavel Lebeshev; music by Edward Artyemiev; a Mosfilm Production; an International Film Exchange Release. At Carnegie Hall Cinema, Seventh Avenue and 56th Street. Running time: 97 minutes. This film has no rating.
WITH: Irina Kupchenko, Mikhail Ulyanov.

UNLIKE the other films by the Soviet director Nikita Mikhalkov that have been released here — "A Slave of Love," "Oblomov" and "Unfinished Piece for Player Piano" — "Without Witness" has a drab look and a claustrophobic feeling. This two-character drama, which opens today at the Carnegie Hall Cinema, is confined to a dingy apartment and has a talky, theatrical style.

It concerns a surprise visit by a man to his former wife long after they have separated, with conversational sparring that gradually reveals all that has passed between them. Neither "Without Witness" nor "A Private Conversation" (the English title that appears on the film itself) captures the tenor of this very well.

•

The husband (Mikhail Ulyanov), who has since remarried, arrives at his former wife's apartment in the kind of drunken stupor that inevitably leads to important character revelations, at least in drama of this kind. Until he reaches the stage of stunned, revelatory silence, Mr. Ulyanov plays his role in a broad and noisy style that is seen to particularly poor advantage in the tight close-ups Mr. Mikhalkov inflicts upon him. If this performance were to work at all, it would certainly work better on the stage. Irina Kupchenko, playing the spurned wife on the verge of marrying another man, has a gentler and more cinematic manner. The drama improves as it goes along, but its denouement is a very long time in coming.

During various parts of the couple's extended conversation, the wife turns on her television, and we see clips from a Soviet variety show. So this is, if not much else, an opportunity to hear "Hello, Dolly" sung in Russian.

Janet Maslin

1984 O 12, C12:5

PARIS, TEXAS, directed by Wim Wenders; written by Sam Shepard; adaptation by L. M. Kit Carson; photography by Robby Müller; edited by Peter Przygodda; music by Ry Cooder; produced by Don Guest. At Avery Fisher Hall, as part of the 22d New York Film Festival. Running time: 145 minutes. This film has no rating.
Travis Harry Dean Stanton
Jane Nastassja Kinski
Walt Dean Stockwell
Anne Aurore Clément
Hunter Hunter Carson
Doctor Ulmer Bernhard Wicki
Carmelita Socorro Valdez
Crying Man Tom Farrell
Slater John Lurie
Stretch Jeni Vici
Nurse Bibbs Sally Norvell
Rehearsing Band The Mydolls

By VINCENT CANBY

A most peculiar-looking figure wanders slowly but with purpose across the bleached expanse of a southwestern American wasteland. He wears a dusty, double-breasted suit, shoes so ragged they no longer qualify as footwear, a dirty shirt with a filthy but neatly knotted necktie, plus a maroon baseball cap. He stops, drinks the last of the water from a plastic container and continues his journey. From nowhere to nowhere.

When, eventually, he stumbles into a seedy little trailer camp, he collapses before he can open a soft-drink bottle. The man, who refuses to talk, is more or less threatened back to life by an ominous, German-accented doctor who, going through the man's pockets, finds a Los Angeles telephone number, which he calls.

These constitute the opening scenes in Wim Wenders's initially promising, new "road" movie, "Paris, Texas," written by Pulitzer Prize-winning playwright Sam Shepard ("Buried Child"), whose screenplay was adapted by L. M. Kit Carson. The movie, the winner of the grand prize at this year's Cannes Festival, will be shown at 8:30 tonight at Avery Fisher Hall to conclude the 22d New York Film Festival at Lincoln Center, and will open here commercially some time in November.

•

The desert derelict is eventually identified as Travis (Harry Dean Stanton), whose younger brother Walt (Dean Stockwell), a prosperous manufacturer of road signs, flies from Los Angeles to Texas to reclaim the brother who has been missing and presumed dead for four years.

As Travis and Walt begin their long drive back to Los Angeles — Travis sitting silently in the back while Walt drives, "Paris, Texas" looks as if it's going to be another classic Shepard tale about sibling relations, explored most effectively in Mr. Shepard's current Off Broadway hit, "Fool for Love," and in his "True West," which recently concluded a long run at the Cherry Lane Theater. Travis and Walt could be first cousins to the brothers in "True West," in which one brother is a foul-mouthed, possibly psychotic thief and the other an uptight, fastidious fellow who aspires to become a screenwriter.

"Paris, Texas" begins so beautifully and so laconically that when, about three-quarters of the way through, it begins to talk more and say less, the great temptation is to yell at it to shut up. If it were a hitchhiker, you'd stop the car and tell it to get out.

"Paris, Texas" has the manner of something to which too many people have made contributions. One problem may be that Mr. Shepard is the kind of writer who writes best when he writes fast. No matter how serious he is, he's also funny. His art — and his temperament — do not seem to adjust well to the sort of long, collaborative process by which movies are made. "Paris, Texas" seems to be a movie that's been worried to death.

Though Mr. Wenders is fascinated by the American scene, as he has shown in his "Alice in the Cities," "The American Friend" and "Hammett," his feeling is as much the result of his knowledge of American movies as of the first-hand experience out of which Mr. Shepard writes. He has a sense of humor, but it's more theoretical than actual.

•

The first half of "Paris, Texas" is Shepard at his best, as, gradually, Travis begins to respond to Walt during the drive to California. At one point, Travis shows Walt a snapshot of a scrubby field in Paris, Texas.

Nastassja Kinski and Harry Dean Stanton in Wim Wenders's "Paris, Texas," the final attraction in the 22d New York Film Festival.

Walt: "How come you got a picture of a vacant lot in Paris, Texas?"

Travis: "I bought it."

Walt: "You bought a picture of a vacant lot?"

Travis: "I bought the lot."

Travis, it turns out, believes that he was conceived in Paris, Texas, and he's always had the dream of one day moving there with his wife, Jane, who has been missing almost as long as Travis, and their small son, Hunter, who has been living with Walt and his wife, Anne, since his parents disappeared.

What has Travis been doing during these last four years, and where is Jane? I've no doubt that, left to his own devices, Mr. Shepard would have come up with a resolution to these mysteries that would have provided a far more satisfactory payoff than the one arrived at by the playwright working in collaboration with the director and Mr. Carson. Mr. Shepard's method is to distill from ordinary experiences and feelings a reality that is so dense it appears to be surreal.

This is exactly the quality that illuminates the first half of "Paris, Texas," when Travis, back in the middle-class environment of Los Angeles, attempts to establish some sort of connections with Hunter, played with enormous, comic self-assurance by Mr. Carson's seven-year-old son, also named Hunter.

Life in the small Los Angeles house is not easy for any of them. Anne (Aurore Clement) is afraid that if Travis takes the boy away, it will somehow threaten her marriage to Walt. Walt is torn by his affection for his older brother, for the boy and for his wife. The boy can't reconcile having a foster father he adores and a real father he doesn't know and whose shabby appearance is — well — embarrassing to him in front of his friends.

Travis is at loose ends. He can't sleep and, on his first night back, he spends the entire night shining every pair of shoes in the house.

The film is wonderful and funny and full of real emotion as it details the means by which Travis and the boy become reconciled. Then it goes flying out the car window when father and son decide to take off for Texas in search of Jane (Nastassja Kinski), Hunter's long-lost mother. Everything suddenly becomes both too explicit and too symbolic. It's not giving anything away to reveal that what the movie — rather tardily — seems to be all about is the difficulty in communication between men and women, nor that the sequences in which this is demonstrated are awful.

•

Mr. Stanton, who can be seen currently in the riotous "Repo Man" and will be remembered for, among other things, his performance in John Huston's "Wild Blood," is a marvelous Shepard character. Every foolish endeavor in American history appears to be written in the deep lines and hollows of his face. There is a gentleness about him that at any moment may erupt in inexpicable violence.

Mr. Stockwell, the former child star, has aged very well, becoming an exceptionally interesting, mature actor. Miss Clement, whose French accent is a bit thick for someone who is supposed to have been living in California for a few years, is also moving as Walt's baffled wife. Miss Kinski, however, is memorably miscast. The more she tries to act, the worse her performance becomes, which is more than unfortunate, considering the importance of her scenes to the end of the film.

Prominent in the supporting cast are Bernhard Wicki, the German director who appears as the menacing doctor early in the movie, and John Lurie, one of the stars of "Stranger Than Paradise," who does a tiny walk-on here for Mr. Wenders, who was one of the earliest supporters of that Jim Jarmusch film.

As photographed by Mr. Wenders's long-time associate, Robby Muller, "Paris, Texas," a French-German co-production made in this country, looks great. However, the film, at best, is extremely diluted Sam Shepard.

1984 O 14, 64:1

FILM VIEW

VINCENT CANBY

Getting Serious About Being Funny

"What!" says the astonished friend, reacting as if he'd just learned that you didn't know how to tie your own shoe laces. "You don't *really* mean to tell me you found that *funny*?"

You're immediately on the defensive so you resort to hyperbole: "I think it's the funniest American comedy since 'Tootsie.'"

"But it's so stupid," says the friend, more in sorrow than anger. "I didn't laugh once. I sat there stoney-faced, from beginning to end."

"It's almost as good as 'Broadway Danny Rose,'" you say, and as soon as you've said it, you know it's the wrong thing. You're aware that your defense is weakening. You suspect what the reply will be, and you're right:

"I'm not crazy about Woody Allen anyway..."

"Woody Allen is a genius," you say.

"Like Einstein?" says the friend. "Like Michelangelo?"

"I mean he's original, talented and brilliant."

"That isn't what you said," says the friend. "You should say what you mean. You shouldn't go around comparing Woody Allen to Einstein."

"I didn't mention Einstein," you say.

"You were talking about genius," says the friend. "I was only attempting to bring some sanity to the discussion..."

And on and on.

Arguments about what is or isn't funny in the movies have probably threatened more friendships than disagreements about religion, politics or sex. It's beside the point that there is no right or wrong about movies, especially comedies, which can't yet be assayed as if they were gold ore. If one fellow laughs helplessly while the person next to him remains bored, the laughter and the boredom turn into accusations concerning the mental fitness of the other.

It is, of course, always safer to attack comedy than to defend it. In spite of what Bing Crosby used to say in song, a smile is not a very effective umbrella, at least, not in our society, and a low threshhold to laughter can as quickly be interpreted as a sign of idiocy as an indication of a profoundly benign or witty nature.

These remarks are prompted by my own bafflement about the public reception to some recent film comedies, especially by the huge response to "Ghostbusters," the biggest money-maker of the summer and a movie that elicited no more than three grins from me, and "All of Me," which, in its first weeks, appears to be turning into a hit and is a movie that, I think, is very funny.

Are the same people supporting both films? Possibly. A single sensibility can be very mysterious, infinitely unpredictable, embrace all sorts of contradictions and, even after the fact, not easily analyzed.

• • •

I've no idea why I laughed a lot at "National Lampoon's Animal House" and, more recently, at "Police Academy," while being left completely unmoved by "Ghostbusters," "Caddie Shack," "Meatballs" and other comedies that seem to differ from the first two films only in details of plot, casting and budget.

In each of these films, the source of the humor is a kind of epically slobbish behavior, epitomized by the food fight in "Animal House" but echoed in the carefully acquired, slovenly attitudes of the heroes in "Ghostbusters." When this kind of comedy works, it's summed up in what I think of as the typical Bill Murray performance in which the character, usually unshaven and dressed in clothes that appear always to have been slept in, never betrays surprise or panic or any emotion except passing lust.

At its best, it suggests that nonchalance is the only sane reaction to the irrationalities of the world. When it doesn't work — as "Ghostbusters" did not work for me — the nonchalance seems to be used as a cover for a screenplay without point and comedy routines that build to no payoff.

"All of Me," directed by Carl Reiner and written by Phil Alden Robinson with, I'm sure, contributions by its two stars, Steve Martin and Lily Tomlin, is something quite other. It's a carefully structured farce with lines that are as funny as the situations. Even more important is the obvious commitment to it made by Mr. Martin and Miss Tomlin, in performances of sometimes furiously ludicrous intensity. There's no way that they could walk away from the film — as can the actors in something like "Meatballs" — shrugging their shoulders as if to say that the film's very sloppiness was its comic point.

• • •

"All of Me" is a farce in the tradition of the novels of Thorne Smith ("Topper"), whose comedies were frequently based on total confusion of identities.

In his "Turnabout," a husband and wife exchange bodies. In "All of Me," Miss Tomlin, as an eccentric, dying multimillionaire, finds herself inhabiting half of the physical body of an unsuccessful lawyer, played by Mr. Martin, because of the ineptness of her guru, who has promised to place her soul in the body of a beautiful young woman. However, in the course of this soul transplant, the bowl containing Miss Tomlin's immortal remains bounces out a window and lands on the lawyer, walking on the sidewalk below.

That's the gimmick that allows Mr. Martin to do a lot of physical comedy in which the male half of him appears to be at war with the female half. Unlike most gimmick-movies, however, this one manages to become funnier as it goes along, ultimately becoming a most improbable but satisfying love story, providing Mr. Martin with his best film role to date and Miss Tomlin with her first, fully realized comedy role since "The Late Show."

Heading the excellent supporting cast is Victoria Tennant, as the young woman whose body Miss Tomlin tries — unsuccessfuly — to hijack, at least spiritually; Richard Libertini, one of the few bright spots in this year's unfortunate remake of Preston Sturges's "Unfaithfully Yours," as the guru, and Dana Elcar as a most unlikely and most successful, middle-aged philanderer.

• • •

A far more difficult comedy to defend before the public-at-large is Eric Rohmer's wonderful "Full Moon in Paris," about the wrong-headed attempts of a bright, beautiful young woman (Pascale Ogier) to lead a completely free love life. Mr. Rohmer's comedies could not work on the stage —

they need the landscapes of reality to give perspective to the adventures they relate. They'd also make very slim volumes as novels.

They are real films but, unlike most films, they are based entirely on character, about otherwise intelligent, perceptive men and women who deceive themselves for the highest of moral reasons. There's not a knee-slapping gag in all of "Full Moon in Paris" but, for everyone who can tune in to Mr. Rohmer's wavelength, the film is terrifically bracing. All others should stay away. There's no way to answer the person who says of a Rohmer film, "You don't *really* mean to tell me you found *that* funny?"

It's still too early to tell how two other, completely dissimilar new comedies will make out with the public, but I wish them both well.

"The Adventures of Buckaroo Banzai," directed by W. D. Richter and written by Earl Mac Rauch, is a science-fiction farce with moments of inspired lunacy, in which Peter Weller plays the title role, that of a hybrid superman, half-American, half-Japanese, who operates with equal facility as a brain surgeon, test driver, physicist and government agent.

The plot, which is more nuttily complicated than that for an old, 15-part "Flash Gordon" serial, may well be too clever for its own good. However, unlike "Ghostbusters," "Buckaroo Banzai" is not a movie that gives the impression that it wants to walk away from itself. Though Mr. Weller "plays" nonchalant, he gives a comic performance as committed to the film as those of Mr. Martin and Miss Tomlin in "All of Me."

Jim Jarmusch's "Stranger Than Paradise," which was introduced at the just-ending New York Film Festival at Lincoln Center, is an existential lark, an independently-made, low-budget high-comedy about the adventures of three oddball friends hanging out in the bleaker banlieues of New York City, Cleveland and Florida. It's already opened to good business at the Cinema Studio here and there's a possibility that it just might become the "My Dinner With Andre" of 1984, which it otherwise resembles not at all. Discover it for yourselves.

Note: In my daily review of "Stranger Than Paradise" I reported that it had been shot in 16 millimeter and blown up to 35mm. Untrue. In fact, it was filmed in 35mm. It just looks that way, and the way it looks is as integral to the overall sense and feeling of the film as the expert performances of the three people who play the central roles, John Lurie, Eszter Balint and Richard Edson. ∎

1984 O 14, II:21:1

Getting to the Top

THE PLOUGHMAN'S LUNCH, directed by Richard Eyre; written by Ian McEwan; director of photography, Clive Tickner; edited by David Martin; music by Dominic Muldowney; produced by Simon Relph and Ann Scott; released by Samuel Goldwyn Company. At the Public Theater, 425 Lafayette Street. Running time: 107 minutes. This film is rated R.
James Penfield Jonathan Pryce
Jeremy Hancock Tim Curry
Susan Barrington Charlie Dore
Ann Barrington Rosemary Harris
Matthew Fox Frank Finlay
Edward Simon Stokes
Lecturer Bill Paterson

By VINCENT CANBY

JAMES PENFIELD, the journalist who glowers at the center of the fine new English film "The Ploughman's Lunch," is a fascinating variation on all of the angry, low-born young men who populated British novels and plays in the late 1950's and 60's. Although he denies it, he *is* angry. At one point he says: "You do everything right and you feel nothing. Either way."

His problem is that he feels everything all too acutely, but it doesn't make him a better person, only more devious.

James Penfield is Jimmy Porter of "Look Back in Anger" updated to the 1980's, specifically to London during the 1982 Falkland war and the Tory leadership of Prime Minister Margaret Thatcher. "The Ploughman's Lunch," the first theatrical film to be written by Ian McEwan and directed by Richard Eyre, is a witty, bitter tale of duplicity and opportunism in both private and public life.

As played by Jonathan Pryce, James Penfield is as determined as he is without conscience. To his friends, who are mostly upper and upper-middle class, and to his associates at BBC Radio, where he works as a news writer, his professed conservatism is something of a joke. To James, who may or may not believe in anything at all, it's also a way of getting to the top in Tory England.

In the course of "The Ploughman's Lunch," a title that becomes clear as the film proceeds, James is working on a book about the 1956 Suez war, which he sees not as a national humiliation but a glorious act that demands "redefinition." When his publisher reminds him to keep the American market in mind, James says glibly that good friends are those who speak the truth, and the officially angry United States response to Britain's invasion of Suez was the response of a good friend. He's not easily thrown.

James always has his eye on the main chance, but he is so obsessed by his own pursuits that he is oblivious to the possibilities that he might become the victim of others as casually dishonest as he is. He falls in love with a chic, bright, sharp-tongued young woman named Susan (Charlie Dore), both for herself and for access to Susan's mother, Ann (Rosemary Harris), an ardent Socialist and respected historian whose brain he wants to pick.

James doesn't hesitate to tell Susan

Left, Jonathan Pryce plays a British journalist who allows his ambition to override ethics in "The Ploughman's Lunch."

that his parents are dead, when, in fact, they lead a marginal existence in a bleak, working-class suburb, nor does he have any compunction about telling Ann that he is, of course, a Socialist. When the mother falls into his bed and in love with him, he obliges her as long as it suits his purpose, then returns to Susan, who can barely tolerate him.

"The Ploughman's Lunch," which opens today at the Public Theater, is one of those rare political films whose scheme grows naturally out of characters and situations. Apparently it was just a fluke that the Falkland war took place not long before production of the film began, thus providing Mr. McEwan and Mr. Eyre with a particular public event to dramatize James's private opportunism.

Mr. McEwan's screenplay is immensely intelligent, although it avoids the cadenced genteelness of the sort of "important" West End drama epitomized by Julian Mitchell's "Another Country," the fictionalized story of Guy Burgess. The people talk well but not especially loftily.

Everybody says exactly what he means, which is not to say that, like James, each one cannot lie with ease. The film's most arresting character is Ann, a beautiful woman whose intelligence is demonstrated both in the writing and in Miss Harris's superlative performance. That James can't see through his own immediate interests — to the truth of the older woman who loves him — provides the film with its dark comedy.

Almost as good as Miss Harris and Mr. Pryce, who won a Tony for his performance some years ago in the Broadway production of "Comedians," are Miss Dore, an unconventional beauty whose Susan is, ultimately, as duplicitous as James, and

Tim Curry as James's best friend, whose upper-class ease and self-assurance will forever elude James. The excellent supporting cast includes Frank Finlay as Susan's stepfather, Simon Stokes as a poet-friend of James and Bill Paterson, who plays the leading role in Bill Forsyth's new "Comfort and Joy," as a university professor.

For a movie that means to be about "serious" things — politics and choices — "The Ploughman's Lunch" looks and sounds unusually spontaneous. There's a wonderful sequence during James's unsuccessful courtship of Susan when they get into an argument about a Wajda film they've just seen and which James thinks is marvelous. "I don't like flashbacks," Susan says in boredom. "They make me feel as if I'm holding my breath."

Although set principally in London, there are two lovely sequences in the marsh country of Norfolk and, toward the end, an extraordinary sequence actually filmed in Brighton during the first Conservative Party congress to be held after the Falkland war.

It's a measure of how good the film is that it's not upstaged by a remarkable shot in which the camera, in one unbroken take, pans from Mrs. Thatcher giving a rousing, patriotic summation on the speaker's platform to James sitting in the audience, for the first time in the film looking utterly bereft.

This is tricky stuff, but "The Ploughman's Lunch" blends fact with fiction with astonishing success.

1984 O 19, C8:1

THE RAZOR'S EDGE, directed by John Byrum; screenplay by Mr. Byrum and Bill Murray; based on the novel by W. Somerset Maugham; director of photography, Peter Hannan; edited by Peter Boyle; music by Jack Nitzsche; produced by Robert P. Marucci and Harry Benn; released by Columbia Pictures. At Ziegfeld, Avenue of the Americas and 54th Street. Running time: 130 minutes.
Larry Darrell Bill Murray
Sophie Theresa Russell
Isabel Catherine Hicks
Elliot Templeton Denholm Elliott
Gray Maturin James Keach
Mackenzie Peter Vaughan
Piedmont Brian Doyle-Murray
Malcolm Stephen Davies
Raaz Saeed Jaffrey
Louisa Bradley Faith Brook
Joseph André Maranne
Henry Maturin Bruce Boa
Coco Serge Feuillard
Bob Joris Stuyck
Red Cross Lady Helen Horton

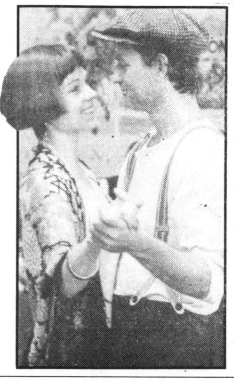

Bill Murray and Theresa Russell in "The Razor's Edge," based on W. Somerset Maugham's novel,

"LET'S talk," says Bill Murray as the idealistic young hero of W. Somerset Maugham's "Razor's Edge" as he prepares to tell his fiancée that he wants to postpone the wedding and is not yet ready to settle down. "*Seal* talk," Mr. Murray adds, since he is playing the scene in a swimming pool. And at this he begins to arf. If "The Razor's Edge" is Mr. Murray's first "serious" movie, he can hardly be accused of bringing an excess of seriousness to its central role.

Nor does he exactly play Larry Darrell, the Chicagoan "dreamer of a beautiful dream" who journeys to Paris and the Far East in search of enlightenment, for the laughs that are his trademark. Certainly Mr. Murray brings his familiar off-handed, wiseguy manner to the tale, as well as a complete indifference to the post-World War I time frame; his performance is both jokey and anachronistic, and the Parisian setting is little more than an excuse for him to show up in a beret. These touches might seem more jarring in a consistent and convincing version of Maugham's novel. As it is, this "Razor's Edge" is itself so disjointed that Mr. Murray, for all his wisecracking inappropriateness, is all that holds it together.

"The Razor's Edge," which opens today at the Ziegfeld, is slow, overlong and ridiculously overproduced. The director, John Byrum, devotes a lengthy and expensive half-hour prelude to establishing what Maugham explains in only a few pages: that Larry has been traumatized by his experience in the war. Though Maugham's hero was an aviator, the film's Larry is in the ambulance corps, allowing Mr. Byrum both an allusion to Hemingway and the chance to demolish a couple of vintage automobiles.

Gradually, the film traces Larry's romances with proper, affluent Isabel (Catherine Hicks) and risqué Sophie (Theresa Russell), a hometown girl turned Parisian prostitute. It also attempts, a lot less successfully, to chart his spiritual progress. Larry's announcement that he wants to delay the marriage to Isabel in order to "loaf" meant, in Maugham's terms, that he would spend most of his waking hours studying William James and Spinoza; when Mr. Murray talks about loafing, he seems to mean it in earnest. The key sequence that has him journeying to an Eastern monastery brings nothing but costly scenery and more gags. "Shouldn't this one be walking by now?" Mr. Murray asks of a large vegetable in the marketplace of a remote mountain village.

Mr. Byrum, who also directed "Inserts" and "Heartbeat," pads everything. To establish that Larry's Paris flat is too squalid for the bourgeois Isabel, for instance, Mr. Byrum brings on a rat, a cackling old man, a filthy toilet and the largest cockroach in captivity. This kind of overstatement, aside from being distracting, also manages to emphasize the utter lack of continuity in Mr. Murray's performance. Scene by scene he can be charming, if noticeably out of sync with everyone around him. (Mr. Murray plays *off* the other actors, but he never plays *to* them.) On the whole, though, he never generates any sense of the character's evolution, nor does he even appear to have much interest in the spirituality that is Larry's signal quality. When another man asks, during a card game, his opinions about salvation, Mr. Murray answers "I believe . . . that you're saving nines."

Denholm Elliott does an elegant, brittle job as Isabel's quintessentially snobbish uncle (the Clifton Webb role in the 1946 version of this story, starring Tyrone Power), and Miss Russell has a welcome vitality. Miss Hicks and James Keach, as the man she eventually marries, are more bloodless. Shirley Russell's costumes are attention-getting but effective and at least help give the film some modicum of visual appeal. But nothing gives it the kind of conviction that would explain why Mr. Murray, as has been so widely reported, was determined to get it made.

•

"The Razor's Edge" is rated PG-13 (Special parental guidance for those younger than 13). It contains some sexual suggestiveness.

Janet Maslin

1984 O 19, C14:6

Rock Without Clichés

STOP MAKING SENSE, a performance film of Talking Heads; directed by Jonathan Demme; director of photography, Jordan Cronenweth; edited by Lisa Day; produced by Gary Goetzman; a Cinecom International Films/Island Alive Release. At 57th Street Playhouse, between Avenue of the Americas and Seventh Avenue. Running time: 88 minutes. This film has no rating.
WITH: Talking Heads, David Byrne, Chris Frantz, Jerry Harrison, Tina Weymouth, Edna Holt, Lynn Mabry, Steve Scales, Alex Weir, Bernie Worrell.

By JANET MASLIN

FROM the opening frames of Jonathan Demme's "Stop Making Sense," which opens today at the 57th Street Playhouse, it's apparent that this is a rock concert film that looks and sounds like no other. The sound is extraordinarily clear, thanks to the pioneering use of 24-track digital recording. And the film's visual style is as coolly iconoclastic as Talking Heads itself. Mr. Demme has captured both the look and the spirit of this live performance with a daring and precision that match the group's own.

It's worth noting some of the things that are *not* to be found here: screaming crowds, gaudy skintight costumes, candid scenes of the band members backstage. Talking Heads' performance style is unlike anything that has ever been captured by a standard concert film, and Mr. Demme is very well attuned to the group's eccentricities. Even the first image — the shadow of a guitar neck looming against a white wall — wittily suggests the menacing and mechanistic qualities of Talking Heads' music, as well as the clean, bold visual imagery they manage to make so surprising. The sight of this sexually and racially integrated nine-member ensemble, in white sneakers and neutral-colored playsuits, jogging in place as if practicing aerobics becomes at least as exciting as any standard rock spectacle.

The focus of both the film and the performance is David Byrne, the lead singer, who is one of the group's four core members. With his hollow-eyed stare and bizarre gestures, Mr. Byrne is surely one of the oddest rock singers; he's also one of the most galvanizing. Mr. Byrne, or at least the sight of his sneakers, is initially seen alone, wandering onto the stage to perform the stark and rousing version of "Psycho Killer" that begins the show. (The other band members enter one at a time, a new one with

each song, as a technical crew wanders conspicuously in their midst. Only in its latter half does the film build into an elaborately staged production, with Mr. Byrne in his Big Suit costume and words like "time clock" and "dustballs" flashing on a colored backdrop.)

Mr. Byrne's studied casualness is matched by a fierce intensity. Even his most peculiar gestures — darting his head and tongue like a lizard, or dancing with stiff, jerky motions and a perfectly immobile torso — have an originality and a mesmerizing strangeness.

And Mr. Byrne's vocals maintain their lucid, unsettling energy throughout the performance (the film actually draws upon four 1983 concerts at the Pantages theater in Hollywood). The film includes especially fine renditions of such Talking Heads classics as "Life During Wartime," "Heaven," "Once in a Lifetime" and "Burnin' Down the House."

Mr. Demme, in addition to avoiding any visual monotony, has gracefully tailored the film to suit the band's stage show. Using long, slow camera motions (the handsome cinematography is by Jordan Cronenweth), he captures the group members at close range without losing the overall visual effects they achieve on stage. The show's conception, which is both subtle and sophisticated, is credited to Mr. Byrne.

"Stop Making Sense" owes very little to the rock film-making formulas of the past. It may well help inspire those of the future.

1984 O 19, C17:1

Above, David Byrne of the Talking Heads in "Stop Making Sense."

ALMOST everybody, including her husband, is aware that Mickey Davis (Barbara Williams), an interior designer, keeps a series of private journals. What they don't know is that the journals record her wildest sexual fantasies. Perhaps because he is a professional author, Ray Davis (John Getz), her husband, a successful writer of children's fiction, never pries and never seems to wonder why Mickey insists on keeping the journals locked up in the house safe.

Very early in "Thief of Hearts," the first film to be directed as well as written by Douglas Day Stewart ("An Officer and a Gentleman"), two young, highly efficient ex-convicts break into the Davis house and, in addition to paintings and smaller valuables, make off with Mickey's journals. It is the premise of this film, which plays a lot better than it sounds, that one of the thieves, Scott Muller (Steven Bauer), reads the journals and falls in love with the woman who wrote them.

Scott, clearly, is not a literary type. From what we hear of the journals, they sound like over-heated Barbara Cartland: "Water washes over me. Water is sexual . . . His tongue moves down my skin."

•

THIEF OF HEARTS, directed and written by Douglas Day Stewart; director of photography, Andrew Laszlo; edited by Tom Rolf; music by Harold Faltermeyer; produced by Don Simpson and Jerry Bruckheimer; released by Paramount Pictures. At Loews State, Broadway and 45th Street; Orpheum Twin, 86th Street and Third Avenue; 34th Street Showplace, between Second and Third Avenues, and other theaters. Running time: 100 minutes. This film is rated R.
Scott Muller Steven Bauer
Mickey Davis Barbara Williams
Ray Davis .. John Getz
Buddy Calamara David Caruso
Janie Pointer Christine Ebersole
Marty Morrison George Wendt
Sweeney ... Alan North
Nicole .. Romy Windsor

"Thief of Hearts," which opens today at Loews State and other theaters, is a good, romantic suspense film that, at its best, has some of the steaminess of Lawrence Kasdan's "Body Heat," although a few important plot twists don't stand careful scrutiny.

Scott, a good-looking, fast-talking young man, finds a way of "accidentally" meeting Mickey. Posing as a rich businessman, he commissions her to redesign his loft apartment and then proceeds to romance her. Having read the journals, he has no difficulty in persuading her that he is the

man she's always dreamed of.

"Thief of Hearts" has the flashy, glittery look of hip boutiques and discothèques, which is perfectly appropriate to fiction of this order. It also has a good cast, including Mr. Bauer, who made a memorable film debut as Al Pacino's sidekick in "Scarface"; Miss Williams, a beautiful Canadian actress new to American films, and Mr. Getz, who is also the star of "Blood Simple," perhaps the most popular film with the ticket-buying public at this year's New York Film Festival.

In prominent support are David Caruso, who plays Mr. Bauer's manic partner in crime, and George Wendt as a children's book publisher who, against his better judgment, finds himself in the middle of a possibly fatal melodrama.

"Thief of Hearts" is not quite film noir and not quite as suspenseful as it wants to be, but it's never boring.

Vincent Canby

1984 O 19, C17:4

An Overstuffed Plot

THE LITTLE DRUMMER GIRL, directed by George Roy Hill; screenplay by Loring Mandel, based on the novel by John le Carré; director of photography, Wolfgang Treu; edited by William Reynolds; music by David Grusin; produced by Robert L. Crawford; released by Warner Bros. At Cinema 2, Third Avenue and 60th Street; Cinema 3, 59th Street and Fifth Avenue; Warner Twin, Broadway and 47th Street; 86th Street Twin, at Lexington Avenue, and other theaters. Running time: 131 minutes. This film is rated R.

Charlie	Diane Keaton
Joseph	Yorgo Voyagis
Kurtz	Klaus Kinski
Khalil	Sami Frey
Tayeh	Michael Cristofer
Mesterbein	David Suchet
Litvak	Eli Danker

MOVIE makers refuse to learn that big, intricately plotted suspense novels, stuffed with characters, incidents, exotic locations and twists of plot, don't always adapt to the screen with ease. A perfect case in point is "The Little Drummer Girl," the film adaptation of John le Carré's best-selling novel, adapted by Loring Mandel, directed by George Roy Hill, and starring Diane Keaton.

The movie, which opens today at the Cinema 2 and other theaters, is more breathless than breathtaking, a kind of overdetailed résumé of the convoluted le Carré story about an actress recruited by a crack Israeli intelligence team to help catch a particular Palestinian terrorist, a fellow who is supposed to represent the lunatic fringe of the Palestinian liberation movement.

Mr. le Carré's novel, which represents this kind of fiction at its classiest, takes its time and more than 500 pages to introduce its characters and to lay out its complex narrative. The movie takes a little more than two hours, but still seems too long, yet not long enough for either the story or the characters to become involving, believable or even coherent.

"The Little Drummer Girl" looks to have been a production manager's dream film. Yet it spends so much time moving around — from Munich to London to Munich to Mykonos to Athens to Turkey to Munich to Beirut and back to Munich — that watching it can induce physical exhaustion. It's a sightseeing bus that you want to get off.

•

Like the novel, the screenplay attempts to dramatize — impartially —

the positions of the Israeli and Palestinian "moderates," as opposed to the extremist positions on each side. However, whether an assassination is committed by moderates or by extremists, the victim is still dead.

What the film demonstrates most obviously is that when there is this much plot on the screen, there isn't time for actors to develop anything much in the way of plausibility of characterization.

In particular, Miss Keaton, a fine actress, is left high and dry by the screenplay. She never gets a chance to find the curious, confused heart of Charlie, the American actress working in England who, though pro-Palestinian, is somehow persuaded to join the Israeli hunt for the Arab terrorist. No more successful are Yorgo Voyagis, as the Israeli spy with whom she falls in love, Klaus Kinski as the chief of the Israeli unit, or Sami Frey as the object of the hunt.

Everybody connected with the film behaves as if he were hanging onto the tail of a tiger and can't let go. They desperately clutch the material but never tame it. Perhaps "The Little Drummer Girl," like Mr. le Carré's "Tinker, Tailor, Soldier, Spy," could have been done successfully as a television mini-series. As it is, it's a big, expensive-looking bore.

Vincent Canby

1984 O 19, C18:1

A World of Sleaziness

CRIMES OF PASSION, directed by Ken Russell; written by Barry Sandler; director of photography, Dick Bush; film editor, Brian Tagg; music by Rick Wakeman; produced by Mr. Sandler; released by New World Pictures. At Astor Plaza, Broadway and 44th Street; Gemini, 64th Street and Second Avenue; New York Twin, Second Avenue and 67th Street, and other theaters. Running time: 102 minutes. This film is rated R.

Hopper	Bruce Davison
Grady	John Laughlin
Shayne	Anthony Perkins
Amy	Annie Potts
Joanna/China Blue	Kathleen Turner

FOR all their extravagance, Ken Russell's films have never lacked exuberance or humor, which makes the flat, joyless tone of "Crimes of Passion" a surprise. Much of this is attributable to a screenplay by Barry Sandler filled with smutty double-entendres and weighty ironies. Only intermittently does Mr. Russell break through with the kind of manic flamboyance that is so singularly and rudely his own.

These are the movie's craziest moments, but "Crimes of Passion," which opens today at Astor Plaza and Gemini, is best off when it makes the least sense. All too often, it becomes just lucid enough for the extreme tawdriness of the material to take over. There is plenty of that to go around, from the stridently sexual dialogue to the lurid peep-show atmosphere in which most of the story takes place.

This world is frequented by a woman calling herself China Blue (Kathleen Turner) by night, and working for a clothing manufacturer by day. She attracts the fanatical attention of a deranged minister who claims he is determined to save her. This man of the cloth, first seen sweatily watching a beat-up looking erotic dancer and then hysterically preaching a sermon right afterward, is played by Anthony Perkins. Mr. Perkins, who also sings "Shout hallelujah, c'mon, get happy!" before attempting to murder someone, did not

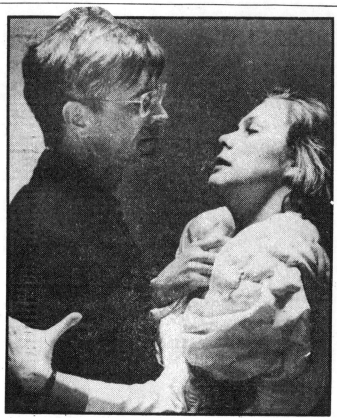

need to play another nut.

Two other key characters are a middle-class suburban couple (John Laughlin and Annie Potts) who have several children and an unsatisfactory love life. The screenplay, to establish their unhappiness, has them talk about appliances at dinner time. It also has the husband perform a party trick that is not easily described here, and that certainly explains some of his wife's indifference.

The sleaziness of "Crimes of Passion," which easily explains the X-rating this film nearly received, seldom has the kind of deliberateness that would make it effective; more often, the film just seems out of con-

Anthony Perkins stars as a street-corner preacher obsessed with a mysterious woman played by Kathleen Turner in "Crimes of Passion."

trol. Even a quick visual wedding pantomime, with a bride and groom relishing wedding gifts and then turning into skeletons, lacks the kind of wordless effervescence that was long Mr. Russell's specialty.

Janet Maslin

1984 O 19, C19:1

FILM VIEW

VINCENT CANBY

A Clear Case For Preservation

Perhaps more important than any other aspect of the 22d New York Film Festival, which ended a week ago today at Lincoln Center, was the emphasis it placed on film preservation — in all its forms. Film preservation is not ordinarily the sort of topic that rivets attention. It's not what people talk about at dinner parties. More than any of the other arts, movies are for the here and now. People want to see and talk about this week's hit to the exclusion of just about everything else. We have our repertory theaters, of course, but even they tend to cater to fads, showing over and over the old films that, at the moment, happen to be in.

If, as seems possible, the growing ubiquity of home video equipment increases the demand for — and interest in — old movies, the preservation of our film heritage becomes something more than a historical obligation. It now makes the kind of business sense that can be understood by the accountants who run the movie industry.

There's money in those film vaults, as long as their contents haven't been allowed to disintegrate with age or been sliced up and "improved" by hack editors.

Dramatizing the problems that face filmmakers, film historians and even filmgoers were two festival selections in particular: the beautifully restored print of Rouben Mamoulian's "Becky Sharp" (1934), the first full-length feature photographed in the still-incomparable, three-strip Technicolor process, and Sergio Leone's "Once Upon a Time in America," released here just last June in a completely inscrutable version that was 91 minutes shorter than Mr. Leone's original cut, which runs three hours and 46 minutes and which was the version the festival had the courage to include in this year's schedule.

I use the word "courage" with purpose since Mr. Leone is not widely regarded as a "serious" filmmaker, someone whose work, with or without its imperfections, must be protected as rigorously as the films of such other contemporary directors as Ingmar Bergman, Federico Fellini, François Truffaut, Jean-Luc Godard, Woody Allen, Satyajit Ray, Steven Spielberg, Francis Ford Coppola and Martin Scorsese.

• • •

What happened to "Once Upon a Time in America" in its initial release here shouldn't happen to a cheap roast of beef. It wasn't carved up — it was pulled to pieces by someone's bare, greedy hands. The nicest thing that can be said about it is that it looked like a trailer, though not a very good one, for the movie the festival finally showed.

Mr. Leone is a special taste, and one that I almost always enjoy even when the movies are less than great. He made his mark in this country with his first, enormously popular "spaghetti westerns," a phrase that his films upgraded from a form of disparagement to a term of endearment.

His are those very European-looking, American-set westerns ("A Fistful of Dollars," "For a Few Dollars More," "The Good, the Bad and the Ugly"), shot mostly in Spain and starring Clint Eastwood, which are outrageously violent, nihilistic, unusually beautiful to look at and frequently funny. At their best, his early films are reinventions of the American-made, Italian-dubbed westerns Mr. Leone saw in his youth, complete even to the English-language soundtracks, post-synchronized in such a haphazard way that the movement of the lips of the supporting European actors seldom have much relation to the words they are saying.

The success of those early films allowed Mr. Leone to work with bigger budgets, established stars and synchronized sound and even to shoot on American locations, which he used for his "Once Upon a Time in the West" (1969) and "Duck, You Sucker" (1972), his wildest film of all until "Once Upon a Time in America," a gloriously gaudy reinvention of the American gangster film.

I'm not sure that I agree with the late Henri Langlois, the film-obsessed founder and driving spirit of the Cinémathèque Française, who believed that all films must be preserved without reference to their quality. Theoretically he was right, but in practice it's virtually impossible. Yet, when one sees what happened so cavalierly to "Once Upon a Time in America" in its release here last June, one begins to share the Langlois obsession.

• • •

In its nearly four-hour form, now on view at the Gemini Theater in New York and which seems about half as long as the shorter version, "Once Upon a Time in America" is not a masterpiece, but it's popular moviemaking of a most entertaining kind, something for which there is no real equivalent in written literature. It may look like trash to middlebrow moviegoers, but it's far more accomplished, more complex and more stylish than most films aimed at the great mass market.

In its shortened form, the film was the chronologically told story of four young men, born and raised in the Jewish ghetto in the Williamsburg section of Brooklyn, and their rise and fall in the criminal underworld from the 1920's to the 1960's. Because of the manner in which it had been edited — read "butchered" — the narrative made little sense and the performances seemed as irrational as they were intense.

In the restored version currently on view, "Once Upon a Time in America" is a memory film — an elegy — built around a mystery, a tale recounted in a series of interlocking flashbacks that are intentionally fantastic, but also comprehensibly violent, romantic, crude and funny. Robert De Niro, as a punk destined always to be a loser, and James Woods, as a hood who achieves a kind of greatness, dominate the movie with performances that can now be seen to be first-rate. Giving them excellent support are Tuesday Weld, Treat Williams, Elizabeth McGovern, Darlene Fleugel, Joe Pesci and a new beauty named Jennifer Connelly, who plays Miss McGovern as a

young girl.

It's expensive to release a film running nearly four hours. The prints are approximately twice the cost of those for a two-hour film and theaters can show it only three times a day, compared to the five or six screenings of a film of conventional length. I've no idea how the restored "Once Upon a Time in America" will do, but it's well worth this second chance.

•

An endeavor of even greater significance to film history and scholarship is the restoration of the 50-year-old "Becky Sharp" by Richard Dayton, Bob Gitt and their associates at the University of California at Los Angeles. For years now film archivists everywhere as well as film makers, particularly Martin Scorsese, have been spreading the terrible word about the ephemeral nature of our color films. Not since the early 1950's have they been photographed in the old three-negative Technicolor process, which guaranteed a long life to color films since the color "information" was safeguarded on black-and-white film stock, and thus was not subject to the fading that occurs to the dyes on single-negative color stock, now used exclusively.

"Becky Sharp" is an extremely short — 84-minute — adaptation of a very long novel, Thackeray's "Vanity Fair," but it is as beautiful — and funny — in this restored print as it must have been when first released. The cost of restoring such a color film is approximately three times the cost of restoring an old black-and-white film and, I assume, just that much more tricky. However, anyone who has wandered into a theater or museum recently to see something on the order of "Giant," and found a color print that had turned entirely beige, realizes the extent of the problem.

Left untreated, all of the color films made after the demise of the original Technicolor laboratories will have turned to beige or pink or blue within a couple of decades.

Just how these films fade was demonstrated in another of this year's festival entries, Kon Ichikawa's 1965 "Tokyo Olympiad." The festival chose to schedule "Tokyo Olympiad" because, when it was originally released here in 1966, it was shown in a 90-minute version, compared to the original 170-minute version.

•

This longer version is engrossing as well as handsomely photographed and edited, though, the festival program notes notwithstanding, it's not to be compared to Leni Riefenstahl's "Olympia." What made the film's festival showing important was the clearly apparent way in which one could see how the original color was disappearing, more or less in front of our eyes. The reds were intensely red, and the yellows very yellow, but all of the other colors were merging into bluey-pink.

The news is not all bad, however. According to Mr. Gitt at U.C.L.A., it's now possible to take a single-negative color film and re-record the color information on black-and-white stock, in this way to preserve the film in a manner comparable to the original Technicolor process. It's not cheap. However, today not only are film archivists at work preserving films that are still in a state to be preserved, but film producers themselves, with an

eye on the residuals to come from home video sales, also are taking these precautions.

Perhaps the festival's most moving restoration job was François Truffaut's "Two English Girls and the Continent," including nine minutes of footage that Mr. Truffaut had been persuaded to cut from the film for its release in 1971. As much as I admired the film when I first saw it, I must also admit that I don't remember that version well enough to be entirely sure which of its present 117 minutes were not in it in 1971.

The revelation is not in the differences one can detect in the two versions but in the realization that the film has been terribly underrated by one's memory. "Two English Girls and the Continent" ranks with Mr. Truffaut's best — a rueful, three-sided love story set just before World War I, involving two young, free-thinking Englishwomen, who are sisters, and the enlightened French cad (Jean-Pierre Leaud), who loves them both.

Much of the film's comedy has to do with the three characters' solemn self-deceptions, which is not unlike the situation in some of Eric Rohmer's films. What immediately identifies "Two English Girls" as a Truffaut work, though, are its conjunction of visual and verbal wit and its narrative economy, which gives the film a kind of density of feeling unequaled by the work of any of his contemporaries.

Just for the record: the colors in the print shown at the festival were as rich and true as anyone, including Nestor Almendros, who photographed it, could have wished. ■

1984 O 21, II:23:1

Evoking Hitchcock

BODY DOUBLE, produced and directed by Brian De Palma; screenplay by Robert J. Avrech and Mr. De Palma; story by Mr. De Palma; music by Pino Donaggio; director of photography, Stephen H. Burum; edited by Jerry Greenberg; production design by Ida Random; executive producer, Howard Gottfried; released by Columbia Pictures. At the U.A. Twin, Broadway at 49th Street; Manhattan Twin, Third Avenue and 59th Street; New Yorker Twin, Broadway and 88th Street; Waverly Twin, Avenue of the Americas at West Third Street, and other theaters. Running time: 110 minutes. This film is rated R.

Jake	Craig Wasson
Holly	Melanie Griffith
Sam	Gregg Henry
Gloria	Deborah Shelton
Jim McLean	Guy Boyd
Rubin	Dennis Franz
Drama Teacher	David Haskell
Kimberly	Rebecca Stanley
Corso	Al Israel
Video Salesman	Douglas Warhit
Douglas	B. J. Jones
Frank	Russ Marin
Billy	Lane Davies
Carol	Barbara Crampton
Assistant Director	Larry (Flash) Jenkins
Sid Goldberg	Monte Landis
Linda Shaw	Linda Shaw
Tina	Mindi Miller
Actress/Vampire Movie	Denise Loveday

By VINCENT CANBY

BRIAN DE PALMA goes too far, which may be not only the most consistent quality through all his films but also the most important and, possibly, the most endearing. Each of his films is guaranteed to offend some of the people all of the time, including his staunchest admirers. He never leaves well enough alone.

He's someone at an otherwise friendly dinner party who can't keep himself from saying the one thing that will infuriate everybody. It's as if he were daring the host to ask him back.

Mr. De Palma's early, independently made comedies, including "Hi, Mom" and "Greetings," set standards for informed rudeness and bad taste that many of us continue to remember with fondness. When he turned to horror films, his ebullient satire occasionally put off the very audiences for which the films were supposedly made, though the on-screen demolition of John Cassavetes' head in "The Fury" set a standard for sheer gore that other, less talented directors are still imitating.

His "Dressed to Kill" and "Blow Out" unashamedly quoted from the films of Alfred Hitchcock, and when last year he remade "Scarface," he couldn't resist ending it with a comic-book Götterdämmerung that produced helpless laughter in part of the audience and outrage in everyone else.

"Body Double," opening today at the United Artists Twin and other theaters, again goes too far, which is the reason to see it. It's sexy and explicitly crude, entertaining and sometimes very funny. It's his most blatant variation to date on a Hitchcock film ("Vertigo"), but it's also a De Palma original, a movie that might have offended Hitchcock's wryly avuncular public personality, while appealing to his darker, most private fantasies.

●

The new film, written by Robert J. Avrech and Mr. De Palma, is a murder mystery that has the effect of sending up the kind of sleaziness that Paul Schrader found so solemnly significant in "American Gigolo." It's about Jake Scully (Craig Wasson), an aspiring but none too promising Hollywood actor who, when first seen, is in process of being fired from his first big break, playing an androgynous vampire in a third-rate horror flick.

Jake's problem is that he has claustrophobia and panics every time he has to climb into his movie coffin. When he gets home that afternoon he finds his girlfriend in bed with another man. That's bad enough but, as he reports later, she was positively glowing. Says the morose Jake, "She never glowed with me."

Having no place to live, Jake accepts a house-sitting offer from Sam (Gregg Henry), a fellow actor who's off for a job in Seattle. It's not exactly an ordinary house. It perches like a giant spaceship atop a cement column on a hillside overlooking Los Angeles. It also comes equipped with a high-powered telescope and something very special to watch.

Each night at the same hour, as Sam shows Jake, the beautiful, dark-haired young woman in the house just below puts on a sort of modified, one-woman porn show, possibly knowing that telescopes all over the neighborhood are trained on her.

●

Night after night Jake watches for the pleasure of it — he's a far less respectable Peeping Tom than the one played by James Stewart in "Rear Window." In time Jake falls in love with the woman who is, it turns out, a battered wife whose name is Gloria (Deborah Shelton). Jake also comes to realize that someone else is watching Gloria and that, indeed, someone is out to murder her.

It's difficult to say any more about the story without giving away its secrets, though "Body Double" does give one of its main secrets away rather sooner than it means to.

However, the film's secrets are not as important to one's enjoyment as the spectacle of poor Jake's dogged pursuit of answers, a journey that introduces him to the world of porn films. In particular, it introduces him to Holly (Melanie Griffith), a pretty, model-thin, absolutely up-front porn actress who has some of the comic candor of a contemporary Billie Dawn in a punk hairdo.

Mr. Wasson ("Four Friends") is extremely good as Jake, a guy whose code of honor doesn't prevent him from accepting a job in a porn film in order to get to the bottom of the mystery. In spite of his actions, Jake goes through these adventures radiating down-home decency, which is funny for being so out of place. Miss Shelton hasn't a great deal to do but she is a lovely victim, even when Mr. De Palma upstages her and Mr. Wasson by photographing them in their first — and last — embrace in one of those lyrical, 360-degree pan-shots that prompt laughter for the way they so brazenly evoke Hitchcock.

Though she comes into "Body Double" quite late — initially as the star of a film-within-the-film titled "Holly Does Hollywood" — Miss Griffith is the movie's real focal point. The daughter of Tippi Hedren, of Hitchcock's "Birds," Miss Griffith gives a perfectly controlled comic performance that successfully neutralizes all questions relating to plausibility. She's not exactly new to films, having played in "Night Moves," "Smile" and "The Drowning Pool" as a very young actress. What is new is the self-assured screen presence she demonstrates here, and it's one of the delights of "Body Double."

Note: It's not necessary to be a Hitchcock student to enjoy "Body Double," and not for nothing is the film rated R.

1984 O 26, C8:1

Oedipal Exploits

FIRSTBORN, directed by Michael Apted; written by Ron Koslow; director of photography, Ralf D. Bode; music by Michael Small; produced by Paul Junger Witt and Tony Thomas; released by Paramount Pictures. At the Embassy 1, Broadway and 46th Street; Loews New York Twin, Second Avenue and 66th Street; Loews 34th Street Showplace, between Second and Third Avenues, and other theaters. Running time: 104 minutes. This film is rated PG-13.

Wendy	Teri Garr
Sam	Peter Weller
Jake	Christopher Collet
Brian	Corey Haim
Lisa	Sarah Jessica Parker
Lee	Robert Downey
Adam	Christopher Gartin
Mr. Rader	James Harper
Dad	Richard Brandon
Joanne	Gayle Harbor

By JANET MASLIN

THE director Michael Apted, who brought so much rural verisimilitude to "Coal Miner's Daughter," creates an equally convincing suburban New York backdrop for "Firstborn." That Mr. Apted was born and raised in England only makes his versatility more impressive.

"Firstborn," which opens today at the Loews New York Twin and other theaters, takes place in a world of backyard barbecues and brand-new clothes, a world in which nothing is supposed to go wrong. The film, which confines itself almost exclusively to one family and one home, tries to show what can happen in this controlled setting when something very important goes wrong.

It is to the credit of Mr. Apted, and

to a cast including some very believable young actors, that "Firstborn" moves swiftly and smoothly enough to dispel much nitpicking about plot points, at least for a time. There's a lot about the story that finally doesn't add up, but the film manages to be engrossing all the same. For one thing, it has its share of built-in emotional force, since its key characters are a teen-age boy, his pretty, divorced mother and the new boyfriend whose presence threatens to disrupt the family. "Firstborn" doesn't do much of a job of examining this situation's Oedipal underpinnings, but it does succeed in exploiting them.

The film's early scenes show 15-year-old Jake (Christopher Collet), his younger brother, Brian (Corey Haim), and their perky mother (Teri Garr) living in cheerfully clamorous

Brian Hamill

Teri Garr in Michael Apted's movie "Firstborn."

domesticity. The boys spar good-naturedly and have plenty of friends; even their mother, though still recovering from her divorce, is doing nicely. The film outlines all this in an effective if not very surprising style. When the mother and sons get dressed up for a visit with the boys' father, and the mother fusses too eagerly with her outfit, it's easy to anticipate that the father will arrive with a girlfriend in tow.

On the rebound, Wendy (Miss Garr) finds a new flame. The boys' first introduction to him is awkward, to say the least; they are joshing one another over breakfast when they suddenly hear a masculine voice coughing upstairs. Jake, whose fond and even flirtatious relationship with his mother has been well established, is particularly unhappy about the arrival of this stranger.

And Sam (Peter Weller) is unquestionably sinister. Even when he tries to buy off the boys with expensive presents, he fools them only momentarily. Jake is quick to notice Sam's incipient bad temper and his disgruntled way of talking about his work; it's not even exactly clear what line he's in. Soon he is talking about opening a restaurant, with Wendy to do the cooking and supply the cash. Soon after that, Jake discovers, he is dealing in drugs.

The main idea in "Firstborn" — and it's the kind of film from which only one idea emerges at a time — is that Jake is more of an adult than any of the authority figures in his life. At school, he has a teacher who loves taking cheap shots at his students' failings; at home, his mother be-

comes progressively more irresponsible, especially under the influence of Sam's cocaine. Jake eventually emerges as the only one capable of rectifying the family's problems, and those problems build to a violent ending. The film's hold on teen-agers will not be diminished by an ending that allows Jake the chance to get even with this father surrogate once and for all.

●

The best things about "Firstborn" are the easy, natural performances of the actors, especially the younger ones — Mr. Collet, Mr. Haim, and Sarah Jessica Parker, as Jake's girlfriend — and the authenticity of its middle-class milieu. The film works less well as an attempt to explore children's feelings about divorce and stepparents, though a serious post-"Kramer vs. Kramer" film on the subject would be welcome. Ron Koslow's screenplay raises some of the key issues involved, but it dispenses with them in a hurry. Since the boys' father is barely present in the film, and since Jake's desire for revenge finally eclipses everything else, there's little opportunity for the film to develop much emotional depth.

Miss Garr and Mr. Weller are both persuasive, but both are undercut by some of the story's implausibilities. Miss Garr's early scenes with the boys are warmly appealing, but the idea that she has never had even the tiniest bad mood before Sam's arrival makes her fall into tawdriness much too abruptly. And Sam, though played by Mr. Weller as a likely suitor for this middle-class mother, is written as a no-account impecunious drifter who hardly seems her type. Nor does it seem likely that Wendy, who has no visible means of support but is still living quite comfortably, would fall for that restaurant scheme.

●

"Firstborn" is rated PG-13 (Special Parental Guidance for Those Younger Than 13). It contains some verbal obscenities and some violence.

1984 O 26, C10:1

Confused in Paris

AMERICAN DREAMER, directed by Rick Rosenthal; screenplay by Jim Kouf and David Greenwalt, from a story by Ann Biderman; executive producer, Barry Krost; director of photography, Giuseppe Rotunno; music by Lewis Furey; costume designer, Michael Kaplan; production designer, Brian Eatwell; edited by Anne Goursaud; released by Warner Bros. At the Sutton, 57th Street between Second and Third Avenues; Murray Hill, 34th Street and Third Avenue; Movieland, Broadway and 47th Street; Loews 83d Street Quad, at Broadway, and other theaters. Running time: 104 minutes. This film is rated PG.

Cathy Palmer	JoBeth Williams
Alan McMann	Tom Conti
Victor Marchand	Giancarlo Giannini
Margaret McMann	Coral Browne
Kevin Palmer	James Staley
Kevin Palmer Jr.	C. B. Barnes
Karl Palmer	Huckleberry Fox
Don Carlos Dominguez	Jean Rougerie
Inspector Klaus	Pierre Santini
Russian Ambassador	Leon Zitrone

BEGINNING with a sequence that, by an unlucky coincidence, duplicates the jokey opening of "Romancing the Stone," "American Dreamer" goes on to become an even less funny comedy about a writer of trashily romantic suspense novels.

JoBeth Williams plays the title character, Cathy Palmer, a bored suburban housewife who fancies herself a writer. At the start of "American Dreamer," Cathy wins a contest for having submitted the best plot out-

line for a new novel featuring the apparently hugely popular Rebecca Ryan. Rebecca Ryan is a fictional character who goes around the world having close brushes with death and handsome men as she settles international crises.

Cathy's prize is a free trip to Paris for two to meet the actual author of the Ryan novels, though she must make the trip alone because her husband (James Staley) is too busy with his boring job and boring friends.

Shortly after she arrives in Paris, Cathy gets conked on the head and wakes up believing she really is Rebecca Ryan and really is in the middle of some totally incomprehensible political plot.

Miss Williams ("Poltergeist," "The Big Chill") is, under better conditions, a most attractive performer, as is her co-star, Tom Conti, who was nominated for an Oscar for his work in "Reuben, Reuben," but they're something less than attractive here. Mr. Conti plays a remarkably patient fellow, falling in love with the clearly bonkers American woman who's under the delusion she's the character in the books written by Mr. Conti's mother (Coral Browne).

"American Dreamer," which opens today at the Sutton and other theaters, is not funny or romantic or suspenseful. It's not even trashy. It has no identity whatsoever other than that of its scenery, which includes the magnificent Vaux-le-Vicomte, the palace that prompted a jealous Louis XIV to upgrade Versailles as a fit setting for a Sun King.

"American Dreamer" was directed by Rick Rosenthal ("Halloween II," "Bad Boys"), who cannot make anything out of the sow's ear of a screenplay by Jim Kouf and David Greenwalt, who earlier wrote the dreadful "Class" for Jacqueline Bisset. Ann Biderman receives credit as "story originator," apparently for

Tom Conti in a scene from the movie "American Dreamer."

having written "the first script of 'American Dreamer' from a story from director Roger Vadim."

This movie has more names on it than a get-well card signed by everybody in the office and the mail room.

•

"American Dreamer," which has been rated PG ("Parental Guidance Suggested"), contains some vulgar language and sexual references.

Vincent Canby

1984 O 26, C12:4

A Missing Tape

GIVE MY REGARDS TO BROAD STREET, directed by Peter Webb; produced by Andros Epaminondas; screenplay and music by Paul McCartney; music produced and directed by George Martin; director of photography, Ian McMillan; costume designer, Milena Canonero; edited by Peter Beston; choreographed by David Toguri; released by 20th Century- Fox Film Corporation. At the Gotham, Third Avenue at 58th Street; Criterion, Broadway between 44th and 45th Streets, and other theaters. Running time: 108 minutes. This film is rated PG.

Chauffeur	John Burgess
Steve	Bryan Brown
Paul	Paul McCartney
Second Chauffeur	Clive Ellis
Ringo	Ringo Starr
Journalist	Barbara Bach
Linda	Linda McCartney
Sandra	Tracey Ullman
Jim	Ralph Richardson

"GIVE MY REGARDS TO BROAD STREET" begins on a note of unexpected candor, with Paul McCartney playing a very rich rock star surrounded by functionaries who attend his every need. He is first seen in a chauffeured car, daydreaming on a rainy day while a song from his Beatle days — "Good Day, Sunshine" — drifts through on the soundtrack. Later on, he attends a recording session and a board meeting, also finding time to perform in various video extravaganzas.

Whenever Mr. McCartney enters any such setting, however nonchalantly, he elicits the kind of deference befitting rock royalty. This, in the film, is as much of a given as the vanity license plates reading "PM 1" and "MUSIC," or the phenomenal number of gold records on the walls at his corporate office. What comes with all this, as "Give My Regards to Broad Street" makes clear, is the kind of business clout that has enabled Mr. McCartney to include family, friends and some of the best technicians available in what is, at least to some extent, a home movie on an amazing scale.

•

"Give My Regards to Broad Street," which opens today at the Criterion and other theaters, has enough good musical sequences — the best of them simply showing Mr. McCartney, under the direction of the producer George Martin, performing alongside Ringo Starr in a recording studio — to please Mr. McCartney's many fans. It also shows the singer in a relaxed, un-self-conscious mood that goes a long way toward making the film appealing. But there are also lengthy passages — like the "Eleanor Rigby" sequence in which the Starrs and the McCartneys dress up for a 19th-century picnic — that must have been a lot more gratifying for the performers than they are for the audience. Peter Webb, the director, lets the film waver very unsteadily from one mood to another.

Like Richard Lester, who brought such exuberance to the Beatle films "A Hard Day's Night" and "Help!," Mr. Webb has a background directing commercials (though he has no comparable flair). And this film shares with "A Hard Day's Night" the kind of loose premise that is little more than an occasion for day-in-the-life antics. The suspense in Mr. Lester's film, what there was of it, revolved around whether the Beatles would make a television appearance scheduled for that evening. In a similar vein, Mr. McCartney's screenplay for the new film involves a day-long search for the missing master tape of his latest album.

Whenever the mood strikes, "Give My Regards to Broad Street" abandons its semi-autobiographical tone and introduces musical production numbers, any of which could be spun off as a self-contained rock video. Some of these are enjoyable ("Ballroom Dancing," staged as a battle between punks and more formal dancers), some are ridiculous (an all-white sci-fi staging for the very incongruous "Silly Love Songs"), and all of them break the otherwise halfway-realistic mood. A lot of effort has gone into this film's production values, but continuity seems, at best, to have been a secondary concern.

With costumes by Milena Canonero ("Chariots of Fire") and special makeup by Barbara Daly (who works on Princess Diana), it's not surprising that the principals — Mr. McCartney; his wife, Linda McCartney; Mr. Starr and his wife, Barbara Bach (playing a sort of groupie journalist), and Bryan Brown as Mr. McCartney's chief business adviser — look great. Nor is it surprising that the musical sequences sound so good, thanks to a stellar cast of guest artists, including Dave Edmunds, David Gilmour and others, to Mr. Martin's arrangement and supervision and, of course, to Mr. McCartney's songs. Also in the cast, though not as well used, are the flame-and-green-haired singer Tracey Ullman, noticeably out of place as a dejected waif, and Ralph Richardson, who has a brief and exceedingly strange scene with a pet monkey.

•

"Give My Regards to Broad Street" is rated PG ("Parental Guidance Suggested"). It contains almost nothing that would disturb small children.

Janet Maslin

1984 O 26, C14:5

Borrowed Mayhem

TERROR IN THE AISLES, directed by Andrew J. Kuehn; screenplay by Margery Doppelt; director of photography, John A. Alonzo; music by John Beal; edited by Gregory McClatchy; clip research and preliminary treatment, John JB Wilson; produced by Stephen J. Netburn and Mr. Kuehn; released by Universal. At the Gramercy, 23d Street near Lexington Avenue; Criterion, Broadway between 44th and 45th Streets; U.A. East 85th Street, at First Avenue, and other theaters. Running time: 85 minutes. This film is rated R.
WITH: Donald Pleasence and Nancy Allen.

"TERROR IN THE AISLES," which opens today at the Criterion and other theaters, poses as a serious exploration of the methods and effects of horror and suspense films. That it looks more like a feature-length trailer for almost 75 such films is not surprising — everyone who worked on it is associated with Kaleidoscope Films, one of the industry's most successful producers of trailers.

Donald Pleasence and Nancy Allen, both of whom have put in time in horror films, sit in a simulated movie theater audience and, from time to time, comment on the endless film clips we see. What they have to say is pretty dumb. More to the point is an interview with Alfred Hitchcock, in which he talks with a good deal of wit about the things he always did best.

The film is mostly a compilation of sequences from other people's movies that, more effectively than necessary, demonstrate the clichés of the genre. After we've seen a number of people murdered in showers, including the classic scene from Hitchcock's "Psycho," Miss Allen comments that the bathroom seems to be the most dangerous room in any house. She also notes that women, "unfortunately," are the principal victims.

•

There's one funny, fast sequence that cuts together a lot of clips in which women — and a few men — are seen desperately dashing around houses and apartments attempting to lock doors and windows against psychopathic maniacs carrying axes, knives, hammers, ice picks, chain saws and other tools of their trade. The rest is neither entertaining nor informative.

Because "Terror in the Aisles" is composed entirely of climaxes, it has none of its own.

Among the films that have been ransacked are "Jaws," "The Shining," "Scanners," "Marathon Man," "Halloween," "What Ever Happened to Baby Jane?" "The Bride of Frankenstein," "Dressed to Kill," "Carrie," "Klute" and "Alien."

Vincent Canby

1984 O 26, C18:6

Arnold Schwarzenegger in "The Terminator."

Monster Mash

THE TERMINATOR, directed by James Cameron; screenplay by James Cameron with Gale Anne Hurd; produced by Gale Anne Hurd; executive producers, John Daly and Derek Gibson; director of photography, Adam Greenberg; edited by Mark Goldblatt; released by Orion Pictures. At Loews State, Broadway and 45th Street; Loews Orpheum, Third Avenue and 86th Street; Loews 34th Street Showplace, between Second and Third Avenues; Olympia Quad, Broadway and 110th Street, and other theaters. Running time: 105 minutes. This film is rated R.

Terminator	Arnold Schwarzenegger
Kyle Reese	Michael Biehn
Sarah Connor	Linda Hamilton
Traxler	Paul Winfield
Vukovich	Lance Henriksen
Matt	Rick Rossovich

ARNOLD SCHWARZENEGGER is about as well suited to movie acting as he would be to ballet, but his presence in "The Terminator" is not a deterrent. This is a monster movie, and the monster's role fits Mr. Schwarzenegger just fine. He plays the computerized automaton of the title, sent from the year 2029 back to 1984 to assassinate a young waitress named Sarah Connor. Even if the movie had nothing else to recommend it, the sheer unlikeliness of this mission, and the teasing gradualness with which its meaning is revealed, would be

enough to hold an audience's attention.

"The Terminator," which opens today at Loews State and other theaters, is a B-movie with flair. Much of it, as directed by James Cameron ("Piranha II"), has suspense and personality, and only the obligatory mayhem becomes dull. There is far too much of the latter, in the form of car chases, messy shootouts and Mr. Schwarzenegger's slamming brutally into anything that gets in his way. Far better are the scenes that follow Sarah (Linda Hamilton) from cheerful obliviousness to the grim knowledge that someone horrible is on her trail.

The denouement is convoluted, to say the very least. But it is set forth engrossingly by Miss Hamilton and by Michael Biehn as another 21st-century warrior, this one actually on Sarah's side. Both he and Mr. Schwarzenegger's Terminator arrive in Los Angeles stark naked, and they must somehow find clothes, weapons and Sarah before they can begin to fight. Mr. Biehn is seen stealing pants from a drunk and shoplifting a combat jacket, which make him a most inferior fashion plate compared with the star. Almost everything Mr. Schwarzenegger commandeers, from his jackboots to his fingerless gloves, is made of dark studded leather.

Paul Winfield and Lance Henriksen have some good moments as a police inspector and his assistant, but they don't last long; hardly anyone in the film does, when pitted against the behemoth of the title. Mr. Schwarzenegger eventually shows signs of wear and tear, losing an eye and part of one forearm before being incinerated down to his gleaming, metallic skeleton. Even in that condition he keeps on marching. The special effects are good enough to allow this skeleton a distinctively lumbering gait that matches Mr. Schwarzenegger's own.

Janet Maslin

1984 O 26, C19:1

THE TIMES OF HARVEY MILK, directed by Robert Epstein; photography by Frances Reid; edited by Deborah Hoffman and Mr. Epstein; narrated by Harvey Fierstein; music by Mark Isham; produced by Richard Schmiechen; released by Teleculture Films Inc. At the Carnegie Hall Cinema, Seventh Avenue between 56th and 57th Streets. Running time: 87 minutes. This film has no rating.

"The Times of Harvey Milk" was shown as part of the 1984 New York Film Festival. Following are excerpts from Janet Maslin's review, which appeared in The New York Times Oct. 7. The film opened yesterday at the Carnegie Hall Cinema, Seventh Avenue between 56th and 57th Streets.

"Harvey stood for something more than just him," someone remarks in "The Times of Harvey Milk," and this warm, well-made documentary makes that eminently clear. The personality of the slain San Francisco Supervisor, who along with Mayor George Moscone was shot in 1978 by Dan White, a disgruntled former Supervisor, comes through strongly, but personality is not the film's foremost concern. Robert Epstein, who co-directed the equally affecting "Word is Out," indicates the ways in which Harvey Milk was emblematic of one segment of society and Dan White of another. And he traces the clash that arose between them.

•

This conflict is intrinsically so dramatic that the film can rely on a simple, straightforward style without lacking momentum or emotion. Mr. Epstein uses abundant news footage of both Mr. Milk and Mr. White, and the ironies are overwhelming. Mr. White, for instance, is heard advocating neighborhood baseball teams and suggesting that maybe his district could challenge Harvey Milk's district to a game. "Dan White comes across as the kind of son any mother would be proud of," a television reporter declares.

Harvey Milk is seen as friendly, charming, intense and instinctively political; in lobbying for a law on dog droppings, for instance, he deliberately plants a specimen in the park and steps in it during a television interview to help make his point. Mr. Milk's friends and associates contribute many anecdotes to the film's portrait of him, but Mr. Epstein is generally careful to keep them in context.

Harvey Milk's political career and the victory it represented for San Francisco's homosexual community is contrasted with the first stirrings of the Moral Majority, stirrings to which Mr. White was especially responsive. The film examines the controversy surrounding Proposition 6, the proposed California ordinance barring homosexuals from teaching in public schools, an issue on which Mr. Milk and Mr. White were sharply divided.

•

It was four days after the proposition was defeated, thanks in large part to Harvey Milk's efforts, that Mr. White resigned his post. Five days later, Mr. White announced he had changed his mind and wanted to be a Supervisor again. It was 12 days after that, on the morning when Mayor Moscone had planned to an-

Harvey Milk

nounce that he would not reinstate Mr. White, that the shootings took place.

Since Mr. Milk's political career embodies the rise of the homosexual community's political power in San Francisco, and since the results of Mr. White's brief trial were evidence of a backlash, the film would have benefited from devoting closer attention to the trial itself. Mr. White's tearful confession, which was thought to have helped sway the jury toward its verdict of involuntary manslaughter, is heard. But his comments explaining his mysterious and abrupt resignation are not, even though they

might have revealed something of Mr. White's mental state at the time and shed some light on the verdict.

If Mr. Epstein can't fully explain what happened, he can certainly tell the story with urgency, passion and, finally, indignation. Toward the end of the film, a young black man asks rhetorically what sort of sentence he might have received for such a crime. Another interviewee speculates that Mr. White's staunch support for mid-

dle-class values and opposition to the homosexual community's growing power contributed to his light sentence. (He was released from prison last January.) And a third man suggests how pivotal Harvey Milk and his cause may have been to the verdict: "I think if it were just Moscone who'd been killed, he would have been in San Quentin for the rest of his life."

1984 O 27, 15:1

FILM VIEW

VINCENT CANBY

Is 'The Gods Must Be Crazy' Only A Comedy?

Watching Jamie Uys's "Gods Must Be Crazy," the hit South African comedy that is currently the longest running movie now in New York first-run, one might suspect that there were no such things as apartheid or the Immorality Act or even South Africa. To be perfectly correct, most of the film takes place not in South Africa but just to the north in Botswana, the independent republic where blacks and whites live on equal terms.

However, "The Gods Must Be Crazy" is so genial, so good-natured and, on occasion, so inventive in its almost Tati-like slapstick routines, that it would would seem to deny the existence of any racial problems anywhere. Is it an ingenious piece of South African propaganda, subtly designed to subvert the effect of the impassioned, anti-apartheid literature of Athol Fugard and Nadine Gordimer? Or, perhaps, is it an equally subtle, if light-hearted, attack on what most of the world takes to be the short-sighted, possibly suicidal South African racial policies? I've just seen the film and I'm still not sure, though I've an idea that the movie is not quite as callous as some of its political critics might think.

Whatever the answer, the film's public appeal is undeniable. Having opened here at the 57th Street Playhouse last July 9, it's still going strong at the 68th Street Playhouse without benefit of a big advertising budget or a high-powered publicity campaign. It's also become a hit in Japan, France, Venezuela, Sweden and a number of other countries. Most interesting of all, I'm told, it's also been very popular with black audiences in West Africa.

On its surface, "The Gods Must Be Crazy" is an innocuous enough tale about the comic conjunction of two wildly different cultures as represented by one Kalahari bushman, whose tribe hasn't yet reached the Stone Age, and by bumbling, neurotic whites and blacks who, in one way and another, cannot cope with contemporary civilization.

The story begins one day when a pilot, flying over the Kalahari desert, casually drops an empty Coca-Cola bottle from his plane.

To the tribe of bushmen who find it, the bottle is a gift from their gods, something that's not only beautiful to look at but, being the hardest object they've ever come upon, is infinitely useful for all kinds of daily chores. However, as the ponderously facetious soundtrack narrator points out, the bottle also introduces the bushmen to feelings of envy and ideas of ownership, thus threatening their idyllic society that, until then, has existed without poverty, greed or crime.

It isn't long before the bushmen decide that the bottle must be gotten rid of. They bury it, but a warthog digs it up and a bushman child brings it back to camp. They try to throw it up to the gods in the sky, but it keeps falling

back to the ground, often bopping someone on the head. They finally decide that Xi, played by a real bushman named N!xau, should take the evil bottle to the edge of the earth, which they estimate to be about a 20 days' walk, and cast it over the side.

In the course of his trek to the earth's edge, Xi stumbles onto 20th-century civilization, which baffles him, as it must all of Nature's innocents. He cannot understand why he is arrested and jailed for killing a goat since, in his tribe, there is no such thing as private property. He is rescued by a good, white — one must assume South African — microbiologist named Andrew Steyn (Marius Weyers), who is a brilliant, humane scientist but who becomes a clumsy oaf in the company of the woman he loves, who's also the only woman in the territory. She is Kate Thompson, who has fled the civilized lunacies of what appears to be Johannesburg to work as a teacher with a Christian missionary in the Kalahari.

• • •

Running through the film is a subplot about a small group of black revolutionaries, commanded by a mean-tempered, completely incompetent fellow named Sam Boga (Louw Verwey), who bellows like Long John Silver and, from his looks, seems to be racially mixed, or what South Africa officially decrees as "colored." These Marxists, having failed in an attempted coup in a neighboring black-ruled country, flee into Botswana where, after one comic mishap and another, they take Kate Thompson and a large group of her small black pupils hostage.

Does the previously all-thumbs Andrew Steyn, with the help of the always willing Xi, succeed in rescuing Kate and her pupils from the Marxists? Does Xi at long last rid himself and his tribe of the dreaded Coke bottle? Does Andrew win Kate's heart? Do hippos snooze in muddy waters?

"The Gods Must Be Crazy" is not Mr. Uys's first film to be released in this country. In addition to this comedy, which he produced, wrote, directed and edited, he also

was responsible for "Dingaka" (1965), in which Stanley Baker, as a white Johannesburg lawyer, defends a Masai warrior in the South African courts, and "After You, Comrade" (1967), a comedy made in Europe about an international walking race. He's also an actor, having appeared in his own "After You, Comrade" and in "The Hellions" (1962), a South African western made by Ken Annakin, the English director.

I think it's safe to guess that Mr. Uys is certainly neither a racist nor an apologist. Nobody with the sense of humor that he displays in "The Gods Must Be Crazy" could be. Nobody who would take the time to choreograph the kind of elaborate sight gags that are the reason to see this film could support the sort of self-interest officially sanctioned by the South African government. Such narrowness of vision is antithetical to the creation of laughter.

Yet there's also something disturbing about the film, perhaps more disturbing to those of us at a distance who know South Africa entirely from the works of Mr. Fugard and Miss Gordimer, among others. Safely isolated in our own comparatively free societies, we tend to feel that any South African work that doesn't actively condemn apartheid has the secondary effect of condoning it, if only through silence.

The film's initial sequences, in which the simple, no-nonsense manners and mores of the bushmen are shown on the screen accompanied by rather coy voice-over narration, are terribly patronizing. The bushmen are seen to be frightfully quaint if not downright cute. The narrator's statement that the bushmen "must be the most contented people in the world" may possibly be true, but one doesn't have to be a political scientist-historian to know that that's exactly the sort of thing that Mussolini might have said when he got those trains running on time.

•

Then there's also the early sequence in which the audience is introduced to Kate Thompson working in a newsroom in an unidentified South African city which — I assume — is Johannesburg. Not only are blacks working alongside whites in comparable jobs and in apparent harmony, but the restaurant where Kate lunches is also similarly mixed. Again, this may well be true in certain areas of South African life, but it doesn't accurately reflect the larger, legislated horrors of apartheid. If all that one knew of South Africa were to be learned from "The Gods Must Be Crazy," one might well wonder what all the fuss has been about.

When the film's locale shifts to Botswana, "The Gods Must Be Crazy" becomes a much more carefree fable. However, one cannot help feeling that there may also be something a tiny bit patronizing in its presentation of black Marxists who are quite as bumbling as the black government members they unsuccessfully try to overthrow. Maybe not, but it's not a concept that would upset the members of any white supremacist government.

Mr. Uys, I suspect, knew exactly what he was doing when he made "The Gods Must Be Crazy," which is a film that is often genuinely, nonpolitically funny. Yet he knows that no film, especially no South African film, can be seen as being without any connections to the society in which it was made. All films, no matter what their subject, are to some extent political, both for what they say and what they don't say.

It's no accident that throughout "The Gods Must Be Crazy," each of the major characters must say with impatience from time to time, always in a comic context, "I don't want to think about it." Kate Thompson says it just after the clumsy Andrew Steyn, carrying her across a stream, has stumbled and dropped her in the mud. Andrew says it when he's reminded that he is, in fact, the world's most inept Romeo. "I don't want to

think about it," says Andrew.

It's just possible that this is the way Mr. Uys would characterize the attitude of many of South Africa's more enlightened white citizens, who may be troubled by the system but incapable of taking any effective stand against it. "I don't want to think about it." It runs through the film like a musical theme. ■

1984 O 28, II:21:1

Pascale Ogier wanders through London and Paris in search of wraiths in the British film "Ghost Dance," directed by Ken McMullen.

GHOST STORY, produced, written and directed by Ken McMullen; in French with English subtitles; photography, Peter Harvey; edited by Robert Hargreaves; music by David Cunningham, Michael Giles, Jamie Muir; a Looseyard Production for Channel 4 and ZDF. At Film Forum, 57 Watts Street. Running time: 100 minutes. This film has no rating.
Pascale .. Pascale Ogier
Marianne Leonie Mellinger
Himself Jacques Derrida
WITH: Stuart Brisley, Robbie Coltrane, Dominique Pinon.

"**G**HOST DANCE," an experimental film by the British director Ken McMullen, is notable for its very leisurely pace, its occasional bizarre humor, its near-perfect opacity and the presence of two striking individuals: Jacques Derrida, the French linguistic philosopher, and Pascale Ogier, the late young actress whose doleful, mature face and mischievous manner held forth such great promise of a remarkable screen career. "Ghost Dance," which mixes these two, Karl Marx, Sigmund Freud, Jacques Rivette and a couple of exceedingly weird supporting players, opens today at the Film Forum.

Mr. Derrida, who plays himself in an improvised sequence with Miss Ogier, observes, "I think cinema, when it's not boring, is the art of letting ghosts come back." He also says that "memory is the past that has never had the form of the present." These remarks, which are by far the most lucid in the film, are more or less elaborated upon by Mr. McMullen in an extremely free-form fashion. His film, which begins with a two-minute blank-screen musical prelude, never pursues these or any other ideas with excessive urgency. He instead relies upon a rambling, spo-

radic style, monotonous more often than not but occasionally conducive to flashes of peculiar ingenuity.

Miss Ogier and Leonie Mellinger, as the film's two wandering heroines, appear in various bleak settings in London and Paris, while various quotations are delivered in voice-over and titles like "Myth: The Voice of Destruction, the Voice of Deliverance" divide the film into subsections. Robbie Coltrane also appears as a droll, homely suitor who muses about improving his looks and is fascinated by weather reports. In one of the film's closing sequences, which is as interesing as anything that has preceded it, a performance artist crawls through a waterlogged corridor, caressing his own reflection. This image, like many in "Ghost Dance," is more startling on its own than effective as part of a whole.

Janet Maslin

1984 O 31, C20:4

Hungary in Late 40's

DIARY FOR MY CHILDREN, directed and written by Marta Meszaros; director of photography, Miklos Jansco Jr.; music by Zsolt Dome; a Mafilm-Budapest Studio Production; a New Yorker Films Release. At Lincoln Plaza, Broadway and 63d Street. Running time: 106 minutes. This film has no rating.
Juli .. Zsuzsa Czinkoczi
Magda .. Anna Polony
Janos .. Jan Nowicki
His son .. Tamas Toth
Grandpa .. Pal Zolnay
Grandma Mari Szemes

"Diary For My Children" was shown as part of this year's New York Film Festival. Following are excerpts from Vincent Canby's review, which appeared in The New York Times on Sept. 30. The film opens today at Lincoln Plaza, Broadway and 63d Street.

"**D**IARY FOR MY CHILDREN," by Marta Meszaros, the highly regarded Hungarian director who's best known in this country for "Adoption," "Women" and "Just Like Home," is her most politically explicit film yet seen here. That Miss Meszaros was able to make the film at all is some kind of political statement, but the film contains much more.

Like Juli (Zsuzsa Czinkoczi), the new film's solemn, skeptical teen-age heroine of "Diary for My Children," Miss Meszaros at the age of 5 migrated to the Soviet Union in 1936 with her father, a sculptor, who was later arrested and then officially disappeared. This new film begins with Juli's return to Hungary in 1947, in the company of her fearful grandparents, to live with her politically committed, Stalinist aunt, Magda (Anna Polony).

Though Juli, played with a kind of independent stoicism by Miss Czinkoczi, is the heart of the film, as well as its eyes and ears, it's Magda who is the most complex and interesting character.

Once a young, fiery revolutionary who endured prison and torture, Magda survived to see her revolution triumph, after which, for what she considered the greater good, she shaped her principles to fit monolithic Stalinism. Though the movie never sentimentalizes Magda by suggesting that she would ever deny her life's work, as other Stalinists later did, the character, as written and directed by Miss Meszaros and played by Miss Polony, provides the film with its sorrowful tone.

Magda is not a stupid woman. It's one of the better ways in which the film works that it is through the reminiscences of one of Magda's former comrades, who becomes a victim of the Stalinist purges she supports in the late 1940's, that Juli comes to understand something of Magda's sacrifices in the name of the Communist Party and its revolution. To understand Magda, however, is not necessarily to like her. She is a fact of history.

Miss Meszaros makes use of a lot of newsreel footage of the period, which is blended with her new material to create an unusually graphic picture of Hungarian political, cultural and social life in the late 40's.

All of the performances are good, including that of Jan Nowicki, who plays the disillusioned party worker whose imprisonment brings the film to its conclusion. Also good is the black-and-white photography of Miklos Jansco Jr., the son of the talented, extremely independent Hungarian director who has recently worked mostly abroad.

1984 O 31, C21:5

Jan Nowicki and Zsuzsa Czinkoczi in "Diary for My Children."

Seriously Lunatic

NOT FOR PUBLICATION, directed by Paul Bartel; screenplay by John Meyer and Mr. Bartel; director of photography, George Tirl; edited by Alan Toomayan; music by Mr. Meyer; produced by Anne Kimmel; released by Samuel Goldwyn Company; a Thorn Emi Screen Entertainment Presentation. At D.W. Griffith, 59th Street, west of Second Avenue. Running time: 87 minutes. This film is rated R.

Lois	Nancy Allen
Barry	David Naughton
Mayor Claude Franklyn	Laurence Luckinbill
Doris	Alice Ghostley
Troppogrosso	Richard Paul
Senor Woparico	Barry Dennen
Odo	Cork Hubbert
Jim	Richard Blackburn
Signore Scoppi	Robert Ahola
Helen	Jeanne Evan
Duffy	J. David Moeller
Eddie	Michael O'Sullivan
Gene	Hart Sprager

By VINCENT CANBY

"NOT FOR PUBLICATION" is the new comedy by Paul Bartel, the almost recklessly independent film maker whose "Eating Raoul" gave a whole new meaning to the term "gourmet cooking." Like B-movies of the 1930's and 40's, "Not for Publication" tears the lid off the whole rotten world of crooked politics and sleazy journalism while demonstrating how one good young woman, who possesses pluck and a certain taste for sleaziness herself, can set things to right.

When first met, Lois Thorndyke (Nancy Allen) is covering yet another sensational story for The New York Informer, a paper once called The New York Enforcer and known for its integrity, but which now devotes itself exclusively to stories with headlines like "Hitler's Baby Raised by WASPs" and "Nun Revealed to Be Mermaid."

Lois is a sort of Clark Kent in reverse. Though she's the best trash reporter in the business — a sort of superwoman of sex, sin and scandal — she has a secret life. She is, deep down, a seriously committed journalist. Her goal is to restore the paper's good name, editorial policies and fair employment practices it enjoyed under its founding editor, her late father.

•

In "Not for Publication," set in Manhattan but apparently filmed at least partly in Dallas, Lois eventually cleans up what in the old B-pictures would have been identified as Big Town, U.S.A. It's not easy, considering the help she gets from Odo (Cork Hubbert), her amorous, pint-sized driver; Barry (David Naughton), a shy news cameraman more accustomed to photographing birds than brothels, and Barry's mother (Alice Ghostley), who wants Barry to sing on the long-gone Major Bowes Amateur Hour and who communicates with the dead via CB radio.

Lois's principal adversaries are Troppogrosso (Richard Paul), the thoroughly disgusting editor of The Informer, and Big Town's unctuous, not entirely on-the-level, reform mayor, Claude Franklyn (Laurence Luckinbill), the sort of man who reads Playboy while taking a shower.

Like all of Mr. Bartel's films, "Not for Publication" has a number of comic conceits that more often prompt knowing smiles than knee-slapping laughter. Unlike the very funny "Eating Raoul," which was so laid-back it was upside down, "Not for Publication" seems to be trying too hard to be comic.

You have to work to find it funny, though the rewards are there, especially in the intensely sincere performances by Miss Allen, Mr. Luckinbill, Mr. Naughton and Mr. Paul, who is to sleazy comedy what John Travolta once was to disco dancing.

"Not for Publication," which was written by Mr. Bartel and John Meyer, gives the unfortunate impression of having too much plot. There are too many obligatory scenes that must be got through to keep the story going. Mr. Bartel's sense of the ridiculous is best seen in the not especially coherent behavor of his perfectly — seriously — lunatic characters. Lois, Troppogrosso, the mayor and Barry would be much better company if they weren't constantly required to rendezvous with the narrative points.

The movie is funniest when it's being most casual. I especially like the idea that the Marriott Marquis Hotel, that gigantic love letter to Las Vegas architecture now under construction near Times Square, should be used in the movie to represent one of Mayor Franklyn's low-income housing projects. There's also an incidental but very funny encounter with a pimp named Woparico, hilariously played by Barry Dennen, who lives in an East Side high-rise, proudly surrounded by objets d'art, including Barcaloungers and an "electrified" El Greco.

"Not for Publication" opens a conventional run today at the D. W. Griffith Theater. However, I have a feeling it would play much better when seen at midnight on a Saturday, after an evening of good food, good drink and whatever else it takes to lower one's resistance to something so cheerfully if intentionally slapdash.

1984 N 4, C17:1

Nancy Allen and David Naughton don animal costumes to infiltrate a sex club called the Bestiary in the Paul Bartel comedy "Not for Publication."

Flowing Meditation

CHOOSE ME, written and directed by Alan Rudolph; director of photography, Jan Kiesser; edited by Mia Goldman; music by various composers; produced by Carolyn Pfeiffer and David Blocker; an Island Alive Production. At the Coronet, Third Avenue and 59th Street. Running time: 114 minutes. This film is rated R.

Nancy	Genevieve Bujold
Mickey	Keith Carradine
Eve	Lesley Ann Warren
Zack Antoine	Patrick Bauchau
Pearl Antoine	Rae Dawn Chong
Billy Ace	John Larroquette
Ralph Chomsky	Edward Ruscha
Mueller	Gailard Sartain
Lou	Robert Gould
Dr. Ernest Greene	John Considine
Babs	Jodi Buss

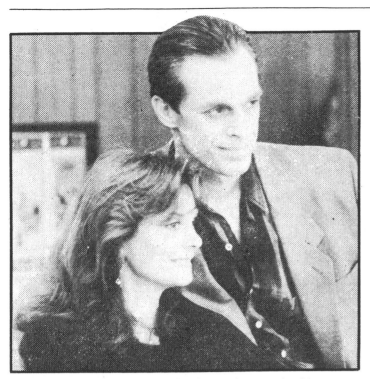

Lesley Ann Warren and Keith Carradine star in Alan Rudolph's "Choose Me," a comedy about five characters whose love lives become intertwined.

By JANET MASLIN

IT's easy to be dismissive of Alan Rudolph's approach to film making, and tempting, too. Mr. Rudolph has an affinity for the purest, most impenetrable jive, for characters who pour forth every innermost thought without revealing anything of interest. That they do this with such fluidity and style only makes the process all the more maddening. But Mr. Rudolph's more daring films, like "Welcome to L.A." and now "Choose Me," have their staying power. Even if it's not entirely evident in the films' slow, teasing exposition or their endless flow of conversation, it's still there.

"Choose Me," which opens today at the Coronet, revolves around five lonely characters and two different forums for their observations about life. The first of these is a call-in radio show starring Dr. Nancy Love (Genevieve Bujold), whose own friendlessness does not impede her from handing out free advice. The second spot is a bar called Eve's, presided over by a siren (Lesley Ann Warren) who says things like, "I've ruined too many marriages to have one of my own." Eve has been having an affair with Zack Antoine (Patrick Bauchau), whose wife, Pearl (Rae Dawn Chong), says of Zack, "Even though he roughs me up, at least he cares enough to do it." The new man in town, and the wild card among all these garrulous, love-starved loners, is a mental patient named Mickey (Keith Carradine), who may or may not be entirely mad.

"Choose Me" develops into a romantic round robin, as Mickey strikes up liaisons with all three women, to Zack's ever-increasing fury. Since Mickey wants to marry anyone he kisses, a certain amount of competition, not to say confusion, sets in. All this might have the makings of bedroom farce if that were the kind of thing Mr. Rudolph were after, but it most assuredly is not. By turns humorous, vacant and reflective, "Choose Me" seems intended as a free-flowing meditation on love, commitment, jealousy, radio call-in shows and just about anything else that might come to mind.

Were it not for the sexy, insistent presence of Mr. Carradine, the film might not work in the slightest. But he does make Mickey a credible force, and he helps to give the film its own peculiar vibrancy. So does Teddy Pendergrass's bluesy singing on the soundtrack, and so does Mr. Rudolph's exceptional visual flair. If the film sometimes gives the impression of too much talent in the service of too little, that talent is evident all the same.

The rest of the cast is as good as circumstances allow, although the material provides at least as much occasion for sheer attitudinizing as for anything else. Fortunately, Mr. Rudolph has paid perhaps even more attention to the film's minor touches than he has to its central action. Abundant, well-chosen paintings and posters comment on the characters, and the supporting cast includes the painter Ed Ruscha in a small but conspicuous role.

1984 N 1, C18:4

Behind the Scenes

OBSERVATIONS UNDER THE VOLCANO, directed, photographed and produced by Christian Blackwood; presented by Christian Blackwood Productions and Teleculture Films. At Vandam Theater, 15 Vandam Street. Running time: 82 minutes. This film has no rating.
With: John Huston, Albert Finney, Jacqueline Bisset, Guy Gallo.

By JANET MASLIN

WHEN documentaries record the making of important feature films, they rarely capture anything to rival the features themselves. Les Blank's "Burden of Dreams," about the making of Werner Herzog's "Fitzcarraldo," is a fascinating exception, since it shows a side of Mr. Herzog that his own work reveals less directly, and since Mr. Herzog's behind-the-scenes exertions were at least on a par with those of his film's fanatical hero.

But for the most part, documentary film makers making on-the-job studies of other film makers wind up with the kind of thing Christian Blackwood presents in "Observations Under the Volcano," his film about John Huston at work in Mexico. The documentary crew records the tedium and the incidentals, spending almost as much time with the producers and screenwriter as it does with the director and his stars.

●

This footage is interspersed with considerable padding, in the form of stills and daily rushes from "Under the Volcano," plus a good deal of dawdling with the crew. There are atmospheric shots of Cuernavaca and its people, although these, like many of Mr. Blackwood's scenes, pale before the memory of Mr. Huston's similar footage. On the soundtrack, John Hurt reads occasional excerpts from Malcolm Lowry's writing. And occasionally Mr. Huston or the actors or the screenwriter, Guy Gallo, is asked a preposterous question. Mr. Gallo, for instance, is asked, "What made your script workable?" Mr. Huston is asked whether his film will stress any of the novel's themes.

Mr. Huston, who greets such inquiries with mild astonishment and flawless good manners, is by far the film's most commanding figure, even when he sits by quietly — as he often does here — and simply watches the cast and crew go about their business. When he is heard conferring with the performers, he displays a keen and precise idea of what he requires of them, and a receptiveness to their suggestions — though there isn't much of this material to Mr. Blackwood's portrait of Mr. Huston, and what there is is welcome. But the fact remains that Mr. Huston's "Under the Volcano" speaks for itself, and speaks much more eloquently than anything Mr. Blackwood has recorded.

"Observations Under the Volcano" opens today at the Vandam Theater, launching a retrospective of Mr. Blackwood's documentaries. Most of the films on the program are in the 50-minute range, which is much better suited to Mr. Blackwood's approach than the 82-minute length of his new film. "Observations Under the Volcano" could have been half as long without losing anything of consequence. In fact, it might have been better.

1984 N 2, C12:3

Story of Cambodia

THE KILLING FIELDS, directed by Roland Joffé; screenplay by Bruce Robinson; director of photography, Chris Menges; edited by Jim Clark; music by Mike Oldfield; produced by David Puttnam; released by Warner Bros. At Cinema 1, Third Avenue and 60th Street. Running time: 139 minutes. This film is rated R.
Sydney Schanberg Sam Waterston
Dith Pran Dr. Haing S. Ngor
Al Rockoff John Malkovich
Jon Swain Julian Sands
Military Attaché Craig T. Nelson
United States Consul Spalding Gray
Dr. Macentire Bill Paterson
Dr. Sundesval Athol Fugard
Dougal Graham Kennedy
Ser Moeun Katherine Krapum Chey
Titonel Oliver Pierpaoli
Sarun Edward Entero Chey

By VINCENT CANBY

ON Jan. 20, 1980, The New York Times Magazine published a remarkable memoir, "The Death and Life of Dith Pran," by Sydney Schanberg, then The Times's metropolitan editor and today a Times columnist but who, from 1972 until 1975, was The Times's correspondent in Cambodia, covering the decline and fall of the United States-backed Lon Nol regime in its civil war with the Communist Khmer Rouge forces.

Mr. Schanberg received the 1976 Pulitzer Prize and a number of other awards for his pieces filed from Phnom Penh, but not until "The Death and Life of Dith Pran" was he able, at last, to come to terms with the experience he had lived through and that, subsequently, haunted him.

Not for nothing does the magazine piece carry the subhead, "A Story of Cambodia."

"'The Death and Life of Dith Pran" is, in Mr. Schanberg's words, about Cambodia "as a nation pushed into the war by other powers, not in control of its destiny, being used callously as battle fodder, its agonies largely ignored as the world focused its attention on neighboring Vietnam."

That's a large subject but Mr. Schanberg was finally able to com-

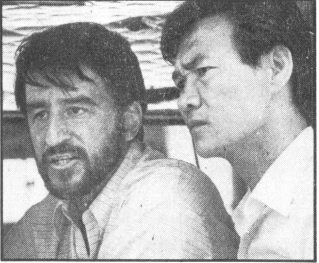

Sam Waterston and Haing J. Ngor play the leads in "The Killing Fields," about the bond between an American foreign correspondent and his Cambodian colleague.

prehend it — and to allow us to share that comprehension — in his moving, precisely detailed recollection of a single friendship. The friend was Dith Pran, his Cambodian assistant for three years, the man who saved his life and those of several other correspondents when the victorious Khmer Rouge occupied Phnom Penh. Mr. Schanberg's agony was that he was not able to protect Mr. Dith when the Khmer Rouge began their systematic purge of all educated Cambodians and especially those who had worked with the Americans during the previous regime.

•

While Mr. Schanberg and other Western correspondents were still in sanctuary in the French Embassy in Phnom Penh in 1975, Dith Pran slipped out of the compound and disappeared. In the years that followed, almost everybody except Mr. Schanberg, who returned to New York, eventually assumed Dith Pran to be dead, one of the estimated three million out of seven million Cambodians who were either massacred by the Khmer Rouge or died of starvation or disease.

That Dith Pran did survive provided the shape and the heart of the Schanberg memoir.

All this needs saying by way of introduction to "The Killing Fields," the ambitious, serious new film that, with great care and respect, has been based on "The Death and Life of Dith Pran."

In most of its surface details, "The Killing Fields" is a faithful adaptation, acted with self-effacing honesty by Sam Waterston as Mr. Schanberg, Dr. Haing S. Ngor — himself a Cambodian refugee — as Mr. Dith, and by the members of the large, meticulously chosen cast. Photographed mainly on location in Thailand in jungles, paddy fields and cities made to appear ravaged, the movie looks amazingly authentic. There's not a cheap shot in the entire film.

Yet something vital is missing, and that's the emotional intensity of Mr. Schanberg's first-person prose. The movie is diffuse and wandering. It's someone telling a long, interesting story who can't get to the point.

•

"The Killing Fields," which opens today at the Cinema 1, is less a cinematic equivalent to the original than a movie *about* those experiences. It's a story told in the third-person, which attempts to make conventional, dramatic order out of the highly dramatic, harrowing, emotional disorder of the memoir. Bruce Robinson's screenplay makes clumsily explicit those subtly implicit feelings of doubt and guilt by which Mr. Schanberg's recollections of Dith Pran become, in fact, "a story of Cambodia."

Mr. Robinson and Roland Joffé, the director, never successfully dramatize the particularity of the events that, over an extended period of time, describe the rare nature of that friendship. It takes such a long, godlike view of things that often we're never sure what or whom the movie is about. Mr. Waterston's Schanberg is on screen most of the time but the camera, instead of convincing us that it's seeing events through his eyes, keeps looking over him to the wartime panorama beyond. The story is there but not the personal impact.

The film begins in 1973 and, with a lot of technical virtuosity, creates a vivid picture of the last, desperate months of the Lon Nol Government. There are Mr. Schanberg's discov-

eries of the terrible "miscalculations" by which innocent Cambodians are bombed to oblivion by United States planes, the increasing panic and high-handedness of American representatives in Phnom Penh and, finally, the abandonment of Phnom Penh.

Mr. Schanberg makes arrangements for the safe evacuation of Mr. Dith's wife and children, and when he, with a handful of other correspondents, elects to remain in the capital, Mr. Dith stays, too.

This decision, which puts Mr. Dith's life on the line, comes to haunt Mr. Schanberg. It also becomes so curiously overstated by the film that it seems that the meaning of the friendship, for dramatic expediency, has been vastly oversimplified and thus, in a way, underrated.

•

The film is most effective when it takes leave of Mr. Schanberg and follows Mr. Dith's dogged attempts to stay alive after he leaves Phnom Penh. At one point he is put into a forced labor camp where he survives on lizards and scorpions and by sucking the blood from living water buffaloes. Though tortured, he refuses to die. There's a good but never fully developed sequence in which he's befriended by a provincial Khmer Rouge official who trusts Mr. Dith to get his small son to the safety of Thailand.

The movie is not easy to watch. The massacres by which the Khmer Rouge attempt to reduce the population to manageable size — and to change the character of the country — are graphically depicted. Prisoners, individually and in odd-lots, are shot casually. Sometimes they're simply beaten to death — it saves bullets. In a nightmare scene near the end, the exhausted Mr. Dith finds himself stumbling through a paddy field whose dikes are composed of human bones.

The performances are uniformly fine. Mr. Waterston possesses the

strength, humor and compassion of the increasingly obsessed Mr. Schanberg, and Dr. Ngor, who's never acted before, reveals an extraordinary screen presence as the resilient Mr. Dith. Prominent in the supporting cast are Julian Sands, Craig T. Nelson, Spalding Gray, Bill Paterson, Athol Fugard and John Malkovich, though, with the exception of Mr. Malkovich, who plays a prickly sort of news camerman, the roles are mostly functions of the plot.

Unfortunately, the most moving aspect of "The Killing Fields" is not the friendship, which should be the film's core, but the fact that the friendship never becomes as inspiriting as the one Mr. Schanberg recalled in his own searching, unhackneyed prose.

1984 N 2, C10:1

Revolution Fever

NICARAGUA: NO PASARAN, directed and produced by David Bradbury; photography by Geoffrey Simpson; edited by Stewart Young; released by New Yorker Films. At Film Forum 2, 57 Watts Street. Running time: 74 minutes. This film has no rating.

By JOHN CORRY

"NICARAGUA: NO PASARAN" is a love letter to a revolution. It looks on the Sandinistas and finds them good. It is possible this is so; it is possible their struggle is just. But it seems unlikely that they bear no responsibility at all for their relationship with Washington, or that the United States, as always, is the source of all Nicaraguan problems. The documentary, which opens today at Film Forum 2, is entitled to a point of view, but it abuses the privilege.

Thus we get a quick rundown on Nicaraguan history: American marines landed in 1927 on a "pretext;" the United States conspired in the

murder of the rebel leader Augusto Sandino; Nicaragua was always an American "outpost." Never mind 300 years of Spanish colonialism, the British influence, many dictatorships, civil wars or the attempt by the diplomat Henry L. Stimson to bring about elections.

Meanwhile, American malevolence continues. In the final sequence in the documentary, artfully done, we see United States planes and Nicaraguan children. Images are juxtaposed, and it is clear that the children, smiling and trusting, are in peril.

Why?

"They resent our independence," the Interior Minister, Tomás Borge, explains. "They can't forgive us. That's why they hate us."

And so on.

•

The problem with this kind of film is not its palpable anti-Americanism or its adherence to Sandinista orthodoxy; it is its simple-mindedness. The Australian film maker David Bradbury is smitten by his subject. Revolutionaries smile easily, and they play great guitar. Even imprisoned Miskito Indians are happy. Interior Minister Borge gets them to sing a song.

Consequently, even though the United States may have much to answer for in Nicaragua — support of the Somoza family, for one thing — a documentary like this washes it out. Nothing has any meaning. It is "claimed the Sandinistas get their weapons from the Soviet Union and Cuba," the narrator says. "While this may be true, they buy them wherever they can."

As tough-minded reporting, that's not much. As a necessary part of a polemic, however, it's everything. The film cannot really ignore all those guns everyone is carrying, and so it explains them away. The split among the Nicaraguan clergy? The good priests "identify with the poor and therefore with the Sandinistas." The

Conflicts among Roman Catholics, arising from a visit to Nicaragua last year by Pope John Paul II, are the focus of David Bradbury's "Nicaragua: No Pasaran,"

key word here is "therefore." Bishops and priests who oppose the Sandinistas obviously side only with the rich.

Mr. Bradbury, who has won awards for his work, has produced not so much a documentary as a round of applause. It's the kind of film you see at fund-raisers.

1984 N 2, C14:1

Surreal Siblings

PARIS, TEXAS, directed by Wim Wenders; written by Sam Shepard; adaptation by L. M. Kit Carson; photography by Robby Müller; edited by Peter Przygodda; music by Ry Cooder; produced by Don Guest. At the Plaza, 58th Street, east of Madison Avenue. Running time: 145 minutes. This film is rated R.
Travis Harry Dean Stanton
Jane .. Nastassia Kinski
Walt .. Dean Stockwell
Anne .. Aurore Clement
Hunter .. Hunter Carson
Doctor Ulmer Bernhard Wicki
Carmelita Socorro Valdez
Crying Man Tom Farrell
Slater ... John Lurie
Stretch ... Jeni Vici
Nurse Bibbs Sally Norvell
Rehearsing Band The Mydolls

"Paris, Texas" was shown as part of this year's New York Film Festival. Following are excerpts from Vincent Canby's review, which appeared in The New York Times on Oct. 14. The film, which won the grand prize at this year's Cannes Festival, opens today at the Plaza, 58th Street east of Madison Avenue.

AMOST peculiar-looking figure wanders slowly but with purpose across the bleached expanse of a Southwestern American wasteland. He wears a dusty, double-breasted suit, shoes so ragged they no longer qualify as footwear, a dirty shirt with a filthy but neatly knotted tie, plus a maroon baseball cap. He stops, drinks the last of the water from a plastic container and continues his journey. From nowhere to nowhere.

When, eventually, he stumbles into a seedy little trailer camp, he collapses before he can open a soft-drink bottle. The man, who refuses to talk, is more or less threatened back to life by an ominous, German-accented doctor who, going through the man's pockets, finds a Los Angeles telephone number, which he calls.

These constitute the opening scenes in Wim Wenders's initially promising, new "road" movie, "Paris, Texas," written by the Pulitzer Prize-winning playwright Sam Shepard ("Buried Child"), whose screenplay was adapted by L. M. Kit Carson.

The desert derelict is eventually identified as Travis (Harry Dean Stanton), whose younger brother, Walt (Dean Stockwell), a prosperous manufacturer of road signs, flies from Los Angeles to Texas to reclaim the brother who has been missing and presumed dead for four years.

•

As Travis and Walt begin their long drive back to Los Angeles — Travis sitting silently in the back while Walt drives — "Paris, Texas" looks as if it's going to be another classic Shepard tale about sibling relations, explored most effectively in Mr. Shepard's current Off Broadway hit, "Fool for Love," and in his "True West," which recently concluded a long run at the Cherry Lane Theater. Travis and Walt could be first cousins to the brothers in "True West," in which one brother is a foul-mouthed, possibly psychotic thief and the other an uptight, fastidious fellow who aspires to become a screenwriter.

"Paris, Texas" begins so beautifully and so laconically that when it begins to talk more and say less, the great temptation is to yell at it to shut up. If it were a hitchhiker, you'd stop the car and tell it to get out.

"Paris, Texas" has the manner of something to which too many people have made contributions — a movie that's been worried to death.

Though Mr. Wenders is fascinated by the American scene, as he has shown in his "Alice in the Cities," "The American Friend" and "Hammett," his feeling is as much the result of his knowledge of American movies as of the firsthand experience out of which Mr. Shepard writes. He

Harry Dean Stanton in the Wim Wenders's film "Paris, Texas."

has a sense of humor, but it's more theoretical than actual.

The first half of "Paris, Texas" is Shepard at his best, as, gradually, Travis begins to respond to Walt during the drive to California. Travis, it turns out, believes that he was conceived in Paris, Texas, and he's always had the dream of one day moving there with his wife, Jane, who has been missing almost as long as Travis, and their small son, Hunter, who has been living with Walt and his wife, Anne, since his parents disappeared.

•

What has Travis been doing during these last four years, and where is Jane? I've no doubt that, left to his own devices, Mr. Shepard would have come up with a resolution to these mysteries that would have provided a far more satisfactory payoff than the one arrived at by the playwright working in collaboration with the director and Mr. Carson. Mr. Shepard's method is to distill from ordinary experiences and feelings a reality that is so dense it appears to be surreal.

The film is initially wonderful and funny and full of real emotion as it details the means by which Travis and the boy become reconciled. Then it goes flying out the car window when father and son decide to take off for Texas in search of Jane (Nastassja Kinski), Hunter's long-lost mother. Everything suddenly becomes both too explicit and too symbolic. It's not giving anything away to reveal that what the movie — rather tardily — seems to be all about is the difficulty in communication between men and women, nor that the sequences in which this is demonstrated are awful.

Mr. Stanton, who can be seen currently in the riotous "Repo Man" and

will be remembered for, among other things, his performance in John Huston's "Wild Blood," is a marvelous Shepard character. Every foolish endeavor in American history appears to be written in the deep lines and hollows of his face. There is a gentleness about him that at any moment may erupt in inexplicable violence.

Mr. Stockwell, the former child star, has aged very well, becoming an exceptionally interesting, mature actor. Miss Clement, whose French accent is a bit thick for someone who is supposed to have been living in California for a few years, is also moving as Walt's baffled wife. Miss Kinski, however, is memorably miscast. The more she tries to act, the worse her performance becomes, which is more than unfortunate, considering the importance of her scenes to the end of the film.

1984 N 9, C4:3

Grand Passion

A LOVE IN GERMANY, directed by Andrzej Wajda; screenplay (German with English subtitles) by Boleslaw Michalek, Agnieszka Holland and Mr. Wajda, from the novel "Eine Liebe in Deutschland" by Rolf Hochhuth; director of photography, Igor Luther; edited by Halina Prugar-Ketling; music by Michel Legrand; produced by Arthur Brauner for CCC Filmkunst (Berlin)/Gaumont/TF 1 Films Production/Stand'art (Paris); released by Triumph Films. At Lincoln Plaza 1, Broadway and 63d Street. Running time: 107 minutes. This film is rated R.
Paulina Kropp Hanna Schygulla
Maria Wyler Marie-Christine Barrault
Mayer Armin Mueller-Stahl
Elsbeth Schnittgens Elisabeth Trissenaar
Wiktorczyk Daniel Olbrychski
Stanislaw Zasada Piotr Lysak
Karl Wyler Gerard Desarthe
Dr. Borg Bernhard Wicki
Schulze Ralf Wolter
Narrator Otto Sander
Klaus Ben Becker
Herbert Thomas Ringelmann
Zinngruber Friedrich G. Beckhaus

"A Love in Germany" was shown as part of this year's New York Film Festival. Following are excerpts from Vincent Canby's review, which appeared in The New York Times on Oct. 2. The film opens today at the Lincoln Plaza 1, Broadway and 63d Street.

AS she demonstrated in Ettore Scola's witty meditation on the French Revolution, "La Nuit de Varennes," Hanna Schygulla will survive the death of Rainer Werner Fassbinder. It was Fassbinder who originally discovered her and for whom she made a whole series of extraordinary films, from the early "Katzelmacher," through "Effi Briest" and, perhaps the best of them all, "The Marriage of Maria Braun."

Now, in Andrzej Wajda's "Love in Germany," she gives what must be called a triumphant performance, one that ranks with the best of her work with Fassbinder, in a film that must be the most romantic ever made by Mr. Wajda, the great Polish director whose best films, from "Ashes and Diamonds" through "Man of Marble" and the recent "Danton," have always been shaped by his political conscience.

"A Love in Germany" is certainly full of political concerns, but it's also a story about a love so all-consuming that its consequences seem less tragic than liberating, politically as well as emotionally. Though it's nowhere near as sexually explicit and violent as Nagisa Oshima's "In the Realm of the Senses," "A Love in Germany" recalls the monomaniacal, self-obsessed passions of the Japanese film.

The screenplay, written by Mr. Wajda with Boleslaw Michalek and Agnieszka Holland, is based on a novel I haven't read by Rolf Hochhuth, best known here as the German playwright who, in the 1960's, offended just about everybody at least part of the time with his unflattering portraits of Pope Pius XII in "The Deputy" and Winston Churchill in "Soldiers."

•

"A Love in Germany" is set during World War II in the small town of Brombach, sometime before the eventual collapse of the Third Reich was even suspected by most citizens. The children of Brombach happily suck on lollipops decorated with

Hanna Schygulla portrays a German shopkeeper who has a forbidden love affair with a young Polish prisoner of war in the Andrzej Wajda film "A Love in Germany."

sugar swastikas. The news from the fronts isn't yet so hopeless that the deaths in battle of husbands and fathers can't be accepted as noble sacrifices in the cause of the fatherland.

In Brombach, everybody knows everybody else's business, and as long as certain activities — those that don't actually threaten the tiny community — aren't flaunted, most people look the other way. Thus almost everyone, from her neighbors to the mayor, are aware that Paulina Kropp (Miss Schygulla), the mother of a small son and whose husband is away in the army, has something more than a passing interest in Stanislaw (Piotr Lysak), the handsome, much younger, Polish prisoner of war who has been billeted in Brombach as a kind of boy-of-all-work.

Paulina runs a small, well-stocked grocery, where she is assisted in the heavy work from time to time by Stanislaw, who lives across the street with an elderly couple. There is every indication that Paulina loves her absent husband, but the affair with Stani, as she calls him, is something quite other, a passionate sexual liaison that comes to dominate every aspect of her life.

Both Paulina and Stani are aware that sexual relations between German nationals and P.O.W.'s are forbidden by a law that decrees the death penalty for the foreigner and imprisonment for the German. Yet Paulina and Stani become increasingly careless about hiding their relationship. Paulina, especially, seems to exult in it. Her happiness makes her euphoric.

Before a rendezvous with Stani in the woods on the outskirts of Brombach, she drops by the local pharmacy and, after making a few innocuous purchases in front of her friends, boldly asks the pharmacist for a condom. As the affair progresses, to the consternation of her closest friends, her fever makes her ever less cautious. When Stani comes by in the middle of the day, she virtually tears his clothes off in the front window of the unlocked shop. It isn't long before the lovers are informed upon by a neighbor who covets Paulina's very profitable little business.

Nobody, especially the army officer in charge of the prosecution, wants to see the case through to its inevitable end. Stani's death sentence can be avoided if it can be proved — or certified — that he is actually German. But Stani refuses to be thus "Germanized" in a bogus physical exam. If Paulina will testify that she was raped, she also might avoid the consequences. The manner in which each lover embraces fate is both exhilarating and terrible. Love so self-destructive is so rare that it appears ludicrous to everyone not a party to it.

This is the secret of the film, and one that perhaps no actress except Miss Schygulla could make so sexually vivid and even so politically important. Miss Schygulla's Paulina is a grandly heedless character, and though Stani, nicely played by Mr. Lysak, seems at first to be something of a victim of her passion, he too achieves a kind of heroic stature as the film moves to its foregone conclusion.

"A Love in Germany" initially appears to be an uncharacteristic Wajda work. Love of this kind has seldom if ever interested him in the past. Yet "A Love in Germany" may be one of his most effective films, evoking, effortlessly, large, haunting associations from a small set of extremely specific circumstances.

1984 N 9, C10:1

Sweet Dreams

A NIGHTMARE ON ELM STREET, written and directed by Wes Craven; director of photography, Jacques Haitkin; music by Charles Bernstein; produced by Robert Shaye; a New Line Cinema, Media Home Entertainment and Smart Egg Pictures presentation of a Robert Shaye Production; a Wes Craven Film. Running time: 91 minutes. This film is rated R.

Lt. Thompson	John Saxon
Marge Thompson	Ronee Blakley
Nancy Thompson	Heather Langenkamp
Tina Grey	Amanda Wyss
Rod Lane	Nick Corri
Glen Lantz	Johnny Depp
Dr. King	Charles Fleischer
Sgt. Parker	Joseph Whipp
The Teacher	Lin Shaye
Fred Krueger	Robert Englund

IN "A Nightmare on Elm Street," several teen-agers start sharing the same dream in which a long-dead child murderer attempts to carry on his mission from the far side of the grave. That he succeeds for a while should come as no surprise to anyone who keeps up with horror films, especially those in which the mortality rate among sexually active teen-agers is always alarmingly high.

John Saxon and Ronee Blakley play — with suitable, furrow-browed seriousness — the parents of the young woman the monster would most love to kill. Her name is Nancy (Heather Langenkamp) and she's pretty and bouncy enough to be a terrific cheerleader. The monster is played by Robert Englund, but what he looks like is anybody's guess, since he wears a lot of masks that are about as scary as those worn by extremely small trick-or-treaters on Halloween.

The film was written and directed by Wes Craven, whose earlier films, "The Last House on the Left" and "The Hills Have Eyes," specialized in graphically depicted mayhem and gore.

"A Nightmare on Elm Street," which opens today at the National and other theaters, puts more emphasis on bizarre special effects, which aren't at all bad.

Vincent Canby

1984 N 9, C10:5

Unspoken Sentiments

LES FLEURS SAUVAGES, direction and screenplay by Jean Pierre Lefebvre; in French with English subtitles; photography by Guy Dufaux; produced and edited by Marguerite Duparc; production company, Cinak Limitée; music by Raoul Duguay. At the Thalia, Broadway and 95th Street. Running time: 152 minutes. This film has no rating.

Simone	Marthe Nadeau
Michele	Michele Magny
Pierre	Pierre Curzi
Eric	Eric Beauséjour
Claudia	Claudia Aubin

Prosaic Pilgrimage

LE VIEUX PAYS OU RIMBAUD EST MORT, directed by Jean Pierre Lefebvre; screenplay (French with English subtitles) by Mr. Lefebvre and Mireille Amiel; photography by Guy Dufaux; edited by Marguerite Duparc; music by Claude Fonfrède; produced by Cinak (Montreal), Filmoblic and l'Institut National de l'Audiovisuel. At the Thalia, Broadway and 95th Street. Running time: 113 minutes. This film has no rating.

Abel	Marcel Sabourin
Anne	Anouk Ferjac
Jeanne	Myriam Boyer
Jeanne's Father	Roger Blin
Anne's Mother	Germaine Delbat
Anne's Husband	François Perrot
Yves	Mark Lesser
Taxi Driver, Painter, Art Dealer	Jean-François Stévenin
Viviane	Viviane Lesser
Mr. de Cassant	Jean Turlier
The Professor	Michel Delahaye
Mrs. de Cassant	Rita Maiden

By VINCENT CANBY

THE Thalia Theater today is presenting the New York premieres of two films by Jean Pierre Lefebvre, a French Canadian director virtually unknown in this country, though apparently well regarded in Europe.

On the basis of his 1981 "Fleurs Sauvages" (Wild Flowers) and the 1977 "Le Vieux Pays où Rimbaud Est Mort" (The Old Country Where Rimbaud Died), Mr. Lefebvre shares with many other French Canadians a strong need to certify his particular past and to clarify his present identity. This would seem to be the impulse behind his work, though these two films suggest that he's an aspiring poet of genteel, middle-class dissatisfaction. His characters strike a lot of picturesque poses, but they don't quite qualify as alienated.

"Les Fleurs Sauvages" is mostly about all the supposedly important things left unsaid between a 70-year-old mother and her 36-year-old daughter when the mother makes her annual one-week visit to her daughter's family in the country.

They are decent people, with decent instincts, but the fact that neither mother nor daughter can quite bring herself to say what's on her mind seems no great loss. What they feel but hesitate to say — which we see and hear in brief, black-and-white inserts in the otherwise color film — doesn't really appear to be that pertinent. Literature of this banal type resolutely refuses to acknowledge the importance of feelings expressed without words.

In "Le Vieux Pays," a young French Canadian named Abel makes a pilgrimage to France to discover if it is still inhabited by the French who were his forebears. Abel's parents, like many of the French he meets in Paris, appear to have had their roots in colonial Algeria, but nothing much is made of this by him or by the director, who also, for reasons that are beyond my understanding, invokes the names of Rimbaud, Colette and Saint-Exupéry.

Mr. Lefebvre's style, which employs a lot of short, seemingly anticlimactic scenes, plus monologues spoken directly to the camera, never disguises the commonplace nature of his cinematic conceptions. Though attractively acted, the two films are utterly without humor, solemn without being serious.

1984 N 9, C12:5

Wise Adolescent

NO SMALL AFFAIR, directed by Jerry Schatzberg; screenplay by Charles Bolt and Terence Mulcahy; story by Charles Bolt; director of photography, Vilmos Zsigmond; edited by Priscilla Nedd, Eve Newman and Melvin Shapiro; music by Rupert Holmes; produced by William Sackheim; released by Columbia Pictures. At Manhattan Twin, 59th Street near Third Avenue; 34th Street East near Second Avenue; New Yorker Twin, Broadway and 88th Street, and RKO Warner Twin, Broadway and 47th Street. Running time: 103 minutes. This film is rated R.

Charles Cummings	Jon Cryer
Laura	Demi Moore
Jake	George Wendt
Leonard	Peter Frechette
Susan	Elizabeth Daily
Joan Cummings	Ann Wedgeworth
Ken	Jeffrey Tambor
Nelson	Tim Robbins
Gus Sosgowski	Hamilton Camp
Scott	Scott Getlin
Stephanie	Judy Baldwin
Mona	Jennifer Tilly

By JANET MASLIN

THE schoolboy precocity of its teen-age hero — the kind of boy who can come home to find a stranger in the family apartment and introduce himself as "Charles Cummings, in case you're wondering whose mother you had your way with" — gives "No Small Affair" a brittle but definite charm.

And Jon Cryer, who plays Charles, makes him a toothy, good-humored adolescent with style. The film is supposed to center on Charles's affair with a glamorous would-be rock singer, Laura Victor (Demi Moore), who at 23 is the older woman in his life. But Charles is more appealing than either Laura or her music, and it's Charles who keeps the movie lively.

"No Small Affair," which opens today at the Manhattan Twin and other theaters, is on the slight side; there's not much more to sustain it than the general impression that Charles is coming of age. However, as directed by Jerry Schatzberg from a screenplay by Charles Bolt and Terence Mulcahy, the film stays snappy much of the way. Even when Charles's manner of being wise beyond his years grows tiresome, as does Laura's determination to make it big and be somebody, the film sustains its quirkiness and keeps moving.

The cast includes Ann Wedgeworth, amusingly frazzled as the mother who can't possibly keep up with Charles, and Jeffrey Tambor as her balding boyfriend; it is he who advises Charles that "being weird, it takes energy — energy you could put into being normal." Then there is Laura's lecherous boss (George Wendt), who runs the rock club at which she sings noisy, indifferent numbers that slow the movie down.

There are a lot of other incidental characters, including Charles's brother and his fiancée and a motherly prostitute who follows Charles home from the stag party, deciding that the younger brother is cute. She (Judy Baldwin) looks much too businesslike for her role, and the fiancée (Elizabeth Daily) is funny but too flashy. With the exception of Miss Wedgeworth, the women in the film seem peculiarly miscast.

Mr. Schatzberg, who shows off a previously undemonstrated knack for comedy, also favors attention-getting bold strokes — the large ethnic wedding that Charles and Laura wind up crashing or the screamingly eclectic, paint-spattered loft in which Laura lives (she says she's only borrowing the place for a while). At least these touches contribute to the film's aura of unpredictability, which is one of its chief assets. Another is Vilmos Zsigmond, whose vibrant cinematography gives the film a bright, colorful gloss.

1984 N 9, C16:1

Soul for Sale

OH GOD! YOU DEVIL, directed by Paul Bogart; written by Andrew Bergman; director of photography, King Baggot; edited by Andy Zall; music by David Shire; produced by Robert M. Sherman; released by Warner Bros. At Murray Hill, 34th Street, east of Lexington Avenue; Gemini, 64th Street and Second Avenue; UA East 85th Street, at First Avenue; 83d Street Quad, at 13th Street west of Fifth Avenue; Criterion, Broadway and 45th Street and other theaters. Running time: 96 minutes. This film is rated PG.

God	George Burns
Bobby Shelton	Ted Wass
Wendy Shelton	Roxanne Hart
Harry O. Tophet	George Burns
Charlie Gray	Eugene Roche
Gary Frantz	Ron Silver

THE latest film in the "Oh God!" series is at least as commendable for what it *doesn't* have — John Denver — as for what it does. George Burns goes it alone in "Oh God! You Devil," and it turns out that he's better off that way.

As the title may indicate, Mr. Burns plays a dual role this time. In addition to allowing him to play poker

games against himself for the fate of a protégé's soul, Mr. Burns' God/Devil impersonation leans heavily towards the diabolical. And he is much more welcome in this capacity than he is shambling about in a golf hat, playing God.

One of the wittier notions of the screenplay, by Andrew Bergman, is that the Devil is a theatrical agent. As the dapper, cigar-smoking Harry O. Tophet, Mr. Burns has "HOT" license plates and more clients than he can handle. The film concentrates on his campaign to win over Bobby Shelton, an aspiring songwriter who makes the mistake of saying he'd sell his soul to make it big.

•

"Oh God! You Devil," which opens today at the Murray Hill and other theaters, takes on more than it can manage when it has Bobby Shelton (Ted Wass) switch identities with a rock star named Billy Wayne (Robert Desiderio). It seems that Billy's seven-year contract with the Devil is expiring, and that it is both convenient and amusing for Mr. Burns's Harry Tophet to reverse their roles. Soon Mr. Wass is seen with a singer's flashy wardrobe and haircut, while Mr. Desiderio enjoys simple domestic life with Bobby Shelton's charming wife (Roxanne Hart). If that's confusing to read about, it becomes even more so to watch. The film does not enhance its credibility by making

the zillionaire rock star's life one of unadulterated gloom.

Mr. Burns trots through these proceedings very spryly, with less sentimentality or sanctimoniousness than in the earlier "Oh God!" films. And there is mercifully little in the way of "Bless Me" witticisms. The material is extremely slight, but at least it's benign. The film begins and ends with renditions of "Fugue For Tinhorns," from "Guys and Dolls," which is just about entirely unrelated to the action but still good to hear.

•

"Oh God! You Devil" is rated PG ("Parental Guidance Suggested"). It contains some mild vulgarity.

Janet Maslin

1984 N 9, C15:1

Stowaways

LA PETITE BANDE, directed by Michel Deville; story (French with English subtitles) by Gilles Perrault; screen adaptation by Mr. Perrault and Mr. Deville; director of photography, Claude Lecomte; edited by Raymonde Guyot; music by Edgar Cosma; a co-production Hamster Productions/Gaumont/Stand'Art/FR3/Elefilm; released by Triumph Films, a Columbia/Gaumont Company. At the Metro, Broadway and 99th Street. Running time: 91 minutes. This film is rated PG.

Female cooper	Yveline Ailhaud
Circus director	Michel Amphoux
Man from Bavaria	Roland Amstutz
Nasty father	Pierre Ascaride
Man with the red car	Jean-Pierre Bagot
Woman from Bavaria	Nathalie Bécue
Second policeman at the road block	
	Didier Bénureau
Woman with the red car	Liliane Bertrand
First policeman at the bridge	Jacques Blot
Psychiatrist at the blackboard	Jean Bois

"LA PETITE BANDE," Michel Deville's French comedy that opens today at the Metro Cinema, is reportedly based on a real-life incident but it's of a coyness to make a sugarplum fairy retch.

It's a fable about a small group of English children, ages five or so to about 10, who somehow manage to hitchhike their way to a channel port and then to stow away aboard a ferry to France, where they have a series of not very amusing adventures.

One of the film's gimmicks is that the soundtrack contains no dialogue,

though it does have sound effects and an awful lot of jaunty music. The children, all nonprofessionals, are pretty enough though they can only be distinguished by sex and height. They aren't characters. They are idealized representatives of a childhood few of us ever knew.

•

"La Petite Bande" has been rated PG ("parental guidance suggested") for reasons not readily understood, except for a couple of scenes in which the kids appear to be in danger of a not very serious sort.

Vincent Canby

1984 N 9, C28:5

George Burns has the opportunity to play two roles — God and the Devil — in his latest comedy, "Oh, God! You Devil," directed by Paul Bogart.

FILM VIEW

VINCENT CANBY

Directors Evoke Many Americas

America, meaning mostly the United States, is not an easy concept to comprehend. It may be appropriate that it was discovered by a Genoese sailor, in the service of the Spanish crown, looking for some place else and that, for the next half-century, it was treated as a geographical impediment to be gotten through or around in order to reach some far-more-profitable other side.

America was born with an inferiority complex — not altogether unhealthy — that no amount of subsequent wealth and power has ever completely erased. For all of his common sense and skepticism concerning things European, Mark Twain was as affected by these feelings as were the furious America Firsters who, in 1939, 1940 and 1941, fought to keep this country out of Europe's war against Hitler.

Just as the continent initially failed to excite the imaginations of Europeans and then resisted their attempts at colonization, it has continued to defy simple definitions — which is as it should be. More than anything else, perhaps, it's a mirror into which our artists, including American and European filmmakers, look and find that which, for whatever reasons, they have been conditioned to see.

• • •

The American dreamlands reflected in the Hollywood movies of the Great Depression were as often made by transplanted European directors as by those who were native born. Most of these movies — there were many exceptions, of course — may not have been especially true to life, but they were true to the fantasies of the people who saw them, here and abroad.

Like everything else, fantasies, whether optimistic or terrifying, are subject to change. In the late 1960's, when opposition to the Vietnam War was becoming a major political issue, Dennis Hopper's seminal "road" movie, "Easy Rider," became a huge hit in this country and in Europe. The ad line — if I remember it correctly — said something to the effect that "They went out looking for America — and found nothing there."

"Easy Rider" was not a great movie, but it was an accurate if overstated dramatization of the fears of many people, especially young people, who were shocked down to their shoes to realize that, perhaps, there were flaws in the system. Almost immediately, Michelangelo Antonioni came along to make "Zabriskie Point," an apocalyptic view of a fascistic America as seen by him with a lot of help from his friends, including Fred Gardner, Tonino Guerra, Clare Peploe and Sam Shepard, who apparently withdrew from the project when he saw the mess it was becoming.

"Easy Rider" was a successful film, and "Zabriskie Point" was a disaster, though it continues to be of historical interest for the way it defines a certain kind of European intellectual's approach to this country. That Mr. Antonioni really didn't know much about this country was beside the point. The problem was that his vision was so limited as to be unintentionally hilarious. There can be more to art than mere accuracy.

However, "Zabriskie Point" was less disturbing for any inaccuracies than for its patronizing point of view. It was a European aristocrat's record of his visit to the colonies. It was also a major disappointment — there's a lot that we can learn from the way we appear to outsiders.

Far more successful in this regard are two current films that look at America through the eyes of filmmakers who — I don't think it's patronizing to say — continue to see this country with the curiosity of informed tourists. They are Wim Wenders's "Paris, Texas," written at least in part by Mr. Shepard with contributions by L. M. Kit Carson and Mr. Wenders, and "Repo Man," a wonderfully lunatic farce written and directed by Alex Cox, a young Englishman who studied at the film school at the University of California at Los Angeles.

• • •

By a remarkable coincidence, both films star Harry Dean Stanton, a character actor now coming into his own as a movie icon, possibly because, more than any other actor at work in this country today, he is able to project a sort of intense, sometimes conscience-stricken sleaziness that reflects large areas of the American landscape.

"Paris, Texas" comes to us with all sorts of fancy credentials. The German-French co-production, shot entirely in this country, took the top prize at this year's Cannes Film Festival and is currently one of the big hits in Paris where, I'm told, grown men are seen to be awash in tears when the lights come up at the end. Americans, I suspect, are not going to be as susceptible.

As long as "Paris, Texas" sticks to the almost surreal world of Sam Shepard, the actor ("Country," "Days of Heaven") and Pulitzer Prize-winning playwright ("Buried Child"), it is funny, mysterious and moving. In a most general way it's a tale about a hapless drifter named Travis (Mr. Stanton) and his relations with the small son (Hunter Carson) he abandoned four years earlier and with his conventional brother (Dean Stockwell), who has become the boy's foster father.

When first seen, Travis is wandering across a Texas wasteland, seemingly a catatonic mute, from nowhere to nowhere. After being reluctantly reunited with his brother and his son, Travis attempts to re-enter the world from which he earlier elected to escape. Mr. Wenders and Mr. Shepard, as well as their actors, are awfully good when they are effortlessly showing us what life is like in rural Texas and suburban Los Angeles.

• • •

The "look" of this world, sometimes bleak and parched, sometimes artifically watered and intensely green, full of labor-saving appliances, describes the contradictory quality of the lives of the characters who, up to this point, are pure Sam Shepard. That is, they are the work of one of our most original playwrights ("Fool for Love," "True West," "Curse of the Starving Class"). Mr. Shepard is not great at plots. He's best at dramatizing the agonizing relationships by which members of a single middle-class family obtain some small inkling of what life is all about. He's the poet laureate of the inarticulate. He's also, I suspect, someone who writes by instinct and whose work doesn't necessarily improve by being made more shapely and orderly.

This, unfortunately, is just what Mr. Wenders and Mr. Carson appear to have tried to do with the screenplay for "Paris, Texas," the last half-hour of which — the half-hour that leaves Paris audiences weeping — is a howler. The film, we are suddenly told, is about the difficulty of communications between men and women, not, as has been shown earlier with great feeling and humor, between brothers or between a father and his son.

The film's penultimate sequence is a scene in which Travis is reunited with his wife, Jane (Nastassja Kinski), who works in what, in New York, used to be called a "rap parlor." The metaphor here is that the husband and wife are separated by a thick glass partition and can only communicate through a small speaker. They eventually see each other but they cannot touch. In any ordinary rap parlor, the woman in the glass booth is supposed to enact the sexual fantasies of the customer, along with appropriately stimulating narration.

It's the terrible conceit of "Paris, Texas" that Travis and Jane don't talk dirty but, instead, talk a lot of nonsense about their lives together, about loving each other too much and about being unable — I think — to grow up. I cannot believe that Mr. Shepard wrote this dialogue willingly or with any conviction. It is, however, just the sort of dialogue — much given to abstract generalities — that, for reasons I've never understood, so fascinates European audiences.

Because it comes at the end of "Paris, Texas," it has the effect of destroying all of the good things that have gone before.

The German-born and bred Mr. Wenders is not a stranger to America. He lives in New York and he has made other movies here, including "Hammett" and "The American Friend," both of which are best in the manner in which they reflect the American films that Mr. Wenders admires. "Paris, Texas," which starts so well, finally comes to sound like a film made by someone who is unfamiliar with America but who knows what he thinks it *should* sound like.

Much less ambitious but, ultimately, far more satisfying is "Repo Man," in which the English-born Mr. Cox sees life in America as a science-fiction farce involving some unexplained creatures from outer space as well as a parody of all of the lonely gunslingers who have stalked through our classic westerns. This character, Bud, played by the incomparable Mr. Stanton, is the best man in his field, which just happens to be repossessing cars on which payments have lapsed. The adventures of Bud, who works for the Helping Hands Acceptance Company, cannot be synopsized but they are far more entertaining and accurate, as a commentary on American life, than anything that happens after the first hour or so of "Paris, Texas."

It's a paradox, I suppose, that "Stranger Than Paradise," written and directed by Jim Jarmusch, an American born and bred, looks and sounds much more like a Wenders film than "Paris, Texas." "Stranger Than Paradise," which Mr. Wenders helped Mr. Jarmusch to get made, has the seedy black-and-white look of the early Wenders films, especially "Kings of the Road" and "Alice in the Cities."

It also has the manner of a movie about America made by an extremely well informed European who resolutely refuses to impose on it any preconceived notions about the country. The movie looks extremely chilly, but it's also very funny and nonjudgmental. It's Mr. Jarmusch's odd achievement to be responsible for one of the best European films ever made about America. We *do* live in peculiar times. ∎

1984 N 11, II:17:1

Ltd. and Ceskoslovensky Filmexport. At Film Forum, 57 Watts Street. Running time: 95 minutes. This film has no rating.
WITH: Rudolf Hrusinsky, Jaromir Hanzlik, Jiri Schmitzer, Petr Cepek, Zdena Hadrbolcova, Josef Somr, Libuse Safrankova, Miloslav Stibich, Eugen Jegorov, Borik Prochazka

By VINCENT CANBY

JIRI MENZEL'S "Snowdrop Festival," the Czechoslovak film that opens today at the Film Forum, is like a month in the country. It's full of fresh air. It's soothing and it's just a little bit longer than is absolutely necessary.

However, it's also full of the sort of understated humor and rueful feelings that are representative of all of Mr. Menzel's films, with the exception — oddly — of "Closely Watched Trains," the melodrama that won the Oscar as the best foreign language film in 1967.

"Snowdrop Festival," which has nothing to do with either snowdrops or festivals, is a bucolic reverie not unlike "Capricious Summer," the funny, autumnal Menzel comedy that was shown at the 1968 New York Film Festival.

The new film actually does take place in autumn in the Kersko forest, which, according to Mr. Menzel, is inhabited exclusively by rustic eccentrics with short tempers and an insatiable thirst for draft beer. One jaunty old fellow drives his goats to pasture in his Pontiac, then, as they graze, soothes them by playing his clarinet. Another man spends most of his time attempting to escape his shrewish wife. The young couple who run the local pub alternately fight and make love.

What narrative line there is in the movie, which moves slowly in the manner of someone who's just gotten out of bed, has to do with the contretemps that develops between two small villages over which one has jurisdiction over the carcass of a wild boar. The boar was initially shot in one village but, after a long, desperate chase, is finally killed in a schoolroom in another village. In a compromise suggested by the schoolteacher, the members of the two hunting clubs decide to share the boar at a feast in the pub, which both clubs also frequent.

At its best moments, "Snowdrop Festival" has some of the witty manner of Milos Forman's last Czechoslovak film, "The Firemen's Ball." It's less a conventional narrative than a comic panorama, but though the comedy is mixed with some pathos, the Menzel film contains none of the political references that gave Mr. Forman's comedy its heft.

"Snowdrop Festival" eventually becomes terribly picturesque. It also features one of the most benign authority figures ever to be seen in film from Eastern or Western Europe. He is the local policeman, a fellow who moves smilingly around the Kersko forest settling minor squabbles, and who, when a bunch of the guys are leaving the pub after having drunk a few beers too many, lets the air out of their bicycle tires. For their own good, he simply will not tolerate drunken bike riding.

1984 N 14, C29:4

Boar at the Pub

SNOWDROP FESTIVAL, directed by Jiri Menzel; written (Czechoslovak with English subtitles) by Bohumil Hrabal and Mr. Menzel; photography by Jiri Macak; music by Jiri Sust; a presentation of International Film Exchange,

A Dinosaur's Fate.

NIGHT OF THE COMET, written and directed by Thom Eberhardt; director of photography, Arthur Albert; edited by Fred Stafford; produced by Andrew Lane and Wayne Crawford; released by Atlantic Releasing Corporation. At

Competition between two hunting associations for the carcass of a boar propels "Snowdrop Festival," a comedy by the Czechoslovak director Jiri Menzel.

Loews State, Broadway and 45th Street; U.A. Eastside Cinema, Third Avenue between 55th and 56th Streets, and Olympia Quad, Broadway at 107th Street. Running time: 100 minutes. This film is rated PG-13.

Regina	Catherine Mary Stewart
Samantha	Kelli Maroney
Hector	Robert Beltran
Carter	Geoffrey Lewis
Audrey	Mary Woronov
Oscar	John Achorn
Doris	Sharon Farrell
Larry	Michael Bowen
Willy	Ivan Roth
Chuck	Raymond Lynch
Sarah	Janice Kawaye
Brian	Chance Boyer
News Reporter	Bob Perlow

By VINCENT CANBY

"**N**IGHT OF THE COMET" is a good-natured, end-of-the-world B-movie, written and directed by Thom Eberhardt, a new film maker whose sense of humor augments rather than upstages the mechanics of the melodrama.

The film's premise: All of the world's scientists have mysteriously died 12 months before the movie begins. At least that's the only way to explain why no one has predicted that the comet, hurtling toward earth during a jolly Christmas season, is going to come a lot closer than all of the comet-party revelers around the country suspect.

On the night of the visitation, people gather in Times Square as if for New Year's Eve. Vendors busily sell funny hats with Martian-like feelers on them. In southern California, there are comet barbecues and comet beer parties around every swimming pool. Only the film's portentous narrator knows what's about to happen. The last time this comet came near earth,

he recalls dolefully, all the dinosaurs disappeared.

Like any good, self-respecting B-movie, "Night of the Comet," which opens today at Loews State and other theaters, couldn't care less

about dinosaurs or humanity at large. The film is, instead, about the adventures of two saucy California teenagers, Regina and Samantha, who are sisters and who possess remarkable pluck as well as syntax. "Why are you so weirded out?" one sister is likely to say to the other after something unspeakable has occurred.

•

Reggie and Sam, as they affectionately call each other, are among the handful of southern Californians to survive the comet's visit, each, for reasons I need not go into, having been safely protected by steel walls. Those who suffered the comet's full impact have been reduced to neat little piles of red dust, leaving behind only the clothes they had on. Those partially exposed have become meat-eating zombies. The comet is benign in the manner of the neutron bomb, destroying people but not property.

For a little while, anyway, Reggie and Sam have quite a lark tooling around a seemingly empty Los Angeles, going on fancy, nonspending sprees in chic boutiques. They even meet a handsome young man who shows a distinct interest in Reggie to Sam's disappointment. Then, however, the zombies attack, and after the zombies, there arrive on the scene the members of some secret Government mission who know that their only hope of survival is to steal the young women's blood.

The film's initial special effects aren't great, but some of the dialogue is funny and Mr. Eberhardt has an effectively comic touch. All of the performers are good, especially Catherine Mary Stewart and Kelli Maroney, who play Reggie and Sam; Robert Beltran, as the young man who fancies Reggie, and Mary Woronov — the classically beautiful comedienne who co-starred with Mr. Beltran in Paul Bartel's "Eating Raoul" — as one of the Government people who, heroically, refuse to steal someone else's blood just to stay alive a little longer.

1984 N 16, C8:1

Sharon Farrell and Raymond Lynch fearfully await the approach of a mysterious astral visitor in "Night of the Comet,"

Family Portrait

A SUNDAY IN THE COUNTRY, directed by Bertrand Tavernier; screenplay (French with English subtitles) by Mr. Tavernier and Colo Tavernier, based on the novel "Monsieur Ladmiral Va Bientôt Mourir" by Pierre Bost; director of photography, Bruno De Keyzer; edited by Armand Psenny; music by Gabriel Fauré; produced by Alain Sarde; a coproduction of Sara Films/Films A2/Little Bear; an MGM/UA Classics Release. At the Paris, 58th Street west of Fifth Avenue. Running time: 94 minutes. This film has no rating.

Monsieur Ladmiral	Louis Ducreux
Irène	Sabine Azema
Gonzague (Edouard)	Michel Aumont
Marie-Thérèse	Geneviève Mnich
Mercedes	Monique Chaumette
Madame Ladmiral	Claude Winter
Emile	Thomas Duval
Lucien	Quentin Ogier
Mireille	Katia Wostrikoff
First Little Girl	Valentine Suard
Second Little Girl	Erika Faivre
Accordionist	Marc Perrone
Open-Air Dance Hall Servant	Pascale Vignal
Hector	Jacques Poitrenaud

"A Sunday in the Country" was shown as part of this year's New York Film Festival. Following are excerpts from Janet Maslin's review, which appeared in The New York Times on Oct. 2. The film opens today at the Paris Theater, 58th Street west of Fifth Avenue.

"**A** SUNDAY IN THE COUNTRY" is exquisite — purposefully and almost painfully so — from beginning to end. Set at the turn of the century, on a single day at the country home of an elderly French gentleman, Monsieur Ladmiral (Louis Ducreux), it records the particulars of a visit from his children.

In addition to underscoring the fact that Monsieur Ladmiral is an artist of wide renown, the film's painterly style is well attuned to its characters. Their behavior through the events of the day rarely breaches the prevailing air of mannerliness and comfort. Yet the director, Bertrand Tavernier, while conveying the elegance of the proceedings, is able to reveal all the inner workings of this family and much about its history.

•

"A Sunday in the Country," which was written by Mr. Tavernier and Colo Tavernier, his wife, and based on the novel "Monsieur Ladmiral Va Bientôt Mourir" by Pierre Bost, is one of the director's very best films, acted as beautifully and thoughtfully as it is staged.

Monsieur Ladmiral, painting in a controlled and classical style despite his awareness of contemporaries like Cézanne and Monet (he makes a number of observations about the work of his fellow artists during the course of the film), is drawn by his daughter, Irène (Sabine Azema), toward different, more vital notions of both art and life; this influence of Irène's helps shape the film's lovely closing scene. Mr. Tavernier is particularly graceful in weaving the family's affairs into the film's perceptions about painting, until the two themes ultimately fuse.

1984 N 16, C11:1

Femme Fatale

JUST THE WAY YOU ARE, directed by Edouard Molinaro; written by Allan Burns; director of photography, Claude Lecomte; edited by Claudio Ventura and Georges Klotz; music by Vladimir Cosma; produced by Leo L. Fuchs; released by MGM/UA Entertainment Company. At Astor Plaza, Broadway and 44th Street; New York Twin, Second Avenue and 67th Street; 34th Street Showplace, at Second Avenue, and other theaters. Running time: 95 minutes. This film is rated PG.

Susan	Kristy McNichol
Peter	Michael Ontkean
Lisa	Kaki Hunter

Michael Ontkean and Kristy McNichol star in "Just the Way You Are," a comedy about a handicapped musician whose life is disrupted when she falls in love.

François	André Dussollier
Nicole	Catherine Salviat
Sam Carpenter	Robert Carradine
Bobbie	Alexandra Paul
Jack	Lance Guest
Frank	Timothy Daly
Steve	Patrick Cassidy

By JANET MASLIN

KRISTY McNICHOL suffers from two serious afflictions in "Just the Way You Are," which opens today at Loews Astor Plaza and other theaters: a crippled leg (as a result of a childhood illness) and a fatal attractiveness to men. The film surrounds Susan Berlanger (Miss McNichol), a talented flutist with more handsome admirers than she cares to count. Everywhere Susan goes, it seems, she is the target of relentless male flirting. Two of the film's problems are that Miss McNichol is never appealing enough to explain all this, and that she hasn't the faintest notion of how to flirt back.

Her role here is on the mature side, which means that it affords no room for the tomboyishness that is Miss McNichol's most disarming quality. As Susan, she flashes a pearly and patently synthetic smile at every suitor. There's one (Lance Guest) who works for her answering service and is entranced with the sound of her voice; there's another (Robert Carradine) who's a masher Susan meets in a restaurant. Then there's the old beau (Timothy Daly) who's trying to talk her into marriage. All this is so strenuous for poor Susan that she eventually takes herself to a French ski resort to get away from it all.

•

There, she dons a plaster cast instead of her customary leg brace, so she can fit in more easily. She also makes a few more male friends: a skier (Patrick Cassidy), a photographer (Michael Ontkean) and a French industrialist (André Dussollier). The process by which she eventually wins a ski contest, learns to live

with her handicap and winnows the field of suitors to one is stupefyingly dull. Edouard Molinaro ("La Cage aux Folles"), who directed, seems no more at home with the French sequences than with the American ones.

Everything about "Just the Way You Are" seems phony, from the sound to the snow. The dialogue often sounds dubbed. And Mr. Ontkean, in a mock-charming sequence that has Miss McNichol throwing a snowball at him, leaves a large wad of snow in his ear for the rest of a longish scene. The snow doesn't hurt him, nor does it melt.

•

"Just the Way You Are" is rated PG ("Parental Guidance Suggested"). It contains brief nudity and some off-color language.

1984 N 16, C14:1

MISSING IN ACTION, directed by Joseph Zito; screenplay by James Bruner, story by John Crowther and Lance Hool, based on characters created by Arthur Silver, Larry Levinson and Steve Bing; director of photography, Joao Fernandes; edited by Joel Goodman and Daniel Loewenthal; music by Jay Chattaway; produced by Menahem Golan and Yoram Globus. Running time: 94 minutes. This film is rated R.

Braddock	Chuck Norris
Tuck	M. Emmet Walsh
Senator Porter	David Tress
Ann	Leonore Kasdorf
General Tran	James Hong
Vinh	Ernie Ortega
Jacques	Pierrino Mascarino
Masucci	E. Erich Anderson

By JANET MASLIN

It's possible to watch a Chuck Norris film like "Missing in Action," which opened yesterday at the United Artists Twin, and come away with the misimpression that Mr. Norris has not said a word. He does talk, of course, but his real eloquence is exclusively physical. There's not quite enough of it to explain why someone of Mr. Norris's taciturn manner and unprepossessing blond looks has managed to become an international

B-movie star. But there *is* enough to carry a simple, bullet-riddled, crowd-pleasing action movie like this one.

Mr. Norris plays an American Army colonel who, after years as a prisoner of war in Vietnam, returns to that country to try to rescue other prisoners. His celebrated martial-arts skills don't figure very prominently in this exploit, although there is one memorable moment when he casually knocks an ax off its handle. Instead, Mr. Norris relies mostly on machine guns and grenades this time. In one slow-motion sequence, he rises up out of a river, looking suitably ferocious in green fatigues and matching headband, and shoots holes in three Vietnamese soldiers who have made the mistake of laughing at him.

Actually, Mr. Norris is a much less

bloodthirsty figure here than the sorts Charles Bronson usually plays. And he approaches each fight with the faint sheepishness that is part of his charm. The fact that he wins every battle is another part, as is his way of driving a hard bargain. In negotiating to buy a raft equipped with a machine gun, for instance, he simply turns the gun to face the man who is offering the thing for sale. This helps reduce the price by half, and very quickly.

In addition to liking Mr. Norris, the Rivoli audience also showed enthusiasm for the film's attitude toward Vietnamese soldiers and officials, who are depicted as no less unequivocally shifty, villainous and deceitful as their stereotyped Japanese counterparts were in B-movies about World War II.

1984 N 17, 11:1

FILM VIEW

VINCENT CANBY

Reporters Are A Continuing Story for Moviemakers

Among others things, the arrival of the Television Age appears to have made more sharp and contradictory the nature of the American public's longstanding love-hate relationship with journalists and journalism. If various polls are to be believed, many Americans today are convinced that newspaper and television reporting, especially of politics, is more biased than it's ever been, usually in favor of liberal positions.

There also are people who seem to feel that too much space is devoted to the reporting of downbeat events — to disasters, natural and man-made, to tales of duplicity in places of public trust, to stories of the private scandals of well-known people. Why, someone must ask at least once each night on a radio phone-in show, don't reporters spend more time on heartwarming, inspiriting stories about heroism and other uplifting human achievements? Isn't there enough trouble in the world without harping on all of the unpleasantnesses? The reporter, like the messenger in Greek tragedy, is punished for the tidings he brings.

Though the public is skeptical of journalism, there probably has never been a time before when journalists have themselves become such stars in their own right that when a familiar-faced television reporter appears at the scene of a major event, it's often the journalist and not the event that receives most of the attention of the onlookers. The reporter has gained such celebrity that autographs may be sought by fans even as the building behind them is going up in flames.

Not unrelated to this more recent phenomenon is the fact that movies about reporters have exerted a continuing appeal for filmmakers and often with the public. This has something to do with the conviction that reporters, being where the action is, lead lives somewhat more full of adventure and thus more glamorous than those of your average computer programmer.

• • •

Considering the apparently widespread public skepticism about journalism, journalists have been treated with a good deal of sympathy by moviemakers, currently by David Puttnam, the producer whose idea it was to make "The Killing Fields." This is the screen adaptation of Sydney Schanberg's New York Times Magazine story (Jan. 20, 1980) about the war in Cambodia and a very special

friendship Mr. Schanberg developed with his Cambodian assistant, Dith Pran.

The magazine story, titled "The Death and Life of Dith Pran," carried the subhead, "A Story of Cambodia," for a very good reason. In recounting the victory of the Communist Khmer Rouge forces in Cambodia, which Mr. Schanberg covered for The New York Times from 1972 to 1975, he also successfully encapsulated in his memoir about his friendship with Mr. Dith what he saw to be the awful fate of a small country not in control of its own destiny. As Mr. Schanberg was unable to protect the life of Mr. Dith, who had earlier saved his life and those of several other Western correspondents, the American forces could not — perhaps "would not" is the term the film would use — save the life of Cambodia.

"The Killing Fields," directed by Roland Joffé and starring Sam Waterston as Mr. Schanberg and Dr. Haing S. Ngor as Mr. Dith, is not a perfect film. It never successfully dramatizes the intensity of the loyalty, the respect and, finally, the guilt Mr. Schanberg felt about the friendship, but it does call attention — very rare in movies — to an unhappy chapter in the history of recent United States diplomacy in Southeast Asia. In this respect, it is more important than actually moving.

• • •

In this respect, too, "The Killing Fields" represents one of the most consistently popular conceits of journalists as seen by moviemakers — that is, the journalist as a tough, committed reporter of the facts, out to get the truth that, in these films, must serve the cause of humanity for being true. If Truth is Beauty, it's also Good.

It hasn't always been this way.

One of the classic American plays of this century, Ben Hecht and Charles MacArthur's "Front Page," set in the world of sleazy Chicago journalism of the 1920's and which has been made into a film at least three times, shows newspaper reporters to be even more corrupt than the petty crooks and shabby politicians they are covering. In Billy Wilder's most mordant film, "Ace in the Hole," Kirk Douglas plays a reporter who, to make more dramatic the story of a man trapped in a cave, is ultimately responsible for the man's death.

By far the toughest film about journalism in recent years was Sydney Pollack's "Absence of Malice," in which an ambitious journalist, played by Sally Field, naïvely allows herself — and her paper — to be used by a conniving district attorney in ways that destroy the lives of several innocent people. "Absence of Malice" is not entirely plausible, at least to newspaper people, but it accurately reflects the suspicions that many members of the public have about the press.

• • •

Somewhat more common has been the use of the reporter as a kind of narrative device, the point of view for a story that would otherwise be too sprawling to be easily encompassed in more conventional ways. Thus the innocuous presence of Arthur Kennedy's reporter as the man who watched the rise and fall of the central figure in "Lawrence of Arabia" and Martin Sheen, who served more or less the same bland function in "Gandhi."

From the 1930's through the 1950's most reporters were romantic types — Clark Gable sent out to cover the story of a runaway heiress in "It Happened One Night" or

as the tough city editor who decides to teach a pretty journalism professor, Doris Day, what the business is all about in "Teacher's Pet." They were both cynical and glamorous as portrayed by James Stewart and Ruth Hussey in "The Philadelphia Story," and incredibly staunch in the person of Joel McCrea in "Foreign Correspondent." The pretty, live-wire television reporter played by Jane Fonda in "The Electric Horseman" is really a 1970's update of the newspaper reporter who set out to expose Gary Cooper's naïve hero in the 1936 "Mr. Deeds Goes to Town."

It is one of the ironies of our particular period that just when the public seems most inclined to express its skepticism about journalism, more good and more truly good serious movies about journalism are being made.

The Sidney Lumet-Paddy Chayefsky "Network" was a seriously manic farce about the inner workings of television. James Bridges's "China Syndrome," in which a plucky TV reporter (Miss Fonda again) and her

associates expose the dangers at a faulty nuclear reactor, would have been a good popular melodrama even without the awful coincidence of the Three Mile Island incident. By far the best of all recent films about journalists as crusaders-for-truth was Alan J. Pakula's adaptation of the Carl Bernstein-Bob Woodward best seller about Watergate, "All the President's Men."

It was one of the splendid achievements of "All the President's Men" that the personal stories of Mr. Bernstein (Dustin Hoffman) and Mr. Woodward (Robert Redford) did not become more important than the story they were covering. This is the problem that must be met and somehow solved in all films about reporters covering great events. Warren Beatty's use of his "witnesses" — the documentary interviews with which he punctuates "Reds" — is enormously helpful in maintaining that film's balance between private romance and epic history.

It's a problem that Peter Weir, the director, never successfully ad-

dresses in his ambitious but finally unsatisfying "Year of Living Dangerously," about a young Australian reporter out to make a name for himself by his coverage of the last days of the one-man rule of President Sukarno of Indonesia. The private problems of the reporter (Mel Gibson) fade into nothingness against the vivid background of a profoundly troubled nation, represented in the film by the small, sorrowing figure of Billy Kwan, the half-Chinese, half-Australian cameraman-reporter, the role for which Linda Hunt was awarded her Oscar.

A good deal more effective is Volker Schlöndorff's "Circle of Deceit," filmed under horrendously difficult circumstances in a Beirut deep in civil war, about a German reporter (Bruno Ganz) whose private problems are mirrored by — but never for a minute take precedence over — the viciousness of the events he is witness to. This is a hard, gritty movie, less romantic than a terrorist-planted car bomb.

A most peculiar attempt to reconcile a journalist's personal story with history is contained in Roger Spottiswoode's "Under Fire," set in Nicaragua in 1979 during the final weeks of the dictatorship of President Somoza. Perhaps because, with the exception of "The Front Page," I was brought up on movies — good, bad and silly — in which journalists usually stood for truth and justice, and because I now work for a newspaper that wouldn't take kindly to a reporter's fabricating a story, I find what I take to be the point of "Under Fire" absolutely absurd.

In "Under Fire," Nick Nolte plays a hotshot news photographer who becomes radicalized while covering the Sandinist revolution against the Somoza regime. When he is persuaded by the Sandinistas that the Administration of President Carter will withdraw its support of Somoza if they believe the charismatic Sandinist leader is still alive, the Nolte character agrees to fake a shot of the Sandinist fellow, to make it appear that the man, actually dead, is very much alive. It is the film's rather gross oversimplification of things that this faked photograph plays a key part in the triumph of the revolutionary cause.

To ask whether or not there are times when faked news can be justified is to ask a spurious question. It also has the effect of making the entire revolution against Somoza — fought for good and reasonable causes — an excuse for the crisis of conscience suffered by the fictitious photographer. "Under Fire" would seem to be a perfect movie for everyone who distrusts our press.

Though "The Killing Fields" never succeeds, as Mr. Schanberg does in his original magazine story, in making the friendship of the American reporter and his Cambodian colleague as moving and important as it should be, it does take an unusually harsh view of United States diplomacy at a crucial time in our relations with Southeast Asia. It also — for the first time in a major commercial American movie — focuses the audience's attention on an instance of genocide that most Americans know little or nothing about.

It respects the practice of journalism, and it respects journalists like Sydney Schanberg who, unlike Clark Kent, must overcome all sorts of bu-

reaucratic and physical difficulties, including boredom, to get the story. The profession is, most of the time, a long, hard, frequently dangerous slog. In places like Cambodia and Nicaragua, there are no phone booths into which the reporter can pop, change into his tights and his cape, and go flying off to make the world safe for democracy. ■

1984 N 18, II:17:1

Hankies and Kisses

FALLING IN LOVE, directed by Ulu Grosbard; written by Michael Cristofer; director of photography, Peter Suschitzky; edited by Michael Kahn; music by Dave Grusin; produced by Marvin Worth; released by Paramount Pictures. At Tower East, 72d Street and Third Avenue; Paramount, at Columbus Circle, and other theaters. Running time: 106 minutes. This film is rated PG-13.

Frank Raftis	Robert De Niro
Molly Gilmore	Meryl Streep
Ed Lasky	Harvey Keitel
Ann Raftis	Jane Kaczmarek
John Trainer	George Martin
Brian Gilmore	David Clennon
Isabelle	Dianne Wiest
Victor Rawlins	Victor Argo
Mike Raftis	Wiley Earl
Joe Raftis	Jesse Bradford

By VINCENT CANBY

"FALLING IN LOVE" is a classy weeper that poses a rude question: What are talented people like Robert De Niro, Meryl Streep and Ulu Grosbard, their director, doing in a sudsy movie like this?

It may be that they were looking to have some fun. Each has been doing fairly heavy duty of late — Mr. De Niro in "Once Upon a Time in America" and "King of Comedy," Miss Streep in "Sophie's Choice" and Mr. Grosbard in "True Confessions" with Mr. De Niro. The change of pace must have appeared terrifically appealing.

"Falling in Love" is not a bad movie by any means. It's not stupid or gross or cheap. It's been done with taste, but it's the sort of production that, even when it works, which it frequently does, seems too small and trite to have had so much care taken on it.

At heart, "Falling in Love," which opens today at the Tower East and other theaters, is an American "Brief Encounter" that goes on too long. It's about two attractive Westchester commuters, each happily married to someone else, who meet, fall in love and then don't know what to do about it.

The principal setting is Manhattan, where Frank Raftis (Mr. De Niro) works in some never clearly defined capacity in the construction business, and Molly Gilmore (Miss Streep), a free-lance commercial artist, comes regularly to sell her work and to visit her hospitalized father.

For what seems an unconscionable amount of time, the Michael Cristofer screenplay crosscuts between the daily routines of Frank and Molly, showing us how, unknown to them, their paths keep crossing — on the train to Manhattan, at Grand Central Station telephone booths, on Fifth Avenue, at restaurants and other pretty locations. However, since Mr. De Niro and Miss Streep are the stars of the film, the movie can keep them apart for only so long without the audience's becoming a wee bit restive.

Even after they meet — on Christmas Eve at the Rizzoli Book Store, where each winds up with the other's purchases — it's still several months before the film gets down to the busi-

ness of their falling in love. At this point it becomes apparent that the inarticulate, tentative nature of most of the dialogue is, virtually, the style of the film. It's also the point at which the film, which seems to yearn to be a romantic comedy of a more sophisticated, sharper sort, becomes most serious and most affecting in an unembarrassedly sentimental way.

It's not easy to make a movie about people who initially communicate by making tentative proposals that are answered with tentative "yeahs," "sures," "unhuhs" and "okays." For a while this also has the effect of bringing out the most tiresome of lifelike gestures, especially in Miss Streep, who spends much of the first part of the movie giving an early Kim Stanley performance composed of shoulder shrugging, expressive but wordless sighs and half-finished sentences.

Mr. De Niro's Frank, who is the more aggressive of the two characters, doesn't have that problem, and once the two do declare their love, Miss Streep is on solid ground with solid material.

The film is well cast from the stars right down to the smallest supporting role with, somewhere in between, Harvey Keitel and Diane Wiest as the respective best friends of Frank and Molly. Also good, though their roles have a kind of built-in superfluousness, are Jane Kaczmarek, as Frank's wife, and David Clennon, as Molly's husband. Only if actors of a stature comparable to the stars' had been playing these roles, would there be a moment of legitimate suspense in "Falling in Love."

•

As it is, one follows the story not to find out what happens next but how it's going to happen.

What keeps the movie going is its combination of intelligent performances and expert timing, which works well up until about 15 minutes before the end. It's then that the very large hankie — which is what Mr. Cristofer's screenplay really is — receives two or three more twists than it can take without being pulled to shreds. One has become all too aware of the studied mechanics of the film, including the Dave Grusin soundtrack music, and of how the mechanism must function if the movie is to end without being a feature-length anticlimax.

When the characters are allowed to become at least partially articulate, their emotions carry real impact. Extremely moving is a scene in which Miss Streep's Molly pours out her feelings about Frank to a skeptical Miss Wiest and reaches her own dead end. Exhausted, she simply says, "I like being with him." Mr. De Niro has an equally wrenching confrontation with his wife, not because he's been physically unfaithful to her, but because he hasn't and desperately wants to be.

There's also one quite wonderful love scene, which may mark a breakthrough for love scenes in this day and age, though not for reasons one would expect.

Under these circumstances, one keeps wanting the film to be much, much better. Mr. Cristofer is capable of writing very funny scenes, as when Mr. De Niro, riding in a packed elevator and chomping on a hot dog, is fiercely scolded by another passenger. "You shouldn't be eating here," says an irate woman. "People have clothes on."

It's at such moments that one realizes the kind of romantic comedy "Falling in Love" might have been,

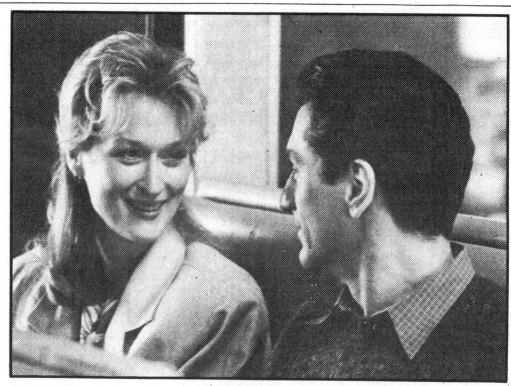

Meryl Streep and Robert De Niro play a couple of Westchester residents — each married to someone else — who are drawn to each other in "Falling in Love."

instead of the high-toned soap opera it seems content to be.

•

"Falling in Love," which has been rated PG-13 ("parental guidance suggested"), contains some vulgar language and one love scene that is unexpectedly erotic without being at all graphic.

1984 N 21, C11:1

Girl of Steel

SUPERGIRL, directed by Jeannot Szwarc; screenplay by David Odell; director of photography, Alan Hume; edited by Malcolm Cooke; music by Jerry Goldsmith; produced by Timothy Burrill; released by Tri Star Pictures. At UA Twin, Broadway and 49th Street; New York Twin, Second Avenue and 66th Street; 86th Street Twin, at Lexington Avenue; 83d Street Quad, at Broadway; 34th Street Showplace, between Second and Third Avenues, and other theaters. Running time: 105 minutes. This film is rated PG.

Selena	Faye Dunaway
Supergirl/Linda Lee	Helen Slater
Zaltar	Peter O'Toole
Alura	Mia Farrow
Bianca	Brenda Vaccaro
Nigel	Peter Cook
Zor-El	Simon Ward
Jimmy Olsen	Marc McClure
Ethan	Hart Bochner
Lucy Lane	Maureen Teefy
Mr. Danvers	David Healy

By JANET MASLIN

"FROM the producers of the Superman movies . . ." say the ads for "Supergirl," and there you have it: this is a brand-name product first and foremost. Among its trademarks are a star in blue tights, a campy villain, ear-splitting theme music to accompany credits of gleaming chrome, and a pre-Earth sequence in a setting (Argo City, a fragment of the planet Krypton) whose gaudiness is beyond belief. If "Superman" fans liked all these things the first three times around, why shouldn't they like them now?

Actually "Supergirl," which opens today at the UA Twin and other theaters, is more or less up to the series' standards. But it's also exceedingly

familiar, despite minor changes in the formula to accommodate a new star. Superman, we are told in passing, is off on "a peacekeeping mission to a galaxy that may be several hundred million light years away." Whether that means a weekend trip or a permanent vacation is moot, since a pretty blond Supercousin has materialized to fill his shoes.

•

Supergirl (Helen Slater), who has superstrength and X-ray vision and various other traits that run in her family, comes to Earth in search of an Omegahedron, a spinning paperweight which has magic powers. The Omegahedron has landed in the clutches of an aspiring witch named Selena (Faye Dunaway), who with its help becomes Supergirl's campy archrival. Supergirl, meanwhile, becomes a schoolgirl named Linda Lee. Just as Superman wore glasses to make himself look nondescript as Clark Kent, Supergirl makes herself a less buxom brunette when she's Linda.

"Supergirl" arouses some initial curiosity about the differences between the two cousins; for instance, that Supergirl can't change in phone

Faye Dunaway, foreground, and Helen Slater, in the title role, stars in "Supergirl."

booths and is much the better flier of the two. However the film, as directed by Jeannot Szwarc and written by David Odell, quickly loses its novelty. It is never as boldly witty as "Superman II," still the best in the series. Even Miss Dunaway, who seems to be vastly enjoying her witch's role, is constrained by the mildness of the material.

Miss Slater makes a four-square heroine of unrelenting sincerity; a sturdy ingenue, she is great fun to look at but hardly a live wire. Peter Cook and Brenda Vaccaro have largish supporting roles in Miss Dunaway's retinue, as opposed to the brief cameos for Peter O'Toole, Mia Farrow and Simon Ward. Hart Bochner plays the bland young man who, after drinking a magic potion, falls head over heels for Supergirl. He is more smitten than Super-weary audiences are likely to be.

•

"Supergirl" is rated PG ("Parental Guidance Suggested"). It contains mild violence that might disturb very small children.

1984 N 22, C15:2

Structure of Death

THE CASE IS CLOSED, direction by Mrinal Sen; screenplay (in Bengali with English subtitles) by Mr. Sen, based on a story by Ramapada Chowdhury; photography directed by K. K. Mahajan; edited by Gan Gadhar and Naskar; music by B. V. Karanth; produced by Neelkanth Films. At Film Forum, 57 Watts Street. Running time: 95 minutes. This film has no rating.
MamataMamata Shankar
Anjan Sen ... Anjan Dutt
SreelaSreela Majumder
PupaiIndranil Moitra
Hari Debapratim Das Gupta
Police Inspector Nilotpal Dey

By JANET MASLIN

MRINAL SEN'S "Case Is Closed" begins by introducing a middle-class Calcutta couple who are flirting with the idea of hiring a young servant. Soon thereafter, a lower-class boy of about 11, not much older than their own son, enters the couple's employ. The film, which opens today at the Film Forum, is about the aftermath of an accident that occurs some months later. The servant dies, apparently of carbon monoxide poisoning, while sleeping in a windowless kitchen on an especially cold night. He was supposed to have slept in an unheated cubbyhole under a stairwell.

The reaction of his employers, who are played by Anjan Dutt and Mamata Shankar, is initially one of fear (since the police are investigating the death) and even surprise. It has not occurred to them that the boy's life was uncomfortable or that his requirements were in any way similar to their own. Later on, the couple grow increasingly guilty over the incident, and increasingly concerned. Their growing misgivings about the young servant and the conditions under which he worked give the film its quiet, steady momentum.

Mr. Sen avoids the material's potential for easy irony, instead developing the story in a realistic and understated way. Some of the footage, particularly the shots of crowds of neighbors gathering around the couple's apartment and seeking news about the crime, even have a documentary air. The values of the couple and their peers are revealed gradually, in scenes with other family members and particularly in one se-

quence that records the wife's annoyance over the husband's having invited some local busybodies into their home. The husband supposes that this is a way of facing up to the accident. But Mr. Sen makes the death part of a complex social and economic structure that is not so easily addressed or changed.

1984 N 28, C19:5

CHINA 9, LIBERTY 37, directed by Monte Hellman; story and screenplay by Jerry Harvey and Douglas Venturelli; director of photography, Giuseppe Rotunno; editor, Cesare d'Amico; music by Pina Donaggio; produced by Gianni Bozzacchi, Valerio de Paolis and Mr. Hellman; a coproduction of Italy-Spain; Compagnia Europea, Aspa Producciones; distributed by Lorimar. At Thalia, 95th Street and Broadway. Running time: 105 minutes. This film is rated R.
MatthewWarren Oates
Clayton ..Fabio Testi
CatherineJenny Agutter
Wilbur OlsenSam Peckinpah
BarbaraIsabel Mestres
JohnnyGianrico Tondinelli
Duke ..Carlos Bravo
Virgil ..Paco Benlloch
ProstituteYvonne Sentis

By JANET MASLIN

THE laconic, supremely masculine style that has made Monte Hellman's films (including "The Shooting," "Ride in the Whirlwind" and "Two-Lane Blacktop") such cult favorites is very well represented by Mr. Hellman's "China 9, Liberty 37," which was made in 1978 and opens today at the Thalia. A Spanish-Italian co-production, it takes place in a charred-looking Spanish landscape meant to represent the American West.

In this setting (which has been beautifully photographed by Giuseppe Rotunno), a gunslinger (Fabio Testi) is given a last-minute reprieve from a death sentence in exchange for his promise to kill a former railroad employee (Warren Oates). On his way to the railroad man's homestead (the title actually denotes a road sign between two prairie hamlets), he happens upon the railroad man's wife (Jenny Agutter), who happens to be bathing in a stream.

The gunslinger is soon embroiled in a set of complications reminiscent of James M. Cain.

Mr. Hellman, who seems to care not a fig for the film's various anachronisms and incongruities ("Red River Valley" comes out "Red Reever Volley" when sung by the mostly-Italian extras), concentrates on the story's moral implications and its possibilities for visual symbolism. His use of shadows and light to represent various degrees of guilt is most expressive, as is his use of the stream to suggest eroticism. His most frequent erotic symbol is Mr. Testi, whose heavy accent as "Clayton" goes unexplained and who plays as many scenes as possible in a shirtless state. Mr. Testi and the late Mr. Oates, who gives a tersely effective performance here, share some well-realized scenes of verbal sparring.

The film is credited as "introducing" Sam Peckinpah, who plays the brief role of a writer who tries to lead the heroine toward self-interest and treachery. This, in the world view that Mr. Hellman and Mr. Peckinpah largely share, is not a difficult thing to do to the female of the species. Mr. Hellman's misogyny also makes for a remarkable moment in which the gunfighter uses the body of a naked prostitute to shield himself from an enemy. Apparently she is killed, although the camera never takes a second look.

1984 N 30, C8:4

Snow Business

SKI COUNTRY, written, directed and produced by Warren Miller; photographed by Don Brolin, Fletcher Manley, Gary Nate, Gary Capo, Lex Fletcher, Gary Bigham, Fletcher Anderson, Brian Sissleman, Karl Herrmann and Warren Miller; edited by Michael Usher, Ray Laurent, Kim Schneider, Robert Knop and Hamilton Camp; released by Warren Miller Productions. At RKO National, Broadway and 44th Street, and other theaters. Running time: 93 minutes. This film is rated G.
WITH: Greg Smith, Hans Fahlen, Lhasa Fahlen, Gunner Moberg, Pierre Vuarnet, John Low, Fred Noble, Otto Lang, Scott Brooksbank, Mike Chew, Judy McClintock, Jeff Sanders, Glenn Thurlow and others.

"WARREN MILLER'S SKI COUNTRY" is a travelogue strictly for ski enthusiasts, none of whom could possibly be as enthusiastic as Mr. Miller himself. The mastermind behind a ski magazine and 34 other films on the subject (with titles like "Sno Wonder"), Mr. Miller peppers his soundtrack with gung-ho hyperbole, inviting the viewer to "steal a brainful of thrills." Meanwhile, the camera watches endless skiers swishing down snow-capped peaks at a wide variety of resorts. One of these, the attentive listener will learn, has parking space for 2,500 cars.

Mr. Miller's film, which opens today at the RKO National and other theaters, is amateurish but good-humored, although most of Mr. Miller's actual attempts at wit — like giving clumsy skiers such nicknames as "Sluggo" and "Maybelline" — could easily have been dispensed with. Sports-minded viewers should enjoy the scenery, though, especially if they find "the look of skiing in the 1980's" a subject of compelling novelty. For others, the news that "the constantly changing ice patterns make every run down the glacier different" may not be news at all.

Janet Maslin

1984 N 30, C13:1

FILM VIEW

JANET MASLIN

Short on Talk, Big at the Box Office

Chuck Norris, Arnold Schwarzenegger, Charles Bronson: not everyone's idea of perfect party guests but nonetheless deserving of attention and even respect, since together they control such a formidable share of the movie market. Only last week, Mr. Norris's "Missing in Action" and Mr. Schwarzenegger's "Terminator" were being advertised as the nation's "New no. 1 hit!" and "The #1 movie in the U.S.A.," respectively. And "The Evil That Men Do," the latest from Mr. Bronson, made a comparable splash several months earlier.

The success of this triumvirate is greeted in some quarters by indifference, even scorn. For all the many filmgoers who would not, even at gunpoint, watch a Bronson or a Schwarzenegger epic, there are even greater numbers who could not pick out Mr. Norris from a lineup of fortyish blond tennis pros. Surely Mr. Norris, who spent many years as a karate instructor (and enjoyed a reign as world karate champion) before launching his film career, is the most underrecognized movie star in America, if not the most underrated.

Empirical evidence, in the form of millions of ticket-buying patrons, tells us that Mr. Norris unquestionably has his appeal. (When persuading a producer to back his debut feature, "Good Guys Wear Black," Mr. Norris is quoted as having made an irresistible numerical argument. "There's four million karate people in America," said he. "They all know who I am. And if only half of them go to the movie, that's a $6 million gross on a $1 million budget." He was right about everything except the gross, which proved three times what he had estimated.) But explaining that appeal isn't easy. Certainly much of it is nonverbal, as is Mr. Bronson's and Mr. Schwarzenegger's. Each of them says so little in their latest films that their collective dialogue wouldn't be enough to keep Clint Eastwood going through one of *his*.

Mr. Eastwood started out in the same tight-lipped action genre as his current disciples, who also owe noticeable debts to strong, silent types like Steve McQueen and John Wayne. Mr. McQueen reportedly advised Mr. Norris that he had spoken too much in his first film, telling him "Too much dialogue. Let the character actors lay out the plot. Then, when there's something important to say, you say it and people will listen." How-

ever, Mr. Eastwood has long since made the leap out of the B-movie chasm in which his successors still toil. "Tightrope," his most recent effort, attributed complex feelings to its hero and made some effort to understand and explain them. This sort of pussyfooting is complete anathema to everything B-moviedom stands for.

• • •

What the Messrs. Norris, Schwarzenegger and Bronson offer audiences is the opportunity for utterly uncomplicated visceral response, often to political-sounding issues. It is no accident that "Missing in Action" concerns itself with prisoners of war in Vietnam, or "The Terminator" with a nuclear holocaust of "The Evil That Men Do" with human rights violations. Mr. Bronson, whose concern with the latter issue comes awfully late in a career of unadulterated mayhem, has understood since "Death Wish" the expediency of using explosive subject matter (in that case, rape and murder) to whet an audience's appetite for revenge. Mr. Norris and Mr. Schwarzenegger, on the other hand, in their current films appear to be using similar tactics in a much less cynical way.

Unlike "Uncommon Valor," another vehement action film about a scheme to rescue missing American soldiers, "Missing in Action" wastes neither time nor words on veterans' complex feelings about Vietnam, or the war's effects on their families. Instead, it begins as an unabashed shoot-'em-up, with Mr. Norris, as an Army colonel, blasting his way through the jungle. Most of his men disappear during the battle, after which the colonel is seen back home, brooding about their fate. A little later, he embarks on his own private rescue mission and returns to Vietnam. The rest of the film is distinguished by its vigorous action sequences, its unequivocal depiction of the Vietnamese as shifty-eyed villains, and an ending in which Mr. Norris's bravado is allowed to show up the weak-kneed foreign policy of the United States Government.

Presumptuous and overbearing as this may sound, it doesn't play that way; in fact, the bashfulness with which Mr. Norris approaches such issues is a large part of his charm. Only with the greatest reluctance does he hurt anyone, albeit also with the greatest finesse. His singlemindedness is so great that he makes a point of not noticing the nude barroom dancers who, in a movie like this, constitute an obligatory bit of atmosphere. And when a female co-star, enlisted in a plot to fool Vietnamese officials by pretending to be in bed with Mr. Norris, tries to pique his genuine interest in such activities, Mr. Norris stares blankly into space. Audiences seem to love his imperviousness even more than his righteous rage.

Of course, no one's self-sufficiency can match Mr. Schwarzenegger's in "The Terminator," which casts him as a post-holocaust robot capable of repairing his own physical equipment. Mr. Schwarzenegger, in preferring the villainous title role to the leading man's heroic part originally offered him, opted for a much steelier character than the grunting lunkheads he had previously played. The change is strategic, since it presents Mr. Schwarzenegger as a figure of pure menace rather than one meant to invite understanding or sympathy. In addition to its lively and intricate plot, which has the Terminator returning from the year 2029 as a hit-man making a mysterious effort to change the future, the film owes much of its success to the star's sheer inexorability. Mr. Schwarzenegger's relentlessness here is matched only by his cautionary import as a harbinger of what a post-nuclear future might bring.

It's true that both Mr. Norris and Mr. Schwarzenegger have a long way to go before they graduate from the ranks of exploitation films to anything above-ground. But both "Missing in Action" and "The Terminator" are significant improvements over what, in each star's career, has come before. Mr. Schwarzenegger may be ready to treat his own hulking strangeness as his most marketable asset, instead of an obstacle to roles that revolve around sex appeal. And Mr. Norris, such a quiet firebrand and so sheepishly sincere, has moved well beyond the all-karate crowd. ■

1984 D 2, II:17:1

Underdog Is Top Dog

BEVERLY HILLS COP, directed by Martin Brest; screenplay by Daniel Petrie, Jr.; story by Danilo Bach and Mr. Petrie; director of photography, Bruce Surtees; edited by Billy Weber and Arthur Coburn; music by Harold Faltermeyer; produced by Don Simpson and Jerry Bruckheimer; released by Paramount Pictures. At Loews State 1 and 2, Broadway and 45th Street; Orpheum, 86th Street and Third Avenue; 34th Street Showplace, between Second and Third Avenues; 83d Street Quad, at Broadway and other theaters. Running time: 105 minutes. This film is rated R.

Alex Foley	Eddie Murphy
Detective Billy Rosewood	Judge Reinhold
Sergeant Taggart	John Ashton
Jenny Summers	Lisa Eilbacher
Lieutenant Bogomil	Ronny Cox
Victor Maitland	Steven Berkoff
Mikey Tandino	James Russo
Zack	Jonathan Banks
Chief Hubbard	Stephen Elliott
Inspector Todd	Gilbert R. Hill
Detective Foster	Art Kimbro
Detective McCabe	Joel Bailey
Serge	Bronson Pinchot
Jeffrey	Paul Reiser
Casey	Michael Champion

By JANET MASLIN

"**B**EVERLY HILLS COP" finds Eddie Murphy doing what he does best: playing the shrewdest, hippest, fastest-talking underdog in a rich man's world. An opening montage establishes the ghetto origins of Axel Foley, the Detroit policeman whom Mr. Murphy plays. But Axel turns out to be much more at home in the posh California settings where most of the film takes place. Cruising the streets of Beverly Hills in his jalopy, or strolling into hotels and restaurants in a well-worn sweatshirt, Axel maintains every bit of his cool. Far from being daunted, he enjoys the challenge. Axel's confidence never wavers, nor does his natural authority — and for that, audiences will love him.

"Beverly Hills Cop," which opens today at Loews State and other theaters, is an even better showcase for Mr. Murphy's talents than "Trading Places" was, although it gets off to a shaky start. A Detroit prologue, combining an over-scored car chase sequence with the murder of Axel's best friend, is somewhat bungled; Martin Brest, the director, establishes the friendship in such brief and sodden terms that it's a wonder Axel cares at all about finding his buddy's killers. But track them he does, and the trail leads him to a Beverly Hills art gallery filled with hilarious modern sculpture. Searching out the owner, Mr. Murphy's Axel is soon booted through a plate-glass window, At that point, two blond policemen arrest him for disturbing the peace.

However, he easily establishes the upper hand. He takes up residence in an elegant hotel that was not expecting him, after loudly intimating that the desk clerk may be practicing racial discrimination and also announcing that he's in town to interview Michael Jackson. He also makes some inroads with the local police force, who get to know him after arresting him and following him around town, and who cannot help but admire his technique. Notwithstanding the title, Axel never does join the Beverly Hills police himself. But he manages to teach them a thing or two about how to invent fish stories, how to bend the rules, and why it's imperative that no one ever put a banana in the tailpipe of a patrol car.

•

Although "Beverly Hills Cop" is less strictly a comedy than "Trading Places" was, it loses nothing by allowing Mr. Murphy a broader role; his brashness is as well suited to detective work as to sweet-talking his way out of trouble. He comes closer than ever to being able to carry a film single-handedly, although this one surrounds him with an excellent supporting cast. Mr. Brest displays a particular talent for positioning just the right actors in small roles and letting them make their marks succinctly. John Aston and Judge Reinhold are well teamed as a stuffy police sergeant and his more laissez-faire young partner, and Ronny Cox is suitably dumbfounded as the superior who can't quite understand why this Mr. Murphy's newcomer has the regulars on the ropes. Steven Berkoff makes a chilling villain named Victor Maitland, and Lisa Eilbacher is appealing as an old friend of Axel's who

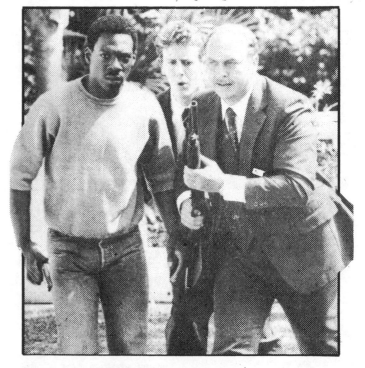

Sweatshirted Eddie Murphy stars in "Beverly Hills Cop" as a Detroit policeman tracking the killer of a friend in Beverly Hills.

happens to be in Maitland's employ. The brief scenes in Maitland's art gallery are greatly enlivened by Bronson Pinchot, whose accent should baffle linguists everywhere. Mr. Pinchot even steals these scenes from Mr. Murphy, which can't have been easy.

"Beverly Hills Cop" was written by Daniel Petrie, Jr., who co-wrote the story with Danilo Bach. The material never makes an overt issue out of Axel's blackness (indeed, the role was once intended for Sylvester Stallone), except on several occasions when Mr. Murphy slyly uses it as one more weapon in his conversational arsenal. However, the mere juxtaposition of a shabbily dressed Mr. Murphy and the film's staid Beverly Hills locations has great comic potential, in view of the star's unfailing superiority. To the extent that Mr. Murphy has a true co-star here it is the city itself, which throws up a long parade of obstacles to his mission, and which seems a constant reproach to his renegade ways. But Mr. Murphy knows exactly what he's doing, and he wins at every turn.

1984 D 5, C25:4

CITY HEAT, directed by Richard Benjamin; screenplay by Sam O. Brown (Blake Edwards) and Joseph C. Stinson; story by Mr. Brown; director of photography, Nick McLean; edited by Jacqueline Cambas; music by Lennie Niehaus; produced by Fritz Manes; released by Warner Bros. At Criterion Center, Broadway and 45th Street; Manhattan Twin, 59th Street east of Third Avenue; 83d Street Quad, at Broadway; 86th Street Twin, at Lexington Avenue; Gramercy, 23d Street near Lexington Avenue, and other theaters. Running time: 94 minutes. This film is rated PG.

Lieutenant Speer	Clint Eastwood
Mike Murphy	Burt Reynolds
Addy	Jane Alexander
Caroline Howley	Madeline Kahn
Primo Pitt	Rip Torn
Ginny Lee	Irene Cara
Dehl Swift	Richard Roundtree
Leon Coll	Tony Lo Bianco
Lonnie Ash	William Sanderson
Troy Roker	Nicholas Worth
Nino	Robert Davi
Dub Slack	Jude Farese

Friendly adversaries as fast-talking private eye and a hard-nosed policeman in the Kansas City of 1933, Burt Reynolds and Clint Eastwood team up in "City Heat," opening Friday at local theaters.

By JANET MASLIN

OVERDRESSED and overplotted as it is, "City Heat" benefits greatly from the sardonic teamwork of Clint Eastwood and Burt Reynolds. Without them the film would be eminently forgettable, but their bantering gives it an enjoyable edge. Working together in very "Sting"-like circumstances, they are cast, respectively, as a hard-boiled police lieutenant and a sharp-dressing private eye. Mr. Eastwood, in this Prohibition era setting, displays both his trademark steeliness and an underused talent for tongue-in-cheek comedy. For his part, Mr. Reynolds looks dashing and is back at the top of his wise-cracking form.

But the film itself, which opens today at the Criterion and other theaters, manages to be both cumbersome and slight. As he did in "My Favorite Year" and, to some extent, in "Racing With the Moon," Richard Benjamin has settled on an evocative time period and a top-notch cast and more or less left things at that. "City Heat" devotes much more energy to props, sets and outfits than to the dramatic streamlining it so badly needed. The screenplay, which is part "Sting," part Sam Spade and part kitchen sink, is either a hopelessly convoluted genre piece or a much too subtle take-off on the same. It was written by Joseph C. Stinson with "Sam O. Brown," a pseudonym for Blake Edwards (note Brown's initials), who at one time planned to direct it.

•

Fortunately, one of Mr. Benjamin's main contributions to the film is a good-humored buoyancy, even when things are at their most muddled. And the supporting cast (with names like Dub Slack and Primo Pitt) is a spirited one. Jane Alexander makes a sporting Girl Friday to Mr. Reynolds's Mike Murphy, her loyalty unimpaired by the vastness of the back salary he owes her; Rip Torn does some inspired eye-rolling and cigar-chomping as a gangster. Tony Lo Bianco plays a rival underworld kingpin and Richard Roundtree is around much too briefly as someone who makes the mistake of trying to double-cross both of these hoodlums. Madeline Kahn flutters by briefly as a dizzy heiress and Irene Cara, while over her head musically as a torch singer, is suitably distraught as a damsel in distress.

But Mr. Eastwood and Mr. Reynolds are of course the main attraction, trading lines like "See you around, Shorty" and "Not if I see you first, Flatfoot." From the film's opening scene in a luncheonette — with Mr. Reynolds taking a terrible beating from some thugs and Mr. Eastwood blithely ignoring this, being angry at Mr. Reynolds over some previous grievance — to a closing shot that leaves them nose-to-nose, the two of them spar charmingly. All too often, though, Mr. Eastwood fixes his face into a comically wild-eyed version of his usual squint, indicating that a shootout is about to begin. For a slick, glossy big-name entertainment, "City Heat" is a good deal more corpse-littered than it had to be.

•

"City Heat" is rated PG ("Parental Guidance Suggested"). It contains a considerable amount of violence.

1984 D 7, C4:3

Will and Destiny

OEDIPUS REX, written and directed Pier Paolo Pasolini, based on "Oedipus Rex" and "Oedipus at Colonus" by Sophocles; director of photography, Giuseppe Ruzzolini; edited by Nino Baragli; music, Rumanian and Japanese folk music; production company, Arco Film; released by Horizon Films. At the Public, 425 Lafayette Street. Running time: 110 minutes. This film has no rating.

Oedipus	Franco Citti
Jocasta	Silvana Mangano
Merope	Alida Valli
Creon	Carmelo Bene
Tiresias	Julian Beck
Laius	Luciano Bartoli
Servant	Francesco Leonetti
Polybus	Ahmed Bellashmi
Shepherd of Polybus	Giandomenico Davoli
Messenger/Angelo	Ninetto Davoli
High Priest	Pier Paolo Pasolini
Priest	Jean-Claude Biette

THROUGH the window on the second floor of a middle-class house, in a room dimly lit by electricity, a woman gives birth to a son. In a quick succession of brief scenes, we see how the baby, as it grows up to be able to totter around on its own, earns the jealousy of his handsome father, a member of Mussolini's militia, while his beautiful mother is torn between love for husband and child. On a night of national celebration, the small boy gets out of bed and makes his way to the window where he watches the fireworks that both enthrall and frighten him.

Cut, suddenly, from this scene, which Freudians might call primal, to some prehistoric past and an arid, barren landscape. A man, in rags, carries an infant. He stops, puts the baby on the ground, raises his sword, but cannot bring himself to skewer it. Instead, he leaves the child to the forces of nature.

It's within this curious, very personal frame that Pier Paolo Pasolini sets his free, sometimes inscrutable but always handsome adaptation of Sophocles's "Oedipus the King" and "Oedipus at Colonus."

Titled "Oedipus Rex," the 1967 film, which has its New York premiere today at the Public Theater, contains somewhat more Pasolini than it does Sophocles. Even though all never becomes clear in it, Pasolini's "Oedipus" remains a fascinating film, one that demonstrates the late, controversial Italian director's gifts as one of the most original and perverse film poets of his generation. It's not always necessary to understand Pasolini to be riveted by what he does.

In terms of the Pasolini filmography, "Oedipus Rex" comes after "Accatone," "Mama Roma," "The Gospel According to Saint Matthew" and "The Hawks and the Sparrows." It immediately precedes his wildly eccentric, psycho-sexual-Marxist "Teorema" and "Pigpen." These in turn were followed by his adaptation of Euripides's "Medea," starring the magnificent face of Maria Callas, his trilogy of features based on "The Decameron," "The Canterbury Tales" and "A Thousand and One Nights" — his most easily entertaining films — and his last effort, the unspeakable "Salo," which he completed shortly before his murder in 1975.

•

By far the most effective portions of this "Oedipus" are those modern, semi-autobiographical sequences by which Pasolini frames the myth of the prince who, in innocence, murders his father, marries his mother and, when he learns the terrible truth, gouges out his eyes and goes into a wandering exile.

These sequences, which form the principal part of the film and were shot in Morocco, are pictorially arresting but so chilly they seem dead. As I'm sure Pasolini intended, they are pageant-like, having the manner less of drama than of ritual that must be played out according to prescribed rules.

"Oedipus Rex" has nothing comparable to the extraordinary screen presense of Miss Callas in "Medea." Silvana Mangano, who also plays the mother in the opening sequence, is a passionate, stunning-looking Jocasta. However, as Oedipus, Franco Citti, whom Pasolini cast in most of his early films, looks so contemporary that one must assume a point is being made. He has the rough good looks of a boxer, but the performance is so stolid that when the camera comes in for a tight close-up of his eyes — as it frequently does — one sees only a pair of disembodied eyes. There's no awareness of a mind behind them.

The excellent supporting cast includes Alida Valli, as Oedipus's adoptive mother; the Living Theater's Julian Beck as Tiresius, the blind seer; Ninetto Davoli, Pasolini's favorite aging-faun of an actor, as the messenger, and Pasolini himself as a high priest.

•

As he did in "Medea," Pasolini shows us a lot of action that the original playwright only talks about. Though "Oedipus at Colonus" is credited as one of the sources, there's nothing of it in the film, unless it has been used to suggest the closing sequence set in contemporary Bologna, the point of which completely escapes me.

It's also difficult to understand how Pasolini connects the contemporary frame with "Oedipus the King," which, toward the end, includes the great if enigmatic speech, "There, now all is clear, willed, not imposed

Franco Citti plays the title role in Pier Paolo Pasolini's 1967 version of "Oedipus Rex," with Silvana Mangano, Alida Valli and Julian Beck.

John Lithgow ventures into space in "2010," based on the Arthur C. Clarke novel and continuing the adventure begun in "2001."

by destiny." Pasolini publicly acknowledged his initial hatred of his own father, but in this film the father is seen as a viciously antagonistic, possessive man who hates his son from birth. The gods have nothing to do with it, nor, for that matter, does the son's attachment for his mother.

Except for some now rather old-fashioned-looking hand-held camera work, Giuseppe Ruzzolini's photography is very good, both in evoking the contemporary world and the legendary past, where even the costumes seem to be alive. People wear bits and pieces of bushes and trees. They decorate themselves with metal ornaments that appear to have been put on right out of the ground, as if the jewelry still belonged to the primeval landscape over which this ancient society has yet to gain dominion.

Vincent Canby

1984 D 7, C8:5

2010, directed and produced by Peter Hyams; screenplay by Mr. Hyams, based on the novel by Arthur C. Clarke; director of photography, Mr. Hyams; visual effects supervisor, Richard Edlund; special effects supervisor, Henry Millar; edited by James Mitchell; music by David Shire; released by MGM/UA Entertainment Co. At Astor Plaza, 44th Street west of Broadway; New York Twin, Second Avenue and 66th Street; 34th Street Showplace, between Second and Third Avenues and other theaters. Running time: 157 minutes. This film is rated PG.

Heywood Floyd	Roy Scheider
Walter Curnow	John Lithgow
Tanya Kirbuk	Helen Mirren
R. Chandra	Bob Balaban
Dave Bowman	Keir Dullea
Hal 9000	Douglas Rain
Caroline Floyd	Madolyn Smith
Dimitri Moisevitch	Dana Elcar
Christopher Floyd	Taliesin Jaffe
Victor Milson	James McEachin
Betty Fernandez	Mary Jo Deschanel
Maxim Brailovsky	Elya Baskin
Vladimir Rudenko	Savely Kramarov
Vasali Orlov	Oleg Rudnik
Irina Yakunina	Natasha Schneider
Yuri Svetlanov	Vladimir Skomarovsky
Mikolai Ternovsky	Victor Steinbach
Alexander Kovalev	Jan Triska

By VINCENT CANBY

THE film "2010" is a perfectly adequate — though not really comparable — sequel to Stanley Kubrick's witty, mind-bending science-fiction classic, "2001: A Space Odyssey." That film, a dazzling invention, was as much about the prepackaged, Musak-orchestrated, flash-frozen consumer society of 1968, and about our primordial past, as it was about our dreams of the future.

The new film was written and directed by Peter Hyams, who was also his own director of photography, and is based on a novel by that guru of sci-fi literature, Arthur C. Clarke, whose original story was the basis of the Kubrick film. Unlike most sequels, this one avoids the tacky, but it never quite escapes the manner of something made by clever copyists who, working in Taiwan or Korea, do their work well and efficiently though without the excitement of truly original inspiration and lunatic risk.

The time, of course, is 2010, nine years after the United States spaceship Discovery, its crew dead or missing, has fallen into a soon-to-be-fatal orbit around Jupiter. At the opening of "2010," Heywood Floyd (Roy Scheider), the man who was responsible for the failed Discovery mission, is approached by a Russian scientist with the proposition that the United States and the Soviet Union launch a joint space probe to find out what happened.

As anyone who saw the original film knows, and as the members of the audience who watch Mr. Hyams's film are carefully told in spoon-fed exposition, the Discovery's master computer, named HAL, malfunctioned, killing all but one of the crew, Dave Bowman (Keir Dullea), whose last message to earth was something to the effect that "My God, it's full of stars!"

•

The Soviet scientist, arguing that the Russians will be able to get a spaceship to Jupiter long before the Americans but will be unable to unravel the mystery without United States cooperation, is able to persuade the American scientists, as well as an American President described as reactionary, to approve the joint operation.

Most of "2010" takes place aboard the Soviet spacecraft Leonov, a fine piece of special effects work that, on the outside, looks like the world's largest baton and, on the inside, like a heavenly video-game parlor. In addition to Floyd, the American crew is composed of Walter Curnow (John Lithgow) and R. Chandra (Bob Balaban), the scientist whose job it will be to rehabilitate the egocentric HAL.

The Russian members of the crew include its captain, Tanya Kirbuk (Helen Mirren), who's a practical but not unfeeling officer, several men whose personalities and duties are never fully explained, and one pretty young woman named Irina (Natasha Schneider) who, at a crucially scary moment, loses her Russian reserve and allows herself to be cuddled by Floyd.

Giving the film a kind of political timeliness is the fact that while the Leonov is approaching Jupiter, the Americans and the Russians on earth are approaching a 2010 equivalent to the 1962 Cuban missile crisis. A Soviet ship, trying to run a United States naval blockade of Honduras, is blown out of the water, and the Russians retaliate by destroying a key American military satellite.

Anyone who doesn't realize that earth wars look silly and puny when compared to the immensity of the mysteries to be solved in space — OUT THERE — has never seen a science-fiction film.

Reappearing in the new film, although not exactly as they did in the original, are Mr. Dullea, the Discovery itself, the embryonic baby last seen floating toward earth, "Thus Spake Zarathustra!" and, of course, the great monolithic slabs that seem to possess the secrets of all creation.

"2010" is not, however, very mysterious, and although it has its own little epiphanies, they are — is it possible to say? — rather conventional epiphanies. Most of the film is devoted to the kinds of special effects and technological problems that, since 1968, have become more or less standard in sci-fi cinema.

Mr. Hyams and Mr. Clarke carefully avoid the sort of poetic and — to some — maddening ambiguities that forever separate the Kubrick film from all that came before and all that have come after. Even the explanation for HAL's murderous behavior in the first film sounds as mundane as a radio-station psychiatrist's words of advice to a mother whose child hyperventilates.

The cast is a good one, although everyone is upstaged by the fancy hardware. Mr. Scheider and Miss Mirren, fine actors both, do exactly what's required of them, which mostly means being strong and stoic. "2010" is without wit, which is not to say that it is witless. A lot of care has gone into it, but it has no satirical substructure to match that of the Kubrick film, and which was eventually responsible for that film's continuing popularity.

"2010," which opens today at Loew's Astor Plaza and other theaters, is not a movie that is likely to attract or interest audiences not already hooked on the genre.

"2010," which has been rated PG ("parental guidance suggested"), contains some mildly vulgar language.

1984 D 7, C15:1

FILM VIEW

JANET MASLIN

'Falling in Love'

F ew things are less easily represented on the screen than ordinary life. The illusion of realism can be disrupted by the slightest false move, and anyhow, ordinary life is something audiences presumably get at home free of charge. Even films that successfully simulate day-to-day activity run the risk of losing the viewer to sheer monotony, since such material may not provide much occasion for thought. On the other hand, when an ordinary-life film does strike the right chord, it can affect an audience overpoweringly.

Such films, when they work, contain few obstacles to direct identification with the characters and to pure, uncomplicated emotional response.

"Falling in Love," as directed by Ulu Grosbard, exemplifies the sort of ordinary-life filmmaking that isn't easily championed, since its characters' inarticulateness borders on the tongue-tied. Without the disagreeable best friends (played by Dianne Wiest and Harvey Keitel) who function as a chorus, reflecting modern mores and presenting Frank Raftis (Robert De Niro) and Molly Gilmore (Meryl Streep) with opportunities to talk about each other, the principals might never say anything at all. In fact, without actors of the caliber of Miss Streep and Mr. De Niro, "Falling in Love" would be entirely becalmed. The screenplay so stresses the characters' suburban drabness that it barely gives them any distinguishing features whatsoever.

And yet "Falling in Love," indefensible as it is from some standpoints, is a film that makes the most of the mundane. On the simplest visceral level, it works. Audiences well schooled in both the "Brief Encounter" style of star-crossed romance and the "Kramer vs. Kramer" brand of upscale realism — both palpable influences on "Falling in Love" — will still be taken in. The film's very ordinariness, which winds up disguising so many missteps and improbabilities, becomes evidence of its skill.

• • •

The story of "Falling in Love," for all its realistic trappings, cannot have been brought to life easily. Frank and Molly, when first seen, are unacquainted commuters, both married, who happen to take the same train. The screenplay, by the playwright Michael Cristofer, insists on involving them in a series of parallel activities, so that they both, while in Manhattan, buy Christmas presents in the same stores, eat hot dogs and make identical phone calls home. These coincidences, redundant and only minimally revealing, very nearly ruin the film's chances of striking a lifelike tone.

But "Falling in Love" seduces the audience as gradually as the characters seduce each other. The viewer grows increasingly able to believe that Frank and Molly, though apparently content with their marriages, are ready to let lightning strike. Each of them is seen buying vaguely inappropriate Christmas gifts for a spouse, indicating that the marriages have lost some of their closeness. Frank's wife (played very appealingly by Jane Kaczmarek) complains jokingly about the intrusiveness of their two young sons; meanwhile Molly, who is childless and is seen drinking champagne with her husband (David Clennon) on Christmas morning, enjoys a warm relationship with her ailing father. This isn't much to explain why Frank and Molly drift into a liaison, but it's all that the screenplay offers. It may even be Mr. Cristofer and Mr. Grosbard's point that it requires hardly anything, in an era of free choice and easy mobility, for marriages to fall apart.

• • •

That the characters do not become sexually involved during the course of the story (although the drama's frustrated eroticism is highly effective) is one of the film's shrewder contemporary touches; sex would offer too easy an explanation for the affair. Another is the film's ability to convey the seriousness of the romance without relying, in the traditional manner, upon guilt to convey gravity. "Falling in Love" seems to be saying something about the heedlessness with which these people can drift, and about the insubstantiality of what look like well-grounded middle-class lives. But it approaches this neither judgmentally nor analytically, allowing the love affair to exist in a near-perfect moral vacuum. The audience can read anything or nothing into these cryptic suburban prototypes and their extracurricular passion.

The stars help give this material its smoothness and simplicity, as well as much of its magnetism. When Mr. De Niro, who has never been anywhere near a small child or a station wagon in previous roles, is heard rehearsing a come-on line like "Hello, what a surprise to see you!" in Grand Central Station, he is indeed a long way from the "You talkin' to me?" of his "Taxi-Driver" days. For both him and Miss Streep, the nervous flirtatiousness and Everyman mufti of "Falling in Love" don't mark the opportunities of a lifetime, but they are something different. These roles, for actors with so many triumphs to their credit, cannot help but seem slight, but the performers' very accessibility holds a certain fascination. Mr. De Niro's utter normalcy here is, in the context of his career, no less bizarre than his mastery of saxophone playing ("New York, New York") or boxing ("Raging Bull"). Miss Streep's tiny nuances in this role, as she transforms herself from a prim, plain figure to a radiant one in full bloom, display equal grace and expertise.

Certainly "Falling in Love" is a conversation piece, one capable of sparking heated debate on some of its more questionable plot points and on other matters; at one recent screening, I heard a fight break out between two previously unacquainted viewers, one who found the film highly romantic and another who pronounced it sappy beyond belief. The latter partisan isn't entirely wrong, but "Falling in Love" has a gentle momentum that manages to render such reactions secondary. Audiences seem quietly and raptly interested in what is, at the very least, a warmly old-fashioned soap opera with several significant new twists. And for all its flaws, "Falling in Love" is one of those ordinary-seeming modern films that present unremarkable characters in the throes of all-too-familiar contemporary crises. When films in this genre succeed fully and realistically in mirroring the audience's concerns, they aren't ordinary at all. ■

1984 D 9, II:21:1

Nate Hardman portrays Charlie Banks in Billy Woodberry's film "Bless Their Little Hearts."

Serene Desperation

BLESS THEIR LITTLE HEARTS, directed, produced and edited by Billy Woodberry; written and photographed by Charles Burnett. At the Film Forum, 57 Watts Street. Running time: 80 minutes. This film has no rating.
Charlie Banks Nate Hardman
Andais Banks Kaycee Moore
Banks Children
 Angela, Ronald and Kimberly Burnett

By VINCENT CANBY

"**B**LESS THEIR LITTLE HEARTS," which opens today at the Film Forum, is a small, self-assured, independent American film that, though severely even-tempered, never disguises its own anger or that of its characters, the members of an economically cornered black family who live in the Watts section of Los Angeles.

In the course of the film, Charlie Banks (Nate Hardman), an unemployed factory worker, and his pretty, tight-lipped wife, Andais (Kaycee Moore), who supports the family by apparently working as a domestic, have only one fight. Most of the time they treat each other with the elaborately polite though genuine concern of people hanging onto sanity by their finger-tips, and now are nearing exhaustion.

Charlie and Andais, who have three young children, have obviously seen better days. Their house, though modest, is neat and clean and comparatively roomy, equipped with all of the appliances standard to average American lives. Though the film never says so, the Banks family seems to have migrated from the South to Los Angeles some years before, when jobs were plentiful and upward mobility a reality.

•

Charlie tries to make ends meet by taking pick-up jobs, most often as a handyman and sometimes as a house painter. He gets no encouragement at the unemployment office. A barber friend suggests that Charlie may just be "too choicy" about the kind of work he'll do, which is clearly not the case.

With some his unemployed pals, he comes up with hare-brained schemes for making money, including fishing off the rocks and selling their catch to passing motorists. Another pal suggests they go shoot some rabbits. "You know how far we'd have to drive to find rabbits?" says another, squelching that plan.

By the time Charlie gets home at night, Andais, worn out, is already in bed, while Angela, 12, the eldest child, feeds her younger brother and sister. It's the children who feel the full impact of Charlie's frustration. He jumps on Ronald, 10, for allowing his fingernails to grow too long. "You want to be a sissy?" Charlie bellows at the boy. "Go get the nail clippers." As Charlie trims Ronald's nails and questions the boy's virility, Ronald's lower lip quivers in humiliation.

Charlie's anger is even expressed by the force with which he turns off the water faucet after shaving. Kimberly, the youngest child, has to use a wrench to turn the faucet back on.

It's through a succession of brief, sometimes comic, emotionally loaded but understated scenes like these that Billy Woodberry, the director and editor, and Charles Burnett, the writer and cameraman, dramatize the almost serenely desperate situation facing Charlie, Andais and their kids. Except for one brief flare-up between Charlie and Andais, when she confronts him by her knowledge that he's been having an affair, the film makers avoid any hint of melodrama. Charlie is being emasculated, not by people or forces he can see, but by a casually disinterested system.

"Bless Their Little Hearts" is so understated that at times it seems diffident, as if it were too shy to display its fury in more robust terms. This, however, is the style of the film that Mr. Woodberry, Mr. Burnett and their splendid cast, headed by Mr. Hardman and Miss Moore, have chosen to make, and it works beautifully.

1984 D 12, C25:5

Taps and Rackets

THE COTTON CLUB, directed by Francis Coppola; screenplay by William Kennedy and Mr. Coppola; story by Mr. Kennedy, Mr. Coppola and Mario Puzo; director of photography, Stephen Goldblatt; edited by Barry Malkin and Robert Q. Lovett; music by John Barry; produced by Robert Evans; released by the Orion Pictures Corporation. At Loews State, Broadway and 45th Street; Orpheum, 86th Street and Third Avenue; 34th Street Showplace, at Second Avenue, and other theaters. Running time: 121 minutes. This film is rated R.
Dixie Dwyer Richard Gere
Sandman Williams Gregory Hines
Vera Cicero Diane Lane
Lila Rose Oliver Lonette McKee
Owney Madden Bob Hoskins
Dutch Schultz James Remar
Vincent Dwyer Nicolas Cage
Abbadabba Berman Allen Garfield
Frenchy Demange Fred Gwynne

"**T**HE COTTON CLUB" may well be a tap-dancing "Cleopatra" for the 1980's, a period movie whose time and — apparently — script had not

come when principal photography began in New York a couple of years ago. It obviously cost a bundle but, considering the rate of inflation since the early 60's, "The Cotton Club" probably didn't cost as much as "Cleopatra," best remembered now for some of the post-production comments made by its exhausted writer-director, Joseph L. Mankiewicz, in his war with 20th Century-Fox: "They could cut it into banjo picks if they want."

Just as "Cleopatra" was somewhat better than its harshest critics said, and considerably worse than its supporters thought, "The Cotton Club" is not a complete disaster, but it's not a whole lot of fun. It just runs on and on at considerable length, doing obligatory things, being photographically fancy but demonstrating no special character, style or excitement.

There is an air about it of expensive desperation that no one, not even Francis Ford Coppola, could ease. It was Mr. Coppola whom the producer Robert Evans initially called in as a "script doctor" to work on Mr. Evans's original inspiration, James Haskins's pictorial history of Harlem's famous Cotton Club in the late 1920's and early 1930's. Mr. Coppola stayed on not only to direct the film, but to create an entirely new story with William Kennedy and Mario Puzo and to write the screenplay with Mr. Kennedy.

Like "Cleopatra," the new movie calls attention to the defects of a system. "The Cotton Club" somehow found itself in production before anybody connected with it had any idea what kind of a movie it was supposed to be. Musicians may noodle, artists sketch and novelists fill notebooks with material they'll never use. When commercial movie makers attempt to do the same thing as they put their thoughts in order, heads roll and entire corporations totter.

•

"The Cotton Club," which opens today at Loew's State and other theaters, means to be a singing, dancing, melodramatic epic set in and around the old Cotton Club, which featured great black entertainers, plus a chorus line of light-skinned dancers described in ads as "tall, tan, terrific," and which practiced its own brand of apartheid — a whites-only admissions policy.

The film's narrative mixes up real-life characters like Dutch Schultz, the mobster; Owney Madden, the owner of the Cotton Club who hobnobbed with gang leaders; Cab Calloway, and Gloria Swanson, with fictitious characters that suggest such people as George Raft, Lena Horne, Texas Guinan and Vincent (Mad Dog) Coll.

Just what the film might have been is evident in its closing moments when, in an expressionistic montage, it cross-cuts between a big Cotton Club production number and what's happening to various characters outside the club. However, the movie, though busy throughout, has created so little interest that this potentially fantastic finale seems designed not to tie up loose ends but to pick up lint.

The story — and there's more than enough of it — principally concerns the fortunes of a handsome young cornet player named Dixie Dwyer (Richard Gere), who unwittingly becomes a favorite go-fer for Dutch Schultz (James Remar), who's intent on cutting himself into the Harlem numbers rackets.

Among his other duties, Dixie acts as Dutch's "beard," that is, as the escort for Dutch's pretty, tough young

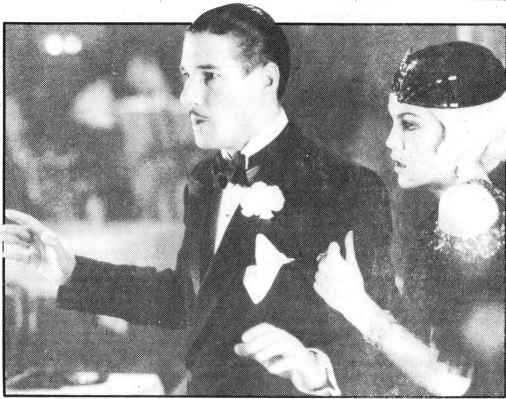

Richard Gere and Diane Lane find themselves involved with notorious New York gangsters and nightclub life and entertainment during the 1920's and 30's in Francis Coppola's "Cotton Club."

mistress, Vera Cicero (Diane Lane), when Dutch's wife is around. Vera, who looks a lot like Tuesday Weld in "Once Upon a Time in America" and tries to behave like Texas Guinan, may love Dixie but her heart has been bought by Dutch, who has promised to set her up in her own nightclub.

A parallel story concerns an ambitious young black tap-dancer, Sandman Williams (Gregory Hines), and his love for a beautiful young showgirl, Lila Rose Oliver (Lonette McKee), who is torn between her love for Sandman and her ability to "pass" for white and live in a world without facing discrimination.

In the several years the film covers, Dixie breaks away from Dutch's control by becoming a big Hollywood movie star who plays gangster roles; his younger brother, Vinnie Dwyer (Nicolas Cage), becomes one of Dutch's hoods and eventually tries to cross Dutch as Dutch himself attempts to cross other mobsters in a gang war. Through it all, the Cotton Club prospers.

The best things in the film are its musical numbers, but though "The Cotton Club" is loaded with period music, it becomes overwhelmed by the general sloppiness of everything that's going on. Several first-rate moments are a terrific "Crazy Rhythm" tap number danced by Gregory Hines and his brother Maurice, an impromptu tap demonstration by Gregory Hines, Charles (Honi) Coles and others at a black dancers' hangout called the Hoofers Club, and a rendition of the great standard "Am I Blue?" seemingly sung by Miss Lane, accompanied by Mr. Gere on his cornet, which the credits say, he plays himself.

Though the rest of the material is less than great, the performances are all more than O.K., especially those by Mr. Gere, Mr. Hines, Miss Lane, Mr. Remar and Miss McKee. In a

class by himself is Britain's Bob Hoskins ("The Long Good Friday"), who is especially effective as Owney Madden.

Noteworthy in a supporting role is Julian Beck, who plays an especially nasty mob member. Also playing supporting roles, but on and off so fast that their use seems to be profligate, are Gwen Verdon, Thelma Carpenter and Joe Dallesandro, the one-time Andy Warhol star, who has aged gracefully enough to stand out in his brief appearance as Charles "Lucky" Luciano.

Vincent Canby

1984 D 14, C4:3

Comedy of Manners

A PASSAGE TO INDIA, directed and edited by David Lean; screenplay by Mr. Lean; director of photography, Ernest Day; music by Maurice Jarre; produced by John Brabourne and Richard Goodwin; released by Columbia Pictures. At the Ziegfeld, Avenue of the Americas and 54th Street. Running time: 160 minutes. This film is rated PG.

Adela Quested	Judy Davis
Doctor Aziz	Victor Banerjee
Mrs. Moore	Peggy Ashcroft
Richard Fielding	James Fox
Godbole	Alec Guinness
Ronny Heaslop	Nigel Havers

By VINCENT CANBY

AFTER watching the first public performance of Santha Rama Rau's dramatization of his "Passage to India" at Oxford in 1960, E. M. Forster, then 81 years old, walked onto the stage to express his pleasure with the performance.

"How good the actors were," said Forster. "And how pleased I am that there were so many of them. I am so used to seeing the sort of play which deals with one man and two women. They do not leave me with the feeling I have made a full theatrical meal . . .

Judy Davis in David Lean's film "A Passage to India."

they do not give me the experience of the multiplicity of life."

Later, as P. N. Furbank reports in his fine biography, "E. M. Forster: A Life," Forster called "absurd" the play's review in The Times of London that described it as being about "the incompatibility of East and West." According to Forster, he was really concerned with "the difficulty of living in the universe."

•

Forster, who died in 1970, might be equally pleased by most of David Lean's respectful, handsome new screen version, which cites as its sources the play as well as the novel.

The film is very much a full theatrical meal," and one that conveys a lot of "the multiplicity of life" one seldom sees on the screen these days.

Alec Guinness stars in "A Passage to India,"

Mr. Lean's "Passage to India," which he wrote and directed, is by far his best work since "The Bridge on the River Kwai" and "Lawrence of Arabia" and perhaps his most humane and moving film since "Brief Encounter." Though vast in physical scale and set against a tumultuous Indian background, it is also intimate, funny and moving in the manner of a film maker completely in control of his material. Mr. Lean shares with Forster an appreciation for the difficulties involved in coping with the universe.

Because of the reputation the novel has acquired as a classic since its publication in 1924, one tends to forget what a smashingly good story it is — a grandly sorrowful muddle that becomes a mystery for the saddest, nastiest of reasons.

Set in the fictitious provincial city of Chandrapore in the 1920's, when the British raj was being threatened by the king-emperor's increasingly impatient Indian subjects, "A Passage to India" is essentially a story of what can happen as a result of a succession of wrong-headed decisions and dreadful misunderstandings, of trust either given too easily or withheld far too long.

Though the initial scenes are set in London, the film really begins with the arrival in Chandrapore of the uncommonly wise, kind and sensitive Mrs. Moore (Peggy Ashcroft), who has come out from England to visit her son Ronny Heaslop (Nigel Havers), the British magistrate, and to chaperon Adela Quested (Judy Davis), the proper young Englishwoman to whom Ronny is unofficially engaged.

•

Almost immediately the liberal-minded Mrs. Moore and Adela are upset by the cloistered life of the small, hopelessly genteel British colony at Chandrapore. They are appalled by the attitudes of their compatriots toward the Indians and by the total lack of interest in what Mrs. Moore and Adela keep referring to as "the real India." They have scarcely settled in at Chandrapore before Adela is speaking about the possibility of "adventures," to which Mrs. Moore, similarly excited, adds that "adventures do occur, but not punctually."

They refuse to fall into the routine of cricket, polo and afternoons at the club followed by the other members of this British station. With the help of the local school superintendent, Richard Fielding (James Fox), Mrs.

Moore and Adela attempt to break the invisible raj-barrier.

Through Fielding, they meet an eccentric old Brahmin scholar, Professor Godbole (Alec Guinness), whose words of wisdom, being inscrutable, they hang onto with delight, and an earnest, eager-to-please young Moslem medical doctor named Aziz (Victor Banerjee), a hard-working, financially impoverished widower who both admires and loathes the British in Chandrapore.

Aziz, who must be one of fiction's most appealing and brave comic heroes, gets carried away by the unexpected friendliness of Mrs. Moore and Adela at a small tea party He invites them, along with Fielding and Professor Godbole, to go on an elaborate outing he cannot afford, a daylong picnic to the Maraban Caves, always called "extraordinary," though for reasons that no one can satisfactorily explain. The caves are not beautiful. They contain no sculpture or wall carvings and have absolutely no religious significance. Their importance seems to predate time.

The disastrous consequences of this outing, which occurs early in the film, set up everything that comes after, including an uproarious, agonizing courtroom melodrama during which Aziz is accused of the rape of the once dazzled, now nearly catatonic, Adela.

•

What happend in the Marabar Caves? That question pursued Forster throughout his life, and he always avoided answering.

In Mr. Lean's screenplay, which in most ways is remarkably faithful to the novel — it includes large swatches of very funny Forster dialogue — there is no longer much of a mystery. The audience knows, or at least thinks it knows, exactly what happened in the caves, which makes poor Aziz's trial even more outrageous than it is in the novel.

This conscious decision on Mr. Lean's part subtly distorts the original, but it also emphasizes some surprising revelations about Adela. Even more peculiar is Mr. Lean's decision

to withhold from the audience a scene in the novel that explains Mrs. Moore's seemingly uncharacteristic actions preceeding Aziz's trial. Though he has made "A Passage to India" both less mysterious and more cryptic than the book, the film remains a wonderfully provocative tale, full of vivid characters, all played to near perfection.

At the film's center is Mr. Banerjee's superb performance as Aziz, a mad mixture of foolishness, bravery, honor and anger. Miss Davis, the young Australian actress who first caught American attention in "My Brilliant Career," is far prettier than Forster's Adela, but she has a particular presence — like that of a younger, less abrasive Glenda Jackson — that helps make the film work. The film's tone is set by the splendid Miss Ashcroft's Mrs. Moore, whose self-assurance slowly ebbs as events and life overwhelm her.

Mr. Guinness doesn't exactly underact. There are times when his performance comes perilously close to a Peter Sellers impersonation, but still he's invigorating company. Equally good in less flamboyant roles are Mr. Fox and Mr. Havers, and the members of the huge supporting cast.

The film contains a rather major flaw, one that keeps a very good film from being great. Though "A Passage to India," which opens today at the Ziegfeld Theater, is essentially a dark comedy of manners, Mr. Lean sometimes appears to think of it as a romance. In this he's being as wrongheaded as the unfortunate Adela. This is the only explanation for the terrible Maurice Jarre score, which contradicts the images and sounds like a reworking of the music he wrote for Mr. Lean's unsuccessful "Ryan's Daughter." This score has nothing to do with Forster, India, the time or the story, but it has everything to do with movie-making in the 1960's, when soundtrack music first became a major element in the merchandising of movies, including Mr. Lean's "Dr. Zhivago."

1984 D 14, C10:1

Sci-Fi Love Story

STARMAN, directed by John Carpenter; written by Bruce A. Evans and Raynold Gideon; director of photography, Donald M. Morgan; edited by Marion Rothman; music by Jack Nitzsche; produced by Larry J. Franco; released by Columbia Pictures. At UA Twin, Broadway and 49th Street; Coronet, Third Avenue and 59th Street; Bay, 32d Street and Second Avenue; 23d Street West, between Eighth and Ninth Avenues and other theaters. Running time: 112 minutes. This film is rated PG.

Starman	Jeff Bridges
Jenny Hayden	Karen Allen
Mark Shermin	Charles Martin Smith
George Fox	Richard Jaeckel
Major Bell	Robert Phalen
Sergeant Lemon	Tony Edwards
Brad Heinmuller	John Walter Davis
Deer Hunter	Ted white
Cops	Dirk Blocker, M.C. Gainey
Hot Rodder	Sean Faro

By JANET MASLIN

IF "Starman" doesn't make a major difference in Jeff Bridges' career, Mr. Bridges is operating in the wrong galaxy. For a long time, in films ranging from "Winter Kills" to "Against All Odds," Mr. Bridges has been shedding baby fat literally and figuratively, evolving into a wonderfully natural and sympathetic leading man. "Starman" provides him with a role that, played by anyone else, might seem preposterous. In Mr. Bridges' hands it becomes the occasion for a sweetly affecting characterization — a fine showcase for the actor's blend of grace, precision and seemingly offhanded charm.

"Starman," which opens today at the Coronet and other theaters, does a great deal for John Carpenter, too. Taking this, a project made notorious by Columbia's having chosen it rather than the thematically similar "E.T.," Mr. Carpenter has elected to turn the material's familiar elements into assets. If this is a science fiction fable with sex appeal, where's the harm? Mr. Carpenter, making his own definitive leap out of the horror genre, gives the story a swift pace, a crisp look and the kind of logic and coherence that, in any kind of material, are welcome.

Karen Allen plays a widow and Jeff Bridges plays an extraterrestrial on an exploratory mission who assumes the form of her late husband in John Carpenter's "Starman,"

Mr. Bridges makes quite an entrance in the film, materializing on the floor of a cabin in Wisconsin where a young widow named Jenny Hayden (Karen Allen) has been watching home movies of her late husband. Mr. Bridges, as a disembodied extraterrestrial sent to Earth in response to Voyager 2's invitation, chooses to become an exact replica of the dead man. The blue light, the hurtling spacecraft, even the rapidly expanding organism (the alien grows from infant to adult in merely a minute) may be staples of this sort of story, but Mr. Carpenter gives them elements of originality all the same. The film sustains its slight but distinctive visual edge throughout, even giving new life to places like Las Vegas and Monument Valley. The latter, for once, is filmed snow-covered.

The Starman, like E.T., must return home quickly before he weakens and fades. He also shares with E.T. a beatific innocence and the ability to understand earthly customs with phenomenal alacrity. In the Starman's case, this means remembering everything perfectly but managing, through his comic obliviousness to nuance, to get things a little bit wrong. "I can't get no . . . satisfaction," he supposes from listening to a record carried by Voyager 2, is a conversational remark. Watching Jenny drive, after he insists that she take him to a rendezvous point in Arizona, he studies her response to traffic lights and deduces that the rule is "red light, stop; green light, go; yellow light, go very fast."

•

"Starman" is also a love story, tracing Jenny's growing attachment to this exact replica of her husband and the Starman's corresponding attraction to her (which she is able to act upon only after studying the beach scene in "From Here to Eternity" on the Late Show.) It works best where it might have been hokiest, depicting earthly customs as perceived by an alien who is utterly benign, even saintly. During the course of the story, it develops that the Starman can start a car with his fingertip and even revive the dead. He is unmistakably the product of a higher civilization, but neither Mr. Bridges nor Mr. Carpenter make the mistake of overaccentuating that fact.

Mr. Bridges, at first using stiff, mechanical head movements and the gait of a giant toddler, moves into more comfortable human gestures by means of a deductive process that the audience can easily follow. And he remains oddly poised even when the character is clumsiest. Miss Allen, throaty and wide-eyed, melts convincingly from fear and disbelief into fondness. Richard Jaeckel and Charles Martin Smith figure in a somewhat gratuitous subplot about the Government's efforts to catch the Starman and dissect him, but they bring conviction to their roles. Lu Leonard, as a sympathetic waitress Jenny meets in a truck stop, does a lot with a very small part.

The usual kudos go to Industrial Light & Magic for special visual effects, to visual consultant Joe Alves and to Dick Smith, Stan Winston and Rick Baker, who collaborated on Starman's transformation scene. If you'd ever like to blossom into a space creature, cat-eyed monster or werewolf, these are the people to call.

"Starman" is rated PG ("Parental Guidance Suggested"). It contains some brief nudity.

1984 D 14, C18:1

War of the Worms

DUNE, directed by David Lynch; screenplay by Mr. Lynch, based on the novel by Frank Herbert; photographed by Freddie Francis; edited by Antony Gibbs; music by Toto; produced by Raffaella DeLaurentiis; released by Universal Pictures. At Movieland, Broadway and 47th Street; Gemini, Second Avenue and 64th Street; Murray Hill, Third Avenue and 34th Street; 83d Street Quad, at Broadway, and other theaters. Running time: 145 minutes. This film is rated PG-13.

Lady Jessica	Francesca Annis
The Baron's Doctor	Leonardo Cimino
Piter De Vries	Brad Dourif
Padishah Emperor Shaddam IV	Jose Ferrer
Shadout Mapes	Linda Hunt
Thufir Hawat	Freddie Jones
Duncan Idaho	Richard Jordan
Paul Atreides	Kyle MacLachlan
Princess Irulan	Virginia Madsen
Rev. Mother Ramallo	Silvano Mangano
Stilgar	Everett McGill
Baron Vladimir Harkonnen	Kenneth McMillan
Nefud	Jack Nance
Rev. Mother Gaius Helen Mohiam	Sian Phillips
Duke Leto Atreides	Jurgen Prochnow
The Beast Rabban	Paul Smith
Gurney Halleck	Patrick Stewart
Feyd Rautha	Sting
Doctor Wellington Yueh	Dean Stockwell
Doctor Kynes	Max Von Sydow
Alia	Alicia Roanne Witt
Chani	Sean Young

SEVERAL of the characters in "Dune" are psychic, which puts them in the unique position of being able to understand what goes on in the movie. The plot of "Dune" is perilously overloaded, as is virtually everything else about it. As the first king-sized, Italian-produced science-fiction epic, "Dune" is an ornate affair, awash in the kind of marble, mosaics, wood paneling, leather tufting and gilt trim more suitable to moguls' offices than to far-flung planets in the year 10191. Not all of the overkill is narrative or decorative. Even the villain, a flying, pustule-covered creature, has more facial sores than he absolutely needs.

"Dune," which opens today at the Gemini and other theaters, is knee-deep in the jargon of Frank Herbert's hugely popular novel, a book better loved for its mysticism and adventure plot than for terms like "Kwisatz Haderach," "Bene Gesserit" and "gom jabbar." Instead of streamlining either the language or plot of this lengthy book, David Lynch, who directed the film and wrote the screenplay, tries to present it in unadulterated form. This means he must pause periodically for great infusions of data, as if the occasional subtitle or breathless voice-over could make sense of it all.

As George Lucas proved with "Star Wars," audiences in the thrall of an exciting story will absorb, even embrace, any amount of strange new facts, words, gadgets or creatures. But in its film version, the story of "Dune" doesn't begin to have that kind of appeal. True, it's about two factions that war bitterly for control of the title planet, which produces a greatly coveted spice called mélange (Mr. Herbert's vocabulary was a marvel of eclectic etymology). And mining for the spice activates the planet's Moby-Dick-like worms. The story also traces the rise of a teenager named Paul from mere boy to Dune-saving messiah. That ought to be more than enough to fill a movie, but it is presented here much too solemnly to leave room for the wit or agility that could have made it fun.

•

The tale is played out by a large, reputable and unglamorous international cast, hardly what was needed to lend the film personality. (The rock star Sting, with his smile of festive malevolence, is a slight exception, but try not to blink if you want to see him; his role is extremely brief.) Actors like Max Von Sydow, Jose Ferrer, Richard Jordan, Linda Hunt, Jurgen Prochnow, Kenneth McMillan

Sting co-stars with Jose Ferrer, among others, in "Dune," David Lynch's version of the Frank Herbert science-fiction epic.

(as the boil-covered villain) and Kyle MacLachlan (as the bland young hero) do what's expected of them, but no one here contributes any real flair. Everyone is upstaged by the dialogue, décor, and fussily attention-getting costumes of the sort that just might be remembered at Oscar time.

There are no traces of Mr. Lynch's "Elephant Man" in "Dune," but the ghoulishness of his "Eraserhead" shows up in the ooze and gore distinguishing many of the story's heavies. Diehard fans of Mr. Herbert's novels may not mind this or anything else about the movie, but its appeal to neophytes is distinctly limited. Some of the special effects, like the glowing blue eyes on Dune's native faction called Fremen, are unusual. There's a nice worm-fight at the end of the story. The music, by Toto and Brian Eno, is intermittently effective. But too many of the fancier touches backfire, like the water-saving "stillsuits" with their black nosepieces, designed to enable people on the bone-dry Dune to preserve bodily fluids. These outfits ought to pique the audience's curiosity. Instead, they have the reverse effect of making anyone who wears one, man, woman or child, look vaguely like Groucho Marx.

"Dune" is rated PG-13 ("Parental Guidance Suggested" for children under 13.) Parts of it are grisly enough to bother small children.

Janet Maslin

1984 D 14, C18:4

Gizmos Amok

RUNAWAY, directed and written by Michael Crichton; director of photography, John A. Alonzo; edited by Glenn Farr; music by Jerry Goldsmith; produced by Michael Rachmil; released by Tri Star Pictures. At New York Twin, Second Avenue and 66th Street; National, Broadway and 44th Street; Waverly Twin, Avenue of the Americas and Third Avenue, and other theaters. Running time: 99 minutes. This film is rated PG-13.

Ramsay	Tom Selleck
Karen Thompson	Cynthia Rhodes
Luther	Gene Simmons
Jackie	Kirstie Alley
Marvin	Stan Shaw
Chief	G. W. Bailey
Bobby	Joey Cramer
Johnson	Chris Mulkey
Hooker at Bar	Anne-Marie Martin

ROBOTS are all the rage this Christmas, and Michael Crichton's "Runaway," which opens today at the National and other theaters, has more of them than any toy store. "Runaway" is about a police sergeant named Ramsay, whose job it is to dismantle things that look like very smart vacuum cleaners should any of them run amok. Tom Selleck, as Ramsay, takes this seriously and makes an affable hero, but he's at a big disadvantage. Mr. Crichton has a much better feel for the film's gadgets than for its human players.

Mr. Crichton by now has the high-tech thriller genre all to himself, but his sovereignty doesn't seem very hotly contested. Even at its fanciest, the form has become somewhat old hat. "Runaway" doesn't stint on the gizmos, and its inventiveness in that respect is its best feature; it comes up with, among other things, foot-long metallic spiders with a deadly sting and heat-seeking bullets that can be programmed to track specific human

targets. There are eyeball identification checks, and little gadgets that dart under cars in speeding traffic. Mr. Crichton is so clever with this sort of thing, in fact, that it's a wonder he can't make the human story more interesting.

His screenplay gives the widowed Ramsay a pretty new partner named Thompson (Cynthia Rhodes) and a son named Bobby (Joey Cramer), who is overly cute. Also cute, and also part of Ramsay's household, is a robot named Lois that cooks him dinner and is a bit nosy about his love life. The most intense interaction between Ramsay and Thompson comes after she is wounded in a shootout, with an unexploded mini-missile imbedded in her arm. She cannot be moved to a hospital for fear of detonating the device, so Ramsay must take it out himself. Afterward. he asks if her arm hurts. This is the kind of movie in which Thompson is so perky that she says no.

Also in the cast is Kirstie Alley, who looks great but hollers too much, as the villain's moll, and Gene Simmons as the heavy himself. Mr. Simmons, of the rock group Kiss, has for years been wearing stage makeup to do exactly what he does here without it: sneer and glower. His presence seems sluggish at first, but it develops a comic-book vitality once the real hissing begins.

•

"Runaway" is rated PG-13 ("Parental Guidance Suggested"). Some of it may be violent enough to scare small children.

Janet Maslin

1984 D 14, C20:1

MAN OF FLOWERS, directed by Paul Cox; screenplay by Mr. Cox and Bob Elli; photography, Yuri Sokol; edited by Tim Lewis; music by Gaetano Donizetti; produced by Jane Ballantyne and Mr. Cox; a Spectrafilm Release. At Lincoln Plaza Cinema 2, Broadway between 62d and 63d Streets. Running time: 91 minutes. This film has no rating.
Charles Bremer Norman Kaye
Lisa .. Alyson Best
David .. Chris Haywood
Jane .. Sarah Walker
Art teacher Julia Blake
Psychiatrist Bob Ellis
Postman Barry Dickins
Coppershop man Patrick Cook
Angela Victoria Eagger
Father Werner Herzog
Mother Hilary Kelly
Young Charlesa......... James Stratford
Aunts Eileen Joyce, Marianne Baillieu

By JANET MASLIN

"Man of Flowers" was shown as part of this year's New York Film Festival. Following are excerpts from Janet Maslin's review, which appeared in The New York Times on Oct. 9. The film opens today at the Lincoln Plaza Cinema 2, Broadway between 62d and 63d Streets.

The leading character in Paul Cox's "Man of Flowers" is Charles Bremer (Norman Kaye), a wealthy Australian esthete who lives alone, studies drawing and flower arrangement, and writes frequent letters to his dead mother. His contact with others is rare, remote and more than a little ghoulish, as when he stands naked in his mirrored bathroom, speaking to a radio evangelist on his cordless telephone. He is asking if the evangelist doesn't share his feeling that flowers have a sensual allure.

The most important relationship in Charles's life, the one about which he writes to his mother, is with Lisa (Alyson Best), a young artist's model. Charles pays Lisa $100 weekly to come to his house and remove her clothes to the tune of the "Love Duet"

from "Lucia di Lammermoor." Immediately after watching her, Charles runs across the street and rapturously plays the church organ.

There is some small element of humor to "Man of Flowers," as when Charles attends the art class for which Lisa poses: he is ordered to "take that vegetable matter off that poor girl" after drawing Lisa with leaves across her torso. Much of it is deadly serious, however. The Freudian flashbacks of a shifty-eyed young Charles, his punishing father (the brief, silent role of the father is played by Werner Herzog) and his sexy mother seem very much in earnest. So do Charles's walks through public parks in search of the erotic statuary he so admires.

Mr. Cox, who directed and co-wrote the film (and who previously directed "Lonely Hearts"), brings a hint of the macabre to Charles, his fascination with Lisa, and his contact with the loutish, over-the-hill "action" painter (Chris Haywood) who is Lisa's lover. So does Mr. Kaye, who plays the role with a measured politeness. "Man of Flowers" has glimmers of both satire and potential horror, but its prevailing tone, while somber, seems more than a little silly. Even Mr. Cox's intentional humor threatens to run away with whatever compassion Charles's loneliness is meant to arouse.

1984 D 16, 78:4

FILM VIEW

VINCENT CANBY

America Rediscovers Its Black Actors

I

t's still too early to tell what the long-range effects will be, but one of the more encouraging — as well as unexpected — movie events of 1984 must be the box office success of "A Soldier's Story." This is Norman Jewison's efficient, solid screen version of Charles Fuller's Pulitzer Prize-winning "Soldier's Play," the Negro Ensemble Company stage production, adapted for the screen by Mr. Fuller and starring Howard E. Rollins Jr., supported by a number of excellent actors from the original New York cast.

The film, about the investigation into the murder of a black sergeant on an Army base in the South during World War II, is not great as cinema, but it's a tightly constructed, socially conscious, entertaining melodrama, unusually well acted and shot with a kind of no-nonsense, self-effacing approach to the material by Mr. Jewison.

The surprise is not that "A Soldier's Story" received the decent reviews it did when it opened here in September but that without a huge follow-up advertising and publicity campaign, it has continued to draw white as well as black audiences that obviously leave the theater satisfied. Here is a movie that defines what the industry means when it talks about favorable word-of-mouth.

• • •

For the first time in almost a decade, it seems that black actors, black performers and essentially black subject matter are being rediscovered by the mass American public. Some of the indicators:

The success of NBC-TV's "Cosby Show," which went on the air in September, is already prompting plans for imitations by other networks.

Just opened in New York is Francis Coppola's "Cotton Club," which is something of a giant nonentity as a movie. However, the film focuses attention on Harlem's famed night club in the 20's, when black performers were featured and black patrons were not allowed in, and, more important, it gives the tap-dancer/actor Gregory Hines his first big movie break.

Turning into one of the major hits of this Christmas season is "Beverly Hills Cop," in which Eddie Murphy gives his most self-assured, most blissfully comic performance to date and demonstrates that, with the right material, there's absolutely no reason why he should not hang onto the superstardom that, according to trade reports, he's already being paid for. He couldn't save the dreadful "Best Defense," which opened here in July (and closed soon afterward), but he's a great comic actor, and a paramedic. Mouth-to-mouth resuscitation is not what he's best at.

Continuing to play to appreciative audiences — black and white — is John Sayles's low-keyed, independently-made comedy, "The Brother From Another Planet," in which Joe Morton is very funny as a sweet-natured, wise, black extraterrestrial who comes to earth to escape slavery on another planet, and finds conditions here not much different from those he left behind.

This may not seem like a huge shift in emphasis, but it's of some importance after a number of years in which the only major black film stars have been Richard Pryor, Sidney Poitier, who now works more frequently as a director than as an actor, and Diana Ross, who hasn't made a movie since the ill-conceived "Wiz" (1979).

This wasn't always so.

In the early 1970's American film producers found that there was, indeed, a large black audience "out there" waiting to pay a lot of money to see macho black actors in action-filled melodramas that Variety lost no time in labeling "blaxploitation pix." Richard Roundtree made his name as "Shaft," Ron O'Neal was "Super Fly" and Fred Williamson was any number of tough guys who, like the characters played by Mr. Roundtree and Mr. O'Neal, demonstrated that a black man could make his way in a white man's world if he knew how to use his fists and his gun. No more Mister Nice Guys. These fellows played for keeps with apologies to no one.

• • •

There was — at least initially — a good deal of "crossing-over" as white audiences added their support to the best of these early black melodramas, which also included such ripoffs as a thinly disguised black variation on "The Exorcist" and even a "Dracula" titled "Blacula."

A lot of professional movie-watchers — black as well as white — were outraged by the graphic violence and the casually amoral attitudes dramatized in films exemplified by "Shaft" and "Super Fly." Black critics were upset by what they saw to be the sleazy sort of role models being offered. White critics raised questions of morality, while others, on the fringe, may also have been responding to fears they wouldn't dare to express forthrightly, that is, that black audiences were restless enough already and didn't need to see movies that romanticized anti-social characters like the drug dealer played with such supercool by Mr. O'Neal in "Super Fly."

Only Sidney Poitier, sometimes working as his own director, most notably in the exuberantly comic "Uptown Saturday Night" (1974), managed to make films that could attract both black and white audiences without offending either.

Whether or not these movies were "morally acceptable," it did seem as if black audiences were making their presence felt in such an effectively economic way that movie producers would never again ignore them. Then, gradually, audiences, including black audiences, apparently lost interest, and the blaxploitation movie all but disappeared, along with the more serious black films. There were occasional exceptions, but mostly it was business as before. Blacks continued to turn up in major movies, but in subsidiary if not just token roles.

Typical is the all-too-brief appearance of Mr. Roundtree, once the invincible Shaft, in "City Heat," the new Clint Eastwood-Burt Reynolds

comedy-melodrama, set in Kansas City during the 1920's. His role is a good if unlikely one — that of the partner of Mr. Reynolds in a seedy private-eye office — but he's literally out of the picture almost before it gets rolling.

This is what makes the current successes of "A Soldier's Story" and of Eddie Murphy, among others, significant, though just how significant is not yet clear.

"Beverly Hills Cop" is a ball, but one doesn't have to be a specialist in movies, in the merchandising of special products or in race relations to detect how carefully Mr. Murphy's career is being shaped to satisfy the largest possible audience without offending anyone. The fact that "Beverly Hills Cop" takes place mostly in and around the fancier reaches of Beverly Hills, which doesn't have a huge black population, may explain why there are so few other blacks in the film, but the story is so set up that even the Murphy character's best friends from Detroit are white.

As one watches Mr. Murphy, as a hilariously cheeky, inventive Detroit cop in search of his best friend's murderer in California, one eventually gets the feeling that he, too, is a brother from another planet.

In "A Soldier's Story," Mr. Rollins, who was so good as Coalhouse Walker in "Ragtime," plays a black Army captain, sent down South by Washington to conduct the investigation into the circumstances of the mysterious death of a tough black sergeant, who may or may not have been murdered by the local Ku Klux Klan.

It's a well-written role, and Mr. Rollins is fine, but there's also something about it that harks back to the early career of Mr. Poitier, and the years when he and Harry Belafonte were virtually the entire black population of Hollywood movies.

⚫

There's genuine bravery about what Captain Davenport (Mr. Rollins) must do in "A Soldier's Story," but the character is almost unspeakably noble, so perfect that he appears to be the kind of role-model that Mr. Poitier was more or less compelled to play in movies like "In the Heat of the Night," which was also directed by Mr. Jewison, "To Sir With Love" and "Guess Who's Coming to Dinner."

It's a measure of how little real progress there has been in the attitude of American movies toward black culture that "A Soldier's Story," which could as easily have been made in 1964 as in 1984, seems newsworthy today for its broad popular success.

Its success is also important for the courage it should give other producers to attempt to make films that, on the surface anyway, would seem to be for specialized audiences. When a film is as effective as "A Soldier's Story," it will eventually go beyond the specialized to attract the mass audience, which is, after all, what every producer dreams of. ■

1984 D 16, II:21:1

Ideological Debate

MASS APPEAL, directed by Glenn Jordan; screenplay by Bill C. Davis, based on his stage play; director of photography, Don Peterman; edited by John Wright; music by Bill Conti; produced by Lawrence Turman and David Foster; released by Universal Pictures. At Sutton, 57th Street and Third Avenue, and Cinema 3, 59th Street at the Plaza. Running time: 99 minutes. This film is rated PG.

Father Farley	Jack Lemmon
Mark Dolson	Zeljko Ivanek
Monsignor Burke	Charles Durning
Margaret	Louise Latham
Mrs. Hart	Alice Hirson
Mrs. Hart's mother	Helene Heigh
Marion Hart	Sharee Gregory
Father De Nicola	James Ray
Mrs. Dolson	Lois De Banzie
Liz Dolson	Talia Balsam
Mr. Dolson	Jerry Hardin

By JANET MASLIN

"MASS APPEAL" is this season's "Educating Rita," which is not to say that it isn't likable, merely that it's blunt. Like "Educating Rita," Bill C. Davis's two-character play (which he has adapted and expanded as a screenplay) takes the form of an extended, snappily paced ideological debate. In drama of this sort, a mature and somewhat jaded father figure finds his ideas challenged and eventually revitalized by a brash young protégé. The process is described in big, bold, simple terms no audience could fail to understand.

Mr. Davis's play has a clerical setting, as the very popular Father Farley finds his methods under attack from the brash young seminary student Mark Dolson. It begins, at least in its screen version, on an uncertain note. Jack Lemmon, in the role of Father Farley, is seen delivering a gag-filled Sunday sermon to a packed house. Mr. Lemmon sounds in this sequence as if his idea of theology were a Friars' Club Roast, but he subsequently takes on a more relaxed and sympathetic manner, and sustains it throughout the rest of the film.

Zeljko Ivanek's Mark Dolson, on the other hand, begins as a firebrand, criticizing Father Farley in front of the entire congregation. "He has passion; sometimes that looks like immaturity," local church officials decide, and they promptly assign him to Father Farley for a monthlong reality lesson. Their personal styles differ vastly, with Mark in shabby running clothes and Father Farley cruising through his affluent parish in a Mercedes-Benz. The two begin by sparring, but they soon come to share the kind of affection and mutual understanding that gives the story its emotional payoff.

"Mass Appeal," which opens today at the Sutton and other theaters, is less strident than "Educating Rita" and more prone to dry humor ("It is no accident that the collection comes *after* the sermon, it's like a Nielsen rating," Father Farley tells Mark, after the young man delivers his first sermon and attacks the entire congregation). The momentum of Mr. Davis's drama and the stars' intensity are enough to sustain interest,

Jack Lemmon is cast as an experienced priest in "Mass Appeal," Glenn Jordan's version of the Bill C. Davis play. Zeljko Ivanek co-stars as the young seminarian he counsels.

even when Glenn Jordan's television-style direction seems excessively bland. And the new supporting characters — a crafty Monsignor played by Charles Durning, the devoted housekeeper (Louise Latham) who looks after Father Farley — bring the story additional interest.

The casting of the two key roles works in the long run, but it initially seems a shade off. Father Farley, as written, is rather too self-satisfied and facile for the priesthood, qualities better emphasized in Milo O'Shea's stage performance than in Mr. Lemmon's on film, since the character's glibness comes too close to the actor's usual screen persona. And Mr. Ivanek, beginning on a note of intelligence and severity, later has moments of surprisingly callowness, even petulance. But the stars work together very effectively, making the story's progress believable as each of their characters evolves into a better man. "Mass Appeal" doesn't have to tug too hard at the audience's heartstrings to arrive at its simple and satisfying resolution.

⚫

"Mass Appeal" is rated PG ("Parental Guidance Suggested"). It contains a slight amount of strong language.

1984 D 17, C12:1

Tennessee Valley

THE RIVER, directed by Mark Rydell; screenplay by Robert Dillon and Julian Barry; story by Mr. Dillon; director of photography, Vilmos Zsigmond; edited by Sidney Levin; music by John Williams; produced by Edward Lewis and Robert Cortes; released by Universal Pictures. At Beekman, 65th Street and Second Avenue. Running time: 122 minutes. This film is rated PG-13.

Tom Garvey	Mel Gibson
Mae Garvey	Sissy Spacek
Lewis Garvey	Shane Bailey
Beth Garvey	Becky Jo Lynch
Joe Wade	Scott Glenn
Senator Neiswinder	Don Hood
Harve Stanley	Billy Green Bush
Howard Simpson	James Tolkan
Hal Richardson	Bob W. Douglas
Dave Birkin	Andy Stahl
Judy Birkin	Lisa Sloan

By VINCENT CANBY

"THE RIVER," which has absolutely nothing to do with Jean Renoir's 1951 classic set in India, is about Tom and Mae Garvey (Mel Gibson and Sissy Spacek), their two children and their attempts to hang on to their farm in spite of mounting bank debts, big business interests and, of course, the river.

The setting is rural Tennessee and the time is now. For generations the Garvey family has been farming the rich, brown, bottom lands along the river's banks. Every few years, after heavy rains, the river does what rivers have tended to do since the beginning of time. It overflows and wipes away crops, livestock, buildings and, frequently, people.

The problems faced by the Garveys are real and, in many parts of this country, they are still almost commonplace. Why do such farmers stay on? The land is incredibly rich and when there are no floods, the harvests are bountiful. It's also *their* land. Their roots are there. There is something staunch and heroic about farmers like the Garveys, but not about this movie, directed by Mark Rydell ("On Golden Pond") and written by Robert Dillon and Julian Barry.

"The River," which opens today at the Beekman Theater, has a meticulously detailed physical production and, from time to time, is acted with passion by its cast. Yet its ideas are so profoundly muddled that the film must run mainly on sentimentality. It is so mixed up, in fact, that it makes Jessica Lange's "Country," which it resembles in many ways and which has its own problems, seem a model of clarity.

The film's most peculiar decision was to make a villain of the one person who has some idea of what might be done to temper the effects of nature. This man is Joe Wade (Scott Glenn), a childhood sweetheart of

Mel Gibson and Sissy Spacek star in "The River," directed by Mark Rydell and dealing with a family's struggle to hold on to its land.

Mae's who has married rich and is a farmer himself. Wade appears to be the only man in the area to understand — as did the Administration of Franklin D. Roosevelt in 1933 — that nature may be altered. Though Wade is out to make his own fortune in the process and, if possible, to seduce Mae, his ideas are essentially sound.

It was in 1933 that the Federal Government sponsored the Tennessee Valley Authority and the eventual construction of a network of dams, canals and locks along the Tennessee River and its tributaries, not only to control flooding but also to provide cheap electrical power and to increase river transportation.

The cost of the project was high, in terms of money and especially in terms of the disruption of the lives of the affected farmers, as Elia Kazan eloquently dramatized in his 1960 "Wild River" with Montgomery Clift, Lee Remick and Jo Van Fleet. Miss Van Fleet, the center of that film, plays a resolute old farm woman who refuses to give up her homestead even though she understands the long-term benefits to be realized.

In Mr. Rydell's revisionist view of things, the Garveys are ennobled by their similar refusal to go along with attempts to tame the river. The director may well realize that there's something askew here, since he attempts to make the Garveys' stubbornness more plausible by suggesting the dam is just the sort of pork-barrel project that the T.V.A. was initially accused of being. In spite of this, the movie's publicity material rather proudly announces that the flood scenes were actually filmed with the cooperation of the T.V.A., which was able to control the flow of water to the film's location.

•

This decision to ignore history undercuts everything in the movie. Though it doesn't deny the validity of the performances by Miss Spacek, Mr. Gibson and Mr. Glenn, it drains them of true emotional impact.

The film's only effective sequence, which has nothing directly to do with the river, occurs when Tom Garvey, in an effort to meet the payments on his bank loans, finds himself working as a scab in a steel mill whose union-

ized workers are on strike. This is an agonizing situation and one that goes to the desperate heart of the Garveys' existence. Even here, however, Mr. Rydell can't resist overstating his sentiments in an interlude involving a lost, frightened Bambi-like fawn that wanders into the steel mill. Tennessee is not Disneyland.

Vilmos Zsigmond has photographed things so dewily that even the disastrous floods look more pretty than terrifying. Life is hard and life is tough but, adds "The River," it's also photogenic.

Of this season's three so-called "country" movies — the other two being "Country" and Robert Benton's fine "Places in the Heart" — "The River" is the wettest.

•

"The River," which has been rated PG-13 ("Parental Guidance Suggested"), contains some vulgar language and partial nudity.

1984 D 19, C19:1

Gotta Dance!

BREAKIN' 2: ELECTRIC BOOGALOO, directed by Sam Firstenberg; written by Jan Ventura and Julie Reichert; director of photography, Hanania Baer; edited by Sally Allen, Bert Glatstein, Bob Jenkis, Barry Zetlin; music supervision, Russ Regan; produced by Menahem Golan and Yoram Globus; released by Tri-Star Pictures. At UA Broadway Twin, at 49th Street; UA East, 85th Street and First Avenue; Eastside Cinema, Third Avenue between 55th and 56th Streets; Olympia, Broadway and 107th Street and other theaters. Running time: 94 minutes. This film is rated PG.
Kelly .. Lucinda Dickey
Ozone Adolfo (Shabba-Doo) Quinones
Turbo Michael (Boogaloo Shrimp) Chambers
Rhonda ... Susie Bono
Byrone ... Harry Caesar
Mrs. Bennett Jo de Winter
Mr. Bennett John Christy Ewing
Strobe Steve (Sugerfoot) Notario

THE kids in "Breakin' 2: Electric Boogaloo" like breakdancing so much that they prefer it to drug-taking and larceny. This, they argue, is the reason a community center called Miracles, which they have covered with blinding graffiti, should not be razed to make way for a mall. One kindly adult in the area understands the kids and their need to dance; the others are steadfastly in favor of the shopping center. And there you have it: A

plot no teen-movie enthusiast could fail to recognize. Be it break-dancing or drag-racing or surfing, some things never change.

"Breakin' 2," which opens today at the UA Twin and other theaters, slights dramatic matters to concentrate exclusively on dancing. The movie contains so much of it that it's exhausting even to watch, but at least the choreography isn't being executed by John Travolta. The cast is made up of more or less real people, with names like Darlene (Shortcake) Pabalan, Dave (Cambell-Lock) Pope and Steven (Sugar Pop) Daniells-Silva. They all dance tirelessly, and the few who are expected to act — notably the leading men Adolfo (Shabba-Doo) Quinones and Michael (Boogaloo Shrimp) Chambers — approach their roles with no apparent stage fright and considerable good humor.

Less convincing is the leading lady named Kelly (Lucinda Dixon), a rich girl who would supposedly be on her way to Princeton if she weren't so head-over-heels about the breakdance craze. Touches like this go unremarked upon, as does the let's-put-on-a-show finale in which the kids raise the $80,000 to save Miracles simply by asking for donations from the audience. Some audience. It should be noted that Miracles could have been saved a lot sooner if everyone had spent less on the Day-Glo glad rags that constitute most of the costumes. When anyone in "Breakin' 2" stops dancing, it's only to change clothes.

•

"Breakin' 2: Electric Boogaloo" is rated PG ("Parental Guidance Suggested"). It contains some strong language.

Janet Maslin

1984 D 19, C22:4

Momentous Summer

THE FLAMINGO KID, directed by Garry Marshall; screenplay by Neal Marshall and Garry Marshall; story by Neal Marshall; director of photography, James A. Contner; edited by Priscilla Nedd; music by various composers; produced by Michael Phillips; released by 20th Century-Fox. At Warner Twin, Broadway at 47th Street; Gotham, Third Avenue and 58th Street, and other theaters. Running time: 100 minutes. This film is rated PG-13.
Jeffrey Willis Matt Dillon
Arthur Willis Hector Elizondo
Ruth Willis Molly McCarthy
Nikki Willis Martha Gehman
Phil Brody Richard Crenna
Phyllis Brody Jessica Walter
Joyce Brody Carole R. Davis
Carla Samson:....... Janet Jones
Steve Dawkins Brian McNamara
Hawk Ganz Fisher Stevens
Fortune Smith Leon Robinson
Alfred Schultz Bronson Pinchot

GARRY MARSHALL'S "Flamingo Kid" is an ebullient, unsentimental "Summer of '42," updated to the summer of 1963, about Jeffrey Willis (Matt Dillon), an upwardly mobile Brooklyn teen-ager whose father is a plumber and proud of it.

The film, which opens today at the Warner Twin and other theaters, is by far the best — and funniest — work yet done by Mr. Dillon, for whom Jeffrey Willis is a welcome change of character from the moody, brooding young men he's played in the past. With his flat-top crew-cut, his utterly open though not unknowing expression — and wearing his somewhat square sports shirts, plus his ever-present pork-pie hat — Mr. Dillon creates a memorably comic hero. His Jeffrey Willis is not exactly Tom Jones, but even if "The Flamingo Kid" comes out of sit-com country,

Matt Dillon plays a high school student with a summer job at a beach club during the 1960's in "The Flamingo Kid."

the character and the performance effortlessly rise above their origins.

"The Flamingo Kid" is also the best work yet done in theatrical films by Mr. Marshall, the television whiz who created, among other hit series, "Happy Days," "Laverne and Shirley" and "Mork and Mindy." The film has the kind of slickness one expects of the most popular television fare, but it also has a bit of the satirical edge of a film like Elaine May's "Heartbreak Kid."

The screenplay, by Mr. Marshall and Neal Marshall, who is no relation, is set mostly in and around a busy, superbly garish Long Island cabana club, always referred to as "the El Flamingo." This is an overcrowded, sweaty playground for Long Island's nouveau riche, mostly nouveaux arrivals from Brooklyn, who spend their days getting dangerously tan, taking rumba lessons and playing nonstop games of gin rummy for huge stakes.

•

In the course of this one, minutely momentous summer, Jeffrey learns all about high life on that part of the south shore of Long Island that's just a ping-pong ball's toss from the Rockaways. Much to the fury of his practical, no-nonsense father, Arthur (Hector Elizondo), Jeffrey has turned down a summer job as a messenger for an engineering firm to become a parking lot attendant at the El Flamingo.

Under the benign guidance of the club's gim rummy champion, Phil Brody (Richard Crenna), who's made his money as a sports car dealer, Jeffrey advances from parking lot attendant to cabana boy and finds himself being groomed by Phil for a career "in sales," which would mean bypassing college. Jeffrey's blue-collar father is furious. On the other hand, Phil blithely points out that he himself didn't need a college education to reach the heights. Says Phil, as he takes Jeffrey for a spin in every young guy's dream of a red Ferrari: "Socrates rode around on a donkey."

Jeffrey's summer, which also includes a fairly chaste but tantalizing affair with a blond beauty (Janet Jones) from California, runs a con-

337

ventional but unexpectedly witty course. The film is very good about Jeffrey's prickly relations with his family, particularly with his father, and about his education by the rich.

There's a very funny dinner at the Brodys' somewhat palatial Long Island residence where Jeffrey learns about tomato aspic, which he doesn't like. Neither does Phil, who yells across the table to his wife (Jessica Walter), "Phyllis, I don't want anything on my plate that moves!" Jeffrey also astonishes the Brody family by his unconscious habit of humming while he eats — he's the Glenn Gould of Brooklyn gourmets.

Beginning with Mr. Dillon's, there's not a bad or even middling performance in the film. Mr. Crenna and Miss Walter are extremely funny as the nouveau riche couple and Mr. Elizondo is excellent as Jeffrey's father, a role written and played with such understanding that the conventions never slip into clichés.

Garry Marshall, who has written and produced several theatrical films, and who made his debut as a director with "Young Doctors in Love," here shows complete control of his material. Unlike something on the order of "The Cotton Club," "The Flamingo Kid" never wanders around looking for itself. Every scene, every cut, every shift in mood demonstrates its efficiency.

●

"The Flamingo Kid," which has been rated PG-13 ("Special Parental Guidance for Those Younger Than 13"), contains some vulgar language and very discreet sex scenes.

Vincent Canby

1984 D 21, C25:1

Life in Foggy Bottom

PROTOCOL, directed by Herbert Ross; screenplay by Buck Henry; story by Charles Shyer and Nancy Meyers and Harvey Miller; director of photography, William A. Fraker; edited by Paul Hirsch; music by Basil Poledouris; produced by Anthea Sylbert; released by Warner Bros. At Warner Twin, Broadway and 47th Street; Gemini, 64th Street and Second Avenue; Art, Eighth Street and University Place; Loews 83d Street Quad, at Broadway and other theaters.

Sunny	Goldie Hawn
Michael Ransome	Chris Sarandon
Emir	Richard Romanus
Nawaf Al Kabeer	Andre Gregory
Mrs. St. John	Gail Strickland
Hilley	Cliff De Young
Crowe	Keith Szarabajka
Hassler	Ed Begley, Jr.
Vice President Merck	James Staley
Lou	Kenneth Mars
Ella	Jean Smart

"PROTOCOL" is a breezy, not entirely unpredictable comedy that was made to order for the gifted Goldie Hawn by Buck Henry, the writer, Herb Ross, the director, and Miss Hawn herself, who is the film's executive producer.

It's perfectly understandable that stars should want to produce their own films as a way of protecting themselves against the idiocies of others. However, there's also the danger that, as in the case of "Protocol," the whole project begins to look a bit overcalculated, not just to protect the star but to beatify her. Miss Hawn has surrounded herself with good people in "Protocol," but, with the exception of André Gregory, who plays a cock-eyed Arab guru with a taste for Western-style hanky-panky, nobody is allowed to come anywhere near the point where the star-producer might be upstaged.

In "Protocol" Miss Hawn plays a

In the Herb Ross comedy "Protocol," Goldie Hawn stars as a Washington cocktail waitress catapulted by a quirk of fate into a top State Department post.

Washington cocktail waitress who, through a series of comic accidents, becomes a national heroine and, for reasons she doesn't immediately understand, is taken on by the State Department as a protocol official. The role of Sunny Davis, having been made to her order, fits.

●

Miss Hawn's Sunny is all those things actresses dream of being simultaneously — naïve, commonsensical, vulnerable, hard, barely literate and a sucker for good writing as represented by the Declaration of Independence, the beginning of which she finds an opportunity to read for the astonished edification of others. Miss Smith has come to Washington.

Though everything in "Protocol" has been most carefully contrived, it has been contrived by talented people, particularly by Mr. Henry. He has a good, rude sense of humor that's well suited to Sunny's adventures as she become a pawn in the State Department's campaign to obtain a military base in a fictitious Middle Eastern country whose emir is partial to blondes like Sunny.

Among the film's better moments is a sequence in which Sunny decides to give the emir a night on the town at Lou's Sahara Club, where she used to work and whose drink bearers wear extremely brief costumes that suggest lions, tigers and other wild animals, and one costume that Sunny insists is a chicken outfit, though Lou (Kenneth Mars) describes it as that of an emu. In any case, it has tail feathers the customers like to pull.

In the course of the evening, everything gets out of hand. The emir's large party is supplemented by a group of Japanese businessmen celebrating a birthday and by the arrival of a gang of leather-clad motorcyclists, plus some happy homosexuals who are friends of Sunny. Inevitably, a riot breaks out. Scandalized State Department functionaries and the police are called, at which point someone wonders what kind of place the Safari Club must be.

Says a policeman, shrugging, "I guess it's one of those gay-Arab-biker-sushi bars," a line that has the ring of vintage Buck Henry about it.

In addition to Mr. Gregory's madcap guru and the emir, played by Richard Romanus, the supporting characters include an elegantly dressed senior protocol official (Gail Strickland), who may or may not be a takeoff on Jeane J. Kirkpatrick, the United States representative to the United Nations, a rather characterless State Department fellow (Chris Sarandon), who falls in love with Sunny, and a Senator (Kenneth McMillan), whose committee is grateful for the Frank Capra-like civics lesson it gets from Sunny.

"Protocol" opens today at the Warner Twin and other theaters.

●

"Protocol," which has been rated PG ("parental guidance suggested"), contains some mildly vulgar language.

Vincent Canby

1984 D 21, C25:1

Airborne Dreams

BIRDY, directed by Alan Parker; screenplay by Sandy Kroopf and Jack Behr, based on the novel "Birdy" by Willam Wharton; director of photography, Michael Seresin; edited by Gerry Hambling; music by Peter Gabriel; produced by Alan Marshall; released by Tri-Star Pictures. At Cinema 1, Third Avenue and 60th Street. Running time: 120 minutes. This film is rated R.

Birdy	Matthew Modine
Al Columbato	Nicolas Cage
Doctor Weiss	John Harkins
Mr. Columbato	Sandy Baron
Hannah Rourke	Karen Young
Renaldi	Bruno Kirby
Mrs. Prevost	Nancy Fish
Birdy's Father	George Buck
Birdy's Mother	Dolores Sage
Joe Sagessa	Robert L. Ryan
Mario Columbato	James Santini

By JANET MASLIN

THE most unusual thing about "Birdy," Willam Wharton's novel about a boy who develops an overwhelming erotic fascination with avian life, is

Matthew Modine portrays a Vietnam veteran confined to a mental institution in Alan Parker's adaptation of "Birdy," the William Wharton novel.

its lack of allegorical implications. The story of Birdy, who actually reaches the point of imagining that he has fathered a family of canaries, can be taken at face value. So can the parallel tale of Al, the boyhood friend who years later, after suffering grave wartime injuries, returns to coax the adult Birdy out of his madness.

Like Mr. Wharton's novel, Alan Parker's film of "Birdy," which opens today at the Beekman Theater, works best when it concentrates on the friendship, and on Birdy's amazing eccentricities. The material is so odd and so powerful that its particulars are of much greater interest than its larger implications. It is some measure of just how compellingly Mr. Parker has set forth this tale that when, barely 20 minutes into the movie, Birdy and Al don feathered pigeon suits for a nocturnal adventure, the episode seems neither silly nor incredible. Birdy's intensity is so captivating, and Al's discomfiture so believable and funny, that their story becomes irresistibly involving.

The film takes the form of a series of flashbacks. Its present-day sections are set in a military hospital, where Al (Nicolas Cage) tries desperately to elicit some human response from his friend. Birdy (Matthew Modine) has finally transformed himself into one of the creatures of his dreams. He stares at Al with one eye, birdlike, and perches naked and motionless on the railing of his hospital bed. These scenes are contrasted with glimpses of the younger, happy-go-lucky Al, whose interests are girls and weight lifting, and the delicate, grinning Birdy, whose obsession has not yet drawn him away from human contact. Mr. Modine's performance is exceptionally sweet and graceful; Mr. Cage very sympathetically captures Al's urgency and frustration. Together, these actors work miracles with what might have been unplayable.

●

Mr. Parker has for the most part directed the film deftly and unobtrusively. Every so often, though, he introduces the kind of overstatement

"Birdy" didn't need, as in a shot of Birdy lying Christlike on the floor of his hospital room. The disco music accompanying Birdy's first dream of flight, the adolescent sex scenes played bluntly for laughs and the combative ending seem similarly unnecessary, as does the updating of the story from the World War II of the novel to the Vietnam era. Fortunately, the heavy-handedness is in limited supply. Most of "Birdy" is enchanting.

The film contains many brief but memorable vignettes, particularly those involving the boys' families; Sandy Baron is especially good as Al's blowhard father, and George Buck has a touching scene as Birdy's father, who works as a janitor at a school and is there cleaning bathrooms on the night his son attends a prom. In addition to its human players, "Birdy" has a large animal contingent, with some remarkable footage of canaries being hatched. To the extent that any film could translate Birdy's obsession into visual terms, this one has. Mr. Parker, in filling the film with animals and studying their motion without giving any of the canaries speaking lines (the book's Birdy has a winged "wife" who eventually begins talking to him), has been wise to leave well enough alone.

1984 D 21, C25:1

Bigamous Bliss

MICKI AND MAUDE, directed by Blake Edwards; written by Jonathan Reynolds; director of photography, Harry Stradling; edited by Ralph E. Winters; music by Lee Holdridge; produced by Tony Adams; released by Columbia Pictures. At National, Broadway and 44th Street; Baronet, Third Avenue and 59th Street; 34th Street East, near Second Avenue; New Yorker Twin, Broadway and 88th Street; 23d Street West Triplex, between Eighth and Ninth Avenues, and other theaters. Running time: 115 minutes. This film is rated PG-13.

Rob Salinger	Dudley Moore
Maude Salinger	Amy Irving
Micki Salinger	Ann Reinking
Leo Brody	Richard Mulligan
Dr. Eugene Glztszki	George Gaynes
Dr. Elliot Fibel	Wallace Shawn
Hap Ludlow	John Pleshette
Barkhas Guillory	H. B. Haggerty
Nurse Verbeck	Lu Leonard
Diana Hutchison	Priscilla Pointer
Ezra Hutchison	Robert Symonds

By VINCENT CANBY

"MICKI AND MAUDE," Blake Edwards's blithe new farce written by Jonathan Reynolds, is the kind of movie that dares to ask timely questions:

What happens when you die? (Mosquitos crawl out of your ears.)

What should a man do when his wife's parents walk by the church where he's about to take a second wife in bigamous union? (Be polite and try not to panic.)

Is it possible for a man to live simultaneously but separately with two wives, neither of whom knows about the other? (Only if the wives remain ignorant and *only* during those periods when he's not having a nervous breakdown.)

"Micki and Maude," which opens today at the National and other theaters, can't always maintain the extraordinary pace and invention of its funniest sequences, but it's never less than a delight. It also reunites Mr. Edwards with Dudley Moore, the star of "10," and is proof, if any were needed, that Mr. Moore's forte is Mr. Edwards's bluntly irreverent kind of comedy.

Though the director usually writes his own screenplays, he appears to have found a soulmate in Mr. Reyn-

olds, who has an ear for ultra-high-frequency lunacies that escape the rest of us. "Micki and Maude" is Mr. Reynolds's first screenplay credit, but he's also the playwright who wrote "Geniuses," the Off Broadway hit based on his bizarre experiences in the Philippines as one of the army of people who contributed to Francis Ford Coppola's "Apocalypse Now."

•

The director, the star and the writer make a fine team in this often riotous tale about Rob Salinger (Mr. Moore), a Los Angeles television newsman who, for the kindest of reasons, finds himself married to two women, each of whom is carrying his child. Rob is the sort of fellow of whom his colleague (Richard Mulligan) can say, "When it comes to value judgments, he's right up there with Custer and Nixon."

Mr. Edwards must also be credited with having had the good sense to give Ann Reinking and Amy Irving the comedy roles of their careers.

The patricianly beautiful Miss Reinking, who has legs to make the incomparable Cyd Charisse's look runty, has been in other movies, including Stanley Donen's "Movie Movie," but she's still best known as the dancing star of Broadway's "Chorus Line" and "Dancin'." Here she plays Micki, the lawyer-wife of Rob Salinger and a woman whose heart is set on accepting her nomination as a Superior Court judge. After nearly a decade of marriage and her career, however, she suddenly decides to bear the child that Rob has always wanted.

As Maude, the concert cellist whom the lonely Rob accidentally makes pregnant, Miss Irving, who was the only valid reason to sit through "Yentl," gets her first chance to show that she's also a first-rate comedienne. Though she is more familiar as a sweet young thing, she can also be devastatingly funny, as when, nine months pregnant and due to be delivered at any moment, Maude insists on carrying on with an audition. Getting close to a cello in her condition is not easy.

"Micki and Maude" works as well as it does because — at least in part — no man in his right mind could easily choose between two such different but bright, intelligent women. It also works because Mr. Edwards and Mr. Reynolds have packed the film with commonplace details inspiritingly transformed into the certifiably farcical.

•

Rob Salinger's initially casual affair with Maude is explained by the fact that Micki is away on business much of the time and he is fed up with his job. Rob has become something of a local television celebrity in Los Angeles by his tireless pursuit of in-depth stories about the quality of food served on election night at campaign headquarters, about artificial organs for dogs and about lingerie for animals.

Two classic, Feydeau-esque sequences are the film's highlights. In one, Maude, who is accompanied by Rob, and Micki turn up in the waiting room shared by their different obstetricians, played with grave nuttiness by George Gaynes and Wallace Shawn. Observing Rob's increasingly manic behavior as he dashes from one wife to the other is a formidably built, highly suspicious nurse (Lu Leonard), who has her own secrets to hide.

Inevitably, the two Mrs. Salingers

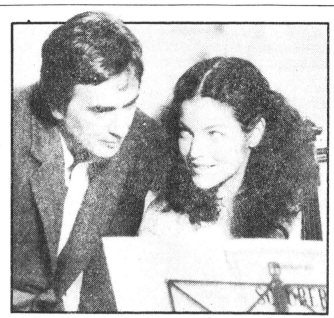

Dudley Moore plays a television reporter who marries Amy Irving, although he already has a wife, in the Blake Edwards comedy "Micki and Maude."

go into labor at the same time and wind up in the same hospital in adjoining rooms. No other American film maker can equal Mr. Edwards's ability to orchestrate gags in such a way that they build to the kind of side-splitting climax that concludes this hospital sequence.

However, "Micki and Maude" ultimately paints itself into a corner. The ending is not really a letdown, but the film just sort of peters out when one longs for some classic topper, something to equal the "Well, nobody's perfect" of "Some Like It Hot."

Among other things, "Micki and Maude" restores Mr. Moore's comic credibility after the fiascos of "Best Defense," "Unfaithfully Yours" and "Six Weeks." As a romantic leading man, he does great pratfalls. In addition to Mr. Mulligan, Mr. Gaynes, Mr. Shawn and Lu Leonard, the fine supporting cast includes H. B. Haggerty, who plays Maude's protective dad, a huge, hulking, sentimental figure of a man who, when he retires from professional wrestling, plans to become an interior decorator.

•

"Micki and Maude," which has been rated PG-13 ("Special Parental Guidance for Those Younger than 13"), includes some mildly sexy sequences and a certain amount of vulgar language.

1984 D 21, C25:4

JOHNNY DANGEROUSLY, directed by Amy Heckerling; written by Norman Steinberg, Bernie Kukoff, Harry Colomby and Jeff Harris; director of photography, David M. Walsh; edited by Pem Herring; music by John Morris; produced by Michael Hertzberg; released by Twentieth Century Fox. At Manhattan, 59th Street between Second and Third Avenues; Criterion, Broadway and 45th Street; 86th Street Twin, at Lexington Avenue and other theaters. Running time: 89 minutes. This film is rated PG-13.

Johnny Dangerously	Michael Keaton
Vermin	Joe Piscopo
Lil	Marilu Henner
Mom	Maureen Stapleton
Dundee	Peter Boyle
Tommy	Griffin Dunne
Sally	Glynnis O'Connor
The Pope	Dom DeLuise
Maroni	Richard Dimitri
Burr	Danny DeVito
Pat	Ron Carey
Vendor	Ray Walston
Arthur	Dick Butkus
Young Johnny	Byron Thames
Desk Sergeant	Alan Hale
Charley	Scott Thomson

"JOHNNY DANGEROUSLY," which opens today at the Criterion and other theaters, starts off with all the ingredients of an "Airplane"-like spoof of gangster movies and their attendant clichés, from a crowded prison cafeteria (even a pet parrot wears stripes) to the bad-boy gangster who really loves his ma. But it also has a 90-minute running time, which is more than an extended skit can really sustain.

•

Amy Heckerling, who directed "Fast Times at Ridgemont High," brought a sense of fun to that film and does the same this time. And Michael Keaton plays the title hoodlum as a snappy, stylish hybrid of gangster heroes. If he doesn't get a chance to yell "Top of the world, Ma" before blowing himself up atop a gas tank or attack a moll with a grapefruit, these are about the only legendary gangster-movie moments that aren't lampooned. Mr. Keaton's hat-tilting and Cagneyesque posture are extremely helpful, as is his perfect deadpan. Not even when someone asks him if he knows his last name's an adverb does Mr. Keaton's Johnny Dangerously break his stride.

The film's opening sequence, in the pet shop the former gangster now operates, is especially promising, as Mr. Keaton goes through the place stamping price tags on the animals. A young boy enters the shop and tries to steal a puppy, which launches Mr. Keaton on a dissertation on the perils of a life of crime. Soon Johnny is relating the story of himself, the nice-guy brother who became district attorney (Griffin Dunne), the mother with no shortage of physical ailments (a hilarious Maureen Stapleton) and the sleazy mobster named Vermin (Joe Piscopo).

But "Johnny Dangerously" winds down as it moves along, eventually descending to a lowest common denominator of dopey adolescent gags that overpower the parody. Still, even at its thinnest, it remains good-humored and intermittently entertaining. The screenplay had four authors and still manages to seem incom-

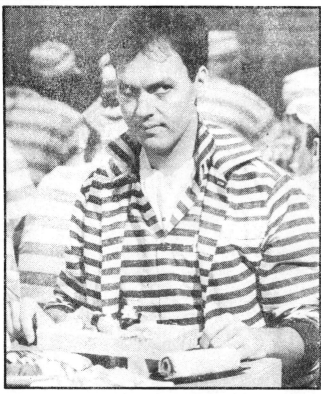

Michael Keaton stars in "Johnny Dangerously," the Amy Heckerling spoof of gangster movies.

plete; as such, it's the weakest thing about the movie. But Miss Heckerling and Mr. Keaton have a chance to display their comic talents. So does "Weird Al" Yankovic, who performs the opening song.

"Johnny Dangerously" is rated PG-13 ("Special Parental Guidance for Those Younger Than 13"). It contains quite a few off-color jokes.

Janet Maslin

1984 D 21, C25:5

FILM VIEW

VINCENT CANBY

Seen in 1984, the Future Looks Bleak

The other Saturday afternoon at Movieland theater on Broadway, where I saw "Dune" with what was clearly a crowd of aficionados of the Frank Herbert sci-fi novels, the letters on the screen spelling out the film's title were so widely spaced that the left side of the "D" and the right side of the "e" were cut off. This may have been the fault of the projection, but I prefer to think it was a conscious comment on the things that were about to come.

"Dune," adapted and directed by David Lynch ("The Elephant Man," "Eraserhead"), simply does not fit onto the screen. It's not too big. It's just misshapen, like many of its characters and all of its monsters, including a great blob of flesh called "the Spacing Guild Navigator."

Whether or not the other members of the audience knew that's what the blob was called, I've no idea. I found out only later by going through the film's press kit. The blob may well have been identified on screen, but by the time it appeared, my mind was already reeling with the immense amount of impenetrable exposition with which the film lurches to its beginning.

Set in the year 10191, "Dune" takes place on a number of planets, including the arid one that gives the film its title, and is about a struggle among several feuding ruling houses, whose tan-

gled alliances make an in-depth account of the Wars of the Roses seem as simple to follow as the directions on a box of Jell-O.

It's not been an especially good movie year for the future. "Dune," which is probably the most elaborate and expensive of the science-fiction offerings, is a total mess. "2010," Peter Hyams's sequel to Stanley Kubrick's classic, "2001: A Space Odyssey," is adequate, meaning that it's nothing to get excited about — you've seen most of it before.

"Supergirl," which is advertised as being "from the producers of the Superman movies," is a good-natured but perfunctory spinoff from the spectacles starring Christopher Reeve, designed, perhaps, to take up the slack if Mr. Reeve decides that enough is enough. "Star Trek III: the Search for Spock," is just more of the same, which, I suppose, is exactly what the "trekkies" want, though the rest of us are becoming restive.

It must be significant that the only halfway decent sci-fi films of the year have been those that never quite lose touch with the manners and mores of earth, 1984.

These would include W. D Richter's farcical "Adventures of Buckaroo Banzai"; Aaron Lipstadt's minuscule-budget "Android," which is virtually a one-set (read one spaceship) movie about a robot named Max, who has all the problems of a nice but none-too-bright teen-ager; Nick Castle's "Last Starfighter," an adventure-comedy about a video-game whiz who gets kidnapped by representatives of another galaxy to help settle its problems, and, by far the best of them all, John Carpenter's "Starman," which is essentially a romantic comedy about a grown-up "E.T."

● ● ●

Our science-fiction film literature now appears to be divided into four fairly distinct categories:

(1) Those that attempt to create their own universes from scratch, complete with their own histories, religions, languages, laws and bizarre rules of behavior. If the brightest, most successful films of this sort have been George Lucas's three "Star Wars" movies, "Dune" must be the absolute worst.

Coming somewhere in between, but nearer the bottom than the top, was Ralph Bakshi's animated "Lord of the Rings" (1978), based on the J. R. R. Tolkien trilogy. Possibly because anything is possible in an animated film, the audience for the Bakshi movie never quite lost itself in the wonderment that the special effects in a live-action film can prompt.

(2) Live-action cartoons, some of them based on comic strips, like the three "Superman" movies and the new "Supergirl."

(3) The out-and-out space adventure film, defined best by the "Star Trek" movies but also including Mr. Hyams's "2010." These films are not especially witty and depend almost entirely on special effects and the "look" of futuristic technology.

(4) Those that are essentially contemporary comedies, like "The Adventures of Buckaroo Banzai," the just-opened "Starman" and John Sayles's "Brother From Another Planet." Though these pictures may use special effects, they don't necessarily depend on them.

Standing just a little apart from these four categories are the pre-space-age fantasy movies, like the "Conan" films, which are set so far in the past they could represent the future, and those movies like "Repo Man" and "Liquid Sky," which use sci-fi elements but are not really sci-fi films.

In the 1950's and 60's, our science-fiction movies played on our lingering, post-World War II, Cold War paranoia by presenting us with visions of Armageddon, best represented by a movie like "When Worlds Collide" (1952), or cautionary fables in which malignant creatures, either come to earth from outer space or created on earth by atomic radiation, gobble up our civilization.

In the 1970's, perhaps because everyone was sick of Vietnam and was longing for some magical force that could straighten out our earthly muddles, our sci-fi films took a sudden turn toward the benign. This switch in direction is best exemplified by Steven Spielberg's 1977 "Close Encounters of the Third Kind," in which the visitors from outer space display a kind of holy innocence that, we are led to believe, can be achieved only by

evolution to a higher intelligence. These creatures are not only benign, but they possess powers that in an earlier movie era were exclusively associated with biblical epics.

Though the black extraterrestrial in "The Brother From Another Planet" cannot speak, he can heal wounds with the touch of his hand. When he loses a foot, he grows a new one. Mr. Carpenter takes these powers a little further when "Starman's" title character, played with what might be described as beatific humor by Jeff Bridges, successfully raises creatures from the dead.

• • •

Though "Starman" has a lot in common with Mr. Spielberg's "E.T.," it has its own easy-to-take, understated charm and a lot of humor, being about an E.T. who has come to earth in answer to the invitation "to come on down" extended to space by Voyager 2. At the film's beginning, Starman is a disembodied presence who, when his spacecraft is thrown off course and drops him into Wisconsin, materializes in the form of the recently dead husband of a pretty young woman, Jenny Hayden, played by Karen Allen.

Though initially scared out of her wits by this clone of her husband, killed in an accident, Jenny, being the spunky type she is, agrees to help Starman get from Wisconsin to Arizona, where he is to rendezvous with his mates and go home. If he misses them, he is destined to fade away and, unlike an old soldier, to die.

Most of the film is occupied with their cross-country journey, which, though they are pursued by scientists whose principal interest is dissecting the visitor, becomes a sort of space-age "It Happened One Night." One of Mr. Carpenter's funnier variations on Mr. Spielberg's "E.T." myth is that Starman, even as he recognizes the superiority of his civilization to that of earth, knows that he's going to miss the excitement of our imperfect world.

When Jenny Hayden asks him if his world is beautiful, he says it is, but it's also different, and the ways in which it is different — no singing, no hunger, no dancing, no wars, no laughter, just perfection — make heaven sound as boring as many of us suspect any ideal state would be.

• • •

It's going to be interesting to see if the fanatically loyal fans of the "Dune" novels will be able to turn this gigantic turkey of a movie into a financial success. I've not read a word of Mr. Herbert's prose, and this movie is not the kind to make you rush off to buy some — does it sell by the pound?

Unlike Mr. Lucas's fictitious universe, which brings to mind the legend of King Arthur and the knights of the Round Table, "The Wizard of Oz," "The Gospel According to St. Matthew," "Ivanhoe" and "Buck Rogers," among other things, "Dune" is not only witless but as tedious to follow as second-rate comic strip. It has no associations to anything that I recognize, which may be why it's called "escapist." Its imagination is limited to strange character names — Padishah Emperor Shaddan IV, Nefud, the Beast Rabban, Shadout Mapes — and to landscapes and décor that suggest not another age and civilization but the memories of someone whose concept of splendor was epitomized by the interior of the old Roxy theater.

If "Dune" suggests anything — which I doubt — it's that we are retrogressing toward the future. ∎

1984 D 23, II:19:1

Good Works

MRS. SOFFEL, directed by Gillian Armstrong; written by Ron Nyswaner; production designer, Luciana Arrighi; director of photography, Russell Boyd; music by Mark Isham; film editor, Nicholas Beauman; produced by Edgar J. Scherick, Scott Rudin and David A. Nicksay; released by MGM/UA Entertainment Company. At Loew's Paramount, Broadway at 61st Street. Running time: 110 minutes. This film is rated PG-13.

Kate Soffel	Diane Keaton
Ed Biddle	Mel Gibson
Jack Biddle	Matthew Modine
Peter Soffel	Edward Herrmann
Irene Soffel	Trini Alvarado
Margaret Soffel	Jennie Dundas
Eddie Soffel	Danny Corkill
Clarence Soffel	Harley Cross
Buck McGovern	Terry O'Quinn
Maggie	Pippa Pearthree
Guard Koslow	William Youmans
Guard Reynolds	Maury Chaykin
Matron Garvey	Joyce Ebert
Guard McGarey	John W. Carroll
Jessie Bodyne	Dana Wheeler-Nicholson
Halliday	Wayne Robson
Mr. Stevenson	Les Rubie
Mrs. Stevenson	Paula Trueman

By VINCENT CANBY

"MRS. SOFFEL," the first American film by Gillian Armstrong, the Australian director of "My Brilliant Career," is a very strange and maddening movie, being a fascinating tale that's nowhere as provocative as it first promises to be and as the reputations of everyone connected with it might lead you to expect.

Ron Nyswaner's original screenplay, based on a true story, is about Mrs. Kate Soffel, the wife of the warden of the Allegheny County Prison in Pittsburgh, who, in 1901, shocked Victorian America down to the soles of its high-button shoes. Mrs. Soffel, in her mid-30's and the mother of four children, was known for her good works among the prisoners in her husband's jail, where she would make regular rounds, giving out Bibles and words of Christian wisdom.

Late that winter, Mrs. Soffel did one good work too many, carrying the concept of Christian charity into the dizzy, unexplored heights of erotic fantasy. She not only engineered the escape of two convicted young murderers, Ed and Jack Biddle, but she also — apparently of her own free will — joined the Biddle brothers in their flight.

Was she mentally unbalanced? She had been ill for some months before she met the Biddles, small-time hold-up men whose youth and good looks had given them a certain romantic notoriety, especially among women. Had she been seduced by Ed, the elder brother with the smooth-talking manner of a ladies man? Had she been abducted?

•

According to Mr. Nyswaner's research, there's reason to believe that Kate Soffel was initially moved by the seeming repentance of Ed Biddle who, with his brother, was sentenced to be hanged for the murder of a grocer — a crime that Ed swore had been committed by a third accomplice still at large. There's also reason to believe that Ed, having successfully obtained her help, which included a couple of small hacksaws, had developed fond feelings for her and insisted that she accompany them, even though her presence would make their escape into Canada just that much more difficult.

This is the shape of the screenplay, which has been well cast by Miss Armstrong with Diane Keaton as Mrs. Soffel, Mel Gibson as Ed Biddle, Matthew Modine — so fine in the title role of "Birdy" — as Jack Biddle and Ed Herrmann as Kate's stuffy husband, Peter. The film has also been beautifully designed by Luciana Arrighi, in sets that include Pittsburgh's still imposing, massive Allegheny County Jail, built in 1883 by Henry Hobson Richardson, and in other locations in this country and Canada.

Though Miss Armstrong does not have the lightest, most ironic of touches, which is evident in the awesome manner by which she introduces Miss Keaton's Kate to the story, the early sequences in which we witness Ed sizing up the possibilities in the intensely sincere Kate are both funny and affecting. A love scene, played by Kate and Ed separated by the cell bars, is wonderfully bizarre, even sort of hair-raising, which is the tone the film loses as it more or less plods to its conclusion.

•

Miss Keaton is utterly convincing as the repressed, proper young matron who suddenly finds herself in circumstances that are the stuff of teen-age dreams. When she abandons herself to the possibly lying Ed — which is Mr. Gibson's first good role and first genuinely solid performance since "The Year of Living Dangerously" — her euphoria is real, and perhaps also an extension of the undiagnosed illness she's been suffering.

Diane Keaton portrays a prison warden's wife and Mel Gibson a condemned inmate in "Mrs. Soffel," set in Pennsylvania in 1901 and based on a true story.

Neither Mr. Modine nor Mr. Herrmann have roles of any such substance, but they and the other members of the large cast are more than adequate. Where the film seems to go flat is in Miss Armstrong's deadly sort of literal approach to the crazily improbable material. "Mrs. Soffel" is immensely solemn when it, like Kate, should be almost drunk with the mad comedy of the events. One effect of this clumsiness is to make one question the plausibility of what, after all, is a true story.

When Jack and Ed, having made their break from jail in the middle of the night, bust into the warden's house to take her away, the handling of the sequence is so flat as to make it seem unbelieveable. And, once the three are on the snowy road to freedom, where does Kate come by her quite spectacular racoon coat and chic, wide-brimmed black hat? These are questions that should never cross one's mind when watching such a film.

"Mrs. Soffel," which opens today at the Paramount Theater, also suffers from one other problem that is not unique to it. The photography by Russell Boyd, the accomplished Australian cinematographer ("The Year of Living Dangerously," "Tender Mercies," among others) favors interior lighting so dim that one doesn't get an impression of the electric lighting of the period, but the feeling that the characters, like bats, can see in the dark.

•

"Mrs. Soffel," which has been rated PG-13 ("parental guidance suggested"), contains some discreet violence and sexual sequences.

1984 D 26, C15:1

Savage Innocence

THE CLAW AND THE TOOTH (1970), a French wildlife documentary directed and photographed by Francois Bel and Gerard Vienne. Produced by Le Cineastes Animaliers Associes. Sound composed by Michel Fano. Edidted by Jacqueline Lecompte. Distributed by Nicole Jouve Interama. At Film Forum, 57 Watts Street. Running time: 98 minutes. This film has no rating.

By JANET MASLIN

"THE CLAW AND THE TOOTH" is a phenomenal wildlife documentary, one that's as brutal as it is beautiful. It has no narration, nor does it require any. It consists entirely of footage in which African animals perform their ordinary rituals. They graze, bathe, nap and copulate; they stalk, kill and eat one another.

The wildlife of the African plains is the focus of attention in "The Claw and the Tooth," a French

This French documentary, which opens today at the Film Forum, records all of this in mesmerizing detail.

Certainly the grisly aspects of "The Claw and the Tooth," if viewed on their own, would put any horror film to shame. But in this context, even a pride of lions pulling apart an antelope retains a kind of innocence. The utter heedlessness with which the animals here attack their prey — most of the hunters seen in the film are big cats, chiefly lions — is counterbalanced by the simple satisfaction they radiate after the kill. One of the film's most striking scenes depicts bloody lion cubs tenderly licking their mother just after having devoured a large carcass.

"The Claw and the Tooth," photographed and directed by Francois Bel and Gerard Vienne, was made in 1970. It contains some especially stunning nighttime hunting footage—the eyes of an oncoming herd can look eerily iridescent in the moonlight—and footage of a number of exotic species. Whether the creature being observed is a vervet or a vulture, the directors study it at close range and with open, intelligent curiosity. The music, ordinarily the bane of this sort of filmmaking, is as understated as everything else in "The Claw and the Tooth," interweaving the various growls, snarls and chirps with subtle percussion. This is aptly credited as

"sound" rather than music, and was composed by Michel Fano.

"The Tooth and the Claw" should fascinate anyone with an interest in animal behavior, and in its bearing upon human habits. However, it is not a film to be seen at mealtime.

1984 D 26, C15:3

New Wave

MEMOIRS, produced and directed by Bachar Chbib. Screenplay by John B. Wimbs and Mr. Chbib based on the play "Memoirs of Johnny Daze" by Mr. Wimbs. Edited by Mr. Chbib and Amy Webb. Photography by Cristian Duguay and Bill Kerrigan. Music by Julia Gilmore and Edward Strawiak. Music performed by Condition. Sound by Gabor Vadney. At the Bleecker Street Theater. Running time: 91 minutes. This film has no rating.

Johnny Daze............................Philip Baylaucq
Ida Rage...........................Norma Jean Sanders
Lotta Lov.....................................Julia Gilmore
Rotwang...Rotwang

By JANET MASLIN

"LIQUID SKY" paved the way for sinister, stylized New Wave melodrama, of which Bachar Chbib's "Memoirs" is an energetic if somewhat less witty example. According to production notes, the Montreal-based Mr. Chbib made the film for $47,000, which is certainly impressive. He wrote it in two weeks, which suggests more coherence than the screenplay actually has.

Julia Gilmore as Lotta Lov in Bachar Chbib's film "Memoirs."

Though based on a play called "Memoirs of Johnny Daze" by John B. Wimbs, "Memoirs," which opens today at the James Agee Room of the Bleecker Street Theater, seems more casual than closely scripted. It concerns the bland, boyish would-be writer Johnny Daze (Philip Baylaucq) and two women named Ida Rage (Norma Jean Sanders) and Lotta Lov (Julia Gilmore), who sneer variously at Johnny and at one another.

Lotta Lov is a performance artist with a riveting musical style, a wardrobe of strapless evening gowns and the eyes of a silent-screen spitfire. Ida Rage collects art from junkheaps and claims it as her own, thus waging war on consumerism in her own way, or so she says. Ida comes to regard Lotta as the ultimate acquisition. Lotta's passion for Ida causes her, finally, to mutilate herself on stage. Lotta and Ida, together, are enough to make Johnny older and wiser, and to drive him back to wherever it is he came from.

All of this is played archly by the three principals, who bring more primitive vitality than evident acting experience to their performances; among them, Miss Sanders is the one who best combines the obligatory drop-dead hostility with recognizably human mannerisms. Fortunately, Mr. Chbib's eye for style is a good deal better than his ear for dialogue. He keeps the film visually interesting throughout, with a rhinestones-in-the-rubble look that's certainly arresting. Its sheer dauntlessness makes his "Memoirs" a feature debut of some promise, even if the film's most pointedly original touches are the ones that wind up seeming least new.

1984 D 28, C14:5

FILM VIEW

VINCENT CANBY

Newcomers, As Well as Veterans, Scored Hits

If you can forget "Rhinestone," in which Dolly Parton and Sylvester Stallone demonstrate that a sum can be considerably less than its parts; earnest teen movies with one word titles like "Footloose" and "Restless" (was there a "Mindless"?); bone-crushing fantasies on the order of "Conan the Destroyer," and John Milius's upbeat, World War III adventure, "Red Dawn," 1984 really hasn't been as terrible a year — at least in retrospect — as it often seemed while it was unraveling.

There were few great movies but there were enough good ones, by new film makers as well as veterans, to make the the compilation of a 10-best list so difficult that at least three of the titles that appear as runners-up might have made it to the first list, except for personal biases and last-minute arbitrariness.

One of the year's oddities has been that four of the films containing some of the best performances of 1984 do not turn up on either list.

These would include "Beverly Hills Cop," with Eddie Murphy's inspired clowning; "Under the Volcano," John Huston's intelligent adaptation of the Malcolm Lowry novel with Albert Finney's superb recreation of the last 24 hours in the life of an alcoholic; "All of Me," with the beautifully complementary performances by Steve Martin and Lily Tomlin, and Alan Parker's adaptation of William Wharton's "Birdy," in which Matthew Modine and Nicolas Cage make something immediately comprehensi-

ble and moving of a most unusual friendship.

Performances, of course, do not exist in vacuums. They are created by the writers and directors as much as by the actors. Yet there are performances that are so good that they somehow manage to overwhelm everything else.

> There were few great movies, but there were plenty of good ones.

It was a year of a number of extremely likable movies — Blake Edwards's "Micki and Maude," Garry Marshall's "Flamingo Kid," Norman Jewison's "Soldier's Story," W.D. Richter's "Adventures of Buckaroo Banzai," Goldie Hawn's "Swing Shift" (mostly directed by Jonathan Demme), John Carpenter's "Starman" and Bill Forsyth's first film, "That Sinking Feeling," and his last, "Comfort and Joy."

It was also a year for the kind of unusual, offbeat film that cannot easily be compared to more conventional releases: Francesco Rosi's opera film, "Bizet's Carmen," and two Athol Fugard films, both directed by Ross Devenish, "The Guest" and "Marigolds in August," which opened here at the consistently rewarding Off Off Broadway movie showcase, the Film Forum.

In this category, too, are five especially good documentaries — "Improper Conduct," by Nestor Almendros and Orlando Jiminez-Leal; "Seeing Red," by Julia Reichert and James Klein; Robert Epstein's "Times of Harvey Milk"; "The Good Fight," by Noel Buckner, Mary Dore and Sam Sills, and "Stop Making Sense," a straight-forward, uncluttered, live-performance, musical film by Jonathan Demme and the Talking Heads.

Now, for the titles of the actual top-10 films themselves, listed, without prejudice, in alphabetical order:

"The Bostonians." Of all the films that have been based on novels by Henry James, this one, created by the long-running team of director James Ivory, writer Ruth Prawer Jhabvala and producer Ismail Merchant, is by far the best. The James story, about the struggle of two domineering personalities for the love of a young woman who may become the spokesperson for the feminist cause, takes place in 1875 but couldn't be more timely. Vanessa Redgrave's performance, as the rich, sexually repressed Olive Chancellor, is among the finest things she's ever done, and Christopher Reeve's, as Olive's arch rival, a

Vanessa Redgrave, seen here with Madeleine Potter, gave one of the finest performances of her career in a memorable screen adaptation of Henry James's "Bostonians."

Woody Allen and Mia Farrow made an offbeat Runyonesque couple in "Broadway Danny Rose," Mr. Allen's most endearing comedy to date.

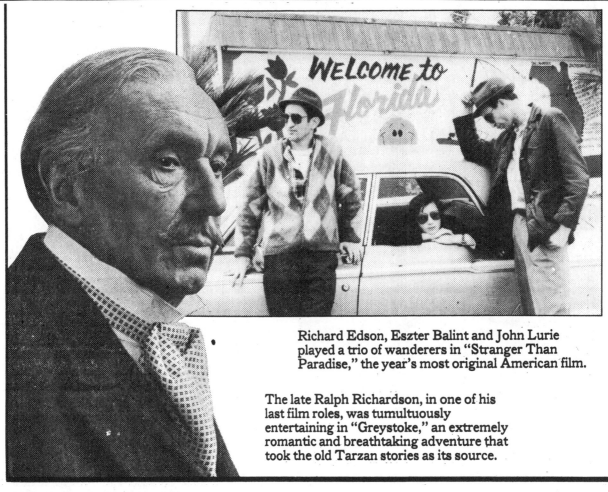

Richard Edson, Eszter Balint and John Lurie played a trio of wanderers in "Stranger Than Paradise," the year's most original American film.

The late Ralph Richardson, in one of his last film roles, was tumultuously entertaining in "Greystoke," an extremely romantic and breathtaking adventure that took the old Tarzan stories as its source.

reactionary, Southern-born, male chauvinist, is light-years ahead of "Superman" and at long last liberates his reputation from the comic strips. The fine cast includes Madeleine Potter, Jessica Tandy, Nancy Marchand, Wesley Addy and Linda Hunt.

"Broadway Danny Rose." In a Runyonesque mood, Woody Allen has created his most seemingly casual, most endearing comedy, about a third-rate theatrical agent (Mr. Allen), his major client (Nick Apollo Forte), a not-great singer who rides the nostalgia wave out of the Catskills to success at the Waldorf-Astoria, the blond doxie (Mia Farrow) they both love, and a gang war. In her skin-tight pedal-pushers, with her hair teased to the brink of madness and talking in authentic, old-fashioned Brooklynese, Miss Farrow almost steals the show, which is not easy, considering the cast also includes a parrot that sings "I Gotta Be Me." "Broadway Danny Rose," wonderfully well photographed by Gordon Willis in period black-and-white, is another comedy classic from America's most authentic, most serious, most consistent film auteur.

"Entre Nous." Neither of Diane Kurys's first two films ("Peppermint Soda" and "Cocktail Molotov") prepares one for the extraordinary scope and assurance of this third film, written as well as directed by the young French film maker. The film, apparently based on the story of Miss Kurys's mother, is about the enduring and life-changing friendship of two very different women, one, played by Isabelle Huppert, a Belgian Jew who marries a guard to escape internment in a French prison camp during the Nazi occupation, and the other (Miou Miou), a high-strung, would-be artist who marries a handsome wimp after her first husband is killed during the war. The film, which begins during the war and ends in the mid-1950's, might be called feminist but its concerns are so much larger than those of any single cause that "Entre Nous" has the qualities of an epic about a time, place and culture. All of the performances are splendid, but particularly those of the two stars and Guy Marchand, who plays Miss Huppert's husband.

"The Family Game." Yoshimitsu Morita, a young (34 years old) Japanese director, makes his debut before American audiences with this odd-ball, provocative, visually stunning comedy about life among Japan's affluent, new, middle class. "The Family Game," set in a Tokyo of modern high-rises and where even the vacant lots look as if they'd been designed by a landscape archi-

tect, is a crazy tale about a teen-age boy and his trials with an arrogant, completely unflappable university student, who is hired to tutor him. The tutor's unconventional methods, which sometimes suggest a Japanese version of a system Saki might have thought up, succeed, but the family that's hired him must pay a high price for his services. The film looks like no other movie you've ever seen and indicates that Mr. Morita might well become the most original Japanese director of his generation.

"Greystoke: the Legend of Tarzan, Lord of the Apes." Taking as their source material the old Edgar Rice Burroughs Tarzan stories, P. H. Vizak (Robert Towne) and Michael Austin, who receive credit for the screenplay, and director Hugh Hudson ("Chariots of Fire") have made a big, handsome epic-of-manners, part adventure, part comedy. Their "Tarzan" (a name that's never spoken on the soundtrack) is about a high-born English foundling, raised by African apes, restored to his family, fortune and title by a Belgian explorer and his adventures in the jungles of British aristocracy and Africa. Filmed both in Africa (Cameroon) and in some of Britain's greatest houses, including Blenheim Palace in England and the Duke of Roxburghe's Floors Castle in Scotland, "Greystoke" is funny, brutal, sad and wise, breathtaking as an adventure and extremely romantic. The late Sir Ralph Richardson, in one of his last film roles, is tumultuously entertaining as Tarzan's crusty old grandfather, but the other members of the cast are never far behind him. They include Ian Holm, James Fox, Ian Charleson, Nigel Davenport and, most important, Christopher Lambert, a handsome, lithe young actor who is fine in the title role, and Andie MaDowell, who's very sweet and comic as the early 20th century virgin Tarzan seduces, chimpanzee-style.

"Love in Germany." This latest film by Andrzej Wajda's, Poland's greatest director, is not only one of his best but it provides Hanna Schygulla ("The Marriage of Maria Braun") with one of her most complex and liberating roles. As a small-

A robust cinematic parody about a rock group on tour, Rob Reiner's "This Is Spinal Tap" turned out to be the funniest film of the year.

town German shopkeeper who falls in love with a Polish prisoner-of-war during World War II, Miss Schygulla gives a performance to match anything she did for the late Rainer Werner Fassbinder. It is Mr. Wajda's rare accomplishment to have made a film that is as political as it is erotic and romantic. Supporting Miss Schygulla are such first-rate European actors as Marie-Christine Barrault, Armin Mueller-Stahl, Elisabeth Trissenaar, Daniel Olbrychski and Piotr Lysak, as the young p.o.w., who, like the German woman, eventually embraces the doom that is demanded by the Nazi laws forbidding sexual relations between Germans and people of "lesser" races.

"A Passage to India." Fourteen years after the fiasco of "Ryan's Daughter," director-writer David Lean has made a brilliant comeback with this literate, pictorially grand, sometimes stately screen adaptation of the classic E. M. Forster novel, about a nasty confrontation between East and West in British India in the early 1920's. The film, like the novel, has an appreciation for the kind of narrative drive, vivid characters and events that one rarely sees any more. The splendid cast is headed by Victor Banerjee, as a young, earnest Indian doctor whose life is almost wrecked by some well-meaning English tourists; Judy Davis, the Australian actress ("My Brilliant Career"), as the instrument of the doctor's torture, and Peggy Ashcroft, the great English dame who plays Forster's most winning — and mysterious — character, Mrs. Moore. Though the physical scale of the film is huge, the intimate aspects of the story never get lost in all of the exotic scenery, as happened with Mr. Lean's "Doctor Zhivago." "A Passage to India" is the best thing Mr. Lean has done since "The Bridge on the River Kwai" and "Lawrence of Arabia."

•

"Places in the Heart." This is the film that writer-director Robert Benton ("The Late Show," "Kramer vs. Kramer") had to make — a memory movie set in the Waxahachie, Tex., of his own youth during the Depression, based on events suggested by the lives of members of his own family. "Places in the Heart" is not, strictly speaking, a "country" movie to be compared to "Country" and "The River." It's far less sentimental and yet far more moving, a film made by a director who has the discipline to deal with the commonplace tribulations of life in such a way that they become the rediscovered material of myth. Nestor Almendros was the cameraman and the cast, which could not be better, is headed by Sally Field, Lindsay Crouse, Ed Harris, Amy Madigan, John Malkovich and Danny Glover.

"Stranger Than Paradise." The year's most original American film, Jim Jarmusch's "Stranger Than Paradise," introduced at the 1984 New York Film Festival, is a low-budget, independent comedy, photographed in grainy black-and-white that appears to reflect the grim prospects of its three nutty characters. They are Willie (John Lurie), a young, slobbish Hungarian émigré who has become completely Americanized and makes his living playing the horses and cheating at cards; Eva (Eszter Balint), his pretty young cousin newly arrived in New York from Hungary, and Eddie (Richard

Edson), Willie's smallish, admiring sidekick. As the three wander, more or less aimlessly, from New York to Cleveland to central Florida, in the middle of winter, in a beat-up car they do not own, "Stranger Than Paradise" gives us a picture of America that you'll never see in New York magazine or People. It's not chic or hip or upwardly mobile. If it moves at all, it moves sideways. The picture is not pretty. It is, in fact, very bleak, but "Stranger Than Paradise" is so witty that the effect is not depressing but immensely invigorating.

"This Is Spinal Tap." To be perfectly frank, "This Is Spinal Tap" is the funniest film of 1984 and maybe even of 1983 and perhaps of 1985, though one shouldn't go too far out on a limb before the arrival of the new year. Rob Reiner's "rockumentary," about the not-so-triumphant American tour of a fictitious British heavy-metal group called Spinal Tap, is the best, most robust, motion-picture parody since "Airplane!" I still laugh just remembering — the only other 1984 film that has that effect on me is "Mike's Murder," which wasn't supposed to be funny. Collaborating with Mr. Reiner on this inspired nonsense were Christopher Guest, Michael McKean and Harry Shearer, who play the key members of Spinal Tap and receive screenplay credit with Mr. Reiner, who, in turn, plays the solemnly earnest director of the film-within-the-film. Glorious pandemonium.

•

The runners-up, in no special order of appreciation, are "Amadeus," Milos Forman's intelligent, carefully thought-out screen adaptation of Peter Shaffer's hit play, with a screenplay by Mr. Shaffer, and excellent performances by F. Murray Abraham, as Salieri, and Tom Hulce as Mozart; Alex Cox's "Repo Man," one of those rare comedies that deserves to be called zany, about the automobile repossession business and creatures from outer space, with Harry Dean Stanton and Emilio Estevez very funny in lead roles; "After the Rehearsal," Ingmar Bergman's haunting, one-set, chamber drama about theater-as-life and life-as-theater, with Erland Josephson, Ingrid Thulin and Lena Olin; "The Killing Fields," a moving remembrance of life and death and life in Cambodia, based on a stirring magazine piece by Sidney Schanberg, directed by Roland Joffe from a screenplay by Bruce Robinson; "L'Argent," Robert Bresson's extraordinarily — and properly — beautiful, austere tale of greed, corruption and murder, acted with chilly distance, in the Bresson manner, by a cast of non-professionals.

Also, Eric Rohmer's "Full Moon in Paris," another typically giddy Rohmer comedy about lovers doing all the wrong things for the right reasons, with a lovely performance by Pascale Ogier, who died much too young not long after the film's release here; Federico Fellini's "And the Ship Sails On," the Italian master's allegorical comedy-spectacle about Europe on the eve of World War I; Pierre Schoendoeffer's "Crabe Tambour," a crazy and fascinating, Joseph Conrad-like tale about a legendary French naval officer in the years after Wrold War II, smashingly photographed in the tropics and near the Arctic Circle by Raoul Coutard; "Last Night at the Alamo," Eagle

Pennell's boisterous, rowdy and profane comedy about life in a sleazy Texas bar on the night before it closes its doors forever; and "Privates on Parade," Michael Blakemore's stylish screen version of Peter Nichols's satirical, caustic play, with screenplay and lyrics by Mr. Nichols, and terrifically comic performances by Denis Quilley and John Cleese. ■

1984 D 30, II:15:1

New York Film Critics Vote 'Passage to India' Best Film

By JANET MASLIN

The New York Film Critics Circle yesterday voted its 50th annual best-film award to "A Passage to India," David Lean's sweeping adaptation of E. M. Forster's novel. Mr. Lean was voted best director, and Peggy Ashcroft, who plays the dowager Mrs. Moore in the film, was voted best actress. Although the group seldom cites comedy performances in the best-acting categories, it named Steve Martin best actor for "All of Me."

Christine Lahti was voted best supporting actress for her role in "Swing Shift," and the late Sir Ralph Richardson was named best supporting actor for "Greystoke." Robert Benton's screenplay for "Places in the Heart" was cited in the screenwriting category. Chris Menges was named best cinematographer for "The Killing Fields."

Documentary Is Cited

The group's voting members, meeting at the offices of the Newspaper Guild of New York, chose Bertrand Tavernier's "Sunday in the Country" as the year's best foreign-language film. The group also elected to cite a documentary this year, although in some years that award is not given. After specifying that the concert film "Stop Making Sense" was not eligible in the documentary category, the group voted "The Times of Harvey Milk" best documentary of 1984. Among the close runners-up were

"The Killing Fields" in the best-film category, Mr. Tavernier in the directing category, Vanessa Redgrave ("The Bostonians") among the leading actresses and John Malkovich ("Places in the Heart") among supporting actors. Miss Lahti was followed by Melanie Griffith, of "Body Double," in the supporting-actress category.

The awards will be presented in a ceremony at Sardi's restaurant on Jan. 27.

The members of the New York Film Critics Circle are:

Judith Crist of TV Guide, chairman
David Ansen of Newsweek
Joy Gould Boyum of Glamour magazine
Dwight Brown of The Black American and Essence
Vincent Canby of The New York Times
Kathleen Carroll of The Daily News
Richard Corliss of Time magazine
David Denby of New York magazine
David Edelstein of The Village Voice
Richard Freedman of Newhouse Newspapers
Joseph Gelmis of Newsday
Roger Greenspun of Penthouse magazine
Molly Haskell of Vogue and Playgirl magazines
J. Hoberman of The Village Voice
Pauline Kael of The New Yorker
Howard Kissel of Women's Wear Daily
Jack Kroll of Newsweek
Ernest Leogrande of The Daily News
Janet Maslin of The New York Times
Rex Reed of The New York Post
Julie Salamon of The Wall Street Journal
Andrew Sarris of The Village Voice
Richard Schickel of Time magazine
Leo Seligson of Newsday
John Simon of The National Review
David Sterritt of The Christian Science Monitor
Bruce Williamson of Playboy magazine
William Wolf of Gannett Newspapers and The Asbury Park Press

1984 D 19, C26:5

'Stranger Than Paradise' Wins Award

By JANET MASLIN

Jim Jarmusch's "Stranger Than Paradise" was voted best film of 1984 last night by the National Society of Film Critics, a 40-member group representing critics from New York, Los Angeles, Boston, Chicago and other areas. The group voted Steve Martin best actor for his performance in "All of Me" and Vanessa Redgrave best actress for her work in "The Bostonians." Robert Bresson was voted best director for "L'Argent."

Meeting at the Algonquin Hotel, the group voted to give its best supporting actor award to John Malkovich,

for both "Places in the Heart" and "The Killing Fields." Melanie Griffith, who appeared in "Body Double," was named best supporting actress. The screenwriting award went to Lowell Ganz, Babaloo Mandell and Bruce Jay Friedman for "Splash!"

In the documentary category, "Stop Making Sense," Jonathan Demme's concert film about the rock group Talking Heads, was chosen as the year's best. The cinematography award was voted to Chris Menges for both "The Killing Fields" and "Comfort and Joy."

The group's chairman, Stephen Schiff of Vanity Fair magazine, was re-elected to a second term.

1985 Ja 3, C14:5

A 'Streamlined' Edition of 1985 Oscar Awards

By JANET MASLIN

HOLLYWOOD presented its Lite Oscars on Monday evening, a trimmed-down version of the usual affair. The evening's traditional dawdling was kept to a minimum, as were jokes, idle remarks and lengthy acceptance speeches. The awards were presented by a revolving group of young actors, who were efficiently recycled so that each could reappear a couple of times. Even the baby elephant, on hand to show off the costume design for "A Passage to India," managed to step lively.

And it all went to show that people — talkative, time-wasting, inefficient people — were never the Oscar show's problem in the first place. If anything, they gave it the personality that this year's streamlined program lacked. The 1985 Oscars — introduced as both the 56th and 57th Oscar awards ceremony (it was the 57th) by a confused announcer at the beginning of the show — were more than half an hour shorter than last year's counterpart, but the new version did not seem appreciably speedier. If anything, it seemed humorless and spare, with a middle hour that was as tedious as ever. No Oscar efficiency plan has ever put a dent in that middle hour.

•

Jack Lemmon made a graceful debut as Oscar host, dispensing with the opening monologue to introduce such co-presenters as William Hurt, Jeff Bridges, Glenn Close and Kathleen Turner. This group, about a dozen in all, began by appearing on stage to take a bow, thus eliminating the usual suspense over who might appear next, and in what outfit. Another of the show's drama-diminishing touches was to substitute trailer-like composites from some of the Best Picture nominees, instead of the lengthier, sustained scenes that are bound to be more engrossing. However, for reasons only the program's

producers (Gregory Peck, Robert Wise, Larry Gelbart and Gene Allen) might understand, sustained scenes from the Best Foreign Films *were* shown. They were shown without subtitles.

It sometimes seemed that the producers were intent on sabotaging the show's natural advantages. This year, for instance, the Academy found itself in the unique position of having five first-rate songs nominated, as opposed to the usual triple nomination for Marilyn and Alan Bergman. It was apparently thought necessary to compensate for this by making the production numbers as wrong-headed as possible. So Ray Parker Jr. sang "Ghostbusters" surrounded by "Cats"-style dancers and by special effects that made the movie's green ghosts look sophisticated. And "Against All Odds" was given a tone-deaf, lip-synched rendition by Ann Reinking (who did a much better job of dancing to the song) while the

writer and far better original singer, Phil Collins, sat glumly in the audience.

•

Mr. Collins, who at least got a nomination, qualified as one of the evening's good sports, along with Steven Spielberg and Steve Martin, both of whom presented awards despite Academy snubs. As for the show's most effusive speaker, that was Sally Field, exuberantly telling the crowd "You *like* me." Miss Fields was also one of the most visibly emotional winners, along with Prince, who won for Best Original Song Score and seemed genuinely surprised by his own rags-to-riches good fortune. Appearing in a purple, hooded minicaftan, Prince edged out Faye Dunaway (clinging, shirred magenta), Candice Bergen (futuristic gold) and Amy Irving (bouffant blue) for the evening's most traffic-stopping outfit.

Hollywood's old guard, as represented by Cary Grant, Laurence Olivier, James Stewart (recipient of a special Oscar), Kirk Douglas, Burt Lancaster and Gene Kelly, stood out this year in particularly strong contrast to the new. A selection of clips showcasing Mr. Stewart's long and varied career was easily the high point of the evening.

Associated Press

Tara the elephant giving Jennifer Beals the name of the winner of the Academy Award for Best Costume Design.

1985 Mr 27, C25:1

Index

This index covers all the film reviews included in this volume. It is divided into three sections: Titles, Personal Names, and Corporate Names.

The Titles Index lists each film reviewed by title. The Persons Index lists by name every performer, producer, director, screenwriter, etc. mentioned in the reviews, with the function in parentheses following the name, and the titles of the movies with which the person was connected, in chronological order. The Corporate Names Index lists all performing arts groups and organizations, and producing, distributing, and otherwise participating companies mentioned in reviews by name, again with the function in parentheses following the name, and the titles of the movies with which they were associated, in chronological order.

Citations in this index are by year, month, day, section of newspaper (if applicable), page and column; for example, 1983 Ja 11,II,12:1. Since the reviews appear in chronological order, the date is the key locator. The citations also serve to locate the reviews in bound volumes and microfilm editions of The Times.

In the citations, the months are abbreviated as follows:

Ja - January	My - May	S - September
F - February	Je - June	O - October
Mr - March	Jl - July	N - November
Ap - April	Ag - August	D - December

TITLES INDEX

All films reviewed are listed alphabetically by title. Titles are inverted only if they begin with an article ("Doctor Glas" is listed under D, not G; but "The Graduate" is listed under G, not T). Titles beginning with a number are alphabetized as though the number were spelled out in English. Wherever possible, foreign films are entered under both the English and foreign-language title. Titles given incorrectly in the review appear correctly here. Films reviewed more than once and films with identical titles are given multiple listings.

PERSONAL NAMES INDEX

All persons included in the credits are listed alphabetically, last name first. Their function in the films is listed after the name in parentheses: Original Author, Screenwriter, Director, Producer, Cinematographer, Composer, Narrator, Miscellaneous. In entries where no such qualifier appears, the person was a performer (actor, actress, singer). A person with multiple functions will have multiple entries; for example, an actor who later turned producer or director will have two listings. A person having two functions in the same film will also have two listings. Functions that are none of the above, such as editors, costume designers, art directors, etc., are given as miscellaneous.

Names beginning with Mc are alphabetized as though spelled Mac.

Names beginning with St. are alphabetized as though spelled Saint.

Entries under each name are by title of film, in chronological order.

CORPORATE NAMES INDEX

All companies mentioned in reviews as involved in the production or distribution of the film or in some other major function connected with it, such as performing arts groups and organizations, are listed here alphabetically. Company names are not inverted unless they start with a personal forename (for example, J Arthur Rank Organization is listed as Rank, J Arthur, Organization). The function of the company is given in parentheses, abbreviated as follows:

Prod. - Producer
Distr. - Distributor
Misc. - Miscellaneous

Misc. is used when the function is uncommon or not precisely defined in the review; it is also used for performing arts groups and organizations. A company that has more than one function is given more than one listing; thus a user who has completed scanning a long listing under RKO (Distr.) will then find an additional listing under RKO (Prod.).

Abbreviations in names are alphabetized as though they were words (RKO as Rko).

Entries under each company name are by title of film, in chronological order.

A

A Nos Amours 1984,O 12,C,10:4
Abismos de Pasion (Wuthering Heights) 1983,D 27,C,11:2
Abuse 1983,Ap 15,C,29:1
Adventures of Buckaroo Banzai, The 1984,O 5,C,8:5
Adventures of Buckaroo Banzai, The 1984,O 14,II,21:1
After the Rehearsal 1984,Je 21,C,14:1
After the Rehearsal 1984,Jl 1,II,13:1
Against All Odds 1984,Mr 1,II,17:1
Against All Odds 1984,Mr 2,C,14:3
Ah Ying 1984,Mr 30,C,7:1
All By Myself 1983,My 6,C,10:2
All of Me 1984,S 21,C,6:1
All of Me 1984,O 14,II,21:1
All the Right Moves 1983,O 21,C,10:3
Alphabet City 1984,My 5,17:1
Alsino and the Condor 1983,My 1,69:1
Amadeus 1984,S 19,C,23:1
Amadeus 1984,S 30,II,1:3
Amator (Camera Buff) 1983,F 24,C,17:1
Amour par Terre, L' (Love on the Ground) 1984,O 7,86:5
America and Lewis Hine 1984,S 29,14:4
America—From Hitler to MX 1983,Ja 5,C,17:1
American Dreamer 1984,O 26,C,12:4
American Friend, The 1984,My 27,II,15:1
American Pictures (Part 1) 1984,S 5,C,16:5
Americana 1983,O 21,C,14:5
Amityville 3-D 1983,N 20,68:3
Anarchism in America 1983,Ja 15,16:1
And God Created Them 1983,Mr 19,11:1
And Nothing But the Truth 1984,Ap 20,C,15:1
And the Ship Sails On 1984,Ja 26,C,17:1
And the Ship Sails On 1984,F 5,II,15:1
Android 1984,F 10,C,28:1
Angel 1984,Ja 13,C,12:5
Angelo My Love 1983,Ap 27,C,17:5
Another Country 1984,Je 29,C,8:1
Another Time, Another Place 1984,Jl 11,C,26:1
Antarctica 1984,Mr 30,C,10:5
Argent, L' (Money) 1983,S 24,11:1
Argent, L' (Money) 1983,O 2,II,21:1
Argent, L' (Money) 1984,Mr 23,C,10:3
Aria for an Athlete 1983,Mr 16,C,21:4

B

Baby It's You 1983,Mr 25,C,6:5
Baby It's You 1983,Je 5,II,19:3
Bachelor Party 1984,Je 30,11:1
Backstage at the Kirov 1984,Ja 18,C,24:3
Bad Boys 1983,Mr 25,C,8:1
Bad Boys 1983,Ap 10,II,17:1
Bal, Le 1984,Mr 23,C,6:1
Balance, La 1983,N 20,72:1
Ballad of Gregorio Cortez, The 1983,O 14,C,6:5
Ballad of Narayama, The 1984,Ap 9,C,14:5
Ballad of Narayama, The 1984,S 7,C,6:1
Ballet Robotique 1983,S 9,C,6:2
Basileus Quartet 1984,Ja 4,C,13:5
Beat Street 1984,Je 8,C,10:5
Becky Sharp 1984,O 21,II,23:1
Before the Nickelodeon 1983,F 28,C,24:5
Below the Belt 1983,Ag 31,C,21:1
Beneath the Angka: A Story of the Khmer Rouge 1983,Ap 29,C,17:5
Berlin Alexanderplatz 1983,Ag 10,C,18:5
Berlin Alexanderplatz 1983,D 25,II,15:1
Best Defense 1984,Jl 20,C,10:1
Best Friends 1983,F 13,II,23:1
Betrayal 1983,F 20,78:1
Betrayal 1983,Mr 6,II,17:1
Betrayal 1983,D 25,II,15:1
Betrayal: The Story of Kamilla (Kamilla) 1983,Mr 20,60:1
Betrayal: The Story of Kamilla (Kamilla) 1984,Ja 13,C,8:1
Beverly Hills Cop 1984,D 5,C,25:4
Beverly Hills Cop 1984,D 16,II,21:1
Beyond Good and Evil 1984,My 18,C,14:1
Beyond Reasonable Doubt 1983,N 22,C,16:4
Beyond the Limit 1983,S 30,C,4:3
Big Chill, The 1983,S 23,C,14:3
Big Chill, The 1983,O 2,II,21:1
Big Chill, The 1983,D 18,II,21:1
Big Chill, The 1983,D 25,II,15:1
Big Score, The 1983,N 20,67:3
Bigger Splash, A 1984,O 5,C,12:1
Bill Cosby—"Himself" 1983,My 21,31:5
Bill Douglas Trilogy, The 1983,My 18,C,26:5
Biquefarre 1984,Ap 5,C,15:1
Birdy 1984,D 21,C,25:1
Bizet's Carmen 1984,S 20,C,21:1
Bizet's Carmen 1984,S 23,II,19:1
Bizet's Carmen 1984,S 30,II,1:3
Black Stallion Returns, The 1983,Mr 27,54:4
Black Stallion Returns, The 1983,Ap 10,II,17:1
Black Wax 1983,Ja 12,C,21:2
Blame It on Rio 1984,F 17,C,10:5
Bless Their Little Hearts 1984,D 12,C,25:5
Blood Simple 1984,O 12,C,10:4
Blue Skies Again 1983,Jl 29,C,8:3
Blue Thunder 1983,My 13,C,17:4
Blue Thunder 1983,My 15,II,13:1
Boat People 1983,S 27,C,17:5
Boat People 1983,N 13,78:1
Body Double 1984,O 26,C,8:1
Body Rock 1984,S 28,C,12:5
Bolero 1984,S 1,9:5
Bolwieser (Stationmaster's Wife, The) 1983,Ja 12,C,21:2
Bona 1984,S 19,C,23:1
Born in Flames 1983,N 10,C,17:1
Bostonians, The 1984,Ag 2,C,15:1
Bostonians, The 1984,Ag 5,II,15:1
Bostonians, The 1984,D 30,II,15:1
Boum, La 1983,My 13,C,28:1
Bounty, The 1984,My 4,C,8:1
Brady's Escape 1984,Je 28,C,17:1
Brainstorm 1983,S 30,C,17:1
Breakin' 1984,My 5,17:1
Breakin' 2: Electric Boogaloo 1984,D 19,C,22:4
Breathless 1983,My 13,C,10:1
Breathless 1983,Je 26,II,1:5
Britannia Hospital 1983,Mr 4,C,10:1
Britannia Hospital 1983,Mr 6,II,17:1
Britannia Hospital 1983,Ap 3,II,15:1
Britannia Hospital 1983,D 18,II,21:1
Britannia Hospital 1983,D 25,II,15:1
Broadway Danny Rose 1984,Ja 27,C,8:1
Broadway Danny Rose 1984,Ja 29,II,13:1
Broadway Danny Rose 1984,D 30,II,15:1
Brother From Another Planet, The 1984,S 14,C,6:5
Bruto, El 1983,S 21,C,22:3
Buddy System, The 1984,My 4,C,15:2
Burroughs 1983,O 8,33:1
Burroughs 1984,F 10,C,12:1

C

C H U D 1984,S 2,II,11:1
Cal 1984,Ag 24,C,6:1
Cal 1984,S 9,II,25:5
Camera Buff (Amator) 1983,F 24,C,17:1
Cammina Cammina (Keep Walking, Keep Walking) 1984,O 4,C,16:5
Can She Bake a Cherry Pie? 1983,D 8,C,22:3
Cannonball Run II 1984,Je 29,C,14:5
Cannonball Run II 1984,Jl 29,II,15:1
Careful He Might Hear You 1984,Je 15,C,8:1
Carmen 1983,O 20,C,21:3
Case is Closed, The 1984,N 28,C,19:5
Chained Heat 1983,Je 5,II,19:3
Champions 1984,Ap 20,C,8:1
Cheech & Chong's The Corsican Brothers 1984,Jl 28,15:5
Chicago Blues 1983,S 1,C,28:1
Chicken Ranch 1983,Je 1,C,14:2
Children (Terence Davies Trilogy, The) 1984,Ap 8,64:3
Children of the Corn 1984,Mr 16,C,7:2
China 9, Liberty 37 1984,N 30,C,8:4
Chip of Glass Ruby, A (Gordimer Stories, The) 1983,My 18,C,26:4
Choice of Arms 1983,Mr 6,65:1
Choose Me 1984,N 1,C,18:4
Chopin 1983,Mr 21,C,10:4
Chopin 1984,F 3,C,13:3
Chords of Fame 1984,F 16,C,23:1
Christine 1983,D 9,C,10:5
Christmas Story, A 1983,N 18,C,36:1
Circle of Power 1984,Mr 2,C,5:1
City Heat 1984,D 7,C,4:3
City Lovers 1983,My 18,C,26:4
City News and News Briefs 1983,S 9,C,6:2
Class 1983,Jl 22,C,10:5
Class Enemy 1984,Jl 13,C,6:1
Class Relations 1984,O 7,86:1
Claw and the Tooth, The 1984,D 26,C,15:3
Clean Slate (Coup de Torchon) 1983,Ja 23,II,17:1
Cloak and Dagger 1984,Ag 10,C,16:1
Cloak and Dagger 1984,S 9,II,25:5
Cold Feet 1984,My 25,C,12:1
Colors of Iris, The 1984,Ap 6,C,14:6
Comfort and Joy 1984,O 10,C,19:1
Comperes, Les 1984,Mr 28,C,24:6
Compleat Beatles, The 1984,F 10,C,8:1
Conan the Destroyer 1984,Je 29,C,8:4
Confidentially Yours (Vivement Dimanche) 1984,Ja 20,C,6:1
Constans (Constant Factor, The) 1983,Mr 10,C,18:3
Constant Factor, The (Constans) 1983,Mr 10,C,18:3
Conversation with Louise Brooks, A 1983,Je 22,C,15:3
Corps a Coeur (Drugstore Romance) 1983,Jl 1,C,8:4
Corrupt 1984,Ja 19,C,16:5
Cotton Club, The 1984,D 14,C,4:3
Country 1984,S 28,20:1
Country Lovers (Gordimer Stories, The) 1983,My 18,C,26:4
Coup de Foudre (Entre Nous) 1983,O 8,35:3
Coup de Foudre (Entre Nous) 1984,Ja 25,C,17:5
Coup de Torchon (Clean Slate) 1983,Ja 23,II,17:1
Crabe Tambour, Le (Drummer Crab) 1984,F 17,C,17:1
Crabe Tambour, Le (Drummer Crab) 1984,F 19,II,15:1
Crackers 1984,F 17,C,19:3
Crimes of Passion 1984,O 19,C,19:1
Cross Creek 1983,S 21,C,19:4
Cruel Story of Youth 1984,Jl 18,C,20:3
Cujo 1983,Ag 13,13:1
Curse of the Pink Panther 1983,Ag 13,13:1

D

Daniel 1983,Ag 26,C,10:4
Daniel 1983,S 4,II,11:1
Danny Boy 1984,My 18,C,11:1
Danton 1983,S 28,C,19:1
Danton 1983,D 25,II,15:1
Dark Circle 1984,My 2,C,25:1
Dawn, The 1983,Mr 23,C,26:4
Dead Zone, The 1983,O 21,C,8:1
Deadly Force 1983,Jl 8,C,4:3
Deadly Spawn, The 1983,Ap 22,C,11:1
Deal of the Century 1983,N 4,C,13:3
Dear Maestro (Chopin) 1984,F 3,C,13:3
Dear Mr Wonderful 1983,D 21,C,26:4
Death and Transfiguration (Terence Davies Trilogy, The) 1984,Ap 8,64:3
Death Watch 1984,S 14,C,6:5
Deep in the Heart 1984,Ja 18,C,24:3
Demonios en el Jardin (Demons in the Garden) 1984,Mr 2,C,5:3
Demons in the Garden (Demonios en el Jardin) 1984,Mr 2,C,5:3
Dernier Combat, Le (Last Battle, The) 1984,Je 22,C,12:1
Dernier Combat, Le (Last Battle, The) 1984,S 2,II,11:1
Dhrupad 1983,O 4,C,14:5
Diary for My Children 1984,S 30,58:1
Diary for My Children 1984,O 31,C,21:5
Dirty Dishes (Jument Vapeur, La) 1983,Mr 25,C,12:5
Divine Emma, The 1983,Je 5,54:1
Doctor Detroit 1983,My 6,C,10:1
Dos Mundos del Angelita, Los (Two Worlds of Angelita, The) 1983,O 28,C,4:3
Draughtsman's Contract, The 1983,Je 22,C,26:4
Draughtsman's Contract, The 1983,D 25,II,15:1
Dreamscape 1984,Ag 15,C,24:4
Dreamscape 1984,S 2,II,11:1
Dresser, The 1983,D 6,C,19:1
Dresser, The 1983,D 18,II,21:1
Drifting 1984,Ap 23,C,12:1
Drugstore Romance (Corps a Coeur) 1983,Jl 1,C,8:4
Drummer Crab (Crabe Tambour, Le) 1984,F 17,C,17:1
Drummer Crab (Crabe Tambour, Le) 1984,F 19,II,15:1
Duel 1983,Ap 15,C,10:1
Dune 1984,D 14,C,18:4
Dune 1984,D 23,II,19:1

L

Langlois 1983,Ag 5,C,10:5
Lassiter 1984,F 17,C,10:5
Last American Virgin, The 1983,Ja 15,48:2
Last Battle, The 1984,Je 22,C,12:1
Last Fight, The 1983,S 7,C,20:1
Last Night at the Alamo 1983,O 2,II,60:3
Last Night at the Alamo 1984,Jl 3,C,10:5
Last Night at the Alamo 1984,Jl 15,II,15:1
Last Sea, The 1984,Jl 4,C,7:5
Last Starfighter, The 1984,Jl 13,C,5:2
Last Starfighter, The 1984,Ag 12,II,17:1
Last Winter, The 1984,S 8,10:4
Leopard, The 1983,S 11,II,21:5
Let's Spend the Night Together 1983,F 11,C,8:1
Letter to Freddy Bauche 1983,Je 24,C,8:1
Lianna 1983,Ja 19,C,22:1
Lianna 1983,Ja 30,II,17:1
Liebelei 1983,My 31,C,10:5
Life is a Bed of Roses 1984,Ag 19,63:1
Light Years Away 1983,Ap 15,C,7:1
Linea del Cielo, La (Skyline) 1984,Ap 3,C,15:1
Linea del Cielo, La (Skyline) 1984,My 27,II,15:1
Linea del Cielo, La (Skyline) 1984,Jl 18,C,20:3
Liquid Sky 1983,Jl 22,C,10:1
Liquid Sky 1983,Jl 31,II,15:1
Liquid Sky 1984,My 27,II,15:1
Little Drummer Girl, The 1984,O 19,C,18:1
Local Hero 1983,F 17,C,25:1
Local Hero 1983,Mr 6,II,17:1
Local Hero 1983,Ap 3,II,15:1
Local Hero 1983,D 25,II,15:1
Lone Wolf McQuade 1983,Ap 16,12:4
Lonely Guy, The 1984,Ja 28,11:5
Lonely Hearts 1983,S 4,58:3
Lonely Lady, The 1983,O 1,13:5
Lords of Discipline, The 1983,F 18,C,16:4
Lords of Discipline, The 1983,Ap 10,II,17:1
Losin' It 1983,Ap 8,C,4:5
Lost Illusions 1983,O 1,16:3
Lost One, The (Verlorene, Der) 1984,Ag 1,C,21:3
Love in Germany, A 1984,O 2,C,13:2
Love in Germany, A 1984,O 7,II,17:1
Love in Germany, A 1984,N 9,C,10:1
Love in Germany, A 1984,D 30,II,15:1
Love Letters 1984,Ja 27,C,14:1
Love on the Ground (L'Amour par Terre) 1984,O 7,86:5
Love Streams 1984,Ag 24,C,8:5
Love Streams 1984,S 9,II,25:5
Loveless, The 1984,Ja 20,C,8:5
Lovesick 1983,F 18,C,19:1
Lucie sur Seine 1983,S 9,C,8:1

M

Madonna and Child (Terence Davies Trilogy, The) 1984,Ap
 8,64:3
Making the Grade 1984,My 18,C,10:5
Malou 1983,D 22,C,22:1
Man from Snowy River, The 1983,Ja 21,C,5:6
Man of Flowers 1984,O 9,C,14:4
Man of Flowers 1984,D 16,78:4
Man Who Loved Women, The 1983,D 16,C,8:1
Man Who Loved Women, The 1984,Ja 1,II,11:1
Man Who Wasn't There, The 1983,Ag 13,13:1
Man With Two Brains, The 1983,Je 3,C,8:1
Man With Two Brains, The 1983,Je 19,II,23:1
Man, Woman and Child 1983,Ap 1,C,8:1
Marigolds in August 1984,Je 20,C,21:1
Marigolds in August 1984,Jl 1,II,13:1
Marriage, A 1983,Mr 30,C,21:1
Mass Appeal 1984,D 17,C,12:1
Mauvaise Conduite (Improper Conduct) 1984,Ap 11,C,19:1
Max Dugan Returns 1983,Mr 25,C,8:5
Meatballs Part II 1984,Ag 18,13:2
Memoirs 1984,D 28,C,14:5
Memoirs of Prison 1984,O 10,C,18:3
Merry Christmas Mr Lawrence 1983,Ag 26,C,10:1
Metalstorm: The Destruction of Jared-Syn 1983,Ag 21,56:4
Metropolis 1984,Ag 19,II,15:1
Micki and Maude 1984,D 21,C,25:4
Mike's Murder 1984,Mr 9,C,16:1
Mike's Murder 1984,Mr 11,II,17:1
Mirror, The 1983,Ag 17,C,16:3

Missing in Action 1984,N 17,11:1
Missing in Action 1984,D 2,II,17:1
Mission, The (Ferestedah) 1983,Mr 30,C,21:2
Mission, The (Ferestedah) 1984,My 2,C,25:1
Mission, The 1984,My 27,II,15:1
Misunderstood 1984,Mr 30,C,10:1
Money (Argent, L') 1983,S 24,11:1
Money (Argent, L') 1984,Mr 23,C,10:3
Mongreloid, The (George Kuchar Sampler, A) 1983,Ag 3,C,21:3
Monkey Grip 1983,N 7,C,16:5
Monty Python's the Meaning of Life 1983,Mr 31,C,13:5
Moon in the Gutter, The 1983,S 9,C,8:1
Moon Over the Alley 1983,Ap 27,C,19:4
Moscow On the Hudson 1984,Ap 6,C,12:1
Moscow on the Hudson 1984,My 6,II,17:1
Moscow on the Hudson 1984,My 27,II,15:1
Mourir a Trente Ans (Half a Life) 1983,Mr 27,55:1
Mourir a Trente Ans (Half a Life) 1984,Ag 15,C,22:5
Mr Mom 1983,Ag 26,C,8:4
Mrs Soffel 1984,D 26,C,15:1
Muddy River 1983,Ja 21,C,4:1
Muppets Take Manhattan, The 1984,Jl 13,C,10:4
Musical Passage 1984,Mr 21,C,20:3
Musical Passage 1984,My 27,II,15:1
My Ain Folk (Bill Douglas Trilogy, The) 1983,My 18,C,26:5
My Best Friend's Girl 1984,Mr 25,56:1
My Brother's Wedding 1984,Mr 30,C,7:1
My Childhood (Bill Douglas Trilogy, The) 1983,My 18,C,26:5
My Name is Anna Magnani 1984,Ag 10,C,12:4
My Way Home (Bill Douglas Trilogy, The) 1983,My 18,C,26:5

N

Nadine Gordimer Interview (Gordimer Stories, The) 1983,My
 18,C,26:4
Nate and Hayes 1983,N 18,C,30:3
Nate and Hayes 1983,D 11,II,23:1
National Lampoon's Vacation 1983,Jl 29,C,10:4
National Lampoon's Vacation 1983,Ag 21,II,17:1
Natural, The 1984,My 11,C,15:1
Neige (Snow) 1983,Jl 5,C,10:1
Never Cry Wolf 1983,O 14,C,8:1
Never Say Never Again 1983,O 7,C,13:1
Never Say Never Again 1983,O 16,II,21:1
Neverending Story, The 1984,Jl 20,C,5:1
New Babylon, The 1983,O 3,C,15:1
Next Year If All Goes Well 1983,Mr 20,60:1
Nicaragua: No Pasaran 1984,N 2,C,14:1
Nicaragua: Report from the Front 1984,Ja 18,C,24:3
Nicaragua: Report from the Front 1984,Ja 22,II,17:1
Night in Heaven, A 1983,N 19,19:3
Night of the Comet 1984,N 16,C,8:1
Night of the Shooting Stars, The 1983,Ja 30,34:3
Nightmare on Elm Street, A 1984,N 9,C,10:5
Nightmares 1983,S 3,14:5
No Small Affair 1984,N 9,C,16:1
Norman Loves Rose 1983,Je 3,C,20:5
Norte, El 1984,Ja 11,C,15:1
Norte, El 1984,Ja 22,II,17:1
Norte, El 1984,My 27,II,15:1
Nostalghia 1983,O 5,C,23:1
Nostalghia (Nostalgia) 1984,Ja 8,47:1
Nostalgia 1984,Ja 8,47:1
Not for Publication 1984,N 1,C,17:1
Now and Forever 1983,Jl 16,14:1
Nudo di Donna 1983,My 13,C,7:5
Nuit de Varennes, La 1983,F 16,C,23:1
Nuit de Varennes, La 1983,F 27,II,1:1
Nuit de Varennes, La 1983,D 25,II,15:1
Nuits de la Pleine Lune, Les (Full Moon in Paris) 1984,S 7,C,5:1

O

Observations Under the Volcano 1984,N 2,12,3:
Octopussy 1983,Je 10,C,17:4
Octopussy 1983,Je 26,II,1:5
Oedipus Rex 1984,D 7,C,8:5
Of Judges and Other Sympathizers 1983,Je 15,C,17:1
Of Unknown Origin 1983,N 24,C,17:1
Oh God! You Devil 1984,N 9,C,15:1
Old Country Where Rimbaud Died, The (Vieux Pays ou Rimbaud
 Est Mort,
 Le) 1984,N 9,C,12:5
Old Enough 1984,Ag 24,C,10:4
Once Upon a Time in America 1984,Je 1,C,8:1

Once Upon a Time in America 1984,O 21,II,23:1
One Deadly Summer 1984,Jl 20,C,10:5
One Man's War (Guerre d'un Seul Homme, La) 1984,F 24,C,9:1
Oral History (Gordimer Stories, The) 1983,My 18,C,26:4
Oridathu Oru Phayaivaan (There Lived a Wrestler) 1983,Mr
 23,C,26:3
Osterman Weekend, The 1983,N 4,C,11:1
Osterman Weekend, The 1983,D 11,II,23:1
Out of the Blue 1983,Ap 8,C,6:5
Outsiders, The 1983,Mr 25,C,3:1
Outsiders, The 1983,Ap 3,II,15:1
Outsiders, The 1983,Ap 10,II,17:1
Over the Brooklyn Bridge 1984,Mr 2,C,6:5
Oxford Blues 1984,Ag 25,9:1

P

Pagan Rhapsody (George Kuchar Sampler, A) 1983,Ag 3,C,21:3
Paris, Texas 1984,O 14,64:1
Paris, Texas 1984,N 9,C,4:3
Paris, Texas 1984,N 11,II,17:1
Parsifal 1983,Ja 23,46:1
Passage to India, A 1984,D 14,C,10:1
Passage to India, A 1984,D 30,II,15:1
Passante, La 1983,Ag 14,47:1
Passion 1983,O 4,C,13:2
Pauline at the Beach 1983,Jl 29,C,6:5
Pauline at the Beach 1983,Ag 21,II,17:1
Pauline at the Beach 1983,D 25,II,15:1
Personals, The 1983,Mr 20,60:1
Petite Bande, La 1984,N 9,C,28:5
Petite Sirene, La 1984,Ag 3,C,15:1
Petria's Wreath 1983,F 6,4,49:1
Phar Lap 1984,Ag 10,C,8:1
Phar Lap 1984,S 9,II,25:5
Pharos of Chaos 1983,O 13,C,13:1
Philadelphia Experiment, The 1984,Ag 17,C,17:4
Philadelphia Experiment, The 1984,S 2,II,11:1
Phoenix Bird 1984,Ag 29,C,19:2
Pile ou Face (Heads or Tails) 1983,My 27,C,4:5
Pirates of Penzance, The 1983,F 20,80:1
Piso Pisello (Sweet Pea) 1983,Ja 23,47:1
Places in the Heart 1984,S 21,C,8:1
Places in the Heart 1984,S 23,II,19:1
Places in the Heart 1984,D 30,II,15:1
Ploughman's Lunch, The 1984,O 19,C,8:1
Police Academy 1984,Mr 23,C,12:1
Poltergeist 1983,Ja 2,II,1:1
Pope of Greenwich Village, The 1984,Je 22,C,12:4
Porky's II: The Next Day 1983,Je 25,12:3
Possession 1983,O 28,C,10:1
Praise (Gordimer Stories, The) 1983,My 18,C,26:4
Princess, The 1984,Ap 1,57:1
Private Conversation, A 1984,O 12,C,12:5
Private Life 1983,F 27,45:1
Private School 1983,Jl 30,11:4
Privates on Parade 1984,Ap 13,C,8:1
Privileged 1983,Ap 8,C,8:5
Prix de Beaute 1983,Je 22,C,15:3
Prophecy, A (Tibet: A Buddhist Trilogy) 1984,Je 8,C,10:5
Protocol 1984,D 21,C,25:1
Provincial Actors 1983,Mr 2,C,20:5
Psycho II 1983,Je 3,C,14:5
Psycho II 1983,Je 26,II,1:5
Puberty Blues 1983,Jl 15,C,13:1
Purple Haze 1983,N 11,C,8:1
Purple Hearts 1984,My 4,C,15:1
Purple Rain 1984,Jl 27,C,5:1
Purple Rain 1984,Ag 12,II,17:1

Q

Querelle 1983,Ap 29,C,8:5
Quest for Power: Sketches of the American New Right 1983,Jl
 13,C,16:3
Question of Silence, A (Stilte Rond Christine M, De) 1983,Mr
 18,C,8:5
Question of Silence, A (Stilte Rond Christine M, De) 1984,Ag
 5,44:6
Quiet Duel 1983,N 25,C,10:1

R

Racing With the Moon 1984,Mr 23,C,5:1
Radiating the Fruit of Truth (Tibet: A Buddhist Trilogy) 1984,Je 8,C,10:5
Rat Trap (Elippathayam) 1983,Mr 27,55:5
Razor's Edge, The 1984,O 19,C,14:6
Reaching Out 1983,My 16,C,20:5
Rear Window 1983,O 9,II,21:1
Reason to Live, A (George Kuchar Sampler, A) 1983,Ag 3,C,21:3
Reassemblage 1983,S 24,11:1
Reckless 1984,F 3,C,8:1
Red Dawn 1984,Ag 10,C,11:1
Red Dawn 1984,Ag 19,II,15:1
Red Dawn 1984,S 2,II,11:1
Red Dawn 1984,S 16,II,19:1
Red Love 1983,O 4,C,13:2
Rent Control 1984,My 4,C,13:3
Repo Man 1984,Jl 6,C,8:5
Repo Man 1984,N 11,II,17:1
Return Engagement 1983,N 23,C,10:5
Return of Martin Guerre, The 1983,Je 10,C,12:5
Return of Martin Guerre, The 1983,Ag 21,II,17:1
Return of Martin Guerre, The 1983,D 25,II,15:1
Return of the Jedi 1983,My 25,C,24:1
Return of the Jedi 1983,My 29,II,15:1
Return of the Jedi 1983,Je 26,II,1:5
Reuben, Reuben 1983,D 19,C,12:5
Revenge of the Nerds 1984,Jl 20,C,8:5
Revenge of the Ninja 1983,S 8,C,23:1
Revolt of Job, The 1984,Mr 28,C,19:3
Rhinestone 1984,Je 22,C,10:5
Rhinestone 1984,Jl 29,II,15:1
Richard Pryor Here and Now 1983,O 28,C,8:1
Riddle of the Sands, The 1984,Ja 6,C,8:1
Right Stuff, The 1983,O 21,C,5:1
Right Stuff, The 1983,N 6,II,21:1
Right Stuff, The 1983,N 27,II,17:1
Right Stuff, The 1983,D 18,II,21:1
Right Stuff, The 1983,D 25,II,15:1
Risky Business 1983,Ag 5,C,13:1
Risky Business 1983,Ag 14,II,15:3
Ritual, A 1983,Mr 30,C,21:1
River, The 1984,D 19,C,19:1
Rockaby 1983,N 23,C,16:3
Romancing the Stone 1984,Mr 30,C,19:1
Romantic Comedy 1983,O 7,C,8:1
Rope 1984,Je 3,II,19:1
Routes of Exile: A Moroccan Jewish Odyssey 1983,My 6,C,15:3
Rumble Fish 1983,O 7,C,10:3
Rumble Fish 1983,O 23,II,19:1
Runaway 1984,D 14,C,20:1

S

Salamander, The 1983,Je 5,53:1
Sandglass, The 1983,My 6,C,16:1
Sans Soleil 1983,O 26,C,24:2
Saraba Itoshiki Daichi (Farewell to the Land, A) 1983,Mr 20,60:3
Savage Streets 1984,O 5,C,14:3
Say Amen, Somebody 1983,Mr 11,C,10:1
Scandalous 1984,Ja 20,C,4:5
Scarface 1983,D 9,C,18:3
Scarface 1983,D 11,II,23:1
Scarface 1983,D 25,II,15:1
Scarface 1984,My 27,II,15:1
Schatten der Engel (Shadow of Angels) 1983,Je 24,C,8:1
Screwballs 1983,Jl 9,10:4
Scrubbers 1984,F 1,C,16:4
Secret Agent, The 1983,O 8,33:1
Secret Agent, The 1984,Mr 21,C,14:4
Secrets 1984,Ag 17,C,13:3
Seeing Red 1983,O 4,C,14:5
Seeing Red 1984,Mr 25,II,19:1
Sekka Tomurai Zashi (Irezumi—Spirit of Tattoo) 1983,Mr 19,10:3
Sekka Tomurai Zashi (Irezumi—Spirit of Tattoo) 1984,My 9,C,23:1
Shadow of Angels (Schatten der Engel) 1983,Je 24,C,8:1
Sheena 1984,Ag 17,C,8:3
Sheena 1984,Ag 19,II,15:1
Shivers 1984,O 4,C,16:1

Si Joli Village, Un (Investigation) 1984,F 3,C,11:1
Signals Through the Flames (The Story of the Living Theater) 1984,F 5,47:1
Signora di Tutti, La 1983,S 25,59:1
Silkwood 1983,D 14,C,27:1
Silkwood 1983,D 18,II,21:1
Silkwood 1983,D 25,II,15:1
Silkwood 1984,Ja 1,II,11:1
Silkwood 1984,F 12,II,19:1
Six Feet of the Country (Gordimer Stories, The) 1983,My 18,C,26:4
Sixteen Candles 1984,My 4,C,14:1
Ski Country 1984,N 30,C,13:1
Skyline (Linea del Cielo, La) 1984,Ap 3,C,15:1
Skyline (Linea del Cielo, La) 1984,My 27,II,15:1
Skyline (Linea del Cielo, La) 1984,Jl 18,C,20:3
SL-1 1984,Mr 21,C,14:4
Slayground 1984,Ja 28,14:5
Slow Attack (Endstation Freiheit) 1983,Ja 12,C,24:1
Smokey and the Bandit, Part 3 1983,S 17,30:4
Snow (Neige) 1983,Jl 5,C,10:1
Snowdrop Festival 1984,N 14,C,29:4
So Far from India 1983,O 9,72:1
Soldier's Story, A 1984,S 14,C,10:5
Soldier's Story, A 1984,S 30,II,1:3
Soldier's Story, A 1984,D 16,II,21:1
Something Wicked This Way Comes 1983,Ap 29,C,8:5
Sophie's Choice 1983,Ja 2,II,1:1
Southerners, The (Sures, Los) 1984,S 29,14:4
Spacehunter: Adventures in the Forbidden Zone 1983,My 21,29:1
Spacehunter: Adventures in the Forbidden Zone 1983,Je 5,II,19:3
SPFX 1983,Mr 27,55:1
Splash 1984,Mr 9,C,15:1
Spring Break 1983,Mr 27,54:4
Spring Break 1983,Ap 10,II,17:1
Spring Fever 1983,Ja 15,48:2
Sprout Wings and Fly 1984,My 23,C,24:1
Star Chamber, The 1983,Ag 5,C,8:5
Star 80 1983,N 10,C,26:3
Star 80 1983,N 27,II,17:1
Star 80 1983,D 11,II,23:1
Star Trek III: The Search for Spock 1984,Je 1,C,14:3
Stardust Memories 1983,N 27,II,17:1
Starman 1984,D 14,C,18:1
Starman 1984,D 23,II,19:1
State of Things, The 1983,F 18,19:4
Stationmaster's Wife, The (Bolwieser) 1983,Ja 12,C,21:2
Staying Alive 1983,Jl 15,C,8:5
Staying Alive 1983,Jl 24,II,15:1
Still Smokin' 1983,My 7,16:3
Stilte Rond Christine M, De (Question of Silence, A) 1983,Mr 18,C,8:5
Stilte Rond Christine M, De (Question of Silence, A) 1984,Ag 5,44:6
Sting II, The 1983,F 18,C,10:6
Stone Boy, The 1984,Ap 4,C,25:1
Stop Making Sense 1984,O 19,C,17:1
Story of Piera, The 1983,S 24,11:5
Story of Piera, The 1983,O 2,II,21:1
Straight Through the Heart 1984,Ap 1,57:1
Strange Brew 1983,Ag 26,C,8:1
Strange Invaders 1983,S 16,C,8:1
Stranger Than Paradise 1984,S 29,14:3
Stranger Than Paradise 1984,O 14,II,21:1
Stranger Than Paradise 1984,N 11,II,17:1
Stranger Than Paradise 1984,D 30,II,15:1
Strangers Kiss 1984,Ag 13,C,19:1
Streamers 1983,O 9,73:1
Streamers 1984,S 30,II,1:3
Street Music 1983,F 25,C,8:1
Streets of Fire 1984,Je 1,C,8:5
Strikebound 1984,O 6,15:5
Stroker Ace 1983,Jl 1,C,8:5
Stroszek 1984,My 27,II,15:1
Stuck On You 1984,F 3,C,8:5
Suburbia 1984,Ap 13,C,10:1
Sudden Impact 1983,D 9,C,12:4
Sugar Cane Alley 1984,Ap 6,C,24:3
Sugar Cane Alley 1984,Ap 22,II,17:1
Sunday in the Country, A 1984,O 2,C,14:3
Sunday in the Country, A 1984,N 16,C,11:1
Super, El 1984,My 27,II,15:1
Supergirl 1984,N 22,C,15:2
Superman III 1983,Je 17,C,4:5
Superman III 1983,Je 26,II,1:5
Superman III 1983,Jl 24,II,15:1
Sures, Los (Southerners, The) 1984,S 29,14:4
Survivors, The 1983,Je 22,C,20:6

Susana 1983,N 8,C,9:2
Suzanne Suzanne 1983,Mr 27,55:1
Swann in Love 1984,S 14,C,4:1
Sweet Pea (Piso Pisello) 1983,Ja 23,47:1
Swing Shift 1984,Ap 13,C,13:1

T

Table for Five 1983,F 18,C,12:1
Tales of Ordinary Madness 1983,Mr 11,C,13:3
Tango 1983,Ap 15,C,14:1
Tank 1984,Mr 16,C,8:1
Target Nicaragua: Inside a Covert War 1983,Jl 13,C,16:3
Teachers 1984,O 5,C,10:1
Ten Commandments, The 1984,Mr 25,II,19:1
10 to Midnight 1983,Mr 13,62:5
Tender Mercies 1983,Mr 4,C,8:1
Tender Mercies 1983,Mr 13,II,21:1
Tender Mercies 1983,Ap 3,II,15:1
Tender Mercies 1983,D 25,II,15:1
Tenderness and Anger 1984,My 9,C,24:1
Terence Davies Trilogy, The 1984,Ap 8,64:3
Terminator, The 1984,O 26,C,19:1
Terminator, The 1984,D 2,II,17:1
Terms of Endearment 1983,N 23,C,18:4
Terms of Endearment 1983,D 4,II,21:1
Terms of Endearment 1983,D 18,II,21:1
Terms of Endearment 1984,Ja 1,II,11:1
Terms of Endearment 1984,F 12,II,19:1
Terror in the Aisles 1984,O 26,C,18:6
Testament 1983,N 4,C,8:1
That Sinking Feeling 1984,F 15,C,21:4
There Lived a Wrestler (Oridathu Oru Phayaivaan) 1983,Mr 23,C,26:3
They Call Me Bruce 1983,Ja 16,48:3
They Don't Wear Black Tie (Eles Nao Usam Black-Tie) 1983,My 27,C,8:5
They Don't Wear Black Tie 1983,Je 12,II,21:1
Thief of Hearts 1984,O 19,C,17:4
This Is Spinal Tap 1984,Mr 2,C,6:1
This Is Spinal Tap 1984,Mr 18,II,17:1
This Is Spinal Tap 1984,D 30,II,15:1
Three Crowns of the Sailor 1984,O 5,C,14:3
Threshold 1983,Ja 21,C,5:3
Tibet: A Buddhist Trilogy 1984,Je 8,C,10:5
Tightrope 1984,Ag 17,C,6:1
Tightrope 1984,S 23,II,19:1
'Til the Butcher Cuts Him Down 1983,S 3,13:3
Time for Revenge 1983,Ja 14,C,8:1
Timerider 1983,Ja 21,C,24:5
Times of Harvey Milk, The 1984,O 7,86:1
Times of Harvey Milk, The 1984,O 27,15:1
To Be or Not to Be 1983,D 16,C,10:1
To Be or Not to Be 1983,D 18,II,21:1
To Be or Not to Be 1983,D 25,II,15:1
To Be or Not to Be 1984,Ja 1,II,11:1
To Begin Again 1983,Ap 22,C,10:5
Tokyo Olympiad 1984,O 21,II,23:1
Too Much Oregano 1983,S 9,C,6:2
Too Shy to Try 1984,Mr 30,C,17:3
Tootsie 1983,Ja 2,II,1:1
Tootsie 1983,F 13,II,23:1
Tootsie 1983,Ap 3,II,15:1
Top Secret! 1984,Je 22,C,10:1
Tough Enough 1983,My 27,C,8:1
Trading Places 1983,Je 8,C,16:1
Trading Places 1983,Je 19,II,23:1
Trading Places 1983,D 18,II,21:1
Traviata, La 1983,Ap 22,C,13:1
Traviata, La 1984,Ja 1,II,11:1
Treasure of the Four Crowns 1983,Ja 23,47:1
Trenchcoat 1983,Mr 12,13:3
Trobriand Cricket 1983,D 7,C,24:5
Trout, The (Truite, La) 1983,My 27,C,10:3
Trout, The (Truite, La) 1983,Je 5,II,19:3
Truite, La (Trout, The) 1983,My 27,C,10:3
Truite, La (Trout, The) 1983,Je 5,II,19:3
Truuuuth, The (Veritaaaa, La) 1983,Mr 27,55:5
Tukana 1984,Ap 7,13:5
Turumba 1984,Ap 12,C,20:5
26 Days in the Life of Dostoyevsky 1983,O 14,C,8:5
Twilight Time 1983,F 13,57:4
Twilight Zone—The Movie 1983,Je 24,C,15:1
Twilight Zone—The Movie (Prologue and Segment 1) 1983,Je 24,C,15:1
Twilight Zone—The Movie (Segment 1) 1983,Je 26,II,1:5
Twilight Zone—The Movie (Segment 2) 1983,Je 24,C,15:1

Twilight Zone—The Movie (Segment 3) 1983,Je 24,C,15:1
Twilight Zone—The Movie (Segment 3) 1983,Je 26,II,1:5
Twilight Zone—The Movie (Segment 4) 1983,Je 24,C,15:1
Two English Girls and the Continent 1984,O 21,II,23:1
Two of a Kind 1983,D 16,C,12:6
2010 1984,D 7,C,15:1
Two Worlds of Angelita, The (Dos Mundos del Angelita, Los)
 1983,O 28,C,4:3

U

Unapproachable, The 1984,F 24,C,8:1
Uncommon Valor 1983,D 16,C,12:1
Under Fire 1983,O 21,C,13:1
Under Fire 1984,N 18,II,17:1
Under the Volcano 1984,Je 13,C,21:4
Under the Volcano 1984,Je 24,II,1:1
Under the Volcano 1984,Jl 22,II,15:1
Unfaithfully Yours 1984,F 10,C,7:1
Unknown Chaplin 1983,My 19,C,19:1
Until September 1984,S 21,C,6:3
Urgh! A Music War 1983,Ap 1,C,9:1
Utu 1984,S 13,C,21:2

V

Valentina 1983,Ag 5,C,15:3
Valley Girl 1983,Ap 29,C,10:1
Vassa 1983,N 18,C,10:5
Verdict, The 1983,Ja 2,II,1:1
Verdict, The 1983,F 13,II,23:1
Veritaaaa, La (Truuuuth, The) 1983,Mr 27,55:5
Verlorene, Der (Lost One, The) 1984,Ag 1,C,21:3
Vertigo 1984,Ja 15,II,19:1
Victory March 1983,Mr 11,C,8:1
Videodrome 1983,F 4,C,9:1
Vieux Pays ou Rimbaud Est Mort, Le (Old Country Where
 Rimbaud Died, The) 1984,N 9,C,12:5
Vivement Dimanche (Confidentially Yours) 1984,Ja 20,C,6:1
Voice Over 1983,Ja 23,47:1
Vortex 1983,F 4,C,5:1

W

Waiting for Gavrilov 1983,Ap 15,C,14:1
War And Peace 1983,D 3,15:1
War Games 1983,Je 3,C,17:1
Ways in the Night 1983,Jl 27,C,17:1
We of the Never Never 1983,F 11,C,12:1
Well, The 1984,Mr 18,53:1
Wend Kuuni (Gift of God) 1983,Mr 27,55:1
When Joseph Returns 1983,F 3,C,20:2
When the Mountains Tremble 1984,Ja 18,C,24:3
Where the Boys Are 1984,Ap 7,14:5
Where the Mountains Tremble 1984,Ja 22,II,17:1
White Rose, The 1983,My 6,C,13:1
Whole Shootin' Match, The 1984,Ag 8,C,16:6
Wicked Lady, The 1983,O 28,C,16:1
Wild Flowers (Fleurs Sauvages, Les) 1984,N 9,C,12:5
Wild Horses 1984,Ap 19,C,15:1
Wild Life, The 1984,S 28,C,8:4
Wild Night in El Reno (George Kuchar Sampler, A) 1983,Ag
 3,C,21:3
Wild Style 1983,Mr 18,C,8:3
Wild Style 1983,N 25,C,10:4
Wind, The 1983,S 24,11:1
Windy City 1984,S 21,C,10:5
Without a Trace 1983,F 4,C,8:1
Without Witness (Private Conversation, A) 1984,O 12,C,12:5
Wizard of Babylon, The 1983,Mr 30,C,25:1
Woman in Flames, A (Flambierte Frau) 1984,F 3,C,11:1
Woman in Red, The 1984,Ag 15,C,24:1
World of Tomorrow, The 1984,Mr 7,C,20:3
Wuthering Heights (Abismos de Pasion) 1983,D 27,C,11:2

Y

Year of Living Dangerously, The 1983,Ja 21,C,4:1
Year of Living Dangerously, The 1983,F 13,II,23:1
Year of Living Dangerously, The 1983,Ap 3,II,15:1
Year Zero: The Silent Death of Cambodia 1983,Ap 29,C,17:5
Yellowbeard 1983,Je 24,C,10:2
Yentl 1983,N 18,C,10:1
Yentl 1983,N 27,II,17:1
Yentl 1984,My 27,II,15:1
Yor, the Hunter from the Future 1983,Ag 21,54:3
Young Warriors 1983,N 12,12:1
Your Neighbor's Son: The Making of a Torturer 1984,Ag
 29,C,19:2

Z

Zappa 1984,Ap 3,C,15:1
Zappa 1984,My 16,C,24:3
Zelig 1983,Jl 17,II,1:4
Zelig 1983,Jl 18,B,1:6
Zelig 1983,N 27,II,17:1
Zelig 1983,D 25,II,15:1
Ziggy Stardust and the Spiders From Mars 1983,D 24,17:5

Bauer, Ellen
 Man Who Loved Women, The 1983,D 16,C,8:1
Bauer, Steven
 Scarface 1983,D 9,C,18:3
 Thief of Hearts 1984,O 19,C,17:4
Bauman, Joanne
 Purple Haze 1983,N 11,C,8:1
Baumann, Christoph
 Kamikaze '89 1983,F 27,48:1
Bausch, Pina
 And the Ship Sails On 1984,Ja 26,C,17:1
Baussy, Didier
 Argent, L' (Money) 1983,S 24,11:1
 Argent, L' (Money) 1984,Mr 23,C,10:3
Baxt, David
 Enigma 1983,Ja 28,C,8:1
Baxter, Anne
 Ten Commandments, The 1984,Mr 25,II,19:1
Baye, Nathalie
 Girl from Lorraine, The 1983,Ja 27,C,13:1
 Return of Martin Guerre, The 1983,Je 10,C,12:5
 I Married a Shadow 1983,Ag 10,C,16:5
 Return of Martin Guerre, The 1983,Ag 21,II,17:1
 Balance, La 1983,N 20,72:1
Bayer, Michael
 Suburbia 1984,Ap 13,C,10:1
Baylaucq, Philip
 Memoirs 1984,D 28,C,14:5
Bayly, Lorraine
 Man from Snowy River, The 1983,Ja 21,C,5:6
Bayrhammer, Gustal
 Stationmaster's Wife, The (Bolwieser) 1983,Ja 12,C,21:2
Bazin, Florent (Cinematographer)
 Confidentially Yours (Vivement Dimanche) 1984,Ja 20,C,6:1
Bazzini, Sergio (Screenwriter)
 Victory March 1983,Mr 11,C,8:1
Bazzoni, Camillo (Cinematographer)
 Ernesto 1983,S 23,C,12:5
 Joke of Destiny, A 1984,S 12,C,21:1
Bea, Mama
 Edith and Marcel 1984,Je 3,60:4
Beach, Scott
 Right Stuff, The 1983,O 21,C,5:1
Beal, John
 Amityville 3-D 1983,N 20,68:3
Beal, John (Composer)
 Terror in the Aisles 1984,O 26,C,18:6
Beall, Sandra
 Night in Heaven, A 1983,N 19,19:3
Beals, Jennifer
 Flashdance 1983,Ap 15,C,13:1
 Flashdance 1983,My 22,II,21:1
Beani, Emily
 Tukana 1984,Ap 7,13:5
Beard, David
 Strange Brew 1983,Ag 26,C,8:1
Beato, Affonso (Cinematographer)
 Routes of Exile: A Moroccan Jewish Odyssey 1983,My
 6,C,15:3
 Two Worlds of Angelita, The (Dos Mundos del Angelita, Los)
 1983,O 28,C,4:3
 Circle of Power 1984,Mr 2,C,5:1
Beatty, Ned
 Stroker Ace 1983,Jl 1,C,8:5
Beaujon, Clayton S
 All the Right Moves 1983,O 21,C,10:3
Beaumen, Nicholas (Miscellaneous)
 Mrs Soffel 1984,D 26,C,15:1
Beausejour, Eric
 Fleurs Sauvages, Les (Wild Flowers) 1984,N 9,C,12:5
Beaver, Chris (Cinematographer)
 Dark Circle 1984,My 2,C,25:1
Beaver, Chris (Director)
 Dark Circle 1984,My 2,C,25:1
Beaver, Chris (Miscellaneous)
 Dark Circle 1984,My 2,C,25:1
Beaver, Chris (Producer)
 Dark Circle 1984,My 2,C,25:1
Beaver, Chris (Screenwriter)
 Dark Circle 1984,My 2,C,25:1
Becerra, Pilar
 Bizet's Carmen 1984,S 20,C,21:1
Beck, Christina
 Suburbia 1984,Ap 13,C,10:1
Beck, Jennifer
 Tightrope 1984,Ag 17,C,6:1
Beck, Julian
 Signals Through the Flames (The Story of the Living Theater)
 1984,F 05,47:1
 Oedipus Rex 1984,D 7,C,8:5
 Cotton Club, The 1984,D 14,C,4:3

Beck, Julian (Original Author)
 Signals Through the Flames (The Story of the Living Theater)
 1984,F 05,47:1
Beck, Kimberly
 Friday the 13th—The Final Chapter 1984,Ap 14,15:1
Beck, Michael
 Golden Seal, The 1983,Ag 12,C,4:5
Becker, Ben
 Love in Germany, A 1984,O 2,C,13:2
 Love in Germany, A 1984,N 9,C,10:1
Becker, Etienne (Cinematographer)
 One Deadly Summer 1984,Jl 20,C,10:5
Becker, Jean (Director)
 One Deadly Summer 1984,Jl 20,C,10:5
Becker, Liliane (Screenwriter)
 My Name is Anna Magnani 1984,Ag 10,C,12:4
Beckerman, Barry (Producer)
 Red Dawn 1984,Ag 10,C,11:1
Beckett, Samuel (Original Author)
 Rockaby 1983,N 23,C,16:3
Beckhaus, Friedrich G
 Love in Germany, A 1984,O 2,C,13:2
 Love in Germany, A 1984,N 9,C,10:1
Becue, Nathalie
 Petite Bande, La 1984,N 9,C,28:5
Bedelia, Bonnie
 Heart Like a Wheel 1983,O 6,C,30:1
 Heart Like a Wheel 1983,O 23,II,19:1
 Heart Like a Wheel 1983,D 25,II,15:1
Bedford, Terry (Director)
 Slayground 1984,Ja 28,14:5
Bedi, Kabir
 Octopussy 1983,Je 10,C,17:4
Beer, Robert
 Right Stuff, The 1983,O 21,C,5:1
Beers, Francine
 Over the Brooklyn Bridge 1984,Mr 2,C,6:5
Beethoven, Ludwig van (Composer)
 Passion 1983,O 4,C,13:2
 Nostalghia 1983,O 5,C,23:1
 Basileus Quartet 1984,Ja 4,C,13:5
 Nostalghia (Nostalgia) 1984,Ja 8,47:1
 First Name: Carmen 1984,Ag 3,C,6:1
Beggins, Francis
 Zelig 1983,Jl 18,B,1:6
Begley, Ed, Jr
 Get Crazy 1983,O 14,C,11:1
 Protocol 1984,D 21,C,25:1
Begun, Jeff (Producer)
 Hardbodies 1984,My 12,12:5
Behr, Jack (Screenwriter)
 Birdy 1984,D 21,C,25:1
Behrens, Bernard
 Man With Two Brains, The 1983,Je 3,C,8:1
 Unfaithfully Yours 1984,F 10,C,7:1
Behrens, Inge (Miscellaneous)
 Unapproachable, The 1984,F 24,C,8:1
 Class Enemy 1984,Jl 13,C,6:1
Beineix, Jean-Jacques (Director)
 Moon in the Gutter, The 1983,S 9,C,8:1
Beineix, Jean-Jacques (Screenwriter)
 Moon in the Gutter, The 1983,S 9,C,8:1
Bel, Francois (Director)
 Claw and the Tooth, The 1984,D 26,C,15:3
Bel, Francois (Cinematographer)
 Claw and the Tooth, The 1984,D 26,C,15:3
Bel Geddes, Barbara
 Vertigo 1984,Ja 15,II,19:1
Belafonte, Harry (Miscellaneous)
 Beat Street 1984,Je 8,C,10:5
Belafonte, Harry (Producer)
 Beat Street 1984,Je 8,C,10:5
Belaubre, Anik
 Confidentially Yours (Vivement Dimanche) 1984,Ja 20,C,6:1
Belen, Ana
 Demons in the Garden (Demonios en el Jardin) 1984,Mr
 2,C,5:3
Belew, Adrian (Composer)
 Return Engagement 1983,N 23,C,10:5
Belfin, Frantisek (Miscellaneous)
 Divine Emma, The 1983,Je 5,54:1
Belford, Christine
 Christine 1983,D 9,C,10:5
Belkin, Elmira
 Musical Passage 1984,Mr 21,C,20:3
Bell, Ann
 Champions 1984,Ap 20,C,8:1
Bell, Daniel (Composer)
 Fanny and Alexander 1983,Je 17,C,8:1

Bell, Neil
 Querelle 1983,Ap 29,C,8:5
Bell, Ronnie
 My Brother's Wedding 1984,Mr 30,C,7:1
Bell, Wayne (Composer)
 Last Night at the Alamo 1983,O 2,II,60:3
 Last Night at the Alamo 1984,Jl 3,C,10:5
Bellamy, Ralph
 Trading Places 1983,Je 8,C,16:1
 Trading Places 1983,Je 19,II,23:1
 Trading Places 1983,D 18,II,21:1
Bellashmi, Ahmed
 Oedipus Rex 1984,D 7,C,8:5
Belle, Ekkehardt
 Victory March 1983,Mr 11,C,8:1
Bellec, Anne
 Investigation (Si Joli Village, Un) 1984,F 3,C,11:1
Belling, Davina (Producer)
 Britannia Hospital 1983,Mr 4,C,10:1
 Comfort and Joy 1984,O 10,C,19:1
Bellini, Vincenzo (Composer)
 Basileus Quartet 1984,Ja 4,C,13:5
Bello, Stephen (Screenwriter)
 Circle of Power 1984,Mr 2,C,5:1
Bellocchio, Marco
 My Name is Anna Magnani 1984,Ag 10,C,12:4
Bellocchio, Marco (Director)
 Victory March 1983,Mr 11,C,8:1
 Eyes, the Mouth, The 1983,D 14,C,24:1
Bellocchio, Marco (Miscellaneous)
 Eyes, the Mouth, The 1983,D 14,C,24:1
Bellocchio, Marco (Screenwriter)
 Victory March 1983,Mr 11,C,8:1
 Eyes, the Mouth, The 1983,D 14,C,24:1
Bellow, Saul
 Zelig 1983,Jl 17,II,1:4
 Zelig 1983,Jl 18,B,1:6
Bellville, Hercules (Producer)
 Strangers Kiss 1984,Ag 13,C,19:1
Belsito, Peter (Producer)
 Home Free All 1984,My 2,C,25:1
Belson, Jordan (Miscellaneous)
 Right Stuff, The 1983,O 21,C,5:1
Beltran, Robert
 Lone Wolf McQuade 1983,Ap 16,12:4
 Night of the Comet 1984,N 16,C,8:1
Belue, Otto
 Burroughs 1983,O 8,33:1
 Burroughs 1984,F 10,C,12:1
Belushi, Jim
 Trading Places 1983,Je 8,C,16:1
Ben Ammar, Tarek (Producer)
 Misunderstood 1984,Mr 30,C,10:1
Benaben, Andre
 Biquefarre 1984,Ap 5,C,15:1
Benaben, Francine
 Biquefarre 1984,Ap 5,C,15:1
Benaben, Helene
 Biquefarre 1984,Ap 5,C,15:1
Benaben, Marie-Helene
 Biquefarre 1984,Ap 5,C,15:1
Benaben, Marius
 Biquefarre 1984,Ap 5,C,15:1
Benackova, Gabriela
 Divine Emma, The 1983,Je 5,54:1
Ben-Ami, Yoram (Producer)
 Lone Wolf McQuade 1983,Ap 16,12:4
Benassi, Memo
 Signora di Tutti, La 1983,S 25,59:1
Benatar, Pat
 Metropolis 1984,Ag 19,II,15:1
Benchley, Peter (Original Author)
 Jaws 3-D 1983,Jl 23,11:1
Bendico, Silvia D'Amico (Miscellaneous)
 Joke of Destiny, A 1984,S 12,C,21:1
Bene, Carmelo
 Oedipus Rex 1984,D 7,C,8:5
Benedek, Barbara (Screenwriter)
 Big Chill, The 1983,S 23,C,14:3
Benedict, Paul
 Man With Two Brains, The 1983,Je 3,C,8:1
Benegas, Alberto
 Time for Revenge 1983,Ja 14,C,8:1
Benfer, Federico
 Signora di Tutti, La 1983,S 25,59:1
Beniaminov, Alexander
 Moscow On the Hudson 1984,Ap 6,C,12:1
Beniloch, Paco
 China 9, Liberty 37 1984,N 30,C,8:4
Benjamin, Mark (Cinematographer)
 Sures, Los (Southerners, The) 1984,S 29,14:4

Brookner, Howard (Director)
 Burroughs 1983,O 8,33:1
Brookner, Howard (Producer)
 Burroughs 1983,O 8,33:1
 Burroughs 1984,F 10,C,12:1
Brooks, Albert
 Twilight Zone—The Movie (Prologue and Segment 1) 1983,Je
 24,C,15:1
 Unfaithfully Yours 1984,F 10,C,7:1
Brooks, Foster
 Cannonball Run II 1984,Je 29,C,14:5
Brooks, James L (Director)
 Terms of Endearment 1983,N 23,C,18:4
 Terms of Endearment 1983,D 4,II,21:1
 Terms of Endearment 1984,F 12,II,19:1
Brooks, James L (Producer)
 Terms of Endearment 1983,N 23,C,18:4
Brooks, James L (Screenwriter)
 Terms of Endearment 1983,N 23,C,18:4
 Terms of Endearment 1983,D 4,II,21:1
Brooks, Joe
 Gremlins 1984,Je 8,C,10:4
Brooks, Joseph (Producer)
 Eddie and the Cruisers 1983,S 23,C,8:3
Brooks, Louise
 Prix de Beaute 1983,Je 22,C,15:3
Brooks, Mel
 To Be or Not to Be 1983,D 16,C,10:1
 To Be or Not to Be 1983,D 18,II,21:1
Brooks, Mel (Director)
 To Be or Not to Be 1983,D 25,II,15:1
Brooks, Mel (Producer)
 To Be or Not to Be 1983,D 16,C,10:1
 To Be or Not to Be 1984,Ja 1,II,11:1
Brooks, Randi
 Man With Two Brains, The 1983,Je 3,C,8:1
 Deal of the Century 1983,N 4,C,13:3
Brooksbank, Scott
 Ski Country 1984,N 30,C,13:1
Broomfield, Nick (Director)
 Chicken Ranch 1983,Je 1,C,14:2
Broomfield, Nick (Producer)
 Chicken Ranch 1983,Je 1,C,14:2
Brothers, Dr Joyce
 King of Comedy, The 1983,F 18,C,10:1
 King of Comedy, The 1983,F 20,II,19:1
 Lonely Guy, The 1984,Ja 28,11:5
Brough, Candi
 Lonely Guy, The 1984,Ja 28,11:5
Brough, Randi
 Lonely Guy, The 1984,Ja 28,11:5
Broughton, Bruce (Composer)
 Ice Pirates, The 1984,Mr 16,C,8:5
Broun, Chris
 Merry Christmas Mr Lawrence 1983,Ag 26,C,10:1
Brouwer, Chris (Producer)
 Girl with the Red Hair, The 1983,Ja 14,C,12:5
Brower, Leo (Composer)
 Alsino and the Condor 1983,My 1,69:1
Browinig, Alistair
 Merry Christmas Mr Lawrence 1983,Ag 26,C,10:1
Brown, Barry (Miscellaneous)
 War And Peace 1983,D 3,15:1
Brown, Blair
 Flash of Green, A 1984,O 5,C,14:3
Brown, Bryan
 Give My Regards to Broad Street 1984,O 26,C,14:5
Brown, Clancy
 Bad Boys 1983,Mr 25,C,8:1
 Adventures of Buckaroo Banzai, The 1984,O 5,C,8:5
Brown, Dennis
 Heartland Reggae 1983,O 14,C,4:3
Brown, Garrett
 Zelig 1983,Jl 18,B,1:6
Brown, Jim (Director)
 Musical Passage 1984,Mr 21,C,20:3
 Musical Passage 1984,My 27,II,15:1
Brown, Jim (Producer)
 Musical Passage 1984,Mr 21,C,20:3
Brown, Jim (Cinematographer)
 Musical Passage 1984,Mr 21,C,20:3
Brown, June
 Misunderstood 1984,Mr 30,C,10:1
Brown, Leigh (Screenwriter)
 Christmas Story, A 1983,N 18,C,36:1
Brown, Lou
 King of Comedy, The 1983,F 18,C,10:1
Brown, Michael (Miscellaneous)
 Nightmares 1983,S 3,14:5
Brown, O Nicholas (Miscellaneous)
 Heart Like a Wheel 1983,O 6,C,30:1

Brown, Philip Martin
 Bounty, The 1984,My 4,C,8:1
Brown, Reb
 Uncommon Valor 1983,D 16,C,12:1
Brown, Rob
 Yor, the Hunter from the Future 1983,Ag 21,54:3
Brown, Robert
 Octopussy 1983,Je 10,C,17:4
Brown, Robert (Miscellaneous)
 Police Academy 1984,Mr 23,C,12:1
 Pope of Greenwich Village, The 1984,Je 22,C,12:4
Brown, Sam O (Blake Edwards) (Miscellaneous)
 City Heat 1984,D 7,C,4:3
Brown, Sam O (Blake Edwards) (Screenwriter)
 City Heat 1984,D 7,C,4:3
Brown, Steve (Miscellaneous)
 Wild Style 1983,Mr 18,C,8:3
 Wild Style 1983,N 25,C,10:4
Browne, Coral
 American Dreamer 1984,O 26,C,12:4
Browne, Jackson (Composer)
 In the King of Prussia 1983,F 13,57:1
Browne, Robert Alan
 Psycho II 1983,Je 3,C,14:5
 Fleshburn 1984,My 26,13:1
Browning, Ivy Ray
 Dear Mr Wonderful 1983,D 21,C,26:4
Brownlow, Kevin (Producer)
 Unknown Chaplin 1983,My 19,C,19:1
Brubaker, James D (Producer)
 Right Stuff, The 1983,O 21,C,5:1
Bruckheimer, Jerry (Producer)
 Flashdance 1983,Ap 15,C,13:1
 Thief of Hearts 1984,O 19,C,17:4
 Beverly Hills Cop 1984,D 5,C,25:4
Brugman, Edyy
 Question of Silence, A (Stilte Rond Christine M, De) 1983,Mr
 18,C,8:5
 Question of Silence, A (Stilte Rond Christine M, De) 1984,Ag
 5,44:6
Bruhne, Frank (Cinematographer)
 Slow Attack (Endstation Freiheit) 1983,Ja 12,C,24:1
Brunelin, Andre G (Miscellaneous)
 Investigation (Si Joli Village, Un) 1984,F 3,C,11:1
Brunelin, Andre G (Screenwriter)
 Investigation (Si Joli Village, Un) 1984,F 3,C,11:1
Bruner, James (Original Author)
 Missing in Action 1984,N 17,11:1
Brunkhorst, Nadja
 Querelle 1983,Ap 29,C,8:5
Bruno, Beatrice
 Drugstore Romance (Corps a Coeur) 1983,Jl 1,C,8:4
Bruns, Phil
 Flashdance 1983,Ap 15,C,13:1
Bryar, Claudia
 Psycho II 1983,Je 3,C,14:5
Bryce, Jim (Screenwriter)
 Treasure of the Four Crowns 1983,Ja 23,47:1
Bryne, Barbara
 Bostonians, The 1984,Ag 5,II,15:1
 Amadeus 1984,S 19,C,23:1
Brynner, Yul
 Ten Commandments, The 1984,Mr 25,II,19:1
Bubetz, Christopher
 Nightmares 1983,S 3,14:5
Buch, Fred
 Spring Break 1983,Mr 27,54:4
 Night in Heaven, A 1983,N 19,19:3
Buchanan, Robert
 That Sinking Feeling 1984,F 15,C,21:4
Buchanan, Russell
 Rhinestone 1984,Je 22,C,10:5
Buchott, Friedel (Miscellaneous)
 Liebelei 1983,My 31,C,10:5
Buchreiser, Franz
 Berlin Alexanderplatz 1983,Ag 10,C,18:5
Buck, George
 Birdy 1984,D 21,C,25:1
Buck, Ronald L (Miscellaneous)
 Harry and Son 1984,Mr 2,C,12:3
Buck, Ronald L (Producer)
 Harry and Son 1984,Mr 2,C,12:3
Buck, Ronald L (Screenwriter)
 Harry and Son 1984,Mr 2,C,12:3
Buckley, Anthony (Producer)
 Killing of Angel Street, The 1983,Mr 26,20:6
 Kitty and the Bagman 1983,Ag 5,C,14:5
Buckley, Betty
 Tender Mercies 1983,Mr 4,C,8:1
 Tender Mercies 1983,Mr 13,II,21:1

Buckner, Noel (Director)
 Good Fight, The 1984,Mr 28,C,24:4
Buckner, Noel (Miscellaneous)
 Good Fight, The 1984,Mr 28,C,24:4
Buckner, Noel (Producer)
 Good Fight, The 1984,Mr 28,C,24:4
Buckwalter, John
 Zelig 1983,Jl 18,B,1:6
Budinova, Slavka
 Fiancee, The 1984,Ap 7,13:3
Bufano, Vincent
 Two of a Kind 1983,D 16,C,12:6
Buhai, Jeff (Miscellaneous)
 Revenge of the Nerds 1984,Jl 20,C,8:5
Buhai, Jeff (Screenwriter)
 Revenge of the Nerds 1984,Jl 20,C,8:5
Buhler, Wolf-Eckart (Director)
 Pharos of Chaos 1983,O 13,C,13:1
Buhler, Wolf-Eckart (Producer)
 Pharos of Chaos 1983,O 13,C,13:1
Bui, Son Hoang
 Table for Five 1983,F 18,C,12:1
Bujold, Genevieve
 Tightrope 1984,Ag 17,C,6:1
 Tightrope 1984,S 23,II,19:1
 Choose Me 1984,N 1,C,18:4
Bujtor, Istvan
 When Joseph Returns 1983,F 3,C,20:2
Bukowski, Charles (Original Author)
 Tales of Ordinary Madness 1983,Mr 11,C,13:3
Bull, Peter
 Yellowbeard 1983,Je 24,C,10:2
Bulloch, Jeremy
 Return of the Jedi 1983,My 25,C,24:1
Bunster, Carmen
 Alsino and the Condor 1983,My 1,69:1
Buntzman, David
 Exterminator 2 1984,S 15,14:5
Buntzman, Mark (Director)
 Exterminator 2 1984,S 15,14:5
Buntzman, Mark (Producer)
 Exterminator 2 1984,S 15,14:5
Buntzman, Mark (Screenwriter)
 Exterminator 2 1984,S 15,14:5
Bunuel, Joyce (Director)
 Dirty Dishes (Jument Vapeur, La) 1983,Mr 25,C,12:5
Bunuel, Joyce (Screenwriter)
 Dirty Dishes (Jument Vapeur, La) 1983,Mr 25,C,12:5
Bunuel, Luis (Director)
 Bruto, El 1983,S 21,C,22:3
 Susana 1983,N 8,C,9:2
 Wuthering Heights (Abismos de Pasion) 1983,D 27,C,11:2
Bunuel, Luis (Screenwriter)
 Bruto, El 1983,S 21,C,22:3
 Wuthering Heights (Abismos de Pasion) 1983,D 27,C,11:2
Burbidge, Derek (Director)
 Urgh! A Music War 1983,Ap 1,C,9:1
Burgess, John
 Give My Regards to Broad Street 1984,O 26,C,14:5
Burke, Kathy
 Scrubbers 1984,F 1,C,16:4
Burke, Martyn (Screenwriter)
 Top Secret! 1984,Je 22,C,10:1
Burke, Mildred
 Below the Belt 1983,Ag 31,C,21:1
Burkhard, Horst (Producer)
 Unapproachable, The 1984,F 24,C,8:1
Burkhart, Jeff (Screenwriter)
 Where the Boys Are 1984,Ap 7,14:5
Burks, Robert (Cinematographer)
 Rear Window 1983,O 9,II,21:1
Burlinson, Tom
 Man from Snowy River, The 1983,Ja 21,C,5:6
 Phar Lap 1984,Ag 10,C,8:1
 Phar Lap 1984,S 9,II,25:5
Burmann, Hans (Cinematographer)
 Holy Innocents, The 1984,S 30,58:3
Burnes, C Stewart
 Nightmares 1983,S 3,14:5
Burnett, Angela
 Bless Their Little Hearts 1984,D 12,C,25:5
Burnett, Bill
 Chords of Fame 1984,F 16,C,23:1
Burnett, Charles (Cinematographer)
 My Brother's Wedding 1984,Mr 30,C,7:1
 Bless Their Little Hearts 1984,D 12,C,25:5
Burnett, Charles (Director)
 My Brother's Wedding 1984,Mr 30,C,7:1
Burnett, Charles (Producer)
 My Brother's Wedding 1984,Mr 30,C,7:1

Burnett, Charles (Screenwriter)
My Brother's Wedding 1984,Mr 30,C,7:1
Bless Their Little Hearts 1984,D 12,C,25:5
Burnett, John F (Miscellaneous)
Irreconcilable Differences 1984,S 28,C,10:5
Burnett, Kimberly
Bless Their Little Hearts 1984,D 12,C,25:5
Burnett, Ronald
Bless Their Little Hearts 1984,D 12,C,25:5
Burney, John (Screenwriter)
Kitty and the Bagman 1983,Ag 5,C,14:5
Burnham, Janet
Home Free All 1984,My 2,C,25:1
Burns, Allan (Screenwriter)
Just the Way You Are 1984,N 16,C,14:1
Burns, Carol
Strikebound 1984,O 6,15:5
Burns, George
Oh God! You Devil 1984,N 9,C,15:1
Burns, Mark (Miscellaneous)
Old Enough 1984,Ag 24,C,10:4
Burns, Michael (Producer)
Threshold 1983,Ja 21,C,5:3
Burns, Ralph (Composer)
National Lampoon's Vacation 1983,Jl 29,C,10:4
Star 80 1983,N 10,C,26:3
Burns, Tim
Monkey Grip 1983,N 7,C,16:5
Burr, Raymond
Out of the Blue 1983,Ap 8,C,6:5
Rear Window 1983,O 9,II,21:1
Burrill, Timothy (Producer)
Supergirl 1984,N 22,C,15:2
Burroughs, Edgar Rice (Original Author)
Greystoke: The Legend of Tarzan, Lord of the Apes 1984,Mr 30,C,5:1
Greystoke: The Legend of Tarzan, Lord of the Apes 1984,Ap 1,II,21:1
Greystoke: The Legend of Tarzan, Lord of the Apes 1984,D 30,II,15:1
Burroughs, Jackie
Grey Fox, The 1983,Jl 13,C,17:4
Dead Zone, The 1983,O 21,C,8:1
Burroughs, Mortimer
Burroughs 1983,O 8,33:1
Burroughs 1984,F 10,C,12:1
Burroughs, Robin
Stuck On You 1984,F 3,C,8:5
Burroughs, William S
Burroughs 1983,O 8,33:1
Burroughs 1984,F 10,C,12:1
Burroughs, William S, Jr
Burroughs 1983,O 8,33:1
Burroughs 1984,F 10,C,12:1
Burrowes, Geoff (Producer)
Man from Snowy River, The 1983,Ja 21,C,5:6
Burstyn, Ellen
In Our Hands 1984,F 16,C,23:1
Burt, Eddie
That Sinking Feeling 1984,F 15,C,21:4
Burtt, Ben (Miscellaneous)
Return of the Jedi 1983,My 25,C,24:1
Burum, Stephen H (Cinematographer)
Entity, The 1983,F 5,12:3
Uncommon Valor 1983,D 16,C,12:1
Rumble Fish 1983,O 7,C,10:3
Body Double 1984,O 26,C,8:1
Burwell, Carter (Composer)
Blood Simple 1984,O 12,C,10:4
Busby, Jane
Return of the Jedi 1983,My 25,C,24:1
Buschmann, Joey
Slow Attack (Endstation Freiheit) 1983,Ja 12,C,24:1
Busfield, Tim
Revenge of the Nerds 1984,Jl 20,C,8:5
Bush, Dick (Cinematographer)
Curse of the Pink Panther 1983,Ag 13,13:1
Philadelphia Experiment, The 1984,Ag 17,C,17:4
Crimes of Passion 1984,O 19,C,19:1
Bush, Raymond (Miscellaneous)
Richard Pryor Here and Now 1983,O 28,C,8:1
Buss, Jodi
Choose Me 1984,N 1,C,18:4
Bussemaker, Reinout
4th Man, The 1984,Je 27,C,21:4
Bussieres, Raymond
Invitation au Voyage 1983,Ap 21,C,20:3
Bustos, Jorge (Miscellaneous)
Bruto, El 1983,S 21,C,22:3
Butkus, Dick
Johnny Dangerously 1984,D 21,C,25:5

Butler, Bill (Cinematographer)
Sting II, The 1983,F 18,C,10:6
Butler, Michael (Screenwriter)
Flashpoint 1984,Ag 31,C,6:5
Butrick, Merritt
Star Trek III: The Search for Spock 1984,Je 1,C,14:3
Buzzo, Silvana (Miscellaneous)
Nudo di Donna 1983,My 13,C,7:5
Bvk, Jost Vacano (Cinematographer)
Neverending Story, The 1984,Jl 20,C,5:1
Bybee, Ariel
Traviata, La 1983,Ap 22,C,13:1
Byner, John
Stroker Ace 1983,Jl 1,C,8:5
Byrde, Edye
Moscow On the Hudson 1984,Ap 6,C,12:1
Byrne, Bobby (Cinematographer)
Going Berserk 1983,O 29,19:1
Sixteen Candles 1984,My 4,C,14:1
Byrne, David
Stop Making Sense 1984,O 19,C,17:1
Byrne, Gabriel
Hanna K 1983,S 30,C,8:1
Byrne, Michael
Champions 1984,Ap 20,C,8:1
Byron, Jeffrey
Metalstorm: The Destruction of Jared-Syn 1983,Ag 21,56:4
Byrum, John (Director)
Razor's Edge, The 1984,O 19,C,14:6
Byrum, John (Miscellaneous)
Scandalous 1984,Ja 20,C,4:5
Byrum, John (Screenwriter)
Scandalous 1984,Ja 20,C,4:5
Razor's Edge, The 1984,O 19,C,14:6
Bythewood, Reggie Rock
Exterminator 2 1984,S 15,14:5

C

Cabrera Infante, Guillermo
Improper Conduct (Mauvaise Conduite) 1984,Ap 11,C,19:1
Caccavo, Roland
Home Free All 1984,My 2,C,25:1
Cachemaille, Gilles
Parsifal 1983,Ja 23,46:1
Cadeau, Lally
Threshold 1983,Ja 21,C,5:3
Videodrome 1983,F 4,C,9:1
Cadenat, Garry
Sugar Cane Alley 1984,Ap 6,C,24:3
Sugar Cane Alley 1984,Ap 22,II,17:1
Caesar, Adolph
Soldier's Story, A 1984,S 14,C,10:5
Soldier's Story, A 1984,S 30,II,1:3
Caesar, Harry
Breakin' 2: Electric Boogaloo 1984,D 19,C,22:4
Caesar, Shirley
Gospel 1983,D 23,C,8:1
Caesar, Sid
Over the Brooklyn Bridge 1984,Mr 2,C,6:5
Cannonball Run II 1984,Je 29,C,14:5
Cannonball Run II 1984,Jl 29,II,15:1
Cafferty, John
Eddie and the Cruisers 1983,S 23,C,8:3
Cafferty, John (Composer)
Eddie and the Cruisers 1983,S 23,C,8:3
Caffrey, Peter
Danny Boy 1984,My 18,C,11:1
Caffrey, Sean
Moon Over the Alley 1983,Ap 27,C,19:4
Cage, Nicolas
Valley Girl 1983,Ap 29,C,10:1
Rumble Fish 1983,O 7,C,10:3
Racing With the Moon 1984,Mr 23,C,5:1
Cotton Club, The 1984,D 14,C,4:3
Birdy 1984,D 21,C,25:1
Cahill, Cathy
Harry and Son 1984,Mr 2,C,12:3
Cahn, Dann (Miscellaneous)
Tough Enough 1983,My 27,C,8:1
Cai Jianzhou
Boat People 1983,S 27,C,17:5
Boat People 1983,N 13,78:1
Caillou, Alan
Ice Pirates, The 1984,Mr 16,C,8:5
Cain, Chris (Director)
Stone Boy, The 1984,Ap 4,C,25:1

Cain, Dean
Stone Boy, The 1984,Ap 4,C,25:1
Caine, Michael
Educating Rita 1983,S 21,C,21:1
Beyond the Limit 1983,S 30,C,4:3
Educating Rita 1983,N 13,II,17:1
Educating Rita 1983,D 18,II,21:1
Blame It on Rio 1984,F 17,C,10:5
Jigsaw Man, The 1984,Ag 24,C,4:5
Cala, Joseph M (Screenwriter)
Angel 1984,Ja 13,C,12:5
Calahorra, Margarita
Malou 1983,D 22,C,22:1
Calderon, Carlos
Erendira 1983,O 1,16:3
Erendira 1984,Ap 27,C,8:5
Calderon, Sergio
Erendira 1983,O 1,16:3
Erendira 1984,Ap 27,C,8:5
Caldicott, Dr Helen
In Our Hands 1984,F 16,C,23:1
Cale, J J (Composer)
My Best Friend's Girl 1984,Mr 25,56:1
Calello, Charles (Composer)
Lonely Lady, The 1983,O 1,13:5
Calfa, Don
Star Chamber, The 1983,Ag 5,C,8:5
Calhoun, Rory
Angel 1984,Ja 13,C,12:5
Calio, Joseph
Lonely Lady, The 1983,O 1,13:5
Call, Ken
Loveless, The 1984,Ja 20,C,8:5
Callado, Tessy
Blame It on Rio 1984,F 17,C,10:5
Callahan, Gene (Miscellaneous)
Survivors, The 1983,Je 22,C,20:6
Callow, Simon
Amadeus 1984,S 19,C,23:1
Calvo, Eduardo
It's Never Too Late 1984,Je 29,C,8:4
Camacho, Ahui
Under Fire 1983,O 21,C,13:1
Camacho, Cecilia
Eagle's Wing 1983,O 9,72:1
Camara, Abou
Jom (Jom or the Story of a People) 1983,Mr 28,C,12:3
Jom (Jom or the Story of a People) 1983,S 7,C,21:2
Camara, Amadou Lamine
Jom (Jom or the Story of a People) 1983,Mr 28,C,12:3
Jom (Jom or the Story of a People) 1983,S 7,C,21:2
Cambas, Jacqueline (Miscellaneous)
Racing With the Moon 1984,Mr 23,C,5:1
City Heat 1984,D 7,C,4:3
Cambern, Donn (Miscellaneous)
Going Berserk 1983,O 29,19:1
Romancing the Stone 1984,Mr 30,C,19:1
Cameron, Cisse
Porky's II: The Next Day 1983,Je 25,12:3
Cameron, Hope
Tales of Ordinary Madness 1983,Mr 11,C,13:3
Cameron, James (Director)
Terminator, The 1984,O 26,C,19:1
Cameron, James (Screenwriter)
Terminator, The 1984,O 26,C,19:1
Cameron, Ken (Director)
Monkey Grip 1983,N 7,C,16:5
Cameron, Ken (Screenwriter)
Monkey Grip 1983,N 7,C,16:5
Camp, Colleen
Valley Girl 1983,Ap 29,C,10:1
Smokey and the Bandit, Part 3 1983,S 17,30:4
Camp, Halim
Under Fire 1983,O 21,C,13:1
Camp, Hamilton
Under Fire 1983,O 21,C,13:1
No Small Affair 1984,N 9,C,16:1
Camp, Hamilton (Miscellaneous)
Ski Country 1984,N 30,C,13:1
Camp, Richard L (Cinematographer)
Burroughs 1983,O 8,33:1
Burroughs 1984,F 10,C,12:1
Campano, Maria
Bizet's Carmen 1984,S 20,C,21:1
Campbell, Cheryl
Greystoke: The Legend of Tarzan, Lord of the Apes 1984,Mr 30,C,5:1
Campbell, David (Composer)
All the Right Moves 1983,O 21,C,10:3
Campbell, Delois Barrett
Say Amen, Somebody 1983,Mr 11,C,10:1

Campbell, Douglas
Strange Brew 1983,Ag 26,C,8:1
Campbell, Erma
Zelig 1983,Jl 18,B,1:6
Campbell, Frank
Say Amen, Somebody 1983,Mr 11,C,10:1
Campbell, Malcolm (Miscellaneous)
Twilight Zone—The Movie (Prologue and Segment 1) 1983,Je 24,C,15:1
Campbell, Mick (Cinematographer)
My Childhood (Bill Douglas Trilogy, The) 1983,My 18,C,26:5
Campbell, Nicholas
Dead Zone, The 1983,O 21,C,8:1
Campbell, Torquil
Golden Seal, The 1983,Ag 12,C,4:5
Campos, Jose, Jr
Under Fire 1983,O 21,C,13:1
Campos, Magaly
Passion 1983,O 4,C,13:2
Campos, Rose Marie
Nightmares 1983,S 3,14:5
Camus, Mario (Director)
Holy Innocents, The 1984,S 30,58:3
Camus, Mario (Screenwriter)
Holy Innocents, The 1984,S 30,58:3
Camuyrano, Carlos Alberto (Miscellaneous)
Memoirs of Prison 1984,O 10,C,18:3
Canady, Melwin (Candy)
Johnny West 1983,Mr 9,C,17:2
Candal, Norma
And God Created Them 1983,Mr 19,11:1
Candy, John
Going Berserk 1983,O 29,19:1
Splash 1984,Mr 9,C,15:1
Canepa, Alberto
Nostalghia 1983,O 5,C,23:1
Nostalghia (Nostalgia) 1984,Ja 8,47:1
Canfield, Sheila
Falls, The 1983,My 4,C,17:4
Cannon, Jack
Zelig 1983,Jl 18,B,1:6
Canonero, Milena (Miscellaneous)
Give My Regards to Broad Street 1984,O 26,C,14:5
Cansler, Larry (Composer)
Smokey and the Bandit, Part 3 1983,S 17,30:4
Cantafora, Antonio
Gabriela 1984,My 11,C,14:1
Cantarelli, Dario
Night of the Shooting Stars, The 1983,Ja 30,34:3
Canter, Stanley S (Producer)
Greystoke: The Legend of Tarzan, Lord of the Apes 1984,Mr 30,C,5:1
Canton, Neil (Producer)
Adventures of Buckaroo Banzai, The 1984,O 5,C,8:5
Capaldi, Peter
Local Hero 1983,F 17,C,25:1
Local Hero 1983,D 25,II,15:1
Capelja, Jad
Puberty Blues 1983,Jl 15,C,13:1
Capetanos, Leon (Screenwriter)
Moscow On the Hudson 1984,Ap 6,C,12:1
Capizzi, Bill
They Call Me Bruce 1983,Ja 16,48:3
Capo, Gary (Cinematographer)
Ski Country 1984,N 30,C,13:1
Cappeliez, Anne-Marie
Golden Eighties, The 1983,O 2,59:1
Capps, Al (Composer)
Stroker Ace 1983,Jl 1,C,8:5
Cannonball Run II 1984,Je 29,C,14:5
Capra, Frank, Jr (Producer)
Firestarter 1984,My 11,C,8:1
Capron, Chantal
Bal, Le 1984,Mr 23,C,6:1
Capshaw, Kate
Indiana Jones and the Temple of Doom 1984,My 23,C,21:1
Best Defense 1984,Jl 20,C,10:1
Dreamscape 1984,Ag 15,C,24:4
Dreamscape 1984,S 2,II,11:1
Windy City 1984,S 21,C,10:5
Capucine
Curse of the Pink Panther 1983,Ag 13,13:1
Cara, Irene
Flashdance 1983,My 22,II,21:1
City Heat 1984,D 7,C,4:3
Caracol
Improper Conduct (Mauvaise Conduite) 1984,Ap 11,C,19:1
Carafotes, Paul
All the Right Moves 1983,O 21,C,10:3
Carberry, Joseph
Survivors, The 1983,Je 22,C,20:6

Cardan, Carlos
Erendira 1983,O 1,16:3
Erendira 1984,Ap 27,C,8:5
Cardiff, Jack (Cinematographer)
Wicked Lady, The 1983,O 28,C,16:1
Scandalous 1984,Ja 20,C,4:5
Conan the Destroyer 1984,Je 29,C,8:4
Cardinale, Claudia
Gift, The 1983,F 27,48:5
Salamander, The 1983,Je 5,53:1
Leopard, The 1983,S 11,II,21:5
Carel, Roger
One Deadly Summer 1984,Jl 20,C,10:5
Carey, Gabrielle (Original Author)
Puberty Blues 1983,Jl 15,C,13:1
Carey, Geoffrey
State of Things, The 1983,F 18,19:4
Carey, Harry, Jr
Gremlins 1984,Je 8,C,10:4
Carey, Ron
Johnny Dangerously 1984,D 21,C,25:5
Carillo, Carmen
Street Music 1983,F 25,C,8:1
Carillo, Mary
Holy Innocents, The 1984,S 30,58:3
Carle, Gilles (Director)
Great Chess Movie, The 1983,Ap 6,C,15:3
Carlino, Lewis John (Director)
Class 1983,Jl 22,C,10:5
Carlisle, Anne
Liquid Sky 1983,Jl 22,C,10:1
Liquid Sky 1983,Jl 31,II,15:1
Carlisle, Anne (Screenwriter)
Liquid Sky 1983,Jl 22,C,10:1
Liquid Sky 1983,Jl 31,II,15:1
Carlos Barreto, Lucy (Producer)
Memoirs of Prison 1984,O 10,C,18:3
Carlos Barreto, Luiz (Producer)
Memoirs of Prison 1984,O 10,C,18:3
Carlsen, Jon Bang (Director)
Phoenix Bird 1984,Ag 29,C,19:2
Carlson, Karen
Fleshburn 1984,My 26,13:1
Carlson, Les
Videodrome 1983,F 4,C,9:1
Carlson, Ralph
Reaching Out 1983,My 16,C,20:5
Carlton, Larry (Composer)
Against All Odds 1984,Mr 2,C,14:3
Carlton, Timothy
High Road to China 1983,Mr 18,C,4:3
Carmet, Jean
Investigation (Si Joli Village, Un) 1984,F 3,C,11:1
Carmichael, Ralph (Composer)
Joni 1983,Mr 4,C,10:5
Carmody, Don (Producer)
Spacehunter: Adventures in the Forbidden Zone 1983,My 21,29:1
Porky's II: The Next Day 1983,Je 25,12:3
Carnes, Conrad D (Original Author)
Circle of Power 1984,Mr 2,C,5:1
Carney, Art
Firestarter 1984,My 11,C,8:1
Muppets Take Manhattan, The 1984,Jl 13,C,10:4
Caro, Leticia
Revolt of Job, The 1984,Mr 28,C,19:3
Caron, Leslie
Unapproachable, The 1984,F 24,C,8:1
Carpenter, John (Composer)
Christine 1983,D 9,C,10:5
Carpenter, John (Director)
Christine 1983,D 9,C,10:5
Starman 1984,D 14,C,18:1
Starman 1984,D 23,II,19:1
Carpenter, Teresa (Original Author)
Star 80 1983,N 10,C,26:3
Carpenter, Thelma
Cotton Club, The 1984,D 14,C,4:3
Carpi, Fabio (Director)
Basileus Quartet 1984,Ja 4,C,13:5
Carpi, Fabio (Screenwriter)
Basileus Quartet 1984,Ja 4,C,13:5
Carpi, Fiorenzo (Composer)
Sweet Pea (Piso Pisello) 1983,Ja 23,47:1
Carpio, Rustica
Bona 1984,S 19,C,23:1
Carr, Adrian (Director)
Now and Forever 1983,Jl 16,14:1
Carr, Adrian (Miscellaneous)
Man from Snowy River, The 1983,Ja 21,C,5:6

Carr, Allan (Producer)
Where the Boys Are 1984,Ap 7,14:5
Cloak and Dagger 1984,Ag 10,C,16:1
Cloak and Dagger 1984,S 9,II,25:5
Carr, Lucien
Burroughs 1983,O 8,33:1
Burroughs 1984,F 10,C,12:1
Carr, Patricia
Falls, The 1983,My 4,C,17:4
Carr, Richard (Screenwriter)
Americana 1983,O 21,C,14:5
Carradine, Bruce
Americana 1983,O 21,C,14:5
Carradine, David
Lone Wolf McQuade 1983,Ap 16,12:4
Americana 1983,O 21,C,14:5
Carradine, David (Director)
Americana 1983,O 21,C,14:5
Carradine, David (Miscellaneous)
Americana 1983,O 21,C,14:5
Carradine, David (Producer)
Americana 1983,O 21,C,14:5
Carradine, John
Ice Pirates, The 1984,Mr 16,C,8:5
Ten Commandments, The 1984,Mr 25,II,19:1
Carradine, Keith
Choose Me 1984,N 1,C,18:4
Carradine, Robert
Revenge of the Nerds 1984,Jl 20,C,8:5
Just the Way You Are 1984,N 16,C,14:1
Carrera, Barbara
Lone Wolf McQuade 1983,Ap 16,12:4
Never Say Never Again 1983,O 7,C,13:1
Carrera, Cathy
Golden Eighties, The 1983,O 2,59:1
Carriere, Jean-Claude (Screenwriter)
Return of Martin Guerre, The 1983,Je 10,C,12:5
Danton 1983,S 28,C,19:1
Swann in Love 1984,S 14,C,4:1
Carriere, Mathieu
Ways in the Night 1983,Jl 27,C,17:1
Passante, La 1983,Ag 14,47:1
Woman in Flames, A (Flambierte Frau) 1984,F 3,C,11:1
Carrillo, Elpidia
Beyond the Limit 1983,S 30,C,4:3
Under Fire 1983,O 21,C,13:1
Carrington, Laura
Alphabet City 1984,My 5,17:1
Carrive, Pierre
Dernier Combat, Le (Last Battle, The) 1984,Je 22,C,12:1
Carroll, Beeson
Spacehunter: Adventures in the Forbidden Zone 1983,My 21,29:1
Carroll, Gordon (Producer)
Blue Thunder 1983,My 13,C,17:4
Carroll, Janet
Risky Business 1983,Ag 5,C,13:1
Carroll, Jill
Psycho II 1983,Je 3,C,14:5
Carroll, John W
Mrs Soffel 1984,D 26,C,15:1
Carroll, Lisa Hart
Terms of Endearment 1983,N 23,C,18:4
Carruth, William (Miscellaneous)
Strangers Kiss 1984,Ag 13,C,19:1
Carson, Hunter
Paris, Texas 1984,O 14,64:1
Paris, Texas 1984,N 9,C,4:3
Paris, Texas 1984,N 11,II,17:1
Carson, L M Kit (Miscellaneous)
Paris, Texas 1984,O 14,64:1
Paris, Texas 1984,N 9,C,4:3
Paris, Texas 1984,N 11,II,17:1
Carson, L M Kit (Screenwriter)
Breathless 1983,My 13,C,10:1
Carson, Shawn
Something Wicked This Way Comes 1983,Ap 29,C,8:5
Carsten, Peter
Twilight Time 1983,F 13,57:4
Carstensen, Margit
Possession 1983,O 28,C,10:1
Carter, Dixie
Going Berserk 1983,O 29,19:1
Carter, Jim
Top Secret! 1984,Je 22,C,10:1
Carter, Michael
Return of the Jedi 1983,My 25,C,24:1
Carter, T K
Doctor Detroit 1983,My 6,C,10:1
Cartwright, Nancy
Twilight Zone—The Movie (Segment 3) 1983,Je 24,C,15:1

367

369

D

374

Deitch, Louise
 Zelig 1983,Jl 18,B,1:6
Del Amo, Pablo G (Miscellaneous)
 Elisa, Vida Mia 1983,Mr 11,C,8:5
del Cid, Josefina
 It's Never Too Late 1984,Je 29,C,8:4
Del Grande, Louis
 Of Unknown Origin 1983,N 24,C,17:1
del Hoyo, Pablo
 To Begin Again 1983,Ap 22,C,10:5
del Lago, Alicia
 Norte, El 1984,Ja 11,C,15:1
Del Monte, Peter (Director)
 Sweet Pea (Piso Pisello) 1983,Ja 23,47:1
 Invitation au Voyage 1983,Ap 21,C,20:3
Del Monte, Peter (Screenwriter)
 Sweet Pea (Piso Pisello) 1983,Ja 23,47:1
 Invitation au Voyage 1983,Ap 21,C,20:3
del Pino, Rafael
 Evening Performance (Funcion de Noche) 1983,Mr 27,55:1
Del Prete, Diulio
 Gift, The 1983,F 27,48:5
del Rey, Pedro (Miscellaneous)
 Carmen 1983,O 20,C,21:3
Del Rio, Pedro
 Demons in the Garden (Demonios en el Jardin) 1984,Mr
 2,C,5:3
Del Ruth, Thomas (Cinematographer)
 Impulse 1984,S 30,58:5
del Sol, Laura
 Carmen 1983,O 20,C,21:3
Del Testa, Guido
 Cammina Cammina (Keep Walking, Keep Walking) 1984,O
 4,C,16:5
Delahaye, Michel
 Vieux Pays ou Rimbaud Est Mort, Le (Old Country Where
 Rimbaud Died, The) 1984,N 9,C,12:5
Delany, Pauline
 Trenchcoat 1983,Mr 12,13:3
DeLaurentiis, Raffaella (Producer)
 Dune 1984,D 14,C,18:4
Delbat, Germaine
 Vieux Pays ou Rimbaud Est Mort, Le (Old Country Where
 Rimbaud Died, The) 1984,N 9,C,12:5
Delerue, Georges (Composer)
 Black Stallion Returns, The 1983,Mr 27,54:4
 Man, Woman and Child 1983,Ap 1,C,8:1
 Exposed 1983,Ap 22,C,10:1
 Passante, La 1983,Ag 14,47:1
 Silkwood 1983,D 14,C,27:1
 Confidentially Yours (Vivement Dimanche) 1984,Ja 20,C,6:1
 One Deadly Summer 1984,Jl 20,C,10:5
Delgado, Marissa
 Bona 1984,S 19,C,23:1
Delibes, Miguel (Original Author)
 Evening Performance (Funcion de Noche) 1983,Mr 27,55:1
 Holy Innocents, The 1984,S 30,58:3
Delli Colli, Tonino (Cinematographer)
 Tales of Ordinary Madness 1983,Mr 11,C,13:3
 Trenchcoat 1983,Mr 12,13:3
Delon, Alain
 Leopard, The 1983,S 11,II,21:5
 Swann in Love 1984,S 14,C,4:1
Delson, Susan (Miscellaneous)
 Far From Poland 1984,O 3,C,22:5
DeLuise, Dom
 Cannonball Run II 1984,Je 29,C,14:5
 Cannonball Run II 1984,Jl 29,II,15:1
 Johnny Dangerously 1984,D 21,C,25:5
Delval, Liliane
 Bal, Le 1984,Mr 23,C,6:1
Demarigny, Sebastien
 Next Year If All Goes Well 1983,Mr 20,60:1
Demarsan, Eric (Composer)
 Heat of Desire 1984,My 25,C,10:1
Demetriescu, Olga
 Red Love 1983,O 4,C,13:2
Demidova, Alia
 Mirror, The 1983,Ag 17,C,16:3
Demjanenko, Milan
 Amadeus 1984,S 19,C,23:1
Demme, Jonathan (Director)
 Swing Shift 1984,Ap 13,C,13:1
 Stop Making Sense 1984,O 19,C,17:1
DeMunn, Jeffrey
 Windy City 1984,S 21,C,10:5
Denault, Edward O (Producer)
 Last Starfighter, The 1984,Jl 13,C,5:2

Deneuve, Catherine
 Choice of Arms 1983,Mr 6,65:1
 Hunger, The 1983,Ap 29,C,32:1
 Hunger, The 1983,My 1,II,17:1
 Langlois 1983,Ag 5,C,10:5
Dennehy, Brian
 Never Cry Wolf 1983,O 14,C,8:1
 Gorky Park 1983,D 16,C,6:5
 Finders Keepers 1984,My 18,C,10:1
Dennen, Barry
 Not for Publication 1984,N 1,C,17:1
Denney, Charles
 Zelig 1983,Jl 18,B,1:6
Denning, Roland (Cinematographer)
 Voice Over 1983,Ja 23,47:1
Dennis, Charles (Original Author)
 Finders Keepers 1984,My 18,C,10:1
Dennis, Charles (Screenwriter)
 Finders Keepers 1984,My 18,C,10:1
Dennis, Gill (Miscellaneous)
 Flash of Green, A 1984,O 5,C,14:3
Densmore, John
 Get Crazy 1983,O 14,C,11:1
Depardieu, Gerard
 Choice of Arms 1983,Mr 6,65:1
 Return of Martin Guerre, The 1983,Je 10,C,12:5
 Return of Martin Guerre, The 1983,Ag 21,II,17:1
 Moon in the Gutter, The 1983,S 9,C,8:1
 Danton 1983,S 28,C,19:1
 Danton 1983,D 25,II,15:1
 Return of Martin Guerre, The 1983,D 25,II,15:1
 Comperes, Les 1984,Mr 28,C,24:6
Depeyrat, Patrick
 Lucie sur Seine 1983,S 9,C,8:1
Deplanche, Philippe
 Three Crowns of the Sailor 1984,O 5,C,14:3
Depp, Johnny
 Nightmare on Elm Street, A 1984,N 9,C,10:5
Derek, Bo
 Bolero 1984,S 1,9:5
Derek, Bo (Producer)
 Bolero 1984,S 1,9:5
Derek, John
 Ten Commandments, The 1984,Mr 25,II,19:1
Derek, John (Cinematographer)
 Bolero 1984,S 1,9:5
Derek, John (Director)
 Bolero 1984,S 1,9:5
Derek, John (Screenwriter)
 Bolero 1984,S 1,9:5
Derepp, Claude
 Three Crowns of the Sailor 1984,O 5,C,14:3
Derocles, Thierry (Miscellaneous)
 Choice of Arms 1983,Mr 6,65:1
Derrick, Goele
 Golden Eighties, The 1983,O 2,59:1
Derricks, Cleavant
 Moscow On the Hudson 1984,Ap 6,C,12:1
Derrida, Jacques
 Ghost Story 1984,O 31,C,20:4
Deruaz, Chantal
 Return of Martin Guerre, The 1983,Je 10,C,12:5
Desailly, Jean
 Heads or Tails (Pile ou Face) 1983,My 27,C,4:5
Desarthe, Gerard
 Love in Germany, A 1984,O 2,C,13:2
 Love in Germany, A 1984,N 9,C,10:1
Desbiez, Helene
 Until September 1984,S 21,C,6:3
Descas, Marie-Jo
 Sugar Cane Alley 1984,Ap 6,C,24:3
Deschamps, Yves (Miscellaneous)
 Moon in the Gutter, The 1983,S 9,C,8:1
Deschanel, Caleb (Cinematographer)
 Let's Spend the Night Together 1983,F 11,C,8:1
 Right Stuff, The 1983,O 21,C,5:1
 Natural, The 1984,My 11,C,15:1
Deschanel, Mary Jo
 Right Stuff, The 1983,O 21,C,5:1
 2010 1984,D 7,C,15:1
Deseur, Jo
 Golden Eighties, The 1983,O 2,59:1
Desideri, Danilo (Cinematographer)
 Nudo di Donna 1983,My 13,C,7:5
Desiderio, Robert
 Oh God! You Devil 1984,N 9,C,15:1
Desjardins, Julie
 Just a Game 1984,Ap 8,64:3
Desmond, James (Cinematographer)
 Ziggy Stardust and the Spiders From Mars 1983,D 24,17:5

Desny, Ivan
 Berlin Alexanderplatz 1983,Ag 10,C,18:5
 Malou 1983,D 22,C,22:1
DeSoto, Edouard
 Crackers 1984,F 17,C,19:3
DeSoto, Rosana
 Ballad of Gregorio Cortez, The 1983,O 14,C,6:5
Despins, Joseph (Director)
 Moon Over the Alley 1983,Ap 27,C,19:4
Despins, Joseph (Miscellaneous)
 Moon Over the Alley 1983,Ap 27,C,19:4
Destri, Robert
 Psycho II 1983,Je 3,C,14:5
Detmers, Maruschka
 First Name: Carmen 1984,Ag 3,C,6:1
Detollenaere, Annick
 Golden Eighties, The 1983,O 2,59:1
Deull, William
 Without a Trace 1983,F 4,C,8:1
Deuters, Kent
 Screwballs 1983,Jl 9,10:4
Deutsch, Stephen (Producer)
 All the Right Moves 1983,O 21,C,10:3
Devane, William
 Testament 1983,N 4,C,8:1
Devenish, Ross (Director)
 Guest, The 1984,Je 6,C,19:1
 Marigolds in August 1984,Je 20,C,21:1
 Marigolds in August 1984,Jl 1,II,13:1
 Guest, The 1984,Jl 1,II,13:1
Deville, Michel (Director)
 Petite Bande, La 1984,N 9,C,28:5
Deville, Michel (Miscellaneous)
 Petite Bande, La 1984,N 9,C,28:5
DeVito, Danny
 Terms of Endearment 1983,N 23,C,18:4
 Romancing the Stone 1984,Mr 30,C,19:1
 Johnny Dangerously 1984,D 21,C,25:5
Devlin, Alan
 Danny Boy 1984,My 18,C,11:1
DeVries, Jon
 Lianna 1983,Ja 19,C,22:1
 Lianna 1983,Ja 30,II,17:1
DeVries, Peter (Original Author)
 Reuben, Reuben 1983,D 19,C,12:5
DeWaay, Larry (Producer)
 Electric Dreams 1984,Jl 20,C,6:5
Dewaere, Patrick
 Victory March 1983,Mr 11,C,8:1
 Heat of Desire 1984,My 25,C,10:1
Dewhurst, Colleen
 Dead Zone, The 1983,O 21,C,8:1
 Good Fight, The 1984,Mr 28,C,24:4
Dey, Nilotpal
 Case is Closed, The 1984,N 28,C,19:5
Di Benedetto, Tony
 Splash 1984,Mr 9,C,15:1
Di Cicco, Bobby
 Splash 1984,Mr 9,C,15:1
 Philadelphia Experiment, The 1984,Ag 17,C,17:4
di Giacomo, Franco di (Cinematographer)
 Night of the Shooting Stars, The 1983,Ja 30,34:3
 Victory March 1983,Mr 11,C,8:1
Di Lello, Richard (Screenwriter)
 Bad Boys 1983,Mr 25,C,8:1
Di Leo, Accursio
 Bizet's Carmen 1984,S 20,C,21:1
Di Lorenzo, Rossana
 Bal, Le 1984,Mr 23,C,6:1
di Palma, Carlo (Cinematographer)
 Black Stallion Returns, The 1983,Mr 27,54:4
 Gabriela 1984,My 11,C,14:1
Dialegmenos, George
 Colors of Iris, The 1983,Ap 6,C,14:6
Diallo, Aimee
 Jom (Jom or the Story of a People) 1983,Mr 28,C,12:3
 Jom (Jom or the Story of a People) 1983,S 7,C,21:2
Diamond, Barry
 Bachelor Party 1984,Je 30,11:1
Diamond, Frank (Director)
 Quest for Power: Sketches of the American New Right 1983,Jl
 13,C,16:3
Diamond, Frank (Producer)
 Quest for Power: Sketches of the American New Right 1983,Jl
 13,C,16:3
Diamond, Selma
 Twilight Zone—The Movie (Segment 2) 1983,Je 24,C,15:1
 Lovesick 1983,F 18,C,19:1
 All of Me 1984,S 21,C,6:1

Diarra, Oumou
Wind, The 1983,S 24,11:1
Diaz, Andre
Nightmares 1983,S 3,14:5
Diaz, Rafael
Demons in the Garden (Demonios en el Jardin) 1984,Mr
2,C,5:3
Diaz, Robert
Street Music 1983,F 25,C,8:1
Dicenta, Daniel
Evening Performance (Funcion de Noche) 1983,Mr 27,55:1
Dicenta Herrera, Daniel
Evening Performance (Funcion de Noche) 1983,Mr 27,55:1
Dicenta Herrera, Natalia
Evening Performance (Funcion de Noche) 1983,Mr 27,55:1
Dicillo, Tom
Stranger Than Paradise 1984,S 29,14:3
Dicillo, Tom (Cinematographer)
Burroughs 1983,O 8,33:1
Burroughs 1984,F 10,C,12:1
Stranger Than Paradise 1984,S 29,14:3
Dickerson, Dez
Purple Rain 1984,Jl 27,C,5:1
Dickerson, Ernest (Cinematographer)
Joe's Bed-Stuy Barbershop: We Cut Heads 1983,Mr 27,55:5
Brother From Another Planet, The 1984,S 14,C,6:5
Dickey, Lucinda
Breakin' 1984,My 5,17:1
Breakin' 2: Electric Boogaloo 1984,D 19,C,22:4
Dickins, Barry
Man of Flowers 1984,O 9,C,14:4
Man of Flowers 1984,D 16,78:4
Dickinson, Douglas (Cinematographer)
Abuse 1983,Ap 15,C,29:1
Dickinson, Sandra
Lonely Lady, The 1983,O 1,13:5
Dickson, Jane (Producer)
Wild Style 1983,Mr 18,C,8:3
Wild Style 1983,N 25,C,10:4
Diczhazy, Denes
Princess, The 1984,Ap 1,57:1
Diddley, Bo
Trading Places 1983,Je 8,C,16:1
Hells Angels Forever 1983,O 9,69:3
Didi, Evelyne
One Deadly Summer 1984,Jl 20,C,10:5
Diego, Juan
Holy Innocents, The 1984,S 30,58:3
Diehl, John
Angel 1984,Ja 13,C,12:5
Dietschy, Veronique
Swann in Love 1984,S 14,C,4:1
DiGesu, Peter
Amadeus 1984,S 19,C,23:1
Dignam, Arthur
We of the Never Never 1983,F 11,C,12:1
Dikker, Loek (Composer)
4th Man, The 1984,Je 27,C,21:4
DiLeo, Mario (Cinematographer)
Nightmares 1983,S 3,14:5
Dilian, Irasema
Wuthering Heights (Abismos de Pasion) 1983,D 27,C,11:2
Dillman, Bradford
Sudden Impact 1983,D 9,C,12:4
Dillon, Matt
Outsiders, The 1983,Mr 25,C,3:1
Outsiders, The 1983,Ap 10,II,17:1
Rumble Fish 1983,O 7,C,10:3
Rumble Fish 1983,O 23,II,19:1
Flamingo Kid, The 1984,D 21,C,25:1
Dillon, Melinda
Christmas Story, A 1983,N 18,C,36:1
Dillon, Mick
Champions 1984,Ap 20,C,8:1
Dillon, Robert (Miscellaneous)
River, The 1984,D 19,C,19:1
Dillon, Robert (Screenwriter)
River, The 1984,D 19,C,19:1
Dimitri, Richard
Johnny Dangerously 1984,D 21,C,25:5
Din-a-Testbild (Composer)
Red Love 1983,O 4,C,13:2
Dinnes, Dr Martin R (Miscellaneous)
Golden Seal, The 1983,Ag 12,C,4:5
Diquero, Luc-Antoine
Balance, La 1983,N 20,72:1
DiSanti, John
Star Chamber, The 1983,Ag 5,C,8:5
Ditson, Harry
Top Secret! 1984,Je 22,C,10:1

Diver, William (Cinematographer)
Children (Terence Davies Trilogy, The) 1984,Ap 8,64:3
Madonna and Child (Terence Davies Trilogy, The) 1984,Ap
8,64:3
Death and Transfiguration (Terence Davies Trilogy, The)
1984,Ap 8,64:3
Diver, William (Miscellaneous)
Children (Terence Davies Trilogy, The) 1984,Ap 8,64:3
Death and Transfiguration (Terence Davies Trilogy, The)
1984,Ap 8,64:3
Dixon, Donna
Doctor Detroit 1983,My 6,C,10:1
Twilight Zone—The Movie (Segment 4) 1983,Je 24,C,15:1
Dixon, Humphrey (Miscellaneous)
Heat and Dust 1983,S 15,C,18:3
Dixon, John (Screenwriter)
Man from Snowy River, The 1983,Ja 21,C,5:6
Dixon, Malcom
Return of the Jedi 1983,My 25,C,24:1
Dixon, Willie
Chicago Blues 1983,S 1,C,28:1
Doblin, Alfred (Original Author)
Berlin Alexanderplatz 1983,Ag 10,C,18:5
Berlin Alexanderplatz 1983,D 25,II,15:1
Doctorow, Caroline
Daniel 1983,S 4,II,11:1
Doctorow, E L (Original Author)
Daniel 1983,Ag 26,C,10:4
Daniel 1983,S 4,II,11:1
Doctorow, E L (Screenwriter)
Daniel 1983,Ag 26,C,10:4
Daniel 1983,S 4,II,11:1
Dods, John (Miscellaneous)
Deadly Spawn, The 1983,Ap 22,C,11:1
Dogileva, Tatiana
Private Life 1983,F 27,45:1
Dolan, Dennis (Miscellaneous)
Repo Man 1984,Jl 6,C,8:5
Dolan, Ed
Scandalous 1984,Ja 20,C,4:5
Doldinger, Klaus (Composer)
Neverending Story, The 1984,Jl 20,C,5:1
Dolina, Larissa
Jazzman 1984,Mr 7,C,19:1
Dombasle, Arielle
Pauline at the Beach 1983,Jl 29,C,6:5
Pauline at the Beach 1983,Ag 21,II,17:1
Dome, Zsolt (Composer)
Diary for My Children 1984,S 30,58:1
Diary for My Children 1984,O 31,C,21:5
Domingo, Placido
Traviata, La 1983,Ap 22,C,13:1
Bizet's Carmen 1984,S 20,C,21:1
Bizet's Carmen 1984,S 23,II,19:1
Dominguez, Chazz
This is Spinal Tap 1984,Mr 2,C,6:1
Donadoni, Maurizio
Story of Piera, The 1983,S 24,11:5
Donaggio, Pino (Composer)
Hercules 1983,Ag 28,61:1
Over the Brooklyn Bridge 1984,Mr 2,C,6:5
Body Double 1984,O 26,C,8:1
China 9, Liberty 37 1984,N 30,C,8:4
Donahue, Elinor
Going Berserk 1983,O 29,19:1
Donahue, Troy
Grandview U S A 1984,Ag 3,C,8:4
Donald, Juliana
Muppets Take Manhattan, The 1984,Jl 13,C,10:4
Donaldson, Roger (Director)
Bounty, The 1984,My 4,C,8:1
Donaldson, Walter (Composer)
Basileus Quartet 1984,Ja 4,C,13:5
Doncheff, Len
Strange Brew 1983,Ag 26,C,8:1
Donen, Stanley (Director)
Blame It on Rio 1984,F 17,C,10:5
Donen, Stanley (Producer)
Blame It on Rio 1984,F 17,C,10:5
Doniol-Valcroze, J
Jeanne Dielman, 23 Quai Du Commerce, 1080 Bruxelles
1983,Mr 23,C,25:4
Donizetti, Gaetano (Composer)
Man of Flowers 1984,O 9,C,14:4
Man of Flowers 1984,D 16,78:4
Donnadieu, Bernard Pierre
Return of Martin Guerre, The 1983,Je 10,C,12:5
Donnelly, James
And Nothing But the Truth 1984,Ap 20,C,15:1

Donner, Jorn (Producer)
After the Rehearsal 1984,Je 21,C,14:1
Donoghue, Mary Angnes (Screenwriter)
Buddy System, The 1984,My 4,C,15:2
Donovan, Arlene (Producer)
Places in the Heart 1984,S 21,C,8:1
Donovan, Terence
Man from Snowy River, The 1983,Ja 21,C,5:6
Dontoh, David
Kukurantumi: The Road to Accra 1984,Ap 1,51:1
Doob, Nick (Cinematographer)
Ziggy Stardust and the Spiders From Mars 1983,D 24,17:5
Doohan, James
Star Trek III: The Search for Spock 1984,Je 1,C,14:3
Dooley, Paul
Strange Brew 1983,Ag 26,C,8:1
Going Berserk 1983,O 29,19:1
Sixteen Candles 1984,My 4,C,14:1
Doppelt, Margery (Screenwriter)
Terror in the Aisles 1984,O 26,C,18:6
Doran, Peter
Experience Preferred...But Not Essential 1983,N 4,C,11:1
Dore, Charlie
Ploughman's Lunch, The 1984,O 19,C,8:1
Dore, Mary (Director)
Good Fight, The 1984,Mr 28,C,24:4
Dore, Mary (Producer)
Good Fight, The 1984,Mr 28,C,24:4
Doree, Jeanne
Death and Transfiguration (Terence Davies Trilogy, The)
1984,Ap 8,64:3
Doria, Oswaldo
Under Fire 1983,O 21,C,13:1
Doring, Arturo R
Under Fire 1983,O 21,C,13:1
Dorn, Eckhard (Cinematographer)
Kukurantumi: The Road to Accra 1984,Ap 1,51:1
Dorn, Veronicka (Miscellaneous)
Parsifal 1983,Ja 23,46:1
Dornacker, Jane
Right Stuff, The 1983,O 21,C,5:1
Dorothee
Heads or Tails (Pile ou Face) 1983,My 27,C,4:5
Dorrie, Doris (Director)
Straight Through the Heart 1984,Ap 1,57:1
Dorsey, Cathy (Cinematographer)
Burroughs 1983,O 8,33:1
Burroughs 1984,F 10,C,12:1
Dorsey, Joe
War Games 1983,Je 3,C,17:1
Brainstorm 1983,S 30,C,17:1
Dorsey, Thomas A
Say Amen, Somebody 1983,Mr 11,C,10:1
Doset, Michel
Dernier Combat, Le (Last Battle, The) 1984,Je 22,C,12:1
Dotrice, Kay
Cheech & Chong's The Corsican Brothers 1984,Jl 28,15:5
Dotrice, Roy
Cheech & Chong's The Corsican Brothers 1984,Jl 28,15:5
Amadeus 1984,S 19,C,23:1
Douglas, Bill (Director)
My Childhood (Bill Douglas Trilogy, The) 1983,My 18,C,26:5
My Ain Folk (Bill Douglas Trilogy, The) 1983,My 18,C,26:5
My Way Home (Bill Douglas Trilogy, The) 1983,My
18,C,26:5
Douglas, Bill (Screenwriter)
My Childhood (Bill Douglas Trilogy, The) 1983,My 18,C,26:5
My Ain Folk (Bill Douglas Trilogy, The) 1983,My 18,C,26:5
My Way Home (Bill Douglas Trilogy, The) 1983,My
18,C,26:5
Douglas, Bob W
River, The 1984,D 19,C,19:1
Douglas, James
Threshold 1983,Ja 21,C,5:3
Douglas, Joel (Producer)
Romancing the Stone 1984,Mr 30,C,19:1
Douglas, Kirk
Man from Snowy River, The 1983,Ja 21,C,5:6
Douglas, Malcolm
Educating Rita 1983,S 21,C,21:1
Douglas, Michael
Star Chamber, The 1983,Ag 5,C,8:5
Romancing the Stone 1984,Mr 30,C,19:1
Douglas, Peter Vincent (Producer)
Something Wicked This Way Comes 1983,Ap 29,C,8:5
Douglas, Sarah
Conan the Destroyer 1984,Je 29,C,8:4
Douglass, Amy
Duel 1983,Ap 15,C,10:1

Eastwood, Alison
 Tightrope 1984,Ag 17,C,6:1
Eastwood, Clint
 Sudden Impact 1983,D 9,C,12:4
 Tightrope 1984,Ag 17,C,6:1
 Tightrope 1984,S 23,II,19:1
 City Heat 1984,D 7,C,4:3
Eastwood, Clint (Director)
 Sudden Impact 1983,D 9,C,12:4
Eastwood, Clint (Producer)
 Sudden Impact 1983,D 9,C,12:4
 Tightrope 1984,Ag 17,C,6:1
Eatman, Laurel
 All the Right Moves 1983,O 21,C,10:3
Eaton, Marjorie
 Street Music 1983,F 25,C,8:1
Eatwell, Brian (Miscellaneous)
 American Dreamer 1984,O 26,C,12:4
Eberhardt, Thom (Director)
 Night of the Comet 1984,N 16,C,8:1
Eberhardt, Thom (Screenwriter)
 Night of the Comet 1984,N 16,C,8:1
Ebersole, Christine
 Amadeus 1984,S 19,C,23:1
 Thief of Hearts 1984,O 19,C,17:4
Ebert, Joyce
 Mrs Soffel 1984,D 26,C,15:1
Eccles, Donald
 Dresser, The 1983,D 6,C,19:1
Echanove, Josefina
 Beyond the Limit 1983,S 30,C,4:3
Echeverria, Diego (Director)
 Sures, Los (Southerners, The) 1984,S 29,14:4
Echeverria, Diego (Producer)
 Sures, Los (Southerners, The) 1984,S 29,14:4
Eck, Imre
 Lost Illusions 1983,O 1,16:3
Eckardt, Hans-Eckardt
 Kamikaze '89 1983,F 27,48:1
Eckstein, George (Producer)
 Duel 1983,Ap 15,C,10:1
Ede, Francois (Miscellaneous)
 Three Crowns of the Sailor 1984,O 5,C,14:3
Ederveen, Arjan
 Still Smokin' 1983,My 7,16:3
Editions Saravah (Composer)
 Erendira 1983,O 1,16:3
 Erendira 1984,Ap 27,C,8:5
Edlund, Richard (Miscellaneous)
 Return of the Jedi 1983,My 25,C,24:1
 2010 1984,D 7,C,15:1
Edmonds, Elizabeth
 Experience Preferred...But Not Essential 1983,N 4,C,11:1
 Experience Preferred...But Not Essential 1983,N 20,17:1
 Scrubbers 1984,F 1,C,16:4
Edmonds, Mike
 Return of the Jedi 1983,My 25,C,24:1
 Return of the Jedi 1983,My 25,C,24:1
Edmunds, Dave
 Give My Regards to Broad Street 1984,O 26,C,14:5
Edson, Richard
 Stranger Than Paradise 1984,S 29,14:3
 Stranger Than Paradise 1984,O 14,II,21:1
 Stranger Than Paradise 1984,D 30,II,15:1
Edson, Richard (Composer)
 Vortex 1983,F 4,C,5:1
Edwall, Allan
 Fanny and Alexander 1983,Je 17,C,8:1
Edward, Marion
 Strikebound 1984,O 6,15:5
Edwards, Anthony
 Heart Like a Wheel 1983,O 6,C,30:1
 Revenge of the Nerds 1984,Jl 20,C,8:5
Edwards, Blake (Director)
 Curse of the Pink Panther 1983,Ag 13,13:1
 Man Who Loved Women, The 1983,D 16,C,8:1
 Man Who Loved Women, The 1984,Ja 1,II,11:1
 Micki and Maude 1984,D 21,C,25:4
Edwards, Blake (Producer)
 Curse of the Pink Panther 1983,Ag 13,13:1
 Man Who Loved Women, The 1983,D 16,C,8:1
Edwards, Blake (Screenwriter) see also Brown, Sam O
 Curse of the Pink Panther 1983,Ag 13,13:1
 Man Who Loved Women, The 1983,D 16,C,8:1
Edwards, Darryl
 Brother from Another Planet, The 1984,S 14,C,6:5
Edwards, Eric (Cinematographer)
 Last Night at the Alamo 1983,O 2,II,60:3
 Last Night at the Alamo 1984,Jl 3,C,10:5
Edwards, Gail
 Get Crazy 1983,O 14,C,11:1

Edwards, Geoffrey (Screenwriter)
 Curse of the Pink Panther 1983,Ag 13,13:1
 Man Who Loved Women, The 1983,D 16,C,8:1
Edwards, Jennifer
 Man Who Loved Women, The 1983,D 16,C,8:1
Edwards, Robert Gordon (Producer)
 Beyond Good and Evil 1984,My 18,C,14:1
Edwards, Tony
 Starman 1984,D 14,C,18:1
Edwards, Vince
 Deal of the Century 1983,N 4,C,13:3
Efe, Pedro
 In the White City 1983,S 26,C,10:5
Efraim, R Ben (Producer)
 Private School 1983,Jl 30,11:4
Efron, Marshall
 First Time, The 1983,Jl 13,C,16:3
 First Time, The 1983,Jl 31,II,15:1
Efroni, Yehuda
 Hercules 1983,Ag 28,61:1
Egerer, Carla
 Slow Attack (Endstation Freiheit) 1983,Ja 12,C,24:1
Eggebrecht, Axel (Screenwriter)
 Lost One, The (Verlorene, Der) 1984,Ag 1,C,21:3
Eguillor, Juan Carlos (Screenwriter)
 It's Never Too Late 1984,Je 29,C,8:4
Ehlers, Beth
 Hunger, The 1983,Ap 29,C,32:1
Ehrig, Maggie
 Suburbia 1984,Ap 13,C,10:1
Ehrlich, Jacquot (Miscellaneous)
 Last Sea, The 1984,Jl 4,C,7:5
Eichberger, Willy
 Liebelei 1983,My 31,C,10:5
Eichinger, Bernd (Producer)
 Neverending Story, The 1984,Jl 20,C,5:1
Eiji, Okada
 Antarctica 1984,Mr 30,C,10:5
Eilbacher, Lisa
 10 to Midnight 1983,Mr 13,62:5
 Beverly Hills Cop 1984,D 5,C,25:4
Eilber, Janet
 Romantic Comedy 1983,O 7,C,8:1
 Hard to Hold 1984,Ap 6,C,16:5
Eins, Mark
 Red Love 1983,O 4,C,13:2
Eisenberg, Ned
 Slayground 1984,Ja 28,14:5
Eisenmann, Ike
 Cross Creek 1983,S 21,C,19:4
Ekblad, Stina
 Fanny and Alexander 1983,Je 17,C,8:1
Ekins, Bud
 Deadly Force 1983,Jl 8,C,4:3
El Cojo, Enrique
 Bizet's Carmen 1984,S 20,C,21:1
Elam, Greg
 Fire and Ice 1983,N 24,C,12:1
Elcar, Dana
 Blue Skies Again 1983,Jl 29,C,8:3
 All of Me 1984,S 21,C,6:1
 All of Me 1984,O 14,II,21:1
 2010 1984,D 7,C,15:1
Elding, Paul
 Personals, The 1983,Mr 20,60:1
Elgar, Edward (Composer)
 Greystoke: The Legend of Tarzan, Lord of the Apes 1984,Mr 30,C,5:1
Elian, Yona
 Last Winter, The 1984,S 8,10:4
Elias, Alix
 Night in Heaven, A 1983,N 19,19:3
Elias, Hector
 Losin' It 1983,Ap 8,C,4:5
 Deadly Force 1983,Jl 8,C,4:3
Elias, Jonathan (Composer)
 Children of the Corn 1984,Mr 16,C,7:2
Elizondo, Fernando
 Under Fire 1983,O 21,C,13:1
Elizondo, Hector
 Flamingo Kid, The 1984,D 21,C,25:1
Elizondo, Humberto
 Erendira 1983,O 1,16:3
 Erendira 1984,Ap 27,C,8:5
Elli and Jacno (Composer)
 Full Moon in Paris (Nuits de la Pleine Lune, Les) 1984,S 7,C,5:1
Elli, Bob (Screenwriter)
 Man of Flowers 1984,D 16,78:4
Ellict, Shawn
 Nicaragua: Report from the Front 1984,Ja 18,C,24:3

Ellington, Duke (Composer)
 City News and News Briefs 1983,S 9,C,6:2
Elliot, Peter (Miscellaneous)
 Greystoke: The Legend of Tarzan, Lord of the Apes 1984,Mr 30,C,5:1
Elliot, Shawn
 Beat Street 1984,Je 8,C,10:5
Elliott, Christopher
 Lianna 1983,Ja 19,C,22:1
Elliott, Dean
 Beat Street 1984,Je 8,C,10:5
Elliott, Denholm
 Trading Places 1983,Je 8,C,16:1
 Trading Places 1983,Je 19,II,23:1
 Wicked Lady, The 1983,O 28,C,16:1
 Trading Places 1983,D 18,II,21:1
 Razor's Edge, The 1984,O 19,C,14:6
Elliott, Stephen
 Beverly Hills Cop 1984,D 5,C,25:4
Elliott, Sumner Locke (Original Author)
 Careful He Might Hear You 1984,Je 15,C,8:1
Elliott, Tim
 Utu 1984,S 13,C,21:2
Ellis, Bob
 Man of Flowers 1984,O 9,C,14:4
 Man of Flowers 1984,D 16,78:4
Ellis, Bob (Screenwriter)
 Man of Flowers 1984,O 9,C,14:4
Ellis, Clive
 Give My Regards to Broad Street 1984,O 26,C,14:5
Ellis, Michael (Miscellaneous)
 Lords of Discipline, The 1983,F 18,C,16:4
 Britannia Hospital 1983,Mr 4,C,10:1
 Death Watch 1984,S 14,C,6:5
 Comfort and Joy 1984,O 10,C,19:1
Ellis, Sarah (Miscellaneous)
 Children (Terence Davies Trilogy, The) 1984,Ap 8,64:3
Ellsberg, Daniel
 America—From Hitler to MX 1983,Ja 5,C,17:1
Ellyn, Maura
 Home Free All 1984,My 2,C,25:1
Elmes, Frederick (Cinematographer)
 Valley Girl 1983,Ap 29,C,10:1
Elorriaga, Xabier
 Escape From Segovia 1984,Je 6,C,21:1
Elphick, Michael
 Gorky Park 1983,D 16,C,6:5
 Privates on Parade 1984,Ap 13,C,8:1
Eluto, Ken (Miscellaneous)
 America—From Hitler to MX 1983,Ja 5,C,17:1
Elwes, Cary
 Another Country 1984,Je 29,C,8:1
Elwes, Cassian (Producer)
 Oxford Blues 1984,Ag 25,9:1
Emil, Michael
 Can She Bake a Cherry Pie? 1983,D 8,C,22:3
Emperio, Mike
 Year of Living Dangerously, The 1983,Ja 21,C,4:1
Endene, David
 Greystoke: The Legend of Tarzan, Lord of the Apes 1984,Mr 30,C,5:1
Endler, Michael (Screenwriter)
 Easy Money 1983,Ag 19,C,8:5
Engelberg, Mort (Producer)
 Smokey and the Bandit, Part 3 1983,S 17,30:4
Engleson, Peter (Miscellaneous)
 Your Neighbor's Son: The Making of a Torturer 1984,Ag 29,C,19:2
Englund, Robert
 Nightmare on Elm Street, A 1984,N 9,C,10:5
Engstfeld, Axel (Director)
 Of Judges and Other Sympathizers 1983,Je 15,C,17:1
Engstfeld, Axel (Miscellaneous)
 War And Peace 1983,D 3,15:1
Engstrom, Charles (Composer)
 Flash of Green, A 1984,O 5,C,14:3
Eno, Brian (Composer)
 Beneath the Angka: A Story of the Khmer Rouge 1983,Ap 29,C,17:5
 Falls, The 1983,My 4,C,17:4
 SL-1 1984,Mr 21,C,14:4
 Dune 1984,D 14,C,18:4
Enrico, Robert (Director)
 Heads or Tails (Pile ou Face) 1983,My 27,C,4:5
Enrico, Robert (Miscellaneous)
 Heads or Tails (Pile ou Face) 1983,My 27,C,4:5
Enright, Don (Producer)
 Private School 1983,Jl 30,11:4
Enriquez, Rene
 Under Fire 1983,O 21,C,13:1
 Evil That Men Do, The 1984,S 22,35:3

Ensign, Michael
War Games 1983,Je 3,C,17:1
All of Me 1984,S 21,C,6:1
Enskat, Claus
Ways in the Night 1983,Jl 27,C,17:1
Epaminondas, Andros (Producer)
Give My Regards to Broad Street 1984,O 26,C,14:5
Ephron, Nora (Screenwriter)
Silkwood 1983,D 14,C,27:1
Silkwood 1984,Ja 1,II,11:1
Epperson, Joe (Cinematographer)
Richard Pryor Here and Now 1983,O 28,C,8:1
Epstein, Julius J (Screenwriter)
Reuben, Reuben 1983,D 19,C,12:5
Epstein, Marcelo (Director)
Body Rock 1984,S 28,C,12:5
Epstein, Mitch (Cinematographer)
So Far from India 1983,O 9,72:1
Epstein, Robert (Director)
Times of Harvey Milk, The 1984,O 7,86:1
Times of Harvey Milk, The 1984,O 27,15:1
Epstein, Robert (Miscellaneous)
Times of Harvey Milk, The 1984,O 7,86:1
Times of Harvey Milk, The 1984,O 27,15:1
Epstein, Ruth (Miscellaneous)
Last Winter, The 1984,S 8,10:4
Erbe, Micky (Composer)
Threshold 1983,Ja 21,C,5:3
Erdoss, Pal (Director)
Princess, The 1984,Ap 1,57:1
Eric, Kai
Vortex 1983,F 4,C,5:1
Erkal, Genco
Horse, The 1984,Ja 4,C,14:3
Erlichman, Martin (Producer)
Breathless 1983,My 13,C,10:1
Ermey, Lee
Purple Hearts 1984,My 4,C,15:1
Errickson, Krista
First Time, The 1983,Jl 13,C,16:3
Erskine, Howard
Zelig 1983,Jl 18,B,1:6
Escamilla, Teo (Cinematographer)
Elisa, Vida Mia 1983,Mr 11,C,8:5
Evening Performance (Funcion de Noche) 1983,Mr 27,55:1
Carmen 1983,O 20,C,21:3
It's Never Too Late 1984,Je 29,C,8:4
Escobedo, Carlos (Producer)
Valentina 1983,Ag 5,C,15:3
Escobedo, Carlos (Screenwriter)
Valentina 1983,Ag 5,C,15:3
Escorel, Eduardo (Miscellaneous)
They Don't Wear Black Tie (Eles Nao Usam Black-Tie)
1983,My 27,C,8:5
Escorel, Lauro (Cinematographer)
They Don't Wear Black Tie (Eles Nao Usam Black-Tie)
1983,My 27,C,8:5
Esham, Faith
Bizet's Carmen 1984,S 20,C,21:1
Bizet's Carmen 1984,S 23,II,19:1
Esinger, Jo (Screenwriter)
Jigsaw Man, The 1984,Ag 24,C,4:5
Esparza, Moctesuma (Producer)
Ballad of Gregorio Cortez, The 1983,O 14,C,6:5
Esposti, Piera Degli (Miscellaneous)
Story of Piera, The 1983,S 24,11:5
Esposti, Piera Degli (Screenwriter)
Story of Piera, The 1983,S 24,11:5
Esquivel, Alan
Alsino and the Condor 1983,My 1,69:1
Estevez, Emilio
Outsiders, The 1983,Mr 25,C,3:1
Nightmares 1983,S 3,14:5
Repo Man 1984,Jl 6,C,8:5
Estienne, Marie-Helene (Screenwriter)
Swann in Love 1984,S 14,C,4:1
Estrin, Bob (Miscellaneous)
Breathless 1983,My 13,C,10:1
Eszterhas, Joe (Screenwriter)
Flashdance 1983,Ap 15,C,13:1
Evan, Jeanne
Not for Publication 1984,N 1,C,17:1
Evans, Angelo
Angelo My Love 1983,Ap 27,C,17:5
Evans, Art
Soldier's Story, A 1984,S 14,C,10:5
Evans, Bruce A (Screenwriter)
Starman 1984,D 14,C,18:1
Evans, Debbie
Angelo My Love 1983,Ap 27,C,17:5
Moon Over the Alley 1983,Ap 27,C,19:4

Evans, Derek
Exterminator 2 1984,S 15,14:5
Evans, Geoffrey (Producer)
My Childhood (Bill Douglas Trilogy, The) 1983,My 18,C,26:5
Evans, Michael
Angelo My Love 1983,Ap 27,C,17:5
Evans, Mostyn
Experience Preferred...But Not Essential 1983,N 4,C,11:1
Evans, Reg
Kitty and the Bagman 1983,Ag 5,C,14:5
Strikebound 1984,O 6,15:5
Evans, Robert (Producer)
Cotton Club, The 1984,D 14,C,4:3
Evans, Ruthie
Angelo My Love 1983,Ap 27,C,17:5
Evans, Tony
Angelo My Love 1983,Ap 27,C,17:5
Even, Mariline
Choice of Arms 1983,Mr 6,65:1
Even, Maryline
Lucie sur Seine 1983,S 9,C,8:1
Everett, Rupert
Another Country 1984,Je 29,C,8:1
Evstegneev, Evgeny
Waiting for Gavrilov 1983,Ap 15,C,14:1
Ewart, John
Kitty and the Bagman 1983,Ag 5,C,14:5
Ewing, John Christy
Breakin' 2: Electric Boogaloo 1984,D 19,C,22:4
Eynon, Howard
Man from Snowy River, The 1983,Ja 21,C,5:6
Eyre, Richard (Director)
Ploughman's Lunch, The 1984,O 19,C,8:1

F

Fabara, Sandra Pink
Wild Style 1983,Mr 18,C,8:3
Wild Style 1983,N 25,C,10:4
Fabiani, Joel
Reuben, Reuben 1983,D 19,C,12:5
Fabiani, M (Screenwriter)
Balance, La 1983,N 20,72:1
Fabiola
Still Smokin' 1983,My 7,16:3
Faenza, Roberto (Director)
Corrupt 1984,Ja 19,C,16:5
Faenza, Roberto (Screenwriter)
Corrupt 1984,Ja 19,C,16:5
Fahlen, Hans
Ski Country 1984,N 30,C,13:1
Fahlen, Lhasa
Ski Country 1984,N 30,C,13:1
Fairfax, Ferdinand (Director)
Nate and Hayes 1983,N 18,C,30:3
Faison, Frankie
Exterminator 2 1984,S 15,14:5
Faison, Sandy
All the Right Moves 1983,O 21,C,10:3
Faivre, Erika
Sunday in the Country, A 1984,O 2,C,14:3
Sunday in the Country, A 1984,N 16,C,11:1
Falcon, Andre
Heads or Tails (Pile ou Face) 1983,My 27,C,4:5
Falcon, Bruno
Breakin' 1984,My 5,17:1
Falk, Ronald
Lonely Hearts 1983,S 4,58:3
Fall, Fatou
Jom (Jom or the Story of a People) 1983,Mr 28,C,12:3
Jom (Jom or the Story of a People) 1983,S 7,C,21:2
Fall, Fatou Samb
Jom (Jom or the Story of a People) 1983,Mr 28,C,12:3
Jom (Jom or the Story of a People) 1983,S 7,C,21:2
Fall, N'Deye Ami
Jom (Jom or the Story of a People) 1983,Mr 28,C,12:3
Jom (Jom or the Story of a People) 1983,S 7,C,21:2
Fallon, Larry (Composer)
Dear Mr Wonderful 1983,D 21,C,26:4
Faltermeyer, Harold (Composer)
Thief of Hearts 1984,O 19,C,17:4
Beverly Hills Cop 1984,D 5,C,25:4
Falwell, Jerry
Quest for Power: Sketches of the American New Right 1983,Jl
13,C,16:3
Fano, Michel (Composer)
Claw and the Tooth, The 1984,D 26,C,15:3

Fanucci, Aldo
Cammina Cammina (Keep Walking, Keep Walking) 1984,O
4,C,16:5
Faraldo, Daniel
Trenchcoat 1983,Mr 12,13:3
Spring Break 1983,Mr 27,54:4
Farcy, Bernard
Moon in the Gutter, The 1983,S 9,C,8:1
Farese, Jude
City Heat 1984,D 7,C,4:3
Fargas, Antonio
Firestarter 1984,My 11,C,8:1
Fargnoli, Steven (Producer)
Purple Rain 1984,Jl 27,C,5:1
Farkas, Zoltan (Miscellaneous)
When Joseph Returns 1983,F 3,C,20:2
Farley, Walter (Original Author)
Black Stallion Returns, The 1983,Mr 27,54:4
Farnsworth, Richard
Independence Day 1983,Ja 21,C,8:1
Grey Fox, The 1983,Jl 13,C,17:4
Natural, The 1984,My 11,C,15:1
Rhinestone 1984,Je 22,C,10:5
Rhinestone 1984,Jl 29,II,15:1
Faro, Sean
Starman 1984,D 14,C,18:1
Farocki, Harun
Class Relations 1984,O 7,86:1
Farot, Marie-Ange
Sugar Cane Alley 1984,Ap 6,C,24:3
Farr, Glenn (Miscellaneous)
Right Stuff, The 1983,O 21,C,5:1
Gospel 1983,D 23,C,8:1
Runaway 1984,D 14,C,20:1
Farr, Jamie
Cannonball Run II 1984,Je 29,C,14:5
Farrel, Nicholas
Greystoke: The Legend of Tarzan, Lord of the Apes 1984,Mr
30,C,5:1
Farrell, Peter
Moon Over the Alley 1983,Ap 27,C,19:4
Farrell, Sharon
Out of the Blue 1983,Ap 8,C,6:5
Lone Wolf McQuade 1983,Ap 16,12:4
Night of the Comet 1984,N 16,C,8:1
Farrell, Tom
Paris, Texas 1984,O 14,64:1
Paris, Texas 1984,N 9,C,4:3
Farrow, Mia
Zelig 1983,Jl 17,II,1:4
Zelig 1983,Jl 18,B,1:6
Zelig 1983,D 25,II,15:1
Broadway Danny Rose 1984,Ja 27,C,8:1
Broadway Danny Rose 1984,Ja 29,II,13:1
Supergirl 1984,N 22,C,15:2
Broadway Danny Rose 1984,D 30,II,15:1
Farrow, Stephanie
Zelig 1983,Jl 18,B,1:6
Fash, Mike (Cinematographer)
Betrayal 1983,F 20,78:1
Britannia Hospital 1983,Mr 4,C,10:1
Fassbinder, Rainer Werner
Kamikaze '89 1983,F 27,48:1
Shadow of Angels (Schatten der Engel) 1983,Je 24,C,8:1
Fassbinder, Rainer Werner (Director)
Stationmaster's Wife, The (Bolwieser) 1983,Ja 12,C,21:2
Querelle 1983,Ap 29,C,8:5
Berlin Alexanderplatz 1983,Ag 10,C,18:5
Berlin Alexanderplatz 1983,D 25,II,15:1
Fassbinder, Rainer Werner (Miscellaneous)
Wizard of Babylon, The 1983,Mr 30,C,25:1
Shadow of Angels (Schatten der Engel) 1983,Je 24,C,8:1
Fassbinder, Rainer Werner (Screenwriter)
Stationmaster's Wife, The (Bolwieser) 1983,Ja 12,C,21:2
Querelle 1983,Ap 29,C,8:5
Shadow of Angels (Schatten der Engel) 1983,Je 24,C,8:1
Berlin Alexanderplatz 1983,Ag 10,C,18:5
Fataliyev, Ramiz (Screenwriter)
Without Witness (Private Conversation, A) 1984,O 12,C,12:5
Faure, Gabriel (Composer)
Drugstore Romance (Corps a Coeur) 1983,Jl 1,C,8:4
Passion 1983,O 4,C,13:2
Sunday in the Country, A 1984,O 2,C,14:3
Sunday in the Country, A 1984,N 16,C,11:1
Favilla, Gian Luca
Another Time, Another Place 1984,Jl 11,C,26:1
Fayolle, Lise (Producer)
Moon in the Gutter, The 1983,S 9,C,8:1
Heat of Desire 1984,My 25,C,10:1
Feast, Michael
Draughtsman's Contract, The 1983,Je 22,C,26:4

Fegan, Jorge
 Erendira 1983,O 1,16:3
 Erendira 1984,Ap 27,C,8:5
Feher, Gabor
 Revolt of Job, The 1984,Mr 28,C,19:3
Fehrenberg, Marianne (Miscellaneous)
 Parsifal 1983,Ja 23,46:1
Feight, Pam
 Last Night at the Alamo 1983,O 2,II,60:3
 Last Night at the Alamo 1984,Jl 3,C,10:5
Feiginova, L (Miscellaneous)
 Mirror, The 1983,Ag 17,C,16:3
Feil, Gerald (Cinematographer)
 Let's Spend the Night Together 1983,F 11,C,8:1
Feinberg, Nina (Miscellaneous)
 Lovesick 1983,F 18,C,19:1
Feindt, Johann (Director)
 Irreconcilable Memories 1983,Je 15,C,17:1
Feitshans, Buzz (Producer)
 Uncommon Valor 1983,D 16,C,12:1
 Red Dawn 1984,Ag 10,C,11:1
Felder, Clarence
 Slayground 1984,Ja 28,14:5
Feldman, Corey
 Friday the 13th—The Final Chapter 1984,Ap 14,15:1
 Gremlins 1984,Je 8,C,10:4
Feldman, Edward S (Producer)
 Hot Dog 1984,Ja 14,10:1
Feldman, Marty
 Yellowbeard 1983,Je 24,C,10:2
Feldman, Tibor
 Well, The 1984,Mr 18,53:1
Feldshuh, Tovah
 Daniel 1983,Ag 26,C,10:4
Felitto, Valerie
 City News and News Briefs 1983,S 9,C,6:2
Felix, Nicole
 Confidentially Yours (Vivement Dimanche) 1984,Ja 20,C,6:1
Fellini, Federico
 My Name is Anna Magnani 1984,Ag 10,C,12:4
Fellini, Federico (Director)
 And the Ship Sails On 1984,Ja 26,C,17:1
 And the Ship Sails On 1984,F 5,II,15:1
Fellini, Federico (Miscellaneous)
 And the Ship Sails On 1984,Ja 26,C,17:1
Fellini, Federico (Screenwriter)
 And the Ship Sails On 1984,Ja 26,C,17:1
Fellows, Don
 Electric Dreams 1984,Jl 20,C,6:5
Fengler, Michael (Producer)
 Shadow of Angels (Schatten der Engel) 1983,Je 24,C,8:1
Fenn, Suzanne (Miscellaneous)
 Two Worlds of Angelita, The (Dos Mundos del Angelita, Los) 1983,O 28,C,4:3
Ferguson, J Don
 Loveless, The 1984,Ja 20,C,8:5
Ferjac, Anouk
 Vieux Pays ou Rimbaud Est Mort, Le (Old Country Where Rimbaud Died, The) 1984,N 9,C,12:5
Fernandes, Joao (Cinematographer)
 Big Score, The 1983,N 20,67:3
 Missing in Action 1984,N 17,11:1
Fernandez, Angel Luis (Cinematographer)
 Skyline (Linea del Cielo, La) 1984,Ap 3,C,15:1
 Skyline (Linea del Cielo, La) 1984,Jl 18,C,20:3
Fernandez, Emilio
 Under the Volcano 1984,Je 13,C,21:4
Fernandez, Esperanza
 Bizet's Carmen 1984,S 20,C,21:1
Ferral, J A
 Under Fire 1983,O 21,C,13:1
Ferrandis, Antonio
 To Begin Again 1983,Ap 22,C,10:5
Ferrare, Ashley
 Revenge of the Ninja 1983,S 8,C,23:1
Ferrari, Nick
 Baby It's You 1983,Mr 25,C,6:5
Ferrario, Enea (Miscellaneous)
 Eyes, the Mouth, The 1983,D 14,C,24:1
Ferreol, Andrea
 Nuit de Varennes, La 1983,F 16,C,23:1
 Nuit de Varennes, La 1983,F 27,II,1:1
Ferrer, Jose
 To Be or Not to Be 1983,D 16,C,10:1
 Evil That Men Do, The 1984,S 22,35:3
 Dune 1984,D 14,C,18:4
Ferrer, Sean (Producer)
 Strangers Kiss 1984,Ag 13,C,19:1

Ferreri, Jacqueline (Producer)
 Tales of Ordinary Madness 1983,Mr 11,C,13:3
Ferreri, Marco (Director)
 Tales of Ordinary Madness 1983,Mr 11,C,13:3
 Story of Piera, The 1983,S 24,11:5
 Story of Piera, The 1983,O 2,II,21:1
Ferreri, Marco (Miscellaneous)
 Tales of Ordinary Madness 1983,Mr 11,C,13:3
Ferreri, Marco (Screenwriter)
 Tales of Ordinary Madness 1983,Mr 11,C,13:3
 Story of Piera, The 1983,S 24,11:5
Ferretti, Dante (Miscellaneous)
 And the Ship Sails On 1984,Ja 26,C,17:1
Ferri, Elda (Producer)
 Corrupt 1984,Ja 19,C,16:5
Ferrier, Noel
 Year of Living Dangerously, The 1983,Ja 21,C,4:1
Ferrigno, Lou
 Hercules 1983,Ag 28,61:1
Ferrini, Franco (Screenwriter)
 Invitation au Voyage 1983,Ap 21,C,20:3
 Once Upon a Time in America 1984,Je 1,C,8:1
Ferro, Turi
 Ernesto 1983,S 23,C,12:5
Ferrol, Sharon
 Zelig 1983,Jl 18,B,1:6
Ferzetti, Gabrielle
 Basileus Quartet 1984,Ja 4,C,13:5
Feuillard, Serge
 Razor's Edge, The 1984,O 19,C,14:6
Feury, Peggy
 All of Me 1984,S 21,C,6:1
Fiddis, Shelby
 Cheech & Chong's The Corsican Brothers 1984,Jl 28,15:5
Fiedler, Bernd (Cinematographer)
 Pharos of Chaos 1983,O 13,C,13:1
Field, Sally
 Kiss Me Goodbye 1983,Ja 2,II,1:1
 Places in the Heart 1984,S 21,C,8:1
 Places in the Heart 1984,S 23,II,19:1
 Places in the Heart 1984,D 30,II,15:1
Field, Ted (Producer)
 Revenge of the Nerds 1984,Jl 20,C,8:5
Fieldhouse, Carnegie (Producer)
 Now and Forever 1983,Jl 16,14:1
Fielding, Jerry (Composer)
 Below the Belt 1983,Ag 31,C,21:1
Fields, Ed (Producer)
 Generation Apart, A 1984,Mr 18,53:1
Fields, Ed (Screenwriter)
 Generation Apart, A 1984,Mr 18,53:1
Fields, W C
 Hollywood Out-Takes and Rare Footage 1983,F 25,C,8:5
Flerberg, Steven (Cinematographer)
 Vortex 1983,F 4,C,5:1
 First Time, The 1983,Jl 13,C,16:3
Fierstein, Harvey
 Garbo Talks 1984,O 12,C,8:1
Fierstein, Harvey (Miscellaneous)
 Times of Harvey Milk, The 1984,O 27,15:1
Fleschi, Jacques
 A Nos Amours 1984,O 12,C,10:4
Figueroa, Gabriel (Cinematographer)
 Under the Volcano 1984,Je 13,C,21:4
Figueroa, Pedro Juan
 And God Created Them 1983,Mr 19,11:1
Filiz, Nuran
 Straight Through the Heart 1984,Ap 1,57:1
Finch, Jon
 And Nothing But the Truth 1984,Ap 20,C,15:1
Finch, Martina
 Bachelor Party 1984,Je 30,11:1
Find, Janne (Miscellaneous)
 Zappa 1984,Ap 3,C,15:1
 Zappa 1984,My 16,C,24:3
Fini, Leonor (Screenwriter)
 My Name is Anna Magnani 1984,Ag 10,C,12:4
Fink, Harry Julian (Miscellaneous)
 Sudden Impact 1983,D 9,C,12:4
Fink, Michael (Miscellaneous)
 Adventures of Buckaroo Banzai, The 1984,O 5,C,8:5
Fink, R M (Miscellaneous)
 Sudden Impact 1983,D 9,C,12:4
Fink, Thomas
 Parsifal 1983,Ja 23,46:1
Finkel, Shimon
 Hanna K 1983,S 30,C,8:1
Finkelman, Penny (Producer)
 Terms of Endearment 1983,N 23,C,18:4

Finkelstein, Anna (Miscellaneous)
 Drifting 1984,Ap 23,C,12:1
Finlay, Frank
 Enigma 1983,Ja 28,C,8:1
 Ploughman's Lunch, The 1984,O 19,C,8:1
Finlay, Peter
 Another Time, Another Place 1984,Jl 11,C,26:1
Finlayson, Jon
 Lonely Hearts 1983,S 4,58:3
Finley, W Franklin (Screenwriter)
 First Time, The 1983,Jl 13,C,16:3
Finn, Pavel (Screenwriter)
 26 Days in the Life of Dostoyevsky 1983,O 14,C,8:5
Finnegan, John
 Natural, The 1984,My 11,C,15:1
Finnegan, Tom
 Repo Man 1984,Jl 6,C,8:5
Finnell, Michael (Producer)
 Gremlins 1984,Je 8,C,10:4
Finnerman, Gerald Perry (Cinematographer)
 Nightmares 1983,S 3,14:5
Finney, Albert
 Dresser, The 1983,D 6,C,19:1
 Dresser, The 1983,D 18,II,21:1
 Under the Volcano 1984,Je 13,C,21:4
 Under the Volcano 1984,Je 24,II,1:1
 Under the Volcano 1984,Jl 22,II,15:1
 Observations Under the Volcano 1984,N 2,12,3:
Fiore, Bob (Cinematographer)
 Can She Bake a Cherry Pie? 1983,D 8,C,22:3
Firestone, Eddie
 Duel 1983,Ap 15,C,10:1
Firstenberg, Sam (Director)
 Revenge of the Ninja 1983,S 8,C,23:1
 Breakin' 2: Electric Boogaloo 1984,D 19,C,22:4
Firth, Colin
 Another Country 1984,Je 29,C,8:1
Firth, Julian
 Oxford Blues 1984,Ag 25,9:1
Firth, Michael (Director)
 Heart of the Stag 1984,Jl 27,C,6:5
Firth, Michael (Producer)
 Heart of the Stag 1984,Jl 27,C,6:5
Fischel, Matt
 Over the Brooklyn Bridge 1984,Mr 2,C,6:5
Fischer, Bobby
 Great Chess Movie, The 1983,Ap 6,C,15:3
Fischler, Steven (Director)
 Anarchism in America 1983,Ja 15,16:1
Fischler, Steven (Producer)
 Anarchism in America 1983,Ja 15,16:1
Fischler, Steven (Screenwriter)
 Anarchism in America 1983,Ja 15,16:1
Fish, Nancy
 Birdy 1984,D 21,C,25:1
Fishburne, Larry
 Rumble Fish 1983,O 7,C,10:3
Fishelson, David
 City News and News Briefs 1983,S 9,C,6:2
Fishelson, David (Director)
 City News and News Briefs 1983,S 9,C,6:2
Fishelson, David (Miscellaneous)
 City News and News Briefs 1983,S 9,C,6:2
Fishelson, David (Producer)
 City News and News Briefs 1983,S 9,C,6:2
Fishelson, David (Screenwriter)
 City News and News Briefs 1983,S 9,C,6:2
Fisher, Alan
 Generation Apart, A 1984,Mr 18,53:1
Fisher, Carrie
 Return of the Jedi 1983,My 25,C,24:1
 Return of the Jedi 1983,My 29,II,15:1
 Garbo Talks 1984,O 12,C,8:1
Fisher, Cindy
 Stone Boy, The 1984,Ap 4,C,25:1
Fisher, Danny
 Generation Apart, A 1984,Mr 18,53:1
Fisher, Danny (Miscellaneous)
 Generation Apart, A 1984,Mr 18,53:1
Fisher, Esther
 Generation Apart, A 1984,Mr 18,53:1
Fisher, Frances
 Can She Bake a Cherry Pie? 1983,D 8,C,22:3
Fisher, Gerry (Cinematographer)
 Lovesick 1983,F 18,C,19:1
 Yellowbeard 1983,Je 24,C,10:2
Fisher, Gregor
 Another Time, Another Place 1984,Jl 11,C,26:1
Fisher, Jack
 Generation Apart, A 1984,Mr 18,53:1

Ghellardini, Tersilio
Cammina Cammina (Keep Walking, Keep Walking) 1984,O 4,C,16:5
Ghent, Treisha (Producer)
Now and Forever 1983,Jl 16,14:1
Ghostley, Alice
Not for Publication 1984,N 1,C,17:1
Giambelvo, Louis
Nightmares 1983,S 3,14:5
Giammarco, Maurizio (Composer)
Nudo di Donna 1983,My 13,C,7:5
Gian, Joey
Night in Heaven, A 1983,N 19,19:3
Giannini, Cheryl
Without a Trace 1983,F 4,C,8:1
Giannini, Giancarlo
American Dreamer 1984,O 26,C,12:4
Gibb, Donald
Revenge of the Nerds 1984,Jl 20,C,8:5
Gibb, Richard (Cinematographer)
Purple Haze 1983,N 11,C,8:1
Gibbes, Robyn
Wild Horses 1984,Ap 19,C,15:1
Gibbs, Anthony (Miscellaneous)
Bad Boys 1983,Mr 25,C,8:1
Dune 1984,D 14,C,18:4
Gibney, Gail
City News and News Briefs 1983,S 9,C,6:2
Gibson, Bob
Chords of Fame 1984,F 16,C,23:1
Gibson, Derek (Producer)
Terminator, The 1984,O 26,C,19:1
Gibson, Julia
Android 1984,F 10,C,28:1
Gibson, Mel
Year of Living Dangerously, The 1983,Ja 21,C,4:1
Year of Living Dangerously, The 1983,F 13,II,23:1
Bounty, The 1984,My 4,C,8:1
River, The 1984,D 19,C,19:1
Mrs Soffel 1984,D 26,C,15:1
Gideon, Raynold (Screenwriter)
Starman 1984,D 14,C,18:1
Gielgud, Sir John
Wicked Lady, The 1983,O 28,C,16:1
Scandalous 1984,Ja 20,C,4:5
Gigliotti, Lupe
Blame It on Rio 1984,F 17,C,10:5
Gilan, Yvonne
Another Time, Another Place 1984,Jl 11,C,26:1
Gilbert, David (Screenwriter)
Beat Street 1984,Je 8,C,10:5
Gilbert, Lewis (Director)
Educating Rita 1983,S 21,C,21:1
Educating Rita 1983,N 13,II,17:1
Gilbert, Lewis (Producer)
Educating Rita 1983,S 21,C,21:1
Gilbert, Mack (Producer)
Hilary's Blues 1983,N 23,C,16:1
Gilbert, Nicholas
Neverending Story, The 1984,Jl 20,C,5:1
Gilbert, Ronnie
Joe Chaikin Going On 1983,N 23,C,16:3
Gilbert, William S (Original Author)
Pirates of Penzance, The 1983,F 20,80:1
Gilbert, Yves (Composer)
Biquefarre 1984,Ap 5,C,15:1
Giles, Michael (Composer)
Ghost Story 1984,O 31,C,20:4
Gill, David (Producer)
Unknown Chaplin 1983,My 19,C,19:1
Gillard, Stuart (Screenwriter)
Spring Fever 1983,Ja 15,48:2
Gillen, Jeff
Christmas Story, A 1983,N 18,C,36:1
Gillespie, Ann
Lovesick 1983,F 18,C,19:1
Gillespie, Dana
Scrubbers 1984,F 1,C,16:4
Gillespie, Dizzy
'Til the Butcher Cuts Him Down 1983,S 3,13:3
Gilliam, Terry
Monty Python's the Meaning of Life 1983,Mr 31,C,13:5
Gilliam, Terry (Miscellaneous)
Monty Python's the Meaning of Life 1983,Mr 31,C,13:5
Gilliam, Terry (Screenwriter)
Monty Python's the Meaning of Life 1983,Mr 31,C,13:5
Gillin, Hugh
Psycho II 1983,Je 3,C,14:5
Circle of Power 1984,Mr 2,C,5:1

Gillis, Herman
Golden Eighties, The 1983,O 2,59:1
Gillis, James
Big Chill, The 1983,S 23,C,14:3
Gilmore, Julia
Memoirs 1984,D 28,C,14:5
Gilmore, Julia (Composer)
Memoirs 1984,D 28,C,14:5
Gilmore, William S (Producer)
Tough Enough 1983,My 27,C,8:1
Against All Odds 1984,Mr 2,C,14:3
Gilmour, David
Give My Regards to Broad Street 1984,O 26,C,14:5
Gilot, Yolande
Gift, The 1983,F 27,48:5
Gilroy, Charles
Strikebound 1984,O 6,15:5
Gimenez, Raul
Shadow of Angels (Schatten der Engel) 1983,Je 24,C,8:1
Gindoff, Bryan (Miscellaneous)
Losin' It 1983,Ap 8,C,4:5
Gindoff, Bryan (Producer)
Losin' It 1983,Ap 8,C,4:5
Gingold, Hermione
Garbo Talks 1984,O 12,C,8:1
Ginsberg, Allen
Burroughs 1983,O 8,33:1
Burroughs 1984,F 10,C,12:1
Ginty, Robert
Exterminator 2 1984,S 15,14:5
Ginzo, Juana
Evening Performance (Funcion de Noche) 1983,Mr 27,55:1
Giordano, Domiziana
Nostalghia (Nostalgia) 1983,O 5,C,23:1
Nostalghia (Nostalgia) 1984,Ja 8,47:1
Giorgi, Eleonora
Nudo di Donna 1983,My 13,C,7:5
Giovannini, Giuseppe (Producer)
Joke of Destiny, A 1984,S 12,C,21:1
Gipe, George (Screenwriter)
Man With Two Brains, The 1983,Je 3,C,8:1
Man With Two Brains, The 1983,Je 19,II,23:1
Girardot, Annie
Jupiter's Thigh 1984,Ja 20,C,6:5
Girardot, Hyppolite
First Name: Carmen 1984,Ag 3,C,6:1
Giraudeau, Bernard
Boum, La 1983,My 13,C,28:1
Gish, Lillian
Langlois 1983,Ag 5,C,10:5
Gitlin, Ric
Marriage, A 1983,Mr 30,C,21:1
Gitt, Bob (Miscellaneous)
Becky Sharp 1984,O 21,II,23:1
Gittes, Harry (Producer)
Timerider 1983,Ja 21,C,24:5
Gittleson, Anthony (Screenwriter)
Stuck On You 1984,F 3,C,8:5
Gkizas, Ionna
Golden Eighties, The 1983,O 2,59:1
Gladstone, Dana
Star Chamber, The 1983,Ag 5,C,8:5
Glan, Joey
Blue Skies Again 1983,Jl 29,C,8:3
Glaser, Jim
Chords of Fame 1984,F 16,C,23:1
Glass, Ned
Street Music 1983,F 25,C,8:1
Glass, Philip (Composer)
Koyaanisqatsi 1983,S 14,C,22:4
Glasser, Isabel
Marriage, A 1983,Mr 30,C,21:1
Glatstein, Bert (Miscellaneous)
Breakin' 2: Electric Boogaloo 1984,D 19,C,22:4
Glattes, Wolfgang (Producer)
Star 80 1983,N 10,C,26:3
Gleason, Jackie
Sting II, The 1983,F 18,C,10:6
Smokey and the Bandit, Part 3 1983,S 17,30:4
Gleason, Paul
Tender Mercies 1983,Mr 4,C,8:1
Trading Places 1983,Je 8,C,16:1
Gledhill, Nicholas
Careful He Might Hear You 1984,Je 15,C,8:1
Glen, John (Director)
Octopussy 1983,Je 10,C,17:4
Glenn, Pierre William (Cinematographer)
Choice of Arms 1983,Mr 6,65:1
Etoile du Nord, L' 1983,Je 12,66:1
Death Watch 1984,S 14,C,6:5

Glenn, Scott
Right Stuff, The 1983,O 21,C,5:1
Right Stuff, The 1983,D 18,II,21:1
Right Stuff, The 1983,D 25,II,15:1
River, The 1984,D 19,C,19:1
Glennon, Gordon (Miscellaneous)
Wicked Lady, The 1983,O 28,C,16:1
Glennon, James (Cinematographer)
Norte, El 1984,Ja 11,C,15:1
Wild Life, The 1984,S 28,C,8:4
Gless, Sharon
Star Chamber, The 1983,Ag 5,C,8:5
Gloag, Helena
My Childhood (Bill Douglas Trilogy, The) 1983,My 18,C,26:5
Globisz, Krzysztof
Danton 1983,S 28,C,19:1
Globus, Yoram (Miscellaneous)
Treasure of the Four Crowns 1983,Ja 23,47:1
Globus, Yoram (Producer)
Last American Virgin, The 1983,Ja 15,48:2
Hercules 1983,Ag 28,61:1
Revenge of the Ninja 1983,S 8,C,23:1
Wicked Lady, The 1983,O 28,C,16:1
Over the Brooklyn Bridge 1984,Mr 2,C,6:5
Love Streams 1984,Ag 24,C,8:5
Exterminator 2 1984,S 15,14:5
Missing in Action 1984,N 17,11:1
Breakin' 2: Electric Boogaloo 1984,D 19,C,22:4
Gloger, Christine
Fiancee, The 1984,Ap 7,13:3
Glover, Bruce
Big Score, The 1983,N 20,67:3
Glover, Crispin
Friday the 13th—The Final Chapter 1984,Ap 14,15:1
Glover, Danny
Iceman 1984,Ap 13,C,10:1
Places in the Heart 1984,S 21,C,8:1
Places in the Heart 1984,S 23,II,19:1
Places in the Heart 1984,D 30,II,15:1
Glover, John
Evil That Men Do, The 1984,S 22,35:3
Flash of Green, A 1984,O 5,C,14:3
Glover, Julian
Heat and Dust 1983,S 15,C,18:3
Gluchkova, A
New Babylon, The 1983,O 3,C,15:1
Glynn, Carlin
Sixteen Candles 1984,My 4,C,14:1
Gnatalli, Radames (Composer)
They Don't Wear Black Tie (Eles Nao Usam Black-Tie) 1983,My 27,C,8:5
Gobert, Boy
Kamikaze '89 1983,F 27,48:1
Shadow of Angels (Schatten der Engel) 1983,Je 24,C,8:1
Gock, Les (Miscellaneous)
Puberty Blues 1983,Jl 15,C,13:1
Godard, Alain (Screenwriter)
Too Shy to Try 1984,Mr 30,C,17:3
Godard, Jean-Luc
First Name: Carmen 1984,Ag 3,C,6:1
Godard, Jean-Luc (Director)
Letter to Freddy Bauche 1983,Je 24,C,8:1
Passion 1983,O 4,C,13:2
First Name: Carmen 1984,Ag 3,C,6:1
Godard, Jean-Luc (Screenwriter)
Passion 1983,O 4,C,13:2
Godfrey, Patrick
Heat and Dust 1983,S 15,C,18:3
Godmilow, Jill (Director)
Far From Poland 1984,O 3,C,22:5
Godmilow, Jill (Producer)
Far From Poland 1984,O 3,C,22:5
Goebel, Michael (Cinematographer)
Straight Through the Heart 1984,Ap 1,57:1
Goelz, Dave
Muppets Take Manhattan, The 1984,Jl 13,C,10:4
Goetz, Peter Michael
Best Defense 1984,Jl 20,C,10:1
Goetze, Helga
Red Love 1983,O 4,C,13:2
Goetzman, Gary (Producer)
Stop Making Sense 1984,O 19,C,17:1
Golan, Menahem (Director)
Over the Brooklyn Bridge 1984,Mr 2,C,6:5
Golan, Menahem (Miscellaneous)
Treasure of the Four Crowns 1983,Ja 23,47:1
Golan, Menahem (Producer)
Last American Virgin, The 1983,Ja 15,48:2
Hercules 1983,Ag 28,61:1
Revenge of the Ninja 1983,S 8,C,23:1
Continued

H

Hatch, James V (Producer)
Suzanne Suzanne 1983,Mr 27,55:1
Hathaway, Noah
Neverending Story, The 1984,Jl 20,C,5:1
Hatlak, Robert
Can She Bake a Cherry Pie? 1983,D 8,C,22:3
Hatsune, Reiko
Muddy River 1983,Ja 21,C,4:1
Hatten, Yankton
Places in the Heart 1984,S 21,C,8:1
Hattingh, Ryno
Country Lovers (Gordimer Stories, The) 1983,My 18,C,26:4
Gordimer Stories, The 1983,My 18,C,26:4
Hatton, David
Pirates of Penzance, The 1983,F 20,80:1
Hatzinassios, Georges (Composer)
Jupiter's Thigh 1984,Ja 20,C,6:5
Hauer, Rutger
Osterman Weekend, The 1983,N 4,C,11:1
Hauff, Reinhard (Director)
Slow Attack (Endstation Freiheit) 1983,Ja 12,C,24:1
Haugland, Aage
Parsifal 1983,Ja 23,46:1
Hauser, Wings
Deadly Force 1983,Jl 8,C,4:3
Soldier's Story, A 1984,S 14,C,10:5
Hausman, Michael (Producer)
Ballad of Gregorio Cortez, The 1983,O 14,C,6:5
Silkwood 1983,D 14,C,27:1
Hausserman, Mischa
Evil That Men Do, The 1984,S 22,35:3
Havers, Nigel
Passage to India, A 1984,D 14,C,10:1
Havet, Bernard
Dernier Combat, Le (Last Battle, The) 1984,Je 22,C,12:1
Hawkins, Anthony
Kitty and the Bagman 1983,Ag 5,C,14:5
Strikebound 1984,O 6,15:5
Hawn, Goldie
Best Friends 1983,F 13,II,23:1
Swing Shift 1984,Ap 13,C,13:1
Protocol 1984,D 21,C,25:1
Hawn, Goldie (Producer)
Protocol 1984,D 21,C,25:1
Hayden, James
Once Upon a Time in America 1984,Je 1,C,8:1
Hayden, Sterling
Pharos of Chaos 1983,O 13,C,13:1
Haydn, Lili
Easy Money 1983,Ag 19,C,8:5
Hayes, Clifford (Miscellaneous)
We of the Never Never 1983,F 11,C,12:1
Hayes, John Michael (Screenwriter)
Rear Window 1983,O 9,II,21:1
Hayes, Patricia
Neverending Story, The 1984,Jl 20,C,5:1
Haynes, Tiger
Moscow On the Hudson 1984,Ap 6,C,12:1
Haynie, Jim
Right Stuff, The 1983,O 21,C,5:1
Country 1984,S 28,20:1
Hays, Lora (Miscellaneous)
America and Lewis Hine 1984,S 29,14:4
Hays, Robert
Trenchcoat 1983,Mr 12,13:3
Scandalous 1984,Ja 20,C,4:5
Hayward, David
Slayground 1984,Ja 28,14:5
Haywood, Chris
Man from Snowy River, The 1983,Ja 21,C,5:6
Heatwave 1983,Je 10,C,17:4
Lonely Hearts 1983,S 4,58:3
Strikebound 1984,O 6,15:5
Man of Flowers 1984,O 9,C,14:4
Man of Flowers 1984,D 16,78:4
Hazan, Jack (Director)
Bigger Splash, A 1984,O 5,C,12:1
Hazan, Jack (Producer)
Bigger Splash, A 1984,O 5,C,12:1
Hazan, Jack (Screenwriter)
Bigger Splash, A 1984,O 5,C,12:1
Hazard, John (Cinematographer)
America—From Hitler to MX 1983,Ja 5,C,17:1
Hazlehurst, Noni
Monkey Grip 1983,N 7,C,16:5
Healy, David
Supergirl 1984,N 22,C,15:2
Healy, Dorothy
Seeing Red 1984,Mr 25,II,19:1

Heaner, John
Last Night at the Alamo 1983,O 2,II,60:3
Last Night at the Alamo 1984,Jl 3,C,10:5
Heather, Roy
Experience Preferred...But Not Essential 1983,N 4,C,11:1
Heaton, Tom
Grey Fox, The 1983,Jl 13,C,17:4
Hebert, Chris
Last Starfighter, The 1984,Jl 13,C,5:2
Heckerling, Amy (Director)
Johnny Dangerously 1984,D 21,C,25:5
Hedaya, Dan
Hunger, The 1983,Ap 29,C,32:1
Reckless 1984,F 3,C,8:1
Tightrope 1984,Ag 17,C,6:1
Blood Simple 1984,O 12,C,10:4
Hedley, Tom (Miscellaneous)
Hard to Hold 1984,Ap 6,C,16:5
Hedley, Tom (Original Author)
Flashdance 1983,Ap 15,C,13:1
Hedley, Tom (Screenwriter)
Flashdance 1983,Ap 15,C,13:1
Hard to Hold 1984,Ap 6,C,16:5
Hedlund, Roland
Hill on the Dark Side of the Moon, A 1984,S 30,58:1
Heesters, Nicole
Kamikaze '89 1983,F 27,48:1
Heffernan, Honor
Danny Boy 1984,My 18,C,11:1
Heffner, Kyle T
Flashdance 1983,Ap 15,C,13:1
Hegedus, Chris (Director)
Rockaby 1983,N 23,C,16:3
Hegewald, Hans-Joachim
Fiancee, The 1984,Ap 7,13:3
Hegnell, Gerd
Hill on the Dark Side of the Moon, A 1984,S 30,58:1
Hehir, Peter
Heatwave 1983,Je 10,C,17:4
Heifich, Bernhard
Stationmaster's Wife, The (Bolwieser) 1983,Ja 12,C,21:2
Heigh, Helene
Mass Appeal 1984,D 17,C,12:1
Heim, Alan (Miscellaneous)
Star 80 1983,N 10,C,26:3
Heimerson, Frans (Composer)
Fanny and Alexander 1983,Je 17,C,8:1
Heinisch, Christian
Class Relations 1984,O 7,86:1
Helberg, Sandy
Up the Creek 1984,Ap 7,13:3
Helbert, Jean Pierre
Heads or Tails (Pile ou Face) 1983,My 27,C,4:5
Helfer, Britt
Young Warriors 1983,N 12,12:1
Helfrich, Mark (Miscellaneous)
Revenge of the Ninja 1983,S 8,C,23:1
Heller, Gregory (Screenwriter)
Alphabet City 1984,My 5,17:1
Heller, Randee
Karate Kid, The 1984,Je 22,C,16:3
Hellman, Monte (Director)
China 9, Liberty 37 1984,N 30,C,8:4
Hellman, Monte (Producer)
China 9, Liberty 37 1984,N 30,C,8:4
Hellwig, Klaus (Producer)
Lucie sur Seine 1983,S 9,C,8:1
Helm, Levon
Right Stuff, The 1983,O 21,C,5:1
Helmen, Heidi
Purple Haze 1983,N 11,C,8:1
Hemingway, Margaux
They Call Me Bruce 1983,Ja 16,48:3
Over the Brooklyn Bridge 1984,Mr 2,C,6:5
Hemingway, Mariel
Star 80 1983,N 10,C,26:3
Star 80 1983,N 27,II,17:1
Hemmings, David
Man, Woman and Child 1983,Ap 1,C,8:1
Beyond Reasonable Doubt 1983,N 22,C,16:4
Hemmingway, Carole
Return Engagement 1983,N 23,C,10:5
Hempstead, Hannah (Producer)
Losin' It 1983,Ap 8,C,4:5
Henchoz, Jean-Marc (Producer)
One Man's War (Guerre d'un Seul Homme, La) 1984,F 24,C,9:1
Hendel, Paolo
Night of the Shooting Stars, The 1983,Ja 30,34:3
Henderson, Bill
Get Crazy 1983,O 14,C,11:1

Henderson, Jo
Lianna 1983,Ja 19,C,22:1
Henderson, Wilt (Miscellaneous)
Angel 1984,Ja 13,C,12:5
Hendra, Tony
This Is Spinal Tap 1984,Mr 2,C,6:1
This Is Spinal Tap 1984,Mr 18,II,17:1
Hendrie, Chris
Psycho II 1983,Je 3,C,14:5
Henkel, Kim
Last Night at the Alamo 1983,O 2,II,60:3
Last Night at the Alamo 1984,Jl 3,C,10:5
Henkel, Kim (Producer)
Last Night at the Alamo 1983,O 2,II,60:3
Last Night at the Alamo 1984,Jl 3,C,10:5
Henkel, Kim (Screenwriter)
Last Night at the Alamo 1983,O 2,II,60:3
Last Night at the Alamo 1984,Jl 3,C,10:5
Last Night at the Alamo 1984,Jl 15,II,15:1
Henner, Marilu
Hammett 1983,Jl 1,C,8:1
Man Who Loved Women, The 1983,D 16,C,8:1
Cannonball Run II 1984,Je 29,C,14:5
Johnny Dangerously 1984,D 21,C,25:5
Hennings, Barbara (Miscellaneous)
White Rose, The 1983,My 6,C,13:1
Henriksen, Lance
Nightmares 1983,S 3,14:5
Right Stuff, The 1983,O 21,C,5:1
Terminator, The 1984,O 26,C,19:1
Henriques, Darryl
Right Stuff, The 1983,O 21,C,5:1
Henry, Buck (Screenwriter)
Protocol 1984,D 21,C,25:1
Henry, David Lee (Screenwriter)
Evil That Men Do, The 1984,S 22,35:3
Henry, Gregg
Body Double 1984,O 26,C,8:1
Henry, Justin
Sixteen Candles 1984,My 4,C,14:1
Henry, Mike
Smokey and the Bandit, Part 3 1983,S 17,30:4
Hensbergen, Lovan
Malou 1983,D 22,C,22:1
Henshaw, Eric
Whole Shootin' Match, The 1984,Ag 8,C,16:6
Henson, Jim
Muppets Take Manhattan, The 1984,Jl 13,C,10:4
Hentschel, David (Composer)
Educating Rita 1983,S 21,C,21:1
Henze, Hans-Werner (Composer)
Swann in Love 1984,S 14,C,4:1
Hepple, Ted
Kitty and the Bagman 1983,Ag 5,C,14:5
Herbert, Frank (Original Author)
Dune 1984,D 14,C,18:4
Dune 1984,D 23,II,19:1
Herbert, Ric
Killing of Angel Street, The 1983,Mr 26,20:6
Herbert, Tim
Duel 1983,Ap 15,C,10:1
Herd, Richard
Deal of the Century 1983,N 4,C,13:3
Herlihy, Ed
King of Comedy, The 1983,F 18,C,10:1
Zelig 1983,Jl 18,B,1:6
Herlitzka, Roberto
Joke of Destiny, A 1984,S 12,C,21:1
Herman, Paul
Dear Mr Wonderful 1983,D 21,C,26:4
Hermann, Irm
Shadow of Angels (Schatten der Engel) 1983,Je 24,C,8:1
Berlin Alexanderplatz 1983,Ag 10,C,18:5
Hern, Bernie
Table for Five 1983,F 18,C,12:1
Man With Two Brains, The 1983,Je 3,C,8:1
Herold, Bernie
Zelig 1983,Jl 18,B,1:6
Heros, Pierre (Producer)
Light Years Away 1983,Ap 15,C,7:1
Herouet, Marc (Composer)
Golden Eighties, The 1983,O 2,59:1
Heroux, Claude (Producer)
Videodrome 1983,F 4,C,9:1
Going Berserk 1983,O 29,19:1
Of Unknown Origin 1983,N 24,C,17:1
Herrera, Jorge (Cinematographer)
Alsino and the Condor 1983,My 1,69:1
Herrera, Lola
Evening Performance (Funcion de Noche) 1983,Mr 27,55:1

Herrera, Lola (Screenwriter)
 Evening Performance (Funcion de Noche) 1983,Mr 27,55:1
Herrier, Mark
 Porky's II: The Next Day 1983,Je 25,12:3
 Tank 1984,Mr 16,C,8:1
Herring, Pem (Miscellaneous)
 National Lampoon's Vacation 1983,Jl 29,C,10:4
 Johnny Dangerously 1984,D 21,C,25:5
Herris, Daniel
 Stuck On You 1984,F 3,C,8:5
Herrmann, Edward
 Mrs Soffel 1984,D 26,C,15:1
Herrmann, Karl (Cinematographer)
 Ski Country 1984,N 30,C,13:1
Hershey, Barbara
 Entity, The 1983,F 5,12:3
 Right Stuff, The 1983,O 21,C,5:1
 Americana 1983,O 21,C,14:5
 Natural, The 1984,My 11,C,15:1
Hershon, Ella (Director)
 Langlois 1983,Ag 5,C,10:5
Hertzberg, Michael (Producer)
 Johnny Dangerously 1984,D 21,C,25:5
Herz, Michael (Director)
 Stuck On You 1984,F 3,C,8:5
 First Turn-On!, The 1984,O 12,C,8:5
Herz, Michael (Producer)
 Stuck On You 1984,F 3,C,8:5
 First Turn-On!, The 1984,O 12,C,8:5
Herz, Michael (Screenwriter)
 Stuck On You 1984,F 3,C,8:5
Herz, Tamara
 Parsifal 1983,Ja 23,46:1
Herzfeld, John (Director)
 Two of a Kind 1983,D 16,C,12:6
Herzfeld, John (Screenwriter)
 Two of a Kind 1983,D 16,C,12:6
 Last Winter, The 1984,S 8,10:4
Herzog, Werner
 Man of Flowers 1984,O 9,C,14:4
 Man of Flowers 1984,D 16,78:4
Herzog, Werner (Director)
 God's Angry Man 1983,Jl 20,C,14:3
 Huie's Sermon 1983,Jl 20,C,14:3
 Stroszek 1984,My 27,II,15:1
Herzog, Werner (Producer)
 God's Angry Man 1983,Jl 20,C,14:3
 Huie's Sermon 1983,Jl 20,C,14:3
Herzog, Werner (Screenwriter)
 God's Angry Man 1983,Jl 20,C,14:3
 Huie's Sermon 1983,Jl 20,C,14:3
Herzstein, Arnold
 Americana 1983,O 21,C,14:5
Hess, Karl
 Anarchism in America 1983,Ja 15,16:1
Hesse, Gerhard
 Malou 1983,D 22,C,22:1
Hesseman, Howard
 Doctor Detroit 1983,My 6,C,10:1
 This Is Spinal Tap 1984,Mr 2,C,6:1
Heston, Charlton
 Ten Commandments, The 1984,Mr 25,II,19:1
Heudeline, Raymonde
 Bal, Le 1984,Mr 23,C,6:1
Hewitt, Martin
 Yellowbeard 1983,Je 24,C,10:2
Heyman, Norma (Producer)
 Beyond the Limit 1983,S 30,C,4:3
Heywood, Pip (Miscellaneous)
 Radiating the Fruit of Truth (Tibet: A Buddhist Trilogy)
 1984,Je 8,C,10:5
 Prophecy, A (Tibet: A Buddhist Trilogy) 1984,Je 8,C,10:5
 Field of the Senses, The (Tibet: A Buddhist Trilogy) 1984,Je
 8,C,10:5
Hickman, Gail Morgan (Screenwriter)
 Big Score, The 1983,N 20,67:3
Hicks, Catherine
 Garbo Talks 1984,O 12,C,8:1
 Razor's Edge, The 1984,O 19,C,14:6
Hickson, Joan
 Wicked Lady, The 1983,O 28,C,16:1
Hidaka, Sumiko
 Farewell to the Land, A (Saraba Itoshiki Daichi) 1983,Mr
 20,60:3
Hidalgo-Gato, Raymundo
 Super, El 1984,My 27,II,15:1
Hidari, Tonpei
 Ballad of Narayama, The 1984,Ap 9,C,14:5
 Ballad of Narayama, The 1984,S 7,C,6:1

Hieu, Joseph
 Twilight Zone—The Movie (Prologue and Segment 1) 1983,Je
 24,C,15:1
Higgins, Anthony
 Draughtsman's Contract, The 1983,Je 22,C,26:4
Higgins, Michael
 Rumble Fish 1983,O 7,C,10:3
Hildebrandt, Charles George
 Deadly Spawn, The 1983,Ap 22,C,11:1
Hill, Bernard
 Bounty, The 1984,My 4,C,8:1
Hill, Dana
 Cross Creek 1983,S 21,C,19:4
Hill, Dave
 Draughtsman's Contract, The 1983,Je 22,C,26:4
Hill, Debra (Producer)
 Dead Zone, The 1983,O 21,C,8:1
Hill, Frank O
 Stroker Ace 1983,Jl 1,C,8:5
Hill, George Roy (Director)
 Little Drummer Girl, The 1984,O 19,C,18:1
Hill, Gilbert R
 Beverly Hills Cop 1984,D 5,C,25:4
Hill, Michael (Miscellaneous)
 Splash 1984,Mr 9,C,15:1
Hill, R Lance (Original Author)
 Evil That Men Do, The 1984,S 22,35:3
Hill, Steven
 Yentl 1983,N 18,C,10:1
 Garbo Talks 1984,O 12,C,8:1
Hill, Thomas
 Neverending Story, The 1984,Jl 20,C,5:1
Hill, Walter (Director)
 48 Hrs 1983,Ja 2,II,1:1
 Streets of Fire 1984,Je 1,C,8:5
Hill, Walter (Screenwriter)
 Streets of Fire 1984,Je 1,C,8:5
Hiller, Arthur (Director)
 Romantic Comedy 1983,O 7,C,8:1
 Lonely Guy, The 1984,Ja 28,11:5
 Teachers 1984,O 5,C,10:1
Hiller, Arthur (Producer)
 Lonely Guy, The 1984,Ja 28,11:5
Hiller, Erica
 Romantic Comedy 1983,O 7,C,8:1
Himmelstoss, Beate
 White Rose, The 1983,My 6,C,13:1
Hindel, Art
 Man Who Wasn't There, The 1983,Ag 13,13:1
Hindman, Bill
 Night in Heaven, A 1983,N 19,19:3
Hines, Gregory
 Deal of the Century 1983,N 4,C,13:3
 Muppets Take Manhattan, The 1984,Jl 13,C,10:4
 Cotton Club, The 1984,D 14,C,4:3
Hines, Maurice
 Cotton Club, The 1984,D 14,C,4:3
Hines, Patrick
 Amadeus 1984,S 19,C,23:1
Hingle, Pat
 Going Berserk 1983,O 29,19:1
 Sudden Impact 1983,D 9,C,12:4
Hinojosa, Joaquin
 Elisa, Vida Mia 1983,Mr 11,C,8:5
Hinton, S E (Original Author)
 Outsiders, The 1983,Mr 25,C,3:1
 Outsiders, The 1983,Ap 3,II,15:1
 Outsiders, The 1983,Ap 10,II,17:1
 Rumble Fish 1983,O 7,C,10:3
 Rumble Fish 1983,O 23,II,19:1
Hinton, S E (Screenwriter)
 Rumble Fish 1983,O 7,C,10:3
Hinz, Theo (Producer)
 War And Peace 1983,D 3,15:1
Hirdwall, Ingvar
 Hill on the Dark Side of the Moon, A 1984,S 30,58:1
Hirsch, Judd
 Without a Trace 1983,F 4,C,8:1
 Teachers 1984,O 5,C,10:1
Hirsch, Lou
 Lonely Lady, The 1983,O 1,13:5
Hirsch, Paul (Miscellaneous)
 Black Stallion Returns, The 1983,Mr 27,54:4
 Footloose 1984,F 17,C,12:3
 Protocol 1984,D 21,C,25:1
Hirsch, Tina (Miscellaneous)
 Twilight Zone—The Movie (Segment 3) 1983,Je 24,C,15:1
 Gremlins 1984,Je 8,C,10:4
Hirschfeld, Alec (Cinematographer)
 Love Letters 1984,Ja 27,C,14:1

Hirschfeld, Gerald (Cinematographer)
 To Be or Not to Be 1983,D 16,C,10:1
Hirson, Alice
 Mass Appeal 1984,D 17,C,12:1
Hirson, Kate (Miscellaneous)
 World of Tomorrow, The 1984,Mr 7,C,20:3
Hirszman, Leon (Director)
 They Don't Wear Black Tie (Eles Nao Usam Black-Tie)
 1983,My 27,C,8:5
 They Don't Wear Black Tie (Eles Nao Usam Black-Tie)
 1983,Je 12,II,21:1
Hirszman, Leon (Miscellaneous)
 They Don't Wear Black Tie (Eles Nao Usam Black-Tie)
 1983,My 27,C,8:5
Hirszman, Leon (Screenwriter)
 They Don't Wear Black Tie (Eles Nao Usam Black-Tie)
 1983,My 27,C,8:5
 They Don't Wear Black Tie (Eles Nao Usam Black-Tie)
 1983,Je 12,II,21:1
Hirt, Eleonore
 Nuit de Varennes, La 1983,F 16,C,23:1
 Nuit de Varennes, La 1983,F 27,II,1:1
Hirtz, Dagmar (Miscellaneous)
 War And Peace 1983,D 3,15:1
 Malou 1983,D 22,C,22:1
Hirzman, Leon (Producer)
 They Don't Wear Black Tie (Eles Nao Usam Black-Tie)
 1983,My 27,C,8:5
Hitchcock, Alfred
 Terror in the Aisles 1984,O 26,C,18:6
Hitchcock, Alfred (Director)
 Rear Window 1983,O 9,II,21:1
 Vertigo 1984,Ja 15,II,19:1
 Rope 1984,Je 3,II,19:1
Hitzig, Rupert (Producer)
 Jaws 3-D 1983,Jl 23,11:1
Hively, George (Miscellaneous)
 Blame It on Rio 1984,F 17,C,10:5
Hixon, Ken (Screenwriter)
 Grandview U S A 1984,Ag 3,C,8:4
Hjulstrom, Lennart (Director)
 Hill on the Dark Side of the Moon, A 1984,S 30,58:1
Ho, A K (Producer)
 Loveless, The 1984,Ja 20,C,8:5
Hobbs, Connie
 Killing of Angel Street, The 1983,Mr 26,20:6
Hobbs, Peter
 Man With Two Brains, The 1983,Je 3,C,8:1
Hobel, Philip S (Producer)
 Tender Mercies 1983,Mr 4,C,8:1
Hochhuth, Rolf (Original Author)
 Love in Germany, A 1984,O 2,C,13:2
 Love in Germany, A 1984,O 7,II,17:1
 Love in Germany, A 1984,N 9,C,10:1
Hockney, David
 Bigger Splash, A 1984,O 5,C,12:1
Hodge, Patricia
 Betrayal 1983,F 20,78:1
 Betrayal 1983,Mr 6,II,17:1
 Betrayal 1983,D 25,II,15:1
Hoenig, Dov (Miscellaneous)
 Beat Street 1984,Je 8,C,10:5
Hoepner, Joachim
 Straight Through the Heart 1984,Ap 1,57:1
Hoerbiger, Paul
 Liebelei 1983,My 31,C,10:5
Hofer, Johanna
 Possession 1983,O 28,C,10:1
Hoff, Morten
 Zappa 1984,Ap 3,C,15:1
 Zappa 1984,My 16,C,24:3
Hoffman, Abbie
 Chords of Fame 1984,F 16,C,23:1
Hoffman, Alice (Screenwriter)
 Independence Day 1983,Ja 21,C,8:1
Hoffman, Deborah (Miscellaneous)
 Times of Harvey Milk, The 1984,O 7,86:1
 Times of Harvey Milk, The 1984,O 27,15:1
Hoffman, Dustin
 Tootsie 1983,Ja 2,II,1:1
 Tootsie 1983,F 13,II,23:1
 Tootsie 1983,Ap 3,II,15:1
Hoffman, Joan
 Out of the Blue 1983,Ap 8,C,6:5
Hoffman, Michael (Director)
 Privileged 1983,Ap 8,C,8:5
Hoffman, Roy
 Skyline (Linea del Cielo, La) 1984,Ap 3,C,15:1
 Skyline (Linea del Cielo, La) 1984,Jl 18,C,20:3
Hoffman, Thom
 4th Man, The 1984,Je 27,C,21:4

Hofstra, Jack (Miscellaneous)
Two of a Kind 1983,D 16,C,12:6
Hogben, Michael
Possession 1983,O 28,C,10:1
Hojfeldt, Solbjorn
Zappa 1984,Ap 3,C,15:1
Zappa 1984,My 16,C,24:3
Holbrook, Hal
Star Chamber, The 1983,Ag 5,C,8:5
Holby, Kristin
Trading Places 1983,Je 8,C,16:1
Trading Places 1983,Je 19,II,23:1
Holden, David (Miscellaneous)
Impulse 1984,S 30,58:5
Holdridge, Lee (Composer)
Mr Mom 1983,Ag 26,C,8:4
Splash 1984,Mr 9,C,15:1
Micki and Maude 1984,D 21,C,25:4
Holdt, Jacob (Director)
American Pictures (Part 1) 1984,S 5,C,16:5
Holdt, Jacob (Screenwriter)
American Pictures (Part 1) 1984,S 5,C,16:5
Holdt, Jacob (Cinematographer)
American Pictures (Part 1) 1984,S 5,C,16:5
Holicker, Heidi
Valley Girl 1983,Ap 29,C,10:1
Holiday, Polly
Gremlins 1984,Je 8,C,10:4
Holland, Agnieszka (Director)
Provincial Actors 1983,Mr 2,C,20:5
Holland, Agnieszka (Miscellaneous)
Danton 1983,S 28,C,19:1
Holland, Agnieszka (Screenwriter)
Provincial Actors 1983,Mr 2,C,20:5
Love in Germany, A 1984,O 2,C,13:2
Love in Germany, A 1984,N 9,C,10:1
Holland, Anthony
Lonely Lady, The 1983,O 1,13:5
Holland, Jools
Urgh! A Music War 1983,Ap 1,C,9:1
Holland, Tom
Psycho II 1983,Je 3,C,14:5
Holland, Tom (Screenwriter)
Psycho II 1983,Je 3,C,14:5
Cloak and Dagger 1984,Ag 10,C,16:1
Holliday, Kene
Philadelphia Experiment, The 1984,Ag 17,C,17:4
Hollon, Andrew Scott
Tender Mercies 1983,Mr 4,C,8:1
Holloway, Ron
Black Wax 1983,Ja 12,C,21:2
Holly, Stanislaw
Knight, The 1983,D 9,C,30:5
Hollywood, Peter (Miscellaneous)
Riddle of the Sands, The 1984,Ja 6,C,8:1
Holm, Arwen
Experience Preferred...But Not Essential 1983,N 4,C,11:1
Holm, Ian
Greystoke: The Legend of Tarzan, Lord of the Apes 1984,Mr 30,C,5:1
Greystoke: The Legend of Tarzan, Lord of the Apes 1984,Ap 1,II,21:1
Greystoke: The Legend of Tarzan, Lord of the Apes 1984,D 30,II,15:1
Holm, Jorg
Kamikaze '89 1983,F 27,48:1
Holman, Joel
Nightmares 1983,S 3,14:5
Holmberg, Henric
Flight of the Eagle, The 1983,Ap 8,C,8:1
Holmberg, Sten (Cinematographer)
Hill on the Dark Side of the Moon, A 1984,S 30,58:1
Holmes, Cecil (Screenwriter)
Killing of Angel Street, The 1983,Mr 26,20:6
Holmes, Jessie
My Brother's Wedding 1984,Mr 30,C,7:1
Holmes, Mark
Monty Python's the Meaning of Life 1983,Mr 31,C,13:5
Holmes, Rupert (Composer)
No Small Affair 1984,N 9,C,16:1
Holoubek, Gustaw
Sandglass, The 1983,My 6,C,16:1
Holt, Edna
Stop Making Sense 1984,O 19,C,17:1
Holt, Will
Zelig 1983,Jl 18,B,1:6
Holten, Bo (Composer)
Zappa 1984,Ap 3,C,15:1
Zappa 1984,My 16,C,24:3
Homyak, Louis
Stuck On You 1984,F 3,C,8:5

Honess, Peter (Miscellaneous)
Champions 1984,Ap 20,C,8:1
Electric Dreams 1984,Jl 20,C,6:5
Honey
Born in Flames 1983,N 10,C,17:1
Hong, Elliott (Director)
They Call Me Bruce 1983,Ja 16,48:3
Hong, Elliott (Producer)
They Call Me Bruce 1983,Ja 16,48:3
Hong, Elliott (Screenwriter)
They Call Me Bruce 1983,Ja 16,48:3
Hong, James
Missing in Action 1984,N 17,11:1
Honma, Yohei (Original Author)
Family Game, The 1984,Ap 1,57:1
Family Game, The 1984,S 14,C,3:1
Hood, Don
River, The 1984,D 19,C,19:1
Hool, Lance (Miscellaneous)
Missing in Action 1984,N 17,11:1
Hooks, Robert
Star Trek III: The Search for Spock 1984,Je 1,C,14:3
Hool, Lance (Producer)
10 to Midnight 1983,Mr 13,62:5
Hooper, Robin
Children (Terence Davies Trilogy, The) 1984,Ap 8,64:3
Hoover, Dana
All the Right Moves 1983,O 21,C,10:3
Hopkins, Anthony
Bounty, The 1984,My 4,C,8:1
Hopkins, Harold
Monkey Grip 1983,N 7,C,16:5
Hopkins, Neil
Falls, The 1983,My 4,C,17:4
Hoppe, Michael (Composer)
Misunderstood 1984,Mr 30,C,10:1
Hopper, Dennis
Out of the Blue 1983,Ap 8,C,6:5
Rumble Fish 1983,O 7,C,10:3
Osterman Weekend, The 1983,N 4,C,11:1
Hopper, Dennis (Director)
Out of the Blue 1983,Ap 8,C,6:5
Hora, John (Cinematographer)
Twilight Zone—The Movie (Segment 3) 1983,Je 24,C,15:1
Gremlins 1984,Je 8,C,10:4
Hordern, Michael
Yellowbeard 1983,Je 24,C,10:2
Hornaday, Jeffrey (Miscellaneous)
Flashdance 1983,Ap 15,C,13:1
Horner, James (Composer)
Something Wicked This Way Comes 1983,Ap 29,C,8:5
Krull 1983,Jl 29,C,10:1
Brainstorm 1983,S 30,C,17:1
Dresser, The 1983,D 6,C,19:1
Gorky Park 1983,D 16,C,6:5
Uncommon Valor 1983,D 16,C,12:1
Stone Boy, The 1984,Ap 4,C,25:1
Star Trek III: The Search for Spock 1984,Je 1,C,14:3
Horowitz, Gideon
Vortex 1983,F 4,C,5:1
Horsch, Katy
Purple Haze 1983,N 11,C,8:1
Horsford, Anna Maria
Crackers 1984,F 17,C,19:3
Horsley, John
Secrets 1984,Ag 17,C,13:3
Horton, Gaylon (Miscellaneous)
Body Rock 1984,S 28,C,12:5
Horton, Helen
Razor's Edge, The 1984,O 19,C,14:6
Horton, Michael (Miscellaneous)
Beyond Reasonable Doubt 1983,N 22,C,16:4
Heart of the Stag 1984,Jl 27,C,6:5
Utu 1984,S 13,C,21:2
Horton, Peter
Children of the Corn 1984,Mr 16,C,7:2
Horvath, Jozsef
Forbidden Relations 1983,S 25,59:1
Horvath, Laszlo
Forbidden Relations 1983,S 25,59:1
Brady's Escape 1984,Je 28,C,17:1
Horvath, Louis (Cinematographer)
Strange Invaders 1983,S 16,C,8:1
Horvitch, Andy (Miscellaneous)
Android 1984,F 10,C,28:1
Hoskins, Bob
Beyond the Limit 1983,S 30,C,4:3
Lassiter 1984,F 17,C,10:5
Cotton Club, The 1984,D 14,C,4:3
Hotton, Donald
Brainstorm 1983,S 30,C,17:1

Houdova, Eva (Miscellaneous)
My Name is Anna Magnani 1984,Ag 10,C,12:4
Hough, Richard (Original Author)
Bounty, The 1984,My 4,C,8:1
Houghton, Barrie
Lassiter 1984,F 17,C,10:5
House, Ronald E
Going Berserk 1983,O 29,19:1
Houseman, John
Good Fight, The 1984,Mr 28,C,24:4
Houser, Patrick
Hot Dog 1984,Ja 14,10:1
Houssiau, Michel (Cinematographer)
Golden Eighties, The 1983,O 2,59:1
Houwer, Rob (Producer)
4th Man, The 1984,Je 27,C,21:4
Hoven, Adrian
Shadow of Angels (Schatten der Engel) 1983,Je 24,C,8:1
Hoven, Louise
Joni 1983,Mr 4,C,10:5
Howard, Alan
Oxford Blues 1984,Ag 25,9:1
Howard, Barbara
Friday the 13th—The Final Chapter 1984,Ap 14,15:1
Howard, Brie
Android 1984,F 10,C,28:1
Howard, John C (Miscellaneous)
Romantic Comedy 1983,O 7,C,8:1
Howard, Kevyn Major
Sudden Impact 1983,D 9,C,12:4
Howard, Mary
Falls, The 1983,My 4,C,17:4
Howard, Rance
Love Letters 1984,Ja 27,C,14:1
Howard, Robert E (Miscellaneous)
Conan the Destroyer 1984,Je 29,C,8:4
Howard, Ron (Director)
Splash 1984,Mr 9,C,15:1
Howard, Sandy (Producer)
Deadly Force 1983,Jl 8,C,4:3
Howard, Trevor
Light Years Away 1983,Ap 15,C,7:1
Howarth, Alan (Miscellaneous)
Christine 1983,D 9,C,10:5
Howe, Irving
Zelig 1983,Jl 17,II,1:4
Zelig 1983,Jl 18,B,1:6
Zelig 1983,D 25,II,15:1
Howell, C Thomas
Outsiders, The 1983,Mr 25,C,3:1
Tank 1984,Mr 16,C,8:1
Grandview U S A 1984,Ag 3,C,8:4
Red Dawn 1984,Ag 10,C,11:1
Howlett, May
Strikebound 1984,O 6,15:5
Howson, Denzil
Strikebound 1984,O 6,15:5
Hoyo, Pablo
To Begin Again 1983,Ap 22,C,10:5
Hoyos, Cristina
Carmen 1983,O 20,C,21:3
Carmen 1984,S 20,C,21:1
Hrabal, Bohumil (Screenwriter)
Snowdrop Festival 1984,N 14,C,29:4
Hrusinsky, Rudolf
Snowdrop Festival 1984,N 14,C,29:4
Hubbard, Allan
Tender Mercies 1983,Mr 4,C,8:1
Tender Mercies 1983,Mr 13,II,21:1
Hubbard, Paul
Christmas Story, A 1983,N 18,C,36:1
Hubbard, Tina
Last Night at the Alamo 1983,O 2,II,60:3
Last Night at the Alamo 1984,Jl 3,C,10:5
Last Night at the Alamo 1984,Jl 15,II,15:1
Hubbert, Cork
Not for Publication 1984,N 1,C,17:1
Huber, Grischa
Malou 1983,D 22,C,22:1
Huberman, Brian (Cinematographer)
Last Night at the Alamo 1983,O 2,II,60:3
Last Night at the Alamo 1984,Jl 3,C,10:5
Hubert, Jean-Loup (Director)
Next Year If All Goes Well 1983,Mr 20,60:1
Hubert, Jean-Loup (Screenwriter)
Next Year If All Goes Well 1983,Mr 20,60:1
Huckabee, Cooper
Joni 1983,Mr 4,C,10:5
Huddleston, Michael
Woman in Red, The 1984,Ag 15,C,24:1

Jordano, Daniel
Alphabet City 1984,My 5,17:1
Joseph, Eric
That Sinking Feeling 1984,F 15,C,21:4
Joseph, Jackie
Gremlins 1984,Je 8,C,10:4
Joseph, Jeanette
Strangers Kiss 1984,Ag 13,C,19:1
Josephson, Erland
Fanny and Alexander 1983,Je 17,C,8:1
Nostalghia 1983,O 5,C,23:1
Fanny and Alexander 1983,D 25,II,15:1
Nostalghia (Nostalgia) 1984,Ja 8,47:1
Beyond Good and Evil 1984,My 18,C,14:1
After the Rehearsal 1984,Je 21,C,14:1
After the Rehearsal 1984,Jl 1,II,13:1
Josey, Jennifer
Terms of Endearment 1983,N 23,C,18:4
Jourdan, Louis
Octopussy 1983,Je 10,C,17:4
Jouvenat, Gary Jules (Producer)
Out of the Blue 1983,Ap 8,C,6:5
Joy, Robert
Amityville 3-D 1983,N 20,68:3
Joyce, Eileen
Man of Flowers 1984,O 9,C,14:4
Man of Flowers 1984,D 16,78:4
Joycee
Rat Trap (Elippathayam) 1983,Mr 27,55:5
Juarbe, Israel
Karate Kid, The 1984,Je 22,C,16:3
Jude, Lee James
Nightmares 1983,S 3,14:5
Jugnot, Gerard
Investigation (Si Joli Village, Un) 1984,F 3,C,11:1
Julian, Marcel (Miscellaneous)
Heads or Tails (Pile ou Face) 1983,My 27,C,4:5
Julien, Jay
Tales of Ordinary Madness 1983,Mr 11,C,13:3
Jump, Gordon
Making the Grade 1984,My 18,C,10:5
Junger, Ernst (Original Author)
One Man's War (Guerre d'un Seul Homme, La) 1984,F 24,C,9:1
Junkersdorf, Eberhardt (Producer)
War And Peace 1983,D 3,15:1
Jurado, Katy
Bruto, El 1983,S 21,C,22:3
Under the Volcano 1984,Je 13,C,21:4
Jurewicz, Jan
Constant Factor, The (Constans) 1983,Mr 10,C,18:3
Jurgenson, Albert (Miscellaneous)
Life is a Bed of Roses 1984,Ag 19,63:1
Jurges, Jurgen (Cinematographer)
Woman in Flames, A (Flambierte Frau) 1984,F 3,C,11:1
Germany Pale Mother 1984,Mr 18,52:1
Jurow, Martin (Producer)
Terms of Endearment 1983,N 23,C,18:4
Justin, John
Trenchcoat 1983,Mr 12,13:3
Juvet, Nathalie
Swann in Love 1984,S 14,C,4:1
Jympson, John (Miscellaneous)
High Road to China 1983,Mr 18,C,4:3

K

Kaa, Wi Kuki
Bounty, The 1984,My 4,C,8:1
Kabat, Carl
In the King of Prussia 1983,F 13,57:1
Kabay, Barna (Director)
Revolt of Job, The 1984,Mr 28,C,19:3
Kabay, Barna (Screenwriter)
Revolt of Job, The 1984,Mr 28,C,19:3
Kabore, Colette
Wend Kuuni (Gift of God) 1983,Mr 27,55:1
Kabore, Gaston J M (Director)
Wend Kuuni (Gift of God) 1983,Mr 27,55:1
Kabore, Gaston J M (Screenwriter)
Wend Kuuni (Gift of God) 1983,Mr 27,55:1
Kaczmarek, Jane
Falling in Love 1984,N 21,C,11:1
Falling in Love 1984,D 9,II,21:1
Kadour
Lucie sur Seine 1983,S 9,C,8:1
Kaff, David
This is Spinal Tap 1984,Mr 2,C,6:1

Kafka, Franz (Original Author)
Class Relations 1984,O 7,86:1
Kaga, Mariko
Muddy River 1983,Ja 21,C,4:1
Kagan, Gerald (Screenwriter)
Anarchism in America 1983,Ja 15,16:1
Kagan, Jeremy Paul (Director)
Sting II, The 1983,F 18,C,10:6
Kahler, Wolf
Riddle of the Sands, The 1984,Ja 6,C,8:1
Kahn, Gus (Miscellaneous)
Basileus Quartet 1984,Ja 4,C,13:5
Kahn, Madeline
Yellowbeard 1983,Je 24,C,10:2
City Heat 1984,D 7,C,4:3
Kahn, Michael (Miscellaneous)
Table for Five 1983,F 18,C,12:1
Twilight Zone—The Movie (Segment 2) 1983,Je 24,C,15:1
Indiana Jones and the Temple of Doom 1984,My 23,C,21:1
Falling in Love 1984,N 21,C,11:1
Kahn, Sheldon (Miscellaneous)
Unfaithfully Yours 1984,F 10,C,7:1
Ghostbusters 1984,Je 8,C,5:1
Kain, Jim
Malou 1983,D 22,C,22:1
Kakutani, Masaru (Producer)
Antarctica 1984,Mr 30,C,10:5
Kalashnikov, Leonid (Cinematographer)
Vassa 1983,N 18,C,10:5
Kaldwell, Kendal
Lonely Lady, The 1983,O 1,13:5
Kalem, Toni
Reckless 1984,F 3,C,8:1
Kalfon, Jean-Pierre
Confidentially Yours (Vivement Dimanche) 1984,Ja 20,C,6:1
Amour par Terre, L' (Love on the Ground) 1984,O 7,86:5
Kalinowski, Waldemar
Breathless 1983,My 13,C,10:1
Kaliuta, Vilen (Cinematographer)
Flights of Fancy 1983,Je 15,C,20:5
Kalpataru, Debria
Shadow of Angels (Schatten der Engel) 1983,Je 24,C,8:1
Kamen, Michael (Composer)
Angelo My Love 1983,Ap 27,C,17:5
Dead Zone, The 1983,O 21,C,8:1
Kamen, Robert Mark (Screenwriter)
Karate Kid, The 1984,Je 22,C,16:3
Kampmann, Winnetou
Malou 1983,D 22,C,22:1
Kana, Henry
Last Night at the Alamo 1983,O 2,II,60:3
Last Night at the Alamo 1984,Jl 3,C,10:5
Kanaly, Steve
Fleshburn 1984,My 26,13:1
Kanamaru, Masumi (Producer)
Irezumi—Spirit of Tattoo (Sekka Tomurai Zashi) 1983,Mr 19,10:3
Irezumi—Spirit of Tattoo (Sekka Tomurai Zashi) 1984,My 9,C,23:1
Kander, John (Composer)
Blue Skies Again 1983,Jl 29,C,8:3
Places in the Heart 1984,S 21,C,8:1
Kane, Carol
Norman Loves Rose 1983,Je 3,C,20:5
Over the Brooklyn Bridge 1984,Mr 2,C,6:5
Racing With the Moon 1984,Mr 23,C,5:1
Hester Street 1984,My 27,II,15:1
Kane, Michael (Screenwriter)
All the Right Moves 1983,O 21,C,10:3
Kanew, Jeff (Director)
Revenge of the Nerds 1984,Jl 20,C,8:5
Kani, John
Marigolds in August 1984,Je 20,C,21:1
Marigolds in August 1984,Jl 1,II,13:1
Killing Heat 1984,O 5,C,16:1
Kanie, Keizo
Muddy River 1983,Ja 21,C,4:1
Farewell to the Land, A (Saraba Itoshiki Daichi) 1983,Mr 20,60:3
Kanievska, Marek (Director)
Another Country 1984,Je 29,C,8:1
Kanter, Marin
Loveless, The 1984,Ja 20,C,8:5
Kanter, Nancy (Miscellaneous)
Loveless, The 1984,Ja 20,C,8:5
Kaplan, Jonathan (Director)
Heart Like a Wheel 1983,O 6,C,30:1
Heart Like a Wheel 1983,O 23,II,19:1
Heart Like a Wheel 1983,D 25,II,15:1

Kaplan, Michael (Miscellaneous)
American Dreamer 1984,O 26,C,12:4
Kapoor, Shashi
Heat and Dust 1983,S 15,C,18:3
Heat and Dust 1983,S 25,II,19:1
Kaprisky, Valerie
Breathless 1983,My 13,C,10:1
Kaproff, Dana (Composer)
Golden Seal, The 1983,Ag 12,C,4:5
Karabatsos, Ron
Flashdance 1983,Ap 15,C,13:1
Karallis, Chris
Kipperbang 1984,Ap 20,C,11:3
Karamana
Rat Trap (Elippathayam) 1983,Mr 27,55:5
Karani, Nizwar
Indiana Jones and the Temple of Doom 1984,My 23,C,21:1
Karanovic, Mirjana
Petria's Wreath 1983,F 6,4,49:1
Karanovic, Srdjan (Director)
Petria's Wreath 1983,F 6,4,49:1
Karanth, B V (Composer)
Case is Closed, The 1984,N 28,C,19:5
Karchevsky, Michel
Golden Eighties, The 1983,O 2,59:1
Kardos, Istvan (Screenwriter)
Princess, The 1984,Ap 1,57:1
Kariachen
There Lived a Wrestler (Oridathu Oru Phayaivaan) 1983,Mr 23,C,26:3
Karlatos, Olga
Purple Rain 1984,Jl 27,C,5:1
Karlen, John
Racing With the Moon 1984,Mr 23,C,5:1
Impulse 1984,S 30,58:5
Karmitz, Marin (Producer)
Half a Life (Mourir a Trente Ans) 1983,Mr 27,55:1
Half a Life (Mourir a Trente Ans) 1984,Ag 15,C,22:5
Karpoff, David (Producer)
Musical Passage 1984,Mr 21,C,20:3
Karpov, Anatoly
Great Chess Movie, The 1983,Ap 6,C,15:3
Karr, Marcia
Savage Streets 1984,O 5,C,14:3
Karras, Alex
Against All Odds 1984,Mr 2,C,14:3
Karyo, Tcheky
Return of Martin Guerre, The 1983,Je 10,C,12:5
Full Moon in Paris (Nuits de la Pleine Lune, Les) 1984,S 7,C,5:1
Kasdan, Jacob
Big Chill, The 1983,S 23,C,14:3
Kasdan, Jon
Big Chill, The 1983,S 23,C,14:3
Kasdan, Lawrence (Director)
Big Chill, The 1983,S 23,C,14:3
Big Chill, The 1983,O 2,II,21:1
Big Chill, The 1983,D 18,II,21:1
Big Chill, The 1983,D 25,II,15:1
Kasdan, Lawrence (Screenwriter)
Return of the Jedi 1983,My 25,C,24:1
Big Chill, The 1983,S 23,C,14:3
Kasdan, Meg
Big Chill, The 1983,S 23,C,14:3
Kasdorf, Lenore
Missing in Action 1984,N 17,11:1
Kase, Susan
Right Stuff, The 1983,O 21,C,5:1
Kasmin
Bigger Splash, A 1984,O 5,C,12:1
Kass, Jerome (Screenwriter)
Black Stallion Returns, The 1983,Mr 27,54:4
Kastner, Elliott (Producer)
Man, Woman and Child 1983,Ap 1,C,8:1
Oxford Blues 1984,Ag 25,9:1
Garbo Talks 1984,O 12,C,8:1
Katamsi, Amoroso
Dawn, The 1983,Mr 23,C,26:4
Katis, Diana
Privileged 1983,Ap 8,C,8:5
Katsura, Chiho (Screenwriter)
Irezumi—Spirit of Tattoo (Sekka Tomurai Zashi) 1983,Mr 19,10:3
Irezumi—Spirit of Tattoo (Sekka Tomurai Zashi) 1984,My 9,C,23:1
Katz, Gloria (Producer)
Best Defense 1984,Jl 20,C,10:1
Katz, Gloria (Screenwriter)
Indiana Jones and the Temple of Doom 1984,My 23,C,21:1
Best Defense 1984,Jl 20,C,10:1

Katz, Robert (Screenwriter)
 Kamikaze '89 1983,F 27,48:1
 Salamander, The 1983,Je 5,53:1
Kauderer, Emilio (Composer)
 Time for Revenge 1983,Ja 14,C,8:1
Kaufman, Lloyd (Cinematographer)
 Stuck On You 1984,F 3,C,8:5
 First Turn-On!, The 1984,O 12,C,8:5
Kaufman, Lloyd (Producer)
 Stuck On You 1984,F 3,C,8:5
 First Turn-On!, The 1984,O 12,C,8:5
Kaufman, Lloyd (Screenwriter)
 Stuck On You 1984,F 3,C,8:5
Kaufman, Philip (Director)
 Right Stuff, The 1983,O 21,C,5:1
 Right Stuff, The 1983,N 6,II,21:1
 Right Stuff, The 1983,N 27,II,17:1
 Right Stuff, The 1983,D 18,II,21:1
 Right Stuff, The 1983,D 25,II,15:1
Kaufman, Philip (Screenwriter)
 Right Stuff, The 1983,O 21,C,5:1
 Right Stuff, The 1983,D 25,II,15:1
Kaufmann, Gunther
 Kamikaze '89 1983,F 27,48:1
 Querelle 1983,Ap 29,C,8:5
 War And Peace 1983,D 3,15:1
Kaul, Mani (Director)
 Dhrupad 1983,O 4,C,14:5
Kavanagh, John
 Cal 1984,Ag 24,C,6:1
Kavoukidis, Nikos (Cinematographer)
 Colors of Iris, The 1983,Ap 6,C,14:6
Kawamata, Takashi (Cinematographer)
 Cruel Story of Youth 1984,Jl 18,C,20:3
Kawashima, Akimasa (Miscellaneous)
 Family Game, The 1984,Ap 1,57:1
 Family Game, The 1984,S 14,C,3:1
Kawaye, Janice
 Night of the Comet 1984,N 16,C,8:1
Kawazu, Yusuke
 Cruel Story of Youth 1984,Jl 18,C,20:3
Kay, Charles
 Amadeus 1984,S 19,C,23:1
Kaye, Norman
 Killing of Angel Street, The 1983,Mr 26,20:6
 Lonely Hearts 1983,S 4,58:3
 Man of Flowers 1984,O 9,C,14:4
 Man of Flowers 1984,D 16,78:4
Kaye, Norman (Composer)
 Lonely Hearts 1983,S 4,58:3
Kaylan, Howard
 Get Crazy 1983,O 14,C,11:1
Kazan, Vangelis
 Colors of Iris, The 1983,Ap 6,C,14:6
Kazanilan, Howard (Producer)
 Return of the Jedi 1983,My 25,C,24:1
Kaznar, Kurt
 Leopard, The 1983,S 11,II,21:5
Ke Huy Quan
 Indiana Jones and the Temple of Doom 1984,My 23,C,21:1
Keach, James
 Love Letters 1984,Ja 27,C,14:1
 Razor's Edge, The 1984,O 19,C,14:6
Kean, Marie
 Danny Boy 1984,My 18,C,11:1
Keane, James
 10 to Midnight 1983,Mr 13,62:5
Keating, Kevin (Cinematographer)
 Hells Angels Forever 1983,O 9,69:3
Keating, Kevin (Director)
 Hells Angels Forever 1983,O 9,69:3
Keaton, Diane
 Little Drummer Girl, The 1984,O 19,C,18:1
 Mrs Soffel 1984,D 26,C,15:1
Keaton, Michael
 Mr Mom 1983,Ag 26,C,8:4
 Johnny Dangerously 1984,D 21,C,25:5
Keays-Bryne, Hugh
 Strikebound 1984,O 6,15:5
Keen, Geoffrey
 Octopussy 1983,Je 10,C,17:4
Keenan, Gabrielle
 Light Years Away 1983,Ap 15,C,7:1
Kehoe, Jack
 Star Chamber, The 1983,Ag 5,C,8:5
 Pope of Greenwich Village, The 1984,Je 22,C,12:4
 Wild Life, The 1984,S 28,C,8:4
Keita, Balla Moussa
 Wind, The 1983,S 24,11:1

Keitel, Harvey
 Nuit de Varennes, La 1983,F 16,C,23:1
 Nuit de Varennes, La 1983,F 27,II,1:1
 Exposed 1983,Ap 22,C,10:1
 Exposed 1983,My 1,II,17:1
 Eagle's Wing 1983,O 9,72:1
 Corrupt 1984,Ja 19,C,16:5
 Death Watch 1984,S 14,C,6:5
 Falling in Love 1984,N 21,C,11:1
 Falling in Love 1984,D 9,II,21:1
Keith, David
 Independence Day 1983,Ja 21,C,8:1
 Lords of Discipline, The 1983,F 18,C,16:4
 Lords of Discipline, The 1983,Ap 10,II,17:1
 Firestarter 1984,My 11,C,8:1
Keleghan, Peter
 Screwballs 1983,Jl 9,10:4
Kell, Michael
 Zelig 1983,Jl 18,B,1:6
Keller, Daniel (Miscellaneous)
 Secret Agent, The 1984,Mr 21,C,14:4
Keller, Daniel (Producer)
 Secret Agent, The 1984,Mr 21,C,14:4
Keller, Harry (Miscellaneous)
 Man Who Wasn't There, The 1983,Ag 13,13:1
Keller, Heinz
 White Rose, The 1983,My 6,C,13:1
Keller, Inge
 Fiancee, The 1984,Ap 7,13:3
Kelley, DeForest
 Star Trek III: The Search for Spock 1984,Je 1,C,14:3
Kellman, Ben
 Stuck On You 1984,F 3,C,8:5
Kelly, David Patrick
 Hammett 1983,Jl 1,C,8:1
 Dreamscape 1984,Ag 15,C,24:4
Kelly, Grace
 Rear Window 1983,O 9,II,21:1
Kelly, Hilary
 Man of Flowers 1984,O 9,C,14:4
 Man of Flowers 1984,D 16,78:4
Kelly, Margaret (Producer)
 Puberty Blues 1983,Jl 15,C,13:1
Kelly, Margaret (Screenwriter)
 Puberty Blues 1983,Jl 15,C,13:1
Kelsey, Thomas (Miscellaneous)
 Purple Haze 1983,N 11,C,8:1
Kelton, Roger
 Android 1984,F 10,C,28:1
Kemp, Jeremy
 Top Secret! 1984,Je 22,C,10:1
Kempel, Arthur (Composer)
 Fleshburn 1984,My 26,13:1
Kemper, Dennis
 My Brother's Wedding 1984,Mr 30,C,7:1
Kemper, Victor J (Cinematographer)
 National Lampoon's Vacation 1983,Jl 29,C,10:4
 Mr Mom 1983,Ag 26,C,8:4
 Lonely Guy, The 1984,Ja 28,11:5
 Cloak and Dagger 1984,Ag 10,C,16:1
Kendal, Jennifer
 Heat and Dust 1983,S 15,C,18:3
 Heat and Dust 1983,S 25,II,19:1
Kendall, David
 Strikebound 1984,O 6,15:5
Kende, Janos (Cinematographer)
 When Joseph Returns 1983,F 3,C,20:2
 Forbidden Relations 1983,S 25,59:1
Kennedy, Alita
 Scandalous 1984,Ja 20,C,4:5
Kennedy, David
 Vortex 1983,F 4,C,5:1
Kennedy, Flo
 Born in Flames 1983,N 10,C,17:1
Kennedy, George
 Bolero 1984,S 1,9:5
Kennedy, Graham
 Killing Fields, The 1984,N 2,C,10:1
Kennedy, Leon Isaac
 Lone Wolf McQuade 1983,Ap 16,12:4
Kennedy, Patrick (Miscellaneous)
 Mr Mom 1983,Ag 26,C,8:4
Kennedy, William (Miscellaneous)
 Cotton Club, The 1984,D 14,C,4:3
Kennedy, William (Screenwriter)
 Cotton Club, The 1984,D 14,C,4:3
Kent, Mr
 Stuck On You 1984,F 3,C,8:5
Kepros, Nicholas
 Amadeus 1984,S 19,C,23:1

Ker, Evelyne
 A Nos Amours 1984,O 12,C,10:4
Keramidas, Harry (Miscellaneous)
 Children of the Corn 1984,Mr 16,C,7:2
Kermack, Paul
 My Childhood (Bill Douglas Trilogy, The) 1983,My 18,C,26:5
Kern, David
 Americana 1983,O 21,C,14:5
Kern, David (Miscellaneous)
 Americana 1983,O 21,C,14:5
Kern, Peter
 Stationmaster's Wife, The (Bolwieser) 1983,Ja 12,C,21:2
Kerova, Nina V (Screenwriter)
 Liquid Sky 1983,Jl 22,C,10:1
 Liquid Sky 1983,Jl 31,II,15:1
Kerr, Bill
 Year of Living Dangerously, The 1983,Ja 21,C,4:1
Kerr, Bruce
 Man from Snowy River, The 1983,Ja 21,C,5:6
Kerr, Charlotte
 Swann in Love 1984,S 14,C,4:1
Kerr, E Katherine
 Silkwood 1983,D 14,C,27:1
 Reuben, Reuben 1983,D 19,C,12:5
Kerr, Elizabeth
 Going Berserk 1983,O 29,19:1
Kerridge, Linda
 Strangers Kiss 1984,Ag 13,C,19:1
Kerrigan, Bill (Cinematographer)
 Memoirs 1984,D 28,C,14:5
Kerry, Anne
 Lovesick 1983,F 18,C,19:1
Kershaw, John (Screenwriter)
 Lonely Lady, The 1983,O 1,13:5
Kershner, Irvin (Director)
 Never Say Never Again 1983,O 7,C,13:1
 Never Say Never Again 1983,O 16,II,21:1
Kerwin, Maureen
 Misunderstood 1984,Mr 30,C,10:1
Keseman, Nadine (Miscellaneous)
 Golden Eighties, The 1983,O 2,59:1
Kessel, Joseph (Original Author)
 Passante, La 1983,Ag 14,47:1
Kessler, Wulf
 White Rose, The 1983,My 6,C,13:1
Kesson, Jessie (Original Author)
 Another Time, Another Place 1984,Jl 11,C,26:1
Kesten, Stephen F (Producer)
 Amityville 3-D 1983,N 20,68:3
Keyes, Irwin
 Exterminator 2 1984,S 15,14:5
Keyloun, Mark
 Sudden Impact 1983,D 9,C,12:4
 Mike's Murder 1984,Mr 9,C,16:1
 Mike's Murder 1984,Mr 11,II,17:1
Keys, Bobby
 Let's Spend the Night Together 1983,F 11,C,8:1
Kezdi-Kovacs, Zsolt (Director)
 Forbidden Relations 1983,S 25,59:1
Khan, Sajid
 Heat and Dust 1983,S 15,C,18:3
Khaner, Julie
 Videodrome 1983,F 4,C,9:1
Khorsand, Philippe
 Comperes, Les 1984,Mr 28,C,24:6
 Edith and Marcel 1984,Je 3,60:4
Khrapachov, Vadim (Composer)
 Flights of Fancy 1983,Je 15,C,20:5
Kidder, Margot
 Trenchcoat 1983,Mr 12,13:3
 Superman III 1983,Je 17,C,4:5
Kier, Udo
 Stationmaster's Wife, The (Bolwieser) 1983,Ja 12,C,21:2
 Berlin Alexanderplatz 1983,Ag 10,C,18:5
Kiersch, Fritz (Director)
 Children of the Corn 1984,Mr 16,C,7:2
Kieschnick, Rod
 Tough Enough 1983,My 27,C,8:1
Kieslowski, Krzysztof (Director)
 Camera Buff (Amator) 1983,F 24,C,17:1
Kieslowski, Krzysztof (Screenwriter)
 Camera Buff (Amator) 1983,F 24,C,17:1
Kiesser, Jan (Cinematographer)
 Return Engagement 1983,N 23,C,10:5
 Purple Hearts 1984,My 4,C,15:1
Kiger, Robby
 Table for Five 1983,F 18,C,12:1
 Children of the Corn 1984,Mr 16,C,7:2
Kikuta, Kazuo (Original Author)
 Quiet Duel 1983,N 25,C,10:1

Kilaidonis, Loukianos (Composer)
 Thiassos, O (Traveling Players, The) 1983,Ap 12,C,12:5
Kilar, Wojciech (Composer)
 Ways in the Night 1983,Jl 27,C,17:1
 Unapproachable, The 1984,F 24,C,8:1
Kildea, Gary (Director)
 Trobriand Cricket 1983,D 7,C,24:5
Kilmer, Val
 Top Secret! 1984,Je 22,C,10:1
Kilpatrick, Lincoln
 Deadly Force 1983,Jl 8,C,4:3
Kim Chiu, Kok
 We of the Never Never 1983,F 11,C,12:1
Kimbrel, Marketa
 Reaching Out 1983,My 16,C,20:5
Kimbro, Art
 Beverly Hills Cop 1984,D 5,C,25:4
Kimbrough, Philip Mont
 Loveless, The 1984,Ja 20,C,8:5
Kime, Jeffrey
 State of Things, The 1983,F 18,19:4
Kimmel, Anne (Producer)
 Not for Publication 1984,N 1,C,17:1
Kimmell, Dana
 Lone Wolf McQuade 1983,Ap 16,12:4
Kimura, Motoyasu (Producer)
 Muddy River 1983,Ja 21,C,4:1
King, Alan
 Lovesick 1983,F 18,C,19:1
King, Betty
 Terms of Endearment 1983,N 23,C,18:4
King, Denis (Composer)
 Privates on Parade 1984,Ap 13,C,8:1
King, Richard (Miscellaneous)
 First Turn-On!, The 1984,O 12,C,8:5
King, Rick
 Before the Nickelodeon 1983,F 28,C,24:5
King, Robert Louis
 Exterminator 2 1984,S 15,14:5
King, Stephen (Original Author)
 Cujo 1983,Ag 13,13:1
 Dead Zone, The 1983,O 21,C,8:1
 Christine 1983,D 9,C,10:5
 Children of the Corn 1984,Mr 16,C,7:2
 Firestarter 1984,My 11,C,8:1
King, Tony
 Big Score, The 1983,N 20,67:3
King-Hall, Magdalen (Original Author)
 Wicked Lady, The 1983,O 28,C,16:1
Kingsley, Barbara
 Personals, The 1983,Mr 20,60:1
Kingsley, Ben
 Betrayal 1983,F 20,78:1
 Gandhi 1983,F 27,II,1:1
 Betrayal 1983,Mr 6,II,17:1
 Betrayal 1983,D 25,II,15:1
Kingsley, Susan
 Old Enough 1984,Ag 24,C,10:4
Kinnear, Roy
 Hammett 1983,Jl 1,C,8:1
Kinoy, Peter (Miscellaneous)
 When the Mountains Tremble 1984,Ja 18,C,24:3
Kinoy, Peter (Producer)
 When the Mountains Tremble 1984,Ja 18,C,24:3
Kinski, Klaus
 Android 1984,F 10,C,28:1
 Little Drummer Girl, The 1984,O 19,C,18:1
Kinski, Nastassia
 Exposed 1983,Ap 22,C,10:1
 Exposed 1983,My 1,II,17:1
 Moon in the Gutter, The 1983,S 9,C,8:1
 Unfaithfully Yours 1984,F 10,C,7:1
 Hotel New Hampshire, The 1984,Mr 9,C,8:1
 Paris, Texas 1984,O 14,64:1
 Paris, Texas 1984,N 9,C,4:3
 Paris, Texas 1984,N 11,II,17:1
Kirana, Eleni
 Colors of Iris, The 1983,Ap 6,C,14:6
Kirby, Ben
 Draughtsman's Contract, The 1983,Je 22,C,26:4
Kirby, Bruno
 This Is Spinal Tap 1984,Mr 2,C,6:1
 Birdy 1984,D 21,C,25:1
Kirby, Terrence (Producer)
 Children of the Corn 1984,Mr 16,C,7:2
Kirchberger, Michael (Miscellaneous)
 Suzanne Suzanne 1983,Mr 27,55:1
Kirchner, Kendra
 Android 1984,F 10,C,28:1
Kirkland, Geoffrey (Miscellaneous)
 Right Stuff, The 1983,O 21,C,5:1

Kirkland, Sally
 Love Letters 1984,Ja 27,C,14:1
Kirkpatrick, Jeane J
 Nicaragua: Report from the Front 1984,Ja 18,C,24:3
Kirkwood, Gene (Producer)
 Night in Heaven, A 1983,N 19,19:3
 Gorky Park 1983,D 16,C,6:5
 Pope of Greenwich Village, The 1984,Je 22,C,12:4
Kirsner, Jacques (Screenwriter)
 Girl from Lorraine, The 1983,Ja 27,C,13:1
 Passante, La 1983,Ag 14,47:1
Kislac, Niva
 Wild Style 1983,Mr 18,C,8:3
 Wild Style 1983,N 25,C,10:4
Kitaen, Tawny
 Bachelor Party 1984,Je 30,11:1
Kitchen, Cathy
 Angelo My Love 1983,Ap 27,C,17:5
Kitt, Eartha
 All By Myself 1983,My 6,C,10:2
Kivits, Martine
 Golden Eighties, The 1983,O 2,59:1
Kizer, R J (Miscellaneous)
 Timerider 1983,Ja 21,C,24:5
Kjellson, Ingvar
 Flight of the Eagle, The 1983,Ap 8,C,8:1
Klak, Edward (Composer)
 Voice Over 1983,Ja 23,47:1
Klane, Robert (Screenwriter)
 Unfaithfully Yours 1984,F 10,C,7:1
Klein, Breindy
 Kaddish 1984,Ap 3,C,15:1
Klein, Gerald
 Zelig 1983,Jl 18,B,1:6
Klein, Gerard
 Passante, La 1983,Ag 14,47:1
Klein, James (Director)
 Seeing Red 1983,O 4,C,14:5
 Seeing Red 1984,Mr 25,II,19:1
Klein, James (Miscellaneous)
 Seeing Red 1983,O 4,C,14:5
Klein, James (Producer)
 Seeing Red 1983,O 4,C,14:5
 Seeing Red 1984,Mr 25,II,19:1
Klein, Jean-Pierre
 Etoile du Nord, L' 1983,Je 12,66:1
Klein, Karen
 Kaddish 1984,Ap 3,C,15:1
Klein, Ralph (Producer)
 America—From Hitler to MX 1983,Ja 5,C,17:1
Klein, Yossi
 Kaddish 1984,Ap 3,C,15:1
Klein, Zoltan
 Kaddish 1984,Ap 3,C,15:1
Kleiser, Randall (Director)
 Grandview U S A 1984,Ag 3,C,8:4
Klellan, Barbie
 Stuck On You 1984,F 3,C,8:5
Klesser, Jan (Cinematographer)
 Choose Me 1984,N 1,C,18:4
Kletter, Richard (Screenwriter)
 Black Stallion Returns, The 1983,Mr 27,54:4
 Never Cry Wolf 1983,O 14,C,8:1
Klimov, Vladimir (Cinematographer)
 26 Days in the Life of Dostoyevsky 1983,O 14,C,8:5
Kline, Elmer (Screenwriter)
 Hilary's Blues 1983,N 23,C,16:1
Kline, Elmer L
 Hammett 1983,Jl 1,C,8:1
Kline, Kevin
 Sophie's Choice 1983,Ja 2,II,1:1
 Pirates of Penzance, The 1983,F 20,80:1
 Big Chill, The 1983,S 23,C,14:3
 Big Chill, The 1983,D 18,II,21:1
 Big Chill, The 1983,D 25,II,15:1
Kline, Richard H (Cinematographer)
 Man, Woman and Child 1983,Ap 1,C,8:1
 Breathless 1983,My 13,C,10:1
 Deal of the Century 1983,N 4,C,13:3
 Hard to Hold 1984,Ap 6,C,16:5
 All of Me 1984,S 21,C,6:1
Kline, Thilo (Screenwriter)
 Kukurantumi: The Road to Accra 1984,Ap 1,51:1
Kllar, Wolciech (Composer)
 Constant Factor, The (Constans) 1983,Mr 10,C,18:3
Kloomok, Darren (Miscellaneous)
 Stuck On You 1984,F 3,C,8:5
Kloomok, Darren (Screenwriter)
 Stuck On You 1984,F 3,C,8:5
Klose, Juergen (Screenwriter)
 Class Enemy 1984,Jl 13,C,6:1

Klotz, Georges (Miscellaneous)
 Just the Way You Are 1984,N 16,C,14:1
Kloves, Steven (Screenwriter)
 Racing With the Moon 1984,Mr 23,C,5:1
Kluge, Alexander (Miscellaneous)
 War And Peace 1983,D 3,15:1
 War And Peace 1983,D 3,15:1
Kluge, P F (Original Author)
 Eddie and the Cruisers 1983,S 23,C,8:3
Knap, Stanley
 Liquid Sky 1983,Jl 22,C,10:1
Knapp, Charles
 Twilight Zone—The Movie (Segment 4) 1983,Je 24,C,15:1
Knapp, Peggy
 Personals, The 1983,Mr 20,60:1
Knapskog, Nina
 Betrayal: The Story of Kamilla (Kamilla) 1983,Mr 20,60:1
 Kamilla (Betrayal: The Story of Kamilla) 1984,Ja 13,C,8:1
Knebel, Levi L
 Country 1984,S 28,20:1
Knell, David
 Spring Break 1983,Mr 27,54:4
Knieper, Jurgen (Composer)
 State of Things, The 1983,F 18,19:4
 Germany Pale Mother 1984,Mr 18,52:1
Knight, Wyatt
 Porky's II: The Next Day 1983,Je 25,12:3
Knittel, Krzysztof (Composer)
 Camera Buff (Amator) 1983,F 24,C,17:1
Knop, Robert (Miscellaneous)
 Ski Country 1984,N 30,C,13:1
Knopfler, Mark (Composer)
 Local Hero 1983,F 17,C,25:1
 Cal 1984,Ag 24,C,6:1
 Cal 1984,S 9,II,25:5
 Comfort and Joy 1984,O 10,C,19:1
Knotts, Don
 Cannonball Run II 1984,Je 29,C,14:5
Knox, Alexander
 Gorky Park 1983,D 16,C,6:5
Knox, Mickey
 Bolero 1984,S 1,9:5
Knudson, Kurt
 Cold Feet 1984,My 25,C,12:1
Kobayashi, Kobi (Cinematographer)
 America and Lewis Hine 1984,S 29,14:4
Kobayashi, Toshiko
 Cruel Story of Youth 1984,Jl 18,C,20:3
Kobritz, Richard (Producer)
 Christine 1983,D 9,C,10:5
Koca, Bogdan
 Shivers 1984,O 4,C,16:1
Koch, C J (Original Author)
 Year of Living Dangerously, The 1983,Ja 21,C,4:1
Koch, C J (Screenwriter)
 Year of Living Dangerously, The 1983,Ja 21,C,4:1
Koch, Edward
 All By Myself 1983,My 6,C,10:2
Koch, Howard W, Jr (Producer)
 Night in Heaven, A 1983,N 19,19:3
 Gorky Park 1983,D 16,C,6:5
Kochonovsky, Zafrir
 Last Winter, The 1984,S 8,10:4
Kociniak, Marian
 Danton 1983,S 28,C,19:1
Koehler, Frederick
 Mr Mom 1983,Ag 26,C,8:4
Koenekamp, Fred (Cinematographer)
 Two of a Kind 1983,D 16,C,12:6
 Adventures of Buckaroo Banzai, The 1984,O 5,C,8:5
Koenig, Walter
 Star Trek III: The Search for Spock 1984,Je 1,C,14:3
Kohlhofer, Christof
 Vortex 1983,F 4,C,5:1
Kohn, John (Producer)
 Racing With the Moon 1984,Mr 23,C,5:1
Kohner, Pancho (Original Author)
 Evil That Men Do, The 1984,S 22,35:3
Kohner, Pancho (Producer)
 10 to Midnight 1983,Mr 13,62:5
Kohut-Svelko, Jean-Pierre
 Confidentially Yours (Vivement Dimanche) 1984,Ja 20,C,6:1
Kok, Marja
 In For Treatment 1983,N 18,C,5:3
Kok, Marja (Director)
 In For Treatment 1983,N 18,C,5:3
Koller, Roald (Director)
 Johnny West 1983,Mr 9,C,17:2
Koller, Roald (Screenwriter)
 Johnny West 1983,Mr 9,C,17:2

M

Marani, Erminia (Miscellaneous)
Nostalghia 1983,O 5,C,23:1
Maranne, Andre
Curse of the Pink Panther 1983,Ag 13,13:1
Razor's Edge, The 1984,O 19,C,14:6
Marcandela, Cecile
Golden Eighties, The 1983,O 2,59:1
Marceau, Sophie
Boum, La 1983,My 13,C,28:1
Marchal, Lynda
High Road to China 1983,Mr 18,C,4:3
Draughtsman's Contract, The 1983,Je 22,C,26:4
Marchand, Guy
Entre Nous (Coup de Foudre) 1983,O 8,35:3
Entre Nous (Coup de Foudre) 1984,Ja 25,C,17:5
Entre Nous (Coup de Foudre) 1984,F 12,II,19:1
Heat of Desire 1984,My 25,C,10:1
Entre Nous (Coup de Foudre) 1984,D 30,II,15:1
Marchand, Nancy
Bostonians, The 1984,Ag 2,C,15:1
Bostonians, The 1984,Ag 5,II,15:1
Bostonians, The 1984,D 30,II,15:1
Marco, Anton
Zelig 1983,Jl 18,B,1:6
Marco, Armand (Cinematographer)
Routes of Exile: A Moroccan Jewish Odyssey 1983,My 6,C,15:3
Marcovicci, Andrea
Spacehunter: Adventures in the Forbidden Zone 1983,My 21,29:1
Marczewska, Teresa
Shivers 1984,O 4,C,16:1
Marczewski, Wojciech (Director)
Shivers 1984,O 4,C,16:1
Marczewski, Wojciech (Screenwriter)
Shivers 1984,O 4,C,16:1
Marden, Richard (Miscellaneous)
Blame It on Rio 1984,F 17,C,10:5
Mareikura, Matiu
Wild Horses 1984,Ap 19,C,15:1
Margittai, Agi
Lost Illusions 1983,O 1,16:3
Margolin, Stuart
Class 1983,Jl 22,C,10:5
Margolis, Mark
Far From Poland 1984,O 3,C,22:5
Margotta, Michael
Can She Bake a Cherry Pie? 1983,D 8,C,22:3
Margulies, David
Ghostbusters 1984,Je 8,C,5:1
Margulies, Michael D (Cinematographer)
Police Academy 1984,Mr 23,C,12:1
Mar-Hayim, Yossi (Composer)
Last Sea, The 1984,Jl 4,C,7:5
Marielle, Jean-Pierre
Coup de Torchon (Clean Slate) 1983,Ja 23,II,17:1
Marignac, Martine (Producer)
Amour par Terre, L' (Love on the Ground) 1984,O 7,86:5
Marin, Cheech
Still Smokin' 1983,My 7,16:3
Yellowbeard 1983,Je 24,C,10:2
Cheech & Chong's The Corsican Brothers 1984,Jl 28,15:5
Marin, Cheech (Screenwriter)
Still Smokin' 1983,My 7,16:3
Cheech & Chong's The Corsican Brothers 1984,Jl 28,15:5
Marin, Jose
Under Fire 1983,O 21,C,13:1
Marin, Rikki
Cheech & Chong's The Corsican Brothers 1984,Jl 28,15:5
Marin, Russ
Body Double 1984,O 26,C,8:1
Marino, Kenny
Alphabet City 1984,My 5,17:1
Exterminator 2 1984,S 15,14:5
Marion, Estelle
Golden Eighties, The 1983,O 2,59:1
Marker, Chris (Cinematographer)
Sans Soleil 1983,O 26,C,24:2
Marker, Chris (Director)
Sans Soleil 1983,O 26,C,24:2
Marker, Chris (Miscellaneous)
Sans Soleil 1983,O 26,C,24:2
Marker, Chris (Screenwriter)
Sans Soleil 1983,O 26,C,24:2
Markham, Ronald
Riddle of the Sands, The 1984,Ja 6,C,8:1
Markle, Peter (Director)
Personals, The 1983,Mr 20,60:1
Hot Dog 1984,Ja 14,10:1

Markle, Peter (Cinematographer)
Personals, The 1983,Mr 20,60:1
Markle, Peter (Screenwriter)
Personals, The 1983,Mr 20,60:1
Markovic, Olivera
Petria's Wreath 1983,F 6,4,49:1
Markowitz, Richard (Composer)
Circle of Power 1984,Mr 2,C,5:1
Marks, Richard (Miscellaneous)
Max Dugan Returns 1983,Mr 25,C,8:5
Terms of Endearment 1983,N 23,C,18:4
Adventures of Buckaroo Banzai, The 1984,O 5,C,8:5
Markstein, George (Original Author)
Final Option, The 1983,S 23,C,8:1
Marley, Bob
Heartland Reggae 1983,O 14,C,4:3
Marley, John
Threshold 1983,Ja 21,C,5:3
Marlowe, Jonas
Children of the Corn 1984,Mr 16,C,7:2
Marlowe, Scott
Circle of Power 1984,Mr 2,C,5:1
Maroney, Kelli
Slayground 1984,Ja 28,14:5
Night of the Comet 1984,N 16,C,8:1
Marquand, Christian
Choice of Arms 1983,Mr 6,65:1
Marquand, Richard (Director)
Return of the Jedi 1983,My 25,C,24:1
Return of the Jedi 1983,My 29,II,15:1
Until September 1984,S 21,C,6:3
Marquez, William
Deal of the Century 1983,N 4,C,13:3
Marquis, Arnold
Kamikaze '89 1983,F 27,48:1
Marrero, Jose Luis
And God Created Them 1983,Mr 19,11:1
Marrgani, Erminia (Miscellaneous)
Nostalghia (Nostalgia) 1984,Ja 8,47:1
Marriner, Neville (Miscellaneous)
Amadeus 1984,S 19,C,23:1
Mars, Kenneth
Yellowbeard 1983,Je 24,C,10:2
Protocol 1984,D 21,C,25:1
Marsala, Michele (Producer)
Yor, the Hunter from the Future 1983,Ag 21,54:3
Marsden, Betty
Dresser, The 1983,D 6,C,19:1
Marsden, Gerry
Compleat Beatles, The 1984,F 10,C,8:1
Marsh, Sandra (Producer)
Finders Keepers 1984,My 18,C,10:1
Marsh, Terence (Producer)
Finders Keepers 1984,My 18,C,10:1
Marsh, Terence (Screenwriter)
Finders Keepers 1984,My 18,C,10:1
Marsh, Tony (Cinematographer)
Heartland Reggae 1983,O 14,C,4:3
Marshall, A David (Miscellaneous)
Fire and Ice 1983,N 24,C,12:1
Marshall, Alan (Producer)
Another Country 1984,Je 29,C,8:1
Birdy 1984,D 21,C,25:1
Marshall, Garry (Director)
Flamingo Kid, The 1984,D 21,C,25:1
Marshall, Garry (Screenwriter)
Flamingo Kid, The 1984,D 21,C,25:1
Marshall, James Vance (Original Author)
Golden Seal, The 1983,Ag 12,C,4:5
Marshall, Julian (Composer)
Old Enough 1984,Ag 24,C,10:4
Marshall, Ken
Krull 1983,Jl 29,C,10:1
Marshall, Neal (Miscellaneous)
Flamingo Kid, The 1984,D 21,C,25:1
Marshall, Neal (Screenwriter)
Flamingo Kid, The 1984,D 21,C,25:1
Marso, Francisco
Ernesto 1983,S 23,C,12:5
Marsuni, Dani
Dawn, The 1983,Mr 23,C,26:4
Marta, Jack A (Cinematographer)
Duel 1983,Ap 15,C,10:1
Martellacci, Eligio
Cammina Cammina (Keep Walking, Keep Walking) 1984,O 4,C,16:5
Martelli, Norma
Night of the Shooting Stars, The 1983,Ja 30,34:3
Martha, Istvan (Composer)
Lost Illusions 1983,O 1,16:3

Martheshmeimer, Peter (Producer)
Berlin Alexanderplatz 1983,Ag 10,C,18:5
Martin, Anne-Marie
Runaway 1984,D 14,C,20:1
Martin, Anthony
Killing of Angel Street, The 1983,Mr 26,20:6
Martin, D'Urville
Big Score, The 1983,N 20,67:3
Martin, David (Miscellaneous)
Ploughman's Lunch, The 1984,O 19,C,8:1
Martin, Dean
Cannonball Run II 1984,Je 29,C,14:5
Cannonball Run II 1984,Jl 29,II,15:1
Martin, Dean Paul
Heart Like a Wheel 1983,O 6,C,30:1
Martin, George
Compleat Beatles, The 1984,F 10,C,8:1
Falling in Love 1984,N 21,C,11:1
Martin, George (Miscellaneous)
Give My Regards to Broad Street 1984,O 26,C,14:5
Martin, Jared
Lonely Lady, The 1983,O 1,13:5
Martin, June
Stuck On You 1984,F 3,C,8:5
Martin, Maribel
Holy Innocents, The 1984,S 30,58:3
Martin, Nan
Doctor Detroit 1983,My 6,C,10:1
All of Me 1984,S 21,C,6:1
Martin, Nieves (Miscellaneous)
Evening Performance (Funcion de Noche) 1983,Mr 27,55:1
Martin, Rosemary
Slayground 1984,Ja 28,14:5
Martin, Sallie
Say Amen, Somebody 1983,Mr 11,C,10:1
Martin, Sarah
Voice Over 1983,Ja 23,47:1
Martin, Steve
Man With Two Brains, The 1983,Je 3,C,8:1
Man With Two Brains, The 1983,Je 19,II,23:1
Golden Seal, The 1983,Ag 12,C,4:5
Lonely Guy, The 1984,Ja 28,11:5
All of Me 1984,S 21,C,6:1
All of Me 1984,O 14,II,21:1
Martin, Steve (Screenwriter)
Man With Two Brains, The 1983,Je 3,C,8:1
Man With Two Brains, The 1983,Je 19,II,23:1
Martin, Susan (Miscellaneous)
Threshold 1983,Ja 21,C,5:3
Martin, Tony
Dear Mr Wonderful 1983,D 21,C,26:4
Martinez, A
Beyond the Limit 1983,S 30,C,4:3
Martinez, Alma
Under Fire 1983,O 21,C,13:1
Martinez, Melicio (Miscellaneous)
Norte, El 1984,Ja 11,C,15:1
Martinez, Pablo (Cinematographer)
Alsino and the Condor 1983,My 1,69:1
Martinez, Paco
Bruto, El 1983,S 21,C,22:3
Marucci, Robert P (Producer)
Razor's Edge, The 1984,O 19,C,14:6
Marvin, Lee
Gorky Park 1983,D 16,C,6:5
Marvin, Mike (Miscellaneous)
Hot Dog 1984,Ja 14,10:1
Marvin, Mike (Screenwriter)
Hot Dog 1984,Ja 14,10:1
Marx, Bill (Composer)
Hilary's Blues 1983,N 23,C,16:1
Marx, Melinda
Hilary's Blues 1983,N 23,C,16:1
Masagwa
Americana 1983,O 21,C,14:5
Mascarino, Pierrino
Missing in Action 1984,N 17,11:1
Mascaro, Marie-Francoise (Producer)
Biquefarre 1984,Ap 5,C,15:1
Masciocchi, Marcello (Cinematographer)
Yor, the Hunter from the Future 1983,Ag 21,54:3
Masio, Karl
Johnny West 1983,Mr 9,C,17:2
Maslansky, Paul (Producer)
Salamander, The 1983,Je 5,53:1
Police Academy 1984,Mr 23,C,12:1
Mason, Dan
Last Starfighter, The 1984,Jl 13,C,5:2
Mason, James
Yellowbeard 1983,Je 24,C,10:2

Morey, Bill
Brainstorm 1983,S 30,C,17:1
Morford, Sam
Street Music 1983,F 25,C,8:1
Morgan, Donald M (Cinematographer)
Christine 1983,D 9,C,10:5
Meatballs Part II 1984,Ag 18,13:2
Starman 1984,D 14,C,18:1
Morgan, Richard
Phar Lap 1984,Ag 10,C,8:1
Mori, Kuroudo (Composer)
Muddy River 1983,Ja 21,C,4:1
Moriani, Alerto (Miscellaneous)
Yor, the Hunter from the Future 1983,Ag 21,54:3
Morier-Genoud, Philippe
Confidentially Yours (Vivement Dimanche) 1984,Ja 20,C,6:1
Morita, Noriyuki (Pat)
Karate Kid, The 1984,Je 22,C,16:3
Karate Kid, The 1984,Ag 12,II,17:1
Morita, Yoshimitsu (Director)
Family Game, The 1984,Ap 1,57:1
Family Game, The 1984,S 14,C,3:1
Family Game, The 1984,D 30,II,15:1
Morita, Yoshimitsu (Screenwriter)
Family Game, The 1984,Ap 1,57:1
Family Game, The 1984,S 14,C,3:1
Moritz, Luisa
Last American Virgin, The 1983,Ja 15,48:2
Morley, Robert
High Road to China 1983,Mr 18,C,4:3
Moro, Javier (Producer)
Valentina 1983,Ag 5,C,15:3
Moro, Javier (Screenwriter)
Valentina 1983,Ag 5,C,15:3
Moroder, Giorgio (Composer)
Flashdance 1983,Ap 15,C,13:1
Flashdance 1983,My 22,II,21:1
Scarface 1983,D 9,C,18:3
Neverending Story, The 1984,Jl 20,C,5:1
Electric Dreams 1984,Jl 20,C,6:5
Metropolis 1984,Ag 19,II,15:1
Morricone, Ennio (Composer)
Treasure of the Four Crowns 1983,Ja 23,47:1
Corrupt 1984,Ja 19,C,16:5
Once Upon a Time in America 1984,Je 1,C,8:1
Morris, Anita
Hotel New Hampshire, The 1984,Mr 9,C,8:1
Morris, Ben (Miscellaneous)
Burroughs 1983,O 8,33:1
Burroughs 1984,F 10,C,12:1
Morris, Brian (Miscellaneous)
Hunger, The 1983,Ap 29,C,32:1
Morris, David Burton (Director)
Purple Haze 1983,N 11,C,8:1
Morris, David Burton (Miscellaneous)
Purple Haze 1983,N 11,C,8:1
Morris, Haviland
Sixteen Candles 1984,My 4,C,14:1
Morris, Howard
Splash 1984,Mr 9,C,15:1
Morris, John (Composer)
Yellowbeard 1983,Je 24,C,10:2
To Be or Not to Be 1983,D 16,C,10:1
Woman in Red, The 1984,Ag 15,C,24:1
Johnny Dangerously 1984,D 21,C,25:5
Morris, Jonathan (Miscellaneous)
Year Zero: The Silent Death of Cambodia 1983,Ap 29,C,17:5
Morris, Judy
Phar Lap 1984,Ag 10,C,8:1
Morris, Megan
Terms of Endearment 1983,N 23,C,18:4
Morris, Phil
Star Trek III: The Search for Spock 1984,Je 1,C,14:3
Morris, Ras Lee
Heartland Reggae 1983,O 14,C,4:3
Morris, Reginald H (Cinematographer)
Porky's II: The Next Day 1983,Je 25,12:3
Christmas Story, A 1983,N 18,C,36:1
Morrison, Jane (Director)
Two Worlds of Angelita, The (Dos Mundos del Angelita, Los) 1983,O 28,C,4:3
Morrison, Jane (Producer)
Two Worlds of Angelita, The (Dos Mundos del Angelita, Los) 1983,O 28,C,4:3
Morrison, Jane (Screenwriter)
Two Worlds of Angelita, The (Dos Mundos del Angelita, Los) 1983,O 28,C,4:3

Morriss, Frank (Miscellaneous)
Duel 1983,Ap 15,C,10:1
Blue Thunder 1983,My 13,C,17:4
Romancing the Stone 1984,Mr 30,C,19:1
Morrow, Cloyce (Miscellaneous)
Joni 1983,Mr 4,C,10:5
Morrow, Vic
Twilight Zone—The Movie (Prologue and Segment 1) 1983,Je 24,C,15:1
Twilight Zone—The Movie (Segment 1) 1983,Je 26,II,1:5
Morse, Susan E (Miscellaneous)
Zelig 1983,Jl 18,B,1:6
Broadway Danny Rose 1984,Ja 27,C,8:1
Morton, Derek (Director)
Wild Horses 1984,Ap 19,C,15:1
Morton, Joe
Brother From Another Planet, The 1984,S 14,C,6:5
Morton, Mickey
Fire and Ice 1983,N 24,C,12:1
Morton, Rob (Screenwriter)
Swing Shift 1984,Ap 13,C,13:1
Morton, Tex
We of the Never Never 1983,F 11,C,12:1
Morton, Will
Fleshburn 1984,My 26,13:1
Mosbiech, Bernd (Cinematographer)
War And Peace 1983,D 3,15:1
Moscati, Italo (Screenwriter)
Beyond Good and Evil 1984,My 18,C,14:1
Moschin, Gastone
Joke of Destiny, A 1984,S 12,C,21:1
Moskvin, Andrei (Cinematographer)
New Babylon, The 1983,O 3,C,15:1
Moss, D'Alan
Street Music 1983,F 25,C,8:1
Moss, Jeff (Composer)
Muppets Take Manhattan, The 1984,Jl 13,C,10:4
Moss, Peter (Cinematographer)
Flashpoint 1984,Ag 31,C,6:5
Mostazo, J (Composer)
Demons in the Garden (Demonios en el Jardin) 1984,Mr 2,C,5:3
Mostel, Josh
Star 80 1983,N 10,C,26:3
Windy City 1984,S 21,C,10:5
Motoki, Shojiro (Producer)
Quiet Duel 1983,N 25,C,10:1
Moulder-Brown, John
Killing Heat 1984,O 5,C,16:1
Moussa, Ibrahim (Producer)
Gabriela 1984,My 11,C,14:1
Mowat, David
Another Time, Another Place 1984,Jl 11,C,26:1
Mowat, Farley (Original Author)
Never Cry Wolf 1983,O 14,C,8:1
Moya, Antoinette
Next Year If All Goes Well 1983,Mr 20,60:1
Mozart, Wolfgang Amadeus (Composer)
Passion 1983,O 4,C,13:2
Amadeus 1984,S 19,C,23:1
Amadeus 1984,S 30,II,1:3
Mrozowska, Zofia
Constant Factor, The (Constans) 1983,Mr 10,C,18:3
Muckensturm, Agnes
Golden Eighties, The 1983,O 2,59:1
Mueller, Robby (Cinematographer)
Class Enemy 1984,Jl 13,C,6:1
Mueller-Stahl, Armin
Love in Germany, A 1984,O 2,C,13:2
Love in Germany, A 1984,N 9,C,10:1
Love in Germany, A 1984,D 30,II,15:1
Mugge, Robert (Director)
Black Wax 1983,Ja 12,C,21:2
Mugge, Robert (Miscellaneous)
Black Wax 1983,Ja 12,C,21:2
Mugge, Robert (Producer)
Black Wax 1983,Ja 12,C,21:2
Muggia, Dan
Hanna K 1983,S 30,C,8:1
Muir, Jamie (Composer)
Ghost Story 1984,O 31,C,20:4
Mulcahy, Terence (Screenwriter)
No Small Affair 1984,N 9,C,16:1
Mulconery, Walt (Miscellaneous)
Flashdance 1983,Ap 15,C,13:1
Karate Kid, The 1984,Je 22,C,16:3
Muldowney, Dominic (Composer)
Betrayal 1983,F 20,78:1
Ploughman's Lunch, The 1984,O 19,C,8:1

Mulkey, Chris
Timerider 1983,Ja 21,C,24:5
Runaway 1984,D 14,C,20:1
Mull, Martin
Mr Mom 1983,Ag 26,C,8:4
Muller, H H
Malou 1983,D 22,C,22:1
Muller, Hero
4th Man, The 1984,Je 27,C,21:4
Muller, Petra
Dernier Combat, Le (Last Battle, The) 1984,Je 22,C,12:1
Muller, Richy
Kamikaze '89 1983,F 27,48:1
Muller, Robby (Cinematographer)
Repo Man 1984,Jl 6,C,8:5
Body Rock 1984,S 28,C,12:5
Paris, Texas 1984,O 14,64:1
Paris, Texas 1984,N 9,C,4:3
Muller-Rastede, Jens
Straight Through the Heart 1984,Ap 1,57:1
Mulligan, Barret
Slayground 1984,Ja 28,14:5
Mulligan, Richard
Teachers 1984,O 5,C,10:1
Micki and Maude 1984,D 21,C,25:4
Mulligan, Robert (Director)
Kiss Me Goodbye 1983,Ja 2,II,1:1
Mumy, Bill
Twilight Zone—The Movie (Segment 3) 1983,Je 24,C,15:1
Hard to Hold 1984,Ap 6,C,16:5
Munoz, Anthony
Right Stuff, The 1983,O 21,C,5:1
Munro, David (Director)
Year Zero: The Silent Death of Cambodia 1983,Ap 29,C,17:5
Munro, David (Producer)
Year Zero: The Silent Death of Cambodia 1983,Ap 29,C,17:5
Munro, Iain
Death and Transfiguration (Terence Davies Trilogy, The) 1984,Ap 8,64:3
Munsen, Judy (Composer)
Street Music 1983,F 25,C,8:1
Murch, Bob
Flash of Green, A 1984,O 5,C,14:3
Muren, Dennis (Miscellaneous)
Return of the Jedi 1983,My 25,C,24:1
Murillo, Christine
Drugstore Romance (Corps a Coeur) 1983,Jl 1,C,8:4
Murillo, Gerry
Testament 1983,N 4,C,8:1
Muro, Marta Fernandez
To Begin Again 1983,Ap 22,C,10:5
Murphy, Eddie
48 Hrs 1983,Ja 2,II,1:1
Trading Places 1983,Je 8,C,16:1
Trading Places 1983,Je 19,II,23:1
Trading Places 1983,D 18,II,21:1
Best Defense 1984,Jl 20,C,10:1
Beverly Hills Cop 1984,D 5,C,25:4
Beverly Hills Cop 1984,D 16,II,21:1
Murphy, Fred (Cinematographer)
State of Things, The 1983,F 18,19:4
Eddie and the Cruisers 1983,S 23,C,8:3
Murphy, Geoff (Director)
Utu 1984,S 13,C,21:2
Murphy, Geoff (Producer)
Utu 1984,S 13,C,21:2
Murphy, Geoff (Screenwriter)
Utu 1984,S 13,C,21:2
Murphy, John
Light Years Away 1983,Ap 15,C,7:1
Murphy, Karen (Producer)
This is Spinal Tap 1984,Mr 2,C,6:1
Murphy, Michael
Year of Living Dangerously, The 1983,Ja 21,C,4:1
Cloak and Dagger 1984,Ag 10,C,16:1
Murphy, Pat
Born in Flames 1983,N 10,C,17:1
Murray, Bill
Ghostbusters 1984,Je 8,C,5:1
Ghostbusters 1984,O 14,II,21:1
Razor's Edge, The 1984,O 19,C,14:6
Murray, Bill (Screenwriter)
Razor's Edge, The 1984,O 19,C,14:6
Murray, Don
I Am the Cheese 1983,N 11,C,12:4
Murray, Michael
Falls, The 1983,My 4,C,17:4
Murray, Patrick
Moon Over the Alley 1983,Ap 27,C,19:4

412

O

O'Bannon, Dan (Screenwriter)
Blue Thunder 1983,My 13,C,17:4
O'Brian, Peter (Producer)
Grey Fox, The 1983,Jl 13,C,17:4
O'Brien, Glenn
Wild Style 1983,Mr 18,C,8:3
Wild Style 1983,N 25,C,10:4
O'Brien, Jane
Below the Belt 1983,Ag 31,C,21:1
O'Brien, Jerry
Light Years Away 1983,Ap 15,C,7:1
O'Brien, Laurie
Timerider 1983,Ja 21,C,24:5
O'Brien, Linda (Composer)
Norte, El 1984,Ja 11,C,15:1
O'Brien, Maria
Table for Five 1983,F 18,C,12:1
O'Brien, Patrick
Personals, The 1983,Mr 20,60:1
O'Brien, Timothy Eric
Suburbia 1984,Ap 13,C,10:1
O'Brien, Tomy
Purple Haze 1983,N 11,C,8:1
O'Byrne, Paddy
Gods Must Be Crazy, The 1984,Jl 9,C,16:1
O'Conner, John (Miscellaneous)
Savage Streets 1984,O 5,C,14:3
O'Connor, Glynnis
Johnny Dangerously 1984,D 21,C,25:5
O'Connor, Pat (Director)
Cal 1984,Ag 24,C,6:1
Cal 1984,S 9,II,25:5
O'Dell, Tony
Karate Kid, The 1984,Je 22,C,16:3
O'Flaherty, Dennis (Screenwriter)
Hammett 1983,Jl 1,C,8:1
O'Hara, Shirley
Duel 1983,Ap 15,C,10:1
O'Herlihy, Dan
Last Starfighter, The 1984,Jl 13,C,5:2
O'Keefe, Michael
Nate and Hayes 1983,N 18,C,30:3
Finders Keepers 1984,My 18,C,10:1
O'Leary, John
Last Starfighter, The 1984,Jl 13,C,5:2
O'Malley, Suzanne (Screenwriter)
Private School 1983,Jl 30,11:4
O'Meara, C Timothy (Miscellaneous)
Last Starfighter, The 1984,Jl 13,C,5:2
O'Neal, Edgar
Say Amen, Somebody 1983,Mr 11,C,10:1
O'Neal, Edward
Say Amen, Somebody 1983,Mr 11,C,10:1
O'Neal, Ron
Red Dawn 1984,Ag 10,C,11:1
Red Dawn 1984,S 16,II,19:1
O'Neal, Ryan
Irreconcilable Differences 1984,S 28,C,10:5
O'Neil, Robert Vincent (Director)
Angel 1984,Ja 13,C,12:5
O'Neil, Robert Vincent (Screenwriter)
Deadly Force 1983,Jl 8,C,4:3
Angel 1984,Ja 13,C,12:5
O'Neill, Eileen
Fire and Ice 1983,N 24,C,12:1
O'Quinn, Terry
Places in the Heart 1984,S 21,C,8:1
Mrs Soffel 1984,D 26,C,15:1
O'Reilly, Cyril
Porky's II: The Next Day 1983,Je 25,12:3
Purple Hearts 1984,My 4,C,15:1
O'Reilly, Salaria Kea
Good Fight, The 1984,Mr 28,C,24:4
O'Rourke, Dennis (Cinematographer)
First Contact 1983,D 7,C,24:5
O'Rourke, P J (Screenwriter)
Easy Money 1983,Ag 19,C,8:5
O'Steen, Sam (Miscellaneous)
Silkwood 1983,D 14,C,27:1
O'Sullivan, Kevin (Screenwriter)
Wild Horses 1984,Ap 19,C,15:1
O'Sullivan, Michael
Not for Publication 1984,N 1,C,17:1

O'Sullivan, Terry
Madonna and Child (Terence Davies Trilogy, The) 1984,Ap 8,64:3
Death and Transfiguration (Terence Davies Trilogy, The) 1984,Ap 8,64:3
O'Toole, Annette
Superman III 1983,Je 17,C,4:5
O'Toole, Peter
Supergirl 1984,N 22,C,15:2
Oates, Warren
Blue Thunder 1983,My 13,C,17:4
Blue Thunder 1983,My 15,II,13:1
Tough Enough 1983,My 27,C,8:1
China 9, Liberty 37 1984,N 30,C,8:4
Obregon, Ana
Treasure of the Four Crowns 1983,Ja 23,47:1
Bolero 1984,S 1,9:5
Occhipinti, Andrea
Bolero 1984,S 1,9:5
Ochs, Jacki (Director)
Secret Agent, The 1983,O 8,33:1
Secret Agent, The 1984,Mr 21,C,14:4
Ochs, Jacki (Miscellaneous)
Secret Agent, The 1984,Mr 21,C,14:4
Ochs, Jacki (Producer)
Secret Agent, The 1984,Mr 21,C,14:4
Ochs, Michael
Christine 1983,D 9,C,10:5
Chords of Fame 1984,F 16,C,23:1
Ochs, Sonny
Chords of Fame 1984,F 16,C,23:1
Oddner, George (Screenwriter)
Flight of the Eagle, The 1983,Ap 8,C,8:1
Odell, David (Miscellaneous)
Nate and Hayes 1983,N 18,C,30:3
Odell, David (Screenwriter)
Nate and Hayes 1983,N 18,C,30:3
Supergirl 1984,N 22,C,15:2
Odent, Christophe
First Name: Carmen 1984,Ag 3,C,6:1
A Nos Amours 1984,O 12,C,10:4
Odenz, Leon (Composer)
Well, The 1984,Mr 18,53:1
Odetta
Chords of Fame 1984,F 16,C,23:1
Odier, Daniel (Original Author)
Light Years Away 1983,Ap 15,C,7:1
Odinokova, Alyona
Flights of Fancy 1983,Je 15,C,20:5
Odorisio, Luciano (Director)
Chopin 1983,Mr 21,C,10:4
Dear Maestro (Chopin) 1984,F 3,C,13:3
Odorisio, Luciano (Screenwriter)
Chopin 1983,Mr 21,C,10:4
Dear Maestro (Chopin) 1984,F 3,C,13:3
Oertel, Gertrud
Parsifal 1983,Ja 23,46:1
Offenbach, Jacques (Composer)
Hotel New Hampshire, The 1984,Mr 9,C,8:1
Ogata, Ken
Ballad of Narayama, The 1984,Ap 9,C,14:5
Ballad of Narayama, The 1984,S 7,C,6:1
Ogawa, Nobuo (Miscellaneous)
Muddy River 1983,Ja 21,C,4:1
Oger, Frank
Three Crowns of the Sailor 1984,O 5,C,14:3
Ogier, Pascale
Full Moon in Paris (Nuits de la Pleine Lune, Les) 1984,S 7,C,5:1
Full Moon in Paris (Nuits de la Pleine Lune, Les) 1984,O 14,II,21:1
Ghost Story 1984,O 31,C,20:4
Ogier, Quentin
Sunday in the Country, A 1984,O 2,C,14:3
Sunday in the Country, A 1984,N 16,C,11:1
Oginome, Keiko
Antarctica 1984,Mr 30,C,10:5
Oguri, Kohei (Director)
Muddy River 1983,Ja 21,C,4:1
Ohana, Claudia
Erendira 1983,O 1,16:3
Erendira 1984,Ap 27,C,8:5
Ojeda, Manuel
Eagle's Wing 1983,O 9,72:1
Romancing the Stone 1984,Mr 30,C,19:1
Okada, Yu (Producer)
Family Game, The 1984,Ap 1,57:1
Family Game, The 1984,S 14,C,3:1
Okay, Yaman
Horse, The 1984,Ja 4,C,14:3

Okking, Jens
Zappa 1984,Ap 3,C,15:1
Zappa 1984,My 16,C,24:3
Okten, Guler
Horse, The 1984,Ja 4,C,14:3
Okumura, Koen
Farewell to the Land, A (Saraba Itoshiki Daichi) 1983,Mr 20,60:3
Okun, Charles (Producer)
Lovesick 1983,F 18,C,19:1
Okura, Johny
Merry Christmas Mr Lawrence 1983,Ag 26,C,10:1
Olbrychski, Daniel
Trout, The (Truite, La) 1983,My 27,C,10:3
Truite, La (Trout, The) 1983,Je 5,II,19:3
Knight, The 1983,D 9,C,30:5
Love in Germany, A 1984,O 2,C,13:2
Love in Germany, A 1984,N 9,C,10:1
Love in Germany, A 1984,D 30,II,15:1
Oldfield, Mike (Composer)
Killing Fields, The 1984,N 2,C,10:1
Olek, Henry (Miscellaneous)
All of Me 1984,S 21,C,6:1
Olin, Lena
After the Rehearsal 1984,Je 21,C,14:1
After the Rehearsal 1984,Jl 1,II,13:1
Oliver, Barret
Neverending Story, The 1984,Jl 20,C,5:1
Oliver, Jonathan
Return of the Jedi 1983,My 25,C,24:1
Oliver, Tristan
Another Country 1984,Je 29,C,8:1
Olivier, Laurence
Bounty, The 1984,My 4,C,8:1
Jigsaw Man, The 1984,Ag 24,C,4:5
Olkewicz, Walter
Circle of Power 1984,Mr 2,C,5:1
Making the Grade 1984,My 18,C,10:5
Olmi, Ermanno (Cinematographer)
Cammina Cammina (Keep Walking, Keep Walking) 1984,O 4,C,16:5
Olmi, Ermanno (Director)
Cammina Cammina (Keep Walking, Keep Walking) 1984,O 4,C,16:5
Olmi, Ermanno (Miscellaneous)
Cammina Cammina (Keep Walking, Keep Walking) 1984,O 4,C,16:5
Olmi, Ermanno (Screenwriter)
Cammina Cammina (Keep Walking, Keep Walking) 1984,O 4,C,16:5
Olmos, Edward James
Ballad of Gregorio Cortez, The 1983,O 14,C,6:5
Olmos, Edward James (Composer)
Ballad of Gregorio Cortez, The 1983,O 14,C,6:5
Olmos, Mico
Testament 1983,N 4,C,8:1
Olonovsky, Nikolai (Cinematographer)
Private Life 1983,F 27,45:1
Olsen, Dana
Making the Grade 1984,My 18,C,10:5
Olsen, Dana (Screenwriter)
Going Berserk 1983,O 29,19:1
Olszewski, Reinhold K
White Rose, The 1983,My 6,C,13:1
Ondricek, Miroslav (Cinematographer)
Divine Emma, The 1983,Je 5,54:1
Silkwood 1983,D 14,C,27:1
Amadeus 1984,S 19,C,23:1
Oneto, Ricardo
Traviata, La 1983,Ap 22,C,13:1
Onofre, Waldyr
Memoirs of Prison 1984,O 10,C,18:3
Ontiveros, Lupe
Norte, El 1984,Ja 11,C,15:1
Ontkean, Michael
Just the Way You Are 1984,N 16,C,14:1
Opatoshu, Danny (Screenwriter)
Get Crazy 1983,O 14,C,11:1
Ophuls, Max (Director)
Liebelei 1983,My 31,C,10:5
Signora di Tutti, La 1984,S 25,59:1
Ophuls, Max (Screenwriter)
Signora di Tutti, La 1983,S 25,59:1
Oppenheimer, Alan
Neverending Story, The 1984,Jl 20,C,5:1
Opper, Don
Android 1984,F 10,C,28:1
Opper, Don (Screenwriter)
Android 1984,F 10,C,28:1
Oppiah, Amy
Kukurantumi: The Road to Accra 1984,Ap 1,51:1

Partridge, Sarah
 Risky Business 1983,Ag 5,C,13:1
Pascal, Christine
 Entre Nous (Coup de Foudre) 1983,O 8,35:3
 Entre Nous (Coup de Foudre) 1984,Ja 25,C,17:5
Pascal, Giselle
 Comperes, Les 1984,Mr 28,C,24:6
Pascale, Philippine
 Swann in Love 1984,S 14,C,4:1
Paskaljevic, Goran (Director)
 Twilight Time 1983,F 13,57:4
Paskaljevic, Goran (Screenwriter)
 Twilight Time 1983,F 13,57:4
Paso, Encarna
 To Begin Again 1983,Ap 22,C,10:5
 Demons in the Garden (Demonios en el Jardin) 1984,Mr
 2,C,5:3
Pasolini, Pier Paolo
 My Name is Anna Magnani 1984,Ag 10,C,12:4
 Oedipus Rex 1984,D 7,C,8:5
Pasolini, Pier Paolo (Director)
 Oedipus Rex 1984,D 7,C,8:5
Pasolini, Pier Paolo (Screenwriter)
 Oedipus Rex 1984,D 7,C,8:5
Patchett, Tom (Miscellaneous)
 Muppets Take Manhattan, The 1984,Jl 13,C,10:4
Patchett, Tom (Screenwriter)
 Muppets Take Manhattan, The 1984,Jl 13,C,10:4
Paterson, A B (Original Author)
 Man from Snowy River, The 1983,Ja 21,C,5:6
Paterson, Bill
 Comfort and Joy 1984,O 10,C,19:1
 Ploughman's Lunch, The 1984,O 19,C,8:1
 Killing Fields, The 1984,N 2,C,10:1
Paterson, Tony (Miscellaneous)
 Phar Lap 1984,Ag 10,C,8:1
Patey, Christian
 Argent, L' (Money) 1983,S 24,11:1
 Argent, L' (Money) 1984,Mr 23,C,10:3
Patinkin, Mandy
 SPFX 1983,Mr 27,55:1
 Daniel 1983,Ag 26,C,10:4
 Daniel 1983,S 4,II,11:1
 Yentl 1983,N 18,C,10:1
Patrick, Vincent (Original Author)
 Pope of Greenwich Village, The 1984,Je 22,C,12:4
Patrick, Vincent (Screenwriter)
 Pope of Greenwich Village, The 1984,Je 22,C,12:4
Patterson, Jay
 Places in the Heart 1984,S 21,C,8:1
Patterson, Kenneth A (Cinematographer)
 Richard Pryor Here and Now 1983,O 28,C,8:1
Patterson, Neva
 All of Me 1984,S 21,C,6:1
Patterson, Raymond
 First Time, The 1983,Jl 13,C,16:3
 First Time, The 1983,Jl 31,II,15:1
Paul, Alexandra
 Christine 1983,D 9,C,10:5
 Just the Way You Are 1984,N 16,C,14:1
Paul, Parveen
 Heat and Dust 1983,S 15,C,18:3
Paul, Richard
 Not for Publication 1984,N 1,C,17:1
Paul, Sandy
 Puberty Blues 1983,Jl 15,C,13:1
Paulin, Scott
 Right Stuff, The 1983,O 21,C,5:1
Pauly, Rebecca
 State of Things, The 1983,F 18,19:4
Pavez, Terele
 Holy Innocents, The 1984,S 30,58:3
Pavicevic, Bozidar
 Twilight Time 1983,F 13,57:4
Pavlis, Johanna
 Until September 1984,S 21,C,6:3
Pavlova, Tatiana
 Signora di Tutti, La 1983,S 25,59:1
Paxton, Bill
 Streets of Fire 1984,Je 1,C,8:5
 Impulse 1984,S 30,58:5
Paxton, Tom
 Chords of Fame 1984,F 16,C,23:1
Paxton, Wild Bill
 Lords of Discipline, The 1983,F 18,C,16:4
Paycheck, Johnny
 Hells Angels Forever 1983,O 9,69:3
Payne, Bruce
 Privates on Parade 1984,Ap 13,C,8:1
Payne, David (Producer)
 Draughtsman's Contract, The 1983,Je 22,C,26:4
 And Nothing But the Truth 1984,Ap 20,C,15:1

Paynter, Robert (Cinematographer)
 Trading Places 1983,Je 8,C,16:1
 Superman III 1983,Je 17,C,4:5
 Muppets Take Manhattan, The 1984,Jl 13,C,10:4
Pays, Amanda
 Oxford Blues 1984,Ag 25,9:1
Pean, Stephane
 Return of Martin Guerre, The 1983,Je 10,C,12:5
Pearce, David
 Voice Over 1983,Ja 23,47:1
Pearce, John
 Fleshburn 1984,My 26,13:1
Pearce, Richard (Director)
 Threshold 1983,Ja 21,C,5:3
 Country 1984,S 28,20:1
Pearson, Patrick
 Privates on Parade 1984,Ap 13,C,8:1
Pearson, Rodney
 Class 1983,Jl 22,C,10:5
Pearthree, Pippa
 Mrs Soffel 1984,D 26,C,15:1
Pec, Steven Apostle
 Rhinestone 1984,Je 22,C,10:5
Pecchi, Bill (Cinematographer)
 Fleshburn 1984,My 26,13:1
Peccianti, Lucia
 Cammina Cammina (Keep Walking, Keep Walking) 1984,O
 4,C,16:5
Pece, Andrew
 Suburbia 1984,Ap 13,C,10:1
Pecheur, Sierra
 Below the Belt 1983,Ag 31,C,21:1
Peckinpah, Sam
 China 9, Liberty 37 1984,N 30,C,8:4
Peckinpah, Sam (Director)
 Osterman Weekend, The 1983,N 4,C,11:1
 Osterman Weekend, The 1983,D 11,II,23:1
Pedersen, Joergen Flint (Director)
 Your Neighbor's Son: The Making of a Torturer 1984,Ag
 29,C,19:2
Pederson, Chris
 Suburbia 1984,Ap 13,C,10:1
Peel, Edward
 Lassiter 1984,F 17,C,10:5
Peerce, Larry (Director)
 Hard to Hold 1984,Ap 6,C,16:5
Peers, Lisa
 Monkey Grip 1983,N 7,C,16:5
Peilicori, Ingrid
 Time for Revenge 1983,Ja 14,C,8:1
Peled, Zipora
 Last Winter, The 1984,S 8,10:4
Pelikan, Lisa
 Swing Shift 1984,Ap 13,C,13:1
Pellegrin, Pascale
 Confidentially Yours (Vivement Dimanche) 1984,Ja 20,C,6:1
Pelligrini, Diana (Miscellaneous)
 Street Music 1983,F 25,C,8:1
Peltier, Kenout (Miscellaneous)
 Erendira 1983,O 1,16:3
 Erendira 1984,Ap 27,C,8:5
 Petite Sirene, La 1984,Ag 3,C,15:1
Pena, Julio (Miscellaneous)
 Escape From Segovia 1984,Je 6,C,21:1
Penchenat, Jean-Claude
 Bal, Le 1984,Mr 23,C,6:1
Penchenat, Jean-Claude (Miscellaneous)
 Bal, Le 1984,Mr 23,C,6:1
Penchenat, Jean-Claude (Screenwriter)
 Bal, Le 1984,Mr 23,C,6:1
Pendergrass, Teddy
 Choose Me 1984,N 1,C,18:4
Pendlebury, Keith
 Falls, The 1983,My 4,C,17:4
Penn, Christopher
 Rumble Fish 1983,O 7,C,10:3
 All the Right Moves 1983,O 21,C,10:3
 Footloose 1984,F 17,C,12:3
 Wild Life, The 1984,S 28,C,8:4
Penn, Sean
 Bad Boys 1983,Mr 25,C,8:1
 Bad Boys 1983,Ap 10,II,17:1
 Crackers 1984,F 17,C,19:3
 Racing With the Moon 1984,Mr 23,C,5:1
Pennebaker, D A
 Before the Nickelodeon 1983,F 28,C,24:5
Pennebaker, D A (Cinematographer)
 Ziggy Stardust and the Spiders From Mars 1983,D 24,17:5
Pennebaker, D A (Director)
 Rockaby 1983,N 23,C,16:3

Pennebaker, D A (Miscellaneous)
 Ziggy Stardust and the Spiders From Mars 1983,D 24,17:5
Pennell, Eagle
 Last Night at the Alamo 1983,O 2,II,60:3
 Last Night at the Alamo 1984,Jl 3,C,10:5
Pennell, Eagle (Cinematographer)
 Whole Shootin' Match, The 1984,Ag 8,C,16:6
Pennell, Eagle (Composer)
 Whole Shootin' Match, The 1984,Ag 8,C,16:6
Pennell, Eagle (Director)
 Last Night at the Alamo 1983,O 2,II,60:3
 Last Night at the Alamo 1984,Jl 3,C,10:5
 Last Night at the Alamo 1984,Jl 15,II,15:1
 Whole Shootin' Match, The 1984,Ag 8,C,16:6
Pennell, Eagle (Producer)
 Last Night at the Alamo 1983,O 2,II,60:3
 Last Night at the Alamo 1984,Jl 3,C,10:5
 Whole Shootin' Match, The 1984,Ag 8,C,16:6
Pennell, Eagle (Screenwriter)
 Whole Shootin' Match, The 1984,Ag 8,C,16:6
Pennell, Larry
 Metalstorm: The Destruction of Jared-Syn 1983,Ag 21,56:4
Pennick, Tom (Miscellaneous)
 My Brother's Wedding 1984,Mr 30,C,7:1
Pennington, Michael
 Return of the Jedi 1983,My 25,C,24:1
Penta, Virginia
 Stuck On You 1984,F 3,C,8:5
Penzer, Jean (Cinematographer)
 My Best Friend's Girl 1984,Mr 25,56:1
Pepper, Martin
 Cheech & Chong's The Corsican Brothers 1984,Jl 28,15:5
Peraboni, Fabio
 Sweet Pea (Piso Pisello) 1983,Ja 23,47:1
Pereira, Hal (Miscellaneous)
 Rear Window 1983,O 9,II,21:1
Pereira, Tonico
 Memoirs of Prison 1984,O 10,C,18:3
Pereira dos Santos, Nelson (Director)
 Memoirs of Prison 1984,O 10,C,18:3
Pereira dos Santos, Nelson (Screenwriter)
 Memoirs of Prison 1984,O 10,C,18:3
Peretz, Susan
 Swing Shift 1984,Ap 13,C,13:1
Perez, Marta Lorena
 Alsino and the Condor 1983,My 1,69:1
Perez Garay, Idalia
 Two Worlds of Angelita, The (Dos Mundos del Angelita, Los)
 1983,O 28,C,4:3
Perez Riera, Marien
 Two Worlds of Angelita, The (Dos Mundos del Angelita, Los)
 1983,O 28,C,4:3
Perez-Porro, Beatriz
 Skyline (Linea del Cielo, La) 1984,Ap 3,C,15:1
 Skyline (Linea del Cielo, La) 1984,Jl 18,C,20:3
Pergament, Andre (Producer)
 Enigma 1983,Ja 28,C,8:1
Pergola, James (Cinematographer)
 Smokey and the Bandit, Part 3 1983,S 17,30:4
Pergolesi, Giovanni Battista (Composer)
 Mirror, The 1983,Ag 17,C,16:3
Perier, Etienne (Director)
 Investigation (Si Joli Village, Un) 1984,F 3,C,11:1
Perier, Etienne (Miscellaneous)
 Investigation (Si Joli Village, Un) 1984,F 3,C,11:1
Periginelli, Uta (Miscellaneous)
 Germany Pale Mother 1984,Mr 18,52:1
Perilstein, Michael (Composer)
 Deadly Spawn, The 1983,Ap 22,C,11:1
Perjanik, Mike (Composer)
 Norman Loves Rose 1983,Je 3,C,20:5
Perkins, Anthony
 Psycho II 1983,Je 3,C,14:5
 Crimes of Passion 1984,O 19,C,19:1
Perkins, Eric Boyd (Miscellaneous)
 Secrets 1984,Ag 17,C,13:3
Perkins, John
 Far From Poland 1984,O 3,C,22:5
Perkins, Millie
 Table for Five 1983,F 18,C,12:1
Perle, Helen
 Well, The 1984,Mr 18,53:1
Perlman, Ron
 Ice Pirates, The 1984,Mr 16,C,8:5
Perlow, Bob
 Night of the Comet 1984,N 16,C,8:1
Perman, Don (Screenwriter)
 Stuck On You 1984,F 3,C,8:5
Perpignani, Roberto (Miscellaneous)
 Night of the Shooting Stars, The 1983,Ja 30,34:3

Perrault, Gilles (Miscellaneous)
Petite Bande, La 1984,N 9,C,28:5
Perrault, Gilles (Screenwriter)
Petite Bande, La 1984,N 9,C,28:5
Perret, Edith
Until September 1984,S 21,C,6:3
Perrier, Jean-Francois
Bal, Le 1984,Mr 23,C,6:1
Perrin, Francis
Jupiter's Thigh 1984,Ja 20,C,6:5
Perrin, Jacques
Crabe Tambour, Le (Drummer Crab) 1984,F 17,C,17:1
Crabe Tambour, Le (Drummer Crab) 1984,F 19,II,15:1
Perrone, Marc
Sunday in the Country, A 1984,O 2,C,14:3
Sunday in the Country, A 1984,N 16,C,11:1
Perrot, Francois
My Best Friend's Girl 1984,Mr 25,56:1
Vieux Pays ou Rimbaud Est Mort, Le (Old Country Where
Rimbaud Died, The) 1984,N 9,C,12:5
Perry, Lou
Last Night at the Alamo 1983,O 2,II,60:3
Last Night at the Alamo 1984,Jl 3,C,10:5
Whole Shootin' Match, The 1984,Ag 8,C,16:6
Perry, Simon (Producer)
Another Time, Another Place 1984,Jl 11,C,26:1
Perry, Terra
Tough Enough 1983,My 27,C,8:1
Perryman, Louis
Last Night at the Alamo 1984,Jl 15,II,15:1
Persoff, Nehemiah
Yentl 1983,N 18,C,10:1
Personne, Fred
Next Year If All Goes Well 1983,Mr 20,60:1
Heads or Tails (Pile ou Face) 1983,My 27,C,4:5
Crabe Tambour, Le (Drummer Crab) 1984,F 17,C,17:1
Pery, Sandrine (Miscellaneous)
Edith and Marcel 1984,Je 3,60:4
Pesce, Frank
Big Score, The 1983,N 20,67:3
Pesci, Joe
Easy Money 1983,Ag 19,C,8:5
Dear Mr Wonderful 1983,D 21,C,26:4
Once Upon a Time in America 1984,Je 1,C,8:1
Once Upon a Time in America 1984,O 21,II,23:1
Pesci, Joe (Composer)
Dear Mr Wonderful 1983,D 21,C,26:4
Petenyi, Katalin (Miscellaneous)
Revolt of Job, The 1984,Mr 28,C,19:3
Petenyi, Katalin (Screenwriter)
Revolt of Job, The 1984,Mr 28,C,19:3
Peter, Paul & Mary
In Our Hands 1984,F 16,C,23:1
Peterman, Don (Cinematographer)
Flashdance 1983,Ap 15,C,13:1
Splash 1984,Mr 9,C,15:1
Best Defense 1984,Jl 20,C,10:1
Mass Appeal 1984,D 17,C,12:1
Peters, Charlie (Screenwriter)
Blame It on Rio 1984,F 17,C,10:5
Petersen, Wolfgang (Director)
Neverending Story, The 1984,Jl 20,C,5:1
Petersen, Wolfgang (Screenwriter)
Neverending Story, The 1984,Jl 20,C,5:1
Peterson, Cassandra
Stroker Ace 1983,Jl 1,C,8:5
Peterson, David
Grey Fox, The 1983,Jl 13,C,17:4
Peterson, Vidal
Something Wicked This Way Comes 1983,Ap 29,C,8:5
Petrella, Ian
Christmas Story, A 1983,N 18,C,36:1
Petrie, Daniel (Miscellaneous)
Beverly Hills Cop 1984,D 5,C,25:4
Petrie, Daniel (Screenwriter)
Beverly Hills Cop 1984,D 5,C,25:4
Petrocelli, Antonio
Eyes, the Mouth, The 1983,D 14,C,24:1
Petrycki, Jacek (Cinematographer)
Camera Buff (Amator) 1983,F 24,C,17:1
Provincial Actors 1983,Mr 2,C,20:5
Pettersen, Kjell
Betrayal: The Story of Kamilla (Kamilla) 1983,Mr 20,60:1
Kamilla (Betrayal: The Story of Kamilla) 1984,Ja 13,C,8:1
Pettifer, Brian
Amadeus 1984,S 19,C,23:1
Pettigrew, Jacques (Producer)
Just a Game 1984,Ap 8,64:3
Pettit, Suzanne (Miscellaneous)
Timerider 1983,Ja 21,C,24:5
Testament 1983,N 4,C,8:1

Pevzner, Paula (Producer)
Well, The 1984,Mr 18,53:1
Peyrot, Yves (Producer)
Girl from Lorraine, The 1983,Ja 27,C,13:1
Peyser, Michael
Before the Nickelodeon 1983,F 28,C,24:5
Pfeffer, Andrew D T (Producer)
Tough Enough 1983,My 27,C,8:1
Pfeifer, Sarah
Red Love 1983,O 4,C,13:2
Pfeiffer, Carolyn (Producer)
Return Engagement 1983,N 23,C,10:5
Choose Me 1984,N 1,C,18:4
Pfeiffer, Michelle
Scarface 1983,D 9,C,18:3
Pfitzner, Hans (Composer)
One Man's War (Guerre d'un Seul Homme, La) 1984,F
24,C,9:1
Phalen, Robert
Starman 1984,D 14,C,18:1
Phelps, Robert
Nightmares 1983,S 3,14:5
Pheneger, George
Last Night at the Alamo 1983,O 2,II,60:3
Last Night at the Alamo 1984,Jl 3,C,10:5
Last Night at the Alamo 1984,Jl 15,II,15:1
Philbin, John
Children of the Corn 1984,Mr 16,C,7:2
Philips, Arlene (Miscellaneous)
Monty Python's the Meaning of Life 1983,Mr 31,C,13:5
Phillips, Art (Composer)
Possession 1983,O 28,C,10:1
Phillips, Bill (Screenwriter)
Christine 1983,D 9,C,10:5
Phillips, Lloyd (Producer)
Nate and Hayes 1983,N 18,C,30:3
Phillips, Michael (Producer)
Flamingo Kid, The 1984,D 21,C,25:1
Phillips, Miriam
Street Music 1983,F 25,C,8:1
Phillips, Shawn (Composer)
Abuse 1983,Ap 15,C,29:1
Phillips, Sian
Dune 1984,D 14,C,18:4
Philpott, Toby
Return of the Jedi 1983,My 25,C,24:1
Phipps, Max
Nate and Hayes 1983,N 18,C,30:3
Pia, Albert
Stuck On You 1984,F 3,C,8:5
First Turn-On!, The 1984,O 12,C,8:5
Pia, Betty
First Turn-On!, The 1984,O 12,C,8:5
Pialat, Maurice
A Nos Amours 1984,O 12,C,10:4
Pialat, Maurice (Director)
A Nos Amours 1984,O 12,C,10:4
Pialat, Maurice (Screenwriter)
A Nos Amours 1984,O 12,C,10:4
Piave, Francesco Maria (Miscellaneous)
Traviata, La 1983,Ap 22,C,13:1
Picasso, Paul
Under Fire 1983,O 21,C,13:1
Picavet, Jean-Louis (Cinematographer)
Enigma 1983,Ja 28,C,8:1
Picchiarini, Anita
Bal, Le 1984,Mr 23,C,6:1
Piccoli, Michel
Nuit de Varennes, La 1983,F 16,C,23:1
Nuit de Varennes, La 1983,F 27,II,1:1
Passante, La 1983,Ag 14,47:1
Passion 1983,O 4,C,13:2
Eyes, the Mouth, The 1983,D 14,C,24:1
Pick, Francois
Bal, Le 1984,Mr 23,C,6:1
Picker, David V (Producer)
Man With Two Brains, The 1983,Je 3,C,8:1
Beat Street 1984,Je 8,C,10:5
Pickett, Cindy
Circle of Power 1984,Mr 2,C,5:1
Pickles, Carolyn
Champions 1984,Ap 20,C,8:1
Pickles, Vivian
Britannia Hospital 1983,Mr 4,C,10:1
Britannia Hospital 1983,Mr 6,II,17:1
Britannia Hospital 1983,D 18,II,21:1
Picon, Molly
Cannonball Run II 1984,Je 29,C,14:5
Piedra, Emiliano (Producer)
Carmen 1983,O 20,C,21:3

Pienaar, Trix
Guest, The 1984,Je 6,C,19:1
Pierce, Charles B (Miscellaneous)
Sudden Impact 1983,D 9,C,12:4
Pierce-Roberts, Tony (Cinematographer)
Kipperbang 1984,Ap 20,C,11:3
Piercey, Jennifer
Another Time, Another Place 1984,Jl 11,C,26:1
Pierpaoli, Oliver
Killing Fields, The 1984,N 2,C,10:1
Pierpoint, Eric
Windy City 1984,S 21,C,10:5
Pierre, Olivier
Lonely Lady, The 1983,O 1,13:5
Pietraszak, Leonard
Danton 1983,S 28,C,19:1
Pietruski, Ryszard
Aria for an Athlete 1983,Mr 16,C,21:4
Pike, Kelvin (Cinematographer)
Dresser, The 1983,D 6,C,19:1
Pilger, John (Narrator)
Year Zero: The Silent Death of Cambodia 1983,Ap 29,C,17:5
Pilkington, Joe
Light Years Away 1983,Ap 15,C,7:1
Pilla, Paulo
Gabriela 1984,My 11,C,14:1
Pinches, Gerry (Cinematographer)
Year Zero: The Silent Death of Cambodia 1983,Ap 29,C,17:5
Pinchot, Bronson
Risky Business 1983,Ag 5,C,13:1
Beverly Hills Cop 1984,D 5,C,25:4
Flamingo Kid, The 1984,D 21,C,25:1
Pinero, Miguel
Breathless 1983,My 13,C,10:1
Pines, Mark (Miscellaneous)
In the King of Prussia 1983,F 13,57:1
Pinheiro, David
Memoirs of Prison 1984,O 10,C,18:3
Pinkins, Tonya
Beat Street 1984,Je 8,C,10:5
Pinnell, Chuck (Composer)
Last Night at the Alamo 1983,O 2,II,60:3
Last Night at the Alamo 1984,Jl 3,C,10:5
Pinnell, Peggy
Last Night at the Alamo 1983,O 2,II,60:3
Last Night at the Alamo 1984,Jl 3,C,10:5
Pinon, Dominique
Return of Martin Guerre, The 1983,Je 10,C,12:5
Moon in the Gutter, The 1983,S 9,C,8:1
Ghost Story 1984,O 31,C,20:4
Pinori, Giuseppe (Cinematographer)
Corrupt 1984,Ja 19,C,16:5
Pinoteau, Claude (Director)
Boum, La 1983,My 13,C,28:1
Pinoteau, Claude (Screenwriter)
Boum, La 1983,My 13,C,28:1
Pintauro, Danny
Cujo 1983,Ag 13,13:1
Pinter, Harold (Original Author)
Betrayal 1983,F 20,78:1
Betrayal 1983,Mr 6,II,17:1
Betrayal 1983,D 25,II,15:1
Pinter, Harold (Screenwriter)
Betrayal 1983,F 20,78:1
Betrayal 1983,Mr 6,II,17:1
Betrayal 1983,D 25,II,15:1
Pinter, Tomislav (Cinematographer)
Petria's Wreath 1983,F 6,4,49:1
Twilight Time 1983,F 13,57:4
Piovanelli, Antonio
Eyes, the Mouth, The 1983,D 14,C,24:1
Piovani, Nicola (Composer)
Girl with the Red Hair, The 1983,Ja 14,C,12:5
Night of the Shooting Stars, The 1983,Ja 30,34:3
Eyes, the Mouth, The 1983,D 14,C,24:1
Piperno, Marina (Producer)
Truuuuth, The (Veritaaaa, La) 1983,Mr 27,55:5
Pires, Gloria
Memoirs of Prison 1984,O 10,C,18:3
Piscopo, Joe
Johnny Dangerously 1984,D 21,C,25:5
Pitchford, Dean (Miscellaneous)
Footloose 1984,F 17,C,12:3
Pitchford, Dean (Screenwriter)
Footloose 1984,F 17,C,12:3
Pitoniak, Anne
Survivors, The 1983,Je 22,C,20:6
Pitt, Ingrid
Final Option, The 1983,S 23,C,8:1
Pizer, Larry (Cinematographer)
Timerider 1983,Ja 21,C,24:5

Prince (Composer)
Purple Rain 1984,Jl 27,C,5:1
Prince, Nicola
Kipperbang 1984,Ap 20,C,11:3
Prince, Richard
Vortex 1983,F 4,C,5:1
Prins, Kees
Still Smokin' 1983,My 7,16:3
Prinsloo, Sandra
Gods Must Be Crazy, The 1984,Jl 9,C,16:1
Priwiezienrew, F
Ways in the Night 1983,Jl 27,C,17:1
Prochazka, Borik
Snowdrop Festival 1984,N 14,C,29:4
Prochnow, Jurgen
War And Peace 1983,D 3,15:1
Dune 1984,D 14,C,18:4
Prodromides, Jean (Composer)
Danton 1983,S 28,C,19:1
Proft, Pat (Miscellaneous)
Police Academy 1984,Mr 23,C,12:1
Proft, Pat (Screenwriter)
Police Academy 1984,Mr 23,C,12:1
Bachelor Party 1984,Je 30,11:1
Prokofyeva, Sofia (Screenwriter)
Without Witness (Private Conversation, A) 1984,O 12,C,12:5
Proser, Chip (Screenwriter)
Iceman 1984,Ap 13,C,10:1
Prosky, Robert
Lords of Discipline, The 1983,F 18,C,16:4
Lords of Discipline, The 1983,Ap 10,II,17:1
Christine 1983,D 9,C,10:5
Natural, The 1984,My 11,C,15:1
Protat, Francois (Cinematographer)
Dirty Dishes (Jument Vapeur, La) 1983,Mr 25,C,12:5
Proust, Marcel (Original Author)
Swann in Love 1984,S 14,C,4:1
Prowse, David
Return of the Jedi 1983,My 25,C,24:1
Pruckner, Tilo
Neverending Story, The 1984,Jl 20,C,5:1
Prugar-Ketling, Halina (Miscellaneous)
Danton 1983,S 28,C,19:1
Love in Germany, A 1984,O 2,C,13:2
Love in Germany, A 1984,N 9,C,10:1
Pryce, Jonathan
Something Wicked This Way Comes 1983,Ap 29,C,8:5
Ploughman's Lunch, The 1984,O 19,C,8:1
Pryor, Nicholas
Risky Business 1983,Ag 5,C,13:1
Pryor, Richard
Superman III 1983,Je 17,C,4:5
Superman III 1983,Je 26,II,1:5
Superman III 1983,Jl 24,II,15:1
Pryor, Richard (Director)
Richard Pryor Here and Now 1983,O 28,C,8:1
Pryor, Richard (Screenwriter)
Richard Pryor Here and Now 1983,O 28,C,8:1
Przybyski, Jerzy
Sandglass, The 1983,My 6,C,16:1
Przybyszewska, Stanislawa (Original Author)
Danton 1983,S 28,C,19:1
Przygodda, Peter (Miscellaneous)
Paris, Texas 1984,O 14,64:1
Paris, Texas 1984,N 9,C,4:3
Psenny, Armand (Miscellaneous)
Death Watch 1984,S 14,C,6:5
Sunday in the Country, A 1984,O 2,C,14:3
Sunday in the Country, A 1984,N 16,C,11:1
Pszoniak, Wojciech
Aria for an Athlete 1983,Mr 16,C,21:4
Danton 1983,S 28,C,19:1
Danton 1983,D 25,II,15:1
Puanaki, Dick
Utu 1984,S 13,C,21:2
Pudovkin, Vsevolod
New Babylon, The 1983,O 3,C,15:1
Purcell, Henry (Composer)
Mirror, The 1983,Ag 17,C,16:3
A Nos Amours 1984,O 12,C,10:4
Purcell, Lee
Valley Girl 1983,Ap 29,C,10:1
Puri, Amrish
Indiana Jones and the Temple of Doom 1984,My 23,C,21:1
Purviance, Edna
Unknown Chaplin 1983,My 19,C,19:1
Purvis, Jack
Return of the Jedi 1983,My 25,C,24:1
Putch, John
Jaws 3-D 1983,Jl 23,11:1

Puttnam, David (Producer)
Local Hero 1983,F 17,C,25:1
Experience Preferred...But Not Essential 1983,N 20,17:1
Kipperbang 1984,Ap 20,C,11:3
Cal 1984,Ag 24,C,6:1
Killing Fields, The 1984,N 2,C,10:1
Killing Fields, The 1984,N 18,II,17:1
Puzo, Mario (Miscellaneous)
Cotton Club, The 1984,D 14,C,4:3
Puzzi, Nicole
Gabriela 1984,My 11,C,14:1

Q

Qi Mengshi
Boat People 1983,S 27,C,17:5
Boat People 1983,N 13,78:1
Quaid, David (Cinematographer)
Night in Heaven, A 1983,N 19,19:3
Quaid, Dennis
Tough Enough 1983,My 27,C,8:1
Jaws 3-D 1983,Jl 23,11:1
Right Stuff, The 1983,O 21,C,5:1
Dreamscape 1984,Ag 15,C,24:4
Dreamscape 1984,S 2,II,11:1
Quaid, Dennis (Cinematographer)
I Am the Cheese 1983,N 11,C,12:4
Quaid, Randy
National Lampoon's Vacation 1983,Jl 29,C,10:4
Quan, Stella
Norte, El 1984,Ja 11,C,15:1
Queffelean, Alain (Producer)
Erendira 1983,O 1,16:3
Erendira 1984,Ap 27,C,8:5
Querejeta, Elias (Producer)
Elisa, Vida Mia 1983,Mr 11,C,8:5
Quester, Hugues
Nuit de Varennes, La 1983,F 16,C,23:1
Quigley, Godfrey
Educating Rita 1983,S 21,C,21:1
Quigley, Linnea
Young Warriors 1983,N 12,12:1
Quilley, Denis
Privates on Parade 1984,Ap 13,C,8:1
Quilligan, Veronica
Danny Boy 1984,My 18,C,11:1
Quinlan, Kathleen
Independence Day 1983,Ja 21,C,8:1
Twilight Zone—The Movie (Segment 3) 1983,Je 24,C,15:1
Last Winter, The 1984,S 8,10:4
Quinn, Aidan
Reckless 1984,F 3,C,8:1
Quinn, Anthony
Salamander, The 1983,Je 5,53:1
Valentina 1983,Ag 5,C,15:3
Quinn, Anthony (Producer)
Circle of Power 1984,Mr 2,C,5:1
Quinn, Bill
Twilight Zone—The Movie (Segment 2) 1983,Je 24,C,15:1
Quinn, J C
Silkwood 1983,D 14,C,27:1
Quinn, Michael
Return of the Jedi 1983,My 25,C,24:1
Quinn, Patricia
Monty Python's the Meaning of Life 1983,Mr 31,C,13:5
Quinones, Adolfo (Shabba-Doo)
Breakin' 1984,My 5,17:1
Breakin' 2: Electric Boogaloo 1984,D 19,C,22:4
Quinones, Delia Esther
Two Worlds of Angelita, The (Dos Mundos del Angelita, Los) 1983,O 28,C,4:3
Quinones, Lee George
Wild Style 1983,Mr 18,C,8:3
Wild Style 1983,N 25,C,10:4
Quintana, Rosita
Susana 1983,N 8,C,9:2
Quintano, Gene
Treasure of the Four Crowns 1983,Ja 23,47:1
Quintano, Gene (Miscellaneous)
Treasure of the Four Crowns 1983,Ja 23,47:1
Making the Grade 1984,My 18,C,10:5
Quintano, Gene (Producer)
Treasure of the Four Crowns 1983,Ja 23,47:1
Making the Grade 1984,My 18,C,10:5
Quintano, Gene (Screenwriter)
Making the Grade 1984,My 18,C,10:5

R

Raab, Kurt
Stationmaster's Wife, The (Bolwieser) 1983,Ja 12,C,21:2
Slow Attack (Endstation Freiheit) 1983,Ja 12,C,24:1
Raahaugh, Bent
Zappa 1984,Ap 3,C,15:1
Zappa 1984,My 16,C,24:3
Rabal, Francisco
Treasure of the Four Crowns 1983,Ja 23,47:1
Holy Innocents, The 1984,S 30,58:3
Rabe, David (Original Author)
Streamers 1983,O 9,73:1
Streamers 1984,S 30,II,1:3
Rabe, David (Screenwriter)
Streamers 1983,O 9,73:1
Raben, Peer
Malou 1983,D 22,C,22:1
Raben, Peer (Composer)
Stationmaster's Wife, The (Bolwieser) 1983,Ja 12,C,21:2
Wizard of Babylon, The 1983,Mr 30,C,25:1
Querelle 1983,Ap 29,C,8:5
Shadow of Angels (Schatten der Engel) 1983,Je 24,C,8:1
Berlin Alexanderplatz 1983,Ag 10,C,18:5
Malou 1983,D 22,C,22:1
Rachmil, Lewis J (Producer)
Footloose 1984,F 17,C,12:3
Rachmil, Michael (Producer)
Runaway 1984,D 14,C,20:1
Rachwalska, B
Ways in the Night 1983,Jl 27,C,17:1
Racine, Tessa (Cinematographer)
Confidentially Yours (Vivement Dimanche) 1984,Ja 20,C,6:1
Radford, Michael (Director)
Another Time, Another Place 1984,Jl 11,C,26:1
Radford, Michael (Screenwriter)
Another Time, Another Place 1984,Jl 11,C,26:1
Radiwilowicz, Jerzy
Passion 1983,O 4,C,13:2
Radner, Gilda
Woman in Red, The 1984,Ag 15,C,24:1
Radnitz, Robert B (Producer)
Cross Creek 1983,S 21,C,19:4
Raeburn, Michael (Director)
Killing Heat 1984,O 5,C,16:1
Raeburn, Michael (Screenwriter)
Killing Heat 1984,O 5,C,16:1
Raffill, Stewart (Director)
Ice Pirates, The 1984,Mr 16,C,8:5
Philadelphia Experiment, The 1984,Ag 17,C,17:4
Raffill, Stewart (Screenwriter)
Ice Pirates, The 1984,Mr 16,C,8:5
Ragalyi, Elemer (Cinematographer)
Brady's Escape 1984,Je 28,C,17:1
Ragland, Robert O (Composer)
10 to Midnight 1983,Mr 13,62:5
Railsback, Steve
Golden Seal, The 1983,Ag 12,C,4:5
Raimondi, Ruggero
Trout, The (Truite, La) 1983,My 27,C,10:3
Life is a Bed of Roses 1984,Ag 19,63:1
Bizet's Carmen 1984,S 20,C,21:1
Bizet's Carmen 1984,S 23,II,19:1
Rain, Douglas
2010 1984,D 7,C,15:1
Raines, Cristina
Nightmares 1983,S 3,14:5
Raiski, Peggy (Producer)
Brother From Another Planet, The 1984,S 14,C,6:5
Raizman, Yuli (Director)
Private Life 1983,F 27,45:1
Raizman, Yuli (Screenwriter)
Private Life 1983,F 27,45:1
Rajot, Pierre-Loup
A Nos Amours 1984,O 12,C,10:4
Rakoff, Ian (Screenwriter)
Flight of the Eagle, The 1983,Ap 8,C,8:1
Raksa, Pola
Aria for an Athlete 1983,Mr 16,C,21:4
Ralston, Ken (Miscellaneous)
Return of the Jedi 1983,My 25,C,24:1
Rambaldi, Carlo (Miscellaneous)
Possession 1983,O 28,C,10:1
Ramirez, David (Miscellaneous)
Still Smokin' 1983,My 7,16:3
Ramis, Harold
Ghostbusters 1984,Je 8,C,5:1

421

Reno, Kelly
 Black Stallion Returns, The 1983,Mr 27,54:4
 Black Stallion Returns, The 1983,Ap 10,II,17:1
 Brady's Escape 1984,Je 28,C,17:1
Renoir, Jean
 Langlois 1983,Ag 5,C,10:5
Renucci, Robin
 Entre Nous (Coup de Foudre) 1983,O 8,35:3
 Entre Nous (Coup de Foudre) 1984,Ja 25,C,17:5
Renz, Rice (Miscellaneous)
 Wizard of Babylon, The 1983,Mr 30,C,25:1
Renzi, Maggie
 Lianna 1983,Ja 19,C,22:1
 Brother From Another Planet, The 1984,S 14,C,6:5
Renzi, Maggie (Producer)
 Brother From Another Planet, The 1984,S 14,C,6:5
Renzulli, Frank
 Broadway Danny Rose 1984,Ja 27,C,8:1
Repola, Art
 Indiana Jones and the Temple of Doom 1984,My 23,C,21:1
Rerberg, Georgy (Cinematographer)
 Mirror, The 1983,Ag 17,C,16:3
Resines, Antonio
 Skyline (Linea del Cielo, La) 1984,Ap 3,C,15:1
 Skyline (Linea del Cielo, La) 1984,Jl 18,C,20:3
Resnais, Alain (Director)
 Life is a Bed of Roses 1984,Ag 19,63:1
Restorick, Hughie
 My Childhood (Bill Douglas Trilogy, The) 1983,My 18,C,26:5
Retz, Danny (Miscellaneous)
 Exterminator 2 1984,S 15,14:5
Reubens, Paul
 Meatballs Part II 1984,Ag 18,13:2
Reuter, Bjarne (Original Author)
 Zappa 1984,Ap 3,C,15:1
 Zappa 1984,My 16,C,24:3
Reuter, Bjarne (Screenwriter)
 Zappa 1984,Ap 3,C,15:1
 Zappa 1984,My 16,C,24:3
Reve, Gerard (Original Author)
 4th Man, The 1984,Je 27,C,21:4
Rexrode, Jim (Miscellaneous)
 Whole Shootin' Match, The 1984,Ag 8,C,16:6
Rexroth, Kenneth
 Anarchism in America 1983,Ja 15,16:1
Rey, Alejandro
 Moscow On the Hudson 1984,Ap 6,C,12:1
Rey, Edith (Screenwriter)
 Spacehunter: Adventures in the Forbidden Zone 1983,My 21,29:1
Rey, Fernando
 Elisa, Vida Mia 1983,Mr 11,C,8:5
Reyes, Franc
 Beat Street 1984,Je 8,C,10:5
Reynolds, Burt
 Best Friends 1983,F 13,II,23:1
 Stroker Ace 1983,Jl 1,C,8:5
 Smokey and the Bandit, Part 3 1983,S 17,30:4
 Man Who Loved Women, The 1983,D 16,C,8:1
 Cannonball Run II 1984,Je 29,C,14:5
 Cannonball Run II 1984,Jl 29,II,15:1
 City Heat 1984,D 7,C,4:3
Reynolds, Buster (Cinematographer)
 Gods Must Be Crazy, The 1984,Jl 9,C,16:1
Reynolds, Don (Producer)
 Heart of the Stag 1984,Jl 27,C,6:5
Reynolds, Herb
 Broadway Danny Rose 1984,Ja 27,C,8:1
Reynolds, Hilary
 Educating Rita 1983,S 21,C,21:1
Reynolds, Jonathan (Screenwriter)
 Micki and Maude 1984,D 21,C,25:4
Reynolds, Kevin (Original Author)
 Red Dawn 1984,Ag 10,C,11:1
Reynolds, Kevin (Screenwriter)
 Red Dawn 1984,Ag 10,C,11:1
 Red Dawn 1984,S 16,II,19:1
Reynolds, Norman (Miscellaneous)
 Return of the Jedi 1983,My 25,C,24:1
Reynolds, William (Miscellaneous)
 Yellowbeard 1983,Je 24,C,10:2
 Lonely Guy, The 1984,Ja 28,11:5
 Little Drummer Girl, The 1984,O 19,C,18:1
Rey-Penchenat, Genevieve
 Bal, Le 1984,Mr 23,C,6:1
Rhodes, Cynthia
 Flashdance 1983,Ap 15,C,13:1
 Staying Alive 1983,Jl 15,C,8:5
 Staying Alive 1983,Jl 24,II,15:1
 Runaway 1984,D 14,C,20:1

Rhoe, Geoff
 Puberty Blues 1983,Jl 15,C,13:1
Ribraka, Katerina
 Angelo My Love 1983,Ap 27,C,17:5
Ricard, Eduardo
 Deal of the Century 1983,N 4,C,13:3
Rice, Bill
 Vortex 1983,F 4,C,5:1
 Wild Style 1983,Mr 18,C,8:3
 Wild Style 1983,N 25,C,10:4
Ricelli, Carlos Alberto
 They Don't Wear Black Tie (Eles Nao Usam Black-Tie) 1983,My 27,C,8:5
 They Don't Wear Black Tie (Eles Nao Usam Black-Tie) 1983,Je 12,II,21:1
Rich, Allan
 Entity, The 1983,F 5,12:3
Rich, Claude
 Crabe Tambour, Le (Drummer Crab) 1984,F 17,C,17:1
 Crabe Tambour, Le (Drummer Crab) 1984,F 19,II,15:1
Rich, Robert III
 Natural, The 1984,My 11,C,15:1
Richard, Jacques
 Investigation (Si Joli Village, Un) 1984,F 3,C,11:1
Richard, Jean-Louis
 Confidentially Yours (Vivement Dimanche) 1984,Ja 20,C,6:1
 Swann in Love 1984,S 14,C,4:1
Richard, Pierre
 Comperes, Les 1984,Mr 28,C,24:6
 Too Shy to Try 1984,Mr 30,C,17:3
Richard, Pierre (Director)
 Too Shy to Try 1984,Mr 30,C,17:3
Richard, Pierre (Screenwriter)
 Too Shy to Try 1984,Mr 30,C,17:3
Richards, Dick (Director)
 Man, Woman and Child 1983,Ap 1,C,8:1
Richards, Emil (Composer)
 Norte, El 1984,Ja 11,C,15:1
Richards, Keith
 Let's Spend the Night Together 1983,F 11,C,8:1
Richards, Keith (Composer)
 Let's Spend the Night Together 1983,F 11,C,8:1
Richards, Kim
 Meatballs Part II 1984,Ag 18,13:2
Richardson, Ed (Miscellaneous)
 Scarface 1983,D 9,C,18:3
Richardson, Henry (Miscellaneous)
 Octopussy 1983,Je 10,C,17:4
Richardson, Sir Ralph
 Greystoke: The Legend of Tarzan, Lord of the Apes 1984,Mr 30,C,5:1
 Greystoke: The Legend of Tarzan, Lord of the Apes 1984,Ap 1,II,21:1
 Greystoke: The Legend of Tarzan, Lord of the Apes 1984,My 6,II,17:1
 Give My Regards to Broad Street 1984,O 26,C,14:5
 Greystoke: The Legend of Tarzan, Lord of the Apes 1984,D 30,II,15:1
Richardson, Sy
 My Brother's Wedding 1984,Mr 30,C,7:1
 Repo Man 1984,Jl 6,C,8:5
Richardson, Tony (Director)
 Hotel New Hampshire, The 1984,Mr 9,C,8:1
Richardson, Tony (Screenwriter)
 Hotel New Hampshire, The 1984,Mr 9,C,8:1
Richer, Jean-Jose (Miscellaneous)
 Possession 1983,O 28,C,10:1
Richmond, Tom (Cinematographer)
 Hardbodies 1984,My 12,12:5
Richter, Robert (Producer)
 In Our Hands 1984,F 16,C,23:1
Richter, W D (Director)
 Adventures of Buckaroo Banzai, The 1984,O 5,C,8:5
 Adventures of Buckaroo Banzai, The 1984,O 14,II,21:1
Richter, W D (Producer)
 Adventures of Buckaroo Banzai, The 1984,O 5,C,8:5
Ridgely, Robert
 Wild Life, The 1984,S 28,C,8:4
Riedel, Cordula
 Malou 1983,D 22,C,22:1
Riegert, Peter
 Local Hero 1983,F 17,C,25:1
 Local Hero 1983,Mr 6,II,17:1
 Local Hero 1983,Ap 3,II,15:1
 Local Hero 1983,D 25,II,15:1
Rifbjerg, Klaus (Screenwriter)
 Flight of the Eagle, The 1983,Ap 8,C,8:1
Rigby, Mercy L
 All the Right Moves 1983,O 21,C,10:3

Riley, Jack
 To Be or Not to Be 1983,D 16,C,10:1
 Finders Keepers 1984,My 18,C,10:1
Riley, Larry
 Crackers 1984,F 17,C,19:3
 Soldier's Story, A 1984,S 14,C,10:5
Rimkus, Steven
 Cal 1984,Ag 24,C,6:1
Rinder, Laurin (Composer)
 Revenge of the Ninja 1983,S 8,C,23:1
Ringelmann, Thomas
 Love in Germany, A 1984,O 2,C,13:2
 Love in Germany, A 1984,N 9,C,10:1
Ringwald, Molly
 Spacehunter: Adventures in the Forbidden Zone 1983,My 21,29:1
 Sixteen Candles 1984,My 4,C,14:1
Rioton, Louise
 Next Year If All Goes Well 1983,Mr 20,60:1
Ripploh, Frank
 Kamikaze '89 1983,F 27,48:1
Ripps, Michael (Miscellaneous)
 Streets of Fire 1984,Je 1,C,8:5
Riquelme, Carlos
 Under the Volcano 1984,Je 13,C,21:4
Risch, Peter D
 Something Wicked This Way Comes 1983,Ap 29,C,8:5
Rispal, Jacques
 Lucie sur Seine 1983,S 9,C,8:1
Risterucci, Vincent
 Argent, L' (Money) 1983,S 24,11:1
 Argent, L' (Money) 1984,Mr 23,C,10:3
Ritchie, Michael (Director)
 Survivors, The 1983,Je 22,C,20:6
Ritt, Martin (Director)
 Cross Creek 1983,S 21,C,19:4
Ritter, Thelma
 Rear Window 1983,O 9,II,21:1
Ritzenberg, Frederick A (Director)
 Gospel 1983,D 23,C,8:1
Ritzenberg, Frederick A (Producer)
 Gospel 1983,D 23,C,8:1
Riva, Emanuelle
 Eyes, the Mouth, The 1983,D 14,C,24:1
Riva, J Michael (Miscellaneous)
 Adventures of Buckaroo Banzai, The 1984,O 5,C,8:5
Rivan, Lucille
 Home Free All 1984,My 2,C,25:1
Rivas, Bimbo
 Two Worlds of Angelita, The (Dos Mundos del Angelita, Los) 1983,O 28,C,4:3
Rivera, Carmelo (Cinematographer)
 And God Created Them 1983,Mr 19,11:1
Rivera Negron, Roberto
 Two Worlds of Angelita, The (Dos Mundos del Angelita, Los) 1983,O 28,C,4:3
Rivers, Joan
 Muppets Take Manhattan, The 1984,Jl 13,C,10:4
Rivers, Larry
 Lovesick 1983,F 18,C,19:1
Rivette, Jacques (Director)
 Amour par Terre, L' (Love on the Ground) 1984,O 7,86:5
Rivette, Jacques (Screenwriter)
 Amour par Terre, L' (Love on the Ground) 1984,O 7,86:5
Rivkin, Stephen (Miscellaneous)
 Personals, The 1983,Mr 20,60:1
 Hot Dog 1984,Ja 14,10:1
Roach, Lesley
 Moon Over the Alley 1983,Ap 27,C,19:4
Roach, Pat
 Conan the Destroyer 1984,Je 29,C,8:4
Robakiewicz, M
 Ways in the Night 1983,Jl 27,C,17:1
Robards, Jason
 Max Dugan Returns 1983,Mr 25,C,8:5
 Something Wicked This Way Comes 1983,Ap 29,C,8:5
Robards, Jason (Narrator)
 World of Tomorrow, The 1984,Mr 7,C,20:3
Robb, Jill (Producer)
 Careful He Might Hear You 1984,Je 15,C,8:1
Robb, R D
 Christmas Story, A 1983,N 18,C,36:1
Robbins, Harold (Original Author)
 Lonely Lady, The 1983,O 1,13:5
Robbins, Rex
 First Time, The 1983,Jl 13,C,16:3
 Reuben, Reuben 1983,D 19,C,12:5
Robbins, Richard (Composer)
 Heat and Dust 1983,S 15,C,18:3
 Bostonians, The 1984,Ag 2,C,15:1

420

Seck, Oumar
 Jom (Jom or the Story of a People) 1983,Mr 28,C,12:3
 Jom (Jom or the Story of a People) 1983,S 7,C,21:2
Secrist, Kim (Miscellaneous)
 Timerider 1983,Ja 21,C,24:5
 This is Spinal Tap 1984,Mr 2,C,6:1
Sedgwick, Angel
 Danton 1983,S 28,C,19:1
Seeger, Pete
 Chords of Fame 1984,F 16,C,23:1
Seel, Charles
 Duel 1983,Ap 15,C,10:1
Segal, Erich (Original Author)
 Man, Woman and Child 1983,Ap 1,C,8:1
Segal, Erich (Screenwriter)
 Man, Woman and Child 1983,Ap 1,C,8:1
Seige, Edgar
 War And Peace 1983,D 3,15:1
Seitz, Jane (Miscellaneous)
 Neverending Story, The 1984,Jl 20,C,5:1
Sekera, Miroslav
 Amadeus 1984,S 19,C,23:1
Selleck, Tom
 High Road to China 1983,Mr 18,C,4:3
 Lassiter 1984,F 17,C,10:5
 Runaway 1984,D 14,C,20:1
Sellers, Arlene (Producer)
 Blue Skies Again 1983,Jl 29,C,8:3
 Scandalous 1984,Ja 20,C,4:5
 Irreconcilable Differences 1984,S 28,C,10:5
Sellers, Kevin (Screenwriter)
 Blue Skies Again 1983,Jl 29,C,8:3
Seltzer, David (Screenwriter)
 Table for Five 1983,F 18,C,12:1
Selwyn, Lionel (Miscellaneous)
 Guest, The 1984,Je 6,C,19:1
 Marigolds in August 1984,Je 20,C,21:1
Semaan, Gerard
 Class Relations 1984,O 7,86:1
Semedo, Artur
 State of Things, The 1983,F 18,19:4
Semmler, Dean (Cinematographer)
 Kitty and the Bagman 1983,Ag 5,C,14:5
Semple, Lorenzo, Jr (Screenwriter)
 Never Say Never Again 1983,O 7,C,13:1
 Sheena 1984,Ag 17,C,8:3
Semprun, Colette (Miscellaneous)
 Bizet's Carmen 1984,S 20,C,21:1
Sen, Mrinal (Director)
 Case is Closed, The 1984,N 28,C,19:5
Sen, Mrinal (Screenwriter)
 Case is Closed, The 1984,N 28,C,19:5
Sender, Ramon J (Original Author)
 Valentina 1983,Ag 5,C,15:3
Sene, Dumi
 Jom (Jom or the Story of a People) 1983,Mr 28,C,12:3
 Jom (Jom or the Story of a People) 1983,S 7,C,21:2
Sengoku, Norika
 Quiet Duel 1983,N 25,C,10:1
Senia, Jean-Marie (Composer)
 Dirty Dishes (Jument Vapeur, La) 1983,Mr 25,C,12:5
Sentis, Yvonne
 China 9, Liberty 37 1984,N 30,C,8:4
Seresin, Michael (Cinematographer)
 Birdy 1984,D 21,C,25:1
Sergides, Miguel
 Moon Over the Alley 1983,Ap 27,C,19:4
Serling, Rod (Miscellaneous)
 Twilight Zone—The Movie 1983,Je 24,C,15:1
 Twilight Zone—The Movie (Segment 2) 1983,Je 24,C,15:1
 Twilight Zone—The Movie (Segment 3) 1983,Je 24,C,15:1
 Twilight Zone—The Movie (Segment 4) 1983,Je 24,C,15:1
Serna, Leon (Composer)
 Nicaragua: Report from the Front 1984,Ja 18,C,24:3
Serna, Pepe
 Ballad of Gregorio Cortez, The 1983,O 14,C,6:5
 Scarface 1983,D 9,C,18:3
 Adventures of Buckaroo Banzai, The 1984,O 5,C,8:5
Serra, Eric (Composer)
 Dernier Combat, Le (Last Battle, The) 1984,Je 22,C,12:1
Serra, Florenzo
 And the Ship Sails On 1984,Ja 26,C,17:1
Serra, Raymond
 Alphabet City 1984,My 5,17:1
Serran, Leopoldo (Screenwriter)
 Gabriela 1984,My 11,C,14:1
Serrault, Michel
 Heads or Tails (Pile ou Face) 1983,My 27,C,4:5
Serwin, Shane
 Terms of Endearment 1983,N 23,C,18:4

Seth, Roshan
 Indiana Jones and the Temple of Doom 1984,My 23,C,21:1
Seuffert, Susanne
 White Rose, The 1983,My 6,C,13:1
Sevareid, Eric
 Right Stuff, The 1983,O 21,C,5:1
Seweryn, Andrzej
 Danton 1983,S 28,C,19:1
Sexton, John (Producer)
 Phar Lap 1984,Ag 10,C,8:1
Seymour, Carolyn
 Mr Mom 1983,Ag 26,C,8:4
Seymour, Jane
 Lassiter 1984,F 17,C,10:5
Seyrig, Delphine
 Jeanne Dielman, 23 Quai Du Commerce, 1080 Bruxelles
 1983,Mr 23,C,25:4
Shackleton, Simon
 Privileged 1983,Ap 8,C,8:5
Shaffer, Deborah (Director)
 Nicaragua: Report from the Front 1984,Ja 18,C,24:3
 Nicaragua: Report from the Front 1984,Ja 22,II,17:1
Shaffer, Deborah (Producer)
 Nicaragua: Report from the Front 1984,Ja 18,C,24:3
Shaffer, Peter (Original Author)
 Amadeus 1984,S 19,C,23:1
 Amadeus 1984,S 30,II,1:3
Shaffer, Peter (Screenwriter)
 Amadeus 1984,S 19,C,23:1
 Amadeus 1984,S 30,II,1:3
Shakhnazarov, Karen (Director)
 Jazzman 1984,Mr 7,C,19:1
Shakhnazarov, Karen (Screenwriter)
 Jazzman 1984,Mr 7,C,19:1
Shakurov, Sergei
 Waiting for Gavrilov 1983,Ap 15,C,14:1
Shale, Kerry
 Lonely Lady, The 1983,O 1,13:5
Shamberg, Michael (Producer)
 Big Chill, The 1983,S 23,C,14:3
Shankar, Mamata
 Case is Closed, The 1984,N 28,C,19:5
Shannon-Burnett, Gaye
 My Brother's Wedding 1984,Mr 30,C,7:1
Shannon-Burnett, Gaye (Producer)
 My Brother's Wedding 1984,Mr 30,C,7:1
Shapiro, Bobbie (Miscellaneous)
 Where the Boys Are 1984,Ap 7,14:5
Shapiro, Melvin (Miscellaneous)
 Where the Boys Are 1984,Ap 7,14:5
 No Small Affair 1984,N 9,C,16:1
Shapter, William (Miscellaneous)
 Deep in the Heart 1984,Ja 18,C,24:3
Sharif, Omar
 Top Secret! 1984,Je 22,C,10:1
Sharkey, Ray
 Body Rock 1984,S 28,C,12:5
Sharon, Naoami
 Last Winter, The 1984,S 8,10:4
Sharp, Alan (Screenwriter)
 Osterman Weekend, The 1983,N 4,C,11:1
Sharp, Ian (Director)
 Final Option, The 1983,S 23,C,8:1
Shatner, William
 Star Trek III: The Search for Spock 1984,Je 1,C,14:3
Shave, Lin
 Nightmare on Elm Street, A 1984,N 9,C,10:5
Shaver, Helen
 Osterman Weekend, The 1983,N 4,C,11:1
 Best Defense 1984,Jl 20,C,10:1
Shaw, Anthony
 Jigsaw Man, The 1984,Ag 24,C,4:5
Shaw, Elizabeth Lloyd
 Fire and Ice 1983,N 24,C,12:1
Shaw, Helen
 Twilight Zone—The Movie (Segment 2) 1983,Je 24,C,15:1
Shaw, Jakob
 Love Streams 1984,Ag 24,C,8:5
Shaw, Linda
 Body Double 1984,O 26,C,8:1
Shaw, Peter (Producer)
 Enigma 1983,Ja 28,C,8:1
 Champions 1984,Ap 20,C,8:1
Shaw, Sebastian
 Return of the Jedi 1983,My 25,C,24:1
Shaw, Stan
 Tough Enough 1983,My 27,C,8:1
 Runaway 1984,D 14,C,20:1
Shawn, Dick
 Young Warriors 1983,N 12,12:1
 Angel 1984,Ja 13,C,12:5

Shawn, Wallace
 Lovesick 1983,F 18,C,19:1
 SPFX 1983,Mr 27,55:1
 First Time, The 1983,Jl 13,C,16:3
 First Time, The 1983,Jl 31,II,15:1
 Strange Invaders 1983,S 16,C,8:1
 Deal of the Century 1983,N 4,C,13:3
 Crackers 1984,F 17,C,19:3
 Hotel New Hampshire, The 1984,Mr 9,C,8:1
 Bostonians, The 1984,Ag 2,C,15:1
 Bostonians, The 1984,Ag 5,II,15:1
 Micki and Maude 1984,D 21,C,25:4
Shaye, Robert (Producer)
 Nightmare on Elm Street, A 1984,N 9,C,10:5
Shayne, Linda
 Screwballs 1983,Jl 9,10:4
Shayne, Linda (Screenwriter)
 Screwballs 1983,Jl 9,10:4
Shcherbakov, Pyotr
 Jazzman 1984,Mr 7,C,19:1
Shea, John
 Windy City 1984,S 21,C,10:5
Sheard, Michael
 High Road to China 1983,Mr 18,C,4:3
 Riddle of the Sands, The 1984,Ja 6,C,8:1
Shearer, Harry
 Right Stuff, The 1983,O 21,C,5:1
 This Is Spinal Tap 1984,Mr 2,C,6:1
 This Is Spinal Tap 1984,Mr 18,II,17:1
 This Is Spinal Tap 1984,D 30,II,15:1
Shearer, Harry (Composer)
 This Is Spinal Tap 1984,Mr 2,C,6:1
Shearer, Harry (Screenwriter)
 This Is Spinal Tap 1984,Mr 2,C,6:1
 This Is Spinal Tap 1984,Mr 18,II,17:1
 This Is Spinal Tap 1984,D 30,II,15:1
Shearman, Roger (Cinematographer)
 Lone Wolf McQuade 1983,Ap 16,12:4
Sheedy, Ally
 Bad Boys 1983,Mr 25,C,8:1
 Bad Boys 1983,Ap 10,II,17:1
 War Games 1983,Je 3,C,17:1
 Oxford Blues 1984,Ag 25,9:1
Sheen, Charlie
 Red Dawn 1984,Ag 10,C,11:1
Sheen, Martin
 Enigma 1983,Ja 28,C,8:1
 In the King of Prussia 1983,F 13,57:1
 Man, Woman and Child 1983,Ap 1,C,8:1
 Eagle's Wing 1983,O 9,72:1
 Dead Zone, The 1983,O 21,C,8:1
 Firestarter 1984,My 11,C,8:1
Sheffield, Kenny
 Black Wax 1983,Ja 12,C,21:2
Sheiner, David S
 Blue Thunder 1983,My 13,C,17:4
Shelach, Riki (Director)
 Last Winter, The 1984,S 8,10:4
Shelton, Deborah
 Body Double 1984,O 26,C,8:1
Shelton, Ron (Screenwriter)
 Under Fire 1983,O 21,C,13:1
Shelton, Zimmie (Producer)
 Joe's Bed-Stuy Barbershop: We Cut Heads 1983,Mr 27,55:5
Shenar, Paul
 Deadly Force 1983,Jl 8,C,4:3
 Scarface 1983,D 9,C,18:3
Shenson, Walter (Producer)
 Reuben, Reuben 1983,D 19,C,12:5
Shepard, Ellen (Miscellaneous)
 Lonely Lady, The 1983,O 1,13:5
Shepard, O-Lan
 Right Stuff, The 1983,O 21,C,5:1
Shepard, Sam
 Right Stuff, The 1983,O 21,C,5:1
 Right Stuff, The 1983,N 6,II,21:1
 Joe Chaikin Going On 1983,N 23,C,16:3
 Right Stuff, The 1983,D 18,II,21:1
 Right Stuff, The 1983,D 25,II,15:1
 Country 1984,S 28,20:1
Shepard, Sam (Screenwriter)
 Paris, Texas 1984,O 14,64:1
 Paris, Texas 1984,N 9,C,4:3
 Paris, Texas 1984,N 11,II,17:1
Shepherd, Jean (Original Author)
 Christmas Story, A 1983,N 18,C,36:1
Shepherd, Jean (Screenwriter)
 Christmas Story, A 1983,N 18,C,36:1
Shepherd, Richard A (Producer)
 Hunger, The 1983,Ap 29,C,32:1

Sheppard, Paula E
Liquid Sky 1983,Jl 22,C,10:1
Sheridan, Tony
Compleat Beatles, The 1984,F 10,C,8:1
Sherman, Bobby
Get Crazy 1983,O 14,C,11:1
Sherman, Robert M (Producer)
Oh God! You Devil 1984,N 9,C,15:1
Sherman, Stanford (Screenwriter)
Krull 1983,Jl 29,C,10:1
Man Who Wasn't There, The 1983,Ag 13,13:1
Ice Pirates, The 1984,Mr 16,C,8:5
Sherwin, David (Screenwriter)
Britannia Hospital 1983,Mr 4,C,10:1
Britannia Hospital 1983,Mr 6,II,17:1
Britannia Hospital 1983,Ap 3,II,15:1
Britannia Hospital 1983,D 25,II,15:1
Sherwood, Skip (Producer)
Americana 1983,O 21,C,14:5
Shevtsik, Vladimir (Cinematographer)
Jazzman 1984,Mr 7,C,19:1
Sheward, Lee
Top Secret! 1984,Je 22,C,10:1
Shibato, Makiko
Muddy River 1983,Ja 21,C,4:1
Shields, Brooke
Muppets Take Manhattan, The 1984,Jl 13,C,10:4
Shigemori, Takako (Screenwriter)
Muddy River 1983,Ja 21,C,4:1
Shigihara, Paul (Composer)
Straight Through the Heart 1984,Ap 1,57:1
Shiizuka, Akira (Cinematographer)
Antarctica 1984,Mr 30,C,10:5
Shikulska, Eva
26 Days in the Life of Dostoyevsky 1983,O 14,C,8:5
Shilo, Benny (Producer)
Last Sea, The 1984,Jl 4,C,7:5
Shilo, Michael
Last Winter, The 1984,S 8,10:4
Shimura, Takashi
Quiet Duel 1983,N 25,C,10:1
Shiraishi, Naomi
Irezumi—Spirit of Tattoo (Sekka Tomurai Zashi) 1983,Mr
19,10:3
Irezumi—Spirit of Tattoo (Sekka Tomurai Zashi) 1984,My
9,C,23:1
Shire, David (Composer)
Max Dugan Returns 1983,Mr 25,C,8:5
Oh God! You Devil 1984,N 9,C,15:1
2010 1984,D 7,C,15:1
Shirley, Aleisa
Spacehunter: Adventures in the Forbidden Zone 1983,My
21,29:1
Shirley, John (Miscellaneous)
Experience Preferred...But Not Essential 1983,N 4,C,11:1
Nate and Hayes 1983,N 18,C,30:3
Kipperbang 1984,Ap 20,C,11:3
Shiu, Larry (Cinematographer)
Burroughs 1983,O 8,33:1
Burroughs 1984,F 10,C,12:1
Shor, Daniel
Mike's Murder 1984,Mr 9,C,16:1
Strangers Kiss 1984,Ag 13,C,19:1
Shore, Howard (Composer)
Videodrome 1983,F 4,C,9:1
Short, Skip (Producer)
Flashpoint 1984,Ag 31,C,6:5
Shostakovich, Dmitri (Composer)
New Babylon, The 1983,O 3,C,15:1
Showalter, Max
Sixteen Candles 1984,My 4,C,14:1
Shryack, Dennis (Screenwriter)
Flashpoint 1984,Ag 31,C,6:5
Shue, Elisabeth
Karate Kid, The 1984,Je 22,C,16:3
Shugrue, Robert F (Miscellaneous)
Star Trek III: The Search for Spock 1984,Je 1,C,14:3
Shuler, Lauren (Producer)
Mr Mom 1983,Ag 26,C,8:4
Shull, Richard B
Spring Break 1983,Mr 27,54:4
Unfaithfully Yours 1984,F 10,C,7:1
Splash 1984,Mr 9,C,15:1
Garbo Talks 1984,O 12,C,8:1
Shultze, Klaus (Composer)
Beneath the Angka: A Story of the Khmer Rouge 1983,Ap
29,C,17:5
Shumlin, Herbert (Original Author)
Reuben, Reuben 1983,D 19,C,12:5
Shyer, Charles (Director)
Irreconcilable Differences 1984,S 28,C,10:5

Shyer, Charles (Miscellaneous)
Protocol 1984,D 21,C,25:1
Shyer, Charles (Screenwriter)
Irreconcilable Differences 1984,S 28,C,10:5
Sidney, P Jay
Trading Places 1983,Je 8,C,16:1
Sidney, Sylvia
Hammett 1983,Jl 1,C,8:1
Corrupt 1984,Ja 19,C,16:5
Sidumo, Fanyana
Gods Must Be Crazy, The 1984,Jl 9,C,16:1
Siebert, Oliver
White Rose, The 1983,My 6,C,13:1
Sieblg, Karl (Director)
Irreconcilable Memories 1983,Je 15,C,17:1
Sievernech, Chris (Producer)
State of Things, The 1983,F 18,19:4
Sigel, Thomas (Cinematographer)
When the Mountains Tremble 1984,Ja 18,C,24:3
Nicaragua: Report from the Front 1984,Ja 18,C,24:3
Sigel, Thomas (Director)
When the Mountains Tremble 1984,Ja 18,C,24:3
Nicaragua: Report from the Front 1984,Ja 18,C,24:3
Where the Mountains Tremble 1984,Ja 22,II,17:1
Nicaragua: Report from the Front 1984,Ja 22,II,17:1
Signorelli, James (Director)
Easy Money 1983,Ag 19,C,8:5
Signoret, Simone
Etoile du Nord, L' 1983,Je 12,66:1
Langlois 1983,Ag 5,C,10:5
Sihol, Caroline
Confidentially Yours (Vivement Dimanche) 1984,Ja 20,C,6:1
Sikes, Cynthia
Man Who Loved Women, The 1983,D 16,C,8:1
Sikivie, Francois
Golden Eighties, The 1983,O 2,59:1
Sikking, James B
Star Chamber, The 1983,Ag 5,C,8:5
Silas, Everett
My Brother's Wedding 1984,Mr 30,C,7:1
Silberg, Joel (Director)
Breakin' 1984,My 5,17:1
Silberg, Nicolas
Drugstore Romance (Corps a Coeur) 1983,Jl 1,C,8:4
Silbert, Denise
Stuck On You 1984,F 3,C,8:5
Silke, James R (Screenwriter)
Revenge of the Ninja 1983,S 8,C,23:1
Sills, Sam (Director)
Good Fight, The 1984,Mr 28,C,24:4
Sills, Sam (Producer)
Good Fight, The 1984,Mr 28,C,24:4
Silva, Henry
Cannonball Run II 1984,Je 29,C,14:5
Silva, Maria
It's Never Too Late 1984,Je 29,C,8:4
Silva, Trinidad
Crackers 1984,F 17,C,19:3
Silvagni, Giorgio (Producer)
Bal, Le 1984,Mr 23,C,6:1
Heat of Desire 1984,My 25,C,10:1
Silver, Arthur (Miscellaneous)
Missing in Action 1984,N 17,11:1
Silver, David (Screenwriter)
Compleat Beatles, The 1984,F 10,C,8:1
Silver, Dina (Producer)
Old Enough 1984,Ag 24,C,10:4
Silver, George
Monty Python's the Meaning of Life 1983,Mr 31,C,13:5
Silver, Joan Micklin (Director)
Hester Street 1984,My 27,II,15:1
Silver, Joel (Producer)
Streets of Fire 1984,Je 1,C,8:5
Silver, Marisa (Director)
Old Enough 1984,Ag 24,C,10:4
Silver, Marisa (Screenwriter)
Old Enough 1984,Ag 24,C,10:4
Silver, Ron
Entity, The 1983,F 5,12:3
Lovesick 1983,F 18,C,19:1
Silkwood 1983,D 14,C,27:1
Garbo Talks 1984,O 12,C,8:1
Oh God! You Devil 1984,N 9,C,15:1
Silverman, Ron (Producer)
Krull 1983,Jl 29,C,10:1
Silverstein, Louis M (Producer)
Strange Brew 1983,Ag 26,C,8:1
Silvestri, Alan (Composer)
Romancing the Stone 1984,Mr 30,C,19:1

Silvi, Roberto (Miscellaneous)
Under the Volcano 1984,Je 13,C,21:4
Silwinska, Uszula (Miscellaneous)
Constant Factor, The (Constans) 1983,Mr 10,C,18:3
Simenon, Georges (Original Author)
Etoile du Nord, L' 1983,Je 12,66:1
Simjanovic, Zoran (Composer)
Petria's Wreath 1983,F 6,4,49:1
Simkovic, John W
All the Right Moves 1983,O 21,C,10:3
Simmonds, Stanley
Zelig 1983,Jl 18,B,1:6
Simmons, Gene
Runaway 1984,D 14,C,20:1
Simmons, Johnny (Cinematographer)
Richard Pryor Here and Now 1983,O 28,C,8:1
Simmons, Matty (Producer)
National Lampoon's Vacation 1983,Jl 29,C,10:4
Simo, Ana Maria
Improper Conduct (Mauvaise Conduite) 1984,Ap 11,C,19:1
Simon, Arlene
Personals, The 1983,Mr 20,60:1
Simon, Barney (Screenwriter)
Gordimer Stories, The 1983,My 18,C,26:4
Six Feet of the Country (Gordimer Stories, The) 1983,My
18,C,26:4
Simon, David
Without a Trace 1983,F 4,C,8:1
Simon, Francois
Basileus Quartet 1984,Ja 4,C,13:5
Simon, Neil (Miscellaneous)
Lonely Guy, The 1984,Ja 28,11:5
Simon, Neil (Producer)
Max Dugan Returns 1983,Mr 25,C,8:5
Simon, Neil (Screenwriter)
Max Dugan Returns 1983,Mr 25,C,8:5
Simono
Cheech & Chong's The Corsican Brothers 1984,Jl 28,15:5
Simonoya, Yevgenia
26 Days in the Life of Dostoyevsky 1983,O 14,C,8:5
Simonsons, M H (Producer)
Can She Bake a Cherry Pie? 1983,D 8,C,22:3
Simpson, Don (Producer)
Flashdance 1983,Ap 15,C,13:1
Thief of Hearts 1984,O 19,C,17:4
Beverly Hills Cop 1984,D 5,C,25:4
Simpson, Geoffrey (Cinematographer)
Nicaragua: No Pasaran 1984,N 2,C,14:1
Sinaiko, Jonathan (Cinematographer)
City News and News Briefs 1983,S 9,C,6:2
Sinatra, Frank
Hollywood Out-Takes and Rare Footage 1983,F 25,C,8:5
Cannonball Run II 1984,Je 29,C,14:5
Cannonball Run II 1984,Jl 29,II,15:1
Sinclair, John Gordon
Local Hero 1983,Mr 6,II,17:1
That Sinking Feeling 1984,F 15,C,21:4
Sine, Babacar (Screenwriter)
Jom (Jom or the Story of a People) 1983,Mr 28,C,12:3
Jom (Jom or the Story of a People) 1983,S 7,C,21:2
Singer, Bruce (Screenwriter)
Meatballs Part II 1984,Ag 18,13:2
Singer, Isaac Bashevis (Original Author)
Yentl 1983,N 18,C,10:1
Yentl 1984,My 27,II,15:1
Singer, Lori
Footloose 1984,F 17,C,12:3
Singer, Raymond
Entity, The 1983,F 5,12:3
Singer, Robert (Producer)
Independence Day 1983,Ja 21,C,8:1
Cujo 1983,Ag 13,13:1
Singh, Raj
Indiana Jones and the Temple of Doom 1984,My 23,C,21:1
Singletary, Vincent (Cinematographer)
Richard Pryor Here and Now 1983,O 28,C,8:1
Sinko, Laszlo
Lost Illusions 1983,O 1,16:3
Sissel, Sandi (Cinematographer)
Chicken Ranch 1983,Je 1,C,14:2
Seeing Red 1983,O 4,C,14:5
Sissel, Sandi (Director)
Chicken Ranch 1983,Je 1,C,14:2
Sissleman, Brian (Cinematographer)
Ski Country 1984,N 30,C,13:1
Sissolo, Fouseyni
Wind, The 1983,S 24,11:1
Sivli, Robert (Miscellaneous)
Of Unknown Origin 1983,N 24,C,17:1

Stephenson, Pamela
Superman III 1983,Je 17,C,4:5
Scandalous 1984,Ja 20,C,4:5
Finders Keepers 1984,My 18,C,10:1
Stern, Daniel
Blue Thunder 1983,My 13,C,17:4
Blue Thunder 1983,My 15,II,13:1
Get Crazy 1983,O 14,C,11:1
Stern, Kimberly
Rent Control 1984,My 4,C,13:3
Sternberg, Tom (Producer)
Black Stallion Returns, The 1983,Mr 27,54:4
Sternburg, David (Producer)
Chords of Fame 1984,F 16,C,23:1
Sternhagen, Frances
Independence Day 1983,Ja 21,C,8:1
Romantic Comedy 1983,O 7,C,8:1
Steven, Carl
Star Trek III: The Search for Spock 1984,Je 1,C,14:3
Steven, Margaret
Lonely Hearts 1983,S 4,58:3
Stevenin, Jean-Francois
Neige (Snow) 1983,Jl 5,C,10:1
Passion 1983,O 4,C,13:2
Vieux Pays ou Rimbaud Est Mort, Le (Old Country Where
Rimbaud Died, The) 1984,N 9,C,12:5
Stevens, Andrew
10 to Midnight 1983,Mr 13,62:5
Stevens, Craig
Trout, The (Truite, La) 1983,My 27,C,10:3
Stevens, Fisher
Flamingo Kid, The 1984,D 21,C,25:1
Stevens, Stella
Chained Heat 1983,Je 5,II,19:3
Stevens, Tom
A Nos Amours 1984,O 12,C,10:4
Stevens, Warren
Stroker Ace 1983,Jl 1,C,8:5
Stevenson, Parker
Stroker Ace 1983,Jl 1,C,8:5
Stevenson, Richard (Producer)
Privileged 1983,Ap 8,C,8:5
Stewart, Alana
Where the Boys Are 1984,Ap 7,14:5
Stewart, Alexandra (Narrator)
Sans Soleil 1983,O 26,C,24:2
Stewart, Catherine Mary
Last Starfighter, The 1984,Jl 13,C,5:2
Night of the Comet 1984,N 16,C,8:1
Stewart, Charles (Cinematographer)
Deep in the Heart 1984,Ja 18,C,24:3
Stewart, Douglas Day (Miscellaneous)
Right Stuff, The 1983,O 21,C,5:1
Stewart, Douglas Day (Director)
Thief of Hearts 1984,O 19,C,17:4
Stewart, Douglas Day (Screenwriter)
Thief of Hearts 1984,O 19,C,17:4
Stewart, Ian
Let's Spend the Night Together 1983,F 11,C,8:1
Stewart, James
Rear Window 1983,O 9,II,21:1
Vertigo 1984,Ja 15,II,19:1
Rope 1984,Je 3,II,19:1
Stewart, Patrick
Dune 1984,D 14,C,18:4
Stewart, Rod (Cinematographer)
Guest, The 1984,Je 6,C,19:1
Stibich, Miloslav
Snowdrop Festival 1984,N 14,C,29:4
Stibich, William L
All the Right Moves 1983,O 21,C,10:3
Stigwood, Robert (Producer)
Staying Alive 1983,Jl 15,C,8:5
Stiles, Mark (Original Author)
Heatwave 1983,Je 10,C,17:4
Stiller, Ludwig
Irreconcilable Memories 1983,Je 15,C,17:1
Stillman, Irene
Skyline (Linea del Cielo, La) 1984,Ap 3,C,15:1
Skyline (Linea del Cielo, La) 1984,Jl 18,C,20:3
Stillman, Whit
Skyline (Linea del Cielo, La) 1984,Ap 3,C,15:1
Skyline (Linea del Cielo, La) 1984,Jl 18,C,20:3
Stiltner, Ira
Big Chill, The 1983,S 23,C,14:3
Sting
Dune 1984,D 14,C,18:4
Stinson, Jana
Threshold 1983,Ja 21,C,5:3

Stinson, Joseph C (Screenwriter)
Sudden Impact 1983,D 9,C,12:4
City Heat 1984,D 7,C,4:3
Stitzel, Robert (Screenwriter)
Brainstorm 1983,S 30,C,17:1
Stockenstrom, Wilma
Guest, The 1984,Je 6,C,19:1
Stocker, Werner
White Rose, The 1983,My 6,C,13:1
Stockwell, Dean
Alsino and the Condor 1983,My 1,69:1
Paris, Texas 1984,O 14,64:1
Paris, Texas 1984,N 9,C,4:3
Paris, Texas 1984,N 11,II,17:1
Dune 1984,D 14,C,18:4
Stockwell, John
Losin' It 1983,Ap 8,C,4:5
Eddie and the Cruisers 1983,S 23,C,8:3
Christine 1983,D 9,C,10:5
Stoetzner, Ernst
Class Enemy 1984,Jl 13,C,6:1
Stogli, Corrado
Another Time, Another Place 1984,Jl 11,C,26:1
Stokes, Simon
Ploughman's Lunch, The 1984,O 19,C,8:1
Stoler, Shirley
Below the Belt 1983,Ag 31,C,21:1
Stoltz, Eric
Wild Life, The 1984,S 28,C,8:4
Stone, Christopher
Cujo 1983,Ag 13,13:1
Stone, John
Killing of Angel Street, The 1983,Mr 26,20:6
Stone, Oliver (Screenwriter)
Scarface 1983,D 9,C,18:3
Scarface 1983,D 11,II,23:1
Stone, Philip
Indiana Jones and the Temple of Doom 1984,My 23,C,21:1
Stone, Sharon
Irreconcilable Differences 1984,S 28,C,10:5
Storch, Buz
Americana 1983,O 21,C,14:5
Storck, Henri
Jeanne Dielman, 23 Quai Du Commerce, 1080 Bruxelles
1983,Mr 23,C,25:4
Storm, Howard
Broadway Danny Rose 1984,Ja 27,C,8:1
Broadway Danny Rose 1984,Ja 29,II,13:1
Strachan, Alan (Miscellaneous)
Jigsaw Man, The 1984,Ag 24,C,4:5
Stradling, Harry (Cinematographer)
Micki and Maude 1984,D 21,C,25:4
Straight, Beatrice
Two of a Kind 1983,D 16,C,12:6
Strandberg, Jan-Olof
Flight of the Eagle, The 1983,Ap 8,C,8:1
Strang, Chris
Vortex 1983,F 4,C,5:1
Strasburg, Ivan (Cinematographer)
Backstage at the Kirov 1984,Ja 18,C,24:3
Stratas, Teresa
Traviata, La 1983,Ap 22,C,13:1
Stratford, James
Man of Flowers 1984,O 9,C,14:4
Man of Flowers 1984,D 16,78:4
Strathairn, David
Lovesick 1983,F 18,C,19:1
Silkwood 1983,D 14,C,27:1
Iceman 1984,Ap 13,C,10:1
Brother From Another Planet, The 1984,S 14,C,6:5
Straub, Jean-Marie (Director)
Class Relations 1984,O 7,86:1
Straub, Jean-Marie (Miscellaneous)
Class Relations 1984,O 7,86:1
Straub, Jean-Marie (Screenwriter)
Class Relations 1984,O 7,86:1
Strauss, John
Amadeus 1984,S 19,C,23:1
Strauss, Peter
Spacehunter: Adventures in the Forbidden Zone 1983,My
21,29:1
Strauss, Richard (Composer)
One Man's War (Guerre d'un Seul Homme, La) 1984,F
24,C,9:1
Strawiak, Edward (Composer)
Memoirs 1984,D 28,C,14:5
Streep, Meryl
Sophie's Choice 1983,Ja 2,II,1:1
Silkwood 1983,D 14,C,27:1
Continued

Silkwood 1983,D 18,II,21:1
Silkwood 1983,D 25,II,15:1
Silkwood 1984,Ja 1,II,11:1
Silkwood 1984,F 12,II,19:1
In Our Hands 1984,F 16,C,23:1
Falling in Love 1984,N 21,C,11:1
Falling in Love 1984,D 9,II,21:1
Streisand, Barbra
Yentl 1983,N 18,C,10:1
Yentl 1983,N 27,II,17:1
Yentl 1984,My 27,II,15:1
Streisand, Barbra (Director)
Yentl 1983,N 18,C,10:1
Yentl 1983,N 27,II,17:1
Yentl 1984,My 27,II,15:1
Streisand, Barbra (Producer)
Yentl 1983,N 18,C,10:1
Yentl 1983,N 27,II,17:1
Streisand, Barbra (Screenwriter)
Yentl 1983,N 18,C,10:1
Streit, David (Producer)
Deep in the Heart 1984,Ja 18,C,24:3
Strick, Joseph (Producer)
Never Cry Wolf 1983,O 14,C,8:1
Strickland, Gail
Uncommon Valor 1983,D 16,C,12:1
Protocol 1984,D 21,C,25:1
Strickler, Dan
Cold Feet 1984,My 25,C,12:1
Strieber, Whitley (Original Author)
Hunger, The 1983,Ap 29,C,32:1
Stringer, Kimberly
This is Spinal Tap 1984,Mr 2,C,6:1
Stringer, Michael (Cinematographer)
Americana 1983,O 21,C,14:5
Stringer, Nick
Children (Terence Davies Trilogy, The) 1984,Ap 8,64:3
Strode, Woody
Black Stallion Returns, The 1983,Mr 27,54:4
Stronach, Tami
Neverending Story, The 1984,Jl 20,C,5:1
Strong, John C, III (Producer)
Savage Streets 1984,O 5,C,14:3
Strooker, Shireen
Still Smokin' 1983,My 7,16:3
In For Treatment 1983,N 18,C,5:3
Stroud, Duke
Fleshburn 1984,My 26,13:1
Strouve, George (Cinematographer)
Drugstore Romance (Corps a Coeur) 1983,Jl 1,C,8:4
Strumpell, Henning
Irreconcilable Memories 1983,Je 15,C,17:1
Strutin, Stuart (Screenwriter)
Stuck On You 1984,F 3,C,8:5
First Turn-On!, The 1984,O 12,C,8:5
Stryker, Amy
Impulse 1984,S 30,58:5
Strzemzalski, Jacek
Constant Factor, The (Constans) 1983,Mr 10,C,18:3
Stuart, Aimee (Miscellaneous)
Wicked Lady, The 1983,O 28,C,16:1
Stuart, Barbara
Bachelor Party 1984,Je 30,11:1
Stuart, Walker
Never Cry Wolf 1983,O 14,C,8:1
Stubblefield, Bruce (Miscellaneous)
Savage Streets 1984,O 5,C,14:3
Stubbs, Imogen
Privileged 1983,Ap 8,C,8:5
Stubbs, Louise
Without a Trace 1983,F 4,C,8:1
Studd, Victoria
Privileged 1983,Ap 8,C,8:5
Stuhr, Jerzy
Camera Buff (Amator) 1983,F 24,C,17:1
Provincial Actors 1983,Mr 2,C,20:5
Stuhr, Jerzy (Miscellaneous)
Camera Buff (Amator) 1983,F 24,C,17:1
Sturges, Preston (Miscellaneous)
Unfaithfully Yours 1984,F 10,C,7:1
Sturmer, Carl
Stuck On You 1984,F 3,C,8:5
Stuyck, Joris
Razor's Edge, The 1984,O 19,C,14:6
Suard, Valentine
Sunday in the Country, A 1984,O 2,C,14:3
Sunday in the Country, A 1984,N 16,C,11:1
Suarez, Miguel A
And God Created Them 1983,Mr 19,11:1

Such, Michel
Lucie sur Seine 1983,S 9,C,8:1
Suchel, David
Greystoke: The Legend of Tarzan, Lord of the Apes 1984,Mr 30,C,5:1
Sucher, Joel (Cinematographer)
Anarchism in America 1983,Ja 15,16:1
Sucher, Joel (Director)
Anarchism in America 1983,Ja 15,16:1
Sucher, Joel (Producer)
Anarchism in America 1983,Ja 15,16:1
Sucher, Joel (Screenwriter)
Anarchism in America 1983,Ja 15,16:1
Suchet, David
Trenchcoat 1983,Mr 12,13:3
Little Drummer Girl, The 1984,O 19,C,18:1
Suchon, Alain
One Deadly Summer 1984,Jl 20,C,10:5
Suhrstedt, Timothy (Cinematographer)
Android 1984,F 10,C,28:1
Suburbia 1984,Ap 13,C,10:1
Sukowa, Barbara
Berlin Alexanderplatz 1983,Ag 10,C,18:5
Berlin Alexanderplatz 1983,D 25,II,15:1
Sukroff, Bettina
Red Love 1983,O 4,C,13:2
Sullivan, Sir Arthur Seymour (Composer)
Pirates of Penzance, The 1983,F 20,80:1
Sullivan, Beth (Screenwriter)
Circle of Power 1984,Mr 2,C,5:1
Sullivan, Paul, Jr
Natural, The 1984,My 11,C,15:1
Sullivan, Sean
Dead Zone, The 1983,O 21,C,8:1
Sumner, Will (Composer)
Personals, The 1983,Mr 20,60:1
Sundberg, Bert (Producer)
Hill on the Dark Side of the Moon, A 1984,S 30,58:1
Sundman, Per Olof (Original Author)
Flight of the Eagle, The 1983,Ap 8,C,8:1
Supandi (Miscellaneous)
Dawn, The 1983,Mr 23,C,26:4
Suparmi
Dawn, The 1983,Mr 23,C,26:4
Suresh, R (Producer)
There Lived a Wrestler (Oridathu Oru Phayaivaan) 1983,Mr 23,C,26:3
Surgere, Helene
Drugstore Romance (Corps a Coeur) 1983,Jl 1,C,8:4
Surtees, Bruce (Cinematographer)
Bad Boys 1983,Mr 25,C,8:1
Risky Business 1983,Ag 5,C,13:1
Sudden Impact 1983,D 9,C,12:4
Tightrope 1984,Ag 17,C,6:1
Beverly Hills Cop 1984,D 5,C,25:4
Susan
Purple Rain 1984,Jl 27,C,5:1
Suschitzky, Peter (Cinematographer)
Krull 1983,Jl 29,C,10:1
Falling in Love 1984,N 21,C,11:1
Suslov, Mikhail (Cinematographer)
Strangers Kiss 1984,Ag 13,C,19:1
Sust, Jiri (Composer)
Snowdrop Festival 1984,N 14,C,29:4
Sutherland, Donald
Threshold 1983,Ja 21,C,5:3
Max Dugan Returns 1983,Mr 25,C,8:5
Crackers 1984,F 17,C,19:3
Sutherland, Lin (Producer)
Whole Shootin' Match, The 1984,Ag 8,C,16:6
Sutherland, Lin (Screenwriter)
Whole Shootin' Match, The 1984,Ag 8,C,16:6
Sutorius, James
Windy City 1984,S 21,C,10:5
Suwastinah
Dawn, The 1983,Mr 23,C,26:4
Suzman, Janet
Draughtsman's Contract, The 1983,Je 22,C,26:4
And the Ship Sails On 1984,Ja 26,C,17:1
Suzuki, Akira (Miscellaneous)
Antarctica 1984,Mr 30,C,10:5
Svetin, Mikhail
Waiting for Gavrilov 1983,Ap 15,C,14:1
Swaby, John (Cinematographer)
Heartland Reggae 1983,O 14,C,4:3
Swados, Elizabeth (Composer)
Reaching Out 1983,My 16,C,20:5
Swaim, Bob (Director)
Balance, La 1983,N 20,72:1

Swaim, Bob (Screenwriter)
Balance, La 1983,N 20,72:1
Swaybill, Roger E (Screenwriter)
Porky's II: The Next Day 1983,Je 25,12:3
Swayze, Patrick
Outsiders, The 1983,Mr 25,C,3:1
Uncommon Valor 1983,D 16,C,12:1
Grandview U S A 1984,Ag 3,C,8:4
Red Dawn 1984,Ag 10,C,11:1
Sweet, Blanche (Narrator)
Before the Nickelodeon 1983,F 28,C,24:5
Swerdlow, Stanley
Zelig 1983,Jl 18,B,1:6
Swinnen, Guy
Golden Eighties, The 1983,O 2,59:1
Swirta, Czeslaw (Cinematographer)
Knight, The 1983,D 9,C,30:5
Swope, Tracy Brooks
Hard to Hold 1984,Ap 6,C,16:5
Syahrir, Faqih
Dawn, The 1983,Mr 23,C,26:4
Syberberg, Amelie
Parsifal 1983,Ja 23,46:1
Syberberg, Hans Jurgen (Director)
Parsifal 1983,Ja 23,46:1
Sylbert, Anthea (Producer)
Protocol 1984,D 21,C,25:1
Sylbert, Lulu
Strange Invaders 1983,S 16,C,8:1
Sylbert, Richard (Miscellaneous)
Breathless 1983,My 13,C,10:1
Sylvester, Harold
Uncommon Valor 1983,D 16,C,12:1
Sylvester, Vari
Moon Over the Alley 1983,Ap 27,C,19:4
Sylvi, Franca (Miscellaneous)
Traviata, La 1983,Ap 22,C,13:1
Symington, Donald
Spring Break 1983,Mr 27,54:4
Symonds, Robert
Micki and Maude 1984,D 21,C,25:4
Syson, Michael (Original Author)
Eagle's Wing 1983,O 9,72:1
Szabo, Gabor (Cinematographer)
Revolt of Job, The 1984,Mr 28,C,19:3
Princess, The 1984,Ap 1,57:1
Szabo, Laszlo
Passion 1983,O 4,C,13:2
Amour par Terre, L' (Love on the Ground) 1984,O 7,86:5
Szarabajka, Keith
Protocol 1984,D 21,C,25:1
Sze Yeun-Ping (Screenwriter)
Ah Ying 1984,Mr 30,C,7:1
Szekely, Miklos B
Forbidden Relations 1983,S 25,59:1
Szemes, Mari
Diary for My Children 1984,S 30,58:1
Diary for My Children 1984,O 31,C,21:5
Szendrei, Andrea
Princess, The 1984,Ap 1,57:1
Szlingerbaum, Samy
Golden Eighties, The 1983,O 2,59:1
Szostak, Zdislaw (Composer)
Aria for an Athlete 1983,Mr 16,C,21:4
Knight, The 1983,D 9,C,30:5
Szurmiej, Jan
Sandglass, The 1983,My 6,C,16:1
Szurmiej, Szymon
Sandglass, The 1983,My 6,C,16:1
Szwarc, Jeannot (Director)
Enigma 1983,Ja 28,C,8:1
Supergirl 1984,N 22,C,15:2
Szwejlich, Michal
Sandglass, The 1983,My 6,C,16:1

T

Tabakov, Oleg
Flights of Fancy 1983,Je 15,C,20:5
Tabourin, Beatrice
Argent, L' (Money) 1983,S 24,11:1
Argent, L' (Money) 1984,Mr 23,C,10:3
Tafier, Jean
Deadly Spawn, The 1983,Ap 22,C,11:1
Tagg, Brian (Miscellaneous)
Crimes of Passion 1984,O 19,C,19:1
Taggert, Brian (Screenwriter)
Of Unknown Origin 1983,N 24,C,17:1

Tagoe, Eddie
Top Secret! 1984,Je 22,C,10:1
Tahimik, Kidlat (Director)
Turumba 1984,Ap 12,C,20:5
Tahimik, Kidlat (Screenwriter)
Turumba 1984,Ap 12,C,20:5
Tailman, Pat
Stuck On You 1984,F 3,C,8:5
Tait, Peter
Wild Horses 1984,Ap 19,C,15:1
Takabayashi, Yoichi (Director)
Irezumi—Spirit of Tattoo (Sekka Tomurai Zashi) 1983,Mr 19,10:3
Irezumi—Spirit of Tattoo (Sekka Tomurai Zashi) 1984,My 9,C,23:1
Takakura, Ken
Antarctica 1984,Mr 30,C,10:5
Takei, George
Star Trek III: The Search for Spock 1984,Je 1,C,14:3
Takejo, Aki
Ballad of Narayama, The 1984,Ap 9,C,14:5
Ballad of Narayama, The 1984,S 7,C,6:1
Takeshi
Merry Christmas Mr Lawrence 1983,Ag 26,C,10:1
Takita, Yusuke
Irezumi—Spirit of Tattoo (Sekka Tomurai Zashi) 1983,Mr 19,10:3
Irezumi—Spirit of Tattoo (Sekka Tomurai Zashi) 1984,My 9,C,23:1
Takvam, Marie
Betrayal: The Story of Kamilla (Kamilla) 1983,Mr 20,60:1
Kamilla (Betrayal: The Story of Kamilla) 1984,Ja 13,C,8:1
Talalay, Rachel
Android 1984,F 10,C,28:1
Talavera, Miriam (Miscellaneous)
Alsino and the Condor 1983,My 1,69:1
Talking Heads
Stop Making Sense 1984,O 19,C,17:1
Tambor, Jeffrey
Man Who Wasn't There, The 1983,Ag 13,13:1
Mr Mom 1983,Ag 26,C,8:4
No Small Affair 1984,N 9,C,16:1
Tamura, Masaki (Cinematographer)
Farewell to the Land, A (Saraba Itoshiki Daichi) 1983,Mr 20,60:3
Tamura, Takahiro
Muddy River 1983,Ja 21,C,4:1
Tan, Phil
Privates on Parade 1984,Ap 13,C,8:1
Tana, Dan (Producer)
Twilight Time 1983,F 13,57:4
Tana, Dan (Screenwriter)
Twilight Time 1983,F 13,57:4
Tana, Temba (Miscellaneous)
Killing Heat 1984,O 5,C,16:1
Tanaguchi, Sumiteru
Dark Circle 1984,My 2,C,25:1
Tandy, Jessica
Bostonians, The 1984,Ag 2,C,15:1
Bostonians, The 1984,Ag 5,II,15:1
Bostonians, The 1984,D 30,II,15:1
Tangerine Dream (Composer)
Risky Business 1983,Ag 5,C,13:1
Firestarter 1984,My 11,C,8:1
Flashpoint 1984,Ag 31,C,6:5
Taniguchi, Senkichi (Screenwriter)
Quiet Duel 1983,N 25,C,10:1
Tann, Philip
Indiana Jones and the Temple of Doom 1984,My 23,C,21:1
Tannen, William (Director)
Flashpoint 1984,Ag 31,C,6:5
Tanner, Alain (Director)
Light Years Away 1983,Ap 15,C,7:1
In the White City 1983,S 26,C,10:5
In the White City 1983,O 2,II,21:1
In the White City 1984,Ag 24,C,4:5
Tanner, Alain (Producer)
In the White City 1983,S 26,C,10:5
In the White City 1984,Ag 24,C,4:5
Tanner, Alain (Screenwriter)
Light Years Away 1983,Ap 15,C,7:1
In the White City 1984,Ag 24,C,4:5
Taplin, Jonathan (Producer)
Under Fire 1983,O 21,C,13:1
Tapsoba, Simone
Wend Kuuni (Gift of God) 1983,Mr 27,55:1
Tardin, Ib (Miscellaneous)
Zappa 1984,Ap 3,C,15:1
Zappa 1984,My 16,C,24:3
Tarkovskaya, L
Mirror, The 1983,Ag 17,C,16:3

Tidy, Frank (Cinematographer)
Spacehunter: Adventures in the Forbidden Zone 1983,My 21,29:1
Grey Fox, The 1983,Jl 13,C,17:4
Tifo, Marie
Just a Game 1984,Ap 8,64:3
Tighe, Karen
Deadly Spawn, The 1983,Ap 22,C,11:1
Tillack, Elfi (Miscellaneous)
Germany Pale Mother 1984,Mr 18,52:1
Tillinger, John
Lovesick 1983,F 18,C,19:1
Tilly, Grant
Nate and Hayes 1983,N 18,C,30:3
Beyond Reasonable Doubt 1983,N 22,C,16:4
Tilly, Jennifer
No Small Affair 1984,N 9,C,16:1
Tilly, Meg
Psycho II 1983,Je 3,C,14:5
Big Chill, The 1983,S 23,C,14:3
Big Chill, The 1983,D 18,II,21:1
Big Chill, The 1983,D 25,II,15:1
Impulse 1984,S 30,58:5
Tilly, Nora
Golden Eighties, The 1983,O 2,59:1
Timmins, Cali
Spacehunter: Adventures in the Forbidden Zone 1983,My 21,29:1
Hotel New Hampshire, The 1984,Mr 9,C,8:1
Tippett, Phil (Miscellaneous)
Return of the Jedi 1983,My 25,C,24:1
Tippins, Sherill (Screenwriter)
Rent Control 1984,My 4,C,13:3
Tirl, George (Cinematographer)
Not for Publication 1984,N 1,C,17:1
Tisch, Steve (Producer)
Risky Business 1983,Ag 5,C,13:1
Toback, James (Director)
Exposed 1983,Ap 22,C,10:1
Exposed 1983,My 1,II,17:1
Toback, James (Producer)
Exposed 1983,Ap 22,C,10:1
Toback, James (Screenwriter)
Exposed 1983,Ap 22,C,10:1
Tobey, Kenneth
Strange Invaders 1983,S 16,C,8:1
Tobias, Oliver
Wicked Lady, The 1983,O 28,C,16:1
Tochi, Brian
Revenge of the Nerds 1984,Jl 20,C,8:5
Tochizawa, Masao (Cinematographer)
Ballad of Narayama, The 1984,Ap 9,C,14:5
Ballad of Narayama, The 1984,S 7,C,6:1
Tocnay, Brunoy (Composer)
Sugar Cane Alley 1984,Ap 6,C,24:3
Todd, Johanne
Android 1984,F 10,C,28:1
Todd, Russell
Where the Boys Are 1984,Ap 7,14:5
Todorovic, Bora
Twilight Time 1983,F 13,57:4
Todorovsky, Pyotr (Director)
Waiting for Gavrilov 1983,Ap 15,C,14:1
Tognazzi, Ugo
Joke of Destiny, A 1984,S 12,C,21:1
Toguri, David (Miscellaneous)
Give My Regards to Broad Street 1984,O 26,C,14:5
Toigo, Teresa
Children of the Corn 1984,Mr 16,C,7:2
Tokuma, Yasuyoshi (Producer)
Irezumi—Spirit of Tattoo (Sekka Tomurai Zashi) 1983,Mr 19,10:3
Irezumi—Spirit of Tattoo (Sekka Tomurai Zashi) 1984,My 9,C,23:1
Tol, Henriette
Question of Silence, A (Stilte Rond Christine M, De) 1983,Mr 18,C,8:5
Question of Silence, A (Stilte Rond Christine M, De) 1984,Ag 5,44:6
Toledo, Pedro Rivera (Composer)
And God Created Them 1983,Mr 19,11:1
Tolkan, James
War Games 1983,Je 3,C,17:1
Nightmares 1983,S 3,14:5
Iceman 1984,Ap 13,C,10:1
River, The 1984,D 19,C,19:1
Toll, Betsy
Love Letters 1984,Ja 27,C,14:1
Tolloczko, Zbigniew (Miscellaneous)
Shivers 1984,O 4,C,16:1

Tolstoy, Leo (Original Author)
Argent, L' (Money) 1983,S 24,11:1
Argent, L' (Money) 1984,Mr 23,C,10:3
Tomic, Mica
Petria's Wreath 1983,F 6,4,49:1
Tomlin, Lily
All of Me 1984,S 21,C,6:1
All of Me 1984,O 14,II,21:1
Tondinelli, Gianrico
China 9, Liberty 37 1984,N 30,C,8:4
Toni, Viviana
Eyes, the Mouth, The 1983,D 14,C,24:1
Tonoyama, Taiji
Irezumi—Spirit of Tattoo (Sekka Tomurai Zashi) 1983,Mr 19,10:3
Irezumi—Spirit of Tattoo (Sekka Tomurai Zashi) 1984,My 9,C,23:1
Tonsberg, Adam
Zappa 1984,Ap 3,C,15:1
Zappa 1984,My 16,C,24:3
Tooke, Peterson (Screenwriter)
Hells Angels Forever 1983,O 9,69:3
Toomayan, Alan (Miscellaneous)
Not for Publication 1984,N 1,C,17:1
Topor, Roland
Swann in Love 1984,S 14,C,4:1
Torlemann, Boaz
Drifting 1984,Ap 23,C,12:1
Torn, Rip
Cross Creek 1983,S 21,C,19:4
Misunderstood 1984,Mr 30,C,10:1
Flashpoint 1984,Ag 31,C,6:5
City Heat 1984,D 7,C,4:3
Torno, Randal (Miscellaneous)
Heartland Reggae 1983,O 14,C,4:3
Toro, Albert
Tukana 1984,Ap 7,13:5
Toro, Albert (Director)
Tukana 1984,Ap 7,13:5
Toro, Albert (Miscellaneous)
Tukana 1984,Ap 7,13:5
Toro, Albert (Screenwriter)
Tukana 1984,Ap 7,13:5
Toro, Elizabeth of
Sheena 1984,Ag 17,C,8:3
Torocsik, Mari
Forbidden Relations 1983,S 25,59:1
Torrent, Ana
Elisa, Vida Mia 1983,Mr 11,C,8:5
Torres Santiago, Jose Manuel (Screenwriter)
Two Worlds of Angelita, The (Dos Mundos del Angelita, Los) 1983,O 28,C,4:3
Torricelli, Robert G
Nicaragua: Report from the Front 1984,Ja 18,C,24:3
Tosh, Peter
Heartland Reggae 1983,O 14,C,4:3
Toth, Arpad
Princess, The 1984,Ap 1,57:1
Toth, Jozsef
Forbidden Relations 1983,S 25,59:1
Toth, Tamas
Diary for My Children 1984,S 30,58:1
Diary for My Children 1984,O 31,C,21:5
Toto (Composer)
Dune 1984,D 14,C,18:4
Toty, Michel
Bal, Le 1984,Mr 23,C,6:1
Toure, Aboubakar
Lucie sur Seine 1983,S 9,C,8:1
Toussaint, Olivier (Composer)
Irreconcilable Differences 1984,S 28,C,10:5
Touzie, Hooshang
Mission, The (Ferestedah) 1983,Mr 30,C,21:2
Mission, The (Ferestedah) 1984,My 2,C,25:1
Tovah, Wilcox
Urgh! A Music War 1983,Ap 1,C,9:1
Towne, Robert see Vazek, P H
Towne, Roger (Screenwriter)
Natural, The 1984,My 11,C,15:1
Towns, Colin (Composer)
Slayground 1984,Ja 28,14:5
Townsend, Claire
Americana 1983,O 21,C,14:5
Townsend, Robert
Soldier's Story, A 1984,S 14,C,10:5
Towska, Lilly
Ways in the Night 1983,Jl 27,C,17:1
Trainor, Mary Ellen
Romancing the Stone 1984,Mr 30,C,19:1

Trajer, Dieter
War And Peace 1983,D 3,15:1
Tramm, Peter
Footloose 1984,Ap 8,II,19:1
Transunto, Gian Franco (Cinematographer)
My Name is Anna Magnani 1984,Ag 10,C,12:4
Traub, Ami
Drifting 1984,Ap 23,C,12:1
Traube, Klaus
Class Relations 1984,O 7,86:1
Trauberg, Leonid (Director)
New Babylon, The 1983,O 3,C,15:1
Trauberg, Leonid (Screenwriter)
New Babylon, The 1983,O 3,C,15:1
Traversa, Fabio
Chopin 1983,Mr 21,C,10:4
Dear Maestro (Chopin) 1984,F 3,C,13:3
Travis, Neil (Miscellaneous)
Cujo 1983,Ag 13,13:1
Philadelphia Experiment, The 1984,Ag 17,C,17:4
Travis, Ron
Scandalous 1984,Ja 20,C,4:5
Travolta, John
Staying Alive 1983,Jl 15,C,8:5
Staying Alive 1983,Jl 24,II,15:1
Two of a Kind 1983,D 16,C,12:6
Traylor, William
Man With Two Brains, The 1983,Je 3,C,8:1
Trebor, Robert
First Time, The 1983,Jl 13,C,16:3
Trejan, Guy
I Married a Shadow 1983,Ag 10,C,16:5
Trela, Jerzy
Danton 1983,S 28,C,19:1
Trenet, Charles (Composer)
Bal, Le 1984,Mr 23,C,6:1
Tress, David
Missing in Action 1984,N 17,11:1
Treu, Wolfgang (Cinematographer)
Little Drummer Girl, The 1984,O 19,C,18:1
Trieste, Leopoldo
Sweet Pea (Piso Pisello) 1983,Ja 23,47:1
Trenchcoat 1983,Mr 12,13:3
Trigg, Derek (Miscellaneous)
Jigsaw Man, The 1984,Ag 24,C,4:5
Trintignant, Jean-Louis
Nuit de Varennes, La 1983,F 16,C,23:1
Under Fire 1983,O 21,C,13:1
Confidentially Yours (Vivement Dimanche) 1984,Ja 20,C,6:1
Triska, Jan
Unfaithfully Yours 1984,F 10,C,7:1
2010 1984,D 7,C,15:1
Trissenaar, Elisabeth
Stationmaster's Wife, The (Bolwieser) 1983,Ja 12,C,21:2
Berlin Alexanderplatz 1983,Ag 10,C,18:5
Berlin Alexanderplatz 1983,D 25,II,15:1
Love in Germany, A 1984,O 2,C,13:2
Love in Germany, A 1984,N 9,C,10:1
Love in Germany, A 1984,D 30,II,15:1
Trivier, Thomas
City News and News Briefs 1983,S 9,C,6:2
Troell, Jan (Cinematographer)
Flight of the Eagle, The 1983,Ap 8,C,8:1
Troell, Jan (Director)
Flight of the Eagle, The 1983,Ap 8,C,8:1
Troell, Jan (Miscellaneous)
Flight of the Eagle, The 1983,Ap 8,C,8:1
Troell, Jan (Screenwriter)
Flight of the Eagle, The 1983,Ap 8,C,8:1
Troisi, Lino
Chopin 1983,Mr 21,C,10:4
Dear Maestro (Chopin) 1984,F 3,C,13:3
Trovajoli, Armando (Composer)
Nuit de Varennes, La 1983,F 16,C,23:1
Trowbridge, Jean
Zelig 1983,Jl 18,B,1:6
Troyer, Debra
Philadelphia Experiment, The 1984,Ag 17,C,17:4
Trueblood, Guerdon (Miscellaneous)
Jaws 3-D 1983,Jl 23,11:1
Trueman, Paula
Mrs Soffel 1984,D 26,C,15:1
Truffaut, Francois
Langlois 1983,Ag 5,C,10:5
Truffaut, Francois (Director)
Confidentially Yours (Vivement Dimanche) 1984,Ja 20,C,6:1
Two English Girls and the Continent 1984,O 21,II,23:1
Truffaut, Francois (Screenwriter)
Confidentially Yours (Vivement Dimanche) 1984,Ja 20,C,6:1

U

V

W

Wenders, Wim (Screenwriter)
State of Things, The 1983,F 18,19:4
Wendt, George
Dreamscape 1984,Ag 15,C,24:4
Thief of Hearts 1984,O 19,C,17:4
No Small Affair 1984,N 9,C,16:1
Wenning, Katherine (Miscellaneous)
Bostonians, The 1984,Ag 2,C,15:1
Wepper, Fritz
Demier Combat, Le (Last Battle, The) 1984,Je 22,C,12:1
Werko, Emily
Fanny and Alexander 1983,Je 17,C,8:1
Werner, Wendelin
Passante, La 1983,Ag 14,47:1
Wertmuller, Lina (Director)
Joke of Destiny, A 1984,S 12,C,21:1
Wertmuller, Lina (Miscellaneous)
Joke of Destiny, A 1984,S 12,C,21:1
Wertmuller, Lina (Screenwriter)
Joke of Destiny, A 1984,S 12,C,21:1
Wertmuller, Massimo
Joke of Destiny, A 1984,S 12,C,21:1
Werzanski, Yossi
Last Winter, The 1984,S 8,10:4
Wessler, Charles (Producer)
Cold Feet 1984,My 25,C,12:1
West, Brian (Cinematographer)
Lonely Lady, The 1983,O 1,13:5
Finders Keepers 1984,My 18,C,10:1
West, Jeremy
Ice Pirates, The 1984,Mr 16,C,8:5
West, Kit (Miscellaneous)
Return of the Jedi 1983,My 25,C,24:1
West, Lockwood
Dresser, The 1983,D 6,C,19:1
West, Morris (Original Author)
Salamander, The 1983,Je 5,53:1
West, Norma
And the Ship Sails On 1984,Ja 26,C,17:1
West, Peter (Miscellaneous)
My Ain Folk (Bill Douglas Trilogy, The) 1983,My 18,C,26:5
Westley, Peter
Falls, The 1983,My 4,C,17:4
Weston, Jack
High Road to China 1983,Mr 18,C,4:3
Weston, Robert R (Producer)
Lonely Lady, The 1983,O 1,13:5
Wetherbee, Dan (Miscellaneous)
Making the Grade 1984,My 18,C,10:5
Wetzel, Kristina Marie
First Tum-On!, The 1984,O 12,C,8:5
Wexler, Haskell (Cinematographer)
Target Nicaragua: Inside a Covert War 1983,Jl 13,C,16:3
Man Who Loved Women, The 1983,D 16,C,8:1
Wexler, Milton (Screenwriter)
Man Who Loved Women, The 1983,D 16,C,8:1
Wexler, Norman (Screenwriter)
Staying Alive 1983,Jl 15,C,8:5
Staying Alive 1983,Jl 24,II,15:1
Weyers, Marius
Guest, The 1984,Je 6,C,19:1
Gods Must Be Crazy, The 1984,Jl 9,C,16:1
Gods Must Be Crazy, The 1984,O 28,II,21:1
Weymouth, Tina
Stop Making Sense 1984,O 19,C,17:1
Wharton, William (Original Author)
Birdy 1984,D 21,C,25:1
Wheaton, Wil
Buddy System, The 1984,My 4,C,15:2
Wheeler, John (Miscellaneous)
Strange Invaders 1983,S 16,C,8:1
Rhinestone 1984,Je 22,C,10:5
Wheeler-Nicholson, Dana
Mrs Soffel 1984,D 26,C,15:1
Whilney, Ake
Flight of the Eagle, The 1983,Ap 8,C,8:1
Whipp, Joseph
Body Rock 1984,S 28,C,12:5
Nightmare on Elm Street, A 1984,N 9,C,10:5
White, Brittany
Mr Mom 1983,Ag 26,C,8:4
White, Carole Ita
Body Rock 1984,S 28,C,12:5
White, Courtney
Mr Mom 1983,Ag 26,C,8:4
White, Dan
Times of Harvey Milk, The 1984,O 7,86:1
Times of Harvey Milk, The 1984,O 27,15:1
White, Dondi
Wild Style 1983,Mr 18,C,8:3
Wild Style 1983,N 25,C,10:4

White, Michael (Producer)
Urgh! A Music War 1983,Ap 1,C,9:1
Strangers Kiss 1984,Ag 13,C,19:1
White, Ted
Starman 1984,D 14,C,18:1
White, Timothy (Producer)
Strikebound 1984,O 6,15:5
Whitehead, Lorry (Miscellaneous)
Ziggy Stardust and the Spiders From Mars 1983,D 24,17:5
Whitehouse, Rob (Producer)
Nate and Hayes 1983,N 18,C,30:3
Whitelaw, Billie
Rockaby 1983,N 23,C,16:3
Slayground 1984,Ja 28,14:5
Whiteley, Arkie
Killing of Angel Street, The 1983,Mr 26,20:6
Whitfield, Lynn
Doctor Detroit 1983,My 6,C,10:1
Whitford, Peter
Careful He Might Hear You 1984,Je 15,C,8:1
Whitmire, Steve
Muppets Take Manhattan, The 1984,Jl 13,C,10:4
Whitmore, James, Jr
Purple Hearts 1984,My 4,C,15:1
Whittingham, Jack (Miscellaneous)
Never Say Never Again 1983,O 7,C,13:1
Whittington, Valerie
Monty Python's the Meaning of Life 1983,Mr 31,C,13:5
Whyland, Andy
Vortex 1983,F 4,C,5:1
Wi Kuki Kaa
Utu 1984,S 13,C,21:2
Wicki, Bernhard
Love in Germany, A 1984,O 2,C,13:2
Paris, Texas 1984,O 14,64:1
Paris, Texas 1984,N 9,C,4:3
Love in Germany, A 1984,N 9,C,10:1
Widdoes, Kathleen
Without a Trace 1983,F 4,C,8:1
Wideman, Henry
Last Night at the Alamo 1983,O 2,II,60:3
Last Night at the Alamo 1984,Jl 3,C,10:5
Widmark, Richard
Final Option, The 1983,S 23,C,8:1
Against All Odds 1984,Mr 2,C,14:3
Against All Odds 1984,Mr 1,II,17:1
Wieand, Dick
Romantic Comedy 1983,O 7,C,8:1
Wiederhorn, Ken (Director)
Meatballs Part II 1984,Ag 18,13:2
Wiegmann, Don (Miscellaneous)
Blood Simple 1984,O 12,C,10:4
Wieland, Lynn
Hot Dog 1984,Ja 14,10:1
Wiener, Jean (Composer)
From Somalia With Love 1984,Ap 12,C,16:3
Wiest, Dianne
Independence Day 1983,Ja 21,C,8:1
Footloose 1984,F 17,C,12:3
Footloose 1984,Ap 8,II,19:1
Falling in Love 1984,N 21,C,11:1
Falling in Love 1984,D 9,II,21:1
Wigand, Thomas (Miscellaneous)
Straight Through the Heart 1984,Ap 1,57:1
Wiggins, Jeanette
Last Night at the Alamo 1983,O 2,II,60:3
Last Night at the Alamo 1984,Jl 3,C,10:5
Wightman, Robert
Impulse 1984,S 30,58:5
Wiklander, Iwar
Hill on the Dark Side of the Moon, A 1984,S 30,58:1
Wilby, James
Privileged 1983,Ap 8,C,8:5
Wilcots, Joseph M (Cinematographer)
Bill Cosby—"Himself" 1983,My 21,31:5
Wilcox, Caroly (Miscellaneous)
Muppets Take Manhattan, The 1984,Jl 13,C,10:4
Wilcoxon, Henry
Ten Commandments, The 1984,Mr 25,II,19:1
Wilde, Andrew
Champions 1984,Ap 20,C,8:1
Wilde, Oscar (Miscellaneous)
Querelle 1983,Ap 29,C,8:5
Wilder, Gene
Woman in Red, The 1984,Ag 15,C,24:1
Wilder, Gene (Director)
Woman in Red, The 1984,Ag 15,C,24:1
Wilder, Gene (Screenwriter)
Woman in Red, The 1984,Ag 15,C,24:1
Wiley, Bill
Porky's II: The Next Day 1983,Je 25,12:3

Wilhelm, Hans (Screenwriter)
Liebelei 1983,My 31,C,10:5
Signora di Tutti, La 1983,S 25,59:1
Wilhelmi, Roman
Aria for an Athlete 1983,Mr 16,C,21:4
Wilholte, Kathleen
Private School 1983,Jl 30,11:4
Wilkes, Donna
Angel 1984,Ja 13,C,12:5
Wilkinson, Maggie
Experience Preferred...But Not Essential 1983,N 4,C,11:1
Experience Preferred...But Not Essential 1983,N 20,17:1
Wilkinson, Marc (Composer)
Eagle's Wing 1983,O 9,72:1
Williame, Nathalie
Golden Eighties, The 1983,O 2,59:1
Williams, Allen
Against All Odds 1984,Mr 2,C,14:3
Williams, Barbara
Thief of Hearts 1984,O 19,C,17:4
Williams, Bernard (Producer)
Bounty, The 1984,My 4,C,8:1
Williams, Bill
Moon Over the Alley 1983,Ap 27,C,19:4
Williams, Billy (Cinematographer)
Survivors, The 1983,Je 22,C,20:6
Eagle's Wing 1983,O 9,72:1
Williams, Billy Dee
Return of the Jedi 1983,My 25,C,24:1
Williams, Charles (Original Author)
Confidentially Yours (Vivement Dimanche) 1984,Ja 20,C,6:1
Williams, Clarence, III
Purple Rain 1984,Jl 27,C,5:1
Williams, Deniece
Footloose 1984,F 17,C,12:3
Williams, Dick Anthony
Star Chamber, The 1983,Ag 5,C,8:5
Williams, Elmo (Producer)
Man, Woman and Child 1983,Ap 1,C,8:1
Williams, Frankie
Angelo My Love 1983,Ap 27,C,17:5
Williams, JoBeth
Big Chill, The 1983,S 23,C,14:3
Big Chill, The 1983,D 18,II,21:1
Big Chill, The 1983,D 25,II,15:1
Teachers 1984,O 5,C,10:1
American Dreamer 1984,O 26,C,12:4
Williams, John (Composer)
Return of the Jedi 1983,My 25,C,24:1
Indiana Jones and the Temple of Doom 1984,My 23,C,21:1
River, The 1984,D 19,C,19:1
Williams, Kent
War Games 1983,Je 3,C,17:1
Williams, Mark
Privileged 1983,Ap 8,C,8:5
Williams, Michael
Enigma 1983,Ja 28,C,8:1
Educating Rita 1983,S 21,C,21:1
Williams, Nigel (Original Author)
Class Enemy 1984,Jl 13,C,6:1
Williams, Patrick (Composer)
Two of a Kind 1983,D 16,C,12:6
Swing Shift 1984,Ap 13,C,13:1
Buddy System, The 1984,My 4,C,15:2
Best Defense 1984,Jl 20,C,10:1
All of Me 1984,S 21,C,6:1
Williams, Paul
Smokey and the Bandit, Part 3 1983,S 17,30:4
Williams, Pega
Careful He Might Hear You 1984,Je 15,C,8:1
Williams, Robin
Survivors, The 1983,Je 22,C,20:6
Moscow On the Hudson 1984,Ap 6,C,12:1
Moscow on the Hudson 1984,My 6,II,17:1
Moscow on the Hudson 1984,My 27,II,15:1
Williams, Samm-Art
Blood Simple 1984,O 12,C,10:4
Williams, Steven
Twilight Zone—The Movie (Prologue and Segment 1) 1983,Je 24,C,15:1
Williams, Treat
Once Upon a Time in America 1984,Je 1,C,8:1
Flashpoint 1984,Ag 31,C,6:5
Once Upon a Time in America 1984,O 21,II,23:1
Williamson, David (Screenwriter)
Year of Living Dangerously, The 1983,Ja 21,C,4:1
Phar Lap 1984,Ag 10,C,8:1
Williamson, Fred
Last Fight, The 1983,S 7,C,20:1
Big Score, The 1983,N 20,67:3

A

A M L F (Prod.)
Crabe Tambour, Le (Drummer Crab) 1984,F 17,C,17:1
ABC Motion Pictures (Misc.)
Silkwood 1983,D 14,C,27:1
Afro Movies Ltd (Prod.)
Kukurantumi: The Road to Accra 1984,Ap 1,51:1
Ager Cinematagrafica (Prod.)
Night of the Shooting Stars, The 1983,Ja 30,34:3
Aimi Classics (Dist.)
Bal, Le 1984,Mr 23,C,6:1
Aires Cinematografica Argentina (Prod.)
Time for Revenge 1983,Ja 14,C,8:1
Albatros Produktion (Prod.)
Ernesto 1983,S 23,C,12:5
Albatros, Munich (Prod.)
Shadow of Angels (Schatten der Engel) 1983,Je 24,C,8:1
Albina (Prod.)
Too Shy to Try 1984,Mr 30,C,17:3
Alley Cast (Misc.)
Urgh! A Music War 1983,Ap 1,C,9:1
Almi Film (Dist.)
Big Score, The 1983,N 20,67:3
Almi Pictures Inc (Dist.)
Bostonians, The 1984,Ag 2,C,15:1
Althea and Donna (Misc.)
Heartland Reggae 1983,O 14,C,4:3
American Pictures Foundation, The (Dist.)
American Pictures (Part 1) 1984,S 5,C,16:5
American Pictures Foundation, The (Prod.)
American Pictures (Part 1) 1984,S 5,C,16:5
Antenne 2 (Prod.)
Improper Conduct (Mauvaise Conduite) 1984,Ap 11,C,19:1
Death Watch 1984,S 14,C,6:5
Three Crowns of the Sailor 1984,O 5,C,14:3
Aquarius Releasing Inc (Dist.)
Gospel 1983,D 23,C,8:1
Arcadia Films (Dist.)
Evening Performance (Funcion de Noche) 1983,Mr 27,55:1
Arco Film (Prod.)
Oedipus Rex 1984,D 7,C,8:5
Argos Films (Prod.)
Sans Soleil 1983,O 26,C,24:2
Aria Film Production, Munich, West Germany (Prod.)
Mission, The (Ferestedah) 1983,Mr 30,C,21:2
Mission, The (Ferestedah) 1984,My 2,C,25:1
Aries Films-ICH (Misc.)
Time for Revenge 1983,Ja 14,C,8:1
Art Theater of Japan (Prod.)
Family Game, The 1984,Ap 1,57:1
Family Game, The 1984,S 14,C,3:1
Artcofilm S A, Geneva (Prod.)
Shadow of Angels (Schatten der Engel) 1983,Je 24,C,8:1
Artists Releasing Corporation (Dist.)
They Call Me Bruce 1983,Ja 16,48:3
Ascot (Prod.)
Story of Piera, The 1983,S 24,11:5
Aspa Producciones (Prod.)
China 9, Liberty 37 1984,N 30,C,8:4
Asya Film (Prod.)
Horse, The 1984,Ja 4,C,14:3
Atari Inc (Misc.)
Last Starfighter, The 1984,Jl 13,C,5:2
Atlantic Releasing Corporation (Dist.)
Valley Girl 1983,Ap 29,C,10:1
Norman Loves Rose 1983,Je 3,C,20:5
Below the Belt 1983,Ag 31,C,21:1
Loveless, The 1984,Ja 20,C,8:5
Alphabet City 1984,My 5,17:1
Night of the Comet 1984,N 16,C,8:1
Au Pairs (Misc.)
Urgh! A Music War 1983,Ap 1,C,9:1

B

B Movies (Prod.)
Vortex 1983,F 4,C,5:1
Babylone Films (Prod.)
Neige (Snow) 1983,Jl 5,C,10:1
Baker, Fred, Films (Dist.)
Tales of Ordinary Madness 1983,Mr 11,C,13:3
Baobab Film, Senegal (Prod.)
Jom (Jom or the Story of a People) 1983,Mr 28,C,12:3
Jom (Jom or the Story of a People) 1983,S 7,C,21:2

Barrandov Studios, Prague (Prod.)
Divine Emma, The 1983,Je 5,54:1
Bavaria Atelier GmbH (Prod.)
Stationmaster's Wife, The (Bolwieser) 1983,Ja 12,C,21:2
Baytide Films (Prod.)
Hells Angels Forever 1983,O 9,69:3
Beach Boys, The (Misc.)
Bizet's Carmen 1984,S 20,C,21:1
Bee Gees, The (Misc.)
Staying Alive 1983,Jl 15,C,8:5
Staying Alive 1983,Jl 24,II,15:1
Beecher Films (Prod.)
SL-1 1984,Mr 21,C,14:4
Bela Production (Prod.)
Crabe Tambour, Le (Drummer Crab) 1984,F 17,C,17:1
Berlin Group (Prod.)
Fiancee, The 1984,Ap 7,13:3
Best Film and Video Corporation (Dist.)
Last Fight, The 1983,S 7,C,20:1
BioskopFilm (Prod.) '
Slow Attack (Endstation Freiheit) 1983,Ja 12,C,24:1
Blackwood, Christian, Productions (Misc.)
Observations Under the Volcano 1984,N 2,12,3:
Bloods, The (Misc.)
Born in Flames 1983,N 10,C,17:1
Bluebird Movie Enterprises Ltd (Prod.)
Boat People 1983,S 27,C,17:5
British Film Institute Production Board (Prod.)
Moon Over the Alley 1983,Ap 27,C,19:4
My Way Home (Bill Douglas Trilogy, The) 1983,My 18,C,26:5
British Film Institute, The (Prod.)
Draughtsman's Contract, The 1983,Je 22,C,26:4
Children (Terence Davies Trilogy, The) 1984,Ap 8,64:3
Death and Transfiguration (Terence Davies Trilogy, The) 1984,Ap 8,64:3
Brooksfilms (Dist.)
To Be or Not to Be 1983,D 16,C,10:1
Buena Vista Distribution Company (Dist.)
Trenchcoat 1983,Mr 12,13:3
Something Wicked This Way Comes 1983,Ap 29,C,8:5
Splash 1984,Mr 9,C,15:1
Country 1984,S 28,20:1
Buffalo (Misc.)
Americana 1983,O 21,C,14:5
Buzzy Enterprises Ltd (Prod.)
Bigger Splash, A 1984,O 5,C,12:1

C

C E P (Prod.)
Basileus Quartet 1984,Ja 4,C,13:5
Canada Offshore Cinema Ltd (Prod.)
Heartland Reggae 1983,O 14,C,4:3
Canadian Film Development Corporation, The (Misc.)
Grey Fox, The 1983,Jl 13,C,17:4
Cannon Films (Dist.)
Treasure of the Four Crowns 1983,Ja 23,47:1
Young Warriors 1983,N 12,12:1
Exterminator 2 1984,S 15,14:5
Cannon Group (Dist.)
10 to Midnight 1983,Mr 13,62:5
Hercules 1983,Ag 28,61:1
Revenge of the Ninja 1983,S 8,C,23:1
Wicked Lady, The 1983,O 28,C,16:1
Over the Brooklyn Bridge 1984,Mr 2,C,6:5
Breakin' 1984,My 5,17:1
Making the Grade 1984,My 18,C,10:5
Love Streams 1984,Ag 24,C,8:5
Bolero 1984,S 1,9:5
Cannon Releasing Corporation (Dist.)
Last American Virgin, The 1983,Ja 15,48:2
Capad (Prod.)
One Deadly Summer 1984,Jl 20,C,10:5
Castle Hill Productions (Dist.)
Heads or Tails (Pile ou Face) 1983,My 27,C,4:5
And Nothing But the Truth 1984,Ap 20,C,15:1
CBS Theatrical Films (Dist.)
Table for Five 1983,F 18,C,12:1
Windy City 1984,S 21,C,10:5
CCC Filmkunst (Berlin) (Misc.)
White Rose, The 1983,My 6,C,13:1
CCC Filmkunst (Berlin) (Prod.)
Love in Germany, A 1984,O 2,C,13:2
Love in Germany, A 1984,N 9,C,10:1
CCFC (Paris) (Prod.)
Next Year If All Goes Well 1983,Mr 20,60:1

Centar Film, Belgrade (Prod.)
Petria's Wreath 1983,F 6,4,49:1
Central Television (Prod.)
Chicken Ranch 1983,Je 1,C,14:2
Cesa Family, The (Misc.)
Tenderness and Anger 1984,My 9,C,24:1
Ceskoslovensky Filmexport (Dist.)
Snowdrop Festival 1984,N 14,C,29:4
Ceskoslovensky Filmexport (Misc.)
Divine Emma, The 1983,Je 5,54:1
Channel 4 (Misc.)
Ghost Story 1984,O 31,C,20:4
Channel Four Television (Misc.)
Black Wax 1983,Ja 12,C,21:2
Draughtsman's Contract, The 1983,Je 22,C,26:4
Cheap Trick (Misc.)
Bizet's Carmen 1984,S 20,C,21:1
Chieftains, The (Misc.)
Grey Fox, The 1983,Jl 13,C,17:4
Children's Chorus of Radio-France (Misc.)
Bizet's Carmen 1984,S 20,C,21:1
Chorus of Radio-France (Misc.)
Bizet's Carmen 1984,S 20,C,21:1
Cinak Limitee (Prod.)
Fleurs Sauvages, Les (Wild Flowers) 1984,N 9,C,12:5
Vieux Pays ou Rimbaud Est Mort, Le (Old Country Where Rimbaud Died, The) 1984,N 9,C,12:5
Cineastes Animaliers Associes, Le (Prod.)
Claw and the Tooth, The 1984,D 26,C,15:3
Cinecom International Films (Dist.)
Angelo My Love 1983,Ap 27,C,17:5
City News and News Briefs 1983,S 9,C,6:2
Monkey Grip 1983,N 7,C,16:5
Norte, El 1984,Ja 11,C,15:1
Cold Feet 1984,My 25,C,12:1
Brother From Another Planet, The 1984,S 14,C,6:5
Stop Making Sense 1984,O 19,C,17:1
Cinematograph AB (Prod.)
Fanny and Alexander 1983,Je 17,C,8:1
Cinematograph (Prod.)
After the Rehearsal 1984,Je 21,C,14:1
Cinevista (Dist.)
Liquid Sky 1983,Jl 22,C,10:1
Citifilmworks Inc (Prod.)
Burroughs 1983,O 8,33:1
Burroughs 1984,F 10,C,12:1
City Lights Productions, Inc (Dist.)
Generation Apart, A 1984,Mr 18,53:1
Clark, Twinkle and The Clark Sisters (Misc.)
Gospel 1983,D 23,C,8:1
Clesi Cinematografica (Prod.)
Sweet Pea (Piso Pisello) 1983,Ja 23,47:1
Victory March 1983,Mr 11,C,8:1
Ernesto 1983,S 23,C,12:5
Columbia Pictures (Dist.)
Spring Break 1983,Mr 27,54:4
Invitation au Voyage 1983,Ap 21,C,20:3
Blue Thunder 1983,My 13,C,17:4
Spacehunter: Adventures in the Forbidden Zone 1983,My 21,29:1
Survivors, The 1983,Je 22,C,20:6
Krull 1983,Jl 29,C,10:1
Yor, the Hunter from the Future 1983,Ag 21,54:3
Educating Rita 1983,S 21,C,21:1
Big Chill, The 1983,S 23,C,14:3
Richard Pryor Here and Now 1983,O 28,C,8:1
Dresser, The 1983,D 6,C,19:1
Christine 1983,D 9,C,10:5
Man Who Loved Women, The 1983,D 16,C,8:1
Against All Odds 1984,Mr 2,C,14:3
Moscow On the Hudson 1984,Ap 6,C,12:1
Hardbodies 1984,My 12,12:5
Ghostbusters 1984,Je 8,C,5:1
Karate Kid, The 1984,Je 22,C,16:3
Sheena 1984,Ag 17,C,8:3
Soldier's Story, A 1984,S 14,C,10:5
Razor's Edge, The 1984,O 19,C,14:6
Body Double 1984,O 26,C,8:1
No Small Affair 1984,N 9,C,16:1
Passage to India, A 1984,D 14,C,10:1
Starman 1984,D 14,C,18:1
Micki and Maude 1984,D 21,C,25:4
Compagnia Europea (Prod.)
China 9, Liberty 37 1984,N 30,C,8:4
Condition, The (Misc.)
Memoirs 1984,D 28,C,14:5
Costa Rican Cinematographic Cooperative (Prod.)
Alsino and the Condor 1983,My 1,69:1
Cramps, The (Misc.)
Urgh! A Music War 1983,Ap 1,C,9:1

H

Hammer, Armand, Productions (Misc.)
Backstage at the Kirov 1984,Ja 18,C,24:3
Hamster Productions (Prod.)
Petite Bande, La 1984,N 9,C,28:5
Hawkins, Walter and The Hawkins Family (Misc.)
Gospel 1983,D 23,C,8:1
Heaven 17 (Misc.)
Electric Dreams 1984,Jl 20,C,6:5
Hell's Angels, The (Misc.)
Hells Angels Forever 1983,O 9,69:3
Hessischen Rundfunk (Misc.)
White Rose, The 1983,My 6,C,13:1
Hessischen Rundfunk (Prod.)
Class Relations 1984,O 7,86:1
Hirzman, Leon (Prod.)
They Don't Wear Black Tie (Eles Nao Usam Black-Tie)
1983,My 27,C,8:5
Horizon Films (Dist.)
Nudo di Donna 1983,My 13,C,7:5
Oedipus Rex 1984,D 7,C,8:5
Human Arts Association (Prod.)
Secret Agent, The 1984,Mr 21,C,14:4

I

I N A (Prod.)
Three Crowns of the Sailor 1984,O 5,C,14:3
I-Threes (Misc.)
Heartland Reggae 1983,O 14,C,4:3
Ibis (Misc.)
Born in Flames 1983,N 10,C,17:1
Ideal (Misc.)
Red Love 1983,O 4,C,13:2
IFEX Films (Dist.)
Private Life 1983,F 27,45:1
Waiting for Gavrilov 1983,Ap 15,C,14:1
Imamura Production, Tokyo (Prod.)
Ballad of Narayama, The 1984,Ap 9,C,14:5
Ballad of Narayama, The 1984,S 7,C,6:1
Incine and Impala (Prod.)
It's Never Too Late 1984,Je 29,C,8:4
Independent Documentary Group, The (Prod.)
Dark Circle 1984,My 2,C,25:1
Industrial Light and Magic (Misc.)
Starman 1984,D 14,C,18:1
Inner Circle Band (Misc.)
Heartland Reggae 1983,O 14,C,4:3
Institut National de l'Audiovisuel (Prod.)
Vieux Pays ou Rimbaud Est Mort, Le (Old Country Where
Rimbaud Died, The) 1984,N 9,C,12:5
Institute for Regional Education, The (Prod.)
Koyaanisqatsi 1983,S 14,C,22:4
Inter Planetary Pictures Inc (Dist.)
Now and Forever 1983,Jl 16,14:1
International Cinematografica (Prod.)
Bruto, El 1983,S 21,C,22:3
International Film Exchange Ltd (Dist.)
Flights of Fancy 1983,Je 15,C,20:5
26 Days in the Life of Dostoyevsky 1983,O 14,C,8:5
Without Witness (Private Conversation, A) 1984,O 12,C,12:5
International Film Exchange Ltd (Misc.)
Snowdrop Festival 1984,N 14,C,29:4
International Film Exchange Ltd (Prod.)
Divine Emma, The 1983,Je 5,54:1
International Rainbow (Misc.)
Can She Bake a Cherry Pie? 1983,D 8,C,22:3
International Spectrafilm (Dist.)
Ernesto 1983,S 23,C,12:5
Balance, La 1983,N 20,72:1
Confidentially Yours (Vivement Dimanche) 1984,Ja 20,C,6:1
Zappa 1984,Ap 3,C,15:1
Zappa 1984,My 16,C,24:3
First Name: Carmen 1984,Ag 3,C,6:1
Life is a Bed of Roses 1984,Ag 19,63:1
Island Alive (Dist.)
Return Engagement 1983,N 23,C,10:5
Norte, El 1984,Ja 11,C,15:1
Android 1984,F 10,C,28:1
Stop Making Sense 1984,O 19,C,17:1
Island Alive (Prod.)
Choose Me 1984,N 1,C,18:4
Italy-Spain (Prod.)
China 9, Liberty 37 1984,N 30,C,8:4
ITC Films International (Dist.)
Salamander, The 1983,Je 5,53:1

J

Jagfilm (Misc.)
Can She Bake a Cherry Pie? 1983,D 8,C,22:3
Janus Film (Prod.)
Lucie sur Seine 1983,S 9,C,8:1
Janus Film and Fernsehen (Prod.)
Class Relations 1984,O 7,86:1
Jemmin Inc (Prod.)
Bill Cosby—"Himself" 1983,My 21,31:5
Jensen Farley Pictures (Misc.)
Timerider 1983,Ja 21,C,24:5
Jewish Media Services (Dist.)
Last Sea, The 1984,Jl 4,C,7:5
Jouve, Nicole, Interama (Dist.)
Elisa, Vida Mia 1983,Mr 11,C,8:5
Prix de Beaute 1983,Je 22,C,15:3
Crabe Tambour, Le (Drummer Crab) 1984,F 17,C,17:1
My Name is Anna Magnani 1984,Ag 10,C,12:4
Claw and the Tooth, The 1984,D 26,C,15:3

K

Kentel Film (Prod.)
Horse, The 1984,Ja 4,C,14:3
Kirov Ballet, The (Misc.)
Backstage at the Kirov 1984,Ja 18,C,24:3
Kislev Films Ltd (Prod.)
Drifting 1984,Ap 23,C,12:1

L

Ladd Company (Dist.)
Mike's Murder 1984,Mr 9,C,16:1
Ladd Company (Misc.)
Right Stuff, The 1983,O 21,C,5:1
Latin American Production of Mexico (Prod.)
Alsino and the Condor 1983,My 1,69:1
Les Films Ariane (Prod.)
Jupiter's Thigh 1984,Ja 20,C,6:5
Les Films de L'Alma (Prod.)
Next Year If All Goes Well 1983,Mr 20,60:1
Libra Cinema 5 (Dist.)
Drugstore Romance (Corps a Coeur) 1983,Jl 1,C,8:4
Passante, La 1983,Ag 14,47:1
Basileus Quartet 1984,Ja 4,C,13:5
Woman in Flames, A (Flambierte Frau) 1984,F 3,C,11:1
In Our Hands 1984,F 16,C,23:1
Home Free All 1984,My 2,C,25:1
Limelight International Films Inc (Dist.)
Possession 1983,O 28,C,10:1
Lira Films (Prod.)
Crabe Tambour, Le (Drummer Crab) 1984,F 17,C,17:1
Lisa Film, Munich (Prod.)
Victory March 1983,Mr 11,C,8:1
Little Bear (Prod.)
Death Watch 1984,S 14,C,6:5
Sunday in the Country, A 1984,O 2,C,14:3
Sunday in the Country, A 1984,N 16,C,11:1
Living Theater, The (Misc.)
Signals Through the Flames (The Story of the Living Theater)
1984,F 5,47:1
Livradois (Prod.)
A Nos Amours 1984,O 12,C,10:4
Looseyard (Prod.)
Ghost Story 1984,O 31,C,20:4
Lorimar Pictures (Dist.)
Urgh! A Music War 1983,Ap 1,C,9:1
China 9, Liberty 37 1984,N 30,C,8:4
Lotus Films S A (Prod.)
Treasure of the Four Crowns 1983,Ja 23,47:1
Love Center Choir, The (Misc.)
Gospel 1983,D 23,C,8:1
Loverboy (Misc.)
Metropolis 1984,Ag 19,II,15:1

M

M K 2 Diffusion (Dist.)
Lucie sur Seine 1983,S 9,C,8:1
Macropus Film (Prod.)
Revolt of Job, The 1984,Mr 28,C,19:3
Mafilm, Budapest Studio (Prod.)
Diary for My Children 1984,S 30,58:1
Diary for My Children 1984,O 31,C,21:5
Mafilm, Tarsulas Studio (Prod.)
Revolt of Job, The 1984,Mr 28,C,19:3
Princess, The 1984,Ap 1,57:1
MainMan (Prod.)
Ziggy Stardust and the Spiders From Mars 1983,D 24,17:5
Mallia Films (Prod.)
Biquefarre 1984,Ap 5,C,15:1
Manhattans, The (Misc.)
Johnny West 1983,Mr 9,C,17:2
Marion's Films (Prod.)
Neige (Snow) 1983,Jl 5,C,10:1
Argent, L' (Money) 1983,S 24,11:1
One Man's War (Guerre d'un Seul Homme, La) 1984,F
24,C,9:1
Argent, L' (Money) 1984,Mr 23,C,10:3
Media Aides Ltd (Misc.)
Heartland Reggae 1983,O 14,C,4:3
Media Home Entertainment (Misc.)
Nightmare on Elm Street, A 1984,N 9,C,10:5
Media Study/Buffalo (Prod.)
World of Tomorrow, The 1984,Mr 7,C,20:3
Metropolitan Opera Chorus, The (Misc.)
Traviata, La 1983,Ap 22,C,13:1
Metropolitan Opera Orchestra, The (Misc.)
Traviata, La 1983,Ap 22,C,13:1
MGM/UA (Dist.)
Hercules 1983,Ag 28,61:1
Revenge of the Ninja 1983,S 8,C,23:1
Wicked Lady, The 1983,O 28,C,16:1
Christmas Story, A 1983,N 18,C,36:1
Yentl 1983,N 18,C,10:1
Over the Brooklyn Bridge 1984,Mr 2,C,6:5
Breakin' 1984,My 5,17:1
Making the Grade 1984,My 18,C,10:5
MGM/UA Classics (Dist.)
Kipperbang 1984,Ap 20,C,11:3
Gabriela 1984,My 11,C,14:1
Sunday in the Country, A 1984,O 2,C,14:3
Sunday in the Country, A 1984,N 16,C,11:1
MGM/UA Entertainment Company (Dist.)
Year of Living Dangerously, The 1983,Ja 21,C,4:1
Twilight Time 1983,F 13,57:4
Black Stallion Returns, The 1983,Mr 27,54:4
Exposed 1983,Ap 22,C,10:1
Hunger, The 1983,Ap 29,C,32:1
War Games 1983,Je 3,C,17:1
Octopussy 1983,Je 10,C,17:4
Curse of the Pink Panther 1983,Ag 13,13:1
Strange Brew 1983,Ag 26,C,8:1
Final Option, The 1983,S 23,C,8:1
Brainstorm 1983,S 30,C,17:1
Romantic Comedy 1983,O 7,C,8:1
Hot Dog 1984,Ja 14,10:1
Reckless 1984,F 3,C,8:1
Ice Pirates, The 1984,Mr 16,C,8:5
Misunderstood 1984,Mr 30,C,10:1
Pope of Greenwich Village, The 1984,Je 22,C,12:4
Electric Dreams 1984,Jl 20,C,6:5
Red Dawn 1984,Ag 10,C,11:1
Oxford Blues 1984,Ag 25,9:1
Until September 1984,S 21,C,6:3
Teachers 1984,O 5,C,10:1
Garbo Talks 1984,O 12,C,8:1
Just the Way You Are 1984,N 16,C,14:1
2010 1984,D 7,C,15:1
Mrs Soffel 1984,D 26,C,15:1
MGM/UA Home Video (Prod.)
Compleat Beatles, The 1984,F 10,C,8:1
Midas S A (Prod.)
Biquefarre 1984,Ap 5,C,15:1
Mighty Clouds of Joy, The (Misc.)
Gospel 1983,D 23,C,8:1
Miller, Warren, Productions (Dist.)
Ski Country 1984,N 30,C,13:1
Miramax Films (Dist.)
Edith and Marcel 1984,Je 3,60:4
Mondex Films (Prod.)
Jupiter's Thigh 1984,Ja 20,C,6:5
Montecarlo Philharmonic Orchestra, The (Misc.)
Parsifal 1983,Ja 23,46:1

V

W

Z